Catalogue
of the
Amon Carter Museum
Photography Collection

5171

2445

Catalogue
of the
Amon Carter Museum
Photography Collection

Carol E. Roark,
Paula Ann Stewart,
and Mary Kennedy McCabe

AMON CARTER MUSEUM
Fort Worth, Texas

© 1993, Amon Carter Museum
All rights reserved

Edited by Matthew Abbate
Designed by Dana Levy, Perpetua Press, Los Angeles,
California
Typeset by Andresen Graphic Services, Tucson, Arizona
Printed and bound in Hong Kong by C&C Offset Printing Co.

This project was supported in part by a grant from the Na-
tional Endowment for the Arts, a federal agency.

Library of Congress Cataloging-in-Publication Data

Amon Carter Museum of Western Art.
 Catalogue of the Amon Carter Museum photography
 collection/Carol E. Roark, Paula Ann Stewart, and Mary
 Kennedy McCabe.
 p. cm.
 Includes bibliographical references.
 ISBN 0-88360-063-3
 1. Amon Carter Museum of Western Art—Photograph
 collections—Catalogs. 2. Photography, Artistic.
 I. Roark, Carol E. II. Stewart, Paula Ann, 1961-
 III. McCabe, Mary Kennedy. IV. Title.
TR6.U62F72 1993
779 ' .0973 ' 0747645315—dc20 92-36173
 CIP

Contents

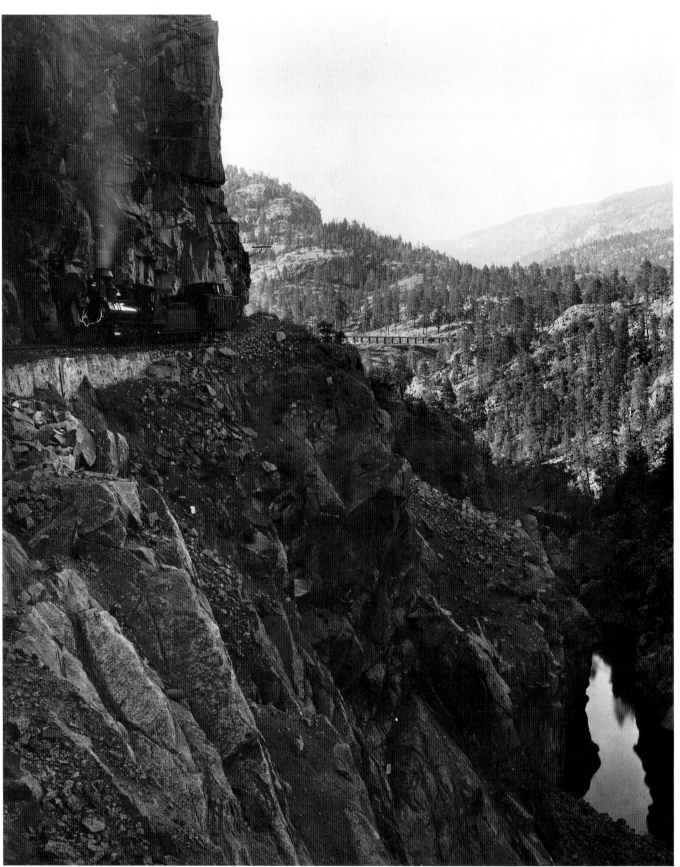

3084

Acknowledgments

T
HIS CATALOGUE OF THE PHOTOGRAPHY
exhibition print collection started as a
master's thesis by Carol Roark when she
was Assistant Curator of Photographs. Her intimate
knowledge of the collection and its various hidden
treasures provided invaluable insights, and her dili-
gent research answered countless questions in docu-
menting the works listed in this publication. Mary
Kennedy McCabe devoted a year of research as well,
and when Carol Roark left the Museum in 1988,
Paula Stewart completed the project.

We extend our special thanks to the many photog-
raphers, photographers' spouses, executors of estates,
and copyright holders who responded to our requests.
They often read and corrected entries, provided
additional information, and generously allowed us to
reproduce the images in this catalogue.

A special debt of gratitude goes to the research-
ers, librarians, archivists, and gallery owners who were
contacted about this project. Without their assistance
we would have been unable to locate photographers
and much of the information needed. We especially
want to thank Ben Breard, Afterimage Gallery;
Peter C. Bunnell, Minor White Archives, Princeton
University; Katherine Chambers, Oakland Museum;
Marjorie H. Ciarlante, Civil Archives Branch,
National Archives; Greg Drake, International
Museum of Photography, George Eastman House;
Paula Fleming, National Anthropology Archives,
Smithsonian Institution; Hal Gould, The Camera
Obscura Gallery; David Horvath, Photographic

Archives, University of Louisville; Melanie Johns,
The Halstead Gallery; Jonathan Kuhn, Department
of Parks and Recreation, New York City; Henry D.
Mavis, Pictorial Photographers of America; Lori
Morrow, Montana Historical Society; Kenneth M.
Newman, The Old Print Shop Inc.; Eric Paddock,
State Historical Society of Colorado; Peter Palmquist;
Richard Rudisill, Photo Archives, Museum of New
Mexico; Michelle Anne Titanic, Division of Photo-
graphic History, National Museum of American His-
tory; Anne Tucker, Museum of Fine Arts, Houston;
Susan Williams; and Melissa Woolaver, Commerce
Graphics Ltd., Inc.

Matthew Abbate deserves special recognition for
his editing skills. He not only edited the text while
he was a Museum staff member, but continued to
work on the catalogue long after he moved to Massa-
chusetts.

Several staff members also assisted with this proj-
ect. Milan Hughston prepared the bibliography.
Linda Lorenz, Rynda White Lemke, Dan Bartow,
Steven Watson, Fran Orphee, and Gayle Herr-
Mendoza made the illustration prints. Helen
Plummer, Jeanie Lively, and Niccol Graf assisted with
numerous tedious yet critical tasks such as labeling
copy prints and compiling lists. Nancy Stevens, Jane
Posey, and Karen Reynolds saw the catalogue through
the production phases.

Last, but certainly not least, this catalogue could
not have been published without the generous sup-
port of the National Endowment for the Arts.

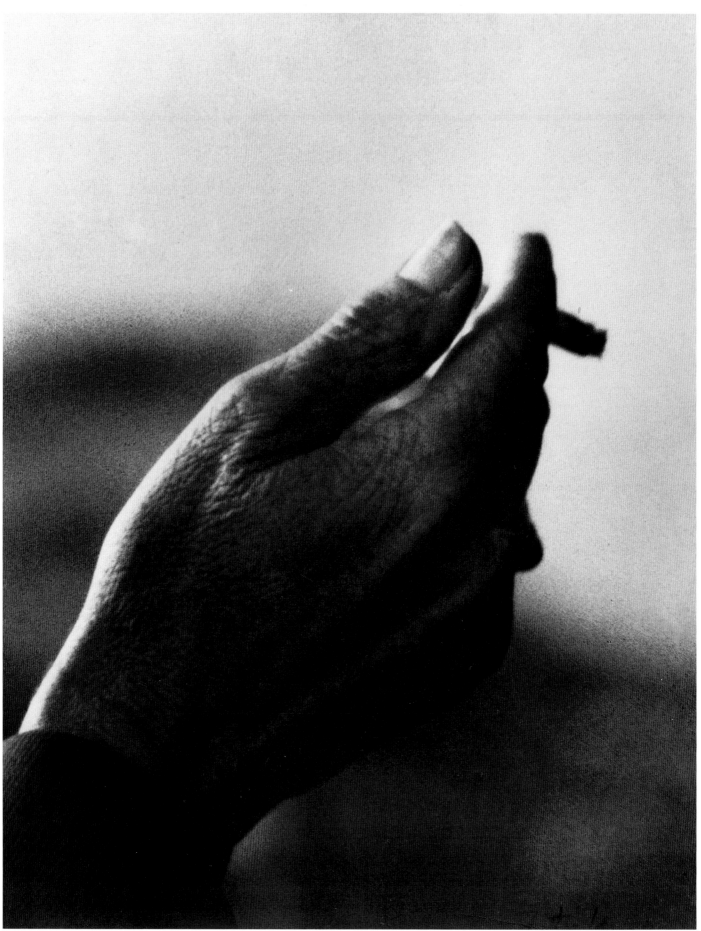

Introduction

PHOTOGRAPHY HAS BEEN AN INTEGRAL PART of the Amon Carter Museum collection and program for over thirty years. Soon after the Museum opened in January 1961 to display Amon G. Carter, Sr.'s, bequest of paintings, sculpture, and drawings by Frederic Remington and Charles Russell, founding director Mitchell A. Wilder (1913-1979) began to include photography in his expansive and imaginative plans for the new museum. Documentary photographer Dorothea Lange provided the first opportunity to expand the collection into photography when she suggested in May 1961 that her photographs of Charles Russell would complement the Museum's holdings of his art. When Wilder was appointed director later that summer, he enthusiastically acquired a selection of her studies of Russell; one, a detail of the artist's hand, became the cover image for the Museum's second exhibition catalogue, *Paper Talk: The Illustrated Letters of Charles Russell*. Lange's portraits of Russell were an especially appropriate cornerstone for the collection, combining the Museum's initial concerns for both the art and the history of the American West.

In the ensuing years, the collection has grown to over 300,000 photographic works and has developed the dual character of being an extensive historical archive documenting American cultural history as well as a selective fine art collection representing some of the greatest American achievements in photographic art. Because it is impossible to catalogue the entire collection in a single volume, this publication is devoted to the most actively used exhibition prints, numbering almost 6,000 works by over 350 different photographers, and features acquisitions up to 1988. The works in this volume cover the broad scope of American photography, beginning with the medium's infancy. Among the earliest works are daguerreotypes from the 1840s and early paper print portraits by such notables as Mathew B. Brady and Southworth and Hawes. Photographs of Native Americans span the full history of photography, including Hill and Adamson's 1840s calotype portrait of the Ojibwa Indian, *Reverend Peter Jones*; early portraits of Indian delegations to Washington taken by Alexander Gardner, Antonio Zeno Shindler, and others; turn-of-the-century documents by Adam Clark Vroman, Frederick Inman Monsen, and Edward Curtis; the extensive Navajo photographs of Laura Gilpin from the 1930s through the 1970s; and recent photographs of the contemporary Native American Southwest by Skeet McAuley. Landscape photographs are especially well represented, with works by pioneering western photographers Timothy H. O'Sullivan, William Henry Jackson, and Carleton E. Watkins; by twentieth-century masters such as Ansel Adams and Edward Weston; and by contemporary artists including William Clift, Frank Gohlke, and Mark Klett. American contributions to the turn-of-the-century effort to establish photography as an independent art form are evident in works by renowned masters such as Alfred Stieglitz and Gertrude Käsebier and by less-famous artists such as Joseph T. Keiley and Albert Schaaf. Among the modernist masterpieces represented in the collection are prints by Paul Strand and Charles Sheeler.

Some of the greatest treasures in the collection are works by lesser-known or unidentified photographers. The creators of many early daguerreotypes, such as the portrait of the rugged forty-niner who appears ready for the adventures of the California

gold fields, may never be identified, but even without further documentation, these works are a compelling testimony to the talents and the general excellence of American photographers in this early period. Similarly, although exhaustive research has failed to identify the enterprising photographer who created the Mexican War daguerreotypes in the Museum's collection, this does not diminish their significance as one of the first photographic records of war. Indeed, many of the collection's historical images demonstrate the new ways in which photographs reported events with startling power and immediacy.

The growth of the photography collection reflects the evolving goals of the Amon Carter Museum's staff and the invaluable contributions of photographers, dealers, and donors. As the defining force behind the Museum's distinctive approach to American photography, Mitchell Wilder interpreted western art and the Museum's mission expansively; the process of "westering," as he called it, was not confined to specific geographical boundaries or a predictable list of known artists and obvious subjects. Thus the Museum not only presented photography exhibitions on established western subjects, but also supported shows of contemporary experimental photography that reflected Wilder's broad definition of concepts such as "frontier" and "exploration" and his imaginative curatorial leadership. During the Museum's formative years, when many other museum professionals were still debating the photographic medium's significance as art, Wilder enthusiastically embraced photography with a diverse approach that defied easy categorization, and the Museum became the main venue for photography in the region.

As indicated by the exhibition list (see appendix), monographic exhibitions were common in the early years, but the Museum's regional emphasis and concern for cultural history led to thematic exhibitions as well. Wilder did not restrict his exhibitions to "vintage" prints—although that emphasis would later become a major concern of fine art photography collecting—but instead took advantage of the Museum's and other negative collections to present numerous exhibitions of modern prints made from historical negatives. In the tradition of the "Family of Man" exhibition that Edward Steichen organized at the Museum of Modern Art in 1955, Wilder frequently had custom enlargements and murals made to serve specific installation needs in the gallery spaces.

The Museum's early pursuit of historical photographs led to rapid growth in numbers of works, including the Everhard collection of some 5,500 glass plate negatives from Midwest studios; a group of more than 3,000 photographs of Native Americans and U.S. military figures assembled by E. A. Brininstool, a noted author on the Plains Indian Wars; and Fred Mazzulla's extensive collection of vintage prints, negatives, and research copy prints focusing on Colorado and the West. Only key works from these collections, by artists such as O'Sullivan, Jackson, and John K. Hillers, have been exhibited and are included in this volume; additional works will be addressed through other finding aids under development.

The photography collection has also grown in relation to the Museum's exhibition and publication projects. Works have sometimes been added in preparation for exhibitions, and exhibited works occasionally have been purchased or donated to the collection following an exhibition. In earlier years, the Museum even sponsored a few photographic projects. Richard Avedon's *In the American West* was by far the most ambitious collaboration with a photographer. Inspired by Avedon's 1978 portrait of Montana rancher Wilbur Powell, Wilder commissioned Avedon to make an extended photographic study of other western subjects. The resulting series of 126 provocative portraits, many printed larger than life, provided a highly personal perspective on the contemporary American West. His unflinching, often painfully revealing portraits of all types of people—ranchers, drifters, prisoners, children, even a Los Alamos scientist—challenged many popular notions of what we look like and how we think of the West today. These photographs were presented in 1985 in one of the most popular exhibitions in the Museum's history, and the works themselves are central to the contemporary photography collection.

Perhaps Wilder's greatest legacy was his work with Laura Gilpin, which established the Amon Carter Museum as a repository for the archives of important American photographers. Wilder, a close friend of Gilpin's since his early years in Colorado Springs, had actively sought her photographic archives, which ideally matched the Museum's dual emphases on art and history. Gilpin had studied with Clarence White and had been a prolific photographer with a well-established reputation as one of the finest pictorial art photographers of her generation. At the same time, her extensive documentation of the Southwest, in particular her exhaustive records of the Navajo from the 1930s through the production of her seminal book *The Enduring Navaho* in the 1960s, made her collection of great historical significance. In the Amon Carter Museum, Gilpin found a place to preserve her archives and to make her work available for generations to come. From these archives, curator of photographs Martha A. Sandweiss, who was hired a little more than a year before Gilpin's death in 1979,

developed a major research project that culminated in the 1986 exhibition and publication titled *Laura Gilpin: An Enduring Grace*.

In addition to the Gilpin bequest of over fifty thousand photographic works, the Museum has acquired comprehensive collections and archives of other important American photographers, including Karl Struss, Carlotta Corpron, Helen Post, Clara Sipprell, Erwin E. Smith, Nell Dorr, and, in 1990, Eliot Porter. These collections, which often include negatives and manuscript materials, offer unique opportunities for in-depth study of key photographers and their contributions to the development of American photography. Significant parts of some archival holdings are represented in this publication, including the Sipprell and Struss prints and all Gilpin prints acquired prior to her bequest, but for the most part these monographic collections and archives are too extensive for inclusion here. They either have been or will be addressed separately, in independent publications and guides.

Martha Sandweiss and Jan Keene Muhlert, who was appointed as Museum Director in 1980, shared Wilder's concern that the photography program and collection address both artistic and historical issues, but they also emphasized key individual works and strove to expand the collection's focus from the American West to the full history of American photography. In almost a decade as curator of photographs, Sandweiss made insightful acquisitions that established new highlights and augmented existing strengths. For example, acquisitions of photographs by Charles Sheeler, Margaret Bourke-White, Paul Strand, and others complemented the Museum's modernist holdings of paintings, drawings, and prints by Georgia O'Keeffe and her contemporaries. One of Sandweiss' first projects at the Museum was an exhibition and publication on Carlotta Corpron that further broadened the photography program to include experimental work. While Corpron's teaching career at Texas Women's University in Denton established her as an important artist of this region, her style and concern for abstraction and experimentation reflected the expressive sensibilities of her mentors, Laslo Moholy-Nagy and Gyorgy Kepes. Another major acquisition in 1981, fifty daguerreotypes from the Mexican War, provided the foundation for an innovative exhibition that compared the daguerreotypes to lithographs and other prints and examined the accuracy and expressive potential of the different media.

Today the Museum's collection covers the full spectrum of American photography, with concentrations in several subjects, including landscape and portraiture, and in major styles such as pictorialism and modernism. Yet the collection's expansion has never been limited by the desire to develop a comprehensive, one-dimensional survey of the medium. Instead, the organic growth of the Museum's photography holdings has produced unusual emphases and diversity. Like American photography itself, which has developed in too complex and multifaceted a form to be easily summed up in a neat chronology, the Amon Carter Museum photography collection has an unpredictability and special character that continues to provide exciting discoveries.

Catalogue

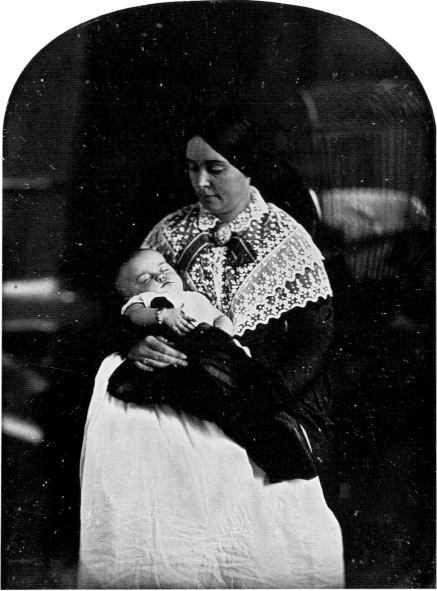

5554

BERENICE ABBOTT, American (1898–1991)

Berenice Abbott first studied sculpture, but learned
photography when she served as Man Ray's assistant
in 1923. She lived in Paris during the 1920s where, in
1926, she met Eugène Atget. After Atget's death in 1927,
Abbott purchased all of his work. She printed some of
his negatives and was largely responsible for promoting
knowledge of his work. In 1929 Abbott returned to the
United States and opened a portrait studio in New
York. She also began photographing New York City for
a Works Progress Administration Federal Art Project.
Abbott did scientific work illustrating the principles of
physics, serving from 1944 to 1945 as the photo editor at
Science Illustrated. Abbott received numerous honors
including several honorary degrees, selection as one of
the Professional Photographers of America's Top Ten
Women Photographers (1959) and an induction into
the Order of Arts and Letters by the French govern-
ment (1988). The International Center of Photography
awarded Abbott the 1989 Master of Photography Award
for her extraordinary lifetime achievement. In 1978 P/K
Associates of New York commissioned a project to print
Abbott's negative files. Abbott identified rough prints,
signing or initialing each image. The printer died be-
fore the project was completed, however, and no further
work was done. One of the two sets of prints thus pro-
duced was subsequently given to the Amon Carter
Museum, where it forms the core of the collection
of Abbott photographs.

1. **A & P** (P1984.35.348)
 Gelatin silver print. negative 1936, print 1978–79
 Image: 7½ x 9⁷⁄₁₆ in. (19.0 x 24.0 cm.)
 Mount: 8 x 10 in. (20.3 x 25.4 cm.)
 Signed, l.r. mount recto: "BA"
 Inscription, mount verso: "563" and rubber stamp
 "BERENICE ABBOTT/ABBOT, MAINE 04406/ALL
 RIGHTS RESERVED"
 Acquired from: gift of P/K Associates, New York, New York

*2. **[Airlines Terminal]** (P1984.35.24)
 Gelatin silver print. negative 1929–39, print 1978–79
 Image: 9½ x 7⁷⁄₁₆ in. (24.1 x 18.9 cm.)
 Mount: 10 x 8 in. (25.4 x 20.3 cm.)
 Signed, l.r. mount recto: "BA"
 Inscription, mount verso: "136-3//232"
 Acquired from: gift of P/K Associates, New York, New York

3. **[Airlines Terminal]** (P1984.35.26)
 Gelatin silver print. negative 1929–39, print 1978–79
 Image: 9⁷⁄₁₆ x 7⁵⁄₁₆ in. (24.0 x 18.5 cm.)
 Mount: 10 x 8 in. (25.4 x 20.3 cm.)
 Signed, l.r. mount recto: "BA"
 Inscription, mount verso: "137-3//234"
 Acquired from: gift of P/K Associates, New York, New York

*4. **ALEXANDER BEEKMAN** (P1984.35.415)
 Gelatin silver print. negative 1926–30, print 1978–79
 Image: 4½ x 3⁵⁄₁₆ in. (11.4 x 8.4 cm.)
 Mount: 10 x 8 in. (25.4 x 20.3 cm.)
 Signed, l.r. mount recto: "BA"
 Inscription, mount recto: "Alexander Berkman [sic]"
 and crop mark
 mount verso: "636"
 Acquired from: gift of P/K Associates, New York, New York

5. **AMERICAN RADIATOR BUILDING** (P1984.35.204)
 Gelatin silver print. negative 1929–39, print 1978–79
 Image: 9⁹⁄₁₆ x 7⁷⁄₁₆ in. (24.3 x 19.2 cm.)
 Mount: 10 x 8 in. (25.4 x 20.3 cm.)

Signed, bottom center mount verso: "Berenice Abbott"
Inscription, mount verso: "323-7//414"
Acquired from: gift of P/K Associates, New York, New York

*6. **AMERICAN SHOPS, LODI, NEW JERSEY** (P1984.35.167)
 Gelatin silver print. negative 1954, print 1978–79
 Image: 7⁹⁄₁₆ x 9½ in. (19.2 x 24.1 cm.)
 Mount: 8 x 10 in. (20.3 x 25.4 cm.)
 Signed, l.r. mount recto: "BA"
 Inscription, mount verso: "377" and rubber stamp
 "BERENICE ABBOTT/ABBOT, MAINE 04406/ALL
 RIGHTS RESERVED"
 Acquired from: gift of P/K Associates, New York, New York

7. **ANDRÉ CALMETTES** (P1984.35.396)
 Gelatin silver print. negative 1927, print 1978–79
 Image: 4¼ x 3⁵⁄₁₆ in. (10.8 x 8.4 cm.)
 Mount: 10 x 8 in. (25.4 x 20.3 cm.)
 Signed, l.r. mount recto: "BA"
 Inscription, mount verso: "André Calmette [sic]//616"
 Acquired from: gift of P/K Associates, New York, New York

8. **ANDRÉ GIDE** (P1984.35.363)
 Gelatin silver print. negative 1927, print 1978–79
 Image: 4⅜ x 3⅜ in. (11.1 x 8.6 cm.)
 Mount: 10 x 8 in. (25.4 x 20.3 cm.)
 Signed, l.r. mount recto: "BA"
 Inscription, mount recto: "André Gide"
 mount verso: "578"
 Acquired from: gift of P/K Associates, New York, New York

9. **ANDRÉ GIDE** (P1984.35.371)
 Gelatin silver print. negative 1927, print 1978–79
 Image: 4⅜ x 3⁵⁄₁₆ in. (11.1 x 8.4 cm.)
 Mount: 10 x 8 in. (25.4 x 20.3 cm.)
 Signed, l.r. mount recto: "BA—"
 Inscription, mount recto: "André Gide"
 mount verso: "588"
 Acquired from: gift of P/K Associates, New York, New York

10. **ANDRÉ GIDE** (P1984.35.373)
 Gelatin silver print. negative 1927, print 1978–79
 Image: 4⁷⁄₁₆ x 3⁵⁄₁₆ in. (11.3 x 8.4 cm.)
 Mount: 10 x 8 in. (25.4 x 20.3 cm.)
 Signed, l.r. mount recto: "BA"
 Inscription, mount verso: "André Gide//590"
 Acquired from: gift of P/K Associates, New York, New York

*11. **ANDRÉ GIDE** (P1984.35.381)
 Gelatin silver print. negative 1927, print 1978–79
 Image: 4⅜ x 3⁵⁄₁₆ in. (11.1 x 8.4 cm.)
 Mount: 10 x 8 in. (25.4 x 20.3 cm.)
 Signed, l.r. mount recto: "BA"
 Inscription, mount recto: "André Gide" and crop marks
 mount verso: "600"
 Acquired from: gift of P/K Associates, New York, New York

12. **ANDRÉ GIDE** (P1984.35.401)
 Gelatin silver print. negative 1927, print 1978–79
 Image: 4⁷⁄₁₆ x 3⅜ in. (11.3 x 8.6 cm.)
 Mount: 10 x 8 in. (25.4 x 20.3 cm.)
 Signed, l.r. mount recto: "BA."
 Inscription, mount recto: "André Gide" and crop marks
 mount verso: "622"
 Acquired from: gift of P/K Associates, New York, New York

13. **ANDRÉ SIEGFRIED** (P1984.35.470)
 Gelatin silver print. negative 1928, print 1978–79
 Image: 4⅜ x 3⁵⁄₁₆ in. (11.1 x 8.4 cm.)
 Mount: 10 x 8 in. (25.4 x 20.3 cm.)
 Signed, l.r. mount recto: "BA"
 Inscription, mount verso: "André Siegfried//694"
 Acquired from: gift of P/K Associates, New York, New York

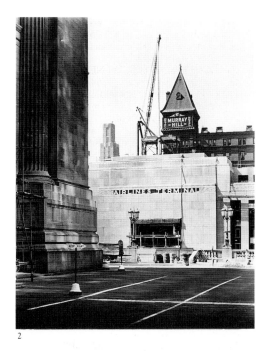

2

4

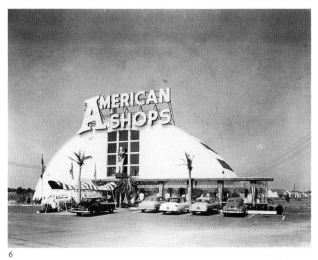

6

11

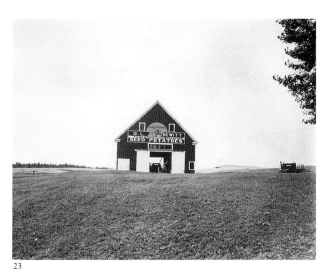

23

14. **ANDRÉ SIEGFRIED** (P1984.35.480)
Gelatin silver print. negative 1928, print 1978–79
Image: 4 5/16 x 3 1/4 in. (11.0 x 8.2 cm.)
Mount: 10 x 8 in. (25.4 x 20.3 cm.)
Signed, l.r. mount recto: "BA"
Inscription, mount recto: "André Siegfried" and crop mark
mount verso: "704"
Acquired from: gift of P/K Associates, New York, New York

15. **ANDRÉ TARDIEU** (P1984.35.414)
Gelatin silver print. negative 1926–30, print 1978–79
Image: 4 3/8 x 3 3/8 in. (11.1 x 8.6 cm.)
Mount: 10 x 8 in. (25.4 x 20.3 cm.)
Signed, l.r. mount recto: "BA"
Inscription, mount recto: "André Tardieu" and crop mark
mount verso: "635"
Acquired from: gift of P/K Associates, New York, New York

16. **ANNA WYCKHAM, ENGLISH POET** (P1984.35.507)
Gelatin silver print. negative 1926–30, print 1978–79
Image: 3 5/16 x 2 3/8 in. (8.4 x 6.0 cm.)
Mount: 10 x 8 in. (25.4 x 20.3 cm.)
Signed, l.r. mount recto: "BA"
Inscription, mount verso: "Anna Wigham [sic], English
Poet//595"
Acquired from: gift of P/K Associates, New York, New York

17. **[Apartment buildings]** (P1984.35.305)
Gelatin silver print. negative 1929–39, print 1978–79
Image: 9 1/2 x 7 1/2 in. (24.1 x 19.0 cm.)
Mount: 10 x 8 in. (25.4 x 20.3 cm.)
Signed, l.r. mount recto: "BA"
Inscription, mount verso: "179-4//519" and rubber stamp
"BERENICE ABBOTT/ABBOT, MAINE 04406/ALL
RIGHTS RESERVED"
Acquired from: gift of P/K Associates, New York, New York

18. **ATGET [Eugène Atget]** (P1984.35.502)
Gelatin silver print. negative 1927, print 1978–79
Image: 4 3/8 x 3 3/8 in. (11.1 x 8.6 cm.)
Mount: 10 x 8 in. (25.4 x 20.3 cm.)
Signed, l.r. mount recto: "BA"
Inscription, mount verso: "Atget//598"
Acquired from: gift of P/K Associates, New York, New York

19. **ATLAS [Louis Atlas]** (P1984.35.474)
Gelatin silver print. negative 1928, print 1978–79
Image: 4 5/16 x 3 3/8 in. (11.0 x 8.6 cm.)
Mount: 10 x 8 in. (25.4 x 20.3 cm.)
Signed, l.r. mount recto: "BA"
Inscription, mount recto: "Atlas"
mount verso: "698"
Acquired from: gift of P/K Associates, New York, New York

20. **BARCLAY ST. ELEVATED** (P1984.35.277)
Gelatin silver print. negative 1936, print 1978–79
Image: 9 7/16 x 7 1/2 in. (24.0 x 19.0 cm.)
Mount: 10 x 8 in. (25.4 x 20.3 cm.)
Signed, l.r. mount recto: "BA"
Inscription, mount verso: "135-3/Barclay St. Elevated//491"
and rubber stamp "BERENICE ABBOTT/ABBOT,
MAINE 04406/ALL RIGHTS RESERVED"
Acquired from: gift of P/K Associates, New York, New York

21. **BARCLAY ST. FERRY [Hoboken Ferry Terminal,
Barclay Street]** (P1984.35.276)
Gelatin silver print. negative 1935, print 1978–79
Image: 7 1/2 x 9 1/2 in. (19.0 x 24.1 cm.)
Mount: 8 x 10 in. (20.3 x 25.4 cm.)
Signed, l.r. mount recto: "BA"
Inscription, mount verso: "133-3 Barclay St. Ferry //490" and
rubber stamp "BERENICE ABBOTT/ABBOT, MAINE
04406/ALL RIGHTS RESERVED"
Acquired from: gift of P/K Associates, New York, New York

22. **BARCLAY ST. STATION** (P1984.35.1)
Gelatin silver print. negative 1936, print 1978–79
Image: 7 1/2 x 9 7/16 in. (19.0 x 24.0 cm.)
Mount: 8 x 10 in. (20.3 x 25.4 cm.)
Signed, l.r. mount recto: "BA"
Inscription, mount verso: "37-1/Barclay St. STATION" and
rubber stamp "BERENICE ABBOTT/ABBOT, MAINE
04406/ALL RIGHTS RESERVED"
Acquired from: gift of P/K Associates, New York, New York

* 23. **[Barn with G. L. Hewitt Seed Potatoes advertisement, Maine]**
(P1984.35.242)
Gelatin silver print. negative 1967–68, print 1978–79
Image: 7 9/16 x 9 7/16 in. (19.2 x 24.0 cm.)
Mount: 8 x 10 in. (20.3 x 25.4 cm.)
Signed, l.r. mount recto: "BA"
Inscription, mount verso: "455" and rubber stamp
"BERENICE ABBOTT/ABBOT, MAINE 04406/ALL
RIGHTS RESERVED"
Acquired from: gift of P/K Associates, New York, New York

24. **[Barn with Sinclair Gasoline advertisement]** (P1984.35.246)
Gelatin silver print. negative 1935–61, print 1978–79
Image: 7 1/2 x 9 7/16 in. (19.0 x 24.0 cm.)
Mount: 8 x 10 in. (20.3 x 25.4 cm.)
Signed, l.r. mount recto: "BA"
Inscription, mount verso: "459" and rubber stamp
"BERENICE ABBOTT/ ABBOT, MAINE 04406/ALL
RIGHTS RESERVED"
Acquired from: gift of P/K Associates, New York, New York

* 25. **BETTY PARSONS** (P1984.35.426)
Gelatin silver print. negative 1927, print 1978–79
Image: 3 3/16 x 2 3/8 in. (8.1 x 6.0 cm.)
Mount: 10 x 8 in. (25.4 x 20.3 cm.)
Signed, l.r. mount recto: "BA"
Inscription, mount verso: "Betty Parsons//648" and rubber
stamp "BERENICE ABBOTT/ABBOT, MAINE 04406/
ALL RIGHTS RESERVED"
Acquired from: gift of P/K Associates, New York, New York

* 26. **"BIRDSMITH," GREENWICH VILLAGE, N.Y.
[John "Birdman" Lacey]** (P1984.35.328)
Gelatin silver print. negative c. 1949, print 1978–79
Image: 9 5/8 x 7 9/16 in. (24.4 x 19.2 cm.)
Mount: 10 x 8 in. (25.4 x 20.3 cm.)
Signed, l.r. mount recto: "BA"
Inscription, mount verso: "159-4//543" and rubber stamp
"BERENICE ABBOTT/ABBOT, MAINE 04406/ALL
RIGHTS RESERVED"
Acquired from: gift of P/K Associates, New York, New York

* 27. **BLOSSOM RESTAURANT, 103 BOWERY** (P1984.35.284)
Gelatin silver print. negative 1935, print 1978–79
Image: 7 1/2 x 9 7/16 in. (19.0 x 24.0 cm.)
Mount: 8 x 10 in. (20.3 x 25.4 cm.)
Signed, l.r. mount recto: "BA"
Inscription, mount verso: "15-1//498" and rubber stamp
"BERENICE ABBOTT/ABBOT, MAINE 04406/ALL
RIGHTS RESERVED"
Acquired from: gift of P/K Associates, New York, New York

28. **BOB McALMON [Robert McAlmon]** (P1984.35.364)
Gelatin silver print. negative 1926–30, print 1978–79
Image: 3 5/16 x 2 5/16 in. (8.4 x 5.8 cm.)
Mount: 10 x 8 in. (25.4 x 20.3 cm.)
Signed, l.r. mount recto: "BA"
Inscription, mount recto: "Bob McAlmon"
mount verso: "580"
Acquired from: gift of P/K Associates, New York, New York

29. **BOB McALMON [Robert McAlmon]** (P1984.35.397)
Gelatin silver print. negative 1926–30, print 1978–79
Image: 3 1/4 x 2 3/16 in. (8.2 x 5.5 cm.)
Mount: 10 x 8 in. (25.4 x 20.3 cm.)

Signed, l.r. mount recto: "BA"
Inscription, mount recto: "Bob McAlmon"
 mount verso: "617"
Acquired from: gift of P/K Associates, New York, New York

30. **BOB McALMON** [Robert McAlmon] (P1984.35.419)
 Gelatin silver print. negative 1926–30, print 1978–79
 Image: 3 x 2 ⁵⁄₁₆ in. (7.6 x 5.8 cm.)
 Mount: 10 x 8 in. (25.4 x 20.3 cm.)
 Signed, l.r. mount recto: "BA"
 Inscription, mount verso: "Bob McAlmon//640" and rubber
 stamp "BERENICE ABBOTT/ABBOT, MAINE 04406/
 ALL RIGHTS RESERVED"
 Acquired from: gift of P/K Associates, New York, New York

31. **BOB McALMON** [Robert McAlmon] (P1984.35.427)
 Gelatin silver print. negative 1926–30, print 1978–79
 Image: 3 ¹⁄₁₆ x 2 ¼ in. (7.8 x 5.7 cm.)
 Mount: 10 x 8 in. (25.4 x 20.3 cm.)
 Signed, l.r. mount recto: "BA"
 Inscription, mount recto: "Bob McAlmon//650"
 Acquired from: gift of P/K Associates, New York, New York

*32. **BOOKSHOP, GREENWICH VILLAGE, N.Y.** (P1984.35.282)
 Gelatin silver print. negative 1948–49, print 1978–79
 Image: 9 ½ x 7 ½ in. (24.1 x 19.0 cm.)
 Mount: 10 x 8 ⅛ in. (25.4 x 20.6 cm.)
 Signed, l.r. mount recto: "BA"
 Inscription, mount verso: "162-4//496" and rubber stamp
 "BERENICE ABBOTT/ABBOT, MAINE 04406/ALL
 RIGHTS RESERVED"
 Acquired from: gift of P/K Associates, New York, New York

33. **BROADWAY AND RECTOR STREET FROM ABOVE**
 (P1984.35.190)
 Gelatin silver print. negative 1935, print 1978–79
 Image: 9 ½ x 6 ¹³⁄₁₆ in. (24.1 x 17.3 cm.)
 Mount: 10 x 8 in. (25.4 x 20.3 cm.)
 Signed, l.r. mount recto: "BA"
 Inscription, mount verso: "400" and rubber stamp
 "BERENICE ABBOTT/ABBOT, MAINE 04406/ALL
 RIGHTS RESERVED"
 Acquired from: gift of P/K Associates, New York, New York

34. **B'WAY TO BATTERY FROM IRVING TRUST ROOF**
 [Broadway to the Battery from roof of Irving Trust
 Company Building, One Wall Street] (P1984.35.271)
 Gelatin silver print. negative 1938, print 1978–79
 Image: 8 ¾ x 6 ¹¹⁄₁₆ in. (22.2 x 17.0 cm.)
 Mount: 10 x 8 in. (25.4 x 20.3 cm.)
 Signed, l.r. mount recto: "BA"
 Inscription, mount verso: "130-3/B'way to Battery/From
 Irving trust Roof//485" and rubber stamp "BERENICE
 ABBOTT/ABBOT, MAINE 04406/ALL RIGHTS
 RESERVED"
 Acquired from: gift of P/K Associates, New York, New York

35. **BROADWAY TO THE BATTERY, FROM ROOF OF**
 IRVING TRUST COMPANY BUILDING, ONE WALL
 STREET (P1984.35.146)
 Gelatin silver print. negative 1938, print 1978–79
 Image: 5 ¼ x 4 in. (13.3 x 10.1 cm.)
 Mount: 10 x 8 in. (25.4 x 20.3 cm.)
 Signed, bottom center mount verso: "Berenice Abbott"
 Inscription, mount verso: "273-6//356"
 Acquired from: gift of P/K Associates, New York, New York

36. **BROADWAY TO THE BATTERY, FROM ROOF OF**
 IRVING TRUST COMPANY BUILDING, ONE WALL
 STREET (P1984.35.148)
 Gelatin silver print. negative 1938, print 1978–79
 Image: 4 ¼ x 3 ³⁄₁₆ in. (10.8 x 8.1 cm.)
 Mount: 10 x 8 in. (25.4 x 20.3 cm.)
 Signed, bottom center mount verso: "Berenice Abbott"
 Inscription, mount verso: "271-6//358"
 Acquired from: gift of P/K Associates, New York, New York

25

26

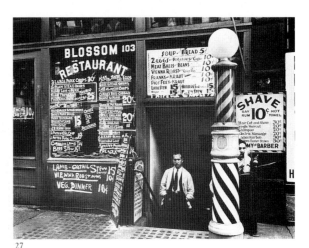

27

37. **BRONX** (P1984.35.253)
Gelatin silver print. negative 1929—39, print 1978—79
Image: 7 7/16 x 9 7/16 in. (18.9 x 24.0 cm.)
Mount: 8 x 10 in. (20.3 x 25.4 cm.)
Signed, l.r. mount recto: "BA"
Inscription, mount verso: "125-3/Bronx//466" and rubber
stamp "BERENICE ABBOTT/ABBOT, MAINE 04406/
ALL RIGHTS RESERVED"
Acquired from: gift of P/K Associates, New York, New York

38. **BRONX** (P1984.35.504)
Gelatin silver print. negative 1929—39, print 1978—79
Image: 7 1/2 x 9 1/2 in. (19.0 x 24.1 cm.)
Mount: 8 x 10 in. (20.3 x 25.4 cm.)
Signed, l.r. mount recto: "BA"
Inscription, mount verso: "124-3/Bronx//467" and rubber
stamp "BERENICE ABBOTT/ABBOT, MAINE 04406/
ALL RIGHTS RESERVED"
Acquired from: gift of P/K Associates, New York, New York

39. **BROOKLYN [Talman Street, between Jay and Bridge Streets,
Brooklyn]** (P1984.35.254)
Gelatin silver print. negative 1936, print 1978—79
Image: 7 1/4 x 9 1/4 in. (18.4 x 23.5 cm.)
Mount: 8 x 10 in. (20.3 x 25.4 cm.)
Signed, l.r. mount recto: "BA"
Inscription, mount verso: "123-3/Brooklyn//468" and rubber
stamp "BERENICE ABBOTT/ABBOT, MAINE 04406/
ALL RIGHTS RESERVED"
Acquired from: gift of P/K Associates, New York, New York

40. **BROOKLYN BRIDGE, WATER & DOCK STS.,
BROOKLYN** (P1984.35.11)
Gelatin silver print. negative 1936, print 1978—79
Image: 9 7/16 x 7 9/16 in. (24.0 x 19.2 cm.)
Mount: 10 x 8 in. (25.4 x 20.3 cm.)
Signed, l.r. mount recto: "BA"
Inscription, mount verso: "114-3/Brooklyn Bridge/Water &
Dock Sts./Brooklyn, May 22, 1936//212" and rubber stamp
"BERENICE ABBOTT/ABBOT, MAINE 04406/ALL
RIGHTS RESERVED"
Acquired from: gift of P/K Associates, New York, New York

*41. **BROOKLYN LOOKING TOWARD WILLIAMSBURG
BRIDGE, N.Y.** (P1984.35.10)
Gelatin silver print. negative 1937, print 1978—79
Image: 9 1/2 x 7 1/2 in. (24.1 x 19.0 cm.)
Mount: 10 x 8 in. (25.4 x 20.3 cm.)
Signed, l.r. mount recto: "BA"
Inscription, mount verso: "113-3/Brooklyn looking
Toward/ Manhatten [sic] Bridge//211" and rubber stamp
"BERENICE ABBOTT/ ABBOT, MAINE 04406/ALL
RIGHTS RESERVED"
Acquired from: gift of P/K Associates, New York, New York

42. **BURNS BROTHERS FACTORY [Burns Brothers Factory,
Routes 1 & 9, Jersey City, N.J.]** (P1984.35.13)
Gelatin silver print. negative 1938, print 1978—79
Image: 9 7/16 x 7 1/2 in. (24.0 x 19.0 cm.)
Mount: 10 x 8 in. (25.4 x 20.3 cm.)
Signed, l.r. mount recto: "BA"
Inscription, mount verso: "116-3/Burns Brothers Factory//214"
and rubber stamp "BERENICE ABBOTT/ABBOT,
MAINE 04406/ALL RIGHTS RESERVED"
Acquired from: gift of P/K Associates, New York, New York

43. **CAFE INTERIOR OF LAFAYETTE HOTEL,
GREENWICH VILLAGE** (P1984.35.308)
Gelatin silver print. negative 1949, print 1978—79
Image: 3 5/8 x 4 3/4 in. (9.2 x 12.0 cm.)
Mount: 10 x 8 in. (25.4 x 20.3 cm.)
Signed, l.r. mount recto: "BA"
Inscription, mount verso: "20-1//522" and rubber stamp
"BERENICE ABBOTT/ABBOT, MAINE 04406/ALL
RIGHTS RESERVED"
Acquired from: gift of P/K Associates, New York, New York

44. **CAFE INTERIOR OF LAFAYETTE HOTEL,
GREENWICH VILLAGE** (P1984.35.309)
Gelatin silver print. negative 1949, print 1978—79
Image: 3 5/8 x 4 1/2 in. (9.2 x 11.4 cm.)
Mount: 10 x 8 in. (25.4 x 20.3 cm.)
Signed, l.r. mount recto: "BA"
Inscription, mount verso: "20-1//523" and rubber stamp
"BERENICE ABBOTT/ABBOT, MAINE 04406/ALL
RIGHTS RESERVED"
Acquired from: gift of P/K Associates, New York, New York

45. **CAILLAUX [Joseph Marie Auguste Caillaux]** (P1984.35.450)
Gelatin silver print. negative c. 1928, print 1978—79
Image: 4 7/16 x 3 3/8 in. (11.3 x 8.6 cm.)
Mount: 10 x 8 in. (25.4 x 20.3 cm.)
Signed, l.r. mount recto: "BA"
Inscription, mount recto: "Caillaux" and crop mark
mount verso: "674"
Acquired from: gift of P/K Associates, New York, New York

46. **[Cedar and Liberty Streets from above]** (P1984.35.37)
Gelatin silver print. negative 1929—39, print 1978—79
Image: 9 7/16 x 6 3/4 in. (24.0 x 17.1 cm.)
Mount: 10 x 8 in. (25.4 x 20.3 cm.)
Signed, bottom center mount verso: "Berenice Abbott"
Inscription, mount verso: "245"
Acquired from: gift of P/K Associates, New York, New York

47. **CEDAR STREET. (FROM WILLIAMS) MANHATTAN**
(P1978.25.3)
Gelatin silver print. 1936
Image: 9 5/8 x 7 1/2 in. (24.5 x 19.0 cm.)
Sheet: 9 15/16 x 7 15/16 in. (25.3 x 20.2 cm.)
Signed, center print verso: "Berenice Abbott"
Inscription, in negative: "91"
print verso: "Cedar Street. (from Williams) Manhattan/
Neg. 91-Code I-C/ 3/26/36 //TR:205-77" and rubber stamps
"FEDERAL ART PROJECT/"Changing New York"/
PHOTOGRAPHS BY BERENICE ABBOTT" and
"photograph/berenice abbott/50 commerce st./new york city"
Acquired from: The Halsted Gallery, Birmingham, Michigan

48. **CEDRIC MORRIS** (P1984.35.468)
Gelatin silver print. negative 1926—30, print 1978—79
Image: 3 1/4 x 2 3/16 in. (8.2 x 5.5 cm.)
Mount: 10 x 8 in. (25.4 x 20.3 cm.)
Signed, l.r. mount recto: "BA"
Inscription, mount recto: "Cedric Morris"
mount verso: "692"
Acquired from: gift of P/K Associates, New York, New York

49. **[Celastic, Ben Walters Inc. storefront]** (P1984.35.28)
Gelatin silver print. negative 1929—39, print 1978—79
Image: 9 7/16 x 7 1/2 in. (24.0 x 19.0 cm.)
Mount: 10 x 8 in. (25.4 x 20.3 cm.)
Signed, l.r. mount recto: "BA"
Inscription, mount verso: "140-3//236"
Acquired from: gift of P/K Associates, New York, New York

*50. **CHANEL (COCO)** (P1984.35.460)
Gelatin silver print. negative 1926—30, print 1978—79
Image: 4 1/2 x 3 5/16 in. (11.4 x 8.4 cm.)
Mount: 10 x 8 in. (25.4 x 20.3 cm.)
Signed, l.r. mount recto: "BA"
Inscription, mount recto: crop marks
mount verso: "Chanel (Coco)//684"
Acquired from: gift of P/K Associates, New York, New York

*51. **CHANIN BLDG.** (P1984.35.258)
Gelatin silver print. negative 1929—39, print 1978—79
Image: 9 7/16 x 7 9/16 in. (24.0 x 19.2 cm.)
Mount: 10 x 8 in. (25.4 x 20.3 cm.)
Signed, l.r. mount recto: "BA"
Inscription, mount verso: "117-3/Chanin Bldg.//472" and
rubber stamp "BERENICE ABBOTT/ABBOT,
MAINE 04406/ALL RIGHTS RESERVED"
Acquired from: gift of P/K Associates, New York, New York

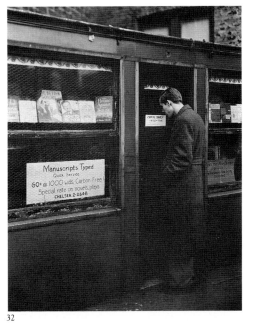

32

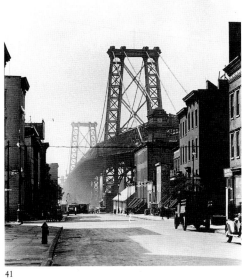

41

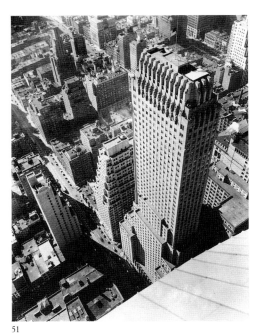

50

51

52. **CHANIN BLDG.** (P1984.35.273)
Gelatin silver print. negative 1929–39, print 1978–79
Image: 9½ x 7½ in. (24.1 x 19.0 cm.)
Mount: 10 x 8 in. (25.4 x 20.3 cm.)
Signed, l.r. mount recto: "BA"
Inscription, mount verso: "42-1/Chanin Bldg.//487" and
rubber stamp "BERENICE ABBOTT/ABBOT,
MAINE 04406/ALL RIGHTS RESERVED"
Acquired from: gift of P/K Associates, New York, New York

53. **CHANIN BLDG.** (P1984.35.292)
Gelatin silver print. negative 1929–39, print 1978–79
Image: 9⁷⁄₁₆ x 7⁷⁄₁₆ in. (24.0 x 18.9 cm.)
Mount: 10 x 8 in. (25.4 x 20.3 cm.)
Signed, l.r. mount recto: "BA"
Inscription, mount verso: "31-1/Chanan [sic] Bldg.//506"
and rubber stamp "BERENICE ABBOTT/ABBOT,
MAINE 04406/ALL RIGHTS RESERVED"
Acquired from: gift of P/K Associates, New York, New York

54. **CHARLTON ST., 6TH AVE.** (P1984.35.257)
Gelatin silver print. negative 1929–39, print 1978–79
Image: 7½ x 9¼ in. (19.0 x 23.5 cm.)
Mount: 8 x 10 in. (20.3 x 25.4 cm.)
Signed, l.r. mount recto: "BA"
Inscription, mount verso: "118-3/Charlton St./
6th Ave.//471"
Acquired from: gift of P/K Associates, New York, New York

55. **CHRISTOPHER ST. GUNSMITH** (P1984.35.223)
Gelatin silver print. negative 1948–49, print 1978–79
Image: 9⅝ x 7⁹⁄₁₆ in. (24.4 x 19.2 cm.)
Mount: 10 x 8 in. (25.4 x 20.3 cm.)
Signed, l.r. mount recto: "BA"
Inscription, mount verso: "93-2 Christopher St.
Gunsmith//436" and rubber stamp "BERENICE ABBOTT/
ABBOT, MAINE 04406/ALL RIGHTS RESERVED"
Acquired from: gift of P/K Associates, New York, New York

56. **CHRYSLER BUILDING** (P1984.35.21)
Gelatin silver print. negative 1929–39, print 1978–79
Image: 9⁷⁄₁₆ x 7⁷⁄₁₆ in. (24.0 x 18.9 cm.)
Mount: 10 x 8 in. (25.4 x 20.3 cm.)
Signed, l.r. mount recto: "BA"
Inscription, mount verso: "268-6//224" and rubber stamp
"BERENICE ABBOTT/ABBOT, MAINE 04406/ALL
RIGHTS RESERVED"
Acquired from: gift of P/K Associates, New York, New York

57. **CHRYSLER BUILDING FROM THE CHANIN
BUILDING** (P1984.35.151)
Gelatin silver print. negative 1929–39, print 1978–79
Image: 9⁷⁄₁₆ x 7⅝ in. (24.0 x 18.5 cm.)
Mount: 10 x 8 in. (25.4 x 20.3 cm.)
Signed, bottom center mount verso: "Berenice Abbott"
Inscription, mount verso: "248-6//361"
Acquired from: gift of P/K Associates, New York, New York

58. **CHRYSLER BUILDING FROM THE CHANIN
BUILDING** (P1984.35.152)
Gelatin silver print. negative 1929–39, print 1978–79
Image: 9½ x 7½ in. (24.1 x 19.0 cm.)
Mount: 10 x 8 in. (25.4 x 20.3 cm.)
Signed, bottom center mount verso: "Berenice Abbott"
Inscription, mount verso: "247-6//362"
Acquired from: gift of P/K Associates, New York, New York

*59. **CHRYSLER BUILDING WITH THE CHANIN
BUILDING** (P1984.35.81)
Gelatin silver print. negative 1929–39, print 1978–79
Image: 7½ x 9½ in. (19.0 x 24.1 cm.)
Mount: 8 x 10 in. (20.3 x 25.4 cm.)
Signed, l.r. mount recto: "BA"
Inscription, print verso [print is mounted, but inscription
is visible in reverse]: "231-5"
mount verso: "289//231-5" and rubber stamp "BERENICE

ABBOTT/ ABBOT, MAINE 04406/ALL RIGHTS
RESERVED"
Acquired from: gift of P/K Associates, New York, New York

60. **CITY HALL [City Hall Park, N.Y.]** (P1984.35.251)
Gelatin silver print. negative c. 1930, print 1978–79
Image: 7⁹⁄₁₆ x 9⁹⁄₁₆ in. (19.2 x 24.3 cm.)
Mount: 8 x 10 in. (20.3 x 25.4 cm.)
Signed, l.r. mount recto: "BA"
Inscription, mount verso: "119-3/City Hall//464" and rubber
stamp "BERENICE ABBOTT/ABBOT, MAINE 04406/
ALL RIGHTS RESERVED"
Acquired from: gift of P/K Associates, New York, New York

*61. **CITY HALL [City Hall Park, N.Y.]** (P1984.35.252)
Gelatin silver print. negative c. 1930, print 1978–79
Image: 7⁷⁄₁₆ x 9½ in. (18.9 x 24.1 cm.)
Mount: 8 x 10 in. (20.3 x 25.4 cm.)
Signed, l.r. mount recto: "BA"
Inscription, mount verso: "120-3/City Hall//465" and rubber
stamp "BERENICE ABBOTT/ABBOT, MAINE 04406/
ALL RIGHTS RESERVED"
Acquired from: gift of P/K Associates, New York, New York

62. **CITY HALL AND PARK WITH WORLD TOWER, N.Y.**
(P1984.35.270)
Gelatin silver print. negative c. 1930, print 1978–79
Image: 7⁷⁄₁₆ x 9⁷⁄₁₆ in. (18.9 x 24.0 cm.)
Mount: 8 x 10 in. (20.3 x 25.4 cm.)
Signed, l.r. mount recto: "BA"
Inscription, mount verso: "132-3//484" and rubber stamp
"BERENICE ABBOTT/ABBOT, MAINE 04406/ALL
RIGHTS RESERVED"
Acquired from: gift of P/K Associates, New York, New York

*63. **CLAUDE McKAY** (P1984.35.361)
Gelatin silver print. negative 1926–30, print 1978–79
Image: 3⅛ x 2¼ in. (7.9 x 5.7 cm.)
Mount: 10 x 8 in. (25.4 x 20.3 cm.)
Signed, l.r. mount recto: "BA"
Inscription, mount recto: "Claude McKay" and crop mark
mount verso: "576"
Acquired from: gift of P/K Associates, New York, New York

64. **CLOTILD VAIL** (P1984.35.459)
Gelatin silver print. negative 1926–30, print 1978–79
Image: 4½ x 3⁵⁄₁₆ in. (11.4 x 8.4 cm.)
Mount: 10 x 8 in. (25.4 x 20.3 cm.)
Signed, l.r. mount recto: "BA"
Inscription, mount verso: "Chlotilde [sic] Vail//683"
Acquired from: gift of P/K Associates, New York, New York

65. **COENTIES SLIP** (P1984.35.123)
Gelatin silver print. negative 1929–39, print 1978–79
Image: 7½ x 9⁷⁄₁₆ in. (19.0 x 24.0 cm.)
Mount: 8 x 10 in. (20.3 x 25.4 cm.)
Signed, l.r. mount recto: "BA"
Inscription, mount verso: "282-6//334" and rubber stamp
"BERENICE ABBOTT/ABBOT, MAINE 04406/ALL
RIGHTS RESERVED"
Acquired from: gift of P/K Associates, New York, New York

66. **COENTIES SLIP** (P1984.35.124)
Gelatin silver print. negative 1929–39, print 1978–79
Image: 7⁷⁄₁₆ x 9⁷⁄₁₆ in. (18.9 x 24.0 cm.)
Mount: 8 x 10 in. (20.3 x 25.4 cm.)
Signed, l.r. mount recto: "BA"
Inscription, mount verso: "283-6 Coenties Slip//334" and
rubber stamp "BERENICE ABBOTT/ABBOT, MAINE
04406/ALL RIGHTS RESERVED"
Acquired from: gift of P/K Associates, New York, New York

67. **COENTIES SLIP** (P1984.35.127)
Gelatin silver print. negative 1929–39, print 1978–79
Image: 7⁷⁄₁₆ x 9½ in. (18.9 x 24.1 cm.)
Mount: 8 x 10 in. (20.3 x 25.4 cm.)

Signed, l.r. mount recto: "BA"
Inscription, mount verso: "337//281-6" and rubber stamp "BERENICE ABBOTT/ABBOT, MAINE 04406/ALL RIGHTS RESERVED"
Acquired from: gift of P/K Associates, New York, New York

68. **COLUMBIA PRESBYTERIAN HOSP.** (P1984.35.256)
Gelatin silver print. negative 1937, print 1978–79
Image: 7 ½ x 9 ⁹/₁₆ in. (19.0 x 24.3 cm.)
Mount: 8 x 10 in. (20.3 x 25.4 cm.)
Signed, l.r. mount recto: "BA"
Inscription, mount verso: "121-3/Columbia Presbyterian Hosp./ 11/16/37//470" and rubber stamp "BERENICE ABBOTT/ABBOT, MAINE 04406/ALL RIGHTS RESERVED"
Acquired from: gift of P/K Associates, New York, New York

69. **[Construction site, Manhattan]** (P1984.35.101)
Gelatin silver print. negative 1929–39, print 1978–79
Image: 9 ½ x 7 ½ in. (24.1 x 19.0 cm.)
Mount: 10 x 8 in. (25.4 x 20.3 cm.)
Signed, l.r. mount recto: "BA"
Inscription, print verso: [print is mounted, but illegible inscription is visible in reverse]
mount verso: "222-5//310" and rubber stamp "BERENICE ABBOTT/ABBOT, MAINE 04406/ALL RIGHTS RESERVED"
Acquired from: gift of P/K Associates, New York, New York

70. **CORNER ORCHARD AND HESTER STREETS, LOWER EAST SIDE, NEW YORK** (P1984.35.102)
Gelatin silver print. negative 1938, print 1978–79
Image: 7 ⁷/₁₆ x 9 ½ in. (18.9 x 24.1 cm.)
Mount: 8 x 10 in. (20.3 x 25.4 cm.)
Signed, l.r. mount recto: "BA"
Inscription, mount verso: "221-5//311" and rubber stamp "BERENICE ABBOTT/ABBOT, MAINE 04406/ALL RIGHTS RESERVED"
Acquired from: gift of P/K Associates, New York, New York

*71. **COURT OF 1ST MODEL TENEMENT IN N.Y.** (P1984.35.503)
Gelatin silver print. negative 1936, print 1978–79
Image: 9 ⅝ x 7 ½ in. (24.4 x 19.0 cm.)
Mount: 10 x 8 in. (25.4 x 20.3 cm.)
Signed, l.r. mount recto: "BA"
Inscription, mount verso: "103-2/Court of 1st Model Tenement in N.Y./Mar. 16, 1936//425" and rubber stamp "BERENICE ABBOTT/ ABBOT, MAINE 04406/ALL RIGHTS RESERVED"
Acquired from: gift of P/K Associates, New York, New York

72. **DAILY NEWS BUILDING, 220 EAST 42ND STREET** (P1984.35.14)
Gelatin silver print. negative 1935, print 1978–79
Image: 9 ½ x 7 ½ in. (24.1 x 19.0 cm.)
Mount: 10 x 8 in. (25.4 x 20.3 cm.)
Signed, l.r. mount recto: "BA"
Inscription, mount verso: "43 1//1935//215" and rubber stamp "BERENICE ABBOTT/ABBOT, MAINE 04406/ALL RIGHTS RESERVED"
Acquired from: gift of P/K Associates, New York, New York

*73. **DAILY NEWS BUILDING, 220 EAST 42ND STREET** (P1984.35.92)
Gelatin silver print. negative 1935, print 1978–79
Image: 9 ¹/₁₆ x 7 ⁷/₁₆ in. (23.0 x 18.9 cm.)
Mount: 10 x 8 in. (25.4 x 20.3 cm.)
Signed, l.r. mount recto: "BA"
Inscription, mount verso: "266-6/1932-3 [sic]//300" and rubber stamp "BERENICE ABBOTT/ABBOT, MAINE 04406/ALL RIGHTS RESERVED"
Acquired from: gift of P/K Associates, New York, New York

59

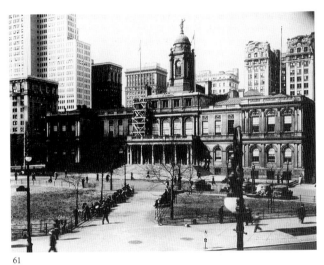
61

63

74. **DAILY NEWS BUILDING, 220 EAST 42ND STREET**
 (P1984.35.263)
 Gelatin silver print. negative 1935, print 1978–79
 Image: 9 ½ x 7 ½ in. (24.1 x 19.0 cm.)
 Mount: 10 x 8 in. (25.4 x 20.3 cm.)
 Signed, l.r. mount recto: "BA"
 Inscription, mount verso: "16-1//477" and rubber stamp
 "BERENICE ABBOTT/ABBOT, MAINE 04406/ALL
 RIGHTS RESERVED"
 Acquired from: gift of P/K Associates, New York, New York

*75. **DESIGNER'S WINDOW, BLEECKER STREET**
 (P1984.35.323)
 Gelatin silver print. negative 1947, print 1978–79
 Image: 8 ½ x 6 ¹¹⁄₁₆ in. (21.6 x 17.0 cm.)
 Mount: 10 x 8 in. (25.4 x 20.3 cm.)
 Signed, l.r. mount recto: "BA"
 Inscription, mount verso: "166-4//538" and rubber stamp
 "BERENICE ABBOTT/ABBOT, MAINE 04406/ALL
 RIGHTS RESERVED"
 Acquired from: gift of P/K Associates, New York, New York

76. **DJUNA BARNES** (P1984.35.375)
 Gelatin silver print. negative c. 1926, print 1978–79
 Image: 4 ⅜ x 3 ¼ in. (11.1 x 8.2 cm.)
 Mount: 10 x 8 in. (25.4 x 20.3 cm.)
 Signed, l.r. mount recto: "BA"
 Inscription, mount verso: "Djuna Barnes//592"
 Acquired from: gift of P/K Associates, New York, New York

77. **DJUNA BARNES** (P1984.35.406)
 Gelatin silver print. negative c. 1926, print 1978–79
 Image: 3 ³⁄₁₆ x 2 ⅜ in. (8.1 x 6.0 cm.)
 Mount: 10 x 8 in. (25.4 x 20.3 cm.)
 Signed, l.r. mount recto: "BA"
 Inscription, mount verso: "Djuna Barnes//627" and rubber
 stamp "BERENICE ABBOTT/ABBOT, MAINE 04406/
 ALL RIGHTS RESERVED"
 Acquired from: gift of P/K Associates, New York, New York

*78. **DJUNA BARNES** (P1984.35.410)
 Gelatin silver print. negative c. 1926, print 1978–79
 Image: 4 ⁵⁄₁₆ x 3 ⁵⁄₁₆ in. (11.0 x 8.4 cm.)
 Mount: 10 x 8 in. (25.4 x 20.3 cm.)
 Signed, l.r. mount recto: "BA"
 Inscription, mount recto: "Djuna Barnes" and crop marks
 mount verso: "631"
 Acquired from: gift of P/K Associates, New York, New York

79. **DOROTHEA OMANKONSKI** (P1984.35.492)
 Gelatin silver print. negative 1926–30, print 1978–79
 Image: 3 ⅛ x 2 ⁵⁄₁₆ in. (7.9 x 5.8 cm.)
 Mount: 10 x 8 in. (25.4 x 20.3 cm.)
 Signed, l.r. mount recto: "BA"
 Inscription, mount recto: "Dorothea Omankonski"
 mount verso: "716"
 Acquired from: gift of P/K Associates, New York, New York

80. **DOROTHY WHITNEY [Mrs. Raymond Massey]**
 (P1984.35.430)
 Gelatin silver print. negative 1926–30, print 1978–79
 Image: 4 ⁷⁄₁₆ x 3 ⅜ in. (11.3 x 8.6 cm.)
 Mount: 10 x 8 in. (25.4 x 20.3 cm.)
 Signed, l.r. mount recto: "BA"
 Inscription, mount recto: crop marks
 mount verso: "Dorothy Whitney//654"
 Acquired from: gift of P/K Associates, New York, New York

81. **DOWNTOWN SKYPORT, FOOT OF WALL STREET,
 EAST RIVER, MANHATTAN** (P1984.35.29)
 Gelatin silver print. negative 1936, print 1978–79
 Image: 9 ⁷⁄₁₆ x 7 ⁷⁄₁₆ in. (24.0 x 18.9 cm.)
 Mount: 10 x 8 in. (25.4 x 20.3 cm.)
 Signed, l.r. mount recto: "BA"
 Inscription, mount verso: "141-3//237"
 Acquired from: gift of P/K Associates, New York, New York

*82. **[East 40th Street]** (P1984.35.30)
 Gelatin silver print. negative 1929–39, print 1978–79
 Image: 9 ⁵⁄₁₆ x 7 ⁷⁄₁₆ in. (23.7 x 18.9 cm.)
 Mount: 10 x 8 in. (25.4 x 20.3 cm.)
 Signed, l.r. mount recto: "BA"
 Inscription, mount verso: "142-4//238"
 Acquired from: gift of P/K Associates, New York, New York

*83. **EAST SIDE PORTRAIT** (P1984.35.19)
 Gelatin silver print. negative 1938, print 1978–79
 Image: 9 ¼ x 7 ½ in. (23.5 x 19.0 cm.)
 Mount: 10 x 8 in. (25.4 x 20.3 cm.)
 Signed, l.r. mount recto: "BA"
 Inscription, mount verso: "17-1//220" and rubber stamp
 "BERENICE ABBOTT/ABBOT, MAINE 04406/ALL
 RIGHTS RESERVED"
 Acquired from: gift of P/K Associates, New York, New York

*84. **EDNA MILLAY [Edna St. Vincent Millay]** (P1984.35.497)
 Gelatin silver print. negative 1930, print 1978–79
 Image: 4 ⅛ x 3 in. (10.5 x 7.6 cm.)
 Mount: 10 x 8 in. (25.4 x 20.3 cm.)
 Signed, l.r. mount recto: "BA"
 Inscription, mount recto: "Edna Millay"
 mount verso: "651"
 Acquired from: gift of P/K Associates, New York, New York

*85. **EDWARD HOPPER, NEW YORK [from the portfolio "Ten
 Photographs"]** (P1980.5)
 Gelatin silver print. negative 1947, print 1976
 Image: 13 ⅜ x 10 ¼ in. (34.0 x 26.0 cm.)
 Mount: 20 x 16 in. (50.8 x 40.7 cm.)
 Signed, l.r. mount recto: "BERENICE ABBOTT"
 Inscription, mount verso, printed paper label: "Berenice/
 Abbott/A portfolio of/10 original prints by/Berenice
 Abbott./A limited edition of/50 portfolios'/this being print
 No. [in ink] 5 /of portfolio No. [in ink] 13/Published April
 1976 by/Witkin-Berley Ltd./ 34 Sherwood Lane/Roslyn
 Heights, New York 11577"
 Acquired from: The Halsted Gallery, Birmingham, Michigan

86. **[Eighth Street, looking west to Sixth Avenue, north side of
 street]** (P1984.35.340)
 Gelatin silver print. negative 1929–39, print 1978–79
 Image: 9 ⁷⁄₁₆ x 7 ⁷⁄₁₆ in. (24.0 x 18.9 cm.)
 Mount: 10 x 8 in. (25.4 x 20.3 cm.)
 Signed, l.r. mount recto: "BA"
 Inscription, mount verso: "153-4//555" and rubber stamp
 "BERENICE ABBOTT/ABBOT, MAINE 04406/ALL
 RIGHTS RESERVED"
 Acquired from: gift of P/K Associates, New York, New York

87. **EL AT COLUMBUS AVENUE AND BROADWAY**
 (P1984.35.36)
 Gelatin silver print. negative 1930, print 1978–79
 Image: 5 ¹⁄₁₆ x 6 ⅞ in. (12.8 x 17.4 cm.)
 Mount: 8 x 10 in. (20.3 x 25.4 cm.)
 Signed, bottom center mount recto: "Berenice Abbott"
 Inscription, mount verso: "244"
 Acquired from: gift of P/K Associates, New York, New York

88. **EL SECOND AND THIRD AVENUE LINES; 250 PEARL
 STREET** (P1984.35.162)
 Gelatin silver print. negative 1936, print 1978–79
 Image: 9 ⁹⁄₁₆ x 7 ⅜ in. (24.3 x 18.7 cm.)
 Mount: 10 x 8 in. (25.4 x 20.3 cm.)
 Signed, bottom center mount verso: "Berenice Abbott"
 Inscription, mount verso: "236-6//372"
 Acquired from: gift of P/K Associates, New York, New York

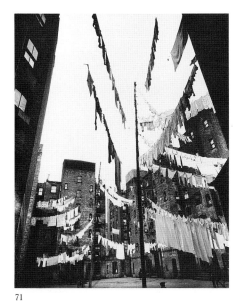

71

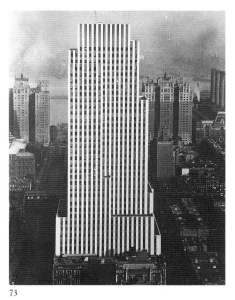

73

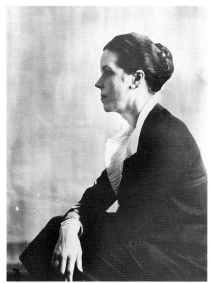

75

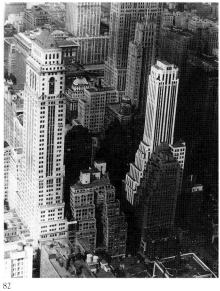

82

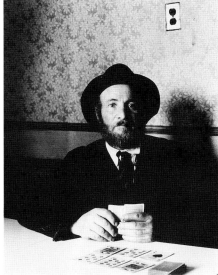

83

*89. **EL STATION, NINTH AVENUE LINE, CHRISTOPHER AND GREENWICH STREETS, MANHATTAN** (P1984.35.33)
Gelatin silver print. negative 1936, print 1978–79
Image: 9 ⅜ x 7 7/16 in. (23.8 x 18.9 cm.)
Mount: 10 x 8 in. (25.4 x 20.3 cm.)
Signed, l.r. mount recto: "BA"
Inscription, mount verso: "295-7//241"
Acquired from: gift of P/K Associates, New York, New York

90. **ELEVATED RAILWAY** (P1984.35.334)
Gelatin silver print. negative 1929–39, print 1978–79
Image: 5 x 7 in. (12.7 x 17.8 cm.)
Mount: 10 x 8 in. (25.4 x 20.3 cm.)
Signed, l.r. mount recto: "BA"
Inscription, mount verso: "549" and rubber stamp
 "BERENICE ABBOTT/ABBOT, MAINE 04406/ALL
 RIGHTS RESERVED"
Acquired from: gift of P/K Associates, New York, New York

91. **[Empire State Building]** (P1984.35.4)
Gelatin silver print. negative 1931–39, print 1978–79
Image: 9 7/16 x 7 ⅜ in. (24.0 x 18.7 cm.)
Mount: 10 x 8 in. (25.4 x 20.3 cm.)
Signed, l.r. mount recto: "BA"
Inscription, mount verso: "288-7//205" and rubber stamp
 "BERENICE ABBOTT/ABBOT, MAINE 04406/ALL
 RIGHTS RESERVED"
Acquired from: gift of P/K Associates, New York, New York

92. **EMPIRE STATE BUILDING** (P1984.35.140)
Gelatin silver print. negative 1931–39, print 1978–79
Image: 9 ⅜ x 7 7/16 in. (23.8 x 18.9 cm.)
Mount: 10 x 8 in. (25.4 x 20.3 cm.)
Signed, bottom center mount verso: "Berenice Abbott"
Inscription, mount verso: "299-7//350"
Acquired from: gift of P/K Associates, New York, New York

*93. **EMPIRE STATE BUILDING** (P1984.35.149)
Gelatin silver print. negative 1931–39, print 1978–79
Image: 9 ⅜ x 7 7/16 in. (23.8 x 18.9 cm.)
Mount: 10 x 8 in. (25.4 x 20.3 cm.)
Signed, bottom center mount verso: "Berenice Abbott"
Inscription, mount verso: "262-6//359"
Acquired from: gift of P/K Associates, New York, New York

94. **EMPIRE STATE BUILDING** (P1984.35.155)
Gelatin silver print. negative 1931–39, print 1978–79
Image: 9 ⅜ x 7 7/16 in. (23.8 x 18.9 cm.)
Mount: 10 x 8 in. (25.4 x 20.3 cm.)
Signed, bottom center mount verso: "Berenice Abbott"
Inscription, mount verso: "244-6//365"
Acquired from: gift of P/K Associates, New York, New York

95. **EMPIRE STATE BUILDING** (P1984.35.156)
Gelatin silver print. negative 1931–39, print 1978–79
Image: 9 ⅜ x 7 7/16 in. (23.8 x 18.9 cm.)
Mount: 10 x 8 in. (25.4 x 20.3 cm.)
Signed, bottom center mount verso: "Berenice Abbott"
Inscription, mount verso: "243-6//366"
Acquired from: gift of P/K Associates, New York, New York

96. **EMPIRE STATE BUILDING** (P1984.35.157)
Gelatin silver print. negative 1931–39, print 1978–79
Image: 9 ⅛ x 7 ½ in. (23.2 x 19.0 cm.)
Mount: 10 x 8 in. (25.4 x 20.3 cm.)
Signed, bottom center mount verso: "Berenice Abbott"
Inscription, mount verso: "242-6//367"
Acquired from: gift of P/K Associates, New York, New York

97. **EMPIRE STATE BUILDING** (P1984.35.158)
Gelatin silver print. negative 1931–39, print 1978–79
Image: 9 3/16 x 7 ⅜ in. (23.3 x 18.7 cm.)
Mount: 10 x 8 in. (25.4 x 20.3 cm.)
Signed, bottom center mount verso: "Berenice Abbott"
Inscription, mount verso: "241-6//368"
Acquired from: gift of P/K Associates, New York, New York

*98. **EMPIRE STATE BUILDING** (P1984.35.159)
Gelatin silver print. negative 1931–39, print 1978–79
Image: 9 7/16 x 7 9/16 in. (24.0 x 19.2 cm.)
Mount: 10 x 8 in. (25.4 x 20.3 cm.)
Signed, bottom center mount verso: "Berenice Abbott"
Inscription, mount verso: "240-6//369"
Acquired from: gift of P/K Associates, New York, New York

99. **ENTRANCE TO WEST SIDE HIGHWAY** (P1984.35.230)
Gelatin silver print. negative 1930–39, print 1978–79
Image: 7 ½ x 9 ½ in. (19.0 x 24.1 cm.)
Mount: 8 x 10 in. (20.3 x 25.4 cm.)
Signed, l.r. mount recto: "BA"
Inscription, mount verso: "84-2//443" and rubber stamp
 "BERENICE ABBOTT/ABBOT, MAINE 04406/ALL
 RIGHTS RESERVED"
Acquired from: gift of P/K Associates, New York, New York

100. **ERIE FERRY** (P1984.35.181)
Gelatin silver print. negative 1929–39, print 1978–79
Image: 7 ⅜ x 9 7/16 in. (18.7 x 24.0 cm.)
Mount: 8 x 10 in. (20.3 x 25.4 cm.)
Signed, l.r. mount recto: "BA"
Inscription, mount verso: "55-2 ERIE Ferry//391" and rubber
 stamp "BERENICE ABBOTT/ABBOT, MAINE 04406/
 ALL RIGHTS RESERVED"
Acquired from: gift of P/K Associates, New York, New York

101. **ERIE STATION** (P1984.35.293)
Gelatin silver print. negative 1929–39, print 1978–79
Image: 7 7/16 x 9 9/16 in. (18.9 x 24.3 cm.)
Mount: 8 x 10 in. (20.3 x 25.4 cm.)
Signed, l.r. mount recto: "BA"
Inscription, mount verso: "35-1//507" and rubber stamp
 "BERENICE ABBOTT/ABBOT, MAINE 04406/ALL
 RIGHTS RESERVED"
Acquired from: gift of P/K Associates, New York, New York

*102. **EUGÈNE ATGET** (P1984.35.368)
Gelatin silver print. negative 1927, print 1978–79
Image: 4 ⅜ x 3 ⅜ in. (11.1 x 8.6 cm.)
Mount: 10 x 8 in. (25.4 x 20.3 cm.)
Signed, l.r. mount recto: "BA"
Inscription, mount recto: "Eugène Atget" and crop marks
 mount verso: "584"
Acquired from: gift of P/K Associates, New York, New York

103. **EVELYN SCOTT** (P1984.35.458)
Gelatin silver print. negative 1926–30, print 1978–79
Image: 4 ⅜ x 3 ¼ in. (11.1 x 8.2 cm.)
Mount: 10 x 8 in. (25.4 x 20.3 cm.)
Signed, l.r. mount recto: "BA"
Inscription, mount verso: "Evelyn Scott//682" and rubber
 stamp "BERENICE ABBOTT/ABBOT, MAINE 04406/
 ALL RIGHTS RESERVED"
Acquired from: gift of P/K Associates, New York, New York

104. **FARM, PULASKI, TENNESSEE** (P1984.35.165)
Gelatin silver print. negative 1935, print 1978–79
Image: 7 7/16 x 9 7/16 in. (18.9 x 24.0 cm.)
Mount: 8 x 10 in. (20.3 x 25.4 cm.)
Signed, l.r. mount recto: "BA"
Inscription, mount verso: "375" and rubber stamp
 "BERENICE ABBOTT/ ABBOT, MAINE 04406/ALL
 RIGHTS RESERVED"
Acquired from: gift of P/K Associates, New York, New York

105. **FATHER DUFFY, TIMES SQUARE** (P1984.35.278)
Gelatin silver print. negative 1936, print 1978–79
Image: 9 ¼ x 7 ½ in. (23.5 x 19.0 cm.)
Mount: 10 x 8 in. (25.4 x 20.3 cm.)
Signed, l.r. mount recto: "BA"
Inscription, mount verso: "13-1//492" and rubber stamp
 "BERENICE ABBOTT/ABBOT, MAINE 04406/ALL
 RIGHTS RESERVED"
Acquired from: gift of P/K Associates, New York, New York

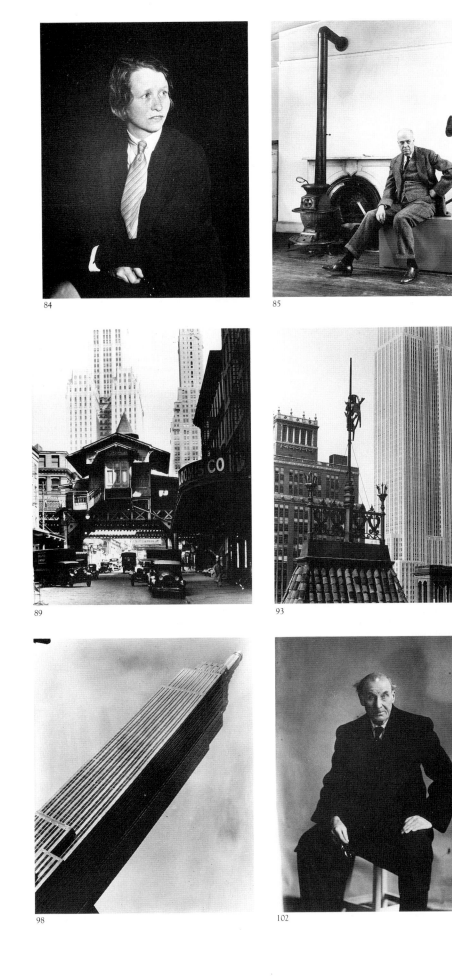

84

85

89

93

98

102

106. **FERRIES, FOOT OF WEST 23RD STREET** (P1984.35.161)
Gelatin silver print. negative 1935, print 1978−79
Image: 7 ⅜ x 9 ½ in. (18.7 x 24.1 cm.)
Mount: 8 x 10 in. (20.3 x 25.4 cm.)
Signed, bottom center mount verso: "Berenice Abbott"
Inscription, mount verso: "237-6//371"
Acquired from: gift of P/K Associates, New York, New York

107. **FIFTH AVENUE COACH COMPANY [Fifth Avenue Coach]** (P1984.35.35)
Gelatin silver print. negative 1932, print 1978−79
Image: 5 ½ x 7 9/16 in. (14.0 x 19.2 cm.)
Mount: 8 x 10 in. (20.3 x 25.4 cm.)
Signed, bottom center mount verso: "Berenice Abbott"
Inscription, mount verso: "243"
Acquired from: gift of P/K Associates, New York, New York

*108. **FIFTH AVENUE HOUSES, NOS. 4, 6, 8** (P1984.35.51)
Gelatin silver print. negative 1936, print 1978−79
Image: 7 7/16 x 9 ½ in. (18.9 x 24.1 cm.)
Mount: 8 x 10 in. (20.3 x 25.4 cm.)
Signed, bottom center mount verso: "Berenice Abbott"
Inscription, mount verso: "305-7//259"
Acquired from: gift of P/K Associates, New York, New York

109. **[Fifth Avenue, looking south across Ninth Street]** (P1984.35.31)
Gelatin silver print. negative c. 1948, print 1978−79
Image: 7 9/16 x 9 9/16 in. (19.2 x 24.3 cm.)
Mount: 8 x 10 in. (20.3 x 25.4 cm.)
Signed, l.r. mount recto: "BA"
Inscription, mount verso: "239//143-4"
Acquired from: gift of P/K Associates, New York, New York

110. **57TH ST.** (P1984.35.207)
Gelatin silver print. negative c. 1976, print 1978−79
Image: 9 9/16 x 7 ⅝ in. (24.3 x 19.4 cm.)
Mount: 10 x 8 in. (25.4 x 20.3 cm.)
Signed, l.l. mount recto: "BA"
Inscription, mount verso: "62-2 57th St.//417" and rubber stamp "BERENICE ABBOTT/ABBOT, MAINE 04406/ALL RIGHTS RESERVED"
Acquired from: gift of P/K Associates, New York, New York

111. **57TH ST. VIEW FROM RITZ** (P1984.35.231)
Gelatin silver print. negative 1976, print 1978−79
Image: 7 9/16 x 9 9/16 in. (19.2 x 24.3 cm.)
Mount: 8 x 10 in. (20.3 x 25.4 cm.)
Signed, l.r. mount recto: "BA"
Inscription, mount verso: "444//57th St. View From Ritz/1976" and rubber stamp "BERENICE ABBOTT/ABBOT, MAINE 04406/ALL RIGHTS RESERVED"
Acquired from: gift of P/K Associates, New York, New York

112. **[56 West Street, looking east on Rector Street across West Street]** (P1984.35.138)
Gelatin silver print. negative 1929−39, print 1978−79
Image: 9 ⅜ x 7 ⅜ in. (23.8 x 18.7 cm.)
Mount: 10 x 8 in. (25.4 x 20.3 cm.)
Signed, bottom center mount verso: "Berenice Abbott"
Inscription, mount verso: "251-6//348"
Acquired from: gift of P/K Associates, New York, New York

113. **FINANCIAL DISTRICT [Canyon, Broadway and Exchange Place]** (P1984.35.344)
Gelatin silver print. negative 1936, print 1978−79
Image: 4 ½ x 3 ⅝ in. (11.4 x 9.2 cm.)
Mount: 10 x 8 in. (25.4 x 20.3 cm.)
Signed, l.r. mount recto: "BA"
Inscription, mount verso: "21-1//559" and rubber stamp "BERENICE ABBOTT/ABBOT, MAINE 04406/ALL RIGHTS RESERVED"
Acquired from: gift of P/K Associates, New York, New York

114. **FIRST STUDIO IN THE VILLAGE** (P1984.35.227)
Gelatin silver print. negative 1929−39, print 1978−79
Image: 9 ⅝ x 7 9/16 in. (24.4 x 19.2 cm.)
Mount: 10 x 8 in. (25.4 x 20.3 cm.)
Signed, l.r. mount recto: "BA"
Inscription, mount verso: "80-2 First Studio in The Villiage [sic]// 440" and rubber stamp "BERENICE ABBOTT/ABBOT, MAINE 04406/ALL RIGHTS RESERVED"
Acquired from: gift of P/K Associates, New York, New York

*115. **FLATIRON BLDG [Broadway and Fifth Avenue]** (P1984.35.139)
Gelatin silver print. negative 1938, print 1978−79
Image: 9 7/16 x 7 ½ in. (24.0 x 19.0 cm.)
Mount: 10 x 8 in. (25.4 x 20.3 cm.)
Signed, bottom center mount verso: "Berenice Abbott"
Inscription, print verso [print is mounted, but inscription is visible in reverse]: "250-6//FLAT IRON BLDG" mount verso: "250-6//349"
Acquired from: gift of P/K Associates, New York, New York

*116. **FLATIRON BUILDING, BROADWAY AND FIFTH AVENUE BETWEEN 22ND AND 23RD STREETS, MANHATTAN** (P1984.35.150)
Gelatin silver print. negative 1934, print 1978−79
Image: 9 7/16 x 7 7/16 in. (24.0 x 18.9 cm.)
Mount: 10 x 8 in. (25.4 x 20.3 cm.)
Signed, bottom center mount verso: "Berenice Abbott"
Inscription, mount verso: "249-6//360"
Acquired from: gift of P/K Associates, New York, New York

117. **42ND ST. LOOKING S.E. [40th Street between Sixth and Seventh Avenues from Salmon Tower, 11 West 42nd Street]** (P1984.35.232)
Gelatin silver print. negative 1938, print 1978−79
Image: 9 7/16 x 7 ½ in. (24.0 x 19.0 cm.)
Mount: 10 x 8 in. (25.4 x 20.3 cm.)
Signed, l.r. mount recto: "BA"
Inscription, mount verso: "87-2 42nd St. Looking S.E.//445" and rubber stamp "BERENICE ABBOTT/ABBOT, MAINE 04406/ALL RIGHTS RESERVED"
Acquired from: gift of P/K Associates, New York, New York

*118. **42ND ST. LOOKING S.E. [40th Street between Sixth and Seventh Avenues from Salmon Tower, 11 West 42nd Street]** (P1984.35.233)
Gelatin silver print. negative 1938, print 1978−79
Image: 9 9/16 x 7 ⅝ in. (24.3 x 19.4 cm.)
Mount: 10 x 8 in. (25.4 x 20.3 cm.)
Signed, l.r. mount recto: "BA"
Inscription, mount verso: "88-2 42nd St. Looking S.E.//446" and rubber stamp "BERENICE ABBOTT/ABBOT, MAINE 04406/ALL RIGHTS RESERVED"
Acquired from: gift of P/K Associates, New York, New York

119. **FOUJITA [Léonard Foujita]** (P1984.35.370)
Gelatin silver print. negative 1927, print 1978−79
Image: 4 7/16 x 3 5/16 in. (11.3 x 8.4 cm.)
Mount: 10 x 8 in. (25.4 x 20.3 cm.)
Signed, l.r. mount recto: "BA"
Inscription, mount recto: crop marks mount verso: "586"
Acquired from: gift of P/K Associates, New York, New York

120. **FRANÇOIS MAURIAC** (P1984.35.429)
Gelatin silver print. negative 1926−30, print 1978−79
Image: 3 ¼ x 2 7/16 in. (8.2 x 6.2 cm.)
Mount: 10 x 8 in. (25.4 x 20.3 cm.)
Signed, l.r. mount recto: "BA"
Inscription, mount recto: "François Mauriac" and crop mark mount verso: "653"
Acquired from: gift of P/K Associates, New York, New York

121. **FRANK DOBSON** (P1984.35.437)
Gelatin silver print. negative 1926, print 1978–79
Image: 3³⁄₁₆ x 2³⁄₈ in. (8.1 x 6.0 cm.)
Mount: 10 x 8 in. (25.4 x 20.3 cm.)
Signed, l.r. mount recto: "BA"
Inscription, mount recto: "Frank Dobson"
 mount verso: "661"
Acquired from: gift of P/K Associates, New York, New York

122. **FRANK DOBSON** (P1984.35.441)
Gelatin silver print. negative 1926, print 1978–79
Image: 3¼ x 2¼ in. (8.2 x 5.8 cm.)
Mount: 10 x 8 in. (25.4 x 20.3 cm.)
Signed, l.r. mount recto: "BA"
Inscription, mount verso: "Frank Dobson//665"
Acquired from: gift of P/K Associates, New York, New York

123. **FRIEDMAN AND SILVER** (P1984.35.39)
Gelatin silver print. negative 1929–39, print 1978–79
Image: 4¾ x 6¹⁵⁄₁₆ in. (12.0 x 17.6 cm.)
Mount: 8 x 10 in. (20.3 x 25.4 cm.)
Signed, bottom center mount verso: "Berenice Abbott"
Inscription, mount verso: "247"
Acquired from: gift of P/K Associates, New York, New York

124. **FROM HANOVER SQUARE** (P1984.35.312)
Gelatin silver print. negative 1929–39, print 1978–79
Image: 9½ x 7⁹⁄₁₆ in. (24.1 x 19.2 cm.)
Mount: 10 x 8 in. (25.4 x 20.3 cm.)
Signed, bottom center mount verso: "Berenice Abbott"
Inscription, mount verso: "253-6 From Hanover Square//527"
Acquired from: gift of P/K Associates, New York, New York

125. **FRONT ST.** (P1984.35.42)
Gelatin silver print. negative 1929–39, print 1978–79
Image: 7½ x 9³⁄₈ in. (19.0 x 23.8 cm.)
Mount: 8 x 10 in. (20.3 x 25.4 cm.)
Signed, bottom center mount verso: "Berenice Abbott"
Inscription, mount verso: "261-6 Front ST//256"
Acquired from: gift of P/K Associates, New York, New York

126. **FRONT ST.** (P1984.35.130)
Gelatin silver print. negative 1929–39, print 1978–79
Image: 7⅝ x 9⁷⁄₁₆ in. (19.4 x 24.0 cm.)
Mount: 8 x 10 in. (20.3 x 25.4 cm.)
Signed, bottom center mount verso: "Berenice Abbott"
Inscription, mount verso: "261-6 Front ST.//340"
Acquired from: gift of P/K Associates, New York, New York

127. **FRONT ST. & PECK SLIP** (P1984.35.220)
Gelatin silver print. negative 1929–39, print 1978–79
Image: 7⁹⁄₁₆ x 9⁹⁄₁₆ in. (19.2 x 24.3 cm.)
Mount: 8 x 10 in. (20.3 x 25.4 cm.)
Signed, l.r. mount recto: "BA"
Inscription, mount verso: "98-2 Front St. & Peck Slip//432"
 and rubber stamp "BERENICE ABBOTT/ABBOT,
 MAINE 04406/ALL RIGHTS RESERVED"
Acquired from: gift of P/K Associates, New York, New York

*128. **FULTON FISH MARKET** (P1984.35.43)
Gelatin silver print. negative 1936, print 1978–79
Image: 7½ x 9½ in. (19.0 x 24.1 cm.)
Mount: 8 x 10 in. (20.3 x 25.4 cm.)
Signed, bottom center mount verso: "Berenice Abbott"
Inscription, mount verso: "258-6//251"
Acquired from: gift of P/K Associates, New York, New York

129. **FULTON FISH MARKET** (P1984.35.45)
Gelatin silver print. negative 1936, print 1978–79
Image: 7½ x 9⁷⁄₁₆ in. (19.0 x 24.0 cm.)
Mount: 8 x 10 in. (20.3 x 25.4 cm.)
Signed, bottom center mount verso: "Berenice Abbott"
Inscription, print verso [print is mounted, but inscription is
 visible in reverse]: "FULTON"
 mount verso: "260-6 Fulton Fish Market//253"
Acquired from: gift of P/K Associates, New York, New York

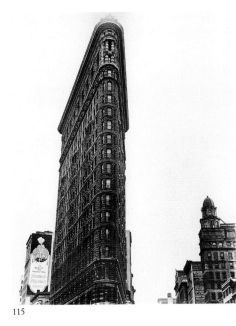
115

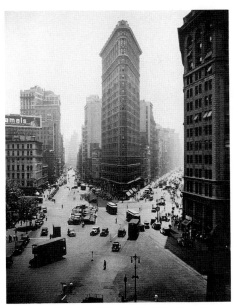
116

108

130. **FULTON FISH MARKET** (P1984.35.90)
Gelatin silver print. negative 1936, print 1978–79
Image: 7 1/2 x 9 9/16 in. (19.0 x 24.3 cm.)
Mount: 8 x 10 in. (20.3 x 25.4 cm.)
Signed, l.r. mount recto: "BA"
Inscription, mount verso: "202-5 Fulton Fish Market//298"
 and rubber stamp "BERENICE ABBOTT/ABBOT,
 MAINE 04406/ALL RIGHTS RESERVED"
Acquired from: gift of P/K Associates, New York, New York

131. **FULTON FISH MARKET** (P1984.35.131)
Gelatin silver print. negative 1936, print 1978–79
Image: 7 1/2 x 9 9/16 in. (19.0 x 24.0 cm.)
Mount: 8 x 10 in. (20.3 x 25.4 cm.)
Signed, bottom center mount verso: "Berenice Abbott"
Inscription, mount verso: "259-6//341"
Acquired from: gift of P/K Associates, New York, New York

132. **FULTON FISH MARKET** (P1984.35.132)
Gelatin silver print. negative 1936, print 1978–79
Image: 7 9/16 x 9 9/16 in. (19.2 x 24.3 cm.)
Mount: 8 x 10 in. (20.3 x 25.4 cm.)
Signed, bottom center mount verso: "Berenice Abbott"
Inscription, mount verso: "258-6//342"
Acquired from: gift of P/K Associates, New York, New York

*133. **FULTON ST. DOCK** (P1984.35.180)
Gelatin silver print. negative 1936, print 1978–79
Image: 7 9/16 x 9 1/2 in. (19.2 x 24.1 cm.)
Mount: 8 x 10 in. (20.3 x 25.4 cm.)
Signed, l.r. mount recto: "BA"
Inscription, mount verso: "54-2 Fulton St. Dock//390"
Acquired from: gift of P/K Associates, New York, New York

134. **[G. Costos florist shop, 66 West Eighth Street]** (P1984.35.351)
Gelatin silver print. negative c. 1938, print 1978–79
Image: 3 5/8 x 4 5/8 in. (9.2 x 11.7 cm.)
Mount: 10 x 8 in. (25.4 x 20.3 cm.)
Signed, l.r. mount recto: "BA"
Inscription, mount verso: "19-1//566" and rubber stamp
 "BERENICE ABBOTT/ABBOT, MAINE 04406/ALL
 RIGHTS RESERVED"
Acquired from: gift of P/K Associates, New York, New York

135. **G. W. BRIDGE [George Washington Bridge under
 construction]** (P1984.35.214)
Gelatin silver print. negative 1929–31, print 1978–79
Image: 6 5/8 x 4 9/16 in. (16.8 x 11.6 cm.)
Mount: 10 x 8 in. (25.4 x 20.3 cm.)
Signed, l.r. mount recto: "BA"
Inscription, mount verso: "91-2 G. W. Bridge//426"
Acquired from: gift of P/K Associates, New York, New York

136. **[Garage and Metropolitan News Co. delivery vans]**
 (P1984.35.186)
Gelatin silver print. negative 1929–39, print 1978–79
Image: 4 9/16 x 6 5/8 in. (11.6 x 16.8 cm.)
Mount: 10 x 8 in. (25.4 x 20.3 cm.)
Signed, l.r. mount recto: "BA"
Inscription, mount verso: "396" and rubber stamp
 "BERENICE ABBOTT/ABBOT, MAINE 04406/ALL
 RIGHTS RESERVED"
Acquired from: gift of P/K Associates, New York, New York

137. **GASOLINE STATION, TENTH AVENUE, N.Y.**
 (P1984.35.153)
Gelatin silver print. negative 1935, print 1978–79
Image: 9 1/2 x 7 9/16 in. (24.1 x 19.2 cm.)
Mount: 10 x 8 in. (25.4 x 20.3 cm.)
Signed, bottom center mount verso: "Berenice Abbott"
Inscription, mount verso: "246-6//363"
Acquired from: gift of P/K Associates, New York, New York

*138. **GASOLINE STATION, TREMONT AVENUE AND
 DOCK STREET, BRONX** (P1984.35.347)
Gelatin silver print. negative 1935, print 1978–79
Image: 9 1/8 x 7 7/16 in. (23.8 x 18.9 cm.)
Mount: 10 x 8 in. (25.4 x 20.3 cm.)
Signed, l.r. mount recto: "BA"
Inscription, mount verso: "562" and rubber stamp
 "BERENICE ABBOTT/ABBOT, MAINE 04406/ALL
 RIGHTS RESERVED"
Acquired from: gift of P/K Associates, New York, New York

139. **GENERAL ELECTRIC [St. Bartholomew's, Waldorf-Astoria,
 and General Electric Building, Manhattan]** (P1984.35.83)
Gelatin silver print. negative 1936, print 1978–79
Image: 9 1/4 x 7 1/4 in. (23.5 x 18.4 cm.)
Mount: 10 x 8 in. (25.4 x 20.3 cm.)
Signed, l.r. mount recto: "BA"
Inscription, mount verso: "230-5/General Electric//291" and
 rubber stamp "BERENICE ABBOTT/ABBOT, MAINE
 04406/ALL RIGHTS RESERVED"
Acquired from: gift of P/K Associates, New York, New York

140. **GENERAL VIEW LOOKING SOUTHWEST TO
 MANHATTAN FROM MANHATTAN BRIDGE**
 (P1984.35.203)
Gelatin silver print. negative 1937, print 1978–79
Image: 7 1/2 x 9 9/16 in. (19.0 x 24.3 cm.)
Mount: 8 x 10 in. (20.3 x 25.4 cm.)
Signed, bottom center mount verso: "Berenice Abbott"
Inscription, mount verso: "324-7//413"
Acquired from: gift of P/K Associates, New York, New York

141. **GEORGE ANTHEIL** (P1984.35.359)
Gelatin silver print. negative 1926–30, print 1978–79
Image: 4 3/8 x 3 3/8 in. (11.1 x 8.6 cm.)
Mount: 10 x 8 in. (25.4 x 20.3 cm.)
Signed, l.r. mount recto: "BA"
Inscription, mount recto: "George Antheil"
 mount verso: "574"
Acquired from: gift of P/K Associates, New York, New York

142. **GEORGE ANTHEIL** (P1984.35.423)
Gelatin silver print. negative 1926–30, print 1978–79
Image: 4 3/8 x 3 5/16 in. (11.1 x 8.4 cm.)
Mount: 10 x 8 in. (25.4 x 20.3 cm.)
Signed, l.r. mount recto: "BA"
Inscription, mount verso: "George Antheil//644"
Acquired from: gift of P/K Associates, New York, New York

*143. **GEORGE ANTHEIL** (P1984.35.456)
Gelatin silver print. negative 1926–30, print 1978–79
Image: 4 5/16 x 3 5/16 in. (11.0 x 8.4 cm.)
Mount: 10 x 8 in. (25.4 x 20.3 cm.)
Signed, l.r. mount recto: "BA"
Inscription, mount verso: "George Antheil//680"
Acquired from: gift of P/K Associates, New York, New York

144. **GOTTHARD JEDLICKA** (P1984.35.467)
Gelatin silver print. negative 1926–30, print 1978–79
Image: 3 1/4 x 2 5/16 in. (8.2 x 5.8 cm.)
Mount: 10 x 8 in. (25.4 x 20.3 cm.)
Signed, l.r. mount recto: "BA"
Inscription, mount verso: "Gerhardt Yedlicka [sic]//691" and
 rubber stamp "BERENICE ABBOTT/ABBOT, MAINE
 04406/ALL RIGHTS RESERVED"
Acquired from: gift of P/K Associates, New York, New York

145. **GOTTHARD JEDLICKA** (P1984.35.472)
Gelatin silver print. negative 1926–30, print 1978–79
Image: 3 3/16 x 2 7/16 in. (8.1 x 6.2 cm.)
Mount: 10 x 8 in. (25.4 x 20.3 cm.)
Signed, l.r. mount recto: "BA"
Inscription, mount verso: "Gotthardt Yedlicka [sic]//696"
Acquired from: gift of P/K Associates, New York, New York

128

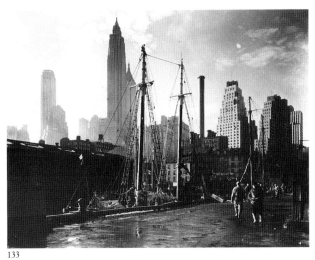

118

133

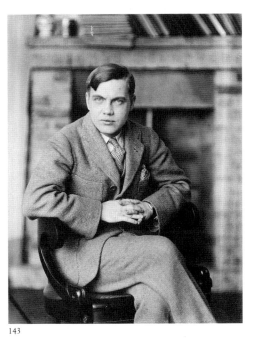

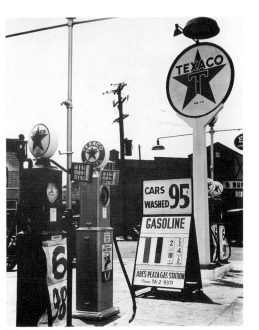

138

143

146. **GRAHAM & METROPOLITAN AVES., BROOKLYN**
(P1984.35.82)
Gelatin silver print. negative 1929–39, print 1978–79
Image: 7⁷/₁₆ x 9⁷/₁₆ in. (18.9 x 24.0 cm.)
Mount: 8 x 10 in. (20.3 x 25.4 cm.)
Signed, l.r. mount recto: "BA."
Inscription, mount verso: "290//232-5 Graham &
Metropolitan/Aves/Brooklyn" and rubber stamp
"BERENICE ABBOTT/ABBOT, MAINE 04406/ALL
RIGHTS RESERVED"
Acquired from: gift of P/K Associates, New York, New York

147. **"THE GRAND TICINO" RESTAURANT, THOMPSON
ST., GREENWICH VILLAGE** (P1984.35.338)
Gelatin silver print. negative c. 1948, print 1978–79
Image: 7½ x 9⅝ in. (19.0 x 24.4 cm.)
Mount: 8 x 10 in. (20.3 x 25.4 cm.)
Signed, l.r. mount recto: "BA"
Inscription, mount verso: "157-4//553" and rubber stamp
"BERENICE ABBOTT/ABBOT, MAINE 04406/ALL
RIGHTS RESERVED"
Acquired from: gift of P/K Associates, New York, New York

148. **"THE GRAND TICINO" RESTAURANT, THOMPSON
ST., GREENWICH VILLAGE** (P1984.35.352)
Gelatin silver print. negative c. 1948, print 1978–79
Image: 7⁷/₁₆ x 9½ in. (18.9 x 24.1 cm.)
Mount: 8 x 10 in. (20.3 x 25.4 cm.)
Signed, l.r. mount recto: "BA"
Inscription, mount verso: "158-4//567" and rubber stamp
"BERENICE ABBOTT/ABBOT, MAINE 04406/ALL
RIGHTS RESERVED"
Acquired from: gift of P/K Associates, New York, New York

149. **[Grave marker for James Heath]** (P1984.35.244)
Gelatin silver print. negative c. 1935, print 1978–79
Image: 9⁹/₁₆ x 7½ in. (24.3 x 19.0 cm.)
Mount: 10 x 8 in. (25.4 x 20.3 cm.)
Signed, l.r. mount recto: "BA"
Inscription, mount verso: "457" and rubber stamp
"BERENICE ABBOTT/ ABBOT, MAINE 04406/ALL
RIGHTS RESERVED"
Acquired from: gift of P/K Associates, New York, New York

150. **GREENWICH VILLAGE, CORNER 10TH STREET**
(P1984.35.50)
Gelatin silver print. negative 1929–39, print 1978–79
Image: 9⁹/₁₆ x 7⁹/₁₆ in. (24.3 x 19.2 cm.)
Mount: 10 x 8 in. (25.4 x 20.3 cm.)
Signed, bottom center mount verso: "Berenice Abbott"
Inscription, print verso: [print is mounted, but illegible
inscription is visible in reverse]
mount verso: "304-7//258"
Acquired from: gift of P/K Associates, New York, New York

151. **GREENWICH VILLAGE, CORNER 10TH STREET**
(P1984.35.141)
Gelatin silver print. negative 1929–39, print 1978–79
Image: 9⁷/₁₆ x 7½ in. (24.0 x 19.0 cm.)
Mount: 10 x 8 in. (25.4 x 20.3 cm.)
Signed, bottom center mount verso: "Berenice Abbott"
Inscription, mount verso: "297-7//351"
Acquired from: gift of P/K Associates, New York, New York

152. **GREENWICH VILLAGE SERIES. GIRL WITH MYNAH
BIRD** (P1984.35.85)
Gelatin silver print. negative c. 1948, print 1978–79
Image: 7½ x 9⁹/₁₆ in. (19.0 x 24.3 cm.)
Mount: 8 x 10 in. (20.3 x 25.4 cm.)
Signed, l.r. mount recto: "BA"
Inscription, mount verso: "293//49-2" and rubber stamp
"BERENICE ABBOTT/ABBOT, MAINE 04406/ALL
RIGHTS RESERVED"
Acquired from: gift of P/K Associates, New York, New York

153. **GREENWICH VILLAGE, WEST 10TH STREET** (?)
(P1984.35.32)
Gelatin silver print. negative 1929–39, print 1978–79
Image: 7⅜ x 9½ in. (18.7 x 24.1 cm.)
Mount: 8 x 10 in. (20.3 x 25.4 cm.)
Signed, l.r. mount recto: "BA"
Inscription, print verso [print is mounted, but inscription is
visible in reverse]: "308-7 [illegible]"
mount verso: "308-7//240"
Acquired from: gift of P/K Associates, New York, New York

*154. **HACKER'S ART BOOKS [Greenwich Village, N.Y.]**
(P1984.35.325)
Gelatin silver print. negative 1947, print 1978–79
Image: 7⁹/₁₆ x 9½ in. (19.2 x 24.1 cm.)
Mount: 8 x 10 in. (20.3 x 25.4 cm.)
Signed, l.r. mount recto: "BA"
Inscription, mount verso: "163-4//540" and rubber stamp
"BERENICE ABBOTT/ABBOT, MAINE 04406/ALL
RIGHTS RESERVED"
Acquired from: gift of P/K Associates, New York, New York

155. **HARDWARE STORE 316 BOWERY AVE. [Hardware store,
316-318 Bowery]** (P1984.35.226)
Gelatin silver print. negative 1938, print 1978–79
Image: 7½ x 9⁹/₁₆ in. (19.0 x 24.3 cm.)
Mount: 8 x 10 in. (20.3 x 25.4 cm.)
Signed, l.r. mount recto: "BA"
Inscription, mount verso: "79-2 Hardware Store 316 Bowery
Ave.// 439" and rubber stamp "BERENICE ABBOTT/
ABBOT, MAINE 04406/ALL RIGHTS RESERVED"
Acquired from: gift of P/K Associates, New York, New York

156. **HARDWARE STORE, 316-318 BOWERY** (P1984.35.96)
Gelatin silver print. negative 1938, print 1978–79
Image: 7³/₁₆ x 9⁷/₁₆ in. (18.2 x 23.0 cm.)
Mount: 8 x 10 in. (20.3 x 25.4 cm.)
Signed, l.r. mount recto: "BA"
Inscription, mount verso: "233-5//305" and rubber stamp
"BERENICE ABBOTT/ABBOT, MAINE 04406/ALL
RIGHTS RESERVED"
Acquired from: gift of P/K Associates, New York, New York

157. **HARLEM** (P1984.35.506)
Gelatin silver print. negative 1938, print 1978–79
Image: 7½ x 9⁷/₁₆ in. (19.0 x 24.0 cm.)
Mount: 8 x 10 in. (20.3 x 25.4 cm.)
Signed, l.r. mount recto: "BA"
Inscription, mount verso: "97-2 Harlem//434" and rubber
stamp "BERENICE ABBOTT/ABBOT, MAINE 04406/
ALL RIGHTS RESERVED"
Acquired from: gift of P/K Associates, New York, New York

*158. **HARLEM ST, 422-424 LENOX AVE.** (P1984.35.228)
Gelatin silver print. negative 1938, print 1978–79
Image: 7½ x 9½ in. (19.0 x 24.0 cm.)
Mount: 8 x 10 in. (20.3 x 25.4 cm.)
Signed, l.r. mount recto: "BA"
Inscription, mount verso: "81-2 Harlem St 422-424/Lenox St
[sic] 6/14/38 //441" and rubber stamp "BERENICE
ABBOTT/ABBOT, MAINE 04406/ALL RIGHTS
RESERVED"
Acquired from: gift of P/K Associates, New York, New York

*159. **HARNESS SHOP** (P1984.35.97)
Gelatin silver print. negative 1929–39, print 1978–79
Image: 9⁷/₁₆ x 7½ in. (24.0 x 19.0 cm.)
Mount: 10 x 8 in. (25.4 x 20.3 cm.)
Signed, l.r. mount recto: "BA"
Inscription, mount verso: "234-5 Harness Shop//306" and
rubber stamp "BERENICE ABBOTT/ABBOT, MAINE
04406/ALL RIGHTS RESERVED"
Acquired from: gift of P/K Associates, New York, New York

160. **HELLGATE [Hellgate Bridge]** (P1984.35.215)
Gelatin silver print. negative 1937, print 1978–79
Image: 7½ x 9½ in. (19.0 x 24.1 cm.)
Mount: 8 x 10 in. (20.3 x 25.4 cm.)

Signed, l.r. mount recto: "BA"
Inscription, mount verso: "102-2 Hellgate//427" and rubber
 stamp "BERENICE ABBOTT/ABBOT, MAINE 04406/
 ALL RIGHTS RESERVED"
Acquired from: gift of P/K Associates, New York, New York

161. **HELLGATE [Hellgate Bridge]** (P1984.35.216)
Gelatin silver print. negative 1937, print 1978–79
Image: 7 9/16 x 9 1/2 in. (19.2 x 24.1 cm.)
Mount: 8 x 10 in. (20.3 x 25.4 cm.)
Signed, l.r. mount recto: "BA"
Inscription, mount verso: "99-2 Hellgate//428" and rubber
 stamp "BERENICE ABBOTT/ABBOT, MAINE 04406/
 ALL RIGHTS RESERVED"
Acquired from: gift of P/K Associates, New York, New York

162. **HELLGATE [Hellgate Bridge]** (P1984.35.217)
Gelatin silver print. negative 1937, print 1978–79
Image: 7 1/2 x 9 1/2 in. (19.0 x 24.1 cm.)
Mount: 8 x 10 in. (20.3 x 25.4 cm.)
Signed, l.r. mount recto: "BA"
Inscription, mount verso: "101-2 Hellgate//429" and rubber
 stamp "BERENICE ABBOTT/ABBOT, MAINE 04406/
 ALL RIGHTS RESERVED"
Acquired from: gift of P/K Associates, New York, New York

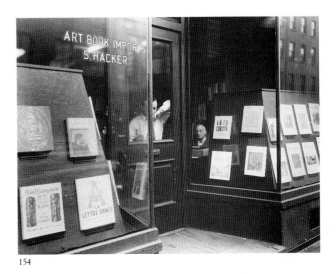

154

163. **HELLGATE [Hellgate Bridge]** (P1984.35.218)
Gelatin silver print. negative 1937, print 1978–79
Image: 7 1/2 x 9 9/16 in. (19.0 x 24.3 cm.)
Mount: 8 x 10 in. (20.3 x 25.4 cm.)
Signed, l.r. mount recto: "BA"
Inscription, mount verso: "99-2 Hellgate//430" and rubber
 stamp "BERENICE ABBOTT/ABBOT, MAINE 04406/
 ALL RIGHTS RESERVED"
Acquired from: gift of P/K Associates, New York, New York

164. **HELLGATE [Hellgate Bridge]** (P1984.35.219)
Gelatin silver print. negative 1937, print 1978–79
Image: 7 7/16 x 9 1/2 in. (18.9 x 24.1 cm.)
Mount: 8 x 10 in. (20.3 x 25.4 cm.)
Signed, l.r. mount recto: "BA"
Inscription, mount verso: "98-2 Hellgate//431" and rubber
 stamp "BERENICE ABBOTT/ABBOT, MAINE 04406/
 ALL RIGHTS RESERVED"
Acquired from: gift of P/K Associates, New York, New York

158

*165. **HERALD SQUARE** (P1984.35.275)
Gelatin silver print. negative 1936, print 1978–79
Image: 7 1/2 x 9 7/16 in. (19.0 x 24.0 cm.)
Mount: 8 x 10 in. (20.3 x 25.4 cm.)
Signed, l.r. mount recto: "BA"
Inscription, mount verso: "39-1//489" and rubber stamp
 "BERENICE ABBOTT/ABBOT, MAINE 04406/ALL
 RIGHTS RESERVED"
Acquired from: gift of P/K Associates, New York, New York

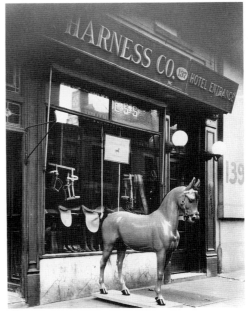

*166. **HESTER ST.** (P1984.35.68)
Gelatin silver print. negative 1929, print 1978–79
Image: 6 x 8 3/4 in. (15.2 x 22.2 cm.)
Mount: 8 x 10 in. (20.3 x 25.4 cm.)
Signed, l.r. mount recto: "BA"
Inscription, mount verso: "276//226-5 Hester St." and rubber
 stamp "BERENICE ABBOTT/ABBOT, MAINE 04406/
 ALL RIGHTS RESERVED"
Acquired from: gift of P/K Associates, New York, New York

167. **HOBOKEN FERRY TERMINAL, BARCLAY STREET**
 (P1984.35.20)
Gelatin silver print. negative 1935, print 1978–79
Image: 7 7/16 x 9 1/8 in. (18.9 x 23.8 cm.)
Mount: 8 x 10 in. (20.3 x 25.4 cm.)
Signed, l.r. mount recto: "BA"
Inscription, mount verso: "221//134-3" and rubber stamp
 "BERENICE ABBOTT/ABBOT, MAINE 04406/ALL
 RIGHTS RESERVED"
Acquired from: gift of P/K Associates, New York, New York

159

168. **HOBOKEN RAILROAD YARDS LOOKING TOWARDS MANHATTAN** (P1984.35.2)
Gelatin silver print. negative 1935, print 1978–79
Image: 7 7/16 x 9 3/8 in. (18.9 x 23.8 cm.)
Mount: 8 x 10 in. (20.3 x 25.4 cm.)
Signed, l.r. mount recto: "BA"
Inscription, mount verso: "36-1//203" and rubber stamp "BERENICE ABBOTT/ABBOT, MAINE 04406/ALL RIGHTS RESERVED"
Acquired from: gift of P/K Associates, New York, New York

*169. **HOSPITAL** (P1984.35.72)
Gelatin silver print. negative 1929–39, print 1978–79
Image: 7 1/2 x 9 7/16 in. (19.0 x 24.0 cm.)
Mount: 8 x 10 in. (20.3 x 25.4 cm.)
Signed, l.r. mount recto: "BA"
Inscription, mount verso: "280//227-5 Hospital" and rubber stamp "BERENICE ABBOTT/ABBOT, MAINE 04406/ALL RIGHTS RESERVED"
Acquired from: gift of P/K Associates, New York, New York

*170. **HOTEL BREVOORT, GREENWICH VILLAGE, N.Y.** (P1984.35.269)
Gelatin silver print. negative 1929–39, print 1978–79
Image: 9 7/16 x 7 1/2 in. (24.0 x 19.0 cm.)
Mount: 10 x 8 in. (25.4 x 20.3 cm.)
Signed, l.r. mount recto: "BA"
Inscription, mount verso: "131-3//483" and rubber stamp "BERENICE ABBOTT/ABBOT, MAINE 04406/ALL RIGHTS RESERVED"
Acquired from: gift of P/K Associates, New York, New York

171. **HOTEL COMMODORE** (P1984.35.255)
Gelatin silver print. negative 1929–39, print 1978–79
Image: 9 1/8 x 7 1/2 in. (23.2 x 19.0 cm.)
Mount: 10 x 8 in. (25.4 x 20.3 cm.)
Signed, l.r. mount recto: "BA"
Inscription, mount verso: "122-3//469" and rubber stamp "BERENICE ABBOTT/ABBOT, MAINE 04406/ALL RIGHTS RESERVED"
Acquired from: gift of P/K Associates, New York, New York

172. **ISAMU NOGUCHI** (P1984.35.313)
Gelatin silver print. negative 1947, print 1978–79
Image: 4 1/2 x 3 7/16 in. (11.4 x 8.7 cm.)
Mount: 10 x 8 in. (25.4 x 20.3 cm.)
Signed, l.r. mount recto: "BA—"
Inscription, mount recto: "Isamu Noguchi" and crop mark mount verso: "528" and rubber stamp "BERENICE ABBOTT/ABBOT, MAINE 04406/ALL RIGHTS RESERVED"
Acquired from: gift of P/K Associates, New York, New York

*173. **ISAMU NOGUCHI** (P1984.35.500)
Gelatin silver print. negative 1929, print 1978–79
Image: 2 7/16 x 3 3/8 in. (6.2 x 8.6 cm.)
Mount: 10 x 8 in. (25.4 x 20.3 cm.)
Signed, l.r. mount recto: "BA"
Inscription, mount recto: "Isamu Noguchi" mount verso: "579"
Acquired from: gift of P/K Associates, New York, New York

174. **JAMES JOYCE** (P1984.35.376)
Gelatin silver print. negative 1926, print 1978–79
Image: 4 7/16 x 3 5/16 in. (11.3 x 8.4 cm.)
Mount: 10 x 8 in. (25.4 x 20.3 cm.)
Signed, l.r. mount recto: "BA"
Inscription, mount verso: "James Joyce//593"
Acquired from: gift of P/K Associates, New York, New York

175. **JAMES JOYCE** (P1984.35.499)
Gelatin silver print. negative 1928, print 1978–79
Image: 4 7/16 x 3 1/4 in. (11.3 x 8.2 cm.)
Mount: 10 x 8 in. (25.4 x 20.3 cm.)
Signed, l.r. mount recto: "BA"
Inscription, mount verso: "James Joyce//612"
Acquired from: gift of P/K Associates, New York, New York

176. **JANE HEAP** (P1984.35.395)
Gelatin silver print. negative c. 1930, print 1978–79
Image: 4 3/8 x 3 5/16 in. (11.1 x 8.4 cm.)
Mount: 10 x 8 in. (25.4 x 20.3 cm.)
Signed, l.r. mount recto: "BA"
Inscription, mount verso: "Jane Heep [sic]//615" and rubber stamp "BERENICE ABBOTT/ABBOT, MAINE 04406/ALL RIGHTS RESERVED"
Acquired from: gift of P/K Associates, New York, New York

177. **JANE HEAP** (P1984.35.411)
Gelatin silver print. negative c. 1930, print 1978–79
Image: 4 3/8 x 3 3/8 in. (11.1 x 8.6 cm.)
Mount: 10 x 8 in. (25.4 x 20.3 cm.)
Signed, l.r. mount recto: "BA"
Inscription, mount recto: "Jane Heep [sic]" and crop marks mount verso: "632"
Acquired from: gift of P/K Associates, New York, New York

*178. **JANET FLANNER** (P1984.35.416)
Gelatin silver print. negative 1927, print 1978–79
Image: 4 3/8 x 3 3/8 in. (11.1 x 8.6 cm.)
Mount: 10 x 8 in. (25.4 x 20.3 cm.)
Signed, l.r. mount recto: "BA"
Inscription, mount recto: "Janet Flanner" and crop marks mount verso: "637"
Acquired from: gift of P/K Associates, New York, New York

179. **JANET FLANNER** (P1984.35.424)
Gelatin silver print. negative 1927, print 1978–79
Image: 4 3/8 x 3 5/16 in. (11.1 x 8.4 cm.)
Mount: 10 x 8 in. (25.4 x 20.3 cm.)
Signed, l.r. mount recto: "BA"
Inscription, mount verso: "Janet Flanner//645"
Acquired from: gift of P/K Associates, New York, New York

*180. **JEAN COCTEAU** (P1984.35.431)
Gelatin silver print. negative 1927, print 1978–79
Image: 3 3/8 x 4 7/16 in. (8.6 x 11.3 cm.)
Mount: 10 x 8 in. (25.4 x 20.3 cm.)
Signed, l.r. mount recto: "BA"
Inscription, mount recto: "Jean/Cocteau" and crop mark mount verso: "655" and rubber stamp "BERENICE ABBOTT/ABBOT, MAINE 04406/ALL RIGHTS RESERVED"
Acquired from: gift of P/K Associates, New York, New York

181. **JEAN GUÉRIN** (P1984.35.433)
Gelatin silver print. negative 1926–30, print 1978–79
Image: 3 1/4 x 2 7/16 in. (8.2 x 6.2 cm.)
Mount: 10 x 8 in. (25.4 x 20.3 cm.)
Signed, l.r. mount recto: "BA"
Inscription, mount recto: "Jean Guerin" and crop mark mount verso: "657" and rubber stamp "BERENICE ABBOTT/ABBOT, MAINE 04406/ALL RIGHTS RESERVED"
Acquired from: gift of P/K Associates, New York, New York

182. **JEAN GUÉRIN** (P1984.35.465)
Gelatin silver print. negative 1926–30, print 1978–79
Image: 3 3/16 x 2 1/16 in. (8.1 x 5.2 cm.)
Mount: 10 x 8 in. (25.4 x 20.3 cm.)
Signed, l.r. mount recto: "BA"
Inscription, mount verso: "Jean Guerin//689"
Acquired from: gift of P/K Associates, New York, New York

183. **JEAN GUÉRIN** (P1984.35.466)
Gelatin silver print. negative 1926–30, print 1978–79
Image: 3 1/8 x 2 3/8 in. (7.9 x 6.0 cm.)
Mount: 10 x 8 in. (25.4 x 20.3 cm.)
Signed, l.r. mount recto: "BA"
Inscription, mount verso: "Jean Guerin//690" and rubber stamp "BERENICE ABBOTT/ABBOT, MAINE 04406/ALL RIGHTS RESERVED"
Acquired from: gift of P/K Associates, New York, New York

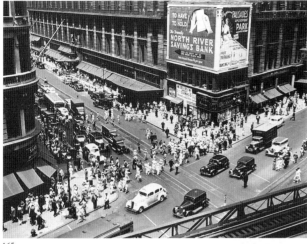

165

166

169

170

173

178

184. **JEAN PREVOST** (P1984.35.366)
Gelatin silver print. negative 1926–30, print 1978–79
Image: 3 ¼ x 2 ⅞₆ in. (8.2 x 6.2 cm.)
Mount: 10 x 8 in. (25.4 x 20.3 cm.)
Signed, l.r. mount recto: "BA"
Inscription, mount recto: "Jean Prevost"
 mount verso: "582"
Acquired from: gift of P/K Associates, New York, New York

185. **JEAN PREVOST** (P1984.35.367)
Gelatin silver print. negative 1926–30, print 1978–79
Image: 3 ³⁄₁₆ x 2 ⅛ in. (8.1 x 6.0 cm.)
Mount: 10 x 8 in. (25.4 x 20.3 cm.)
Signed, l.r. mount recto: "BA"
Inscription, mount recto: "Jean Prevost" and crop mark
 mount verso: "583"
Acquired from: gift of P/K Associates, New York, New York

186. **JEAN PREVOST** (P1984.35.494)
Gelatin silver print. negative 1926–30, print 1978–79
Image: 3 ³⁄₁₆ x 2 ⅛ in. (8.1 x 6.0 cm.)
Mount: 10 x 8 in. (25.4 x 20.3 cm.)
Signed, l.r. mount recto: "BA"
Inscription, mount recto: "Jean Prevost" and crop mark
 mount verso: "649" and rubber stamp "BERENICE
 ABBOTT/ABBOT, MAINE 04406/ALL RIGHTS
 RESERVED"
Acquired from: gift of P/K Associates, New York, New York

187. **JEFFERSON COURTHOUSE [Jefferson Market Courthouse,
Sixth Avenue at 10th Street]** (P1984.35.53)
Gelatin silver print. negative 1929–39, print 1978–79
Image: 9 ½ x 7 ½ in. (24.1 x 19.0 cm.)
Mount: 10 x 8 in. (25.4 x 20.3 cm.)
Signed, bottom center mount verso: "Berenice Abbott"
Inscription, print verso [print is mounted, but inscription is
 visible in reverse]: "307-9/[illegible]"
 mount verso: "307-7//261"
Acquired from: gift of P/K Associates, New York, New York

188. **JEFFERSON COURTHOUSE [Jefferson Market Courthouse,
Sixth Avenue at 10th Street]** (P1984.35.128)
Gelatin silver print. negative 1929–39, print 1978–79
Image: 9 ½ x 7 ⁹⁄₁₆ in. (24.1 x 19.2 cm.)
Mount: 10 x 8 in. (25.4 x 20.3 cm.)
Signed, l.r. mount recto: "BA"
Inscription, print verso [print is mounted, but inscription is
 visible in reverse]: "25-5 Jefferson Courthouse"
 mount verso: "225-5 Jefferson Courthouse//338" and rubber
 stamp "BERENICE ABBOTT/ABBOT, MAINE 04406/
 ALL RIGHTS RESERVED"
Acquired from: gift of P/K Associates, New York, New York

*189. **[Jersey City Ferry Terminal between Warren and Chambers
Streets and Piers 19 and 20 along the Hudson River]**
(P1984.35.327)
Gelatin silver print. negative 1929–39, print 1978–79
Image: 7 ⅛ x 9 ⁹⁄₁₆ in. (18.7 x 24.3 cm.)
Mount: 8 x 10 in. (20.3 x 25.4 cm.)
Signed, l.r. mount recto: "BA"
Inscription, mount verso: "160-4//542" and rubber stamp
 "BERENICE ABBOTT/ABBOT, MAINE 04406/ALL
 RIGHTS RESERVED"
Acquired from: gift of P/K Associates, New York, New York

*190. **JOHN SLOAN** (P1978.69)
Gelatin silver print. negative 1947, print later
Image: 9 ½ x 7 ⅝ in. (24.1 x 19.3 cm.)
Mount: 16 ¼ x 14 in. (42.5 x 35.6 cm.)
Signed, l.r. mount recto: "BERENICE ABBOTT"
Inscription, mount verso: "25//#18//0400//Box 13/14" and
 rubber stamp "PHOTOGRAPH/BERENICE ABBOTT/
 ABBOTT [sic], MAINE 04406"
Acquired from: Graphics International, Ltd.,
 Washington, D. C.

191. **JOHN WANAMAKER BUILDING, N.Y.** (P1984.35.280)
Gelatin silver print. negative 1933, print 1978–79
Image: 7 ⁵⁄₁₆ x 9 ⁷⁄₁₆ in. (18.5 x 24.0 cm.)
Mount: 8 x 10 in. (20.3 x 25.4 cm.)
Signed, l.r. mount recto: "BA"
Inscription, mount verso: "5-1//494" and rubber stamp
 "BERENICE ABBOTT/ABBOT, MAINE 04406/ALL
 RIGHTS RESERVED"
Acquired from: gift of P/K Associates, New York, New York

*192. **JOHN WANAMAKER BULDING, N.Y.** (P1984.35.286)
Gelatin silver print. negative 1933, print 1978–79
Image: 7 ⁵⁄₁₆ x 9 ⅜ in. (18.5 x 23.8 cm.)
Mount: 8 x 10 in. (20.3 x 25.4 cm.)
Signed, l.r. mount recto: "BA"
Inscription, mount verso: "4-1//500" and rubber stamp
 "BERENICE ABBOTT/ABBOT, MAINE 04406/ALL
 RIGHTS RESERVED"
Acquired from: gift of P/K Associates, New York, New York

193. **JOHN WATTS STATUE, FROM TRINITY CHURCH
LOOKING TOWARD ONE WALL STREET**
(P1984.35.200)
Gelatin silver print. negative 1938, print 1978–79
Image: 9 ½ x 7 ⁹⁄₁₆ in. (24.1 x 19.2 cm.)
Mount: 10 x 8 in. (25.4 x 20.3 cm.)
Signed, l.r. mount recto: "BA"
Inscription, mount verso: "164-4//410" and rubber stamp
 "BERENICE ABBOTT/ABBOT, MAINE 04406/ALL
 RIGHTS RESERVED"
Acquired from: gift of P/K Associates, New York, New York

194. **JOYCE [James Joyce]** (P1984.35.382)
Gelatin silver print. negative 1928, print 1978–79
Image: 4 ⁵⁄₁₆ x 3 ³⁄₁₆ in. (11.0 x 8.1 cm.)
Mount: 10 x 8 in. (25.4 x 20.3 cm.)
Signed, l.r. mount recto: "BA"
Inscription, mount recto: "Joyce" and crop marks
 mount verso: "601"
Acquired from: gift of P/K Associates, New York, New York

195. **JOYCE [James Joyce]** (P1984.35.392)
Gelatin silver print. negative 1928, print 1978–79
Image: 4 ⁷⁄₁₆ x 3 ⁵⁄₁₆ in. (11.3 x 8.4 cm.)
Mount: 10 x 8 in. (25.4 x 20.3 cm.)
Signed, l.r. mount recto: "BA"
Inscription, mount verso: "Joyce//611" and rubber stamp
 "BERENICE ABBOTT/ABBOT, MAINE 04406/ALL
 RIGHTS RESERVED"
Acquired from: gift of P/K Associates, New York, New York

196. **JOYCE [James Joyce]** (P1984.35.393)
Gelatin silver print. negative 1928, print 1978–79
Image: 4 ⁷⁄₁₆ x 3 ⅜ in. (11.3 x 8.6 cm.)
Mount: 10 x 8 in. (25.4 x 20.3 cm.)
Signed, l.r. mount recto: "BA"
Inscription, mount verso: "Joyce//613" and rubber stamp
 "BERENICE ABBOTT/ABBOT, MAINE 04406/ALL
 RIGHTS RESERVED"
Acquired from: gift of P/K Associates, New York, New York

*197. **JOYCE [James Joyce]** (P1984.35.404)
Gelatin silver print. negative 1926, print 1978–79
Image: 4 ⅝ x 3 ¹¹⁄₁₆ in. (11.7 x 9.4 cm.)
Mount: 10 x 8 in. (25.4 x 20.3 cm.)
Signed, l.r. mount recto: "BA"
Inscription, mount recto: "Joyce" and crop marks
 mount verso: "625" and rubber stamp "BERENICE
 ABBOTT/ABBOT, MAINE 04406/ALL RIGHTS
 RESERVED"
Acquired from: gift of P/K Associates, New York, New York

198. **JOYCE [James Joyce]** (P1984.35.449)
Gelatin silver print. negative 1926, print 1978–79
Image: 4 ⅜ x 3 ³⁄₁₆ in. (11.1 x 8.1 cm.)
Mount: 10 x 8 in. (25.4 x 20.3 cm.)

Signed, l.r. mount recto: "BA."
Inscription, mount recto: "Joyce" and crop marks
 mount verso: "673" and rubber stamp "BERENICE
 ABBOTT/ABBOT, MAINE 04406/ALL RIGHTS
 RESERVED"
Acquired from: gift of P/K Associates, New York, New York

180

199. **JULES ROMAINS** (P1984.35.486)
Gelatin silver print. negative 1926, print 1978–79
Image: 4 ⅜ x 3 ⅜ in. (11.1 x 8.6 cm.)
Mount: 10 x 8 in. (25.4 x 20.3 cm.)
Signed, l.r. mount recto: "BA"
Inscription, mount verso: "Jules Romain [sic]//710"
Acquired from: gift of P/K Associates, New York, New York

200. **JULES ROMAINS** (P1984.35.488)
Gelatin silver print. negative 1926, print 1978–79
Image: 4 ⅜ x 3 in. (11.1 x 7.6 cm.)
Mount: 10 x 8 in. (25.4 x 20.3 cm.)
Signed, l.r. mount recto: "BA"
Inscription, mount recto: crop marks
 mount verso: "Jules Romains//712"
Acquired from: gift of P/K Associates, New York, New York

201. **JULIA REINER** (P1984.35.389)
Gelatin silver print. negative 1927, print 1978–79
Image: 3 3/16 x 2 ¼ in. (8.1 x 5.7 cm.)
Mount: 10 x 8 in. (25.4 x 20.3 cm.)
Signed, l.r. mount recto: "BA"
Inscription, mount verso: "Julia Reiner//608"
Acquired from: gift of P/K Associates, New York, New York

189

202. **JULIA REINER** (P1984.35.394)
Gelatin silver print. negative 1927, print 1978–79
Image: 3 ¼ x 2 ½ in. (8.2 x 6.3 cm.)
Mount: 10 x 8 in. (25.4 x 20.3 cm.)
Signed, l.r. mount recto: "BA"
Inscription, mount recto: "Julia Reiner"
 mount verso: "614"
Acquired from: gift of P/K Associates, New York, New York

203. **JULIA REINER** (P1984.35.479)
Gelatin silver print. negative 1927, print 1978–79
Image: 4 7/16 x 3 7/16 in. (11.3 x 8.7 cm.)
Mount: 10 x 8 in. (25.4 x 20.3 cm.)
Signed, l.r. mount recto: "BA"
Inscription, mount recto: "Julia Reiner" and crop marks
 mount verso: "703"
Acquired from: gift of P/K Associates, New York, New York

204. **JULIA REINER** (P1984.35.481)
Gelatin silver print. negative 1927, print 1978–79
Image: 3 3/16 x 2 9/16 in. (8.1 x 6.5 cm.)
Mount: 10 x 8 in. (25.4 x 20.3 cm.)
Signed, l.r. mount recto: "BA"
Inscription, mount recto: "Julia Reiner"
 mount verso: "705"
Acquired from: gift of P/K Associates, New York, New York

190

*205. **KAUFFMAN'S SHOP** (P1984.35.15)
Gelatin silver print. negative 1929–39, print 1978–79
Image: 7 ½ x 9 ½ in. (19.0 x 24.1 cm.)
Mount: 8 x 10 in. (20.3 x 25.4 cm.)
Signed, l.r. mount recto: "BA"
Inscription, mount verso: "216//30-1" and rubber stamp
 "BERENICE ABBOTT/ABBOT, MAINE 04406/ALL
 RIGHTS RESERVED"
Acquired from: gift of P/K Associates, New York, New York

206. **KIKI PRESTON'S DAUGHTER** (P1984.35.451)
Gelatin silver print. negative 1926, print 1978–79
Image: 4 ⅜ x 3 ¼ in. (11.1 x 8.2 cm.)
Mount: 10 x 8 in. (25.4 x 20.3 cm.)
Signed, l.r. mount recto: "BA"
Inscription, mount verso: "Kiki Preston's daughter//675"
Acquired from: gift of P/K Associates, New York, New York

207. **LELIA WALKER** (P1984.35.428)
Gelatin silver print. negative c. 1930, print 1978–79
Image: 4 7/16 x 3 3/8 in. (11.3 x 8.6 cm.)
Mount: 10 x 8 in. (25.4 x 20.3 cm.)
Signed, l.r. mount recto: "BA"
Inscription, mount verso: "652"
Acquired from: gift of P/K Associates, New York, New York

*208. **LEO STEIN** (P1984.35.400)
Gelatin silver print. negative 1928, print 1978–79
Image: 3 1/4 x 2 7/16 in. (8.2 x 6.2 cm.)
Mount: 10 x 8 in. (25.4 x 20.3 cm.)
Signed, l.r. mount recto: "BA"
Inscription, mount recto: "Leo Stein"
 mount verso: "621"
Acquired from: gift of P/K Associates, New York, New York

209. **LEO STEIN** (P1984.35.403)
Gelatin silver print. negative 1928, print 1978–79
Image: 3 3/16 x 2 5/16 in. (8.1 x 5.8 cm.)
Mount: 10 x 8 in. (25.4 x 20.3 cm.)
Signed, l.r. mount recto: "BA"
Inscription, mount recto: "Leo Stein"
 mount verso: "624"
Acquired from: gift of P/K Associates, New York, New York

*210. **LEROY ST.—VILL.** (P1984.35.87)
Gelatin silver print. negative c. 1948, print 1978–79
Image: 9 1/2 x 7 9/16 in. (24.1 x 19.2 cm.)
Mount: 10 x 8 in. (25.4 x 20.3 cm.)
Signed, l.r. mount recto: "BA"
Inscription, mount verso: "48-2 le Ray St. [sic]—Vill.//295"
 and rubber stamp "BERENICE ABBOTT/ABBOT,
 MAINE 04406/ALL RIGHTS RESERVED"
Acquired from: gift of P/K Associates, New York, New York

211. **LEWIS HINE** [Lewis Hine, Dobbs Ferry, N.Y.]
 (P1984.35.310)
Gelatin silver print. negative 1938, print 1978–79
Image: 4 5/16 x 3 1/16 in. (11.0 x 7.8 cm.)
Mount: 10 x 8 in. (25.4 x 20.3 cm.)
Signed, l.r. mount recto: "BA"
Inscription, mount recto: "Lewis Hine" and crop mark
 mount verso: "525" and rubber stamp "BERENICE
 ABBOTT/ABBOT, MAINE 04406/ALL RIGHTS
 RESERVED"
Acquired from: gift of P/K Associates, New York, New York

212. **LEWIS HINE** [Lewis Hine, Dobbs Ferry, N.Y.]
 (P1984.35.314)
Gelatin silver print. negative 1938, print 1978–79
Image: 4 1/4 x 3 1/16 in. (10.8 x 7.8 cm.)
Mount: 10 x 8 in. (25.4 x 20.3 cm.)
Signed, l.r. mount recto: "BA"
Inscription, mount recto: "Lewis Hine" and crop mark
 mount verso: "529" and rubber stamp "BERENICE
 ABBOTT/ABBOT, MAINE 04406/ALL RIGHTS
 RESERVED"
Acquired from: gift of P/K Associates, New York, New York

*213. **LEWIS HINE** [Lewis Hine, Dobbs Ferry, N.Y.]
 (P1984.35.316)
Gelatin silver print. negative 1938, print 1978–79
Image: 4 3/8 x 3 1/16 in. (11.1 x 7.8 cm.)
Mount: 10 x 8 in. (25.4 x 20.3 cm.)
Signed, l.r. mount recto: "BA."
Inscription, mount recto: "Lewis Hine" and crop marks
 mount verso: "531" and rubber stamp "BERENICE
 ABBOTT/ABBOT, MAINE 04406/ALL RIGHTS
 RESERVED"
Acquired from: gift of P/K Associates, New York, New York

214. **LEWIS HINE** [Lewis Hine, Dobbs Ferry, N.Y.]
 (P1984.35.501)
Gelatin silver print. negative 1938, print 1978–79
Image: 4 3/8 x 3 1/4 in. (11.1 x 8.2 cm.)
Mount: 10 x 8 in. (25.4 x 20.3 cm.)

Signed, l.r. mount recto: "BA"
Inscription, mount recto: "Lewis Hine" and crop marks
 mount verso: "524" and rubber stamp "BERENICE
 ABBOTT/ABBOT, MAINE 04406/ALL RIGHTS
 RESERVED"
Acquired from: gift of P/K Associates, New York, New York

*215. **LITTLE CHURCH AROUND THE CORNER,
 NEW YORK** (P1984.35.71)
Gelatin silver print. negative 1929–39, print 1978–79
Image: 7 9/16 x 9 7/16 in. (19.2 x 24.0 cm.)
Mount: 8 x 10 in. (20.3 x 25.4 cm.)
Signed, l.r. mount recto: "BA"
Inscription, mount verso: "279//220-5" and rubber stamp
 "BERENICE ABBOTT/ABBOT, MAINE 04406/ALL
 RIGHTS RESERVED"
Acquired from: gift of P/K Associates, New York, New York

*216. **[Lower Manhattan from Battery Park showing the Standard
 Oil Building and the U.S. Custom House]** (P1984.35.317)
Gelatin silver print. negative 1957, print 1978–79
Image: 7 3/8 x 9 3/8 in. (18.7 x 23.8 cm.)
Mount: 8 x 10 in. (20.3 x 25.4 cm.)
Signed, l.r. mount recto: "BA"
Inscription, print verso: [print is mounted, but illegible
 inscription is visible in reverse]
 mount verso: "168-4//532" and rubber stamp "BERENICE
 ABBOTT/ABBOT, MAINE 04406/ALL RIGHTS
 RESERVED"
Acquired from: gift of P/K Associates, New York, New York

217. **LOWER WEST ST.** (P1984.35.99)
Gelatin silver print. negative 1936, print 1978–79
Image: 7 7/16 x 9 1/2 in. (18.9 x 24.1 cm.)
Mount: 8 x 10 in. (20.3 x 25.4 cm.)
Signed, l.r. mount recto: "BA"
Inscription, mount verso: "223-5 Lower West St.//308" and
 rubber stamp "BERENICE ABBOTT/ABBOT, MAINE
 04406/ALL RIGHTS RESERVED"
Acquired from: gift of P/K Associates, New York, New York

218. **LUCIA JOYCE** (P1984.35.383)
Gelatin silver print. negative 1927–29, print 1978–79
Image: 4 3/8 x 3 3/8 in. (11.1 x 8.6 cm.)
Mount: 10 x 8 in. (25.4 x 20.3 cm.)
Signed, l.r. mount recto: "BA"
Inscription, mount recto: "Lucia Joyce"
 mount verso: "602"
Acquired from: gift of P/K Associates, New York, New York

219. **LUCIA JOYCE** (P1984.35.385)
Gelatin silver print. negative 1927–29, print 1978–79
Image: 4 5/16 x 2 13/16 in. (11.0 x 7.1 cm.)
Mount: 10 x 8 in. (25.4 x 20.3 cm.)
Signed, l.r. mount recto: "BA"
Inscription, mount verso: "Lucia Joyce//604"
Acquired from: gift of P/K Associates, New York, New York

220. **LUCIA JOYCE** (P1984.35.387)
Gelatin silver print. negative 1927–29, print 1978–79
Image: 4 3/16 x 3 in. (10.6 x 7.6 cm.)
Mount: 10 x 8 in. (25.4 x 20.3 cm.)
Signed, l.r. mount recto: "BA"
Inscription, mount recto: crop mark
 mount verso: "Lucia Joyce//606"
Acquired from: gift of P/K Associates, New York, New York

*221. **LUCIA JOYCE** (P1984.35.405)
Gelatin silver print. negative 1927–29, print 1978–79
Image: 4 5/16 x 3 3/8 in. (11.0 x 8.6 cm.)
Mount: 10 x 8 in. (25.4 x 20.3 cm.)
Signed, l.r. mount recto: "BA—"
Inscription, mount recto: crop marks
 mount verso: "Lucia/Lucya/Joyce//626"
Acquired from: gift of P/K Associates, New York, New York

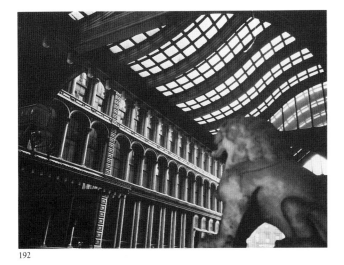

192

197

205

208

210

213

*222. **LYRIC THEATRE, 100 THIRD AVENUE** (P1984.35.73)
Gelatin silver print. negative 1936, print 1978—79
Image: 7 9/16 x 9 1/2 in. (19.2 x 24.1 cm.)
Mount: 8 x 10 in. (20.3 x 25.4 cm.)
Signed, l.r. mount recto: "BA"
Inscription, mount verso: "281//218-5" and rubber stamp
"BERENICE ABBOTT/ABBOT, MAINE 04406/ALL
RIGHTS RESERVED"
Acquired from: gift of P/K Associates, New York, New York

223. **LYRIC THEATRE, 100 THIRD AVENUE** (P1984.35.175)
Gelatin silver print. negative 1936, print 1978—79
Image: 7 1/2 x 9 1/2 in. (19.0 x 24.1 cm.)
Mount: 8 x 10 in. (20.3 x 25.4 cm.)
Signed, l.r. mount recto: "BA"
Inscription, mount verso: "68-2//385" and rubber stamp
"BERENICE ABBOTT/ABBOT, MAINE 04406/ALL
RIGHTS RESERVED"
Acquired from: gift of P/K Associates, New York, New York

224. **[MacDougal Alley, looking east]** (P1984.35.95)
Gelatin silver print. negative 1929—39, print 1978—79
Image: 9 9/16 x 7 5/8 in. (24.3 x 19.4 cm.)
Mount: 10 x 8 in. (25.4 x 20.3 cm.)
Signed, l.r. mount recto: "BA"
Inscription, mount verso: "217-5//304" and rubber stamp
"BERENICE ABBOTT/ABBOT, MAINE 04406/ALL
RIGHTS RESERVED"
Acquired from: gift of P/K Associates, New York, New York

225. **MacDOUGAL ALLEY VILL.** (P1984.35.98)
Gelatin silver print. negative 1929—39, print 1978—79
Image: 9 9/16 x 7 1/2 in. (24.3 x 19.0 cm.)
Mount: 10 x 8 in. (25.4 x 20.3 cm.)
Signed, l.r. mount recto: "BA."
Inscription, mount verso: "46-2/McDougal [sic] Alley
Vill.//307" and rubber stamp "BERENICE ABBOTT/
ABBOT, MAINE 04406/ALL RIGHTS RESERVED"
Acquired from: gift of P/K Associates, New York, New York

226. **MME GUÉRIN** (P1984.35.464)
Gelatin silver print. negative 1926—30, print 1978—79
Image: 3 1/4 x 2 3/8 in. (8.2 x 6.0 cm.)
Mount: 10 x 8 in. (25.4 x 20.3 cm.)
Signed, l.r. mount recto: "BA"
Inscription, mount recto: "Mme Guerin" and crop mark
mount verso: "688" and rubber stamp "BERENICE
ABBOTT/ABBOT, MAINE 04406/ALL RIGHTS
RESERVED"
Acquired from: gift of P/K Associates, New York, New York

227. **MME GUÉRIN** (P1984.35.484)
Gelatin silver print. negative 1926—30, print 1978—79
Image: 3 5/16 x 2 3/8 in. (8.4 x 6.0 cm.)
Mount: 10 x 8 in. (25.4 x 20.3 cm.)
Signed, l.r. mount recto: "BA"
Inscription, mount recto: "Mme Guerin" and crop mark
mount verso: "708"
Acquired from: gift of P/K Associates, New York, New York

228. **MME PAUL CLAUDEL [Reine Sainte Marie Perrin]**
(P1984.35.440)
Gelatin silver print. negative 1928, print 1978—79
Image: 4 1/2 x 3 7/16 in. (11.4 x 8.7 cm.)
Mount: 10 x 8 in. (25.4 x 20.3 cm.)
Signed, l.r. mount recto: "BA"
Inscription, mount verso: "Mme Paul Claudel//664"
Acquired from: gift of P/K Associates, New York, New York

229. **MME PAUL CLAUDEL [Reine Sainte Marie Perrin]**
(P1984.35.442)
Gelatin silver print. negative 1928, print 1978—79
Image: 4 7/16 x 3 3/8 in. (11.3 x 8.6 cm.)
Mount: 10 x 8 in. (25.4 x 20.3 cm.)
Signed, l.r. mount recto: "BA"
Inscription, mount verso: "Mme Paul Claudel//666"
Acquired from: gift of P/K Associates, New York, New York

230. **MME PAUL CLAUDEL [Reine Sainte Marie Perrin]**
(P1984.35.443)
Gelatin silver print. negative 1928, print 1978—79
Image: 4 3/8 x 3 3/8 in. (11.1 x 8.6 cm.)
Mount: 10 x 8 in. (25.4 x 20.3 cm.)
Signed, l.r. mount recto: "BA"
Inscription, mount verso: "Mme Paul Claudel//667"
Acquired from: gift of P/K Associates, New York, New York

231. **MME RENÉ CLAIR [Bronja Perlmutter]** (P1984.35.377)
Gelatin silver print. negative 1926, print 1978—79
Image: 3 1/4 x 2 3/8 in. (8.2 x 6.0 cm.)
Mount: 10 x 8 in. (25.4 x 20.3 cm.)
Signed, l.r. mount recto: "BA—"
Inscription, mount verso: "Mme René Clair//594"
Acquired from: gift of P/K Associates, New York, New York

232. **MADISON SQUARE** (P1984.35.94)
Gelatin silver print. negative c. 1930, print 1978—79
Image: 9 3/8 x 7 7/16 in. (23.8 x 18.9 cm.)
Mount: 10 x 8 in. (25.4 x 20.3 cm.)
Signed, l.r. mount recto: "BA."
Inscription, mount verso: "219-5 MADISON Square//302"
and rubber stamp "BERENICE ABBOTT/ABBOT,
MAINE 04406/ALL RIGHTS RESERVED"
Acquired from: gift of P/K Associates, New York, New York

*233. **MAN ON BROOKLYN BRIDGE** (P1984.35.192)
Gelatin silver print. negative c. 1934, print 1978—79
Image: 5 1/16 x 6 15/16 in. (12.8 x 17.6 cm.)
Mount: 10 x 8 in. (25.4 x 20.3 cm.)
Signed, l.r. mount recto: "BA"
Inscription, mount verso: "402" and rubber stamp
"BERENICE ABBOTT/ABBOT, MAINE 04406/ALL
RIGHTS RESERVED"
Acquired from: gift of P/K Associates, New York, New York

*234. **MANHATTAN BRIDGE (ABBOTT'S FIRST
PHOTOGRAPH WITH CENTURY UNIVERSAL
CAMERA)** (P1984.35.108)
Gelatin silver print. negative c. 1931, print 1978—79
Image: 9 1/4 x 7 1/2 in. (23.5 x 19.0 cm.)
Mount: 10 x 8 in. (25.4 x 20.3 cm.)
Signed, l.r. mount recto: "BA"
Inscription, print verso: [print is mounted, but illegible
inscription is visible in reverse]
mount verso: "195-5//317" and rubber stamp "BERENICE
ABBOTT/ABBOT, MAINE 04406/ALL RIGHTS
RESERVED"
Acquired from: gift of P/K Associates, New York, New York

235. **[Manhattan Bridge and FDR/East River Drive]** (P1984.35.196)
Gelatin silver print. negative 1937—39, print 1978—79
Image: 6 3/16 x 4 5/8 in. (15.7 x 11.7 cm.)
Mount: 10 x 8 in. (25.4 x 20.3 cm.)
Signed, l.r. mount recto: "BA"
Inscription, mount verso: "151-4//406" and rubber stamp
"BERENICE ABBOTT/ABBOT, MAINE 04406/ALL
RIGHTS RESERVED"
Acquired from: gift of P/K Associates, New York, New York

236. **[Manhattan Bridge and FDR/East River Drive]** (P1984.35.198)
Gelatin silver print. negative 1937—39, print 1978—79
Image: 6 3/16 x 4 5/8 in. (15.7 x 11.7 cm.)
Mount: 10 x 8 in. (25.4 x 20.3 cm.)
Signed, l.r. mount recto: "BA"
Inscription, mount verso: "150-4//408" and rubber stamp
"BERENICE ABBOTT/ABBOT, MAINE 04406/ALL
RIGHTS RESERVED"
Acquired from: gift of P/K Associates, New York, New York

27

215

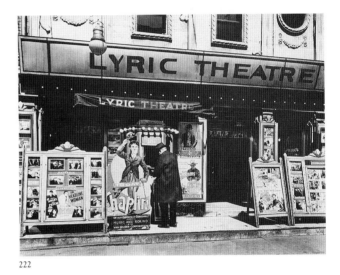
216

221

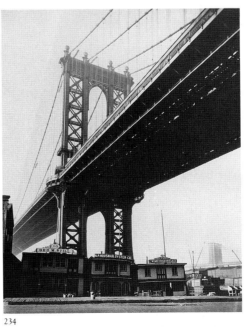
222

233

234

237. **MANHATTAN 1848, OLD HOUSE, WEEHAWKEN ST.**
[Oldest frame house in Manhattan, Weehawken Street]
(P1984.35.234)
Gelatin silver print. negative 1935, print 1978–79
Image: 7½ x 9½ in. (19.0 x 24.1 cm.)
Mount: 8 x 10 in. (20.3 x 25.4 cm.)
Signed, l.r. mount recto: "BA"
Inscription, mount verso: "89-2 Manhatten [sic]
1848/Old House/ Wheauken [sic] St.//447" and rubber
stamp "BERENICE ABBOTT/ ABBOT, MAINE 04406/
ALL RIGHTS RESERVED"
Acquired from: gift of P/K Associates, New York, New York

238. **MANHATTAN FROM PIER 11, SOUTH STREET AND
JONES LANE** (P1984.35.266)
Gelatin silver print. negative 1936, print 1978–79
Image: 7⁷⁄₁₆ x 9⁹⁄₁₆ in. (18.9 x 24.3 cm.)
Mount: 8 x 10 in. (20.3 x 25.4 cm.)
Signed, l.r. mount recto: "BA"
Inscription, mount verso: "29-1//480" and rubber stamp
"BERENICE ABBOTT/ABBOT, MAINE 04406/ALL
RIGHTS RESERVED"
Acquired from: gift of P/K Associates, New York, New York

239. **[Manhattan from West Street near the Hudson River]**
(P1984.35.295)
Gelatin silver print. negative 1929–39, print 1978–79
note: this print is printed backwards
Image: 7¼ x 9⁷⁄₁₆ in. (18.4 x 24.0 cm.)
Mount: 8⅛ x 10 in. (20.6 x 25.4 cm.)
Signed, l.r. mount recto: "BA"
Inscription, mount verso: "152-4//509" and rubber stamp
"BERENICE ABBOTT/ABBOT, MAINE 04406/ALL
RIGHTS RESERVED"
Acquired from: gift of P/K Associates, New York, New York

240. **MANHATTAN SKYLINE, FROM BOULEVARD EAST
AND HUDSON PLACE, WEEHAWKEN, NEW JERSEY**
(P1984.35.189)
Gelatin silver print. negative 1937, print 1978–79
Image: 4⁷⁄₁₆ x 6⁹⁄₁₆ in. (11.3 x 16.7 cm.)
Mount: 10 x 8 in. (25.4 x 20.3 cm.)
Signed, l.r. mount recto: "BA"
Inscription, mount verso: "399" and rubber stamp
"BERENICE ABBOTT/ABBOT, MAINE 04406/ALL
RIGHTS RESERVED"
Acquired from: gift of P/K Associates, New York, New York

241. **MARCELLE AUCLAIR** (P1984.35.489)
Gelatin silver print. negative 1926–30, print 1978–79
Image: 3⁵⁄₁₆ x 2⅜ in. (8.4 x 6.0 cm.)
Mount: 10 x 8 in. (25.4 x 20.3 cm.)
Signed, l.r. mount recto: "BA"
Inscription, mount verso: "Marcelle Auclair//713"
Acquired from: gift of P/K Associates, New York, New York

242. **MARGARET ANDERSON** (P1984.35.372)
Gelatin silver print. negative 1930, print 1978–79
Image: 4⁷⁄₁₆ x 3⅛ in. (11.3 x 7.9 cm.)
Mount: 10 x 8 in. (25.4 x 20.3 cm.)
Signed, l.r. mount recto: "BA"
Inscription, mount verso: "Margaret Anderson//589"
Acquired from: gift of P/K Associates, New York, New York

*243. **MARGARET ANDERSON** (P1984.35.418)
Gelatin silver print. negative 1930, print 1978–79
Image: 4⁵⁄₁₆ x 3⁷⁄₁₆ in. (11.0 x 8.7 cm.)
Mount: 10 x 8 in. (25.4 x 20.3 cm.)
Signed, l.r. mount recto: "BA"
Inscription, mount recto: "Margaret Anderson"
and crop marks
mount verso: "639"
Acquired from: gift of P/K Associates, New York, New York

244. **MARGARET ANDERSON'S NEPHEW** (P1984.35.473)
Gelatin silver print. negative 1926–30, print 1978–79
Image: 3¼ x 2⅜ in. (8.2 x 6.0 cm.)
Mount: 10 x 8 in. (25.4 x 20.3 cm.)
Signed, l.r. mount recto: "BA"
Inscription, mount verso: "697"
Acquired from: gift of P/K Associates, New York, New York

245. **MARGARET ANDERSON'S NEPHEW** (P1984.35.475)
Gelatin silver print. negative 1926–30, print 1978–79
Image: 3¼ x 2⁷⁄₁₆ in. (8.2 x 6.2 cm.)
Mount: 10 x 8 in. (25.4 x 20.3 cm.)
Signed, l.r. mount recto: "BA"
Inscription, mount verso: "Margaret Anderson's
nephew//699" and rubber stamp "BERENICE ABBOTT/
ABBOT, MAINE 04406/ALL RIGHTS RESERVED"
Acquired from: gift of P/K Associates, NewYork, NewYork

*246. **MARKET SLIP** (P1984.35.78)
Gelatin silver print. negative 1929–39, print 1978–79
Image: 7⁵⁄₁₆ x 9½ in. (18.5 x 24.1 cm.)
Mount: 8 x 10 in. (20.3 x 25.4 cm.)
Signed, l.r. mount recto: "BA"
Inscription, mount verso: "286//212-5 Market Slip" and
rubber stamp "BERENICE ABBOTT/ABBOT,
MAINE 04406/ALL RIGHTS RESERVED"
Acquired from: gift of P/K Associates, NewYork, NewYork

*247. **MARY MULLER'S ANTIQUE SHOP—VILLAGE**
(P1984.35.86)
Gelatin silver print. negative 1929–39, print 1978–79
Image: 7⁷⁄₁₆ x 9½ in. (18.9 x 24.1 cm.)
Mount: 8 x 10 in. (20.3 x 25.4 cm.)
Signed, l.r. mount recto: "BA"
Inscription, mount verso: "294//47-2/Mary Miller's [sic]
Antique Shop—Villiage [sic]" and rubber stamp
"BERENICE ABBOTT/ABBOT, MAINE 04406/ALL
RIGHTS RESERVED"
Acquired from: gift of P/K Associates, NewYork, NewYork

248. **[Mary Muller's Antique Shop—Village, West 10th Street and
Greenwich Avenue]** (P1984.35.265)
Gelatin silver print. negative 1929–39, print 1978–79
Image: 9⅝ x 7⁹⁄₁₆ in. (24.4 x 19.2 cm.)
Mount: 10 x 8 in. (25.4 x 20.3 cm.)
Signed, l.r. mount recto: "BA"
Inscription, mount verso: "28-1//479" and rubber stamp
"BERENICE ABBOTT/ABBOT, MAINE 04406/ALL
RIGHTS RESERVED"
Acquired from: gift of P/K Associates, NewYork, NewYork

249. **MARY TORR** (P1984.35.439)
Gelatin silver print. negative 1926–30, print 1978–79
Image: 3¼ x 2⁷⁄₁₆ in. (8.2 x 6.2 cm.)
Mount: 10 x 8 in. (25.4 x 20.3 cm.)
Signed, l.r. mount recto: "BA"
Inscription, mount recto: "Mary Torr" and crop mark
mount verso: "663"
Acquired from: gift of P/K Associates, NewYork, NewYork

*250. **MARY TORR** (P1984.35.448)
Gelatin silver print. negative 1926–30, print 1978–79
Image: 3¼ x 2³⁄₁₆ in. (8.2 x 5.5 cm.)
Mount: 10 x 8 in. (25.4 x 20.3 cm.)
Signed, l.r. mount recto: "BA"
Inscription, mount verso: "Mary Torr//672"
Acquired from: gift of P/K Associates, New York, New York

*251. **MAX ERNST** (P1984.35.402)
Gelatin silver print. negative c. 1929, print 1978–79
Image: 3⅛ x 2⅜ in. (7.9 x 6.0 cm.)
Mount: 10 x 8 in. (25.4 x 20.3 cm.)
Signed, l.r. mount recto: "BA"
Inscription, mount verso: "Max Ernst//623" and rubber stamp
"BERENICE ABBOTT/ABBOT, MAINE 04406/ALL
RIGHTS RESERVED"
Acquired from: gift of P/K Associates, New York, New York

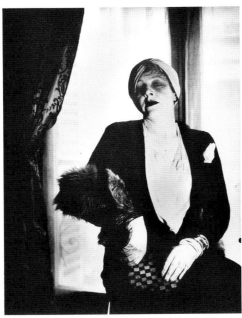

243

246

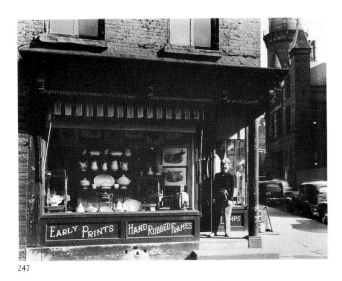

247

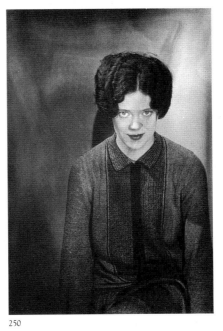

250

251

253

252. **[Midtown Manhattan looking northeast]** (P1984.35.164)
Gelatin silver print. negative 1929–39, print 1978–79
Image: 7 1/4 x 4 13/16 in. (18.4 x 12.2 cm.)
Mount: 10 x 8 in. (25.4 x 20.3 cm.)
Signed, bottom center mount verso: "Berenice Abbott"
Inscription, mount verso: "327-7//374"
Acquired from: gift of P/K Associates, New York, New York

*253. **MIDTOWN TUNNEL, UNFINISHED** (P1984.35.63)
Gelatin silver print. negative 1936–39, print 1978–79
Image: 4 1/2 x 6 9/16 in. (11.4 x 16.7 cm.)
Mount: 10 x 8 in. (25.4 x 20.3 cm.)
Signed, bottom center mount verso: "Berenice Abbott"
Inscription, mount verso: "325-7//271"
Acquired from: gift of P/K Associates, New York, New York

254. **MIDTOWN TUNNEL, UNFINISHED** (P1984.35.195)
Gelatin silver print. negative 1936–39, print 1978–79
Image: 6 5/8 x 4 9/16 in. (16.8 x 11.6 cm.)
Mount: 10 x 8 in. (25.4 x 20.3 cm.)
Signed, l.r. mount recto: "BA"
Inscription, mount verso: "26-1//405" and rubber stamp
"BERENICE ABBOTT/ABBOT, MAINE 04406/ALL
RIGHTS RESERVED"
Acquired from: gift of P/K Associates, New York, New York

255. **MIDTOWN TUNNEL, UNFINISHED** (P1984.35.264)
Gelatin silver print. negative 1936–39, print 1978–79
Image: 6 9/16 x 4 5/8 in. (16.7 x 11.7 cm.)
Mount: 10 x 8 in. (25.4 x 20.3 cm.)
Signed, l.r. mount recto: "BA"
Inscription, mount verso: "22-1//478" and rubber stamp
"BERENICE ABBOTT/ABBOT, MAINE 04406/ALL
RIGHTS RESERVED"
Acquired from: gift of P/K Associates, New York, New York

256. **MIDTOWN TUNNEL, UNFINISHED** (P1984.35.272)
Gelatin silver print. negative 1936–39, print 1978–79
Image: 4 9/16 x 6 5/8 in. (11.6 x 16.8 cm.)
Mount: 10 x 8 in. (25.4 x 20.3 cm.)
Signed, l.r. mount recto: "BA"
Inscription, mount verso: "22-1//486" and rubber stamp
"BERENICE ABBOTT/ABBOT, MAINE 04406/ALL
RIGHTS RESERVED"
Acquired from: gift of P/K Associates, New York, New York

*257. **[Miners' housing]** (P1984.35.245)
Gelatin silver print. negative 1935, print 1978–79
Image: 7 7/16 x 9 7/16 in. (18.9 x 24.0 cm.)
Mount: 8 x 10 in. (20.3 x 25.4 cm.)
Signed, l.r. mount recto: "BA"
Inscription, mount verso: "458" and rubber stamp
"BERENICE ABBOTT/ABBOT, MAINE 04406/ALL
RIGHTS RESERVED"
Acquired from: gift of P/K Associates, New York, New York

258. **MISS ALLEN** (P1984.35.445)
Gelatin silver print. negative 1926, print 1978–79
Image: 3 3/16 x 2 1/4 in. (8.1 x 5.7 cm.)
Mount: 10 x 8 in. (25.4 x 20.3 cm.)
Signed, l.r. mount recto: "BA."
Inscription, mount recto: "Miss Allen" and crop marks
mount verso: "669" and rubber stamp "BERENICE
ABBOTT/ABBOT, MAINE 04406/ALL RIGHTS
RESERVED"
Acquired from: gift of P/K Associates, New York, New York

259. **M. CAILLAUX [Joseph Marie Auguste Caillaux]**
(P1984.35.438)
Gelatin silver print. negative 1926–30, print 1978–79
Image: 4 3/8 x 3 5/16 in. (11.1 x 8.4 cm.)
Mount: 10 x 8 in. (25.4 x 20.3 cm.)
Signed, l.r. mount recto: "BA"
Inscription, mount recto: "M. Caillaux"
mount verso: "662"
Acquired from: gift of P/K Associates, New York, New York

260. **M. GUÉRIN** (P1984.35.477)
Gelatin silver print. negative 1926–30, print 1978–79
Image: 2 15/16 x 2 7/16 in. (7.4 x 6.2 cm.)
Mount: 10 x 8 in. (25.4 x 20.3 cm.)
Signed, l.r. mount recto: "BA"
Inscription, mount recto: "M. Guerin"
mount verso: "701"
Acquired from: gift of P/K Associates, New York, New York

261. **M. GUÉRIN** (P1984.35.493)
Gelatin silver print. negative 1926–30, print 1978–79
Image: 3 3/16 x 2 7/16 in. (8.1 x 6.2 cm.)
Mount: 10 x 8 in. (25.4 x 20.3 cm.)
Signed, l.r. mount recto: "BA"
Inscription, mount recto: "M. Guerin" and crop mark
mount verso: "717" and rubber stamp "BERENICE
ABBOTT/ABBOT, MAINE 04406/ALL RIGHTS
RESERVED"
Acquired from: gift of P/K Associates, New York, New York

*262. **["Moss Rose" movie billboard, Palisades Amusement Park,
N.J.]** (P1984.35.193)
Gelatin silver print. negative c. 1947, print 1978–79
Image: 7 3/8 x 9 3/8 in. (18.7 x 23.8 cm.)
Mount: 8 x 10 in. (20.3 x 25.4 cm.)
Signed, l.r. mount recto: "BA"
Inscription, mount verso: "403" and rubber stamp
"BERENICE ABBOTT/ ABBOT, MAINE 04406/ALL
RIGHTS RESERVED"
Acquired from: gift of P/K Associates, New York, New York

263. **MURDER OF A HOUSE (MARK TWAIN)** (P1984.35.116)
Gelatin silver print. negative c. early 1950s, print 1978–79
Image: 9 1/2 x 7 9/16 in. (24.1 x 19.2 cm.)
Mount: 10 x 8 in. (25.4 x 20.3 cm.)
Signed, l.r. mount recto: "BA"
Inscription, mount verso: "144-4//327"
Acquired from: gift of P/K Associates, New York, New York

264. **MURDER OF A HOUSE (MARK TWAIN)** (P1984.35.185)
Gelatin silver print. negative c. early 1950s, print 1978–79
Image: 9 1/2 x 7 1/2 in. (24.1 x 19.0 cm.)
Mount: 10 x 8 in. (25.4 x 20.3 cm.)
Signed, l.r. mount recto: "BA"
Inscription, mount verso: "145-4//395"
Acquired from: gift of P/K Associates, New York, New York

265. **MURDER OF A HOUSE (MARK TWAIN)** (P1984.35.336)
Gelatin silver print. negative c. early 1950s, print 1978–79
Image: 9 1/2 x 7 9/16 in. (24.1 x 19.2 cm.)
Mount: 10 x 8 in. (25.4 x 20.3 cm.)
Signed, l.r. mount recto: "BA:"
Inscription, mount recto: "Murder of a House (Mark Twain)"
mount verso: "147-4//551" and rubber stamp "BERENICE
ABBOTT/ ABBOT, MAINE 04406/ALL RIGHTS
RESERVED"
Acquired from: gift of P/K Associates, New York, New York

266. **MURRAY HILL HOTEL, 112 PARK AVENUE**
(P1984.35.174)
Gelatin silver print. negative 1935, print 1978–79
Image: 9 9/16 x 7 9/16 in. (24.3 x 19.2 cm.)
Mount: 10 x 8 in. (25.4 x 20.3 cm.)
Signed, l.r. mount recto: "BA"
Inscription, mount verso: "67-2//384" and rubber stamp
"BERENICE ABBOTT/ABBOT, MAINE 04406/ALL
RIGHTS RESERVED"
Acquired from: gift of P/K Associates, New York, New York

*267. **THE NAPOLITANA KITCHEN, GREENWICH
VILLAGE, N.Y.** (P1984.35.324)
Gelatin silver print. negative 1948–49, print 1978–79
Image: 9 1/2 x 7 9/16 in. (24.1 x 19.2 cm.)
Mount: 10 x 8 in. (25.4 x 20.3 cm.)
Signed, l.r. mount recto: "BA"

Inscription, mount verso: "161-4//539" and rubber stamp "BERENICE ABBOTT/ABBOT, MAINE 04406/ALL RIGHTS RESERVED"
Acquired from: gift of P/K Associates, New York, New York

268. **THE NAPOLITANA KITCHEN, GREENWICH VILLAGE, N.Y.** (P1984.35.349)
Gelatin silver print. negative 1948–49, print 1978–79
Image: 9 7/16 x 7 1/2 in. (24.0 x 19.0 cm.)
Mount: 10 x 8 in. (25.4 x 20.3 cm.)
Signed, l.r. mount recto: "B.A."
Inscription, mount verso: "154-4//564" and rubber stamp "BERENICE ABBOTT/ABBOT, MAINE 04406/ALL RIGHTS RESERVED"
Acquired from: gift of P/K Associates, New York, New York

*269. **NEW WEST SIDE STATION** (P1984.35.129)
Gelatin silver print. negative 1936–39, print 1978–79
Image: 7 9/16 x 9 1/2 in. (19.2 x 24.1 cm.)
Mount: 8 x 10 in. (20.3 x 25.4 cm.)
Signed, l.r. mount recto: "BA"
Inscription, print verso [print is mounted, but inscription is visible in reverse]: "201-5/New West [illegible]"
mount verso: "339//201-5/New West Side STATION" and rubber stamp "BERENICE ABBOTT/ABBOT, MAINE 04406/ALL RIGHTS RESERVED"
Acquired from: gift of P/K Associates, New York, New York

270. **NEW WEST ST.** (P1984.35.112)
Gelatin silver print. negative 1929–39, print 1978–79
Image: 7 1/2 x 9 1/2 in. (19.0 x 24.1 cm.)
Mount: 8 x 10 in. (20.3 x 25.4 cm.)
Signed, l.r. mount recto: "BA"
Inscription, mount verso: "321//200-5/New West St." and rubber stamp "BERENICE ABBOTT/ABBOT, MAINE 04406/ALL RIGHTS RESERVED"
Acquired from: gift of P/K Associates, New York, New York

271. **N.Y.** (P1984.35.106)
Gelatin silver print. negative 1929–39, print 1978–79
Image: 7 1/2 x 9 3/8 in. (19.0 x 23.8 cm.)
Mount: 8 x 10 in. (20.3 x 25.4 cm.)
Signed, l.r. mount recto: "BA"
Inscription, print verso [print is mounted, but inscription is visible in reverse]: "198-5/N.Y."
mount verso: "198-5 N.Y.//315" and rubber stamp "BERENICE ABBOTT/ABBOT, MAINE 04406/ALL RIGHTS RESERVED"
Acquired from: gift of P/K Associates, New York, New York

272. **NEW YORK AT NIGHT** (P1978.25.2) duplicate of P1984.35.110
Gelatin silver print. negative 1933, print later
Image: 13 5/8 x 10 9/16 in. (34.5 x 26.8 cm.)
Mount: 19 15/16 x 16 1/8 in. (50.6 x 40.9 cm.)
Signed, l.r. mount recto: "BERENICE ABBOTT"
Acquired from: The Halsted Gallery, Birmingham, Michigan

273. **NEW YORK AT NIGHT** (P1984.35.110) duplicate of P1978.25.2
Gelatin silver print. negative 1933, print 1978–79
Image: 9 5/8 x 7 3/8 in. (24.4 x 18.7 cm.)
Mount: 10 x 8 in. (25.4 x 20.3 cm.)
Signed, l.r. mount recto: "BA"
Inscription, mount verso: 205-5//319" and rubber stamp "BERENICE ABBOTT/ABBOT, MAINE 04406/ALL RIGHTS RESERVED"
Acquired from: gift of P/K Associates, New York, New York

274. **NEW YORK AT NIGHT WITH FOG** (P1984.35.163)
Gelatin silver print. negative 1929–39, print 1978–79
Image: 9 1/2 x 7 1/2 in. (24.1 x 19.0 cm.)
Mount: 10 x 8 in. (25.4 x 20.3 cm.)
Signed, bottom center mount verso: "Berenice Abbott"
Inscription, mount verso: "235-6//373"
Acquired from: gift of P/K Associates, New York, New York

257

262

267

275. **N.Y. COMPARISONS** (P1984.35.107)
Gelatin silver print. negative 1929—39, print 1978—79
Image: 7 9/16 x 9 5/8 in. (19.2 x 24.4 cm.)
Mount: 8 x 10 in. (20.3 x 25.4 cm.)
Signed, l.r. mount recto: "BA"
Inscription, mount verso: "316//199-5 N.Y. Comparisons" and
rubber stamp "BERENICE ABBOTT/ABBOT, MAINE
04406/ALL RIGHTS RESERVED"
Acquired from: gift of P/K Associates, New York, New York

276. **N.Y. COMPOSITION** (P1984.35.60)
Gelatin silver print. negative 1929—39, print 1978—79
Image: 7 3/8 x 9 3/8 in. (18.7 x 23.8 cm.)
Mount: 8 x 10 in. (20.3 x 25.4 cm.)
Signed, bottom center mount verso: "Berenice Abbott"
Inscription, mount verso: "319-7//268"
Acquired from: gift of P/K Associates, New York, New York

277. **N.Y. COMPOSITION** (P1984.35.117)
Gelatin silver print. negative 1929—39, print 1978—79
Image: 7 3/8 x 9 3/8 in. (18.7 x 23.8 cm.)
Mount: 8 x 10 in. (20.3 x 25.4 cm.)
Signed, l.r. mount recto: "B.A."
Inscription, mount verso: "292-7//328"
Acquired from: gift of P/K Associates, New York, New York

278. **N.Y. COMPOSITION** (P1984.35.229)
Gelatin silver print. negative 1929—39, print 1978—79
Image: 7 9/16 x 9 1/2 in. (19.2 x 24.1 cm.)
Mount: 8 x 10 in. (20.3 x 25.4 cm.)
Signed, l.r. mount recto: "BA"
Inscription, mount verso: "83-2 N.Y. Composition//442" and
rubber stamp "BERENICE ABBOTT/ABBOT, MAINE
04406/ALL RIGHTS RESERVED"
Acquired from: gift of P/K Associates, New York, New York

279. **[New York Institute of Modern Psychology, doorway]**
(P1984.35.346)
Gelatin silver print. negative 1929—39, print 1978—79
Image: 4 11/16 x 3 5/8 in. (11.9 x 9.2 cm.)
Mount: 10 x 8 in. (25.4 x 20.3 cm.)
Signed, l.r. mount recto: "BA"
Inscription, mount verso: "18-1//561" and rubber stamp
"BERENICE ABBOTT/ABBOT, MAINE 04406/ALL
RIGHTS RESERVED"
Acquired from: gift of P/K Associates, New York, New York

*280. **[New York Institute of Modern Psychology, doorway]**
(P1984.35.354)
Gelatin silver print. negative 1929—39, print 1978—79
Image: 4 5/8 x 3 1/2 in. (11.7 x 8.9 cm.)
Mount: 10 x 8 1/8 in. (25.4 x 20.5 cm.)
Signed, l.r. mount recto: "BA"
Inscription, mount verso: "18-1//569" and rubber stamp
"BERENICE ABBOTT/ABBOT, MAINE 04406/ALL
RIGHTS RESERVED"
Acquired from: gift of P/K Associates, New York, New York

281. **N.Y.—JESY [Manhattan skyline from Jersey City]**
(P1984.35.342)
Gelatin silver print. negative c. 1931, print 1978—79
Image: 4 1/2 x 6 1/2 in. (11.4 x 16.5 cm.)
Mount: 10 x 8 in. (25.4 x 20.3 cm.)
Signed, l.r. mount recto: "BA"
Inscription, print verso [print is mounted, but inscription is
visible in reverse]: "33-1 N.Y.—Jesy"
mount verso: "33-1//557" and rubber stamp "BERENICE
ABBOTT/ABBOT, MAINE 04406/ALL RIGHTS
RESERVED"
Acquired from: gift of P/K Associates, New York, New York

*282. **NEW YORK SKYLINE FROM NEW JERSEY** (P1984.35.111)
Gelatin silver print. negative 1929—39, print 1978—79
Image: 7 7/16 x 9 3/8 in. (18.9 x 23.8 cm.)
Mount: 8 x 10 in. (20.3 x 25.4 cm.)

Signed, l.r. mount recto: "BA"
Inscription, mount verso: "264-6//320" and rubber stamp
"BERENICE ABBOTT/ABBOT, MAINE 04406/ALL
RIGHTS RESERVED"
Acquired from: gift of P/K Associates, New York, New York

283. **[New York Steam Company at the southwest corner of Water
Street and Burling Slip]** (P1984.35.91)
Gelatin silver print. negative 1929—39, print 1978—79
Image: 9 7/16 x 7 1/2 in. (24.0 x 19.0 cm.)
Mount: 10 x 8 in. (25.4 x 20.3 cm.)
Signed, l.r. mount recto: "BA"
Inscription, mount verso: "265-6//299" and rubber stamp
"BERENICE ABBOTT/ABBOT, MAINE 04406/ALL
RIGHTS RESERVED"
Acquired from: gift of P/K Associates, New York, New York

*284. **[New York Steam Company at the southwest corner of Water
Street and Burling Slip]** (P1984.35.134)
Gelatin silver print. negative 1929—39, print 1978—79
Image size: 9 1/2 x 7 9/16 in. (24.1 x 19.2 cm.)
Mount size: 10 x 8 in. (25.4 x 20.3 cm.)
Signed, bottom center mount verso: "Berenice Abbott"
Inscription, mount verso: "256-6//344"
Acquired from: gift of P/K Associates, New York, New York

285. **NEW YORK STOCK EXCHANGE INTERIOR**
(P1984.35.187)
Gelatin silver print. negative 1957, print 1978—79
Image: 3 9/16 x 4 1/2 in. (9.0 x 11.4 cm.)
Mount: 10 x 8 in. (25.4 x 20.3 cm.)
Signed, l.r. mount recto: "BA"
Inscription, mount verso: "23-1//397" and rubber stamp
"BERENICE ABBOTT/ABBOT, MAINE 04406/ALL
RIGHTS RESERVED"
Acquired from: gift of P/K Associates, New York, New York

286. **NEW YORK STOCK EXCHANGE INTERIOR**
(P1984.35.350)
Gelatin silver print. negative 1957, print 1978—79
Image: 3 5/8 x 4 9/16 in. (9.2 x 11.6 cm.)
Mount: 10 x 8 in. (25.4 x 20.3 cm.)
Signed, l.r. mount recto: "BA"
Inscription, mount verso: "23-1//565" and rubber stamp
"BERENICE ABBOTT/ABBOT, MAINE 04406/ALL
RIGHTS RESERVED"
Acquired from: gift of P/K Associates, New York, New York

287. **[New York Telephone Company Building (Barclay-Vesey
Building)]** (P1984.35.57)
Gelatin silver print. negative 1929—39, print 1978—79
Image: 9 3/8 x 7 1/2 in. (23.8 x 19.0 cm.)
Mount: 10 x 8 in. (25.4 x 20.3 cm.)
Signed, bottom center mount verso: "Berenice Abbott"
Inscription, mount verso: "314-7//265"
Acquired from: gift of P/K Associates, New York, New York

288. **[New York Telephone Company Building (Barclay-Vesey
Building)]** (P1984.35.289)
Gelatin silver print. negative 1929—39, print 1978—79
Image: 9 3/8 x 7 5/16 in. (23.8 x 18.5 cm.)
Mount: 10 x 8 in. (25.4 x 20.3 cm.)
Signed, l.r. mount recto: "BA"
Inscription, mount verso: "82-2//503" and rubber stamp
"BERENICE ABBOTT/ABBOT, MAINE 04406/ALL
RIGHTS RESERVED"
Acquired from: gift of P/K Associates, New York, New York

289. **NEW YORK VIEW, DAILY NEWS BUILDING ON RIGHT**
 (P1984.35.113)
 Gelatin silver print. negative 1935, print 1978—79
 Image: 7½ x 8⅜ in. (19.0 x 21.3 cm.)
 Mount: 8 x 10 in. (20.3 x 25.4 cm.)
 Signed, l.r. mount recto: "BA"
 Inscription, mount verso: "202-5//322" and rubber stamp
 "BERENICE ABBOTT/ABBOT, MAINE 04406/ALL
 RIGHTS RESERVED"
 Acquired from: gift of P/K Associates, New York, New York

290. **NEWARK FLATS** (P1984.35.93)
 Gelatin silver print. negative 1935, print 1978—79
 Image: 7½ x 9½ in. (19.0 x 24.1 cm.)
 Mount: 8 x 10 in. (20.3 x 25.4 cm.)
 Signed, l.r. mount recto: "BA"
 Inscription, mount verso: "204-5/Newark Flats//301" and
 rubber stamp "BERENICE ABBOTT/ABBOT, MAINE
 04406/ALL RIGHTS RESERVED"
 Acquired from: gift of P/K Associates, New York, New York

291. **NEWS BUILDING [Daily News Building, 220 East 42nd
 Street]** (P1984.35.208)
 Gelatin silver print. negative 1935, print 1978—79
 Image: 7⅜ x 9⅜ in. (18.7 x 23.8 cm.)
 Mount: 8 x 10 in. (20.3 x 25.4 cm.)
 Signed, l.r. mount recto: "BA"
 Inscription, mount verso: "64-2 News Building//418" and
 rubber stamp "BERENICE ABBOTT/ABBOT, MAINE
 04406/ALL RIGHTS RESERVED"
 Acquired from: gift of P/K Associates, New York, New York

292. **NEWS BUILDING [Daily News Building, 220 East 42nd
 Street]** (P1984.35.209)
 Gelatin silver print. negative 1935, print 1978—79
 Image: 7½ x 9⅜ in. (19.0 x 23.8 cm.)
 Mount: 8 x 10 in. (20.3 x 25.4 cm.)
 Signed, l.r. mount recto: "BA"
 Inscription, mount verso: "63-2 News Building//419" and
 rubber stamp "BERENICE ABBOTT/ABBOT, MAINE
 04406/ALL RIGHTS RESERVED"
 Acquired from: gift of P/K Associates, New York, New York

*293. **NEWSSTAND, 32ND STREET AND THIRD AVENUE**
 (P1984.35.166)
 Gelatin silver print. negative 1935, print 1978—79
 Image: 7⁷⁄₁₆ x 9⁹⁄₁₆ in. (18.9 x 24.3 cm.)
 Mount: 8 x 10 in. (20.3 x 25.4 cm.)
 Signed, l.r. mount recto: "BA"
 Inscription, mount verso: "376" and rubber stamp
 "BERENICE ABBOTT/ ABBOT, MAINE 04406/ALL
 RIGHTS RESERVED"
 Acquired from: gift of P/K Associates, New York, New York

294. **NIGHT VIEW** (P1984.35.104)
 Gelatin silver print. negative 1933, print 1978—79
 Image: 9½ x 7⁹⁄₁₆ in. (24.1 x 19.2 cm.)
 Mount: 10 x 8 in. (25.4 x 20.3 cm.)
 Signed, l.r. mount recto: "BA"
 Inscription, print verso [print is mounted, but inscription is
 visible in reverse]: "206-5 NIGHT VIEW"
 mount verso: "206-5//313" and rubber stamp "BERENICE
 ABBOTT/ ABBOT, MAINE 04406/ALL RIGHTS
 RESERVED"
 Acquired from: gift of P/K Associates, New York, New York

295. **NIGHT VIEW FROM EMPIRE STATE BUILDING
 (HORIZONTAL)** (P1984.35.46)
 Gelatin silver print. negative 1933, print 1978—79
 Image: 7½ x 9⁷⁄₁₆ in. (19.0 x 24.0 cm.)
 Mount: 8 x 10 in. (20.3 x 25.4 cm.)
 Signed, bottom center mount verso: "Berenice Abbott"
 Inscription, print verso: [print is mounted, but illegible
 inscription is visible in reverse]
 mount verso: "300-7//254"
 Acquired from: gift of P/K Associates, New York, New York

269

280

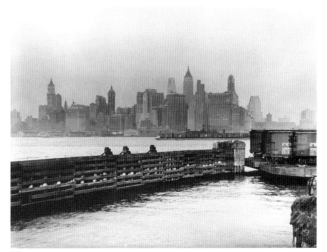
282

*296. **NOGUCHI [Isamu Noguchi]** (P1984.35.315)
Gelatin silver print. negative c. 1947, print 1978–79
Image: 4 9/16 x 3 1/2 in. (11.6 x 8.9 cm.)
Mount: 10 x 8 in. (25.4 x 20.3 cm.)
Signed, l.r. mount recto: "BA"
Inscription, mount recto: "Noguchi" and crop marks
mount verso: "530" and rubber stamp "BERENICE
ABBOTT/ABBOT, MAINE 04406/ALL RIGHTS
RESERVED"
Acquired from: gift of P/K Associates, New York, New York

* 297. **NOGUCHI'S STUDIO [33 MacDougal Alley, New York]**
(P1984.35.122)
Gelatin silver print. negative c. 1947, print 1978–79
Image: 8 15/16 x 6 15/16 in. (22.6 x 17.6 cm.)
Mount: 10 x 8 in. (25.4 x 20.3 cm.)
Signed, l.r. mount recto: "BA"
Inscription, mount verso: "207-5/Noguchi's Studio//333" and
rubber stamp "BERENICE ABBOTT/ABBOT, MAINE
04406/ALL RIGHTS RESERVED"
Acquired from: gift of P/K Associates, New York, New York

*298. **NORA JOYCE (MRS J.)** (P1984.35.412)
Gelatin silver print. negative 1927, print 1978–79
Image: 4 3/8 x 3 1/4 in. (11.1 x 8.2 cm.)
Mount: 10 x 8 in. (25.4 x 20.3 cm.)
Signed, l.r. mount recto: "BA"
Inscription, mount verso: "Nora Joyce (Mrs J.)//633"
Acquired from: gift of P/K Associates, New York, New York

299. **NORA JOYCE (MRS. J.)** (P1984.35.413)
Gelatin silver print. negative 1927, print 1978–79
Image: 4 5/16 x 3 1/4 in. (11.0 x 8.2 cm.)
Mount: 10 x 8 in. (25.4 x 20.3 cm.)
Signed, l.r. mount recto: "BA"
Inscription, mount verso: "Nora Joyce (Mrs. J.)//634"
Acquired from: gift of P/K Associates, New York, New York

300. **[Ohio River scene, Cincinnati]** (P1984.35.239)
Gelatin silver print. negative 1935, print 1978–79
Image: 7 1/2 x 9 1/2 in. (19.0 x 24.1 cm.)
Mount: 8 x 10 in. (20.3 x 25.4 cm.)
Signed, l.r. mount recto: "BA"
Inscription, mount verso: "452" and rubber stamp
"BERENICE ABBOTT/ABBOT, MAINE 04406/ALL
RIGHTS RESERVED"
Acquired from: gift of P/K Associates, New York, New York

301. **OLD HOUSE CHERRY ST.** (P1984.35.79)
Gelatin silver print. negative 1934, print 1978–79
Image: 7 5/16 x 9 1/2 in. (18.5 x 24.1 cm.)
Mount: 8 x 10 in. (20.3 x 25.4 cm.)
Signed, l.r. mount recto: "BA"
Inscription, mount verso: "287//211-5 Old House Cherry St."
and rubber stamp "BERENICE ABBOTT/ABBOT,
MAINE 04406/ALL RIGHTS RESERVED"
Acquired from: gift of P/K Associates, New York, New York

302. **OLD NEW YORK (HESTER STREET?)** (P1984.35.40)
Gelatin silver print. negative c. 1930, print 1978–79
Image: 4 7/8 x 6 7/8 in. (12.4 x 17.4 cm.)
Mount: 8 x 10 in. (20.3 x 25.4 cm.)
Signed, bottom center mount verso: "Berenice Abbott"
Inscription, mount verso: "248"
Acquired from: gift of P/K Associates, New York, New York

303. **"OLD PRINT SHOP"—SON—LEX—& 29 ST. [Kenneth M. Newman]** (P1984.35.311)
Gelatin silver print. negative 1945, print 1978–79
Image: 4 5/8 x 3 9/16 in. (11.7 x 9.0 cm.)
Mount: 10 x 8 in. (25.4 x 20.3 cm.)
Signed, l.r. mount recto: "BA—"
Inscription, mount recto: ""Old Print Shop"—Son—Lex—
& 29 St." and crop marks
mount verso: "526" and rubber stamp "BERENICE
ABBOTT/ABBOT, MAINE 04406/ALL RIGHTS
RESERVED"
Acquired from: gift of P/K Associates, New York, New York

304. **OLD SAILOR SHOP, WATER ST.** (P1984.35.77)
Gelatin silver print. negative 1929–39, print 1978–79
Image: 9 3/8 x 7 1/2 in. (23.8 x 19.0 cm.)
Mount: 10 x 8 in. (25.4 x 20.3 cm.)
Signed, l.r. mount recto: "BA"
Inscription, mount verso: "213-5 Old Sailor Shop/Water St.//
285" and rubber stamp "BERENICE ABBOTT/ABBOT,
MAINE 04406/ ALL RIGHTS RESERVED"
Acquired from: gift of P/K Associates, New York, New York

305. **OLD SAILOR SHOP, WATER ST.** (P1984.35.115)
Gelatin silver print. negative 1929–39, print 1978–79
Image: 7 7/16 x 9 1/2 in. (18.9 x 24.1 cm.)
Mount: 8 x 10 in. (20.3 x 25.4 cm.)
Signed, l.r. mount recto: "BA"
Inscription, mount verso: "146-4//326"
Acquired from: gift of P/K Associates, New York, New York

306. **OLD WASHINGTON MARKET, WEST ST.** (P1984.35.75)
Gelatin silver print. negative 1929–39, print 1978–79
Image: 7 1/2 x 9 1/2 in. (19.0 x 24.1 cm.)
Mount: 8 x 10 in. (20.3 x 25.4 cm.)
Signed, l.r. mount recto: "BA"
Inscription, print verso [print is mounted, but inscription is
visible in reverse]: "214-5/Old [illegible]"
mount verso: "214-5/Old Washington Market/West
St.//283" and rubber stamp "BERENICE ABBOTT/
ABBOT, MAINE 04406/ALL RIGHTS RESERVED"
Acquired from: gift of P/K Associates, New York, New York

307. **OLD WINDMILL** (P1984.35.34)
Gelatin silver print. negative 1929–39, print 1978–79
Image: 7 1/4 x 9 7/16 in. (18.4 x 24.0 cm.)
Mount: 8 x 10 in. (20.3 x 25.4 cm.)
Signed, l.r. mount recto: "BA"
Inscription, print verso [print is mounted, but inscription is
visible in reverse]: "94-7/[illegible]"
mount verso: "242//294-7"
Acquired from: gift of P/K Associates, New York, New York

308. **OLD WINDMILL** (P1984.35.74)
Gelatin silver print. negative 1929–39, print 1978–79
Image: 7 1/2 x 9 7/16 in. (19.0 x 24.0 cm.)
Mount: 8 x 10 in. (20.3 x 25.4 cm.)
Signed, l.r. mount recto: "BA"
Inscription, mount verso: "282//216-5 Old Windmill" and
rubber stamp "BERENICE ABBOTT/ABBOT, MAINE
04406/ALL RIGHTS RESERVED"
Acquired from: gift of P/K Associates, New York, New York

309. **OLD WINDMILL** (P1984.35.120)
Gelatin silver print. negative 1929–39, print 1978–79
Image: 7 5/16 x 9 7/16 in. (18.5 x 24.0 cm.)
Mount: 8 x 10 in. (20.3 x 25.4 cm.)
Signed, l.r. mount recto: "BA"
Inscription, mount verso: "293-7//331"
Acquired from: gift of P/K Associates, New York, New York

310. **ORCHARD & STANTON** (P1984.35.76)
Gelatin silver print. negative c. 1930, print 1978–79
Image: 9 1/2 x 7 1/2 in. (24.1 x 19.0 cm.)
Mount: 10 x 8 in. (25.4 x 20.3 cm.)
Signed, l.r. mount recto: "BA"
Inscription, print verso: [print is mounted, but illegible
inscription is visible in reverse]
mount verso: "215-5 Orchard & Stanton//284" and rubber
stamp "BERENICE ABBOTT/ABBOT, MAINE 04406/
ALL RIGHTS RESERVED"
Acquired from: gift of P/K Associates, New York, New York

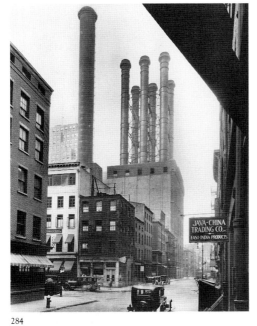

284

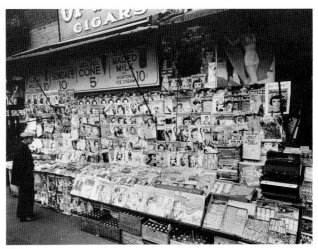

293

296

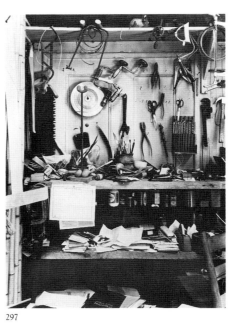

297

298

311. **ORCHARD & STANTON** (P1984.35.319)
Gelatin silver print. negative c. 1930, print 1978—79
Image: 7⅜ x 9⅜ in. (18.7 x 23.8 cm.)
Mount: 8⅛ x 10 in. (20.6 x 25.4 cm.)
Signed, l.r. mount recto: "BA"
Inscription, mount verso: "186-4//534" and rubber stamp
"BERENICE ABBOTT/ABBOT, MAINE 04406/ALL
RIGHTS RESERVED"
Acquired from: gift of P/K Associates, New York, New York

312. **O'ROURKE'S HOTEL, DOWNTOWN, N.Y.** (P1984.35.80)
Gelatin silver print. negative 1929—39, print 1978—79
Image: 7⁹⁄₁₆ x 9⅜ in. (19.2 x 23.8 cm.)
Mount: 8 x 10 in. (20.3 x 25.4 cm.)
Signed, l.r. mount recto: "BA"
Inscription, print verso [print is mounted, but inscription is
visible in reverse]: "210-5"
mount verso: "210-5//288" and rubber stamp "BERENICE
ABBOTT/ ABBOT, MAINE 04406/ALL RIGHTS
RESERVED"
Acquired from: gift of P/K Associates, New York, New York

313. **PAINTER** (P1984.35.483)
Gelatin silver print. negative 1928, print 1978—79
Image: 4⅜ x 3⁵⁄₁₆ in. (11.1 x 8.4 cm.)
Mount: 10 x 8 in. (25.4 x 20.3 cm.)
Signed, l.r. mount recto: "BA"
Inscription, mount recto: crop marks
mount verso: "707"
Acquired from: gift of P/K Associates, New York, New York

314. **PARAFOTI** (P1984.35.178)
Gelatin silver print. negative 1935, print 1978—79
Image: 7⁷⁄₁₆ x 9⅜ in. (18.9 x 23.8 cm.)
Mount: 8 x 10 in. (20.3 x 25.4 cm.)
Signed, l.r. mount recto: "BA"
Inscription, mount verso: "388//71-2" and rubber stamp
"BERENICE ABBOTT/ABBOT, MAINE 04406/ALL
RIGHTS RESERVED"
Acquired from: gift of P/K Associates, New York, New York

315. **PARK AVE. & 39TH ST.** (P1984.35.23)
Gelatin silver print. negative 1936, print 1978—79
Image: 7½ x 9½ in. (19.0 x 24.1 cm.)
Mount: 8 x 10 in. (20.3 x 25.4 cm.)
Signed, l.r. mount recto: "BA"
Inscription, mount verso: "105-3/Park Ave. & 39th St.//231"
and rubber stamp "BERENICE ABBOTT/ABBOT,
MAINE 04406/ALL RIGHTS RESERVED"
Acquired from: gift of P/K Associates, New York, New York

316. **PASCAL COVICI** (P1984.35.491)
Gelatin silver print. negative 1926—30, print 1978—79
Image: 4⅜ x 3⁵⁄₁₆ in. (11.1 x 8.4 cm.)
Mount: 10 x 8 in. (25.4 x 20.3 cm.)
Signed, l.r. mount recto: "BA"
Inscription, mount verso: "715" and rubber stamp
"BERENICE ABBOTT/ABBOT, MAINE 04406/ALL
RIGHTS RESERVED"
Acquired from: gift of P/K Associates, New York, New York

317. **PASSPORT PHOTOS, DOWNTOWN, NEW YORK**
(P1984.35.121)
Gelatin silver print. negative 1936, print 1978—79
Image: 7⁹⁄₁₆ x 9½ in. (19.2 x 24.1 cm.)
Mount: 8 x 10 in. (20.3 x 25.4 cm.)
Signed, l.r. mount recto: "BA"
Inscription, mount verso: "332//195-5" and rubber stamp
"BERENICE ABBOTT/ABBOT, MAINE 04406/ALL
RIGHTS RESERVED"
Acquired from: gift of P/K Associates, New York, New York

*318. **PATCHIN PLACE WITH JEFFERSON MARKET COURT
IN BACKGROUND, OPENING OFF WEST 10TH
STREET BETWEEN SIXTH AVENUE AND
GREENWICH AVENUE, MANHATTAN** (P1984.35.299)
Gelatin silver print. negative 1937, print 1978—79
Image: 9½ x 7⁷⁄₁₆ in. (24.1 x 18.9 cm.)
Mount: 10 x 8 in. (25.4 x 20.3 cm.)
Signed, l.r. mount recto: "BA"
Inscription, print verso: [print is mounted, but illegible
inscription is visible in reverse]
mount verso: "177-4//513" and rubber stamp "BERENICE
ABBOTT/ ABBOT, MAINE 04406/ALL RIGHTS
RESERVED"
Acquired from: gift of P/K Associates, New York, New York

319. **PAUL [Paul Morand]** (P1984.35.482)
Gelatin silver print. negative 1927, print 1978—79
Image: 4⅜ x 3¼ in. (11.1 x 8.2 cm.)
Mount: 10 x 8 in. (25.4 x 20.3 cm.)
Signed, l.r. mount recto: "B.A."
Inscription, mount recto: "Paul" and crop marks
mount verso: "706" and rubber stamp "BERENICE
ABBOTT/ABBOT, MAINE 04406/ALL RIGHTS
RESERVED"
Acquired from: gift of P/K Associates, New York, New York

320. **PAUL CROSS** (P1984.35.384)
Gelatin silver print. negative 1926—30, print 1978—79
Image: 4⁵⁄₁₆ x 3¼ in. (11.0 x 8.2 cm.)
Mount: 10 x 8 in. (25.4 x 20.3 cm.)
Signed, l.r. mount recto: "BA"
Inscription, mount verso: "Paul Cross//603"
Acquired from: gift of P/K Associates, New York, New York

321. **[Pearl Street, looking north under the Elevated towards Ferry
Street]** (P1984.35.133)
Gelatin silver print. negative 1936, print 1978—79
Image: 9½ x 7½ in. (24.1 x 19.0 cm.)
Mount: 10 x 8 in. (25.4 x 20.3 cm.)
Signed, bottom center mount verso: "Berenice Abbott"
Inscription, mount verso: "257-6//343"
Acquired from: gift of P/K Associates, New York, New York

322. **PEGEEN GUGGENHEIM [Pegeen Jezebel Vail]**
(P1984.35.378)
Gelatin silver print. negative 1926, print 1978—79
Image: 4⁵⁄₁₆ x 3¼ in. (11.0 x 8.2 cm.)
Mount: 10 x 8 in. (25.4 x 20.3 cm.)
Signed, l.r. mount recto: "BA"
Inscription, mount verso: "596"
Acquired from: gift of P/K Associates, New York, New York

*323. **PEGGY GUGGENHEIM** (P1984.35.388)
Gelatin silver print. negative 1926, print 1978—79
Image: 3¼ x 2¼ in. (8.2 x 5.7 cm.)
Mount: 10 x 8 in. (25.4 x 20.3 cm.)
Signed, l.r. mount recto: "BA"
Inscription, mount verso: "Peggy Guggenheim//607"
Acquired from: gift of P/K Associates, New York, New York

324. **PEGGY GUGGENHEIM** (P1984.35.407)
Gelatin silver print. negative 1926, print 1978—79
Image: 3¼ x 2⅜ in. (8.2 x 6.0 cm.)
Mount: 10 x 8 in. (25.4 x 20.3 cm.)
Signed, l.r. mount recto: "BA"
Inscription, mount recto: "Peggy Guggenheim"
and crop mark
mount verso: "628" and rubber stamp "BERENICE
ABBOTT/ABBOT, MAINE 04406/ALL RIGHTS
RESERVED"
Acquired from: gift of P/K Associates, New York, New York

325. **PEGGY GUGGENHEIM** (P1984.35.498)
Gelatin silver print. negative 1926, print 1978—79
Image: 3¼ x 2⅜ in. (8.2 x 6.0 cm.)
Mount: 10 x 8 in. (25.4 x 20.3 cm.)

Signed, l.r. mount recto: "BA"
Inscription, mount recto: "Peggy Guggenheim"
 and crop mark
 mount verso: "647"
Acquired from: gift of P/K Associates, New York, New York

326. **PEGGY GUGGENHEIM [Peggy Guggenheim and Pegeen]**
 (P1984.35.432)
 Gelatin silver print. negative 1926, print 1978—79
 Image: 4 7/16 x 3 1/4 in. (11.3 x 8.2 cm.)
 Mount: 10 x 8 in. (25.4 x 20.3 cm.)
 Signed, l.r. mount recto: "BA"
 Inscription, mount verso: "Peggy Guggenheim//656"
 Acquired from: gift of P/K Associates, New York, New York

327. **PEGGY GUGGENHEIM AND PEGEEN** (P1984.35.447)
 Gelatin silver print. negative 1926, print 1978—79
 Image: 4 7/16 x 3 7/16 in. (11.3 x 8.7 cm.)
 Mount: 10 x 8 in. (25.4 x 20.3 cm.)
 Signed, l.r. mount recto: "BA"
 Inscription, mount recto: "Peggie [sic] Guggenheim & Pegine
 [sic]" and crop marks
 mount verso: "671" and rubber stamp "BERENICE
 ABBOTT/ABBOT, MAINE 04406/ALL RIGHTS
 RESERVED"
 Acquired from: gift of P/K Associates, New York, New York

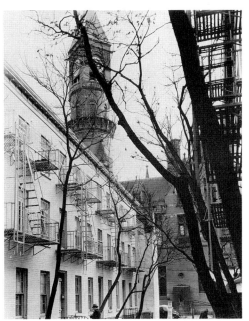

318

328. **PEGGY GUGGENHEIM WITH HER TWO CHILDREN**
 (P1984.35.386)
 Gelatin silver print. negative 1926, print 1978—79
 Image: 4 1/2 x 3 5/16 in. (11.4 x 8.4 cm.)
 Mount: 10 x 8 in. (25.4 x 20.3 cm.)
 Signed, l.r. mount recto: "BA"
 Inscription, mount recto: "Peggy Gugenheim [sic] with her
 two children" and crop marks
 mount verso: "605"
 Acquired from: gift of P/K Associates, New York, New York

329. **PENN STATION** (P1984.35.47)
 Gelatin silver print. negative 1929—39, print 1978—79
 Image: 7 7/16 x 9 3/8 in. (18.9 x 23.8 cm.)
 Mount: 8 x 10 in. (20.3 x 25.4 cm.)
 Signed, bottom center mount verso: "Berenice Abbott"
 Inscription, mount verso: "301-7//255"
 Acquired from: gift of P/K Associates, New York, New York

*330. **PENNSYLVANIA STATION INTERIOR** (P1980.36)
 duplicate of P1984.35.298
 Gelatin silver print. negative 1936, print 1979
 Image: 9 3/8 x 7 9/16 in. (23.9 x 19.1 cm.)
 Mount: 17 1/16 x 14 1/8 in. (43.4 x 35.8 cm.)
 Signed, l.r. mount recto: "BERENICE ABBOTT"
 Inscription, mount verso: "13510" and rubber stamp
 "BERENICE ABBOTT/ABBOT, MAINE 04406/ALL
 RIGHTS RESERVED"
 Acquired from: Edwynn Houk, Ann Arbor, Michigan

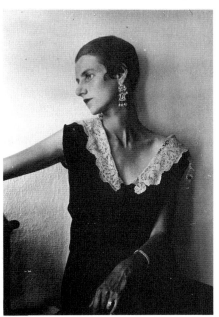

323

331. **PENNSYLVANIA STATION INTERIOR** (P1984.35.296)
 Gelatin silver print. negative 1936, print 1978—79
 Image: 7 7/16 x 9 3/8 in. (18.9 x 23.8 cm.)
 Mount: 8 x 10 in. (20.3 x 25.4 cm.)
 Signed, l.r. mount recto: "BA"
 Inscription, mount verso: "171-4//510" and rubber stamp
 "BERENICE ABBOTT/ABBOT, MAINE 04406/ALL
 RIGHTS RESERVED"
 Acquired from: gift of P/K Associates, New York, New York

332. **PENNSYLVANIA STATION INTERIOR** (P1984.35.297)
 Gelatin silver print. negative 1936, print 1978—79
 Image: 9 7/16 x 7 7/16 in. (24.0 x 18.9 cm.)
 Mount: 10 x 8 in. (25.4 x 20.3 cm.)
 Signed, l.r. mount recto: "BA"
 Inscription, mount verso: "170-4//511" and rubber stamp
 "BERENICE ABBOTT/ABBOT, MAINE 04406/ALL
 RIGHTS RESERVED"
 Acquired from: gift of P/K Associates, New York, New York

333. **PENNSYLVANIA STATION INTERIOR** (P1984.35.298)
duplicate of P1980.36
Gelatin silver print. negative 1936, print 1978–79
Image: 9 5/16 x 7 1/4 in. (23.7 x 18.4 cm.)
Mount: 10 x 8 in. (25.4 x 20.3 cm.)
Signed, l.r. mount recto: "BA"
Inscription, mount verso: "170-4//512" and rubber stamp
"BERENICE ABBOTT/ABBOT, MAINE 04406/ALL
RIGHTS RESERVED"
Acquired from: gift of P/K Associates, New York, New York

*334. **PENNSYLVANIA STATION INTERIOR** (P1984.35.301)
Gelatin silver print. negative 1936, print 1978–79
Image: 7 7/16 x 9 3/8 in. (18.9 x 23.8 cm.)
Mount: 8 x 10 in. (20.3 x 25.4 cm.)
Signed, l.r. mount recto: "BA"
Inscription, mount verso: "172-4//515" and rubber stamp
"BERENICE ABBOTT/ABBOT, MAINE 04406/ALL
RIGHTS RESERVED"
Acquired from: gift of P/K Associates, New York, New York

335. **PENNSYLVANIA STATION INTERIOR** (P1984.35.302)
Gelatin silver print. negative 1936, print 1978–79
Image: 9 1/2 x 7 1/2 in. (24.1 x 19.0 cm.)
Mount: 10 x 8 in. (25.4 x 20.3 cm.)
Signed, l.r. mount recto: "BA"
Inscription, mount verso: "173-4//516" and rubber stamp
"BERENICE ABBOTT/ABBOT, MAINE 04406/ALL
RIGHTS RESERVED"
Acquired from: gift of P/K Associates, New York, New York

*336. **PENTHOUSE 7TH AVE. [General view from penthouse at
56 Seventh Avenue]** (P1984.35.171)
Gelatin silver print. negative 1937, print 1978–79
Image: 9 1/2 x 7 1/2 in. (24.1 x 19.0 cm.)
Mount: 10 x 8 in. (25.4 x 20.3 cm.)
Signed, l.r. mount recto: "BA"
Inscription, mount verso: "75-2 Penthouse 7th Ave.//381" and
rubber stamp "BERENICE ABBOTT/ABBOT, MAINE
04406/ALL RIGHTS RESERVED"
Acquired from: gift of P/K Associates, New York, New York

337. **PERPETUAL LIGHT—VILLAGE** (P1984.35.236)
Gelatin silver print. negative 1929–39, print 1978–79
Image: 9 1/2 x 7 1/2 in. (24.1 x 19.0 cm.)
Mount: 10 x 8 in. (25.4 x 20.3 cm.)
Signed, l.r. mount recto: "BA"
Inscription, mount verso: "91-2 Perpetual Light—Villiage
[sic]// 449" and rubber stamp "BERENICE ABBOTT/
ABBOT, MAINE 04406/ALL RIGHTS
RESERVED//13510"
Acquired from: gift of P/K Associates, New York, New York

338. **PHILIPPE SOUPAULT** (P1984.35.358)
Gelatin silver print. negative 1926–30, print 1978–79
Image: 3 1/4 x 2 3/16 in. (8.2 x 5.5 cm.)
Mount: 10 x 8 in. (25.4 x 20.3 cm.)
Signed, l.r. mount recto: "BA"
Inscription, mount recto: "Philip [sic] Soupault"
mount verso: "573"
Acquired from: gift of P/K Associates, New York, New York

339. **PHILIPPE SOUPAULT** (P1984.35.391)
Gelatin silver print. negative 1926–30, print 1978–79
Image: 4 7/16 x 3 1/4 in. (11.3 x 8.2 cm.)
Mount: 10 x 8 in. (25.4 x 20.3 cm.)
Signed, l.r. mount recto: "BA"
Inscription, mount recto: crop marks
mount verso: "Philippe Soupault//610"
Acquired from: gift of P/K Associates, New York, New York

340. **PHILIPPE SOUPAULT** (P1984.35.398)
Gelatin silver print. negative 1926–30, print 1978–79
Image: 3 1/4 x 2 5/16 in. (8.2 x 5.8 cm.)
Mount: 10 x 8 in. (25.4 x 20.3 cm.)

Signed, l.r. mount recto: "BA"
Inscription, mount recto: "Philip Souppault [sic]"
and crop mark
mount verso: "618"
Acquired from: gift of P/K Associates, New York, New York

341. **PHILIPPE SOUPAULT** (P1984.35.420)
Gelatin silver print. negative 1926–30, print 1978–79
Image: 4 3/8 x 3 5/16 in. (11.1 x 8.4 cm.)
Mount: 10 x 8 in. (25.4 x 20.3 cm.)
Signed, l.r. mount recto: "BA"
Inscription, mount verso: "Philip [sic] Soupault//641" and
rubber stamp "BERENICE ABBOTT/ABBOT, MAINE
04406/ALL RIGHTS RESERVED"
Acquired from: gift of P/K Associates, New York, New York

*342. **[Pier 2, Meyer Line]** (P1984.35.341)
Gelatin silver print. negative 1929–39, print 1978–79
Image: 4 1/2 x 6 3/16 in. (11.4 x 15.7 cm.)
Mount: 10 x 8 in. (25.4 x 20.3 cm.)
Signed, l.r. mount recto: "BA"
Inscription, mount verso: "32-1//556" and rubber stamp
"BERENICE ABBOTT/ABBOT, MAINE 04406/ALL
RIGHTS RESERVED"
Acquired from: gift of P/K Associates, New York, New York

*343. **PIKE AND HENRY STREETS** (P1984.35.304)
Gelatin silver print. negative 1936, print 1978–79
Image: 7 3/8 x 9 7/16 in. (18.7 x 24.0 cm.)
Mount: 8 x 10 in. (20.3 x 25.4 cm.)
Signed, l.r. mount recto: "BA"
Inscription, mount verso: "178-4//518" and rubber stamp
"BERENICE ABBOTT/ABBOT, MAINE 04406/ALL
RIGHTS RESERVED"
Acquired from: gift of P/K Associates, New York, New York

*344. **PINE STREET: U.S. TREASURY IN FOREGROUND**
(P1986.31)
Gelatin silver print. 1936
Image: 9 5/8 x 7 15/16 in. (24.5 x 20.1 cm.)
Sheet: 9 15/16 x 8 in. (25.2 x 20.3 cm.)
Signed: see inscription
Inscription, print verso: "PF Streets//BA 7413" and rubber
stamps "MUNICIPAL REFERENCE/LIBRARY/
RECEIVED/FEB 6—1952/MUNICIPAL BUILDING/NEW
YORK CITY" and "FEDERAL ART PROJECT/"Changing
New York"/PHOTOGRAPHS BY BERENICE ABBOTT"
and "Title: [in pencil] Pine Street: U.S. Treasury/In
Foreground/Place: [in pencil] Manhattan/Angle of View:/
Date: [in pencil] Mar 26, 1936/Neg. # [in pencil] 85
Code: [in pencil] IA1/IC"
Acquired from: Hirschl & Adler Galleries, Inc., New York,
New York

345. **POULTRY SHOP, EAST 7TH STREET** (P1984.35.125)
Gelatin silver print. negative 1935, print 1978–79
Image: 9 1/2 x 7 9/16 in. (24.1 x 19.2 cm.)
Mount: 10 x 8 in. (25.4 x 20.3 cm.)
Signed, l.r. mount recto: "BA"
Inscription, mount verso: "52-2//335" and rubber stamp
"BERENICE ABBOTT/ABBOT, MAINE 04406/ALL
RIGHTS RESERVED"
Acquired from: gift of P/K Associates, New York, New York

*346. **PRINCESS EUGÈNE MURAT** (P1984.35.495)
Gelatin silver print. negative 1930, print 1978–79
Image: 4 3/8 x 3 3/8 in. (11.1 x 8.6 cm.)
Mount: 10 x 8 in. (25.4 x 20.3 cm.)
Signed, l.r. mount recto: "BA"
Inscription, mount verso: "Princess Eugène Murat//620" and
rubber stamp "BERENICE ABBOTT/ABBOT, MAINE
04406/ALL RIGHTS RESERVED"
Acquired from: gift of P/K Associates, New York, New York

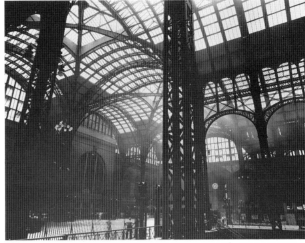

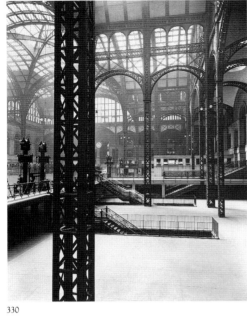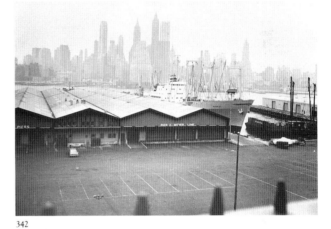

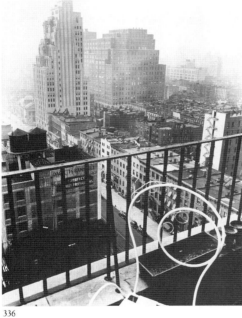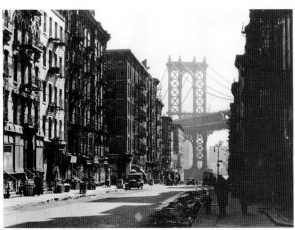

330

334

336

342

343

344

347. **PRINCESSE MARTHE BIBESCO** (P1984.35.453)
Gelatin silver print. negative 1927, print 1978–79
Image: 4 5/16 x 3 3/8 in. (11.0 x 8.6 cm.)
Mount: 10 x 8 in. (25.4 x 20.3 cm.)
Signed, l.r. mount recto: "BA"
Inscription, mount verso: "Princesse Marthe Bibesco//677"
Acquired from: gift of P/K Associates, New York, New York

348. **PRINCESSE MARTHE BIBESCO** (P1984.35.454)
Gelatin silver print. negative 1927, print 1978–79
Image: 4 1/4 x 3 3/16 in. (10.8 x 8.1 cm.)
Mount: 10 x 8 in. (25.4 x 20.3 cm.)
Signed, l.r. mount recto: "BA"
Inscription, mount verso: "Princesse Marthe Bibesco//678"
Acquired from: gift of P/K Associates, New York, New York

349. **PUCK [Puck Building]** (P1984.35.172)
Gelatin silver print. negative 1929–39, print 1978–79
Image: 9 5/16 x 7 3/8 in. (23.7 x 18.7 cm.)
Mount: 10 x 8 in. (25.4 x 20.3 cm.)
Signed, l.r. mount recto: "BA"
Inscription, mount verso: "76-2Puck//382" and rubber stamp "BERENICE ABBOTT/ABBOT, MAINE 04406/ALL RIGHTS RESERVED"
Acquired from: gift of P/K Associates, New York, New York

350. **PUCK [Puck Building]** (P1984.35.355)
Gelatin silver print. negative 1929–39, print 1978–79
Image: 9 1/4 x 7 7/16 in. (23.5 x 18.9 cm.)
Mount: 10 x 8 1/8 in. (25.4 x 20.6 cm.)
Signed, l.r. mount recto: "BA"
Inscription, mount verso: "109-3/Puck//570" and rubber stamp "BERENICE ABBOTT/ABBOT, MAINE 04406/ALL RIGHTS RESERVED"
Acquired from: gift of P/K Associates, New York, New York

351. **PUCK BUILDING** (P1984.35.261)
Gelatin silver print. negative 1929–39, print 1978–79
Image: 9 1/8 x 7 3/8 in. (23.2 x 18.7 cm.)
Mount: 10 x 8 in. (25.4 x 20.3 cm.)
Signed, l.r. mount recto: "BA"
Inscription, mount recto: crop mark
mount verso: "167-4//475" and rubber stamp "BERENICE ABBOTT/ ABBOT, MAINE 04406/ALL RIGHTS RESERVED"
Acquired from: gift of P/K Associates, New York, New York

352. **PUCK BUILDING** (P1984.35.343)
Gelatin silver print. negative 1929–39, print 1978–79
Image: 9 5/16 x 7 7/16 in. (23.7 x 18.9 cm.)
Mount: 10 x 8 in. (25.4 x 20.3 cm.)
Signed, l.r. mount recto: "BA"
Inscription, mount recto: crop mark
mount verso: "165-4//558" and rubber stamp "BERENICE ABBOTT/ ABBOT, MAINE 04406/ALL RIGHTS RESERVED"
Acquired from: gift of P/K Associates, New York, New York

353. **QUEENS BRIDGE FROM 63RD ST. [Queensboro Bridge from pier at 41st Road, Queens]** (P1984.35.250)
Gelatin silver print. negative 1937, print 1978–79
Image: 7 9/16 x 9 1/2 in. (19.2 x 24.1 cm.)
Mount: 8 x 10 in. (20.3 x 25.4 cm.)
Signed, l.r. mount recto: "BA"
Inscription, mount verso: "106-3/Queens bridge/From 63rd st.//463" and rubber stamp "BERENICE ABBOTT/ ABBOT, MAINE 04406/ALL RIGHTS RESERVED"
Acquired from: gift of P/K Associates, New York, New York

354. **QUEENSBORO BRIDGE** (P1984.35.281)
Gelatin silver print. negative 1937, print 1978–79
Image: 7 5/16 x 9 7/16 in. (18.5 x 24.0 cm.)
Mount: 8 x 10 in. (20.3 x 25.4 cm.)
Signed, l.r. mount recto: "BA"

Inscription, mount verso: "187-4//495" and rubber stamp "BERENICE ABBOTT/ABBOT, MAINE 04406/ALL RIGHTS RESERVED"
Acquired from: gift of P/K Associates, New York, New York

355. **QUEENSBORO BRIDGE AND PIER** (P1984.35.318)
Gelatin silver print. negative 1937, print 1978–79
Image: 7 5/16 x 9 5/16 in. (18.5 x 23.7 cm.)
Mount: 8 x 10 in. (20.3 x 25.4 cm.)
Signed, l.r. mount recto: "BA"
Inscription, mount verso: "169-4//533" and rubber stamp "BERENICE ABBOTT/ABBOT, MAINE 04406/ALL RIGHTS RESERVED"
Acquired from: gift of P/K Associates, New York, New York

356. **QUEENSBORO BRIDGE AND PIER** (P1984.35.337)
Gelatin silver print. negative 1937, print 1978–79
Image: 7 7/16 x 9 1/4 in. (18.9 x 23.5 cm.)
Mount: 8 x 10 in. (20.3 x 25.4 cm.)
Signed, l.r. mount recto: "BA"
Inscription, mount verso: "148-4//552" and rubber stamp "BERENICE ABBOTT/ABBOT, MAINE 04406/ALL RIGHTS RESERVED"
Acquired from: gift of P/K Associates, New York, New York

357. **QUEENSBORO BRIDGE AND TUGBOAT** (P1984.35.335)
Gelatin silver print. negative 1937, print 1978–79
Image: 7 3/8 x 9 3/8 in. (18.7 x 23.8 cm.)
Mount: 8 x 10 in. (20.3 x 25.4 cm.)
Signed, l.r. mount recto: "BA"
Inscription, mount verso: "149-4//550" and rubber stamp "BERENICE ABBOTT/ABBOT, MAINE 04406/ALL RIGHTS RESERVED"
Acquired from: gift of P/K Associates, New York, New York

358. **QUEENSBORO BRIDGE, LOOKING SOUTHWEST FROM PIER AT 41ST ROAD, LONG ISLAND CITY, QUEENS** (P1984.35.285)
Gelatin silver print. negative 1937, print 1978–79
Image: 7 3/8 x 9 1/2 in. (18.7 x 24.1 cm.)
Mount: 8 x 10 in. (20.3 x 25.4 cm.)
Signed, l.r. mount recto: "BA"
Inscription, mount verso: "6-1//499" and rubber stamp "BERENICE ABBOTT/ABBOT, MAINE 04406/ALL RIGHTS RESERVED"
Acquired from: gift of P/K Associates, New York, New York

359. **QUEENSBORO BRIDGE S.W. FROM 41ST ROAD, N.Y TERMINAL** (P1984.35.249)
Gelatin silver print. negative 1937, print 1978–79
Image: 7 7/16 x 9 3/8 in. (18.9 x 23.8 cm.)
Mount: 8 x 10 in. (20.3 x 25.4 cm.)
Signed, l.r. mount recto: "BA"
Inscription, mount verso: "108-3/Queensboro Bridge/S.W. From 41st st. [sic]/N.Y. Terminal//462" and rubber stamp "BERENICE ABBOTT/ ABBOT, MAINE 04406/ALL RIGHTS RESERVED"
Acquired from: gift of P/K Associates, New York, New York

360. **RACHEL LEFLERS** (P1984.35.379)
Gelatin silver print. negative 1926–30, print 1978–79
Image: 3 3/16 x 2 3/8 in. (8.1 x 6.0 cm.)
Mount: 10 x 8 in. (25.4 x 20.3 cm.)
Signed, l.r. mount recto: "BA"
Inscription, mount verso: "Rachel Leflers—//597"
Acquired from: gift of P/K Associates, New York, New York

361. **RACHEL LEFLERS** (P1984.35.446)
Gelatin silver print. negative 1926–30, print 1978–79
Image: 3 5/16 x 2 5/16 in. (8.4 x 5.8 cm.)
Mount: 10 x 8 in. (25.4 x 20.3 cm.)
Signed, l.r. mount recto: "BA"
Inscription, mount recto: "Rachel Leflers"
mount verso: "670"
Acquired from: gift of P/K Associates, New York, New York

*362. **RAG MERCHANT** (P1984.35.197)
 Gelatin silver print. negative c. 1930, print 1978–79
 Image: 4 13/16 x 7 in. (12.2 x 17.8 cm.)
 Mount: 10 x 8 in. (25.4 x 20.3 cm.)
 Signed, l.r. mount recto: "BA"
 Inscription, mount verso: "407" and rubber stamp
 "BERENICE ABBOTT/ ABBOT, MAINE 04406/ALL
 RIGHTS RESERVED"
 Acquired from: gift of P/K Associates, New York, New York

363. **RAIN FROM 50 COMMERCE ST.** (P1984.35.322)
 Gelatin silver print. negative c. 1950, print 1978–79
 Image: 5 1/8 x 3 15/16 in. (13.0 x 10.0 cm.)
 Mount: 10 x 8 in. (25.4 x 20.3 cm.)
 Signed, l.r. mount recto: "BA"
 Inscription, mount verso: "107-3/Rain from 50 Commerce
 St.// 537" and rubber stamp "BERENICE ABBOTT/
 ABBOT, MAINE 04406/ ALL RIGHTS RESERVED"
 Acquired from: gift of P/K Associates, New York, New York

364. **[RCA Building]** (P1984.35.52)
 Gelatin silver print. negative 1932, print 1978–79
 Image: 9 7/16 x 7 7/16 in. (24.0 x 18.9 cm.)
 Mount: 10 x 8 in. (25.4 x 20.3 cm.)
 Signed, bottom center mount verso: "Berenice Abbott"
 Inscription, mount verso: "306-7//260"
 Acquired from: gift of P/K Associates, New York, New York

365. **[RCA Building]** (P1984.35.119)
 Gelatin silver print. negative 1932, print 1978–79
 Image: 9 3/16 x 7 3/8 in. (23.3 x 18.7 cm.)
 Mount: 10 x 8 in. (25.4 x 20.3 cm.)
 Signed, l.r. mount recto: "BA"
 Inscription, mount verso: "310-7//330"
 Acquired from: gift of P/K Associates, New York, New York

*366. **[RCA Building]** (P1984.35.177)
 Gelatin silver print. negative 1932, print 1978–79
 Image: 9 7/16 x 7 5/8 in. (24.0 x 19.4 cm.)
 Mount: 10 x 8 in. (25.4 x 20.3 cm.)
 Signed, l.r. mount recto: "BA"
 Inscription, mount verso: "70-2//387" and rubber stamp
 "BERENICE ABBOTT/ABBOT, MAINE 04406/ALL
 RIGHTS RESERVED"
 Acquired from: gift of P/K Associates, New York, New York

367. **RECTOR ST. [San Janeiro Festival]** (P1984.35.44)
 Gelatin silver print. negative 1936, print 1978–79
 Image: 9 7/16 x 7 7/16 in. (24.0 x 18.9 cm.)
 Mount: 10 x 8 in. (25.4 x 20.3 cm.)
 Signed, bottom center mount verso: "Berenice Abbott"
 Inscription, mount verso: "254-6 Rector St.//252"
 Acquired from: gift of P/K Associates, New York, New York

368. **RECTOR ST. [San Janeiro Festival]** (P1984.35.136)
 Gelatin silver print. negative 1936, print 1978–79
 Image: 9 7/16 x 7 9/16 in. (24.0 x 19.2 cm.)
 Mount: 10 x 8 in. (25.4 x 20.3 cm.)
 Signed, bottom center mount verso: "Berenice Abbott"
 Inscription, mount verso: "254-6 Rector St.//346"
 Acquired from: gift of P/K Associates, New York, New York

369. **[Riker's Diner]** (P1984.35.353)
 Gelatin silver print. negative 1929–39, print 1978–79
 Image: 3 11/16 x 4 3/4 in. (9.4 x 12.0 cm.)
 Mount: 10 x 8 1/8 in. (25.4 x 20.6 cm.)
 Signed, l.r. mount recto: "BA"
 Inscription, mount verso: "25-1//568" and rubber stamp
 "BERENICE ABBOTT/ABBOT, MAINE 04406/ALL
 RIGHTS RESERVED"
 Acquired from: gift of P/K Associates, New York, New York

346

362

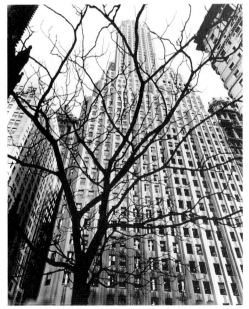
366

370. [Row house doorways] (P1984.35.326)
Gelatin silver print. negative 1929–39, print 1978–79
Image: 9 9/16 x 7 9/16 in. (24.3 x 19.2 cm.)
Mount: 10 x 8 in. (25.4 x 20.3 cm.)
Signed, l.r. mount recto: "BA"
Inscription, mount verso: "156-4//541" and rubber stamp
"BERENICE ABBOTT/ABBOT, MAINE 04406/ALL
RIGHTS RESERVED"
Acquired from: gift of P/K Associates, New York, New York

371. [Row houses] (P1984.35.240)
Gelatin silver print. negative 1929–39, print 1978–79
Image: 7 1/2 x 9 1/2 in. (19.0 x 24.0 cm.)
Mount: 8 x 10 in. (20.3 x 25.4 cm.)
Signed, l.r. mount recto: "BA"
Inscription, mount verso: "453" and rubber stamp
"BERENICE ABBOTT/ABBOT, MAINE 04406/ALL
RIGHTS RESERVED"
Acquired from: gift of P/K Associates, New York, New York

372. [Row houses] (P1984.35.339)
Gelatin silver print. negative 1929–39, print 1978–79
Image: 9 1/2 x 7 9/16 in. (24.1 x 19.2 cm.)
Mount: 10 x 8 in. (25.4 x 20.3 cm.)
Inscription, mount recto: crop marks
mount verso: "155-4//554" and rubber stamp "BERENICE
ABBOTT/ ABBOT, MAINE 04406/ALL RIGHTS
RESERVED"
Acquired from: gift of P/K Associates, New York, New York

373. ST. DEPASTER ST. (P1984.35.505)
Gelatin silver print. negative 1929–39, print 1978–79
Image: 9 3/16 x 7 5/8 in. (23.3 x 19.4 cm.)
Mount: 10 x 8 in. (25.4 x 20.3 cm.)
Signed, l.r. mount recto: "BA"
Inscription, mount verso: "71-2 St Depaster St.//422" and
rubber stamp "BERENICE ABBOTT/ABBOT, MAINE
04406/ALL RIGHTS RESERVED"
Acquired from: gift of P/K Associates, New York, New York

374. ST. MARK'S CHURCH (P1984.35.345)
Gelatin silver print. negative 1929–39, print 1978–79
Image: 9 1/4 x 7 7/16 in. (23.5 x 18.9 cm.)
Mount: 10 x 8 in. (25.4 x 20.3 cm.)
Signed, l.r. mount recto: "BA"
Inscription, mount recto: crop marks
mount verso: "180-4//560" and rubber stamp "BERENICE
ABBOTT/ABBOT, MAINE 04406/ALL RIGHTS
RESERVED"
Acquired from: gift of P/K Associates, New York, New York

375. ST. PAUL'S CHURCH (P1984.35.17)
Gelatin silver print. negative 1929–39, print 1978–79
Image: 9 7/16 x 7 1/2 in. (24.0 x 19.0 cm.)
Mount: 10 x 8 in. (25.4 x 20.3 cm.)
Signed, l.r. mount recto: "BA"
Inscription, mount verso: "104-3/ST. Pauls Church//218" and
rubber stamp "BERENICE ABBOTT/ABBOT, MAINE
04406/ALL RIGHTS RESERVED"
Acquired from: gift of P/K Associates, New York, New York

376. ST. PAUL'S CHURCH (P1984.35.303)
Gelatin silver print. negative 1929–39, print 1978–79
Image: 9 3/8 x 7 1/2 in. (23.8 x 19.0 cm.)
Mount: 10 x 8 in. (25.4 x 20.3 cm.)
Signed, l.r. mount recto: "BA"
Inscription, mount verso: "517" and rubber stamp
"BERENICE ABBOTT/ ABBOT, MAINE 04406/ALL
RIGHTS RESERVED"
Acquired from: gift of P/K Associates, New York, New York

377. SAINTS FOR SALE (P1984.35.3)
Gelatin silver print. negative 1932, print 1978–79
Image: 7 1/2 x 9 7/16 in. (19.0 x 24.0 cm.)
Mount: 8 x 10 in. (20.3 x 25.4 cm.)

Signed, l.r. mount recto: "BA"
Inscription, mount verso: "40-1//204" and rubber stamp
"BERENICE ABBOTT/ABBOT, MAINE 04406/ALL
RIGHTS RESERVED"
Acquired from: gift of P/K Associates, New York, New York

378. SAINTS FOR SALE (P1984.35.224)
Gelatin silver print. negative 1932, print 1978–79
Image: 7 9/16 x 9 1/2 in. (19.2 x 24.1 cm.)
Mount: 8 x 10 in. (20.3 x 25.4 cm.)
Signed, l.r. mount recto: "BA"
Inscription, mount verso: "77-2 Saints For Sale//437" and
rubber stamp "BERENICE ABBOTT/ABBOT, MAINE
04406/ALL RIGHTS RESERVED"
Acquired from: gift of P/K Associates, New York, New York

*379. SAM PUTNAM (P1984.35.455)
Gelatin silver print. negative c. 1929, print 1978–79
Image: 4 7/16 x 3 5/16 in. (11.3 x 8.4 cm.)
Mount: 10 x 8 in. (25.4 x 20.3 cm.)
Signed, l.r. mount recto: "BA"
Inscription, mount verso: "Sam Putnam//679" and rubber
stamp "BERENICE ABBOTT/ABBOT, MAINE 04406/
ALL RIGHTS RESERVED"
Acquired from: gift of P/K Associates, New York, New York

*380. SCAPINI, BLIND DEPUTY [M. Scapini] (P1984.35.390)
Gelatin silver print. negative c. 1927, print 1978–79
Image: 4 3/8 x 3 1/8 in. (11.1 x 7.9 cm.)
Mount: 10 x 8 in. (25.4 x 20.3 cm.)
Signed, l.r. mount recto: "BA"
Inscription, mount verso: "Scapini, blind deputy//609" and
rubber stamp "BERENICE ABBOTT/ABBOT, MAINE
04406/ALL RIGHTS RESERVED"
Acquired from: gift of P/K Associates, New York, New York

381. SCRUTON'S PHARMACY (P1984.35.9)
Gelatin silver print. negative 1931, print 1978–79
Image: 9 1/4 x 6 15/16 in. (23.5 x 17.6 cm.)
Mount: 10 x 8 in. (25.4 x 20.3 cm.)
Signed, l.r. mount recto: "BA"
Inscription, mount verso: "3-1//210" and rubber stamp
"BERENICE ABBOTT/ABBOT, MAINE 04406/ALL
RIGHTS RESERVED"
Acquired from: gift of P/K Associates, New York, New York

382. SCRUTON'S PHARMACY (P1984.35.103)
Gelatin silver print. negative 1931, print 1978–79
Image: 9 5/16 x 7 in. (23.7 x 17.8 cm.)
Mount: 10 x 8 in. (25.4 x 20.3 cm.)
Signed, l.r. mount recto: "BA"
Inscription, mount verso: "194-5//312" and rubber stamp
"BERENICE ABBOTT/ABBOT, MAINE 04406/ALL
RIGHTS RESERVED"
Acquired from: gift of P/K Associates, New York, New York

383. SCRUTON'S PHARMACY (P1984.35.126)
Gelatin silver print. negative 1931, print 1978–79
Image: 9 1/2 x 7 1/2 in. (24.1 x 19.0 cm.)
Mount: 10 x 8 in. (25.4 x 20.3 cm.)
Signed, l.r. mount recto: "BA"
Inscription, mount verso: "208-5//336" and rubber stamp
"BERENICE ABBOTT/ABBOT, MAINE 04406/ALL
RIGHTS RESERVED"
Acquired from: gift of P/K Associates, New York, New York

*384. [Seventh Avenue, looking south from above Pennsylvania
Station] (P1984.35.147)
Gelatin silver print. negative 1929–39, print 1978–79
Image: 5 11/16 x 4 1/4 in. (14.4 x 10.8 cm.)
Mount: 10 x 8 in. (25.4 x 20.3 cm.)
Signed, bottom center mount verso: "Berenice Abbott"
Inscription, print verso: [print is mounted, but illegible
inscription is visible in reverse]
mount verso: "272-6//357"
Acquired from: gift of P/K Associates, New York, New York

379

380

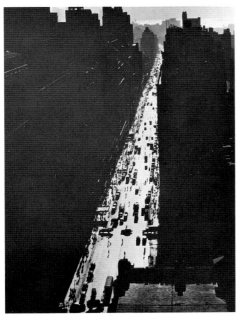

384

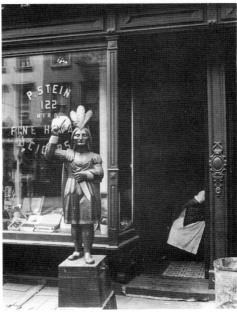

389

385. [Sheriff Street] (P1984.35.8)
Gelatin silver print. negative c. 1938, print 1978–79
Image: 7 1/2 x 9 9/16 in. (19.0 x 24.3 cm.)
Mount: 8 x 10 in. (20.3 x 25.4 cm.)
Signed, l.r. mount recto: "BA"
Inscription, mount verso: "209/284-7" and rubber stamp
 "BERENICE ABBOTT/ABBOT, MAINE 04406/ALL
 RIGHTS RESERVED"
Acquired from: gift of P/K Associates, New York, New York

386. **SHOE SHINE PARLOR** (P1984.35.169)
Gelatin silver print. negative 1929–39, print 1978–79
Image: 7 7/16 x 9 1/2 in. (18.9 x 24.1 cm.)
Mount: 8 x 10 in. (20.3 x 25.4 cm.)
Signed, l.r. mount recto: "BA"
Inscription, mount verso: "73-2 Shoe Shine Parlor//379" and
 rubber stamp "BERENICE ABBOTT/ABBOT, MAINE
 04406/ALL RIGHTS RESERVED"
Acquired from: gift of P/K Associates, New York, New York

387. **"SINDBAD" GUGGENHEIM (VAIL) [Michael Cedric
 Sindbad Vail]** (P1984.35.435)
Gelatin silver print. negative 1926, print 1978–79
Image: 4 5/16 x 3 5/16 in. (11.0 x 8.4 cm.)
Mount: 10 x 8 in. (25.4 x 20.3 cm.)
Signed, l.r. mount recto: "BA."
Inscription, mount recto: ""Sinbad" [sic] Guggenheim
 (Vail)" and crop mark
 mount verso: "659"
Acquired from: gift of P/K Associates, New York, New York

388. **SISLEY HUDDLESTON** (P1984.35.471)
Gelatin silver print. negative 1926–30, print 1978–79
Image: 3 5/16 x 2 5/16 in. (8.4 x 5.8 cm.)
Mount: 10 x 8 in. (25.4 x 20.3 cm.)
Signed, l.r. mount recto: "BA"
Inscription, mount verso: "Sisley Huddleston//695"
Acquired from: gift of P/K Associates, New York, New York

*389. **SNUFF SHOP, N.Y.** (P1984.35.294)
Gelatin silver print. negative 1935, print 1978–79
Image: 9 3/8 x 7 7/16 in. (23.8 x 18.9 cm.)
Mount: 10 x 8 in. (25.4 x 20.3 cm.)
Signed, l.r. mount recto: "BA"
Inscription, mount verso: "8-1//508" and rubber stamp
 "BERENICE ABBOTT/ABBOT, MAINE 04406/ALL
 RIGHTS RESERVED"
Acquired from: gift of P/K Associates, New York, New York

390. **SNUFF SHOP, N.Y.** (P1984.35.306)
Gelatin silver print. negative 1935, print 1978–79
Image: 9 1/4 x 7 5/16 in. (23.5 x 18.5 cm.)
Mount: 10 x 8 in. (25.4 x 20.3 cm.)
Signed, l.r. mount recto: "BA"
Inscription, mount verso: "182-4//520" and rubber stamp
 "BERENICE ABBOTT/ABBOT, MAINE 04406/ALL
 RIGHTS RESERVED"
Acquired from: gift of P/K Associates, New York, New York

*391. **SNUFF SHOP, 113 DIVISION STREET** (P1984.35.260)
Gelatin silver print. negative 1938, print 1978–79
Image: 9 9/16 x 7 9/16 in. (24.3 x 19.2 cm.)
Mount: 10 x 8 in. (25.4 x 20.3 cm.)
Signed, l.r. mount recto: "BA"
Inscription, mount verso: "7-1//474" and rubber stamp
 "BERENICE ABBOTT/ABBOT, MAINE 04406/ALL
 RIGHTS RESERVED"
Acquired from: gift of P/K Associates, New York, New York

392. **SNUFF SHOP, 113 DIVISION STREET** (P1984.35.283)
Gelatin silver print. negative 1938, print 1978–79
Image: 9 7/16 x 7 9/16 in. (24.0 x 19.2 cm.)
Mount: 10 x 8 in. (25.4 x 20.3 cm.)
Signed, l.r. mount recto: "BA"
Inscription, mount verso: "14-1//497" and rubber stamp

"BERENICE ABBOTT/ABBOT, MAINE 04406/ALL
 RIGHTS RESERVED"
Acquired from: gift of P/K Associates, New York, New York

393. **SNUFF SHOP, 113 DIVISION STREET** (P1984.35.291)
Gelatin silver print. negative 1938, print 1978–79
Image: 9 3/8 x 7 9/16 in. (23.8 x 19.2 cm.)
Mount: 10 x 8 in. (25.4 x 20.3 cm.)
Signed, l.r. mount recto: "BA"
Inscription, mount verso: "44-1//505" and rubber stamp
 "BERENICE ABBOTT/ABBOT, MAINE 04406/ALL
 RIGHTS RESERVED"
Acquired from: gift of P/K Associates, New York, New York

*394. **SOBOL GAS STATION** (P1984.35.114)
Gelatin silver print. negative 1929–39, print 1978–79
Image: 7 1/2 x 9 1/2 in. (19.0 x 24.1 cm.)
Mount: 8 x 10 in. (20.3 x 25.4 cm.)
Signed, l.r. mount recto: "BA"
Inscription, mount verso: "270-6//325" and rubber stamp
 "BERENICE ABBOTT/ABBOT, MAINE 04406/ALL
 RIGHTS RESERVED"
Acquired from: gift of P/K Associates, New York, New York

395. **SOBOL GAS STATION AT NIGHT, NEW YORK**
 (P1984.35.69)
Gelatin silver print. negative 1929–39, print 1978–79
Image: 7 11/16 x 9 1/2 in. (19.5 x 24.1 cm.)
Mount: 8 x 10 in. (20.3 x 25.4 cm.)
Signed, l.r. mount recto: "BA"
Inscription, mount verso: "228-5//277" and rubber stamp
 "BERENICE ABBOTT/ABBOT, MAINE 04406/ALL
 RIGHTS RESERVED"
Acquired from: gift of P/K Associates, New York, New York

*396. **SOBOL GAS STATION AT NIGHT, NEW YORK**
 (P1984.35.70)
Gelatin silver print. negative 1929–39, print 1978–79
Image: 7 5/8 x 9 1/2 in. (19.4 x 24.1 cm.)
Mount: 8 x 10 in. (20.3 x 25.4 cm.)
Signed, l.r. mount recto: "BA"
Inscription, mount verso: "278//229-5" and rubber stamp
 "BERENICE ABBOTT/ABBOT, MAINE 04406/ALL
 RIGHTS RESERVED"
Acquired from: gift of P/K Associates, New York, New York

397. **SOLITA SOLANO** (P1984.35.422)
Gelatin silver print. negative 1926–30, print 1978–79
Image: 4 7/16 x 3 5/16 in. (11.3 x 8.4 cm.)
Mount: 10 x 8 in. (25.4 x 20.3 cm.)
Signed, l.r. mount recto: "BA"
Inscription, mount verso: "Solita Solano//643"
Acquired from: gift of P/K Associates, New York, New York

398. **SOLITA SOLANO** (P1984.35.425)
Gelatin silver print. negative 1926–30, print 1978–79
Image: 4 7/16 x 3 7/16 in. (11.3 x 8.7 cm.)
Mount: 10 x 8 in. (25.4 x 20.3 cm.)
Signed, l.r. mount recto: "BA"
Inscription, mount verso: "Solita Solano//646"
Acquired from: gift of P/K Associates, New York, New York

399. **SOLITA SOLANO** (P1984.35.444)
Gelatin silver print. negative 1926–30, print 1978–79
Image: 4 5/16 x 3 5/16 in. (11.0 x 8.4 cm.)
Mount: 10 x 8 in. (25.4 x 20.3 cm.)
Signed, l.r. mount recto: "BA"
Inscription, mount verso: "Solita Solano//668"
Acquired from: gift of P/K Associates, New York, New York

400. **SOPHIE VICTOR** (P1984.35.409)
Gelatin silver print. negative 1926–30, print 1978–79
Image: 4 1/4 x 3 5/16 in. (10.8 x 8.4 cm.)
Mount: 10 x 8 in. (25.4 x 20.3 cm.)
Signed, l.r. mount recto: "BA"
Inscription, mount recto: "Sophy [sic] Victor" and crop marks
 mount verso: "630"
Acquired from: gift of P/K Associates, New York, New York

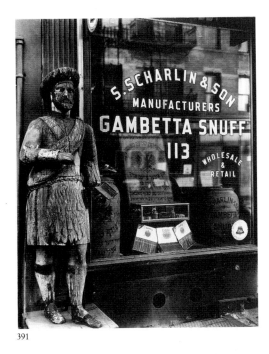

391

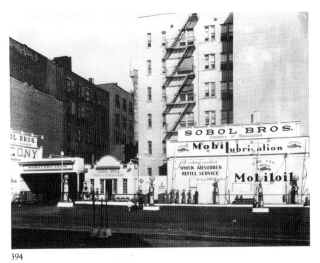

394

407

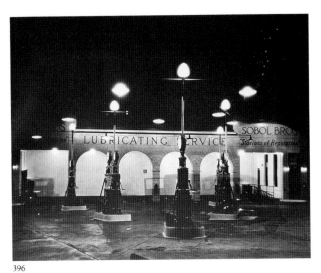

396

411

401. **SOUTH STREET** (P1984.35.194)
Gelatin silver print. negative 1929–39, print 1978–79
Image: 7 5/16 x 9 3/16 in. (18.5 x 23.3 cm.)
Mount: 8 x 10 in. (20.3 x 25.4 cm.)
Signed, l.r. mount recto: "BA"
Inscription, mount recto: crop marks
mount verso: "183-4//404" and rubber stamp "BERENICE
ABBOTT/ABBOT, MAINE 04406/ALL RIGHTS
RESERVED"
Acquired from: gift of P/K Associates, New York, New York

402. **SOUTH STREET** (P1984.35.321)
Gelatin silver print. negative 1929–39, print 1978–79
Image: 7 5/16 x 9 1/2 in. (18.5 x 24.1 cm.)
Mount: 8 1/8 x 10 in. (20.6 x 25.4 cm.)
Signed, l.r. mount recto: "BA"
Inscription, mount verso: "185-4//536" and rubber stamp
"BERENICE ABBOTT/ABBOT, MAINE 04406/ALL
RIGHTS RESERVED"
Acquired from: gift of P/K Associates, New York, New York

403. **SOUTH ST., MANHATTAN BRIDGE** (P1984.35.18)
Gelatin silver print. negative 1937, print 1978–79
Image: 7 1/2 x 9 1/2 in. (19.0 x 24.1 cm.)
Mount: 8 x 10 in. (20.3 x 25.4 cm.)
Signed, l.r. mount recto: "BA"
Inscription, mount verso: "219//104-3/South ST./Manhatten
[sic] Bridge" and rubber stamp "BERENICE ABBOTT/
ABBOT, MAINE 04406/ ALL RIGHTS RESERVED"
Acquired from: gift of P/K Associates, New York, New York

404. **[South Union Township School, District No. 2]**
(P1984.35.238)
Gelatin silver print. negative 1935–61, print 1978–79
Image: 7 1/2 x 9 3/8 in. (19.0 x 23.8 cm.)
Mount: 8 x 10 in. (20.3 x 25.4 cm.)
Signed, l.r. mount recto: "BA"
Inscription, mount verso: "451" and rubber stamp
"BERENICE ABBOTT/ ABBOT, MAINE 04406/ALL
RIGHTS RESERVED"
Acquired from: gift of P/K Associates, New York, New York

405. **SQUIBB BUILDING** (P1984.35.320)
Gelatin silver print. negative 1929–39, print 1978–79
Image: 7 5/16 x 9 3/16 in. (18.5 x 23.3 cm.)
Mount: 8 1/8 x 10 in. (20.6 x 25.4 cm.)
Signed, l.r. mount recto: "BA"
Inscription, mount verso: "184-4//535" and rubber stamp
"BERENICE ABBOTT/ABBOT, MAINE 04406/ALL
RIGHTS RESERVED"
Acquired from: gift of P/K Associates, New York, New York

406. **SQUIBB BUILDING WITH SHERRY NETHERLAND IN
BACKGROUND** (P1984.35.49)
Gelatin silver print. negative 1935, print 1978–79
Image: 9 7/16 x 7 3/8 in. (24.0 x 18.7 cm.)
Mount: 10 x 8 in. (25.4 x 20.3 cm.)
Signed, bottom center mount verso: "Berenice Abbott"
Inscription, mount verso: "303-7//257"
Acquired from: gift of P/K Associates, New York, New York

*407. **STARIN HOUSE** (P1984.35.84)
Gelatin silver print. negative 1929–39, print 1978–79
Image: 9 1/2 x 7 5/8 in. (24.1 x 19.4 cm.)
Mount: 10 x 8 in. (25.4 x 20.3 cm.)
Signed, l.r. mount recto: "BA"
Inscription, mount verso: "50-2 Starin House//292" and
rubber stamp "BERENICE ABBOTT/ABBOT, MAINE
04406/ALL RIGHTS RESERVED"
Acquired from: gift of P/K Associates, New York, New York

408. **STARRETT-LEHIGH BUILDING** (P1984.35.173)
Gelatin silver print. negative 1929–39, print 1978–79
Image: 7 1/2 x 9 7/16 in. (19.0 x 24.0 cm.)
Mount: 8 x 10 in. (20.3 x 25.4 cm.)

Signed, l.r. mount recto: "BA"
Inscription, mount verso: "66-2 Leheigh-Starrett [sic]// 383"
and rubber stamp "BERENICE ABBOTT/ABBOT,
MAINE, 04406/ ALL RIGHTS RESERVED"
Acquired from: gift of P/K Associates, New York, New York

409. **STARRETT-LEHIGH BUILDING** (P1984.35.188)
Gelatin silver print. negative 1929–39, print 1978–79
Image: 9 1/16 x 7 5/16 in. (23.0 x 18.5 cm.)
Mount: 10 x 8 in. (25.4 x 20.3 cm.)
Signed, l.r. mount recto: "BA"
Inscription, mount verso: "188-4//398" and rubber stamp
"BERENICE ABBOTT/ABBOT, MAINE 04406/ALL
RIGHTS RESERVED"
Acquired from: gift of P/K Associates, New York, New York

410. **STATEN ISLAND [Italianate house]** (P1984.35.331)
Gelatin silver print. negative 1935–61, print 1978–79
Image: 7 3/8 x 9 1/4 in. (18.7 x 23.5 cm.)
Mount: 8 x 10 in. (20.3 x 25.4 cm.)
Signed, l.r. mount recto: "BA"
Inscription, print verso [print is mounted, but inscription is
visible in reverse]: "91-4 Staten Island [illegible]"
mount verso: "191-4//546" and rubber stamp "BERENICE
ABBOTT/ ABBOT, MAINE 04406/ALL RIGHTS
RESERVED"
Acquired from: gift of P/K Associates, New York, New York

*411. **STOCK EXCHANGE** (P1984.35.202)
Gelatin silver print. negative 1933, print 1978–79
Image: 9 1/2 x 7 7/16 in. (24.1 x 18.9 cm.)
Mount: 10 x 8 in. (25.4 x 20.3 cm.)
Signed, l.r. mount recto: "BA"
Inscription, mount verso: "111-3//411" and rubber stamp
"BERENICE ABBOTT/ABBOT, MAINE 04406/ALL
RIGHTS RESERVED"
Acquired from: gift of P/K Associates, New York, New York

412. **STOCK EXCHANGE** (P1984.35.222)
Gelatin silver print. negative 1933, print 1978–79
Image: 9 7/16 x 7 1/2 in. (24.0 x 19.0 cm.)
Mount: 10 x 8 in. (25.4 x 20.3 cm.)
Signed, l.r. mount recto: "BA"
Inscription, mount verso: "94-2//435" and rubber stamp
"BERENICE ABBOTT/ABBOT, MAINE 04406/ALL
RIGHTS RESERVED"
Acquired from: gift of P/K Associates, New York, New York

413. **STOCK EXCHANGE** (P1984.35.329)
Gelatin silver print. negative 1933, print 1978–79
Image: 9 1/2 x 7 7/16 in. (24.1 x 19.2 cm.)
Mount: 10 x 8 1/8 in. (25.4 x 20.6 cm.)
Signed, l.r. mount recto: "BA."
Inscription, mount verso: "190-4//544" and rubber stamp
"BERENICE ABBOTT/ABBOT, MAINE 04406/ALL
RIGHTS RESERVED"
Acquired from: gift of P/K Associates, New York, New York

414. **STOCK EXCHANGE** (P1984.35.356)
Gelatin silver print. negative 1933, print 1978–79
Image: 9 7/16 x 7 9/16 in. (24.0 x 19.2 cm.)
Mount: 10 x 8 1/8 in. (25.4 x 20.5 cm.)
Signed, l.r. mount recto: "BA"
Inscription, mount verso: "110-3/Stock Exchange//571" and
rubber stamp "BERENICE ABBOTT/ABBOT, MAINE
04406/ALL RIGHTS RESERVED"
Acquired from: gift of P/K Associates, New York, New York

415. **STOCK EXCHANGE** (P1984.35.357)
Gelatin-silver print. negative 1933, print 1978–79
Image: 9 1/2 x 7 5/8 in. (24.1 x 19.4 cm.)
Mount: 10 x 8 1/8 in. (25.4 x 20.6 cm.)
Signed, l.r. mount recto: "BA"
Inscription, mount verso: "112-3//572" and rubber stamp
"BERENICE ABBOTT/ABBOT, MAINE 04406/ALL
RIGHTS RESERVED"
Acquired from: gift of P/K Associates, New York, New York

416. **STONE AND WILLIAM STREETS** (P1984.35.176)
Gelatin silver print. negative 1936, print 1978–79
Image: 9½ x 7½ in. (24.1 x 19.0 cm.)
Mount: 10 x 8 in. (25.4 x 20.3 cm.)
Signed, l.r. mount recto: "BA"
Inscription, mount verso: "68-2//386" and rubber stamp
"BERENICE ABBOTT/ABBOT, MAINE 04406/ALL
RIGHTS RESERVED"
Acquired from: gift of P/K Associates, New York, New York

*417. **STOREFRONT** (P1984.35.38)
Gelatin silver print. negative c. 1930, print 1978–79
Image: 5 x 6¾ in. (12.7 x 17.1 cm.)
Mount: 8 x 10 in. (20.3 x 25.4 cm.)
Signed, bottom center mount verso: "Berenice Abbott"
Inscription, mount verso: "246"
Acquired from: gift of P/K Associates, New York, New York

418. **STOREFRONT** (P1984.35.66)
Gelatin silver print. negative c. 1930, print 1978–79
Image: 3 x 4¼ in. (7.6 x 10.8 cm.)
Mount: 8 x 10 in. (20.3 x 25.4 cm.)
Signed, bottom center mount verso: "Berenice Abbott"
Inscription, mount verso: "274"
Acquired from: gift of P/K Associates, New York, New York

417

419. **[Storefronts of Stanley W. Ferguson, Inc., D. & L. Slade Co., and Chadwick & Carr Co.]** (P1984.35.247)
Gelatin silver print. negative 1929–39, print 1978–79
Image: 7½ x 9½ in. (19.0 x 24.1 cm.)
Mount: 8 x 10 in. (20.3 x 25.4 cm.)
Signed, l.r. mount recto: "BA"
Inscription, mount verso: "460" and rubber stamp
"BERENICE ABBOTT/ ABBOT, MAINE 04406/ALL
RIGHTS RESERVED"
Acquired from: gift of P/K Associates, New York, New York

*420. **[Street in rural town]** (P1984.35.241)
Gelatin silver print. negative 1935–40s, print 1978–79
Image: 7½ x 9⁷⁄₁₆ in. (19.0 x 24.0 cm.)
Mount: 8 x 10 in. (20.3 x 25.4 cm.)
Signed, l.r. mount recto: "BA"
Inscription, mount verso: "454" and rubber stamp
"BERENICE ABBOTT/ABBOT, MAINE 04406/ALL
RIGHTS RESERVED"
Acquired from: gift of P/K Associates, New York, New York

420

421. **[Street scene]** (P1984.35.105)
Gelatin silver print. negative 1929–39, print 1978–79
Image: 7¹⁄₁₆ x 7½ in. (17.9 x 19.0 cm.)
Mount: 10 x 8 in. (25.4 x 20.3 cm.)
Signed, l.r. mount recto: "BA"
Inscription, mount verso: "196-5//314" and rubber stamp
"BERENICE ABBOTT/ABBOT, MAINE 04406/ALL
RIGHTS RESERVED"
Acquired from: gift of P/K Associates, New York, New York

422. **[Street vendor]** (P1984.35.88)
Gelatin silver print. negative 1929–39, print 1978–79
Image: 7¹¹⁄₁₆ x 5⁹⁄₁₆ in. (19.5 x 14.1 cm.)
Mount: 10 x 8 in. (25.4 x 20.3 cm.)
Signed, bottom center mount verso: "Berenice Abbott"
Inscription, mount verso: "296"
Acquired from: gift of P/K Associates, New York, New York

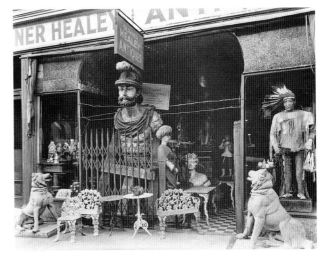
425

423. **SUB-TREASURY [Federal Reserve Building]** (P1984.35.170)
Gelatin silver print. negative 1929–39, print 1978–79
Image: 7⅝ x 9½ in. (19.4 x 24.1 cm.)
Mount: 8 x 10 in. (20.3 x 25.4 cm.)
Signed, l.r. mount recto: "BA"
Inscription, mount verso: "74-2 Sub-Treasury//380" and
rubber stamp "BERENICE ABBOTT/ABBOT,
MAINE 04406/ALL RIGHTS RESERVED"
Acquired from: gift of P/K Associates, New York, New York

424. **[Subway entrance, BMT Lines]** (P1984.35.191)
Gelatin silver print. negative 1929–39, print 1978–79
Image: 6¹⁵⁄₁₆ x 5 in. (17.6 x 12.7 cm.)
Mount: 10 x 8 in. (25.4 x 20.3 cm.)
Signed, l.r. mount recto: "BA"
Inscription, mount verso: "401" and rubber stamp
 "BERENICE ABBOTT/ABBOT, MAINE 04406/ALL
 RIGHTS RESERVED"
Acquired from: gift of P/K Associates, New York, New York

*425. **SUMNER HEALY ANTIQUE SHOP** (P1984.35.199)
Gelatin silver print. negative 1935, print 1978–79
Image: 7⁹⁄₁₆ x 9⁷⁄₁₆ in. (19.2 x 24.0 cm.)
Mount: 8 x 10 in. (20.3 x 25.4 cm.)
Signed, l.r. mount recto: "BA"
Inscription, mount verso: "192-4//409" and rubber stamp
 "BERENICE ABBOTT/ABBOT, MAINE 04406/ALL
 RIGHTS RESERVED"
Acquired from: gift of P/K Associates, New York, New York

426. **SUMNER HEALY ANTIQUE SHOP** (P1984.35.330)
Gelatin silver print. negative 1935, print 1978–79
Image: 9⁷⁄₁₆ x 7⁷⁄₁₆ in. (24.0 x 18.9 cm.)
Mount: 10 x 8 in. (25.4 x 20.3 cm.)
Signed, l.r. mount recto: "BA"
Inscription, mount verso: "192-4//545" and rubber stamp
 "BERENICE ABBOTT/ABBOT, MAINE 04406/ALL
 RIGHTS RESERVED"
Acquired from: gift of P/K Associates, New York, New York

427. **SWISS PAINTER** (P1984.35.434)
Gelatin silver print. negative 1926–30, print 1978–79
Image: 4⅜ x 3⁵⁄₁₆ in. (11.1 x 8.4 cm.)
Mount: 10 x 8 in. (25.4 x 20.3 cm.)
Signed, l.r. mount recto: "BA"
Inscription, mount verso: "Swiss Painter//658"
Acquired from: gift of P/K Associates, New York, New York

428. **SWISS PAINTER** (P1984.35.478)
Gelatin silver print. negative 1926–30, print 1978–79
Image: 4⁵⁄₁₆ x 3¼ in. (11.0 x 8.2 cm.)
Mount: 10 x 8 in. (25.4 x 20.3 cm.)
Signed, l.r. mount recto: "BA"
Inscription, mount verso: "Swiss Painter//702"
Acquired from: gift of P/K Associates, New York, New York

*429. **SYLVIA BEACH** (P1984.35.408)
Gelatin silver print. negative 1927, print 1978–79
Image: 4⅜ x 3³⁄₁₆ in. (11.1 x 8.1 cm.)
Mount: 10 x 8 in. (25.4 x 20.3 cm.)
Signed, l.r. mount recto: "BA"
Inscription, mount recto: "Sylvia Beach" and crop marks
 mount verso: "629"
Acquired from: gift of P/K Associates, New York, New York

430. **TAMARIS [Helen Tamaris]** (P1984.35.399)
Gelatin silver print. negative 1926–30, print 1978–79
Image: 4⅜ x 3¼ in. (11.1 x 8.2 cm.)
Mount: 10 x 8 in. (25.4 x 20.3 cm.)
Signed, l.r. mount recto: "BA"
Inscription, mount verso: "Tamaris//619" and rubber stamp
 "BERENICE ABBOTT/ABBOT, MAINE 04406/ALL
 RIGHTS RESERVED"
Acquired from: gift of P/K Associates, New York, New York

*431. **TEMPO OF THE CITY [Fifth Avenue at 44th Street]**
 (P1984.35.22)
Gelatin silver print. negative 1937, print 1978–79
Image: 3⅛ x 3⅛ in. (8.6 x 7.9 cm.)
Mount: 10 x 8 in. (25.4 x 20.3 cm.)
Signed: see inscription
Inscription, mount verso: "23-1/Tempo of The City//230" and
 rubber stamp "BERENICE ABBOTT/ABBOT, MAINE
 04406/ALL RIGHTS RESERVED"
Acquired from: gift of P/K Associates, New York, New York

432. **THELMA WOOD** (P1984.35.452)
Gelatin silver print. negative 1926–30, print 1978–79
Image: 3¹⁄₁₆ x 2³⁄₁₆ in. (7.8 x 5.5 cm.)
Mount: 10 x 8 in. (25.4 x 20.3 cm.)
Signed, l.r. mount recto: "BA"
Inscription, mount verso: "Thelma Wood//676"
Acquired from: gift of P/K Associates, New York, New York

*433. **"THEOLINE," PIER 11, EAST RIVER, MANHATTAN**
 (P1980.29)
Gelatin silver print. 1936
Image: 9⁹⁄₁₆ x 7½ in. (24.3 x 19.0 cm.)
Mount: 14 x 10¹³⁄₁₆ in. (35.6 x 27.5 cm.)
Signed, l.r. mount recto: "BERENICE ABBOTT"
Inscription, mount verso, rubber stamp: "PHOTOGRAPH/
 BERENICE ABBOTT/ ABBOTT [sic], MAINE 04406"
Acquired from: gift of James Maroney, Inc., New York, New York

434. **"THEOLINE," PIER 11, EAST RIVER, MANHATTAN**
 (P1984.35.307)
Gelatin silver print. negative 1936, print 1978–79
Image: 9⅜ x 7½ in. (23.8 x 19.0 cm.)
Mount: 10 x 8 in. (25.4 x 20.3 cm.)
Signed, l.r. mount recto: "BA"
Inscription, mount verso: "183-4//521" and rubber stamp
 "BERENICE ABBOTT/ABBOT, MAINE 04406/ALL
 RIGHTS RESERVED"
Acquired from: gift of P/K Associates, New York, New York

435. **[34th Street showing the Armory and the Empire State
 Building]** (P1984.35.25)
Gelatin silver print. negative 1931–39, print 1978–79
Image: 9⁷⁄₁₆ x 7½ in. (24.0 x 19.0 cm.)
Mount: 10 x 8 in. (25.4 x 20.3 cm.)
Signed, l.r. mount recto: "BA"
Inscription, mount verso: "138-3//233"
Acquired from: gift of P/K Associates, New York, New York

436. **TRIBOROUGH BRIDGE** (P1984.35.7)
Gelatin silver print. negative 1937, print 1978–79
Image: 8¾ x 7⁷⁄₁₆ in. (22.2 x 18.9 cm.)
Mount: 10 x 8 in. (25.4 x 20.3 cm.)
Signed, l.r. mount recto: "BA"
Inscription, mount verso: "285-7//208" and rubber stamp
 "BERENICE ABBOTT/ABBOT, MAINE 04406/ALL
 RIGHTS RESERVED"
Acquired from: gift of P/K Associates, New York, New York

*437. **TRINITY [Trinity Church]** (P1984.35.212)
Gelatin silver print. negative 1934, print 1978–79
Image: 7½ x 9⁷⁄₁₆ in. (19.0 x 24.0 cm.)
Mount: 8 x 10 in. (20.3 x 25.4 cm.)
Signed, l.r. mount recto: "BA"
Inscription, mount verso: "60-2 Trinity//423" and rubber
 stamp "BERENICE ABBOTT/ABBOT, MAINE 04406/
 ALL RIGHTS RESERVED"
Acquired from: gift of P/K Associates, New York, New York

438. **TRINITY [Trinity Church]** (P1984.35.221)
Gelatin silver print. negative 1934, print 1978–79
Image: 7⁷⁄₁₆ x 9½ in. (18.9 x 24.1 cm.)
Mount: 8 x 10 in. (20.3 x 25.4 cm.)
Signed, l.r. mount recto: "BA"
Inscription, mount verso: "95-2 Trinity//433" and rubber
 stamp "BERENICE ABBOTT/ABBOT, MAINE 04406/
 ALL RIGHTS RESERVED"
Acquired from: gift of P/K Associates, New York, New York

439. **TRINITY [Trinity Church and Wall Street Towers]**
 (P1984.35.225)
Gelatin silver print. negative 1934, print 1978–79
Image: 9⅜ x 7⁷⁄₁₆ in. (23.8 x 18.9 cm.)
Mount: 10 x 8 in. (25.4 x 20.3 cm.)
Signed, l.r. mount recto: "BA"
Inscription, mount verso: "78-2 Trinity//438" and rubber
 stamp "BERENICE ABBOTT/ABBOT, MAINE 04406/
 ALL RIGHTS RESERVED"
Acquired from: gift of P/K Associates, New York, New York

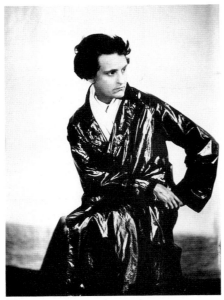

429

431

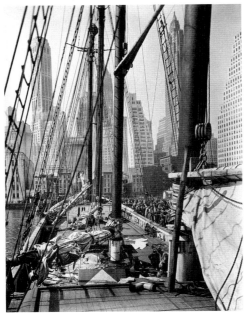

433

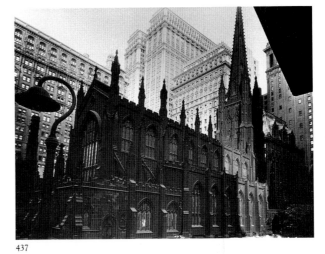

437

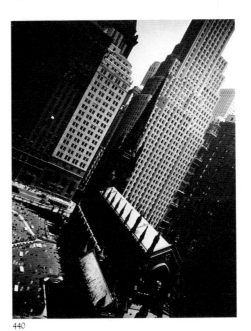

440

*440. **TRINITY CHURCH** (P1984.35.6)
Gelatin silver print. negative 1934, print 1978−79
Image: 9½ x 7⅜ in. (24.1 x 18.7 cm.)
Mount: 10 x 8 in. (25.4 x 20.3 cm.)
Signed, l.r. mount recto: "BA"
Inscription, mount verso: "286-7//207" and rubber stamp
"BERENICE ABBOTT/ABBOT, MAINE 04406/ALL
RIGHTS RESERVED"
Acquired from: gift of P/K Associates, New York, New York

441. **TRINITY CHURCH** (P1984.35.262)
Gelatin silver print. negative 1934, print 1978−79
Image: 9⅛ x 7⅜ in. (23.8 x 18.7 cm.)
Mount: 10 x 8 in. (25.4 x 20.3 cm.)
Signed, l.r. mount recto: "BA"
Inscription, mount verso: "10-1//476" and rubber stamp
"BERENICE ABBOTT/ABBOT, MAINE 04406/ALL
RIGHTS RESERVED"
Acquired from: gift of P/K Associates, New York, New York

442. **TRINITY CHURCH** (P1984.35.288)
Gelatin silver print. negative 1934, print 1978−79
Image: 9⁷⁄₁₆ x 7½ in. (24.0 x 19.0 cm.)
Mount: 10 x 8 in. (25.4 x 20.3 cm.)
Signed, l.r. mount recto: "BA"
Inscription, mount verso: "41-1//502" and rubber stamp
"BERENICE ABBOTT/ABBOT, MAINE 04406/ALL
RIGHTS RESERVED"
Acquired from: gift of P/K Associates, New York, New York

443. **TRINITY CHURCHYARD** (P1984.35.5)
Gelatin silver print. negative 1934, print 1978−79
Image: 7⅜ x 9⅜ in. (18.7 x 23.8 cm.)
Mount: 8 x 10 in. (20.3 x 25.4 cm.)
Signed, l.r. mount recto: "BA"
Inscription, mount verso: "287-7//206" and rubber stamp
"BERENICE ABBOTT/ABBOT, MAINE 04406/ALL
RIGHTS RESERVED"
Acquired from: gift of P/K Associates, New York, New York

444. **[26 Broadway, Standard Oil Building]** (P1984.35.267)
Gelatin silver print. negative 1929−39, print 1978−79
Image: 8⅞ x 7⁷⁄₁₆ in. (22.5 x 18.9 cm.)
Mount: 10 x 8 in. (25.4 x 20.3 cm.)
Signed, l.r. mount recto: "BA"
Inscription, mount verso: "129-3//481" and rubber stamp
"BERENICE ABBOTT/ABBOT, MAINE 04406/ALL
RIGHTS RESERVED"
Acquired from: gift of P/K Associates, New York, New York

445. **[26 Broadway, Standard Oil Building]** (P1984.35.268)
Gelatin silver print. negative 1929−39, print 1978−79
Image: 9⁷⁄₁₆ x 7⁷⁄₁₆ in. (24.0 x 18.9 cm.)
Mount: 10 x 8 in. (25.4 x 20.3 cm.)
Signed, l.r. mount recto: "BA"
Inscription, mount verso: "128-3//482" and rubber stamp
"BERENICE ABBOTT/ABBOT, MAINE 04406/ALL
RIGHTS RESERVED"
Acquired from: gift of P/K Associates, New York, New York

446. **[22 East 40th Street, east from Park Avenue]** (P1984.35.58)
Gelatin silver print. negative 1929−39, print 1978−79
Image: 9½ x 7¾ in. (24.1 x 19.7 cm.)
Mount: 10 x 8 in. (25.4 x 20.3 cm.)
Signed, bottom center mount verso: "Berenice Abbott"
Inscription, mount verso: "317-7//266"
Acquired from: gift of P/K Associates, New York, New York

*447. **[22 Louisburg Square, Boston, Massachusetts]** (P1984.35.248)
Gelatin silver print. negative 1934, print 1978−79
Image: 9⁹⁄₁₆ x 7⁹⁄₁₆ in. (24.3 x 19.2 cm.)
Mount: 10 x 8 in. (25.4 x 20.3 cm.)
Signed, l.r. mount recto: "BA"
Inscription, mount verso: "461" and rubber stamp
"BERENICE ABBOTT/ ABBOT, MAINE 04406/ALL
RIGHTS RESERVED"
Acquired from: gift of P/K Associates, New York, New York

*448. **[Two-story frame house in country]** (P1984.35.100)
Gelatin silver print. negative 1935−61, print 1978−79
Image: 7½ x 9⁷⁄₁₆ in. (19.0 x 24.0 cm.)
Mount: 8 x 10 in. (20.3 x 25.4 cm.)
Signed, l.r. mount recto: "BA"
Inscription, mount verso: "224-5//309" and rubber stamp
"BERENICE ABBOTT/ABBOT, MAINE 04406/ALL
RIGHTS RESERVED"
Acquired from: gift of P/K Associates, New York, New York

449. **TYLIA PERLMUTTER** (P1984.35.380)
Gelatin silver print. negative 1926−30, print 1978−79
Image: 3 x 4⅟₁₆ in. (7.6 x 10.3 cm.)
Mount: 10 x 8 in. (25.4 x 20.3 cm.)
Signed, l.r. mount recto: "BA"
Inscription, mount verso: "Tylia Perlmutter//599"
Acquired from: gift of P/K Associates, New York, New York

450. **UNDER PENN STATION VIADUCT** (P1984.35.300)
Gelatin silver print. negative 1936, print 1978−79
Image: 7⁷⁄₁₆ x 9⁷⁄₁₆ in. (18.9 x 24.0 cm.)
Mount: 8 x 10 in. (20.3 x 25.4 cm.)
Signed, l.r. mount recto: "BA"
Inscription, mount verso: "174-4//514" and rubber stamp
"BERENICE ABBOTT/ABBOT, MAINE 04406/ALL
RIGHTS RESERVED"
Acquired from: gift of P/K Associates, New York, New York

*451. **UNDER THE EL** (P1984.35.12)
Gelatin silver print. negative 1936, print 1978−79
Image: 7¼ x 8¹¹⁄₁₆ in. (18.4 x 22.1 cm.)
Mount: 8 x 10 in. (20.3 x 25.4 cm.)
Signed, l.r. mount recto: "BA"
Inscription, mount verso: "213//115-3" and rubber stamp
"BERENICE ABBOTT/ABBOT, MAINE 04406/ALL
RIGHTS RESERVED"
Acquired from: gift of P/K Associates, New York, New York

452. **UNDER THE EL** (P1984.35.67)
Gelatin silver print. negative 1936, print 1978−79
Image: 4⅛ x 2¹⁵⁄₁₆ in. (10.5 x 7.4 cm.)
Mount: 10 x 8 in. (25.4 x 20.3 cm.)
Signed, bottom center mount verso: "Berenice Abbott"
Inscription, mount verso: "275"
Acquired from: gift of P/K Associates, New York, New York

453. **UNDER THE EL** (P1984.35.109)
Gelatin silver print. negative 1936, print 1978−79
Image: 9½ x 7½ in. (24.1 x 19.0 cm.)
Mount: 10 x 8 in. (25.4 x 20.3 cm.)
Signed, l.r. mount recto: "BA"
Inscription, mount verso: "263-6//318" and rubber stamp
"BERENICE ABBOTT/ABBOT, MAINE 04406/ALL
RIGHTS RESERVED"
Acquired from: gift of P/K Associates, New York, New York

*454. **UNDER THE EL AT THE BATTERY** (P1984.35.54)
Gelatin silver print. negative 1932, print 1978−79
Image: 7½ x 9⅜ in. (19.0 x 23.8 cm.)
Mount: 8 x 10 in. (20.3 x 25.4 cm.)
Signed, bottom center mount verso: "Berenice Abbott"
Inscription, mount verso: "312-7//262"
Acquired from: gift of P/K Associates, New York, New York

455. **UNDER THE EL AT THE BATTERY** (P1984.35.56)
Gelatin silver print. negative 1932, print 1978−79
Image: 7½ x 9⁷⁄₁₆ in. (19.0 x 24.0 cm.)
Mount: 8 x 10 in. (20.3 x 25.4 cm.)
Signed, bottom center mount verso: "Berenice Abbott"
Inscription, mount verso: "311-7//264"
Acquired from: gift of P/K Associates, New York, New York

456. **[Unidentified boy holding a carved paddle]** (P1984.35.487)
Gelatin silver print. negative 1926−30, print 1978−79
Image: 4⁵⁄₁₆ x 3⁵⁄₁₆ in. (11.0 x 8.4 cm.)
Mount: 10 x 8 in. (25.4 x 20.3 cm.)

Inscription, mount recto: crop mark
 mount verso: "711"
Acquired from: gift of P/K Associates, New York, New York

457. **[Unidentified boy looking over his shoulder]** (P1984.35.362)
Gelatin silver print. negative 1926–30, print 1978–79
Image: 3¼ x 2⁷⁄₁₆ in. (8.2 x 6.2 cm.)
Mount: 10 x 8 in. (25.4 x 20.3 cm.)
Signed, l.r. mount recto: "BA"
Inscription, mount verso: "577"
Acquired from: gift of P/K Associates, New York, New York

458. **[Unidentified boy looking over his shoulder]** (P1984.35.369)
Gelatin silver print. negative 1926–30, print 1978–79
Image: 3¼ x 2⁵⁄₁₆ in. (8.2 x 5.8 cm.)
Mount: 10 x 8 in. (25.4 x 20.3 cm.)
Signed, l.r. mount recto: "BA"
Inscription, mount recto: crop mark
 mount verso: "585"
Acquired from: gift of P/K Associates, New York, New York

459. **[Unidentified man seated in chair]** (P1984.35.374)
Gelatin silver print. negative 1926–30, print 1978–79
Image: 4⁷⁄₁₆ x 3⁵⁄₁₆ in. (11.3 x 8.4 cm.)
Mount: 10 x 8 in. (25.4 x 20.3 cm.)
Signed, l.r. mount recto: "BA"
Inscription, mount verso: "591" and rubber stamp
 "BERENICE ABBOTT/ABBOT, MAINE 04406/ALL
 RIGHTS RESERVED"
Acquired from: gift of P/K Associates, New York, New York

460. **[Unidentified man seated in chair with his legs crossed]**
 (P1984.35.476)
Gelatin silver print. negative 1926–30, print 1978–79
Image: 4¼ x 3⁵⁄₁₆ in. (10.8 x 8.4 cm.)
Mount: 10 x 8 in. (25.4 x 20.3 cm.)
Signed, l.r. mount recto: "BA"
Inscription, mount verso: "700"
Acquired from: gift of P/K Associates, New York, New York

461. **[Unidentified man seated in chair with his legs crossed]**
 (P1984.35.490)
Gelatin silver print. negative 1926–30, print 1978–79
Image: 4⅜ x 3¼ in. (11.1 x 8.2 cm.)
Mount: 10 x 8 in. (25.4 x 20.3 cm.)
Signed, l.r. mount recto: "BA."
Inscription, mount recto: crop marks
 mount verso: "714"
Acquired from: gift of P/K Associates, New York, New York

462. **[Unidentified man wearing dark glasses, seated on trunk]**
 (P1984.35.461)
Gelatin silver print. negative 1926–30, print 1978–79
Image: 3¼ x 2⁵⁄₁₆ in. (8.2 x 5.8 cm.)
Mount: 10 x 8 in. (25.4 x 20.3 cm.)
Signed, l.r. mount recto: "BA"
Inscription, mount verso: "685"
Acquired from: gift of P/K Associates, New York, New York

463. **[Unidentified woman holding cigarette]** (P1984.35.365)
Gelatin silver print. negative 1926–30, print 1978–79
Image: 3¼ x 2⁷⁄₁₆ in. (8.2 x 6.2 cm.)
Mount: 10 x 8 in. (25.4 x 20.3 cm.)
Signed, l.r. mount recto: "BA"
Inscription, mount verso: "581"
Acquired from: gift of P/K Associates, New York, New York

464. **[Unidentified woman wearing jacket with embroidered flowers]**
 (P1984.35.462)
Gelatin silver print. negative 1926–30, print 1978–79
Image: 3³⁄₁₆ x 2⅜ in. (8.1 x 6.0 cm.)
Mount: 10 x 8 in. (25.4 x 20.3 cm.)
Signed, l.r. mount recto: "BA"
Inscription, mount verso: "686"
Acquired from: gift of P/K Associates, New York, New York

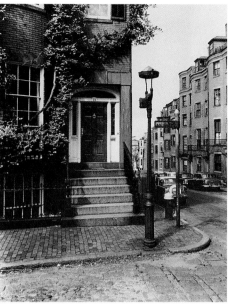
447

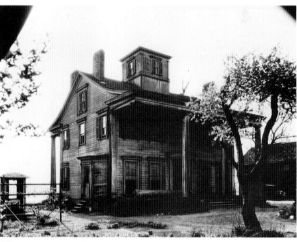
448

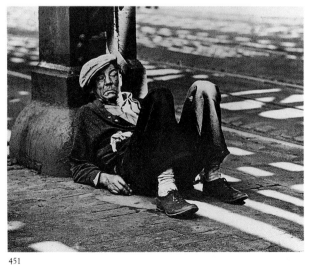
451

465. **[Unidentified woman wearing jacket with embroidered flowers]**
(P1984.35.469)
Gelatin silver print. negative 1926–30, print 1978–79
Image: 3¼ x 2⁷⁄₁₆ in. (8.2 x 6.2 cm.)
Mount: 10 x 8 in. (25.4 x 20.3 cm.)
Signed, l.r. mount recto: "BA"
Inscription, mount verso: "693"
Acquired from: gift of P/K Associates, New York, New York

466. **[Unidentified woman wearing strands of beads]** (P1984.35.417)
Gelatin silver print. negative 1926–30, print 1978–79
Image: 3³⁄₁₆ x 2⅜ in. (8.1 x 6.0 cm.)
Mount: 10 x 8 in. (25.4 x 20.3 cm.)
Signed, l.r. mount recto: "BA"
Inscription, mount verso: "638"
Acquired from: gift of P/K Associates, New York, New York

467. **[Unidentified young woman seated, holding cigarette in her right hand]** (P1984.35.421)
Gelatin silver print. negative 1926–30, print 1978–79
Image: 4⁵⁄₁₆ x 3⅜ in. (11.0 x 8.6 cm.)
Mount: 10 x 8 in. (25.4 x 20.3 cm.)
Signed, l.r. mount recto: "BA"
Inscription, in negative: "5"
mount verso: "642"
Acquired from: gift of P/K Associates, New York, New York

468. **[Unidentified young woman seated in chair]** (P1984.35.457)
Gelatin silver print. negative 1926–30, print 1978–79
Image: 3¹³⁄₁₆ x 3⁵⁄₁₆ in. (9.7 x 8.4 cm.)
Mount: 10 x 8 in. (25.4 x 20.3 cm.)
Signed, l.r. mount recto: "BA"
Inscription, mount verso: "681"
Acquired from: gift of P/K Associates, New York, New York

469. **[Unidentified young woman wearing beads and striped dress]**
(P1984.35.436)
Gelatin silver print. negative 1926–30, print 1978–79
Image: 4⁷⁄₁₆ x 3¼ in. (11.3 x 8.2 cm.)
Mount: 10 x 8 in. (25.4 x 20.3 cm.)
Signed, l.r. mount recto: "BA"
Inscription, mount verso: "660" and rubber stamp
"BERENICE ABBOTT/ABBOT, MAINE 04406/ALL
RIGHTS RESERVED"
Acquired from: gift of P/K Associates, New York, New York

470. **UNION SQ.** (P1984.35.211)
Gelatin silver print. negative 1936, print 1978–79
Image: 7⁹⁄₁₆ x 9½ in. (19.2 x 24.1 cm.)
Mount: 8 x 10 in. (20.3 x 25.4 cm.)
Signed, l.r. mount recto: "BA"
Inscription, mount verso: "59-2 Union Sq.//421" and rubber
stamp "BERENICE ABBOTT/ABBOT, MAINE 04406/
ALL RIGHTS RESERVED"
Acquired from: gift of P/K Associates, New York, New York

*471. **[Union Square Cigar Store]** (P1984.35.182)
Gelatin silver print. negative 1929–39, print 1978–79
Image: 7½ x 9½ in. (19.0 x 24.1 cm.)
Mount: 8 x 10 in. (20.3 x 25.4 cm.)
Signed, l.r. mount recto: "BA"
Inscription, mount verso: "56-2//392" and rubber stamp
"BERENICE ABBOTT/ABBOT, MAINE 04406/ALL
RIGHTS RESERVED"
Acquired from: gift of P/K Associates, New York, New York

472. **UNION SQUARE, MANHATTAN** (P1984.35.168)
Gelatin silver print. negative 1936, print 1978–79
Image: 7½ x 9½ in. (19.0 x 24.1 cm.)
Mount: 8 x 10 in. (20.3 x 25.4 cm.)
Signed, l.r. mount recto: "BA"
Inscription, mount verso: "378" and rubber stamp
"BERENICE ABBOTT/ ABBOT, MAINE 04406/ALL
RIGHTS RESERVED"
Acquired from: gift of P/K Associates, New York, New York

473. **VIEW—BROOKLYN BRIDGE** (P1984.35.210)
Gelatin silver print. negative 1929–39, print 1978–79
Image: 7⁷⁄₁₆ x 9½ in. (18.9 x 24.1 cm.)
Mount: 8 x 10 in. (20.3 x 25.4 cm.)
Signed, l.r. mount recto: "BA"
Inscription, mount verso: "58-2 View—Brooklyn
Bridge//420" and rubber stamp "BERENICE ABBOTT/
ABBOT, MAINE 04406/ALL RIGHTS RESERVED"
Acquired from: gift of P/K Associates, New York, New York

474. **VIEW DOWN 42ND STREET** (P1984.35.135)
Gelatin silver print. negative 1929–39, print 1978–79
Image: 7⁷⁄₁₆ x 9½ in. (18.9 x 24.1 cm.)
Mount: 8 x 10 in. (20.3 x 25.4 cm.)
Signed, bottom center mount verso: "Berenice Abbott"
Inscription, mount verso: "345//255-6"
Acquired from: gift of P/K Associates, New York, New York

475. **VIEW DOWN 42ND STREET** (P1984.35.137)
Gelatin silver print. negative 1929–39, print 1978–79
Image: 7½ x 9½ in. (19.0 x 24.1 cm.)
Mount: 8 x 10 in. (20.3 x 25.4 cm.)
Signed, bottom center mount verso: "Berenice Abbott"
Inscription, print verso [print is mounted, but inscription is
visible in reverse]: "252-[illegible]/[illegible]"
mount verso: "252-6//347"
Acquired from: gift of P/K Associates, New York, New York

476. **VIEW FROM MIDTOWN** (P1984.35.48)
Gelatin silver print. negative 1929–39, print 1978–79
Image: 9⁷⁄₁₆ x 7½ in. (24.0 x 19.0 cm.)
Mount: 10 x 8 in. (25.4 x 20.3 cm.)
Signed, bottom center mount verso: "Berenice Abbott"
Inscription, print verso [print is mounted, but inscription is
visible in reverse]: "302-7 VIEW FROM MIDTOWN"
mount verso: "302-7//256"
Acquired from: gift of P/K Associates, New York, New York

477. **VIEW OF EXCHANGE PLACE FROM BROADWAY**
(P1984.35.154)
Gelatin silver print. negative 1933, print 1978–79
Image: 9⁵⁄₁₆ x 7⅜ in. (23.7 x 18.7 cm.)
Mount: 10 x 8 in. (25.4 x 20.3 cm.)
Signed, bottom center mount verso: "Berenice Abbott"
Inscription, mount verso: "245-6//364"
Acquired from: gift of P/K Associates, New York, New York

478. **VIEW OF EXCHANGE PLACE FROM BROADWAY**
(P1984.35.160)
Gelatin silver print. negative 1933, print 1978–79
Image: 9⁹⁄₁₆ x 7⁹⁄₁₆ in. (24.3 x 19.2 cm.)
Mount: 10 x 8 in. (25.4 x 20.3 cm.)
Signed, bottom center mount verso: "Berenice Abbott"
Inscription, mount verso: "238-6//370"
Acquired from: gift of P/K Associates, New York, New York

479. **VILLAGE COMMUNITY CHURCH** (P1984.35.27)
Gelatin silver print. negative 1929–39, print 1978–79
Image: 7⁹⁄₁₆ x 9⅝ in. (19.2 x 24.4 cm.)
Mount: 8 x 10 in. (20.3 x 25.4 cm.)
Signed, l.r. mount recto: "BA"
Inscription, mount verso: "235//139-3"
Acquired from: gift of P/K Associates, New York, New York

480. **VILLAGE PAINTER** (P1984.35.259)
Gelatin silver print. negative 1929–39, print 1978–79
Image: 7⁷⁄₁₆ x 9½ in. (18.9 x 24.1 cm.)
Mount: 8 x 10 in. (20.3 x 25.4 cm.)
Signed, l.r. mount recto: "BA"
Inscription, mount verso: "27-1/Villiage [sic] Painter//473"
and rubber stamp "BERENICE ABBOTT/ABBOT,
MAINE 04406/ALL RIGHTS RESERVED"
Acquired from: gift of P/K Associates, New York, New York

481. **VILLAGE—WASHINGTON SQUARE** (P1984.35.61)
Gelatin silver print. negative 1929–39, print 1978–79
Image: 7⁷⁄₁₆ x 9½ in. (18.9 x 24.1 cm.)
Mount: 8 x 10 in. (20.3 x 25.4 cm.)

Signed, bottom center mount verso: "Berenice Abbott"
Inscription, print verso [print is mounted, but inscription is
 visible in reverse]: "321-7"
 mount verso: "321-7//269"
Acquired from: gift of P/K Associates, New York, New York

482. **VILLAGE—WASHINGTON SQUARE** (P1984.35.62)
 Gelatin silver print. negative 1929–39, print 1978–79
 Image: 7 5/8 x 9 7/16 in. (19.4 x 24.0 cm.)
 Mount: 8 x 10 in. (20.3 x 25.4 cm.)
 Signed, bottom center mount verso: "Berenice Abbott"
 Inscription, mount verso: "320-7//270"
 Acquired from: gift of P/K Associates, New York, New York

483. **VILLAGE—WASHINGTON SQ.** (P1984.35.235)
 Gelatin silver print. negative 1929–39, print 1978–79
 Image: 7 3/8 x 9 1/2 in. (18.7 x 24.1 cm.)
 Mount: 8 x 10 in. (20.3 x 25.4 cm.)
 Signed, l.r. mount recto: "BA"
 Inscription, mount verso: "90-2 Villiage [sic]—Washington
 Sq.// 448" and rubber stamp "BERENICE ABBOTT/
 ABBOT, MAINE 04406/ALL RIGHTS RESERVED"
 Acquired from: gift of P/K Associates, New York, New York

484. **VILL.—WASH. SQ.** (P1984.35.237)
 Gelatin silver print. negative 1929–39, print 1978–79
 Image: 7 5/8 x 9 5/8 in. (19.4 x 24.4 cm.)
 Mount: 8 x 10 in. (20.3 x 25.4 cm.)
 Signed, l.r. mount recto: "BA"
 Inscription, mount verso: "92-2 Vill.—Wash. Sq.//450" and
 rubber stamp "BERENICE ABBOTT/ABBOT, MAINE
 04406/ALL RIGHTS RESERVED"
 Acquired from: gift of P/K Associates, New York, New York

485. **WALL ST.** (P1984.35.184)
 Gelatin silver print. negative 1933, print 1978–79
 Image: 9 11/16 x 7 3/4 in. (24.6 x 19.7 cm.)
 Mount: 10 x 8 in. (25.4 x 20.3 cm.)
 Signed, l.r. mount recto: "BA"
 Inscription, mount verso: "57-2 Wall St.//394" and rubber
 stamp "BERENICE ABBOTT/ABBOT, MAINE 04406/
 ALL RIGHTS RESERVED"
 Acquired from: gift of P/K Associates, New York, New York

*486. **WALL STREET** (P1984.35.206)
 Gelatin silver print. negative 1933, print 1978–79
 Image: 9 1/2 x 7 7/16 in. (24.1 x 18.9 cm.)
 Mount: 10 x 8 in. (25.4 x 20.3 cm.)
 Signed, bottom center mount verso: "Berenice Abbott"
 Inscription, mount verso: "315-7//416"
 Acquired from: gift of P/K Associates, New York, New York

487. **WALL STREET, LOOKING WEST TOWARD TRINITY
 CHURCH** (P1984.35.41)
 Gelatin silver print. negative 1957, print 1978–79
 Image: 6 5/8 x 4 9/16 in. (16.8 x 11.6 cm.)
 Mount: 10 x 8 in. (25.4 x 20.3 cm.)
 Signed, bottom center mount verso: "Berenice Abbott"
 Inscription, mount verso: "326-7//249"
 Acquired from: gift of P/K Associates, New York, New York

488. **WALL STREET, LOOKING WEST TOWARD TRINITY
 CHURCH** (P1984.35.201)
 Gelatin silver print. negative 1957, print 1978–79
 Image: 6 5/8 x 4 1/2 in. (16.8 x 11.4 cm.)
 Mount: 10 x 8 in. (25.4 x 20.3 cm.)
 Signed, bottom center mount verso: "Berenice Abbott"
 Inscription, mount verso: "326-7//412"
 Acquired from: gift of P/K Associates, New York, New York

*489. **WALL ST., PINHOLE CAMERA** (P1984.35.183)
 Gelatin silver print. negative 1957, print 1978–79
 Image: 7 5/8 x 9 1/2 in. (19.4 x 24.1 cm.)
 Mount: 8 x 10 in. (20.3 x 25.4 cm.)
 Signed, l.r. mount recto: "BA"
 Inscription, mount verso: "65-2 Wall St. Pinhole Camera//
 393" and rubber stamp "BERENICE ABBOTT/ABBOT,
 MAINE 04406/ALL RIGHTS RESERVED"
 Acquired from: gift of P/K Associates, New York, New York

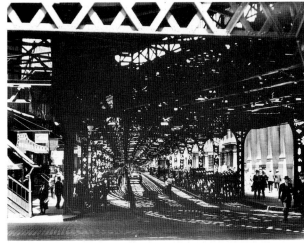
454

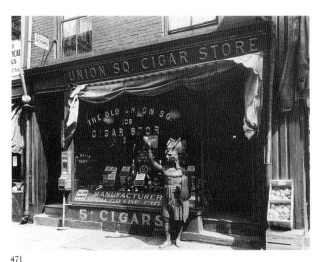
471

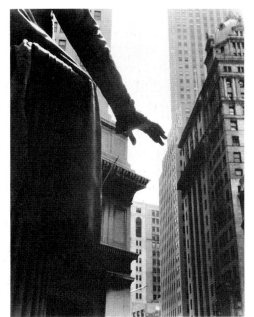
486

490. **WALL ST., PINHOLE CAMERA** (P1984.35.213)
Gelatin silver print. negative 1957, print 1978–79
Image: 9 ¾ x 7 ¾ in. (24.8 x 19.7 cm.)
Mount: 10 x 8 in. (25.4 x 20.3 cm.)
Signed, l.r. mount recto: "BA"
Inscription, mount verso: "61-2 Wall St. Pinhole Camera//
424" and rubber stamp "BERENICE ABBOTT/ABBOT,
MAINE 04406/ALL RIGHTS RESERVED"
Acquired from: gift of P/K Associates, New York, New York

491. **WASHINGTON IN UNION SQUARE** (P1984.35.333)
Gelatin silver print. negative 1930, print 1978–79
Image: 6 ¹⁵⁄₁₆ x 4 ⅞ in. (17.6 x 12.4 cm.)
Mount: 10 x 8 in. (25.4 x 20.3 cm.)
Signed, l.r. mount recto: "BA"
Inscription, mount verso: "548" and rubber stamp
"BERENICE ABBOTT/ABBOT, MAINE 04406/ALL
RIGHTS RESERVED"
Acquired from: gift of P/K Associates, New York, New York

492. **THE "WATUPPA" OFF MANHATTAN ISLAND**
(P1984.35.205)
Gelatin silver print. negative 1936, print 1978–79
Image: 6 ³⁄₁₆ x 7 ⅝ in. (15.7 x 19.4 cm.)
Mount: 8 x 10 in. (20.3 x 25.4 cm.)
Signed, bottom center mount verso: "Berenice Abbott"
Inscription, mount verso: "316-7//415"
Acquired from: gift of P/K Associates, New York, New York

493. **THE "WATUPPA" OFF MANHATTAN ISLAND**
(P1984.35.279)
Gelatin silver print. negative 1936, print 1978–79
Image: 7 ⁷⁄₁₆ x 9 ½ in. (18.9 x 24.1 cm.)
Mount: 8 x 10 in. (20.3 x 25.4 cm.)
Signed, l.r. mount recto: "BA"
Inscription, mount verso: "12-1//493" and rubber stamp
"BERENICE ABBOTT/ABBOT, MAINE 04406/ALL
RIGHTS RESERVED"
Acquired from: gift of P/K Associates, New York, New York

*494. **THE "WATUPPA" OFF MANHATTAN ISLAND**
(P1984.35.332)
Gelatin silver print. negative 1936, print 1978–79
Image: 9 ⁵⁄₁₆ x 7 ⁷⁄₁₆ in. (23.6 x 18.9 cm.)
Mount: 10 x 8 ⅛ in. (25.4 x 20.6 cm.)
Signed, l.r. mount recto: "BA"
Inscription, mount verso: "189-4//547" and rubber stamp
"BERENICE ABBOTT/ABBOT, MAINE 04406/ALL
RIGHTS RESERVED"
Acquired from: gift of P/K Associates, New York, New York

495. **WEAVER'S STORE, NEAR MARSHALL, ILLINOIS**
(P1984.35.243)
Gelatin silver print. negative 1935, print 1978–79
Image: 7 ½ x 9 ½ in. (19.0 x 24.1 cm.)
Mount: 8 x 10 in. (20.3 x 25.4 cm.)
Signed, l.r. mount recto: "BA"
Inscription, mount verso: "456" and rubber stamp
"BERENICE ABBOTT/ABBOT, MAINE 04406/ALL
RIGHTS RESERVED"
Acquired from: gift of P/K Associates, New York, New York

496. **[West 40th Street between Fifth and Sixth Avenues, looking
north]** (P1984.35.59)
Gelatin silver print. negative 1929–39, print 1978–79
Image: 7 ⁷⁄₁₆ x 9 ½ in. (18.9 x 24.1 cm.)
Mount: 8 x 10 in. (20.3 x 25.4 cm.)
Signed, bottom center mount verso: "Berenice Abbott"
Inscription, print verso [print is mounted, but inscription is
visible in reverse]: "18-7 [illegible]"
mount verso: "318-7//267"
Acquired from: gift of P/K Associates, New York, New York

497. **WEST SIDE HIGHWAY** (P1984.35.64)
Gelatin silver print. negative 1930–39, print 1978–79
Image: 4 ½ x 6 ⅝ in. (11.4 x 16.8 cm.)
Mount: 10 x 8 in. (25.4 x 20.3 cm.)
Signed, bottom center mount verso: "Berenice Abbott"
Inscription, mount verso: "327-7//272"
Acquired from: gift of P/K Associates, New York, New York

498. **WEST SIDE HIGHWAY** (P1984.35.65)
Gelatin silver print. negative 1930–39, print 1978–79
Image: 4 ½ x 6 ⁹⁄₁₆ in. (11.4 x 16.7 cm.)
Mount: 10 x 8 in. (25.4 x 20.3 cm.)
Signed, bottom center mount verso: "Berenice Abbott"
Inscription, mount verso: "328-7//273"
Acquired from: gift of P/K Associates, New York, New York

*499. **WEST ST.** (P1984.35.16)
Gelatin silver print. negative 1936, print 1978–79
Image: 7 ⁹⁄₁₆ x 9 ½ in. (19.2 x 24.1 cm.)
Mount: 8 x 10 in. (20.3 x 25.4 cm.)
Signed, l.r. mount recto: "BA"
Inscription, mount verso: "217//45-1/West St." and rubber
stamp "BERENICE ABBOTT/ABBOT, MAINE 04406/
ALL RIGHTS RESERVED"
Acquired from: gift of P/K Associates, New York, New York

500. **WEST STREET** (P1984.35.143)
Gelatin silver print. negative 1936, print 1978–79
Image: 7 ⁹⁄₁₆ x 9 ½ in. (19.2 x 24.1 cm.)
Mount: 8 x 10 in. (20.3 x 25.4 cm.)
Signed, bottom center mount verso: "Berenice Abbott"
Inscription, mount verso: "291-7//353"
Acquired from: gift of P/K Associates, New York, New York

501. **WEST STREET** (P1984.35.144)
Gelatin silver print. negative 1936, print 1978–79
Image: 7 ⅜ x 9 ⅜ in. (18.7 x 23.8 cm.)
Mount: 8 x 10 in. (20.3 x 25.4 cm.)
Signed, bottom center mount verso: "Berenice Abbott"
Inscription, mount verso: "290-7//354"
Acquired from: gift of P/K Associates, New York, New York

502. **WEST STREET** (P1984.35.145)
Gelatin silver print. negative 1936, print 1978–79
Image: 7 ½ x 9 ½ in. (19.0 x 24.1 cm.)
Mount: 8 x 10 in. (20.3 x 25.4 cm.)
Signed, bottom center mount verso: "Berenice Abbott"
Inscription, mount verso: "289-7//355"
Acquired from: gift of P/K Associates, New York, New York

503. **WEST STREET** (P1984.35.274)
Gelatin silver print. negative 1936, print 1978–79
Image: 7 ½ x 9 ½ in. (19.0 x 24.1 cm.)
Mount: 8 x 10 in. (20.3 x 25.4 cm.)
Signed, l.r. mount recto: "BA"
Inscription, mount verso: "38-1//488" and rubber stamp
"BERENICE ABBOTT/ABBOT, MAINE 04406/ALL
RIGHTS RESERVED"
Acquired from: gift of P/K Associates, New York, New York

504. **WHEELOCK HOUSE [Wheelock House, 661 West 158th
Street, Manhattan]** (P1984.35.179)
Gelatin silver print. negative 1937, print 1978–79
Image: 9 ⁹⁄₁₆ x 7 ⁹⁄₁₆ in. (24.3 x 19.2 cm.)
Mount: 10 x 8 in. (25.4 x 20.3 cm.)
Signed, l.r. mount recto: "BA"
Inscription, print verso [print is mounted, but inscription is
visible in reverse]: "53-2//Wheelock House"
mount verso: "53-2 Wheelock House//389" and rubber
stamp "BERENICE ABBOTT/ABBOT, MAINE 04406/
ALL RIGHTS RESERVED"
Acquired from: gift of P/K Associates, New York, New York

505. **WHITNEY MUSEUM OF AMERICAN ART, 8-10-12
WEST EIGHTH STREET** (P1984.35.118)
Gelatin silver print. negative 1931–39, print 1978–79
Image: 7 ½ x 9 ⁹⁄₁₆ in. (19.0 x 24.3 cm.)
Mount: 8 x 10 in. (20.3 x 25.4 cm.)
Signed, l.r. mount recto: "BA"
Inscription, mount verso: "309-7//329"
Acquired from: gift of P/K Associates, New York, New York

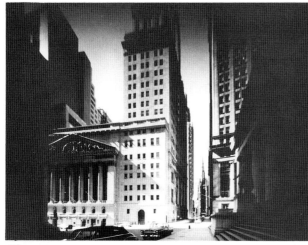

489

494

499

507

512

513

506. **WILLIAM GOLDBERG STORE, 771 BROADWAY**
(P1984.35.290)
Gelatin silver print. negative 1937, print 1978–79
Image: 9 ⅛ x 7 ½ in. (23.8 x 19.0 cm.)
Mount: 10 x 8 in. (25.4 x 20.3 cm.)
Signed, l.r. mount recto: "BA"
Inscription, mount verso: "1-2//504" and rubber stamp
"BERENICE ABBOTT/ABBOT, MAINE 04406/ALL
RIGHTS RESERVED"
Acquired from: gift of P/K Associates, New York, New York

*507. **WILLOW PLACE, NOS. 43-49, BROOKLYN** (P1984.35.287)
Gelatin silver print. negative 1936, print 1978–79
Image: 7 ⅜ x 9 ½ in. (18.7 x 24.1 cm.)
Mount: 8 x 10 in. (20.3 x 25.4 cm.)
Signed, l.r. mount recto: "BA"
Inscription, mount verso: "11-1//501" and rubber stamp
"BERENICE ABBOTT/ABBOT, MAINE 04406/ALL
RIGHTS RESERVED"
Acquired from: gift of P/K Associates, New York, New York

508. **WOOLWORTH BUILDING** (P1984.35.142)
Gelatin silver print. negative c. 1930, print 1978–79
Image: 9 3/16 x 7 7/16 in. (23.3 x 18.9 cm.)
Mount: 10 x 8 in. (25.4 x 20.3 cm.)
Signed, bottom center mount verso: "Berenice Abbott"
Inscription, mount verso: "296-7//352"
Acquired from: gift of P/K Associates, New York, New York

509. **WRITER?** (P1984.35.463)
Gelatin silver print. negative 1926–30, print 1978–79
Image: 4 ¼ x 3 ¼ in. (10.8 x 8.2 cm.)
Mount: 10 x 8 in. (25.4 x 20.3 cm.)
Signed, l.r. mount recto: "BA."
Inscription, mount recto: "Writer?" and crop marks
mount verso: "687" and rubber stamp "BERENICE
ABBOTT/ABBOT, MAINE 04406/ALL RIGHTS
RESERVED"
Acquired from: gift of P/K Associates, New York, New York

510. **YOUNG DUTCHMAN** (P1984.35.485)
Gelatin silver print. negative 1926–30, print 1978–79
Image: 3 5/16 x 2 5/16 in. (8.4 x 5.8 cm.)
Mount: 10 x 8 in. (25.4 x 20.3 cm.)
Signed, l.r. mount recto: "BA"
Inscription, mount recto: "Young Dutchman"
and crop mark
mount verso: "709" and rubber stamp "BERENICE
ABBOTT/ ABBOT, MAINE 04406/ALL RIGHTS
RESERVED"
Acquired from: gift of P/K Associates, New York, New York

511. **YUBAN WAREHOUSE, WATER AND DOCK STREETS,
BROOKLYN** (P1978.25.1) duplicate of P1984.35.55
Gelatin silver print. negative 1936, print later
Image: 10 13/16 x 13 9/16 in. (27.4 x 34.5 cm.)
Sheet: 11 x 13 15/16 in. (28.0 x 35.4 cm.)
Signed, center print verso: "Berenice Abbott"
Acquired from: The Halsted Gallery, Birmingham, Michigan

*512. **YUBAN WAREHOUSE, WATER AND DOCK STREETS,
BROOKLYN** (P1984.35.55) duplicate of P1978.25.1
Gelatin silver print. negative 1936, print 1978–79
Image: 7 ½ x 9 ⅜ in. (19.0 x 23.8 cm.)
Mount: 8 x 10 in. (20.3 x 25.4 cm.)
Signed, bottom center mount verso: "Berenice Abbott"
Inscription, mount verso: "313-7//263"
Acquired from: gift of P/K Associates, New York, New York

C. YARNALL ABBOTT

See *Camera Notes* and *Camera Work*

ANSEL ADAMS, American (1902–1984)

One of the most widely recognized American photographers, Adams was best known for his technical excellence and his ability to make images that expressed his reverence for the grandeur and beauty of nature. Trained as a musician, he transferred many musical concepts about harmony and balance to his photographic work. One of the pioneers of "straight" photography, founding the Group f/64 with Willard Van Dyke, Edward Weston, Imogen Cunningham, and others, Adams was also famous for development of the "zone system," through which the photographer controls exposure and development of his images to get a full range of tonal values.

*513. **ALFRED STIEGLITZ, "AN AMERICAN PLACE"**
(P1969.21)
Gelatin silver print. negative 1938, print 1969
Image: 11 11/16 x 8 ⅝ in. (29.6 x 21.9 cm.)
Mount: 18 x 14 in. (45.8 x 35.6 cm.)
Signed, l.r. mount recto: "Ansel Adams"
Inscription, mount verso: "Alfred Stieglitz, "An American
Place"" and rubber stamp "Photograph/by/Ansel Adams/
Route 1, Box 181/Carmel, California/93921"
Acquired from: the photographer

514. **[Beaumont Newhall]** (P1971.46.1)
Gelatin silver print. c. 1950
Image: 9 ½ x 7 ½ in. (24.0 x 19.1 cm.)
Sheet: 10 x 8 1/16 in. (25.3 x 20.4 cm.)
Inscription, mount verso, rubber stamps: "FOR
REPRODUCTION ONLY"// "Photograph/by/Ansel
Adams/Route 1, Box 181/Carmel, California"
Acquired from: unknown source

*515. **BEAUMONT NEWHALL** (P1971.46.2)
Gelatin silver print. 1965
Image: 9 ½ x 7 ½ in. (24.0 x 19.1 cm.)
Sheet: 10 x 8 in. (25.4 x 20.3 cm.)
Inscription, mount verso: "Beaumont Newhall/Photo by
Ansel Adams, 1965//66//Reduce 9 5/16" to 2"/21 ¼%//
Photo B//Proof//H5022/811 21 ½ dn/9 5/16 to2//dn"
Acquired from: unknown source

516. **BOQUILLAS, MEXICO, DUST STORM FROM NORTH
BANK OF THE RIO GRANDE, BIG BEND
NATIONAL PARK, TEXAS** (P1975.118.8)
Gelatin silver print. negative c. 1942, print 1975
Image: 15 ¼ x 18 15/16 in. (38.7 x 48.0 cm.)
Mount: 22 x 27 ½ in. (55.9 x 69.9 cm.)
Signed, l.r. mount recto: "Ansel Adams"
Inscription, mount verso: "Boquias [sic], Mexico, Dust
Storm/from north bank of the Rio Grande/Big Bend
National Park, Texas" contained within rubber stamp
"Photograph by Ansel Adams/Route 1 Box 181/Carmel,
California 93921"
Acquired from: the photographer

*517. **CANYON DE CHELLE NATIONAL MONUMENT,
ARIZONA** (P1969.29)
Gelatin silver print. negative 1943–44, print 1969
Image: 15 7/16 x 19 ½ in. (39.2 x 49.5 cm.)
Mount: 22 x 25 ¾ in. (55.8 x 65.4 cm.)
Signed, l.r. mount recto: "Ansel Adams"
Inscription, mount verso: "Canyon de Chelle National
Monument, Arizona/1943–44" and rubber stamp
"Photograph/by/Ansel Adams/ Route 1, Box 181/
Carmel, California/93921"
Acquired from: the photographer

515

519

517

520

521

523

518. **DOORWAY OF OLD BUILDING, BIG BEND NATIONAL PARK, TEXAS** (P1975.118.3)
Gelatin silver print. negative 1947, print 1975
Image: 13 3/8 x 10 5/8 in. (34.0 x 26.9 cm.)
Mount: 18 x 14 in. (45.7 x 35.6 cm.)
Signed, l.r. mount recto: "Ansel Adams"
Inscription, mount verso: "Doorway of old building/Big Bend National Park, Texas" contained within rubber stamp "Photograph by Ansel Adams/Route 1 Box 181 Carmel, California 93921"
Acquired from: the photographer

*519. **EDWARD WESTON** (P1969.20)
Gelatin silver print. negative 1950, print 1969
Image: 11 7/8 x 9 3/16 in. (30.1 x 23.3 cm.)
Mount: 18 x 14 in. (45.7 x 35.6 cm.)
Signed, l.r. mount recto: "Ansel Adams"
Inscription, mount verso: "Edward Weston" and rubber stamp "Photograph/ by/Ansel Adams/Route 1, Box 181/Carmel, California/93921"
Acquired from: the photographer

*520. **GOLDEN GATE, SAN FRANCISCO—(BEFORE BUILDING OF BRIDGE)** (P1969.24)
Gelatin silver print. negative 1932, print 1969
Image: 10 1/8 x 13 1/16 in. (25.7 x 33.2 cm.)
Mount: 14 x 18 in. (35.6 x 45.8 cm.)
Signed, l.r. mount recto: "Ansel Adams"
Inscription, mount verso: "Golden Gate, San Francisco—(before building of bridge)//1932" and rubber stamp "Photograph/by/ Ansel Adams/ Route 1, Box 181/Carmel, California/93921"
Acquired from: the photographer

*521. **HALF DOME, FROM MIRROR LAKE, WINTER** (P1969.23)
Gelatin silver print. negative c. 1938, print 1969
Image: 15 5/16 x 19 5/8 in. (38.8 x 49.8 cm.)
Mount: 21 7/8 x 25 3/4 in. (55.5 x 65.4 cm.)
Signed, l.r. mount recto: "Ansel Adams"
Inscription, mount verso: "Half Dome, from Mirror Lake, Winter" and rubber stamp "Photograph/by/Ansel Adams/ Route 1, Box 181/Carmel, California/93921"
Acquired from: the photographer

522. **IN CHISOS MOUNTAINS? BIG BEND NATIONAL PARK, TEXAS** (P1975.118.9)
Gelatin silver print. negative c. 1947, print 1975
Image: 14 9/16 x 19 5/16 in. (37.0 x 49.0 cm.)
Mount: 22 x 28 in. (55.9 x 71.1 cm.)
Signed, l.r. mount recto: "Ansel Adams"
Inscription, mount verso: "In Chisos Mountains?/Big Bend National Park, Texas" contained within rubber stamp "Photograph by Ansel Adams/Route 1 Box 181 Carmel, California 93921"
note: Adams was not sure that this photograph was actually of the Chisos Mountains
Acquired from: gift of the photographer

*523. **JOHN MARIN IN HIS STUDIO, CLIFFSIDE, NEW JERSEY** (P1969.19)
Gelatin silver print. negative 1949, print 1969
Image: 12 13/16 x 8 3/8 in. (32.5 x 21.3 cm.)
Mount: 18 x 14 in. (45.8 x 35.6 cm.)
Signed, l.r. mount recto: "Ansel Adams"
Inscription, mount verso: "John Marin in his Studio, Cliffside, New Jersey" and rubber stamp "Photograph/by/Ansel Adams/Route 1, Box 181/Carmel, California/93921"
Acquired from: the photographer

524. **MISSION, SAN XAVIER DEL BAC, ARIZONA** (P1969.27)
Gelatin silver print. negative c. 1948, print 1969
Image: 15 9/16 x 19 1/2 in. (39.5 x 49.5 cm.)
Mount: 22 x 27 1/2 in. (56.0 x 69.9 cm.)
Signed, l.r. mount recto: "Ansel Adams"
Inscription, mount verso: "Mission, San Xavier Del Bac, Arizona" and rubber stamp "Photograph/by/Ansel Adams/Route 1, Box 181/ Carmel, California/93921"
Acquired from: the photographer

525. **MOONRISE OVER HERNANDEZ, N.M.** (P1965.41)
Gelatin silver print. negative 1941, print later
Image: 15 1/16 x 19 1/4 in. (38.3 x 48.8 cm.)
Mount: 22 x 25 1/8 in. (55.9 x 63.8 cm.)
Signed, l.r. mount recto: "Ansel Adams"
Inscription, mount verso: "4483/Moonrise over Hernandez/N.M." and rubber stamp "Photograph/by/Ansel Adams/Route 1, Box 181/Carmel, California"
Acquired from: the photographer

*526. **MOUNTAINS AND CLOUDS, BIG BEND NATIONAL PARK, TEXAS [Burro Mesa and the Chisos Mountains]** (P1975.118.6)
Gelatin silver print. negative 1942, print 1975
Image: 15 3/4 x 19 5/8 in. (40.0 x 49.8 cm.)
Mount: 22 x 28 in. (55.9 x 71.1 cm.)
Signed, l.r. mount recto: "Ansel Adams"
Inscription, mount verso: "Mountains and Clouds/Big Bend National Park, Texas" contained within rubber stamp "Photograph by Ansel Adams/Route 1 Box 181 Carmel, California 93921"
Acquired from: the photographer

527. **MOUNTAINS AND DESERT, BIG BEND NATIONAL PARK, TEXAS [Chisos Mountains]** (P1975.118.7)
Gelatin silver print. negative 1942, print 1975
Image: 15 9/16 x 19 3/8 in. (39.5 x 49.2 cm.)
Mount: 22 x 27 1/2 in. (55.9 x 69.9 cm.)
Signed, l.r. mount recto: "Ansel Adams"
Inscription, mount verso: "Mountains and Desert/Big Bend National Park, Texas" contained within rubber stamp "Photograph by Ansel Adams/Route 1 Box 181 Carmel, California 93921"
Acquired from: the photographer

528. **NORTHERN CALIFORNIA COAST REDWOODS [Bull Creek Flat, California]** (P1966.12) duplicate of P1966.11.10
Gelatin silver print (photomural mounted on Masonite). negative c. 1960, print c. 1966
Image: 38 1/4 x 46 7/8 in. (97.2 x 119.1 cm.)
Mount: same as image size
Acquired from: the photographer

529. **OAKTREE, SNOWSTORM, YOSEMITE** (P1972.43.2)
Gelatin silver print. negative 1948, print c. 1972
Image: 13 3/8 x 10 5/8 in. (34.0 x 27.0 cm.)
Mount: 18 x 14 in. (45.8 x 35.6 cm.)
Signed, l.r. mount recto: "Ansel Adams"
Inscription, mount verso: "Oaktree, Snowstorm/Yosemite" and rubber stamp "Photograph/by/Ansel Adams/Route 1, Box 181/Carmel, California/93921"
Acquired from: Friends of Photography, Carmel, California; gift print with sustaining membership, 1972

PORTFOLIO IV: WHAT MAJESTIC WORD (P1966.11.1-15)

This portfolio was published by the Sierra Club in 1963 and dedicated to the memory of Russell Varian. Each print has a portfolio label on the mount verso that reads: "Portfolio Four/What Majestic Word/by/Ansel Adams/In Memory of Russell Varian/[# in portfolio/title/location]/Set number 123/Published by the Sierra Club/San Francisco, 1963/Reproduction rights reserved." The edition consists of 250 portfolios and 10 artist's copies.

530. **TEKLANIKA RIVER, MOUNT McKINLEY NATIONAL PARK, ALASKA** (P1966.11.1)
Gelatin silver print. negative 1947, print 1963
Image: 9 1/8 x 11 1/2 in. (23.1 x 29.2 cm.)
Mount: 14 x 18 in. (35.6 x 45.8 cm.)
Signed, l.r. mount recto: "Ansel Adams"
Acquired from: unknown source

531. **SEQUOIA ROOTS, MARIPOSA GROVE, YOSEMITE NATIONAL PARK, CALIFORNIA** (P1966.11.2)
Gelatin silver print. negative c. 1950, print 1963
Image: 9 ⁹⁄₁₆ x 7 ½ in. (24.2 x 19.1 cm.)
Mount: 18 x 14 in. (45.8 x 35.6 cm.)
Signed, l.r. mount recto: "Ansel Adams"
Acquired from: unknown source

*532. **LEAF, GLACIER BAY NATIONAL MONUMENT, ALASKA** (P1966.11.3)
Gelatin silver print. negative c. 1948, print 1963
Image: 6 ¹³⁄₁₆ x 9 in. (17.2 x 22.8 cm.)
Mount: 14 x 18 in. (35.6 x 45.8 cm.)
Signed, l.r. mount recto: "Ansel Adams"
Acquired from: unknown source

533. **DUNES, OCEANO, CALIFORNIA** (P1966.11.4)
Gelatin silver print. 1963
Image: 7 ¼ x 7 ¹³⁄₁₆ in. (18.4 x 19.8 cm.)
Mount: 18 x 14 in. (45.8 x 35.6 cm.)
Signed, l.r. mount recto: "Ansel Adams"
Acquired from: unknown source

534. **CATHEDRAL PEAK AND LAKE, YOSEMITE NATIONAL PARK, CALIFORNIA** (P1966.11.5)
Gelatin silver print. negative 1960, print 1963
Image: 7 x 9 ⁷⁄₁₆ in. (17.8 x 24.0 cm.)
Mount: 14 x 18 in. (35.6 x 45.8 cm.)
Signed, l.r. mount recto: "Ansel Adams"
Acquired from: unknown source

535. **VERNAL FALLS, YOSEMITE VALLEY, CALIFORNIA** (P1966.11.6)
Gelatin silver print. negative 1920, print 1963
Image: 10 ⅞ x 8 ¹⁄₁₆ in. (27.6 x 20.4 cm.)
Mount: 18 x 14 in. (45.8 x 35.6 cm.)
Signed, l.r. mount recto: "Ansel Adams"
Acquired from: unknown source

536. **CLEARING STORM, SONOMA COUNTY HILLS, CALIFORNIA** (P1966.11.7)
Gelatin silver print. negative 1951, print 1963
Image: 8 ¹⁵⁄₁₆ x 11 ⁹⁄₁₆ in. (22.7 x 29.3 cm.)
Mount: 14 x 18 in. (35.6 x 45.8 cm.)
Signed, l.r. mount recto: "Ansel Adams"
Acquired from: unknown source

537. **OAK TREE, SUNSET CITY, SIERRA FOOTHILLS, CALIFORNIA** (P1966.11.8)
Gelatin silver print. negative 1962, print 1963
Image: 7 ¼ x 8 ⁹⁄₁₆ in. (18.4 x 21.7 cm.)
Mount: 14 x 18 in. (35.6 x 45.8 cm.)
Signed, l.r. mount recto: "Ansel Adams"
Acquired from: unknown source

538. **CASTLE ROCK, SUMMIT ROAD ABOVE SARATOGA, CALIFORNIA** (P1966.11.9)
Gelatin silver print. 1963
Image: 9 ½ x 7 ³⁄₁₆ in. (24.2 x 18.2 cm.)
Mount: 18 x 14 in. (45.8 x 35.6 cm.)
Signed, l.r. mount recto: "Ansel Adams"
Acquired from: unknown source

539. **NORTHERN CALIFORNIA COAST REDWOODS [Bull Creek Flat, California]** (P1966.11.10) duplicate of P1966.12
Gelatin silver print. negative c. 1960, print 1963
Image: 9 ⁷⁄₁₆ x 11 ½ in. (23.9 x 29.1 cm.)
Mount: 14 x 18 in. (35.6 x 45.8 cm.)
Signed, l.r. mount recto: "Ansel Adams"
Acquired from: unknown source

*540. **ORCHARD, EARLY SPRING, NEAR STANFORD UNIVERSITY, CALIFORNIA [Portola Valley]** (P1966.11.11)
Gelatin silver print. negative c. 1940, print 1963
Image: 10 ¹⁄₁₆ x 12 ¼ in. (25.5 x 32.4 cm.)
Mount: 14 x 18 in. (35.6 x 45.8 cm.)
Signed, l.r. mount recto: "Ansel Adams"
Acquired from: unknown source

526

532

540

541. **SIESTA LAKE, YOSEMITE NATIONAL PARK, CALIFORNIA** (P1966.11.12)
Gelatin silver print. negative c. 1958, print 1963
Image: 7½ x 9½ in. (19.1 x 24.1 cm.)
Mount: 14 x 18 in. (35.6 x 45.8 cm.)
Signed, l.r. mount recto: "Ansel Adams"
Acquired from: unknown source

542. **STORM SURF, TIMER COVE, CALIFORNIA** (P1966.11.13)
Gelatin silver print. negative c. 1960, print 1963
Image: 7 3/16 x 9⅛ in. (18.3 x 23.2 cm.)
Mount: 14 x 18 in. (35.6 x 45.8 cm.)
Signed, l.r. mount recto: "Ansel Adams"
Acquired from: unknown source

543. **TUOLUMNE MEADOWS, YOSEMITE NATIONAL PARK, CALIFORNIA** (P1966.11.14)
Gelatin silver print. negative 1941, print 1963
Image: 9 3/16 x 7 5/16 in. (23.4 x 18.5 cm.)
Mount: 18 x 14 in. (45.8 x 35.6 cm.)
Signed, l.r. mount recto: "Ansel Adams"
Acquired from: unknown source

544. **SIERRA NEVADA, WINTER EVENING, FROM THE OWENS VALLEY, CALIFORNIA** (P1966.11.15)
Gelatin silver print. negative 1962, print 1963
Image: 11⅝ x 9 in. (29.6 x 22.8 cm.)
Mount: 18 x 14 in. (45.8 x 35.6 cm.)
Signed, l.r. mount recto: "Ansel Adams"
Acquired from: unknown source

* * * *

*545. **PORTRAIT OF CADY WELLS** (P1967.228)
Gelatin silver print. c. 1950s
Image: 9½ x 7½ in. (24.1 x 19.1 cm.)
Mount: 20¼ x 16 1/16 in. (51.1 x 40.7 cm.)
Signed, mount verso: "Ansel Adams"
Inscription, mount verso: "—Portrait of Cady Wells—//10/80"
Acquired from: the photographer

546. **RAILS AND JET TRAILS, ROSEVILLE, CALIFORNIA** (P1969.18)
Gelatin silver print. negative 1954, print 1969
Image: 19¼ x 14 15/16 in. (48.9 x 37.9 cm.)
Mount: 28 x 22 in. (71.2 x 56.0 cm.)
Signed, l.r. mount recto: "Ansel Adams"
Inscription, mount verso: "Rails and Jet trails, Roseville, California" and rubber stamp "Photograph/by/Ansel Adams/Route 1, Box 181/Carmel, California/93921"
Acquired from: the photographer

547. **RIO GRANDE (AND MOUNTAINS IN MEXICO), BIG BEND NATIONAL PARK, TEXAS** (P1975.118.2)
Gelatin silver print. negative 1947, print 1975
Image: 10 5/16 x 13 11/16 in. (26.2 x 34.7 cm.)
Mount: 14 x 18 in. (35.6 x 45.7 cm.)
Signed, l.r. mount recto: "Ansel Adams"
Inscription, mount verso: "Rio Grande (and mountains in Mexico)/Big Bend National Park, Texas" contained within rubber stamp "Photograph by Ansel Adams/Route 1 Box 181 Carmel, California 93921"
Acquired from: the photographer

548. **THE RIO GRANDE, BIG BEND NATIONAL PARK, TEXAS** (P1975.118.5)
Gelatin silver print. negative c. 1942, print 1975
Image: 15⅜ x 19 9/16 in. (39.0 x 49.7 cm.)
Mount: 22 x 27½ in. (55.9 x 69.9 cm.)
Signed, l.r. mount recto: "Ansel Adams"
Inscription, mount verso: "The Rio Grande/Big Bend National Park, Texas" contained within rubber stamp "Photograph by Ansel Adams/ Route 1 Box 181 Carmel, California 93921"
Acquired from: the photographer

*549. **THE RIO GRANDE, LATE AFTERNOON, BIG BEND NATIONAL PARK, TEXAS** (P1975.118.1)
Gelatin silver print. negative 1947, print 1975
Image: 10 1/16 x 13 13/16 in. (25.5 x 35.0 cm.)
Mount: 14 x 17 15/16 in. (35.6 x 45.5 cm.)
Signed, l.r. mount recto: "Ansel Adams"
Inscription, mount verso: "The Rio Grande, Late Afternoon/Big Bend National Park, Texas" contained within rubber stamp "Photograph by Ansel Adams/Route 1 Box 181 Carmel, California 93921"
Acquired from: the photographer

550. **SALT FLATS NEAR WENDOVER, UTAH** (P1969.28)
Gelatin silver print. negative 1953, print 1969
Image: 15 5/16 x 19⅝ in. (38.9 x 49.8 cm.)
Mount: 22 x 28 in. (56.0 x 71.2 cm.)
Signed, l.r. mount recto: "Ansel Adams"
Inscription, mount verso: "Salt flats near Wendover, Utah/1953" and rubber stamp "Photograph/by/Ansel Adams/Route 1, Box 181/Carmel, California/93921"
Acquired from: the photographer

551. **SAN FRANCISCO FROM TWIN PEAKS** (P1969.25)
Gelatin silver print. negative 1953, print 1969
Image: 15 5/16 x 19¼ in. (38.9 x 48.9 cm.)
Mount: 22 x 28 in. (56.0 x 71.2 cm.)
Signed, l.r. mount recto: "Ansel Adams"
Inscription, mount verso: "San Francisco from Twin Peaks—" and rubber stamp "Photograph/by/Ansel Adams/Route 1, Box 181/Carmel, California/93921"
Acquired from: the photographer

552. **SANTA ELENA CANYON, BIG BEND NATIONAL PARK, TEXAS** (P1975.118.4)
Gelatin silver print. negative 1947, print 1975
Image: 15⅛ x 19 in. (38.3 x 48.3 cm.)
Mount: 22 x 27½ in. (55.9 x 69.9 cm.)
Signed, l.r. mount recto: "Ansel Adams"
Inscription, mount verso: "Santa Elena Canyon/Big Bend National Park, Texas" contained within rubber stamp "Photograph by Ansel Adams/Route 1 Box 181 Carmel, California 93921"
Acquired from: the photographer

*553. **SELF-PORTRAIT, MONUMENT VALLEY, UTAH** (P1978.70)
Gelatin silver print. 1958
Image: 13 7/16 x 9 9/16 in. (34.1 x 24.3 cm.)
Mount: 18 x 14 in. (45.7 x 35.6 cm.)
Signed, l.r. mount recto: "Ansel Adams"
Inscription, mount verso: "Self-Portrait/Monument Valley, Utah 1958" contained within rubber stamp "Photograph by Ansel Adams/Route 1 Box 181 Carmel, California 93921" and "451"
Acquired from: Graphics International, Ltd., Washington, D. C.

*554. **SILVERTON, COLORADO** (P1969.30)
Gelatin silver print. negative 1951, print 1969
Image: 15¼ x 19¼ in. (38.7 x 48.9 cm.)
Mount: 22 x 28 in. (56.0 x 71.2 cm.)
Signed, l.r. mount recto: "Ansel Adams"
Inscription, mount verso: "Silverton, Colorado/1951" and rubber stamp "Photograph/by/Ansel Adams/Route 1, Box 181/Carmel, California/93921"
Acquired from: the photographer

555. **SNOWBANK, YOSEMITE VALLEY** (P1975.2)
Gelatin silver print (photomural mounted on Masonite). n. d., print by The Atelier
Image: 38¾ x 48¼ in. (98.4 x 122.5 cm.)
Mount: same as image size
Inscription, mount verso: "#97/Snowbank/Yosemite Valley/Ansel Adams//The "Atelier"/5860 GEARY BLVD./SAN FRANCISCO 21/ SKyline 1-3631"
Acquired from: gift of the photographer

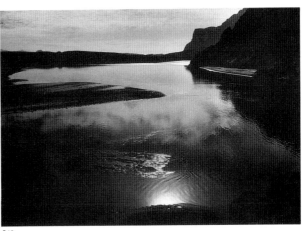

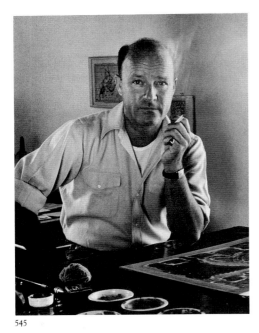

545

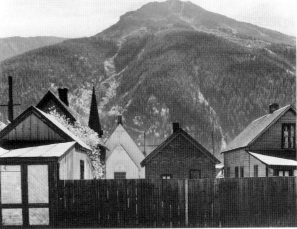
549

553

554

556

575. **ALMOST/YA MERO** (LP1980.63.12)
Gelatin silver print. negative 1968, print 1977
Image: 7⅞ x 9½ in. (18.9 x 24.1 cm.)
Sheet: 8 x 10 in. (20.3 x 25.4 cm.)
Signed, l.r. print verso: "M. Alvarez Bravo./Mexico."
Inscription, print verso: "39/100"
Acquired from: long-term loan from George Peterkin, Jr.,
Houston, Texas

576. **SKYLIGHT/GORRIÓN, CLARO** (P1980.63.13)
Gelatin silver print. negative 1938–40, print 1977
Image: 7³⁄₁₆ x 9½ in. (18.3 x 24.1 cm.)
Sheet: 8 x 10 in. (20.3 x 25.4 cm.)
Signed, l.r. print verso: "M. Alvarez Bravo./Mexico."
Inscription, print verso: "39/100"
Acquired from: gift of George Peterkin, Jr., Houston, Texas

*577. **THRESHOLD/UMBRAL** (P1980.63.14) duplicate of
P1979.97.3
Gelatin silver print. negative 1947, print 1977
Image: 9⁹⁄₁₆ x 7¹¹⁄₁₆ in. (24.2 x 19.6 cm.)
Sheet: 10 x 8 in. (25.4 x 20.3 cm.)
Signed, l.r. print verso: "M. Alvarez Bravo./Mexico."
Inscription, print verso: "39/100"
Acquired from: gift of George Peterkin, Jr., Houston, Texas

*578. **WOMAN COMBING HER HAIR/RETRATO DE LO
ETERNO** (P1980.63.15)
Gelatin silver print. negative 1932–33, print 1977
Image: 9⅞ x 7½ in. (24.0 x 19.1 cm.)
Sheet: 10 x 8 in. (25.4 x 20.3 cm.)
Signed, l.r. print verso: "M. Alvarez Bravo./Mexico."
Inscription, print verso: "39/100"
Acquired from: gift of George Peterkin, Jr., Houston, Texas

＊ ＊ ＊ ＊

579. **SLEEPING DOGS BARK/LOS PERROS DURMIENDO
LADRAN [from the portfolio "Photographs by Manuel
Alvarez Bravo"]** (P1979.97.2) duplicate of P1980.63.9
Gelatin silver print. negative 1966, print 1977
Image: 9¹⁄₁₆ x 7⁹⁄₁₆ in. (23.0 x 19.2 cm.)
Sheet: 9¹⁵⁄₁₆ x 8 in. (25.3 x 20.3 cm.)
Signed, l.r. print verso: "M. Alvarez Bravo./Mexico."
Inscription, print verso: "78/100"
Acquired from: gift of R. G. Nichols, Greenwich,
Connecticut

580. **THRESHOLD/UMBRAL [from the portfolio "Photographs
by Manuel Alvarez Bravo"]** (P1979.97.3) duplicate of
P1980.63.14
Gelatin silver print. negative 1947, print 1977
Image: 9⁹⁄₁₆ x 7¹¹⁄₁₆ in. (24.2 x 19.5 cm.)
Sheet: 10 x 8 in. (25.4 x 20.3 cm.)
Signed, l.r. print verso: "M. Alvarez Bravo./Mexico."
Inscription, print verso: "78/100"
Acquired from: gift of R. G. Nichols, Greenwich,
Connecticut

PAUL L. ANDERSON, American (1880–1956)

Anderson was born in Trenton, New Jersey, and gradu-
ated from Lehigh University with a degree in electrical
engineering in 1901. Impressed by the pictorial images
in Alfred Stieglitz's *Camera Work*, Anderson took up
photography and, in 1909, left his job with the tele-
phone company to open a portrait studio. In 1914 he be-
came a technical instructor at the Clarence White
School, where he taught until 1918. Laura Gilpin was
among his pupils. Anderson published several books on
pictorial technique and platinum printing and from 1917
to 1919 ran Karl Struss' studio in New York. Anderson
all but gave up photography in 1925 to write historical
novels. In 1933 he began to write about photography
again, but the pictorial ideals he espoused were no
longer in vogue.

*581. **PURPLE SHADOWS** (P1978.46)
Platinum print. negative 1910, print 1918
Image: 3¹³⁄₁₆ x 4¹¹⁄₁₆ in. (9.7 x 12.0 cm.)
Sheet: 5½ x 6¹³⁄₁₆ in. (14.0 x 17.4 cm.) irregular
1st mount: 10¾ x 13½ in. (27.3 x 34.2 cm.)
2nd mount: 10¹³⁄₁₆ x 13¹¹⁄₁₆ in. (27.5 x 34.7 cm.)
Signed, l.r. print recto: "Paul L. Anderson 1918"
Acquired from: Hastings Gallery, New York, New York

LEE ANGLE, American (b. 1922)

Angle is a commercial photographer. A native of Fort
Worth, Texas, he studied photography and motion
picture production while serving in the Navy during
World War II. Afterward he continued studies at Texas
Christian University and the Fred Archer School of
Photography in Los Angeles. He founded Lee Angle
Photography in Fort Worth in 1949. Apart from
illustrative and commercial photography, Angle's own
work focuses on southwestern scenes and the places and
people of Europe.

582. **THE CATTLE BARON** (P1976.145)
Gelatin silver print. 1976
Image: 15¹⁵⁄₁₆ x 20 in. (40.4 x 50.8 cm.)
Mount: same as image size
Signed, l.r. print recto: "Lee Angle"
Inscription, print recto: "1/50"
Acquired from: Reminisce Gallery, Fort Worth, Texas

J. CRAIG ANNAN, Scottish (1864–1946)

See *Camera Notes* and *Camera Work*

DIANE ARBUS, American (1923–1971)

Diane Nemerov Arbus was born in New York City
and educated at the Feldston School and the Ethical
Culture School, which promoted a curriculum that
fostered understanding of social problems and condi-
tions. She became interested in photography following
her marriage to fashion photographer Allan Arbus
in 1941. After a period of study with Lisette Model
in 1955–57, her work focused on personal images of
people living on the very margins of society. Decidedly
confrontational, Arbus' work nevertheless shows a
strong empathy for those she photographed. She re-
ceived Guggenheim fellowships in 1963 and 1966 to
support a project on "American Rites, Manners, and
Customs." These images, shown at the 1967 exhibition
"New Documents" at the Museum of Modern Art in
New York, helped to further establish her role as a devel-
oper of a social documentary approach to photography.

*583. **TRIPLETS IN THEIR BEDROOM, NJ 1963** (P1984.23)
Gelatin silver print. negative 1963, print later by Neil Selkirk
Image: 14⅞ x 15 in. (37.7 x 38.1 cm.)
Sheet: 19¹³⁄₁₆ x 15¹⁵⁄₁₆ in. (50.4 x 40.5 cm.)
Inscription, print verso: "3437//43/75/TRIPLETS IN THEIR
BEDROOM,/NJ 1963/NEIL SELKIRK/Doon Arbus"
contained within rubber stamp "A Diane Arbus
photograph" and rubber stamps "Not to be reproduced in
any way without/written permission from Doon Arbus.//
Copyright © 1963/The estate of Diane Arbus"
Acquired from: Fraenkel Gallery, San Francisco, California

566. **VOTIVE OFFERING/VOTOS** (P1980.63.3)
Gelatin silver print. negative 1969, print 1977
Image: 7 7/16 x 9 5/8 in. (18.9 x 24.4 cm.)
Sheet: 8 x 10 in. (20.3 x 25.4 cm.)
Signed, l.r. print verso: "M. Alvarez Bravo./Mexico."
Inscription, print verso: "39/100"
Acquired from: gift of George Peterkin, Jr., Houston, Texas

567. **LENGTHENED LIGHT/LUZ RESTIRADA** (P1980.63.4)
Gelatin silver print. negative 1944, print 1977
Image: 9 9/16 x 6 15/16 in. (24.2 x 17.6 cm.)
Sheet: 10 x 8 in. (25.4 x 20.3 cm.)
Signed, l.r. print verso: "M. Alvarez Bravo./Mexico."
Inscription, print verso: "39/100"
Acquired from: gift of George Peterkin, Jr., Houston, Texas

558

568. **TWO WOMEN, A LARGE BLIND, AND SHADOWS/DOS MUJERES Y LA GRAN CORTINA CON SOMBRAS** (P1980.63.5)
Gelatin silver print. 1977
Image: 7 1/4 x 9 5/8 in. (18.4 x 24.4 cm.)
Sheet: 8 x 10 in. (20.3 x 25.4 cm.)
Signed, l.r. print verso: "M. Alvarez Bravo./Mexico."
Inscription, print verso: "39/100"
Acquired from: gift of George Peterkin, Jr., Houston, Texas

569. **FIRST ACT/ACTO PRIMERO** (P1980.63.6)
Gelatin silver print. negative 1975, print 1977
Image: 7 1/8 x 9 1/2 in. (18.1 x 24.1 cm.)
Sheet: 8 x 10 in. (20.3 x 25.4 cm.)
Signed, l.r. print verso: "M. Alvarez Bravo./Mexico."
Inscription, print verso: "39/100"
Acquired from: gift of George Peterkin, Jr., Houston, Texas

560

570. **BOX OF VISIONS/CAJA DE VISIONES** (P1980.63.7)
Gelatin silver print. negative c. 1930s, print 1977
Image: 7 9/16 x 9 5/16 in. (19.2 x 23.7 cm.)
Sheet: 8 x 10 in. (20.3 x 25.4 cm.)
Signed, l.r. print verso: "M. Alvarez Bravo./Mexico."
Inscription, print verso: "39/100"
Acquired from: gift of George Peterkin, Jr., Houston, Texas

571. **THE MAN FROM PAPANTLA/SEÑOR DE PAPANTLA** (P1980.63.8) duplicate of P1979.97.1
Gelatin silver print. negative 1934–35, print 1977
Image: 9 5/16 x 7 1/4 in. (23.7 x 18.4 cm.)
Sheet: 10 x 8 in. (25.4 x 20.3 cm.)
Signed, l.r. print verso: "M. Alvarez Bravo./Mexico."
Inscription, print verso: "39/100"
Acquired from: gift of George Peterkin, Jr., Houston, Texas

572. **SLEEPING DOGS BARK/LOS PERROS DURMIENDO LADRAN** (P1980.63.9) duplicate of P1979.97.2
Gelatin silver print. negative 1966, print 1977
Image: 9 1/16 x 7 9/16 in. (23.0 x 19.2 cm.)
Sheet: 10 x 8 in. (25.4 x 20.3 cm.)
Signed, l.r. print verso: "M. Alvarez Bravo./Mexico."
Inscription, print verso: "39/100"
Acquired from: gift of George Peterkin, Jr., Houston, Texas

562

* 573. **TWO PAIRS OF LEGS/DOS PARES DE PIERNAS** (P1980.63.10)
Gelatin silver print. negative 1928–29, print 1977
Image: 9 1/4 x 7 1/4 in. (23.5 x 18.4 cm.)
Sheet: 10 x 8 in. (25.4 x 20.3 cm.)
Signed, l.r. print verso: "M. Alvarez Bravo./Mexico."
Inscription, print verso: "39/100"
Acquired from: gift of George Peterkin, Jr., Houston, Texas

* 574. **"...A FISH CALLED SAW"/"...UN PEZ QUE LLAMAN SIERRA"** (P1980.63.11)
Gelatin silver print. negative 1942, print 1977
Image: 9 1/2 x 6 7/8 in. (24.1 x 17.5 cm.)
Sheet: 10 x 8 in. (25.4 x 20.3 cm.)
Signed, l.r. print verso: "M. Alvarez Bravo./Mexico."
Inscription, print verso: "39/100"
Acquired from: gift of George Peterkin, Jr., Houston, Texas

575. **ALMOST/YA MERO** (LP1980.63.12)
Gelatin silver print. negative 1968, print 1977
Image: 7 7/16 x 9 1/2 in. (18.9 x 24.1 cm.)
Sheet: 8 x 10 in. (20.3 x 25.4 cm.)
Signed, l.r. print verso: "M. Alvarez Bravo./Mexico."
Inscription, print verso: "39/100"
Acquired from: long-term loan from George Peterkin, Jr.,
Houston, Texas

576. **SKYLIGHT/GORRIÓN, CLARO** (P1980.63.13)
Gelatin silver print. negative 1938–40, print 1977
Image: 7 3/16 x 9 1/2 in. (18.3 x 24.1 cm.)
Sheet: 8 x 10 in. (20.3 x 25.4 cm.)
Signed, l.r. print verso: "M. Alvarez Bravo./Mexico."
Inscription, print verso: "39/100"
Acquired from: gift of George Peterkin, Jr., Houston, Texas

*577. **THRESHOLD/UMBRAL** (P1980.63.14) duplicate of
P1979.97.3
Gelatin silver print. negative 1947, print 1977
Image: 9 9/16 x 7 11/16 in. (24.2 x 19.6 cm.)
Sheet: 10 x 8 in. (25.4 x 20.3 cm.)
Signed, l.r. print verso: "M. Alvarez Bravo./Mexico."
Inscription, print verso: "39/100"
Acquired from: gift of George Peterkin, Jr., Houston, Texas

*578. **WOMAN COMBING HER HAIR/RETRATO DE LO
ETERNO** (P1980.63.15)
Gelatin silver print. negative 1932–33, print 1977
Image: 9 7/16 x 7 1/2 in. (24.0 x 19.1 cm.)
Sheet: 10 x 8 in. (25.4 x 20.3 cm.)
Signed, l.r. print verso: "M. Alvarez Bravo./Mexico."
Inscription, print verso: "39/100"
Acquired from: gift of George Peterkin, Jr., Houston, Texas

＊ ＊ ＊ ＊

579. **SLEEPING DOGS BARK/LOS PERROS DURMIENDO
LADRAN [from the portfolio "Photographs by Manuel
Alvarez Bravo"]** (P1979.97.2) duplicate of P1980.63.9
Gelatin silver print. negative 1966, print 1977
Image: 9 1/16 x 7 9/16 in. (23.0 x 19.2 cm.)
Sheet: 9 15/16 x 8 in. (25.3 x 20.3 cm.)
Signed, l.r. print verso: "M. Alvarez Bravo./Mexico."
Inscription, print verso: "78/100"
Acquired from: gift of R. G. Nichols, Greenwich,
Connecticut

580. **THRESHOLD/UMBRAL [from the portfolio "Photographs
by Manuel Alvarez Bravo"]** (P1979.97.3) duplicate of
P1980.63.14
Gelatin silver print. negative 1947, print 1977
Image: 9 9/16 x 7 11/16 in. (24.2 x 19.5 cm.)
Sheet: 10 x 8 in. (25.4 x 20.3 cm.)
Signed, l.r. print verso: "M. Alvarez Bravo./Mexico."
Inscription, print verso: "78/100"
Acquired from: gift of R. G. Nichols, Greenwich,
Connecticut

PAUL L. ANDERSON, American (1880–1956)

Anderson was born in Trenton, New Jersey, and gradu-
ated from Lehigh University with a degree in electrical
engineering in 1901. Impressed by the pictorial images
in Alfred Stieglitz's *Camera Work*, Anderson took up
photography and, in 1909, left his job with the tele-
phone company to open a portrait studio. In 1914 he be-
came a technical instructor at the Clarence White
School, where he taught until 1918. Laura Gilpin was
among his pupils. Anderson published several books on
pictorial technique and platinum printing and from 1917
to 1919 ran Karl Struss' studio in New York. Anderson
all but gave up photography in 1925 to write historical
novels. In 1933 he began to write about photography
again, but the pictorial ideals he espoused were no
longer in vogue.

*581. **PURPLE SHADOWS** (P1978.46)
Platinum print. negative 1910, print 1918
Image: 3 13/16 x 4 11/16 in. (9.7 x 12.0 cm.)
Sheet: 5 1/2 x 6 13/16 in. (14.0 x 17.4 cm.) irregular
1st mount: 10 3/4 x 13 1/2 in. (27.3 x 34.2 cm.)
2nd mount: 10 13/16 x 13 11/16 in. (27.5 x 34.7 cm.)
Signed, l.r. print recto: "Paul L. Anderson 1918"
Acquired from: Hastings Gallery, New York, New York

LEE ANGLE, American (b. 1922)

Angle is a commercial photographer. A native of Fort
Worth, Texas, he studied photography and motion
picture production while serving in the Navy during
World War II. Afterward he continued studies at Texas
Christian University and the Fred Archer School of
Photography in Los Angeles. He founded Lee Angle
Photography in Fort Worth in 1949. Apart from
illustrative and commercial photography, Angle's own
work focuses on southwestern scenes and the places and
people of Europe.

582. **THE CATTLE BARON** (P1976.145)
Gelatin silver print. 1976
Image: 15 15/16 x 20 in. (40.4 x 50.8 cm.)
Mount: same as image size
Signed, l.r. print recto: "Lee Angle"
Inscription, print recto: "1/50"
Acquired from: Reminisce Gallery, Fort Worth, Texas

J. CRAIG ANNAN, Scottish (1864–1946)

See *Camera Notes* and *Camera Work*

DIANE ARBUS, American (1923–1971)

Diane Nemerov Arbus was born in New York City
and educated at the Feldston School and the Ethical
Culture School, which promoted a curriculum that
fostered understanding of social problems and condi-
tions. She became interested in photography following
her marriage to fashion photographer Allan Arbus
in 1941. After a period of study with Lisette Model
in 1955–57, her work focused on personal images of
people living on the very margins of society. Decidedly
confrontational, Arbus' work nevertheless shows a
strong empathy for those she photographed. She re-
ceived Guggenheim fellowships in 1963 and 1966 to
support a project on "American Rites, Manners, and
Customs." These images, shown at the 1967 exhibition
"New Documents" at the Museum of Modern Art in
New York, helped to further establish her role as a devel-
oper of a social documentary approach to photography.

*583. **TRIPLETS IN THEIR BEDROOM, NJ 1963** (P1984.23)
Gelatin silver print. negative 1963, print later by Neil Selkirk
Image: 14 7/8 x 15 in. (37.7 x 38.1 cm.)
Sheet: 19 13/16 x 15 15/16 in. (50.4 x 40.5 cm.)
Inscription, print verso: "3437//43/75/TRIPLETS IN THEIR
BEDROOM,/NJ 1963/NEIL SELKIRK/Doon Arbus"
contained within rubber stamp "A Diane Arbus
photograph" and rubber stamps "Not to be reproduced in
any way without/written permission from Doon Arbus.//
Copyright © 1963/The estate of Diane Arbus"
Acquired from: Fraenkel Gallery, San Francisco, California

545

549

553

554

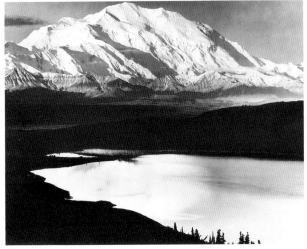

556

*556. **SUNRISE, MOUNT McKINLEY, MOUNT McKINLEY NATIONAL PARK, ALASKA** (P1969.26)
Gelatin silver print. negative 1948, print 1969
Image: 14 15/16 x 18 3/4 in. (37.9 x 47.6 cm.)
Mount: 22 x 28 in. (56.0 x 71.2 cm.)
Signed, l.r. mount recto: "Ansel Adams"
Inscription, mount verso: "Sunrise, Mount McKinley, Mount McKinley National Park/ALASKA" and rubber stamp "Photograph/by/Ansel Adams/Route 1, Box 181/Carmel, California/93921"
Acquired from: the photographer

557. **YOSEMITE VALLEY, THUNDERSTORM** (P1969.22)
Gelatin silver print. negative c. 1940s, print 1969
Image: 14 1/2 x 19 1/4 in. (36.8 x 48.9 cm.)
Mount: 22 1/16 x 28 in. (56.0 x 71.1 cm.)
Signed, l.r. mount recto: "Ansel Adams"
Inscription, mount verso: "Yosemite Valley, Thunderstorm" and rubber stamp "Photograph/by/Ansel Adams/Route 1, Box 181/Carmel, California/93921"
Acquired from: the photographer

ROBERT ADAMS, American (b. 1937)

Robert Adams received his doctorate in English from the University of Southern California and was a lecturer and assistant professor at Colorado College for several years before teaching himself photography. He has received fellowships from both the National Endowment for the Arts and the John Simon Guggenheim Memorial Foundation and, in 1982, received a Peer Award in Creative Photography from the Friends of Photography. His work portrays the hand of man on the landscape rather than the unspoiled beauty of nature. He has retraced the steps of nineteenth-century western photographers, photographing the changes the twentieth century has brought to the land.

*558. **ALKALI LAKE, ALBANY COUNTY, WYOMING** (P1980.20.2)
Gelatin silver print. negative 1977, print 1979
Image: 8 15/16 x 11 3/16 in. (22.7 x 28.4 cm.)
Sheet: 10 15/16 x 14 in. (27.7 x 35.6 cm.)
Signed, l.r. print verso: "Robert Adams 1979"
Inscription, print verso: "Alkali Lake, Albany County, Wyoming" and rubber stamp with handwritten date "Copyright © 1977 by Robert Adams"
Acquired from: Fraenkel Gallery, San Francisco, California

559. **SOUTH OF ROCKY FLATS, JEFFERSON COUNTY, COLORADO** (P1980.20.1)
Gelatin silver print. 1978
Image: 8 11/16 x 11 1/8 in. (22.1 x 28.2 cm.)
Sheet: 10 15/16 x 13 15/16 in. (27.7 x 35.4 cm.)
Signed, l.r. print verso: "Robert Adams 1978"
Inscription, print verso: "RA.03/South of Rocky Flats, Jefferson County, Colorado" and rubber stamp "Copyright © by Robert Adams"
Acquired from: Fraenkel Gallery, San Francisco, California

PRESCOTT ADAMSON, American

See *Camera Notes*

ROBERT ADAMSON, Scottish (1821–1848)

See David Octavius Hill and *Camera Work*

KENNETH ALEXANDER (active 1930s)

Alexander was a Hollywood portrait photographer.

*560. **KARL STRUSS [with his cinematography Oscar for the film *Sunrise*]** (P1983.23.185)
Toned gelatin silver print. c. 1929
Image: 19 5/16 x 15 3/8 in. (48.9 x 39.0 cm.)
Mount: 23 9/16 x 19 1/4 in. (59.7 x 48.9 cm.)
Signed, l.r. mount recto: "Kenneth L. Alexander"
Inscription, mount recto: "KARL•STRUSS" mount verso: "#100."
Acquired from: Stephen White Gallery of Photography, Inc., Los Angeles, California (in Karl Struss Estate)

MANUEL ALVAREZ BRAVO, Mexican (b. 1902)

Alvarez Bravo, who began to make photographs in 1924, was encouraged in 1929 by Edward Weston to pursue a career in photography. His work also owes much to the Mexican muralist movement of the 1930s. He was a close friend of Diego Rivera and other Mexican artists who made powerful social and political statements through their work. Spurred by an intense native pride, his work is an intuitive and incisive portrait of Mexican people and culture.

561. **EL SISTEMA NERVIOSO DEL GRAN SIMPATICO [from the portfolio "Fifteen Photographs"]** (P1985.22)
Gelatin silver print. negative n.d., print 1974
Image: 9 5/8 x 7 11/16 in. (24.4. x 19.4 cm.)
Mount: 19 3/4 x 14 3/4 in. (50.1 x 37.5 cm.)
Signed, l.r. mount recto: "M. Alvarez Bravo."
Inscription, mount recto: "46/75"
Acquired from: gift of Paul Brauchle, Dallas, Texas.

*562. **INSTRUMENTAL** (P1985.24)
Gelatin silver print. 1931
Image: 7 9/16 x 9 3/4 in. (19.1 x 24.8 cm.)
Signed, l.r. print verso: "M. Alvarez Bravo/1.931"
Inscription, print verso: "Lt 263" and dealer's stamp
Acquired from: Edwynn Houk Gallery, Chicago, Illinois

563. **THE MAN FROM PAPANTLA/SEÑOR DE PAPANTLA [from the portfolio "Photographs by Manuel Alvarez Bravo"]** (P1979.97.1) duplicate of P1980.63.8
Gelatin silver print. negative 1934–35, print 1977
Image: 9 5/16 x 7 3/16 in. (23.7 x 18.3 cm.)
Sheet: 10 1/16 x 8 in. (25.5 x 20.3 cm.)
Signed, l.r. print verso: "M. Alvarez Bravo./Mexico."
Inscription, print verso: "78/100"
Acquired from: gift of R. G. Nichols, Greenwich, Connecticut

PHOTOGRAPHS BY MANUEL ALVAREZ BRAVO (P1980.63.1-15)

This portfolio was published in 1977 by Acorn Editions Limited of Geneva, Switzerland. This is portfolio number 39 of an edition of 100.

564. **SAND AND SMALL PINES/ARENA Y PINITOS** (P1980.63.1)
Gelatin silver print. negative c. 1920s, print 1977
Image: 6 5/8 x 9 9/16 in. (16.8 x 24.2 cm.)
Sheet: 8 x 10 in. (20.3 x 25.4 cm.)
Signed, l.r. print verso: "M. Alvarez Bravo./Mexico."
Inscription, print verso: "39/100"
Acquired from: gift of George Peterkin, Jr., Houston, Texas

*565. **GROWING LANDSCAPE/PAISAJE DE SIEMBRAS** (P1980.63.2)
Gelatin silver print. negative 1972–74, print 1977
Image: 7 1/8 x 9 5/8 in. (18.1 x 24.4 cm.)
Sheet: 8 x 10 in. (20.3 x 25.4 cm.)
Signed, l.r. print verso: "M. Alvarez Bravo./Mexico."
Inscription, print verso: "39/100"
Acquired from: gift of George Peterkin, Jr., Houston, Texas

565

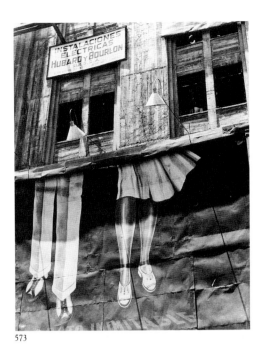

573

574

577

578

581

DICK ARENTZ, American (b. 1935)

From 1953 to 1964 Dick Arentz studied dentistry and oral and maxillofacial surgery at the University of Michigan, receiving a D.D.S. and Master of Science in jaw and facial surgery. In 1969 he became interested in photography and returned to school, studying photography with Phil Davies at the University of Michigan. Since 1970 Arentz has photographed throughout Europe and the southwestern United States. In 1978 the Arts and Humanities Commission selected Arentz as one of the "Twenty Arizona Artists." He has received an Edna Rider Whiteman Foundation Grant (1986) and an Isaac W. Bernheim Fellowship (1988). His platinum/palladium prints have appeared in numerous group and individual exhibitions, as well as several books and portfolios. Arentz has taught at Northern Arizona University and now regularly conducts workshops on platinum/palladium printing. Most recently he has concentrated on photographing the landscape of the midsouthern and southeastern regions of the United States.

*584. **ROMEO, COLO.** (P1986.5)
Hand-coated platinum/palladium print. 1984
Image: 11 7/16 x 19 1/2 in. (29.0 x 49.4 cm.)
Sheet: 20 13/16 x 26 1/8 in. (52.8 x 66.4 cm.)
Signed, l.r. sheet recto: "Arentz 84"
Inscription, sheet recto: "1/50//ROMEO, COLO//122076" and embossed "PLATINUM/PALLADIUM/© DICK ARENTZ"
Acquired from: Etherton Gallery, Tucson, Arizona

FRANK ARMSTRONG, American (b. 1935)

Armstrong became interested in photography while serving with the Navy in Alaska. He received a bachelor's degree in journalism from the University of Texas at Austin, but was self-taught as a photographer. Armstrong served as the chief photographer for the University's News and Information Service from 1969 to 1979. Supported by a Dobie-Paisano fellowship, he left the school in 1979 to pursue his own work full-time. Working with a large-format camera, Armstrong documents both the classical, natural landscape and what he refers to as the "social landscape," the result of man's interaction with his environment.

585. **AF & AM LODGE, GRANDFALLS, TEXAS, 5/12/84** [from "Contemporary Texas: A Photographic Portrait"] (P1985.17.4)
Gelatin silver print. 1984
Image: 9 7/16 x 12 in. (24.0 x 30.5 cm.)
Sheet: 11 x 13 15/16 in. (28.0 x 35.4 cm.)
Signed, l.r. print recto: "Frank Armstrong/ 1984"
Inscription, print verso: "84/5-27 #3 11/84"
Acquired from: gift of the Texas Historical Foundation with support from a major grant from the Du Pont Company and Conoco, its energy subsidiary, and assistance from the Texas Commission on the Arts and the National Endowment for the Arts

586. **ANDREWS, TEXAS, 5/8/84** [from "Contemporary Texas: A Photographic Portrait"] (P1985.17.8)
Gelatin silver print. 1984
Image: 9 1/2 x 11 1/4 in. (24.1 x 28.5 cm.)
Sheet: 10 15/16 x 13 15/16 in. (27.8 x 35.4 cm.)
Signed, l.r. print recto: "Frank Armstrong/ 1984"
Inscription, print verso: "84/5-10 #2 11/84"

Acquired from: gift of the Texas Historical Foundation with support from a major grant from the Du Pont Company and Conoco, its energy subsidiary, and assistance from the Texas Commission on the Arts and the National Endowment for the Arts

587. **DENNIS YADON, MIDLAND COUNTY, TEXAS, 5/11/84** [from "Contemporary Texas: A Photographic Portrait"] (P1985.17.1)
Gelatin silver print. 1984
Image: 10 3/8 x 19 in. (26.4 x 48.2 cm.)
Sheet: 15 7/8 x 19 15/16 in. (40.3 x 50.7 cm.)
Signed, l.r. print recto: "Frank Armstrong/ 1984"
Inscription, print verso: "84/5-22 #2 11/84"
Acquired from: gift of the Texas Historical Foundation with support from a major grant from the Du Pont Company and Conoco, its energy subsidiary, and assistance from the Texas Commission on the Arts and the National Endowment for the Arts

588. **ELMER HUNT, LARRY HUNT, TODD HUNT, WARD COUNTY, TEXAS, 5/12/84** [from "Contemporary Texas: A Photographic Portrait"] (P1985.17.6)
Gelatin silver print. 1984
Image: 13 7/16 x 19 1/16 in. (34.1 x 48.4 cm.)
Sheet: 15 7/8 x 19 15/16 in. (40.3 x 50.7 cm.)
Signed, l.r. print recto: "Frank Armstrong/ 1984"
Inscription, print verso: "84/5-26 #3 11/84"
Acquired from: gift of the Texas Historical Foundation with support from a major grant from the Du Pont Company and Conoco, its energy subsidiary, and assistance from the Texas Commission on the Arts and the National Endowment for the Arts

589. **HOT SPRINGS, BIG BEND NAT'L PARK, TX 11/19/79** (P1980.34)
Gelatin silver print. negative 1979, print 1980
Image: 9 3/8 x 12 1/2 in. (23.8 x 31.7 cm.)
Mount: 16 x 20 in. (40.7 x 50.8 cm.)
Signed, l.r. mount recto: "©Frank Armstrong '79"
Inscription, print verso: "Hot Springs, Big Bend/Nat'l Park, TX 11/79/603 (6/80)" contained within rubber stamp "© FRANK ARMSTRONG/This photograph may not be/ reproduced in part or whole/without the express/written consent of the/photographer.// FRANK ARMSTRONG/ P.O. BOX 4104/AUSTIN, TX.78765/(512)459-9276"
Acquired from: the photographer

*590. **SAN FRANCISCO DE ASSIS, EL PASO COUNTY, TEXAS, 5/16/84** [from "Contemporary Texas: A Photographic Portrait"] (P1985.17.7)
Gelatin silver print. 1984
Image: 11 7/16 x 9 7/16 in. (29.0 x 24.0 cm.)
Sheet: 13 15/16 x 10 15/16 in. (35.4 x 27.8 cm.)
Signed, l.r. print recto: "Frank Armstrong/© 1984"
Inscription, print verso: "84/5-38 #2 11/84"
Acquired from: gift of the Texas Historical Foundation with support from a major grant from the Du Pont Company and Conoco, its energy subsidiary, and assistance from the Texas Commission on the Arts and the National Endowment for the Arts

591. **SMELTER CEMETERY, EL PASO, TEXAS, 5/17/84** [from "Contemporary Texas: A Photographic Portrait"] (P1985.17.5)
Gelatin silver print. 1984
Image: 11 15/16 x 9 1/2 in. (30.3 x 24.1 cm.)
Sheet: 14 x 10 15/16 in. (35.6 x 27.8 cm.)
Signed, l.r. print recto: "Frank Armstrong/© 1984"
Inscription, print verso: "84/5-44 #2 11/84"
Acquired from: gift of the Texas Historical Foundation with support from a major grant from the Du Pont Company and Conoco, its energy subsidiary, and assistance from the Texas Commission on the Arts and the National Endowment for the Arts

592. **STANTON, TEXAS, 5/8/84 [from "Contemporary Texas: A Photographic Portrait"]** (P1985.17.3)
Gelatin silver print. 1984
Image: 8 1/16 x 12 1/16 in. (20.5 x 30.7 cm.)
Sheet: 10 15/16 x 13 15/16 in. (27.8 x 35.4 cm.)
Signed, l.r. print recto: "Frank Armstrong/© 1984"
Inscription, print verso: "84/5-13 #2 11/84"
Acquired from: gift of the Texas Historical Foundation with support from a major grant from the Du Pont Company and Conoco, its energy subsidiary, and assistance from the Texas Commission on the Arts and the National Endowment for the Arts

593. **TEXAS HIGHWAY 20, EL PASO COUNTY, TEXAS, 5/16/84 [from "Contemporary Texas: A Photographic Portrait"]** (P1985.17.9)
Gelatin silver print. 1984
Image: 9 7/16 x 11 1/4 in. (24.0 x 28.5 cm.)
Sheet: 11 x 13 15/16 in. (28.0 x 35.4 cm.)
Signed, l.r. print recto: "Frank Armstrong/© 1984"
Inscription, print verso: "84/5-39 #3 11/84"
Acquired from: gift of the Texas Historical Foundation with support from a major grant from the Du Pont Company and Conoco, its energy subsidiary, and assistance from the Texas Commission on the Arts and the National Endowment for the Arts

594. **TEXAS HIGHWAY 158, MIDLAND COUNTY, TEXAS, 5/8/84 [from "Contemporary Texas: A Photographic Portrait"]** (P1985.17.10)
Gelatin silver print. 1984
Image: 9 3/16 x 12 1/2 in. (23.3 x 31.8 cm.)
Sheet: 10 15/16 x 13 15/16 in. (27.8 x 35.4 cm.)
Signed, l.r. print recto: "Frank Armstrong/© 1984"
Inscription, print verso: "84/5-9 #2 11/84"
Acquired from: gift of the Texas Historical Foundation with support from a major grant from the Du Pont Company and Conoco, its energy subsidiary, and assistance from the Texas Commission on the Arts and the National Endowment for the Arts

*595. **YELLOW JACKET DRIVE-IN, KERMIT, TEXAS, 5/9/84 [from "Contemporary Texas: A Photographic Portrait"]** (P1985.17.2)
Gelatin silver print. 1984
Image: 8 x 11 15/16 in. (20.3 x 30.3 cm.)
Sheet: 11 x 13 15/16 in. (28.0 x 35.4 cm.)
Signed, l.r. print recto: "Frank Armstrong/© 1984"
Inscription, print verso: "84/5-19 #2 11/84"
Acquired from: gift of the Texas Historical Foundation with support from a major grant from the Du Pont Company and Conoco, its energy subsidiary, and assistance from the Texas Commission on the Arts and the National Endowment for the Arts

ERNEST R. ASHTON, British (c. 1867–1951/52)

See *Camera Notes*

FRANÇOIS AUBERT, French (1829–1906)

François Aubert was an art student at the Ecole des Beaux-Arts in Paris before going to Central America about 1854. He traveled to Mexico City where he probably learned photography from Jules Amiel and a French photographer named Merille. Aubert purchased Amiel's studio in 1864 and operated a business that specialized in portraits. He frequently photographed French, Austrian, and Belgian soldiers stationed in Mexico as well as members of the local aristocracy and business class. Aubert also did work for the military,

583

584

590

copying maps and battle plans. In 1867 Aubert was in Queretaro when the Emperor Maximilian and other officers were executed. Following the execution, Aubert made a series of views of the site, the bodies, and the clothing Maximilian had been wearing. Aubert left Mexico for Algeria about 1890 and died in 1906. Much of his work is held by the Belgian Army Museum.

*596. [Shirt, worn by the Emperor Maximilian of Mexico on the day of his execution, pinned to a door] (P1984.7)
Albumen silver print. c. 1867
Image: 8 11/16 x 6 3/8 in. (22.1 x 16.2 cm.)
Acquired from: Paul Hertzmann, Inc., San Francisco, California

RICHARD AVEDON, American (b. 1923)

Richard Avedon was born in New York City and attended its public schools. He served in the photographic section of the U.S. Merchant Marine from 1942 to 1944, where he made identification photographs. Avedon studied with Alexey Brodovitch, the art director for *Harper's Bazaar,* and worked for the magazine from 1945 to 1965. He then joined the staff of *Vogue.* Although well known for his innovative and dynamic fashion photographs, Avedon has also created a large body of portraits of artists, political leaders, and ordinary citizens that document the temper of American life. In 1979 the Amon Carter Museum commissioned Avedon to produce a series of portraits of people in the western United States. The exhibition prints resulting from the five-year project "In the American West: Photographs by Richard Avedon" form the Museum's collection of Avedon photographs.

597. A. L. BEAN, COTTON FARMER, SWEETWATER, TEXAS, 3/10/79 [from "In the American West: Photographs by Richard Avedon"] (P1985.28.40)
Gelatin silver print mounted on aluminum panel. negative 1979, print 1985
Image: 47 x 37½ in. (119.4 x 95.2 cm.)
Mount: 50⅛ x 39¼ in. (127.2 x 99.7 cm.)
Signed, bottom center mount verso and l.r. print recto: "Avedon"
Inscription, mount verso, rubber stamp: "IN THE AMERICAN WEST/A project commissioned by the/ Amon Carter Museum, Fort Worth, Texas./ This photograph may not be reproduced without/the written permission of Richard Avedon Inc./Copyright © 1985 by Richard Avedon Inc./All rights reserved./This photograph was printed in 1985./A. L. Bean, cotton farmer/ Sweetwater, Texas, 3/10/79/This photograph was printed for and first exhibited/at the Amon Carter Museum, Fort Worth, Texas/September 14–November 17, 1985."
Acquired from: the photographer

*598. ALFRED LESTER, DRYLAND FARMER, CHARBONEAU, NORTH DAKOTA, 8/17/82 [from "In the American West: Photographs by Richard Avedon"] (P1985.28.80)
Gelatin silver print mounted on aluminum panel. negative 1982, print 1985
Image: 47 x 37¼ in. (119.4 x 95.9 cm.)
Mount: 50⅛ x 39¼ in. (127.2 x 99.7 cm.)
Signed, bottom center mount verso and l.r. print recto: "Avedon A.P./1/2"
Inscription, mount verso, rubber stamp: "IN THE AMERICAN WEST/A project commissioned by the/ Amon Carter Museum, Fort Worth, Texas./ Richard Avedon warrants and represents that,/aside from the signed and numbered photographs/in this edition of 6 plus 2 artist's proofs, no/other original prints of this photograph will/be made by him or under his authority./This photograph may not be reproduced without/the written

permission of Richard Avedon Inc./Copyright © 1985 by Richard Avedon Inc./All rights reserved./This photograph was printed in 1985./Alfred Lester, dryland farmer/ Charboneau, North Dakota, 8/17/82/This photograph was printed for and first exhibited/at the Amon Carter Museum, Fort Worth, Texas/September 14–November 17, 1985."
Acquired from: the photographer

*599. ALLEN SILVY, DRIFTER, ROUTE 93, CHLORIDE, NEVADA, 12/14/80 [from "In the American West: Photographs by Richard Avedon"] (P1985.28.41)
Gelatin silver print mounted on aluminum panel. negative 1980, print 1985
Image: 56¼ x 45 in. (142.8 x 114.3 cm.)
Mount: 60 x 47 in. (152.4 x 119.4 cm.)
Signed, bottom center mount verso and l.r. print recto: "Avedon A.P. 1/2"
Inscription, mount verso, rubber stamp: "IN THE AMERICAN WEST/A project commissioned by the/ Amon Carter Museum, Fort Worth, Texas./ Richard Avedon warrants and represents that,/aside from the signed and numbered photographs/in this edition of 5 plus 2 artist's proofs, no/other original prints of this photograph will be/made by him or under his authority except for one/80½ x 64½" print made for exhibition purposes./ This photograph may not be reproduced without/the written permission of Richard Avedon Inc./Copyright © 1985 by Richard Avedon Inc./All rights reserved./This photograph was printed in 1985./Allen Silvy, drifter/Route 93, Chloride, Nevada, 12/14/80/This photograph was printed for the/Amon Carter Museum, Fort Worth, Texas."
Acquired from: the photographer

600. ALTON TERRY, OIL FIELD WORKER, FRENSTAT, TEXAS, 9/28/80 [from "In the American West: Photographs by Richard Avedon"] (P1985.28.58)
Gelatin silver print mounted on aluminum panel. negative 1980, print 1985
Image: 56¼ x 45 in. (142.8 x 114.3 cm.)
Mount: 59¾ x 47 in. (151.8 x 119.4 cm.)
Signed, center mount verso and l.r. print recto: "Avedon."
Inscription, mount verso, rubber stamp: "IN THE AMERICAN WEST/A project commissioned by the/ Amon Carter Museum, Fort Worth, Texas./ This photograph may not be reproduced without/the written permission of Richard Avedon Inc./Copyright © 1985 by Richard Avedon Inc./All rights reserved./This photograph was printed in 1985./Alton Terry, oil field worker/Frenstat, Texas, 9/28/80/This photograph was printed for and first exhibited/at the Amon Carter Museum, Fort Worth, Texas/ September 14–November 17, 1985."
Acquired from: the photographer

601. ANDREA D'AMATO, STUDENT, SANTA FE, NEW MEXICO, 4/3/80 [from "In the American West: Photographs by Richard Avedon"] (P1985.28.83)
Gelatin silver print mounted on aluminum panel. negative 1980, print 1985
Image: 46¾ x 37½ in. (118.8 x 95.2 cm.)
Mount: 50⅛ x 39¼ in. (127.2 x 99.7 cm.)
Signed, center mount verso and l.r. print recto: "Avedon."
Inscription, mount verso, rubber stamp: "IN THE AMERICAN WEST/A project commissioned by the/ Amon Carter Museum, Fort Worth, Texas./ This photograph may not be reproduced without/the written permission of Richard Avedon Inc./Copyright © 1985 by Richard Avedon Inc./All rights reserved./This photograph was printed in 1985./Andrea D'Amato, student/Santa Fe, New Mexico, 4/3/80/This photograph was printed for and first exhibited/at the Amon Carter Museum, Fort Worth, Texas/September 14–November 17, 1985."
Acquired from: the photographer

*602. **ANN MARIE GUSTIN, EQUIPMENT SPECIALIST, USAF, FORT BRIDGER, WYOMING, 9/2/83** [from "In the American West: Photographs by Richard Avedon"] (P1985.28.71)
Gelatin silver print mounted on aluminum panel. negative 1983, print 1985
Image: 46½ x 37½ in. (118.1 x 95.2 cm.)
Mount: 50⅛ x 39¼ in. (127.2 x 99.7 cm.)
Signed, bottom center mount verso and l.r. print recto: "Avedon A.P./1/2"
Inscription, mount verso, rubber stamp: "IN THE AMERICAN WEST/A project commissioned by the/ Amon Carter Museum, Fort Worth, Texas./ This photograph may not be reproduced without/the written permission of Richard Avedon Inc./Copyright © 1985 by Richard Avedon Inc./All rights reserved./This photograph was printed in 1985./Ann Marie Gustin, equipment specialist, USAF/Fort Bridger, Wyoming, 9/2/83/ This photograph was printed for and first exhibited/at the Amon Carter Museum, Fort Worth, Texas/September 14– November 17, 1985."
Acquired from: the photographer

603. **ANNETTE GONZALES, HOUSEWIFE, AND HER SISTER LYDIA RANCK, SECRETARY, SANTUARIO DE CHIMAYO, NEW MEXICO, EASTER SUNDAY, 4/6/80** [from "In the American West: Photographs by Richard Avedon"] (P1985.28.27)
Gelatin silver print mounted on aluminum panel. negative 1980, print 1985
Image: 47 x 37¾ in. (119.4 x 95.9 cm.)
Mount: 50⅛ x 39¼ in. (127.2 x 99.7 cm.)
Signed, center mount verso and l.r. print recto: "Avedon A.P. 1/2"
Inscription, mount verso, rubber stamp: "IN THE AMERICAN WEST/A project commissioned by the/ Amon Carter Museum, Fort Worth, Texas./ Richard Avedon warrants and represents that,/aside from the signed and numbered photographs/in this edition of 6 plus 2 artist's proofs, no/other original prints of this photograph will/be made by him or under his authority./This photograph may not be reproduced without/the written permission of Richard Avedon Inc./Copyright © 1985 by Richard Avedon Inc./All rights reserved./This photograph was printed in 1985./Annette Gonzalez [sic], housewife, and her sister Lydia Ranck, secretary/Santuario de Chimayo, New Mexico, Easter Sunday, 4/6/80/This photograph was printed for and first exhibited/at the Amon Carter Museum, Fort Worth, Texas/September 14– November 17, 1985."
Acquired from: the photographer

*604. **B. J. VAN FLEET, NINE YEAR OLD, ENNIS, MONTANA, 7/2/82** [from "In the American West: Photographs by Richard Avedon"] (P1985.28.65)
Gelatin silver print mounted on aluminum panel. negative 1982, print 1985
Image: 56 x 45 in. (142.2 x 114.3 cm.)
Mount: 59¾ x 47 in. (151.8 x 119.4 cm.)
Signed, bottom center mount verso and l.r. print recto: "Avedon A.P. 1/2"
Inscription, mount verso, rubber stamp: "IN THE AMERICAN WEST/A project commissioned by the/ Amon Carter Museum, Fort Worth, Texas./ Richard Avedon warrants and represents that,/aside from the signed and numbered photographs/in this edition of 4 plus 2 artist's proofs, no/other original prints of this photograph will/be made by him or under his authority./This photograph may not be reproduced without/the written permission of Richard Avedon Inc./Copyright © 1985 by Richard Avedon Inc./All rights reserved./This photograph was printed in 1985./B. J. Van Fleet, nine year old/Ennis, Montana, 7/2/82/This photograph was printed for and first exhibited/at the Amon Carter Museum, Fort Worth, Texas/ September 14–November 17, 1985."
Acquired from: the photographer

595

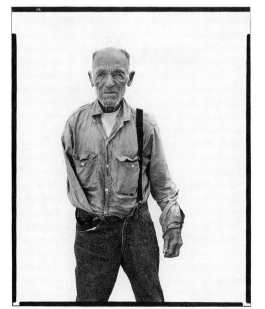

596

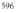

598

*605. **BENSON JAMES, DRIFTER, ROUTE 66, GALLUP, NEW MEXICO, 6/30/79 [from "In the American West: Photographs by Richard Avedon"]** (P1985.28.26)
Gelatin silver print mounted on aluminum panel. negative 1979, print 1985
Image: 46¾ x 37¼ in. (118.8 x 94.7 cm.)
Mount: 50⅛ x 39¼ in. (127.2 x 99.7 cm.)
Signed, bottom center mount verso and l.r. print recto: "Avedon A.P./1/2"
Inscription, mount verso, rubber stamp: "IN THE AMERICAN WEST/A project commissioned by the/ Amon Carter Museum, Fort Worth, Texas./ Richard Avedon warrants and represents that,/aside from the signed and numbered photographs/in this edition of 5 plus 2 artist's proofs, no/other original prints of this photograph will/be made by him or under his authority./This photograph may not be reproduced without/the written permission of Richard Avedon Inc./Copyright © 1985 by Richard Avedon Inc./All rights reserved./This photograph was printed in 1985./Benson James, drifter/Route 66, Gallup, New Mexico, 6/30/79/This photograph was printed for and first exhibited/ at the Amon Carter Museum, Fort Worth, Texas/September 14–November 17, 1985."
Acquired from: the photographer

606. **BEVERLY JANE FRAZIER, TRUCK DRIVER, BURLEY, IDAHO, 8/20/83 [from "In the American West: Photographs by Richard Avedon"]** (P1985.28.79)
Gelatin silver print mounted on aluminum panel. negative 1983, print 1985
Image: 19 x 15¼ in. (48.2 x 38.7 cm.)
Mount: 20 x 16 in. (50.8 x 40.7 cm.)
Signed, bottom center mount verso and l.r. print recto: "Avedon."
Inscription, mount verso, rubber stamp: "IN THE AMERICAN WEST/A project commissioned by the/ Amon Carter Museum, Fort Worth, Texas./ This photograph may not be reproduced without/the written permission of Richard Avedon Inc./Copyright © 1985 by Richard Avedon Inc./All rights reserved./This photograph was printed in 1985./Beverly Jane Frazier, truck driver/ Burley, Idaho, 8/20/83/This photograph was printed for and first exhibited/at the Amon Carter Museum, Fort Worth, Texas/September 14–November 17, 1985."
Acquired from: the photographer

607. **BILL CURRY, DRIFTER, INTERSTATE 40, YUKON, OKLAHOMA, 6/16/80 [from "In the American West: Photographs by Richard Avedon"]** (P1985.28.46)
Gelatin silver print mounted on aluminum panel. negative 1980, print 1985
Image: 47 x 37½ in. (119.4 x 95.2 cm.)
Mount: 50⅛ x 39¼ in. (127.2 x 99.7 cm.)
Signed, center mount verso and l.r. print recto: "Avedon A.P./1/2"
Inscription, mount verso, rubber stamp: "IN THE AMERICAN WEST/A project commissioned by the/ Amon Carter Museum, Fort Worth, Texas./ Richard Avedon warrants and represents that,/aside from the signed and numbered photographs/in this edition of 5 plus 2 artist's proofs, no/other original prints of this photograph will/be made by him or under his authority./This photograph may not be reproduced without/the written permission of Richard Avedon Inc./Copyright © 1985 by Richard Avedon Inc./All rights reserved./This photograph was printed in 1985./Bill Curry, drifter/Interstate 40, Yukon, Oklahoma, 6/16/80/This photograph was printed for and first exhibited/at the Amon Carter Museum, Fort Worth, Texas/September 14–November 17, 1985."
Acquired from: the photographer

608. **BILL HANKEN, CONSTRUCTION WORKER, CODY, WYOMING, 7/4/82 [from "In the American West: Photographs by Richard Avedon"]** (P1985.28.47)
Gelatin silver print mounted on aluminum panel. negative 1982, print 1985
Image: 46¾ x 37½ in. (118.8 x 95.2 cm.)
Mount: 50⅛ x 39¼ in. (127.2 x 99.7 cm.)

Signed, center mount verso and l.r. print recto: "Avedon."
Inscription, mount verso, rubber stamp: "IN THE AMERICAN WEST/A project commissioned by the/ Amon Carter Museum, Fort Worth, Texas./ This photograph may not be reproduced without/the written permission of Richard Avedon Inc./Copyright © 1985 by Richard Avedon Inc./All rights reserved./This photograph was printed in 1985./Bill Hanken, construction worker/ Cody, Wyoming, 7/4/82/This photograph was printed for and first exhibited/at the Amon Carter Museum, Fort Worth, Texas/September 14–November 17, 1985."
Acquired from: the photographer

609. **BILLY JOE DANOS, DAY LABORER, CHEYENNE, WYOMING, 7/25/82 [from "In the American West: Photographs by Richard Avedon"]** (P1985.28.44)
Gelatin silver print mounted on aluminum panel. negative 1982, print 1985
Image: 46¾ x 37½ in. (118.8 x 95.2 cm.)
Mount: 50⅛ x 39¼ in. (127.2 x 99.7 cm.)
Signed, center mount verso and l.r. print recto: "Avedon."
Inscription, mount verso, rubber stamp: "IN THE AMERICAN WEST/A project commissioned by the/ Amon Carter Museum, Fort Worth, Texas./ This photograph may not be reproduced without/the written permission of Richard Avedon Inc./Copyright © 1985 by Richard Avedon Inc./All rights reserved./This photograph was printed in 1985./Billy Joe Danos, day laborer/ Cheyenne, Wyoming, 7/25/82/This photograph was printed for and first exhibited/at the Amon Carter Museum, Fort Worth, Texas/September 14–November 17, 1985."
Acquired from: the photographer

*610. **BILLY MUDD, TRUCKER, ALTO, TEXAS, 5/7/81 [from "In the American West: Photographs by Richard Avedon"]** (P1985.28.105)
Gelatin silver print mounted on aluminum panel. negative 1981, print 1988
Image: 56¼ x 45 in. (142.8 x 114.3 cm.)
Mount: 59½ x 47 in. (151.2 x 119.4 cm.)
Signed, bottom center mount verso and l.r. print recto: "Avedon/ A.P./1/2"
Inscription, mount verso, rubber stamp: "IN THE AMERICAN WEST/A project commissioned by the/ Amon Carter Museum, Fort Worth, Texas./ Richard Avedon warrants and represents that,/aside from the signed and numbered photographs/in this edition of 6 plus 2 artist's proofs, no/be/made by him or under his authority except for one/ 80½ x 64½" print made for exhibition purposes./ This photograph may not be reproduced without/the written permission of Richard Avedon Inc./Copyright © 1985 by Richard Avedon Inc./All rights reserved./This photograph was printed in 1985 [sic]./Billy Mudd, trucker/Alto, Texas, 5/7/81/This photograph was printed for the/Amon Carter Museum, Fort Worth, Texas."
Acquired from: the photographer

611. **BLUE CLOUD WRIGHT, SLAUGHTERHOUSE WORKER, OMAHA, NEBRASKA, 8/10/79 [from "In the American West: Photographs by Richard Avedon"]** (P1985.28.62)
Gelatin silver print mounted on aluminum panel. negative 1979, print 1985
Image: 56½ x 45 in. (143.5 x 114.3 cm.)
Mount: 59¾ x 47¼ in. (151.8 x 120.0 cm.)
Signed, bottom center mount verso and l.r. print recto: "Avedon A.P./1/2"
Inscription, mount verso, rubber stamp: "IN THE AMERICAN WEST/A project commissioned by the/ Amon Carter Museum, Fort Worth, Texas./ Richard Avedon warrants and represents that,/aside from the signed and numbered photographs/in this edition of 6 plus 2 artist's proofs, no/other original prints of this photograph will/be made by him or under his authority./This

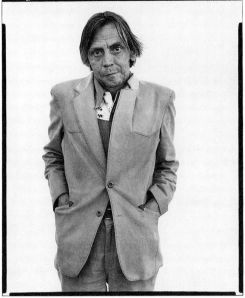

599

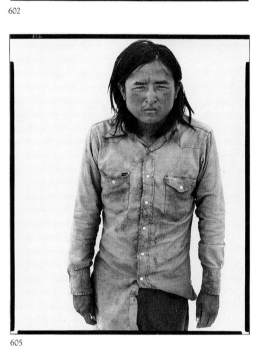

602

604

605

photograph may not be reproduced without/the written permission of Richard Avedon Inc./Copyright © 1985 by Richard Avedon Inc./All rights reserved./This photograph was printed in 1985./Blue Cloud Wright, slaughterhouse worker/Omaha, Nebraska, 8/10/79/This photograph was printed for and first exhibited/at the Amon Carter Museum, Fort Worth, Texas/September 14–November 17, 1985."
Acquired from: the photographer

* 612. **BOYD FORTIN, THIRTEEN YEAR OLD RATTLESNAKE SKINNER, SWEETWATER, TEXAS, 3/10/79 [from "In the American West: Photographs by Richard Avedon"]** (P1985.28.81)
Gelatin silver print mounted on aluminum panel. negative 1979, print 1985
Image: 56¼ x 45 in. (142.8 x 114.3 cm.)
Mount: 59¾ x 47 in. (151.8 x 119.4 cm.)
Signed, bottom center mount verso and l.r. print recto: "Avedon A.P./1/2"
Inscription, mount verso, rubber stamp: "IN THE AMERICAN WEST/A project commissioned by the/Amon Carter Museum, Fort Worth, Texas./ Richard Avedon warrants and represents that,/aside from the signed and numbered photographs/in this edition of 6 plus 2 artist's proofs, no/other original prints of this photograph will/be made by him or under his authority./This photograph may not be reproduced without/the written permission of Richard Avedon Inc./Copyright © 1985 by Richard Avedon Inc./All rights reserved./This photograph was printed in 1985./Boyd Fortin, thirteen year old rattlesnake skinner/Sweetwater, Texas, 3/10/79/ This photograph was printed for and first exhibited/at the Amon Carter Museum, Fort Worth, Texas/September 14–November 17, 1985."
Acquired from: the photographer

*613. **BUBBA MORRISON, OIL FIELD WORKER, ALBANY, TEXAS, 6/10/79 [from "In the American West: Photographs by Richard Avedon"]** (P1985.28.55)
Gelatin silver print mounted on aluminum panel. negative 1979, print 1985
Image: 58½ x 45 in. (148.6 x 114.3 cm.)
Mount: 59¾ x 47⅛ in. (151.8 x 119.7 cm.)
Signed, bottom center mount verso and l.r. print recto: "Avedon A.P. 1/2"
Inscription, mount verso, rubber stamp: "IN THE AMERICAN WEST/A project commissioned by the/Amon Carter Museum, Fort Worth, Texas./ Richard Avedon warrants and represents that,/aside from the signed and numbered photographs/in this edition of 6 plus 2 artist's proofs, no/other original prints of this photograph will/be made by him or under his authority./This photograph may not be reproduced without/the written permission of Richard Avedon Inc./Copyright © 1985 by Richard Avedon Inc./All rights reserved./This photograph was printed in 1985./Bubba Morrison, oil field worker/Albany, Texas, 6/10/79/This photograph was printed for and first exhibited/at the Amon Carter Museum, Fort Worth, Texas/September 14–November 17, 1985."
Acquired from: the photographer

614. **CAREY WRIGHT, CROP DUSTER, LAMESA, TEXAS, 3/10/79 [from "In the American West: Photographs by Richard Avedon"]** (P1985.28.100)
Gelatin silver print mounted on aluminum panel. negative 1979, print 1985
Image: 19 x 15¼ in. (48.2 x 38.7 cm.)
Mount: 20 x 16 in. (50.8 x 40.7 cm.)
Signed, bottom edge mount verso and l.r. print recto: "Avedon"
Inscription, mount verso, rubber stamp: "IN THE AMERICAN WEST/A project commissioned by the/Amon Carter Museum, Fort Worth, Texas./ This photograph may not be reproduced without/the written permission of Richard Avedon Inc./Copyright © 1985 by Richard Avedon Inc./All rights reserved./This photograph

was printed in 1985./Carey Wright, crop duster/Lamesa, Texas, 3/10/79/This photograph was printed for and first exhibited/at the Amon Carter Museum, Fort Worth, Texas/September 14–November 17, 1985."
Acquired from: the photographer

615. **CARL HOEFERT, UNEMPLOYED BLACKJACK DEALER, RENO, NEVADA, 8/30/80 [from "In the American West: Photographs by Richard Avedon"]** (P1985.28.34)
Gelatin silver print mounted on aluminum panel. negative 1980, print 1985
Image: 46¾ x 37¾ in. (118.8 x 95.9 cm.)
Mount: 50⅛ x 39¼ in. (127.2 x 99.7 cm.)
Signed, center mount verso and l.r. print recto: "Avedon."
Inscription, mount verso, rubber stamp: "IN THE AMERICAN WEST/A project commissioned by the/Amon Carter Museum, Fort Worth, Texas./ This photograph may not be reproduced without/the written permission of Richard Avedon Inc./Copyright © 1985 by Richard Avedon Inc./All rights reserved./This photograph was printed in 1985./Carl Hoefert, unemployed blackjack dealer/Reno, Nevada, 8/30/83/This photograph was printed for and first exhibited/at the Amon Carter Museum, Fort Worth, Texas/September 14–November 17, 1985."
Acquired from: the photographer

616. **CAROL CRITTENDON, BARTENDER, BUTTE, MONTANA, 7/1/81 [from "In the American West: Photographs by Richard Avedon"]** (P1985.28.45)
Gelatin silver print mounted on aluminum panel. negative 1981, print 1985
Image: 47 x 37½ in. (119.4 x 95.2 cm.)
Mount: 50⅛ x 39¼ in. (127.2 x 99.7 cm.)
Signed, bottom center mount verso and l.r. print recto: "Avedon A.P./1/2"
Inscription, mount verso, rubber stamp: "IN THE AMERICAN WEST/A project commissioned by the/Amon Carter Museum, Fort Worth, Texas./ Richard Avedon warrants and represents that,/aside from the signed and numbered photographs/in this edition of 6 plus 2 artist's proofs, no/other original prints of this photograph will/be made by him or under his authority./This photograph may not be reproduced without/the written permission of Richard Avedon Inc./Copyright © 1985 by Richard Avedon Inc./All rights reserved./This photograph was printed in 1985./Carol Crittendon, bartender/Butte, Montana, 7/1/81/ This photograph was printed for and first exhibited/at the Amon Carter Museum, Fort Worth, Texas/September 14–November 17, 1985."
Acquired from: the photographer

*617. **CHARLENE VAN TIGHEM, PHYSICAL THERAPIST, AUGUSTA, MONTANA, 6/23/83 [from "In the American West: Photographs by Richard Avedon"]** (P1985.28.1)
Gelatin silver print mounted on aluminum panel. negative 1983, print 1985
Image: 56¼ x 45 in. (142.8 x 114.3 cm.)
Mount: 60 x 47 in. (152.4 x 119.4 cm.)
Signed, bottom center mount verso and l.r. print recto: "Avedon A.P. 1/2"
Inscription, mount verso, rubber stamp: "IN THE AMERICAN WEST/A project commissioned by the/Amon Carter Museum, Fort Worth, Texas./ Richard Avedon warrants and represents that,/aside from the signed and numbered photographs/in this edition of 6 plus 2 artist's proofs, no/other original prints of this photograph will be/made by him or under his authority except for one/80½ x 64½" print made for exhibition purposes./ This photograph may not be reproduced without/the written permission of Richard Avedon Inc./Copyright © 1985 by Richard Avedon Inc./All rights reserved./This photograph was printed in 1985./Charlene Van Tighem, physical therapist/Augusta, Montana, 6/23/83/This photograph was printed for and first exhibited/at the/Amon Carter Museum, Fort Worth, Texas."
Acquired from: the photographer

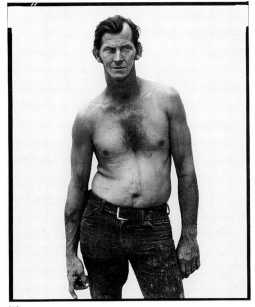

610

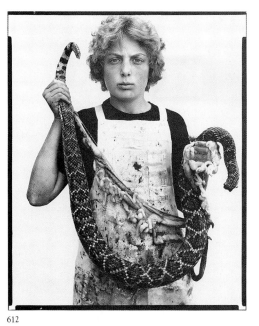

612

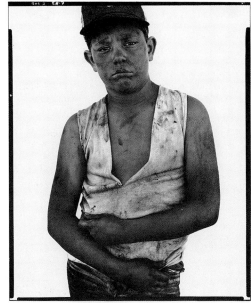

613

617

618. **CLARENCE LIPPARD, DRIFTER, INTERSTATE 80, SPARKS, NEVADA, 8/29/83 [from "In the American West: Photographs by Richard Avedon"]** (P1985.28.70)
Gelatin silver print mounted on aluminum panel. negative 1983, print 1985
Image (diptych): a) 56⅛ x 45⅛ in. (142.5 x 114.6 cm.)
b) 56¼ x 45¼ in. (142.8 x 114.9 cm.)
overall image: 56¼ x 90⅜ in. (142.8 x 229.5 cm.)
Mount: a) 59¾ x 46¼ in. (151.8 x 117.5 cm.)
b) 59¾ x 46¼ in. (151.8 x 117.5 cm.)
overall mount: 59¾ x 92½ in. (151.8 x 235.0 cm.)
Signed, bottom center mount verso and l.r. print recto:
a) "Avedon." and b) "Avedon"
Inscription, mount verso, rubber stamp (on both prints):
"IN THE AMERICAN WEST/A project commissioned by the/Amon Carter Museum, Fort Worth, Texas./This photograph may not be reproduced without/the written permission of Richard Avedon Inc./Copyright © 1985 by Richard Avedon Inc./All rights reserved./This photograph was printed in 1985./Clarence Lippard, drifter/Interstate 80, Sparks, Nevada, 8/29/83/This photograph was printed for and first exhibited/at the Amon Carter Museum, Fort Worth, Texas/September 14–November 17, 1985."
Acquired from: the photographer

619. **CLIFFORD FELDNER, UNEMPLOYED RANCH HAND, GOLDEN, COLORADO, 6/15/83 [from "In the American West: Photographs by Richard Avedon"]** (P1985.28.37)
Gelatin silver print mounted on aluminum panel. negative 1983, print 1985
Image: 56¼ x 45 in. (142.8 x 114.3 cm.)
Mount: 59¾ x 47 in. (151.8 x 119.4 cm.)
Signed, bottom center mount verso and l.r. print recto:
"Avedon A.P./1/2"
Inscription, mount verso, rubber stamp: "IN THE AMERICAN WEST/A project commissioned by the/Amon Carter Museum, Fort Worth, Texas./ Richard Avedon warrants and represents that,/aside from the signed and numbered photographs/in this edition of 5 plus 2 artist's proofs, no/other original prints of this photograph will/be made by him or under his authority./This photograph may not be reproduced without/the written permission of Richard Avedon Inc./Copyright © 1985 by Richard Avedon Inc./All rights reserved./This photograph was printed in 1985./Clifford Feldner, unemployed ranch hand/Golden, Colorado, 6/15/83/This photograph was printed for and first exhibited/at the Amon Carter Museum, Fort Worth, Texas/September 14–November 17, 1985."
Acquired from: the photographer

620. **CLYDE CORLEY, RANCHER, BELGRADE, MONTANA, 8/26/79 [from "In the American West: Photographs by Richard Avedon"]** (P1985.28.96)
Gelatin silver print mounted on aluminum panel. negative 1979, print 1985
Image: 46¾ x 37½ in. (118.8 x 95.2 cm.)
Mount: 50⅛ x 39¼ in. (127.2 x 99.7 cm.)
Signed, bottom center mount verso and l.r. print recto:
"Avedon."
Inscription, mount verso, rubber stamp: "IN THE AMERICAN WEST/A project commissioned by the/Amon Carter Museum, Fort Worth, Texas./ This photograph may not be reproduced without/the written permission of Richard Avedon Inc./Copyright © 1985 by Richard Avedon Inc./All rights reserved./This photograph was printed in 1985./Clyde Corley, rancher/Belgrade, Montana, 8/26/79/This photograph was printed for and first exhibited/at the Amon Carter Museum, Fort Worth, Texas/September 14–November 17, 1985."
Acquired from: the photographer

*621. **COTTON THOMPSON, MAINTENANCE MAN, FAT STOCK SHOW, FORT WORTH, TEXAS, 2/2/80 [from "In the American West: Photographs by Richard Avedon"]** (P1985.28.93)
Gelatin silver print mounted on aluminum panel. negative 1980, print 1985

Image: 41¼ x 33 in. (104.8 x 83.8 cm.)
Mount: 43¾ x 34¾ in. (111.2 x 88.3 cm.)
Signed, bottom center mount verso and l.r. print recto:
"Avedon."
Inscription, mount verso, rubber stamp: "IN THE AMERICAN WEST/A project commissioned by the/Amon Carter Museum, Fort Worth, Texas./ This photograph may not be reproduced without/the written permission of Richard Avedon Inc./Copyright © 1985 by Richard Avedon Inc./All rights reserved./This photograph was printed in 1985./Cotton Thompson, maintenance man/Fat Stock Show, Fort Worth, Texas, 2/2/80/This photograph was printed for and first exhibited/at the Amon Carter Museum, Fort Worth, Texas/September 14–November 17, 1985."
Acquired from: the photographer

622. **CRAIG PANIKE, DRUMMER, HIGH SCHOOL BAND, WEISER, IDAHO, 6/27/81 [from "In the American West: Photographs by Richard Avedon"]** (P1985.28.87)
Gelatin silver print mounted on aluminum panel. negative 1981, print 1985
Image: 19 x 15¼ in. (48.2 x 38.7 cm.)
Mount: 20 x 16 in. (50.8 x 40.7 cm.)
Signed, bottom center mount verso and l.r. print recto:
"Avedon"
Inscription, mount verso, rubber stamp: "IN THE AMERICAN WEST/A project commissioned by the/Amon Carter Museum, Fort Worth, Texas./ This photograph may not be reproduced without/the written permission of Richard Avedon Inc./Copyright © 1985 by Richard Avedon Inc./All rights reserved./This photograph was printed in 1985./Craig Panike, drummer/High School Band, Weiser, Idaho, 6/27/81/This photograph was printed for and first exhibited/at the Amon Carter Museum, Fort Worth, Texas/September 14–November 17, 1985."
Acquired from: the photographer

623. **DANIEL SALOZAR, FARMER, SANTUARIO DE CHIMAYO, NEW MEXICO, GOOD FRIDAY, 4/4/80 [from "In the American West: Photographs by Richard Avedon"]** (P1985.28.50)
Gelatin silver print mounted on aluminum panel. negative 1980, print 1985
Image: 46¾ x 37¾ in. (118.8 x 95.9 cm.)
Mount: 50⅛ x 39¼ in. (127.2 x 99.7 cm.)
Signed, bottom center mount verso and l.r. print recto:
"Avedon."
Inscription, mount verso, rubber stamp: "IN THE AMERICAN WEST/A project commissioned by the/Amon Carter Museum, Fort Worth, Texas./ This photograph may not be reproduced without/the written permission of Richard Avedon Inc./Copyright © 1985 by Richard Avedon Inc./All rights reserved./This photograph was printed in 1985./Daniel Salozar, farmer/Santuario de Chimayo, New Mexico, Good Friday, 4/4/80/This photograph was printed for and first exhibited/at the Amon Carter Museum, Fort Worth, Texas/September 14–November 17, 1985."
Acquired from: the photographer

*624. **DANNY LANE, FOURTEEN YEAR OLD, CHRISTINE COIL, SEVENTEEN YEAR OLD, CALHAN, COLORADO, 7/31/81 [from "In the American West: Photographs by Richard Avedon"]** (P1985.28.77)
Gelatin silver print mounted on aluminum panel. negative 1981, print 1985
Image: 56¼ x 45 in. (142.8 x 114.3 cm.)
Mount: 60 x 47 in. (152.4 x 119.4 cm.)
Signed, bottom center mount verso and l.r. print recto:
"Avedon A.P./1/2"
Inscription, mount verso, rubber stamp: "IN THE AMERICAN WEST/A project commissioned by the/Amon Carter Museum, Fort Worth, Texas./ Richard Avedon warrants and represents that,/aside from the signed and numbered photographs/in this edition of 5 plus 2 artist's proofs, no/other original prints of this photograph will be/made by him or under his authority except for one/

80½ x 64½" print made for exhibition purposes./ This photograph may not be reproduced without/the written permission of Richard Avedon Inc./Copyright © 1985 by Richard Avedon Inc./All rights reserved./This photograph was printed in 1985./Danny Lane, fourteen year old, Christine Coil, seventeen year old/Calhan, Colorado, 7/31/81/This photograph was printed for the/Amon Carter Museum, Fort Worth, Texas."

Acquired from: the photographer

625. **DAVE TIMOTHEY, NUCLEAR FALLOUT VICTIM, OREM, UTAH, 8/8/80 [from "In the American West: Photographs by Richard Avedon"]** (P1985.28.54)

Gelatin silver print mounted on aluminum panel. negative 1980, print 1985

Image: 56¼ x 45 in. (142.8 x 114.3 cm.)

Mount: 60 x 47¼ in. (152.4 x 120.0 cm.)

Signed, bottom center mount verso and l.r. print recto: "Avedon."

Inscription, mount verso, rubber stamp: "IN THE AMERICAN WEST/A project commissioned by the/ Amon Carter Museum, Fort Worth, Texas./ This photograph may not be reproduced without/the written permission of Richard Avedon Inc./Copyright © 1985 by Richard Avedon Inc./All rights reserved./This photograph was printed in 1985./Dave Timothey, nuclear fallout victim/ Orem, Utah, 8/8/80/This photograph was printed for and/ first exhibited/at the Amon Carter Museum, Fort Worth, Texas/September 14–November 17, 1985."

Acquired from: the photographer

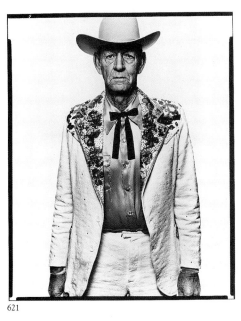
621

626. **DAVID BEASON, SHIPPING CLERK, DENVER, COLORADO, 7/25/81 [from "In the American West: Photographs by Richard Avedon"]** (P1985.28.16)

Gelatin silver print mounted on aluminum panel. negative 1981, print 1985

Image: 47 x 37½ in. (119.4 x 95.2 cm.)

Mount: 50⅛ x 39¼ in. (127.2 x 99.7 cm.)

Signed, bottom center mount verso and l.r. print recto: "Avedon A.P./1/2"

Inscription, mount verso, rubber stamp: "IN THE AMERICAN WEST/A project commissioned by the/ Amon Carter Museum, Fort Worth, Texas./ Richard Avedon warrants and represents that,/aside from the signed and numbered photographs/in this edition of 5 plus 2 artist's proofs, no/other original prints of this photograph will/be made by him or under his authority./This photograph may not be reproduced without/the written permission of Richard Avedon Inc./Copyright © 1985 by Richard Avedon Inc./All rights reserved./This photograph was printed in 1985./David Beason, shipping clerk/Denver, Colorado, 7/25/81/This photograph was printed for and first exhibited/at the Amon Carter Museum, Fort Worth, Texas/ September 14–November 17, 1985."

Acquired from: the photographer

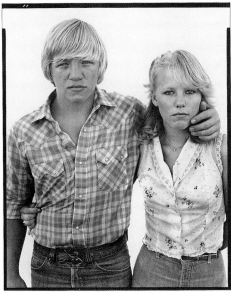
624

627. **DAVID WURTZ, CEMETERY MAN, HUTTERITE COLONY, CHESTER, MONTANA, 7/21/83 [from "In the American West: Photographs by Richard Avedon"]** (P1985.28.85)

Gelatin silver print mounted on aluminum panel. negative 1983, print 1985

Image: 19 x 15¼ in. (48.2 x 38.7 cm.)

Mount: 20 x 16 in. (50.8 x 40.7 cm.)

Signed. bottom center mount verso and l.r. print recto: "Avedon."

Inscription, mount verso, rubber stamp: "IN THE AMERICAN WEST/A project commissioned by the/ Amon Carter Museum, Fort Worth, Texas./ This photograph may not be reproduced without/the written permission of Richard Avedon Inc./Copyright © 1985 by Richard Avedon Inc./All rights reserved./This photograph was printed in 1985./David Wurtz, cemetery man/Hutterite Colony, Chester, Montana, 7/21/83/This photograph was printed for and first exhibited/at the Amon Carter Museum, Fort Worth, Texas/September 14–November 17, 1985."

Acquired from: the photographer

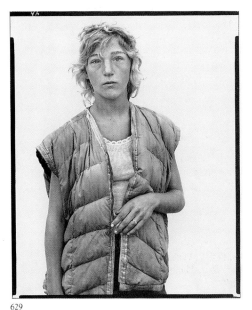
629

628. **DAWN JAYNES, WAITRESS, CLINT JONES, RANCH HAND, ROCKY FORD, COLORADO, 8/23/80 [from "In the American West: Photographs by Richard Avedon"]** (P1985.28.11)
Gelatin silver print mounted on aluminum panel. negative 1980, print 1985
Image: 47 x 37½ in. (119.4 x 95.2 cm.)
Mount: 50⅛ x 39¼ in. (127.2 x 99.7 cm.)
Signed, center mount verso and l.r. print recto: "Avedon A/P 1/2"
Inscription, mount verso, rubber stamp: "IN THE AMERICAN WEST/A project commissioned by the/ Amon Carter Museum, Fort Worth, Texas./ Richard Avedon warrants and represents that,/aside from the signed and numbered photographs/in this edition of 6 plus 2 artist's proofs, no/other original prints of this photograph will/be made by him or under his authority./This photograph may not be reproduced without/the written permission of Richard Avedon Inc./Copyright © 1985 by Richard Avedon Inc./All rights reserved./This photograph was printed in 1985./Dawn Jaynes, waitress, Clint Jones, ranch hand/Rocky Ford, Colorado, 8/23/80/ This photograph was printed for and first exhibited/at the Amon Carter Museum, Fort Worth, Texas/September 14– November 17, 1985."
Acquired from: the photographer

*629. **DEBBIE McCLENDON, CARNEY, THERMOPOLIS, WYOMING, 7/29/81 [from "In the American West: Photographs by Richard Avedon"]** (P1985.28.32)
Gelatin silver print mounted on aluminum panel. negative 1981, print 1985
Image: 47 x 37¼ in. (119.4 x 95.9 cm.)
Mount: 50⅛ x 39¼ in. (127.2 x 99.7 cm.)
Signed, bottom center mount verso and l.r. print recto: "Avedon A.P./1/2"
Inscription, mount verso, rubber stamp: "IN THE AMERICAN WEST/A project commissioned by the/ Amon Carter Museum, Fort Worth, Texas./ Richard Avedon warrants and represents that,/aside from the signed and numbered photographs/in this edition of 6 plus 2 artist's proofs, no/other original prints of this photograph will/be made by him or under his authority./This photograph may not be reproduced without/the written permission of Richard Avedon Inc./Copyright © 1985 by Richard Avedon Inc./All rights reserved./This photograph was printed in 1985./Debbie McClendon, carney/ Thermopolis, Wyoming, 7/29/81/This photograph was printed for and first exhibited/at the Amon Carter Museum, Fort Worth, Texas/September 14–November 17, 1985."
Acquired from: the photographer

630. **DEBBIE McINTYRE, PRACTICAL NURSE, AND HER DAUGHTER MARIE, CORTEZ, COLORADO, 6/11/83 [from "In the American West: Photographs by Richard Avedon"]** (P1985.28.109)
Gelatin silver print mounted on aluminum panel. negative 1983, print 1985
Image: 56 x 45 in. (142.3 x 114.3 cm.)
Mount: 59¾ x 47⅛ in. (151.8 x 119.8 cm.)
Signed, bottom center mount verso and l.r. print recto: "Avedon A.P. 1/2"
Inscription, mount verso, rubber stamp: "IN THE AMERICAN WEST/A project commissioned by the/ Amon Carter Museum, Fort Worth, Texas./ Richard Avedon warrants and represents that,/aside from the signed and numbered photographs/in this edition of 5 plus 2 artist's proofs, no/other original prints of this photograph will/be made by him or under his authority./This photograph may not be reproduced without/the written permission of Richard Avedon Inc./Copyright © 1985 by Richard Avedon Inc./All rights reserved./This photograph was printed in 1985./Debbie McIntyre, practical nurse, and her daughter Marie/Cortez, Colorado, 6/11/83/This photograph was printed for and first exhibited/at the Amon Carter Museum, Fort Worth, Texas/September 14– November 17, 1985."
Acquired from: the photographer

631. **DELLA TRUJILLO, WAITRESS, SANTUARIO DE CHIMAYO, NEW MEXICO, GOOD FRIDAY, 4/4/80 [from "In the American West: Photographs by Richard Avedon"]** (P1985.28.21)
Gelatin silver print mounted on aluminum panel. negative 1980, print 1985
Image: 47 x 37½ in. (119.4 x 95.2 cm.)
Mount: 50⅛ x 39¼ in. (127.2 x 99.7 cm.)
Signed, bottom center mount verso and l.r. print recto: "Avedon A.P./1/2"
Inscription, mount verso, rubber stamp: "IN THE AMERICAN WEST/A project commissioned by the/ Amon Carter Museum, Fort Worth, Texas./ Richard Avedon warrants and represents that,/aside from the signed and numbered photographs/in this edition of 6 plus 2 artist's proofs, no/other original prints of this photograph will/be made by him or under his authority./This photograph may not be reproduced without/the written permission of Richard Avedon Inc./Copyright © 1985 by Richard Avedon Inc./All rights reserved./This photograph was printed in 1985./Della Trujillo, waitress/Santuario de Chimayo, New Mexico, Good Friday, 4/4/80/ This photograph was printed for and first exhibited/at the Amon Carter Museum, Fort Worth, Texas/ September 14– November 17, 1985."
Acquired from: the photographer

632. **DONALD KEEN, COAL MINER, RELIANCE, WYOMING, 8/28/79 [from "In the American West: Photographs by Richard Avedon"]** (P1985.28.116)
Gelatin silver print mounted on aluminum panel. negative 1979, print 1985
Image: 56 x 44¾ in. (142.3 x 113.8 cm.)
Mount: 59¾ x 47⅛ in. (151.8 x 119.7 cm.)
Signed, bottom center mount verso and l.r. print recto: "Avedon A.P. 1/2"
Inscription, mount verso, rubber stamp: "IN THE AMERICAN WEST/A project commissioned by the/ Amon Carter Museum, Fort Worth, Texas./ Richard Avedon warrants and represents that,/aside from the signed and numbered photographs/in this edition of 6 plus 2 artist's proofs, no/other original prints of this photograph will/be made by him or under his authority./This photograph may not be reproduced without/the written permission of Richard Avedon Inc./Copyright © 1985 by Richard Avedon Inc./All rights reserved./This photograph was printed in 1985./Donald Keen, coal miner/Reliance, Wyoming, 8/28/79/This photograph was printed for and first exhibited/at the Amon Carter Museum, Fort Worth, Texas/September 14–November 17, 1985."
Acquired from: the photographer

633. **DOUG HARPER, COAL MINER, SOMERSET, COLORADO, 8/29/80 [from "In the American West: Photographs by Richard Avedon"]** (P1985.28.122)
Gelatin silver print mounted on aluminum panel. negative 1980, print 1985
Image: 46½ x 37½ in. (117.5 x 95.2 cm.)
Mount: 50⅛ x 39¼ in. (127.2 x 99.7 cm.)
Signed, bottom center mount verso and l.r. print recto: "Avedon A.P. 1/2"
Inscription, mount verso, rubber stamp: "IN THE AMERICAN WEST/A project commissioned by the/ Amon Carter Museum, Fort Worth, Texas./ Richard Avedon warrants and represents that,/aside from the signed and numbered photographs/in this edition of 5 plus 2 artist's proofs, no/other original prints of this photograph will/be made by him or under his authority./This photograph may not be reproduced without/the written permission of Richard Avedon Inc./Copyright © 1985 by Richard Avedon Inc./All rights reserved./This photograph was printed in 1985./Doug Harper, coal miner/Somerset, Colorado, 8/29/80/This photograph was printed for and first exhibited/at the Amon Carter Museum, Fort Worth, Texas/September 14–November 17, 1985."
Acquired from: the photographer

634. **EDWARD ROOP, COAL MINER, PAONIA, COLORADO, 12/19/79 [from "In the American West: Photographs by Richard Avedon"]** (P1985.28.117)
Gelatin silver print mounted on aluminum panel. negative 1979, print 1985
Image: 56 x 45⅛ in. (142.2 x 114.6 cm.)
Mount: 59¾ x 47⅛ in. (151.8 x 119.7 cm.)
Signed, bottom center mount verso and l.r. print recto: "Avedon/ A.P./1/2"
Inscription, mount verso, rubber stamp: "IN THE AMERICAN WEST/A project commissioned by the/ Amon Carter Museum, Fort Worth, Texas./ Richard Avedon warrants and represents that,/aside from the signed and numbered photographs/in this edition of 6 plus 2 artist's proofs, no/other original prints of this photograph will/be made by him or under his authority./This photograph may not be reproduced without/the written permission of Richard Avedon Inc./Copyright © 1985 by Richard Avedon Inc./All rights reserved./This photograph was printed in 1985./Edward Roop, coal miner/Paonia, Colorado, 12/19/79/This photograph was printed for and first exhibited/at the Amon Carter Museum, Fort Worth, Texas/September 14–November 17, 1985."
Acquired from: the photographer

*635. **ELI WALTER, JR., CHICKEN MAN, HUTTERITE COLONY, STANFORD, MONTANA, 7/23/83 [from "In the American West: Photographs by Richard Avedon"]** (P1985.28.86)
Gelatin silver print mounted on aluminum panel. negative 1983, print 1985
Image: 19 x 15¼ in. (48.2 x 38.7 cm.)
Mount: 20 x 16 in. (50.8 x 40.7 cm.)
Signed, bottom center mount verso and l.r. print recto: "Avedon"
Inscription, mount verso, rubber stamp: "IN THE AMERICAN WEST/A project commissioned by the/ Amon Carter Museum, Fort Worth, Texas./ This photograph may not be reproduced without/the written permission of Richard Avedon Inc./Copyright © 1985 by Richard Avedon Inc./All rights reserved./This photograph was printed in 1985./Eli Walter, Jr., chicken man/Hutterite Colony, Stanford, Montana, 7/23/83/This photograph was printed for and first exhibited/at the Amon Carter Museum, Fort Worth, Texas/September 14–November 17, 1985."
Acquired from: the photographer

636. **EMMA LEE WELLINGTON, HOUSEWIFE, NORTH LAS VEGAS, NEVADA, 12/15/80 [from "In the American West: Photographs by Richard Avedon"]** (P1985.28.18)
Gelatin silver print mounted on aluminum panel. negative 1980, print 1985
Image: 47 x 37¾ in. (120.6 x 95.2 cm.)
Mount: 50⅛ x 39¼ in. (127.2 x 99.7 cm.)
Signed, center mount verso and l.r. print recto: "Avedon A.P. 1/2"
Inscription, mount verso, rubber stamp: "IN THE AMERICAN WEST/A project commissioned by the/ Amon Carter Museum, Fort Worth, Texas./ Richard Avedon warrants and represents that,/aside from the signed and numbered photographs/in this edition of 6 plus 2 artist's proofs, no/other original prints of this photograph will/be made by him or under his authority./This photograph may not be reproduced without/the written permission of Richard Avedon Inc./Copyright © 1985 by Richard Avedon Inc./All rights reserved./This photograph was printed in 1985./Emma Lee Wellington, housewife/ North Las Vegas, Nevada, 12/15/80/This photograph was printed for and first exhibited/at the Amon Carter Museum, Fort Worth, Texas/September 14–November 17, 1985."
Acquired from: the photographer

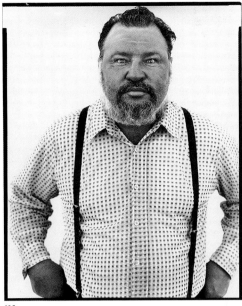
635

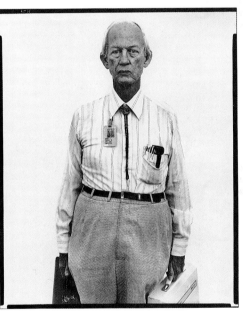
637

*637. EMORY J. STOVALL, SCIENTIST, LOS ALAMOS, NEW
MEXICO, 6/12/79 [from "In the American West:
Photographs by Richard Avedon"] (P1985.28.72)
Gelatin silver print mounted on aluminum panel. negative
1979, print 1985
Image: 47 x 37½ in. (119.4 x 95.2 cm.)
Mount: 50⅛ x 39¼ in. (127.2 x 99.7 cm.)
Signed, bottom center mount verso and l.r. print recto:
"Avedon"
Inscription, mount verso, rubber stamp: "IN THE
AMERICAN WEST/A project commissioned by the/
Amon Carter Museum, Fort Worth, Texas./ This
photograph may not be reproduced without/the written
permission of Richard Avedon Inc./Copyright © 1985 by
Richard Avedon Inc./All rights reserved./This photograph
was printed in 1985./Emory J. Stovall, scientist/Los
Alamos, New Mexico, 6/12/79/This photograph was
printed for and first exhibited/at the Amon Carter
Museum, Fort Worth, Texas/September 14–November 17,
1985."
Acquired from: the photographer

*638. FREIDA KLEINSASSER, THIRTEEN YEAR OLD,
HUTTERITE COLONY, HARLOWTON, MONTANA,
6/23/83 [from "In the American West: Photographs by
Richard Avedon"] (P1985.28.84)
Gelatin silver print mounted on aluminum panel. negative
1983, print 1985
Image: 41¼ x 33 in. (104.8 x 83.8 cm.)
Mount: 43½ x 34½ in. (110.5 x 87.7 cm.)
Signed, bottom center mount verso and l.r. print recto:
"Avedon"
Inscription, mount verso, rubber stamp: "IN THE
AMERICAN WEST/A project commissioned by the/
Amon Carter Museum, Fort Worth, Texas./ This
photograph may not be reproduced without/the written
permission of Richard Avedon Inc./Copyright © 1985 by
Richard Avedon Inc./All rights reserved./This photograph
was printed in 1985./Freida Kleinsasser, thirteen year old/
Hutterite Colony, Harlowton, Montana, 6/23/83/This
photograph was printed for and first exhibited/at the Amon
Carter Museum, Fort Worth, Texas/September 14–
November 17, 1985."
Acquired from: the photographer

639. G. R. COOK III, RODEO CONTESTANT, DOUGLAS,
WYOMING, 7/27/81 [from "In the American West:
Photographs by Richard Avedon"] (P1985.28.5)
Gelatin silver print mounted on aluminum panel. negative
1981, print 1985
Image: 47 x 38 in. (119.4 x 96.5 cm.)
Mount: 50⅛ x 39¼ in. (127.2 x 99.7 cm.)
Signed, center mount verso and l.r. print recto: "Avedon."
Inscription, mount verso, rubber stamp: "IN THE
AMERICAN WEST/A project commissioned by the/
Amon Carter Museum, Fort Worth, Texas./ This
photograph may not be reproduced without/the written
permission of Richard Avedon Inc./Copyright © 1985 by
Richard Avedon Inc./All rights reserved./This photograph
was printed in 1985./G. R. Cook III, rodeo contestant/
Douglas, Wyoming, 7/27/81/This photograph was printed
for and first exhibited/at the Amon Carter Museum, Fort
Worth, Texas/September 14–November 17, 1985."
Acquired from: the photographer

640. GARY POLSON, ALVIN ROWLEY, COAL MINERS,
SOMERSET, COLORADO, 12/18/79 [from "In the
American West: Photographs by Richard Avedon"]
(P1985.28.120)
Gelatin silver print mounted on aluminum panel. negative
1979, print 1985
Image: 40½ x 33 in. (102.8 x 83.8 cm.)
Mount: 44 x 34½ in. (111.8 x 87.7 cm.)
Signed, bottom center mount verso and l.r. print recto:
"Avedon"
Inscription, mount verso, rubber stamp: "IN THE
AMERICAN WEST/A project commissioned by the/

Amon Carter Museum, Fort Worth, Texas./ This
photograph may not be reproduced without/the written
permission of Richard Avedon Inc./Copyright © 1985 by
Richard Avedon Inc./All rights reserved./This photograph
was printed in 1985./Gary Polson, Alvin Rowley, coal
miners/Somerset, Colorado, 12/18/79/This photograph was
printed for and first exhibited/at the Amon Carter
Museum, Fort Worth, Texas/September 14–November 17,
1985."
Acquired from: the photographer

641. GILBERT SAAVEDRA, PATIENT, STATE HOSPITAL,
LAS VEGAS, NEW MEXICO, 4/1/80 [from "In the
American West: Photographs by Richard Avedon"]
(P1985.28.104)
Gelatin silver print mounted on aluminum panel. negative
1980, print 1985
Image: 41¼ x 33 in. (104.8 x 83.8 cm.)
Mount: 43¾ x 34¾ in. (111.2 x 88.3 cm.)
Signed, bottom center mount verso and l.r. print recto:
"Avedon A.P. 1/2"
Inscription, mount verso, rubber stamp: "IN THE
AMERICAN WEST/A project commissioned by the/
Amon Carter Museum, Fort Worth, Texas./ Richard
Avedon warrants and represents that,/aside from the signed
and numbered photographs/in this edition of 6 plus 2
artist's proofs, no/other original prints of this photograph
will/be made by him or under his authority./This
photograph may not be reproduced without/the written
permission of Richard Avedon Inc./Copyright © 1985 by
Richard Avedon Inc./All rights reserved./This photograph
was printed in 1985./Gilbert Saavedra, patient/State
Hospital, Las Vegas, New Mexico, 4/1/80/ This photograph
was printed for and first exhibited/at the Amon Carter
Museum, Fort Worth, Texas/ September 14–November 17,
1985."
Acquired from: the photographer

642. GLORIA CLOUD, WAITRESS, HOBBS, NEW MEXICO,
9/27/80 [from "In the American West: Photographs by
Richard Avedon"] (P1985.28.67)
Gelatin silver print mounted on aluminum panel. negative
1980, print 1985
Image: 41¼ x 33⅛ in. (104.8 x 84.2 cm.)
Mount: 43¾ x 34¾ in. (111.2 x 88.3 cm.)
Signed, bottom center mount verso and l.r. print recto:
"Avedon."
Inscription, mount verso, rubber stamp: "IN THE
AMERICAN WEST/A project commissioned by the/
Amon Carter Museum, Fort Worth, Texas./ This
photograph may not be reproduced without/the written
permission of Richard Avedon Inc./Copyright © 1985 by
Richard Avedon Inc./All rights reserved./This photograph
was printed in 1985./Gloria Cloud, waitress/Hobbs, New
Mexico, 9/27/80/This photograph was printed for and first
exhibited/at the Amon Carter Museum, Fort Worth, Texas/
September 14–November 17, 1985."
Acquired from: the photographer

643. GORDON STEVENSON, DRIFTER, INTERSTATE 90,
BUTTE, MONTANA, 8/25/79 [from "In the American
West: Photographs by Richard Avedon"] (P1985.28.102)
Gelatin silver print mounted on aluminum panel. negative
1979, print 1985
Image (diptych): a) 41⅛ x 33⅛ in. (104.4 x 84.2 cm.)
 b) 41⅛ x 33¼ in. (104.4 x 84.4 cm.)
overall image: 41⅛ x 66⅜ in. (104.4 x 168.6 cm.)
Mount: a) 43¾ x 34 in. (111.2 x 86.3 cm.)
 b) 43¾ x 34 in. (111.2 x 86.3 cm.)
overall mount: 43¾ x 68 in. (111.2 x 172.6 cm.)
Signed, bottom center mount verso and l.r. print recto (on
both prints): "Avedon."
Inscription, mount verso, rubber stamp (on both prints):
"IN THE AMERICAN WEST/A project commissioned
by the/Amon Carter Museum, Fort Worth, Texas./This
photograph may not be reproduced without/ the written
permission of Richard Avedon Inc./Copyright © 1985 by
Richard Avedon Inc./All rights reserved./This photograph

was printed in 1985./Gordon Stevenson, drifter/Interstate 90, Butte, Montana, 8/25/79/This photograph was printed for and first exhibited/at the Amon Carter Museum, Fort Worth, Texas/September 14—November 17, 1985."
Acquired from: the photographer

*644. **HANSEL NICHOLAS BURUM, COAL MINER, SOMERSET, COLORADO, 12/17/79 [from "In the American West: Photographs by Richard Avedon"]**
(P1985.28.123)
Gelatin silver print mounted on aluminum panel. negative 1979, print 1985
Image: 55¾ x 44¾ in. (141.6 x 113.7 cm.)
Mount: 59¾ x 47⅛ in. (151.8 x 119.7 cm.)
Signed, bottom center mount verso and l.r. print recto: "Avedon A.P./1/2"
Inscription, mount verso, rubber stamp: "IN THE AMERICAN WEST/A project commissioned by the/ Amon Carter Museum, Fort Worth, Texas./ Richard Avedon warrants and represents that,/aside from the signed and numbered photographs/in this edition of 5 plus 2 artist's proofs, no/other original prints of this photograph will/be made by him or under his authority./This photograph may not be reproduced without/the written permission of Richard Avedon Inc./Copyright © 1985 by Richard Avedon Inc./All rights reserved./This photograph was printed in 1985./Hansel Nicholas Burum, coal miner/ Somerset, Colorado, 12/17/79/This photograph was printed for and first exhibited/at the Amon Carter Museum, Fort Worth, Texas/September 14—November 17, 1985."
Acquired from: the photographer

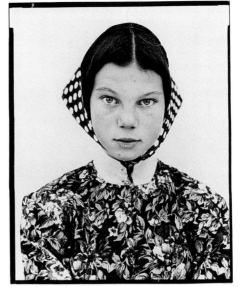
638

*645. **HARRISON TSOSIE, COWBOY, NAVAJO RESERVATION, WINDOW ROCK, ARIZONA, 6/13/79 [from "In the American West: Photographs by Richard Avedon"]** (P1985.28.82)
Gelatin silver print mounted on aluminum panel. negative 1979, print 1985
Image: 19 x 15⅛ in. (48.2 x 38.4 cm.)
Mount: 20 x 16 in. (50.8 x 40.7 cm.)
Signed, bottom center mount verso and l.r. print recto: "Avedon."
Inscription, mount verso, rubber stamp: "IN THE AMERICAN WEST/A project commissioned by the/ Amon Carter Museum, Fort Worth, Texas./ This photograph may not be reproduced without/the written permission of Richard Avedon Inc./Copyright © 1985 by Richard Avedon Inc./All rights reserved./This photograph was printed in 1985./Harrison Tsosie, cowboy/Navajo Reservation, Window Rock, Arizona, 6/13/79/ This photograph was printed for and first exhibited/at the Amon Carter Museum, Fort Worth, Texas/September 14— November 17, 1985."
Acquired from: the photographer

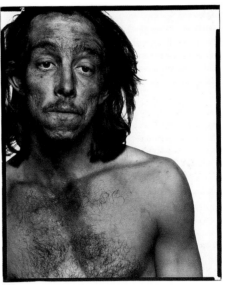
644

646. **HEIDI HAMILTON, GORDY BRAY, RODEO CONTESTANTS, DOUGLAS, WYOMING, 7/28/81 [from "In the American West: Photographs by Richard Avedon"]** (P1985.28.94)
Gelatin silver print mounted on aluminum panel. negative 1981, print 1985
Image: 19 x 15¼ in. (48.2 x 38.7 cm.)
Mount: 20 x 16 in. (50.8 x 40.7 cm.)
Signed, bottom center mount verso and l.l. print recto: "Avedon"
Inscription, mount verso, rubber stamp: "IN THE AMERICAN WEST/A project commissioned by the/ Amon Carter Museum, Fort Worth, Texas./ This photograph may not be reproduced without/the written permission of Richard Avedon Inc./Copyright © 1985 by Richard Avedon Inc./All rights reserved./This photograph was printed in 1985./Heidi Hamilton, Gordy Bray, rodeo contestants/Douglas, Wyoming, 7/28/81/ This photograph was printed for and first exhibited/at the Amon Carter Museum, Fort Worth, Texas/September 14—November 17, 1985."
Acquired from: the photographer

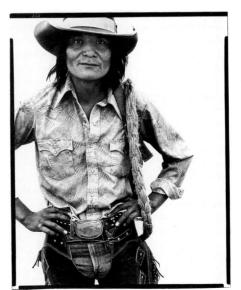
645

647. **HENRY GLISAN, DRIFTER, DENVER, COLORADO, 6/15/83 [from "In the American West: Photographs by Richard Avedon"]** (P1985.28.13)
Gelatin silver print mounted on aluminum panel. negative 1983, print 1985
Image: 46¾ x 37½ in. (118.8 x 95.2 cm.)
Mount: 50⅛ x 39¼ in. (127.2 x 99.7 cm.)
Signed, bottom center mount verso and l.r. print recto: "Avedon."
Inscription, mount verso, rubber stamp: "IN THE AMERICAN WEST/A project commissioned by the/ Amon Carter Museum, Fort Worth, Texas./ This photograph may not be reproduced without/the written permission of Richard Avedon Inc./Copyright © 1985 by Richard Avedon Inc./All rights reserved./This photograph was printed in 1985./Henry Glisan, drifter/Denver, Colorado, 6/15/83/This photograph was printed for and first exhibited/at the Amon Carter Museum, Fort Worth, Texas/ September 14–November 17, 1985."
Acquired from: the photographer

648. **HOMER EMMONS, COAL MINER, SOMERSET, COLORADO, 8/28/80 [from "In the American West: Photographs by Richard Avedon"]** (P1985.28.124)
Gelatin silver print mounted on aluminum panel. negative 1980, print 1985
Image: 47 x 37½ in. (119.4 x 95.2 cm.)
Mount: 50⅛ x 39¼ in. (127.2 x 99.7 cm.)
Signed, bottom center mount verso and l.r. print recto: "Avedon A.P./1/2"
Inscription, mount verso, rubber stamp: "IN THE AMERICAN WEST/A project commissioned by the/ Amon Carter Museum, Fort Worth, Texas./ Richard Avedon warrants and represents that,/aside from the signed and numbered photographs/in this edition of 4 plus 2 artist's proofs, no/other original prints of this photograph will/be made by him or under his authority./This photograph may not be reproduced without/the written permission of Richard Avedon Inc./Copyright © 1985 by Richard Avedon Inc./All rights reserved./This photograph was printed in 1985./Homer Emmons, coal miner/Somerset, Colorado, 8/28/80/This photograph was printed for and first exhibited/at the Amon Carter Museum, Fort Worth, Texas/September 14–November 17, 1985."
Acquired from: the photographer

649. **JAMES KIMBERLIN, DRIFTER, STATE ROAD 18, HOBBS, NEW MEXICO, 10/7/80 [from "In the American West: Photographs by Richard Avedon"]** (P1985.28.22)
Gelatin silver print mounted on aluminum panel. negative 1980, print 1985
Image: 47 x 37¾ in. (119.4 x 95.9 cm.)
Mount: 50⅛ x 39¼ in. (127.2 x 99.7 cm.)
Signed, bottom center mount verso and l.r. print recto: "Avedon A.P./1/2"
Inscription, mount verso, rubber stamp: "IN THE AMERICAN WEST/A project commissioned by the/ Amon Carter Museum, Fort Worth, Texas./ Richard Avedon warrants and represents that,/aside from the signed and numbered photographs/in this edition of 6 plus 2 artist's proofs, no/other original prints of this photograph will/be made by him or under his authority./This photograph may not be reproduced without/the written permission of Richard Avedon Inc./Copyright © 1985 by Richard Avedon Inc./All rights reserved./This photograph was printed in 1985./James Kimberlin, drifter/State Road 18, Hobbs, New Mexico, 10/7/80/This photograph was printed for and first exhibited/at the Amon Carter Museum, Fort Worth, Texas/September 14–November 17, 1985."
Acquired from: the photographer

650. **JAMES LYKINS, OIL FIELD WORKER, RAWSON, NORTH DAKOTA, 8/17/82 [from "In the American West: Photographs by Richard Avedon"]** (P1985.28.49)
Gelatin silver print mounted on aluminum panel. negative 1982, print 1985
Image: 46¾ x 37¾ in. (118.7 x 95.9 cm.)
Mount: 50⅛ x 39¼ in. (127.2 x 99.7 cm.)
Signed, center mount verso and l.r. print recto: "Avedon"
Inscription, mount verso, rubber stamp: "IN THE AMERICAN WEST/A project commissioned by the/ Amon Carter Museum, Fort Worth, Texas./ This photograph may not be reproduced without/the written permission of Richard Avedon Inc./Copyright © 1985 by Richard Avedon Inc./All rights reserved./This photograph was printed in 1985./James Lykins, oil field worker/Rawson, North Dakota, 8/17/82/This photograph was printed for and first exhibited/at the Amon Carter Museum, Fort Worth, Texas/September 14–November 17, 1985."
Acquired from: the photographer

651. **JAMES STORY, COAL MINER, SOMERSET, COLORADO, 12/18/79 [from "In the American West: Photographs by Richard Avedon"]** (P1985.28.119)
Gelatin silver print mounted on aluminum panel. negative 1979, print 1985
Image: 56 x 45 in. (142.2 x 114.3 cm.)
Mount: 59¾ x 47 in. (151.8 x 119.4 cm.)
Signed, bottom center mount verso and l.r. print recto: "Avedon A.P./1/2"
Inscription, mount verso, rubber stamp: "IN THE AMERICAN WEST/A project commissioned by the/ Amon Carter Museum, Fort Worth, Texas./ Richard Avedon warrants and represents that,/aside from the signed and numbered photographs/in this edition of 6 plus 2 artist's proofs, no/other original prints of this photograph will/be made by him or under his authority./This photograph may not be reproduced without/the written permission of Richard Avedon Inc./Copyright © 1985 by Richard Avedon Inc./All rights reserved./This photograph was printed in 1985./James Story, coal miner/Somerset, Colorado, 12/18/79/This photograph was printed for and first exhibited/at the Amon Carter Museum, Fort Worth, Texas/September 14–November 17, 1985."
Acquired from: the photographer

652. **JANET TOBLER, HOUSEWIFE, AND HER HUSBAND RANDY, INSULATOR, GLENROCK, WYOMING, 9/4/83 [from "In the American West: Photographs by Richard Avedon"]** (P1985.28.99)
Gelatin silver print mounted on aluminum panel. negative 1983, print 1985
Image: 19 x 15⅛ in. (48.2 x 38.4 cm.)
Mount: 20 x 16 in. (50.8 x 40.7 cm.)
Signed, bottom center mount verso and l.r. print recto: "Avedon"
Inscription, mount verso, rubber stamp: "IN THE AMERICAN WEST/A project commissioned by the/ Amon Carter Museum, Fort Worth, Texas./ This photograph may not be reproduced without/the written permission of Richard Avedon Inc./Copyright © 1985 by Richard Avedon Inc./All rights reserved./This photograph was printed in 1985./Janet Tobler, housewife, and her husband Randy, insulator/Glenrock, Wyoming, 9/4/83/ This photograph was printed for and first exhibited/at the Amon Carter Museum, Fort Worth, Texas/September 14–November 17, 1985."
Acquired from: the photographer

*653. **JASON JADE HESS, FIFTEEN YEAR OLD, BURLEY, IDAHO, 8/19/83 [from "In the American West: Photographs by Richard Avedon"]** (P1985.28.2)
Gelatin silver print mounted on aluminum panel. negative 1983, print 1985
Image: 47 x 37¾ in. (119.4 x 95.9 cm.)
Mount: 50⅛ x 39¼ in. (127.2 x 99.7 cm.)
Signed, bottom center mount verso and l.r. print recto: "Avedon"

Inscription, mount verso, rubber stamp: "IN THE
AMERICAN WEST/A project commissioned by the/
Amon Carter Museum, Fort Worth, Texas./ This
photograph may not be reproduced without/the written
permission of Richard Avedon Inc./Copyright © 1985 by
Richard Avedon Inc./All rights reserved./This photograph
was printed in 1985./Jason Jade Hess, fifteen year old/
Burley, Idaho, 8/19/83/This photograph was printed for and
first exhibited/at the Amon Carter Museum, Fort Worth,
Texas/September 14–November 17, 1985."
Acquired from: the photographer

654. **JAY GREENE, GRAIN THRESHER, BURLEY, IDAHO,**
8/19/83 [from "In the American West: Photographs by
Richard Avedon"] (P1985.28.9)
Gelatin silver print mounted on aluminum panel. negative
1983, print 1985
Image: 47 x 37¾ in. (119.4 x 95.9 cm.)
Mount: 50⅛ x 39¼ in. (127.2 x 99.7 cm.)
Signed, center mount verso and l.r. print recto: "Avedon."
Inscription, mount verso, rubber stamp: "IN THE
AMERICAN WEST/A project commissioned by the/
Amon Carter Museum, Fort Worth, Texas./ This
photograph may not be reproduced without/the written
permission of Richard Avedon Inc./Copyright © 1985 by
Richard Avedon Inc./All rights reserved./This photograph
was printed in 1985./Jay Greene, grain thresher/Burley,
Idaho, 8/19/83/This photograph was printed for and first
exhibited/at the Amon Carter Museum, Fort Worth, Texas/
September 14–November 17, 1985."
Acquired from: the photographer

655. **JEANNIE BANTA, WAITRESS, SALMON, IDAHO,**
8/25/83 [from "In the American West: Photographs by
Richard Avedon"] (P1985.28.42)
Gelatin silver print mounted on aluminum panel. negative
1983, print 1985
Image: 47 x 37½ in. (119.4 x 95.2 cm.)
Mount: 50⅛ x 39¼ in. (127.2 x 99.7 cm.)
Signed, center mount verso and l.r. print recto: "Avedon."
Inscription, mount verso, rubber stamp: "IN THE
AMERICAN WEST/A project commissioned by the/
Amon Carter Museum, Fort Worth, Texas./ This
photograph may not be reproduced without/the written
permission of Richard Avedon Inc./Copyright © 1985 by
Richard Avedon Inc./All rights reserved./This photograph
was printed in 1985./Jeannie Banta, waitress/Salmon,
Idaho, 8/25/83/This photograph was printed for and first
exhibited/at the Amon Carter Museum, Fort Worth, Texas/
September 14–November 17, 1985."
Acquired from: the photographer

656. **JERRY DON KEETER, OIL FIELD WORKER, EL RENO,**
OKLAHOMA, 6/16/80 [from "In the American West:
Photographs by Richard Avedon"] (P1985.28.60)
Gelatin silver print mounted on aluminum panel. negative
1980, print 1985
Image: 56¼ x 45 in. (142.8 x 114.3 cm.)
Mount: 59¾ x 47⅛ in. (151.8 x 119.7 cm.)
Signed, center mount verso and l.r. print recto: "Avedon."
Inscription, mount verso, rubber stamp: "IN THE
AMERICAN WEST/A project commissioned by the/
Amon Carter Museum, Fort Worth, Texas./ This
photograph may not be reproduced without/the written
permission of Richard Avedon Inc./Copyright © 1985 by
Richard Avedon Inc./All rights reserved./This photograph
was printed in 1985./Jerry Don Keeter, oil field worker/El
Reno, Oklahoma, 6/16/80/This photograph was printed for
and first exhibited/at the Amon Carter Museum, Fort
Worth, Texas/September 14–November 17, 1985."
Acquired from: the photographer

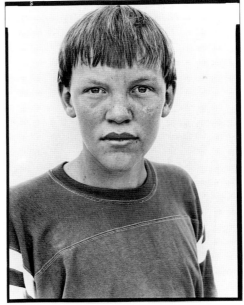
653

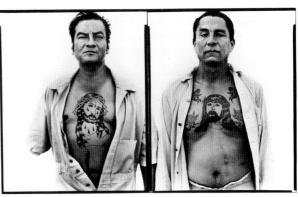
658

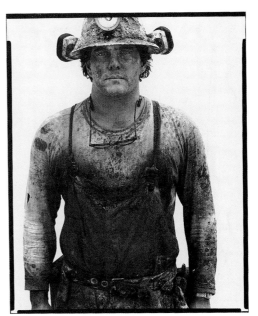
661

657. **JESSE KLEINSASSER, PIG MAN, HUTTERITE COLONY, HARLOWTON, MONTANA, 6/23/83 [from "In the American West: Photographs by Richard Avedon"]** (P1985.28.90)
Gelatin silver print mounted on aluminum panel. negative 1983, print 1985
Image: 19 x 15¼ in. (48.2 x 38.7 cm.)
Mount: 20 x 16 in. (50.8 x 40.7 cm.)
Signed, bottom center mount verso and l.r. print recto: "Avedon"
Inscription, mount verso, rubber stamp: "IN THE AMERICAN WEST/A project commissioned by the/ Amon Carter Museum, Fort Worth, Texas./ This photograph may not be reproduced without/the written permission of Richard Avedon Inc./Copyright © 1985 by Richard Avedon Inc./All rights reserved./This photograph was printed in 1985./Jesse Kleinsasser, pig man/Hutterite Colony, Harlowton, Montana, 6/23/83/ This photograph was printed for and first exhibited/at the Amon Carter Museum, Fort Worth, Texas/September 14—November 17, 1985."
Acquired from: the photographer

*658. **JESUS CERVANTES, MANUEL HEREDIA, PRISONERS, BEXAR COUNTY JAIL, SAN ANTONIO, TEXAS, 6/5/80 [from "In the American West: Photographs by Richard Avedon"]** (P1985.28.114)
Gelatin silver print mounted on aluminum panel. negative 1980, print 1985
Image (diptych): a) 46½ x 37½ in. (118.1 x 95.2 cm.)
 b) 46½ x 37½ in. (118.1 x 95.2 cm.)
overall image: 46½ x 75 in. (118.1 x 190.4 cm.)
Mount: a) 50⅛ x 38½ in. (127.2 x 97.8 cm.)
 b) 50⅛ x 38½ in. (127.2 x 97.8 cm.)
overall mount: 50⅛ x 77 in. (127.2 x 195.6 cm.)
Signed, bottom center mount verso and l.r. print recto (on both prints): "Avedon A.P./1/2"
Inscription, mount verso, rubber stamp (on both prints): "IN THE AMERICAN WEST/A project commissioned by the/Amon Carter Museum, Fort Worth, Texas./Richard Avedon warrants and represents that,/ aside from the signed and numbered photographs/in this edition of 6 plus 2 artist's proofs, no/other original prints of this photograph will/be made by him or under his authority./This photograph may not be reproduced without/the written permission of Richard Avedon Inc./Copyright © 1985 by Richard Avedon Inc./ All rights reserved./This photograph was printed in 1985./Jesus Cervantes, Manuel Heredia, prisoners/ Bexar County Jail, San Antonio, Texas, 6/5/80/ This photograph was printed for and first exhibited/at the Amon Carter Museum, Fort Worth, Texas/ September 14—November 17, 1985."
Acquired from: the photographer

659. **JIMMY LOPEZ, GYPSUM MINER, SWEETWATER, TEXAS, 6/15/79 [from "In the American West: Photographs by Richard Avedon"]** (P1985.28.59)
Gelatin silver print mounted on aluminum panel. negative 1979, print 1985
Image: 56½ x 45⅛ in. (143.5 x 114.7 cm.)
Mount: 59¾ x 47⅛ in. (151.8 x 119.7 cm.)
Signed, bottom center mount verso and l.r. print recto: "Avedon."
Inscription, mount verso, rubber stamp: "IN THE AMERICAN WEST/A project commissioned by the/ Amon Carter Museum, Fort Worth, Texas./ This photograph may not be reproduced without/the written permission of Richard Avedon Inc./All rights reserved./This photograph was printed in 1985./Jimmy Lopez, gypsum miner/ Sweetwater, Texas, 6/15/79/This photograph was printed for and first exhibited/at the Amon Carter Museum, Fort Worth, Texas/September 14—November 17, 1985."
Acquired from: the photographer

660. **JOE BUTLER, COAL MINER, RELIANCE, WYOMING, 8/28/79 [from "In the American West: Photographs by Richard Avedon"]** (P1985.28.53)
Gelatin silver print mounted on aluminum panel. negative 1979, print 1985
Image: 56¼ x 45 in. (142.8 x 114.3 cm.)
Mount: 59¾ x 47 in. (151.8 x 119.4 cm.)
Signed, center mount verso and l.r. print recto: "Avedon"
Inscription, mount verso, rubber stamp: "IN THE AMERICAN WEST/A project commissioned by the/ Amon Carter Museum, Fort Worth, Texas./ This photograph may not be reproduced without/the written permission of Richard Avedon Inc./Copyright © 1985 by Richard Avedon Inc./All rights reserved./This photograph was printed in 1985./Joe Butler, coal miner/Reliance, Wyoming, 8/28/79/This photograph was printed for and first exhibited/at the Amon Carter Museum, Fort Worth, Texas/September 14—November 17, 1985."
Acquired from: the photographer

*661. **JOE DOBOSZ, URANIUM MINER, CHURCH ROCK, NEW MEXICO, 6/13/79 [from "In the American West: Photographs by Richard Avedon"]** (P1985.28.57)
Gelatin silver print mounted on aluminum panel. negative 1979, print 1985
Image: 56¼ x 45⅛ in. (142.8 x 114.7 cm.)
Mount: 59¾ x 47⅛ in. (151.8 x 119.7 cm.)
Signed, bottom center mount verso and l.r. print recto: "Avedon A.P./1/2"
Inscription, mount verso, rubber stamp: "IN THE AMERICAN WEST/A project commissioned by the/ Amon Carter Museum, Fort Worth, Texas./ Richard Avedon warrants and represents that,/aside from the signed and numbered photographs/in this edition of 6 plus 2 artist's proofs, no/other original prints of this photograph will/be made by him or under his authority./This photograph may not be reproduced without/the written permission of Richard Avedon Inc./Copyright © 1985 by Richard Avedon Inc./All rights reserved./This photograph was printed in 1985./Joe Dobosz, uranium miner/Church Rock, New Mexico, 6/13/79/This photograph was printed for and first exhibited/at the Amon Carter Museum, Fort Worth, Texas/September 14—November 17, 1985."
Acquired from: the photographer

*662. **JOHN HARRISON, LUMBER SALESMAN, AND HIS DAUGHTER MELISSA, LEWISVILLE, TEXAS, 11/22/81 [from "In the American West: Photographs by Richard Avedon"]** (P1985.28.68)
Gelatin silver print mounted on aluminum panel. negative 1981, print 1985
Image: 56¼ x 45 in. (142.8 x 114.3 cm.)
Mount: 59¾ x 47⅛ in. (151.8 x 119.8 cm.)
Signed, bottom center mount verso and l.r. print recto: "Avedon A.P./1/2"
Inscription, mount verso, rubber stamp: "IN THE AMERICAN WEST/A project commissioned by the/ Amon Carter Museum, Fort Worth, Texas./ Richard Avedon warrants and represents that,/aside from the signed and numbered photographs/in this edition of 6 plus 2 artist's proofs, no/other original prints of this photograph will/be made by him or under his authority./This photograph may not be reproduced without/the written permission of Richard Avedon Inc./Copyright © 1985 by Richard Avedon Inc./All rights reserved./This photograph was printed in 1985./John Harrison, lumber salesman, and his daughter Melissa/Lewisville, Texas, 11/22/81/ This photograph was printed for and first exhibited/at the Amon Carter Museum, Fort Worth, Texas/September 14—November 17, 1985."
Acquired from: the photographer

663. **JON WEARLEY, RANCH HAND, AUGUSTA, MONTANA, 6/27/82 [from "In the American West: Photographs by Richard Avedon"]** (P1985.28.74)
Gelatin silver print mounted on aluminum panel. negative 1982, print 1985
Image: 56½ x 45½ in. (143.5 x 115.6 cm.)
Mount: 59¾ x 47⅛ in. (151.8 x 119.8 cm.)

Signed, bottom center mount verso and l.r. print recto: "Avedon."

Inscription, mount verso, rubber stamp: "IN THE AMERICAN WEST/A project commissioned by the/ Amon Carter Museum, Fort Worth, Texas./ This photograph may not be reproduced without/the written permission of Richard Avedon Inc./Copyright © 1985 by Richard Avedon Inc./All rights reserved./This photograph was printed in 1985./Jon Wearley, ranch hand/Augusta, Montana, 6/27/82/This photograph was printed for and first exhibited/at the Amon Carter Museum, Fort Worth, Texas/ September 14–November 17, 1985."

Acquired from: the photographer

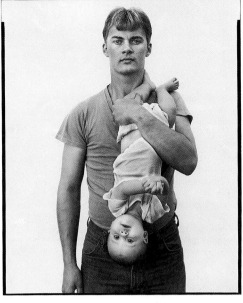

662

664. **JONATHAN STAHL, BLACKSMITH, SAM STAHL, FARMER, HUTTERITE COLONY, GILFORD, MONTANA, 7/19/83 [from "In the American West: Photographs by Richard Avedon"]** (P1985.28.89)

Gelatin silver print mounted on aluminum panel. negative 1983, print 1985

Image: 19 x 15¼ in. (48.2 x 38.7 cm.)

Mount: 20 x 16 in. (50.8 x 40.7 cm.)

Signed, bottom center mount verso and l.r. print recto: "Avedon"

Inscription, mount verso, rubber stamp: "IN THE AMERICAN WEST/A project commissioned by the/ Amon Carter Museum, Fort Worth, Texas./ This photograph may not be reproduced without/the written permission of Richard Avedon Inc./Copyright © 1985 by Richard Avedon Inc./All rights reserved./This photograph was printed in 1985./Jonathan Stahl, blacksmith, Sam Stahl, farmer/Hutterite Colony, Gilford, Montana, 7/19/83/ This photograph was printed for and first exhibited/ at the Amon Carter Museum, Fort Worth, Texas/September 14–November 17, 1985."

Acquired from: the photographer

*665. **JUAN PATRICIO LOBATO, CARNEY, ROCKY FORD, COLORADO, 8/23/80 [from "In the American West: Photographs by Richard Avedon"]** (P1985.28.12)

Gelatin silver print mounted on aluminum panel. negative 1980, print 1985

Image: 56¼ x 45 in. (142.8 x 114.3 cm.)

Mount: 60 x 47 in. (152.4 x 119.4 cm.)

Signed, bottom center mount verso and l.r. print recto: "Avedon A.P./1/2"

Inscription, mount verso, rubber stamp: "IN THE AMERICAN WEST/A project commissioned by the/ Amon Carter Museum, Fort Worth, Texas./ Richard Avedon warrants and represents that,/aside from the signed and numbered photographs/in this edition of 6 plus 2 artist's proofs, no/other original prints of this photograph will be/made by him or under his authority except for one/80½ x 64½" print made for exhibition purposes./ This photograph may not be reproduced without/the written permission of Richard Avedon Inc./Copyright © 1985 by Richard Avedon Inc./All rights reserved./This photograph was printed in 1985./Juan Patricio Lobato, carney/Rocky Ford, Colorado, 8/23/80/This photograph was printed for the/Amon Carter Museum, Fort Worth, Texas."

Acquired from: the photographer

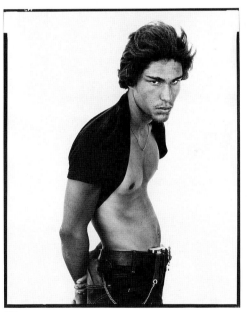

665

666. **JULIA WALDNER, FIFTEEN YEAR OLD, HUTTERITE COLONY, HARLOWTON, MONTANA, 6/23/83 [from "In the American West: Photographs by Richard Avedon"]** (P1985.28.92)

Gelatin silver print mounted on aluminum panel. negative 1983, print 1985

Image: 19 x 15¼ in. (48.2 x 38.7 cm.)

Mount: 20 x 16 in. (50.8 x 40.7 cm.)

Signed, bottom center mount verso and l.r. print recto: "Avedon"

Inscription, mount verso, rubber stamp: "IN THE AMERICAN WEST/A project commissioned by the/ Amon Carter Museum, Fort Worth, Texas./ This photograph may not be reproduced without/the written permission of Richard Avedon Inc./Copyright © 1985 by

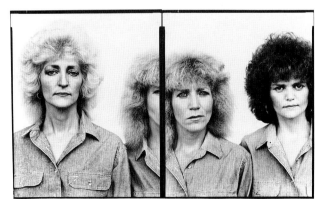

670

Richard Avedon Inc./All rights reserved./This photograph was printed in 1985./Julia Waldner, fifteen year old/ Hutterite Colony, Harlowton, Montana, 6/23/83/ This photograph was printed for and first exhibited/at the Amon Carter Museum, Fort Worth, Texas/September 14–November 17, 1985."
Acquired from: the photographer

667. **LANCE BARRON, MEL PYEATT, COAL MINERS, RELIANCE, WYOMING, 8/28/79 [from "In the American West: Photographs by Richard Avedon"]** (P1985.28.118)
Gelatin silver print mounted on aluminum panel. negative 1979, print 1985
Image: 56⅛ x 45 in. (142.5 x 114.3 cm.)
Mount: 59¾ x 47⅛ in. (151.8 x 119.7 cm.)
Signed, bottom center mount verso and l.r. print recto: "Avedon."
Inscription, mount verso, rubber stamp: "IN THE AMERICAN WEST/A project commissioned by the/ Amon Carter Museum, Fort Worth, Texas./ This photograph may not be reproduced without/the written permission of Richard Avedon Inc./Copyright © 1985 by Richard Avedon Inc./All rights reserved./This photograph was printed in 1985./Lance Barron, Mel Pyeatt, coal miners/Reliance, Wyoming, 8/28/79/This photograph was printed for and first exhibited/at the Amon Carter Museum, Fort Worth, Texas/September 14–November 17, 1985."
Acquired from: the photographer

668. **LEONARD RAY BLANCHARD, EX-PRIZE FIGHTER, LAS VEGAS, NEVADA, 12/14/80 [from "In the American West: Photographs by Richard Avedon"]** (P1985.28.6)
Gelatin silver print mounted on aluminum panel. negative 1980, print 1985
Image: 46¾ x 37½ in. (118.8 x 95.2 cm.)
Mount: 50⅛ x 39¼ in. (127.2 x 99.7 cm.)
Signed, bottom center mount verso and l.r. print recto: "Avedon A.P. 1/2"
Inscription, mount verso, rubber stamp: "IN THE AMERICAN WEST/A project commissioned by the/ Amon Carter Museum, Fort Worth, Texas./ Richard Avedon warrants and represents that,/aside from the signed and numbered photographs/in this edition of 6 plus 2 artist's proofs, no/other original prints of this photograph will/be made by him or under his authority./ This photograph may not be reproduced without/the written permission of Richard Avedon Inc./Copyright © 1985 by Richard Avedon Inc./All rights reserved./This photograph was printed in 1985./Leonard Ray Blanchard, ex-prize fighter/Las Vegas, Nevada 12/14/80/This photograph was printed for and first exhibited/at the Amon Carter Museum, Fort Worth, Texas/September 14–November 17, 1985."
Acquired from: the photographer

669. **LLOYD BLOOM, OIL FIELD WORKER, WILLISTON, NORTH DAKOTA, 8/21/82 [from "In the American West: Photographs by Richard Avedon"]** (P1985.28.111)
Gelatin silver print mounted on aluminum panel. negative 1982, print 1985
Image: 41 x 33⅛ in. (104.2 x 84.2 cm.)
Mount: 43¾ x 34¾ in. (111.2 x 88.3 cm.)
Signed, center mount verso and l.r. print recto: "Avedon."
Inscription, mount verso, rubber stamp: "IN THE AMERICAN WEST/A project commissioned by the/ Amon Carter Museum, Fort Worth, Texas./ This photograph may not be reproduced without/the written permission of Richard Avedon Inc./Copyright © 1985 by Richard Avedon Inc./All rights reserved./This photograph was printed in 1985./Lloyd Bloom, oil field worker/ Williston, North Dakota, 8/21/82/This photograph was printed for and first exhibited/at the Amon Carter Museum, Fort Worth, Texas/September 14–November 17, 1985."
Acquired from: the photographer

*670. **LORETTA, LOUDILLA, AND KAY JOHNSON, CO-PRESIDENTS, LORETTA LYNN FAN CLUB, WILD HORSE, COLORADO, 6/16/83 [from "In the American West: Photographs by Richard Avedon"]** (P1985.28.48)
Gelatin silver print mounted on aluminum panel. negative 1983, print 1985
Image (diptych): a) 47 x 37¾ in. (119.4 x 95.9 cm.)
　　　　　　　　b) 47 x 37¾ in. (119.4 x 95.9 cm.)
overall image: 47 x 75½ in. (119.4 x 191.8 cm.)
Mount: a) 50⅛ x 38½ in. (127.2 x 97.8 cm.)
　　　　b) 50⅛ x 38½ in. (127.2 x 97.8 cm.)
overall mount: 50⅛ x 77 in. (127.2 x 195.6 cm.)
Signed, bottom center mount verso and l.r. print recto: a) "Avedon" and b) "Avedon."
Inscription, mount verso, rubber stamp (on both prints): "IN THE AMERICAN WEST/A project commissioned by the/ Amon Carter Museum, Fort Worth, Texas./This photograph may not be reproduced without/the written permission of Richard Avedon Inc./Copyright © 1985 by Richard Avedon Inc./All rights reserved./This photograph was printed in 1985./Loretta, Loudilla, and Kay Johnson, co-presidents, Loretta Lynn Fan Club/Wild Horse, Colorado, 6/16/83/This photograph was printed for and first exhibited/at the Amon Carter Museum, Fort Worth, Texas/September 14–November 17, 1985."
Acquired from: the photographer

671. **LYAL BURR, COAL MINER, AND HIS SONS KERRY AND PHILLIP, THE CHURCH OF JESUS CHRIST OF LATTER-DAY SAINTS, KOOSHAREM, UTAH, 5/7/81 [from "In the American West: Photographs by Richard Avedon"]** (P1985.28.52)
Gelatin silver print mounted on aluminum panel. negative 1981, print 1985
Image: 56¼ x 45 in. (142.8 x 114.3 cm.)
Mount: 59½ x 47¼ in. (151.1 x 120.0 cm.)
Signed, bottom center mount verso and l.r. print recto: "Avedon A.P./1/2"
Inscription, mount verso, rubber stamp: "IN THE AMERICAN WEST/A project commissioned by the/ Amon Carter Museum, Fort Worth, Texas./ Richard Avedon warrants and represents that,/aside from the signed and numbered photographs/in this edition of 6 plus 2 artist's proofs, no/other original prints of this photograph will be/made by him or under his authority except for one/ 80½ x 64½" print made for exhibition purposes./This photograph may not be reproduced without/the written permission of Richard Avedon Inc./Copyright © 1985 by Richard Avedon Inc./All rights reserved./This photograph was printed in 1985./Lyal Burr, coal miner, and his sons Kerry and Phillip/The Church of Jesus Christ of Latter-Day Saints, Koosharem, Utah, 5/7/81/This photograph was printed for the/Amon Carter Museum, Fort Worth, Texas."
Acquired from: the photographer

*672. **MARIE LARSEN, PATIENT, STATE HOSPITAL, LAS VEGAS, NEW MEXICO, 4/1/80 [from "In the American West: Photographs by Richard Avedon"]** (P1985.28.64)
Gelatin silver print mounted on aluminum panel. negative 1980, print 1985
Image: 41⅛ x 33 in. (104.4 x 83.8 cm.)
Mount: 43¾ x 34¾ in. (111.2 x 88.3 cm.)
Signed, bottom center mount verso and l.r. print recto: "Avedon A.P./1/2"
Inscription, mount verso, rubber stamp: "IN THE AMERICAN WEST/A project commissioned by the/ Amon Carter Museum, Fort Worth, Texas./ Richard Avedon warrants and represents that,/aside from the signed and numbered photographs/in this edition of 6 plus 2 artist's proofs, no/other original prints of this photograph will/be made by him or under his authority./ This photograph may not be reproduced without/the written permission of Richard Avedon Inc./Copyright © 1985 by Richard Avedon Inc./All rights reserved./This photograph was printed in 1985./Marie Larsen, patient/State Hospital, Las Vegas, New Mexico, 4/1/80/This photograph was

printed for and first exhibited/at the Amon Carter
Museum, Fort Worth, Texas/ September 14–November 17,
1985."
Acquired from: the photographer

673. **MARK WYATT, TWELVE YEAR OLD, BURLEY, IDAHO,
8/19/83 [from "In the American West: Photographs by
Richard Avedon"]** (P1985.28.78)
Gelatin silver print mounted on aluminum panel. negative
1983, print 1985
Image: 19 x 15 in. (48.2 x 38.1 cm.)
Mount: 20 x 16 in. (50.8 x 40.7 cm.)
Signed, bottom center mount verso and l.r. print recto:
"Avedon."
Inscription, mount verso, rubber stamp; "IN THE
AMERICAN WEST/A project commissioned by the/
Amon Carter Museum, Fort Worth, Texas./ This
photograph may not be reproduced without/the written
permission of Richard Avedon Inc./Copyright © 1985 by
Richard Avedon Inc./All rights reserved./This photograph
was printed in 1985./Mark Wyatt, twelve year old/Burley,
Idaho, 8/19/83/This photograph was printed for and first
exhibited/at the Amon Carter Museum, Fort Worth, Texas/
September 14–November 17, 1985."
Acquired from: the photographer

674. **MART KLEINSASSER, SHEEP MAN, MIKE
KLEINSASSER, COW MAN, HUTTERITE COLONY,
HARLOWTON, MONTANA, 6/23/83 [from "In the
American West: Photographs by Richard Avedon"]**
(P1985.28.91)
Gelatin silver print mounted on aluminum panel. negative
1983, print 1985
Image: 19 x 15¼ in. (48.2 x 38.7 cm.)
Mount: 20 x 16 in. (50.8 x 40.7 cm.)
Signed, bottom center mount verso and l.r. print recto:
"Avedon"
Inscription, mount verso, rubber stamp: "IN THE
AMERICAN WEST/A project commissioned by the/
Amon Carter Museum, Fort Worth, Texas./ This
photograph may not be reproduced without/the written
permission of Richard Avedon Inc./Copyright © 1985 by
Richard Avedon Inc./All rights reserved./This photograph
was printed in 1985./Mart Kleinsasser, sheep man, Mike
Kleinsasser, cow man/Hutterite Colony, Harlowton,
Montana, 6/23/83/This photograph was printed for and first
exhibited/at the Amon Carter Museum, Fort Worth, Texas/
September 14–November 17, 1985."
Acquired from: the photographer

675. **MARVIN MORRISON, HAY HAULER, KELLIE
BENNETT, SALESGIRL, BURLEY, IDAHO, 8/19/83
[from "In the American West: Photographs by Richard
Avedon"]** (P1985.28.20)
Gelatin silver print mounted on aluminum panel. negative
1983, print 1985
Image: 46¾ x 37½ in. (118.8 x 95.2 cm.)
Mount: 50½ x 39¼ in. (128.2 x 99.7 cm.)
Signed, bottom center mount verso and l.r. print recto:
"Avedon."
Inscription, mount verso, rubber stamp: "IN THE
AMERICAN WEST/A project commissioned by the/
Amon Carter Museum, Fort Worth, Texas./ This
photograph may not be reproduced without/the written
permission of Richard Avedon Inc./Copyright © 1985 by
Richard Avedon Inc./All rights reserved./This photograph
was printed in 1985./Marvin Morrison, hay hauler, Kellie
Bennett, salesgirl/Burley, Idaho, 8/19/83/This photograph
was printed for and first exhibited/at the Amon Carter
Museum, Fort Worth, Texas/September 14–November 17,
1985."
Acquired from: the photographer

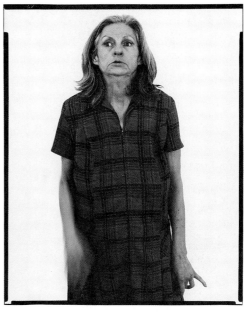
672

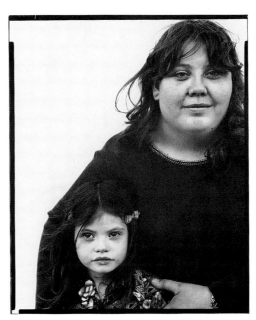
676

*676. MARY WATTS, FACTORY WORKER, AND HER NIECE
TRICIA STEWARD SWEETWATER, TEXAS, 3/10/79
[from "In the American West: Photographs by Richard
Avedon"] (P1985.28.43)
Gelatin silver print mounted on aluminum panel. negative
1979, print 1988
Image: 56 x 45 in. (142.2 x 114.3 cm.)
Mount: 59¾ x 47⅛ in. (151.8 x 119.7 cm.)
Signed, center mount verso and l.r. print recto: "Avedon
A.P./1/2"
Inscription, mount verso, rubber stamp: "IN THE
AMERICAN WEST/A project commissioned by the/
Amon Carter Museum, Fort Worth, Texas./ Richard
Avedon warrants and represents that,/aside from the signed
and numbered photographs/in this edition of 6 plus 2
artist's proofs, no/other original prints of this photograph
will/be made by him or under his authority./ This
photograph may not be reproduced without/the written
permission of Richard Avedon Inc./Copyright © 1985 by
Richard Avedon Inc./All rights reserved./This photograph
was printed in 1985./Mary Watts, factory worker, and her
niece Tricia Steward/Sweetwater, Texas, 3/10/79/This
photograph was printed for and first exhibited/at the
Amon Carter Museum, Fort Worth, Texas/September 14–
November 17, 1985."
Acquired from: the photographer

677. MAX BENNETT, RETIRED COPPER SMELTER, AND
HIS DAUGHTER SHANNON, FORT BRIDGER,
WYOMING, 9/4/83 [from "In the American West:
Photographs by Richard Avedon"] (P1985.28.4)
Gelatin silver print mounted on aluminum panel. negative
1983, print 1985
Image: 47 x 37¾ in. (119.4 x 95.9 cm.)
Mount: 50⅛ x 39¼ in. (127.2 x 99.7 cm.)
Signed, bottom center mount verso and l.r. print recto:
"Avedon"
Inscription, mount verso, rubber stamp: "IN THE
AMERICAN WEST/A project commissioned by the/
Amon Carter Museum, Fort Worth, Texas./ This
photograph may not be reproduced without/the written
permission of Richard Avedon Inc./Copyright © 1985 by
Richard Avedon Inc./All rights reserved./This photograph
was printed in 1985./Max Bennett, retired copper smelter,
and his daughter Shannon/Fort Bridger, Wyoming, 9/4/83/
This photograph was printed for and first exhibited/ at the
Amon Carter Museum, Fort Worth, Texas/September
14–November 17, 1985."
Acquired from: the photographer

678. MIKE BENCICH, DAN ASHBERGER, COAL MINERS,
SOMERSET, COLORADO, 8/29/80 [from "In the
American West: Photographs by Richard Avedon"]
(P1985.28.3)
Gelatin silver print mounted on aluminum panel. negative
1980, print 1985
Image: 56¼ x 45 in. (142.8 x 114.3 cm.)
Mount: 59¾ x 47⅛ in. (151.8 x 119.7 cm.)
Signed, bottom center mount verso and l.r. print recto:
"Avedon A.P./1/2"
Inscription, mount verso, rubber stamp: "IN THE
AMERICAN WEST/A project commissioned by the/
Amon Carter Museum, Fort Worth, Texas./ Richard
Avedon warrants and represents that,/aside from the signed
and numbered photographs/in this edition of 6 plus 2
artist's proofs, no/other original prints of this photograph
will/be made by him or under his authority./ This
photograph may not be reproduced without/the written
permission of Richard Avedon Inc./Copyright © 1985 by
Richard Avedon Inc./All rights reserved./This photograph
was printed in 1985./Mike Bencich, Dan Ashberger, coal
miners/ Somerset, Colorado, 8/29/80/This photograph
was printed for and first exhibited/at the Amon Carter
Museum, Fort Worth, Texas/ September 14–November 17,
1985."
Acquired from: the photographer

679. MILO DEWITT, COWBOY, PAYSON, ARIZONA, 8/29/82
[from "In the American West: Photographs by Richard
Avedon"] (P1985.28.10)
Gelatin silver print mounted on aluminum panel. negative
1982, print 1985
Image: 47 x 37¾ in. (119.4 x 95.9 cm.)
Mount: 50⅛ x 39¼ in. (127.2 x 99.7 cm.)
Signed, center mount verso and l.r. print recto: "Avedon."
Inscription, mount verso, rubber stamp: "IN THE
AMERICAN WEST/A project commissioned by the/
Amon Carter Museum, Fort Worth, Texas./ This
photograph may not be reproduced without/the written
permission of Richard Avedon Inc./Copyright © 1985 by
Richard Avedon Inc./All rights reserved./This photograph
was printed in 1985./Milo DeWitt, cowboy/Payson,
Arizona, 8/29/82/This photograph was printed for and first
exhibited/at the Amon Carter Museum, Fort Worth, Texas/
September 14–November 17, 1985."
Acquired from: the photographer

680. MYRNA SANDOVAL, EIGHTEEN YEAR OLD, AND
HER SISTER CLAUDIA, FOURTEEN YEAR OLD, EL
PASO, TEXAS, 4/20/82 [from "In the American West:
Photographs by Richard Avedon"] (P1985.28.51)
Gelatin silver print mounted on aluminum panel. negative
1982, print 1985
Image: 47 x 37¾ in. (119.4 x 95.9 cm.)
Mount: 50⅛ x 39¼ in. (127.2 x 99.7 cm.)
Signed, bottom center mount verso and l.r. print recto:
"Avedon A.P./1/2"
Inscription, mount verso, rubber stamp: "IN THE
AMERICAN WEST/A project commissioned by the/
Amon Carter Museum, Fort Worth, Texas./ This
photograph may not be reproduced without/the written
permission of Richard Avedon Inc./Copyright © 1985 by
Richard Avedon Inc./All rights reserved./This photograph
was printed in 1985./Myrna Sandoval, eighteen year
old, and her sister Claudia, fourteen year old/El Paso,
Texas, 4/20/82/This photograph was printed for and first
exhibited/at the Amon Carter Museum, Fort Worth, Texas/
September 14–November 17, 1985."
Acquired from: the photographer

*681. PATRICIA WILDE, HOUSEKEEPER, KALISPELL,
MONTANA, 6/12/81 [from "In the American West:
Photographs by Richard Avedon"] (P1985.28.63)
Gelatin silver print mounted on aluminum panel. negative
1981, print 1985
Image: 56¼ x 45 in. (142.8 x 114.3 cm.)
Mount: 60 x 47 in. (152.4 x 119.4 cm.)
Signed, bottom center mount verso and l.r. print recto:
"Avedon A.P. 1/2"
Inscription, mount verso, rubber stamp: "IN THE
AMERICAN WEST/A project commissioned by the/
Amon Carter Museum, Fort Worth, Texas./ Richard
Avedon warrants and represents that,/aside from the signed
and numbered photographs/in this edition of 6 plus 2
artist's proofs, no/other original prints of this photograph
will be/made by him or under his authority except for one/
80½ x 64½" print made for exhibition purposes./This
photograph may not be reproduced without/the written
permission of Richard Avedon Inc./Copyright © 1985 by
Richard Avedon Inc./All rights reserved./This photograph
was printed in 1985./Patricia Wilde, housekeeper/Kalispell,
Montana, 6/12/81/This photograph was printed for/the
Amon Carter Museum, Fort Worth, Texas."
Acquired from: the photographer

682. **PEGGY DANIELS, CASHIER, GIDDINGS, TEXAS, 5/7/81**
[from "In the American West: Photographs by Richard
Avedon"] (P1985.28.39)
Gelatin silver print mounted on aluminum panel. negative
1981, print 1985
Image: 47 x 37¾ in. (119.4 x 95.9 cm.)
Mount: 50⅛ x 39¼ in. (127.2 x 99.7 cm.)
Signed, bottom center mount verso and l.r. print recto:
"Avedon A.P./1/2"
Inscription, mount verso, rubber stamp: "IN THE
AMERICAN WEST/A project commissioned by the/
Amon Carter Museum, Fort Worth, Texas./ Richard
Avedon warrants and represents that,/aside from the signed
and numbered photographs/in this edition of 6 plus 2
artist's proofs, no/other original prints of this photograph
will/be made by him or under his authority./ This
photograph may not be reproduced without/the written
permission of Richard Avedon Inc./Copyright © 1985 by
Richard Avedon Inc./All rights reserved./This photograph
was printed in 1985./Peggy Daniels, cashier/Giddings,
Texas, 5/7/81/This photograph was printed for and first
exhibited/at the Amon Carter Museum, Fort Worth, Texas/
September 14–November 17, 1985."
Acquired from: the photographer

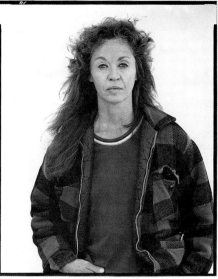
681

*683. **PETRA ALVARADO, FACTORY WORKER, EL PASO,
TEXAS, ON HER BIRTHDAY, 4/22/82** [from "In the
American West: Photographs by Richard Avedon"]
(P1985.28.14)
Gelatin silver print mounted on aluminum panel. negative
1982, print 1985
Image: 56¼ x 45¼ in. (142.8 x 114.9 cm.)
Mount: 59¾ x 47⅛ in. (151.8 x 119.7 cm.)
Signed, bottom center mount verso and l.r. print recto:
"Avedon A.P. 1/2"
Inscription, mount verso, rubber stamp: "IN THE
AMERICAN WEST/A project commissioned by the/
Amon Carter Museum, Fort Worth, Texas./ Richard
Avedon warrants and represents that,/aside from the signed
and numbered photographs/in this edition of 6 plus 2
artist's proofs, no/other original prints of this photograph
will/be made by him or under his authority./ This
photograph may not be reproduced without/the written
permission of Richard Avedon Inc./Copyright © 1985 by
Richard Avedon Inc./All rights reserved./This photograph
was printed in 1985./Petra Alvarado, factory worker/
El Paso, Texas, on her birthday, 4/22/82/This photograph
was printed for and first exhibited/at the Amon Carter
Museum, Fort Worth, Texas/September 14–November 17,
1985."
Acquired from: the photographer

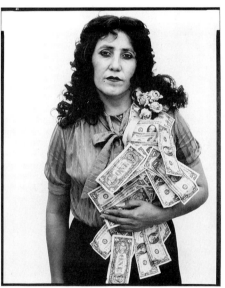
683

*684. **RED OWENS, OIL FIELD WORKER, VELMA,
OKLAHOMA, 6/12/80** [from "In the American West:
Photographs by Richard Avedon"] (P1985.28.23)
Gelatin silver print mounted on aluminum panel. negative
1980, print 1988
Image: 56⅛ x 45 in. (142.5 x 114.3 cm.)
Mount: 59¾ x 47⅛ in. (151.8 x 119.7 cm.)
Signed, bottom center mount verso and l.r. print recto:
"Avedon A.P./1/2"
Inscription, mount verso, rubber stamp: "IN THE
AMERICAN WEST/A project commissioned by the/
Amon Carter Museum, Fort Worth, Texas./ Richard
Avedon warrants and represents that,/aside from the signed
and numbered photographs/in this edition of 6 plus 2
artist's proofs, no/other original prints of this photograph
will be/made by him or under his authority except for one/
80½ x 64½" print made for exhibition purposes./This
photograph may not be reproduced without/the written
permission of Richard Avedon Inc./Copyright © 1985 by
Richard Avedon Inc./All rights reserved./This photograph
was printed in 1985 [sic]./Red Owens, oil field worker/
Velma, Oklahoma, 6/12/80/This photograph was printed
for/the Amon Carter Museum, Fort Worth, Texas."
Acquired from: the photographer

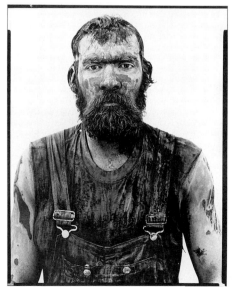
684

685. **REVEREND ANDREW GOODWIN, PASTOR, BAPTIST CHURCH, MILES CITY, MONTANA, 5/18/81 [from "In the American West: Photographs by Richard Avedon"]** (P1985.28.24)
Gelatin silver print mounted on aluminum panel. negative 1981, print 1985
Image: 47 x 37½ in. (119.4 x 95.2 cm.)
Mount: 50¼ x 39¼ in. (127.6 x 99.7 cm.)
Signed, bottom center mount verso and l.r. print recto: "Avedon"
Inscription, mount. verso, rubber stamp: "IN THE AMERICAN WEST/A project commissioned by the/ Amon Carter Museum, Fort Worth, Texas./ This photograph may not be reproduced without/the written permission of Richard Avedon Inc./Copyright © 1985 by Richard Avedon Inc./All rights reserved./This photograph was printed in 1985./Reverend Andrew Goodwin, pastor/ Baptist Church, Miles City, Montana, 5/18/81/ This photograph was printed for and first exhibited/at the Amon Carter Museum, Fort Worth, Texas/September 14– November 17, 1985."
Acquired from: the photographer

686. **RICHARD GARBER, DRIFTER, INTERSTATE 15, PROVO, UTAH, 8/20/80 [from "In the American West: Photographs by Richard Avedon"]** (P1985.28.110)
Gelatin silver print mounted on aluminum panel. negative 1980, print 1985
Image: 56 x 45 in. (142.2 x 114.3 cm.)
Mount: 59¾ x 47⅛ in. (151.8 x 119.7 cm.)
Signed, bottom center mount verso and l.r. print recto: "Avedon A.P. 1/2"
Inscription, mount verso, rubber stamp: "IN THE AMERICAN WEST/A project commissioned by the/ Amon Carter Museum, Fort Worth, Texas./ Richard Avedon warrants and represents that,/aside from the signed and numbered photographs/in this edition of 5 plus 2 artist's proofs, no/other original prints of this photograph will/be made by him or under his authority./ This photograph may not be reproduced without/the written permission of Richard Avedon Inc./Copyright © 1985 by Richard Avedon Inc./All rights reserved./This photograph was printed in 1985./Richard Garber, drifter/Interstate 15, Provo, Utah, 8/20/80/This photograph was printed for and first exhibited/ at the Amon Carter Museum, Fort Worth, Texas/September 14–November 17, 1985."
Acquired from: the photographer

*687. **RICHARD WHEATCROFT, RANCHER, JORDAN, MONTANA, 6/19/81 AND 6/27/83 [from "In the American West: Photographs by Richard Avedon"]** (P1985.28.35)
Gelatin silver print mounted on aluminum panel. negatives 1981 and 1983, print 1985
Image (diptych): a) 46¾ x 37½ in. (118.8 x 95.2 cm.)
b) 46¾ x 37½ in. (118.8 x 95.2 cm.)
overall image: 46¾ x 75 in. (118.8 x 190.4 cm.)
Mount: a) 50⅛ x 38½ in. (127.2 x 97.8 cm.)
b) 50⅛ x 38½ in. (127.2 x 97.8 cm.)
overall mount: 50⅛ x 77 in. (127.2 x 195.6 cm.)
Signed, bottom center mount verso and l.r. print recto (on both prints): "Avedon."
Inscription, mount verso, rubber stamp (on both prints): "IN THE AMERICAN WEST/A project commissioned by the/ Amon Carter Museum, Fort Worth, Texas./This photograph may not be reproduced without/the written permission of Richard Avedon Inc./Copyright © 1985 by Richard Avedon Inc./All rights reserved./This photograph was printed in 1985./Richard Wheatcroft, rancher/Jordan, Montana, 6/19/81 and 6/27/83/This photograph was printed for and first exhibited/at the Amon Carter Museum, Fort Worth, Texas/September 14–November 17, 1985."
Acquired from: the photographer

688. **RICK DAVIS, DRIFTER, INTERSTATE 94, BUFFALO, NORTH DAKOTA, 7/13/82 [from "In the American West: Photographs by Richard Avedon"]** (P1985.28.113)
Gelatin silver print mounted on aluminum panel. negative 1982, print 1985
Image: 41¼ x 33 in. (104.8 x 83.8 cm.)
Mount: 43¾ x 34½ in. (111.2 x 87.7 cm.)
Signed, bottom center mount verso and l.r. print recto: "Avedon A.P./1/2"
Inscription, mount verso, rubber stamp: "IN THE AMERICAN WEST/A project commissioned by the/ Amon Carter Museum, Fort Worth, Texas./ Richard Avedon warrants and represents that,/aside from the signed and numbered photographs/in this edition of 6 plus 2 artist's proofs, no/other original prints of this photograph will/be made by him or under his authority./ This photograph may not be reproduced without/the written permission of Richard Avedon Inc./Copyright © 1985 by Richard Avedon Inc./All rights reserved./This photograph was printed in 1985./Rick Davis, drifter/Interstate 94, Buffalo, North Dakota, 7/13/82/This photograph was printed for and first exhibited/at the Amon Carter Museum, Fort Worth, Texas/September 14–November 17, 1985."
Acquired from: the photographer

689. **RICK WALTERS, AUTO MECHANIC, THORA RASMUSSEN, WAITRESS, CALGARY, ALBERTA, 7/16/83 [from "In the American West: Photographs by Richard Avedon"]** (P1985.28.95)
Gelatin silver print mounted on aluminum panel. negative 1983, print 1985
Image: 15½ x 19 in. (39.3 x 48.2 cm.)
Mount: 16½ x 19½ in. (41.9 x 49.5 cm.)
Signed, bottom edge mount verso and l.r. print recto: "Avedon"
Inscription, mount verso, rubber stamp: "IN THE AMERICAN WEST/A project commissioned by the/ Amon Carter Museum, Fort Worth, Texas./ This photograph may not be reproduced without/the written permission of Richard Avedon Inc./Copyright © 1985 by Richard Avedon Inc./All rights reserved./This photograph was printed in 1985./Rick Walters, auto mechanic, Thora Rasmussen, waitress/Calgary, Alberta, 7/16/83/ This photograph was printed for and first exhibited/at the Amon Carter Museum, Fort Worth, Texas/September 14– November 17, 1985."
Acquired from: the photographer

*690. **RITA CARL, LAW ENFORCEMENT STUDENT, SWEETWATER, TEXAS, 3/10/79 [from "In the American West: Photographs by Richard Avedon"]** (P1985.28.15)
Gelatin silver print mounted on aluminum panel. negative 1979, print 1985
Image: 47 x 37½ in. (119.4 x 95.2 cm.)
Mount: 50⅛ x 39¼ in. (127.2 x 99.7 cm.)
Signed, bottom center mount verso and l.r. print recto: "Avedon A.P./1/2"
Inscription, mount verso, rubber stamp: "IN THE AMERICAN WEST/A project commissioned by the/ Amon Carter Museum, Fort Worth, Texas./ This photograph may not be reproduced without/the written permission of Richard Avedon Inc./Copyright © 1985 by Richard Avedon Inc./All rights reserved./This photograph was printed in 1985./Rita Carl, law enforcement student/ Sweetwater, Texas, 3/10/79/This photograph was printed for and first exhibited/at the Amon Carter Museum, Fort Worth, Texas/September 14–November 17, 1985."
Acquired from: the photographer

691. **ROBERT DIXON, MEAT PACKER, AURORA, COLORADO, 6/15/83 [from "In the American West: Photographs by Richard Avedon"]** (P1985.28.17)
Gelatin silver print mounted on aluminum panel. negative 1983, print 1985
Image: 47 x 37 ¾ in. (119.4 x 95.9 cm.)
Mount: 50 ⅛ x 39 ¼ in. (127.2 x 99.7 cm.)
Signed, bottom center mount verso and l.r. print recto: "Avedon"
Inscription, mount verso, rubber stamp: "IN THE AMERICAN WEST/A project commissioned by the/ Amon Carter Museum, Fort Worth, Texas./ This photograph may not be reproduced without/the written permission of Richard Avedon Inc./Copyright © 1985 by Richard Avedon Inc./All rights reserved./This photograph was printed in 1985./Robert Dixon, meat packer/Aurora, Colorado, 6/15/83/This photograph was printed for and first exhibited/at the Amon Carter Museum, Fort Worth, Texas/ September 14–November 17, 1985."
Acquired from: the photographer

692. **ROBERT GONZALEZ, PRISONER, BEXAR COUNTY JAIL, SAN ANTONIO, TEXAS, 6/5/80 [from "In the American West: Photographs by Richard Avedon"]** (P1985.28.103)
Gelatin silver print mounted on aluminum panel. negative 1980, print 1985
Image: 19 x 15 ¼ in. (48.2 x 38.7 cm.)
Mount: 20 x 16 in. (50.8 x 40.7 cm.)
Signed, bottom center mount verso and l.r. print recto: "Avedon"
Inscription, mount verso, rubber stamp: "IN THE AMERICAN WEST/A project commissioned by the/ Amon Carter Museum, Fort Worth, Texas./ This photograph may not be reproduced without/the written permission of Richard Avedon Inc./Copyright © 1985 by Richard Avedon Inc./All rights reserved./This photograph was printed in 1985./Robert Gonzalez, prisoner/Bexar County Jail, San Antonio, Texas, 6/5/80/ This photograph was printed for and first exhibited/at the Amon Carter Museum, Fort Worth, Texas/September 14–November 17, 1985."
Acquired from: the photographer

693. **ROBERTO LOPEZ, OIL FIELD WORKER, LYONS, TEXAS, 9/28/80 [from "In the American West: Photographs by Richard Avedon"]** (P1985.28.76)
Gelatin silver print mounted on aluminum panel. negative 1980, print 1985
Image: 56 ¼ x 45 in. (142.8 x 114.3 cm.)
Mount: 59 ¾ x 47 ⅛ in. (151.8 x 119.7 cm.)
Signed, bottom center mount verso and l.r. print recto: "Avedon A.P./1/2"
Inscription, mount verso, rubber stamp: "IN THE AMERICAN WEST/A project commissioned by the/ Amon Carter Museum, Fort Worth, Texas./ Richard Avedon warrants and represents that,/aside from the signed and numbered photographs/in this edition of 6 plus 2 artist's proofs, no/other original prints of this photograph will/be made by him or under his authority./ This photograph may not be reproduced without/the written permission of Richard Avedon Inc./Copyright © 1985 by Richard Avedon Inc./All rights reserved./This photograph was printed in 1985./Roberto Lopez, oil field worker/Lyons, Texas, 9/28/80/This photograph was printed for and first exhibited/at the Amon Carter Museum, Fort Worth, Texas/ September 14–November 17, 1985."
Acquired from: the photographer

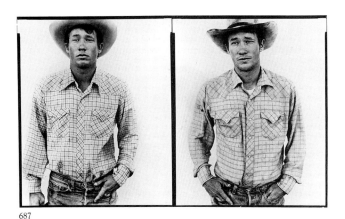
687

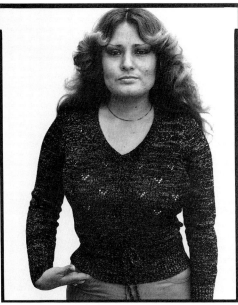
690

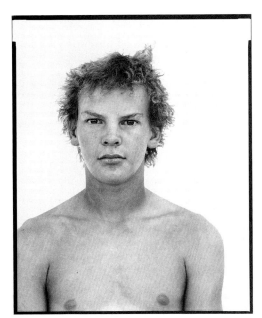
695

694. ROCHELLE JUSTIN, PATIENT, STATE HOSPITAL, LAS VEGAS, NEW MEXICO, 4/1/80 [from "In the American West: Photographs by Richard Avedon"] (P1985.28.69)
Gelatin silver print mounted on aluminum panel. negative 1980, print 1985
Image: 41 ½ x 33 ½ in. (105.4 x 85.1 cm.)
Mount: 43 ¾ x 34 ¾ in. (111.2 x 88.3 cm.)
Signed, center mount verso and l.r. print recto: "Avedon A.P./1/2"
Inscription, mount verso, rubber stamp: "IN THE AMERICAN WEST/A project commissioned by the/ Amon Carter Museum, Fort Worth, Texas./ Richard Avedon warrants and represents that,/aside from the signed and numbered photographs/in this edition of 6 plus 2 artist's proofs, no/other original prints of this photograph will/be made by him or under his authority./ This photograph may not be reproduced without/the written permission of Richard Avedon Inc./Copyright © 1985 by Richard Avedon Inc./All rights reserved./This photograph was printed in 1985./Rochelle Justin, patient/State Hospital, Las Vegas, New Mexico, 4/1/80/This photograph was printed for and first exhibited/at the Amon Carter Museum, Fort Worth, Texas/ September 14–November 17, 1985."
Acquired from: the photographer

*695. ROCKY BURCH, FIFTEEN YEAR OLD, BURLEY, IDAHO, 8/19/83 [from "In the American West: Photographs by Richard Avedon"] (P1985.28.7)
Gelatin silver print mounted on aluminum panel. negative 1983, print 1985
Image: 46 ¾ x 37 ½ in. (118.8 x 95.2 cm.)
Mount: 50 ⅛ x 39 ¼ in. (127.2 x 99.7 cm.)
Signed, center mount verso and l.r. print recto: "Avedon"
Inscription, mount verso, rubber stamp: "IN THE AMERICAN WEST/A project commissioned by the/ Amon Carter Museum, Fort Worth, Texas./ This photograph may not be reproduced without/the written permission of Richard Avedon Inc./Copyright © 1985 by Richard Avedon Inc./All rights reserved./This photograph was printed in 1985./Rocky Burch, fifteen year old/Burley, Idaho, 8/19/83/This photograph was printed for and first exhibited/at the Amon Carter Museum, Fort Worth, Texas/ September 14–November 17, 1985."
Acquired from: the photographer

696. ROGER SKAARLAND, JIM BINGHAM, COAL MINERS, RELIANCE, WYOMING, 8/29/79 [from "In the American West: Photographs by Richard Avedon"] (P1985.28.115)
Gelatin silver print mounted on aluminum panel. negative 1979, print 1985
Image: 56 ¼ x 45 in. (142.8 x 114.3 cm.)
Mount: 59 ½ x 47 in. (151.1 x 119.4 cm.)
Signed, bottom center mount verso and l.r. print recto: "Avedon A.P./1/2"
Inscription, mount verso, rubber stamp: "IN THE AMERICAN WEST/A project commissioned by the/ Amon Carter Museum, Fort Worth, Texas./ Richard Avedon warrants and represents that,/aside from the signed and numbered photographs/in this edition of 6 plus 2 artist's proofs, no/other original prints of this photograph will be/made by him or under his authority except for one/ 80 ½ x 64 ½" print made for exhibition purposes./This photograph may not be reproduced without/the written permission of Richard Avedon Inc./Copyright © 1985 by Richard Avedon Inc./All rights reserved./This photograph was printed in 1985./Roger Skaarland, Jim Bingham, coal miners/ Reliance, Wyoming, 8/29/79/This photograph was printed for/the Amon Carter Museum, Fort Worth, Texas."
Acquired from: the photographer

*697. ROGER TIMS, JIM DUNCAN, LEONARD MARKLEY, DON BELAK, COAL MINERS, RELIANCE, WYOMING, 8/29/79 [from "In the American West: Photographs by Richard Avedon"] (P1985.28.121)
Gelatin silver print mounted on aluminum panel. negatives 1979, print 1985
Image (triptych): a) 56 x 45 in. (142.2 x 114.3 cm.)
 b) 56 x 45 in. (142.2 x 114.3 cm.)
 c) 56 x 45 ⅛ in. (142.2 x 114.6 cm.)
overall image: 56 x 135 ⅛ in. (142.2 x 343.2 cm.)
Mount: a) 59 ¾ x 46 ¼ in. (151.8 x 117.5 cm.)
 b) 59 ½ x 45 in. (151.1 x 114.3 cm.)
 c) 59 ¾ x 46 ¼ in. (151.8 x 117.5 cm.)
overall mount: 59 ¾ x 137 ½ in. (151.8 x 349.3 cm.)
Signed, bottom center mount verso and l.r. print recto (on all three prints): "Avedon A.P./1/2"
Inscription, mount verso, rubber stamp (on all three prints): "IN THE AMERICAN WEST/A project commissioned by the/Amon Carter Museum, Fort Worth, Texas./Richard Avedon warrants and represents that,/ aside from the signed and numbered photographs/in this edition of 6 plus 2 artist's proofs, no/other original prints of this photograph will/be made by him or under his authority./This photograph may not be reproduced without/the written permission of Richard Avedon Inc./Copyright © 1985 by Richard Avedon Inc./All rights reserved./This photograph was printed in 1985./Roger Tims, Jim Duncan, Leonard Markley, Don Belak, coal miners/Reliance, Wyoming, 8/29/79/This photograph was printed for and first exhibited/at the Amon Carter Museum, Fort Worth, Texas/ September 14–November 17, 1985."
Acquired from: the photographer

*698. RONALD FISCHER, BEEKEEPER, DAVIS, CALIFORNIA, 5/9/81 [from "In the American West: Photographs by Richard Avedon"] (P1985.28.107)
Gelatin silver print mounted on aluminum panel. negative 1981, print 1985
Image: 56 ¼ x 45 in. (142.8 x 114.3 cm.)
Mount: 59 ¾ x 47 ¼ in. (151.8 x 120.0 cm.)
Signed, bottom center mount verso and l.r. print recto: "Avedon A.P./1/2"
Inscription, mount verso, rubber stamp: "IN THE AMERICAN WEST/A project commissioned by the/ Amon Carter Museum, Fort Worth, Texas./ Richard Avedon warrants and represents that,/aside from the signed and numbered photographs/in this edition of 6 plus 2 artist's proofs, no/other original prints of this photograph will/be made by him or under his authority./This photograph may not be reproduced without/the written permission of Richard Avedon Inc./Copyright © 1985 by Richard Avedon Inc./All rights reserved./This photograph was printed in 1985./Ronald Fischer, beekeeper/Davis, California, 5/9/81/This photograph was printed for and first exhibited/at the Amon Carter Museum, Fort Worth, Texas/ September 14–November 17, 1985."
Acquired from: the photographer

699. ROY GUSTAVSON, UNEMPLOYED COPPER MINER, AND HIS WIFE JUDY, WAITRESS, BUTTE, MONTANA, 7/1/83 [from "In the American West: Photographs by Richard Avedon"] (P1985.28.38)
Gelatin silver print mounted on aluminum panel. negative 1983, print 1985
Image: 47 x 37 ½ in. (119.4 x 95.2 cm.)
Mount: 50 ⅛ x 39 ¼ in. (127.2 x 99.7 cm.)
Signed, bottom center mount verso and l.r. print recto: "Avedon"
Inscription, mount verso, rubber stamp: "IN THE AMERICAN WEST/A project commissioned by the/ Amon Carter Museum, Fort Worth, Texas./ This photograph may not be reproduced without/the written permission of Richard Avedon Inc./Copyright © 1985 by Richard Avedon Inc./All rights reserved./This photograph was printed in 1985./Roy Gustavson, unemployed copper miner, and his wife Judy, waitress/Butte, Montana, 7/1/83/ This photograph was printed for and first exhibited/at the

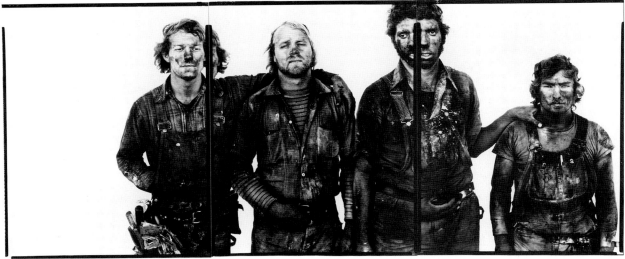

697

Amon Carter Museum, Fort Worth, Texas/September 14–
November 17, 1985."
Acquired from: the photographer

700. **ROY HONEYCUTT, RODEO STOCK CONTRACTOR,
ALAMOSA, COLORADO, 6/13/83 [from "In the
American West: Photographs by Richard Avedon"]**
(P1985.28.33)
Gelatin silver print mounted on aluminum panel. negative
1983, print 1985
Image: 56⅛ x 45¼ in. (142.6 x 114.9 cm.)
Mount: 59¾ x 47 in. (151.8 x 119.4 cm.)
Signed, bottom center mount verso and l.r. print recto:
"Avedon"
Inscription, mount verso, rubber stamp: "IN THE
AMERICAN WEST/A project commissioned by the/
Amon Carter Museum, Fort Worth, Texas./ This
photograph may not be reproduced without/the written
permission of Richard Avedon Inc./Copyright © 1985
by Richard Avedon Inc./All rights reserved./This
photograph was printed in 1985./Roy Honeycutt, rodeo
stock contractor/Alamosa, Texas [sic], 6/13/83/This
photograph was printed for and first exhibited/at the
Amon Carter Museum, Fort Worth, Texas/September 14–
November 17, 1985."
Acquired from: the photographer

701. **RUBY HOLDEN, PAWNBROKER, HENDERSON,
NEVADA, 12/17/80 [from "In the American West:
Photographs by Richard Avedon"]** (P1985.28.30)
Gelatin silver print mounted on aluminum panel. negative
1980, print 1985
Image: 47 x 37¾ in. (119.4 x 95.9 cm.)
Mount: 50⅛ x 39¼ in. (127.2 x 99.7 cm.)
Signed, bottom center mount verso and l.r. print recto:
"Avedon A.P./1/2"
Inscription, mount verso, rubber stamp: "IN THE
AMERICAN WEST/A project commissioned by the/
Amon Carter Museum, Fort Worth, Texas./ Richard
Avedon warrants and represents that,/aside from the signed
and numbered photographs/in this edition of 5 plus 2
artist's proofs, no/other original prints of this photograph
will/be made by him or under his authority./This
photograph may not be reproduced without/the written
permission of Richard Avedon Inc./Copyright © 1985 by
Richard Avedon Inc./All rights reserved./This photograph
was printed in 1985./Ruby Holden, pawnbroker/Henderson,
Nevada, 12/17/80/This photograph was printed for and first
exhibited/at the Amon Carter Museum, Fort Worth, Texas/
September 14–November 17, 1985."
Acquired from: the photographer

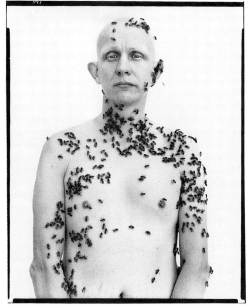

698

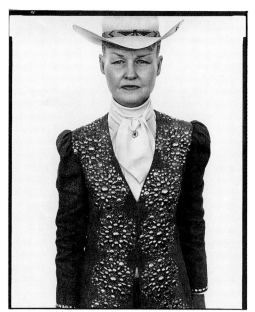

702

*702. **RUBY MERCER, PUBLICIST, FRONTIER DAYS, CHEYENNE, WYOMING, 7/31/82 [from "In the American West: Photographs by Richard Avedon"]** (P1985.28.73)
Gelatin silver print mounted on aluminum panel. negative 1982, print 1985
Image: 41 ¼ x 33 ⅛ in. (104.8 x 84.2 cm.)
Mount: 43 ¼ x 34 ¼ in. (111.2 x 88.3 cm.)
Signed, bottom center mount verso and l.r. print recto: "Avedon"
Inscription, mount verso, rubber stamp: "IN THE AMERICAN WEST/A project commissioned by the/ Amon Carter Museum, Fort Worth, Texas./ This photograph may not be reproduced without/the written permission of Richard Avedon Inc./Copyright © 1985 by Richard Avedon Inc./All rights reserved./This photograph was printed in 1985./Ruby Mercer, publicist/Frontier Days, Cheyenne, Wyoming, 7/31/82/This photograph was printed for and first exhibited/at the Amon Carter Museum, Fort Worth, Texas/September 14–November 17, 1985."
Acquired from: the photographer

*703. **RUSSELL LAIRD, TAMMY BAKER, SEVENTEEN YEAR OLDS, SWEETWATER, TEXAS, 3/10/79 [from "In the American West: Photographs by Richard Avedon"]** (P1985.28.28)
Gelatin silver print mounted on aluminum panel. negative 1979, print 1985
Image: 46 ¾ x 37 ½ in. (118.8 x 95.2 cm.)
Mount: 50 ⅛ x 39 ¼ in. (127.2 x 99.7 cm.)
Signed, bottom center mount verso and l.r. print recto: "Avedon."
Inscription, mount verso, rubber stamp: "IN THE AMERICAN WEST/A project commissioned by the/ Amon Carter Museum, Fort Worth, Texas./ This photograph may not be reproduced without/the written permission of Richard Avedon Inc./Copyright © 1985 by Richard Avedon Inc./All rights reserved./This photograph was printed in 1985./Russell Laird, Tammy Baker, seventeen year olds/Sweetwater, Texas, 3/10/79/This photograph was printed for and first exhibited/at the Amon Carter Museum, Fort Worth, Texas/September 14– November 17, 1985."
Acquired from: the photographer

704. **RUSTY McCRICKARD, JANITOR, TRACEY FEATHERSTON, MOTEL MAID, DIXON, CALIFORNIA, 5/10/81 [from "In the American West: Photographs by Richard Avedon"]** (P1985.28.75)
Gelatin silver print mounted on aluminum panel. negative 1981, print 1985
Image: 46 ¼ x 37 ½ in. (118.8 x 95.2 cm.)
Mount: 50 ⅛ x 39 ¼ in. (127.2 x 99.7 cm.)
Signed, bottom center mount verso and l.r. print recto: "Avedon A.P./1/2"
Inscription, mount verso, rubber stamp: "IN THE AMERICAN WEST/A project commissioned by the/ Amon Carter Museum, Fort Worth, Texas./Richard Avedon warrants and represents that,/ aside from the signed and numbered photographs/in this edition of 6 plus 2 artist's proofs, no/other original prints of this photograph will/be made by him or under his authority./ This photograph may not be reproduced without/the written permission of Richard Avedon Inc./Copyright © 1985 by Richard Avedon Inc./All rights reserved./This photograph was printed in 1985./Rusty McCrickard, janitor, Tracey Featherston, motel maid/Dixon, California, 5/10/81."
Acquired from: the photographer

705. **SAMYE HUNT, ELEMENTARY SCHOOL TEACHER, AND HER DAUGHTER SUZI GAMEZ, HOUSEWIFE, FORT WORTH, TEXAS, 1/29/80 [from "In the American West: Photographs by Richard Avedon"]** (P1985.28.88)
Gelatin silver print mounted on aluminum panel. negative 1980, print 1985
Image: 19 x 15 ¼ in. (48.2 x 38.7 cm.)
Mount: 20 x 16 in. (50.8 x 40.7 cm.)
Signed, bottom center mount verso and l.r. print recto: "Avedon."
Inscription, mount verso, rubber stamp: "IN THE AMERICAN WEST/A project commissioned by the/ Amon Carter Museum, Fort Worth, Texas./ This photograph may not be reproduced without/the written permission of Richard Avedon Inc./Copyright © 1985 by Richard Avedon Inc./All rights reserved./This photograph was printed in 1985./Samye Hunt, elementary school teacher, and her daughter Suzi Gamez, housewife/ Fort Worth, Texas, 1/29/80/This photograph was printed for and first exhibited/at the Amon Carter Museum, Fort Worth, Texas/ September 14–November 17, 1985."
Acquired from: the photographer

*706. **SANDRA BENNETT, TWELVE YEAR OLD, ROCKY FORD, COLORADO, 8/23/80 [from "In the American West: Photographs by Richard Avedon"]** (P1985.28.31)
Gelatin silver print mounted on aluminum panel. negative 1980, print 1985
Image: 56 ¼ x 45 in. (142.8 x 114.3 cm.)
Mount: 60 x 47 in. (152.4 x 119.4 cm.)
Signed, bottom center mount verso and l.r. print recto: "Avedon A.P. 1/2"
Inscription, mount verso, rubber stamp: "IN THE AMERICAN WEST/A project commissioned by the/ Amon Carter Museum, Fort Worth, Texas./ Richard Avedon warrants and represents that,/aside from the signed and numbered photographs/in this edition of 6 plus 2 artist's proofs, no/other original prints of this photograph will be/made by him or under his authority except for one/ 80 ½ x 64 ½" print made for exhibition purposes./This photograph may not be reproduced without/the written permission of Richard Avedon Inc./Copyright © 1985 by Richard Avedon Inc./All rights reserved./This photograph was printed in 1985./Sandra Bennett, twelve year old/ Rocky Ford, Colorado, 8/23/80/This photograph was printed for the/ Amon Carter Museum, Fort Worth, Texas."
Acquired from: the photographer

707. **SHAWNA CALLAHAN, THIRTEEN YEAR OLD, CHEYENNE, WYOMING, 7/30/82 [from "In the American West: Photographs by Richard Avedon"]** (P1985.28.8)
Gelatin silver print mounted on aluminum panel. negative 1982, print 1985
Image: 56 ¼ x 45 ¼ in. (142.8 x 114.3 cm.)
Mount: 59 ¾ x 47 ⅛ in. (151.8 x 119.7 cm.)
Signed, bottom center mount verso and l.r. print recto: "Avedon."
Inscription, mount verso, rubber stamp: "IN THE AMERICAN WEST/A project commissioned by the/ Amon Carter Museum, Fort Worth, Texas./ This photograph may not be reproduced without/the written permission of Richard Avedon Inc./Copyright © 1985 by Richard Avedon Inc./All rights reserved./This photograph was printed in 1985./Shawna Callahan, thirteen year old/ Cheyenne, Wyoming, 7/30/82/This photograph was printed for and first exhibited/at the Amon Carter Museum, Fort Worth, Texas/September 14–November 17, 1985."
Acquired from: the photographer

708. **SHEEP, SLAUGHTERHOUSE, ENNIS, MONTANA, 6/30/83 [from "In the American West: Photographs by Richard Avedon"]** (P1985.28.112)
Gelatin silver print mounted on aluminum panel. negatives 1983, print 1985
Image (diptych): a) 56 x 45 in. (142.2 x 114.3 cm.)
 b) 56 x 45 ⅛ in. (142.2 x 114.7 cm.)
 overall image: 56 x 90 ⅛ in. (142.2 x 229.0 cm.)
Mount: a) 59 ¾ x 46 ⅛ in. (151.8 x 117.2 cm.)
 b) 59 ¾ x 46 ⅛ in. (151.8 x 117.2 cm.)
 overall mount: 59 ¾ x 92 ¼ in. (151.8 x 234.4 cm.)
Signed, bottom center mount verso and l.r. print recto: a) "Avedon" and b) "Avedon."
Inscription, mount verso, rubber stamp (on both prints): "IN THE AMERICAN WEST/A project commissioned by the/ Amon Carter Museum, Fort Worth, Texas./This

photograph may not be reproduced without/ the written permission of Richard Avedon Inc./Copyright © 1985 by Richard Avedon Inc./All rights reserved./This photograph was printed in 1985./Sheep/Slaughterhouse, Ennis, Montana, 6/30/83/ This photograph was printed for and first exhibited/at the Amon Carter Museum, Fort Worth, Texas/September 14–November 17, 1985."
Acquired from: the photographer

709. **SHELIA BOLIN, SEVENTEEN YEAR OLD, LAMESA, TEXAS, 3/10/79 [from "In the American West: Photographs by Richard Avedon"]** (P1985.28.101)
Gelatin silver print mounted on aluminum panel. negative 1979, print 1985
Image: 18 ¾ x 15 ⅛ in. (47.6 x 38.4 cm.)
Mount: 20 x 16 in. (50.8 x 40.7 cm.)
Signed, bottom center mount verso and l.r. print recto: "Avedon"
Inscription, mount verso, rubber stamp: "IN THE AMERICAN WEST/A project commissioned by the/ Amon Carter Museum, Fort Worth, Texas./ This photograph may not be reproduced without/the written permission of Richard Avedon Inc./Copyright © 1985 by Richard Avedon Inc./All rights reserved./This photograph was printed in 1985./Shelia Bolin, seventeen year old/ Lamesa, Texas, 3/10/79/This photograph was printed for and first exhibited/at the Amon Carter Museum, Fort Worth, Texas/September 14–November 17, 1985."
Acquired from: the photographer

710. **STAN RILEY, JAMES LAW, OIL FIELD WORKERS, ALBANY, TEXAS, 6/10/79 [from "In the American West: Photographs by Richard Avedon"]** (P1985.28.61)
Gelatin silver print mounted on aluminum panel. negative 1979, print 1985
Image: 56 ¼ x 45 ½ in. (142.8 x 115.6 cm.)
Mount: 59 ¾ x 47 ⅛ in. (151.8 x 119.8 cm.)
Signed, bottom center mount verso and l.r. print recto: "Avedon."
Inscription, mount verso, rubber stamp: "IN THE AMERICAN WEST/A project commissioned by the/ Amon Carter Museum, Fort Worth, Texas./ This photograph may not be reproduced without/the written permission of Richard Avedon Inc./Copyright © 1985 by Richard Avedon Inc./All rights reserved./This photograph was printed in 1985./Stan Riley, James Law, oil field workers/Albany, Texas, 6/10/79/This photograph was printed for and first exhibited/at the Amon Carter Museum, Fort Worth, Texas/September 14–November 17, 1985."
Acquired from: the photographer

711. **STEER, SLAUGHTERHOUSE, AMARILLO, TEXAS, 11/19/81 [from "In the American West: Photographs by Richard Avedon"]** (P1985.28.106)
Gelatin silver print mounted on aluminum panel. negative 1981, print 1985
Image: 56 ½ x 45 ⅛ in. (143.5 x 114.6 cm.)
Mount: 59 ¾ x 47 ⅛ in. (151.8 x 119.8 cm.)
Signed, bottom center mount verso and l.r. print recto: "Avedon A.P./1/2"
Inscription, mount verso, rubber stamp: "IN THE AMERICAN WEST/A project commissioned by the/ Amon Carter Museum, Fort Worth, Texas./ Richard Avedon warrants and represents that,/aside from the signed and numbered photographs/in this edition of 4 plus 2 artist's proofs, no/other original prints of this photograph will/be made by him or under his authority./This photograph may not be reproduced without/the written permission of Richard Avedon Inc./Copyright © 1985 by Richard Avedon Inc./All rights reserved./This photograph was printed in 1985./Steer/ Slaughterhouse, Amarillo, Texas, 11/19/81/This photograph was printed for and first exhibited/at the Amon Carter Museum, Fort Worth, Texas/September 14–November 17, 1985."
Acquired from: the photographer

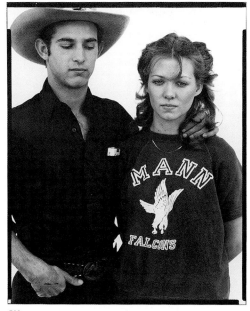
703

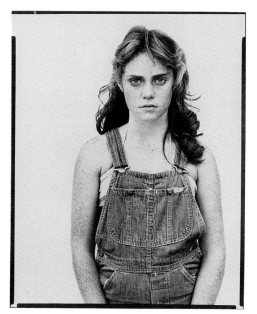
706

*712. **STEER, SLAUGHTERHOUSE, OMAHA, NEBRASKA,**
8/10/79 [from "In the American West: Photographs by
Richard Avedon"] (P1985.28.108)
Gelatin silver print mounted on aluminum panel. negative
1979, print 1985
Image: 56 x 44 ¾ in. (142.3 x 113.7 cm.)
Mount: 59 ¾ x 47 ⅛ in. (151.8 x 119.7 cm.)
Signed, bottom center mount verso and l.r. print recto:
"Avedon A. P./1/2"
Inscription, mount verso, rubber stamp: "IN THE
AMERICAN WEST/A project commissioned by the/
Amon Carter Museum, Fort Worth, Texas./ Richard
Avedon warrants and represents that,/aside from the signed
and numbered photographs/in this edition of 3 plus 2
artist's proofs, no/other original prints of this photograph
will/be made by him or under his authority./This
photograph may not be reproduced without/the written
permission of Richard Avedon Inc./Copyright © 1985 by
Richard Avedon Inc./All rights reserved./This photograph
was printed in 1985./Steer/Slaughterhouse, Omaha,
Nebraska, 8/10/79/This photograph was printed for and first
exhibited/at the Amon Carter Museum, Fort Worth, Texas/
September 14–November 17, 1985."
Acquired from: the photographer

713. **STEVEN O'NEILL, FOURTEEN YEAR OLD, MILES**
CITY, MONTANA, 6/1/84 [from "In the American West:
Photographs by Richard Avedon"] (P1985.28.97)
Gelatin silver print mounted on aluminum panel. negative
1984, print 1985
Image: 46 ¾ x 37 ½ in. (118.8 x 95.2 cm.)
Mount: 50 ¼ x 39 ¼ in. (127.6 x 99.7 cm.)
Signed, bottom center mount verso and l.r. print recto:
"Avedon"
Inscription, mount verso, rubber stamp: "IN THE
AMERICAN WEST/A project commissioned by the/
Amon Carter Museum, Fort Worth, Texas./ This
photograph may not be reproduced without/the written
permission of Richard Avedon Inc./Copyright © 1985 by
Richard Avedon Inc./All rights reserved./This photograph
was printed in 1985./Steven O'Neill, fourteen year old/
Miles City, Montana, 6/1/84/This photograph was printed
for and first exhibited/at the Amon Carter Museum, Fort
Worth, Texas/September 14–November 17, 1985."
Acquired from: the photographer

*714. **TERESA WALDRON, FOURTEEN YEAR OLD, JOE**
COLLEGE, RODEO CONTESTANT, SIDNEY, IOWA,
8/11/79 [from "In the American West: Photographs by
Richard Avedon"] (P1985.28.29)
Gelatin silver print mounted on aluminum panel. negative
1979, print 1985
Image: 46 ¾ x 37 ½ in. (118.8 x 95.2 cm.)
Mount: 50 ⅛ x 39 ¼ in. (127.2 x 99.7 cm.)
Signed, bottom center mount verso and l.r. print recto:
"Avedon A. P./1/2"
Inscription, mount verso, rubber stamp: "IN THE
AMERICAN WEST/A project commissioned by the/
Amon Carter Museum, Fort Worth, Texas./ Richard
Avedon warrants and represents that,/aside from the signed
and numbered photographs/in this edition of 6 plus 2
artist's proofs, no/other original prints of this photograph
will/be made by him or under his authority./This
photograph may not be reproduced without/the written
permission of Richard Avedon Inc./Copyright © 1985 by
Richard Avedon Inc./All rights reserved./This photograph
was printed in 1985./Teresa Waldron, fourteen year old,
Joe College, rodeo contestant/Sidney, Iowa, 8/11/79/This
photograph was printed for and first exhibited/ at the
Amon Carter Museum, Fort Worth, Texas/September 14–
November 17, 1985."
Acquired from: the photographer

*715. **TOM STROUD, OIL FIELD WORKER, VELMA,**
OKLAHOMA, 6/12/80 [from "In the American West:
Photographs by Richard Avedon"] (P1985.28.56)
Gelatin silver print mounted on aluminum panel. negative
1980, print 1985
Image: 56 ¼ x 45 ¼ in. (142.8 x 114.9 cm.)
Mount: 59 ¾ x 47 ⅛ in. (151.8 x 119.7 cm.)
Signed, bottom center mount verso and l.r. print recto:
"Avedon A. P. 1/2"
Inscription, mount verso, rubber stamp: "IN THE
AMERICAN WEST/A project commissioned by the/
Amon Carter Museum, Fort Worth, Texas./ Richard
Avedon warrants and represents that,/aside from the signed
and numbered photographs/in this edition of 6 plus 2
artist's proofs, no/other original prints of this photograph
will/be made by him or under his authority./This
photograph may not be reproduced without/the written
permission of Richard Avedon Inc./Copyright © 1985 by
Richard Avedon Inc./All rights reserved./This photograph
was printed in 1985./Tom Stroud, oil field worker/Velma,
Oklahoma, 6/12/80/This photograph was printed for and
first exhibited/at the Amon Carter Museum, Fort Worth,
Texas/September 14–November 17, 1985."
Acquired from: the photographer

716. **TONY PETROSKY, SEVENTEEN YEAR OLD, CLANCY,**
MONTANA, 8/26/79 [from "In the American West:
Photographs by Richard Avedon"] (P1985.28.98)
Gelatin silver print mounted on aluminum panel. negative
1979, print 1985
Image: 19 x 15 ¼ in. (48.2 x 38.7 cm.)
Mount: 20 x 16 in. (50.8 x 40.7 cm.)
Signed, bottom center mount verso and l.r. print recto:
"Avedon"
Inscription, mount verso, rubber stamp: "IN THE
AMERICAN WEST/A project commissioned by the/
Amon Carter Museum, Fort Worth, Texas./ This
photograph may not be reproduced without/the written
permission of Richard Avedon Inc./Copyright © 1985 by
Richard Avedon Inc./All rights reserved./This photograph
was printed in 1985./Tony Petrosky, seventeen year old/
Clancy, Montana, 8/26/79/This photograph was printed
for and first exhibited/at the Amon Carter Museum, Fort
Worth, Texas/September 14–November 17, 1985."
Acquired from: the photographer

*717. **UNIDENTIFIED MIGRANT WORKER, EAGLE PASS,**
TEXAS, 12/10/79 [from "In the American West:
Photographs by Richard Avedon"] (P1985.28.19)
Gelatin silver print mounted on aluminum panel. negative
1979, print 1985
Image: 56 ¼ x 45 ¼ in. (142.9 x 114.9 cm.)
Mount: 59 ½ x 47 ⅛ in. (151.1 x 119.7 cm.)
Signed, bottom center mount verso and l.r. print recto:
"Avedon A. P./1/2"
Inscription, mount verso, rubber stamp: "IN THE
AMERICAN WEST/A project commissioned by the/
Amon Carter Museum, Fort Worth, Texas./ Richard
Avedon warrants and represents that,/aside from the signed
and numbered photographs/in this edition of 6 plus 2
artist's proofs, no/other original prints of this photograph
will/be made by him or under his authority./This
photograph may not be reproduced without/the written
permission of Richard Avedon Inc./Copyright © 1985 by
Richard Avedon Inc./All rights reserved./This photograph
was printed in 1985./Unidentified migrant worker/Eagle
Pass, Texas, 12/10/79/This photograph was printed for and
first exhibited/at the Amon Carter Museum, Fort Worth,
Texas/September 14–November 17, 1985."
Acquired from: the photographer

712

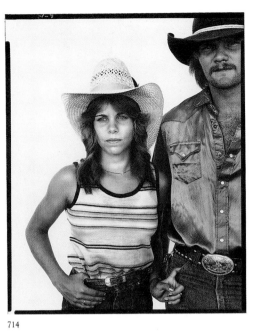

714

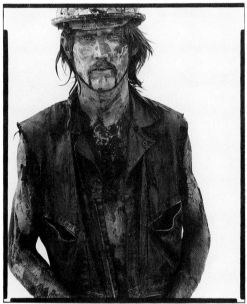

715

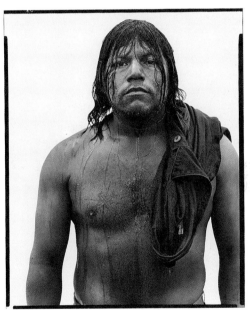

717

*718. **VALENTINO CURLEY, GRAVE DIGGER, NAVAJO RESERVATION, GANADO, ARIZONA, 12/6/80 [from "In the American West: Photographs by Richard Avedon"]** (P1985.28.66)
Gelatin silver print mounted on aluminum panel. negative 1980, print 1985
Image: 41¼ x 33 in. (104.8 x 83.8 cm.)
Mount: 43¾ x 34¾ in. (111.2 x 88.3 cm.)
Signed, center mount verso and l.r. print recto: "Avedon A.P. 1/2"
Inscription, mount verso, rubber stamp: "IN THE AMERICAN WEST/A project commissioned by the/ Amon Carter Museum, Fort Worth, Texas./ Richard Avedon warrants and represents that,/aside from the signed and numbered photographs/in this edition of 6 plus 2 artist's proofs, no/other original prints of this photograph will/be made by him or under his authority./This photograph may not be reproduced without/the written permission of Richard Avedon Inc./Copyright © 1985 by Richard Avedon Inc./All rights reserved./This photograph was printed in 1985./Valentino Curley, grave digger/Navajo Reservation, Ganado, Arizona, 12/6/80/This photograph was printed for and first exhibited/at the Amon Carter Museum, Fort Worth, Texas/September 14–November 17, 1985."
Acquired from: the photographer

*719. **VIVIAN RICHARDSON AND HER GRANDDAUGHTER HEIDI ZACHER, DEADWOOD, SOUTH DAKOTA, 8/6/82 [from "In the American West: Photographs by Richard Avedon"]** (P1985.28.36)
Gelatin silver print mounted on aluminum panel. negative 1982, print 1985
Image: 47 x 37¾ in. (119.4 x 95.9 cm.)
Mount: 50⅛ x 39¼ in. (127.2 x 99.7 cm.)
Signed, bottom center mount verso and l.r. print recto: "Avedon A.P./1/2"
Inscription, mount verso, rubber stamp: "IN THE AMERICAN WEST/A project commissioned by the/ Amon Carter Museum, Fort Worth, Texas./ Richard Avedon warrants and represents that,/aside from the signed and numbered photographs/in this edition of 6 plus 2 artist's proofs, no/other original prints of this photograph will/be made by him or under his authority./This photograph may not be reproduced without/the written permission of Richard Avedon Inc./Copyright © 1985 by Richard Avedon Inc./All rights reserved./This photograph was printed in 1985./Vivian Richardson and her granddaughter Heidi Zacher/Deadwood, South Dakota, 8/6/82/This photograph was printed for and first exhibited/ at the Amon Carter Museum, Fort Worth, Texas/ September 14–November 17, 1985."
Acquired from: the photographer

*720. **WILBUR POWELL, RANCHER, ENNIS, MONTANA, 7/4/78 [from "In the American West: Photographs by Richard Avedon"]** (P1985.28.25)
Gelatin silver print mounted on aluminum panel. negative 1978, print 1988
Image: 56 x 45 in. (142.2 x 114.3 cm.)
Mount: 59½ x 47 in. (151.1 x 119.4 cm.)
Signed, bottom center mount verso and l.r. print recto: "Avedon A.P./1/2"
Inscription, mount verso, rubber stamp: "IN THE AMERICAN WEST/A project commissioned by the/ Amon Carter Museum, Fort Worth, Texas./ Richard Avedon warrants and represents that,/aside from the signed and numbered photographs/in this edition of 2 plus 2 artist's proofs, no/other original prints of this photograph will/be made by him or under his authority./This photograph may not be reproduced without/the written permission of Richard Avedon Inc./Copyright © 1985 by Richard Avedon Inc./All rights reserved./This photograph was printed in 1985./Wilbur Powell, rancher/ Ennis, Montana, 7/4/78/ This photograph was printed for and first exhibited/at the Amon Carter Museum, Fort Worth, Texas/September 14–November 17, 1985."
Acquired from: the photographer

MORLEY BAER, American (b. 1916)

Born and raised in Toledo, Ohio, Morley Baer received a B.A. in English from the University of Michigan in 1938. After a short period during which he worked in the advertising department of Marshall Fields, Baer took up photography, working mainly for architects and architectural publications. During World War II he documented the war in the Pacific for the U.S. Navy's photography department, run by Edward Steichen. From 1962 to 1965 Baer served as chairman of the Photography Department at the San Francisco Art Institute. An active member of the Friends of Photography, Baer in his work has focused on the landscape, natural scenes, and historic architecture in the Southwest, California, Italy, and Spain.

721. **ADOBE HOUSE, MONTEREY, 1969** (P1975.78)
Gelatin silver print. negative 1969, print 1975
Image: 9⅝ x 7⅝ in. (24.3 x 19.3 cm.)
Mount: 16 x 14 1/16 in. (40.7 x 35.7 cm.)
Signed, l.r. mount recto: "Morley Baer, 1969"
Inscription, mount verso: "83208-4/ADOBE HOUSE, MONTEREY, 1969/(from Adobes in the Sun, Chronicle Books)" contained within rubber stamp "PHOTOGRAPH BY/MORLEY BAER/P.O. Box 2228, Monterey, Cal. 93940"
Acquired from: Friends of Photography, Carmel, California; gift print with sustaining membership, 1974

*722. **KIVA, SAN ILDEFONSO** (P1976.153)
Gelatin silver print. 1973
Image: 9 9/16 x 7⅝ in. (24.3 x 19.4 cm.)
Mount: 16 x 14 in. (40.7 x 35.6 cm.)
Signed, l.r. mount recto: "Morley Baer"
Inscription, mount verso: "83694-8/KIVA, SAN ILDEFONSO, 1973" contained within rubber stamp "PHOTOGRAPH BY MORLEY BAER/P. O. BOX 2228, MONTEREY, CAL. 93940/ALL REPRODUCTION RIGHTS RESERVED"
Acquired from: the photographer

FREDERICK C. BALDWIN, American, born Switzerland (b. 1929)

See Wendy Watriss

Documentary photographer Fred Baldwin earned a B.A. degree from Columbia University in 1955. From 1958 to 1964 he did freelance work for *Sports Illustrated, National Geographic, Audubon, Mademoiselle,* and other national publications. In 1963 he was also a volunteer photographer for the Southern Christian Leadership Conference, documenting the activities of the civil rights movement in the South. A selection of these photographs was published in 1983 in the book *"…We Ain't What We Used to Be…,"* along with an oral history of movement activities. Baldwin served with the Peace Corps in Borneo from 1964 to 1966, resuming freelance work upon his return to the United States. In addition to freelance work, Baldwin taught photography at the University of Texas at Austin from 1981 to 1982 and served as the director of the photojournalism program at the University of Houston from 1982 to 1984. He has also helped to organize the Houston Fotofest, a biennial month-long program of photography exhibitions and lectures.

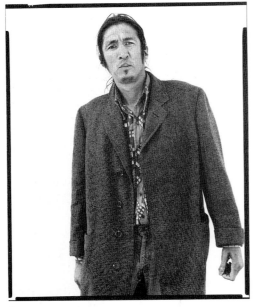

718

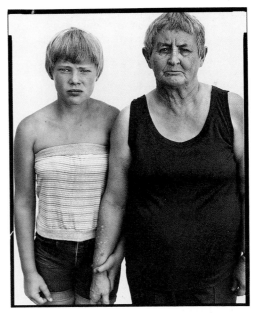

719

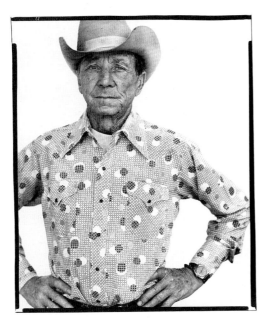

720

722

GEORGE BARKER, American, born Canada (1844–1894)

George Barker spent his life around Niagara Falls and made his living selling photographs of scenic attractions. Born in Canada, he studied painting for five years and planned to become a professional landscape painter before a financial panic changed his plans. He moved to Niagara Falls, New York, in 1862 and became one of the city's most respected photographers, winning numerous awards at various national and international competitions.

*723. [Niagara Falls] (P1981.79)
Albumen silver print. 1888
Image: 19 5/16 x 16 1/2 in. (49.1 x 41.8 cm.)
Sheet: 19 7/8 x 17 1/16 in. (50.5 x 43.3 cm.)
Mount: 25 7/8 x 20 in. (65.7 x 50.8 cm.)
Acquired from: Photocollect, New York, New York

GEORGE N. BARNARD, American (1819–1902)

See also *Gardner's Photographic Sketch Book of the War*

Barnard began his career as a photographer in Oswego, New York, in 1847 and became secretary of the New York Daguerrean Association in 1853. He joined Mathew Brady's gallery in 1861 and photographed Lincoln's inauguration. In 1864, as a photographer for the Union Army during the Civil War, Barnard made views of battlefields and followed Sherman's campaign on the March to the Sea. His work was published in *Photographic Views of Sherman's Campaign* and *Gardner's Photographic Sketch Book of the War*. *Harper's Weekly* also published line engravings made from his photographs to accompany articles on the war. After the Civil War Barnard worked in Chicago and South Carolina before returning to New York, where he helped George Eastman establish his photographic business.

*724. CITY OF ATLANTA, GA. NO. 2 (P1978.57.2)
Albumen silver print. 1864
Image: 10 1/8 x 14 1/8 in. (25.7 x 35.8 cm.)
Mount: 16 1/8 x 20 1/8 in. (41.0 x 51.2 cm.)
Signed: see inscription
Inscription, mount recto: "Photo. from nature By. G. N. Barnard/ CITY OF ATLANTA, GA. No. 2"
Acquired from: Hastings Gallery, New York, New York

725. REBEL WORKS IN FRONT OF ATLANTA, GA. NO. 2 (P1978.57.1)
Albumen silver print. 1864
Image: 10 1/8 x 14 1/16 in. (25.7 x 35.7 cm.)
Mount: 16 1/8 x 19 3/4 in. (41.0 x 50.2 cm.)
Signed: see inscription
Inscription, mount recto: "Photo. from nature By. G. N. Barnard/ REBEL WORKS IN FRONT OF ATLANTA, GA. No. 2//39//26//30//very rare"
Acquired from: Hastings Gallery, New York, New York

*726. REBEL WORKS IN FRONT OF ATLANTA, GA. NO. 4 (P1978.57.3)
Albumen silver print. 1864
Image: 10 1/8 x 14 1/8 in. (25.7 x 35.8 cm.)
Mount: 16 1/8 x 20 3/16 in. (41.0 x 51.3 cm.)
Signed: see inscription
Inscription, mount recto: "Photo. from nature By. G. N. Barnard/ REBEL WORKS IN FRONT OF ATLANTA, GA. No. 4//2"
Acquired from: Hastings Gallery, New York, New York

727. George N. Barnard and James F. Gibson
STONE CHURCH, CENTREVILLE, VA. (P1979.78.2)
duplicate of P1984.30.4
Albumen silver print. negative 1862, print c. 1865 by Alexander Gardner
Image: 6 7/8 x 8 15/16 in. (17.4 x 22.7 cm.)
Mount: 12 1/4 x 15 11/16 in. (31.2 x 39.8 cm.)
Signed: see inscription
Inscription, mount recto: "Negative by BARNARD & GIBSON./ Entered according to act of Congress, in the year 1865, by A. Gardner, in the Clerk's Office of the District Court of the District of Columbia. Positive by A. GARDNER, 511 7th St., Washington.// Incidents of the War./STONE CHURCH, CENTREVILLE, VA./4/ Published by PHILP & SOLOMONS, Washington.// March 1862."
Acquired from: Frontier America Corporation, Bryan, Texas

BRUCE BARNBAUM, American (b. 1943)

Trained in mathematics and as a computer analyst, Barnbaum began his photographic career after attending an Ansel Adams workshop at Yosemite National Park. Although best known for his western landscapes, he has also done architectural work, including a series on English cathedrals. Barnbaum has been active in the Sierra Club and received the Ansel Adams award for Conservation and Photography in 1974. In 1975 Barnbaum founded the Owens Valley Photography Workshops. He has also presented independent workshops for many other schools and galleries.

*728. BASIN MOUNTAIN, APPROACHING STORM (P1978.146.2)
Gelatin silver print. 1973
Image: 15 3/16 x 19 5/16 in. (38.6 x 49.0 cm.)
Mount: 22 x 28 in. (56.0 x 71.2 cm.)
Signed, l.r. mount recto: "Barnbaum"
Inscription, mount recto: "1973"
mount verso: "45-958A/BASIN MOUNTAIN, APPROACHING STORM" and rubber stamp "BRUCE BARNBAUM/Photographer/29322 Trailway Lane/Agoura, Calif. 91301/(213) 889-9498"
Acquired from: Stephen White Gallery, Los Angeles, California

729. BENEATH SANTA MONICA PIER (P1978.146.6)
Gelatin silver print. 1970
Image: 15 3/8 x 19 5/16 in. (39.0 x 49.0 cm.)
Mount: 22 x 28 in. (56.0 x 71.2 cm.)
Signed, l.r. mount recto: "Barnbaum"
Inscription, mount recto: "1970"
mount verso: "45-177A/BENEATH SANTA MONICA PIER" and rubber stamp "BRUCE BARNBAUM/ Photographer/29322 Trailway Lane/Agoura, Calif. 91301/(213) 889-9498"
Acquired from: Stephen White Gallery, Los Angeles, California

730. MUD FLATS, PARIA RIVER (P1978.146.5)
Gelatin silver print. 1978
Image: 19 5/16 x 15 5/16 in. (49.0 x 38.9 cm.)
Mount: 28 x 22 in. (71.2 x 56.0 cm.)
Signed, l.r. mount recto: "Barnbaum"
Inscription, mount recto: "1978"
mount verso: "45-1865A/MUD FLATS, PARIA RIVER" and rubber stamp "BRUCE BARNBAUM/ Photographer/29322 Trailway Lane/Agoura, Calif. 91301/(213) 889-9498"
Acquired from: Stephen White Gallery, Los Angeles, California

723

724

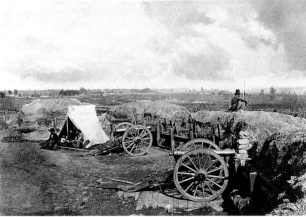

726

728

732

733

731. **ROCKS, PEBBLE BEACH** (P1978.146.4)
Gelatin silver print. 1977
Image: 15 3/16 x 19 1/4 in. (38.6 x 48.9 cm.)
Mount: 22 x 28 in. (56.0 x 71.2 cm.)
Signed, l.r. mount recto: "Barnbaum"
Inscription, mount recto: "1977"
mount verso: "45-1647A/ROCKS, PEBBLE BEACH 1977"
and rubber stamp "BRUCE BARNBAUM/
Photographer/29322 Trailway Lane/Agoura, Calif.
91301/(213) 889-9498"
Acquired from: Stephen White Gallery, Los Angeles,
California

*732. **SANDSTONE AND SAGE, PARIA CANYON** (P1978.146.3)
Gelatin silver print. 1978
Image: 13 7/8 x 17 7/8 in. (35.2 x 45.4 cm.)
Mount: 22 x 28 in. (56.0 x 71.2 cm.)
Signed, l.r. mount recto: "Barnbaum"
Inscription, mount recto: "1978"
mount verso: "45-1858A/SANDSTONE AND SAGE,
PARIA CANYON" and rubber stamp "BRUCE
BARNBAUM/Photographer/29322 Trailway Lane/Agoura,
Calif. 91301/(213) 889-9498"
Acquired from: Stephen White Gallery, Los Angeles,
California

*733. **SCULPTURED WALL, BUCKSKIN GULCH** (P1978.146.7)
Gelatin silver print. 1978
Image: 18 13/16 x 15 3/16 in. (47.8 x 38.6 cm.)
Mount: 28 x 22 in. (71.2 x 56.0 cm.)
Signed, l.r. mount recto: "Barnbaum"
Inscription, mount recto: "1978"
mount verso: photographer's stamp and "45-1878A/
SCULPTURED WALL, BUCKSKIN GULCH//BK 20,
204" and rubber stamp "BRUCE BARNBAUM/
Photographer/29322 Trailway Lane/Agoura, Calif.
91301/(213) 889-9498"
Acquired from: Stephen White Gallery, Los Angeles,
California

734. **WATERFALL, SIERRA NEVADA** (P1978.146.1)
Gelatin silver print. 1978
Image: 7 13/16 x 9 13/16 in. (19.8 x 24.9 cm.)
Mount: 14 x 17 in. (35.6 x 43.2 cm.)
Signed, l.r. mount recto: "Barnbaum"
Inscription, mount recto: "1978"
mount verso: photographer's stamp and "45-2069A/
WATERFALL, SIERRA NEVADA" and rubber stamp
"BRUCE BARNBAUM/Photographer/ 29322 Trailway
Lane/Agoura, Calif. 91301/(213) 889-9498"
Acquired from: Stephen White Gallery, Los Angeles,
California

FELICE A. BEATO, Italian (1825–1903)

Felice A. Beato was first assistant and then partner of James Robertson, the Scottish photographer. As Robertson Beato and Company, the men documented military campaigns in the Middle East and Far East from 1852 to 1865. Beato also photographed on his own, covering the siege of Lucknow in 1857–58 and the Chinese opium war in 1860. In 1871 Beato was the official expedition photographer for a United States diplomatic mission seeking to open Korea to the West. However, the Koreans fired upon two gunboats sent to explore the Han River, and the American troops retaliated by destroying all fortifications on Kanghoa Island. Beato's documentation of the war included images far stronger than those made by the photographers of the Civil War. Besides war photographs, he is noted for his travel views of the Middle East. Beato also was one of the first European photographers in Japan and in his later years photographed Japanese landscapes and genre scenes.

Korean-American War photographs (P1986.16.1-10)
note: individual print titles are inscribed on mount verso
Albumen silver prints. 1871
Acquired from: gift of Paul Katz, North Bennington, Vermont

*735. A HEAD MAN, OR PETTY OFFICIAL OF A COREAN FISHING VILLAGE NEAR THE ANCHORAGE IN THE RIVER SALEE, COREA. SHOWING THE COSTUME (P1986.16.1)

736. THESE MEN CAME ON BOARD THE "COLORADO," WITH DISPATCHES FROM THE COREAN GOVERNMENT. THEIR COSTUME IS LIKE THAT OF THE CHINESE EXCEPT THE HAT. THE HAT IS MADE OF BAMBOO SHAVINGS WOVEN TOGETHER (P1986.16.2)

737. THE "MONOCACY" AND "PALOS" IN THE RIVER SALEE, JUNE 10TH 1871. BEFORE THE ENGAGEMENT WITH FORT MONOCACY (P1986.16.3)

738. "FORT MONOCACY" SO CALLED FOR WANT OF THE TRUE NAME. THE ENEMY WERE DRIVEN OUT BY THE "MONOCACY" ON THE EVENING OF THE 10TH OF JUNE AND THE U.S. MARINES ARE DISMANTLING IT ON THE MORNING OF THE 11TH OF JUNE (P1986.16.4)

739. VIEWS OF "FORT McKEE" SO NAMED IN HONOR OF LIEUT. HUGH McKEE U.S.N. WHO WAS MORTALLY WOUNDED WHILE LEADING THE STORMING PARTY. THIS WAS THE LAST RESORT OF THE NATIVES AND WAS DEFENDED WITH DESPERATIONS [sic]. IT WAS HERE, THAT THE GREAT SLAUGHTER TOOK PLACE, FOR THE NATIVES REFUSED TO YIELD TILL DRIVEN OUT OF THE FORT AND INTO THE RIVER WHERE MANY WERE DROWNED (P1986.16.5)

740. [Fort McKee; Korean Headquarters] (P1986.16.6)

741. CHART OF THE OPERATIONS IN SALEE RIVER COREA JUNE 1ST, 10TH & 11TH 1871 (P1986.16.7)

*742. COREAN PRISONERS CAPTURED IN "FORT McKEE" JUNE 11TH, 1871 (P1986.16.8)

*743. U.S.S. MONOCACY RETURNING FROM EXPEDITION, UP THE SALEE RIVER, COREA (P1986.16.9)

744. [U.S. Navy crew on board ship] (P1986.16.10)

ARTHUR E. BECHER

See *Camera Notes*

JOHN BECK, American (b. 1947)

Beck, a Texas photographer and instructor, has taught at Sam Houston State University in Huntsville, Texas.

745. **BOAT** (1976.61.5)
Gelatin silver print. 1975
Image: 5 1/8 x 7 1/2 in. (13.0 x 19.1 cm.)
Mount: 11 x 14 in. (28.0 x 35.6 cm.)
Signed, l.r. mount recto: "John Beck/75"
Acquired from: the photographer

746. **HILL COUNTRY, TEXAS** (P1976.61.1)
Platinum print. 1974
Image: 4 ¹¹/₁₆ x 3 ¹¹/₁₆ in. (11.9 x 9.4 cm.)
Sheet: 8 ³/₁₆ x 6 ³/₈ in. (20.8 x 16.2 cm.)
Signed, l.r. sheet recto: "John Beck"
Inscription, sheet recto: "1974"
Acquired from: the photographer

747. **HOUSE IN SHADOW** (P1976.61.6)
Gelatin silver print. 1975
Image: 6 ½ x 8 ¼ in. (16.5 x 20.9 cm.)
Mount: 12 x 15 in. (30.5 x 38.2 cm.)
Signed, l.r. sheet recto: "John Beck/75"
Acquired from: the photographer

748. **MACHINERY** (P1976.61.2)
Platinum print. 1974
Image: 3 ¹¹/₁₆ x 4 ¾ in. (9.4 x 12.0 cm.)
Sheet: 6 ¹/₁₆ x 6 ⁵/₁₆ in. (15.4 x 16.0 cm.)
Signed, l.r. sheet recto: "J Beck 74"
Acquired from: the photographer

*749. **MOCKINGBIRD** (P1976.61.3)
Platinum print. 1974
Image: 4 ¹¹/₁₆ x 3 ¹¹/₁₆ in. (11.9 x 9.4 cm.)
Sheet: 7 ¹/₁₆ x 6 ¹/₁₆ in. (18.0 x 15.4 cm.)
Signed, l.r. sheet recto: "J Beck 74"
Acquired from: the photographer

750. **SPANISH DAGGER, BURNET, TEXAS** (P1976.61.4)
Platinum print. 1974
Image: 4 ⁵/₈ x 3 ⁵/₈ in. (11.8 x 9.2 cm.)
Sheet: 7 ⁵/₈ x 6 ¾ in. (19.4 x 17.1 cm.)
Signed, l.r. sheet recto: "John Beck"
Inscription, sheet recto: "1974"
Acquired from: the photographer

WILLIAM BELL, American (1836–1902)

Bell was the chief photographer at the Army Medical
Museum from 1865 to 1869 and for a time ran a studio
purchased from James E. McClees, a Washington,
D.C., photographer who took some of the earliest In-
dian portraits made in the capital city (1857–58) and
taught Bell how to make daguerreotypes. Bell is best
known as the photographer attached to the 1872 expe-
dition of the Geographical Explorations and Surveys
West of the 100th Meridian, led by First Lieutenant
George M. Wheeler. He was one of the first photogra-
phers to use dry-plate negatives, developing a process
that became the basis for the commercial dry-plate
negatives manufactured in the 1880s.

*751. **CANON OF KANAB WASH, COLORADO RIVER,
LOOKING NORTH** [from the album "Geographical
Explorations and Surveys West of the 100th Meridian—
Wheeler Photographs"] (P1982.27.18)
Albumen silver print. 1872
Image: 10 ⁷/₈ x 8 in. (27.6 x 20.3 cm.)
Mount: 19 ½ x 15 ½ in. (49.5 x 39.4 cm.)
Signed: see inscription
Inscription, in negative: "2"
 mount recto: "Explorations & Surveys West of the 100th
 Meridian./ WAR DEPARTMENT [emblem] CORPS OF
 ENGINEERS. U. S. ARMY./Expedition of 1872—Lieut.
 Geo. M. Wheeler, Commanding/W. Bell, Phot./No. 2/
 CANON OF KANAB WASH, COLORADO RIVER,
 LOOKING NORTH."
Acquired from: Zeitlin and VerBrugge, Los Angeles,
California

735

742

743

752. **CANON OF KANAB WASH, COLORADO RIVER, LOOKING SOUTH** [from the album "Geographical Explorations and Surveys West of the 100th Meridian— Wheeler Photographs"] (P1982.27.17)
Albumen silver print. 1872
Image: 10 15/16 x 8 1/16 in. (27.7 x 20.5 cm.)
Mount: 19 1/2 x 15 1/2 in. (49.5 x 39.4 cm.)
Signed: see inscription
Inscription, in negative: "1"
 mount recto: "Explorations & Surveys West of the 100th Meridian./ WAR DEPARTMENT [emblem] CORPS OF ENGINEERS. U. S. ARMY./Expedition of 1872—Lieut. Geo. M. Wheeler, Commanding/W. Bell, Phot./No. 1/ CANON OF KANAB WASH, COLORADO RIVER, LOOKING SOUTH"
Acquired from: Zeitlin and VerBrugge, Los Angeles, California

753. **CANON OF KANAB WASH, COLORADO RIVER, LOOKING SOUTH** [from the album "Geographical Explorations and Surveys West of the 100th Meridian— Wheeler Photographs"] (P1982.27.19)
Albumen silver print. 1872
Image: 10 7/8 x 7 15/16 in. (27.7 x 20.2 cm.)
Mount: 19 1/2 x 15 1/2 in. (49.5 x 39.4 cm.)
Signed: see inscription
Inscription, in negative: "3//3"
 mount recto: "Explorations & Surveys West of the 100th Meridian./ WAR DEPARTMENT [emblem] CORPS OF ENGINEERS. U. S. ARMY./Expedition of 1872—Lieut. Geo. M. Wheeler, Commanding/W. Bell, Phot./No. 3/ CANON OF KANAB WASH, COLORADO RIVER, LOOKING SOUTH."
Acquired from: Zeitlin and VerBrugge, Los Angeles, California

*754. **CANON OF KANAB WASH, COLORADO RIVER, LOOKING SOUTH** [from the album "Geographical Explorations and Surveys West of the 100th Meridian— Wheeler Photographs"] (P1982.27.20)
Albumen silver print. 1872
Image: 10 5/8 x 8 in. (27.0 x 20.4 cm.)
Mount: 19 1/2 x 15 1/2 in. (49.5 x 39.4 cm.)
Signed: see inscription
Inscription, mount recto: "Explorations & Surveys West of the 100th Meridian./WAR DEPARTMENT [emblem] CORPS OF ENGINEERS. U. S. ARMY./Expedition of 1872—Lieut. Geo. M. Wheeler, Commanding/ W. Bell, Phot./No. 4/CANON OF KANAB WASH, COLORADO RIVER, LOOKING SOUTH."
Acquired from: Zeitlin and VerBrugge, Los Angeles, California

755. **COLORADO RIVER, MOUTH OF KANAB WASH, LOOKING WEST** [from the album "Geographical Explorations and Surveys West of the 100th Meridian— Wheeler Photographs"] (P1982.27.21)
Albumen silver print. 1872
Image: 8 x 10 13/16 in. (20.4 x 27.5 cm.)
Mount: 15 1/2 x 19 1/2 in. (39.4 x 49.5 cm.)
Signed: see inscription
Inscription, in negative: "5//80"
 mount recto: "Explorations & Surveys West of the 100th Meridian./ WAR DEPARTMENT [emblem] CORPS OF ENGINEERS. U. S. ARMY/Expedition of 1872—Lieut. Geo. M. Wheeler, Commanding/W. Bell, Phot./No. 5./ COLORADO RIVER, MOUTH OF KANAB WASH, LOOKING WEST."
Acquired from: Zeitlin and VerBrugge, Los Angeles, California

756. **GRAND CANON, COLORADO RIVER, NEAR PARIA CREEK, LOOKING EAST** [from the album "Geographical Explorations and Surveys West of the 100th Meridian— Wheeler Photographs"] (P1976.142.9)
Albumen silver print. 1872
Image: 10 7/8 x 8 in. (27.6 x 20.3 cm.)
Mount: 19 1/4 x 15 1/2 in. (49.0 x 34.9 cm.)
Signed: see inscription

Inscription, mount recto: "Explorations & Surveys West of the 100th Meridian./WAR DEPARTMENT [emblem] CORPS OF ENGINEERS. U. S. ARMY./ Expedition of 1872—Lieut. Geo. M. Wheeler, Commanding./W. Bell, Phot./ No. 8//GRAND CANON, COLORADO RIVER, NEAR PARIA CREEK, LOOKING EAST."
Acquired from: Frontier America Corporation, Bryan, Texas

757. **GRAND CANON, COLORADO RIVER, NEAR PARIA CREEK, LOOKING WEST** [from the album "Geographical Explorations and Surveys West of the 100th Meridian— Wheeler Photographs"] (P1982.27.22)
Albumen silver print. 1872
Image: 10 7/8 x 7 13/16 in. (27.6 x 19.8 cm.)
Mount: 19 1/2 x 15 1/2 in. (49.5 x 39.4 cm.)
Signed: see inscription
Inscription, in negative: "7//88"
 mount recto: "Explorations and Surveys West of the 100th Meridian./ WAR DEPARTMENT [emblem] CORPS OF ENGINEERS. U. S. ARMY./Expedition of 1872—Lieut. Geo. M. Wheeler, Commanding/W. Bell, Phot./No. 7./ GRAND CANON, COLORADO RIVER, NEAR PARIA CREEK, LOOKING WEST."
Acquired from: Zeitlin and VerBrugge, Los Angles, California

758. **GRAND CANON OF THE COLORADO RIVER, MOUTH OF KANAB WASH, LOOKING EAST** [from the album "Geographical Explorations and Surveys West of the 100th Meridian—Wheeler Photographs"] (P1982.27.27)
Albumen silver print. 1872
Image: 10 7/8 x 8 in. (27.6 x 20.3 cm.)
Mount: 19 1/2 x 15 1/2 in. (49.5 x 39.4 cm.)
Signed: see inscription
Inscription, in negative: "12//53"
 mount recto: "Explorations & Surveys West of the 100th Meridian./ WAR DEPARTMENT [emblem] CORPS OF ENGINEERS. U. S. ARMY./Expedition of 1872—Lieut. Geo. M. Wheeler, Commanding/W. Bell, Phot./No. 12/ GRAND CANON OF THE COLORADO RIVER, MOUTH OF KANAB WASH, LOOKING EAST."
Acquired from: Zeitlin and VerBrugge, Los Angeles, California

759. **GRAND CANON OF THE COLORADO RIVER, MOUTH OF KANAB WASH, LOOKING WEST** [from the album "Geographical Explorations and Surveys West of the 100th Meridian—Wheeler Photographs"] (P1982.27.26)
Albumen silver print. 1872
Image: 10 7/8 x 8 in. (27.6 x 20.3 cm.)
Mount: 19 1/2 x 15 1/2 in. (49.5 x 39.4 cm.)
Signed: see inscription
Inscription, in negative: "11//52"
 mount recto: "Explorations & Surveys West of the 100th Meridian./ WAR DEPARTMENT [emblem] CORPS OF ENGINEERS. U. S. ARMY./Expedition of 1872—Lieut. Geo. M. Wheeler, Commanding/W. Bell, Phot./No. 11/ GRAND CANON OF THE COLORADO RIVER, MOUTH OF KANAB WASH, LOOKING WEST."
Acquired from: Zeitlin and VerBrugge, Los Angeles, California

760. **GRAND CANON OF THE COLORADO RIVER, MOUTH OF KANAB WASH, LOOKING WEST** [from the album "Geographical Explorations and Surveys West of the 100th Meridian—Wheeler Photographs"] (P1982.27.28)
Albumen silver print. 1872
Image: 10 7/8 x 8 in. (27.6 x 20.3 cm.)
Mount: 19 1/2 x 15 1/2 in. (49.5 x 39.4 cm.)
Signed: see inscription
Inscription, in negative: "54"
 mount recto: "Explorations & Surveys West of the 100th Meridian./ WAR DEPARTMENT [emblem] CORPS OF ENGINEERS. U. S. ARMY/Expedition of 1872—Lieut. Geo. M. Wheeler, Commanding/W. Bell, Phot./No. 13/ GRAND CANON OF THE COLORADO RIVER, MOUTH OF KANAB WASH, LOOKING WEST."
Acquired from: Zeitlin and VerBrugge, Los Angeles, California

103

749

751

754

761

* 761. **LEFT SCAPULA, SHOWING A GUNSHOT FRACTURE NEARLY PARALLEL WITH THE SPINE OF THE SCAPULA, WITH TWO FRAGMENTS OF A CONOIDAL MUSKET BALL** (P1985.10)
Albumen silver print. 1865
Image: 7 ¼ x 6 ½ in. (19.7 x 16.5 cm.)
Mount: 14 x 11 in. (35.6 x 28.0 cm.)
Inscription, in negative: "86//86"
mount verso, on paper label: "Surgeon General's Office./ ARMY MEDICAL MUSEUM./Specimen No. 809-Photographic Series, No. 86. Left/Scapula, showing a Gunshot Fracture nearly parallel with the/Spine of the scapula, with two Fragments of a Conoidal Musket/Ball./ Private William Fuller, Co. F, 18th Massachusetts Vols., aged 30/years, was wounded at the second battle of Bull Run, August 30th, 1862,/by a conoidal musket ball, which entered to the left of the spinal column,/and passing outwards, traversed the body of the scapula and the muscles/of the upper part of the arm./The patient was conveyed to Union Chapel Hospital at Alexandria,/On the 3d, and again on the 5th of September, misshapen pieces of ball/and a few fragments of bone were extracted through an incision on the outer edge of the scapula./On September 19th, symptoms of purulent infection were manifested./An active treatment of stimulants, quinia, iron, and ammonia, was/instituted, but unavailingly, and on September 25th, 1862, the case/terminated fatally./At the autopsy, a large collection of extravasated blood was found/beneath the scapula and between the muscles of the shoulder. There was/extensive serous effusion in the left pleural cavity, and numerous/metatastatic foci in both lungs./The scapula is numbered: Specimen 188, in the Museum Collection./Full notes of the case were forwarded by Acting Assistant Surgeon W.H. Butler, U.S.A./ Photographed at the Army Medical Museum, BY ORDER OF THE SURGEON GENERAL:/GEORGE A. OTIS,/ Bv't Lt. Col. and Surg. U.S.V., Curator A.M.M." and stamped "Surgeon General's Office./ARMY MEDICAL MUSEUM/PHOTOGRAPHIC SERIES."
Acquired from: gift of Paul Katz, North Bennington, Vermont

762. **LIMESTONE WALLS, KANAB WASH, COLORADO RIVER [from the album "Geographical Explorations and Surveys West of the 100th Meridian—Wheeler Photographs"]** (P1982.27.30)
Albumen silver print. 1872
Image: 10 ⅞ x 8 in. (27.6 x 20.3 cm.)
Mount: 19 ½ x 15 ½ in. (49.5 x 39.4 cm.)
Signed: see inscription
Inscription, in negative: "15"
mount recto: "Explorations & Surveys West of the 100th Meridian./ WAR DEPARTMENT [emblem] CORPS OF ENGINEERS. U. S. ARMY./Expedition of 1872—Lieut. Geo. M. Wheeler, Commanding/W. Bell, Phot./No. 15/ LIMESTONE WALLS, KANAB WASH, COLORADO RIVER."
Acquired from: Zeitlin and VerBrugge, Los Angeles, California

* 763. **LOOKING SOUTH INTO THE GRAND CANON, COLORADO RIVER. SHEAVWITZ CROSSING [from the album "Geographical Explorations and Surveys West of the 100th Meridian—Wheeler Photographs"]** (P1976.142.10)
Albumen silver print. 1872
Image: 10 ⅞ x 8 in. (27.6 x 20.3 cm.)
Mount: 19 ¼ x 15 ½ in. (49.0 x 34.9 cm.)
Signed: see inscription
Inscription, mount recto: "Explorations & Surveys West of the 100th Meridian./WAR DEPARTMENT [emblem] CORPS OF ENGINEERS. U. S. ARMY./ Expedition of 1872—Lieut. Geo. M. Wheeler, Commanding/W. Bell, Phot./No. 9//LOOKING SOUTH INTO THE GRAND CANON, COLORADO RIVER. Sheavwitz Crossing."
Acquired from: Frontier America Corporation, Bryan, Texas

*764. **PERCHED ROCK, ROCKER CREEK, ARIZONA [from the album "Geographical Explorations and Surveys West of the 100th Meridian—Wheeler Photographs"]** (P1982.27.29)
Albumen silver print. 1872
Image: 10 ⅞ x 8 in. (27.6 x 20.3 cm.)
Mount: 19 ½ x 15 ½ in. (49.5 x 39.4 cm.)
Signed: see inscription
Inscription, in negative: "55//14"
mount recto: "Explorations and Surveys West of the 100th Meridian./ WAR DEPARTMENT [emblem] CORPS OF ENGINEERS. U. S. ARMY/Expedition of 1872—Lieut. Geo. M. Wheeler, Commanding/W. Bell, Phot./No. 14./ PERCHED ROCK, ROCKER CREEK, ARIZONA."
Acquired from: Zeitlin and VerBrugge, Los Angeles, California

* 765. **RAIN SCULPTURE, SALT CREEK CANON, UTAH [from the album "Geographical Explorations and Surveys West of the 100th Meridian—Wheeler Photographs"]** (P1976.142.11)
Albumen silver print. 1872
Image: 10 ⅞ x 8 in. (27.6 x 20.3 cm.)
Mount: 19 ¼ x 15 ½ in. (49.0 x 34.9 cm.)
Signed: see inscription
Inscription, mount recto: "Explorations & Surveys West of the 100th Meridian./WAR DEPARTMENT [emblem] CORPS OF ENGINEERS. U. S. ARMY./ Expedition of 1872—Lieut. Geo. M. Wheeler, Commanding./W. Bell, Phot./No. 10//RAIN SCULPTURE, SALT CREEK CANON, UTAH."
Acquired from: Frontier America Corporation, Bryan, Texas

* 766. **RAIN SCULPTURE, SALT CREEK CANON, UTAH [from the album "Geographical Explorations and Surveys West of the 100th Meridian—Wheeler Photographs"]** (P1982.27.25)
Albumen silver print. 1872
Image: 10 ⅞ x 7 ⅞ in. (27.7 x 20.0 cm.)
Mount: 19 ½ x 15 ½ in. (49.5 x 39.4 cm.)
Signed: see inscription
Inscription, mount recto: "Explorations & Surveys West of the 100th Meridian./WAR DEPARTMENT [emblem] CORPS OF ENGINEERS, U. S. ARMY./Expedition of 1872—Lieut. Geo. M. Wheeler, Commanding/ W. Bell, Phot./No. 10/RAIN SCULPTURE, SALT CREEK CANON, UTAH."
Acquired from: Zeitlin and VerBrugge, Los Angeles, California

LIONEL C. BENNETT

See *Camera Notes*

DOROTHY BENRIMO,
American, born Chile (1903–1977)

Dorothy Schmalhorst Benrimo was a jeweler, ceramicist, weaver, and printmaker who taught at Pratt Institute from 1935 to 1939. She and her husband, artist Tom Benrimo, moved to New Mexico in 1939. Benrimo's photographic work stems from her feeling for the *camposantos* or folk grave markers made by Hispanic New Mexicans. She felt that they were one of the last pure cultural expressions of these people and made a series of photographs of the vanishing forms over a twenty-five-year period.

* 767. **CAMPOSANTO CATÓLICO DE COSTILLA [from "Camposantos: A Photographic Essay"]** (P1977.35.31)
Gelatin silver print mounted on plywood. negative c. 1965, print 1965–66 by Joe Baum
Image: 11 ⅝ x 10 ⅜ in. (29.5 x 26.4 cm.)
Mount: same as image size
Inscription, mount verso: "166" and ACM exhibition label
Acquired from: the photographer and printer

763

764

765

766

768. **CAMPOSANTO CATÓLICO DE COSTILLA [from "Camposantos: A Photographic Essay"]** (P1977.35.76)
Gelatin silver print mounted on plywood. negative c. 1965, print 1965—66 by Joe Baum
Image: 16 ¾ x 13 ⅞ in. (42.6 x 35.2 cm.)
Mount: same as image size
Inscription, mount verso: "090" and ACM exhibition label
Acquired from: the photographer and printer

769. **CAMPOSANTO CATÓLICO DE COSTILLA [from "Camposantos: A Photographic Essay"]** (P1977.35.83)
Gelatin silver print mounted on plywood. negative c. 1965, print 1965—66 by Joe Baum
Image: 13 ⁷⁄₁₆ x 10 ⁷⁄₁₆ in. (34.1 x 26.6 cm.)
Mount: same as image size
Inscription, mount verso: "167" and ACM exhibition label
Acquired from: the photographer and printer

770. **CAMPOSANTO CATÓLICO DE COSTILLA [from "Camposantos: A Photographic Essay"]** (P1977.35.95)
Gelatin silver print mounted on plywood. negative 1939—65, print 1965—66 by Joe Baum
Image: 13 ¼ x 8 ¹¹⁄₁₆ in. (33.7 x 22.0 cm.)
Mount: same as image size
Inscription, mount verso: "204" and ACM exhibition label
Acquired from: the photographer and printer

771. **CAMPOSANTO CATÓLICO DE DIXON [from "Camposantos: A Photographic Essay"]** (P1977.35.69)
Gelatin silver print mounted on plywood. negative 1939—65, print 1965—66 by Joe Baum
Image: 13 ⁷⁄₁₆ x 10 ¼ in. (34.1 x 26.1 cm.)
Mount: same as image size
Inscription, mount verso: "251" and ACM exhibition label
Acquired from: the photographer and printer

772. **CAMPOSANTO CATÓLICO DE DIXON [from "Camposantos: A Photographic Essay"]** (P1977.35.96)
Gelatin silver print mounted on plywood. negative 1939—65, print 1965—66 by Joe Baum
Image: 10 ½ x 13 ⁷⁄₁₆ in. (26.6 x 34.1 cm.)
Mount: same as image size
Inscription, mount verso: ACM exhibition label
Acquired from: the photographer and printer

773. **CAMPOSANTO CATÓLICO DE QUESTA [from "Camposantos: A Photographic Essay"]** (P1977.35.78)
Gelatin silver print mounted on plywood. negative c. 1965, print 1965—66 by Joe Baum
Image: 18 ¾ x 15 ¹⁵⁄₁₆ in. (47.5 x 40.5 cm.)
Mount: same as image size
Inscription, mount verso: "022" and ACM exhibition label
Acquired from: the photographer and printer

774. **CAMPOSANTO CATÓLICO DE QUESTA [from "Camposantos: A Photographic Essay"]** (P1977.35.98)
Gelatin silver print mounted on plywood. negative 1941—65, print 1965—66 by Joe Baum
Image: 13 ⁷⁄₁₆ x 8 ⅝ in. (34.1 x 22.0 cm.)
Mount: same as image size
Inscription, mount verso: ACM exhibition label
Acquired from: the photographer and printer

775. **CAMPOSANTO CATÓLICO DE VELARDE [from "Camposantos: A Photographic Essay"]** (P1977.35.88)
Gelatin silver print mounted on plywood. negative c. 1965, print 1965-66 by Joe Baum
Image: 12 ⅞ x 10 ⁷⁄₁₆ in. (32.7 x 26.5 cm.)
Mount: same as image size
Inscription, mount verso: "125" and ACM exhibition label
Acquired from: the photographer and printer

776. **CAMPOSANTO CATÓLICO DE VELARDE [from "Camposantos: A Photographic Essay"]** (P1977.35.90)
Gelatin silver print mounted on plywood. negative 1939-65, print 1965-66 by Joe Baum
Image: 13 ⅛ x 10 ⅜ in. (34.0 x 26.4 cm.)
Mount: same as image size
Inscription, mount verso: "11 x 14" and ACM exhibition label
Acquired from: the photographer and printer

777. **CAMPOSANTO DE ABIQUIU [from "Camposantos: A Photographic Essay"]** (P1977.35.7)
Gelatin silver print mounted on plywood. negative c. 1965, print 1965-66 by Joe Baum
Image: 10 ⁷⁄₁₆ x 13 ⁷⁄₁₆ in. (26.5 x 34.1 cm.)
Mount: same as image size
Inscription, mount verso: "107" and ACM exhibition label
Acquired from: the photographer and printer

778. **CAMPOSANTO DE ABIQUIU [from "Camposantos: A Photographic Essay"]** (P1977.35.11)
Gelatin silver print mounted on plywood. negative c. 1965, print 1965-66 by Joe Baum
Image: 13 ⅛ x 10 ⁷⁄₁₆ in. (34.0 x 26.5 cm.)
Mount: same as image size
Inscription, mount verso: "001" and ACM exhibition label
Acquired from: the photographer and printer

779. **CAMPOSANTO DE AMALIA [from "Camposantos: A Photographic Essay"]** (P1977.35.25)
Gelatin silver print mounted on plywood. negative c. 1965, print 1965-66 by Joe Baum
Image: 13 ⁷⁄₁₆ x 10 ⅛ in. (34.1 x 25.7 cm.)
Mount: same as image size
Inscription, mount verso: "082" and ACM exhibition label
Acquired from: the photographer and printer

780. **CAMPOSANTO DE AMALIA [from "Camposantos: A Photographic Essay"]** (P1977.35.44)
Gelatin silver print mounted on plywood. negative c. 1965, print 1965—66 by Joe Baum
Image: 13 ⁵⁄₁₆ x 10 ⁵⁄₁₆ in. (33.8 x 26.2 cm.)
Mount: same as image size
Inscription, mount verso: "074/Caption/3/Camposanto de Amalia/ Plate 44 in/book/30"/Enlargement in show/This is duplicate"
Acquired from: the photographer and printer

781. **CAMPOSANTO DE AMALIA [from "Camposantos: A Photographic Essay"]** (P1977.35.70)
Gelatin silver print mounted on plywood. negative c. 1965, print 1965—66 by Joe Baum
Image: 12 ³⁄₁₆ x 10 ⅜ in. (31.2 x 26.4 cm.)
Mount: same as image size
Inscription, mount verso: "084" and ACM exhibition label
Acquired from: the photographer and printer

782. **CAMPOSANTO DE AMALIA [from "Camposantos: A Photographic Essay"]** (P1977.35.74)
Gelatin silver print mounted on plywood. negative c. 1965, print 1965—66 by Joe Baum
Image: 13 ⅛ x 10 ⁷⁄₁₆ in. (34.0 x 26.5 cm.)
Mount: same as image size
Inscription, mount verso: "099" and ACM exhibition label
Acquired from: the photographer and printer

783. **CAMPOSANTO DE AMALIA [from "Camposantos: A Photographic Essay"]** (P1977.35.75)
Gelatin silver print mounted on plywood. negative c. 1965, print 1965—66 by Joe Baum
Image: 13 x 10 ⅜ in. (33.0 x 26.4 cm.)
Mount: same as image size
Inscription, mount verso: "08" and ACM exhibition label
Acquired from: the photographer and printer

784. **CAMPOSANTO DE AMALIA [from "Camposantos: A Photographic Essay"]** (P1977.35.81)
Gelatin silver print mounted on plywood. negative c. 1965, print 1965–66 by Joe Baum
Image: 19 1/8 x 15 15/16 in. (48.5 x 40.5 cm.)
Mount: same as image size
Inscription, mount verso: "07" and ACM exhibition label
Acquired from: the photographer and printer

785. **CAMPOSANTO DE AMALIA [from "Camposantos: A Photographic Essay"]** (P1977.35.82)
Gelatin silver print mounted on plywood. negative c. 1965, print 1965–66 by Joe Baum
Image: 16 3/4 x 13 7/8 in. (42.5 x 35.2 cm.)
Mount: same as image size
Inscription, mount verso: "06" and ACM exhibition label
Acquired from: the photographer and printer

786. **CAMPOSANTO DE CHAMITA [from "Camposantos: A Photographic Essay"]** (P1977.35.15)
Gelatin silver print mounted on plywood. negative 1939–65, print 1965–66 by Joe Baum
Image: 30 x 30 in. (76.2 x 76.2 cm.)
Mount: same as image size
Inscription, mount verso: "117" and ACM exhibition label
Acquired from: the photographer and printer

*787. **CAMPOSANTO DE CHIMAYÓ [from "Camposantos: A Photographic Essay"]** (P1977.35.21)
Gelatin silver print mounted on plywood. negative c. 1965, print 1965–66 by Joe Baum
Image: 18 9/16 x 16 in. (47.1 x 40.7 cm.)
Mount: same as image size
Inscription, mount verso: "065" and ACM exhibition label
Acquired from: the photographer and printer

788. **CAMPOSANTO DE CHIMAYÓ [from "Camposantos: A Photographic Essay"]** (P1977.35.77)
Gelatin silver print mounted on plywood. negative c. 1965, print 1965–66 by Joe Baum
Image: 16 13/16 x 13 7/8 in. (42.7 x 35.2 cm.)
Mount: same as image size
Inscription, mount verso: "068" and ACM exhibition label
Acquired from: the photographer and printer

789. **CAMPOSANTO DE EL MONTE CALVARIO, LAS VEGAS [from "Camposantos: A Photographic Essay"]** (P1977.35.86)
Gelatin silver print mounted on plywood. negative c. 1965, print 1965–66 by Joe Baum
Image: 10 5/16 x 13 7/16 in. (26.1 x 34.1 cm.)
Mount: same as image size
Inscription, mount verso: "152" and ACM exhibition label
Acquired from: the photographer and printer

790. **CAMPOSANTO DE EL RANCHO DE LA CRUZ, POJOAQUE [from "Camposantos: A Photographic Essay"]** (P1977.35.6)
Gelatin silver print mounted on plywood. negative c. 1965, print 1965–66 by Joe Baum
Image: 13 3/8 x 10 3/8 in. (34.0 x 26.4 cm.)
Mount: same as image size
Inscription, mount verso: "054" and ACM exhibition label
Acquired from: the photographer and printer

791. **CAMPOSANTO DE EL RANCHO DE LA CRUZ, POJOAQUE [from "Camposantos: A Photographic Essay"]** (P1977.35.65)
Gelatin silver print mounted on plywood. negative c. 1965, print 1965–66 by Joe Baum
Image: 16 5/16 x 13 7/8 in. (41.4 x 35.2 cm.)
Mount: same as image size
Inscription, mount verso: "044" and ACM exhibition label
Acquired from: the photographer and printer

767

787

793

792. **CAMPOSANTO DE EL RANCHO DE LA CRUZ, POJOAQUE** [from "Camposantos: A Photographic Essay"] (P1977.35.73)
Gelatin silver print mounted on plywood. negative c. 1965, print 1965–66 by Joe Baum
Image: 13 7/16 x 10 5/16 in. (34.0 x 26.1 cm.)
Mount: same as image size
Inscription, mount verso: "155" and ACM exhibition label
Acquired from: the photographer and printer

*793. **CAMPOSANTO DE EL VALLE** [from "Camposantos: A Photographic Essay"] (P1977.35.42)
Gelatin silver print mounted on plywood. negative 1939–65, print 1965–66 by Joe Baum
Image: 9 3/4 x 13 5/16 in. (24.7 x 33.9 cm.)
Mount: same as image size
Inscription, mount verso: "239" and ACM exhibition label
Acquired from: the photographer and printer

*794. **CAMPOSANTO DE ESPAÑOLA** [from "Camposantos: A Photographic Essay"] (P1977.35.45)
Gelatin silver print mounted on plywood. negative c. 1965, print 1965–66 by Joe Baum
Image: 13 3/8 x 10 7/16 in. (34.0 x 26.5 cm.)
Mount: same as image size
Inscription, mount verso: "095" and ACM exhibition label
Acquired from: the photographer and printer

795. **CAMPOSANTO DE LA COMUNIDAD DE LLANO QUEMADO** [from "Camposantos: A Photographic Essay"] (P1977.35.10)
Gelatin silver print mounted on plywood. negative c. 1965, print 1965–66 by Joe Baum
Image: 12 7/8 x 10 7/16 in. (32.6 x 26.5 cm.)
Mount: same as image size
Inscription, mount verso: "149" and ACM exhibition label
Acquired from: the photographer and printer

796. **CAMPOSANTO DE LA SIERRA VISTA, TAOS** [from "Camposantos: A Photographic Essay"] (P1977.35.99)
Gelatin silver print mounted on plywood. negative 1939–65, print 1965–66 by Joe Baum
Image: 13 3/8 x 10 3/16 in. (34.0 x 25.9 cm.)
Mount: same as image size
Inscription, mount verso: ACM exhibtion label
Acquired from: the photographer and printer

*797. **CAMPOSANTO DE LAS RAELES, ARROYO HONDO** [from "Camposantos: A Photographic Essay"] (P1977.35.18)
Gelatin silver print mounted on plywood. negative c. 1965, print 1965–66 by Joe Baum
Image: 13 3/8 x 10 3/8 in. (34.0 x 26.3 cm.)
Mount: same as image size
Inscription, mount verso: "021" and ACM exhibition label
Acquired from: the photographer and printer

798. **CAMPOSANTO DE MEDENALES** [from "Camposantos: A Photographic Essay"] (P1977.35.91)
Gelatin silver print mounted on plywood. negative c. 1965, print 1965–66 by Joe Baum
Image: 10 3/8 x 13 3/8 in. (26.4 x 34.0 cm.)
Mount: same as image size
Inscription, mount verso: ACM exhibition label
Acquired from: the photographer and printer

*799. **CAMPOSANTO DE NUESTRA SEÑORA DE LOS DOLORES, ARROYO SECO** [from "Camposantos: A Photographic Essay"] (P1977.35.16)
Gelatin silver print mounted on plywood. negative 1939–65, print 1965–66 by Joe Baum
Image: 13 1/8 x 10 3/8 in. (33.3 x 26.3 cm.)
Mount: same as image size
Inscription, mount verso: "227" and ACM exhibition label
Acquired from: the photographer and printer

800. **CAMPOSANTO DE NUESTRA SEÑORA DE LOS DOLORES, ARROYO SECO** [from "Camposantos: A Photographic Essay"] (P1977.35.63)
Gelatin silver print mounted on plywood. negative c. 1965, print 1965–66 by Joe Baum
Image: 13 1/4 x 10 3/8 in. (33.7 x 26.3 cm.)
Mount: same as image size
Inscription, mount verso: "172" and ACM exhibition label
Acquired from: the photographer and printer

801. **CAMPOSANTO DE NUESTRA SEÑORA DE LOS DOLORES, ARROYO SECO** [from "Camposantos: A Photographic Essay"] (P1977.35.72)
Gelatin silver print mounted on plywood. negative c. 1965, print 1965–66 by Joe Baum
Image: 13 3/16 x 10 7/16 in. (33.5 x 26.5 cm.)
Mount: same as image size
Inscription, mount verso: "014" and ACM exhibition label
Acquired from: the photographer and printer

802. **CAMPOSANTO DE NUESTRA SEÑORA DE LOS DOLORES, ARROYO SECO** [from "Camposantos: A Photographic Essay"] (P1977.35.94)
Gelatin silver print mounted on plywood. negative c. 1965, print 1965–66 by Joe Baum
Image: 11 3/8 x 10 7/16 in. (28.8 x 26.5 cm.)
Mount: same as image size
Inscription, mount verso: ACM exhibition label
Acquired from: the photographer and printer

803. **CAMPOSANTO DE NUESTRA SEÑORA DE LOS DOLORES, CAÑON** [from "Camposantos: A Photographic Essay"] (P1977.35.67)
Gelatin silver print mounted on plywood. negative c. 1965, print 1965–66 by Joe Baum
Image: 13 5/16 x 8 11/16 in. (33.8 x 22.0 cm.)
Mount: same as image size
Inscription, mount verso: ACM exhibition label
Acquired from: the photographer and printer

804. **CAMPOSANTO DE NUESTRA SEÑORA DE LOS DOLORES, CAÑON** [from "Camposantos: A Photographic Essay"] (P1977.35.71)
Gelatin silver print mounted on plywood. negative 1939–65, print 1965–66 by Joe Baum
Image: 13 7/16 x 8 9/16 in. (34.0 x 21.7 cm.)
Mount: same as image size
Inscription, mount verso: ACM exhibition label
Acquired from: the photographer and printer

*805. **CAMPOSANTO DE NUESTRA SEÑORA DE LOS DOLORES, TAOS** [from "Camposantos: A Photographic Essay"] (P1977.35.12)
Gelatin silver print mounted on plywood. negative 1939–65, print 1965–66 by Joe Baum
Image: 30 x 24 in. (76.2 x 61.0 cm.)
Mount: same as image size
Inscription, mount verso: "120" and ACM exhibition label
Acquired from: the photographer and printer

806. **CAMPOSANTO DE NUESTRA SEÑORA DE LOS DOLORES, TAOS** [from "Camposantos: A Photographic Essay"] (P1977.35.34)
Gelatin silver print mounted on plywood. negative c. 1965, print 1965–66 by Joe Baum
Image: 16 7/8 x 13 15/16 in. (42.8 x 35.4 cm.)
Mount: same as image size
Inscription, mount verso: "019" and ACM exhibition label
Acquired from: the photographer and printer

807. **CAMPOSANTO DE NUESTRA SEÑORA DE LOS DOLORES, TAOS** [from "Camposantos: A Photographic Essay"] (P1977.35.35a) duplicate of P1977.35.35b
Gelatin silver print mounted on plywood. negative 1939–65, print 1965–66 by Joe Baum
Image: 16 7/8 x 11 3/4 in. (42.8 x 29.9 cm.)
Mount: same as image size
Inscription, mount verso: ACM exhibition label
Acquired from: the photographer and printer

794

797

799

805

808. CAMPOSANTO DE NUESTRA SEÑORA DE LOS
DOLORES, TAOS [from "Camposantos: A Photographic
Essay"] (P1977.35.35b) duplicate of P1977.35.35a
Gelatin silver print mounted on plywood. negative 1939–65,
print 1965–66 by Joe Baum
Image: 10 ¹⁵⁄₁₆ x 7 ⅞ in. (27.7 x 20.0 cm.)
Mount: same as image size
Inscription, mount verso: "Duplicate/#/206"
Acquired from: the photographer and printer

*809. CAMPOSANTO DE NUESTRA SEÑORA DE LOS
DOLORES, TAOS [from "Camposantos: A Photographic
Essay"] (P1977.35.36)
Gelatin silver print mounted on plywood. negative 1939–65,
print 1965–66 by Joe Baum
Image: 13 ⁵⁄₁₆ x 9 in. (33.8 x 22.7 cm.)
Mount: same as image size
Inscription, mount verso: "234" and ACM exhibition label
Acquired from: the photographer and printer

810. CAMPOSANTO DE NUESTRA SEÑORA DE LOS
DOLORES, TAOS [from "Camposantos: A Photographic
Essay"] (P1977.35.43)
Gelatin silver print mounted on plywood. negative 1939–65,
print 1965–66 by Joe Baum
Image: 13 ⁷⁄₁₆ x 10 ⅜ in. (34.1 x 26.3 cm.)
Mount: same as image size
Inscription, mount verso: "217" and ACM exhibition label
Acquired from: the photographer and printer

811. CAMPOSANTO DE NUESTRA SEÑORA DE LOS
DOLORES, TAOS [from "Camposantos: A Photographic
Essay"] (P1977.35.93)
Gelatin silver print mounted on plywood. negative c. 1965,
print 1965–66 by Joe Baum
Image: 13 ⅜ x 10 ⅜ in. (34.0 x 26.4 cm.)
Mount: same as image size
Inscription, mount verso: ACM exhibition label
Acquired from: the photographer and printer

*812. CAMPOSANTO DE NUESTRA SEÑORA DE LOS
DOLORES, TECOLOTE [from "Camposantos: A
Photographic Essay"] (P1977.35.47)
Gelatin silver print mounted on plywood. negative c. 1965,
print 1965–66 by Joe Baum
Image: 24 ⅛ x 23 ⅞ in. (61.3 x 60.6 cm.)
Mount: same as image size
Inscription, mount verso: "139" and ACM exhibition label
Acquired from: the photographer and printer

*813. CAMPOSANTO DE NUESTRA SEÑORA DE LOS
DOLORES, TECOLOTE [from "Camposantos: A
Photographic Essay"] (P1977.35.54)
Gelatin silver print mounted on plywood. negative 1939–65,
print 1965–66 by Joe Baum
Image: 13 ⁵⁄₁₆ x 7 ³⁄₁₆ in. (33.8 x 18.3 cm.)
Mount: same as image size
Inscription, mount verso: "224" and ACM exhibition label
Acquired from: the photographer and printer

814. CAMPOSANTO DE NUESTRO PADRE JESÚS
NAZARENO, RANCHOS DE TAOS [from
"Camposantos: A Photographic Essay"] (P1977.35.87)
Gelatin silver print mounted on plywood. negative c. 1965,
print 1965–66 by Joe Baum
Image: 13 ¹⁵⁄₁₆ x 16 ⅞ in. (35.4 x 42.9 cm.)
Mount: same as image size
Inscription, mount verso: "102 [sic]" and ACM exhibition
label
Acquired from: the photographer and printer

815. CAMPOSANTO DE NUESTRO PADRE JESÚS
NAZARENO, RANCHOS DE TAOS [from
"Camposantos: A Photographic Essay"] (P1977.35.100)
Gelatin silver print mounted on plywood. negative c. 1965,
print 1965–66 by Joe Baum
Image: 30 x 24 ⅛ in. (76.1 x 61.3 cm.)

Mount: same as image size
Inscription, mount verso: "011" and ACM exhibition label
Acquired from: the photographer and printer

816. CAMPOSANTO DE ROMEROVILLE [from "Camposantos:
A Photographic Essay"] (P1977.35.28)
Gelatin silver print mounted on plywood. negative c. 1965,
print 1965–66 by Joe Baum
Image: 12 ½ x 10 ⅜ in. (31.8 x 26.4 cm.)
Mount: same as image size
Inscription, mount verso: "072" and ACM exhibition label
Acquired from: the photographer and printer

*817. CAMPOSANTO DE ROMEROVILLE [from "Camposantos:
A Photographic Essay"] (P1977.35.30)
Gelatin silver print mounted on plywood. negative c. 1965,
print 1965–66 by Joe Baum
Image: 10 ⁷⁄₁₆ x 12 ⁷⁄₁₆ in. (26.4 x 31.6 cm.)
Mount: same as image size
Inscription, mount verso: "137" and ACM exhibition label
Acquired from: the photographer and printer

818. CAMPOSANTO DE SAN JOSÉ [from "Camposantos: A
Photographic Essay"] (P1977.35.60)
Gelatin silver print mounted on plywood. negative 1939–65,
print 1965–66 by Joe Baum
Image: 10 ⁷⁄₁₆ x 13 ⁵⁄₁₆ in. (26.5 x 33.8 cm.)
Mount: same as image size
Inscription, mount verso: "244" and ACM exhibition label
Acquired from: the photographer and printer

819. CAMPOSANTO DE SAN JOSÉ DEL CHAMA,
HERNANDEZ [from "Camposantos: A Photographic
Essay"] (P1977.35.8)
Gelatin silver print mounted on plywood. negative 1939–65,
print 1965–66 by Joe Baum
Image: 30 x 22 in. (76.2 x 55.8 cm.)
Mount: same as image size
Inscription, mount verso: "073" and ACM exhibition label
Acquired from: the photographer and printer

820. CAMPOSANTO DE SAN JOSÉ DEL CHAMA,
HERNANDEZ [from "Camposantos: A Photographic
Essay"] (P1977.35.92)
Gelatin silver print mounted on plywood. negative c. 1965,
print 1965–66 by Joe Baum
Image: 13 ⁷⁄₁₆ x 10 ⁷⁄₁₆ in. (34.1 x 26.5 cm.)
Mount: same as image size
Inscription, mount verso: ACM exhibition label
Acquired from: the photographer

821. CAMPOSANTO DE SAN JOSÉ, LAS VEGAS [from
"Camposantos: A Photographic Essay"] (P1977.35.49)
Gelatin silver print mounted on plywood. negative 1939–65,
print 1965–66 by Joe Baum
Image: 13 ¼ x 8 ¼ in. (33.7 x 20.9 cm.)
Mount: same as image size
Inscription, mount verso: "253" and ACM exhibition label
Acquired from: the photographer and printer

*822. CAMPOSANTO DE SAN JUAN [from "Camposantos: A
Photographic Essay"] (P1977.35.57)
Gelatin silver print mounted on plywood. negative c. 1965,
print 1965–66 by Joe Baum
Image: 13 ⅜ x 10 ⅜ in. (34.0 x 26.4 cm.)
Mount: same as image size
Inscription, mount verso: "086" and ACM exhibition label
Acquired from: the photographer and printer

823. CAMPOSANTO DE SANTA CRUZ [from "Camposantos:
A Photographic Essay"] (P1977.35.1)
Gelatin silver print mounted on plywood. negative 1939–65,
print 1965–66 by Joe Baum
Image: 30 x 24 ⅞ in. (76.2 x 63.2 cm.)
Mount: same as image size
Inscription, mount verso: "040" and ACM exhibition label
Acquired from: the photographer and printer

809

813

822

812

817

824. **CAMPOSANTO DE SANTA CRUZ [from "Camposantos: A Photographic Essay"]** (P1977.35.55)
Gelatin silver print mounted on plywood. negative c. 1965, print 1965–66 by Joe Baum
Image: 12 1/16 x 10 3/8 in. (30.7 x 26.3 cm.)
Mount: same as image size
Inscription, mount verso: "033" and ACM exhibition label
Acquired from: the photographer and printer

*825. **CAMPOSANTO DE SANTA CRUZ [from "Camposantos: A Photographic Essay"]** (P1977.35.56)
Gelatin silver print mounted on plywood. negative c. 1965, print 1965–66 by Joe Baum
Image: 12 1/4 x 10 7/16 in. (31.2 x 26.5 cm.)
Mount: same as image size
Inscription, mount verso: ACM exhibition label
Acquired from: the photographer and printer

826. **CAMPOSANTO DE SANTA CRUZ [from "Camposantos: A Photographic Essay"]** (P1977.35.62)
Gelatin silver print mounted on plywood. negative c. 1965, print 1965–66 by Joe Baum
Image: 12 1/4 x 10 7/16 in. (31.1 x 26.5 cm.)
Mount: same as image size
Inscription, mount verso: "028" and ACM exhibition label
Acquired from: the photographer and printer

827. **CAMPOSANTO DE SANTA CRUZ [from "Camposantos: A Photographic Essay"]** (P1977.35.64)
Gelatin silver print mounted on plywood. negative c. 1965, print 1965–66 by Joe Baum
Image: 13 3/8 x 10 1/4 in. (34.0 x 26.1 cm.)
Mount: same as image size
Inscription, mount verso: "145" and ACM exhibition label
Acquired from: the photographer and printer

*828. **CAMPOSANTO DE SANTA RITA BERNAL, SERAFINA [from "Camposantos: A Photographic Essay"]** (P1977.35.38)
Gelatin silver print mounted on plywood. negative 1939–65, print 1965–66 by Joe Baum
Image: 30 x 20 1/8 in. (76.2 x 51.1 cm.)
Mount: same as image size
Inscription, mount verso: "205" and ACM exhibition label
Acquired from: the photographer and printer

829. **CAMPOSANTO DE SANTA RITA BERNAL, SERAFINA [from "Camposantos: A Photographic Essay"]** (P1977.35.84)
Gelatin silver print mounted on plywood. negative 1939–65, print 1965–66 by Joe Baum
Image: 14 x 14 11/16 in. (35.6 x 37.2 cm.)
Mount: same as image size
Inscription, mount verso: "212" and ACM exhibition label
Acquired from: the photographer and printer

*830. **CAMPOSANTO DEL MEDIO DE SAN FRANCISCO, RANCHOS DE TAOS [from "Camposantos: A Photographic Essay"]** (P1977.35.22)
Gelatin silver print mounted on plywood. negative c. 1965, print 1965–66 by Joe Baum
Image: 12 3/4 x 10 1/2 in. (32.4 x 26.6 cm.)
Mount: same as image size
Inscription, mount verso: "094" and ACM exhibition label
Acquired from: the photographer and printer

831. **CAMPOSANTO DEL MEDIO DE SAN FRANCISCO, RANCHOS DE TAOS [from "Camposantos: A Photographic Essay"]** (P1977.35.23)
Gelatin silver print mounted on plywood. negative c. 1965, print 1965–66 by Joe Baum
Image: 10 5/16 x 10 3/8 in. (26.2 x 26.4 cm.)
Mount: same as image size
Inscription, mount verso: "092" and ACM exhibition label
Acquired from: the photographer and printer

832. **CAMPOSANTO DEL MEDIO DE SAN FRANCISCO, RANCHOS DE TAOS [from "Camposantos: A Photographic Essay"]** (P1977.35.24)
Gelatin silver print mounted on plywood. negative c. 1965, print 1965–66 by Joe Baum

Image: 13 7/16 x 10 7/16 in. (34.1 x 26.5 cm.)
Mount: same as image size
Inscription, mount verso: "093" and ACM exhibition label
Acquired from: the photographer and printer

833. **CAMPOSANTO DEL RÍO CHIQUITO [from "Camposantos: A Photographic Essay"]** (P1977.35.59)
Gelatin silver print mounted on plywood. negative c. 1965, print 1965–66 by Joe Baum
Image: 12 15/16 x 10 3/8 in. (32.9 x 26.4 cm.)
Mount: same as image size
Inscription, mount verso: "174" and ACM exhibition label
Acquired from: the photographer and printer

*834. **CAMPOSANTO DEL RÍO CHIQUITO [from "Camposantos: A Photographic Essay"]** (P1977.35.61)
Gelatin silver print mounted on plywood. negative c. 1965, print 1965–66 by Joe Baum
Image: 13 7/16 x 10 3/8 in. (34.1 x 26.4 cm.)
Mount: same as image size
Inscription, mount verso: "177" and ACM exhibition label
Acquired from: the photographer and printer

835. **CAMPOSANTO DEL RÍO CHIQUITO [from "Camposantos: A Photographic Essay"]** (P1977.35.68)
Gelatin silver print mounted on plywood. negative c. 1965, print 1965–66 by Joe Baum
Image: 13 7/16 x 10 1/2 in. (34.0 x 26.6 cm.)
Mount: same as image size
Inscription, mount verso: "109" and ACM exhibition label
Acquired from: the photographer and printer

836. **CAMPOSANTO DEL RÍO CHIQUITO [from "Camposantos: A Photographic Essay"]** (P1977.35.85)
Gelatin silver print mounted on plywood. negative c. 1965, print 1965–66 by Joe Baum
Image: 9 3/16 x 13 3/8 in. (23.3 x 34.0 cm.)
Mount: same as image size
Inscription, mount verso: "175" and ACM exhibition label
Acquired from: the photographer and printer

837. **CAMPOSANTO DEL SAGRADO CORAZON DE NAMBE [from "Camposantos: A Photographic Essay"]** (P1977.35.97)
Gelatin silver print mounted on plywood. negative 1939–65, print 1965–66 by Joe Baum
Image: 11 7/8 x 8 11/16 in. (30.2 x 22.1 cm.)
Mount: same as image size
Inscription, mount verso: ACM exhibition label
Acquired from: the photographer and printer

838. **CAMPOSANTO VIEJO DE ALCALDE [from "Camposantos: A Photographic Essay"]** (P1977.35.37)
Gelatin silver print mounted on plywood. negative c. 1965, print 1965–66 by Joe Baum
Image: 16 7/8 x 13 15/16 in. (42.8 x 35.4 cm.)
Mount: same as image size
Inscription, mount verso: "013" and ACM exhibition label
Acquired from: the photographer and printer

839. **CAMPOSANTO VIEJO DE COSTILLA [from "Camposantos: A Photographic Essay"]** (P1977.35.66)
Gelatin silver print mounted on plywood. negative c. 1965, print 1965–66 by Joe Baum
Image: 13 3/8 x 10 3/8 in. (33.9 x 26.4 cm.)
Mount: same as image size
Inscription, mount verso: "089" and ACM exhibition label
Acquired from: the photographer and printer

840. **CAMPOSANTO VIEJO DE QUESTA [from "Camposantos: A Photographic Essay"]** (P1977.35.79)
Gelatin silver print mounted on plywood. negative c. 1965, print 1965–66 by Joe Baum
Image: 13 3/16 x 10 5/16 in. (33.5 x 26.2 cm.)
Mount: same as image size
Inscription, mount verso: "143 [sic]" and ACM exhibition label
Acquired from: the photographer and printer

825

828

830

834

*841. **CAMPOSANTO VIEJO DE SAN PEDRO, QUESTA**
[from "Camposantos: A Photographic Essay"] (P1977.35.9)
Gelatin silver print mounted on plywood. negative c. 1965,
print 1965–66 by Joe Baum
Image: 48 x 36 in. (122.0 x 91.4 cm.)
Mount: same as image size
Inscription, mount verso: "241" and ACM exhibition label
Acquired from: the photographer and printer

842. **STATION OF THE CROSS ON HIGHWAY NEAR LAS
TRUCHAS** [from "Camposantos: A Photographic Essay"]
(P1977.35.29)
Gelatin silver print mounted on plywood. negative c. 1965,
print 1965–66 by Joe Baum
Image: 13 5/16 x 10 7/16 in. (33.8 x 26.5 cm.)
Mount: same as image size
Inscription, mount verso: "115" and ACM exhibition label
Acquired from: the photographer and printer

CHARLES I. BERG

See *Camera Notes*

RUTH BERNHARD,
American, born Germany (b. 1905)

Ruth Bernhard was born in Berlin and studied for two
years at the Berlin Academy of Art before moving to
New York in 1927. Self-taught, she admired the work of
Edward Weston and the clarity of his prints. From 1930
on Bernhard photographed professionally, first in New
York and later in Los Angeles. She worked in New York
during World War II but returned to California follow-
ing the war and eventually settled in San Francisco.
Although her work is "straight" in terms of technique,
it has a unique sensual quality drawn from her concept
of life and natural order. In her nudes and natural ob-
jects line, rhythm, and form transcend actual physical
shape.

*843. **APPLE TREE** (P1987.14)
Gelatin silver print. 1970
Image: 10 9/16 x 13 3/4 in. (26.9 x 34.8 cm.)
Mount: 16 1/16 x 20 in. (40.7 x 50.8 cm.)
Signed, l.r. mount recto and u.l. mount verso:
"Ruth Bernhard"
Inscription, mount verso: "Apple tree 1970" and dealer's mark
Acquired from: gift of Paul Brauchle, Dallas, Texas

844. **CREATION** (P1986.28)
Gelatin silver print. 1936
Image: 7 7/8 x 9 13/16 in. (19.9 x 24.9 cm.)
Mount: same as image size
Signed, center mount verso: "Ruth Bernhard"
Inscription, mount verso: "Creation 1936" and dealer's mark
Acquired from: Paul M. Hertzmann, Inc., San Francisco,
California

*845. **IN THE BOX—HORIZONTAL** (P1981.76)
Gelatin silver print. 1962
Image: 7 3/8 x 13 3/8 in. (18.7 x 33.9 cm.)
Mount: 15 7/8 x 19 7/8 in. (40.3 x 50.5 cm.)
Signed, l.r. mount recto: "Ruth Bernhard"
Inscription, mount verso: "In the Box—Horizontal 1962/
Ruth Bernhard"
Acquired from: Nichol Photographs, Inc., Berkeley,
California

RONALD BINKS, American (b. 1934)

A native of Oak Park, Illinois, Binks received a B.F.A.
from the Rhode Island School of Design in 1956 and an
M.F.A. from Yale in 1960. He also studied with Minor

White during the summer of 1954. From 1962 until
1975, Binks taught figure drawing, design, painting,
and film classes at the Rhode Island School of Design.
In 1976 he moved to the University of Texas at San
Antonio, where he taught painting, drawing, and
photography.

846. **GUY WIRE AND TREES** [from the Society for
Photographic Education's "South Central Regional
Photography Exhibition"] (P1983.31.1)
Gelatin silver print. 1978
Image: 9 5/16 x 11 5/8 in. (23.6 x 29.5 cm.)
Sheet: 11 x 13 15/16 in. (27.9 x 35.4 cm.)
Acquired from: gift of the Society for Photographic
Education, South Central Region

RALF W. BLACKSTONE,
American (b. 1953)

Native Texan Renny Blackstone did his undergraduate
work at Sam Houston State University in Huntsville,
Texas, where he studied photography with John Beck
in 1973. Blackstone attended medical school at the Uni-
versity of Texas at San Antonio, graduating in 1978. He
then took a position as an emergency room physician at
St. Bernardines Hospital in San Bernardino, Califor-
nia, continuing to photograph on a limited basis.

847. **UNTITLED** [Nude sitting on bed in front of window]
(P1974.25)
Platinum print. 1974
Image: 7 1/16 x 9 5/16 in. (17.9 x 23.8 cm.)
Sheet: 8 1/2 x 11 in. (21.6 x 28.0 cm.) irregular
Signed, l.r. print recto: "RB '74"
Acquired from: the photographer

GAY BLOCK, American (b. 1942)

Gay Block was born in Houston, Texas. She attended
Sophie Newcomb College in New Orleans and studied
architecture at the University of Houston before taking
courses in photography under Geoff Winningham,
Garry Winogrand, and Anne Tucker from 1973 to 1976.
Block taught photography at the University of Houston,
1979–80 and 1982–83. She received a National Endow-
ment for the Arts Photographer's Fellowship in 1978
and a National Endowment for the Arts Survey Grant
in 1981.

848. **ED AND LINDA BLACKBURN. FORT WORTH** [from
"Contemporary Texas: A Photographic Portrait"]
(P1985.17.25)
Gelatin silver print. 1984
Image: 10 9/16 x 13 1/2 in. (26.8 x 34.3 cm.)
Sheet: 11 x 13 15/16 in. (28.0 x 35.4 cm.)
Signed, bottom center print verso: "Gay Block 1984"
Inscription, print verso: "Linda Blackburn/Ed Blackburn/
painters/ Ft. Worth"
Acquired from: gift of the Texas Historical Foundation with
support from a major grant from the Du Pont Company
and Conoco, its energy subsidiary, and assistance from
the Texas Commission on the Arts and the National
Endowment for the Arts

849. **GAEL STACK. HOUSTON** [from "Contemporary Texas: A
Photographic Portrait"] (P1985.17.30)
Gelatin silver print (photomontage). 1984
Image: 15 x 19 in. (38.1 x 48.2 cm.)
Sheet: 15 15/16 x 20 in. (40.5 x 50.8 cm.)
Signed, right center print verso: "Gay Block"
Inscription, print verso: "GAEL STACK/HOUSTON, TX
1984//Bottom"

Acquired from: gift of the Texas Historical Foundation with
support from a major grant from the Du Pont Company
and Conoco, its energy subsidiary, and assistance from
the Texas Commission on the Arts and the National
Endowment for the Arts

841

*850. **JAMES SURLS WITH LILLIE. SPLENDORA** [from
"Contemporary Texas: A Photographic Portrait"]
(P1985.17.28)
Gelatin silver print. 1984
Image: 13½ x 10⁹⁄₁₆ in. (34.3 x 26.8 cm.)
Sheet: 14 x 11 in. (35.6 x 28.0 cm.)
Signed, bottom center print verso: "Gay Block 1984"
Inscription, print verso: "James Surls, sculptor/Splendora"
Acquired from: gift of the Texas Historical Foundation with
support from a major grant from the Du Pont Company
and Conoco, its energy subsidiary, and assistance from
the Texas Commission on the Arts and the National
Endowment for the Arts

851. **JIM LOVE. HOUSTON** [from "Contemporary Texas: A
Photographic Portrait"] (P1985.17.26)
Gelatin silver print. 1984
Image: 13½ x 10⁹⁄₁₆ in. (34.3 x 26.8 cm.)
Sheet: 13¹⁵⁄₁₆ x 11 in. (35.4 x 28.0 cm.)
Signed, bottom center print verso: "Gay Block 1984"
Inscription, print verso: "Jim Love/Sculptor, Houston"
Acquired from: gift of the Texas Historical Foundation with
support from a major grant from the Du Pont Company
and Conoco, its energy subsidiary, and assistance from
the Texas Commission on the Arts and the National
Endowment for the Arts

843

852. **LEE SMITH. DALLAS** [from "Contemporary Texas: A
Photographic Portrait"] (P1985.17.23)
Gelatin silver print. 1984
Image: 9¹¹⁄₁₆ x 12⅜ in. (24.6 x 31.4 cm.)
Sheet: 11 x 13¹⁵⁄₁₆ in. (28.0 x 35.4 cm.)
Signed, bottom center print verso: "Gay Block 1984"
Inscription, print verso: "Lee Smith, painter/Dallas"
Acquired from: gift of the Texas Historical Foundation with
support from a major grant from the Du Pont Company
and Conoco, its energy subsidiary, and assistance from
the Texas Commission on the Arts and the National
Endowment for the Arts

853. **LUIS JIMENEZ. EL PASO** [from "Contemporary Texas: A
Photographic Portrait"] (P1985.17.24)
Gelatin silver print. 1984
Image: 10⁹⁄₁₆ x 13⁷⁄₁₆ in. (26.8 x 34.1 cm.)
Sheet: 11 x 13¹⁵⁄₁₆ in. (28.0 x 35.4 cm.)
Signed, bottom center print verso: "Gay Block 1984"
Inscription, print verso: "Luis Jimenez, sculptor/El Paso"
Acquired from: gift of the Texas Historical Foundation with
support from a major grant from the Du Pont Company
and Conoco, its energy subsidiary, and assistance from
the Texas Commission on the Arts and the National
Endowment for the Arts

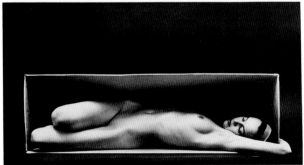

845

854. **MELISSA MILLER. AUSTIN** [from "Contemporary Texas:
A Photographic Portrait"] (P1985.17.27)
Gelatin silver print. 1984
Image: 10⅝ x 13½ in. (26.9 x 34.3 cm.)
Sheet: 11 x 13¹⁵⁄₁₆ in. (28.0 x 35.4 cm.)
Signed, bottom center print verso: "Gay Block 1984"
Inscription, print verso: "Melissa Miller, painter/Austin"
Acquired from: gift of the Texas Historical Foundation with
support from a major grant from the Du Pont Company
and Conoco, its energy subsidiary, and assistance from
the Texas Commission on the Arts and the National
Endowment for the Arts

855. NIC NICOSIA. DALLAS [from "Contemporary Texas: A
 Photographic Portrait"] (P1985.17.22)
 Gelatin silver print. 1984
 Image (triptych): a) 10 x 9 ⅞ in. (25.4 x 25.1 cm.)
 b) 10 x 9 ⅞ in. (25.4 x 25.1 cm.)
 c) 10 x 9 ⅞ in. (25.4 x 25.1 cm.)
 Sheet: a) 13 ¹⁵⁄₁₆ x 11 in. (35.4 x 28.0 cm.)
 b) 13 ¹⁵⁄₁₆ x 11 in. (35.4 x 28.0 cm.)
 c) 13 ¹⁵⁄₁₆ x 11 in. (35.4 x 28.0 cm.)
 Signed, bottom center print verso (on all three prints): "Gay
 Block 1984"
 Inscription, print verso: a) "#3/Nic Nicosia, photog./Dallas"
 b) "#2 Nic Nicosia, photog./Dallas"
 c) "#1 Nic Nicosia, photog./Dallas"
 Acquired from: gift of the Texas Historical Foundation with
 support from a major grant from the Du Pont Company
 and Conoco, its energy subsidiary, and assistance from
 the Texas Commission on the Arts and the National
 Endowment for the Arts

*856. RUSSELL LEE. AUSTIN [from "Contemporary Texas: A
 Photographic Portrait"] (P1985.17.29)
 Gelatin silver print. 1984
 Image (three images on one sheet):
 a) 6 ⁹⁄₁₆ x 5 ⁵⁄₁₆ in. (16.7 x 13.5 cm.)
 b) 6 ⁹⁄₁₆ x 5 ⅜ in. (16.7 x 13.7 cm.)
 c) 9 ¾ x 13 ⅛ in. (24.8 x 33.3 cm.)
 Sheet: 20 x 16 in. (50.8 x 40.7 cm.)
 Signed, center print verso: "Gay Block"
 Inscription, print recto: "RUSSELL LEE: FISHERMAN,
 POLITICAL ACTIVIST,/PHOTOGRAPHER//RUSSELL'S
 1982 OPEN HEART SURGERY SCAR// RUSSELL LEE
 IN HIS BACK YARD, AUSTIN, TX. 1984"
 print verso: "RUSSELL LEE/AUSTIN, TX 1984//Bottom"
 Acquired from: gift of the Texas Historical Foundation with
 support from a major grant from the Du Pont Company
 and Conoco, its energy subsidiary, and assistance from
 the Texas Commission on the Arts and the National
 Endowment for the Arts

857. VERNON FISHER. FORT WORTH [from
 "Contemporary Texas: A Photographic Portrait"]
 (P1985.17.21)
 Gelatin silver print. 1984
 Image: 12 ½ x 9 ⅝ in. (31.8 x 24.4 cm.)
 Sheet: 14 ¹⁄₁₆ x 11 in. (35.7 x 28.0 cm.)
 Signed, center print verso: "Gay Block"
 Inscription, print verso: "VERNON FISHER/FT. WORTH,
 TX 1984"
 Acquired from: gift of the Texas Historical Foundation with
 support from a major grant from the Du Pont Company
 and Conoco, its energy subsidiary, and assistance from
 the Texas Commission on the Arts and the National
 Endowment for the Arts

AVE BONAR, American (b. 1948)

Ave Bonar was born in Lubbock, Texas. From 1973 to
1974 she served as the chief photographer for the *Daily
Democrat* in Davis, California, but returned to Texas
and completed a bachelor's degree in journalism at the
University of Texas at Austin in 1976. She helped edit
the 1977 and 1978 editions of the *Book of Days*, a calen-
dar published in Austin, Texas, that features the work
of regional photographers. In 1983 Bonar became the
staff photographer for Austin's Laguna Gloria Art
Museum but continued to pursue her own work.

858. ADALBERTO Y HERMILIA, ALAMO [from
 "Contemporary Texas: A Photographic Portrait"]
 (P1985.17.34)
 Gelatin silver print. 1984
 Image: 9 ⅛ x 13 ⅜ in. (23.2 x 34.0 cm.)
 Sheet: 11 x 14 in. (28.0 x 35.6 cm.)

Signed: see inscription
Inscription, print verso, typed on paper label: "© 1984/By
 Ave Bonar"
Acquired from: gift of the Texas Historical Foundation with
 support from a major grant from the Du Pont Company
 and Conoco, its energy subsidiary, and assistance from
 the Texas Commission on the Arts and the National
 Endowment for the Arts

859. CANTALOUPE PACKER, GRIFFIN AND BRAND
 PACKING SHED, RIO GRANDE CITY [from
 "Contemporary Texas: A Photographic Portrait"]
 (P1985.17.36)
 Gelatin silver print. 1984
 Image: 9 x 13 ⁵⁄₁₆ in. (22.8 x 33.8 cm.)
 Sheet: 10 ¹⁵⁄₁₆ x 14 in. (27.8 x 35.6 cm.)
 Signed: see inscription
 Inscription, print verso, typed on paper label: "© 1984/By
 Ave Bonar"
 Acquired from: gift of the Texas Historical Foundation with
 support from a major grant from the Du Pont Company
 and Conoco, its energy subsidiary, and assistance from
 the Texas Commission on the Arts and the National
 Endowment for the Arts

860. CIMARRON COUNTRY CLUB, McALLEN [from
 "Contemporary Texas: A Photographic Portrait"]
 (P1985.17.37)
 Gelatin silver print. 1984
 Image: 13 ⅛ x 8 ⅞ in. (34.0 x 22.5 cm.)
 Sheet: 14 x 10 ¹⁵⁄₁₆ in. (35.6 x 27.8 cm.)
 Signed: see inscription
 Inscription, print verso, typed on paper label: "© 1984/By
 Ave Bonar"
 Acquired from: gift of the Texas Historical Foundation with
 support from a major grant from the Du Pont Company
 and Conoco, its energy subsidiary, and assistance from
 the Texas Commission on the Arts and the National
 Endowment for the Arts

861. DEPORTEES IN CUSTODY OF BORDER PATROL,
 BROWNSVILLE [from "Contemporary Texas: A
 Photographic Portrait"] (P1985.17.40)
 Gelatin silver print. 1984
 Image: 8 ⅞ x 13 ⁵⁄₁₆ in. (22.5 x 33.8 cm.)
 Sheet: 11 x 14 in. (28.0 x 35.6 cm.)
 Signed: see inscription
 Inscription, print verso, typed on paper label: "© 1984/By
 Ave Bonar"
 Acquired from: gift of the Texas Historical Foundation with
 support from a major grant from the Du Pont Company
 and Conoco, its energy subsidiary, and assistance from
 the Texas Commission on the Arts and the National
 Endowment for the Arts

862. ILLEGALS CROSSING UNDER BRIDGE,
 BROWNSVILLE [from "Contemporary Texas: A
 Photographic Portrait"] (P1985.17.39)
 Gelatin silver print. 1984
 Image: 8 ¹⁵⁄₁₆ x 13 ⁵⁄₁₆ in. (22.6 x 33.8 cm.)
 Sheet: 11 x 14 in. (28.0 x 35.6 cm.)
 Signed: see inscription
 Inscription, print verso, typed on paper label: "© 1984/By
 Ave Bonar"
 Acquired from: gift of the Texas Historical Foundation with
 support from a major grant from the Du Pont Company
 and Conoco, its energy subsidiary, and assistance from
 the Texas Commission on the Arts and the National
 Endowment for the Arts

863. LA ESTRELLA BAKERY, McALLEN [from "Contemporary
 Texas: A Photographic Portrait"] (P1985.17.35)
 Gelatin silver print. 1984
 Image: 8 ⅞ x 13 ⅜ in. (22.5 x 34.0 cm.)
 Sheet: 10 ¹⁵⁄₁₆ x 14 in. (27.8 x 35.6 cm.)
 Signed: see inscription

Inscription, print verso, typed on paper label: "© 1984/By
Ave Bonar"

Acquired from: gift of the Texas Historical Foundation with
support from a major grant from the Du Pont Company
and Conoco, its energy subsidiary, and assistance from
the Texas Commission on the Arts and the National
Endowment for the Arts

*864. **PARADISE MOTEL, McALLEN [from "Contemporary
Texas: A Photographic Portrait"]** (P1985.17.31)
Gelatin silver print. 1984
Image: 8 15/16 x 13 5/16 in. (22.6 x 33.8 cm.)
Sheet: 10 15/16 x 14 in. (27.8 x 35.6 cm.)
Signed: see inscription
Inscription, print verso, typed on paper label: "© 1984/By
Ave Bonar"
Acquired from: gift of the Texas Historical Foundation with
support from a major grant from the Du Pont Company
and Conoco, its energy subsidiary, and assistance from
the Texas Commission on the Arts and the National
Endowment for the Arts

865. **UNITED FARM WORKERS STATE HEADQUARTERS,
SAN JUAN [from "Contemporary Texas: A Photographic
Portrait"]** (P1985.17.33)
Gelatin silver print. 1984
Image: 8 15/16 x 13 1/4 in. (22.6 x 33.7 cm.)
Sheet: 10 15/16 x 14 in. (27.8 x 35.6 cm.)
Signed: see inscription
Inscription, print verso, typed on paper label: "© 1984/By
Ave Bonar"
Acquired from: gift of the Texas Historical Foundation with
support from a major grant from the Du Pont Company
and Conoco, its energy subsidiary, and assistance from
the Texas Commission on the Arts and the National
Endowment for the Arts

866. **WINDSOR COURT, McALLEN [from "Contemporary
Texas: A Photographic Portrait"]** (P1985.17.32)
Gelatin silver print. 1984
Image: 8 15/16 x 13 5/16 in. (22.6 x 33.8 cm.)
Sheet: 10 15/16 x 14 in. (27.8 x 35.6 cm.)
Signed: see inscription
Inscription, print verso, typed on paper label: "© 1984/By
Ave Bonar"
Acquired from: gift of the Texas Historical Foundation with
support from a major grant from the Du Pont Company
and Conoco, its energy subsidiary, and assistance from
the Texas Commission on the Arts and the National
Endowment for the Arts

*867. **WOMAN AT A TEA, McALLEN [from "Contemporary
Texas: A Photographic Portrait"]** (P1985.17.38)
Gelatin silver print. 1984
Image: 13 3/8 x 8 7/8 in. (34.0 x 22.5 cm.)
Sheet: 14 x 10 15/16 in. (35.6 x 27.8 cm.)
Signed: see inscription
Inscription, print verso, typed on paper label: "© 1984/By
Ave Bonar"
Acquired from: gift of the Texas Historical Foundation with
support from a major grant from the Du Pont Company
and Conoco, its energy subsidiary, and assistance from
the Texas Commission on the Arts and the National
Endowment for the Arts

HOWARD BOND, American (b. 1931)

Bond was born in Ohio and for several years pursued a
musical career, teaching in public schools, composing,
and conducting. He began to make photographs during
high school, but developed a serious interest in artistic
photography after attending an Ansel Adams Yosemite
Workshop in 1967. He has cited Adams, Brett Weston,
and Imogen Cunningham as major influences on his

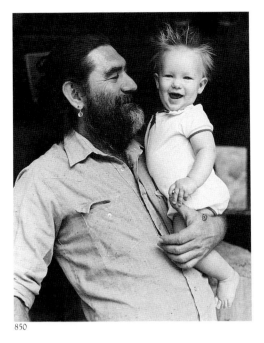

850

856

864

work. Bond's photographs are made only with view cameras, and in 1979 he gave up other endeavors to concentrate on his own photography and teach workshops.

*868. EVENING SKY—ESTES PARK [Estes Park, Colorado] (P1978.24.2)
Gelatin silver print. 1976
Image: 10 5/16 x 13 in. (26.1 x 33.1 cm.)
Mount: 16 x 20 in. (40.7 x 50.8 cm.)
Signed, l.r. mount recto: "Howard Bond"
Acquired from: Halsted Gallery, Birmingham, Michigan

869. PROCESSION (P1978.24.1)
Gelatin silver print. 1967
Image: 11 3/8 x 19 1/4 in. (28.9 x 48.9 cm.)
Mount: 18 x 24 in. (45.7 x 61.0 cm.)
Signed, l.r. mount recto: "Howard Bond"
Inscription, mount verso: "PROCESSION" and rubber stamp "HOWARD BOND/1095 HAROLD CIRCLE/ANN ARBOR, MICHIGAN 48103/(313) 665-6597"
Acquired from: Halsted Gallery, Birmingham, Michigan

JIM BONES, American (b. 1943)

Bones depicts mainly scenes in nature, capturing intense colors in his dye-transfer prints. He studied design, etching, art history, and photography at the University of Texas and, for a time, was a printer for Eliot Porter in Santa Fe. Although his early work was black and white, Bones later worked almost exclusively with color, focusing on rhythmic and textural variations found in the landscape. Many of his images depict the Big Bend area of Texas. Bones has published several books of nature photographs including *Texas Wild, Texas Earth Surfaces, Texas Heartland,* and *Texas West of the Pecos.*

870. APRIL DUST STORM, MARISCAL CROSS-CANYON, RIO GRANDE [from "Texas West of the Pecos"] (P1982.17.25)
Dye-transfer print. 1981
Image: 12 13/16 x 9 15/16 in. (32.5 x 25.3 cm.)
Mount: 20 x 16 in. (50.8 x 40.7 cm.)
Signed, l.r. mount recto: "Jim Bones"
Inscription, mount verso: "April dust storm, Mariscal cross-canyon, Rio Grande/#1981" and rubber stamps "© JIM BONES/REPRODUCTION/ PROHIBITED" and "JIM BONES/P.O. Box 458/Tesuque, New Mexico 87574/(515) 988-1662"
Acquired from: gift of the photographer

871. ASH AND LAVA REMNANTS ON THE SUNKEN BLOCK OF UDDEN, TEXAS [from "Texas West of the Pecos"] (P1982.17.26)
Dye-transfer print. 1981
Image: 12 15/16 x 10 1/16 in. (32.8 x 25.5 cm.)
Mount: 20 x 16 in. (50.8 x 40.7 cm.)
Signed, l.r. mount recto: "Jim Bones"
Inscription, mount verso: "Ash and lava remnants on The Sunken Block of Udden, Texas/#1981" and rubber stamps "© JIM BONES/ REPRODUCTION/PROHIBITED" and "JIM BONES/P.O. Box 458/Tesuque, New Mexico 87574/(515) 988-1662"
Acquired from: gift of the photographer

872. AUTUMN BLUESTEM GRASS, DECATUR, WISE COUNTY [from "Contemporary Texas: A Photographic Portrait"] (P1985.17.50)
Dye-transfer print. negative 1983, print 1984
Image: 12 15/16 x 10 1/16 in. (32.9 x 25.5 cm.)
Sheet: 13 15/16 x 11 in. (35.4 x 28.0 cm.)
Signed, l.r. print verso: "Jim Bones"

Inscription, print verso: "Autumn grasslands and trees near Decater [sic], Texas"
Acquired from: gift of the Texas Historical Foundation with support from a major grant from the Du Pont Company and Conoco, its energy subsidiary, and assistance from the Texas Commission on the Arts and the National Endowment for the Arts

*873. BARTON CREEK, NEAR BEE CAVES, TRAVIS COUNTY [from "Contemporary Texas: A Photographic Portrait"] (P1985.17.44)
Dye-transfer print. negative 1983, print 1984
Image: 10 1/16 x 12 15/16 in. (25.5 x 32.9 cm.)
Sheet: 11 x 13 15/16 in. (28.0 x 35.4 cm.)
Signed, bottom center print verso: "Jim Bones"
Inscription, print verso: "#5 Barton Creek"
Acquired from: gift of the Texas Historical Foundation with support from a major grant from the Du Pont Company and Conoco, its energy subsidiary, and assistance from the Texas Commission on the Arts and the National Endowment for the Arts

874. BASKETGRASS, CROTON, AND RAIN-SOAKED MARFA PLAINS, TEXAS [from "Texas West of the Pecos"] (P1982.17.18)
Dye-transfer print. 1981
Image: 9 15/16 x 12 7/8 in. (25.2 x 32.7 cm.)
Mount: 16 x 20 in. (40.7 x 50.8 cm.)
Signed, l.r. mount recto: "Jim Bones"
Inscription, mount verso: "Basketgrass, croton, and rain-soaked Marfa Plains, Texas/#1981" and rubber stamps "© JIM BONES/ REPRODUCTION/PROHIBITED" and "JIM BONES/P.O. Box 458/Tesuque, New Mexico 87574/(515) 988-1662"
Acquired from: gift of the photographer

875. BIGTOOTH MAPLES AND ERODED FOSSIL MOUNDS IN A GUADALUPE CANYON, TEXAS [from "Texas West of the Pecos"] (P1982.17.12)
Dye-transfer print. 1981
Image: 10 1/16 x 12 15/16 in. (25.5 x 32.8 cm.)
Mount: 16 x 20 in. (40.7 x 50.8 cm.)
Signed, l.r. mount recto: "Jim Bones"
Inscription, mount verso: "Bigtooth maples and eroded fossil mounds in a Guadalupe Canyon, Texas/#1981" and rubber stamps "© JIM BONES/REPRODUCTION/ PROHIBITED" and "JIM BONES/P.O. Box 458/Tesuque, New Mexico 87574/(515) 988-1662"
Acquired from: gift of the photographer

876. BLIZZARD AROUND EL CAPITAN, GUADALUPE PASS, TEXAS [from "Texas West of the Pecos"] (P1982.17.11)
Dye-transfer print. 1981
Image: 10 1/16 x 12 7/8 in. (25.5 x 32.7 cm.)
Mount: 16 x 20 in. (40.7 x 50.8 cm.)
Signed, l.r. mount recto: "Jim Bones"
Inscription, mount verso: "Blizzard around El Capitan, Guadalupe Pass, Texas/#1981" and rubber stamps "© JIM BONES/REPRODUCTION/ PROHIBITED" and "JIM BONES/P.O. Box 458/Tesuque, New Mexico 87574/ (515) 988-1662"
Acquired from: gift of the photographer

*877. COLLAPSED CLIFF AT THE ROCK SLIDE, SANTA ELENA CANYON, RIO GRANDE [from "Texas West of the Pecos"] (P1982.17.29)
Dye-transfer print. 1981
Image: 12 15/16 x 10 in. (32.8 x 25.4 cm.)
Mount: 20 x 16 in. (50.8 x 40.7 cm.)
Signed, l.r. mount recto: "Jim Bones"
Inscription, mount verso: "Collapsed Cliff at The Rock Slide, Santa Elena, Canyon, Rio Grande/#1981" and rubber stamps "© JIM BONES/REPRODUCTION/ PROHIBITED" and "JIM BONES/P.O. Box 458/Tesuque, New Mexico 87574/(515) 988-1662"
Acquired from: gift of the photographer

867

868

873

877

878

883

*878. COLORADO CANYON AND THE RIO GRANDE [from
"Texas West of the Pecos"] (P1982.17.30)
Dye-transfer print. 1981
Image: 12 ¹⁵/₁₆ x 10 in. (32.8 x 25.4 cm.)
Mount: 20 x 16 in. (50.8 x 40.7 cm.)
Signed, l.r. mount recto: "Jim Bones"
Inscription, mount verso: "Colorado Canyon and The Rio
Grande/#1981" and rubber stamps "© JIM BONES/
REPRODUCTION/PROHIBITED" and "JIM BONES/
P.O. Box 458/Tesuque, New Mexico 87574/(515) 988-1662"
Acquired from: gift of the photographer

879. COTTONWOODS, WILLOWS AND NEW DEAL WEED,
TEXAS [from "Texas West of the Pecos"] (P1982.17.32)
Dye-transfer print. 1981
Image: 12 ¹⁵/₁₆ x 10 in. (32.8 x 25.4 cm.)
Mount: 20 x 16 in. (50.8 x 40.7 cm.)
Signed, l.r. mount recto: "Jim Bones"
Inscription, mount verso: "Cottonwoods, willows and New
Deal Weed, Texas/#1981" and rubber stamps "© JIM
BONES/REPRODUCTION/ PROHIBITED" and "JIM
BONES/P.O. Box 458/Tesuque, New Mexico 87574/ (515)
988-1662"
Acquired from: gift of the photographer

880. CYPRESS SWAMP, NECHES RIVER, TYLER COUNTY
[from "Contemporary Texas: A Photographic Portrait"]
(P1985.17.46)
Dye-transfer print. 1984
Image: 10 ¹/₁₆ x 12 ¹⁵/₁₆ in. (25.5 x 32.9 cm.)
Sheet: 11 x 13 ¹⁵/₁₆ in. (28.0 x 35.4 cm.)
Signed, bottom center print verso: "Jim Bones"
Inscription, print verso: "#7 Cypress Swamp"
Acquired from: gift of the Texas Historical Foundation with
support from a major grant from the Du Pont Company
and Conoco, its energy subsidiary, and assistance from
the Texas Commission on the Arts and the National
Endowment for the Arts

881. DESERT SCRUB AND STEAMY RIVER WILLOWS
NEAR LANGTRY, TEXAS [from "Texas West of the
Pecos"] (P1982.17.3)
Dye-transfer print. 1981
Image: 12 ¹⁵/₁₆ x 10 ¹/₁₆ in. (32.8 x 25.5 cm.)
Mount: 20 x 16 in. (50.8 x 40.7 cm.)
Signed, l.r. mount recto: "Jim Bones"
Inscription, mount verso: "Desert Scrub and Steamy River
Willows near Langtry, Texas/#1981" and rubber stamps
"© JIM BONES/ REPRODUCTION/PROHIBITED"
and "JIM BONES/P.O. Box 458/Tesuque, New Mexico
87574/(515) 988-1662"
Acquired from: gift of the photographer

882. DRY COYOTILLO AND EMERGING YUCCA FLOWERS,
TEXAS [from "Texas West of the Pecos"] (P1982.17.23)
Dye-transfer print. 1981
Image: 12 ¹⁵/₁₆ x 10 in. (32.8 x 25.4 cm.)
Mount: 20 x 16 in. (50.8 x 40.7 cm.)
Signed, l.r. mount recto: "Jim Bones"
Inscription, mount verso: "Dry coyotillo and emerging yucca
flowers, Texas/#1981" and rubber stamps "© JIM BONES/
REPRODUCTION/PROHIBITED" and "JIM BONES/
P.O. Box 458/Tesuque, New Mexico 87574/(515) 988-1662"
Acquired from: gift of the photographer

*883. EL CAPITAN AND GUADALUPE MOUNTAINS,
CULBERSON COUNTY [from "Contemporary Texas:
A Photographic Portrait"] (P1985.17.42)
Dye-transfer print. negative 1983, print 1984
Image: 10 ¹/₁₆ x 12 ¹⁵/₁₆ in. (25.5 x 32.9 cm.)
Sheet: 11 ¹/₁₆ x 13 ¹⁵/₁₆ in. (28.1 x 35.4 cm.)
Signed, bottom center print verso: "Jim Bones"
Inscription, print verso: "#2 El Capitan, Guadalupe Mts."
Acquired from: gift of the Texas Historical Foundation with
support from a major grant from the Du Pont Company
and Conoco, its energy subsidiary, and assistance from
the Texas Commission on the Arts and the National
Endowment for the Arts

884. ERODED CAPROCK AND BRUSH, PALO DURO
CANYON, RANDALL COUNTY [from "Contemporary
Texas: A Photographic Portrait"] (P1985.17.43)
Dye-transfer print. negative 1983, print 1984
Image: 10 ¹/₁₆ x 12 ¹⁵/₁₆ in. (25.5 x 32.9 cm.)
Sheet: 11 x 13 ¹⁵/₁₆ in. (28.0 x 35.4 cm.)
Signed, bottom center print verso: "Jim Bones"
Inscription, print verso: "#3 Eroded Caprock Palo Duro
Canyon"
Acquired from: gift of the Texas Historical Foundation with
support from a major grant from the Du Pont Company
and Conoco, its energy subsidiary, and assistance from
the Texas Commission on the Arts and the National
Endowment for the Arts

885. FLOOD-CARVED ICEBERG ROCK, MARISCAL
CANYON, RIO GRANDE [from "Texas West of the
Pecos"] (P1982.17.4)
Dye-transfer print. 1981
Image: 10 x 12 ⁷/₈ in. (25.4 x 32.7 cm.)
Mount: 16 x 19 ⁷/₈ in. (40.7 x 50.5 cm.)
Signed, l.r. mount recto: "Jim Bones"
Inscription, mount verso: "Flood-carved iceberg rock,
Mariscal Canyon, Rio Grande/#1981" and rubber stamps
"© JIM BONES/ REPRODUCTION/PROHIBITED" and
"JIM BONES/P.O. Box 458/Tesuque, New Mexico 87574/
(515) 988-1662"
Acquired from: gift of the photographer

886. HURRICANE CLOUDS BLOWING THROUGH
GUADALUPE PASS, TEXAS [from "Texas West of
the Pecos"] (P1982.17.19)
Dye-transfer print. 1981
Image: 12 ¹⁵/₁₆ x 10 in. (32.8 x 25.4 cm.)
Mount: 20 x 16 in. (50.8 x 40.7 cm.)
Signed, l.r. mount recto: "Jim Bones"
Inscription, mount verso: "Hurricane Clouds blowing
Through Guadalupe Pass, Texas/#1981" and rubber stamps
"© JIM BONES/REPRODUCTION/ PROHIBITED" and
"JIM BONES/P.O. Box 458/Tesuque, New Mexico 87574/
(515) 988-1662"
Acquired from: gift of the photographer

887. IGNEOUS SILLS AND LOW ERODED LANDS BY THE
RIO GRANDE [from "Texas West of the Pecos"]
(P1982.17.22)
Dye-transfer print. 1981
Image: 12 ⁷/₈ x 10 in. (32.7 x 25.4 cm.)
Mount: 20 x 16 in. (50.8 x 40.7 cm.)
Signed, l.r. mount recto: "Jim Bones"
Inscription, mount verso: "Igneous sills and low eroded lands
by the Rio Grande/#1981" and rubber stamps "© JIM
BONES/REPRODUCTION/ PROHIBITED" and "JIM
BONES/P.O. Box 458/Tesuque, New Mexico 87574/
(515) 988-1662"
Acquired from: gift of the photographer

*888. JUNIPER SEEDLING AND NEW RED BERRIES,
SAWTOOTH MT., TEXAS [from "Texas West of the
Pecos"] (P1982.17.17)
Dye-transfer print. 1981
Image: 12 ¹⁵/₁₆ x 10 ¹/₁₆ in. (32.8 x 25.5 cm.)
Mount: 20 x 16 in. (50.8 x 40.7 cm.)
Signed, l.r. mount recto: "Jim Bones"
Inscription, mount verso: "Juniper seedling and new red
berries, Sawtooth Mt., Texas/#1981" and rubber stamps
"© JIM BONES/ REPRODUCTION/PROHIBITED//
© JIM BONES/REPRODUCTION/PROHIBITED" and
"JIM BONES/P.O. Box 458/Tesuque, New Mexico 87574/
(515) 988-1662"
Acquired from: gift of the photographer

889. LIGHTNING-BLAZED ALLIGATOR JUNIPER, TEXAS
[from "Texas West of the Pecos"] (P1982.17.15)
Dye-transfer print. 1981
Image: 12 ⁷/₈ x 10 in. (32.7 x 25.4 cm.)
Mount: 20 x 16 in. (50.8 x 40.7 cm.)

Signed, l.r. mount recto: "Jim Bones"
Inscription, mount verso: "Lightning-blazed alligator juniper,
 Texas/#1981" and rubber stamps "© JIM BONES/
 REPRODUCTION/ PROHIBITED" and "JIM BONES/
 P.O. Box 458/Tesuque, New Mexico 87574/
 (515) 988-1662"
Acquired from: gift of the photographer

890. **MADISON FALLS BELOW BURRO BLUFF, RIO
 GRANDE [from "Texas West of the Pecos"]** (P1982.17.6)
Dye-transfer print. 1981
Image: 12 ¹⁵/₁₆ x 10 in. (32.8 x 25.4 cm.)
Mount: 20 x 16 in. (50.8 x 40.7 cm.)
Signed, l.r. mount recto: "Jim Bones"
Inscription, mount verso: "Madison Falls below Burro
 Bluff, Rio Grande/#1981" and rubber stamps "© JIM
 BONES/REPRODUCTION/ PROHIBITED" and "JIM
 BONES/P.O. Box 458/Tesuque, New Mexico 87574/
 (515) 988-1662"
Acquired from: gift of the photographer

891. **MADRONE BARK, TEXAS [from "Texas West of the
 Pecos"]** (P1982.17.16)
Dye-transfer print. 1981
Image: 10 x 12 ¹⁵/₁₆ in. (25.4 x 32.8 cm.)
Mount: 16 x 20 in. (40.7 x 50.8 cm.)
Signed, l.r. mount recto: "Jim Bones"
Inscription, mount verso: "Madrone bark, Texas/#1981"
 and rubber stamps "© JIM BONES/REPRODUCTION/
 PROHIBITED" and "JIM BONES/P.O. Box 458/Tesuque,
 New Mexico 87574/(515) 988-1662"
Acquired from: gift of the photographer

892. **MAPLES, OAKS, PINES, AND LIMESTONE BOULDERS,
 TEXAS [from "Texas West of the Pecos"]** (P1982.17.13)
Dye-transfer print. 1981
Image: 12 ¹¹/₁₆ x 10 in. (32.2 x 25.4 cm.)
Mount: 20 x 15 ⅞ in. (50.8 x 40.3 cm.)
Signed, l.r. mount recto: "Jim Bones"
Inscription, mount verso: "Maples, oaks, pines, and
 limestone boulders, Texas/#1981" and rubber stamps
 "© JIM BONES/ REPRODUCTION/PROHIBITED"
 and "JIM BONES/P.O. Box 458/Tesuque, New Mexico
 87574/(515) 988-1662"
Acquired from: gift of the photographer

893. **MARIOLA, LECHUGUILLA, AND STRAWBERRY
 PITAYA, TEXAS [from "Texas West of the Pecos"]**
 (P1982.17.8)
Dye-transfer print. 1981
Image: 10 ¹/₁₆ x 12 ⅞ in. (25.5 x 32.7 cm.)
Mount: 16 x 20 in. (40.7 x 50.8 cm.)
Signed, l.r. mount recto: "Jim Bones"
Inscription, mount verso: "Mariola, lechuguilla, and
 strawberry pitaya, Texas/#1981" and rubber stamps
 "© JIM BONES/REPRODUCTION/ PROHIBITED"
 and "JIM BONES/P.O. Box 458/Tesuque, New Mexico
 87574/(515) 988-1662"
Acquired from: gift of the photographer

894. **MARISCAL CANYON ABOVE THE TIGHT SQUEEZE,
 RIO GRANDE [from "Texas West of the Pecos"]**
 (P1982.17.24)
Dye-transfer print. 1981
Image: 12 ⅞ x 10 ¹/₁₆ in. (32.7 x 25.5 cm.)
Mount: 20 x 15 ⅞ in. (50.8 x 40.3 cm.)
Signed, l.r. mount recto: "Jim Bones"
Inscription, mount verso: "Mariscal Canyon above The Tight
 Squeeze, Rio Grande/#1981" and rubber stamps "© JIM
 BONES/REPRODUCTION/ PROHIBITED" and "JIM
 BONES/P.O. Box 458/Tesuque, New Mexico 87574/
 (515) 988-1662"
Acquired from: gift of the photographer

888

896

895. **MARSHGRASS AND CATTAILS, HIGH ISLAND, GALVESTON COUNTY** [from "Contemporary Texas: A Photographic Portrait"] (P1985.17.47)
Dye-transfer print. 1984
Image: 10 1/16 x 12 15/16 in. (25.5 x 32.9 cm.)
Sheet: 11 x 14 in. (28.0 x 35.6 cm.)
Signed, bottom center print verso: "Jim Bones"
Inscription, print verso: "#9 Marsh land"
Acquired from: gift of the Texas Historical Foundation with support from a major grant from the Du Pont Company and Conoco, its energy subsidiary, and assistance from the Texas Commission on the Arts and the National Endowment for the Arts

*896. **MESCAL AGAVE, SNAKEBRUSH AND PRICKLY PEAR IN THE CHISOS BASIN, TEXAS** [from "Texas West of the Pecos"] (P1982.17.10)
Dye-transfer print. 1981
Image: 12 15/16 x 10 1/16 in. (32.8 x 25.5 cm.)
Mount: 19 7/8 x 16 in. (50.5 x 40.7 cm.)
Signed, l.r. mount recto: "Jim Bones"
Inscription, mount verso: "Mescal agave, snakebrush and prickly pear in The Chisos Basin, Texas/#1981" and rubber stamps "© JIM BONES/REPRODUCTION/PROHIBITED" and "JIM BONES/ P.O. Box 458/Tesuque, New Mexico 87574/(515) 988-1662"
Acquired from: gift of the photographer

897. **MINERAL-STAINED BOX CANYON WALLS, MEXICO** [from "Texas West of the Pecos"] (P1982.17.9)
Dye-transfer print. 1981
Image: 12 15/16 x 9 3/4 in. (32.8 x 24.8 cm.)
Mount: 20 x 16 in. (50.8 x 40.7 cm.)
Signed, l.r. mount recto: "Jim Bones"
Inscription, mount verso: "Mineral-stained box canyon walls, Mexico/ #1981" and rubber stamps "© JIM BONES/ REPRODUCTION/PROHIBITED" and "JIM BONES/ P.O. Box 458, Tesuque, New Mexico 87574/(515) 988-1662"
Acquired from: gift of the photographer

*898. **PALMETTO LEAF, OTTINE, GONZALES COUNTY** [from "Contemporary Texas: A Photographic Portrait"] (P1985.17.45)
Dye-transfer print. 1984
Image: 12 15/16 x 10 1/16 in. (32.9 x 25.5 cm.)
Sheet: 13 15/16 x 11 in. (35.4 x 28.0 cm.)
Signed, bottom center print verso: "Jim Bones"
Inscription, print verso: "#6 Palmetto"
Acquired from: gift of the Texas Historical Foundation with support from a major grant from the Du Pont Company and Conoco, its energy subsidiary, and assistance from the Texas Commission on the Arts and the National Endowment for the Arts

899. **RIO DEL CARMEN, ABOVE BOQUILLAS CANYON AND THE RIO GRANDE** [from "Texas West of the Pecos"] (P1982.17.7)
Dye-transfer print. 1981
Image: 12 7/8 x 10 in. (32.7 x 25.4 cm.)
Mount: 20 x 16 in. (50.8 x 40.7 cm.)
Signed, l.r. mount recto: "Jim Bones"
Inscription, mount verso: "Rio del Carmen, above Boquillas Canyon and the Rio Grande/#1981" and rubber stamps "© JIM BONES/ REPRODUCTION/PROHIBITED" and "JIM BONES/P.O. Box 458/Tesuque, New Mexico 87574/(515) 988-1662"
Acquired from: gift of the photographer

*900. **RIO GRANDE VALLEY BOULDERS, TEXAS** [from "Texas West of the Pecos"] (P1982.17.2)
Dye-transfer print. 1981
Image: 9 3/4 x 12 5/8 in. (24.8 x 32.0 cm.)
Mount: 16 x 20 in. (40.7 x 50.8 cm.)
Signed, l.r. mount recto: "Jim Bones"
Inscription, mount verso: "Rio Grande Valley Boulders, Texas/#1981" and rubber stamps "© JIM BONES/

REPRODUCTION/PROHIBITED" and "JIM BONES/ P.O. Box 458/Tesuque, New Mexico 87574/ (515) 988-1662"
Acquired from: gift of the photographer

*901. **ROCK NETTLES, MEXICO** [from "Texas West of the Pecos"] (P1982.17.28)
Dye-transfer print. 1981
Image: 12 7/8 x 10 1/16 in. (32.7 x 25.5 cm.)
Mount: 20 x 16 in. (50.8 x 40.7 cm.)
Signed, l.r. mount recto: "Jim Bones"
Inscription, mount verso: "Rock nettles, Mexico/#1981" and rubber stamps "© JIM BONES/REPRODUCTION/ PROHIBITED" and "JIM BONES/P.O. Box 458/Tesuque, New Mexico 87574/(515) 988-1662"
Acquired from: gift of the photographer

*902. **SAND DUNES AND SHINOAK, MONAHANS, WARD COUNTY** [from "Contemporary Texas: A Photographic Portrait"] (P1985.17.49)
Dye-transfer print. negative 1983, print 1984
Image: 10 1/16 x 12 15/16 in. (25.5 x 32.9 cm.)
Sheet: 11 x 13 15/16 in. (28.0 x 35.4 cm.)
Signed, bottom center print verso: "Jim Bones"
Inscription, print verso: "#15 Sand dunes near Monahans"
Acquired from: gift of the Texas Historical Foundation with support from a major grant from the Du Pont Company and Conoco, its energy subsidiary, and assistance from the Texas Commission on the Arts and the National Endowment for the Arts

903. **SANDBAR AND REFLECTED BOULDERS, RIO GRANDE** [from "Texas West of the Pecos"] (P1982.17.34)
Dye-transfer print. 1981
Image: 9 15/16 x 12 15/16 in. (25.3 x 32.8 cm.)
Mount: 15 7/8 x 19 7/8 in. (40.3 x 50.5 cm.)
Signed, l.r. mount recto: "Jim Bones"
Inscription, mount verso: "Sandbar and reflected boulders, Rio Grande/#1981" and rubber stamps "© JIM BONES/REPRODUCTION/ PROHIBITED" and "JIM BONES/P.O. Box 458/Tesuque, New Mexico 87574/ (515) 988-1662"
Acquired from: gift of the photographer

904. **SANDBURS AND BIG BEND BLUEBONNETS, TEXAS** [from "Texas West of the Pecos"] (P1982.17.27)
Dye-transfer print. 1981
Image: 12 7/8 x 9 15/16 in. (32.7 x 25.3 cm.)
Mount: 19 7/8 x 16 in. (50.5 x 40.7 cm.)
Signed, l.r. mount recto: "Jim Bones"
Inscription, mount verso: "Sandburs and Big Bend bluebonnets, Texas/#1981" and rubber stamps "© JIM BONES/REPRODUCTION/ PROHIBITED" and "JIM BONES/P.O. Box 458/Tesuque, New Mexico 87574/ (515) 988-1662"
Acquired from: gift of the photographer

905. **SNOW ON YUCCA AND CHOLLA, TEXAS** [from "Texas West of the Pecos"] (P1982.17.20)
Dye-transfer print. 1981
Image: 12 13/16 x 10 in. (32.5 x 25.4 cm.)
Mount: 20 x 16 in. (50.8 x 40.7 cm.)
Signed, l.r. mount recto: "Jim Bones"
Inscription, mount verso: "Snow on yucca and cholla, Texas/#1981" and rubber stamps "© JIM BONES/ REPRODUCTION/PROHIBITED" and "JIM BONES/ P.O. Box 458/Tesuque, New Mexico 87574/ (515) 988-1662"
Acquired from: gift of the photographer

898

900

902

901

907

910

906. **SOUTH RIM CHISOS MOUNTAINS, TEXAS** [from "Texas West of the Pecos"] (P1982.17.5)
Dye-transfer print. 1981
Image: 9 9/16 x 12 1/2 in. (24.3 x 31.8 cm.)
Mount: 16 x 20 in. (40.7 x 50.8 cm.)
Signed, l.r. mount recto: "Jim Bones"
Inscription, mount verso: "South Rim Chisos Mountains, Texas/#1981" and rubber stamps "© JIM BONES/REPRODUCTION/PROHIBITED" and "JIM BONES/P.O. Box 458/Tesuque, New Mexico 87574/(515) 988-1662"
Acquired from: gift of the photographer

*907. **SUMMER THREE-AWN GRASSES, ALPINE MEADOW, TEXAS** [from "Texas West of the Pecos"] (P1982.17.21)
Dye-transfer print. 1981
Image: 12 15/16 x 10 in. (32.8 x 25.4 cm.)
Mount: 20 x 16 in. (50.8 x 40.7 cm.)
Signed, l.r. mount recto: "Jim Bones"
Inscription, mount verso: "Summer three-awn grasses, Alpine meadow, Texas/#1981" and rubber stamps "© JIM BONES/REPRODUCTION/ PROHIBITED" and "JIM BONES/ P.O. Box 458/Tesuque, New Mexico 87574/ (515) 988-1662"
Acquired from: gift of the photographer

908. **SUNDOWN BY THE RIO GRANDE, SIERRA VIEJA, PRESIDIO COUNTY** [from "Contemporary Texas: A Photographic Portrait"] (P1985.17.41)
Dye-transfer print. 1984
Image: 12 15/16 x 10 1/16 in. (32.9 x 25.5 cm.)
Sheet: 13 15/16 x 11 in. (35.4 x 28.0 cm.)
Signed, bottom center print verso: "Jim Bones"
Inscription, print verso: "#1 Sundown by The Rio Grande"
Acquired from: gift of the Texas Historical Foundation with support from a major grant from the Du Pont Company and Conoco, its energy subsidiary, and assistance from the Texas Commission on the Arts and the National Endowment for the Arts

909. **SUNRISE ON DRY GRASSES NEAR CERRO CASTOLAN, TEXAS** [from "Texas West of the Pecos"] (P1982.17.33)
Dye-transfer print. 1981
Image: 12 13/16 x 9 15/16 in. (32.5 x 25.3 cm.)
Mount: 20 x 16 in. (50.8 x 40.7 cm.)
Signed, l.r. mount recto: "Jim Bones"
Inscription, mount verso: "Sunrise on dry grasses near Cerro Castolan, Texas/#1981" and rubber stamps "© JIM BONES/ REPRODUCTION/ PROHIBITED" and "JIM BONES/P.O. Box 458/Tesuque, New Mexico 87574/ (515) 988-1662"
Acquired from: gift of the photographer

*910. **SUNRISE OVER THE GULF OF MEXICO, PADRE ISLAND, KLEBERG COUNTY** [from "Contemporary Texas: A Photographic Portrait"] (P1985.17.48)
Dye-transfer print. 1984
Image: 12 15/16 x 10 1/16 in. (32.9 x 25.5 cm.)
Sheet: 13 15/16 x 11 in. (35.4 x 28.0 cm.)
Signed, bottom center print verso: "Jim Bones"
Inscription, print verso: "#10 Padre Island Sunrise"
Acquired from: gift of the Texas Historical Foundation with support from a major grant from the Du Pont Company and Conoco, its energy subsidiary, and assistance from the Texas Commission on the Arts and the National Endowment for the Arts

*911. **UPLIFTED PERMIAN FOSSIL REEF, SIERRA DIABLO (VICTORIO CANYON) TEXAS** [from "Texas West of the Pecos"] (P1982.17.14)
Dye-transfer print. 1981
Image: 12 7/8 x 10 1/16 in. (32.7 x 25.5 cm.)
Mount: 20 x 16 in. (50.8 x 40.7 cm.)
Signed, l.r. mount recto: "Jim Bones"
Inscription, mount verso: "Uplifted Permian fossil reef, Sierra Diablo (Victorio Canyon) Texas/#1981" and rubber stamps

"© JIM BONES/REPRODUCTION/PROHIBITED" and "JIM BONES/P.O. Box 458/Tesuque, New Mexico 85754/(515) 988-1662"
Acquired from: gift of the photographer

912. **VOLCANIC TINAJA, TEXAS** [from "Texas West of the Pecos"] (P1982.17.31)
Dye-transfer print. 1981
Image: 12 15/16 x 10 in. (32.9 x 25.4 cm.)
Mount: 20 x 16 in. (50.8 x 40.7 cm.)
Signed, l.r. mount recto: "Jim Bones"
Inscription, mount verso: "Volcanic tinaja, Texas/#1981" and rubber stamps "© JIM BONES/REPRODUCTION/PROHIBITED" and "JIM BONES/P.O. Box 458/Tesuque, New Mexico 87574/(515) 988-1662"
Acquired from: gift of the photographer

*913. **WHITE WATER RAPIDS AT BURRO BLUFF, RIO GRANDE** [from "Texas West of the Pecos"] (P1982.17.1)
Dye-transfer print. 1981
Image: 10 1/16 x 12 15/16 in. (25.5 x 32.8 cm.)
Mount: 16 x 20 in. (40.7 x 50.8 cm.)
Signed, l.r. mount recto: "Jim Bones"
Inscription, mount verso: "White Water Rappids [sic] at Burro Bluff, Rio Grande/#1981" and rubber stamps "© JIM BONES/ REPRODUCTION/PROHIBITED" and "JIM BONES/P.O. Box 458/Tesuque, New Mexico 87574/(515) 988-1662"
Acquired from: gift of the photographer

914. **WILD PLUMS, PAISANO, TEXAS** (P1980.6)
Dye-transfer print. 1978
Image: 8 x 10 5/16 in. (20.3 x 26.2 cm.)
Mount: 11 3/8 x 15 1/8 in. (28.9 x 38.4 cm.)
Signed, l.r. mount recto: "Jim Bones"
Inscription, mount verso: "Wild Plums, Paisano, Texas/#1978" and rubber stamp "© JIM BONES/REPRODUCTION/PROHIBITED"
Acquired from: The Afterimage, Dallas, Texas

W. HANSON BOORNE, English (1860—1945)

Boorne was an English amateur photographer and inventor. He moved to Canada in 1882 and purchased a ranch at Bird's Hill, Manitoba, northwest of Winnipeg. There he made photographs of his new operation, and soon expanded his work to include scenes of town life and the Canadian cattle business. In 1885 he returned to England and purchased the equipment necessary to open a professional studio. With his cousin, Ernest May, he opened a studio and photographic publishing firm in Calgary in 1886. For the next three years, Boorne made an extensive series of photographs of western Canada. He usually handled the field operations while his cousin was responsible for making portraits and handled the business and darkroom functions of the studio. Boorne photographed the Sun Dance ceremony at the Blood Indian Reserve south of Fort McLeod, for which he won the Gold Medal at the 1893 Chicago World's Fair. May left the firm in 1889 but Boorne continued the operation until 1893, when the severe economic recession forced him to declare bankruptcy. He remained in Canada for another six years but finally returned to England, where he abandoned photography and turned his attention to inventing and to his mining and chemical interests.

*915. **BIRD'S EYE VIEW OF BANFF, FROM TUNNEL MOUNTAIN** (P1978.60)
Albumen silver print. 1888
Image: 4 1/2 x 7 11/16 in. (11.4 x 19.4 cm.) irregular
Mount: 4 5/8 x 7 13/16 in. (11.8 x 19.9 cm.)
Inscription, in negative: "757. Bird's Eye View of Banff, from Tunnel Mountain."
Acquired from: Hastings Gallery, New York, New York

ALICE BOUGHTON, American (1865–1943)

Alice Boughton studied painting in Paris but, following a period of study with Gertrude Käsebier, opened a photographic portrait studio in New York in 1890. She maintained the studio for over forty years, making pictorial images of prominent literary and theatrical figures as well as portraits of her two daughters.

*916. **MARGARET—BOUGHTON** (P1980.10.1)
Platinum print. c. 1909
Image: 5 15/16 x 6 3/8 in. (15.1 x 16.2 cm.)
Signed: see inscription
Inscription, print verso: "Margaret—Boughton"
Acquired from: The Witkin Gallery, New York, New York

*917. **[Two young girls, one holding plate]** (P1980.10.2)
Platinum print. c. 1905–10
Image: 7 7/8 x 2 1/4 in. (20.0 x 5.6 cm.)
Acquired from: The Witkin Gallery, New York, New York

MARGARET BOURKE-WHITE, American (1904–1971)

Photojournalist Margaret Bourke-White studied with Clarence White before beginning a career that included assignments for *LIFE, Fortune,* and a variety of commercial clients. She collaborated with Erskine Caldwell, later to become her husband, on a book about the effects of the Depression on the American South entitled *You Have Seen Their Faces.* Bourke-White was also fascinated by the form and structure of heavy industrial machines, often photographing them in an abstract, highly simplified manner. Her photograph of the Fort Peck Dam in Montana was used on the cover of the first issue of *LIFE* magazine. The photographs she made of Russia during the 1930s, the European theater during World War II, South African gold mines, and the India-Pakistan political dispute brought millions of Americans face to face with the subjects through her books and photo essays.

*918. **EARLY RUSSIA/DNIEPERSTROI** (P1980.24)
Gelatin silver print. 1930
Image: 19 3/8 x 13 13/16 in. (49.2 x 35.0 cm.)
Sheet: 19 1/2 x 13 15/16 in. (49.5 x 35.4 cm.)
Acquired from: gift of James Maroney, Inc., New York, New York

919. **U.S.S. AKRON, WORLD'S LARGEST AIRSHIP** (P1985.38)
Gelatin silver print or bromide print. 1931
Image: 17 9/16 x 23 1/8 in. (44.6 x 58.7 cm.) irregular
Signed: see inscription
Inscription, print recto, rubber stamp: "Bourke/White" frame, engraved plaque: "U.S.S. AKRON/WORLD'S LARGEST AIRSHIP//THIS FRAME IS MADE OF DURALUMIN USED IN GIRDER CONSTRUCTION OF THE UNITED STATES AIRSHIP "AKRON"/BUILT BY THE GOODYEAR ZEPPELIN CORPORATION"
Acquired from: Gordon L. Bennett, Kentfield, California

MATHEW BRADY, American (1823–1896)

Brady is generally considered to be one of the foremost Civil War photographers, and photographic wagons staffed by his employees photographed military leaders, battle sites, and camp life during the conflict. He was also well known for his "Gallery of Illustrious Americans," published in 1850, which was an attempt to photograph all of the country's political leaders and other

913

911

915

notable personalities. Brady operated several studios (in New York City and Washington, D. C.) and hired many assistants, including such well-known photographers as Alexander Gardner and Timothy O'Sullivan. Throughout his career, most of the work attributed to Brady was done by assistants, although published under the Brady imprint.

Mathew Brady studio
*920. **GEN. JOHN C. FRÉMONT** (P1983.4)
Salt print with black wash. c. 1860−64
Image: 9 x 8½ in. (22.9 x 21.6 cm.)
Sheet: 18 9/16 x 15 9/16 in. (47.2 x 39.5 cm.)
Inscriptions, print verso: "7⁵⁰//+49/Genl Fremont/Gov. Fremont" and typed on paper label "Gen. John C. Fremont"
Acquired from: Paul Katz, North Bennington, Vermont

Mathew Brady studio
921. **U. S. GRANT, LT. GEN. U.S.A.** (P1980.49)
Albumen silver print. negative 1864, print 1890s
Image: 6⅞ x 4 13/16 in. (17.5 x 12.2 cm.)
Sheet: 7⅜ x 5 in. (18.8 x 12.7 cm.)
Mount: 10⅞ x 7¾ in. (27.7 x 19.7 cm.)
Signed: see inscription
Inscription, mount recto: "U.S. Grant/Lt. Gen. U.S.A." and stamp "Brady/Washington"
Acquired from: Mazzulla Collection, Fred Mazzulla, Denver, Colorado

TALBOT M. BREWER,
American (active 20th century)

Businessman Tal Brewer married Walker Evans' sister, Jane, during the late 1920s. He was not a professional photographer but did some 35mm work during the time that he had a close association with Evans.

*922. **OLD BENNINGTON, VT. [Cemetery]** (P1978.49)
Gelatin silver print. c. 1920s−30s
Image: 5 13/16 x 7⅝ in. (14.8 x 19.3 cm.)
Sheet: 6⅛ x 8 in. (15.5 x 20.3 cm.)
Signed, center print verso: "photo T M Brewer"
Inscription, print verso: "Ex-Collection Walker Evans//Old Bennington Vt./photo T.M. Brewer//R-632" and rubber stamp "CREDIT MUST BE/GIVEN TO/T. M. BREWER"
Acquired from: Hastings Gallery, New York, New York

TOM BRIGHT

See *Camera Notes*

ANNE W. BRIGMAN, American (1869−1950)

See also *Camera Work*

Anne W. Brigman was born in Honolulu, Hawaii, but her family moved to California when she was about seventeen. She became allied with Alfred Stieglitz and the Photo-Secession in 1903, exhibiting her work in the Little Galleries of the Photo-Secession in 1905−06. Stieglitz also published gravures of her photographs in *Camera Work*. She later studied with Clarence White, but unlike many other pictorialists, did not completely sever her ties with Stieglitz. Brigman's photographs were usually allegorical compositions that featured nudes in the landscape and other romanticized subject matter. In

1930 Brigman moved to Long Beach, California, to be near her two sisters, and began a photographic study of tides and beaches. As her eyesight began to fail in the 1930s, she turned her efforts from photography to poetry. Brigman died in 1950 while working on a book entitled *Child of Hawaii.*

*923. **FLAME** (P1984.27)
Toned gelatin silver print. 1927
Image: 9½ x 7 11/16 in. (24.1 x 19.5 cm.)
Mount: 18¼ x 15 in. (46.4 x 38.1 cm.)
Signed, l. r. mount recto: "Anne Brigman—/1927—"
Inscription, mount verso: "Anne Brigman/683 Brockhurst St/ Oakland Cal.//—Flame—"
Acquired from: Stephen Lieber, San Francisco, California

FRANCIS BRUGUIÈRE, American (1879−1945)

See *Camera Work*

ESTHER BUBLEY, American (b. 1921)

Esther Bubley was raised in Superior, Wisconsin, but left in the late 1930s to study painting at the Minneapolis School of Design. She moved to Washington, D.C., in 1940 and in 1941 became a microfilmer at the National Archives. Several months later Roy Stryker hired her as a darkroom technician for the Farm Security Administration photography project. She eventually took a few photographs for the FSA, but most of her images were made for Stryker's next project. The Standard Oil Company hired Stryker to produce a picture file that showed how oil affected the lives of the American people. Although she photographed in other states, Bubley spent several weeks in Texas and produced a comprehensive series on Tomball, Texas, a Standard Oil (Humble Oil and Refining Co.) company town. Bubley left the Standard Oil project during the late 1940s to work for *LIFE* magazine, and after it ceased publication she became a freelance photographer.

924. **AFTER THE RODEO, THE STORE AT THE CROSSROADS BETWEEN TOWN AND THE HUMBLE CAMP IS A FAVORITE RENDEZVOUS FOR PARTICIPANTS AND SPECTATORS WHO DRINK POP AND DISCUSS THE EVENT. TOMBALL, TEXAS** [from the exhibition "Out of the Forties: A Portrait of Texas from the Standard Oil Collection"] (P1984.37.54)
Gelatin silver print. negative 1945, print 1982
Image: 10 11/16 x 10 11/16 in. (27.1 x 27.1 cm.)
Sheet: 11 x 12¾ in. (28.0 x 32.4 cm.)
Signed, center print verso: "Esther Bubley"
Acquired from: gift of Texas Monthly, Inc., Austin, Texas, printed from a negative in the Standard Oil of New Jersey Collection, University of Louisville Photographic Archives

925. **AT A PUBLIC PRAYER MEETING HELD ON MAIN STREET. TOMBALL, TEXAS** [from the exhibition "Out of the Forties: A Portrait of Texas from the Standard Oil Collection"] (P1984.37.49)
Gelatin silver print. negative 1945, print 1982
Image: 10 9/16 x 10½ in. (26.8 x 26.6 cm.)
Sheet: 11 x 13 5/16 in. (28.0 x 33.8 cm.)
Signed, u. r. print verso: "Esther Bubley"
Inscription, print verso: "24370/A"
Acquired from: gift of Texas Monthly, Inc., Austin, Texas, printed from a negative in the Standard Oil of New Jersey Collection, University of Louisville Photographic Archives

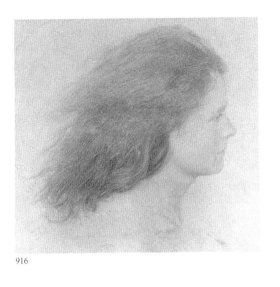

916

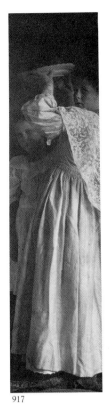

917

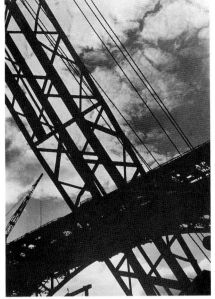

918

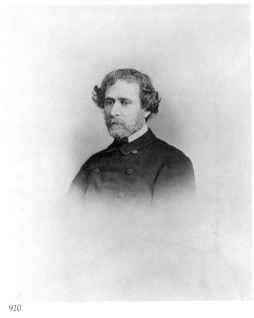

920

922

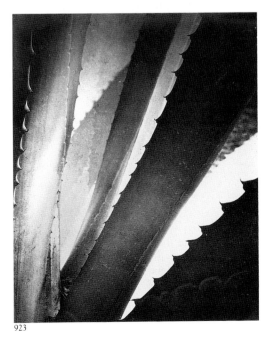

923

*926. BAPTIST CHURCH. CHILD ABOUT TO BE IMMERSED
IN WATER DURING BAPTISMAL CEREMONY.
TOMBALL, TEXAS [from the exhibition "Out of the
Forties: A Portrait of Texas from the Standard Oil
Collection"] (P1984.37.38)
Gelatin silver print. negative 1945, print 1982
Image: 10 11/16 x 12 3/8 in. (27.1 x 31.4 cm.)
Sheet: 11 x 13 3/8 in. (28.0 x 34.0 cm.)
Signed, center print verso: "Esther/Bubley"
Inscription, print verso: "25175"
Acquired from: gift of Texas Monthly, Inc., Austin, Texas,
printed from a negative in the Standard Oil of New Jersey
Collection, University of Louisville Photographic Archives

927. BAPTIST CHURCH. CHILDREN WHO HAVE JUST
BEEN BAPTIZED ARE GREETED BY MEMBERS OF
THE CONGREGATION. TOMBALL, TEXAS [from the
exhibition "Out of the Forties: A Portrait of Texas from the
Standard Oil Collection"] (P1984.37.37)
Gelatin silver print. negative 1945, print 1982
Image: 10 11/16 x 11 1/8 in. (27.1 x 28.3 cm.)
Sheet: 11 x 13 15/16 in. (28.0 x 35.4 cm.)
Signed, u.r. print verso: "Esther Bubley"
Inscription, print verso: "25172"
Acquired from: gift of Texas Monthly, Inc., Austin, Texas,
printed from a negative in the Standard Oil of New Jersey
Collection, University of Louisville Photographic Archives

928. BAPTIST CHURCH. DURING AN EVENING PRAYER
MEETING. TOMBALL, TEXAS [from the exhibition
"Out of the Forties: A Portrait of Texas from the Standard
Oil Collection"] (P1984.37.48)
Gelatin silver print. negative 1945, print 1982
Image: 11 15/16 x 10 11/16 in. (30.3 x 27.1 cm.)
Sheet: 13 7/16 x 11 in. (34.1 x 28.0 cm.)
Signed, bottom center print verso: "Esther Bubley"
Inscription, print verso: "25135/A"
Acquired from: gift of Texas Monthly, Inc., Austin, Texas,
printed from a negative in the Standard Oil of New Jersey
Collection, University of Louisville Photographic Archives

*929. BAPTIST CHURCH. MIXED QUARTET SINGING
DURING EVENING PRAYER SERVICE. TOMBALL,
TEXAS [from the exhibition "Out of the Forties:
A Portrait of Texas from the Standard Oil Collection"]
(P1984.37.39)
Gelatin silver print. 1945
Image: 9 9/16 x 13 in. (24.3 x 33.0 cm.)
Signed, u.r. print verso: "Esther Bubley"
Inscription, print verso: "7//25//2 separate cuts/Minicam/
each measures/9 3/4 dup/6 5/8 wi/black flie/sid" and typed
on paper label "4492/Bubley/Tomball, Texas/May,
1945/25178Baptist church. Mixed quartet singing during
even-/ing prayer service." and rubber stamps "PLEASE
CREDIT/STANDARD OIL CO. (N. J.)/PHOTO BY
BUBLEY" and "PLEASE RETURN UNUSED PHOTOS
TO/STANDARD OIL CO., (N. J.)/PUBLIC RELATIONS
DEPT./30 ROCKEFELLER PLAZA/NEW YORK 20 NEW
YORK"
Acquired from: gift of the photographer

*930. CECIL FARIS, MAYOR OF TOMBALL, OPERATES A
FILLING STATION. TOMBALL, TEXAS [from the
exhibition "Out of the Forties: A Portrait of Texas from the
Standard Oil Collection"] (P1984.37.46)
Gelatin silver print. negative 1945, print 1982
Image: 10 11/16 x 10 1/2 in. (27.1 x 26.6 cm.)
Sheet: 11 x 13 15/16 in. (28.0 x 35.4 cm.)
Signed, u.l. print verso: "Esther Bubley"
Inscription, print verso: "neg. 25 115"
Acquired from: gift of Texas Monthly, Inc., Austin, Texas,
printed from a negative in the Standard Oil of New Jersey
Collection, University of Louisville Photographic Archives

931. CECIL FARIS, MAYOR OF TOMBALL, SITTING IN
FRONT OF HIS GAS STATION. TOMBALL, TEXAS
[from the exhibition "Out of the Forties: A Portrait of
Texas from the Standard Oil Collection"] (P1984.37.60)
Gelatin silver print. negative 1945, print 1982 by Bill Carner
Image: 13 x 9 5/8 in. (33.0 x 24.4 cm.)
Sheet: 13 15/16 x 11 in. (35.4 x 28.0 cm.)
Inscription, print verso: "SONJ 25102" and rubber stamp
"PLEASE CREDIT:/UNIVERSITY OF LOUISVILLE/
PHOTOGRAPHIC ARCHIVES"
Acquired from: gift of Texas Monthly, Inc., Austin, Texas,
printed from a negative in the Standard Oil of New Jersey
Collection, University of Louisville Photographic Archives

932. CHILDREN WAITING FOR THEIR MOTHER TO
FINISH HER SHOPPING. TOMBALL, TEXAS [from
the exhibition "Out of the Forties: A Portrait of Texas from
the Standard Oil Collection"] (P1984.37.33)
Gelatin silver print. negative 1945, print 1982
Image: 10 x 10 7/8 in. (25.4 x 27.6 cm.)
Sheet: 10 1/4 x 13 1/4 in. (26.0 x 33.7 cm.)
Signed, center print verso: "Esther Bubley"
Inscription, print verso: "26162/A"
Acquired from: gift of Texas Monthly, Inc., Austin, Texas,
printed from a negative in the Standard Oil of New Jersey
Collection, University of Louisville Photographic Archives

933. CHURCH AT SUBLIME, TEXAS. WEST TEXAS [from
the exhibition "Out of the Forties: A Portrait of Texas from
the Standard Oil Collection"] (P1984.37.10)
Gelatin silver print. negative 1945, print 1982
Image: 9 7/8 x 12 15/16 in. (25.1 x 32.9 cm.)
Signed, center print verso: "Esther Bubley"
Inscription, print verso: "31191"
Acquired from: gift of Texas Monthly, Inc., Austin, Texas,
printed from a negative in the Standard Oil of New Jersey
Collection, University of Louisville Photographic Archives

934. DEEP PAY VILLAGE SIGN. THIS IS A WAR HOUSING
PROJECT TRAILER CAMP WHERE MANY OF THE
OIL FIELD WORKERS LIVE. ANDREWS, TEXAS [from
the exhibition "Out of the Forties: A Portrait of Texas from
the Standard Oil Collection"] (P1984.37.17)
Gelatin silver print. negative 1945, print 1982
Image: 10 5/8 x 10 5/8 in. (26.9 x 26.9 cm.)
Sheet: 11 x 13 5/16 in. (28.0 x 33.8 cm.)
Signed, center print verso: "Esther Bubley"
Inscription, print verso: "27299/A"
Acquired from: gift of Texas Monthly, Inc., Austin, Texas,
printed from a negative in the Standard Oil of New Jersey
Collection, University of Louisville Photographic Archives

*935. E. N. TIMMONS, OIL FIELD ROUSTABOUT, AND TWO
OF HIS EIGHT CHILDREN. THE FAMILY LIVES IN A
TENT ON THE OUTSKIRTS OF ANDREWS.
ANDREWS, TEXAS [from the exhibition "Out of the
Forties: A Portrait of Texas from the Standard Oil
Collection"] (P1984.37.15)
Gelatin silver print. negative 1945, print 1982
Image: 10 11/16 x 11 5/8 in. (27.1 x 29.5 cm.)
Sheet: 11 x 13 1/4 in. (28.0 x 33.7 cm.)
Signed, center print verso: "Esther Bubley"
Inscription, print verso: "27238"
Acquired from: gift of Texas Monthly, Inc., Austin, Texas,
printed from a negative in the Standard Oil of New Jersey
Collection, University of Louisville Photographic Archives

936. EATING PLACE ON THE HIGHWAY BETWEEN
HOUSTON AND TOMBALL [from the exhibition "Out
of the Forties: A Portrait of Texas from the Standard Oil
Collection"] (P1984.37.2)
Gelatin silver print. negative 1945, print 1982
Image: 10 7/8 x 13 3/4 in. (27.6 x 34.9 cm.)
Sheet: 11 x 13 15/16 in. (28.0 x 35.4 cm.)

Signed, u.r. print verso: "Esther Bubley"
Inscription, print verso: "31304"
Acquired from: gift of Texas Monthly, Inc., Austin, Texas,
 printed from a negative in the Standard Oil of New Jersey
 Collection, University of Louisville Photographic Archives

*937. ELEMENTARY SCHOOL. AT A PROGRAM
 PRESENTED BY GRADE SCHOOL PUPILS.
 TOMBALL, TEXAS [from the exhibition "Out of the
 Forties: A Portrait of Texas from the Standard Oil
 Collection"] (P1984.37.22)
 Gelatin silver print. negative 1945, print 1982
 Image: 11 9/16 x 10 11/16 in. (29.3 x 27.1 cm.)
 Sheet: 13 7/16 x 11 in. (34.1 x 28.0 cm.)
 Signed, center print verso: "Esther Bubley"
 Inscription, print verso: "26596"
 Acquired from: gift of Texas Monthly, Inc., Austin, Texas,
 printed from a negative in the Standard Oil of New Jersey
 Collection, University of Louisville Photographic Archives

938. ELEMENTARY SCHOOL. FIRST GRADE STUDENT.
 TOMBALL, TEXAS [from the exhibition "Out of the
 Forties: A Portrait of Texas from the Standard Oil
 Collection"] (P1984.37.51)
 Gelatin silver print. negative 1945, print 1982
 Image: 10 11/16 x 11 1/2 in. (27.1 x 29.2 cm.)
 Sheet: 11 x 13 in. (28.0 x 33.0 cm.)
 Signed, center print verso: "Esther Bubley"
 Inscription, print verso: "24380/A"
 Acquired from: gift of Texas Monthly, Inc., Austin, Texas,
 printed from a negative in the Standard Oil of New Jersey
 Collection, University of Louisville Photographic Archives

939. ELEMENTARY SCHOOL. FIRST GRADE STUDENTS
 START THE DAY BY RECITING THE PLEDGE OF
 ALLEGIANCE. TOMBALL, TEXAS [from the exhibition
 "Out of the Forties: A Portrait of Texas from the Standard
 Oil Collection"] (P1984.37.57)
 Gelatin silver print. negative 1945, print 1982
 Image: 10 11/16 x 10 in. (27.1 x 25.4 cm.)
 Sheet: 11 x 13 15/16 in. (28.0 x 35.4 cm.)
 Signed, u.r. print verso: "Esther Bubley"
 Inscription, print verso: "24351"
 Acquired from: gift of Texas Monthly, Inc., Austin, Texas,
 printed from a negative in the Standard Oil of New Jersey
 Collection, University of Louisville Photographic Archives

*940. FEED STORE. TOMBALL, TEXAS [from the exhibition
 "Out of the Forties: A Portrait of Texas from the Standard
 Oil Collection"] (P1984.37.34)
 Gelatin silver print. negative 1945, print 1982
 Image: 9 5/8 x 13 in. (24.4 x 33.0 cm.)
 Sheet: 11 x 13 15/16 in. (28.0 x 35.4 cm.)
 Signed, u.r. print verso: "E Bubley"
 Inscription, print verso: "SONJ 26191"
 Acquired from: gift of Texas Monthly, Inc., Austin, Texas,
 printed from a negative in the Standard Oil of New Jersey
 Collection, University of Louisville Photographic Archives

941. FULLERTON FIELD. ROUGHNECKS AT WORK ON A
 WELL. ANDREWS COUNTY, TEXAS [from the
 exhibition "Out of the Forties: A Portrait of Texas from the
 Standard Oil Collection"] (P1984.37.9)
 Gelatin silver print. negative 1945, print 1982
 Image: 13 x 9 7/16 in. (33.0 x 24.0 cm.)
 Signed, center print verso: "Esther Bubley"
 Inscription, print verso: "31063//A"
 Acquired from: gift of Texas Monthly, Inc., Austin, Texas,
 printed from a negative in the Standard Oil of New Jersey
 Collection, University of Louisville Photographic Archives

926

929

930

942. HAYDEN MILES RANCH. BRANDING A CALF.
ANDREWS COUNTY, TEXAS [from the exhibition "Out
of the Forties: A Portrait of Texas from the Standard Oil
Collection"] (P1984.37.4)
Gelatin silver print. negative 1945, print 1982
Image: 10 ¹¹/₁₆ x 12 ³/₁₆ in. (27.1 x 31.0 cm.)
Sheet: 11 x 13 ¹⁵/₁₆ in. (28.0 x 35.4 cm.)
Signed, u.r. print verso: "Esther Bubley"
Inscription, print verso: "31321"
Acquired from: gift of Texas Monthly, Inc., Austin, Texas,
printed from a negative in the Standard Oil of New Jersey
Collection, University of Louisville Photographic Archives

943. HAYDEN MILES RANCH. EATING AT THE CHUCK
WAGON DURING ROUND-UP. ANDREWS
COUNTY, TEXAS [from the exhibition "Out of the
Forties: A Portrait of Texas from the Standard Oil
Collection"] (P1984.37.6)
Gelatin silver print. negative 1945, print 1982
Image: 10 ⁵/₈ x 11 ⁵/₈ in. (26.9 x 29.5 cm.)
Sheet: 11 x 13 in. (28.0 x 33.0 cm.)
Signed, center print verso: "Esther Bubley"
Inscription, print verso: "31343/A"
Acquired from: gift of Texas Monthly, Inc., Austin, Texas,
printed from a negative in the Standard Oil of New Jersey
Collection, University of Louisville Photographic Archives

944. HAYDEN MILES RANCH. EVENING IN THE
BUNKHOUSE AT ROUND-UP TIME. ANDREWS
COUNTY, TEXAS [from the exhibition "Out of the
Forties: A Portrait of Texas from the Standard Oil
Collection"] (P1984.37.5)
Gelatin silver print. negative 1945, print 1982
Image: 10 ⁵/₁₆ x 10 in. (26.2 x 25.4 cm.)
Sheet: 10 ¹⁵/₁₆ x 13 ³/₈ in. (27.8 x 34.0 cm.)
Signed, top center print verso: "Esther Bubley"
Inscription, print verso: "31350"
Acquired from: gift of Texas Monthly, Inc., Austin, Texas,
printed from a negative in the Standard Oil of New Jersey
Collection, University of Louisville Photographic Archives

945. HIGH SCHOOL. BAND AND BATON TWIRLERS
PRACTICING ON THE FOOTBALL FIELD. NOTICE
TANK BATTERY IN BACKGROUND. TOMBALL,
TEXAS [from the exhibition "Out of the Forties: A
Portrait of Texas from the Standard Oil Collection"]
(P1984.37.55)
Gelatin silver print. negative 1945, print 1982
Image: 10 ¹¹/₁₆ x 13 ⁵/₁₆ in. (27.1 x 33.8 cm.)
Sheet: 11 x 13 ¾ in. (28.0 x 34.9 cm.)
Signed, center print verso: "Esther Bubley"
Inscription, print verso: "24335/A"
Acquired from: gift of Texas Monthly, Inc., Austin, Texas,
printed from a negative in the Standard Oil of New Jersey
Collection, University of Louisville Photographic Archives

946. HIGH SCHOOL. DURING GOLD STAR CEREMONY
HELD TO HONOR ONE OF LAST YEAR'S
GRADUATES KILLED IN THE WAR. TOMBALL,
TEXAS [from the exhibition "Out of the Forties: A
Portrait of Texas from the Standard Oil Collection"]
(P1984.37.56)
Gelatin silver print. negative 1945, print 1982
Image: 10 ¾ x 10 ¹³/₁₆ in. (27.3 x 27.5 cm.)
Sheet: 11 x 13 ¹⁵/₁₆ in. (28.0 x 35.4 cm.)
Signed, u.r. print verso: "Esther Bubley"
Inscription, print verso: "24367"
Acquired from: gift of Texas Monthly, Inc., Austin, Texas,
printed from a negative in the Standard Oil of New Jersey
Collection, University of Louisville Photographic Archives

*947. HIGH SCHOOL. MEMBERS OF AGRICULTURE CLASS
CAPONIZING A CHICKEN. TOMBALL, TEXAS [from
the exhibition "Out of the Forties: A Portrait of Texas from
the Standard Oil Collection"] (P1984.37.25)
Gelatin silver print. negative 1945, print 1982

Image: 10 ⁷/₁₆ x 13 ⁵/₈ in. (26.5 x 34.6 cm.)
Sheet: 11 x 13 ¹⁵/₁₆ in. (28.0 x 35.4 cm.)
Signed, u.r. print verso: "Esther Bubley"
Inscription, in negative: "102//26199"
print verso: "26199"
Acquired from: gift of Texas Monthly, Inc., Austin, Texas,
printed from a negative in the Standard Oil of New Jersey
Collection, University of Louisville Photographic Archives

948. HIGH SCHOOL. TYPING CLASS. TOMBALL, TEXAS
[from the exhibition "Out of the Forties: A Portrait of
Texas from the Standard Oil Collection"] (P1984.37.35)
Gelatin silver print. negative 1945, print 1982
Image: 13 ¾ x 10 ⁷/₈ in. (34.9 x 27.6 cm.)
Sheet: 13 ¹⁵/₁₆ x 11 in. (35.4 x 28.0 cm.)
Signed, u.r. print verso: "Esther Bubley"
Inscription, print verso: "26165"
Acquired from: gift of Texas Monthly, Inc., Austin, Texas,
printed from a negative in the Standard Oil of New Jersey
Collection, University of Louisville Photographic Archives

949. HUMBLE CAMP. AT A BOY SCOUT MEETING.
MEMBERS OF THIS TROOP ARE ALL CHILDREN OF
HUMBLE EMPLOYEES. THEIR MEETINGS ARE
HELD AT A SCOUT HOUSE BUILT FOR THEM IN
THE CAMP. TOMBALL, TEXAS [from the exhibition
"Out of the Forties: A Portrait of Texas from the Standard
Oil Collection"] (P1984.37.44)
Gelatin silver print. negative 1945, print 1982
Image: 11 ³/₈ x 10 ⁹/₁₆ in. (28.8 x 26.8 cm.)
Sheet: 13 ½ x 11 in. (34.3 x 28.0 cm.)
Signed, u.r. print verso: "Esther Bubley"
Inscription, print verso: "25059"
Acquired from: gift of Texas Monthly, Inc., Austin, Texas,
printed from a negative in the Standard Oil of New Jersey
Collection, University of Louisville Photographic Archives

950. HUMBLE CAMP. GENE TANNER AND HIS DOG,
SERGEANT. TOMBALL, TEXAS [from the exhibition
"Out of the Forties: A Portrait of Texas from the Standard
Oil Collection"] (P1984.37.41)
Gelatin silver print. negative 1945, print 1982
Image: 10 ¹¹/₁₆ x 12 ³/₁₆ in. (27.1 x 31.0 cm.)
Sheet: 11 x 12 ½ in. (28.0 x 31.8 cm.)
Signed, center print verso: "Esther Bubley"
Inscription, print verso: "25780"
Acquired from: gift of Texas Monthly, Inc., Austin, Texas,
printed from a negative in the Standard Oil of New Jersey
Collection, University of Louisville Photographic Archives

951. HUMBLE CAMP. JESSE S. MOORE AND HIS WIFE,
IRENE, IN THEIR LIVING ROOM. TOMBALL,
TEXAS [from the exhibition "Out of the Forties: A Portrait
of Texas from the Standard Oil Collection"] (P1984.37.43)
Gelatin silver print. negative 1945, print 1982
Image: 10 ¹¹/₁₆ x 10 ¹¹/₁₆ in. (27.1 x 27.1 cm.)
Sheet: 11 x 13 ¹⁵/₁₆ in. (28.0 x 35.4 cm.)
Signed, u.r. print verso: "Esther Bubley"
Inscription, print verso: "25054"
Acquired from: gift of Texas Monthly, Inc., Austin, Texas,
printed from a negative in the Standard Oil of New Jersey
Collection, University of Louisville Photographic Archives

952. HUMBLE CAMP. SIGN AT WAREHOUSE ON V. E. DAY.
TOMBALL, TEXAS [from the exhibition "Out of the
Forties: A Portrait of Texas from the Standard Oil
Collection"] (P1984.37.47)
Gelatin silver print. negative 1945, print 1982
Image: 10 ¹¹/₁₆ x 11 ⁹/₁₆ in. (27.1 x 29.3 cm.)
Sheet: 11 x 13 ⁹/₁₆ in. (28.0 x 34.4 cm.)
Signed, center print verso: "Esther Bubley"
Inscription, print verso: "25144/A"
Acquired from: gift of Texas Monthly, Inc., Austin, Texas,
printed from a negative in the Standard Oil of New Jersey
Collection, University of Louisville Photographic Archives

935

937

940

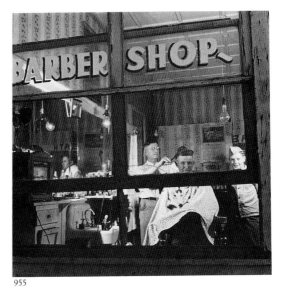

947

953

955

*953. HUMBLE CAMP. TANNER FAMILY SAYING GRACE
BEFORE DINNER. TOMBALL, TEXAS [from the
exhibition "Out of the Forties: A Portrait of Texas from the
Standard Oil Collection"] (P1984.37.52)
Gelatin silver print. negative 1945, print 1982
Image: 10 ⅞ x 13 ¹³⁄₁₆ in. (27.6 x 35.1 cm.)
Sheet: 11 x 13 ¹⁵⁄₁₆ in. (28.0 x 35.4 cm.)
Signed, u.r. print verso: "Esther Bubley"
Inscription, print verso: "24414"
Acquired from: gift of Texas Monthly, Inc., Austin, Texas,
printed from a negative in the Standard Oil of New Jersey
Collection, University of Louisville Photographic Archives

954. HUMBLE COMPANY GEOLOGIC LABORATORY.
HARRY KIRKPATRICK, LAB ASSISTANT, MAKES A
RECORD OF INCOMING SAMPLES PREPARATORY
TO FILING THEM. THEY ARE SENT IN FROM THE
FIELD IN THESE BAGS. HOUSTON, TEXAS [from the
exhibition "Out of the Forties: A Portrait of Texas from the
Standard Oil Collection"] (P1984.37.16)
Gelatin silver print. negative 1945, print 1982
Image: 10 ¹⁄₁₆ x 12 ¹¹⁄₁₆ in. (25.9 x 32.2 cm.)
Signed, top center print verso: "Esther Bubley"
Inscription, print verso: "27344//[illegible]A"
Acquired from: gift of Texas Monthly, Inc., Austin, Texas,
printed from a negative in the Standard Oil of New Jersey
Collection, University of Louisville Photographic Archives

*955. LONGLEY'S BARBER SHOP. ANDREWS, TEXAS [from
the exhibition "Out of the Forties: A Portrait of Texas from
the Standard Oil Collection"] (P1984.37.7)
Gelatin silver print. negative 1945, print 1982 by Bill Carner
Image: 10 ¹⁄₁₆ x 10 ¹⁄₁₆ in. (25.5 x 25.5 cm.)
Sheet: 13 ¹⁵⁄₁₆ x 11 in. (35.4 x 28.0 cm.)
Inscription, print verso: "SONJ 27365" and rubber stamp
"PLEASE CREDIT:/UNIVERSITY OF LOUISVILLE/
PHOTOGRAPHIC ARCHIVES"
Acquired from: gift of Texas Monthly, Inc., Austin, Texas,
printed from a negative in the Standard Oil of New Jersey
Collection, University of Louisville Photographic Archives

956. MAILBOXES AND HOUSE NEAR HOUSTON [from the
exhibition "Out of the Forties: A Portrait of Texas from the
Standard Oil Collection"] (P1984.37.11)
Gelatin silver print. negative 1945, print 1982
Image: 10 x 13 in. (25.4 x 33.0 cm.)
Signed, center print verso: "Esther Bubley"
Inscription, print verso: "A//31299"
Acquired from: gift of Texas Monthly, Inc., Austin, Texas,
printed from a negative in the Standard Oil of New Jersey
Collection, University of Louisville Photographic Archives

957. MAIN STREET. CHICKENS ROOSTING NEAR FEED
STORE. TOMBALL, TEXAS [from the exhibition "Out of
the Forties: A Portrait of Texas from the Standard Oil
Collection"] (P1984.37.29)
Gelatin silver print. negative 1945, print 1982
Image: 10 ¼ x 9 ¹³⁄₁₆ in. (26.0 x 24.9 cm.)
Signed, top center print verso: "Esther Bubley"
Inscription, print verso: "26272//A"
Acquired from: gift of Texas Monthly, Inc., Austin, Texas,
printed from a negative in the Standard Oil of New Jersey
Collection, University of Louisville Photographic Archives

958. MAIN STREET. IN FRONT OF THE BANK. TOMBALL,
TEXAS [from the exhibition "Out of the Forties: A
Portrait of Texas from the Standard Oil Collection"]
(P1984.37.45)
Gelatin silver print. negative 1945, print 1982
Image: 10 ¹¹⁄₁₆ x 10 ⅞ in. (27.1 x 27.6 cm.)
Sheet: 11 ¹⁄₁₆ x 13 ¹⁵⁄₁₆ in. (28.1 x 35.4 cm.)
Signed, center print verso: "Esther Bubley"
Inscription, print verso: "25111/A"
Acquired from: gift of Texas Monthly, Inc., Austin, Texas,
printed from a negative in the Standard Oil of New Jersey
Collection, University of Louisville Photographic Archives

959. MEMBER OF SHOOTING CREW TAKES A NAP ON
THE REEL TRUCK DURING LUNCH TIME.
SEISMOGRAPH PARTY 17, VICINITY OF
HUNTSVILLE, TEXAS [from the exhibition "Out of the
Forties: A Portrait of Texas from the Standard Oil
Collection"] (P1984.37.32)
Gelatin silver print. negative 1945, print 1982
Image: 10 ⅜ x 13 ⁷⁄₁₆ in. (26.4 x 34.1 cm.)
Signed, top center print verso: "Esther Bubley"
Inscription, print verso: "A//25856"
Acquired from: gift of Texas Monthly, Inc., Austin, Texas,
printed from a negative in the Standard Oil of New Jersey
Collection, University of Louisville Photographic Archives

*960. METHODIST CHURCH, PIANIST. TOMBALL, TEXAS
[from the exhibition "Out of the Forties: A Portrait of
Texas from the Standard Oil Collection"] (P1984.37.23)
Gelatin silver print. negative 1945, print 1982
Image: 10 ⁵⁄₁₆ x 10 ⁹⁄₁₆ in. (26.2 x 26.8 cm.)
Sheet: 11 x 12 ¼ in. (28.0 x 32.4 cm.)
Signed, center print verso: "Esther Bubley"
Inscription, print verso: "26571/A"
Acquired from: gift of Texas Monthly, Inc., Austin, Texas,
printed from a negative in the Standard Oil of New Jersey
Collection, University of Louisville Photographic Archives

961. MOTEL IN HOUSTON [from the exhibition "Out of the
Forties: A Portrait of Texas from the Standard Oil
Collection"] (P1984.37.3)
Gelatin silver print. negative 1945, print 1982
Image: 10 x 13 ½ in. (25.4 x 34.3 cm.)
Signed, u.l. print verso: "Esther Bubley"
Inscription, print verso: "31305//A"
Acquired from: gift of Texas Monthly, Inc., Austin, Texas,
printed from a negative in the Standard Oil of New Jersey
Collection, University of Louisville Photographic Archives

962. NOBLE HOLT RANCH. THE LINE CAMP AT THE
RANCH HAS NO ELECTRICITY. GENE AND WILLIE
BISHOP EAT THEIR EVENING MEAL BY KEROSENE
LAMP LIGHT. NEAR DRYDEN, TERRELL COUNTY,
TEXAS [from the exhibition "Out of the Forties: A
Portrait of Texas from the Standard Oil Collection"]
(P1984.37.8)
Gelatin silver print. negative 1945, print 1982
Image: 10 ¼ x 11 ½ in. (27.3 x 29.2 cm.)
Sheet: 11 x 13 ¹⁵⁄₁₆ in. (28.0 x 35.4 cm.)
Signed, u.l. print verso: "Esther Bubley"
Inscription, print verso: "Neg 30910"
Acquired from: gift of Texas Monthly, Inc., Austin, Texas,
printed from a negative in the Standard Oil of New Jersey
Collection, University of Louisville Photographic Archives

963. OIL FIELD. BEN G. SHERE NO. 2. WORKOVER JOB.
BREAKING OUT DRILL PIPE. TOMBALL, TEXAS
[from the exhibition "Out of the Forties: A Portrait of
Texas from the Standard Oil Collection"] (P1984.37.27)
Gelatin silver print. negative 1945, print 1982
Image: 10 ⅝ x 10 ⅞ in. (26.9 x 27.6 cm.)
Sheet: 11 x 13 ¹⁵⁄₁₆ in. (28.0 x 35.4 cm.)
Signed, center print verso: "Esther Bubley"
Inscription, print verso: "26265/A"
Acquired from: gift of Texas Monthly, Inc., Austin, Texas,
printed from a negative in the Standard Oil of New Jersey
Collection, University of Louisville Photographic Archives

964. OIL FIELD. FRITZ KOBS B-3. WORKOVER JOB.
DRILLING CREW DRINKING COFFEE WHILE
WAITING FOR THE PERFORATING TO BE
FINISHED. WORKOVER RIGS ARE HANDLED BY
CONTRACTORS. TOMBALL, TEXAS [from the
exhibition "Out of the Forties: A Portrait of Texas from the
Standard Oil Collection"] (P1984.37.24)
Gelatin silver print. negative 1945, print 1982
Image: 10 ³⁄₁₆ x 13 ⁷⁄₁₆ in. (25.9 x 34.1 cm.)
Signed, top center mount verso: "Esther Bubley"
Inscription, print verso: "26193//A"

Acquired from: gift of Texas Monthly, Inc., Austin, Texas,
 printed from a negative in the Standard Oil of New Jersey
 Collection, University of Louisville Photographic Archives

965. OIL FIELD. HUMBLE OIL AND REFINING CO.
 DISTRICT OFFICE. A. R. BRUCE, FARM BOSS.
 TOMBALL, TEXAS [from the exhibition "Out of the
 Forties: A Portrait of Texas from the Standard Oil
 Collection"] (P1984.37.21)
 Gelatin silver print. negative 1945, print 1982
 Image: 10 x 12 in. (25.4 x 30.5 cm.)
 Signed, center print verso: "Esther Bubley"
 Inscription, print verso: "26525"
 Acquired from: gift of Texas Monthly, Inc., Austin, Texas,
 printed from a negative in the Standard Oil of New Jersey
 Collection, University of Louisville Photographic Archives

966. OIL FIELD. LEASE PUMPER AND GAUGER, P. D.
 DONOVAN, IN HIS DOGHOUSE. TOMBALL, TEXAS
 [from the exhibition "Out of the Forties: A Portrait of
 Texas from the Standard Oil Collection"] (P1984.37.28)
 Gelatin silver print. negative 1945, print 1982
 Image: 13 9/16 x 10 11/16 in. (34.4 x 27.1 cm.)
 Signed, top center print verso: "Esther Bubley"
 Inscription, print verso: "26278"
 Acquired from: gift of Texas Monthly, Inc., Austin, Texas,
 printed from a negative in the Standard Oil of New Jersey
 Collection, University of Louisville Photographic Archives

*967. OUTSKIRTS OF HOUSTON [from the exhibition "Out of
 the Forties: A Portrait of Texas from the Standard Oil
 Collection"] (P1984.37.1)
 Gelatin silver print. negative 1945, print 1982 by Bill Carner
 Image: 9 5/8 x 12 15/16 in. (24.4 x 32.9 cm.)
 Sheet: 11 x 14 in. (28.0 x 35.6 cm.)
 Inscription, print verso: "SONJ 31303" and rubber stamp
 "PLEASE CREDIT:/UNIVERSITY OF LOUISVILLE/
 PHOTOGRAPHIC ARCHIVES"
 Acquired from: gift of Texas Monthly, Inc., Austin, Texas,
 printed from a negative in the Standard Oil of New Jersey
 Collection, University of Louisville Photographic Archives

968. OWNER OF ONE OF TOMBALL'S TWO DRY
 CLEANING SHOPS STANDING IN FRONT OF HIS
 STORE. TOMBALL, TEXAS [from the exhibition "Out of
 the Forties: A Portrait of Texas from the Standard Oil
 Collection"] (P1984.37.59)
 Gelatin silver print. negative 1945, print 1982 by Bill Carner
 Image: 13 x 9 5/8 in. (33.0 x 24.4 cm.)
 Sheet: 14 x 11 in. (35.6 x 28.0 cm.)
 Inscription, print verso: "SONJ 26190" and rubber stamp
 "PLEASE CREDIT:/UNIVERSITY OF LOUISVILLE/
 PHOTOGRAPHIC ARCHIVES"
 Acquired from: gift of Texas Monthly, Inc., Austin, Texas,
 printed from a negative in the Standard Oil of New Jersey
 Collection, University of Louisville Photographic Archives

969. PERMIT MAN GEORGE LORE, TALKING TO A
 FARMER WHOSE LAND HAS BEEN SELECTED FOR
 EXPLORATION. THE PERMIT MAN TRAVELS WELL
 IN ADVANCE OF THE SHOOTING CREW GETTING
 PERMISSION FOR THEIR WORK. HE ALSO
 HANDLES ANY COMPLAINTS WHICH MAY BE
 MADE AFTER CREW HAS FINISHED.
 SEISMOGRAPH PARTY 17, VICINITY OF
 HUNTSVILLE, TEXAS [from the exhibition "Out of the
 Forties: A Portrait of Texas from the Standard Oil
 Collection"] (P1984.37.31)
 Gelatin silver print. negative 1945, print 1982
 Image: 10 5/8 x 10 1/2 in. (26.9 x 26.6 cm.)
 Sheet: 11 x 12 1/16 in. (28.0 x 30.7 cm.)
 Signed, top center print verso: "Esther Bubley"
 Inscription, print verso: "25840"
 Acquired from: gift of Texas Monthly, Inc., Austin, Texas,
 printed from a negative in the Standard Oil of New Jersey
 Collection, University of Louisville Photographic Archives

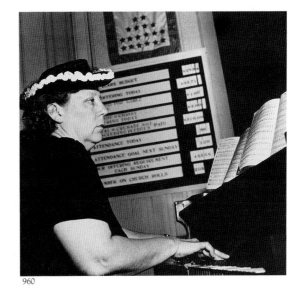
960

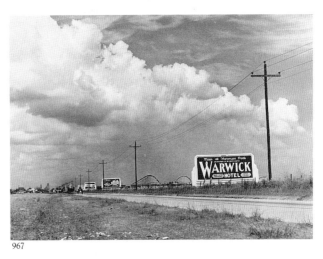
967

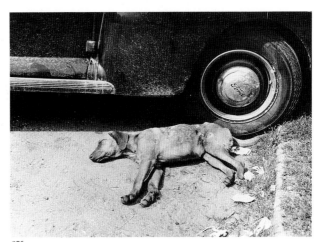
975

970. POOL HALL OWNED BY E. D. SMITH, HUMBLE
ROUSTABOUT. PLAYING "MOON," A DOMINO
GAME. E. A. ROY, HUMBLE EMPLOYEE, AND
"CHICKEN" JONES. TOMBALL, TEXAS [from the
exhibition "Out of the Forties: A Portrait of Texas from the
Standard Oil Collection"] (P1984.37.26)
Gelatin silver print. negative 1945, print 1982
Image: 10 11/16 x 12 1/2 in. (27.1 x 31.8 cm.)
Sheet: 11 x 13 7/8 in. (28.0 x 35.2 cm.)
Signed, u.l. print verso: "Esther Bubley"
Inscription, print verso: "26238/A"
Acquired from: gift of Texas Monthly, Inc., Austin, Texas,
printed from a negative in the Standard Oil of New Jersey
Collection, University of Louisville Photographic Archives

971. RUBBER-COVERED CONDUCTOR CABLE BEING
LAID BY REEL TRUCK BETWEEN THE
SHOTHOLES. SHOOTING TRUCK SETS UP
ADJACENT TO THE SHOTHOLE AND CONNECTS
BACK TO HOLE JUST FINISHED AND TO CABLE
THAT EXTENDS FORWARD SO THAT
OVERLAPPING RECORDS OF EACH SHOT ARE
MADE. THREE GEOPHONES ARE CONNECTED TO
THE CONDUCTOR CABLE AT EACH PICK UP
STATION. SEISMOGRAPH PARTY 17, VICINITY OF
HUNTSVILLE, TEXAS [from the exhibition "Out of the
Forties: A Portrait of Texas from the Standard Oil
Collection"] (P1984.37.42)
Gelatin silver print. negative 1946, print 1983
Image: 10 3/16 x 10 5/16 in. (25.9 x 26.2 cm.)
Sheet: 14 x 11 in. (35.6 x 28.0 cm.)
Signed, u.r. print verso: "Esther Bubley"
Inscription, print verso: "25755"
Acquired from: gift of Texas Monthly, Inc., Austin, Texas,
printed from a negative in the Standard Oil of New Jersey
Collection, University of Louisville Photographic Archives

972. SATURDAY AFTERNOON ON MAIN STREET.
TOMBALL, TEXAS [from the exhibition "Out of the
Forties: A Portrait of Texas from the Standard Oil
Collection"] (P1984.37.36)
Gelatin silver print. negative 1945, print 1982
Image: 10 11/16 x 11 7/16 in. (27.1 x 29.0 cm.)
Sheet: 11 x 13 3/8 in. (28.0 x 34.0 cm.)
Signed, center print verso: "Esther Bubley"
Inscription, print verso: "25164/A"
Acquired from: gift of Texas Monthly, Inc., Austin, Texas,
printed from a negative in the Standard Oil of New Jersey
Collection, University of Louisville Photographic Archives

973. SIGN ON THE OUTSKIRTS OF HOUSTON [from the
exhibition "Out of the Forties: A Portrait of Texas from the
Standard Oil Collection"] (P1984.37.12)
Gelatin silver print. negative 1945, print 1982
Image: 10 5/8 x 10 1/4 in. (26.9 x 26.0 cm.)
Sheet: 11 x 13 in. (28.0 x 33.0 cm.)
Signed, u.r. print verso: "Esther Bubley"
Acquired from: gift of Texas Monthly, Inc., Austin, Texas,
printed from a negative in the Standard Oil of New Jersey
Collection, University of Louisville Photographic Archives

974. STREET SCENE. MAIN STREET. TOMBALL, TEXAS
[from the exhibition "Out of the Forties: A Portrait of
Texas from the Standard Oil Collection"] (P1984.37.13)
Gelatin silver print. negative 1945, print 1982
Image: 10 1/8 x 10 5/16 in. (26.4 x 26.2 cm.)
Sheet: 11 x 12 9/16 in. (28.0 x 31.9 cm.)
Signed, u.l. print verso: "Esther Bubley"
Inscription, print verso: "26600"
Acquired from: gift of Texas Monthly, Inc., Austin, Texas,
printed from a negative in the Standard Oil of New Jersey
Collection, University of Louisville Photographic Archives

*975. STREET SCENE. MAIN STREET. TOMBALL, TEXAS
[from the exhibition "Out of the Forties: A Portrait of
Texas from the Standard Oil Collection"] (P1984.37.58)
Gelatin silver print. negative 1945, print 1982 by Bill Carner
Image: 9 5/8 x 12 15/16 in. (24.4 x 32.9 cm.)
Sheet: 11 x 13 15/16 in. (28.0 x 35.4 cm.)
Inscription, print verso: "SONJ 26188" and rubber stamp
"PLEASE CREDIT:/UNIVERSITY OF LOUISVILLE/
PHOTOGRAPHIC ARCHIVES"
Acquired from: gift of Texas Monthly, Inc., Austin, Texas,
printed from a negative in the Standard Oil of New Jersey
Collection, University of Louisville Photographic Archives

976. STREET SCENE. SATURDAY AFTERNOON. HUMBLE
CO., HUNTSVILLE, TEXAS [from the exhibition "Out of
the Forties: A Portrait of Texas from the Standard Oil
Collection"] (P1984.37.30)
Gelatin silver print. negative 1945, print 1983
Image: 10 11/16 x 11 in. (27.1 x 28.0 cm.)
Sheet: 11 x 13 1/2 in. (28.0 x 34.3 cm.)
Signed, u.l. print verso: "Esther Bubley"
Inscription, print verso: "Neg. 25803"
Acquired from: gift of Texas Monthly, Inc., Austin, Texas,
printed from a negative in the Standard Oil of New Jersey
Collection, University of Louisville Photographic Archives

977. STREET SCENE. SATURDAY AFTERNOON.
HUNTSVILLE, TEXAS [from the exhibition "Out of the
Forties: A Portrait of Texas from the Standard Oil
Collection"] (P1984.37.40)
Gelatin silver print. negative 1945, print 1982
Image: 10 11/16 x 10 5/16 in. (27.1 x 26.2 cm.)
Sheet: 10 15/16 x 13 7/16 in. (27.8 x 34.1 cm.)
Signed, u.r. print verso: "Esther Bubley"
Inscription, print verso: "25784"
Acquired from: gift of Texas Monthly, Inc., Austin, Texas,
printed from a negative in the Standard Oil of New Jersey
Collection, University of Louisville Photographic Archives

978. THE TIMMONS FAMILY LIVES IN A TENT ON THE
OUTSKIRTS OF TOWN. RICHARD TIMMONS PLAYS
THE GUITAR WHILE HIS BROTHERS AND
FATHER, E. N. TIMMONS, AN OIL FIELD
ROUSTABOUT, LISTEN. ANDREWS, TEXAS [from the
exhibition "Out of the Forties: A Portrait of Texas from the
Standard Oil Collection"] (P1984.37.14)
Gelatin silver print. negative 1945, print 1982
Image: 12 3/16 x 10 1/16 in. (31.0 x 25.5 cm.)
Sheet: 13 15/16 x 11 in. (35.4 x 28.0 cm.)
Signed, u.l. print verso: "Esther Bubley"
Inscription, print verso: "SONJ 27235"
Acquired from: gift of Texas Monthly, Inc., Austin, Texas,
printed from a negative in the Standard Oil of New Jersey
Collection, University of Louisville Photographic Archives

979. TOMBALL GASOLINE PLANT. STEAM EXPANSION
LOOP WITH DISTILLATION UNIT IN THE
BACKGROUND. TOMBALL, TEXAS [from the
exhibition "Out of the Forties: A Portrait of Texas from the
Standard Oil Collection"] (P1984.37.53)
Gelatin silver print. negative 1945, print 1983
Image: 13 1/4 x 10 1/2 in. (33.7 x 26.6 cm.)
Signed, u.r. print verso: "Esther Bubley"
Acquired from: gift of Texas Monthly, Inc., Austin, Texas,
printed from a negative in the Standard Oil of New Jersey
Collection, University of Louisville Photographic Archives

*980. V. E. DAY. MAYOR CECIL FARIS PROCLAIMS V. E. DAY
TO BE AN OFFICIAL HOLIDAY. TOMBALL, TEXAS
[from the exhibition "Out of the Forties: A Portrait of
Texas from the Standard Oil Collection"] (P1984.37.50)
Gelatin silver print. negative 1945, print 1982
Image: 10 1/2 x 10 7/16 in. (26.6 x 26.5 cm.)
Sheet: 11 x 12 5/8 in. (28.0 x 32.0 cm.)
Signed, u.r. print verso: "Esther Bubley"

Inscription, print verso: "24371"
Acquired from: gift of Texas Monthly, Inc., Austin, Texas, printed from a negative in the Standard Oil of New Jersey Collection, University of Louisville Photographic Archives

981. VANDERPOOL, TEXAS. AT LEIGHTON'S STORE, HUMBLE STATION, AND POST OFFICE. JOE LEIGHTON WAITS ON A YOUNG CUSTOMER. BANDERA COUNTY, TEXAS [from the exhibition "Out of the Forties: A Portrait of Texas from the Standard Oil Collection"] (P1984.37.20)
Gelatin silver print. negative 1945, print 1982
Image: 12 ¾ x 10 ⅝ in. (32.4 x 26.9 cm.)
Sheet: 13 ⅝ x 11 in. (34.6 x 28.0 cm.)
Signed, center print verso: "Esther Bubley"
Inscription, print verso: "26423"
Acquired from: gift of Texas Monthly, Inc., Austin, Texas, printed from a negative in the Standard Oil of New Jersey Collection, University of Louisville Photographic Archives

982. VANDERPOOL, TEXAS. AT THE HUMBLE STATION, GENERAL STORE AND POST OFFICE OPERATED BY JOE LEIGHTON, NEIGHBORING RANCHERS OFTEN GATHER FOR A GAME OF DOMINOES WHILE WAITING FOR THE MAIL. BANDERA COUNTY, TEXAS [from the exhibition "Out of the Forties: A Portrait of Texas from the Standard Oil Collection"] (P1984.37.18)
Gelatin silver print. negative 1945, print 1982
Image: 10 ½ x 11 ¼ in. (26.6 x 28.5 cm.)
Signed, center print verso: "Esther Bubley"
Inscription, print verso: "26400"
Acquired from: gift of Texas Monthly, Inc., Austin, Texas, printed from a negative in the Standard Oil of New Jersey Collection, University of Louisville Photographic Archives

983. VANDERPOOL, TEXAS. AT THE HUMBLE STATION, GENERAL STORE AND POST OFFICE OPERATED BY JOE LEIGHTON, NEIGHBORING RANCHERS OFTEN GATHER FOR A GAME OF DOMINOES WHILE WAITING FOR THE MAIL. BANDERA COUNTY, TEXAS [from the exhibition "Out of the Forties: A Portrait of Texas from the Standard Oil Collection"] (P1984.37.19)
Gelatin silver print. negative 1945, print 1982
Image: 10 ⅝ x 10 ⅜ in. (26.9 x 26.4 cm.)
Sheet: 11 ¹⁄₁₆ x 13 in. (28.1 x 33.0 cm.)
Signed, u.l. print verso: "Esther Bubley"
Inscription, print verso: "A//26403"
Acquired from: gift of Texas Monthly, Inc., Austin, Texas, printed from a negative in the Standard Oil of New Jersey Collection, University of Louisville Photographic Archives

*984. YOUNGSTER EATING WATERMELON AT A PICNIC HELD BY HUMBLE PIPELINE STATION EMPLOYEES. BANDERA COUNTY, TEXAS [from the exhibition "Out of the Forties: A Portrait of Texas from the Standard Oil Collection"] (P1984.37.61)
Gelatin silver print. negative 1945, print 1982 by Bill Carner
Image: 10 x 10 ¹⁄₁₆ in. (25.4 x 25.5 cm.)
Sheet: 13 ¹⁵⁄₁₆ x 11 in. (35.4 x 28.0 cm.)
Inscription, print verso: "SONJ 26346"
Acquired from: gift of Texas Monthly, Inc., Austin, Texas, printed from a negative in the Standard Oil of New Jersey Collection, University of Louisville Photographic Archives

JOHN G. BULLOCK, American (1854—1939)

Bullock, an amateur Philadelphia pictorialist, studied photography under John C. Browne and began taking pictures in 1882. He was elected a member of the Photo-Secession in 1902. Bullock exhibited his work

980

984

985

widely between 1886 and 1910, participating in many salon shows. With Louise Deshong Woodbridge, Henry Troth, John C. Browne, and Robert S. Redfield he was a member of the "Bullock Group," which produced fine eastern landscapes. Bullock moved to West Chester, Pennsylvania, in 1923 and became the curator of the Chester County Historical Society.

*985. [Blacksmith shop] (P1978.45)
Platinum print. c. 1892
Image: 6 1/16 x 8 1/16 in. (15.3 x 20.4 cm.)
Mount: 14 1/16 x 11 in. (35.7 x 28.0 cm.)
Signed, l.r. print recto: "J/G/B"
Acquired from: Hastings Gallery, New York, New York

WYNN BULLOCK, American (1902–1975)

Trained as a singer, Bullock became interested in photography as a method of expressing philosophical views about reality. He studied with Edward Kaminski at the Los Angeles Art Center School and was influenced by the work of Edward Weston and László Moholy-Nagy. Bullock took up photography full time in 1949. A good photograph could, he felt, capture the essence of the object completely and be as "real" as the object itself. Much of his work deals with man and his relationship to the natural world. Bullock was a member of the founding group of the Friends of Photography and served as a board trustee from 1967 to 1975.

986. BOY ON FOREST ROAD [Child on Forest Road]
(P1974.20.4)
Gelatin silver print. 1958
Image: 8 13/16 x 7 1/16 in. (22.4 x 18.0 cm.)
Mount: 15 x 13 1/4 in. (38.1 x 33.6 cm.)
Signed, l.r. mount recto: "Wynn Bullock '58"
Inscription, mount verso: "1558—Boy on Forest Road 1958"
Acquired from: the photographer

987. BURNT CHAIR (P1972.43.1)
Gelatin silver print. negative 1954, print c. 1972
Image: 9 1/2 x 7 9/16 in. (24.2 x 19.2 cm.)
Mount: 15 x 13 5/16 in. (38.1 x 33.9 cm.)
Signed, l.r. mount recto: "Wynn Bullock '54"
Acquired from: Friends of Photography, Carmel, California; gift print with sustaining membership, 1971

*988. CHILD IN THE FOREST (P1974.20.1)
Gelatin silver print. 1951
Image: 7 9/16 x 9 9/16 in. (19.2 x 24.3 cm.)
Mount: 13 1/4 x 15 in. (33.6 x 38.1 cm.)
Signed, l.r. mount recto: "Wynn Bullock '53 [sic]"
Inscription, mount verso: "17B—Child in the Forest 1953 [sic]"
Acquired from: the photographer

*989. HALF-AN-APPLE (P1974.20.3)
Gelatin silver print. 1953
Image: 7 1/2 x 8 5/8 in. (19.0 x 22.0 cm.)
Mount: 13 1/4 x 14 13/16 in. (33.6 x 37.6 cm.)
Signed, l.r. mount recto: "Wynn Bullock '53"
Inscription, mount verso: "#661 Half-an-apple—1953"
Acquired from: the photographer

990. THE MEADOW (P1974.20.2)
Gelatin silver print. 1953
Image: 7 7/16 x 9 1/2 in. (18.8 x 24.0 cm.)
Mount: 13 1/4 x 15 in. (33.6 x 38.1 cm.)
Signed, l.r. mount recto: "Wynn Bullock '53"
Inscription, mount verso: "#199—The Meadow 1953//Wynn Bullock/ 155 Mar Vista Dr./Monterey, Cal."
Acquired from: the photographer

991. NUDE BEHIND COBWEB WINDOW (P1974.20.6)
Gelatin silver print. 1955
Image: 9 5/16 x 7 1/4 in. (23.7 x 18.4 cm.)
Mount: 15 x 13 1/4 in. (38.1 x 33.6 cm.)
Inscription, mount verso: "#484—Nude Behind Cobweb Window—1955"
Acquired from: the photographer

*992. SEASCAPE [Sunset, Big Sur Country] (P1974.20.5)
Gelatin silver print. 1958
Image: 7 9/16 x 9 9/16 in. (19.1 x 24.2 cm.)
Mount: 13 1/4 x 15 in. (33.6 x 38.1 cm.)
Signed, l.r. mount recto: "Wynn Bullock"
Inscription, mount verso: "#1258—Seascape—1958//Wynn Bullock/ Monterey, Calif."
Acquired from: the photographer

JON BURRIS, American (b. 1951)

Burris received a B.F.A. in commercial art and art history from Southwestern Oklahoma State University in 1973. Beginning as a photo stringer for newspapers, Burris worked for a time as a freelance commercial photographer. He served as the Director of Photography at the National Cowboy Hall of Fame in Oklahoma City from 1975 to 1980 and established Portfolio, a photographic gallery and publishing house, in 1980. Burris has had a special interest in landscape images and cites associations with Laura Gilpin and Ansel Adams as major influences on his personal work.

*993. [Cactus, New Mexico] (P1978.44.3)
Gelatin silver print. 1978
Image: 5 5/16 x 6 3/4 in. (13.5 x 17.2 cm.)
Sheet: 7 15/16 x 10 1/16 in. (20.3 x 25.6 cm.)
Mount: 14 3/4 x 15 in. (37.5 x 38.1 cm.)
Signed, l.r. sheet recto: "J. Burris '78"
Acquired from: the photographer

994. [Graffiti] (P1978.44.2)
Gelatin silver print. 1978
Image: 5 5/16 x 6 3/4 in. (13.5 x 17.2 cm.)
Sheet: 8 1/16 x 10 1/16 in. (20.4 x 25.6 cm.)
Mount: 14 3/4 x 15 in. (37.5 x 38.1 cm.)
Signed, l.r. sheet recto: "J. Burris '78"
Acquired from: the photographer

*995. [Laura Gilpin] (P1978.16)
Gelatin silver print. 1978
Image: 7 13/16 x 9 3/4 in. (19.9 x 24.7 cm.)
Mount: 12 x 13 3/4 in. (30.4 x 35.0 cm.)
Signed, l.r. mount recto: "J. Burris '78"
Acquired from: gift of the photographer

996. [Rake against wall] (P1978.44.1)
Gelatin silver print. 1978
Image: 5 1/4 x 6 11/16 in. (13.3 x 17.0 cm.)
Sheet: 8 1/16 x 10 1/16 in. (20.4 x 25.6 cm.)
Mount: 14 3/4 x 15 in. (37.5 x 38.1 cm.)
Signed, l.r. sheet recto: "J. Burris '78"
Acquired from: the photographer

997. [Two leaves on wood] (P1978.44.4)
Gelatin silver print. 1978
Image: 5 5/16 x 6 13/16 in. (13.5 x 17.3 cm.)
Sheet: 8 1/8 x 10 1/16 in. (20.6 x 25.6 cm.)
Mount: 14 3/4 x 15 in. (37.5 x 38.1 cm.)
Signed, l.r. sheet recto: "J. Burris '78"
Acquired from: the photographer

988

989

992

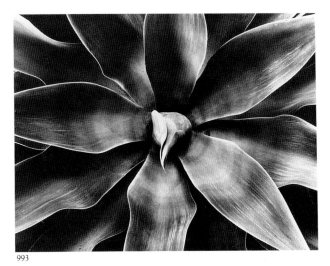

993

995

998

CAROL COHEN BURTON, American (b. 1945)

Born in Cleburne, Texas, Carol Cohen Burton studied
with Russell Lee at the University of Texas at Austin,
receiving a B.F.A. in painting and photography in 1967.
She became the photography instructor at St. Stephen's
Episcopal School in Austin, Texas, in 1980 and has
made freelance color photographs since 1979. Burton
also paints, and both her paintings and photographs
focus on environmental abstractions.

*998. BARRIER HIGHWAY. AUSTIN [from "Contemporary
Texas: A Photographic Portrait"] (P1985.17.58)
Cibachrome print. negative 1984, print 1986 by Ron Sawasky
Image: 9 5/16 x 13 9/16 in. (23.7 x 34.4 cm.)
Sheet: 11 x 14 in. (28.0 x 35.6 cm.)
Signed, l.l. print verso: "Carol Cohen"
Inscription, print verso: "cibachrome print 1986.
transparency 1984©"
Acquired from: gift of the Texas Historical Foundation with
support from a major grant from the Du Pont Company
and Conoco, its energy subsidiary, and assistance from
the Texas Commission on the Arts and the National
Endowment for the Arts

999. CORRUGATION WITH BANNER. AUSTIN [from
"Contemporary Texas: A Photographic Portrait"]
(P1985.17.56)
Cibachrome print. negative 1984, print 1986 by Ron Sawasky
Image: 9 5/16 x 13 9/16 in. (23.7 x 34.4 cm.)
Sheet: 11 x 14 in. (28.0 x 35.6 cm.)
Signed, l.l. print verso: "Carol Cohen"
Inscription, print verso: "cibachrome print 1986.
transparency 1984©"
Acquired from: gift of the Texas Historical Foundation with
support from a major grant from the Du Pont Company
and Conoco, its energy subsidiary, and assistance from
the Texas Commission on the Arts and the National
Endowment for the Arts

1000. COUNTRY BARRIER. EAST OF MONTGOMERY [from
"Contemporary Texas: A Photographic Portrait"]
(P1985.17.53)
Cibachrome print. negative 1984, print 1986 by Ron Sawasky
Image: 9 5/16 x 13 9/16 in. (23.7 x 34.4 cm.)
Sheet: 11 x 14 in. (28.0 x 35.6 cm.)
Signed, l.l. print verso: "Carol Cohen"
Inscription, print verso: "cibachrome print 1986.
transparency 1984©"
Acquired from: gift of the Texas Historical Foundation with
support from a major grant from the Du Pont Company
and Conoco, its energy subsidiary, and assistance from
the Texas Commission on the Arts and the National
Endowment for the Arts

*1001. COWTOWN. FORT WORTH [from "Contemporary Texas:
A Photographic Portrait"] (P1985.17.51)
Cibachrome print. negative 1984, print 1986 by Ron Sawasky
Image: 9 5/16 x 13 9/16 in. (23.7 x 34.4 cm.)
Sheet: 11 x 14 in. (28.0 x 35.6 cm.)
Signed, l.l. print verso: "Carol Cohen"
Inscription, print verso: "cibachrome print 1986.
transparency 1984©"
Acquired from: gift of the Texas Historical Foundation with
support from a major grant from the Du Pont Company
and Conoco, its energy subsidiary, and assistance from
the Texas Commission on the Arts and the National
Endowment for the Arts

1002. INDUSTRIAL YELLOW. DALLAS [from "Contemporary
Texas: A Photographic Portrait"] (P1985.17.52)
Cibachrome print. negative 1984, print 1986 by Ron Sawasky
Image: 9 5/16 x 13 1/2 in. (23.7 x 34.3 cm.)
Sheet: 11 x 14 in. (28.0 x 35.6 cm.)
Signed, l.l. print verso: "Carol Cohen"

Inscription, print verso: "cibachrome print 1986.
transparency 1984©"
Acquired from: gift of the Texas Historical Foundation with
support from a major grant from the Du Pont Company
and Conoco, its energy subsidiary, and assistance from
the Texas Commission on the Arts and the National
Endowment for the Arts

*1003. OWN A SIGN. CONROE [from "Contemporary Texas: A
Photographic Portrait"] (P1985.17.55)
Cibachrome print. negative 1984, print 1986 by Ron Sawasky
Image: 9 5/16 x 13 9/16 in. (23.7 x 34.4 cm.)
Sheet: 11 x 14 in. (28.0 x 35.6 cm.)
Signed, l.l. print verso: "Carol Cohen"
Inscription, print verso: "cibachrome print 1986.
transparency 1984©"
Acquired from: gift of the Texas Historical Foundation with
support from a major grant from the Du Pont Company
and Conoco, its energy subsidiary, and assistance from
the Texas Commission on the Arts and the National
Endowment for the Arts

1004. PRAIRIE CITY. DALLAS [from "Contemporary Texas: A
Photographic Portrait"] (P1985.17.60)
Cibachrome print. negative 1984, print 1986 by Ron Sawasky
Image: 9 5/16 x 13 9/16 in. (23.7 x 34.4 cm.)
Sheet: 11 x 14 in. (28.0 x 35.6 cm.)
Signed, l.l. print verso: "Carol Cohen"
Inscription, print verso: "cibachrome print 1986,
transparency 1984©"
Acquired from: gift of the Texas Historical Foundation with
support from a major grant from the Du Pont Company
and Conoco, its energy subsidiary, and assistance from
the Texas Commission on the Arts and the National
Endowment for the Arts

1005. RURAL ROAD. WEST OF ENNIS [from "Contemporary
Texas: A Photographic Portrait"] (P1985.17.59)
Cibachrome print. negative 1984, print 1986 by Ron Sawasky
Image: 9 5/16 x 13 9/16 in. (23.7 x 34.4 cm.)
Sheet: 11 x 14 in. (28.0 x 35.6 cm.)
Signed, l.l. print verso: "Carol Cohen"
Inscription, print verso: "cibachrome print 1986,
transparency 1984©"
Acquired from: gift of the Texas Historical Foundation with
support from a major grant from the Du Pont Company
and Conoco, its energy subsidiary, and assistance from
the Texas Commission on the Arts and the National
Endowment for the Arts

1006. TOWN AND COUNTRY MALL. TEMPLE [from
"Contemporary Texas: A Photographic Portrait"]
(P1985.17.57)
Cibachrome print. negative 1984, print 1986 by Ron Sawasky
Image: 9 5/16 x 13 9/16 in. (23.7 x 34.4 cm.)
Sheet: 10 15/16 x 14 in. (27.8 x 35.6 cm.)
Signed, l.l. print verso: "Carol Cohen"
Inscription, print verso: "cibachrome print 1986,
transparency 1984©"
Acquired from: gift of the Texas Historical Foundation with
support from a major grant from the Du Pont Company
and Conoco, its energy subsidiary, and assistance from
the Texas Commission on the Arts and the National
Endowment for the Arts

1007. TRUCK TRANSPORT. FORT WORTH [from
"Contemporary Texas: A Photographic Portrait"]
(P1985.17.54)
Cibachrome print. negative 1984, print 1986 by Ron Sawasky
Image: 9 5/16 x 13 9/16 in. (23.7 x 34.4 cm.)
Sheet: 11 x 14 in. (28.0 x 35.6 cm.)
Signed, l.l. print verso: "Carol Cohen"
Inscription, print verso: "cibachrome print 1986,
transparency 1984©"

Acquired from: gift of the Texas Historical Foundation with support from a major grant from the Du Pont Company and Conoco, its energy subsidiary, and assistance from the Texas Commission on the Arts and the National Endowment for the Arts

JOHN E. CAKEBREAD, American (b. 1930)

Jack Cakebread's images focus on the landscape of California, his native state, and on winemaking activities. He founded Cakebread Cellars in 1973 and from 1979 to 1983 did not produce photographs, focusing his attention on the family-run winemaking operation. He took up photography again in 1983, producing both original prints and luxury-edition photographic publications.

1001

1008. **DEATH VALLEY** (P1966.402)
Gelatin silver print. 1961
Image: 13 ⅝ x 10 ¾ in. (34.5 x 27.2 cm.)
Mount: 22 x 17 in. (55.9 x 43.3 cm.)
Signed, l.r. mount recto: "J E Cakebread"
Inscription, mount verso: "Wait on Tamarind" and "DEATH VALLEY" contained on paper label "J.E. CAKEBREAD/4170 LAGUNA AVENUE/ OAKLAND, CALIF. 94602/PRINTED ESPECIALLY/FOR/ LOCATION/INFORMATION" and rubber stamp "PHOTOGRAPHS/All rights reserved/Written permission for/use required./J.E. CAKEBREAD/4170 LAGUNA AVE./OAKLAND, CALIF. 94602"
Acquired from: the photographer

1003

*1009. **STATE HOUSE, BENCIA, CALIFORNIA** (P1966.401)
Gelatin silver print. 1962
Image: 13 ⁹⁄₁₆ x 10 ⁹⁄₁₆ in. (34.4 x 26.8 cm.)
Mount: 22 x 17 in. (55.9 x 43.3 cm.)
Signed, l.r. mount recto: "J E Cakebread"
Inscription, mount verso: "Wait on Tamarind" and "State House/Bencia, California" contained on paper label "J.E. CAKEBREAD/4170 LAGUNA AVENUE/OAKLAND, CALIF. 94602/PRINTED ESPECIALLY/FOR/ LOCATION/ INFORMATION" and rubber stamp "PHOTOGRAPHS/All rights reserved/ Written permission for/use required./J.E. CAKEBREAD/4170 LAGUNA AVE./OAKLAND, CALIF. 94602"
Acquired from: the photographer

1010. **WHITE CHURCH, BRIDGEPORT, CALIFORNIA** (P1966.400)
Gelatin silver print. 1964
Image: 13 ⁷⁄₁₆ x 10 ¾ in. (34.0 x 27.3 cm.)
Mount: 22 x 17 in. (55.9 x 43.3 cm.)
Signed, l.r. mount recto: "J E Cakebread"
Inscription, mount verso: "White Church/Bridgeport, California" contained on paper label "J.E. CAKEBREAD/4170 LAGUNA AVENUE/ OAKLAND, CALIF. 94602/PRINTED ESPECIALLY/FOR/ LOCATION/INFORMATION" and rubber stamp "PHOTOGRAPHS/All rights reserved/Written permission for/use required./J.E. CAKEBREAD/4170 LAGUNA AVE./ OAKLAND, CALIF. 94602"
Acquired from: the photographer

1009

H. B. CALFEE, American (active 1870s—1890s)

H. B. Calfee, a commercial photographer located in Bozeman, Montana, photographed the Yellowstone region from the late 1870s through the late 1880s. Calfee was in Bozeman at the same time as William Henry Jackson, but it is not known if Calfee ever accompanied Jackson on photographic trips to Yellowstone. Indians still posed a threat at the time, and military escorts

often accompanied photographers. One of Calfee's wagons was in Yellowstone Park in 1877 when Nez Percé Indians attacked some tourists. One series of Calfee's stereos was entitled "Views of the Wonderland." Most of the images in the series "The Enchanted Land" are straight images of the sights in Yellowstone National Park, but several images have surreal characters worked into the rocks or strange figural juxtapositions.

A collection of 39 stereographs and 2 single images
(P1987.13.1−41)
note: accession numbers P1987.13.1−39 are attributed to Calfee, while P1987.13.40−41 are attributed to an unknown photographer. Titles are inscribed on mounts or in negatives.
Albumen silver prints and collodio-chloride prints.
c. 1870s−90s
Inscription on P1987.13.1−39, mount verso, printed: "The Enchanted Land/-OR-/Wonders of the Yellowstone/National Park,/-BY-/H. B. Calfee,// Magic Lantern and Stereopticon Views/a specialty./ Price List furnished on application."
Acquired from: Russ Todd Books, Cave Creek, Arizona

*1011. **THE GEORGON'S LABYRINTH Y.N.P.** [altered image; faces in rock] (P1987.13.1)

*1012. **THE GODDESS OF PANDEMONIUM. IN THE YELLOWSTONE PARK** [altered image] (P1987.13.2)

1013. **KING OF BEDLUM** [altered image] (P1987.13.3)

1014. **BOILING POOL IN YELLOWSTONE LAKE** [retouched dog/sheep?] (P1987.13.4)

1015. **GARDNER FALLS** (P1987.13.5)

1016. **GRAND CANYON** (P1987.13.6)

1017. **MANERRVIE TERRIS MAMMOTH HOT SPRINGS** (P1987.13.7)

1018. **FARRIES WELL. UPPER GEYSER BASIN** (P1987.13.8)

1019. **HELL GATE CANYON** (P1987.13.9)

1020. **YELLOWSTONE RAPIDS** (P1987.13.10)

1021. **OLD BEE HIVE CRATER** (P1987.13.11)

1022. **GIANTESS GEYSER NAT. PARK** (P1987.13.12)

1023. **CRYSTAL FOREST** (P1987.13.13)

1024. **SCROLLWORK IN BOTTOM OF PERIODICAL LAKE** (P1987.13.14)

1025. **STAIRWAY UP DEBRI HILL** (P1987.13.15)

*1026. **PULPIT BASINS** (P1987.13.16)

1027. **MIDWAY BASINS MAMMOTH** [illegible] (P1987.13.17)

1028. **OLD FAITHFUL GEYSER** (P1987.13.18)

1029. **CRATER OF GIANTESS GEYSER** (P1987.13.19)

1030. **TOURISTS TRAVELING** (P1987.13.20)

1031. **SECTION OF CRATER OF THE CASTLE GEYSER** (P1987.13.21)

1032. **GIANTESS GROUP OF GEYSERS** (P1987.13.22)

*1033. **SPECIMEN CREEK, FAIRIES FALL** (P1987.13.23)

1034. **ANNIE'S LAKE AND PYRAMID MOUNTAIN REFLECTED** (P1987.13.24) (P1987.13.24)

1035. **PILOT PEAK. INDEX MOUNTAIN** (P1987.13.25)

1036. **SUCCESSFUL HUNTER** (P1987.13.26)

1037. **SILVER CASCADE** (P1987.13.27)

1038. **NATURAL PAINT POTS** (P1987.13.28)

1039. **MT. SHERIDAN** (P1987.13.29)

1040. **FINGER ROCK** (P1987.13.30)

1041. **BEAR ROCK** (P1987.13.31)

1042. **MAIN CRATER IN PERIODICAL LAKE** (P1987.13.32)

1043. **DEBRI HILL** (P1987.13.33)

*1044. **A DINNER IN THE PARK** (P1987.13.34)

1045. **GRAND CANYON FROM THE FALLS** (P1987.13.35)

*1046. **DISMAL VIEW, LOOKING IN GRAND CANYON** (P1987.13.36)

1047. [Swiftly flowing stream, bare bushes and trees along banks] (P1987.13.37)

*1048. [Studio shot of two men holding rifles and dressed in hunting garb, dog sitting between them] (P1987.13.38)

1049. [Group of five men and five women with cameras photographing a cow] (P1987.13.39)

1050. [Camp site among the trees with two women, two men, tents, and a wagon labeled "TRANSFER BAGGAGE"; rifles and gear piled against tree in foreground] (P1987.13.40)

1051. [Still life of fishing gear (creel, waders, net, pole, hat, fish) on bed of reeds next to trees] (P1987.13.41)

HARRY CALLAHAN, American (b. 1912)

After earning an engineering degree at Michigan State University in 1933, Callahan worked for the Chrysler Corporation from 1934 until 1944. Self-taught as a photographer, he began to make photographs in 1938 and in 1944 took a position with the General Motors Photographic Laboratory. While in Detroit, Callahan joined the Detroit Photo Guild, where he learned of and was influenced by Ansel Adams' work. In 1946 Callahan joined the staff of the Chicago Institute of Design and became the photography department head in 1949. In 1961 he left Chicago and joined the faculty

1011

1012

1026

1033

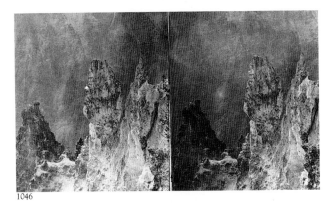

1044

1046

1048

1052

of the Rhode Island School of Design, where he served as head of the photography program until 1973 and as an instructor until he retired in 1977. Callahan also taught courses at a number of other colleges and universities. In 1976 he received the Photographer and Educator Award from the Society for Photographic Education. Among his other major awards were a Graham Foundation Grant in 1956 and a Guggenheim Fellowship in 1972. Callahan's work is highly personal, consisting primarily of images of his wife, his daughter, and the areas in which he has lived. The studies are frequently abstractions of representational forms.

*1052. **CAMERA MOVEMENT ON FLASHLIGHT, CHICAGO** (P1985.39.3)
Gelatin silver print. c. 1949
Image: 4 ⅜ x 3 ⁵⁄₁₆ in. (11.1 x 8.3 cm.)
Mount: 9 ½ x 7 in. (24.1 x 17.7 cm.)
Signed, l.r. mount recto: "Harry Callahan"
Inscription, mount verso: "22"
Acquired from: Pace MacGill, New York, New York

1053. **ELEANOR, CHICAGO** [arms over face and breasts] (P1985.39.2)
Gelatin silver print. 1948
Image: 2 ⁵⁄₁₆ x 2 ¼ in. (5.9 x 5.7 cm.)
Mount: 9 ½ x 7 ½ in. (24.1 x 19.0 cm.)
Signed, center mount verso: "H. Callahan"
Inscription, mount verso: "MOMA I 17//H C 10700 C"
 mat backing recto: "3200//MOMA I 17//HC 10700 C"
Acquired from: Pace MacGill, New York, New York

1054. **ELEANOR, CHICAGO** [legs and buttocks] (P1985.39.1)
Gelatin silver print. 1947
Image: 4 ⁷⁄₁₆ x 2 ¾ in. (11.2 x 6.9 cm.)
Signed, top center print verso: "Callahan"
Inscription, print verso: "170//7 ⅜//HC4" and printer's marks
Acquired from: Pace MacGill, New York, New York

*1055. **WEED AGAINST SKY, DETROIT** (P1983.6)
Gelatin silver print. 1948
Image: 3 ¾ x 3 ⅝ in. (9.6 x 9.3 cm.)
Mount: 10 x 8 in. (25.4 x 20.3 cm.)
Signed, l.r. mount recto and center mount verso: "Harry Callahan"
Inscription, mount verso: "Box 1 #//3.15.55"
Acquired from: Houk Gallery, Chicago, Illinois

EUSTACE CALLAND, English (active c. 1900)

See *Camera Notes*

CAMERA NOTES

Camera Notes, the official publication of the Camera Club of New York, was developed and edited by Alfred Stieglitz. It was published quarterly from 1897 until 1903. The volumes contain tipped-in photogravures by leading pictorialist photographers of the day, articles pertaining to photographic aesthetics and technique, and halftone reproductions. This entry lists the photogravures by volume and number and then alphabetically by photographer.
Acquired from: gift of Paul Brauchle, Dallas, Texas, in honor of Kristen Brauchle

Camera Notes, Volume 2 (P1981.89.1)

Volume 2 Number 1, July 1898

1056.	Day, F. Holland	EBONY AND IVORY
1057.	Demachy, Robert	STUDY IN RED
1058.	Post, W. B.	A PASADENA LANDSCAPE

Volume 2 Number 2, October 1898

1059.	Ashton, Ernest R.	EVENING NEAR THE PYRAMIDS
*1060.	Clarkson, E. V.	SPINNING
1061.	Eickemeyer, Rudolf	A RANCHMAN

Volume 2 Number 3, January 1899

1062.	Berg, Charles I.	MAGDALEN
1063.	Bright, Tom	RETURNING FROM THE PASTURE
1064.	Fraser, W. A.	A WET NIGHT, COLUMBUS CIRCLE
*1065.	Stieglitz, Alfred	MENDING NETS

Volume 2 Number 4, April 1899

1066.	Dumont, John E.	CLARIONET [sic] PLAYER
*1067.	Johnston, Frances B.	GAINSBOROUGH GIRL
1068.	Murphy, W. D.	NIAGARA FALLS
1069.	Watzek, Hans	MICHEL

Camera Notes, Volume 3 (P1981.89.2)

Volume 3 Number 1, July 1899

1070.	Hinton, A. Horsley	DAY'S DECLINE
1071.	Käsebier, Gertrude	PORTRAIT STUDY
*1072.	Käsebier, Gertrude	PORTRAIT OF F. H. DAY
1073.	Le Bégue, R.	DECORATIVE FIGURE

Volume 3 Number 2, October 1899

1074.	Annan, J. Craig	THE LITTLE PRINCESS
1075.	Keiley, Joseph T.	ARABIAN NOBLEMAN
1076.	Stieglitz, Alfred	SCURRYING HOME
1077.	White, Clarence H.	SPRING

Volume 3 Number 3, January 1900

1078.	Berg, Charles I.	ODALISQUE
1079.	Calland, Eustace	THE MALL
1080.	Demachy, Robert	A STREET IN MENTONE
1081.	Farnsworth, E. J.	LA CIGALE
1082.	Weil, Mathilde	BEATRICE

Volume 3 Number 4, April 1900

1083.	Eugene, Frank	LADY OF CHARLOTTE
1084.	Eugene, Frank	LA CIGALE
1085.	Eugene, Frank	A PORTRAIT

Camera Notes, Volume 4 (P1981.89.3)

Volume 4 Number 1, July 1900

1086.	Käsebier, Gertrude	THE MANGER
	Käsebier, Gertrude	[Blessed Art Thou Among Women—missing plate]
1087.	Käsebier, Gertrude	A PORTRAIT
1088.	Robinson, R. W.	OLD CRONIES

Volume 4 Number 2, October 1900

*1089.	Bennett, Lionel C.	A STORMY EVENING
1090.	Champney, J. Wells	A STUDY
1091.	Eickemeyer, Rudolf	THE DANCE
1092.	Eickemeyer, Rudolf	BY THE WAYSIDE

Volume 4 Number 3, January 1901

1093.	Annan, J. Craig	WHITEFRIAR MONKS
1094.	Annan, J. Craig	JANE BURNET
1095.	Annan, J. Craig	LOMBARDY PLOWING TEAM
	Eugene, Frank	[Portrait of Alfred Stieglitz—missing plate]
1096.	Steichen, Eduard	LANDSCAPE
1097.	Watson, Eva	A STUDY HEAD

Volume 4 Number 4, April 1901

1098.	Ashton, Ernest R.	A CAIRENE CAFE
1099.	Clark, Rose, and Wade, Elizabeth	PORTRAIT OF MISS M
1100.	White, Clarence H.	TELEGRAPH POLES
1101.	White, Clarence H.	AT THE EDGE OF THE WOODS—EVENING

1055

1060

1065

1067

1072

1089

Camera Notes, Volume 5 (P1981.89.4)

Volume 5 Number 1, July 1901

1102.	Adamson, Prescott	MIDST STEAM AND SMOKE
1103.	Dyer, William B.	CLYTIE
*1104.	Keiley, Joseph T.	ZITKALA-SA
1105.	Keiley, Joseph T.	SHYLOCK—A STUDY
1106.	Post, William B.	INTERVALE, WINTER

Volume 5 Number 2, October 1901

1107.	Käsebier, Gertrude	FRUITS OF THE EARTH
	Renwick, William W.	[Nude—missing plate]
	Stieglitz, Alfred	[An Icy Night—missing plate]

Volume 5 Number 3, January 1902

1108.	Abbott, C. Yarnall	DECORATIVE LANDSCAPE
1109.	Stieglitz, Alfred	SPRING
1110.	Stieglitz, Alfred	SPRING FLOWERS—THE COACH
1111.	Stieglitz, Alfred	SPRING FLOWERS—THE SWEEPER

Volume 5 Number 4, April 1902

1112.	Davison, George	THE PART OF THE DAY
1113.	Stirling, Edmund	BAD NEWS

Camera Notes, Volume 6 (P1981.89.5)

Volume 6 Number 1, July 1902

1114.	Becher, Arthur E.	WHEN THE HILLS ARE MOWN
1115.	Devens, Mary	CHARCOAL EFFECT
*1116.	Eickemeyer, Rudolf	WINTER LANDSCAPE
1117.	Fichte, Albert	TOIL
1118.	Fuguet, Dallett	THE STREET
1119.	Käsebier, Gertrude	INDIAN CHIEF duplicate of P1978.62
1120.	Maurer, Oscar	APPROACHING STORM
1121.	White, Clarence H.	PORTRAIT

Volume 6 Number 2, October 1902

1122.	Keck, Edward W.	THE SHORT CUT HOME
1123.	Latimer, H. A.	A WATER CARRIER, CUBA
1124.	Moses, Will H.	BROTHER CAROLL
1125.	Murphy, William D.	ON THE BEACH

CAMERA WORK

Camera Work, a quarterly journal devoted to the promotion of photography as a fine art, was published by Alfred Stieglitz from 1903 to 1917. The publication featured hand-pulled photogravure reproductions of photographs that Stieglitz considered to be fine art prints in themselves. There were also halftone and collotype illustrations and articles about photography, photographers, and the modern art movement.
The cover and typography were designed by Edward Steichen, and the paper and letterpress printing followed the highest printing standards. The following entries list the gravure plates present in volumes owned by the Amon Carter Museum. The entries are listed by volume and then alphabetically by photographer. Alfred Stieglitz supplied dates for his images, and those dates are listed following the print title.
A few plates are missing and, in some cases, the plates present differ from the standard issue.

Camera Work, No. 1 [January 1903] (P1979.153.1)

1126.	Dugmore, A. Radclyffe	A STUDY IN NATURAL HISTORY
1127.	Käsebier, Gertrude	DOROTHY
1128.	Käsebier, Gertrude	THE MANGER
1129.	Käsebier, Gertrude	BLESSED ART THOU AMONG WOMEN

*1130.	Käsebier, Gertrude	PORTRAIT (MISS N.)
1131.	Käsebier, Gertrude	THE RED MAN
	Stieglitz, Alfred	[The Hand of Man—missing plate]

Acquired from: bequest of Laura Gilpin

Camera Work, No. 12 [October 1905] (P1979.153.2)

1132.	Herzog, F. Benedict	MARCELLA
1133.	Herzog, F. Benedict	ANGELA
1134.	Herzog, F. Benedict	THE TALE OF ISOLDE
1135.	Stieglitz, Alfred	HORSES (1904)
*1136.	Stieglitz, Alfred	WINTER—FIFTH AVENUE (1892)
1137.	Stieglitz, Alfred	GOING TO THE START (1904)
1138.	Stieglitz, Alfred	SPRING (1901)
1139.	Stieglitz, Alfred	NEARING LAND (1904)
1140.	Stieglitz, Alfred	KATHERINE (1905)
1141.	Stieglitz, Alfred	MISS S. R. (1904)
1142.	Stieglitz, Alfred	PLOUGHING (1904)

Acquired from: bequest of Laura Gilpin

Camera Work, No. 16 [October 1906] (P1979.153.3)

1143.	Demachy, Robert	TOUCQUES VALLEY
1144.	Demachy, Robert	A MODEL
1145.	Demachy, Robert	BEHIND THE SCENES
1146.	Le Bégue, Renée	STUDY

Acquired from: bequest of Laura Gilpin

Camera Work, No. 19 [July 1907] (P1979.153.4)

1147.	Annan, J. Craig	STIRLING CASTLE
1148.	Annan, J. Craig	THE ETCHING PRINTER—WILLIAM STRANG, ESQ., A. R. A.
1149.	Annan, J. Craig	PORTRAIT OF MRS. C
1150.	Annan, J. Craig	JANET BURNET
1151.	Annan, J. Craig	PLOUGHING TEAM
*1152.	Steichen, Eduard J.	PASTORAL—MOONLIGHT

Acquired from: bequest of Laura Gilpin

Camera Work, No. 21 [January 1908] (P1979.153.5)

1153.	Coburn, Alvin Langdon	EL TOROS
1154.	Coburn, Alvin Langdon	ROAD TO ALGECIRAS
1155.	Coburn, Alvin Langdon	THE DUCK POND
1156.	Coburn, Alvin Langdon	RODIN
1157.	Coburn, Alvin Langdon	BERNARD SHAW
*1158.	Coburn, Alvin Langdon	ALFRED STIEGLITZ, ESQ.

Acquired from: bequest of Laura Gilpin

Camera Work, No. 23 [July 1908] (P1979.153.6)

1159.	White, Clarence H.	PORTRAIT—MISS MARY EVERETT
1160.	White, Clarence H.	MORNING
1161.	White, Clarence H.	THE ARBOR
1162.	White, Clarence H.	LADY IN BLACK WITH STATUETTE
1163.	White, Clarence H.	BOYS GOING TO SCHOOL
1164.	White, Clarence H.	LANDSCAPE—WINTER
1165.	White, Clarence H.	PORTRAIT—MASTER TOM
1166.	White, Clarence H.	BOYS WRESTLING
*1167.	White, Clarence H.	THE PIPES OF PAN
1168.	White, Clarence H.	NUDE
1169.	White, Clarence H.	ENTRANCE TO THE GARDEN
1170.	White, Clarence H.	PORTRAIT—MRS. CLARENCE H. WHITE
*1171.	White, Clarence H.	DROPS OF RAIN
1172.	White, Clarence H.	BOY WITH WAGON
1173.	White, Clarence H.	PORTRAIT—MRS. HARRINGTON MANN
1174.	White, Clarence H.	GIRL WITH ROSE

Acquired from: bequest of Laura Gilpin

Camera Work, No. 24 [October 1908] (P1979.153.7 and P1979.153.8)
note: there are duplicate copies of this issue

1175.	De Meyer, Baron A.	STILL LIFE [plate missing in P1979.153.7]

145

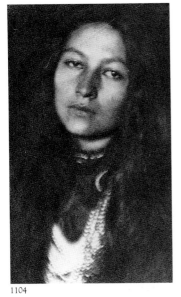 1104
 1116
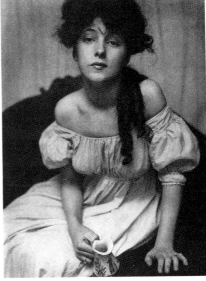 1130
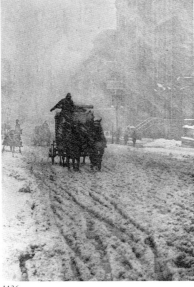 1136
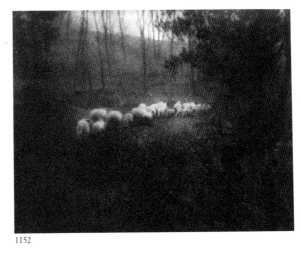 1152
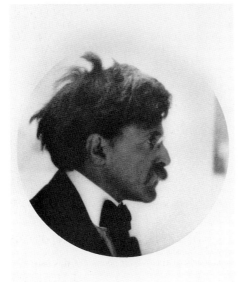 1158
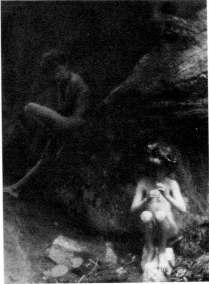 1167

*1176. De Meyer, Baron A. STILL LIFE
1177. De Meyer, Baron A. STILL LIFE [plate missing in
 P1979.153.7]
1178. De Meyer, Baron A. STILL LIFE
1179. De Meyer, Baron A. MRS. BROWN POTTER [plate
 missing in P1979.153.7]
1180. De Meyer, Baron A. GUITAR PLAYER OF SEVILLE
 [plate missing in P1979.153.7]
1181. De Meyer, Baron A. STUDY OF A GITANA [plate
 missing in P1979.153.7]
1182. Rey, Guido THE LETTER
1183. Rey, Guido A FLEMISH INTERIOR
1184. Wilmerding, William OVER THE HOUSE-TOPS—
 NEW YORK [plate missing in
 P1979.153.7]
 Acquired from: bequest of Laura Gilpin

Camera Work, No. 25 [January 1909] (P1979.153.9)

1185. Abbott, C. Yarnall SENTINELS
*1186. Brigman, Anne W. SOUL OF BLASTED PINE
1187. Brigman, Anne W. THE DYING CEDAR
1188. Brigman, Anne W. THE BROOK
 Brigman, Anne W. [The Source—plate missing]
1189. Brigman, Anne W. THE BUBBLE
1190. Eugene, Frank MR. ALFRED STIEGLITZ
 Eugene, Frank [Lady of Charlotte—plate
 missing]
1191. Spencer, Ema GIRL WITH PARASOL
 Acquired from: bequest of Laura Gilpin

Camera Work, No. 28 [October 1909] (P1979.153.10)

1192. Coburn, Alvin Langdon ON THE EMBANKMENT
1193. Davison, George HOUSE NEAR AIX-LES-BAINS
1194. Haviland, Paul B. PORTRAIT—MISS G. G.
1195. Hill, David Octavius THE MINNOW POOL
 [and Robert Adamson]
1196. Hill, David Octavius THE BIRD-CAGE
 [and Robert Adamson]
1197. Hill, David Octavius PORTRAITS—A GROUP
 [and Robert Adamson]
1198. Hill, David Octavius PORTRAIT—THE GOWN
 [and Robert Adamson] AND THE CASKET
1199. Hill, David Octavius MRS. RIGBY
 [and Robert Adamson]
1200. Hill, David Octavius NEWHAVEN FISHERIES
 [and Robert Adamson]
1201. Kernochan, Marshall R. PONTE VECCHIO—
 FLORENCE
 Acquired from: bequest of Laura Gilpin

Camera Work, No. 30 [April 1910] (P1979.153.11)

1202. Eugene, Frank ADAM AND EVE
1203. Eugene, Frank PRINCESS RUPPRECHT AND
 HER CHILDREN
*1204. Eugene, Frank REBECCA
1205. Eugene, Frank MASTER FRANK JEFFERSON
1206. Eugene, Frank SIR HENRY IRVING
1207. Eugene, Frank MOSAIC
1208. Eugene, Frank MAN IN ARMOR
1209. Eugene, Frank HORSE
1210. Eugene, Frank MINUET
1211. Eugene, Frank BRIGITTA
 Acquired from: bequest of Laura Gilpin

Camera Work, No. 31 [July 1910] (P1979.153.12)

1212. Eugene, Frank H.R.H. RUPPRECHT, PRINCE
 OF BAVARIA
1213. Eugene, Frank FRITZ V. UHDE
1214. Eugene, Frank PROF. ADOLF HENGELER
1215. Eugene, Frank PROF. FRANZ V. STUCK
1216. Eugene, Frank WILLI GEIGER
1217. Eugene, Frank PROF. ADOLF V. SEITZ
1218. Eugene, Frank DR. GEORG HIRTH
1219. Eugene, Frank DR. EMANUEL LASKER AND
 HIS BROTHER
1220. Eugene, Frank KIMONO—FRL. V. S.
1221. Eugene, Frank FRAU LUDWIG VON
 HOHLWEIN

1171

1176

1186

1204

1225

1234

1243

1247

1222.	Eugene, Frank	NUDE—A CHILD
1223.	Eugene, Frank	"HORTENSIA"
1224.	Eugene, Frank	NUDE—A STUDY
*1225.	Eugene, Frank	DIREKTOR F. GOETZ

Acquired from: bequest of Laura Gilpin

Camera Work, No. 32 [October 1910] (P1979.153.13)

1226.	Annan, J. Craig	EAST & WEST
1227.	Annan, J. Craig	MAN SKETCHING
1228.	Annan, J. Craig	HARLECH CASTLE
1229.	Annan, J. Craig	BOLNEY BACKWATER
1230.	Annan, J. Craig	THE WHITE HOUSE
1231.	Craig, Gordon	NINTH MOVEMENT [photogravure of etching]
1232.	Matisse, Henri	PHOTOGRAVURE OF DRAWING
1233.	Matisse, Henri	PHOTOGRAVURE OF DRAWING
*1234.	White, Clarence H.	ALVIN LANGDON COBURN AND HIS MOTHER

Acquired from: bequest of Laura Gilpin

Camera Work, No. 33 [January 1911] (P1979.153.14)

1235.	Kuehn, Heinrich	PORTRAIT—MEINE MUTTER
1236.	Kuehn, Heinrich	ON THE SHORE
1237.	Kuehn, Heinrich	WINDBLOWN
1238.	Kuehn, Heinrich	HARBOUR OF HAMBURG
1239.	Kuehn, Heinrich	PORTRAIT
	Kuehn, Heinrich	[Portrait—missing plate]
1240.	Kuehn, Heinrich	PORTRAIT—THE MIRROR
1241.	Kuehn, Heinrich	LANDSCAPE
1242.	Kuehn, Heinrich	ON THE DUNES
*1243.	Kuehn, Heinrich	STUDY
1244.	Kuehn, Heinrich	WINTER LANDSCAPE

Acquired from: bequest of Laura Gilpin

Camera Work, No. 34/35 [April/July 1911] (P1979.153.15)

1245.	Rodin, Auguste	PHOTOGRAVURE OF DRAWING
1246.	Rodin, Auguste	PHOTOGRAVURE OF DRAWING
*1247.	Steichen, Eduard J.	M. AUGUSTE RODIN
1248.	Steichen, Eduard J.	BALZAC—THE OPEN SKY
1249.	Steichen, Eduard J.	BALZAC—TOWARDS THE LIGHT, MIDNIGHT
1250.	Steichen, Eduard J.	BALZAC—THE SILHOUETTE, 4 A.M.

Acquired from: bequest of Laura Gilpin

Camera Work, No. 36 [October 1911] (P1979.153.16)

1251.	Stieglitz, Alfred	THE CITY OF AMBITION (1910)
*1252.	Stieglitz, Alfred	THE CITY ACROSS THE RIVER (1910)
1253.	Stieglitz, Alfred	THE FERRY BOAT (1910)
1254.	Stieglitz, Alfred	THE MAURETANIA (1910)
1255.	Stieglitz, Alfred	LOWER MANHATTAN (1910)
*1256.	Stieglitz, Alfred	OLD AND NEW NEW YORK (1910)
1257.	Stieglitz, Alfred	THE AEROPLANE (1910)
1258.	Stieglitz, Alfred	A DIRIGIBLE (1910)
1259.	Stieglitz, Alfred	THE STEERAGE (1907)
1260.	Stieglitz, Alfred	EXCAVATING—NEW YORK (1911)
1261.	Stieglitz, Alfred	THE SWIMMING LESSON (1906)
*1262.	Stieglitz, Alfred	THE POOL—DEAL (1910)
1263.	Stieglitz, Alfred	THE HAND OF MAN (1902)
*1264.	Stieglitz, Alfred	IN THE NEW YORK CENTRAL YARDS (1903)
1265.	Stieglitz, Alfred	THE TERMINAL (1892)
1266.	Stieglitz, Alfred	SPRING SHOWERS, NEW YORK (1900)

Acquired from: bequest of Laura Gilpin

Camera Work, No. 38 [April 1912] (P1983.40)

1267.	Brigman, Anne W.	THE CLEFT OF THE ROCK
*1268.	Brigman, Anne W.	DAWN
1269.	Brigman, Anne W.	FINIS
1270.	Brigman, Anne W.	THE WONDROUS GLOBE
1271.	Brigman, Anne W.	THE POOL
1272.	Struss, Karl	DUCKS, LAKE COMO
1273.	Struss, Karl	SUNDAY MORNING, CHESTER, NOVA SCOTIA
1274.	Struss, Karl	THE OUTLOOK, VILLA CARLOTTA
1275.	Struss, Karl	ON THE EAST RIVER, NEW YORK
1276.	Struss, Karl	CAPRI
1277.	Struss, Karl	THE LANDING PLACE, VILLA CARLOTTA
1278.	Struss, Karl	OVER THE HOUSETOPS, MISSEN
1279.	Struss, Karl	THE CLIFFS, SORRENTO

Acquired from: Stephen White Gallery of Photography, Inc., Beverly Hills, California

Camera Work, No. 41 [January 1913] (P1979.153.17)

1280.	Cameron, Julia Margaret	CARLYLE
1281.	Cameron, Julia Margaret	CARLYLE
*1282.	Cameron, Julia Margaret	HERSCHEL
1283.	Cameron, Julia Margaret	JOACHIM
1284.	Cameron, Julia Margaret	ELLEN TERRY, AT THE AGE OF SIXTEEN
*1285.	Stieglitz, Alfred	A SNAPSHOT; PARIS (1911)
1286.	Stieglitz, Alfred	A SNAPSHOT; PARIS (1911)
1287.	Stieglitz, Alfred	THE ASPHALT PAVER; NEW YORK (1892)
1288.	Stieglitz, Alfred	PORTRAIT—S.R. (1904)

Acquired from: bequest of Laura Gilpin

Camera Work, No. 42/43 [April/July 1913] (P1979.153.18)

	Steichen, Eduard J.	[Vitality—Yvette Guilbert—missing plate]
*1289.	Steichen, Eduard J.	ISADORA DUNCAN
1290.	Steichen, Eduard J.	CYCLAMEN—MRS. PHILIP LYDIG
1291.	Steichen, Eduard J.	MARY LEARNS TO WALK
1292.	Steichen, Eduard J.	ANATOLE FRANCE
1293.	Steichen, Eduard J.	HENRI MATISSE
1294.	Steichen, Eduard J.	THE MAN THAT RESEMBLES ERASMUS
1295.	Steichen, Eduard J.	HENRY W. TAFT
1296.	Steichen, Eduard J.	E. GORDON CRAIG
1297.	Steichen, Eduard J.	THE PHOTOGRAPHERS' BEST MODEL—G. BERNARD SHAW
*1298.	Steichen, Eduard J.	STEEPLECHASE DAY, PARIS; AFTER THE RACES
1299.	Steichen, Eduard J.	STEEPLECHASE DAY, PARIS; GRAND STAND
1300.	Steichen, Eduard J.	NOCTURNE—ORANGERIE STAIRCASE, VERSAILLES
1301.	Steichen, Eduard J.	LATE AFTERNOON—VENICE

Acquired from: bequest of Laura Gilpin

Camera Work, No. 45 [January 1914] (P1979.153.19)

1302.	Annan, J. Craig	A BLIND MUSICIAN—GRANADA
1303.	Annan, J. Craig	A GITANA—GRANADA
1304.	Annan, J. Craig	A CARPENTER'S SHOP—TOLEDO
1305.	Annan, J. Craig	GROUP ON A HILL ROAD—GRANADA
1306.	Annan, J. Craig	BRIDGE OF ST. MARTIN—TOLEDO
1307.	Annan, J. Craig	OLD CHURCH—BURGOS
1308.	Annan, J. Craig	A SQUARE—RONDA
1309.	Annan, J. Craig	A GATEWAY—SEGOVIA

Acquired from: bequest of Laura Gilpin

1252

1256

1262

1268

1282

1264

Camera Work, No. 48 [October 1916] (P1979.153.20)

1310. Bruguière, Francis A PORTRAIT
1311. Eugene, Frank THE CAT
1312. Lewis, Arthur Allen WINTER
*1313. Strand, Paul NEW YORK
1314. Strand, Paul TELEGRAPH POLES
1315. Strand, Paul NEW YORK
 Strand, Paul [New York—missing plate]
1316. Strand, Paul NEW YORK
 duplicate of P1987.15
 Strand, Paul [New York—missing plate]
 Acquired from: bequest of Laura Gilpin

Camera Work, No. 49/50 [June 1917] (P1979.153.21)

1317. Strand, Paul PHOTOGRAPH—NEW YORK
1318. Strand, Paul PHOTOGRAPH—NEW YORK
*1319. Strand, Paul PHOTOGRAPH—NEW YORK
1320. Strand, Paul PHOTOGRAPH—NEW YORK
1321. Strand, Paul PHOTOGRAPH—NEW YORK
1322. Strand, Paul PHOTOGRAPH—NEW YORK
1323. Strand, Paul PHOTOGRAPH—NEW YORK
1324. Strand, Paul PHOTOGRAPH—NEW YORK
1325. Strand, Paul PHOTOGRAPH
*1326. Strand, Paul PHOTOGRAPH
1327. Strand, Paul PHOTOGRAPH
 Acquired from: bequest of Laura Gilpin

JULIA MARGARET CAMERON,
British, born India (1815–1879)

See *Camera Work*

PAUL CAPONIGRO, American (b. 1932)

Paul Caponigro developed an interest in both music and photography at an early age. Although he left the Boston University College of Music after one year to work in a commercial photography lab, he continued his musical training with a private instructor. Caponigro was drafted in 1953 and served two years as a U.S. Army photographer. During his service, he met and worked with Benjamin Chin, a civilian photographer who taught him the technical aspects of photography and introduced him to several West Coast photographers. After his discharge, Caponigro worked as a freelance photographer while refining his own craft. "In the Presence of . . .," at the George Eastman House in 1958, was the first of many solo exhibitions. Caponigro received Guggenheim Fellowships in 1966 and 1975 and numerous other awards during his career. He has published several portfolios and monographs of his work and has taught and conducted workshops throughout the United States.

1328. **ENCHANTED MESA, ACOMA, NEW MEXICO [from the portfolio "New Mexico Landscapes"]** (P1983.38.2)
Gelatin silver print. negative 1976, print 1983
Image: 11 15/16 x 8 1/2 in. (30.3 x 21.6 cm.)
Mount: 19 15/16 x 15 15/16 in. (50.6 x 40.5 cm.)
Signed, l.r. mount recto: "Paul Caponigro"
Acquired from: Portfolio Editions, Oklahoma City, Oklahoma

1329. **FROSTED WINDOW, MASSACHUSETTS [Revere, Massachusetts; from "Portfolio II"]** (P1986.29.1)
Gelatin silver print. negative 1957, print 1973
Image: 7 13/16 x 9 3/16 in. (19.9 x 23.3 cm.)
Mount: 15 1/16 x 18 1/8 in. (38.3 x 46.0 cm.)
Signed, l.r. mount recto: "Paul Caponigro"
Acquired from: gift of William Clift, Santa Fe, New Mexico

*1330. **LEE'S FERRY, ARIZONA** (P1984.11)
Gelatin silver print. negative 1975, print 1984
Image: 13 1/2 x 19 1/8 in. (34.2 x 48.6 cm.)
Mount: 22 x 28 in. (55.9 x 71.2 cm.)
Signed, l.r. mount recto: "Paul Caponigro"
Inscription, mount verso: "Vc. Lee's Ferry Arizona 1975"
Acquired from: the photographer

1331. **MONUMENT VALLEY, NEW MEXICO [from "Portfolio II"]** (P1986.29.3)
Gelatin silver print. negative 1970, print 1973
Image: 8 9/16 x 12 1/2 in. (21.7 x 31.7 cm.)
Mount: 15 x 18 1/16 in. (38.1 x 45.9 cm.)
Signed, l.r. mount recto: "Paul Caponigro"
Acquired from: gift of William Clift, Santa Fe, New Mexico

1332. **NAHANT BEACH, MASSACHUSETTS [Nahant, Massachusetts; from "Portfolio II"]** (P1986.29.2)
Gelatin silver print. negative 1958, print 1973
Image: 6 7/16 x 5 3/8 in. (16.4 x 13.6 cm.)
Mount: 18 x 15 1/16 in. (45.8 x 38.3 cm.)
Signed, l.r. mount recto: "Paul Caponigro"
Acquired from: gift of William Clift, Santa Fe, New Mexico

1333. **NEW MEXICO LANDSCAPE [from the portfolio "New Mexico Landscapes"]** (P1983.38.1)
Gelatin silver print. negative 1978, print 1983
Image: 12 x 8 9/16 in. (30.4 x 21.7 cm.)
Mount: 19 7/8 x 15 15/16 in. (50.5 x 40.5 cm.)
Signed, l.r. mount recto: "Paul Caponigro"
Acquired from: Portfolio Editions, Oklahoma City, Oklahoma

*1334. **ROCK WALL** (P1978.28.2)
Gelatin silver print. 1958
Image: 10 7/16 x 13 1/16 in. (26.4 x 33.2 cm.)
Mount: 18 x 22 in. (45.7 x 55.8 cm.)
Signed, l.r. mount recto: "Paul Caponigro"
Inscription, mount recto: "58"
 old mat verso: "CAPONIGRO/ROCK WALL"
Acquired from: The Halsted Gallery, Birmingham, Michigan

1335. **RUNNING DEER, COUNTY WICKLOW, IRELAND** (P1978.28.3)
Gelatin silver print. 1967
Image: 7 1/4 x 19 in. (18.3 x 48.2 cm.)
Mount: 14 x 26 in. (35.6 x 66.0 cm.)
Signed, l.r. mount recto: "Paul Caponigro"
Inscription, mount recto: "67"
Acquired from: The Halsted Gallery, Birmingham, Michigan

1336. **WOOD SERIES, REDDING, CONN.** (P1978.28.1)
Gelatin silver print. 1968
Image: 9 5/8 x 13 3/16 in. (24.4 x 33.5 cm.)
Mount: 18 x 22 in. (45.7 x 55.8 cm.)
Signed, l.r. mount recto: "Paul Caponigro"
Inscription, mount verso: "WOOD SERIES, REDDING CONN. 1968"
Acquired from: The Halsted Gallery, Birmingham, Michigan

W. J. CARPENTER, American (1861–after 1900)

Carpenter worked as a photographer in South Texas about 1880 before moving to Durango, Colorado, in 1887. He ran a photographic studio in Silverton in 1889 and during the 1890s ran his business from Telluride, forming a number of studio partnerships. Carpenter spent the latter years of his life in Spokane, Washington, where his photographic work included experimentation with motion pictures.

1285

1289

1298

1313

1319

1326

***1337. BURROS PACKING CORDWOOD TO THE MINES AT POINT MINERAL, COLORADO** (P1979.94)
Albumen silver print. c. 1890s
Image: 10 ⅛ x 13 %₁₆ in. (25.7 x 34.3 cm.)
Mount: 13 ¾ x 16 ⅝ in. (34.9 x 42.2 cm.)
Signed: see inscription
Inscription, mount verso: "81" and rubber stamps "Art/ Studio/of/W. J. Carpenter/Telluride, Colo." and "FOR ONE TIME USE ONLY/CREDIT COLLECTION OF/ FRED AND JO. MAZZULLA/1930 EAST 8TH AVE./ DENVER, COLORADO 80206"
Acquired from: Mazzulla Collection, Fred Mazzulla, Denver, Colorado

KEITH CARTER, American (b. 1948)

Keith Carter was born in Madison, Wisconsin, and received a bachelor's degree in business management from Lamar University in Beaumont, Texas. He studied at the Winona School of Professional Photography in Indiana and has taken workshops led by Wynn Bullock, Henry Holmes Smith, and Paul Caponigro. Carter opened a photographic studio in Beaumont, Texas, in 1977. He served as a Visual Arts and Architecture Advisor to the Texas Commission on the Arts from 1979 to 1980. More recently, he has received a Mid-America Arts Alliance/National Endowment for the Arts Regional Fellowship in Photography and the Lange-Taylor Prize from the Center for Documentary Studies at Duke University.

***1338. LAS ANGELITAS, SAN MIGUEL DE ALLENDE, MEXICO** (P1980.16.1)
Gelatin silver print. 1979
Image: 14 x 14 in. (35.6 x 35.6 cm.)
Sheet: 20 x 16 in. (50.8 x 40.7 cm.)
Signed, l.r. sheet recto: "Keith Carter"
Inscription, mat verso: "Las Angelitas/San Miguel De Allende, Mexico/1979/Keith Carter"
Acquired from: gift of the photographer

1339. SAN MIGUEL DE ALLENDE, MEXICO (P1980.16.2)
Gelatin silver print. 1979
Image: 14 ¹⁄₁₆ x 13 ¹⁵⁄₁₆ in. (35.7 x 35.4 cm.)
Sheet: 20 x 15 ⅞ in. (50.8 x 40.3 cm.)
Signed, l.r. sheet recto: "Keith Carter"
Inscription, mat verso: "San Miguel De Allende, Mexico/1979/ Keith Carter"
Acquired from: gift of the photographer

1340. SANTO TOMÁS CHURCH, CHICHICASTENANGO, GUATEMALA (P1980.16.3)
Gelatin silver print. 1976
Image: 13 ¹⁵⁄₁₆ x 13 ¹⁵⁄₁₆ in. (35.4 x 35.4 cm.)
Sheet: 20 x 16 in. (50.8 x 40.7 cm.)
Signed, l.r. sheet recto: "Keith Carter"
Inscription, mat verso: "Santo Thomas Church/ Chichicastenango, Guatemala/1976/Keith Carter"
Acquired from: gift of the photographer

GARY CAWOOD, American (b. 1947)

Born in Chattanooga, Tennessee, Cawood received a bachelor's degree in architecture from Auburn University in 1970 and an M.F.A. in photography from East Tennessee State University in 1976. After teaching at the University of Delaware, 1975–76, he was on the faculty of Louisiana Tech University in Ruston, Louisiana, from 1976 to 1985, where he was also the director of the E. J. Bellocq Gallery from 1980 to 1983. In 1985 he became an associate professor at the University of Arkansas in Little Rock. Cawood received a National Endowment for the Arts Visual Artist Fellowship Grant in 1982 and served a term as chair of the South Central

Region of the Society for Photographic Education. His many exhibition activities have included participation in the "Louisiana Major Work" exhibition at the World Exposition in New Orleans in 1984.

1341. THE POET MARIANNE MOORE WAS PHOTOGRAPHED BY RICHARD AVEDON [from the Society for Photographic Education's "South Central Regional Photography Exhibition"] (P1983.31.2)
Gelatin silver print. 1980
Image: 8 ⅛ x 12 in. (20.6 x 30.5 cm.)
Sheet: 10 ⅞ x 13 ⅞ in. (27.6 x 35.2 cm.)
Signed, l.r. sheet recto: "Cawood/1980"
Inscription, sheet recto: "The Poet Marianne Moore was photographed by Richard Avedon."
Acquired from: gift of the Society for Photographic Education, South Central Region

J. WELLS CHAMPNEY

See *Camera Notes*

LARRY CLARK, American (b. 1943)

Larry Clark was born in Tulsa, Oklahoma, and worked in his family's commercial portrait business before studying with Walter Scheffer at the Layton School of Art in Milwaukee, Wisconsin, in 1961–62. Since 1964, Clark has worked as a photographer in New York and Tulsa. He received a National Endowment for the Arts Fellowship in 1973 and a Creative Arts Public Service Photographers' Grant in 1980. Clark's best-known work documenting the marginal elements of society has appeared in two books and portfolios, *Tulsa* (1971, 1975) and *Teenage Lust* (1974, 1982).

***1342. TULSA [man looking through car windshield]** (P1985.23)
Gelatin silver print. c. 1971
Image: 8 ³⁄₁₆ x 12 ⅜ in. (20.8 x 31.4 cm.)
Sheet: 10 ¹⁵⁄₁₆ x 13 ¹⁵⁄₁₆ in. (27.7 x 35.4 cm.)
Signed, l.r. print verso: "Larry Clark"
Inscription, old mat backing verso, "Larry Clark "Tulsa p. 15" c. 1971"
Acquired from: gift of Paul Brauchle, Dallas, Texas

ROSE CLARK

See *Camera Notes*

E. V. CLARKSON

See *Camera Notes*

JAMES ATKINS CLAYTON, American, born England (1831–1896)

One of twelve children, Clayton was born in New Mills, Derbyshire, England, and immigrated to the United States with his parents in 1839. The family settled on a farm near Mifflin, Wisconsin, where his father worked as a farmer and lead miner. Clayton moved to California in 1850 with his brother Joel. He first worked for his brother Charles as a store clerk in Santa Clara, but soon left to try his luck in the gold fields. Unsuccessful in his California mining ventures, he went to try the Australian gold mines in 1851, but returned to California in 1852. In 1853 he opened a photography studio in Santa Clara; in 1856 he moved to San Jose and opened a second studio, which he operated for thirteen years. Elected county clerk in

1330

1334

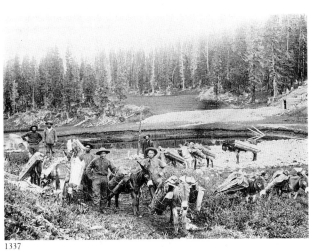

1337

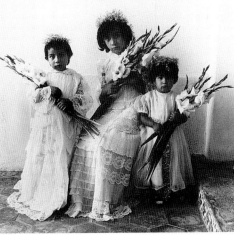

1338

1342

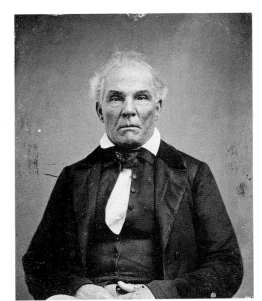

1343

1861, Clayton began to discover income-generating possibilities other than photography. He opened a real estate office in 1867 and after 1869 abandoned the photography studio to pursue a career in real estate, insurance, and banking. He owned the first abstract and title business in Santa Clara County and at the time of his death in 1896 was one of the largest landholders in the county.

Attributed to James A. Clayton
*1343. **JOSEPH RUTHERFORD WALKER** (P1985.6.1)
Tintype with applied coloring. c. 1865−70
Image: 3 ¹/₁₆ x 2 ¹³/₁₆ in. (7.8 x 6.7 cm.)
Case: 3 ¾ x 3 ¼ in. (9.4 x 8.2 cm.)
Signed: see inscription
Inscription, brass overmat, stamped: "J. A. CLAYTON/ [S]AN JOSE CAL."
Acquired from: gift of Carroll M. Walker, Sacramento, California

WILLIAM CLIFT, American (b. 1944)

Originally from Boston, Clift studied with Paul Caponigro and worked as a commercial architectural photographer before moving to Santa Fe, New Mexico. The New Mexico landscape captivated Clift and became a focus of his work during the early 1970s. In 1975−76 Clift worked with the Seagram Corporation-sponsored courthouse photographic project, which documented structures nationwide and resulted in a book and traveling exhibition. He received National Endowment for the Arts grants in 1972 and 1979 and two Guggenheim Fellowships in 1974 and 1980. Although he worked in France in 1981−82 on the second Guggenheim, the southwestern landscape remains at the center of Clift's work. His interest focuses on the relationship of land masses, the dramatic effect of light and shadows, and man's influence upon the land.

1344. **CACTUS, SANTA FE RIVER GORGE, NEW MEXICO** [from the portfolio "New Mexico Landscapes"] (P1983.38.3)
Gelatin silver print. negative 1981, portfolio published 1983
Image: 9 ³/₁₆ x 13 ³/₁₆ in. (23.3 x 33.5 cm.)
Mount: 15 ⅞ x 20 in. (40.3 x 50.8 cm.)
Signed, l.r. mount recto: "William Clift"
Acquired from: Portfolio Editions, Oklahoma City, Oklahoma

1345. **CANYON DE CHELLY, ARIZONA—WHITE HOUSE RUIN** (P1980.1.3)
Gelatin silver print. 1975
Image: 13 ½ x 19 ⅛ in. (34.3 x 48.6 cm.)
Sheet: 14 x 19 ½ in. (35.6 x 49.5 cm.)
Mount: 20 x 28 in. (50.8 x 71.1 cm.)
Signed, l.r. overmat recto and l.r. mount recto: "William Clift"
Inscription, mount recto: "Canyon de Chelly, Arizona— White House Ruin 1975"
Acquired from: the photographer

1346. **FROM LA BAJADA MESA TOWARD THE ORTIZ MOUNTAINS, NEW MEXICO** (P1980.1.1)
Gelatin silver print. 1978
Image: 12 ¹/₁₆ x 17 ⅛ in. (30.7 x 43.4 cm.)
Sheet: 12 ⁹/₁₆ x 17 ⅝ in. (31.9 x 44.8 cm.)
Mount: 18 x 24 in. (45.8 x 61.0 cm.)
Signed, l.r. overmat recto and l.r. mount recto: "William Clift"
Inscription, mount recto: "From La Bajada Mesa Towards the Ortiz Mountains, New Mexico 1978"
Acquired from: the photographer

1347. **LA MESITA FROM CERRO SEGURO, NEW MEXICO** (P1980.1.2)
Gelatin silver print. 1978
Image: 13 ½ x 19 ⅜ in. (34.3 x 49.3 cm.)
Sheet: 14 x 19 ¾ in. (35.6 x 50.2 cm.)
Mount: 20 x 28 in. (50.8 x 71.1 cm.)
Signed, l.r. overmat recto and l.r. mount recto: "William Clift"
Inscription, mount recto: "La Mesita from Cerro Seguro, New Mexico 1978"
Acquired from: the photographer

*1348. **SHEEP AND PETROGLYPHS, CANYON DEL MUERTO, ARIZONA** (P1980.1.4)
Gelatin silver print. 1975
Image: 7 ⁹/₁₆ x 10 ⁹/₁₆ in. (19.2 x 26.8 cm.)
Sheet: 8 x 10 ⅞ in. (20.3 x 27.6 cm.)
Mount: 14 x 17 in. (35.6 x 43.2 cm.)
Signed, l.r. overmat recto and l.r. mount recto: "William Clift"
Inscription, mount recto: "Sheep and Petroglyphs, Canyon del Muerto, Arizona 1975"
Acquired from: the photographer

1349. **SNOW, SANDIA FOOTHILLS, NEW MEXICO** [from the portfolio "New Mexico Landscapes"] (P1983.38.4)
Gelatin silver print. negative 1973, portfolio published 1983
Image: 9 ³/₁₆ x 13 ³/₁₆ in. (23.3 x 33.5 cm.)
Mount: 16 x 20 in. (40.7 x 50.8 cm.)
Signed, l.r. mount recto: "William Clift"
Acquired from: Portfolio Editions, Oklahoma City, Oklahoma

ALVIN LANGDON COBURN, American (1882−1966)

See also *Camera Work*

Coburn was a pictorialist best known for his portrait work. A member of the Photo-Secession, he favored the gum-bichromate, platinum, gum-platinum, and photogravure processes embraced by other soft-focus photographers. He had a strong interest in book illustrations, and the photogravure portraits of influential leaders in his books *Men of Mark* (1913) and *More Men of Mark* (1922) are probably his best-known work, although he also made architectural pictures, published in *New York* (1910), and experimented with abstract compositions.

*1350. **BROADWAY AT NIGHT** [plate from *New York* (New York: Brentano's, 1910)] (P1978.67.1)
Photogravure. 1910
Image: 7 ¹⁵/₁₆ x 5 ⅞ in. (20.2 x 14.9 cm.)
Sheet: 8 ½ x 6 ³/₁₆ in. (21.5 x 15.7 cm.)
Mount: 15 ¾ x 11 ⅜ in. (40.0 x 28.8 cm.)
Inscription, mount verso: "Broadway at Night"
Acquired from: Edward Kaufman, Chicago, Illinois

1351. **THE KNICKERBOCKER TRUST COMPANY** [plate from *New York* (New York: Brentano's, 1910)] (P1978.67.2)
Photogravure. 1910
Image: 7 ½ x 6 ⅛ in. (19.0 x 15.6 cm.)
Sheet: 8 ³/₁₆ x 6 ⁹/₁₆ in. (20.8 x 16.6 cm.)
Mount: 15 ¾ x 11 ⁵/₁₆ in. (40.0 x 28.7 cm.)
Inscription, mount verso: "The Knickerbocker Trust Company"
Acquired from: Edward Kaufman, Chicago, Illinois

1352. **WILLIAMSBURG BRIDGE** [plate from *New York* (New York: Brentano's, 1910)] (P1978.67.3)
Photogravure. 1910
Image: 7 ½ x 6 in. (19.0 x 15.2 cm.)
Sheet: 8 ³/₁₆ x 6 ⅜ in. (20.8 x 16.2 cm.)
Mount: 15 ¾ x 11 ⅜ in. (40.0 x 28.9 cm.)
Inscription, mount verso: "Williamsburg Bridge"
Acquired from: Edward Kaufman, Chicago, Illinois

JOHN COLLIER, JR., American (b. 1913)

1348

Born in Sparkill, New York, John Collier studied painting with Maynard Dixon, husband of photographer Dorothea Lange, at the California School of Fine Arts (now the San Francisco Art Institute) from 1931 until 1935. He studied photography informally with Lange beginning in 1935, but was largely self-taught. After working in California, Collier joined the Historical Section of the Farm Security Administration under the direction of Roy E. Stryker in 1941. He continued the association with Stryker in 1942–43 under the Office of War Information and from 1945 to 1949 with the Standard Oil of New Jersey project. Collier's documentary work drew on an interest in anthropology, and he spent time working on anthropological projects in Canada, Peru, and on the Navajo Indian reservation. He has also taught courses in anthropology at California State University in San Francisco and in photography at the San Francisco Art Institute. Among his awards are a Wenner Gren Fellowship awarded in 1950 and a Guggenheim Fellowship in 1957. In 1967 he published *Visual Anthropology: Photography as a Research Method*, which combined his interest in both fields.

1350

1353. **CHANNEL AND FURNACE BLACK PLANTS OF THE HUBER OIL AND CARBON CO. BORGER, TEXAS** [from the exhibition "Out of the Forties: A Portrait of Texas from the Standard Oil Collection"] (P1984.37.64)
Gelatin silver print. negative 1947, print 1982 by Bill Carner
Image: 10 1/16 x 12 15/16 in. (25.5 x 32.9 cm.)
Sheet: 11 x 13 15/16 in. (28.0 x 35.4 cm.)
Inscription, print verso: "SONJ 54890" and rubber stamps "UNIVERSITY OF LOUISVILLE/PHOTOGRAPHIC ARCHIVES" and "PLEASE CREDIT:/UNIVERSITY OF LOUISVILLE/PHOTOGRAPHIC ARCHIVES"
Acquired from: gift of Texas Monthly, Inc., Austin, Texas, printed from a negative in the Standard Oil of New Jersey Collection, University of Louisville Photographic Archives

*1354. **HAWAIIAN MUSIC STUDIO IN BORGER. BORGER, TEXAS** [from the exhibition "Out of the Forties: A Portrait of Texas from the Standard Oil Collection"] (P1984.37.62)
Gelatin silver print. negative 1947, print 1982 by Bill Carner
Image: 9 15/16 x 12 5/8 in. (25.3 x 32.0 cm.)
Sheet: 11 x 13 15/16 in. (28.0 x 35.4 cm.)
Inscription, print verso: "SONJ 54675"
Acquired from: gift of Texas Monthly, Inc., Austin, Texas, printed from a negative in the Standard Oil of New Jersey Collection, University of Louisville Photographic Archives

1355. **TO ALLEVIATE THE PRESSURE CAUSED BY THE EXPANSION OF BORGER'S INDUSTRIES DURING THE WAR, THE GOVERNMENT BUILT BLOCKS OF TEMPORARY HOUSING FOR ITS WORKERS, INCLUDING THIS MESS HALL NEAR THE PHILLIPS PETROLEUM COMPANY REFINERY. BORGER, TEXAS** [from the exhibition "Out of the Forties: A Portrait of Texas from the Standard Oil Collection"] (P1984.37.63)
Gelatin silver print. negative 1947, print 1982 by Bill Carner
Image: 12 5/8 x 10 in. (32.0 x 25.4 cm.)
Sheet: 13 15/16 x 11 in. (35.4 x 28.0 cm.)
Inscription, print verso: "SONJ 64/54682"
Acquired from: gift of Texas Monthly, Inc., Austin, Texas, printed from a negative in the Standard Oil of New Jersey Collection, University of Louisville Photographic Archives

1354

WILL CONNELL, American (1898–1961)

Connell was born in McPherson, Kansas, but raised in Los Angeles. He held a variety of odd jobs as a young man but taught himself photography and opened a

studio in Los Angeles about 1925. He had his first major show in 1926 with Edward Weston at the Los Angeles Public Library. In 1931 he began teaching at the Art Center School (now the Art Center College of Design), but continued to maintain his commercial photography business. Connell had close ties to many people involved in the arts and entertainment industries and is remembered for the sense of humor often reflected in his work.

*1356. **CHURCH AT RANCHOS DE TAOS** (P1981.40)
Gelatin silver print. 1932
Image: 11 9/16 x 9 1/2 in. (29.4 x 24.2 cm.)
Mount: 18 x 14 in. (45.7 x 35.6 cm.)
Signed, l.r. mount recto: "Will Connell 32"
Inscription, mount recto: ""Church at Rancho [sic] de Taos""
Acquired from: Margolis and Moss, Santa Fe, New Mexico

LINDA S. CONNOR, American (b. 1944)

Linda Connor studied photography under Harry Callahan at the Rhode Island School of Design, graduating with a B.F.A. in 1967. She also received an M.S. in 1969 from the Institute of Design, Illinois Institute of Technology, where she studied with Aaron Siskind. Connor joined the staff of the San Francisco Art Institute in 1969 but has taught courses at a number of other institutions. She has received a number of grants and awards, including a National Endowment for the Arts grant in 1976 and a 1979 Guggenheim Fellowship. Connor's early work included assemblages utilizing objects and older photographs. She later worked with a view camera and produced gold-toned contact prints. Both bodies of work evoke the past and contain personal and mysterious overtones.

*1357. **SPANISH ENTERING THE CANYON DE CHELLY, ARIZONA** (P1984.8)
Gold-toned gelatin silver print on printing-out paper. 1982
Image: 7 5/8 x 9 5/8 in. (19.4 x 24.5 cm.)
Sheet: 8 x 10 in. (20.3 x 25.4 cm.)
Signed, l.r. print verso: "Linda S. Connor"
Inscription, print verso: "Spanish Entering Canyon de Chelly, Arizona 1982"
Acquired from: Etherton Gallery, Tucson, Arizona

CARLOTTA M. CORPRON, American (1901–1988)

Carlotta M. Corpron was born in Blue Earth, Minnesota, but raised in India, where her father worked as a missionary and surgeon. She received her B.S. in art education from Michigan State Normal College (now Eastern Michigan University) in 1925 and her M.A. from Teachers College of Columbia University in 1926. Corpron began to make photographs in 1933 while teaching at the University of Cincinnati. She accepted a teaching position at Texas State College for Women (now Texas Woman's University) in Denton, Texas, in 1935 and worked there until 1968. Her photographic work, which began in the mid-1930s and was actively pursued for only a ten-year period during the 1940s, deals almost exclusively with an investigation of light, a focus intensified by study with Gyorgy Kepes. While much of her early work depicts light as it related to natural forms, further investigation led her to photograph light itself as a pattern in abstract compositions. Corpron's work was the subject of an exhibition at the Amon Carter Museum in 1980, and her negatives are housed at the Museum.

*1358. **BISYMMETRIC DESIGN** (P1981.32)
Gelatin silver print. 1944
Image: 9 3/4 x 13 1/2 in. (24.8 x 34.3 cm.)
Mount: 10 9/16 x 13 13/16 in. (26.8 x 35.1 cm.)
Signed, l.r. mount recto: "Carlotta M. Corpron 1944"
l.r. overmat recto: "Carlotta M. Corpron"
Inscription, mount verso, rubber stamp: "Carlotta M. Corpron/Denton, Texas"
overmat recto: "Bisymmetric Design"
old mat verso: "Needs a new mat—N. top mat glued on/chic/17 vintage print—1944/1944/Photograph—Light design with white paper/Exhibition Art Alliance"
Acquired from: Marcuse Pfeifer Gallery, New York, New York

1359. **CAPTURED LIGHT** (P1985.2.4)
Gelatin silver print. c. 1947
Image: 9 5/8 x 13 9/16 in. (24.4 x 34.4 cm.)
Mount: 12 3/16 x 15 15/16 in. (31.0 x 40.5 cm.)
Signed, l.r. overmat recto, l.r. mount recto, and l.r. mount verso: "Carlotta M. Corpron"
Inscription, mount verso: "II. Captured Light//1st photograph of Fluid Light Series//Captured Light" and rubber stamps "Carlotta M. Corpron/Denton, Texas//Carlotta M. Corpron/Denton, Texas"
mat verso: ACM exhibition label
Acquired from: gift of the Dorothea Leonhardt Fund of the Communities Foundation of Texas, Inc., Dallas, Texas

*1360. **CHAMBERED NAUTILUS WITH CREATED LIGHT AND SHADOW BACKGROUND** (P1981.35.6)
Gelatin silver print. c. 1945
Image: 7 15/16 x 9 3/8 in. (20.1 x 24.4 cm.)
Sheet: 7 15/16 x 9 7/16 in. (20.1 x 24.6 cm.)
Signed, l.r. overmat recto: "Carlotta M. Corpron"
Inscription, print verso: "27"
mat verso: ACM exhibition label and "30"
Acquired from: gift of the photographer

1361. **CHURCH—HAVANA** (P1985.2.17)
Gelatin silver print. 1942
Image: 10 1/2 x 13 3/8 in. (26.7 x 34.0 cm.)
Sheet: 11 x 13 15/16 in. (28.0 x 35.4 cm.)
Inscription, print verso: "II O497//I-II-BF"
Acquired from: gift of the Dorothea Leonhardt Fund of the Communities Foundation of Texas, Inc., Dallas, Texas

*1362. **COMMENTARY ON CIVILIZATION** (P1981.35.2)
duplicate of P1985.2.13
Gelatin silver print. c. 1940
Image: 10 5/16 x 13 1/4 in. (26.2 x 33.7 cm.)
Mount: 10 9/16 x 13 1/2 in. (26.8 x 34.3 cm.)
Signed, l.r. overmat recto: "Carlotta M. Corpron"
Inscription, overmat recto: "Commentary on Civilization"
print verso, rubber stamp: "Carlotta M. Corpron/Denton, Texas"
old mat verso: "Commentary on Civilization?—Most people go around in circles—a few have luminosity—/and some are individual and can move away from the crowd—some are indiv [sic]/Light drawing (lights & camera moving)"
mat verso: ACM exhibition label and "13"
Acquired from: gift of the photographer

1363. **COMMENTARY ON CIVILIZATION** (P1985.2.13)
duplicate of P1981.35.2
Gelatin silver print. c. 1940
Image: 10 9/16 x 13 7/16 in. (26.8 x 34.1 cm.)
Sheet: 10 13/16 x 13 11/16 in. (27.3 x 34.7 cm.)
Mount: 20 x 16 in. (50.8 x 40.7 cm.)
Signed, l.r. overmat recto: "Carlotta M Corpron"
Inscription, overmat recto: "Commentary on Civilization"
mount verso: "ACM 13/modern print" and typed on dealer's label "CARLOTTA M. CORPRON/Commentary on Civilization"
Acquired from: gift of the Dorothea Leonhardt Fund of the Communities Foundation of Texas, Inc., Dallas, Texas

1356

1357

1358

1360

1362

1370

1364. **DELORES—MELROSE PLANTATION, LA** (P1985.2.33)
Gelatin silver print. 1950
Image: 12 ½ x 10 in. (31.6 x 25.4 cm.) sight size
Mount: 20 x 16 in. (50.8 x 40.7 cm.)
Signed, l.r. overmat recto: "Carlotta M. Corpron"
Inscription, overmat recto: "Delores—Melrose Plantation, La"
mount verso: "Delores—grand-daughter of Clementine
Hunter, primitive painter/Melrose Plantation, La//
Photographed while in Melrose plantation with Clarence
Laughlin/who was photographing Clementine Hunter's
work for Look magazine 1950//Carlotta M. Corpron/
Denton, Texas//vintage"
Acquired from: gift of the Dorothea Leonhardt Fund of the
Communities Foundation of Texas, Inc., Dallas, Texas

1365. **DESIGN** (P1985.2.27)
Gelatin silver print. negative c. 1949, print 1976
Image: 13 ¼ x 10 ⅜ in. (33.6 x 26.3 cm.)
Mount: 20 x 16 in. (50.8 x 40.7 cm.)
Signed, l.r. overmat recto: "Carlotta M Corpron"
Inscription, overmat recto: "Design"
mount verso: "DESIGN/original design through pond of
fluted glass/ negative c. 1949/Print 1976//Carlotta M.
Corpron/Denton, Texas"
Acquired from: gift of the Dorothea Leonhardt Fund of the
Communities Foundation of Texas, Inc., Dallas, Texas

1366. **DISTORTED HOLES** (P1985.2.14)
Gelatin silver print. 1948
Image: 13 ⁷⁄₁₆ x 10 ¹⁄₁₆ in. (34.1 x 25.6 cm.)
Mount: 20 x 16 in. (50.8 x 40.7 cm.)
Signed, l.r. overmat recto: "Carlotta M. Corpron"
Inscription, overmat recto: "Distorted Holes"
mount verso: "Space composition series/1948/Distorted
Holes—one of many studies of distortion to create design—
/emphasis on space composition//vintage//Carlotta M.
Corpron/Denton, Texas"
Acquired from: gift of the Dorothea Leonhardt Fund of the
Communities Foundation of Texas, Inc., Dallas, Texas

1367. **EGGS ENCIRCLED** (P1985.2.15) duplicate of P1987.5.3
Gelatin silver print. negative 1948, print later
Image: 13 ⁷⁄₁₆ x 10 ½ in. (34.1 x 26.7 cm.)
Sheet: 13 ¹¹⁄₁₆ x 10 ¾ in. (34.7 x 27.3 cm.)
Mount: 20 x 16 in. (50.8 x 40.7 cm.)
Signed, l.r. overmat recto: "Carlotta M. Corpron"
Inscription, overmat recto: "Eggs Encircled"
mount verso: "A.C. catalogue no. 37//modern print" and
typed on dealer's label "CARLOTTA M. CORPRON/Eggs
Encircled"
Acquired from: gift of the Dorothea Leonhardt Fund of the
Communities Foundation of Texas, Inc., Dallas, Texas

1368. **EGGS ENCIRCLED** (P1987.5.3) duplicate of P1985.2.15
Gelatin silver print. negative 1948, print c. 1948
Image: 9 ⁹⁄₁₆ x 7 ¹³⁄₁₆ in. (24.3 x 19.8 cm.)
Sheet: 10 x 8 ³⁄₁₆ in. (25.4 x 20.7 cm.)
Signed, center print verso: "Carlotta M. Corpron"
Inscription, print verso: "Eggs encircled//Mf//"Eggs
Encircled"//[illegible]//2 col/Thurs pm soc sub/[illegible] &
Smith//53.//7170/3m//47 ⅞//DB276" and paper label "THE
ART INSTITUTE OF CHICAGO/Chicago 3, Illinois/
ARTIST [typed] Carlotta Corpron/TITLE [typed] "Eggs
Encircled"/MEDIUM/EXHIBITION [typed] Abstract
Photographs by Car-/lotta Corpron/DATE/[remainder of
label is missing]" and rubber stamps "PETER POLLACK/
PUBLIC RELATIONS COUNSEL/ART INSTITUTE OF
CHICAGO" and "KINDLY RETURN PHOTOGRAPH
AFTER USE" and "Carlotta M. Corpron/Denton, Texas"
Acquired from: gift of the photographer

1369. **EGGS IN STAGE SETTING** (P1985.2.1)
Gelatin silver print. c. 1948
Image: 10 ¹⁵⁄₁₆ x 8 ⁵⁄₁₆ in. (27.8 x 21.0 cm.)
Signed, l.r. overmat recto and l.r. print verso: "Carlotta M.
Corpron"

Inscription, print verso: "8 Eggs in stage setting//E//.35" and
rubber stamp "Carlotta M. Corpron/Denton, Texas"
Acquired from: gift of the Dorothea Leonhardt Fund of the
Communities Foundation of Texas, Inc., Dallas, Texas

*1370. **EGGS REFLECTED AND MULTIPLIED** (P1980.9)
duplicate of P1985.2.10
Gelatin silver print. negative 1948, print 1975
Image: 10 ⁷⁄₁₆ x 13 ¼ in. (26.5 x 33.6 cm.) sight size
Mount: 20 ¹⁄₁₆ x 16 in. (50.9 x 40.7 cm.)
Signed, l.r. overmat recto: "Carlotta M. Corpron"
l.r. mount verso: "Carlotta M. Corpron/Denton, Texas"
Inscription, overmat recto: "Eggs reflected and multiplied"
mount verso: "Eggs reflected and multiplied 1948/Space
composition with eggs/(print made in 1975)" and ACM
exhibition label
Acquired from: The Afterimage, Dallas, Texas

1371. **EGGS REFLECTED AND MULTIPLIED** (P1985.2.10)
duplicate of P1980.9
Gelatin silver print. negative 1948, print 1978
Image: 10 ½ x 13 ½ in. (26.6 x 34.3 cm.)
Sheet: 11 x 14 in. (28.0 x 35.6 cm.)
Mount: 20 x 16 in. (50.8 x 40.7 cm.)
Signed, l.r. overmat recto: "Carlotta M Corpron"
Inscription, overmat recto: "Eggs Reflected and Multiplied"
mount verso: "Recent" and typed on dealer's label
"CARLOTTA M. CORPRON/Eggs Reflected and
Multiplied/Negative 1948/Print 1978"
Acquired from: gift of the Dorothea Leonhardt Fund of the
Communities Foundation of Texas, Inc., Dallas, Texas

1372. **ELLEN** (P1985.2.31)
Gelatin silver print. c. 1941
Image: 10 ⁵⁄₁₆ x 8 ⁷⁄₁₆ in. (26.4 x 21.5 cm.) sight size
Mount: 20 x 16 in. (50.8 x 40.7 cm.)
Signed, l.r. overmat recto: "Carlotta M. Corpron"
Inscription, overmat recto: "Ellen"
mount verso: "Ellen—/Portrait of a child and her Teddy
Bear//c. 1941//vintage//Carlotta M. Corpron/Denton,
Texas"
Acquired from: gift of the Dorothea Leonhardt Fund of the
Communities Foundation of Texas, Inc., Dallas, Texas

1373. **A FIGURE AROSE FROM CORAL AND GLASS**
(P1985.2.16)
Gelatin silver print. 1949
Image: 12 ¹¹⁄₁₆ x 10 ³⁄₁₆ in. (32.1 x 25.8 cm.) sight size
Mount: 20 x 16 in. (50.8 x 40.7 cm.)
Signed, l.r. overmat recto: "Carlotta M Corpron"
Inscription, overmat recto: "A FIGURE AROSE FROM
CORAL AND GLASS"
mount verso: "A FIGURE AROSE FROM CORAL AND
GLASS 1949//vintage// Carlotta M. Corpron/Denton,
Texas"
Acquired from: gift of the Dorothea Leonhardt Fund of the
Communities Foundation of Texas, Inc., Dallas, Texas

1374. **FLOWING LIGHT** (P1981.35.7)
Gelatin silver print. c. 1947
Image: 10 ⅝ x 13 ¹¹⁄₁₆ in. (26.9 x 34.8 cm.)
Mount: same as image size
Signed, l.r. overmat recto: "Carlotta M. Corpron"
Inscription, mount verso: "FLOWING LIGHT" and rubber
stamp "Carlotta M. Corpron/Denton, Texas"
mat verso: "43//34" and ACM exhibition label
Acquired from: gift of the photographer

1375. **FLUID LIGHT** (P1987.5.1) duplicate of P1985.2.3
Gelatin silver print. c. 1946
Image: 9 ⁷⁄₁₆ x 7 ⁹⁄₁₆ in. (24.0 x 19.2 cm.)
Signed, l.r. print verso: "Carlotta M. Corpron"
Inscription, print verso: "Fluid Light/(Hi [partially erased]
Museum of Modern Art/collection)//Light Series x pool//
DB276"
Acquired from: gift of the photographer

*1376. **FLUID LIGHT DESIGN** (P1985.2.3) duplicate of P1987.5.1
Gelatin silver print. negative c. 1946, print 1946
Image: 9 3/16 x 7 3/16 in. (23.3 x 18.4 cm.) sight size
Mount: 20 x 16 in. (50.8 x 40.7 cm.)
Signed, l.r. overmat recto: "Carlotta M. Corpron"
Inscription, mount verso: ""Fluid Light Design": 1946/
CARLOTTA M. CORPRON/Early morning light reflected
from plastic/4 x 5 view camera—Goerz-Dagor lens—/N.
Print made in 1946/(Steichen bought a print of this for the
M.O.M.A. Collection)" and typed on dealer's label
"CARLOTTA CORPRON/ FLUID LIGHT DESIGN/
Vintage Print"
Acquired from: gift of the Dorothea Leonhardt Fund of the
Communities Foundation of Texas, Inc., Dallas, Texas

1377. **GLASS CUBES AND PATTERNED GLASS** (P1981.35.4)
Gelatin silver print. c. 1945
Image: 13 3/8 x 10 1/2 in. (34.0 x 26.6 cm.)
Sheet: 14 x 11 in. (35.6 x 28.0 cm.)
Signed, l.r. overmat recto: "Carlotta M. Corpron"
Inscription, mat verso: "23" and ACM exhibition label
Acquired from: gift of the photographer

*1378. **ILLUSION OF MALE AND FEMALE** (P1985.2.22)
 duplicate of P1985.2.30
Gelatin silver print. negative 1946, print 1975
Image: 13 1/8 x 10 5/16 in. (33.3 x 26.3 cm.) sight size
Mount: 20 x 16 in. (50.8 x 40.7 cm.)
Signed, l.r. overmat recto and l.r. mount verso: "Carlotta M.
Corpron"
Inscription, overmat recto: "Illusion of MALE & FEMALE"
mount verso: "SHADOW ON FACE GIVES ILLUSION
OF MALE & FEMALE// 1946/CARLOTTA M.
CORPRON/Light follows form series—/Sunlight through a
piece of plastic on Greek plaster head/4 x 5 view camera//
print 1975"
Acquired from: gift of the Dorothea Leonhardt Fund of the
Communities Foundation of Texas, Inc., Dallas, Texas

1379. **ILLUSION OF MALE AND FEMALE** (P1985.2.30)
 duplicate of P1985.2.22
Gelatin silver print. negative 1946, print 1976
Image: 13 3/16 x 10 1/8 in. (33.5 x 26.4 cm.)
Mount: 19 7/8 x 15 7/8 in. (50.5 x 40.3 cm.)
Signed, l.r. overmat recto: "Carlotta M. Corpron"
Inscription, overmat recto: "Illusion of Male and Female"
mount verso: "neg. 1946/print 1976//LIGHT follows FORM
series/ Illusion of Male and Female/Sunlight through a
piece of patterned glass//Carlotta M Corpron/Denton,
Texas" and typed on dealer's label "CARLOTTA
CORPRON/ILLUSION OF MALE & FEMALE/(Modern
print)" and ACM exhibition label
Acquired from: gift of the Dorothea Leonhardt Fund of the
Communities Foundation of Texas, Inc., Dallas, Texas

1380. **LIGHT CREATES BIRD SYMBOLS** (P1985.2.9)
Gelatin silver print. 1946 or 1948
Image: 13 7/16 x 10 1/4 in. (34.1 x 26.0 cm.) sight size
Mount: 20 x 16 in. (50.8 x 40.7 cm.)
Signed, l.r. overmat recto: "Carlotta M. Corpron"
Inscription, overmat recto: "Light creates bird symbols"
mount verso: "Fluid Light Series/LIGHT CREATES BIRD
SYMBOLS (2 negatives//1946 or 1948//vintage"
Acquired from: gift of the Dorothea Leonhardt Fund of the
Communities Foundation of Texas, Inc., Dallas, Texas

1381. **LIGHT FOLLOWS FORM** (P1981.35.5)
Gelatin silver print. negative 1946, print 1976
Image: 10 7/16 x 13 3/16 in. (26.5 x 33.5 cm.) sight size
Signed, l.r. overmat recto and old overmat recto: "Carlotta
M. Corpron"
Inscription, overmat recto and old overmat recto: "Light
Follows Form"
mat verso: "Light Follows Form/1st in a series/negative 194
[sic] Print 1976//Carlotta M. Corpron/Denton, Texas//25"
and ACM exhibition label
Acquired from: gift of the photographer

1376

1378

1382. **LIGHT FOLLOWS FORM OF GREEK HEAD** (P1985.2.20)
duplicate of P1985.2.29
Gelatin silver print. negative c. 1946–47, print 1975
Image: 13 ¼ x 10 ⁵⁄₁₆ in. (33.3 x 26.1 cm.) sight size
Mount: 20 x 16 in. (50.8 x 40.7 cm.)
Signed, l.r. overmat recto: "Carlotta M. Corpron"
Inscription, overmat recto: "Light follows form of Greek head"
 mount verso: "LIGHT FOLLOWS FORM—of Greek
 head/Sun Light through Venetian blind on Greek head/
 negative c. 1946/print 1975//Carlotta M. Corpron/Denton,
 Texas//Recent" and ACM exhibition label
Acquired from: gift of the Dorothea Leonhardt Fund of the
 Communities Foundation of Texas, Inc., Dallas, Texas

1383. **LIGHT FOLLOWS FORM OF GREEK HEAD** (P1985.2.29)
duplicate of P1985.2.20
Gelatin silver print. negative c. 1946–47, print 1975
Image: 13 ⁷⁄₁₆ x 10 ½ in. (34.1 x 26.6 cm.) sight size
Mount: 20 x 16 in. (50.8 x 40.7 cm.)
Signed, l.r. overmat recto: "Carlotta M. Corpron"
Inscription, overmat recto: "Light follows form of Greek
 head"
 mount verso: "LIGHT FOLLOWS FORM (OF GREEK
 HEAD) 1947/Sun Light through a panel of fluted glass/
 Face reflected on panel/Print made in 1975//Carlotta M.
 Corpron/Denton, Texas//negative 1946/print 1975"
Acquired from: gift of the Dorothea Leonhardt Fund of the
 Communities Foundation of Texas, Inc., Dallas, Texas

*1384. **LIGHT, WHITE PAPER AND GLASS** (P1985.2.21)
Gelatin silver print. negative c. 1944, print 1978
Image: 13 ½ x 10 ½ in. (34.2 x 26.6 cm.)
Sheet: 14 x 11 in. (35.6 x 28.0 cm.)
Mount: 20 x 16 in. (50.8 x 40.7 cm.)
Signed, l.r. overmat recto: "Carlotta M. Corpron"
Inscription, overmat recto: "Light, White Paper and Glass"
 mount recto: "Negative 1949 [sic]/Print 1978"
 mount verso: "Recent print//Recent print//cc//20" and
 ACM exhibition label and dealer's label
Acquired from: gift of the Dorothea Leonhardt Fund of the
 Communities Foundation of Texas, Inc., Dallas, Texas

1385. **MENACING FIGURE—DRIED PALM LEAF** (P1985.2.25)
Gelatin silver print. 1948
Image: 13 ¼ x 10 ⅛ in. (33.6 x 25.7 cm.) sight size
Mount: 20 x 16 in. (50.8 x 40.7 cm.)
Signed, l.r. overmat recto: "Carlotta M. Corpron"
 l.r. mount verso: "Carlotta M Corpron"
Inscription, overmat recto: "Menacing Figure—Dried Palm Leaf"
 mount verso: "MENACING FIGURE—(Dried Palm
 Leaf) 1948/Vintage"
Acquired from: gift of the Dorothea Leonhardt Fund of the
 Communities Foundation of Texas, Inc., Dallas, Texas

1386. **NAUTILUS ON MIRROR** (P1987.5.2)
Gelatin silver print. c. 1946–48
Image: 12 ⁵⁄₁₆ x 10 ½ in. (31.3 x 26.7 cm.)
Signed, l.r. print verso: "Carlotta M. Corpron"
Inscription, print verso: "DB276"
Acquired from: gift of the photographer

1387. **OIL TANKS NEAR JEFFERSON, TEXAS** (P1985.2.7)
Gelatin silver print. c. 1942
Image: 10 ⁵⁄₁₆ x 13 ⁵⁄₁₆ in. (26.2 x 33.9 cm.)
Signed, l.r. overmat recto: "Carlotta M. Corpron"
Inscription, overmat recto: "Oil tanks near Jefferson, Texas"
 print verso: "33"
 mat verso: ACM exhibition label
Acquired from: gift of the Dorothea Leonhardt Fund of the
 Communities Foundation of Texas, Inc., Dallas, Texas

*1388. **OIL TANKS WITH BRIDGE** (P1981.35.1)
Gelatin silver print. c. 1942
Image: 10 ¼ x 13 ¼ in. (26.0 x 33.6 cm.)
Signed, l.r. overmat recto: "Carlotta M. Corpron"
Inscription, print verso: "34"
 mat verso: ACM exhibition label
Acquired from: gift of the photographer

*1389. **PANORAMA [Eggs]** (P1985.2.19)
Gelatin silver print. negative 1948, print later
Image: 6 ⅜ x 13 ⁷⁄₁₆ in. (16.2 x 34.1 cm.)
Sheet: 6 ¾ x 13 ⅝ in. (17.1 x 34.6 cm.)
Mount: 20 x 16 in. (50.8 x 40.7 cm.)
Signed, l.r. overmat recto: "Carlotta M. Corpron"
Inscription, overmat recto: "Panorama"
 mount verso: "cc recent print" and ACM exhibition label
 and dealer's label
Acquired from: gift of the Dorothea Leonhardt Fund of the
 Communities Foundation of Texas, Inc., Dallas, Texas

1390. **PRIMITIVE VISION** (P1985.2.28)
Gelatin silver print. negative 1950, print 1978
Image: 13 ½ x 10 ½ in. (34.3 x 26.6 cm.)
Sheet: 14 x 10 ¹⁵⁄₁₆ in. (35.6 x 27.8 cm.)
Mount: 20 x 16 in. (50.8 x 40.7 cm.)
Signed, l.r. overmat recto: "Carlotta M. Corpron"
Inscription, overmat recto: "Primitive Vision"
 mount recto: "Negative 1950/Print 1978"
 mount verso: "Primitive Vision/Sculptured Face"
Acquired from: gift of the Dorothea Leonhardt Fund of the
 Communities Foundation of Texas, Inc., Dallas, Texas

*1391. **PYRAMID OF LIGHT** (P1985.2.5) duplicate of P1985.2.8
Gelatin silver print. negative 1943, print 1978
Image: 10 ⁷⁄₁₆ x 13 ⁷⁄₁₆ in. (26.5 x 34.1 cm.)
Sheet: 10 ⁹⁄₁₆ x 13 ½ in. (26.8 x 34.3 cm.)
Mount: 20 x 15 ⅞ in. (50.8 x 40.3 cm.)
Signed, l.r. overmat recto: "Carlotta M. Corpron"
Inscription, overmat recto: "Pyramid of Light"
 mount recto: "Pyramid of Light//Negative 1943/Print 1978"
 mount verso: ACM exhibition label
Acquired from: gift of the Dorothea Leonhardt Fund of the
 Communities Foundation of Texas, Inc., Dallas, Texas

1392. **PYRAMID OF LIGHT** (P1985.2.8) duplicate of P1985.2.5
Gelatin silver print. negative 1943, print later
Image: 10 ½ x 13 ⁷⁄₁₆ in. (26.6 x 34.1 cm.)
Sheet: 10 ⅝ x 13 ¹¹⁄₁₆ in. (27.1 x 34.7 cm.)
Mount: 20 x 16 in. (50.8 x 40.7 cm.)
Signed, l.r. overmat recto: "Carlotta M. Corpron"
Inscription, overmat recto: "Pyramid of Light"
 mount verso: "A catalogue/No 11/modern print" and typed
 on dealer's label "Pyramid of Light"
Acquired from: gift of the Dorothea Leonhardt Fund of the
 Communities Foundation of Texas, Inc., Dallas, Texas

1393. **QUIET HARMONY** (P1985.2.2)
Gelatin silver print. 1948
Image: 8 ⁹⁄₁₆ x 10 ⁹⁄₁₆ in. (21.8 x 26.8 cm.)
Mount: 9 x 10 ¹⁵⁄₁₆ in. (22.8 x 27.8 cm.)
Signed, l.r. overmat recto and old mat recto: "Carlotta M.
 Corpron"
Inscription, overmat recto: "Quiet Harmony"
 old mat (attached to verso of new mat): "QUIET
 HARMONY 1948/(EGGS in space)//vintage" and
 ACM exhibition label
Acquired from: gift of the Dorothea Leonhardt Fund of the
 Communities Foundation of Texas, Inc., Dallas, Texas

*1394. **SOLARIZED CALLA LILIES** (P1980.31) duplicate of
P1987.5.4
Gelatin silver print. negative c. 1948, print 1978
Image: 13 ½ x 10 ½ in. (34.3 x 26.5 cm.)
Sheet: 13 ¾ x 10 ¾ in. (34.9 x 27.3 cm.)
Mount: 20 x 16 in. (50.8 x 40.7 cm.)
Signed, l.r. overmat recto and l.r. mount recto: "Carlotta M.
 Corpron"
Inscription, overmat recto and mount recto: "Solarized Calla
 Lilies"
 mount verso, typed on dealer's label: "CARLOTTA
 CORPRON/Solarized Calla Lilies/printed 1978 from
 a/1948 negative" and ACM exhibition label
Acquired from: Marcuse Pfeifer Gallery, New York, New York

1384

1388

1389

1391

1394

1397

1395. **SOLARIZED CALLA LILIES** (P1987.5.4) duplicate of
P1980.31
Gelatin silver print. negative c. 1948, print later
Image: 9 ½ x 7 ¼ in. (24.1 x 19.7 cm.)
Sheet: 10 x 8 ³/₁₆ in. (25.4 x 20.8 cm.)
Signed, l.r. print verso: "Carlotta M Corpron"
Inscription, print verso: "DA637"
Acquired from: gift of the photographer

1396. **SOLARIZED PORTRAIT OF RAY ANN**
[Ray Ann] (P1985.2.24)
Gelatin silver print. 1949
Image: 13 ⅛ x 10 ⅛ in. (33.2 x 25.7 cm.) sight size
Mount: 20 x 16 in. (50.8 x 40.7 cm.)
Signed, l.r. overmat recto: "Carlotta M. Corpron"
Inscription, overmat recto: "Ray Ann"
mount verso: "Solarized Portrait of Ray Ann/1949/vintage"
Acquired from: gift of the Dorothea Leonhardt Fund of the
Communities Foundation of Texas, Inc., Dallas, Texas

*1397. **SPACE DEFINED WITH LIGHTS IN A CHURCH IN**
HAVANA (P1983.1)
Gelatin silver print. 1942
Image: 10 ⁹/₁₆ x 12 ¼ in. (26.8 x 31.2 cm.)
Sheet: 10 ¹¹/₁₆ x 12 ¼ in. (27.1 x 31.2 cm.)
Signed, l.r. print verso: "Carlotta M Corpron"
Inscription, print verso: "Space defined with Lights/in a
church in Havana//1942" and rubber stamps "Carlotta M.
Corpron/Denton, Texas//Carlotta M. Corpron/Denton,
Texas"
Acquired from: gift of Jonathan Stein, New York, New York

1398. **SUNLIGHT THROUGH A VENETIAN BLIND**
(P1985.2.26)
Gelatin silver print. negative 1946–47, print 1977
Image: 13 ⁷/₁₆ x 10 ⁹/₁₆ in. (34.1 x 26.8 cm.)
Sheet: 14 x 11 in. (35.6 x 28.0 cm.)
Mount: 20 x 16 in. (50.8 x 40.7 cm.)
Signed, l.r. overmat recto: "Carlotta M. Corpron"
Inscription, overmat recto: "Sunlight through a Venetian
Blind"
mount verso: "I "Light follows form" Series/1 of 3 prints
with sunlight on Greek head//Recent//Carlotta M.
Corpron/ Denton, Texas/Negative dates from 1946 or '47/
Print made in February, 1977" and ACM exhibition label
Acquired from: gift of the Dorothea Leonhardt Fund of the
Communities Foundation of Texas, Inc., Dallas, Texas

1399. **SURLY FACES** (P1985.2.23)
Gelatin silver print. c. 1948
Image: 11 ⅛ x 9 ⅜ in. (28.2 x 23.7 cm.) sight size
Mount: 20 x 16 in. (50.8 x 40.7 cm.)
Signed, l.r. overmat recto: "Carlotta M. Corpron"
Inscription, overmat recto: "Surly Faces"
mount verso: "SURLY FACES/c 1948/Carlotta M.
Corpron/Denton, Texas/ Taken during cold war with
Russia/(N. Find Stalin)/(1 heavy bowl, 1 glass paperweight
and small liquor glasses in curved ferrotype)/ N. In 1952
when I had a one-woman show at the Art Institute of
Chicago/this photograph was used in "Chicago Today" to
announce the exhibition//vintage//Carlotta M. Corpron/
Denton, Texas" and ACM exhibition label
Acquired from: gift of the Dorothea Leonhardt Fund of the
Communities Foundation of Texas, Inc., Dallas, Texas

*1400. **TAOS INDIAN** (P1985.2.32)
Gelatin silver print. 1938
Image: 13 ¹/₁₆ x 10 ³/₁₆ in. (33.2 x 25.9 cm.) sight size
Mount: 20 x 16 in. (50.8 x 40.7 cm.)
Signed, l.r. overmat recto: "Carlotta M. Corpron 1938"
Inscription, overmat recto: "Taos Indian"
mount verso: "TAOS INDIAN—photographed in 1938 in
TAOS—Print made in 1938/Rolleiflex negative//vintage//
Carlotta M. Corpron/ Denton, Texas"
Acquired from: gift of the Dorothea Leonhardt Fund of the
Communities Foundation of Texas, Inc., Dallas, Texas

*1401. **A WALK IN FAIR PARK, DALLAS** (P1981.35.3)
duplicate of P1985.2.11
Gelatin silver print. c. 1943
Image: 10 ⁷/₁₆ x 13 ⁷/₁₆ in. (26.5 x 34.2 cm.)
Sheet: 10 ⁹/₁₆ x 13 ⁹/₁₆ in. (26.8 x 34.5 cm.)
Signed, l.r. overmat recto: "Carlotta M. Corpron"
Inscription, overmat recto: "A walk in Fair Park, Dallas"
mat verso: "14" and ACM exhibition label
Acquired from: gift of the photographer

1402. **A WALK IN FAIR PARK, DALLAS** (P1985.2.11)
duplicate of P1981.35.3
Gelatin silver print. negative c. 1943, print later
Image: 10 ½ x 13 ⁷/₁₆ in. (26.6 x 34.2 cm.)
Sheet: 10 ¾ x 13 ¹¹/₁₆ in. (27.2 x 34.7 cm.)
Mount: 20 x 16 in. (50.8 x 40.7 cm.)
Signed, l.r. overmat recto: "Carlotta M. Corpron"
Inscription, overmat recto: "A Walk in Fair Park, Dallas"
mount verso: "ACM-14//modern print" and typed on
dealer's label "CARLOTTA M. CORPRON/A Walk in
Fair Park,/Dallas"
Acquired from: gift of the Dorothea Leonhardt Fund of the
Communities Foundation of Texas, Inc., Dallas, Texas

*1403. **WINDS BETWEEN THE WORLDS** (P1985.2.12)
Gelatin silver print. c. 1948
Image: 13 ¼ x 10 ⁹/₁₆ in. (33.5 x 26.8 cm.) sight size
Mount: 20 x 16 in. (50.8 x 40.7 cm.)
Signed, l.r. overmat recto: "Carlotta M. Corpron"
Inscription, overmat recto: "Winds between the worlds"
mount verso: "Fluid Light Series c. 1948/WINDS
BETWEEN THE WORLDS/ N. in Museum of Modern
Art, N. Y.//cc/vintage/Exhibited: Marcuse Pfeifer Gallery
1977—one person show/University of Missouri "Light
Abstractions"/April 1980" and dealer's label
Acquired from: gift of the Dorothea Leonhardt Fund of the
Communities Foundation of Texas, Inc., Dallas, Texas

1404. **WORM PATHS IN CYPRESS—MELROSE PLANTATION,**
LA (1) AFTERMATH OF WAR (2) BATTLE OF THE
SKY GODS AND EARTHLINGS (P1985.2.18)
Gelatin silver print. 1950
Image (two prints on one mount):
a) 6 x 12 ¹/₁₆ in. (15.2 x 30.6 cm.) sight size
b) 6 ¼ x 12 ¹/₁₆ in. (15.9 x 30.6 cm.) sight size
Mount: 20 x 16 in. (50.8 x 40.7 cm.)
Signed, l.r. overmat recto beneath second image: "Carlotta
M. Corpron"
Inscription, overmat recto: "Aftermath of War//Battle of the
sky gods and earthlings"
mount verso: "WORM PATHS IN CYPRESS—Melrose
Plantation, LA/ (1) Aftermath of War/(2) Battle of the sky
gods and earthlings// Carlotta M. Corpron/1950/vintage"
Acquired from: gift of the Dorothea Leonhardt Fund of the
Communities Foundation of Texas, Inc., Dallas, Texas

1405. **WOVEN LIGHT** (P1985.2.6)
Gelatin silver print. negative 1944, print later
Image: 13 ⁵/₁₆ x 10 ⁵/₁₆ in. (33.8 x 26.2 cm.) sight size
Mount: 19 ⅞ x 16 in. (50.5 x 40.7 cm.)
Signed, l.r. overmat recto: "Carlotta M. Corpron"
Inscription, overmat recto: "Woven Light"
mount verso: "vintage or older print//No.-21-A.C.M." and
ACM exhibition label and dealer's label
Acquired from: gift of the Dorothea Leonhardt Fund of the
Communities Foundation of Texas, Inc., Dallas, Texas

HAROLD CORSINI, American (b. 1919)

Harold Corsini began to make photographs in 1934
while a high school student. Following graduation he
worked as a photography teacher for the National Youth
Administration. From 1938 to 1943 Corsini made his
living as a freelance photographer in the New York City
area, where, impressed by the documentary work being

done for the Farm Security Administration, he became a member of the New York Photo League. Corsini met Roy Stryker in 1943 and joined his Standard Oil of New Jersey photography project, photographing in Canada and the southern United States. He worked for Stryker at Standard Oil until 1950 and then went with him to Pittsburgh to work at the Pittsburgh Photographic Library at the University of Pittsburgh. Corsini left the university in 1954 and opened a commercial studio in Pittsburgh. In 1974 he sold the studio and became a professor in the Design Department at Carnegie Mellon University, where he worked until his retirement in 1984.

1406. 50,000-BARREL STORAGE TANKS. BAYTOWN, TEXAS [from the exhibition "Out of the Forties: A Portrait of Texas from the Standard Oil Collection"] (P1984.37.69)
Dye-transfer print. transparency 1944, print 1982 by Jim Bones
Image: 13 x 10 1/16 in. (33.0 x 25.5 cm.)
Sheet: 13 15/16 x 11 in. (35.4 x 28.0 cm.)
Inscription, print verso: "Corsini—50,000 Barrel Storage Tanks"
Acquired from: gift of Texas Monthly, Inc., Austin, Texas, printed from a transparency in the Standard Oil of New Jersey Collection, University of Louisville Photographic Archives

1407. HORTON SPHERES CONTAINING BUTADIENE AT THE HUMBLE OIL AND REFINING CO. BAYTOWN, TEXAS [from the exhibition "Out of the Forties: A Portrait of Texas from the Standard Oil Collection"] (P1984.37.70)
Dye-transfer print. transparency 1944, print 1982 by Jim Bones
Image: 13 x 10 1/16 in. (33.0 x 25.5 cm.)
Sheet: 13 15/16 x 11 in. (35.4 x 28.0 cm.)
Inscription, print verso: "Corsini—Horton Spheres"
Acquired from: gift of Texas Monthly, Inc., Austin, Texas, printed from a transparency in the Standard Oil of New Jersey Collection, University of Louisville Photographic Archives

1408. HUMBLE REFINERY. SIDE OF BOILER HOUSE #2. BAYTOWN, TEXAS [from the exhibition "Out of the Forties: A Portrait of Texas from the Standard Oil Collection"] (P1984.37.71)
Dye-transfer print. transparency 1944, print 1982 by Jim Bones
Image: 13 x 10 in. (33.0 x 25.4 cm.)
Sheet: 13 7/8 x 11 in. (35.2 x 28.0 cm.)
Inscription, print verso: "Corsini—Humble—Side of Boiler #2"
Acquired from: gift of Texas Monthly, Inc., Austin, Texas, printed from a transparency in the Standard Oil of New Jersey Collection, University of Louisville Photographic Archives

1409. M. M. FAULK, PIPESTILL OPERATOR. HUMBLE OIL AND REFINING CO., BAYTOWN, TEXAS [from the exhibition "Out of the Forties: A Portrait of Texas from the Standard Oil Collection"] (P1984.37.65)
Gelatin silver print. negative 1946, print 1982 by Bill Carner
Image: 10 15/16 x 10 in. (27.8 x 25.4 cm.)
Sheet: 13 15/16 x 11 in. (35.4 x 28.0 cm.)
Inscription, print verso: "SONJ 37838"
Acquired from: gift of Texas Monthly, Inc., Austin, Texas, printed from a negative in the Standard Oil of New Jersey Collection, University of Louisville Photographic Archives

1400

1401

1403

1410. **NORTH TANK FARM. CATTLE ARE HERDED ON THE TANK FARM TO KEEP THE GRASS UNDER CONTROL. THE WATER WELL SUPPLIES WATER FOR THE REFINERY AND THE CATTLE. HUMBLE OIL AND REFINING CO., BAYTOWN, TEXAS [from the exhibition "Out of the Forties: A Portrait of Texas from the Standard Oil Collection"]** (P1984.37.68)
Gelatin silver print. negative 1944, print 1982 by Bill Carner
Image: 10 ¾ x 10 in. (27.3 x 25.4 cm.)
Sheet: 13 ¹⁵/₁₆ x 11 in. (35.4 x 28.0 cm.)
Inscription, print verso: "SONJ 19446"
Acquired from: gift of Texas Monthly, Inc., Austin, Texas, printed from a negative in the Standard Oil of New Jersey Collection, University of Louisville Photographic Archives

*1411. **REFINERY WORKMEN'S OVERALLS HUNG ON LINE TO DRY. HUMBLE OIL AND REFINING CO., BAYTOWN, TEXAS [from the exhibition "Out of the Forties: A Portrait of Texas from the Standard Oil Collection"]** (P1984.37.66)
Gelatin silver print. negative 1946, print 1982 by Bill Carner
Image: 10 ¹/₁₆ x 9 ¹⁵/₁₆ in. (25.5 x 25.3 cm.)
Sheet: 11 x 13 ¹⁵/₁₆ in. (28.0 x 35.4 cm.)
Inscription, print verso: "SONJ 37832"
Acquired from: gift of Texas Monthly, Inc., Austin, Texas, printed from a negative in the Standard Oil of New Jersey Collection, University of Louisville Photographic Archives

1412. **WORKERS LEAVING THE REFINERY AT THE 4:30 SHIFT CHANGE. HUMBLE OIL AND REFINING CO., BAYTOWN, TEXAS [from the exhibition "Out of the Forties: A Portrait of Texas from the Standard Oil Collection"]** (P1984.37.67)
Gelatin silver print. negative 1944, print 1982 by Bill Carner
Image: 9 ¹¹/₁₆ x 13 in. (24.6 x 33.0 cm.)
Sheet: 11 x 13 ¹⁵/₁₆ in. (28.0 x 35.4 cm.)
Inscription, print verso: "SONJ 17843"
Acquired from: gift of Texas Monthly, Inc., Austin, Texas, printed from a negative in the Standard Oil of New Jersey Collection, University of Louisville Photographic Archives

KONRAD CRAMER,
American, born Germany (1888–1963)

Painter, designer, and photographer Konrad Cramer was introduced to photography as a fine art from his visits to Alfred Stieglitz's 291 gallery as early as 1912, but it was not until the 1930s that Cramer took up photography as a career. Born in Wurtzburg, Germany, and instilled with an appreciation of art by his grandparents, who were both painters, Cramer began his formal studies in 1906 at the Fine Arts Academy of Karlsruhe. However, he eventually left the conservative academy and established his own studio under the influence of the German avant-garde. By 1912, Cramer and his wife settled in the thriving artistic community of Woodstock, New York, where he continued to live and work until his death. Taking up photography after seemingly becoming disillusioned with painting, he became the center of a group of Woodstock artists who were fascinated by the camera. Cramer's photographic work was marked by experimentation with photomontages, photograms, solarization, extreme close-ups, and light drawings. In addition to photographing, he assisted in establishing the Woodstock Artist's Association, the Woodstock School of Art, Bard College's photography program, and the Woodstock School of Miniature Photography. He also was a member of the Circle of Confusion, a national organization for Leica camera users.

1413. **ABSTRACTION [plant leaves]** (P1986.32)
Gelatin silver print. c. 1935
Image: 9 ¹⁵/₁₆ x 7 ¹⁵/₁₆ in. (25.2 x 20.2 cm.)
Mount: 16 ⅝ x 13 ¼ in. (42.2 x 33.6 cm.)
Signed, l.r. mount recto: "KONRAD CRAMER/ WOODSTOCK"
Inscription, mount verso: "90mm Elmar//1000-// HOO2191//74:065:194//A̶C̶C̶.8̶3̶9̶8̶f̶.2̶0̶//#5//C889//GEH Neg" and dealer's mark and rubber stamp "11431"
Acquired from: Hirschl & Adler Galleries Inc., New York, New York

*1414. **[Cut paper and sticks]** (P1986.40)
Gelatin silver print. 1938
Image: 9 ⅝ x 6 ¾ in. (24.3 x 17.0 cm.)
Mount: 16 ¹¹/₁₆ x 13 ¼ in. (42.3 x 33.6 cm.)
Inscription, mount verso: "74:065:264/6̶9̶.6̶7̶.5̶7̶// PHOTOGRAPH BY KONRAD CRAMER/Aileen B. Cramer//c889//P.P.6/8 ½" wide/plus ⅛" bleed" and rubber stamp "5693"
Acquired from: Photofind, New York, New York

IMOGEN CUNNINGHAM,
American (1883–1976)

Imogen Cunningham's photographic career covered nearly three-quarters of a century, one of the longest on record. She worked for Edward S. Curtis from 1907 to 1909, learning the platinum printing process appropriate to the soft-focus style she then used. Later, however, she adopted the principles of "straight" photography and was one of the co-founders of Group f/64 with Ansel Adams, Edward Weston, and Willard Van Dyke. Although she did commercial assignments, Cunningham is best known for her form studies— nudes, plants, and portraits of dancers and fellow photographers.

1415. **ALOE** (P1977.36.2)
Gelatin silver print. negative c. 1920, print later
Image: 13 ⅝ x 10 ¹¹/₁₆ in. (34.6 x 27.2 cm.)
Mount: 19 ⁵/₁₆ x 15 in. (49.1 x 38.2 cm.)
Signed, l.r. mount recto: "Imogen Cunningham 1920"
Inscription, mount verso: "Aloe, 1920s" and typed on printed paper label "PHOTOGRAPH BY/Imogen Cunningham/ THE IMOGEN CUNNINGHAM TRUST/862 FOLSOM STREET, SAN FRANCISCO, CALIFORNIA 94107" mat verso: "Aloe 1920's/Trust Print"
Acquired from: The Witkin Gallery, New York, New York

1416. **CALLA LILY LEAVES** (P1985.29)
Gelatin silver print. c. 1929
Image: 9 ⁷/₁₆ x 7 ½ in. (24.0 x 19.1 cm.)
Mount: 10 x 8 in. (25.4 x 20.3 cm.)
Acquired from: Paul Hertzmann, San Francisco, California

*1417. **FALSE HELLEBORE [glacial lily]** (P1982.32)
Gelatin silver print. 1926
Image: 11 ¹³/₁₆ x 9 ⁷/₁₆ in. (29.9 x 23.9 cm.)
Sheet: 14 ¹/₁₆ x 11 in. (35.7 x 28.0 cm.)
Signed, l.r. print recto: "Imogen Cunningham"
Inscription, print recto: "To Mary Ann Domilange"
Acquired from: Daniel Wolf, Inc., New York, New York

1418. **MORRIS GRAVES, PAINTER** (P1977.36.1)
Gelatin silver print. 1950
Image: 9 ⅜ x 12 ½ in. (23.7 x 31.8 cm.)
Mount: 15 x 20 in. (38.2 x 50.8 cm.)
Signed, l.r. mount recto: "Imogen Cunningham 1950"
Inscription, mount verso: "Morris Graves, painter, 1950" typed on printed paper label "PHOTOGRAPH BY/Imogen Cunningham/1331 Green Street, San Francisco 9"
Acquired from: The Witkin Gallery, New York, New York

*1419. **WILLARD VAN DYKE** (P1984.33)
Gelatin silver print. 1933
Image: 8 x 6 ¾ in. (20.2 x 17.1 cm.)
Mount: 12 ⅜ x 8 ⅜ in. (31.5 x 21.2 cm.)
Signed, l.r. mount recto: "Imogen Cunningham"
Inscription, old mat verso: "Willard Van Dyke" typed on
printed paper label "PHOTOGRAPH BY/IMOGEN/
CUNNINGHAM/MILLS COLLEGE P. O./
CALIFORNIA/TITLE/PROCESS/PRICE"
Acquired from: Paul M. Hertzman, Inc., San Francisco,
California

1420. **WYNN BULLOCK, PHOTOGRAPHER** (P1978.113)
Gelatin silver print. 1966
Image: 7 ¾ x 7 ¹¹⁄₁₆ in. (19.7 x 19.6 cm.)
Mount: 14 ½ x 11 ½ in. (36.8 x 29.2 cm.)
Signed, l.r. mount recto: "Imogen Cunningham 1966"
Inscription, mount verso: "Wynn Bullock, Photographer,
1966" typed on printed paper label "PHOTOGRAPH BY/
Imogen Cunningham/THE IMOGEN CUNNINGHAM
TRUST/862 Folsom Street, San Francisco, California
94107"
Acquired from: Sotheby-Park Bernet, Inc., New York,
New York

1411

WILLIAM R. CURRENT,
American (1923–1986)

William Current studied design with Paul Outerbridge
and worked with friends Brett Weston and Wynn Bul-
lock. His photographs focus primarily on landscape and
architecture. Current worked with the Amon Carter
Museum on three exhibition/publications: *Pueblo Archi-
tecture of the Southwest* and *Greene and Greene, Architects
in the Residential Style,* both of which utilized his own
photographs, and *Photography and the Old West,* for
which Current reprinted the work of early western
photographers.

1414

*1421. **ANTELOPE HOUSE—CANYON DEL MUERTO [from
"Pueblo Architecture of the Southwest"]** (P1971.63.75)
Gelatin silver print. 1964
Image: 10 ⁹⁄₁₆ x 10 ⁹⁄₁₆ in. (26.8 x 26.8 cm.)
Mount: same as image size
Signed, l.r. mount verso: "Wm R Current"
Inscription, mount verso: "14//Antelope House—/ Canyon de
Chelly [sic]"
Acquired from: the photographer

1422. **ANTELOPE HOUSE FROM BELOW [Canyon del Muerto;
from "Pueblo Architecture of the Southwest"]** (P1971.63.60)
Gelatin silver print. 1964
Image: 10 ⁹⁄₁₆ x 10 ⁹⁄₁₆ in. (26.8 x 26.8 cm.)
Mount: same as image size
Signed, l.r. mount verso: "Wm R Current"
Inscription, mount verso: "15//Fig. 63./Antelope House from
Below."
Acquired from: the photographer

1423. **AZTEC. KIVAS. DETAIL [Aztec National Monument; from
"Pueblo Architecture of the Southwest"]** (P1971.63.20)
Gelatin silver print. 1964
Image (diptych):
a) 10 ⁹⁄₁₆ x 10 ⁹⁄₁₆ in. (26.8 x 26.8 cm.)
b) 10 ⁹⁄₁₆ x 10 ½ in. (26.8 x 26.7 cm.)
Mount: 10 ⁹⁄₁₆ x 21 ¹⁄₁₆ in. (26.8 x 53.5 cm.)
Signed, l.r. mount verso: "Wm R Current"
Inscription, mount verso: "20//Fig. 18./Aztec. Kivas. Detail."
Acquired from: the photographer

1417

1424. **AZTEC NATIONAL MONUMENT, NEW MEXICO. KIVAS IN MAIN BLOCK** [from "Pueblo Architecture of the Southwest"] (P1971.63.14)
Gelatin silver print. 1964
Image: 10 9/16 x 10 9/16 in. (26.8 x 26.8 cm.)
Mount: same as image size
Signed, l.r. mount verso: "Wm R Current"
Inscription, mount verso: "19//Fig. 17/Aztec National Monument, New Mexico./Kivas in Main Block."
Acquired from: the photographer

*1425. **BALCONY HOUSE DETAIL** [Mesa Verde; from "Pueblo Architecture of the Southwest"] (P1971.63.21)
Gelatin silver print. negative 1964, print 1969
Image: 10 9/16 x 10 9/16 in. (26.8 x 26.8 cm.)
Mount: same as image size
Signed, l.r. mount verso: "Wm R Current"
Inscription, mount verso: "21//Fig. 31./Balcony House Detail/re"
Acquired from: the photographer

1426. **BALCONY HOUSE, MESA VERDE** [from "Pueblo Architecture of the Southwest"] (P1971.63.66)
Gelatin silver print. 1964
Image (two prints on one mount):
 a) 4 13/16 x 10 in. (12.1 x 25.4 cm.)
 b) 5 1/2 x 5 1/2 in. (13.9 x 13.9 cm.)
Mount: 10 9/16 x 10 9/16 in. (26.8 x 26.8 cm.)
Signed, l.r. mount verso: "Wm R Current"
Inscription, mount verso: "20//Balcony House/Mesa Verde"
Acquired from: the photographer

1427. **BALCONY HOUSE. RETAINING WALL AND KIVAS** [Mesa Verde; from "Pueblo Architecture of the Southwest"] (P1971.63.22)
Gelatin silver print. 1964
Image: 10 9/16 x 10 9/16 in. (26.8 x 26.8 cm.)
Mount: same as image size
Signed, l.r. mount verso: "Wm R Current"
Inscription, mount verso: "19//Fig. 30./Balcony House. Retaining Wall and Kivas."
Acquired from: the photographer

1428. **BETATAKIN. GENERAL VIEW** [Navajo National Monument; from "Pueblo Architecture of the Southwest"] (P1971.63.43)
Gelatin silver print. 1964
Image (diptych):
 a) 10 9/16 x 10 9/16 in. (26.8 x 26.8 cm.)
 b) 10 9/16 x 10 1/2 in. (26.8 x 26.7 cm.)
Mount: 10 9/16 x 21 1/16 in. (26.8 x 53.5 cm.)
Signed, l.r. mount verso: "Wm R Current"
Inscription, mount verso: "2//Fig. 40/Betatakin. General View."
Acquired from: the photographer

1429. **BETATAKIN. PRINCIPAL GROUP** [Navajo National Monument; from "Pueblo Architecture of the Southwest"] (P1971.63.42)
Gelatin silver print. 1964
Image: 10 9/16 x 10 9/16 in. (26.8 x 26.8 cm.)
Mount: same as image size
Signed, l.r. mount verso: "Wm R Current"
Inscription, mount verso: "3//Fig. 41/Betatakin. Principal Group."
Acquired from: the photographer

1430. **BETATAKIN. ROOMS AND COURTYARD. MASONRY AND JACAL** [Navajo National Monument; from "Pueblo Architecture of the Southwest"] (P1971.63.40)
Gelatin silver print. 1964
Image: 10 9/16 x 10 9/16 in. (26.8 x 26.8 cm.)
Mount: same as image size
Inscription, mount curso: "5//Fig. 43./Betatakin. Rooms and Courtyard. Masonry and Jacal."
Acquired from: the photographer

1431. **BETATAKIN. WALL CONSTRUCTION** [Navajo National Monument; from "Pueblo Architecture of the Southwest"] (P1971.63.39)
Gelatin silver print. 1964
Image (two prints on one mount):
 a) 6 1/16 x 10 in. (15.4 x 25.4 cm.)
 b) 4 x 3 15/16 in. (10.1 x 10.0 cm.)
Mount: 10 9/16 x 10 9/16 in. (26.8 x 26.8 cm.)
Inscription, mount verso: "6//Fig. 44/Betatakin. Wall Construction."
Acquired from: the photographer

*1432. **BETATAKIN. WALLS AND SLOPE** [Navajo National Monument; from "Pueblo Architecture of the Southwest"] (P1971.63.41)
Gelatin silver print. 1964
Image: 10 9/16 x 10 9/16 in. (26.8 x 26.8 cm.)
Mount: same as image size
Inscription, mount verso: "4//Fig. 42/Betatakin. Walls and Slope."
Acquired from: the photographer

1433. **THE BLACKER HOUSE. DETAIL, TERRACE DOOR** [from "Greene and Greene, Architects in the Residential Style"] (P1976.94.8)
Gelatin silver print. c. 1972
Image: 7 5/8 x 7 5/8 in. (19.4 x 19.4 cm.) sight size
Mount: 10 1/2 x 10 1/2 in. (26.7 x 26.7 cm.)
Inscription, mount verso on paper label: "11."
Acquired from: gift of the photographer

1434. **THE BLACKER HOUSE. GRAND STAIRWAY** [from "Greene and Greene, Architects in the Residential Style"] (P1976.94.10)
Gelatin silver print. 1969
Image: 10 9/16 x 10 9/16 in. (26.8 x 26.8 cm.)
Mount: same as image size
Signed, l.r. mount verso: "Wm R Current '69"
Inscription, mount verso on paper label: "13."
Acquired from: gift of the photographer

1435. **THE BLACKER HOUSE. STAIRWAY FIXTURE** [from "Greene and Greene, Architects in the Residential Style"] (P1976.94.9)
Gelatin silver print. c. 1972
Image: 9 1/16 x 7 3/8 in. (23.1 x 18.6 cm.) sight size
Mount: 10 1/2 x 10 1/2 in. (26.7 x 26.7 cm.)
Inscription, mount verso on paper label: "12."
Acquired from: gift of the photographer

*1436. **THE BLACKER HOUSE. STRAIGHT BACK LIVING ROOM CHAIR** [from "Greene and Greene, Architects in the Residential Style"] (P1976.94.11)
Gelatin silver print. c. 1969–72
Image: 6 1/8 x 6 1/8 in. (15.6 x 15.6 cm.) sight size
Mount: 10 1/2 x 10 1/2 in. (26.7 x 26.7 cm.)
Inscription, mount verso on paper label: "14."
Acquired from: gift of the photographer

*1437. **CANYON DE CHELLY** [from "Pueblo Architecture of the Southwest"] (P1971.63.70)
Gelatin silver print. 1964
Image: 10 9/16 x 10 9/16 in. (26.8 x 26.8 cm.)
Mount: same as image size
Signed, l.r. mount verso: "Wm R Current"
Inscription, mount verso: "8//Canyon de Chelly"
Acquired from: the photographer

1438. **CANYON DE CHELLY** [from "Pueblo Architecture of the Southwest"] (P1971.63.71)
Gelatin silver print. 1964
Image (two prints on one mount):
 a) 4 3/4 x 10 1/16 in. (12.0 x 25.6 cm.)
 b) 5 9/16 x 5 1/2 in. (14.1 x 13.9 cm.)
Mount: 10 9/16 x 10 9/16 in. (26.8 x 26.8 cm.)
Signed, l.r. mount verso: "Wm R Current"
Inscription, mount verso: "16//Canyon de Chelly"
Acquired from: the photographer

1419

1421

1425

1432

1436

1437

*1439. CANYON DE CHELLY, ARIZONA. GENERAL VIEW
[from "Pueblo Architecture of the Southwest"]
(P1971.63.80)
Gelatin silver print. negative 1964, print 1971
Image: 10⁹/₁₆ x 10⁹/₁₆ in. (26.8 x 26.8 cm.)
Mount: same as image size
Signed, l.r. mount verso: "Wm R Current '64"
Inscription, mount verso: "Fig 2, p. 28/Fig 2-Canyon de
Chelly, Arizona. General View."
Acquired from: the photographer

*1440. [Canyon de Chelly, eight miles above junction of Monument
Canyon; from "Pueblo Architecture of the Southwest"]
(P1971.63.77)
Gelatin silver print. 1964
Image: 10⁹/₁₆ x 10⁹/₁₆ in. (26.8 x 26.8 cm.)
Mount: same as image size
Signed, l.r. mount verso: "Wm R Current"
Inscription, mount verso: "9//Mindeleff p. 66?/site apparently
very difficult of access/in de Chelly 8 miles above junction
of monument canyon"
Acquired from: the photographer

*1441. CANYON DE CHELLY. NAVAJO PETROGLYPHS [from
"Pueblo Architecture of the Southwest"] (P1971.63.62)
Gelatin silver print. negative 1964, print 1971
Image: 10⁹/₁₆ x 10⁹/₁₆ in. (26.8 x 26.8 cm.)
Mount: same as image size
Signed, l.r. mount verso: "Wm R Current"
Inscription, mount verso: "20//Fig. 65/Canyon de Chelly/
Navajo Petroglyphs."
Acquired from: the photographer

*1442. CANYON DE CHELLY. RIO DE CHELLY AND CANYON
WALL [from "Pueblo Architecture of the Southwest"]
(P1971.63.50)
Gelatin silver print. 1964
Image: 10⁹/₁₆ x 10⁹/₁₆ in. (26.8 x 26.8 cm.)
Mount: same as image size
Signed, l.r. mount verso: "Wm R Current"
Inscription, mount verso: "1//Fig. 53/Canyon de Chelly./Rio
de Chelly and Canyon Wall."
Acquired from: the photographer

1443. CANYON DE CHELLY. RUIN # 16 (MINDELEFF) [from
"Pueblo Architecture of the Southwest"] (P1971.63.56)
Gelatin silver print. 1964
Image: 10⁹/₁₆ x 10⁹/₁₆ in. (26.8 x 26.8 cm.)
Mount: same as image size
Signed, l.r. mount verso: "Wm R Current"
Inscription, mount verso: "11//Fig. 59/Canyon de Chelly./Ruin
#. 16 (Mindeleff)."
Acquired from: the photographer

1444. CANYON DE CHELLY. SUN ON THE RIVER [from
"Pueblo Architecture of the Southwest"] (P1971.63.51)
Gelatin silver print. 1964
Image: 10⁹/₁₆ x 10⁹/₁₆ in. (26.8 x 26.8 cm.)
Mount: same as image size
Signed, l.r. mount verso: "Wm R Current"
Inscription, mount verso: "2//Fig. 54/Canyon de Chelly./Sun
on the River."
Acquired from: the photographer

1445. CANYON DE CHELLY. THE WHITE HOUSE IN THE
CANYON WALL [from "Pueblo Architecture of the
Southwest"] (P1971.63.52)
Gelatin silver print. 1964
Image: 10⁹/₁₆ x 10⁹/₁₆ in. (26.8 x 26.8 cm.)
Mount: same as image size
Signed, l.r. mount verso: "Wm R Current"
Inscription, mount verso: "6//Fig. 55./Canyon de Chelly./The
White House in the Canyon Wall."
Acquired from: the photographer

*1446. CANYON DEL MUERTO. ANTELOPE HOUSE [from
"Pueblo Architecture of the Southwest"] (P1971.63.59)
Gelatin silver print. 1964
Image: 10⁹/₁₆ x 10⁹/₁₆ in. (26.8 x 26.8 cm.)
Mount: same as image size
Signed, l.r. mount verso: "Wm R Current"
Inscription, mount verso: "13//Fig. 62/Canyon del Muerto.
Antelope House."
Acquired from: the photographer

1447. CANYON DEL MUERTO. NAVAJO PAINTINGS NEAR
ANTELOPE HOUSE [from "Pueblo Architecture of the
Southwest"] (P1971.63.61)
Gelatin silver print. 1964
Image: 10⁹/₁₆ x 10⁹/₁₆ in. (26.8 x 26.8 cm.)
Mount: same as image size
Signed, l.r. mount verso: "Wm R Current"
Inscription, mount verso: "12//Fig. 64./Canyon del Muerto./
Navajo Paintings near Antelope House."
Acquired from: the photographer

1448. CANYON DEL MUERTO. RUIN # 10 (MINDELEFF)
[from "Pueblo Architecture of the Southwest"]
(P1971.63.55)
Gelatin silver print. 1964
Image: 10⁹/₁₆ x 10⁹/₁₆ in. (26.8 x 26.8 cm.)
Mount: same as image size
Signed, l.r. mount verso: "Wm R Current"
Inscription, mount verso: "10//Fig. 58./Canyon del Muerto./
Ruin #. 10 (Mindeleff)."
Acquired from: the photographer

1449. CHACO CANYON. CHETRO KETL. LONG WALL
DETAIL [from "Pueblo Architecture of the Southwest"]
(P1971.63.9)
Gelatin silver print. 1964
Image: 10⁹/₁₆ x 10⁹/₁₆ in. (26.8 x 26.8 cm.)
Mount: same as image size
Signed, l.r. mount verso: "Wm R Current"
Inscription, mount verso: "18//Fig. 12/Chaco Canyon. Chetro
Ketl./ Long wall detail"
Acquired from: the photographer

1450. CHACO CANYON. DETAIL OF CANYON WALL [from
"Pueblo Architecture of the Southwest"] (P1971.63.2)
Gelatin silver print. 1964
Image 10⁹/₁₆ x 10⁹/₁₆ in. (26.8 x 26.8 cm.)
Mount: same as image size
Signed, l.r. mount verso: "Wm R Current '64"
Inscription, mount verso: "2//Fig 5/Chaco Canyon. Detail of
Canyon Wall."
Acquired from: the photographer

1451. CHACO CANYON. GENERAL VIEW [from "Pueblo
Architecture of the Southwest"] (P1971.63.15)
Gelatin silver print. 1964
Image: 10⁹/₁₆ x 10⁹/₁₆ in. (26.8 x 26.8 cm.)
Mount: same as image size
Signed, l.r. mount verso: "Wm R Current '64"
Inscription, mount verso: "1//Fig. 4/Chaco canyon.
General view"
Acquired from: the photographer

*1452. CHACO CANYON, NEW MEXICO. PUEBLO BONITO.
DETAIL [from "Pueblo Architecture of the Southwest"]
(P1971.63.17)
Gelatin silver print. negative 1964, print 1971
Image: 10⁹/₁₆ x 10⁹/₁₆ in. (26.8 x 26.8 cm.)
Mount: same as image size
Signed, l.r. mount verso: "Wm R Current"
Inscription, mount verso: "5//Fig. 1 Chaco Canyon, New
Mexico, Pueblo Bonito. Detail"
Acquired from: the photographer

1439

1440

1441

1442

1446

1452

1453. CHACO CANYON. PUEBLO BONITO. FIVE-STORIED WALL AND CLIFF FROM THE SOUTH [from "Pueblo Architecture of the Southwest"] (P1971.63.3)
Gelatin silver print. 1964
Image: 10⁹/₁₆ x 10⁹/₁₆ in. (26.8 x 26.8 cm.)
Mount: same as image size
Signed, l.r. mount verso: "Wm R Current '64"
Inscription, mount verso: "8//Fig 6/Chaco Canyon. Five-storied wall and cliff from the south/K717"
Acquired from: the photographer

1454. CHACO CANYON. WALL MOSAICS. BELOW CASA RINCONADA [from "Pueblo Architecture of the Southwest"] (P1971.63.8)
Gelatin silver print. 1964
Image (two prints on one mount):
 a) 5⅛ x 10¹/₁₆ in. (13.1 x 25.5 cm.)
 b) 5⅛ x 10¹/₁₆ in. (13.1 x 25.5 cm.)
Mount: 10⁹/₁₆ x 10⁹/₁₆ in. (26.8 x 26.8 cm.)
Signed, l.r. mount verso: "Wm R Current"
Inscription, mount verso: "10//Fig 11/Chaco Canyon. Wall Mosaics//Below Casa Rinconada"
Acquired from: the photographer

*1455. CHETRO KETL. CHACO CANYON [from "Pueblo Architecture of the Southwest"] (P1971.63.65)
Gelatin silver print. 1964
Image: 10⁹/₁₆ x 10⁹/₁₆ in. (26.8 x 26.8 cm.)
Mount: same as image size
Signed, l.r. mount verso: "Wm R Current"
Inscription, mount verso: "17//Chetro Ketl./Chaco Canyon"
Acquired from: the photographer

*1456. CHETRO KETL. LONG WALL [Chaco Canyon; from "Pueblo Architecture of the Southwest"] (P1971.63.10)
Gelatin silver print. negative 1964, print 1969
Image: 10⁹/₁₆ x10⁹/₁₆ in. (26.8 x 26.8 cm.)
Mount: same as image size
Signed, l.r. mount verso: "Wm R Current"
Inscription, mount verso: "16//Fig 13/Chetro Ketl. Long Wall"
Acquired from: the photographer

1457. CLIFF PALACE. KIVAS AND CYLINDRICAL TOWER [from "Pueblo Architecture of the Southwest"] (P1971.63.19)
Gelatin silver print. 1964
Image: 10⁹/₁₆ x 10⁹/₁₆ in. (26.8 x 26.8 cm.)
Mount: same as image size
Signed, l.r. mount verso: "Wm R Current"
Inscription, mount verso: "15//Fig. 21/Cliff Palace. Kivas and Cylindrical Tower"
Acquired from: the photographer

*1458. CLIFF PALACE. KIVAS AND RECTANGULAR TOWER [from "Pueblo Architecture of the Southwest"] (P1971.63.1)
Gelatin silver print. 1964
Image: 10⁹/₁₆ x 10⁹/₁₆ in. (26.8 x 26.8 cm.)
Mount: same as image size
Signed, l.r. mount verso: "Wm R Current '64"
Inscription, mount verso: "14//Fig 22/Cliff Palace. Kivas and Rectangular Tower."
Acquired from: the photographer

1459. CLIFF PALACE. VIEW LOOKING NORTH [from "Pueblo Architecture of the Southwest"] (P1971.63.78)
Gelatin silver print. 1964
Image: 10⁹/₁₆ x 10⁹/₁₆ in. (26.8 x 26.8 cm.)
Mount: same as image size
Signed, l.r. mount verso: "Wm R Current"
Inscription, mount verso: "13//Fig. 20/Cliff Palace. View Looking North."
Acquired from: the photographer

*1460. THE GAMBLE HOUSE. BUFFET, DINING ROOM [from "Greene and Greene, Architects in the Residential Style"] (P1976.94.6)
Gelatin silver print. c. 1972
Image: 6½ x 6 in. (16.5 x 15.2 cm.) sight size
Mount: 10½ x 10½ in. (26.7 x 26.7 cm.)
Inscription, mount verso on paper label: "9."
Acquired from: gift of the photographer

1461. THE GAMBLE HOUSE. DRESSING TABLE, MASTER BEDROOM [from "Greene and Greene, Architects in the Residential Style"] (P1976.94.4)
Gelatin silver print. c. 1972
Image: 7⅝ x 7¹¹/₁₆ in. (19.3 x 19.5 cm.) sight size
Mount: 10⅝ x 10⅝ in. (27.0 x 27.0 cm.)
Inscription, mount verso on paper label: "7."
Acquired from: gift of the photographer

1462. THE GAMBLE HOUSE. FRONT ELEVATION [from "Greene and Greene, Architects in the Residential Style"] (P1976.94.1)
Gelatin silver print. c. 1972
Image (diptych): a) 10⁹/₁₆ x 10⁹/₁₆ in. (26.8 x 26.8 cm.)
 b) 10⁹/₁₆ x 10½ in. (26.8 x 26.7 cm.)
Mount: 10⁹/₁₆ x 21¹/₁₆ in. (26.8 x 53.5 cm.)
Inscription, mount verso on paper label: "4."
Acquired from: gift of the photographer

*1463. THE GAMBLE HOUSE. LIVING ROOM [from "Greene and Greene, Architects in the Residential Style"] (P1976.94.3)
Gelatin silver print. c. 1972
Image: 10⁹/₁₆ x 10⁹/₁₆ in. (26.8 x 26.8 cm.)
Mount: same as image size
Inscription, mount verso on paper label: "6."
Acquired from: gift of the photographer

1464. THE GAMBLE HOUSE. NORTH ELEVATION [from "Greene and Greene, Architects in the Residential Style"] (P1976.94.7)
Gelatin silver print. c. 1972
Image (diptych): a) 10½ x 10⁹/₁₆ in. (26.7 x 26.8 cm.)
 b) 10½ x 10½ in. (26.7 x 26.7 cm.)
Mount: 10½ x 21¹/₁₆ in. (26.7 x 53.5 cm.)
Inscription, mount verso on paper label: "10."
Acquired from: gift of the photographer

*1465. THE GAMBLE HOUSE. STAIRWAY [from "Greene and Greene, Architects in the Residential Style"] (P1976.94.2)
Gelatin silver print. c. 1972
Image: 10⁹/₁₆ x 10⁹/₁₆ in. (26.8 x 26.8 cm.)
Mount: same as image size
Inscription, mount verso on paper label: "5."
Acquired from: gift of the photographer

1466. THE GAMBLE HOUSE. WALL FIXTURE, DINING ROOM [from "Greene and Greene, Architects in the Residential Style"] (P1976.94.5)
Gelatin silver print. c. 1972
Image: 7¼ x 6¹/₁₆ in. (18.5 x 15.3 cm.) sight size
Mount: 10⅝ x 10⅝ in. (27.0 x 27.0 cm.)
Inscription, mount verso on paper label: "8."
Acquired from: gift of the photographer

1467. GREAT KIVA—CHACO CANYON [from "Pueblo Architecture of the Southwest"] (P1971.63.67)
Gelatin silver print. 1964
Image (two prints on one mount):
 a) 4¾ x 10¹/₁₆ in. (12.1 x 25.5 cm.)
 b) 5⁹/₁₆ x 5⁹/₁₆ in. (14.1 x 14.1 cm.)
Mount: 10⁹/₁₆ x 10⁹/₁₆ in. (26.8 x 26.8 cm.)
Signed, l.r. mount verso: "Wm R Current"
Inscription, mount verso: "15//Great Kiva—/Chaco Canyon"
Acquired from: the photographer

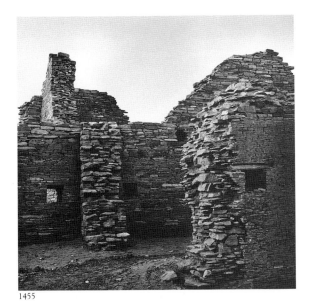

1455

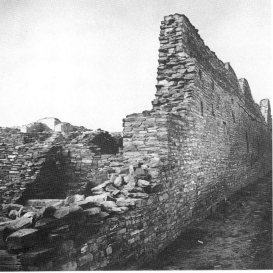

1456

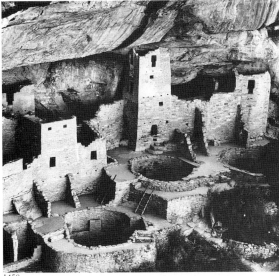

1458

1460

1463

1465

1468. INSCRIPTION HOUSE, NAVAJO NATIONAL
MONUMENT—KAYENTA—UPPER SAN JUAN
BASIN [from "Pueblo Architecture of the Southwest"]
(P1971.63.76)
Gelatin silver print. 1964
Image: 10 9/16 x 10 9/16 in. (26.8 x 26.8 cm.)
Mount: same as image size
Signed, l.r. mount verso: "Wm R Current"
Inscription, mount verso: "19//Inscription House/Navajo
National Monument—/Kayenta—Upper San Juan Basin"
Acquired from: the photographer

*1469. THE JAMES HOUSE. CLIFF VIEW, SOUTH EXPOSURE
[from "Greene and Greene, Architects in the Residential
Style"] (P1976.94.17)
Gelatin silver print. 1970
Image: 10 9/16 x 10 9/16 in. (26.8 x 26.8 cm.)
Mount: same as image size
Inscription, mount verso on paper label: "20."
Acquired from: gift of the photographer

1470. THE JAMES HOUSE. ORIGINAL PLAN, CHARLES
GREENE [from "Greene and Greene, Architects in the
Residential Style"] (P1976.94.16)
Gelatin silver print. c. 1972
Image: 5 1/4 x 6 13/16 in. (13.4 x 17.2 cm.)
Mount: 10 1/2 x 10 1/2 in. (26.7 x 26.7 cm.)
Inscription, mount verso on paper label: "19."
Acquired from: gift of the photographer

1471. KAYENTA, ARIZONA. NAVAJO NATIONAL
MONUMENT. GENERAL VIEW OF CANYON FROM
ABOVE [from "Pueblo Architecture of the Southwest"]
(P1971.63.16)
Gelatin silver print. 1964
Image: 10 9/16 x 10 9/16 in. (26.8 x 26.8 cm.)
Mount: same as image size
Signed, l.r. mount verso: "Wm R Current"
Inscription, mount verso: "8//Fig. 3/Kayenta, Arizona. Navajo
National Monument./General view of canyon from above."
Acquired from: the photographer

1472. KAYENTA. NAVAJO NATIONAL MONUMENT.
CANYON WALL OPPOSITE BETATAKIN [from
"Pueblo Architecture of the Southwest"] (P1971.63.38)
Gelatin silver print. 1964
Image: 10 9/16 x 10 9/16 in. (26.8 x 26.8 cm.)
Mount: same as image size
Inscription, mount verso: "7//Fig. 38/Kayenta./Navajo
National Monument./Canyon Wall opposite Betatakin."
Acquired from: the photographer

1473. KEET SEEL [Navajo National Monument; from "Pueblo
Architecture of the Southwest"] (P1971.63.74)
Gelatin silver print. 1964
Image (two prints on one mount):
a) 4 1/4 x 4 3/8 in. (10.8 x 11.0 cm.)
b) 10 x 5 15/16 in. (25.4 x 15.1 cm.)
Mount: 10 9/16 x 10 9/16 in. (26.8 x 26.8 cm.)
Signed, l.r. mount verso: "Wm R Current"
Inscription, mount verso: "16//Keet Seel—"
Acquired from: the photographer

1474. KEET SEEL. DETAIL OF EASTERN SECTIONS [Navajo
National Monument; from "Pueblo Architecture of the
Southwest"] (P1971.63.49)
Gelatin silver print. 1964
Image: 10 9/16 x 10 9/16 in. (26.8 x 26.8 cm.)
Mount: same as image size
Signed, l.r. mount verso: "Wm R Current"
Inscription, mount verso: "17//Fig. 52/Keet Seel. Detail of
Eastern Sections."
Acquired from: the photographer

1475. KEET SEEL. GENERAL VIEW [Navajo National
Monument; from "Pueblo Architecture of the Southwest"]
(P1971.63.45)
Gelatin silver print. 1964
Image: 10 9/16 x 21 1/16 in. (26.8 x 53.5 cm.)
Mount: same as image size (two prints hinged together)
Signed, l.r. mount verso: "Wm R Current"
Inscription, mount verso: "11//Fig. 47/Keet Seel.
General View."
Acquired from: the photographer

*1476. KEET SEEL. JACAL [Navajo National Monument; from
"Pueblo Architecture of the Southwest"] (P1971.63.48)
Gelatin silver print. 1964
Image: 10 9/16 x 10 9/16 in. (26.8 x 26.8 cm.)
Mount: same as image size
Signed, l.r. mount verso: "Wm R Current"
Inscription, mount verso: "15//Fig. 51/Keet Seel. Jacal."
Acquired from: the photographer

1477. KEET SEEL. MASONRY [Navajo National Monument; from
"Pueblo Architecture of the Southwest"] (P1971.63.47)
Gelatin silver print. 1964
Image: 10 9/16 x 10 9/16 in. (26.8 x 26.8 cm.)
Mount: same as image size
Signed, l.r. mount verso: "Wm R Current"
Inscription, mount verso: "14//Fig. 50/Keet Seel. Masonry."
Acquired from: the photographer

*1478. KEET SEEL. RETAINING WALL AND CAVERN ROOF.
LOOKING WEST [Navajo National Monument; from
"Pueblo Architecture of the Southwest"] (P1971.63.46)
Gelatin silver print. 1964
Image: 10 9/16 x 10 9/16 in. (26.8 x 26.8 cm.)
Mount: same as image size.
Signed, l.r. mount verso: "Wm R Current"
Inscription, mount verso: "12//Fig. 48./Keet Seel. Retaining
Wall and Cavern/roof. Looking West."
Acquired from: the photographer

1479. KEET SEEL. VIEW EASTWARD [Navajo National
Monument; from "Pueblo Architecture of the Southwest"]
(P1971.63.79)
Gelatin silver print. 1964
Image: 10 9/16 x 10 9/16 in. (26.8 x 26.8 cm.)
Mount: same as image size
Signed, l.r. mount verso: "Wm R Current"
Inscription, mount verso: "13//Fig 49 (p. 81)/Keet Seel.
View Eastward."
Acquired from: the photographer

*1480. MESA VERDE [from "Pueblo Architecture of the
Southwest"] (P1971.63.63)
Gelatin silver print. 1964
Image: 10 9/16 x 10 9/16 in. (26.8 x 26.8 cm.)
Mount: same as image size
Signed, l.r. mount verso: "Wm R Current"
Inscription, mount verso: "11//Mesa Verde"
Acquired from: the photographer

1481. MESA VERDE. BALCONY HOUSE [from "Pueblo
Architecture of the Southwest"] (P1971.63.23)
Gelatin silver print. 1964
Image: 10 9/16 x 10 9/16 in. (26.8 x 26.8 cm.)
Mount: same as image size
Signed, l.r. mount verso: "Wm R Current"
Inscription, mount verso: "18//Fig. 29/Mesa Verde. Balcony
House."
Acquired from: the photographer

1482. MESA VERDE, COLORADO CLIFF PALACE. GENERAL
VIEW LOOKING SOUTH [from "Pueblo Architecture of
the Southwest"] (P1971.63.18)
Gelatin silver print. 1964
Image (diptych):
a) 10 9/16 x 10 9/16 in. (26.8 x 26.8 cm.)
b) 10 9/16 x 10 1/2 in. (26.8 x 26.7 cm.)
Mount: 10 9/16 x 21 1/16 in. (26.8 x 53.5 cm.)

Signed, l.r. mount verso: "Wm R Current"
Inscription, mount verso: "12//Fig 19/Mesa Verde, Colorado
Cliff Palace. General view looking south."
Acquired from: the photographer

1483. **MESA VERDE. MUMMY HOUSE [from "Pueblo Architecture of the Southwest"]** (P1971.63.35)
Gelatin silver print. 1964
Image: 10 %16 x 10 %16 in. (26.8 x 26.8 cm.)
Mount: same as image size
Signed, l.r. mount verso: "Wm R Current"
Inscription, mount verso: "10//Fig. 36./Mesa Verde. Mummy House."
Acquired from: the photographer

1484. **MESA VERDE. NEW FIRE HOUSE. DETAIL [from "Pueblo Architecture of the Southwest"]** (P1971.63.37)
Gelatin silver print. 1964
Image: 10 %16 x 10 %16 in. (26.8 x 26.8 cm.)
Mount: same as image size
Signed, l.r. mount verso: "Wm R Current"
Inscription, mount verso: "8//Fig. 39./Mesa Verde./Long House [sic]. Detail."
Acquired from: the photographer

1469

1485. **MESA VERDE. NEW FIRE HOUSE. GENERAL VIEW [from "Pueblo Architecture of the Southwest"]** (P1971.63.26)
Gelatin silver print. 1964
Image (diptych):
 a) 10 %16 x 10 %16 in. (26.8 x 26.8 cm.)
 b) 10 %16 x 10 ½" (26.8 x 26.7 cm.)
Mount: 10 %16 x 21 1/16 in. (26.8 x 53.5 cm.)
Signed, l.r. mount verso: "Wm R Current"
Inscription, mount verso: "7//Fig. 35/Mesa Verde. Long House [sic]. General View."
Acquired from: the photographer

1486. **MESA VERDE. OAK TREE HOUSE [from "Pueblo Architecture of the Southwest"]** (P1971.63.36)
Gelatin silver print. 1964
Image: 10 %16 x 10 %16 in. (26.8 x 26.8 cm.)
Mount: same as image size
Signed, l.r. mount verso: "Wm R Current"
Inscription, mount verso: "9//Fig. 37/Mesa Verde. Mug House [sic]."
Acquired from: the photographer

1476

1487. **MESA VERDE. SPRUCE TREE HOUSE. GENERAL VIEW OF FIRST AND SECOND COURTS [from "Pueblo Architecture of the Southwest"]** (P1971.63.32)
Gelatin silver print. 1964
Image: 10 %16 x 10 %16 in. (26.8 x 26.8 cm.)
Mount: same as image size
Signed, l.r. mount verso: "Wm R Current"
Inscription, mount verso: "1//Fig. 23./Mesa Verde. Spruce Tree House./General View of First and Second Courts."
Acquired from: the photographer

1488. **MESA VERDE. SQUARE TOWER HOUSE. DETAIL [from "Pueblo Architecture of the Southwest"]** (P1971.63.24)
Gelatin silver print. 1964
Image: 10 %16 x 21 1/16 in. (26.8 x 53.5 cm.)
Mount: same as image size (two prints hinged together)
Signed, l.r. mount verso: "Wm R Current"
Inscription, mount verso: "17//Fig. 32/Mesa Verde./Square Tower House. Detail."
Acquired from: the photographer

1489. **MESA VERDE. SQUARE TOWER HOUSE. GENERAL VIEW [from "Pueblo Architecture of the Southwest"]** (P1971.63.25)
Gelatin silver print. 1964
Image: 10 %16 x 10 %16 in. (26.8 x 26.8 cm.)
Mount: same as image size
Signed, l.r. mount verso: "Wm R Current"
Inscription, mount verso: "16//Fig. 33/Mesa Verde. Square Tower House. General View."
Acquired from: the photographer

1478

*1490. **NAVAJO NATIONAL MONUMENT. BETATAKIN FROM ACROSS THE CANYON [from "Pueblo Architecture of the Southwest"]** (P1971.63.44)
Gelatin silver print. 1964
Image: 10⁹⁄₁₆ x 10⁹⁄₁₆ in. (26.8 x 26.8 cm.)
Mount: same as image size
Signed, l.r. mount verso: "Wm R Current"
Inscription, mount verso: "1//Fig. 39/Navajo National Monument./ Betatakin from across the Canyon."
Acquired from: the photographer

1491. **NAVAJO NATIONAL MONUMENT. INSCRIPTION HOUSE [from "Pueblo Architecture of the Southwest"]** (P1971.63.33)
Gelatin silver print. 1964
Image: 10⁹⁄₁₆ x 10⁹⁄₁₆ in. (26.8 x 26.8 cm.)
Mount: same as image size
Signed, l.r. mount verso: "Wm R Current"
Inscription, mount verso: "18//Fig. 45./Navajo National Monument. Inscription House."
Acquired from: the photographer

*1492. **NAVAJO NATIONAL MONUMENT. KEET SEEL. FROM THE CANYON FLOOR [from "Pueblo Architecture of the Southwest"]** (P1971.63.34)
Gelatin silver print. 1964
Image: 10⁹⁄₁₆ x 10⁹⁄₁₆ in. (26.8 x 26.8 cm.)
Mount: same as image size
Inscription, mount verso: "10//Fig. 46/Navajo National Monument. Keet Seel./From the Canyon Floor."
Acquired from: the photographer

1493. **THE PRATT HOUSE. ELEVATIONS FROM ORIGINAL DRAWINGS [from "Greene and Greene, Architects in the Residential Style"]** (P1976.94.12)
Gelatin silver print. c. 1969–72
Image (diptych):
 a) 10⁹⁄₁₆ x 10⁹⁄₁₆ in. (26.8 x 26.8 cm.)
 b) 10⁹⁄₁₆ x 10½ in. (26.8 x 26.7 cm.)
Mount: 10⁹⁄₁₆ x 21¹⁄₁₆ in. (26.8 x 53.5 cm.)
Inscription, mount verso on paper label: "15."
Acquired from: gift of the photographer

1494. **THE PRATT HOUSE. ROCKER DESIGNED BY CHARLES GREENE [from "Greene and Greene, Architects in the Residential Style"]** (P1976.94.15)
Gelatin silver print. c. 1969–72
Image: 9 x 7⁵⁄₁₆ in. (22.9 x 18.6 cm.) sight size
Mount: 10½ x 10½ in. (26.7 x 26.7 cm.)
Inscription, mount verso on paper label: "18."
Acquired from: gift of the photographer

1495. **THE PRATT HOUSE. SECTION DETAIL [from "Greene and Greene, Architects in the Residential Style"]** (P1976.94.13)
Gelatin silver print. c. 1972
Image: 10⁹⁄₁₆ x 10⁹⁄₁₆ in. (26.8 x 26.8 cm.)
Mount: same as image size
Inscription, mount verso: "16"
Acquired from: gift of the photographer

1496. **THE PRATT HOUSE. STRAIGHT-BACK LIVING ROOM CHAIR [from "Greene and Greene, Architects in the Residential Style"]** (P1976.94.14)
Gelatin silver print. c. 1969–72
Image: 9¹⁄₁₆ x 7⅜ in. (23.1 x 18.6 cm.) sight size
Mount: 10½ x 10½ in. (26.7 x 26.7 cm.)
Inscription, mount verso on paper label: "17."
Acquired from: gift of the photographer

1497. **PUEBLO ARROYO—CHACO CANYON [from "Pueblo Architecture of the Southwest"]** (P1971.63.68)
Gelatin silver print. 1964
Image: 10⁹⁄₁₆ x 10⁹⁄₁₆ in. (26.8 x 26.8 cm.)
Mount: same as image size
Signed, l.r. mount verso: "Wm R Current"

Inscription, mount verso: "4//Pueblo Arroyo—/Chaco Canyon"
Acquired from: the photographer

*1498. **PUEBLO ARROYO—CHACO CANYON [from "Pueblo Architecture of the Southwest"]** (P1971.63.73)
Gelatin silver print. 1964
Image: 10⁹⁄₁₆ x 10⁹⁄₁₆ in. (26.8 x 26.8 cm.)
Mount: same as image size
Signed, l.r. mount verso: "Wm R Current"
Inscription, mount verso: "3//Pueblo Arroyo—/Chaco Canyon"
Acquired from: the photographer

1499. **PUEBLO BONITO. EAST WALL AND CLIFF [Chaco Canyon; from "Pueblo Architecture of the Southwest"]** (P1971.63.5)
Gelatin silver print. 1964
Image: 10⁹⁄₁₆ x 10⁹⁄₁₆ in. (26.8 x 26.8 cm.)
Mount: same as image size
Signed, l.r. mount verso: "Wm R Current"
Inscription, mount verso: "14//Fig. 8 Pueblo Bonito. East Wall and Cliff."
Acquired from: the photographer

*1500. **PUEBLO BONITO. FIVE-STORIED WALL. EXTERIOR FACE [Chaco Canyon; from "Pueblo Architecture of the Southwest"]** (P1971.63.4)
Gelatin silver print. 1964
Image: 10⁹⁄₁₆ x 10⁹⁄₁₆ in. (26.8 x 26.8 cm.)
Mount: same as image size
Signed, l.r. mount verso: "Wm R Current"
Inscription, mount verso: "9//Pueblo Bonito. Five-storied wall./ Exterior face."
Acquired from: the photographer

1501. **PUEBLO BONITO. GREAT KIVA [Chaco Canyon; from "Pueblo Architecture of the Southwest"]** (P1971.63.7)
Gelatin silver print. 1964
Image: 10⁹⁄₁₆ x 10⁹⁄₁₆ in. (26.8 x 26.8 cm.)
Mount: same as image size
Signed, l.r. mount verso: "Wm R Current"
Inscription, mount verso: "7//Fig. 10/Pueblo Bonito. Great Kiva."
Acquired from: the photographer

1502. **PUEBLO BONITO. INTERIOR DOORWAY [Chaco Canyon; from "Pueblo Architecture of the Southwest"]** (P1971.63.12)
Gelatin silver print. 1964
Image: 10⁹⁄₁₆ x 10⁹⁄₁₆ in. (26.8 x 26.8 cm.)
Mount: same as image size
Signed, l.r. mount verso: "Wm R Current"
Inscription, mount verso: "11//Fig 15/Pueblo Bonito. Interior Doorway."
Acquired from: the photographer

1503. **PUEBLO BONITO. ROOMS EN SUITE [Chaco Canyon; from "Pueblo Architecture of the Southwest"]** (P1971.63.13)
Gelatin silver print. 1964
Image: 10⁹⁄₁₆ x 10⁹⁄₁₆ in. (26.8 x 26.8 cm.)
Mount: same as image size
Signed, l.r. mount verso: "Wm R Current"
Inscription, mount verso: "12//Fig. 16/Pueblo Bonito. Rooms en suite"
Acquired from: the photographer

1504. **PUEBLO BONITO. SOUTHEAST CORNER [Chaco Canyon; from "Pueblo Architecture of the Southwest"]** (P1971.63.6)
Gelatin silver print. 1964
Image: 10⁹⁄₁₆ x 10⁹⁄₁₆ in. (26.8 x 26.8 cm.)
Mount: same as image size
Signed, l.r. mount verso: "Wm R Current"
Inscription, mount verso: "6//Fig 9/Pueblo Bonito. Southeast corner"
Acquired from: the photographer

175

1480

1490

1492

1498

1500

1512

1505. PUEBLO BONITO. WALL AND BEAM-ENDS [Chaco Canyon; from "Pueblo Architecture of the Southwest"] (P1971.63.11)
Gelatin silver print. 1964
Image: 10 9/16 x 10 9/16 in. (26.8 x 26.8 cm.)
Mount: same as image size
Signed, l.r. mount verso: "Wm R Current"
Inscription, mount verso: "13//Fig 14/Pueblo Bonito./Wall and Beam-ends."
Acquired from: the photographer

1506. ROCK ESCARPMENT—CHACO CANYON [from "Pueblo Architecture of the Southwest"] (P1971.63.72)
Gelatin silver print. 1964
Image: 10 9/16 x 10 9/16 in. (26.8 x 26.8 cm.)
Mount: same as image size
Signed, l.r. mount verso: "Wm R Current"
Inscription, mount verso: "7//Rock escarpment—Chaco Canyon"
Acquired from: the photographer

1507. SEGI CANYON, KAYENTA [from "Pueblo Architecture of the Southwest"] (P1971.63.69)
Gelatin silver print. 1964
Image: 10 9/16 x 10 9/16 in. (26.8 x 26.8 cm.)
Mount: same as image size
Signed, l.r. mount verso: "Wm R Current"
Inscription, mount verso: "9//T Segi Canyon/ Keyenta [sic]"
Acquired from: the photographer

1508. SPRUCE TREE HOUSE. FIRST COURT. PLASTERED WALL [Mesa Verde; from "Pueblo Architecture of the Southwest"] (P1971.63.31)
Gelatin silver print. negative 1964, print 1969
Image: 10 9/16 x 10 9/16 in. (26.8 x 26.8 cm.)
Mount: same as image size
Inscription, mount verso: "2//Fig. 24./Spruce Tree House. First Court./Plastered wall."
Acquired from: the photographer

1509. SPRUCE TREE HOUSE. FOURTH COURT. KIVA LADDER, DOORS, WINDOWS, AND WOODEN BALCONY BEAMS [Mesa Verde; from "Pueblo Architecture of the Southwest"] (P1971.63.30)
Gelatin silver print. 1964
Image: 10 9/16 x 10 9/16 in. (26.8 x 26.8 cm.)
Mount: same as image size
Signed, l.r. mount verso: "Wm R Current"
Inscription, mount verso: "3//Fig. 28./Spruce Tree House. Fourth Court./Kiva ladder, Doors, Windows, and Wooden Balcony Beams."
Acquired from: the photographer

1510. SPRUCE TREE HOUSE. KIVA DETAIL AND FIFTH COURT DETAIL [Mesa Verde; from "Pueblo Architecture of the Southwest"] (P1971.63.27)
Gelatin silver print. 1964
Image (two prints on one mount):
 a) 4 x 4 in. (10.1 x 10.1 cm.)
 b) 10 1/16 x 6 1/16 in. (25.5 x 15.4 cm.)
Mount: 10 9/16 x 10 9/16 in. (26.8 x 26.8 cm.)
Signed, l.r. mount verso: "Wm R Current"
Inscription, mount verso: "6//Fig. 27./Spruce Tree House./ Kiva Detail and Fifth Court detail."
Acquired from: the photographer

1511. SPRUCE TREE HOUSE. THIRD COURT. KEYHOLE DOORWAYS AND BALCONY [Mesa Verde; from "Pueblo Architecture of the Southwest"] (P1971.63.28)
Gelatin silver print. negative 1964, print 1969
Image: 10 9/16 x 10 9/16 in. (26.8 x 26.8 cm.)
Mount: same as image size
Signed, l.r. mount verso: "Wm R Current"
Inscription, mount verso: "5//Fig. 26/Spruce Tree House./ Third Court./Keyhole doorways and Balcony."
Acquired from: the photographer

*1512. SPRUCE TREE HOUSE. THIRD COURT. ROOMS AND KIVA [Mesa Verde; from "Pueblo Architecture of the Southwest"] (P1971.63.29)
Gelatin silver print. negative 1964, print 1969
Image: 10 9/16 x 10 9/16 in. (26.8 x 26.8 cm.)
Mount: same as image size
Inscription, mount verso: "4//Fig. 25/Spruce Tree House. Third Court./Rooms and Kiva."
Acquired from: the photographer

1513. THREE-TURKEY CANYON. THREE-TURKEY RUIN FROM THE OPPOSITE RIM OF THE CANYON [from "Pueblo Architecture of the Southwest"] (P1971.63.57)
Gelatin silver print. 1964
Image: 10 9/16 x 10 9/16 in. (26.8 x 26.8 cm.)
Mount: same as image size
Signed, l.r. mount verso: "Wm R Current"
Inscription, mount verso: "18//Fig. 60/Three-Turkey Canyon. Three-Turkey Ruin/from the opposite rim of the canyon."
Acquired from: the photographer

*1514. THREE-TURKEY RUIN. BLOW-UP [from "Pueblo Architecture of the Southwest"] (P1971.63.58)
Gelatin silver print. 1964
Image: 10 9/16 x 10 9/16 in. (26.8 x 26.8 cm.)
Mount: same as image size
Signed, l.r. mount verso: "Wm R Current"
Inscription, mount verso: "19//Fig. 61./Three-Turkey Ruin. Blow-up."
Acquired from: the photographer

*1515. WHITE HOUSE. DETAIL [Canyon de Chelly; from "Pueblo Architecture of the Southwest"] (P1971.63.54)
Gelatin silver print. 1964
Image: 10 9/16 x 10 9/16 in. (26.8 x 26.8 cm.)
Mount: same as image size
Signed, l.r. mount verso: "Wm R Current"
Inscription, mount verso: "5//Fig. 57/White House. Detail."
Acquired from: the photographer

1516. WHITE HOUSE RUIN. CANYON DE CHELLY. WHITE HOUSE BELOW [from "Pueblo Architecture of the Southwest"] (P1971.63.64)
Gelatin silver print. 1964
Image (two prints on one mount):
 a) 4 3/4 x 10 in. (12.1 x 25.4 cm.)
 b) 5 1/2 x 5 1/2 in. (14.0 x 14.0 cm.)
Mount: 10 9/16 x 10 9/16 in. (26.8 x 26.8 cm.)
Signed, l.r. mount verso: "Wm R Current"
Inscription, mount verso: "4//White House ruin/Canyon de Chelly/ White House/below"
Acquired from: the photographer

1517. WHITE HOUSE WITH LOWER STRUCTURE [Canyon de Chelly; from "Pueblo Architecture of the Southwest"] (P1971.63.53)
Gelatin silver print. 1964
Image: 10 9/16 x 10 9/16 in. (26.8 x 26.8 cm.)
Mount: same as image size
Signed, l.r. mount verso: "Wm R Current"
Inscription, mount verso: "3//Fig. 56/White House With Lower Structure."
Acquired from: the photographer

EDWARD S. CURTIS, American (1868–1952)

Curtis spent the early years of his life in Wisconsin but in 1877 moved to Washington state, where he developed an interest in photography and opened a studio. His life's work was the compilation of over 2,200 photographs in *The North American Indian*, published between 1907 and 1930 as a series of 20 volumes and portfolios that documented disappearing Indian lifestyles and customs. This enormous undertaking was

sponsored by J. Pierpont Morgan and encouraged by President Theodore Roosevelt. During the course of his work Curtis made over 40,000 negatives of more than 80 tribes and gathered corresponding ethnographic data. He also made photographs on the Harriman Alaska Expedition of 1899, which explored the Bering Straits and Cook Inlet. Although most of his work is known through *The North American Indian* portfolio photogravures, Curtis also made platinum prints, gelatin silver prints, orotones, and occasionally cyanotypes.

1514

1518. **ACOMA AND OLD BELL TOWER** (P1979.54.1)
Platinum print. 1904
Image: 6 x 8 in. (15.2 x 20.3 cm.)
1st mount: 6 5/16 x 8 3/16 in. (16.0 x 20.8 cm.)
2nd mount: 6 5/8 x 8 7/16 in. (16.9 x 21.5 cm.)
3rd mount: 11 x 12 5/8 in. (28.0 x 32.1 cm.)
Signed, l.r. print recto: "Curtis"
Inscription, print recto, embossed: "COPYRIGHTED 1904/ by E. S. Curtis"
1st mount recto: "Acoma and Old Bell Tower"
3rd mount recto, embossed: "THE/CURTIS/ STUDIO/SEATTLE"
3rd mount verso: "$2.50—Old Mission Bell at Acoma" and fragment of copyright label
Acquired from: Andrew Smith, Albuquerque, New Mexico

*1519. **CANON DE CHELLY** (P1979.54.3)
Toned gelatin silver print. 1904
Image: 5 5/8 x 7 3/4 in. (14.3 x 19.7 cm.)
Sheet: 7 7/8 x 9 7/8 in. (20.0 x 25.1 cm.)
Signed, l.r. sheet recto: "Curtis/L. A."
Inscription, in negative: "Copyright 1904/by E. S. Curtis/ [illegible]"
Acquired from: Andrew Smith, Albuquerque, New Mexico

1520. **CASCADE [Columbia River, Oregon]** (P1982.36.1)
Cyanotype. c. 1909–11
Image: 5 7/8 x 7 15/16 in. (14.9 x 20.2 cm.)
Inscription, print verso: "58-X//Cascade"
Acquired from: gift of Marcus J. and Carol K. Smith, Santa Fe, New Mexico

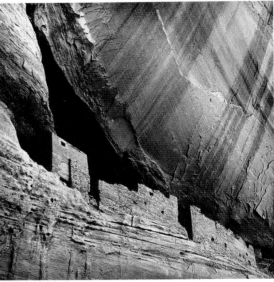

1515

*1521. **KYETANI—WISHHAM** (P1982.36.2)
Cyanotype. 1910
Image: 7 3/4 x 5 15/16 in. (19.7 x 15.1 cm.)
Inscription, print verso: "Kyetani—Wishham//Small// x3071//37-x"
Acquired from: gift of Marcus J. and Carol K. Smith, Santa Fe, New Mexico

THE NORTH AMERICAN INDIAN: LARGE PLATES SUPPLEMENTING VOLUMES 1-20 (P1977.1.1−722)

These photogravure plates accompanied Curtis' text volumes. The gravures are printed either on vellum or tissue. The image size for the vellum sheets is generally about 12 x 16 inches (30.4 x 40.7 cm.) on an 18 x 22 inch (45.7 x 56.0 cm.) sheet. The images on tissue measure approximately 13 x 16 1/2 inches (33.0 x 41.9 cm.) on a 17 1/4 x 21 inch (43.8 x 53.3 cm.) sheet. The inscription for all plates follows the form: "Plate [#]// [Title, in capital letters]//From copyright Photograph [date] by E. S. Curtis//Photogravure [name of company]" around the image. The plate number is at the top left; the rest of the information is below the image. Accession numbers are not all sequential, but correspond to plate numbers for simplicity. The portfolio was acquired from an unknown source. Purchased in 1965 or 1966 for the Museum library, it was transferred to the photography collection in 1977.

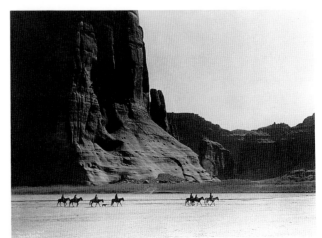

1519

Volume One

The photogravures in Volume One are on vellum. The gravure company was John Andrew & Son.

P1977.1.

1522.	1. THE VANISHING RACE—NAVAJO	1904
1523.	2. GERONIMO—APACHE	negative 1905; gravure 1907
1524.	3. DESERT ROVERS—APACHE	1903
1525.	4. APACHE-LAND	1903
1526.	5. ALCHĪSÉ—APACHE	1903
1527.	6. SÍGĒSH—APACHE	1903
1528.	7. THE APACHE	1906
1529.	8. THE APACHE REAPER	1906
1530.	9. THE STORM—APACHE	1906
1531.	10. GETTING WATER—APACHE	1903
1532.	11. STORY TELLING—APACHE	1903
1533.	12. RENEGADE TYPE—APACHE	1903
1534.	13. THE SCOUT—APACHE	1906
*1535.	14. THE MORNING BATH—APACHE	1906
1536.	15. APACHE NALĪN	1903
1537.	16. ĒSKADI—APACHE	1903
1538.	17. AN APACHE BABE	1903
1539.	18. CHIDĒH—APACHE	1903
1540.	19. THE LOST TRAIL—APACHE	1903
*1541.	20. VASH GON—JICARILLA	1903
1542.	21. CHIEF GARFIELD—JICARILLA	1904
1543.	22. JICARILLA MAIDEN	1904
1544.	23. JICARILLA MATRON	1904
1545.	24. A HILLTOP CAMP—JICARILLA	1904
1546.	25. JICARILLA WOMEN	1904
1547.	26. A CHIEF OF THE DESERT—NAVAHO	1904
1548.	27. WOMEN OF THE DESERT—NAVAHO	1906
1549.	28. CAÑON DE CHELLY—NAVAHO	1904
1550.	29. CAÑON DEL MUERTO—NAVAHO	1906
1551.	30. AT THE SHRINE—NAVAHO	1904
1552.	31. NĒSJÁJA HATÁLĬ—NAVAHO	1904
1553.	32. A SON OF THE DESERT—NAVAHO	1904
1554.	33. NAVAHO FLOCKS	1904
1555.	34. THE BLANKET WEAVER—NAVAHO	1904
1556.	35. HASTOBÍGA, NAVAHO MEDICINE-MAN	1904
*1557.	36. A POINT OF INTEREST—NAVAHO	1904
1558.	37. OUT OF THE DARKNESS—NAVAHO	1904
*1559.	38. SUNSET IN NAVAHO-LAND	1904
1560.	39. ALHKĬDÓKĬHĬ—NAVAHO	1907

Volume Two

The gravures in Volume Two are on vellum. The gravure company was John Andrew & Son.

P1977.1.

1561.	40. SAGUARO HARVEST—PIMA	1907
*1562.	41. PIMA BASKETS	1907
1563.	42. KÁVIU—PIMA	1907
1564.	43. THE BURDEN BEARER—PIMA	1907
1565.	44. THE PIMA WOMAN	1907
1566.	45. PIMA KI	1907
*1567.	46. PIMA MATRON	1907
1568.	47. CHIJÁKO—PIMA	1907
1569.	48. PAPAGO GIRL	1907
1570.	49. GATHERING HÁNAMH—PAPAGO	1907
1571.	50. CARLOS RIOS—PAPAGO CHIEF	1907
1572.	51. FAÇADE—SAN XAVIER DEL BAC MISSION	1907
*1573.	52. PORTAL—SAN XAVIER DEL BAC MISSION	1907
1574.	53. LÚZI—PAPAGO	1907
1575.	54. QAHÁTĬKA WATER GIRL	1907
1576.	55. RESTING IN THE HARVEST FIELD—QAHÁTĬKA	1907
1577.	56. QAHÁTĬKA GIRL	1907
1578.	57. MOHAVE CHIEF	1903
1579.	58. MOHAVE WATER CARRIER	1903
1580.	59. JUDITH—MOHAVE	1903
1581.	60. QÚNIÁIKA—MOHAVE	1903
*1582.	61. MÓSA—MOHAVE	1903
*1583.	62. THE YUMA	1907
1584.	63. HWÁLYA—YUMA	1907
*1585.	64. HAVACHÁCH—MARICOPA	1907
1586.	65. MARICOPA GIRL	1907
1587.	66. MAT STAMS—MARICOPA	1907

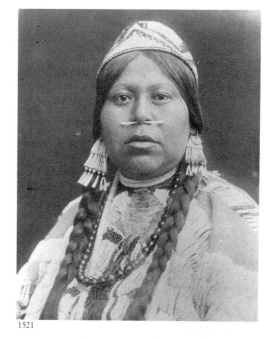

1521

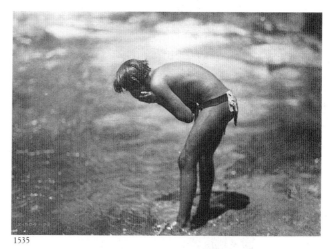

1535

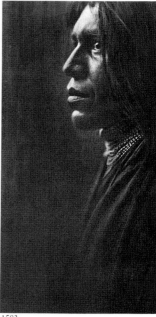

1541

1583

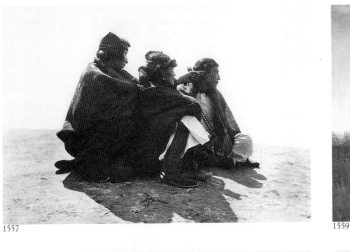

1557

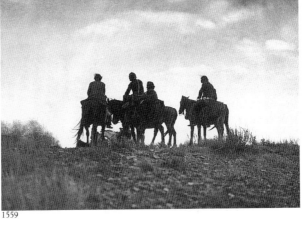

1559

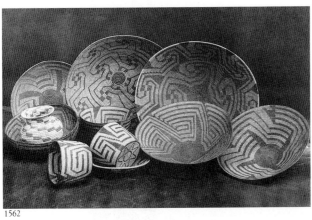

1562

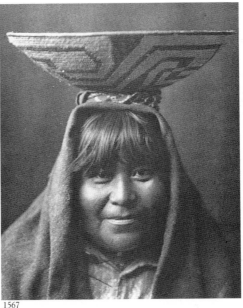

1567

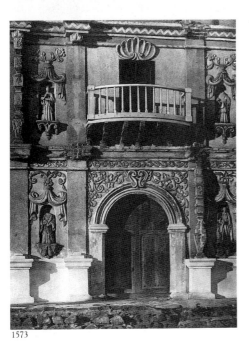

1573

1582

1588.	67.	HIPÁH WITH ARROW-BRUSH—MARICOPA	1907
1589.	68.	BY THE CANAL—MARICOPA	1907
1590.	69.	SAGUARO FRUIT GATHERERS—MARICOPA	1907
1591.	70.	PAKĬT—MARICOPA	1907
1592.	71.	CAPTAIN CHARLEY—MARICOPA	1907
1593.	72.	HOME OF THE HAVASUPAI	1903
1594.	73.	PACHÍLAWA—WALAPAI CHIEF	1907
1595.	74.	TONOVÍGĔ—HAVASUPAI	1907
1596.	75.	GETTING WATER—HAVASUPAI	1903

Volume Five

The gravures in Volume Five are on vellum. The gravure company was John Andrew & Son.

P1977.1.

1597.	148.	YELLOW OWL—MANDAN	1908
1598.	149.	SPOTTED BULL—MANDAN	1908
*1599.	150.	BEAR'S BELLY—ARIKARA	1908
1600.	151.	FOUR HORNS—ARIKARA	1908
1601.	152.	WHITE SHIELD—ARIKARA	1908
1602.	153.	SITTING BEAR—ARIKARA	1908
1603.	154.	BEAR'S TEETH—ARIKARA	1908
1604.	155.	LITTLE SIOUX—ARIKARA	1908
1605.	156.	BULL NECK—ARIKARA	1908
1606.	157.	ARIKARA MEDICINE FRATERNITY	1908
1607.	158.	ARIKARA MEDICINE CEREMONY—DANCE OF THE FRATERNITY	1908
1608.	159.	THE ANNOUNCEMENT—ARIKARA	1908
*1609.	160.	THE RUSH GATHERER—ARIKARA	1908
1610.	161.	ARIKARA MEDICINE CEREMONY—THE BEARS	1908
1611.	162.	ARIKARA MEDICINE CEREMONY—DANCE OF THE BLACK-TAIL DEER	1908
*1612.	163.	ARIKARA MEDICINE CEREMONY—THE DUCKS	1908
1613.	164.	ARIKARA MEDICINE FRATERNITY—THE PRAYER	1908
1614.	165.	ARIKARA GIRL	1908
1615.	166.	ARIKARA CHIEF	1908
1616.	167.	NO BEAR—ATSINA	1908
1617.	168.	EAGLE CHILD—ATSINA	1908
1618.	169.	THE LAND OF THE ATSINA	1908
1619.	170.	HORSE CAPTURE—ATSINA	1908
1620.	171.	ASSINIBOIN BOY—ATSINA	1908
1621.	172.	ATSINA CHIEFS	1908
1622.	173.	ON THE WAR-PATH—ATSINA	1908
1623.	174.	RED WHIP—ATSINA	1908
*1624.	175.	ATSINA CAMP	1908
1625.	176.	THE SCOUT—ATSINA	1908
1626.	177.	HEAD-DRESS—ATSINA	1908
1627.	178.	WAR-PARTY'S FAREWELL—ATSINA	1908
1628.	179.	ATSINA WARRIORS	1908
1629.	180.	LONE FLAG—ATSINA	1908
1630.	181.	AWAITING THE SCOUTS' RETURN—ATSINA	1908
1631.	182.	THE SCOUT'S REPORT—ATSINA	1908
1632.	183.	OTTER ROBE—ATSINA	1908

Volume Seven

The gravures in Volume Seven are on vellum. The gravure company was John Andrew & Son.

P1977.1.

1633.	220.	ÍNASHAĤ—YAKIMA	1910
1634.	221.	WIFE OF MNAÍNAK—YAKIMA	1910
1635.	222.	WĬSHNAI—YAKIMA	1910
1636.	223.	A CAMP OF THE YAKIMA	1909
1637.	224.	A MOUNTAIN CAMP—YAKIMA	1910
1638.	225.	KLICKITAT TYPE	1910
*1639.	226.	KLICKITAT PROFILE	1910
1640.	227.	FLATHEAD TYPE	1910
1641.	228.	FLATHEAD PROFILE	1910
1642.	229.	A FLATHEAD CHIEF	1900
1643.	230.	BIG KNIFE—FLATHEAD	1910
1644.	231.	FLATHEAD CAMP	1910
1645.	232.	FLATHEAD CAMP ON JOCKO RIVER	1910
1646.	233.	A STORMY DAY—FLATHEAD	1910
1647.	234.	A FLATHEAD DANCE	1910
1648.	235.	FLATHEAD CHILDHOOD	1910
1649.	236.	BY THE RIVER—FLATHEAD	1910

1650.	237.	KALISPEL TYPE	1910
*1651.	238.	DUSTY DRESS—KALISPEL	1910
1652.	239.	VILLAGE OF THE KALISPEL	1910
1653.	240.	KALISPEL SCENE	1910
1654.	241.	SPOKAN MAN	1910
1655.	242.	ON SPOKANE RIVER	1910
1656.	243.	SPOKAN CAMP	1910
1657.	244.	NESPILIM MAN	1905
1658.	245.	NESPILIM WOMAN	1905
1659.	246.	NESPILIM GIRL	1905
1660.	247.	LUQAÍÔT—KITTITAS	1910
1661.	248.	COUNTRY OF THE KUTENAI	1910
1662.	249.	KUTENAI DUCK HUNTER	1910
1663.	250.	EMBARKING—KUTENAI	1910
1664.	251.	ON THE SHORE OF THE LAKE—KUTENAI	1910
1665.	252.	CROSSING THE LAKE—KUTENAI	1910
1666.	253.	KUTENAI GIRLS	1910
1667.	254.	KUTENAI CAMP	1910
*1668.	255.	THE RUSH GATHERER—KUTENAI	1910

Volume Eight

The gravures in Volume Eight are on vellum. The gravure company was John Andrew & Son.

P1977.1.

1669.	256.	CHIEF JOSEPH—NEZ PERCÉ	1903
1670.	257.	YELLOW BULL—NEZ PERCÉ	1905
1671.	258.	TYPICAL NEZ PERCÉ	1899
1672.	259.	RAVEN BLANKET—NEZ PERCÉ	1910
1673.	260.	NIGHT SCOUT—NEZ PERCÉ	1910
*1674.	261.	WATCHING FOR THE SIGNAL—NEZ PERCÉ	1910
1675.	262.	NEZ PERCÉ WARRIOR	1905
*1676.	263.	NEZ PERCÉ BRAVE	1905
1677.	264.	LAWYER—NEZ PERCÉ	1905
1678.	265.	BLACK EAGLE—NEZ PERCÉ	1905
1679.	266.	NEZ PERCÉ BABE	1900
1680.	267.	PIÓPIO-MAKSMAKS—WALLAWALLA	1905
1681.	268.	PIÓPIO-MAKSMAKS, PROFILE—WALLAWALLA	1905
1682.	269.	UMATILLA MAID	1910
1683.	270.	INNOCENCE—UMATILLA	1910
1684.	271.	A WAR CHIEF—NEZ PERCÉ	1905
1685.	272.	CAYUSE WARRIOR	1910
1686.	273.	HOLIDAY TRAPPINGS—CAYUSE	1910
1687.	274.	THE FISHERMAN—WISHHAM	1909
1688.	275.	DIP-NETTING IN POOLS—WISHHAM	1909
1689.	276.	SPEARING SALMON—WISHHAM	1909
1690.	277.	THE FISH CARRIER—WISHHAM	1909
1691.	278.	WISHHAM GIRL	1910
1692.	279.	WISHHAM GIRL, PROFILE	1910
*1693.	280.	WISHHAM WOMAN	1909
1694.	281.	WISHHAM BRIDE	1910
1695.	282.	HLALÁKŬM—WISHHAM	1909
1696.	283.	KÁSHHILA—WISHHAM	1909
1697.	284.	WISHHAM MAID	1909
1698.	285.	THE COLUMBIA NEAR WIND RIVER	1910
1699.	286.	THE LOWER COLUMBIA	1910
1700.	287.	EVENING ON THE COLUMBIA	1910
1701.	288.	THE MIDDLE COLUMBIA	1910
1702.	289.	ON KLICKITAT RIVER (a)	1910
1703.	290.	ON KLICKITAT RIVER (b)	1910
1704.	291.	ON KLICKITAT RIVER (c)	1910
1705.	292.	ON THE BEACH—CHINOOK	1910

Volume Nine

The gravures in Volume Nine are on vellum. The gravure company was John Andrew & Son.

P1977.1.

1706.	293.	A PRIMITIVE QUINAULT	1912
1707.	294.	QUINAULT FEMALE TYPE	1912
1708.	295.	QUINAULT FEMALE PROFILE	1912
1709.	296.	THE MOUTH OF QUINAULT RIVER	1912
1710.	297.	ON QUINAULT RIVER	1912
1711.	298.	HLEÁSTÚNŬH—SKOKOMISH	1912
1712.	299.	TSÁTSALATSA—SKOKOMISH	1912
1713.	300.	A CHIEF'S DAUGHTER—SKOKOMISH	1912
*1714.	301.	A MAT HOUSE—SKOKOMISH	1912
1715.	302.	FISHING CAMP—SKOKOMISH	1912

1585

1599

1609

1612

1624

1639

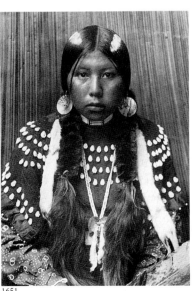

1651

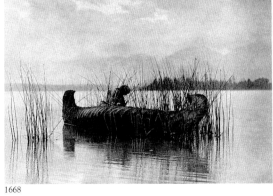

1668

Volume Ten

The gravures in Volume Ten are on tissue. The gravure company was John Andrew & Son.

P1977.1.

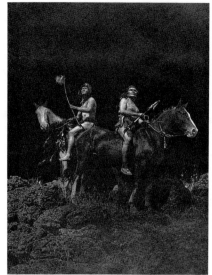

1674

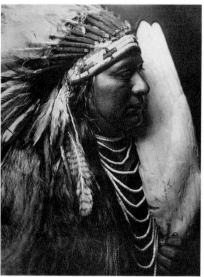

1676

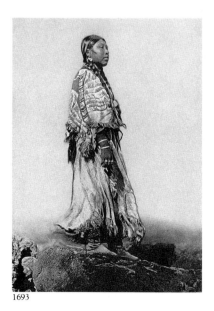

1693

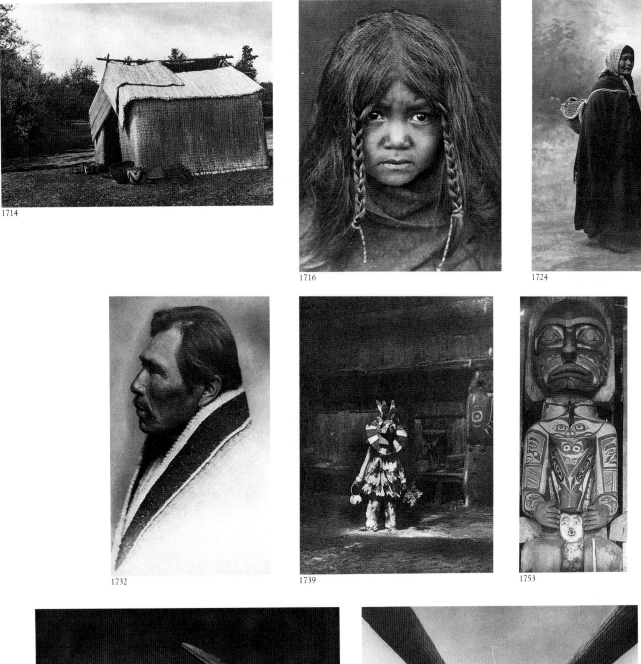

1714

1716

1724

1732

1739

1753

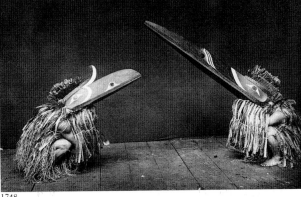

1748

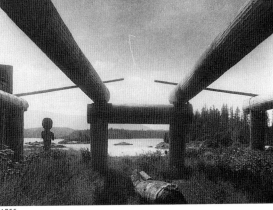

1755

Volume Eleven

The gravures in Volume Eleven are on tissue. The gravure company was John Andrew & Son.

P1977.1. note: there are two plates numbered 400. One is in Volume 11 and the other in Volume 12. They are not duplicates.

*1774.	365.	THE BOWMAN	1915
1775.	366.	ON THE SHORES AT NOOTKA	1915
1776.	367.	HESQUIAT ROOT DIGGER	1915
1777.	368.	THE BERRY PICKER—CLAYOQUOT	1915
1778.	369.	THE SEAWEED GATHERER	1915
1779.	370.	WHALE CEREMONIAL—CLAYOQUOT	1915
1780.	371.	BOARDING THE CANOE	1915
	372.	[Clayoquot Girl—missing plate]	
1781.	373.	CANOEING ON CLAYOQUOT SOUND	1915
1782.	374.	NOOTKA METHOD OF SPEARING	1915
	375.	[The Oldest Man of Nootka—missing plate]	
1783.	376.	CEREMONIAL BATHING	1915
1784.	377.	A HESQUIAT WOMAN	1915
1785.	378.	A CLAYOQUOT TYPE	1915
1786.	379.	A HESQUIAT MAIDEN	1915
1787.	380.	INTO THE SHADOW—CLAYOQUOT	1915
1788.	381.	NOOTKA WOMAN WEARING CEDAR-BARK BLANKET	1915
*1789.	382.	THE WHALER	1915
1790.	383.	THE BARK GATHERER	1915
1791.	384.	A NOOTKA WOMAN	1915
	385.	[A Makah Maiden—missing plate]	
1792.	386.	AT NOOTKA	1915
1793.	387.	WAITING FOR THE CANOE	1915
1794.	388.	HAIYAHL—NOOTKA	1915
1795.	389.	SHORES OF NOOTKA SOUND	1915
1796.	390.	A NOOTKA MAN	1915
1797.	391.	ON THE WEST COAST OF VANCOUVER ISLAND	1915
*1798.	392.	FISH SPEARING—CLAYOQUOT	1915
	393.	[Return of the Halibut Fishers—missing plate]	
1799.	394.	THE WHALER—CLAYOQUOT	1915
1800.	395.	THE WHALER—MAKAH	1915
1801.	396.	THE CAPTURED WHALE	1915
*1802.	397.	A HAIDA CHIEF'S TOMB AT YAN	1915
1803.	398.	A HAIDA OF MASSETT	1915
1804.	399.	A HAIDA OF KUNG	1915
1805.	400.	HAIDA SLATE CARVINGS	1915

Volume Twelve

The gravures in Volume Twelve are on tissue. The gravure company was Suffolk Eng. Co., Boston.

P1977.1. note: there are two plates numbered 400. One is in Volume 11 and the other in Volume 12. They are not duplicates.

1806.	400.	LOITERING AT THE SPRING	1921
1807.	401.	BUFFALO DANCE AT HANO	1921
1808.	402.	A TEWA GIRL	1921
1809.	403.	A HOPI MOTHER	1921
1810.	404.	ANTELOPES AND SNAKES AT ORAIBI	1921
1811.	405.	WATCHING THE DANCERS	1906
	406.	[A Hopi Girl—missing plate]	
1812.	407.	EVENING IN HOPI LAND	1907
1813.	408.	HÓNOVI—WALPI SNAKE PRIEST, WITH TOTÓKYA DAY PAINTING	1921
*1814.	409.	ON THE HOUSETOP	1921
1815.	410.	WALPI	1907
1816.	411.	A HOPI WOMAN	1905
	412.	[The Hopi Maiden—missing plate]	
1817.	413.	COUNTING THE RECORD	1921
1818.	414.	CHAÍWA—TEWA	1921
*1819.	415.	CHAÍWA—TEWA—PROFILE	1921
1820.	416.	AT THE TRYSTING PLACE	1921
1821.	417.	EAST SIDE OF WALPI	1921
*1822.	418.	A SNAKE PRIEST	1900
1823.	419.	THE POTTER MIXING CLAY	1921
	420.	[A Hopi Man—missing plate]	
1824.	421.	WALPI ARCHITECTURE	1921
1825.	422.	SNAKE DANCERS ENTERING THE PLAZA	1921
1826.	423.	PRIMITIVE STYLE OF HAIR DRESSING	1921

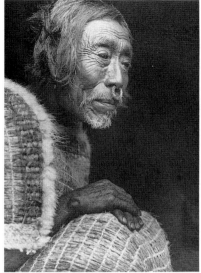
1759

1774

1789

1798

1814

1819

1802

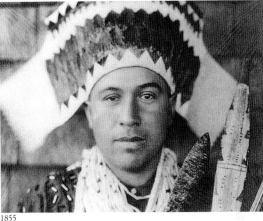

1855

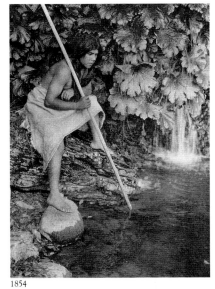

1822

1834

1854

	424.	[A Walpi Man—missing plate]	
1827.	425.	MISHONGNOVI	1900
1828.	426.	THE POTTER	1906
1829.	427.	EAST MESA GIRLS	1921
1830.	428.	MODIFIED STYLE OF HAIR DRESSING	1921
1831.	429.	A WALPI SNAKE PRIEST	1900
1832.	430.	SNAKE DANCER IN COSTUME	1900
1833.	431.	FLUTE DANCERS AT TUREVA SPRING	1921
*1834.	432.	THE PIKI MAKER	1906
1835.	433.	DEPOSITING A PRAYER-STICK	1921
1836.	434.	TEWA GIRLS	1921
1837.	435.	THE WATER CARRIERS	1921

Volume Thirteen

The gravures in Volume Thirteen are on tissue. The gravure company was Suffolk Eng. Co., Cambridge, Mass.

P1977.1.

1838.	436.	KLAMATH WOMAN	1923
1839.	437.	SAM EWING—YUROK	1923
	438.	[Karok Baskets—missing plate]	
1840.	439.	HUPA TROUT-TRAP	1923
1841.	440.	OLD KLAMATH WOMAN	1923
1842.	441.	A KLAMATH	1923
1843.	442.	HUPA JUMPING DANCE COSTUME	1923
1844.	443.	YUROK CANOE ON TRINITY RIVER	1923
1845.	444.	QUIET WATERS—YUROK	1923
1846.	445.	WIFE OF MODOC HENRY—KLAMATH	1923
1847.	446.	A KLAMATH TYPE	1923
1848.	447.	FISHING FROM CANOE—HUPA	1923
	448.	[In the Forest—Klamath—missing plate]	
1849.	449.	KLAMATH WARRIOR'S HEAD-DRESS	1923
1850.	450.	HUPA MOTHER AND CHILD	1923
1851.	451.	HUPA WOMAN	1923
1852.	452.	THE SALMON STREAM	1923
1853.	453.	HUPA FISHERMAN	1923
*1854.	454.	SPEARING SALMON	1923
*1855.	455.	TOLOWA DANCING HEAD-DRESS	1923
1856.	456.	KLAMATH LAKE MARSHES	1923
1857.	457.	YUROK DRUMMER	1923
1858.	458.	THE KLAMATH HUNTER	1923
1859.	459.	FISH-WEIR ACROSS TRINITY RIVER—HUPA	1923
*1860.	460.	GATHERING WÓKAS—KLAMATH	1923
1861.	461.	WOMAN'S PRIMITIVE DRESS—TOLOWA	1923
1862.	462.	THE WÓKAS SEASON—KLAMATH	1923
	463.	[Crater Lake—missing plate]	
1863.	464.	ACHOMAWI BASKET-MAKER	1923
1864.	465.	FISHING PLATFORM ON TRINITY RIVER—HUPA	1923
*1865.	466.	ACHOMAWI MAN	1923
1866.	467.	PRINCIPAL FEMALE SHAMAN OF THE HUPA	1923
1867.	468.	HUPA WOMAN IN PRIMITIVE COSTUME	1923
	469.	[The Smelt Fisher—Trinidad Yurok—missing plate]	
	470.	[The Chief—Klamath—missing plate]	
1868.	471.	A SMOKY DAY AT THE SUGAR BOWL—HUPA	1923

Volume Fourteen

The gravures in Volume Fourteen are on tissue. The gravure company was Suffolk Eng. Co., Cambridge, Mass.

P1977.1.

1869.	472.	MÍTAT—WAILAKI	1924
1870.	473.	OLD "UKIAH"—POMO	1924
1871.	474.	THE HUNTER—LAKE POMO	1924
1872.	475.	THE BURDEN BASKET—COAST POMO	1924
1873.	476.	A MIXED-BLOOD COAST POMO	1924
1874.	477.	ON THE SHORES OF CLEAR LAKE	1924
1875.	478.	SHATÍLA—POMO	1924
1876.	479.	A SUMMER CAMP—LAKE POMO	1924
1877.	480.	WILD GRAPES—POMO	1924
1878.	481.	GATHERING TULES—LAKE POMO	1924
*1879.	482.	A POMO GIRL	1924
1880.	483.	A COAST POMO WOMAN	1924
1881.	484.	POMO SEED-GATHERING UTENSILS	1924
1882.	485.	POMO BASKETS, MORTAR, AND PESTLE	1924
1883.	486.	A COAST POMO GIRL	1924
*1884.	487.	FISHING CAMP—LAKE POMO	1924
1885.	488.	AGED POMO WOMAN	1924

*1886.	489.	CANOE OF TULES—POMO	1924
1887.	490.	A WAPPO	1924
1888.	491.	A WAPPO WOMAN	1924
1889.	492.	OTÍLA—MAIDU	1924
1890.	493.	A MIWOK HEAD-MAN	1924
1891.	494.	THE FISHING POOL—SOUTHERN MIWOK	1924
1892.	495.	A SOUTHERN MIWOK	1924
1893.	496.	THE FISHERMAN—SOUTHERN MIWOK	1924
1894.	497.	A CHUKCHANSI YOKUTS	1924
1895.	498.	A YAUELMANI YOKUTS	1924
1896.	499.	ART AS OLD AS THE TREE—SOUTHERN YOKUTS	1924
*1897.	500.	RATTLESNAKE DESIGN IN YOKUTS BASKETRY	1924
1898.	501.	BY THE POOL—TULE RIVER RESERVATION	1924
1899.	502.	YOKUTS BASKETRY DESIGNS (a)	1924
1900.	503.	YOKUTS BASKETRY DESIGNS (b)	1924
1901.	504.	A CHUKCHANSI YOKUTS TYPE	1924
1902.	505.	A CHUKCHANSI MATRON	1924
1903.	506.	QUIET WATERS—TULE RIVER RESERVATION	1924
1904.	507.	A YAUDANCHI YOKUTS WOMAN	1924

Volume Fifteen

The gravures in Volume Fifteen are on tissue. The gravure company was Suffolk Eng. Co., Cambridge, Mass.

P1977.1.

1905.	508.	BEFORE THE WHITE MAN CAME—PALM CAÑON	1924
1906.	509.	BASKETRY OF THE MISSION INDIANS	1924
1907.	510.	A CUPEÑO WOMAN	1924
*1908.	511.	MODERN CUPEÑO HOUSE	1924
1909.	512.	A SERRANO WOMAN OF TEJON	1924
1910.	513.	A TEJON SERRANO	1924
1911.	514.	MODERN HOUSE AT TEJON	1924
1912.	515.	CHEMEHUEVI HOUSE	1924
1913.	516.	A HOME IN THE MESQUITE—CHEMEHUEVI	1924
1914.	517.	MARCOS—PALM CAÑON CAHUILLA	1924
1915.	518.	PALM CAÑON	1924
1916.	519.	NUMERO—DESERT CAHUILLA	1924
1917.	520.	CAHUILLA HOUSE IN THE DESERT	1924
1918.	521.	UNDER THE PALMS—CAHUILLA	1924
1919.	522.	A DESERT CAHUILLA WOMAN	1924
*1920.	523.	ANDRÉS CAÑON	1924
1921.	524.	A DIEGUEÑO HOME	1924
1922.	525.	DIEGUEÑO HOUSE AT CAMPO	1924
1923.	526.	A DIEGUEÑO OF CAPITAN GRANDE	1924
1924.	527.	A DIEGUEÑO WOMAN OF SANTA YSABEL	1924
1925.	528.	SOUTHERN DIEGUEÑO HOUSE	1924
1926.	529.	A SOUTHERN DIEGUEÑO	1924
1927.	530.	A DIEGUEÑO WOMAN OF CAMPO	1924
1928.	531.	DIEGUEÑO HOUSE AT SANTA YSABEL	1924
1929.	532.	A DIEGUEÑO OF SANTA YSABEL	1924
1930.	533.	A MONO HOME	1924
1931.	534.	SHORES OF WALKER LAKE	1924
1932.	535.	A PYRAMID LAKE PAVIOTSO	1924
1933.	536.	THE PRIMITIVE ARTIST—PAVIOTSO	1924
*1934.	537.	AN AGED PAVIOTSO OF PYRAMID LAKE	1924
	538.	[Fishing with a Gaff-Hook—Paviotso—missing plate]	
1935.	539.	A WALKER LAKE PAVIOTSO	1924
1936.	540.	DATSOLALI, WASHO BASKET-MAKER	1924
	541.	[Washo Baskets—missing plate]	
1937.	542.	MODERN DESIGNS IN WASHO BASKETRY	1924
1938.	543.	A WASHO WOMAN	1924

Volume Sixteen

The gravures in Volume Sixteen are on tissue. The gravure company was Suffolk Eng. Co., Cambridge, Mass.

P1977.1.

*1939.	544.	TAOS WATER GIRLS	1905
	545.	[Iãhla ("Willow")—Taos—missing plate]	
1940.	546.	NORTH PUEBLO AT TAOS	1925
	547.	[Walvía ("Medicine Root")—Taos—missing plate]	
*1941.	548.	A TAOS WOMAN	1905
1942.	549.	AN ISLETA MAN	1925
1943.	550.	FRANCISCA CHIWIWI—ISLETA	1925
1944.	551.	JEMEZ ARCHITECTURE	1925

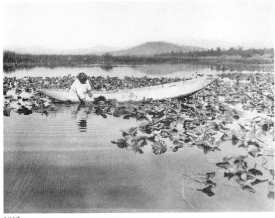

1860

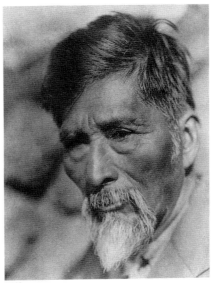

1865

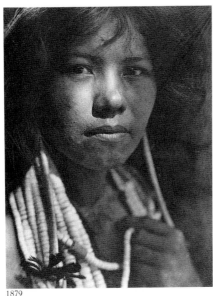

1879

1884

1886

1897

552. [A Jemez Fiscal—missing plate]
553. [Tûvahé—Jemez—missing plate]

1945.	554. COCHITI AND SIA POTTERY	1925
1946.	555. TÍ'MU—COCHITI	1925
1947.	556. AÍYOWITS!A—COCHITI	1925
1948.	557. LUCERO—SANTO DOMINGO	1925
	558. [Ḳyĕllo—Santo Domingo—missing plate]	
1949.	559. ON A SIA HOUSETOP	1925
1950.	560. SIA BUFFALO DANCER	1925
1951.	561. SHÚAṬI—SIA	1925
1952.	562. SIA STREET SCENE	1925
*1953.	563. SIA BUFFALO MASK	1925
*1954.	564. ACOMA BELFRY	1904
1955.	565. A FEAST DAY AT ACOMA	1904
1956.	566. ACOMA FROM THE SOUTH	1904
1957.	567. OLD TRAIL AT ACOMA	1904
1958.	568. ACOMA WATER CARRIERS	1904
	569. [At the Gateway—Acoma—missing plate]	
1959.	570. ACOMA ROADWAY	1904
1960.	571. AT THE OLD WELL OF ACOMA	1904
1961.	572. AN ACOMA WOMAN	1904
1962.	573. ACOMA WATER GIRLS	1904
1963.	574. PAGUATE	1925
1964.	575. LAGUNA ARCHITECTURE	1925
1965.	576. REPLASTERING A PAGUATE HOUSE	1925
1966.	577. LAGUNA WATCHTOWER	1925
1967.	578. A PAGUATE ENTRANCE	1925
1968.	579. PAGUATE WATCHTOWER	1925

Volume Seventeen

The gravures in Volume Seventeen are on tissue. The gravure company was Suffolk Eng. Co., Cambridge, Mass.

P1977.1.

	580. [The Sentinel—San Ildefonso—missing plate]	
1969.	581. PÓVI-TÁMUᴺ ("FLOWER MORNING")— SAN ILDEFONSO	1925
1970.	582. OKÚWA-TSE ("CLOUD YELLOW")— SAN ILDEFONSO	1905
1971.	583. ON THE RIO GRANDE—SAN ILDEFONSO	1905
1972.	584. THE KIVA STAIRS—SAN ILDEFONSO	1925
1973.	585. THE FRUIT GATHERER—SAN ILDEFONSO	1905
	586. [The Offering—San Ildefonso—missing plate]	
1974.	587. SAN ILDEFONSO POTTERY	1925
1975.	588. TABLITA DANCERS AND SINGERS— SAN ILDEFONSO	1905
1976.	589. IN SAN ILDEFONSO	1925
*1977.	590. GIRL AND JAR—SAN ILDEFONSO	1905
1978.	591. IN THE GRAY MORNING—SAN ILDEFONSO	1905
	592. [Offering to the Sun—San Ildefonso—missing plate]	
1979.	593. FROM THE THRESHING-FLOOR—SAN JUAN	1926
1980.	594. WASHING WHEAT—SAN JUAN	1905
1981.	595. STREET SCENE AT SAN JUAN	1925
1982.	596. AMBROSIO MARTÍNEZ—SAN JUAN	1905
1983.	597. SAN JUAN POTTERY	1905
1984.	598. GOSSIPING—SAN JUAN	1905
*1985.	599. AN OFFERING AT THE WATERFALL—NAMBÉ	1925
1986.	600. TESUQUE BUFFALO DANCERS	1925
1987.	601. OYÍᴺ-TSÄᴺ ("DUCK WHITE"), SUMMER CACIQUE OF SANTA CLARA	1905
1988.	602. THE POTTER—SANTA CLARA	1905
1989.	603. POTTERY BURNERS AT SANTA CLARA	1905
	604. [Inscription Rock—missing plate]	
1990.	605. ZUÑI STREET SCENE	1925
*1991.	606. GRINDING MEDICINE—ZUÑI	1925
	607. [A Zuñi Governor—missing plate]	
*1992.	608. A LOAD OF FUEL—ZUÑI	1903
1993.	609. THE TERRACED HOUSES OF ZUÑI	1903
1994.	610. ZUÑI GIRLS AT THE RIVER	1903
1995.	611. LÚTAKAWI, ZUÑI GOVERNOR	1925
1996.	612. WAÍHUSIWA, A ZUÑI KYÁQÎMÂSSI	1903
1997.	613. A ZUÑI GIRL	1903
1998.	614. A ZUÑI WOMAN	1903
1999.	615. A CORNER OF ZUÑI	1903

1908

1920

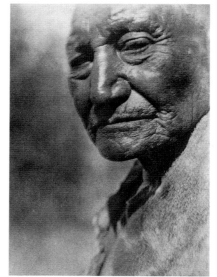

1934

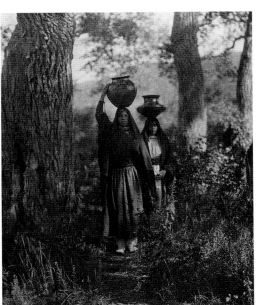

1939

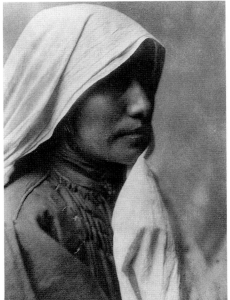

1941

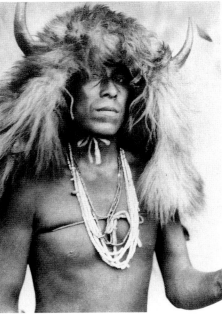

1953

1977

1954

1985

Volume Eighteen

The gravures in Volume Eighteen are on tissue. The gravure company was Suffolk Eng. Co., Cambridge, Mass.

P1977.1.

Volume Nineteen

The gravures in Volume Nineteen are on tissue. The gravure company was Suffolk Eng. Co., Cambridge, Mass.

P1977.1.

1991

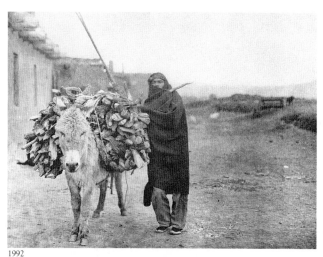

1992

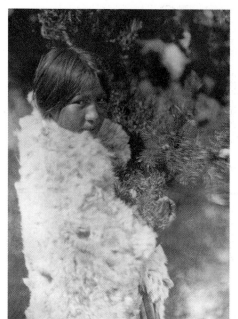

2003

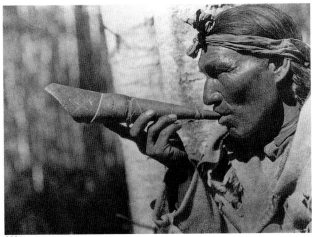

2004

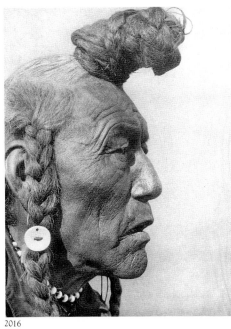

2016

2021

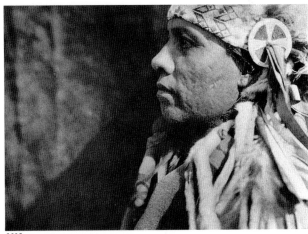

2025

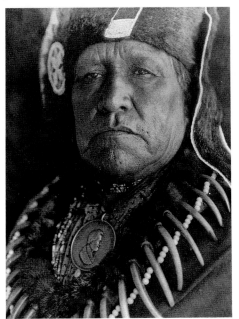

2049

2057

2048.	678.	PIPE-STEM—OTO	1927
*2049.	679.	OLD EAGLE—OTO	1927
2050.	680.	JOHN ABBOTT—OSAGE	1927
2051.	681.	JOHN QUAPAW (HÚNTA WAKÚNTA)—	
		QUAPAW	1927
2052.	682.	ÉSIPÉRMI—COMANCHE	1927
2053.	683.	LEFTHAND—COMANCHE	1927
2054.	684.	ÚWAT—COMANCHE	1927
2055.	685.	A COMANCHE MOTHER	1927
2056.	686.	A COMANCHE	1927
*2057.	687.	PEYOTE DRUMMER	1927

Volume Twenty
The gravures in Volume Twenty are on tissue. The gravure company was Suffolk Eng. Co., Cambridge, Mass.
P1977.1.

2058.	688.	NUNIVAK CHILDREN	1928
2059.	689.	REINDEER—NUNIVAK	1928
2060.	690.	BOYS IN KAIAK—NUNIVAK	1928
2061.	691.	KENÓWŬN—NUNIVAK	1928
2062.	692.	THE DRUMMER—NUNIVAK	1928
2063.	693.	ÚGIYAKÚ—NUNIVAK	1928
2064.	694.	WOMAN AND CHILD—NUNIVAK	1928
2065.	695.	READY FOR SEALING—NUNIVAK	1928
2066.	696.	UYOWŬTCHA—NUNIVAK	1928
*2067.	697.	ÚGIYAKÚ—NUNIVAK	1928
2068.	698.	HOOPER BAY YOUTH	1928
2069.	699.	THE VILLAGE—HOOPER BAY	1928
2070.	700.	KING ISLAND VILLAGE FROM THE SEA	1928
2071.	701.	KING ISLAND VILLAGE	1928
2072.	702.	KING ISLAND HOMES	1928
2073.	703.	QUNANÏNRU—KING ISLAND	1928
*2074.	704.	LAUNCHING THE BOAT—DIOMEDE ISLAND	1928
2075.	705.	DIOMEDE BOAT CREW, ASIATIC	
		SHORE IN DISTANCE	1928
2076.	706.	OLD STONE HOUSE—DIOMEDE ISLAND	1928
2077.	707.	LAUNCHING THE WHALEBOAT—	
		CAPE PRINCE OF WALES	1928
2078.	708.	CAPE PRINCE OF WALES MAN	1928
2079.	709.	WHALING CREW—CAPE PRINCE OF WALES	1928
2080.	710.	A KOTZEBUE MAN	1928
2081.	711.	A FOGGY DAY—KOTZEBUE	1928
2082.	712.	STARTING UP THE NOATAK RIVER—	
		KOTZEBUE	1928
*2083.	713.	JACKSON, INTERPRETER AT KOTZEBUE	1928
2084.	714.	THE MUSKRAT HUNTER—KOTZEBUE	1928
2085.	715.	ARRIVING HOME—NOATAK	1928
2086.	716.	ÓLA—NOATAK	1928
*2087.	717.	A FAMILY GROUP—NOATAK	1928
2088.	718.	NOATAK KAIAKS	1928
2089.	719.	NUNGÓKTŎK—NOATAK	1928
2090.	720.	JÁJŬK—SELAWIK	1928
2091.	721.	CHARLIE WOOD—KOBUK	1928
2092.	722.	KOBUK COSTUME	1928

2093. **QUINAULT** (P1979.80)
Cyanotype. c. 1912
Image: 6 x 7 13/16 in. (15.3 x 19.9 cm.)
Inscription, print verso: "197-X//Quinault"
Acquired from: Andrew Smith, Albuquerque, New Mexico

*2094. **WATCHING THE DANCERS** (P1979.54.2)
Platinum print. 1906
Image: 7 5/8 x 5 15/16 in. (19.4 x 15.0 cm.)
1st mount: 8 x 6 1/8 in. (20.3 x 15.5 cm.)
2nd mount: 13 9/16 x 10 1/8 in. (34.4 x 25.6 cm.)
Inscription, in negative: "X2010-06"
2nd mount verso, paper label: "This picture is copy-/
righted and so stamped/on its face. Publishers/are closely
watched/and infringement will/be vigorously prose-/
cuted.—E. S. Curtis"
Acquired from: Andrew Smith, Albuquerque, New Mexico

*2095. **YIBICHAI, BASKET CAP MASKER, NAVAJO** (P1981.50)
Gelatin silver print. 1904
Image: 18 1/16 x 12 in. (45.9 x 30.5 cm.)
Mount: 19 1/16 x 13 in. (48.4 x 33.0 cm.)

Signed: see inscription
Inscription, in negative: "X 069-04"
mount recto, embossed: "Copyrighted 1904/by
E. S. Curtis"
mount verso: "Yibichai/Basket Cap Masker/Navajo"
Acquired from: John Howell—Books, San Francisco,
California

DEAN DABLOW, American (b. 1946)

Dablow was born in Superior, Wisconsin, and attended the University of Wisconsin, Stevens Point, where he received his B.S. in 1969. He completed an M.A. and M.F.A. at the University of Iowa in 1972 and 1974 respectively. From 1974 until 1976 Dablow taught art at Coe College in Cedar Rapids, Iowa, moving in 1976 to teach at Louisiana Tech University in Ruston, Louisiana.

2096. **PHOTOGRAPH OUT OF CONTEXT #7 [from the Society for Photographic Education's "South Central Regional Photography Exhibition"]** (P1983.31.3)
Gelatin silver print. 1980
Image (diptych): a) 3 3/4 x 5 15/16 in. (9.5 x 15.0 cm.)
b) 3 3/4 x 5 15/16 in. (9.5 x 15.0 cm.)
Sheet: a) 5 15/16 x 7 3/4 in. (15.0 x 19.7 cm.)
b) 5 7/8 x 7 11/16 in. (14.9 x 19.4 cm.)
Signed, l.r. sheet recto: "Dablow 1980"
Inscription, sheet recto: "[under left image] THE
HINDQUARTERS OF A LION SCULPTURE IN
NAUVOO, ILLINOIS/WHERE MORMONS ONCE
ESTABLISHED THE LARGEST CITY IN THE/STATE.
THE LION WAS ONCE AN ADORNMENT FOR THE
CHURCH.//[under right image] FROM A HISTORY
BOOK OF THE FAR EAST, "...THE CULTURE HAS/
FOR CENTURIES WORSHIPED THE PHALLUS AS
A SOURCE OF/FERTILITY. THIS EXAMPLE OF
PHALLIC ICON WAS FOUND AT/THE ENTRANCE
TO A ROCK GARDEN.""
Acquired from: gift of the Society for Photographic
Education, South Central Region

BILL DANE, American (b. 1938)

A native Californian, Bill Dane studied art at the University of California at Berkeley during the 1960s, taking up photography in the early 1970s. He received Guggenheim Fellowships in 1973 and 1982 and National Endowment for the Arts Fellowships in 1976 and 1977. Dane has traveled worldwide to make his photographs, which often isolate and focus on vernacular elements in order to restate or debunk popular myths.

*2097. **LOS ANGELES ZOO** (P1981.63)
Gelatin silver print. 1979
Image: 8 5/8 x 12 7/8 in. (21.9 x 32.6 cm.)
Sheet: 11 x 14 in. (28.0 x 35.6 cm.)
Signed, u.l. print verso: "Bill Dane"
Inscription, print verso: "LA Zoo 1979 Gift to the Amon
Carter Museum Ft. Worth, Texas//BZD.188.y//79-185"
Acquired from: gift of Fraenkel Gallery, San Francisco,
California, and the photographer

GEORGE DAVISON, British (1856–1930)

See *Camera Notes* and *Camera Work*

F. HOLLAND DAY, American (1864–1933)

See *Camera Notes*

2067

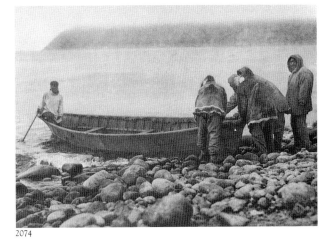

2074

2083

2094

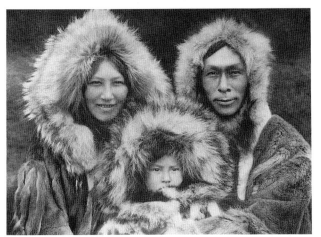

2087

2095

JIM DAY, American (b. 1941)

Day earned a B.F.A. in photography and filmmaking from North Texas State University in 1975 and has had shows at museums in Texas, Colorado, Utah, and Wyoming. His work focuses on the Southwest, the western landscape, and places of historical interest.

2098. **BILLIARD ROOM AND SNOW, BENT'S OLD FORT, COLORADO 1976** (P1976.173)
Gelatin silver print. 1976
Image: 7 ¾ x 9 ¾ in. (19.7 x 24.7 cm.)
Mount: 16 x 19 ¹¹⁄₁₆ in. (40.7 x 50.3 cm.)
Signed, l.r. mount recto: "© J L Day 1976"
Acquired from: gift of the photographer

2099. **INTERIOR (TRADE ROOM) AND COURTYARD, BENT'S OLD FORT, COLORADO 1976** (P1977.92)
Gelatin silver print. 1976
Image: 7 ¹³⁄₁₆ x 9 ¾ in. (19.8 x 24.8 cm.)
Mount: 16 x 20 in. (40.7 x 50.8 cm.)
Signed, l.r. mount recto: "II © J L DAY 1976"
Acquired from: the photographer

LILIANE DE COCK,
American, born Belgium (b. 1939)

Liliane de Cock came to the United States from Belgium in 1960. She was Ansel Adams' assistant from 1963 to 1972 and has taught at several Yosemite Workshops. De Cock married Doug Morgan, son of photographer Barbara Morgan. She was awarded a Guggenheim Fellowship in 1972 and has designed photography books and edited *Photo-Lab Index* for the publishing firm Morgan and Morgan. Her work focuses on landscapes and portraits that Ansel Adams said showed "a world of individualistic beauty and intensity." De Cock had a major exhibition of her photographs at the Amon Carter Museum in 1973.

2100. **AT THE BASE OF ACOMA, NEW MEXICO** (P1974.23.6)
Gelatin silver print. 1970
Image: 15 ¼ x 18 ⁷⁄₁₆ in. (38.7 x 46.8 cm.)
Mount: 22 x 27 ⅞ in. (56.0 x 70.9 cm.)
Signed, l.r. mount recto: "Liliane De Cock"
Inscription, mount verso: "PHOTOGRAPH BY LILIANE DE COCK/At the base of ACOMA, New Mexico—1970"
Acquired from: the photographer

*2101. **BARN AND SMOKESTACKS—MOSS LANDING—CALIFORNIA** (P1974.23.2)
Gelatin silver print. 1968
Image: 12 ¼ x 19 ⅝ in. (31.2 x 49.9 cm.)
Mount: 22 x 27 ⅞ in. (56.0 x 70.9 cm.)
Signed, l.r. mount recto: "Liliane De Cock"
Inscription, mount verso: "PHOTOGRAPH BY LILIANE DE COCK/Barn and Smokestacks—Moss Landing—California 1968"
Acquired from: the photographer

2102. **MONTANA** (P1974.23.7)
Gelatin silver print. 1969
Image: 14 ⅞ x 19 ½ in. (37.8 x 49.5 cm.)
Mount: 22 x 27 ⅞ in. (56.0 x 70.9 cm.)
Signed, l.r. mount recto: "Liliane De Cock"
Inscription, mount verso: "PHOTOGRAPH BY LILIANE DE COCK/MONTANA 1969"
Acquired from: the photographer

2103. **REAR OF CHURCH—RANCHOS DE TAOS, NEW MEXICO** (P1974.23.8)
Gelatin silver print. 1972
Image: 15 ⅛ x 19 ⅜ in. (38.4 x 49.2 cm.)
Mount: 22 x 27 ¼ in. (56.0 x 70.5 cm.)
Signed, l.r. mount recto: "Liliane De Cock"
Inscription, mount verso: "PHOTOGRAPH BY LILIANE DE COCK/Rear of Church—Ranchos de Taos, New Mexico 1972"
Acquired from: the photographer

2104. **SIDE GATE—LAGUNA PUEBLO CHURCH, N. M.** (P1974.23.5)
Gelatin silver print. 1970
Image: 18 ¹¹⁄₁₆ x 14 ⁹⁄₁₆ in. (47.5 x 36.9 cm.)
Mount: 28 x 22 in. (71.2 x 56.0 cm.)
Signed, l.r. mount recto: "Liliane De Cock"
Inscription, mount verso: "Photograph by Liliane De Cock/Side gate—Laguna Pueblo Church, N. M. 1970"
Acquired from: the photographer

2105. **STORM NEAR HOWE, IDAHO** (P1974.23.3)
Gelatin silver print. 1969
Image: 14 ¹⁵⁄₁₆ x 19 ⅝ in. (38.0 x 49.9 cm.)
Mount: 22 x 27 ⅞ in. (56.0 x 70.9 cm.)
Signed, l.r. mount recto: "Liliane De Cock"
Inscription, mount verso: "PHOTOGRAPH BY LILIANE DE COCK/STORM Near Howe, Idaho 1969"
Acquired from: the photographer

*2106. **STORM NEAR SANTA FE, NEW MEXICO** (P1974.23.4)
Gelatin silver print. 1965
Image: 14 ⁷⁄₁₆ x 18 ⅛ in. (36.7 x 46.6 cm.)
Mount: 22 x 27 ½ in. (56.0 x 69.8 cm.)
Signed, l.r. mount recto: "Liliane De Cock"
Inscription, mount verso: "Photograph by Liliane De Cock/Storm near Santa Fe, New Mexico 1965"
Acquired from: the photographer

2107. **STORMFRONT, NEVADA** (P1974.23.1)
Gelatin silver print. 1970
Image: 19 ⅛ x 14 ¹⁵⁄₁₆ in. (49.1 x 38.0 cm.)
Mount: 27 ⅞ x 22 in. (70.9 x 56.0 cm.)
Signed, l.r. mount recto: "Liliane De Cock"
Inscription, mount verso: "Photograph by Liliane De Cock/Stormfront, Nevada 1970"
Acquired from: the photographer

GERI DELLA ROCCA DE CANDAL,
Italian (b. 1942)

An Italian freelance photographer, Della Rocca de Candal has made frequent photographic trips to the United States. He studied at the University of Milan before taking up photography in 1963. A number of his images have been exhibited in European and American galleries and published in photography and travel magazines. From 1976 to 1978 he produced a photographic essay entitled "Winter in Venice." His subsequent personal work has focused on an abstract interpretation of the urban landscape.

2108. **BROOKLYN BRIDGE—NEW YORK CITY** (P1977.69.3)
Gelatin silver print. negative 1968, print 1977
Image: 5 ⁵⁄₁₆ x 7 ⅞ in. (13.4 x 19.9 cm.)
Sheet: 9 ⁷⁄₁₆ x 12 ¹⁄₁₆ in. (24.0 x 30.6 cm.)
Signed, l.r. sheet recto and l.r. sheet verso: "Geri D R/de Candal"
Inscription, sheet recto: "New York City 1968"
print verso: "#6839NY7/32Ap//Brooklyn Bridge—New York City 1968"
Acquired from: the photographer

* 2109. **GENERAL POST OFFICE—NEW YORK CITY**
(P1977.69.4)
Gelatin silver print. negative 1972, print 1977
Image: 5⁵⁄₁₆ x 7⅞ in. (13.4 x 19.9 cm.)
Sheet: 9⁷⁄₁₆ x 12¹⁄₁₆ in. (24.0 x 30.6 cm.)
Signed, l.r. sheet recto and l.r. sheet verso: "Geri D R/de
Candal"
Inscription, sheet recto: "New York City 1972"
print verso: "#7243NY64/03A//General Post Office—New
York City 1972"
Acquired from: the photographer

2110. **LOWER MANHATTAN SKYLINE—NEW YORK CITY**
(P1977.69.5)
Gelatin silver print. negative 1968, print 1977
Image: 5⁵⁄₁₆ x 7⅞ in. (13.4 x 19.9 cm.)
Sheet: 9⁷⁄₁₆ x 12¹⁄₁₆ in. (24.0 x 30.6 cm.)
Signed, l.r. sheet recto and l.r. sheet verso: "Geri D R/de
Candal"
Inscription, sheet recto: "New York City 1968"
print verso: "#6836NY6/16A//Lower Manhattan Skyline—
New York City 1968"
Acquired from: gift of the photographer

2111. **MOJAVE DESERT, NEVADA [road]** (P1977.69.1)
Gelatin silver print. negative 1970, print 1977
Image: 5⁵⁄₁₆ x 7⅞ in. (13.4 x 19.9 cm.)
Sheet: 9⁷⁄₁₆ x 12¹⁄₁₆ in. (24.0 x 30.6 cm.)
Signed, l.r. sheet recto and l.r. sheet verso: "Geri D R/De
Candal"
Inscription, sheet recto: "Mojave Desert 1970"
print verso: "#7047US20/07A//Mojave Desert, Nevada
1970"
Acquired from: the photographer

2112. **MOJAVE DESERT, NEVADA [real estate sign]** (P1977.69.2)
Gelatin silver print. negative 1970, print 1977
Image: 7⅞ x 5⁵⁄₁₆ in. (19.9 x 13.4 cm.)
Sheet: 12¹⁄₁₆ x 9⁷⁄₁₆ in. (30.6 x 24.0 cm.)
Signed, l.r. sheet recto and l.r. sheet verso: "Geri D R/De
Candal"
Inscription, sheet recto: "Mojave Desert 1970"
print verso: "#7047US20/018A//Mojave Desert, Nevada
1970"
Acquired from: the photographer

ROBERT DEMACHY, French (1859–1936)

See *Camera Notes* and *Camera Work*

ADELAIDE DE MENIL,
American, born France (b. 1935)

Adelaide de Menil, a graduate of Sarah Lawrence Col-
lege, worked at the American Museum of Natural His-
tory, serving as staff photographer on an archaeological
expedition to Greece. She also worked with Magnum
Photo in Paris and has photographed in Brazil, Peru,
Japan, New Guinea, Cambodia, and Alaska. In 1971
Outerbridge and Dienstfrey published *Out of the Silence*,
a book of de Menil's photographs of Alaskan totem
poles, in conjunction with an exhibition of her photo-
graphs at the Amon Carter Museum.

2113. **HAIDA, HOWKAN, ALASKA** (P1972.12.13)
Gelatin silver print. 1968
Image: 16¹⁵⁄₁₆ x 11½ in. (43.0 x 29.2 cm.)
Sheet: 16¹⁵⁄₁₆ x 14 in. (43.0 x 35.6 cm.)
Inscription, print verso: "HAIDA/HOWKAN/
ALASKA//68-9-18L/15"
Acquired from: gift of the photographer

2097

2101

2106

2114. **HAIDA, KIUSTA, QUEEN CHARLOTTE ISLS.,**
BRITISH COLUMBIA (P1972.12.12)
Gelatin silver print. 1968
Image: 16¹⁵⁄₁₆ x 11½ in. (43.0 x 29.2 cm.)
Sheet: 16¹⁵⁄₁₆ x 14 in. (43.0 x 35.6 cm.)
Inscription, print verso: "HAIDA/KIUSTA/QUEEN
CHARLOTTE ISLS./BRITISH COLUMBIA//68-8-14F/6"
Acquired from: gift of the photographer

*2115. **HAIDA, OLD KASAAN, ALASKA** (P1972.12.9)
Gelatin silver print. 1966
Image: 16¹⁵⁄₁₆ x 11¹¹⁄₁₆ in. (43.0 x 29.6 cm.)
Sheet: 16¹⁵⁄₁₆ x 14 in. (43.0 x 35.6 cm.)
Inscription, print verso: "HAIDA/OLD KASAAN/
ALASKA//66-8-39J/7A"
Acquired from: gift of the photographer

2116. **HAIDA, SKEDANS, QUEEN CHARLOTTE ISLS.,**
BRITISH COLUMBIA (P1972.12.11)
Gelatin silver print. 1967
Image: 11½ x 16¹⁵⁄₁₆ in. (29.2 x 43.0 cm.)
Sheet: 14 x 16¹⁵⁄₁₆ in. (35.6 x 43.0 cm.)
Inscription, print verso: "HAIDA/SKEDANS/QUEEN
CHARLOTTE ISLS./BRITISH COLUMBIA//
67-8-18Y/20"
Acquired from: gift of the photographer

2117. **KWAKIUTL, BELLA BELLA, BRITISH COLUMBIA**
(P1972.12.8)
Gelatin silver print. 1967
Image: 16¹⁵⁄₁₆ x 11½ in. (43.0 x 29.2 cm.)
Sheet: 16¹⁵⁄₁₆ x 14 in. (43.0 x 35.6 cm.)
Inscription, print verso: "KWAKIUTL/BELLA BELLA/
BRITISH COLUMBIA//67-8-17C/12A"
Acquired from: gift of the photographer

2118. **KWAKIUTL, KINGCOME INLET, BRITISH COLUMBIA**
(P1972.12.3)
Gelatin silver print. 1967
Image: 11½ x 16¹⁵⁄₁₆ in. (29.2 x 43.0 cm.)
Sheet: 14 x 16¹⁵⁄₁₆ in. (35.6 x 43.0 cm.)
Inscription, print verso: "KWAKIUTL/KINGCOME INLET/
BRITISH COLUMBIA//67-7-16S/6A"
Acquired from: the photographer

2119. **KWAKIUTL, KINGCOME INLET, BRITISH COLUMBIA**
(P1972.12.4)
Gelatin silver print. 1967
Image: 16¹⁵⁄₁₆ x 11½ in. (43.0 x 29.2 cm.)
Sheet: 16¹⁵⁄₁₆ x 14 in. (43.0 x 35.6 cm.)
Inscription, print verso: "KWAKIUTL/KINGCOME INLET/
BRITISH COLUMBIA//67-7-16S/15"
Acquired from: the photographer

*2120. **KWAKIUTL, KINGCOME INLET, BRITISH COLUMBIA**
(P1972.12.5)
Gelatin silver print. 1967
Image: 16¹⁵⁄₁₆ x 11½ in. (43.0 x 29.2 cm.)
Sheet: 16¹⁵⁄₁₆ x 14 in. (43.0 x 35.6 cm.)
Inscription, print verso: "KWAKIUTL/KINGCOME INLET/
BRITISH COLUMBIA//67-7-16F/27"
Acquired from: the photographer

2121. **KWAKIUTL, PARK/CEMETERY, ALERT BAY,**
BRITISH COLUMBIA (P1972.12.6)
Gelatin silver print. 1967
Image: 11½ x 16⅞ in. (29.2 x 42.9 cm.)
Sheet: 14 x 16⅞ in. (35.6 x 42.9 cm.)
Inscription, print verso: "KWAKIUTL/PARK/CEMETARY
[sic]/ALERT BAY/BRITISH COLUMBIA//67-7-162/11A"
Acquired from: the photographer

2122. **TLINGIT, CAPE FOX, ALASKA** (P1972.12.1)
Gelatin silver print. 1966
Image: 16¹⁵⁄₁₆ x 11½ in. (43.0 x 29.3 cm.)
Sheet: 16¹⁵⁄₁₆ x 14 in. (43.0 x 35.6 cm.)

Inscription, print verso: "TLINGIT/CAPE FOX/
ALASKA//66-8-41Q/19"
Acquired from: the photographer

2123. **TLINGIT, CAPE FOX, ALASKA** (P1972.12.7)
Gelatin silver print. 1966
Image: 11½ x 16¹⁵⁄₁₆ in. (29.2 x 43.0 cm.)
Sheet: 14 x 16¹⁵⁄₁₆ in. (35.6 x 43.0 cm.)
Inscription, print verso: "TLINGIT/CAPE FOX/
ALASKA//66-8-41R/14A"
Acquired from: gift of the photographer

*2124. **TLINGIT, VILLAGE ISLAND, ALASKA** (P1972.12.2)
Gelatin silver print. 1966
Image: 16⅞ x 14¹⁄₁₆ in. (42.9 x 35.7 cm.)
Sheet: same as image size
Inscription, print verso: "TLINGIT/VILLAGE ISLAND/
ALASKA//66-7-38V/12A"
Acquired from: the photographer

2125. **TSIMSHIAN, KISPIOX, BRITISH COLUMBIA**
(P1972.12.10)
Gelatin silver print. 1967
Image: 11½ x 16¹⁵⁄₁₆ in. (29.2 x 43.0 cm.)
Sheet: 14 x 16¹⁵⁄₁₆ in. (35.6 x 43.0 cm.)
Inscription, print verso: "TSIMSHIAN/KISPIOX/BRITISH
COLUMBIA//67-8-19H/18A"
Acquired from: gift of the photographer

ADOLF DE MEYER,
American, born France (1868–1946)

See *Camera Work*

MARY DEVENS, English (active c. 1900)

See *Camera Notes*

RITA DEWITT, American (b. 1948)

Rita DeWitt was born in Covington, Kentucky, and
received her B.F.A. and M.F.A. from the University
of Alabama. She also studied with Todd Walker at the
Penland School of Crafts in 1979. DeWitt has taught at
the University of Southern Mississippi since 1977. In
1984 she received a National Endowment for the Arts
Fellowship Grant; in academic years 1987–89 she was
visiting artist at the School of the Art Institute of Chi-
cago. Her work consists primarily of manipulated color
images, which often include mixed-media collage and
Xerox color copier elements.

2126. **PREYING HANDS PURSUING FLOCK OF HEARTS**
[from the Society for Photographic Education's "South
Central Regional Photography Exhibition"] (P1983.31.4)
Hand colored gelatin silver print with applied foil labels. 1978
Image: 6¹⁄₁₆ x 9³⁄₁₆ in. (15.4 x 23.3 cm.)
Sheet: 7⅝ x 9⅝ in. (19.4 x 24.4 cm.)
Mount: 12 x 13¹⁵⁄₁₆ in. (30.5 x 35.4 cm.)
Signed, l.r. sheet recto: "Rita DeWitt © 1978"
Inscription, sheet recto: "Preying Hands Pursuing Flock of
Hearts"
Acquired from: gift of the Society for Photographic
Education, South Central Region

EDWARD R. DICKSON,
American (active 1910s–20s)

Edward R. Dickson attended the Clarence White
School. A founding member of the Pictorial Photog-
raphers of America, Dickson served as recording sec-

2109

2115

2120

2124

2128

retary and on the Executive Council. Articles and photographs by him appeared in the organization's publications, and his photographs were exhibited in its salons. Dickson and Karl Struss were editors of *Platinum Print.* Dickson died at an early age, and his work is not as well known as the work of some of his contemporaries.

2127. **[Tree branches and boat]** (P1984.1.685)
Platinum print. c. 1920
Image: 9½ x 7½ in. (24.1 x 19.0 cm.)
Signed, l.r. print recto: "ERD"
Acquired from: gift of the Dorothea Leonhardt Fund of the Communities Foundation of Texas, Inc., Dallas, Texas

RICK DINGUS, American (b. 1951)

Rick Dingus received his B.A. in fine arts from the University of California at Santa Barbara and his M.A. and M.F.A. in studio art—photography from the University of New Mexico. Best known for landscape photography, Dingus has received numerous grants, including three Ford Foundation Grants (1977, 1978, 1979) and a Special Projects Grant from the Graduate School of the University of New Mexico (1979). He also participated in the exhibition "Marks and Measures: Rock Art in Modern Art Context" and the Rephotographic Survey Project, photographing sites in the Southwest originally photographed by nineteenth-century expeditionary photographers. Dingus has written, contributed to, or coordinated several published books and articles. He also has taught at the University of New Mexico, New Mexico Tech, University of Colorado at Boulder, and Texas Tech University.

*2128. **MARKING THE PASSAGE, THREE RIVERS, NM** (P1986.21)
Gelatin silver print and graphite. 1983—86
Image: 16 x 20 in. (40.7 x 50.8 cm.)
Signed, center print verso: "Rick Dingus, 1983—86"
Inscription, print verso: "Marking the Passage, Three Rivers, NM"
Acquired from: Etherton Gallery, Tucson, Arizona

WESLEY DISNEY, American (b. 1946)

A Vermont photographer and instructor, Wes Disney is a 1968 graduate of Oberlin College. He was artist in residence at the University of Vermont in 1975 and has since taught at the School of Visual Arts in New York City and at the Zone VI Photography Workshops in Putney, Vermont. Disney has also served as a member of the Vermont Council for the Arts advisory panel. Since 1978 Disney has made photographs, including several large panoramic prints, but has concentrated primarily on painting and sculpture.

2129. **SUNRISE—RAINBOW QUICKSILVER MINE** (P1979.3)
Gelatin silver print and black tape (six-print panorama). negative 1977, print 1979
Image: 7⅞ x 57 in. (20.0 x 144.7 cm.)
Mount: 15⅞ x 74 in. (40.3 x 188.0 cm.)
Signed, l.r. mount recto: "Wes Disney"
Inscription, print recto: "SUNRISE—RAINBOW QUICKSILVER MINE, 1977"
Acquired from: the photographer

2130. **THREE PIONEERING WESTERN WOMEN** (P1979.4)
Gelatin silver print and ink. c. 1979
Image: 10½ x 13½ in. (26.7 x 34.3 cm.)
Sheet: 11 x 14 in. (28.0 x 35.6 cm.)
Acquired from: gift of the photographer

ROBERT DISRAELI,
American, born Germany (1905—1988)

Robert Disraeli, a native of Cologne, Germany, immigrated to the United States in 1913. During the 1920s and 1930s he worked for a New York motion picture company and a commercial photographer before beginning work as a freelance photographer. His work was published in *Life, Look, Fortune, Vogue, Vanity Fair,* and other magazines. Influenced by the work of Moholy-Nagy, Disraeli experimented with still photography, producing photograms and montages during the 1920s. His photographic images were among those exhibited by Julien Levy, a New York dealer noted for his promotion of avant-garde photography. In 1939 Disraeli moved to California and began a career as a filmmaker, writer, and photographer working for the Metro Goldwyn Mayer studio.

*2131. **MOVING UPWARD!** (P1983.8)
Toned gelatin silver print (photogram). 1929
Image: 9⁹⁄₁₆ x 6⁵⁄₁₆ in. (24.3 x 16.0 cm.)
Signed: see inscription
Inscription, print verso: "OW Float" and rubber stamp "Robert Disraeli"
Acquired from: Prakapas Gallery, New York

NELL DORR, American (1893—1989)

Nell Dorr's father, John Becker, was a photographer for the B & O Railroad. Dorr began photographing as a child and opened her own studio in Florida during the 1920s. She moved to New York during the 1930s, where she ran a studio and participated in several exhibitions, including the 1955 Museum of Modern Art show "The Family of Man." Her romantic photographs were made using only available light and have appeared in several books of her work, including *In a Blue Moon* (1939), *Mother and Child* (1954, 1972), *The Bare Feet* (1962), and *Of Night and Day* (1967).

*2132. **HAPPINESS** [from *Mother and Child*] (P1981.77)
Gelatin silver print. negative 1940, print later
Image: 13⅞ x 10¹³⁄₁₆ in. (35.3 x 27.4 cm.)
Sheet: 14 x 11 in. (35.6 x 28.0 cm.)
Signed, l.r. print recto: "Nell Dorr"
Acquired from: Marcuse Pfeifer Gallery, New York, New York

A. RADCLYFFE DUGMORE (1870—after 1900s)

See *Camera Work*

JOHN E. DUMONT,
American (active late 19th century)

See *Camera Notes*

WILLIAM B. DYER, American (1860—1931)

See *Camera Notes*

THOMAS EAKINS, American (1844—1916)

Thomas Eakins is best known as one of America's foremost painters, but he was interested in photography throughout his life. He used a 4 x 5 inch camera to make his photographs, many of which are of family and friends. From the early 1880s Eakins used photographs

as visual aids for painting, particularly to study the body and its movements. However, several of his photographs were intended to be complete works of art in their own right.

2131

*2133. **WILLIAM H. MACDOWELL** (P1981.90)
Platinum print. 1884
Image: 3 9/16 x 2 9/16 in. (9.0 x 6.4 cm.)
Mount: 8 x 5 7/16 in. (20.4 x 13.7 cm.)
Acquired from: Edwynn Houk Gallery, Chicago, Illinois

MICHAEL EASTMAN, American (b. 1947)

Self-taught as a photographer, Michael Eastman, a native of St. Louis, Missouri, has also worked with metal sculpture, collage, and photographic silkscreen. Although he did commercial art work for twelve years, in 1984 he shifted his emphasis to personal work. He has described his images as "more painterly than photographic. . . . I see the world as full of sculpture and paintings and record them."

2134. **MARCELLA'S RESORT** (P1984.12)
Ektacolor print. 1983
Image: 10 x 18 3/4 in. (25.4 x 47.8 cm.)
Sheet: 16 x 20 in. (40.7 x 50.8 cm.)
Signed, l.r. sheet recto: "Michael Eastman 1983"
Inscription, sheet recto: "Marcella's Resort// 14/50"
Acquired from: gift of the photographer in honor
 of Etta Taylor

TOM ECKSTROM, American (b. 1950)

Tom Eckstrom was born in New Haven, Connecticut, and received a B.A. from the San Francisco Art Institute in 1972. He was Imogen Cunningham's assistant from 1975 until her death in 1976 and assisted with her book *After Ninety*. Eckstrom has worked as a freelance photographer since 1973.

2132

*2135. **IMOGEN [Imogen Cunningham]** (P1978.21)
Gelatin silver print. 1976
Image: 9 x 6 13/16 in. (22.8 x 17.3 cm.)
Mount: 14 1/2 x 11 1/2 in. (36.8 x 29.2 cm.)
Signed, l.r. mount recto: "TE/76"
Inscription, mount verso, rubber stamps: "CREDIT TO:
 TOM ECKSTROM/946A GREENWICH STREET/SAN
 FRANCISCO, CA 94133//ALL REPRODUCTION
 RIGHTS/RESERVED BY THE PHOTOGRAPHER"
Acquired from: Halsted Gallery, Birmingham, Michigan

HAROLD E. EDGERTON,
American (1903–1990)

Trained as an electrical engineer at the University of Nebraska, Harold Edgerton was an innovator in the field of high-speed, stroboscopic photography. He worked for General Electric from 1925 to 1926 and then pursued advanced degrees at the Massachusetts Institute of Technology. His studies at MIT focused on the light-emitting discharge of gas-filled tubes stimulated by high-voltage electric charges. This work provided the technical basis for the development of photographic electronic flash units. Edgerton's own work reflects his interest in high-speed, stop-action photography, and his most famous images document split-second action. He won many awards for his achievements, including the United States Medal of Science and the Royal Photographic Society of London's Silver Medal, and his work appeared in several publications.

2133

Harold Edgerton and Kim Vandiver

2136. **BULLET THRU FLAME** (P1985.46)
Dye-transfer print. 1973
Image: 18 ¼ x 12 ³/₁₆ in. (46.3 x 31.0 cm.)
Sheet: 20 x 16 in. (50.8 x 40.7 cm.)
Signed, l.r. sheet recto: "HAROLD EDGERTON"
Acquired from: gift of James P. Harrington, West Chester,
Pennsylvania

2137. **CUP ON FLOOR** (P1985.33)
Gelatin silver print. c. 1938
Image: 6 ⁹/₁₆ x 8 ⁹/₁₆ in. (16.6 x 21.7 cm.)
Sheet: 8 x 10 in. (20.3 x 25.4 cm.)
Mount: 8 ¹/₁₆ x 10 in. (20.4 x 25.4 cm.)
Signed: see inscription
Inscription, mount verso: "[covered by brown paper]
T Photo/8 x 10- 8513//cup on floor./Harold Edgerton/
M.I.T./Taken about 1938±."
Acquired from: Paul Katz, North Bennington, Vermont

*2138. **HOME BREW** [rodeo cowboy] (P1984.17)
Gelatin silver print. negative 1949, print later
Image: 17 x 14 ⅛ in. (43.2 x 35.9 cm.)
Sheet: 19 ⅞ x 16 ¹/₁₆ in. (50.5 x 40.8 cm.)
Signed, l.r. print verso: "HAROLD EDGERGTON"
Acquired from: Janet Lehr, Inc., New York, New York

2139. **TENNIS—FOREHAND DRIVE, JENNY TUCKEY**
(P1986.12)
Gelatin silver print. negative 1938, print c. 1986
Image: 9 ¹¹/₁₆ x 12 ¹⁵/₁₆ in. (24.6 x 32.8 cm.)
Sheet: 10 ¹⁵/₁₆ x 14 in. (27.8 x 35.5 cm.)
Signed, bottom center print verso: "HAROLD EDGERTON"
Inscription, print verso: "4903.575"
Acquired from: Friends of Photography, Carmel, California;
gift print with sustaining membership, 1986

JOHN PAUL EDWARDS, American (1883–1958)

John Paul Edwards was a serious amateur photographer
who began his career as a pictorialist but, through asso-
ciation with Edward Weston, Willard Van Dyke, and
Imogen Cunningham, shifted to a more straightforward
style. He exhibited his photographs with Group f/64 in
1932. Trained as an engineer at the University of Min-
nesota in his home town of Minneapolis, Edwards
learned photography to help his father document family
mining interests. He moved to Sacramento, California,
in 1907 and took a job in retail merchandising. While
living in Sacramento he photographed for his own plea-
sure; the images were primarily portraits and soft-focus
landscapes printed on chloride and bromide papers. He
moved to San Francisco in 1922 to work as a buyer for
the Hale Brothers Department Store. The job required
that he make periodic buying trips to New York and
Europe, which gave him the opportunity to photograph
New York's buildings and European towns and villages.
During this period he experimented with bromoil and
bromoil transfer printing processes. Edwards was an
active participant in local camera clubs, frequently ex-
hibiting his prints and contributing to journals such as
Camera Craft. During the early 1930s Edwards' images
became more sharply focused and his subject matter
typically dealt with buildings and architectural details.

*2140. **CROSSING THE OCEAN** [Stern of the Mauretania]
(P1984.29.27)
Chloride or bromide print. c. 1920s
Image: 13 ¾ x 10 ⅝ in. (34.9 x 27.0 cm.)
Sheet: 13 ¹⁵/₁₆ x 10 ¹⁵/₁₆ in. (35.3 x 27.8 cm.)
Inscription, print verso: "Crossing the ocean"
Acquired from: Willard Van Dyke, Santa Fe, New Mexico

*2141. **DECK SPORTS** (P1984.29.23)
Bromoil print. 1926
Image: 11 ³/₁₆ x 9 in. (28.4 x 22.9 cm.) sight size
Mount: 18 ¾ x 15 ¹³/₁₆ in. (47.5 x 40.1 cm.)
Signed, l.r. overmat: "JOHN PAUL EDWARDS"
Inscription, overmat: "833/USA 1926"
mount verso: "E4//#1//[illegible]/A//Deck Sports//PRINT
BY//John Paul Edwards/1347 Cavanagh Road/Oakland//
$15.00//230-E/#793- 74//#3//533//88//1059//212//4//2758"
and printed paper labels "This Certifies/that THIS PRINT
WAS ONE of/three hundred and thirteen/prints exhibited
at the/Eleventh/International/Salon of Photography/held by
the/Camera Pictorialist/of Los Angeles, California/January
third to thirty first/1928" and "PPS/SAN FRANCISCO/
ACCEPTED/Fourth International/Exhibition/San
Francisco/1926 (Catalogue Number/78)" and "third/
chicago/international/photographic/salon/chicago/art/
institute/1931"
Acquired from: Willard Van Dyke, Santa Fe, New Mexico

2142. **A DWELLER IN THE ALLEYS** [passageway in a European
city] (P1984.29.15)
Bromoil print. c. 1924
Image: 11 ⅝ x 9 ⅞ in. (29.5 x 23.9 cm.)
Sheet: 12 x 9 ⅞ in. (30.3 x 25.1 cm.)
Mount: 19 ⅝ x 15 ¾ in. (49.8 x 40.0 cm.)
Signed, l.r. overmat: "JOHN PAUL EDWARDS"
Inscription, mount verso: "9 "A Dweller in the Alleys"/John
Paul Edwards"
note: the inscription is upside down; this may be a reused
mount
Acquired from: Willard Van Dyke, Santa Fe, New Mexico

*2143. **FOUR PINES OF CARMEL** (P1984.29.34)
Chloride print. c. 1923–24
Image: 13 ⁹/₁₆ x 10 ½ in. (34.3 x 26.7 cm.)
Mount: 19 ¹⁵/₁₆ x 16 ¹/₁₆ in. (50.5 x 40.9 cm.)
Signed, l.r. print recto: "JOHN PAUL EDWARDS"
Inscription, mount recto: "U.S.A."
mount verso: "Mounted $10.00//make cut 3 ¼ x 5 ¼//#864/
A//B//202/528" and printed paper label "PSP/OF SAN
FRANCISCO/Number 6/price £ 2-0-0/Title: Four Pines of
Carmel/Process: Chloride/By John Paul Edwards/Address:
1347 Cavanagh Road/Oakland—California/MEMBER OF
THE PICTORIAL PHOTOGRAPHIC SOCIETY/OF
SAN FRANCISCO"
Acquired from: Willard Van Dyke, Santa Fe, New Mexico

2144. **FROM THE PANTHEON—PARIS** (P1984.29.17)
Bromoil print. c. 1923–24
Image: 9 ⁹/₁₆ x 11 ⁵/₁₆ in. (24.2 x 28.7 cm.)
Sheet: 9 ¹⁵/₁₆ x 12 in. (25.2 x 30.4 cm.)
Mount: 19 ⅞ x 16 in. (50.5 x 40.7 cm.)
Signed, l.r. overmat: "JOHN PAUL EDWARDS."
Inscription, mount verso: "# 4/FROM THE PANTHEON—/
PARIS./JOHN PAUL EDWARDS/1347 TRESTLE GLEN
ROAD/OAKLAND//#150//$15.00"
Acquired from: Willard Van Dyke, Santa Fe, New Mexico

*2145. **THE GARGOYLE** [Le Gargoyle] (P1984.29.7)
Chloride print. c. 1923
Image: 10 ¼ x 13 ⁵/₁₆ in. (26.0 x 33.8 cm.)
1st mount: 10 ¹⁵/₁₆ x 13 ¹⁵/₁₆ in. (27.7 x 35.4 cm.)
2nd mount: 14 ¼ x 16 ¹³/₁₆ in. (36.1 x 42.7 cm.) irregular
Signed, l.r. 2nd mount recto: "JOHN PAUL EDWARDS"
Inscription, 2nd mount verso: "JOHN PAUL
EDWARDS/1347 Cavanagh Road/Oakland/Calif.//A//
Very good—/Judges gave it/highest award//L//The
Gargoyle//15.00//408//10 ½ x 13 ¼/Main court—very/
dark browns in places.//Picture taken from/cathedral
tower" and rubber stamp "PITTSBURGH/SALON OF/
PHOTOGRAPHY/1923/PPS" and printed on paper label
"EXHIBITED/SEATTLE/SALON/1925/FREDERICK &
NELSON" and remnants of printed paper labels from
Pictorial Photographic Society of San Francisco, 1925 (?),
Pictorial Photographers of America, New York City, 1923,
California Camera Club, n.d., and unidentified label
Acquired from: Willard Van Dyke, Santa Fe, New Mexico

2135

2138

2140

2141

2143

2145

2146. **HALF DOME, YOSEMITE VALLEY** (P1984.29.30)
Chloride or bromide print. c. 1920s
Image: 13 7/16 x 10 7/16 in. (34.1 x 26.5 cm.)
Mount: 20 x 16 in. (50.8 x 40.7 cm.)
Signed, l.r. print recto: "JOHN PAUL EDWARDS"
Inscription, mount recto: "107. U.S.A./Half Dome Yosemite
 Valley"
 mount verso: "15/Half Dome/15.00"
Acquired from: Willard Van Dyke, Santa Fe, New Mexico

*2147. **HANGMAN'S BRIDGE—NUREMBERG** (P1984.29.8)
duplicate of P1984.29.9
Bromoil print. c. 1924
Image: 11 5/8 x 8 3/4 in. (29.2 x 22.2 cm.)
Mount: 20 x 16 in. (50.8 x 40.7 cm.)
Signed, l.r. overmat: "JOHN PAUL EDWARDS/25. [sic]"
Inscription, overmat: "NURENBERG [sic]"
 mount verso: "To/Willard Van Dyke/with the regards of/
 John Paul Edwards/Christmas 1926.//#3 "Hangman's
 Bridge"—/Nürenberg [sic]./John Paul Edwards/1347
 Cavanagh Road/Oakland/Calif.//A//#77//16 x 20"
 and rubber stamp "PITTSBURGH/SALON OF/
 PHOTOGRAPHY/—1925—//15.00/If sold—cannot
 be/delivered before Art Center/P.P.A. Exhibition"
Acquired from: Willard Van Dyke, Santa Fe, New Mexico

2148. **HANGMAN'S BRIDGE, NUREMBERG, GERMANY**
(P1984.29.9) duplicate of P1984.29.8
Bromoil print. c. 1924
Image: 11 5/8 x 8 5/8 in. (29.6 x 21.9 cm.)
Sheet: 11 15/16 x 9 15/16 in. (30.3 x 25.2 cm.)
Mount: 20 x 16 in. (50.8 x 40.7 cm.)
Signed, l.r. overmat: "JOHN PAUL EDWARDS"
Inscription, overmat: "Hangman's Bridge Nuremberg
 Germany"
 mount verso: "Hangman's Bridge/Nuremberg Germany"
Acquired from: Willard Van Dyke, Santa Fe, New Mexico

2149. **HILLS OF CALIFORNIA** [Design for a Tapestry]
(P1984.29.20)
Chloride or bromide print. c. 1919
Image: 13 1/8 x 10 1/2 in. (34.0 x 26.7 cm.)
Mount: 17 1/4 x 13 9/16 in. (43.8 x 34.4 cm.) irregular
Signed, top center mount verso: "JOHN PAUL EDWARDS"
Inscription, mount recto: "1"
 mount verso: "[Ori]GINAL/[N]OT FOR SALE/
 [Duplicat]ES $25.00//#1 HILLS OF CALIFORNIA/
 [signature]/1347 TRESTLE GLEN ROAD/OAKLAND/
 CALIF." and printed paper labels "100" and "EXHIBITED
 AT/THE/LONDON SALON/OF PHOTOGRAPHY/1924
 [sic]"
Acquired from: Willard Van Dyke, Santa Fe, New Mexico

2150. **HOUSE TOPS—A PATTERN** (P1984.29.4)
Chloride or bromide print. c. 1920
Image: 13 9/16 x 10 9/16 in. (34.3 x 26.8 cm.)
1st mount: 14 x 11 in. (35.6 x 28.0 cm.)
2nd mount: 19 15/16 x 16 in. (50.6 x 40.7 cm.)
Signed, top center 2nd mount verso: "John Paul Edwards."
Inscription, 2nd mount recto: "c"
 2nd mount verso: "[illeg] House Tops [illeg]/
 [signature]/Save for collection" and rubber stamp
 "INTERNATIONAL SALON/Los Angeles, California,
 U.S.A./No. [in ink] 66"
Acquired from: Willard Van Dyke, Santa Fe, New Mexico

*2151. **IN GREENWICH VILLAGE** (P1984.29.25)
Chloride print. c. 1921
Image: 13 9/16 x 10 9/16 in. (34.4 x 26.7 cm.)
Mount: 20 7/8 x 16 3/16 in. (53.0 x 41.2 cm.)
Signed, l.r. mount recto: "JOHN PAUL EDWARDS"
Inscription, mount recto: "In Greenwich Village/S New York"
 mount verso, on printed paper label: "#2/PSP/OF SAN
 FRANCISCO/Number IV IV/Price $10.00/Title "In

Greenwich Village"/Process Chloride/By John Paul
Edwards/Address 1347 Cavanagh Road/Oakland/Calif./
MEMBER OF THE/PICTORIAL PHOTOGRAPHIC
SOCIETY/OF SAN FRANCISCO" and rubber stamp
"EXHIBITION OF THE/PICTORIAL PHOTOGRAPHERS
OF AMERICA/ART CENTER/NEW YORK CITY/NO. "
Acquired from: Willard Van Dyke, Santa Fe, New Mexico

*2152. **[Iron hinge on a wooden door]** (P1984.29.43)
Gelatin silver print. c. 1930s
Image: 9 9/16 x 7 1/2 in. (24.6 x 19.1 cm.)
Mount: 18 x 14 in. (45.7 x 35.6 cm.)
Signed, l.r. mount recto: "JOHN PAUL EDWARDS"
Acquired from: Willard Van Dyke, Santa Fe, New Mexico

*2153. **LANDSCAPE JAPANESQUE, DESOLATION VALLEY**
[Desolation Valley Near Lake Tahoe] (P1984.29.33)
Chloride or bromide print. c. 1920s
Image: 13 9/16 x 10 11/16 in. (34.4 x 27.1 cm.)
Mount: 20 x 16 in. (50.8 x 40.7 cm.)
Signed, l.r. print recto: "JOHN PAUL EDWARDS"
Inscription, mount recto: "20/Landscape Japanesque/
 Desolation Valley"
 mount verso: "To Will//DESOLATION VALLEY/NEAR
 LAKE TAHOE"
Acquired from: Willard Van Dyke, Santa Fe, New Mexico

2154. **THE LITTLE CHURCH ACROSS THE RIVER** [Little
Church of the Sacramento River] (P1984.29.1)
Chloride print. c. 1919
Image: 11 5/8 x 8 5/8 in. (29.5 x 22.0 cm.)
1st mount: 12 1/8 x 9 1/8 in. (30.8 x 23.2 cm.)
2nd mount: 19 15/16 x 14 7/8 in. (50.7 x 37.8 cm.)
Signed, l.r. 2nd mount recto: "JOHN PAUL EDWARDS"
Inscription, 2nd mount recto: "13//U.S.A./c./The Little
 Church Across the River"
 2nd mount verso: "Chloride Print/by/John Paul Edwards/
 Sacramento.//72/Little Church/of the Sacramento/
 River//31//London Salon/Pittsburgh Salon/Yonkers/Toronto/
 Montreal//H" and rubber stamp "INTERNATIONAL
 SALON/Los Angeles, California, U.S.A./Jan'y No.72 1919"
Acquired from: Willard Van Dyke, Santa Fe, New Mexico

2155. **THE LOW MAN ON THE TOTEM POLE** (P1984.29.41)
Gelatin silver print. 1942
Image: 13 3/16 x 10 3/16 in. (33.5 x 25.9 cm.)
Mount: 20 x 16 in. (50.8 x 40.7 cm.)
Signed, l.r. mount recto: "JOHN PAUL EDWARDS/42."
Inscription, mount verso: "THE LOW MAN/ON/THE
 TOTEM POLE/JOHN PAUL EDWARDS/1347 TRESTLE
 GLEN ROAD/OAKLAND//15-1//203" and on printed
 paper label "SAN FRANCISCO MUSEUM OF ART/
 EXHIBITION BAY AREA CAMERA CLUBS/ARTIST
 JOHN PAUL EDWARDS/TITLE THE LOW MAN ON
 THE TOTEM POLE/No. 6793.42 DATE IN 11/22/42/
 LENDER/ADDRESS"
Acquired from: Willard Van Dyke, Santa Fe, New Mexico

2156. **MISSION SAN JUAN BAUTISTA** (P1984.29.6)
Bromoil print. c. 1923
Image: 11 5/8 x 9 9/16 in. (29.5 x 24.3 cm.)
Sheet: 11 7/8 x 10 in. (30.1 x 25.4 cm.)
Mount: 19 3/4 x 15 3/4 in. (50.2 x 40.0 cm.)
Signed, l.r. overmat: "JOHN PAUL EDWARDS"
Inscription, overmat: "U.S.A."
 mount verso: "MISSION/SAN JUAN BAUTISTA" and
 remnant of label from The John Wanamaker Exhibition of
 Photographs, Philadelphia, n.d.
 note: this may be a reused mount as the label seems to refer
 to another photograph
Acquired from: Willard Van Dyke, Santa Fe, New Mexico

2147

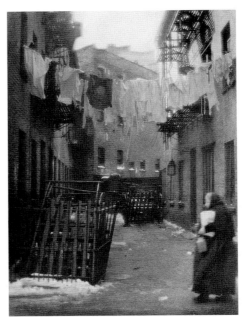

2151

2152

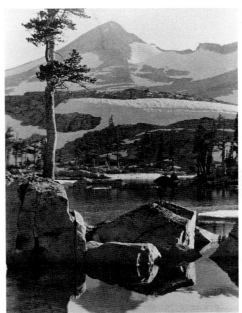

2153

2157. **MITCHLER'S HOTEL, MURPHYS** [Murphys, California]
(P1984.29.42)
Gelatin silver print. 1942
Image: 12 7/8 x 10 1/16 in. (32.7 x 25.6 cm.)
Mount: 20 x 16 in. (50.8 x 40.7 cm.)
Signed, l.r. mount recto: "JOHN PAUL EDWARDS/42"
Inscription, mount verso: "MITCHLER'S HOTEL/
MURPHY'S [sic]/JOHN PAUL EDWARDS/1347
TRESTLE GLEN ROAD/OAKLAND//16-1//203" and
on printed paper label "SAN FRANCISCO MUSEUM
OF ART/EXHIBITION [typed] BAY AREA CAMERA
CLUBS/ARTIST [typed] JOHN PAUL EDWARDS/TITLE
[typed] MITCHEL [sic] HOTEL/no. 6790.42/DATE IN
[typed] 11/22/42/LENDER/ADDRESS"
Acquired from: Willard Van Dyke, Santa Fe, New Mexico

2158. **MONTEREY BAY** (P1984.29.22)
Chloride or bromide print. c. 1924
Image: 13 x 10 7/16 in. (33.0 x 26.5 cm.)
Mount: 20 x 16 in. (50.8 x 40.7 cm.)
Signed, l.r. mount recto: "JOHN PAUL EDWARDS"
Inscription, mount recto: "c"
mount verso: "Monterey Bay/John Paul Edwards//Save for
collection// 10.00" and rubber stamp "EXHIBITION OF
THE/PICTORIAL PHOTOGRAPHERS OF AMERICA/
ART CENTER/[in ink] OCT 1924/NEW YORK CITY"
Acquired from: Willard Van Dyke, Santa Fe, New Mexico

*2159. **A MONTEREY MORNING** (P1984.29.21)
Chloride print. c. 1924
Image: 13 1/4 x 10 9/16 in. (33.7 x 26.9 cm.)
Mount: 19 15/16 x 16 in. (50.6 x 40.7 cm.)
Signed, l.r. mount recto: "JOHN PAUL EDWARDS"
Inscription, mount verso: "2//350//#4//3//A Monterey
Morning/JOHN PAUL EDWARDS/1347 CAVANAGH
ROAD/OAKLAND//J/Taken in Desolation—tree at/or/
near Desolation/end.//Chloride//10-12—original//Lake
Tahoe//Branch of lake/in Desolation/Valley.//A/88//
Original/not for sale—/Duplicates $10.00/Mildred wants
2//16 x 20" and rubber stamps "EXHIBITION OF THE/
PICTORIAL PHOTOGRAPHERS OF AMERICA/ ART
CENTER/[in ink] OCT. 1924/NEW YORK CITY" and
"PITTSBURGH/SALON OF/PHOTOGRAPHY/1924/
PPS" and printed paper label "THE TORONTO
SALON/ 1926/THIRTY-FIFTH ANNUAL SALON/
OF PICTORIAL PHOTOGRAPHY/HELD AT THE/
CANADIAN NATIONAL EXHIBITION/TORONTO.
CANADA/August Twenty Eighth - September Eleventh/
Under...the...direction...of/THE TORONTO CAMERA
CLUB/Affiliated with the Royal Photographic Society of
Great Britain/ONE This print Accepted/1926" and two
remnants of unidentified labels
Acquired from: Willard Van Dyke, Santa Fe, New Mexico

2160. **NUREMBERG** [buildings by waterside] (P1984.29.11)
Bromoil print. c. 1924
Image: 11 1/2 x 8 in. (29.1 x 20.3 cm.)
Sheet: 12 x 10 in. (30.5 x 25.4 cm.)
Mount: 19 3/4 x 15 3/4 in. (50.2 x 40.0 cm.)
Signed, l.l. overmat: "JOHN PAUL EDWARDS"
note: signature may not be in Edwards' hand
Inscription, overmat: "Nurenberg [sic]"
Acquired from: Willard Van Dyke, Santa Fe, New Mexico

2161. **NUREMBERG** [stucco and wooden buildings by waterside]
(P1984.29.12)
Bromoil print. c. 1924
Image: 12 1/16 x 9 3/8 in. (30.6 x 23.8 cm.)
Sheet: 12 1/16 x 10 in. (30.6 x 25.4 cm.)
Mount: 20 x 16 in. (50.8 x 40.7 cm.)
Signed, l.l. overmat: "JOHN PAUL EDWARDS"
note: signature may not be in Edwards' hand
Inscription, overmat: "Nurenberg [sic]"
mount recto: "JOHN PAUL EDWARDS"
note: this appears to be a reused mount
Acquired from: Willard Van Dyke, Santa Fe, New Mexico

Attributed to John Paul Edwards or W. H. Rabe
*2162. [Older man with horse and hay wagon in tree-shaded lane]
(P1984.29.38)
Platinum print. c. 1910–20
Image: 7 11/16 x 13 1/8 in. (19.6 x 33.3 cm.)
1st mount: 8 5/8 x 13 1/2 in. (21.9 x 34.3 cm.)
2nd mount: 13 1/2 x 19 1/8 in. (34.2 x 48.6 cm.)
Signed, l.r. 2nd mount recto: "JOHN PAUL EDWARDS"
note: signature may not be in Edwards' hand
Inscription, 2nd mount recto: "W. H. Rabe"
Acquired from: Willard Van Dyke, Santa Fe, New Mexico

*2163. **ON COAST NEAR CARMEL** (P1984.29.28)
Chloride or bromide print. c. 1920s
Image: 11 5/8 x 9 1/2 in. (29.4 x 24.1 cm.)
Mount: 12 1/16 x 9 15/16 in. (30.6 x 25.2 cm.)
Signed, u.r. mount verso: "By/John Paul Edwards"
note: signature may not be in Edwards' hand
Inscription, mount verso: "On Coast near Carmel"
Acquired from: Willard Van Dyke, Santa Fe, New Mexico

2164. **PARIS** (P1984.29.16)
Bromoil print. c. 1923
Image: 11 3/4 x 9 1/2 in. (29.8 x 24.1 cm.)
Sheet: 11 15/16 x 9 15/16 in. (30.3 x 25.2 cm.)
Mount: 19 9/16 x 15 3/4 in. (49.5 x 39.9 cm.)
Signed, l.r. overmat and l.r. mount recto: "JOHN PAUL
EDWARDS"
Inscription, mount verso: "#4/"PARIS"/JOHN PAUL
EDWARDS/1347 Trestle Glen Road/OAKLAND/
CALIFORNIA.//E-1"
Acquired from: Willard Van Dyke, Santa Fe, New Mexico

2165. **PIONEER BARN** (P1984.29.39)
Gelatin silver print. 1938
Image: 6 7/8 x 8 5/16 in. (17.5 x 21.2 cm.)
Mount: 17 1/8 x 14 in. (43.5 x 35.6 cm.)
Signed, l.r. mount recto: "JOHN PAUL EDWARDS/'38"
Inscription, mount verso: "#1/PIONEER BARN/JOHN
PAUL EDWARDS/1347 TRESTLE GLEN ROAD/
OAKLAND/CALIF//$10.00" and rubber stamp with
pencil "Pkge No. 65/Print No. 1/section 2"
Acquired from: Willard Van Dyke, Santa Fe, New Mexico

*2166. **PIONEER'S CABIN** (P1984.29.40)
Gelatin silver print. 1941
Image: 13 1/4 x 10 1/2 in. (33.6 x 26.6 cm.)
Mount: 20 x 16 in. (50.8 x 40.7 cm.)
Signed, l.r. mount recto: "JOHN PAUL EDWARDS/41."
Inscription, mount verso: "PIONEER'S CABIN/JOHN PAUL
EDWARDS/1347 TRESTLE GLEN ROAD/OAKLAND//1"
Acquired from: Willard Van Dyke, Santa Fe, New Mexico

2167. [Pyramid Lake, Desolation Valley—landscape with tree and
lake] (P1984.29.35)
Chloride or bromide print. c. 1920s
Image: 13 3/16 x 10 1/2 in. (33.4 x 26.7 cm.)
Mount: 18 5/16 x 13 7/16 in. (46.5 x 34.1 cm.)
Signed, l.r. print recto: "JOHN PAUL EDWARDS"
Acquired from: Willard Van Dyke, Santa Fe, New Mexico

2168. **PYRAMID PEAK** [The Glory of the Heights] (P1984.29.31)
Chloride or bromide print. c. 1920s
Image: 10 5/8 x 13 9/16 in. (27.0 x 34.5 cm.)
Mount: 20 x 16 in. (50.8 x 40.7 cm.)
Signed, l.r. print recto and l.r. mount recto: "JOHN PAUL
EDWARDS"
Inscription, mount recto: "U.S.A./2 Pyramid Peak USA/
The Glory of the Heights"
mount verso: "PYRAMID PEAK/By JOHN PAUL
EDWARDS/1347 TRESTLE GLEN ROAD/OAKLAND//
Bromoil [sic]//THIS PRINT OR COPIES $15.00"
Acquired from: Willard Van Dyke, Santa Fe, New Mexico

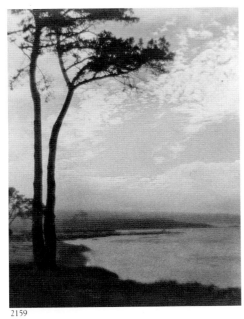

2159

2162

2163

2166

2171

2172

2169. **ROTHENBERG** [view of street from rooftop, probably Rothenburg, Germany] (P1984.29.14)
Bromide print. c. 1923–26
Image: 12 x 9¹³⁄₁₆ in. (30.5 x 24.9 cm.)
Mount: 20 x 16 in. (50.8 x 40.7 cm.)
Signed, l.r. mount recto: "JOHN PAUL EDWARDS"
Inscription, mount verso: "#5/Rothenberg/John Paul Edwards/1347 Cavanagh Road/Oakland/Calif./on/Dassonville/Charcoal Black.//Save for collection" and remnant of a label from California Camera Club, n.d.
Acquired from: Willard Van Dyke, Santa Fe, New Mexico

2170. **ST. FRANCIS OF THE MOUNTAINS AT THE CROSSROADS** (P1984.29.36)
Chloride or bromide print. c. 1920s
Image: 12¹¹⁄₁₆ x 10⁹⁄₁₆ in. (32.2 x 26.8 cm.)
Mount: 19¹³⁄₁₆ x 16 in. (50.2 x 40.7 cm.)
Signed, l.r. print recto: "JOHN PAUL EDWARDS"
Inscription, mount recto: "U.S.A.//49./St. Francis of the Mountains/At the Crossroads"
mount verso: "No 2."
Acquired from: Willard Van Dyke, Santa Fe, New Mexico

*2171. [Shoppers in open air market] (P1984.29.19)
Bromoil print. c. 1924
Image: 9⁹⁄₁₆ x 11¹¹⁄₁₆ in. (24.2 x 29.6 cm.)
Sheet: 9¹⁵⁄₁₆ x 11¹⁵⁄₁₆ in. (25.3 x 30.4 cm.)
Signed, u.l. print verso: "John Paul Edwards"
Inscription, print verso: "On Thames—Paris [sic]//Outside Sibsury [sic]//By/[signature]/Bromoil//©"
Acquired from: Willard Van Dyke, Santa Fe, New Mexico

*2172. **THE SOLITARY ONE** (P1984.29.3)
Chloride print. c. 1921–22
Image: 13½ x 10½ in. (34.3 x 26.6 cm.)
Mount: 15½ x 12½ in. (39.4 x 31.7 cm.)
Signed, l.r. mount recto: "JOHN PAUL EDWARDS"
Inscription, mount verso: "#3/The [illegible]/JOHN PAUL EDWARDS/~~SACRAMENTO~~/1347 Cavanagh Road/Oakland/Calif.//A//193.//Not for sale" and rubber stamps "SIXTH INTERNATIONAL SALON/LOS ANGELES, CALIFORNIA/1922/CAMERA PICTORIALISTS/of LOS ANGELES" and "PITTSBURGH SALON/MARCH 1922—No 75" and printed paper label "Accepted/First Annual/Oregon International/Salon/OREGON/CAMERA/CLUB/1926/This print was one of/206 selected/Catalogue No. 51"
Acquired from: Willard Van Dyke, Santa Fe, New Mexico

2173. [Street in old European town] (P1984.29.13)
Bromoil print. c. 1924
Image: 11⅝ x 9⁹⁄₁₆ in. (29.5 x 24.3 cm.)
Sheet: 12 x 10 in. (30.5 x 25.4 cm.)
Mount: 12⅞ x 10⅛ in. (32.6 x 25.6 cm.)
Inscription, mount verso: "19½ x 22½" and Los Angeles Salon Exhibition rubber stamp almost completely trimmed off
Acquired from: Willard Van Dyke, Santa Fe, New Mexico

*2174. **STREET IN OLD NUREMBERG** (P1984.29.10)
Bromoil print. c. 1924
Image: 11¹¹⁄₁₆ x 9⁹⁄₁₆ in. (29.6 x 24.3 cm.)
Sheet: 11¹⁵⁄₁₆ x 9¹⁵⁄₁₆ in. (30.3 x 25.2 cm.)
Mount: 17 x 11⅞ in. (43.2 x 30.2 cm.)
Signed, u.r. mount verso: "JOHN PAUL EDWARDS"
Inscription, mount verso: "~~30~~//4//~~#295~~/76//#2 Street in Old Nürnberg/print by/[signature]/1347 Cavanagh Road/Oakland/Calif.//#5/Original/not for sale/Duplicates $25.00//7353/17//16 x 20//4½" and printed paper labels "Fourteenth/Pittsburgh/Salon/1927/pps/This picture was accepted by the/jury and was exhibited in the/Fine Arts Galleries of the Car-/negie Institute at Pittsburgh/from March 19 to April 17, 1927/Catalogue No. 76" and

"PPS/SAN FRANCISCO/BY INVITATION/FIFTH/INTERNATIONAL/EXHIBITION/ Pictorial Photographic Society/of San Francisco/1928" and "third/ chicago/ international/photographic/salon/art institute/1931"
Acquired from: Willard Van Dyke, Santa Fe, New Mexico

2175. **STREET IN OLD PARIS** [Le Quartier Latin] (P1984.29.18)
Bromoil print. 1924
Image: 11⅝ x 9⁹⁄₁₆ in. (29.5 x 24.2 cm.)
Sheet: 12 x 10 in. (30.4 x 25.3 cm.)
Mount: 20 x 16 in. (50.8 x 40.7 cm.)
Signed, l.r. overmat: "JOHN PAUL EDWARDS"
Inscription, overmat: "American Photographic Salon Picture taken in France//Mrs Jean Newton"
mount verso: "#1 Street in Old Paris/John Paul Edwards/1347 Cavanagh Road/Oakland—//(Duplicate)//212//57//~~76~~" and printed paper labels "PPS/SAN FRANCISCO/ACCEPTED/FOURTH INTERNATIONAL/EXHIBITION/SAN FRANCISCO/1926/Catalogue Number/76" and "ALL AMERICAN/PHOTOGRAPHIC/SALON—1927/Los Angeles Camera Club/LOS ANGELES/SIXTH YEAR/JURY OF SELECTION/LOUIS FLECKENSTEIN/WILLIAM A. GRIFFITH/PHIL TOWNSEND"
Acquired from: Willard Van Dyke, Santa Fe, New Mexico

Attributed to John Paul Edwards, G. H. S. Harding, or W. H. Rabe

2176. [Street repairmen working] (P1984.29.24)
Bromide or chloride print. 1917
Image: 9⁷⁄₁₆ x 11⅝ in. (23.9 x 29.5 cm.)
1st mount: 10¹⁄₁₆ x 12 in. (25.5 x 30.5 cm.)
2nd mount: 14⅛ x 17⁷⁄₁₆ in. (35.8 x 43.7 cm.)
Signed, l.r. 2nd mount recto: "JOHN PAUL EDWARDS"
note: signature may not be in Edwards' hand
Inscription, 2nd mount recto: "W. H. Rabe"
Acquired from: Willard Van Dyke, Santa Fe, New Mexico

*2177. **SUNDAY MORNING ON THE RIVER** [Sunday Morning on the Sacramento] (P1984.29.5)
Chloride or bromide print. c. 1918
Image: 11⅝ x 9¼ in. (29.5 x 23.5 cm.)
Mount: 21½ x 16 in. (54.7 x 40.7 cm.)
Signed, l.r. mount recto: "JOHN PAUL EDWARDS"
Inscription, mount recto: "Sunday Morning on the Sacramento"
mount verso: "Sunday Morning on the River/John Paul Edwards/Sacramento" and rubber stamp "NATIONAL SALON/BUFFALO CAMERA CLUB/BUFFALO, N.Y./1921"
Acquired from: Willard Van Dyke, Santa Fe, New Mexico

2178. **SWIRLING CLOUDS, PYRAMID PEAK** (P1984.29.32)
Chloride or bromide print. c. 1920s
Image: 13⅛ x 10⁹⁄₁₆ in. (33.3 x 26.8 cm.)
Mount: 20 x 16 in. (50.8 x 40.7 cm.)
Signed, l.l. print recto and l.r. mount recto: "JOHN PAUL EDWARDS"
Inscription, mount recto: "U.S.A./SWIRLING CLOUDS/Pyramid Peak"
mount verso: "NO 27/SWIRLING CLOUDS $12.00/D/John Paul Edwards/1347 Trestle Glen/Oakland/Calif."
Acquired from: Willard Van Dyke, Santa Fe, New Mexico

2179. **THE THAMES, LONDON** (P1984.29.37)
Chloride or bromide print. c. 1920s
Image: 8¹⁄₁₆ x 11⁹⁄₁₆ in. (20.4 x 29.3 cm.)
1st mount: 8⁷⁄₁₆ x 11⅞ in. (21.4 x 30.1 cm.)
2nd mount: 20 x 16 in. (50.8 x 40.7 cm.)
Signed, l.r. print recto and l.r. 2nd mount recto: "JOHN PAUL EDWARDS"
Inscription, 2nd mount recto: "The Thames London"
2nd mount verso: "NO 5/RIVER NEAR SACRAMENTO"
note: this may be a reused mount
Acquired from: Willard Van Dyke, Santa Fe, New Mexico

*2180. **TWIN PEAKS, YOSEMITE [Cathedral Spires, Yosemite Valley]** (P1984.29.29)
 Chloride or bromide print. c. 1920s
 Image: 13½ x 9⁷⁄₁₆ in. (34.2 x 23.9 cm)
 Mount: 20 x 16 in. (50.8 x 40.7 cm.)
 Signed, l.r. print recto and l.r. mount recto: "JOHN PAUL EDWARDS"
 Inscription, mount recto: "CATHEDRAL SPIRES/Yosemite Valley./Twin Peaks/U.S.A."
 mount verso: "Twin Peaks Yosemite/John Paul Edwards"
 Acquired from: Willard Van Dyke, Santa Fe, New Mexico

*2181. **THE WEB [The Web, Brooklyn Bridge]** (P1984.29.2)
 Chloride or bromide print. c. 1921
 Image: 13⁵⁄₈ x 9⁷⁄₈ in. (34.6 x 25.1 cm.)
 Mount: 18 x 14¼ in. (45.7 x 37.4 cm.)
 Signed, l.r. mount recto: "JOHN PAUL EDWARDS"
 Inscription, overmat: "USA/London Bridges, 1922 [sic]"
 mount verso: 206//#71" and rubber stamp "Fourth/INTERNATONAL SALON/Los Angeles, California, U.S.A./Jan'y No. 72/1921" and printed paper label "PSP/OF SAN FRANCISCO/ACCEPTED:/SAN FRANCISCO/ SALON 1922/Pictorial Photographic Society/of San Francisco/Catalogue No. 71"
 note: inscription on overmat may refer to another photograph
 Acquired from: Willard Van Dyke, Santa Fe, New Mexico

2182. **[Wind-blown tree by coastline]** (P1984.29.26)
 Chloride or bromide print. c. 1915–20
 Image: 10³⁄₈ x 13³⁄₈ in. (26.3 x 33.8 cm.)
 Mount: 13⁷⁄₁₆ x 15¼ in. (34.1 x 40.0 cm.)
 Signed, l.r. mount recto: "JOHN PAUL EDWARDS"
 Inscription, mount verso: "1865/263" and a series of numbers—addition and multiplication problems
 Acquired from: Willard Van Dyke, Santa Fe, New Mexico

RUDOLF EICKEMEYER, JR.,
American (1862–1932)

See *Camera Notes*

MORRIS ENGEL, American (b. 1918)

Morris Engel joined the Film and Photo League in New York City in 1935 when he was seventeen years old. He credits a League class taught by Berenice Abbott as his introduction to the medium. Through the League he met Paul Strand and learned the fundamentals of cinematography while shooting sequences for Strand's film *Native Land.* In 1940 Engel joined the staff of the newspaper *PM,* where he worked until 1947 except for a tour of duty as a naval combat photographer during World War II. After leaving the newspaper Engel did freelance work for *Collier's, Fortune, McCall's,* and *Ladies' Home Journal.* He made photographs for a series of articles on the lifestyles of American families, published as "How America Lives" in the *Ladies' Home Journal* during the late 1940s and early 1950s. In 1952 Engel turned to filmmaking and independently produced and directed *The Little Fugitive* (1953), *Lovers and Lollipops* (1955), and *Weddings and Babies* (1959). French director, producer, and author François Truffaut credited Engel with originating the "new wave" film, saying that Engel showed filmmakers "the way to independent production with his fine movie *Little Fugitive.*" Engel began to make still photographs again in 1976, concentrating on street life in New York City. Engel's recent wide-angle color work is among the rare contemporary work that earned photographer Berenice Abbott's admiration.

2174

2177

2180

2183. BOY—EAST SIDE—NYC (P1986.38.8)
Gelatin silver print. negative 1936, print c. 1980
Image: 5 ¼ x 4 ⅜ in. (14.6 x 11.1 cm.)
Sheet: 10 x 8 in. (25.3 x 20.3 cm.)
Signed, l.r. sheet recto: "C1980 Morris Engel"
Inscription, sheet recto: "Boy—East Side—NYC 1936—"
Acquired from: gift of Kurt and Paulette Olden, New York,
New York

*2184. BUDA, TEXAS, DAIRY FARMER, RYLANDER FAMILY—
HOW AMERICA LIVES—LADIES HOME JOURNAL
[Maurine Rylander in front of Clem's Cash Store]
(P1983.32.18)
Gelatin silver print. 1949
Image: 8 ¹⁵⁄₁₆ x 11 ⁹⁄₁₆ in. (22.7 x 29.3 cm.)
Sheet: 10 ¹⁵⁄₁₆ x 13 ¹⁵⁄₁₆ in. (27.8 x 35.4 cm.)
Signed, center print verso: "Morris Engel"
Inscription, print verso: "1949/Buda, Texas, Dairy Farmer,
Rylander Family—How America Lives—Ladies Home
Journal" and rubber stamp "Morris Engel-SCOPE"
Acquired from: gift of Mr. and Mrs. Kurt A. Olden,
Sarasota, Florida

2185. BUDA, TEXAS, FARMER—RYLANDER FAMILY
[Maurine Rylander holding a newspaper] (P1983.32.1)
Gelatin silver print. 1949
Image: 11 ⅜ x 8 ¹⁵⁄₁₆ in. (28.8 x 22.7 cm.)
Sheet: 13 ¹⁵⁄₁₆ x 11 in. (35.4 x 28.0 cm.)
Signed, left edge print verso: "Morris Engel"
Inscription, print verso: "Buda, Texas, Farmer,
Rylander Family—1949L.H.J."
Acquired from: Janet Lehr, New York, New York

*2186. BUDA, TEXAS, FARMER—RYLANDER FAMILY
[Ray Rylander leaning against a truck] (P1983.32.2)
Gelatin silver print. 1949
Image: 10 ⁷⁄₁₆ x 8 ¹⁵⁄₁₆ in. (26.4 x 22.7 cm.)
Sheet: 13 ¹⁵⁄₁₆ x 11 in. (35.4 x 28.0 cm.)
Signed, left edge print verso: "Morris Engel"
Inscription, print verso: "Buda, Texas Farmer—
Rylander Family 1949—LHJ"
Acquired from: Janet Lehr, New York, New York

2187. BUDA, TEXAS, FARMER—RYLANDER FAMILY
[Maurine and Ray Rylander standing by the side of a lake]
(P1983.32.3)
Gelatin silver print. 1949
Image: 9 ⁷⁄₁₆ x 9 ¹⁄₁₆ in. (24.0 x 23.0 cm.)
Sheet: 13 ¹⁵⁄₁₆ x 11 in. (35.4 x 28.0 cm.)
Signed, center print verso: "Morris Engel"
Inscription, print verso: "Buda, Texas Farmer—
Rylander Family 1949—LHJ" and rubber stamp
"Morris EngelSCOPE"
Acquired from: Janet Lehr, New York, New York

*2188. BUDA, TEXAS, FARMER—RYLANDER FAMILY
[Shirley Rylander curling her hair in front of a mirror]
(P1983.32.4)
Gelatin silver print. 1949
Image: 10 ¹⁵⁄₁₆ x 8 in. (27.7 x 20.3 cm.)
Sheet: 13 ¹⁵⁄₁₆ x 11 in. (35.4 x 28.0 cm.)
Signed, left edge print verso: "Morris Engel"
Inscription, print verso: "Buda, Texas, Farmer—Rylander
Family 1949 LHJ" and rubber stamp "Morris EngelSCOPE"
Acquired from: Janet Lehr, New York, New York

*2189. BUDA, TEXAS, FARMER—RYLANDER FAMILY
[Ray Bob Rylander watching his mother mend clothes]
(P1983.32.5)
Gelatin silver print. 1949
Image: 10 ⅝ x 9 ¹⁄₁₆ in. (27.0 x 23.0 cm.)
Sheet: 13 ¹⁵⁄₁₆ x 11 in. (35.4 x 28.0 cm.)
Signed, left edge print verso: "Morris Engel"
Inscription, print verso: "Buda, Texas, Farmer,
Rylander Family 1949, L.H.J." and rubber stamp
"Morris EngelSCOPE"
Acquired from: Janet Lehr, New York, New York

2190. BUDA, TEXAS, FARMER—RYLANDER FAMILY
[Maurine Rylander reading magazines with her children]
(P1983.32.6)
Gelatin silver print. 1949
Image: 9 x 10 ¹⁵⁄₁₆ in. (22.8 x 27.7 cm.)
Sheet: 11 x 13 ¹⁵⁄₁₆ in. (28.0 x 35.4 cm.)
Signed, bottom edge print verso: "Morris Engel"
Inscription, print verso: "Buda, Texas—Farmer—
Rylander Family—1949— L.H.J." and rubber stamp
"Morris EngelSCOPE"
Acquired from: gift of Mr. and Mrs. Kurt A. Olden,
Sarasota, Florida

2191. BUDA, TEXAS, FARMER—RYLANDER FAMILY
[Maurine and Ray Rylander with the family in the kitchen]
(P1983.32.7)
Gelatin silver print. 1949
Image: 7 ¹⁄₁₆ x 8 ⅞ in. (17.9 x 22.5 cm.)
Sheet: 11 x 13 ¹⁵⁄₁₆ in. (28.0 x 35.4 cm.)
Signed, bottom center print verso: "Morris Engel"
Inscription, print verso: "Buda, Texas, Farmer.
Rylander Family 1949, L.H.J." and rubber stamp
"Morris EngelSCOPE"
Acquired from: gift of Mr. and Mrs. Kurt A. Olden,
Sarasota, Florida

2192. BUDA, TEXAS, FARMER—RYLANDER FAMILY
[Ray and Ray Bob Rylander reading the newspaper]
(P1983.32.8)
Gelatin silver print. 1949
Image: 9 ¼ x 8 ¹⁵⁄₁₆ in. (24.6 x 22.7 cm.)
Sheet: 13 ¹⁵⁄₁₆ x 10 ¹⁵⁄₁₆ in. (35.4 x 27.8 cm.)
Signed, center print verso: "Morris Engel"
Inscription, print verso: "Buda Texas Farmer.
Rylander Family—1949 LHJ" and rubber stamp
"Morris EngelSCOPE"
Acquired from: gift of Mr. and Mrs. Kurt A. Olden,
Sarasota, Florida

*2193. BUDA, TEXAS, FARMER—RYLANDER FAMILY
[Shirley Rylander helps "Donski" with his homework]
(P1983.32.9)
Gelatin silver print. 1949
Image: 9 ¼ x 8 ¹⁵⁄₁₆ in. (23.4 x 22.8 cm.)
Sheet: 13 ¹⁵⁄₁₆ x 11 in. (35.4 x 28.0 cm.)
Signed, center print verso: "Morris Engel"
Inscription, print verso: "Buda, Texas—Farmer—
Rylander Family—1949. L.H.J." and rubber stamp
"Morris EngelSCOPE"
Acquired from: gift of Mr. and Mrs. Kurt A. Olden,
Sarasota, Florida

2194. BUDA, TEXAS, FARMER—RYLANDER FAMILY
[Maurine and Ray Rylander watch Hazel and "Donski"
play dominoes] (P1983.32.10)
Gelatin silver print. 1949
Image: 11 ¹⁄₁₆ x 9 ¹⁄₁₆ in. (28.1 x 23.1 cm.)
Sheet: 13 ¹⁵⁄₁₆ x 11 in. (35.4 x 28.0 cm.)
Signed, left edge print verso: "Morris Engel"
Inscription, print verso: "Buda, Texas, Farmer,
Rylander Family 1949. L.H.J."
Acquired from: gift of Mr. and Mrs. Kurt A. Olden,
Sarasota, Florida

2195. BUDA, TEXAS, FARMER—RYLANDER FAMILY
[Rylander family praying before a meal] (P1983.32.11)
Gelatin silver print. 1949
Image: 8 ¹¹⁄₁₆ x 9 in. (22.3 x 22.8 cm.)
Sheet: 13 ¹⁵⁄₁₆ x 11 in. (35.4 x 28.0 cm.)
Signed, center print verso: "Morris Engel"
Inscription, print verso: "Buda, Texas, Farmer. Rylander
Family 1949 LHJ" and rubber stamp "Morris EngelSCOPE"
Acquired from: gift of Mr. and Mrs. Kurt A. Olden,
Sarasota, Florida

209

2181

2184

2186

2188

2189

2193

2196. **BUDA, TEXAS, FARMER—RYLANDER FAMILY**
[Rylander family gathered around the table, Ray Rylander hugging Nikki] (P1983.32.12)
Gelatin silver print. 1949
Image: 6 13/16 x 7 1/8 in. (17.3 x 18.1 cm.)
Sheet: 13 15/16 x 11 in. (35.4 x 28.0 cm.)
Signed, left edge print verso: "Morris Engel"
Inscription, print verso: "Buda, Texas, Farmer. Rylander Family, 1949, L.H.J."
Acquired from: gift of Mr. and Mrs. Kurt A. Olden, Sarasota, Florida

2197. **BUDA, TEXAS, FARMER—RYLANDER FAMILY**
[Ray Bob Rylander reading on his bed] (P1983.32.13)
Gelatin silver print. 1949
Image: 9 5/16 x 6 15/16 in. (23.6 x 17.6 cm.)
Sheet: 13 15/16 x 10 15/16 in. (35.4 x 27.8 cm.)
Signed, center print verso: "Morris Engel"
Inscription, print verso: "Buda, Texas, Farmer, Rylander Family 1949. L.H.J."
Acquired from: gift of Mr. and Mrs. Kurt A. Olden, Sarasota, Florida

2198. **BUDA, TEXAS, FARMER—RYLANDER FAMILY**
[Maurine Rylander at a Buda beauty shop] (P1983.32.14)
Gelatin silver print. 1949
Image: 11 x 9 in. (28.0 x 22.8 cm.)
Sheet: 13 15/16 x 10 15/16 in. (35.4 x 27.8 cm.)
Signed, center print verso: "Morris Engel"
Inscription, print verso: "Buda, Texas Farmer—Rylander Family 1949 LHJ"
Acquired from: gift of Mr. and Mrs. Kurt A. Olden, Sarasota, Florida

2199. **BUDA, TEXAS, FARMER—RYLANDER FAMILY**
[Ray Rylander watching cows being milked] (P1983.32.15)
Gelatin silver print. 1949
Image: 7 5/16 x 10 15/16 in. (18.6 x 27.8 cm.)
Sheet: 11 x 13 15/16 in. (28.0 x 35.4 cm.)
Signed, l.l. print verso: "Morris Engel"
Inscription, print verso: "Buda Texas Farmer—Rylander Family 1949 LHJ"
Acquired from: gift of Mr. and Mrs. Kurt A. Olden, Sarasota, Florida

2200. **BUDA, TEXAS, FARMER—RYLANDER FAMILY**
[Ray Rylander feeding his cattle] (P1983.32.16)
Gelatin silver print. 1949
Image: 7 1/2 x 10 13/16 in. (19.0 x 27.5 cm.)
Sheet: 11 x 13 15/16 in. (28.0 x 35.4 cm.)
Signed, bottom edge print verso: "Morris Engel"
Inscription, print verso: "Buda, Texas, Farmer, Rylander Family 1949, L.H.J."
Acquired from: gift of Mr. and Mrs. Kurt A. Olden, Sarasota, Florida

2201. **BUDA, TEXAS, FARMER—RYLANDER FAMILY**
[Maurine Rylander at a P.T.A. coffee] (P1983.32.17)
Gelatin silver print. 1949
Image: 8 x 9 11/16 in. (20.3 x 24.5 cm.)
Sheet: 11 x 13 15/16 in. (28.0 x 35.4 cm.)
Signed, u.l. print verso: "Morris Engel"
Inscription, print verso: "Buda, Texas—Farmer—Rylander Family 1949— LHJ" and rubber stamp "Morris EngelSCOPE"
Acquired from: gift of Mr. and Mrs. Kurt A. Olden, Sarasota, Florida

2202. **BUDA, TEXAS, FARMER—RYLANDER FAMILY**
[Maurine Rylander washing clothes] (P1983.32.19)
Gelatin silver print. 1949
Image: 7 1/2 x 10 13/16 in. (19.0 x 27.4 cm.)
Sheet: 11 x 13 15/16 in. (28.0 x 35.4 cm.)
Signed, bottom edge print verso: "Morris Engel"
Inscription, print verso: "Buda, Texas, Farmer. Rylander Family 1949. L.H.J."
Acquired from: gift of Mr. and Mrs. Kurt A. Olden, Sarasota, Florida

2203. **BUDA, TEXAS, FARMER—RYLANDER FAMILY**
[Maurine Rylander hanging wash on the line] (P1983.32.20)
Gelatin silver print. 1949
Image: 7 7/16 x 10 7/8 in. (18.9 x 27.6 cm.)
Sheet: 10 15/16 x 13 15/16 in. (27.8 x 35.4 cm.)
Signed, center print verso: "Morris Engel"
Inscription, print verso: "Buda Texas Farmer. Rylander Family 1949—LHJ"
Acquired from: gift of Mr. and Mrs. Kurt A. Olden, Sarasota, Florida

2204. **CONEY ISLAND, NY [girls and sailor in crowd]**
(P1986.38.11)
Gelatin silver print. c. 1940s
Image: 13 1/2 x 10 9/16 in. (34.2 x 26.7 cm.)
Sheet: 13 15/16 x 10 15/16 in. (35.3 x 27.8 cm.)
Signed, top center print verso and l.r. overmat recto: "Morris Engel"
Inscription, overmat recto: "Coney Island, NY. 1940's"
Acquired from: gift of Kurt and Paulette Olden, New York, New York

2205. **CONEY ISLAND, NY [couple walking and eating hot dogs]**
(P1986.38.12)
Gelatin silver print. c. 1940s
Image: 12 9/16 x 10 1/2 in. (31.9 x 26.7 cm.)
Sheet: 13 x 10 15/16 in. (33.0 x 27.8 cm.)
Signed, top center print verso and l.r. overmat recto: "Morris Engel"
Inscription, overmat recto: "Coney Island, NY—1940's"
Acquired from: gift of Kurt and Paulette Olden, New York, New York

*2206. **CONEY ISLAND, NY [children eating hot dogs]**
(P1986.38.13)
Gelatin silver print. c. 1940s
Image: 13 1/2 x 10 9/16 in. (34.2 x 26.7 cm.)
Sheet: 13 15/16 x 10 15/16 in. (35.3 x 27.8 cm.)
Signed, top center print verso and l.r. overmat recto: "Morris Engel"
Inscription, overmat recto: "Coney Island, NY—1940's"
Acquired from: gift of Kurt and Paulette Olden, New York, New York

2207. **DELANCEY ST., NYC** (P1986.38.1)
Gelatin silver print. negative 1937, print later
Image: 18 3/8 x 14 3/8 in. (46.6 x 36.5 cm.)
Mount: 20 x 16 in. (50.8 x 40.7 cm.)
Signed, l.r. mount recto: "Morris Engel"
Inscription, mount recto: "Delancey St, NYC—1937"
Acquired from: gift of Kurt and Paulette Olden, New York, New York

2208. **EAST SIDE PAINTER, NYC** (P1986.38.2)
Gelatin silver print. 1983
Image: 12 5/8 x 18 3/4 in. (32.1 x 47.6 cm.)
Sheet: 16 x 19 15/16 in. (40.7 x 50.6 cm.)
Mount: same as sheet size
Signed, l.r. sheet recto: "Morris Engel"
Inscription, sheet recto: "East Side painter, NYC—1983"
Acquired from: gift of Kurt and Paulette Olden, New York, New York

2209. **EAST TENTH ST., NYC** (P1986.38.15)
Gelatin silver print. 1947
Image: 10 1/2 x 13 1/2 in. (26.7 x 34.2 cm.)
Sheet: 10 15/16 x 13 7/8 in. (27.7 x 35.2 cm.)
Signed, l.r. old overmat recto: "Morris Engel"
Inscription, old overmat recto: "East Tenth St, NYC—1947"
Acquired from: gift of Kurt and Paulette Olden, New York, New York

*2210. **HARLEM MERCHANT, NY** (P1986.38.16)
Gelatin silver print. negative 1938, print later
Image: 10 9/16 x 13 7/16 in. (26.8 x 34.2 cm.)
Sheet: 11 1/16 x 14 in. (28.1 x 35.5 cm.)
Signed, bottom center print verso and l.r. overmat recto:
"Morris Engel"
Inscription, overmat recto: "Harlem Merchant, NY 1938"
Acquired from: gift of Kurt and Paulette Olden, New York,
New York

2211. **HORSES, CENTRAL PARK SOUTH, NYC**
(P1986.38.4)
Gelatin silver print. 1981
Image: 15 x 19 1/8 in. (38.0 x 48.5 cm.)
Mount: 16 1/16 x 20 in. (40.7 x 50.8 cm.)
Signed, l.r. mount recto: "Morris Engel"
Inscription, mount recto: "Horses, Central Park South,
NYC—1981"
Acquired from: gift of Kurt and Paulette Olden, New York,
New York

2212. **MET PERFORMANCE, NYC [performer outside the
Metropolitan Museum of Art]** (P1986.38.5)
Gelatin silver print. 1980
Image: 15 1/16 x 19 3/8 in. (38.2 x 49.2 cm.)
Mount: 16 1/16 x 20 in. (40.7 x 50.8 cm.)
Signed, l.r. mount recto: "Morris Engel"
Inscription, mount recto: "Met performance, NYC—1980"
Acquired from: gift of Kurt and Paulette Olden, New York,
New York

2213. **PAUL STRAND** (P1986.38.17) duplicate of P1986.38.7
Gelatin silver print. 1947
Image: 10 9/16 x 13 7/16 in. (26.9 x 34.2 cm.)
Sheet: 11 1/16 x 13 15/16 in. (28.1 x 35.4 cm.)
Signed, l.r. old overmat recto: "Morris Engel"
Inscription, old overmat recto: "PAUL STRAND—1947"
Acquired from: gift of Kurt and Paulette Olden, New York,
New York

2214. **PAUL STRAND, NEW JERSEY** (P1986.38.7) duplicate of
P1986.38.17
Gelatin silver print. 1947
Image: 10 5/8 x 13 7/16 in. (26.9 x 34.2 cm.)
Sheet: 11 1/16 x 13 15/16 in. (28.1 x 35.4 cm.)
Signed, bottom center print verso and l.r. overmat recto:
"Morris Engel"
Inscription, overmat recto: "Paul Strand, 1947, New Jersey—"
Acquired from: gift of Kurt and Paulette Olden, New York,
New York

2215. **PAUL STRAND, NEW JERSEY** (P1986.38.9)
Gelatin silver print. 1947
Image: 13 1/2 x 10 5/8 in. (34.2 x 26.9 cm.)
Sheet: 13 15/16 x 11 1/16 in. (35.4 x 28.2 cm.)
Signed, bottom center print verso and l.r. overmat recto:
"Morris Engel"
Inscription, overmat recto: "Paul Strand, 1947, New Jersey—"
Acquired from: gift of Kurt and Paulette Olden, New York,
New York

2216. **THE RACE—NYC** (P1986.38.14)
Gelatin silver print. negative 1936, print c. 1980
Image: 4 5/16 x 6 1/8 in. (10.9 x 15.6 cm.)
Sheet: 8 x 10 in. (20.3 x 25.3 cm.)
Signed, l.r. sheet recto: "C1980 Morris Engel"
Inscription, sheet recto: "The Race—NYC—1936"
Acquired from: gift of Kurt and Paulette Olden, New York,
New York

2206

2210

2218

2217. **REBECCA OF HARLEM, NYC** [Rebecca, Harlem, NYC]
(P1986.38.10)
Gelatin silver print. negative 1947, print c. 1980
Image: 10 ⅜ x 12 ¹⁵⁄₁₆ in. (26.3 x 32.9 cm.)
Sheet: 10 ¹³⁄₁₆ x 13 ⁷⁄₁₆ in. (27.4 x 34.1 cm.)
Signed, l.l. print verso: "Morris Engel"
l.r. overmat recto: "© 1980 Morris Engel"
Inscription, print verso: "[signature]—Rebecca of Harlem,
NYC— 1947—"
overmat recto: "Rebecca, Harlem, NYC—1947"
Acquired from: gift of Kurt and Paulette Olden, New York,
New York

* 2218. **SKYLINE, NYC** (P1986.38.19)
Type C color print. negative 1981, print 1982 by Kodak
Image: 11 x 14 ¹⁄₁₆ in. (27.8 x 35.7 cm.)
Signed, l.r. old overmat recto: "© 1981 Morris Engel"
Inscription, old overmat recto: "Skyline, NYC—1981"
Acquired from: gift of Kurt and Paulette Olden, New York,
New York

2219. **SUNRISE, NYC** (P1986.38.18)
Type C color print. negative 1981, print 1982 by Kodak
Image: 11 x 14 in. (27.8 x 35.5 cm.)
Signed, l.r. old overmat recto: "Morris Engel"
Inscription, old overmat recto: "Sunrise, NYC—1981"
old mat backing verso, rubber stamp:
"MORRIS ENGEL/66 CENTRAL PARK WEST/
NEW YORK, N. Y."
Acquired from: gift of Kurt and Paulette Olden, New York,
New York

2220. **SWEET POTATO PEDDLER** (P1986.38.6)
Gelatin silver print. negative 1937, print later
Image: 18 ½ x 14 ¾ in. (46.9 x 37.5 cm.)
Mount: 20 x 16 ¹⁄₁₆ in. (50.8 x 40.8 cm.)
Signed, l.r. mount recto: "Morris Engel"
Inscription, mount recto: "Sweet potato pedler
[sic], NYC 1937"
Acquired from: gift of Kurt and Paulette Olden, New York,
New York

2221. **TENTH ST., NY** (P1986.38.3)
Gelatin silver print. c. 1940s
Image: 13 ½ x 10 ⁹⁄₁₆ in. (34.3 x 26.9 cm.)
Sheet: 13 ¹⁵⁄₁₆ x 11 in. (35.4 x 28.0 cm.)
Signed, bottom center print verso and l.r. overmat recto:
"Morris Engel"
Inscription, overmat recto: "Tenth St, NY. 1940's"
Acquired from: gift of Kurt and Paulette Olden, New York,
New York

ELLIOTT ERWITT,
American, born France (b. 1928)

Erwitt studied photography while attending high school
in Hollywood, California. After serving as an army
photographer during the Korean War, he joined the
Magnum photo agency. Erwitt has also made documen-
tary films and done commercial work.

PHOTOGRAPHS: ELLIOTT ERWITT (LP1978.19.1 and P1980.66.1–14)

This portfolio was published in 1977 by Acorn Editions, Ltd.
of Geneva, Switzerland. It consists of 100 signed and
numbered portfolios. This is portfolio number 21.

* 2222. **YALE/NEW HAVEN** (LP1978.19.1)
Gelatin silver print. negative 1955, print 1977
Image: 6 ⁷⁄₁₆ x 9 ⁹⁄₁₆ in. (16.3 x 24.3 cm.)
Sheet: 8 x 10 in. (20.3 x 25.4 cm.)
Signed, bottom print verso: "Elliott Erwitt"
Inscription, print verso: "21/100//737/2"
Acquired from: long-term loan from
George Peterkin, Jr., Houston, Texas

2223. **PARADE GROUP/PARIS** (P1980.66.1)
Gelatin silver print. negative 1951, print 1977
Image: 9 ⁹⁄₁₆ x 6 ⁷⁄₁₆ in. (24.3 x 16.3 cm.)
Sheet: 10 x 8 in. (25.4 x 20.3 cm.)
Signed, l.r. print verso: "Elliott Erwitt"
Inscription, print verso: "21/100//72/3"
Acquired from: gift of George Peterkin, Jr., Houston, Texas

2224. **INSPECTING GUARDS/TEHERAN** (P1980.66.2)
Gelatin silver print. negative 1967, print 1977
Image: 9 ⁹⁄₁₆ x 6 ⁷⁄₁₆ in. (24.3 x 16.3 cm.)
Sheet: 10 x 8 in. (25.4 x 20.3 cm.)
Signed, l.r. print verso: "Elliott Erwitt"
Inscription, print verso: "21/100//67-35 22/11A"
Acquired from: gift of George Peterkin, Jr., Houston, Texas

2225. **GEESE/HUNGARY** (P1980.66.3)
Gelatin silver print. negative 1964, print 1977
Image: 6 ⁷⁄₁₆ x 9 ⁹⁄₁₆ in. (16.3 x 24.3 cm.)
Sheet: 8 x 10 in. (20.3 x 25.4 cm.)
Signed, l.r. print verso: "Elliott Erwitt"
Inscription, print verso: "21/100//64-43 17/21A"
Acquired from: gift of George Peterkin, Jr., Houston, Texas

2226. **MONKEY PAW/ST. TROPEZ** (P1980.66.4)
Gelatin silver print. negative 1968, print 1977
Image: 6 ⁷⁄₁₆ x 9 ½ in. (16.3 x 24.2 cm.)
Sheet: 8 x 10 in. (20.3 x 25.4 cm.)
Signed, l.r. print verso: "Elliott Erwitt"
Inscription, print verso: "21/100//68-1 27/2A"
Acquired from: gift of George Peterkin, Jr., Houston, Texas

* 2227. **CONFESSIONAL/CZESTOCHOWA, POLAND**
(P1980.66.5)
Gelatin silver print. negative 1964, print 1977
Image: 6 ⅛ x 9 ½ in. (16.2 x 24.2 cm.)
Sheet: 8 x 10 in. (20.3 x 25.4 cm.)
Signed, l.r. print verso: "Elliott Erwitt"
Inscription, print verso: "21/100//64-41 51/16"
Acquired from: gift of George Peterkin, Jr., Houston, Texas

2228. **PIANO LESSON/ODESSA** (P1980.66.6)
Gelatin silver print. negative 1957, print 1977
Image: 6 ⅛ x 9 ½ in. (16.2 x 24.2 cm.)
Sheet: 8 x 10 in. (20.3 x 25.4 cm.)
Signed, l.r. print verso: "Elliott Erwitt"
Inscription, print verso: "21/100//1742/20"
Acquired from: gift of George Peterkin, Jr., Houston, Texas

2229. **WAVES/BRIGHTON** (P1980.66.7)
Gelatin silver print. negative 1956, print 1977
Image: 6 ⅛ x 9 ⁹⁄₁₆ in. (16.2 x 24.3 cm.)
Sheet: 8 x 10 in. (20.3 x 25.4 cm.)
Signed, l.r. print verso: "Elliott Erwitt"
Inscription, print verso: "21/100//66-1 29/35"
Acquired from: gift of George Peterkin, Jr., Houston, Texas

2230. **SOUTHERN CHARM/ALABAMA** (P1980.66.8)
Gelatin silver print. negative 1955, print 1977
Image: 6 ⁷⁄₁₆ x 9 ⁹⁄₁₆ in. (16.3 x 24.3 cm.)
Sheet: 8 x 10 in. (20.3 x 25.4 cm.)
Signed, l.r. print verso: "Elliott Erwitt"
Inscription, print verso: "21/100//418/27"
Acquired from: gift of George Peterkin, Jr., Houston, Texas

2231. **DIANA/NEW YORK** (P1980.66.9)
Gelatin silver print. negative 1949, print 1977
Image: 9 ⁹⁄₁₆ x 6 ⅛ in. (24.3 x 16.2 cm.)
Sheet: 10 x 8 in. (25.4 x 20.3 cm.)
Signed, l.r. print verso: "Elliott Erwitt"
Inscription, print verso: "21/100//317/27"
Acquired from: gift of George Peterkin, Jr., Houston, Texas

2232. BEACH GROUP/SYLT, WEST GERMANY (P1980.66.10)
Gelatin silver print. negative 1968, print 1977
Image: 6 ⅛ x 9 ½ in. (16.2 x 24.2 cm.)
Sheet: 8 x 10 in. (20.3 x 25.4 cm.)
Signed, l.r. print verso: "Elliott Erwitt"
Inscription, print verso: "21/100//68-22 20/9A"
Acquired from: gift of George Peterkin, Jr., Houston, Texas

*2233. **LOST PERSONS/PASADENA** (P1980.66.11)
Gelatin silver print. negative 1963, print 1977
Image: 6 ⅛ x 9 ½ in. (16.2 x 24.2 cm.)
Sheet: 8 x 10 in. (20.3 x 25.4 cm.)
Signed, l.r. print verso: "Elliott Erwitt"
Inscription, print verso: "21/100//63-3 1/27"
Acquired from: gift of George Peterkin, Jr., Houston, Texas

2234. MAN AND DOG/SOUTH CAROLINA (P1980.66.12)
Gelatin silver print. negative 1962, print 1977
Image: 9 ⁷⁄₁₆ x 6 ⁷⁄₁₆ in. (24.0 x 16.3 cm.)
Sheet: 10 x 8 in. (25.4 x 20.3 cm.)
Signed, l.r. print verso: "Elliott Erwitt"
Inscription, print verso: "21/100//62-57 2/18"
Acquired from: gift of George Peterkin, Jr., Houston, Texas

2235. SOLDIER/NEW JERSEY (P1980.66.13)
Gelatin silver print. negative 1951, print 1977
Image: 6 ⅛ x 9 ⁹⁄₁₆ in. (16.2 x 24.3 cm.)
Sheet: 8 x 10 in. (20.3 x 25.4 cm.)
Signed, l.r. print verso: "Elliott Erwitt"
Inscription, print verso: "21/100//-15/34"
Acquired from: gift of George Peterkin, Jr., Houston, Texas

*2236. **CARS AND POLES/ROME** (P1980.66.14)
Gelatin silver print. negative 1965, print 1977
Image: 9 ½ x 6 ⅛ in. (24.2 x 16.2 cm.)
Sheet: 10 x 8 in. (25.4 x 20.3 cm.)
Signed, l.r. print verso: "Elliott Erwitt"
Inscription, print verso: "21/100//65-29-2/27A"
Acquired from: gift of George Peterkin, Jr., Houston, Texas

FRANK EUGENE,
German, born United States (1865–1936)

See *Camera Notes* and *Camera Work*

RON EVANS, American (b. 1943)

Evans worked as a musician for eight years before taking
up photography in 1968. A native of Little Rock,
Arkansas, he has lived in Dallas, Texas, since 1969.
Evans has had exhibitions at the Afterimage and Allen
Street Galleries in Dallas, the Friends of Photography
in Carmel, California, and The Waco Art Center.

*2237. **JAZZ CONCERT, DALLAS** (P1978.37)
Toned gelatin silver print. 1977
Image: 4 ⅛ x 3 ½ in. (10.4 x 8.8 cm.)
Mount: 14 x 11 ⅛ in. (35.6 x 28.9 cm.)
Signed, center mount verso: "RON EVANS/1977"
Inscription, mount verso: "JAZZ CONCERT, DALLAS 1977"
Acquired from: The Afterimage, Dallas, Texas

WALKER EVANS, American (1903–1975)

Walker Evans began making photographs in the 1920s
and photographed for the Farm Security Administra-
tion during the 1930s. He worked in a straightforward
style, often photographing the American vernacular—
signs, buildings, people—as the truest representation
of experience. In 1938 the Museum of Modern Art in
New York featured Evans' work made during the prolific
years of 1929–37 in the seminal exhibition "Walker
Evans: American Photographs." He and James Agee

2222

2227

2233

began an independent project for *Fortune* magazine that eventually was published in book form as *Let Us Now Praise Famous Men* (1941). This account of cotton sharecroppers in the South during the Depression, with text by Agee and photographs by Evans, contained what have come to be some of Evans' most famous images. He also made a series of candid photographs of individuals traveling the New York subways during the late 1930s and early 1940s and photographed a wide variety of subjects for *Fortune* magazine from 1945 to 1965.

* 2238. **ALLIE MAY BURROUGHS, HALE COUNTY, ALABAMA** (P1978.48.1)
Gelatin silver print. 1936
Image: 9 9/16 x 7 9/16 in. (24.2 x 19.3 cm.)
Sheet: 10 x 8 1/16 in. (25.3 x 20.4 cm.)
Signed: see inscription
Inscription, print verso: "144" and rubber stamp "Walker Evans/ 1 36 "
Acquired from: Hastings Gallery, New York, New York

* 2239. **BEN SHAHN** (P1978.71.2)
Gelatin silver print. negative 1934, print 1971 by the Museum of Modern Art
Image: 3 15/16 x 5 7/8 in. (9.9 x 14.9 cm.)
Sheet: 7 5/16 x 9 5/8 in. (18.5 x 24.4 cm.)
Signed: see inscription
Inscription, print verso: "P-334 B//IV" and rubber stamp "Walker Evans/ ☐ ☐ "
Acquired from: Graphics International, Ltd., Washington, D. C.

2240. **BERENICE ABBOTT** (P1978.71.1)
Gelatin silver print. c. 1930
Image: 6 1/2 x 4 11/16 in. (16.5 x 11.9 cm.)
Sheet: 7 x 5 in. (17.7 x 12.7 cm.)
Signed: see inscription
Inscription, print verso, rubber stamp: "Walker Evans/ IV ☐ "
Acquired from: Graphics International, Ltd., Washington, D. C.

2241. **FLOYD BURROUGHS, HALE COUNTY ALABAMA** [Sharecropper, Hale County, Alabama] (P1987.4.2)
Gelatin silver print. 1936
Image: 9 1/2 x 7 9/16 in. (24.1 x 19.2 cm.)
Acquired from: W. Bradley Lemery, San Diego, California

2242. **MINSTREL SHOWBILL** (P1978.48.2)
Gelatin silver print. 1936
Image: 7 1/2 x 9 9/16 in. (19.1 x 24.2 cm.)
Sheet: 8 x 10 in. (20.3 x 25.3 cm.)
Signed: see inscription
Inscription, print verso: "6//#739 Minstrel Showbill, 1936" and rubber stamp "Walker Evans/ 1 92 "
Acquired from: Hastings Gallery, New York, New York

* 2243. **THE QUEEN MARY, VENTILATOR AND BOW SHROUDS, PROMENADE DECK, BOW** (P1980.26)
Gelatin silver print. 1958
Image: 10 7/16 x 10 9/16 in. (26.5 x 26.9 cm.)
Sheet: 13 15/16 x 11 1/16 in. (35.5 x 28.1 cm.)
Signed, center print verso: "Walker Evans"
Inscription, sheet recto: "The Queen Mary//Ventilator and Bow Shrouds/Promenade Deck, Bow//Walker Evans//80 % POS"
Acquired from: James Maroney, Inc., New York, New York

2244. **STORE DISPLAY, FLORIDA** (P1978.48.3)
Gelatin silver print. 1941
Image: 5 13/16 x 4 13/16 in. (14.7 x 12.2 cm.)
Sheet: 7 x 5 1/16 in. (17.7 x 12.8 cm.)
Inscription, sheet recto: "14 Aug 73/Chicago/ Happy pre birthday George/I'm in the suit Arnold//R-500"
sheet verso: "This here is a Walker Evans from mine [sic]/ collection Arnold Crane//R-500"
Acquired from: Hastings Gallery, New York, New York

2245. **STUDIO PORTRAITS, BIRMINGHAM, ALABAMA** [possibly Savannah, Georgia] (P1987.4.1)
Gelatin silver print. c. 1935–36
Image: 8 9/16 x 6 3/4 in. (21.7 x 17.1 cm.)
Acquired from: W. Bradley Lemery, San Diego, California

2246. **TIN FALSE FRONT BUILDING, MOUNDVILLE, ALABAMA** [from "Selected Photographs" portfolio by Double Elephant Press] (P1978.27)
Gelatin silver print. negative 1936, print 1974 by Richard Benson, John Decks, or Lee Friedlander under Evans' supervision
Image: 9 9/16 x 13 in. (24.4 x 33.1 cm.)
Mount: 14 13/16 x 19 13/16 in. (37.6 x 50.3 cm.)
Signed, l. r. mount recto: "Walker Evans"
Inscription, mount recto: "18/75"
mount verso: "13. Tin False Front Building, Moundville, Alabama, 1936"
Acquired from: The Halsted Gallery, Birmingham, Michigan

2247. **222 COLUMBIA HEIGHTS, BROOKLYN** (P1978.65)
Gelatin silver print. negative c. 1930s, print later
Image: 6 3/8 x 8 3/8 in. (16.2 x 21.3 cm.)
Sheet: 8 x 10 in. (20.4 x 25.3 cm.)
Signed: see inscription
Inscription, print verso, rubber stamp: "Walker Evans/ II 28 "
Acquired from: Edward Kaufman, Chicago, Illinois

* 2248. **UNTITLED, SUBWAY SERIES** (P1982.2)
Gelatin silver print. 1938
Image: 5 1/16 x 7 5/8 in. (12.8 x 19.5 cm.) irregular
Sheet: 8 x 10 in. (20.3 x 25.4 cm.)
Signed: see inscription
Inscription, print verso: "#2/WEv. 127.Y" and rubber stamp "Walker Evans/ VI 40 "
Acquired from: Fraenkel Gallery, San Francisco, California

GEORGE ROBINSON FARDON,
English (1806–1886)

Fardon, an Englishman, spent only ten years making photographs in San Francisco before moving to Victoria, British Columbia, in 1859. Nonetheless, he had a profound impact on western American photography, bringing the wet collodion negative process to California and producing some of the earliest paper photographic prints of the region. His *San Francisco Album. Photographs of the Most Beautiful Views and Public Buildings of San Francisco*, published in 1856, was also one of the earliest series of photographs of any American city. Fardon continued to make photographs until the early 1870s.

* 2249. **VIEW OVER THE CITY, CONTAINING THE PORTIONS BETWEEN CALIFORNIA & BUSH STREETS** [San Francisco, Grant Street between California and Bush Streets, with St. Mary's in foreground; from *San Francisco Album* (San Francisco: Herre and Bauer, 1856)] (P1980.42)
Salt print. 1856
Image: 6 1/8 x 8 1/16 in. (15.6 x 20.4 cm.)
Sheet: 8 3/8 x 10 9/16 in. (21.3 x 26.7 cm.)
Inscription, sheet verso: "13/View over the City, containing the portions between California & Bush Streets./26"
Acquired from: John Howell—Books, San Francisco, California

E. J. FARNSWORTH,
American (active 1886–1902)

See *Camera Notes*

2236

2237

2238

2239

2248

2243

JAMES FENNEMORE,
American, born England (1849–1941)

Fennemore worked in Charles R. Savage's Salt Lake City, Utah, studio before John Wesley Powell hired him as the photographer for his 1872 survey down the Colorado River. Powell had brought a box of photographer E. O. Beaman's negatives to Savage's studio and placed a print order. Although the negatives were reportedly of poor quality, Fennemore produced prints that pleased Powell. A few months later Powell returned to the studio and offered Fennemore a position as survey photographer. He left the expedition at an early stage when he became ill and was replaced by John K. Hillers. Fennemore later ran his own Utah photographic studio. Although he made only about seventy negatives for the survey, Fennemore was remembered as the last surviving member of the Powell Colorado River expeditions.

2250. **HOOSIER BOY MINE—STAR, UTAH** (P1974.81.1)
Albumen silver print. c. 1870s
Image: 6 ⅜ x 8 ¼ in. (16.2 x 20.9 cm.)
Mount: 10 x 12 in. (25.4 x 30.5 cm.)
Signed: see inscription
Inscription, mount recto: "Hoosier Boy Mine—Star Utah" and rubber stamp "J. Fennemore, Photo./Utah"
Acquired from: Neikrug Galleries, Inc., New York, New York

*2251. **SHAUNTIE SMELTING WORKS—STAR [Star, Utah]** (P1974.81.2)
Albumen silver print. c. 1870s
Image: 6 ⅝ x 8 ½ in. (16.8 x 21.5 cm.)
Mount: 10 x 12 in. (25.4 x 30.5 cm.)
Signed: see inscription
Inscription, mount recto: "Shauntie Smelting Works—Star" and rubber stamp "J. Fennemore, Photo./Utah"
Acquired from: Neikrug Galleries, Inc., New York, New York

PHYLLIS FENNER, American (1899–1982)

Phyllis Fenner, author and compiler of more than fifty anthologies of children's stories, was born in Almond, New York. She received her A.B. from Mt. Holyoke College in 1921 and a B.L.S. from Columbia University in 1934. Fenner was an innovative librarian of the Plandome Road School in Manhasset, New York, from 1923 to 1955 and was a masterful storyteller. She was a book reviewer for the *New York Times* and served on the editorial board of the *Weekly Reader* Club and the *Children's Digest.* Her writings included *The Proof of the Pudding: What Children Read* (1957), and among her anthologies are *Giants, Witches and a Dragon or Two* (1941), *Adventure Rare and Magical* (1945), and *Keeping Christmas: Stories of the Joyous Season* (1979). Fenner was a close friend and companion of the photographer Clara E. Sipprell; the two lived together beginning in the 1940s and moved to Manchester, Vermont, following Fenner's retirement in 1955. Fenner encouraged Sipprell to publish *Moment of Light.*

*2252. **CLARA [Clara E. Sipprell]** (P1985.3)
Toned gelatin silver print. 1967
Image: 8 ¹⁵⁄₁₆ x 7 ½ in. (22.8 x 19.1 cm.)
Mount: 10 ¹⁵⁄₁₆ x 16 ⅞ in. (27.8 x 41.7 cm.)
Signed: see inscription
Inscription, mount recto: "Clara/1967//by/Phyllis"
Acquired from: gift of Carol Fenner Williams, Battle Creek, Michigan

PETER HELMS FERESTEN, American (b. 1945)

Born in Newport, Rhode Island, Peter Feresten studied sociology at Columbia University from 1963 to 1967 before completing a B.F.A. (1972) and M.F.A. (1974) at the Rhode Island School of Design. He moved to Texas and became an assistant professor of photography at Tarrant County Junior College in 1975. During the course of a photographic project documenting the black community in Fort Worth, Feresten became an active participant in the effort to preserve local black heritage and history. His documentary work has focused primarily on the Fort Worth area, but he has also photographed in Spain.

*2253. **ABRAHAM'S SACRIFICE. CALUMET BAPTIST CHURCH. FORT WORTH [from "Contemporary Texas: A Photographic Portrait"]** (P1985.17.64)
Gelatin silver print. 1984
Image: 8 ⅜ x 12 ½ in. (21.3 x 31.8 cm.)
Sheet: 10 ¹⁵⁄₁₆ x 13 ¹⁵⁄₁₆ in. (27.8 x 35.4 cm.)
Signed, l.r. print verso: "Peter Feresten"
Inscription, print verso: "Abraham's Sacrifice, Calumet Baptist Church, Fort Worth, Tx. '84"
Acquired from: gift of the Texas Historical Foundation with support from a major grant from the Du Pont Company and Conoco, its energy subsidiary, and assistance from the Texas Commission on the Arts and the National Endowment for the Arts

2254. **THE ARK OF GOD. FORT WORTH [from "Contemporary Texas: A Photographic Portrait"]** (P1985.17.61)
Gelatin silver print. negative 1983, print 1984
Image: 8 ¹¹⁄₁₆ x 12 ½ in. (22.1 x 31.8 cm.)
Sheet: 10 ¹⁵⁄₁₆ x 14 in. (27.8 x 35.6 cm.)
Signed, l.r. print verso: "Peter Feresten"
Inscription, print verso: "The Ark of God, Fort Worth, Tx. '83"
Acquired from: gift of the Texas Historical Foundation with support from a major grant from the Du Pont Company and Conoco, its energy subsidiary, and assistance from the Texas Commission on the Arts and the National Endowment for the Arts

2255. **BRIGHT GLORY BAPTIST CHURCH. FORT WORTH [from "Contemporary Texas: A Photographic Portrait"]** (P1985.17.63)
Gelatin silver print. negative 1983, print 1984
Image: 8 ½ x 12 ½ in. (21.6 x 31.8 cm.)
Sheet: 10 ⅞ x 14 in. (27.6 x 35.6 cm.)
Signed, l.r. print verso: "Peter Feresten"
Inscription, print verso: "Bright Glory Baptist Church, Fort Worth, Tx., '83"
Acquired from: gift of the Texas Historical Foundation with support from a major grant from the Du Pont Company and Conoco, its energy subsidiary, and assistance from the Texas Commission on the Arts and the National Endowment for the Arts

*2256. **EVANGELIST SCOTT. FORT WORTH [from "Contemporary Texas: A Photographic Portrait"]** (P1985.17.62)
Gelatin silver print. negative 1983, print 1984
Image: 8 ½ x 12 ½ in. (21.6 x 31.8 cm.)
Sheet: 10 ¹⁵⁄₁₆ x 13 ¹⁵⁄₁₆ in. (27.8 x 35.4 cm.)
Signed, l.r. print verso: "Peter Feresten"
Inscription, print verso: "Evangelist Scott, The Ark of God, Fort Worth, Tx. '83"
Acquired from: gift of the Texas Historical Foundation with support from a major grant from the Du Pont Company and Conoco, its energy subsidiary, and assistance from the Texas Commission on the Arts and the National Endowment for the Arts

2249

2251

2252

2253

2258

2256

2257. **GRAND HIGH COURT, HEROINES OF JERICHO, PRINCE HALL GRAND LODGE. FORT WORTH** [from "Contemporary Texas: A Photographic Portrait"] (P1985.17.67)
Gelatin silver print. 1984
Image: 8½ x 12½ in. (21.6 x 31.8 cm.)
Sheet: 10¹⁵⁄₁₆ x 13¹⁵⁄₁₆ in. (27.8 x 35.4 cm.)
Signed, l.r. print verso: "Peter Feresten"
Inscription, print verso: "Grand High Court, Heroines of Jericho, Prince Hall Grand Lodge, Fort Worth, Tx., June '84"
Acquired from: gift of the Texas Historical Foundation with support from a major grant from the Du Pont Company and Conoco, its energy subsidiary, and assistance from the Texas Commission on the Arts and the National Endowment for the Arts

*2258. **LOVE TEMPLE, NEW BORN HOLINESS CHURCH. FORT WORTH** [from "Contemporary Texas: A Photographic Portrait"] (P1985.17.65)
Gelatin silver print. negative 1983, print 1984
Image: 8⅜ x 12½ in. (21.3 x 31.8 cm.)
Sheet: 10⅞ x 13¹⁵⁄₁₆ in. (27.6 x 35.4 cm.)
Signed, l.r. print verso: "Peter Feresten"
Inscription, print verso: "Love Temple Newborn Holiness Church, Fort Worth, Tx. '83"
Acquired from: gift of the Texas Historical Foundation with support from a major grant from the Du Pont Company and Conoco, its energy subsidiary, and assistance from the Texas Commission on the Arts and the National Endowment for the Arts

2259. **MASONIC MOSQUE, PRINCE HALL AFFILIATION, FREE AND ACCEPTED MASONS, JURISDICTION OF TEXAS; EAST 1ST STREET. FORT WORTH** [from "Contemporary Texas: A Photographic Portrait"] (P1985.17.69)
Gelatin silver print. 1984
Image: 8¹¹⁄₁₆ x 12½ in. (22.1 x 31.8 cm.)
Sheet: 10¹⁵⁄₁₆ x 14 in. (27.8 x 35.6 cm.)
Signed, l.r. print verso: "Peter Feresten"
Inscription, print verso: "Masonic Mosque, Prince Hall Affilliation [sic], Free & Accepted Masons, Jurisdiction of Texas, East 1st St., Fort Worth, Tx. June '84"
Acquired from: gift of the Texas Historical Foundation with support from a major grant from the Du Pont Company and Conoco, its energy subsidiary, and assistance from the Texas Commission on the Arts and the National Endowment for the Arts

2260. **MASTER MASONS, PRINCE HALL GRAND LODGE. FORT WORTH** [from "Contemporary Texas: A Photographic Portrait"] (P1985.17.66)
Gelatin silver print. 1984
Image: 8½ x 12½ in. (21.6 x 31.8 cm.)
Sheet: 10⅞ x 13¹⁵⁄₁₆ in. (27.6 x 35.4 cm.)
Signed, l.r. print verso: "Peter Feresten"
Inscription, print verso: "Master Masons, Prince Hall Grand Lodge, Fort Worth, Tx, June '84"
Acquired from: gift of the Texas Historical Foundation with support from a major grant from the Du Pont Company and Conoco, its energy subsidiary, and assistance from the Texas Commission on the Arts and the National Endowment for the Arts

2261. **MISS JUNETEENTH, SYCAMORE PARK. FORT WORTH** [from "Contemporary Texas: A Photographic Portrait"] (P1985.17.70)
Gelatin silver print. 1984
Image: 8½ x 12½ in. (21.6 x 31.8 cm.)
Sheet: 10¹⁵⁄₁₆ x 13¹⁵⁄₁₆ in. (27.8 x 35.4 cm.)
Signed, l.r. print verso: "Peter Feresten"
Inscription, print verso: "Miss Juneteenth, Sycamore Park, Fort Worth, Tx. '84"
Acquired from: gift of the Texas Historical Foundation with

support from a major grant from the Du Pont Company and Conoco, its energy subsidiary, and assistance from the Texas Commission on the Arts and the National Endowment for the Arts

2262. **MOST WORSHIPFUL GRAND MASTER, REUBEN G. WHITE; INSTALLATION OF OFFICERS, PRINCE HALL GRAND LODGE. FORT WORTH** [from "Contemporary Texas: A Photographic Portrait"] (P1985.17.68)
Gelatin silver print. 1984
Image: 8½ x 12½ in. (21.6 x 31.8 cm.)
Sheet: 10¹⁵⁄₁₆ x 13¹⁵⁄₁₆ in. (27.8 x 35.4 cm.)
Signed, l.r. print verso: "Peter Feresten"
Inscription, print verso: "Most Worshipful Grand Master, Reuben G. White, Installation of Officers, Prince Hall Grand Lodge, Fort Worth, Tx., '84"
Acquired from: gift of the Texas Historical Foundation with support from a major grant from the Du Pont Company and Conoco, its energy subsidiary, and assistance from the Texas Commission on the Arts and the National Endowment for the Arts

JIM FERGUSON, American (b. 1954)

Ferguson graduated from the School of the Art Institute of Chicago and the San Francisco Art Institute and has worked for the Chicago Architecture Foundation and the National Historic Landmark Survey. He made archaeological site photographs for the National Museum of Anthropology in Mexico City and was a founding member of the Santa Fe Gallery of Photography.

2263. **UNTITLED** [Lake Powell and bridge, Arizona] (P1978.35)
Gelatin silver print. 1977
Image: 8⁷⁄₁₆ x 12⁹⁄₁₆ in. (21.4 x 31.9 cm.)
Mount: 11 x 13¹⁵⁄₁₆ in. (28.0 x 35.4 cm.)
Signed, l.r. on overmat: "Jim Ferguson"
Acquired from: The Afterimage, Dallas, Texas

ALBERT FICHTE (active c. 1900s)

See *Camera Notes*

GEORGE FISKE, American (1835–1918)

Fiske is best remembered for his Yosemite landscape work. He was Carleton Watkins' assistant but never adopted the large-plate format that Watkins used, preferring instead to make smaller cabinet-size or 10 x 13 inch views. Fiske and his wife lived in the Yosemite Valley intermittently for forty years and marketed a series of winter and summer views of "Yosemite and the Big Trees."

2264. **BRIDAL VEIL FALL. 900 FEET** (P1980.57.3)
Albumen silver print. c. 1879–81
Image: 7⅛ x 4⁵⁄₁₆ in. (18.1 x 10.9 cm.) irregular
Signed: see inscription
Inscription, in negative: "#308./FISKE"
Acquired from: Mazzulla Collection, Fred Mazzulla, Denver, Colorado

*2265. **CATARACT OF DIAMONDS BELOW NEVADA FALLS** (P1980.57.2)
Albumen silver print. 1884
Image: 4¼ x 7³⁄₁₆ in. (10.8 x 18.3 cm.)
Signed: see inscription
Inscription, in negative: "345. CATARACT OF DIAMONDS BELOW NEVADA FALLS./COPYRIGHT 1884 BY GEO. FISKE"
Acquired from: Mazzulla Collection, Fred Mazzulla, Denver, Colorado

2266. **EL CAPITAN. 3300 FEET** (P1980.51.4)
Albumen silver print. c. 1879–81
Image: 7 9/16 x 4 7/16 in. (19.2 x 11.2 cm.)
Mount: 8 1/2 x 5 1/4 in. (21.5 x 13.3 cm.)
Signed: see inscription
Inscription, in negative: "311/FISKE"
 mount verso: "El Capitan. 3300 feet."
Acquired from: Kamp Gallery, St. Louis, Missouri

2267. **HALF DOME (5000 FEET) AND GLACIER POINT
(3200 FEET)** (P1980.51.1)
Albumen silver print. c. 1879–81
Image: 7 1/2 x 4 3/8 in. (19.1 x 11.1 cm.)
Mount: 8 1/2 x 5 1/4 in. (21.5 x 13.3 cm.)
Signed: see inscription
Inscription, in negative: "357/FISKE"
 mount verso: "Half Dome (5000 feet) and/Glacier Point
 (3200 ft.)"
Acquired from: Kamp Gallery, St. Louis, Missouri

2268. **INSTANTANEOUS VIEW OF NEVADA FALL. 700 FEET**
(P1980.57.1)
Albumen silver print. c. 1879–81
Image: 7 1/4 x 4 3/8 in. (18.5 x 11.1 cm.)
Signed: see inscription
Inscription, in negative: "#350./FISKE."
Acquired from: Mazzulla Collection, Fred Mazzulla, Denver,
Colorado

2269. **OVERHANGING ROCK. AT GLACIER POINT,
3200 FEET** (P1980.51.3)
Albumen silver print. c. 1886–1904
Image: 7 1/2 x 4 3/8 in. (19.1 x 11.1 cm.)
Mount: 8 1/2 x 5 1/4 in. (21.5 x 13.3 cm.)
Signed: see inscription
Inscription, in negative: "287/FISKE"
 mount verso: "Overhanging Rock./At Glacier Point,
 3200 feet."
Acquired from: Kamp Gallery, St. Louis, Missouri

2270. **PROFILE OF NEVADA FALL. 700 FEET** (P1980.57.8)
Albumen silver print. c. 1883–84
Image: 7 1/8 x 4 5/16 in. (18.1 x 10.9 cm.)
Signed: see inscription
Inscription, in negative: "439/FISKE"
Acquired from: Mazzulla Collection, Fred Mazzulla, Denver,
Colorado

2271. **PROFILE OF UPPER YOSEMITE FALL. 1600 FEET. FROM
EAGLE POINT TRAIL** (P1980.57.4)
Albumen silver print. c. 1883–84
Image: 7 1/8 x 4 5/16 in. (18.1 x 10.9 cm.)
Signed: see inscription
Inscription, in negative: "500/FISKE"
Acquired from: Mazzulla Collection, Fred Mazzulla, Denver,
Colorado

2272. **STAIRWAY ON CLOUDS' REST TRAIL** (P1980.51.2)
Albumen silver print. c. 1881–84
Image: 7 1/2 x 4 3/8 in. (19.1 x 11.1 cm.)
Mount: 8 1/2 x 5 1/4 in. (21.5 x 13.3 cm.)
Signed: see inscription
Inscription, in negative: "440/FISKE"
 mount verso: "Stairway on Clouds' Rest Trail."
Acquired from: Kamp Gallery, St. Louis, Missouri

*2273. **STORM IN YOSEMITE** (P1980.57.6)
Albumen silver print. c. 1879–81
Image: 4 3/8 x 7 1/4 in. (11.1 x 18.4 cm.)
Signed: see inscription
Inscription, in negative: "371/FISKE"
Acquired from: Mazzulla Collection, Fred Mazzulla, Denver,
Colorado

2265

2273

2275

2274. **UP THE VALLEY. FROM BRIDAL VEIL MEADOWS**
(P1980.57.9)
Albumen silver print. c. 1879–81
Image: 4 3/8 x 7 1/4 in. (11.1 x 18.4 cm.)
Signed: see inscription
Inscription, in negative: "304/FISKE"
Acquired from: Mazzulla Collection, Fred Mazzulla, Denver, Colorado

*2275. **VERNAL FALL. 350 FEET** (P1980.57.7)
Albumen silver print. c. 1879–81
Image: 7 1/8 x 4 5/16 in. (18.1 x 10.9 cm.) irregular
Signed: see inscription
Inscription, in negative: "341/FISKE"
Acquired from: Mazzulla Collection, Fred Mazzulla, Denver, Colorado

2276. **YOSEMITE FALL. 2634 FEET** (P1980.57.5)
Albumen silver print. c. 1879–81
Image: 7 1/8 x 4 5/16 in. (18.1 x 10.9 cm.) irregular
Signed: see inscription
Inscription, in negative: "327/FISKE"
Acquired from: Mazzulla Collection, Fred Mazzulla, Denver, Colorado

STEVE FITCH, American (b. 1949)

Steve Fitch received a B.A. in anthropology, followed by an M.A. in photography from the University of New Mexico. Fitch participated in "Marks and Measures: Rock Art in Modern Art Context," a project funded by the National Endowment for the Arts, and has received two NEA grants (1973, 1975). Fitch's photographs of sites along highways in the western United States have appeared in a book, *Diesels and Dinosaurs* (1976), and a portfolio, "American Roads" (1982). Fitch has made several films, including a short television spot for the Society of Nutritional Education in Berkeley, California, and "Working Steel," which documents the life and working conditions of smelters. He also has worked as a visiting professor and lecturer at the University of Colorado, University of Texas at San Antonio, Bucks County Community College, and Princeton University.

*2277. **SHAMAN-LIKE FIGURES IN HORSESHOE CANYON, UTAH** (P1986.19)
Ektacolor print. 1983
Image: 13 7/8 x 17 5/8 in. (35.3 x 44.6 cm.)
Sheet: 16 x 20 in. (40.7 x 50.8 cm.)
Signed, bottom center print verso: "Steve Fitch"
Inscription, print verso: " "Shaman-like figures in Horseshoe Canyon, Utah, June 1, 1983" "
Acquired from: Etherton Gallery, Tucson, Arizona

WILLIAM GRANCEL FITZ, American (1894–1963)

Fitz, a pioneer in using photographs as a marketing tool, began photographing as a hobby in 1914. His first recognition was as a pictorialist; over a four-year period, he won 89 awards in international pictorial photography salons. In the early 1920s Fitz entered the commercial market of advertising photography. In 1929 he opened a commercial studio in New York. His clients included AT&T, the Chrysler Corporation, Corning Glass, General Motors, and Westinghouse Electric. Fitz's advertising photographs associated the product with a lifestyle of luxury and leisure by showing glamorous people rather than the product itself. His photographs often included abstractions of light and form bordering on the surreal. Between 1924 and 1945 Fitz received eight Art Director Club Awards for his work. He also served three terms as president of the Society

of Photography Illustrators. In 1986 the Museum of Modern Art in New York exhibited Fitz's photographs; it was the museum's first exhibition of an advertising photographer's work.

*2278. **[Advertising image for Chevrolet Motor Company; man photographing seated woman]** (P1985.34)
Gelatin silver print. 1934
Image: 9 5/8 x 10 3/8 in. (24.4 x 26.3 cm.)
1st mount: 9 3/4 x 10 1/2 in. (24.8 x 26.7 cm.)
2nd mount: 17 1/2 x 14 in. (44.4 x 35.6 cm.)
Signed, l.l. 2nd mount recto: "Fitz"
Inscription, 2nd mount verso: "#27" and paper label "PHOTOGRAPHIC ILLUSTRATION BY GRANCEL FITZ/For Chevrolet Motor Company/Agency Campbell-Ewald Company/Art Director Halsey Davidson/NO. 7"
Acquired from: Paul Katz, North Bennington, Vermont

EGBERT GUY FOWX, American (b. 1821–after 1883)

According to census records, Civil War photographer Egbert Guy Fowx was born in Kentucky. Both of his parents were natives of Virginia. Fowx worked for Mathew Brady during the early years of the Civil War but left, as many other photographers did, to work for several months in 1863 with the official photographer for the U.S. Army, A. J. Russell, and for a time for Alexander Gardner. Following the war, Fowx ran a photo studio in Baltimore, Maryland, from 1867 until about 1881. For a time his brother-in-law, Harry C. Hewitt, worked with him. Fowx is listed in the Baltimore city directory for the last time in 1883, but no occupation is given. Fowx was married to Estelle Hewitt and the couple had four children.

*2279. **PONTOON CROSSING JAMES RIVER AT DEEP BOTTOM, VA.** (P1983.19)
Albumen silver print. 1864
Image: 6 x 8 1/8 in. (15.1 x 20.7 cm.) oval
Sheet: 6 3/16 x 8 1/4 in. (15.7 x 21.0 cm.)
Mount: 10 x 12 in. (25.4 x 30.5 cm.)
Signed, right edge mount recto: "Fowx"
Inscription, mount recto: "Pontoon crossing James River at deep Botom [sic] va"
mount verso: "45 to 54 /5/5"
Acquired from: George Rinhart, Colebrook, Connecticut, Amon Carter Foundation purchase

*2280. **PROF. GEO. FOX, IMITATOR OF BIRDS & C.E.** (P1985.36)
Albumen silver print. c. 1870–76
Image: 5 3/4 x 4 1/16 in. (14.6 x 10.3 cm.)
Mount: 6 1/2 x 4 1/4 in. (16.6 x 10.7 cm.)
Signed: see inscription
Inscription, mount verso: "Prof Geo Fox/Imatator [sic] of Birds & C. E" and printed "EGBERT GUY FOWX'S/NEW/PORCELAIN/CARD PHOTOGRAPH,/PUBLISHED ONLY AT/No. 1 N. GAY STREET./Photograph Gallery,/OVER ROBINSON & TRAIL'S CARPET STORE, Baltimore, Md./Patented October 19, [18]69./Photographers are cautioned against/infringing on this Patent. The/Right to use for sale/Copying old pictures a specialty./Negative No.........."
Acquired from: gift of Paul Katz, North Bennington, Vermont

DOUGLAS FRANK, American (b. 1948)

Douglas Frank was born in Milwaukee, Wisconsin, and received his bachelor's and master's degrees from Marquette University. He studied photography under Murray Weiss, Arthur Lazar, and Kipton Kumler and worked for three years as a commercial photographer.

Currently he lives and works in Oregon, where he produces platinum/palladium prints. His photographs have appeared in numerous individual and group exhibitions.

2277

*2281. **CANATA HILLS, SOUTH DAKOTA** (P1986.7)
Hand-coated platinum/palladium print. 1984
Image: 7⅝ x 9¹¹⁄₁₆ in. (19.5 x 24.6 cm.)
Sheet: 8⅛ x 10⅛ in. (20.6 x 25.6 cm.)
Signed, l.r. print verso: "Douglas Frank"
l.r. overmat recto: "Douglas Frank/1984"
Inscription, print verso: "Canata Hills, South Dakota, 1984// 4/50"
mat backing verso: "AC//Canata Hills, South Dakota, 1984/ 4/50"
Acquired from: The Halsted Gallery, Birmingham, Michigan

ROBERT FRANK,
American, born Switzerland (b. 1924)

A Swiss expatriate, Frank received a Guggenheim Fellowship in 1955 to photograph the United States. The resulting work, *The Americans,* focused on commonplace subjects and caused a major shift in the way many American photographers looked at their subject matter. Prior to *The Americans,* Frank had been active as a fashion photographer, photojournalist, and filmmaker. Since 1966 he has worked primarily as a filmmaker but has continued to photograph. There have been several retrospective exhibitions of his work in the United States and Europe.

2278

*2282. **FUNERAL—ST. HELENA, SOUTH CAROLINA**
(P1981.46.1)
Gelatin silver print. 1956
Image: 13 x 8½ in. (33.1 x 21.6 cm.)
Sheet: 14 x 11 in. (35.6 x 28.0 cm.)
Signed, u.l. print verso: "Robert Frank/34 Third Ave/ N.Y.C."
Inscription, print verso: "12/12//#3//12 to 6/Focus 25" and rubber stamp with pencil "ROBERT FRANK ARCHIVE// Americans 56/Funeral—St. Helena,/South Carolina/414" old mat verso: "ROBERT FRANK, FUNERAL— ST. HELENA, SOUTH CAROLINA, AM. 56"
Acquired from: gift of James H. Maroney, New York, New York

2283. **[Madison Square Garden Rodeo Series; calf roper, left, and bronc rider, right]** (P1983.42.4)
Gelatin silver print. c. 1955—56
Image: 13½ x 9⅜ in. (34.3 x 23.8 cm.)
Sheet: 13¹⁵⁄₁₆ x 11 in. (35.4 x 28.0 cm.)
Signed, l.l. print verso: "R. F."
Inscription, print recto, rubber stamp: "ROUGH PRINT" print verso, rubber stamps: "GAMMA/PICTURE AGENCY/60 West 55th Street/New York 19, N. Y./JU. 6- 4523/CREDIT:" and "CREDIT PHOTO TO ROBERT FRANK"
Acquired from: gift of P/K Associates, New York, New York

2284. **[Madison Square Garden Rodeo Series; cowboy Bill Lender on right, bulldogger Todd Whatley on left, and girl]**
(P1983.42.14)
Gelatin silver print. c. 1955—56
Image: 9⁵⁄₁₆ x 13½ in. (23.8 x 34.3 cm.)
Sheet: 11 x 13¹⁵⁄₁₆ in. (28.0 x 35.4 cm.)
Signed, l.r. print verso: "R. F."
Inscription, print recto, rubber stamp: "ROUGH PRINT" print verso, rubber stamp: "CREDIT PHOTO TO/ ROBERT FRANK"
Acquired from: gift of P/K Associates, New York, New York

2279

2285. **[Madison Square Garden Rodeo Series; cowboy leaning against metal pole]** (P1983.42.1)
Gelatin silver print. c. 1955–56
Image: 13½ x 9 in. (34.2 x 22.8 cm.)
Sheet: 13¹⁵⁄₁₆ x 11 in. (35.4 x 27.9 cm.)
Signed, l.r. print verso: "R Frank"
Inscription, print recto, rubber stamps: "ROUGH PRINT// ROUGH PRINT"
 print verso: "796" and rubber stamps "GAMMA/ PICTURE AGENCY/60 West 55th Street/New York, N. Y./JU.6-4523/CREDIT" and "CREDIT PHOTO TO/ ROBERT FRANK" and crop marks and measurements
Acquired from: gift of P/K Associates, New York, New York

2286. **[Madison Square Garden Rodeo Series; cowboy leaning on metal rail in front of building, two children sitting on ledge to his right]** (P1983.42.8) duplicate of P1983.42.20
Gelatin silver print. c. 1955–56
Image: 13½ x 9 in. (34.3 x 22.8 cm.)
Sheet: 13¹⁵⁄₁₆ x 11 in. (35.4 x 28.0 cm.)
Signed, l.r. print verso: "R. Frank."
Inscription, print recto, rubber stamp: "ROUGH PRINT"
 print verso: "798//55" and rubber stamps "GAMMA/ PICTURE AGENCY/60 West 55th Street/New York 19, N. Y./JU. 6-4523/CREDIT:" and "NEW ADDRESS: 33 WEST 42nd STREET/NEW YORK, 18 N.Y./L.A. 4-5578" and "CREDIT PHOTO TO/ROBERT FRANK"
Acquired from: gift of P/K Associates, New York, New York

2287. **[Madison Square Garden Rodeo Series; cowboy leaning on metal rail in front of building, two children sitting on ledge to his right]** (P1983.42.20) duplicate of P1983.42.8
Gelatin silver print. c. 1955–56
Image: 12¾ x 8⅜ in. (32.4 x 21.2 cm.)
Sheet: 14 x 10¹⁵⁄₁₆ in. (35.6 x 27.8 cm.)
Signed, bottom center print verso: "R. F."
Acquired from: gift of P/K Associates, New York, New York

2288. **[Madison Square Garden Rodeo Series; cowboy sitting on trunk of Buick]** (P1983.42.2)
Gelatin silver print. c. 1955–56
Image: 13½ x 9 in. (34.3 x 22.8 cm.)
Sheet: 13¹⁵⁄₁₆ x 11 in. (35.4 x 27.9 cm.)
Signed, bottom center print verso: "R.F."
Inscription, print recto, rubber stamp: "ROUGH PRINT"
 print verso: "98+//3″ 3½″" and rubber stamps "GAMMA/ PICTURE AGENCY/60 West 55th Street/New York 19, N. Y./JU. 6-4523/CREDIT" and "CREDIT PHOTO TO/ ROBERT FRANK//CREDIT PHOTO TO/ROBERT FRANK" and crop marks
Acquired from: gift of P/K Associates, New York, New York

2289. **[Madison Square Garden Rodeo Series; cowboy standing on patch of grass, horse grazing behind him]** (P1983.42.3)
Gelatin silver print. c. 1955–56
Image: 13½ x 8¹⁵⁄₁₆ in. (34.3 x 22.7 cm.)
Sheet: 13¹⁵⁄₁₆ x 11 in. (35.4 x 28.0 cm.)
Signed, l.r. print verso: "R Frank"
Inscription, print recto, rubber stamp: "ROUGH PRINT"
 print verso: "391" and rubber stamps "GAMMA/ PICTURE AGENCY/60 West 55th Street/New York 19, N. Y./JU. 6-4523/CREDIT:" and "CREDIT PHOTO TO/ ROBERT FRANK" and crop marks and measurements
Acquired from: gift of P/K Associates, New York, New York

2290. **[Madison Square Garden Rodeo Series; Don Coates, rodeo announcer, next to cowboy sitting on the hood of a truck]** (P1983.42.5)
Gelatin silver print. c. 1955–56
Image: 13½ x 9 in. (34.3 x 22.7 cm.)
Sheet: 13¹⁵⁄₁₆ x 11 in. (35.4 x 28.0 cm.)
Signed, bottom center print verso: "R.F."
Inscription, print recto, rubber stamp: "ROUGH PRINT"
 print verso, rubber stamps: "GAMMA/PICTURE AGENCY/60 West 55th Street/New York 19, N.Y./JU.
6-4523/CREDIT:" and "CREDIT PHOTO TO ROBERT FRANK" and crop marks and measurements
Acquired from: gift of P/K Associates, New York, New York

2291. **[Madison Square Garden Rodeo Series; Everitt Colburn, rodeo producer]** (P1983.42.17)
Gelatin silver print. c. 1955–56
Image: 13½ x 8¹⁵⁄₁₆ in. (34.3 x 22.7 cm.)
Sheet: 13¹⁵⁄₁₆ x 11 in. (35.4 x 28.0 cm.)
Signed, center print verso: "R.F."
Inscription, print recto, rubber stamp: "ROUGH PRINT"
 print verso, rubber stamp: "CREDIT PHOTO TO/ ROBERT FRANK"
Acquired from: gift of P/K Associates, New York, New York

2292. **[Madison Square Garden Rodeo Series; groom smoking pipe while holding horse's reins]** (P1983.42.12)
Gelatin silver print. c. 1955–56
Image: 8⁵⁄₁₆ x 13½ in. (21.1 x 34.3 cm.)
Sheet: 11 x 13¹⁵⁄₁₆ in. (28.0 x 35.4 cm.)
Signed, l.r. print verso: "R. Frank"
Inscription, print recto, rubber stamps: "ROUGH PRINT// ROUGH PRINT"
 print verso: "795//69+" and rubber stamps "GAMMA/ PICTURE AGENCY/60 West 55th Street/New York 19, N. Y./JU. 6-4523/CREDIT:" and "CREDIT PHOTO TO/ ROBERT FRANK" and crop marks and measurements
Acquired from: gift of P/K Associates, New York, New York

2293. **[Madison Square Garden Rodeo Series; horse, car, and horse trailer in front of building]** (P1983.42.11)
Gelatin silver print. c. 1955–56
Image: 7⁷⁄₁₆ x 13½ in. (18.9 x 34.3 cm.)
Sheet: 11 x 13¹⁵⁄₁₆ in. (28.0 x 35.4 cm.)
Signed, center print verso: "R.F."
Inscription, print recto, rubber stamp: "ROUGH PRINT"
 print verso, rubber stamps: "GAMMA/PICTURE AGENCY/60 West 55th Street/New York 19, N. Y./JU. 6-4523/CREDIT:" and "CREDIT PHOTO TO/ ROBERT FRANK" and crop marks and measurements
Acquired from: gift of P/K Associates, New York, New York

2294. **[Madison Square Garden Rodeo Series; June Ivory, trick rider, crossing the street next to a group of cowboys]** (P1983.42.10)
Gelatin silver print. c. 1955–56
Image: 10¼ x 13½ in. (26.0 x 34.3 cm.)
Sheet: 11 x 13¹⁵⁄₁₆ in. (28.0 x 35.4 cm.)
Signed, bottom center print verso: "R.F."
Inscription, print recto, rubber stamp: "ROUGH PRINT"
 print verso, rubber stamps: "GAMMA/PICTURE AGENCY/60 West 55th Street/New York 19, N. Y./JU. 6-4523/CREDIT:" and "CREDIT PHOTO TO/ ROBERT FRANK" and measurements
Acquired from: gift of P/K Associates, New York, New York

2295. **[Madison Square Garden Rodeo Series; man crossing the street carrying a jacket and magazine]** (P1983.42.9)
Gelatin silver print. c. 1955–56
Image: 13½ x 8¾ in. (34.3 x 22.2 cm.)
Sheet: 13¹⁵⁄₁₆ x 11 in. (35.4 x 28.0 cm.)
Signed, l.r. print verso: "R. Frank—"
Inscription, print recto, rubber stamps: "ROUGH PRINT// ROUGH PRINT"
 print verso: "794//59+" and rubber stamps "GAMMA/ PICTURE AGENCY/60 West 55th Street/New York 19, N. Y./JU. 6-4523/CREDIT:" and "CREDIT PHOTO TO/ ROBERT FRANK"
Acquired from: gift of P/K Associates, New York, New York

2296. **[Madison Square Garden Rodeo Series; man resting on fire hydrant]** (P1983.42.15)
Gelatin silver print. c. 1955–56
Image: 13½ x 8¹⁵⁄₁₆ in. (34.3 x 22.6 cm.)
Sheet: 13¹⁵⁄₁₆ x 11 in. (35.4 x 28.0 cm.)
Signed, l.r. print verso: "R. Frank"
Inscription, print recto, rubber stamp: "ROUGH PRINT"

print verso: "152" and rubber stamp "CREDIT PHOTO
TO/ROBERT FRANK"
Acquired from: gift of P/K Associates, New York, New York

2297. **[Madison Square Garden Rodeo Series; Pete Logan, rodeo
announcer, talking with June Ivory, trick rider]** (P1983.42.6)
Gelatin silver print. c. 1955–56
Image: 13 ½ x 8 ¾ in. (34.3 x 22.2 cm.)
Sheet: 13 ¹⁵⁄₁₆ x 11 in. (35.4 x 28.0 cm.)
Signed, bottom center print verso: "R.F."
Inscription, print recto, rubber stamp: "ROUGH PRINT"
print verso, rubber stamps: "GAMMA/PICTURE
AGENCY/60 West 55th Street/New York 19, N.Y./JU.
6-4523/CREDIT:" and "CREDIT PHOTO TO ROBERT
FRANK" and crop marks and measurements
Acquired from: gift of P/K Associates, New York, New York

2298. **[Madison Square Garden Rodeo Series; rodeo producer Everitt
Colburn with his daughter Carolyn]** (P1983.42.7)
Gelatin silver print. c. 1955–56
Image: 13 ½ x 9 ¼ in. (34.3 x 23.4 cm.)
Sheet: 13 ¹⁵⁄₁₆ x 11 in. (35.4 x 28.0 cm.)
Signed, l.r. print verso: "Frank—"
Inscription, print recto, rubber stamp: "ROUGH PRINT"
print verso: "339" and rubber stamps "GAMMA/
PICTURE AGENCY/60 West 55th Street/New York 19,
N. Y./JU. 6-4523/CREDIT:" and "CREDIT PHOTO TO/
ROBERT FRANK"
Acquired from: gift of P/K Associates, New York, New York

2299. **[Madison Square Garden Rodeo Series; saddle bronc saddles
piled on floor]** (P1983.42.13)
Gelatin silver print. c. 1955–56
Image: 9 ⁵⁄₁₆ x 13 ½ in. (23.8 x 34.3 cm.)
Sheet: 11 x 13 ¹⁵⁄₁₆ in. (28.0 x 35.4 cm.)
Signed, l.r. print verso: "R.F"
Inscription, print recto, rubber stamp: "ROUGH PRINT"
print verso, rubber stamp: "CREDIT PHOTO TO/
ROBERT FRANK"
Acquired from: gift of P/K Associates, New York, New York

2300. **[Madison Square Garden Rodeo Series; three cowboys]**
(P1983.42.19)
Gelatin silver print. c. 1955–56
Image: 13 ½ x 9 in. (34.3 x 22.8 cm.)
Sheet: 13 ¹⁵⁄₁₆ x 11 in. (35.4 x 28.0 cm.)
Signed, l.r. print verso: "R. Frank."
Inscription, print recto, rubber stamp: "ROUGH PRINT"
print verso: "376" and rubber stamp "CREDIT PHOTO
TO/ROBERT FRANK"
Acquired from: gift of P/K Associates, New York, New York

2301. **[Madison Square Garden Rodeo Series; two men facing each
other]** (P1983.42.16)
Gelatin silver print. c. 1955–56
Image: 13 ½ x 9 ⁵⁄₁₆ in. (34.3 x 23.6 cm.)
Sheet: 13 ¹⁵⁄₁₆ x 11 in. (35.4 x 28.0 cm.)
Signed, bottom center print verso: "R.F."
Inscription, print recto, rubber stamp: "ROUGH PRINT"
print verso, rubber stamp: "CREDIT PHOTO TO/
ROBERT FRANK"
Acquired from: gift of P/K Associates, New York, New York

2302. **[Madison Square Garden Rodeo Series; young boy and cowboy
leaning against a brick wall]** (P1983.42.18)
Gelatin silver print. c. 1955–56
Image: 13 ½ x 8 ⁵⁄₈ in. (34.3 x 21.9 cm.)
Sheet: 13 ¹⁵⁄₁₆ x 11 in. (35.4 x 28.0 cm.)
Signed, l.r. print verso: "R. Frank"
Inscription, print recto, rubber stamps: "ROUGH PRINT//
ROUGH PRINT//ROUGH PRINT"
print verso: "375" and rubber stamp "CREDIT PHOTO TO/
ROBERT FRANK"
Acquired from: gift of P/K Associates, New York, New York

2280

2281

2282

*2303. **WASHINGTON 1960** (P1981.46.2)
Gelatin silver print. 1960
Image: 8 ⅜ x 12 ⅞ in. (21.3 x 32.7 cm.)
Sheet: 11 x 14 in. (28.0 x 35.6 cm.)
Signed, l.r. print recto: "R. Frank."
Inscription, print recto: "WASHINGTON 1960"
print verso, rubber stamps with pencil: "COPYRIGHT ©
Robert Frank 1979/ALL RIGHTS RESERVED" and
"ROBERT FRANK ARCHIVE/Washington 1960/575"
Acquired from: gift of James H. Maroney, New York,
New York

W. A. FRASER, American (active 1890s)

See *Camera Notes*

TONI FRISSELL (Antoinette Frissell Bacon), American (b. 1907)

Known during the 1940s as one of America's leading
fashion photographers, Frissell began her professional
career in the theater, acting in several Max Reinhardt
productions. In 1930, while working for *Vogue* as a cap-
tion writer, she became interested in photography as a
profession. Her first fashion photographs appeared in
Vogue in 1931. Frissell photographed her models outdoors
in natural light in order to make them look "not like
Powers girls modeling, but like human beings." Her
work was also published in *Harper's Bazaar, Life,* and
Look. During World War II Frissell served as an official
photographer for the Women's Army Corps. Her work
was not limited to fashion shots but also included can-
did images of children and lifestyles. Her friendship
with the Kleberg family led to a project focusing on
ranch life and the cattle industry at the King Ranch
from 1939 to 1944. Negatives from that project are now
housed at the Library of Congress. Frissell's photo-
graphs of the ranch were featured in a 1975 Amon
Carter Museum exhibition and publication.

*2304. **EMILIANO GARCIA AT A LOOM IN THE WEAVING
SHOP** (P1975.92.5)
Gelatin silver print mounted on Masonite. negative 1939–44,
print c. 1974 by Modernage
Image: 30 x 30 in. (76.2 x 76.2 cm.)
Mount: same as image size
Inscription, mount verso: "PANEL 5/424" and ACM
exhibition label
Acquired from: the photographer and the Library of Congress

*2305. **HENRIETTA KLEBERG ARMSTRONG** (P1975.92.3)
Gelatin silver print mounted on Masonite. negative 1939–44,
print c. 1974 by Modernage
Image: 24 x 23 ¹⁵/₁₆ inc. (60.9 x 60.8 cm.)
Mount: same as image size
Inscription, mount verso: "PANEL 4/41Q3/
PANEL/2[illegible]" and ACM exhibition label
Acquired from: the photographer and the Library of Congress

2306. **HERD OF HORSES AND CATTLE** (P1975.92.1)
Gelatin silver print mounted on Masonite (ten-part
panorama). negative 1939–44, print c. 1974 by Modernage
Image: a) 96 x 36 ³/₁₆ in. (243.9 x 92.0 cm.)
b) 96 x 48 ¹/₁₆ in. (243.9 x 122.0 cm.)
c) 96 x 48 ¹/₁₆ in. (243.9 x 122.0 cm.)
d) 96 x 48 ¹/₁₆ in. (243.9 x 122.0 cm.)
e) 96 ⅛ x 36 ³/₁₆ in. (244.2 x 91.9 cm.)
f) 96 ¹/₁₆ x 36 ⅛ in. (244.1 x 91.8 cm.)
g) 96 ¹/₁₆ x 48 ¹/₁₆ in. (244.1 x 122.0 cm.)
h) 96 ⅛ x 48 ¹/₁₆ in. (244.2 x 122.0 cm.)
i) 96 ¹/₁₆ x 48 ¹/₁₆ in. (244.1 x 122.0 cm.)
j) 96 ⅛ x 36 ⅛ in. (244.2 x 91.8 cm.)
overall image: 192 ¼ x 216 ⁹/₁₆ in. (488.4 x 549.9 cm.)

Mount: same as image size for all
Acquired from: the photographer and the Library of Congress

2307. **MEMBERS OF A KING RANCH COW CAMP** (P1975.92.4)
Gelatin silver print mounted on Masonite. negative 1939–44,
print c. 1974 by Modernage
Image: 30 x 30 in. (76.2 x 76.2 cm.)
Mount: same as image size
Inscription, mount verso: "PANEL 5/42R3" and ACM
exhibition label
Acquired from: the photographer and the Library of Congress

2308. **NORIAS DIVISION'S FAMED SAM CHESSHIRE AND
SOME OF HIS BEST TRAINED BIRD DOGS**
(P1975.92.6)
Gelatin silver print mounted on Masonite. negative 1939–44,
print c. 1974 by Modernage
Image: 30 ¹/₁₆ x 36 in. (76.3 x 91.4 cm.)
Mount: same as image size
Inscription, mount verso: "1/21R2" and ACM exhibition label
Acquired from: the photographer and the Library of Congress

2309. **ROBERT J. KLEBERG, JR., AND HIS COUSIN CAESAR
KLEBERG** (P1975.92.7)
Gelatin silver print mounted on Masonite. negative 1939–44,
print c. 1974 by Modernage
Image: 36 ⅛ x 36 ⅛ in. (91.7 x 91.7 cm.)
Mount: same as image size
Inscription, mount verso: "42Q2/36x36 P4" and ACM
exhibition label
Acquired from: the photographer and the Library of Congress

2310. **THIS YOUNG COWHAND IS AT PRACTICE, ROPE-
WISE AND READY** (P1975.92.2)
Gelatin silver print mounted on Masonite. negative 1939–44,
print c. 1974 by Modernage
Image: 48 x 24 ¹/₁₆ in. (121.9 x 61.1 cm.)
Mount: same as image size
Inscription, mount verso: "PANEL 5/54x6" and ACM
exhibition label
Acquired from: the photographer and the Library of Congress

DALLETT FUGUET, American (active 1890s)

See *Camera Notes*

OLIVER GAGLIANI, American (b. 1917)

Although Gagliani intended to pursue a musical career,
a hearing loss and a lengthy illness led him to abandon
music and take up photography. Gagliani was strongly
influenced by Paul Strand and has indicated that the
Museum of Modern Art exhibition "Paul Strand Retro-
spective, 1915–1945" had a great impact on his work.
He studied with Ansel Adams and Minor White,
adopting Adams' zone system. Gagliani's printing tech-
niques reflect the same technical precision as Adams'
work. Gagliani has taught numerous creative photogra-
phy workshops and college courses, and most recently
he has been a graduate instructor at California State
University in San Francisco. His photographs are
highly personal images focusing on the landscape and
abstract close-ups.

2311. **MITSUBISHI [original print included in limited-edition
catalogue, *Oliver Gagliani Retrospective 1937–1984*]**
(P1987.7)
Gelatin silver print. 1984
Image: 4 ⁹/₁₆ x 6 ⅛ in. (11.7 x 15.6 cm.)
Sheet: 7 ¹⁵/₁₆ x 10 in. (20.2 x 25.3 cm.)
Signed, bottom center sheet recto: "Oliver L Gagliani"
Inscription, sheet recto: "93//© 1984" and embossed

2303

"ARCHIVAL PRINT//Oliver L Gagliani [facsimile
signature]"
print verso, rubber stamps: "PRINT [handwritten] 93 OF
SPECIAL PRINTING//MITSUBISHI"
Acquired from: gift of the photographer

*2312. **WHITE DOOR, EUREKA, NEVADA** (P1981.34)
Gelatin silver print. negative 1973, print 1980
Image: 10 ¼ x 13 in. (26.0 x 33.0 cm.)
Sheet: 11 x 14 in. (28.0 x 35.6 cm.)
Signed, right edge sheet recto: "Oliver Gagliani ©"
old overmat recto: "Oliver Gagliani"
Inscription, print recto: "1973"
print verso: "73-150-1LB//*"
mat verso: "73.150" and rubber stamp "OLIVER
GAGLIANI/605 ROCCA AVENUE/SO. SAN
FRANCISCO, CA 94080" and "Amon Carter Museum"
contained within rubber stamp "ASSIGNED PRINT/
Printed For"
old overmat: "1973©"
Acquired from: The Afterimage, Dallas, Texas

ALEXANDER GARDNER,
American, born Scotland (1821–1882)

See also *Gardner's Photographic Sketch Book of the War*

Gardner trained as a jeweler but had outside interests in
optics, astronomy, and chemistry. In 1849 Gardner and
his brother-in-law founded the Utopian community of
Clydesdale, Iowa, for members of a political party of
working-class Scots. He returned to Scotland to raise
funds for the settlement, but it was ravaged by a flu
epidemic while he was gone. Gardner moved to New
York in 1856 and went to work for Mathew Brady,
teaching him how to make salt prints. He left the Brady
Studio in 1862 in a dispute over print attribution and
copyright, becoming the official photographer for
the Army of the Potomac under General George
McClellan. Although Gardner published a number of
his war views in *Catalogue of the Photographic Incidents
of War* (1866), the volume was not a financial success.
In 1867 Gardner was hired by the Kansas Pacific and
Union Pacific Railroads to document the building of a
rail route to California. In 1868 he photographed the
Fort Laramie Treaty Council and was the first photogra-
pher to make images of the Plains Indians in their
home territory. During the 1870s Gardner ran a studio
in Washington, D. C., where he photographed mem-
bers of Indian treaty delegations.

2304

2305

*2313. **ANTIETAM BRIDGE, MARYLAND** (P1979.78.1) duplicate
of P1984.30.19 in *Gardner's Photographic Sketch Book of the
War*
Albumen silver print. 1862
Image: 7 x 9 1/16 in. (17.8 x 23.0 cm.)
Mount: 12 1/16 x 15 ¾ in. (30.6 x 40.1 cm.)
Signed: see inscription
Inscription, mount recto, printed: "ALEX. GARDNER,
Photographer,/Entered according to act of Congress, in the
year 1866, by A. Gardner, in the Clerk's Office of the
District Court of the District of Columbia. 511 Seventh
Street, Washington.//ANTIETEM [sic] BRIDGE,
MARYLAND./No. 19./September 1862"
Acquired from: Frontier America Corporation, Bryan, Texas

Mathew Brady studio, probably by Alexander Gardner
GEN. JOHN C. FRÉMONT (P1983.4)
See entry under Mathew Brady

***2314. HDQTS. J. H. H. WARD** (P1984.28)
Albumen silver print. c. 1861–64
Image: 6 ¹⁵⁄₁₆ x 9 ⁷⁄₁₆ in. (17.6 x 24.0 cm.) irregular
Mount: 9 x 11 in. (22.9 x 27.9 cm.)
Signed, l.l. print verso [print is mounted, but signature is visible in reverse]: "Gardner"
Inscription, print verso [print is mounted, but inscription is visible in reverse]: "Hdqts J H H Ward"
mount verso: "627-IX/Hdqtrs. J. H. H. Ward"
Acquired from: gift of Paul Katz, North Bennington, Vermont

2315. NEAR CALEBACH'S RANCHE, TEHACHAPI
[near Tehachapi Pass, California] (P1982.24)
Albumen silver print. 1867–68
Image: 5 ¹⁵⁄₁₆ x 8 ⅛ in. (15.1 x 20.6 cm.)
Mount: 11 ¹⁵⁄₁₆ x 17 ¼ in. (30.3 x 45.1 cm.)
Signed: see inscription
Inscription, mount recto: "Across the Continent on the Union Pacific Railway, E. D.//Near Calebachs Ranche Tahachapi [sic]//No 160" and printed "A. Gardner, Photographer,/511 Seventh Street, Washington."
Acquired from: Andrew Smith, Inc., Albuquerque, New Mexico

JAMES GARDNER,
American, born Scotland (active 1860s)

See *Gardner's Photographic Sketch Book of the War*

GARDNER'S PHOTOGRAPHIC SKETCH BOOK OF THE WAR (P1984.30.1–100)

This two-volume set of 100 Civil War photographs was published in 1865–66 by Philip & Solomons, Publishers, of Washington, D. C. The volumes contain images by Alexander Gardner, who compiled the album and printed each of the negatives, as well as by George N. Barnard, James Gardner, James F. Gibson, David Knox, Timothy H. O'Sullivan, William R. Pywell, John Reekie, W. Morris Smith, John Wood, and David B. Woodbury. Each volume contains a lithographed title page and a descriptive text plate.

Volume I (P1984.30.1–50)

William R. Pywell
2316. MARSHALL HOUSE, ALEXANDRIA, VIRGINIA
(P1984.30.1)
Albumen silver print. negative 1862, print 1866 by Alexander Gardner
Image: 7 x 9 ¹⁄₁₆ in. (17.7 x 23.0 cm.)
Mount: 12 x 15 ⅝ in. (30.3 x 39.7 cm.)
Signed: see inscription
Inscription, mount recto, printed: "Negative by WM. R. PYWELL./Entered according to act of Congress, in the year 1866, by A. Gardner, in the Clerk's Office of the District Court of the District of Columbia./Positive by A. GARDNER, 511 7th St., Washington.//MARSHALL HOUSE, ALEXANDRIA, VIRGINIA.//No. 1.//August, 1862."
Acquired from: Zeitlin & VerBrugge Booksellers, Los Angeles, California

William R. Pywell
2317. SLAVE PEN, ALEXANDRIA, VIRGINIA (P1984.30.2)
Albumen silver print. negative 1862, print 1866 by Alexander Gardner
Image: 7 x 9 ¹⁄₁₆ in. (17.7 x 23.0 cm.)
Mount: 12 x 15 ⅝ in. (30.3 x 39.7 cm.)
Signed: see inscription

Inscription, mount recto, printed: "Negative by WM. R. PYWELL./Entered according to act of Congress, in the year 1866, by A. Gardner, in the Clerk's Office of the District Court of the District of Columbia./Positive by A. GARDNER, 511 7th St., Washington.//SLAVE PEN, ALEXANDRIA, VIRGINIA.//No. 2.//August, 1862."
Acquired from: Zeitlin & VerBrugge Booksellers, Los Angeles, California

Timothy H. O'Sullivan
2318. FAIRFAX COURT-HOUSE (P1984.30.3)
Albumen silver print. negative 1863, print 1865 by Alexander Gardner
Image: 6 ⅞ x 8 ¹¹⁄₁₆ in. (17.4 x 22.0 cm.)
Mount: 12 x 15 ⅝ in. (30.3 x 39.7 cm.)
Signed: see inscription
Inscription, in negative: "Pe[illegible]"
mount recto, printed: "Negative by T. H. O'SULLIVAN./Entered according to act of Congress, in the year 1865, by A. Gardner, in the Clerk's Office of the District Court of the District of Columbia./Positive by A. GARDNER, 511 7th St., Washington.//FAIRFAX COURT-HOUSE.//No. 3.//June, 1863."
Acquired from: Zeitlin & VerBrugge Booksellers, Los Angeles, California

George N. Barnard and James F. Gibson
***2319. STONE CHURCH, CENTREVILLE, VA.** (P1984.30.4)
duplicate of P1979.78.2
Albumen silver print. negative 1862, print 1865 by Alexander Gardner
Image: 6 ¾ x 8 ⁹⁄₁₆ in. (17.1 x 21.7 cm.)
Mount: 12 x 15 ⅝ in. (30.3 x 39.7 cm.)
Signed: see inscription
Inscription, mount recto, printed: "Negative by BARNARD & GIBSON./Entered according to act of Congress, in the year 1865, by A. Gardner, in the Clerk's Office of the District Court of the District of Columbia./Positive by A. GARDNER, 511 7th St., Washington.//STONE CHURCH, CENTREVILLE, VA.//No. 4.//March, 1862."
Acquired from: Zeitlin & VerBrugge Booksellers, Los Angeles, California

George N. Barnard and James F. Gibson
2320. FORTIFICATIONS ON HEIGHTS OF CENTREVILLE, VIRGINIA (P1984.30.5)
Albumen silver print. negative 1862, print 1865 by Alexander Gardner
Image: 6 ⅞ x 8 ⅝ in. (17.4 x 21.9 cm.)
Mount: 12 x 15 ⅝ in. (30.3 x 39.7 cm.)
Signed: see inscription
Inscription, mount recto, printed: "Negative by BARNARD & GIBSON./Entered according to act of Congress, in the year 1865, by A. Gardner, in the Clerk's Office of the District Court of the District of Columbia./Positive by A. GARDNER, 511 7th St., Washington.//FORTIFICATIONS ON HEIGHTS OF CENTREVILLE, VIRGINIA.//No. 5.//March, 1862."
Acquired from: Zeitlin & VerBrugge Booksellers, Los Angeles, California

George N. Barnard and James F. Gibson
***2321. QUAKER GUNS, CENTREVILLE, VIRGINIA**
(P1984.30.6)
Albumen silver print. negative 1862, print 1865 by Alexander Gardner
Image: 7 x 9 ¹⁄₁₆ in. (17.7 x 23.0 cm.)
Mount: 12 x 15 ⅝ in. (30.3 x 39.7 cm.)
Signed: see inscription
Inscription, mount recto, printed: "Negative by BARNARD & GIBSON./Entered according to act of Congress, in the year 1865, by A. Gardner, in the Clerk's Office of the District Court of the District of Columbia./Positive by A. GARDNER, 511 7th St., Washington.//QUAKER GUNS, CENTREVILLE, VIRGINIA.//No. 6.//March, 1862."
Acquired from: Zeitlin & VerBrugge Booksellers, Los Angeles, California

2312

2313

2314

2319

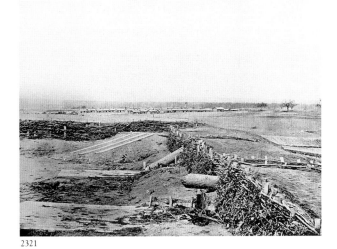

2321

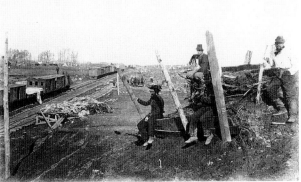

2325

George N. Barnard and James F. Gibson
2322. **RUINS OF STONE BRIDGE, BULL RUN** (P1984.30.7)
Albumen silver print. negative 1862, print 1865 by Alexander
 Gardner
Image: 7 x 9 1/16 in. (17.7 x 23.0 cm.)
Mount: 12 x 15 5/8 in. (30.3 x 39.7 cm.)
Signed: see inscription
Inscription, mount recto, printed: "Negative by BARNARD
 & GIBSON./Entered according to act of Congress, in the
 year 1865, by A. Gardner, in the Clerk's Office of the
 District Court of the District of Columbia./Positive by
 A. GARDNER, 511 7th St., Washington.//RUINS OF
 STONE BRIDGE, BULL RUN.//No. 7.//March, 1862."
Acquired from: Zeitlin & VerBrugge Booksellers,
 Los Angeles, California

George N. Barnard and James F. Gibson
2323. **MATHEWS' HOUSE, BATTLE-FIELD OF BULL RUN**
 (P1984.30.8)
Albumen silver print. negative 1862, print 1865 by Alexander
 Gardner
Image: 6 7/8 x 8 7/8 in. (17.4 x 22.5 cm.)
Mount: 12 x 15 5/8 in. (30.3 x 39.7 cm.)
Signed: see inscription
Inscription, mount recto, printed: "Negative by BARNARD
 & GIBSON./Entered according to act of Congress, in the
 year 1865, by A. Gardner, in the Clerk's Office of the
 District Court of the District of Columbia./Positive by
 A. GARDNER, 511 7th St., Washington.//MATHEWS'
 HOUSE, BATTLE-FIELD OF BULL RUN.//No. 8.//
 March, 1862."
Acquired from: Zeitlin & VerBrugge Booksellers,
 Los Angeles, California

George N. Barnard and James F. Gibson
2324. **RUINS AT MANASSAS JUNCTION** (P1984.30.9)
Albumen silver print. negative 1862, print 1865 by Alexander
 Gardner
Image: 6 13/16 x 9 1/16 in. (17.3 x 23.0 cm.)
Mount: 12 x 15 5/8 in. (30.3 x 39.7 cm.)
Signed: see inscription
Inscription, mount recto, printed: "Negative by BARNARD
 & GIBSON./Entered according to act of Congress, in the
 year 1865, by A. Gardner, in the Clerk's Office of the
 District Court of the District of Columbia./Positive by
 A. GARDNER, 511 7th St., Washington.//RUINS AT
 MANASSAS JUNCTION.//No. 9.//March, 1862."
Acquired from: Zeitlin & VerBrugge Booksellers,
 Los Angeles, California

George N. Barnard and James F. Gibson
*2325. **MANASSAS JUNCTION** (P1984.30.10)
Albumen silver print. negative 1862, print 1865 by Alexander
 Gardner
Image: 6 13/16 x 9 in. (17.3 x 22.8 cm.)
Mount: 12 x 15 5/8 in. (30.3 x 39.7 cm.)
Signed: see inscription
Inscription, mount recto, printed: "Negative by BARNARD
 & GIBSON./Entered according to act of Congress, in the
 year 1865, by A. Gardner, in the Clerk's Office of the
 District Court of the District of Columbia./Positive by
 A. GARDNER, 511 7th St., Washington.//MANASSAS
 JUNCTION.//No. 10.//March, 1862."
Acquired from: Zeitlin & VerBrugge Booksellers,
 Los Angeles, California

George N. Barnard and James F. Gibson
2326. **FORTIFICATIONS AT MANASSAS** (P1984.30.11)
Albumen silver print. negative 1862, print 1865 by Alexander
 Gardner
Image: 7 x 9 1/16 in. (17.7 x 23.0 cm.)
Mount: 12 x 15 5/8 in. (30.3 x 39.7 cm.)
Signed: see inscription
Inscription, mount recto, printed: "Negative by BARNARD
 & GIBSON./Entered according to act of Congress, in the

year 1865, by A. Gardner, in the Clerk's Office of the
 District Court of the District of Columbia./Positive by
 A. GARDNER, 511 7th St., Washington.//
 FORTIFICATIONS AT MANASSAS.//No. 11.//March,
 1862."
Acquired from: Zeitlin & VerBrugge Booksellers,
 Los Angeles, California

John Wood and James F. Gibson
*2327. **BATTERY NO. 1, NEAR YORKTOWN, VIRGINIA**
 (P1984.30.12)
Albumen silver print. negative 1862, print 1865 by Alexander
 Gardner
Image: 6 7/8 x 8 15/16 in. (17.4 x 22.7 cm.)
Mount: 12 x 15 5/8 in. (30.3 x 39.7 cm.)
Signed: see inscription
Inscription, mount recto, printed: "Negative by WOOD &
 GIBSON./Entered according to act of Congress, in the
 year 1865, by A. Gardner, in the Clerk's Office of the
 District Court of the District of Columbia./Positive by
 A. GARDNER, 511 7th St., Washington.//BATTERY
 NO. 1, NEAR YORKTOWN, VIRGINIA.//No. 12.//
 May, 1862."
Acquired from: Zeitlin & VerBrugge Booksellers,
 Los Angeles, California

John Wood and James F. Gibson
2328. **BATTERY NO. 1, NEAR YORKTOWN, VIRGINIA**
 (P1984.30.13)
Albumen silver print. negative 1862, print 1865 by Alexander
 Gardner
Image: 6 11/16 x 8 15/16 in. (16.9 x 22.7 cm.)
Mount: 12 x 15 5/8 in. (30.3 x 39.7 cm.)
Signed: see inscription
Inscription, mount recto, printed: "Negative by WOOD &
 GIBSON./Entered according to act of Congress, in the
 year 1865, by A. Gardner, in the Clerk's Office of the
 District Court of the District of Columbia./Positive by
 A. GARDNER, 511 7th St., Washington.//BATTERY
 NO. 1, NEAR YORKTOWN, VIRGINIA.//No. 13.//
 May, 1862."
Acquired from: Zeitlin & VerBrugge Booksellers,
 Los Angeles, California

John Wood and James F. Gibson
2329. **BATTERY NO. 4, NEAR YORKTOWN, VIRGINIA**
 (P1984.30.14)
Albumen silver print. negative 1862, print 1865 by Alexander
 Gardner
Image: 6 13/16 x 8 7/8 in. (17.3 x 22.5 cm.)
Mount: 12 x 15 5/8 in. (30.3 x 39.7 cm.)
Signed: see inscription
Inscription, mount recto, printed: "Negative by WOOD &
 GIBSON./Entered according to act of Congress, in the
 year 1865, by A. Gardner, in the Clerk's Office of the
 District Court of the District of Columbia./Positive by
 A. GARDNER, 511 7th St., Washington.//BATTERY
 NO. 4, NEAR YORKTOWN, VIRGINIA.//No. 14.//
 May, 1862."
Acquired from: Zeitlin & VerBrugge Booksellers,
 Los Angeles, California

John Wood and James F. Gibson
2330. **MOORE HOUSE, YORKTOWN, VIRGINIA** (P1984.30.15)
Albumen silver print. negative 1862, print 1865 by Alexander
 Gardner
Image: 6 7/8 x 8 15/16 in. (17.5 x 22.6 cm.)
Mount: 12 x 15 5/8 in. (30.3 x 39.7 cm.)
Signed: see inscription
Inscription, mount recto, printed: "Negative by WOOD &
 GIBSON./Entered according to act of Congress, in the
 year 1865, by A. Gardner, in the Clerk's Office of the
 District Court of the District of Columbia./Positive by
 A. GARDNER, 511 7th St., Washington.//MOORE
 HOUSE, YORKTOWN, VIRGINIA.//No. 15.//May, 1862."
Acquired from: Zeitlin & VerBrugge Booksellers,
 Los Angeles, California

John Wood and James F. Gibson
**2331. INSPECTION OF TROOPS AT CUMBERLAND
 LANDING, PAMUNKEY, VIRGINIA** (P1984.30.16)
 Albumen silver print. negative 1862, print 1865 by Alexander
 Gardner
 Image: 6 ¼ x 8 ¹³⁄₁₆ in. (17.1 x 22.4 cm.)
 Mount: 12 x 15 ⅝ in. (30.3 x 39.7 cm.)
 Signed: see inscription
 Inscription, mount recto, printed: "Negative by WOOD &
 GIBSON./Entered according to act of Congress, in the
 year 1865, by A. Gardner, in the Clerk's Office of the
 District Court of the District of Columbia./Positive by
 A. GARDNER, 511 7th St., Washington.//INSPECTION
 OF TROOPS AT CUMBERLANDING [sic],
 PAMUNKEY, VIRGINIA.//No. 16.//May, 1862."
 Acquired from: Zeitlin & VerBrugge Booksellers,
 Los Angeles, California

David B. Woodbury
**2332. MILITARY BRIDGE, ACROSS THE CHICKAHOMINY,
 VIRGINIA** (P1984.30.17)
 Albumen silver print. negative 1862, print 1865 by Alexander
 Gardner
 Image: 6 ¹³⁄₁₆ x 8 ¹³⁄₁₆ in. (17.2 x 22.4 cm.)
 Mount: 12 x 15 ⅝ in. (30.3 x 39.7 cm.)
 Signed: see inscription
 Inscription, mount recto, printed: "Negative by D. B.
 WOODBURY./Entered according to act of Congress, in
 the year 1865, by A. Gardner, in the Clerk's Office of the
 District Court of the District of Columbia./Positive by
 A. GARDNER, 511 7th St., Washington.//MILITARY
 BRIDGE, ACROSS THE CHICKAHOMINY,
 VIRGINIA.//No. 17.//June, 1862."
 Acquired from: Zeitlin & VerBrugge Booksellers,
 Los Angeles, California

James Gardner
***2333. RUINS OF NORFOLK NAVY YARD, VIRGINIA**
 (P1984.30.18)
 Albumen silver print. negative 1864, print 1866 by Alexander
 Gardner
 Image: 7 x 9 in. (17.7 x 22.9 cm.)
 Mount: 12 x 15 ⅝ in. (30.3 x 39.7 cm.)
 Signed: see inscription
 Inscription, mount recto, printed: "Negative by J.
 GARDNER./Entered according to act of Congress, in the
 year 1866, by A. Gardner, in the Clerk's Office of the
 District Court of the District of Columbia./Positive by
 A. GARDNER, 511 7th st., Washington.//RUINS OF
 NORFOLK NAVY YARD, VIRGINIA.//No. 18.//
 December, 1864."
 Acquired from: Zeitlin & VerBrugge Booksellers,
 Los Angeles, California

Alexander Gardner
2334. ANTIETAM BRIDGE, MARYLAND (P1984.30.19)
 duplicate of P1979.78.1
 Albumen silver print. negative 1862, print 1866
 Image: 7 x 8 ¹⁵⁄₁₆ in. (17.7 x 22.7 cm.)
 Mount: 12 x 15 ⅝ in. (30.3 x 39.7 cm.)
 Signed: see inscription
 Inscription, mount recto, printed: "ALEX. GARDNER,
 Photographer,/Entered according to act of Congress, in
 the year 1866, by A. Gardner, in the Clerk's Office of the
 District Court of the District of Columbia./511 Seventh
 Street, Washington.//ANTIETAM BRIDGE,
 MARYLAND.//No. 19.//September, 1862."
 Acquired from: Zeitlin & VerBrugge Booksellers,
 Los Angeles, California

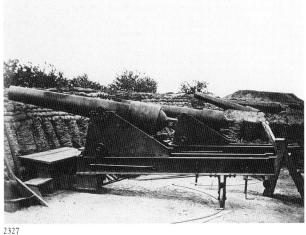

2327

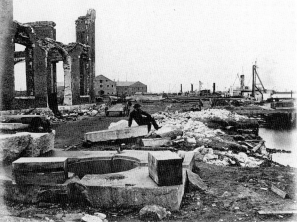

2333

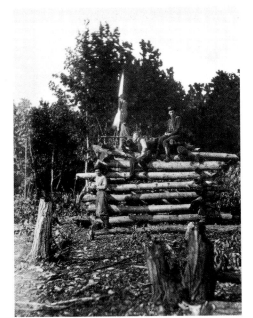

2337

Alexander Gardner
2335. **BURNSIDE BRIDGE, ACROSS ANTIETAM CREEK, MARYLAND** (P1984.30.20)
Albumen silver print. negative 1862, print 1866
Image: 7 x 9 1/16 in. (17.7 x 23.0 cm.)
Mount: 12 x 15 5/8 in. (30.3 x 39.7 cm.)
Signed: see inscription
Inscription, mount recto, printed: "ALEX. GARDNER, Photographer,/Entered according to act of Congress, in the year 1866, by A. Gardner in the Clerk's Office of the District Court of the District of Columbia./511 Seventh Street, Washington.//BURNSIDE BRIDGE, ACROSS ANTIETAM CREEK, MARYLAND.//No. 20.// September, 1862."
Acquired from: Zeitlin & VerBrugge Booksellers, Los Angeles, California

James Gardner
2336. **DUNKER CHURCH, BATTLE-FIELD OF ANTIETAM, MARYLAND** (P1984.30.21)
Albumen silver print. negative 1863, print 1866 by Alexander Gardner
Image: 6 7/8 x 8 15/16 in. (17.5 x 22.7 cm.)
Mount: 12 x 15 5/8 in. (30.3 x 39.7 cm.)
Signed: see inscription
Inscription, mount recto, printed: "Negative by J. GARDNER./Entered according to act of Congress, in the year 1866, by A. Gardner, in the Clerk's Office of the District Court of the District of Columbia./Positive by A. GARDNER, 511 7th st., Washington.//DUNKER CHURCH, BATTLE-FIELD OF ANTIETAM, MARYLAND.//No. 21.//July, 1863."
Acquired from: Zeitlin & VerBrugge Booksellers, Los Angeles, California

Timothy H. O'Sullivan
*2337. **SIGNAL TOWER ON ELK MOUNTAIN, MARYLAND, OVERLOOKING BATTLE-FIELD OF ANTIETAM** (P1984.30.22)
Albumen silver print. negative 1862, print 1865 by Alexander Gardner
Image: 9 1/16 x 7 in. (22.9 x 17.9 cm.)
Mount: 15 5/8 x 12 in. (39.7 x 30.3 cm.)
Signed: see inscription
Inscription, mount recto, printed: "Negative by T. H. O'SULLIVAN./Entered according to act of Congress, in the year 1865, by A. Gardner, in the Clerk's Office of the District Court of the District of Columbia./Positive by A. GARDNER, 511 7th St., Washington.//SIGNAL TOWER ON ELK MOUNTAIN, MARYLAND, OVERLOOKING BATTLE-FIELD OF ANTIETAM.// No. 22.//September, 1862."
Acquired from: Zeitlin & VerBrugge Booksellers, Los Angeles, California

Alexander Gardner
2338. **PRESIDENT LINCOLN ON BATTLE-FIELD OF ANTIETAM** (P1984.30.23)
Albumen silver print. negative 1862, print 1866
Image: 6 5/8 x 8 15/16 in. (16.8 x 22.7 cm.)
Mount: 12 x 15 5/8 in. (30.3 x 39.7 cm.)
Signed: see inscription
Inscription, in negative: "2050"
mount recto, printed: "ALEX. GARDNER, Photographer,/Entered according to act of Congress, in the year 1866, by A. Gardner, in the Clerk's Office of the District Court of the District of Columbia./511 Seventh Street, Washington.//PRESIDENT LINCOLN ON BATTLE-FIELD OF ANTIETAM.// No. 23.//October, 1862."
Acquired from: Zeitlin & VerBrugge Booksellers, Los Angeles, California

Alexander Gardner
2339. **SCENE IN PLEASANT VALLEY, MARYLAND** (P1984.30.24)
Albumen silver print. negative 1862, print 1866
Image: 6 13/16 x 9 in. (17.2 x 22.8 cm.)
Mount: 12 x 15 5/8 in. (30.3 x 39.7 cm.)
Signed: see inscription
Inscription, mount recto, printed: "ALEX. GARDNER, Photographer,/Entered according to act of Congress, in the year 1866, by A. Gardner, in the Clerk's Office of the District Court of the District of Columbia./511 Seventh Street, Washington.//SCENE IN PLEASANT VALLEY, MARYLAND.//No. 24.//October, 1862."
Acquired from: Zeitlin & VerBrugge Booksellers, Los Angeles, California

Timothy H. O'Sullivan
2340. **LACEY HOUSE, FALMOUTH, VIRGINIA** (P1984.30.25)
Albumen silver print. negative 1862, print 1865 by Alexander Gardner
Image: 7 x 9 1/16 in. (17.8 x 23.0 cm.)
Mount: 12 x 15 5/8 in. (30.3 x 39.7 cm.)
Signed: see inscription
Inscription, mount recto, printed: "Negative by T. H. O'SULLIVAN./Entered according to act of Congress, in the year 1865, by A. Gardner, in the Clerk's Office of the District Court of the District of Columbia./Positive by A. GARDNER, 511 7th St., Washington.//LACEY HOUSE, FALMOUTH, VIRGINIA.//No. 29.//December, 1862."
Acquired from: Zeitlin & VerBrugge Booksellers, Los Angeles, California

Timothy H. O'Sullivan
2341. **FREDERICKSBURG, VIRGINIA** (P1984.30.26)
Albumen silver print. negative 1863, print 1865 by Alexander Gardner
Image: 7 x 9 1/16 in. (17.7 x 23.0 cm.)
Mount: 12 x 15 5/8 in. (30.3 x 39.7 cm.)
Signed: see inscription
Inscription, mount recto, printed: "Negative by T. H. O'SULLIVAN./Entered according to act of Congress, in the year 1865, by A. Gardner, in the Clerk's Office of the District Court of the District of Columbia./Positive by A. GARDNER, 511 7th St., Washington.//FREDERICKSBURG, VIRGINIA.//No. 30.//February, 1863."
Acquired from: Zeitlin & VerBrugge Booksellers, Los Angeles, California

Timothy H. O'Sullivan
2342. **BATTERY D, FIFTH U. S. ARTILLERY, IN ACTION, FREDERICKSBURG, VA.** (P1984.30.27)
Albumen silver print. negative 1863, print 1866 by Alexander Gardner
Image: 6 15/16 x 8 13/16 in. (17.6 x 22.4 cm.)
Mount: 12 x 15 5/8 in. (30.3 x 39.7 cm.)
Signed: see inscription
Inscription, mount recto, printed: "Negative by T. H. O'SULLIVAN./Entered according to act of Congress, in the year 1866, by A. Gardner, in the Clerk's Office of the District Court of the District of Columbia./Positive by A. GARDNER, 511 7th st., Washington.//BATTERY D, FIFTH U. S. ARTILLERY, IN ACTION, FREDERICKSBURG, VA.//No. 31.//May, 1863."
Acquired from: Zeitlin & VerBrugge Booksellers, Los Angeles, California

Timothy H. O'Sullivan
*2343. **PONTOON BRIDGE ACROSS THE RAPPAHANNOCK** (P1984.30.28)
Albumen silver print. negative 1863, print 1866 by Alexander Gardner
Image: 6 13/16 x 8 15/16 in. (17.3 x 22.7 cm.)
Mount: 12 x 15 5/8 in. (30.3 x 39.7 cm.)
Signed: see inscription

Inscription, mount recto, printed: "Negative by T. H.
O'SULLIVAN./Entered according to act of Congress, in
the year 1866, by A. Gardner, in the Clerk's Office of the
District Court of the District of Columbia./Positive by
A. GARDNER, 511 7th st., Washington.//PONTOON
BRIDGE ACROSS THE RAPPAHANNOCK.//No. 32.//
May, 1863."

Acquired from: Zeitlin & VerBrugge Booksellers,
Los Angeles, California

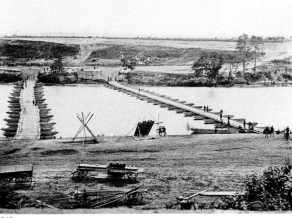

2343

Alexander Gardner

2344. **PONTOON BRIDGE ACROSS THE POTOMAC, AT
BERLIN** (P1984.30.29)

Albumen silver print. negative 1862, print 1866

Image: 6 ¹⁵/₁₆ x 9 in. (17.7 x 22.8 cm.)

Mount: 12 x 15 ⅝ in. (30.3 x 39.7 cm.)

Signed: see inscription

Inscription, mount recto, printed: "ALEX. GARDNER,
Photographer,/Entered according to act of Congress, in
the year 1866, by A. Gardner, in the Clerk's Office of the
District Court of the District of Columbia./511 Seventh
Street, Washington.//PONTOON BRIDGE ACROSS
THE POTOMAC, AT BERLIN.//No. 25.//November,
1862."

Acquired from: Zeitlin & VerBrugge Booksellers,
Los Angeles, California

James Gardner

2345. **MEETING OF THE SHENANDOAH AND POTOMAC
AT HARPER'S FERRY** (P1984.30.30)

Albumen silver print. negative 1865, print 1866 by Alexander
Gardner

Image: 7 x 9 ¹/₁₆ in. (17.8 x 22.9 cm.)

Mount: 12 x 15 ⅝ in. (30.3 x 39.7 cm.)

Signed: see inscription

Inscription, mount recto, printed: "Negative by J.
GARDNER./Entered according to act of Congress, in
the year 1866, by A. Gardner, in the Clerk's Office of the
District Court of the District of Columbia./Positive by
A. GARDNER, 511 7th st., Washington.//MEETING OF
THE SHENANDOAH AND POTOMAC AT HARPER'S
FERRY.//No. 26.//July, 1865."

Acquired from: Zeitlin & VerBrugge Booksellers,
Los Angeles, California

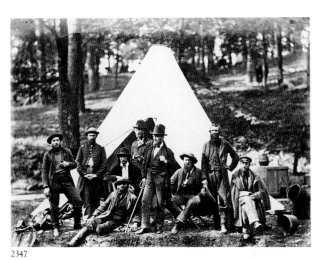

2347

Alexander Gardner

2346. **WHAT DO I WANT, JOHN HENRY?** (P1984.30.31)

Albumen silver print. negative 1862, print 1866

Image: 7 x 9 ¹/₁₆ in. (17.7 x 23.1 cm.)

Mount: 12 x 15 ⅝ in. (30.3 x 39.7 cm.)

Signed: see inscription

Inscription, mount recto, printed: "ALEX. GARDNER,
Photographer,/Entered according to act of Congress, in
the year 1866, by A. Gardner, in the Clerk's Office of the
District Court of the District of Columbia./511 Seventh
Street, Washington.//WHAT DO I WANT, JOHN
HENRY?//No. 27.//Warrenton, Va., November, 1862."

Acquired from: Zeitlin & VerBrugge Booksellers,
Los Angeles, California

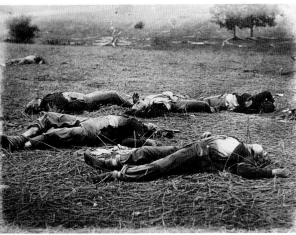

2352

Alexander Gardner

*2347. **SCOUTS AND GUIDES TO THE ARMY OF THE
POTOMAC** (P1984.30.32)

Albumen silver print. negative 1862, print 1866

Image: 7 x 9 ¹/₁₆ in. (17.8 x 23.0 cm.)

Mount: 12 x 15 ⅝ in. (30.3 x 39.7 cm.)

Signed: see inscription

Inscription, mount recto, printed: "ALEX. GARDNER,
Photographer,/Entered according to act of Congress, in
the year 1866, by A. Gardner, in the Clerk's Office of the
District Court of the District of Columbia./511 Seventh
Street, Washington.//SCOUTS AND GUIDES TO THE
ARMY OF THE POTOMAC.//No. 28.//Berlin, October,
1862."

Acquired from: Zeitlin & VerBrugge Booksellers,
Los Angeles, California

Timothy H. O'Sullivan
2348. **EVACUATION OF AQUIA CREEK** (P1984.30.33)
Albumen silver print. negative 1863, print 1865 by Alexander
Gardner
Image: 7 x 9 1/16 in. (17.8 x 23.0 cm.)
Mount: 12 x 15 5/8 in. (30.3 x 39.7 cm.)
Signed: see inscription
Inscription, mount recto, printed: "Negative by T. H.
O'SULLIVAN./Entered according to act of Congress, in
the year 1865, by A. Gardner, in the Clerk's Office of the
District Court of the District of Columbia./Positive by
A. GARDNER, 511 7th St., Washington.//EVACUATION
OF AQUIA CREEK.//No. 33.//June, 1863."
Acquired from: Zeitlin & VerBrugge Booksellers,
Los Angeles, California

Timothy H. O'Sullivan
2349. **GROUP OF CONFEDERATE PRISONERS AT FAIRFAX
COURT-HOUSE** (P1984.30.34)
Albumen silver print. negative 1863, print 1866 by Alexander
Gardner
Image: 7 x 9 1/16 in. (17.8 x 23.0 cm.)
Mount: 12 x 15 5/8 in. (30.3 x 39.7 cm.)
Signed: see inscription
Inscription, mount recto, printed: "Negative by T. H.
O'SULLIVAN./Entered according to act of Congress, in
the year 1866, by A. Gardner, in the Clerk's Office of the
District Court of the District of Columbia./Positive by
A. GARDNER, 511 7th st., Washington.//GROUP OF
CONFEDERATE PRISONERS AT FAIRFAX COURT-
HOUSE.//No. 34.//June, 1863."
Acquired from: Zeitlin & VerBrugge Booksellers,
Los Angeles, California

Timothy H. O'Sullivan
2350. **GETTYSBURG, PENNSYLVANIA** (P1984.30.35)
Albumen silver print. negative 1863, print 1866 by Alexander
Gardner
Image: 6 15/16 x 8 15/16 in. (17.6 x 22.7 cm.)
Mount: 12 x 15 5/8 in. (30.3 x 39.7 cm.)
Signed: see inscription
Inscription, mount recto, printed: "Negative by T. H.
O'SULLIVAN./Entered according to act of Congress, in
the year 1866, by A. Gardner, in the Clerk's Office of the
District Court of the District of Columbia./Positive by
A. GARDNER, 511 7th st., Washington.//GETTYSBURG,
PENNSYLVANIA.//No. 35.//July, 1863."
Acquired from: Zeitlin & VerBrugge Booksellers,
Los Angeles, California

Timothy H. O'Sullivan
2351. **A HARVEST OF DEATH, GETTYSBURG,
PENNSYLVANIA** (P1984.30.36)
Albumen silver print. negative 1863, print 1865 by Alexander
Gardner
Image: 6 13/16 x 8 1/4 in. (17.3 x 22.2 cm.)
Mount: 12 x 15 5/8 in. (30.3 x 39.7 cm.)
Signed: see inscription
Inscription, mount recto, printed: "Negative by T. H.
O'SULLIVAN./Entered according to act of Congress, in
the year 1865, by A. Gardner, in the Clerk's Office of the
District Court of the District of Columbia./Positive by
A. GARDNER, 511 7th St., Washington.//A HARVEST
OF DEATH, GETTYSBURG, PENNSYLVANIA.//
No. 36.//July, 1863."
Acquired from: Zeitlin & VerBrugge Booksellers,
Los Angeles, California

Timothy H. O'Sullivan
*2352. **FIELD WHERE GENERAL REYNOLDS FELL,
GETTYSBURG** (P1984.30.37)
Albumen silver print. negative 1863, print 1866 by Alexander
Gardner
Image: 7 x 9 1/16 in. (17.8 x 23.0 cm.)
Mount: 12 x 15 5/8 in. (30.3 x 39.7 cm.)

Signed: see inscription
Inscription, mount recto, printed: "Negative by T. H.
O'SULLIVAN./Entered according to act of Congress, in
the year 1866, by A. Gardner, in the Clerk's Office of the
District Court of the District of Columbia./Positive by
A. GARDNER, 511 7th st., Washington.//FIELD WHERE
GENERAL REYNOLDS FELL, GETTYSBURG.//No. 37.//
July, 1863."
Acquired from: Zeitlin & VerBrugge Booksellers,
Los Angeles, California

Timothy H. O'Sullivan
2353. **INTERIOR OF BREASTWORKS ON ROUND TOP,
GETTYSBURG** (P1984.30.38)
Albumen silver print. negative 1863, print 1865 by Alexander
Gardner
Image: 7 x 8 15/16 in. (17.8 x 22.6 cm.)
Mount: 12 x 15 5/8 in. (30.3 x 39.7 cm.)
Signed: see inscription
Inscription, mount recto, printed: "Negative by T. H.
O'SULLIVAN./Entered according to act of Congress, in
the year 1865, by A. Gardner, in the Clerk's Office of the
District Court of the District of Columbia./Positive by
A. GARDNER, 511 7th St., Washington.//INTERIOR OF
BREASTWORKS ON ROUND TOP, GETTYSBURG.//
No. 38.//July, 1863."
Acquired from: Zeitlin & VerBrugge Booksellers,
Los Angeles, California

Timothy H. O'Sullivan
2354. **GATEWAY OF CEMETERY, GETTYSBURG** (P1984.30.39)
Albumen silver print. negative 1863, print 1866 by Alexander
Gardner
Image: 7 x 9 1/16 in. (17.8 x 23.0 cm.)
Mount: 12 x 15 5/8 in. (30.3 x 39.7 cm.)
Signed: see inscription
Inscription, mount recto, printed: "Negative by T. H.
O'SULLIVAN./Entered according to act of Congress, in
the year 1866, by A. Gardner, in the Clerk's Office of the
District Court of the District of Columbia./Positive by
A. GARDNER, 511 7th st., Washington.//GATEWAY OF
CEMETERY, GETTYSBURG.//No. 39//July, 1863."
Acquired from: Zetlin & VerBrugge Booksellers, Los Angeles,
California

Alexander Gardner
2355. **A SHARPSHOOTER'S LAST SLEEP, GETTYSBURG,
PENNSYLVANIA** (P1984.30.40)
Albumen silver print. negative 1863, print 1866
Image: 7 x 9 1/16 in. (17.8 x 23.0 cm.)
Mount: 12 x 15 5/8 in. (30.3 x 39.7 cm.)
Signed: see inscription
Inscription, mount recto, printed: "ALEX. GARDNER,
Photographer,/Entered according to act of Congress, in
the year 1866, by A. Gardner, in the Clerk's Office of the
District Court of the District of Columbia./511 Seventh
Street, Washington.//A SHARPSHOOTER'S LAST
SLEEP, GETTYSBURG, PENNSYLVANIA.//No. 40.//July,
1863."
Acquired from: Zeitlin & VerBrugge Booksellers,
Los Angeles, California

Alexander Gardner
*2356. **HOME OF A REBEL SHARPSHOOTER, GETTYSBURG**
(P1984.30.41)
Albumen silver print. negative 1863, print 1866
Image: 6 3/4 x 9 1/16 in. (17.2 x 23.0 cm.)
Mount: 12 x 15 5/8 in. (30.3 x 39.7 cm.)
Signed: see inscription
Inscription, mount recto, printed: "ALEX. GARDNER,
Photographer,/Entered according to act of Congress,
in the year 1866, by A. Gardner, in the Clerk's Office of
the District Court of the District of Columbia./511
Seventh Street, Washington.//HOME OF A REBEL
SHARPSHOOTER, GETTYSBURG.//No. 41.//July, 1863."
Acquired from: Zeitlin & VerBrugge Booksellers,
Los Angeles, California

Timothy H. O'Sullivan
2357. **TROSSELL'S HOUSE, BATTLE-FIELD OF GETTYSBURG**
(P1984.30.42)
Albumen silver print. negative 1863, print 1865 by Alexander
Gardner
Image: 6 ¾ x 9 ¹/₁₆ in. (17.1 x 23.0 cm.)
Mount: 12 x 15 ⅝ in. (30.3 x 39.7 cm.)
Signed: see inscription
Inscription, mount recto, printed: "Negative by T. H.
O'SULLIVAN./Entered according to act of Congress, in
the year 1865, by A. Gardner, in the Clerk's Office of the
District Court of the District of Columbia./Positive by
A. GARDNER, 511 7th St., Washington.//TROSSELL'S
HOUSE, BATTLE-FIELD OF GETTYSBURG.//No. 42.//
July, 1863."
Acquired from: Zeitlin & VerBrugge Booksellers, Los
Angeles, California

2356

Timothy H. O'Sullivan
2358. **HEAD-QUARTERS MAJOR GENERAL GEORGE G.
MEADE, DURING THE BATTLE OF GETTYSBURG**
(P1984.30.43)
Albumen silver print. negative 1863, print 1866 by Alexander
Gardner
Image: 7 x 9 ¹/₁₆ in. (17.8 x 23.0 cm.)
Mount: 12 x 15 ⅝ in. (30.3 x 39.7 cm.)
Signed: see inscription
Inscription, mount recto, printed: "Negative by T. H.
O'SULLIVAN./Entered according to act of Congress, in
the year 1866, by A. Gardner, in the Clerk's Office of the
District Court of the District of Columbia./Positive by
A. GARDNER, 511 7th st., Washington.//HEAD-
QUARTERS MAJOR GENERAL GEORGE G. MEADE,/
DURING THE BATTLE OF GETTYSBURG.//No. 43.//
July, 1863."
Acquired from: Zeitlin & VerBrugge Booksellers,
Los Angeles, California

2360

Timothy H. O'Sullivan
2359. **SLAUGHTER PEN, FOOT OF ROUND TOP,
GETTYSBURG** (P1984.30.44)
Albumen silver print. negative 1863, print 1866 by Alexander
Gardner
Image: 6 ¾ x 8 ⅞ in. (17.1 x 22.5 cm.)
Mount: 12 x 15 ⅝ in. (30.3 x 39.7 cm.)
Signed: see inscription
Inscription, mount recto, printed: "Negative by T. H.
O'SULLIVAN./Entered according to act of Congress, in
the year 1866, by A. Gardner, in the Clerk's Office of the
District Court of the District of Columbia./Positive by
A. GARDNER, 7th st., Washington.//SLAUGHTER
PEN, FOOT OF ROUND TOP, GETTYSBURG.//
No. 44.//July, 1863."
Acquired from: Zeitlin & VerBrugge Booksellers,
Los Angeles, California

Alexander Gardner
*2360. **STUDYING THE ART OF WAR** (P1984.30.45)
Albumen silver print. negative 1863, print 1866
Image: 7 x 9 ¹/₁₆ in. (17.8 x 23.0 cm.)
Mount: 12 x 15 ⅝ in. (30.3 x 39.7 cm.)
Signed: see inscription
Inscription, mount recto, printed: "ALEX. GARDNER,
Photographer,/Entered according to act of Congress, in
the year 1866, by A. Gardner, in the Clerk's Office of the
District Court of the District of Columbia./511 Seventh
Street, Washington.//STUDYING THE ART OF WAR.//
No. 45.//Fairfax Court-House, June, 1863."
Acquired from: Zeitlin & VerBrugge Booksellers,
Los Angeles, California

2362

Timothy H. O'Sullivan
2361. **PROVOST MARSHAL'S OFFICE, AQUIA CREEK**
(P1984.30.46)
Albumen silver print. negative 1863, print 1865 by Alexander
Gardner
Image: 7 x 9 1/16 in. (17.8 x 23.0 cm.)
Mount: 12 x 15 5/8 in. (30.3 x 39.7 cm.)
Signed: see inscription
Inscription, mount recto, printed: "Negative by T. H.
O'SULLIVAN./Entered according to act of Congress, in
the year 1865, by A. Gardner, in the Clerk's Office of the
District Court of the District of Columbia./Positive by
A. GARDNER, 511 7th St., Washington.//PROVOST
MARSHAL'S OFFICE, AQUIA CREEK.//No. 46.//
February, 1863."
Acquired from: Zeitlin & VerBrugge Booksellers,
Los Angeles, California

Timothy H. O'Sullivan
*2362. **CASTLE MURRAY, NEAR AUBURN, VIRGINIA**
(P1984.30.47)
Albumen silver print. negative 1863, print 1865 by Alexander
Gardner
Image: 6 7/8 x 8 7/8 in. (17.4 x 22.5 cm.)
Mount: 12 x 15 5/8 in. (30.3 x 39.7 cm.)
Signed: see inscription
Inscription, mount recto, printed: "Negative by T. H.
O'SULLIVAN./Entered according to act of Congress, in
the year 1865, by A. Gardner, in the Clerk's Office of the
District Court of the District of Columbia./Positive by
A. GARDNER, 511 7th St., Washington.//CASTLE
MURRAY, NEAR AUBURN, VIRGINIA.//No. 47.//
November, 1863."
Acquired from: Zeitlin & VerBrugge Booksellers,
Los Angeles, California

Timothy H. O'Sullivan
2363. **CULPEPER, VIRGINIA** (P1984.30.48)
Albumen silver print. negative 1863, print 1866 by Alexander
Gardner
Image: 7 x 9 1/16 in. (17.8 x 23.0 cm.)
Mount: 12 x 15 5/8 in. (30.3 x 39.7 cm.)
Signed: see inscription
Inscription, mount recto, printed: "Negative by T. H.
O'SULLIVAN./Entered according to act of Congress, in
the year 1866, by A. Gardner, in the Clerk's Office of the
District Court of the District of Columbia./Positive by
A. GARDNER, 511 7th st., Washington.//CULPEPER,
VIRGINIA.//No. 48.//November, 1863."
Acquired from: Zeitlin & VerBrugge Booksellers,
Los Angeles, California

Timothy H. O'Sullivan
2364. **GENERAL POST-OFFICE, ARMY OF THE POTOMAC,
BRANDY STATION, VIRGINIA** (P1984.30.49)
Albumen silver print. negative 1863, print 1866 by Alexander
Gardner
Image: 7 x 9 1/16 in. (17.8 x 23.0 cm.)
Mount: 12 x 15 5/8 in. (30.3 x 39.7 cm.)
Signed: see inscription
Inscription, mount recto, printed: "Negative by T. H.
O'SULLIVAN./Entered according to act of Congress, in
the year 1866, by A. Gardner, in the Clerk's Office of the
District Court of the District of Columbia./Positive by
A. GARDNER, 511 7th st., Washington.//GENERAL
POST-OFFICE, ARMY OF THE POTOMAC,/BRANDY
STATION, VIRGINIA.//No. 49.//December, 1863."
Acquired from: Zeitlin & VerBrugge Booksellers,
Los Angeles, California

Timothy H. O'Sullivan
2365. **THE HALT** (P1984.30.50)
Albumen silver print. negative 1864, print 1865 by Alexander
Gardner
Image: 7 x 9 1/8 in. (17.8 x 23.1 cm.)
Mount: 12 x 15 5/8 in. (30.3 x 39.7 cm.)

Signed: see inscription
Inscription, mount recto, printed: "Negative by T. H.
O'SULLIVAN./Entered according to act of Congress, in
the year 1865, by A. Gardner, in the Clerk's Office of the
District Court of the District of Columbia./Positive by
A. GARDNER, 511 7th St., Washington.//THE HALT.//
No. 50.//May, 1864."
Acquired from: Zeitlin & VerBrugge Booksellers,
Los Angeles, California

Volume II (P1984.30.51–100)

James Gardner
2366. **THE SHEBANG, OR QUARTERS OF U. S. SANITARY
COMMISSION, BRANDY STATION** (P1984.30.51)
Albumen silver print. negative 1863, print 1866 by Alexander
Gardner
Image: 7 x 9 1/16 in. (17.8 x 22.9 cm.)
Mount: 12 x 15 5/8 in. (30.3 x 39.7 cm.)
Signed: see inscription
Inscription, mount recto, printed: "Negative by
J. GARDNER./Entered according to act of Congress, in
the year 1866, by A. Gardner, in the Clerk's Office of
the District Court of the District of Columbia./Positive
by A. GARDNER, 511 7th st., Washington.//THE
SHEBANG, OR QUARTERS OF U. S. SANITARY
COMMISSION,/BRANDY STATION.//No. 51.//
November, 1863."
Acquired from: Zeitlin & VerBrugge Booksellers,
Los Angeles, California

James Gardner
2367. **RESIDENCE CHIEF QUARTERMASTER THIRD ARMY
CORPS, BRANDY STATION** (P1984.30.52)
Albumen silver print. negative 1863, print 1866 by Alexander
Gardner
Image: 6 7/8 x 9 1/16 in. (17.3 x 22.9 cm.)
Mount: 12 x 15 5/8 in. (30.3 x 39.7 cm.)
Signed: see inscription
Inscription, mount recto, printed: "Negative by
J. GARDNER./Entered according to act of Congress, in
the year 1866, by A. Gardner, in the Clerk's Office of the
District Court of the District of Columbia./Positive
by A. GARDNER, 511 7th st., Washington.//RESIDENCE
CHIEF QUARTERMASTER THIRD ARMY CORPS,
BRANDY STATION.//No. 52.//December, 1863."
Acquired from: Zeitlin & VerBrugge Booksellers,
Los Angeles, California

James Gardner
*2368. **HEADQUARTERS CHRISTIAN COMMISSION IN THE
FIELD, GERMANTOWN** (P1984.30.53)
Albumen silver print. negative 1863, print 1866 by Alexander
Gardner
Image: 7 x 9 1/16 in. (17.8 x 22.9 cm.)
Mount: 12 x 15 5/8 in. (30.3 x 39.7 cm.)
Signed: see inscription
Inscription, mount recto, printed: "Negative by
J. GARDNER./Entered according to act of Congress, in
the year 1866, by A. Gardner, in the Clerk's Office of the
District Court of the District of Columbia./Positive by
A. GARDNER, 511 7th st., Washington.//
HEADQUARTERS CHRISTIAN COMMISSION IN
THE FIELD, GERMANTOWN.//No. 53.//September,
1863."
Acquired from: Zeitlin & VerBrugge Booksellers,
Los Angeles, California

James Gardner

2369. **FIELD HOSPITAL, SECOND ARMY CORPS, BRANDY STATION** (P1984.30.54)

Albumen silver print. negative 1864, print 1866 by Alexander Gardner

Image: 7 x 9 1/16 in. (17.8 x 22.9 cm.)

Mount: 12 x 15 5/8 in. (30.3 x 39.7 cm.)

Signed: see inscription

Inscription, mount recto, printed: "Negative by J. GARDNER./Entered according to act of Congress, in the year 1866, by A. Gardner, in the Clerk's Office of the District Court of the District of Columbia./Positive by A. GARDNER, 511 7th st., Washington.//FIELD HOSPITAL, SECOND ARMY CORPS, BRANDY STATION.//No. 54.//February, 1864."

Acquired from: Zeitlin & VerBrugge Booksellers, Los Angeles, California

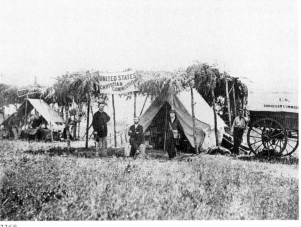

2368

Timothy H. O'Sullivan

*2370. **GUARD MOUNT, HEAD-QUARTERS ARMY OF THE POTOMAC** (P1984.30.55)

Albumen silver print. negative 1864, print 1866 by Alexander Gardner

Image: 7 x 9 1/16 in. (17.8 x 23.0 cm.)

Mount: 12 x 15 5/8 in. (30.3 x 39.7 cm.)

Signed: see inscription

Inscription, mount recto, printed: "Negative by T. H. O'SULLIVAN./Entered according to act of Congress, in the year 1866, by A. Gardner, in the Clerk's Office of the District Court of the District of Columbia./Positive by A. GARDNER, 511 7th st., Washington.//GUARD MOUNT, HEAD-QUARTERS ARMY OF THE POTOMAC.//No. 55.//February, 1864."

Acquired from: Zeitlin & VerBrugge Booksellers, Los Angeles, California

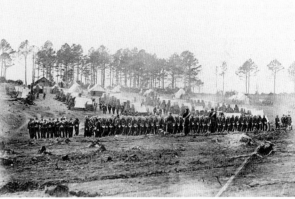

2370

Timothy H. O'Sullivan

2371. **HEAD-QUARTERS NEW YORK HERALD, ARMY OF THE POTOMAC. BEALTON** (P1984.30.56)

Albumen silver print. negative 1863, print 1866 by Alexander Gardner

Image: 7 x 9 1/16 in. (17.8 x 23.0 cm.)

Mount: 12 x 15 5/8 in. (30.3 x 39.7 cm.)

Signed: see inscription

Inscription, mount recto, printed: "Negative by T. H. O'SULLIVAN./Entered according to act of Congress, in the year 1866, by A. Gardner, in the Clerk's Office of the District Court of the District of Columbia./Positive by A. GARDNER, 511 7th st., Washington.//HEAD-QUARTERS NEW YORK HERALD, ARMY OF THE POTOMAC./BEALTON.//No. 56.//September, 1863."

Acquired from: Zeitlin & VerBrugge Booksellers, Los Angeles, California

Timothy H. O'Sullivan

2372. **CAMP ARCHITECTURE, BRANDY STATION, VIRGINIA** (P1984.30.57)

Albumen silver print. negative 1864, print 1865 by Alexander Gardner

Image: 6 13/16 x 8 7/8 in. (17.3 x 22.5 cm.)

Mount: 12 x 15 5/8 in. (30.3 x 39.7 cm.)

Signed: see inscription

Inscription, mount recto, printed: "Negative by T. H. O'SULLIVAN./Entered according to act of Congress, in the year 1865, by A. Gardner, in the Clerk's Office of the District Court of the District of Columbia./Positive by A. GARDNER, 511 7th St., Washington.//CAMP ARCHITECTURE, BRANDY STATION, VIRGINIA.//No. 57.//January, 1864."

Acquired from: Zeitlin & VerBrugge Booksellers, Los Angeles, California

2373

Timothy H. O'Sullivan
*2373. **PONTOON BOAT, BRANDY STATION, VIRGINIA**
(P1984.30.58)
Albumen silver print. negative 1864, print 1865 by Alexander
Gardner
Image: 7 x 9 1/16 in. (17.8 x 23.0 cm.)
Mount: 12 x 15 5/8 in. (30.3 x 39.7 cm.)
Signed: see inscription
Inscription, mount recto, printed: "Negative by T. H.
O'SULLIVAN./Entered according to act of Congress, in
the year 1866, by A. Gardner, in the Clerk's Office of the
District Court of the District of Columbia./Positive by
A. GARDNER, 511 7th st., Washington.//PONTOON
BOAT, BRANDY STATION, VIRGINIA.//No. 58.//
February, 1864."
Acquired from: Zeitlin & VerBrugge Booksellers,
Los Angeles, California

James Gardner
2374. **BATTERY A, FOURTH U. S. ARTILLERY, ROBERTSON'S
BRIGADE** (P1984.30.59)
Albumen silver print. negative 1864, print 1866 by Alexander
Gardner
Image: 7 x 9 1/16 in. (17.8 x 22.9 cm.)
Mount: 12 x 15 5/8 in. (30.3 x 39.7 cm.)
Signed: see inscription
Inscription, mount recto, printed: "Negative by
J. GARDNER./Entered according to act of Congress, in
the year 1866, by A. Gardner, in the Clerk's Office of the
District Court of the District of Columbia./Positive by
A. GARDNER, 511 7th st., Washington.//BATTERY A,
FOURTH U. S. ARTILLERY, ROBERTSON'S
BRIGADE.//No. 59.//February, 1864."
Acquired from: Zeitlin & VerBrugge Booksellers,
Los Angeles, California

Timothy H. O'Sullivan
2375. **HEAD-QUARTERS ARMY OF THE POTOMAC,
BRANDY STATION, VIRGINIA** (P1984.30.60)
Albumen silver print. negative 1864, print 1866 by Alexander
Gardner
Image: 7 x 9 1/8 in. (17.8 x 23.1 cm.)
Mount: 12 x 15 5/8 in. (30.3 x 39.7 cm.)
Signed: see inscription
Inscription, mount recto, printed: "Negative by T. H.
O'SULLIVAN./Entered according to act of Congress,
in the year 1866, by A. Gardner, in the Clerk's Office
of the District Court of the District of Columbia./Positive
by A. GARDNER, 511 7th st., Washington.//HEAD-
QUARTERS ARMY OF THE POTOMAC,/BRANDY
STATION, VIRGINIA.//No. 60.//February, 1864."
Acquired from: Zeitlin & VerBrugge Booksellers,
Los Angeles, California

Timothy H. O'Sullivan
2376. **COMMISSARY DEPARTMENT, HEAD-QUARTERS
ARMY OF THE POTOMAC** (P1984.30.61)
Albumen silver print. negative 1864, print 1865 by Alexander
Gardner
Image: 6 11/16 x 8 7/8 in. (17.3 x 22.5 cm.)
Mount: 12 x 15 5/8 in. (30.3 x 39.7 cm.)
Signed: see inscription
Inscription, mount recto, printed: "Negative by T. H.
O'SULLIVAN./Entered according to act of Congress, in
the year 1865, by A. Gardner, in the Clerk's Office of the
District Court of the District of Columbia./Positive by
A. GARDNER, 511 7th St., Washington.//COMMISSARY
DEPARTMENT, HEAD-QUARTERS ARMY OF THE
POTOMAC.//No. 61.//February, 1864."
Acquired from: Zeitlin & VerBrugge Booksellers,
Los Angeles, California

Timothy H. O'Sullivan
*2377. **U. S. MILITARY TELEGRAPH CONSTRUCTION CORPS**
(P1984.30.62)
Albumen silver print. negative 1864, print 1866 by Alexander
Gardner

Image: 7 x 9 1/16 in. (17.8 x 23.0 cm.)
Mount: 12 x 15 5/8 in. (30.3 x 39.7 cm.)
Signed: see inscription
Inscription, mount recto, printed: "Negative by T. H.
O'SULLIVAN./Entered according to act of Congress,
in the year 1866, by A. Gardner, in the Clerk's Office
of the District Court of the District of Columbia./Positive
by A. GARDNER, 511 7th st., Washington.//U. S.
MILITARY TELEGRAPH CONSTRUCTION CORPS.//
No. 62.//April, 1864."
Acquired from: Zeitlin & VerBrugge Booksellers,
Los Angeles, California

James Gardner
2378. **BREAKING CAMP, BRANDY STATION, VIRGINIA**
(P1984.30.63)
Albumen silver print. negative 1864, print 1866 by Alexander
Gardner
Image: 7 x 9 1/16 in. (17.8 x 22.9 cm.)
Mount: 12 x 15 5/8 in. (30.3 x 39.7 cm.)
Signed: see inscription
Inscription, mount recto, printed: "Negative by
J. GARDNER./Entered according to act of Congress, in
the year 1866, by A. Gardner, in the Clerk's Office of the
District Court of the District of Columbia./Positive by
A. GARDNER, 511 7th st., Washington.//BREAKING
CAMP, BRANDY STATION, VIRGINIA.//No. 63.//May,
1864."
Acquired from: Zeitlin & VerBrugge Booksellers,
Los Angeles, California

Timothy H. O'Sullivan
2379. **WAGON PARK, BRANDY STATION, VIRGINIA**
(P1984.30.64)
Albumen silver print. negative 1863, print 1865 by Alexander
Gardner
Image: 7 x 9 1/16 in. (17.8 x 23.0 cm.)
Mount: 12 x 15 5/8 in. (30.3 x 39.7 cm.)
Signed: see inscription
Inscription, mount recto, printed: "Negative by T. H.
O'SULLIVAN./Entered according to act of Congress,
in the year 1865, by A. Gardner, in the Clerk's Office
of the District Court of the District of Columbia./Positive
by A. GARDNER, 511 7th St., Washington.//WAGON
PARK, BRANDY STATION, VIRGINIA//No. 64.//
May, 1863."
Acquired from: Zeitlin & VerBrugge Booksellers,
Los Angeles, California

Alexander Gardner
*2380. **JERICHO MILLS, NORTH ANNA, VIRGINIA**
(P1984.30.65)
Albumen silver print. negative 1864, print 1866
Image: 7 1/16 x 9 1/16 in. (17.9 x 23.0 cm.)
Mount: 12 x 15 5/8 in. (30.3 x 39.7 cm.)
Signed: see inscription
Inscription, mount recto, printed: "ALEX. GARDNER,
Photographer,/Entered according to act of Congress, in
the year 1866, by A. Gardner, in the Clerk's Office of the
District Court of the District of Columbia./511 Seventh
Street, Washington.//JERICHO MILLS, NORTH ANNA,
VIRGINIA.//No. 65.//May, 1864."
Acquired from: Zeitlin & VerBrugge Booksellers,
Los Angeles, California

Timothy H. O'Sullivan
2381. **CHESTERFIELD BRIDGE, NORTH ANNA, VIRGINIA**
(P1984.30.66)
Albumen silver print. negative 1864, print 1866 by Alexander
Gardner
Image: 6 15/16 x 9 1/16 in. (17.7 x 23.0 cm.)
Mount: 12 x 15 5/8 in. (30.3 x 39.7 cm.)
Signed: see inscription
Inscription, mount recto, printed: "Negative by T. H.
O'SULLIVAN./Entered according to act of Congress, in
the year 1866, by A. Gardner, in the Clerk's Office of the

District Court of the District of Columbia./Positive by A. GARDNER, 511 7th st., Washington.//CHESTERFIELD BRIDGE, NORTH ANNA, VIRGINIA.//No. 66.//May, 1864."

Acquired from: Zeitlin & VerBrugge Booksellers, Los Angeles, California

2377

Alexander Gardner

2382. **QUARLES' MILL, NORTH ANNA, VIRGINIA**
(P1984.30.67)
Albumen silver print. negative 1864, print 1866
Image: 6 15/16 x 9 1/16 in. (17.6 x 23.0 cm.)
Mount: 12 x 15 5/8 in. (30.3 x 39.7 cm.)
Signed: see inscription
Inscription, mount recto, printed: "ALEX. GARDNER, Photographer,/Entered according to act of Congress, in the year 1866, by A. Gardner, in the Clerk's Office of the District Court of the District of Columbia./511 Seventh Street, Washington.//QUARLES' MILL, NORTH ANNA, VIRGINIA.//No. 67.//May, 1864."
Acquired from: Zeitlin & VerBrugge Booksellers, Los Angeles, California

Timothy H. O'Sullivan

2383. **CHARLES CITY COURT-HOUSE, VIRGINIA**
(P1984.30.68)
Albumen silver print. negative 1864, print 1865 by Alexander Gardner
Image: 7 x 9 1/16 in. (17.7 x 23.0 cm.)
Mount: 12 x 15 5/8 in. (30.3 x 39.7 cm.)
Signed: see inscription
Inscription, mount recto, printed: "Negative by T. H. O'SULLIVAN./Entered according to act of Congress, in the year 1865, by A. Gardner, in the Clerk's Office of the District Court of the District of Columbia./Positive by A. GARDNER, 511 7th St., Washington.//CHARLES CITY COURT-HOUSE, VIRGINIA.//No. 68.// June, 1864."
Acquired from: Zeitlin & VerBrugge Booksellers, Los Angeles, California

2380

James Gardner

*2384. **PONTOON BRIDGE ACROSS THE JAMES** (P1984.30.69)
Albumen silver print. negative 1864, print 1866 by Alexander Gardner
Image: 7 x 9 1/16 in. (17.8 x 22.9 cm.)
Mount: 12 x 15 5/8 in. (30.3 x 39.7 cm.)
Signed: see inscription
Inscription, mount recto, printed: "Negative by J. GARDNER./Entered according to act of Congress, in the year 1866, by A. Gardner, in the Clerk's Office of the District Court of the District of Columbia./Positive by A. GARDNER, 511 7th st., Washington.//PONTOON BRIDGE ACROSS THE JAMES.//No. 69.//June, 1864."
Acquired from: Zeitlin & VerBrugge Booksellers, Los Angeles, California

Timothy H. O'Sullivan

2385. **ARMY REPAIR SHOP** (P1984.30.70)
Albumen silver print. negative 1864, print 1865 by Alexander Gardner
Image: 6 7/8 x 8 7/8 in. (17.4 x 22.5 cm.)
Mount: 12 x 15 5/8 in. (30.3 x 39.7 cm.)
Signed: see inscription
Inscription, mount recto, printed: "Negative by T. H. O'SULLIVAN./Entered according to act of Congress, in the year 1865, by A. Gardner, in the Clerk's Office of the District Court of the District of Columbia./Positive by A. GARDNER, 511 7th St., Washington.//ARMY REPAIR SHOP.//No. 70.//February, 1864."
Acquired from: Zeitlin & VerBrugge Booksellers, Los Angeles, California

2384

John Reekie
2386. **AIKEN HOUSE ON WELDON RAILROAD, VIRGINIA**
(P1984.30.71)
Albumen silver print. negative 1865, print 1865 by Alexander
Gardner
Image: 6 7/8 x 8 7/8 in. (17.3 x 22.5 cm.) irregular
Mount: 12 x 15 5/8 in. (30.3 x 39.7 cm.)
Signed: see inscription
Inscription, mount recto, printed: "Negative by J. REEKIE./
Entered according to act of Congress, in the year 1865, by
A. Gardner, in the Clerk's Office of the District Court of
the District of Columbia./Positive by A. GARDNER, 511
7th St., Washington.//AIKEN HOUSE ON WELDON
RAILROAD, VIRGINIA.//No. 71.//February, 1865."
Acquired from: Zeitlin & VerBrugge Booksellers,
Los Angeles, California

John Reekie
*2387. **MEDICAL SUPPLY BOAT, APPOMATTOX LANDING,
VIRGINIA** (P1984.30.72)
Albumen silver print. negative 1865, print 1865 by Alexander
Gardner
Image: 6 1/2 x 9 in. (16.5 x 22.9 cm.)
Mount: 12 x 15 5/8 in. (30.3 x 39.7 cm.)
Signed: see inscription
Inscription, mount recto, printed: "Negative by J. REEKIE./
Entered according to act of Congress, in the year 1865, by
A. Gardner, in the Clerk's Office of the District Court
of the District of Columbia./Positive by A. GARDNER,
511 7th St., Washington.//MEDICAL SUPPLY BOAT,
APPOMATTOX LANDING, VIRGINIA.//No. 72.//
January, 1865."
Acquired from: Zeitlin & VerBrugge Booksellers,
Los Angeles, California

David Knox
*2388. **FIELD TELEGRAPH, BATTERY WAGON** (P1984.30.73)
Albumen silver print. negative 1864, print 1865 by Alexander
Gardner
Image: 7 x 9 1/16 in. (17.8 x 23.0 cm.)
Mount: 12 x 15 5/8 in. (30.3 x 39.7 cm.)
Signed: see inscription
Inscription, mount recto, printed: "Negative by DAVID
KNOX./Entered according to act of Congress, in the
year 1865, by A. Gardner, in the Clerk's Office of the
District Court of the District of Columbia./Positive by
A. GARDNER, 511 7th St., Washington.//FIELD
TELEGRAPH, BATTERY WAGON.//No. 73.//September,
1864."
Acquired from: Zeitlin & VerBrugge Booksellers,
Los Angeles, California

Timothy H. O'Sullivan
2389. **POPLAR GROVE CHURCH** (P1984.30.74)
Albumen silver print. negative 1865, print 1865 by Alexander
Gardner
Image: 9 1/16 x 7 1/16 in. (23.0 x 17.9 cm.)
Mount: 15 5/8 x 12 in. (39.7 x 30.3 cm.)
Signed: see inscription
Inscription, mount recto, printed: "Negative by T. H.
O'SULLIVAN./Entered according to act of Congress, in
the year 1865, by A. Gardner, in the Clerk's Office of the
District Court of the District of Columbia./Positive by
A. GARDNER, 511 7th St., Washington.//POPLAR
GROVE CHURCH.//No. 74."
Acquired from: Zeitlin & VerBrugge Booksellers,
Los Angeles, California

David Knox
2390. **MORTAR DICTATOR, IN FRONT OF PETERSBURG**
(P1984.30.75)
Albumen silver print. negative 1864, print 1865 by Alexander
Gardner
Image: 6 7/8 x 8 7/8 in. (17.5 x 22.5 cm.)
Mount: 12 x 15 5/8 in. (30.3 x 39.7 cm.)

Signed: see inscription
Inscription, mount recto, printed: "Negative by DAVID
KNOX./Entered according to act of Congress, in the
year 1865, by A. Gardner, in the Clerk's Office of the
District Court of the District of Columbia./Positive by
A. GARDNER, 511 7th St., Washington.//MORTAR
DICTATOR, IN FRONT OF PETERSBURG.//No. 75.//
October, 1864."
Acquired from: Zeitlin & VerBrugge Booksellers,
Los Angeles, California

David Knox
*2391. **A FANCY GROUP, IN FRONT OF PETERSBURG**
(P1984.30.76)
Albumen silver print. negative 1864, print 1865 by Alexander
Gardner
Image: 7 x 9 1/16 in. (17.8 x 23.0 cm.)
Mount: 12 x 15 5/8 in. (30.3 x 39.7 cm.)
Signed: see inscription
Inscription, mount recto, printed: "Negative by DAVID
KNOX./Entered according to act of Congress, in the
year 1865, by A. Gardner, in the Clerk's Office of the
District Court of the District of Columbia./Positive by
A. GARDNER, 511 7th St., Washington.//A FANCY
GROUP, IN FRONT OF PETERSBURG.//No. 76.//
August, 1864."
Acquired from: Zeitlin & VerBrugge Booksellers,
Los Angeles, California

David Knox
2392. **ARMY FORGE SCENE, IN FRONT OF PETERSBURG**
(P1984.30.77)
Albumen silver print. negative 1864, print 1865 by Alexander
Gardner
Image: 7 1/16 x 9 1/16 in. (17.9 x 23.0 cm.)
Mount: 12 x 15 5/8 in. (30.3 x 39.7 cm.)
Signed: see inscription
Inscription, mount recto, printed: "Negative by DAVID
KNOX./Entered according to act of Congress, in the
year 1865, by A. Gardner, in the Clerk's Office of the
District Court of the District of Columbia./Positive by
A. GARDNER, 511 7th St., Washington.//ARMY
FORGE SCENE, IN FRONT OF PETERSBURG.//
No. 77.//August, 1864."
Acquired from: Zeitlin & VerBrugge Booksellers,
Los Angeles, California

Timothy H. O'Sullivan
2393. **THREE FIRST TRAVERSES ON LAND END, FORT
FISHER, N. C.** (P1984.30.78)
Albumen silver print. negative 1865, print 1866 by Alexander
Gardner
Image: 6 7/8 x 9 1/16 in. (17.4 x 23.0 cm.)
Mount: 12 x 15 5/8 in. (30.3 x 39.7 cm.)
Signed: see inscription
Inscription, mount recto, printed: "Negative by T. H.
O'SULLIVAN./Entered according to act of Congress, in
the year 1866, by A. Gardner, in the Clerk's Office of the
District Court of the District of Columbia./Positive by
A. GARDNER, 511 7th st., Washington.//THREE FIRST
TRAVERSES ON LAND END, FORT FISHER, N. C.//
No. 78.//January, 1865."
Acquired from: Zeitlin & VerBrugge Booksellers,
Los Angeles, California

Timothy H. O'Sullivan
2394. **THE PULPIT, FORT FISHER, N. C.** (P1984.30.79)
Albumen silver print. negative 1865, print 1865 by Alexander
Gardner
Image: 6 7/8 x 8 15/16 in. (17.4 x 22.6 cm.)
Mount: 12 x 15 5/8 in. (30.3 x 39.7 cm.)
Signed: see inscription
Inscription, mount recto, printed: "Negative by T. H.
O'SULLIVAN./Entered according to act of Congress, in
the year 1865, by A. Gardner, in the Clerk's Office of the
District Court of the District of Columbia./Positive by

A. GARDNER, 511 7th St., Washington.//THE PULPIT, FORT FISHER, N. C.//No. 79.//January, 1865."
Acquired from: Zeitlin & VerBrugge Booksellers, Los Angeles, California

Timothy H. O'Sullivan
2395. **JOHNSON'S MILL, PETERSBURG, VIRGINIA**
(P1984.30.80)
Albumen silver print. negative 1865, print 1866 by Alexander Gardner
Image: 7 x 9 ¹/₁₆ in. (17.8 x 23.0 cm.)
Mount: 12 x 15 ⅝ in. (30.3 x 39.7 cm.)
Signed: see inscription
Inscription, mount recto, printed: "Negative by T. H. O'SULLIVAN./Entered according to act of Congress, in the year 1866, by A. Gardner, in the Clerk's Office of the District Court of the District of Columbia./Positive by A. GARDNER, 511 7th st., Washington.//JOHNSON'S MILL, PETERSBURG, VIRGINIA.//No. 80.//May, 1865."
Acquired from: Zeitlin & VerBrugge Booksellers, Los Angeles, California

Timothy H. O'Sullivan
2396. **VIEW OF THE PETERSBURG GAS WORKS** (P1984.30.81)
Albumen silver print. negative 1865, print 1865 by Alexander Gardner
Image: 7 x 9 ¹/₁₆ in. (17.8 x 23.0 cm.)
Mount: 12 x 15 ⅝ in. (30.3 x 39.7 cm.)
Signed: see inscription
Inscription, mount recto, printed: "Negative by T. H. O'SULLIVAN./Entered according to act of Congress, in the year 1865, by A. Gardner, in the Clerk's Office of the District Court of the District of Columbia./Positive by A. GARDNER, 511 7th St., Washington.//VIEW OF THE PETERSBURG GAS WORKS.//No. 81.//May, 1865."
Acquired from: Zeitlin & VerBrugge Booksellers, Los Angeles, California

Timothy H. O'Sullivan
2397. **VIEW ON THE APPOMATTOX RIVER, NEAR CAMPBELL'S BRIDGE, PETERSBURG, VA.**
(P1984.30.82)
Albumen silver print. negative 1865, print 1866 by Alexander Gardner
Image: 7 x 9 ¹/₁₆ in. (17.8 x 23.0 cm.)
Mount: 12 x 15 ⅝ in. (30.3 x 39.7 cm.)
Signed: see inscription
Inscription, mount recto, printed: "Negative by T. H. O'SULLIVAN./Entered according to act of Congress, in the year 1866, by A. Gardner, in the Clerk's Office of the District Court of the District of Columbia./Positive by A. GARDNER, 511 7th st., Washington.//VIEW ON THE APPOMATTOX RIVER,/NEAR CAMPBELL'S BRIDGE, PETERSBURG, VA.//No. 82.//May, 1865."
Acquired from: Zeitlin & VerBrugge Booksellers, Los Angeles, California

Timothy H. O'Sullivan
*2398. **QUARTERS OF MEN IN FORT SEDWICK, GENERALLY KNOWN AS FORT HELL** (P1984.30.83)
Albumen silver print. negative 1865, print 1866 by Alexander Gardner
Image: 7 x 9 ¹/₁₆ in. (17.8 x 23.0 cm.)
Mount: 12 x 15 ⅝ in. (30.3 x 39.7 cm.)
Signed: see inscription
Inscription, mount recto, printed: "Negative by T. H. O'SULLIVAN./Entered according to act of Congress, in the year 1866, by A. Gardner, in the Clerk's Office of the District Court of the District of Columbia./Positive by A. GARDNER, 511 7th st., Washington.//QUARTERS OF MEN IN FORT SEDWICK,/GENERALLY KNOWN AS FORT HELL.//No. 83.//May, 1865."
Acquired from: Zeitlin & VerBrugge Booksellers, Los Angeles, California

2387

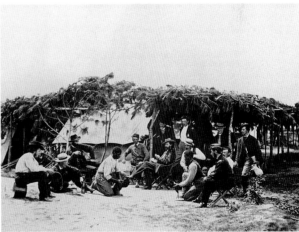
2388

2391

Timothy H. O'Sullivan
2399. **VIEW OF THE INTERIOR OF FORT STEDMAN**
(P1984.30.84)
Albumen silver print. negative 1865, print 1865 by Alexander
Gardner
Image: 6 ¾ x 8 ¹³/₁₆ in. (17.1 x 22.4 cm.)
Mount: 12 x 15 ⅝ in. (30.3 x 39.7 cm.)
Signed: see inscription
Inscription, mount recto, printed: "Negative by T. H.
O'SULLIVAN./Entered according to act of Congress, in
the year 1865, by A. Gardner, in the Clerk's Office of the
District Court of the District of Columbia./Positive by
A. GARDNER, 511 7th St., Washington.//VIEW OF
THE INTERIOR OF FORT STEADMAN [sic].//
No. 84.//May, 1865."
Acquired from: Zeitlin & VerBrugge Booksellers,
Los Angeles, California

Timothy H. O'Sullivan
2400. **BLANDFORD CHURCH, PETERSBURG, VIRGINIA**
(P1984.30.85)
Albumen silver print. negative 1865, print 1865 by Alexander
Gardner
Image: 7 x 9 ¹/₁₆ in. (17.8 x 23.0 cm.)
Mount: 12 x 15 ⅝ in. (30.3 x 39.7 cm.)
Signed: see inscription
Inscription, mount recto, printed: "Negative by T. H.
O'SULLIVAN./Entered according to act of Congress, in
the year 1865, by A. Gardner, in the Clerk's Office of the
District Court of the District of Columbia./Positive by
A. GARDNER, 511 7th St., Washington.//BLANDFORD
CHURCH, PETERSBURG, VIRGINIA.//No. 85.//April,
1865."
Acquired from: Zeitlin & VerBrugge Booksellers,
Los Angeles, California

Timothy H. O'Sullivan
*2401. **INTERIOR VIEW OF THE CONFEDERATE LINE, AT
GRACIE'S SALIENT** (P1984.30.86)
Albumen silver print. negative 1865, print 1866 by Alexander
Gardner
Image: 6 ¹⁵/₁₆ x 8 ⅞ in. (17.5 x 22.5 cm.)
Mount: 12 x 15 ⅝ in. (30.3 x 39.7 cm.)
Signed: see inscription
Inscription, mount recto, printed: "Negative by T. H.
O'SULLIVAN./Entered according to act of Congress, in
the year 1866, by A. Gardner, in the Clerk's Office of the
District Court of the District of Columbia./Positive by
A. GARDNER, 511 7th st., Washington.//INTERIOR
VIEW OF THE CONFEDERATE LINE,/AT GRACIE'S
SALIENT.//No. 86.//May, 1865."
Acquired from: Zeitlin & VerBrugge Booksellers,
Los Angeles, California

John Reekie
2402. **DUTCH GAP CANAL, JAMES RIVER, VIRGINIA**
(P1984.30.87)
Albumen silver print. negative 1865, print 1865 by Alexander
Gardner
Image: 7 x 9 ¹/₁₆ in. (17.8 x 23.0 cm.)
Mount: 12 x 15 ⅝ in. (30.3 x 39.7 cm.)
Signed: see inscription
Inscription, mount recto, printed: "Negative by J. REEKIE./
Entered according to act of Congress, in the year 1865, by
A. Gardner, in the Clerk's Office of the District Court of
the District of Columbia./Positive by A. GARDNER, 511
7th St., Washington.//DUTCH GAP CANAL, JAMES
RIVER, VIRGINIA.//No. 87.//March, 1864 [sic]."
Acquired from: Zeitlin & VerBrugge Booksellers, Los
Angeles, California

Alexander Gardner
2403. **RUINS OF PETERSBURG AND RICHMOND
RAILROAD BRIDGE, ACROSS THE JAMES**
(P1984.30.88)
Albumen silver print. negative 1865, print 1866
Image: 7 x 9 ¹/₁₆ in. (17.8 x 23.0 cm.)
Mount: 12 x 15 ⅝ in. (30.3 x 39.7 cm.)
Signed: see inscription
Inscription, mount recto, printed: "ALEX. GARDNER,
Photographer,/Entered according to act of Congress, in
the year 1866, by A. Gardner, in the Clerk's Office of the
District Court of the District of Columbia./511 Seventh
Street, Washington.//RUINS OF PETERSBURG AND
RICHMOND RAILROAD BRIDGE,/ACROSS THE
JAMES.//No. 88.//April, 1864 [sic]."
Acquired from: Zeitlin & VerBrugge Booksellers,
Los Angeles, California

Alexander Gardner
2404. **LIBBY PRISON, RICHMOND, VIRGINIA** (P1984.30.89)
Albumen silver print. negative 1865, print 1866
Image: 7 ¹/₁₆ x 9 ¹/₁₆ in. (17.9 x 23.0 cm.)
Mount: 12 x 15 ⅝ in. (30.3 x 39.7 cm.)
Signed: see inscription
Inscription, mount recto, printed: "ALEX. GARDNER,
Photographer,/Entered according to act of Congress, in
the year 1866, by A. Gardner, in the Clerk's Office of the
District Court of the District of Columbia./511 Seventh
Street, Washington.//LIBBY PRISON, RICHMOND,
VIRGINIA.//No. 89.//April, 1864 [sic]."
Acquired from: Zeitlin & VerBrugge Booksellers,
Los Angeles, California

William R. Pywell
2405. **OLD CAPITOL PRISON, WASHINGTON** (P1984.30.90)
Albumen silver print. negative c. 1865, print 1866 by
Alexander Gardner
Image: 7 x 9 ¹/₁₆ in. (17.7 x 22.9 cm.)
Mount: 12 x 15 ⅝ in. (30.3 x 39.7 cm.)
Signed: see inscription
Inscription, mount recto, printed: "Negative by WM. R.
PYWELL./Entered according to act of Congress, in the
year 1866, by A. Gardner, in the Clerk's Office of the
District Court of the District of Columbia./Positive by
A. GARDNER, 511 7th St., Washington.//OLD
CAPITOL PRISON, WASHINGTON.//No. 90."
Acquired from: Zeitlin & VerBrugge Booksellers,
Los Angeles, California

Alexander Gardner
*2406. **RUINS OF ARSENAL, RICHMOND, VIRGINIA**
(P1984.30.91)
Albumen silver print. negative 1865, print 1866
Image: 6 ¹³/₁₆ x 9 ¹/₁₆ in. (17.2 x 23.0 cm.)
Mount: 12 x 15 ⅝ in. (30.3 x 39.7 cm.)
Signed: see inscription
Inscription, mount recto, printed: "ALEX. GARDNER,
Photographer,/Entered according to act of Congress, in
the year 1866, by A. Gardner, in the Clerk's Office of the
District Court of the District of Columbia./511 Seventh
Street, Washington.//RUINS OF ARSENAL,
RICHMOND, VIRGINIA.//No. 91.//April, 1863 [sic]."
Acquired from: Zeitlin & VerBrugge Booksellers,
Los Angeles, California

Alexander Gardner
*2407. **VIEW ON CANAL, NEAR CRENSHAW'S MILL,
RICHMOND, VIRGINIA** (P1984.30.92)
Albumen silver print. negative 1865, print 1866
Image: 6 ⅞ x 9 ¹/₁₆ in. (17.4 x 23.0 cm.)
Mount: 12 x 15 ⅝ in. (30.3 x 39.7 cm.)
Signed: see inscription
Inscription, mount recto, printed: "ALEX. GARDNER,
Photographer,/Entered according to act of Congress, in
the year 1866, by A. Gardner, in the Clerk's Office of the
District Court of the District of Columbia./511 Seventh
Street, Washington.//VIEW ON CANAL, NEAR

CRENSHAW'S MILL, RICHMOND, VIRGINIA.//
No. 92.//April, 1864 [sic]."
Acquired from: Zeitlin & VerBrugge Booksellers,
Los Angeles, California

John Reekie
2408. **RUINS OF GAINES' MILL, VIRGINIA** (P1984.30.93)
Albumen silver print. negative 1865, print 1865 by Alexander
Gardner
Image: 7 x 9 1/16 in. (17.8 x 23.0 cm.)
Mount: 12 x 15 5/8 in. (30.3 x 39.7 cm.)
Signed: see inscription
Inscription, mount recto, printed: "Negative by J. REEKIE./
Entered according to act of Congress, in the year 1865, by
A. Gardner, in the Clerk's Office of the District Court of
the District of Columbia./Positive by A. GARDNER, 511
7th St., Washington.//RUINS OF GAINES' MILL,
VIRGINIA.//No. 93.//April, 1865."
Acquired from: Zeitlin & VerBrugge Booksellers.
Los Angeles, California

2398

John Reekie
*2409. **A BURIAL PARTY, COLD HARBOR, VIRGINIA**
(P1984.30.94)
Albumen silver print. negative 1865, print 1865 by Alexander
Gardner
Image: 6 13/16 x 8 15/16 in. (17.2 x 22.7 cm.)
Mount: 12 x 15 5/8 in. (30.3 x 39.7 cm.)
Signed: see inscription
Inscription, mount recto, printed: "Negative by J. REEKIE./
Entered according to act of Congress, in the year 1865, by
A. Gardner, in the Clerk's Office of the District Court of
the District of Columbia./Positive by A. GARDNER, 511
7th St., Washington.//A BURIAL PARTY, COLD
HARBOR, VIRGINIA.//No. 94.//April, 1865."
Acquired from: Zeitlin & VerBrugge Booksellers,
Los Angeles, California

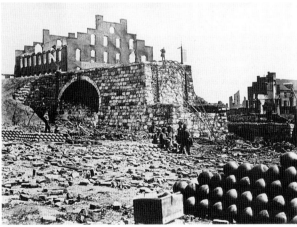
2401

John Reekie
2410. **MECHANICSVILLE, VIRGINIA** (P1984.30.95)
Albumen silver print. negative 1865, print 1865 by Alexander
Gardner
Image: 7 x 9 1/16 in. (17.8 x 23.0 cm.)
Mount: 12 x 15 5/8 in. (30.3 x 39.7 cm.)
Signed: see inscription
Inscription, mount recto, printed: "Negative by J. REEKIE./
Entered according to act of Congress, in the year 1865, by
A. Gardner, in the Clerk's Office of the District Court of
the District of Columbia./Positive by A. GARDNER, 511
7th St., Washington.//MECHANICSVILLE, VIRGINIA.//
No. 95.//April, 1865."
Acquired from: Zeitlin & VerBrugge Booksellers,
Los Angeles, California

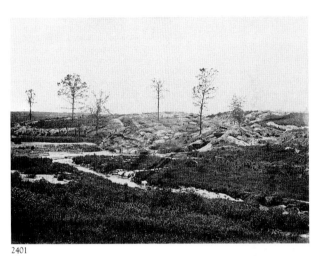
2406

John Reekie
*2411. **EXTREME LINE OF CONFEDERATE WORKS, COLD
HARBOR, VIRGINIA** (P1984.30.96)
Albumen silver print. negative 1865, print 1865 by Alexander
Gardner
Image: 6 7/8 x 8 7/8 in. (17.3 x 22.5 cm.)
Mount: 12 x 15 5/8 in. (30.3 x 39.7 cm.)
Signed: see inscription
Inscription, mount recto, printed: "Negative by J. REEKIE./
Entered according to act of Congress, in the year 1865, by
A. Gardner, in the Clerk's Office of the District Court of
the District of Columbia./Positive by A. GARDNER, 511
7th St., Washington.//EXTREME LINE OF
CONFEDERATE WORKS, COLD HARBOR,
VIRGINIA.//No. 96.//April, 1865."
Acquired from: Zeitlin & VerBrugge Booksellers,
Los Angeles, California

Timothy H. O'Sullivan
2412. **APPOMATTOX STATION, VIRGINIA** (P1984.30.97)
Albumen silver print. negative 1865, print 1865 by Alexander
Gardner
Image: 7 1/16 x 9 1/16 in. (17.9 x 23.0 cm.)
Mount: 12 x 15 5/8 in. (30.3 x 39.7 cm.)
Signed: see inscription
Inscription, mount recto, printed: "Negative by T. H.
O'SULLIVAN./Entered according to act of Congress,
in the year 1865, by A. Gardner, in the Clerk's Office
of the District Court of the District of Columbia./Positive
by A. GARDNER, 511 7th St., Washington.//
APPOMATTOX STATION, VIRGINIA.//No. 97.//
April, 1865."
Acquired from: Zeitlin & VerBrugge Booksellers,
Los Angeles, California

Timothy H. O'Sullivan
*2413. **HIGH BRIDGE CROSSING THE APPOMATTOX, NEAR
FARMVILLE, ON SOUTH SIDE RAILROAD, VA.**
(P1984.30.98)
Albumen silver print. negative 1865, print 1866 by Alexander
Gardner
Image: 6 11/16 x 9 1/16 in. (17.0 x 23.0 cm.)
Mount: 12 x 15 5/8 in. (30.3 x 39.7 cm.)
Signed: see inscription
Inscription, mount recto, printed: "Negative by T. H.
O'SULLIVAN./Entered according to act of Congress,
in the year 1866, by A. Gardner, in the Clerk's Office
of the District Court of the District of Columbia./Positive
by A. GARDNER, 511 7th st., Washington.//HIGH
BRIDGE CROSSING THE APPOMATTOX, NEAR
FARMVILLE,/ON SOUTH SIDE RAILROAD, VA.//
No. 98.//1865."
Acquired from: Zeitlin & VerBrugge Booksellers,
Los Angeles, California

Timothy H. O'Sullivan
2414. **McLEAN'S HOUSE, APPOMATTOX COURT-HOUSE,
VIRGINIA, WHERE THE CAPITULATION WAS
SIGNED BETWEEN GENERALS GRANT AND LEE**
(P1984.30.99)
Albumen silver print. negative 1865, print 1866 by Alexander
Gardner
Image: 6 7/8 x 8 7/8 in. (17.3 x 22.5 cm.)
Mount: 12 x 15 5/8 in. (30.3 x 39.7 cm.)
Signed: see inscription
Inscription, mount recto, printed: "Negative by T. H.
O'SULLIVAN./Entered according to act of Congress,
in the year 1866, by A. Gardner, in the Clerk's Office
of the District Court of the District of Columbia./Positive
by A. GARDNER, 511 7th st., Washington.//McLEAN'S
HOUSE, APPOMATTOX COURT-HOUSE, VIRGINIA,/
Where the Capitulation was Signed between Generals
Grant and Lee.//No. 99.//April, 1865."
Acquired from: Zeitlin & VerBrugge Booksellers,
Los Angeles, California

W. Morris Smith
*2415. **DEDICATION OF MONUMENT ON BULL RUN
BATTLE-FIELD** (P1984.30.100)
Albumen silver print. negative 1865, print 1865 by Alexander
Gardner
Image: 7 x 9 1/16 in. (17.8 x 23.0 cm.)
Mount: 12 x 15 5/8 in. (30.3 x 39.7 cm.)
Signed: see inscription
Inscription, mount recto, printed: "Negative by W. MORRIS
SMITH./Entered according to act of Congress, in the
year 1865, by A. Gardner, in the Clerk's Office of the
District Court of the District of Columbia./Positive by
A. GARDNER, 511 7th St., Washington.//DEDICATION
OF MONUMENT ON BULL RUN BATTLE-FIELD.//
No. 100.//June, 1865."
Acquired from: Zeitlin & VerBrugge Booksellers,
Los Angeles, California

WILLIAM GARNETT, American (b. 1916)

William Garnett is an aerial photographer who began
making photographs from airplanes in 1947 after a trip
home in the navigator's seat of a troop transport plane
at the end of World War II. Garnett has received three
Guggenheim Fellowships (1953, 1956, and 1975) and
taught photography for sixteen years in the College of
Environmental Design at the University of California at
Berkeley. He works in both black and white and color,
capturing the abstract patterns and textures of nature.
In 1983 Garnett received the American Society of
Magazine Photographers Lifetime Achievement Award
in Landscape Photography.

*2416. **PLOWED FIELD, ARVIN, CALIFORNIA** (P1981.73)
Gelatin silver print. negative 1951, print later
Image: 19 7/8 x 15 13/16 in. (50.4 x 40.1 cm.)
Mount: 28 1/16 x 22 in. (71.4 x 56.0 cm.)
Signed, l.r. mount recto and center mount verso: "Garnett"
Inscription, mount verso: "PLOWED FIELD, ARVIN,
CALIFORNIA//1951" and rubber stamps "TOP" and
"COPYRIGHTED/WILLIAM A. GARNETT/
PHOTOGRAPHER/1286 CONGRESS VALLEY
ROAD, NAPA, CA 94558/ "ALL RIGHTS TO THIS
PHOTOGRAPH, OTHER THAN FOR/THE PURPOSE
FOR WHICH IT IS SOLD, ARE RETAINED BY/
WILLIAM A. GARNETT AND HIS HEIRS,
ADMINISTRATORS,/EXECUTORS AND ASSIGNS.
REPRODUCTION BY ANY/MEANS, IS PROHIBITED
EXCEPT BY EXPRESS WRITTEN/CONSENT FOR
EACH SPECIFIC USE.""
Acquired from: The Halsted Gallery, Birmingham, Michigan

2417. **SAND DUNE #1, PALM DESERT, CALIFORNIA**
(P1981.42)
Gelatin silver print. 1975
Image: 9 x 7 in. (22.9 x 17.8 cm.)
Sheet: 14 x 11 in. (35.6 x 28.0 cm.)
Signed, l.r. sheet recto and center print verso: "Garnett"
Inscription, print verso: "SAND DUNE #1 PALM DESERT,
CALIFORNIA//1975" and rubber stamps "TOP" and
"COPYRIGHTED/WILLIAM A. GARNETT/
PHOTOGRAPHER/1286 CONGRESS VALLEY
ROAD, NAPA, CA 94558/ "ALL RIGHTS TO THIS
PHOTOGRAPH, OTHER THAN FOR/THE PURPOSE
FOR WHICH IT IS SOLD, ARE RETAINED BY/
WILLIAM A. GARNETT AND HIS HEIRS,
ADMINISTRATORS,/EXECUTORS AND ASSIGNS.
REPRODUCTION BY ANY/MEANS, IS PROHIBITED
EXCEPT BY EXPRESS WRITTEN/CONSENT FOR
EACH SPECIFIC USE.""
Acquired from: Friends of Photography, Carmel, California;
gift print with sustaining membership, 1981

RICK GAST, American (b. 1950)

Rick Gast received a B.S. in photography from Sam
Houston State University in 1972 and an M.F.A. in the
same field from Western Michigan State University in
1979. From 1979 until 1981 he served first as Video Pro-
gram Coordinator and then as Director of Photography
for the Galveston Art Center in Galveston, Texas. He
also taught art at Galveston College from 1981 to 1983.
Gast has been active in the South Central Region of
the Society for Photographic Education and served two
terms as the group's treasurer.

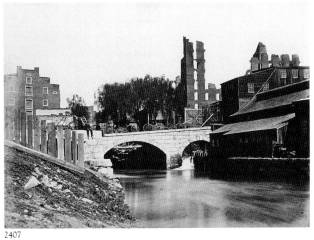

2407

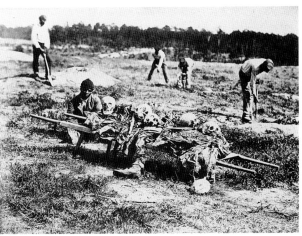

2409

2411

2413

2415

2416

2418. GRASSES—GALVESTON [from the Society for
Photographic Education's "South Central Regional
Photography Exhibition"] (P1983.31.5)
Gelatin silver print. 1980
Image (triptych): each image 4 ⅛ x 5 in.
(10.4 x 12.7 cm.)
Sheet: 16 x 19 ¹⁵/₁₆ in. (40.7 x 50.7 cm.)
Acquired from: gift of the Society for Photographic
Education, South Central Region

ARNOLD GENTHE,
American, born Germany (1869–1942)

Arnold Genthe is best known for his turn-of-the-
century photographs of life in San Francisco's China-
town and views of the 1906 fire and earthquake.
Trained in literature and linguistics, Genthe began to
make photographs as a hobby shortly after he moved to
the United States in 1895. He often worked with a con-
cealed camera to avoid disrupting his subject's activi-
ties. Genthe moved to New York City in 1911 where he
made portraits of leading stage personalities. Genthe
worked in the pictorialist mode and published several
books of his photographs.

*2419. [Old Chinatown, woman in black silk pants and tunic]
(P1980.25.5)
Gelatin silver print. c. 1896–1906
Image: 8 x 6 in. (20.3 x 15.3 cm.)
Inscription, print verso: "4//8x6//8//#8" and rubber stamp
"JFC"
mat backing verso, written and stamped on paper label:
"OLD CHINATOWN. CHINESE/WOMAN IN BLACK
SILK./8" x 6".//This Vintage Print by Arnold Genthe/was
shown in the Genthe Exhibition/at the Staten Island
Museum 28/September to 2 November 1975./Catalog
number [in ink] 8//This original photograph by Arnold
Genthe, came/from the collection of a fellow countryman
and/long-time friend of Genthe's, the late William E./
Neumeyer and Mrs. Neumeyer of New York City" and
dealer's label
Acquired from: gift of James Maroney, Inc., New York,
New York

2420. SAN FRANCISCO, APRIL 18TH, 1906 [looking down
Market Street] (P1980.25.4)
Toned gelatin silver print. 1906
Image: 7 ¹¹/₁₆ x 13 in. (19.5 x 33.0 cm.)
Mount: 14 x 17 ¹⁵/₁₆ in. (35.6 x 45.6 cm.)
Signed, l.l. mount recto: "Arnold Genthe/N.Y."
Inscription, mount recto: "San Francisco, April 18th 1906."
mount verso: "34//#123//791117//property of Dorothy
Lilcock Neumeyer//7 ⅝ x 12 ¹⁵/₁₆//#123" and rubber
stamps "JFC//JFC" and typed on paper label "10. San
Francisco April 18, 1906" and printed on paper label
"From/ARNOLD GENTHE/41 EAST 49th STREET/
NEW YORK"
old mat backing verso, written and stamped on paper label:
"SIGNED "A.G. N.Y." AND/TITLED "SAN
FRANCISCO,/APRIL 18th, 1906" IN/A.G.'s HAND.
LOOKING DOWN/MARKET STREET WITH A.G.'s
PRINTED LABEL ON VERSO./7 ⅝" x 12 ¹⁵/₁₆".//This
Vintage Print by Arnold Genthe/was shown in the Genthe
Exhibition/at the Staten Island Museum 28/September
to 2 November 1975./Catalog number 16//This original
photograph by Arnold Genthe, came/from the collection of
a fellow countryman and/long-time friend of Genthe's, the
late William E./Neumeyer and Mrs. Neumeyer of New York
City" and dealer's label
Acquired from: James Maroney, Inc., New York, New York

2421. SAN FRANCISCO, APRIL 18TH, 1906, 10AM [looking
down Market Street with two Chinese figures in the
foreground] (P1980.25.2)
Toned gelatin silver print. 1906
Image: 13 ⅝ x 10 ³/₁₆ in. (34.6 x 25.9 cm.)
Mount: 18 x 14 in. (45.7 x 35.6 cm.)
Signed, l.l. mount recto: "Arnold Genthe/N.Y."
Inscription, mount verso: "No 11.//216//San Francisco/April
18th 1906 10 A.M.//13 ⁹/₁₆ x 10 ⅛//#120//791106//#120"
and rubber stamp "JFC" and printed paper label "From
ARNOLD GENTHE/41 EAST 49th STREET/NEW
YORK" and printed and typed on paper label
"DEPARTMENT OF FINE ARTS/GOLDEN GATE
INTERNATIONAL EXPOSITION/Photography/Title
San Francisco Fire 1906/Artist Dr. Arnold Genthe/
No. G17/Box 401"
mat backing verso, written and stamped on paper label:
" "SAN FRANCISCO, APRIL 18th, 1906./10 AM," (ON
VERSO IN AG's handwriting)/SIGNED ON FRONT
A.G. N.Y./LOOKING DOWN MARKET STREET
WITH/2 CHINESE FIGS. IN FOREGROUND./WITH
THE DEPT. OF FINE ARTS—/GOLDEN GATE INT'L.
EXPOSITION/PRINTED LABEL./13 ⁹/₁₆" x 10 ⅛."//This
Vintage Print by Arnold Genthe/was shown in the Genthe
Exhibition/at the Staten Island Museum 28/September
to 2 November 1975./Catalog number 17//This original
photograph by Arnold Genthe, came/from the collection of a
fellow countryman and/long-time friend of Genthe's, the
late William E./Neumeyer and Mrs. Neumeyer of New York
City" and dealer's label
Acquired from: James Maroney, Inc., New York, New York

2422. [San Francisco Earthquake, temporary sheds and outdoor
cooking stoves] (P1980.25.1)
Gelatin silver print. 1906
Image: 5 ⅜ x 9 ⅞ in. (13.7 x 25.0 cm.) irregular
Sheet: 8 x 9 ¹⁵/₁₆ in. (20.3 x 25.3 cm.)
Inscription, print verso: "8 x 10//#15" and rubber stamp
"JFC"
mat verso: dealer's label
Acquired from: James Maroney, Inc., New York, New York

*2423. [Watching the approach of the fire after the San Francisco
earthquake] (P1980.25.3)
Gelatin silver print. 1906
Image: 13 ¾ x 10 ¼ in. (34.9 x 26.0 cm.)
Sheet: 13 ¹⁵/₁₆ x 10 ¹⁵/₁₆ in. (35.3 x 27.8 cm.)
Inscription, print verso: "San Francisco burning—/after
Earthquake 1904 [sic]//Photo by Dr. Arnold Genthe//
14 x 11//#111" and rubber stamp "JFC"
old mat backing verso, written and stamped on paper label:
"SAN FRANCISCO FIRE AFTER/EARTHQUAKE.
LOOKING/DOWNHILL TOWARD CENTER/OF
CITY/14" x 11"//This Vintage Print by Arnold Genthe/
was shown in the Genthe Exhibition/at the Staten Island
Museum 28/September to 2 November 1975./Catalog
number 18//This original photograph by Arnold Genthe,
came/from the collection of a fellow countryman and/long-
time friend of Genthe's, the late William E./Neumeyer and
Mrs. Neumeyer of New York City" and dealer's label
Acquired from: James Maroney, Inc., New York, New York

JAMES F. GIBSON, American (active 1860s)

See George N. Barnard and *Gardner's Photographic
Sketch Book of the War*

HENRY GILPIN, American (b. 1922)

Gilpin studied engineering at Los Angeles City College
and UCLA from 1946 to 1949 and ceramics at the
Cleveland Institute of Art in 1950. Later he studied
photography with Ansel Adams at a Yosemite workshop
in 1959 and with Wynn Bullock in 1963. In 1951 he be-

gan a law enforcement career in Monterey, California, and served for a time as captain of detectives in the Monterey County Sheriff's Department. He has taught photography at Monterey Peninsula College since 1963. Gilpin has also served as an instructor at numerous Yosemite workshops and was a Friends of Photography trustee (1969–78) and advisory trustee (1978–83).

2424. **HIGHWAY ONE** (P1980.8)
Gelatin silver print. negative 1965, print c. 1980
Image: 7 ¾ x 9 ¾ in. (19.7 x 24.7 cm.)
Mount: 11 x 16 in. (28.0 x 40.7 cm.)
Signed, l.r. mount recto: "H. GILPIN"
Inscription, mount verso, rubber stamp: "PHOTOGRAPHS by/HENRY E. GILPIN/ 1353 Jacks Road/Monterey, Calif. 93948/File No: 2–38"
Acquired from: Friends of Photography, Carmel, California; gift print with sustaining membership, 1980

LAURA GILPIN, American (1891–1979)

Laura Gilpin's career as a photographer, writer, designer, and publisher spanned seven decades. Gilpin made photographs at the 1904 Louisiana Purchase Exposition in St. Louis with a Brownie camera she had received for her birthday. In 1908 she began experimenting with autochromes, an early color process. She studied at the Clarence White School in 1917–18, and her early work is strongly pictorial, reflecting White's influence. Gilpin returned to her native Colorado Springs to establish a publishing company and her own studio for portraiture and architectural work, but left to work for the Boeing Aircraft Corporation during World War II. After the war she settled in Santa Fe, New Mexico, where she supported herself with commercial assignments while working on her personal projects. She published *The Pueblos* (1941), *Temples in Yucatan* (1948), and *The Rio Grande* (1949), contributing both photographs and text. However, *The Enduring Navaho* (1968) represents her most significant project. Gilpin began photographing the Navajo in the early 1930s and continued throughout her career. By the 1940s she had abandoned the pictorial style, and her photographs of the Southwest and its inhabitants reflect a more straightforward approach. Gilpin left her photographic estate of 27,000 negatives and over 20,000 prints to the Amon Carter Museum upon her death in 1979. In 1986 the Museum organized "Laura Gilpin: An Enduring Grace," a major retrospective of Gilpin's work, and published an accompanying catalogue.

Note: This catalogue includes photographs by Laura Gilpin that were purchased or given prior to Miss Gilpin's death or after the acquisition of her estate. The material received directly from the Gilpin Estate (P1979.101–151 and P1980.35) will be catalogued in a later publication.

*2425. **[Above Ute Pass]** (P1978.84.12)
Platinum print. c. 1920s
Image: 7 ⅜ x 9 ³⁄₁₆ in. (18.8 x 23.4 cm.)
Acquired from: gift of the photographer

2426. **[Above Ute Pass]** (P1978.84.16)
Platinum print. c. 1920s
Image: 9 ⅝ x 7 ⅝ in. (24.4 x 19.3 cm.)
Sheet: 10 x 8 in. (25.4 x 20.3 cm.) irregular
Acquired from: gift of the photographer

2419

2423

2425

2427. **ABSTRACT OF ROCKS, CANYON DE CHELLY**
(P1979.95.54)
Type C color print. 1972
Image: 10 ¼ x 7 ⅝ in. (26.0 x 19.4 cm.)
Signed, l.r. overmat recto: "Laura Gilpin/1972"
Inscription, mat backing verso: "96" and "ABSTRACT OF
ROCKS, CANYON DE CHELLY/ARIZONA/(Courtesy
of School of/American Research)/ 1972" typed on printed
paper label "LG/ A PHOTOGRAPH BY/LAURA GILPIN/
SANTA FE, NEW MEXICO"
overmat recto: printed title, date, medium, and credit line
Acquired from: gift of the photographer

2428. **AGNES SIMS** (P1978.92.35)
Gelatin silver print. 1946
Image: 9 ½ x 7 7/16 in. (24.1 x 18.9 cm.)
Sheet: 10 x 7 15/16 in. (25.4 x 20.2 cm.)
Mount: 17 x 14 in. (43.2 x 35.6 cm.)
Signed, l.r. overmat recto: "Laura Gilpin/1946"
Inscription, mount verso: "6" and "AGNES SIMS 1946"
typed on printed paper label "LG/ A PHOTOGRAPH BY/
LAURA GILPIN/SANTA FE, NEW MEXICO"
overmat recto: printed title and date
Acquired from: gift of the photographer

2429. **AIR SHOT OF CANYON DE CHELLY, ARIZONA**
(P1979.95.99)
Gelatin silver print. 1972
Image: 13 15/16 x 11 1/16 in. (35.4 x 28.1 cm.)
Sheet: 14 x 11 ¼ in. (35.6 x 28.5 cm.)
Mount: 20 x 16 in. (50.8 x 40.7 cm.)
Signed, l.r. overmat recto: "Laura Gilpin/1972"
Inscription, mount verso: "91" and "AIR SHOT OF
CANYON DE CHELLY,/ARIZONA/1972" typed on
printed paper label "LG/ A PHOTOGRAPH BY/LAURA
GILPIN/SANTA FE, NEW MEXICO"
overmat verso: "91 Air Shot"
overmat recto: printed title and date
Acquired from: gift of the photographer

*2430. **ANDREW DASBURG** (P1978.92.50) duplicate of P1979.48.1
Gelatin silver print. 1971
Image: 9 ⅜ x 7 7/16 in. (23.8 x 18.9 cm.)
Mount: 10 x 8 in. (25.4 x 20.3 cm.)
Signed, l.r. overmat recto: "Laura Gilpin/1971"
Inscription, mount verso: "157/Andrew Dasburg/1972 [sic]"
overmat recto: printed title and date
mat backing verso: "17" and "ANDREW DASBURG 1971"
typed on printed paper label "LG/ A PHOTOGRAPH BY/
LAURA GILPIN/SANTA FE, NEW MEXICO"
Acquired from: gift of the photographer

2431. **ANDREW DASBURG** (P1979.48.1) duplicate of P1978.92.50
Gelatin silver print. 1971
Image: 13 11/16 x 10 ¾ in. (34.7 x 27.3 cm.)
Sheet: 13 ⅞ x 11 in. (35.3 x 27.9 cm.)
Mount: 20 x 16 in. (50.8 x 40.7 cm.)
Signed, l.r. overmat recto: "Laura Gilpin/1971"
Inscription, mount verso: "ANDREW DASBURG 1971"
typed on printed paper label "LG/ A PHOTOGRAPH BY/
LAURA GILPIN/SANTA FE, NEW MEXICO"
Acquired from: the photographer

*2432. **ANEMONES** (P1979.44.5)
Platinum print. 1924
Image: 4 ½ x 3 9/16 in. (11.3 x 9.0 cm.)
Mount: 9 x 7 in. (22.8 x 17.8 cm.)
Signed, l.r. mount recto: "Laura Gilpin/1924"
Inscription, mount verso: "Anemones/by/Laura Gilpin/
Price $3.50"
Acquired from: the photographer

2433. **AT THE SAN ILDEFONSO PUEBLO, NEW MEXICO**
(P1979.95.56)
Platinum print. 1927
Image: 9 ⅝ x 7 11/16 in. (24.4 x 19.5 cm.)
Sheet: 9 ⅞ x 7 ⅞ in. (25.0 x 19.9 cm.)

Signed, l.r. old overmat recto: "Laura Gilpin/1928 [sic]"
Inscription, print recto: "©"
print verso: "San Ildefonso Pueblo/Juanita Pena &
Rosa/1925 [sic]"
old mat backing verso: "#22" and "A PLATINUM
PRINT/AT THE SAN ILDEFONSO PUEBLO,/NEW
MEXICO/1928 [sic]" typed on printed paper label "LG/
A PHOTOGRAPH BY/LAURA GILPIN/SANTA FE,
NEW MEXICO"
old overmat recto: printed title, [incorrect] date, and
medium
Acquired from: gift of the photographer

2434. **AVIATOR, WORLD WAR II [Portrait of Aviator in
Training]**(P1978.92.31)
Platinum print. 1942
Image: 9 ½ x 7 ⅝ in. (24.1 x 19.4 cm.)
Mount: 14 x 11 in. (35.6 x 28.0 cm.)
Signed, l.r. overmat recto and l.r. mount recto:
"Laura Gilpin/1942"
Inscription, mount verso: "#123//Portrait of Aviator in
Training/1942"
overmat recto: printed title and date
mat backing verso: "123" and "AVIATOR, WORLD
WAR II/1942" typed on printed paper label "LG/ A
PHOTOGRAPH BY/LAURA GILPIN/SANTA FE,
NEW MEXICO"
Acquired from: gift of the photographer

*2435. **B-29 BOMBER COMING OUT OF THE FACTORY**
(P1979.44.10) duplicate of P1979.95.97
Gelatin silver print. 1944
Image: 15 ½ x 19 ⅜ in. (39.4 x 49.2 cm.)
Sheet: 15 ¾ x 19 11/16 in. (40.0 x 50.0 cm.)
Mount: 20 x 24 in. (50.8 x 61.0 cm.)
Signed, l.r. overmat recto: "Laura Gilpin/1945 [sic]"
Inscription, mount verso: "B-29 BOMBER COMING OUT
OF THE/FACTORY 1945 [sic]" typed on printed paper
label "LG/ A PHOTOGRAPH BY/LAURA GILPIN/
SANTA FE, NEW MEXICO"
Acquired from: the photographer

2436. **A B-29 BOMBER LEAVING THE FACTORY** (P1979.95.97)
duplicate of P1979.44.10
Gelatin silver print. 1944
Image: 14 x 18 3/16 in. (35.6 x 45.8 cm.)
Sheet: 16 x 20 in. (40.7 x 50.8 cm.)
Mount: 20 x 24 in. (50.8 x 61.0 cm.)
Signed, l.r. overmat recto: "Laura Gilpin/1943 [sic]"
Inscription, mount verso: "#125" and "A B-29 BOMBER
LEAVING THE FACTORY/1943 [sic]" typed on printed
paper label "LG/ A PHOTOGRAPH BY/LAURA GILPIN/
SANTA FE, NEW MEXICO"
overmat recto: printed title and [incorrect] date
Acquired from: gift of the photographer

*2437. **BALCONY HOUSE, MESA VERDE, COLORADO**
(P1979.95.61)
Platinum print. 1924
Image: 9 1/16 x 7 ¼ in. (23.0 x 18.3 cm.)
Signed, l.r. old overmat recto: "Laura Gilpin/1923 [sic]"
Inscription, print recto: "©"
print verso: "Balcony House/Mesa Verde/photograph by/
Laura Gilpin/Colorado Springs/©/1926 [sic]"
old mat backing verso: "#15" and "A PLATINUM
PRINT/BALCONY HOUSE, MESA VERDE,/
COLORADO/1923 [sic]" typed on printed paper label
"LG/ A PHOTOGRAPH BY/LAURA GILPIN/
SANTA FE, NEW MEXICO"
old overmat recto: printed title, [incorrect] date, and
medium
Acquired from: gift of the photographer

2430

2432

2435

2437

2441

2438. **BALUSTRADE, TEMPLE OF KUKULCAN, CHICHÉN ITZÁ, YUCATÁN** [Steps of the Castillo, Chichén Itzá]
(P1979.95.80) duplicate of P1964.130
Gelatin silver print. 1932
Image: 13 7/8 x 10 7/8 in. (35.2 x 27.6 cm.)
Sheet: 14 x 11 in. (35.4 x 28.0 cm.)
Mount: 24 x 20 in. (61.0 x 50.8 cm.)
Signed, l.r. overmat recto: "Laura Gilpin/1932"
Inscription, mount verso: "33"
 overmat recto: printed title and date
Acquired from: gift of the photographer

2439. **BERNIQUE** [Bernique Longley] (P1978.92.46)
Gelatin silver print. 1959
Image: 7 3/16 x 9 1/2 in. (18.3 x 24.1 cm.)
Sheet: 8 x 10 in. (20.3 x 25.4 cm.)
Mount: 14 x 17 in. (35.6 x 43.2 cm.)
Signed, l.r. overmat recto: "Laura Gilpin/1959"
Inscription, mount verso: "14" and "BERNIQUE 1959" typed
 on printed paper label "LG/ A PHOTOGRAPH BY/
 LAURA GILPIN/SANTA FE, NEW MEXICO"
 overmat recto: printed title and date
Acquired from: gift of the photographer

2440. **BIG AND LITTLE SHIPROCK, NEW MEXICO**
(P1979.95.10)
Gelatin silver print. negative 1951, print later
Image: 10 1/2 x 13 1/2 in. (26.7 x 34.3 cm.)
Sheet: 11 x 13 7/8 in. (28.0 x 35.3 cm.)
Mount: 16 x 20 in. (40.7 x 50.8 cm.)
Signed, l.r. old overmat recto: "Laura Gilpin/1951"
Inscription, mount verso: "#76" and "BIG AND LITTLE
 SHIPROCK/NEW MEXICO/1951" typed on printed paper
 label "LG/ A PHOTOGRAPH BY/LAURA GILPIN/
 SANTA FE, NEW MEXICO"
 old overmat recto: printed title and date
Acquired from: gift of the photographer

*2441. **THE BLACK MESA** (P1979.44.4)
Platinum print. 1929
Image: 7 1/2 x 9 1/8 in. (19.1 x 23.2 cm.)
Sheet: 7 7/8 x 9 7/8 in. (20.0 x 25.1 cm.)
Signed, l.r. overmat recto: "Laura Gilpin"
 l.r. print recto: "©/Laura Gilpin"
Inscription, print verso: "The Black Mesa. Platinum."
 mat backing verso: "BLACK MESA/A PLATINUM
 PRINT" typed on printed paper label "LG/ A
 PHOTOGRAPH BY/LAURA GILPIN/SANTA FE,
 NEW MEXICO"
Acquired from: the photographer

2442. **BOYS AT LOS ALAMOS SCHOOL** (P1978.92.17)
Gelatin silver print. 1939
Image: 7 1/8 x 9 1/4 in. (18.1 x 23.5 cm.)
Mount: 11 x 14 in. (28.0 x 35.6 cm.)
Signed, l.r. overmat recto: "Laura Gilpin/ca 1930"
Inscription, mount verso: "LOS ALAMOS RANCH
 SCHOOL" typed on printed paper label "A
 PHOTOGRAPH/LG/By LAURA GILPIN/ COLORADO
 SPRINGS. COLORADO//TITLE:" and two rubber stamps
 "LAURA GILPIN/BOX 1173, SANTA FE, NEW
 MEXICO"
 mat backing verso: "2" and "BOYS AT LOS ALAMOS
 SCHOOL/circa 1930" typed on printed paper label "LG/
 A PHOTOGRAPH BY/LAURA GILPIN/SANTA FE,
 NEW MEXICO"
 overmat recto: printed title and date
Acquired from: gift of the photographer

2443. **[Brancusi's "Birds in Flight." Colorado Springs Fine Arts
Center]** (P1970.5)
Gelatin silver print. c. 1936–38
Image: 9 5/8 x 7 3/4 in. (24.4 x 19.7 cm.)
Sheet: 10 x 8 in. (25.4 x 20.3 cm.)
Acquired from: unknown source

*2444. **BRENDA PUTNAM** (P1979.44.8)
Platinum print. 1921
Image: 8 13/16 x 7 in. (22.4 x 17.7 cm.)
Signed, l.r. old overmat recto: "Laura Gilpin/1918 [sic]"
Inscription, old mat backing verso: "BRENDA PUTNAM"
 typed on printed paper label "LG/ A PHOTOGRAPH BY/
 LAURA GILPIN/SANTA FE, NEW MEXICO"
Acquired from: the photographer

*2445. **BRYCE CANYON #2** (P1976.158.1)
Platinum print. 1930
Image: 9 11/16 x 7 5/8 in. (24.6 x 19.4 cm.)
Sheet: 9 7/8 x 7 13/16 in. (25.1 x 19.8 cm.)
Signed, l.r. old overmat recto: "Laura Gilpin/1930"
Inscription, old mat backing verso: "BRYCE CANYON #2
 1930/A Platinum Print" typed on printed paper label "LG/
 A PHOTOGRAPH BY/LAURA GILPIN/SANTA FE,
 NEW MEXICO"
Acquired from: the photographer

2446. **BRYCE CANYON, UTAH** (P1979.95.82)
Platinum print. 1930
Image: 9 1/2 x 7 1/2 in. (24.1 x 19.0 cm.)
Sheet: 9 3/4 x 7 13/16 in. (24.8 x 19.8 cm.)
Signed, l.r. print recto: "© L. Gilpin"
 l.r. overmat recto: "Laura Gilpin/1930"
Inscription, print verso: "Bryce Canyon/1930"
 mat backing verso: "#24" and "A PLATINUM PRINT/
 BRYCE CANYON, UTAH/1930" typed on printed paper
 label "LG/ A PHOTOGRAPH BY/LAURA GILPIN/
 SANTA FE, NEW MEXICO" and "PROPERTY OF
 AMON CARTER MUSEUM/NOT FOR SALE" typed
 on printed paper label "LG/ A PHOTOGRAPH BY/
 LAURA GILPIN/SANTA FE, NEW MEXICO"
 overmat recto: printed title, date, and medium
Acquired from: gift of the photographer

2447. **[The Business of Getting Well or Girls Out of Doors]**
(P1978.84.14)
Platinum print. 1923
Image: 9 1/2 x 7 5/8 in. (24.1 x 19.4 cm.)
Acquired from: gift of the photographer

2448. **CADY WELLS IN HIS STUDIO** (P1979.48.4)
Gelatin silver print. 1954
Image: 10 7/8 x 13 3/4 in. (27.6 x 34.9 cm.)
Sheet: 11 x 13 7/8 in. (28.0 x 35.3 cm.)
Mount: 16 1/16 x 20 in. (40.8 x 50.8 cm.)
Signed, l.r. overmat recto: "Laura Gilpin/1954"
Inscription, mount recto: "see mark/for mat" and crop marks
 mount verso: "CADY WELLS IN HIS STUDIO/1954"
 typed on printed paper label "LG/ A PHOTOGRAPH BY/
 LAURA GILPIN/SANTA FE, NEW MEXICO"
Acquired from: the photographer

2449. **A CAMPO SANTO** [Camposanto El Valle] (P1979.95.47)
Gelatin silver print. 1961
Image: 9 3/4 x 7 7/8 in. (24.8 x 20.0 cm.)
Sheet: 10 x 8 in. (25.3 x 20.3 cm.)
Mount: 17 x 14 in. (43.2 x 35.6 cm.)
Signed, l.r. old overmat recto: "Laura Gilpin/1961"
Inscription, mount verso: "#87" and "A
 CAMPOSANTO/1961" typed on printed paper label "LG/
 A PHOTOGRAPH BY/LAURA GILPIN/SANTA FE,
 NEW MEXICO"
 old overmat recto: printed title and date
Acquired from: gift of the photographer

2450. **CANYON DE CHELLY** (P1978.92.4)
Gelatin silver print. c. 1951
Image: 13 3/4 x 10 7/8 in. (35.0 x 27.6 cm.)
Sheet: 13 15/16 x 11 in. (35.4 x 28.0 cm.)
Mount: 20 x 16 in. (50.8 x 40.7 cm.)
Signed, bottom mount verso: "L. Gilpin"
Inscription, mount verso: "©//[signature]/Canyon de Chelley
 [sic]"
Acquired from: gift of the photographer

2451. **CANYON DE CHELLY AFTER A RAIN** (P1979.95.68)
Type C color print. 1972
Image: 10 x 8 in. (25.5 x 20.3 cm.)
Signed, l.r. overmat recto: "Laura Gilpin/1972"
Inscription, mat backing verso: "#94" and "CANYON DE
CHELLY AFTER A RAIN/(ARIZONA)/(Courtesy of
School of/American Research)/1972" typed on printed
paper label "LG/ A PHOTOGRAPH BY/LAURA GILPIN/
SANTA FE, NEW MEXICO"
overmat recto: printed title, date, medium, and credit line
Acquired from: gift of the photographer

*2452. **CANYON DE CHELLY, ARIZONA** (P1978.92.48)
Gelatin silver print. 1964
Image: 9¾ x 7¹¹/₁₆ in. (24.8 x 19.5 cm.)
Mount: 17 x 14 in. (43.2 x 35.6 cm.)
Signed, l.r. overmat recto and l.r. mount recto:
"Laura Gilpin/1964"
Inscription, mount verso: "148//1" and "CANYON DE
CHELLY/AFTER A RAIN/1964./from THE ENDURING
NAVAHO/UNIVERSITY OF TEXAS PRESS. 1968" typed
on printed paper label "LG/ A PHOTOGRAPH BY/
LAURA GILPIN/SANTA FE, NEW MEXICO"
overmat recto: printed title and date
Acquired from: gift of the photographer

2453. **[Canyon walls with ruins below]** (P1978.92.5)
Gelatin silver print. c. 1951
Image: 13¹³/₁₆ x 10¹³/₁₆ in. (35.0 x 27.5 cm.)
Sheet: 13⅞ x 11 in. (35.2 x 27.9 cm.)
Mount: 20 x 16 in. (50.8 x 40.6 cm.)
Signed, l.r. mount verso: "L. Gilpin ©"
Inscription, mount verso: "24"
overmat verso: "for print Laura is/making today"
and "Gilpin/view from above"
Acquired from: gift of the photographer

*2454. **CARRINGTON WOOLEY [We]** (P1978.92.14)
Platinum print. c. 1921–22
Image: 9½ x 7½ in. (24.1 x 19.0 cm.)
Signed, l.r. old overmat recto: "Laura Gilpin/1919 [sic]"
Inscription, print verso: "Carrington Wolley [sic]//We/by/
Laura Gilpin/Colo Springs/Colorado/1919 [sic]"
mat backing verso: "1//J" and "A PLATINUM PRINT/
CARRINGTON WOOLEY 1919" typed on printed paper
label "LG/ A PHOTOGRAPH BY/LAURA GILPIN/
SANTA FE, NEW MEXICO"
old overmat recto: printed title and date
Acquired from: gift of the photographer

*2455. **CAVE OF THE WINDS** (P1978.84.21)
Platinum print. 1925
Image: 9⁷/₁₆ x 7½ in. (24.0 x 19.0 cm.)
Inscription, print verso: "Cave of the Winds"
Acquired from: gift of the photographer

2456. **[Central City, Colorado]** (P1970.6)
Gelatin silver print. c. 1932–33
Image: 10 x 7¹/₁₆ in. (25.4 x 18.0 cm.)
Sheet: 10¹/₁₆ x 8 in. (25.6 x 20.3 cm.)
Signed: see inscription
Inscription, print verso, rubber stamp: "PHOTOGRAPH BY/
LAURA GILPIN/COLORADO SPRINGS, COLO."
Acquired from: unknown source

2457. **CENTRAL CITY DRESSING ROOM, RICHARD
BONELLI** (P1978.92.21)
Gelatin silver print. 1933
Image: 8 x 9⅞ in. (20.3 x 25.1 cm.)
Mount: 14 x 17 in. (35.6 x 43.2 cm.)
Signed, l.r. overmat recto: "Laura Gilpin/1933"
Inscription, mount verso: "#109" and "CENTRAL CITY
DRESSING ROOM/RICHARD BONELLI/1933" typed on
printed paper label "LG/ A PHOTOGRAPH BY/LAURA
GILPIN/SANTA FE, NEW MEXICO"
overmat recto: printed title and date
Acquired from: gift of the photographer

2444

2445

2452

*2458. **A CHANCE MEETING IN THE DESERT** (P1968.48.2)
duplicate of P1979.95.81
Gelatin silver print. negative 1950, print 1968
Image: 13 3/16 x 19 1/4 in. (33.4 x 48.9 cm.)
Mount: same as image size
Inscription, mount verso: "A CHANCE MEETING IN THE
DESERT/Negative made in 1950/Print made in 1968/From
The Enduring Navaho/University of Texas Press/1968"
typed on printed paper label "LG/ A PHOTOGRAPH BY/
LAURA GILPIN/SANTA FE, NEW MEXICO"
Acquired from: the photographer

2459. **A CHANCE MEETING IN THE DESERT** (P1979.95.81)
duplicate of P1968.48.2
Gelatin silver print. negative 1950, print later
Image: 13 1/4 x 18 5/8 in. (33.6 x 47.3 cm.)
Sheet: 15 7/8 x 20 in. (40.3 x 50.8 cm.)
Mount: 20 x 24 in. (50.8 x 61.0 cm.)
Signed, l.r. old overmat recto: "Laura Gilpin/1950"
Inscription, mount verso: "A CHANCE MEETING/1950//
from The Enduring Navaho/University of Texas Press.
Publishers" typed on printed paper label "LG/ A
PHOTOGRAPH BY/LAURA GILPIN/SANTA FE,
NEW MEXICO"
old overmat recto: printed title and date
Acquired from: gift of the photographer

2460. **[Chartres Gate]** (P1979.44.2)
Platinum print. 1922
Image: 9 1/4 x 7 1/16 in. (23.4 x 18.0 cm.)
Signed, l.l. print verso: "Laura Gilpin"
Inscription, print recto: "©"
Acquired from: the photographer

2461. **CHILD WITH TISSUE PAPER FLOWERS, YUCATÁN**
(P1979.95.74)
Type C color print. 1960
Image: 9 1/2 x 6 1/2 in. (24.0 x 16.5 cm.)
Mount: 17 x 13 15/16 in. (43.2 x 35.4 cm.)
Signed, l.r. overmat recto and l.r. mount recto:
"Laura Gilpin/1961 [sic]"
Inscription, mount verso: "#88" and "MERIDA,
YUCATAN, MEXICO/CHILD WITH TISSUE PAPER/
FLOWERS/1961 [sic]" typed on printed paper label "LG/
A PHOTOGRAPH BY/LAURA GILPIN/SANTA FE,
NEW MEXICO"
overmat recto: printed title and [incorrect] date
Acquired from: gift of the photographer

*2462. **CHILD'S PORTRAIT** [Louisa Graham] (P1979.95.50)
Platinum print. 1936
Image: 9 5/8 x 7 5/8 in. (24.4 x 19.4 cm.)
Sheet: 9 3/4 x 7 13/16 in. (24.8 x 19.8 cm.)
Signed, l.r. old overmat recto: "Laura Gilpin/1936"
Inscription, old mat backing verso: "#53" and "A
PLATINUM PRINT/CHILD'S PORTRAIT/1936" typed
on printed paper label "LG/ A PHOTOGRAPH BY/
LAURA GILPIN/SANTA FE, NEW MEXICO"
old overmat recto: printed title, date, and medium
Acquired from: gift of the photographer

2463. **CHURCH AT CUNDIYO, NEW MEXICO** (P1979.95.9)
Gelatin silver print. 1945
Image: 10 x 13 1/8 in. (25.4 x 33.3 cm.)
Mount: 15 1/8 x 17 5/8 in. (38.4 x 44.7 cm.)
Signed, l.r. overmat recto and l.r. mount recto:
"Laura Gilpin/1945"
Inscription, mount verso: "#60//1945" and "THE CHURCH
AT CUNDIYO" typed on printed paper label "LG/
PHOTOGRAPHS/BY LAURA GILPIN/BOX 1173,
SANTA FE, NEW MEXICO"
overmat recto: printed title and date
Acquired from: gift of the photographer

2464. **CHURCH AT PICURIS PUEBLO, NEW MEXICO**
(P1979.65) duplicate of P1979.95.93
Gelatin silver print. 1963
Image: 10 11/16 x 13 1/16 in. (27.1 x 33.2 cm.)
Sheet: 11 x 13 7/8 in. (27.9 x 35.3 cm.)
Acquired from: the photographer

2465. **THE CHURCH AT PICURIS PUEBLO, NEW MEXICO**
[Picuris Church, New Mexico] (P1979.95.93) duplicate of
P1979.65
Gelatin silver print. 1963
Image: 7 3/4 x 9 13/16 in. (19.7 x 24.9 cm.)
Sheet: 8 x 10 in. (20.4 x 25.4 cm.)
Mount: 14 x 17 in. (35.6 x 43.2 cm.)
Signed, l.r. old overmat recto: "Laura Gilpin/1962 [sic]"
Inscription, mount verso: "#89" and "THE CHURCH AT
PICURIS PUEBLO/NEW MEXICO/1962 [sic]" typed on
printed paper label "LG/ A PHOTOGRAPH BY/LAURA
GILPIN/SANTA FE, NEW MEXICO"
old overmat recto: printed title and [incorrect] date
Acquired from: gift of the photographer

2466. **CLIFF DWELLING OF BETA-TA-KIN, ARIZONA**
(P1979.95.4)
Gelatin silver print. 1930
Image: 13 1/2 x 10 5/8 in. (34.2 x 27.0 cm.)
Mount: 20 1/16 x 16 in. (51.0 x 40.7 cm.)
Signed, l.r. old overmat recto: "Laura Gilpin/1930"
Inscription, mount verso: "#25" and "CLIFF DWELLING
OF BETA-TA-KIN,/ARIZONA/1930" typed on printed
paper label "LG/ A PHOTOGRAPH BY/LAURA GILPIN/
SANTA FE, NEW MEXICO"
old overmat recto: printed title and date
Acquired from: gift of the photographer

*2467. **COLORADO SAND DUNES** (P1979.44.3)
Platinum print. c. 1946
Image: 7 9/16 x 9 1/2 in. (19.1 x 24.2 cm.)
Sheet: 7 3/4 x 9 13/16 in. (19.7 x 24.8 cm.)
Signed, l.r. overmat recto: "Laura Gilpin"
Inscription, print recto: "©"
mat backing verso: "COLORADO SAND DUNES/A
PLATINUM PRINT" typed on printed paper label "LG/
A PHOTOGRAPH BY/LAURA GILPIN/SANTA FE,
NEW MEXICO"
Acquired from: the photographer

2468. **COLORADO SAND DUNES NO. 2** (P1978.84.22)
Platinum print. c. 1946
Image: 7 1/2 x 9 1/2 in. (19.0 x 24.1 cm.)
Sheet: 8 x 9 7/8 in. (20.3 x 25.1 cm.)
Signed, bottom print verso: "Laura Gilpin"
Inscription, print verso: "Colo Sand dunes No 2/[signature]"
Acquired from: gift of the photographer

*2469. **CORLEY ROAD TUNNEL** (P1978.84.11)
Platinum print. 1925
Image: 9 5/8 x 7 11/16 in. (24.4 x 19.5 cm.)
Acquired from: gift of the photographer

2470. **CORN DANCE, SAN ILDEFONSO PUEBLO** (P1979.95.77)
Gelatin silver print. 1945
Image: 13 1/4 x 19 1/2 in. (33.7 x 49.5 cm.)
Mount: same as image size
Signed, l.r. overmat recto: "Laura Gilpin/1945"
Inscription, mat backing verso: "#59" and "CORN
DANCE,/SAN ILDEFONSO PUEBLO/1945" typed on
printed paper label "LG/ A PHOTOGRAPH BY/LAURA
GILPIN/SANTA FE, NEW MEXICO"
overmat recto: printed title and date
Acquired from: gift of the photographer

2454

2455

2458

2462

2469

2467

2471. **COTTONWOOD IN BLOOM** (P1978.92.44)
Gelatin silver print. 1956
Image: 7½ x 9½ in. (19.1 x 24.1 cm.)
Signed, l.r. overmat recto: "Laura Gilpin/1956"
Inscription, print verso, rubber stamp: "LAURA GILPIN/
BOX 1173, SANTA FE, NEW MEXICO"
mat backing verso: "142" and "COTTONWOOD IN
BLOOM/1956" typed on printed paper label "LG/ A
PHOTOGRAPH BY/LAURA GILPIN/SANTA FE,
NEW MEXICO"
overmat recto: printed title and date
Acquired from: gift of the photographer

2472. **[Cottonwood trees in winter]** (P1978.84.24)
Platinum print. 1928
Image: 9⅜ x 7½ in. (23.8 x 19.0 cm.)
Sheet: 9¾ x 7⅞ in. (24.8 x 20.0 cm.)
Acquired from: gift of the photographer

2473. **COTTONWOODS [Glen Eyrie]** (P1978.84.15)
Platinum print. 1928
Image: 9½ x 7½ in. (24.1 x 19.0 cm.)
Sheet: 9⅞ x 7⅞ in. (25.1 x 20.0 cm.)
Inscription, print verso: "Cottonwoods/1928/(I believe this
was done in Glen Eyre [sic])"
Acquired from: gift of the photographer

*2474. **THE COVE, ARIZONA [The Summer Hogan]** (P1979.95.78)
duplicate of P1968.48.6
Gelatin silver print. 1934
Image: 14¾ x 18¾ in. (37.4 x 47.6 cm.)
Sheet: 15¹¹⁄₁₆ x 19³⁄₁₆ in. (39.8 x 48.8 cm.)
Mount: 20 x 24 in. (50.8 x 61.0 cm.)
Signed, l.r. overmat recto: "Laura Gilpin/1934"
Inscription, mount verso: "#51" and "A NAVAHO
SUMMER HOGAN/THE COVE, ARIZONA/1934" typed
on printed paper label "LG/ A PHOTOGRAPH BY/
LAURA GILPIN/SANTA FE, NEW MEXICO"
overmat recto: printed title and date
Acquired from: gift of the photographer

*2475. **THE COVERED WAGON [Navaho Covered Wagon]**
(P1968.48.7) duplicate of P1978.85.3 and P1979.95.98
Gelatin silver print. negative 1934, print 1968
Image: 19⁷⁄₁₆ x 15½ in. (49.4 x 39.3 cm.)
Mount: same as image size
Inscription, mount verso: ".10 1.90 1.80/CS-128" and "THE
COVERED WAGON./Negative made in 1934./Print made
in 1968/Fron [sic] The Enduring Navaho/University of
Texas Press/1968" typed on printed paper label "LG/
A PHOTOGRAPH BY/LAURA GILPIN/SANTA FE,
NEW MEXICO"
Acquired from: the photographer

2476. **THE COVERED WAGON [Navaho Covered Wagon]**
(P1978.85.3) duplicate of P1968.48.7 and P1979.95.98
Gelatin silver print, mounted on Masonite.
negative 1934, print later
Image: 51½ x 40 in. (130.8 x 101.6 cm.)
Mount: same as image size
Acquired from: gift of the photographer

2477. **CROSS AND CANDLES** (P1979.95.23)
Gelatin silver print. 1959
Image: 4¾ x 3⅞ in. (12.0 x 9.9 cm.)
Sheet: 4¹⁵⁄₁₆ x 4 in. (12.6 x 10.1 cm.)
Mount: 9¹⁵⁄₁₆ x 8 in. (25.3 x 20.3 cm.)
Signed, l.r. overmat recto: "Laura Gilpin/1959"
Inscription, mount verso: "#86" and "CROSS AND
CANDLES/1959" typed on printed paper label "LG/
A PHOTOGRAPH BY/LAURA GILPIN/SANTA FE,
NEW MEXICO"
overmat recto: printed title and date
Acquired from: gift of the photographer

2478. **THE DENTIST [The Clinic]** (P1978.92.15)
Platinum print. 1924
Image: 9¹¹⁄₁₆ x 7¹¹⁄₁₆ in. (24.5 x 19.5 cm.)
Signed, l.r. overmat recto: "Laura Gilpin/1924"
l.r. print recto: "Laura Gilpin"
Inscription, mat backing verso: "#103" and "A PLATINUM
PRINT/THE DENTIST Clinic/1924" typed on printed
paper label "LG/ A PHOTOGRAPH BY/LAURA GILPIN/
SANTA FE, NEW MEXICO"
overmat recto: printed title, date, and medium
Acquired from: gift of the photographer

2479. **DOOR AT RANCHOS DE TAOS CHURCH,
NEW MEXICO** (P1979.95.73)
Gelatin silver print. 1947
Image: 9½ x 7⅝ in. (24.1 x 19.3 cm.)
Sheet: 9¹¹⁄₁₆ x 7⅞ in. (24.9 x 19.9 cm.)
Mount: 17 x 14 in. (43.1 x 35.6 cm.)
Signed, l.r. old overmat recto: "Laura Gilpin/1947"
Inscription, mount verso: "#68" and "DOOR AT
RANCHOS DE TAOS CHURCH/TAOS, NEW
MEXICO/1947" typed on printed paper label "LG/ A
PHOTOGRAPH BY/LAURA GILPIN/SANTA FE,
NEW MEXICO"
old overmat recto: printed title and date
Acquired from: gift of the photographer

2480. **DOROTHY STEWART** (P1978.92.33)
Gelatin silver print. 1946
Image: 8⅞ x 7 in. (22.6 x 17.8 cm.)
Mount: 17 x 14 in. (43.2 x 35.6 cm.)
Signed, l.r. overmat recto: "Laura Gilpin/1946"
Inscription, mount verso: "7" and "DOROTHY STEWART
1946" typed on printed paper label "LG/ A
PHOTOGRAPH BY/LAURA GILPIN/SANTA FE,
NEW MEXICO"
overmat recto: printed title and date
Acquired from: gift of the photographer

2481. **DOROTHY STEWART'S DOORWAY, SANTA FE,
NEW MEXICO** (P1978.92.36)
Gelatin silver print. 1947
Image: 9½ x 7⁹⁄₁₆ in. (24.1 x 19.2 cm.)
Sheet: 9⅞ x 8 in. (25.1 x 20.3 cm.)
Mount: 17 x 14 in. (43.2 x 35.6 cm.)
Signed, l.r. overmat recto: "Laura Gilpin/1947"
Inscription, mount verso: "#134" and "DOROTHY
STEWART'S DOORWAY,/SANTA FE/1947" typed on
printed paper label "LG/ A PHOTOGRAPH BY/LAURA
GILPIN/SANTA FE, NEW MEXICO"
overmat recto: printed title and date
Acquired from: gift of the photographer

2482. **DRUMMER, TAOS PUEBLO** (P1979.95.22)
Gelatin silver print. 1947
Image: 4⅝ x 5⁷⁄₁₆ in. (11.8 x 13.8 cm.)
Sheet: 5 x 5¾ in. (12.7 x 14.6 cm.)
Mount: 14 x 11 in. (35.6 x 28.0 cm.)
Signed, l.r. overmat recto: "Laura Gilpin/1948 [sic]"
Inscription, mount verso: "#70" and "DRUMMER, TAOS,
PUEBLO/1948 [sic]" typed on printed paper label "LG/
A PHOTOGRAPH BY/LAURA GILPIN/SANTA FE,
NEW MEXICO"
overmat recto: printed title and [incorrect] date
Acquired from: gift of the photographer

2483. **DRUMMERS, TESUQUE PUEBLO, NEW MEXICO**
(P1979.95.6)
Type C color print. c. 1950
Image: 10¹⁵⁄₁₆ x 13¾ in. (27.8 x 34.9 cm.)
Mount: 15⅛ x 20¹⁄₁₆ in. (38.4 x 51.0 cm.)
Signed, l.r. overmat recto: "Laura Gilpin/ca 1950"
l.r. mount recto: "Laura Gilpin"
Inscription, mount verso: "#72" and "DRUMMERS,
TESUQUE PUEBLO,/NEW MEXICO/ca. 1950" typed on
printed paper label "LG/ A PHOTOGRAPH BY/LAURA

GILPIN/SANTA FE, NEW MEXICO"
overmat recto: printed title and date
Acquired from: gift of the photographer

2484. **EL SANTUARIO DE CHIMAYO** (P1979.95.11)
Gelatin silver print. 1945
Image: 10 ⁷/₈ x 13 ⁷/₈ in. (27.6 x 35.0 cm.)
Sheet: 11 x 14 in. (28.0 x 35.4 cm.)
Mount: 16 ¹/₁₆ x 20 in. (40.7 x 50.8 cm.)
Signed, l.r. overmat recto: "Laura Gilpin/1946 [sic]"
Inscription, mount recto: "CHIMIYO [sic]"
mount verso: "#62" and "EL SANTUARIO DE
CHIMAYO/1946 [sic]" typed on printed paper label "LG/
A PHOTOGRAPH BY/LAURA GILPIN/SANTA FE,
NEW MEXICO"
overmat recto: printed title and [incorrect] date
Acquired from: gift of the photographer

2474

*2485. **ELIOT PORTER** (P1978.92.39)
Gelatin silver print. 1952
Image: 9 ½ x 7 ½ in. (24.1 x 19.1 cm.)
Sheet: 10 x 8 in. (25.4 x 20.3 cm.)
Mount: 17 x 14 in. (43.2 x 35.6 cm.)
Signed, l.r. overmat recto: "Laura Gilpin/1952"
Inscription, mount verso: "#10" and "ELIOT PORTER 1952"
typed on printed paper label "LG/ A PHOTOGRAPH BY/
LAURA GILPIN/SANTA FE, NEW MEXICO"
overmat recto: printed title and date
Acquired from: gift of the photographer

2486. **ESTES PARK LANDSCAPE** (P1978.84.9)
Platinum print. 1920
Image: 9 ⁵/₈ x 7 ⁵/₈ in. (24.4 x 19.3 cm.)
Acquired from: gift of the photographer

2487. **EUGENIE SHONNARD [Eugenie Ludlam Shonnard]**
(P1978.92.28)
Gelatin silver print. 1940
Image: 9 ⁵/₈ x 7 ½ in. (24.4 x 19.1 cm.)
Sheet: 10 x 8 in. (25.4 x 20.3 cm.)
Mount: 17 x 14 in. (43.2 x 35.6 cm.)
Signed, l.r. overmat recto: "Laura Gilpin/1940"
Inscription, mount verso: "3" and "EUGENIE
SHONNARD/1940" typed on printed paper label "LG/
A PHOTOGRAPH BY/LAURA GILPIN/SANTA FE,
NEW MEXICO"
overmat recto: printed title and date
Acquired from: gift of the photographer

2475

2488. **EVENING IN NAVAHO LAND** (P1979.95.46)
Gelatin silver print. 1932
Image: 7 ½ x 9 ⁵/₈ in. (19.0 x 24.5 cm.)
Sheet: 8 x 9 ¹⁵/₁₆ in. (20.4 x 25.2 cm.)
Mount: 14 x 16 ¹⁵/₁₆ in. (35.6 x 43.0 cm.)
Signed, l.r. overmat recto: "Laura Gilpin/1932"
Inscription, mount verso: "#43" and "EVENING IN
NAVAHO LAND/1932" typed on printed paper label "LG/
A PHOTOGRAPH BY/LAURA GILPIN/SANTA FE,
NEW MEXICO"
overmat recto: printed title and date
Acquired from: gift of the photographer

2489. **FAITH BEMIS MEEM** (P1978.92.43)
Gelatin silver print. 1955
Image: 9 ½ x 7 ½ in. (24.1 x 19.1 cm.)
Sheet: 10 x 8 in. (25.4 x 20.3 cm.)
Mount: 17 x 14 in. (43.2 x 35.6 cm.)
Signed, l.r. overmat recto: "Laura Gilpin/1955"
Inscription, mount verso: "#21" and "FAITH MEEM/1955"
typed on printed paper label "LG/ A PHOTOGRAPH BY/
LAURA GILPIN/SANTA FE, NEW MEXICO"
overmat recto: printed title and date
Acquired from: gift of the photographer

2485

*2490. **FEEDING TIME** (P1978.84.20)
Platinum print. 1923
Image: 9 ½ x 7 ⅝ in. (24.1 x 19.4 cm.)
Signed, center print verso: "Laura Gilpin"
Inscription, print verso: "Feeding Time/by/[signature]/Colo.
 Springs Colo/© 1923"
Acquired from: gift of the photographer

*2491. **FISHERMEN AT CONCARNEAU, FRANCE** (P1978.92.11)
Platinum print. 1922
Image: 12 ¼ x 9 ¾ in. (31.1 x 24.8 cm.)
Signed, l.r. old overmat recto: "Laura Gilpin/1922"
Inscription, old mat backing verso: "#102" and "A
 PLATINUM PRINT/FISHERMEN AT CONCARNEAU,
 FRANCE/1922" typed on printed paper label "LG/ A
 PHOTOGRAPH BY/LAURA GILPIN/SANTA FE,
 NEW MEXICO"
 old overmat recto: printed title, date, and medium
Acquired from: gift of the photographer

*2492. **THE FLOWER GARDEN** [Waring Children, Iris]
 (P1979.95.76)
Platinum print. 1927
Image: 9 9/16 x 7 11/16 in. (24.3 x 19.5 cm.)
Sheet: 10 ¾ x 9 in. (27.3 x 22.8 cm.)
Signed, l.r. print recto: "Laura Gilpin"
 l.r. old overmat recto: "Laura Gilpin/1927"
Inscription, old mat backing verso: "#20" and "A
 PLATINUM PRINT/THE FLOWER GARDEN/1927"
 typed on printed paper label "LG/ A PHOTOGRAPH BY/
 LAURA GILPIN/SANTA FE, NEW MEXICO"
 old overmat recto: printed title, date, and medium
Acquired from: gift of the photographer

2493. **[Fountain Valley School]** (P1978.84.18)
Platinum print. n.d.
Image: 7 ½ x 9 ⅜ in. (19.0 x 23.8 cm.)
Acquired from: gift of the photographer

2494. **FRANK WATERS** (P1978.92.51)
Gelatin silver print. 1971
Image: 8 ⅞ x 6 ½ in. (22.6 x 16.5 cm.)
Sheet: 10 x 8 in. (25.4 x 20.3 cm.)
Mount: 17 x 14 in. (43.2 x 35.6 cm.)
Signed, l.r. overmat recto: "Laura Gilpin/1971"
Inscription, mount verso: "20" and "FRANK WATERS 1971"
 typed on printed paper label "LG/ A PHOTOGRAPH BY/
 LAURA GILPIN/SANTA FE, NEW MEXICO"
 overmat recto: printed title and date
Acquired from: gift of the photographer

2495. **FROSTED PINON TREE, CANYON DE CHELLY**
 (P1979.95.53)
Type C color print. 1974
Image: 8 x 10 in. (20.3 x 25.4 cm.)
Signed, l.r. overmat recto: "Laura Gilpin/1974"
Inscription, mat backing verso: "#99" and "FROSTED
 PINON TREE/CANYON DE CHELLY,
 ARIZONA/(Courtesy of School of/American
 Research)/1974" typed on printed paper label "LG/ A
 PHOTOGRAPH BY/LAURA GILPIN/SANTA FE,
 NEW MEXICO"
 overmat recto: printed title, date, medium, and credit line
Acquired from: gift of the photographer

2496. **FUN AT THE FAIR, GALLUP, NEW MEXICO**
 (P1979.95.41)
Type C color print. 1952
Image: 5 ¼ x 7 ⅝ in. (13.2 x 19.3 cm.)
Sheet: 8 ⅛ x 10 in. (20.6 x 25.4 cm.)
Signed, l.r. overmat recto: "Laura Gilpin/1952"
Inscription, mat backing verso: "#81" and "FUN AT THE
 FAIR,/GALLUP, NEW MEXICO/1952" typed on printed
 paper label "LG/A PHOTOGRAPH BY/LAURA GILPIN/
 SANTA FE, NEW MEXICO"
 overmat recto: printed title and date
Acquired from: gift of the photographer

*2497. **GARDEN OF THE GODS. MOONLIGHT** [Moonlight,
 Garden of the Gods, Colorado; The Moonlit Temple,
 Garden of the Gods] (P1979.44.7) duplicate of P1979.95.85
Platinum print. 1922
Image: 9 ½ x 7 ⅛ in. (24.1 x 18.8 cm.)
Signed, l.r. overmat recto: "Laura Gilpin"
Inscription, print verso: "Garden of the Gods. Moonlight/
 photograph by/Laura Gilpin"
 mat backing verso: "GARDEN OF THE GODS,
 MOONLIGHT/A PLATINUM PRINT" typed on printed
 paper label "LG/ A PHOTOGRAPH BY/LAURA GILPIN/
 SANTA FE, NEW MEXICO"
Acquired from: the photographer

*2498. **THE GATE, LAGUNA, N. M.** (P1979.95.28)
Platinum print. 1924
Image: 9 ¼ x 7 ⅛ in. (23.5 x 18.8 cm.)
Signed, l.r. old overmat recto: "Laura Gilpin/1923 [sic]"
Inscription, print verso: "The Gate, Laguna. N. M./
 1923 [sic]"
 old mat backing verso: "#14" and "A PLATINUM
 PRINT/THE GATE, LAGUNA, NEW MEXICO/1923
 [sic]" typed on printed paper label "LG/ A
 PHOTOGRAPH BY/LAURA GILPIN/SANTA FE,
 NEW MEXICO"
 old overmat recto: printed title, [incorrect] date, and
 medium
Acquired from: gift of the photographer

2499. **GATEWAY, BROADMOOR ART ACADEMY** (P1978.84.2)
Platinum print. 1920
Image: 9 ½ x 6 15/16 in. (24.1 x 17.6 cm.)
Mount: 9 ⅞ x 7 ¼ in. (25.1 x 18.3 cm.)
Signed, l.r. print recto: "© LG"
 l.r. mount recto: "Photograph by Laura Gilpin"
Inscription, mount verso: "Laura Gilpin—/Broadmoor Art
 Academy/Colo Sps—//Gateway/Broadmoor Art Academy/
 Colo. Springs Colo/Photograph by/Laura Gilpin—©1920//
 To be returned to sender" and rubber stamp "Credit Line/
 Photograph by/Laura Gilpin"
Acquired from: gift of the photographer

*2500. **GEORGIA O'KEEFFE** (P1978.92.40)
Gelatin silver print. 1953
Image: 9 ½ x 7 7/16 in. (24.2 x 18.9 cm.)
Sheet: 9 15/16 x 7 15/16 in. (25.3 x 20.2 cm.)
Mount: 17 x 14 in. (43.2 x 35.6 cm.)
Signed, l.r. old overmat recto: "Laura Gilpin/1953"
Inscription, mount verso: "GEORGIA O'KEEFFE 1953"
 typed on printed paper label "LG/ A PHOTOGRAPH BY/
 LAURA GILPIN/SANTA FE, NEW MEXICO"
 old overmat recto: printed title and date
Acquired from: gift of the photographer

2501. **GEORGIE GARCIA** (P1968.48.13)
Gelatin silver print. negative 1953, print c. 1967–68
Image: 13 ¾ x 10 13/16 in. (34.8 x 27.5 cm.)
Mount: 20 1/16 x 15 ⅛ in. (51.0 x 38.3 cm.)
Signed, l.r. mount recto: "Laura Gilpin/1953"
Acquired from: the photographer

*2502. **THE GHOST ROCK** [Ghost Rock, Garden of the Gods,
 Colorado] (P1979.95.66)
Platinum print. 1919
Image: 9 ½ x 7 ½ in. (24.1 x 19.1 cm.)
Signed, l.r. print recto: "LG"
 l.r. old overmat recto: "Laura Gilpin/1919"
Inscription, print verso: "The Ghost Rock/by/Laura Gilpin/
 Colo. Springs. Colo/1919"
 old mat backing verso: "#8" and "A PLATINUM PRINT/
 GHOST ROCK, GARDEN OF THE GODS/
 COLORADO/1919" typed on printed paper label "LG/
 A PHOTOGRAPH BY/LAURA GILPIN/SANTA FE,
 NEW MEXICO"
 old overmat recto: printed title, date, and medium
Acquired from: gift of the photographer

2490

2491

2492

2497

2498

2500

2503. **GIRLS OUT OF DOORS** (P1978.84.7)
Platinum print. 1923
Image: 9 ½ x 7 9/16 in. (24.1 x 19.2 cm.)
Acquired from: gift of the photographer

2504. **GLEN EYRIE** (P1978.84.19)
Platinum print. 1928
Image: 7 ½ x 9 5/16 in. (19.0 x 23.6 cm.)
Acquired from: gift of the photographer

*2505. **GOING HOME FROM A NAVAHO TRADING POST,
NEW MEXICO** (P1978.92.38)
Gelatin silver print. 1950
Image: 10 x 8 in. (25.4 x 20.3 cm.)
Mount: 17 x 14 in. (43.2 x 35.6 cm.)
Signed, l.r. overmat recto: "Laura Gilpin/1950"
Inscription, mount verso: "#135" and "GOING HOME
FROM A NAVAHO/TRADING POST, NEW
MEXICO/1950" typed on printed paper label "LG/ A
PHOTOGRAPH BY/LAURA GILPIN/SANTA FE,
NEW MEXICO"
overmat recto: printed title and date
Acquired from: gift of the photographer

*2506. **GOTHIC, COLORADO** (P1978.92.29)
Gelatin silver print. 1941
Image: 9 5/8 x 7 9/16 in. (24.4 x 19.2 cm.)
Sheet: 9 15/16 x 8 in. (25.2 x 20.3 cm.)
Mount: 17 x 14 in. (43.2 x 35.6 cm.)
Signed, l.r. overmat recto: "Laura Gilpin/1941"
Inscription, print recto: "A"
mount recto: "A"
mount verso: "#122" and "GOTHIC, COLORADO/1941"
typed on printed paper label "LG/ A PHOTOGRAPH BY/
LAURA GILPIN/SANTA FE, NEW MEXICO"
overmat verso: "A"
overmat recto: printed title and date
Acquired from: gift of the photographer

2507. **GOTHIC, COLORADO** (P1979.48.2)
Gelatin silver print. 1941
Image: 9 11/16 x 7 5/8 in. (24.6 x 19.3 cm.)
Sheet: 10 x 7 15/16 in. (25.4 x 20.1 cm.)
Mount: 17 x 14 in. (43.2 x 35.6 cm.)
Signed, l.r. overmat recto: "Laura Gilpin/1941"
Inscription, mount verso: "Amon Carter" and "GOTHIC,
COLORADO/1941" typed on printed paper label "LG/ A
PHOTOGRAPH BY/LAURA GILPIN/SANTA FE,
NEW MEXICO"
Acquired from: the photographer

2508. **GOVERNOR, TAOS PUEBLO, NEW MEXICO** [Governor
Juan Reyna, Taos] (P1979.95.38)
Gelatin silver print. 1971
Image: 9 5/8 x 7 ½ in. (24.4 x 19.1 cm.)
Sheet: 9 15/16 x 8 in. (25.2 x 20.3 cm.)
Mount: 17 x 14 in. (43.2 x 35.6 cm.)
Signed, l.r. old overmat recto: "Laura Gilpin/1971"
Inscription, mount verso: "#90" and "GOVERNOR, TAOS
PUEBLO,/NEW MEXICO/1971" typed on printed paper
label "LG/ A PHOTOGRAPH BY/LAURA GILPIN/
SANTA FE, NEW MEXICO"
old overmat recto: printed title and date
Acquired from: gift of the photographer

2509. **GRACE CHURCH, COLORADO SPRINGS** (P1978.84.27)
Platinum print. 1928
Image: 9 9/16 x 7 ½ in. (24.3 x 19.1 cm.)
Inscription, print verso: "Grace Church/Colorado Springs.//
PHOTOGRAPH BY LAURA GILPIN/COLORADO
SPRINGS, COLO"
Acquired from: gift of the photographer

2510. **GRACE CHURCH NAVE—WINDOW** (P1978.84.28)
Platinum print. 1928
Image: 9 3/8 x 7 1/8 in. (23.8 x 18.1 cm.)
Acquired from: gift of the photographer

*2511. **GRAND CANYON. SUNRISE** [Sunrise, Grand Canyon]
(P1976.158.2)
Platinum print. 1930
Image: 7 3/4 x 9 5/8 in. (19.7 x 24.4 cm.)
Sheet: 8 x 9 7/8 in. (20.3 x 25.1 cm.)
Signed, l.r. old overmat recto: "Laura Gilpin/1930"
Inscription, print verso: "Grand Canyon. Sunrise/
Sept. 1935 [sic]"
old mat backing verso: "41" and "GRAND CANYON
1930/A PLATINUM PRINT" typed on printed paper
label "LG/ A PHOTOGRAPH BY/LAURA GILPIN/
SANTA FE, NEW MEXICO"
Acquired from: the photographer

*2512. **GRANDMOTHER AND CHILD, SAN ILDEFONSO
PUEBLO, NEW MEXICO** [Susanna & Baby]
(P1979.95.89)
Platinum print. 1925
Image: 8 5/8 x 6 5/8 in. (21.9 x 16.8 cm.)
Sheet: 9 1/16 x 7 in. (23.0 x 17.8 cm.)
Signed, l.r. old overmat recto: "Laura Gilpin/1931 [sic]"
Inscription, print recto: "©"
print verso: "Susanna/San Ildefonso/1931 [sic]"
old mat backing verso: "#26" and "A PLATINUM
PRINT/GRANDMOTHER AND CHILD,/SAN
ILDEFONSO PUEBLO, NEW MEXICO/1931 [sic]" typed
on printed paper label "LG/ A PHOTOGRAPH BY/
LAURA GILPIN/SANTA FE, NEW MEXICO"
old overmat recto: printed title, [incorrect] date, and
medium
Acquired from: gift of the photographer

2513. **HARDBELLY'S GRANDDAUGHTER, ARIZONA**
(P1978.92.22)
Gelatin silver print. 1933
Image: 9 ½ x 7 ½ in. (24.1 x 19.1 cm.)
Mount: 17 x 13 7/8 in. (43.2 x 35.2 cm.)
Signed, l.r. old overmat recto: "Laura Gilpin/1933"
Inscription, old overmat recto: printed title and date
Acquired from: gift of the photographer

*2514. **HARDBELLY'S HOGAN, ARIZONA** (P1979.95.100)
Gelatin silver print. negative 1932, print later
Image: 10 11/16 x 13 ½ in. (27.1 x 34.2 cm.)
Mount: 10 13/16 x 14 ½ in. (27.5 x 36.7 cm.)
Signed, l.r. print recto and l.r. old overmat recto:
"Laura Gilpin/1932"
Inscription, mount verso: "#45" and "HARDBELLY'S
HOGAN, ARIZONA/1932//Nurse administering medicine
to sick old man." typed on printed paper label "LG/ A
PHOTOGRAPH BY/LAURA GILPIN/SANTA FE,
NEW MEXICO"
old overmat recto: printed title and date
Acquired from: gift of the photographer

2515. **HAT MAKERS, YUCATÁN** (P1978.92.8)
Gelatin silver print. 1960
Image: 9 3/4 x 13 7/16 in. (24.8 x 34.1 cm.)
Mount: 16 x 19 7/8 in. (40.7 x 50.5 cm.)
Signed, l.r. overmat recto and l.r. mount recto:
"Laura Gilpin/1960"
Inscription, mount verso: "#144//1960" and "HAT MAKERS
IN YUCATAN" typed on printed paper label "LG/ A
PHOTOGRAPH BY/LAURA GILPIN/SANTA FE,
NEW MEXICO"
overmat recto: printed title and date
Acquired from: gift of the photographer

2516. **HEADWATERS OF THE RIO GRANDE BEFORE A
STORM** [Rio Grande Before a Storm, Colorado]
(P1978.85.2) duplicate of P1979.95.101
Gelatin silver print mounted on Masonite. negative 1945,
print later
Image: 40 x 30 in. (101.6 x 76.2 cm.)
Mount: same as image size
Acquired from: gift of the photographer

2502

2505

2506

2511

2514

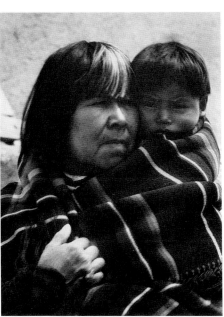

2512

2517. **HELEN FREEMAN IN THE ROBERT EDMONDS JONES PRODUCTION OF *CAMILLE* IN CENTRAL CITY, COLORADO** (P1979.95.27)
Platinum print. 1932
Image: 7 ½ x 9 ½ in. (19.0 x 24.1 cm.)
Sheet: 7 ⅞ x 9 ¾ in. (20.0 x 24.8 cm.)
Signed, l.r. overmat recto: "Laura Gilpin/1932"
Inscription, mat backing verso: "#30" and "A PLATINUM PRINT/HELEN FREEMAN AS OLYMPE, IN/CAMILLE, IN CENTRAL CITY, COLORADO/1932" typed on printed paper label "LG/ A PHOTOGRAPH BY/LAURA GILPIN/SANTA FE, NEW MEXICO"
overmat recto: printed title and date
Acquired from: gift of the photographer

2518. **HERITAGE FROM SPAIN** [Fray Angélico Chávez] (P1979.95.1)
Gelatin silver print. 1948
Image: 13 ¼ x 10 ⅜ in. (33.7 x 26.3 cm.)
Mount: 17 ⅝ x 15 ⅛ in. (44.8 x 38.4 cm.)
Signed, l.r. overmat recto and l.r. mount recto: "Laura Gilpin/1947 [sic]"
Inscription, mount verso: "#67" and "HERITAGE FROM SPAIN/from/THE RIO GRANDE, by Laura Gilpin/1947 [sic]/$ [illegible]" on printed paper label "LG/ PHOTOGRAPHS/BY LAURA GILPIN/BOX 1173, SANTA FE, NEW MEXICO"
overmat recto: printed title and [incorrect] date
Acquired from: gift of the photographer

2519. **ILLUSTRATION FOR THE NAVAHO CREATION MYTH** (P1978.92.2) duplicate of P1979.45
Gelatin silver print. negative 1956, print 1963
Image: 6 ⅞ x 4 ¹¹⁄₁₆ in. (17.5 x 12.3 cm.)
Sheet: 7 x 4 ⅞ in. (17.8 x 12.5 cm.)
Mount: 14 x 11 in. (35.6 x 28.0 cm.)
Signed, l.r. overmat recto: "Laura Gilpin/1963"
Inscription, mount verso: "#147" and "ILLUSTRATION FOR THE NAVAHO/CREATION MYTH/1963" typed on printed paper label "LG/ A PHOTOGRAPH BY/LAURA GILPIN/SANTA FE, NEW MEXICO"
overmat recto: printed title and print date
Acquired from: gift of the photographer

2520. **ILLUSTRATION FOR THE NAVAHO CREATION MYTH** (P1979.45) duplicate of P1978.92.2
Gelatin silver print. 1956
Image: 5 ⅜ x 4 ⁷⁄₁₆ in. (13.7 x 11.3 cm.)
Mount: 7 ⅞ x 5 ¹¹⁄₁₆ in. (20.0 x 14.4 cm.)
Inscription, mount recto: "GK"
mount verso, rubber stamp: "LAURA GILPIN/ 409 CAMINO DEL MONTE SOL/SANTA FE, NEW MEXICO 87501"
Acquired from: gift of the photographer

2521. **IN A NAVAHO SHELTER** [Shelter. Timothy Kellywood's Mother and Child] (P1979.95.40)
Gelatin silver print. 1951
Image: 9 ⁹⁄₁₆ x 7 ⅝ in. (24.3 x 19.4 cm.)
1st mount: same as image size
2nd mount: 17 x 14 in. (43.2 x 35.5 cm.)
Signed, l.r. overmat recto: "Laura Gilpin/1951"
Inscription, 2nd mount verso: "#78" and "IN A NAVAHO SHELTER/1951" typed on printed paper label "LG/ A PHOTOGRAPH BY/LAURA GILPIN/SANTA FE, NEW MEXICO"
overmat recto: printed title and date
Acquired from: gift of the photographer

*2522. **INTERIOR AT CHARTRES CATHEDRAL** (P1979.44.1)
Platinum print. 1922
Image: 9 ½ x 7 ³⁄₁₆ in. (24.1 x 18.2 cm.)
Sheet: 9 ¹¹⁄₁₆ x 7 ³⁄₁₆ in. (24.6 x 18.2 cm.)
Signed, l.r. old overmat recto: "Laura Gilpin/1922"
Inscription, old mat backing verso: "INTERIOR AT CHARTRES CATHEDRAL/A PLATINUM PRINT"

typed on printed paper label "LG/ A PHOTOGRAPH BY/ LAURA GILPIN/SANTA FE, NEW MEXICO"
Acquired from: the photographer

2523. **THE JOHN GAW MEEM FAMILY** (P1978.92.34)
Gelatin silver print. 1946
Image: 9 ½ x 7 ½ in. (24.1 x 19.0 cm.)
Sheet: 13 ½ x 10 ⅜ in. (34.3 x 26.3 cm.)
Signed, l.r. print recto and l.r. overmat recto: "Laura Gilpin/1946"
Inscription, mat backing verso: "5" and "THE JOHN GAW MEEM FAMILY/1946" typed on printed paper label "LG/ A PHOTOGRAPH BY/LAURA GILPIN/SANTA FE, NEW MEXICO"
overmat recto: printed title and date
Acquired from: gift of the photographer

2524. **JUNCTION OVERLOOK, CANYON DEL MUERTO (FAR), CANYON DE CHELLY (NEAR)** (P1968.48.9)
Gelatin silver print. negative 1953, print 1968
Image: 19 ¹¹⁄₁₆ x 15 ³⁄₁₆ in. (50.0 x 38.6 cm.)
Mount: same as image size
Inscription, mount verso: "JUNCTION OVERLOOK/ CANYON DEL MUERTO (far)/CANYON DE CHELLY (near)/Negative made in 1953/Print made in 1968/From The Enduring Navaho/University of Texas Press/1968" typed on printed paper label "LG/ A PHOTOGRAPH BY/ LAURA GILPIN/SANTA FE, NEW MEXICO"
Acquired from: the photographer

*2525. **JUSTICE McREYNOLDS** [U. S. Supreme Court Justice McReynolds] (P1979.95.48)
Platinum print. 1934
Image: 9 ½ x 7 ⅝ in. (24.2 x 19.3 cm.)
Sheet: 9 ¼ x 7 ¹³⁄₁₆ in. (24.8 x 19.8 cm.)
Signed, l.r. old overmat recto: "Laura Gilpin/1940 [sic]"
Inscription, print verso: "Justice McReynolds."
old mat backing verso: "#54" and "A PLATINUM PRINT/U.S. SUPREME COURT/JUSTICE McREYNOLDS/1940 [sic]" typed on printed paper label "LG/ A PHOTOGRAPH BY/ LAURA GILPIN/ SANTA FE, NEW MEXICO"
old overmat recto: printed title, [incorrect] date, and medium
Acquired from: gift of the photographer

2526. **LAGUNA PUEBLO** (P1979.44.9)
Platinum print. 1924
Image: 7 ⅞ x 9 ³⁄₁₆ in. (18.6 x 23.3 cm.)
Sheet: 7 ⅞ x 9 ¾ in. (20.0 x 24.7 cm.)
Signed, l.r. overmat recto: "Laura Gilpin/1923 [sic]"
Inscription, print verso: "Fiesta/Laguna Pueblo/1923 [sic]"
mat backing verso: "LAGUNA PUEBLO/A PLATINUM PRINT" typed on printed paper label "LG/ A PHOTOGRAPH BY/LAURA GILPIN/SANTA FE, NEW MEXICO"
Acquired from: the photographer

2527. **LAGUNA PUEBLO MISSION, NEW MEXICO** (P1979.95.51)
Platinum print. 1924
Image: 9 ¼ x 7 ⅜ in. (23.5 x 18.7 cm.)
Signed, l.r. old overmat recto: "Laura Gilpin/1924"
Inscription, print recto: "©"
old mat backing verso: "#17" and "A PLATINUM PRINT/LAGUNA PUEBLO MISSION, NEW MEXICO/1924" typed on printed paper label "LG/ A PHOTOGRAPH BY/LAURA GILPIN/SANTA FE, NEW MEXICO"
old overmat recto: printed title, date, and medium
Acquired from: gift of the photographer

2528. **LANDSCAPE CLASS** (P1978.84.6)
Platinum print. 1921
Image: 9 ½ x 7 ½ in. (24.1 x 19.1 cm.)
Signed, center print verso: "L. Gilpin"

Inscription, print verso: "No. 2/Landscape Class/John/
[signature]/Colo. Springs Colo."
Acquired from: gift of the photographer

*2529. **LANDSCAPE CLASS, BROADMOOR ART ACADEMY**
[Garden of the Gods] (P1978.84.4)
Platinum print. 1920
Image: 7½ x 9¼ in. (19.1 x 23.4 cm.)
Mount: 7¾ x 9½ in. (19.7 x 24.1 cm.)
Signed, l.r. print recto: "L Gilpin ©"
Inscription, print verso rubber stamp: "CREDIT LINE/
PHOTOGRAPH BY/LAURA GILPIN"
 mount verso: "Landscape Class/Broadmoor Art Academy/
 photograph by/Laura Gilpin/Colorado Springs. Colo ©//To
 be returned to sender" and rubber stamp "CREDIT LINE/
 PHOTOGRAPH BY/LAURA GILPIN" and *Christian
 Science Monitor* photograph identification slip
Acquired from: gift of the photographer

2530. **LEONA BOYTEL IN THE ROBERT EDMONDS JONES**
PRODUCTION OF *CAMILLE*, **CENTRAL CITY,**
COLORADO (P1978.92.19)
Gelatin silver print. 1932
Image: 7⅜ x 9⅝ in. (18.7 x 24.4 cm.)
Sheet: 7⅞ x 9¹¹⁄₁₆ in. (20.0 x 24.9 cm.)
Mount: 14 x 17 in. (35.6 x 43.2 cm.)
Inscription, mount verso: "#111" and "LEONA BOYTEL
 AS MICHETTE/IN CAMILLE, CENTRAL CITY,/
 COLORADO/1932" typed on printed paper label "LG/
 A PHOTOGRAPH BY/LAURA GILPIN/SANTA FE,
 NEW MEXICO"
 overmat recto: printed title and date
Acquired from: gift of the photographer

2531. **THE LETTER** (P1968.48.4)
Gelatin silver print. negative 1952, print 1968
Image: 14¹³⁄₁₆ x 19¼ in. (37.6 x 48.9 cm.)
Mount: same as image size
Inscription, mount verso: "THE LETTER/Negative made
 in 1952/Print made in 1968/From The Enduring Navaho/
 University of Texas Press/1968" typed on printed paper
 label "LG/ A PHOTOGRAPH BY/LAURA GILPIN/
 SANTA FE, NEW MEXICO"
Acquired from: the photographer

*2532. **LILLIAN GISH IN THE ROBERT EDMONDS JONES**
PRODUCTION OF *CAMILLE* **IN CENTRAL CITY,**
COLORADO (P1979.95.26)
Platinum print. 1932
Image: 9⅝ x 7⁹⁄₁₆ in. (24.5 x 19.2 cm.)
Sheet: 9⅞ x 7⅞ in. (25.0 x 20.0 cm.)
Signed, l.r. overmat recto: "Laura Gilpin/1932"
Inscription, mat backing verso: "#29" and "A PLATINUM
 PRINT/LILLIAN GISH AS CAMILLE, IN/CAMILLE, IN
 CENTRAL CITY, COLORADO/1932" typed on printed
 paper label "LG/ A PHOTOGRAPH BY/LAURA GILPIN/
 SANTA FE, NEW MEXICO"
 overmat recto: printed title, date, and medium
Acquired from: gift of the photographer

*2533. **LIVE OAK TREE** (P1978.92.32)
Gelatin silver print. 1946
Image: 7½ x 9⁹⁄₁₆ in. (19.1 x 24.3 cm.)
Sheet: 8 x 9¹⁵⁄₁₆ in. (20.3 x 25.2 cm.)
Mount: 14 x 17 in. (35.6 x 43.2 cm.)
Signed, l.r. overmat recto: "Laura Gilpin/1946"
Inscription, mount verso: "#130" and "LIVE OAK
 TREE/1946" typed on printed paper label "LG/ A
 PHOTOGRAPH BY/ LAURA GILPIN/SANTA FE,
 NEW MEXICO"
 overmat recto: printed title and date
Acquired from: gift of the photographer

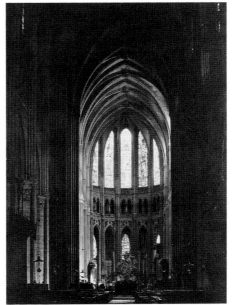
2522

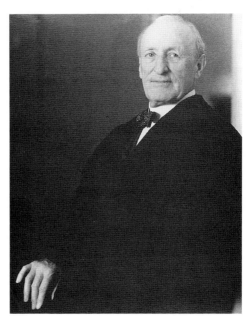
2525

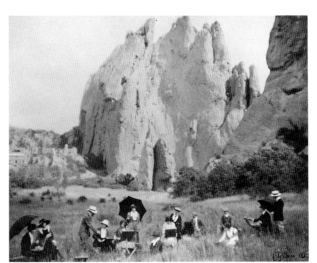
2529

2534. **LOS ALAMOS PATROL AND ENTIRE SCHOOL**
(P1986.30.2) duplicate of P1986.30.3
Gelatin silver print. 1939
Image: 7 ½ x 9 ½ in. (19.0 x 24.1 cm.)
Sheet: 10 ¹⁵⁄₁₆ x 13 ⅞ in. (27.8 x 35.2 cm.)
Signed, l.r. sheet recto: "Laura Gilpin/1939"
Acquired from: gift of Alan H. Meyer, Dallas, Texas

2535. **LOS ALAMOS PATROL AND ENTIRE SCHOOL**
(P1986.30.3) duplicate of P1986.30.2
Gelatin silver print. 1939
Image: 7 ⁵⁄₁₆ x 9 ⁷⁄₁₆ in. (18.5 x 23.9 cm.)
Signed, l.r. old mount recto: "Laura Gilpin"
Acquired from: gift of Alan H. Meyer, Dallas, Texas

2536. **LOS ALAMOS SCHOOL DANCE** (P1986.30.1)
Gelatin silver print. 1940
Image: 7 ¼ x 9 ⅜ in. (18.5 x 23.8 cm.)
Signed: see inscription
Inscription, print verso: "Alan Meyer//No 27//A dance at Los
Alamos/(with Brownmoor) my Senior/Year (39–40) there//
M" and rubber stamp "PHOTOGRAPH BY/LAURA
GILPIN/COLORADO SPRINGS, COLO."
Acquired from: gift of Alan H. Meyer, Dallas, Texas

*2537. **MABEL LUHAN** [Mabel Dodge Luhan] (P1979.48.5)
Gelatin silver print. 1947
Image: 13 ¹⁄₁₆ x 10 ⅜ in. (33.5 x 26.4 cm.)
Sheet: 13 ⅞ x 11 in. (35.3 x 28.0 cm.)
Mount: 20 x 16 in. (50.8 x 40.7 cm.)
Signed, l.r. overmat recto: "Laura Gilpin/1947"
Inscription, mount verso: "MABEL LUHAN 1947" typed on
printed paper label "LG/ A PHOTOGRAPH BY/LAURA
GILPIN/SANTA FE, NEW MEXICO"
Acquired from: the photographer

2538. **MARGARET OWINGS** [Margaret Owings at Studio,
Pojoaque] (P1978.92.45)
Gelatin silver print. 1956
Image: 9 ⁷⁄₁₆ x 7 ⅝ in. (23.9 x 19.4 cm.)
Sheet: 10 x 8 in. (25.4 x 20.3 cm.)
Mount: 17 x 14 in. (43.2 x 35.6 cm.)
Signed, l.r. overmat recto: "Laura Gilpin/1956"
Inscription, mount verso: "13" and "MARGARET
OWINGS 1956" typed on printed paper label "LG/ A
PHOTOGRAPH BY/LAURA GILPIN/SANTA FE,
NEW MEXICO"
overmat recto: printed title and date
Acquired from: gift of the photographer

2539. **MARIA MARTINEZ AND POPOVI DA** (P1978.92.49)
Type C color print. 1967
Image: 8 ¼ x 8 in. (21.0 x 20.3 cm.)
Mount: 15 x 12 in. (38.1 x 30.5 cm.)
Signed, l.r. mount recto: "Laura Gilpin/1967"
Inscription, mount verso: "16" and "MARIA MARTINEZ
AND POPOVI DA/1967" typed on printed paper label
"LG/ A PHOTOGRAPH BY/LAURA GILPIN/SANTA
FE, NEW MEXICO"
overmat recto: printed title and date
Acquired from: gift of the photographer

2540. **MARY BROWN SPINNING** (P1979.95.55)
Type C color print. 1973
Image: 7 ⅞ x 9 ¹⁵⁄₁₆ in. (20.0 x 25.2 cm.)
Mount: 11 ½ x 14 in. (29.2 x 35.6 cm.)
Signed, l.r. overmat recto: "Laura Gilpin/1973"
Inscription, mat backing verso: "#98" and "MARY BROWN
SPINNING/(Courtesy of School of/American
Research)/1973" typed on printed paper label "LG/ A
PHOTOGRAPH BY/LAURA GILPIN/SANTA FE,
NEW MEXICO"
overmat recto: printed title, date, medium, and credit line
Acquired from: gift of the photographer

2541. **MAYAN WOMEN, YUCATÁN** [Piste, Maya Woman &
Child, Group in Doorway] (P1979.95.65)
Gelatin silver print. negative 1932, print later
Image: 9 ¾ x 7 ½ in. (24.7 x 19.0 cm.)
Sheet: 9 ¹⁵⁄₁₆ x 8 ¹⁄₁₆ in. (25.3 x 20.5 cm.)
Mount: 17 x 14 in. (43.2 x 35.6 cm.)
Signed, l.r. old overmat recto: "Laura Gilpin/1932"
Inscription, mount verso: "#40" and "MAYAN WOMEN,
YUCATAN/1932" typed on printed paper label "LG/
A PHOTOGRAPH BY/LAURA GILPIN/SANTA FE,
NEW MEXICO"
old overmat recto: printed title and date
Acquired from: gift of the photographer

2542. **A MEETING IN A HOGAN** (P1968.48.1)
Gelatin silver print. negative 1953, print 1968
Image: 13 ³⁄₁₆ x 19 in. (33.4 x 48.2 cm.)
Mount: same as image size
Inscription, mount verso: "A MEETING IN A HOGAN/
Negative made in 1953/Print made in 1968/From The
Enduring Navaho/University of Texas Press/1968" typed on
printed paper label "LG/ A PHOTOGRAPH BY/LAURA
GILPIN/SANTA FE, NEW MEXICO"
Acquired from: the photographer

2543. **MISS ALICE HOWLAND AND MISS ELEANOR
BROWNELL** (P1978.92.55)
Gelatin silver print. 1947
Image: 6 ⅝ x 9 ½ in. (16.8 x 24.1 cm.)
Sheet: 8 x 10 in. (20.3 x 25.4 cm.)
Mount: 14 x 17 in. (35.6 x 43.2 cm.)
Signed, l.r. overmat recto: "Laura Gilpin/1947"
Inscription, mount verso: "8" and "MISS ALICE
HOWLAND and/MISS ELEANOR BROWNELL 1947"
typed on printed paper label "LG/ A PHOTOGRAPH BY/
LAURA GILPIN/SANTA FE, NEW MEXICO"
overmat recto: printed title and date
Acquired from: gift of the photographer

2544. **MONUMENT VALLEY PARK** (P1978.84.10)
Platinum print. 1925
Image: 9 ⅛ x 7 ⁷⁄₁₆ in. (23.8 x 18.9 cm.)
Signed, center print verso: "Laura Gilpin"
Inscription, print recto: "©"
print verso: "Monument Valley Park/Photograph by/
[signature]/Colorado Springs/Copyright/1925"
Acquired from: gift of the photographer

2545. **MOONLIGHT, GARDEN OF THE GODS, COLORADO**
[Garden of the Gods. Moonlight; The Moonlit Temple,
Garden of the Gods] (P1979.95.85) duplicate of P1979.44.7
Platinum print. 1922
Image: 9 ⁷⁄₁₆ x 7 ⅜ in. (23.9 x 18.8 cm.)
Signed, l.r. overmat recto: "Laura Gilpin/1920 [sic]"
Inscription, print verso: "The Moonlit Temple/Garden of the
Gods/1926 [sic]"
mat backing verso: "#9" and "A PLATINUM PRINT/
MOONLIGHT, GARDEN OF THE GODS,/
COLORADO/1920 [sic]" typed on printed paper label
"LG/ A PHOTOGRAPH BY/LAURA GILPIN/
SANTA FE, NEW MEXICO"
overmat recto: printed title, [incorrect] date, and medium
Acquired from: gift of the photographer

2546. **THE MOUNTAIN CLIMBERS** (P1978.84.5)
Platinum print. 1923
Image: 9 ⅝ x 7 ⅝ in. (24.5 x 19.3 cm.)
Acquired from: gift of the photographer

2532

2533

2537

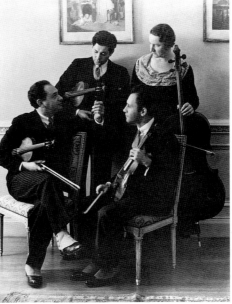

2548

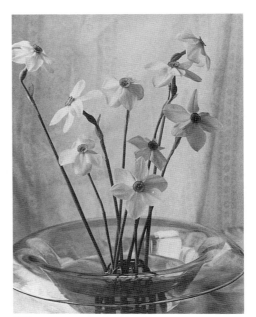

2549

2547. **MUSHROOM ROCK, CANYON DE CHELLY, ARIZ.**
(P1978.92.54)
Type C color print. 1973
Image: 8 x 10 in. (20.3 x 25.4 cm.)
Mount: 14 x 17 in. (35.6 x 43.2 cm.)
Signed, l.r. overmat recto: "Laura Gilpin/1973"
Inscription, mount verso: "#150" and "MUSHROOM
ROCK, CANYON DE CHELLY,/ARIZONA/(Courtesy
of School of/American Research)/1973" typed on printed
paper label "LG/ A PHOTOGRAPH BY/LAURA GILPIN/
SANTA FE, NEW MEXICO"
overmat recto: printed title, medium, date, and "Courtesy
of School of American Research"
Acquired from: gift of the photographer

*2548. **MUSICAL ART QUARTET** (P1978.92.24)
Platinum print. 1936
Image: 9 ⅝ x 7 ½ in. (24.4 x 19.1 cm.)
Sheet: 9 ¹³⁄₁₆ x 8 in. (24.8 x 20.3 cm.)
Signed, l.r. overmat recto: "Laura Gilpin/1936"
Inscription, mat backing verso: "#117" and "A PLATINUM
PRINT/MUSICAL ART QUARTET/1936" typed on
printed paper label "LG/ A PHOTOGRAPH BY/LAURA
GILPIN/SANTA FE, NEW MEXICO"
overmat recto: printed title, medium, and date
Acquired from: gift of the photographer

*2549. **NARCISSUS** (P1979.95.84)
Platinum print. 1928
Image: 9 ⁹⁄₁₆ x 7 ⅝ in. (24.2 x 19.4 cm.)
Signed, l.r. old overmat recto: "Laura Gilpin/1928"
Inscription, print verso: "Narcissus/1926 [sic]/Exhibited/
Brooklyn Institute of Arts & Sciences/Oct. 1922 [sic]/
Photographic Society of Philadelphia/Chicago Camera
Club. 1929 (Feb)/ Omaha Camera Club/Photo Pictorialists
of Milwaukee [sic] 1929/California Camera Club May 1929/
Camera Club of New York. Dec 1–15 1928/Hon. Mention
8th Annual Competition American Photography"
old mat backing verso: "#21" and "A PLATINUM
PRINT/NARCISSUS/1928" typed on printed paper
label "LG/ A PHOTOGRAPH BY/LAURA GILPIN/
SANTA FE, NEW MEXICO"
old overmat recto: printed title, date, and medium
Acquired from: gift of the photographer

2550. **A NAVAHO COURT, ARIZONA** (P1978.92.42)
Gelatin silver print. 1954
Image: 7 ¼ x 9 ⅝ in. (19.7 x 24.4 cm.)
Sheet: 8 x 10 in. (20.3 x 25.4 cm.)
Mount: 14 x 17 in. (35.6 x 43.2 cm.)
Signed, l.r. old overmat recto: "Laura Gilpin"
Inscription, mount verso: "#141" and "A NAVAHO COURT,
ARIZONA/1954" typed on printed paper label "LG/ A
PHOTOGRAPH BY/LAURA GILPIN/SANTA FE,
NEW MEXICO"
old overmat recto: printed title and date
Acquired from: gift of the photographer

2551. **NAVAHO COVERED WAGON [The Covered Wagon]**
(P1979.95.98) duplicate of P1968.48.7 and P1978.85.3
Gelatin silver print. negative 1934, print later
Image: 13 ¼ x 10 ¹³⁄₁₆ in. (35.0 x 27.4 cm.)
Sheet: 13 ¹⁵⁄₁₆ x 11 in. (35.3 x 28.0 cm.)
Mount: 20 x 16 in. (50.8 x 40.7 cm.)
Signed, l.r. old overmat recto: "Laura Gilpin/1934"
Inscription, mount verso: "#49" and "NAVAHO COVERED
WAGON/1934" typed on printed paper label "LG/ A
PHOTOGRAPH BY/LAURA GILPIN/SANTA FE,
NEW MEXICO"
old overmat recto: printed title and date
Acquired from: gift of the photographer

2552. **A NAVAHO FAMILY** (P1978.92.41)
Gelatin silver print. 1953
Image: 11 ¼ x 7 ¾ in. (28.5 x 19.7 cm.)
Sheet: 14 x 11 in. (35.6 x 28.0 cm.)

Mount: 17 x 14 in. (43.2 x 35.6 cm.)
Signed, l.r. overmat recto: "Laura Gilpin/1953"
Inscription, mount verso: "#139" and "A NAVAHO
FAMILY/1953" typed on printed paper label "LG/ A
PHOTOGRAPH BY/LAURA GILPIN/SANTA FE,
NEW MEXICO"
overmat recto: printed title and date
Acquired from: gift of the photographer

*2553. **NAVAHO FAMILY [Francis Nakai and Family, Red Rock]**
(P1979.95.15)
Gelatin silver print. 1950
Image: 13 ¾ x 10 ¾ in. (34.9 x 27.3 cm.)
Sheet: 13 ¹⁵⁄₁₆ x 11 in. (35.4 x 27.9 cm.)
Mount: 20 x 15 ¹⁵⁄₁₆ in. (50.8 x 40.5 cm.)
Signed, l.r. old overmat recto: "Laura Gilpin/1950"
Inscription, mount verso: "#71" and "A NAVAHO
FAMILY/1950" typed on printed paper label "LG/ A
PHOTOGRAPH BY/LAURA GILPIN/SANTA FE, NEW
MEXICO" and Phoenix Art Museum exhibition label
old overmat recto: printed title and date
Acquired from: gift of the photographer

2554. **NAVAHO FAMILY [Timothy, Ethel, Charles, & Juan
Kellywood]** (P1979.95.34)
Gelatin silver print. 1932
Image: 9 ⅝ x 7 ⅝ in. (24.5 x 19.5 cm.)
Sheet: 9 ⅞ x 8 in. (25.1 x 20.3 cm.)
Mount: 17 x 14 in. (43.2 x 35.6 cm.)
Signed, l.r. overmat recto: "Laura Gilpin/1933 [sic]"
Inscription, mount verso: "#48" and "NAVAHO
FAMILY/1933 [sic]" typed on printed paper label "LG/
A PHOTOGRAPH BY/LAURA GILPIN/SANTA FE,
NEW MEXICO"
overmat recto: printed title and [incorrect] date
Acquired from: gift of the photographer

*2555. **NAVAHO FAMILY UNDER TREE, ARIZONA** (P1978.92.1)
Gelatin silver print. 1932
Image: 6 ½ x 4 ⅝ in. (16.5 x 11.7 cm.)
Sheet: 6 ¹³⁄₁₆ x 5 in. (17.5 x 12.7 cm.)
Mount: 14 x 11 in. (35.6 x 28.0 cm.)
Signed, l.r. old overmat recto: "Laura Gilpin/1933 [sic]"
Inscription, old overmat recto: printed title and [incorrect]
date
Acquired from: gift of the photographer

2556. **A NAVAHO FENCE [Fence at Wide Ruins]** (P1979.95.2)
Gelatin silver print. negative 1950, print 1952
Image: 10 ⅞ x 13 ¹¹⁄₁₆ in. (27.5 x 34.7 cm.)
Sheet: 10 ¹⁵⁄₁₆ x 13 ⅞ in. (27.6 x 35.3 cm.)
Mount: 16 x 20 in. (40.7 x 50.8 cm.)
Signed, l.r. overmat recto: "Laura Gilpin/1952"
Inscription, mount verso: "#79" and "A NAVAHO
FENCE/1952" typed on printed paper label "LG/ A
PHOTOGRAPH BY/LAURA GILPIN/SANTA FE,
NEW MEXICO"
overmat recto: printed title and date
Acquired from: gift of the photographer

2557. **NAVAHO GRANDMOTHER [Ason Kinlichini from Round
Rock, Arizona]** (P1979.95.69)
Gelatin silver print. 1951
Image: 9 ⅝ x 7 ⅝ in. (24.5 x 19.4 cm.)
Sheet: 9 ⅞ x 8 in. (25.1 x 20.3 cm.)
Mount: 16 ¹⁵⁄₁₆ x 14 in. (43.0 x 35.6 cm.)
Signed, l.r. old overmat recto: "Laura Gilpin/1951"
Inscription, mount verso: "#77" and "NAVAHO
GRANDMOTHER/1951" typed on printed paper
label "LG/ A PHOTOGRAPH BY/LAURA GILPIN/
SANTA FE, NEW MEXICO"
old overmat recto: printed title and date
Acquired from: gift of the photographer

2558. **NAVAHO MADONNA** (P1978.92.20)
Gelatin silver print. 1932
Image: 9 9/16 x 7 5/8 in. (24.2 x 19.4 cm.)
Sheet: 9 15/16 x 8 in. (25.3 x 20.3 cm.)
Mount: 17 x 14 in. (43.2 x 35.6 cm.)
Signed, l.r. overmat recto: "Laura Gilpin"
Inscription, printed overmat recto: title, medium, "courtesy of Ann Dietz," and date
Acquired from: gift of the photographer

2559. **A NAVAHO MAN** [Luke Yazzie, Pine Springs] (P1979.95.36)
Gelatin silver print. 1952
Image: 9 3/4 x 7 7/8 in. (24.7 x 19.9 cm.)
Sheet: 10 x 8 in. (25.2 x 20.3 cm.)
Mount: 17 x 14 in. (43.2 x 35.6 cm.)
Signed, l.r. overmat recto: "Laura Gilpin/1952"
Inscription, mount verso: "#80" and "NAVAHO MAN/1952" typed on printed paper label "LG/ A PHOTOGRAPH BY/LAURA GILPIN/SANTA FE, NEW MEXICO"
overmat recto: printed title and date
Acquired from: gift of the photographer

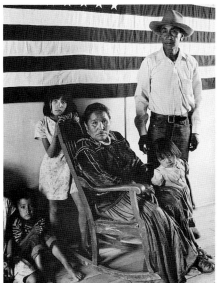

2553

* 2560. **NAVAHO MEDICINE MAN** [Setah Begay, Navaho Medicine Man, Red Rock] (P1979.95.31)
Hand-coated platinum print. 1932
Image: 9 1/2 x 7 1/2 in. (24.1 x 19.0 cm.)
Sheet: 10 x 8 in. (25.4 x 20.3 cm.)
Signed, l.r. old overmat recto: "Laura Gilpin/1932"
Inscription, print recto: Laura Gilpin monogram
print verso: "Navaho Medicine Man/looks like a hand coated platinum."
old mount verso: "#31" and "A PLATINUM PRINT/SETAH BEGAY. NAVAHO MEDICINE/MAN./1932// Original negative 8 x 10. Made at Red/Rock, Arizona." typed on printed paper label "LG/ A PHOTOGRAPH BY/LAURA GILPIN/SANTA FE, NEW MEXICO"
old overmat recto: printed title, date, and medium
Acquired from: gift of the photographer

2561. **NAVAHO PORTRAIT** [Tsetah Senior] (P1979.95.24)
Gelatin silver print. 1932
Image: 6 1/2 x 4 1/2 in. (16.5 x 11.4 cm.)
Sheet: 6 15/16 x 4 15/16 in. (17.6 x 12.5 cm.)
Mount: 14 x 11 in. (35.6 x 28.0 cm.)
Signed, l.r. overmat recto: "Laura Gilpin/1932"
Inscription, mount verso: "#44" and "NAVAHO PORTRAIT/1932" typed on printed paper label "LG/ A PHOTOGRAPH BY/LAURA GILPIN/SANTA FE, NEW MEXICO"
overmat recto: printed title and date
Acquired from: gift of the photographer

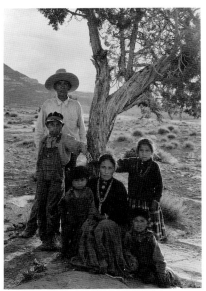

2555

2562. **NAVAHO SACRED MOUNTAIN OF THE EAST** (P1979.95.94)
Gelatin silver print. 1953
Image: 20 x 15 13/16 in. (50.8 x 40.1 cm.)
Sheet: 20 x 15 7/8 in. (50.8 x 40.3 cm.)
Mount: 23 7/8 x 20 in. (60.6 x 50.8 cm.)
Signed, l.r. overmat recto: "Laura Gilpin/1953"
Inscription, mount verso: "NAVAHO SACRED MOUNTAIN OF THE EAST./1953/from The Enduring Navaho/University of Texas Press. Publishers/(This Mountain is known to us as Mount/Blanca, in the San Luis Valley)/The Rio Grande in the foreground." typed on printed paper label "LG/ A PHOTOGRAPH BY/LAURA GILPIN/SANTA FE, NEW MEXICO"
overmat recto: printed title and date
Acquired from: gift of the photographer

2563. **NAVAHO SHEPHERD** (P1978.92.23)
Gelatin silver print. 1933
Image: 7 3/8 x 9 in. (18.7 x 22.9 cm.)
Sheet: 8 x 10 in. (20.3 x 25.4 cm.)
Mount: 14 x 17 in. (35.6 x 43.2 cm.)
Signed, l.r. overmat recto: "Laura Gilpin/1933"
Inscription, overmat recto: printed title and date
Acquired from: gift of the photographer

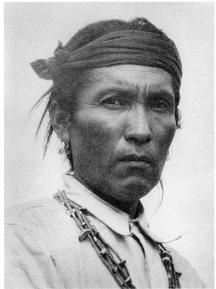

2560

2564. **NAVAHO SHEPHERD BOY** [The Little Shepherd]
(P1979.95.79)
Gelatin silver print. 1950
Image: 16 x 20 in. (40.7 x 50.8 cm.)
Mount: 20 x 24 in. (50.8 x 61.0 cm.)
Signed, l.r. overmat recto: "Laura Gilpin/1950"
Inscription, overmat verso: "UP//THE LITTLE SHEPERD
[sic]"
mount verso: "THE LITTLE SHEPHERD. 1950/from The
Enduring Navaho/University of Texas Press. Publishers."
typed on printed paper label "LG/ A PHOTOGRAPH BY/
LAURA GILPIN/SANTA FE, NEW MEXICO"
overmat recto: printed title and date
Acquired from: gift of the photographer

* 2565. **A NAVAHO SILVERSMITH** (P1979.95.3)
Gelatin silver print. 1934
Image: 13 ¼ x 10 ¹¹/₁₆ in. (34.9 x 27.1 cm.)
Mount: 20 x 15 ¹⁵/₁₆ in. (50.8 x 40.4 cm.)
Signed, l.r. overmat recto and l.r. mount recto:
"Laura Gilpin/1934"
Inscription, mount verso: "#52" and "A NAVAHO
SILVERSMITH/1934/from THE ENDURING NAVAHO./
University of Texas Press. 1969" typed on printed paper
label "LG/ A PHOTOGRAPH BY/LAURA GILPIN/
SANTA FE, NEW MEXICO"
overmat recto: printed title and date
Acquired from: gift of the photographer

* 2566. **A NAVAHO SUMMER HOGAN** [The Summer Hogan of
Old Lady Long Salt] (P1979.95.21) duplicate of P1968.48.11
Gelatin silver print. 1953
Image: 10 ⅞ x 13 ¹³/₁₆ in. (27.5 x 35.0 cm.)
Sheet: 11 x 13 ¹⁵/₁₆ in. (28.0 x 35.3 cm.)
Mount: 16 x 20 in. (40.7 x 50.8 cm.)
Signed, l.r. overmat recto: "Laura Gilpin/1953"
Inscription, mount recto: "Long Salt"
mount verso: "82" and "A NAVAHO SUMMER
HOGAN/1953" typed on printed paper label "LG/ A
PHOTOGRAPH BY/LAURA GILPIN/SANTA FE,
NEW MEXICO"
overmat recto: printed title and date
Acquired from: gift of the photographer

2567. **NAVAHO WEAVER** [Timothy's Mother, Lukachukai]
(P1979.95.8)
Platinum print. 1933
Image: 13 ⅜ x 9 ⅜ in. (34.0 x 23.8 cm.)
Sheet: 13 ⅝ x 9 ⅝ in. (34.6 x 24.4 cm.)
Signed, l.r. old overmat recto: "Laura Gilpin/1932 [sic]"
Inscription, print verso: "1939 [sic]"
old mat backing verso: "27" and "A PLATINUM PRINT/
NAVAHO WEAVER/1932 [sic]" typed on printed paper
label "LG/ A PHOTOGRAPH BY/LAURA GILPIN/
SANTA FE, NEW MEXICO"
old overmat recto: printed title, [incorrect] date, and
medium
Acquired from: gift of the photographer

2568. **NAVAHO WEAVER** (P1979.95.72)
Gelatin silver print. 1951
Image: 9 ⅝ x 7 ¾ in. (24.4 x 19.7 cm.)
Sheet: 10 x 8 in. (25.3 x 20.4 cm.)
Mount: 16 ¹⁵/₁₆ x 14 in. (43.0 x 35.5 cm.)
Signed, l.r. overmat recto: "Laura Gilpin/1951"
Inscription, mount verso: "#75" and "NAVAHO
WEAVER/1951" typed on printed paper label "LG/ A
PHOTOGRAPH BY/LAURA GILPIN/SANTA FE,
NEW MEXICO"
overmat recto: printed title and date
Acquired from: gift of the photographer

2569. **NAVAHO WOMAN AND CHILD IN HOGAN**
(P1979.95.25)
Gelatin silver print. negative 1932, print later
Image: 9 ½ x 7 ⁵/₁₆ in. (24.1 x 18.5 cm.)
Sheet: 9 ⅞ x 8 in. (25.2 x 20.3 cm.)
Mount: 16 ¹⁵/₁₆ x 14 in. (43.0 x 35.6 cm.)
Signed, l.r. old overmat recto: "Laura Gilpin/1933 [sic]"
Inscription, mount verso: "#47" and "NAVAHO WOMAN
AND CHILD IN HOGAN/1933 [sic]" typed on printed
paper label "LG/ A PHOTOGRAPH BY/LAURA GILPIN/
SANTA FE, NEW MEXICO"
old overmat recto: printed title and [incorrect] date
Acquired from: gift of the photographer

* 2570. **NAVAHO WOMAN, CHILD AND LAMBS** (P1979.95.90)
Platinum print. 1932
Image: 13 ⅛ x 10 ½ in. (34.0 x 26.7 cm.)
Sheet: 13 ¹³/₁₆ x 10 ⅞ in. (35.0 x 27.6 cm.)
Signed, l.r. old overmat recto: "Laura Gilpin/1932"
Inscription, old mat backing verso: "A PLATINUM PRINT/
NAVAHO WOMAN, CHILD AND LAMBS/1931 [sic]"
typed on printed paper label "LG/A PHOTOGRAPH BY/
LAURA GILPIN/SANTA FE, NEW MEXICO"
old overmat recto: printed title, [incorrect] date, and
medium
Acquired from: gift of the photographer

2571. **A NAVAHO YOUTH** [Hana Tsosie's Son] (P1979.95.7)
Gelatin silver print. 1932
Image: 13 ¼ x 10 ¼ in. (34.8 x 27.2 cm.)
Mount: 19 ¹⁵/₁₆ x 15 ¹⁵/₁₆ in. (50.7 x 40.5 cm.)
Signed, l.r. overmat recto and l.r. mount recto:
"Laura Gilpin/1932"
Inscription, mount verso: "#41//1932" and "A NAVAHO
YOUTH" typed on printed paper label "LG/ A
PHOTOGRAPH BY/LAURA GILPIN/SANTA FE,
NEW MEXICO"
overmat recto: printed title and date
Acquired from: gift of the photographer

2572. **NEAR THE OLD COMANCHE TRAIL, BIG BEND
NATIONAL PARK** (P1975.141.4)
Gelatin silver print. negative 1946, print 1975
Image: 15 ⅜ x 19 ⅜ in. (39.0 x 49.2 cm.)
Sheet: 15 ¾ x 19 ½ in. (40.0 x 49.5 cm.)
Mount: 20 x 24 in. (50.8 x 61.0 cm.)
Signed, l.r. old overmat recto: "Laura Gilpin/1946"
Inscription, mount verso: "NEAR THE OLD COMANCHE
TRAIL/BIG BEND NATIONAL PARK/1946/from The Rio
Grande. Duell, Sloan & Pearce Pub." typed on printed
paper label "LG/ A PHOTOGRAPH BY/LAURA GILPIN/
SANTA FE, NEW MEXICO"
Acquired from: the photographer

* 2573. **NEW MEXICO CLOUDS** (P1984.20)
Platinum print. 1933
Image: 9 ⅝ x 7 ⅝ in. (24.5 x 19.4 cm.)
Sheet: 9 ¹⁵/₁₆ x 7 ⅞ in. (25.2 x 20.0 cm.)
Signed, bottom edge print verso: "Laura Gilpin"
Inscription, print verso: "A Platinum Print. [signature]
New Mexico Clouds"
Acquired from: The Witkin Gallery, New York, New York

2574. **NORTH COLONNADE, CHICHÉN ITZÁ, YUCATÁN**
(P1979.95.91)
Silver bromide print on Gevaluxe paper. 1932
Image: 10 ¼ x 14 in. (26.0 x 35.6 cm.)
Sheet: 11 x 14 in. (28.0 x 35.6 cm.)
Signed, l.r. old overmat recto: "Laura Gilpin/1932"
Inscription, print verso: "#36//9 ⅝ x 3 ⅞"
old mat backing verso: "#36" and photographer's label
with title and date
old overmat recto: printed title and date
Acquired from: gift of the photographer

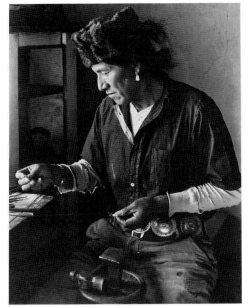

2565

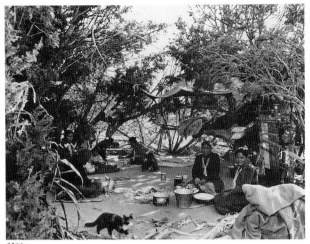

2566

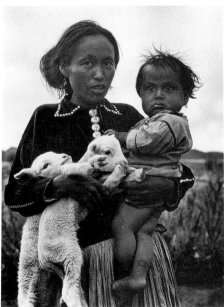

2570

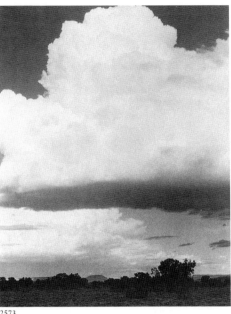

2573

2579

2575. **NUNNERY COURTYARD, UXMAL, YUCATAN**
(P1978.92.7)
Gelatin silver print. 1960
Image: 10 ¾ x 13 ¹³⁄₁₆ in. (27.4 x 35.1 cm.)
Sheet: 11 x 13 ¹⁵⁄₁₆ in. (27.8 x 35.4 cm.)
Mount: 16 x 20 in. (40.7 x 50.8 cm.)
Signed, l.r. overmat recto: "Laura Gilpin/1960"
Inscription, mount verso: "#145".and "NUNNERY
COURTYARD, UXMAL,/YUCATAN/1960" typed on
printed paper label "LG/A PHOTOGRAPH BY/LAURA
GILPIN/SANTA FE, NEW MEXICO"
overmat recto: printed title and date
Acquired from: gift of the photographer

2576. **OLD ADOBE AND SALT CEDAR** (P1987.17) duplicate of
P1975.141.1
Gelatin silver print. negative 1946, print 1978–79 by
Mary Peck
Image: 9 ⁹⁄₁₆ x 7 ⅛ in. (24.2 x 18.1 cm.)
Sheet: 9 ⁹⁄₁₆ x 7 ³⁄₁₆ in. (24.3 x 18.2 cm.)
Mount: 18 x 13 ¹⁵⁄₁₆ in. (45.7 x 35.4 cm.)
Signed, l.r. mount recto and l.r. overmat recto:
"Laura Gilpin/1946"
Inscription, mount verso: "OLD ADOBE AND SALT
CEDAR" typed on printed paper label "LG/
PHOTOGRAPHS/BY LAURA GILPIN/409 CAMINO
DEL MONTE SOL/SANTA FE, NEW MEXICO 87501"
Acquired from: gift of Paul Brauchle, Dallas, Texas

2577. **OLD ADOBE AND SALT CEDARS NEAR PRESIDIO,
TEXAS** (P1975.141.1) duplicate of P1987.17
Gelatin silver print. 1946
Image: 19 ⁷⁄₁₆ x 15 ³⁄₁₆ in. (49.3 x 38.7 cm.)
Sheet: 19 ⁹⁄₁₆ x 15 ¾ in. (49.7 x 40.0 cm.)
Mount: 24 x 20 in. (61.0 x 50.8 cm.)
Signed, l.r. overmat recto: "Laura Gilpin/1946"
Inscription, mount verso: "OLD ADOBE AND SALT
CEDARS/NEAR PRESIDIO, TEXAS. 1946//from The Rio
Grande Duell, Sloan & Pearce" typed on printed paper
label "LG/ A PHOTOGRAPH BY/LAURA GILPIN/
SANTA FE, NEW MEXICO"
Acquired from: the photographer

2578. **OLD HOUSE, ROSITA, COLORADO** (P1978.92.30)
Gelatin silver print. 1941
Image: 7 ⅜ x 9 ¼ in. (18.7 x 23.5 cm.)
1st mount: same as image size
2nd mount: 14 x 17 in. (35.6 x 43.2 cm.)
Signed, l.r. overmat recto and l.r. 2nd mount recto:
"Laura Gilpin/1941"
Inscription, 2nd mount verso: "121" and "OLD HOUSE/
ROSITA, COLORADO/1941" typed on printed paper
label "LG/ A PHOTOGRAPH BY/LAURA GILPIN/
SANTA FE, NEW MEXICO"
overmat recto: printed title and date
Acquired from: gift of the photographer

*2579. **OLD LADY LONG SALT** (P1968.48.3)
Gelatin silver print. negative 1954, print 1968
Image: 19 ¼ x 14 ¾ in. (48.9 x 37.3 cm.)
Mount: same as image size
Inscription, mount verso: "OLD LADY LONG SALT/
Negative made in 1954/Print made in 1968/From The
Enduring Navaho/University of Texas Press./1968" typed
on printed paper label "LG/ A PHOTOGRAPH BY/
LAURA GILPIN/SANTA FE, NEW MEXICO"
Acquired from: the photographer

2580. **AN OLD NAVAHO WOMAN** (P1968.48.12)
Gelatin silver print. negative 1963, print 1968
Image: 13 ¾ x 10 ¼ in. (35.0 x 27.3 cm.)
Mount: 20 ¹⁄₁₆ x 15 ⅛ in. (50.9 x 38.3 cm.)
Signed, l.r. mount recto: "Laura Gilpin/1963"
Inscription, mount verso: "AN OLD NAVAHO WOMAN/
Negative made in 1963/Print made in 1968/From The

Enduring Navaho/University of Texas Press/1968" typed on
printed paper label "LG/ A PHOTOGRAPH BY/LAURA
GILPIN/SANTA FE, NEW MEXICO"
Acquired from: the photographer

2581. **ON GUARD, BOEING AIRPLANE COMPANY**
(P1979.95.17)
Gelatin silver print. 1942
Image: 13 ⅜ x 10 ⅛ in. (34.0 x 26.4 cm.)
Mount: 20 x 15 ⁹⁄₁₆ in. (50.5 x 38.2 cm.)
Signed, l.r. overmat recto: "Laura Gilpin/1942"
l.r. mount recto: "Laura Gilpin/1943 [sic]"
Inscription, mount recto: "ON GUARD"
mount verso: "#55/On Guard #[illegible]//B//No.55/1942"
and "ON GUARD./COURTESY BOEING
CO.//807 Carter Ave./Wichita, kan." typed on printed
paper label "A PHOTOGRAPH/LG/By LAURA
GILPIN/BOX 1173, SANTA FE, NEW MEXICO//TITLE:"
and "ON GUARD/BOEING AIRPLANE
COMPANY/1942" typed on printed paper label "LG/
A PHOTOGRAPH BY/LAURA GILPIN/SANTA FE,
NEW MEXICO" [this label covers first label] and rubber
stamp "LAURA GILPIN/BOX 1173, SANTA FE, NEW
MEXICO" and remnant of printed paper label "Make One
Copper"
overmat recto: printed title and date
Acquired from: gift of the photographer

2582. **OUTSIDE THE RED ROCK TRADING POST, ARIZONA**
(P1978.92.10)
Gelatin silver print. 1951
Image: 10 ⅜ x 13 ¾ in. (26.3 x 34.9 cm.)
Mount: 16 x 20 in. (40.7 x 50.8 cm.)
Signed, l.r. overmat recto and l.r. mount recto: "Laura
Gilpin/1951"
Inscription, mount verso: "#138" and "THE RED ROCK
TRADING POST/1951/from THE ENDURING
NAVAHO/UNIVERSITY OF TEXAS PRESS PUB."
typed on printed paper label "LG/ A PHOTOGRAPH
BY/LAURA GILPIN/SANTA FE, NEW MEXICO"
overmat recto: printed title and date
Acquired from: gift of the photographer

2583. **THE OVERLOOK** (P1978.84.3)
Platinum print. 1923
Image: 7 ½ x 5 ⅞ in. (19.1 x 14.9 cm.)
Signed, center print verso: "Laura Gilpin"
Inscription, print verso: "The Overlook/by/[signature]/Colo
Springs Colo/© 1923"
Acquired from: gift of the photographer

*2584. **PARADISE VALLEY. NEAR THE BIG BEND. TEXAS**
(P1975.141.2)
Gelatin silver print. negative 1946, print 1975
Image: 15 ⁹⁄₁₆ x 19 ⅜ in. (39.5 x 49.2 cm.)
Sheet: 16 x 19 ½ in. (40.7 x 49.5 cm.)
Mount: 20 x 24 in. (50.8 x 61.0 cm.)
Signed, l.r. old overmat recto: "Laura Gilpin/1946"
Inscription, mount verso: "PARADISE VALLEY. NEAR/THE
BIG BEND. TEXAS./1946//from The Rio Grande. Duell,
Sloan & Pearce Pub." typed on printed paper label "LG/
A PHOTOGRAPH BY/LAURA GILPIN/SANTA FE,
NEW MEXICO"
Acquired from: the photographer

2585. **PAULINE CHAPEL [Broadmoor Art Academy, Colorado
Springs, Colorado]** (P1978.84.13)
Platinum print. 1929
Image: 9 x 7 ⅜ in. (22.8 x 18.8 cm.)
Acquired from: gift of the photographer

2586. **PAULINE CHAPEL, BROADMOOR, COLO. SPRINGS,
COLORADO** (P1978.84.29)
Gelatin silver print. 1929
Image: 9 ¾ x 7 ¹³⁄₁₆ in. (24.7 x 19.8 cm.)
Sheet: 10 x 8 in. (25.4 x 20.3 cm.)
Inscription, print verso: "Pauline Chapel/Broadmoor/Colo.

Springs/Colorado" and rubber stamp "Photograph by/
Laura Gilpin/Colorado Springs, Colo."
Acquired from: gift of the photographer

2587. **PETROGLYPH, NEW MEXICO** (P1978.92.6)
Gelatin silver print. 1959
Image: 13 13/16 x 10 13/16 in. (35.1 x 27.5 cm.)
Sheet: 13 15/16 x 11 in. (35.4 x 28.0 cm.)
Mount: 20 x 16 in. (50.8 x 40.7 cm.)
Signed, l.r. overmat recto: "Laura Gilpin/1959"
Inscription, mount recto: "5"
mount verso: "143" and "PETROGLYPH, NEW
MEXICO/1959" typed on printed paper label "LG/ A
PHOTOGRAPH BY/LAURA GILPIN/SANTA FE,
NEW MEXICO"
overmat recto: printed title and date
overmat verso: "5"
Acquired from: gift of the photographer

2584

2588. **PICURIS CHURCH, NEW MEXICO** (P1978.92.3)
Gelatin silver print. 1963
Image: 5 1/16 x 3 15/16 in. (12.8 x 10.0 cm.)
Mount: 10 x 8 in. (25.4 x 20.3 cm.)
Signed, l.r. overmat recto: "Laura Gilpin/1963"
Inscription, overmat recto: printed title and [incorrect] date
Acquired from: gift of the photographer

2589. **[Pike's Peak]** (P1978.84.23)
Platinum print. c. 1920s
Image: 8 1/8 x 6 1/16 in. (20.6 x 15.4 cm.)
Acquired from: gift of the photographer

2590. **PIKE'S PEAK** (P1978.92.27)
Gelatin silver print. 1939
Image: 7 3/4 x 9 5/8 in. (19.7 x 24.5 cm.)
Sheet: 8 x 9 15/16 in. (20.3 x 25.2 cm.)
Mount: 14 x 17 in. (35.6 x 43.2 cm.)
Signed, l.r. overmat recto: "Laura Gilpin/1939"
Inscription, mount verso: "#120" and "PIKES PEAK/
ca.1939" typed on printed paper label "LG/ A
PHOTOGRAPH BY/LAURA GILPIN/SANTA FE,
NEW MEXICO"
overmat recto: printed title and date
Acquired from: gift of the photographer

2594

2591. **A PIÑON SEA, MESA VERDE, COLORADO** (P1978.84.8)
Platinum print. 1923
Image: 9 1/2 x 7 1/2 in. (24.1 x 19.1 cm.)
Acquired from: gift of the photographer

2592. **PORTRAIT [woman with baby]** (P1978.92.13)
Type C color print. autochrome 1914, print c. 1975
Image: 9 1/2 x 7 1/2 in. (24.1 x 19.1 cm.)
Sheet: 10 x 8 1/8 in. (25.4 x 20.6 cm.)
Signed, l.r. overmat recto: "Laura Gilpin/1914"
Inscription, mat backing verso: "#101" and "PORTRAIT/
Color print from original/Lumiere Autochrome plate/1914"
typed on printed paper label "LG/ A PHOTOGRAPH BY/
LAURA GILPIN/SANTA FE, NEW MEXICO"
overmat recto: printed title and date
Acquired from: gift of the photographer

2593. **PORTRAIT [woman with fur muff]** (P1979.95.39)
Type C color print. autochrome 1910, print c. 1975
Image: 9 1/2 x 5 3/8 in. (24.1 x 13.6 cm.)
Sheet: 10 x 8 1/8 in. (25.3 x 20.5 cm.)
Signed, l.r. overmat recto: "Laura Gilpin/1910"
Inscription, mat backing verso: "#1." and "PORTRAIT/
Color print from original/Lumiere Autochrome plate/1910"
typed on printed paper label "LG/ A PHOTOGRAPH BY/
LAURA GILPIN/SANTA FE, NEW MEXICO"
overmat recto: printed title, date, and medium
Acquired from: gift of the photographer

2595

*2594. **PORTRAIT—EDITH FARNSWORTH** (P1979.95.44)
Platinum print. 1917
Image: 8 x 5 15/16 in. (20.3 x 15.0 cm.)
Signed, l.r. old overmat recto: "Laura Gilpin/1917"
Inscription, print verso: "Edith/Portrait Miss Farnsworth/1917/
by/Laura Gilpin/Colo. Springs. Colo."
old mat backing verso: "#6" and "A PLATINUM PRINT/
PORTRAIT—EDITH FARNSWORTH/1917" typed on
printed paper label "LG/ A PHOTOGRAPH BY/LAURA
GILPIN/SANTA FE, NEW MEXICO"
old overmat recto: printed title, date, and medium
Acquired from: gift of the photographer

*2595. **PORTRAIT, ELIZA M. SWIFT** (P1979.95.30)
Platinum print. 1922
Image: 9 5/8 x 7 5/8 in. (24.5 x 19.4 cm.)
Signed, l.r. overmat recto: "Laura Gilpin/1922"
Inscription, print verso: "Portrait of/Eliza Morgan Swift/by/
Laura Gilpin/Colorado Springs./Dec. 1922."
mat backing verso: "#12" and "A PLATINUM PRINT/
PORTRAIT—ELIZA M. SWIFT/1922" typed on printed
paper label "LG/ A PHOTOGRAPH BY/LAURA GILPIN/
SANTA FE, NEW MEXICO"
overmat recto: printed title, date, and medium
Acquired from: gift of the photographer

*2596. **PORTRAIT—MARGARET CARLSON** (P1979.95.86)
Platinum print. 1921
Image: 9 5/8 x 7 11/16 in. (24.4 x 19.5 cm.)
Sheet: 9 11/16 x 7 7/8 in. (24.6 x 20.0 cm.)
Signed, l.r. old overmat recto: "Laura Gilpin/1921"
Inscription, old mat backing verso: "#10" and "A
PLATINUM PRINT/PORTRAIT—MARGARET
CARLSON/1921" typed on printed paper label "LG/
A PHOTOGRAPH BY/LAURA GILPIN/SANTA FE,
NEW MEXICO"
old overmat recto: printed title, date, and medium
Acquired from: gift of the photographer

2597. **PRAIRIE SKY, TEXAS [The Texas Sky Line, Big Bend
Area]** (P1979.95.16) duplicate of P1975.141.3 and P1987.18
Gelatin silver print. 1946
Image: 13 5/16 x 10 3/8 in. (33.9 x 26.3 cm.)
Mount: 20 x 16 in. (50.8 x 40.7 cm.)
Signed, l.r. overmat recto and l.r. mount recto:
"Laura Gilpin/1946"
Inscription, mount verso: "#63" and "PRAIRIE SKY/from/
RIO GRANDE, RIVER OF DESTINY/DUELL, SLOAN
& PEARCE. PUB./1946" typed on printed paper label
"LG/ A PHOTOGRAPH BY/LAURA GILPIN/
SANTA FE, NEW MEXICO"
overmat recto: printed title and date
Acquired from: gift of the photographer

*2598. **THE PRELUDE** (P1977.64.1) duplicate of P1979.95.87
Platinum print. 1917
Image: 6 1/8 x 7 3/4 in. (15.5 x 19.7 cm.)
Mount: 11 x 14 in. (27.9 x 35.5 cm.)
Signed, l.r. mount recto: "Laura Gilpin/1917 ©"
Inscription, mount verso: "The Prelude./by Laura Gilpin/
Colorado Springs, Colo/Copyright.//Exhibited/.1917.
P.P.A./1920 Los Angeles. Salon/1920 Copenhagen
[Salon]/1921 Photo. Guild Baltimire [sic]./1922 London
Salon./1922 San Francisco Art Museum (one man
show)/1923 American Photography Competition 5th
Prize/1924 Toronto Salon/1925 Frederick & Nelson (Seatle
[sic]) Competition. Hon. Men./1926 Portland Oregon.
International/1926. Antwerp International/1927 New
Westminster B.C./1927 Liverpool International/1927 Paris
[International]/1928 Stockholm"
Acquired from: the photographer

2599. **THE PRELUDE** (P1979.95.87) duplicate of P1977.64.1
Platinum print. 1917
Image: 6 1/8 x 7 13/16 in. (15.6 x 19.8 cm.)
Signed, l.r. old overmat recto: "Laura Gilpin/1917"

Inscription, old mat backing verso: "#4" and "A
PLATINUM PRINT/THE PRELUDE/1917" typed on
printed paper label "LG/ A PHOTOGRAPH BY/LAURA
GILPIN/SANTA FE, NEW MEXICO"
old overmat recto: printed title, date, and medium
Acquired from: gift of the photographer

2600. **PUEBLO INDIAN [Tony Peña]** (P1979.95.71)
Gelatin silver print. 1945
Image: 9 5/8 x 7 5/8 in. (24.5 x 19.4 cm.)
Sheet: 9 7/8 x 8 in. (25.1 x 20.3 cm.)
Mount: 17 x 14 in. (43.2 x 35.6 cm.)
Signed, l.r. overmat recto: "Laura Gilpin/1945"
Inscription, mount verso: "#58" and "PUEBLO
INDIAN/1945" typed on printed paper label "LG/ A
PHOTOGRAPH BY/LAURA GILPIN/SANTA FE,
NEW MEXICO"
overmat recto: printed title and date
Acquired from: gift of the photographer

*2601. **RAINDROPS ON LUPIN LEAVES** (P1978.92.18)
Platinum print. 1931
Image: 4 5/8 x 6 5/8 in. (11.8 x 16.8 cm.)
Sheet: 4 7/8 x 7 1/16 in. (12.4 x 17.9 cm.)
Mount: 5 1/4 x 7 5/16 in. (13.4 x 18.6 cm.)
Signed, l.r. old overmat recto: "Laura Gilpin/1931"
Inscription, old overmat recto: printed title, date, and
medium
Acquired from: gift of the photographer

2602. **RANCHOS DE TAOS GATE, NEW MEXICO
[Ranchos de Taos Church]** (P1979.95.5)
Gelatin silver print. 1939
Image: 10 1/8 x 12 5/16 in. (25.8 x 31.3 cm.)
Mount: 15 1/8 x 20 1/16 in. (38.3 x 51.0 cm.)
Signed, l.r. overmat recto: "Laura Gilpin/1947 [sic]"
l.r. mount recto: "Laura Gilpin ©/1947 [sic]"
Inscription, mount verso: "#69/#69" and "RANCHOS DE
TAOS CHURCH. 1947. [sic]/from RIO GRANDE, RIVER
OF DESTINY/Duell, Sloan & Pearce, Inc. Pub./
Copyright" typed on printed paper label "LG/
PHOTOGRAPHS/BY LAURA GILPIN/BOX 1173,
SANTA FE, NEW MEXICO"
old overmat recto: printed title and [incorrect] date
Acquired from: gift of the photographer

2603. **RANDALL DAVEY [Randall Davey in His Studio]**
(P1978.92.37) duplicate of P1979.48.3
Gelatin silver print. 1947
Image: 9 1/8 x 7 3/8 in. (23.2 x 18.7 cm.)
Mount: 17 x 14 in. (43.2 x 35.6 cm.)
Signed, l.r. overmat recto: "Laura Gilpin/1947"
Inscription, mount verso: "9" and "RANDALL DAVEY 1947"
typed on printed paper label "LG/ A PHOTOGRAPH BY/
LAURA GILPIN/SANTA FE, NEW MEXICO"
overmat recto: printed title and date
Acquired from: gift of the photographer

2604. **RANDALL DAVEY IN HIS STUDIO** (P1979.48.3) duplicate
of P1978.92.37
Gelatin silver print. 1947
Image: 9 3/8 x 7 3/8 in. (23.8 x 18.8 cm.)
Sheet: 9 15/16 x 8 1/8 in. (25.2 x 20.5 cm.)
Mount: 18 x 14 in. (45.7 x 35.6 cm.)
Signed, l.r. overmat recto: "Laura Gilpin/1947"
Inscription, mount verso: "RANDALL DAVEY IN HIS
STUDIO/1947" typed on printed paper label "LG/ A
PHOTOGRAPH BY/LAURA GILPIN/SANTA FE,
NEW MEXICO"
Acquired from: the photographer

2596

2598

2601

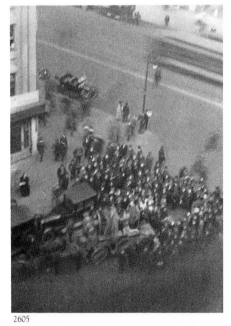

2605

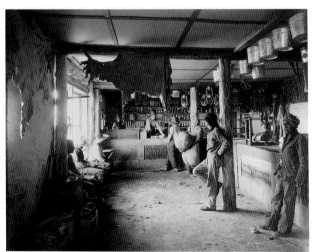

2606

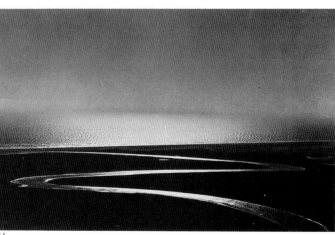

2611

*2605. **RECRUITING SCENE, NEW YORK CITY** (P1979.95.45)
Platinum print. 1917
Image: 7 7/8 x 5 11/16 in. (20.0 x 14.4 cm.)
Signed, l.r. old overmat recto: "Laura Gilpin/1917"
Inscription, old mat backing verso: "#5" and "A
PLATINUM PRINT/RECRUITING SCENE, NEW
YORK CITY/(Pin Hole Photograph)/1917" typed on
printed paper label "LG/ A PHOTOGRAPH BY/LAURA
GILPIN/SANTA FE, NEW MEXICO"
old overmat recto: printed title, date, and medium
Acquired from: gift of the photographer

*2606. **RED ROCK TRADING POST, ARIZONA** (P1976.158.5)
duplicate of P1979.95.88
Gelatin silver print. 1932
Image: 16 x 20 in. (40.7 x 50.8 cm.)
Mount: 20 x 24 in. (50.8 x 61.0 cm.)
Signed, l.r. overmat recto: "Laura Gilpin/1932"
Acquired from: the photographer

2607. **RED ROCK TRADING POST, ARIZONA** (P1979.95.88)
duplicate of P1976.158.5
Gelatin silver print. 1932
Image: 7 1/2 x 9 3/8 in. (19.0 x 23.8 cm.)
Mount: 14 x 17 in. (35.5 x 43.1 cm.)
Signed, l.r. old overmat recto: "Laura Gilpin/1932"
Inscription, mount verso: "#42" and "RED ROCK
TRADING POST, ARIZONA/1932" typed on printed
paper label "LG/ A PHOTOGRAPH BY/LAURA GILPIN/
SANTA FE, NEW MEXICO"
old overmat recto: printed title and date
Acquired from: gift of the photographer

2608. **REYNOLDS—SHERIFF OF EL PASO CO.** (P1978.84.26)
Platinum print. c. 1924
Image: 9 3/8 x 7 1/2 in. (23.8 x 19.1 cm.)
Signed, l.l. print recto: "L. Gilpin"
Inscription, print verso: "Reynolds—Sheriff of El Paso Co./
Made in the 1920s or early 30s.//Laura Gilpin"
Acquired from: gift of the photographer

2609. **THE RIM IN THE FOG, CANYON DE CHELLY,
ARIZONA** (P1979.95.58)
Type C color print. 1974
Image: 10 x 6 7/8 in. (25.4 x 17.5 cm.)
Signed, l.r. overmat recto: "Laura Gilpin/1974"
Inscription, mat backing verso: "#100" and "THE RIM IN
THE FOG,/CANYON DE CHELLY, ARIZONA/(Courtesy
of School of/American Research)/1974" typed on printed
paper label "LG/ A PHOTOGRAPH BY/LAURA GILPIN/
SANTA FE, NEW MEXICO"
overmat recto: printed title, date, medium, and credit line
Acquired from: gift of the photographer

2610. **RIO GRANDE BEFORE A STORM, COLORADO**
[Headwaters of the Rio Grande Before a Storm]
(P1979.95.101) duplicate of P1978.85.2
Gelatin silver print. 1945
Image: 19 7/16 x 15 3/8 in. (49.4 x 39.0 cm.)
Mount: 20 1/16 x 16 in. (50.9 x 40.7 cm.)
Signed, l.r. overmat recto: "Laura Gilpin/1945"
l.r. mount recto: "Laura Gilpin 1945"
Inscription, mount verso: "#57/Rio Grande before a
Storm/1945/from Rio Grande Book"
overmat recto: printed title and date
Acquired from: gift of the photographer

*2611. **THE RIO GRANDE YIELDS ITS SURPLUS TO THE
SEA** (P1979.95.35)
Gelatin silver print. 1947
Image: 8 11/16 x 13 3/4 in. (22.0 x 34.9 cm.)
Mount: 15 13/16 x 19 13/16 in. (40.0 x 50.3 cm.)
Signed, l.r. old overmat recto: "Laura Gilpin/1949 [sic]"
l.r. mount recto: "Laura Gilpin/1947"
Inscription, mount verso: "66" and "THE RIO GRANDE
YIELDS ITS SURPLUS/TO THE SEA./from/THE RIO

GRANDE, RIVER OF DESTINY/DUELL, SLOAN &
PEARCE, PUB. N. Y. 1949 [sic]" typed on printed paper
label "LG/ A PHOTOGRAPH BY/LAURA GILPIN/
SANTA FE, NEW MEXICO"
old overmat recto: printed title and date
Acquired from: gift of the photographer

*2612. **ROBERT REID LIFE CLASS. BROADMOOR ART
ACADEMY** (P1978.84.30)
Platinum print. 1921
Image: 7 5/8 x 9 9/16 in. (19.3 x 24.3 cm.)
Signed, l.r. print recto: "L. Gilpin ©"
Inscription, print verso: "No. 3/Robert Reid/Life Class.
Broadmoor Art Academy/L. Gilpin/Colo Springs Colo"
and rubber stamp "CREDIT LINE/PHOTOGRAPH BY
LAURA GILPIN"
Acquired from: gift of the photographer

2613. **ROCK FORMATION, CANYON DE CHELLY, ARIZONA**
(P1979.95.57)
Type C color print. 1972
Image: 8 x 10 in. (20.3 x 25.4 cm.)
Signed, l.r. overmat recto: "Laura Gilpin/1972"
Inscription, mat backing verso: "#97" and "ROCK
FORMATION, CANYON DE CHELLY,/
ARIZONA/(Courtesy of School of/American
Research)/1972" typed on printed paper label "LG/ A
PHOTOGRAPH BY/LAURA GILPIN/SANTA FE,
NEW MEXICO"
overmat recto: printed title, date, medium, and credit line
Acquired from: gift of the photographer

2614. **SANGRE DE CRISTO RANGE, COLORADO**
(P1979.95.95)
Gelatin silver print. 1945
Image: 15 x 19 3/16 in. (38.0 x 48.7 cm.)
Mount: 15 7/8 x 20 1/8 in. (40.2 x 51.0 cm.)
Signed, l.r. overmat recto and l.r. mount recto: "Laura
Gilpin/1945"
Inscription, mount verso: "#56" and "SANGRE DE
CRISTO RANGE,/SAN LUIS VALLEY 1945" typed
on printed paper label "LG/ A PHOTOGRAPH BY/
LAURA GILPIN/SANTA FE, NEW MEXICO"
old overmat recto: printed title and date
Acquired from: gift of the photographer

*2615. **SANTA ELENA CANYON, BIG BEND NATIONAL
PARK, TEXAS AND MEXICO** (P1979.95.83)
Gelatin silver print. 1946
Image: 19 3/8 x 15 3/8 in. (49.2 x 39.0 cm.)
Mount: same as image size
Signed, l.r. overmat recto: "Laura Gilpin/1946"
Inscription, mount verso: "SANTA ELENA CANYON/BIG
BEND NATIONAL PARK/from/RIO GRANDE, RIVER
OF DESTINY/DUELL, SLOAN & PEARCE. PUB./1946"
typed on printed paper label "LG/ A PHOTOGRAPH BY/
LAURA GILPIN/SANTA FE, NEW MEXICO"
mat backing verso: "#65"
overmat recto: printed title and date
Acquired from: gift of the photographer

2616. **A SANTO, NEW MEXICO** [San José de Chama] (P1977.88)
duplicate of P1978.92.26
Gelatin silver print. negative 1938, print c. 1977
Image: 5 3/16 x 3 3/4 in. (13.2 x 9.5 cm.)
Mount: 7 x 5 in. (17.8 x 12.7 cm.)
Signed, inside card: "The Best of Christmas/Wishes—/
Laura G."
Acquired from: gift of Mitchell A. Wilder, Fort Worth, Texas

2617. **A SANTO, NEW MEXICO** [San José de Chama]
(P1978.92.26) duplicate of P1977.88
Gelatin silver print. 1938
Image: 9 1/2 x 7 5/8 in. (24.1 x 19.3 cm.)
Sheet: 10 x 8 in. (25.4 x 20.3 cm.)
Signed, l.r. overmat recto: "Laura Gilpin/1938"
Inscription, mat backing verso: "119//NOT FOR SALE

FROM RETROSPECTIVE" and "A SANTO, NEW
MEXICO/1938" typed on printed paper label "LG/ A
PHOTOGRAPH BY/LAURA GILPIN/SANTA FE,
NEW MEXICO"
overmat recto: printed title and date
Acquired from: gift of the photographer

2618. **SERPENT HEADS, TEMPLE OF THE WARRIORS,
CHICHÉN ITZÁ, YUCATÁN** (P1978.92.12)
Gelatin silver print. 1932
Image: 9 ½ x 13 ⁷/₁₆ in. (24.1 x 34.2 cm.)
Sheet: 11 x 14 in. (28.0 x 35.4 cm.)
Mount: 16 x 20 in. (40.7 x 50.8 cm.)
Signed, l.r. overmat recto: "Laura Gilpin/1932"
Inscription, print recto: "crop" and crop marks
mount verso: "#108" and "SERPENT HEADS,
TEMPLE OF THE WARRIORS/CHICHEN ITZA,
YUCATAN/1932" typed on printed paper label "LG/
A PHOTOGRAPH BY/LAURA GILPIN/SANTA FE,
NEW MEXICO"
overmat recto: printed title and date
Acquired from: gift of the photographer

2619. **SEVEN FALLS [Seven Falls, Colorado]** (P1978.84.17)
Platinum print. 1925
Image: 9 ½ x 7 ⁵/₈ in. (24.1 x 19.4 cm.)
Signed, l.l. print recto: "© Laura Gilpin"
Inscription, print verso: "Seven Falls/Photograph by/
Laura Gilpin/Colorado Springs/1925/©/Copyright 1926"
Acquired from: gift of the photographer

2620. **SHEPHERDS OF THE DESERT** (P1968.48.10) duplicate of
P1979.95.18
Gelatin silver print. negative 1934, print 1967
Image: 15 ⁵/₁₆ x 19 ¹/₁₆ in. (38.8 x 48.4 cm.)
Mount: same as image size
Inscription, mount verso: "SHEPHERDS OF THE DESERT/
Negative made li [sic] 1934/Print made in 1967/From The
Enduring Navaho/University of Texas Press./1968" typed
on printed paper label "LG/ A PHOTOGRAPH BY/
LAURA GILPIN/SANTA FE, NEW MEXICO"
Acquired from: the photographer

2621. **SHEPHERDS OF THE DESERT** (P1979.95.18) duplicate of
P1968.48.10
Gelatin silver print. negative 1934, print later
Image: 10 ⁹/₁₆ x 13 ³/₈ in. (26.8 x 33.9 cm.)
Mount: 15 ¹⁵/₁₆ x 20 in. (40.5 x 50.8 cm.)
Signed, l.r. old overmat recto: "Laura Gilpin/1934"
Inscription, mount verso: "Shepherds of the Desert/
photograph by/Laura Gilpin/1934©/from The Enduring
Navaho/University of Texas Press Pub.//No 48"
old mat backing verso: "46" and "SHEPHERDS OF THE
DESERT/1934" typed on printed paper label "LG/ A
PHOTOGRAPH BY/LAURA GILPIN/SANTA FE,
NEW MEXICO"
old overmat recto: printed title and [incorrect] date
Acquired from: gift of the photographer

2622. **SHIPROCK, NEW MEXICO** (P1979.95.70)
Type C color print. 1974
Image: 9 ⁷/₈ x 7 ⁷/₈ in. (25.1 x 20.0 cm.)
Mount: 16 ¹⁵/₁₆ x 13 ¹⁵/₁₆ in. (43.0 x 35.3 cm.)
Signed, l.r. overmat recto: "Laura Gilpin/1973 [sic]"
Inscription, mount verso: "#92" and "SHIPROCK, NEW
MEXICO/1973 [sic]" typed on printed paper label "LG/
A PHOTOGRAPH BY/LAURA GILPIN/SANTA FE,
NEW MEXICO"
overmat recto: printed title and [incorrect] date
Acquired from: gift of the photographer

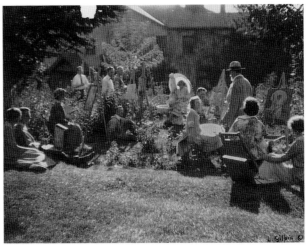

2612

2615

2624

2623. **SISAL PLANT, YUCATÁN** (P1979.95.14)
Gelatin silver print. 1932
Image: 9⅛ x 13⁷⁄₁₆ in. (23.8 x 34.2 cm.) irregular
Sheet: 11 x 13⅞ in. (28.0 x 35.2 cm.)
Mount: 16 x 20¹⁄₁₆ in. (40.7 x 50.9 cm.)
Signed, l.r. overmat recto: "Laura Gilpin 1932"
Inscription, mount recto: "39"
 overmat verso: "39"
 mount verso: "#39" and "SISAL PLANT (cut ends)/
YUCATAN/1932" typed on printed paper label "LG/
A PHOTOGRAPH BY/LAURA GILPIN/SANTA FE,
NEW MEXICO"
 overmat recto: printed title and date
Acquired from: gift of the photographer

*2624. **SISAL PLANT, YUCATÁN** (P1979.95.43)
Gelatin silver print. 1932
Image: 11½ x 8⅛ in. (29.2 x 20.7 cm.)
Sheet: 13 x 9⅝ in. (33.0 x 24.4 cm.)
Mount: 17 x 14 in. (43.2 x 35.6 cm.)
Signed, l.r. overmat recto: "Laura Gilpin/1932"
Inscription, mount verso: "#38" and "SISAL PLANT/
YUCATAN/1932" typed on printed paper label "LG/
A PHOTOGRAPH BY/LAURA GILPIN/SANTA FE,
NEW MEXICO"
 overmat recto: printed title and date
Acquired from: gift of the photographer

2625. **SNOW IN SANTA FE** (P1979.95.37)
Gelatin silver print. 1956
Image: 9⁹⁄₁₆ x 7⅝ in. (24.3 x 19.3 cm.)
Mount: 14⁷⁄₁₆ x 11½ in. (36.7 x 29.2 cm.)
Signed, l.r. overmat recto and l.r. mount recto:
 "Laura Gilpin/1956"
Inscription, mount verso: "Photograph by/Laura Gilpin/Box
~~1173~~/Santa Fe, New Mexico/Snow in Santa Fe//#85//~~#158~~"
 mat backing verso: "#85" and "SNOW IN SANTA FE,
NEW MEXICO/1956" typed on printed paper label "LG/
A PHOTOGRAPH BY/LAURA GILPIN/SANTA FE,
NEW MEXICO"
 overmat recto: printed title and date
Acquired from: gift of the photographer

*2626. **SNOWSTORM, CENTRAL PARK, NEW YORK**
(P1979.95.64)
Platinum print. 1917
Image: 8³⁄₁₆ x 6⅛ in. (20.8 x 15.6 cm.)
Signed, l.r. overmat recto: "Laura Gilpin/1917"
Inscription, mat backing verso: "#7" and "A PLATINUM
PRINT/SNOW STORM, CENTRAL PARK, N.Y./1917"
typed on printed paper label "LG/ A PHOTOGRAPH BY/
LAURA GILPIN/SANTA FE, NEW MEXICO"
 overmat recto: printed title, date, and medium
Acquired from: gift of the photographer

2627. **SOUTH PARK, COLORADO** (P1976.158.6)
Gelatin silver print. negative 1941, print later
Image: 14⅞ x 18⅞ in. (37.8 x 47.9 cm.)
Sheet: 16 x 19¹⁵⁄₁₆ in. (40.7 x 50.7 cm.)
Mount: 20 x 24 in. (50.8 x 61.0 cm.)
Signed, l.r. old overmat recto: "Laura Gilpin/1943 [sic]"
Inscription, mount verso: "7" and "SOUTH PARK,
COLORADO/1943 [sic]//R" typed on printed paper
label "LG/ A PHOTOGRAPH BY/LAURA GILPIN/
SANTA FE, NEW MEXICO"
 old overmat recto: printed title and [incorrect] date
Acquired from: the photographer

2628. **SPANISH CHURCH AT CHICHÉN ITZÁ, YUCATÁN**
[San Ysidro] (P1979.95.20)
Silver bromide print on Gevaluxe paper. 1932
Image: 13¹⁵⁄₁₆ x 9¹³⁄₁₆ in. (35.3 x 25.0 cm.)
Sheet: 14 x 10¹⁵⁄₁₆ in. (35.5 x 27.8 cm.)
Signed, l.r. overmat recto: "Laura Gilpin/1932"

Inscription, print verso: "#37//13⅝ x 9½"
 mat backing verso: "#37" and "SPANISH CHURCH AT
CHICHÉN ITZÁ,/YUCATAN/1932" typed on printed
paper label "LG/ A PHOTOGRAPH BY/LAURA GILPIN/
SANTA FE, NEW MEXICO"
 overmat recto: printed title and date
Acquired from: gift of the photographer

2629. **SPIDER ROCK, CANYON DE CHELLY** (P1979.95.52)
Type C color print. 1972
Image: 10 x 7⅛ in. (25.4 x 18.0 cm.)
Signed, l.r. overmat recto: "Laura Gilpin/1972"
Inscription, mat backing verso: "#95" and "SPIDER ROCK,
CANYON DE CHELLY,/ARIZONA/(Courtesy of School
of/American Research)/1972" typed on printed paper
label "LG/ A PHOTOGRAPH BY/LAURA GILPIN/
SANTA FE, NEW MEXICO"
 overmat recto: printed title, date, medium, and credit line
Acquired from: gift of the photographer

*2630. **THE SPIRIT OF THE PRAIRIE** [Sunlight and Silence]
(P1977.64.2) duplicate of P1978.84.1
Platinum print. 1921
Image: 7⁵⁄₁₆ x 9⅜ in. (18.6 x 23.8 cm.)
Signed, l.r. overmat recto: "Laura Gilpin/1924 [sic]"
Inscription, print recto: "©"
 mat backing verso: "The Spirit of the Prairie/1924 [sic]"
typed on printed paper label "LG/ A PHOTOGRAPH BY/
LAURA GILPIN/SANTA FE, NEW MEXICO"
Acquired from: the photographer

2631. **STEPS OF THE CASTILLO, CHICHÉN ITZÁ** [Temple
Stairway, Kukulcan, Chichén Itzá, Yucatán] (P1964.129)
duplicate of P1979.95.12
Silver bromide print on Gevaluxe paper. 1932
Image: 13⅝ x 9⅝ in. (34.9 x 24.5 cm.)
Sheet: 13¹⁵⁄₁₆ x 11 in. (35.4 x 27.8 cm.)
Inscription, print recto: "©"
Acquired from: the photographer

*2632. **STEPS OF THE CASTILLO, CHICHÉN ITZÁ** [Balustrade,
Temple of Kukulcan, Chichén Itzá, Yucatán] (P1964.130)
duplicate of P1979.95.80
Silver bromide print on Gevaluxe paper. 1932
Image: 14 x 10½ in. (35.6 x 26.6 cm.)
Sheet: 14 x 11 in. (35.6 x 28.0 cm.)
Signed, l.r. old overmat recto: "Laura Gilpin/1932"
Inscription, print recto: "©"
Acquired from: the photographer

2633. **STILL LIFE** (P1979.95.42)
Type C color print. autochrome 1912, print c. 1975
Image: 5⅜ x 9½ in. (13.7 x 24.1 cm.)
Sheet: 8¹⁄₁₆ x 10 in. (20.5 x 25.4 cm.)
Signed, l.r. overmat recto: "Laura Gilpin/1912"
Inscription, mat backing verso: "#2" and "STILL LIFE/Color
print from original/Lumiere Autochrome plate/1912" typed
on printed paper label "LG/ A PHOTOGRAPH BY/
LAURA GILPIN/SANTA FE, NEW MEXICO"
 overmat recto: printed title, date, and medium
Acquired from: gift of the photographer

2634. **STORM FROM LA BAJADA HILL, NEW MEXICO**
(P1978.85.1) duplicate of P1979.95.96
Gelatin silver print, mounted on Masonite. negative 1946,
print later
Image: 30 x 40 in. (76.2 x 101.6 cm.)
Mount: same as image size
Acquired from: gift of the photographer

*2635. **STORM FROM LA BAJADA HILL, NEW MEXICO**
(P1979.95.96) duplicate of P1978.85.1
Gelatin silver print. negative 1946, print later
Image: 16½ x 20¹¹⁄₁₆ in. (41.8 x 52.5 cm.)
Sheet: 18⅜ x 23¹³⁄₁₆ in. (46.6 x 60.5 cm.)
Mount: 20 x 24 in. (50.8 x 61.0 cm.)
Signed, l.r. old overmat recto: "Laura Gilpin/1946"

Inscription, mount verso: "STORM FROM LA BAJADA
HILL, N.M./1946" typed on printed paper label "LG/
A PHOTOGRAPH BY/LAURA GILPIN/SANTA FE,
NEW MEXICO"
old overmat recto: printed title and date
Acquired from: gift of the photographer

2636. **STORM FROM LA BAJADA, NEW MEXICO** (P1979.71)
Gelatin silver print. 1946
Image: 15 ½ x 19 ⅜ in. (39.4 x 49.2 cm.)
Sheet: 16 x 19 ⅞ in. (40.6 x 50.5 cm.)
Acquired from: the photographer

*2637. **A STRING OF PEPPERS** (P1979.95.32)
Platinum print. 1921
Image: 7 ½ x 9 ⅜ in. (19.0 x 23.8 cm.)
Signed, l.r. overmat recto: "Laura Gilpin/1921"
Inscription, print verso: "A String of Peppers/by/Laura
Gilpin/Colo Springs/1921.//Made at San Ildefonso"
mat backing verso: "#11" and "A PLATINUM PRINT/A
STRING OF PEPPERS/1921" typed on printed paper label
"LG/ A PHOTOGRAPH BY/LAURA GILPIN/SANTA
FE, NEW MEXICO"
overmat recto: printed title, date, and medium
Acquired from: gift of the photographer

2626

2638. **THE SUMMER HOGAN [The Cove, Arizona]** (P1968.48.6)
duplicate of P1979.95.78
Gelatin silver print. negative 1934, print 1967
Image: 15 ½ x 19 ⁵⁄₁₆ in. (39.4 x 49.1 cm.)
Mount: same as image size
Inscription, mount verso: "THE SUMMER HOGAN/
Negative made in 1934/Print made in k967 [sic]/Fron [sic]
The Enduring Navaho/University of Texas Prdss [sic]/1968"
typed on printed paper label "LG/ A PHOTOGRAPH BY/
LAURA GILPIN/SANTA FE, NEW MEXICO"
Acquired from: the photographer

2639. **THE SUMMER HOGAN OF OLD LADY LONG SALT**
[A Navaho Summer Hogan] (P1968.48.11) duplicate of
P1979.95.21
Gelatin silver print. negative 1953, print 1967
Image: 15 ½ x 19 ⅜ in. (39.4 x 49.2 cm.)
Mount: same as image size
Inscription, mount verso: "THE SUMMER HOGAN OF
OLD LADY/LONG SALT./Negative made in 1954 [sic]/
Print made in 1967/From The Enduring Navaho/University
of Texas Press./1968" typed on printed paper label "LG/
A PHOTOGRAPH BY/LAURA GILPIN/SANTA FE,
NEW MEXICO"
Acquired from: the photographer

2630

2640. **SUMMIT OF SHIPROCK, NEW MEXICO** (P1979.95.67)
Type C color print. 1974
Image: 8 x 10 in. (20.3 x 25.4 cm.)
Mount: 14 x 17 in. (35.6 x 43.2 cm.)
Signed, l.r. overmat recto: "Laura Gilpin/1973 [sic]"
Inscription, mount verso: "#93" and "SUMMIT OF
SHIPROCK, NEW MEXICO/1973 [sic]" typed on printed
paper label "LG/ A PHOTOGRAPH BY/LAURA GILPIN/
SANTA FE, NEW MEXICO"
overmat recto: printed title and [incorrect] date
Acquired from: gift of the photographer

*2641. **SUNBURST, KUKULCAN, CHICHÉN ITZÁ, YUCATÁN**
[Sunburst, the Castillo, Chichén Itzá] (P1979.95.13)
Silver bromide print on Gevaluxe paper. 1932
Image: 14 x 10 in. (35.6 x 25.4 cm.)
Sheet: 14 x 11 in. (35.6 x 28.0 cm.)
Signed, l.r. old overmat recto: "Laura Gilpin/1932"
Inscription, print verso: "#35/13 ⅜ x 9 ¼"
old overmat recto: printed title and date
old mat backing verso: "35" and photographer's label with
title and date
Acquired from: gift of the photographer

2632

2642. **SUNLIGHT AND SILENCE** [The Spirit of the Prairie]
(P1978.84.1) duplicate of P1977.64.2
Platinum print. 1921
Image: 7 3/16 x 9 3/8 in. (18.3 x 23.8 cm.)
Signed, u.l. print verso: "Laura Gilpin"
Inscription, print verso: "Sunlight and Silence/by/[signature]/
Colorado Springs. Colo.//To Gertrude Käsebier/Aug 13.
1921"
Acquired from: gift of the photographer

* 2643. **SUNRISE FROM LUKACHUKAI MOUNTAINS,
ARIZONA** [Shiprock from Mountains, Sunrise]
(P1979.95.19)
Gelatin silver print. negative 1934, print later
Image: 10 1/2 x 13 1/4 in. (26.7 x 33.6 cm.)
Sheet: 11 x 13 15/16 in. (28.0 x 35.4 cm.)
Mount: 16 x 20 1/16 in. (40.6 x 50.9 cm.)
Signed, l.r. old overmat recto: "Laura Gilpin/1934"
Inscription, mount verso: "#50" and "SUNRISE FROM
LUKACHUKAI MOUNTAINS/1934" typed on printed
paper label "LG/ A PHOTOGRAPH BY/LAURA GILPIN/
SANTA FE, NEW MEXICO"
old overmat recto: printed title and date
Acquired from: gift of the photographer

2644. **SUNRISE, GRAND CANYON** [Point Imperial (Sunrise),
North Rim] (P1979.95.60)
Platinum print. 1930
Image: 9 1/2 x 7 11/16 in. (24.2 x 19.5 cm.)
Sheet: 9 3/4 x 7 13/16 in. (24.8 x 19.9 cm.)
Signed, l.r. overmat recto: "Laura Gilpin/1930"
Inscription, mat backing verso: "#23" and "A PLATINUM
PRINT/SUNRISE, GRAND CANYON/1930" typed on
printed paper label "LG/ A PHOTOGRAPH BY/LAURA
GILPIN/SANTA FE, NEW MEXICO"
overmat recto: printed title, date, and medium
Acquired from: gift of the photographer

* 2645. **SUNRISE ON THE DESERT** [Desert near Questa]
(P1979.95.59)
Platinum print. 1921
Image: 7 1/4 x 9 1/4 in. (19.6 x 23.5 cm.)
Sheet: 7 7/8 x 9 13/16 in. (20.0 x 25.0 cm.)
Signed, l.r. old overmat recto: "Laura Gilpin/1924 [sic]"
Inscription, print verso: "Sunrise on the Desert/1921"
old mat backing verso: "#18" and "A PLATINUM
PRINT/SUNRISE ON THE DESERT/1924 [sic]" typed
on printed paper label "LG/A PHOTOGRAPH BY/
LAURA GILPIN/SANTA FE, NEW MEXICO"
old overmat recto: printed title, medium, and [incorrect]
date
Acquired from: gift of the photographer

2646. **TAOS OVENS, NEW MEXICO** [Indian Ovens, Taos, N.M.]
(P1979.95.29)
Platinum print. 1923
Image: 8 3/4 x 6 3/4 in. (22.2 x 17.2 cm.)
Signed, l.r. old overmat recto: "Laura Gilpin/1923"
Inscription, print verso: "Indian Ovens/Taos, N.M/1923"
old mat backing verso: "#13" and "A PLATINUM
PRINT/TAOS OVENS, NEW MEXICO/1923" typed
on printed paper label "LG/ A PHOTOGRAPH BY/
LAURA GILPIN/SANTA FE, NEW MEXICO"
old overmat recto: printed title, date, and medium
Acquired from: gift of the photographer

2647. **TAOS PUEBLO INDIAN** (P1978.92.16)
Platinum print. 1924
Image: 9 1/8 x 7 5/16 in. (23.8 x 18.6 cm.)
Sheet: 9 11/16 x 7 9/16 in. (24.6 x 19.2 cm.)
Signed, l.r. overmat recto: "Laura Gilpin/1924"
Inscription, mat backing verso: "#104" and "TAOS
PUEBLO INDIAN/1924" typed on printed paper
label "LG/ A PHOTOGRAPH BY/LAURA GILPIN/
SANTA FE, NEW MEXICO"
overmat recto: printed title and date
Acquired from: gift of the photographer

* 2648. **THE T. B. CLINIC** (P1979.95.63)
Platinum print. 1924
Image: 7 5/8 x 9 5/8 in. (19.3 x 24.4 cm.)
Sheet: 7 15/16 x 9 13/16 in. (20.0 x 24.9 cm.)
Signed, l.r. overmat recto: "Laura Gilpin/1924"
Inscription, mat backing verso: "#19" and "A PLATINUM
PRINT/THE T. B. CLINIC/1924" typed on printed paper
label "LG/A PHOTOGRAPH BY/LAURA GILPIN/
SANTA FE, NEW MEXICO"
overmat recto: printed title, date, and medium
Acquired from: gift of the photographer

2649. **TEMPLE OF KUKULCAN FROM THE DANCE
PLATFORM, CHICHÉN ITZÁ, YUCATÁN** (P1978.92.9)
Gelatin silver print. 1946
Image: 10 7/8 x 13 13/16 in. (27.6 x 35.1 cm.)
Sheet: 11 x 13 15/16 in. (28.0 x 35.4 cm.)
Mount: 16 x 20 in. (40.7 x 50.8 cm.)
Signed, l.r. overmat recto: "Laura Gilpin/1946"
Inscription, mount verso: "128" and "TEMPLE OF
KUKULCAN FROM THE/DANCE PLATFORM,/
CHICHEN ITZA, YUCATAN/1946" typed on printed
paper label "LG/ A PHOTOGRAPH BY/LAURA GILPIN/
SANTA FE, NEW MEXICO"
overmat recto: printed title and date
Acquired from: gift of the photographer

2650. **TEMPLE OF THE THREE LINTELS, CHICHÉN ITZÁ,
YUCATÁN** (P1979.95.92)
Gelatin silver print. 1932
Image: 19 5/16 x 14 1/4 in. (49.0 x 36.1 cm.)
Mount: 20 1/16 x 16 in. (50.9 x 40.7 cm.)
Signed, l.r. overmat recto and l.r. mount recto: "Laura
Gilpin/1932"
Inscription, mount verso: "#32" and "TEMPLE OF THE
~~TWO~~ THREE LINTELS/CHICHEN ITZA.
YUCATAN/1932/from TEMPLES IN YUCATAN/
HASTINGS HOUSE. PUB. 1948" typed on printed paper
label "LG/ A PHOTOGRAPH BY/LAURA GILPIN/
SANTA FE, NEW MEXICO"
overmat recto: printed title and date
Acquired from: gift of the photographer

2651. **TEMPLE STAIRWAY, KUKULCAN, CHICHÉN ITZÁ,
YUCATÁN** [Steps of the Castillo, Chichén Itzá]
(P1979.95.12) duplicate of P1964.129
Gelatin silver print. 1932
Image: 13 1/2 x 9 9/16 in. (34.3 x 24.3 cm.)
Sheet: 14 x 11 in. (35.6 x 28.0 cm.)
Mount: 20 x 16 in. (50.8 x 40.6 cm.)
Signed, l.r. overmat recto: "Laura Gilpin/1932"
Inscription, overmat verso: "YUCATAN 32"
mount recto: "YUCATAN 32"
mount verso: "#34" and "TEMPLE STAIRWAY,
CHICHEN ITZA,/YUCATAN/1932" typed on printed
paper label "LG/ A PHOTOGRAPH BY/LAURA GILPIN/
SANTA FE, NEW MEXICO"
overmat recto: printed title and date
Acquired from: gift of the photographer

* 2652. **THE TEXAS SKY LINE, BIG BEND AREA** [Prairie Sky,
Texas] (P1975.141.3) duplicate of P1979.95.16 and P1987.18
Gelatin silver print. negative 1946, print 1975
Image: 19 3/8 x 15 9/16 in. (49.2 x 39.5 cm.)
Sheet: 19 5/8 x 16 in. (49.8 x 40.7 cm.)
Mount: 24 x 20 in. (61.0 x 50.8 cm.)
Signed, l.r. overmat recto: "Laura Gilpin/1946"
Inscription, mount verso: "THE TEXAS SKY LINE/BIG
BEND AREA/1946/from The Rio Grande. Duell, Sloan
& Pearce Pub." typed on printed paper label "LG/ A
PHOTOGRAPH BY/LAURA GILPIN/SANTA FE,
NEW MEXICO"
Acquired from: the photographer

2635

2637

2641

2643

2645

2648

2653. **TEXAS SKYLINE [Prairie Sky, Texas]** (P1987.18) duplicate of P1975.141.3 and P1979.95.16
Gelatin silver print. negative 1946, print 1978–79 by Mary Peck
Image: 13 7/16 x 10 9/16 in. (34.2 x 26.8 cm.)
Sheet: 14 x 11 1/16 in. (35.5 x 28.0 cm.)
Mount: 20 x 16 1/8 in. (50.8 x 40.9 cm.)
Signed, l.r. sheet recto: "1946 Laura Gilpin"
l.r. overmat recto: "Laura Gilpin/1946"
Inscription, mount verso: "TEXAS SKYLINE 1946" typed on printed paper label "LG/ PHOTOGRAPHS/BY LAURA GILPIN/409 CAMINO DEL MONTE SOL/SANTA FE, NEW MEXICO 87501"
Acquired from: gift of Paul Brauchle, Dallas, Texas

2654. **THE THUNDER CLOUD FROM SHORT LINE ROAD OVERLOOKING COLO. SPRINGS** (P1978.84.25)
Platinum print. 1929
Image: 7 5/16 x 9 5/16 in. (18.5 x 23.6 cm.)
Mount: 7 7/16 x 9 7/16 in. (18.9 x 24.0 cm.)
Inscription, mount verso: "The Thunder Cloud/from Short Line Road/overlooking Colo. Springs/1929"
Acquired from: gift of the photographer

2655. **TWO NAVAHO WOMEN** (P1968.48.8)
Gelatin silver print. negative 1953, print 1968
Image: 19 3/8 x 15 9/16 in. (49.1 x 39.4 cm.)
Mount: same as image size
Inscription, mount verso: "TWO NAVAHO WOMEN/Negative made in 1953/Print made in 1968/From The Enduring Navaho/University of Texas Press./1968" typed on printed paper label "LG/A PHOTOGRAPH BY/LAURA GILPIN/SANTA FE, NEW MEXICO"
Acquired from: the photographer

2656. **TYING A CHONGO, NAVAHO [Hand Study, Emma Yazzie Tying Hair, Chaco Area]** (P1979.95.75)
Gelatin silver print. 1954
Image: 7 5/8 x 9 3/4 in. (19.3 x 24.8 cm.)
Mount: 14 x 16 15/16 in. (35.6 x 43.0 cm.)
Signed, l.r. overmat recto and l.r. mount recto: "Laura Gilpin/1954"
Inscription, mount verso: "84" and "TYING A CHONGO/1954/from THE ENDURING NAVAHO/UNIVERSITY OF TEXAS PRESS. PUB." typed on printed paper label "LG/ A PHOTOGRAPH BY/LAURA GILPIN/SANTA FE, NEW MEXICO" and rubber stamp "PROPERTY OF/CENTER FOR ARTS OF INDIAN AMERICA/WASHINGTON D. C."
overmat recto: printed title and date
Acquired from: gift of the photographer

2657. **UNA HANBURY** (P1978.92.53)
Gelatin silver print. 1972
Image: 9 11/16 x 7 5/8 in. (24.6 x 19.4 cm.)
Mount: 14 x 11 in. (35.6 x 28.0 cm.)
Signed, l.r. overmat recto and l.r. mount recto: "Laura Gilpin/1972"
Inscription, mat backing verso: "18" and "UNA HANBURY 1972" typed on printed paper label "LG/ A PHOTOGRAPH BY/LAURA GILPIN/SANTA FE, NEW MEXICO"
overmat recto: printed title and date
Acquired from: gift of the photographer

2658. **THE UTE WOMAN** (P1968.48.5)
Gelatin silver print. negative 1934, print 1968
Image: 19 3/16 x 15 in. (48.7 x 38.0 cm.)
Mount: same as image size
Inscription, mount verso: "THE UTE WOMAN/Negative made in 1934/Print made in 1968/From The Enduring Navaho/University of Texas Press/1968" typed on printed paper label "LG/ A PHOTOGRAPH BY/LAURA GILPIN/SANTA FE, NEW MEXICO"
Acquired from: the photographer

*2659. **A VISITING NURSE [The New Baby]** (P1976.158.4)
duplicate of P1979.95.62
Platinum print. 1924
Image: 7 13/16 x 9 5/8 in. (19.8 x 24.4 cm.)
Signed, l.r. overmat recto: "Laura Gilpin/1924"
Inscription, mat backing verso: "24" and "A VISITING NURSE/1924/A PLATINUM PRINT" typed on printed paper label "LG/ A PHOTOGRAPH BY/LAURA GILPIN/SANTA FE, NEW MEXICO"
Acquired from: the photographer

2660. **A VISITING NURSE [The New Baby]** (P1979.95.62)
duplicate of P1976.158.4
Platinum print. 1924
Image: 7 5/8 x 9 3/4 in. (19.4 x 24.8 cm.)
Signed, l.r. old overmat recto: "Laura Gilpin/1924"
Inscription, old mat backing verso: "#16" and "A PLATINUM PRINT/A VISITING NURSE/1924" typed on printed paper label "LG/ A PHOTOGRAPH BY/LAURA GILPIN/SANTA FE, NEW MEXICO"
old overmat recto: printed title, date, and medium
Acquired from: gift of the photographer

2661. **WARREN AND LYDIA CHAPPELL** (P1978.92.25)
Platinum print. c. 1937–40
Image: 9 9/16 x 7 1/2 in. (24.3 x 19.1 cm.)
Mount: 14 x 11 in. (35.6 x 28.0 cm.)
Signed, l.r. overmat recto and l.r. mount recto: "Laura Gilpin/1937"
Inscription, mat backing verso: "#118" and "A PLATINUM PRINT/WARREN AND LYDIA CHAPPELL/1937" typed on printed paper label "LG/ A PHOTOGRAPH BY/LAURA GILPIN/SANTA FE, NEW MEXICO"
overmat recto: printed title, date, and medium
Acquired from: gift of the photographer

*2662. **WASHINGTON SQUARE, NEW YORK** (P1979.95.33)
Platinum print. 1916
Image: 8 x 6 1/16 in. (20.4 x 15.4 cm.)
Signed, l.r. old overmat recto: "Laura Gilpin/1916"
Inscription, old mat backing verso: "A PLATINUM PRINT./WASHINGTON SQUARE, NEW YORK/1916" typed on printed paper label "LG/ A PHOTOGRAPH BY/LAURA GILPIN/SANTA FE, NEW MEXICO"
old overmat recto: printed title, date, and medium
Acquired from: gift of the photographer

2663. **WHITE SANDS #3, NEW MEXICO** (P1979.95.49)
Gelatin silver print. negative 1947, print later
Image: 7 1/2 x 9 1/2 in. (19.1 x 24.1 cm.)
Sheet: 8 x 9 15/16 in. (20.3 x 25.3 cm.)
Mount: 14 x 17 in. (35.6 x 43.2 cm.)
Signed, l.r. old overmat recto: "Laura Gilpin/1945 [sic]"
Inscription, mount verso: "#61" and "WHITE SANDS #3, NEW MEXICO/1945 [sic]" typed on printed paper label "LG/ A PHOTOGRAPH BY/LAURA GILPIN/SANTA FE, NEW MEXICO"
old overmat recto: printed title and [incorrect] date
Acquired from: gift of the photographer

2664. **WILLIAM FLETCHER** (P1978.92.52)
Gelatin silver print. 1972
Image: 9 5/8 x 7 5/8 in. (24.4 x 19.4 cm.)
Sheet: 10 x 8 in. (25.4 x 20.3 cm.)
Mount: 17 x 14 in. (43.2 x 35.6 cm.)
Signed, l.r. overmat recto: "Laura Gilpin/1972"
Inscription, mount verso: "19" and "WILLIAM FLETCHER 1972" typed on printed paper label "LG/ A PHOTOGRAPH BY/LAURA GILPIN/SANTA FE, NEW MEXICO"
overmat recto: printed title and date
Acquired from: gift of the photographer

2665. **THE WINFIELD SCOTT FAMILY** (P1978.92.47)
Gelatin silver print. 1961
Image: 7 1/4 x 9 1/4 in. (18.4 x 23.5 cm.)
Sheet: 8 1/16 x 10 in. (20.5 x 25.4 cm.)
Mount: 14 x 17 in. (35.6 x 43.2 cm.)

Signed, l.r. overmat recto: "Laura Gilpin/1961"
Inscription, mount verso: "15" and "THE WINFIELD
 SCOTT FAMILY/1961" typed on printed paper label "LG/
 A PHOTOGRAPH BY/LAURA GILPIN/SANTA FE,
 NEW MEXICO"
 overmat recto: printed title and date
Acquired from: gift of the photographer

2652

2666. **ZION CANYON** (P1979.44.6)
Platinum print. 1930
Image: 9 ⁷⁄₁₆ x 7 ½ in. (24.1 x 19.1 cm.)
Sheet: 9 ¼ x 7 ⅞ in. (24.5 x 20.0 cm.)
Signed, l.r. overmat recto: "Laura Gilpin/1930"
Inscription, print verso: "Zion National Park"
 overmat verso: "Gilpin/Zion/75"
 mat backing verso: "8589//A Platinum Print." and "ZION
 CANYON 1930" typed on printed paper label "LG/ A
 PHOTOGRAPH BY/LAURA GILPIN/SANTA FE,
 NEW MEXICO"
Acquired from: the photographer

FRANK WILLIAM GOHLKE,
American (b. 1942)

Gohlke, a native of Wichita Falls, Texas, studied
English literature in college and did not begin to photo-
graph seriously until his third year of graduate study
at Yale, when Walker Evans saw his work and gave
encouragement. He studied with Paul Caponigro in
1967–68, a relationship that had a profound technical
and emotional impact on his work. Gohlke moved to
Minnesota in 1971 where, freed from what he calls the
"lush beauty" of the eastern landscape, he made photo-
graphs of the man-made environment that capture a
personal sense of place. Best known for his series of
grain elevator photographs, Gohlke also worked on
the Seagram Corporation courthouse project and made
a series of views of the aftermath of the eruption of
Mount Saint Helens. He has taught photography at the
high school level in Minneapolis, in various college and
workshop settings, and in the graduate program in pho-
tography at Yale.

2659

*2667. **THE BACKYARD OF MY PARENTS' HOME, 2201
 WENONAH, WICHITA FALLS, TEXAS [from
 "Contemporary Texas: A Photographic Portrait"]**
 (P1985.17.71)
Gelatin silver print. 1984
Image: 14 ½ x 17 ⅞ in. (36.8 x 45.4 cm.)
Sheet: 16 x 19 ¹⁵⁄₁₆ in. (40.7 x 50.7 cm.)
Signed, l.r. print verso: "Frank Gohlke 1984"
Inscription, print recto: "The backyard of my parents'
 home—2201 Wenonah, Wichita Falls, Texas 1984"
 print verso: "1//P684-2-1"
Acquired from: gift of the Texas Historical Foundation with
 support from a major grant from the Du Pont Company
 and Conoco, its energy subsidiary, and assistance from
 the Texas Commission on the Arts and the National
 Endowment for the Arts

2668. **CEDAR TREES (MARKING FORMER HOUSE SITE)
 ON KELL BLVD. MEDIAN, WICHITA FALLS, TEXAS
 [from "Contemporary Texas: A Photographic Portrait"]**
 (P1985.17.73)
Gelatin silver print. 1984
Image: 14 ⁷⁄₁₆ x 17 ⅞ in. (36.7 x 45.4 cm.)
Sheet: 16 x 19 ¹⁵⁄₁₆ in. (40.7 x 50.7 cm.)
Signed, l.r. print verso: "Frank Gohlke 1984"
Inscription, print recto: "Cedar trees (marking former house site)
 on Kell Blvd. median—Wichita Falls, Texas 1984"
 print verso: "3//684-4"
Acquired from: gift of the Texas Historical Foundation with
 support from a major grant from the Du Pont Company
 and Conoco, its energy subsidiary, and assistance from
 the Texas Commission on the Arts and the National
 Endowment for the Arts

2662

2669. **CORRUGATED SHED—WICHITA FALLS, TEX.**
(P1974.7.8)
Gelatin silver print. 1974
Image: 8 1/16 x 7 15/16 in. (20.5 x 20.2 cm.) irregular
Sheet: 13 15/16 x 10 15/16 in. (35.4 x 27.8 cm.)
Signed, l.r. print verso and l.r. overmat recto: "Frank W. Gohlke 1974"
Inscription, overmat recto: "Corrugated Shed—Wichita Falls, Tex."
print verso: "Corrugated Shed—Wichita Falls, Tex.//191 72//#2f16th/ 12/10/12/14/2 ½"
Acquired from: the photographer

2670. **DENTON COUNTY COURTHOUSE, DENTON, TEXAS, W. C. DODSON, ARCHITECT, 1895–6** (P1977.48.4)
Gelatin silver print. 1976–77
Image: 9 7/16 x 11 7/8 in. (24.0 x 30.1 cm.)
Sheet: 11 x 13 15/16 in. (28.0 x 35.4 cm.)
Signed, l.r. print verso: "Frank W. Gohlke 1976/77"
Inscription, print verso: "Denton County Courthouse, Denton, Texas/W. C. Dodson, Architect 1895–6// Photograph commissioned by the Seagram's Corp, NYC// Tex—Dent 3"
Acquired from: the photographer

*2671. **EDGE OF THUNDERSTORM LOOKING SOUTH NEAR DEAN, TEXAS [from "Contemporary Texas: A Photographic Portrait"]** (P1985.17.80)
Gelatin silver print. negative 1982, print 1984
Image: 14 7/16 x 17 7/8 in. (36.7 x 45.4 cm.)
Sheet: 16 x 19 15/16 in. (40.7 x 50.7 cm.)
Signed, l.r. print verso: "Frank Gohlke 1984"
Inscription, print recto: "Edge of a thunderstorm—looking south near Dean, Texas 1982"
print verso: "10//1082-53"
Acquired from: gift of the Texas Historical Foundation with support from a major grant from the Du Pont Company and Conoco, its energy subsidiary, and assistance from the Texas Commission on the Arts and the National Endowment for the Arts

2672. **FLOUR MILL. KINGFISHER, OKLA.** (P1975.143.3)
Gelatin silver print. negative 1973, print 1974
Image: 13 ½ x 13 5/16 in. (34.3 x 33.8 cm.) irregular
Sheet: 19 7/8 x 15 7/8 in. (50.4 x 40.3 cm.)
Signed, l.r. print verso: "Frank W. Gohlke 1974"
Inscription, print verso: "Flour Mill. Kingfisher, Okla. 1973//11-290-73//#2 + 11/14/12/+2/16 12 8 12/10/12 10 12/ 2 ⅓–3"
Acquired from: Light Gallery, New York, New York

2673. **GRAIN ELEVATOR—FT. WORTH, TEXAS** (P1975.143.1)
Gelatin silver print. negative 1974, print 1975
Image: 9 ½ x 9 ½ in. (24.2 x 24.2 cm.)
Sheet: 13 7/8 x 10 15/16 in. (35.3 x 27.8 cm.)
Signed, l.r. print verso: "Frank W. Gohlke 1975"
Inscription, print verso: "93 + 93//Grain elevator— Ft. Worth, Texas 1974//4-355-74"
Acquired from: Light Gallery, New York, New York

2674. **GRAIN ELEVATOR—LAKE CITY, WISC.** (P1974.7.5)
Gelatin silver print. negative 1973, print 1974
Image: 8 x 7 15/16 in. (20.3 x 20.2 cm.) irregular
Sheet: 13 15/16 x 10 15/16 in. (35.4 x 27.8 cm.)
Signed, l.r. print verso: "Frank W. Gohlke 1974"
Inscription, print verso: "Grain Elevator—Lake City, Wisc.//248-73//#2 + 22 +/16/14/2 ½"
Acquired from: the photographer

2675. **GRAIN ELEVATORS AND IRRIGATION EQUIPMENT—WOODWARD, OKLA.** (P1975.143.2)
Gelatin silver print. negative 1973, print 1974
Image: 13 ½ x 13 3/8 in. (34.3 x 34.0 cm.)
Sheet: 19 7/8 x 15 7/8 in. (50.4 x 40.3 cm.)
Signed, l.r. print verso: "Frank W. Gohlke 1974"
Inscription, print verso: "Grain Elevators and Irrigation Equipment—Woodward, Okla. 1973//2-298-73 #2 f8/18/16/12 16/18/10/12/1¼"
Acquired from: Light Gallery, New York, New York

2676. **GRAIN ELEVATORS—MINNEAPOLIS—I,11** (P1974.7.1)
Gelatin silver print. 1973
Image: 7 7/8 x 7 3/4 in. (20.0 x 19.7 cm.) irregular
Sheet: 13 15/16 x 10 15/16 in. (35.4 x 27.8 cm.)
Signed, l.r. print verso and l.r. overmat recto: "Frank W. Gohlke 1973"
Inscription, overmat recto: "Grain Elevators— Minneapolis—I,11"
print verso: "Grain Elevators—Minneapolis—I,11//178- 72//#1 f11/16 14 8 12/12/2"
Acquired from: the photographer

2677. **GRAIN ELEVATORS—MINNEAPOLIS—I,15** (P1974.7.2)
Gelatin silver print. 1972
Image: 8 ¼ x 8 1/8 in. (20.9 x 20.6 cm.) irregular
Sheet: 13 15/16 x 10 15/16 in. (35.4 x 27.8 cm.)
Signed, l.r. print verso and l.r. overmat recto: "Frank W. Gohlke 1972"
Inscription, overmat recto: "Grain Elevators— Minneapolis—I,15"
print verso: "Grain Elevators—Minneapolis—I,15//144-72"
Acquired from: the photographer

2678. **GRAIN ELEVATORS—MINNEAPOLIS—I,24** (P1974.7.3)
Gelatin silver print. negative 1972, print 1973
Image: 8 x 7 3/4 in. (20.3 x 19.7 cm.) irregular
Sheet: 13 15/16 x 10 15/16 in. (35.4 x 27.8 cm.)
Signed, l.r. print verso and l.r. overmat recto: "Frank W. Gohlke 1973"
Inscription, overmat recto: "Grain Elevators, Minneapolis—I,24"
print verso: "Grain Elevators, Minneapolis—I,24//179- 72//#2 f16/10/2 1/32—3"
Acquired from: the photographer

*2679. **GRAIN ELEVATORS—MINNEAPOLIS—I,25** (P1974.7.4)
Gelatin silver print. negative 1972, print 1973
Image: 8 ¼ x 8 1/8 in. (20.9 x 20.6 cm.) irregular
Sheet: 13 15/16 x 10 15/16 in. (35.4 x 27.8 cm.)
Signed, l.r. print verso and l.r. overmat recto: "Frank W. Gohlke 1973"
Inscription, overmat recto: "Grain Elevators— Minneapolis—I,25"
print verso: "Grain Elevators—Minneapolis—I,25//179-72// MAM/#2 f16/6/2 ½"
Acquired from: the photographer

2680. **LANDSCAPE—ALBUQUERQUE, N.M.** (P1974.7.7)
Gelatin silver print. negative 1973, print 1974
Image: 8 1/8 x 8 in. (20.6 x 20.3 cm.) irregular
Sheet: 13 15/16 x 10 15/16 in. (35.4 x 27.8 cm.)
Signed, l.r. print verso and l.r. overmat recto: "Frank W. Gohlke 1974"
Inscription, overmat recto: "Landscape—Albuquerque, N.M."
print verso: "Landscape—Albuquerque, N.M.//231- 73//#3 + 8/28 24 [illegible]/20/16 14/18/4"
Acquired from: the photographer

2681. **LOOKING SOUTH ACROSS THE RED RIVER NEAR BYERS, TEXAS [from "Contemporary Texas: A Photographic Portrait"]** (P1985.17.75)
Gelatin silver print. 1984
Image: 14 7/16 x 17 7/8 in. (36.7 x 45.4 cm.)
Sheet: 16 x 19 15/16 in. (40.7 x 50.7 cm.)
Signed, l.r. print verso: "Frank Gohlke 1984"
Inscription, print recto: "Looking south across the Red River—near Byers, Texas 1984"
print verso: "5//P 684-22-5"
Acquired from: gift of the Texas Historical Foundation with support from a major grant from the Du Pont Company and Conoco, its energy subsidiary, and assistance from the Texas Commission on the Arts and the National Endowment for the Arts

* 2682. **PARKER COUNTY COURTHOUSE, WEATHERFORD, TEXAS, DODSON & DUDLEY, ARCHITECTS, 1884–86** (P1977.48.5)
Gelatin silver print. 1976–77
Image: 9½ x 11¼ in. (24.1 x 29.8 cm.)
Sheet: 11 x 13 ¹⁵⁄₁₆ in. (28.0 x 35.4 cm.)
Signed, l.r. print verso: "Frank W. Gohlke 1976/77"
Inscription, print verso: "Parker County Courthouse, Weatherford, Tex./Dodson & Dudley, Architects/1884–86// Photograph commissioned by the Seagram's Corp., NYC// Tex—Park 6"
Acquired from: the photographer

2667

* 2683. **PLAYGROUND OF DAVID CROCKETT ELEMENTARY SCHOOL, WHERE I ATTENDED GRADES 1–7, WICHITA FALLS, TEXAS** [from "Contemporary Texas: A Photographic Portrait"] (P1985.17.72)
Gelatin silver print. 1984
Image: 14 ⁷⁄₁₆ x 17 ⁷⁄₈ in. (36.7 x 45.4 cm.)
Sheet: 16 x 19 ¹⁵⁄₁₆ in. (40.7 x 50.7 cm.)
Signed, l.r. print verso: "Frank Gohlke 1984"
Inscription, print recto: "Playground of David Crockett Elementary School, where I attended grades 1–7—Wichita Falls, Texas 1984"
print verso: "2//684-33"
Acquired from: gift of the Texas Historical Foundation with support from a major grant from the Du Pont Company and Conoco, its energy subsidiary, and assistance from the Texas Commission on the Arts and the National Endowment for the Arts

2684. **ROAD CUT, SANDSTONE STRATA LOOKING NORTH ACROSS RED RIVER VALLEY, NEAR PETROLIA, TEXAS. (MY GRANDFATHER'S EARLY VENTURES IN THE OIL BUSINESS WERE LOCATED NEAR HERE.)** [from "Contemporary Texas: A Photographic Portrait"] (P1985.17.76)
Gelatin silver print. 1984
Image: 14 ⁷⁄₁₆ x 17 ⁷⁄₈ in. (36.7 x 45.4 cm.)
Sheet: 16 x 19 ¹⁵⁄₁₆ in. (40.7 x 50.7 cm.)
Signed, l.r. print verso: "Frank Gohlke 1984"
Inscription, print recto: "Road cut, sandstone strata—looking north across Red River Valley, near Petrolia, Texas 1984 (my grandfather's early ventures in the oil business were near here.)"
print verso: "6//1084-24"
Acquired from: gift of the Texas Historical Foundation with support from a major grant from the Du Pont Company and Conoco, its energy subsidiary, and assistance from the Texas Commission on the Arts and the National Endowment for the Arts

2671

2685. **ROSS FAMILY RANCH HOUSE NEAR JOLLY, TEXAS, WHERE MY MOTHER SPENT PART OF HER CHILDHOOD (1919–1924)** [from "Contemporary Texas: A Photographic Portrait"] (P1985.17.77)
Gelatin silver print. 1984
Image: 14 ⁷⁄₁₆ x 17 ⁷⁄₈ in. (36.7 x 45.4 cm.)
Sheet: 16 x 19 ¹⁵⁄₁₆ in. (40.7 x 50.7 cm.)
Signed, l.r. print verso: "Frank Gohlke 1984"
Inscription, print recto: "Ross family ranch house near Jolly, Texas, where my mother spent part of her childhood (1919–1924)—1984"
print verso: "7//684-49"
Acquired from: gift of the Texas Historical Foundation with support from a major grant from the Du Pont Company and Conoco, its energy subsidiary, and assistance from the Texas Commission on the Arts and the National Endowment for the Arts

2679

2686. STORM CELLAR BEHIND THE (VANISHED)
FOREMAN'S HOUSE, ROSS FAMILY RANCH,
NEAR JOLLY, TEXAS [from "Contemporary Texas:
A Photographic Portrait"] (P1985.17.78)
Gelatin silver print. 1984
Image: 14 7/$_{16}$ x 17 7/$_8$ in. (36.7 x 45.4 cm.)
Sheet: 16 x 19 15/$_{16}$ in. (40.7 x 50.7 cm.)
Signed, l.r. print verso: "Frank Gohlke 1984"
Inscription, print recto: "Storm cellar behind the (vanished)
foreman's house—Ross family ranch, near Jolly, Texas
1984"
print verso: "8//684-41"
Acquired from: gift of the Texas Historical Foundation with
support from a major grant from the Du Pont Company
and Conoco, its energy subsidiary, and assistance from
the Texas Commission on the Arts and the National
Endowment for the Arts

2687. TARRANT COUNTY COURTHOUSE, FORT WORTH,
TEXAS, FREDERICK C. GUNN AND LOUIS CURTIS,
ARCHITECTS, 1893–95 (P1977.48.2)
Gelatin silver print. 1976–77
Image: 9 1/$_2$ x 11 13/$_{16}$ in. (24.1 x 30.0 cm.)
Sheet: 11 x 13 15/$_{16}$ in. (28.0 x 35.4 cm.)
Signed, l.r. print verso: "Frank W. Gohlke 1976/77"
Inscription, print verso: "Tarrant County Courthouse,
Fort Worth, Texas/Frederick C. Gunn and Louis Curtis,
Architects/1893–95//Photograph commissioned by the
Seagram's Corp., NYC//Tex—Tarr 10"
Acquired from: the photographer

2688. TARRANT COUNTY COURTHOUSE, FORT WORTH,
TEXAS, FREDERICK C. GUNN AND LOUIS CURTIS,
ARCHITECTS, 1893–95 (P1977.48.3)
Gelatin silver print. 1976–77
Image: 11 13/$_{16}$ x 9 7/$_{16}$ in. (30.0 x 24.0 cm.)
Sheet: 13 15/$_{16}$ x 11 in. (35.4 x 28.0 cm.)
Signed, l.r. print verso: "Frank W. Gohlke 1976/77"
Inscription, print verso: "Tarrant County Courthouse,
Fort Worth, Texas/Frederick C. Gunn & Louis Curtis,
Architects/1893–95//Photograph commissioned by the
Seagram's Corp., NYC//Tex—Tarr 7"
Acquired from: the photographer

*2689. WATER STORAGE TANK—RED WING, MINN.
(P1974.7.6)
Gelatin silver print. 1974
Image: 8 1/$_{16}$ x 7 15/$_{16}$ in. (20.5 x 20.2 cm.) irregular
Sheet: 13 15/$_{16}$ x 10 15/$_{16}$ in. (35.4 x 27.8 cm.)
Signed, l.r. print verso and l.r. overmat recto:
"Frank W. Gohlke 1974"
Inscription, overmat recto: "Water Storage Tank—Red Wing,
Minn."
print verso: "Water Storage Tank—Red Wing, Minn."
Acquired from: the photographer

2690. WICHITA RIVER, BETWEEN PETROLIA AND
CHARLIE, TEXAS [from "Contemporary Texas:
A Photographic Portrait"] (P1985.17.74)
Gelatin silver print. 1984
Image: 14 7/$_{16}$ x 17 7/$_8$ in. (36.7 x 45.4 cm.)
Sheet: 16 x 19 15/$_{16}$ in. (40.7 x 50.7 cm.)
Signed, l.r. print verso: "Frank Gohlke 1984"
Inscription, print recto: "Wichita River, between Petrolia and
Charlie, Texas 1984"
print verso: "4//P684-21-3"
Acquired from: gift of the Texas Historical Foundation with
support from a major grant from the Du Pont Company
and Conoco, its energy subsidiary, and assistance from
the Texas Commission on the Arts and the National
Endowment for the Arts

2691. WILLOW TREES BESIDE STOCK TANK NEAR LAKE
ARROWHEAD, OUTSIDE OF WICHITA FALLS,
TEXAS [from "Contemporary Texas: A Photographic
Portrait"] (P1985.17.79)
Gelatin silver print. 1984
Image: 14 7/$_{16}$ x 17 7/$_8$ in. (36.7 x 45.4 cm.)
Sheet: 16 x 19 15/$_{16}$ in. (40.7 x 50.7 cm.)
Signed, l.r. print verso: "Frank Gohlke 1984"
Inscription, print recto: "Willow trees beside stock tank—
near Lake Arrowhead, outside of Wichita Falls, Texas
1984"
print verso: "9//P684-27-9"
Acquired from: gift of the Texas Historical Foundation with
support from a major grant from the Du Pont Company
and Conoco, its energy subsidiary, and assistance from
the Texas Commission on the Arts and the National
Endowment for the Arts

2692. WISE COUNTY COURTHOUSE, DECATUR, TEXAS
(P1977.48.1)
Gelatin silver print. 1976–77
Image: 9 7/$_{16}$ x 11 7/$_8$ in. (23.9 x 30.1 cm.)
Sheet: 11 x 13 15/$_{16}$ in. (28.0 x 35.4 cm.)
Signed, l.r. sheet verso: "Frank W. Gohlke 1976/77"
Inscription, print verso: "Wise County Courthouse, Decatur,
Texas//Photograph commissioned by the Seagram's Corp.,
NYC//Tex—Wise 1"
Acquired from: the photographer

2693. YOUNG TREES, KILLED BY HEAT AND DOWNED BY
BLAST—VALLEY OF HOFFSTADT CREEK, 13 MILES
NW OF MT. ST. HELENS, WASH. (P1986.37)
Gelatin silver print. negative 1981, print 1984
Image: 18 x 22 1/$_4$ in. (45.8 x 56.5 cm.)
Sheet: 20 x 23 7/$_8$ in. (50.8 x 60.7 cm.)
Signed, l.r. sheet verso: "Frank Gohlke 1984"
Inscription, sheet recto: "Young trees, killed by heat and
downed by blast—valley of Hoffstadt Creek, 13 miles NW
of Mt. St. Helens, Wash. 1981"
print verso: "(JC)//3b//781-100"
Acquired from: the photographer

JOHN C. H. GRABILL (active c. 1886–91)

Little is known about Grabill before he arrived in
South Dakota Territory in 1886, but the fact that he
immediately went to work as a photographer suggests
that it was a previously acquired skill. Grabill pho-
tographed not only the frontier landscape but also
those who were "civilizing" the West and the Indians
who were being pushed aside. He made views at the
Pine Ridge Agency at Wounded Knee, South Dakota,
only days after the 1890 massacre. Most of his images
are carefully titled and copyrighted, but the informa-
tion on the prints is frequently the only clue left to
trace his work. Prints indicate that in addition to
studios in Deadwood and Lead City, South Dakota,
Grabill also operated a studio in Colorado and either
operated or had a publishing arrangement with the
Grabill Chicago Portrait and View Company.

2694. "CROW DOG" AND FAMILY AT HOME (P1975.191.2)
Albumen silver print. 1891
Image: 9 3/$_4$ x 12 13/$_{16}$ in. (24.7 x 32.5 cm.)
Mount: 10 7/$_8$ x 13 7/$_{16}$ in. (27.6 x 34.2 cm.)
Signed: see inscription
Inscription, in negative: "Photo and copyright by Grabill,
1891, Deadwood, S. D."
mount recto: "3649//3649. "Crow Dog" and Family at
home." and printed "J.C.H. GRABILL, Official
Photographer of the Black Hills & F.P.R.R. and Home
Stake Mining Co./Studios: Deadwood and Lead City, S. D.
Copyrighted.//A Handsome Reward given/for detection

of any one copying any of my Photographic Views"
mount verso: "Dup" and "8164W2" contained within rubber stamp "LIBRARY OF CONGRESS/COPYRIGHT MAR 3 1891/WASHINGTON" and rubber stamps "LIBRARY OF CONGRESS-7/SURPLUS DUPLICATE" and "3076"
Acquired from: Library of Congress, trade for duplicate materials

2695. **DEADWOOD. FROM MT. MORIAH** (P1975.191.5)
Albumen silver print. 1888
Image: 12 ¹⁵/₁₆ x 16 ¹¹/₁₆ in. (32.9 x 42.4 cm.)
Mount: 13 ¹/₁₆ x 16 ¹⁵/₁₆ in. (33.2 x 43.0 cm.)
Signed: see inscription
Inscription, in negative: "No. 1453 DEADWOOD./From Mt. Moriah./(Photo and copyright by Grabill. '88)"
mount verso: "Dupl.//Dupl." and rubber stamp "LIBRARY OF CONGRESS-7/ SURPLUS DUPLICATE"
Acquired from: Library of Congress, trade for duplicate materials

2696. **DEADWOOD, SOUTH DAKOTA** (P1975.191.4)
Albumen silver print. 1888
Image: 13 ⅜ x 16 ⁹/₁₆ in. (34.0 x 42.1 cm.) irregular
Mount: 13 ⁹/₁₆ x 16 ¼ in. (34.5 x 42.5 cm.) irregular
Inscription, mount verso: "Dupl.//Dupl.//South Dakota/ Deadwood." and "Dec 24, 1888/36754" contained within rubber stamp "LIBRARY OF CONGRESS/Copy Received/ Copyright Entry,/CLASS [illegible]/COPY DELIVERED/ DIVISION"
Acquired from: Library of Congress, trade for duplicate materials

*2697. **THE INDIAN GIRL'S HOME** (P1975.191.3)
Albumen silver print. 1890
Image: 7 ⁹/₁₆ x 9 ⁵/₁₆ in. (19.2 x 23.7 cm.)
Mount: 8 x 10 in. (20.3 x 25.4 cm.)
Signed: see inscription
Inscription, in negative, printed: "No. 2558. The Indian Girl's Home./A group of Indian Girls/and Indian police at Big Foot's village on/reservation./Photo and copyright by Grabill, '90."
mount recto, printed: "J.C.H. GRABILL, OFFICIAL PHOTOGRAPHER OF THE BLACK HILLS & F.P.R.R. AND HOME STAKE MINING CO./STUDIOS: DEADWOOD AND LEAD CITY, SOUTH DAKOTA."
mount verso: "Dup//lot 3076" and "36493V2" contained within rubber stamp "LIBRARY OF CONGRESS/ COPYRIGHT/NOV 18 1890/WASHINGTON" and rubber stamp "LIBRARY OF CONGRESS-7/SURPLUS DUPLICATE"
Acquired from: Library of Congress, trade for duplicate materials

2698. **LAST DEADWOOD COACH** (P1975.191.1)
Albumen silver print. 1890
Image: 9 ¾ x 12 ¾ in. (24.8 x 32.4 cm.)
Mount: 10 ⅞ x 13 ⁷/₁₆ in. (27.6 x 34.2 cm.) irregular
Signed: see inscription
Inscription, in negative: "No. 3533. "Last Deadwood Coach."/The last trip of the famous Stage Dec. 28, '90/ Photo and copyright '90 & '91 by Grabill,/Send for newspaper description."
mount recto: "3533" and printed "J.C.H. GRABILL, Official Photographer of the Black Hills & F.P.R.R. and Home Stake Mining Co. Studios: Deadwood and Lead City, S. D. Copyrighted. A Handsome Reward given for detection of any one copying any of my Pictures."
mount verso: "Dup" and "1286W" contained within rubber stamp "LIBRARY OF CONGRESS/COPYRIGHT JAN 7 1891/WASHINGTON" and rubber stamp "LIBRARY OF CONGRESS-7/SURPLUS DUPLICATE" and "3076"
Acquired from: Library of Congress, trade for duplicate materials

2682

2683

2689

SIDNEY GROSSMAN, American (1913–1955)

Grossman attended the City College of New York and studied painting with Hans Hoffman, but was self-taught in photography. He worked as a freelance documentary photographer in New York from 1934 through 1955. His early work was done with Sol Libsohn; both photographers thought that photography should serve a social purpose. In 1934 Grossman and Libsohn founded the Film and Photo League, and Grossman remained active in this organization until 1949. Grossman's best-known work includes a series of photographs of blacks in Harlem and farmers in Oklahoma and Arkansas made for the Works Progress Administration, portraits of folk singers and ballet dancers, Coney Island images, and "The Black Christ" series done in Panama.

2699. **CONEY ISLAND** (P1985.40)
Gelatin silver print. 1947
Image: 9 9/16 x 7 5/8 in. (24.3 x 19.4 cm.)
Mount: same as image size
Signed: see inscription
Inscription, mount verso: "C-13 D//CROP//CONEY ISLAND/major negatives 20.11a/B//LR 37248//c/o PRATT/242 E. 68 ST.,/NEW YORK, N.Y./Y08-6188//4 1/4"//5"//84//No Rules//57† [marked out]//57//Cut D/p. 94/ Documentary Photog.//4//J//GROSSMAN//H3204-9-9// CROP" and crop marks and rubber stamp "SID GROSSMAN"
Acquired from: Photofind Gallery, Inc., Woodstock, New York

PAUL GROTZ, American, born Germany (b. 1902)

Paul Grotz, a trained architect, immigrated to the United States in 1928. He was a close friend of Walker Evans and the two shared a studio for a brief period shortly after Grotz settled in America. Grotz had a one-man show at the Julien Levy Gallery in 1932–33, but he decided that he could not successfully pursue a photographic career and went to work as the art director for *Architectural Forum*. He remained with the magazine until his retirement in 1971. During the 1950s Grotz continued his friendship with Walker Evans, who was working for *Fortune* magazine. Grotz's work is always carefully composed, suggesting his architectural training.

*2700. **BEFORE THE RACES** (P1980.47)
Gelatin silver print. 1929
Image: 6 9/16 x 9 1/8 in. (16.6 x 23.2 cm.)
Mount: 14 1/16 x 11 in. (35.7 x 27.9 cm.)
Signed, l.r. mount recto: "Paul Grotz"
Acquired from: Prakapas Gallery, New York, New York

JOHN GUTMANN, American, born Germany (b. 1905)

John Gutmann was a promising expressionist painter when he fled Germany in 1933. He settled in San Francisco and began a forty-year career as a teacher and photojournalist. Gutmann taught at San Francisco State University from 1937 until his retirement in 1973 and published his photographs in *Time*, *Life*, *National Geographic*, and the *Saturday Evening Post*. A strong interest in language and the written word is often reflected in his work.

*2701. **APOLOGY [Message]** (P1985.13)
Gelatin silver print. 1938
Image: 7 1/4 x 9 1/4 in. (18.4 x 23.5 cm.)
Mount: 18 1/16 x 14 in. (45.8 x 35.5 cm.)
Signed, l.r. mount recto: "John Gutmann"
Inscription, mount recto: "7"
mount verso: "X290,6//Documents of the Street/Message"
Acquired from: Fraenkel Gallery, San Francisco, California

*2702. **"THE WORLD'S EGG BASKET," PETALUMA, CALIFORNIA** (P1980.21)
Gelatin silver print. 1938
Image: 7 3/4 x 8 5/16 in. (19.7 x 21.1 cm.)
Signed, l.r. print verso: "John Gutmann"
Inscription, print verso: "268.3//"THE WORLD'S EGG BASKET"/PETALUMA 1938"
Acquired from: Fraenkel Gallery, San Francisco, California

PHILIPPE HALSMAN, American, born Latvia (1906–1979)

Halsman is best known for his portraits of famous individuals. His work aims for psychological insight; many of his photographs have become accepted as the definitive portrayals of his subjects. Halsman worked as a professional photographer in Paris during the 1930s but fled in 1940 when the Germans invaded France. His photographs were chosen for the cover of *Life* magazine 101 times, more than those of any other photographer. He was listed by a 1958 *Popular Photography* poll as one of the ten best-known photographers and in 1975 received the American Society of Magazine Photographers Lifetime Achievement Award. Among his most revealing portraits are a series showing famous people jumping—an action that Halsman felt caused the person to drop all defenses and reveal his true personality. Halsman also had a unique sense of humor, evidenced in his collaboration with the artist Salvador Dali on a book of visual puns entitled *Dali's Mustache*.

2703. **[Georgia O'Keeffe]** (P1978.50)
Gelatin silver print. 1967
Image: 13 11/16 x 10 13/16 in. (34.8 x 27.5 cm.)
Sheet: 13 15/16 x 11 in. (35.5 x 28.0 cm.)
Signed: see inscription
Inscription, print verso, rubber stamp: "COPYRIGHT/© BY/ PHILIPPE HALSMAN"
Acquired from: Hastings Gallery, New York, New York

HALSMAN/DALI (P1984.32.1–10)
This portfolio, containing ten images by Philippe Halsman of the artist Salvador Dali, was published by Neikrug Photographica Ltd. in 1981. It consists of an edition of 250 portfolios plus 10 artist's proofs. The prints were made by Stephen Gersh under the supervision of Yvonne Halsman. This is portfolio number 34 of 250.

*2704. **DALI ATOMICUS** (P1984.32.1)
Gelatin silver print. negative 1948, print 1981 by Stephen Gersh
Image: 9 1/16 x 12 7/8 in. (22.9 x 32.7 cm.)
Sheet: 11 x 13 15/16 in. (28.0 x 35.4 cm.)
Inscription, print verso, rubber stamp: "HALSMAN/DALI/ COPYRIGHT PHILIPPE HALSMAN © 81/ALL RIGHTS RESERVED/EDITION NUMBER [in ink] 34/250"
Acquired from: gift of Neikrug Photographica Ltd., New York, New York

2697

2700

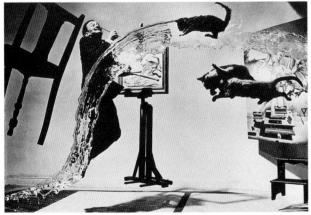

2701

2702

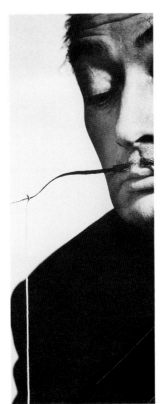

2704

2712

2705. **DALI CYCLOPS** (P1984.32.2)
Gelatin silver print. negative 1953, print 1981 by
Stephen Gersh
Image: 12 ⅞ x 7 ¾ in. (32.7 x 19.7 cm.)
Sheet: 13 ¹⁵⁄₁₆ x 11 in. (35.4 x 28.0 cm.)
Inscription, print verso, rubber stamp: "HALSMAN/DALI/
COPYRIGHT PHILIPPE HALSMAN © 81/ALL
RIGHTS RESERVED/EDITION NUMBER [in ink]
34/250"
Acquired from: gift of Neikrug Photographica Ltd.,
New York, New York

2706. **DALI WITH RHINOCEROS** (P1984.32.3)
Gelatin silver print. negative 1956, print 1981 by
Stephen Gersh
Image: 10 x 12 ¹⁵⁄₁₆ in. (25.3 x 32.8 cm.)
Sheet: 11 x 13 ¹⁵⁄₁₆ in. (28.0 x 35.4 cm.)
Inscription, print verso, rubber stamp: "HALSMAN/DALI/
COPYRIGHT PHILIPPE HALSMAN © 81/ALL
RIGHTS RESERVED/EDITION NUMBER [in ink]
34/250"
Acquired from: gift of Neikrug Photographica Ltd.,
New York, New York

2707. **DALI SKULL** (P1984.32.4)
Gelatin silver print. negative 1951, print 1981 by
Stephen Gersh
Image: 12 ⁷⁄₁₆ x 10 ¼ in. (31.5 x 26.0 cm.)
Sheet: 13 ¹⁵⁄₁₆ x 11 in. (35.4 x 28.0 cm.)
Inscription, print verso, rubber stamp: "HALSMAN/DALI/
COPYRIGHT PHILIPPE HALSMAN © 81/ALL
RIGHTS RESERVED/EDITION NUMBER [in ink]
34/250"
Acquired from: gift of Neikrug Photographica Ltd.,
New York, New York

2708. **DALI CLOCKFACE** (P1984.32.5)
Gelatin silver print. negative 1953, print 1981 by
Stephen Gersh
Image: 12 ⅞ x 9 ⅞ in. (32.7 x 25.1 cm.)
Sheet: 13 ¹⁵⁄₁₆ x 11 in. (35.4 x 28.0 cm.)
Inscription, print verso, rubber stamp: "HALSMAN/DALI/
COPYRIGHT PHILIPPE HALSMAN © 81/ALL
RIGHTS RESERVED/EDITION NUMBER [in ink]
34/250"
Acquired from: gift of Neikrug Photographica Ltd.,
New York, New York

2709. **DALI SCULPTURE WITH LIGHT** (P1984.32.6)
Gelatin silver print. negative 1950, print 1981 by
Stephen Gersh
Image: 12 ⅞ x 9 ⅞ in. (32.7 x 25.1 cm.)
Sheet: 13 ¹⁵⁄₁₆ x 11 in. (35.4 x 28.0 cm.)
Inscription, print verso, rubber stamp: "HALSMAN/DALI/
COPYRIGHT PHILIPPE HALSMAN © 81/ALL
RIGHTS RESERVED/EDITION NUMBER [in ink]
34/250"
Acquired from: gift of Neikrug Photographica Ltd.,
New York, New York

2710. **INVISIBLE DALI** (P1984.32.7)
Gelatin silver print. negative 1954, print 1981 by
Stephen Gersh
Image: 13 x 9 ⅞ in. (33.0 x 25.1 cm.)
Sheet: 13 ¹⁵⁄₁₆ x 11 in. (35.4 x 28.0 cm.)
Inscription, print verso, rubber stamp: "HALSMAN/DALI/
COPYRIGHT PHILIPPE HALSMAN © 81/ALL
RIGHTS RESERVED/EDITION NUMBER [in ink]
34/250"
Acquired from: gift of Neikrug Photographica Ltd.,
New York, New York

2711. **DALI'S MUSTACHE** (P1984.32.8)
Gelatin silver print. negative 1953, print 1981 by
Stephen Gersh
Image: 12 ⅞ x 9 ⅞ in. (32.7 x 25.1 cm.)
Sheet: 13 ¹⁵⁄₁₆ x 11 in. (35.4 x 28.0 cm.)

Inscription, print verso, rubber stamp: "HALSMAN/DALI/
COPYRIGHT PHILIPPE HALSMAN © 81/ALL
RIGHTS RESERVED/EDITION NUMBER [in ink]
34/250"
Acquired from: gift of Neikrug Photographica Ltd.,
New York, New York

*2712. **DALI FISHING** (P1984.32.9)
Gelatin silver print. negative 1954, print 1981 by
Stephen Gersh
Image: 12 ¹⁵⁄₁₆ x 5 in. (32.8 x 12.7 cm.)
Sheet: 13 ¹⁵⁄₁₆ x 11 in. (35.4 x 28.0 cm.)
Inscription, print verso, rubber stamp: "HALSMAN/DALI/
COPYRIGHT PHILIPPE HALSMAN © 81/ALL
RIGHTS RESERVED/EDITION NUMBER [in ink]
34/250"
Acquired from: gift of Neikrug Photographica Ltd.,
New York, New York

2713. **DALI IN PORT LLIGAT** (P1984.32.10)
Gelatin silver print. negative 1964, print 1981 by
Stephen Gersh
Image: 13 x 10 in. (32.9 x 25.4 cm.)
Sheet: 13 ¹⁵⁄₁₆ x 11 in. (35.4 x 28.0 cm.)
Inscription, print verso, rubber stamp: "HALSMAN/DALI/
COPYRIGHT PHILIPPE HALSMAN © 81/ALL
RIGHTS RESERVED/EDITION NUMBER [in ink]
34/250"
Acquired from: gift of Neikrug Photographica Ltd.,
New York, New York

* * * *

HALSMAN/MARILYN (P1984.31.1–10)

This portfolio, containing ten images of Marilyn Monroe
by Philippe Halsman, was published in 1981 by Neikrug
Photographica Ltd. It consists of an edition of 250 portfolios
plus 10 artist's proofs. The prints were made in 1981 by
Stephen Gersh under the supervision of Yvonne Halsman.
This is portfolio number 21 of 250.

2714. **PORTRAIT OF MARILYN** (P1984.31.1)
Gelatin silver print. negative 1952, print 1981 by
Stephen Gersh
Image: 11 ³⁄₁₆ x 8 ½ in. (28.3 x 21.6 cm.)
Sheet: 13 ¹⁵⁄₁₆ x 11 in. (35.4 x 28.0 cm.)
Inscription, print verso, rubber stamp: "HALSMAN/
MARILYN/COPYRIGHT PHILIPPE HALSMAN © 81/
ALL RIGHTS RESERVED/EDITION NUMBER [in ink]
21/250"
Acquired from: gift of Neikrug Photographica Ltd.,
New York, New York

2715. **MARILYN WITH BARBELLS** (P1984.31.2)
Gelatin silver print. negative 1952, print 1981 by
Stephen Gersh
Image: 9 ¹⁵⁄₁₆ x 12 ¹³⁄₁₆ in. (25.1 x 32.5 cm.)
Sheet: 11 x 13 ¹⁵⁄₁₆ in. (28.0 x 35.4 cm.)
Inscription, print verso, rubber stamp: "HALSMAN/
MARILYN/COPYRIGHT PHILIPPE HALSMAN © 81/
ALL RIGHTS RESERVED/EDITION NUMBER [in ink]
21/250"
Acquired from: gift of Neikrug Photographica Ltd.,
New York, New York

*2716. **MARILYN LIFE COVER** (P1984.31.3)
Gelatin silver print. negative 1952, print 1981 by
Stephen Gersh
Image: 13 x 10 in. (32.9 x 25.4 cm.)
Sheet: 13 ¹⁵⁄₁₆ x 11 in. (35.4 x 28.0 cm.)
Inscription, print verso, rubber stamp: "HALSMAN/
MARILYN/COPYRIGHT PHILIPPE HALSMAN © 81/
ALL RIGHTS RESERVED/EDITION NUMBER [in ink]
21/250"
Acquired from: gift of Neikrug Photographica Ltd.,
New York, New York

2717. **MARILYN JUMPING** (P1984.31.4)
Gelatin silver print. negative 1959, print 1981 by
Stephen Gersh
Image: 12 7/8 x 9 15/16 in. (32.7 x 25.2 cm.)
Sheet: 13 15/16 x 11 in. (35.4 x 28.0 cm.)
Inscription, print verso, rubber stamp: "HALSMAN/
MARILYN/COPYRIGHT PHILIPPE HALSMAN © 81/
ALL RIGHTS RESERVED/EDITION NUMBER [in ink]
21/250"
Acquired from: gift of Neikrug Photographica Ltd.,
New York, New York

*2718. **MARILYN ENTERING THE CLOSET** (P1984.31.5)
Gelatin silver print. negative 1952, print 1981 by
Stephen Gersh
Image: 12 15/16 x 7 1/8 in. (32.8 x 18.1 cm.)
Sheet: 13 15/16 x 11 in. (35.4 x 28.0 cm.)
Inscription, print verso, rubber stamp: "HALSMAN/
MARILYN/COPYRIGHT PHILIPPE HALSMAN © 81/
ALL RIGHTS RESERVED/EDITION NUMBER [in ink]
21/250"
Acquired from: gift of Neikrug Photographica Ltd.,
New York, New York

2719. **MARILYN FLIRTING** (P1984.31.6)
Gelatin silver print. negative 1952, print 1981 by
Stephen Gersh
Image: 10 1/16 x 13 in. (25.6 x 33.0 cm.)
Sheet: 11 x 13 15/16 in. (28.0 x 35.4 cm.)
Inscription, print verso, rubber stamp: "HALSMAN/
MARILYN/COPYRIGHT PHILIPPE HALSMAN © 81/
ALL RIGHTS RESERVED/EDITION NUMBER [in ink]
21/250"
Acquired from: gift of Neikrug Photographica Ltd.,
New York, New York

2720. **MARILYN AT THE DRIVE-IN** (P1984.31.7)
Gelatin silver print. negative 1952, print 1981 by
Stephen Gersh
Image: 9 7/8 x 12 15/16 in. (25.1 x 32.8 cm.)
Sheet: 11 x 13 15/16 in. (28.0 x 35.4 cm.)
Inscription, print verso, rubber stamp: "HALSMAN/
MARILYN/COPYRIGHT PHILIPPE HALSMAN © 81/
ALL RIGHTS RESERVED/EDITION NUMBER [in ink]
21/250"
Acquired from: gift of Neikrug Photographica Ltd.,
New York, New York

2721. **MARILYN LISTENING TO MUSIC** (P1984.31.8)
Gelatin silver print. negative 1952, print 1981 by
Stephen Gersh
Image: 12 7/8 x 9 7/8 in. (32.7 x 25.1 cm.)
Sheet: 13 15/16 x 11 in. (35.4 x 28.0 cm.)
Inscription, print verso, rubber stamp: "HALSMAN/
MARILYN/COPYRIGHT PHILIPPE HALSMAN © 81/
ALL RIGHTS RESERVED/EDITION NUMBER [in ink]
21/250"
Acquired from: gift of Neikrug Photographica Ltd.,
New York, New York

2722. **THE TRUE MARILYN** (P1984.31.9)
Gelatin silver print. negative 1952, print 1981 by
Stephen Gersh
Image: 10 x 13 in. (25.3 x 33.0 cm.)
Sheet: 11 x 13 15/16 in. (28.0 x 35.4 cm.)
Inscription, print verso, rubber stamp: "HALSMAN/
MARILYN/COPYRIGHT PHILIPPE HALSMAN © 81/
ALL RIGHTS RESERVED/EDITION NUMBER [in ink]
21/250"
Acquired from: gift of Neikrug Photographica Ltd.,
New York, New York

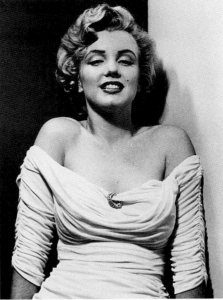
2716

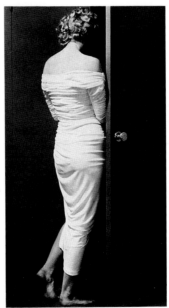
2718

*2723. **MARILYN—MAO** (P1984.31.10)
Gelatin silver print. negative 1952, print 1981 by
Stephen Gersh
Image: 12 ⅞ x 9 ¹⁵⁄₁₆ in. (32.7 x 25.2 cm.)
Sheet: 13 ¹⁵⁄₁₆ x 11 in. (35.4 x 28.0 cm.)
Inscription, print verso, rubber stamp: "HALSMAN/
MARILYN/COPYRIGHT PHILIPPE HALSMAN © 81/
ALL RIGHTS RESERVED/EDITION NUMBER [in ink]
21/250"
Acquired from: gift of Neikrug Photographica Ltd.,
New York, New York

WANDA LEE HAMMERBECK,
American (b. 1945)

Wanda Lee Hammerbeck received a B.A. in psychology
from the University of North Carolina at Chapel Hill
in 1967 and an M.F.A. in photography from the San
Francisco Art Institute in 1977. After completing her
M.F.A. she taught photography at Holy Names College
in Oakland, California. She has served on the board of
the West Coast Visual Arts Archive and been an active
member of the Society for Photographic Education.
Hammerbeck focused on conceptual art during the late
1970s, but her more recent work, executed primarily in
color, explores people's relationships with the land.

*2724. **UNTITLED [canyon view]** (P1983.22)
Color coupler print. 1982
Image: 13 ¼ x 19 ⁵⁄₁₆ in. (33.7 x 49.1 cm.)
Sheet: 16 x 20 in. (40.7 x 50.8 cm.)
Signed, l.r. sheet recto: "Wanda Lee Hammerbeck"
Acquired from: Friends of Photography, Carmel, California;
gift print with sustaining membership, 1983

G. H. S. HARDING (active early 1900s)

See John Paul Edwards works

GOODWIN HARDING, American (b. 1947)

Oregon landscape photographer Goodwin Harding
grew up in Boston and received a B.A. in English from
Harvard in 1969. He took his first photography class
in 1968, studying with Minor White from 1968 to 1970.
He moved to Oregon in 1970 and has been a freelance
photographer there since 1972. He has received an
Individual Artist Fellowship from the Oregon Arts
Commission (1985) and served as an artist-in-residence
for the Commission in 1978. Harding's work consists
mainly of platinum prints made from 8 x 10 inch
negatives.

*2725. **STONE BEACH, POINT LOBOS, CALIFORNIA** (P1985.5)
Palladium print. negative 1983, print 1984
Image: 7 ¹¹⁄₁₆ x 9 ¹¹⁄₁₆ in. (19.6 x 24.6 cm.)
Sheet: 9 x 11 ½ in. (22.9 x 29.2 cm.)
Signed, l.r. sheet recto: "© 1983 Goodwin Harding"
Inscription, sheet recto: "Stone Beach, Point Lobos,
California, 1983/negative: 7/83 palladium print: 11/84"
Acquired from: Friends of Photography, Carmel, California;
gift print with sustaining membership, 1985

JOHN HARKEY, American (b. 1950)

Harkey worked for the Public Broadcasting System
affiliate KERA in Dallas, Texas, before moving to San
Antonio in 1973, where he was briefly on the staff of
the Witte Museum. While doing freelance work in
1975 he made a series of photographs of San Antonio

for a bicentennial project sponsored by the National
Endowment for the Humanities. The resulting exhi-
bition, shown at the University of Texas Health
Sciences Center, was called "Mirror of the Past,
Window to the Future." Harkey left Texas in 1976 to
study at the Rhode Island School of Design, where he
received a master's in photography in 1978. He cur-
rently works as a commercial photographer in
Providence, Rhode Island.

2726. **MAUSOLEUM GATES AND DOORS, SAN ANTONIO**
(P1976.151.1)
Gelatin silver print. 1976
Image: 15 ¹⁄₁₆ x 12 in. (38.2 x 30.5 cm.)
Sheet: 19 ¹⁵⁄₁₆ x 16 ¹⁄₁₆ in. (50.6 x 40.8 cm.)
Signed, l.l. sheet recto: "John Harkey '76"
Inscription, sheet recto: "Mausoleum gates and doors/
San Antonio 1976"
Acquired from: gift of the photographer

2727. **SO. PINE ST., SAN ANTONIO** (P1976.151.2)
Gelatin silver print. 1976
Image: 10 ¹⁵⁄₁₆ x 14 in. (27.7 x 35.6 cm.)
Sheet: 19 ¹⁵⁄₁₆ x 16 in. (50.6 x 40.7 cm.)
Signed, l.l. sheet recto: "John Harkey '76"
Inscription, sheet recto: "So. Pine St., San Antonio 1976"
Acquired from: the photographer

PAUL B. HAVILAND,
American, born France (1880–1950)

See *Camera Work*

JOSIAH JOHNSTON HAWES

See Albert Sands Southworth

RICHARD E. HAYES, American (b. 1936)

Richard Hayes received a B.A. from Southern Illinois
University in 1965 and an M.F.A. from Indiana Uni-
versity in 1969. He taught photography at Sam Houston
State University from 1969 to 1971 and at Northeast
Louisiana University after 1971. An active member of
the Society for Photographic Education, Hayes has
also participated in numerous regional and national
exhibitions.

2728. **FROM THE SERIES "FRIENDS," SARAH [from the
Society for Photographic Education's "South Central
Regional Photography Exhibition"]** (P1983.31.6)
Gelatin silver print. 1979
Image: 6 ⅞ x 8 ¹⁄₁₆ in. (16.3 x 20.5 cm.)
Sheet: 8 ¹⁄₁₆ x 9 ¹⁵⁄₁₆ in. (20.5 x 25.3 cm.)
Mount: 16 x 20 in. (40.7 x 50.8 cm.)
Inscription, mount verso: "Richard E. Hayes/S.P.E./ART
DEPT., N.L.J. [sic]/MONROE, LA. 71201"
Acquired from: gift of the Society for Photographic
Education, South Central Region

FRANK JAY HAYNES, American (1853–1921)

In 1874, after a brief period working in his family's mer-
cantile business and as a traveling salesman, Haynes
apprenticed himself to a photographer named S. C.
Graham in Beaver Dam, Wisconsin. By 1876, after a
second apprenticeship with William H. Lockwood,
Haynes had moved to Moorhead, Minnesota, and
opened his own studio. Shortly thereafter he received a
lucrative contract to make views along the lines of the
Northern Pacific Railroad. He operated a Palace Studio

2723

2724

2725

Car that traveled the NPRR route until 1905. In 1881 Haynes made a trip to the Yellowstone region and immediately saw the potential for a photographic business there. By 1884 he had obtained a concession as the park photographer and built a seasonal studio on the park grounds. His views of Yellowstone scenery and park activities were instrumental in publicizing the wonders of the park landscape throughout the country. The lucrative Yellowstone business remained in the family when it was transferred to Haynes' son Jack in 1916.

2729. **ACROSS THE RIVER FROM THE GIANT** [geyser in winter] (P1979.72.16)
Albumen silver print. 1887
Image: 5 1/16 x 8 3/16 in. (12.8 x 20.8 cm.)
Mount: 5 1/4 x 8 1/2 in. (13.4 x 21.6 cm.)
Signed: see inscription
Inscription, mount verso: "wi/35//17//3517 Across the River From the Giant" and printed "BOUDOIR VIEWS./OUR COLLECTION OF VIEWS IN THIS POPULAR SIZE/EMBRACES SCENERY/ALONG THE ENTIRE LINE OF THE NORTHERN PACIFIC,/INCLUDING/Yellowstone, National Park,/Clark's Forks and Columbia River,/MT. HOOD, MT. TACOMA AND PACIFIC COAST,/ MONTANA, WYOMING, DAKOTA, ETC./ DESCRIPTIVE CATALOGUE FREE./ PHOTOGRAPHED AND PUBLISHED BY/F. JAY HAYNES,/Official Photographer N. P. R. R./FARGO, DAKOTA." and printed paper label "JAS. W. QUEEN & CO./924/Chestnut/St./PHILAD."
Acquired from: Mazzulla Collection, Fred Mazzulla, Denver, Colorado

2730. **BISCUIT BASIN, SAPPHIRE POOL** [from Yellowstone Park Views set] (P1979.72.8)
Toned gelatin silver print. negative 1886, print later
Image: 5 1/16 x 8 3/16 in. (12.8 x 20.8 cm.)
Mount: 5 1/4 x 8 1/2 in. (13.4 x 21.6 cm.)
Signed: see inscription
Inscription, mount recto, printed: "3578-Biscuit Basin, Sapphire Pool." and written on paper label "3578" mount verso, printed: "F. JAY HAYNES,/OFFICIAL PHOTOGRAPHER N. P. R. R./SELBY AVE., COR. VIRGINIA.//SEND FOR/CATALOGUE OF/VIEWS.// NORTHERN PACIFIC,/YELLOWSTONE PARK,/ PACIFIC COAST AND ALASKA." and rubber stamp "ST. PAUL, MINN." and Fred and Jo Mazzulla stamp
Acquired from: Mazzulla Collection, Fred Mazzulla, Denver, Colorado

2731. **CASTLE BEE HIVE AND OLD FAITHFUL GEYSERS** (P1971.36.9)
Albumen silver print. c. 1880s–90s
Image: 5 x 8 1/4 in. (12.7 x 20.9 cm.)
Mount: 5 1/4 x 8 1/2 in. (13.3 x 21.6 cm.)
Signed: see inscription
Inscription, mount recto, printed: "3610 CASTLE BEE HIVE AND OLD FAITHFUL GEYSERS" mount verso: "Castle Geyser/9//X/LMDHN/9-30-26" and printed "BOUDOIR VIEWS./OUR COLLECTION OF VIEWS IN THIS POPULAR SIZE/EMBRACES SCENERY/ALONG THE ENTIRE LINE OF THE NORTHERN PACIFIC,/INCLUDING/Yellowstone, National Park,/Clark's Forks and Columbia River,/MT. HOOD, MT. TACOMA AND PACIFIC COAST,/ MONTANA, WYOMING, DAKOTA, ETC./ DESCRIPTIVE CATALOGUE FREE./ PHOTOGRAPHED AND PUBLISHED BY/F. JAY HAYNES,/Official Photographer N. P. R. R./FARGO, DAKOTA."
Acquired from: Fred Rosenstock, Denver, Colorado

*2732. **CLEOPATRA'S TERRACE, MAMMOTH HOT SPRINGS**
(P1971.36.7)
Albumen silver print. 1886
Image: 5 x 8 ¼ in. (12.7 x 20.9 cm.)
Mount: 5 ¼ x 8 ½ in. (13.3 x 21.6 cm.)
Signed: see inscription
Inscription, mount recto, printed: "3544 CLEOPATRAS
TERRACE MAMMOTH HOT SPRINGS"
mount verso: "Minurva [sic] Terrace/Mammoth Hot
Springs/7//x/LMDHN/9-30-26" and printed "BOUDOIR
VIEWS./OUR COLLECTION OF VIEWS IN THIS
POPULAR SIZE/EMBRACES SCENERY/ALONG THE
ENTIRE LINE OF THE NORTHERN PACIFIC,/
INCLUDING/Yellowstone, National Park,/Clark's Forks
and Columbia River,/MT. HOOD, MT. TACOMA AND
PACIFIC COAST,/MONTANA, WYOMING, DAKOTA,
ETC./DESCRIPTIVE CATALOGUE FREE./
PHOTOGRAPHED AND PUBLISHED BY/F. JAY
HAYNES,/Official Photographer N. P. R. R./FARGO,
DAKOTA."
Acquired from: Fred Rosenstock, Denver, Colorado

*2733. **EAST ENTRANCE TO GOLDEN GATE** [Yellowstone Park]
(P1971.36.6)
Albumen silver print. c. 1890
Image: 4 ⅞ x 8 ⁵⁄₁₆ in. (12.4 x 21.0 cm.)
Mount: 5 ¼ x 8 ½ in. (13.3 x 21.6 cm.)
Signed: see inscription
Inscription, mount recto, printed: "3551 EAST ENTRANCE
TO GOLDEN GATE"
mount verso: "Golden Gate Entrance/to Yellowstone
Park/6//y/LMDHN/9-30-26" and printed "BOUDOIR
SERIES./Our collection of Views in this popular size
embraces scenery/along the entire line of the Northern
Pacific./Yellowstone Park, Columbia River, Seattle,/Tacoma
and Portland,/St. Paul and Duluth to the Pacific./
CATALOGUES FREE./Published by/F. JAY HAYNES &
BRO., 392 Jackson Street, ST. PAUL./OFFICIAL
PHOTOGRAPHERS N. P. R. R."
Acquired from: Fred Rosenstock, Denver, Colorado

2734. **EXCELSIOR GEYSER** (P1971.36.5)
Albumen silver print. 1888
Image: 5 x 8 ¼ in. (12.7 x 20.9 cm.)
Mount: 5 ¼ x 8 ½ in. (13.3 x 21.6 cm.)
Signed: see inscription
Inscription, mount recto, printed: "3672 EXCELSIOR
GEYSER"
mount verso: "Excelsior Geyser/5//x/LMDHN/9-30-26"
and printed "BOUDOIR VIEWS./OUR COLLECTION
OF VIEWS IN THIS POPULAR SIZE/EMBRACES
SCENERY/ALONG THE ENTIRE LINE OF THE
NORTHERN PACIFIC,/INCLUDING/Yellowstone,
National Park,/Clark's Forks and Columbia River,/MT.
HOOD, MT. TACOMA AND PACIFIC COAST,/
MONTANA, WYOMING, DAKOTA, ETC./
DESCRIPTIVE CATALOGUE FREE./
PHOTOGRAPHED AND PUBLISHED BY/F. JAY
HAYNES,/Official Photographer N. P. R. R./FARGO,
DAKOTA."
Acquired from: Fred Rosenstock, Denver, Colorado

2735. **GIANT GEYSER** [from Yellowstone Park Views set]
(P1979.72.2)
Toned gelatin silver print. negative c. 1893–95, print later
Image: 8 ¼ x 5 in. (20.9 x 12.7 cm.)
Mount: 8 ½ x 5 ¼ in. (21.6 x 13.4 cm.)
Signed: see inscription
Inscription, mount recto: "3592-Giant Geyser."
mount verso, printed: "F JAY HAYNES,/OFFICIAL
PHOTOGRAPHER N. P. R. R./ SELBY AVE., COR.
VIRGINIA, ST. PAUL, MINN.//SEND FOR/
CATALOGUE OF/VIEWS.//NORTHERN PACIFIC,/
YELLOWSTONE PARK,/PACIFIC COAST AND
ALASKA." and Fred and Jo Mazzulla stamp
Acquired from: Mazzulla Collection, Fred Mazzulla, Denver,
Colorado

*2736. **GIBBON FALLS, 84 FEET** (P1971.9.1)
Albumen silver print. c. 1884
Image: 17 ½ x 21 ⅝ in. (44.5 x 54.9 cm.)
Mount: 22 x 26 in. (55.8 x 66.0 cm.)
Signed: see inscription
Inscription, in negative: "3108 GIBBON FALLS, 84 FEET./
F. JAY HAYNES, FARGO, D. T."
mount recto: "F. JAY HAYNES,/YELLOWSTONE
NATIONAL PARK./FARGO, D. T."
Acquired from: Fred Rosenstock, Denver, Colorado

2737. **GRAND CANYON FROM BRINK OF LOWER FALLS**
[Yellowstone Park] (P1971.36.2)
Albumen silver print. 1885
Image: 4 ¹⁵⁄₁₆ x 8 ⅜ in. (12.5 x 21.3 cm.)
Mount: 5 ¼ x 8 ½ in. (13.3 x 21.6 cm.)
Signed: see inscription
Inscription, mount recto, printed: "3641 GRAND CANYON
FROM BRINK OF LOWER FALLS"
mount verso: "Canon of the Yellowstone/2//
X/LMDHN/9-30-26" and printed "BOUDOIR VIEWS./
OUR COLLECTION OF VIEWS IN THIS POPULAR
SIZE/EMBRACES SCENERY/ALONG THE ENTIRE
LINE OF THE NORTHERN PACIFIC,/INCLUDING/
Yellowstone, National Park,/Clark's Forks and Columbia
River,/MT. HOOD, MT. TACOMA AND PACIFIC
COAST,/MONTANA, WYOMING, DAKOTA,
ETC./DESCRIPTIVE CATALOGUE FREE./
PHOTOGRAPHED AND PUBLISHED BY/F. JAY
HAYNES,/Official Photographer N. P. R. R./FARGO,
DAKOTA."
Acquired from: Fred Rosenstock, Denver, Colorado

2738. **GREAT FALLS OF THE YELLOWSTONE** [from
Yellowstone Park Views set] (P1979.72.10)
Toned gelatin silver print. negative c. 1893–96, print later
Image: 8 ³⁄₁₆ x 5 ¹⁄₁₆ in. (20.7 x 12.8 cm.)
Mount: 8 ½ x 5 ¼ in. (21.6 x 13.4 cm.)
Signed: see inscription
Inscription, mount recto, printed: "3622-Great Falls
of the Yellowstone."
mount verso, printed: "F. JAY HAYNES,/OFFICIAL
PHOTOGRAPHER N. P. R. R./SELBY AVE., COR.
VIRGINIA.//SEND FOR/CATALOGUE OF/VIEWS.//
NORTHERN PACIFIC,/YELLOWSTONE PARK,/
PACIFIC COAST AND ALASKA." and rubber stamp
"ST. PAUL, MINN." and Fred and Jo Mazzulla stamp
Acquired from: Mazzulla Collection, Fred Mazzulla,
Denver, Colorado

*2739. **GREAT FALLS 360 FEET** [Yellowstone Falls] (P1971.36.1)
Albumen silver print. c. 1880s–90s
Image: 8 ¼ x 5 in. (20.9 x 12.7 cm.)
Mount: 8 ½ x 5 ¼ in. (21.6 x 13.3 cm.)
Signed: see inscription
Inscription, mount recto, printed: "3663 GREAT FALLS
360 FEET"
mount verso: "Yellowstone Falls/1//X/LMDHN/9-30-26"
and printed "BOUDOIR VIEWS./OUR COLLECTION
OF VIEWS IN THIS POPULAR SIZE/EMBRACES
SCENERY/ALONG THE ENTIRE LINE OF THE
NORTHERN PACIFIC,/INCLUDING/Yellowstone,
National Park,/Clark's Forks and Columbia River,/MT.
HOOD, MT. TACOMA AND PACIFIC COAST,/
MONTANA, WYOMING, DAKOTA, ETC./
DESCRIPTIVE CATALOGUE FREE./
PHOTOGRAPHED AND PUBLISHED BY/F. JAY
HAYNES,/Official Photographer N. P. R. R./FARGO,
DAKOTA."
Acquired from: Fred Rosenstock, Denver, Colorado

2732

2733

2736

2739

2741

2744

2740. **GROTTO GEYSER** (P1971.36.4)
Albumen silver print. c. 1880s–90s
Image: 5 x 8¼ in. (12.6 x 20.9 cm.)
Mount: 5¼ x 8½ in. (13.3 x 21.6 cm.)
Signed: see inscription
Inscription, mount recto, printed: "3590 GROTTO GEYSER"
mount verso: "Grotto Geyser/4//x/MDHN/9-30-26" and
printed "BOUDOIR SERIES./Our collection of Views in
this popular size embraces scenery/along the entire line of
the Northern Pacific./Yellowstone Park, Columbia River,
Seattle,/Tacoma and Portland,/St. Paul and Duluth to
the Pacific./CATALOGUES FREE./Published by/F. JAY
HAYNES & BRO., 392 Jackson Street, ST. PAUL./
OFFICIAL PHOTOGRAPHERS N. P. R. R."
Acquired from: Fred Rosenstock, Denver, Colorado

*2741. **HOTEL AND STAGES. MAMMOTH HOT SPRINGS**
[National Hotel; from Yellowstone Park Views set]
(P1979.72.11)
Toned gelatin silver print. negative 1890, print later
Image: 5 x 8⁵⁄₁₆ in. (12.7 x 21.1 cm.)
Mount: 5¼ x 8½ in. (13.4 x 21.6 cm.)
Signed: see inscription
Inscription, mount recto, printed: "3530-Hotel and Stages.
Mammoth Hot Springs."
mount verso, printed: "F. JAY/HAYNES,/OFFICIAL
PHOTOGRAPHER N. P. R. R./SELBY AVE., COR.
VIRGINIA, ST. PAUL, MINN.//SEND FOR/
CATALOGUE OF/VIEWS.//NORTHERN PACIFIC,/
YELLOWSTONE PARK,/PACIFIC COAST AND
ALASKA." and Fred and Jo Mazzulla stamp
Acquired from: Mazzulla Collection, Fred Mazzulla,
Denver, Colorado

2742. **IN GOLDEN GATE [from Yellowstone Park Views set]**
(P1979.72.6)
Toned gelatin silver print. negative c. 1883–95, print later
Image: 5¹⁄₁₆ x 8¼ in. (12.8 x 20.9 cm.)
Mount: 5¼ x 8½ in. (13.4 x 21.6 cm.)
Signed: see inscription
Inscription, mount recto, printed: "3555-In Golden Gate."
mount verso, printed: "F. JAY HAYNES,/OFFICIAL
PHOTOGRAPHER N. P. R. R./SELBY AVE., COR.
VIRGINIA.//SEND FOR/CATALOGUE OF/VIEWS.//
NORTHERN PACIFIC,/YELLOWSTONE PARK,/
PACIFIC COAST AND ALASKA." and rubber stamp
"ST. PAUL, MINN." and Fred and Jo Mazzulla stamp
Acquired from: Mazzulla Collection, Fred Mazzulla,
Denver, Colorado

2743. **IN NORRIS GEYSER BASIN IN WINTER [Entrance
to Norris Geyser Basin in Winter]** (P1979.72.17)
Albumen silver print. 1887
Image: 5¹⁄₁₆ x 8³⁄₁₆ in. (12.8 x 20.8 cm.)
Mount: 5¼ x 8½ in. (13.4 x 21.6 cm.)
Signed: see inscription
Inscription, mount verso: "wi/35//3504 In Norris Geyser
Basin in Winter" and printed "BOUDOIR VIEWS./OUR
COLLECTION OF VIEWS IN THIS POPULAR SIZE/
EMBRACES SCENERY/ALONG THE ENTIRE LINE OF
THE NORTHERN PACIFIC,/INCLUDING/Yellowstone,
National Park,/Clark's Forks and Columbia River,/MT.
HOOD, MT. TACOMA AND PACIFIC COAST,/
MONTANA, WYOMING, DAKOTA, ETC./
DESCRIPTIVE CATALOGUE FREE./
PHOTOGRAPHED AND PUBLISHED BY/F. JAY
HAYNES,/Official Photographer N. P. R. R./FARGO,
DAKOTA." and printed paper label "JAS. W. QUEEN &
CO./924/Chestnut/St./PHILAD."
Acquired from: Mazzulla Collection, Fred Mazzulla,
Denver, Colorado

*2744. **INSPIRATION POINT FROM ARTIST'S POINT**
[from Yellowstone Park Views set] (P1979.72.3)
Toned gelatin silver print. negative c. 1883–95, print later
Image: 8¼ x 5⅛ in. (20.9 x 13.0 cm.)
Mount: 8½ x 5¼ in. (21.6 x 13.4 cm.)
Signed: see inscription
Inscription, mount recto, printed: "3650-Inspiration Point
from Artist's Point."
mount verso, printed: "F JAY/HAYNES,/OFFICIAL
PHOTOGRAPHER N. P. R. R./SELBY AVE., COR.
VIRGINIA, ST. PAUL, MINN.//SEND FOR/
CATALOGUE OF/VIEWS.//NORTHERN PACIFIC,/
YELLOWSTONE PARK,/PACIFIC COAST AND
ALASKA." and Fred and Jo Mazzulla stamp
Acquired from: Mazzulla Collection, Fred Mazzulla,
Denver, Colorado

*2745. **LONE STAR GEYSER** (P1971.36.8) duplicate of P1979.72.14
Albumen silver print. c. mid-1880s
Image: 8⅛ x 5¹⁄₁₆ in. (20.6 x 12.8 cm.)
Mount: 8½ x 5¼ in. (21.6 x 13.3 cm.)
Signed: see inscription
Inscription, mount recto, printed: "3690 LONE STAR
GEYSER"
mount verso: "Lone Star Geyser/8//X/LMDHN/9-30-26"
and printed "BOUDOIR SERIES./Our collection of Views
in this popular size embraces scenery/along the entire line
of the Northern Pacific./Yellowstone Park, Columbia River,
Seattle,/Tacoma and Portland,/St. Paul and Duluth to the
Pacific./CATALOGUES FREE./Published by/F. JAY
HAYNES & BRO., 392 Jackson Street, ST. PAUL./
OFFICIAL PHOTOGRAPHERS N. P. R. R."
Acquired from: Fred Rosenstock, Denver, Colorado

2746. **LONE STAR GEYSER** (P1979.72.14) duplicate of P1971.36.8
Albumen silver print. c. mid-1880s
Image: 8³⁄₁₆ x 4¹⁵⁄₁₆ in. (20.8 x 12.5 cm.)
Mount: 8½ x 5¼ in. (21.6 x 13.4 cm.)
Signed: see inscription
Inscription, mount verso: "wi/35" and printed "BOUDOIR
VIEWS./OUR COLLECTION OF VIEWS IN THIS
POPULAR SIZE/EMBRACES SCENERY/ALONG
THE ENTIRE LINE OF THE NORTHERN PACIFIC,/
INCLUDING/Yellowstone, National Park,/Clark's Forks
and Columbia River,/MT. HOOD, MT. TACOMA AND
PACIFIC COAST,/MONTANA, WYOMING, DAKOTA,
ETC./DESCRIPTIVE CATALOGUE FREE./
PHOTOGRAPHED AND PUBLISHED BY/F. JAY
HAYNES,/Official Photographer N. P. R. R./FARGO,
DAKOTA." and printed paper label "JAS. W. QUEEN &
CO./924/Chestnut/St./PHILAD."
Acquired from: Mazzulla Collection, Fred Mazzulla,
Denver, Colorado

2747. **NATURAL BRIDGE [from Yellowstone Park Views set]**
(P1979.72.1)
Toned gelatin silver print. negative c. 1883–95, print later
Image: 5⅛ x 8¼ in. (13.0 x 20.9 cm.)
Mount: 5¼ x 8½ in. (13.4 x 21.6 cm.)
Signed: see inscription
Inscription, mount recto: "3633-NATURAL BRIDGE"
mount verso, printed: "3633-Natural Bridge.//F JAY/
HAYNES,/OFFICIAL PHOTOGRAPHER N. P. R. R./
SELBY AVE., COR. VIRGINIA, ST. PAUL, MINN.//
SEND FOR/CATALOGUE OF/VIEWS.//NORTHERN
PACIFIC,/YELLOWSTONE PARK,/PACIFIC COAST
AND ALASKA." and Fred and Jo Mazzulla stamp
Acquired from: Mazzulla Collection, Fred Mazzulla,
Denver, Colorado

2748. **OLD FAITHFUL GEYSER** (P1971.36.3)
Albumen silver print. c. mid-1880s
Image: 8 3/16 x 5 in. (20.8 x 12.7 cm.)
Mount: 8 1/2 x 5 1/4 in. (21.6 x 13.3 cm.)
Inscription, mount recto, printed: "3628 OLD FAITHFUL
GEYSER"
mount verso: "Old Faithful Geyser/3//X/LMDHN/9-30-26"
and printed "BOUDOIR SERIES./Our collection of Views
in this popular size embraces scenery/along the entire line
of the Northern Pacific./Yellowstone Park, Columbia River,
Seattle,/Tacoma and Portland,/St. Paul and Duluth to the
Pacific./CATALOGUES FREE./Published by/F. JAY
HAYNES & BRO., 392 Jackson Street, ST. PAUL./
OFFICIAL PHOTOGRAPHERS N. P. R. R."
Acquired from: Fred Rosenstock, Denver, Colorado

*2749. **OLD FAITHFUL GEYSER** [from Yellowstone Park Views set]
(P1979.72.9)
Toned gelatin silver print. negative c. 1883—95, print later
Image: 8 1/4 x 5 1/8 in. (20.8 x 13.0 cm.)
Mount: 8 1/2 x 5 1/4 in. (21.6 x 13.4 cm.)
Signed: see inscription
Inscription, mount recto, printed: "3620-Old Faithful
Geyser."
mount verso, printed: "F JAY/HAYNES,/OFFICIAL
PHOTOGRAPHER N. P. R. R./SELBY AVE., COR.
VIRGINIA, ST. PAUL, MINN.//SEND FOR/
CATALOGUE OF/VIEWS.//NORTHERN PACIFIC,/
YELLOWSTONE PARK,/PACIFIC COAST AND
ALASKA." and Fred and Jo Mazzulla stamp
Acquired from: Mazzulla Collection, Fred Mazzulla,
Denver, Colorado

2750. **OLD FAITHFUL GEYSER** (P1979.72.13)
Albumen silver print. c. 1883—95
Image: 8 1/16 x 4 13/16 in. (20.5 x 12.2 cm.)
Mount: 8 1/2 x 5 1/4 in. (21.6 x 13.4 cm.)
Signed: see inscription
Inscription, in negative: "3625 OLD FAITHFUL GEYSER/
HAYNES—PHOTO."
mount verso: "wi/35" and printed "BOUDOIR VIEWS./
OUR COLLECTION OF VIEWS IN THIS POPULAR
SIZE/EMBRACES SCENERY/ALONG THE ENTIRE
LINE OF THE NORTHERN PACIFIC,/INCLUDING/
Yellowstone, National Park,/Clark's Forks and Columbia
River,/MT. HOOD, MT. TACOMA AND PACIFIC
COAST,/MONTANA, WYOMING, DAKOTA,
ETC./DESCRIPTIVE CATALOGUE FREE./
PHOTOGRAPHED AND PUBLISHED BY/F. JAY
HAYNES,/Official Photographer N. P. R. R./FARGO,
DAKOTA." and printed paper label "JAS. W. QUEEN &
CO./924/Chestnut/St./PHILAD."
Acquired from: Mazzulla Collection, Fred Mazzulla,
Denver, Colorado

2751. **PAINT POTS, YELLOWSTONE LAKE** [from Yellowstone
Park Views set] (P1979.72.12)
Toned gelatin silver print. negative c. 1883—95, print later
Image: 5 1/16 x 8 5/16 in. (12.8 x 21.1 cm.)
Mount: 5 1/4 x 8 1/2 in. (13.4 x 21.6 cm.)
Signed: see inscription
Inscription, mount recto: "3629-Paint Pots, Yellowstone Lake."
mount verso, printed: "F JAY/HAYNES,/OFFICIAL
PHOTOGRAPHER N. P. R. R./SELBY AVE., COR.
VIRGINIA, ST. PAUL, MINN.//SEND FOR/
CATALOGUE OF/VIEWS.//NORTHERN PACIFIC,/
YELLOWSTONE PARK,/PACIFIC COAST AND
ALASKA." and Fred and Jo Mazzulla stamp
Acquired from: Mazzulla Collection, Fred Mazzulla,
Denver, Colorado

2745

2749

2757

2752. **PULPIT TERRACE, MAMMOTH HOT SPRINGS [from Yellowstone Park Views set]** (P1979.72.4)
Toned gelatin silver print. negative c. 1883–93, print later
Image: 5 x 8⅛ in. (12.7 x 20.7 cm.)
Mount: 5¼ x 8½ in. (13.4 x 21.6 cm.)
Signed: see inscription
Inscription, mount recto, printed: "3549-Pulpit Terrace, Mammoth Hot Springs."
mount verso, printed: "F JAY/HAYNES,/OFFICIAL PHOTOGRAPHER N. P. R. R./SELBY AVE., COR. VIRGINIA, ST. PAUL, MINN.//SEND FOR/CATALOGUE OF/VIEWS.//NORTHERN PACIFIC,/YELLOWSTONE PARK,/PACIFIC COAST AND ALASKA." and Fred and Jo Mazzulla stamp
Acquired from: Mazzulla Collection, Fred Mazzulla, Denver, Colorado

2753. **SAW MILL GEYSER AND FIRE HOLE RIVER** (P1979.72.18)
Albumen silver print. 1887
Image: 5¹⁄₁₆ x 8¼ in. (12.8 x 20.9 cm.)
Mount: 5¼ x 8½ in. (13.4 x 21.6 cm.)
Signed: see inscription
Inscription, in negative: "3518 SAW MILL GEYSER AND FIRE HOLE RIVER/HAYNES—PHOTO."
mount verso: "wi/35" and printed "BOUDOIR VIEWS./OUR COLLECTION OF VIEWS IN THIS POPULAR SIZE/EMBRACES SCENERY/ALONG THE ENTIRE LINE OF THE NORTHERN PACIFIC,/INCLUDING/Yellowstone, National Park,/Clark's Forks and Columbia River,/MT. HOOD, MT. TACOMA AND PACIFIC COAST,/MONTANA, WYOMING, DAKOTA, ETC./DESCRIPTIVE CATALOGUE FREE./PHOTOGRAPHED AND PUBLISHED BY/F. JAY HAYNES,/Official Photographer N. P. R. R./FARGO, DAKOTA." and printed paper label "JAS. W. QUEEN & CO./924/Chestnut/St./PHILAD."
Acquired from: Mazzulla Collection, Fred Mazzulla, Denver, Colorado

2754. **SEA SHELL GEYSER** (P1979.72.15)
Albumen silver print. c. 1880s
Image: 4¹⁵⁄₁₆ x 8³⁄₁₆ in. (12.5 x 20.8 cm.)
Mount: 5¼ x 8½ in. (13.4 x 21.6 cm.)
Signed: see inscription
Inscription, in negative: "3580 SEA SHELL GEYSER/HAYNES—PHOTO."
mount verso, printed: "BOUDOIR VIEWS./OUR COLLECTION OF VIEWS IN THIS POPULAR SIZE/EMBRACES SCENERY/ALONG THE ENTIRE LINE OF THE NORTHERN PACIFIC,/INCLUDING/Yellowstone, National Park,/Clark's Forks and Columbia River,/MT. HOOD, MT. TACOMA AND PACIFIC COAST,/MONTANA, WYOMING, DAKOTA, ETC./DESCRIPTIVE CATALOGUE FREE./PHOTOGRAPHED AND PUBLISHED BY/F. JAY HAYNES,/Official Photographer N. P. R. R./FARGO, DAKOTA."
Acquired from: Mazzulla Collection, Fred Mazzulla, Denver, Colorado

2755. **TURBAN GEYSER [from Yellowstone Park Views set]** (P1979.72.7)
Toned gelatin silver print. negative c. 1883–95, print later
Image: 5⅛ x 8¼ in. (13.0 x 20.9 cm.)
Mount: 5¼ x 8½ in. (13.4 x 21.6 cm.)
Signed: see inscription
Inscription, mount recto: "3600-TURBAN GEYSER"
mount verso, printed: "3600-Turban Geyser.//F JAY/HAYNES,/OFFICIAL PHOTOGRAPHER N. P. R. R./SELBY AVE., COR. VIRGINIA, ST. PAUL, MINN.//SEND FOR/CATALOGUE OF/VIEWS.//NORTHERN PACIFIC,/YELLOWSTONE PARK,/PACIFIC COAST AND ALASKA." and Fred and Jo Mazzulla stamp
Acquired from: Mazzulla Collection, Fred Mazzulla, Denver, Colorado

2756. **UPPER FALLS FROM THE ROAD [from Yellowstone Park Views set]** (P1979.72.5)
Toned gelatin silver print. negative 1885, print later
Image: 5¹⁄₁₆ x 8³⁄₁₆ in. (12.8 x 20.8 cm.)
Mount: 5¼ x 8½ in. (13.4 x 21.6 cm.)
Signed: see inscription
Inscription, mount recto, printed: "3640-Upper Falls from the Road."
mount verso, printed: "F. JAY HAYNES,/OFFICIAL PHOTOGRAPHER N. P. R. R./SELBY AVE., COR. VIRGINIA.//SEND FOR/CATALOGUE OF/VIEWS.//NORTHERN PACIFIC,/YELLOWSTONE PARK,/PACIFIC COAST AND ALASKA." and rubber stamp "ST. PAUL, MINN." and Fred and Jo Mazzulla stamp
Acquired from: Mazzulla Collection, Fred Mazzulla, Denver, Colorado

JOHN P. HEINS, American (1896–1969)

John Heins studied at the Art Students' League, Pratt Institute, the Institute of Fine Arts of New York University, and the Academy of Graphic Arts in Leipzig, Germany, and received a B.S. and an M.A. from Columbia University. He taught at Teachers College at Columbia, Skidmore College, and the Clarence White School of Photography, where Paul Outerbridge was one of Heins' students and friends. In addition to teaching, Heins also worked as a freelance printmaker, painter, book designer, and illustrator.

*2757. **PORTRAIT OF PAUL OUTERBRIDGE** (P1987.10)
Platinum print. c. 1921
Image: 4¹³⁄₁₆ x 3¾ in. (12.2 x 9.5 cm.)
1st mount: 9⁹⁄₁₆ x 6½ in. (24.3 x 16.5 cm.)
2nd mount: 13 x 9¼ in. (33.0 x 23.5 cm.)
Signed: see inscription
Inscription, 2nd mount verso: "A/WW F1//"Portrait of Paul Outerbridge"/Photograph by John P. Heins, Lecturer Clarence H. White,/School, N. Y./Frances Heins, Trustee, U/W."
Acquired from: Paul Katz, North Bennington, Vermont

SHEL HERSHORN, American (b. 1929)

Hershorn did photographic work for UPI and the *Dallas Times Herald* before pursuing freelance work in Dallas from 1954 to 1971. His photographs were published in *Life, Fortune, Newsweek, National Geographic,* and *Playboy.* In 1971 Hershorn moved to New Mexico, eventually giving up photography to pursue furniture making. In 1969 for the Amon Carter Museum Hershorn created a photographic essay and slide show on West Texas based on A. C. Greene's narrative "A Personal Country."

*2758. **[Dallas, Texas, boarding house porch with sign]** (P1981.69)
Gelatin silver print. c. 1969
Image: 13⅝ x 19⅜ in. (34.5 x 49.1 cm.)
Mount: 13¹¹⁄₁₆ x 19⁷⁄₁₆ in. (34.7 x 49.3 cm.)
Inscription, mount verso: "Photo made in Dallas, Texas, by Shel Hershorn"
Acquired from: gift of the photographer

F. BENEDICT HERZOG, American (d. 1921)

See *Camera Work*

PAUL HESTER, American (b. 1948)

A native of Nashville, Tennessee, Paul Hester attended Rice University, where he received a B.A. in 1971. He completed an M.F.A. at the Rhode Island School of Design in 1976. In 1972–73 Hester taught at the High School for the Visual and Performing Arts in Houston and in 1976–77 at the Dana Hall School in Wellesley, Massachusetts. Returning to Texas in 1977, Hester became the photography coordinator at the Media Center at Rice University, where he worked until 1979. He has been a visiting critic at the University of Houston and the Rice University School of Architecture and since 1979 has worked as an architectural photographer. Hester was president of the Houston Center for Photography in 1982 and has exhibited his work there and in other regional exhibitions. He received fellowships from the National Endowment for the Arts in 1973 and 1980 and a National Endowment for the Humanities Photo Survey grant in 1978.

2758

*2759. **CITY POST OAK. DENTIST'S OFFICE. HOUSTON**
[from "Contemporary Texas: A Photographic Portrait"]
(P1985.17.90)
Gelatin silver print. 1984
Image: 10½ x 13½ in. (26.6 x 34.3 cm.)
Sheet: 10¹⁵/₁₆ x 13⅞ in. (27.8 x 35.2 cm.)
Signed: see inscription
Inscription, print verso: "CITY POST OAK. DENTIST OFFICE. HOUSTON 1984//84.333/2/f22/8s" and rubber stamp "© 1984 PAUL HESTER"
Acquired from: gift of the Texas Historical Foundation with support from a major grant from the Du Pont Company and Conoco, its energy subsidiary, and assistance from the Texas Commission on the Arts and the National Endowment for the Arts

2759

2760. **1100 MILAM BUILDING. UNDERGROUND CAFETERIA. HOUSTON** [from "Contemporary Texas: A Photographic Portrait"] (P1985.17.81)
Gelatin silver print. 1984
Image: 13½ x 10½ in. (34.3 x 26.6 cm.)
Sheet: 13⅞ x 10¹⁵/₁₆ in. (35.2 x 27.8 cm.)
Signed: see inscription
Inscription, print verso: "84.386/2/f22/6s//1100 MILAM BUILDING. UNDERGROUND CAFETERIA. HOUSTON 1984" and rubber stamp "© 1984 PAUL HESTER"
Acquired from: gift of the Texas Historical Foundation with support from a major grant from the Du Pont Company and Conoco, its energy subsidiary, and assistance from the Texas Commission on the Arts and the National Endowment for the Arts

2764

2761. **INTERSTATE 610. WEST LOOP LOOKING SOUTH. HOUSTON** [from "Contemporary Texas: A Photographic Portrait"] (P1985.17.89)
Gelatin silver print. 1984
Image: 10½ x 10⅜ in. (26.6 x 26.4 cm.)
Sheet: 10¹⁵/₁₆ x 13¹⁵/₁₆ in. (27.8 x 35.4 cm.)
Signed: see inscription
Inscription, print verso: "84.331/803/f16/5s/bal/+3// INTERSTATE 610. WEST LOOP LOOKING SOUTH. HOUSTON 1984." and rubber stamp "© 1984 PAUL HESTER"
Acquired from: gift of the Texas Historical Foundation with support from a major grant from the Du Pont Company and Conoco, its energy subsidiary, and assistance from the Texas Commission on the Arts and the National Endowment for the Arts

2772. **BULLION CAÑON, UTAH** (P1975.103.3)
Albumen silver print. 1874
Image: 13 1/8 x 9 7/8 in. (33.3 x 25.0 cm.)
Mount: 20 1/16 x 16 1/16 in. (50.9 x 40.8 cm.)
Signed: see inscription
Inscription, in negative: "BULLION CAÑON, UTAH//
HILLERS"
Acquired from: Fred Mazzulla, Denver, Colorado

*2773. **[Canon de Chelly, Arizona]** (P1980.15.2)
Albumen silver print. 1879
Image: 9 3/8 x 12 7/16 in. (23.9 x 31.6 cm.)
Inscription, print verso: crop marks
Acquired from: Mazzulla Collection, Fred Mazzulla, Denver,
Colorado

2774. **CANON DE CHELLY, MONUMENT. ARIZ.** [De Chelley
Monument. Canon de Chelley, Arizona] (P1975.103.17)
duplicate of P1980.15.1
Albumen silver print. 1879
Image: 13 5/16 x 10 1/16 in. (33.8 x 25.6 cm.)
Mount: 20 1/16 x 16 1/16 in. (50.9 x 40.8 cm.)
Signed: see inscription
Inscription, in negative: "CANON DE CHELLY,
MONUMENT. ARIZ.//HILLERS"
Acquired from: Fred Mazzulla, Denver, Colorado

*2775. **CANON DEL MUERTE. FROM MUMMY CAVE. ARIZ.**
[Mummy Cave. Canon de Chelly] (P1975.103.18) duplicate of
P1980.15.4
Albumen silver print. 1879
Image: 10 1/16 x 13 3/16 in. (25.6 x 33.5 cm.)
Mount: 16 1/16 x 20 1/16 in. (40.8 x 50.9 cm.)
Signed: see inscription
Inscription, in negative: "CANON DEL MUERTE. FROM
MUMMY CAVE. ARIZ//HILLERS"
Acquired from: Fred Mazzulla, Denver, Colorado

*2776. **THE CAPTAIN OF THE RIO VIRGEN, UTAH** [The
Dome. Rio Virgen. Utah] (P1980.15.9) duplicate of
P1975.103.5
Albumen silver print. 1872
Image: 12 1/2 x 9 3/4 in. (31.7 x 24.7 cm.)
Inscription, in negative: "THE CAPTAIN OF THE RIO
VIRGEN, UTAH//[illegible]"
Acquired from: Mazzulla Collection, Fred Mazzulla, Denver,
Colorado

*2777. **CAPTAINS OF THE CANON, DE CHELLY CANON,
ARIZONA** (P1980.15.5)
Albumen silver print. 1879
Image: 12 1/2 x 9 3/4 in. (31.8 x 24.7 cm.)
Signed: see inscription
Inscription, in negative: "CAPTAINS OF THE CANON,
DE CHELLY CANON, ARIZONA//HILLERS, PHOTO"
Acquired from: Mazzulla Collection, Fred Mazzulla, Denver,
Colorado

2778. **DE CHELLEY CANON LOOKING EAST** (P1975.103.19)
Albumen silver print. 1879
Image: 10 1/8 x 13 1/4 in. (25.7 x 33.6 cm.)
Mount: 16 1/16 x 20 1/16 in. (40.8 x 50.9 cm.) irregular
Signed: see inscription
Inscription, in negative: "DE CHELLEY CANON
LOOKING EAST.//HILLERS"
Acquired from: Fred Mazzulla, Denver, Colorado

2779. **DE CHELLEY MONUMENT. CANON DE CHELLEY,
ARIZONA** [Canon de Chelly Monument. Ariz.]
(P1980.15.1) duplicate of P1975.103.17
Albumen silver print. 1879
Image: 12 7/16 x 9 11/16 in. (31.6 x 24.6 cm.)
Signed: see inscription
Inscription, in negative: "DE CHELLEY MONUMENT.
CANON DE CHELLEY, ARIZONA.//HILLERS,
PHO[illegible]"
Acquired from: Mazzulla Collection, Fred Mazzulla, Denver,
Colorado

2780. **THE DOME. RIO VIRGEN. UTAH** [The Captain of the
Rio Virgen, Utah] (P1975.103.5) duplicate of P1980.15.9
Albumen silver print. 1872
Image: 13 1/16 x 9 7/8 in. (33.2 x 25.0 cm.)
Mount: 20 1/16 x 16 1/16 in. (50.9 x 40.8 cm.)
Signed: see inscription
Inscription, in negative: "THE DOME. RIO VIRGEN.
UTAH//HILLERS"
Acquired from: Fred Mazzulla, Denver, Colorado

2781. **THE DOMES. RIO VIRGEN** (P1975.103.8)
Albumen silver print. 1872
Image: 13 1/8 x 9 15/16 in. (33.3 x 25.2 cm.)
Mount: 20 1/16 x 16 1/16 in. (50.9 x 40.8 cm.)
Signed: see inscription
Inscription, in negative: "THE DOMES. RIO VIRGEN.//
HILLERS."
Acquired from: Fred Mazzulla, Denver, Colorado

2782. **[The Domes, Rio Virgen, Utah]** (P1975.103.9)
Albumen silver print. 1872
Image: 13 1/8 x 9 15/16 in. (33.3 x 25.2 cm.)
Mount: 20 1/16 x 16 1/16 in. (50.9 x 40.8 cm.) irregular
Inscription, in negative: [illegible]
Acquired from: Fred Mazzulla, Denver, Colorado

2783. **EAGLE CRAG RIO VIRGEN. UTAH** (P1975.103.10)
Albumen silver print. 1872
Image: 13 1/8 x 9 15/16 in. (33.3 x 25.2 cm.)
Mount: 20 1/16 x 16 1/16 in. (50.9 x 40.8 cm.)
Signed: see inscription
Inscription, in negative: "EAGLE CRAG RIO VIRGEN.
UTAH./VIRG [illegible]//HILLERS."
Acquired from: Fred Mazzulla, Denver, Colorado

2784. **EAST FORK, CANON DE CHELLY** [East Fork De Chelly
River. Arizona] (P1980.15.8) duplicate of P1975.103.20
Albumen silver print. 1879
Image: 12 7/16 x 9 11/16 in. (31.5 x 24.5 cm.)
Inscription, in negative: "EAST FORK, CANON DE
CHELLY."
Acquired from: Mazzulla Collection, Fred Mazzulla, Denver,
Colorado

2785. **EAST FORK DE CHELLY RIVER. ARIZONA** [East Fork,
Canon de Chelly] (P1975.103.20) duplicate of P1980.15.8
Albumen silver print. 1879
Image: 13 3/16 x 9 7/8 in. (33.5 x 25.1 cm.)
Mount: 20 1/16 x 16 1/16 in. (50.9 x 40.8 cm.) irregular
Signed: see inscription
Inscription, in negative: "EAST FORK DE CHELLY RIVER.
ARIZONA.//HILLERS"
Acquired from: Fred Mazzulla, Denver, Colorado

2786. **GRAND CANON OF THE COLORADO. WEST**
(P1980.15.7)
Albumen silver print. 1872
Image: 12 7/16 x 9 11/16 in. (31.5 x 24.5 cm.)
Inscription, in negative: "GRAND CANON OF THE
COLORADO. WEST"
Acquired from: Mazzulla Collection, Fred Mazzulla, Denver,
Colorado

2787. **HAND ROCK, CANON DE CHELLY** (P1980.15.6) duplicate
of P1975.103.21 and P1975.103.22
Albumen silver print. 1879
Image: 12 7/16 x 9 3/4 in. (31.5 x 24.7 cm.)
Inscription, in negative: "HAND ROCK, CANON DE
CHELLY.//[illegible]"
print verso: crop marks
Acquired from: Mazzulla Collection, Fred Mazzulla, Denver,
Colorado

*2769. **CLIFF HOUSE SAN FRANCISCO CAL.** (P1982.26)
Albumen silver print. c. 1880s
Image: 6⁹⁄₁₆ x 9 in. (16.7 x 22.8 cm.)
Mount: 7⅞ x 9¹⁵⁄₁₆ in. (20.0 x 25.2 cm.)
Signed: see inscription
Inscription, in negative: "Cliff House San Francisco Cal.//
Hill & Watkins. San Jose. Cal."
mount recto: "Hill and Watkins,//79 AND 81 W./SANTA
CLARA ST./San Jose, Cal."
mount verso: "25-/dyA//YEX-82"
Acquired from: John Howell—Books, San Francisco,
California

DAVID OCTAVIUS HILL, Scottish (1802–1870), and ROBERT ADAMSON, Scottish (1821–1848)

See also *Camera Work*

Hill and Adamson made photographs together for a
period of four years, and together they produced a
remarkable group of portraits and views of the Scottish
countryside. Adamson was the technical expert, having
learned the calotype process (salted paper print from a
waxed paper negative) from his brother. Hill was a
painter and printmaker who first intended to use pho-
tography as an aid in composing a monumental portrait
of 474 ministers of the Church of Scotland. The part-
nership expanded beyond this project, however, as the
two men exhibited calotypes at the Royal Scottish
Academy between 1844 and 1848 and in 1846 copub-
lished "A Series of Calotype Views of St. Andrews."
The collaborative effort ended with Adamson's death
in 1848. Compared to those of other early photog-
raphers, their portraits are remarkable for the character
and individuality of their sitters. Alfred Stieglitz
admired the Hill and Adamson portraits, publishing a
number of them in *Camera Work*.

*2770. **REV. PETER JONES (KAHKEWAQUONABY) [The Waving
Plume]** (P1979.38)
Calotype. c. 1845
Image: 7⅞ x 5¹³⁄₁₆ in. (20.0 x 14.8 cm.)
Acquired from: Frontier America Corporation, Bryan, Texas

JOHN K. HILLERS, American, born Germany (1843–1925)

Hillers came to the United States from Hanover, Ger-
many, in 1852. He enlisted in the New York Naval
Brigade at the outbreak of the Civil War and later joined
the Union army. Hillers remained in the army until
1870, when he visited San Francisco. On the return
trip he met Major John Wesley Powell in Salt Lake City,
Utah, and joined the second Powell expedition down
the Colorado River. Beginning as a boatman, Hillers
learned photography by assisting the expedition pho-
tographers. He outlasted several photographers and was
finally named expedition photographer early in the
1872 season. When Powell was named director of
the Bureau of American Ethnology in 1879 he hired
Hillers, who made a large number of Indian portraits
for the Bureau. Hillers also continued his work for the
United States Geological Survey, still under Powell's
direction.

2771. **BULLION CANON UTAH** (P1975.103.1)
Albumen silver print. 1874
Image: 13 x 9⅞ in. (32.9 x 25.0 cm.) irregular
Mount: 20¹⁄₁₆ x 16¹⁄₁₆ in. (50.9 x 40.8 cm.) irregular
Signed: see inscription
Inscription, in negative: "BULLION CANON UTAH//
HILLERS."
Acquired from: Fred Mazzulla, Denver, Colorado

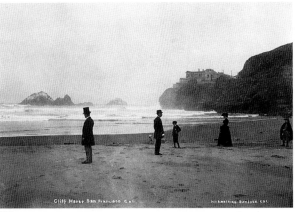

2769

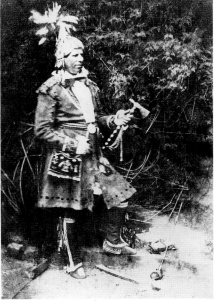

2770

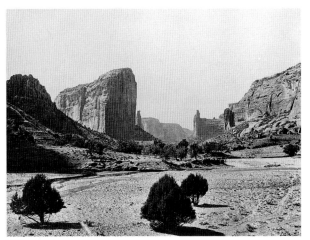

2773

2772. **BULLION CAÑON, UTAH** (P1975.103.3)
Albumen silver print. 1874
Image: 13 ⅛ x 9 ⅞ in. (33.3 x 25.0 cm.)
Mount: 20 1/16 x 16 1/16 in. (50.9 x 40.8 cm.)
Signed: see inscription
Inscription, in negative: "BULLION CAÑON, UTAH//
HILLERS"
Acquired from: Fred Mazzulla, Denver, Colorado

*2773. **[Canon de Chelly, Arizona]** (P1980.15.2)
Albumen silver print. 1879
Image: 9 ⅜ x 12 7/16 in. (23.9 x 31.6 cm.)
Inscription, print verso: crop marks
Acquired from: Mazzulla Collection, Fred Mazzulla, Denver,
Colorado

2774. **CANON DE CHELLY, MONUMENT. ARIZ. [De Chelley
Monument. Canon de Chelley, Arizona]** (P1975.103.17)
duplicate of P1980.15.1
Albumen silver print. 1879
Image: 13 5/16 x 10 1/16 in. (33.8 x 25.6 cm.)
Mount: 20 1/16 x 16 1/16 in. (50.9 x 40.8 cm.)
Signed: see inscription
Inscription, in negative: "CANON DE CHELLY,
MONUMENT. ARIZ.//HILLERS"
Acquired from: Fred Mazzulla, Denver, Colorado

*2775. **CANON DEL MUERTE. FROM MUMMY CAVE. ARIZ.
[Mummy Cave. Canon de Chelly]** (P1975.103.18) duplicate of
P1980.15.4
Albumen silver print. 1879
Image: 10 1/16 x 13 3/16 in. (25.6 x 33.5 cm.)
Mount: 16 1/16 x 20 1/16 in. (40.8 x 50.9 cm.)
Signed: see inscription
Inscription, in negative: "CANON DEL MUERTE. FROM
MUMMY CAVE. ARIZ//HILLERS"
Acquired from: Fred Mazzulla, Denver, Colorado

*2776. **THE CAPTAIN OF THE RIO VIRGEN, UTAH [The
Dome. Rio Virgen. Utah]** (P1980.15.9) duplicate of
P1975.103.5
Albumen silver print. 1872
Image: 12 ½ x 9 ¾ in. (31.7 x 24.7 cm.)
Inscription, in negative: "THE CAPTAIN OF THE RIO
VIRGEN, UTAH//[illegible]"
Acquired from: Mazzulla Collection, Fred Mazzulla, Denver,
Colorado

*2777. **CAPTAINS OF THE CANON, DE CHELLY CANON,
ARIZONA** (P1980.15.5)
Albumen silver print. 1879
Image: 12 ½ x 9 ¾ in. (31.8 x 24.7 cm.)
Signed: see inscription
Inscription, in negative: "CAPTAINS OF THE CANON,
DE CHELLY CANON, ARIZONA//HILLERS, PHOTO"
Acquired from: Mazzulla Collection, Fred Mazzulla, Denver,
Colorado

2778. **DE CHELLEY CANON LOOKING EAST** (P1975.103.19)
Albumen silver print. 1879
Image: 10 ⅛ x 13 ¼ in. (25.7 x 33.6 cm.)
Mount: 16 1/16 x 20 1/16 in. (40.8 x 50.9 cm.) irregular
Signed: see inscription
Inscription, in negative: "DE CHELLEY CANON
LOOKING EAST.//HILLERS"
Acquired from: Fred Mazzulla, Denver, Colorado

2779. **DE CHELLEY MONUMENT. CANON DE CHELLEY,
ARIZONA [Canon de Chelly Monument. Ariz.]**
(P1980.15.1) duplicate of P1975.103.17
Albumen silver print. 1879
Image: 12 7/16 x 9 11/16 in. (31.6 x 24.6 cm.)
Signed: see inscription
Inscription, in negative: "DE CHELLEY MONUMENT.
CANON DE CHELLEY, ARIZONA.//HILLERS,
PHO[illegible]"
Acquired from: Mazzulla Collection, Fred Mazzulla, Denver,
Colorado

2780. **THE DOME. RIO VIRGEN. UTAH [The Captain of the
Rio Virgen, Utah]** (P1975.103.5) duplicate of P1980.15.9
Albumen silver print. 1872
Image: 13 1/16 x 9 ⅞ in. (33.2 x 25.0 cm.)
Mount: 20 1/16 x 16 1/16 in. (50.9 x 40.8 cm.)
Signed: see inscription
Inscription, in negative: "THE DOME. RIO VIRGEN.
UTAH//HILLERS"
Acquired from: Fred Mazzulla, Denver, Colorado

2781. **THE DOMES. RIO VIRGEN** (P1975.103.8)
Albumen silver print. 1872
Image: 13 ⅛ x 9 15/16 in. (33.3 x 25.2 cm.)
Mount: 20 1/16 x 16 1/16 in. (50.9 x 40.8 cm.)
Signed: see inscription
Inscription, in negative: "THE DOMES. RIO VIRGEN.//
HILLERS."
Acquired from: Fred Mazzulla, Denver, Colorado

2782. **[The Domes, Rio Virgen, Utah]** (P1975.103.9)
Albumen silver print. 1872
Image: 13 ⅛ x 9 15/16 in. (33.3 x 25.2 cm.)
Mount: 20 1/16 x 16 1/16 in. (50.9 x 40.8 cm.) irregular
Inscription, in negative: [illegible]
Acquired from: Fred Mazzulla, Denver, Colorado

2783. **EAGLE CRAG RIO VIRGEN. UTAH** (P1975.103.10)
Albumen silver print. 1872
Image: 13 ⅛ x 9 15/16 in. (33.3 x 25.2 cm.)
Mount: 20 1/16 x 16 1/16 in. (50.9 x 40.8 cm.)
Signed: see inscription
Inscription, in negative: "EAGLE CRAG RIO VIRGEN.
UTAH./VIRG [illegible]//HILLERS."
Acquired from: Fred Mazzulla, Denver, Colorado

2784. **EAST FORK, CANON DE CHELLY [East Fork De Chelly
River. Arizona]** (P1980.15.8) duplicate of P1975.103.20
Albumen silver print. 1879
Image: 12 7/16 x 9 11/16 in. (31.5 x 24.5 cm.)
Inscription, in negative: "EAST FORK, CANON DE
CHELLY."
Acquired from: Mazzulla Collection, Fred Mazzulla, Denver,
Colorado

2785. **EAST FORK DE CHELLY RIVER. ARIZONA [East Fork,
Canon de Chelly]** (P1975.103.20) duplicate of P1980.15.8
Albumen silver print. 1879
Image: 13 3/16 x 9 ⅞ in. (33.5 x 25.1 cm.)
Mount: 20 1/16 x 16 1/16 in. (50.9 x 40.8 cm.) irregular
Signed: see inscription
Inscription, in negative: "EAST FORK DE CHELLY RIVER.
ARIZONA.//HILLERS"
Acquired from: Fred Mazzulla, Denver, Colorado

2786. **GRAND CANON OF THE COLORADO. WEST**
(P1980.15.7)
Albumen silver print. 1872
Image: 12 7/16 x 9 11/16 in. (31.5 x 24.5 cm.)
Inscription, in negative: "GRAND CANON OF THE
COLORADO. WEST"
Acquired from: Mazzulla Collection, Fred Mazzulla, Denver,
Colorado

2787. **HAND ROCK, CANON DE CHELLY** (P1980.15.6) duplicate
of P1975.103.21 and P1975.103.22
Albumen silver print. 1879
Image: 12 7/16 x 9 ¾ in. (31.5 x 24.7 cm.)
Inscription, in negative: "HAND ROCK, CANON DE
CHELLY.//[illegible]"
print verso: crop marks
Acquired from: Mazzulla Collection, Fred Mazzulla, Denver,
Colorado

PAUL HESTER, American (b. 1948)

A native of Nashville, Tennessee, Paul Hester attended
Rice University, where he received a B.A. in 1971. He
completed an M.F.A. at the Rhode Island School of
Design in 1976. In 1972–73 Hester taught at the High
School for the Visual and Performing Arts in Houston
and in 1976–77 at the Dana Hall School in Wellesley,
Massachusetts. Returning to Texas in 1977, Hester be-
came the photography coordinator at the Media Center
at Rice University, where he worked until 1979. He has
been a visiting critic at the University of Houston and
the Rice University School of Architecture and since
1979 has worked as an architectural photographer.
Hester was president of the Houston Center for Pho-
tography in 1982 and has exhibited his work there and
in other regional exhibitions. He received fellowships
from the National Endowment for the Arts in 1973 and
1980 and a National Endowment for the Humanities
Photo Survey grant in 1978.

2758

*2759. **CITY POST OAK. DENTIST'S OFFICE. HOUSTON**
[from "Contemporary Texas: A Photographic Portrait"]
(P1985.17.90)
Gelatin silver print. 1984
Image: 10½ x 13½ in. (26.6 x 34.3 cm.)
Sheet: 10¹⁵⁄₁₆ x 13⅞ in. (27.8 x 35.2 cm.)
Signed: see inscription
Inscription, print verso: "CITY POST OAK. DENTIST
OFFICE. HOUSTON 1984//84.333/2/f22/8s" and rubber
stamp "© 1984 PAUL HESTER"
Acquired from: gift of the Texas Historical Foundation with
support from a major grant from the Du Pont Company
and Conoco, its energy subsidiary, and assistance from
the Texas Commission on the Arts and the National
Endowment for the Arts

2760. **1100 MILAM BUILDING. UNDERGROUND
CAFETERIA. HOUSTON** [from "Contemporary Texas:
A Photographic Portrait"] (P1985.17.81)
Gelatin silver print. 1984
Image: 13½ x 10½ in. (34.3 x 26.6 cm.)
Sheet: 13⅞ x 10¹⁵⁄₁₆ in. (35.2 x 27.8 cm.)
Signed: see inscription
Inscription, print verso: "84.386/2/f22/6s//1100 MILAM
BUILDING. UNDERGROUND CAFETERIA.
HOUSTON 1984" and rubber stamp "© 1984 PAUL
HESTER"
Acquired from: gift of the Texas Historical Foundation with
support from a major grant from the Du Pont Company
and Conoco, its energy subsidiary, and assistance from
the Texas Commission on the Arts and the National
Endowment for the Arts

2761. **INTERSTATE 610. WEST LOOP LOOKING SOUTH.
HOUSTON** [from "Contemporary Texas: A Photographic
Portrait"] (P1985.17.89)
Gelatin silver print. 1984
Image: 10½ x 10⅜ in. (26.6 x 26.4 cm.)
Sheet: 10¹⁵⁄₁₆ x 13¹⁵⁄₁₆ in. (27.8 x 35.4 cm.)
Signed: see inscription
Inscription, print verso: "84.331/803/f16/5s/bal/+3//
INTERSTATE 610. WEST LOOP LOOKING SOUTH.
HOUSTON 1984." and rubber stamp "© 1984 PAUL
HESTER"
Acquired from: gift of the Texas Historical Foundation with
support from a major grant from the Du Pont Company
and Conoco, its energy subsidiary, and assistance from
the Texas Commission on the Arts and the National
Endowment for the Arts

2759

2764

2762. **ONE SHELL PLAZA. ELEVATOR LOBBY. HOUSTON**
[from "Contemporary Texas: A Photographic Portrait"]
(P1985.17.86)
Gelatin silver print. 1984
Image: 10 7/16 x 9 13/16 in. (26.5 x 24.9 cm.)
Sheet: 10 15/16 x 14 in. (27.8 x 35.6 cm.)
Signed: see inscription
Inscription, print verso: "84.65.8/G3/f8/8s/+3//ONE SHELL
PLAZA. ELEVATOR LOBBY. HOUSTON 1984." and
rubber stamp "© 1984 PAUL HESTER"
Acquired from: gift of the Texas Historical Foundation with
support from a major grant from the Du Pont Company
and Conoco, its energy subsidiary, and assistance from
the Texas Commission on the Arts and the National
Endowment for the Arts

2763. **PENNZOIL PLACE. ATRIUM. HOUSTON [from
"Contemporary Texas: A Photographic Portrait"]**
(P1985.17.85)
Gelatin silver print. 1984
Image: 13 1/2 x 10 1/2 in. (34.3 x 26.6 cm.)
Sheet: 13 15/16 x 10 15/16 in. (35.4 x 27.8 cm.)
Signed: see inscription
Inscription, print verso: "84.386/G4/f16/4/2/2//PENNZOIL
PLACE. ATRIUM. HOUSTON 1984" and rubber stamp
"© 1984 PAUL HESTER"
Acquired from: gift of the Texas Historical Foundation with
support from a major grant from the Du Pont Company
and Conoco, its energy subsidiary, and assistance from
the Texas Commission on the Arts and the National
Endowment for the Arts

2764. **REPUBLICBANK. LOAN DEPARTMENT. HOUSTON**
[from "Contemporary Texas: A Photographic Portrait"]
(P1985.17.83)
Gelatin silver print. 1984
Image: 13 1/2 x 10 9/16 in. (34.3 x 26.8 cm.)
Sheet: 13 7/8 x 10 15/16 in. (35.2 x 27.8 cm.)
Signed: see inscription
Inscription, print verso: "84.403/2/f22/8s//REPUBLIC
BANK. LOAN DEPARTMENT. HOUSTON 1984" and
rubber stamp "© 1984 PAUL HESTER"
Acquired from: gift of the Texas Historical Foundation with
support from a major grant from the Du Pont Company
and Conoco, its energy subsidiary, and assistance from
the Texas Commission on the Arts and the National
Endowment for the Arts

2765. **REPUBLICBANK. OFFICE. HOUSTON [from
"Contemporary Texas: A Photographic Portrait"]**
(P1985.17.82)
Gelatin silver print. 1984
Image: 13 1/2 x 10 9/16 in. (34.3 x 26.8 cm.)
Sheet: 13 7/8 x 10 15/16 in. (35.2 x 27.8 cm.)
Signed: see inscription
Inscription, print verso: "84.323/2/f22/6s//REPUBLICBANK.
OFFICE. HOUSTON 1984" and rubber stamp "© 1984
PAUL HESTER"
Acquired from: gift of the Texas Historical Foundation with
support from a major grant from the Du Pont Company
and Conoco, its energy subsidiary, and assistance from
the Texas Commission on the Arts and the National
Endowment for the Arts

2766. **TENNECO EMPLOYEE CENTER. RUNNING TRACK.
HOUSTON [from "Contemporary Texas: A Photographic
Portrait"]** (P1985.17.87)
Gelatin silver print. 1984
Image: 13 1/2 x 10 7/16 in. (34.3 x 26.5 cm.)
Sheet: 13 15/16 x 10 15/16 in. (35.4 x 27.8 cm.)
Signed: see inscription
Inscription, print verso: "84.423/G3/f16/512/+3//TENNECO
EMPLOYEE CENTER. RUNNING TRACK. HOUSTON
1984" and rubber stamp "© 1984 PAUL HESTER"
Acquired from: gift of the Texas Historical Foundation with

support from a major grant from the Du Pont Company
and Conoco, its energy subsidiary, and assistance from
the Texas Commission on the Arts and the National
Endowment for the Arts

2767. **TEXAS COMMERCE BANK TOWER IN UNITED
ENERGY PLAZA. HOUSTON [from "Contemporary
Texas: A Photographic Portrait"]** (P1985.17.84)
Gelatin silver print. 1984
Image: 13 1/2 x 10 7/16 in. (34.3 x 26.5 cm.)
Sheet: 13 15/16 x 10 15/16 in. (35.4 x 27.8 cm.)
Signed: see inscription
Inscription, print verso: "84.367/G3/f16/7s/−2 LL//TEXAS
COMMERCE BANK TOWER IN UNITED ENERGY
PLAZA. HOUSTON 1984" and rubber stamp "© 1984
PAUL HESTER"
Acquired from: gift of the Texas Historical Foundation with
support from a major grant from the Du Pont Company
and Conoco, its energy subsidiary, and assistance from
the Texas Commission on the Arts and the National
Endowment for the Arts

2768. **TRANSCO TOWER. GERALD D. HINES INTERESTS
RECEPTION. HOUSTON [from "Contemporary Texas:
A Photographic Portrait"]** (P1985.17.88)
Gelatin silver print. 1984
Image: 10 1/2 x 13 1/2 in. (26.6 x 34.3 cm.)
Sheet: 10 15/16 x 13 15/16 in. (27.8 x 35.4 cm.)
Signed: see inscription
Inscription, print verso: "84.348/3/f16/512//TRANSCO
TOWER. GERALD D. HINES INTERESTS
RECEPTION. HOUSTON 1984" and rubber stamp
"© 1984 PAUL HESTER"
Acquired from: gift of the Texas Historical Foundation with
support from a major grant from the Du Pont Company and
Conoco, its energy subsidiary, and assistance from the
Texas Commission on the Arts and the National
Endowment for the Arts

ANDREW PUTNAM HILL,
American (1853–1922),
and MRS. LAURA J. BROUGHTON WATKINS,
American (c. 1820s–c. late 1800s)

Painter and photographer Andrew Putnam Hill and his
mother-in-law, Laura J. Broughton Watkins, were part-
ners in the San Jose studio of Hill and Watkins. Mrs.
Watkins was not actually involved in the photography;
she financed the studio. Hill was a native of Indiana,
but when he was 14 he moved to California, where he
lived with an uncle. Hill attended the Catholic College
of Santa Clara but did not complete his studies. In 1870
he went to work on another uncle's ranch; however, he
soon moved to San Francisco to study art at the Cal-
ifornia School of Design. A respected painter, Hill
accepted commissions for paintings, taught classes, and
ran a portrait painting studio. Although painting kept
him busy, he was unable to earn a living from it and
decided to try photography. In 1889 Hill became part-
ners with J. C. Franklin, but Franklin soon left the
business. With the financial backing of his mother-in-
law, Hill established the studio of Hill and Watkins,
which operated through 1891. In 1892 Hill formed a
partnership with Sidney J. Yard, and over the next
three years the two photographed much of Santa Clara
County. Financial problems forced Hill and Yard to dis-
solve the partnership, but Hill went on to establish a
successful business providing illustrations for publica-
tions. In addition to his artistic endeavors, Hill was
active in the conservation movement and helped pre-
serve the Big Basin Redwood Park.

2788. **HAND ROCK. CANON DE CHELLEY. ARIZ.**
(P1975.103.21) duplicate of P1975.103.22 and P1980.15.6
Albumen silver print. 1879
Image: 13 3/16 x 10 1/16 in. (33.5 x 25.6 cm.)
Mount: 20 1/16 x 16 1/16 in. (50.9 x 40.8 cm.)
Signed: see inscription
Inscription, in negative: "HAND ROCK. CANON DE
CHELLEY. ARIZ//HILLERS"
Acquired from: Fred Mazzulla, Denver, Colorado

2789. **HAND ROCK. CANON DE CHELLEY. ARIZ.**
(P1975.103.22) duplicate of P1975.103.21 and P1980.15.6
Albumen silver print. 1879
Image: 13 x 9 7/8 in. (33.0 x 25.1 cm.)
Mount: 20 1/16 x 16 1/16 in. (50.9 x 40.8 cm.)
Signed: see inscription
Inscription, in negative: "HAND ROCK. CANON DE
CHELLEY. ARIZ//HILLERS"
Acquired from: Fred Mazzulla, Denver, Colorado

2775

Attributed to John K. Hillers
2790. **IN CANON DE CHELLY** (P1975.103.23) duplicate of
P1975.103.24
Albumen silver print. c. 1879
Image: 10 1/8 x 13 3/16 in. (25.7 x 33.5 cm.)
Mount: 16 1/16 x 20 1/16 in. (40.8 x 50.9 cm.) irregular
Inscription, mount verso: "In Canon De Chelly"
Acquired from: Fred Mazzulla, Denver, Colorado

Attributed to John K. Hillers
2791. **IN CANON DE CHELLY** (P1975.103.24) duplicate of
P1975.103.23
Albumen silver print. c. 1879
Image: 10 1/16 x 13 1/4 in. (25.6 x 33.7 cm.)
Mount: 16 1/16 x 20 1/16 in. (40.8 x 50.9 cm.) irregular
Inscription, mount verso: "In Canon De Chelly"
Acquired from: Fred Mazzulla, Denver, Colorado

*2792. **MARY'S WATERFALL, BULLION CANON UTAH**
[High Falls, Bullion Canyon, Utah] (P1975.103.2)
Albumen silver print. 1874
Image: 12 3/4 x 9 7/8 in. (32.4 x 25.0 cm.)
Mount: 20 1/16 x 16 1/16 in. (50.9 x 40.8 cm.)
Signed: see inscription
Inscription, in negative: "MARY'S W[illegible] BULLION
CANON UTAH//HILLERS."
Acquired from: Fred Mazzulla, Denver, Colorado

2776

2793. **MONUMENT CANON DEL MUERTE** (P1980.15.3)
Albumen silver print. 1879
Image: 12 7/16 x 9 11/16 in. (31.5 x 24.7 cm.)
Inscription, in negative: "MONUMENT CANON DEL
MUERTE."
Acquired from: Mazzulla Collection, Fred Mazzulla,
Denver, Colorado

2794. **MUMMY CAVE. CANON DE CHELLY [Canon del Muerte.**
From Mummy Cave. Ariz.] (P1980.15.4) duplicate of
P1975.103.18
Albumen silver print. 1879
Image: 9 3/4 x 12 7/16 in. (24.7 x 31.6 cm.)
Inscription, in negative: "MUMMY CAVE. CANON DE
CHELLY"
Acquired from: Mazzulla Collection, Fred Mazzulla,
Denver, Colorado

2795. **NAN KUN TO WIP VALLEY** (P1975.103.28)
Albumen silver print. 1872
Image: 13 x 9 7/8 in. (33.1 x 25.1 cm.)
Mount: 20 1/16 x 16 1/16 in. (50.9 x 40.8 cm.)
Signed: see inscription
Inscription, in negative: "NAN KUN TO WIP VALLEY.//
HILLERS."
mount recto: "Ea[illegible]"
Acquired from: Fred Mazzulla, Denver, Colorado

2777

2796. **NAVAJO CHURCH, NEAR FORT WINGATE**
[McKinley County, New Mexico] (P1975.103.15)
Albumen silver print. 1882
Image: 13 3/16 x 10 1/16 in. (33.5 x 25.6 cm.)
Mount: 20 1/16 x 16 1/16 in. (50.9 x 40.8 cm.)
Signed: see inscription
Inscription, in negative: "NAVAJO CHURCH, NEAR FORT
WING[ate]//HILLERS"
Acquired from: Fred Mazzulla, Denver, Colorado

2797. **PA-GUMP CANON. KAIBAB PLATEAU. ARIZ.**
(P1975.103.25) duplicate of P1975.103.26
Albumen silver print. 1873
Image: 13 1/16 x 9 7/8 in. (33.2 x 25.1 cm.)
Mount: 20 1/16 x 16 1/16 in. (50.9 x 40.8 cm.)
Signed: see inscription
Inscription, in negative: "PA-GUMP CANON. KAIBAB
PLATEAU. ARIZ.//HILLERS."
Acquired from: Fred Mazzulla, Denver, Colorado

*2798. **PA-GUMP CANON. KAIBAB PLATEAU. ARIZ.**
(P1975.103.26) duplicate of P1975.103.25
Albumen silver print. 1873
Image: 13 1/16 x 9 7/8 in. (33.2 x 25.1 cm.)
Mount: 20 1/16 x 16 1/16 in. (50.9 x 40.8 cm.)
Signed: see inscription
Inscription, in negative: "PA-GUMP CANON. KAIBAB
PLATEAU. ARIZ.//HILLERS"
mount recto: "Calo Plateau"
Acquired from: Fred Mazzulla, Denver, Colorado

2799. **PILLINGS CASCADE. BULLION CANON, UTAH**
(P1975.103.4)
Albumen silver print. 1873
Image: 13 x 9 7/8 in. (33.1 x 25.0 cm.)
Mount: 20 1/16 x 16 1/16 in. (50.9 x 40.8 cm.)
Inscription, in negative: "PILLINGS [casca]DE. BULLION
CAN[o]N, UTAH//[illegible]"
Acquired from: Fred Mazzulla, Denver, Colorado

2800. **REFLECTED TOWER. RIO VIRGEN UTAH** (P1975.103.6)
duplicate of P1975.103.7
Albumen silver print. 1873
Image: 13 3/16 x 9 15/16 in. (33.4 x 25.2 cm.)
Mount: 20 1/16 x 16 1/16 in. (50.9 x 40.8 cm.) irregular
Signed: see inscription
Inscription, in negative: "REFLECTED TOWER. RIO
VIRGEN UTAH//HILLERS"
Acquired from: Fred Mazzulla, Denver, Colorado

2801. **REFLECTED TOWER. RIO VIRGEN. UTAH** (P1975.103.7)
duplicate of P1975.103.6
Albumen silver print. 1873
Image: 13 x 9 7/8 in. (33.1 x 25.0 cm.)
Mount: 20 1/16 x 16 1/16 in. (50.9 x 40.8 cm.) irregular
Signed: see inscription
Inscription, in negative: "REFLECTED TOWER. RIO
VIRGEN. UTAH//HILLERS"
Acquired from: Fred Mazzulla, Denver, Colorado

Attributed to John K. Hillers
2802. **[Rock wall built on top of boulder, tree limb leaning against
front of boulder]** (P1975.103.27)
Albumen silver print. c. 1870s
Image: 9 7/8 x 12 15/16 in. (25.3 x 32.9 cm.)
Mount: 16 1/16 x 20 1/16 in. (40.8 x 50.9 cm.) irregular
Inscription, in negative: [illegible—retouched]
Acquired from: Fred Mazzulla, Denver, Colorado

*2803. **SAN FRANCISCO MOUNTAINS** (P1975.103.30)
Albumen silver print. 1885
Image: 13 1/8 x 9 7/8 in. (33.3 x 25.1 cm.)
Mount: 20 1/16 x 16 1/16 in. (50.9 x 40.8 cm.) irregular
Inscription, in negative: "SAN FRANCISCO
MOUNTAINS./[illegible]"
Acquired from: Fred Mazzulla, Denver, Colorado

2804. **SHI. PAU. EL. AVI. MOKI [Pueblo on mesa]** (P1975.103.16)
Albumen silver print. 1872 or 1879
Image: 9 13/16 x 13 1/16 in. (24.9 x 33.1 cm.)
Mount: 16 1/16 x 20 1/16 in. (40.8 x 50.9 cm.)
Signed: see inscription
Inscription, in negative: "SHI. PAU. EL. AVI. MOKI//
HILLERS."
Acquired from: Fred Mazzulla, Denver, Colorado

2805. **SHINI-MO ALTAR FROM BRINK OF MARBLE CANON,
COLORADO RIVER ARIZONA** (P1975.103.29)
Albumen silver print. c. 1872
Image: 13 1/16 x 9 7/8 in. (33.2 x 25.1 cm.)
Mount: 20 1/16 x 13 1/4 in. (50.9 x 33.7 cm.) irregular
Signed: see inscription
Inscription, in negative: "SHINI-MO ALTAR FROM BRINK
OF MARBLE/CANON, COLORADO RIVER
ARIZONA//HILLERS"
Acquired from: Fred Mazzulla, Denver, Colorado

*2806. **[Taos Pueblo]** (P1981.52)
Platinum print. negative 1879, print later, possibly by
DeLancey Gill
Image: 9 11/16 x 12 1/8 in. (24.6 x 30.8 cm.)
Inscription, in negative: [illegible—retouched]
Acquired from: John Howell—Books, San Francisco,
California

*2807. **THREE PATRIARCHS, ZION CANYON, UTAH**
(P1975.103.11) duplicate of P1975.103.12
Albumen silver print. 1872
Image: 9 15/16 x 13 1/8 in. (25.2 x 33.3 cm.)
Mount: 16 1/16 x 20 1/16 in. (40.8 x 50.9 cm.)
Signed: see inscription
Inscription, in negative: "[illegible]//HILLERS"
Acquired from: Fred Mazzulla, Denver, Colorado

2808. **THREE PATRIARCHS, ZION CANYON, UTAH**
(P1975.103.12) duplicate of P1975.103.11
Albumen silver print. 1872
Image: 9 15/16 x 12 15/16 in. (25.2 x 32.8 cm.)
Mount: 16 1/16 x 20 1/16 in. (40.8 x 50.9 cm.) irregular
Signed: see inscription
Inscription, in negative: "[illegible]//HILLERS"
Acquired from: Fred Mazzulla, Denver, Colorado

2809. **ZION'S PEAK. RIO VIRGEN UTAH** (P1975.103.13)
duplicate of P1975.103.14
Albumen silver print. 1872
Image: 9 11/16 x 12 3/4 in. (24.9 x 32.4 cm.)
Mount: 16 1/16 x 20 1/16 in. (40.8 x 50.9 cm.) irregular
Signed: see inscription
Inscription, in negative: "[Z]ION'S PEAK. RIO VIRGEN
UTAH//HILLERS"
Acquired from: Fred Mazzulla, Denver, Colorado

2810. **ZION'S PEAK. RIO VIRGEN UTAH** (P1975.103.14)
duplicate of P1975.103.13
Albumen silver print. 1872
Image: 9 7/8 x 13 1/16 in. (25.1 x 33.1 cm.)
Mount: 16 1/16 x 20 1/16 in. (40.8 x 50.9 cm.) irregular
Signed: see inscription
Inscription, in negative: "[Z]ION'S PEAK. RIO VIRGEN
UTAH//HILLERS"
Acquired from: Fred Mazzulla, Denver, Colorado

HAMILTON BISCOE HILLYER,
American (1833–1903)

A native of Georgia, Hillyer moved to Galveston with
his parents in 1845. He farmed near Goliad for several
years before moving to Austin, where he opened a
photographic studio about 1857. Hillyer is thought to
have been be one of the first Texas photographers to
make paper prints. During the Civil War he was
appointed as the official photographer for the state

2792

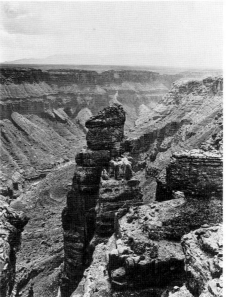

2798

2803

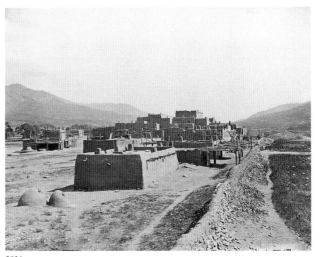

2806

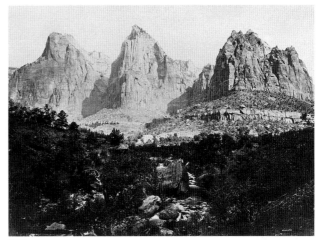

2807

of Texas and held the post for many years, making photographs of early elected officials, views of the state capitol, and scenes around Austin. Hillyer operated his Austin studio through the mid-1880s, then closed it and moved to Bowie where he continued to photograph until his death.

2811. [Texas (?) border town, street scene with carriages in front of large white building; Sierra Madre Mountains in the background] (P1978.53.2)
Albumen silver print. c. 1878–79
Image: 4 ¼ x 6 ⅜ in. (10.7 x 16.1 cm.) irregular
Mount: 4 ⁵⁄₁₆ x 6 ⁷⁄₁₆ in. (10.9 x 16.3 cm.) irregular
Signed: see inscription
Inscription, mount verso: "Sierra Madre in the Distance// R-618" and printed "H. B. HILLYER'S/[drawing of gallery]/ NEW GALLERY/Austin, Texas."
Acquired from: Hastings Gallery, New York, New York

*2812. [Texas (?) border town, street scene with Sierra Madre Mountains in the background] (P1978.53.1)
Albumen silver print. c. 1878–79
Image: 4 ⅛ x 6 ⁷⁄₁₆ in. (10.5 x 16.4 cm.) irregular
Mount: same as image size
Signed: see inscription
Inscription, mount verso: "Sierra Madre in the Distance// R-617" and printed "H. B. HILLYER'S/[drawing of gallery]/ NEW GALLERY/Austin, Texas."
Acquired from: Hastings Gallery, New York, New York

LEWIS WICKES HINE, American (1874–1940)

Hine first experimented with photography as a tool to spur social reform while he was teaching at the progressive Ethical Culture School in New York City. His first project was a series of photographs made at the United States immigration center at Ellis Island. The photographs made there sought to develop sympathy for the plight of the non-English-speaking immigrants processed through the center. Between 1908 and 1916 Hine was an investigator for the Child Labor Study Commission. His views of field and factory labor conditions were instrumental in the development of the first child labor laws. Hine had a strong sympathy for the laborer, and during the early 1920s his "Work-Portraits" sought to dramatize the power and energy generated by the American labor force. This work included a series documenting the construction of the Empire State Building and power plants in Pennsylvania. His photographs are straightforward and unmanipulated, as Hine felt it essential that the viewer believe that the situation existed exactly as he photographed it.

*2813. AUSTIN, TEX. OCT. 1913 [Albert Schafer, eight-year-old newsboy] (P1978.111.13)
Gelatin silver print. 1913
Image: 4 ⁷⁄₁₆ x 6 ⅜ in. (11.3 x 16.2 cm.) irregular
Inscription, print recto: "3574"
print verso: "3574"
Acquired from: gift of Mr. and Mrs. Allan M. Disman, New York, New York

2814. AUSTIN, TEX. OCT. 1913 [Norval Sharp, eleven-year-old newsboy] (P1978.111.14)
Gelatin silver print. 1913
Image: 4 ⁷⁄₁₆ x 6 ⁷⁄₁₆ in. (11.3 x 16.2 cm.) irregular
Inscription, print recto: "3575"
print verso: "3575//N 3575"
Acquired from: gift of Mr. and Mrs. Allan M. Disman, New York, New York

2815. AUSTIN, TEX. OCT. 1913 [Paul Luna, nine-year-old newsboy] (P1978.111.15)
Gelatin silver print. 1913
Image: 4 ⅜ x 3 ⅞ in. (11.1 x 9.8 cm.) irregular
Inscription, print verso: "3576"
Acquired from: gift of Mr. and Mrs. Allan M. Disman, New York, New York

*2816. BEAUMONT, TEX. NOV. 1913 [general utility boy at Vidor Sawmill] (P1978.111.48)
Gelatin silver print. 1913
Image: 4 ⁷⁄₁₆ x 5 ¾ in. (11.2 x 14.6 cm.) irregular
Inscription, print recto: "3669"
print verso: "3669//69"
Acquired from: gift of Mr. and Mrs. Allan M. Disman, New York, New York

2817. BEAUMONT, TEX. NOV. 1913 [Charlie McBride, twelve-year-old worker at Miller & Vidor Lumber Co.] (P1978.111.49)
Gelatin silver print. 1913
Image: 4 ⁷⁄₁₆ x 4 ½ in. (11.2 x 11.5 cm.) irregular
Inscription, print recto: "3670"
print verso: "3670"
Acquired from: gift of Mr. and Mrs. Allan M. Disman, New York, New York

2818. BEAUMONT, TEX. NOV. 1913 [workers at Miller & Vidor Lumber Co.] (P1978.111.50)
Gelatin silver print. 1913
Image: 4 ⁷⁄₁₆ x 6 ⁷⁄₁₆ in. (11.2 x 16.4 cm.)
Sheet: 5 x 7 in. (12.7 x 17.7 cm.)
Inscription, print verso: "N/3671//3671"
Acquired from: gift of Mr. and Mrs. Allan M. Disman, New York, New York

2819. BEAUMONT, TEX. NOV. 1913 [Charlie McBride, twelve-year-old worker at Miller & Vidor Lumber Co.] (P1978.111.51)
Gelatin silver print. 1913
Image: 4 ½ x 6 ½ in. (11.4 x 16.4 cm.) irregular
Sheet: 5 x 7 in. (12.7 x 17.7 cm.) irregular
Inscription, print verso: "N./3674//3674"
Acquired from: gift of Mr. and Mrs. Allan M. Disman, New York, New York

2820. BEAUMONT, TEX. NOV. 1913 [one of Beaumont's many little newsboys] (P1978.111.54)
Gelatin silver print. 1913
Image: 4 ⁷⁄₁₆ x 6 ⁷⁄₁₆ in. (11.3 x 16.3 cm.)
Sheet: 5 x 7 in. (12.7 x 17.8 cm.)
Inscription, print verso: "3681//N./3681"
Acquired from: gift of Mr. and Mrs. Allan M. Disman, New York, New York

2821. BEAUMONT, TEX. NOV. 1913 [Sam, five-year-old newsboy] (P1978.111.55)
Gelatin silver print. 1913
Image: 4 ⁷⁄₁₆ x 5 ½ in. (11.3 x 14.0 cm.) irregular
Inscription, print recto: "3682"
print verso: "3682//3682"
Acquired from: gift of Mr. and Mrs. Allan M. Disman, New York, New York

*2822. BEAUMONT, TEX. NOV. 1913 [Tony and Charlie, a pair of six-year-old newsies] (P1978.111.56)
Gelatin silver print. 1913
Image: 4 ⁷⁄₁₆ x 6 ⁷⁄₁₆ in. (11.3 x 16.3 cm.) irregular
Inscription, print recto: "3684"
print verso: "3684//N./3[684]"
Acquired from: gift of Mr. and Mrs. Allan M. Disman, New York, New York

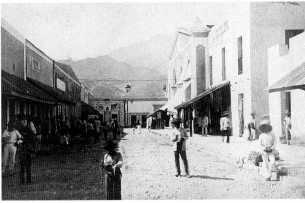

2812

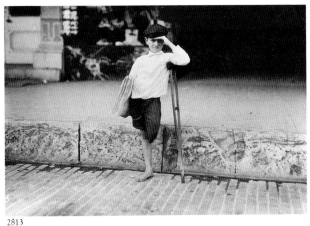

2813

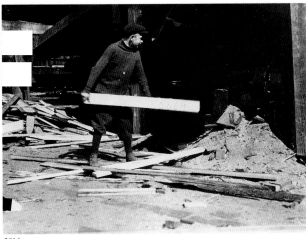

2816

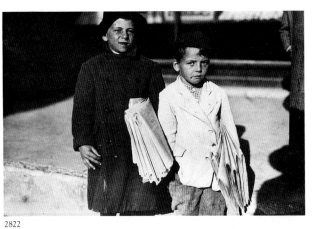

2822

2823

2825

*2823. **BELLS, TEX. SEPT. 1913** [Edith, five years old, picks cotton
all day] (P1978.111.1)
Gelatin silver print. 1913
Image: 4 3/16 x 6 1/2 in. (10.6 x 16.5 cm.)
Sheet: 5 1/16 x 7 in. (12.8 x 17.8 cm.)
Inscription, print verso: "[3]548//Edith, 5 year old, picks
cotton all day//4" and rubber stamp "National Child Labor
Committee,/1230-Fifth Ave., N. Y. City."
Acquired from: gift of Mr. and Mrs. Allan M. Disman,
New York, New York

2824. **BELLS, TEX. SEPT. 1913** [children picking cotton on
M. H. Lane's farm] (P1978.111.2)
Gelatin silver print. 1913
Image: 4 5/16 x 6 5/16 in. (10.9 x 16.1 cm.)
Sheet: 5 1/16 x 7 in. (12.8 x 17.7 cm.) irregular
Inscription, print verso: "3550" and rubber stamp "National
Child Labor Committee./1230-Fifth Ave., N. Y. City."
Acquired from: gift of Mr. and Mrs. Allan M. Disman,
New York, New York

*2825. **BELLS, TEX. SEPT. 1913** [Ruth] (P1978.111.3)
Gelatin silver print. 1913
Image: 4 7/16 x 5 1/2 in. (11.3 x 14.0 cm.) irregular
Inscription, print recto: "3552"
print verso: "3552"
Acquired from: gift of Mr. and Mrs. Allan M. Disman,
New York, New York

2826. **BELLS, TEX. SEPT. 1913** [Alton] (P1978.111.4)
Gelatin silver print. 1913
Image: 4 7/8 x 6 3/4 in. (12.4 x 17.2 cm.)
Sheet: 5 x 7 in. (12.7 x 17.7 cm.)
Inscription, print verso: "3553"
Acquired from: gift of Mr. and Mrs. Allan M. Disman,
New York, New York

2827. **BELLS, TEX. SEPT. 1913** [children picking cotton on
M. H. Lane's farm] (P1978.111.5)
Gelatin silver print. 1913
Image: 4 7/16 x 6 in. (11.2 x 15.3 cm.) irregular
Inscription, print recto: "3555"
print verso: "3555"
Acquired from: gift of Mr. and Mrs. Allan M. Disman,
New York, New York

*2828. **COMANCHE CO., OKLA. 10-10-16** [family of
L. H. Kirkpatrick] (P1978.111.57)
Gelatin silver print. 1916
Image: 4 7/8 x 6 13/16 in. (12.4 x 17.3 cm.)
Sheet: 5 x 6 7/8 in. (12.7 x 17.5 cm.)
Inscription, print verso: "4557//4557//A cotton field family/
Photo by Hine/Courtesy Nat'l Child/Labor Committee"
Acquired from: gift of Mr. and Mrs. Allan M. Disman,
New York, New York

2829. **COMANCHE CO. OKLA. 10-10-16** [Mart Payne, five-year-old
cotton picker] (P1978.111.58)
Gelatin silver print. 1916
Image: 4 5/8 x 6 5/8 in. (11.6 x 16.8 cm.)
Sheet: 5 x 7 in. (12.6 x 17.7 cm.)
Inscription, print verso: "5 year old boy picks from/10 to
20 lbs of cotton per day.//4562//4562" and rubber stamp
"National Child Labor Committee/215 Fourth Ave.,
N. Y. City"
Acquired from: gift of Mr. and Mrs. Allan M. Disman,
New York, New York

*2830. **CORSICANA, TEX. OCT. 1913** ["Renters"] (P1978.38.2)
Gelatin silver print. 1913
Image: 4 3/8 x 6 1/2 in. (11.2 x 16.4 cm.) irregular
Inscription, print recto: "3650"
print verso: "3650//N./3[650]"
Acquired from: The Afterimage, Dallas, Texas

2831. **CORSICANA, TEX. OCT. 1913** ["Renters"—itinerant
farmers] (P1978.111.41)
Gelatin silver print. 1913
Image: 4 3/8 x 6 1/4 in. (11.1 x 15.9 cm.) irregular
Inscription, print verso: "3649//N./3649/3649"
Acquired from: gift of Mr. and Mrs. Allan M. Disman,
New York, New York

2832. **COTTON MILL LETTER** [New Orleans, November 1913]
(P1978.111.11)
Gelatin silver print. 1913
Image: 4 1/2 x 6 1/2 in. (11.4 x 16.4 cm.)
Sheet: 5 x 7 in. (12.6 x 17.7 cm.)
Inscription, print verso: "N./3571//3571"
Acquired from: gift of Mr. and Mrs. Allan M. Disman,
New York, New York

2833. **CUERO, TEX. OCT. 1913** [John Huggins, doffer at Guadalupe
Valley Cotton Mills] (P1978.111.16)
Gelatin silver print. 1913
Image: 4 3/8 x 6 7/16 in. (11.0 x 16.3 cm.) irregular
Inscription, print recto: "3577/3577"
print verso: "3577"
Acquired from: gift of Mr. and Mrs. Allan M. Disman,
New York, New York

2834. **CUERO, TEX. OCT. 1913** ["Spider" Estes, fourteen-year-old
doffer at Guadalupe Valley Cotton Mills] (P1978.111.17)
Gelatin silver print. 1913
Image: 4 3/8 x 5 5/16 in. (11.1 x 13.5 cm.) irregular
Inscription, print recto: "3579"
print verso: "3597/3579//N3579"
Acquired from: gift of Mr. and Mrs. Allan M. Disman,
New York, New York

2835. **CUERO, TEX. OCT. 1913** ["Spider" Estes, fourteen-year-old
doffer at Guadalupe Valley Cotton Mills] (P1978.111.18)
Gelatin silver print. 1913
Image: 4 3/8 x 6 7/16 in. (11.1 x 16.4 cm.) irregular
Inscription, print recto: "3580"
print verso: "3580//N./3580"
Acquired from: gift of Mr. and Mrs. Allan M. Disman,
New York, New York

2836. **DALLAS, TEX. OCT. 1913** [group of typical mill girls at
Dallas Cotton Mill] (P1978.38.1)
Gelatin silver print. 1913
Image: 4 1/2 x 6 7/16 in. (11.4 x 16.3 cm.) irregular
Inscription, print recto: "3616"
print verso: "3616//N./3616"
Acquired from: The Afterimage, Dallas, Texas

2837. **DALLAS, TEX. OCT. 1913** [group of kindergarten students,
children of Dallas Cotton Mill workers] (P1978.111.24)
Gelatin silver print. 1913
Image: 4 7/16 x 6 7/16 in. (11.2 x 16.3 cm.) irregular
Inscription, print recto: "3602"
print verso: "3602//N/3602"
Acquired from: gift of Mr. and Mrs. Allan M. Disman,
New York, New York

2838. **DALLAS, TEX. OCT. 1913** [noon hour at the Dallas Cotton
Mill] (P1978.111.25)
Gelatin silver print. 1913
Image: 4 1/2 x 5 3/4 in. (11.3 x 14.7 cm.) irregular
Inscription, print recto: "3604"
print verso: "3604"
Acquired from: gift of Mr. and Mrs. Allan M. Disman,
New York, New York

2839. **DALLAS, TEX. OCT. 1913** [Rosy Phillips, fifteen-year-old
spinner at Dallas Cotton Mill and her twelve-year-old
brother] (P1978.111.26)
Gelatin silver print. 1913
Image: 4 3/8 x 6 3/8 in. (11.2 x 16.2 cm.) irregular
Inscription, print recto: "3605"
print verso: "3605//N./3605"
Acquired from: gift of Mr. and Mrs. Allan M. Disman,
New York, New York

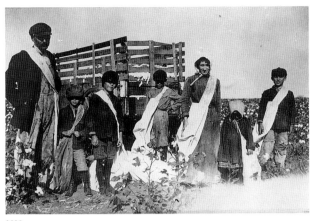

2828

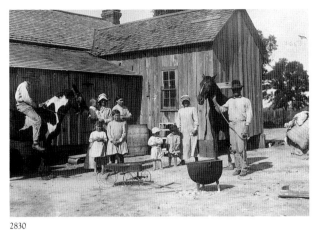

2830

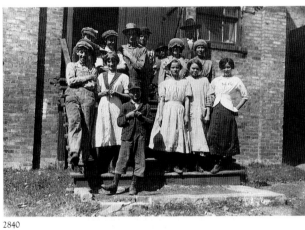

2840

2841

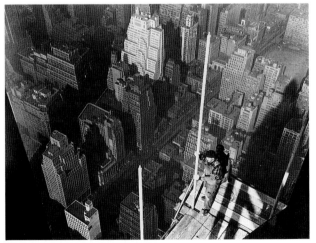

2844

2845

*2840. **DALLAS, TEX. OCT. 1913** [group of workers at Dallas Cotton Mill] (P1978.111.27)
Gelatin silver print. 1913
Image: 4½ x 6⁷⁄₁₆ in. (11.4 x 16.4 cm.) irregular
Inscription, print recto: "3606"
print verso: "3606/N./36[06]"
Acquired from: gift of Mr. and Mrs. Allan M. Disman, New York, New York

*2841. **DALLAS, TEX. OCT. 1913** [messenger boy] (P1978.111.33)
Gelatin silver print. 1913
Image: 4⁷⁄₁₆ x 4¹⁵⁄₁₆ in. (11.2 x 12.5 cm.) irregular
Inscription, print recto: "2624 [sic]"
print verso: "3624"
Acquired from: gift of Mr. and Mrs. Allan M. Disman, New York, New York

2842. **DALLAS, TEX. OCT. 1913** [The Virginia A. Johnson Home. A House of Refuge for Unmarried Mothers Under Twenty-one Years Old.] (P1978.111.39)
Gelatin silver print. 1913
Image: 4⁷⁄₁₆ x 5⁷⁄₁₆ in. (11.3 x 13.7 cm.) irregular
Inscription, print recto: "3647"
print verso: "3647"
Acquired from: gift of Mr. and Mrs. Allan M. Disman, New York, New York

2843. **DALLAS, TEX. OCT. 1913** [The Virginia A. Johnson Home. A House of Refuge for Unmarried Mothers Under Twenty-one Years Old.] (P1978.111.40)
Gelatin silver print. 1913
Image: 4⅜ x 6⅜ in. (11.1 x 16.1 cm.) irregular
Inscription, print recto: "3648"
print verso: "3648//N/3[648]"
Acquired from: gift of Mr. and Mrs. Allan M. Disman, New York, New York

*2844. **EMPIRE STATE BLDG** [Topping the Mast] (P1986.33)
Gelatin silver print. 1931
Image: 10⁹⁄₁₆ x 13⁹⁄₁₆ in. (26.8 x 34.4 cm.)
Sheet: 10¹⁵⁄₁₆ x 13¹⁵⁄₁₆ in. (27.7 x 35.4 cm.)
Signed, center print verso: "Hine"
Inscription, print verso: "EMPIRE STATE BLDG—1931" and rubber stamp "LEWIS W. HINE/INTERPRETIVE PHOTOGRAPHY/HASTINGS-ON-HUDSON, NEW YORK"
Acquired from: Hirschl & Adler Galleries, Inc., New York, New York

*2845. **FORT WORTH, TEX. NOV. 1913** [messenger boy in front of Texas and Pacific Railroad Station] (P1978.38.3)
Gelatin silver print. 1913
Image: 4⅜ x 6⁷⁄₁₆ in. (11.1 x 16.3 cm.) irregular
Inscription, print recto: "3666"
print verso: "3666//N./6"
Acquired from: The Afterimage, Dallas, Texas

*2846. **FRESH AIR FOR THE BABY, N.Y. EAST SIDE** (P1981.80.2)
Gelatin silver print. 1907
Image: 4¾ x 6¾ in. (12.1 x 17.2 cm.)
Sheet: 5 x 7 in. (12.7 x 17.8 cm.)
Signed: see inscription
Inscription, print verso: "Fresh air for the baby/N.Y. East Side//1907//#662" and rubber stamp "LEWIS W. HINE/INTERPRETIVE PHOTOGRAPHY/HASTINGS-ON-HUDSON, NEW YORK"
Acquired from: Photocollect, New York, New York

*2847. **HOUSTON, TEX. OCT. 1913** [J. T. Marshall, eleven-year-old Western Union messenger] (P1978.111.19)
Gelatin silver print. 1913
Image: 4⁷⁄₁₆ x 6⅜ in. (11.2 x 16.2 cm.) irregular
Inscription, print recto: "3582"
print verso: "3582//N 3582"
Acquired from: gift of Mr. and Mrs. Allan M. Disman, New York, New York

2848. **HOUSTON, TEX. OCT. 1913** [Curtis Hines, fourteen-year-old Western Union messenger] (P1978.111.20)
Gelatin silver print. 1913
Image: 4⅝ x 6⅝ in. (11.8 x 16.8 cm.) irregular
Sheet: 5 x 7 in. (12.6 x 17.7 cm.) irregular
Inscription, in negative, in reverse: "39"
print verso: "3584/3584"
Acquired from: gift of Mr. and Mrs. Allan M. Disman, New York, New York

*2849. **LOOKING FOR LOST BAGGAGE, ELLIS ISLAND** (P1981.80.1)
Gelatin silver print. negative 1905, print later
Image: 5⅝ x 4⅜ in. (14.3 x 11.1 cm.)
Acquired from: Photocollect, New York, New York

2850. **McKINNEY, TEX. OCT. 1913** [noon hour at Texas Cotton Mill] (P1978.111.34)
Gelatin silver print. 1913
Image: 4½ x 6⁷⁄₁₆ in. (11.4 x 16.3 cm.) irregular
Inscription, print recto: "3625"
print verso: "3625/[3]62[5]"
Acquired from: gift of Mr. and Mrs. Allan M. Disman, New York, New York

2851. **NEAR CORSICANA, TEX. OCT. 1913** [a group of children at a District School during cotton picking season] (P1978.111.42)
Gelatin silver print. 1913
Image: 4⁷⁄₁₆ x 6⁷⁄₁₆ in. (11.2 x 16.4 cm.) irregular
Inscription, print recto: "3651"
print verso: "N/3651//3651"
Acquired from: gift of Mr. and Mrs. Allan M. Disman, New York, New York

2852. **NEAR HOUSTON, TEX. OCT 1913** [Eddie Marek, six-year-old cotton picker] (P1978.111.21)
Gelatin silver print. 1913
Image: 4⁷⁄₁₆ x 6⁷⁄₁₆ in. (11.2 x 16.4 cm.) irregular
Inscription, print recto: "3597"
print verso: "3597//N/35[97]"
Acquired from: gift of Mr. and Mrs. Allan M. Disman, New York, New York

2853. **NEAR HOUSTON, TEX. OCT. 1913** [Millie, four-year-old cotton picker] (P1978.111.22)
Gelatin silver print. 1913
Image: 4⁷⁄₁₆ x 6⁷⁄₁₆ in. (11.3 x 16.4 cm.) irregular
Sheet: 5 x 7 in. (12.7 x 17.8 cm.) irregular
Inscription, print verso: "3599//N./3599"
Acquired from: gift of Mr. and Mrs. Allan M. Disman, New York, New York

2854. **NEAR HOUSTON, TEX. OCT. 1913** [Millie, four-year-old cotton picker] (P1978.111.23)
Gelatin silver print. 1913
Image: 4⁷⁄₁₆ x 6⁷⁄₁₆ in. (11.3 x 16.4 cm.) irregular
Sheet: 5 x 7 in. (12.6 x 17.7 cm.) irregular
Inscription, print verso: "3600//N/3600"
Acquired from: gift of Mr. and Mrs. Allan M. Disman, New York, New York

*2855. **NEAR McKINNEY, TEX. OCT. 1913** [Lloyd McMahan, seven-year-old cotton picker] (P1978.111.35)
Gelatin silver print. 1913
Image: 4⅜ x 6⅜ in. (11.1 x 16.2 cm.) irregular
Inscription, print verso: "3628//N./3628"
Acquired from: gift of Mr. and Mrs. Allan M. Disman, New York, New York

2856. **NEAR WAXAHACHIE, TEX. OCT. 1913** [scene in cotton field of the Baptist orphanage] (P1978.111.28)
Gelatin silver print. 1913
Image: 4⁷⁄₁₆ x 5⁹⁄₁₆ in. (11.2 x 14.1 cm.) irregular
Inscription, print recto: "3608"
print verso: "3608"
Acquired from: gift of Mr. and Mrs. Allan M. Disman, New York, New York

2846

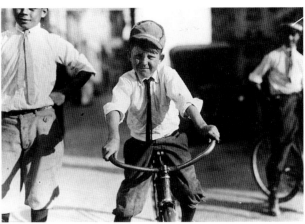

2847

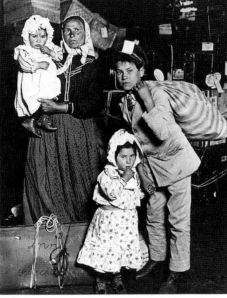

2849

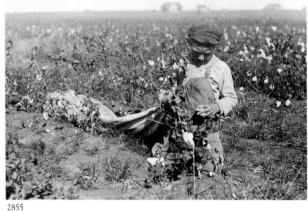

2855

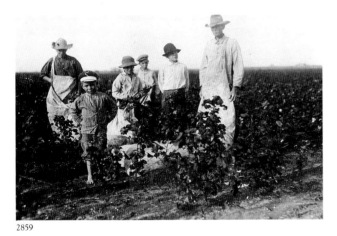

2859

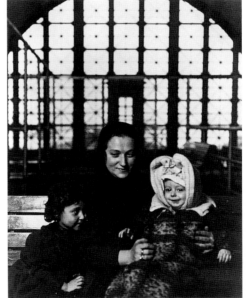

2868

2857. **NEAR WAXAHACHIE, TEX. OCT. 1913** [scene in cotton field of the Baptist orphanage] (P1978.111.29)
Gelatin silver print. 1913
Image: 4⅜ x 6⁷⁄₁₆ in. (11.1 x 16.3 cm.) irregular
Inscription, print recto: "3609"
 print verso: "3609//N/3"
Acquired from: gift of Mr. and Mrs. Allan M. Disman, New York, New York

2858. **NEAR WAXAHACHIE, TEX. OCT. 1913** [scene in cotton field of the Baptist orphanage] (P1978.111.30)
Gelatin silver print. 1913
Image: 4¹⁄₁₆ x 6³⁄₁₆ in. (10.4 x 15.7 cm.) irregular
Inscription, print recto: "3610"
 print verso: "3610/3610"
Acquired from: gift of Mr. and Mrs. Allan M. Disman, New York, New York

*2859. **NEAR WAXAHACHIE, TEX. OCT. 1913** [scene in cotton field of the Baptist orphanage] (P1978.111.31)
Gelatin silver print. 1913
Image: 4³⁄₁₆ x 6¼ in. (10.6 x 15.9 cm.) irregular
Inscription, print verso: "[3]611//3611//3611"
Acquired from: gift of Mr. and Mrs. Allan M. Disman, New York, New York

2860. **NEAR WAXAHACHIE, TEX. OCT. 1913** [Grady Carroll, nine-year-old cotton picker] (P1978.111.52)
Gelatin silver print. 1913
Image: 4⁷⁄₁₆ x 6⁷⁄₁₆ in. (11.3 x 16.3 cm.) irregular
Inscription, print verso: "3677//N./3677"
Acquired from: gift of Mr. and Mrs. Allan M. Disman, New York, New York

2861. **NEAR WAXAHACHIE, TEX. OCT. 1913** [two families working together on Kimball farm near Waxahachie] (P1978.111.53)
Gelatin silver print. 1913
Image: 4⁷⁄₁₆ x 6⁷⁄₁₆ in. (11.3 x 16.3 cm.)
Sheet: 5 x 7 in. (12.7 x 17.7 cm.)
Inscription, print verso: "3678//N./3678"
Acquired from: gift of Mr. and Mrs. Allan M. Disman, New York, New York

2862. **ORANGE, TEX. NOV. 1913** [thirteen-year-old worker at Miller-Link Lumber Co.] (P1978.111.46)
Gelatin silver print. 1913
Image: 4⅜ x 6⅜ in. (11.1 x 16.3 cm.) irregular
Inscription, print recto: "3664"
 print verso: "3664//N. 3664"
Acquired from: gift of Mr. and Mrs. Allan M. Disman, New York, New York

2863. **ORANGE, TEX. NOV. 1913** [two young boys working at Miller-Link Lumber Co.] (P1978.111.47)
Gelatin silver print. 1913
Image: 4⁷⁄₁₆ x 6⁷⁄₁₆ in. (11.3 x 16.4 cm.) irregular
Inscription, print recto: "3665"
 print verso: "3665//N/3665"
Acquired from: gift of Mr. and Mrs. Allan M. Disman, New York, New York

2864. **POSTAL TELEGRAPH CO.** [Letter, New Orleans, January 1914] (P1978.111.12)
Gelatin silver print. 1914
Image: 4⁷⁄₁₆ x 6⁷⁄₁₆ in. (11.2 x 16.3 cm.)
Sheet: 5 x 7 in. (12.6 x 17.7 cm.)
Inscription, print verso: "N./3572//3572"
Acquired from: gift of Mr. and Mrs. Allan M. Disman, New York, New York

2865. **POTTAWATOMIE CO., OKLA.** 10-10-16 [Cleo Campbell, nine-year-old cotton picker] (P1978.111.59)
Gelatin silver print. 1916
Image: 4⅝ x 6⁹⁄₁₆ in. (11.6 x 16.7 cm.)
Sheet: 5 x 7 in. (12.6 x 17.7 cm.)
Inscription, print verso: "4592//4592//4592" and rubber

stamp "This photograph is loaned by the/ NATIONAL CHILD LABOR COMMITTEE/with the distinct understanding that/credit will be given the Committee in/ publication."
Acquired from: gift of Mr. and Mrs. Allan M. Disman, New York, New York

2866. **POTTAWATOMIE CO., OKLA.** 10-10-16 [Callie Campbell, eleven-year-old cotton picker] (P1978.111.60)
Gelatin silver print. 1916
Image: 4⁹⁄₁₆ x 6³⁄₁₆ in. (11.5 x 15.7 cm.) irregular
Inscription, print verso: "4596//4596//Totes 50 lbs of cotton/ when the bag is full.//7 [sic]-YEAR OLD COTTON PICKER//[4]596" and rubber stamp "National Child Labor Committee/215 Fourth Ave., N. Y. City"
Acquired from: gift of Mr. and Mrs. Allan M. Disman, New York, New York

2867. **POTTAWATOMIE CO., OKLA.** 10-10-16 [Pioneer School #13] (P1978.111.61)
Gelatin silver print. 1916
Image: 4⁵⁄₁₆ x 6 in. (10.9 x 15.2 cm.) irregular
Inscription, print verso: "4600//1//4 ¼//50875//D7696/133/17-2/with line/Flush Bottom" and rubber stamp "CLARENCE S. NATHAN/241-245 West 37th St." and NCLC text label
Acquired from: gift of Mr. and Mrs. Allan M. Disman, New York, New York

*2868. **A RUSSIAN FAMILY GROUP AT ELLIS ISLAND** (P1981.78)
Gelatin silver print. 1905
Image: 9⁹⁄₁₆ x 7⅝ in. (24.3 x 19.4 cm.)
Sheet: 10 x 8 in. (25.4 x 20.3 cm.)
Signed: see inscription
Inscription, print verso: "1113.4//105" and rubber stamp "LEWIS W. HINE/INTERPRETIVE PHOTOGRAPHY/ HASTINGS-ON-HUDSON, NEW YORK"
Acquired from: Edwynn Houk Gallery, Chicago, Illinois

*2869. **SAN ANTONIO, TEX. OCT. 1913** [Raymond Miller, six-year-old newsboy] (P1978.111.6)
Gelatin silver print. 1913
Image: 4⅜ x 5⅜ in. (11.2 x 13.7 cm.) irregular
Inscription, print recto: "3564"
 print verso: "3564//3564"
Acquired from: gift of Mr. and Mrs. Allan M. Disman, New York, New York

2870. **SAN ANTONIO, TEX. OCT. 1913** [Luther Wharton, drug store delivery boy] (P1978.111.7)
Gelatin silver print. 1913
Image: 4⅜ x 6½ in. (11.1 x 16.4 cm.) irregular
Inscription, print recto: "3565"
 print verso: "3565"
Acquired from: gift of Mr. and Mrs. Allan M. Disman, New York, New York

2871. **SAN ANTONIO, TEX. OCT. 1913** [Preston De Costa, fifteen-year-old messenger boy on bicycle] (P1978.111.8)
Gelatin silver print. 1913
Image: 4⅝ x 6⅝ in. (11.7 x 16.8 cm.)
Sheet: 5 x 7 in. (12.6 x 17.8 cm.)
Inscription, print verso: "3568"
Acquired from: gift of Mr. and Mrs. Allan M. Disman, New York, New York

2872. **SAN ANTONIO, TEX. OCT. 1913** [Preston De Costa, fifteen-year-old messenger boy] (P1978.111.9)
Gelatin silver print. 1913
Image: 4⁷⁄₁₆ x 5⁹⁄₁₆ in. (11.2 x 14.2 cm.) irregular
Inscription, print recto: "3569"
 print verso: "N./3[569]/3569"
Acquired from: gift of Mr. and Mrs. Allan M. Disman, New York, New York

2873. SAN ANTONIO, TEX. OCT. 1913 [sixteen-year-old
messenger boy entering "crib" in red-light district]
(P1978.111.10)
Gelatin silver print. 1913
Image: 4 ⅜ x 6 ⅜ in. (11.1 x 16.2 cm.) irregular
Inscription, print recto: "3570"
print verso: "N./35[70]//3570"
Acquired from: gift of Mr. and Mrs. Allan M. Disman,
New York, New York

*2874. STEAMFITTER [Powerhouse Mechanic] (P1981.80.3)
Toned gelatin silver print. 1921
Image: 16 ⅝ x 12 3/16 in. (42.2 x 30.9 cm.) irregular
Sheet: 16 15/16 x 12 ½ in. (43.0 x 31.7 cm.) irregular
Signed: see inscription
Inscription, print recto: crop marks
print verso: "2//42//T8450-11-2" and rubber stamp
"LEWIS W. HINE/Work Portraits/HASTINGS-ON-
HUDSON, N. Y."
Acquired from: Photocollect, New York, New York

2875. WACO, TEX. NOV. 1913 [Isaac Boyett, twelve-year-old
proprietor, Club Messenger Service] (P1978.111.36)
Gelatin silver print. 1913
Image: 4 ⅜ x 6 7/16 in. (11.1 x 16.4 cm.) irregular
Inscription, print recto: "3637"
print verso: "3637"
Acquired from: gift of Mr. and Mrs. Allan M. Disman,
New York, New York

*2876. WACO, TEX. NOV. 1913 [Isaac Boyett, twelve-year-old
proprietor, Club Messenger Service] (P1978.111.37)
Gelatin silver print. 1913
Image: 4 7/16 x 6 7/16 in. (11.3 x 16.4 cm.) irregular
Inscription, print recto: "3638"
print verso: "3638//N/3[638]"
Acquired from: gift of Mr. and Mrs. Allan M. Disman,
New York, New York

2877. WAXAHACHIE, TEX. OCT. 1913 [group of workers in
Waxahachie Cotton Mill] (P1978.111.32)
Gelatin silver print. 1913
Image: 4 7/16 x 5 ⅞ in. (11.2 x 15.0 cm.) irregular
Inscription, print recto: "3617"
print verso: "3617//361[7]"
Acquired from: gift of Mr. and Mrs. Allan M. Disman,
New York, New York

*2878. WEST, TEX. NOV. 1913 [a dilapidated "renters" home]
(P1978.111.38)
Gelatin silver print. 1913
Image: 4 7/16 x 6 7/16 in. (11.3 x 16.4 cm.)
Inscription, print recto: "3646"
print verso: "3646//N/36[46]"
Acquired from: gift of Mr. and Mrs. Allan M. Disman,
New York, New York

2879. WEST, TEX. NOV. 1913 [home of family of "renters"]
(P1978.111.43)
Gelatin silver print. 1913
Image: 4 7/16 x 5 ⅛ in. (11.2 x 13.0 cm.) irregular
Inscription, print verso: "3657"
Acquired from: gift of Mr. and Mrs. Allan M. Disman,
New York, New York

2880. WEST, TEX. NOV. 1913 [Willie Hesse, five-year-old cotton
picker] (P1978.111.44)
Gelatin silver print. 1913
Image: 4 7/16 x 6 7/16 in. (11.2 x 16.3 cm.)
Sheet: 4 15/16 x 6 15/16 in. (12.5 x 17.6 cm.)
Inscription, print verso: "3658//N/3658"
Acquired from: gift of Mr. and Mrs. Allan M. Disman,
New York, New York

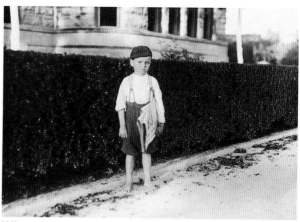
2869

2874

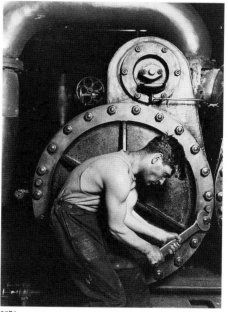
2876

2881. **WEST, TEX. NOV. 1913** [Girard farm, near West]
(P1978.111.45)
Gelatin silver print. 1913
Image: 4 7/16 x 6 1/2 in. (11.2 x 16.4 cm.) irregular
Inscription, print recto: "3661"
 print verso: "3661"
Acquired from: gift of Mr. and Mrs. Allan M. Disman,
New York, New York

HORSLEY A. HINTON, British (1863–1906)

See *Camera Notes*

ROBERT JAY HIRSCH, American (b. 1949)

Bob Hirsch was born in Ann Arbor, Michigan. He
received a B.F.A. from the Rochester Institute of
Technology in 1971 and an M.F.A. from Arizona State
University in 1974. Following graduation, Hirsch be-
came the director of the Instructional Materials Center
for the public schools in Kayenta, Arizona, and then a
media director at Design Associates in New York City;
in 1976 he went to Amarillo College as an assistant
professor of photography and director of the Southern
Lights Gallery. Hirsch is an active member of the So-
ciety for Photographic Education and has participated
in many regional photography exhibitions.

2882. **"ART"** [from the Society for Photographic Education's "South
Central Regional Photography Exhibition"] (P1983.31.7)
Gelatin silver print. 1980
Image: 8 1/2 x 12 1/2 in. (21.6 x 31.8 cm.)
Sheet: 11 x 13 15/16 in. (27.9 x 35.3 cm.)
Signed, l.r. print verso: " "ART" © BOB HIRSCH 1980"
Acquired from: gift of the Society for Photographic
Education, South Central Region

H. S. HOLMES, JR., American (b. 1926)

Holmes was born in Ellensburg, Washington, and at-
tended Central Washington State College. He has held
several positions as an industrial photographer on dam
projects, working on projects at the Columbia Basin in
Ephrata, Washington, at Niagara Falls, New York, and
at the Boundary Dam in Pend Oreille County, Wash-
ington. He also spent two years as an army photogra-
pher making photographs of rocket assembly and testing
procedures. In 1967 Holmes became the project pho-
tographer on the Bureau of Reclamation's Third
Powerplant project at the Grand Coulee Dam, where
his job included documentation of the excavation and
construction of the Third Powerplant and its hydro-
generators and the ongoing operations of the plant.

2883. [Night construction activity at the Third Powerplant, Forebay
Dam—looking across spillway of Grand Coulee Dam]
(P1972.24.2)
Ektacolor print. 1971
Image: 24 x 20 in. (61.0 x 50.8 cm.)
Mount: same as image size
Inscription, mount verso: "Mar 8, 71/CN-1222-124-2939/
By H S Holmes Jr" and U. S. Department of the Interior,
Bureau of Reclamation stamp
Acquired from: gift of the U.S. Department of the Interior,
Bureau of Reclamation, Grand Coulee, Washington

*2884. [Night construction activity on the Grand Coulee Third
Powerplant and Forebay Dam] (P1972.24.3)
Ektacolor print. 1971
Image: 24 x 20 1/16 in. (61.0 x 50.9 cm.)
Mount: same as image size

Inscription, mount verso: "Mar 8, 71/CN-1222-142-2940/
by H S Holmes Jr" and U. S. Department of the Interior,
Bureau of Reclamation stamp
Acquired from: gift of the U.S. Department of the Interior,
Bureau of Reclamation, Grand Coulee, Washington

LATON ALTON HUFFMAN, American
(1854–1931)

Huffman was born in Iowa and worked for his father,
who had purchased a photographic studio in Waukon,
Iowa, in 1865. In 1878 Huffman secured the nonpaying
job of unofficial post photographer at Fort Keogh, Mon-
tana, using the post as a base to establish his own busi-
ness. Huffman eventually opened a studio in Miles
City, Montana, the base of his operations for many
years. He photographed the closing days of the western
frontier, chronicling Indians, ranch life, and cattle
drives on the Montana grasslands. Huffman's views
were widely distributed, first as albumen prints and la-
ter, around the turn of the century, as collotypes and
gelatin silver prints. Following Huffman's death in 1931
his daughter, Ruth Huffman Scott, continued to sell his
collotypes, which had been printed in large quantities.
She eventually designated Coffrin's Old West Gallery
as the agent for her father's stock. They sold prints
from Huffman's original inventory until 1981. In 1981
Huffman's granddaughter and great-grandsons formed
Huffman Photos Ltd. to sell the remaining collotypes.

*2885. **BRANDING** (P1979.51.25)
Albumen silver print. c. 1885
Image: 3 7/8 x 4 7/8 in. (9.8 x 12.4 cm.) irregular
Sheet: 4 x 5 in. (10.0 x 12.7 cm.) irregular
Signed: see inscription
Inscription, in negative: "11"
 print verso: "INV# 75198 [UR]/Branding//2/ca 1885" and
 rubber stamp "L A Huffman"
Acquired from: Robert Schoelkopf Gallery, New York,
New York

2886. **BREAKS OF THE MISSOURI** (P1979.51.5)
Toned gelatin silver print. negative c. 1901, print later
Image: 6 x 7 15/16 in. (15.2 x 20.1 cm.)
Signed: see inscription
Inscription, in negative: "167 COPYRIGHT BY HUFFMAN,
MILES, MONT."
 print verso: "192//Breaks of the Missouri//INV# 7609
 [RX]//5"
Acquired from: Robert Schoelkopf Gallery, New York,
New York

2887. **CATHOLIC SCHOOL FOR INDIANS** (P1979.51.20)
Albumen silver print. c. 1898
Image: 6 3/8 x 8 1/8 in. (16.2 x 20.8 cm.) irregular
Sheet: 6 7/16 x 8 7/16 in. (16.3 x 21.4 cm.)
Inscription, print verso: "indian [sic] School//Catholic School
for/Indians, c. 1900//INV# 7627 [XX]"
Acquired from: Robert Schoelkopf Gallery, New York,
New York

2888. **CATTLE CHUTE** (P1979.51.2)
Toned gelatin silver print. negative c. 1885, print later
Image: 3 1/2 x 4 in. (8.9 x 10.1 cm.)
Signed: see inscription
Inscription, in negative: "10/HUFFMAN PHOTO., MILES
CITY, MONT."
 print verso: "INV# 75199//Cattle Shute [sic]/[UR]//22/
 ca/1885"
Acquired from: Robert Schoelkopf Gallery, New York,
New York

2878

11

2885

2884

C.K. COWBOYS IN CAMP ON 13 MILE CREEK MONT.

2890

2889

*2889. **C.K. COWBOYS IN CAMP ON 13 MILE CREEK MONT.**
(P1979.51.17)
Collotype (?). negative 1904, print later
Image: 5 ¹/₁₆ x 15 in. (12.8 x 38.1 cm.)
Sheet: 6 ¹/₁₆ x 15 ¹⁵/₁₆ in. (15.3 x 40.4 cm.)
Inscription, in negative: "C.K. COWBOYS IN CAMP ON
13 MILE CREEK MONT."
print verso: "Attrib to Laton A. Huffman//INV# 75288/
UX//2//4"
Acquired from: Robert Schoelkopf Gallery, New York,
New York

*2890. **THE DESERTED CAMP [Old Buffalo Hunters' Camp—
Breaks of Missouri]** (P1979.51.11)
Toned gelatin silver print. negative 1901, print later
Image: 6 ³/₁₆ x 8 in. (15.7 x 20.3 cm.)
Sheet: 6 ¼ x 8 ³/₁₆ in. (15.8 x 20.8 cm.)
Signed: see inscription
Inscription, print recto: "163" and rubber stamp "L A
Huffman"
print verso: "Relic of the 70's/Old Buffalo Hunters Camp—
Breaks of Missouri/built 1879 photographed 1901/Huffman
hunted buffalo here in 79/the tall hill in background was
the lookout/point for spotting the buffalo herds//"The
Deserted Camp"/ p. 67 The Frontier Years//#7//Hold
for P. Coffren [sic]/INV# 7611 RX"
Acquired from: Robert Schoelkopf Gallery, New York,
New York

2891. **EVENING AT THE ROUND-UP [At Big Pumpkin Creek]**
(P1979.51.13)
Collotype (?). negative 1907, print later
Image: 7 ¹/₁₆ x 11 ½ in. (17.8 x 29.2 cm.)
Signed: see inscription
Inscription, in negative: "#B Evening at the Round-up, Neg
Print & copyright by Huffman Milestown Mont 05."
print verso: "Evening at the Roundup//INV# 74614//
#/289A" and rubber stamp "L.A. Huffman/All rights
reserved/COFFRIN'S OLD WEST GALLERY/1600 MAIN
ST.—Miles City, MT. 59301"
Acquired from: Robert Schoelkopf Gallery, New York,
New York

2892. **GOING TO THE ROUNDUP [The Roundup on the Move]**
(P1979.51.4)
Toned gelatin silver print. negative c. 1897, print later
Image: 6 x 7 ⅞ in. (15.2 x 20.0 cm.)
Signed: see inscription
Inscription, in negative: "239 COPYRIGHT BY HUFFMAN,
MILES, MONT."
print verso: "RX/INV# 75204//Going to the Roundup/ca.
1890 [sic]//X"
Acquired from: Robert Schoelkopf Gallery, New York,
New York

*2893. **HERDING CATTLE BENEATH A BUTTE [Working a
Little in the Hills]** (P1979.51.6)
Toned gelatin silver print. negative c. 1880s–90s, print later
Image: 6 x 8 in. (15.2 x 20.3 cm.) irregular
Signed: see inscription
Inscription, in negative: "236 COPYRIGHT BY HUFFMAN,
MILES, MONT."
print verso: "266//8//Herding Cattle Beneath a Butte//
INV# 7615 RX"
Acquired from: Robert Schoelkopf Gallery, New York,
New York

2894. **HERDING SHEEP** (P1979.51.8)
Toned gelatin silver print. negative c. 1880s–90s, print later
Image: 6 x 7 ¹⁵/₁₆ in. (15.2 x 20.1 cm.)
Inscription, in negative: "5"
print verso: "#320/Herding Sheep//INV# 7621 RX//305"
Acquired from: Robert Schoelkopf Gallery, New York,
New York

2895. **HERDING SHEEP ALONG THE RIVER [Sheep by the
Waterside, Powder River]** (P1979.51.23)
Toned gelatin silver print. negative c. 1886, print later
Image: 6 x 8 in. (15.2 x 20.3 cm.)
Inscription, in negative: "4"
print verso: "323//Hold for P. Coffeen[sic]//Herding Sheep
along the River/INV# 7622 RX"
Acquired from: Robert Schoelkopf Gallery, New York,
New York

2896. **HUNT IN BIG HORN MTNS.** (P1979.51.3)
Toned gelatin silver print. negative 1882, print later
Image: 4 x 3 ½ in. (10.1 x 8.9 cm.)
Signed: see inscription
Inscription, in negative: "483//COPYRIGHT BY
HUFFMAN, MILES, MONT."
print verso: "1882/[illegible]/UR/75201/Hunt in Big Horn
Mtns//8" and rubber stamp "L A Huffman"
Acquired from: Robert Schoelkopf Gallery, New York,
New York

2897. **LONG PINES S.E. MONT.** (P1979.51.9)
Toned gelatin silver print. negative c. 1900, print later
Image: 8 ³/₁₆ x 6 ¼ in. (20.8 x 15.8 cm.) irregular
Signed: see inscription
Inscription, print verso: "ca 1900//Long Pines SE Mont.//
INV# 75205/UR" and rubber stamp "L A Huffman"
Acquired from: Robert Schoelkopf Gallery, New York,
New York

2898. **"OLD POWDER RIVER DAYS"** (P1979.51.26)
Gelatin silver print. negative 1885, print c. 1920s
Image: 5 ¹¹/₁₆ x 8 ⁵/₁₆ in. (14.5 x 21.1 cm.) irregular
Sheet: 5 ¹³/₁₆ x 8 ¹¹/₁₆ in. (14.8 x 22.0 cm.)
Mount: 6 x 9 ⁵/₁₆ in. (15.2 x 23.7 cm.)
Signed: see inscription
Inscription, in negative: "© L A Huffman/16"
mount verso: invoice sheet with portrait of Huffman and
advertising copy, inscribed "RX/INV# 7610//#2" and
typed " "Old Powder River Days". The Spring Roundup at/
work among the old Buffalo Wallows which are/still to be
seen, if you have the eye, in pastures/and unplowed
places./1885"
Acquired from: Robert Schoelkopf Gallery, New York,
New York

2899. **RIDING THE HERD** (P1979.51.7)
Toned gelatin silver print. negative c. 1880s–90s, print later
Image: 6 x 8 in. (15.2 x 20.3 cm.)
Signed: see inscription
Inscription, in negative: "234 COPYRIGHT BY HUFFMAN,
MILES, MONT."
print verso: "#276//5//Riding the Herd//Inv# 7620 RX"
Acquired from: Robert Schoelkopf Gallery, New York,
New York

*2900. **ROPING CATTLE** (P1979.51.24)
Toned gelatin silver print. negative c. 1885, print later
Image: 3 ⅝ x 4 ⁹/₁₆ in. (9.2 x 11.5 cm.)
Signed: see inscription
Inscription, in negative: "1"
print verso: "INV# 75200/Roping Cattle UR//2//ca 1885"
and rubber stamp "L A Huffman"
Acquired from: Robert Schoelkopf Gallery, New York,
New York

*2901. **THE ROUND-UP BREAKING CAMP** (P1979.51.15)
Collotype (?). negative 1904, print later
Image: 9 ½ x 11 in. (24.0 x 28.0 cm.)
Signed: see inscription
Inscription, in negative: "#176 The Round-up Breaking
Camp, Negative, Print and Copyright by L. A. Huffman
Miles C Mont 04."
print verso: "INV# 74622//#263" and rubber stamp
"COFFRIN STUDIO, AGENT/MILES CITY, MONT./
RE-ORDER NO. 263"
Acquired from: Robert Schoelkopf Gallery, New York,
New York

2902. **SHEEP AT A BEND IN THE RIVER [Big Dry, Montana]**
(P1979.51.10)
Toned gelatin silver print. negative c. 1880s–90s, print later
Image: 6 x 7¹⁵⁄₁₆ in. (15.2 x 20.1 cm.)
Signed: see inscription
Inscription, in negative: "304 COPYRIGHT BY
HUFFMAN, MILES, MONT."
print verso: "#304//5//Sheep at a Bend in the River//
INV# 7625/⊡RX⊡"
Acquired from: Robert Schoelkopf Gallery, New York,
New York

2903. **SHOT STAG** (P1979.51.22)
Toned gelatin silver print. negative c. 1890s, print later
Image: 6⅛ x 8¼ in. (15.3 x 20.9 cm.)
Inscription, print verso: "335//Shot Stag 1890s//INV#
7619 ⊡RX⊡"
Acquired from: Robert Schoelkopf Gallery, New York,
New York

2904. **SLAIN ELK AND 2 SLAIN GRIZZLIES IN BIG HORN
MTNS.** (P1979.51.1)
Toned gelatin silver print. negative 1882, print later
Image: 3¹⁵⁄₁₆ x 3½ in. (10.0 x 8.8 cm.)
Signed: see inscription
Inscription, in negative: "476/COPYRIGHT BY HUFFMAN,
MILES, MONT."
print verso: "⊡UR⊡/1882//INV#75202//Slain Elk & 2 slain/
Grizzlies/in Big Horn Mtns//18"
Acquired from: Robert Schoelkopf Gallery, New York,
New York

2905. **A TRAIL HERD, POWDER RIVER** (P1979.51.16)
Collotype (?). negative 1886, print later
Image: 10⅛ x 15½ in. (25.7 x 39.4 cm.)
Signed: see inscription
Inscription, print recto: "#226 A Trail Herd, Powder River,
Negative, Print and Copyright by LA Huffman Milestown
Mont 1886."
print verso: "A Trail Herd, Powder River 1886//
INV#74610" and rubber stamp "COFFRIN STUDIO,
AGENT/MILES CITY, MONT./RE-ORDER NO. 245B"
Acquired from: Robert Schoelkopf Gallery, New York,
New York

2906. **TRAILING SHEEP, POWDER RIVER BADLANDS**
(P1979.51.12)
Collotype (?). negative 1884, print later
Image: 8 x 10 in. (20.3 x 25.4 cm.)
Signed: see inscription
Inscription, in negative: "#300 Trailing Sheep, Powder river
badlands, Neg Print and copyright by Huffman/Milestown
Mont 1884."
print verso: "INV# 75191" and rubber stamp "COFFRIN
STUDIO, AGENT./MILES CITY, MONT./RE-ORDER
NO. 3111"
Acquired from: Robert Schoelkopf Gallery, New York,
New York

2907. **WAGON RUTS IN PRAIRIE** (P1979.51.18)
Toned gelatin silver print. negative c. 1900, print later
Image: 10 x 15¾ in. (25.4 x 39.9 cm.) irregular
Sheet: 10⅛ x 16 in. (25.7 x 40.7 cm.) irregular
Signed: see inscription
Inscription, print recto: "L A Huffman"
print verso: "Wagon ruts/in prairie//GrpC//INV#
7635 ⊡RX⊡"
Acquired from: Robert Schoelkopf Gallery, New York,
New York

2893

2900

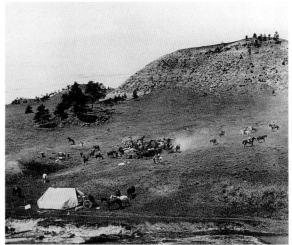

2901

2908. THE XIT CATTLE ROUND UP WAGON AND 165 HEAD OF SADDLE PONIES BREAKING CAMP AT BURNS CREEK MON. (P1979.51.14)
Collotype (?). negative c. 1904, print later
Image: 5 x 15 in. (12.7 x 38.1 cm.)
Sheet: 6 x 15 15/16 in. (15.2 x 40.4 cm.)
Inscription, in negative: "THE XIT CATTLE ROUND UP WAGON AND 165 HEAD OF SADDLE PONIES BREAKING CAMP AT BURNS CREEK MON"
print verso: "UX"
Acquired from: Robert Schoelkopf Gallery, New York, New York

*2909. YOUNG 'PLENTY BIRD' BESIDE HIS TEPEE IN HIS DANCING COSTUME (P1979.51.21)
Toned gelatin silver print. negative c. 1890s, print later
Image: 6 x 7 15/16 in. (15.1 x 20.1 cm.)
Inscription, in negative: "203"
print verso: "#28A//"Young 'Plenty Bird' beside his tepee in/his dancing costume."/p. 214/The Frontier Years, 1890s//INV# 7618/RX"
Acquired from: Robert Schoelkopf Gallery, New York, New York

2910. YOUNG PLENTY BIRD'S FAMILY (P1979.51.19)
Toned gelatin silver print. negative c. 1890s, print later
Image: 6 x 7 15/16 in. (15.2 x 20.1 cm.)
Inscription, in negative: "202"
print verso: "Young Plenty Bird's Family//#28//INV# 7612 XX"
Acquired from: Robert Schoelkopf Gallery, New York, New York

The following group of 135 photographs by Huffman is being processed at this catalogue's time of publication.
P1986.36.1-135
Albumen silver prints, gelatin silver prints, and gelatino-chloride prints. late 1800s—early 1900s
Acquired from: gift of Daniel A. Don, Chicago, Illinois

2911. ST. MARY'S LAKE NEAR ST. IGNATIUS MISSION, MONTANA (P1986.36.1)

2912. SIOUX WOMAN, WIFE OF "MAN-ON-THE-HILL" (P1986.36.2)

2913. CROW INDIANS DANCING (P1986.36.3)

2914. CHEYENNE INDIAN POLICE AT LAME DEER (P1986.36.4)

2915. [Sheep watering at Big Dry Creek, Montana] (P1986.36.5)

2916. CUSTER'S BATTLEFIELD, 40TH ANNIVERSARY (P1986.36.6)

2917. [Ducks on a stream] (P1986.36.7)

2918. DIAMOND W CATTLE, NORTH SIDE YELLOWSTONE RIVER, SHEFFIELD, MT. (P1986.36.8)

2919. OWL CREEK SLOPE, SPEAR ROUNDUP (P1986.36.9)

2920. [Man walking toward cabin] (P1986.36.10)

*2921. MEXICAN JOHN, XIT COOK [The Mess Wagon] (P1986.36.11)

2922. [Camp at edge of ravine] (P1986.36.12)

2923. JERKLINE TWELVE ON THE OLD FREIGHT ROAD (P1986.36.13)

2924. CUSTER'S BATTLEFIELD (P1986.36.14)

2925. EACH EVENING A BEEF MUST BE KILLED (P1986.36.15)

2926. LAME DEER (P1986.36.16)

*2927. THE LAMB WAGON (P1986.36.17)

2928. THE DESERTED CAMP (P1986.36.18)

2929. [Wagon train] (P1986.36.19)

2930. OLD SIXTEEN AT FOOT OF THE JUMP-OFF (P1986.36.20)

2931. THE CHEYENNE AGENCY AND CAMP MERRITT. LOOKING TOWARD THE ROSEBUD (P1986.36.21)

2932. [Ranch house] (P1986.36.22)

2933. [Man, boy, and three women at camp site] (P1986.36.23)

2934. [Flatlands] (P1986.36.24)

2935. BRANDING CALVES IN CORRAL (P1986.36.25)

2936. ROUNDUP (P1986.36.26)

*2937. [Horse races] (P1986.36.27)

2938. THE N BAR (N) CROSSING, POWDER RIVER (P1986.36.28)

2939. EARLY DAY SHEEP SHEARERS AT WORK IN A BOWER (P1986.36.29)

2940. [Railroad dining car] (P1986.36.30)

2941. [Man seated in a railroad car] (P1986.36.31)

2942. [Railroad car interior, sleeping car] (P1986.36.32)

2943. [Bedroom] (P1986.36.33)

2944. [Hallway] (P1986.36.34)

2945. [Parlor] (P1986.36.35)

2946. COMENHA, DAUGHTER OF DULL KNIFE (P1986.36.36)

2947. COMENHA, DAUGHTER OF DULL KNIFE (P1986.36.37)

2948. SIOUX MOTHER & BABE (P1986.36.38)

2949. [Seated Indian man with pipe] (P1986.36.39)

2950. SPOTTED BEAR, HUNKAPAPA SIOUX IN HUFFMAN'S STUDIO AT FORT KEOGH (P1986.36.40)

2951. SON OF WILD HOG (P1986.36.41)

2952. "CHIEF JOSEPH." NEZ PERCE (P1986.36.42)

2953. [Indian woman, three-quarter-length portrait] (P1986.36.43)

2954. MRS. STANDING ELK (P1986.36.44)

2955. [Indian woman] (P1986.36.45)

2956. FIRE WOLF (P1986.36.46)

2957. FIRE WOLF (P1986.36.47)

2958. DAUGHTERS OF DULL KNIFE—CHEYENNES (P1986.36.48)

2959. THREE CHEYENNE WOMEN (P1986.36.49)

2960. RAIN-IN-THE-FACE'S WIVES (P1986.36.50)

2961. [Four Indian women] (P1986.36.51)

2962. [Seated Indian man wearing headdress and smoking pipe] (P1986.36.52)

2963. TALL BEAR, MINNECONJOUX MEDICINE MAN IN DANCE COSTUME (P1986.36.53)

2964. TWO MOON'S CHILDREN (P1986.36.54)

2965. CHEYENNE GIRL "ANNIE" (P1986.36.55)

2966. SPOTTED FAWN (P1986.36.56)

2967. YOUNG PLENTY BIRD, CHEYENNE, IN HIS SWEAT LODGE (P1986.36.57)

2968. CHEYENNE [Young Plenty Bird and family] (P1986.36.58)

2969. PLENTY BIRD & FAMILY (P1986.36.59)

2970. [Chief Plenty Bird's family] (P1986.36.60)

2971. AMERICAN HORSE, CHEYENNE (P1986.36.61)

2972. AMERICAN HORSE, CHEYENNE (P1986.36.62)

2973. PRIVATE DAVID SWEETMEDICINE (P1986.36.63)

2974. [Indian gathering] (P1986.36.64)

2975. SIOUX CHIEF BUFFALO HUMP & HEAD WARRIORS, FORT KEOGH, M.T. (P1986.36.65)

2976. SPOTTED EAGLE VILLAGE (P1986.36.66)

2977. KILLING A BEEF FOR THE ROUNDUP (P1986.36.67)

2978. KILLING A YOUNG BEEF AT THE ROUNDUP (P1986.36.68)

2979. THE SLAIN MONARCH OF THE MOUNTAIN (P1986.36.69)

2980. THE SLAIN MONARCH OF THE MOUNTAIN (P1986.36.70)

2981. THE SLAIN MONARCH OF THE MOUNTAIN (P1986.36.71)

2982. MOUNTAIN SHEEP (P1986.36.72)

2983. MOUNTAIN SHEEP (P1986.36.73)

2984. [Bull tied for branding lying on the ground] (P1986.36.74)

2985. [Cattle and cowboys] (P1986.36.75)

2986. [Man holding horse on lead] (P1986.36.76)

2987. [Roping cattle] (P1986.36.77)

2988. [Cattle herd] (P1986.36.78)

2989. [Ranch house with people and dog on porch] (P1986.36.79)

2990. [Man and woman talking at window of log cabin with sod roof] (P1986.36.80)

2991. PICKING A BRAND TO DETERMINE OWNERSHIP(P1986.36.81)

2992. [Cow camp scene] (P1986.36.82)

2993. [Horse and rider by stream] (P1986.36.83)

2994. [Flock of sheep] (P1986.36.84)

2995. THE ROUNDUP ON THE MOVE (P1986.36.85)

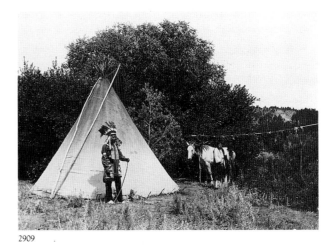

2909

2921

2927

2996. HOLDING A HERD ON BIG PUMPKIN CREEK (P1986.36.86)

2997. [Herding cattle into corral] (P1986.36.87)

2998. [Hunter sitting on ground next to pack horse] (P1986.36.88)

2999. [Man holding horse on lead] (P1986.36.89)

3000. [Ranch house] (P1986.36.90)

3001. O W RANCH ON HANGING WOMAN CREEK (P1986.36.91)

3002. THE BIG O W RANCH ON HANGING WOMAN CREEK (P1986.36.92)

3003. THE BIG O W RANCH ON HANGING WOMAN CREEK (P1986.36.93)

3004. LAME DEER (P1986.36.94)

3005. LAME DEER (P1986.36.95)

*3006. AGENT CLIFFORD AND FAMILY. THE MISSION FATHER AND "WALK SLANT," A CHEYENNE WOMAN (P1986.36.96)

3007. OLD BUFFALO HUNTERS CAMP (P1986.36.97)

3008. [Wagons at a depot] (P1986.36.98)

3009. PUSHING THEM FROM BED, COLD MORNING (P1986.36.99)

3010. [Fallen deer] (P1986.36.100)

3011. [Fallen deer] (P1986.36.101)

3012. A TRAIL HERD, POWDER RIVER (P1986.36.102)

3013. [Man walking toward cabin] (P1986.36.103)

3014. [Horse and rider in field] (P1986.36.104)

3015. [Horse and rider in field] (P1986.36.105)

3016. THE BARRANGER RANCH, TONGUE RIVER, 3500 ACRES (P1986.36.106)

*3017. [Pompey's Pillar] (P1986.36.107)

3018. BILL REECE'S DANCE HALL, THE FIRST LOW NECKED CARRIAGE, THE TOWN WELL (P1986.36.108)

3019. [Ranch at river's edge] (P1986.36.109)

3020. [Sheep at river bend] (P1986.36.110)

3021. [Sheep at river bend] (P1986.36.111)

3022. YELLOWSTONE RIVER NEAR TERRY, MT. (P1986.36.112)

3023. ROUNDUP ON THE MOVE (P1986.36.113)

3024. THE OLD A BAR RANCH (P1986.36.114)

3025. LOCK BLUFF, CMPS&P EXTEN, MONT, BEFORE DETONATING 1300 LB BLAST OF BLACK AND GIANT POWDER (P1986.36.115)

3026. [Herd of cattle] (P1986.36.116)

3027. SHEEP NEAR TERRY ON YELLOWSTONE (P1986.36.117)

3028. DOWN THE YELLOWSTONE FROM TOP OF POMPEY'S PILLAR (P1986.36.118)

3029. [Parade] (P1986.36.119)

3030. A SPEAR HERD ON OLD INDIAN CREEK TRAIL. SPEAR ZIMMERMAN AND FEDDES. CROW LASE NEAR 40 MILES. FAMOUS OLD "40 MILE RANCH" ON LITTLE HORN NEAR LODGE GRASS (P1986.36.120)

3031. [Sheep by Powder River] (P1986.36.121)

3032. SPEAR ROUNDUP (P1986.36.122)

3033. [Roundup, Sheffield, Montana] (P1986.36.123)

3034. SPEAR [illegible] RDUP, BIG WOLF MTN (P1986.36.124)

3035. SPEAR ROUNDUP (P1986.36.125)

3036. SPEAR ROUNDUP (P1986.36.126)

3037. SPEAR ROUNDUP (P1986.36.127)

3038. [Sheffield, Montana; cattle standing in river] (P1986.36.128)

3039. [Horses in front of log ranch house] (P1986.36.129)

3040. [Teacher and students in front of school] (P1986.36.130)

3041. MILES CITY, M.T. 1877 [Log buildings at end of dirt road] (P1986.36.131)

3042. [Dining room] (P1986.36.132)

3043. [Parlor and staircase] (P1986.36.133)

3044. [Dining room] (P1986.36.134)

3045. [Dining car on train] (P1986.36.135)

DIANE HOPKINS HUGHS, American (b. 1935)

Diane Hopkins Hughs holds undergraduate and graduate degrees in art education from the University of Texas and Indiana University and has studied photography at workshops with Brett Weston, Paul Caponigro, Nathan Lyons, and Ralph Gibson. She has taught art in high schools, colleges, and adult workshops. Her work includes southwestern scenes and abstract views of structural forms.

3046. CADDO LAKE [Caddo Lake, Texas] (P1972.41.3)
Gelatin silver print. 1971
Image: 7 11/16 x 7 9/16 in. (19.5 x 19.3 cm.)
Mount: 15 x 13 1/4 in. (38.1 x 33.7 cm.)
Signed, l.r. mount recto: "D Hopkins"
Inscription, mount recto: "Caddo Lake 1971"
mount verso: "Caddo Lake, Texas"
Acquired from: the photographer

*3047. CONSTRUCTION/RECONSTRUCTION SERIES [from the Society for Photographic Education's "South Central Regional Photography Exhibition"] (P1983.31.8)
Gelatin silver print (collage). 1980
Image: 12 3/8 x 10 3/8 in. (31.4 x 26.4 cm.)
Mount: 20 x 16 in. (50.8 x 40.7 cm.)
Signed, l.r. mount recto: "D. Hopkins-Hughs 1980"
Inscription, mount recto: "Construction/Reconstruction Series"
mount verso: "Diane Hopkins-Hughs/Construction/Reconstruction Series 1980/709 Galbraith/Kerrville, TX 78028"
Acquired from: gift of the Society for Photographic Education, South Central Region

3048. **HONOLULU 1972** (P1974.19.3)
Gelatin silver print. 1972
Image: 7¾ x 9¾ in. (19.6 x 24.8 cm.)
Mount: 13¼ x 15⅛ in. (33.7 x 38.4 cm.)
Signed, l.r. mount recto: "D Hopkins-Hughs"
Inscription, mount recto: "Honolulu 1972"
Acquired from: the photographer

3049. **I-30 #2** (P1972.41.5)
Gelatin silver print (collage). 1969–70
Image: 18⅛ x 15 in. (45.9 x 38.2 cm.)
Mount: 20 x 16 in. (50.8 x 40.7 cm.)
Inscription, old mat backing: "D HOPKINS/I-30/24 x 28/2"
and written on paper label "HOPKINS, DIANE/MCV-
POPh-4067AF/I-30 #2" and typed and written on printed
label "MAIN PLACE GALLERY/ONE MAIN PLACE/
DALLAS TEXAS 75250/ARTIST [typed] Diane Hopkins/
TITLE [typed] I-30/MEDIUM [in ink] Photo-collage/SIZE
[typed] 24 x 28/CATALOGUE NUMBER [Typed] MCV-
POPh 4067"
Acquired from: the photographer

3050. **INTERSTATE 30 [Interstate 30—Portfolio #1]** (P1972.41.4)
Gelatin silver print. 1971
Image: 15½ x 19⁹⁄₁₆ in. (39.3 x 49.6 cm.)
Mount: 23¹⁵⁄₁₆ x 27¹⁵⁄₁₆ in. (60.8 x 71.0 cm.)
Signed, l.r. mount recto: "D Hopkins 1970"
Inscription, mount recto: "Interstate 30"
 mount verso: "Interstate 30—Portfolio #1"
Acquired from: the photographer

3051. **INTERSTATE 30 #4** (P1972.41.6)
Gelatin silver print (collage). 1970–71
Image: 21⅝ x 27¾ in. (54.9 x 70.5 cm.)
Mount: 28 x 32¼ in. (71.1 x 82.0 cm.)
Signed, l.r. overmat recto: "D Hopkins 1970–71"
Inscription, overmat recto: "Interstate 30 #4"
Acquired from: the photographer

3052. **INTERSTATE 30 #7** (P1972.41.7)
Gelatin silver print (collage). 1972
Image: 9⅛ x 24½ in. (23.2 x 62.2 cm.)
Mount: 11¼ x 29⅛ in. (28.5 x 73.9 cm.) irregular
Signed, l.r. overmat recto: "D Hopkins 1972"
Inscription, overmat recto: "Interstate 30 #7"
 mount verso: "Interstate 30 #7 collage/30 x 13"
 old mat backing verso: "Interstate 30 #7/Collage/
 DH Hughs 1972/13X30"
Acquired from: the photographer

*3053. **RANCHOS DE TAOS—1** (P1974.19.5)
Gelatin silver print. 1970
Image: 7¾ x 7¹³⁄₁₆ in. (19.6 x 19.8 cm.)
Mount: 15 x 13¼ in. (38.1 x 33.6 cm.)
Signed, l.r. mount recto: "D Hopkins 1970"
Inscription, mount recto: "Ranchos de Taos—1"
Acquired from: the photographer

3054. **RANCHOS DE TAOS—3** (P1974.19.4)
Gelatin silver print. 1970
Image: 7¹³⁄₁₆ x 7¹³⁄₁₆ in. (19.8 x 19.8 cm.)
Mount: 15 x 13¼ in. (38.1 x 33.6 cm.)
Signed, l.r. mount recto: "D Hopkins 1970"
Inscription, mount recto: "Ranchos de Taos—3"
Acquired from: the photographer

3055. **RANCHOS DE TAOS—4** (P1974.19.1)
Gelatin silver print. 1970
Image: 7¾ x 7⁹⁄₁₆ in. (19.6 x 19.2 cm.)
Mount: 15 x 13¼ in. (38.1 x 33.6 cm.)
Signed, l.r. mount recto: "D Hopkins 1970"
Inscription, mount recto: "Ranchos de Taos—4"
 mount verso: "Iglesia/Ranchos de Taos—4/1970"
Acquired from: the photographer

2937

3006

3017

3056. **RANCHOS DE TAOS—6** (P1974.19.2)
Gelatin silver print. 1970
Image: 7 5/8 x 7 3/4 in. (19.3 x 19.7 cm.)
Mount: 15 x 13 1/4 in. (38.1 x 33.6 cm.)
Signed, l.r. mount recto: "D Hopkins 1970"
Inscription, mount recto: "Ranchos de Taos—6"
Acquired from: the photographer

*3057. **TERLINGUA [Adobe House, Terlingua, Texas]** (P1972.41.1)
Gelatin silver print. 1971
Image: 7 13/16 x 7 5/8 in. (19.9 x 19.4 cm.)
Mount: 15 x 13 1/4 in. (38.1 x 33.7 cm.)
Signed, l.r. mount recto: "D Hopkins 1971"
Inscription, mount recto: "Terlingua"
mount verso: "Adobe House/Terlingua—1971/55"
Acquired from: the photographer

3058. **TERLINGUA [Church at Terlingua, Texas]** (P1972.41.2)
Gelatin silver print. 1971
Image: 7 1/2 x 7 3/4 in. (19.0 x 19.7 cm.)
Mount: 15 x 13 1/4 in. (38.1 x 33.7 cm.)
Signed, l.r. mount recto: "D Hopkins '71"
Inscription, mount recto: "Terlingua"
mount verso: "Church at Terlingua"
Acquired from: the photographer

LEOPOLD HUGO,
American, born Prussia (1863–1933)

Hugo was a landscape photographer who made views in California at the height of the pictorialist movement. His landscape scenes are strongly within the pictorialist tradition, and he experimented with different developing methods, papers, and toners to obtain a soft-grain texture in his prints.

*3059. **[California scene]** (P1980.53)
Bromoil or gum bichromate print. c. 1910–20
Image: 5 7/8 x 7 15/16 in. (14.9 x 20.2 cm.)
Sheet: 7 15/16 x 10 in. (20.2 x 25.4 cm.)
Signed: see inscription
Inscription, print verso: "27/28" and rubber stamp "photograph by Leopold Hugo"
Acquired from: Kamp Gallery, St. Louis, Missouri

W. R. HUMPHRIES,
American (active early 20th century)

Humphries moved to Bisbee, Arizona, from El Paso, Texas, in 1903. His photographic work in the town was generally limited to mining and street scenes.

*3060. **BISBEE [Bisbee, Arizona]** (P1975.191.6)
Gelatin silver print. 1904
Image: 4 1/2 x 23 1/4 in. (11.4 x 59.1 cm.)
Sheet: 4 11/16 x 23 7/16 in. (11.9 x 59.5 cm.)
Mount: 7 3/8 x 24 in. (18.6 x 61.0 cm.) irregular
Signed: see inscription
Inscription, in negative: "BISBEE//—COPYRIGHTED—1904—/—W.R. HUMPHRIES—/—BISBEE—ARIZ—"
mount verso, rubber stamp: "LIBRARY OF CONGRESS-7/SURPLUS DUPLICATE"
Acquired from: Library of Congress, trade for duplicate materials

ROBERT L. ISOM, American (b. 1928)

Bob Isom, a native of San Francisco, received his photographic training at the U.S. Air Force Technical School at Lowery Air Force Base in Colorado. His military work included public relations photography, aircraft crash documentation, and maintenance of aerial cameras for a reconnaissance squadron. Isom was employed on the Bureau of Reclamation's Grand Coulee Dam Third Powerplant project from 1968 until he established his own photographic business in 1978. The studio's business has consisted primarily of industrial photography and contract lab work for the Bureau of Reclamation. Isom has also photographed a series of old homesteads in the area surrounding his home in Grand Coulee, Washington.

3061. **[Night construction at U.S. Bureau of Reclamation Third Powerplant at Grand Coulee Dam]** (P1972.24.1)
Ektacolor print. 1971
Image: 20 1/16 x 24 in. (50.9 x 61.0 cm.)
Mount: same as image size
Inscription, mount verso: "Mar 8 71/CN-1222-142-2931/by Bob Isom" and rubber stamp "CREDIT/BUREAU OF RECLAMATION/U.S. DEPARTMENT OF THE INTERIOR/THIRD POWERPLANT CONSTRUCTION OFFICE/P.O. BOX 620/GRAND COULEE, WASHINGTON 99133"
Acquired from: gift of the U.S. Department of the Interior, Bureau of Reclamation, Grand Coulee, Washington

WILLIAM HENRY JACKSON,
American (1843–1942)

See also Jackson Collages

Jackson's lengthy photographic career and the wide distribution and reproduction of his images make him one of the best-known nineteenth-century American photographers. After a brief period as a studio photographer in Omaha, Nebraska, Jackson found his calling making views of the exploration and settlement of the western United States. He was the official photographer on the Hayden United States Geological Survey from 1870 until 1879. In addition he did extensive work with the Bureau of American Ethnology, printing Indian portraits made by himself and other photographers. After opening a studio in Denver in 1879 Jackson did commission work for the railroads, producing spectacular mammoth-plate views of the landscape and towns along the rail routes. He also distributed thousands of smaller views and stereographs. In 1897 Jackson acquired part interest in the Detroit Publishing Company, which distributed his photographs and published them widely. Although Jackson was a prolific photographer, the size of his publishing operation, the use of numerous assistants, and the fact that he sometimes published other photographers' work as his own can make it difficult to determine a date or attribution for a Jackson photograph.

*3062. **APPROACHING HELL GATE, COL. MIDLAND R.R.** (P1979.40.19)
Albumen silver print. 1888
Image: 16 3/4 x 21 in. (42.6 x 53.3 cm.)
Mount: 24 x 30 in. (61.0 x 76.2 cm.)
Signed: see inscription
Inscription, in negative: "1269. APPROACHING HELL GATE/COL. MIDLAND R.R.//W.H. JACKSON & CO. PHOT. DENVER"
Acquired from: Frontier America Corporation, Bryan, Texas

3063. **B & F Herd** (P1978.83.26)
Albumen silver print. c. 1885
Image: 4 5/8 x 7 1/4 in. (11.8 x 18.4 cm.)
Mount: 5 x 8 in. (12.7 x 20.3 cm.)
Inscription, mount verso: "B & F herd//This must be 1/2 ranch brand cattle/on the range to south of ranch./L.G. 1/18/78"
Acquired from: gift of Laura Gilpin, Santa Fe, New Mexico

3047

3053

3059

3057

3060

*3064. **BAKER'S PARK AND SULTAN M'TN.** (P1971.94.2)
Albumen silver print. 1875
Image: 17 ¹/₁₆ x 21 in. (43.4 x 53.4 cm.)
Mount: 24 ⁷/₈ x 30 in. (63.2 x 76.3 cm.)
Signed: see inscription
Inscription, in negative: "BAKER'S PARK AND SULTAN M'TN."
mount recto, printed: "Department of the Interior./U.S. Geological Survey [USGS emblem] of the Territories./ PROF. F. V. HAYDEN IN CHARGE.//W. H. JACKSON, PHOTO."
Acquired from: Richard A. Ronzio, Golden, Colorado

3065. **[Battle Mountain]** (P1971.94.1)
Toned gelatin silver print. negative c. 1890, print later
Image: 20 x 27 ¼ in. (50.8 x 69.2 cm.) irregular
Signed: see inscription
Inscription, print recto: "W. H. Jackson Phot. Co./Denver."
Acquired from: Richard A. Ronzio, Golden, Colorado

3066. **[The Black Canyon near Cimarron]** (P1979.40.15)
Albumen silver print. 1885
Image: 10 ⁵/₈ x 10 ¹/₁₆ in. (27.0 x 25.5 cm.)
Mount: 18 x 14 in. (45.7 x 35.6 cm.)
Acquired from: Frontier America Corporation, Bryan, Texas

3067. **BRAND OF ½ RANCH [on a bull]** (P1978.83.24)
Albumen silver print. c. 1885
Image: 4 ⁵/₈ x 7 ⁵/₁₆ in. (11.8 x 18.6 cm.)
Mount: 5 x 8 in. (12.7 x 20.3 cm.)
Inscription, mount verso: "Brand of ½ Ranch:/½ Bernard, ½ Frank Gilpin"
Acquired from: gift of Laura Gilpin, Santa Fe, New Mexico

3068. **BRANDING [branding a calf at Horse Creek Ranch]** (P1978.83.13)
Albumen silver print. c. 1885
Image: 4 ¾ x 7 ⅜ in. (12.1 x 18.7 cm.)
Mount: 5 x 8 in. (12.7 x 20.3 cm.)
Inscription, mount verso: "On the horse creek Ranch. I believe it is my father/on horseback./This whole series of photographs was made/by W. H. Jackson./L.G."
Acquired from: gift of Laura Gilpin, Santa Fe, New Mexico

3069. **BRANDING [branding a calf at Horse Creek Ranch]** (P1978.83.14)
Albumen silver print. c. 1885
Image: 4 ¾ x 7 ⅜ in. (12.1 x 18.7 cm.)
Mount: 5 x 8 in. (12.7 x 20.3 cm.)
Inscription, mount verso: "Frank Gilpin on left//Do not know who wrote above./Am certain it is my father at left."
Acquired from: gift of Laura Gilpin, Santa Fe, New Mexico

3070. **[Branding a calf, back view]** (P1978.83.15)
Albumen silver print. c. 1885
Image: 4 ¾ x 7 ⅜ in. (12.1 x 18.7 cm.)
Mount: 5 x 8 in. (12.7 x 20.3 cm.)
Inscription, mount verso: "This could be my father on horseback./L. G. 1/18/78"
Acquired from: gift of Laura Gilpin, Santa Fe, New Mexico

3071. **BRIDGE IN ANIMAS CANON** (P1967.3349)
Albumen silver print. c. 1882
Image: 9 ⁵/₁₆ x 13 ⁵/₁₆ in. (23.5 x 33.8 cm.)
Sheet: 10 ¼ x 13 ⁵/₁₆ in. (26.0 x 33.8 cm.)
Mount: 16 x 20 in. (40.7 x 50.8 cm.)
Signed: see inscription
Inscription, in negative: "126 Bridge in Animas Canon.// W. H. Jackson & Co. Phot., Denver, Colo."
Acquired from: Fred Rosenstock, Denver, Colorado

*3072. **BUENA VISTA AND MT. PRINCETON. COLORADO MIDLAND R.R.** (P1971.94.9)
Albumen silver print. 1887
Image: 16 ¾ x 21 ¼ in. (42.5 x 53.9 cm.)
Mount: 21 ⅞ x 28 in. (55.4 x 71.1 cm.)

Inscription, in negative: "+213 BUENA VISTA AND MT. PRINCETON./COLORADO MIDLAND R.R."
Acquired from: Richard A. Ronzio, Golden, Colorado

3073. **BUENA VISTA MINE AND PIKES PEAK, WILSON CREEK** (P1979.82.2)
Albumen silver print. c. 1880s
Image: 4 ⅜ x 7 ⁵/₁₆ in. (11.1 x 18.6 cm.)
Mount: 5 x 8 in. (12.7 x 20.3 cm.)
Signed: see inscription
Inscription, in negative: "484. BUENA VISTA MINE AND PIKE'S PEAK, WILSON CREEK."
mount verso, printed: "[around emblem] W. H. JACKSON PHOTOGRAPH AND PUBLISHING CO. DENVER, COL.//RAILROAD AND LANDSCAPE PHOTOGRAPHY OUR SPECIALTIES"
Acquired from: Photo-Graphics, Ltd., Santa Fe, New Mexico

3074. **[Bunkhouse at Horse Creek Ranch]** (P1978.83.11)
Albumen silver print. c. 1885
Image: 4 ¾ x 7 ¼ in. (12.1 x 18.4 cm.)
Mount: 5 x 8 in. (12.7 x 20.3 cm.)
Inscription, mount verso: "W.H. Jackson photo series/Am not sure if my father is one of these./L. Gilpin 1/18/78"
Acquired from: gift of Laura Gilpin, Santa Fe, New Mexico

3075. **[Bunkhouse at Horse Creek Ranch]** (P1978.83.12)
Albumen silver print. c. 1885
Image: 4 ¾ x 7 ⅜ in. (12.1 x 18.7 cm.)
Mount: 5 x 8 in. (12.7 x 20.3 cm.)
Inscription, mount verso: "I believe this is the first/building on the Horse Creek Ranch (65 miles East of Colo. Springs)/My father could be the one lying down./It looks like his horse."
Acquired from: gift of Laura Gilpin, Santa Fe, New Mexico

3076. **[Bunkhouse, corner interior, with guitar on bed]** (P1978.83.19)
duplicate of P1978.83.20
Albumen silver print. c. 1885
Image: 4 ¾ x 7 ⅜ in. (12.1 x 18.7 cm.)
Mount: 5 x 8 in. (12.7 x 20.3 cm.)
Acquired from: gift of Laura Gilpin, Santa Fe, New Mexico

*3077. **[Bunkhouse, corner interior, with guitar on bed]** (P1978.83.20)
duplicate of P1978.83.19
Albumen silver print. c. 1885
Image: 4 ¹¹/₁₆ x 7 ¼ in. (11.9 x 18.5 cm.)
Mount: 5 x 8 in. (12.7 x 20.3 cm.)
Acquired from: gift of Laura Gilpin, Santa Fe, New Mexico

3078. **[Bunkhouse interior with guitar and hat on bed]** (P1978.83.17)
duplicate of P1978.83.18
Albumen silver print. c. 1885
Image: 4 ⅝ x 7 ⅜ in. (11.8 x 18.7 cm.)
Mount: 5 x 8 in. (12.7 x 20.3 cm.)
Acquired from: gift of Laura Gilpin, Santa Fe, New Mexico

3079. **[Bunkhouse interior with guitar and hat on bed]** (P1978.83.18)
duplicate of P1978.83.17
Albumen silver print. c. 1885
Image: 4 ¾ x 7 ⅜ in. (12.1 x 18.7 cm.)
Mount: 5 x 8 in. (12.7 x 20.3 cm.)
Acquired from: gift of Laura Gilpin, Santa Fe, New Mexico

*3080. **CAMP OF THE U.S.G.S. AT THE FOOT OF THE THREE TETONS** (P1979.77.2)
Albumen silver print. 1872
Image: 8 ¹/₁₆ x 13 ¼ in. (20.5 x 33.6 cm.)
Mount: 16 x 20 in. (40.7 x 50.8 cm.)
Signed: see inscription
Inscription, in negative: "CAMP OF THE U.S.G.S. AT THE FOOT OF THE THREE TETONS."
mount recto, printed: "DEP'T OF THE INTERIOR U.S. GEOLOGICAL SURVEY OF THE TERRITORIES.// W. H. JACKSON, PHOTO.//WASHINGTON, D. C."
Acquired from: Frontier America Corporation, Bryan, Texas

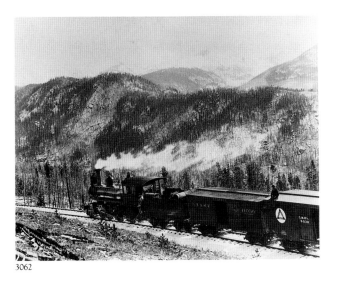

3062

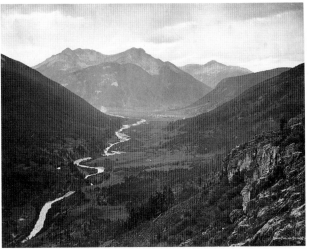

3064

3072

3077

3080

3083

3081. **CAMP ON MYSTIC LAKE** [Montana] (P1979.77.1)
Albumen silver print. 1872
Image: 10 ¼ x 13 ¼ in. (26.1 x 33.6 cm.)
Mount: 16 x 19 ¹⁵⁄₁₆ in. (40.7 x 50.6 cm.)
Signed: see inscription
Inscription, in negative: "CAMP ON MYSTIC LAKE."
mount recto, printed: "DEP'T OF THE INTERIOR U.S.
GEOLOGICAL SURVEY OF THE TERRITORIES.//
W. H. JACKSON, PHOTO//WASHINGTON, D. C."
Acquired from: Frontier America Corporation, Bryan, Texas

3082. **THE CAMP WAGON** [The ½ Ranch chuck wagon]
(P1978.83.10)
Albumen silver print. c. 1885
Image: 4 ⅝ x 7 ⅜ in. (11.8 x 18.7 cm.)
Mount: 5 x 8 in. (12.7 x 20.3 cm.)
Inscription, mount verso: "The ½ Ranch chuck wagon/
W. H. Jackson photo./L. Gilpin. 1/18/78"
Acquired from: gift of Laura Gilpin, Santa Fe, New Mexico

*3083. **CAÑON OF THE RIO LAS ANIMAS** [with train]
(P1971.22.55)
Albumen silver print. c. mid-1880s
Image: 21 ¹⁄₁₆ x 16 ³⁄₁₆ in. (53.5 x 41.1 cm.) irregular
Signed: see inscription
Inscription, in negative: "1077. A./CAÑON/OF THE/RIO/
LAS ANIMAS/W. H. JACKSON/PHOT./DENVER/
COL."
Acquired from: Fred Mazzulla, Denver, Colorado

*3084. **CANON OF THE RIO LAS ANIMAS** [Rockwood]
(P1971.94.18)
Albumen silver print. 1882
Image: 21 ⅛ x 16 ¹⁵⁄₁₆ in. (53.7 x 43.0 cm.)
Mount: 30 x 25 in. (76.2 x 63.5 cm.)
Signed: see inscription
Inscription, in negative: "1037. CANON OF THE RIO LAS
ANIMAS"
mount recto, printed: "DENVER/W. H. JACKSON &
CO. PHOTOGRAPHERS/COLORADO"
Acquired from: Richard A. Ronzio, Golden, Colorado

3085. **CANON OF THE RIO LAS ANIMAS** [Needle Mountains]
(P1971.94.19)
Albumen silver print. c. 1884
Image: 16 ⅝ x 21 ⅛ in. (42.1 x 53.6 cm.)
Mount: 20 ³⁄₁₆ x 24 ¾ in. (51.2 x 62.9 cm.) irregular
Signed: see inscription
Inscription, in negative: "1039. CANON OF THE RIO LAS
ANIMAS./W. H. JACKSON & CO. PHOT. DENVER,
COL."
mount recto, printed: "[on emblem] DENVER & RIO
GRANDE R.R./SCENIC LINE/OF THE WORLD//THE
ROCKY MOUNTAINS./SCENES ALONG THE LINE
OF THE/DENVER & RIO GRANDE RAILROAD."
Acquired from: Richard A. Ronzio, Golden, Colorado

3086. **CANON OF THE RIO LAS ANIMAS** [with train]
(P1979.40.17)
Albumen silver print. c. 1882–86
Image: 16 ⁷⁄₁₆ x 21 ⅛ in. (41.7 x 53.6 cm.)
Mount: 24 x 30 in. (61.0 x 76.2 cm.)
Signed: see inscription
Inscription, in negative: "1077. CANON OF THE RIO LAS
ANIMAS/W.H.J. & CO. DENVER"
Acquired from: Frontier America Corporation, Bryan, Texas

3087. **CASTLE GATE D. &. R.G. W. RY.** [Price Canyon, Utah]
(P1971.94.25)
Albumen silver print. c. 1880s
Image: 17 ¼ x 21 ⅛ in. (43.8 x 53.6 cm.)
Mount: 18 ³⁄₁₆ x 22 in. (46.2 x 55.9 cm.)
Signed: see inscription
Inscription, in negative: "1060 CASTLE GATE D. &. R.G.
W. RY./W.H. JACKSON & CO. PHOT. DENVER."
mount recto, printed: "THE ROCKY MOUNTAINS./
SCENES ALONG [illegible—mount has been trimmed]"
Acquired from: Richard A. Ronzio, Golden, Colorado

*3088. **CATHEDRAL SPIRES** [Garden of the Gods, Colorado]
(P1979.82.1)
Albumen silver print. c. 1880s
Image: 4 ⅜ x 7 ⁵⁄₁₆ in. (11.1 x 18.6 cm.)
Mount: 5 x 8 in. (12.7 x 20.3 cm.)
Signed: see inscription
Inscription, in negative: "604. CATHEDRAL SPIRES. C//
W. H. JACKSON PHOTO. CO./DENVER, CO."
mount verso, printed: "W. H. JACKSON PHOTOGRAPH
AND PUBLISHING CO. DENVER, COL.//RAILROAD
AND LANDSCAPE PHOTOGRAPHY OUR
SPECIALTIES"
Acquired from: Photo-Graphics, Ltd., Santa Fe, New Mexico

3089. **CATTLE DRIVE B. & F. HERD RANCH** (P1978.83.21)
Albumen silver print. c. 1885
Image: 4 ¹¹⁄₁₆ x 7 ⅜ in. (11.9 x 18.7 cm.)
Mount: 5 x 8 in. (12.7 x 20.3 cm.)
Inscription, mount verso: "Cattle drive B. & F. herd ranch//
Cattle on range south of Colo. Springs. This is not/my
father on horseback./L. G. 1/18/78"
Acquired from: gift of Laura Gilpin, Santa Fe, New Mexico

3090. **[Cattle on ranch]** (P1978.83.25)
Albumen silver print. c. 1885
Image: 4 ⅛ x 6 ⁹⁄₁₆ in. (10.5 x 16.7 cm.)
Sheet: 4 ¾ x 7 ¹¹⁄₁₆ in. (12.0 x 19.5 cm.)
Mount: 5 x 8 in. (12.7 x 20.3 cm.)
Inscription, mount verso: "W. H. Jackson Ranch series./Do
not think either horseman is my father/Laura Gilpin./
1/18/78"
Acquired from: gift of Laura Gilpin, Santa Fe, New Mexico

3091. **CATTLE ON THE RANGE** (P1978.83.22)
Albumen silver print. c. 1885
Image: 4 ⅝ x 7 ⅜ in. (11.7 x 18.7 cm.)
Mount: 5 x 8 in. (12.7 x 20.3 cm.)
Inscription, mount verso: "Cattle on the range./Horseman
could be my father. but not sure./L. Gilpin 1/18/78"
Acquired from: gift of Laura Gilpin, Santa Fe, New Mexico

3092. **CHALK CREEK CAÑON** (P1971.94.10)
Albumen silver print. c. 1887
Image: 17 ⁹⁄₁₆ x 21 ³⁄₁₆ in. (44.5 x 53.8 cm.)
Mount: 24 x 30 in. (61.0 x 76.2 cm.)
Inscription, in negative: "871. CHALK CREEK CAÑON"
mount verso: "D & RG//7082//D.S.P.&P./R.R."
Acquired from: Richard A. Ronzio, Golden, Colorado

*3093. **CHIPETA FALLS—BLACK CANON OF THE
GUNNISON** (P1971.94.23)
Albumen silver print. 1883
Image: 17 x 21 ³⁄₁₆ in. (43.2 x 53.8 cm.)
Mount: 24 ¹⁵⁄₁₆ x 30 in. (63.3 x 76.2 cm.)
Signed: see inscription
Inscription, in negative: "1052. CHIPETA FALLS—BLACK
CANON OF THE GUNNISON."
mount recto, printed: "DENVER/W. H. JACKSON &
CO., PHOTOGRAPHERS/COLORADO"
Acquired from: Richard A. Ronzio, Golden, Colorado

*3094. **CHURCH OF SAN MIGUEL. SANTA FÉ** (P1971.94.16)
Albumen silver print. c. 1883
Image: 17 ½ x 21 ³⁄₁₆ in. (44.3 x 53.8 cm.)
Mount: 24 ¹⁵⁄₁₆ x 29 ¾ in. (63.3 x 75.5 cm.)
Signed: see inscription
Inscription, in negative: "1022. [sic] CHURCH OF SAN
MIGUEL. SANTA FÉ//W. H. JACKSON, PHOT.,
DENVER, COLO."
Acquired from: Richard A. Ronzio, Golden, Colorado

3084

3088

3093

3094

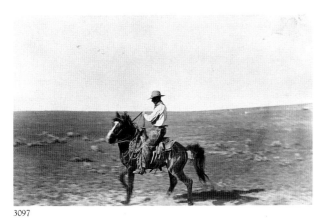

3097

3103

3095. **COLORADO. ROUNDING UP. BUNCHING THE HERD
[B & E herd]** (P1978.83.23)
Albumen silver print. c. 1885
Image: 4 ⅝ x 7 ¼ in. (11.7 x 18.4 cm.)
Mount: 5 x 8 in. (12.7 x 20.3 cm.)
Inscription, mount verso: "B & F herd/(Bernie & Frank)/
½ brand//Do not know who wrote the above/Laura Gilpin
1/18/78"
Acquired from: gift of Laura Gilpin, Santa Fe, New Mexico

3096. **COMANCHE CAÑON [New Mexico]** (P1971.94.11)
Albumen silver print. c. 1880s
Image: 17 ½ x 21 ³⁄₁₆ in. (44.5 x 53.8 cm.)
Mount: 25 x 30 in. (63.5 x 76.2 cm.)
Signed: see inscription
Inscription, in negative: "878. COMANCHE CAÑON.//
JACKSON, PHOTO."
mount verso: "Page 259/Full page//7039//43 ½%//Ronzio"
and typed on paper label "Narrow Gauge Freight Train of
the Denver & Rio/Grande R.R. dropping to the floor of
the Rio/Grande River as it descends down Comanche
Canyon./Richard A. Ronzio/Box 344/Golden, Colo./CR
9-1507"
Acquired from: Richard A. Ronzio, Golden, Colorado

*3097. **COW BOY, FRANK GILPIN** (P1978.83.8)
Albumen silver print. c. 1885
Image: 4 ⅝ x 7 ⁵⁄₁₆ in. (11.7 x 18.6 cm.)
Mount: 5 x 8 in. (12.7 x 20.3 cm.)
Inscription, mount verso: "Cow boy/Frank Gilpin"
Acquired from: gift of Laura Gilpin, Santa Fe, New Mexico

3098. **A COWBOY** (P1978.83.6)
Albumen silver print. c. 1885
Image: 4 ¹¹⁄₁₆ x 7 ⅜ in. (11.9 x 18.7 cm.)
Mount: 5 x 8 in. (12.7 x 20.3 cm.)
Acquired from: gift of Laura Gilpin, Santa Fe, New Mexico

3099. **CRATER OF GRAND GEYSER** (P1979.40.4)
Albumen silver print. 1872
Image: 6 ¾ x 8 ¹⁵⁄₁₆ in. (17.1 x 22.7 cm.)
Sheet: 10 x 13 in. (25.4 x 33.0 cm.)
Mount: 15 ¹¹⁄₁₆ x 19 ⁷⁄₁₆ in. (39.8 x 49.4 cm.)
Inscription, in negative: "444. CRATER of GRAND
GEYSER."
mount verso: "Y3"
Acquired from: Frontier America Corporation, Bryan, Texas

3100. **CRATER OF OLD FAITHFUL** (P1981.53.3)
Albumen silver print. 1872
Image: 6 ⁹⁄₁₆ x 8 ⁷⁄₁₆ in. (16.6 x 21.5 cm.)
Mount: 11 x 14 in. (28.0 x 35.6 cm.)
Signed: see inscription
Inscription, in negative: "439 CRATER of OLD FAITHFUL"
mount recto: "#439" and printed "Dept. of the Interior:
U. S. Geological Survey of the Territories/Prof. F. V.
Hayden in Charge.//W. H. Jackson, Photo.//Washington,
D. C."
mount verso: "150-/WM #76"
Acquired from: John Howell—Books, San Francisco,
California

3101. **CRATER OF THE GIANT GEYSER** (P1975.103.38)
Albumen silver print. c. 1872
Image: 9 ⅝ x 13 in. (24.4 x 33.1 cm.)
Mount: 16 ¹⁄₁₆ x 20 ¹⁄₁₆ in. (40.8 x 50.9 cm.)
Inscription, in negative: "CRATER OF THE GIANT
GEYSER."
Acquired from: Fred Mazzulla, Denver, Colorado

3102. **CRATER OF THE GROTTO GEYSER** (P1975.103.47)
duplicate of P1975.103.48
Albumen silver print. 1872
Image: 9 ⁷⁄₁₆ x 13 ¹⁄₁₆ in. (23.9 x 33.2 cm.)
Mount: 16 ¹⁄₁₆ x 20 ¹⁄₁₆ in. (40.8 x 50.9 cm.)
Inscription, in negative: "CRATER OF THE GROTTO
GEYSER."
Acquired from: Fred Mazzulla, Denver, Colorado

*3103. **CRATER OF THE GROTTO GEYSER** (P1975.103.48)
duplicate of P1975.103.47
Albumen silver print. 1872
Image: 9 ⁷⁄₁₆ x 12 ¹⁵⁄₁₆ in. (23.9 x 32.9 cm.)
Mount: 16 ¹⁄₁₆ x 20 ¹⁄₁₆ in. (40.8 x 50.9 cm.) irregular
Inscription, in negative: "CRATER OF THE GROTTO
GEYSER."
Acquired from: Fred Mazzulla, Denver, Colorado

3104. **CRATER OF THE LONE STAR GEYSER** (P1975.103.42)
duplicate of P1975.103.43
Albumen silver print. c. 1872
Image: 9 ⁷⁄₁₆ x 12 ¹⁵⁄₁₆ in. (24.0 x 32.8 cm.)
Mount: 16 ¹⁄₁₆ x 20 ¹⁄₁₆ in. (40.8 x 50.9 cm.) irregular
Inscription, in negative: "CRATER OF THE LONE STAR
GEYSER."
Acquired from: Fred Mazzulla, Denver, Colorado

3105. **CRATER OF THE LONE STAR GEYSER** (P1975.103.43)
duplicate of P1975.103.42
Albumen silver print. c. 1872
Image: 9 ⁷⁄₁₆ x 13 in. (24.0 x 33.1 cm.)
Mount: 16 ¹⁄₁₆ x 20 ¹⁄₁₆ in. (40.8 x 50.9 cm.) irregular
Inscription, in negative: "CRATER OF THE LONE STAR
GEYSER."
Acquired from: Fred Mazzulla, Denver, Colorado

*3106. **DENVER & RIO GRANDE DEPOT. MANITOU
[Manitou, Colorado]** (P1971.94.37)
Albumen silver print. c. 1887
Image: 16 ⅞ x 21 ¹⁄₁₆ in. (42.8 x 53.4 cm.)
Mount: 20 ⅜ x 25 ¹⁄₁₆ in. (51.8 x 63.7 cm.)
Signed: see inscription
Inscription, in negative: "1424. DENVER & RIO GRANDE
DEPOT. MANITOU.//W. H. JACKSON & CO. PHOT.
DENVER."
mount recto, printed: "[on emblem] DENVER & RIO
GRANDE R.R./SCENIC LINE OF THE WORLD//THE
ROCKY MOUNTAINS./SCENES ALONG THE LINE
OF THE/DENVER AND RIO GRANDE RAILROAD."
Acquired from: Richard A. Ronzio, Golden, Colorado

3107. **DISTANT VIEW OF THE CASTLE IN ERUPTION**
(P1979.40.8)
Albumen silver print. 1872
Image: 6 ¹¹⁄₁₆ x 8 ¹⁵⁄₁₆ in. (17.0 x 22.7 cm.)
Sheet: 10 x 13 in. (25.4 x 33.0 cm.)
Mount: 15 ¹¹⁄₁₆ x 19 ⁷⁄₁₆ in. (39.8 x 49.4 cm.)
Inscription, in negative: "445. DISTANT VIEW OF THE
CASTLE IN ERUPTION"
mount verso: "1/¥"
Acquired from: Frontier America Corporation, Bryan, Texas

3108. **DOGS AT HORSE CREEK RANCH EAST OF COLO.
SPRINGS** (P1978.83.29)
Albumen silver print. c. 1885
Image: 4 ½ x 7 ¾ in. (11.4 x 19.7 cm.)
Mount: 4 ¾ x 8 in. (12.1 x 20.3 cm.)
Inscription, mount verso: "Dogs at Horse Creek Ranch east
of Colo Springs"
Acquired from: gift of Laura Gilpin, Santa Fe, New Mexico

*3109. **DOME ROCK. 11 MILE CANON, COL. MIDLAND R.R.**
(P1971.94.8)
Albumen silver print. c. 1888–90
Image: 21 ¼ x 16 ¹³⁄₁₆ in. (53.9 x 42.7 cm.)
Mount: 28 x 22 in. (71.1 x 55.9 cm.)
Signed: see inscription
Inscription, in negative: "+208. DOME ROCK. 11 MILE
CANON. COL. MIDLAND R.R.//W. H. JACKSON &
CO. PHOT. DENVER"
Acquired from: Richard A. Ronzio, Golden, Colorado

3110. **EAGLE RIVER CAÑON—BEN BUTLER MINE.
GLENWOOD EXTENSION D. & R.G.R.R.** (P1971.94.28)
Albumen silver print. 1887
Image: 16⅞ x 21³⁄₁₆ in. (42.8 x 53.8 cm.)
Mount: 21⅞ x 28 in. (55.5 x 71.1 cm.)
Signed: see inscription
Inscription, in negative: "1233. EAGLE RIVER CAÑON—
BEN BUTLER MINE./GLENWOOD EXTENSION D. &
R.G.R.R.//W.H. JACKSON & CO. PHOT. DENVER."
Acquired from: Richard A. Ronzio, Golden, Colorado

3111. **ELK PARK [Denver and Rio Grande Railway, Animas
Canyon, Colorado]** (P1967.3351)
Albumen silver print. 1882
Image: 9⅞ x 13⅝ in. (25.1 x 34.6 cm.)
Sheet: 10¼ x 13⅝ in. (26.0 x 34.6 cm.)
Mount: 16 x 20 in. (40.7 x 50.8 cm.)
Signed: see inscription
Inscription, in negative: "128. Elk Park.//W.H. Jackson &
Co. Phot., Denver, Colo."
Acquired from: Fred Rosenstock, Denver, Colorado

3106

3112. **EMBUDO, NEW MEXICO** (P1967.3350)
Albumen silver print. c. 1880s
Image: 9⅞ x 13⅜ in. (25.2 x 34.0 cm.)
Sheet: 10¼ x 13⅜ in. (26.0 x 34.0 cm.)
Mount: 16 x 20 in. (40.7 x 50.8 cm.)
Signed: see inscription
Inscription, in negative: "78. Embudo, New Mexico.//
W. H. Jackson & Co. Phot. Denver, Colo."
Acquired from: Fred Rosenstock, Denver, Colorado

*3113. **EMBUDO N. M.** (P1971.94.12)
Albumen silver print. c. 1880s
Image: 20¹¹⁄₁₆ x 16⁵⁄₁₆ in. (52.5 x 41.5 cm.) oval
Sheet: 21½ x 17½ in. (54.5 x 44.4 cm.)
Mount: 30⅛ x 25 in. (76.4 x 63.5 cm.)
Signed: see inscription
Inscription, in negative: "879. EMBUDO N.M./JACKSON,
PHOTO."
Acquired from: Richard A. Ronzio, Golden, Colorado

3109

3114. **[Engine No. 92 at Veta Pass Station]** (P1967.3354)
Albumen silver print. c. 1879–80
Image: 10¼ x 13¾ in. (25.9 x 34.9 cm.)
Mount: 16 x 20 in. (40.7 x 50.8 cm.)
Acquired from: Fred Rosenstock, Denver, Colorado

Attributed to William H. Jackson
3115. **[Engine No. 92 on Rockwood Ledge in Animas Canyon]**
(P1967.3352)
Albumen silver print. c. 1879–80
Image: 10⅛ x 13⅜ in. (25.8 x 34.0 cm.)
Mount: 16 x 20 in. (40.7 x 50.8 cm.)
Acquired from: Fred Rosenstock, Denver, Colorado

3116. **FRANK GILPIN** (P1978.83.9)
Albumen silver print. c. 1885
Image: 4⅝ x 7⁵⁄₁₆ in. (11.7 x 18.6 cm.)
Mount: 5 x 8 in. (12.7 x 20.3 cm.)
Inscription, mount verso: "Frank Gilpin//(I do not recognize
hand writing of above)/Unquestionably my father/L.G.
1/18/78"
Acquired from: gift of Laura Gilpin, Santa Fe, New Mexico

3117. **FREMONT'S PEAK** (P1975.103.44) duplicate of P1975.103.45
Albumen silver print. 1878
Image: 9¾ x 12¹⁵⁄₁₆ in. (24.8 x 32.8 cm.)
Mount: 16¹⁄₁₆ x 20¹⁄₁₆ in. (40.8 x 50.9 cm.)
Inscription, in negative: "421. FREMO[nt's] PEAK"
Acquired from: Fred Mazzulla, Denver, Colorado

*3118. **FREMONT'S PEAK** (P1975.103.45) duplicate of P1975.103.44
Albumen silver print. 1878
Image: 9⁹⁄₁₆ x 12¾ in. (24.3 x 32.4 cm.)
Mount: 16¹⁄₁₆ x 20¹⁄₁₆ in. (40.8 x 50.9 cm.)
Inscription, in negative: "421. FREMO[nt's] PEAK"
Acquired from: Fred Mazzulla, Denver, Colorado

3113

*3119. **GARDINER'S RIVER HOT-SPRINGS. DIANA'S BATHS**
[Thomas Moran at the Hot Springs of Gardner River]
(P1980.17)
Albumen silver print. 1871
Image: 6 x 8 1/16 in. (15.2 x 20.5 cm.)
Mount: 11 x 14 in. (27.9 x 35.6 cm.)
Signed: see inscription
Inscription, in negative: "217. GARDINER'S RIVER HOT-SPRINGS. DIANA'S BATHS."
mount recto, printed: "Department of the Interior./U. S. Geological Survey of the Territories./PROF. F. V. HAYDEN IN CHARGE.// W. H. JACKSON, PHOTO."
Acquired from: gift of James Maroney, Inc., New York, New York

*3120. **GIHIGA'S LODGE, OMAHA** (P1970.54.11)
Albumen silver print. 1868–69
Image: 7 3/8 x 5 1/4 in. (18.7 x 13.4 cm.)
Mount: 14 x 11 in. (35.5 x 27.9 cm.)
Signed: see inscription
Inscription, in negative: "464"
mount recto, printed: "W.H. JACKSON PHOTO.//DEPT. OF THE INTERIOR U.S. GEOLOGICAL SURVEY OF THE TERRITORIES./PROF F. V. HAYDEN IN CHARGE.//150"
mount verso: "P493/464 Gihiga's Lodge (Omaha)//142"
Acquired from: Kennedy Galleries, New York, New York

3121. **GILPIN DOGS AT HORSE CREEK RANCH. 65 M. EAST OF COLO. SPRINGS** (P1978.83.27)
Albumen silver print. c. 1885
Image: 4 1/2 x 7 11/16 in. (11.5 x 19.5 cm.)
Mount: 5 x 8 1/4 in. (12.7 x 20.9 cm.)
Inscription, mount verso: "Gilpin dogs at Horse Creek Ranch. 65 m. east of/Colo. Springs./L.G. 1/18/78"
Acquired from: gift of Laura Gilpin, Santa Fe, New Mexico

3122. **GLENWOOD. COL.** [Glenwood Springs, Colorado]
(P1971.94.29)
Albumen silver print. c. 1887
Image: 16 3/4 x 20 7/8 in. (42.5 x 53.0 cm.)
Mount: 22 x 28 in. (55.9 x 71.2 cm.)
Signed: see inscription
Inscription, in negative: "1257. GLENWOOD. COL.// W.H. JACKSON & CO. PHOT. DENVER."
mount recto: crop marks
mount verso, typed on paper label: "LAYING OF TRACK ON THE DENVER AND RIO GRANDE/TO GLENWOOD SPRINGS, DOWN GLENWOOD CANYON AND/UP THE ROARING RORK [sic] RIVER./Richard A. Ronzio/Box 344/Golden, Colo./CR.9-1057"
Acquired from: Richard A. Ronzio, Golden, Colorado

*3123. **A GLIMPSE OF GUANAJUATO, MEXICO** (P1981.47.1)
Albumen silver print. c. 1883–84
Image: 17 1/8 x 21 5/16 in. (43.5 x 54.2 cm.) irregular
Mount: 22 1/8 x 28 in. (56.2 x 71.2 cm.)
Signed: see inscription
Inscription, in negative: "1124. A GLIMPSE OF GUANAJUATO, MEXICO./W.H. JACKSON & CO. DENVER, COL."
Acquired from: Fraenkel Gallery, San Francisco, California

3124. **GRAND CAÑON OF THE YELLOWSTONE** (P1975.103.49)
Albumen silver print. 1872
Image: 13 1/16 x 9 5/8 in. (33.2 x 24.5 cm.)
Mount: 20 1/16 x 13 in. (50.9 x 33.0 cm.) irregular
Inscription, in negative: "GRAND CAÑON OF THE YELLOWSTONE."
Acquired from: Fred Rosenstock, Denver, Colorado

3125. **GRAND CAÑON OF THE YELLOWSTONE** (P1979.40.1)
Albumen silver print. 1872
Image: 12 7/16 x 9 3/16 in. (31.6 x 23.3 cm.)
Sheet: 13 x 10 in. (33.0 x 25.4 cm.)
Mount: 19 7/16 x 15 5/8 in. (49.3 x 39.8 cm.)

Inscription, in negative: "GRAND CAÑON OF THE YELLOWSTONE."
mount verso: "Y1"
Acquired from: Frontier America Corporation, Bryan, Texas

3126. **GRAND CAÑON OF THE YELLOWSTONE** (P1979.40.2)
Albumen silver print. 1872
Image: 12 7/8 x 10 in. (32.7 x 25.4 cm.)
Mount: 19 7/16 x 15 5/8 in. (49.3 x 39.8 cm.)
Inscription, in negative: "GRAND CAÑON OF THE YELLOWSTONE."
mount verso: "Y4"
Acquired from: Frontier America Corporation, Bryan, Texas

3127. **GREAT MORAINAL VALLEY ON THE ARKANSAS AT MOUTH OF LA PLATA** [New Mexico?] (P1971.94.3)
Albumen silver print. 1875
Image: 17 1/16 x 21 in. (43.4 x 53.4 cm.)
Mount: 24 15/16 x 30 in. (63.3 x 76.3 cm.)
Signed: see inscription
Inscription, in negative: "GREAT MORAINAL VALLEY/ON THE ARKANSAS AT MOUTH OF LA PLATA./ JACKSON PHOTO."
mount recto, printed: "Department of the Interior./U.S. Geological Survey [USGS emblem] of the Territories./PROF. F. V. HAYDEN IN CHARGE.//W. H. JACKSON, PHOTO."
Acquired from: Richard A. Ronzio, Golden, Colorado

*3128. **HANGING ROCK. CLEAR CREEK CANON. COL.**
(P1979.40.20)
Albumen silver print. c. 1885
Image: 21 1/16 x 16 7/8 in. (53.5 x 42.9 cm.)
Mount: 30 x 24 in. (76.2 x 61.0 cm.)
Signed: see inscription
Inscription, in negative: "1171. HANGING ROCK. CLEAR CREEK CANON. COL.//W.H. JACKSON & CO. PHOT. DENVER."
Acquired from: Frontier America Corporation, Bryan, Texas

3129. **HEAD OF THE ARKANSAS. FREMONT PASS**
(P1971.94.17)
Albumen silver print. c. 1883
Image: 16 7/8 x 21 1/8 in. (42.8 x 53.7 cm.) irregular
Mount: 25 x 30 in. (63.5 x 76.2 cm.)
Signed: see inscription
Inscription, in negative: "1024. HEAD OF THE ARKANSAS. FREMONT PASS.//JACKSON PHOT. DENVER."
mount recto, printed: "DENVER//W. H. JACKSON & CO., PHOTOGRAPHERS//COLORADO"
Acquired from: Richard A. Ronzio, Golden, Colorado

3130. **HELLGATE COL. MID. RY.** (P1979.40.18)
Albumen silver print. c. 1888
Image: 16 15/16 x 21 1/8 in. (43.0 x 53.6 cm.)
Mount: 24 x 30 in. (61.0 x 76.2 cm.)
Signed: see inscription
Inscription, in negative: "1394—HELLGATE COL. MID. RY./W.H. JACKSON & CO. PHOT. DENVER."
Acquired from: Frontier America Corporation, Bryan, Texas

*3131. **HERCULES' PILLARS—COLUMBIA RIVER, OR.**
(P1971.22.56)
Albumen silver print. c. 1892
Image: 16 7/16 x 20 3/4 in. (41.6 x 52.8 cm.) irregular
Signed: see inscription
Inscription, in negative: "1375. HERCULES' PILLARS—COLUMBIA RIVER, OR./W. H. JACKSON & CO. DENVER."
Acquired from: Fred Mazzulla, Denver, Colorado

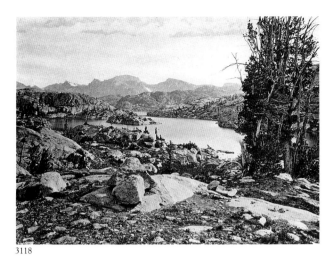

3118

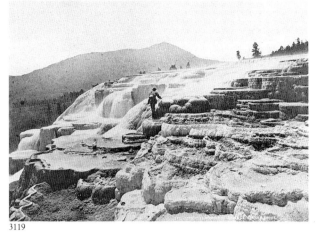

3119

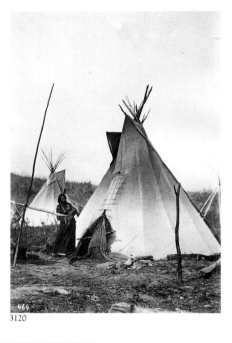

3120

3123

3131

3128

*3132. **HOTEL DEL MONTE. MONTEREY [Monterey, California]**
(P1971.22.58)
Albumen silver print. c. 1889
Image: 16 7/16 x 20 15/16 in. (41.7 x 53.2 cm.)
Signed: see inscription
Inscription, in negative: "1318. HOTEL DEL MONTE.
MONTEREY./W. H. JACKSON & CO. PHOT.
DENVER."
Acquired from: Fred Mazzulla, Denver, Colorado

3133. **IN THE CORRAL [Colorado "The Roundup." Roping a
Steer]** (P1978.83.16)
Albumen silver print. c. 1885
Image: 4 5/8 x 7 3/8 in. (11.7 x 18.7 cm.)
Mount: 5 x 8 in. (12.7 x 20.3 cm.)
Inscription, mount verso: "W. H. Jackson Ranch Series./
My father at left./Laura Gilpin 1/18/78"
Acquired from: gift of Laura Gilpin, Santa Fe, New Mexico

*3134. **INDEPENDENCE ROCK** (P1976.85)
Collodion or gelatin aristotype. negative 1870, print 1925
Image: 9 13/16 x 20 1/4 in. (24.9 x 51.1 cm.)
Sheet: 11 x 21 5/16 in. (28.0 x 54.4 cm.)
Signed, l.r. sheet recto: "W H Jackson Phot. 1870."
Inscription, sheet recto: "S. R. Gifford. H. W. Elliott
Dr. F. V. Hayden."
Acquired from: gift of Mitchell A. Wilder, Fort Worth, Texas

3135. **JUNCTION CLIFF, KINGS RIVER, CAL.** (P1979.87)
Albumen silver print. c. 1888–89
Image: 13 1/8 x 9 15/16 in. (33.3 x 25.2 cm.)
Mount: 14 x 11 in. (35.6 x 28.0 cm.)
Inscription, in negative: "JUNCTION CLIFF, KINGS
RIVER, CAL."
mount recto: "A 359/8"
Acquired from: Stephen White Gallery, Los Angeles,
California

3136. **LAKE SAN MIGUEL. COLORADO [Trout Lake]**
(P1971.94.5)
Albumen silver print. 1875
Image: 17 1/16 x 21 3/16 in. (43.3 x 53.8 cm.)
Mount: 24 15/16 x 30 in. (63.3 x 76.3 cm.)
Signed: see inscription
Inscription, in negative: "LAKE SAN MIGUEL.
COLORADO."
mount recto: "[Trout Lake]" and printed "Department of
the Interior./U.S. Geological Survey [USGS Emblem] of
the Territories./PROF. F. V. HAYDEN IN CHARGE.//
W.H. JACKSON, PHOTO."
Acquired from: Richard A. Ronzio, Golden, Colorado

3137. **LEADVILLE** (P1963.13) duplicate of P1971.94.26 and
P1971.94.27 (together)
Albumen silver print (panorama). 1885
Image: 17 1/4 x 55 15/16 in. (43.9 x 142.1 cm.)
Mount: 18 5/8 x 57 3/4 in. (47.3 x 146.7 cm.)
Signed: see inscription
Inscription, in negative: "1161. LEADVILLE./W.H.
JACKSON & CO. DENVER.//1162. LEADVILLE.//
W. H. J. & CO. DEN."
mount verso: "Leadville in the Eighties/A rare photo
taken by Wm. H. Jackson/Presented to the Historical
Association/by A. A. Brenard"
Acquired from: Fred Rosenstock, Denver, Colorado

3138. **LEADVILLE [Leadville and Mount Massive]** (P1971.94.26)
part of mammoth-plate panorama; with P1971.94.27
a duplicate of P1963.13
Albumen silver print. 1885
Image: 16 3/4 x 21 1/8 in. (42.5 x 53.7 cm.)
Mount: 22 x 28 in. (55.9 x 71.1 cm.)
Signed: see inscription
Inscription, in negative: "1161 LEADVILLE./W.H. JACKSON
& CO. DENVER."
Acquired from: Richard A. Ronzio, Golden, Colorado

3139. **LEADVILLE [general view]** (P1971.94.27) part of mammoth-
plate panorama; with P1971.94.26 a duplicate of P1963.13
Albumen silver print. 1885
Image: 16 15/16 x 21 3/16 in. (42.9 x 53.8 cm.)
Mount: 22 x 28 in. (55.9 x 71.1 cm.)
Signed: see inscription
Inscription, in negative: "1162. LEADVILLE./W.H.J. & CO.
DENVER"
Acquired from: Richard A. Ronzio, Golden, Colorado

*3140. **LIBERTY CAP AND NEVADA FALL [Yosemite]**
(P1971.94.31)
Albumen silver print. c. 1888–89
Image: 20 9/16 x 16 9/16 in. (52.3 x 42.2 cm.)
Signed: see inscription
Inscription, in negative: "1343. LIBERTY CAP AND
NEVADA FALL.//W.H. JACKSON & CO. PHOT.
DENVER, COL."
Acquired from: Richard A. Ronzio, Golden, Colorado

3141. **THE LOOP NEAR CHATTANOOGA—OURAY &
SILVERTON R.R.** (P1971.94.33)
Albumen silver print mounted on Masonite. c. 1889
Image: 16 13/16 x 20 9/16 in. (42.6 x 52.2 cm.) irregular
Mount: 16 7/8 x 20 11/16 in. (42.8 x 52.5 cm.)
Signed: see inscription
Inscription, in negative: "1396—THE LOOP NEAR
CHATANOOGA [sic]—OURAY & SILVERTON R.R./
W. H. JACKSON & CO. PHOT. DENVER."
mount verso: "Richard A. Ronzio/Box 344/Golden, Colo./
CR9-1507"
Acquired from: Richard A. Ronzio, Golden, Colorado

3142. **"THE LOOP." UNION PACIFIC RY. NEAR
GEORGETOWN, COLORADO** (P1979.40.12)
Albumen silver print. 1884–85
Image: 9 1/16 x 12 1/8 in. (23.0 x 30.9 cm.)
Mount: 14 x 18 in. (35.6 x 45.7 cm.)
Inscription, in negative: "['The Loo]P.'/[Union Pa]CIFIC RY
NEAR GEORGETOWN, COLORADO./[De]NVER
COL."
Acquired from: Frontier America Corporation, Bryan, Texas

*3143. **THE LOWER TWIN LAKE** (P1971.22.45)
Albumen silver print. c. 1880s
Image: 10 1/4 x 13 3/4 in. (25.9 x 34.9 cm.)
Signed: see inscription
Inscription, in negative: "283. THE LOWER TWIN LAKE/
W. H. JACKSON & CO. PHOT"
Acquired from: Fred Mazzulla, Denver, Colorado

3144. **MAMMOTH HOT SPRINGS** (P1979.40.9)
Albumen silver print. 1872
Image: 9 11/16 x 13 in. (24.6 x 32.9 cm.)
Mount: 16 x 20 in. (40.7 x 50.8 cm.)
Inscription, in negative: "MAMMOTH HOT SPRINGS"
Acquired from: Frontier America Corporation, Bryan, Texas

3145. **MAMMOTH HOT SPRINGS ON GARDINERS RIVER**
(P1979.40.5)
Albumen silver print. 1872
Image: 8 9/16 x 11 11/16 in. (21.7 x 29.8 cm.)
Sheet: 10 1/4 x 12 7/8 in. (26.0 x 32.7 cm.)
Mount: 15 11/16 x 19 7/16 in. (39.8 x 49.4 cm.)
Inscription, in negative: "MAMMOTH HOT SPRINGS ON
GARDINERS RIVER."
mount verso: "Y5"
Acquired from: Frontier America Corporation, Bryan, Texas

3146. **MAMMOTH HOT SPRINGS ON GARDINERS RIVER**
(P1979.40.7)
Albumen silver print. 1872
Image: 10 1/16 x 13 in. (25.5 x 33.0 cm.)
Mount: 15 11/16 x 19 7/16 in. (39.8 x 49.4 cm.)
Inscription, in negative: "24 MAMMOTH HOT SPRINGS
ON GARDINERS RIVER."
mount verso: "Y 6"
Acquired from: Frontier America Corporation, Bryan, Texas

3132

3134

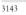

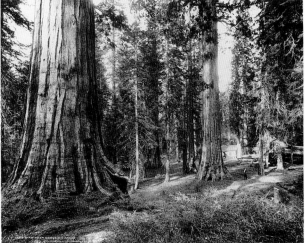

3143

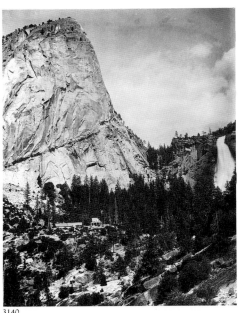

3140

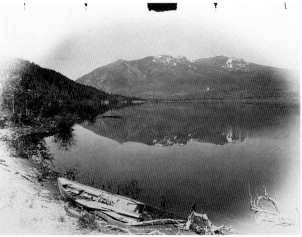

3148

3147

*3147. **MARIA AND BENINA, PUEBLO WOMEN** [Pueblo of San
Juan Group of Women] (P1970.20.13)
Albumen silver print. c. 1881
Image: 13 7/16 x 10 1/4 in. (34.2 x 26.0 cm.)
Mount: 20 x 16 in. (50.8 x 40.7 cm.)
Signed: see inscription
Inscription, in negative: "85. Maria and Benina, Pueblo
Women./W. H. Jackson & Co. Phot. Denver, Colo."
Acquired from: Fred Rosenstock, Denver, Colorado

*3148. **MARIPOSA GROVE. BIG TREES** (P1971.22.57)
Albumen silver print. c. 1880s
Image: 16 3/8 x 21 in. (41.5 x 53.3 cm.) irregular
Signed: see inscription
Inscription, in negative: "1328. MARIPOSA GROVE. BIG
TREES./W. H. JACKSON & CO. PHOT. DENVER.
COL."
Acquired from: Fred Mazzulla, Denver, Colorado

3149. **MARSHALL PASS** (P1979.40.13)
Albumen silver print. c. 1880–82
Image: 10 x 12 1/16 in. (25.4 x 30.7 cm.)
Mount: 14 x 18 in. (35.6 x 45.7 cm.)
Signed: see inscription
Inscription, in negative: "48. Marshall Pass./W. H. Jackson &
Co.. Phot"
Acquired from: Frontier America Corporation, Bryan, Texas

*3150. **MEXICO, GARITA DE LA VIGA** (P1979.86.2)
Albumen silver print. c. 1883–84
Image: 4 1/8 x 6 9/16 in. (10.5 x 16.6 cm.)
Mount: 4 1/2 x 7 in. (11.5 x 17.7 cm.)
Signed: see inscription
Inscription, in negative: "5280 Mexico, Garita de la Viga./
W. H. JACKSON & CO./PHOTOGRAPHERS OF/
ROCKY MOUNTAIN SCENERY/DENVER,
COLORADO."
Acquired from: Stephen White Gallery, Los Angeles,
California

3151. **MT. HARVARD, AND THE VALLEY OF THE
ARKANSAS** (P1971.94.4)
Albumen silver print. 1875
Image: 17 1/4 x 21 7/8 in. (43.8 x 55.6 cm.)
Mount: 24 15/16 x 30 in. (63.3 x 76.3 cm.)
Signed: see inscription
Inscription, in negative: "MT. HARVARD, AND THE
VALLEY OF THE ARKANSAS./JACKSON. PHOT."
mount recto, printed: "Department of the Interior./U.S.
Geological Survey [USGS emblem] of the Territories./
PROF. F.V. HAYDEN IN CHARGE.//W. H. JACKSON,
PHOTO."
Acquired from: Richard A. Ronzio, Golden, Colorado

*3152. **MULTNOMAH FALLS. OREGON** (P1971.94.32)
Albumen silver print. c. 1880s
Image: 20 15/16 x 16 1/4 in. (53.1 x 41.2 cm.) irregular
Signed: see inscription
Inscription, in negative: "1376. MULTNOMAH FALLS.
OREGON/W. H. JACKSON & CO."
Acquired from: Richard A. Ronzio, Golden, Colorado

3153. **NEAR SAPINERO—ENTRANCE TO THE BLACK
CANON** (P1971.94.22)
Albumen silver print. 1883
Image: 16 3/4 x 20 11/16 in. (42.2 x 52.5 cm.) irregular
Mount: 20 3/16 x 24 7/8 in. (51.2 x 63.1 cm.)
Signed: see inscription
Inscription, in negative: "1051 NEAR SAPINERO—
ENTRANCE TO THE BLACK CANON./PHOT. BY
W.H. JACKSON & CO. DENVER"
mount recto, printed: "[on emblem] DENVER & RIO
GRANDE R.R./SCENIC LINE/of the WORLD//THE
ROCKY MOUNTAINS./SCENES ALONG THE LINE
OF THE/DENVER & RIO GRANDE RAILROAD."
mount verso: "7066//Richard A. Ronzio/Box 344/Golden,
Colo./CR9-1507"
Acquired from: Richard A. Ronzio, Golden, Colorado

3154. **NEVADA FALL** [Yosemite] (P1971.94.30)
Albumen silver print. c. 1888–89
Image: 20 15/16 x 16 7/8 in. (53.2 x 42.8 cm.) irregular
Signed: see inscription
Inscription, in negative: "1342. NEVADA FALL./
W. H. JACKSON & CO. PHOT. DENVER"
Acquired from: Richard A. Ronzio, Golden, Colorado

3155. **OGDEN CAÑON, WASATCH MOUNTAIN SERIES**
(P1981.53.2)
Albumen silver print. 1871
Image: 8 3/4 x 6 7/8 in. (22.2 x 17.4 cm.)
Mount: 13 15/16 x 10 15/16 in. (35.3 x 27.8 cm.)
Signed: see inscription
Inscription, in negative: "168"
mount recto, printed: "Department of the Interior./U.S.
Geological Survey of the Territories.//W. H. JACKSON,
PHOTO./WASHINGTON, D.C.//OGDEN CAÑON,/
WASATCH MOUNTAIN SERIES"
mount verso: "150-/WM #69"
Acquired from: John Howell—Books, San Francisco,
California

Attributed to William H. Jackson or George Mellen
3156. **THE OLD ROADMASTER—CLEAR CREEK CANON**
(P1979.40.16)
Albumen silver print. 1885
Image: 20 13/16 x 17 1/16 in. (52.9 x 43.3 cm.)
Mount: 30 x 23 1/2 in. (76.2 x 59.7 cm.)
Signed: see inscription
Inscription, in negative: "1417—THE OLD
ROADMASTER—CLEAR CREEK CANON//
W. H. JACKSON & CO. PHOT. DENVER COL.//
GEO. E. MELLEN PHOT"
Acquired from: Frontier America Corporation, Bryan, Texas

*3157. **PETA LASHARO—PAWNEE CHIEF** (P1979.85) duplicate
of P1967.3254, Brininstool Collection
Albumen silver print. 1868 or 1871
Image: 9 3/16 x 6 15/16 in. (23.3 x 17.6 cm.)
Mount: 13 15/16 x 10 7/8 in. (35.4 x 27.7 cm.)
Inscription, in negative: "328"
mount recto: "Peta lasharo—Paunee [sic] Chief"
mount verso: "cc.61//William Henry Jackson/See:
Collection— Huntington Library"
Acquired from: Stephen White Gallery, Los Angeles,
California

3158. **PIKES PEAK & GARDEN OF THE GODS** (P1979.40.11)
Albumen silver print. 1873
Image: 9 1/8 x 12 7/8 in. (23.1 x 32.7 cm.)
Mount: 16 x 20 in. (40.7 x 50.8 cm.)
Inscription, in negative: "78. PIKE'S PEAK & GARDEN OF
THE GODS."
mount recto, rubber stamp: "DEPARTMENT OF THE
INTERIOR/U.S. GEOLOGICAL SURVEY/(of the)/
TERRITORIES"
Acquired from: Frontier America Corporation, Bryan, Texas

3159. **PITKIN** [Pitkin, Colorado] (P1971.94.21)
Albumen silver print. c. 1880s
Image: 16 3/4 x 21 1/8 in. (42.5 x 53.6 cm.)
Mount: 21 1/4 x 25 5/8 in. (53.9 x 65.1 cm.)
Inscription, in negative: "1048. PITKIN."
Acquired from: Richard A. Ronzio, Golden, Colorado

*3160. **PUEBLO DE TAOS. N. M.** (P1971.94.15)
Albumen silver print. c. 1883
Image: 16 7/8 x 21 1/8 in. (42.9 x 53.6 cm.)
Mount: 24 15/16 x 30 in. (63.3 x 76.2 cm.)
Signed: see inscription
Inscription, in negative: "1021. PUEBLO DE TAOS. N. M.//
W. H. JACKSON, PHOT. DENVER, COLO."
mount recto, printed: "DENVER/W. H. JACKSON &
CO., PHOTOGRAPHERS/COLORADO"
Acquired from: Richard A. Ronzio, Denver, Colorado

3161. **[Ranch house at Horse Creek]** (P1978.83.28)
Albumen silver print. c. 1885
Image: 4 9/16 x 7 3/4 in. (11.6 x 20.0 cm.)
Mount: 5 x 8 in. (12.7 x 20.3 cm.)
Inscription, mount verso: "ranch 60 miles off//This must be
the house at/Horse Creek, East of Colo Springs./This is the
great dane & fox terrier/that my father had at that time./
L.G. 1978"
Acquired from: gift of Laura Gilpin, Santa Fe, New Mexico

3162. **RANCH HOUSE AT 1/2 RANCH** (P1978.83.2)
Albumen silver print. c. 1885
Image: 4 1/16 x 6 7/16 in. (10.3 x 16.4 cm.)
Mount: 4 1/2 x 7 in. (11.4 x 17.8 cm.)
Inscription, mount verso: "Ranch house at 1/2 ranch just south
of the Black/Forest, n. of Colo Springs. My uncle Bearnie
was/here and as far as I know my father, Francis Gilpin,/
joined him in 1882. The west line of this ranch/is directly
east of the present Air Force Academy/Laura Gilpin
1/18/78"
Acquired from: gift of Laura Gilpin, Santa Fe, New Mexico

3163. **[Ranch house with picket fence and three men on front porch]**
(P1978.83.3) cropped duplicate of P1978.83.5
Albumen silver print. c. 1885
Image: 4 3/8 x 6 11/16 in. (11.1 x 17.0 cm.)
Mount: 4 5/8 x 7 in. (11.4 x 17.8 cm.)
Acquired from: gift of Laura Gilpin, Santa Fe, New Mexico

3164. **[Ranch house with picket fence and three men on front porch]**
(P1978.83.5) uncropped duplicate of P1978.83.3
Albumen silver print. c. 1885
Image: 4 3/8 x 7 1/2 in. (11.1 x 19.0 cm.)
Mount: 5 x 8 in. (12.7 x 20.3 cm.)
Inscription, mount verso: "Mr Gilpin/2 Frames 1 '
[illegible]point/125 Lamvolle St/near Park We/4 1/4 2 1/4/3
3/2 1/4 10 1/4"
Acquired from: gift of Laura Gilpin, Santa Fe, New Mexico

3165. **RAPIDS OF THE YELLOWSTONE ABOVE THE FALLS**
(P1975.103.36) duplicate of P1975.103.37
Albumen silver print. c. 1872
Image: 9 1/2 x 13 1/16 in. (24.1 x 33.2 cm.)
Mount: 16 1/16 x 20 1/16 in. (40.8 x 50.9 cm.)
Inscription, in negative: "RAPIDS OF THE
YELLOWSTONE ABOVE THE FALLS."
Acquired from: Fred Mazzulla, Denver, Colorado

3166. **RAPIDS OF THE YELLOWSTONE ABOVE THE FALLS**
(P1975.103.37) duplicate of P1975.103.36
Albumen silver print. c. 1872
Image: 9 1/2 x 13 1/16 in. (24.1 x 33.2 cm.)
Mount: 16 1/16 x 20 1/16 in. (40.8 x 50.9 cm.)
Inscription, in negative: "RAPIDS OF THE
YELLOWSTONE ABOVE THE FALLS."
mount recto: "Not Colo Plateau"
Acquired from: Fred Mazzulla, Denver, Colorado

3167. **"ROUND UP." IN THE CORRAL [The Rounding Up,
B & F Herd]** (P1978.83.7)
Albumen silver print. c. 1885
Image: 4 3/4 x 7 3/8 in. (12.1 x 18.7 cm.)
Mount: 5 x 8 in. (12.7 x 20.3 cm.)
Inscription, mount verso: "The rounding up/B & F herd//
B & F = Bernard & Frank Gilpin/Rider is Frank Gilpin//
Not sure if this is my father's hand/writing or not. This
is one of the/branding series./Laura Gilpin 1/18/78"
Acquired from: gift of Laura Gilpin, Santa Fe, New Mexico

*3168. **ROYAL GORGE. GRAND CANON OF THE ARKANSAS**
(P1971.94.13)
Albumen silver print. 1880–81
Image: 21 x 16 5/8 in. (53.3 x 42.3 cm.)
Mount: 29 7/8 x 24 15/16 in. (76.0 x 63.3 cm.)
Signed: see inscription
Inscription, in negative: "1010. THE ROYAL GORGE.
GRAND CANON OF THE ARKANSAS./

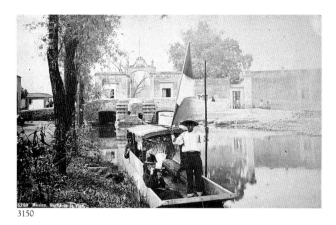
3150

3152

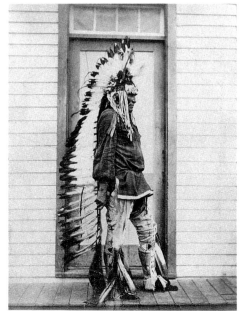
3157

W. H. JACKSON & CO. PHOT DENVER"
mount recto, printed: "[on emblem] DENVER & RIO
GRANDE R.R./SCENIC LINE/of the WORLD//SCENES
ALONG THE LINE OF/DENVER & RIO GRANDE
RAILROAD"
Acquired from: Richard A. Ronzio, Golden, Colorado

3169. **[Saddled horse and man]** (P1978.83.4)
Albumen silver print. c. 1885
Image: 4 5/16 x 6 1/8 in. (11.0 x 16.3 cm.)
Mount: 4 1/2 x 7 in. (11.4 x 17.8 cm.)
Acquired from: gift of Laura Gilpin, Santa Fe, New Mexico

3170. **SANDY SPRING MD. MEETING HOUSE** (P1978.83.1)
Albumen silver print. c. 1885
Image: 4 1/8 x 6 1/2 in. (10.5 x 16.5 cm.)
Mount: 4 1/2 x 7 in. (11.4 x 17.8 cm.)
Signed: see inscription
Inscription, mount recto: "W. H. Jackson & Co. Denver
Col."
mount verso: "Sandy Spring Md. Meeting House//
Mr. Jackson's 2nd wife was a cousin of my fathers as
I/remember. She could have come from Sandy Spring or/
my father somehow got a hold of this. It is a Jackson photo./
—Laura Gilpin 1/18/78."
Acquired from: gift of Laura Gilpin, Santa Fe, New Mexico

*3171. **THE SANGRE DE CRISTO FROM MARSHALL PASS**
(P1971.94.24)
Albumen silver print. 1883
Image: 16 15/16 x 21 1/8 in. (43.0 x 53.6 cm.)
Mount: 23 5/8 x 28 1/16 in. (60.0 x 71.2 cm.)
Signed: see inscription
Inscription, in negative: "1054. The SANGRE DE CRISTO
FROM MARSHALL PASS."
mount recto, printed: "DENVER/W. H. JACKSON &
CO., PHOTOGRAPHERS/COLORADO"
Acquired from: Richard A. Ronzio, Golden, Colorado

3172. **SIERRA BLANCA [from Garland, Colorado]** (P1971.94.36)
Albumen silver print mounted on Masonite. c. 1880s
Image: 16 3/4 x 20 7/8 in. (42.5 x 53.0 cm.)
Mount: 16 13/16 x 21 in. (42.7 x 53.3 cm.) irregular
Signed: see inscription
Inscription, in negative: "1414. SIERRA BLANCA./
W. H. JACKSON & CO. DENVER, COL."
Acquired from: Richard A. Ronzio, Golden, Colorado

3173. **[Silverton, Baker's Park and Sultan Mountain]** (P1967.3355)
cropped duplicate of P1971.94.20
Albumen silver print. c. 1883
Image: 10 1/8 x 13 7/16 in. (25.7 x 34.1 cm.)
Mount: 16 x 20 in. (40.7 x 50.8 cm.)
Acquired from: Fred Rosenstock, Denver, Colorado

3174. **SILVERTON, BAKER'S PARK AND SULTAN
MOUNTAIN** (P1971.94.20) uncropped duplicate of
P1967.3355
Albumen silver print. c. 1883
Image: 17 1/2 x 21 1/8 in. (44.4 x 53.6 cm.)
Mount: 25 x 30 in. (63.4 x 76.2 cm.)
Signed: see inscription
Inscription, in negative: "1041. SILVERTON, BAKER'S
PARK AND SULTAN MOUNTAIN."
mount recto, printed: "SILVERTON, BAKER'S PARK,/
Sultan Mountain in distance./Denver and Rio Grande
Railway.//Denver/W. H. JACKSON & CO.,
PHOTOGRAPHERS/COLORADO"
Acquired from: Richard A. Ronzio, Golden, Colorado

3175. **THE SPANISH PEAKS [from near La Veta, Colorado]**
(P1967.3347)
Albumen silver print. c. 1880–85
Image: 10 3/16 x 13 5/8 in. (25.9 x 34.5 cm.)
Mount: 16 x 20 in. (40.7 x 50.8 cm.)
Signed: see inscription
Inscription, in negative: "298 THE SPANISH PEAKS.
W. H. J. & Co."
Acquired from: Fred Rosenstock, Denver, Colorado

3176. **SULTAN MTN. BAKER'S PARK** (P1971.22.46)
Albumen silver print. c. 1880s
Image: 10 1/8 x 13 5/8 in. (25.7 x 34.6 cm.)
Signed: see inscription
Inscription, in negative: "186. SULTAN MTN. BAKER'S
PARK./W. H. JACKSON & CO. DENVER."
Acquired from: Fred Mazzulla, Denver, Colorado

3177. **TEZCOCINGO, EXCAVATIONS AND OLD RUINS**
[Mexico] (P1979.86.1)
Albumen silver print. c. 1883–84
Image: 4 3/16 x 6 9/16 in. (10.6 x 16.6 cm.)
Mount: 4 1/2 x 7 in. (11.5 x 17.7 cm.)
Signed: see inscription
Inscription, in negative: "5641 Tezcocingo, Excavations and
old ruins."
mount verso, printed: "W. H. JACKSON & CO./
PHOTOGRAPHERS OF/ROCKY MOUNTAIN
SCENERY/DENVER, COLORADO."
Acquired from: Stephen White Gallery, Los Angeles,
California

3178. **TOLL GATE AT BEAR CREEK FALLS** (P1971.94.35)
Albumen silver print mounted on Masonite. 1885
Image: 20 15/16 x 16 3/4 in. (53.1 x 42.6 cm.) irregular
Mount: 21 x 16 7/8 in. (53.3 x 42.8 cm.)
Signed: see inscription
Inscription, in negative: "1399—TOLL GATE AT BEAR
CREEK FALLS./W. H. JACKSON & CO. PHOT.
DENVER, COL."
Acquired from: Richard A. Ronzio, Golden, Colorado

3179. **TOWER FALLS** (P1975.103.41) duplicate of P1975.103.46
Albumen silver print. 1872
Image: 13 x 9 1/2 in. (33.1 x 24.1 cm.)
Mount: 20 1/16 x 13 in. (50.9 x 33.1 cm.) irregular
Inscription, in negative: "TOWER FALLS."
Acquired from: Fred Mazzulla, Denver, Colorado

3180. **TOWER FALLS** (P1975.103.46) duplicate of P1975.103.41
Albumen silver print. 1872
Image: 13 1/16 x 9 1/2 in. (33.2 x 24.1 cm.)
Mount: 20 1/16 x 12 15/16 in. (50.9 x 32.8 cm.) irregular
Inscription, in negative: "TOWER FALLS."
Acquired from: Fred Mazzulla, Denver, Colorado

*3181. **TOWER FALLS** (P1979.40.3)
Albumen silver print. 1872
Image: 12 7/16 x 9 3/16 in. (31.6 x 23.3 cm.)
Sheet: 13 x 10 in. (33.0 x 25.4 cm.)
Mount: 19 3/8 x 15 5/8 in. (49.2 x 39.7 cm.)
Inscription, in negative: "TOWER FALLS"
mount recto: "12"
mount verso: "12"
Acquired from: Frontier America Corporation, Bryan, Texas

*3182. **TOWER OF BABEL. GARDEN OF THE GODS**
(P1981.47.2)
Albumen silver print. c. 1880s
Image: 21 1/4 x 17 in. (54.0 x 43.2 cm.)
Mount: 28 1/8 x 22 3/16 in. (71.4 x 56.3 cm.)
Signed: see inscription
Inscription, in negative: "1007. TOWER OF BABLE [sic].
GARDEN OF THE GODS//W.H. JACKSON & CO.
PHOT. DENVER/W. H. JACKSON. DENVER. CO."
Acquired from: Fraenkel Gallery, San Francisco, California

3183. **TUNNELS 10 AND 11. 11 MILE CANON. COLO.
MIDLAND R.R.** (P1971.94.7)
Albumen silver print. 1887
Image: 16 3/4 x 21 3/16 in. (42.5 x 53.8 cm.)
Mount: 22 x 28 in. (55.9 x 71.1 cm.)
Signed: see inscription
Inscription, in negative: "+202A. TUNNELS 10 AND 11.
11 MILE CANON. COLO. MIDLAND R.R./
W. H. JACKSON & CO. DENVER."
Acquired from: Richard A. Ronzio, Golden, Colorado

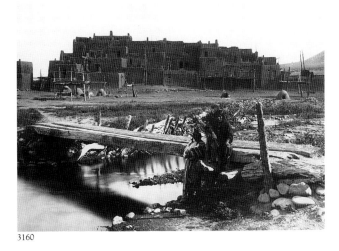

3160

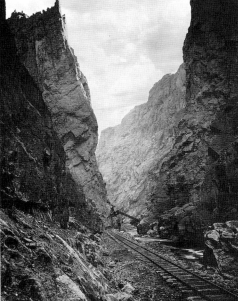

3168

3171

3181

3182

3190

3184. **UNCOMPAGRE CANON—OURAY AND SILVERTON TOLL ROAD** (P1971.94.34)
Albumen silver print mounted on Masonite. 1885
Image: 16 ¾ x 21 ¾ in. (42.6 x 55.2 cm.) irregular
Mount: 16 ⅞ x 21 ¹³⁄₁₆ in. (42.8 x 55.4 cm.)
Signed: see inscription
Inscription, in negative: "1398—UNCOMPAGRE CANON—OURAY AND SILVERTON TOLL ROAD./ W. H. JACKSON & CO. PHOT."
Acquired from: Richard A. Ronzio, Golden, Colorado

3185. **UPPER FALLS OF THE YELLOWSTONE** (P1975.103.50)
duplicate of P1975.103.51
Albumen silver print. 1872
Image: 9 ¹¹⁄₁₆ x 12 ¹⁵⁄₁₆ in. (24.6 x 32.8 cm.)
Mount: 16 ¹⁄₁₆ x 20 ¹⁄₁₆ in. (40.8 x 50.9 cm.) irregular
Inscription, in negative: "UPPER FALLS OF THE YELLOWSTONE."
Acquired from: Fred Mazzulla, Denver, Colorado

3186. **UPPER FALLS OF THE YELLOWSTONE** (P1975.103.51)
duplicate of P1975.103.50
Albumen silver print. 1872
Image: 9 ¾ x 12 ⅞ in. (24.8 x 32.7 cm.)
Mount: 16 ¹⁄₁₆ x 20 ¹⁄₁₆ in. (40.8 x 50.9 cm.)
Inscription, in negative: "UPPER FALLS OF THE YELLOWSTONE."
Acquired from: Fred Mazzulla, Denver, Colorado

3187. **UPPER FALLS, YELLOWSTONE, NEAR VIEW FROM THE WEST SIDE** (P1981.53.1)
Albumen silver print. 1871
Image: 8 ⅞ x 6 ¾ in. (22.5 x 17.1 cm.)
Mount: 13 ¹⁵⁄₁₆ x 10 ¹⁵⁄₁₆ in. (35.5 x 27.8 cm.)
Signed: see inscription
Inscription, in negative: "[2]47"
mount recto: "Upper Falls Yellowstone 2416//850/WM #66" and printed "DEPARTMENT OF THE INTERIOR./ U.S. GEOLOGICAL SURVEY./W. H. JACKSON, PHOTO./WASHINGTON, D.C."
Acquired from: John Howell—Books, San Francisco, California

3188. **UPPER FIRE HOLE, FROM "OLD FAITHFUL"** (P1979.40.6)
Albumen silver print. 1872
Image: 10 ¼ x 13 ⅛ in. (26.0 x 33.3 cm.)
Mount: 15 ¹¹⁄₁₆ x 19 ⅜ in. (39.8 x 49.2 cm.)
Inscription, in negative: "UPPER FIRE HOLE, FROM "OLD FAITHFUL""
mount verso: "Y10"
Acquired from: Frontier America Corporation, Bryan, Texas

3189. **THE UPPER TWIN LAKE** (P1971.22.44)
Albumen silver print. c. 1880–85
Image: 10 ³⁄₁₆ x 13 ⅝ in. (25.9 x 34.6 cm.) irregular
Signed: see inscription
Inscription, in negative: "279. THE UPPER TWIN LAKE.// W. H. JACKSON & CO. DENVER."
Acquired from: Fred Mazzulla, Denver, Colorado

*3190. **UPPER TWIN LAKE** (P1971.94.6)
Albumen silver print. c. early 1880s
Image: 16 ¾ x 20 ⁷⁄₁₆ in. (42.5 x 51.9 cm.)
Mount: 18 ¹⁵⁄₁₆ x 22 ⅜ in. (48.1 x 56.8 cm.)
Signed: see inscription
Inscription, in negative: "+159. UPPER TWIN LAKE./ W. H. JACKSON & CO. DENVER."
Acquired from: Richard A. Ronzio, Golden, Colorado

3191. **UTE PASS** (P1970.20.12)
Albumen silver print. c. 1880–83
Image: 13 ⅝ x 10 ⅛ in. (34.6 x 25.7 cm.)
Mount: 16 ⅛ x 12 ⅞ in. (41.0 x 32.8 cm.)
Signed: see inscription
Inscription, in negative: "268. UTE PASS/W.H. JACKSON & CO. PHOT. DENVER"
Acquired from: Fred Rosenstock, Denver, Colorado

3192. **UTE TEPEE. LOS PINOS AGENCY** (P1970.20.16)
Albumen silver print. c. 1870s–80s
Image: 10 ³⁄₁₆ x 13 ⅝ in. (25.8 x 34.6 cm.)
Mount: 16 ¹⁄₁₆ x 20 ¹⁄₁₆ in. (40.8 x 50.9 cm.) irregular
Acquired from: Fred Rosenstock, Denver, Colorado

3193. **VALLEY OF THE YELLOWSTONE. EAST** (P1979.40.10)
Albumen silver print. 1872
Image: 10 ³⁄₁₆ x 12 ⅞ in. (25.9 x 32.6 cm.)
Mount: 15 ⅝ x 19 ⅜ in. (39.6 x 49.3 cm.)
Inscription, in negative: "VALLEY of the YELLOWSTONE. east."
mount verso: "Y8"
Acquired from: Frontier America Corporation, Bryan, Texas

3194. **VETA PASS [Dump Mtn. & La Veta Pass, D & RG RR]** (P1970.15) duplicate of P1971.94.14
Albumen silver print. 1882
Image: 16 ¹¹⁄₁₆ x 21 ³⁄₁₆ in. (42.4 x 53.9 cm.)
Mount: 19 ⅞ x 24 ⁵⁄₁₆ in. (50.5 x 61.8 cm.)
Signed: see inscription
Inscription, in negative: "1017. VETA PASS./W. H. JACKSON & CO. PHOT. DENVER."
mount recto, printed: "THE ROCKY MOUNTAINS./ SCENES ALONG THE LINE OF THE DENVER AND RIO GRANDE RAILWAY."
Acquired from: Fred Rosenstock, Denver, Colorado

*3195. **VETA PASS [Dump Mtn. & La Veta Pass, D & RG RR]** (P1971.94.14) duplicate of P1970.15
Albumen silver print. 1882
Image: 16 ⅞ x 21 ⅛ in. (42.9 x 53.6 cm.)
Mount: 25 x 30 in. (63.4 x 76.2 cm.)
Signed: see inscription
Inscription, mount recto, printed: "DENVER/ W. H. JACKSON & CO., PHOTOGRAPHERS/ COLORADO"
mount verso: "D&RG//Richard A. Ronzio/Box 344/ Golden, Colo./CR9-1507//7297//DUMP MTN./& LA VETA/PASS/D & RG RR"
Acquired from: Richard A. Ronzio, Golden, Colorado

3196. **VILLAGE OF THE OMAHA INDIANS** (P1970.54.1)
Albumen silver print. c. 1868–69
Image: 4 ¹³⁄₁₆ x 8 ¹³⁄₁₆ in. (12.3 x 22.3 cm.)
Mount: 11 x 14 in. (27.9 x 35.5 cm.)
Signed: see inscription
Inscription, in negative: "339"
mount recto: "W. H. JACKSON, PHOTO.// WASHINGTON, D. C.//Village of the Omaha Indians"
mount verso: "P477/337 Village of the Omaha Indians"
Acquired from: Kennedy Galleries, New York, New York

3197. **WEST END TOLTEC TUNNEL** (P1979.40.14)
Albumen silver print. c. early 1880s
Image: 10 ⅛ x 13 ⅜ in. (25.7 x 34.0 cm.)
Mount: 16 x 20 in. (40.7 x 50.8 cm.)
Signed: see inscription
Inscription, in negative: "68. West end Toltec Tunnel./ W. H. Jackson & Co. Phot., Denver. Colo."
mount verso: "5/47F" and rubber stamp "L. L. WOODRUFF/207 Harrison Av./LEADVILLE, COLO."
Acquired from: Frontier America Corporation, Bryan, Texas

William Henry Jackson & Co., publisher
*3198. **[William Henry Jackson and family]** (P1973.20)
Albumen silver print. c. 1881–82
Image: 11 x 7 ⁹⁄₁₆ in. (28.0 x 19.2 cm.) irregular
Mount: 12 x 8 in. (30.5 x 20.3 cm.)
Signed: see inscription
Inscription, mount recto, printed: "W. H. Jackson & Co./ Denver."
mount verso: "Photographed in Denver/in 1881 or 2-"
Acquired from: unknown source

3199. **YELLOWSTONE LAKE** (P1975.103.39) duplicate of P1975.103.40
Albumen silver print. c. 1872

Image: 9 ¹¹⁄₁₆ x 13 ¹⁄₁₆ in. (24.5 x 33.2 cm.)
Mount: 16 ¹⁄₁₆ x 20 ¹⁄₁₆ in. (40.8 x 50.9 cm.) irregular
Inscription, in negative: "YELLOWSTONE LAKE."
Acquired from: Fred Mazzulla, Denver, Colorado

3200. **YELLOWSTONE LAKE** (P1975.103.40) duplicate of
P1975.103.39
Albumen silver print. c. 1872
Image: 9 ⁹⁄₁₆ x 13 ¹⁄₁₆ in. (24.3 x 33.2 cm.)
Mount: 16 ¹⁄₁₆ x 20 ¹⁄₁₆ in. (40.8 x 50.9 cm.)
Inscription, in negative: "YELLOWSTONE LAKE."
Acquired from: Fred Mazzulla, Denver, Colorado

JACKSON COLLAGES

The identity of the creator, the exact uses, and the sub-
sequent history of these photo collages are not certain.
They were acquired from Fred Mazzulla, who is be-
lieved to have acquired them from Clarence Jackson,
son of William Henry Jackson. Printers' inscriptions
on the mounts indicate that the images were used
in various publishing endeavors, including ones by
William Henry Jackson and the Detroit Publishing
Company and by Clarence Jackson. Several of these
illustrations appear in booklets of Colorado, Utah,
and Washington scenery published by William H.
Crane in the early 1900s.

The collages combine the work of numerous pho-
tographers, including William Henry Jackson, Darius
Kinsey, Louis McClure, and Harry Shipler. In most
cases, the photographer's inscriptions have been re-
moved or covered; in some, however, a few remaining
marks do indicate the photographer. The name of the
original photographer is given when enough evidence
is present to confirm an attribution, but collage artists
are mainly responsible for the finished appearance of
the composite photographs.

3201. **BEAR RIVER CANYON UTAH ON LINE OF OREGON
SHORT LINE R.R. TO BUTTE** (P1971.22.17)
Gelatin silver print and gouache. negative n.d., paste-up
c. 1913
Image: 7 ⁵⁄₈ x 9 ⁹⁄₁₆ in. (19.5 x 24.3 cm.)
Mount: 10 ¹⁵⁄₁₆ x 14 ¹⁄₈ in. (27.8 x 35.9 cm.) irregular
Inscription, mount recto: "OK/WHC"
mount verso: "Bear River Canyon Utah/on line of Oregon
short line/R.R. To Butte//211" and art department stamp
with check number "1261" and "4 color/6 ¹⁄₈ x 5//211"
overlay: "23"
Acquired from: Fred Mazzulla, Denver, Colorado

3202. **BIG COTTON WOOD CANYON [Utah]** (P1971.22.25)
Gelatin silver print. negative n.d., paste-up c. 1913
Image: 9 ¹⁄₂ x 7 ¹⁄₂ in. (24.1 x 19.0 cm.)
Sheet: 9 ³⁄₄ x 7 ³⁄₄ in. (24.7 x 19.7 cm.)
Mount: 14 ¹⁄₈ x 10 ³⁄₈ in. (35.9 x 26.4 cm.) irregular
Inscription, mount recto: "OK/WHC" and printer's
crop marks
mount verso: "Big Cotton Wood Canyon//216" and art
department rubber stamp with check number "1261" and
"4 color/6 ¹⁄₈ x 5"
Acquired from: Fred Mazzulla, Denver, Colorado

From a photograph by William H. Jackson
3203. **CENTRAL CITY, COLO.** (P1971.22.47)
Toned gelatin silver print and gouache. negative c. 1880s−90s
paste-up c. 1913
Image: 10 ¹⁄₄ x 13 ¹⁄₈ in. (26.0 x 33.3 cm.)
Mount: 15 ⁷⁄₈ x 19 ³⁄₄ in. (40.3 x 50.1 cm.)
Signed: see inscription
Inscription, in negative: "W. H. Jackson & Co. Phot.
Denver, Colo.//146. Central City, Colo."
mount verso: "287"
Acquired from: Fred Mazzulla, Denver, Colorado

3195

3198

3204

*3204. **[City view, possibly in Washington state]** (P1971.22.42)
Gelatin silver print, collage, and gouache. negative n.d.,
paste-up 1913
Image: 8⅛ x 10 1/16 in. (20.7 x 25.6 cm.)
Mount: 10⅝ x 14¼ in. (26.9 x 36.2 cm.)
Inscription, mount recto: "OK/WH Crane//8316" and
printer's crop marks and measurements
mount verso: "306" and art department rubber stamp with
check number "8316" and date "1913"
Acquired from: Fred Mazzulla, Denver, Colorado

*3205. **[Colorado Springs, Colorado]** (P1971.22.9)
Gelatin silver print, collage, and gouache. negative n.d.,
paste-up c. 1913
Image: 11 x 16⅜ in. (28.0 x 41.6 cm.) irregular
Mount: 13¾ x 19 13/16 in. (34.9 x 50.3 cm.) irregular
Inscription, mount recto: "large and small cuts/#475/4 color"
and printer's crop marks and measurements
mount verso: "103" and Mazzulla Collection stamp
Acquired from: Fred Mazzulla, Denver, Colorado

3206. **CONCRETE BRIDGE ACROSS THE YELLOWSTONE
RIVER [Chittenden Bridge, Yellowstone National Park]**
(P1971.22.24)
Gelatin silver print and gouache. negative n.d., paste-up
c. 1913
Image: 7½ x 9 9/16 in. (19.1 x 24.3 cm.)
Sheet: 9¼ x 10 in. (23.5 x 25.4 cm.)
Mount: 10⅜ x 14 1/16 in. (26.3 x 35.7 cm.)
Inscription, in negative: "No 3009."
mount recto: "Concrete Bridge Across the Yellowstone
River//OK C"
mount verso: "Concrete bridge/Yellowstone N.P.//157" and
art department rubber stamp with check number "1261"
and "4 color/6⅛ x 5"
overlay: "33"
Acquired from: Fred Mazzulla, Denver, Colorado

3207. **[Curicanti Needle in the Black Canyon of the Gunnison]**
(P1971.22.12)
Gelatin silver print, collage, and gouache. negative n.d.,
paste-up 1913
Image: 9⅝ x 12½ in. (24.4 x 31.8 cm.) irregular
Sheet: 10⅞ x 14⅛ in. (27.6 x 35.9 cm.)
Mount: 12¾ x 16¼ in. (32.3 x 41.2 cm.) irregular
Inscription, mount recto: "Print 981 reversed" and printer's
crop marks
mount verso: "91"
overlay: "10//26/2//Van Noys/OK by/M[illegible]shaw/4/2//2"
and art department rubber stamp with check number "9200"
Acquired from: Fred Mazzulla, Denver, Colorado

From a photograph by Louis McClure
*3208. **DENVER, COLO.** (P1971.22.11)
Gelatin silver print, collage, and gouache. negative 1911,
paste-up c. 1913
Image: 10¾ x 17¾ in. (27.2 x 45.1 cm.) irregular
Mount: 11½ x 18 1/16 in. (29.1 x 45.8 cm.)
Signed: see inscription
Inscription, in negative: "1425. DENVER COLO/
COPYRIGHT 1911 by L C [monogram] Mc Clure//1425.
DENVER, COLO/PHOTO BY L C [monogram]
MCCLURE"
mount recto: printer's crop marks and measurements
mount verso: "101" and Mazzulla collection stamp
overlay: "OK Hynes/with st car//#9200//Four Colors" and
art department stamp with check number "9199"
Acquired from: Fred Mazzulla, Denver, Colorado

3209. **[Devil's Slide, Weber's Canyon, Utah]** (P1971.22.35)
Gelatin silver print and gouache. negative n.d., paste-up
c. 1913
Image: 9¾ x 7⅞ in. (24.9 x 20.0 cm.)
Sheet: 10 x 8⅛ in. (25.4 x 20.6 cm.)
Mount: 11 5/16 x 9 9/16 in. (28.6 x 24.2 cm.)

Inscription, in negative: [illegible]
mount recto: printer's crop marks
mount verso: "14 Lt. Buff Rocks//221" and art department
rubber stamp with check number "8316"
overlay: "1J"
Acquired from: Fred Mazzulla, Denver, Colorado

From a photograph by Darius Kinsey
*3210. **FIR LOG IN WASHINGTON. 13 FT. DIAMETER**
(P1971.22.40)
Gelatin silver print and gouache. negative 1907, paste-up
c. 1913–14
Image: 13⅜ x 8¾ in. (33.9 x 22.2 cm.)
Mount: 15 x 10 5/16 in. (38.1 x 26.2 cm.) irregular
Signed: see inscription
Inscription, in negative: "Copyrighted 1907 by Darius Kinsey/
[illegible] St. Seattle, Wash//197. FIR LOG IN
W[illegible]"
mount verso: "Fir Log in Washington 13 ft. Diameter/Take
out saw and 2 poles/change man//275"
Acquired from: Fred Mazzulla, Denver, Colorado

3211. **GEORGETOWN FROM LEAVENWORTH MOUNTAIN**
(P1971.22.48)
Toned gelatin silver print and gouache. negative c. 1880s–90s,
paste-up c. 1913
Image: 10¼ x 13⅛ in. (26.0 x 33.3 cm.)
Mount: 15¾ x 19 11/16 in. (40.0 x 50.0 cm.)
Signed: see inscription
Inscription, in negative: "117. Georgetown from Leavenworth
Mountain.//[illegible] [D]enver, Colo."
Acquired from: Fred Mazzulla, Denver, Colorado

3212. **[Glenwood Springs, Colorado]** (P1971.22.5)
Gelatin silver print and gouache. negative n.d., paste-up
c. 1913–14
Image: 8 x 9⅝ in. (20.3 x 24.4 cm.) irregular
Mount: 10 15/16 x 12⅝ in. (27.7 x 32.1 cm.) irregular
Inscription, mount recto: "4756/21//(4 color)" and printer's
crop marks and measurements
mount verso: "109"
Acquired from: Fred Mazzulla, Denver, Colorado

3213. **GREAT NORTHERN DOCKS, SEATTLE** (P1971.22.37)
Gelatin silver print and gouache. negative n.d., paste-up
c. 1913
Image: 7⅜ x 9 9/16 in. (18.7 x 24.3 cm.)
Mount: 10 5/16 x 15 in. (26.2 x 38.1 cm.) irregular
Inscription, mount recto: "8316" and printer's measurements
and crop marks
mount verso: "7—Great Northern Docks, Seattle,/
Showing the giant/liners of the Great Northern Steamship
Company/and a vessel of the Nippon Yusen Kaisha
(Japanese/line to the Orient) in port. The Great Northern
Oriental/Limited appears on the trestle in the forground
[sic]/approching [sic] the city.//272"
Acquired from: Fred Mazzulla, Denver, Colorado

3214. **[Hell Gate on the Colorado Midland Railway]** (P1971.22.6)
Gelatin silver print, collage, and gouache. negative n.d.,
paste-up c. 1913
Image: 7¾ x 9 15/16 in. (19.6 x 25.3 cm.) irregular
Sheet: 9 x 10 13/16 in. (22.8 x 27.4 cm.)
Mount: 9⅞ x 11 13/16 in. (25.1 x 30.0 cm.) irregular
Inscription, mount recto: printer's crop marks and
measurements
mount verso: "22/4" and Mazzulla Collection stamp
overlay: "#4757"
Acquired from: Fred Mazzulla, Denver, Colorado

3215. **KEPLER CASCADE—PINCHOLE RIVER,
YELLOWSTONE** (P1971.22.32)
Gelatin silver print and gouache. negative n.d., paste-up
c. 1913
Image: 9⅞ x 7 9/16 in. (25.1 x 19.1 cm.)
Sheet: 10 x 7¾ in. (25.3 x 19.7 cm.)
Mount: 14⅛ x 11 5/16 in. (35.8 x 28.7 cm.)

Inscription, mount recto: printer's crop marks
 mount verso: "Kepler Cascade—/Pinchole River.//163" and
 art department stamp with check number "1261" and "4
 color/Yellowstone/6⅛ x 5"
 overlay: "OK WHCrane//31"
 Acquired from: Fred Mazzulla, Denver, Colorado

3205

*3216. **LAS ANIMAS CANON** (P1971.22.13)
 Gelatin silver print, collage, and gouache. negative n.d.,
 paste-up c. 1913
 Image: 9⅛ x 12½ in. (23.2 x 31.7 cm.) irregular
 Sheet: 9⅝ x 12¾ in. (24.5 x 32.4 cm.) irregular
 Mount: 11¼ x 15 in. (28.5 x 38.1 cm.)
 Inscription, mount recto: printer's measurements and
 crop marks
 mount verso: "Las Animas Canon/115" and Mazzulla
 Collection stamp
 Acquired from: Fred Mazzulla, Denver, Colorado

3217. **[Lyons, Colorado]** (P1971.22.15)
 Gelatin silver print, collage, and gouache. negative n.d.,
 paste-up 1914
 Image: 7¹¹⁄₁₆ x 9¹⁵⁄₁₆ in. (19.5 x 25.2 cm.)
 Mount: 12 x 14 in. (30.5 x 35.5 cm.)
 Inscription, mount recto: advertising copy for Hotel
 Burlington, reading "WHEN YOU COME TO
 COLORADO this summer, plan to make your headquarters
 at LYONS…"
 mount verso: "35" and art department rubber stamp with
 check number "8231" and "8231/Set 6.#17/2-23/4"
 overlay: "29"
 Acquired from: Fred Mazzulla, Denver, Colorado

3208

3218. **[Manitou, Colorado]** (P1971.22.8)
 Gelatin silver print, collage, and gouache. negative n.d.,
 paste-up c. 1913
 Image: 9⅜ x 9⅝ in. (23.8 x 24.5 cm.) irregular
 Sheet: 6½ x 9⅝ in. (16.5 x 24.4 cm.) irregular
 Mount: 15 x 13⅛ in. (38.1 x 33.4 cm.) irregular
 Inscription, mount recto: "#4757/4 colors/No 9" and printer's
 crop marks and measurements
 mount verso: "Crane//119"
 overlay: "14"
 Acquired from: Fred Mazzulla, Denver, Colorado

*3219. **MORNING GLORY SPRINGS, YELLOWSTONE**
 (P1971.22.28)
 Gelatin silver print and gouache. negative n.d., paste-up 1913
 Image: 8⅝ x 10⁷⁄₁₆ in. (21.8 x 26.6 cm.) irregular
 Sheet: 6½ x 8⅜ in. (16.5 x 21.3 cm.) irregular
 Mount: 11⅜ x 13⅝ in. (28.8 x 34.6 cm.)
 Inscription, mount recto: printer's crop marks
 mount verso: "Morning Glory Springs//154" and art
 department rubber stamp with check number "1261" and
 "Yellowstone/5-22/1913"
 overlay: "33"
 Acquired from: Fred Mazzulla, Denver, Colorado

 Composite of photographs by Louis McClure and William
 Henry Jackson
*3220. **[Mountain of the Holy Cross]** (P1971.22.7)
 Gelatin silver print, collage, and gouache. negatives 1873 and
 c. 1880s, paste-up c. 1913
 Image: 10¾ x 13¼ in. (27.3 x 33.6 cm.) irregular
 Sheet: 11⅝ x 14⁷⁄₁₆ in. (29.5 x 36.6 cm.)
 Mount: 13⅝ x 17¹⁄₁₆ in. (34.6 x 43.3 cm.)
 Inscription, in negative: "T23 Arch Rock in Platte Canon.
 C. S. & P./Photo by L C [monogram] McClure, Denver."
 mount recto: "#4757" and printer's crop marks and
 measurements
 mount verso: "#4757//#4757" and Mazzulla Collection
 stamp
 Acquired from: Fred Mazzulla, Denver, Colorado

3210

3221. **OUTLET OF POYETTE LAKE, IDAHO. ON O.S.L.R.R.**
(P1971.22.23)
Gelatin silver print and gouache. negative n.d., paste-up
c. 1913
Image: 11 x 13 ¾ in. (28.0 x 34.9 cm.) irregular
Sheet: 11 ¼ x 14 in. (28.5 x 35.6 cm.)
Mount: 14 ⅜ x 16 ⁷⁄₁₆ in. (36.5 x 41.7 cm.)
Inscription, mount recto: "OK/WHC//Colors"
mount verso: "Outlet of Poyette Lake, Idaho./On
O.S.L.R.R.//215" and art department stamp with
check number "1261" and "4 color/6 ⅛ x 5"
overlay: "13"
Acquired from: Fred Mazzulla, Denver, Colorado

3222. **PIKES PEAK, COLORADO** (P1971.22.54)
Chromolithograph. 1899
Image: 17 ⅛ x 21 ¼ in. (43.4 x 53.9 cm.)
Mount: 18 ¼ x 23 ¼ in. (46.3 x 59.0 cm.)
Signed: see inscription
Inscription, print recto, stamped: "COPYRIGHT, 1899, BY
DETROIT PHOTOGRAPHIC CO.//59005. PIKE'S
PEAK, COLORADO"
Acquired from: Fred Mazzulla, Denver, Colorado

3223. **POINT LOOKOUT & GREAT FALLS. YELLOWSTONE
NAT. PARK** (P1971.22.31)
Gelatin silver print and gouache. negative n.d., paste-up
c. 1913
Image: 6 ¼ x 8 ¼ in. (15.9 x 20.9 cm.)
Sheet: 6 ½ x 8 ⁷⁄₁₆ in. (16.5 x 21.4 cm.)
Mount: 11 ⁵⁄₁₆ x 14 ¹⁄₁₆ in. (28.7 x 35.8 cm.)
Inscription, mount recto: printer's crop marks
mount verso: "Point Lookout. & great falls./Yellow Stone
Nat. Park.//Point Look out & Gt. Falls.//150" and art
department rubber stamp with check number "1261" and
"4 color/Yellowstone/6 ⅛ x 5"
overlay: "34//OK [illegible]"
Acquired from: Fred Mazzulla, Denver, Colorado

3224. **ROAD TO YELLOWSTONE CANON** (P1971.22.33)
Gelatin silver print and gouache. negative n.d., paste-up
c. 1913
Image: 7 ⅞ x 9 ¾ in. (20.0 x 24.8 cm.)
Sheet: 8 ³⁄₁₆ x 10 ¹⁄₁₆ in. (20.8 x 25.4 cm.)
Mount: 11 ⁵⁄₁₆ x 14 ¹⁄₁₆ in. (28.7 x 35.8 cm.)
Inscription, in negative: "[illegible] Road to Yellowstone
Canon, [illegible]/[illegible]"
mount recto: printer's crop marks
mount verso: "155" and art department rubber stamp with
check number "1261" and "4 color/Yellowstone/6 ⅛ x 5"
overlay: "35"
Acquired from: Fred Mazzulla, Denver, Colorado

*3225. **[Salt Air Pavilion, Salt Lake City]** (P1971.22.20)
Gelatin silver print, collage, and gouache. negative
c. 1902–12, paste-up before 1922
Image: 9 ½ x 11 ⅞ in. (24.1 x 30.2 cm.) irregular
Mount: 12 x 16 ⁹⁄₁₆ in. (30.5 x 42.1 cm.) irregular
Inscription, in negative: "325"
mount recto: printer's crop marks
mount verso: "204//35" and art department stamp with
check number "186" and "Engraving Dept/11 ⅛ x 8 ⅝/4
color"
Acquired from: Fred Mazzulla, Denver, Colorado

*3226. **[Salt Lake City]** (P1971.22.18)
Gelatin silver print, collage, and gouache. negative n.d.,
paste-up c. 1913
Image: 12 ½ x 17 ¼ in. (31.8 x 43.8 cm.) irregular
Sheet: 9 ⅛ x 17 ¼ in. (23.2 x 43.8 cm.)
Mount: 13 ¼ x 18 ½ in. (33.7 x 47.0 cm.)
Inscription, mount recto: printer's crop marks
mount verso: "200"
overlay: art department rubber stamp with "Postal Card
#1261//8//Check No. 186/Salt Lake Book"
Acquired from: Fred Mazzulla, Denver, Colorado

3227. **[Salt Lake City, Main Street looking north from South 4th]**
(P1971.22.19)
Gelatin silver print and gouache. negative n.d., paste-up
c. 1913
Image: 7 ½ x 9 ½ in. (19.0 x 24.1 cm.) irregular
Mount: 11 ⅜ x 14 ⅛ in. (28.8 x 35.9 cm.)
Inscription, mount recto: "OK/WHC"
mount verso: "213" and art department rubber stamp with
check number "1261" and "4 color/6 ⅛ x 5"
overlay: "24"
Acquired from: Fred Mazzulla, Denver, Colorado

3228. **SECOND AVENUE LOOKING NORTH, SEATTLE
WASH.** (P1971.22.38)
Gelatin silver print and gouache. negative n.d., paste-up
c. 1913
Image: 9 ⁷⁄₁₆ x 7 ¼ in. (23.9 x 18.4 cm.)
Mount: 15 x 10 ⁵⁄₁₆ in. (38.1 x 26.2 cm.) irregular
Inscription, in negative: "769"
mount recto: "8316//19//as it goes" and printer's crop marks
mount verso: "Second Ave Looking North/Seattle Wash//
W. P. Romans/627 Colmon Building/Seattle Washington//+
street-scene/for folder"
Acquired from: Fred Mazzulla, Denver, Colorado

*3229. **SECOND TUNNEL, CANON OF THE GRAND RIVER**
(P1971.22.10)
Gelatin silver print, collage, and gouache. negative n.d.,
paste-up 1913
Image: 9 ¹³⁄₁₆ x 13 ½ in. (24.8 x 34.3 cm.) irregular
Mount: 10 ¹⁵⁄₁₆ x 13 ¹¹⁄₁₆ in. (27.8 x 34.8 cm.) irregular
Inscription, in negative: "5./SECOND TUNNEL/CANON
OF THE GRAND RIVER"
mount recto: "Houston" and printer's crop marks and
measurements
mount verso: "Grand Canon/D. & R.G./TUNNEL
#2/Van Noys//92"
overlay: "Van Noys/O.K. by Muk[illegible]haw/4/15/13/40/
A1/A1/C//26" and art department rubber stamp with check
number "9199" and "Van Noys"
Acquired from: Fred Mazzulla, Denver, Colorado

3230. **SHOSHONE FALLS [Idaho]** (P1971.22.21)
Gelatin silver print and gouache. negative n.d., paste-up
c. 1913
Image: 10 ⅜ x 14 in. (26.3 x 35.6 cm.)
Mount: 14 ⅛ x 17 ⅝ in. (35.8 x 44.7 cm.)
Inscription, mount recto: "OK/WHC"
mount verso: "Salt Lake/Shoshone Falls//209" and art
department rubber stamp with check number "1261" and
"4 color/6 ⅛ x 5"
Acquired from: Fred Mazzulla, Denver, Colorado

3231. **SPIRIT KNOB, LAKE MINNETONKA, BOAT**
(P1971.22.41)
Toned gelatin silver print. negative n.d., paste-up c. 1913
Image: 7 ⁵⁄₁₆ x 9 ¼ in. (18.5 x 23.5 cm.)
Mount: 10 ⁵⁄₁₆ x 14 ¾ in. (26.2 x 37.4 cm.) irregular
Inscription, in negative: [illegible]
mount recto: printer's crop marks
mount verso: "Spirit Knob/Lake Minnetonka/Boat//302"
Acquired from: Fred Mazzulla, Denver, Colorado

3232. **[Spokane Falls, Spokane, Washington]** (P1971.22.36)
Gelatin silver print and gouache. negative n.d., paste-up
c. 1913
Image: 7 ⅞ x 9 ⅜ in. (20.0 x 23.9 cm.)
Sheet: 8 ⅛ x 10 ⅛ in. (20.6 x 25.6 cm.)
Mount: 9 ½ x 11 ¼ in. (24.1 x 28.6 cm.)
Inscription, in negative: [illegible]
mount recto: "5" and printer's crop marks and
measurements
mount verso: "222" and art department rubber stamp with
check number "8316"
overlay: "17"
Acquired from: Fred Mazzulla, Denver, Colorado

3216

3219

3220

3225

3226

3229

3233. **THE SPONGE, UPPER GEYSER BASIN, Y. N. P.**
(P1971.22.27)
Gelatin silver print and gouache. negative n.d., paste-up
c. 1913
Image: 7 ⅞ x 9 ¾ in. (20.0 x 24.8 cm.) irregular
Sheet: 8 ³⁄₁₆ x 10 in. (20.8 x 25.4 cm.) irregular
Mount: 11 ⁵⁄₁₆ x 14 ¹⁄₁₆ in. (28.6 x 35.7 cm.)
Inscription, in negative: "318 The Sponge, Upper Geyser
Basin, Y. N. P."
mount recto: printer's crop marks
mount verso: "2 ⅝ x 6 ½//164" and art department rubber
stamp with check number "1261" and "4 color/Yellowstone/
6 ⅛ x 5"
overlay: "32"
Acquired from: Fred Mazzulla, Denver, Colorado

3234. **STAR GEYSER, YELLOWSTONE** (P1971.22.26)
Gelatin silver print and gouache. negative n.d., paste-up
c. 1913
Image: 9 ⅝ x 7 ½ in. (24.4 x 19.0 cm.)
Sheet: 9 ⅞ x 7 ¹¹⁄₁₆ in. (25.1 x 19.5 cm.)
Mount: 14 ¹⁄₁₆ x 9 ¾ in. (35.8 x 24.7 cm.)
Inscription, mount verso: "Star/Geyser//162" and art
department rubber stamp with check number "1261" and
"4 color/Yellowstone/6 ⅛ x 5"
overlay: "38"
Acquired from: Fred Mazzulla, Denver, Colorado

*3235. **TOLTEC GORGE** (P1971.22.14)
Gelatin silver print, collage, and gouache. negative n.d.,
paste-up c. 1913
Image: 9 ⁷⁄₁₆ x 13 ¹⁄₁₆ in. (23.9 x 33.1 cm.) irregular
Sheet: 10 ⅝ x 13 ⅜ in. (26.9 x 34.0 cm.) irregular
Mount: 12 ¹³⁄₁₆ x 16 ¹⁄₁₆ in. (32.5 x 40.8 cm.)
Inscription, mount recto: "888/888//4 colors/4 colors//#475/
#475" and printer's crop marks and measurements
mount verso: "19/Toltec Gorge" and Mazzulla Collection
stamp
overlay: "9200/Page 19—2nd Form"
Acquired from: Fred Mazzulla, Denver, Colorado

3236. **[Union Pacific Station, West Entrance, Yellowstone National
Park]** (P1971.22.34)
Gelatin silver print and gouache. negative n.d., paste-up
c. 1913
Image: 11 x 13 ¹³⁄₁₆ in. (27.9 x 35.0 cm.) irregular
Sheet: 11 ¼ x 14 ¹⁄₁₆ in. (28.5 x 35.6 cm.)
Mount: 14 ⅛ x 16 ¹⁵⁄₁₆ in. (35.8 x 43.0 cm.)
Inscription, mount recto: "OK/WHC" and printer's
crop marks
mount verso: "167//Crane" and art department rubber
stamp with check number "1261" and "4 color/Yellowstone/
6 ⅛ x 5"
overlay: "12"
Acquired from: Fred Mazzulla, Denver, Colorado

3237. **UPPER GEYSER BASIN, YELLOWSTONE** (P1971.22.29)
Gelatin silver print and gouache. negative n.d., paste-up
c. 1913
Image: 7 ¹¹⁄₁₆ x 9 ¹¹⁄₁₆ in. (19.4 x 24.6 cm.) irregular
Sheet: 7 ¾ x 9 ¹⁵⁄₁₆ in. (19.7 x 25.3 cm.)
Mount: 11 ⁵⁄₁₆ x 14 ⅛ in. (28.6 x 35.8 cm.)
Inscription, mount verso: "Upper Geyser Basin//165" and art
department rubber stamp with check number "1261" and
"4 color/Yellowstone/6 ⅛ x 5"
overlay: "30"
Acquired from: Fred Mazzulla, Denver, Colorado

3238. **UTAH COPPER CO.'S MILLS, GARFIELD UTAH, 14
MILES WEST OF SALT LAKE CITY** (P1971.22.22)
Gelatin silver print and gouache. negative n.d., paste-up
c. 1913
Image: 10 ¹¹⁄₁₆ x 13 ⅞ in. (27.1 x 35.3 cm.)
Mount: 14 ⅛ x 16 ¾ in. (35.9 x 42.6 cm.)
Inscription, mount recto: "OK/WHC"
mount verso: "Utah Copper Co.'s Mills/Garfield Utah/14

Miles West of Salt Lake City.//212" and art department
rubber stamp with check number "1261"
overlay: "9"
Acquired from: Fred Mazzulla, Denver, Colorado

3239. **UTAH STATE CAPITOL, SALT LAKE CITY, IN COURSE
OF ERECTION** (P1971.22.16)
Gelatin silver print and gouache. c. 1913–15
Image: 7 ½ x 9 ½ in. (19.0 x 24.1 cm.) irregular
Mount: 10 x 14 ⅛ in. (25.4 x 35.9 cm.) irregular
Inscription, mount verso: "Utah State Capitol/Salt Lake City/
In Course of Erection//210" and art department stamp with
check number "1261" and "4 color/6 ⅛ x 5"
overlay: "22"
Acquired from: Fred Mazzulla, Denver, Colorado

3240. **WEYERHAEUSER TIMBER CO.'S LUMBER PLANT AT
EVERETT, WASH.** (P1971.22.39)
Gelatin silver print and gouache. negative n.d., paste-up
c. 1913–14
Image: 7 ¾ x 9 ¹³⁄₁₆ in. (19.7 x 24.9 cm.)
Mount: 10 ⁵⁄₁₆ x 15 in. (26.2 x 38.1 cm.) irregular
Inscription, mount recto: printer's crop marks and
measurements
mount verso: "Weyerhaeuser Timber Co.'s lumber plant/
at Everett Wash. showing St. Nor. Oriental/dock on the
right.//274"
Acquired from: Fred Mazzulla, Denver, Colorado

From a photograph by Harry Shipler
3241. **YELLOWSTONE CANYON FROM INSPIRATION
POINT** (P1971.22.30)
Gelatin silver print and gouache. negative 1908, paste-up
c. 1913
Image: 7 ⁹⁄₁₆ x 9 ⁷⁄₁₆ in. (19.2 x 24.0 cm.) irregular
Sheet: 7 ⅞ x 9 ¾ in. (19.9 x 24.7 cm.) irregular
Mount: 11 ¼ x 14 ¹⁄₁₆ in. (28.6 x 35.7 cm.)
Signed: see inscription
Inscription, print recto: "COPYRIGHT 1908 BY HARRY
SHIPLER SALT LAKE CITY"
mount recto: printer's crop marks
mount verso: "Yellowstone Canyon From/Inspiration
Point.//158" and art department rubber stamp with check
number "1261" and "4 color/Yellowstone/6 ⅛ x 5"
overlay: "36//O.K./WHCrane"
Acquired from: Fred Mazzulla, Denver, Colorado

LOTTE JOHANNA JACOBI,
American, born Germany (1896–1990)

A member of a family of photographers, Lotte Jacobi
studied at the Bavarian State Academy of Photography
in Munich. She ran the family studio in Munich from
1927 until 1935, when she came to the United States.
She opened a gallery in New York. Albert Einstein
helped establish her career when he insisted that
Jacobi's portrait of him be used in an article for *Life*
magazine. Another assignment made Jacobi the first
woman admitted on the floor of the New York Stock
Exchange during trading hours. Although Jacobi first
gained recognition as a portrait photographer, she
is also well known for her "photogenics," or camera-
less drawings, first exhibited in 1948. These drawings
were made on light-sensitive paper by moving the
light source, glass, or cellophane to create subtle
changes of light. Jacobi's work has been exhibited
throughout the United States and Europe and pub-
lished in three portfolios.

3242. **PHOTOGENIC** (P1986.27)
Gelatin silver print. c. 1940s
Image: 8 x 9¾ in. (20.3 x 24.7 cm.)
Mount: same as image size
Signed, l.r. print recto: "Lotte Jacobi"
Acquired from: Paul M. Hertzmann, Inc., San Francisco,
California

FRANCES BENJAMIN JOHNSTON,
American (1864–1952)

See also *Camera Notes*

Johnston is generally considered to have been the first
woman press photographer. Although she had studied
art, Johnston at first considered herself a writer and
took up photography only because she needed illustra-
tions to use with her articles. The work, however, led
her to give up writing and pursue a photographic career.
She opened a studio in Washington, D. C., during the
1890s and received many commissions from the govern-
ment, school systems, and magazines. She began a
series of photographs documenting historic buildings
and gardens in the southern United States about 1909.
Although Johnston was a close friend of the pictorialist
photographer Gertrude Käsebier, her work falls within
the documentary tradition of straightforward and un-
manipulated views.

*3243. **[Blowing pinwheels]** (P1982.13)
Platinum print. c. 1900
Image: 7½ x 9⁹⁄₁₆ in. (19.0 x 24.2 cm.)
Sheet: 8 x 10 in. (20.3 x 25.4 cm.)
Acquired from: Marcuse Pfeifer Gallery, New York, New York

CHARLES CLIFFORD JONES,
American (active 1881–1901)

C. C. Jones worked as a United States Geological Sur-
vey photographer from 1881 until 1901 under John K.
Hillers. He was based in Washington, D. C., and fre-
quently dispatched to photograph in surrounding areas.
For a time Jones was the only assistant working under
Hillers; as additional assistants were hired, Jones as-
sumed the rank of chief assistant.

*3244. **[Charleston, South Carolina; displaced coping on portico of
old guardhouse, southwest corner of Meeting and Broad
Streets, as seen from northwest]** (P1975.103.31)
Albumen silver print. 1886
Image: 9¹⁵⁄₁₆ x 13¼ in. (25.2 x 33.6 cm.)
Mount: 16¹⁄₁₆ x 20¹⁄₁₆ in. (40.8 x 50.9 cm.) irregular
Inscription, in negative: "16."
Acquired from: Fred Mazzulla, Denver, Colorado

PIRKLE JONES, American (b. 1914)

Pirkle Jones was born in Shreveport, Louisiana, but
raised in Indiana and Ohio. He became interested in
photography during the 1930s and exhibited his work in
pictorialist salons. After a tour of duty in the army dur-
ing World War II, Jones moved to California, where he
studied photography under Ansel Adams and Minor
White at the California School of Fine Arts. He served
as Adams' photographic assistant from 1951 until 1953.
Jones taught at the school from 1952 to 1958 and has
also led photographic workshops with Al Weber. In
1956 Jones worked with Dorothea Lange on "Death of a
Valley," a project that documented California's Berry-
essa Valley before it was flooded as part of an Army
Corps of Engineers dam project. He was also commis-

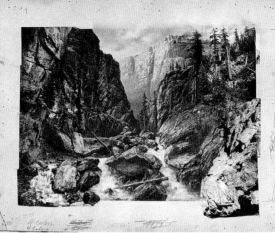

3235

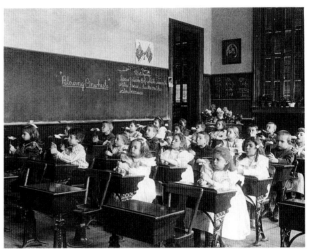

3243

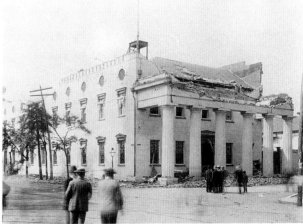

3244

sioned to produce a portfolio commemorating the tenth
anniversary of the signing of the United Nations char-
ter in 1955 and from 1963 to 1965 worked with Ansel
Adams on an exhibition entitled "The Story of a
Winery." With his wife, Ruth-Marion Baruch, he pub-
lished *The Vanguard: A Photographic Essay on the Black
Panthers* in 1970. He has taught at the San Francisco
Art Institute since 1970 and received a National
Endowment for the Arts Fellowship in 1977.

3245. **HOME PLACE. THE VALLEY HELD GENERATIONS
IN ITS PALM. MONTICELLO, CALIFORNIA [part of
Dorothea Lange's "The American Country Woman"]**
(P1965.172.26)
Gelatin silver print. negative 1956, print later
Image: 9¼ x 13 9/16 in. (23.4 x 34.4 cm.)
Mount: same as image size
Inscription, mount verso, on paper label: "Pirkle Jones/File
#OA21034/(from Death/of a Valley)//#14a/of the/Series"
Acquired from: Dorothea Lange, Berkeley, California

**PORTFOLIO TWO: TWELVE PHOTOGRAPHS BY
PIRKLE JONES** (P1968.59.1–12)
This portfolio was published in 1968 in Mill Valley,
California. The foreword is by Ansel Adams, and the
portfolio is dedicated to Ruth-Marion Baruch, Jones'
wife. This is portfolio number 21 of an edition of 110.

*3246. **BREAKING WAVE, GOLDEN GATE, SAN FRANCISCO**
(P1968.59.1)
Gelatin silver print. negative 1952, print 1968
Image: 9 5/16 x 13 5/16 in. (23.6 x 33.8 cm.)
Mount: 14 x 18 in. (35.6 x 45.8 cm.)
Signed, center mount verso: "Pirkle Jones"
Inscription, mount verso: "1421" and rubber stamp "663
LOVELL AVENUE/MILL VALLEY, CALIFORNIA 94941/
The photographer reserves all rights/to reproduction./SET
NUMBER [in ink] 21/PRINT NUMBER [in ink] 1"
Acquired from: the photographer

3247. **LOG AND GOLDEN GATE BRIDGE, SAN FRANCISCO**
(P1968.59.2)
Gelatin silver print. negative 1952, print 1968
Image: 9 7/16 x 13 3/8 in. (24.0 x 33.9 cm.)
Mount: 14 x 18 in. (35.6 x 45.8 cm.)
Signed, center mount verso: "Pirkle Jones"
Inscription, mount verso, rubber stamp: "663 LOVELL
AVENUE/MILL VALLEY, CALIFORNIA 94941/The
photographer reserves all rights/to reproduction./SET
NUMBER [in ink] 21/PRINT NUMBER [in ink] 2"
Acquired from: the photographer

3248. **VIEW OF SAN FRANCISCO IN THE RAIN** (P1968.59.3)
Gelatin silver print. negative 1952, print 1968
Image: 9 3/8 x 13 3/8 in. (23.8 x 34.0 cm.)
Mount: 14 x 18 in. (35.6 x 45.8 cm.)
Signed, center mount verso: "Pirkle Jones"
Inscription, mount verso, rubber stamp: "663 LOVELL
AVENUE/MILL VALLEY, CALIFORNIA 94941/The
photographer reserves all rights/to reproduction./SET
NUMBER [in ink] 21/PRINT NUMBER [in ink] 3"
Acquired from: the photographer

3249. **WOMAN WITH UMBRELLA, SAN FRANCISCO**
(P1968.59.4)
Gelatin silver print. negative 1955, print 1968
Image: 13 9/16 x 9 7/16 in. (34.5 x 24.0 cm.)
Mount: 18 x 13 11/16 in. (45.8 x 34.6 cm.)
Signed, center mount verso: "Pirkle Jones"
Inscription, mount verso: "1421" and rubber stamp "663
LOVELL AVENUE/MILL VALLEY, CALIFORNIA 94941/
The photographer reserves all rights/to reproduction./SET
NUMBER [in ink] 21/PRINT NUMBER [in ink] 4"
Acquired from: the photographer

3250. **SUNSET DISTRICT AND PACIFIC OCEAN,
SAN FRANCISCO** (P1968.59.5)
Gelatin silver print. negative 1951, print 1968
Image: 9 5/8 x 13 3/8 in. (24.4 x 33.9 cm.)
Mount: 14 x 18 in. (35.6 x 45.8 cm.)
Signed, center mount verso: "Pirkle Jones"
Inscription, mount verso, rubber stamp: "663 LOVELL
AVENUE/MILL VALLEY, CALIFORNIA 94941/The
photographer reserves all rights/to reproduction./SET
NUMBER [in ink] 21/PRINT NUMBER [in ink] 5"
Acquired from: the photographer

*3251. **FIGURES IN THE RAIN, SAN FRANCISCO** (P1968.59.6)
Gelatin silver print. negative 1955, print 1968
Image: 9 15/16 x 13 1/2 in. (25.3 x 34.3 cm.)
Mount: 14 x 18 in. (35.6 x 45.8 cm.)
Signed, center mount verso: "Pirkle Jones"
Inscription, mount verso, rubber stamp: "663 LOVELL
AVENUE/MILL VALLEY, CALIFORNIA 94941/The
photographer reserves all rights/to reproduction./SET
NUMBER [in ink] 21/PRINT NUMBER [in ink] 6"
Acquired from: the photographer

3252. **WORKER, SARATOGA, CALIFORNIA** (P1968.59.7)
Gelatin silver print. negative 1958, print 1968
Image: 13 1/16 x 10 1/4 in. (33.1 x 26.0 cm.)
Mount: 18 x 14 in. (45.8 x 35.6 cm.)
Signed, center mount verso: "Pirkle Jones"
Inscription, mount verso, rubber stamp: "663 LOVELL
AVENUE/MILL VALLEY, CALIFORNIA 94941/The
photographer reserves all rights/to reproduction./SET
NUMBER [in ink] 21/PRINT NUMBER [in ink] 7"
Acquired from: the photographer

3253. **GRAPE PICKER, BERRYESSA VALLEY, CALIFORNIA**
(P1968.59.8)
Gelatin silver print. negative 1956, print 1968
Image: 13 1/8 x 10 1/2 in. (33.3 x 26.7 cm.)
Mount: 18 x 14 in. (45.8 x 35.6 cm.)
Signed, center mount verso: "Pirkle Jones"
Inscription, mount verso, rubber stamp: "663 LOVELL
AVENUE/MILL VALLEY, CALIFORNIA 94941/The
photographer reserves all rights/to reproduction./SET
NUMBER [in ink] 21/PRINT NUMBER [in ink] 8"
Acquired from: the photographer

3254. **OAK TREE AND ROCK, BLACK HAWK, CALIFORNIA**
(P1968.59.9)
Gelatin silver print. negative 1954, print 1968
Image: 9 1/4 x 13 1/4 in. (23.5 x 33.7 cm.)
Mount: 14 x 18 in. (35.6 x 45.8 cm.)
Signed, center mount verso: "Pirkle Jones"
Inscription, mount verso, rubber stamp: "663 LOVELL
AVENUE/MILL VALLEY, CALIFORNIA 94941/The
photographer reserves all rights/to reproduction./SET
NUMBER [in ink] 21/PRINT NUMBER [in ink] 9"
Acquired from: the photographer

3255. **COWBOY, ARIZONA** (P1968.59.10)
Gelatin silver print. negative 1957, print 1968
Image: 10 3/16 x 13 5/16 in. (25.9 x 33.8 cm.)
Mount: 14 x 18 in. (35.6 x 45.8 cm.)
Signed, center mount verso: "Pirkle Jones"
Inscription, mount verso, rubber stamp: "663 LOVELL
AVENUE/MILL VALLEY, CALIFORNIA 94941/The
photographer reserves all rights/to reproduction./SET
NUMBER [in ink] 21/PRINT NUMBER [in ink] 10"
Acquired from: the photographer

*3256. **LANDSCAPE, JACKSON, CALIFORNIA** (P1968.59.11)
Gelatin silver print. negative 1948, print 1968
Image: 9 1/16 x 13 7/16 in. (23.0 x 34.1 cm.)
Mount: 14 x 18 in. (35.6 x 45.8 cm.)
Signed, center mount verso: "Pirkle Jones"
Inscription, mount verso, rubber stamp: "663 LOVELL
 AVENUE/MILL VALLEY, CALIFORNIA 94941/The
 photographer reserves all rights/to reproduction./SET
 NUMBER [in ink] 21/PRINT NUMBER [in ink] 11"
Acquired from: the photographer

3257. **GARDEN DETAIL, SAN FRANCISCO** (P1968.59.12)
Gelatin silver print. negative 1947, print 1968
Image: 6 3/4 x 8 7/16 in. (17.1 x 21.4 cm.)
Mount: 14 x 18 in. (35.6 x 45.8 cm.)
Signed, center mount verso: "Pirkle Jones"
Inscription, mount verso, rubber stamp: "663 LOVELL
 AVENUE/MILL VALLEY, CALIFORNIA 94941/The
 photographer reserves all rights/to reproduction./SET
 NUMBER [in ink] 21/PRINT NUMBER [in ink] 12"
Acquired from: the photographer

ARTHUR F. KALES, American (1882–1936)

Kales was an accomplished amateur pictorialist pho-
tographer. Born in Arizona, he grew up in Oakland,
California. Although Kales obtained a law degree from
the University of California at Berkeley in 1903 he
never practiced, working instead as an advertising man-
ager for the firm of Earle C. Anthony. He began to
make photographs about 1915, printing his work in plati-
num, carbon, and gum and exhibiting in various
salons. Kales was elected to the London Salon in 1916
and was a member of the Royal Photographic Society.
He mastered the art of bromoil printing about 1920 and
thereafter worked almost exclusively in that medium.

*3258. **THE DRESSING ROOM DOOR** (P1983.37)
Bromoil transfer print. c. 1923
Image: 5 7/8 x 4 3/8 in. (14.9 x 11.1 cm.)
Sheet: 11 1/8 x 8 1/2 in. (28.3 x 21.5 cm.)
Inscription, sheet recto: "29"
 print verso: "129"
Acquired from: Paul M. Hertzman, Inc., San Francisco,
 California

CONSUELO KANAGA, American (1894–1978)

Consuelo Kanaga's first job was as a newspaper reporter
for the *San Francisco Chronicle*. At the urging of her edi-
tor she learned photography and became a photogra-
pher; after a short time she began to feel that her own
portrait work was more fulfilling than photojournalism
and spent less time working for the newspaper. She
participated in the original Group f/64 show in 1932 but
did not consider herself to be a member of the group.
Kanaga moved to New York in 1934 and became a
member of the New York City-based Photo League, a
group of photographers committed to using documen-
tary photography to spur social change. She also worked
on the Works Progress Administration-sponsored
Federal Art Project on the changing face of New York
in 1936. Kanaga was a close friend of Imogen Cun-
ningham and of Edward Steichen, who hung her photo-
graphs in the 1955 "Family of Man" exhibition.

3246

3251

3256

3259. **BERENICE ABBOTT** (P1978.26)
Gelatin silver print. c. 1935
Image: 10 x 7 15/16 in. (25.4 x 20.2 cm.)
Inscription, print verso: "Berenice Abbott//Photograph by
Consuela [sic] Kanaga—" and rubber stamp
"PHOTOGRAPH/BERENICE ABBOTT/ABBOTT,
MAINE"
mat backing verso: "Berenice Abbott/Photograph by/
Consuela Kanaza [sic]"
Acquired from: The Halsted Gallery, Birmingham, Michigan

*3260. **BERENICE ABBOTT** (P1986.15)
Gelatin silver print. c. 1935
Image: 5 5/8 x 6 1/2 in. (14.2 x 16.5 cm.)
Mount: 16 3/4 x 13 11/16 in. (42.5 x 34.8 cm.)
Signed: see inscription
Inscription, mount verso: "Berenice Abbott/photographed by/
Consuelo Kanaga//Collection: Paul Katz"
Acquired from: gift of Paul Katz, North Bennington, Vermont

YOUSUF KARSH,
Canadian, born Armenia (b. 1908)

Born in Armenia, Karsh was brought to Canada by his
uncle in 1924. He studied photography under John H.
Garo of Boston, Massachusetts. Karsh opened a studio
in Ottawa, Ontario, Canada, in 1932. He became fa-
mous when his 1941 photograph of Winston Churchill
was published on the cover of *Life* magazine. Karsh has
photographed scores of well-known political leaders,
artists, and scientists.

*3261. **EDWARD STEICHEN** (P1978.72)
Gelatin silver print. 1965
Image: 19 3/4 x 15 13/16 in. (50.2 x 40.2 cm.)
Mount: 27 9/16 x 21 1/4 in. (70.0 x 54.0 cm.)
Signed, l.l. mount recto: "Karsh"
Inscription, mount verso: "EDWARD STEICHEN, 1965/
By YOUSUF KARSH"
Acquired from: Graphics International, Ltd.,
Washington, D.C.

GERTRUDE KÄSEBIER, American (1852–1934)

See also *Camera Notes* and *Camera Work*

A founding member of the Photo-Secession, Käsebier
worked primarily as a portrait photographer. She took
up photography only after her children were grown, but
once she decided to pursue it as a career she devoted
herself totally to the craft. She had a close professional
relationship with Alfred Stieglitz, who frequently pub-
lished her work in *Camera Notes* and *Camera Work*. In
1916 she broke with Stieglitz over his commitment to
straight photography and was one of the founding mem-
bers of the Pictorial Photographers of America. Al-
though her photographs are pictorial in terms of tone
and technique, her portraits have a natural and direct
quality. She frequently made photographs of mothers
and children but also photographed fellow artists and
the Indians of the Buffalo Bill Wild West Show.

3262. **[Back portrait showing beadwork vest]** (P1979.35.4)
Platinum print. c. 1898
Image: 8 1/16 x 6 3/16 in. (20.6 x 15.7 cm.)
Inscription, mat backing verso: "Back Portrait Showing
Beadwork Vest"
Acquired from: Robert Schoelkopf Gallery, New York,
New York

*3263. **HAS-NO-HORSE** (P1979.35.3)
Platinum print. 1898
Image: 8 x 6 in. (20.3 x 15.3 cm.)
Mount: 9 5/16 x 7 1/8 in. (23.5 x 18.1 cm.)
Signed: see inscription
Inscription, print recto, embossed: "Gertrude Käsebier"
mount recto: "Copyrighted 1898/HAS-NO-HORSES [sic]."
mount verso: "platinum print"
Acquired from: Robert Schoelkopf Gallery, New York,
New York

3264. **INDIAN CHIEF [from *Camera Notes*, Volume 6, Number 1,
July 1902]** (P1978.62) duplicate in P1981.89.5, *Camera Notes*,
Vol. 6
Photogravure. published 1902
Image: 6 5/16 x 5 in. (16.1 x 12.7 cm.)
Sheet: 11 x 8 in. (28.0 x 20.3 cm.)
Inscription, sheet verso: "44 7/CAMERA NOTES"
Acquired from: Edward Kaufman, Chicago, Illinois

3265. **SCAR FACE** (P1979.35.2)
Platinum print. c. 1898
Image: 7 3/4 x 5 13/16 in. (19.6 x 14.7 cm.)
Inscription, mat backing verso: "Scar Face"
Acquired from: Robert Schoelkopf Gallery, New York,
New York

*3266. **SITTING-HOLY** (P1979.35.1)
Platinum print. c. 1898
Image: 7 13/16 x 6 in. (19.8 x 15.3 cm.)
Signed, l.r. print recto: "Gertrude Käsebier"
Inscription, print recto, embossed: "Gertrude Käsebier"
print verso: "Sitting-Holy."
Acquired from: Robert Schoelkopf Gallery, New York,
New York

3267. **[Unidentified Indian brave]** (P1978.73.2)
Platinum print. c. 1899
Image: 8 1/16 x 5 9/16 in. (20.4 x 14.2 cm.)
Mount: 12 3/8 x 9 13/16 in. (31.5 x 25.0 cm.)
Inscription, mount recto: "42"
Acquired from: Graphics International, Ltd.,
Washington, D.C.

3268. **WHITE WAR BONNET** (P1978.73.1)
Kallitype. 1899
Image: 8 1/16 x 5 15/16 in. (20.4 x 15.0 cm.)
Mount: 12 3/4 x 9 3/4 in. (32.3 x 24.7 cm.)
Inscription, mount recto: "43"
Acquired from: Graphics International, Ltd.,
Washington, D.C.

EDWARD W. KECK, American (active 1900s)

See *Camera Notes*

JOSEPH T. KEILEY, American (1869–1914)

See also *Camera Notes*

Pictorialist photographer Joseph T. Keiley was born in
Brooklyn, New York. An active member of the New
York Camera Club, he became an associate editor of
the club's publication, *Camera Notes*, in 1898 and
through the club developed a close relationship with Al-
fred Stieglitz. Keiley was elected to the exclusive British
photography group the Linked Ring in 1900 and was
active on their salon committee. He maintained his ties
with Stieglitz when Stieglitz resigned from the New
York Camera Club and founded his own publication,
Camera Work. Keiley became an associate editor of
Camera Work and over the years contributed many arti-



3258

3260

3261

3263

3266

cles and reviews. He traveled widely and exhibited his prints in salons throughout the United States and Europe. Keiley died in 1914 of Bright's disease.

*3269. **PHILIP STANDING SOLDIER** (P1984.14)
Glycerine-developed platinum print. 1898
Image: 7 11/$_{16}$ x 5 5/$_{8}$ in. (19.5 x 14.3 cm.)
Mount: 7 13/$_{16}$ x 5 3/$_{4}$ in. (19.8 x 14.6 cm.)
Acquired from: Paul Katz, North Bennington, Vermont

GIBSON KENNEDY, JR., American (b. 1949)

Kennedy holds a degree in motion picture production and worked as a freelance cameraman before taking up still photography about 1972. He first did commercial work but later became the supervisor of the photographic laboratory at Harvard College Observatory. Kennedy, who is self-taught, prefers to work with view cameras and has experimented with cameras as large as 20 x 24 inches. He began making platinum/palladium prints about 1977.

3270. **FEDERAL RESERVE BUILDING, BOSTON, NO. 2**
(P1978.30.2)
Platinum/palladium print. 1977
Image: 9 3/$_{4}$ x 7 11/$_{16}$ in. (24.7 x 19.5 cm.)
Sheet: 10 15/$_{16}$ x 9 in. (27.8 x 22.9 cm.)
Signed, bottom edge sheet recto: "Gibson B. Kennedy Jr."
Inscription, sheet recto: "1c [in each corner]//Federal Reserve
Building, Boston, No. 2 July 1977"
mat backing verso: "Gibson B. Kennedy Jr./Federal
Reserve Building, Boston, July 1977, No 2/#2"
Acquired from: The Halsted Gallery, Birmingham, Michigan

3271. **SHED STAIRS** (P1978.30.3)
Platinum/palladium print. 1977
Image: 9 5/$_{8}$ x 7 11/$_{16}$ in. (24.5 x 19.5 cm.)
Sheet: 10 15/$_{16}$ x 8 15/$_{16}$ in. (27.8 x 22.7 cm.)
Signed, left edge sheet recto: "Gibson B. Kennedy Jr."
Inscription, sheet recto: "Lc//'Shed Stairs' November 1977
[signature] #4//Lc"
print verso: "1"
mat backing verso: "Gibson B. Kennedy Jr./Shed Stairs,
November 1977/#4"
Acquired from: The Halsted Gallery, Birmingham, Michigan

*3272. **SHOVEL HANDLE** (P1978.30.1)
Platinum/palladium print. 1977
Image: 9 5/$_{8}$ x 7 11/$_{16}$ in. (24.5 x 19.5 cm.)
Sheet: 11 x 9 in. (28.0 x 22.9 cm.)
Signed, bottom edge sheet recto: "Gibson B. Kennedy Jr."
Inscription, sheet recto: "'Shovel Handle' November 1977
[signature] #3"
mat verso: "Gibson B. Kennedy, Jr./Shovel Handle,
November 1977/#3"
Acquired from: The Halsted Gallery, Birmingham, Michigan

VICTOR KEPPLER, American (1904–1987)

Keppler became interested in photography at an early age, selling photographs to finance his education. He attended the City College of New York and New York University and then took a job with commercial photographer Robert Waida, who had studied under Clarence White. Keppler did commercial work for many major United States companies, including the Batten, Barton, Durstin & Osborne and the J. Walter Thompson advertising agencies. During World War II he designed war bond ads for the Treasury Department and later worked as a creative consultant for Hallmark Cards. Keppler also designed several covers for the *Saturday Evening Post*. His awards included the Harvard

Award for excellence in newspaper and magazine advertising photography and the City College of New York alumni award for achievement in photography. Keppler was also instrumental in founding the Famous Photographers School.

MAN + CAMERA I (P1982.18.1–10)

This is portfolio number 7 of an edition of 25 published by Victor Keppler.

3273. **[Keppler's oldest sister]** (P1982.18.1)
Gelatin silver print. negative 1917, print later
Image: 10 x 7 11/$_{16}$ in. (25.4 x 19.5 cm.)
Sheet: 14 x 11 in. (35.6 x 28.0 cm.)
Signed, l.r. sheet recto: "Victor Keppler"
Inscription, sheet recto: "7/25"
Acquired from: gift of John W. Weikert, Westport,
Connecticut

3274. **[Still life: wooden bowl, vase, and plate]** (P1982.18.2)
Gelatin silver print. negative 1921, print later
Image: 8 13/$_{16}$ x 7 11/$_{16}$ in. (22.3 x 19.5 cm.)
Sheet: 14 x 11 in. (35.6 x 28.0 cm.)
Signed, l.r. sheet recto: "Victor Keppler"
Inscription, sheet recto: "7/25"
Acquired from: gift of John W. Weikert, Westport,
Connecticut

*3275. **[Eyeglasses: studio assignment for American Optical
Company]** (P1982.18.3)
Gelatin silver print. negative 1927, print later
Image: 9 15/$_{16}$ x 7 1/$_{2}$ in. (25.2 x 19.0 cm.)
Sheet: 14 x 11 in. (35.6 x 28.0 cm.)
Signed, l.r. sheet recto: "Victor Keppler"
Inscription, sheet recto: "7/25"
Acquired from: gift of John W. Weikert, Westport,
Connecticut

3276. **[Construction worker at Rockefeller Center; ad for
Chesterfield cigarettes]** (P1982.18.4)
Gelatin silver print. negative 1932, print later
Image: 9 13/$_{16}$ x 7 3/$_{4}$ in. (24.8 x 19.7 cm.)
Sheet: 14 x 11 in. (35.6 x 28.0 cm.)
Signed, l.r. sheet recto: "Victor Keppler"
Inscription, sheet recto: "7/25"
Acquired from: gift of John W. Weikert, Westport,
Connecticut

3277. **EDDIE CANTOR** (P1982.18.5)
Gelatin silver print. negative 1938, print later
Image: 10 x 7 5/$_{8}$ in. (25.4 x 19.4 cm.)
Sheet: 14 x 11 in. (35.6 x 28.0 cm.)
Signed, l.r. sheet recto: "Victor Keppler"
Inscription, sheet recto: "7/25"
Acquired from: gift of John W. Weikert, Westport,
Connecticut

3278. **[Spool and thread design]** (P1982.18.6)
Gelatin silver print. negative 1939, print later
Image: 6 7/$_{8}$ x 10 in. (17.5 x 25.4 cm.)
Sheet: 11 x 14 in. (28.0 x 35.6 cm.)
Signed, l.r. sheet recto: "Victor Keppler"
Inscription, sheet recto: "7/25"
Acquired from: gift of John W. Weikert, Westport,
Connecticut

*3279. **IMPRISONED BY A LUMP OF COAL** (P1982.18.7)
Gelatin silver print. negative 1940, print later
Image: 7 7/$_{16}$ x 9 5/$_{16}$ in. (18.9 x 23.7 cm.)
Sheet: 11 1/$_{8}$ x 14 in. (28.3 x 35.6 cm.)
Signed, l.r. sheet recto: "Victor Keppler"
Inscription, sheet recto: "7/25"
Acquired from: gift of John W. Weikert, Westport,
Connecticut

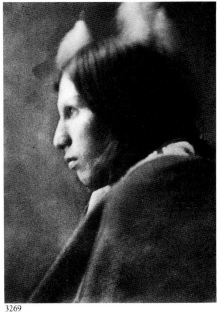

3269

3272

3275

3279

3280

*3280. **UNCLE SAM FIGHTING MAD** (P1982.18.8)
Gelatin silver print. negative 1942, print later
Image: 9 15/16 x 7 11/16 in. (25.2 x 19.5 cm.)
Sheet: 14 x 11 in. (35.6 x 28.0 cm.)
Signed, l.r. sheet recto: "Victor Keppler"
Inscription, sheet recto: "7/25"
Acquired from: gift of John W. Weikert, Westport,
Connecticut

3281. **SWANS, TREES AND BED SHEETS** (P1982.18.9)
Gelatin silver print. negative 1969, print later
Image: 10 x 6 7/8 in. (25.2 x 17.5 cm.)
Sheet: 14 x 11 in. (35.6 x 28.0 cm.)
Signed, l.r. sheet recto: "Victor Keppler"
Inscription, sheet recto: "7/25"
Acquired from: gift of John W. Weikert, Westport,
Connecticut

3282. **DOGWOOD** (P1982.18.10)
Gelatin silver print. negative 1969, print later
Image: 7 1/4 x 9 15/16 in. (18.4 x 25.2 cm.)
Sheet: 11 1/8 x 14 in. (28.3 x 35.6 cm.)
Signed, l.r. sheet recto: "Victor Keppler"
Inscription, sheet recto: "7/25"
Acquired from: gift of John W. Weikert, Westport,
Connecticut

MARSHALL R. KERNOCHAN,
American (active 1900s)

See *Camera Work*

ANDRÉ KERTÉSZ,
American, born Austria-Hungary (1894–1985)

Born in Budapest, Kertész was forced to take a job as a
clerk in the stock exchange at the age of fourteen fol-
lowing his father's death. He bought a camera with his
earnings and by the time he became a soldier in the
Austro-Hungarian army during World War I, he was
deeply involved in photography. After a brief return to
work at the stock exchange following the war, Kertész
moved to Paris in 1925. There he became part of the
avant-garde art movement and his freelance work was
widely published. Kertész was one of the first photogra-
phers to use the 35mm camera on a regular basis. In
1936 he came to the United States under a contract
with Keystone Studios. The arrangement did not work
out, however, and the outbreak of World War II pre-
vented him from returning to Europe. He became an
American citizen in 1944 and in 1946 went to work for
Condé Nast publications. Although not happy with his
work for the publisher, he remained at Condé Nast until
his retirement in 1962, when he resumed his personal
work. Kertész did not make his own prints after 1941,
due to health problems, and Igor Bahkt became his
exclusive printer. Among the many awards Kertész
received during the later years of his life was the 1984
Friends of Photography Peer Award for a Distinguished
Career in Photography.

*3283. **NEWTON COUNTY, U.S.A.** (P1984.19)
Gelatin silver print. 1958, print by Igor Bahkt
Image: 7 3/8 x 9 5/8 in. (18.8 x 24.5 cm.)
Mount: 15 15/16 x 19 15/16 in. (40.4 x 50.6 cm.)
Signed, l.r. mount recto: "A. Kertész"
Inscription, mount recto: "1958"
 mount verso: "Oct 5-1958." and rubber stamp "© PHOTO
 BY/ANDRÉ KERTÉSZ"
Acquired from: The Witkin Gallery, New York, New York

ROBERT GLENN KETCHUM,
American (b. 1947)

Ketchum received a B.A. in design at the University
of California at Los Angeles, after first majoring in poli-
tical history. He received an M.F.A. in photography
from the California Institute of the Arts. Ketchum was
one of the earliest photographers to make large-scale
color prints (having worked in this format since 1971)
and to use cibachrome color material exclusively.
Ketchum's landscape photographs reveal an interest
in biology and the natural world, focusing on biologi-
cal objects rather than geographical locations; the
images also are overtly political and critical of the gov-
ernment's destruction of federally managed lands.
In addition to numerous other grants, commissions,
and awards, he received the Sierra Club's 1989
Ansel Adams Award for Conservation Photography.
Ketchum's work has been exhibited in over 250 group
and individual shows. In 1979 he was one of twelve pho-
tographers in "Landscape Photographers and America's
National Parks: A Symbiosis," the first photography ex-
hibition to hang in the White House. Among the pub-
lications in which his work appears are *The Tongass:
Alaska's Vanishing Rain Forest, The Hudson River and the
Highlands, American Photographers and the National
Parks, Seafarm, Chinese Influence on American West
Coast Contemporary Art,* and *Robert Glenn Ketchum:
A Survey of Work/1970–1987.* Ketchum also has curated
several shows, including "American Photographers
and the National Parks," which appeared at the
Amon Carter Museum in 1982. He was recently named
to the United Nations Global 500 Roll of Honor for
Outstanding Environment Achievement.

3284. **GAMBEL OAK, MESA VERDE** [from the portfolio "Robert
Glenn Ketchum—Selections from American Photographers
and the National Parks"] (P1987.6.1)
Cibachrome print. negative 1977, print 1981 by Michael
Wilder
Image: 23 1/4 x 29 11/16 in. (59.1 x 75.4 cm.)
Sheet: 25 1/16 x 30 in. (63.6 x 76.1 cm.)
Signed, right center print verso and l.r. overmat recto: "RG
Ketchum"
Inscription, print verso: " "Gambel Oak, Mesa Verde" 1977//
17/25"
 overmat recto: " "Gambel Oak, Mesa Verde" 1977// 17/25"
Acquired from: anonymous gift

3285. **JEDEDIAH, AFTER THE RAIN** [from the portfolio
"Robert Glenn Ketchum—Selections from American
Photographers and the National Parks"] (P1987.6.2)
Cibachrome print. negative 1978, print 1981 by
Michael Wilder
Image: 23 1/2 x 29 9/16 in. (59.6 x 75.1 cm.)
Sheet: 25 1/16 x 30 in. (63.6 x 76.1 cm.)
Signed, right center print verso and l.r. overmat recto:
"RG Ketchum"
Inscription, print verso: " "Jedediah, After the Rain" 1978//
17/25"
 overmat recto: " "Jedediah, After the Rain" 1978// 17/25"
Acquired from: anonymous gift

*3286. **TRANSITION** [from the portfolio "Robert Glenn
Ketchum—Selections from American Photographers and the
National Parks"] (P1987.6.3)
Cibachrome print. negative 1980, print 1981 by
Michael Wilder
Image: 23 3/8 x 29 5/8 in. (59.2 x 75.3 cm.)
Sheet: 25 x 30 in. (63.5 x 76.1 cm.)
Signed, right center print verso and l.r. overmat recto:
"RG Ketchum"
Inscription, print verso: " "Transition" 1980// 17/25"
 overmat recto: " "Transition" 1980// 17/25"
Acquired from: anonymous gift

DARIUS KINSEY, American (1871–1945)

See also Jackson Collages

With his wife Tabitha running his darkroom, Darius Kinsey spent over fifty years recording life in the logging camps of Washington state. He opened a studio in Sedro-Wooley, Washington, about 1890, where he made portraits, logging views, and the general work expected of a small town photographer. In 1906 he moved to Seattle and gave up portrait work to concentrate on lumbering views. Kinsey's views, made for commercial purposes and for the lumbering crews, are significant documents of life and commerce in the region.

*3287. **[Group portrait at District No. 71 Schoolhouse]** (P1979.88)
Albumen silver print. c. 1906
Image: 13 9/16 x 10 13/16 in. (34.4 x 27.4 cm.)
Mount: 13 5/8 x 10 7/8 in. (34.5 x 27.5 cm.)
Signed: see inscription
Inscription, in negative: "KINSEY/1970"
Acquired from: Stephen White Gallery, Los Angeles, California

CHARLES D. KIRKLAND,
American (1857–1926)

Kirkland was a native of Crawford County, Ohio, and reportedly learned the photographic trade while living there. He moved to Denver, Colorado, in 1872 and opened a studio with his brothers George and P. G. Kirkland. Charles D. Kirkland moved to Cheyenne, Wyoming, in 1877 and took over the studio of D. D. Ware. There Kirkland made numerous views of cowboys, the cattle industry, and ranch life. He sold his Cheyenne studio to William G. Walker about 1895 and returned to Denver, where he continued to run a studio for several years. Many of Kirkland's negatives were sold to Walker with the studio; Walker and a later owner, Mack Fishback, printed the negatives under their own name, creating a good deal of confusion about the attribution of Kirkland's views.

*3288. **BRANDING ON THE PRAIRIE** (P1979.36.15)
Albumen silver print. c. 1890
Image: 4 9/16 x 7 1/2 in. (11.6 x 19.0 cm.)
Mount: 9 13/16 x 12 1/4 in. (25.0 x 31.1 cm.)
Inscription, in negative: "No 54 Branding on The Prairie"
mount recto: "Wyoming—"
Acquired from: Fifth Avenue Gallery, Scottsdale, Arizona

3289. **CHASING A YEARLING** (P1979.36.11)
Albumen silver print. c. 1877–95
Image: 4 3/4 x 7 11/16 in. (12.0 x 19.4 cm.)
Mount: 9 13/16 x 12 1/4 in. (25.0 x 31.1 cm.)
Inscription, in negative: "Chasing A Yearling"
mount recto: "Wyoming—"
Acquired from: Fifth Avenue Gallery, Scottsdale, Arizona

3290. **COW BOYS AT REST** (P1967.2099)
Albumen silver print. c. 1877–95
Image: 4 5/16 x 7 13/16 in. (10.9 x 19.8 cm.)
Mount: 5 1/4 x 8 1/2 in. (13.3 x 21.6 cm.)
Signed: see inscription
Inscription, in negative: "No 66 COW BOYS AT REST."
mount recto: "C. D. KIRKLAND, PHOTOGRAPHER, CHEYENNE, WYO."
mount verso: "KIRKLAND'S/VIEWS OF COW-BOY LIFE/AND THE CATTLE BUSINESS.//[Series description/List of titles published]"
Acquired from: Fred Rosenstock, Denver, Colorado

3283

3286

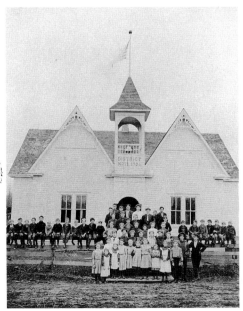
3287

*3291. COW PONY (P1979.36.2)
Albumen silver print. c. 1877–95
Image: 4½ x 7⅜ in. (11.3 x 18.6 cm.)
Mount: 9¹³⁄₁₆ x 12¼ in. (25.0 x 31.1 cm.)
Inscription, in negative: "No. 16 COW PONY"
 mount recto: "Wyoming—"
Acquired from: Fifth Avenue Gallery, Scottsdale, Arizona

3292. CUTTING OUT (P1967.2098)
Albumen silver print. c. 1895
Image: 4³⁄₁₆ x 7⅞ in. (10.6 x 19.9 cm.)
Mount: 5¼ x 8½ in. (13.3 x 21.6 cm.)
Signed: see inscription
Inscription, in negative: "No 46 CUTTING OUT"
 mount recto: "C. D. KIRKLAND, PHOTOGRAPHER,
 CHEYENNE, WYO."
 mount verso: "KIRKLAND'S/VIEWS OF COW-BOY
 LIFE/AND THE CATTLE BUSINESS.//[Series
 description/List of titles published]"
Acquired from: Fred Rosenstock, Denver, Colorado

*3293. DINNER ON HUNTON CREEK (P1979.36.4)
Albumen silver print. c. 1877–95
Image: 4⁹⁄₁₆ x 7¾ in. (11.6 x 19.7 cm.)
Mount: 9¹³⁄₁₆ x 12¼ in. (25.0 x 31.1 cm.)
Inscription, in negative: "No 15 DINNER ON HUNTON
 CREEK"
 mount recto: "Round up—"
Acquired from: Fifth Avenue Gallery, Scottsdale, Arizona

3294. GENERAL VIEW OF ROUND UP (P1979.36.8)
Albumen silver print. c. 1890
Image: 4¾ x 7⅞ in. (12.0 x 20.0 cm.)
Mount: 9¹³⁄₁₆ x 12¼ in. (25.0 x 31.1 cm.)
Inscription, in negative: "[illegible] General View of
 Round Up"
 mount recto: "Wyoming—"
Acquired from: Fifth Avenue Gallery, Scottsdale, Arizona

3295. GINNING (P1979.36.9)
Albumen silver print. c. 1877–95
Image: 4⅝ x 7¾ in. (11.7 x 19.6 cm.)
Mount: 9¹³⁄₁₆ x 12¼ in. (25.0 x 31.1 cm.)
Inscription, in negative: "No 32 Ginning"
 mount recto: "Round Up Wyoming."
Acquired from: Fifth Avenue Gallery, Scottsdale, Arizona

3296. GROUP OF COWBOYS (P1979.36.7)
Albumen silver print. c. 1877–95
Image: 4⅝ x 7¾ in. (11.7 x 19.6 cm.)
Mount: 9¹³⁄₁₆ x 12¼ in. (25.0 x 31.1 cm.)
Inscription, in negative: "No 39 Group of Cowboys"
 mount recto: "Montana Cow Boys—"
Acquired from: Fifth Avenue Gallery, Scottsdale, Arizona

3297. THE HERD (P1979.36.1)
Albumen silver print. c. 1877–95
Image: 4⅜ x 7⅞ in. (11.2 x 19.4 cm.)
Mount: 9¾ x 12¼ in. (24.8 x 31.1 cm.)
Inscription, in negative: "No. 3—The Herd"
 mount recto: "a Wyoming "Round Up"—"
Acquired from: Fifth Avenue Gallery, Scottsdale, Arizona

*3298. HORSE HERD (P1979.36.10)
Albumen silver print. c. 1877–95
Image: 4½ x 7¹¹⁄₁₆ in. (11.3 x 19.5 cm.)
Mount: 9¹³⁄₁₆ x 12¼ in. (25.0 x 31.1 cm.)
Inscription, in negative: "No 37 Horse Herd"
 mount recto: "A Bunch Wild Horses—Montana."
Acquired from: Fifth Avenue Gallery, Scottsdale, Arizona

3299. INSPECTING A HERD OF HALF BREEDS (P1967.2097)
Albumen silver print. c. 1877–95
Image: 4⁷⁄₁₆ x 7¹³⁄₁₆ in. (11.3 x 19.8 cm.)
Mount: 5⁵⁄₁₆ x 8½ in. (13.4 x 21.6 cm.)
Signed: see inscription

Inscription, in negative: "No 26 INSPECTING A HERD OF
 HALF BREEDS."
 mount recto: "C. D. KIRKLAND, PHOTOGRAPHER,
 CHEYENNE, WYO."
 mount verso: "120 l. 7" x 3½" (FAR)//KIRKLAND'S/
 VIEWS OF COW-BOY LIFE/AND THE CATTLE
 BUSINESS//[Series description/List of titles published]"
Acquired from: Fred Rosenstock, Denver, Colorado

*3300. A PITCHING BRONCO (P1979.36.5)
Albumen silver print. c. 1877–87
Image: 4⅝ x 7¾ in. (11.7 x 19.7 cm.)
Mount: 9¹³⁄₁₆ x 12¼ in. (25.0 x 31.1 cm.)
Inscription, in negative: "No 48 A Pitching Broncho"
 mount recto: "Cowponies—Wyoming."
Acquired from: Fifth Avenue Gallery, Scottsdale, Arizona

3301. ROPING A STEER TO INSPECT BRAND (P1979.36.16)
Albumen silver print. c. 1877–95
Image: 4⁵⁄₁₆ x 7¹³⁄₁₆ in. (10.9 x 19.8 cm.)
Mount: 9¹³⁄₁₆ x 12¼ in. (25.0 x 31.1 cm.)
Inscription, in negative: "No. 38 Roping a Steer to inspect
 brand"
 mount recto: "Wyoming—//Kirkland's Views of Cow boy
 Life and the Cattle Business"
Acquired from: Fifth Avenue Gallery, Scottsdale, Arizona

3302. ROPING AND CUTTING OUT (P1979.36.12)
Albumen silver print. c. 1877–95
Image: 4¾ x 8¹⁄₁₆ in. (12.0 x 20.4 cm.)
Mount: 9¹³⁄₁₆ x 12¼ in. (25.0 x 31.1 cm.)
Inscription, in negative: "No 21 ROPING AND CUTTING
 OUT"
 mount recto: "Wyoming—"
Acquired from: Fifth Avenue Gallery, Scottsdale, Arizona

3303. ROUNDING EM UP (P1979.36.13)
Albumen silver print. c. 1877–95
Image: 4¾ x 8 in. (12.0 x 20.3 cm.)
Mount: 9¹³⁄₁₆ x 12¼ in. (25.0 x 31.1 cm.)
Inscription, in negative: "No 30 Rounding Em Up"
 mount recto: "Wyoming—"
Acquired from: Fifth Avenue Gallery, Scottsdale, Arizona

3304. THROWING A STEER (P1979.36.14)
Albumen silver print. c. 1877–87
Image: 4⁷⁄₁₆ x 7⅜ in. (11.2 x 18.7 cm.)
Mount: 9¹³⁄₁₆ x 12¼ in. (25.0 x 31.1 cm.)
Inscription, in negative: "No 44 Throwing A Steer"
 mount recto: "Wyoming—"
Acquired from: Fifth Avenue Gallery, Scottsdale, Arizona

Attributed to Charles D. Kirkland
*3305. WYOMING COW·BOY (P1979.36.3)
Albumen silver print. c. 1877–95
Image: 7⁷⁄₁₆ x 4½ in. (18.9 x 11.5 cm.)
Mount: 12¼ x 9¹³⁄₁₆ in. (31.1 x 25.0 cm.)
Signed: see inscription
Inscription, print recto, embossed: "Graham"
 mount recto: "Wyoming Cow·Boy—"
Acquired from: Fifth Avenue Gallery, Scottsdale, Arizona

3306. WYOMING COW·BOY (P1979.36.6)
Albumen silver print. c. 1877–95
Image: 4⁷⁄₁₆ x 7⅜ in. (11.2 x 18.7 cm.)
Mount: 9¹³⁄₁₆ x 12¼ in. (25.0 x 31.1 cm.)
Inscription, mount recto: "Wyoming Cow·Boy."
Acquired from: Fifth Avenue Gallery, Scottsdale, Arizona

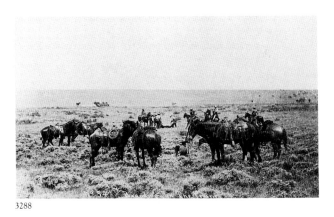

3288

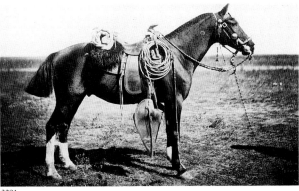

3291

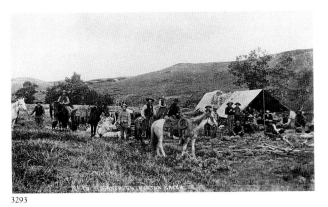

3293

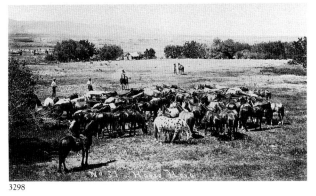

3298

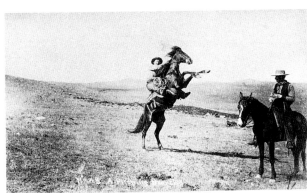

3300

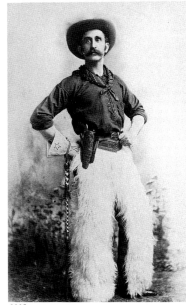

3305

MARK KLETT, American (b. 1952)

Mark Klett received a B.S. in geology from St. Law-
rence University in Canton, New York, in 1974 and an
M.F.A. in photography from the State University of
New York at Buffalo program at the Visual Studies
Workshop in Rochester, New York, in 1977. He worked
as a geology field assistant from 1974 to 1976 and, follow-
ing his graduate training, combined his interests in
geology and photography by working as the chief
photographer for the Rephotographic Survey Project,
a study that rephotographed sites documented by
nineteenth-century survey photographers. During this
period Klett also served as the Assistant Director of the
Photography Department at the Sun Valley Center for
the Arts and Humanities in Sun Valley, Idaho. In 1982
he became the Studio Manager/Printer of the Photogra-
phy Collaborative Facility at the Arizona State Univer-
sity School of Art. Klett has exhibited his work widely
and has received several awards for his work, including
Fellowships from the National Endowment for the Arts
in 1982 and 1984.

3307. **AROUND TOROWEAP POINT JUST BEFORE AND
AFTER SUNDOWN BEGINNING AND ENDING
WITH VIEWS USED BY J.K. HILLERS OVER ONE
HUNDRED YEARS AGO, GRAND CANYON** (P1987.11)
Dye-transfer print (five-print panorama). 1986
Image: a) 19¼ x 15 in. (48.9 x 38.1 cm.)
 b) 19¼ x 15 in. (48.9 x 38.1 cm.)
 c) 19¼ x 14¹⁵/₁₆ in. (48.9 x 37.9 cm.)
 d) 19¼ x 15 in. (48.9 x 38.1 cm.)
 e) 19¼ x 14¹⁵/₁₆ in. (48.9 x 37.9 cm.)
Sheet: a) 19¹⁵/₁₆ x 15¾ in. (50.6 x 39.9 cm.)
 b) 19¹⁵/₁₆ x 15⁷/₁₆ in. (50.6 x 39.2 cm.)
 c) 19¹⁵/₁₆ x 15⁷/₁₆ in. (50.6 x 39.2 cm.)
 d) 19¹⁵/₁₆ x 15½ in. (50.6 x 39.3 cm.)
 e) 19¹⁵/₁₆ x 15¹¹/₁₆ in. (50.6 x 39.8 cm.)
Overall (sheet size): 19¹⁵/₁₆ x 77¹³/₁₆ in. (50.6 x 197.5 cm.)
Signed, each panel, l.l. print verso: "Mark Klett"
Inscription, each panel, print verso: "© 1986 [signature] dye
 transfer print Oct '86 #4/5 (part [number] of 5)"
Acquired from: Etherton Gallery, Tucson, Arizona;
 purchased with funds provided by Polaroid Foundation,
 Inc., Cambridge, Massachusetts

*3308. **CAMPSITE REACHED BY BOAT THROUGH WATERY
CANYONS, LAKE POWELL** (P1984.25)
Gelatin silver print. 1983
Image: 16 x 19⅞ in. (40.7 x 50.5 cm.)
Sheet: 22 x 27¾ in. (55.9 x 70.5 cm.)
Inscription, print recto: "Campsite reached by boat through
 watery canyons Lake Powell 8/20/83"
 mount recto: "MK 180.Y"
Acquired from: Fraenkel Gallery, San Francisco, California

STUART KLIPPER, American (b. 1945)

Stuart Klipper was born in the Bronx and received a
B.A. from the University of Michigan in 1962. Al-
though he helped edit and produce films during the late
1960s, Klipper's career has focused on still photography.
He has also taught or served as a visiting artist at a
number of midwestern colleges and universities and
conducted several photography workshops. Klipper re-
ceived a National Endowment for the Arts Pilot Pho-
tographic Survey Project grant in 1976–77, an NEA
Photographer's Fellowship in 1979–80, a Guggenheim
Fellowship for the same period, and another Guggen-
heim Fellowship in 1989.

3309. **BENEATH ACID VAPORIZER, GULF COAST
CHEMICAL PLANT** [from "Contemporary Texas:
A Photographic Portrait"] (P1985.17.98)
Type C color print. 1984
Image: 11¹⁵/₁₆ x 38⅛ in. (30.3 x 96.8 cm.)
Sheet: 15¹⁵/₁₆ x 44¼ in. (40.5 x 112.4 cm.)
Signed, bottom edge print verso: "STUART D KLIPPER"
Inscription, print verso: "TX 384 BENEATH ACID
 VAPORIZER, DU PONT DEER PART [sic] VINYL
 ACETATE PLANT, DEER PARK, TEXAS, SPRING
 1984—FROM "THE WORLD IN A FEW STATES""
Acquired from: gift of the Texas Historical Foundation with
 support from a major grant from the Du Pont Company
 and Conoco, its energy subsidiary, and assistance from
 the Texas Commission on the Arts and the National
 Endowment for the Arts

3310. **BETH JACOB SYNAGOGUE, GALVESTON** [from
"Contemporary Texas: A Photographic Portrait"]
(P1985.17.97)
Type C color print. 1984
Image: 11¹⁵/₁₆ x 38⅛ in. (30.3 x 96.8 cm.)
Sheet: 15¹⁵/₁₆ x 44¼ in. (40.5 x 112.4 cm.)
Signed, bottom edge print verso: "STUART D KLIPPER"
Inscription, print verso: "TX 439 BETH JACOB
 SYNAGOGUE, GALVESTON, TEXAS, SPRING 1984—
 FROM "THE WORLD IN A FEW STATES""
Acquired from: gift of the Texas Historical Foundation with
 support from a major grant from the Du Pont Company
 and Conoco, its energy subsidiary, and assistance from
 the Texas Commission on the Arts and the National
 Endowment for the Arts

3311. **BOX CAR, OFF PORT INDUSTRIAL BOULEVARD,
PORT OF GALVESTON** [from "Contemporary Texas:
A Photographic Portrait"] (P1985.17.93)
Type C color print. 1984
Image: 11¹⁵/₁₆ x 38³/₁₆ in. (30.3 x 96.9 cm.)
Sheet: 15¹⁵/₁₆ x 44³/₁₆ in. (40.5 x 112.3 cm.)
Signed, bottom edge print verso: "STUART D. KLIPPER"
Inscription, print verso: "TX 431 BOX CAR, OFF PORT
 INDUSTRIAL BLVD., PORT OF GALVESTON, TEXAS,
 SPRING 1984—FROM "THE WORLD IN A FEW
 STATES""
Acquired from: gift of the Texas Historical Foundation with
 support from a major grant from the Du Pont Company
 and Conoco, its energy subsidiary, and assistance from
 the Texas Commission on the Arts and the National
 Endowment for the Arts

*3312. **HITCHCOCK BAYOU FROM I-75, GALVESTON
COUNTY** [from "Contemporary Texas: A Photographic
Portrait"] (P1985.17.91)
Type C color print. 1984
Image: 11¹⁵/₁₆ x 38⅛ in. (30.3 x 96.8 cm.)
Sheet: 15¹⁵/₁₆ x 44 in. (40.5 x 111.8 cm.)
Signed, bottom edge print verso: "STUART D. KLIPPER"
Inscription, print verso: "TX 426 HITCHCOCK BAYOU
 FROM I75, GALVESTON CO., TEXAS, SPRING 1984—
 FROM "THE WORLD IN A FEW STATES""
Acquired from: gift of the Texas Historical Foundation with
 support from a major grant from the Du Pont Company
 and Conoco, its energy subsidiary, and assistance from
 the Texas Commission on the Arts and the National
 Endowment for the Arts

3313. **INDUSTRIAL DISTRICT, McKINNEY, TEXAS** [EDC Ag
Center and grain elevators] (P1986.13.1)
Gelatin silver print. 1985
Image: 8¹³/₁₆ x 13⅛ in. (22.4 x 33.3 cm.)
Sheet: 10¹⁵/₁₆ x 14 in. (27.8 x 35.5 cm.)
Signed, bottom edge print verso: "STUART KLIPPER"
Inscription, print verso: "INDUSTRIAL DISTRICT,
 McKINNEY, TEXAS, 1985"
Acquired from: gift of the photographer

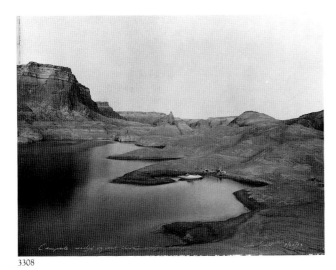

3308

3314

3312

3321

*3314. **INDUSTRIAL DISTRICT, McKINNEY, TEXAS** [railroad crossing] (P1986.13.3)
Gelatin silver print. 1985
Image: 8 13/16 x 13 1/8 in. (22.4 x 33.3 cm.)
Sheet: 11 x 14 in. (27.9 x 35.6 cm.)
Signed, bottom edge print verso: "STUART KLIPPER"
Inscription, print verso: "INDUSTRIAL DISTRICT, McKINNEY, TEXAS, 1985"
Acquired from: gift of the photographer

3315. **INDUSTRIAL DISTRICT, McKINNEY, TEXAS** [Rhodes Ammonia tank cars] (P1986.13.2)
Gelatin silver print. 1985
Image: 8 13/16 x 13 1/16 in. (22.4 x 33.2 cm.)
Sheet: 11 x 14 in. (27.9 x 35.6 cm.)
Signed, bottom edge print verso: "STUART KLIPPER"
Inscription, print verso: "INDUSTRIAL DISTRICT, McKINNEY, TEXAS, 1985"
Acquired from: gift of the photographer

3316. **LOOKING OUT FROM LOADING AREA, DU PONT VINYL ACETATE PLANT, DEER PARK** [from "Contemporary Texas: A Photographic Portrait"] (P1985.17.95)
Type C color print. 1984
Image: 11 15/16 x 38 3/16 in. (30.3 x 96.9 cm.)
Sheet: 15 15/16 x 43 7/8 in. (40.5 x 111.3 cm.)
Signed, bottom edge print verso: "STUART D KLIPPER"
Inscription, print verso: "TX 388 LOOKING OUT FROM LOADING AREA, DU PONT DEER PARK VINYL ACETATE PLANT, DEER PARK, TEXAS, SPRING 1984—FROM "THE WORLD IN A FEW STATES" "
Acquired from: gift of the Texas Historical Foundation with support from a major grant from the Du Pont Company and Conoco, its energy subsidiary, and assistance from the Texas Commission on the Arts and the National Endowment for the Arts

3317. **PIPES, LOADING AREA, DU PONT VINYL ACETATE PLANT, DEER PARK** [from "Contemporary Texas: A Photographic Portrait"] (P1985.17.99)
Type C color print. 1984
Image: 11 15/16 x 38 3/16 in. (30.3 x 96.9 cm.)
Sheet: 15 15/16 x 44 in. (40.5 x 111.8 cm.)
Signed, bottom edge print verso: "STUART D. KLIPPER"
Inscription, print verso: "TX 389 LOADING AREA, DEER PARK VINYL ACETATE PLANT, DEER PARK, TEXAS, SUMMER 1984—FROM "THE WORLD IN A FEW STATES" "
Acquired from: gift of the Texas Historical Foundation with support from a major grant from the Du Pont Company and Conoco, its energy subsidiary, and assistance from the Texas Commission on the Arts and the National Endowment for the Arts

3318. **SKYLINE, FORT WORTH** [from "The World in a Few States" series] (P1983.29)
Ektacolor print. 1983
Image: 12 x 38 1/8 in. (30.4 x 96.8 cm.)
Sheet: 16 x 42 1/4 in. (40.6 x 112.4 cm.)
Signed, bottom edge print verso: "STUART KLIPPER"
Inscription, print verso: "71//SKYLINE, FORT WORTH" and rubber stamp " "—FROM: THE WORLD IN A FEW STATES." "
Acquired from: gift of the photographer

3319. **TANK FARM, DU PONT POLYVINYL ALCOHOL PLANT, DEER PARK** [from "Contemporary Texas: A Photographic Portrait"] (P1985.17.96)
Type C color print. 1985
Image: 11 15/16 x 38 1/8 in. (30.3 x 96.8 cm.)
Sheet: 15 15/16 x 44 1/8 in. (40.5 x 112.0 cm.)
Signed, bottom edge print verso: "STUART D KLIPPER"
Inscription, print verso: "TX 369 TANK FARM, DU PONT DEER PARK POLYVINYL ALCOHOL PLANT, DEER PARK, TEXAS, SPRING 1985—FROM "THE WORLD IN A FEW STATES" "
Acquired from: gift of the Texas Historical Foundation with support from a major grant from the Du Pont Company and Conoco, its energy subsidiary, and assistance from the Texas Commission on the Arts and the National Endowment for the Arts

3320. **TRACTOR TRAILERS OFF PORT INDUSTRIAL BOULEVARD, PORT OF GALVESTON** [from "Contemporary Texas: A Photographic Portrait"] (P1985.17.92)
Type C color print. 1984
Image: 11 15/16 x 38 3/16 in. (30.3 x 96.9 cm.)
Sheet: 15 15/16 x 44 3/16 in. (40.5 x 112.3 cm.)
Signed, bottom edge print verso: "STUART D. KLIPPER"
Inscription, print verso: "TX 346 TRACTOR TRAILORS [sic], OFF PORT INDUSTRIAL BLVD., PORT OF GALVESTON, TEXAS, SPRING 1984—FROM "THE WORLD IN A FEW STATES" "
Acquired from: gift of the Texas Historical Foundation with support from a major grant from the Du Pont Company and Conoco, its energy subsidiary, and assistance from the Texas Commission on the Arts and the National Endowment for the Arts

*3321. **VALVES AT BASE OF CRUDE STORAGE TANK, DU PONT METHANOL COMPLEX, LA PORTE** [from "Contemporary Texas: A Photographic Portrait"] (P1985.17.100)
Type C color print. 1984
Image: 11 15/16 x 38 3/16 in. (30.3 x 96.9 cm.)
Sheet: 15 15/16 x 44 1/16 in. (40.5 x 112.2 cm.)
Signed, bottom edge print verso: "STUART D KLIPPER"
Inscription, print verso: "TX 406 PIPES FROM CRUDE STORAGE TANK, DU PONT LA PORTE METHANOL COMPLEX, LA PORTE, TEXAS, SPRING 1984—FROM "THE WORLD IN A FEW STATES" "
Acquired from: gift of the Texas Historical Foundation with support from a major grant from the Du Pont Company and Conoco, its energy subsidiary, and assistance from the Texas Commission on the Arts and the National Endowment for the Arts

3322. **VFW POST, 24TH STREET, GALVESTON** [from "Contemporary Texas: A Photographic Portrait"] (P1985.17.94)
Type C color print. 1984
Image: 11 15/16 x 38 3/16 in. (30.3 x 96.8 cm.)
Sheet: 15 15/16 x 44 5/16 in. (40.5 x 112.5 cm.)
Signed, bottom edge print verso: "STUART D KLIPPER"
Inscription, print verso: "TX 440 VFW POST, 24TH ST. GALVESTON, TEXAS, SPRING 1984—FROM "THE WORLD IN A FEW STATES" "
Acquired from: gift of the Texas Historical Foundation with support from a major grant from the Du Pont Company and Conoco, its energy subsidiary, and assistance from the Texas Commission on the Arts and the National Endowment for the Arts

ERNEST KNEE,
American, born Canada (1907–1982)

Born in Montreal, Knee joined the Canadian Merchant Marine as a steward after graduating from high school. Following his tour of duty, he went to work for a restaurant chain, planning to make a career in restaurant management. Those plans fell through when Knee contracted tuberculosis and, in 1929, he moved to Tucson, Arizona, in an attempt to regain his health. In Arizona he met Gina Schnaufer, a painter, who encouraged him to move to Santa Fe. The two married and for nearly ten years Knee lived near Santa Fe making photographs. He was a close friend of Edward Weston, who stayed at his home for a month during the 1937 Guggenheim Fellowship trip. Knee exhibited widely during the 1930s, making large-format landscapes and views of New Mexico architecture. During World War II he ran the photography laboratory for Hughes Aircraft. In 1947 Knee went to Venezuela, where he made motion pictures for an oil company. In 1949 he returned to Venezuela with a National Geographic Society expedition to photograph Angel Falls. He gave up photography in 1949 and opened a company that manufactured carved wooden doors, working there until his retirement in 1970. He came out of retirement in 1979 and began once again to print and exhibit his work.

3323

*3323. **ALCALDE CHURCH N. M.** (P1981.41.2)
Gelatin silver print. 1941
Image: 7 ¹¹/₁₆ x 9 ⁹/₁₆ in. (19.5 x 24.3 cm.)
Sheet: 8 x 10 in. (20.3 x 25.4 cm.)
Signed, l.r. overmat recto: "Ernest Knee 1941"
Inscription, overmat recto: "Alcalde Church N. M"
 overmat verso: "935-10//PG/935-10"
Acquired from: Bob Kapoun Vintage Photograph Gallery,
 Santa Fe, New Mexico

3324. **WINTER IN TAOS** (P1981.41.1)
Gelatin silver print. 1935
Image: 6 ⁹/₁₆ x 8 ⅞ in. (16.7 x 22.5 cm.)
Mount: 12 x 14 in. (30.4 x 35.6 cm.)
Signed, l.r. mount recto: "Ernest Knee 1935"
Inscription, mount recto: "Winter in Taos."
Acquired from: Bob Kapoun Vintage Photograph Gallery,
 Santa Fe, New Mexico

3333

DAVID KNOX (active 1860s)

See *Gardner's Photographic Sketch Book of the War*

MICHAEL KOSTIUK, American (b. 1944)

Kostiuk was born in Paris, Texas, and studied with Russell Lee at the University of Texas at Austin and at the Maryland Institute of Arts. He spent his early years working as a commercial photographer and cinematographer and taught both subjects while in the U.S. Army. In 1971 the Amon Carter Museum commissioned him to document the Big Thicket region of East Texas in a photographic essay and slide show entitled "The Big Thicket: A Way of Life." Kostiuk's later projects have included still photography and multimedia projects as well as one-of-a-kind books, photo groupings, stereos, and life-sized photographs.

3334

3325. [Back of pickup truck overlooking oil well] (P1975.91.14)
Gelatin silver print. 1970−71
Image: 19 ⅛ x 13 in. (48.5 x 33.0 cm.)
Sheet: 19 ⅜ x 13 ³⁄₁₆ in. (49.2 x 33.4 cm.)
Signed, bottom print verso: "M. Kostiuk"
Acquired from: the photographer

3326. [First Assembly of God Church] (P1975.91.15)
Gelatin silver print. 1970−71
Image: 12 ¹⁵⁄₁₆ x 19 ¼ in. (32.9 x 48.9 cm.)
Sheet: 13 ³⁄₁₆ x 19 ½ in. (33.4 x 49.5 cm.)
Signed, bottom print verso: "M. Kostiuk"
Acquired from: the photographer

3327. [Grocery store doorway] (P1975.91.11)
Gelatin silver print. 1970−71
Image: 19 ⅛ x 12 ¹⁵⁄₁₆ in. (48.5 x 32.9 cm.)
Sheet: 19 ⅜ x 13 ³⁄₁₆ in. (49.2 x 33.4 cm.)
Signed, bottom print verso: "M. Kostiuk"
Acquired from: the photographer

3328. [Hardwood tree (detail)] (P1975.91.7)
Gelatin silver print. negative 1970−71, print 1975
Image: 18 ⅛ x 12 ¼ in. (46.1 x 31.2 cm.)
Sheet: 20 x 16 in. (50.8 x 40.7 cm.)
Signed, l.r. print verso: "M. Kostiuk"
Acquired from: trade with the photographer

3329. [Office window] (P1975.91.13)
Gelatin silver print. 1970−71
Image: 19 ⅛ x 12 ¹⁵⁄₁₆ in. (48.5 x 32.9 cm.)
Sheet: 19 ⁵⁄₁₆ x 13 ³⁄₁₆ in. (49.0 x 33.4 cm.)
Signed, bottom print verso: "M. Kostiuk"
Acquired from: the photographer

3330. [Oilers cafe] (P1975.91.12)
Gelatin silver print. 1970−71
Image: 19 ⅛ x 12 ¹⁵⁄₁₆ in. (48.5 x 32.9 cm.)
Sheet: 19 ⅜ x 13 ³⁄₁₆ in. (49.2 x 33.4 cm.)
Signed, bottom print verso: "M. Kostiuk"
Acquired from: the photographer

3331. [One of the typical houses in the area (still being used in 1971)] (P1975.91.5)
Gelatin silver print. negative - 1970−71, print 1975
Image: 18 ⅛ x 12 ¼ in. (46.1 x 31.1 cm.)
Sheet: 20 x 16 in. (50.8 x 40.7 cm.)
Signed, l.r. print verso: "M. Kostiuk"
Acquired from: trade with the photographer

3332. [One of the typical landscapes of the area—cypress knees, bagals, cypress trees, and roots] (P1975.91.6)
Gelatin silver print. negative 1970−71, print 1975
Image: 18 ⅛ x 12 ⁵⁄₁₆ in. (46.1 x 31.2 cm.)
Sheet: 20 x 16 in. (50.8 x 40.7 cm.)
Signed, l.r. print verso: "M. Kostiuk"
Acquired from: trade with the photographer

*3333. [Pre-Civil War house with dog run. (People still lived in it without electricity in 1971)] (P1975.91.4)
Gelatin silver print. negative 1970−71, print 1975
Image: 12 ¼ x 18 ⅛ in. (31.1 x 46.1 cm.)
Sheet: 16 x 20 in. (40.7 x 50.8 cm.)
Signed, l.r. print verso: "M. Kostiuk"
Acquired from: trade with the photographer

*3334. [A resident of the Big Thicket going hunting with four dogs] (P1975.91.10)
Gelatin silver print. negative 1970−71, print 1975
Image: 12 ⁵⁄₁₆ x 18 ³⁄₁₆ in. (31.2 x 46.2 cm.)
Sheet: 16 x 20 in. (40.7 x 50.8 cm.)
Signed, l.r. print verso: "M. Kostiuk"
Acquired from: trade with the photographer

3335. [Salt water dump (before the days of separation tanks and pumping salt water back into the ground as is done today)] (P1975.91.3)
Gelatin silver print. negative 1970−71, print 1975
Image: 18 ⁵⁄₁₆ x 12 ⁵⁄₁₆ in. (46.4 x 31.3 cm.)
Sheet: 20 x 16 in. (50.8 x 40.7 cm.)
Signed, l.r. print verso: "M. Kostiuk"
Acquired from: trade with the photographer

3336. [Salt water separation tank] (P1975.91.1)
Gelatin silver print. negative 1970−71, print 1975
Image: 12 ¼ x 18 ⅛ in. (31.1 x 46.1 cm.)
Sheet: 16 x 20 in. (40.7 x 50.8 cm.)
Signed, l.r. print verso: "M. Kostiuk"
Acquired from: trade with the photographer

*3337. [Town in Big Thicket, typical of area] (P1975.91.2)
Gelatin silver print. negative 1970−71, print 1975
Image: 12 ³⁄₁₆ x 18 ¼ in. (31.0 x 46.3 cm.)
Sheet: 16 x 20 in. (40.7 x 50.8 cm.)
Signed, l.r. print verso: "M. Kostiuk"
Acquired from: trade with the photographer

3338. [Typical landscape scene with fog] (P1975.91.8)
Gelatin silver print. negative 1970−71, print 1975
Image: 18 ⅛ x 12 ⁵⁄₁₆ in. (46.1 x 31.2 cm.)
Sheet: 20 x 16 in. (50.8 x 40.7 cm.)
Signed, l.r. print verso: "M. Kostiuk"
Acquired from: trade with the photographer

3339. [Typical landscape scene with single tree, crawdad hole in foreground] (P1975.91.9)
Gelatin silver print. negative 1970−71, print 1975
Image: 18 ⅛ x 12 ¼ in. (46.1 x 31.1 cm.)
Sheet: 20 x 16 in. (50.8 x 40.7 cm.)
Signed, l.r. print verso: "M. Kostiuk"
Acquired from: trade with the photographer

GEORGE KRAUSE, American (b. 1937)

Krause developed an interest in photography while attending the Philadelphia College of Art during the 1950s. He taught art after graduation but moved toward a career in commercial photography and graphic design. By the early 1970s he had decided to pursue his own work and teach photography and since 1975 has taught at the University of Houston. His work deals with street scenes, nudes, landscapes, and the fantasy elements in real life. Krause was the first photographer to receive a Fulbright grant (1963−64), has since received two Guggenheim Fellowships (1967 and 1976−77) for still photography and one for filmmaking, and in 1976 was the first photographer to receive the Prix de Rome awarded by the American Academy in Rome. In 1979 he spent a year at the Academy as their first photographer in residence.

*3340. BIRDS (P1978.34)
Gelatin silver print. negative c. 1965, print 1976
Image: 4 ⅝ x 6 ¾ in. (11.7 x 17.1 cm.)
Mount: 14 x 11 in. (35.6 x 28.0 cm.)
Signed, u.r. mount verso: "George Krause 1976"
Acquired from: The Afterimage, Dallas, Texas

3341. **CONCRETE BAYOUS [from "Contemporary Texas: A Photographic Portrait"]** (P1985.17.108)
Gelatin silver print. 1984
Image: 6 15/16 x 9 5/8 in. (17.6 x 24.4 cm.)
Sheet: 7 15/16 x 10 in. (20.2 x 25.4 cm.)
Inscription, print recto: "Concrete Bayous"
Acquired from: gift of the Texas Historical Foundation with support from a major grant from the Du Pont Company and Conoco, its energy subsidiary, and assistance from the Texas Commission on the Arts and the National Endowment for the Arts

3342. **DOWNTOWN DALLAS [from "Contemporary Texas: A Photographic Portrait"]** (P1985.17.107)
Gelatin silver print. 1984
Image: 7 5/16 x 9 1/2 in. (18.5 x 24.1 cm.)
Sheet: 7 15/16 x 10 in. (20.2 x 25.4 cm.)
Inscription, print recto: "Downtown Dallas"
Acquired from: gift of the Texas Historical Foundation with support from a major grant from the Du Pont Company and Conoco, its energy subsidiary, and assistance from the Texas Commission on the Arts and the National Endowment for the Arts

3343. **DOWNTOWN HOUSTON [from "Contemporary Texas: A Photographic Portrait"]** (P1985.17.103)
Gelatin silver print. 1984
Image: 6 9/16 x 9 3/8 in. (16.7 x 23.8 cm.)
Sheet: 7 15/16 x 10 in. (20.2 x 25.4 cm.)
Inscription, print recto: "Downtown Houston"
Acquired from: gift of the Texas Historical Foundation with support from a major grant from the Du Pont Company and Conoco, its energy subsidiary, and assistance from the Texas Commission on the Arts and the National Endowment for the Arts

3344. **GALVESTON [from "Contemporary Texas: A Photographic Portrait"]** (P1985.17.110)
Gelatin silver print. 1984
Image: 6 9/16 x 9 3/16 in. (16.7 x 23.3 cm.)
Sheet: 7 15/16 x 10 in. (20.2 x 25.4 cm.)
Inscription, print recto: "Galveston"
Acquired from: gift of the Texas Historical Foundation with support from a major grant from the Du Pont Company and Conoco, its energy subsidiary, and assistance from the Texas Commission on the Arts and the National Endowment for the Arts

3345. **HOUSTON [from "Contemporary Texas: A Photographic Portrait"]** (P1985.17.105)
Gelatin silver print. 1984
Image: 6 13/16 x 9 11/16 in. (17.3 x 24.6 cm.)
Sheet: 7 15/16 x 10 in. (20.2 x 25.4 cm.)
Inscription, print recto: "Houston"
Acquired from: gift of the Texas Historical Foundation with support from a major grant from the Du Pont Company and Conoco, its energy subsidiary, and assistance from the Texas Commission on the Arts and the National Endowment for the Arts

*3346. **NASA [from "Contemporary Texas: A Photographic Portrait"]** (P1985.17.102)
Gelatin silver print. 1984
Image: 6 11/16 x 9 3/8 in. (17.0 x 23.8 cm.)
Sheet: 7 15/16 x 10 in. (20.2 x 25.4 cm.)
Inscription, print recto: "NASA"
Acquired from: gift of the Texas Historical Foundation with support from a major grant from the Du Pont Company and Conoco, its energy subsidiary, and assistance from the Texas Commission on the Arts and the National Endowment for the Arts

3337

3340

3346

3347. **OFF 610 LOOP WEST, HOUSTON** [from "Contemporary
Texas: A Photographic Portrait"] (P1985.17.109)
Gelatin silver print. 1984
Image: 6 9/16 x 9 5/16 in. (16.7 x 23.7 cm.)
Sheet: 7 15/16 x 10 in. (20.2 x 25.4 cm.)
Inscription, print recto: "Off 610 Loop West, Houston"
Acquired from: gift of the Texas Historical Foundation with
support from a major grant from the Du Pont Company
and Conoco, its energy subsidiary, and assistance from
the Texas Commission on the Arts and the National
Endowment for the Arts

3348. **PARKING GARAGE, HOUSTON** [from "Contemporary
Texas: A Photographic Portrait"] (P1985.17.104)
Gelatin silver print. 1984
Image: 6 3/16 x 9 1/4 in. (15.7 x 23.5 cm.)
Sheet: 7 15/16 x 10 in. (20.2 x 25.4 cm.)
Inscription, print recto: "Parking Garage, Houston"
Acquired from: gift of the Texas Historical Foundation with
support from a major grant from the Du Pont Company
and Conoco, its energy subsidiary, and assistance from
the Texas Commission on the Arts and the National
Endowment for the Arts

*3349. **PENNZOIL BUILDING, HOUSTON** [from "Contemporary
Texas: A Photographic Portrait"] (P1985.17.101)
Gelatin silver print. 1984
Image: 6 5/16 x 9 1/4 in. (16.0 x 23.5 cm.)
Sheet: 7 15/16 x 10 in. (20.2 x 25.4 cm.)
Inscription, print recto: "Pennzoil Building, Houston"
Acquired from: gift of the Texas Historical Foundation with
support from a major grant from the Du Pont Company
and Conoco, its energy subsidiary, and assistance from
the Texas Commission on the Arts and the National
Endowment for the Arts

3350. **610 LOOP EAST, HOUSTON** [from "Contemporary Texas:
A Photographic Portrait"] (P1985.17.106)
Gelatin silver print. 1984
Image: 6 15/16 x 9 3/16 in. (17.6 x 23.3 cm.)
Sheet: 7 15/16 x 10 in. (20.2 x 25.4 cm.)
Inscription, print recto: "610 Loop East, Houston"
Acquired from: gift of the Texas Historical Foundation with
support from a major grant from the Du Pont Company
and Conoco, its energy subsidiary, and assistance from
the Texas Commission on the Arts and the National
Endowment for the Arts

HEINRICH KÜHN,
Austrian, born Germany (1866–1944)

See *Camera Work*

KIPTON C. KUMLER, American (b. 1940)

Kumler received an undergraduate degree from Cornell
University and master's degrees from both Cornell and
Harvard before taking up photography in 1966. He
studied with Minor White at the Massachusetts In-
stitute of Technology and later with Paul Caponigro.
Kumler made a one-year trip to photograph the French
Pyrenees in 1972. Much of his work is done in platinum
and palladium processes, techniques that require con-
tact printing, so Kumler has made most of his images
with an 8 x 10 inch view camera. Kumler's work in-
cludes landscapes, architectural views, and plant stud-
ies, which are essentially classically composed abstract
designs using nature and light.

A PORTFOLIO OF PLANTS (P1978.145.1–10)
This portfolio was published by Kumler in Lexington,
Massachusetts, in December 1977. It consists of ten platinum
and palladium prints in an edition of 50 numbered portfolios
and 7 artist's proofs. This portfolio is number 17. The portfolio
introduction is by Hilton Kramer.

3351. **FRONDS, WELLESLEY** (P1978.145.1)
Platinum/palladium print. negative 1972, print 1977
Image: 13 1/2 x 10 11/16 in. (34.2 x 27.1 cm.)
Sheet: 14 7/8 x 11 in. (37.7 x 28.0 cm.) irregular
Signed, l.r. sheet recto: "Kumler"
Acquired from: The Halsted Gallery, Birmingham, Michigan

3352. **ARCHITECT'S LEAVES, WELLESLEY** (P1978.145.2)
Platinum/palladium print. negative 1971, print 1977
Image: 13 11/16 x 10 5/8 in. (34.6 x 27.0 cm.)
Sheet: 14 15/16 x 11 in. (37.8 x 28.0 cm.) irregular
Signed, l.r. sheet recto: "Kumler"
Acquired from: The Halsted Gallery, Birmingham, Michigan

3353. **ELEPHANT EAR, WELLESLEY** (P1978.145.3)
Platinum/palladium print. negative 1970, print 1977
Image: 13 5/8 x 9 13/16 in. (34.5 x 24.9 cm.)
Sheet: 14 15/16 x 11 in. (37.8 x 28.0 cm.) irregular
Signed, l.r. sheet recto: "Kumler"
Acquired from: The Halsted Gallery, Birmingham, Michigan

*3354. **ALTERNATING LEAVES, WELLESLEY** (P1978.145.4)
Platinum/palladium print. negative 1970, print 1977
Image: 13 5/8 x 10 11/16 in. (34.6 x 27.2 cm.)
Sheet: 14 7/8 x 11 in. (37.7 x 28.0 cm.) irregular
Signed, l.r. sheet recto: "Kumler"
Acquired from: The Halsted Gallery, Birmingham, Michigan

3355. **TEXTURED LEAVES, WELLESLEY** (P1978.145.5)
Platinum/palladium print. negative 1970, print 1977
Image: 13 3/4 x 9 13/16 in. (34.9 x 24.9 cm.)
Sheet: 14 7/8 x 11 in. (37.7 x 28.0 cm.) irregular
Signed, l.r. sheet recto: "Kumler"
Acquired from: The Halsted Gallery, Birmingham, Michigan

3356. **SUCCULENT PLANT, WELLESLEY** (P1978.145.6)
Platinum/palladium print. 1977
Image: 13 9/16 x 10 5/8 in. (34.4 x 27.0 cm.)
Sheet: 14 7/8 x 11 in. (37.7 x 28.0 cm.) irregular
Signed, l.r. sheet recto: "Kumler"
Inscription, sheet verso: "Cactus/36-2 10 50/?"
Acquired from: The Halsted Gallery, Birmingham, Michigan

3357. **CABBAGE, WELLESLEY** (P1978.145.7)
Platinum/palladium print. negative 1972, print 1977
Image: 13 11/16 x 9 3/4 in. (34.6 x 24.8 cm.)
Sheet: 14 7/8 x 11 in. (37.7 x 28.0 cm.) irregular
Signed, l.r. sheet recto: "Kumler"
Acquired from: The Halsted Gallery, Birmingham, Michigan

3358. **NEW PHILODENDRON, WELLESLEY** (P1978.145.8)
Platinum/palladium print. negative 1974, print 1977
Image: 13 3/4 x 10 3/4 in. (34.9 x 27.2 cm.)
Sheet: 14 7/8 x 11 in. (37.7 x 28.0 cm.) irregular
Signed, l.r. sheet recto: "Kumler"
Acquired from: The Halsted Gallery, Birmingham, Michigan

3359. **GRANT LEAVES, LEXINGTON** (P1978.145.9)
Platinum/palladium print. negative 1974, print 1977
Image: 13 9/16 x 10 5/8 in. (34.4 x 26.9 cm.)
Sheet: 14 7/8 x 11 in. (37.7 x 28.0 cm.) irregular
Signed, l.r. sheet recto: "Kumler"
Acquired from: The Halsted Gallery, Birmingham, Michigan

*3360. **REEDS, WELLESLEY** (P1978.145.10)
Platinum/palladium print. negative 1971, print 1977
Image: 13 3/4 x 10 3/4 in. (34.9 x 27.2 cm.)
Sheet: 14 7/8 x 11 in. (37.7 x 28.0 cm.) irregular
Signed, l.r. sheet recto: "Kumler"
Acquired from: The Halsted Gallery, Birmingham, Michigan

DOROTHEA LANGE, American (1895–1965)

Lange studied photography with Clarence White at Columbia University and in 1919 opened a portrait studio in San Francisco. At the time she was married to the painter Maynard Dixon and the bulk of her work was studio portrait photography. In the early 1930s the increasingly evident effects of the Depression inspired her to take her camera out of the studio and photograph the unemployed and disadvantaged. As a result of her independent documentary work she was hired by the economist Paul S. Taylor, whom she later married, to photograph migrant workers for the California State Emergency Relief Administration. In 1935 this led Lange to a job with the Resettlement Administration (later renamed the Farm Security Administration). Lange's documentary images reflect a sincere empathy for those she photographed and a strong sensitivity to their situation.

3349

THE AMERICAN COUNTRY WOMAN (P1965.172.1–28)

This photographic essay was an ongoing project to which Lange devoted twenty-five years of her life. She aimed to praise "women of the American soil," using portraits paired with images of the women's environments. This is one of two copies of the essay that Lange printed during the last years of her life.

3361. **EARLY CALIFORNIAN. HER FAMILY MIGRATED AFTER THE CIVIL WAR FROM DEER CREEK PLANTATION, MISSISSIPPI, TO THE GREAT EMPTY CENTRAL VALLEY OF CALIFORNIA, WHERE SHE WAS BORN EIGHTY-ONE YEARS AGO. THE FAMILY TRACED LINEAGE BACK TO WILLIAMSBURG, VIRGINIA—THE FIRST SEVENTEENTH CENTURY SETTLEMENT IN AMERICA—AND HAD BEEN SLAVEHOLDERS. NOW SHE TENDS HER FLOWER GARDEN ON A MARIN COUNTY HILLSIDE. SAUSALITO, CALIFORNIA** [Rebecca Chambers] (P1965.172.1)
Gelatin silver print. negative 1954, print 1965
Image: 10½ x 13⅜ in. (26.7 x 33.9 cm.)
Mount: same as image size
Signed, u.l. print recto: "Dorothea Lange 1954–65"
Inscription, mount verso: "Neg./#52139//#1/of the/Series"
Acquired from: the photographer

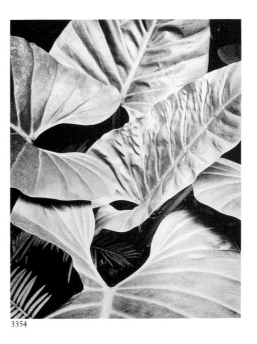
3354

*3362. **THE WOMAN CALLED "QUEEN" ON A SUNDAY MORNING AT CHURCH-TIME. NORTH CAROLINA** (P1965.172.2)
Gelatin silver print. negative 1939, print 1965
Image: 13¼ x 10⁷⁄₁₆ in. (33.7 x 26.5 cm.)
Mount: same as image size
Signed, u.l. print recto: "Dorothea Lange 1939–65"
Inscription, mount verso: "Neg./#38145//#2/of the/Series"
Acquired from: the photographer

3363. **CHURCH-TIME. NORTH CAROLINA** (P1965.172.3)
Gelatin silver print. negative 1939, print later
Image: 7⅝ x 9½ in. (19.3 x 24.1 cm.)
Mount: same as image size
Signed, u.r. print recto: "Dorothea Lange"
Inscription, mount verso: "Neg./#38145A//#2a/of the/Series"
Acquired from: the photographer

3364. **FARM WIFE LIVES ON THE GREAT PLAINS. NEBRASKA** (P1965.172.4)
Gelatin silver print. negative 1940, print later
Image: 11½ x 9⅛ in. (29.2 x 23.1 cm.)
Mount: same as image size
Signed, u.r. print recto: "Dorothea Lange"
Inscription, mount verso: "Neg./#41097//#3/of the/Series"
Acquired from: the photographer

3360

*3365. FAMILY FARMSTEAD. NEIGHBORS EXCHANGE
LABOR, BY AN OLD CUSTOM. NEBRASKA
(P1965.172.5)
Gelatin silver print. negative 1940, print later
Image: 10 7/16 x 13 5/16 in. (26.5 x 33.8 cm.)
Mount: same as image size
Signed, l.l. print recto: "Dorothea Lange"
Inscription, mount verso: "Neg./#41096//#3a/of the/Series"
Acquired from: the photographer

3366. BESSIE, DAUGHTER OF ZION, MOTHER OF THREE,
SHE LIVES IN A SMALL VILLAGE SETTLED ON
AN ISOLATED OX-CART TRAIL IN 1858 BY TEN
FAMILIES. TOQUERVILLE, UTAH (P1965.172.6)
Gelatin silver print. negative 1953, print later
Image: 9 7/8 x 9 1/8 in. (25.1 x 23.2 cm.)
Mount: same as image size
Signed, u.l. print recto: "Dorothea Lange 1953"
Inscription, mount verso: "Neg./#53308//#4/of the/Series"
Acquired from: the photographer

3367. TOQUERVILLE IS A TOWN WITH—NO BANK—NO
MOVIE HOUSE—NO GARAGE— NO MOTEL—NO
CAFE. THERE IS A POST OFFICE AND TWO SMALL
GROCERY STORES. THERE IS NO NEON SIGN.
TOQUERVILLE, UTAH (P1965.172.7)
Gelatin silver print. negative 1953, print later
Image: 10 x 11 1/4 in. (25.4 x 28.5 cm.)
Mount: same as image size
Signed, l.r. print recto: "Dorothea Lange 1953"
Inscription, mount verso: "53202//Neg./#53202//#4a/of the/
Series"
Acquired from: the photographer

*3368. WOMAN OF THE HIGH PLAINS "IF YOU DIE, YOU'RE
DEAD—THAT'S ALL." TEXAS PANHANDLE
(P1965.172.8)
Gelatin silver print. negative 1938, print later
Image: 12 3/4 x 10 1/4 in. (32.4 x 26.0 cm.)
Mount: same as image size
Signed, l.r. print recto: "Dorothea Lange 1938"
Inscription, mount verso: "Neg./#38258//#5/of the/Series"
Acquired from: the photographer

3369. DROUGHT YEARS. TEXAS PANHANDLE (P1965.172.9)
Gelatin silver print. negative 1938, print later
Image: 12 11/16 x 10 1/16 in. (32.3 x 25.5 cm.)
Mount: same as image size
Signed, u.r. print recto: "Dorothea Lange 1938"
Inscription, mount verso: "Neg./38257//#5a/of the/Series"
Acquired from: the photographer

3370. YOUNG GIRL, COTTON PICKER, SHE MIGRATES
WITH HER FAMILY FROM CROP TO CROP, AND
LIVES UNDER CONDITIONS OF DEPRIVATION.
ARIZONA (P1965.172.10)
Gelatin silver print. negative 1941, print later
Image: 11 3/4 x 9 1/2 in. (29.7 x 24.2 cm.)
Mount: same as image size
Signed, l.l. print recto: "Dorothea Lange 1941"
Inscription, mount verso: "38016-A//Neg./#38016A//#6/of
the/Series//10"
Acquired from: the photographer

3371. SHE PICKS IN THESE BROAD FIELDS OF COTTON
(SEEN ACROSS THE ROAD) AND LIVES IN ONE
OF THESE CABINS. ARIZONA (P1965.172.11)
Gelatin silver print. negative 1941, print later
Image: 9 x 13 in. (22.9 x 33.0 cm.)
Mount: same as image size
Signed, l.r. print recto: "Dorothea Lange 1941"
Inscription, mount verso: "/11//BAE No 41822//Reduce 12 13/16
to 8 1/16/63%//Neg./#41822/National Archives//#6a/of the/
Series"
Acquired from: the photographer

3372. MARY ANN SAVAGE WAS A FAITHFUL MORMON ALL
HER LIFE. SHE WAS A PLURAL WIFE. SHE WAS A
PIONEER. SHE CROSSED THE PLAINS IN 1856
WITH HER FAMILY WHEN SHE WAS SIX YEARS
OLD. HER MOTHER PUSHED HER LITTLE
CHILDREN ACROSS PLAIN AND DESERT IN A
HAND-CART. A SISTER DIED ALONG THE WAY.
"MY MOTHER WRAPPED HER IN A BLANKET
AND PUT HER TO ONE SIDE." TOQUERVILLE,
UTAH (P1965.172.12)
Gelatin silver print. negative 1931, print 1965
Image: 11 11/16 x 10 1/4 in. (29.6 x 26.0 cm.)
Mount: same as image size
Signed, u.r. print recto: "Dorothea Lange 1931–65"
Inscription, mount verso: "Neg./#33015//#7/of the/Series"
Acquired from: the photographer

3373. THE PORTRAIT OF MARY ANN SAVAGE WAS MADE
IN 1931. SHE DIED FIVE YEARS LATER. MANY
YEARS LATER, IN 1953, HER GRAVESTONE WAS
PHOTOGRAPHED AS IT STOOD IN THE VILLAGE
GRAVEYARD. HER SON, AT AGE 85, RECALLED:
"SHE HELPED BUILD THIS MORMON VILLAGE IN
THE WILDERNESS." TOQUERVILLE, UTAH
(P1965.172.13)
Gelatin silver print. negative 1953, print later
Image: 11 3/4 x 7 in. (29.7 x 17.8 cm.)
Mount: same as image size
Signed, u.r. print recto: "D. L 1953"
Inscription, mount verso: "Neg./#53300//#7a/of the/Series"
Acquired from: the photographer

*3374. FRIEND AND NEIGHBOR, WHO MAKES "THE
WORLD'S BEST APPLE PIE," AND KNOWS
EVERYTHING GOING ON FOR MILES AROUND.
NORTHERN CALIFORNIA [Lyde Wall] (P1965.172.14)
Gelatin silver print. negative 1944, print later
Image: 12 11/16 x 10 1/2 in. (32.2 x 26.6 cm.)
Mount: same as image size
Signed, l.r. print recto: "D. L."
Inscription, mount verso: "Neg./#42122//#8/of the/Series"
Acquired from: the photographer

3375. SHE PRACTICED THE HOUSEHOLD ARTS OF HER
GENERATION. UTAH (P1965.172.15)
Gelatin silver print. negative 1953, print later
Image: 4 3/4 x 10 9/16 in. (12.0 x 26.8 cm.)
Mount: same as image size
Signed, u.r. print recto: "Dorothea Lange"
Inscription, mount verso: "Neg./#53304//#8a/of the/Series"
Acquired from: the photographer

3376. YOUNG MOTHER. SHE LIVES IN A MORMON
HAMLET STRUNG ALONG A SMALL RIVER, FIVE
MILES INLAND FROM THE HIGHWAY. "IF YOU
RUN OUT OF MONEY HERE IN GUNLOCK, YOU
CAN GO PICK YOURSELF SOMETHING OUT OF
THE GARDEN." GUNLOCK, WASHINGTON
COUNTY, UTAH (P1965.172.16)
Gelatin silver print. negative 1953, print later
Image: 11 15/16 x 7 13/16 in. (30.3 x 19.8 cm.)
Mount: same as image size
Signed, u.r. print recto: "Dorothea Lange 1953"
Inscription, mount verso: "Neg./#53146//#9/of the/Series"
Acquired from: the photographer

3377. "THIS IS A TOWN WHERE EVERYBODY KNOWS
EVERYBODY." THE CHURCH IS THE CENTER OF
THE LIFE. GUNLOCK, WASHINGTON COUNTY,
UTAH (P1965.172.17)
Gelatin silver print. negative 1953, print later
Image: 12 x 9 in. (30.4 x 22.8 cm.)
Mount: same as image size
Signed, u.r. print recto: "Dorothea Lange 1953"
Inscription, mount verso: "Neg./#53133//#9/of the/Series"
Acquired from: the photographer

3378. **LIKE MANY OTHERS ON THE GREAT PLAINS FROM SCANDINAVIA, SHE HOMESTEADED WHERE HER SON NOW FARMS. SOUTH DAKOTA** (P1965.172.18)
Gelatin silver print. negative 1939, print later
Image: 10 ⅛ x 12 ⅝ in. (25.7 x 32.1 cm.)
Mount: same as image size
Signed, l.l. print recto: "Dorothea Lange 1939"
Inscription, mount verso: "Neg./#41029//#10/of the/Series"
Acquired from: the photographer

3379. **THIS IS THE FAMILY FARMSTEAD. SOUTH DAKOTA** (P1965.172.19)
Gelatin silver print. negative 1939, print later
Image: 9 ⁷⁄₁₆ x 11 ¾ in. (23.9 x 29.9 cm.)
Mount: same as image size
Signed, u.r. print recto: "Dorothea Lange"
Inscription, mount verso: "Neg./#41028//#10a/of the/Series"
Acquired from: the photographer

*3380. **EX-SLAVE WITH A LONG MEMORY. ALABAMA** (P1965.172.20)
Gelatin silver print. negative 1938, print later
Image: 13 ⅜ x 10 ⅜ in. (33.9 x 26.3 cm.)
Mount: same as image size
Signed, l.l. print recto: "Dorothea Lange"
Inscription, mount verso: "Neg./#38164//#11/of the/Series"
Acquired from: the photographer

*3381. **ACCOMPANIES "EX-SLAVE WITH A LONG MEMORY." ALABAMA** (P1965.172.21)
Gelatin silver print. negative 1938, print later
Image: 8 x 11 ⅝ in. (20.4 x 29.5 cm.)
Mount: same as image size
Signed, l.l. print recto: "Dorothea Lange"
Inscription, mount verso: "Neg./#38164A//#11a/of the/Series"
Acquired from: the photographer

3382. **MORMON MOTHER WHO SAYS SHE'S "BEEN LOOKING UP AT THAT OLD BLACK RIDGE" SINCE 1877. SHE HAS BORNE TEN CHILDREN. SITTING WITH HER HUSBAND ON THE STEPS OF THEIR OLD STONE HOUSE AT EVENING, SHE TURNED TO HIM AND QUIETLY SAID: "AND NONE DIED, IS THERE, DAD?" AND HE, AS QUIETLY, ANSWERED: "YES, JIM DIED." GUNLOCK, UTAH** (P1965.172.22)
Gelatin silver print. negative 1953, print later
Image: 13 ³⁄₁₆ x 10 ½ in. (33.4 x 26.6 cm.)
Mount: same as image size
Signed, u.r. print recto: "Dorothea Lange 1953"
 l.l. print recto: "Dorothea Lange"
Inscription, mount verso: "Neg./#53141//#12/of the/Series"
Acquired from: the photographer

3383. **THIS IS THE ROAD THAT RUNS THROUGH HER FAR-WEST VILLAGE. GUNLOCK, UTAH** (P1965.172.23)
Gelatin silver print. negative 1953, print later
Image: 13 ⅛ x 10 ¼ in. (33.3 x 26.1 cm.)
Mount: same as image size
Signed, u.r. print recto: "Dorothea Lange"
Inscription, mount verso: "Neg./#53122//#12a/of the/Series"
Acquired from: the photographer

*3384. **"SHE'S A JIM-DANDY." TULARE COUNTY, CALIFORNIA** (P1965.172.24)
Gelatin silver print. negative 1938, print later
Image: 12 ⅞ x 10 ⁵⁄₁₆ in. (32.7 x 26.2 cm.)
Mount: same as image size
Signed, u.l. print recto: "Dorothea Lange 1938"
Inscription, mount verso: "Neg.No./LC-18660/Library of Congre/ss//#13/of the/Series"
Acquired from: the photographer

3362

3365

3368

3385. **WOMAN OF THE FAR WEST WELCOMES FRIENDS GATHERING ON MEMORIAL DAY IN THE OLD CEMETERY. THIS IS AN ANNUAL OCCASION AND GREAT DAY FOR THE COUNTRY PEOPLE. THEY BRING THEIR LUNCHES AND STAY ALL DAY IN THE VALLEY, "VISITING" WITH OLD ASSOCIATES AND "CLEANING UP" THE FAMILY GRAVES. BERRYESSA VALLEY, CALIFORNIA** (P1965.172.25)
Gelatin silver print. negative 1956, print later
Image: 10 ⅜ x 11 ½ in. (26.2 x 29.2 cm.)
Mount: same as image size
Signed, l.l. print recto: "Dorothea Lange"
Inscription, mount verso: "Neg. No./Pirkle Jones/ File-OA21034/IV#66//#14/of the/Series"
Acquired from: the photographer

HOME PLACE. THE VALLEY HELD GENERATIONS IN ITS PALM. MONTICELLO, CALIFORNIA (P1965.172.26)
See entry under Pirkle Jones

3386. **MA BURNHAM FROM CONROY ARKANSAS. ARKANSAS** (P1965.172.27)
Gelatin silver print. negative 1938, print later
Image: 11 ¹⁵⁄₁₆ x 10 in. (30.3 x 25.3 cm.)
Mount: same as image size
Signed, l.r. print recto: "Dorothea Lange"
Inscription, mount verso: "Neg./#38267//#15/of the/Series"
Acquired from: the photographer

3387. **ACCOMPANIES "MA BURNHAM." ARKANSAS** (P1965.172.28)
Gelatin silver print. negative 1938, print later
Image: 11 ¹⁵⁄₁₆ x 9 ⅝ in. (30.3 x 24.5 cm.)
Mount: same as image size
Signed, u.l. print recto: "Dorothea Lange"
Inscription, mount verso: "Neg./#38268//15a/of the/Series"
Acquired from: the photographer

✻ ✻ ✻ ✻

3388. **[Charles M. Russell]** (P1961.422.1) duplicate of P1961.422.2
Gelatin silver print. negative c. 1924–26, print 1961
Image: 15 ⁹⁄₁₆ x 19 ⁹⁄₁₆ in. (39.6 x 49.7 cm.)
Mount: same as image size
Signed, l.r. print recto: "Dorothea Lange"
Acquired from: the photographer

3389. **[Charles M. Russell]** (P1961.422.2) duplicate of P1961.422.1
Gelatin silver print. negative c. 1924–26, print 1961
Image: 10 ⅜ x 13 ¼ in. (26.4 x 33.7 cm.)
Mount: same as image size
Inscription, mount verso, printed paper label: "DOROTHEA LANGE/1163 EUCLID AVENUE/BERKELEY 8, CALIFORNIA"
Acquired from: the photographer

✻3390. **[Charles M. Russell smoking]** (P1961.424)
Gelatin silver print. negative c. 1924–26, print 1961
Image: 11 ¹³⁄₁₆ x 10 ¹⁄₁₆ in. (30.0 x 25.6 cm.)
Mount: same as image size
Acquired from: the photographer

3391. **[Charles M. Russell's hand]** (P1961.421.1)
Gelatin silver print. negative c. 1924–26, print 1961
Image: 11 ⅛ x 9 ¹⁄₁₆ in. (28.2 x 23.1 cm.)
Mount: same as image size
Signed, l.r. print recto: "Dorothea Lange"
Acquired from: the photographer

3392. **[Charles M. Russell's hand, detail]** (P1961.421.2)
Gelatin silver print. negative c. 1924–26, print 1961
Image: 6 ⅞ x 6 ⅛ in. (17.5 x 15.5 cm.)
Mount: same as image size
Inscription, mount verso: "4" on printed paper label "From/ DOROTHEA LANGE/1163 EUCLID AVENUE/ BERKELEY 8, CALIFORNIA"
Acquired from: the photographer

✻3393. **CHILDRESS COUNTY, TEXAS 1938** (P1965.155.1)
Gelatin silver print. negative 1938, print later
Image: 12 ⅜ x 10 ⁹⁄₁₆ in. (31.5 x 26.8 cm.)
Mount: same as image size
Signed, u.l. print recto: "Dorothea Lange"
Inscription, mount verso: "38237"
Acquired from: the photographer

3394. **CHILDRESS COUNTY, TEXAS 1938 [detail]** (P1965.155.2)
Gelatin silver print. negative 1938, print later
Image: 9 x 7 ⅝ in. (22.9 x 19.4 cm.)
Mount: same as image size
Signed, u.l. print recto: "Dorothea Lange"
Inscription, print verso: "Hardeman Co. Texas [sic]/June 1938"
mount verso: "38237"
Acquired from: the photographer

ROBERT B. LANGHAM III, American (b. 1952)

Langham began to make photographs in 1971 while attending Tyler Junior College. He was an assistant at the Ansel Adams Yosemite workshops from 1973 to 1975 and received a B.A. in photography from Sam Houston State University in Huntsville, Texas, in 1975. Langham has taught photography at Tyler Junior College since 1977, working also as a freelance photographer and writer.

✻3395. **BALLOON, EDOM, TEXAS** (P1974.24.4)
Gelatin silver print. 1974
Image: 6 ⅛ x 6 in. (15.5 x 15.3 cm.)
Mount: 11 ¹³⁄₁₆ x 10 ⅞ in. (30.0 x 27.7 cm.)
Signed, l.r. mount recto: "Robert Langham '74"
Inscription, mount verso: "Balloon, Edom, Texas, 1974/ Robert Langham/ (Huntsville Print)/[photographer's insignia]"
Acquired from: the photographer

3396. **HILLS ABOVE GARRAPATA POINT, CALIFORNIA** (P1974.24.6)
Gelatin silver print. 1974
Image: 5 ⅝ x 8 ¹⁵⁄₁₆ in. (14.3 x 22.7 cm.)
Mount: 11 x 13 ½ in. (28.0 x 34.4 cm.)
Signed, l.r. mount recto: "Robert Langham"
Acquired from: the photographer

3397. **MORNING, MIRROR LAKE, YOSEMITE** (P1974.24.3)
Gelatin silver print. 1973
Image: 10 ³⁄₁₆ x 10 ⅛ in. (25.8 x 25.6 cm.)
Sheet: 10 ¾ x 10 ¾ in. (27.4 x 27.4 cm.)
Mount: 17 ⅛ x 16 ¹⁄₁₆ in. (43.5 x 40.8 cm.)
Signed, l.r. on overmat: "Robert Langham, 73"
Inscription, mount verso: "MORNING, MIRROR LAKE, YOSEMITE/JUNE 1973/Robert Langham/[photographer's insignia]//#1"
Acquired from: the photographer

3398. **SHOWER, 2018 AVE. L ½ HUNTSVILLE, TEX.** (P1974.24.8)
Ektacolor print. 1974
Image: 5 ¹⁵⁄₁₆ x 7 ¼ in. (15.1 x 18.5 cm.)
Mount: 10 ⅛ x 12 ⅛ in. (25.7 x 30.8 cm.)
Signed, l.r. mount recto: "Robert Langham"
Inscription, mount verso: "SHOWER, 2018 AVE. L ½ /HUNTSVILLE, TEX./Robert Langham/[photographer's insignia]"
Acquired from: gift of the photographer

3374

3380

3381

3384

3390

3393

3399. **SLEEPING BAG, HUNTSVILLE TEXAS** (P1974.24.1)
Ektacolor print. 1974
Image: 5 3/8 x 5 3/8 in. (13.7 x 13.7 cm.)
Mount: 12 1/16 x 10 1/16 in. (30.7 x 25.6 cm.)
Signed, center mount verso: "Robert Langham"
Inscription, mount verso: "SLEEPING BAG, HUNTSVILLE
TEXAS, 1974/[signature]/[photographer's insignia]"
Acquired from: the photographer

3400. **TREE TRUNK, 1974, HUNTSVILLE** (P1974.24.2)
Ektacolor print. 1974
Image: 7 1/2 x 4 15/16 in. (19.0 x 12.6 cm.)
Sheet: 7 15/16 x 5 1/4 in. (20.2 x 13.4 cm.)
Mount: 11 15/16 x 10 1/16 in. (30.3 x 25.5 cm.)
Signed, center mount verso: "Robert Langham"
Inscription, mount verso: "TREE TRUNK, 1974,
HUNTSVILLE/[signature]/[photographer's insignia]"
Acquired from: the photographer

3401. **YOSEMITE VALLEY, DAWN** (P1974.24.7)
Gelatin silver print. 1974
Image: 6 1/8 x 8 7/16 in. (15.5 x 21.4 cm.)
Sheet: 6 7/16 x 8 3/4 in. (16.3 x 22.2 cm.)
Mount: 13 x 15 in. (33.0 x 38.1 cm.)
Signed, l.r. mount recto: "Robert Langham"
Inscription, mount verso: "Yosemite Valley, Dawn. 1974/
Robert Bruce Langham III/[photographer's insignia]"
Acquired from: the photographer

3402. **YOSEMITE VALLEY FROM WASHBURN POINT**
(P1974.24.5)
Gelatin silver print. 1974
Image: 5 3/4 x 6 9/16 in. (14.6 x 16.7 cm.)
Mount: 11 x 13 1/2 in. (28.0 x 34.4 cm.)
Signed, l.r. mount recto: "Robert Langham"
Inscription, mount verso: "Yosemite Valley from Washburn
Point/1974/Robert Bruce Langham III/[photographer's
insignia]"
Acquired from: the photographer

H. A. LATIMER (active 1890s)

See *Camera Notes*

CLARENCE JOHN LAUGHLIN,
American (1905–1985)

Laughlin considered himself to be a writer who took up
photography as an adjunct to his prose and poetry. He
was strongly influenced by the French symbolists and
the surrealist movement. He earned his living as an ar-
chitectural photographer, also working for *Vogue* for a
short period during the 1940s and in the photography
department at the National Archives. Most of his sub-
sequent career was spent in Louisiana, making photo-
graphs and lecturing.

*3403. **A SINUOUS POEM** [Gaston Lachaise's *Elevation* sculpture]
(P1971.86.2)
Gelatin silver print. 1955
Image: 13 7/16 x 7 1/2 in. (34.1 x 19.0 cm.) irregular polygon
Mount: 17 x 14 in. (43.1 x 35.6 cm.)
Signed, l.r. mount recto: "Clarence John Laughlin—1955"
Inscription, mount recto: "A Sinuous Poem"
mount verso: "3/#9366/B1479/9/20/56/H2//#19 in set//
C/7/6°" and rubber stamp "Print No.__ /C. J.
LAUGHLIN/627 DECATUR ST./NEW ORLEANS 16,
LA./ALL REPRODUCTION AND AD-/VERTISING
RIGHTS RETAINED/BY THE PHOTOGRAPHER"
Acquired from: gift of Zeitlin and Ver Brugge, Los Angeles,
California

*3404. **THE VISION IN THE MIRROR** [Gaston Lachaise's
Elevation sculpture] (P1971.86.1)
Gelatin silver print. 1955
Image: 13 3/4 x 8 5/16 in. (34.9 x 21.1 cm.)
Mount: 17 x 14 in. (43.1 x 35.6 cm.)
Signed, l.r. mount recto: "Clarence John Laughlin—1955"
Inscription, mount recto: "The Vision in the Mirror"
mount verso: "1//#9365/B+537/7/22/60/H1//#17 in set//
E/7/6°" and rubber stamp "Print No. /C. J.
LAUGHLIN/627 DECATUR ST./NEW ORLEANS 16,
LA./ALL REPRODUCTION AND AD-/VERTISING
RIGHTS RETAINED BY THE PHOTOGRAPHER"
Acquired from: gift of Zeitlin and Ver Brugge, Los Angeles,
California

ALMA R. LAVENSON, American (1897–1989)

Alma Lavenson began photographing while studying
psychology at the University of California at Berkeley.
The man in charge of the darkroom where she had her
photographs processed taught Lavenson to develop and
print negatives. During her career, she often photo-
graphed with her friends Imogen Cunningham and
Consuelo Kanaga. Lavenson's early pictorial work was
included in both national and international salons, and
the first photograph she entered in a monthly magazine
competition was selected to appear on the magazine
cover. However, Edward Weston convinced her to
switch to a sharp-focus style more suited to her land-
scape photographs. This change resulted in an invita-
tion to exhibit her work in the first exhibition of Group
f/64 in 1932. Lavenson primarily photographed land-
scapes and people in their natural environments,
emphasizing form and texture and light and shadow.
One of her most extensive projects documented
California's Mother Lode country. In 1979 Lavenson
received an award from the National Endowment for
the Arts and a Dorothea Lange Award as an outstand-
ing woman photographer.

*3405. **EUCALYPTUS LEAVES** (P1987.3)
Gelatin silver print. negative 1933, print c. 1986 by
Jim Alinder
Image: 11 15/16 x 8 15/16 in. (30.4 x 22.7 cm.)
Sheet: 14 x 10 15/16 in. (35.5 x 27.8 cm.)
Signed, l.r. print verso: "Alma Lavenson"
Inscription, print verso, rubber stamp: "Alma Lavenson,
EUCALYPTUS LEAVES, 1933/Printed from the original
negative by Jim Alinder/The Friends of Photography's
Collectors Print Program."
Acquired from: Friends of Photography, Carmel, California;
gift print with sustaining membership, 1987

RENÉE LE BÉGUE, French (active 1890s–1900s)

See *Camera Notes* and *Camera Work*

RUSSELL LEE, American (1903–1986)

Trained as a chemical engineer, Russell Lee left the
profession to study painting and finally found his niche
when he began to make photographs in 1935. Intending
at first to use photographs as aids for his painting, Lee
soon embraced documentary photography as an end in
itself. Roy Stryker hired him as a Farm Security Ad-
ministration photographer in 1936 and hired him again
in 1947 on the Standard Oil of New Jersey project. Lee
also worked for the U. S. Air Transport Command dur-
ing World War II and then made a study of coal miners
for the U. S. government. Lee settled in Austin, Texas,
in 1947, where he taught at the University of Texas from
1965 to 1973 in addition to undertaking freelance
photojournalism projects.

*3406. **AFTERMATH OF FLOOD, MOUNT VERNON, INDIANA** (P1987.16)
Gelatin silver print. negative 1937, print c. 1976
Image: 9 9/16 x 13 9/16 in. (24.2 x 34.2 cm.)
Sheet: 11 1/16 x 13 15/16 in. (28.0 x 35.4 cm.)
Signed, bottom center print verso: "Russell Lee"
Inscription, print verso: "49680/F341-10865//RS//#28-[signature]" and rubber stamp "Reproduced from the collection of the Library of Congress"
Acquired from: gift of Paul Brauchle, Dallas, Texas

3407. **AGRICULTURAL LABORERS CUTTING BROCCOLI. HARVESTING OF THIS CROP IS HIGHLY SPECIALIZED WORK. ON PANCHITA RANCH OF F. H. VAHLSING, INC., NEAR EDCOUCH, TEXAS. LOWER RIO GRANDE VALLEY, TEXAS [from the exhibition "Out of the Forties: A Portrait of Texas from the Standard Oil Collection"]** (P1984.37.88)
Gelatin silver print. negative 1948, print 1982 by Bill Carner
Image: 9 5/16 x 12 1/2 in. (23.7 x 31.8 cm.)
Sheet: 11 x 13 15/16 in. (28.0 x 35.4 cm.)
Signed, l.r. print verso: "xxR.L."
Inscription, print verso: "SONJ 57292" and rubber stamp "PLEASE CREDIT:/UNIVERSITY OF LOUISVILLE/ PHOTOGRAPHIC ARCHIVES"
Acquired from: gift of Texas Monthly, Inc., Austin, Texas, printed from a negative in the Standard Oil of New Jersey Collection, University of Louisville Photographic Archives

*3408. **BARBECUE FOR HUMBLE EMPLOYEES, HUMBLE CAMP, McCAMEY, TEXAS. WEST TEXAS [from the exhibition "Out of the Forties: A Portrait of Texas from the Standard Oil Collection"]** (P1984.37.76)
Gelatin silver print. negative 1947, print 1982 by Bill Carner
Image: 8 1/16 x 12 1/4 in. (20.5 x 31.2 cm.)
Sheet: 11 1/16 x 13 15/16 in. (28.1 x 35.4 cm.)
Signed, l.r. print verso: "x R.L."
Inscription, print verso: "SONJ 53409 M-16" and rubber stamp "PLEASE CREDIT:/UNIVERSITY OF LOUISVILLE/PHOTOGRAPHIC ARCHIVES"
Acquired from: gift of Texas Monthly, Inc., Austin, Texas, printed from a negative in the Standard Oil of New Jersey Collection, University of Louisville Photographic Archives

3409. **C. R. CHURCH, JR., SEISMOGRAPHIC COMPUTER, CHECKING AND COMPARING SEISMOGRAPH REFLECTIONS SENT IN FROM THE FIELD. HUMBLE OIL AND REFINING CO., HOUSTON, TEXAS [from the exhibition "Out of the Forties: A Portrait of Texas from the Standard Oil Collection"]** (P1984.37.74)
Gelatin silver print. negative 1947, print 1982 by Bill Carner
Image: 9 5/16 x 12 1/2 in. (23.7 x 31.8 cm.)
Sheet: 11 x 13 15/16 in. (28.0 x 35.4 cm.)
Signed, l.r. print verso: "x R.L."
Inscription, print verso: "Sonj 52319" and rubber stamp "PLEASE CREDIT:/UNIVERSITY OF LOUISVILLE/ PHOTOGRAPHIC ARCHIVES"
Acquired from: gift of Texas Monthly, Inc., Austin, Texas, printed from a negative in the Standard Oil of New Jersey Collection, University of Louisville Photographic Archives

*3410. **CHILDREN WATCHING ELECTRIC TRAINS IN DOWNTOWN WINDOW, HARLINGEN, TEXAS. LOWER RIO GRANDE VALLEY, TEXAS [from the exhibition "Out of the Forties: A Portrait of Texas from the Standard Oil Collection"]** (P1984.37.84)
Gelatin silver print. negative 1947, print 1982 by Bill Carner
Image: 9 1/8 x 12 3/16 in. (23.2 x 31.0 cm.)
Sheet: 11 x 13 15/16 in. (28.0 x 35.4 cm.)
Signed, l.r. print verso: "R.L."
Inscription, print verso: "SONJ 57139" and rubber stamp "PLEASE CREDIT:/UNIVERSITY OF LOUISVILLE/ PHOTOGRAPHIC ARCHIVES"
Acquired from: gift of Texas Monthly, Inc., Austin, Texas, printed from a negative in the Standard Oil of New Jersey Collection, University of Louisville Photographic Archives

3395

3403

3405

3411. CONSTRUCTION OF 18-INCH PIPE LINE FOR
HUMBLE PIPE LINE CO. NEAR BIG LAKE, TEXAS.
ONE OF THE FOUR DRILL OPERATORS WORKING
HIS PARTICULAR AIR HAMMER DRILL. THE
HOLES DRILLED WILL BE FILLED WITH
EXPLOSIVES WHICH WILL BE DETONATED TO
DEEPEN THE SHALLOW DITCH. WEST TEXAS
[from the exhibition "Out of the Forties: A Portrait of
Texas from the Standard Oil Collection"] (P1984.37.96)
Gelatin silver print. negative 1950, print 1982 by Bill Carner
Image: 9 ½ x 10 ¹⁵/₁₆ in. (24.1 x 27.8 cm.)
Sheet: 11 x 13 ¹⁵/₁₆ in. (28.0 x 35.4 cm.)
Signed, l.r. print verso: "R.L."
Inscription, print verso: "SONJ 67127" and rubber stamp
"PLEASE CREDIT:/UNIVERSITY OF LOUISVILLE/
PHOTOGRAPHIC ARCHIVES"
Acquired from: gift of Texas Monthly, Inc., Austin, Texas,
printed from a negative in the Standard Oil of New Jersey
Collection, University of Louisville Photographic Archives

3412. CONSTRUCTION OF 18-INCH PIPE LINE FOR
HUMBLE PIPE LINE CO. NEAR BIG LAKE, TEXAS.
WELDERS APPLYING THE "STRINGER BEAD," THE
FIRST WELD THAT HOLDS THE PIPE TOGETHER.
WEST TEXAS [from the exhibition "Out of the Forties:
A Portrait of Texas from the Standard Oil Collection"]
(P1984.37.98)
Gelatin silver print. negative 1950, print 1982 by Bill Carner
Image: 9 ¼ x 12 ½ in. (23.5 x 31.8 cm.)
Sheet: 11 x 13 ¹⁵/₁₆ in. (28.0 x 35.4 cm.)
Signed, l.r. print verso: "R.L."
Inscription, print verso: "SONJ 67149" and rubber stamp
"PLEASE CREDIT:/UNIVERSITY OF LOUISVILLE/
PHOTOGRAPHIC ARCHIVES"
Acquired from: gift of Texas Monthly, Inc., Austin, Texas,
printed from a negative in the Standard Oil of New Jersey
Collection, University of Louisville Photographic Archives

3413. THE CORNER DRUG STORE ON MAIN STREET.
WEST TEXAS [from the exhibition "Out of the Forties:
A Portrait of Texas from the Standard Oil Collection"]
(P1984.37.110)
Dye-transfer print. transparency 1947, print 1982 by Jim Bones
Image: 10 ¹/₁₆ x 12 ¹⁵/₁₆ in. (25.5 x 32.9 cm.)
Sheet: 11 ¹/₁₆ x 13 ¹⁵/₁₆ in. (28.1 x 35.4 cm.)
Inscription, print recto: "9—Lee" and crop marks
print verso: "Lee—Corner Drug"
Acquired from: gift of Texas Monthly, Inc., Austin, Texas,
printed from a transparency in the Standard Oil of New
Jersey Collection, University of Louisville Photographic
Archives

3414. COTTON GIN, COUPLAND, TEXAS. EAST TEXAS
[from the exhibition "Out of the Forties: A Portrait of
Texas from the Standard Oil Collection"] (P1984.37.75)
Gelatin silver print. negative 1947, print 1982 by Bill Carner
Image: 9 ⁵/₁₆ x 12 ½ in. (23.7 x 31.8 cm.)
Sheet: 11 x 13 ¹⁵/₁₆ in. (28.0 x 35.4 cm.)
Signed, l.r. print verso: "R.L."
Inscription, print verso: "SONJ 52324" and rubber stamp
"PLEASE CREDIT:/UNIVERSITY OF LOUISVILLE/
PHOTOGRAPHIC ARCHIVES"
Acquired from: gift of Texas Monthly, Inc., Austin, Texas,
printed from a negative in the Standard Oil of New Jersey
Collection, University of Louisville Photographic Archives

*3415. COWBOY MEDITATING AFTER NOON-DAY MEAL IN
CHUCK TENT. WAGGONER ESTATE RANCH, NEAR
VERNON, TEXAS [from the exhibition "Out of the
Forties: A Portrait of Texas from the Standard Oil
Collection"] (P1984.37.101)
Gelatin silver print. negative 1953, print 1982 by Bill Carner
Image: 12 ¼ x 8 ⅛ in. (31.2 x 20.6 cm.)
Sheet: 14 x 11 in. (35.6 x 28.0 cm.)
Signed, l.r. print verso: "RL"
Inscription, print verso: "SONJ 76418 M-17" and rubber

stamp "PLEASE CREDIT:/UNIVERSITY OF
LOUISVILLE/PHOTOGRAPHIC ARCHIVES"
Acquired from: gift of Texas Monthly, Inc., Austin, Texas,
printed from a negative in the Standard Oil of New Jersey
Collection, University of Louisville Photographic Archives

3416. COWBOYS IN CORRAL MOVE CATTLE TOWARD THE
CUTTING CHUTE. WAGGONER ESTATE RANCH,
NEAR VERNON, TEXAS [from the exhibition "Out of
the Forties: A Portrait of Texas from the Standard Oil
Collection"] (P1984.37.102)
Gelatin silver print. negative 1953, print 1982 by Bill Carner
Image: 8 ½ x 12 ¼ in. (21.6 x 31.2 cm.)
Sheet: 11 x 13 ¹⁵/₁₆ in. (28.0 x 35.4 cm.)
Signed, l.r. print verso: "xxR.L."
Inscription, print verso: "SONJ 76425 M-6" and rubber
stamp "PLEASE CREDIT:/UNIVERSITY OF
LOUISVILLE/PHOTOGRAPHIC ARCHIVES"
Acquired from: gift of Texas Monthly, Inc., Austin, Texas,
printed from a negative in the Standard Oil of New Jersey
Collection, University of Louisville Photographic Archives

*3417. DAUGHTER OF WM. HURAVITCH, WILLIAMS
COUNTY, NO. DAKOTA (P1984.34)
Gelatin silver print. 1937
Image: 7 ¼ x 9 ⁹/₁₆ in. (18.3 x 24.3 cm.)
Signed: see inscription
Inscription, print verso: "Ra 304 63-D" and rubber stamp
"Kindly use the following credit line/FARM SECURITY
ADMINISTRATION PHOTOGRAPH BY LEE"
Acquired from: Nancy Medwell, Seattle, Washington

3418. DRIFTING SAND IS CONTROLLED AT EDGE OF
HIGHWAY 80 [from the exhibition "Out of the Forties: A
Portrait of Texas from the Standard Oil Collection"]
(P1984.37.107)
Dye-transfer print. transparency 1947, print 1982 by Jim Bones
Image: 10 x 12 ¹⁵/₁₆ in. (25.4 x 32.9 cm.)
Sheet: 11 x 13 ¹⁵/₁₆ in. (28.0 x 35.4 cm.)
Inscription, print recto: "6—Lee" and crop marks
print verso: "Lee—Drifting Sand"
Acquired from: gift of Texas Monthly, Inc., Austin, Texas,
printed from a transparency in the Standard Oil of New
Jersey Collection, University of Louisville Photographic
Archives

3419. DRIVE-IN THEATER NEAR PHARR, TEXAS. LOWER
RIO GRANDE VALLEY, TEXAS [from the exhibition
"Out of the Forties: A Portrait of Texas from the Standard
Oil Collection"] (P1984.37.80)
Gelatin silver print. negative 1947, print 1982 by Bill Carner
Image: 9 ⁵/₁₆ x 12 ½ in. (23.7 x 31.8 cm.)
Sheet: 11 x 13 ¹⁵/₁₆ in. (28.0 x 35.4 cm.)
Signed, l.r. print verso: "x R.L."
Inscription, print verso: "SONJ 57090" and rubber stamp
"PLEASE CREDIT:/UNIVERSITY OF LOUISVILLE/
PHOTOGRAPHIC ARCHIVES"
Acquired from: gift of Texas Monthly, Inc., Austin, Texas,
printed from a negative in the Standard Oil of New Jersey
Collection, University of Louisville Photographic Archives

3420. FARM WORKER FILLING HOPPER OF COTTON
PLANTER WITH COTTON SEED. HIDALGO
COUNTY, TEXAS [from the exhibition "Out of the
Forties: A Portrait of Texas from the Standard Oil
Collection"] (P1984.37.100)
Gelatin silver print. negative 1952, print 1982 by Bill Carner
Image: 12 ¾ x 9 ⅜ in. (32.4 x 23.8 cm.)
Sheet: 13 ¹⁵/₁₆ x 11 ¹/₁₆ in. (35.4 x 28.1 cm.)
Signed, l.r. print verso: "R.L."
Inscription, print verso: "SONJ 71747" and rubber stamp
"PLEASE CREDIT:/UNIVERSITY OF LOUISVILLE/
PHOTOGRAPHIC ARCHIVES"
Acquired from: gift of Texas Monthly, Inc., Austin, Texas,
printed from a negative in the Standard Oil of New Jersey
Collection, University of Louisville Photographic Archives

3406

3408

3410

3415

3417

3424

3421. **FIVE GANG DISC PLOW DRAWN BY CATERPILLAR DIESEL TRACTOR. THIS GANG PLOW CUTS A SWATH 66 FEET WIDE. WHEAT STUBBLE IS PLOWED UNDER IMMEDIATELY AFTER THE WHEAT IS CUT TO ALLOW ROTTING OF THE STUBBLE WITH EXPECTED RAINS. INSECT CONTROL IS FURTHERED IN THIS MANNER. IN THE VICINITY OF VERNON, TEXAS** [from the exhibition "Out of the Forties: A Portrait of Texas from the Standard Oil Collection"] (P1984.37.91)
Gelatin silver print. negative 1949, print 1982 by Bill Carner
Image: 9 5/16 x 12 1/2 in. (23.7 x 31.8 cm.)
Sheet: 11 1/16 x 13 15/16 in. (28.1 x 35.4 cm.)
Signed, l.r. print verso: "R.L."
Inscription, print verso: "SONJ 64049" and rubber stamp "PLEASE CREDIT:/UNIVERSITY OF LOUISVILLE/ PHOTOGRAPHIC ARCHIVES"
Acquired from: gift of Texas Monthly, Inc., Austin, Texas, printed from a negative in the Standard Oil of New Jersey Collection, University of Louisville Photographic Archives

3422. **HARVESTING CARROTS AT PANCHITA RANCH. F. H. VAHLSING, INC., NEAR EDCOUCH, TEXAS. LOWER RIO GRANDE VALLEY, TEXAS** [from the exhibition "Out of the Forties: A Portrait of Texas from the Standard Oil Collection"] (P1984.37.106)
Dye-transfer print. transparency 1948, print 1982 by Jim Bones
Image: 10 x 13 in. (25.4 x 33.0 cm.)
Sheet: 11 x 13 15/16 in. (28.0 x 35.4 cm.)
Inscription, print recto: "ST—Lee" and crop marks
print verso: "Lee—Harvesting Carrots"
Acquired from: gift of Texas Monthly, Inc., Austin, Texas, printed from a transparency in the Standard Oil of New Jersey Collection, University of Louisville Photographic Archives

3423. **HOME OF FRUIT RANCHER A FEW MILES NORTH OF WESLACO, TEXAS** [from the exhibition "Out of the Forties: A Portrait of Texas from the Standard Oil Collection"] (P1984.37.108)
Dye-transfer print. transparency 1948, print 1982 by Jim Bones
Image: 10 1/16 x 13 in. (25.5 x 33.0 cm.)
Sheet: 11 x 13 15/16 in. (28.0 x 35.4 cm.)
Inscription, print recto: "7—Lee"
print verso: "Lee—Home of a Fruit Rancher"
Acquired from: gift of Texas Monthly, Inc., Austin, Texas, printed from a transparency in the Standard Oil of New Jersey Collection, University of Louisville Photographic Archives

*3424. **MAINTENANCE TRUCK OF N. R. HAMM'S FLEET OF TWELVE SELF-PROPELLED COMBINES FROM PERRY, KANSAS. IN THE VICINITY OF VERNON, TEXAS** [from the exhibition "Out of the Forties: A Portrait of Texas from the Standard Oil Collection"] (P1984.37.93)
Gelatin silver print. negative 1949, print 1982 by Bill Carner
Image: 9 5/16 x 12 1/2 in. (23.7 x 31.8 cm.)
Sheet: 11 x 13 15/16 in. (28.0 x 35.4 cm.)
Signed, l.r. print verso: "R.L."
Inscription, print verso: "SONJ 64055" and rubber stamp "PLEASE CREDIT:/UNIVERSITY OF LOUISVILLE/ PHOTOGRAPHIC ARCHIVES"
Acquired from: gift of Texas Monthly, Inc., Austin, Texas, printed from a negative in the Standard Oil of New Jersey Collection, University of Louisville Photographic Archives

*3425. **NAPHTHA STORAGE TANK BATTERY ACROSS ROAD FROM CATALYTIC LIGHT END UNITS. BAYTOWN REFINERY OF HUMBLE OIL AND REFINING CO., BAYTOWN, TEXAS** [from the exhibition "Out of the Forties: A Portrait of Texas from the Standard Oil Collection"] (P1984.37.90)
Gelatin silver print. negative 1949, print 1982 by Bill Carner
Image: 9 7/16 x 12 1/16 in. (24.0 x 30.7 cm.)
Sheet: 11 x 13 15/16 in. (28.0 x 35.4 cm.)
Signed, l.r. print verso: "R.L."
Inscription, print verso: "SONJ 63403" and rubber stamp "PLEASE CREDIT:/UNIVERSITY OF LOUISVILLE/ PHOTOGRAPHIC ARCHIVES"
Acquired from: gift of Texas Monthly, Inc., Austin, Texas, printed from a negative in the Standard Oil of New Jersey Collection, University of Louisville Photographic Archives

3426. **PACKED GREEN PEPPERS AT SHED OF F. H. VAHLSING, INC., ELSA, TEXAS. LOWER RIO GRANDE VALLEY, TEXAS** [from the exhibition "Out of the Forties: A Portrait of Texas from the Standard Oil Collection"] (P1984.37.82)
Gelatin silver print. negative 1947, print 1982 by Bill Carner
Image: 9 1/8 x 12 1/2 in. (23.2 x 31.8 cm.)
Sheet: 11 1/16 x 13 15/16 in. (28.1 x 35.4 cm.)
Signed, l.r. print verso: "R.L."
Inscription, print verso: "SONJ 57114" and rubber stamp "PLEASE CREDIT:/UNIVERSITY OF LOUISVILLE/ PHOTOGRAPHIC ARCHIVES"
Acquired from: gift of Texas Monthly, Inc., Austin, Texas, printed from a negative in the Standard Oil of New Jersey Collection, University of Louisville Photographic Archives

3427. **PACKING HOUSE WORKER HAND TRUCKING ORANGES TO LOADING PLATFORM OF VALLEY FRUIT CO., PHARR, TEXAS. RIO GRANDE VALLEY, TEXAS** [from the exhibition "Out of the Forties: A Portrait of Texas from the Standard Oil Collection"] (P1984.37.109)
Dye-transfer print. transparency 1948, print 1982 by Jim Bones
Image: 10 1/16 x 13 in. (25.5 x 33.0 cm.)
Sheet: 11 1/16 x 13 15/16 in. (28.1 x 35.4 cm.)
Inscription, print recto: "80—Lee//Best//Set I-2"
Acquired from: gift of Texas Monthly, Inc., Austin, Texas, printed from a transparency in the Standard Oil of New Jersey Collection, University of Louisville Photographic Archives

*3428. **A QUILTING PARTY IN AN ALVIN, WISCONSIN, HOME** (P1983.7)
Gelatin silver print. 1937
Image: 7 1/16 x 9 11/16 in. (17.9 x 24.6 cm.)
Sheet: 8 x 10 1/16 in. (20.3 x 25.4 cm.)
Signed: see inscription
Inscription, print verso: "Ra 10885-D//A quilting party in an Alvin, Wisconsin, home." and rubber stamp "Kindly use the following credit line:/RESETTLEMENT ADMINISTRATION PHOTOGRAPH BY—LEE"
Acquired from: gift of Paul Brauchle, Dallas, Texas

3429. **REAR OF TRACTOR WHICH IS CULTIVATING COTTON WHILE APPLYING LIQUID AMMONIA AS FERTILIZER AT SAME TIME. THE TANK HOLDS THE AMMONIA. HIDALGO COUNTY, TEXAS** [from the exhibition "Out of the Forties: A Portrait of Texas from the Standard Oil Collection"] (P1984.37.99)
Gelatin silver print. negative 1952, print 1982 by Bill Carner
Image: 10 x 10 15/16 in. (25.4 x 27.8 cm.)
Sheet: 11 x 13 15/16 in. (28.0 x 35.4 cm.)
Inscription, print verso: "SONJ 71204"
Acquired from: gift of Texas Monthly, Inc., Austin, Texas, printed from a negative in the Standard Oil of New Jersey Collection, University of Louisville Photographic Archives

*3430. **SEEDS FOR SALE IN FRONT OF GROCERY STORE.
BURNET, TEXAS. WEST TEXAS** [from the exhibition
"Out of the Forties: A Portrait of Texas from the Standard
Oil Collection"] (P1984.37.97)
Gelatin silver print. negative 1950, print 1982 by Bill Carner
Image: 8 7/16 x 10 13/16 in. (21.4 x 27.5 cm.)
Sheet: 11 x 13 15/16 in. (28.0 x 35.4 cm.)
Signed, l.r. print verso: "R.L."
Inscription, print verso: "SONJ 67085" and rubber stamp
"PLEASE CREDIT:/UNIVERSITY OF LOUISVILLE/
PHOTOGRAPHIC ARCHIVES"
Acquired from: gift of Texas Monthly, Inc., Austin, Texas,
printed from a negative in the Standard Oil of New Jersey
Collection, University of Louisville Photographic Archives

*3431. **SIGN ALONG STATE HIGHWAY #82 NEAR WINK,
TEXAS. WEST TEXAS** [from the exhibition "Out of
the Forties: A Portrait of Texas from the Standard Oil
Collection"] (P1984.37.78)
Gelatin silver print. negative 1947, print 1982 by Bill Carner
Image: 8 7/8 x 12 5/16 in. (22.5 x 31.3 cm.)
Sheet: 11 x 13 15/16 in. (28.0 x 35.4 cm.)
Signed, l.r. print verso: "xx R.L."
Inscription, print verso: "SONJ 53433" and rubber stamp
"PLEASE CREDIT:/UNIVERSITY OF LOUISVILLE/
PHOTOGRAPHIC ARCHIVES"
Acquired from: gift of Texas Monthly, Inc., Austin, Texas,
printed from a negative in the Standard Oil of New Jersey
Collection, University of Louisville Photographic Archives

3432. **SIGN ALONG U. S. HIGHWAY #87 A FEW MILES
SOUTH OF TULIA, TEXAS** [from the exhibition "Out
of the Forties: A Portrait of Texas from the Standard Oil
Collection"] (P1984.37.95)
Gelatin silver print. negative 1949, print 1982 by Bill Carner
Image: 9 5/16 x 12 1/2 in. (23.7 x 31.8 cm.)
Sheet: 11 1/16 x 13 15/16 in. (28.1 x 35.4 cm.)
Signed, l.r. print verso: "R.L."
Inscription, print verso: "SONJ 65257" and rubber stamp
"PLEASE CREDIT:/UNIVERSITY OF LOUISVILLE/
PHOTOGRAPHIC ARCHIVES"
Acquired from: gift of Texas Monthly, Inc., Austin, Texas,
printed from a negative in the Standard Oil of New Jersey
Collection, University of Louisville Photographic Archives

3433. **SIGN AT SOUTH ENTRANCE TO HARLINGEN,
TEXAS, ON CITY ROUTE U. S. HIGHWAY #77.
LOWER RIO GRANDE VALLEY, TEXAS** [from the
exhibition "Out of the Forties: A Portrait of Texas from
the Standard Oil Collection"] (P1984.37.79)
Gelatin silver print. negative 1947, print 1982 by Bill Carner
Image: 9 5/16 x 12 1/2 in. (23.7 x 31.8 cm.)
Sheet: 11 1/16 x 13 15/16 in. (28.1 x 35.4 cm.)
Signed, l.r. print verso: "R.L."
Inscription, print verso: "SONJ 57094" and rubber stamp
"PLEASE CREDIT:/UNIVERSITY OF LOUISVILLE/
PHOTOGRAPHIC ARCHIVES"
Acquired from: gift of Texas Monthly, Inc., Austin, Texas,
printed from a negative in the Standard Oil of New Jersey
Collection, University of Louisville Photographic Archives

3434. **SOFT DRINK STAND AT HIGH SCHOOL FOOTBALL
GAME, HARLINGEN, TEXAS. LOWER RIO GRANDE
VALLEY, TEXAS** [from the exhibition "Out of the Forties:
A Portrait of Texas from the Standard Oil Collection"]
(P1984.37.86)
Gelatin silver print. negative 1947, print 1982 by Bill Carner
Image: 9 5/16 x 12 7/16 in. (23.7 x 31.6 cm.)
Sheet: 11 x 13 15/16 in. (28.0 x 35.4 cm.)
Signed, l.r. print verso: "R.L."
Inscription, print verso: "SONJ 57144" and rubber stamp
"PLEASE CREDIT:/UNIVERSITY OF LOUISVILLE/
PHOTOGRAPHIC ARCHIVES"
Acquired from: gift of Texas Monthly, Inc., Austin, Texas,
printed from a negative in the Standard Oil of New Jersey
Collection, University of Louisville Photographic Archives

3425

3428

3430

3435. **STREET SCENE, BUSINESS SECTION, HOUSTON, TEXAS** [from the exhibition "Out of the Forties: A Portrait of Texas from the Standard Oil Collection"] (P1984.37.73)
Gelatin silver print. negative 1947, print 1982 by Bill Carner
Image: 9 ½ x 10 ¹⁵/₁₆ in. (24.1 x 27.8 cm.)
Sheet: 11 x 13 ¹⁵/₁₆ in. (28.0 x 35.4 cm.)
Signed, l.r. print verso: "x R.L."
Inscription, print verso: "SONJ 50408" and rubber stamp "PLEASE CREDIT:/UNIVERSITY OF LOUISVILLE/ PHOTOGRAPHIC ARCHIVES"
Acquired from: gift of Texas Monthly, Inc., Austin, Texas, printed from a negative in the Standard Oil of New Jersey Collection, University of Louisville Photographic Archives

*3436. **STRING BEAN PICKER AND HIS DAUGHTER SACKING BEANS, NEAR HARLINGEN, TEXAS. LOWER RIO GRANDE VALLEY, TEXAS** [from the exhibition "Out of the Forties: A Portrait of Texas from the Standard Oil Collection"] (P1984.37.85)
Gelatin silver print. negative 1947, print 1982 by Bill Carner
Image: 12 ½ x 9 ⁵/₁₆ in. (31.8 x 23.7 cm.)
Sheet: 13 ¹⁵/₁₆ x 11 in. (35.4 x 28.0 cm.)
Signed, l.r. print verso: "R.L"
Inscription, print verso: "SONJ 57161" and rubber stamp "PLEASE CREDIT:/UNIVERSITY OF LOUISVILLE/ PHOTOGRAPHIC ARCHIVES"
Acquired from: gift of Texas Monthly, Inc., Austin, Texas, printed from a negative in the Standard Oil of New Jersey Collection, University of Louisville Photographic Archives

3437. **TANK CARS AT THE LOADING RACK WITH THE STORAGE TANKS OF THE BAYTOWN REFINERY IN THE BACKGROUND. BAYTOWN, TEXAS** [from the exhibition "Out of the Forties: A Portrait of Texas from the Standard Oil Collection"] (P1984.37.103)
Dye-transfer print. transparency 1947, print 1982 by Jim Bones
Image: 10 x 12 ¹⁵/₁₆ in. (25.4 x 32.9 cm.)
Sheet: 11 x 13 ¹⁵/₁₆ in. (28.0 x 35.4 cm.)
Inscription, print verso: "Lee—Tank Cars at loading rack"
Acquired from: gift of Texas Monthly, Inc., Austin, Texas, printed from a transparency in the Standard Oil of New Jersey Collection, University of Louisville Photographic Archives

*3438. **TIRE STORE IN VERNON, TEXAS. IN THE VICINITY OF VERNON, TEXAS** [from the exhibition "Out of the Forties: A Portrait of Texas from the Standard Oil Collection"] (P1984.37.94)
Gelatin silver print. negative 1949, print 1982 by Bill Carner
Image: 9 ¼ x 12 ⁵/₁₆ in. (23.5 x 31.3 cm.)
Sheet: 11 x 13 ¹⁵/₁₆ in. (28.0 x 35.4 cm.)
Inscription, print verso: "SONJ 64086"
Acquired from: gift of Texas Monthly, Inc., Austin, Texas, printed from a negative in the Standard Oil of New Jersey Collection, University of Louisville Photographic Archives

*3439. **TOURISTS' HEADQUARTERS FOR ANNUAL CITRUS FESTIVAL AT MISSION, TEXAS. LOWER RIO GRANDE VALLEY, TEXAS** [from the exhibition "Out of the Forties: A Portrait of Texas from the Standard Oil Collection"] (P1984.37.87)
Gelatin silver print. negative 1947, print 1982 by Bill Carner
Image: 9 ⁵/₁₆ x 12 ½ in. (23.7 x 31.8 cm.)
Sheet: 11 x 13 ¹⁵/₁₆ in. (28.0 x 35.4 cm.)
Signed, l.r. print verso: "R.L."
Inscription, print verso: "SONJ 57285" and rubber stamp "PLEASE CREDIT:/UNIVERSITY OF LOUISVILLE/ PHOTOGRAPHIC ARCHIVES"
Acquired from: gift of Texas Monthly, Inc., Austin, Texas, printed from a negative in the Standard Oil of New Jersey Collection, University of Louisville Photographic Archives

3440. **TRAILERS PARKED IN GROVE OF PALM TREES. McALLEN, TEXAS** [from the exhibition "Out of the Forties: A Portrait of Texas from the Standard Oil Collection"] (P1984.37.104)
Dye-transfer print. transparency 1948, print 1982 by Jim Bones
Image: 10 ¹/₁₆ x 12 ¹⁵/₁₆ in. (25.5 x 32.9 cm.)
Sheet: 11 ¹/₁₆ x 13 ¹⁵/₁₆ in. (28.1 x 35.4 cm.)
Inscription, print verso: "Lee—Trailers in Grove of Palm Trees"
Acquired from: gift of Texas Monthly, Inc., Austin, Texas, printed from a transparency in the Standard Oil of New Jersey Collection, University of Louisville Photographic Archives

3441. **TRUCK DRIVER OF N. R. HAMM'S TWELVE SELF-PROPELLED COMBINES AND TRUCK FLEET FROM PERRY, KANSAS, DIRECTS FLOW OF WHEAT FROM COMBINE ELEVATOR WITH HIS SCOOP TO EVENLY LOAD HIS TRUCK. IN THE VICINITY OF VERNON, TEXAS** [from the exhibition "Out of the Forties: A Portrait of Texas from the Standard Oil Collection"] (P1984.37.92)
Gelatin silver print. negative 1949, print 1982 by Bill Carner
Image: 9 ½ x 9 ½ in. (24.1 x 24.1 cm.)
Sheet: 11 ¹/₁₆ x 13 ¹⁵/₁₆ in. (28.1 x 35.4 cm.)
Signed, l.r. print verso: "R.L."
Inscription, print verso: "SONJ 64022" and rubber stamp "PLEASE CREDIT:/UNIVERSITY OF LOUISVILLE/ PHOTOGRAPHIC ARCHIVES"
Acquired from: gift of Texas Monthly, Inc., Austin, Texas, printed from a negative in the Standard Oil of New Jersey Collection, University of Louisville Photographic Archives

3442. **TRUCKS LOADED WITH GRAPEFRUIT LINED UP BEFORE THE WORLD'S LARGEST CITRUS JUICE CANNING PLANT AT WESLACO, TEXAS** [from the exhibition "Out of the Forties: A Portrait of Texas from the Standard Oil Collection"] (P1984.37.105)
Dye-transfer print. transparency 1948, print 1982 by Jim Bones
Image: 10 x 13 in. (25.4 x 33.0 cm.)
Sheet: 11 x 13 ¹⁵/₁₆ in. (28.0 x 35.4 cm.)
Inscription, print recto: "4—Lee//Best//set 1-2"
Acquired from: gift of Texas Monthly, Inc., Austin, Texas, printed from a transparency in the Standard Oil of New Jersey Collection, University of Louisville Photographic Archives

3443. **WASHING BEETS IN PACKING SHEDS OF F. H. VAHLSING, INC., ELSA, TEXAS. LOWER RIO GRANDE VALLEY, TEXAS** [from the exhibition "Out of the Forties: A Portrait of Texas from the Standard Oil Collection"] (P1984.37.83)
Gelatin silver print. negative 1947, print 1982 by Bill Carner
Image: 8 ⁵/₈ x 12 ½ in. (21.9 x 31.8 cm.)
Sheet: 11 ¹/₁₆ x 13 ¹⁵/₁₆ in. (28.1 x 35.4 cm.)
Signed, l.r. print verso: "xx R L."
Inscription, print verso: "SONJ 57122" and rubber stamp "PLEASE CREDIT:/UNIVERSITY OF LOUISVILLE/ PHOTOGRAPHIC ARCHIVES"
Acquired from: gift of Texas Monthly, Inc., Austin, Texas, printed from a negative in the Standard Oil of New Jersey Collection, University of Louisville Photographic Archives

*3444. **WATERMELONS FOR SALE. FARMERS' MARKET, HOUSTON, TEXAS** [from the exhibition "Out of the Forties: A Portrait of Texas from the Standard Oil Collection"] (P1984.37.72)
Gelatin silver print. negative 1947, print 1982 by Bill Carner
Image: 9 ⁷/₁₆ x 12 in. (24.0 x 30.5 cm.)
Sheet: 11 ¹/₁₆ x 13 ¹⁵/₁₆ in. (28.1 x 35.4 cm.)
Signed, l.r. print verso: "R.L."
Inscription, print verso: "SONJ 50407" and rubber stamp "PLEASE CREDIT:/UNIVERSITY OF LOUISVILLE/ PHOTOGRAPHIC ARCHIVES"
Acquired from: gift of Texas Monthly, Inc., Austin, Texas, printed from a negative in the Standard Oil of New Jersey Collection, University of Louisville Photographic Archives

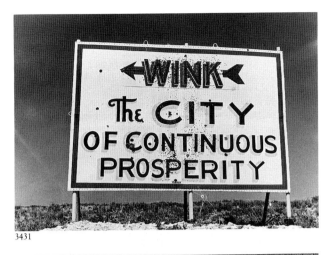

3431

3436

3438

3439

3447

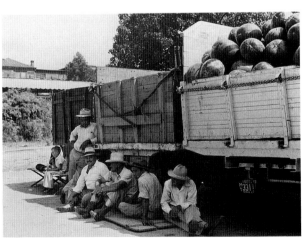

3444

3445. **WEIGHING FRESHLY BALED COTTON AT COTTON GIN, COUPLAND, TEXAS. EAST TEXAS [from the exhibition "Out of the Forties: A Portrait of Texas from the Standard Oil Collection"]** (P1984.37.77)
Gelatin silver print. negative 1947, print 1982 by Bill Carner
Image: 9 5/16 x 12 1/2 in. (23.7 x 31.8 cm.)
Sheet: 11 x 13 15/16 in. (28.0 x 35.4 cm.)
Signed, l.r. print verso: "R.L."
Inscription, print verso: "SONJ 52355" and rubber stamp "PLEASE CREDIT:/UNIVERSITY OF LOUISVILLE/ PHOTOGRAPHIC ARCHIVES"
Acquired from: gift of Texas Monthly, Inc., Austin, Texas, printed from a negative in the Standard Oil of New Jersey Collection, University of Louisville Photographic Archives

3446. **WORKER DUMPS BASKET OF RADISHES INTO WASHING COMPARTMENTS IN THE PACKING SHED OF F. H. VAHLSING, INC., ELSA, TEXAS. LOWER RIO GRANDE VALLEY, TEXAS [from the exhibition "Out of the Forties: A Portrait of Texas from the Standard Oil Collection"]** (P1984.37.81)
Gelatin silver print. negative 1947, print 1982 by Bill Carner
Image: 9 1/4 x 12 1/2 in. (23.5 x 31.8 cm.)
Sheet: 11 x 13 15/16 in. (28.0 x 35.4 cm.)
Signed, l.r. print verso: "R.L."
Inscription, print verso: "SONJ 57108" and rubber stamp "PLEASE CREDIT:/UNIVERSITY OF LOUISVILLE/ PHOTOGRAPHIC ARCHIVES"
Acquired from: gift of Texas Monthly, Inc., Austin, Texas, printed from a negative in the Standard Oil of New Jersey Collection, University of Louisville Photographic Archives

*3447. **WRAPPING HEAD OF CAULIFLOWER IN PAPER BEFORE PACKING IN BOX. ON PANCHITA RANCH OF F. H. VAHLSING, INC., NEAR EDCOUCH, TEXAS. LOWER RIO GRANDE VALLEY, TEXAS [from the exhibition "Out of the Forties: A Portrait of Texas from the Standard Oil Collection"]** (P1984.37.89)
Gelatin silver print. negative 1948, print 1982 by Bill Carner
Image: 12 1/2 x 9 1/4 in. (31.8 x 23.5 cm.)
Sheet: 13 15/16 x 11 in. (35.4 x 28.0 cm.)
Signed, l.r. print verso: "R.L."
Inscription, print verso: "SONJ 57301" and rubber stamp "PLEASE CREDIT:/UNIVERSITY OF LOUISVILLE/ PHOTOGRAPHIC ARCHIVES"
Acquired from: gift of Texas Monthly, Inc., Austin, Texas, printed from a negative in the Standard Oil of New Jersey Collection, University of Louisville Photographic Archives

NATHAN LERNER, American (b. 1915)

After course work at the National Academy of Art in Chicago and the Art Institute of Chicago, Lerner studied photography with László Moholy-Nagy and Gyorgy Kepes at the New Bauhaus School in Chicago. His studies of light as a creative medium reflect their influence. The New Bauhaus School later became the Institute of Design and Lerner remained as a teacher and administrator. During World War II he served as a civilian light consultant and designer for the U. S. Navy. He also founded a design firm, Lerner-Bredendiek Designs, in 1949 and has held visiting professorships at both the Illinois Institute of Technology and the University of Illinois.

*3448. **LIGHT VOLUME** (P1978.20)
Gelatin silver print. negative 1937, print c. 1978
Image: 8 15/16 x 12 7/16 in. (22.7 x 31.5 cm.)
Sheet: 10 15/16 x 14 in. (27.7 x 35.5 cm.)
Signed, center print verso: "Nathan Lerner/1937"
Inscription, print verso: ""Light Volume"/[signature]//Friends of Photography print"
Acquired from: Friends of Photography, Carmel, California; gift print with sustaining membership, 1978

HELEN LEVITT, American (b. 1918)

Helen Levitt is a native of New York City, and many of her documentary images focus on life on the city streets. Her first book of her photographs, A Way of Seeing, was prepared in 1946 but not published until 1965; it included an essay by her friend James Agee. She also made two films about the city entitled In the Street and The Quiet One. Although her early work was done in black and white, Levitt began working with color in the 1960s. She received three Guggenheim Fellowships for the study of color photography, and in 1980 she published a volume of her color photographs. In 1987, Levitt earned a Peer Award in Creative Photography from the Friends of Photography.

*3449. **N.Y. [three masked children on stoop]** (P1983.2.1)
Gelatin silver print. negative 1942, print later
Image: 7 9/16 x 11 in. (19.2 x 28.0 cm.)
Sheet: 11 x 13 9/16 in. (28.0 x 34.4 cm.)
Signed, l.r. print recto: "Helen Levitt"
Inscription, print verso: "H//N.Y./CIRCA 1942/Helen Levitt"
Acquired from: Fraenkel Gallery, San Francisco, California

3450. **N.Y. [four boys]** (P1983.2.2)
Gelatin silver print. negative c. 1942, print later
Image: 6 3/8 x 9 5/8 in. (16.2 x 24.4 cm.)
Sheet: 10 7/8 x 13 1/2 in. (27.6 x 34.3 cm.)
Signed, center print verso: "Helen Levitt"
Inscription, print verso: "N.Y. CIRCA 1942"
Acquired from: Fraenkel Gallery, San Francisco, California

*3451. **N.Y. [laughing child in a baby carriage]** (P1984.24)
Gelatin silver print. c. 1942
Image: 9 3/8 x 6 3/8 in. (23.8 x 16.2 cm.)
Mount: 11 7/8 x 8 7/16 in. (30.1 x 21.4 cm.)
Signed, center mount verso: "Helen Levitt"
Inscription, mount verso: "N.Y. CIRCA 1942//(VINTAGE PRINT)"
Acquired from: Fraenkel Gallery, San Francisco, California

3452. **N.Y. [woman with milk bottles]** (P1987.2)
Gelatin silver print. negative c. 1942, print later
Image: 10 7/16 x 6 15/16 in. (26.5 x 17.6 cm.)
Sheet: 13 15/16 x 11 in. (35.4 x 27.9 cm.)
Signed, center print verso: "Helen Levitt"
Inscription, print verso: "N.Y. CIRCA 1942//All Rights Reserved"
Acquired from: gift of Marvin Hoshino, New York, New York

*3453. **WALKER EVANS** (P1978.48.4)
Gelatin silver print. c. 1938–39
Image: 4 1/4 x 2 7/8 in. (10.8 x 7.3 cm.)
Sheet: 5 1/8 x 3 13/16 in. (13.1 x 9.7 cm.)
Inscription, print verso: "R-524 Walker Evans"
Acquired from: Hastings Gallery, New York, New York

ARTHUR ALLEN LEWIS, American (1873–1957)

See Camera Work

ROBERT LEWIS, American (b. 1953)

Robert Lewis studied at Arizona State University and Texas Christian University and has taught photography in Arlington, Texas, and done advertising photography in New York. Lewis works with nonsilver processes such as gum-bichromate printing because of the freedom of color and texture that they provide the photographer.

*3454. **STOCKBROKER** [men playing checkers] (P1979.11)
Gum-bichromate print. 1979
Image: 4¾ x 6⅞ in. (12.1 x 17.5 cm.)
Sheet: 7 x 11½ in. (17.8 x 29.3 cm.)
Signed, l.r. sheet recto: "Robert Lewis 79"
Inscription, mat backing, recto: ""STOCKBROKER"/Gum Print 1979/Robert Lewis b. 1953. American/12.2 x 16.5 cm. [sic]"
Acquired from: gift of the photographer

JEROME LIEBLING, American (b. 1924)

Jerome Liebling is a noted filmmaker as well as documentary photographer. He studied photography and design at Brooklyn College, motion picture production at the Film Workshop of the New School for Social Research, and photography with Paul Strand at the Photo League. In 1950 Liebling received a research grant from the University of Minnesota with which he produced the series "The Minnesota Scene." He has since received a fellowship from the Massachusetts Council of the Arts, three grants from the National Endowment for the Arts (1972, 1979, and 1980), and two Guggenheim grants (1976 and 1981). Liebling's photographs have been widely exhibited, and in 1978 the Friends of Photography held a retrospective exhibition. His films *89 Years, Art and Seeing, A Tree Is Dead*, and *Pow-Wow* also have won numerous national and international awards. A founding member of the Society for Photographic Education, he has taught photography and filmmaking at the University of Minnesota, the State University of New York at New Paltz, Hampshire College, and Yale University.

*3455. **BUTTERFLY BOY** (P1985.41)
Gelatin silver print. 1949
Image: 9⁹⁄₁₆ x 9⁹⁄₁₆ in. (24.3 x 24.3 cm.) irregular
Sheet: 10⁹⁄₁₆ x 10 in. (26.7 x 25.3 cm.)
Signed, top edge print verso: "Jerome Liebling"
Inscription, print verso: "[signature] Photo League '49" and rubber stamp "Jerome Liebling·PHOTOGRAPHY·39 Dana Street·Amherst, Mass. 01003"
Acquired from: Photofind Gallery, Inc., Woodstock, New York

EDWIN HALE LINCOLN, American (1848–1938)

Edwin Hale Lincoln had planned to attend Harvard College, but instead took a job in a Boston wholesale dry goods house and later became a partner in a photographic business. Lincoln began making photographs in 1877. He photographed many New England estates and was one of the first photographers to specialize in house interiors. Two complete estate portfolios and over seven hundred negatives of estates still exist. He also pioneered the use of the newly invented dry-plate negatives, using them to record wooden sailing vessels. Many of these appeared in his portfolio "Typical Wooden Vessels of the 19th Century, 1883-1889," published in 1929. Lincoln is best known, however, for his

3448

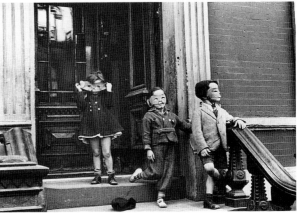
3449

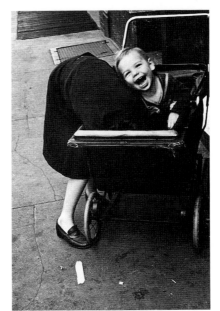
3451

delicate plant images printed on platinum paper. In 1914 he produced "Wild Flowers of New England," the culmination of twenty years' work. The portfolio consisted of eight bound volumes of four hundred 8 x 10 inch mounted platinum prints. Two smaller, unbound editions had been published in 1904 and 1907. Lincoln, a charter member of the American Orchid Society, published the two-volume portfolio "Orchids of the North Eastern United States Photographed from Nature" in 1913. He also published an undated portfolio, "New England Trees."

*3456. [Indian Pipe, *Monotropa uniflora*] (P1985.30)
Platinum print. c. 1893–1904
Image: 6¾ x 4¹¹/₁₆ in. (17.1 x 11.9 cm.)
Acquired from: Paul M. Hertzmann, Inc., San Francisco, California

O. WINSTON LINK, American (b. 1914)

Ogle Winston Link, born in Brooklyn, took up photography as a hobby. He received a Bachelor in Civil Engineering degree from the Polytechnic Institute of Brooklyn in 1937, but after graduation he became chief photographer of a New York public relations firm. In 1942 Link joined the Columbia University Division of War Research, where he experimented with various multiple-flash night photography techniques. After World War II Link opened a commercial studio with clients such as The BF Goodrich Company, Texaco, Inc., Alcoa, and the Triboro Bridge and Tunnel Authority. A turning point in his career came while on a commercial assignment in Staunton, Virginia, in 1955. Link, a long-time train enthusiast, began photographing the steam trains of the Norfolk and Western Railway. This wholly self-supported project occupied him between jobs for five years. During that time he made more than 2,200 photographs depicting the trains and their effects on the people and places around them. Although Link did photograph trains during the day, most of his photographs are night images for which he employed a complex series of connected cameras, flashes, and reflectors to illuminate the trains. This artificial illumination added an almost surreal quality to the night photographs. Publications of his steam train images include *Ghost Trains* (1983) and *Steam, Steel & Stars: America's Last Steam Railroads* (1987). Although Link returned to his commercial photography after the demise of the N & W steam trains in 1960, the recognition he received from photographic collectors in the 1970s and 1980s has required him to spend a great deal of time printing in his lab.

*3457. **THE POPES AND THE LAST STEAM PASSENGER TRAIN** (P1985.16)
Gelatin silver print. negative 1957, print 1985
Image: 19⁷/₁₆ x 15½ in. (49.4 x 39.4 cm.)
Sheet: 19⁷/₈ x 16 in. (50.5 x 40.7 cm.)
Signed, l.r. print verso: "Printed by/O Winston Link/2-85"
Inscription, print verso: "NW 1648/KE 3 ARCH/2-85" and "NW 1648" contained within rubber stamp "NOTICE!/ THIS PHOTOGRAPH MUST/NOT BE REPRODUCED EITHER/WHOLE OR IN PART BY ANY/METHOD, PHOTOGRAPHIC OR/ART, FOR ANY PURPOSE WITH-/OUT WRITTEN PERMISSION/FROM/ O. WINSTON LINK/381 PARK AVE. SOUTH/ NEW YORK, N. Y. 10016/COPYRIGHT NO."
Acquired from: Pace/MacGill, New York, New York

CHARLES F. LUMMIS, American (1859–1928)

Lummis was a writer and photographer who moved to Los Angeles from Ohio in 1885 to become the city editor of the *Los Angeles Times*. He did some photographic work during his two years with the paper but in 1887 suffered a paralyzing stroke and moved to Isleta, New Mexico, to recover. There he continued to write and lecture but made an increasing number of photographs, printing his own cyanotypes and sending his negatives to Albuquerque to have silver prints made. In 1888 he met the archaeologist Adolph Bandelier and assisted with his work for four years, including a field trip to the Andes. After his return from South America Lummis became editor of a magazine called *Land of Sunshine* (he changed the name to *Out West* in 1902), in which he reproduced many of his own images. In the publication Lummis argued for the preservation of the West and more sensitive handling of the American Indian situation. He also published the work of other photographers, including Arnold Genthe, but held the work of William Henry Jackson in highest esteem because of his admiration for Jackson's awe-inspiring landscapes. Lummis left New Mexico in 1905 and became the assistant librarian at the Los Angeles Public Library, where he worked to establish a strong Southwest history collection.

*3458. [Pueblo Indian woman] (P1980.14)
Cyanotype. c. 1890s
Image: 7⁵/₈ x 4½ in. (19.3 x 11.3 cm.)
Sheet: 8 x 5¹/₁₆ in. (20.3 x 12.9 cm.)
Acquired from: Robert Schoelkopf Gallery, New York, New York

GEORGE PLATT LYNES, American (1907–1955)

Educated in private schools and briefly studying at Yale University, George Platt Lynes was a self-taught photographer. Books interested Lynes, and in the early 1920s he worked as a salesman in a bookstore. In 1926, working under the name "As Stable Productions," Lynes published short works by authors such as Gertrude Stein, Rene Crevel, and Ernest Hemingway. He began photographing at this time, and in 1928 he held his first exhibition in the bookstore he owned. Lynes worked as a freelance photographer in New York and Paris between 1928 and 1932 and then opened a photographic studio in New York. In 1946 he moved to Hollywood, California, to run a studio but returned to New York after two years. From 1948 through 1955, he worked as a fashion photographer, his photographs appearing in *Town and Country*, *Vogue*, and *Harper's Bazaar*. Lynes' commercial work consisted of portraits and fashion and advertising photographs; male nudes, ballet photographs, and surrealistic still lifes made up his personal photography.

3459. [Ted Starkowski and friend] (P1985.26)
Gelatin silver print. c. 1951
Image: 9¹/₁₆ x 6¹³/₁₆ in. (23.0 x 17.2 cm.)
Signed: see inscription
Inscription, print verso: "20.4" and rubber stamp "GEORGE PLATT LYNES/229 EAST 47 STREET NEW YORK"
Acquired from: Steve Dohen, Los Angeles, California

DANNY LYON, American (b. 1942)

Photographer and filmmaker Danny Lyon's work has a keen sense of social awareness. He photographed the civil rights movement in the South as staff photographer for the Student Non-Violent Coordinating Committee in 1963–64 and later worked with motorcycle club members and prisoners to produce collaborative statements about their lives. In 1988–89 he produced a series on stock car races and demolition derbies, titled "The Pit." His views depict what Lyon calls a "social landscape" in which the photographer not only comments on the world but represents his own involvement in it.

DANNY LYON (P1980.67.1–30)

This portfolio was published by Hyperion Press of New York City in 1979.

3460. **TRUCK IN THE DESERT NEAR YUMA, ARIZONA**
(P1980.67.1)
Gelatin silver print. negative 1962, print 1979
Image: 8 13/16 x 13 in. (22.4 x 33.0 cm.)
Sheet: 11 x 14 in. (28.0 x 35.6 cm.)
Signed, l.r. print verso: "Danny Lyon"
Inscription, print verso: "1"
Acquired from: gift of George Peterkin, Jr., Houston, Texas

3461. **UPTOWN CHICAGO [three boys in front of graffiti-covered building]** (P1980.67.2)
Gelatin silver print. negative 1965, print 1979
Image: 9 13/16 x 9 3/4 in. (24.9 x 24.8 cm.)
Sheet: 14 x 11 in. (35.6 x 28.0 cm.)
Signed, l.r. print verso: "Danny Lyon"
Inscription, print verso: "2"
Acquired from: gift of George Peterkin, Jr., Houston, Texas

3462. **UPTOWN CHICAGO [boy kissing girl in curlers]**
(P1980.67.3)
Gelatin silver print. negative 1965, print 1979
Image: 8 11/16 x 13 in. (22.1 x 33.0 cm.)
Sheet: 11 x 14 in. (28.0 x 35.6 cm.)
Signed, l.r. print verso: "Danny Lyon"
Inscription, print verso: "3"
Acquired from: gift of George Peterkin, Jr., Houston, Texas

3463. **ROUTE 12, WISCONSIN** (P1980.67.4)
Gelatin silver print. negative 1963, print 1979
Image: 8 13/16 x 12 15/16 in. (22.4 x 32.8 cm.)
Sheet: 11 x 13 7/8 in. (28.0 x 35.2 cm.)
Signed, l.r. print verso: "Danny Lyon"
Inscription, print verso: "4"
Acquired from: gift of George Peterkin, Jr., Houston, Texas

3464. **SCRAMBLES TRACK, McHENRY, ILLINOIS** (P1980.67.5)
Gelatin silver print. negative 1966, print 1979
Image: 10 1/16 x 10 1/16 in. (25.6 x 25.6 cm.)
Sheet: 14 x 11 in. (35.6 x 28.0 cm.)
Signed, l.r. print verso: "Danny Lyon"
Inscription, print verso: "5"
Acquired from: gift of George Peterkin, Jr., Houston, Texas

3465. **RACER, SCHERERVILLE, INDIANA** (P1980.67.6)
Gelatin silver print. negative 1965, print 1979
Image: 8 3/4 x 13 1/16 in. (22.2 x 33.2 cm.)
Sheet: 11 x 14 in. (28.0 x 35.6 cm.)
Signed, u.l. print verso: "Danny Lyon"
Inscription, print verso: "6"
Acquired from: gift of George Peterkin, Jr., Houston, Texas

3466. **JACK, CHICAGO** (P1980.67.7)
Gelatin silver print. negative 1965–66, print 1979
Image: 13 x 8 3/4 in. (33.0 x 22.2 cm.)
Sheet: 14 x 11 in. (35.6 x 28.0 cm.)
Signed, l.r. print verso: "Danny Lyon"
Inscription, print verso: "7"
Acquired from: gift of George Peterkin, Jr., Houston, Texas

3453

3454

3455

3467. **ANDY, MEETING AT THE STOPLIGHT, CICERO, ILLINOIS** (P1980.67.8)
Gelatin silver print. negative 1965–66, print 1979
Image: 13 x 8¾ in. (33.0 x 22.2 cm.)
Sheet: 14 x 10⅞ in. (35.6 x 27.7 cm.)
Signed, l.r. print verso: "Danny Lyon"
Inscription, print verso: "8"
Acquired from: gift of George Peterkin, Jr., Houston, Texas

3468. **SPARKY AND COWBOY, SCHERERVILLE, INDIANA** (P1980.67.9)
Gelatin silver print. negative 1965–66, print 1979
Image: 8¾ x 13 in. (22.2 x 33.0 cm.)
Sheet: 11 x 14 in. (28.0 x 35.6 cm.)
Signed, l.r. print verso: "Danny Lyon"
Inscription, print verso: "9"
Acquired from: gift of George Peterkin, Jr., Houston, Texas

3469. **CROSSING THE OHIO, LOUISVILLE** (P1980.67.10)
Gelatin silver print. negative 1966, print 1979
Image: 8¾ x 13 in. (22.2 x 33.0 cm.)
Sheet: 11 x 14 in. (28.0 x 35.6 cm.)
Signed, l.r. print verso: "Danny Lyon"
Inscription, print verso: "10"
Acquired from: gift of George Peterkin, Jr., Houston, Texas

3470. **THE LINE, FERGUSON UNIT, TEXAS** (P1980.67.11)
Gelatin silver print. negative 1967–69, print 1979
Image: 8¾ x 13 in. (22.2 x 33.0 cm.)
Sheet: 11 x 14 in. (28.0 x 35.6 cm.)
Signed, l.r. print verso: "Danny Lyon"
Inscription, print verso: "11"
Acquired from: gift of George Peterkin, Jr., Houston, Texas

3471. **COTTON PICKERS, FERGUSON UNIT, TEXAS** (P1980.67.12)
Gelatin silver print. negative 1967–69, print 1979
Image: 8¾ x 13 in. (22.2 x 33.0 cm.)
Sheet: 10⅞ x 14 in. (27.6 x 35.6 cm.)
Signed, l.r. print verso: "Danny Lyon"
Inscription, print verso: "12"
Acquired from: gift of George Peterkin, Jr., Houston, Texas

3472. **CLEARING LAND, ELLIS UNIT** (P1980.67.13)
Gelatin silver print. negative 1967–69, print 1979
Image: 8¾ x 13 in. (22.2 x 33.0 cm.)
Sheet: 11 x 14 in. (28.0 x 35.6 cm.)
Signed, l.r. print verso: "Danny Lyon"
Inscription, print verso: "13"
Acquired from: gift of George Peterkin, Jr., Houston, Texas

3473. **THE CORNWAGON, RAMSEY UNIT, TEXAS** (LP1980.67.14)
Gelatin silver print. negative 1967–69, print 1979
Image: 8¾ x 13 in. (22.2 x 33.0 cm.)
Sheet: 11 x 14 in. (28.0 x 35.6 cm.)
Signed, l.r. print verso: "Danny Lyon"
Inscription, print verso: "14"
Acquired from: long-term loan from George Peterkin, Jr., Houston, Texas

3474. **FROM THE PICKET TOWER, FERGUSON UNIT** (P1980.67.15)
Gelatin silver print. negative 1967–69, print 1979
Image: 8¾ x 13⅛ in. (22.2 x 33.3 cm.)
Sheet: 11 x 14 in. (28.0 x 35.6 cm.)
Signed, l.r. print verso: "Danny Lyon"
Inscription, print verso: "15"
Acquired from: gift of George Peterkin, Jr., Houston, Texas

3475. **SHOWERS, DIAGNOSTIC UNIT, TEXAS** (P1980.67.16)
Gelatin silver print. negative 1967–69, print 1979
Image: 13⅛ x 8¾ in. (33.3 x 22.2 cm.)
Sheet: 14⅛ x 11 in. (35.8 x 28.0 cm.)
Signed, l.r. print verso: "Danny Lyon"
Inscription, print verso: "16"
Acquired from: gift of George Peterkin, Jr., Houston, Texas

3476. **SHAKEDOWN, RAMSEY UNIT, TEXAS** (P1980.67.17)
Gelatin silver print. negative 1967–69, print 1979
Image: 8¾ x 13 in. (22.2 x 33.0 cm.)
Sheet: 11 x 14 in. (28.0 x 35.6 cm.)
Signed, l.r. print verso: "Danny Lyon"
Inscription, print verso: "17"
Acquired from: gift of George Peterkin, Jr., Houston, Texas

3477. **DOMINOES, WALLS UNIT, TEXAS** (P1980.67.18)
Gelatin silver print. negative 1967–69, print 1979
Image: 8¾ x 13 in. (22.2 x 33.0 cm.)
Sheet: 11 x 14 in. (28.0 x 35.6 cm.)
Signed, l.r. print verso: "Danny Lyon"
Inscription, print verso: "18"
Acquired from: gift of George Peterkin, Jr., Houston, Texas

3478. **HEAT EXHAUSTION, ELLIS UNIT, TEXAS** (P1980.67.19)
Gelatin silver print. negative 1967–69, print 1979
Image: 8¹³⁄₁₆ x 13¹⁄₁₆ in. (22.4 x 33.2 cm.)
Sheet: 11 x 14 in. (28.0 x 35.6 cm.)
Signed, l.r. print verso: "Danny Lyon"
Inscription, print verso: "19"
Acquired from: gift of George Peterkin, Jr., Houston, Texas

3479. **LLANITO, NEW MEXICO** (P1980.67.20)
Gelatin silver print. negative 1970, print 1979
Image: 8¹¹⁄₁₆ x 12¹⁵⁄₁₆ in. (22.0 x 32.9 cm.)
Sheet: 11 x 14 in. (28.0 x 35.6 cm.)
Signed, l.r. print verso: "Danny Lyon"
Inscription, print verso: "20"
Acquired from: gift of George Peterkin, Jr., Houston, Texas

3480. **SANTA MARTA, COLOMBIA** (P1980.67.21)
Gelatin silver print. negative 1972, print 1979
Image: 8⅝ x 13 in. (21.9 x 33.0 cm.)
Sheet: 11 x 14 in. (28.0 x 35.6 cm.)
Signed, l.r. print verso: "Danny Lyon"
Inscription, print verso: "21"
Acquired from: gift of George Peterkin, Jr., Houston, Texas

3481. **JOSELIN, SANTA MARTA, COLOMBIA** (P1980.67.22)
Gelatin silver print. negative 1972, print 1979
Image: 8⅝ x 13 in. (21.9 x 33.0 cm.)
Sheet: 11 x 14 in. (28.0 x 35.6 cm.)
Signed, l.r. print verso: "Danny Lyon"
Inscription, print verso: "22"
Acquired from: gift of George Peterkin, Jr., Houston, Texas

3482. **MARY, SANTA MARTA, COLOMBIA** (P1980.67.23)
Gelatin silver print. negative 1972, print 1979
Image: 8⅝ x 13 in. (21.9 x 33.0 cm.)
Sheet: 11 x 14 in. (28.0 x 35.6 cm.)
Signed, l.r. print verso: "Danny Lyon"
Inscription, print verso: "23"
Acquired from: gift of George Peterkin, Jr., Houston, Texas

3483. **NAMEQUEPA, CHIHUAHUA, MEXICO** (P1980.67.24)
Gelatin silver print. negative 1972, print 1979
Image: 13 x 8¾ in. (33.0 x 22.2 cm.)
Sheet: 14 x 11 in. (35.6 x 28.0 cm.)
Signed, l.r. print verso: "Danny Lyon"
Inscription, print verso: "24"
Acquired from: gift of George Peterkin, Jr., Houston, Texas

3484. **TRUCK IN NUEVA CASAS GRANDES, CHIHUAHUA, MEXICO** (P1980.67.25)
Gelatin silver print. negative 1975, print 1979
Image: 8⅝ x 13 in. (21.9 x 33.0 cm.)
Sheet: 11 x 14 in. (28.0 x 35.6 cm.)
Signed, l.r. print verso: "Danny Lyon"
Inscription, print verso: "25"
Acquired from: gift of George Peterkin, Jr., Houston, Texas

3485. **ANDREW AT SIXTEEN, BERNALILLO, NEW MEXICO**
(P1980.67.26)
Gelatin silver print. negative 1976, print 1979
Image: 8 13/16 x 13 1/2 in. (22.4 x 34.3 cm.)
Sheet: 11 x 14 3/16 in. (28.0 x 36.0 cm.)
Signed, l.r. print verso: "Danny Lyon"
Inscription, print verso: "26"
Acquired from: gift of George Peterkin, Jr., Houston, Texas

3486. **MORELIA, MICHOACAN, MEXICO** (P1980.67.27)
Gelatin silver print. negative 1977, print 1979
Image: 8 3/4 x 13 in. (22.2 x 33.0 cm.)
Sheet: 11 x 14 in. (28.0 x 35.6 cm.)
Signed, l.r. print verso: "Danny Lyon"
Inscription, print verso: "27"
Acquired from: gift of George Peterkin, Jr., Houston, Texas

3487. **BUS STOP, TEHUANTEPEC, OAXACA** (P1980.67.28)
Gelatin silver print. negative 1978, print 1979
Image: 13 1/8 x 8 3/4 in. (33.3 x 22.2 cm.)
Sheet: 14 x 11 in. (35.6 x 28.0 cm.)
Signed, l.l. print verso: "Danny Lyon"
Inscription, print verso: "28"
Acquired from: gift of George Peterkin, Jr., Houston, Texas

3456

3488. **IRT 2, SOUTH BRONX, NEW YORK CITY [interior of
subway car]** (P1980.67.29)
Gelatin silver print. 1979
Image: 8 3/4 x 13 1/8 in. (22.2 x 33.3 cm.)
Sheet: 11 x 14 in. (28.0 x 35.6 cm.)
Signed, l.r. print verso: "Danny Lyon"
Inscription, print verso: "29"
Acquired from: gift of George Peterkin, Jr., Houston, Texas

3489. **IRT 2, SOUTH BRONX, NEW YORK CITY [two children]**
(P1980.67.30)
Gelatin silver print. 1979
Image: 8 7/8 x 13 3/8 in. (22.5 x 34.0 cm.)
Sheet: 11 x 14 1/8 in. (28.0 x 35.9 cm.)
Signed, l.r. print verso: "Danny Lyon"
Inscription, print verso: "30"
Acquired from: gift of George Peterkin, Jr., Houston, Texas

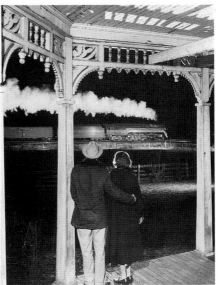

3457

SKEET McAULEY, American (b. 1951)

Skeet McAuley received a B.F.A. from Sam Houston
State University in 1976 and an M.F.A. from Ohio
University in 1978. He taught at Spring Hill College
in Mobile, Alabama, and Tyler Junior College in Tyler,
Texas, and has been at the University of North Texas
since 1981. He received National Endowment for the
Arts Individual Artist Fellowships in 1984 and 1986 and
a Polaroid Artist Support Grant in 1988 and has partici-
pated in numerous regional and national exhibitions. In
1989 the Amon Carter Museum organized "Sign Lan-
guage: Contemporary Southwest Native America," an
exhibition of 54 of his cibachrome photographs depict-
ing the relationship of southwestern Native Americans
and the forces affecting their lives and environments.

*3490. **NATIVE AMERICAN SERIES, NAVAJO POWER PLANT
NEAR SHIPROCK, N.M.** (P1986.23)
Cibachrome print. 1986
Image: 15 5/8 x 19 13/16 in. (39.6 x 50.3 cm.)
Sheet: 16 x 20 in. (40.7 x 50.8 cm.)
Signed, l.r. print verso: "Skeet McAuley"
Inscription, print verso: "NATIVE AMERICAN SERIES,
NAVAJO POWER PLANT NEAR SHIPROCK, N.M.
1986"
Acquired from: the photographer

3458

3491. WORKPERSON SERIES, CEILING TILE WORKER
USING LASER DEVICE FOR LEVELING, DALLAS
[from "Contemporary Texas: A Photographic Portrait"]
(P1985.17.116)
Type C color print. 1984
Image: 15 5/8 x 19 5/8 in. (39.7 x 49.8 cm.)
Sheet: 16 x 20 in. (40.7 x 50.8 cm.)
Acquired from: gift of the Texas Historical Foundation with
support from a major grant from the Du Pont Company
and Conoco, its energy subsidiary, and assistance from
the Texas Commission on the Arts and the National
Endowment for the Arts

3492. WORKPERSON SERIES, CONCRETE WORKERS,
DOWNTOWN DALLAS [from "Contemporary Texas:
A Photographic Portrait"] (P1985.17.115)
Type C color print. 1984
Image: 15 9/16 x 19 11/16 in. (39.5 x 50.0 cm.)
Sheet: 16 x 20 in. (40.7 x 50.8 cm.)
Acquired from: gift of the Texas Historical Foundation with
support from a major grant from the Du Pont Company
and Conoco, its energy subsidiary, and assistance from
the Texas Commission on the Arts and the National
Endowment for the Arts

3493. WORKPERSON SERIES, CRANE OPERATOR AND
STEEL WORKER, DOWNTOWN, DALLAS [from
"Contemporary Texas: A Photographic Portrait"]
(P1985.17.118)
Type C color print. 1984
Image: 15 5/8 x 19 1/2 in. (39.7 x 49.5 cm.)
Sheet: 16 x 20 in. (40.7 x 50.8 cm.)
Acquired from: gift of the Texas Historical Foundation with
support from a major grant from the Du Pont Company
and Conoco, its energy subsidiary, and assistance from
the Texas Commission on the Arts and the National
Endowment for the Arts

3494. WORKPERSON SERIES, GROUNDSKEEPER,
STOCKYARDS ARENA, FORT WORTH [from
"Contemporary Texas: A Photographic Portrait"]
(P1985.17.120)
Type C color print. 1984
Image: 15 5/8 x 19 3/4 in. (39.7 x 50.2 cm.)
Sheet: 16 x 20 in. (40.7 x 50.8 cm.)
Acquired from: gift of the Texas Historical Foundation with
support from a major grant from the Du Pont Company
and Conoco, its energy subsidiary, and assistance from
the Texas Commission on the Arts and the National
Endowment for the Arts

3495. WORKPERSON SERIES, LOADING NEWSPRINT ON
PRESS AT DALLAS MORNING NEWS, DALLAS [from
"Contemporary Texas: A Photographic Portrait"]
(P1985.17.117)
Type C color print. 1984
Image: 15 11/16 x 19 1/2 in. (39.8 x 49.5 cm.)
Sheet: 16 x 20 in. (40.7 x 50.8 cm.)
Acquired from: gift of the Texas Historical Foundation with
support from a major grant from the Du Pont Company
and Conoco, its energy subsidiary, and assistance from
the Texas Commission on the Arts and the National
Endowment for the Arts

3496. WORKPERSON SERIES, MUSEUM WORKER WITH
BOTTOM PORTION OF OLDENBURG'S "STAKE
HITCH," DALLAS [from "Contemporary Texas:
A Photographic Portrait"] (P1985.17.114)
Type C color print. 1984
Image: 15 5/8 x 19 11/16 in. (39.7 x 50.0 cm.)
Sheet: 16 x 20 in. (40.7 x 50.8 cm.)
Acquired from: gift of the Texas Historical Foundation with
support from a major grant from the Du Pont Company
and Conoco, its energy subsidiary, and assistance from
the Texas Commission on the Arts and the National
Endowment for the Arts

*3497. WORKPERSON SERIES, MUSEUM WORKER WITH
TOP PORTION OF OLDENBURG'S "STAKE HITCH,"
DALLAS [from "Contemporary Texas: A Photographic
Portrait"] (P1985.17.113)
Type C color print. 1984
Image: 15 5/8 x 19 11/16 in. (39.7 x 50.0 cm.)
Sheet: 16 x 20 in. (40.7 x 50.8 cm.)
Acquired from: gift of the Texas Historical Foundation with
support from a major grant from the Du Pont Company
and Conoco, its energy subsidiary, and assistance from
the Texas Commission on the Arts and the National
Endowment for the Arts

3498. WORKPERSON SERIES, PERFUMER OR "NOSE" FOR
MARY KAY COSMETICS, DALLAS [from
"Contemporary Texas: A Photographic Portrait"]
(P1985.17.119)
Type C color print. 1984
Image: 15 11/16 x 19 1/2 in. (39.8 x 49.5 cm.)
Sheet: 16 x 20 in. (40.7 x 50.8 cm.)
Acquired from: gift of the Texas Historical Foundation with
support from a major grant from the Du Pont Company
and Conoco, its energy subsidiary, and assistance from
the Texas Commission on the Arts and the National
Endowment for the Arts

3499. WORKPERSON SERIES, SET FOR "GUILTY OR
INNOCENT," DALLAS COMMUNICATIONS
COMPLEX, IRVING [from "Contemporary Texas:
A Photographic Portrait"] (P1985.17.112)
Type C color print. 1984
Image: 15 5/8 x 19 5/8 in. (39.7 x 49.8 cm.)
Sheet: 16 x 20 in. (40.7 x 50.8 cm.)
Acquired from: gift of the Texas Historical Foundation with
support from a major grant from the Du Pont Company
and Conoco, its energy subsidiary, and assistance from
the Texas Commission on the Arts and the National
Endowment for the Arts

*3500. WORKPERSON SERIES, SOUTHWEST AIRLINES
FLIGHT TRAINER DEMONSTRATING USE OF FIRE
EXTINGUISHER, IRVING [from "Contemporary Texas:
A Photographic Portrait"] (P1985.17.111)
Type C color print. 1984
Image: 15 11/16 x 19 1/2 in. (39.8 x 49.5 cm.)
Sheet: 16 x 20 in. (40.7 x 50.8 cm.)
Acquired from: gift of the Texas Historical Foundation with
support from a major grant from the Du Pont Company
and Conoco, its energy subsidiary, and assistance from
the Texas Commission on the Arts and the National
Endowment for the Arts

LOUIS McCLURE, American (1867–1957)

See Jackson Collages

LAWRENCE McFARLAND, American (b. 1942)

Lawrence McFarland was born in Wichita, Kansas. He
received a B.F.A. from the Kansas City Art Institute in
1973 and an M.F.A. from the University of Nebraska in
1976. McFarland has received two National Endowment
for the Arts Visual Artists Fellowships, in 1978–79 and
1984–85. McFarland joined the staff of the University
of Texas at Austin in 1985.

*3501. WUKOKI RUIN, AT WUPATKI NATIONAL
MONUMENT, ARIZONA, JULY 1984 (P1984.9)
Selenium-toned gelatin silver print. 1984
Image: 10 7/16 x 16 15/16 in. (26.4 x 43.0 cm.)
Sheet: 15 15/16 x 19 15/16 in. (40.5 x 50.6 cm.)
Signed, l.r. sheet recto: "Lawrence McFarland"
Acquired from: Etherton Gallery, Tucson, Arizona

ALEN MacWEENEY,
American, born Ireland (b. 1939)

MacWeeney was born in Dublin and worked as a press photographer for the *Irish Times* as a teenager. He opened his own portrait studio at the age of twenty but in 1961 moved to New York, where he became Richard Avedon's assistant and learned fashion photography. He has worked as a freelance photographer since 1963, and his commercial images have been published in *Life*, *Esquire*, *Fortune*, *GEO*, and the *New York Times*. Much of MacWeeney's personal work was done in Ireland.

ALEN MacWEENEY (P1980.64.1–12)

This portfolio was published by Hyperion Press Limited in 1979. It consists of twelve signed and numbered prints in an edition of 90 portfolios and 10 artist's proofs. This is portfolio number 59.

3502. **WHITE HORSE. DONEGAL, IRELAND** (P1980.64.1)
Gelatin silver print. negative 1965–66, print 1979
Image: 11 7/8 x 11 7/8 in. (30.2 x 30.2 cm.)
Sheet: 19 7/8 x 15 3/4 in. (50.5 x 40.0 cm.)
Mount: same as sheet size
Signed, bottom center mount verso: "Alen MacWeeney/ 59/90"
Inscription, mount verso: "1"
Acquired from: gift of George Peterkin, Jr., Houston, Texas

*3503. **WICKLOW TREES. COUNTY WICKLOW, IRELAND**
(P1980.64.2)
Gelatin silver print. negative 1965–66, print 1979
Image: 11 7/8 x 11 7/8 in. (30.2 x 30.2 cm.)
Sheet: 19 7/8 x 15 15/16 in. (50.5 x 40.5 cm.)
Mount: same as sheet size
Signed, bottom center mount verso: "Alen MacWeeney/ 59/90"
Inscription, mount verso: "2"
Acquired from: gift of George Peterkin, Jr., Houston, Texas

3504. **CHIMNEY SWEEP AND CHILDREN. IRELAND**
(P1980.64.3)
Gelatin silver print. negative 1965–66, print 1979
Image: 11 3/4 x 11 3/4 in. (29.8 x 29.8 cm.)
Sheet: 19 7/8 x 16 in. (50.5 x 40.7 cm.)
Mount: same as sheet size
Signed, bottom center mount verso: "Alen MacWeeney/ 59/90"
Inscription, mount verso: "3"
Acquired from: gift of George Peterkin, Jr., Houston, Texas

3505. **FLIES IN THE WINDOW. CASTLETOWN HOUSE,
IRELAND** (P1980.64.4)
Gelatin silver print. negative 1972, print 1979
Image: 10 3/4 x 15 5/8 in. (27.3 x 39.7 cm.)
Sheet: 16 x 19 7/8 in. (40.7 x 50.5 cm.)
Mount: same as sheet size
Signed, bottom center mount verso: "Alen MacWeeney/ 59/90"
Inscription, mount verso: "4"
Acquired from: gift of George Peterkin, Jr., Houston, Texas

3506. **HORSEWOMAN. IRELAND** (P1980.64.5)
Gelatin silver print. negative 1965, print 1979
Image: 11 3/4 x 11 3/4 in. (29.8 x 29.8 cm.)
Sheet: 19 7/8 x 15 13/16 in. (50.5 x 40.1 cm.)
Mount: same as sheet size
Signed, bottom center mount verso: "Alen MacWeeney/ 59/90"
Inscription, mount verso: "5"
Acquired from: gift of George Peterkin, Jr., Houston, Texas

3490

3497

3500

3507. **THE HEAD OF BLESSED OLIVER PLUNKETT.
IRELAND** (P1980.64.6)
Gelatin silver print. negative 1965–66, print 1979
Image: 12 ⅛ x 11 3/16 in. (30.7 x 28.4 cm.)
Sheet: 19 ⅞ x 15 ¾ in. (50.5 x 40.0 cm.)
Mount: same as sheet size
Signed, bottom center mount verso: "Alen MacWeeney/
59/90"
Inscription, mount verso: "6"
Acquired from: gift of George Peterkin, Jr., Houston, Texas

*3508. **NIGHTWALKERS. DUBLIN, IRELAND** (LP1980.64.7)
Gelatin silver print. negative 1965–66, print 1979
Image: 10 ⅝ x 15 ½ in. (27.0 x 39.4 cm.)
Sheet: 15 15/16 x 19 13/16 in. (40.5 x 50.3 cm.)
Mount: same as sheet size
Signed, bottom center mount verso: "Alen MacWeeney/
59/90"
Inscription, mount verso: "7"
Acquired from: long-term loan from George Peterkin, Jr.,
Houston, Texas

3509. **JOE AND OLIVENE. IRELAND** (P1980.64.8)
Gelatin silver print. negative 1965–66, print 1979
Image: 10 ½ x 15 ¾ in. (26.7 x 40.0 cm.)
Sheet: 16 x 19 ⅞ in. (40.7 x 50.5 cm.)
Mount: same as sheet size
Signed, bottom center mount verso: "Alen MacWeeney/
59/90"
Inscription, mount verso: "8"
Acquired from: gift of George Peterkin, Jr., Houston, Texas

3510. **JOHN GROGAN, A PATRIOT AND HIS DOG.
IRELAND** (P1980.64.9)
Gelatin silver print. negative 1965–66, print 1979
Image: 12 ⅛ x 11 15/16 in. (30.8 x 30.3 cm.)
Sheet: 19 ⅞ x 15 ⅝ in. (50.5 x 39.6 cm.)
Mount: same as sheet size
Signed, bottom center mount verso: "Alen MacWeeney/
59/90"
Inscription, mount verso: "9"
Acquired from: gift of George Peterkin, Jr., Houston, Texas

3511. **WATCHING—A STREET SCENE. DUBLIN, IRELAND**
(P1980.64.10)
Gelatin silver print. negative 1965–66, print 1979
Image: 12 13/16 x 11 ⅜ in. (32.6 x 28.9 cm.)
Sheet: 19 ⅞ x 15 15/16 in. (50.5 x 40.5 cm.)
Mount: same as sheet size
Signed, bottom center mount verso: "Alen MacWeeney/
59/90"
Inscription, mount verso: "10"
Acquired from: gift of George Peterkin, Jr., Houston, Texas

*3512. **LITTLE TINKER CHILD. IRELAND** (P1980.64.11)
Gelatin silver print. negative 1965–66, print 1979
Image: 11 ½ x 11 ½ in. (29.2 x 29.2 cm.)
Sheet: 19 ⅞ x 16 in. (50.5 x 40.7 cm.)
Mount: same as sheet size
Signed, bottom center mount verso: "Alen MacWeeney/
59/90"
Inscription, mount verso: "11"
Acquired from: gift of George Peterkin, Jr., Houston, Texas

3513. **THE TOWNLAND. DONEGAL, IRELAND** (P1980.64.12)
Gelatin silver print. negative 1965–66, print 1979
Image: 11 ⅝ x 11 ⅝ in. (29.6 x 29.6 cm.)
Sheet: 19 ⅞ x 16 in. (50.5 x 40.7 cm.)
Mount: same as sheet size
Signed, bottom center mount verso: "Alen MacWeeney/
59/90"
Inscription, mount verso: "12"
Acquired from: gift of George Peterkin, Jr., Houston, Texas

MAN RAY (EMMANUEL RUDNITSKY),
American (1890–1976)

Man Ray originally worked as an independent painter
and sculptor and only bought a camera to reproduce
his work. He championed the Dada movement in New
York, but in 1921 he moved to Paris to join other sur-
realist artists. While in Paris, he worked as a freelance
photographer, filmmaker, and painter. In 1922 he pro-
duced the first Rayographs, or photograms. He returned
to the United States in 1940, settling in Hollywood,
California, where he became a freelance fashion pho-
tographer and painter. He also taught photography and
lectured. In 1951 he returned to Europe to resume his
own photography and painting; he received the Gold
Medal for Photography at the 1961 Biennale in Venice.
Man Ray is credited with pioneering the aesthetic use
of darkroom manipulations such as photograms, solar-
ization, granulation, and distortions. He is also noted
for his experimentation in combining photography and
painting, his combinations of objects and paintings to
produce assemblages, and an automatic painting tech-
nique he called "natural painting."

3514. **B. ABBOTT** (P1984.35.360)
Gelatin silver print. negative c. 1924–30, print 1978–79
Image: 3 ¼ x 2 ⅜ in. (8.2 x 6.0 cm.)
Mount: 10 x 8 in. (25.4 x 20.3 cm.)
Signed: see inscription
Inscription, mount recto: "Man Ray//B. Abbott" and
crop mark
note: this inscription is in Berenice Abbott's hand
mount verso: "575"
Acquired from: gift of P/K Associates, New York, New York

*3515. **BERENICE ABBOTT** (P1984.35.496)
Gelatin silver print. negative c. 1924–30, print 1978–79
Image: 2 13/16 x 2 ¼ in. (7.1 x 5.7 cm.)
Mount: 10 x 8 in. (25.4 x 20.3 cm.)
Signed: see inscription
Inscription, mount recto: "Man Ray—"
note: this inscription is in Berenice Abbott's hand
mount verso: "Berenice Abbott//718 1"
Acquired from: gift of P/K Associates, New York, New York

*3516. **THE PRAYER [La Prière]** (P1986.17)
Gelatin silver print. 1930
Image: 11 ⅜ x 8 ⅞ in. (28.8 x 22.5 cm.)
Signed, l.r. print recto: "Man Ray 1930"
Inscription, print recto: "1/1"
note: this is not a unique print
print verso: "Ref. 4639//336 PAC" and rubber stamp
"MAN RAY/PARIS"
Acquired from: Paul Katz, North Bennington, Vermont

FRED E. MANG, JR., American (b. 1924)

Mang graduated from the New York Institute of Pho-
tography and the Winona School of Photography. He
ran a studio and camera store before joining the Weth-
erill Mesa Archaeology Project in Mesa Verde National
Park as a scientific photographer in 1961. He later
worked for the National Park Service's Southwest Re-
gional Office, serving as chief photographer from 1979
to 1983. Mang met Ansel Adams while working on the
Wetherill Mesa project and adopted Adams' zone sys-
tem. Mang also knew and worked with Laura Gilpin.

3501

3503

3508

3512

3515

3516

3517. **LAURA GILPIN AND HER FAMOUS SHIPROCK**
(P1982.16)
Gelatin silver print. c. 1972
Image: 4 7/16 x 6 9/16 in. (11.3 x 16.7 cm.)
Sheet: 8 x 10 in. (20.3 x 25.4 cm.)
Signed, l.r. print verso: "Fred E. Mang Jr."
Inscription, print verso: "LAURA GILPIN AND HER
FAMOUS SHIPROCK/TAKEN NEAR SHIPROCK,
NEW MEXICO, ABOUT 1972"
Acquired from: gift of the photographer

*3518. **[Laura Gilpin photographing along dirt road]** (P1979.98)
Gelatin silver print. 1971
Image: 10 13/16 x 13 5/8 in. (27.4 x 34.7 cm.)
Mount: 16 x 20 in. (40.7 x 50.8 cm.)
Signed, l.r. mount recto: "Fred E. Mang Jr./1971"
Acquired from: gift of the photographer and Laura Gilpin,
Santa Fe, New Mexico

ROGER B. MANLEY, American (b. 1952)

Freelance curator, folklorist, and photographer Roger
Manley received a B.A. from Davidson College and has
also studied at St. Anne's College at Oxford, Denver
University, and the University of North Carolina at
Chapel Hill. Manley met Laura Gilpin in 1969 when
he was first learning to use a 4 x 5 inch camera; Gilpin
and Manley corresponded over the next several years.
After a year of living with and photographing two Ab-
original tribes in Australia's Central Desert, Manley
moved to Santa Fe. His photographic projects have
included documenting ten counties for the Western
North Carolina Historic Sites Survey, life in Gullah
maritime communities of the Carolina coast, and life
in a gold mining camp in the remote Canadian arctic.
His images have appeared in numerous solo and group
exhibitions as well as in journals, films, videotapes,
and with record albums.

3519. **LAURA GILPIN** (P1987.8)
Gelatin silver print. negative 1977, print 1983
Image: 10 7/16 x 7 1/2 in. (26.6 x 19.0 cm.)
Sheet: 14 1/16 x 10 15/16 in. (35.6 x 27.8 cm.)
Signed, bottom center print verso: "Roger B. Manley"
Inscription, print verso: "Laura Gilpin 1977/by [signature]/
printed 1983/©"
mat backing verso: "15" and rubber stamp
"COPYRIGHTED/PHOTOGRAPH/BY/ROGER
MANLEY"
Acquired from: gift of the photographer

ELLI MARCUS, German (1899–1977)

Marcus apprenticed herself to a photographer at the age
of seventeen and established her own studio by the time
she was eighteen. She is best known for her photo-
graphs of Berlin stage personalities during the 1920s.
Marcus fled Berlin in the 1930s, moved to Paris, and fi-
nally settled in New York in 1941, where she continued
to photograph well-known personalities. Marcus had
a long-standing interest in graphology and often used
samples of her sitters' handwriting to help her under-
stand their character. Frustrated by artistic compro-
mises, she gave up photography during the mid-1950s
and became a full-time graphologist.

3520. **GEORGIA O'KEEFFE** (P1977.44)
Gelatin silver print. 1944
Image: 9 13/16 x 7 11/16 in. (24.9 x 19.5 cm.)
Sheet: 10 1/8 x 8 1/16 in. (25.6 x 20.4 cm.)
Signed, center print verso and l.r. overmat recto:
"Elli Marcus"

Inscription, print verso: "Georgia O'Keeffe/(90)/CREDIT
MUST BE GIVEN/M/[signature]" and rubber stamp
"PHOTOGRAPHED BY/ELLI MARCUS/5 East 82nd
Street/BUtterfield 8-0074"
mat backing verso: "#90/Georgia O'Keeffe 1944/against
one of/her paintings"
Acquired from: The Witkin Gallery, New York, New York

IRA W. MARTIN, American (1886–1960)

Martin, for many years the staff photographer at the
Frick Collection, was the president of the Pictorial Pho-
tographers of America during the late 1920s and early
1930s. The organization encouraged the work of estab-
lished photographers through traveling exhibitions and
promoted artistic photography among its members
through lecture meetings and monthly print competi-
tions. Martin's work is clearly in the pictorialist vein,
favoring classical composition and the use of platinum
printing.

*3521. **[Still life]** (P1981.60)
Platinum print. c. 1921
Image: 6 x 4 9/16 in. (15.3 x 11.5 cm.)
Mount: 16 15/16 x 12 13/16 in. (43.0 x 32.6 cm.)
Acquired from: Tom Jacobson, San Diego, California

3522. **TULIPS** (P1982.29)
Platinum print. 1923
Image: 6 9/16 x 4 11/16 in. (16.7 x 11.9 cm.)
Sheet: 6 5/8 x 4 3/4 in. (16.8 x 12.1 cm.)
Mount: 14 x 11 in. (35.6 x 28.0 cm.)
Signed, bottom center print recto: "I W Martin/1923"
l.r. mount recto: "Ira W. Martin"
Inscription, mount recto: "Tulips." and rubber stamp "126"
mount verso: "#4/"Tulips"/Platinum—regular YY/Ira W.
Martin/6 E. 71st st./New York" and "February, 1933./Robert
A. Barrows" on printed paper label "EXHIBITED/IN THE
GALLERY OF THE/PHOTOGRAPHIC/SOCIETY/OF/
PHILADELPHIA//[society insignia]//THE OLDEST
PHOTOGRAPHIC/ORGANIZATION IN AMERICA//
PRINT DIRECTOR" and printed paper label "PACIFIC
INTERNATIONAL/SALON OF PHOTOGRAPHIC
ART//PORTLAND AND EUGENE, ORE., U.S.A./
SEPTEMBER AND OCTOBER, 1929/THIS PRINT,
No. 126 WAS ACCEPTED"
Acquired from: Jonathan Stein, New York, New York

OSCAR MAURER, American (1871–1965)

See *Camera Notes*

RALPH EUGENE MEATYARD,
American (1925–1972)

Born and raised in Normal, Illinois, Meatyard lived a
life that was as unique as his photographs. Trained as
an optician, he made his living selling eyeglasses and
ran his own shop, Eyeglasses of Kentucky, in a Lex-
ington shopping center from 1967 to 1972. Meatyard
studied photography with Van Deren Coke, Henry
Holmes Smith, and Minor White but essentially worked
out his own approach to the medium. Van Deren Coke
said that "Ralph Eugene Meatyard's work is undoubt-
edly visionary, but takes place in settings that are real-
istic." Meatyard made his photographs on evenings and
weekends, printing during his annual two-week vaca-
tions from 1953 until his death from cancer in 1972.

Attributed to George E. Mellen
3528. **MARSHALL PASS—CONTINENTAL DIVIDE, D. & R.G. RY.** (P1971.22.50)
Albumen silver print. c. 1880s
Image: 16 ⅛ x 20 ⁹⁄₁₆ in. (41.0 x 52.3 cm.)
Mount: 18 ⁷⁄₁₆ x 21 ¹¹⁄₁₆ in. (46.8 x 55.0 cm.)
Inscription, in negative: "2421 MARSHALL PASS—
CONTINENTAL DIVIDE, D.&R.G Ry"
mount recto: "15"
Acquired from: Fred Mazzulla, Denver, Colorado

George E. Mellen or William H. Jackson
THE OLD ROADMASTER (P1979.40.16)
See entry under William H. Jackson

Attributed to George E. Mellen
3529. **PIKES PEAK IN ALL ITS BEAUTY** (P1971.22.53)
Albumen silver print. c. 1880s
Image: 20 ¾ x 16 ⁵⁄₁₆ in. (52.7 x 41.4 cm.)
Mount: 21 ¹¹⁄₁₆ x 19 ⅛ in. (55.0 x 48.4 cm.)
Inscription, in negative: "2356 PIKE'S PEAK IN ALL ITS
BEAUTY"
Acquired from: Fred Mazzulla, Denver, Colorado

3530. **SILVERTON AND SULTAN MT.** (P1971.94.40)
Albumen silver print. c. 1884
Image: 15 ¹³⁄₁₆ x 20 ⅜ in. (40.1 x 51.7 cm.)
Mount: 17 ⅝ x 21 ¼ in. (44.6 x 55.2 cm.)
Signed: see inscription
Inscription, in negative: "2455 SILVERTON AND SULTAN
MT.//GEO. E. MELLEN PHOTO LP 1[illegible]O"
mount recto: "6"
Acquired from: Richard A. Ronzio, Golden, Colorado

Attributed to George E. Mellen
*3531. **SOUTH PARK FROM KENOSHA HILL D.S.P. & P. RY.**
(P1971.22.49)
Albumen silver print. c. 1880–84
Image: 16 ⅜ x 20 ⅝ in. (41.6 x 52.5 cm.)
Mount: 18 ⅝ x 21 ¹¹⁄₁₆ in. (46.6 x 55.0 cm.)
Inscription, in negative: "2502 SOUTH PARK/FROM
KENOSHA HILL D.S.P.& P.Ry."
mount recto: "X//22"
Acquired from: Fred Mazzulla, Denver, Colorado

MELISSA MIAL, American (b. 1954)

Melissa Mial grew up in San Antonio, Texas, and received a B.F.A. from the University of Texas at San Antonio in 1979. In 1986 she was pursuing a master's degree in social work from the same institution.

3532. **UNTITLED [overpass abstraction; from the Society for Photographic Education's "South Central Regional Photography Exhibition"]** (P1983.31.9)
Gelatin silver print. 1979
Image: 9 ¹⁄₁₆ x 13 ⅜ in. (23.0 x 34.0 cm.)
Sheet: 11 x 14 in. (28.0 x 35.6 cm.)
Acquired from: gift of the Society for Photographic
Education, South Central Region

ROBERT MIAL, American (b. 1948)

Robert Mial received a B.A. in psychology in 1970 from Willamette University in Oregon, an M.A. in the same field in 1972 from Bowling Green State University in Ohio, and an M.F.A. from the University of Texas at San Antonio in 1978. Active in regional photography exhibitions through the late 1970s and early 1980s, Mial later worked in home construction.

3533. **UNTITLED [adobe building with wooden door; from the Society for Photographic Education's "South Central Regional Photography Exhibition"]** (P1983.31.10)
Gelatin silver print. 1978
Image: 5 ⁵⁄₁₆ x 6 ⅞ in. (13.5 x 17.4 cm.)
Sheet: 8 ¹⁄₁₆ x 10 in. (20.5 x 25.4 cm.)
Acquired from: gift of the Society for Photographic
Education, South Central Region

TOM MILLEA, American (b. 1944)

Tom Millea was born in Bridgeport, Connecticut, and received his B.A. from the University of Western Connecticut in 1966. He originally studied acting and writing but found photography to be a more fulfilling method of expression. He studied with Paul Caponigro and H. Jonathon Greenwald from 1967 to 1973 and worked as an architectural and industrial photographer during the late 1960s. He served as director of photography at the Photo-Graphic workshop in New Canaan, Connecticut, in the early 1970s but moved to California after attending a Yosemite workshop. Millea has taught at several California schools and workshops and has produced platinum/palladium prints for several California landscape projects. He received a Friends of Photography Ruttenberg Grant in 1982 to print a series of Death Valley images and a Friends of Photography Publication Workshop Grant in 1983.

3534. **REDDING, CONNECTICUT** (P1984.2)
Platinum print. negative 1969, print c. 1983
Image: 3 ¹¹⁄₁₆ x 4 ¹¹⁄₁₆ in. (9.4 x 11.8 cm.)
Sheet: 9 x 10 ¹¹⁄₁₆ in. (22.8 x 27.1 cm.)
Signed, l.r. sheet recto: "T. Millea"
Inscription, sheet recto: "Redding 1969"
Acquired from: Friends of Photography, Carmel, California;
gift print with sustaining membership, 1984

*3535. **YOSEMITE 1980** (P1986.10)
Hand-coated platinum/palladium print. 1980
Image: 7 ⅝ x 9 ½ in. (19.4 x 24.1 cm.)
Sheet: 10 ¹⁵⁄₁₆ x 13 ¹⁵⁄₁₆ in. (27.7 x 35.3 cm.)
Signed, l.r. sheet recto: "T. Millea"
Inscription, sheet recto: "Yosemite 1980//85"
Acquired from: Portfolio, Oklahoma City, Oklahoma

JUDY MILLER, American (b. 1951)

Born in Tulsa, Oklahoma, Judy Miller received a B.A.E. from the University of Kansas in 1972, an M.A. in printmaking from the University of Tulsa in 1975, and an M.F.A. in photography from the University of Iowa in 1976. She taught at the University of Arkansas at Little Rock from 1977 to 1978 and at Austin College in Sherman, Texas, from 1978 to 1983. Miller directed the programs of the Allen Street Gallery, a nonprofit photography gallery in Dallas, Texas, from 1984 until 1986, when she left to pursue her own photographic career. Her collage and multimedia images have appeared in many regional exhibitions.

3536. **LOY LAKE [from the Society for Photographic Education's "South Central Regional Photography Exhibition"]**
(P1983.31.11)
Gelatin silver print (collage with twigs and applied coloring). 1980
Image: 10 ⁹⁄₁₆ x 9 ⁵⁄₁₆ in. (26.8 x 23.6 cm.)
Mount: 20 x 16 in. (50.8 x 40.7 cm.)
Signed, l.r. mount recto: "J. Miller '80"
Inscription, mount recto: " "Loy Lake" "
Acquired from: gift of the Society for Photographic
Education, South Central Region

RICHARD MISRACH, American (b. 1949)

Richard Misrach has been a freelance photographer in California since 1971 when he received his B.A. in psychology from the University of California at Berkeley. Misrach is a self-taught photographer; his work has included images documenting street life in Berkeley and photographs of the desert at dusk. Misrach received three National Endowment for the Arts grants (1973, 1977, 1984), a Guggenheim Fellowship (1978), a Prize of the Bell Corporation (1978), and a Ferguson Prize from the Friends of Photography (1976). He received the International Center for Photography award for outstanding publication for 1987 for his book *Desert Cantos*. He has taught at the Associated Students of the University of California Studio and has given workshops for the San Francisco Art Institute, the University of Illinois at Carbondale, the Friends of Photography, and the Center for Creative Photography.

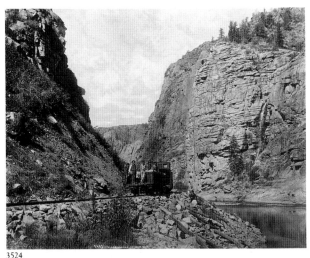
3524

*3537. **FLOODED SNACK BAR, SALTON SEA** (P1986.20)
Ektacolor print. negative 1984, print 1985
Image: 18 5/16 x 21 1/8 in. (46.5 x 53.7 cm.)
Sheet: 20 x 24 in. (50.8 x 61.0 cm.)
Signed, l.r. print recto: "© Richard Misrach 1984/p 85"
Inscription, print recto: "4/25 FLOODED SNACK BAR, SALTON SEA"
Acquired from: Etherton Gallery, Tucson, Arizona

ERIC H. MITCHELL,
Canadian, born Scotland (b. 1927)

Mitchell was educated in Edinburgh, Scotland, and graduated from Leith Nautical College. He worked in the Antarctic before moving to Canada in 1949, where he was employed by the Hudson's Bay Company. Mitchell spent much time during this period learning Eskimo history and language and studying Eskimo art. He joined Canadian Arctic Producers Limited in 1965 as general manager, directing the sale of Indian arts and crafts. He was named president and general manager in 1971, a position he held for two years. During his tenure with Canadian Arctic Producers Limited, he traveled to many Eskimo villages to procure craft items and made photographs of many of the artists represented by the firm. In 1979 Mitchell opened a gallery that specialized in Eskimo and wildlife art.

3531

3538. **AKEEAH—BAKER LAKE** (P1972.23.11)
Gelatin silver print. negative 1967, print 1972
Image: 19 7/8 x 15 13/16 in. (50.5 x 40.2 cm.)
Inscription, print verso: "Akeeah—Baker Lake"
Acquired from: Canadian Arctic Producers Ltd., Ottawa, Ontario, Canada

3539. **JEANNE ANARIAK—PELLY BAY** (P1972.23.10)
Gelatin silver print. negative 1968, print 1972
Image: 19 13/16 x 15 7/8 in. (50.3 x 40.3 cm.)
Inscription, print verso: "Jeanne Anariak—Pelly Bay"
Acquired from: Canadian Arctic Producers Ltd., Ottawa, Ontario, Canada

*3540. **KALVAK—FAMOUS PRINT MAKER—HOLMAN ISLAND** (P1972.23.12)
Gelatin silver print. negative 1968, print 1972
Image: 19 7/8 x 15 15/16 in. (50.5 x 40.5 cm.)
Inscription, print verso: "Kalvak—famous print maker—Holman Island"
Acquired from: Canadian Arctic Producers Ltd., Ottawa, Ontario, Canada

3535

3541. **KENOJUAK—FAMOUS PRINTMAKER—CAPE DORSET** (P1972.23.1)
Gelatin silver print. negative 1969, print 1972
Image: 19 ⅞ x 15 ⅞ in. (50.4 x 40.3 cm.)
Inscription, print verso: "Kenojuak—famous printmaker—Cape Dorset"
Acquired from: Canadian Arctic Producers Ltd., Ottawa, Ontario, Canada

*3542. **KRINGORN—PELLY BAY** (P1972.23.14)
Gelatin silver print. negative 1968, print 1972
Image: 19 ¹³⁄₁₆ x 15 ⅞ in. (50.3 x 40.3 cm.)
Inscription, print verso: "Kringorn—Pelly Bay"
Acquired from: Canadian Arctic Producers Ltd., Ottawa, Ontario, Canada

3543. **KUNUK KATSIAK—ARCTIC BAY** (P1972.23.8)
Gelatin silver print. negative 1968, print 1972
Image: 19 ¹³⁄₁₆ x 15 ¹³⁄₁₆ in. (50.3 x 40.2 cm.)
Inscription, print verso: "Koonoo [sic] Keechak [sic]—Artic [sic] Bay"
Acquired from: Canadian Arctic Producers Ltd., Ottawa, Ontario, Canada

3544. **MOSESSEE E7-231—LAKE HARBOUR** (P1972.23.13)
Gelatin silver print. negative 1969, print 1972
Image: 19 ¾ x 15 ⅞ in. (50.1 x 40.3 cm.)
Inscription, print verso: "Mosessee—Lake Harbour"
Acquired from: Canadian Arctic Producers Ltd., Ottawa, Ontario, Canada

3545. **MUKPA—BAKER LAKE** (P1972.23.15)
Gelatin silver print. negative 1967, print 1972
Image: 19 ¹³⁄₁₆ x 15 ⅞ in. (50.3 x 40.3 cm.)
Inscription, print verso: "Mukpa—Baker Lake"
Acquired from: Canadian Arctic Producers Ltd., Ottawa, Ontario, Canada

3546. **NOAH URNAKAK—PANGNIRTUNG** (P1972.23.2)
Gelatin silver print. negative 1969, print 1972
Image: 19 ¾ x 15 ¹³⁄₁₆ in. (50.1 x 40.2 cm.)
Inscription, print verso: "Noah Oonakak [sic]—Pangnirtung"
Acquired from: Canadian Arctic Producers Ltd., Ottawa, Ontario, Canada

3547. **NOOGILIAK—LAKE HARBOUR** (P1972.23.7)
Gelatin silver print. negative 1969, print 1972
Image: 19 ¹³⁄₁₆ x 15 ¹⁵⁄₁₆ in. (50.3 x 40.5 cm.)
Inscription, print verso: "Noogliak [sic]—Lake Harbour"
Acquired from: Canadian Arctic Producers Ltd., Ottawa, Ontario, Canada

3548. **PAUTA—CAPE DORSET** (P1972.23.9)
Gelatin silver print. negative 1969, print 1972
Image: 19 ¾ x 15 ⅞ in. (50.1 x 40.3 cm.)
Inscription, print verso: "Pauta—Cape Dorset"
Acquired from: Canadian Arctic Producers Ltd., Ottawa, Ontario, Canada

3549. **SUSAN TEEYEETSIAK—REPULSE BAY** (P1972.23.4)
Gelatin silver print. negative 1969, print 1972
Image: 19 ¹³⁄₁₆ x 15 ⅞ in. (50.3 x 40.3 cm.)
Inscription, print verso: "Susan Teeyeetsiak Repulse Bay"
Acquired from: Canadian Arctic Producers Ltd., Ottawa, Ontario, Canada

3550. **SUSAN TEEYEETSIAK—REPULSE BAY [with children]** (P1972.23.5)
Gelatin silver print. negative 1969, print 1972
Image: 19 ⅞ x 15 ⅞ in. (50.4 x 40.3 cm.)
Inscription, print verso: "Susan Teeyeetsiak—Repulse Bay"
Acquired from: Canadian Arctic Producers Ltd., Ottawa, Ontario, Canada

3551. **TIMOTHY KAYASARK—PELLY BAY** (P1972.23.3)
Gelatin silver print. negative 1968, print 1972
Image: 19 ¹³⁄₁₆ x 15 ⅞ in. (50.3 x 40.3 cm.)
Inscription, print verso: "Timothy Kayasak [sic]—Pelly Bay"
Acquired from: Canadian Arctic Producers Ltd., Ottawa, Ontario, Canada

3552. **ZACHARY ITIMANGNARK—PELLY BAY** (P1972.23.6)
Gelatin silver print. negative 1968, print 1972
Image: 19 ¹³⁄₁₆ x 15 ¹³⁄₁₆ in. (50.3 x 40.2 cm.)
Inscription, print verso: "Zachary Itimangnak [sic]—Pelly Bay"
Acquired from: Canadian Arctic Producers Ltd., Ottawa, Ontario, Canada

LISETTE MODEL (ELISE FELIC AMELIE SYEBERT), American, born Austria (1906–1983)

Model received her early training in music and painting and began photographing in 1937. In 1938 she and her husband, painter Evsa Model, moved to New York. Lisette Model gained critical success in 1940 when her photographs of the Promenade des Anglais on the French Riviera were published in a New York newspaper. From 1941 to 1953 she worked as a freelance photographer, with her images appearing in magazines such as *Harper's Bazaar*, *Look*, and the *Ladies' Home Journal*. Model also taught at the School of Arts in San Francisco and the New School for Social Research in New York. She received a Guggenheim Fellowship in 1965. She became an honorary member of the American Society of Magazine Photographers in 1968 and was honored at the 1978 Rencontres Internationales de la Photographie in Arles, France. In 1982 she received the Vermeil medal of the Ville de Paris.

*3553. **SINGER AT SAMMYS BAR [267 Bowery, New York City]** (P1986.6)
Gelatin silver print. c. 1940
Image: 13 ¹¹⁄₁₆ x 10 ¹³⁄₁₆ in. (34.8 x 27.4 cm.)
Signed: see inscription
Inscription, print verso: "X" and rubber stamp "© ESTATE OF LISETTE MODEL/1983 ARCHIVE NO."
Acquired from: Sander Gallery, New York, New York

TINA MODOTTI, Italian (1896–1942)

Modotti was a student, model, and companion of Edward Weston and made many of her photographs during the time that she was involved with him. She emigrated from Italy with her family and spent her early years doing factory work. After a brief career as an actress and a marriage that left her a widow after five years, Modotti moved to Mexico with Weston in 1923. They lived together for several years, making photographs and exhibiting their work. They were part of a circle of avant-garde Mexican artists who were at the forefront of the political and artistic scene. After Weston returned to the United States Modotti continued to photograph, but became more and more involved with her activities in the Communist party. After she was expelled from Mexico in 1930 for political reasons Modotti largely abandoned photography in favor of political activism. She was finally able to return to Mexico in 1939 under an assumed name, but died shortly thereafter.

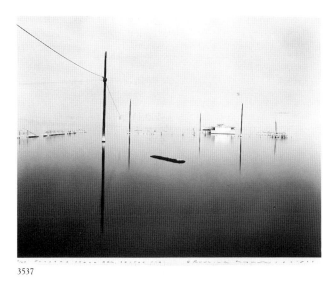

3537

3540

3542

3553

3554

3557

Attributed to Tina Modotti or Edward Weston
*3554. **[Edward Weston]** (P1980.38)
Gelatin silver print. c. 1923–24
Image: 3 7/16 x 4 3/16 in. (8.7 x 10.6 cm.)
1st mount: same as image size
2nd mount: 10 x 9 13/16 in.
(25.4 x 25.0 cm.)
Acquired from: Edwynn Houk, Ann Arbor, Michigan

FREDERICK INMAN MONSEN,
American, born Norway (1865–1929)

Frederick Monsen was an ethnologist who studied the Indians of the Southwest using his camera as a professional tool. His father had worked for the Denver and Rio Grande Railroad as a photographer and Monsen himself worked with William Henry Jackson for a time. Monsen was unofficially attached to several western exploring expeditions during the 1880s but began his own southwestern work about 1894–95. He traveled with the Yosemite National Park Survey in 1896 and spent some time working with fellow photographer A. C. Vroman. Monsen typically used glass slides of his images to illustrate lectures, but he also produced prints in a San Francisco studio. He lost most of his negative file in the 1906 San Francisco fire and earthquake.

3555. **[Canyon de Chelly]** (P1980.50.2)
Toned gelatin silver print. c. 1897–1910
Image: 12 1/2 x 16 15/16 in. (31.7 x 43.0 cm.)
Sheet: 16 x 20 1/16 in. (40.7 x 50.9 cm.)
Signed, l.r. sheet recto: "Frederick Monsen"
Inscription, sheet recto: "©"
Acquired from: Bob Kapoun, Photo-Graphics Ltd., Santa Fe, New Mexico

3556. **[Laguna Pueblo]** (P1980.50.5)
Toned gelatin silver print. c. 1897–1910
Image: 12 1/2 x 16 15/16 in. (31.7 x 43.0 cm.)
Sheet: 16 x 20 in. (40.7 x 50.8 cm.)
Signed, l.r. sheet recto: "Frederick Monsen"
Inscription, sheet recto: "©"
Acquired from: Bob Kapoun, Photo-Graphics, Ltd., Santa Fe, New Mexico

*3557. **MOJAVE INDIAN CHILDREN ON THE RIO COLORADO, ARIZONA** (P1980.50.1)
Toned gelatin silver print. c. 1897–1910
Image: 10 9/16 x 16 5/16 in. (26.8 x 41.4 cm.)
1st mount: 11 9/16 x 17 5/16 in. (29.3 x 43.9 cm.)
2nd mount: 17 1/4 x 23 5/16 in. (43.7 x 59.2 cm.)
Signed, l.r. 1st mount recto: "Frederick Monsen"
Inscription, 2nd mount verso: "1042//Mojave Indian Children on the/Rio Colorado, Arizona." typed on printed paper label "THE FREDERICK MONSEN/INDIAN PHOTOGRAPHS/THIS PHOTOGRAPH IS PROTECTED BY COPYRIGHT. PUBLISHERS AND/OTHERS ARE CAUTIONED NOT TO REPRODUCE THIS PICTURE/WITHOUT PERMISSION.//NUMBER/PRICE/NAME/DESCRIPTION//FREDERICK I. MONSEN, 14 W. TWELFTH STREET, NEW YORK"
Acquired from: Bob Kapoun, Photo-Graphics, Ltd., Santa Fe, New Mexico

3558. **NAVAJO INDIANS, ARIZONA** (P1980.50.3)
Toned gelatin silver print. c. 1897–1910
Image: 13 1/2 x 18 9/16 in. (34.4 x 47.1 cm.)
Mount: 14 1/4 x 19 1/4 in. (36.2 x 48.9 cm.)
Signed, l.r. print recto: "Frederick I. Monsen"
Acquired from: Bob Kapoun, Photo-Graphics, Ltd., Santa Fe, New Mexico

3559. **[Women and children on kiva roof]** (P1980.50.6)
Toned gelatin silver print. c. 1897–1910
Image: 13 x 16 5/8 in. (33.1 x 42.3 cm.)
1st mount: 14 3/4 x 17 5/8 in. (37.4 x 44.8 cm.)
2nd mount: 19 9/16 x 24 15/16 in. (49.7 x 63.4 cm.)
Signed, l.r. 1st mount recto: "Frederick Monsen"
Acquired from: Bob Kapoun, Photo-Graphics, Ltd., Santa Fe, New Mexico

*3560. **ZUNI, NEW MEXICO [child on ladder]** (P1980.50.4)
Toned gelatin silver print. c. 1897–1907
Image: 16 15/16 x 11 in. (43.1 x 27.9 cm.)
Sheet: 24 x 17 in. (61.0 x 43.2 cm.)
Signed, l.r. sheet recto: "Frederick Monsen"
Inscription, sheet recto: "©//12.50"
Acquired from: Bob Kapoun, Photo-Graphics, Ltd., Santa Fe, New Mexico

GUY MONTHAN, American (b. 1925)

Guy Monthan is a commercial artist and photographer who has taught commercial art at Northern Arizona University in Flagstaff since 1969. With his wife, Doris, he wrote *Art and Indian Individualists*, a survey of the work of seventeen southwestern Indian artists. Later publications have also focused on the artistic traditions of American Indians.

3561. **DOUGLAS HYDE** (P1977.52)
Gelatin silver print. 1974
Image: 9 1/2 x 7 1/2 in. (24.1 x 19.0 cm.)
Sheet: 10 x 8 in. (25.4 x 20.3 cm.)
Signed: see inscription
Inscription, print verso: "Douglas Hyde//Credit Line:/From Art and Indian Individualists/by Guy and Doris Monthan"
Acquired from: the photographer

JOHN MORAN,
American, born England (1831–1903)

Although less well known than his brother, landscape artist Thomas Moran, John Moran made a significant contribution to nineteenth-century American landscape and architectural photography. The second oldest of the four Moran brothers, he is first listed as a photographer in the 1859 Philadelphia city directory. His earliest known work is a group of landscape and architectural views made in Philadelphia about 1863. He also made views along the Delaware and Lehigh Rivers and in the White Mountains of New Hampshire during the mid-1860s. From December 1870 until July 1871 Moran was the official photographer for the Darien Expedition led by Naval Commander Thomas O. Selfridge, Jr., which surveyed the Isthmus of Panama looking for a route for a Panama canal. Timothy H. O'Sullivan was the photographer on the 1870 survey expedition and also made a number of photographs of survey activities. Moran was also on an 1874 expedition to Tasmania and South Africa and made photographs of the transit of Venus. He continued to work as a photographer in Philadelphia during the 1870s, but apparently gave it up and devoted the later years of his life to landscape painting.

*3562. **BANKS OF LIMON RIVER, AT THE FALLS [Falls of Quebrada del Mar, Limon Bay; from Selfridge-Darien Expedition album]** (P1982.1.12)
Albumen silver print. 1871
Image: 11 3/16 x 7 3/4 in. (28.4 x 19.7 cm.)
Mount: 12 7/8 x 15 1/16 in. (32.7 x 38.3 cm.)
Inscription, print recto: "40"
Acquired from: anonymous gift

3563. **THE BROOK, EL BANO, CHIPIGANA [from Selfridge-Darien Expedition album]** (P1982.1.4)
Albumen silver print. 1871
Image: 11 ⅛ x 7 ¹⁵⁄₁₆ in. (28.3 x 20.3 cm.)
Mount: 12 ⅞ x 15 ¹⁄₁₆ in. (32.7 x 38.3 cm.)
Inscription, print recto: "26"
Acquired from: anonymous gift

3564. **CASCADE, LIMON RIVER [from Selfridge-Darien Expedition album]** (P1982.1.11)
Albumen silver print. 1871
Image: 11 ⅛ x 7 ¹⁵⁄₁₆ in. (28.3 x 20.2 cm.)
Mount: 12 ⅞ x 15 ¹⁄₁₆ in. (32.7 x 38.3 cm.)
Inscription, print recto: "38"
Acquired from: anonymous gift

Attributed to John Moran
3565. **CATHEDRAL CARTAGENA [from Selfridge-Darien Expedition album]** (P1982.1.16)
Albumen silver print. 1870
Image: 7 ¹⁵⁄₁₆ x 11 ³⁄₁₆ in. (20.2 x 28.4 cm.)
Mount: 12 ⅞ x 15 ¹⁄₁₆ in. (32.7 x 38.3 cm.)
Inscription, in negative: "19"
 print recto: "45"
Acquired from: anonymous gift

3566. **CLIFF, LIMON BAY [from Selfridge-Darien Expedition album]** (P1981.91.18)
Albumen silver print. 1871
Image: 7 ¹⁵⁄₁₆ x 11 ⅛ in. (20.1 x 28.3 cm.)
Mount: 12 ⅞ x 15 ¹⁄₁₆ in. (32.7 x 38.3 cm.)
Inscription, print recto: "17"
Acquired from: anonymous gift

John Moran or Timothy H. O'Sullivan
*3567. **[Close-up of fallen palm fronds; from Selfridge-Darien Expedition album]** (P1982.1.15)
Albumen silver print. 1870–71
Image: 7 ¾ x 10 ¹¹⁄₁₆ in. (19.7 x 27.1 cm.)
Mount: 12 ⅞ x 15 ¹⁄₁₆ in. (32.7 x 38.3 cm.)
Inscription, print recto: "44//25"
Acquired from: anonymous gift

3568. **DARIEN HARBOR, CHIPIGANA [from Selfridge-Darien Expedition album]** (P1981.91.10)
Albumen silver print. 1871
Image: 7 ⅞ x 11 ³⁄₁₆ in. (20.1 x 28.4 cm.)
Mount: 12 ⅞ x 15 ¹⁄₁₆ in. (32.7 x 38.3 cm.)
Inscription, in negative: "14"
 print recto: "9"
Acquired from: anonymous gift

3569. **DARIEN HARBOR, LOOKING NORTH [from Selfridge-Darien Expedition album]** (P1981.91.14)
Albumen silver print. 1871
Image: 7 ¹⁵⁄₁₆ x 11 ³⁄₁₆ in. (20.1 x 28.4 cm.)
Mount: 12 ⅞ x 15 ¹⁄₁₆ in. (32.7 x 38.3 cm.)
Inscription, print recto: "13"
Acquired from: anonymous gift

3570. **DARIEN HARBOR, LOOKING SOUTH [from Selfridge-Darien Expedition album]** (P1981.91.12)
Albumen silver print. 1871
Image: 7 ⅞ x 11 ³⁄₁₆ in. (20.1 x 28.4 cm.)
Mount: 12 ⅞ x 15 ¹⁄₁₆ in. (32.7 x 38.3 cm.)
Inscription, in negative: "15"
 print recto: "11"
Acquired from: anonymous gift

Attributed to John Moran
3571. **[Fallen tree in jungle; from Selfridge-Darien Expedition album]** (P1982.1.6)
Albumen silver print. 1871
Image: 11 ³⁄₁₆ x 7 ¹⁵⁄₁₆ in. (28.4 x 20.3 cm.)
Mount: 12 ⅞ x 15 ¹⁄₁₆ in. (32.7 x 38.3 cm.)
Inscription, print recto: "28"
Acquired from: anonymous gift

3560

3562

3567

*3572. **FOREST NEAR TURBO [from Selfridge-Darien Expedition album]** (P1982.1.5)
Albumen silver print. 1871
Image: 11 3/16 x 7 15/16 in. (28.4 x 20.3 cm.)
Mount: 12 7/8 x 15 1/16 in. (32.7 x 38.3 cm.)
Inscription, print recto: "27"
Acquired from: anonymous gift

Attributed to John Moran
3573. **FORTRESS OF SAN LORENZO, CARTAGENA [from Selfridge-Darien Expedition album]** (P1982.1.17)
Albumen silver print. 1870
Image: 7 15/16 x 11 3/16 in. (20.2 x 28.4 cm.)
Mount: 12 7/8 x 15 1/16 in. (32.7 x 38.3 cm.)
Inscription, in negative: "2"
print recto: "46"
Acquired from: anonymous gift

John Moran or Timothy H. O'Sullivan
*3574. **[Fronds on a shore; from Selfridge-Darien Expedition album]** (P1982.1.14)
Albumen silver print. 1870–71
Image: 7 3/4 x 10 5/8 in. (19.7 x 27.0 cm.)
Mount: 12 7/8 x 15 1/16 in. (32.7 x 38.3 cm.)
Inscription, print recto: "No 1//43"
Acquired from: anonymous gift

3575. **GORGE NEAR CHIPIGANA [Tropical Forest; from Selfridge-Darien Expedition album]** (P1982.1.13)
Albumen silver print. 1871
Image: 11 1/8 x 7 15/16 in. (28.3 x 20.2 cm.)
Mount: 12 7/8 x 15 1/16 in. (32.7 x 38.3 cm.)
Inscription, print recto: "42"
Acquired from: anonymous gift

3576. **GREAT FALLS, LIMON RIVER [from Selfridge-Darien Expedition album]** (P1982.1.8)
Albumen silver print. 1871
Image: 11 1/8 x 7 15/16 in. (28.3 x 20.2 cm.)
Mount: 12 7/8 x 15 1/16 in. (32.7 x 38.3 cm.)
Inscription, print recto: "35"
Acquired from: anonymous gift

*3577. **HOUSE AT TURBO [Native Hut, Turbo; from Selfridge-Darien Expedition album]** (P1981.91.27)
Albumen silver print. 1871
Image: 7 7/8 x 11 1/8 in. (20.1 x 28.3 cm.)
Mount: 12 7/8 x 15 1/16 in. (32.7 x 38.3 cm.)
Inscription, print recto: "33"
Acquired from: anonymous gift

John Moran or Timothy H. O'Sullivan
3578. **[Huts on distant island; from Selfridge-Darien Expedition album]** (P1981.91.23)
Albumen silver print. 1870–71
Image: 6 5/8 x 10 3/4 in. (16.8 x 27.3 cm.)
Mount: 12 7/8 x 15 1/16 in. (32.7 x 38.3 cm.)
Inscription, print recto: "23"
Acquired from: anonymous gift

Attributed to John Moran
3579. **INQUISITION [Cartagena; from Selfridge-Darien Expedition album]** (P1982.1.18)
Albumen silver print. 1870
Image: 7 15/16 x 11 3/16 in. (20.2 x 28.4 cm.)
Mount: 12 7/8 x 15 1/16 in. (32.7 x 38.3 cm.)
Inscription, in negative: "13"
print recto: "47"
Acquired from: anonymous gift

3580. **ISLAND, LIMON BAY [from Selfridge-Darien Expedition album]** (P1981.91.11)
Albumen silver print. 1871
Image: 7 7/8 x 11 3/16 in. (20.1 x 28.4 cm.)
Mount: 12 7/8 x 15 1/16 in. (32.7 x 38.3 cm.)
Inscription, print recto: "10"
Acquired from: anonymous gift

John Moran or Timothy H. O'Sullivan
3581. **[Island with bird; from Selfridge-Darien Expedition album]** (P1982.1.1)
Albumen silver print. 1870–71
Image: 7 11/16 x 10 5/8 in. (19.6 x 27.0 cm.)
Mount: 12 7/8 x 15 1/16 in. (32.7 x 38.3 cm.)
Inscription, print recto: "21"
Acquired from: anonymous gift

3582. **LANDING, CHIPIGANA [from Selfridge-Darien Expedition album]** (P1981.91.24)
Albumen silver print. 1871
Image: 7 15/16 x 10 7/8 in. (20.2 x 27.6 cm.)
Mount: 12 7/8 x 15 1/16 in. (32.7 x 38.3 cm.)
Inscription, print recto: "29"
Acquired from: anonymous gift

3583. **LIMON BAY, LOW TIDE [from Selfridge-Darien Expedition album]** (P1981.91.16)
Albumen silver print. 1871
Image: 7 15/16 x 11 3/16 in. (20.1 x 28.4 cm.)
Mount: 12 7/8 x 15 1/16 in. (32.7 x 38.3 cm.)
Inscription, print recto: "15"
Acquired from: anonymous gift

Attributed to John Moran
3584. **[Makeshift jungle hut; from Selfridge-Darien Expedition album]** (P1982.1.3)
Albumen silver print. 1871
Image: 7 13/16 x 10 5/8 in. (19.7 x 27.0 cm.)
Mount: 12 7/8 x 15 1/16 in. (32.7 x 38.3 cm.)
Inscription, print recto: "25//38"
Acquired from: anonymous gift

*3585. **MANGO TREE, NEAR PINOGANA [from Selfridge-Darien Expedition album]** (P1982.1.7)
Albumen silver print. 1871
Image: 7 15/16 x 11 1/8 in. (20.2 x 28.3 cm.)
Mount: 12 7/8 x 15 1/16 in. (32.7 x 38.3 cm.)
Inscription, print recto: "32"
Acquired from: anonymous gift

3586. **MARTYR TREE AND RUIN OF OLD FORT SANTA MARIA DEL REAL [from Selfridge-Darien Expedition album]** (P1981.91.30)
Albumen silver print. 1871
Image: 7 15/16 x 11 3/16 in. (20.2 x 28.4 cm.)
Mount: 12 7/8 x 15 1/16 in. (32.7 x 38.3 cm.)
Inscription, print recto: "41"
Acquired from: anonymous gift

*3587. **NATIVE HUT, TURBO [from Selfridge-Darien Expedition album]** (P1981.91.29)
Albumen silver print. 1871
Image: 7 15/16 x 11 3/16 in. (20.2 x 28.4 cm.)
Mount: 12 7/8 x 15 1/16 in. (32.7 x 38.3 cm.)
Inscription, print recto: "39"
Acquired from: anonymous gift

*3588. **NATURAL ARCH, CUPICA BAY [from Selfridge-Darien Expedition album]** (P1981.91.17)
Albumen silver print. 1871
Image: 11 3/16 x 7 15/16 in. (28.4 x 20.1 cm.)
Mount: 12 7/8 x 15 1/16 in. (32.7 x 38.3 cm.)
Inscription, print recto: "16"
Acquired from: anonymous gift

John Moran or Timothy H. O'Sullivan
3589. **[Palm trees on island; from Selfridge-Darien Expedition album]** (P1982.1.2)
Albumen silver print. 1871
Image: 6 13/16 x 10 1/2 in. (17.4 x 26.7 cm.)
Mount: 12 7/8 x 15 1/16 in. (32.7 x 38.3 cm.)
Inscription, print recto: "24"
Acquired from: anonymous gift

3574

3572

3585

3577

3587

3588

3590. **PATH NEAR CHIPIGANA** [from Selfridge-Darien
Expedition album] (P1982.1.9)
Albumen silver print. 1871
Image: 11 ⅛ x 7 ¹⁵/₁₆ in. (28.3 x 20.2 cm.)
Mount: 12 ⅞ x 15 ¹/₁₆ in. (32.7 x 38.3 cm.)
Inscription, print recto: "36"
Acquired from: anonymous gift

*3591. **[Rock outcroppings in Limon Bay; from Selfridge-Darien
Expedition album]** (P1981.91.15)
Albumen silver print. 1871
Image: 7 ¹⁵/₁₆ x 11 ³/₁₆ in. (20.1 x 28.4 cm.)
Mount: 12 ⅞ x 15 ¹/₁₆ in. (32.7 x 38.3 cm.)
Inscription, print recto: "14"
Acquired from: anonymous gift

3592. **SANTA MARIA DEL REAL, DARIEN** [from Selfridge-
Darien Expedition album] (P1981.91.25)
Albumen silver print. 1871
Image: 7 ¹⁵/₁₆ x 10 ⅞ in. (20.2 x 27.6 cm.)
Mount: 12 ⅞ x 15 ¹/₁₆ in. (32.7 x 38.3 cm.)
Inscription, in negative: "6"
 print recto: "30"
Acquired from: anonymous gift

3593. **STREET, CHIPIGANA** [from Selfridge-Darien Expedition
album] (P1981.91.26)
Albumen silver print. 1871
Image: 7 ⅞ x 11 ³/₁₆ in. (20.1 x 28.4 cm.)
Mount: 12 ⅞ x 15 ¹/₁₆ in. (32.7 x 38.3 cm.)
Inscription, in negative: "11"
 print recto: "31"
Acquired from: anonymous gift

3594. **THE TERMINUS OF THE PROPOSED CANAL, LIMON
BAY** [from the Selfridge-Darien Expedition album]
(P1981.91.13)
Albumen silver print. 1871
Image: 7 ¹⁵/₁₆ x 11 ⅛ in. (20.1 x 28.3 cm.)
Mount: 12 ⅞ x 15 ¹/₁₆ in. (32.7 x 38.3 cm.)
Inscription, print recto: "12"
Acquired from: anonymous gift

3595. **TURBO VILLAGE** [from Selfridge-Darien Expedition album]
(P1981.91.22) duplicate of P1981.91.28
Albumen silver print. 1871
Image: 9 x 11 ¼ in. (22.8 x 28.5 cm.)
Mount: 12 ⅞ x 15 ¹/₁₆ in. (32.7 x 38.3 cm.)
Inscription, print recto: "22"
Acquired from: anonymous gift

3596. **TURBO VILLAGE** [from Selfridge-Darien Expedition album]
(P1981.91.28) duplicate of P1981.91.22
Albumen silver print. 1871
Image: 7 ¹⁵/₁₆ x 11 ³/₁₆ in. (20.2 x 28.4 cm.)
Mount: 12 ⅞ x 15 ¹/₁₆ in. (32.7 x 38.3 cm.)
Inscription, in negative: "10"
 print recto: "34"
Acquired from: anonymous gift

3597. **VIEW NEAR CHIPIGANA** [from Selfridge-Darien
Expedition album] (P1982.1.10)
Albumen silver print. 1871
Image: 7 ¾ x 10 ⅝ in. (19.7 x 27.0 cm.)
Mount: 12 ⅞ x 15 ¹/₁₆ in. (32.7 x 38.3 cm.)
Inscription, print recto: "37"
Acquired from: anonymous gift

3598. **VIEW OF LIMON BAY** [from Selfridge-Darien Expedition
album] (P1981.91.19)
Albumen silver print. 1871
Image: 7 ¹⁵/₁₆ x 11 ⅛ in. (20.1 x 28.3 cm.)
Mount: 12 ⅞ x 15 ¹/₁₆ in. (32.7 x 38.3 cm.)
Inscription, print recto: "18"
Acquired from: anonymous gift

BARBARA MORGAN, American (1900–1992)

Barbara Morgan set her sights on a career as a painter
when she was a child. She studied painting at UCLA
and in 1925 joined the faculty, teaching design, land-
scape, and woodcut. Her husband, Willard Morgan,
was a photographer and encouraged her to take a cam-
era on their summer trips to record the southwestern
Indian dances she was then painting. Morgan also
gained respect for the photographic medium in 1926
when she hung a show of Edward Weston's photographs
at UCLA. Morgan gave up painting after the birth of
her second child in 1935, turning to photography be-
cause it offered a more flexible work schedule. That
same year she saw a dance performance by Martha
Graham and the two began to work together on a series
of dance photographs featuring Graham. Morgan has
made black and white images of dancers, children, and
the city, often experimenting with photomontages and
light drawings. She received a National Endowment for
the Arts grant in 1975 and a Lifetime Achievement
Award from the American Society of Magazine Pho-
tographers in 1988. Her work has appeared in individ-
ual and group exhibitions world-wide.

3599. **AMARYLLIS SEED POD** (P1974.21.23)
Gelatin silver print mounted on Masonite. negative 1943,
 print 1972 by Modernage
Image: 60 x 30 ¾ in. (152.4 x 78.2 cm.)
Mount: same as image size
Inscription, mount verso: ACM exhibition label
Acquired from: gift of the photographer

*3600. **BEAUMONT NEWHALL & ANSEL ADAMS JUMPING**
(P1974.21.15)
Gelatin silver print. negative 1942, print 1970
Image: 14 ⅛ x 16 ⅝ in. (35.9 x 42.2 cm.)
Mount: 21 x 23 in. (53.2 x 58.5 cm.)
Signed, l.r. mount recto: "Barbara Morgan—1942"
Inscription, mount recto: "Beaumont Newhall & Ansel
Adams Jumping"
 mount verso: "I/A//Beaumont Newhall & Ansel Adams
Jumping—1942/ (In B.B.M. Studio) (Speedlight Strobe)/
Barbara Morgan//ARCHIVALLY PRINTED—1970/AND
MOUNTED by B.B.M.//14" x 16½" on 21" x 23"//2nd"
and rubber stamp "COPYRIGHT PHOTO/Not To Be
Reproduced/Without Written Permission/BARBARA
MORGAN/120 High Point Road/Scarsdale, New York
10584/WHEN USED IN ANY MEDIA/CREDIT MUST
BE GIVEN:/PHOTOGRAPH BY BARBARA MORGAN/
NO ARBITRARY CROPPING MAYBE [sic] DONE"
Acquired from: the photographer

3601. **BEECH TREE IV** (P1974.21.25)
Gelatin silver print mounted on Masonite. negative 1945,
 print 1972 by Modernage
Image: 47 x 48 in. (119.4 x 121.9 cm.)
Mount: same as image size
Inscription, mount verso: ACM exhibition label
Acquired from: gift of the photographer

3602. **CADENZA LIGHT DRAWING** (P1974.21.22)
Gelatin silver print mounted on Masonite. negative 1940,
 print 1972 by Modernage
Image: 58 x 48 in. (147.3 x 121.9 cm.)
Mount: same as image size
Inscription, mount verso: ACM exhibition label
Acquired from: gift of the photographer

3603. **CHARLES SHEELER AND HIS FAVORITE BEECH TREE**
(P1972.9)
Gelatin silver print. negative 1945, print 1971
Image: 12 ¹⁵/₁₆ x 10 ⁷/₁₆ in. (32.8 x 26.5 cm.)
Mount: 20 x 16 in. (50.8 x 40.7 cm.)

Signed, l.r. mount recto: "Barbara Morgan—1945"
Inscription, mount recto: "Charles Sheeler and his Favorite
 Beech Tree"
 mount verso: "Charles Sheeler and his Favorite Beech
 Tree—1945/Barbara Morgan//Archivally Printed—1971/
 B.B.M." and rubber stamp "COPYRIGHT PHOTO/Not To
 Be Reproduced/Without Written Permission/BARBARA
 MORGAN/120 High Point Road/Scarsdale, New York,
 10583"
Acquired from: the photographer

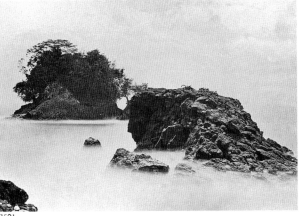

3591

3604. **CHARLES WEIDMAN—"LYNCHTOWN"—
 (HUMPHREY-WEIDMAN GROUP)** (P1974.21.11)
 Gelatin silver print. negative 1938, print later
 Image: 12 ¼ x 18 ½ in. (31.2 x 47.0 cm.)
 Mount: 19 ⅛ x 25 ⅛ in. (48.5 x 63.7 cm.)
 Signed, l.r. mount recto: "Barbara Morgan—1938"
 Inscription, mount recto: "Charles Weidman—
 "Lynchtown"—(Humphrey-Weidman Group)"
 mount verso: "Charles Weidman—"Lynchtown"—
 (Humphrey-Weidman Group)—1938/Barbara Morgan//
 12 ¼" x 18 ⅜" on 19" x 25"" and rubber stamp
 "COPYRIGHT PHOTO/Not To Be Reproduced/Without
 Written Permission/BARBARA MORGAN/120 High Point
 Road/Scarsdale, New York 10584/WHEN USED IN ANY
 MEDIA/CREDIT MUST BE GIVEN:/PHOTOGRAPH
 BY BARBARA MORGAN/NO ARBITRARY CROPPING
 MAYBE [sic] DONE"
 Acquired from: the photographer

3600

3605. **CHASSIS—CRANIUM (JUNKYARD SERIES)**
 (P1974.21.14)
 Gelatin silver print. negative 1947, print 1971
 Image: 15 ⁵⁄₁₆ x 13 ³⁄₁₆ in. (38.9 x 33.4 cm.)
 Mount: 23 x 20 in. (58.5 x 50.8 cm.)
 Signed, l.r. mount recto: "Barbara Morgan—1947"
 Inscription, mount recto: "Chassis-Cranium"
 mount verso: "A//CHASSIS—CRANIUM—1947
 (Junkyard Series)/Barbara Morgan//Archivally Printed—
 1971/B.B.M.//15 ¼" x 13 ⅛" on 23" x 20"" and rubber stamp
 "COPYRIGHT PHOTO/Not To Be Reproduced/Without
 Written Permission/BARBARA MORGAN/120 High Point
 Road/Scarsdale, New York 10584/WHEN USED IN ANY
 MEDIA/CREDIT MUST BE GIVEN:/PHOTOGRAPH
 BY BARBARA MORGAN/NO ARBITRARY CROPPING
 MAYBE [sic] DONE"
 Acquired from: the photographer

3606. **CHILDREN DANCING BY LAKE** (P1974.21.26)
 Gelatin silver print mounted on Masonite. negative 1940,
 print 1972 by Modernage
 Image: 45 ½ x 60 in. (115.5 x 152.4 cm.)
 Mount: same as image size
 Inscription, mount verso: ACM exhibition label
 Acquired from: gift of the photographer

3608

3607. **DORIS HUMPHREY—MATRIARCH—FROM "WITH
 MY RED FIRES"** (P1974.21.9)
 Gelatin silver print. negative 1938, print 1969
 Image: 12 ⅞ x 14 ⅛ in. (32.7 x 35.9 cm.)
 Mount: 20 x 20 in. (50.8 x 50.8 cm.)
 Signed, l.r. mount recto: "Barbara Morgan—1938"
 Inscription, mount recto: "Doris Humphrey—Matriarch—
 from "With My Red Fires""
 mount verso: "I-28//(Matriarch)/Doris Humphrey—With
 My Red Fires—1938/ Barbara Morgan//ARCHIVALLY/
 PRINTED—1969/B.B.M.//13" x 14 ⅛"—21" x 20"" and
 rubber stamp "COPYRIGHT PHOTO/Not To Be
 Reproduced/Without Written Permission/BARBARA
 MORGAN/120 High Point Road/Scarsdale, New York
 10584/WHEN USED IN ANY MEDIA/CREDIT MUST
 BE GIVEN:/PHOTOGRAPH BY BARBARA MORGAN/
 NO ARBITRARY CROPPING MAYBE [sic] DONE"
 Acquired from: the photographer

*3608. **GIRLS DANCING BY LAKE** (P1974.21.5)
Gelatin silver print. negative 1945, print 1972
Image: 13 7/16 x 10 3/8 in. (34.1 x 26.4 cm.)
Mount: 20 x 16 in. (50.8 x 40.7 cm.)
Signed, l.r. mount recto: "Barbara Morgan—1945"
Inscription, mount recto: "Girls Dancing by Lake"
mount verso: "GIRLS DANCING By LAKE—1945/
Barbara Morgan//ArchivallyProcessed—1972/B.B.M.//
13 1/2" x 10 1/4" on 20" x 16"//From book: SUMMER'S
CHILDRENN [sic]/by/Barbara Morgan" and rubber stamp
"COPYRIGHT PHOTO/Not To Be Reproduced/Without
Written Permission/BARBARA MORGAN/120 High Point
Road/Scarsdale, New York 10584/WHEN USED IN ANY
MEDIA/CREDIT MUST BE GIVEN:/PHOTOGRAPH
BY BARBARA MORGAN/NO ARBITRARY CROPPING
MAYBE [sic] DONE"
Acquired from: the photographer

*3609. **HEARST OVER THE PEOPLE** (P1974.21.4)
Gelatin silver print (photomontage). negative 1939, print 1972
Image: 10 3/4 x 13 3/8 in. (27.3 x 34.0 cm.)
Mount: 16 x 19 in. (40.7 x 48.2 cm.)
Signed, l.r. in negative: "Barbara Morgan"
l.r. mount recto: "Barbara Morgan—1939"
Inscription, mount recto: "HEARST OVER THE PEOPLE"
mount verso: "HEARST OVER THE PEOPLE—1939
(photomontage)/Barbara Morgan//Archivally Printed—
1972/B.B.M.//10 3/4 x 13 3/8 on 16 x 19" and rubber stamp
"COPYRIGHT PHOTO/Not To Be Reproduced/Without
Written Permission/BARBARA MORGAN/120 High Point
Road/Scarsdale, New York 10584/WHEN USED IN ANY
MEDIA/CREDIT MUST BE GIVEN:/PHOTOGRAPH
BY BARBARA MORGAN/NO ARBITRARY CROPPING
MAYBE [sic] DONE"
Acquired from: the photographer

3610. **MARTHA GRAHAM—CELEBRATION (TRIO)**
(P1974.21.24)
Gelatin silver print mounted on Masonite. negative 1937,
print 1972 by Modernage
Image: 57 1/2 x 48 1/8 in. (146.0 x 122.2 cm.)
Mount: same as image size
Inscription, mount verso: ACM exhibition label
Acquired from: gift of the photographer

*3611. **MARTHA GRAHAM—EKSTASIS (TORSO)** (P1974.21.20)
Gelatin silver print. negative 1935, print 1972
Image: 18 1/2 x 13 3/4 in. (46.9 x 34.9 cm.)
Mount: 27 1/8 x 21 in. (68.8 x 53.4 cm.)
Signed, l.r. mount recto: "Barbara Morgan—1935"
Inscription, mount recto: "Martha Graham—EKSTASIS"
mount verso: "Martha Graham—EKSTASIS—1935—
(Torso)/Barbara Morgan//Archivally Printed—1972/
BBM.//18 3/8 x 13 5/8 ON 27 x 21" and rubber stamp
"COPYRIGHT PHOTO/Not To Be Reproduced/Without
Written Permission/BARBARA MORGAN/120 High Point
Road/Scarsdale, New York 10584/WHEN USED IN ANY
MEDIA/CREDIT MUST BE GIVEN:/PHOTOGRAPH
BY BARBARA MORGAN/NO ARBITRARY CROPPING
MAYBE [sic] DONE"
Acquired from: the photographer

*3612. **MARTHA GRAHAM—EL PENITENTE—(SOLO—
HAWKINS AS EL FLAGELLANTE)** (P1974.21.19)
duplicate of P1974.21.31
Gelatin silver print. negative 1940, print 1972
Image: 18 3/4 x 14 13/16 in. (47.7 x 37.6 cm.)
Mount: 27 x 22 in. (68.6 x 56.0 cm.)
Signed, l.r. mount recto: "Barbara Morgan—1940"
Inscription, mount recto: "Martha Graham—EL
PENITENTE—(Solo—Hawkins as EL FLAGELLANTE)"
mount verso: "Martha Graham—EL PENITENTE—
(Solo—Hawkins as EL FLAGELLANTE)—1940/Barbara
Morgan//Archivally Printed—1972/B.B.M.//18 3/4" x 14 3/4"
on 27" x 22"" and rubber stamp "COPYRIGHT PHOTO/
Not To Be Reproduced/Without Written Permission/
BARBARA MORGAN/ 120 High Point Road/Scarsdale,

New York 10584/WHEN USED IN ANY MEDIA/
CREDIT MUST BE GIVEN:/PHOTOGRAPH BY
BARBARA MORGAN/NO ARBITRARY CROPPING
MAYBE [sic] DONE"
Acquired from: the photographer

3613. **MARTHA GRAHAM—EL PENITENTE—(SOLO—
HAWKINS AS EL FLAGELLANTE)** (P1974.21.31)
duplicate of P1974.21.19
Gelatin silver print mounted on Masonite. negative 1940,
print 1972 by Modernage
Image: 60 x 48 in. (152.4 x 121.9 cm.)
Mount: same as image size
Inscription, mount verso: ACM exhibition label
Acquired from: gift of the photographer

3614. **MARTHA GRAHAM—FRONTIER (FEAR)** (P1974.21.18)
Gelatin silver print. negative 1935, print 1969
Image: 13 15/16 x 19 3/16 in. (35.4 x 48.7 cm.)
Mount: 22 x 26 in. (55.9 x 66.0 cm.)
Signed, l.r. mount recto: "Barbara Morgan—1935"
Inscription, mount recto: "Martha Graham—Frontier"
mount verso: "X EX//Martha Graham—Frontier—1935
(Fear)/Barbara Morgan//ARCHIVALLY PRINTED—1969/
B.B.M.//14" x 19 1/8" on 22" x 26"" and rubber stamp
"COPYRIGHT PHOTO/Not To Be Reproduced/Without
Written Permission/BARBARA MORGAN/120 High Point
Road/Scarsdale, New York 10584/WHEN USED IN ANY
MEDIA/CREDIT MUST BE GIVEN:/PHOTOGRAPH
BY BARBARA MORGAN/NO ARBITRARY CROPPING
MAYBE [sic] DONE"
Acquired from: the photographer

3615. **MARTHA GRAHAM—LAMENTATION** (P1974.21.28)
Gelatin silver print mounted on Masonite. negative 1941, print
1972 by Modernage
Image: 59 x 48 in. (149.8 x 121.9 cm.)
Mount: same as image size
Inscription, mount verso: ACM exhibition label
Acquired from: gift of the photographer

3616. **MARTHA GRAHAM—LAMENTATION (OBLIQUE)**
(P1974.21.6)
Gelatin silver print. negative 1935, print 1972
Image: 13 1/4 x 10 5/8 in. (33.6 x 26.9 cm.)
Mount: 20 x 16 in. (50.8 x 40.7 cm.)
Signed, l.r. mount recto: "Barbara Morgan—1935"
Inscription, mount recto: "Martha Graham—
LAMENTATION"
mount verso: "Martha Graham—Lamentation—1935
(OBLIQUE)/Barbara Morgan//Archivally Printed—1972/
B.B.M.//13 1/8 x 10 1/2 ON 20 x 16" and rubber stamp
"COPYRIGHT PHOTO/Not To Be Reproduced/Without
Written Permission/BARBARA MORGAN/120 High Point
Road/Scarsdale, New York 10584/WHEN USED IN ANY
MEDIA/CREDIT MUST BE GIVEN:/PHOTOGRAPH
BY BARBARA MORGAN/NO ARBITRARY CROPPING
MAYBE [sic] DONE"
Acquired from: the photographer

3617. **MARTHA GRAHAM—LETTER TO THE WORLD
(FINALE)** (P1974.21.7)
Gelatin silver print. negative 1940, print 1972
Image: 13 9/16 x 10 5/16 in. (34.5 x 26.2 cm.)
Mount: 20 1/8 x 16 in. (51.0 x 40.7 cm.)
Signed, l.r. mount recto: "Barbara Morgan—1940"
Inscription, mount recto: "Martha Graham—Letter to
the World"
mount verso: "Martha Graham—Letter to the World—
1940 (FINALE)/Barbara Morgan//Archivally Printed—
1972/BBM.//13 3/8" x 10 1/4" on 20" x 16"" and rubber stamp
"COPYRIGHT PHOTO/Not To Be Reproduced/Without
Written Permission/BARBARA MORGAN/120 High Point
Road/Scarsdale, New York 10584/WHEN USED IN ANY
MEDIA/CREDIT MUST BE GIVEN:/PHOTOGRAPH
BY BARBARA MORGAN/NO ARBITRARY CROPPING
MAYBE [sic] DONE"
Acquired from: the photographer

*3618. **MARTHA GRAHAM—LETTER TO THE WORLD
(SWIRL)** (P1974.21.17) duplicate of P1974.21.30
Gelatin silver print. negative 1940, print 1972
Image: 15 5/16 x 19 1/4 in. (38.9 x 48.9 cm.)
Mount: 22 x 26 in. (55.9 x 66.0 cm.)
Signed, l.r. mount recto: "Barbara Morgan—1940"
Inscription, mount recto: "Martha Graham—Letter to
the World"
mount verso: "Martha Graham—Letter to the World—
1940 (SWIRL)/Barbara Morgan//Archivally Printed—1972/
B.B.M.//15 1/4" x 19 1/4" on 22" x 26"" and rubber stamp
"COPYRIGHT PHOTO/Not To Be Reproduced/Without
Written Permission/BARBARA MORGAN/120 High Point
Road/Scarsdale, New York 10584/WHEN USED IN ANY
MEDIA/CREDIT MUST BE GIVEN:/PHOTOGRAPH
BY BARBARA MORGAN/NO ARBITRARY CROPPING
MAYBE [sic] DONE"
Acquired from: the photographer

3609

3619. **MARTHA GRAHAM—LETTER TO THE WORLD
(SWIRL)** (P1974.21.30) duplicate of P1974.21.17
Gelatin silver print mounted on Masonite. negative 1940,
print 1972 by Modernage
Image: 48 x 53 in. (121.9 x 134.6 cm.)
Mount: same as image size
Inscription, mount verso: ACM exhibition label
Acquired from: gift of the photographer

3620. **OPACITIES. MONTAGE. SERIAL PHOTOGRAM**
(P1974.21.27)
Gelatin silver print mounted on Masonite. negative 1968,
print 1972 by Modernage
Image: 57 1/4 x 48 in. (145.4 x 121.9 cm.)
Mount: same as image size
Inscription, mount verso: ACM exhibition label
Acquired from: gift of the photographer

3611

3621. **PREGNANT** (P1974.21.12)
Gelatin silver print. negative 1940, print 1970
Image: 16 1/8 x 12 11/16 in. (41.0 x 32.2 cm.)
Mount: 24 x 19 in. (61.0 x 48.3 cm.)
Signed, l.r. mount recto: "Barbara Morgan—1940"
Inscription, mount recto: "Pregnant"
mount verso: "A//Pregnant—1945 1940/Barbara Morgan//
Archivally Printed—1970/B.B.M.//16 1/4" x 12 5/8" on 24" x
19"" and rubber stamp "COPYRIGHT PHOTO/Not To Be
Reproduced/Without Written Permission/BARBARA
MORGAN/120 High Point Road/Scarsdale, New York
10584/WHEN USED IN ANY MEDIA/CREDIT MUST
BE GIVEN:/PHOTOGRAPH BY BARBARA MORGAN/
NO ARBITRARY CROPPING MAYBE [sic] DONE"
Acquired from: the photographer

*3622. **PURE ENERGY AND NEUROTIC MAN** (P1974.21.16)
duplicate of P1974.21.29
Gelatin silver print (photomontage). negative 1941, print 1972
Image: 19 1/8 x 15 3/16 in. (48.5 x 38.5 cm.)
Mount: 27 x 22 in. (68.6 x 55.9 cm.)
Signed, l.r. mount recto: "Barbara Morgan—1941"
Inscription, mount recto: "Pure Energy and Neurotic Man—"
mount verso: "Pure Energy and Neurotic Man—1941
(Light Drawing Photomontage)/Barbara Morgan//Printed
Archivally—1972/B.B.M.//19" x 15 1/8" on 27" x 22"" and
rubber stamp "COPYRIGHT PHOTO/Not To Be
Reproduced/Without Written Permission/BARBARA
MORGAN/120 High Point Road/Scarsdale, New York
10584/WHEN USED IN ANY MEDIA/CREDIT MUST
BE GIVEN:/PHOTOGRAPH BY BARBARA MORGAN/
NO ARBITRARY CROPPING MAYBE [sic] DONE"
Acquired from: the photographer

3612

3623. **PURE ENERGY AND NEUROTIC MAN** (P1974.21.29)
duplicate of P1974.21.16
Gelatin silver print mounted on Masonite. negative 1941,
print 1972 by Modernage
Image: 59 x 48 in. (149.8 x 121.9 cm.)
Mount: same as image size
Inscription, mount verso: ACM exhibition label
Acquired from: gift of the photographer

3624. **SOLSTICE** (P1974.21.10)
Gelatin silver print. negative 1942, print 1969
Image: 16⅜ x 11 in. (41.5 x 28.0 cm.)
Mount: 23 x 17 in. (58.4 x 43.2 cm.)
Signed, l.r. mount recto: "Barbara Morgan—1942"
Inscription, mount recto: "SOLSTICE—"
 mount verso: "II-31//A//SOLSTICE—1942/Barbara
 Morgan//Archivally Printed—1969/B.B.M.//16⅜" x 11"—
 23" x 17"" and rubber stamp "COPYRIGHT PHOTO/
 Not To Be Reproduced/Without Written Permission/
 BARBARA MORGAN/120 High Point Road/Scarsdale,
 New York 10584/WHEN USED IN ANY MEDIA/CREDIT
 MUST BE GIVEN:/PHOTOGRAPH BY BARBARA
 MORGAN/NO ARBITRARY CROPPING MAYBE [sic]
 DONE"
Acquired from: the photographer

*3625. **SPRING ON MADISON SQUARE** (P1974.21.13)
Gelatin silver print (photomontage). negative 1938, print later
Image: 13⅝ x 16⁹⁄₁₆ in. (34.7 x 42.1 cm.)
Mount: 20 x 24 in. (50.8 x 61.0 cm.)
Signed, l.r. mount recto: "Barbara Morgan 1938"
Inscription, mount recto: "SPRING ON MADISON
 SQUARE"
 mount verso: "SPRING ON MADISON SQUARE—
 Barbara Morgan/Photomontage—1938//13⅝ x 16⅝ on
 20 x 24" and rubber stamp "COPYRIGHT PHOTO/Not To
 Be Reproduced/Without Written Permission/BARBARA
 MORGAN/120 High Point Road/Scarsdale, New York
 10584/WHEN USED IN ANY MEDIA/CREDIT MUST
 BE GIVEN:/PHOTOGRAPH BY BARBARA MORGAN/
 NO ARBITRARY CROPPING MAYBE [sic] DONE"
Acquired from: the photographer

3626. **VALERIE BETTIS—DESPERATE HEART** (P1974.21.21)
Gelatin silver print (photomontage). negative 1944, print 1972
Image: 15⅜ x 19 in. (39.0 x 48.2 cm.)
Mount: 22 x 27 in. (56.0 x 68.6 cm.)
Signed, l.r. mount recto: "Barbara Morgan—1944"
Inscription, mount recto: "Valerie Bettis—Desperate Heart"
 mount verso: "Valerie Bettis—DESPERATE HEART—
 1944 (photomontage #1)/ Barbara Morgan//Archivally
 Printed—1972/B.B.M.//15⅜" x 19" on 22" x 27"" and
 rubber stamp "COPYRIGHT PHOTO/Not To Be
 Reproduced/Without Written Permission/BARBARA
 MORGAN/120 High Point Road/Scarsdale, New York
 10584/WHEN USED IN ANY MEDIA/CREDIT MUST
 BE GIVEN:/PHOTOGRAPH BY BARBARA MORGAN/
 NO ARBITRARY CROPPING MAYBE [sic] DONE"
Acquired from: the photographer

3627. **WILLARD MORGAN WITH MODEL A LEICA—
BANDELIER NATIONAL MONUMENT** (P1974.21.8)
Gelatin silver print. negative 1928, print 1972
Image: 13⅜ x 10 in. (34.0 x 25.3 cm.)
Mount: 20 x 16 in. (50.8 x 40.7 cm.)
Signed, l.r. mount recto: "Barbara Morgan—1928"
Inscription, mount recto: "Willard Morgan with Model A
 Leica— Bandelier National Monument"
 mount verso: "WILLARD MORGAN WITH MODEL A
 LEICA—1928/BANDELIER NATIONAL MONUMENT/
 Barbara Morgan//Archivally Printed—1972//13⅜ x 19⅞
 [sic] ON 20 x 16" and rubber stamp "COPYRIGHT
 PHOTO/Not To Be Reproduced/Without Written
 Permission/BARBARA MORGAN/120 High Point Road/
 Scarsdale, New York 10584/WHEN USED IN ANY

MEDIA/CREDIT MUST BE GIVEN:/PHOTOGRAPH
BY BARBARA MORGAN/NO ARBITRARY CROPPING
MAYBE [sic] DONE"
Acquired from: the photographer

3628. **WILLARD'S FIST** (P1974.21.3)
Gelatin silver print. negative 1942, print 1972
Image: 12⅝ x 10⅝ in. (32.1 x 27.0 cm.)
Mount: 19 x 16 in. (48.2 x 40.7 cm.)
Signed, l.r. mount recto: "Barbara Morgan—1942"
Inscription, mount recto: "Willard's Fist"
 mount verso: "A//WILLARD'S FIST—1942/Barbara
 Morgan//Archivally Printed—1972/B.B.M.//12½ x 10½ ON
 19 x 16" and rubber stamp "COPYRIGHT PHOTO/Not To
 Be Reproduced/Without Written Permission/BARBARA
 MORGAN/120 High Point Road/Scarsdale, New York
 10584/WHEN USED IN ANY MEDIA/CREDIT MUST
 BE GIVEN:/PHOTOGRAPH BY BARBARA MORGAN/
 NO ARBITRARY CROPPING MAYBE [sic] DONE"
Acquired from: the photographer

WILLARD D. MORGAN, American (1900–1967)

Willard Morgan was a photographer and publisher
who wrote many technical articles and books on pho-
tography and was an early advocate of the 35mm
"miniature" camera. He was the first editor of *Leica
Photography* and an editor of the magazine *Photo Minia-
ture*. Morgan and Henry Lester formed a publishing
house; later he and his wife Barbara Morgan were co-
owners of Morgan and Morgan Publishing Company.
Willard Morgan also was a founding member of
the Circle of Confusion, an organization for Leica
camera users.

*3629. **BARBARA MORGAN COOKING—CANYON DE
CHELLY** (P1974.21.1)
Gelatin silver print. negative 1928, print 1973 by Barbara
Morgan
Image: 8¹⁵⁄₁₆ x 13⅝ in. (22.7 x 34.7 cm.)
Mount: 14 x 19 in. (35.6 x 48.3 cm.)
Inscription, mount recto: "photograph by Willard D.
 Morgan—1928//Barbara Morgan Cooking—CANYON de
 CHELLY"
 mount verso: "BARBARA MORGAN COOKING—
 CANYON de CHELLY—1928/ Photograph by Willard D.
 Morgan/% Barbara Morgan/120 High Point Road/
 Scarsdale—N.Y.—10583//8⅞ x 13⅝ ON 14 x 19"
Acquired from: Barbara Morgan, Scarsdale, New York

3630. **BARBARA MORGAN PAINTING IN GRAND CANYON**
(P1974.21.2)
Gelatin silver print. negative 1928, print 1972 by Barbara
Morgan
Image: 9⁹⁄₁₆ x 6¾ in. (24.2 x 17.2 cm.)
Mount: 14³⁄₁₆ x 12 in. (36.0 x 30.5 cm.)
Inscription, mount recto: "WILLARD D. MORGAN—1928//
 Barbara Morgan Painting—Grand Canyon"
 mount verso: "Barbara Morgan Painting in Grand
 Canyon—1928/Photograph by Willard D. Morgan//
 Archivally Printed—1972/by B.B.M.//9½" x 6¾" on
 14" x 12"" and rubber stamp "COPYRIGHT PHOTO/
 Not To Be Reproduced/Without Written Permission/
 BARBARA MORGAN/120 High Point Road/Scarsdale,
 New York 10584/WHEN USED IN ANY MEDIA/CREDIT
 MUST BE GIVEN:/PHOTOGRAPH BY BARBARA
 MORGAN/NO ARBITRARY CROPPING MAY BE
 DONE"
Acquired from: Barbara Morgan, Scarsdale, New York

GUSTAVE A. MOSES,
American, born Bavaria (1836–1915),
and **EUGENE A. PIFFET**
(active mid-19th century)

Gustave A. Moses was one of four sons of Samuel Wolfgang Moses, an early New Orleans photographer. Gustave Moses opened a "daguerrean saloon" [sic] in 1854 at which he offered stereoscopic portraits. From 1857 to 1861 he was a partner with his brother Bernard in a photographic studio. When the Civil War broke out, he joined the 21st Infantry as a first lieutenant, serving until about 1864, when he formed a partnership with Eugene A. Piffet. Little is known about Piffet. He was a New Orleans photographer, and it is supposed that he took charge of the technical end of the gallery since he is listed in later New Orleans directories as a manufacturer of albumenized paper. The Moses and Piffet partnership lasted for only one or two years, and Moses eventually resumed the partnership with his brother in 1867.

*3631. **VIEW OF CITADEL LOOKING SOUTH-EAST [Fort Morgan, Alabama]** (P1978.59)
Albumen silver print. 1864
Image: 9½ x 12⅞ in. (24.1 x 32.7 cm.)
Mount: 13 x 15¼ in. (33.0 x 38.7 cm.)
Signed: see inscription
Inscription, mount recto: "Fort Morgan, Ala." and printed "Entered according to Act of Congress, in the year 1864, by MOSES & PIFFET, in the Clerk's office, of the District Court of the U. S., for the Eastern District of La.//3. VIEW OF CITADEL LOOKING SOUTH-EAST."
mount verso: "275"
Acquired from: Hastings Gallery, New York, New York

WILL H. MOSES (active c. 1900s)

See *Camera Notes*

MICHAEL ALLEN MURPHY,
American (b. 1952)

Michael Allen Murphy was born in Houston. He received a bachelor's degree in journalism from the University of Texas in 1976 and an M.A. from the same institution in 1982. He has worked as a photographer for the *Dallas Morning News* (1978), the *Houston Chronicle* (1979), where he also served as an information specialist, and the Texas Tourist Development Agency (1979–83). Murphy taught at the University of Texas at Austin from 1982 to 1984 while pursuing a career as a freelance photojournalist.

3632. **ARTHUR TEMPLE, LUMBER MAGNATE IN LUFKIN [from "Contemporary Texas: A Photographic Portrait"]** (P1985.17.126)
Gelatin silver print. 1984
Image: 9 1/16 x 10½ in. (23.0 x 26.6 cm.)
Sheet: 11 x 13 15/16 in. (28.0 x 35.4 cm.)
Signed: see inscription
Inscription, print verso: "Arthur Temple/24 Jul 84" and rubber stamp "©1984 Michael A. Murphy. This photograph/cannot be copied, televised, reproduced, or/used in any form without the express and/written permission of:/Michael A. Murphy/Vista Bella Enterprises, Inc./Star Route 1, Box 20/Dripping Springs, Texas 78620/512/264-2347"
Acquired from: gift of the Texas Historical Foundation with support from a major grant from the Du Pont Company and Conoco, its energy subsidiary, and assistance from the Texas Commission on the Arts and the National Endowment for the Arts

3618

3622

3625

3633. **BEN LOVE, BANKER, TEXAS COMMERCE BANK, HOUSTON** [from "Contemporary Texas: A Photographic Portrait"] (P1985.17.122)
Gelatin silver print. 1984
Image: 9 9/16 x 10 1/16 in. (24.3 x 25.5 cm.)
Sheet: 11 x 13 15/16 in. (28.0 x 35.4 cm.)
Signed: see inscription
Inscription, print verso: "Ben Love—Texas Commerce Bank (HOUSTON)/31 Aug 84" and rubber stamp "©1984 Michael A. Murphy. This photograph/cannot be copied, televised, reproduced, or/used in any form without the express and/written permission of:/Michael A. Murphy/Vista Bella Enterprises, Inc./Star Route 1, Box 20/Dripping Springs, Texas 78620/512/264-2347"
Acquired from: gift of the Texas Historical Foundation with support from a major grant from the Du Pont Company and Conoco, its energy subsidiary, and assistance from the Texas Commission on the Arts and the National Endowment for the Arts

3634. **BOBBY RAY INMAN—MCC [acquired in conjunction with the exhibition "Contemporary Texas: A Photographic Portrait"]** (P1985.17.128)
Gelatin silver print. 1984
Image: 13 3/16 x 15 15/16 in. (33.5 x 40.5 cm.)
Sheet: 16 x 19 15/16 in. (40.7 x 50.7 cm.)
Signed: see inscription
Inscription, print verso: "Bobby Ray Inman—MCC/12 Sep 84" and rubber stamp "©1984 Michael A. Murphy. This photograph/cannot be copied, televised, reproduced, or/used in any form without the express and/written permission of:/Michael A. Murphy/Vista Bella Enterprises, Inc./Star Route 1, Box 20/Dripping Springs, Texas 78620/512/264-2347"
Acquired from: gift of the Texas Historical Foundation with support from a major grant from the Du Pont Company and Conoco, its energy subsidiary, and assistance from the Texas Commission on the Arts and the National Endowment for the Arts

*3635. **DR. MICHAEL DEBAKEY, RENOWNED SURGEON, IN HIS OFFICE, HOUSTON** [from "Contemporary Texas: A Photographic Portrait"] (P1985.17.127)
Gelatin silver print. 1984
Image: 9 x 12 1/2 in. (22.8 x 31.8 cm.)
Sheet: 11 x 13 15/16 in. (28.0 x 35.4 cm.)
Signed: see inscription
Inscription, print verso: "Dr. Michael Debakey/28 Aug 84" and rubber stamp "©1984 Michael A. Murphy. This photograph/cannot be copied, televised, reproduced, or/used in any form without the express and/written permission of:/Michael A. Murphy/Vista Bella Enterprises, Inc./Star Route 1, Box 20/Dripping Springs, Texas 78620/512/264-2347"
Acquired from: gift of the Texas Historical Foundation with support from a major grant from the Du Pont Company and Conoco, its energy subsidiary, and assistance from the Texas Commission on the Arts and the National Endowment for the Arts

*3636. **DR. SALLY RIDE IN THE SHUTTLE TRAINER, NASA** [from "Contemporary Texas: A Photographic Portrait"] (P1985.17.124)
Gelatin silver print. 1984
Image: 8 1/2 x 12 in. (21.6 x 30.5 cm.)
Sheet: 11 x 13 15/16 in. (28.0 x 35.4 cm.)
Signed: see inscription
Inscription, print verso: "Dr. Sally Ride (In orbiter trainer @NASA)/3 Sep 84" and rubber stamp "©1984 Michael A. Murphy. This photograph/cannot be copied, televised, reproduced, or/used in any form without the express and/written permission of:/Michael A. Murphy/Vista Bella Enterprises, Inc./Star Route 1, Box 20/Dripping Springs, Texas 78620/512/264-2347"
Acquired from: gift of the Texas Historical Foundation with

support from a major grant from the Du Pont Company and Conoco, its energy subsidiary, and assistance from the Texas Commission on the Arts and the National Endowment for the Arts

3637. **HERBERT KELLEHER, CHIEF OF SOUTHWEST AIRLINES, AT LOVE FIELD IN DALLAS** [from "Contemporary Texas: A Photographic Portrait"] (P1985.17.130)
Gelatin silver print. 1984
Image: 16 x 13 1/8 in. (40.7 x 33.3 cm.)
Sheet: 19 15/16 x 16 in. (50.7 x 40.7 cm.)
Signed: see inscription
Inscription, print verso: "Herbert Kelleher—Southwest Airlines/6 Sep 84" and rubber stamp "©1984 Michael A. Murphy. This photograph/cannot be copied, televised, reproduced, or/used in any form without the express and/written permission of:/Michael A. Murphy/Vista Bella Enterprises, Inc./Star Route 1, Box 20/Dripping Springs, Texas 78620/512/264-2347"
Acquired from: gift of the Texas Historical Foundation with support from a major grant from the Du Pont Company and Conoco, its energy subsidiary, and assistance from the Texas Commission on the Arts and the National Endowment for the Arts

3638. **HOUSTON MAYOR KATHERINE J. WHITMIRE IN HER OFFICE** [from "Contemporary Texas: A Photographic Portrait"] (P1985.17.123)
Gelatin silver print. 1984
Image: 9 1/16 x 10 1/2 in. (23.0 x 26.6 cm.)
Sheet: 11 x 13 15/16 in. (28.0 x 35.4 cm.)
Signed: see inscription
Inscription, print verso: "HOUSTON Mayor Kathy Whitmire/30 Aug 84" and rubber stamp "©1984 Michael A. Murphy. This photograph/cannot be copied, televised, reproduced, or/used in any form without the express and/written permission of:/Michael A. Murphy/Vista Bella Enterprises, Inc./Star Route 1, Box 20/Dripping Springs, Texas 78620/512/264-2347"
Acquired from: gift of the Texas Historical Foundation with support from a major grant from the Du Pont Company and Conoco, its energy subsidiary, and assistance from the Texas Commission on the Arts and the National Endowment for the Arts

3639. **LIEUTENANT GOVERNOR WILLIAM P. HOBBY IN THE SENATE CHAMBERS, AUSTIN** [from "Contemporary Texas: A Photographic Portrait"] (P1985.17.131)
Gelatin silver print. 1984
Image: 15 15/16 x 14 9/16 in. (40.5 x 37.2 cm.)
Sheet: 19 15/16 x 16 in. (50.7 x 40.7 cm.)
Signed: see inscription
Inscription, print verso: "Lt. Gov. William P. Hobby/13 Sep 84" and rubber stamp "©1984 Michael A. Murphy. This photograph/cannot be copied, televised, reproduced, or/used in any form without the express and/written permission of:/Michael A. Murphy/Vista Bella Enterprises, Inc./Star Route 1, Box 20/Dripping Springs, Texas 78620/512/264-2347"
Acquired from: gift of the Texas Historical Foundation with support from a major grant from the Du Pont Company and Conoco, its energy subsidiary, and assistance from the Texas Commission on the Arts and the National Endowment for the Arts

3640. **STANLEY AND RICHARD MARCUS IN THE ORIENTAL GALLERY AT NEIMAN-MARCUS (DOWNTOWN) DALLAS** [from "Contemporary Texas: A Photographic Portrait"] (P1985.17.121)
Gelatin silver print. 1984
Image: 9 x 11 in. (22.8 x 28.0 cm.)
Sheet: 11 x 14 in. (28.0 x 35.6 cm.)
Signed: see inscription
Inscription, print verso: "Richard & Stanley Marcus/10 Aug 84" and rubber stamp "©1984 Michael A. Murphy. This

photograph/cannot be copied, televised, reproduced, or/ used in any form without the express and/written permission of:/Michael A. Murphy/Vista Bella Enterprises, Inc./Star Route 1, Box 20/Dripping Springs, Texas 78620/512/264-2347"

Acquired from: gift of the Texas Historical Foundation with support from a major grant from the Du Pont Company and Conoco, its energy subsidiary, and assistance from the Texas Commission on the Arts and the National Endowment for the Arts

3629

3641. **T. BOONE PICKENS, CHIEF OF MESA PETROLEUM, NEAR HIS 2-B RANCH NORTHEAST OF AMARILLO** [from "Contemporary Texas: A Photographic Portrait"] (P1985.17.129)

Gelatin silver print. 1984

Image: 13 ¼ x 16 in. (33.7 x 40.7 cm.)

Sheet: 16 ¹/₁₆ x 19 ¹⁵/₁₆ in. (40.8 x 50.7 cm.)

Signed: see inscription

Inscription, print verso: "T. Boone Pickens—Mesa Petroleum/15 Sep 84" and rubber stamp "©1984 Michael A. Murphy. This photograph/cannot be copied, televised, reproduced, or/used in any form without the express and/ written permission of:/Michael A. Murphy/Vista Bella Enterprises, Inc./Star Route 1, Box 20/Dripping Springs, Texas 78620/512/264-2347"

Acquired from: gift of the Texas Historical Foundation with support from a major grant from the Du Pont Company and Conoco, its energy subsidiary, and assistance from the Texas Commission on the Arts and the National Endowment for the Arts

3631

3642. **W.A. "MONTY" MONCRIEF, SON W.A. "TEX" MONCRIEF, JR., AND GRANDSONS RICHARD W. MONCRIEF AND CHARLES B. MONCRIEF AT THE MONCRIEF BUILDING, FORT WORTH** [from "Contemporary Texas: A Photographic Portrait"] (P1985.17.125)

Gelatin silver print. 1984

Image: 9 ⁹/₁₆ x 10 ¹/₁₆ in. (24.3 x 25.5 cm.)

Sheet: 11 x 13 ¹⁵/₁₆ in. (28.0 x 35.4 cm.)

Signed: see inscription

Inscription, print verso: "W.A. 'Monty' Moncrief, Sr. (seated)/W.A. 'Tex' Moncrief, Jr./Charlie (left) & Richard Moncrief (grandsons) 14 Aug 84" and rubber stamp "©1984 Michael A. Murphy. This photograph/cannot be copied, televised, reproduced, or/used in any form without the express and/written permission of:/Michael A. Murphy/ Vista Bella Enterprises, Inc./Star Route 1, Box 20/Dripping Springs, Texas 78620/512/264-2347"

Acquired from: gift of the Texas Historical Foundation with support from a major grant from the Du Pont Company and Conoco, its energy subsidiary, and assistance from the Texas Commission on the Arts and the National Endowment for the Arts

WILLIAM D. MURPHY,
American (active 1890s)

See *Camera Notes*

EADWEARD MUYBRIDGE,
American, born England (1830–1904)

3635

Muybridge, born Edward Muggeridge, first came to the United States about 1850 as a commission merchant representing book publishers. He eventually made his way west, opening an antiquarian book shop in San Francisco in 1856. About 1860 he returned to England where, because of a serious accident, he remained for several years. By the time he made his way back to the United States in 1867 he was an accomplished pho-

tographer. Muybridge made two trips to Yosemite (1867 and 1872) and did a substantial amount of work in San Francisco and along the Pacific coast. He also accompanied the 1868 expedition to Alaska led by General Henry W. Halleck. Muybridge made a series of photographs in Central and South America for the Pacific Mail Steamship Company in 1875. In 1872, just before his second trip to Yosemite, Muybridge was commissioned by California Governor Leland Stanford to make photographs of his horse Occident in motion. His first instantaneous photographs of a horse in motion were published in 1878. In 1884 he moved his work to the University of Pennsylvania where he made over 20,000 negatives of people and animals in motion, eventually published in 1887 as a series of 781 collotype plates entitled *Animal Locomotion*. Muybridge was also one of the first to experiment with motion in photography with his invention of the zoopraxiscope, a forerunner of the modern motion picture machine.

3643. **ANNIE G. WITH JOCKEY (.023 SECOND), ONE STRIDE IN 20 PHASES (RIGHT LEAD)** (P1970.56.8)
Collotype. published 1887
Image: 8 5/16 x 13 1/16 in. (21.1 x 33.2 cm.)
Sheet: 18 5/8 x 23 13/16 in. (47.3 x 60.5 cm.)
Signed: see inscription
Inscription, sheet recto, printed: "ANIMAL LOCOMOTION. PLATE. 627/Copyright, 1887, by EADWEARD MUYBRIDGE. All rights reserved."
Acquired from: Kennedy Galleries, New York, New York

3644. **ANNIE G. WITH JOCKEY (.031 SECOND), ONE STRIDE IN 16 PHASES (RIGHT LEAD), TIME OF STRIDE: .46 SECOND; STRIDES PER MILE: 233; SPEED: 1 MILE IN ABOUT 107 SECONDS** (P1970.56.7)
Collotype. published 1887
Image: 9 1/2 x 12 1/8 in. (24.1 x 30.8 cm.)
Sheet: 18 5/8 x 23 13/16 in. (47.3 x 60.5 cm.)
Signed: see inscription
Inscription, sheet recto, printed: "ANIMAL LOCOMOTION. PLATE. 626/Copyright, 1887, by EADWEARD MUYBRIDGE. All rights reserved."
Acquired from: Kennedy Galleries, New York, New York

3645. **ANNIE G. WITH JOCKEY (.049 SECOND), ONE STRIDE IN 12 PHASES (LEFT LEAD)** (P1970.56.3)
Collotype. published 1887
Image: 7 1/2 x 16 in. (18.9 x 40.7 cm.)
Sheet: 18 5/8 x 23 13/16 in. (47.3 x 60.5 cm.)
Signed: see inscription
Inscription, sheet recto, printed: "ANIMAL LOCOMOTION. PLATE. 620/Copyright, 1887, by EADWEARD MUYBRIDGE. All rights reserved."
Acquired from: Kennedy Galleries, New York, New York

3646. **ANNIE G. WITH JOCKEY (.056 SECOND), ONE STRIDE IN 12 PHASES (RIGHT LEAD), LENGTH OF STRIDE 114" (2.9 METRES)** (P1970.56.4)
Collotype. published 1887
Image: 7 1/4 x 16 1/8 in. (18.3 x 41.0 cm.)
Sheet: 18 5/8 x 23 13/16 in. (47.3 x 60.5 cm.)
Signed: see inscription
Inscription, sheet recto, printed: "ANIMAL LOCOMOTION. PLATE. 621/Copyright, 1887, by EADWEARD MUYBRIDGE. All rights reserved."
Acquired from: Kennedy Galleries, New York, New York

3647. **BEAUTY WITH RIDER (.052 SECOND) IRREGULAR ONE-HALF STRIDE** (P1970.55.3)
Collotype. published 1887
Image: 7 11/16 x 14 7/8 in. (19.5 x 37.7 cm.)
Sheet: 18 5/8 x 23 13/16 in. (47.3 x 60.5 cm.)
Signed: see inscription

Inscription, sheet recto, printed: "ANIMAL LOCOMOTION. PLATE. 584/Copyright, 1887, by EADWEARD MUYBRIDGE. All rights reserved."
Acquired from: Kennedy Galleries, New York, New York

3648. **BOUQUET WITH RIDER (.037 SECOND), INCOMPLETE STRIDE (RIGHT LEAD), LENGTH OF STRIDE: 230" (5.75 METRES)** (P1970.56.12)
Collotype. published 1887
Image: 7 5/16 x 16 1/2 in. (18.6 x 41.9 cm.)
Sheet: 18 5/8 x 23 13/16 in. (47.3 x 60.5 cm.)
Signed: see inscription
Inscription, sheet recto, printed: "ANIMAL LOCOMOTION. PLATE. 633/Copyright, 1887, by EADWEARD MUYBRIDGE. All rights reserved."
Acquired from: Kennedy Galleries, New York, New York

3649. **BOUQUET WITH RIDER (.044 SECOND), ALMOST ONE STRIDE (RIGHT LEAD), LENGTH OF STRIDE: 244" (5.6 METRES)** (P1970.56.11)
Collotype. published 1887
Image: 7 3/16 x 16 1/4 in. (18.2 x 41.3 cm.)
Sheet: 18 5/8 x 23 13/16 in. (47.3 x 60.5 cm.)
Signed: see inscription
Inscription, sheet recto, printed: "ANIMAL LOCOMOTION. PLATE. 631/Copyright, 1887, by EADWEARD MUYBRIDGE. All rights reserved."
Acquired from: Kennedy Galleries, New York, New York

3650. **BUCKSKIN, LAME RIGHT FRONT FOOT (.104 SECOND), ONE STRIDE IN 10 PHASES** (P1970.55.8)
Collotype. published 1887
Image: 7 5/8 x 14 7/8 in. (19.4 x 37.8 cm.)
Sheet: 19 1/16 x 24 1/16 in. (48.4 x 61.2 cm.)
Signed: see inscription
Inscription, sheet recto, printed: "ANIMAL LOCOMOTION. PLATE 654/Copyright 1887, by EADWEARD MUYBRIDGE. All rights reserved."
Acquired from: Kennedy Galleries, New York, New York

3651. **BUCKSKIN, LAME RIGHT FRONT FOOT (.116 SECOND), ONE STRIDE IN 12 PHASES** (P1970.55.7)
Collotype. published 1887
Image: 7 9/16 x 14 13/16 in. (19.2 x 37.7 cm.)
Sheet: 19 1/16 x 24 1/8 in. (48.3 x 61.3 cm.)
Signed: see inscription
Inscription, sheet recto, printed: "ANIMAL LOCOMOTION. PLATE 653/Copyright 1887, by EADWEARD MUYBRIDGE. All rights reserved."
Acquired from: Kennedy Galleries, New York, New York

3652. **CAP OF LIBERTY. VALLEY OF THE YOSEMITE** (P1972.32.3)
Albumen silver print. 1872
Image: 16 15/16 x 21 5/8 in. (43.0 x 55.0 cm.)
Mount: 19 3/4 x 24 3/8 in. (50.1 x 61.9 cm.)
Signed: see inscription
Inscription, mount recto: "100-/CHS" and printed "BRADLEY & RULOFSON,/ 429 Montgomery St., S. F., Publishers.//Cap of Liberty. Valley of the Yosemite.// No. 31.//MUYBRIDGE,/Photo."
mount verso: "101//Yosemite Valley//File: Oversize Picts// Yosemite Valley"
Acquired from: John Howell—Books, San Francisco, California

*3653. **CAPE SAN LUCAS IN MOONLIGHT** (P1982.21.1)
Albumen silver print. 1875
Image: 5 3/8 x 9 3/16 in. (13.6 x 23.2 cm.)
Signed, l.r. in negative: "Muybridge"
Inscription, print verso: "4482"
Acquired from: Charles Isaacs, Philadelphia, Pennsylvania

*3654. **CEMETERY, GUATEMALA** (P1982.21.2)
Albumen silver print. 1875
Image: 5 3/8 x 9 3/16 in. (13.6 x 23.2 cm.)
Signed, l.r. in negative: "Muybridge"
Inscription, print verso: "434851"
Acquired from: Charles Isaacs, Philadelphia, Pennsylvania

*3655. **CLINTON WITH RIDER (.052 SECOND), AN
IRREGULAR STRIDE IN 11 PHASES** (P1970.55.4)
Collotype. published 1887
Image: 5 1/2 x 18 1/16 in. (13.9 x 45.9 cm.)
Sheet: 18 5/8 x 23 13/16 in. (47.3 x 60.5 cm.)
Signed: see inscription
Inscription, sheet recto, printed: "ANIMAL
LOCOMOTION. PLATE. 589/Copyright, 1887, by
EADWEARD MUYBRIDGE. All rights reserved."
Acquired from: Kennedy Galleries, New York, New York

3656. **CLINTON WITH RIDER (.056 SECOND) IRREGULAR
ONE-HALF STRIDE** (P1970.55.1)
Collotype. published 1887
Image: 5 11/16 x 18 1/4 in. (14.4 x 46.4 cm.)
Sheet: 18 5/8 x 23 13/16 in. (47.3 x 60.5 cm.)
Signed: see inscription
Inscription, sheet recto, printed: "ANIMAL
LOCOMOTION. PLATE. 577/Copyright, 1887, by
EADWEARD MUYBRIDGE. All rights reserved."
Acquired from: Kennedy Galleries, New York, New York

3657. **[Daisy with rider]** (P1970.56.9)
Collotype. published 1887
Image: 8 15/16 x 13 11/16 in. (22.7 x 34.7 cm.)
Sheet: 18 5/8 x 23 13/16 in. (47.3 x 60.5 cm.)
Signed: see inscription
Inscription, sheet recto, printed: "ANIMAL
LOCOMOTION. PLATE. 628/Copyright, 1887, by
EADWEARD MUYBRIDGE. All rights reserved."
Acquired from: Kennedy Galleries, New York, New York

3658. **DAISY WITH RIDER, ALMOST ONE STRIDE IN 12
PHASES (RIGHT LEAD)** (P1970.56.5)
Collotype. published 1887
Image: 6 1/8 x 16 15/16 in. (15.6 x 43.0 cm.)
Sheet: 18 5/8 x 23 13/16 in. (47.3 x 60.5 cm.)
Signed: see inscription
Inscription, sheet recto, printed: "ANIMAL
LOCOMOTION. PLATE. 624/Copyright, 1887, by
EADWEARD MUYBRIDGE. All rights reserved."
Acquired from: Kennedy Galleries, New York, New York

3636

3653

3654

3655

3659. **DAISY WITH RIDER, ONE STRIDE IN 18 PHASES, LENGTH OF STRIDE: 118″ (2.96 METRES)** (P1970.55.6)
Collotype. published 1887
Image: 9 13/16 x 11 1/2 in. (24.9 x 29.2 cm.)
Sheet: 18 5/8 x 23 13/16 in. (47.3 x 60.5 cm.)
Signed: see inscription
Inscription, sheet recto, printed: "ANIMAL
 LOCOMOTION. PLATE. 598/Copyright, 1887, by
 EADWEARD MUYBRIDGE. All rights reserved."
Acquired from: Kennedy Galleries, New York, New York

*3660. **DAN WITH RIDER (.064 SECOND), ONE STRIDE IN 8 PHASES (LEFT LEAD)** (P1970.56.13)
Collotype. published 1887
Image: 7 1/2 x 15 3/8 in. (19.0 x 39.1 cm.)
Sheet: 18 5/8 x 23 13/16 in. (47.3 x 60.5 cm.)
Signed: see inscription
Inscription, sheet recto, printed: "ANIMAL
 LOCOMOTION. PLATE. 634/Copyright, 1887, by
 EADWEARD MUYBRIDGE. All rights reserved."
Acquired from: Kennedy Galleries, New York, New York

3661. **ELBERON WITH RIDER (.126 SECOND) INCOMPLETE STRIDE IN 10 PHASES** (P1970.55.2)
Collotype. published 1887
Image: 8 3/4 x 13 11/16 in. (22.1 x 34.7 cm.)
Sheet: 18 5/8 x 23 13/16 in. (47.3 x 60.5 cm.)
Signed: see inscription
Inscription, sheet recto, printed: "ANIMAL
 LOCOMOTION. PLATE. 579/Copyright, 1887, by
 EADWEARD MUYBRIDGE. All rights reserved."
Acquired from: Kennedy Galleries, New York, New York

*3662. **THE GALLOP** (P1970.56.6)
Collotype. published 1887
Image: 7 13/16 x 14 1/2 in. (19.8 x 36.9 cm.)
Sheet: 18 5/8 x 23 13/16 in. (47.3 x 60.5 cm.)
Signed: see inscription
Inscription, sheet recto, printed: "ANIMAL
 LOCOMOTION. PLATE. 625/Copyright, 1887, by
 EADWEARD MUYBRIDGE. All rights reserved."
Acquired from: Kennedy Galleries, New York, New York

3663. **GAZELLE, SPAVIN RIGHT HIND LEG (.099 SECOND), ALMOST ONE STRIDE** (P1970.55.9)
Collotype. published 1887
Image: 9 7/8 x 11 1/4 in. (25.0 x 28.6 cm.)
Sheet: 19 1/16 x 24 1/8 in. (48.3 x 61.3 cm.)
Signed: see inscription
Inscription, sheet recto, printed: "ANIMAL
 LOCOMOTION. PLATE. 655/Copyright, 1887, by
 EADWEARD MUYBRIDGE. All rights reserved."
Acquired from: Kennedy Galleries, New York, New York

3664. **HANSEL WITH RIDER (.035 SECOND), ALMOST ONE STRIDE** (P1970.55.5)
Collotype. published 1887
Image: 9 1/16 x 12 11/16 in. (23.0 x 32.2 cm.)
Sheet: 18 5/8 x 23 13/16 in. (47.3 x 60.5 cm.)
Signed: see inscription
Inscription, sheet recto, printed: "ANIMAL
 LOCOMOTION. PLATE. 597/Copyright, 1887, by
 EADWEARD MUYBRIDGE. All rights reserved."
Acquired from: Kennedy Galleries, New York, New York

*3665. **MARIPOSA GROVE OF MAMMOTH TREES. WM. H. SEWARD, 85 FEET IN CIRCUMFERENCE, 268 FEET HIGH** (P1972.32.5)
Albumen silver print. c. 1872
Image: 16 7/8 x 21 5/16 in. (42.9 x 54.1 cm.)
1st mount: same as image size
2nd mount: 22 x 28 in. (56.0 x 71.1 cm.)
Inscription, 2nd mount recto: "OA?/175-/CHS//12"
 2nd mount verso: "Mariposa Grove of Mammoth Trees./
 Wm H Seward, 85 Feet in Circumference, 268 feet
 High.//103"
Acquired from: John Howell—Books, San Francisco,
 California

3666. **PANDORA WITH RIDER (.042 SECOND), ONE STRIDE IN 12 PHASES (RIGHT LEAD)** (P1970.56.10)
Collotype. published 1887
Image: 5 9/16 x 17 11/16 in. (14.1 x 45.0 cm.)
Sheet: 18 5/8 x 23 11/16 in. (47.3 x 60.1 cm.)
Signed: see inscription
Inscription, sheet recto, printed: "ANIMAL
 LOCOMOTION. PLATE. 630/Copyright, 1887, by
 EADWEARD MUYBRIDGE. All rights reserved."
Acquired from: Kennedy Galleries, New York, New York

*3667. **PANORAMA OF SAN FRANCISCO, FROM CALIFORNIA-ST. HILL** (P1979.76)
Albumen silver print (eleven-part folding panorama bound in
 stiff boards and key). 1877
Image: 7 5/16 x 86 1/8 in. (18.5 x 218.7 cm.)
Mount: 12 1/16 x 90 1/4 in. (30.6 x 229.1 cm.)
Signed: see inscription, panel 6
Inscription, panel 1: "86" and rubber stamp "W. OSSORIA
 KOCH,/EASEBOURNE,/MIDHURST."
 panel 6, printed: "MUYBRIDGE, Photo.//Entered
 according to Act of Congress, in the year 1877, by EDW. J.
 MUYBRIDGE, in the office of Librarian of Congress at
 Washington.//MORSE'S GALLERY.//PANORAMA OF
 SAN FRANCISCO,/FROM CALIFORNIA-ST. HILL"
Acquired from: Frontier America Corporation, Bryan, Texas

3668. **PRONTO WITH RIDER (.026 SECOND), ONE STRIDE IN 20 PHASES** (P1970.56.1)
Collotype. published 1887
Image: 9 x 13 3/16 in. (22.8 x 33.5 cm.)
Sheet: 18 5/8 x 23 13/16 in. (47.3 x 60.5 cm.)
Signed: see inscription
Inscription, sheet recto, printed: "ANIMAL
 LOCOMOTION. PLATE. 591/Copyright, 1887, by
 EADWEARD MUYBRIDGE. All rights reserved."
Acquired from: Kennedy Galleries, New York, New York

3669. **PRONTO WITH RIDER (.051 SECOND), ONE STRIDE IN 10 PHASES** (P1970.56.2)
Collotype. published 1887
Image: 7 1/4 x 16 1/2 in. (18.5 x 42.0 cm.)
Sheet: 18 5/8 x 23 13/16 in. (47.3 x 60.5 cm.)
Signed: see inscription
Inscription, sheet recto: "ANIMAL LOCOMOTION.
 PLATE. 592/Copyright, 1887, by EADWEARD
 MUYBRIDGE. All rights reserved."
Acquired from: Kennedy Galleries, New York, New York

3670. **RUNNING, LENGTH OF STRIDE 19 FEET 6 INCHES, HATTIE H.** (P1986.26)
Albumen silver print. 1878–79
Image: 6 1/4 x 8 13/16 in. (15.9 x 22.4 cm.)
Mount: 9 3/4 x 12 1/2 in. (24.8 x 31.8 cm.)
Signed: see inscription
Inscription, mount recto: "38" and printed "COPYRIGHT
 1881 BY EDW. J. MUYBRIDGE."
Acquired from: Stephen White Gallery, Beverly Hills,
 California

3671. **SYLVAN BAR. VALLEY OF THE YOSEMITE** (P1972.32.1)
Albumen silver print. 1872
Image: 17 x 21 5/8 in. (43.2 x 54.9 cm.)
Mount: 18 9/16 x 22 7/8 in. (47.2 x 57.9 cm.)
Signed: see inscription
Inscription, mount recto, printed: "BRADLEY &
 RULOFSON,/429 Montgomery St., S. F., Publishers.//
 Sylvan Bar. Valley of the Yosemite.//No. 16.//
 MUYBRIDGE,/Photo."
 mount verso: "#42854"
Acquired from: John Howell—Books, San Francisco,
 California

3660

3665

3662

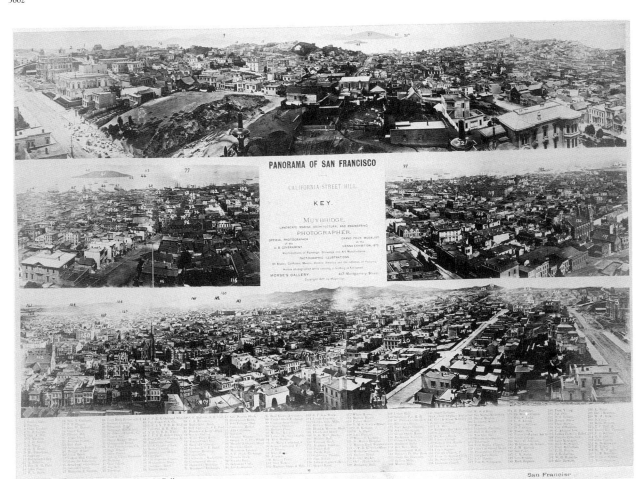

PANORAMA OF SAN FRANCISCO

CALIFORNIA STREET HILL

KEY.

MUYBRIDGE,

LANDSCAPE, MARINE, ARCHITECTURAL AND ENGINEERING

PHOTOGRAPHER.

MUYBRIDGE, Photo., Morse's Gallery,

3667

3672. **TUTOKANULA. VALLEY OF THE YO-SEMITE. (THE GREAT CHIEF) "EL CAPITAN." 3500 FEET HIGH** (P1972.32.4)
Albumen silver print. c. 1872
Image: 16¹³⁄₁₆ x 21⁹⁄₁₆ in. (42.7 x 54.8 cm.)
Mount: 20¾ x 25½ in. (52.7 x 64.8 cm.)
Signed: see inscription
Inscription, mount recto, printed: "17//BRADLEY & RULOFSON, 429 Montgomery St., S. F., Publishers.// TUTOKANULA. VALLEY OF THE YO-SEMITE./ (The Great Ghief [sic]) "El Capitan." 3500 feet high.// MUYBRIDGE,/Photo."
mount verso: "99//BL"
Acquired from: John Howell—Books, San Francisco, California

3673. **WILD CAT FALL. VALLEY OF THE YO-SEMITE** (P1972.32.2)
Albumen silver print. c. 1872
Image: 16⅞ x 21⅝ in. (42.9 x 54.9 cm.)
Mount: 20¾ x 25½ in. (52.8 x 64.8 cm.)
Signed: see inscription
Inscription, mount recto: "6a." and printed "BRADLEY & RULOFSON,/429 Montgomery Street, S. F. Publishers.// WILD CAT FALL. VALLEY OF THE YO-SEMITE.// MUYBRIDGE,/Photo."
mount verso: "100//BL"
Acquired from: John Howell—Books, San Francisco, California

*3674. **WOMAN PIROUETTING (.277 SECOND)** (P1981.81)
Collotype. published 1887
Image: 7³⁄₁₆ x 16⅝ in. (18.3 x 42.2 cm.)
Sheet: 18¹³⁄₁₆ x 23¾ in. (47.7 x 60.4 cm.)
Signed: see inscription
Inscription, sheet recto: "BR 210/135" and printed "ANIMAL LOCOMOTION. PLATE. 187/Copyright, 1887, by EADWEARD MUYBRIDGE. All rights reserved."
sheet verso: "MUYBRIDGE, E./1.25-12:78/©"
Acquired from: Photocollect, New York, New York

CARL MYDANS, American (b. 1907)

Carl Mydans has been one of America's leading photo-journalists for over fifty years, employing both words and photographs to report a story. Born and raised in Boston, Mydans received a B.S. from the Boston University School of Journalism in 1930. For the next several years, he worked first as a freelance writer and then as a reporter for the *American Banker*. During this time he also acquired a 35mm camera and studied photography at the Brooklyn Institute of Arts and Sciences. In 1935 Mydans joined the Farm Security Administration as a photographer, but he left the next year when he was hired as one of five photographers for the newly established *Life* magazine. In 1938 he married Shelley Smith, a *Life* reporter, and they formed a pho-tographer-reporter team. Mydans' assignments for *Life* included covering major campaigns in World War II, as well as the Chinese Civil War and the Korean and Indochinese wars. He covered stories in the United States, Europe, the USSR, Asia, and the Far East, pho-tographing the common people as well as famous art-ists, celebrities, and political and military leaders. Since his retirement from *Life* in 1972, Mydans has been a photojournalist on the staff of *Time*. The photographs from the exhibition "Carl Mydans: A Photojournalist's Journey Through War and Peace" were printed by the Time Inc. Photo Lab under Mydans' supervision.

3675. **THE ABBEY OF MONTE CASINO, ITALY, AFTER THE ALLIED BOMBING IN THE SPRING OF 1944** [from "Carl Mydans: A Photojournalist's Journey Through War and Peace"] (P1985.27.85)
Gelatin silver print. negative 1944, print 1985
Image: 14¹⁄₁₆ x 14¹⁄₁₆ in. (35.7 x 35.7 cm.)
Signed: see inscription
Inscription, print verso: "#14992/R-4//Casino/1944//P" and rubber stamps "PHOTO BY/CARL MYDANS//CM"
Acquired from: gift of Time Inc., New York, New York

3676. **AGED MENTAL PATIENTS IN A STATE HOSPITAL. 1959** [from "Carl Mydans: A Photojournalist's Journey Through War and Peace"] (P1985.27.128)
Gelatin silver print. negative 1959, print 1985
Image: 24 x 16½ in. (61.0 x 41.9 cm.) irregular
Sheet: 24 x 16⁹⁄₁₆ in. (61.0 x 42.1 cm.)
Signed, center print verso: "Carl Mydans"
Inscription, print verso: "#56813/10C78/3//Old Age Institution/1959//P" and rubber stamps "PHOTO BY/ CARL MYDANS//CM"
Acquired from: gift of Time Inc., New York, New York

3677. **THE AIR RAID CONTROL CENTER IN CHUNGKING IS HIDDEN IN A SECRET CAVE. 1941** [from "Carl Mydans: A Photojournalist's Journey Through War and Peace"] (P1985.27.63)
Gelatin silver print. negative 1941, print 1985
Image: 19⁹⁄₁₆ x 15¹¹⁄₁₆ in. (49.7 x 39.8 cm.) irregular
Sheet: 19¹⁵⁄₁₆ x 16¹⁄₁₆ in. (50.7 x 40.8 cm.)
Signed, center print verso: "Carl Mydans"
Inscription, print verso: "H2/8306/R-25A//Chungking 1941// Air Raid Control Center, Chungking 1941//P." and rubber stamps "PHOTO BY/CARL MYDANS//CM"
Acquired from: gift of Time Inc., New York, New York

3678. **AN AMATEUR BARBER SHAVES A CUSTOMER ON FULTON PIER, EAST RIVER, NEW YORK CITY. 1936** [from "Carl Mydans: A Photojournalist's Journey Through War and Peace"] (P1985.27.31)
Gelatin silver print. negative 1936, print 1985
Image: 10⁷⁄₁₆ x 13¹⁄₁₆ in. (26.5 x 33.2 cm.)
Sheet: 10⁹⁄₁₆ x 13¹⁄₁₆ in. (26.8 x 33.2 cm.)
Signed, center print verso: "Carl Mydans"
Inscription, print verso: "Fulton Pier, N.Y.C./1936//(my neg)//#77/Fi12/Rod//P" and rubber stamps "PHOTO BY/ CARL MYDANS//CM"
Acquired from: gift of the photographer

3679. **AMERICAN TOURISTS IN AMERICAN SAMOA. 1962** [from "Carl Mydans: A Photojournalist's Journey Through War and Peace"] (P1985.27.129)
Gelatin silver print. negative 1962, print 1985
Image: 29¹¹⁄₁₆ x 20 in. (75.4 x 50.8 cm.)
Signed, l.r. print verso: "Carl Mydans"
Inscription, print verso: "#65301/C-12/22//Round-THE-World Tourists/at American Samoa/1962//P" and rubber stamps "PHOTO BY/CARL MYDANS//CM"
Acquired from: gift of Time Inc., New York, New York

3680. **AT THE KURIHAMA NAVAL BASE THE JAPANESE COMMANDER SURRENDERS HIS SWORD TO AN AMERICAN MARINE OFFICER. AUGUST, 1945** [from "Carl Mydans: A Photojournalist's Journey Through War and Peace"] (P1985.27.108)
Gelatin silver print. negative 1945, print 1985
Image: 16 x 24 in. (40.7 x 61.0 cm.)
Signed, center print verso: "Carl Mydans"
Inscription, print verso: "18627/C-2/15//Surrender at Kurihama/Naval Base to/4th U.S. Marines/1945// P//18718/C-2½/5/2CC/26/2C2-2 Destroyed Japanese battleship/photographed before the/Surrender/August 1945" and rubber stamps "PHOTO BY/CARL MYDANS//CM"
Acquired from: gift of Time Inc., New York, New York

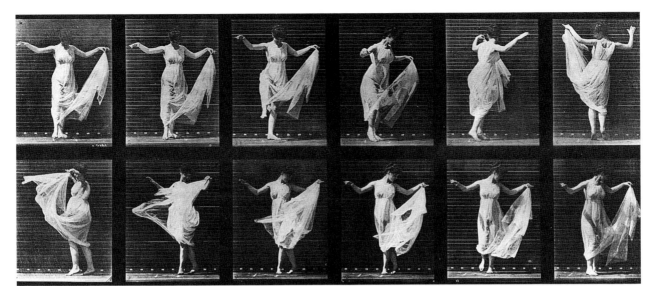

3674

3681. **THE BATTLE FOR MANILA LEAVES DEATH AND DEVASTATION IN THE STREETS.** 1945 [from "Carl Mydans: A Photojournalist's Journey Through War and Peace"] (P1985.27.102)
Gelatin silver print. negative 1945, print 1985
Image: 20 x 29 ¹³⁄₁₆ in. (50.8 x 75.7 cm.)
Signed, center print verso: "Carl Mydans"
Inscription, print verso: "#17030/C-4/5//Street Fighting, Manila/1945//P" and rubber stamps "PHOTO BY/CARL MYDANS//CM"
Acquired from: gift of Time Inc., New York, New York

3682. **BOBBY FISCHER, CHESS CHAMPION, IN NEW YORK.** 1962 [from "Carl Mydans: A Photojournalist's Journey Through War and Peace"] (P1985.27.89)
Gelatin silver print. negative 1962, print 1985
Image: 19 ⁹⁄₁₆ x 15 ¹¹⁄₁₆ in. (49.7 x 39.8 cm.)
Sheet: 20 x 16 ¹⁄₁₆ in. (50.8 x 40.8 cm.)
Signed, center print verso: "Carl Mydans"
Inscription, print verso: "#64874/5C/9//Bobby Fischer/NEW York/1962//P" and rubber stamps "PHOTO BY/CARL MYDANS//CM"
Acquired from: gift of Time Inc., New York, New York

3683. **A BORED FLORENTINE TAKES THE RAPE OF A SABINE WOMAN CALMLY.** 1940 [from "Carl Mydans: A Photojournalist's Journey Through War and Peace"] (P1985.27.37)
Gelatin silver print. negative 1940, print 1985
Image: 29 ¹¹⁄₁₆ x 20 in. (75.4 x 50.8 cm.)
Signed, center print verso: "Carl Mydans"
Inscription, print verso: "#6320/C-66/15//ROME 1940//P." and rubber stamps "PHOTO BY/CARL MYDANS//CM"
Acquired from: gift of Time Inc., New York, New York

*3684. **CAROLE LOMBARD AND CLARK GABLE AT A MOVIE PREVIEW IN HOLLYWOOD.** 1936 [from "Carl Mydans: A Photojournalist's Journey Through War and Peace"] (P1985.27.72)
Gelatin silver print. negative 1936, print 1985
Image: 20 x 28 in. (50.8 x 71.1 cm.)
Signed, center print verso: "Carl Mydans"
Inscription, print verso: "Carol [sic] Lombard and/Clark Gable/Hollywood Preview/1936/(My Neg)//P" and rubber stamps "PHOTO BY/CARL MYDANS//CM"
Acquired from: gift of the photographer

3684

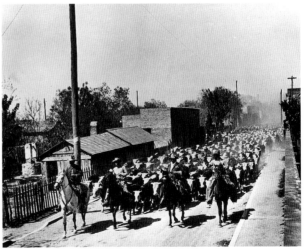

3685

*3685. **A CATTLE DRIVE FROM MEXICO ENTERS EAGLE PASS, TEXAS.** 1937 [from "Carl Mydans: A Photojournalist's Journey Through War and Peace"] (P1985.27.7)
Gelatin silver print. negative 1937, print 1985
Image: 15 ½ x 19 ⁷⁄₁₆ in. (39.3 x 49.3 cm.) irregular
Sheet: 15 ¹³⁄₁₆ x 19 ¹³⁄₁₆ in. (40.1 x 50.3 cm.)
Signed, bottom center print verso: "Carl Mydans"
Inscription, print verso: "Set No 1/P.20//Mexican Cattle Entering/Eagle Pass, Texas/March 8, 1937//P" and rubber stamps "PHOTO BY/CARL MYDANS//CM"
Acquired from: gift of Time Inc., New York, New York

*3686. **CHAINED CONSCRIPTS OF THE CHINESE NATIONALIST ARMY WALK THROUGH CHUNGKING ON A WORK DETAIL IN 1941** [from "Carl Mydans: A Photojournalist's Journey Through War and Peace"] (P1985.27.48)
Gelatin silver print. negative 1941, print 1985
Image: 20 ¹⁄₁₆ x 29 ¹⁵⁄₁₆ in. (50.9 x 76.1 cm.)
Signed, center print verso: "Carl Mydans"
Inscription, print verso: "8306/C-13A/3//Conscripts in chains/ChungKing/1941//P" and rubber stamps "PHOTO BY/CARL MYDANS//CM"
Acquired from: gift of Time Inc., New York, New York

3687. **CHARLES LINDBERGH, AVIATION PIONEER, ENVIRONMENTALIST AND DEFENDER OF PRIMITIVE PEOPLES, IN THE PHILIPPINES.** 1970 [from "Carl Mydans: A Photojournalist's Journey Through War and Peace"] (P1985.27.70)
Gelatin silver print. negative 1970, print 1985
Image: 24 ¹⁄₁₆ x 20 in. (61.1 x 50.8 cm.) irregular
Signed, l. r. print verso: "Carl Mydans"
Inscription, print verso: "Charles Lindberg [sic]/in the Philippines/1970//#84984/Take 2 C-2/5A//P" and rubber stamps "PHOTO BY/CARL MYDANS//CM"
Acquired from: gift of Time Inc., New York, New York

*3688. **CHIEF OF POLICE IN THE OIL BOOM TOWN OF FREER, TEXAS.** 1937 [from "Carl Mydans: A Photojournalist's Journey Through War and Peace"] (P1985.27.2)
Gelatin silver print. negative 1937, print 1985
Image: 29 ⁷⁄₈ x 19 ¹⁵⁄₁₆ in. (75.9 x 50.7 cm.)
Signed, center print verso: "Carl Mydans"
Inscription, print verso: "Set NO 1-/5C-4/(no frame NO)//Chief of Police/Freer, Texas//P" and rubber stamps "PHOTO BY/CARL MYDANS//CM"
Acquired from: gift of Time Inc., New York, New York

3689. **CHIEF OF POLICE IN THE OIL BOOM TOWN OF FREER, TEXAS.** 1937 [cigar and hand; from "Carl Mydans: A Photojournalist's Journey Through War and Peace"] (P1985.27.3)
Gelatin silver print. negative 1937, print 1985
Image: 10 ½ x 13 in. (26.6 x 33.0 cm.) irregular
Signed, center print verso: "Carl Mydans"
Inscription, print verso: "Set No 1/C5-4 (no frame NO)/The Law/Oil Boom Town/Freer Texas/1937//P" and rubber stamps "PHOTO BY/CARL MYDANS//CM"
Acquired from: gift of Time Inc., New York, New York

3690. **CHIEF OF POLICE IN THE OIL BOOM TOWN OF FREER, TEXAS.** 1937 [boots; from "Carl Mydans: A Photojournalist's Journey Through War and Peace"] (P1985.27.4)
Gelatin silver print. negative 1937, print 1985
Image: 10 ½ x 13 ¹⁄₁₆ in. (26.6 x 33.2 cm.)
Sheet: 10 ⁹⁄₁₆ x 13 ¹⁄₁₆ in. (26.8 x 33.2 cm.)
Signed, center print verso: "Carl Mydans"
Inscription, print verso: "Set No 1/5C4/(no Frame No)//THE Law/Freer, Texas/1937//P" and rubber stamps "PHOTO BY/CARL MYDANS//CM//CM"
Acquired from: gift of Time Inc., New York, New York

*3691. **CHILD OF THE OIL BOOM. FREER, TEXAS, 1937** [from "Carl Mydans: A Photojournalist's Journey Through War and Peace"] (P1985.27.18)
Gelatin silver print. negative 1937, print 1985
Image: 24 ¹⁄₈ x 20 ¹⁄₁₆ in. (61.3 x 50.9 cm.)
Signed, center print verso: "Carl Mydans"
Inscription, print verso: "Oil Boom Town/Freer, Texas//Texas Essay Set #1/5-C-2/no frame No/a verticle [sic] from a horizontal/1938 [sic]" and rubber stamps "PHOTO BY/CARL MYDANS//CM"
Acquired from: gift of the photographer

3692. **CHILDREN OF A MULTI GRADE SCHOOL IN SCOTTSBORO, ALABAMA, PLAY IN THE SCHOOLYARD.** 1936 (FARM SECURITY ADMINISTRATION PHOTOGRAPH) [from "Carl Mydans: A Photojournalist's Journey Through War and Peace"] (P1985.27.32)
Gelatin silver print. negative 1936, print 1985
Image: 15 ³⁄₈ x 19 ⁷⁄₁₆ in. (39.0 x 49.3 cm.)
Sheet: 15 ¾ x 19 ¹³⁄₁₆ in. (40.0 x 50.3 cm.)
Signed, bottom center print verso: "Carl Mydans"
Inscription, print verso: "RA-6622D/(9 USF-34//FSA// Scottsboro, Ala School/June 1936/Cumberland Mountains//P" and rubber stamps "PHOTO BY/ CARL MYDANS//CM"
Acquired from: gift of the photographer

3693. **CHINESE OPIUM SMOKER DULLS THE PAIN OF A LABORER'S LIFE WITH A PIPE. SINGAPORE, 1941** [from "Carl Mydans: A Photojournalist's Journey Through War and Peace"] (P1985.27.53)
Gelatin silver print. negative 1941, print 1985
Image: 17 ¹⁵⁄₁₆ x 25 in. (45.5 x 63.5 cm.)
Signed, center print verso: "Carl Mydans"
Inscription, print verso: "Opium Den/Singapore/1941//8693/C 11/5//Print" and rubber stamp "PHOTO BY/CARL MYDANS"
Acquired from: gift of Time Inc., New York, New York

3694. **CHINESE TIN WORKER LOADS INGOTS IN A BRITISH SMELTING PLANT IN MALAYA.** 1941 [from "Carl Mydans: A Photojournalist's Journey Through War and Peace"] (P1985.27.55)
Gelatin silver print. negative 1941, print 1985
Image: 19 ½ x 15 ⁵⁄₈ in. (49.5 x 39.7 cm.)
Sheet: 19 ¹⁵⁄₁₆ x 16 ¹⁄₁₆ in. (50.7 x 40.8 cm.) irregular
Signed, center print verso: "Carl Mydans"
Inscription, print verso: "#8693/R-76A//Tin Worker/ Singapore 1941//P" and rubber stamps "PHOTO BY/CARL MYDANS//CM"
Acquired from: gift of Time Inc., New York, New York

3695. **A COAL MINER IN DURHAM, ENGLAND.** 1952 [from "Carl Mydans: A Photojournalist's Journey Through War and Peace"] (P1985.27.137)
Gelatin silver print. negative 1952, print 1985
Image: 28 x 20 ¹⁄₁₆ in. (71.1 x 50.9 cm.)
Signed: see inscription
Inscription, print verso: "#37973/C-64/36//Coal Miner in Britain/1952//P" and rubber stamps "PHOTO BY/CARL MYDANS//CM"
Acquired from: gift of Time Inc., New York, New York

3696. **COAL MINER'S DAUGHTER, YORKSHIRE, ENGLAND.** 1952 [from "Carl Mydans: A Photojournalist's Journey Through War and Peace"] (P1985.27.138)
Gelatin silver print. negative 1952, print 1985
Image: 29 ¹¹⁄₁₆ x 20 ¹⁄₁₆ in. (75.4 x 50.9 cm.)
Signed, l. r. print verso: "Carl Mydans"
Inscription, print verso: "#37973/C-64/12//Coal Miner's Child/Village Yorks,/Britain 1942 [sic]//P" and rubber stamps "PHOTO BY/CARL MYDANS//PHOTO BY/ CARL MYDANS//CM"
Acquired from: gift of Time Inc., New York, New York

3697. COTTON DOMINATES A GENERAL STORE IN
MARIANNA, ARKANSAS. 1936 (FARM SECURITY
ADMINISTRATION PHOTOGRAPH) [from "Carl
Mydans: A Photojournalist's Journey Through War and
Peace"] (P1985.27.26)
Gelatin silver print. negative 1936, print 1985
Image: 18 x 25 in. (45.7 x 63.5 cm.) irregular
Signed, bottom center print verso: "Carl Mydans"
Inscription, print verso: "FSA USF-33/FSA-00596//
Marianna, Ark/1936//P" and rubber stamps "PHOTO BY/
CARL MYDANS//CM"
Acquired from: gift of the photographer

*3698. THE COUP DE GRACE IS GIVEN TO YOUNG
COLLABORATORS. 1944 [from "Carl Mydans: A
Photojournalist's Journey Through War and Peace"]
(P1985.27.96)
Gelatin silver print. negative 1944, print 1985
Image: 13 ¹³⁄₁₆ x 17 ⁹⁄₁₆ in. (35.1 x 44.6 cm.) irregular
Sheet: 14 ¹⁄₁₆ x 18 in. (35.7 x 45.7 cm.)
Signed, center print verso: "Carl Mydans"
Inscription, print verso: "#15877/C-1/16//Grenoble,
France/1944//P//P." and rubber stamps "PHOTO BY/CARL
MYDANS//CM//C"
Acquired from: gift of Time Inc., New York, New York

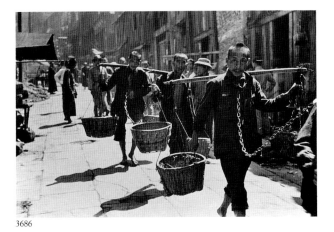
3686

3699. A CUSTOMER COMES TO THE GENERAL STORE IN
TERLINGUA, TEXAS. 1937 [from "Carl Mydans:
A Photojournalist's Journey Through War and Peace"]
(P1985.27.22)
Gelatin silver print. negative 1937, print 1985
Image: 20 ¹⁄₁₆ x 26 in. (50.9 x 66.0 cm.)
Signed: see inscription
Inscription, print verso: "SET No 1/3C/44//Country Store/
Big Bend Country, Texas/1937//P" and rubber stamps
"PHOTO BY/CARL MYDANS//CM"
Acquired from: gift of Time Inc., New York, New York

3700. THE DAILY MORNING GATHERING AT CITY HALL,
BATESVILLE, ARKANSAS. 1936 (FARM SECURITY
ADMINISTRATION PHOTOGRAPH) [from "Carl
Mydans: A Photojournalist's Journey Through War and
Peace"] (P1985.27.16)
Gelatin silver print. negative 1936, print 1985
Image: 20 x 29 ⅞ in. (50.8 x 75.9 cm.)
Signed, center print verso: "Carl Mydans"
Inscription, print verso: "USF-33/FSA-00598//Batesville,
Ark/June 1936//P" and rubber stamps "PHOTO BY/CARL
MYDANS//CM"
Acquired from: gift of the photographer

3688

*3701. DAUGHTER OF MIGRANT WORKERS IN
RAYMONDVILLE, TEXAS. 1937 [from "Carl Mydans:
A Photojournalist's Journey Through War and Peace"]
(P1985.27.19)
Gelatin silver print. negative 1937, print 1985
Image: 29 ⅞ x 20 ⅛ in. (75.9 x 51.1 cm.)
Signed, l.r. print verso: "Carl Mydans"
Inscription, print verso: "Set #1/C-4/12//Daughter, Migratory
Workers/lower Rio Grande/near Raymondville, Texas/1937//
P" and rubber stamps "PHOTO BY/CARL MYDANS//
CM"
Acquired from: gift of Time Inc., New York, New York

3702. DESTROYED JAPANESE BATTLESHIP LIES OFF THE
COAST NEAR SASEBO, JAPAN. AUGUST, 1945 [from
"Carl Mydans: A Photojournalist's Journey Through War
and Peace"] (P1985.27.105)
Gelatin silver print. negative 1945, print 1985
Image: 16 ⅛ x 24 ¹⁄₁₆ in. (40.9 x 61.1 cm.)
Signed, l.r. print verso: "Carl Mydans"
Inscription, print verso: "#18718/C-2/5/(2C2-2?)//Destroyed
Japanese/battleship/—photographed before the/surrender/
August 1945//P" and rubber stamps "PHOTO BY/CARL
MYDANS//CM"
Acquired from: gift of Time Inc., New York, New York

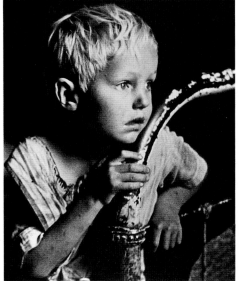
3691

3703. DR. MOHAMMED MOSSADEGH, PREMIER OF IRAN, AT HIS TRIAL IN TEHERAN. 1953 [from "Carl Mydans: A Photojournalist's Journey Through War and Peace"] (P1985.27.88)
Gelatin silver print. negative 1953, print 1985
Image: 19 1/16 x 14 1/16 in. (48.4 x 35.7 cm.)
Signed, center print verso: "Carl Mydans"
Inscription, print verso: "#40782/2c9/5//Mossadegh on Trial/Iran/1953//P." and rubber stamps "PHOTO BY/CARL MYDANS//CM"
Acquired from: gift of Time Inc., New York, New York

3704. DOWN AND OUT IN CHICAGO DURING THE GREAT DEPRESSION. 1936 [from "Carl Mydans: A Photojournalist's Journey Through War and Peace"] (P1985.27.12)
Gelatin silver print. negative 1936, print 1985
Image: 19 7/8 x 28 in. (50.5 x 71.1 cm.)
Signed, center print verso: "Carl Mydans"
Inscription, print verso: "Michigan AVE/Chicago, 1936/(my negative)//P." and rubber stamps "PHOTO BY/CARL MYDANS//CM"
Acquired from: gift of the photographer

3705. DOWN IN THE MINES IN 1952, BRITISH COAL MINERS WORK AN EIGHTEEN-INCH NARROW SEAM. [from "Carl Mydans: A Photojournalist's Journey Through War and Peace"] (P1985.27.139)
Gelatin silver print. negative 1952, print 1985
Image: 20 1/16 x 29 3/4 in. (50.9 x 75.6 cm.)
Signed, l.r. print verso: "Carl Mydans"
Inscription, print verso: "#37973/C-41/23A//British Coal Miners/Working in 18" Seam/1952//P." and rubber stamps "PHOTO BY/CARL MYDANS//CM"
Acquired from: gift of Time Inc., New York, New York

3706. EAMON DE VALERA, PRESIDENT OF IRELAND, UNDER A PLAQUE OF THE MARTYRED PATRIOT MICHAEL COLLINS. 1954 [from "Carl Mydans: A Photojournalist's Journey Through War and Peace"] (P1985.27.71)
Gelatin silver print. negative 1954, print 1985
Image: 26 x 20 1/16 in. (66.0 x 50.9 cm.)
Signed, l.r. print verso: "Carl Mydans"
Inscription, print verso: "#42330/2-C-8/1//Eamon De Valera/President of Ireland/1954/under plaque of Martered [sic] Patriet [sic]/Michael Collins//P." and rubber stamps "PHOTO BY/CARL MYDANS//CM"
Acquired from: gift of Time Inc., New York, New York

*3707. THE ECCENTRIC RECTOR OF WARLEGGAN, CORNWALL, THE REV. FREDERICK BENSHAM, GLORIES IN HIS ECCENTRICITY. 1953 [from "Carl Mydans: A Photojournalist's Journey Through War and Peace"] (P1985.27.141)
Gelatin silver print. negative 1953, print 1985
Image: 29 3/4 x 20 in. (75.6 x 50.8 cm.)
Signed, center print verso: "Carl Mydans"
Inscription, print verso: "#38842/C-5/16//Rector/Warleggan, England/1953//P." and rubber stamps "PHOTO BY/CARL MYDANS//CM"
Acquired from: gift of Time Inc., New York, New York

*3708. "THE ELDERLY BUTCHER BOY OF FASCISM STEPS OUT" WAS THE LIFE CAPTION FOR THIS PICTURE OF MUSSOLINI ON PARADE IN MAY, 1940 [from "Carl Mydans: A Photojournalist's Journey Through War and Peace"] (P1985.27.40)
Gelatin silver print. negative 1940, print 1985
Image: 18 1/16 x 24 7/8 in. (45.9 x 63.2 cm.) irregular
Sheet: 18 1/16 x 25 in. (45.9 x 63.5 cm.) irregular
Signed, center print verso: "Carl Mydans"
Inscription, print verso: "#6320/C-67-35//Rome 1940//at the Victor Emanuel [sic] Monument/Mussolini/for fallen Italians in/Abyssion [sic] War/June 1940//P." and rubber stamps "PHOTO BY/CARL MYDANS//CM"
Acquired from: gift of Time Inc., New York, New York

3709. ELECTION BANNERS SPAN THE STREET IN HARDWICK, VERMONT, FOR THE 1936 PRESIDENTIAL RACE (FARM SECURITY ADMINISTRATION PHOTOGRAPH) [from "Carl Mydans: A Photojournalist's Journey Through War and Peace"] (P1985.27.29)
Gelatin silver print. negative 1936, print 1985
Image: 12 15/16 x 19 5/8 in. (32.9 x 49.8 cm.) irregular
Sheet: 13 x 20 in. (33.0 x 50.8 cm.)
Signed, l.r. print verso: "Carl Mydans"
Inscription, print verso: "FSA:/Political Banners/Harwich [sic], Vermont Sept. 1936//USF-33/FSA 00816//P." and rubber stamps "PHOTO BY/CARL MYDANS//CM//CM"
Acquired from: gift of the photographer

*3710. EMMA MAI OF ANSBACH, BAVARIA, GATHERS FAGOTS IN THE FOREST NEAR HER HOME DURING THE PINCHED YEARS OF POSTWAR GERMANY. 1954 [from "Carl Mydans: A Photojournalist's Journey Through War and Peace"] (P1985.27.143)
Gelatin silver print. negative 1954, print 1985
Image: 19 5/16 x 15 5/8 in. (49.0 x 39.7 cm.)
Sheet: 19 3/4 x 15 13/16 in. (50.2 x 40.1 cm.)
Signed, bottom center print verso: "Carl Mydans"
Inscription, print verso: "#41811/4C-62/25(25)//In post-war Germany/inAusbach [sic], family gathers wood/in nearby Forest/1954//P." and rubber stamps "PHOTO BY/CARL MYDANS//CM"
Acquired from: gift of Time Inc., New York, New York

3711. EVEN IN PROSPEROUS LUNG CHUAN-I, FARMERS SUFFERED IN CHINA IN 1941 [from "Carl Mydans: A Photojournalist's Journey Through War and Peace"] (P1985.27.50)
Gelatin silver print. negative 1941, print 1985
Image: 19 7/16 x 15 1/2 in. (49.3 x 39.3 cm.) irregular
Sheet: 19 3/4 x 15 1/2 in. (50.2 x 39.3 cm.)
Signed, center print verso: "Carl Mydans"
Inscription, print verso: "#8433/C-24/19//Village Scene/Lung Ch-a Chuan-i/1941//China//P." and rubber stamps "PHOTO BY/CARL MYDANS//PHOTO BY/CARL MYDANS//CM"
Acquired from: gift of Time Inc., New York, New York

*3712. EZRA POUND, POET, IN MILAN, ITALY. 1940 [from "Carl Mydans: A Photojournalist's Journey Through War and Peace"] (P1985.27.59)
Gelatin silver print. negative 1940, print 1985
Image: 19 13/16 x 15 15/16 in. (50.3 x 40.5 cm.)
Sheet: 19 15/16 x 16 1/16 in. (50.7 x 40.8 cm.)
Signed, bottom center print verso: "Carl Mydans"
Inscription, print verso: "#6320/C-38/#16 17//EZRA POUND/Milan, Italy/1940//P." and rubber stamps "PHOTO BY/CARL MYDANS//CM"
Acquired from: gift of Time Inc., New York, New York

3713. FASCIST PROPAGANDA MINISTER PAVOLINI, UNDER A PORTRAIT OF MUSSOLINI IN HIS OFFICE IN ROME. 1940 [from "Carl Mydans: A Photojournalist's Journey Through War and Peace"] (P1985.27.69)
Gelatin silver print. negative 1940, print 1985
Image: 29 15/16 x 19 15/16 in. (76.1 x 50.7 cm.)
Signed: see inscription
Inscription, print verso: "Fascist official:/Propaganda official/Pavolini/Rome 1940//P." and rubber stamps "PHOTO BY/CARL MYDANS//CM"
Acquired from: gift of Time Inc., New York, New York

3698

3701

3707

3710

3708

3712

3714. **FATHER AND SON IN THEIR COLD WATER TENEMENT, CINCINNATI. 1936 (FARM SECURITY ADMINISTRATION PHOTOGRAPH)** [from "Carl Mydans: A Photojournalist's Journey Through War and Peace"] (P1985.27.28)
Gelatin silver print. negative 1936, print 1985
Image: 20 1/16 x 24 1/16 in. (50.9 x 61.1 cm.)
Signed, l.r. print verso: "Carl Mydans"
Inscription, print verso: "FSA/USA-33/FSA-0036//Tenement Kitchen/Cincinatti [sic], Ohio/December 1936//CM/?P" and rubber stamp "PHOTO BY/CARL MYDANS"
Acquired from: gift of the photographer

*3715. **FIRE RAGES AND STREETS CRACK OPEN AS A MAJOR EARTHQUAKE STRIKES FUKUI, JAPAN, IN 1948** [from "Carl Mydans: A Photojournalist's Journey Through War and Peace"] (P1985.27.110)
Gelatin silver print. negative 1948, print 1985
Image: 24 1/8 x 19 15/16 in. (61.3 x 50.7 cm.)
Signed, l.r. print verso: "Carl Mydans"
Inscription, print verso: "#26902/R-7/4//Earthquake/Fukui, Japan/1948" and rubber stamps "PHOTO BY/CARL MYDANS//CM"
Acquired from: gift of Time Inc., New York, New York

*3716. **THE FIRST AMERICAN SOLDIER KILLED IN THE KOREAN WAR IS SURROUNDED BY HIS COMRADES. JULY 5, 1950** [from "Carl Mydans: A Photojournalist's Journey Through War and Peace"] (P1985.27.123)
Gelatin silver print. negative 1950, print 1985
Image: 10 13/16 x 16 7/8 in. (27.5 x 42.9 cm.)
Sheet: 11 x 17 in. (28.0 x 43.2 cm.)
Signed, l.r. print verso: "Carl Mydans"
Inscription, print verso: "#32407/C6/37//First American Dead/Korean War/1950//P" and rubber stamps "PHOTO BY/CARL MYDANS//CM"
Acquired from: gift of Time Inc., New York, New York

3717. **THE FIRST JEEP IN THE AMERICAN OCCUPATION OF JAPAN SPEARHEADS THE DRIVE TO YOKOHAMA. AUGUST, 1945** [from "Carl Mydans: A Photojournalist's Journey Through War and Peace"] (P1985.27.109)
Gelatin silver print. negative 1945, print 1985
Image: 16 1/16 x 24 in. (40.8 x 61.0 cm.)
Signed, l.r. print verso: "Carl Mydans"
Inscription, print verso: "#18564/C-3/17/1st Jeep of American Occupying Force/Passes Japanese Farmer with his/house hold goods stacked on his/Waggon [sic] on the Road from Atsugi Air base/to Yokohama/Sept 1945//P" and rubber stamps "PHOTO BY/CARL MYDANS//CM"
Acquired from: gift of Time Inc., New York, New York

3718. **FRAU MAI DOES THE FAMILY LAUNDRY IN THE COURTYARD OF THEIR HOME IN ANSBACH. 1954** [from "Carl Mydans: A Photojournalist's Journey Through War and Peace"] (P1985.27.144)
Gelatin silver print. negative 1954, print 1985
Image: 19 3/8 x 15 9/16 in. (49.2 x 39.5 cm.) irregular
Sheet: 19 13/16 x 15 13/16 in. (50.3 x 40.1 cm.)
Signed, center print verso: "Carl Mydans"
Inscription, print verso: "41811/C4-8//[illegible] #41811/C-4-8//Ansback [sic], in Post War/Germany//P" and rubber stamps "PHOTO BY/CARL MYDANS//CM"
Acquired from: gift of Time Inc., New York, New York

3719. **FRAU MAI SCRAPES THE POT TO FEED HER HUSBAND AND THREE BOYS. 1954** [from "Carl Mydans: A Photojournalist's Journey Through War and Peace"] (P1985.27.145)
Gelatin silver print. negative 1954, print 1985
Image: 19 3/8 x 15 1/2 in. (49.2 x 39.3 cm.) irregular
Sheet: 19 13/16 x 15 7/8 in. (50.3 x 40.3 cm.)
Signed, center print verso: "Carl Mydans"
Inscription, print verso: "Post war Germany 1954/Ansbach—

/Mother scrapes bottom of Pot/and gives self smallest/Portion in years of shortages//#41811/2C-35/12/P" and rubber stamps "PHOTO BY/CARL MYDANS//CM"
Acquired from: gift of Time Inc., New York, New York

3720. **FREDI MAI PREPARES FOR HIS FIRST COMMUNION. 1954** [from "Carl Mydans: A Photojournalist's Journey Through War and Peace"] (P1985.27.146)
Gelatin silver print. negative 1954, print 1985
Image: 19 7/16 x 15 9/16 in. (49.3 x 39.5 cm.)
Sheet: 19 1/4 x 15 3/4 in. (50.2 x 40.0 cm.)
Signed, l.r. print verso: "Carl Mydans"
Inscription, print verso: "[illegible] 41811/3C49/#3H//#41811/3C-49/3A//Preparing for Confirmation/Ausbach [sic], Germany/1954//P" and rubber stamps "PHOTO BY/CARL MYDANS//CM"
Acquired from: gift of Time Inc., New York, New York

*3721. **FRENCH CITIZENS FLEE THE APPROACHING NAZIS SOUTH OF PARIS. JUNE, 1940** [from "Carl Mydans: A Photojournalist's Journey Through War and Peace"] (P1985.27.35)
Gelatin silver print. negative 1940, print 1985
Image: 10 1/2 x 12 1/16 in. (26.6 x 30.7 cm.) irregular
Signed, l.r. print verso: "Carl Mydans"
Inscription, print verso: "6776/C1-29/[illegible]//#6776/C-1/29/Fall of France/Refugees fleeing/Paris/June 1940//P" and rubber stamps "PHOTO BY/CARL MYDANS//CM"
Acquired from: gift of Time Inc., New York, New York

3722. **FRENCH SOLDIERS STRAGGLE SOUTH AFTER THE GERMAN BREAKTHROUGH AT SEDAN IN MAY, 1940** [from "Carl Mydans: A Photojournalist's Journey Through War and Peace"] (P1985.27.150)
Gelatin silver print. negative 1940, print 1985
Image: 20 x 29 11/16 in. (50.8 x 75.4 cm.)
Signed, l.r. print verso: "Carl Mydans"
Inscription, print verso: "#//#8306-A//C-2/6//France May 1940/Near Verdun after/German Break-through/at Sedan//P" and rubber stamps "PHOTO BY/CARL MYDANS//CM"
Acquired from: gift of Time Inc., New York, New York

3723. **FRENCH TANK BRIGADE OFFICERS TAKE MESS ALFRESCO NEAR VERDUN AFTER A CRITICAL GERMAN BREAKTHROUGH IN JUNE, 1940** [from "Carl Mydans: A Photojournalist's Journey Through War and Peace"] (P1985.27.36)
Gelatin silver print. negative 1940, print 1985
Image: 27 x 17 7/8 in. (68.6 x 45.4 cm.)
Sheet: 27 x 18 1/16 in. (68.6 x 45.9 cm.)
Signed, center print verso: "Carl Mydans"
Inscription, print verso: "#8306-A/C-2/22//with French tank Brigade/near Verdun after German/Breakthrough at Sedan//P" and rubber stamps "PHOTO BY/CARL MYDANS//CM"
Acquired from: gift of Time Inc., New York, New York

*3724. **A FRENCH WOMAN ACCUSED OF COLLABORATION WITH THE GERMANS IS SHAVED BY VINDICTIVE NEIGHBORS IN A VILLAGE NEAR MARSEILLE. AUGUST, 1944** [from "Carl Mydans: A Photojournalist's Journey Through War and Peace"] (P1985.27.84)
Gelatin silver print. negative 1944, print 1985
Image: 12 3/4 x 19 1/16 in. (32.4 x 48.4 cm.)
Sheet: 13 x 19 1/16 in. (33.0 x 48.4 cm.)
Signed, center print verso: "Carl Mydans"
Inscription, print verso: "War: Southern France/Collaborist [sic]/Marseille/August 1944//#15760/C-1/12//P." and rubber stamps "PHOTO BY/CARL MYDANS//CM"
Acquired from: gift of Time Inc., New York, New York

3715

3721

3727

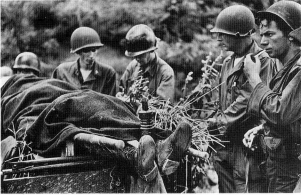

3716

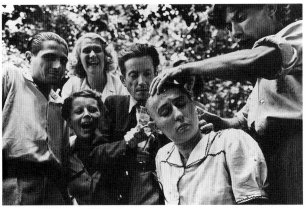

3724

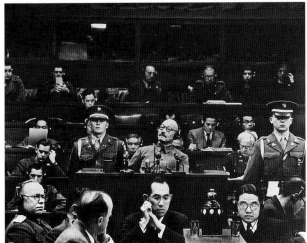

3735

3725. **FRIGHTENED RUSSIAN PRISONERS TAKEN IN THE RUSSO-FINNISH WAR ARE DETAINED BY THEIR CAPTORS IN ROVANIEMI, FINLAND. 1939** [from "Carl Mydans: A Photojournalist's Journey Through War and Peace"] (P1985.27.34)
Gelatin silver print. negative 1939, print 1985
Image: 10 9/16 x 13 in. (26.8 x 33.0 cm.) irregular
Signed, center print verso: "Carl Mydans"
Inscription, print verso: "5618/C-2/3//Russo-Finnish war 1939–1940/Captured Russian Prisoners/Finland//P." and rubber stamps "PHOTO BY/CARL MYDANS//CM"
Acquired from: gift of Time Inc., New York, New York

3726. **GENERAL DOUGLAS MacARTHUR IN HIS PLANE, THE BATAAN, DURING THE KOREAN WAR. 1950** [from "Carl Mydans: A Photojournalist's Journey Through War and Peace"] (P1985.27.80)
Gelatin silver print. negative 1950, print 1985
Image: 29 7/8 x 20 in. (75.9 x 50.8 cm.)
Signed, center print verso: "Carl Mydans"
Inscription, print verso: "General MacArthur/in "THE Bataan"/in Korean War—1950//32918/C-18/5//P" and rubber stamps "PHOTO BY/CARL MYDANS//CM"
Acquired from: gift of Time Inc., New York, New York

*3727. **GENERAL DOUGLAS MacARTHUR WADES ASHORE DURING THE AMERICAN LANDING AT LINGAYEN GULF, LUZON, IN THE PHILIPPINES. JANUARY 9, 1945** [from "Carl Mydans: A Photojournalist's Journey Through War and Peace"] (P1985.27.148)
Gelatin silver print. negative 1945, print 1984
Image: 30 x 39 7/8 in. (76.2 x 101.3 cm.) irregular
Acquired from: gift of Time Inc., New York, New York

3728. **GENERAL HIDEKI TOJO RECEIVES BLOOD FROM AMERICAN ARMY DOCTORS AFTER ATTEMPTING SUICIDE IN 1945** [from "Carl Mydans: A Photojournalist's Journey Through War and Peace"] (P1985.27.114)
Gelatin silver print. negative 1945, print 1985
Image: 12 x 10 9/16 in. (30.5 x 26.8 cm.) irregular
Signed, center print verso: "Carl Mydans"
Inscription, print verso: "[illegible]/18718/2R2//Tojo: after Suicide attempt/Tokyo 1945/#18718/R-2//P" and rubber stamps "PHOTO BY/CARL MYDANS//CM"
Acquired from: gift of Time Inc., New York, New York

3729. **GENERAL HIDEKI TOJO, WARTIME PRIME MINISTER OF JAPAN, AT HIS WAR CRIMES TRIAL IN TOKYO. 1947** [from "Carl Mydans: A Photojournalist's Journey Through War and Peace"] (P1985.27.64)
Gelatin silver print. negative 1947, print 1985
Image: 19 13/16 x 19 7/8 in. (50.3 x 50.5 cm.) irregular
Sheet: 20 x 20 1/16 in. (50.8 x 50.9 cm.) irregular
Signed, l.r. print verso: "Carl Mydans"
Inscription, print verso: "#25380/R-4//War Crimes Trials//Tokyo 1947//TOJO//P" and rubber stamps "PHOTO BY/CARL MYDANS//CM"
Acquired from: gift of Time Inc., New York, New York

3730. **GENERAL JIRO MINAMI, DEFENDANT IN THE MAJOR WAR CRIMES TRIALS. TOKYO, 1947** [from "Carl Mydans: A Photojournalist's Journey Through War and Peace"] (P1985.27.65)
Gelatin silver print. negative 1947, print 1985
Image: 22 x 19 15/16 in. (55.9 x 50.7 cm.)
Signed: see inscription
Inscription, print verso: "#25380/R-1/General Jiro Minami/ at War Crimes Trials/in Tokyo/1947" and rubber stamps "PHOTO BY/CARL MYDANS//CM [partial]"
Acquired from: gift of Time Inc., New York, New York

3731. **GENERAL MacARTHUR FORDS A RIVER IN A JEEP ON THE RACE SOUTH TO THE BATTLE FOR MANILA. JANUARY, 1945** [from "Carl Mydans: A Photojournalist's Journey Through War and Peace"] (P1985.27.100)
Gelatin silver print. negative 1945, print 1985
Image: 20 x 29 15/16 in. (50.8 x 76.1 cm.)
Signed, l.r. print verso: "Carl Mydans"
Inscription, print verso: "#17045/C-2/28//MacArthur in Combat in Jeep/in Philippines being hauled/across Small River in the Philipines [sic]/(Luzon)/1945//P" and rubber stamps "PHOTO BY/CARL MYDANS//CM"
Acquired from: gift of Time Inc., New York, New York

3732. **GENERAL MacARTHUR VISITS THE BATTLEFIELD ON BATAAN. MARCH, 1945** [from "Carl Mydans: A Photojournalist's Journey Through War and Peace"] (P1985.27.103)
Gelatin silver print. negative 1945, print 1985
Image: 19 3/4 x 15 13/16 in. (50.2 x 40.1 cm.)
Sheet: 19 15/16 x 16 in. (50.7 x 40.7 cm.)
Signed, l.r. print verso: "Carl Mydans"
Inscription, print verso: "#17045/C-4/(no number)/Bataan 1945/Battlefield//P" and rubber stamps "PHOTO BY/CARL MYDANS//CM"
Acquired from: gift of Time Inc., New York, New York

3733. **GENERAL MacARTHUR WITH HIS STAFF DURING THE DARING LANDING AT INCHON, KOREA. 1951** [from "Carl Mydans: A Photojournalist's Journey Through War and Peace"] (P1985.27.121)
Gelatin silver print. negative 1951, print 1985
Image: 11 1/16 x 16 13/16 in. (28.1 x 42.7 cm.)
Sheet: 11 1/16 x 17 in. (28.1 x 43.2 cm.)
Signed, l.r. print verso: "Carl Mydans"
Inscription, print verso: "#32872/4/17//Inchon Landing/1950 [sic]//P" and rubber stamps "PHOTO BY/CARL MYDANS//CM//CM"
Acquired from: gift of Time Inc., New York, New York

3734. **GENERAL SADAO ARAKI DURING HIS TRIAL FOR WAR CRIMES. TOKYO, 1947** [from "Carl Mydans: A Photojournalist's Journey Through War and Peace"] (P1985.27.67)
Gelatin silver print. negative 1947, print 1985
Image: 19 13/16 x 19 13/16 in. (50.3 x 50.3 cm.)
Sheet: 20 x 20 in. (50.8 x 50.8 cm.)
Signed, l.r. print verso: "Carl Mydans"
Inscription, print verso: "#25380/R-1//War Crimes Trials, Tokyo 1947/Sadao Ariki [sic]/Former War Minister//P 1st" and rubber stamps "PHOTO BY/CARL MYDANS//CM"
Acquired from: gift of Time Inc., New York, New York

*3735. **GENERAL TOJO LISTENS TO TESTIMONY DURING HIS TRIAL FOR WAR CRIMES. TOKYO, 1948** [from "Carl Mydans: A Photojournalist's Journey Through War and Peace"] (P1985.27.115)
Gelatin silver print. negative 1948, print 1985
Image: 15 5/8 x 19 5/8 in. (39.7 x 49.8 cm.) irregular
Sheet: 16 x 19 15/16 in. (40.7 x 50.7 cm.)
Signed, l.r. print verso: "Carl Mydans"
Inscription, print verso: "25380/C-3/4//#25380/C-3/4//TOJO at MAJOR War Crimes Trials/Tokyo. 1947 [sic]//P" and rubber stamps "PHOTO BY/CARL MYDANS//CM"
Acquired from: gift of Time Inc., New York, New York

3736. **GENERALISSIMO AND MADAME CHIANG KAI-SHEK LUNCH IN THEIR HOME IN CHUNGKING. 1941** [from "Carl Mydans: A Photojournalist's Journey Through War and Peace"] (P1985.27.61)
Gelatin silver print. negative 1941, print 1985
Image: 19 9/16 x 15 3/4 in. (49.7 x 40.0 cm.) irregular
Sheet: 19 15/16 x 16 1/16 in. (50.7 x 40.8 cm.)
Signed, bottom center print verso: "Carl Mydans"
Inscription, print verso: "8306/P.1//Generalissimo Chaing [sic]

Kai-shek/and Madame Chiang/at lunch, Chungking 1941//
P//[illegible]" and rubber stamps "PHOTO BY/CARL
MYDANS//CM"
Acquired from: gift of Time Inc., New York, New York

3737. GERMAN DEAD ON THE ROAD TO ROME. 1944 [from
"Carl Mydans: A Photojournalist's Journey Through War
and Peace"] (P1985.27.93)
Gelatin silver print. negative 1944, print 1985
Image: 25 9/16 x 20 in. (64.9 x 50.8 cm.)
Signed, l.r. print verso: "Carl Mydans"
Inscription, print verso: "15/#15100/R-3//on the Road to
Rome/1944//P" and rubber stamps "PHOTO BY/CARL
MYDANS//CM"
Acquired from: gift of Time Inc., New York, New York

3738. GERMAN NOVELIST THOMAS MANN IN HIS HOME
IN PRINCETON, NEW JERSEY. 1939 [from "Carl
Mydans: A Photojournalist's Journey Through War and
Peace"] (P1985.27.57)
Gelatin silver print. negative 1939, print 1985
Image: 19 3/4 x 15 13/16 in. (50.2 x 40.1 cm.)
Sheet: 20 x 16 in. (50.8 x 40.7 cm.)
Signed, center print verso: "Carl Mydans"
Inscription, print verso: "Thomas MANN/Princeton/Feb
1939//Set #3719//(4 x 5 Neg)//R. Remake//P" and rubber
stamps "PHOTO BY/CARL MYDANS//CM"
Acquired from: gift of Time Inc., New York, New York

3739. A GERMAN PRISONER IS TAKEN IN THE FIGHTING
SOUTH OF ROME. 1944 [from "Carl Mydans: A
Photojournalist's Journey Through War and Peace"]
(P1985.27.83)
Gelatin silver print. negative 1944, print 1985
Image: 19 1/16 x 13 1/16 in. (48.4 x 33.2 cm.)
Signed, center print verso: "Carl Mydans"
Inscription, print verso: "Surrendering German, Italian
Campaign/South of Rome//#15100/C-2/5//P" and rubber
stamps "PHOTO BY/CARL MYDANS//CM"
Acquired from: gift of Time Inc., New York, New York

*3740. GERMAN SOLDIERS TAKEN BY THE FRENCH ARE
MARCHED THROUGH A VILLAGE IN SOUTHERN
FRANCE. 1944 [from "Carl Mydans: A Photojournalist's
Journey Through War and Peace"] (P1985.27.91)
Gelatin silver print. negative 1944, print 1985
Image: 11 7/8 x 17 in. (30.2 x 43.2 cm.)
Sheet: 12 1/16 x 17 in. (30.7 x 43.2 cm.)
Signed, l.r. print verso: "Carl Mydans"
Inscription, print verso: "Surrendering Germans During/
Liberation of Southern France/near St. Tropez/August
1944//#15761/C-4/12//P//15261/C4/12/[illegible]" and rubber
stamps "PHOTO BY/CARL MYDANS//CM"
Acquired from: gift of Time Inc., New York, New York

*3741. GERTRUDE STEIN AND ALICE B. TOKLAS WITH
"BASKET," AT THEIR HOME IN SOUTHERN
FRANCE AT THE TIME OF THEIR LIBERATION,
SEPTEMBER, 1944. [from "Carl Mydans: A
Photojournalist's Journey Through War and Peace"]
(P1985.27.73)
Gelatin silver print. negative 1944, print 1985
Image: 20 1/16 x 20 1/16 in. (50.9 x 50.9 cm.)
Signed, l.r. print verso: "Carl Mydans"
Inscription, print verso: "15876/R-4//Gertrude Stein and/
Alice B. Toklas/on liberation in France/1944//with
"Basket"//CM/P" and rubber stamp "PHOTO BY/CARL
MYDANS"
Acquired from: gift of Time Inc., New York, New York

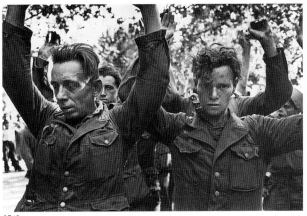

3740

3741

3742

*3742. **G.I.S CARRY A WOUNDED SOLDIER TO SAFETY IN THE FIGHTING IN MANILA. FEBRUARY, 1945** [from "Carl Mydans: A Photojournalist's Journey Through War and Peace"] (P1985.27.97)
Gelatin silver print. negative 1945, print 1985
Image: 20 1/16 x 29 13/16 in. (50.9 x 75.7 cm.)
Signed, l.r. print verso: "Carl Mydans"
Inscription, print verso: "#17182/C-8/30//Fight for Manila/1945//1P" and rubber stamps "PHOTO BY/CARL MYDANS//CM"
Acquired from: gift of Time Inc., New York, New York

*3743. **HEADLINES, NOVEMBER 22, 1963, ON A COMMUTER TRAIN TO STAMFORD, CONNECTICUT** [from "Carl Mydans: A Photojournalist's Journey Through War and Peace"] (P1985.27.131)
Gelatin silver print. negative 1963, print 1985
Image: 13 7/8 x 19 15/16 in. (35.2 x 50.7 cm.)
Sheet: 14 x 19 15/16 in. (35.6 x 50.7 cm.)
Signed, l.r. print verso: "Carl Mydans"
Inscription, print verso: "#69377/C-1/24//on 6:25 Train from/Grand Central to Stanford [sic]/Nov 22, 1963//P" and rubber stamps "PHOTO BY/CARL MYDANS//CM"
Acquired from: gift of Time Inc., New York, New York

3744. **HENRY KISSINGER IN 1958 WHEN HE WAS PROFESSOR OF INTERNATIONAL STUDIES AT HARVARD** [from "Carl Mydans: A Photojournalist's Journey Through War and Peace"] (P1985.27.75)
Gelatin silver print. negative 1958, print 1985
Image: 29 7/8 x 20 in. (75.9 x 50.8 cm.)
Signed, center print verso: "Carl Mydans"
Inscription, print verso: "#53015//#53015/C-1-/38//Henry Kissinger/in New York/(while teaching at Harvard)/1953 [sic]/P." and rubber stamps "PHOTO BY/CARL MYDANS//CM"
Acquired from: gift of Time Inc., New York, New York

3745. **THE HIWA DEPARTMENT STORE TOPPLES IN THE FIRST SHOCK OF THE FUKUI QUAKE. 1948** [from "Carl Mydans: A Photojournalist's Journey Through War and Peace"] (P1985.27.113)
Gelatin silver print. negative 1948, print 1985
Image: 20 x 20 1/16 in. (50.8 x 50.9 cm.)
Signed, center print verso: "Carl Mydans"
Inscription, print verso: "Earthquake/Fukui, Japan/1948//#26902/R-3-7//P" and rubber stamps "PHOTO BY/CARL MYDANS//CM"
Acquired from: gift of Time Inc., New York, New York

3746. **HORSETRADERS TALK BUSINESS IN ALBANY, VERMONT. 1936 (FARM SECURITY ADMINISTRATION PHOTOGRAPH)** [from "Carl Mydans: A Photojournalist's Journey Through War and Peace"] (P1985.27.30)
Gelatin silver print. negative 1936, print 1985
Image: 11 1/16 x 17 1/16 in. (28.1 x 43.3 cm.) irregular
Signed, center print verso: "Carl Mydans"
Inscription, print verso: "FSA/Carriage with Two men/near Albany, Vermont/RA-00778/USF-33/Sept 1936//P" and rubber stamp "PHOTO BY/CARL MYDANS"
Acquired from: gift of the photographer

3747. **IN A COLLIERY CLUB IN YORKSHIRE, BRITISH MINERS RELAX WITH A PINT. 1952** [from "Carl Mydans: A Photojournalist's Journey Through War and Peace"] (P1985.27.140)
Gelatin silver print. negative 1952, print 1985
Image: 20 1/16 x 29 3/4 in. (50.9 x 75.6 cm.)
Signed, center print verso: "Carl Mydans"
Inscription, print verso: "#37973/C-1/33//Coal Miners/British Pub/1952//P" and rubber stamps "PHOTO BY/CARL MYDANS//CM"
Acquired from: gift of Time Inc., New York, New York

3748. **IN A RUNNING GAME OF "21" SANDHOGS GAMBLE THEIR WAGES BETWEEN SHIFTS. 1939** [from "Carl Mydans: A Photojournalist's Journey Through War and Peace"] (P1985.27.10)
Gelatin silver print. negative 1939, print 1985
Image: 25 x 20 in. (63.5 x 50.8 cm.)
Signed, center print verso: "Carl Mydans"
Inscription, print verso: "#3974/P.3/5//Sand Hogs,/N.Y. City//P" and rubber stamps "PHOTO BY/CARL MYDANS//CM"
Acquired from: gift of Time Inc., New York, New York

3749. **IN SWANSEA, WALES, THE FOG COMES IN OVER THE CHIMNEY POTS. 1954** [from "Carl Mydans: A Photojournalist's Journey Through War and Peace"] (P1985.27.136)
Gelatin silver print. negative 1954, print 1985
Image: 24 x 20 in. (61.0 x 50.8 cm.)
Signed, center print verso: "Carl Mydans"
Inscription, print verso: "Fog: Swansea, Wales/1954/Personal Negative/No Set Number//ROLL #1/36//P" and rubber stamps "PHOTO BY/CARL MYDANS//CM"
Acquired from: gift of the photographer

3750. **IN WARLEGGAN CHURCH, THE RECTOR LEADS A LONELY LIFE, HAVING QUARRELED WITH HIS PARISHIONERS. 1953** [from "Carl Mydans: A Photojournalist's Journey Through War and Peace"] (P1985.27.142)
Gelatin silver print. negative 1953, print 1985
Image: 29 3/4 x 20 1/16 in. (75.6 x 50.9 cm.)
Signed, l.r. print verso: "Carl Mydans"
Inscription, print verso: "38842/C-4/30//Rector at Warleggan/England/1953//P" and rubber stamps "PHOTO BY/CARL MYDANS//CM"
Acquired from: gift of Time Inc., New York, New York

*3751. **INDIRA GANDHI IN CANADA. 1956** [from "Carl Mydans: A Photojournalist's Journey Through War and Peace"] (P1985.27.77)
Gelatin silver print. negative 1956, print 1985
Image: 29 3/4 x 20 3/16 in. (75.6 x 51.3 cm.)
Signed, center print verso: "Carl Mydans"
Inscription, print verso: "#50055/3C-22/27//Madame Indira Ghandi [sic]/In Canada/1956//P" and rubber stamps "PHOTO BY/CARL MYDANS//CM"
Acquired from: gift of Time Inc., New York, New York

*3752. **INTERNED BY THE JAPANESE, CIVILIANS LEE ROGERS AND JOHN TODD LOST 131 POUNDS BETWEEN THEM IN THEIR FOUR YEARS IN SANTO TOMAS CAMP. 1945** [from "Carl Mydans: A Photojournalist's Journey Through War and Peace"] (P1985.27.101)
Gelatin silver print. negative 1945, print 1985
Image: 20 1/16 x 20 in. (50.9 x 50.8 cm.)
Signed, bottom center print verso: "Carl Mydans"
Inscription, print verso: "#17030/C-//1945//Prison Camp Manila/Santo Tomas/1945//P" and rubber stamps "PHOTO BY/CARL MYDANS//CM//C"
Acquired from: gift of Time Inc., New York, New York

3753. **INTRAMUROS, THE OLD WALLED CITY OF MANILA, IS SHELLED BY ADVANCING AMERICANS IN JANUARY, 1945** [from "Carl Mydans: A Photojournalist's Journey Through War and Peace"] (P1985.27.98)
Gelatin silver print. negative 1945, print 1985
Image: 20 x 29 7/8 in. (50.8 x 75.9 cm.)
Signed, l.r. print verso: "Carl Mydans"
Inscription, print verso: "#17141/C-1/28//Shelling of Walled City/in Manila/1945//P" and rubber stamps "PHOTO BY/CARL MYDANS//CM"
Acquired from: gift of Time Inc., New York, New York

3754. **AN ITALIAN WOMAN APPRAISES FASCIST OFFICERS IN ROME. 1940** [from "Carl Mydans: A Photojournalist's Journey Through War and Peace"] (P1985.27.38)
Gelatin silver print. negative 1940, print 1985
Image: 18 1/16 x 24 13/16 in. (45.9 x 63.0 cm.)
Sheet: 18 1/16 x 25 1/16 in. (45.9 x 63.6 cm.) irregular
Signed, center print verso: "Carl Mydans"
Inscription, print verso: "Fascist Italy—Rome/June 1940//#6320/C-62/12//P" and rubber stamps "PHOTO BY/ CARL MYDANS//CM"
Acquired from: gift of Time Inc., New York, New York

3755. **JAPANESE "POLICE FORCE," FORERUNNER OF THE SELF-DEFENSE FORCE, MANEUVERS IN THE SNOW IN HOKKAIDO IN 1951** [from "Carl Mydans: A Photojournalist's Journey Through War and Peace"] (P1985.27.117)
Gelatin silver print. negative 1951, print 1985
Image: 15 3/4 x 19 11/16 in. (40.0 x 50.0 cm.) irregular
Sheet: 16 x 19 15/16 in. (40.7 x 50.7 cm.)
Signed, center print verso: "Carl Mydans"
Inscription, print verso: "Earlist [sic] Training of NEW Japanese/National Police force/(Army Army)/Hoikado [sic], Japan 1951//33662/C-6/5//P" and rubber stamps "PHOTO BY/CARL MYDANS//CM"
Acquired from: gift of the photographer

3756. **THE JAPANESE SURRENDER ON THE USS MISSOURI IN TOKYO BAY. SEPTEMBER 2, 1945** [from "Carl Mydans: A Photojournalist's Journey Through War and Peace"] (P1985.27.106)
Gelatin silver print. negative 1945, print 1985
Image: 16 x 24 1/16 in. (40.7 x 61.1 cm.)
Signed, l.r. print verso: "Carl Mydans"
Inscription, print verso: "#18586/2/23//Surrender on the Missouri/1945//P" and rubber stamps "PHOTO BY/CARL MYDANS//CM"
Acquired from: gift of Time Inc., New York, New York.

3757. **KOKICHI MIKIMOTO, 90 YEARS OLD IN 1940, CELEBRATES THE SUCCESS OF HIS PEARL FARM OFF THE TOBA PENINSULA IN JAPAN** [from "Carl Mydans: A Photojournalist's Journey Through War and Peace"] (P1985.27.66)
Gelatin silver print. negative 1940, print 1985
Image: 22 x 20 in. (55.9 x 50.8 cm.)
Signed, l.r. print verso: "Carl Mydans"
Inscription, print verso: "Mikomoto [sic] in/Japan/ 1945[sic]//(Personal Negative)//P" and rubber stamps "PHOTO BY/CARL MYDANS//CM"
Acquired from: gift of the photographer

*3758. **KOREAN MOTHER AND DAUGHTER, FLEEING THE WINTER ATTACK ON SEOUL, DRINK FROM THE FROZEN HAN RIVER. 1951** [from "Carl Mydans: A Photojournalist's Journey Through War and Peace"] (P1985.27.124)
Gelatin silver print. negative 1951, print 1985
Image: 22 x 18 in. (55.9 x 45.7 cm.) irregular
Signed, l.r. print verso: "Carl Mydans"
Inscription, print verso: "#33571/C-2/14//Korean Refugees fleeing/Seoul/1951//P" and rubber stamps "PHOTO BY/ CARL MYDANS//CM"
Acquired from: gift of Time Inc., New York, New York

*3759. **A KOREAN MOTHER CARRYING HER BABY AND HER WORLDLY GOODS FLEES THE FIGHTING AROUND SEOUL DURING THE WINTER ATTACK OF 1951** [from "Carl Mydans: A Photojournalist's Journey Through War and Peace"] (P1985.27.149)
Gelatin silver print. negative 1951, print 1984
Image: 60 x 40 in. (152.4 x 101.6 cm.) irregular
Acquired from: gift of Time Inc., New York, New York

3743

3751

3752

3760. THE KREMLIN AND SPASSKY TOWER UNDER A
FULL MOON. MOSCOW, 1960 [from "Carl Mydans:
A Photojournalist's Journey Through War and Peace"]
(P1985.27.132)
Gelatin silver print. negative 1960, print 1985
Image: 24 1/16 x 16 in. (61.1 x 40.7 cm.)
Signed, l.r. print verso: "Carl Mydans"
Inscription, print verso: "#58702/C-1/11//Kremlin/1959 [sic]//
P" and rubber stamps "PHOTO BY/CARL MYDANS//
CM"
Acquired from: gift of Time Inc., New York, New York

3761. KUO TUNG, COFFIN MAKER OF LANCHOW, CHINA,
CLAIMED TO BE 130 YEARS OLD IN 1941 [from "Carl
Mydans: A Photojournalist's Journey Through War and
Peace"] (P1985.27.51)
Gelatin silver print. negative 1941, print 1985
Image: 19 7/16 x 15 9/16 in. (49.3 x 39.5 cm.)
Sheet: 19 3/4 x 15 3/4 in. (50.2 x 40.0 cm.)
Signed, center print verso: "Carl Mydans"
Inscription, print verso: "9257/R2/[illegible]//9257/R-2//one
hundred year old Man/Sian Area/China 1941//P" and
rubber stamps "PHOTO BY/CARL MYDANS//CM"
Acquired from: gift of Time Inc., New York, New York

*3762. LADY OF PLEASURE IN THE WIDE OPEN OIL BOOM
TOWN OF FREER, TEXAS. 1937 [from "Carl Mydans:
A Photojournalist's Journey Through War and Peace"]
(P1985.27.5)
Gelatin silver print. negative 1937, print 1985
Image: 15 11/16 x 19 7/16 in. (39.8 x 49.3 cm.) irregular
Sheet: 15 13/16 x 19 3/4 in. (40.1 x 50.2 cm.)
Signed, bottom center print verso: "Carl Mydans"
Inscription, print verso: "Oilboom Town/Freer, Texas/1937/
lady of pleasure//Set NO 1/7C3/unnumbered//P" and
rubber stamps "PHOTO BY/CARL MYDANS//CM"
Acquired from: gift of Time Inc., New York, New York

3763. LEONARD BERNSTEIN WITH THE NEW YORK
PHILHARMONIC ORCHESTRA IN MOSCOW, 1959
[from "Carl Mydans: A Photojournalist's Journey Through
War and Peace"] (P1985.27.58)
Gelatin silver print. negative 1959, print 1985
Image: 15 13/16 x 19 9/16 in. (40.1 x 49.7 cm.)
Sheet: 16 1/16 x 19 15/16 in. (40.8 x 50.7 cm.) irregular
Signed, center print verso: "Carl Mydans"
Inscription, print verso: "Leonard Bernstein/In
Moscow/1959//#57818/C-6/31//P" and rubber stamps
"PHOTO BY/CARL MYDANS//CM"
Acquired from: gift of Time Inc., New York, New York

3764. LIMOUSINES AWAIT MUSSOLINI'S FUNCTIONARIES
IN THE PIAZZA DEL CAMPIDOGLIO, ROME. 1940
[from "Carl Mydans: A Photojournalist's Journey Through
War and Peace"] (P1985.27.39)
Gelatin silver print. negative 1940, print 1985
Image: 17 13/16 x 26 13/16 in. (45.2 x 68.1 cm.)
Sheet: 18 1/16 x 27 1/8 in. (45.9 x 68.9 cm.) irregular
Signed, center print verso: "Carl Mydans"
Inscription, print verso: "Rome—1940//#6320/C-5/10//P"
and rubber stamps "PHOTO BY/CARL MYDANS//CM"
Acquired from: gift of Time Inc., New York, New York

3765. A LONDON NEWS VENDOR DEFIES HITLER
DURING THE "PHONY WAR." NOVEMBER, 1939
[from "Carl Mydans: A Photojournalist's Journey Through
War and Peace"] (P1985.27.33)
Gelatin silver print. negative 1939, print 1985
Image: 27 x 18 1/16 in. (68.5 x 45.9 cm.) irregular
Signed, l.r. print verso: "Carl Mydans"
Inscription, print verso: "#5245D/H 15/17/Wartime Street
Scene/London 1939//P" and rubber stamps "PHOTO BY/
CARL MYDANS//CM"
Acquired from: gift of Time Inc., New York, New York

3766. MAIN STREET OF THE MARKET VILLAGE OF LUNG
CHUAN-I, CHINA. 1941 [from "Carl Mydans: A
Photojournalist's Journey Through War and Peace"]
(P1985.27.47)
Gelatin silver print. negative 1941, print 1985
Image: 26 x 20 in. (66.0 x 50.8 cm.) irregular
Signed, center print verso: "Carl Mydans"
Inscription, print verso: "#8433/C-24-A/4//Village of Lung
Chuan-i/Main Street/1941" and rubber stamps "PHOTO
BY/CARL MYDANS//CM"
Acquired from: gift of Time Inc., New York, New York

*3767. MAMORU SHIGEMITSU AND GENERAL YOSHIJIRO
UMEZU STAND READY TO SIGN THE SURRENDER
ON THE DECK OF THE USS MISSOURI. 1945 [from
"Carl Mydans: A Photojournalist's Journey Through War
and Peace"] (P1985.27.107)
Gelatin silver print. negative 1945, print 1985
Image: 19 1/8 x 15 15/16 in. (50.5 x 40.5 cm.)
Sheet: 19 15/16 x 16 in. (50.7 x 40.7 cm.)
Signed, l.r. print verso: "Carl Mydans"
Inscription, print verso: "18586/C-3/9//Surrender on the
Missouri/1945//P" and rubber stamps "PHOTO BY/CARL
MYDANS//CM"
Acquired from: gift of Time Inc., New York, New York

3768. MAN-POWERED WATER WHEEL RAISES PADDY
WATER FROM A LOWER TO HIGHER FIELD.
SZECHUAN, 1941 [from "Carl Mydans: A
Photojournalist's Journey Through War and Peace"]
(P1985.27.44)
Gelatin silver print. negative 1941, print 1985
Image: 25 15/16 x 20 in. (65.9 x 50.8 cm.)
Signed, center print verso: "Carl Mydans"
Inscription, print verso: "8433/R-65//Farmers raise
paddywater/to Higher Rice Field/near Luan Lung Chuan-i
Village/1941//P." and rubber stamps "PHOTO BY/CARL
MYDANS//CM"
Acquired from: gift of Time Inc., New York, New York

3769. A MIGRANT FAMILY AT HOME ON THE ROAD.
RAYMONDVILLE, TEXAS, 1937 [from "Carl Mydans:
A Photojournalist's Journey Through War and Peace"]
(P1985.27.21)
Gelatin silver print. negative 1937, print 1985
Image: 29 x 20 in. (73.6 x 50.8 cm.)
Signed, bottom center print verso: "Carl Mydans"
Inscription, print verso: "Set #1/C-5/39//Texas Migratory
Workers/lower Rio Grande/Raymondville Texas/1937//P//
Remake for/Deeper Mood" and rubber stamps "PHOTO
BY/CARL MYDANS//CM"
Acquired from: gift of Time Inc., New York, New York

3770. MILITARY MARCH PAST IN RED SQUARE, MOSCOW,
ON THE 42ND ANNIVERSARY OF THE OCTOBER
REVOLUTION. 1959 [from "Carl Mydans: A
Photojournalist's Journey Through War and Peace"]
(P1985.27.133)
Gelatin silver print. negative 1959, print 1985
Image: 13 9/16 x 19 15/16 in. (34.4 x 50.7 cm.)
Sheet: 14 1/16 x 19 15/16 in. (35.7 x 50.7 cm.)
Signed, l.r. print verso: "Carl Mydans"
Inscription, print verso: "#58432/C-6/2//March Past/Red
Square, Moscow/42nd Anniversary/October
Revolution/1959/Made Nov 7, '1959/P" and rubber stamps
"PHOTO BY/CARL MYDANS//CM"
Acquired from: gift of Time Inc., New York, New York

*3771. MODEL AND CUSTOMERS: NEIMAN-MARCUS
DEPARTMENT STORE, DALLAS. 1938 [from "Carl
Mydans: A Photojournalist's Journey Through War and
Peace"] (P1985.27.27)
Gelatin silver print. negative 1938, print 1985
Image: 20 x 27 15/16 in. (50.8 x 71.0 cm.)
Signed, center print verso: "Carl Mydans"
Inscription, print verso: "SET #1/26/8//Neiman Marcus/
Texas 1938//P" and rubber stamps "PHOTO BY/CARL
MYDANS//CM"
Acquired from: gift of Time Inc., New York, New York

3758

3759

3762

3767

3771

*3772. **MOTHER AND CHILD IN AN ITALIAN REFUGEE CAMP. CESANO, ITALY, 1944** [from "Carl Mydans: A Photojournalist's Journey Through War and Peace"] (P1985.27.86)
Gelatin silver print. negative 1944, print 1985
Image: 19 7/16 x 15 9/16 in. (49.3 x 39.5 cm.)
Sheet: 19 3/4 x 15 13/16 in. (50.2 x 40.1 cm.) irregular
Signed, center print verso: "Carl Mydans"
Inscription, print verso: "Italian Refugee Camp/Cesano, Italy 1944//(Father Taken By Germans When They retreated)//15339/R-6/7//Print/P/2nd/2nd" and rubber stamps "PHOTO BY/CARL MYDANS//CM"
Acquired from: gift of Time Inc., New York, New York

3773. **MUSSOLINI DOMINATES HIS PARLIAMENT AS ITALY PREPARES TO ENTER THE WAR AGAINST THE ALLIES. 1940** [from "Carl Mydans: A Photojournalist's Journey Through War and Peace"] (P1985.27.41)
Gelatin silver print. negative 1940, print 1985
Image: 29 13/16 x 20 1/16 in. (75.7 x 50.9 cm.)
Signed, center print verso: "Carl Mydans"
Inscription, print verso: "#6320/C-25/6//Fascist Italy/Rome 1940//P." and rubber stamps "PHOTO BY/CARL MYDANS//CM"
Acquired from: gift of Time Inc., New York, New York

3774. **MUTINOUS SOLDIERS OF THE YOSU UPRISING ARE TRUCKED TO THEIR COURT-MARTIAL. 1948** [from "Carl Mydans: A Photojournalist's Journey Through War and Peace"] (P1985.27.120)
Gelatin silver print. negative 1948, print 1985
Image: 11 x 17 in. (28.0 x 43.2 cm.)
Sheet: 11 x 17 1/16 in. (28.0 x 43.3 cm.)
Signed, l.r. print verso: "Carl Mydans//Carl Mydans"
Inscription, print verso: "#27911/C-2/31//South Korean uprising/1948//P" and rubber stamps "PHOTO BY/CARL MYDANS//CM"
Acquired from: gift of Time Inc., New York, New York

3775. **NATIONALIST SOLDIERS ON THE YELLOW RIVER FRONT FIRE ON THE JAPANESE FROM THE ANCIENT TUNGKUAN FORT. 1941** [from "Carl Mydans: A Photojournalist's Journey Through War and Peace"] (P1985.27.62)
Gelatin silver print. negative 1941, print 1985
Image: 15 x 15 in. (38.1 x 38.1 cm.)
Sheet: 15 1/16 x 15 in. (38.2 x 38.1 cm.) irregular
Signed, l.r. print verso: "Carl Mydans"
Inscription, print verso: "#9257?/R-1//Yellow River Front/—Beau Gest Scene—/Sian/Sian Region/1941//P." and rubber stamps "PHOTO BY/CARL MYDANS//CM"
Acquired from: gift of Time Inc., New York, New York

*3776. **NIKITA KHRUSHCHEV DENOUNCING PRESIDENT EISENHOWER. MOSCOW, 1960** [from "Carl Mydans: A Photojournalist's Journey Through War and Peace"] (P1985.27.78)
Gelatin silver print. negative 1960, print 1985
Image: 29 7/8 x 20 in. (75.9 x 50.8 cm.)
Signed, l.l. print verso: "Carl Mydans"
Inscription, print verso: "#59858/C-8/19//Khruschev [sic]/Moscow 1960/(announcing and condemning downing of the U-2)//P" and rubber stamps "PHOTO BY/CARL MYDANS//CM"
Acquired from: gift of Time Inc., New York, New York

3777. **NIKITA KHRUSHCHEV MAKES A FRIENDLY VISIT TO THE UNITED STATES. SEPTEMBER, 1959** [from "Carl Mydans: A Photojournalist's Journey Through War and Peace"] (P1985.27.135)
Gelatin silver print. negative 1959, print 1985
Image: 20 x 29 in. (50.8 x 73.6 cm.)
Signed: see inscription
Inscription, print verso: "#57967/#7C2/4//Khruschev [sic]

visit to the U.S./1959//P" and rubber stamps "PHOTO BY/CARL MYDANS//CM"
Acquired from: gift of Time Inc., New York, New York

3778. **NOBEL PRIZE LAUREATE WILLIAM FAULKNER AT WEST POINT. 1962** [from "Carl Mydans: A Photojournalist's Journey Through War and Peace"] (P1985.27.56)
Gelatin silver print. negative 1962, print 1985
Image: 19 3/4 x 15 15/16 in. (50.2 x 40.5 cm.) irregular
Sheet: 19 15/16 x 16 in. (50.7 x 40.7 cm.)
Signed, center print verso: "Carl Mydans"
Inscription, print verso: "#64442/12C-4/12//William Faulkner/at West Point/1962/1962//P" and rubber stamps "PHOTO BY/CARL MYDANS//CM"
Acquired from: gift of Time Inc., New York, New York

3779. **OIL DOMINATES FREER, TEXAS, IN 1937** [from "Carl Mydans: A Photojournalist's Journey Through War and Peace"] (P1985.27.6)
Gelatin silver print. negative 1937, print 1985
Image: 19 15/16 x 26 in. (50.7 x 66.0 cm.)
Signed, center print verso: "Carl Mydans"
Inscription, print verso: "Set No 1/5.P/5//Freer, Texas/1937//P" and rubber stamps "PHOTO BY/CARL MYDANS//CM"
Acquired from: gift of Time Inc., New York, New York

3780. **OILMEN GATHER AT THE DUVAL CLUB LUNCHROOM IN FREER, TEXAS. 1937** [from "Carl Mydans: A Photojournalist's Journey Through War and Peace"] (P1985.27.17)
Gelatin silver print. negative 1937, print 1985
Image: 20 1/16 x 29 11/16 in. (50.9 x 75.4 cm.)
Signed, center print verso: "Carl Mydans"
Inscription, print verso: "No 1/6.P/10//Oil Boom Town/Freer, Texas/1937//P" and rubber stamps "PHOTO BY/CARL MYDANS//CM"
Acquired from: gift of Time Inc., New York, New York

3781. **ON A BATTLEFIELD IN KOREA, A MEDIC FROM THE UNITED NATIONS FORCES' TURKISH BRIGADE TREATS A BURNED WOMAN. 1951** [from "Carl Mydans: A Photojournalist's Journey Through War and Peace"] (P1985.27.118)
Gelatin silver print. negative 1951, print 1985
Image: 21 15/16 x 16 in. (55.7 x 40.7 cm.)
Signed: see inscription
Inscription, print verso: "#33780/C-9/5//United Nations Turkish Brigade/in Korean War/1951//P//P" and rubber stamps "PHOTO BY/CARL MYDANS//CM"
Acquired from: gift of Time Inc., New York, New York

3782. **ON THE ROAD TO MANILA AMERICAN TROOPS AND FILIPINO GUERRILLAS JOIN FORCES AGAINST THE JAPANESE. JANUARY, 1945** [from "Carl Mydans: A Photojournalist's Journey Through War and Peace"] (P1985.27.99)
Gelatin silver print. negative 1945, print 1985
Image: 20 1/16 x 29 3/4 in. (50.9 x 75.6 cm.)
Signed, l.r. print verso: "Carl Mydans"
Inscription, print verso: "#17030/C-2/23//American and Filipino Guerellas [sic]/Join Forces with Americans/in attack on Japanese in/Northern Luzon/1945//P" and rubber stamps "PHOTO BY/CARL MYDANS//CM"
Acquired from: gift of Time Inc., New York, New York

*3783. **OPIUM DEN IN SINGAPORE WAS CONTROLLED BY THE BRITISH IN 1941** [from "Carl Mydans: A Photojournalist's Journey Through War and Peace"] (P1985.27.52)
Gelatin silver print. negative 1941, print 1985
Image: 18 1/16 x 24 15/16 in. (45.9 x 63.3 cm.)
Signed, center print verso: "Carl Mydans"
Inscription, print verso: "opium Den/Singapore/1941//#8693/C-28/18//P" and rubber stamps "PHOTO BY/CARL MYDANS//CM"
Acquired from: gift of Time Inc., New York, New York

3784. **PANDIT JAWAHARLAL NEHRU, FIRST PRESIDENT OF
 INDIA. 1956 [from "Carl Mydans: A Photojournalist's
 Journey Through War and Peace"]** (P1985.27.76)
 Gelatin silver print. negative 1956, print 1985
 Image: 29 ¾ x 20 in. (75.6 x 50.8 cm.)
 Signed, center print verso: "Carl Mydans"
 Inscription, print verso: "50055/C-7/7//NEHRU/New York
 1956//P." and rubber stamps "PHOTO BY/CARL
 MYDANS//CM"
 Acquired from: gift of Time Inc., New York, New York

*3785. **PRIME MINISTER WINSTON CHURCHILL AT
 BIGGLESWADE, ENGLAND, 1955 [from "Carl Mydans:
 A Photojournalist's Journey Through War and Peace"]**
 (P1985.27.74)
 Gelatin silver print. negative 1955, print 1984
 Image: 40 x 30 in. (101.6 x 76.2 cm.)
 Acquired from: gift of Time Inc., New York, New York

3772

3786. **THE QUEEN, QUEEN MOTHER AND PRINCESS
 ROYAL AT A WEDDING RECEPTION IN ST. JAMES
 PALACE, LONDON. 1954 [from "Carl Mydans: A
 Photojournalist's Journey Through War and Peace"]**
 (P1985.27.87)
 Gelatin silver print. negative 1954, print 1985
 Image: 19 ½ x 15 ⁹⁄₁₆ in. (49.5 x 39.5 cm.)
 Sheet: 19 ¾ x 15 ¾ in. (50.2 x 39.9 cm.)
 Signed, l.r. print verso: "Carl Mydans"
 Inscription, print verso: "#42354/CIA/45//Royal Wedding—
 London/Althorp Royal wedding/St. James Palace/March
 1954//P" and rubber stamps "PHOTO BY/CARL
 MYDANS//CM"
 Acquired from: gift of Time Inc., New York, New York

3787. **REFUGEE FROM THE JAPANESE-OCCUPIED CITIES
 OF COASTAL CHINA WAITS OUT THE WAR IN
 CHUNGKING. 1941 [from "Carl Mydans: A
 Photojournalist's Journey Through War and Peace"]**
 (P1985.27.54)
 Gelatin silver print. negative 1941, print 1985
 Image: 19 ⅜ x 15 ½ in. (49.2 x 39.3 cm.)
 Sheet: 19 ¾ x 15 ¾ in. (50.2 x 40.0 cm.)
 Signed, l.r. print verso: "Carl Mydans"
 Inscription, print verso: "#8306/C-13A//ChungKing
 Portrait/1941//Remake//P" and rubber stamps "PHOTO BY/
 CARL MYDANS//CM"
 Acquired from: gift of Time Inc., New York, New York

3776

3788. **RICHARD NIXON CAMPAIGNS FOR VICE-
 PRESIDENT IN 1956 [from "Carl Mydans: A
 Photojournalist's Journey Through War and Peace"]**
 (P1985.27.126)
 Gelatin silver print. negative 1956, print 1985
 Image: 29 ¹⁵⁄₁₆ x 20 in. (76.1 x 50.8 cm.)
 Signed, l.r. print verso: "Carl Mydans"
 Inscription, print verso: "#49524/4C39-14//Nixon Campaign
 Tour/1956//P" and rubber stamps "PHOTO BY/CARL
 MYDANS//CM"
 Acquired from: gift of Time Inc., New York, New York

3789. **THE RICKSHAW WAS THE COMMON CARRIER IN
 PRE-COMMUNIST CHINA. 1941 [from "Carl Mydans:
 A Photojournalist's Journey Through War and Peace"]**
 (P1985.27.43)
 Gelatin silver print. negative 1941, print 1985
 Image: 20 x 28 ¾ in. (50.8 x 73.0 cm.)
 Signed, center print verso: "Carl Mydans"
 Inscription, print verso: "Rickshaw Puller/on road near
 ChungKing/1941//P." and rubber stamps "PHOTO BY/
 CARL MYDANS//CM"
 Acquired from: gift of Time Inc., New York, New York

3783

*3790. **ROUSTABOUTS IN THE OIL BOOM TOWN OF FREER, TEXAS, TAKE TIME OFF FROM THEIR JOBS.** 1937 [from "Carl Mydans: A Photojournalist's Journey Through War and Peace"] (P1985.27.147)
Gelatin silver print. negative 1937, print 1984
Image: 30 x 39 ¾ in. (76.2 x 101.0 cm.)
Acquired from: gift of Time Inc., New York, New York

*3791. **RUSSIAN WOMEN SWEEP THE PAVEMENT OF MANEGE SQUARE FOR UNITS OF THE SOVIET ARMY MARCHING TO RED SQUARE FOR THE ANNIVERSARY PARADE.** 1959 [from "Carl Mydans: A Photojournalist's Journey Through War and Peace"] (P1985.27.134)
Gelatin silver print. negative 1959, print 1985
Image: 15 ¹³⁄₁₆ x 19 ¹⁵⁄₁₆ in. (40.1 x 50.7 cm.)
Sheet: 16 x 19 ¹⁵⁄₁₆ in. (40.7 x 50.7 cm.)
Signed, l.r. print verso: "Carl Mydans"
Inscription, print verso: "#58432/C-1/19//42nd Birthday of THE/October Socialist Revolution/Red Army, Moscow/1959//P" and rubber stamps "PHOTO BY/CARL MYDANS//CM"
Acquired from: gift of Time Inc., New York, New York

3792. **SANDHOG CALLS THE INCHES OF THE "SHOVE" AT THE FACE OF THE MIDTOWN TUNNEL.** 1939 [from "Carl Mydans: A Photojournalist's Journey Through War and Peace"] (P1985.27.9)
Gelatin silver print. negative 1939, print 1985
Image: 22 ⅛ x 17 ¹⁵⁄₁₆ in. (56.2 x 45.5 cm.)
Sheet: 22 ⅛ x 18 ¹⁄₁₆ in. (56.2 x 45.9 cm.) irregular
Signed, l.r. print verso: "Carl Mydans"
Inscription, print verso: "#3974/C-11//Sand Hog/Midtown tunnel/N.Y. City/1939//P//CM" and rubber stamp "PHOTO BY/CARL MYDANS"
Acquired from: gift of Time Inc., New York, New York

3793. **SANDHOGS CONSTRUCTING THE MIDTOWN TUNNEL UNDER THE EAST RIVER IN NEW YORK CITY IN 1939 WORK IN PRESSURIZED AIR** [from "Carl Mydans: A Photojournalist's Journey Through War and Peace"] (P1985.27.8)
Gelatin silver print. negative 1939, print 1985
Image: 25 x 18 in. (63.5 x 45.7 cm.) irregular
Signed, center print verso: "Carl Mydans"
Inscription, print verso: "Sand Hogs/New York//3974/CIA/(no frame NO)/N.Y. Midtown Tunnel/1939//P" and rubber stamps "PHOTO BY/CARL MYDANS//CM"
Acquired from: gift of Time Inc., New York, New York

3794. **SECRETARY OF STATE JOHN FOSTER DULLES AT THE UNITED NATIONS.** 1958 [from "Carl Mydans: A Photojournalist's Journey Through War and Peace"] (P1985.27.81)
Gelatin silver print. negative 1958, print 1985
Image: 29 ⅞ x 20 in. (75.9 x 50.8 cm.)
Signed, center print verso: "Carl Mydans"
Inscription, print verso: "54868/C-5/6//Dulles at U.S. [sic] General Assembly/1958//P" and rubber stamps "PHOTO BY/CARL MYDANS//CM"
Acquired from: gift of Time Inc., New York, New York

3795. **SENATOR JOE McCARTHY HAS HIS PICTURE TAKEN IN 1951** [from "Carl Mydans: A Photojournalist's Journey Through War and Peace"] (P1985.27.127)
Gelatin silver print. negative 1951, print 1985
Image: 15 ¹¹⁄₁₆ x 19 ¹⁵⁄₁₆ in. (39.8 x 50.7 cm.)
Sheet: 16 x 19 ¹⁵⁄₁₆ in. (40.7 x 50.7 cm.)
Signed, center print verso: "Carl Mydans"
Inscription, print verso: "#35058/C-10(10)/24//Joe McCarthy/in THE Northwest/1951//P.//1" and rubber stamps "PHOTO BY/CARL MYDANS//CM"
Acquired from: gift of Time Inc., New York, New York

3796. **SENATOR JOHN F. KENNEDY CAMPAIGNING WITH HIS WIFE IN BOSTON.** 1958 [from "Carl Mydans: A Photojournalist's Journey Through War and Peace"] (P1985.27.130)
Gelatin silver print. negative 1958, print 1985
Image: 20 x 29 ¹⁵⁄₁₆ in. (50.8 x 76.1 cm.)
Signed, l.r. print verso: "Carl Mydans"
Inscription, print verso: "#55363/C-5/5//The Senator Kennedys/Campaigning in Boston/1958/P" and rubber stamps "PHOTO BY/CARL MYDANS//CM"
Acquired from: gift of Time Inc., New York, New York

3797. **SENATORS HARRY S. TRUMAN AND BURTON K. WHEELER AT THE CAPITOL. WASHINGTON, D.C.,** 1939 [from "Carl Mydans: A Photojournalist's Journey Through War and Peace"] (P1985.27.79)
Gelatin silver print. negative 1939, print 1985
Image: 29 ⅞ x 20 in. (75.9 x 50.8 cm.)
Signed, center print verso: "Carl Mydans"
Inscription, print verso: "#4598/C-3/26//Senators Truman +/Wheeler, Washington/1939//P" and rubber stamps "PHOTO BY/CARL MYDANS//CM//CM"
Acquired from: gift of Time Inc., New York, New York

*3798. **SIX FRENCHMEN CONVICTED OF COLLABORATION ARE EXECUTED BY FIRING SQUAD.** 1944 [from "Carl Mydans: A Photojournalist's Journey Through War and Peace"] (P1985.27.95)
Gelatin silver print. negative 1944, print 1985
Image: 11 ¹⁄₁₆ x 16 ¹³⁄₁₆ in. (28.1 x 42.7 cm.)
Sheet: 11 ¹⁄₁₆ x 17 ¹⁄₁₆ in. (28.1 x 43.3 cm.)
Signed, l.r. print verso: "Carl Mydans"
Inscription, print verso: "Shooting of French Youths/who Collaborated with/the Germans/Grenoble, France/on liberation of City/1944//P" and rubber stamps "PHOTO BY/CARL MYDANS//CM"
Acquired from: gift of Time Inc., New York, New York

3799. **SLUMS FRAME THE CAPITOL, WASHINGTON, D.C.,** 1935 (FARM SECURITY ADMINISTRATION PHOTOGRAPH) [from "Carl Mydans: A Photojournalist's Journey Through War and Peace"] (P1985.27.25)
Gelatin silver print. negative 1935, print 1985
Image: 18 ¹⁄₁₆ x 24 ⅞ in. (45.9 x 63.2 cm.)
Sheet: 18 ¹⁄₁₆ x 25 in. (45.9 x 63.5 cm.)
Signed, center print verso: "Carl Mydans"
Inscription, print verso: "FSA//RA 194-M/USF-33//Washington, D.C. near Capitol/Sept 1935//P" and rubber stamps "PHOTO BY/CARL MYDANS//CM"
Acquired from: gift of the photographer

*3800. **SOLE SURVIVOR OF A VILLAGE NEAR PENGPU, CHINA, MOURNS IN THE RUINS AFTER THE CIVIL WAR PASSED THROUGH IN DECEMBER, 1948** [from "Carl Mydans: A Photojournalist's Journey Through War and Peace"] (P1985.27.49)
Gelatin silver print. negative 1948, print 1985
Image: 20 x 29 ¹³⁄₁₆ in. (50.8 x 75.7 cm.)
Signed, center print verso: "Carl Mydans"
Inscription, print verso: "China War 1949 [sic]/Ruins near Pungpu [sic]//#28275/C-6/31//Pri[illegible]//(a remake)//Jul" and rubber stamps "PHOTO BY/CARL MYDANS//CM"
Acquired from: gift of Time Inc., New York, New York

3801. **SOME SURVIVORS OF THE FUKUI EARTHQUAKE SALVAGE A FEW POSSESSIONS, BUT OTHERS ARE TRAPPED IN THEIR BURNING HOMES.** 1948 [from "Carl Mydans: A Photojournalist's Journey Through War and Peace"] (P1985.27.112)
Gelatin silver print. negative 1948, print 1985
Image: 13 ⁹⁄₁₆ x 16 ⅞ in. (34.4 x 41.7 cm.) irregular
Sheet: 14 x 16 ½ in. (35.6 x 41.9 cm.)
Signed, center print verso: "Carl Mydans"
Inscription, print verso: "Fukui, Japan Earthquake/1948//26902/R-6/1//P" and rubber stamps "PHOTO BY/CARL MYDANS//CM"
Acquired from: gift of Time Inc., New York, New York

3785

3790

3791

3798

3800

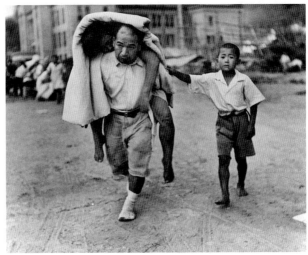

3802

*3802. A SURVIVOR OF THE FUKUI EARTHQUAKE
CARRIES HIS DEAD WIFE THROUGH THE RUINS.
1948 [from "Carl Mydans: A Photojournalist's Journey
Through War and Peace"] (P1985.27.111)
Gelatin silver print. negative 1948, print 1985
Image: 13 7/8 x 16 15/16 in. (35.2 x 43.0 cm.)
Sheet: 14 x 17 1/16 in. (35.6 x 43.3 cm.)
Signed, center print verso: "Carl Mydans"
Inscription, print verso: "[illegible]/26902/R6/#10//Fukui,
Japan Earthquake/1948//26902/R-6/10//P" and rubber
stamps "PHOTO BY/CARL MYDANS//CM"
Acquired from: gift of Time Inc., New York, New York

3803. THE TEAHOUSE WAS THE SOCIAL CENTER OF THE
VILLAGE OF LUNG CHUAN-I IN SZECHUAN IN
1941 [from "Carl Mydans: A Photojournalist's Journey
Through War and Peace"] (P1985.27.45)
Gelatin silver print. negative 1941, print 1985
Image: 20 1/16 x 29 7/8 in. (50.9 x 75.9 cm.)
Signed, center print verso: "Carl Mydans"
Inscription, print verso: "#4833/C-24A/18//Tea Room Scene/
Lung Chung-I [sic] Village/1941//P" and rubber stamps
"PHOTO BY/CARL MYDANS//CM"
Acquired from: gift of Time Inc., New York, New York

3804. A TEXAS COWBOY. 1938 [from "Carl Mydans: A
Photojournalist's Journey Through War and Peace"]
(P1985.27.1)
Gelatin silver print. negative 1938, print 1985
Image: 20 x 29 15/16 in. (50.8 x 76.1 cm.)
Signed, l.r. print verso: "Carl Mydans"
Inscription, print verso: "Set No 1/(negative lost)//Texas
Cowboy/Fence Rider/1938//P" and rubber stamps "PHOTO
BY/CARL MYDANS//CM"
Acquired from: gift of Time Inc., New York, New York

*3805. THREE GENERATIONS OF THE FANG FAMILY,
PROSPEROUS FARMERS IN THE FERTILE
SZECHUAN RICE BOWL OF CHINA, IN 1941 [from
"Carl Mydans: A Photojournalist's Journey Through War
and Peace"] (P1985.27.46)
Gelatin silver print. negative 1941, print 1985
Image: 20 x 29 15/16 in. (50.8 x 76.1 cm.)
Signed, center print verso: "Carl Mydans"
Inscription, print verso: "8433/P8//Farm Family/Near Luan
[sic] Chuan-I/Village/1941//P" and rubber stamps "PHOTO
BY/CARL MYDANS//CM"
Acquired from: gift of Time Inc., New York, New York

3806. TRANSIENT COTTON CHOPPERS TAKE TO THE
ROAD IN SEARCH OF WORK. CRITTENDEN
COUNTY, ARKANSAS, 1936 (FARM SECURITY
ADMINISTRATION PHOTOGRAPH) [from "Carl
Mydans: A Photojournalist's Journey Through War and
Peace"] (P1985.27.20)
Gelatin silver print. negative 1936, print 1985
Image: 24 1/16 x 20 1/16 in. (61.1 x 50.9 cm.)
Signed, center print verso: "Carl Mydans"
Inscription, print verso: "LC USF/34-6322 D//Tranisent [sic]
Cotton Choppers/Critten [sic] County, Ark/1936//CM/P"
and rubber stamp "PHOTO BY/CARL MYDANS"
Acquired from: gift of the photographer

3807. A TRENCH ROADWAY CUT INTO THE SOFT LOESS
EARTH PROTECTS TRAVELERS FROM JAPANESE
SHELLING NEAR THE TUNGKUAN FORT ON
THE CHINESE FRONT. 1941 [from "Carl Mydans:
A Photojournalist's Journey Through War and Peace"]
(P1985.27.151)
Gelatin silver print. negative 1941, print 1985
Image: 19 15/16 x 29 5/8 in. (50.7 x 75.2 cm.)
Signed, l.r. print verso: "Carl Mydans"
Inscription, print verso: "9257/C-16/15//Yellow River Front/
Roadway/1941//P" and rubber stamps "PHOTO BY/CARL
MYDANS//CM"
Acquired from: gift of Time Inc., New York, New York

*3808. A TURKISH SENTRY OF THE UNITED NATIONS
FORCES STANDS WATCHING THE FROZEN DAWN.
KOREA, 1951 [from "Carl Mydans: A Photojournalist's
Journey Through War and Peace"] (P1985.27.125)
Gelatin silver print. negative 1951, print 1985
Image: 21 7/8 x 15 9/16 in. (55.5 x 39.5 cm.)
Sheet: 22 x 16 in. (55.9 x 40.7 cm.)
Signed, l.r. print verso: "Carl Mydans"
Inscription, print verso: "#33780/C-1/16//United Nations
Line/Turkish Sentry at Dawn/Korean War/1951//P" and
rubber stamps "PHOTO BY/CARL MYDANS//CM"
Acquired from: gift of Time Inc., New York, New York

3809. TWO GERMAN SOLDIERS ARE CAPTURED NEAR
ST. TROPEZ IN THE LIBERATION OF SOUTHERN
FRANCE. 1944 [from "Carl Mydans: A Photojournalist's
Journey Through War and Peace"] (P1985.27.92)
Gelatin silver print. negative 1944, print 1985
Image: 11 15/16 x 17 5/8 in. (30.3 x 44.8 cm.)
Sheet: 12 1/16 x 18 in. (30.7 x 45.7 cm.)
Signed, l.r. print verso: "Carl Mydans"
Inscription, print verso: "#15761/C-2/7//Captured Germans/
liberation of Southern France/August 1944/near St.
Tropez//P" and rubber stamps "PHOTO BY/CARL
MYDANS//CM"
Acquired from: gift of the photographer

3810. UNEMPLOYED GATHER ON SOUTH STREET ALONG
THE WATERFRONT IN NEW YORK CITY IN THE
GREAT DEPRESSION OF 1935 [from "Carl Mydans:
A Photojournalist's Journey Through War and Peace"]
(P1985.27.15)
Gelatin silver print. negative 1935, print 1985
Image: 20 x 28 in. (50.8 x 71.1 cm.)
Signed, center print verso: "Carl Mydans"
Inscription, print verso: "South Street/N.Y. City/Winter,
1935/(my Neg)//P//2nd" and rubber stamps "PHOTO BY/
CARL MYDANS//CM"
Acquired from: gift of the photographer

3811. UNEMPLOYED IN HOLLYWOOD IN 1939 [from "Carl
Mydans: A Photojournalist's Journey Through War and
Peace"] (P1985.27.13)
Gelatin silver print. negative 1939, print 1985
Image: 29 7/8 x 20 in. (75.9 x 50.8 cm.)
Signed, center print verso: "Carl Mydans"
Inscription, print verso: "Unemployed Maurice J.
Shannon,/54 year old Construction Engineer/on Sunset
Boulevard, Hollywood/July 1939/(my negative)//a
remake//P" and rubber stamps "PHOTO BY/CARL
MYDANS//CM"
Acquired from: gift of the photographer

3812. A UNION ORGANIZER WORKS THE CROWD ON
WALL STREET, NEW YORK CITY. 1936 [from "Carl
Mydans: A Photojournalist's Journey Through War and
Peace"] (P1985.27.24)
Gelatin silver print. negative 1936, print 1985
Image: 20 1/16 x 24 1/16 in. (50.9 x 61.1 cm.) irregular
Signed, center print verso: "Carl Mydans"
Inscription, print verso: "Noon Day Speaker/Wall and Broad
Streets, N.Y.C./1936//(my neg)//P." and rubber stamps
"PHOTO BY/CARL MYDANS//CM"
Acquired from: gift of the photographer

3813. U.S. MARINES PASS A BURNING KOREAN VILLAGE
IN THE RAIN. 1950 [from "Carl Mydans: A
Photojournalist's Journey Through War and Peace"]
(P1985.27.122)
Gelatin silver print. negative 1950, print 1985
Image: 11 7/8 x 17 in. (30.2 x 43.2 cm.)
Sheet: 12 x 17 1/16 in. (30.5 x 43.3 cm.)
Signed, center print verso: "Carl Mydans"
Inscription, print verso: "#33923/C-4/17//U.S. Marines/
Korean War/1950//P" and rubber stamps "PHOTO BY/
CARL MYDANS//CM"
Acquired from: gift of Time Inc., New York, New York

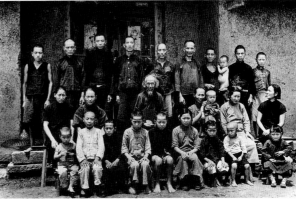

3805

3814. **VICE-PRESIDENT JOHN NANCE GARNER IN HIS OFFICE IN THE CAPITOL. WASHINGTON, D.C., 1939** [from "Carl Mydans: A Photojournalist's Journey Through War and Peace"] (P1985.27.82)
Gelatin silver print. negative 1939, print 1985
Image: 29 15/16 x 20 1/16 in. (76.1 x 50.9 cm.)
Signed, center print verso: "Carl Mydans"
Inscription, print verso: "Vice President Garner/Washington 1939//4598/C-1/34//P." and rubber stamps "PHOTO BY/CARL MYDANS//CM"
Acquired from: gift of Time Inc., New York, New York

*3815. **VICTIM OF THE HIROSHIMA BOMBING IS MEASURED IN A JAPANESE-AMERICAN STUDY OF THE EFFECTS OF NUCLEAR CONTAMINATION. 1949** [from "Carl Mydans: A Photojournalist's Journey Through War and Peace"] (P1985.27.116)
Gelatin silver print. negative 1949, print 1985
Image: 13 11/16 x 14 1/16 in. (34.7 x 35.7 cm.)
Sheet: 14 x 14 1/16 in. (35.6 x 35.7 cm.)
Signed, l. r. print verso: "Carl Mydans"
Inscription, print verso: "30692/R5//Hiroshima/4 years after/1949//#30692/R-5//P" and rubber stamps "PHOTO BY/CARL MYDANS//CM"
Acquired from: gift of Time Inc., New York, New York

3808

3816. **VILLAGERS IN FAR WESTERN CHINA IN 1941 VIEW FOREIGNERS WITH SUSPICION** [from "Carl Mydans: A Photojournalist's Journey Through War and Peace"] (P1985.27.42)
Gelatin silver print. negative 1941, print 1985
Image: 20 1/16 x 29 15/16 in. (50.9 x 76.1 cm.)
Signed, center print verso: "Carl Mydans"
Inscription, print verso: "8306/C-24/29//THREE amazed men at/Village Table/ChungKing 1941//P." and rubber stamps "PHOTO BY/CARL MYDANS//CM"
Acquired from: gift of Time Inc., New York, New York

*3817. **VLADIMIR NABOKOV, NOVELIST AND LEPIDOPTERIST, IN ITHACA, NEW YORK. 1958** [from "Carl Mydans: A Photojournalist's Journey Through War and Peace"] (P1985.27.90)
Gelatin silver print. negative 1958, print 1985
Image: 19 9/16 x 13 11/16 in. (49.7 x 34.7 cm.)
Sheet: 19 15/16 x 14 in. (50.7 x 35.6 cm.)
Signed, center print verso: "Carl Mydans"
Inscription, print verso: "55103/C13-1/1//Valdimir [sic] Nabokov/at Ithaca/1958//P//[illegible]" and rubber stamps "PHOTO BY/CARL MYDANS//CM"
Acquired from: gift of Time Inc., New York, New York

3815

*3818. **VOLUNTEER FIRE BRIGADE OF LUNG CHUAN-I VILLAGE POSES WITH THEIR WATER PUMP. 1941** [from "Carl Mydans: A Photojournalist's Journey Through War and Peace"] (P1985.27.60)
Gelatin silver print. negative 1941, print 1985
Image: 19 5/8 x 15 3/4 in. (49.8 x 40.0 cm.)
Sheet: 20 x 16 1/16 in. (50.8 x 40.8 cm.)
Signed, bottom center print verso: "Carl Mydans"
Inscription, print verso: "8433/R-71//Village Fire Department/Lung Chuan-i ~~Village~~/1941//P" and rubber stamps "PHOTO BY/CARL MYDANS//CM"
Acquired from: gift of Time Inc., New York, New York

3819. **WALL STREET "CHAIN GANG" CARRIES SECURITIES FROM THE STOCK EXCHANGE TO BANKS IN NEW YORK CITY. 1937** [from "Carl Mydans: A Photojournalist's Journey Through War and Peace"] (P1985.27.11)
Gelatin silver print. negative 1937, print 1985
Image: 20 x 25 7/8 in. (50.8 x 65.7 cm.)
Signed, center print verso: "Carl Mydans"
Inscription, print verso: "Chain Gang/Wall Street/Spring 1937/(my negative)//P" and rubber stamps "PHOTO BY/CARL MYDANS//CM"
Acquired from: gift of the photographer

3820. **WALTER LIPPMANN, SAGE AND COLUMNIST, IN HIS WASHINGTON, D.C., HOME. 1964 [from "Carl Mydans: A Photojournalist's Journey Through War and Peace"]** (P1985.27.68)
Gelatin silver print. negative 1964, print 1985
Image: 22 1/16 x 19 7/8 in. (56.0 x 50.5 cm.)
Sheet: 22 1/16 x 20 1/16 in. (56.0 x 50.9 cm.)
Signed, l.r. print verso: "Carl Mydans"
Inscription, print verso: "#71671/4C1-24//Walter Lippman [sic]/in Washington Home/1964//P//CM" and rubber stamps "PHOTO BY/CARL MYDANS//CM"
Acquired from: gift of Time Inc., New York, New York

3821. **A WHITEFACE STEER CHARGES THE PHOTOGRAPHER NEAR GALLAGHER RANCH, TEXAS. 1937 [from "Carl Mydans: A Photojournalist's Journey Through War and Peace"]** (P1985.27.23)
Gelatin silver print. negative 1937, print 1985
Image: 20 1/16 x 29 3/4 in. (50.9 x 75.6 cm.)
Signed, center print verso: "Carl Mydans"
Inscription, print verso: "Whiteface charging/Texas 1937// (my negative)//P//P" and rubber stamps "PHOTO BY/ CARL MYDANS//CM"
Acquired from: gift of Time Inc., New York, New York

3822. **A WIFE AND CHILDREN FIND THEIR DEAD AFTER A BLOODY UPRISING IN YOSU, KOREA, IN 1948 [from "Carl Mydans: A Photojournalist's Journey Through War and Peace"]** (P1985.27.119)
Gelatin silver print. negative 1948, print 1985
Image: 21 13/16 x 14 3/4 in. (55.4 x 37.4 cm.) irregular
Sheet: 22 1/8 x 15 1/16 in. (56.2 x 38.2 cm.)
Signed, l.r. print verso: "Carl Mydans"
Inscription, print verso: "#27911/C-5/26//Korean uprising/in South/1948//P" and rubber stamps "PHOTO BY/CARL MYDANS//CM"
Acquired from: gift of Time Inc., New York, New York

3823. **WOUNDED FILIPINA WOMEN ARE CARRIED TO A FIELD HOSPITAL IN A MAKESHIFT AMBULANCE DURING THE FIGHT FOR MANILA. 1945 [from "Carl Mydans: A Photojournalist's Journey Through War and Peace"]** (P1985.27.104)
Gelatin silver print. negative 1945, print 1985
Image: 19 15/16 x 29 7/8 in. (50.7 x 75.9 cm.)
Signed, l.r. print verso: "Carl Mydans"
Inscription, print verso: "17030/C-4/35//Street battles/ Manila/1945//P" and rubber stamps "PHOTO BY/CARL MYDANS//CM"
Acquired from: gift of Time Inc., New York, New York

*3824. **A YOUNG FRENCHMAN CONVICTED OF COLLABORATION WITH THE GERMANS IS TIED TO A STAKE IN GRENOBLE, FRANCE. SEPTEMBER, 1944 [from "Carl Mydans: A Photojournalist's Journey Through War and Peace"]** (P1985.27.94)
Gelatin silver print. negative 1944, print 1985
Image: 26 x 18 9/16 in. (66.0 x 47.1 cm.) irregular
Signed, center print verso: "Carl Mydans"
Inscription, print verso: "#15877/C-1//Execution unfaithful Youth/on liberation of City from Germans/Grenoble, France/August 1944//P" and rubber stamps "PHOTO BY/ CARL MYDANS//CM"
Acquired from: gift of Time Inc., New York, New York

3825. **YOUNG MEN OF THE CIVILIAN CONSERVATION CORPS WORK ON A CONSTRUCTION DETAIL IN PRINCE GEORGES COUNTY, MARYLAND. 1936 (FARM SECURITY ADMINISTRATION PHOTOGRAPH) [from "Carl Mydans: A Photojournalist's Journey Through War and Peace"]** (P1985.27.14)
Gelatin silver print. negative 1936, print 1985
Image: 20 x 29 1/16 in. (50.8 x 73.8 cm.)
Signed, l.r. print verso: "Carl Mydans"
Inscription, print verso: "FSA//USF-33/FSA 00115//CCCorp workers/Prince George [sic] Md/NOV 1936//P" and rubber stamps "PHOTO BY/CARL MYDANS//CM"
Acquired from: gift of the photographer

JOAN MYERS, American (b. 1944)

Myers received a master's degree in musicology from Stanford University in 1966 but turned to a career in photography during the early 1970s. She is primarily a southwestern landscape photographer who works with nonsilver processes because of their warm color and texture. Many of her photographs are printed using platinum or palladium processes, some with hand-applied color. In 1982 Myers received a grant from the National Endowment for the Humanities and the Museum of New Mexico to photograph along the Santa Fe Trail. In 1983 she began to photograph Japanese relocation camps from the 1940s.

*3826. **AZTEC, NEW MEXICO [from the portfolio "New Mexico Landscapes"]** (P1983.38.6)
Palladium print. negative 1979, print 1983
Image: 9 5/8 x 7 3/8 in. (24.4 x 18.7 cm.)
Signed, l.r. print verso: "© Joan Myers 1983"
l.r. mat backing recto: "Joan Myers"
Inscription, print verso: "14/25///n 1979/Aztec, New Mexico/ palladium"
Acquired from: Portfolio Editions, Oklahoma City, Oklahoma

3827. **CHIMAYO, NEW MEXICO [from the portfolio "New Mexico Landscapes"]** (P1983.38.5)
Palladium print. negative 1979, print 1983
Image: 7 9/16 x 9 3/16 in. (19.1 x 23.3 cm.)
Signed, l.r. print verso: "© Joan Myers, 1983"
l.r. mat backing recto: "Joan Myers"
Inscription, print verso: "14/15///n1979/Chimayo, N. M./ palladium"
Acquired from: Portfolio Editions, Oklahoma City, Oklahoma

3828. **WHITE SANDS** (P1981.62)
Palladium print. 1980
Image: 12 3/16 x 10 in. (31.0 x 25.4 cm.)
Sheet: 18 1/2 x 13 13/16 in. (47.0 x 35.1 cm.)
Signed, l.r. print recto: "Joan Myers, 1980"
l.r. print verso: "© Joan Myers 1980"
Inscription, print recto: "White Sands"
print verso: "P 1980"
Acquired from: the photographer

NEW MEXICO LANDSCAPES (P1983.38.1–12)

This portfolio, which includes the work of six New Mexico photographers, was published in 1983 by Portfolio Editions of Oklahoma City, Oklahoma. Each photographer contributed two prints. This is number 14 of an edition of 25 portfolios. Full information on the individual prints is listed by print title under the photographer's name.

Paul Caponigro, NEW MEXICO LANDSCAPE (P1983.38.1)
Paul Caponigro, ENCHANTED MESA, ACOMA, NEW MEXICO (P1983.38.2)
William Clift, CACTUS, SANTA FE RIVER GORGE, NEW MEXICO (P1983.38.3)
William Clift, SNOW, SANDIA FOOTHILLS, NEW MEXICO (P1983.38.4)
Joan Myers, CHIMAYO, NEW MEXICO (P1983.38.5)
Joan Myers, AZTEC, NEW MEXICO (P1983.38.6)
Bernard Plossu, CHIMAYO, NEW MEXICO (P1983.38.7)
Bernard Plossu, WINTER IN TAOS PUEBLO, NEW MEXICO (P1983.38.8)
Edward Ranney, BANDELIER, NEW MEXICO (P1983.38.9)
Edward Ranney, LLANO, NEW MEXICO (P1983.38.10)
Ted Rice III, TREE, WHITE SANDS, NEW MEXICO (P1983.38.11)
Ted Rice III, STREAM, ROCKS, AGUIRRE SPRINGS, NEW MEXICO (P1983.38.12)

3817

3818

3824

3826

BEAUMONT NEWHALL, American (b. 1908)

Beaumont Newhall pioneered the field of photographic history. He received an A.B. in fine arts and an M.A. from Harvard University, also studying at the Institut d'Art et d'Archéologie at the University of Paris and the Courtauld Institute of Art at the University of London. Newhall was the first curator of photography at both the Museum of Modern Art in New York and the International Museum of Photography at the George Eastman House; he later became director of the IMP. From 1971 to 1985 he taught art history at the University of New Mexico, where his work helped establish the school as an important center for photographic education. Newhall has received numerous honors and awards, including two Guggenheim Fellowships (1947 and 1975), the Kulturpreis from the Deutsche Gesellschaft für Photographie (1970), the Progress Medal from the Royal Photographic Society of Great Britain (1975), honorary doctorates from Harvard University (1978) and the State University of New York (1986), the New Mexico Governor's Art Award (1983), and the Peer Award, Distinguished Career in Photography from the Friends of Photography (1985). His books include the landmark *History of Photography*, *Masters of Photography*, *The Daguerreotype in America*, and *Photography: Essays and Images*, as well as monographs on Frederick E. Evans, T. H. O'Sullivan, William Henry Jackson, and Edward Weston. Although Newhall has photographed throughout his career, he did not begin exhibiting his own photographs until 1978. His work has appeared in exhibitions throughout the United States and in Austria, Japan, and Brazil.

*3829. **EDWARD WESTON'S KITCHEN [from the Santa Fe Center for Photography, "Portfolio II"]** (P1984.4.1)
Gelatin silver print. negative 1940, print c. 1983 by David Scheinbaum
Image: 10⅝ x 8⅜ in. (27.0 x 21.2 cm.)
Sheet: 13⅞ x 10¹⁵⁄₁₆ in. (35.2 x 27.7 cm.)
Signed, l.r. print verso: "Beaumont Newhall"
Acquired from: Santa Fe Center for Photography, Santa Fe, New Mexico

NICHOLAS NIXON, American (b. 1947)

Nicholas Nixon was born in Detroit and received a B.A. from the University of Michigan in 1969 and an M.A. from the University of New Mexico in 1974. He was a volunteer with VISTA from 1969 to 1970 and a freelance architectural photographer and teacher from 1970 to 1973. Nixon has taught at the Massachusetts College of Art in Boston since 1974 and continues to make freelance photographs. He received National Endowment for the Arts Photography Fellowships in 1976, 1980, and 1987 and Guggenheim Fellowships in 1977 and 1986. He also was named as the Friends of Photography's Photographer of the Year for 1988.

*3830. **CHELSEA, MASSACHUSETTS** (P1983.43.1)
Gelatin silver print. 1981
Image: 7¹¹⁄₁₆ x 9¹¹⁄₁₆ in. (19.5 x 24.6 cm.)
Sheet: 8 x 10 in. (20.3 x 25.4 cm.)
Signed, l.r. print verso: "Nicholas Nixon"
Inscription, print verso: "Chelsea, Massachusetts 1981// NN·237·Y"
Acquired from: Fraenkel Gallery, San Francisco, California

3831. **YAZOO CITY, MISSISSIPPI** (P1983.43.2)
Gelatin silver print. 1979
Image: 7¹¹⁄₁₆ x 9¹¹⁄₁₆ in. (19.6 x 24.6 cm.)
Sheet: 8 x 10 in. (20.3 x 25.4 cm.)
Signed, l.r. print verso: "Nicholas Nixon"
Inscription, print verso: "Yazoo City, Mississippi 1979// NN·225·Y"
Acquired from: Fraenkel Gallery, San Francisco, California

ANNE NOGGLE, American (b. 1922)

Noggle is an Illinois native who came to New Mexico after a career as an Air Force pilot. She received a B.F.A. in art history and a master's in photography from the University of New Mexico, where she continues to teach part-time. From 1970 to 1976 she was Curator of Photography at the Fine Arts Museum of New Mexico; she received National Endowment for the Arts fellowships in 1975 and 1978. Noggle is a portrait photographer; her work focuses on images of older women, documenting the process of aging. Her book, *For God, Country, and the Thrill of It: Women Air Force Service Pilots in World War II*, appeared in 1990, and the related exhibition, organized by the Amon Carter Museum, traveled in 1991–93.

*3832. **LAURA GILPIN** (P1979.96)
Gelatin silver print. 1978
Image: 11¼ x 16¹⁄₁₆ in. (28.6 x 40.8 cm.)
Sheet: 14 x 16¹⁵⁄₁₆ in. (35.6 x 43.0 cm.)
Signed, l.r. sheet recto: "Anne Noggle"
Inscription, sheet recto: "Laura Gilpin, 1978"
Acquired from: gift of the photographer

GUSTAF NILS ADOLF NORDENSKIÖLD, Swedish (1868–1895)

Nordenskiöld, the second child in a prominent family of Swedish Finns, was interested in natural history from an early age, particularly mineralogy and the lepidoptera. After completing his studies at the University of Uppsala in 1890, he joined an archaeological expedition to study the Spitzbergen glaciers in the Arctic. Nordenskiöld was the photographer for the expedition, and he identified his photographs so succinctly that later researchers could locate their cameras at the same positions in order to record the movement of the ice sheets. Nordenskiöld developed tuberculosis upon his return from the Arctic and spent from December 1890 to February 1891 convalescing in Berlin. Afterward he traveled to Munich, Rome, Naples, and Paris before sailing to the United States. In the U.S. Nordenskiöld visited New York, Washington, Charleston, Mammoth Cave, Chicago, and Denver. He spent two months in archaeological work at the recently discovered ruins of cliff dwellings near Mesa Verde in southwestern Colorado, sending for his view camera to photograph them. The existence of about 50 cellulose negatives of the Mesa Verde ruins and a later trip to the Grand Canyon suggests that he may have borrowed a camera to use until his view camera arrived. After his stay in Mesa Verde, Nordenskiöld traveled to Ute Mountain Indian Reservation and then on to the Grand Canyon. On this trip, he stopped in Walpi, where he photographed a dance. Nordenskiöld returned to Sweden in late 1891; an archaeological report of his excavation at Mesa Verde was published in 1893 and was printed in both Swedish and English. Soon after that, Nordenskiöld's health deteriorated, and he died in June 1895.

RUINER AF KLIPPBONINGAR I, MESA VERDE'S CAÑONS (P1983.34.1–9)

This volume, published in Stockholm by P. A. Norstedt & Söners in 1893, is an account of Nordenskiöld's archaeological expedition made during the summer and autumn of 1891. The report is illustrated with his photographs, a number of which are reproduced as photogravures.

3833. **THE KODAK HOUSE** (P1983.34.1)
Photogravure. negative 1891, gravure by Librairies-
Imprimeries Réunies, Paris, published 1893
Image: 7 3/8 x 9 1/2 in. (18.7 x 24.1 cm.)
Sheet: 10 3/4 x 14 3/8 in. (27.3 x 36.5 cm.)
Signed: see inscription
Inscription, sheet recto, printed: "G. Nordenskiöld:
Klippboningar//I//THE KODAK HOUSE"
Acquired from: William Reese Co., New Haven, Connecticut

3834. **RUIN 11, MOUNTAIN SHEEP CAÑON** (P1983.34.2)
Photogravure. negative 1891, gravure by Librairies-
Imprimeries Réunies, Paris, published 1893
Image (two prints on one sheet):
 a) 7 9/16 x 4 1/2 in. (19.2 x 11.4 cm.)
 b) 7 9/16 x 4 1/2 in. (19.2 x 11.4 cm.)
Sheet: 10 3/4 x 14 3/8 in. (27.3 x 36.5 cm.)
Signed: see inscription
Inscription, sheet recto, printed: "G. Nordenskiöld:
Klippboningar//V//1//2//RUIN 11, MOUNTAIN SHEEP
CAÑON"
Acquired from: William Reese Co., New Haven, Connecticut

3835. **RUIN 18, MOUNTAIN SHEEP CAÑON** (P1983.34.3)
Photogravure. negative 1891, gravure by Librairies-
Imprimeries Réunies, Paris, published 1893
Image (two prints on one sheet):
 a) 7 5/8 x 4 1/2 in. (19.4 x 11.4 cm.)
 b) 7 5/8 x 4 1/2 in. (19.4 x 11.4 cm.)
Sheet: 10 3/4 x 14 3/8 in. (27.3 x 36.5 cm.)
Signed: see inscription
Inscription, sheet recto, printed: "G. Nordenskiöld:
Klippboningar//VI//1//2//RUIN 18, MOUNTAIN SHEEP
CAÑON"
Acquired from: William Reese Co., New Haven, Connecticut

3836. **THE SPRING HOUSE** (P1983.34.4)
Photogravure. negative 1891, gravure by Librairies-
Imprimeries Réunies, Paris, published 1893
Image: 9 7/16 x 7 7/16 in. (24.0 x 18.9 cm.)
Sheet: 14 3/8 x 10 3/4 in. (36.5 x 27.3 cm.)
Signed: see inscription
Inscription, sheet recto, printed: "G. Nordenskiöld:
Klippboningar//VIII//THE SPRING HOUSE"
Acquired from: William Reese Co., New Haven, Connecticut

3837. **THE SPRUCE TREE HOUSE** (P1983.34.5)
Photogravure. negative 1891, gravure by Librairies-
Imprimeries Réunies, Paris, published 1893
Image (two prints on one sheet):
 a) 4 1/2 x 7 in. (11.4 x 17.8 cm.)
 b) 4 1/2 x 7 5/8 in. (11.4 x 19.3 cm.)
Sheet: 14 3/8 x 10 3/4 in. (36.5 x 27.3 cm.)
Signed: see inscription
Inscription, sheet recto, printed: "G. Nordenskiöld:
Klippboningar//X//1//2//THE SPRUCE TREE HOUSE"
Acquired from: William Reese Co., New Haven, Connecticut

3838. **THE CLIFF PALACE** (P1983.34.6)
Photogravure. negative 1891, gravure by Librairies-
Imprimeries Réunies, Paris, published 1893
Image: 7 1/2 x 9 1/2 in. (19.0 x 24.1 cm.)
Sheet: 10 3/4 x 14 3/8 in. (27.3 x 36.5 cm.)
Signed: see inscription
Inscription, sheet recto, printed: "G. Nordenskiöld:
Klippboningar//XII//THE CLIFF PALACE"
Acquired from: William Reese Co., New Haven, Connecticut

3829

3830

3832

*3839. **THE CLIFF PALACE** (P1983.34.7)
Photogravure. negative 1891, gravure by Librairies-
Imprimeries Réunies, Paris, published 1893
Image: 7 7/16 x 18 5/16 in. (18.8 x 46.5 cm.)
Sheet: 14 3/8 x 20 15/16 in. (36.5 x 53.2 cm.)
Signed: see inscription
Inscription, sheet recto, printed: "G. Nordenskiöld:
Klippboningar.//XIII//THE CLIFF PALACE"
Acquired from: William Reese Co., New Haven, Connecticut

3840. **THE BALCONY HOUSE** (P1983.34.8)
Photogravure. negative 1891, gravure by Librairies-
Imprimeries Réunies, Paris, published 1893
Image: 7 7/16 x 9 1/2 in. (18.8 x 24.1 cm.)
Sheet: 10 3/4 x 14 3/8 in. (27.3 x 36.5 cm.)
Signed: see inscription
Inscription, sheet recto, printed: "G. Nordenskiöld:
Klippboningar//XIV//THE BALCONY HOUSE"
Acquired from: William Reese Co., New Haven, Connecticut

*3841. **THE BALCONY HOUSE** (P1983.34.9)
Photogravure. negative 1891, gravure by Librairies-
Imprimeries Réunies, Paris, published 1893
Image: 7 7/16 x 9 7/16 in. (18.8 x 24.0 cm.)
Sheet: 10 3/4 x 14 3/8 in. (27.3 x 36.5 cm.)
Signed: see inscription
Inscription, sheet recto, printed: "G. Nordenskiöld:
Klippboningar//XV//THE BALCONY HOUSE"
Acquired from: William Reese Co., New Haven, Connecticut

DOROTHY NORMAN, American (b. 1905)

Dorothy Norman, a native of Philadelphia, is an
accomplished writer and photographer. During the
1930s she worked with Alfred Stieglitz at his gallery,
An American Place. Stieglitz published a volume of
Norman's poems in 1933. Norman coedited and contrib-
uted to the book *America and Alfred Stieglitz* in 1934.
Norman's photographs have been exhibited at the
Museum of Modern Art, New York; the George East-
man House, Rochester; the Los Angeles Museum,
the San Francisco Museum, and the Philadelphia
Museum of Art, among others. During her career,
Norman has remained active in a number of civic
and cultural organizations.

*3842. **ALFRED STIEGLITZ—HANDS** (P1983.5.3)
Gelatin silver print. c. 1930s
Image: 3 3/8 x 2 7/16 in. (8.5 x 6.2 cm.)
Mount: 14 x 11 in. (35.6 x 28.0 cm.)
Signed, l.l. mount verso: "Dorothy Norman"
Inscription, mount verso: "Alfred Stieglitz—Hands/1930s//
Variant of/DN69" and rubber stamp "ORIGINAL BY/
DOROTHY NORMAN"
Acquired from: Houk Gallery, Chicago, Illinois

3843. **ALFRED STIEGLITZ IN CAPE—AN AMERICAN
PLACE** (P1983.5.4)
Gelatin silver print. c. 1930s
Image: 3 1/2 x 2 5/8 in. (9.0 x 6.7 cm.)
1st mount: same as image size
2nd mount: 14 x 11 in. (35.6 x 28.0 cm.)
Signed, l.l. 2nd mount verso: "Dorothy Norman"
Inscription, 2nd mount verso: "[Portrait of] Alfred Steiglitz
[sic] in Cape—/An American Place—1930's//DN-U12/82"
and rubber stamp "ORIGINAL BY/DOROTHY
NORMAN"
Acquired from: Houk Gallery, Chicago, Illinois

*3844. **AN AMERICAN PLACE—TELEPHONE AND
EQUIVALENT** (P1983.5.1)
Gelatin silver print. c. 1930s
Image: 3 13/16 x 2 9/16 in. (9.7 x 6.5 cm.)
Mount: 14 x 11 in. (35.6 x 28.0 cm.)

Signed, l.l. mount verso: "Dorothy Norman"
Inscription, mount verso: "An American Place—/Telephone
and Equivalent//U16/DN82" and rubber stamp
"ORIGINAL BY/DOROTHY NORMAN"
Acquired from: Houk Gallery, Chicago, Illinois

3845. **EXTERIOR MOMA—STIEGLITZ EXHIBIT** (P1983.5.2)
Gelatin silver print. 1947
Image: 3 3/4 x 2 7/8 in. (9.5 x 7.3 cm.)
1st mount: same as image size
2nd mount: 8 11/16 x 6 7/8 in. (22.1 x 17.5 cm.)
Signed, bottom center 2nd mount verso and l.l. mat backing
verso: "Dorothy Norman"
Inscription, 2nd mount verso: "Exterior MOMA—Stieglitz
Exhibit/Summer 1947//AC11/MH" and rubber stamp
"ORIGINAL BY/DOROTHY NORMAN"
mat backing verso: "Exterior MOMA—Stieglitz Exhibit/
Summer 1947///AC 11" and rubber stamp "ORIGINAL BY/
DOROTHY NORMAN"
Acquired from: Houk Gallery, Chicago, Illinois

WILLIAM C. NORTH (1814–1890)

Active in Cleveland and Dayton, Ohio, North began
making daguerreotypes about 1852 but switched to
ambrotypes about 1860. In 1863 he began a two-year
partnership with Christian F. Schwerdt. Edward H.
Stein became North's partner in 1879 and took over
the studio when North retired in 1880.

Attributed to William C. North
*3846. **[Woman holding riding crop]** (P1970.67.1)
Daguerreotype, quarter-plate. c. 1853–54
Image: 4 1/4 x 3 3/16 in. (10.8 x 8.1 cm.)
Case: 5 1/16 x 4 1/4 in. (12.9 x 10.7 cm.)
Signed: see inscription
Inscription, mat recto, stamped: "Wm C. NORTH/
CLEVELAND, O."
Acquired from: Caroline Smurthwaite, Phoenix, Arizona

SONYA NOSKOWIAK,
American, born Germany (1900–1975)

Sonya Noskowiak was born in Leipzig, Germany, and
spent her childhood in Chile. In 1915 her family moved
to California. Noskowiak was interested in photogra-
phy at an early age and was working as a receptionist
in Johan Hagemeyer's studio when she met Edward
Weston. Encouraged by Weston, she studied photogra-
phy with him and worked as his darkroom assistant
from 1929 to 1934. The sharply focused style of pho-
tography suited Noskowiak's landscape photographs,
and she was one of the founding members of Group
f/64. Her work in Group f/64's first exhibition in 1932
emphasized the forms, patterns, and textures of natural
objects. Noskowiak continued photographing land-
scapes and still lifes, but also began making portraits.
In 1935 she opened her own studio; her commercial
work included portrait, fashion, and architectural
photography. The Center for Creative Photography
mounted a retrospective exhibition of Noskowiak's
work in 1978.

3847. **[Chambered nautilus]** (P1985.31)
Gelatin silver print. 1937
Image: 7 5/8 x 9 9/16 in. (19.3 x 24.3 cm.)
Mount: 14 x 18 in. (35.6 x 45.7 cm.)
Signed, l.r. mount recto: "Sonya Noskowiak 1937"
Acquired from: Paul Hertzmann, San Francisco, California

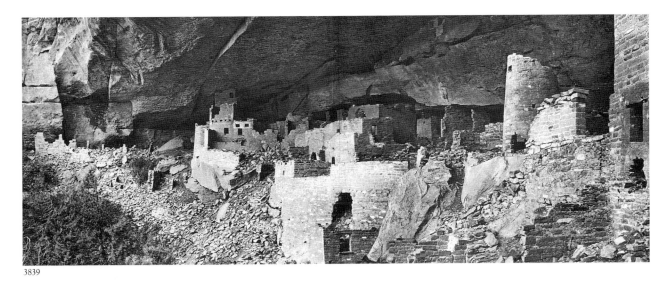

3839

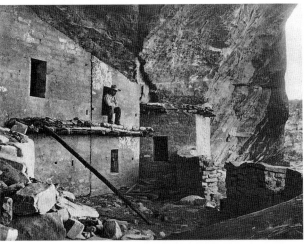

3841

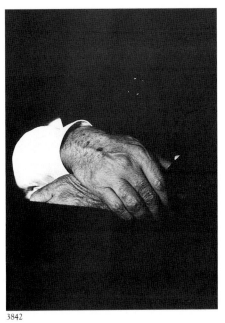

3842

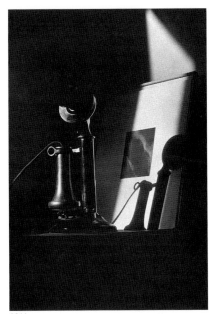

3844

3846

WILLIAM NOTMAN
Canadian, born Scotland (1826–1891)

One of Canada's best-known photographers, Notman settled in Montreal in 1856. His studio made portraits of many well-known individuals as well as of Indians, trappers, and traders. Notman also made landscape views and, in later years, sent photographers throughout Canada to make views for his firm. He frequently made composite views in which individual photographic elements were placed against a background and the entire scene copied, and he also photographed scenic dioramas constructed in his studio. Notman's company was quite large and, as with Mathew Brady, not all of the images bearing the Notman logo were actually made by him.

*3848. [Niagara Falls] (P1982.34)
Albumen silver print. 1860
Image: 16 3/16 x 20 5/8 in. (41.1 x 52.3 cm.)
Mount: 21 1/4 x 28 15/16 in. (54.0 x 73.5 cm.)
Inscription, mount verso: "#39"
Acquired from: Fraenkel Gallery, San Francisco, California

ARTHUR OLLMAN, American (b. 1947)

Arthur Ollman was born in Milwaukee, Wisconsin. He received his B.A. in art history from the University of Wisconsin and his M.F.A. in photography from Lone Mountain College, San Francisco. He has also studied at Columbia College, Chicago, the San Francisco Art Institute, and the Visual Studies Workshop, Rochester. From 1975 to 1977 Ollman founded, ran, and produced "Photo History Video," a project on the older generation of photographers in the American West. In 1976 he was a founding member of the Board of Directors of Camerawork, a San Francisco gallery, and in 1978–80 served as president of the Board. Ollman is known for his color work, especially night photography and experimentation with long exposures. He is also a curator and teacher; he has received several National Endowment for the Arts grants for research in the history of photography as well as for his own work.

3849. UNTITLED [Golden Gate Bridge silhouetted by beacon lights] (P1983.27)
C-41 color print. negative 1979, print 1983
Image: 8 13/16 x 13 1/4 in. (22.3 x 33.7 cm.)
Sheet: 11 1/16 x 14 1/16 in. (28.1 x 35.7 cm.)
Signed, l.r. print verso: "Arthur Ollman 1979"
Acquired from: Friends of Photography, Carmel, California; gift print with sustaining membership, 1982

JOEL ORENT, American (b. 1930)

Orent, a native of Massachusetts, is an ordained rabbi and holds advanced degrees in business administration, Hebrew literature, and English literature. Among his photographic mentors are Ansel Adams, John Howard Griffin, Eliot Porter, and Clara Sipprell, whom Orent credits with having taught him to love the art and science of modern photography. Orent's photographs have been exhibited in the United States, Canada, Wales, Scotland, Belgium, and Israel. In 1976 he published My Enlightening Heart, containing portraits and landscapes made during an earlier trip to Israel.

3850. [Clara Estelle Sipprell] (P1984.1.274)
Gelatin silver print. negative c. 1970, print 1970
Image: 12 1/2 x 8 11/16 in. (31.8 x 22.1 cm.)
Mount: 19 15/16 x 16 in. (50.6 x 40.6 cm.)
Signed, l.r. mount recto: "Orent"
Inscription, mount verso: "[inscription in Hebrew: 12 late August 1970/with the blessing of peace]/13 September 1970/ For my friend and teacher in photography & the Spirit/ Clara Sipprell/with the Blessing of Peace/]/Joel Orent// OB2"
Acquired from: gift of the Dorothea Leonhardt Fund of the Communities Foundation of Texas, Inc., Dallas, Texas

RUTH ORKIN, American (1921–1985)

Fascinated by the movies as a young woman, Ruth Orkin had hoped to become a cinematographer, but after discovering that there were no women members of the union, she moved to New York to begin a career as a freelance photojournalist. Her photographs have appeared in magazines such as Life, Look, Ladies' Home Journal, and Cosmopolitan. In 1952, Orkin married photographer and filmmaker Morris Engel. Over the next three years they made films such as The Little Fugitive (1952) and Lovers and Lollipops (1954–55). In 1955 Orkin's "The Cardplayers" appeared in "The Family of Man" exhibition at the Museum of Modern Art. The six-photograph sequence of children playing cards was the only sequence included in the show. In 1950 Orkin began photographing from her apartment window, a practice she continued as she moved. The resulting candid images of daily activities were published in the books A World Through My Window (1978) and More Pictures from My Window (1983). In 1981, Orkin published her autobiography, A Photo Journalist.

3851. EINSTEIN AT PRINCETON, N.J. (P1986.39.1)
Gelatin silver print. 1953
Image: 17 5/16 x 13 1/2 in. (43.9 x 34.3 cm.)
Mount: 20 x 16 in. (50.8 x 40.7 cm.)
Signed, l.r. mount recto: "Ruth Orkin"
Inscription, mount verso: "EINSTEIN AT PRINCETON, N.J."
Acquired from: gift of Kurt and Paulette Olden, New York, New York

3852. FLOATING [#5 Balloon; from the series "A World Through My Window"] (P1986.39.8)
Type C color print. 1969
Image: 9 5/8 x 13 1/4 in. (24.4 x 33.6 cm.)
Signed, bottom center print verso and l.r. old mount recto: "© Ruth Orkin"
Inscription, print verso: "#5 Balloon 1969" old mount recto: "#5//"Floating"//CARTER CAMPAIGN—N.Y.C." and rubber stamp "Ruth Orkin/65 Central Park West/N.Y.C., N.Y. 10023"
Acquired from: gift of Kurt and Paulette Olden, New York, New York

3853. GIRL IN ITALY—FLORENCE [American Girl in Italy— Florence] (P1986.39.2)
Gelatin silver print. 1951
Image: 9 1/4 x 13 3/4 in. (23.4 x 35.0 cm.)
Sheet: 10 3/4 x 13 15/16 in. (27.3 x 35.4 cm.)
Signed, l.r. print verso and l.r. old mount recto: "Ruth Orkin"
Inscription, print verso: ""Girl in Italy"—Florence, 1951" old mount recto: ""Girl in Italy"...Florence, 1951"
Acquired from: gift of Kurt and Paulette Olden, New York, New York

*3854. MIST [The Mist, Central Park; from the series "A World Through My Window"] (P1986.39.7)
Type C color print. c. 1960s
Image: 9 x 13 %₆ in. (22.9 x 34.5 cm.)
Sheet: 11 x 14 in. (28.0 x 35.6 cm.)
Signed, bottom center print verso and l.r. old overmat recto: "Ruth Orkin"
Inscription, print verso: ""Mist" from the book "A World Through My Window""
 old overmat recto: "The Mist...from "A World Through My Window"...Central Park, 1960's"
Acquired from: gift of Kurt and Paulette Olden, New York, New York

3855. PHILHARMONIC CONCERT [from the series "A World Through My Window"] (P1986.39.6)
Type C color print. 1975
Image: 8 ¾ x 13 ⅞ in. (22.3 x 35.2 cm.)
Signed, bottom center print verso and l.r. old mount recto: "Ruth Orkin"
Inscription, print verso: "Philharmonic Concert, from the book/"A World Through My Window"—Harper & Row 1978"
 old mount recto: "Philharmonic Concert, 1975, from "A World Through My Window.""
Acquired from: gift of Kurt and Paulette Olden, New York, New York

*3856. REFUGEES—JEWISH TEENAGERS FROM IRAQ [Jewish-refugees from Iraq, Lydda Airport, Tel Aviv] (P1986.39.3)
Gelatin silver print. 1951
Image: 10 ⅝ x 13 ½ in. (26.9 x 34.3 cm.)
Sheet: 11 1/16 x 13 15/16 in. (28.0 x 35.4 cm.)
Signed, bottom center print verso and l.r. old mount recto: "Ruth Orkin"
Inscription, print verso: "S//"Refugees"—Jewish Teenagers from Iraq, 1951"
 old mount recto: "Jewish-refugees from Iraqui [sic], Lydda Airport, Tel Aviv, 1951"
Acquired from: gift of Kurt and Paulette Olden, New York, New York

3857. STORM OVER FIFTH AVE. [from the series "A World Through My Window"] (P1986.39.5)
Type C color print. c. 1960s–1978
Image: 8 ⅞ x 13 ⅞ in. (22.6 x 35.2 cm.)
Signed, bottom center print verso and l.r. old mount recto: "Ruth Orkin"
Inscription, print verso: ""A World Through My Window"/ From the Harper & Row book by [signature]"
 old mount recto: "Storm Over Fifth Ave, from "A World Through My Window"......"
Acquired from: gift of Kurt and Paulette Olden, New York, New York

3858. WOODY ALLEN—METROPOLITAN MUSEUM OF ART [Woody Allen at the Met] (P1986.39.4)
Gelatin silver print. 1963
Image: 12 15/16 x 9 15/16 in. (32.8 x 25.2 cm.)
Sheet: 13 11/16 x 11 in. (34.7 x 28.0 cm.)
Signed, bottom center print verso and l.r. old mount recto: "Ruth Orkin"
Inscription, print verso: "Woody Allen—1963/Metropolitan Museum of Art"
 old mount recto: "Woody Allen at the Met, 1963"
Acquired from: gift of Kurt and Paulette Olden, New York, New York

TED ORLAND, American (b. 1941)

Orland, a West Coast photographer, received his B.S. from the University of Southern California, Los Angeles, and his M.A. in interdisciplinary creative arts from San Francisco State University. He has studied with Wynn Bullock, Dave Bohn, and Paul Caponigro

3848

3854

3856

and has worked with Ansel Adams and Charles Eames. Orland was a founding member of the Image Continuum and served as the editor for its journal. He has received several awards and grants, including National Endowment for the Arts awards for his work in Diablo Valley and Volcanos National Park in Hawaii and the first National Park Service artist-in-residence award at Yosemite National Park. Orland also has taught at universities and workshops, and in 1987 he led a photographic tour through the Soviet Union. Orland's work has appeared in numerous individual and group exhibitions. He recently has been working with computerized images.

***3859. MANDIBLE, TRACTUS CONSTRUCTIVUS** (P1983.28.1)
Toned gelatin silver print. negative 1979, print 1983
Image: 8⅜ x 13⅛₆ in. (21.3 x 33.2 cm.)
Mount: 16 x 20 in. (40.7 x 50.8 cm.)
Signed, l.r. mount recto: "Ted Orland"
 top center mount verso: "Ted [rubber stamp: artist's monogram] Orland"
Inscription, mount verso: "mandible, tractus constructivus" and rubber stamp "Photograph by/TED ORLAND"
Acquired from: trade with the photographer

3860. **UNTITLED** [steam vent in Yellowstone National Park; from "Interstate Landscape Series"] (P1983.28.2)
Toned gelatin silver print. negative 1982, print 1983
Image: 9⅝ x 11⅛₆ in. (24.4 x 30.1 cm.)
Sheet: 10⅞ x 13⁹⁄₁₆ in. (27.6 x 34.7 cm.)
Signed, l.r. sheet-recto: "Ted Orland"
 top center mount verso: "Ted [rubber stamp: artist's monogram] Orland"
Inscription, mount verso, rubber stamp: "Photograph by/TED ORLAND"
Acquired from: trade with the photographer

TIMOTHY H. O'SULLIVAN,
American, born Ireland (1840–1882)

See also *Gardner's Photographic Sketch Book of the War* and John Moran

O'Sullivan's family immigrated to the United States in 1842, and he was a young boy when he began working for Mathew Brady. He received his photographic training in the Mathew Brady studio, working for a time under Alexander Gardner. As Brady's assistant he made photographs of early Civil War battles, but in 1862 he left the Brady studio and went to work for Gardner, who had left Brady because of a dispute over attribution of photographs. O'Sullivan worked for Gardner through the close of the Civil War, and several of his photographs were published by the Gardner firm. In 1867 he began a career as an expeditionary photographer, working in 1867–69 for Clarence King's Geological Survey of the Fortieth Parallel. In 1870, when funding for the survey was in doubt, O'Sullivan sailed for the Isthmus of Darien (Panama) with a Navy Department expedition led by Commander Thomas O. Selfridge, Jr., that was looking for a route for an interoceanic canal. O'Sullivan was not able to fully document the operation because of dense jungle vegetation. In 1871 O'Sullivan joined the Wheeler Survey, an exploration of Nevada and Utah commissioned to document the terrain from a military point of view. O'Sullivan returned to the King Survey in 1872, then rejoined Wheeler in 1873 and 1874, his last western expeditions. After returning to Washington, O'Sullivan continued to print negatives from his expedition work and pursued his own commercial business. After several

extremely lean years he was finally appointed Photographer of the Treasury Department in 1880, but only six months later he discovered that he had tuberculosis and died shortly after resigning his post.

3861. **ALPINE LAKE, IN THE SIERRA NEVADA, CALIFORNIA** [from the album "Geographical Explorations and Surveys West of the 100th Meridian—Wheeler Photographs"] (P1982.27.16)
Albumen silver print. 1871
Image: 8 x 10¹³⁄₁₆ in. (20.4 x 27.5 cm.)
Mount: 15⅝ x 19½ in. (39.7 x 49.5 cm.)
Signed: see inscription
Inscription, mount recto, printed: "Explorations in Nevada and Arizona.//WAR DEPARTMENT [emblem] CORPS OF ENGINEERS. U. S. ARMY.//Expedition 1871.—Lieut. Geo. M. Wheeler, Com'd'g.//T. H. O'Sullivan, Phot.//No. 16.//ALPINE LAKE, IN THE SIERRA NEVADA, CALIFORNIA."
Acquired from: Zeitlin and VerBrugge, Los Angeles, California

3862. **ANCIENT RUINS IN THE CAÑON DE CHELLE, N. M. IN A NICHE 50 FEET ABOVE PRESENT CAÑON BED** [from the album "Geographical Explorations and Surveys West of the 100th Meridian—Wheeler Photographs"] (P1982.27.38)
Albumen silver print. 1873
Image: 10⅞ x 8⅛ in. (27.6 x 20.5 cm.)
Mount: 19½ x 15½ in. (49.5 x 39.4 cm.)
Signed: see inscription
Inscription, in negative: "33//[illegible]//[illegible]"
 mount recto, printed: "Geographical & Geological Explorations & Surveys West of the 100th Meridian.//WAR DEPARTMENT [emblem] CORPS OF ENGINEERS. U. S. ARMY.//Expedition of 1873.—Lieut. Geo. M. Wheeler, Corps of Engineers, Commanding.//T. H. O'Sullivan, Phot.//No. 10.//ANCIENT RUINS IN THE CAÑON DE CHELLE, N. M./In a niche 50 feet above present Cañon bed."
Acquired from: Zeitlin and VerBrugge, Los Angeles, California

3863. **APACHE LAKE, SIERRA BLANCA RANGE, ARIZONA** [from the album "Geographical Explorations and Surveys West of the 100th Meridian—Wheeler Photographs"] (P1982.27.31)
Albumen silver print. 1873
Image: 8 x 10⅞ in. (20.4 x 27.6 cm.)
Mount: 15⅝ x 19½ in. (39.7 x 49.5 cm.)
Signed: see inscription
Inscription, in negative: "1"
 mount recto, printed: "Geographical & Geological Explorations & Surveys West of the 100th Meridian.//WAR DEPARTMENT [emblem] CORPS OF ENGINEERS. U. S. ARMY.//Expedition of 1873.—Lieut. Geo. M. Wheeler, Corps of Engineers, Commanding.//T. H. O'Sullivan, Phot.//No. 1.// APACHE LAKE, SIERRA BLANCA RANGE, ARIZONA"
Acquired from: Zeitlin and VerBrugge, Los Angeles, California

***3864. AUSTIN CITY SECTION 1—NA** [Austin City, Nevada] (P1979.89.2)
Albumen silver print. c. 1867
Image: 8¹³⁄₁₆ x 11¼ in. (22.3 x 28.5 cm.)
Sheet: 8¹³⁄₁₆ x 11⁷⁄₁₆ in. (22.3 x 29.1 cm.)
Inscription, print verso: "Austin city Section 1—Na" and illegible rubber stamp
Acquired from: Bryan Furtek, New Haven, Connecticut

*3865. BLACK CAÑON, COLORADO RIVER, FROM CAMP 8,
LOOKING ABOVE [from the album "Geographical
Explorations and Surveys West of the 100th Meridian—
Wheeler Photographs"] (P1982.27.8)
Albumen silver print. 1871
Image: 8 x 10¹³⁄₁₆ in. (20.4 x 27.5 cm.)
Mount: 15¹¹⁄₁₆ x 19½ in. (39.8 x 49.5 cm.)
Signed: see inscription
Inscription, in negative: "8 [illegible]//8"
 mount recto, printed: "Explorations in Nevada and
 Arizona.//WAR DEPARTMENT [emblem] CORPS OF
 ENGINEERS. U. S. ARMY.//Expedition of 1871.—Lieut.
 Geo. M. Wheeler, Com'd'g.//T. H. O'Sullivan, Phot.//
 No. 8.//BLACK CAÑON, COLORADO RIVER, FROM
 CAMP 8, LOOKING ABOVE."
Acquired from: Zeitlin and VerBrugge, Los Angeles,
California

3859

3866. BLACK CAÑON, COLORADO RIVER, LOOKING
ABOVE FROM CAMP 7 [from the album "Geographical
Explorations and Surveys West of the 100th Meridian—
Wheeler Photographs"] (P1982.27.5)
Albumen silver print. 1871
Image: 8⅛ x 10¹⁵⁄₁₆ in. (20.6 x 27.7 cm.)
Mount: 15½ x 19½ in. (39.4 x 49.5 cm.)
Signed: see inscription
Inscription, mount recto, printed: "Explorations in Nevada
 and Arizona.//WAR DEPARTMENT [emblem] CORPS OF
 ENGINEERS. U. S. ARMY.//Expedition of 1871.—Lieut.
 Geo. M. Wheeler, Com'd'g.//T. H. O'Sullivan, Phot.//No.
 5.//BLACK CAÑON, COLORADO RIVER, LOOKING
 ABOVE FROM CAMP 7."
Acquired from: Zeitlin and VerBrugge, Los Angeles,
California

3864

3867. BLACK CAÑON, COLORADO RIVER, LOOKING
ABOVE FROM MIRROR BAR [from the album
"Geographical Explorations and Surveys West of the 100th
Meridian—Wheeler Photographs"] (P1982.27.9)
Albumen silver print. 1871
Image: 8¹⁄₁₆ x 10⅞ in. (20.5 x 27.6 cm.)
Mount: 15¹¹⁄₁₆ x 19½ in. (39.8 x 49.5 cm.)
Signed: see inscription
Inscription, in negative: "9 [reversed]"
 mount recto, printed: "Explorations in Nevada and
 Arizona.//WAR DEPARTMENT [emblem] CORPS OF
 ENGINEERS. U. S. ARMY.//Expedition of 1871.—Lieut.
 Geo. M. Wheeler, Com'd'g.//T. H. O'Sullivan, Phot.//No.
 9.//BLACK CAÑON, COLORADO RIVER, LOOKING
 ABOVE FROM MIRROR BAR."
Acquired from: Zeitlin and VerBrugge, Los Angeles,
California

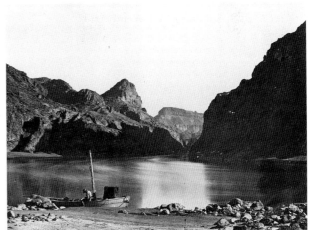

3865

3868. BLACK CAÑON, COLORADO RIVER, LOOKING
BELOW FROM BIG HORN CAMP [from the album
"Geographical Explorations and Surveys West of the 100th
Meridian—Wheeler Photographs"] (P1982.27.4)
Albumen silver print. 1871
Image: 7¹⁵⁄₁₆ x 10¹³⁄₁₆ in. (20.3 x 27.4 cm.)
Mount: 15½ x 19½ in. (39.4 x 49.5 cm.)
Signed: see inscription
Inscription, in negative: "4//7̶1̶"
 mount recto, printed: "Explorations in Nevada and
 Arizona.//WAR DEPARTMENT [emblem] CORPS OF
 ENGINEERS. U. S. ARMY.//Expedition of 1871.—Lieut.
 Geo. M. Wheeler, Com'd'g.//T. H. O'Sullivan, Phot.//No.
 4.//BLACK CAÑON, COLORADO RIVER, LOOKING
 BELOW FROM BIG HORN CAMP."
Acquired from: Zeitlin and VerBrugge, Los Angeles,
California

3869. **BLACK CAÑON, COLORADO RIVER, LOOKING BELOW, NEAR CAMP 7** [from the album "Geographical Explorations and Surveys West of the 100th Meridian— Wheeler Photographs"] (P1982.27.6)
Albumen silver print. 1871
Image: 8 x 10⅞ in. (20.4 x 27.6 cm.)
Mount: 15⅝ x 19½ in. (39.6 x 49.5 cm.)
Signed: see inscription
Inscription, in negative: "6"
mount recto, printed: "Explorations in Nevada and Arizona.//WAR DEPARTMENT [emblem] CORPS OF ENGINEERS. U. S. ARMY.//Expedition of 1871.—Lieut. Geo. M. Wheeler, Com'd'g.//T. H. O'Sullivan, Phot.//No. 6.//BLACK CAÑON, COLORADO RIVER, LOOKING BELOW, NEAR CAMP 7."
Acquired from: Zeitlin and VerBrugge, Los Angeles, California

3870. **BLACK CAÑON, COLORADO RIVER, LOOKING BELOW NEAR CAMP 7** [from the album "Geographical Explorations and Surveys West of the 100th Meridian— Wheeler Photographs"] (P1982.27.7)
Albumen silver print. 1871
Image: 8 x 10⅞ in. (20.4 x 27.6 cm.)
Mount: 15¹¹⁄₁₆ x 19½ in. (39.8 x 49.5 cm.)
Signed: see inscription
Inscription, mount recto, printed: "Explorations in Nevada and Arizona.//WAR DEPARTMENT [emblem] CORPS OF ENGINEERS. U. S. ARMY.// Expedition of 1871.—Lieut. Geo. M. Wheeler, Com'd'g.//T. H. O'Sullivan, Phot.//No. 7.//BLACK CAÑON, COLORADO RIVER, LOOKING BELOW NEAR CAMP 7."
Acquired from: Zeitlin and VerBrugge, Los Angeles, California

3871. **BLUFF OPPOSITE BIG HORN CAMP, BLACK CAÑON, COLORADO RIVER** [from the album "Geographical Explorations and Surveys West of the 100th Meridian— Wheeler Photographs"] (P1982.27.3)
Albumen silver print. 1871
Image: 8 x 10¹⁵⁄₁₆ in. (20.3 x 27.7 cm.)
Mount: 15⅝ x 19½ in. (39.7 x 49.5 cm.)
Signed: see inscription
Inscription, mount recto, printed: "Explorations in Nevada and Arizona.//WAR DEPARTMENT [emblem] CORPS OF ENGINEERS. U. S. ARMY.// Expedition of 1871.—Lieut. Geo. M. Wheeler, Com'd'g.//T. H. O'Sullivan, Phot.// No. 3.//BLUFF OPPOSITE BIG HORN CAMP, BLACK CAÑON, COLORADO RIVER."
Acquired from: Zeitlin and VerBrugge, Los Angeles, California

3872. **CAÑON DE CHELLE. WALLS OF THE GRAND CAÑON ABOUT 1200 FEET IN HEIGHT** [from the album "Geographical Explorations and Surveys West of the 100th Meridian—Wheeler Photographs"] (P1982.27.43)
Albumen silver print. 1873
Image: 8⅛ x 10¹⁵⁄₁₆ in. (20.5 x 27.7 cm.)
Mount: 15½ x 19½ in. (39.4 x 49.5 cm.)
Signed: see inscription
Inscription, in negative: "14//15//18//26"
mount recto, printed: "Geographical & Geological Explorations & Surveys West of the 100th Meridian.// WAR DEPARTMENT [emblem] CORPS OF ENGINEERS. U. S. ARMY.//Expedition of 1873.—Lieut. Geo. M. Wheeler, Corps of Engineers, Commanding.//T. H. O'Sullivan, Phot.//No. 15.// CAÑON DE CHELLE./ Walls of the Grand Cañon about 1200 feet in height."
Acquired from: Zeitlin and VerBrugge, Los Angeles, California

3873. **CAÑON OF THE COLORADO RIVER, NEAR MOUTH OF SAN JUAN RIVER, ARIZONA** [from the album "Geographical Explorations and Surveys West of the 100th Meridian—Wheeler Photographs"] (P1976.142.19)
Albumen silver print. 1873
Image: 7¹⁵⁄₁₆ x 10⅞ in. (20.2 x 27.6 cm.)
Mount: 15½ x 19⅛ in. (39.4 x 48.6 cm.)

Signed: see inscription
Inscription, in negative: "13"
mount recto, printed: "Geographical & Geological Explorations & Surveys West of the 100th Meridian.// WAR DEPARTMENT [emblem] CORPS OF ENGINEERS. U. S. ARMY.//Expedition of 1873.—Lieut. Geo. M. Wheeler, Corps of Engineers, Commanding.//T. H. O'Sullivan, Phot.//No. 13.// CAÑON OF THE COLORADO RIVER,/near Mouth of San Juan River, Arizona."
Acquired from: Frontier America Corporation, Bryan, Texas

*3874. **CEREUS GIGANTEUS, ARIZONA** [from the album "Geographical Explorations and Surveys West of the 100th Meridian—Wheeler Photographs"] (P1982.27.12)
Albumen silver print. 1871
Image: 10⅞ x 8 in. (27.6 x 20.4 cm.)
Mount: 19½ x 15⅝ in. (49.5 x 39.7 cm.)
Signed: see inscription
Inscription, in negative: "12//101"
mount recto, printed: "Explorations in Nevada and Arizona.//WAR DEPARTMENT [emblem] CORPS OF ENGINEERS. U. S. ARMY.//Expedition of 1871.—Lieut. Geo. M. Wheeler, Com'd'g.//T. H. O'Sullivan, Phot.// No 12//CEREUS GIGANTEUS, ARIZONA."
Acquired from: Zeitlin and VerBrugge, Los Angeles, California

*3875. **THE CHURCH OF SAN MIGUEL, THE OLDEST IN SANTA FÉ, N. M.** [from the album "Geographical Explorations and Surveys West of the 100th Meridian— Wheeler Photographs"] (P1982.27.39)
Albumen silver print. 1873
Image: 10¹⁵⁄₁₆ x 8¹⁄₁₆ in. (27.7 x 20.5 cm.)
Mount: 19½ x 15½ in. (49.5 x 39.4 cm.)
Signed: see inscription
Inscription, mount recto, printed: "Geographical & Geological Explorations & Surveys West of the 100th Meridian.//WAR DEPARTMENT [emblem] CORPS OF ENGINEERS. U. S. ARMY.//Expedition of 1873.— Lieut. Geo. M. Wheeler, Corps of Engineers, Commanding.// T. H. O'Sullivan, Phot.//No. 11.//THE CHURCH OF SAN MIGUEL,/The oldest in Santa Fé, N. M."
Acquired from: Zeitlin and VerBrugge, Los Angeles, California

John Moran or Timothy H. O'Sullivan
[Close-up of fallen palm fronds; from Selfridge-Darien Expedition album] (P1982.1.15)
See entry under John Moran

3876. **COMMANDER SELFRIDGE ON HIS RETURN RECONNAISSANCE INTO THE INTERIOR OF DARIEN** [from Selfridge-Darien Expedition album] (P1981.91.9)
Albumen silver print. 1870
Image: 7³⁄₁₆ x 11³⁄₁₆ in. (18.3 x 28.4 cm.)
Mount: 12⅞ x 15¹⁄₁₆ in. (32.7 x 38.3 cm.)
Inscription, print recto: "8"
Acquired from: anonymous donor

3877. **COOLEY'S PARK, SIERRA BLANCA RANGE, ARIZONA** [from the album "Geographical Explorations and Surveys West of the 100th Meridian—Wheeler Photographs"] (P1982.27.34)
Albumen silver print. 1873
Image: 8⅛ x 10¹⁵⁄₁₆ in. (20.6 x 27.7 cm.)
Mount: 15⅝ x 19½ in. (39.7 x 49.5 cm.)
Signed: see inscription
Inscription, in negative: "5//4"
mount recto, printed: "Geographical & Geological Explorations & Surveys West of the 100th Meridian.// WAR DEPARTMENT [emblem] CORPS OF ENGINEERS. U. S. ARMY.//Expedition of 1873.—Lieut. Geo. M. Wheeler, Corps of Engineers, Commanding.//T. H. O'Sullivan, Phot.//No. 5.//COOLEY'S PARK, SIERRA

BLANCA RANGE, ARIZONA."
Acquired from: Zeitlin and VerBrugge, Los Angeles,
California

3878. **DISTANT VIEW OF CAMP APACHE, ARIZONA** [from
the album "Geographical Explorations and Surveys West of
the 100th Meridian—Wheeler Photographs"] (P1982.27.35)
Albumen silver print. 1873
Image: 7 15/16 x 10 13/16 in. (20.1 x 27.4 cm.)
Mount: 15 1/2 x 19 1/2 in. (39.4 x 49.5 cm.)
Signed: see inscription
Inscription, in negative: "6"
 mount recto, printed: "Geographical & Geological
 Explorations & Surveys West of the 100th Meridian.//
 WAR DEPARTMENT [emblem] CORPS OF ENGINEERS.
 U. S. ARMY.//Expedition of 1873.—Lieut. Geo. M.
 Wheeler, Corps of Engineers, Commanding.//T. H.
 O'Sullivan, Phot.//No. 6.//DISTANT VIEW OF CAMP
 APACHE, ARIZONA."
Acquired from: Zeitlin and VerBrugge, Los Angeles,
California

3879. **ENTRANCE TO BLACK CAÑON, COLORADO RIVER,
FROM ABOVE** [from the album "Geographical
Explorations and Surveys West of the 100th Meridian—
Wheeler Photographs"] (P1982.27.10)
Albumen silver print. 1871
Image: 8 x 10 7/8 in. (20.4 x 27.6 cm.)
Mount: 15 11/16 x 19 1/2 in. (39.8 x 49.5 cm.)
Signed: see inscription
Inscription, in negative: "10//85"
 mount recto, printed: "Explorations in Nevada and
 Arizona.//WAR DEPARTMENT [emblem] CORPS OF
 ENGINEERS. U. S. ARMY.//Expedition of 1871.—Lieut.
 Geo. M. Wheeler, Com'd'g.//T. H. O'Sullivan, Phot.//No.
 10.//ENTRANCE TO BLACK CAÑON, COLORADO
 RIVER, FROM ABOVE"
Acquired from: Zeitlin and VerBrugge, Los Angeles,
California

Attributed to Timothy H. O'Sullivan
3880. **[Expedition portrait on beach; from Selfridge-Darien
Expedition album]** (P1981.91.3)
Albumen silver print. 1870
Image: 7 3/4 x 10 5/8 in. (19.6 x 27.0 cm.)
Mount: 12 7/8 x 15 1/16 in. (32.7 x 38.3 cm.)
Inscription, print recto: "3"
Acquired from: anonymous donor

John Moran or Timothy H. O'Sullivan
[Fronds on a shore; from Selfridge-Darien Expedition album]
(P1982.1.14)
See entry under John Moran

3881. **GROUP OF PAH-UTE INDIANS, NEVADA** [from the
album "Geographical Explorations and Surveys West of the
100th Meridian—Wheeler Photographs"] (P1982.27.2)
Albumen silver print. 1871
Image: 8 1/16 x 10 7/8 in. (20.5 x 27.6 cm.)
Mount: 15 5/8 x 19 1/2 in. (39.7 x 49.5 cm.)
Signed: see inscription
Inscription, in negative: "[illegible] 8//2"
 mount recto, printed: "Explorations in Nevada and
 Arizona.//WAR DEPARTMENT [emblem] CORPS OF
 ENGINEERS. U. S. ARMY.//Expedition of 1871.—Lieut.
 Geo. M. Wheeler, Com'd'g.//T. H. O'Sullivan, Phot.//
 No. 2.//GROUP OF PAH-UTE INDIANS, NEVADA."
Acquired from: Zeitlin and VerBrugge, Los Angeles,
California

Attributed to Timothy H. O'Sullivan
3882. **[Group portrait in jungle; from Selfridge-Darien Expedition
album]** (P1981.91.8)
Albumen silver print. 1870
Image: 7 11/16 x 10 5/8 in. (19.5 x 27.0 cm.)
Mount: 12 7/8 x 15 1/16 in. (32.7 x 38.3 cm.)
Inscription, print recto: "7//19"
Acquired from: anonymous donor

3874

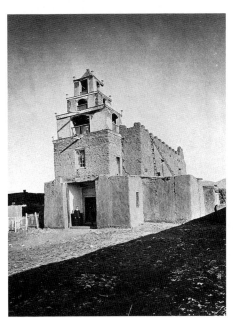
3875

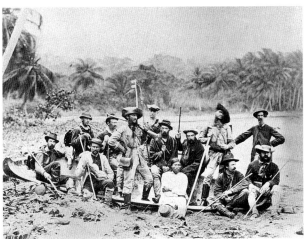
3884

Attributed to Timothy H. O'Sullivan

3883. [Group portrait of expedition crew; from Selfridge-Darien
Expedition album] (P1981.91.2)
Albumen silver print. 1870
Image: 8 5/16 x 11 1/16 in. (21.1 x 28.1 cm.)
Mount: 12 7/8 x 15 1/16 in. (32.7 x 38.3 cm.)
Inscription, print recto: "2"
Acquired from: anonymous donor

*3884. [Group portrait of expedition crew in dugout canoe; from
Selfridge-Darien Expedition album] (P1981.91.7)
Albumen silver print. 1870
Image: 8 3/16 x 10 3/4 in. (20.8 x 27.2 cm.)
Mount: 12 7/8 x 15 1/16 in. (32.7 x 38.3 cm.)
Inscription, print recto: "6"
Acquired from: anonymous donor

Attributed to Timothy H. O'Sullivan

3885. [Group portrait on ship; from Selfridge-Darien Expedition
album] (P1981.91.4)
Albumen silver print. 1870
Image: 7 3/4 x 10 5/8 in. (19.6 x 27.0 cm.)
Mount: 12 7/8 x 15 1/16 in. (32.7 x 38.3 cm.)
Inscription, print recto: "4"
Acquired from: anonymous donor

3886. HEAD OF CAÑON DE CHELLE, LOOKING DOWN,
WALLS ABOUT 1200 FEET IN HEIGHT [from the
album "Geographical Explorations and Surveys West of the
100th Meridian—Wheeler Photographs"] (P1976.142.22)
Albumen silver print. 1873
Image: 8 x 10 7/8 in. (20.3 x 27.6 cm.)
Mount: 15 1/2 x 19 1/8 in. (39.4 x 48.6 cm.)
Signed: see inscription
Inscription, in negative: "2+//2+//16"
mount recto, printed: "Geographical & Geological
Explorations & Surveys West of the 100th Meridian.//
WAR DEPARTMENT [emblem] CORPS OF ENGINEERS.
U. S. ARMY.//Expedition of 1873.—Lieut. Geo. M.
Wheeler, Corps of Engineers, Commanding.//T. H.
O'Sullivan, Phot.//No. 6.//HEAD OF CAÑON DE
CHELLE, LOOKING DOWN,/Walls about 1200 feet
in height."
Acquired from: Frontier America Corporation, Bryan, Texas

3887. HISTORIC SPANISH RECORD OF THE CONQUEST,
SOUTH SIDE OF INSCRIPTION ROCK, N. M. [from
the album "Geographical Explorations and Surveys West of
the 100th Meridian—Wheeler Photographs"] (P1982.27.36)
Albumen silver print. 1873
Image: 7 15/16 x 10 7/8 in. (20.1 x 27.6 cm.)
Mount: 15 5/8 x 19 1/2 in. (39.7 x 49.5 cm.)
Signed: see inscription
Inscription, in negative: "27"
mount recto, printed: "Geographical & Geological
Explorations & Surveys West of the 100th Meridian.//
WAR DEPARTMENT [emblem] CORPS OF ENGINEERS.
U. S. ARMY.//Expedition of 1873.—Lieut. Geo. M.
Wheeler, Corps of Engineers, Commanding.//T. H.
O'Sullivan, Phot.//No. 8.//HISTORIC SPANISH
RECORD OF THE CONQUEST,/South Side of
Inscription Rock, N. M."
Acquired from: Zeitlin and VerBrugge, Los Angeles,
California

*3888. HISTORIC SPANISH RECORD OF THE CONQUEST,
SOUTH SIDE OF INSCRIPTION ROCK, N. M. NO. 3
[from the album "Geographical Explorations and Surveys
West of the 100th Meridian—Wheeler Photographs"]
(P1982.27.37)
Albumen silver print. 1873
Image: 8 1/16 x 10 7/8 in. (20.5 x 27.6 cm.)
Mount: 15 5/8 x 19 1/2 in. (39.7 x 49.5 cm.)
Signed: see inscription

Inscription, in negative: "2+//9 [reversed]"
mount recto, printed: "Geographical & Geological
Explorations & Surveys West of the 100th Meridian.//
WAR DEPARTMENT [emblem] CORPS OF ENGINEERS.
U. S. ARMY.//Expedition of 1873.—Lieut. Geo. M.
Wheeler, Corps of Engineers, Commanding.//T. H.
O'Sullivan, Phot.//No. 9//HISTORIC SPANISH
RECORD OF THE CONQUEST,/South Side of
Inscription Rock, N. M. No. 3."
Acquired from: Zeitlin and VerBrugge, Los Angeles,
California

John Moran or Timothy H. O'Sullivan
[Huts on distant island; from Selfridge-Darien Expedition
album] (P1981.91.23)
See entry under John Moran

3889. ICEBERG CAÑON, COLORADO RIVER, LOOKING
ABOVE [from the album "Geographical Explorations and
Surveys West of the 100th Meridian—Wheeler
Photographs"] (P1982.27.15)
Albumen silver print. 1871
Image: 7 5/8 x 10 13/16 in. (19.4 x 27.5 cm.)
Mount: 15 5/8 x 19 1/2 in. (39.7 x 49.5 cm.)
Signed: see inscription
Inscription, in negative: "90//90//15"
mount recto, printed: "Explorations in Nevada and
Arizona.//WAR DEPARTMENT [emblem] CORPS OF
ENGINEERS. U. S. ARMY.//Expedition of 1871.—Lieut.
Geo. M. Wheeler, Com'd'g.//T. H. O'Sullivan, Phot.//
No. 15.//ICEBERG CAÑON, COLORADO RIVER,
LOOKING ABOVE."
Acquired from: Zeitlin and VerBrugge, Los Angeles,
California

*3890. INDIAN PUEBLO, ZUNI, N. M., VIEW FROM THE
SOUTH [from the album "Geographical Explorations and
Surveys West of the 100th Meridian—Wheeler
Photographs"] (P1982.27.45)
Albumen silver print. 1873
Image: 8 1/16 x 10 7/8 in. (20.5 x 27.6 cm.)
Mount: 15 5/8 x 19 1/2 in. (39.7 x 49.5 cm.)
Signed: see inscription
Inscription, in negative: "8//16//17//[illegible]"
mount recto, printed: "Geographical & Geological
Explorations & Surveys West of the 100th Meridian.//
WAR DEPARTMENT [emblem] CORPS OF ENGINEERS.
U. S. ARMY.//Expedition of 1873.—Lieut. Geo. M.
Wheeler, Corps of Engineers, Commanding.//T. H.
O'Sullivan, Phot.//No. 17.//INDIAN PUEBLO, ZUNI,
N. M./View from the South."
Acquired from: Zeitlin and VerBrugge, Los Angeles,
California

*3891. INDIAN SETTLEMENT, BAY OF SAN BLAS [from
Selfridge-Darien Expedition album] (P1981.91.20)
Albumen silver print. 1870
Image: 7 3/4 x 10 5/8 in. (19.6 x 27.0 cm.)
Mount: 12 7/8 x 15 1/16 in. (32.7 x 38.3 cm.)
Inscription, print recto: "19//6"
Acquired from: anonymous donor

3892. INDIAN VILLAGE OF SARDI, CALEDONIA HARBOR
[from Selfridge-Darien Expedition album] (P1981.91.21)
Albumen silver print. 1870
Image: 7 x 11 1/4 in. (17.8 x 28.5 cm.)
Mount: 12 7/8 x 15 1/16 in. (32.7 x 38.3 cm.)
Inscription, print recto: "20"
Acquired from: anonymous donor

John Moran or Timothy H. O'Sullivan
[Island with bird; from Selfridge-Darien Expedition album]
(P1982.1.1)
See entry under John Moran

3893. **LOOKING ACROSS THE COLORADO RIVER TO MOUTH OF PARIA CREEK** [from the album "Geographical Explorations and Surveys West of the 100th Meridian—Wheeler Photographs"] (P1982.27.40)
Albumen silver print. 1873
Image: 8 1/16 x 10 15/16 in. (20.4 x 27.7 cm.)
Mount: 15 5/8 x 19 1/2 in. (39.7 x 49.5 cm.)
Signed: see inscription
Inscription, in negative: "2//13//12//13//30//31"
mount recto, printed: "Geographical & Geological Explorations & Surveys West of the 100th Meridian.// WAR DEPARTMENT [emblem] CORPS OF ENGINEERS. U. S. ARMY.//Expedition of 1873.—Lieut. Geo. M. Wheeler, Corps of Engineers, Commanding.//T. H. O'Sullivan, Phot.//No. 12.// LOOKING ACROSS THE COLORADO RIVER TO MOUTH OF PARIA CREEK."
Acquired from: Zeitlin and VerBrugge, Los Angeles, California

3894. **NORTH FORK CAÑON, SIERRA BLANCA CREEK, ARIZONA** [from the album "Geographical Explorations and Surveys West of the 100th Meridian—Wheeler Photographs"] (P1982.27.33)
Albumen silver print. 1873
Image: 8 x 10 13/16 in. (20.3 x 27.4 cm.)
Mount: 15 1/2 x 19 1/2 in. (39.4 x 49.5 cm.)
Signed: see inscription
Inscription, in negative: "[illegible]//8//4//4"
mount recto, printed: "Geographical & Geological Explorations & Surveys West of the 100th Meridian.// WAR DEPARTMENT [emblem] CORPS OF ENGINEERS. U. S. ARMY.//Expedition of 1873.—Lieut. Geo. M. Wheeler, Corps of Engineers, Commanding.//T. H. O'Sullivan, Phot.//No. 4.//NORTH FORK CAÑON, SIERRA BLANCA CREEK, ARIZONA."
Acquired from: Zeitlin and VerBrugge, Los Angeles, California

*3895. **OFFICERS' QUARTERS POST RUBY—NA—** [Fort Ruby, Nevada] (P1979.89.1)
Albumen silver print. c. 1868
Image: 8 1/2 x 11 3/8 in. (21.6 x 28.9 cm.)
Sheet: 8 13/16 x 11 3/8 in. (22.3 x 28.9 cm.)
Inscription, print verso: "officers quarters Post Ruby—Na—"
Acquired from: Bryan Furtek, New Haven, Connecticut

*3896. **OLD MISSION CHURCH, ZUNI PUEBLO, N. M., VIEW FROM THE PLAZA** [from the album "Geographical Explorations and Surveys West of the 100th Meridian—Wheeler Photographs"] (P1976.142.24)
Albumen silver print. 1873
Image: 8 1/16 x 10 7/8 in. (20.4 x 27.6 cm.)
Mount: 15 1/2 x 19 1/4 in. (39.4 x 48.9 cm.)
Signed: see inscription
Inscription, in negative: "18//22//22"
mount recto, printed: "Geographical & Geological Explorations & Surveys West of the 100th Meridian.// WAR DEPARTMENT [emblem] CORPS OF ENGINEERS. U. S. ARMY.//Expedition of 1873.—Lieut. Geo. M. Wheeler, Corps of Engineers, Commanding.//T. H. O'Sullivan, Phot.//No. 18.//OLD MISSION CHURCH, ZUNI PUEBLO, N. M./View from the Plaza."
Acquired from: Frontier America Corporation, Bryan, Texas

John Moran or Timothy H. O'Sullivan
[Palm trees on island; from Selfridge-Darien Expedition album] (P1982.1.2)
See entry under John Moran

Attributed to Timothy H. O'Sullivan
*3897. **[Panamanians on ship; from Selfridge-Darien Expedition album]** (P1981.91.5)
Albumen silver print. 1870
Image: 7 3/4 x 10 5/8 in. (19.6 x 27.0 cm.)
Mount: 12 7/8 x 15 1/16 in. (32.7 x 38.3 cm.)
Inscription, print recto: "4a//36"
Acquired from: anonymous donor

3888

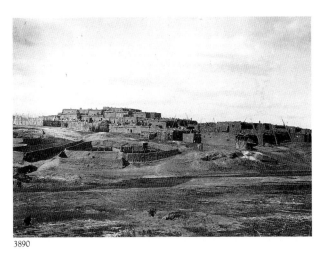
3890

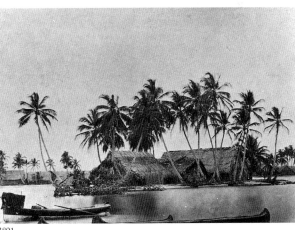
3891

3898. ROCK CARVED BY DRIFTING SAND, BELOW
FORTIFICATION ROCK, ARIZONA [from the album
"Geographical Explorations and Surveys West of the 100th
Meridian—Wheeler Photographs"] (P1982.27.14)
Albumen silver print. 1871
Image: 8 x 10⅞ in. (20.4 x 27.6 cm.)
Mount: 15⅝ x 19½ in. (39.7 x 49.5 cm.)
Signed: see inscription
Inscription, in negative: "14//88"
mount recto, printed: "Explorations in Nevada and
Arizona.//WAR DEPARTMENT [emblem] CORPS OF
ENGINEERS. U. S. ARMY.//Expedition of 1871.—Lieut.
Geo. M. Wheeler, Com'd'g.//T. H. O'Sullivan, Phot.//
No. 14//ROCK CARVED BY DRIFTING SAND, BELOW
FORTIFICATION ROCK, ARIZONA."
Acquired from: Zeitlin and VerBrugge, Los Angeles,
California

3899. SECTION OF SOUTH SIDE OF ZUNI PUEBLO, N. M.
[from the album "Geographical Explorations and Surveys
West of the 100th Meridian—Wheeler Photographs"]
(P1976.142.25)
Albumen silver print. 1873
Image: 7¹⁵⁄₁₆ x 10⅞ in. (20.1 x 27.6 cm.)
Mount: 15½ x 19¼ in. (39.3 x 48.9 cm.)
Signed: see inscription
Inscription, in negative: "[illegible]//28//28"
mount recto, printed: "Geographical & Geological
Explorations & Surveys West of the 100th Meridian.//
WAR DEPARTMENT [emblem] CORPS OF ENGINEERS.
U. S. ARMY.//Expedition of 1873.—Lieut. Geo. M.
Wheeler, Corps of Engineers, Commanding.//T. H.
O'Sullivan, Phot.//No. 19.// SECTION OF SOUTH SIDE
OF ZUNI PUEBLO, N. M."
Acquired from: Frontier America Corporation, Bryan, Texas

*3900. SHOSHONE FALLS, SNAKE RIVER, IDAHO. FULL
LATERAL VIEW—ON UPPER LEVEL (P1979.8)
Albumen silver print. 1874
Image: 8 x 10⅞ in. (20.3 x 27.6 cm.)
Mount: 15⅞ x 20 in. (40.3 x 50.8 cm.)
Signed: see inscription
Inscription, mount recto, printed: "Geographical Explorations
and Surveys West of the 100th Meridian//WAR
DEPARTMENT, CORPS [emblem] OF ENGINEERS, U.S.
ARMY.//Expedition of 1874. Under Command of Lieut.
Geo. M. Wheeler, Corps of Eng'rs.//T. H. O'Sullivan,
Phot.//No. 24//SHOSHONE FALLS, SNAKE RIVER,
IDAHO/Full lateral view—on upper level."
Acquired from: Sotheby Parke Bernet, Los Angeles,
California

3901. SNOW PEAKS, BULL RUN MINING DISTRICT,
NEVADA [from the album "Geographical Explorations
and Surveys West of the 100th Meridian—Wheeler
Photographs"] (P1982.27.1)
Albumen silver print. 1871
Image: 8 x 10¹³⁄₁₆ in. (20.4 x 27.5 cm.)
Mount: 15½ x 19½ in. (39.4 x 49.5 cm.)
Signed: see inscription
Inscription, in negative: "1"
mount recto, printed: "Explorations in Nevada and
Arizona.//WAR DEPARTMENT [emblem] CORPS OF
ENGINEERS. U. S. ARMY.//Expedition of 1871.—Lieut.
Geo. M. Wheeler, Com'd'g.//T. H. O'Sullivan, Phot.//
No. 1.//SNOW PEAKS, BULL RUN MINING DISTRICT,
NEVADA."
Acquired from: Zeitlin and VerBrugge, Los Angeles,
California

3902. SOUTH SIDE OF INSCRIPTION ROCK, N. M. [from the
album "Geographical Explorations and Surveys West of the
100th Meridian—Wheeler Photographs"] (P1982.27.42)
Albumen silver print. 1873
Image: 8 x 10⅞ in. (20.3 x 27.6 cm.)
Mount: 15¹¹⁄₁₆ x 19½ in. (39.8 x 49.5 cm.)
Signed: see inscription
Inscription, in negative: "10//14//[illegible]//[illegible]//18"
mount recto, printed: "Geographical & Geological
Explorations & Surveys West of the 100th Meridian.//
WAR DEPARTMENT [emblem] CORPS OF ENGINEERS.
U. S. ARMY.//Expedition of 1873.—Lieut. Geo. M.
Wheeler, Corps of Engineers, Commanding.//T. H.
O'Sullivan, Phot.//No. 14//SOUTH SIDE OF
INSCRIPTION ROCK, N. M."
Acquired from: Zeitlin and VerBrugge, Los Angeles,
California

Attributed to Timothy H. O'Sullivan
*3903. [Thomas Oliver Selfridge, Jr.; from Selfridge-Darien
Expedition album] (P1981.91.1)
Albumen silver print. 1870
Image: 11¹⁄₁₆ x 9⁵⁄₁₆ in. (28.1 x 23.7 cm.)
Mount: 12⅞ x 15¹⁄₁₆ in. (32.7 x 38.3 cm.)
Inscription, print recto: "1"
Acquired from: anonymous donor

Attributed to Timothy H. O'Sullivan
*3904. [U. S. Observatory; from Selfridge-Darien Expedition album]
(P1981.91.6)
Albumen silver print. 1870
Image: 10⅝ x 7¾ in. (27.0 x 19.6 cm.) irregular
Mount: 12⅞ x 15¹⁄₁₆ in. (32.7 x 38.3 cm.)
Inscription, print recto: "5//34//34"
Acquired from: anonymous donor

3905. VIEW ON APACHE LAKE, SIERRA BLANCA RANGE,
ARIZONA. TWO APACHE SCOUTS IN THE
FOREGROUND [from the album "Geographical
Explorations and Surveys West of the 100th Meridian—
Wheeler Photographs"] (P1982.27.32)
Albumen silver print. 1873
Image: 10¾ x 7¹⁵⁄₁₆ in. (27.3 x 20.1 cm.)
Mount: 19½ x 15½ in. (49.5 x 39.4 cm.)
Signed: see inscription
Inscription, in negative: "3"
mount recto, printed: "Geographical & Geological
Explorations & Surveys West of the 100th Meridian.//
WAR DEPARTMENT [emblem] CORPS OF ENGINEERS.
U. S. ARMY.//Expedition of 1873.—Lieut. Geo. M.
Wheeler, Corps of Engineers, Commanding.//T. H.
O'Sullivan, Phot.//No. 3.//VIEW ON APACHE LAKE,
SIERRA BLANCA RANGE, ARIZONA./Two Apache
Scouts in The foreground."
Acquired from: Zeitlin and VerBrugge, Los Angeles,
California

*3906. WALL IN THE GRAND CAÑON, COLORADO RIVER
[from the album "Geographical Explorations and Surveys
West of the 100th Meridian—Wheeler Photographs"]
(P1982.27.11)
Albumen silver print. 1871
Image: 10⅞ x 8¹⁄₁₆ in. (27.6 x 20.5 cm.)
Mount: 19½ x 15½ in. (49.5 x 39.4 cm.)
Signed: see inscription
Inscription, in negative: "[illegible]"
mount recto, printed: "Explorations in Nevada and
Arizona.//WAR DEPARTMENT [emblem] CORPS OF
ENGINEERS. U. S. ARMY.//Expedition of 1871.—Lieut.
Geo. M. Wheeler, Com'd'g.//T. H. O'Sullivan, Phot.//
No. 11.//WALL IN THE GRAND CAÑON, COLORADO
RIVER."
Acquired from: Zeitlin and VerBrugge, Los Angeles,
California

3895

3896

3897

3900

3903

3904

3907. **WATER RHYOLITES, NEAR LOGAN SPRINGS, NEVADA [from the album "Geographical Explorations and Surveys West of the 100th Meridian—Wheeler Photographs"]** (P1982.27.13)
Albumen silver print. 1871
Image: 8 x 10 ⅞ in. (20.4 x 27.6 cm.)
Mount: 15 ⅝ x 19 ½ in. (39.7 x 49.5 cm.)
Signed: see inscription
Inscription, in negative: "40//13"
 mount recto, printed: "Explorations in Nevada and Arizona.//WAR DEPARTMENT [emblem] CORPS OF ENGINEERS. U. S. ARMY.//Expedition of 1871.—Lieut. Geo. M. Wheeler, Com'd'g.//T. H. O'Sullivan, Phot.//No. 13.//WATER RHYOLITES, NEAR LOGAN SPRINGS, NEVADA."
Acquired from: Zeitlin and VerBrugge, Los Angeles, California

PAUL OUTERBRIDGE, JR.,
American (1896–1958)

Outerbridge enrolled at the Art Students' League in New York City in 1915, where he studied drawing. He established himself as a freelance illustrator by the time he was nineteen, but left the field in 1921 to study photography at the Clarence White School. During the 1920s Outerbridge produced artistic still lifes, figures, and cityscapes as well as innovative commercial work for a number of magazines. In 1925 he moved to Paris and joined the arts scene there. His business ventures were failures, however, and in 1929 he returned to New York. During the 1930s Outerbridge developed a Carbro color printing process that was used mainly for his commercial work and opened a portrait studio in Laguna Beach, California, in 1942. In 1945 he married an interior designer and gave up photography to help with her career. He later wrote a column on color photography for *U.S. Camera*, but did not return to the studio.

*3908. **[Green peppers]** (P1980.37)
Platinum print. 1923
Image: 4 ⁹⁄₁₆ x 3 ⁷⁄₁₆ in. (11.6 x 8.7 cm.)
Mount: 14 x 11 ¹⁄₁₆ in. (35.6 x 28.1 cm.)
Inscription, mount recto: "030//Metropolitan 2//#102/ #415-L/RSS"
Acquired from: Edwynn Houk, Ann Arbor, Michigan

WILLIAM W. PANKEY, American (b. 1953)

Chip Pankey took up photography as a hobby while studying theater at Memphis State University. In 1976 he moved to Houston to act. Pankey began his photographic career as publicity photographer for the Houston company of *The Best Little Whorehouse in Texas*. He accompanied the company on its national tour, and when the tour stopped in California, he attended a workshop on platinum printing conducted by George Tice. Pankey moved to Dallas in 1982 and has spent his time documenting neighborhoods. In 1984 he was one of ten photographers commissioned by the City of Dallas to document the downtown area. Pankey has said that in his photographs he attempts to show how people shape their environments. Many of his neighborhood photographs appeared in his book *Urban Options* (1986).

3909. **"URBAN OPTIONS," PLATE 4 [brick wall and water tower]** (P1986.18.1)
Hand-coated platinum/palladium print. negative 1985, print 1986
Image: 7 ¹¹⁄₁₆ x 9 ¹¹⁄₁₆ in. (19.5 x 24.6 cm.)
Sheet: 7 ¹⁵⁄₁₆ x 9 ¹⁵⁄₁₆ in. (20.1 x 25.3 cm.)

Signed, l.l. print verso: "WM Pankey 3/30"
Inscription, print verso: "#4 URBAN OPTIONS// PLATINUM/PALLADIUM//1985"
Acquired from: the photographer

*3910. **"URBAN OPTIONS," PLATE 43 [garden hose and tricycle]** (P1986.18.2)
Hand-coated platinum/palladium print. negative 1983, print 1986
Image: 7 ¹¹⁄₁₆ x 9 ¹¹⁄₁₆ in. (19.5 x 24.6 cm.)
Sheet: 7 ¹⁵⁄₁₆ x 10 ¹⁄₁₆ in. (20.1 x 25.5 cm.)
Signed, l.l. print verso: "WM Pankey 4/30"
Inscription, print verso: "#43 URBAN OPTIONS// PLATINUM/PALLADIUM//1983"
Acquired from: the photographer

3911. **"URBAN OPTIONS," PLATE 45 [back of house]** (P1986.18.3)
Hand-coated platinum/palladium print. negative 1983, print 1986
Image: 7 ¹¹⁄₁₆ x 9 ¹¹⁄₁₆ in. (19.5 x 24.6 cm.)
Sheet: 8 x 10 in. (20.2 x 25.4 cm.)
Signed, l.l. print verso: "WM Pankey #6/30"
Inscription, print verso: "#45 URBAN OPTIONS// PLATINUM/PALLADIUM//1983"
Acquired from: the photographer

3912. **"URBAN OPTIONS," PLATE 55 [wooden fence and top of swimming pool ladder]** (P1986.18.4)
Hand-coated platinum/palladium print. negative 1985, print 1986
Image: 7 ¹¹⁄₁₆ x 9 ¹¹⁄₁₆ in. (19.5 x 24.6 cm.)
Sheet: 7 ¹⁵⁄₁₆ x 10 in. (20.1 x 25.4 cm.)
Signed, l.l. print verso: "WM Pankey 4/30"
Inscription, print verso: "#55 URBAN OPTIONS// PLATINUM/PALLADIUM//1985"
Acquired from: the photographer

ROBERT EDWIN PEARY,
American (1856–1920)

Robert Edwin Peary, arctic explorer and first to reach the North Pole, took along photographic equipment to document his travels. Many of his photographs illustrate his publications. The two-volume work *Northward Over the "Great Ice"* (1898) narrates Peary's explorations in northern Greenland in 1886 and 1891–97. From June 1891 through September 1892, Peary headed an arctic expedition to the northeast angle of Greenland. Peary detailed this expedition in volume I, part II, of *Northward Over the "Great Ice,"* noting that his photographic equipment for this trip consisted of "two No. 4 kodaks made expressly for me by the Eastman Co., and two rolls of films, one hundred negatives each." The photograph of Mrs. Peary appears on page 137 in this section.

*3913. **MRS. PEARY [Josephine Diebitsch Peary]** (P1985.35)
Albumen silver print. c. 1891–92
Image: 3 ¾ x 4 ¹³⁄₁₆ in. (9.5 x 12.2 cm.)
Sheet: 4 ¹⁄₁₆ x 5 in. (10.2 x 12.6 cm.)
Mount: 4 ¼ x 6 ½ in. (10.7 x 16.5 cm.)
Inscription, in negative: "P"
 print recto: crop marks
 mount recto: "#85"
 mount verso: "253"
Acquired from: Paul Katz, North Bennington, Vermont

MARY PECK, American (b. 1952)

Peck is a New Mexico photographer who specializes in architectural and landscape work. She received her B.F.A. in photography and philosophy from Utah State University in 1974 and shortly thereafter served as Paul Caponigro's darkroom assistant. She also served as

Laura Gilpin's assistant from 1977 to 1979. In 1981 Peck produced a portfolio of photographs of Greek temples and in 1985 a portfolio of Fort Meigs photographs. She participated in the National Endowment for the Arts survey grant, exhibition, and publication *The Essential Landscape* (1982), and in the Texas Historical Foundation's Sesquicentennial exhibition and publication project, *Contemporary Texas: A Photographic Portrait* (1984). Peck also has worked in the Everglades. In 1988, she received a Willard Van Dyke Memorial Grant.

3914. **ABANDONED HOMESITE, RITA BLANCA GRASSLANDS [from "Contemporary Texas: A Photographic Portrait"]** (P1985.17.140)
Gelatin silver print. 1984
Image: 6 ³/₁₆ x 18 ⅝ in. (15.7 x 47.3 cm.)
Sheet: 7 ¹⁵/₁₆ x 19 ¹⁵/₁₆ in. (20.2 x 50.7 cm.)
Signed, center print verso: "Mary Peck 1984"
Acquired from: gift of the Texas Historical Foundation with support from a major grant from the Du Pont Company and Conoco, its energy subsidiary, and assistance from the Texas Commission on the Arts and the National Endowment for the Arts

3915. **BANDELIER NATIONAL MONUMENT [from the Santa Fe Center for Photography "Portfolio I"]** (P1982.35.1)
Gelatin silver print. negative 1977, print 1982
Image: 10 ½ x 13 ⅛ in. (26.6 x 33.3 cm.)
Sheet: 11 x 13 ¹⁵/₁₆ in. (28.0 x 35.4 cm.)
Signed, center print verso and l.r. overmat recto: "Mary Peck/© 1980"
Inscription, printed paper label on mat backing verso: "Santa Fe Center for Photography/PORTFOLIO I/Portfolio no. 10 Print no. 1"
Acquired from: Santa Fe Center for Photography, Santa Fe, New Mexico

3916. **BIG TOP, DALHART [from "Contemporary Texas: A Photographic Portrait"]** (P1985.17.136)
Gelatin silver print. 1984
Image: 6 ½ x 19 ⁷/₁₆ in. (16.5 x 49.3 cm.)
Sheet: 8 x 19 ¹⁵/₁₆ in. (20.3 x 50.7 cm.)
Signed, center print verso: "Mary Peck 1984"
Acquired from: gift of the Texas Historical Foundation with support from a major grant from the Du Pont Company and Conoco, its energy subsidiary, and assistance from the Texas Commission on the Arts and the National Endowment for the Arts

3917. **CHAQUACO, NEW MEXICO** (P1979.6.6)
Gelatin silver print. 1975
Image: 6 ⅜ x 8 ⅞ in. (16.1 x 22.5 cm.)
Mount: 13 x 15 in. (33.0 x 38.1 cm.)
Signed, l.r. mount recto: "Mary Peck"
Inscription, mount verso: "Chaquaco, New Mexico/1975"
Acquired from: the photographer

3918. **CLOUD, NEW MEXICO** (P1979.6.2)
Gelatin silver print. 1975
Image: 12 ¹⁵/₁₆ x 10 ⅜ in. (32.9 x 26.4 cm.)
Mount: 20 x 16 in. (50.8 x 40.7 cm.)
Signed, l.r. mount recto: "Mary Peck"
Inscription, mount verso: "Cloud, New Mexico/1975"
Acquired from: the photographer

3919. **COTTON TRAILERS, EASTER [from "Contemporary Texas: A Photographic Portrait"]** (P1985.17.138)
Gelatin silver print. 1984
Image: 6 ⁵/₁₆ x 19 in. (16.0 x 48.2 cm.)
Sheet: 8 ¹/₁₆ x 19 ⅞ in. (20.5 x 50.5 cm.)
Signed, center print verso: "Mary Peck 1984"
Acquired from: gift of the Texas Historical Foundation with support from a major grant from the Du Pont Company and Conoco, its energy subsidiary, and assistance from the Texas Commission on the Arts and the National Endowment for the Arts

3906

3908

3910

3920. **ENOCH, TEXAS** (P1979.69.1)
Gelatin silver print. 1979
Image: 10¼ x 13¹¹⁄₁₆ in. (26.1 x 34.7 cm.)
Mount: 16⅛ x 20 in. (41.0 x 50.8 cm.)
Signed, l.r. mount recto: "Mary Peck"
Inscription, mount verso: "Enoch, Texas 1979"
Acquired from: the photographer

3921. **ESTELLINE, TEXAS** (P1979.69.2)
Gelatin silver print. 1978
Image: 9¼ x 13¾ in. (23.5 x 34.9 cm.)
Mount: 16⅛ x 20 in. (41.0 x 50.8 cm.)
Signed, l.r. mount recto: "Mary Peck"
Inscription, mount verso: "Estelline, Texas 1978"
Acquired from: the photographer

3922. **FREIGHT TRAIN, NEAR AMARILLO [from "Contemporary Texas: A Photographic Portrait"]** (P1985.17.132)
Gelatin silver print. 1984
Image: 6½ x 19⁹⁄₁₆ in. (16.5 x 49.7 cm.)
Sheet: 8¼ x 19¹⁵⁄₁₆ in. (20.9 x 50.7 cm.)
Signed, center print verso: "Mary Peck 1984"
Acquired from: gift of the Texas Historical Foundation with support from a major grant from the Du Pont Company and Conoco, its energy subsidiary, and assistance from the Texas Commission on the Arts and the National Endowment for the Arts

3923. **GIBSON'S FIRE, CHILDRESS [from "Contemporary Texas: A Photographic Portrait"]** (P1985.17.137)
Gelatin silver print. 1984
Image: 6½ x 19⁷⁄₁₆ in. (16.5 x 49.3 cm.)
Sheet: 8¹⁄₁₆ x 19¹⁵⁄₁₆ in. (20.5 x 50.7 cm.)
Signed, center print verso: "Mary Peck 1984"
Acquired from: gift of the Texas Historical Foundation with support from a major grant from the Du Pont Company and Conoco, its energy subsidiary, and assistance from the Texas Commission on the Arts and the National Endowment for the Arts

*3924. **HIPPOPOTAMU, DALHART [from "Contemporary Texas: A Photographic Portrait"]** (P1985.17.133)
Gelatin silver print. 1984
Image: 6½ x 19⁹⁄₁₆ in. (16.5 x 49.7 cm.)
Sheet: 8¹⁄₁₆ x 19¹⁵⁄₁₆ in. (20.5 x 50.7 cm.)
Signed, center print verso: "Mary Peck 1984"
Acquired from: gift of the Texas Historical Foundation with support from a major grant from the Du Pont Company and Conoco, its energy subsidiary, and assistance from the Texas Commission on the Arts and the National Endowment for the Arts

3925. **KEFALONIA, GREECE** (P1979.6.5)
Gelatin silver print. 1977
Image: 10⁹⁄₁₆ x 13⁹⁄₁₆ in. (26.8 x 34.5 cm.)
Mount: 17 x 21 in. (43.2 x 53.4 cm.)
Signed, l.r. mount recto: "Mary Peck"
Inscription, mount verso: "Kefalonia, Greece/1977"
Acquired from: the photographer

3926. **LAURA GILPIN** (P1980.7)
Gelatin silver print. 1978
Image: 7¹³⁄₁₆ x 9¹¹⁄₁₆ in. (19.9 x 24.6 cm.)
Mount: 11⅝ x 13⅞ in. (29.4 x 35.3 cm.)
Signed, l.r. mount recto: "Mary Peck"
Inscription, mount verso: "Laura Gilpin, 1978"
Acquired from: gift of the photographer

3927. **MITCHELL 450, SPEARMAN [from "Contemporary Texas: A Photographic Portrait"]** (P1985.17.134)
Gelatin silver print. 1984
Image: 6⁷⁄₁₆ x 19¼ in. (16.3 x 48.9 cm.)
Sheet: 7¹⁵⁄₁₆ x 19¹⁵⁄₁₆ in. (20.2 x 50.7 cm.)
Signed, center print verso: "Mary Peck 1984"
Acquired from: gift of the Texas Historical Foundation with support from a major grant from the Du Pont Company and Conoco, its energy subsidiary, and assistance from the Texas Commission on the Arts and the National Endowment for the Arts

*3928. **MORA, NEW MEXICO** (P1979.6.7)
Gelatin silver print. 1976
Image: 7¼ x 9⁵⁄₁₆ in. (18.5 x 23.6 cm.)
Mount: 14 x 17 in. (35.6 x 43.2 cm.)
Signed, l.r. mount recto: "Mary Peck"
Inscription, mount verso: "Mora, New Mexico/1976"
Acquired from: the photographer

*3929. **NEAR LESLEY [from "Contemporary Texas: A Photographic Portrait"]** (P1985.17.135)
Gelatin silver print. 1984
Image: 6½ x 19½ in. (16.5 x 49.5 cm.)
Sheet: 8 x 19¹⁵⁄₁₆ in. (20.3 x 50.7 cm.)
Signed, center print verso: "Mary Peck 1984"
Acquired from: gift of the Texas Historical Foundation with support from a major grant from the Du Pont Company and Conoco, its energy subsidiary, and assistance from the Texas Commission on the Arts and the National Endowment for the Arts

3930. **NEAR UMBARGER [from "Contemporary Texas: A Photographic Portrait"]** (P1985.17.141)
Gelatin silver print. 1984
Image: 6½ x 19⁹⁄₁₆ in. (16.5 x 49.7 cm.)
Sheet: 8 x 19¹⁵⁄₁₆ in. (20.3 x 50.7 cm.)
Signed, center print verso: "Mary Peck 1984"
Acquired from: gift of the Texas Historical Foundation with support from a major grant from the Du Pont Company and Conoco, its energy subsidiary, and assistance from the Texas Commission on the Arts and the National Endowment for the Arts

*3931. **PAINTED CAVE, BANDELIER NATIONAL MONUMENT, NEW MEXICO** (P1979.6.1)
Gelatin silver print. 1976
Image: 9¹¹⁄₁₆ x 12⅝ in. (24.6 x 32.1 cm.)
Mount: 16 x 20 in. (40.7 x 50.8 cm.)
Signed, l.r. mount recto: "Mary Peck"
Inscription, mount verso: "Painted Cave, Bandelier National Monument/New Mexico, 1976"
Acquired from: the photographer

3932. **RICH WILDER, PECOS CANYON, NEW MEXICO** (P1979.6.8)
Gelatin silver print. 1977
Image: 12⅞ x 10⅜ in. (32.6 x 26.4 cm.)
Mount: 20 x 16 in. (50.8 x 40.7 cm.)
Signed, l.r. mount recto: "Mary Peck"
Inscription, mount verso: "Rich Wilder/Pecos Canyon/New Mexico/1977"
Acquired from: the photographer

*3933. **ROME** (P1979.6.4)
Gelatin silver print. 1977
Image: 10¹³⁄₁₆ x 13¹¹⁄₁₆ in. (27.4 x 34.8 cm.)
Mount: 17¹⁄₁₆ x 21⅛ in. (43.4 x 53.6 cm.)
Signed, l.r. mount recto: "Mary Peck"
Inscription, mount verso: "Rome, 1977"
Acquired from: the photographer

3934. **WHEATFIELD, HAPPY [from "Contemporary Texas: A Photographic Portrait"]** (P1985.17.139)
Gelatin silver print. 1984
Image: 6⁵⁄₁₆ x 19¹⁄₁₆ in. (16.0 x 48.4 cm.)
Sheet: 8 x 19¹⁵⁄₁₆ in. (20.3 x 50.7 cm.)
Signed, center print verso: "Mary Peck 1984"
Acquired from: gift of the Texas Historical Foundation with support from a major grant from the Du Pont Company and Conoco, its energy subsidiary, and assistance from the Texas Commission on the Arts and the National Endowment for the Arts

3913

3928

3924

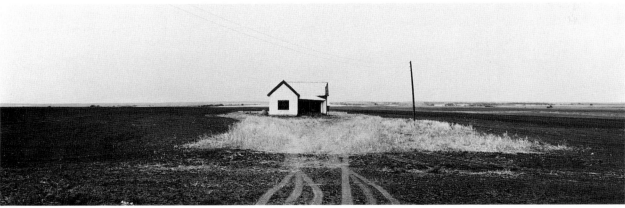

3929

3935. **WISCONSIN WOODS** (P1979.6.3)
Gelatin silver print. 1975
Image: 10 ⅜ x 13 in. (26.3 x 33.0 cm.)
Mount: 16 x 20 in. (40.7 x 50.8 cm.)
Signed, l.r. mount recto: "Mary Peck"
Inscription, mount verso: "Wisconsin Woods/1975"
Acquired from: the photographer

IRVING PENN, American (b. 1917)

Irving Penn studied design at the Philadelphia Museum
School of Industrial Arts and worked as a graphic artist
in New York from 1938 to 1941. After spending a year
painting in Mexico, Penn joined the staff of *Vogue*, first
as a designer and then as a photographer. Over the
years, he has established himself as one of the country's
leading fashion photographers.

*3936. **JOHN MARIN** (P1984.15)
Hand-coated multiple platinum/palladium print. negative
1948, print 1977
Image: 21 ⅜ x 15 ¹¹⁄₁₆ in. (54.3 x 39.8 cm.)
Sheet: 26 x 22 ⅟₁₆ in. (66.0 x 56.0 cm.)
Signed, center print verso: "Irving Penn"
Inscription, print verso: "85/JOHN MARIN// 23/40 //BF 360
Paper on Aluminum/Multiple Coating and Printing/1
Platinum/2 Platinum-palladium/Print made April—May
1977." and rubber stamps "Deacidified" and
"PHOTOGRAPH BY IRVING PENN/Copyright © 1948
by/THE CONDE NAST PUBLICATIONS INC./Not to be
reproduced without/written permission of the/copyright
owner." and "In addition to 40 numbered prints of this
image/in platinum metals, unnumbered, but signed, silver/
prints not exceeding a total of 42 may exist" and "Hand-
coated by the photographer"
Acquired from: Vision Gallery, Boston, Massachusetts

MICHAEL PEVEN, American (b. 1949)

Michael Peven received a B.A. in photo design from
the University of Illinois at Chicago in 1971 and an
M.F.A. in Photography from the School of the Art In-
stitute of Chicago. Since 1977, Peven has taught pho-
tography and directed the photography program at the
University of Arkansas. He has also given lectures and
workshops and curated exhibitions. Peven received two
Fellowship Awards from the Mid-America Arts Alli-
ance (1982 and 1983), research incentive grants from
the J. W. Fulbright College of Arts and Sciences, Uni-
versity of Arkansas (1982 and 1985), a Photographer's
Fellowship from the Arkansas Arts Council (1986—87),
and the Kodak Award for Excellence. Among his many
publications are *The Marriage of Heaven and Hell* (1985),
Outstanding Young Men of America (1985), and *The Key
to Knowledge* (1985). His work challenges the objective
depiction of reality through physical manipulations of
color photography and offset production.

3937. **PNINN PICTURE [from the Society for Photographic
Education's "South Central Regional Photography
Exhibition"]** (P1983.31.12)
Type C color print with straight pins. 1978
Image: 6 ³⁄₁₆ x 9 ¼ in. (15.7 x 23.5 cm.)
Sheet: 8 x 10 in. (20.3 x 25.4 cm.)
Signed, l.l. print verso and u.l. old mat backing verso:
"© michael peven, 1978"
Inscription, old mat backing verso: "MICHAEL PEVEN/
ART DEPT./116 F.A. BLDG./UNIVERSITY OF
ARKANSAS/FAYETTEVILLE, AR. 72701/(501)
443—2215//"PNINN PICTURE""
Acquired from: gift of the Society for Photographic
Education, South Central Region

BRENT PHELPS, American (b. 1946)

Phelps, an Illinois native, received his B.S. from
Southern Illinois University and his M.F.A. from Ari-
zona State University. Since receiving his graduate de-
gree, he has taught at various institutions, including
Tuba City High School, Tuba City, Arizona; Yavapai
Community College, Prescott, Arizona; Northern Ari-
zona University, Flagstaff, Arizona; Sam Houston State
University, Huntsville, Texas; and North Texas State
University, Denton, Texas. Phelps received the Hunts-
ville Arts Commission grant in 1979 and a National
Endowment for the Arts grant in 1981.

3938. **CROCKETT, TX [from the Society for Photographic
Education's "South Central Regional Photography
Exhibition"]** (P1983.31.13)
Type C color print. 1980
Image: 10 ¹¹⁄₁₆ x 13 ⁹⁄₁₆ in. (27.1 x 34.4 cm.)
Sheet: 11 x 14 in. (28.0 x 35.6 cm.)
Signed, l.r. sheet verso: "Brent Phelps"
Inscription, sheet verso: "Y 79/M 42 ½/X/X/16 @ 12 sec//
Crockett, TX 1980"
Acquired from: gift of the Society for Photographic
Education, South Central Region

EUGENE A. PIFFET

See Gustave A. Moses

BERNARD PLOSSU,
French, born Vietnam (b. 1945)

Raised in Paris, Plossu got his first photographic assign-
ment almost by chance when he stepped in to replace a
last-minute dropout on a British expedition sent to
explore three unmapped Mexican rivers. The body
of work produced on that trip launched his career as a
traveler and commercial photographer. Plossu gave up
his commercial work after a 1975 trip to Africa. From
1977 to 1984 he lived in Santa Fe, New Mexico, but
now resides in Paris. In 1988 he became the youngest
recipient of France's Grands Prix Nationaux de la Pho-
tographie. Plossu photographs using only a 35mm cam-
era and a 50mm lens. He prints full frame, believing
that the mind and eye should do the composing. He
works in both black and white and color; his color work
is printed in the Fresson process, a carbon-based print-
ing process.

*3939. **CHIMAYO, NEW MEXICO [from the portfolio "New
Mexico Landscapes"]** (P1983.38.7)
Gelatin silver print. negative 1978, print 1983 by Ray Belcher
Image: 7 ¾ x 11 ⁹⁄₁₆ in. (19.7 x 29.3 cm.)
Mount: 16 x 19 ⅞ in. (40.7 x 50.5 cm.)
Signed, l.r. mount recto: "B Plossu"
Acquired from: Portfolio Editions, Oklahoma City, Oklahoma

3940. **COLORADO GREAT SAND DUNES [from the series "The
Garden of Dust"]** (P1985.8.1)
Gelatin silver print. 1984, print by Ray Belcher
Image: 3 ⅟₁₆ x 4 ⁹⁄₁₆ in. (7.7 x 11.5 cm.)
Sheet: 7 ¹⁵⁄₁₆ x 10 ³⁄₁₆ in. (20.1 x 25.8 cm.)
Signed, l.l. print verso: "B Plossu."
Inscription, print verso: "Colorado Great Sand Dunes./(Serie
"The garden of dust")//Printed by R. Belcher 1984"
Acquired from: gift of the photographer

3931

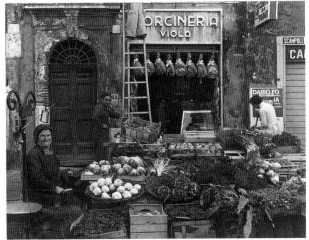

3933

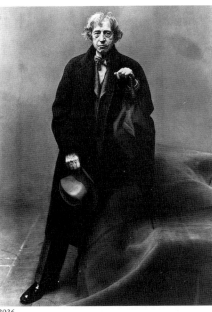

3936

3939

3947

3950

3941. **MAGDALENA** (P1981.55.1)
Gelatin silver print. negative 1974, print 1981
Image: 7 x 10⅝ in. (17.8 x 27.0 cm.)
Sheet: 9⁷⁄₁₆ x 12 in. (23.9 x 30.5 cm.)
Signed, l.l. print verso: "B Plossu."
 l.r. overmat recto: "B Plossu"
Inscription, print verso: "magdalena—74//US74.1/25."
 mat backing verso: "6/81"
Acquired from: the photographer

3942. **MONUMENT VALLEY [from the series "The Garden of Dust"]** (P1985.8.2)
Gelatin silver print. negative 1981, print 1984 by Ray Belcher
Image: 3 x 4½ in. (7.6 x 11.4 cm.)
Sheet: 7⅞ x 10¹⁄₁₆ in. (20.0 x 25.5 cm.)
Signed, l.l. print verso: "B Plossu."
Inscription, print verso: "Monument Valley. (Serie "The garden of dust")//Printed by R. Belcher 1984"
Acquired from: gift of the photographer

3943. **NEVADA [from the series "The Garden of Dust"]** (P1985.8.4)
Gelatin silver print. negative 1980, print 1984 by Ray Belcher
Image: 4⁹⁄₁₆ x 3 in. (11.6 x 7.6 cm.)
Sheet: 10 x 8 in. (25.4 x 20.3 cm.)
Signed, l.l. print verso: "B Plossu."
Inscription, print verso: "Nevada./(Serie "The garden of dust")//Printed by R. Belcher 1984"
Acquired from: gift of the photographer

3944. **NEW MEXICO** (P1981.55.3)
Gelatin silver print. negative 1980, print 1981
Image: 7 x 10⅝ in. (17.8 x 27.0 cm.)
Sheet: 9⁷⁄₁₆ x 12 in. (23.9 x 30.5 cm.)
Signed, l.l. print verso: "B Plossu."
 l.r. overmat recto: "B Plossu"
Inscription, print verso: "New Mexico 80//US80−38/31A"
 mat backing verso: "6/81"
Acquired from: the photographer

[RANCHOS DE TAOS CHURCH] (P1981.56.1−8)
This is a unique version of Plossu's unpublished Ranchos de Taos portfolio. The untoned gelatin silver prints were printed especially for the Amon Carter Museum. Previous portfolios were sepia-toned prints.

3945. **RANCHOS CHURCH [detail of apse]** (P1981.56.1)
Gelatin silver print. negative 1978, print 1981
Image: 4¹¹⁄₁₆ x 7 in. (11.9 x 17.8 cm.)
Sheet: 7 x 9⁷⁄₁₆ in. (17.8 x 23.9 cm.)
Signed, l.l. print verso: "B Plossu."
 l.r. overmat recto: "B Plossu"
Inscription, print verso: "Ranchos church 78//US 78.130/14"
Acquired from: the photographer

3946. **RANCHOS CHURCH [apse and shadows]** (P1981.56.2)
Gelatin silver print. negative 1978, print 1981
Image: 7 x 4¹¹⁄₁₆ in. (17.8 x 11.9 cm.)
Sheet: 9⁷⁄₁₆ x 7 in. (23.9 x 17.8 cm.)
Signed, l.l. print verso: "B Plossu."
 l.r. overmat recto: "B Plossu"
Inscription, print verso: "Ranchos church 78//US '78.16/24"
Acquired from: the photographer

*3947. **RANCHOS CHURCH [rocks next to church base]** (P1981.56.3)
Gelatin silver print. negative 1978, print 1981
Image: 4¹¹⁄₁₆ x 7 in. (11.9 x 17.8 cm.)
Sheet: 7 x 9⁷⁄₁₆ in. (17.8 x 23.9 cm.)
Signed, l.l. print verso: "B Plossu."
 l.r. overmat recto: "B Plossu"
Inscription, print verso: "Ranchos church 78//US 78.130/29"
Acquired from: the photographer

3948. **RANCHOS CHURCH [truck parked at back of church during restoration work]** (P1981.56.4)
Gelatin silver print. negative 1979, print 1981
Image: 4¹¹⁄₁₆ x 7 in. (11.9 x 17.8 cm.)
Sheet: 7 x 9⁷⁄₁₆ in. (17.8 x 23.9 cm.)
Signed, l.l. print verso: "B Plossu."
 l.r. overmat recto: "B Plossu"
Inscription, print verso: "Ranchos church 79//US 79.82/18A"
Acquired from: the photographer

3949. **RANCHOS CHURCH [side of church showing electric wires and adobe bricks piled by wall]** (P1981.56.5)
Gelatin silver print. negative 1979, print 1981
Image: 7 x 4¹¹⁄₁₆ in. (17.8 x 11.9 cm.)
Sheet: 9⁷⁄₁₆ x 7 in. (23.9 x 17.8 cm.)
Signed, l.l. print verso: "B Plossu."
 l.r. overmat recto: "B Plossu"
Inscription, print verso: "Ranchos church 79//US 79.84/24"
Acquired from: the photographer

*3950. **RANCHOS CHURCH [church wall, cross, and electric line]** (P1981.56.6)
Gelatin silver print. negative 1979, print 1981
Image: 7 x 4¹¹⁄₁₆ in. (17.8 x 11.9 cm.)
Sheet: 9⁷⁄₁₆ x 7 in. (23.9 x 17.8 cm.)
Signed, l.l. print verso: "B Plossu."
 l.r. overmat recto: "B Plossu"
Inscription, print verso: "Ranchos church 79//US'79.69/29A"
Acquired from: the photographer

3951. **RANCHOS CHURCH [stack of adobe bricks next to church wall]** (P1981.56.7)
Gelatin silver print. negative 1979, print 1981
Image: 7 x 4¹¹⁄₁₆ in. (17.8 x 11.9 cm.)
Sheet: 9⁷⁄₁₆ x 7 in. (23.9 x 17.8 cm.)
Signed, l.l. print verso: "B Plossu."
 l.r. overmat recto: "B Plossu"
Inscription, print verso: "Ranchos church 79//US'79.86/35"
Acquired from: the photographer

3952. **RANCHOS CHURCH [pile of sand and shadows on church wall]** (P1981.56.8)
Gelatin silver print. negative 1979, print 1981
Image: 7 x 4¹¹⁄₁₆ in. (17.8 x 11.9 cm.)
Sheet: 9⁷⁄₁₆ x 7 in. (23.9 x 17.8 cm.)
Signed, l.l. print verso: "B Plossu."
 l.r. overmat recto: "B Plossu"
Inscription, print verso: "Ranchos church. 79// US'79.69/33A"
Acquired from: the photographer

* * * *

3953. **SANTA CLARA PUEBLO [from the Santa Fe Center for Photography "Portfolio I"]** (P1982.35.2)
Gelatin silver print. negative 1978, print 1982
Image: 6¼ x 9⅝ in. (15.9 x 24.4 cm.)
Sheet: 8 x 10 in. (20.3 x 25.4 cm.)
Signed, l.r. print verso and l.r. overmat recto: "B Plossu"
Inscription, printed paper label on mat backing verso: "Santa Fe Center for Photography/PORTFOLIO I/Portfolio no. 10 Print no. 2"
Acquired from: Santa Fe Center for Photography, Santa Fe, New Mexico

3954. **SANTA FE** (P1983.11.3)
Fresson print. negative 1980, print 1983 by Atelier Fresson
Image: 7⅜ x 10⅞ in. (18.7 x 27.7 cm.)
Sheet: 7¾ x 11½ in. (19.6 x 29.2 cm.) irregular
Signed, l.l. print verso: "B Plossu"
Inscription, print verso: "SANTA FE. 1980//Photo Plossu/ Print FRESSON (totally archival)"
Acquired from: the photographer

*3955. **TAOS** (P1981.55.2)
Gelatin silver print. negative 1978, print 1981
Image: 7 x 10⅝ in. (17.8 x 27.0 cm.)
Sheet: 9⁷⁄₁₆ x 12 in. (23.9 x 30.5 cm.)

Signed, l.l. print verso: "B Plossu."
 l.r. overmat recto: "B Plossu"
Inscription, print verso: "TAOS 78//US78.123/22A"
 mat backing verso: "6/81"
Acquired from: the photographer

3956. **TAOS PLAZA** (P1981.57)
Gelatin silver print. negative 1979, print 1981
Image: 7 x 10⅝ in. (17.8 x 27.0 cm.)
Sheet: 9⁷⁄₁₆ x 12 in. (23.9 x 30.5 cm.)
Signed, l.l. print verso: "B Plossu."
 l.r. overmat recto: "B Plossu"
Inscription, print verso: "TAOS plaza 79//US'79.158/7"
 mat backing verso: "6/81"
Acquired from: gift of the photographer

*3957. **TAOS PUEBLO** (P1981.55.4)
Gelatin silver print. negative 1977, print 1981
Image: 7 x 10⅝ in. (17.8 x 27.0 cm.)
Sheet: 9⁷⁄₁₆ x 12 in. (23.9 x 30.5 cm.)
Signed, l.l. print verso: "B Plossu."
 l.r. overmat recto: "B Plossu"
Inscription, print verso: "TAOS pueblo 77//US78.17/28"
 mat backing verso: "6/81"
Acquired from: the photographer

*3958. **TAOS—ROAD ON THE MESA I** (P1983.11.1)
Fresson print. negative 1977, print 1983 by Atelier Fresson
Image: 7⁷⁄₁₆ x 11 in. (18.9 x 28.0 cm.)
Sheet: 7¾ x 11⁵⁄₁₆ in. (19.6 x 28.8 cm.)
Signed, l.r. print verso: "B Plossu"
Inscription, print verso: "Photo PLOSSU/print FRESSON//
 TAOS—1977/"Road on the Mesa I""
Acquired from: the photographer

3959. **TAOS STORM** (P1981.55.5)
Gelatin silver print. negative 1978, print 1981
Image: 7 x 10⅝ in. (17.8 x 27.0 cm.)
Sheet: 9⁷⁄₁₆ x 12 in. (23.9 x 30.5 cm.)
Signed, l.l. print verso: "B Plossu."
 l.r. overmat recto: "B Plossu"
Inscription, print verso: "TAOS Storm 78//US'78.16/34A"
Acquired from: the photographer

3960. **TAOS WINTER** (P1981.55.6)
Gelatin silver print. negative 1977, print 1981
Image: 7 x 10⅝ in. (17.8 x 27.0 cm.)
Sheet: 9⁷⁄₁₆ x 12 in. (23.9 x 30.5 cm.)
Signed, l.l. print verso: "B Plossu."
 l.r. overmat recto: "B Plossu"
Inscription, print verso: "TAOS winter 77//US78.29/31A"
 mat backing verso: "6/81"
Acquired from: the photographer

3961. **WHITE SANDS** (P1983.11.2)
Fresson print. negative 1980, print 1983 by Atelier Fresson
Image: 7⅜ x 10⅞ in. (18.7 x 27.7 cm.)
Sheet: 7¾ x 11½ in. (19.6 x 29.2 cm.)
Signed, l.l. print verso: "B Plossu."
Inscription, print verso: "White Sands. 1980.//Photo
 PLOSSU/print FRESSON (Totally archival)"
Acquired from: the photographer

3962. **WHITE SANDS [from the series "The Garden of Dust"]**
 (P1985.8.3)
Gelatin silver print. negative 1979, print 1984 by Ray Belcher
Image: 3¹⁄₁₆ x 4½ in. (7.7 x 11.4 cm.)
Sheet: 7¹⁵⁄₁₆ x 9¹⁵⁄₁₆ in. (20.2 x 25.3 cm.)
Signed, l.l. print verso: "B Plossu."
Inscription, print verso: "White Sands./(Serie "The garden
 of dust")//Printed by R. Belcher 1984"
Acquired from: gift of the photographer

3955

3957

3958

3963. **WINTER IN TAOS PUEBLO, NEW MEXICO [from the portfolio "New Mexico Landscapes"]** (P1983.38.8)
Gelatin silver print. negative 1977, print 1983 by Ray Belcher
Image: 7 7/8 x 11 11/16 in. (20.0 x 29.7 cm.)
Mount: 15 15/16 x 19 7/8 in. (40.5 x 50.5 cm.)
Signed, l.r. mount recto: "B Plossu"
Acquired from: Portfolio Editions, Oklahoma City, Oklahoma

ELIOT PORTER, American (1901–1990)

Although Porter received a medical degree from Harvard in 1929 and taught biochemistry and biology for several years, he worked exclusively as a photographer after 1939, when his work was first exhibited at Alfred Stieglitz's gallery, An American Place. In 1941 Porter received a Guggenheim fellowship for bird photography and took up color work, mastering the dye-transfer process that he used thereafter. A second grant followed in 1946. In 1967 Porter received the United States Department of the Interior Conservation Service Award. An ardent conservationist, Porter published much of his work in volumes done for the Sierra Club. His work also has been published in numerous portfolios. In 1987 the Amon Carter Museum organized a retrospective exhibition of Porter's work; the accompanying book *Eliot Porter* included an autobiographical essay by the photographer. Porter bequeathed his photographic estate of prints, negatives, and manuscripts to the Amon Carter Museum.

*3964. **ARCTIC TERN** (P1974.22.6)
Gelatin silver print. 1949
Image: 14 3/4 x 17 5/8 in. (37.4 x 44.8 cm.)
Mount: 21 1/2 x 24 1/2 in. (54.6 x 62.2 cm.)
Signed, l.r. mount recto: "Eliot Porter"
Inscription, mount verso, rubber stamp: "PHOTOGRAPH/ By/ELIOT PORTER/No. [in ink] 2 2-5 2/Title [in ink] Arctic Tern"
Acquired from: the photographer

*3965. **AUTUMN LEAVES, N. H.** (P1974.22.1)
Dye-transfer print. 1956
Image: 10 3/4 x 8 3/8 in. (27.3 x 21.3 cm.)
Mount: 20 x 15 in. (50.8 x 38.2 cm.)
Signed, l.r. mount recto: "Eliot Porter"
Inscription, mount verso, rubber stamp: "PHOTOGRAPH/ By/ELIOT PORTER/No. [in ink] 56-307/Title [in ink] Autumn Leaves/N. H."
Acquired from: the photographer

BIRDS IN FLIGHT (P1979.5.1–8)

The portfolio was published by Bell Editions of Santa Fe, New Mexico, in 1978. It consists of eight dye-transfer prints of Porter's bird photographs. This is portfolio number 8 of an edition of 20 plus 6 artist's copies.

*3966. **OSPREY. PANDION HALIAETUS CAROLINENSIS, PENOBSCOT BAY, MAINE** (P1979.5.1)
Dye-transfer print. negative 1976, print 1978
Image: 15 7/8 x 12 3/8 in. (40.3 x 31.3 cm.)
Mount: 24 x 20 in. (61.0 x 50.8 cm.)
Signed, l.r. mount recto: "Eliot Porter"
Inscription, mount recto: "1"
Acquired from: Bell Editions, Santa Fe, New Mexico

3967. **BARN SWALLOW. HIRUNDO RUSTICA ERYTHROGASTER, GREAT SPRUCE HEAD ISLAND, MAINE** (P1979.5.2)
Dye-transfer print. negative 1974, print 1978
Image: 12 11/16 x 10 7/8 in. (32.2 x 26.5 cm.)
Mount: 24 x 20 in. (61.0 x 50.8 cm.)
Signed, l.r. mount recto: "Eliot Porter"
Inscription, mount recto: "2"
Acquired from: Bell Editions, Santa Fe, New Mexico

3968. **CHIPPING SPARROW. SPIZELLA PASSERINA PASSERINA, GREAT SPRUCE HEAD ISLAND, MAINE** (P1979.5.3)
Dye-transfer print. negative 1971, print 1978
Image: 10 5/8 x 8 in. (26.9 x 20.3 cm.)
Mount: 24 x 20 in. (61.0 x 50.8 cm.)
Signed, l.r. mount recto: "Eliot Porter"
Inscription, mount recto: "3"
Acquired from: Bell Editions, Santa Fe, New Mexico

3969. **PARULA WARBLER. PARULA AMERICANA, GREAT SPRUCE HEAD ISLAND, MAINE** (P1979.5.4)
Dye-transfer print. negative 1968, print 1978
Image: 8 1/2 x 10 1/16 in. (21.6 x 25.5 cm.)
Mount: 24 x 20 in. (61.0 x 50.8 cm.)
Signed, l.r. mount recto: "Eliot Porter"
Inscription, mount recto: "4"
Acquired from: Bell Editions, Santa Fe, New Mexico

3970. **WOOD IBIS. MYCTERIA AMERICANA, CORKSCREW SWAMP, FLORIDA** (P1979.5.5)
Dye-transfer print. negative 1974, print 1978
Image: 12 3/8 x 15 7/8 in. (31.5 x 40.4 cm.)
Mount: 19 3/4 x 24 in. (50.2 x 61.0 cm.)
Signed, l.r. mount recto: "Eliot Porter"
Inscription, mount recto: "5"
Acquired from: Bell Editions, Santa Fe, New Mexico

3971. **ARCTIC TERN. STERNA PARADISAEA, MATINICUS ROCK, MAINE** (P1979.5.6)
Dye-transfer print. negative 1976, print 1978
Image: 10 3/8 x 12 11/16 in. (26.4 x 32.2 cm.)
Mount: 20 x 24 in. (50.8 x 61.0 cm.)
Signed, l.r. mount recto: "Eliot Porter"
Inscription, mount recto: "6"
Acquired from: Bell Editions, Santa Fe, New Mexico

3972. **BLUE-THROATED HUMMINGBIRD. LAMPORNIS CLEMENCIAE, CHIRICAHUA MOUNTAINS, ARIZONA** (P1979.5.7)
Dye-transfer print. negative 1959, print 1978
Image: 9 3/8 x 7 3/4 in. (23.7 x 19.7 cm.)
Mount: 24 x 20 in. (61.0 x 50.8 cm.)
Signed, l.r. mount recto: "Eliot Porter"
Inscription, mount recto: "7"
Acquired from: Bell Editions, Santa Fe, New Mexico

* 3973. **SNOWY EGRET. LEUCOPHOYX THULA THULA, EVERGLADES NATIONAL PARK, FLORIDA** (P1979.5.8)
Dye-transfer print. negative 1974, print 1978
Image: 11 1/2 x 15 3/4 in. (29.1 x 40.1 cm.)
Mount: 19 13/16 x 24 in. (50.3 x 61.0 cm.)
Signed, l.r. mount recto: "Eliot Porter"
Inscription, mount recto: "8"
Acquired from: Bell Editions, Santa Fe, New Mexico

* * * *

3974. **BRYCE CANYON UTAH** (P1974.22.3)
Dye-transfer print. 1963
Image: 8 3/4 x 8 9/16 in. (22.1 x 21.7 cm.)
Mount: 20 x 15 in. (50.8 x 38.1 cm.)
Signed, l.r. mount recto: "Eliot Porter"
Inscription, mount verso, rubber stamp: "PHOTOGRAPH/ By/ELIOT PORTER/No. [in ink] 63-474/Title [in ink] Bryce Canyon/Utah"
Acquired from: the photographer

3975. **CABO SAN LUCAS** (P1974.22.4)
Dye-transfer print. 1964
Image: 7 15/16 x 10 3/16 in. (20.2 x 25.9 cm.)
Mount: 15 x 17 1/2 in. (38.1 x 44.5 cm.)
Signed, l.r. mount recto: "Eliot Porter"
Inscription, mount verso, rubber stamp: "PHOTOGRAPH/ By/ELIOT PORTER/No. [in ink] 64-155/Title [in ink] Cabo San Lucas"
Acquired from: the photographer

3976. **LANDSCAPE, NEW MEXICO [from the Santa Fe Center
for Photography "Portfolio I"]** (P1982.35.3)
Dye-transfer print. negative 1960, print 1982
Image: 10½ x 8 3/16 in. (26.6 x 20.7 cm.)
Sheet: 11 15/16 x 10 in. (30.4 x 25.3 cm.)
Signed, l.l. print verso: "© Eliot Porter 1960"
l.r. overmat recto: "Eliot Porter"
Inscription, mat backing verso, printed paper label: "Santa Fe
Center for Photography/PORTFOLIO I/Portfolio no. [in
ink] 10 Print no. [in ink] 3"
Acquired from: Santa Fe Center for Photography, Santa Fe,
New Mexico

3977. **SANGRE DE CRISTO MTS., N. M.** (P1974.22.5)
Dye-transfer print. 1958
Image: 8 5/8 x 8½ in. (21.9 x 21.6 cm.)
Mount: 20 x 15 in. (50.8 x 38.1 cm.)
Signed, l.r. mount recto: "Eliot Porter"
Inscription, mount verso, rubber stamp: "PHOTOGRAPH/
By/ELIOT PORTER/No. [in ink] 58-406/Title [in ink]
Sangre de Cristo Mts./N. M."
Acquired from: the photographer

3978. **WINDOW, TRUCHES, N. M.** (P1974.22.2)
Dye-transfer print. 1961
Image: 10 5/16 x 8 1/16 in. (26.2 x 20.5 cm.)
Mount: 20 x 15 in. (50.8 x 38.1 cm.)
Signed, l.r. mount recto: "Eliot Porter"
Inscription, mount verso, rubber stamp: "PHOTOGRAPH/
By/ELIOT PORTER/No. [in ink] 61-140/Title [in ink]
Window, Truches/N. M."
Acquired from: the photographer

HELEN POST, American (1907–1978)

Helen Margaret Post, older sister of Marion Post
Wolcott, was born in Bloomfield, New Jersey. After
graduating in 1932 from Alfred University, in upstate
New York, with a degree in applied arts, Post taught
school for a short while. By 1933 she went to Europe to
study photography and apprenticed with noted Vien-
nese photographer Trude Fleischmann, who taught Post
composition and darkroom techniques. Post returned
to the United States and started a career as a freelance
photographer. Her specialization was documenting
educational institutions, but she also accepted other
assignments. In 1937 Post married Rudolf Modley, an
economist and management consultant. As a result of
her desire to travel with Modley while he researched
erosion and conservation techniques in the West, Post
began photographing American Indians. From 1936 to
1941, she traveled throughout the West and Southwest
documenting Sioux, Navajo, Apache, Hopi, and Pueblo
Indians. Like her older contemporary, Laura Gilpin,
Post gained the trust and friendship of the Indians and
thereby gained access to traditionally closed societies.
The resulting images, mostly made with a 70 mm
Roliflex, offer a realistic view of the Indians' daily
activities. Post sold some of her photographs to the
Bureau of Indian Affairs to use in various publications.
Her images also were used as illustrations in *As Long as
the Grass Shall Grow* by Oliver La Farge, *Brave Against
the Enemy* by Ann Clarke, and numerous magazine arti-
cles, and occasionally were exhibited between 1940 and
1978. However, most of her collection of over 5,000 im-
ages of American Indians was never published or ex-
hibited. Post abandoned her photographic career to
work assisting refugees fleeing Europe during World
War II and later to raise her two children and to man-
age a country property. In the 1970s, she attempted to

3964

3965

3966

resume her career; she planned to visit the Indians she had photographed in the late 1930s and photograph them or their descendants, but she never followed through with the project.

Note: The Helen Post Collection (P1985.47), donated to the Museum by Peter Modley, Post's son, in 1985, is being processed at the time of publication of this catalogue. This collection of Post's American Indian photography includes almost 6,000 gelatin silver prints (over 4,000 contact prints and over 1,500 enlargements and exhibition prints), 4,070 film negatives, related papers, and ephemera. Most of the images date from circa 1936–41.

WILLIAM B. POST, American (1857–1925)

See *Camera Notes*

ROGER PRATHER, American (b. 1959)

Roger Prather was born in Amarillo, Texas, and received an A.A.S. in photography from Amarillo College. Since receiving his degree Prather has done newspaper, architectural, and, most recently, portrait photography.

3979. **PARKING LOT #69 [Call It Marilyn Monroe, If You Want; from the Society for Photographic Education's "South Central Regional Photography Exhibition"]** (P1983.31.14)
Gelatin silver print. 1979
Image: 8 13/16 x 13 in. (22.4 x 33.0 cm.)
Sheet: 10 1/16 x 13 15/16 in. (25.4 x 35.4 cm.)
Signed: see inscription
Inscription, old mat backing verso: "Roger Prather/2825 Armand/Amarillo, Texas/79110"
Acquired from: gift of the Society for Photographic Education, South Central Region

WINTER PRATHER, American (b. 1926)

Prather took up photography at the age of seventeen while he was a student at the University of Denver. In 1944 he got a job as publicity photographer at the university and later worked on a high-speed motion picture research project for the Denver Research Institute. Prather has done architectural, industrial, and landscape work, living for a time in Taos, New Mexico. He currently lives in Denver, Colorado.

3980. **[Approaching train at dusk]** (P1974.26.7)
Gelatin silver print. 1945
Image: 8 1/2 x 15 5/8 in. (21.6 x 39.7 cm.)
Mount: 18 x 26 in. (45.7 x 66.0 cm.)
Signed, l.r. mount recto: "Winter Prather '45"
left center mount verso: "Winter Prather 1945"
Inscription, mount verso: "5 x 7 Graflex Wratten G filter/8" Wollensak Velostiginet/Isopan 5 x 7 film, ABC Pyro/ probably 1/60 @ 4.5"
Acquired from: the photographer

3981. **ASSIGNMENT FOR B & L WRECKING CO. DENVER** (P1974.26.6)
Gelatin silver print. 1966
Image: 11 3/4 x 10 5/8 in. (29.8 x 27.0 cm.)
Mount: 20 x 16 in. (50.8 x 40.7 cm.)
Signed, l.r. mount recto: "Winter Prather '66"
u.l. mount verso: "Winter Prather 1966"
Inscription, mount verso: "Hasselblad 80mm Tensar/ Assignment for B & L Wrecking Co. Denver/ Brovira print"
Acquired from: the photographer

3982. **BANFF JASPER AREA** (P1972.2.2) duplicate of P1972.2.9
Negative gelatin silver print. c. 1971
Image: 9 13/16 x 13 1/16 in. (24.9 x 33.2 cm.)
Sheet: 11 x 14 1/16 in. (28.0 x 35.8 cm.)
Signed: see inscription
Inscription, print verso: "Banff Jasper Area" and rubber stamp "Photo by WINTER PRATHER/Box 138, Taos, New Mexico/All reproduction rights reserved/except by written permission of/the above photographer."
Acquired from: gift of the photographer

3983. **BANFF JASPER AREA [trees on hillside]** (P1972.2.6)
Negative gelatin silver print. c. 1971
Image: 9 3/4 x 13 1/16 in. (24.8 x 33.2 cm.)
Sheet: 11 x 14 1/16 in. (27.9 x 35.8 cm.)
Signed: see inscription
Inscription, print verso: "Banff Jasper area" and rubber stamp "Photo by WINTER PRATHER/Box 138, Taos, New Mexico/All reproduction rights reserved/except by written permission of/the above photographer."
Acquired from: gift of the photographer

3984. **BANFF JASPER AREA** (P1972.2.9) duplicate of P1972.2.2
Negative gelatin silver print. c. 1971
Image: 5 x 6 1/2 in. (12.7 x 16.5 cm.)
Sheet: 7 1/16 x 8 9/16 in. (17.9 x 21.7 cm.)
Signed, l.r. print recto: "Winter Prather"
Acquired from: gift of the photographer

3985. **BARN NEAR KIOWA COLORADO** (P1974.26.4)
Gelatin silver print. 1949
Image: 10 5/16 x 13 9/16 in. (26.2 x 34.5 cm.)
Mount: 16 x 20 in. (40.7 x 50.8 cm.)
Signed, l.r. mount recto: "Winter Prather '49"
u.l. mount verso: "Winter Prather 1949"
Inscription, mount verso: "Barn near Kiowa Colorado/4 x 5 back on 5 x 7 Linhof technika/210mm Xenar lens"
Acquired from: the photographer

*3986. **[Canadian Pacific Railroad cars beside buildings]** (P1972.2.7)
Negative gelatin silver print. c. 1971
Image: 8 11/16 x 13 1/16 in. (22.0 x 33.2 cm.)
Sheet: 11 x 14 1/16 in. (27.9 x 35.8 cm.)
Signed: see inscription
Inscription, print verso, rubber stamp: "Photo by WINTER PRATHER/Box 138, New Mexico/All reproduction rights reserved/except by written permission of/the above photographer."
Acquired from: gift of the photographer

*3987. **[Cello]** (P1972.2.12)
Gelatin silver print. negative 1949, print later
Image: 6 9/16 x 4 15/16 in. (16.7 x 12.6 cm.)
Sheet: 8 9/16 x 7 1/16 in. (21.7 x 17.9 cm.)
Signed, l.r. print recto: "Winter Prather"
Acquired from: gift of the photographer

3988. **CIRRUS—SOUTH DAKOTA** (P1972.2.4)
Negative gelatin silver print. c. 1971
Image: 9 7/8 x 13 1/16 in. (25.1 x 33.2 cm.)
Sheet: 10 15/16 x 14 1/16 in. (27.7 x 35.8 cm.)
Signed: see inscription
Inscription, print verso: "Cirrus—South Dakota" and rubber stamp "Photo by WINTER PRATHER/Box 138, Taos, New Mexico/All reproduction rights reserved/except by written permission of/the above photographer."
Acquired from: gift of the photographer

3989. **THE COLUMBIA ICE FIELDS—BANFF JASPER AREA** (P1972.2.5)
Negative gelatin silver print. c. 1971
Image: 8 15/16 x 13 1/16 in. (22.6 x 33.2 cm.)
Sheet: 11 x 14 1/16 in. (27.9 x 35.8 cm.)
Signed: see inscription
Inscription, print verso: "The Columbia Ice Fields—Banff Jasper area" and rubber stamp "Photo by WINTER

PRATHER/Box 138, Taos, New Mexico/All reproduction rights reserved/except by written permission of/the above photographer."
Acquired from: gift of the photographer

3990. **DEAD COYOTE—TAOS** (P1974.26.5)
Negative gelatin silver print. 1971
Image: 12 ¹⁵/₁₆ x 8 ¹³/₁₆ in. (32.8 x 22.4 cm.)
Mount: 20 x 16 in. (50.8 x 40.7 cm.)
Signed, l.r. mount recto and u.l. mount verso:
"Winter Prather '71"
Inscription, mount verso: "Dead Coyote—Taos/Nikon F 85mm 1.8/Kodachrome II/Brovira negative print"
Acquired from: the photographer

3973

3991. **DIANNE** (P1973.49.6)
Gelatin silver print. c. 1961–73
Image: 6 ½ x 4 ⁷/₈ in. (16.5 x 12.5 cm.)
Sheet: 8 x 6 ¹¹/₁₆ in. (20.3 x 17.0 cm.)
Signed, u.l. print verso: "Winter Prather"
Inscription, print verso: "6/Dianne"
Acquired from: gift of the photographer

3992. **DIANNE** (P1973.49.7)
Negative gelatin silver print. c. 1961–73
Image: 6 ³/₈ x 4 ⁷/₈ in. (16.2 x 12.5 cm.)
Sheet: 8 x 6 ¹¹/₁₆ in. (20.3 x 17.0 cm.)
Signed, u.l. print verso: "Winter Prather"
Inscription, print verso: "7/Dianne"
Acquired from: gift of the photographer

3993. **DIANNE** (P1973.49.8)
Negative gelatin silver print. c. 1961–73
Image: 6 ³/₈ x 4 ⁷/₈ in. (16.2 x 12.5 cm.)
Sheet: 8 x 6 ¹¹/₁₆ in. (20.3 x 17.0 cm.)
Signed, u.l. print verso: "Winter Prather"
Inscription, print verso: "8/Dianne"
Acquired from: gift of the photographer

3986

3994. **END OF SUMMER** (P1974.26.3)
Gelatin silver print. 1946
Image: 9 ⁵/₁₆ x 13 ⁷/₁₆ in. (23.7 x 34.1 cm.)
Mount: 16 x 20 in. (40.7 x 50.8 cm.)
Signed, l.r. mount recto: "Winter Prather 46"
u.l. mount verso: "Winter Prather 1946"
Inscription, mount recto: "End of Summer"
mount verso: "End of Summer/(near Parker Colorado)/ 5 x 7 Graflex 8″ Wollensak Velostiginet/5 x 7 Isopan ABC Pyro developer/Brovira print"
Acquired from: the photographer

3995. **FALFURRIAS—GAS PLANT** (P1973.49.10) duplicate of P1973.49.11
Gelatin silver print. c. 1960–73
Image: 8 ⁵/₁₆ x 7 ¼ in. (21.1 x 18.5 cm.)
Mount: 11 x 9 ½ in. (28.0 x 24.2 cm.)
Signed, u.l. mount verso: "Winter Prather"
Inscription, mount verso: "Falfurrias—Gas Plant"
Acquired from: gift of the photographer

3996. **FALFURRIAS—GAS PLANT** (P1973.49.11) duplicate of P1973.49.10
Gelatin silver print. c. 1960–73
Image: 8 ⁵/₁₆ x 7 ¼ in. (21.1 x 18.5 cm.)
Mount: 11 x 9 ½ in. (28.0 x 24.2 cm.)
Signed, u.l. mount verso: "Winter Prather"
Inscription, mount verso: "Falfurrias—Gas Plant"
Acquired from: gift of the photographer

3987

*3997. **THE FAMILY OF MAN—CALGARY** (P1972.2.8)
Negative gelatin silver print. c. 1971
Image: 8¾ x 13 1/16 in. (22.2 x 33.2 cm.)
Sheet: 11 x 14 1/16 in. (27.9 x 35.8 cm.)
Signed: see inscription
Inscription, print verso: "The Family of Man—Calgary/this
was shown at Expo in 67" and rubber stamp "Photo by
WINTER PRATHER/Box 138, Taos, New Mexico/All
reproduction rights reserved/except by written permission
of/the above photographer."
Acquired from: gift of the photographer

3998. **[Forest fire]** (P1969.40)
Gelatin silver print. 1963
Image: 18 11/16 x 15 7/8 in. (47.5 x 40.3 cm.)
Mount: 24 x 20 in. (61.0 x 50.8 cm.)
Signed, l.r. mount recto: "Winter Prather"
Inscription, mount verso: "1963"
Acquired from: the photographer

3999. **GREAT SAND DUNES—ALAMOSA COLORADO**
(P1974.26.10)
Gelatin silver print. 1947
Image: 9 5/8 x 15 7/8 in. (24.4 x 40.3 cm.)
Mount: 18 x 26 in. (45.7 x 66.0 cm.)
Signed, l.r. mount recto: "Winter Prather '47"
u.l. mount verso: "Winter Prather 1947"
Inscription, mount verso: "Great Sand Dunes—Alamosa
Colorado/Deardorf View 5 x 7 21" element of/12" Turner-
Reich lens/Isopan film ABC Pyro/Brovira print Amidol
developer"
Acquired from: the photographer

4000. **A HUGE (100 x 1000 YARDS) TURBULENT AREA OF
EMERALD GREEN BOILS OUT OF THE PENSTOCKS
BELOW OAHE DAM, S. DAKOTA** (P1972.2.3)
Negative gelatin silver print. c. 1971
Image: 10 x 13 in. (25.4 x 33.0 cm.)
Sheet: 11 x 14 in. (28.0 x 35.6 cm.)
Signed: see inscription
Inscription, print verso: "a huge (100 x 1000 yards) turbulent/
area of emerald green boils out of/the penstocks below
Oahe dam/S. Dakota" and rubber stamp "Photo by
WINTER PRATHER/Box 138, Taos, New Mexico/All
reproduction rights reserved/except by written permission
of/the above photographer."
Acquired from: gift of the photographer

4001. **KANSAS WINDMILL—VICINITY McPHERSON
KANSAS** (P1974.26.2)
Negative gelatin silver print. 1966
Image: 18½ x 15 9/16 in. (47.0 x 39.5 cm.)
Mount: 26 x 20 in. (66.0 x 50.8 cm.)
Signed, l.r. mount recto: "Winter Prather '66"
u.l. mount verso: "Winter Prather 1966"
Inscription, mount verso: "Kansas Windmill—vicinity
McPherson Kansas/Hassel 127 4.7 Xenar Ektachrome/
Brovira negative print"
Acquired from: the photographer

4002. **MANNEQUIN—FREDERICKSBURG HISTORICAL
MUSEUM** (P1973.49.5)
Negative gelatin silver print. c. 1961–73
Image: 6 3/8 x 4 15/16 in. (16.2 x 12.5 cm.)
Sheet: 8 x 6 11/16 in. (20.3 x 17.0 cm.)
Signed, u.l. print verso: "Winter Prather"
Inscription, print verso: "5/Mannequin—Fredericksburg
museum/historical museum"
Acquired from: gift of the photographer

4003. **NADELMAN—HORSE** (P1973.49.9)
Negative gelatin silver print. c. 1967–73
Image: 6 3/8 x 4 7/8 in. (16.2 x 12.5 cm.)
Sheet: 8 x 4 7/8 in. (20.3 x 12.5 cm.)
Signed, u.l. print verso: "Winter Prather"
Inscription, print verso: "9/Marini [sic]—horse"
Acquired from: gift of the photographer

4004. **NORTH DAKOTA** (P1972.2.1)
Negative gelatin silver print. c. 1971
Image: 6 5/8 x 13 in. (16.8 x 33.0 cm.)
Sheet: 7 5/8 x 14 1/16 in. (19.3 x 35.7 cm.)
Signed: see inscription
Inscription, print verso: "North Dakota" and rubber stamp
"Photo by WINTER PRATHER/Box 138, Taos, New
Mexico/All reproduction rights reserved/except by written
permission of/the above photographer."
Acquired from: gift of the photographer

4005. **PENITENTE MORADA AT TALPA, EAST OF
RANCHOS DE TAOS NEW MEXICO** (P1974.26.1)
Gelatin silver print. 1946
Image: 6 15/16 x 15 13/16 in. (17.6 x 40.1 cm.)
Mount: 18 x 26 in. (45.7 x 66.0 cm.)
Signed, l.r. mount recto: "Winter Prather '46"
u.l. mount verso: "Winter Prather 1946"
Inscription, mount verso: "Penitente Morada/at Talpa, east of
Ranchos de Taos New Mexico/5 x 7 Graflex 8" Wollensak
Velostiginet/Isopan film ABC Pyro developer/Brovira print
in Amidol developer"
Acquired from: the photographer

PORTFOLIO I (P1969.39.1–16)

The portfolio consists of fifteen photographs of architectural
and nature subjects and a self-portrait of Prather. The
portfolio is not numbered and the edition size is not known.

4006. **ISLETA BUTTRESS** (P1969.39.1)
Gelatin silver print. negative 1947, print later
Image: 13 9/16 x 10 7/16 in. (34.4 x 26.5 cm.)
Mount: 18 x 15 in. (45.7 x 38.1 cm.)
Signed, l.r. mount recto: "Winter Prather"
Inscription, mount verso: "Isleta Buttress 1947/
Winter Prather/Taos New Mexico U.S.A."
Acquired from: the photographer

4007. **BALLUSTRADE** (P1969.39.2)
Gelatin silver print. negative 1950, print later
Image: 13 7/16 x 10 7/16 in. (34.1 x 26.5 cm.)
Mount: 18 x 15 in. (45.7 x 38.1 cm.)
Signed, l.r. mount recto: "Winter Prather"
Inscription, mount verso: "Ballustrade 1950/Winter Prather/
Taos New Mexico U.S.A."
Acquired from: the photographer

4008. **UNAWEEP CANYON** (P1969.39.3)
Gelatin silver print. negative 1951, print later
Image: 13 5/16 x 10 7/16 in. (33.7 x 26.5 cm.)
Mount: 18 x 15 in. (45.7 x 38.1 cm.)
Signed, l.r. mount recto: "Winter Prather"
Inscription, mount verso: "Unaweep Canyon 1951/
Winter Prather/Taos New Mexico U.S.A."
Acquired from: the photographer

*4009. **SETTLING POND** (P1969.39.4)
Gelatin silver print. negative 1952, print later
Image: 13½ x 10½ in. (34.2 x 26.5 cm.)
Mount: 18 x 15 in. (45.7 x 38.1 cm.)
Signed, l.r. mount recto: "Winter Prather"
Inscription, mount verso: "Settling Pond 1952/Winter Prather/
Taos New Mexico U.S.A."
Acquired from: the photographer

4010. **LONE CONE AND THE SAN JUANS (COLORADO)**
(P1969.39.5)
Gelatin silver print. negative 1952, print later
Image: 5 13/16 x 13 3/8 in. (14.7 x 34.0 cm.)
Mount: 15 x 18 in. (38.1 x 45.7 cm.)
Signed, l.r. mount recto: "Winter Prather"
Inscription, mount verso: "Lone Cone and the San Juans
(Colorado)/Winter Prather/Taos New Mexico U.S.A."
Acquired from: the photographer

4011. **TIMBERLINE** (P1969.39.6)
Gelatin silver print. negative 1955, print later
Image: 10 ¾ x 10 ⅜ in. (27.3 x 26.4 cm.)
Mount: 18 x 15 in. (45.7 x 38.1 cm.)
Signed, l.r. mount recto: "Winter Prather"
Inscription, mount verso: "Timberline 1955/Winter Prather/
 Taos New Mexico U.S.A."
Acquired from: the photographer

4012. **BENTLEY HOOD** (P1969.39.7)
Gelatin silver print. negative 1959, print later
Image: 10 ¼ x 10 ³⁄₁₆ in. (25.9 x 25.8 cm.)
Mount: 18 x 15 in. (45.7 x 38.1 cm.)
Signed, l.r. mount recto: "Winter Prather"
Inscription, mount verso: "Bentley Hood 1959/
 Winter Prather/Taos New Mexico U.S.A."
Acquired from: the photographer

4013. **VINE TANGLE I** (P1969.39.8)
Gelatin silver print. negative 1962, print later
Image: 13 ⁷⁄₁₆ x 10 ½ in. (34.2 x 26.6 cm.)
Mount: 18 x 15 in. (45.7 x 38.1 cm.)
Signed, l.r. mount recto: "Winter Prather"
Inscription, mount verso: "Vine Tangle I 1962/
 Winter Prather/Taos New Mexico U.S.A."
Acquired from: the photographer

*4014. **VINE TANGLE II** (P1969.39.9)
Gelatin silver print. negative 1962, print later
Image: 13 ½ x 10 ½ in. (34.3 x 26.6 cm.)
Mount: 18 x 15 in. (45.7 x 38.1 cm.)
Signed, l.r. mount recto: "Winter Prather"
Inscription, mount verso: "Vine Tangle II 1962/
 Winter Prather/Taos New Mexico U.S.A."
Acquired from: the photographer

4015. **CANYON** (P1969.39.10)
Gelatin silver print. negative 1963, print later
Image: 10 ⅜ x 13 ⅜ in. (26.4 x 34.0 cm.)
Mount: 15 ⅛ x 18 in. (38.3 x 45.7 cm.)
Signed, l.r. mount recto: "Winter Prather"
Inscription, mount verso: "Canyon 1963/Winter Prather/Taos
 New Mexico U.S.A."
Acquired from: the photographer

*4016. **REFLECTION** (P1969.39.11)
Gelatin silver print. negative 1964, print later
Image: 10 ⅞ x 10 ⁹⁄₁₆ in. (27.5 x 26.8 cm.)
Mount: 18 x 15 in. (45.7 x 38.1 cm.)
Signed, l.r. mount recto: "Winter Prather"
Inscription, mount verso: "Reflection 1964/Winter Prather/
 Taos New Mexico U.S.A."
Acquired from: the photographer

4017. **GRASSES I** (P1969.39.12)
Gelatin silver print. negative 1968, print later
Image: 10 ⁹⁄₁₆ x 10 ⁷⁄₁₆ in. (26.7 x 26.5 cm.)
Mount: 18 x 15 ⅛ in. (45.7 x 38.4 cm.)
Signed, l.r. mount recto: "Winter Prather"
Inscription, mount verso: "Grasses I 1968/Winter Prather/
 Taos New Mexico U.S.A."
Acquired from: the photographer

4018. **GRASSES II** (P1969.39.13)
Gelatin silver print. negative 1968, print later
Image: 10 ½ x 10 ⁹⁄₁₆ in. (26.6 x 26.8 cm.)
Mount: 18 x 15 ⅛ in. (45.7 x 38.4 cm.)
Signed, l.r. mount recto: "Winter Prather"
Inscription, mount verso: "Grasses II 1968/Winter Prather/
 Taos New Mexico U.S.A."
Acquired from: the photographer

3997

4009

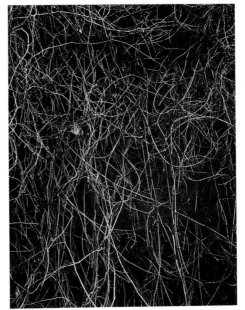
4014

4019. **GRASSES III** (P1969.39.14)
Gelatin silver print. negative 1968, print later
Image: 11 11/16 x 10 1/2 in. (29.7 x 26.7 cm.)
Mount: 18 x 15 in. (45.7 x 38.1 cm.)
Signed, l.r. mount recto: "Winter Prather"
Inscription, mount verso: "Grasses III 1968/Winter Prather/
Taos New Mexico U.S.A."
Acquired from: the photographer

4020. **GRASSES IV** (P1969.39.15)
Gelatin silver print. negative 1968, print later
Image: 13 5/16 x 10 1/2 in. (33.8 x 26.6 cm.)
Mount: 18 x 15 in. (45.7 x 38.1 cm.)
Signed, l.r. mount recto: "Winter Prather"
Inscription, mount verso: "Grasses IV 1968/Winter Prather/
Taos New Mexico U.S.A."
Acquired from: the photographer

4021. **[Self-portrait with camera and street scene reflected in metallic
sphere]** (P1969.39.16)
Gelatin silver print. n.d.
Image: 10 3/4 x 10 11/16 in. (27.2 x 27.1 cm.)
Mount: 18 x 15 in. (45.7 x 38.1 cm.)
Signed, l.r. mount recto: "Winter Prather"
Acquired from: the photographer

* * * *

4022. **SUNSET IN TALPA, EAST OF RANCHOS DE TAOS
LOOKING SOUTHEAST ACROSS THE VALLEY**
(P1974.26.9)
Gelatin silver print. c. 1955
Image: 13 5/16 x 16 3/8 in. (33.8 x 41.6 cm.)
Mount: 20 1/8 x 24 1/16 in. (51.1 x 61.1 cm.)
Signed, l.r. mount recto: "Winter Prather"
u.l. mount verso: "Winter Prather 1955?"
Inscription, mount verso: "13//Sunset in Talpa, east of
Ranchos de Taos/looking southeast across the valley/4 x 5
View probably 90mm Angalon/Tri X film in split D-23
(Adams formula)/Brovira print"
Acquired from: the photographer

4023. **TAOS SKY—AUTUMN** (P1974.26.8)
Gelatin silver print. 1947
Image: 9 3/16 x 15 13/16 in. (23.3 x 40.2 cm.)
Mount: 18 x 26 in. (45.7 x 66.0 cm.)
Signed, l.r. mount recto: "Winter Prather '47"
u.l. mount verso: "Winter Prather 1947"
Inscription, mount verso: "Taos Sky—Autumn/5 x 7
Deardorf View/21" element of 12" Turner Reich lens/Isopan
film ABC Pyro Wratten G filter/Brovira print Amidol
developer"
Acquired from: the photographer

*4024. **[Twigs]** (P1972.2.10)
Gelatin silver print. negative 1954, print later
Image: 5 x 5 5/8 in. (12.6 x 14.3 cm.)
Sheet: 7 x 7 9/16 in. (17.8 x 19.3 cm.)
Signed, l.r. print recto: "Winter Prather"
Acquired from: gift of the photographer

4025. **[Water]** (P1972.2.11)
Gelatin silver print. negative 1956, print later
Image: 5 x 6 9/16 in. (12.7 x 16.7 cm.)
Sheet: 7 1/16 x 8 1/2 in. (17.9 x 21.6 cm.)
Signed, l.r. print recto: "Winter Prather"
Acquired from: gift of the photographer

4026. **ZORACH-TORSO 1** (P1973.49.1)
Negative gelatin silver print. c. 1967–73
Image: 6 7/16 x 4 15/16 in. (16.4 x 12.5 cm.)
Sheet: 8 x 6 3/4 in. (20.4 x 17.1 cm.)
Signed, u.l. print verso: "Winter Prather"
Inscription, print verso: "1/Zorach-Torso"
Acquired from: gift of the photographer

4027. **ZORACH-TORSO 2** (P1973.49.2)
Negative gelatin silver print. c. 1967–73
Image: 6 1/8 x 4 15/16 in. (16.2 x 12.5 cm.)
Sheet: 8 x 6 3/4 in. (20.4 x 17.1 cm.)
Signed, u.l. print verso: "Winter Prather"
Inscription, print verso: "2/Zorach-Torso"
Acquired from: gift of the photographer

4028. **ZORACH-TORSO 3** (P1973.49.3)
Negative gelatin silver print. c. 1967–73
Image: 4 15/16 x 6 3/8 in. (12.5 x 16.2 cm.)
Sheet: 6 3/4 x 8 in. (17.1 x 20.4 cm.)
Signed, right edge print verso: "Winter Prather"
Inscription, print verso: "3/Zorach Torso"
Acquired from: gift of the photographer

4029. **ZORACH-TORSO 4** (P1973.49.4)
Negative gelatin silver print. c. 1967–73
Image: 6 7/16 x 4 15/16 in. (16.3 x 12.5 cm.)
Sheet: 8 x 6 11/16 in. (20.3 x 17.0 cm.)
Signed, u.l. print verso: "Winter Prather"
Inscription, print verso: "4 Zorach-Torso"
Acquired from: gift of the photographer

WILLIAM R. PYWELL, American (1843–1887)

See *Gardner's Photographic Sketch Book of the War*

WILLIAM HENRY RABE, American (d. 1919)

See John Paul Edwards

EDWARD RANNEY, American (b. 1942)

Ranney graduated from Yale University in 1964 and was
awarded a Fulbright Fellowship to study anthropology
and literature in Peru. Under this grant photography
became a dominant interest, and the groundwork for
the long-term book project *Monuments of the Incas*
(1982) was established. Upon his return to the United
States he apprenticed to the photographer David
Plowden from 1965 to 1966 and taught school in Ver-
mont from 1966 to 1970. In 1970 Ranney decided to
pursue photography full-time and moved to Santa Fe,
New Mexico. He also began work on a project docu-
menting Mexican archaeological sites. Ranney returned
to Peru in 1974 on a National Endowment for the Arts
grant and in 1977 coordinated a project for Earthwatch
Explorations to inventory and organize the negatives
of the Peruvian photographer Martin Chambi. He re-
ceived a 1977 Guggenheim Fellowship to document the
relationship between New Mexico landscape and archi-
tecture. Ranney works with a 5 x 7 inch view camera,
exploring what he calls the "cultural landscape" in a
style that he feels can bridge the gap between docu-
mentary and aesthetic photography.

4030. **BANDELIER, NEW MEXICO [from the portfolio
"New Mexico Landscapes"]** (P1983.38.9)
Gelatin silver print. negative 1979, print 1983
Image: 8 11/16 x 12 7/16 in. (22.1 x 31.6 cm.)
Mount: 16 x 19 7/8 in. (40.6 x 50.5 cm.)
Signed, l.r. mount recto and l.r. mount verso:
"Edward Ranney"
Inscription, mount verso: "Bandelier, New Mexico/1979"
Acquired from: Portfolio Editions, Oklahoma City, Oklahoma

4031. **LLANO, NEW MEXICO [from the portfolio "New Mexico
Landscapes"]** (P1983.38.10)
Gelatin silver print. negative 1978, print 1983
Image: 8 7/16 x 12 3/16 in. (21.4 x 30.9 cm.)
Mount: 15 15/16 x 19 7/8 in. (40.5 x 50.5 cm.)

Signed, l.r. mount recto and l.r. mount verso:
 "Edward Ranney"
Inscription, mount verso: "Llano, New Mexico/1978"
Acquired from: Portfolio Editions, Oklahoma City, Oklahoma

* 4032. **RANCHOS DE TAOS, N. M.** (P1979.91)
 Gelatin silver print. 1979
 Image: 6 ¾ x 9 ½ in. (17.2 x 24.0 cm.)
 Mount: 11 ¾ x 17 in. (29.8 x 43.2 cm.)
 Signed, l.r. mount recto and l.r. mount verso:
 "Edward Ranney"
 Inscription, mount verso: "Ranchos de Taos, N. M./1979"
 Acquired from: the photographer

WILLIAM H. RAU, American (1855–1920)

Rau's father, George Rau, was an active photographer;
his father-in-law, William Bell, worked as a survey pho-
tographer with the United States Geological Survey.
William H. Rau was one of the photographers on the
1874 expedition to record the transit of Venus and in
1877 formed a partnership with his father-in-law. Rau
purchased Bell's stereograph company in 1877 and con-
tinued to publish stereographs under his own name
until 1901, when the company was acquired by Under-
wood and Underwood. Although best known for his
eastern landscape views, Rau did some work in the
West during the 1880s, including a short period in 1881
when he worked with William Henry Jackson in Colo-
rado and New Mexico. Some of these views were pub-
lished as original tipped-in plates in the *Philadelphia
Photographer*. Hired by the Lehigh Valley Railroad in
1899 to make views along its lines, Rau gained a repu-
tation as a railroad photographer, but he also made
notable photographs of the 1889 Johnstown, Pennsyl-
vania, flood and the 1904 Baltimore fire.

* 4033. **EAST RUSH, L.V.R.R. [Lehigh Valley Railroad, New York]**
 (P1982.9.1)
 Albumen silver print. c. 1898–99
 Image: 17 x 20 ⁷⁄₁₆ in. (43.1 x 51.9 cm.)
 Mount: 17 ³⁄₈ x 20 ¹³⁄₁₆ in. (44.1 x 52.9 cm.)
 Signed: see inscription
 Inscription, in negative: "682 EAST RUSH, L.V.R.R.//
 WILLIAM H. RAU, PHILA."
 Acquired from: Robert Miller Gallery, New York, New York

* 4034. **THE LEHIGH, AT LAURY'S ISLAND. L.V.R.R.**
 [Lehigh Valley Railroad] (P1982.9.2)
 Albumen silver print. c. 1898–99
 Image: 17 ⅛ x 20 ⁷⁄₁₆ in. (43.4 x 51.9 cm.)
 Mount: 17 ½ x 20 ¾ in. (44.5 x 52.7 cm.)
 Signed: see inscription
 Inscription, in negative: "537 THE LEHIGH, AT LAURY'S
 ISLAND. L.V.R.R.//WILLIAM H. RAU, PHILA."
 Acquired from: Robert Miller Gallery, New York, New York

 4035. **RAINBOW FALLS [Ute Pass, Colorado; frontispiece from
 May 1883 issue of *The Philadelphia Photographer*]**
 (P1982.30.2)
 Albumen silver print. negative 1881, print 1883
 Image: 7 ⁵⁄₁₆ x 4 ⅝ in. (18.6 x 11.8 cm.)
 Mount: 9 ¾ x 6 in. (24.7 x 15.2 cm.)
 Signed: see inscription
 Inscription, mount recto: "WM. H. RAU,//
 PHILADELPHIA.//A VIEW IN COLORADO."
 Acquired from: Margolis and Moss, Santa Fe, New Mexico

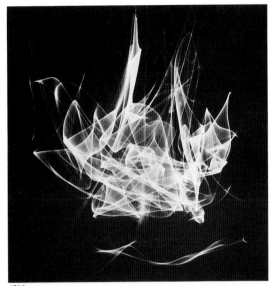
4016

4024

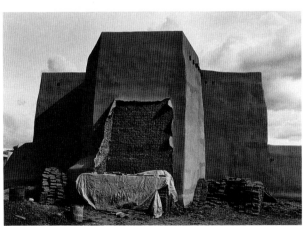
4032

4036. ROYAL GORGE [frontispiece from May 1883 issue of
 The Philadelphia Photographer] (P1982.30.1)
 Albumen silver print. negative 1881, print 1883
 Image: 7 5/16 x 4 3/16 in. (18.6 x 10.7 cm.)
 Mount: 9 3/4 x 6 in. (24.7 x 15.2 cm.)
 Signed: see inscription
 Inscription, mount recto: "WM. H RAU,//
 PHILADELPHIA.//A VIEW IN COLORADO."
 Acquired from: Margolis and Moss, Santa Fe, New Mexico

4037. VULCAN'S ANVIL, MONUMENT PARK [frontispiece
 from May 1883 issue of *The Philadelphia Photographer*]
 (P1982.30.3)
 Albumen silver print. negative 1881, print 1883
 Image: 7 5/16 x 4 11/16 in. (18.6 x 11.9 cm.)
 Mount: 9 3/4 x 6 in. (24.7 x 15.2 cm.)
 Signed: see inscription
 Inscription, mount recto: "WM H. RAU,//
 PHILADELPHIA.//A VIEW IN COLORADO."
 Acquired from: Margolis and Moss, Santa Fe, New Mexico

ROBERT S. REDFIELD, American (1849–1923)

Robert Stuart Redfield was one of the leaders of the
movement to have photography established as a fine art.
Redfield was born in New York but was raised in the
scientific community of post-war Philadelphia. In 1866
Coleman Sellers introduced him to photography, but it
was not until the advent of dry-plate negatives in 1881
that Redfield began photographing. He joined the Pho-
tographic Society of Philadelphia, serving as secretary
from 1893 until he became president in 1898. He sup-
ported the New School of American Photography's at-
tempt to persuade people to accept photography not
only as a way to record fact but also as a way to convey
emotion. Redfield also was one of the founding mem-
bers of the Photo-Secession. However, he did not ac-
cept either organization's premise that it was the sole
arbiter of artistic standards for photography. As a result,
Redfield's work is found in only a few collections, such
as the History of Photography collection at the National
Museum of American Art and the International Mu-
seum of Photography at the George Eastman House.

*4038. MOUNT WASHINGTON, MASS. (P1984.16)
 Platinum print. 1890
 Image: 7 3/8 x 9 7/16 in. (18.8 x 24.0 cm.)
 Mount: 11 x 14 1/8 in. (28.0 x 35.9 cm.)
 Signed: see inscription
 Inscription, print recto, embossed: "R. S. REDFIELD"
 mount recto: "47//#1507—Mount Washington, Mass.
 July 28th 1890"
 mount verso: "10520"
 Acquired from: Janet Lehr, Inc., New York, New York

JANE REECE, American (1869–1961)

Jane Reece set her mind on a career in the arts at an
early age, taking music lessons as payment for house-
work and babysitting. She later dropped music in favor
of drawing and painting and with the encouragement
of Howard Chandler Christy sold some of her early
sketches. An almost fatal attack of spinal meningitis
forced Reece to give up painting, and she began to pho-
tograph, opening a studio in Dayton, Ohio, after her
recovery. Over the years her studio was closely linked
with the Dayton art world, and she frequently partici-
pated in salon exhibitions organized by the Pictorial
Photographers of America. Reece also was an ardent
admirer of the photographers of the Photo-Secession.
Reece is known primarily for her portraits, usually
printed by the platinum, palladium, or carbon process.

*4039. LORADO TAFT: THE MAN AND HIS WORK (P1981.61)
 Carbon print. 1917
 Image: 8 1/8 x 6 1/2 in. (21.3 x 16.5 cm.)
 Sheet: 8 9/16 x 6 1/2 in. (21.7 x 16.5 cm.)
 Mount: 11 9/16 x 8 11/16 in. (29.3 x 22.1 cm.)
 Signed, top center mount verso: "For A. F. S. Coles—/with
 all good wishes/Jane Reece"
 Acquired from: Tom Jacobson, San Diego, California

JOHN REEKIE, American (active 1860s)

See *Gardner's Photographic Sketch Book of the War*

GUIDO REY, Italian (active 1890s—mid 1920s)

See *Camera Work*

EDWARD RICE III, American (b. 1951)

Edward Rice III has worked primarily in the platinum
and palladium processes since 1977. Rice attended Cal-
ifornia College of Arts and Crafts in Oakland and re-
ceived his B.F.A. in 1974. As an expert on the history
and the techniques of platinum printing, Rice has given
numerous workshops on platinum processes. In 1981 he
was co-curator of the exhibition "The 19th Century
Process." He is the proprietor of a gallery devoted to
fine prints and graphics. Rice's work has appeared in
two portfolios, "New Mexico Landscapes" (1983) and
"Still Lives" (1984).

4040. STREAM, ROCKS, AGUIRRE SPRINGS, NEW MEXICO
 [from the portfolio "New Mexico Landscapes"]
 (P1983.38.12)
 Palladium print. 1983
 Image: 9 11/16 x 7 5/8 in. (24.6 x 19.4 cm.)
 Signed, l.r. print verso: "Ted Rice/1983"
 l.l. mat backing recto: "Ted Rice"
 Inscription, mat backing recto: "1983"
 Acquired from: Portfolio Editions, Oklahoma City, Oklahoma

*4041. TREE, WHITE SANDS, NEW MEXICO [from the portfolio
 "New Mexico Landscapes"] (P1983.38.11)
 Palladium print. 1983
 Image: 7 5/8 x 9 11/16 in. (19.4 x 24.6 cm.)
 Signed, l.r. print verso: "Ted Rice/1983"
 l.l. mat backing recto: "Ted Rice"
 Inscription, mat backing recto: "1983"
 Acquired from: Portfolio Editions, Oklahoma City, Oklahoma

FRANK A. RINEHART, American (1861–1928)

An Illinois native, Rinehart worked with his brother,
Alfred Evans Rinehart, in Charles Bohm's Denver stu-
dio from 1878 until about 1881. In 1885 he opened his
own photographic studio in Omaha, Nebraska. He is
best known as the official photographer for the Trans-
Mississippi International Exposition held in Omaha in
1898. From a studio on the grounds, Rinehart made
photographs of the fair buildings and a good many of
the 500 Plains Indians who performed at the Exposi-
tion. George Marsden joined Rinehart as an assistant
in 1919, eventually taking over the studio on Rinehart's
death. Marsden continued to print and sell Rinehart's
Indian negatives, assembling albums of some of the
best prints.

4033

4034

4038

4039

4041

4045

4042. **EL CAPITAINE—KIOWA** (P1978.51.4)
Platinum print. 1900
Image: 9 1/8 x 7 1/4 in. (23.2 x 18.5 cm.)
Sheet: 9 3/8 x 7 1/2 in. (23.7 x 19.0 cm.)
Signed, l.l. in negative: "COPYRIGHT 1900/F. A.
RINEHART,/OMAHA."
Inscription, in negative: "EL CAPITAINE/—KIOWA—//
No 1564"
print verso: "1"
Acquired from: Hastings Gallery, New York, New York

Attributed to Frank A. Rinehart or Adolph Muhr
4043. **JEANETTE GRAY BLANKET** (P1978.51.2)
Platinum print. 1900
Image: 8 7/8 x 6 7/8 in. (22.6 x 17.4 cm.)
Sheet: 9 3/16 x 7 3/16 in. (23.2 x 18.2 cm.)
Signed, l.r. in negative: "F. A. RINEHART—/OMAHA."
Inscription, in negative: "Jeanette Gray Blanket./4199/
Copyright 1900./Keyn & Mortsen [retouched]/Chicago
[retouched]//No 1790"
print verso: "8//H-159"
Acquired from: Hastings Gallery, New York, New York

4044. **SHERMAN NILES—TONKAWA** (P1978.51.1)
Platinum print. 1900
Image: 9 1/8 x 7 3/16 in. (23.2 x 18.3 cm.)
Sheet: 9 1/2 x 7 1/2 in. (24.1 x 19.1 cm.)
Signed, l.l. in negative: "COPYRIGHT 1900/F. A.
RINEHART,/OMAHA."
Inscription, in negative: "—SHERMAN NILES—/
—TONKAWA—//No 1575"
print verso: "2//H-137"
Acquired from: Hastings Gallery, New York, New York

*4045. **VAPORE—MARICOPA** (P1978.51.3)
Platinum print. 1899
Image: 9 1/4 x 7 3/16 in. (23.4 x 18.2 cm.)
Sheet: 9 1/2 x 7 7/16 in. (24.1 x 18.9 cm.)
Signed, l.l. in negative: "COPYRIGHT 1899/F. A.
RINEHART,/OMAHA."
Inscription, in negative: "—VAPORE—/—MARICOPA—//
No 1431"
Acquired from: Hastings Gallery, New York, New York

CHARLES RIVERS, American (b. 1904)

Charles Rivers was born in Colorado, but shortly after
his birth his family moved to the northeastern United
States, where they moved from textile town to textile
town. After holding various jobs, Rivers worked on the
construction of the Chrysler and Empire State buildings
from 1929 to 1930. While working, he made photo-
graphs using a camera he kept in a tool box that was al-
ways on the floor where the derrick was located. The
resulting images offer an ironworker's unique perspec-
tive on architecture. Although his construction images
constitute his largest body of work, Rivers has contin-
ued to photograph, documenting various aspects of life
in New York City.

*4046. **ASSEMBLING ONE MORE FLOOR ON THE EMPIRE
STATE BUILDING** (P1986.24.8)
Gelatin silver print. 1930
Image: 13 3/4 x 8 7/8 in. (35.0 x 22.5 cm.)
Mount: same as image size
Signed, center mount verso: "Charles Rivers"
Inscription, mount verso, typed on paper label: "Assembling
one more floor/on the Empire State Building/1930."
Acquired from: gift of the photographer

4047. **ASSEMBLING THE 78TH—THE LAST FLOOR OF THE
CHRYSLER BUILDING** (P1986.24.3)
Gelatin silver print. 1929
Image: 10 x 8 1/16 in. (25.4 x 20.4 cm.)
Mount: same as image size

Signed, center mount verso: "Charles Rivers"
Inscription, mount verso, typed on paper label: "Assembling
the 68th [sic]—the last floor/of the Chrysler Building—
1929/Charles Rivers"
Acquired from: gift of the photographer

*4048. **THE BOLTER UP—EMPIRE STATE BUILDING
[Self-portrait]** (P1986.24.7)
Gelatin silver print. 1930
Image: 9 13/16 x 7 15/16 in. (24.9 x 20.1 cm.)
Mount: same as image size
Signed, center mount verso: "Charles Rivers"
Inscription, mount verso: "self portrait" and typed on paper
label "The Bolter Up—Empire State Build- [sic]/1930—
Charles Rivers"
Acquired from: gift of the photographer

4049. **JACK TIGHTENING A BOLT ON THE LINE HOLDING
THE DERRICK ON THE CHRYSLER BUILDING**
(P1986.24.6)
Gelatin silver print. 1929
Image: 13 3/4 x 10 3/4 in. (35.0 x 27.3 cm.)
Mount: same as image size
Signed, center mount verso: "Charles Rivers"
Inscription, mount verso, typed on paper label: "Jack
tightening a bolt on the/line hilding [sic] the derrick on/the
Chrysler Building—1929"
Acquired from: gift of the photographer

4050. **A LOAD OF STEEL BEING HOISTED ON THE EMPIRE
STATE BUILDING** (P1986.24.9)
Gelatin silver print. 1930
Image: 13 15/16 x 11 in. (35.3 x 27.9 cm.)
Mount: same as image size
Signed, l.r. print recto: "C. Rivers/1930"
center mount verso: "Charles Rivers"
Inscription, mount verso, typed on paper label: "A load of
steel being hoist-/ed on the Empire State Build-/ing—1930"
Acquired from: gift of the photographer

*4051. **LUNCH HOUR ON THE CHRYSLER BUILDING**
(P1986.24.4)
Gelatin silver print. 1929
Image: 10 13/16 x 13 1/4 in. (27.5 x 33.8 cm.)
Mount: same as image size
Signed, center mount verso: "Charles Rivers"
Inscription, mount verso, typed on paper label: "Lunch Hour
on the Chrysler/Building—1929"
Acquired from: gift of the photographer

4052. **REPAIRING THE DERRICK ON THE CHRYSLER
BUILDING** (P1986.24.2)
Gelatin silver print. 1929
Image: 13 15/16 x 11 in. (35.3 x 28.0 cm.)
Mount: same as image size
Signed, l.r. print recto: "Charles Rivers 1929"
center mount verso: "Charles Rivers"
Inscription, mount verso, typed on paper label: "Repairing
the derrick on the/Chrysler Building—1929"
Acquired from: gift of the photographer

4053. **A SECTION OF THE SPIRE. WHEN ALL SECTIONS
WERE SECRETLY ASSEMBLED IN THE CENTER OF
THE BUILDING IT RESULTED IN SPIRE TOTALING
174 FEET—CHRYSLER BUILDING** (P1986.24.5)
Gelatin silver print. 1929
Image: 9 11/16 x 7 in. (24.7 x 17.9 cm.)
Mount: same as image size
Signed, l.r. print recto: "Charles Rivers/1929"
center mount verso: "Charles Rivers"
Inscription, mount verso, typed on paper label: "A section of
the spire. When/all sections were secretly/assembled in the
center of/the building it resulted in/spire totaling 174 feet—
/ChryslerBuilding—1929"
Acquired from: gift of the photographer

4054. **SHADOW OF THE CHRYSLER OVER THE GRAYBAR BUILDING WHILE A LOAD OF STEEL IS BEING RELAYED FROM DERRICK TO DERRICK TO REACH THE FLOOR WHERE IT IS TO BE ERECTED INTO PLACE** (P1986.24.1)
Gelatin silver print. 1929
Image: 19 ½ x 15 ¹³⁄₁₆ in. (49.5 x 40.1 cm.)
Mount: same as image size
Signed, center mount verso: "Charles Rivers/1929"
Inscription, mount verso, typed on paper label: "Shadow of the Chrysler over/the Graybar Building while/a load of steel is being/relayed from derrick to/derrick to reach the floor/where it is to be erected/into place."
Acquired from: gift of the photographer

CERVIN ROBINSON, American (b. 1928)

At the age of seven, Cervin Robinson received a camera and a developing and printing kit from his father, but the young Robinson did not ask how to use the kit until he was twelve. After receiving an A.B. in English literature from Harvard in 1950, Robinson served two years in the U.S. Army. He gained a lasting interest in map projections and perspective during his service. From 1953 to 1957 he worked as an assistant to Walker Evans. Robinson began working as a freelance photographer in 1957 when he worked for the Historical American Buildings Survey and *Architectural Review*. Since then, his photographs have appeared in magazines, books, and movies. In 1971 he received a Guggenheim Fellowship to photograph New York art deco architecture. In 1978 he was the J. Clawson Mill Scholar and the director of a project funded by the National Endowment for the Arts and the New York Council on the Arts. During 1982 and 1983, Robinson photographed for two Municipal Art Society exhibitions and for the Saint Louis Art Museum exhibition on Louis Sullivan. He also photographed for the 1973 exhibition and catalogue "The Architecture of Frank Furness," for the Philadelphia Museum of Art. Robinson was coauthor (with Rosemarie Haag Bletter) of *Skyscraper Style: Art Deco New York* (1975) and (with Joel Hershman) of *Architecture Transformed: A History of the Photography of Buildings from 1839 to the Present* (1987). "Cervin Robinson: Cleveland, Ohio" opened at the Cleveland Museum of Art in the fall of 1989.

*4055. **MUNICIPAL, TRIBUNE, AND AMERICAN TRACT SOCIETY BUILDINGS** (P1986.14.1)
Gelatin silver print. negative 1966, print 1986
Image: 10 ¹¹⁄₁₆ x 12 in. (27.0 x 30.4 cm.)
Sheet: 11 ¹⁄₁₆ x 13 ¹⁵⁄₁₆ in. (28.0 x 35.4 cm.)
Signed, right edge print recto: "© Cervin Robinson 1986"
Acquired from: gift of Malcolm Holzman, New York, New York

4056. **RCA VICTOR, CHRYSLER BUILDINGS AND WALDORF-ASTORIA HOTEL** (P1986.14.2)
Gelatin silver print. negative 1966, print 1986
Image: 13 ⁹⁄₁₆ x 9 ⁷⁄₁₆ in. (34.3 x 24.0 cm.)
Sheet: 14 x 11 ¹⁄₁₆ in. (35.6 x 28.0 cm.)
Signed, right edge print recto: "© Cervin Robinson 1986"
Acquired from: gift of Malcolm Holzman, New York, New York

R. W. ROBINSON, English (1862—1942)

See *Camera Notes*

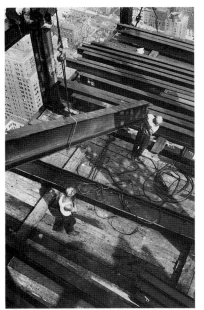

4046

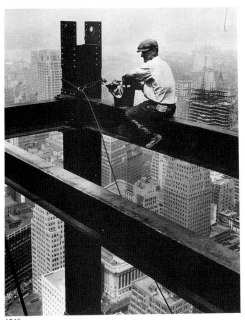

4048

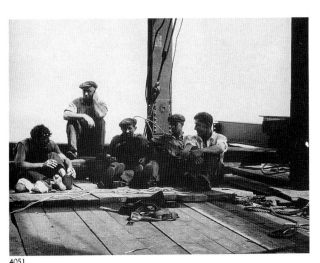

4051

BYRON ROGERS, American (b. 1952)

Byron Rogers attended Sam Houston State University in Huntsville, Texas, in 1974, where he majored in photography. He also studied with Paul Caponigro at an Ansel Adams Yosemite workshop in 1975 and with George Krause in 1978. Rogers, also a sculptor, has exhibited both his photographs and his sculpture throughout Texas.

4057. **THE HAIRCUT** (P1976.120)
Gelatin silver print. 1973
Image: 7½ x 7¹³⁄₁₆ in. (19.1 x 19.9 cm.)
Mount: 12⅞ x 15⅞ in. (32.6 x 40.4 cm.)
Signed, l.r. mount recto: "Byron Rogers"
Acquired from: the photographer

EDWIN ROSSKAM,
American, born Germany (1903–1985)

Edwin Rosskam immigrated to the United States from Munich, Germany, with his parents in 1919. He studied painting at the Philadelphia Academy of Art and spent several years in Paris and Polynesia before returning to the United States. In 1936 he and his wife Louise Rosskam joined the staff of the *Philadelphia Record* as a photographic team. From 1938 to 1943 Rosskam worked for the Farm Security Administration as an editor and layout artist, but when he joined the Standard Oil project in 1943 he resumed his photographic work. Together he and his wife documented petrochemical plants and life on the Mississippi River, a project that resulted in the publication of *Towboat River* in 1948. Though his photographs are documentary, his art training frequently produced compositions that incorporate a strong sense of design and scale.

*4058. **ASBESTOS SUIT SUCH AS IS WORN FOR HOT WORK. BAYTOWN, TEXAS** [from the exhibition "Out of the Forties: A Portrait of Texas from the Standard Oil Collection"] (P1984.37.111)
Gelatin silver print. negative 1944, print 1982 by Bill Carner
Image: 10 x 11¼ in. (25.4 x 28.5 cm.)
Sheet: 11 x 13¹⁵⁄₁₆ in. (28.0 x 35.4 cm.)
Inscription, print verso: "SONJ 2146"
Acquired from: gift of Texas Monthly, Inc., Austin, Texas, printed from a negative in the Standard Oil of New Jersey Collection, University of Louisville Photographic Archives

ARTHUR ROTHSTEIN, American (1915–1985)

Rothstein set the course for his career when he took a class in contemporary civilization from economist Roy Stryker at Columbia University in 1934. During this period Rothstein, already a photographer, made photographs for a book Stryker was writing on agriculture. As a result of the association Rothstein was the first photographer hired in 1935 when Stryker was chosen to head the Resettlement Administration (later the Farm Security Administration) project. In 1940 Rothstein joined the staff of *Look* magazine, but the outbreak of World War II led him immediately to an assignment in the United States Army Signal Corps in the Pacific theater. After the war he rejoined *Look*, where he served as director of photography until 1971. Rothstein was active in several press photography organizations and was one of the founders of the American Society of Magazine Photographers. He was an associate editor of *Parade* magazine from 1972 until his death.

ARTHUR ROTHSTEIN (P1980.56.1–8)

This portfolio was published in 1976 by Arthur Rothstein in New Rochelle, New York. It consists of an edition of 25 portfolios of which this is number 15.

*4059. **WIFE AND CHILD OF A SHARECROPPER, WASHINGTON COUNTY, ARKANSAS. AUGUST 1935.** [USF33-2022] (P1980.56.1)
Gelatin silver print. negative 1935, print 1976
Image: 12¾ x 8½ in. (32.3 x 21.5 cm.)
Mount: 20 x 16 in. (50.8 x 40.7 cm.)
Signed, l.r. mount recto: "Arthur Rothstein"
Inscription, mount verso, printed paper label: "A LIMITED EDITION OF/25 PORTFOLIOS/THIS BEING PRINT NO. [in ink] 1/OF PORTFOLIO NO. [in ink] 15"
Acquired from: the photographer

4060. **INTERIOR OF POSTMASTER BROWN'S HOME AT OLD RAG. SHENANDOAH NATIONAL PARK, VIRGINIA. OCTOBER 1935.** [USF34-372] (P1980.56.2) duplicate of LP1982.7.1
Gelatin silver print. negative 1935, print 1976
Image: 9¾ x 12½ in. (24.7 x 31.8 cm.)
Mount: 20 x 16 in. (50.8 x 40.7 cm.)
Signed, l.r. mount recto: "Arthur Rothstein"
Inscription, mount verso, printed paper label: "A LIMITED EDITION OF/25 PORTFOLIOS/THIS BEING PRINT NO. [in ink] 2/OF PORTFOLIO NO. [in ink] 15"
Acquired from: the photographer

*4061. **FARMER AND SONS WALKING IN THE FACE OF A DUST STORM, CIMARRON COUNTY, OKLAHOMA. APRIL 1936.** [USF34-4052] (P1980.56.3) duplicate of LP1982.7.5
Gelatin silver print. negative 1936, print 1976
Image: 10¹⁄₁₆ x 9¹⁵⁄₁₆ in. (25.5 x 25.3 cm.)
Mount: 19⅞ x 16 in. (50.5 x 40.7 cm.)
Signed, l.r. mount recto: "Arthur Rothstein"
Inscription, mount verso, printed paper label: "A LIMITED EDITION OF/25 PORTFOLIOS/THIS BEING PRINT NO. [in ink] 3/OF PORTFOLIO NO. [in ink] 15"
Acquired from: the photographer

4062. **THE BLEACHED SKULL OF A STEER ON THE DRY SUN-BAKED EARTH OF THE SOUTH DAKOTA BAD LANDS. MAY 1936.** [USF34-4507] (P1980.56.4) duplicate of LP1982.7.6
Gelatin silver print. negative 1936, print 1976
Image: 9¹⁵⁄₁₆ x 9¹⁵⁄₁₆ in. (25.2 x 25.2 cm.)
Mount: 20 x 16 in. (50.8 x 40.7 cm.)
Signed, l.r. mount recto: "Arthur Rothstein"
Inscription, mount verso, printed paper label: "A LIMITED EDITION OF/25 PORTFOLIOS/THIS BEING PRINT NO. [in ink] 4/OF PORTFOLIO NO. [in ink] 15"
Acquired from: the photographer

4063. **GIRL AT GEE'S BEND, ALABAMA. APRIL 1937.** [USF34-25359] (P1980.56.5) duplicate of LP1982.7.2
Gelatin silver print. negative 1937, print 1976
Image: 9¹¹⁄₁₆ x 12¹⁵⁄₁₆ in. (24.6 x 32.9 cm.)
Mount: 20 x 16 in. (50.8 x 40.7 cm.)
Signed, l.r. mount recto: "Arthur Rothstein"
Inscription, mount verso, printed paper label: "A LIMITED EDITION OF/25 PORTFOLIOS/THIS BEING PRINT NO. [in ink] 5/OF PORTFOLIO NO. [in ink] 15"
Acquired from: the photographer

4064. **MINNIE KNOX, WIDOW LIVING WITH HER DAUGHTER ON FARM. GARRETT COUNTY, MARYLAND. DECEMBER 1937.** [USF34-26097] (P1980.56.6) duplicate of LP1982.7.7
Gelatin silver print. negative 1937, print 1976
Image: 13¹⁄₁₆ x 9¾ in. (33.1 x 24.7 cm.)
Mount: 20 x 16 in. (50.8 x 40.7 cm.)
Signed, l.r. mount recto: "Arthur Rothstein"

Inscription, mount verso, printed paper label: "A LIMITED
EDITION OF/25 PORTFOLIOS/THIS BEING PRINT
NO. [in ink] 6/OF PORTFOLIO NO. [in ink] 15"
Acquired from: the photographer

*4065. **MR. & MRS. ANDY BAHAIN, FSA BORROWERS ON
THEIR FARM NEAR KERSEY, COLORADO.
OCTOBER 1939.** [USF34-28372] (P1980.56.7)
Gelatin silver print. negative 1939, print 1976
Image: 12 13/16 x 9 3/4 in. (32.5 x 24.7 cm.)
Mount: 20 x 16 in. (50.8 x 40.7 cm.)
Signed, l.r. mount recto: "Arthur Rothstein"
Inscription, mount verso, printed paper label: "A LIMITED
EDITION OF/25 PORTFOLIOS/THIS BEING PRINT
NO. [in ink] 7/OF PORTFOLIO NO. [in ink] 15"
Acquired from: the photographer

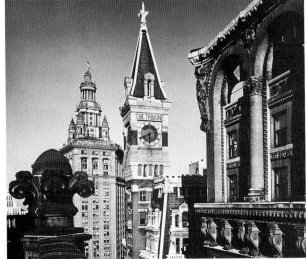

4055

4066. **HOTEL DE PARIS, GEORGETOWN, COLORADO.
OCTOBER 1939.** [USF34-28840] (P1980.56.8) duplicate of
LP1982.7.15
Gelatin silver print. negative 1939, print 1976
Image: 12 13/16 x 9 11/16 in. (32.5 x 24.5 cm.)
Mount: 20 x 16 in. (50.8 x 40.7 cm.)
Signed, l.r. mount recto: "Arthur Rothstein"
Inscription, mount verso, printed paper label: "A LIMITED
EDITION OF/25 PORTFOLIOS/THIS BEING PRINT
NO. [in ink] 8/OF PORTFOLIO NO. [in ink] 15"
Acquired from: the photographer

*** * * ***

ARTHUR ROTHSTEIN (LP1982.7.1–30)

This portfolio was published in 1981 by Hyperion Press. There
are 50 numbered portfolios and 2 artist's proofs. This is
portfolio number 3.

4058

4067. **POSTMASTER BROWN, OLD RAG, VIRGINIA**
(LP1982.7.1) duplicate of P1980.56.2
Gelatin silver print. negative 1935, print 1981
Image: 8 13/16 x 11 9/16 in. (22.4 x 29.3 cm.)
Sheet: 11 x 14 in. (28.0 x 35.6 cm.)
Signed, l.r. sheet recto: "Arthur Rothstein"
Inscription, sheet recto, embossed: "h/p"
print verso: "1"
Acquired from: long-term loan from L. G. and Lynn Hecht
Schafran, New York, New York

4068. **GIRL AT GEE'S BEND, ALABAMA** (LP1982.7.2) duplicate
of P1980.56.5
Gelatin silver print. negative 1937, print 1981
Image: 8 15/16 x 12 1/16 in. (22.7 x 30.6 cm.)
Sheet: 10 7/8 x 14 in. (27.7 x 35.6 cm.)
Signed, l.r. sheet recto: "Arthur Rothstein"
Inscription, sheet recto, embossed: "h/p"
print verso: "2"
Acquired from: long-term loan from L. G. and Lynn Hecht
Schafran, New York, New York

4059

4069. **VERNON EVANS, MIGRANT TO OREGON FROM
SOUTH DAKOTA** (LP1982.7.3)
Gelatin silver print. negative 1936, print 1981
Image: 9 x 12 1/8 in. (22.8 x 30.8 cm.)
Sheet: 10 7/8 x 14 in. (27.7 x 35.6 cm.)
Signed, l.r. sheet recto: "Arthur Rothstein"
Inscription, sheet recto, embossed: "h/p"
print verso: "3"
Acquired from: long-term loan from L. G. and Lynn Hecht
Schafran, New York, New York

*4070. **MIGRANT FAMILY, OKLAHOMA** (LP1982.7.4)
Gelatin silver print. negative 1936, print 1981
Image: 8 1/16 x 12 1/8 in. (20.5 x 30.8 cm.)
Sheet: 11 x 14 in. (28.0 x 35.6 cm.)
Signed, l.r. sheet recto: "Arthur Rothstein"
Inscription, sheet recto, embossed: "h/p"
print verso: "4"
Acquired from: long-term loan from L. G. and Lynn Hecht
Schafran, New York, New York

4071. **DUST STORM, CIMARRON COUNTY, OKLAHOMA**
(LP1982.7.5) duplicate of P1980.56.3
Gelatin silver print. negative 1936, print 1981
Image: 9 1/16 x 8 15/16 in. (22.9 x 22.6 cm.)
Sheet: 14 x 11 in. (35.6 x 28.0 cm.)
Signed, l.r. sheet recto: "Arthur Rothstein"
Inscription, sheet recto, embossed: "h/p"
 print verso: "5"
Acquired from: long-term loan from L. G. and Lynn Hecht
 Schafran, New York, New York

4072. **SKULL, BADLANDS, SOUTH DAKOTA** (LP1982.7.6)
duplicate of P1980.56.4
Gelatin silver print. negative 1936, print 1981
Image: 9 x 8 13/16 in. (22.8 x 22.4 cm.)
Sheet: 14 x 11 in. (35.6 x 28.0 cm.)
Signed, l.r. sheet recto: "Arthur Rothstein"
Inscription, sheet recto, embossed: "h/p"
 print verso: "6"
Acquired from: long-term loan from L. G. and Lynn Hecht
 Schafran, New York, New York

4073. **MINNIE KNOX, GARRETT COUNTY, MARYLAND**
(LP1982.7.7) duplicate of P1980.56.6
Gelatin silver print. negative 1937, print 1981
Image: 12 1/8 x 9 1/16 in. (30.8 x 23.0 cm.)
Sheet: 14 x 10 7/8 in. (35.6 x 27.7 cm.)
Signed, l.r. sheet recto: "Arthur Rothstein"
Inscription, sheet recto, embossed: "h/p"
 print verso: "7"
Acquired from: long-term loan from L. G. and Lynn Hecht
 Schafran, New York, New York

4074. **MIGRANT WORKER, VISALIA, CALIFORNIA**
(LP1982.7.8)
Gelatin silver print. negative 1940, print 1981
Image: 12 x 9 1/16 in. (30.4 x 23.0 cm.)
Sheet: 13 7/8 x 11 in. (35.3 x 28.0 cm.)
Signed, l.r. sheet recto: "Arthur Rothstein"
Inscription, sheet recto, embossed: "h/p"
 print verso: "8"
Acquired from: long-term loan from L. G. and Lynn Hecht
 Schafran, New York, New York

4075. **JOHN DUDECK, DALTON, NEW YORK** (LP1982.7.9)
Gelatin silver print. negative 1937, print 1981
Image: 12 x 8 1/8 in. (30.4 x 20.6 cm.)
Sheet: 13 7/8 x 11 in. (35.3 x 28.0 cm.)
Signed, l.r. sheet recto: "Arthur Rothstein"
Inscription, sheet recto, embossed: "h/p"
 print verso: "9"
Acquired from: long-term loan from L. G. and Lynn Hecht
 Schafran, New York, New York

4076. **FLOOD VICTIM, MISSOURI** (LP1982.7.10)
Gelatin silver print. negative 1938, print 1981
Image: 12 1/8 x 9 1/8 in. (30.8 x 23.1 cm.)
Sheet: 14 x 10 7/8 in. (35.6 x 27.7 cm.)
Signed, l.r. sheet recto: "Arthur Rothstein"
Inscription, sheet recto, embossed: "h/p"
 print verso: "10"
Acquired from: long-term loan from L. G. and Lynn Hecht
 Schafran, New York, New York

*4077. **MISSISSIPPI RIVER FLOOD, ST. LOUIS, MISSOURI**
(LP1982.7.11)
Gelatin silver print. negative 1943, print 1981
Image: 9 1/8 x 12 in. (23.1 x 30.4 cm.)
Sheet: 11 x 14 in. (28.0 x 35.6 cm.)
Signed, l.r. sheet recto: "Arthur Rothstein"
Inscription, sheet recto, embossed: "h/p"
 print verso: "11"
Acquired.from: long-term loan from L. G. and Lynn Hecht
 Schafran, New York, New York

4078. **AGATE, NEBRASKA** (LP1982.7.12)
Gelatin silver print. negative 1939, print 1981
Image: 9 1/16 x 12 1/8 in. (23.0 x 30.8 cm.)
Sheet: 10 7/8 x 14 in. (27.7 x 35.6 cm.)
Signed, l.r. sheet recto: "Arthur Rothstein"
Inscription, sheet recto, embossed: "h/p"
 print verso: "12"
Acquired from: long-term loan from L. G. and Lynn Hecht
 Schafran, New York, New York

4079. **SHEEPHERDER'S CAMP, MONTANA** (LP1982.7.13)
Gelatin silver print. negative 1939, print 1981
Image: 9 x 12 1/8 in. (22.8 x 30.8 cm.)
Sheet: 10 7/8 x 14 in. (27.7 x 35.6 cm.)
Signed, l.r. sheet recto: "Arthur Rothstein"
Inscription, sheet recto, embossed: "h/p"
 print verso: "13"
Acquired from: long-term loan from L. G. and Lynn Hecht
 Schafran, New York, New York

4080. **HOTEL DE PARIS, EXTERIOR, GEORGETOWN,
COLORADO** (LP1982.7.14)
Gelatin silver print. negative 1939, print 1981
Image: 8 15/16 x 11 9/16 in. (22.8 x 29.4 cm.)
Sheet: 11 x 14 in. (28.0 x 35.6 cm.)
Signed, l.r. sheet recto: "Arthur Rothstein"
Inscription, sheet recto, embossed: "h/p"
 print verso: "14"
Acquired from: long-term loan from L. G. and Lynn Hecht
 Schafran, New York, New York

4081. **HOTEL DE PARIS, INTERIOR, GEORGETOWN,
COLORADO** (LP1982.7.15) duplicate of P1980.56.8
Gelatin silver print. negative 1939, print 1981
Image: 12 x 8 7/8 in. (30.4 x 22.6 cm.)
Sheet: 14 x 11 in. (35.6 x 28.0 cm.)
Signed, l.r. sheet recto: "Arthur Rothstein"
Inscription, sheet recto, embossed: "h/p"
 print verso: "15"
Acquired from: long-term loan from L. G. and Lynn Hecht
 Schafran, New York, New York

4082. **SHOESHINE MAN, NEW YORK CITY** (LP1982.7.16)
Gelatin silver print. negative 1937, print 1981
Image: 11 7/8 x 8 7/8 in. (30.1 x 22.6 cm.)
Sheet: 14 x 11 in. (35.6 x 28.0 cm.)
Signed, l.r. sheet recto: "Arthur Rothstein"
Inscription, sheet recto, embossed: "h/p"
 print verso: "16"
Acquired from: long-term loan from L. G. and Lynn Hecht
 Schafran, New York, New York

*4083. **GAMBLERS, LAS VEGAS, NEVADA** (LP1982.7.17)
Gelatin silver print. negative 1947, print 1981
Image: 9 1/8 x 8 7/8 in. (23.1 x 22.5 cm.)
Sheet: 14 x 11 in. (35.6 x 28.0 cm.)
Signed, l.r. sheet recto: "Arthur Rothstein"
Inscription, sheet recto, embossed: "h/p"
 print verso: "17"
Acquired from: long-term loan from L. G. and Lynn Hecht
 Schafran, New York, New York

4084. **POOL HALL, CULP, ILLINOIS** (LP1982.7.18)
Gelatin silver print. negative 1940, print 1981
Image: 9 1/16 x 12 in. (23.0 x 30.4 cm.)
Sheet: 11 x 14 in. (28.0 x 35.6 cm.)
Signed, l.r. sheet recto: "Arthur Rothstein"
Inscription, sheet recto, embossed: "h/p"
 print verso: "18"
Acquired from: long-term loan from L. G. and Lynn Hecht
 Schafran, New York, New York

4061

4065

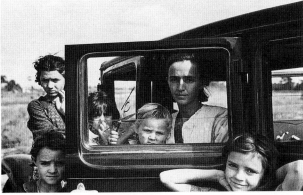

4070

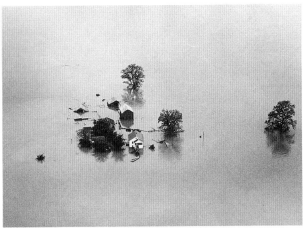

4077

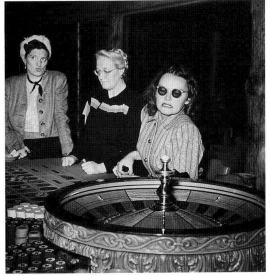

4083

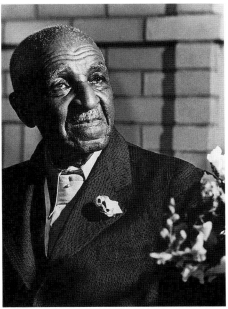

4085

*4085. **GEORGE WASHINGTON CARVER, TUSKEGEE, ALABAMA** (LP1982.7.19)
Gelatin silver print. negative 1941, print 1981
Image: 12 x 9 1/16 in. (30.4 x 23.0 cm.)
Sheet: 14 x 11 in. (35.6 x 28.0 cm.)
Signed, l.r. sheet recto: "Arthur Rothstein"
Inscription, sheet recto, embossed: "h/p"
 print verso: "19"
Acquired from: long-term loan from L. G. and Lynn Hecht
 Schafran, New York, New York

*4086. **BOY WITH CHICKEN, HUNGJAO, CHINA** (LP1982.7.20)
Gelatin silver print. negative 1945, print 1981
Image: 12 x 9 1/16 in. (30.4 x 23.0 cm.)
Sheet: 14 x 11 in. (35.6 x 28.0 cm.)
Signed, l.r. sheet recto: "Arthur Rothstein"
Inscription, sheet recto, embossed: "h/p"
 print verso: "20"
Acquired from: long-term loan from L. G. and Lynn Hecht
 Schafran, New York, New York

4087. **THE BURMA ROAD** (LP1982.7.21)
Gelatin silver print. negative 1945, print 1981
Image: 9 x 8 7/8 in. (22.8 x 22.5 cm.)
Sheet: 13 7/8 x 11 in. (35.3 x 28.0 cm.)
Signed, l.r. sheet recto: "Arthur Rothstein"
Inscription, sheet recto, embossed: "h/p"
 print verso: "21"
Acquired from: long-term loan from L. G. and Lynn Hecht
 Schafran, New York, New York

4088. **FAMINE VICTIM, HENGYANG, CHINA** (LP1982.7.22)
Gelatin silver print. negative 1946, print 1981
Image: 12 1/8 x 9 in. (30.8 x 22.8 cm.)
Sheet: 14 x 11 in. (35.6 x 28.0 cm.)
Signed, l.r. sheet recto: "Arthur Rothstein"
Inscription, sheet recto, embossed: "h/p"
 print verso: "22"
Acquired from: long-term loan from L. G. and Lynn Hecht
 Schafran, New York, New York

4089. **BURIAL OF FAMINE VICTIM, HENGYANG, CHINA** (LP1982.7.23)
Gelatin silver print. negative 1946, print 1981
Image: 12 1/16 x 9 in. (30.6 x 22.8 cm.)
Sheet: 14 x 11 in. (35.6 x 28.0 cm.)
Signed, l.r. sheet recto: "Arthur Rothstein"
Inscription, sheet recto, embossed: "h/p"
 print verso: "23"
Acquired from: long-term loan from L. G. and Lynn Hecht
 Schafran, New York, New York

4090. **COAL MINERS, WALES** (LP1982.7.24)
Gelatin silver print. negative 1947, print 1981
Image: 12 1/8 x 9 1/16 in. (30.8 x 23.0 cm.)
Sheet: 14 x 10 7/8 in. (35.6 x 27.7 cm.)
Signed, l.r. sheet recto: "Arthur Rothstein"
Inscription, sheet recto, embossed: "h/p"
 print verso: "24"
Acquired from: long-term loan from L. G. and Lynn Hecht
 Schafran, New York, New York

4091. **YOUNG COAL MINER, WALES** (LP1982.7.25)
Gelatin silver print. negative 1947, print 1981
Image: 12 x 9 1/16 in. (30.4 x 23.0 cm.)
Sheet: 14 x 11 in. (35.6 x 28.0 cm.)
Signed, l.r. sheet recto: "Arthur Rothstein"
Inscription, sheet recto, embossed: "h/p"
 print verso: "25"
Acquired from: long-term loan from L. G. and Lynn Hecht
 Schafran, New York, New York

4092. **FARMERS IN THE MARKET, TOCCO, ITALY** (LP1982.7.26)
Gelatin silver print. negative 1947, print 1981
Image: 8 3/16 x 12 in. (20.7 x 30.4 cm.)
Sheet: 11 x 13 7/8 in. (28.0 x 35.3 cm.)

Signed, l.r. sheet recto: "Arthur Rothstein"
Inscription, sheet recto, embossed: "h/p"
 print verso: "26"
Acquired from: long-term loan from L. G. and Lynn Hecht
 Schafran, New York, New York

*4093. **JOHN MARIN IN HIS STUDIO, HOBOKEN, NEW JERSEY** (LP1982.7.27)
Gelatin silver print. negative 1949, print 1981
Image: 8 7/8 x 12 1/16 in. (22.5 x 30.6 cm.)
Sheet: 11 x 14 in. (27.8 x 35.6 cm.)
Signed, l.r. sheet recto: "Arthur Rothstein"
Inscription, sheet recto, embossed: "h/p"
 print verso: "27"
Acquired from: long-term loan from L. G. and Lynn Hecht
 Schafran, New York, New York

4094. **AMERICAN SOLDIERS IN NIGHTCLUB, VIENNA, AUSTRIA** (LP1982.7.28)
Gelatin silver print. negative 1947, print 1981
Image: 12 1/16 x 9 in. (30.6 x 22.8 cm.)
Sheet: 14 x 10 7/8 in. (35.6 x 27.7 cm.)
Signed, l.r. sheet recto: "Arthur Rothstein"
Inscription, sheet recto, embossed: "h/p"
 print verso: "28"
Acquired from: long-term loan from L. G. and Lynn Hecht
 Schafran, New York, New York

4095. **AT A CHARITY BALL, NEW YORK CITY** (LP1982.7.29)
Gelatin silver print. negative 1951, print 1981
Image: 9 5/16 x 9 1/16 in. (23.6 x 23.0 cm.)
Sheet: 14 x 11 in. (35.6 x 28.0 cm.)
Signed, l.r. sheet recto: "Arthur Rothstein"
Inscription, sheet recto, embossed: "h/p"
 print verso: "29"
Acquired from: long-term loan from L. G. and Lynn Hecht
 Schafran, New York, New York

4096. **ROCKLAND, MAINE** (LP1982.7.30)
Gelatin silver print. negative 1937, print 1981
Image: 8 1/8 x 12 1/16 in. (20.6 x 30.6 cm.)
Sheet: 11 x 14 in. (28.0 x 35.6 cm.)
Signed, l.r. sheet recto: "Arthur Rothstein"
Inscription, sheet recto, embossed: "h/p"
 print verso: "30"
Acquired from: long-term loan from L. G. and Lynn Hecht
 Schafran, New York, New York

CHARLES ROTKIN, American (b. 1916)

Charles Rotkin studied at both the City College of New York and Columbia University before he was drafted into the Army Air Force during World War II. He spent his military service in Puerto Rico making documentary photographs of the island. From 1945 to 1948 he continued the project as the chief photographer for the Puerto Rican government. In 1948 Rotkin was the last project photographer hired to work on Roy Stryker's Standard Oil project. Although he specialized in low-altitude aerial photography, Rotkin also made ground views for the project. After leaving Standard Oil, Rotkin established his own Manhattan-based firm called Photography for Industry and was a contributing photographer to *Life, Forbes, Newsweek*, the *New York Times*, and other publications. He has also published volumes of his aerial photography of both the United States and Europe.

*4097. GRAIN ELEVATOR ALONG RAILROAD TRACK
 NORTH OF HAPPY, TEXAS, ABOUT 40 MILES
 SOUTH OF AMARILLO. TEXAS PANHANDLE
 [from the exhibition "Out of the Forties: A Portrait of
 Texas from the Standard Oil Collection"] (P1984.37.112)
 Gelatin silver print. negative 1950, print 1982 by Bill Carner
 Image: 10 x 12 ⅝ in. (25.4 x 32.0 cm.)
 Sheet: 11 x 13 ¹⁵⁄₁₆ in. (28.0 x 35.4 cm.)
 Inscription, print verso: "SONJ 67353"
 Acquired from: gift of Texas Monthly, Inc., Austin, Texas,
 printed from a negative in the Standard Oil of New Jersey
 Collection, University of Louisville Photographic Archives

MERIDEL RUBENSTEIN, American (b. 1948)

Meridel Rubenstein received a B.A. from Sarah Law-
rence College in Bronxville, New York, and an M.F.A.
from the University of New Mexico, where she studied
with Beaumont Newhall and Van Deren Coke. Ruben-
stein also spent a year studying with Minor White at
the Massachusetts Institute of Technology. Among the
many awards she has received are a New Mexico Bicen-
tennial Grant (1975–77), four National Endowment for
the Arts grants (1976, 1978, 1982, 1982–83), a Ferguson
Grant from the Friends of Photography (1977), and a
Guggenheim Foundation fellowship (1981).

4098. PAUL, ANNABELLE, AND PAULA MEDINA, CHIMAYO,
 NEW MEXICO [from the Santa Fe Center for Photography
 "Portfolio II"] (P1984.4.2)
 Type C color print. negative 1981, print c. 1983
 Image: 6 ⁹⁄₁₆ x 9½ in. (16.6 x 24.1 cm.)
 Sheet: 8 x 10 in. (20.2 x 25.4 cm.)
 Signed, l.r. sheet recto: "© 1981 Meridel Rubenstein"
 note: portfolio title sheet incorrectly lists the date as 1980
 Acquired from: Santa Fe Center for Photography, Santa Fe,
 New Mexico

HARRY C. RUBINCAM, American (1871–1940)

Harry C. Rubincam was born in Philadelphia, Pennsyl-
vania. In the mid-1880s he began working in his father's
fruit importing firm. When the business failed, Rubin-
cam moved to New York, where he worked in several
jobs before being employed by the Equitable Life As-
surance Company. About 1897 tuberculosis forced Ru-
bincam to move to Denver. He originally opened an
office for the Equitable Company but later was employed
by the Capitol Life Insurance Company. It was at this
time that Rubincam first became interested in pho-
tography, after helping a friend learn to operate a cam-
era. A retired photographer, who later accompanied
Rubincam on his expeditions, taught him photographic
techniques. Rubincam joined the Colorado Camera
Club but left a year later over an aesthetic disagree-
ment. In 1901 he began writing on photography for Out-
door Life; his "Darkroom Dissertations" appeared in
each monthly issue from August 1901 to December
1904. In 1903 Rubincam became an associate of the
Photo-Secession; between 1904 and 1907 his work was
exhibited in Photo-Secession galleries, as well as being
published in Camera Work (January 1907). Between
1903 and 1910 Rubincam exhibited his photographs in
San Francisco, The Hague, London, Pittsburgh, Wash-
ington, New York, and Buffalo. In addition to pho-
tographing, Rubincam also continued writing; his
articles appeared in Camera Work, The Photographer,
Camera Craft, American Amateur Photographer, and
American Annual for Photography and Photographic Times
Almanac for 1904. In 1914 Rubincam established his own
insurance agency in Denver. Around 1917–18 he was

4086

4093

4097

elected president of a small company drilling for oil in Oklahoma, but the company dissolved in 1919. Rubincam and his family moved to a ranch in Douglas County, Colorado, returning to Denver in 1925 where Rubincam managed the real estate loan division of the Capitol Life Insurance Company.

*4099. **[Circus rider]** (P1984.13)
Gelatin silver print. c. 1904
Image: 3 ⅞ x 4 ⅞ in. (9.8 x 12.3 cm.)
Sheet: 4 x 5 in. (10.2 x 12.6 cm.)
Signed: see inscription
Inscription, print verso, rubber stamp:
"HARRY C. RUBINCAM"
Acquired from: Paul Katz, North Bennington, Vermont

WILLIAM HERMAN RULOFSON,
American, born Canada (1826–1878)

Daguerreotypy fascinated William Rulofson as a young boy, and he was apprenticed in James C. Melick's daguerreotype studio in his hometown of St. John, New Brunswick. Although he was an established daguerreotypist by 1846, Rulofson traveled throughout the United States and Europe to gain additional training. In 1848 he left his family to join the gold rush to California. He went to mine and to photograph, but his photographic endeavors were much more successful. In Sonora he became partners with J. D. Cameron. Their small, mobile studio was the beginning of what probably was the earliest permanently established photography business on the West Coast. They produced daguerreotypes, ambrotypes, paper prints, and prints from a process Rulofson referred to as "stereoscopic." In 1857 Rulofson bought out Cameron's interest and built a frame house and gallery. In 1863 he leased the Sonora gallery and moved to San Francisco, where he became partners with Henry W. Bradley. Rulofson supervised the gallery, and Bradley ran a separate company that sold photographic supplies. Rulofson was an astute businessman; he trained promising young photographers, sharing the firm's profits with them, and encouraged photographic experimentation and invention. While he spent a lot of money on advertisement, he often would trade photographs to newspapers in exchange for a credit line. Rulofson was primarily a portrait photographer, also recording a few town scenes.

*4100. **[Butterfield's Dry Goods Store on Main Street, Jamestown, California]** (P1983.10)
Pannotype. 1861
Image: 10 ¹³⁄₁₆ x 15 ⅛ in. (27.4 x 39.0 cm.)
Plate: 12 ⁵⁄₁₆ x 16 ¹⁵⁄₁₆ in. (31.2 x 43.0 cm.)
Signed: see inscription
Inscription, broadside found inside original frame:
"AMBROTYPES & PHOTOGRAPHS!/W. H. RULOFSON/of Sonora, desires to notify the Citizens/of/ JAMESTOWN & VICINITY/That he has fitted up the Theater building, Jamestown, for taking Ambrotypes,/ where he is prepared to execute likenesses of every style, from the cheapest to those/set in the richest and most expensive cases and frames. He is also prepared to exe-/ cute views, of large size, cheap and beautiful, to frame for parlor or to send to/friends at home./All kinds of work done at such prices as will suit the most fastidious, but only for/a few days as owing to the very hot weather and previous business engagements his/stop must be short./On exhibition and free to all, a most beautiful collection of stereoscopes. Call/early and save a trip to Sonora. Every thing appertaining to the Art for sale cheap./Jamestown,

July 3d, 1861. W. H. RULOFSON./"Democratic Age" Job Printing Office, Sonora."
Acquired from: John Howell—Books, San Francisco, California

Attributed to William H. Rulofson
*4101. **[Saw Mill Flat, California]** (P1987.12)
Pannotype. c. 1858
Image: 9 x 12 ¹⁄₁₆ in. (22.9 x 30.7 cm.)
Plate: 9 ¹⁵⁄₁₆ x 12 ⅞ in. (25.2 x 32.6 cm.) irregular
Acquired from: Jacob Barendregt, Jamestown, California

HAL RUMEL, American (1909–1980)

Rumel studied art at the University of Utah and at the Art Center in Los Angeles, receiving a master's degree in commercial photography. He opened a studio in Salt Lake City during the early 1940s and produced numerous fashion, landscape, industrial, and commercial photographs. His Utah landscapes were used to promote the scenic beauty of the state and were widely published in *Reader's Digest, Holiday,* and *National Geographic.*

4102. **[Open pit mine, Kennecott Copper Co.]** (P1964.195)
Gelatin silver print mounted on plywood. c. 1960s
Image: 15 ¹⁵⁄₁₆ x 19 ½ in. (40.5 x 49.5 cm.)
Mount: same as image size
Signed, l.r. print recto: "Hal Rumel"
Inscription, top edge of mount, remnant of typed paper label:
"necott Copper Co"
Acquired from: the photographer

ANDREW J. RUSSELL, American (1830–1902)

Russell joined the 141st New York Infantry Volunteers as a captain in 1862 and shortly thereafter was appointed as the first member of the army officially assigned to photograph the Civil War. He did most of his work for General Herman Haupt of the United States Military Railroad, for whom he photographed devices used to transport troops and the construction of roads and bridges. He left the army in 1865 and began his most famous work photographing construction along the lines of the Union Pacific Railroad. This culminated in a series of photographs made at the joining of the transcontinental railroad at Promontory Point, Utah, in May of 1869. The UPRR published an album of Russell's photographs of construction on the line in Wyoming and Utah in 1869. A number of Russell's photographs for the UPRR also were published in a volume entitled *Sun Pictures of Rocky Mountain Scenery.* Russell left the UPRR during the early 1870s and returned to New York, where he ran a studio.

4103. **COAL BEDS OF BEAR RIVER** [Utah] (P1970.28.11)
duplicate of P1983.44.28
Albumen silver print. c. 1868–69
Image: 9 ⅜ x 12 ¹⁄₁₆ in. (23.7 x 30.6 cm.)
Mount: 10 ½ x 13 ¹³⁄₁₆ in. (26.7 x 35.1 cm.) irregular
Inscription, mount recto: "Coal Beds//Coal Beds of Bear River— (illeg.)//Bear River Valley (Cal.) [sic] along Central Pac. R.R."
mount verso: "355"
Acquired from: Kennedy Galleries, New York, New York

4104. **EMPLOYEES U.P.R.R.** (P1967.3346.2)
Albumen silver print. c. 1867–68
Image: 9 ⅛ x 12 ⁷⁄₁₆ in. (23.2 x 31.6 cm.)
Mount: 13 ⁹⁄₁₆ x 17 in. (34.5 x 43.1 cm.)
Inscription, mount recto: "Employee's [sic] U P R R"
Acquired from: Fred Rosenstock, Denver, Colorado

4105. **GRANITE CANON. U.P.R.R.** [west of Cheyenne, Wyoming]
(P1967.2749) duplicate of P1983.44.2
Albumen silver print. 1868
Image: 8¼ x 11 1/16 in. (20.9 x 28.1 cm.)
Mount: 11⅛ x 13 13/16 in. (28.3 x 35.1 cm.)
Inscription, mount verso: "Granite Canon. U.P.R.R."
Acquired from: Fred Rosenstock, Denver, Colorado

THE GREAT WEST ILLUSTRATED (P1983.44.1—51)

This album, published by the Union Pacific Railroad in 1869,
contains Andrew J. Russell's photographs of construction
on the line in Wyoming and Utah made between 1867
and 1869. The information on the title page reads:
"THE GREAT WEST ILLUSTRATED/IN A SERIES OF/
PHOTOGRAPHIC VIEWS ACROSS THE/ CONTINENT;/
TAKEN ALONG THE LINE OF THE/UNION PACIFIC
RAILROAD,/ WEST FROM OMAHA, NEBRASKA./
WITH AN ANNOTATED TABLE OF CONTENTS,
GIVING A BRIEF DESCRIPTION OF EACH VIEW;
ITS PECULIARITIES, CHARACTERISTICS, AND/
CONNECTION WITH THE DIFFERENT POINTS ON
THE ROAD./BY A. J. RUSSELL./VOL. I./PUBLISHED BY
AUTHORITY OF THE UNION PACIFIC RAILROAD
COMPANY./NEW YORK: OFFICE, 20 NASSAU
STREET./1869."

4099

4106. **CARMICHAEL'S CUT, GRANITE CANON** (P1983.44.1)
Albumen silver print. negative c. 1868, album published 1869
Image: 9¼ x 12 3/16 in. (23.5 x 31.0 cm.)
Mount: 12 13/16 x 17⅝ in. (32.6 x 44.8 cm.)
Inscription, mount recto, printed: "CARMICHAEL'S CUT,
GRANITE CANON."
Acquired from: Fraenkel Gallery, San Francisco, California

*4107. **GRANITE CANON, FROM THE WATER TANK**
(P1983.44.2) duplicate of P1967.2749
Albumen silver print. negative c. 1868, album published 1869
Image: 9⅛ x 12 5/16 in. (23.2 x 31.3 cm.)
Mount: 12 13/16 x 17⅝ in. (32.6 x 44.8 cm.)
Inscription, mount recto, printed: "GRANITE CANON,
FROM THE WATER TANK."
Acquired from: Fraenkel Gallery, San Francisco, California

4100

4108. **GRANITE ROCK, NEAR BEAUFORT STATION**
(P1983.44.3)
Albumen silver print. negative c. 1868, album published 1869
Image: 8 9/16 x 11¼ in. (21.7 x 28.6 cm.)
Mount: 12 13/16 x 17⅝ in. (32.6 x 44.8 cm.)
Inscription, mount recto, printed: "GRANITE ROCK,
NEAR BEAUFORT STATION."
Acquired from: Fraenkel Gallery, San Francisco, California

4109. **MALLOY'S CUT** (P1983.44.4)
Albumen silver print. negative c. 1868, album published 1869
Image: 9¼ x 12⅛ in. (23.5 x 30.8 cm.)
Mount: 12 13/16 x 17⅝ in. (32.6 x 44.8 cm.)
Acquired from: Fraenkel Gallery, San Francisco, California

4110. **HALL'S CUT** (P1983.44.5)
Albumen silver print. negative c. 1868, album published 1869
Image: 9 1/16 x 12⅜ in. (23.0 x 31.5 cm.)
Mount: 12 13/16 x 17⅝ in. (32.6 x 44.8 cm.)
Inscription, mount recto, printed: "PLATE 5./HALL'S CUT."
Acquired from: Fraenkel Gallery, San Francisco, California

4101

*4111. **SKULL ROCK** (P1983.44.6)
Albumen silver print. negative c. 1868, album published 1869
Image: 9¼ x 12 3/16 in. (23.5 x 30.9 cm.)
Mount: 12 13/16 x 17⅝ in. (32.6 x 44.8 cm.)
Inscription, mount recto, printed: "SKULL ROCK."
Acquired from: Fraenkel Gallery, San Francisco, California

4112. **DALE CREEK BRIDGE, GENERAL VIEW** (P1983.44.7)
Albumen silver print. negative c. 1868, album published 1869
Image: 9⅛ x 12⅝₁₆ in. (23.1 x 31.3 cm.)
Mount: 12¹³⁄₁₆ x 17⅝ in. (32.6 x 44.8 cm.)
Inscription, mount recto, printed: "DALE CREEK BRIDGE, GENERAL VIEW."
Acquired from: Fraenkel Gallery, San Francisco, California

*4113. **DALE CREEK BRIDGE, FROM ABOVE** (P1983.44.8)
Albumen silver print. negative c. 1868, album published 1869
Image: 8¹³⁄₁₆ x 11¹¹⁄₁₆ in. (22.3 x 29.7 cm.)
Mount: 12¹³⁄₁₆ x 17⅝ in. (32.6 x 44.8 cm.)
Inscription, mount recto, printed: "DALE CREEK BRIDGE, FROM ABOVE."
Acquired from: Fraenkel Gallery, San Francisco, California

4114. **EASTERN APPROACH TO DALE CREEK BRIDGE**
[Reynolds and Darlings work hut No 1-2-3 near Dale Creek, U.P.R.R.] (P1983.44.9) duplicate of P1967.2747
Albumen silver print. negative c. 1868, album published 1869
Image: 9⅛ x 11¹³⁄₁₆ in. (23.1 x 29.9 cm.)
Mount: 12¹³⁄₁₆ x 17⅝ in. (32.6 x 44.8 cm.)
Inscription, mount recto, printed: "EASTERN APPROACH TO DALE CREEK BRIDGE."
Acquired from: Fraenkel Gallery, San Francisco, California

4115. **DEVIL'S GATE, DALE CREEK CANON** (P1983.44.10)
Albumen silver print. negative c. 1867–68, album published 1869
Image: 9⅛ x 11⅝ in. (23.2 x 29.5 cm.)
Mount: 12¹³⁄₁₆ x 17⅝ in. (32.6 x 44.8 cm.)
Inscription, mount recto: "PLATE 10./DEVIL'S GATE, DALE CREEK CANON."
Acquired from: Fraenkel Gallery, San Francisco, California

4116. **GEN. GRANT AND PARTY AT FORT SANDERS**
(P1983.44.11)
Albumen silver print. negative c. 1868, album published 1869
Image: 9⅛ x 12⅝₁₆ in. (23.1 x 31.2 cm.)
Mount: 12¹³⁄₁₆ x 17⅝ in. (32.6 x 44.8 cm.)
Inscription, mount recto, printed: "GEN. GRANT AND PARTY AT FORT SANDERS."
Acquired from: Fraenkel Gallery, San Francisco, California

*4117. **DIAL ROCK, RED BUTTES** (P1983.44.12)
Albumen silver print. negative c. 1868, album published 1869
Image: 9¹⁄₁₆ x 12⅝₁₆ in. (23.1 x 31.2 cm.)
Mount: 12¹³⁄₁₆ x 17⅝ in. (32.6 x 44.8 cm.)
Inscription, mount recto, printed: "DIAL ROCK, RED BUTTES."
Acquired from: Fraenkel Gallery, San Francisco, California

4118. **SNOW AND TIMBER LINE, LARAMIE MOUNTAINS**
(P1983.44.13)
Albumen silver print. negative c. 1868, album published 1869
Image: 9⅛ x 12⅝₁₆ in. (23.1 x 31.3 cm.)
Mount: 12¹³⁄₁₆ x 17⅝ in. (32.6 x 44.8 cm.)
Inscription, mount recto, printed: "SNOW AND TIMBR [sic] LINE, LARAMIE MOUNTAINS."
Acquired from: Fraenkel Gallery, San Francisco, California

4119. **VALLEY OF THE GREAT LARAMIE, FROM THE MOUNTAINS** (P1983.44.14)
Albumen silver print. negative c. 1868, album published 1869
Image: 9⅛ x 12 in. (23.1 x 30.4 cm.)
Mount: 12¹³⁄₁₆ x 17⅝ in. (32.6 x 44.8 cm.)
Inscription, mount recto, printed: "VALLEY OF THE GREAT LARAMIE, FROM THE MOUNTAINS."
Acquired from: Fraenkel Gallery, San Francisco, California

4120. **LARAMIE HOTEL, LARAMIE CITY** (P1983.44.15)
Albumen silver print. negative c. 1868, album published 1869
Image: 9⅛ x 12 in. (23.1 x 30.4 cm.)
Mount: 12¹³⁄₁₆ x 17⅝ in. (32.6 x 44.8 cm.)
Inscription, mount recto, printed: "LARAMIE HOTEL, LARAMIE CITY."
Acquired from: Fraenkel Gallery, San Francisco, California

*4121. **THE WIND MILL AT LARAMIE** (P1983.44.16)
Albumen silver print. negative c. 1868, album published 1869
Image: 9¹⁄₁₆ x 12⅝₁₆ in. (23.0 x 31.3 cm.)
Mount: 12¹³⁄₁₆ x 17⅝ in. (32.6 x 44.8 cm.)
Inscription, mount recto, printed: "THE WIND MILL AT LARAMIE."
Acquired from: Fraenkel Gallery, San Francisco, California

4122. **LARAMIE MACHINE SHOPS, FROM THE SOUTHWEST** (P1983.44.17)
Albumen silver print. negative c. 1868, album published 1869
Image: 9¹⁄₁₆ x 12⅛ in. (23.1 x 30.8 cm.)
Mount: 12¹³⁄₁₆ x 17⅝ in. (32.6 x 44.8 cm.)
Inscription, mount recto, printed: "LARAMIE MACHINE SHOPS, FROM THE SOUTHWEST."
Acquired from: Fraenkel Gallery, San Francisco, California

4123. **VALLEY OF THE LITTLE LARAMIE RIVER** (P1983.44.18)
Albumen silver print. negative c. 1868, album published 1869
Image: 9⅛ x 12¼ in. (23.2 x 31.2 cm.)
Mount: 12¹³⁄₁₆ x 17⅝ in. (32.6 x 44.8 cm.)
Inscription, in negative: "2-"
mount recto, printed: "VALLEY OF THE LITTLE LARAMIE RIVER."
Acquired from: Fraenkel Gallery, San Francisco, California

4124. **AMONG THE TIMBER AT THE HEAD OF THE LITTLE LARAMIE RIVER** (P1983.44.19)
Albumen silver print. negative c. 1868, album published 1869
Image: 8⅞ x 11½ in. (22.5 x 29.2 cm.)
Mount: 12¹³⁄₁₆ x 17⅝ in. (32.6 x 44.8 cm.)
Inscription, mount recto, printed: "AMONG THE TIMBER AT THE HEAD OF THE LITTLE LARAMIE/RIVER."
Acquired from: Fraenkel Gallery, San Francisco, California

4125. **SOURCE OF THE LARAMIE RIVER** (P1983.44.20)
Albumen silver print. negative c. 1868, album published 1869
Image: 9⅛ x 12¹⁄₁₆ in. (23.2 x 30.7 cm.)
Mount: 12¹³⁄₁₆ x 17⅝ in. (32.6 x 44.8 cm.)
Inscription, mount recto, printed: "SOURCE OF THE LARAMIE RIVER."
Acquired from: Fraenkel Gallery, San Francisco, California

*4126. **HIGH BLUFF, BLACK BUTTES** (P1983.44.21)
Albumen silver print. negative c. 1868, album published 1869
Image: 8¹⁵⁄₁₆ x 11¹³⁄₁₆ in. (22.6 x 30.0 cm.)
Mount: 12¹³⁄₁₆ x 17⅝ in. (32.6 x 44.8 cm.)
Inscription, mount recto, printed: "HIGH BLUFF, BLACK BUTTES."
Acquired from: Fraenkel Gallery, San Francisco, California

4127. **BURNING ROCK CUT** (P1983.44.22)
Albumen silver print. negative c. 1868, album published 1869
Image: 9¼ x 12³⁄₁₆ in. (23.5 x 30.9 cm.)
Mount: 12¹³⁄₁₆ x 17⅝ in. (32.6 x 44.8 cm.)
Inscription, in negative: "[in reverse] 055 Carv [illeg.] Cut Burning Rock seen in [illegible]"
mount recto, printed: "BURNING ROCK CUT."
Acquired from: Fraenkel Gallery, San Francisco, California

4128. **ON THE MOUNTAINS OF GREEN RIVER, LOOKING UP THE VALLEY** (P1983.44.23)
Albumen silver print. negative c. 1868, album published 1869
Image: 9⅛ x 12⅛ in. (23.2 x 30.8 cm.)
Mount: 12¹³⁄₁₆ x 17⅝ in. (32.6 x 44.8 cm.)
Inscription, mount recto, printed: "ON THE MOUNTAINS OF GREEN RIVER, LOOKING UP THE/VALLEY."
Acquired from: Fraenkel Gallery, San Francisco, California

*4129. **CASTLE ROCK, GREEN RIVER VALLEY** (P1983.44.24)
Albumen silver print. negative c. 1868, album published 1869
Image: 9¼ x 12³⁄₁₆ in. (23.5 x 31.0 cm.)
Mount: 12¹³⁄₁₆ x 17⅝ in. (32.6 x 44.8 cm.)
Inscription, mount recto, printed: "CASTLE ROCK, GREEN RIVER VALLEY."
Acquired from: Fraenkel Gallery, San Francisco, California

4107

4111

4113

4117

4121

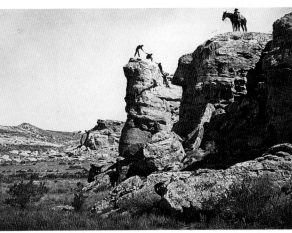

4126

4130. **GREEN RIVER VALLEY, LOOKING DOWN THE RIVER**
(P1983.44.25)
Albumen silver print. negative c. 1868, album published 1869
Image: 9¼ x 11¼ in. (23.5 x 28.5 cm.)
Mount: 12¹³/₁₆ x 17⅝ in. (32.6 x 44.8 cm.)
Inscription, mount recto, printed: "GREEN RIVER VALLEY,
LOOKING DOWN THE RIVER."
Acquired from: Fraenkel Gallery, San Francisco, California

4131. **CHURCH BUTTES** (P1983.44.26)
Albumen silver print. negative c. 1868, album published 1869
Image: 9 x 11¹⁵/₁₆ in. (22.8 x 30.3 cm.)
Mount: 12¹³/₁₆ x 17⅝ in. (32.6 x 44.8 cm.)
Inscription, mount recto, printed: "CHURCH BUTTES."
Acquired from: Fraenkel Gallery, San Francisco, California

* 4132. **SUPPLY TRAINS** (P1983.44.27)
Albumen silver print. negative c. 1868, album published 1869
Image: 9⅛ x 12⅝/₁₆ in. (23.1 x 31.3 cm.)
Mount: 12¹³/₁₆ x 17⅝ in. (32.6 x 44.8 cm.)
Inscription, mount recto, printed: "SUPPLY TRAINS."
Acquired from: Fraenkel Gallery, San Francisco, California

4133. **COAL BEDS OF BEAR RIVER** (P1983.44.28) duplicate of
P1970.28.11
Albumen silver print. negative c. 1868–69, album published
1869
Image: 9⅛ x 12⅝/₁₆ in. (23.1 x 31.3 cm.)
Mount: 12¹³/₁₆ x 17⅝ in. (32.6 x 44.8 cm.)
Inscription, mount recto, printed: "COAL BEDS OF BEAR
RIVER."
Acquired from: Fraenkel Gallery, San Francisco, California

4134. **BEAR RIVER CITY, NEAR THE COAL FIELDS**
(P1983.44.29)
Albumen silver print. negative c. 1868–69, album published
1869
Image: 9¼ x 12³/₁₆ in. (23.5 x 30.9 cm.)
Mount: 12¹³/₁₆ x 17⅝ in. (32.6 x 44.8 cm.)
Inscription, mount recto, printed: "BEAR RIVER CITY,
NEAR THE COAL FIELDS."
Acquired from: Fraenkel Gallery, San Francisco, California

4135. **LOOKING DOWN ECHO CANON, FROM DEATH'S
ROCK** (P1983.44.30)
Albumen silver print. negative c. 1868–69, album published
1869
Image: 9⅛ x 12⅝/₁₆ in. (23.2 x 31.3 cm.)
Mount: 12¹³/₁₆ x 17⅝ in. (32.6 x 44.8 cm.)
Inscription, mount recto, printed: "LOOKING DOWN
ECHO CANON, FROM DEATH'S ROCK."
Acquired from: Fraenkel Gallery, San Francisco, California

4136. **MONUMENT ROCK, MOUTH OF ECHO CANON**
(P1983.44.31)
Albumen silver print. 1869
Image: 12⅝/₁₆ x 9⅛ in. (31.2 x 23.1 cm.)
Mount: 17⅝ x 12¹³/₁₆ in. (44.8 x 32.6 cm.)
Inscription, mount recto, printed: "MONUMENT ROCK,
MOUTH OF ECHO CANON."
Acquired from: Fraenkel Gallery, San Francisco, California

* 4137. **HANGING ROCK, FOOT OF ECHO CANON**
(P1983.44.32)
Albumen silver print. 1869
Image: 9⅛ x 12⅝/₁₆ in. (23.2 x 31.3 cm.)
Mount: 12¹³/₁₆ x 17⅝ in. (32.6 x 44.8 cm.)
Inscription, mount recto, printed: "HANGING ROCK,
FOOT OF ECHO CANON."
Acquired from: Fraenkel Gallery, San Francisco, California

4138. **SPHYNX OF THE VALLEY** (P1983.44.33)
Albumen silver print. 1869
Image: 9⅛ x 12⅜ in. (23.2 x 31.4 cm.)
Mount: 12¹³/₁₆ x 17⅝ in. (32.6 x 44.8 cm.)
Inscription, mount recto, printed: "SPHYNX OF THE
VALLEY."
Acquired from: Fraenkel Gallery, San Francisco, California

* 4139. **SENTINEL ROCK, NEAR THE MOUTH OF ECHO
CANON** (P1983.44.34)
Albumen silver print. 1869
Image: 9¼ x 12⅛ in. (23.4 x 30.8 cm.)
Mount: 12¹³/₁₆ x 17⅝ in. (32.6 x 44.8 cm.)
Inscription, mount recto, printed: "SENTINEL ROCK,
NEAR THE MOUTH OF ECHO CANON."
Acquired from: Fraenkel Gallery, San Francisco, California

4140. **LOOKING UP WEBER RIVER, ECHO CITY** (P1983.44.35)
Albumen silver print. 1869
Image: 9⅝/₁₆ x 12⅛ in. (23.6 x 30.8 cm.)
Mount: 12¹³/₁₆ x 17⅝ in. (32.6 x 44.8 cm.)
Inscription, mount recto, printed: "LOOKING UP WEBER
RIVER, ECHO CITY."
Acquired from: Fraenkel Gallery, San Francisco, California

4141. **COALVILLE, WEBER VALLEY** (P1983.44.36)
Albumen silver print. 1869
Image: 7¹⁵/₁₆ x 11⁹/₁₆ in. (20.2 x 29.3 cm.)
Mount: 12¹³/₁₆ x 17⅝ in. (32.6 x 44.8 cm.)
Inscription, mount recto, printed: "COALVILLE, WEBER
VALLEY."
Acquired from: Fraenkel Gallery, San Francisco, California

4142. **WILHELMINA PASS, FROM THE EAST** (P1983.44.37)
Albumen silver print. 1869
Image: 9 x 12¹/₁₆ in. (22.8 x 30.6 cm.)
Mount: 12¹³/₁₆ x 17⅝ in. (32.6 x 44.8 cm.)
Inscription, mount recto: "PLATE 37./WILLHELMINA [sic]
PASS, FROM THE EAST."
Acquired from: Fraenkel Gallery, San Francisco, California

4143. **ROCK GREAT EASTERN** (P1983.44.38)
Albumen silver print. 1869
Image: 9¹/₁₆ x 12⅝/₁₆ in. (23.0 x 31.2 cm.)
Mount: 12¹³/₁₆ x 17⅝ in. (32.6 x 44.8 cm.)
Inscription, mount recto, printed: "ROCK GREAT
EASTERN."
Acquired from: Fraenkel Gallery, San Francisco, California

4144. **EAST END OF TUNNEL NO. 3, WEBER VALLEY**
(P1983.44.39)
Albumen silver print. 1869
Image: 9⅛ x 12⁷/₁₆ in. (23.2 x 31.6 cm.)
Mount: 12¹³/₁₆ x 17⅝ in. (32.6 x 44.8 cm.)
Inscription, mount recto, printed: "EAST END OF
TUNNEL No. 3, WEBER VALLEY."
Acquired from: Fraenkel Gallery, San Francisco, California

* 4145. **DEVIL'S GATE, WEBER CANON** (P1983.44.40)
Albumen silver print. 1869
Image: 12³/₁₆ x 9¼ in. (31.0 x 23.4 cm.)
Mount: 17⅝ x 12¹³/₁₆ in. (44.8 x 32.6 cm.)
Inscription, mount recto, printed: "DEVIL'S GATE, WEBER
CANON."
Acquired from: Fraenkel Gallery, San Francisco, California

4146. **WEBER CANON, FROM BELOW THE DEVIL'S GATE**
(P1983.44.41)
Albumen silver print. 1869
Image: 9⅛ x 12⁷/₁₆ in. (23.2 x 31.5 cm.)
Mount: 12¹³/₁₆ x 17⅝ in. (32.6 x 44.8 cm.)
Inscription, mount recto, printed: "WEBER CANON, FROM
BELOW THE DEVIL'S GATE."
Acquired from: Fraenkel Gallery, San Francisco, California

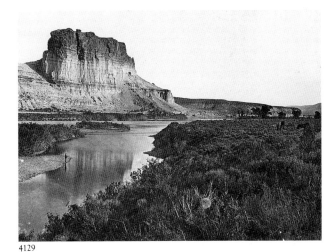

4129

4132

4137

4139

4145

4153

4147. **MORMON TURNPIKE BRIDGE, MOUTH OF WEBER CANON** (P1983.44.42)
Albumen silver print. 1869
Image: 9 3/16 x 11 3/4 in. (23.2 x 29.8 cm.)
Mount: 12 13/16 x 17 5/8 in. (32.6 x 44.8 cm.)
Inscription, mount recto: "PLATE 42./MORMON TURNPIKE BRIDGE, MOUTH OF WEBER CANON."
Acquired from: Fraenkel Gallery, San Francisco, California

4148. **WEBER VALLEY, FROM WILHELMINA PASS** (P1983.44.43)
Albumen silver print. 1869
Image: 9 5/16 x 12 1/8 in. (23.7 x 30.8 cm.)
Mount: 12 13/16 x 17 5/8 in. (32.6 x 44.8 cm.)
Inscription, mount recto, printed: "WEBER VALLEY, FROM WILHELMINA PASS."
Acquired from: Fraenkel Gallery, San Francisco, California

4149. **GEN. CASEMENT'S CONSTRUCTION TRAIN** (P1983.44.44)
Albumen silver print. 1869
Image: 9 1/8 x 11 3/4 in. (23.1 x 29.8 cm.)
Mount: 12 13/16 x 17 5/8 in. (32.6 x 44.8 cm.)
Inscription, mount recto, printed: "GEN. CASEMENT'S CONSTRUCTION TRAIN."
Acquired from: Fraenkel Gallery, San Francisco, California

4150. **SALT LAKE CITY, FROM THE TOP OF THE TABERNACLE** (P1983.44.45)
Albumen silver print. 1869
Image: 9 1/8 x 11 3/8 in. (23.1 x 28.8 cm.)
Mount: 12 13/16 x 17 5/8 in. (32.6 x 44.8 cm.)
Inscription, mount recto, printed: "SALT LAKE CITY, FROM THE TOP OF THE TABERNACLE."
Acquired from: Fraenkel Gallery, San Francisco, California

4151. **CITY CREEK CANON, NEAR CITY CREEK FALLS** (P1983.44.46)
Albumen silver print. 1869
Image: 12 3/8 x 9 1/8 in. (31.4 x 23.2 cm.)
Mount: 17 5/8 x 12 13/16 in. (44.8 x 32.6 cm.)
Inscription, mount recto, printed: "CITY CREEK CANON, NEAR CITY CREEK FALLS."
Acquired from: Fraenkel Gallery, San Francisco, California

4152. **RESIDENCE OF BRIGHAM YOUNG** (P1983.44.47)
Albumen silver print. 1869
Image: 8 5/8 x 12 7/16 in. (21.8 x 31.6 cm.)
Mount: 12 13/16 x 17 5/8 in. (32.6 x 44.8 cm.)
Inscription, mount recto, printed: "RESIDENCE OF BRIGHAM YOUNG."
Acquired from: Fraenkel Gallery, San Francisco, California

*4153. **MORMON FAMILY, GREAT SALT LAKE VALLEY** (P1983.44.48)
Albumen silver print. 1869
Image: 8 3/4 x 12 3/8 in. (22.2 x 31.4 cm.)
Mount: 12 13/16 x 17 5/8 in. (32.6 x 44.8 cm.)
Inscription, mount recto, printed: "MORMON FAMILY, GREAT SALT LAKE VALLEY."
Acquired from: Fraenkel Gallery, San Francisco, California

4154. **BRIGHAM YOUNG'S COTTON AND WOOLEN FACTORIES** (P1983.44.49)
Albumen silver print. 1869
Image: 9 1/8 x 12 1/8 in. (23.2 x 30.8 cm.)
Mount: 12 13/16 x 17 5/8 in. (32.6 x 44.8 cm.)
Inscription, mount recto, printed: "BRIGHAM YOUNG'S COTTON AND WOOLEN FACTORIES."
Acquired from: Fraenkel Gallery, San Francisco, California

*4155. **GREAT MORMON TABERNACLE** (P1983.44.50)
Albumen silver print. 1869
Image: 9 1/4 x 12 3/16 in. (23.4 x 31.0 cm.)
Mount: 12 13/16 x 17 5/8 in. (32.6 x 44.8 cm.)
Inscription, mount recto, printed: "GREAT MORMON TABERNACLE."
Acquired from: Fraenkel Gallery, San Francisco, California

*4156. **GRANITE CANYON** (P1983.44.51)
Albumen silver print. negative c. 1867–68, album published 1869
Image: 9 1/4 x 12 1/8 in. (23.4 x 30.8 cm.)
Mount: 12 13/16 x 17 5/8 in. (32.6 x 44.8 cm.)
Inscription, mount recto: "granite canyon"
Acquired from: Fraenkel Gallery, San Francisco, California

★ ★ ★ ★

4157. **LATHROP STATION. U.P.R.R.** (P1967.2745)
Albumen silver print. c. 1867–69
Image: 7 1/2 x 10 5/16 in. (19.1 x 26.2 cm.)
Mount: 11 x 14 in. (28.0 x 35.6 cm.)
Inscription, mount verso: "Lathrop Station./U.P.R.R."
Acquired from: Fred Rosenstock, Denver, Colorado

4158. **REYNOLDS AND DARLINGS WORK HUT NO 1-2-3 NEAR DALE CREEK, U.P.R.R. [Eastern Approach to Dale Creek Bridge]** (P1967.2747) duplicate of P1983.44.9
Albumen silver print. c. 1868
Image: 8 5/16 x 11 3/16 in. (21.2 x 28.4 cm.)
Mount: 11 1/8 x 13 15/16 in. (28.2 x 35.4 cm.)
Inscription, mount verso: "Reynolds and Darlings Work Hut No 1-2-3 near Dale Creek,/U.P.R.R."
Acquired from: Fred Rosenstock, Denver, Colorado

4159. **SHERMAN ROCKS NEAR SHERMAN STATION U.P.R.R.** (P1967.3344)
Albumen silver print. c. 1867–68
Image: 9 5/8 x 12 3/8 in. (24.4 x 31.4 cm.)
Mount: 13 15/16 x 17 7/8 in. (35.4 x 45.5 cm.)
Inscription, mount verso: "Sherman Rocks near Sherman Station U.P.R.R."
Acquired from: Fred Rosenstock, Denver, Colorado

4160. **SUPPLY CAMP, ECHO CANYON [Echo Canyon, Summit Co., Utah]** (P1967.2750.2)
Albumen silver print. c. 1868–69
Image: 8 5/16 x 11 7/8 in. (21.1 x 30.2 cm.)
Mount: 10 15/16 x 13 7/8 in. (27.8 x 35.3 cm.)
Inscription, mount verso: "Suply [sic] Camp, Echo Cannon [sic]"
Acquired from: Fred Rosenstock, Denver, Colorado

4161. **TEMPORARY BRIDGE ACROSS WEBER RIVER AT DEVILS GATE. WEBER CAÑON** (P1967.2750.1)
Albumen silver print. 1869
Image: 9 3/16 x 12 1/4 in. (23.3 x 31.1 cm.)
Mount: 11 x 13 15/16 in. (28.0 x 35.4 cm.)
Inscription, mount recto: "Teporery [sic] Bridge across Weber River/at Devils Gate, Weber Cañon"
Acquired from: Fred Rosenstock, Denver, Colorado

*4162. **U.P.R.R. [Dan Casement and Clerks at Echo City]** (P1967.2748)
Albumen silver print. c. 1867–68
Image: 9 1/8 x 12 1/8 in. (23.4 x 30.7 cm.)
Mount: 11 x 13 7/8 in. (27.9 x 35.3 cm.)
Inscription, mount verso: "U.P.R.R."
Acquired from: Fred Rosenstock, Denver, Colorado

*4163. **U.P.R.R. [employees seated around table in tent]** (P1967.3346.1)
Albumen silver print. c. 1867–68
Image: 8 13/16 x 11 7/8 in. (22.4 x 29.0 cm.)
Mount: 13 5/8 x 18 5/16 in. (34.6 x 46.5 cm.)
Inscription, mount verso: "U.P.R.R."
Acquired from: Fred Rosenstock, Denver, Colorado

4164. **[U.P.R.R. employees in front of superintendent's and engineer's construction office]** (P1967.3345)
Albumen silver print. c. 1867–68
Image: 7 ¼ x 12 ³⁄₁₆ in. (18.5 x 31.0 cm.)
Mount: 13 ¹⁵⁄₁₆ x 18 ⁷⁄₁₆ in. (35.4 x 46.8 cm.)
Acquired from: Fred Rosenstock, Denver, Colorado

4165. **VALLEY OF THE LITTLE LARAMIE. ON LINE OF U.P.R.R.** (P1967.3343)
Albumen silver print. 1868
Image: 8 ½ x 11 ⅜ in. (21.6 x 28.9 cm.)
Mount: 13 ⅝ x 17 ¹³⁄₁₆ in. (34.6 x 45.3 cm.)
Inscription, mount verso: "Valley of the Little Laramie. on Line of U.P.R.R."
Acquired from: Fred Rosenstock, Denver, Colorado

4166. **WILHELMINA'S PASS, WEBER CAÑON [1000 Mile Tree]** (P1967.2746)
Albumen silver print. c. 1869
Image: 12 ¼ x 9 ³⁄₁₆ in. (31.1 x 23.2 cm.)
Mount: 13 ¹⁵⁄₁₆ x 11 in. (35.4 x 28.0 cm.)
Inscription, mount recto: "Wilomenee [sic] Pass Weber Cañon/Rocks on right—1800 feet high"
Acquired from: Fred Rosenstock, Denver, Colorado

SANTA FE CENTER FOR PHOTOGRAPHY

PORTFOLIO I (P1982.35.1–5)

This portfolio consists of five photographs by New Mexico photographers and was published in 1982 by the Santa Fe Center for Photography. This is portfolio number 10 of an edition of 16 portfolios. Full information on the individual prints is listed by print title under the photographer's name.

Mary Peck, BANDELIER NATIONAL MONUMENT (P1982.35.1)
Bernard Plossu, SANTA CLARA PUEBLO (P1982.35.2)
Eliot Porter, LANDSCAPE, NEW MEXICO (P1982.35.3)
David Scheinbaum, CHURCH, CANADA DE LOS ALAMOS (P1982.35.4)
Susan Steffy, SQUASH ON BLACK (P1982.35.5)

PORTFOLIO II (P1984.4.1–5)

This portfolio consists of five photographs by New Mexico photographers and was published in 1983 by the Santa Fe Center for Photography. It was produced by Janet Russek and Richard Wickstrom and is the second of a series. This is portfolio number 13 of an edition of 21. Full information on the individual prints is listed by print title under the photographer's name.

Beaumont Newhall, EDWARD WESTON'S KITCHEN (P1984.4.1)
Meridel Rubenstein, PAUL, ANNABELLE, AND PAULA MEDINA, CHIMAYO, NEW MEXICO (P1984.4.2)
Nancy Sutor, SKELETON (P1984.4.3)
Willard Van Dyke, BARN, RAMONA, CALIFORNIA (P1984.4.4)
Richard Wilder, NAMBE, NEW MEXICO (P1984.4.5)

NAPOLEON SARONY,
American, born Canada (1821–1896)

Napoleon Sarony operated one of the most famous portrait studios of the late 1800s. Sarony was born in Quebec, his family moving to New York when he was ten. Apprenticed to a lithographer as a child, Sarony opened his own lithography studio in New York in 1848. After opening his studio, Sarony and his brother Olivier spent eight years traveling throughout Europe visiting artists and photographers. During his travels, his lithography studio collapsed, and Sarony opened his

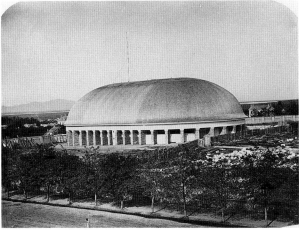
4155

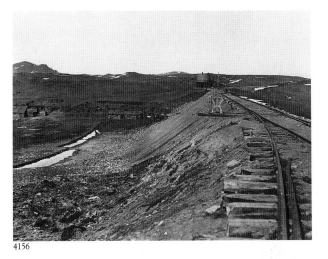
4156

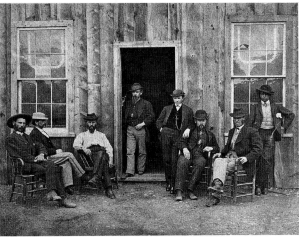
4162

own photographic studio, first in Edinburgh and then in Birmingham. Despite his success in Great Britain, he was homesick and returned to the United States in 1866 to open a photography studio on Broadway in New York. Sarony's creative use of poses and settings earned him a reputation as one of the most original theater photographers. Personalities sought him out, and he reportedly posed and photographed over 200,000 people, many of them actors and celebrities of the time. Sarony also created pose accessories that carried his name.

*4167. **MRS. LANGTRY AND SARA BERNHARDT** (P1986.3)
Albumen silver print. c. 1887
Image: 5 ⅜ x 3 ¹⁵⁄₁₆ in. (13.7 x 10.0 cm.)
Mount: 6 ½ x 4 ¼ in. (16.5 x 10.7 cm.)
Signed: see inscription
Inscription, mount recto, printed: "Sarony//87 UNION SQR. N. Y." and rubber stamp "MRS. LANGTRY AND SARA BERNHARDT/COPYRIGHT 1887 BY NAPOLEON SARONY."
Acquired from: gift of Paul Katz, North Bennington, Vermont

CHARLES R. SAVAGE,
American, born England (1832–1909)

Savage emigrated to New York City from England in 1856. After learning photography he set up a studio in Florence, Nebraska, in 1859, but moved his operation to Salt Lake City, Utah, in 1860. That city was the base of operations for his railroad, landscape, and church-related work (he had converted to Mormonism in England). Savage admired Carleton Watkins' dramatic landscape images and made at least one trip to visit him in California. Savage also made a notable journey to the East to purchase supplies in 1866, and accounts of his trip were published in installments in the *Philadelphia Photographer*. He also photographed the driving of the golden spike at Promontory Point, Utah, in 1869. Many of his views were published through his firm, Savage and Ottinger. Savage lost most of his early negatives in an 1883 studio fire.

*4168. **BLACK ROCK & ANTELOPE ISLAND SALT LAKE** (P1982.22)
Albumen silver print. c. 1870s
Image: 5 ⁵⁄₁₆ x 8 ⁵⁄₁₆ in. (13.5 x 21.1 cm.)
Mount: 7 x 10 in. (17.8 x 25.4 cm.)
Signed: see inscription
Inscription, in negative: "BLACK ROCK & ANTELOPE ISLAND SALT LAKE. C. R. SAVAGE, Pho[illegible]"
mount recto: "C. R. Savage,/Salt Lake City, Utah."
Acquired from: Andrew Smith, Inc., Albuquerque, New Mexico

4169. **LONE PEAK, AMERICAN FORK CANON, UTAH** (P1986.25)
Albumen silver print. c. 1870s
Image: 9 ½ x 11 ¾ in. (24.2 x 29.9 cm.)
Mount: 12 ⁵⁄₁₆ x 18 ⅜ in. (31.3 x 46.6 cm.)
Signed: see inscription
Inscription, in negative: "LONE PEAK, AMERICAN FORK CANON, UTAH./C.R. SAVAGE SALT LAKE."
mount recto: dealer's mark
Acquired from: Lee Gallery, Boston, Massachusetts

4170. **TEMPLE BLOCK. SALT LAKE CITY** (P1970.28.7)
Albumen silver print. c. late 1880s
Image: 3 ⅞ x 6 ¼ in. (9.8 x 15.8 cm.)
Mount: 4 ¼ x 6 ½ in. (10.8 x 16.6 cm.)
Signed: see inscription
Inscription, in negative: "Temple Block. Salt Lake City"
mount verso, printed: "C.R. Savage,/Art Bazar/Salt Lake

City, Utah./A Complete Assortment of Views of the Great West."
mount verso: dealer's stamp and "Assembly Hall at left/Main Street lower l. to r. in front/(ca. 1875) [sic]"
Acquired from: Kennedy Galleries, New York, New York

FRANCESCO SCAVULLO, American (b. 1929)

In his late teens Francesco Scavullo worked for *Vogue* and at nineteen was employed by *Seventeen*. Since then, he has photographed many international celebrities, models, and the collections of major fashion designers. His photographs have appeared in magazines such as *Harper's Bazaar*, *Cosmopolitan*, *Esquire*, *Newsweek*, and *Time*, as well as on record covers, book jackets, and movie posters. During the past ten years, Scavullo has also produced silkscreens and enamel on canvas paintings. He also is a television director.

4171. **ANDREW AND JAMIE WYETH** (P1987.9.1)
Gelatin silver print. negative 1982, print 1987
Image: 15 ¼ x 22 ¹⁵⁄₁₆ in. (38.7 x 58.2 cm.)
Sheet: 19 ¹⁵⁄₁₆ x 23 ¹⁵⁄₁₆ in. (50.6 x 60.9 cm.)
Signed, l.r. print verso: "Fran Scavullo 82"
Inscription, print verso: inverted check mark and rubber stamp "NO REPRODUCTION RIGHTS/© FRANCESCO SCAVULLO/LIMITED EDITION [in pencil] 10/10"
Acquired from: gift of Sean Byrnes, New York, New York

*4172. **JANIS JOPLIN** (P1987.9.2)
Gelatin silver print. negative 1969, print 1987
Image: 22 ⅞ x 15 ⅜ in. (58.1 x 39.0 cm.)
Sheet: 23 ¹⁵⁄₁₆ x 19 ¹⁵⁄₁₆ in. (60.9 x 50.6 cm.)
Signed, l.r. print verso: "Fran Scavullo 69"
Inscription, print verso: inverted check mark and rubber stamp "NO REPRODUCTION RIGHTS/© FRANCESCO SCAVULLO/LIMITED EDITION [in pencil] 10/10"
Acquired from: gift of Sean Byrnes, New York, New York

4173. **JOE DALLESANDRO AND CHILD** (P1987.9.6)
Gelatin silver print. negative 1968, print 1987
Image: 22 ⅞ x 19 in. (58.2 x 48.2 cm.)
Sheet: 23 ¹⁵⁄₁₆ x 19 ¹⁵⁄₁₆ in. (60.9 x 50.6 cm.)
Signed, l.r. print verso: "Fran Scavullo 68"
Inscription, print verso: inverted check mark and rubber stamp "NO REPRODUCTION RIGHTS © FRANCESCO SCAVULLO/LIMITED EDITION [in pencil] 8/10"
Acquired from: gift of Sean Byrnes, New York, New York

*4174. **LOUISE NEVELSON** (P1987.9.4)
Gelatin silver print. negative 1981, print 1987
Image: 22 ⅞ x 15 ⁵⁄₁₆ in. (58.1 x 38.9 cm.)
Sheet: 23 ¹⁵⁄₁₆ x 19 ⅞ in. (60.8 x 50.5 cm.)
Signed, l.r. print verso: "Fran Scavullo 81"
Inscription, print verso: inverted check mark and rubber stamp "NO REPRODUCTION RIGHTS © FRANCESCO SCAVULLO/LIMITED EDITION [in pencil] 10/10"
Acquired from: gift of Sean Byrnes, New York, New York

4175. **ROBERT LaFOSSE** (P1987.9.5)
Gelatin silver print. negative 1981, print 1987
Image: 22 ¹³⁄₁₆ x 18 ⅞ in. (57.8 x 47.9 cm.)
Sheet: 23 ⅞ x 19 ¹⁵⁄₁₆ in. (60.7 x 50.6 cm.)
Signed, l.r. print verso: "Fran Scavullo 81"
Inscription, print verso: inverted check mark and rubber stamp "NO REPRODUCTION RIGHTS © FRANCESCO SCAVULLO/LIMITED EDITION [in pencil] 10/10"
Acquired from: gift of Sean Byrnes, New York, New York

4163

4167

4168

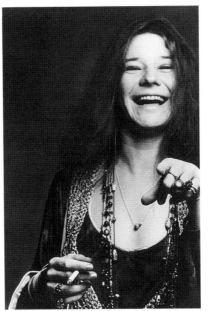

4172

4174

4176. **ROSE F. KENNEDY** (P1987.9.3)
Gelatin silver print. negative 1982, print 1987
Image: 15 3/16 x 22 7/8 in. (38.6 x 58.1 cm.)
Sheet: 19 15/16 x 23 7/8 in. (50.6 x 60.7 cm.)
Signed, l.r. print verso: "Fran Scavullo 82"
Inscription, print verso: inverted check mark and rubber
stamp "NO REPRODUCTION RIGHTS/©
FRANCESCO SCAVULLO/LIMITED EDITION
[in pencil] 10/10"
Acquired from: gift of Sean Byrnes, New York, New York

4177. **SAMUEL J. WAGSTAFF JR. AND ROBERT
MAPPLETHORPE** (P1987.9.7)
Gelatin silver print. negative 1974, print 1987
Image: 18 15/16 x 22 13/16 in. (48.1 x 58.0 cm.)
Sheet: 19 15/16 x 23 15/16 in. (50.6 x 60.9 cm.)
Signed, l.r. print verso: "Fran Scavullo 74"
Inscription, print verso: inverted check mark and
rubber stamp "NO REPRODUCTION RIGHTS
© FRANCESCO SCAVULLO/LIMITED EDITION
[in pencil] 10/10"
Acquired from: gift of Sean Byrnes, New York, New York

ALBERT E. SCHAAF, Canadian (1866–1950)

Albert Schaaf was involved in cycling during its pioneer
days. Although he studied law, he found that he was
not suited to it and wandered from job to job until he
became a traveling salesman for the Gormully & Jeffery
Manufacturing Company, which made Rambler bicy-
cles. He married in 1888 and quit traveling the next
year, moving his family to Boston; he worked in a
branch office of the company. Throughout his life,
Schaaf continued to work in the transportation field,
first with bicycles and later with automobiles. In the
late 1800s he also became interested in sailing. Schaaf
began photographing in 1885 and continued through
1899. Many of his photographs show cycling club ac-
tivities and cycling pioneers. Schaaf also produced bro-
moil prints. His bromoil photographs hung in salons
world-wide, and one, an image of a sloop entitled *The
Greenwich Reach*, appeared on the cover of the Decem-
ber 1915 issue of *The Photographic Journal of America*.
Schaaf was a member of the Pictorial Photographers of
America and served on its Council.

*4178. **ARMISTICE MORNING—FIFTH AVENUE** (P1986.34)
Bromoil transfer print. 1918
Image: 10 1/8 x 6 7/8 in. (25.7 x 17.4 cm.)
Sheet: 12 x 10 in. (30.4 x 25.3 cm.)
Mount: 19 x 14 1/4 in. (48.2 x 36.2 cm.)
Signed, l.r. sheet recto: "Albert E. Schaaf/NOV.11/1918"
Inscription, sheet recto: "Armistice Morning—Fifth Avenue"
mount verso: " "Armistice Morning—Fifth Avenue."/
Bromoil.//Albert E. Schaaf,/2034 East 83rd St.,/Cleveland,
Ohio.//Buffalo and Pittsburg [sic].//S-22//A//30//14X20//
AES-7//267" and printed paper labels "This photograph/
was accepted and/hung in the Albright/Art Gallery at/
Buffalo, New York,/in the Ninth Annual/Salon of
Photogra-/phy under the aus-/pices of the Buffalo/Camera
Club in/January 1928." and "THE FIFTEENTH/
PITTSBURGH SALON/OF PHOTOGRAPHIC ART/
[PSPA insignia]/This picture was accepted by the/jury of
selection and was ex-/hibited in the Fine Arts Gal-/leries of
Carnegie Institute from/March 17th to April 15th, 1928./
THE JURY/Nicholas Haz, F.R.P.S., New York/Holmes I.
Mettee, Baltimore/Paul Wierum, Chicago"
old tissue overlay: "Armistice Morning/5th Ave. Hung 5
Salons"
Acquired from: Paul Katz, North Bennington, Vermont

DAVID SCHEINBAUM, American (b. 1951)

Scheinbaum received his bachelor's degree in photogra-
phy from Brooklyn College in 1973. While he was in
school he also studied independently at the Fashion
Institute of Technology and with George Tice at the
New School for Social Research. From 1974 to 1979
Scheinbaum was a media and curriculum developer for
"Growth through Art and Museum Experience," a pro-
gram developed to integrate art and education through
schools and museums, and from 1975 to 1978 he taught
photography at LaGuardia Community College. He
moved to Santa Fe, New Mexico, in 1979 and began to
make landscape photographs with a view camera. Since
1980 he has operated Scheinbaum and Russek Gallery
of Photography and taught photography at the College
of Santa Fe.

4179. **CHURCH, CANADA DE LOS ALAMOS [from Santa Fe
Center for Photography "Portfolio I"]** (P1982.35.4)
Gelatin silver print. negative 1980, print 1982
Image: 7 9/16 x 9 15/16 in. (19.1 x 25.3 cm.)
Sheet: 10 15/16 x 13 15/16 in. (27.7 x 35.4 cm.)
Signed, l.l. print verso: "David Scheinbaum © 1982"
Inscription, mat backing verso, printed paper label: "Santa Fe
Center for Photography/PORTFOLIO I/Portfolio no. [in
ink] 10/Print no. [in ink] 4"
Acquired from: Santa Fe Center for Photography, Santa Fe,
New Mexico

GEORGE H. SEELEY, American (1880–1955)

George H. Seeley was born in Stockbridge, Massachu-
setts, and lived there for most of his life. He studied
drawing and painting for three and a half years at the
Massachusetts Normal Art School in Boston, begin-
ning in 1897. While there he met F. Holland Day, who
introduced him to photography; when Seeley returned
to Stockbridge in 1902, he took with him an 8 x 10
view camera. Seeley taught art in the public school
system but was also an active amateur photographer.
Between 1902 and 1912, his most productive years, he
made numerous images printed in platinum, gum plati-
num, and bromoil and exhibited them widely. The
works are strongly pictorial and frequently portray alle-
gorical subjects. Seeley became a member of the Photo-
Secession in 1904, exhibiting his work at Stieglitz's
Little Galleries of the Photo-Secession as well as in
the more traditional pictorial salons. In 1910 Seeley ex-
hibited his photographs in the International Exhibition
of Pictorial Photography at the Albright Art Gallery
in Buffalo, New York. Following the show his relation-
ship with Stieglitz cooled and Seeley aligned himself
with the ideas promoted by photographers such as
Clarence H. White and Gertrude Käsebier. He contin-
ued to make photographs until his father's death in
1920, but during the 1930s exhibited his work much
less frequently.

*4180. **MAIDEN WITH BOWL** (P1984.18)
Gum-platinum print. c. 1907–09
Image: 13 7/16 x 10 5/8 in. (34.1 x 26.9 cm.)
Mount: 14 x 11 in. (35.6 x 27.9 cm.)
Signed, l.r. print recto: "George H. Seeley."
Inscription, print verso: "[illegible]/George H. Seeley/
Stockbridge, Massachusetts./U.S.A."
mount verso: "379//C-2//Maiden with Bowl./by/George H.
Seeley/Stockbridge,/Mass. U.S.A.//[Japanese script]" and
rubber stamp "569" and stamp in Japanese script and
printed paper label "THE FOURTH INTERNATIONAL
PHOTOGRAPHIC SALON OF JAPAN//Selected/for/The

Fourth/International/Photographic Salon/of Japan,/Under
the Auspices of/The All Japan Association/of Photographic
Societies,/In The Asahi Shimbun,/Tokyo & Osaka,/1930/
[printing in Japanese script]"
Acquired from: Robert Miller Gallery, New York, New York

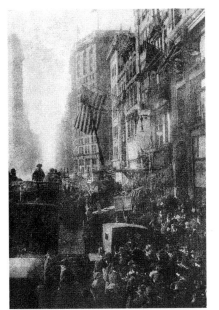

4178

BEN SHAHN,
American, born Lithuania (1898–1969)

Best known as a painter and graphic artist, Shahn
made most of his 6,000 photographic images for the
Farm Security Administration between 1935 and 1938.
Before and after that period his photographs served
mainly as aides for his drawing and painting. Shahn
was less concerned with the technical aspects of pho-
tography than with documenting social conditions and
personal situations. He frequently worked with a right-
angle view finder to photograph people without letting
them know that they were his subjects. For a time
Shahn shared a studio with Walker Evans, but the two
never had a significant impact on each other's work.
Shahn experimented freely with his image composi-
tion, sometimes exposing film under conditions that
were unlikely to produce successful images.

4181. **AMISH HORSE-DRAWN WAGON, PLAIN CITY, OHIO,
AUGUST 1938** (P1980.30.8)
Gelatin silver print. 1938
Image: 6½ x 9⅝ in. (16.5 x 24.4 cm.)
Sheet: 8⅛ x 10 in. (20.6 x 25.4 cm.)
Signed: see inscription
Inscription, print verso: "M//6648M3" and rubber stamp
"BEN SHAHN/PHOTOGRAPHER/FARM SECURITY
ADMINISTRATION/formerly from the collection of The
Fogg Museum"
Acquired from: James Maroney, Inc., New York, New York

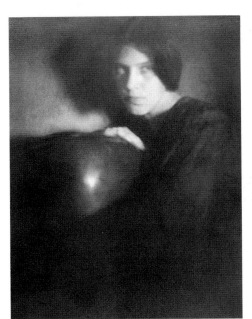

4180

*4182. **CRANKING CAR TO GET IT STARTED, THE OLD
WAY, WORTHINGTON, OHIO, AUGUST 1938**
(P1980.30.2)
Gelatin silver print. 1938
Image: 6⁷⁄₁₆ x 9⁹⁄₁₆ in. (16.3 x 24.3 cm.)
Sheet: 8⅛ x 10 in. (20.6 x 25.4 cm.)
Signed: see inscription
Inscription, print verso: "6670-M2" and rubber stamp
"BEN SHAHN/PHOTOGRAPHER/FARM SECURITY
ADMINISTRATION/formerly from the collection of
The Fogg Museum"
Acquired from: James Maroney, Inc., New York, New York

*4183. **DAUGHTER OF MR. THAXTON, FARMER, NEAR
MECHANICSBURG, OHIO, SUMMER 1938**
(P1980.30.9)
Gelatin silver print. 1938
Image: 6⅜ x 9⁹⁄₁₆ in. (16.2 x 24.3 cm.)
Sheet: 8⅛ x 10¹⁄₁₆ in. (20.6 x 25.5 cm.)
Signed: see inscription
Inscription, print verso: "18//6488 M4//H" and rubber stamps
"PLEASE CREDIT/F.S.A./FARM SECURITY
ADMINISTRATION/PHOTO BY: SHAHN" and
"BEN SHAHN/PHOTOGRAPHER/FARM SECURITY
ADMINISTRATION/formerly from the collection of
The Fogg Museum"
Acquired from: James Maroney, Inc., New York, New York

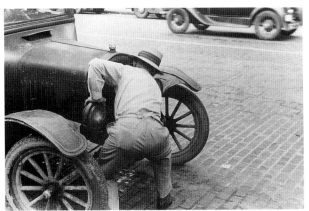

4182

4184. **MAIN AND COURT STREETS, CIRCLEVILLE, OHIO, SUMMER 1938 ["Butch" at 8:20]** (P1980.30.6)
Gelatin silver print. 1938
Image: 6⅝ x 9⁹⁄₁₆ in. (16.8 x 24.3 cm.)
Sheet: 8⅛ x 10 in. (20.6 x 25.4 cm.)
Signed: see inscription
Inscription, print verso: "35//duplicate/P1970.2695//6391 M3" and rubber stamp "BEN SHAHN/PHOTOGRAPHER/FARM SECURITY ADMINISTRATION/formerly from the collection of The Fogg Museum"
Acquired from: James Maroney, Inc., New York, New York

4185. **MAN WITH TROUBLES, CIRCLEVILLE'S "HOOVERVILLE," OHIO, SUMMER 1938** (P1980.30.7)
Gelatin silver print. 1938
Image: 6⁷⁄₁₆ x 9⅝ in. (16.3 x 24.4 cm.)
Sheet: 8⅛ x 10¹⁄₁₆ in. (20.6 x 25.5 cm.)
Signed: see inscription
Inscription, print verso: "C34//6628M5//Circleville" and rubber stamp "PLEASE CREDIT/F.S.A./FARM SECURITY ADMINISTRATION/PHOTO BY: SHAHN"
Acquired from: James Maroney, Inc., New York, New York

*4186. **THE PICKAWAY LIVESTOCK COOPERATIVE ASSOCIATION IN CENTRAL OHIO, "BOYS" [Keep Me Close]** (P1980.30.4)
Gelatin silver print. 1938
Image: 6½ x 9⁹⁄₁₆ in. (16.5 x 24.3 cm.)
Sheet: 8⅛ x 10¹⁄₁₆ in. (20.6 x 25.5 cm.)
Signed: see inscription
Inscription, print verso: "38//6384 M2//D" and rubber stamp "PLEASE CREDIT/F.S.A./FARM SECURITY ADMINISTRATION/PHOTO BY: SHAHN"
Acquired from: James Maroney, Inc., New York, New York

*4187. **A PUBLIC AUCTION IN CENTRAL OHIO, AUGUST 1938** (P1980.30.1)
Gelatin silver print. 1938
Image: 6⁷⁄₁₆ x 9⁹⁄₁₆ in. (16.3 x 24.3 cm.)
Sheet: 8⅛ x 10¹⁄₁₆ in. (20.6 x 25.5 cm.)
Signed: see inscription
Inscription, print verso: "8//P1970//6681M1//F" and rubber stamp "BEN SHAHN/PHOTOGRAPHER/FARM SECURITY ADMINISTRATION/formerly from the collection of The Fogg Museum"
Acquired from: James Maroney, Inc., New York, New York

4188. **STREET SCENE, WORTHINGTON, OHIO, AUGUST 1938 [Chapin Bros. Home Dressed Meats, Poultry and Eggs]** (P1980.30.3)
Gelatin silver print. 1938
Image: 6⁷⁄₁₆ x 9⁹⁄₁₆ in. (16.3 x 24.3 cm.)
Sheet: 8⅛ x 10 in. (20.6 x 25.4 cm.)
Signed: see inscription
Inscription, print verso: "2//6670-M5//O" and rubber stamp "BEN SHAHN/PHOTOGRAPHER/FARM SECURITY ADMINISTRATION/formerly from the collection of The Fogg Museum"
Acquired from: James Maroney, Inc., New York, New York

4189. **TRUCK OF A BASKET AND CHAIR PEDDLER ALONG THE U.S. HIGHWAY 40 IN CENTRAL OHIO** (P1980.30.10)
Gelatin silver print. 1938
Image: 6½ x 9⁹⁄₁₆ in. (16.5 x 24.3 cm.)
Sheet: 8⅛ x 10¹⁄₁₆ in. (20.6 x 25.5 cm.)
Signed: see inscription
Inscription, print verso: "A 5//2//6568M1" and rubber stamp "PLEASE CREDIT/F.S.A./FARM SECURITY ADMINISTRATION/PHOTO BY: SHAHN"
Acquired from: James Maroney, Inc., New York, New York

4190. **WILLIAM A. SWIFT, ONCE A FARMER, NOW A RESIDENT OF CIRCLEVILLE'S "HOOVERVILLE," SUMMER 1938 [Hooverville Resident, Circleville, Ohio, Summer 1938]** (P1980.30.5)
Gelatin silver print. 1938
Image: 6⅛ x 9⁷⁄₁₆ in. (15.5 x 24.0 cm.)
Signed: see inscription
Inscription, print verso: "21//William A. Swift once a/farmer, now a resident of/Circlevilles [sic] Hooverville. When he/returned from war went west/"made awful good money job-/bin' around." Depression brought/him home. Since then he has/been on C.W.A. P.W.A. W.P.A.—"on/all of 'em" for the last 4 or 5/years. apologetic for toothlessness//6408 M5//explained that last year doctor/advised pulling all his (Perfectly/good) teeth because of headaches./Headaches remain. "If I knew/then what I know now, I'd not/have had those teeth taken out for/one thousand dollars."" and rubber stamp "BEN SHAHN/PHOTOGRAPHER/FARM SECURITY ADMINISTRATION/formerly from the collection of The Fogg Museum"
Acquired from: James Maroney, Inc., New York, New York

CHARLES SHEELER, American (1883–1965)

Known primarily as one of America's foremost precisionist painters, Sheeler took up photography as a means of support while attending art school. At first he made documentary photographs of buildings for Philadelphia architects, but, as his own artistic career took hold, the scope of his commercial activity broadened. He began to make images of industrial subjects, photographed sculpture and paintings for museums and galleries, and did fashion and figure work for Condé Nast publications. His most significant commercial commission was a 1927 project for Ford Motor Company to photograph their River Rouge assembly plant. The photographs were widely published and served as an inspiration for a number of Sheeler's paintings. In 1932 he gave up commercial photography, continuing to make photographs only as studies for his paintings. Sheeler had an early working friendship with Paul Strand that dissolved over a disagreement about the significance of photography. Sheeler did maintain a long-distance friendship with Edward Weston and admired his work. Sheeler photographed intermittently between 1932 and the 1950s.

*4191. **BUCKS COUNTY BARN** (P1980.22.2)
Gelatin silver print. 1918
Image: 9¹¹⁄₁₆ x 7⅝ in. (24.5 x 19.4 cm.)
Sheet: 9¹⁵⁄₁₆ x 7¹⁵⁄₁₆ in. (25.3 x 20.1 cm.)
Signed: see inscription
Inscription, old mat backing: "Bucks County barn/photograph by/Charles Sheeler 1918"
old paper backing: "Photograph of a Barn in Bucks County Pa./Taken by Mr Charles Sheeler of/Phila and New York—"
Acquired from: James Maroney, Inc., New York, New York

*4192. **FORD PLANT—DETROIT [Production Foundry]** (P1980.22.1)
Gelatin silver print. 1927
Image: 7⅜ x 9⁷⁄₁₆ in. (18.8 x 24.0 cm.)
Signed, center print verso: "Charles Sheeler."
Inscription, print verso: "Ford Plant—Detroit"
Acquired from: James Maroney, Inc., New York, New York

*4193. **FORD PLANT—DETROIT [Bleeder Stacks]** (P1980.22.4)
Gelatin silver print. 1927
Image: 9½ x 7⁹⁄₁₆ in. (24.2 x 19.2 cm.)
Signed, top center print verso: "Charles Sheeler."
Inscription, print verso: "Ford Plant—Detroit//photo by/[signature]//7//4½//114"
Acquired from: James Maroney, Inc., New York, New York

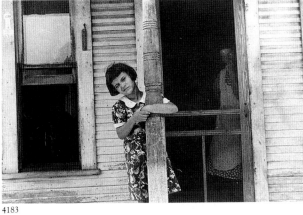

4183

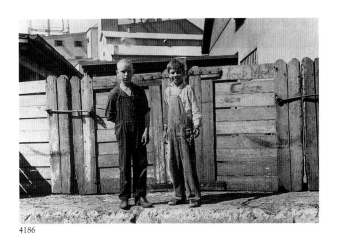

4186

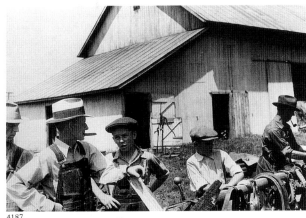

4187

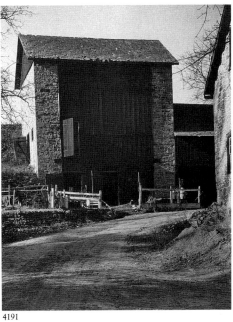

4191

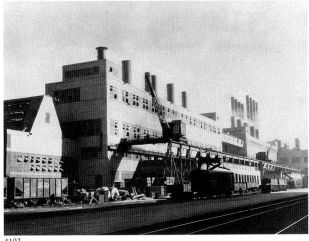

4192

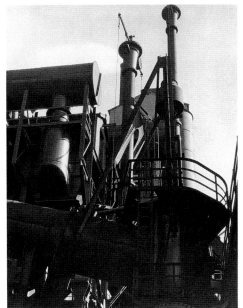

4193

4194. **THE OPEN DOOR** (P1980.22.3)
Gelatin silver print. c. 1915
Image: 9⅝ x 7³/₁₆ in. (24.4 x 18.2 cm.)
Sheet: 10 x 7¹⁵/₁₆ in. (25.4 x 20.2 cm.)
Mount: same as sheet size
Acquired from: James Maroney, Inc., New York, New York

HARRY SHIPLER, American

See Jackson Collages

PHILIP SHULTZ, American (b. 1917)

Shultz is a retired surgeon, a board member of the
School of American Research, and an avid hiker and
outdoorsman. He was a friend of Laura Gilpin for over
thirty years. Shultz's own photographic work focuses on
wildlife, birds of prey, and black and white landscape
images.

4195. **LAURA GILPIN AT CANYON DE CHELLY** (P1981.39)
Gelatin silver print. 1976
Image: 10¹³/₁₆ x 14 in. (27.5 x 35.6 cm.)
Sheet: 11 x 14¹/₁₆ in. (27.9 x 35.7 cm.)
Mount: 16 x 20 in. (40.7 x 50.8 cm.)
Signed, l.r. on overmat: "P. Shultz"
Inscription, mount verso: "LAURA GILPIN AT CANYON
 DE CHELLY"
Acquired from: gift of the photographer

ARTHUR REEDER SINSABAUGH,
American (1924—1983)

During World War II, Art Sinsabaugh served two years
as a U. S. Army Air Force photographer in the Far
East. In 1945 he returned to Chicago, where he worked
as a freelance photographer. He also studied photogra-
phy with László Moholy-Nagy, Harry Callahan, and
Aaron Siskind at the Institute of Design at the Illinois
Institute of Technology in Chicago. He received his
B.A. in 1949 and his M.A. in 1967. Sinsabaugh used
4 x 5, 8 x 10, and 12 x 20 inch cameras to make his
panoramic rural and urban landscapes. He was awarded
numerous honors, including a New Talent Award from
Art in America (1962), the Award of the Art Directors
Club of Indiana and Los Angeles (1964), bursaries from
the Society of Typographic Arts (1964, 1965, and
1966), an Illinois Arts Council Grant (1966), a
Graham Foundation Grant (1966), a Guggenheim
Foundation grant (1969), and a National Endowment
for the Arts grant (1979). From 1951 to 1959 he taught
at the Institute of Design, and from 1959 until his death
he was professor of art at the University of Illinois at
Champaign, where he also served as head of the De-
partment of Photography and Cinematography. He was
one of the founding members of the Society for Pho-
tographic Education in 1959.

4196. **ARIZ. LANDSCAPE #26** (P1983.45.2)
Gelatin silver print. 1980
Image: 11¹⁵/₁₆ x 19⁹/₁₆ in. (30.3 x 49.7 cm.)
Sheet: 16 x 20 in. (40.7 x 50.8 cm.)
Signed, l.r. print verso: "Art Sinsabaugh"
Inscription, print verso: "Ariz 26//"Ariz. Landscape #26,
 1980"/American Landscape Group/ 3/20"
Acquired from: The Afterimage, Dallas, Texas

*4197. **NEW HAMPSHIRE LANDSCAPE #21** (P1983.45.1)
Gelatin silver print. 1969
Image: 11 x 19⁹/₁₆ in. (27.9 x 49.6 cm.)
Mount: 16½ x 24⁹/₁₆ in. (42.0 x 62.4 cm.)

Signed, l.r. mount recto: "Art Sinsabaugh 1969"
Inscription, mount recto: "N. H. CA. #21 A. P. #9/9"
 mat backing verso: "AS-P4i"
Acquired from: The Afterimage, Dallas, Texas

ALLEN SIPPRELL, American (b. 1919)

Allen Sipprell, son of photographer Francis J. Sipprell
and Lucy Allen Sipprell and nephew of photographer
Clara E. Sipprell, was born in Buffalo, New York. Prior
to his service in the navy during World War II, Sip-
prell's contact with photography was limited to oil col-
oring of portraits on canvas and porcelain, a process his
father taught him. After his discharge in 1946 Sipprell
applied for admission to Trinity College. However,
while waiting for acceptance, he became involved in his
father's photographic studio in East Aurora, New York.
His father taught him processing, retouching, and
finishing. In 1949—50 he took a class in portraiture
from William Gerddes in New Haven, Connecticut.
Sipprell has exhibited his black and white photographs
and won several blue ribbons in the early 1950s. Since
his father's death in 1958, he has run the studio.

*4198. **CLARA [Clara Estelle Sipprell]** (P1984.1.275)
Gelatin silver print. 1970
Image: 6⁷/₁₆ x 6⁷/₁₆ in. (16.3 x 16.3 cm.)
Sheet: 9¹⁵/₁₆ x 8 in. (25.3 x 20.3 cm.)
Signed, l.r. sheet recto: "Allen Sipprell"
Inscription, sheet recto: "for Phyllis/1970"
 overmat recto: "Clara//x"
 mount verso: "OP.1."
Acquired from: gift of the Dorothea Leonhardt Fund of the
 Communities Foundation of Texas, Inc., Dallas, Texas

CLARA ESTELLE SIPPRELL,
American, born Canada (1885—1975)

Sipprell was born in Tillsonburg, Ontario, but moved
with her family to Buffalo, New York, in 1895. Some-
time between the ages of sixteen and nineteen, she
went to work for her brother Frank in his photographic
studio. From 1910 until 1914 she exhibited her own work
regularly at the Buffalo Camera Club. About 1915 she
moved to New York City and opened a portrait studio.
She later opened a second studio in Thetford, Vermont.
Sipprell traveled widely, photographed many famous
people, and received numerous awards for her portrait
and landscape work. Her photographs were all done in
the pictorial style, but she did not manipulate her prints
as did many other pictorial photographers. Sipprell was
a member of the Pictorial Photographers of America
and the Royal Photographic Society of Great Britain
and was active in photography until the mid-1960s. A
volume of her photographs, *Moment of Light*, was pub-
lished in 1966. In 1990 the Amon Carter Museum
organized a retrospective exhibition and published a
catalogue, *Clara Sipprell, Pictorial Photographer*, by Mary
Kennedy McCabe, featuring 60 of Sipprell's photo-
graphs drawn mainly from the Museum's collection.

Note: The Clara Sipprell Collection (P1984.1) contains 702
exhibition prints (included in the following entries) plus
several thousand uncatalogued prints, papers, and ephemera.

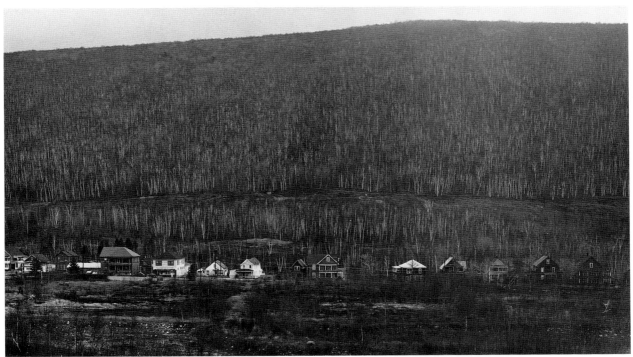

4197

4198

4199. **AN ABYSSINIAN JEW** (P1984.1.16)
Gelatin silver print on tissue. negative c. 1920s, print later
Image: 9 x 7 in. (22.8 x 17.8 cm.)
Sheet: 10 x 8 in. (25.4 x 20.3 cm.)
Signed, l.r. old overmat recto: "Clara E. Sipprell"
Inscription, old overmat recto: "An Abysinnian [sic] Jew//23"
old overmat verso: "IG35//PF"
mat backing verso: dealer's label
Acquired from: gift of the Dorothea Leonhardt Fund of the
Communities Foundation of Texas, Inc., Dallas, Texas

*4200. **AN ABYSSINIAN JEW** (P1984.1.91)
Gelatin silver print on tissue. c. 1920s
Image: 8 15/16 x 6 15/16 in. (22.6 x 17.6 cm.) sight size
Signed, l.r. overmat recto: "Clara E. Sipprell"
Inscription, print verso: "Bl10"
overmat recto: "An Abysinnian [sic] Jew"
overmat verso: "Bl10//Bl10"
mat backing verso: "ROE-4-II//Bl10"
Acquired from: gift of the Dorothea Leonhardt Fund of the
Communities Foundation of Texas, Inc., Dallas, Texas

4201. **ACAYAPAN—PUBLIC WASH HOUSE, TEPIC, MEXICO**
(P1984.1.300)
Gelatin silver print on tissue. c. 1931
Image: 9 3/16 x 7 1/8 in. (23.3 x 18.1 cm.) sight size
Signed, l.r. overmat recto: "Clara E. Sipprell"
Inscription, overmat recto, typed on paper label:
"Acayapan—Public Wash House/Tepic, Mexico"
mat backing verso: "M-9//MEX19"
Acquired from: gift of the Dorothea Leonhardt Fund of the
Communities Foundation of Texas, Inc., Dallas, Texas

4202. **ACOMITA, NEW MEXICO** (P1984.1.370)
Gelatin silver print. negative 1949, print c. 1949
Image: 9 5/8 x 7 11/16 in. (24.4 x 19.5 cm.)
Sheet: 10 x 8 in. (25.4 x 20.3 cm.)
Mount: same as sheet size
Signed, l.r. overmat recto: "Clara E. Sipprell/1949"
Inscription, overmat recto: "Acomita/New Mexico"
mat backing verso: "A-L-19//AA3"
note: an unidentified print is affixed to print verso
Acquired from: gift of the Dorothea Leonhardt Fund of the
Communities Foundation of Texas, Inc., Dallas, Texas

4200

*4203. **ADOBE WALL, TAOS, NEW MEXICO** (P1980.13.1)
Platinum print on tissue. 1928–29
Image: 9 9/16 x 7 5/8 in. (24.3 x 19.3 cm.)
Sheet: 9 15/16 x 8 in. (25.3 x 20.3 cm.)
Signed, l.r. overmat recto: "Clara E. Sipprell"
Inscription, overmat recto, typed on paper label:
"Adobe Wall/Taos, New Mexico"
old mat backing verso: "A-L-16" and rubber stamp
"CLARA E. SIPPRELL/MANCHESTER,
VERMONT/200 West 16th St.—New York City"
Acquired from: Daniel Wolf, Inc., New York, New York

4204. **ALENUSHKA** (P1984.1.228)
Gelatin silver print on tissue. c. 1920s–30s
Image: 8 15/16 x 7 3/16 in. (22.6 x 18.2 cm.) sight size
Signed, l.r. overmat recto: "Clara E. Sipprell"
Inscription, print verso: "C41"
overmat recto, typed on paper label: "Alenushka"
mat backing verso: "C-55//C41"
Acquired from: gift of the Dorothea Leonhardt Fund of the
Communities Foundation of Texas, Inc., Dallas, Texas

*4205. **ALFRED STIEGLITZ** (P1984.1.3)
Gelatin silver print on tissue. negative 1932, print c. 1932
Image: 9 5/8 x 7 3/4 in. (24.4 x 19.5 cm.)
Sheet: 10 x 8 in. (25.4 x 20.3 cm.)
Signed, l.r. overmat recto: "Clara E. Sipprell"
Inscription, overmat recto: "Alfred Stieglitz"
overmat verso: "IG31"
old mount verso, rubber stamps: "In the reproduction
of/this photograph give/credit to Clara E. Sipprell" and
"CLARA E. SIPPRELL/Manchester, Vermont"
old mat backing verso: dealer's label
Acquired from: gift of the Dorothea Leonhardt Fund of the
Communities Foundation of Texas, Inc., Dallas, Texas

4206. **ALICE FREEMAN MEMORIAL—WELLESLEY COLLEGE**
(P1984.1.440)
Gelatin silver print on tissue. c. 1920s
Image: 9 7/16 x 7 3/16 in. (24.0 x 18.2 cm.) sight size
Signed, l.r. overmat recto: "Clara E. Sipprell"
Inscription, overmat recto: "26" and typed on paper label
"Alice Freeman Memorial—Wellesley College"
mat backing verso: "WC-8//WC8"
Acquired from: gift of the Dorothea Leonhardt Fund of the
Communities Foundation of Texas, Inc., Dallas, Texas

4207. **ALIDA'S HAND** (P1984.1.266)
Gelatin silver print. 1957
Image: 7 1/4 x 9 1/4 in. (18.4 x 23.5 cm.)
1st mount: 9 x 9 7/8 in. (22.7 x 25.1 cm.)
2nd mount: 11 15/16 x 10 15/16 in. (30.4 x 27.8 cm.)
3rd mount: 19 7/8 x 14 7/16 in. (50.5 x 36.7 cm.)
Signed, l.r. 1st mount recto: "Clara E. Sipprell/1957"
Inscription, 3rd mount recto: "Alida's Hand"
3rd mount verso: "H5"
Acquired from: gift of the Dorothea Leonhardt Fund of the
Communities Foundation of Texas, Inc., Dallas, Texas

4208. **ALIDA'S HANDS** (P1984.1.264)
Gelatin silver print. c. 1957
Image: 6 7/8 x 8 15/16 in. (17.4 x 22.6 cm.) sight size
Sheet: 8 x 9 15/16 in. (20.3 x 25.3 cm.)
Mount: same as sheet size
Signed, l.r. overmat recto: "Clara E. Sipprell"
Inscription, overmat recto: "Alida's hands"
overmat verso: "H-2"
mount verso: "H-2"
note: a print of an Indian woman in a sari is affixed to
print verso
Acquired from: gift of the Dorothea Leonhardt Fund of the
Communities Foundation of Texas, Inc., Dallas, Texas

4209. **ALIDA'S HANDS** (P1984.1.265)
Gelatin silver print. c. 1957
Image: 6 7/8 x 8 15/16 in. (17.4 x 22.6 cm.) sight size
Sheet: 8 x 9 15/16 in. (20.3 x 25.3 cm.)

Signed, l.r. overmat recto: "Clara E. Sipprell"
Inscription, print verso: "H3"
overmat recto: "Alida's hands"
overmat verso: "H3"
Acquired from: gift of the Dorothea Leonhardt Fund of the
Communities Foundation of Texas, Inc., Dallas, Texas

*4210. **APPLE BLOSSOMS IN JUNE, QUEBEC** (P1984.1.411)
Gelatin silver print on tissue. c. 1932
Image: 7 3/16 x 9 3/16 in. (18.2 x 23.3 cm.) sight size
Signed, l.r. overmat recto: "Clara E. Sipprell"
Inscription, overmat recto, typed on paper label:
"Apple Blossoms in June/Quebec"
mat backing verso: "GP-25//GP25"
Acquired from: gift of the Dorothea Leonhardt Fund of the
Communities Foundation of Texas, Inc., Dallas, Texas

4211. **[Apple on cloth]** (P1984.1.511) duplicate of P1984.1.512
Gelatin silver print. c. 1950s
Image: 7 1/4 x 8 7/8 in. (18.4 x 22.5 cm.)
Mount: 11 x 14 in. (28.0 x 35.6 cm.)
Inscription, mount verso: "SL-5-b//SL2" and rubber stamps
"CLARA E. SIPPRELL/[remainder of stamp did not
print]" and "CLARA E. SIPPRELL/Manchester, Vermont"
Acquired from: gift of the Dorothea Leonhardt Fund of the
Communities Foundation of Texas, Inc., Dallas, Texas

4212. **[Apple on cloth]** (P1984.1.512) duplicate of P1984.1.511
Gelatin silver print. c. 1950s
Image: 7 1/4 x 8 7/8 in. (18.4 x 22.5 cm.)
Mount: 11 1/16 x 14 in. (28.1 x 35.6 cm.)
Inscription, mount verso: "SL1" and rubber stamp "CLARA
E. SIPPRELL/Manchester, Vermont"
Acquired from: gift of the Dorothea Leonhardt Fund of the
Communities Foundation of Texas, Inc., Dallas, Texas

4213. **THE APPROACH TO ACOMA, NEW MEXICO**
(P1984.1.356)
Gelatin silver print. negative 1949, print c. 1949
Image: 9 5/8 x 7 5/8 in. (24.4 x 19.4 cm.)
Sheet: 9 15/16 x 8 in. (25.3 x 20.3 cm.)
Mount: same as sheet size
Signed, l.r. overmat recto: "Clara E. Sipprell/1949"
Inscription, overmat recto: "The approach to Acoma/
New Mexico"
overmat verso: "WL30"
mat backing verso: "A-L-17//WL30"
Acquired from: gift of the Dorothea Leonhardt Fund of the
Communities Foundation of Texas, Inc., Dallas, Texas

4214. **AN APPROACHING STORM, TEPIC** (P1984.1.288)
duplicate of P1984.1.295
Gelatin silver print on tissue. c. 1931
Image: 9 1/8 x 6 15/16 in. (23.2 x 17.6 cm.)
Signed, l.r. overmat recto: "Clara E. Sipprell"
Inscription, print verso: "ML13"
overmat verso: "ML13"
mat backing verso: "M-25-b//ML13"
Acquired from: gift of the Dorothea Leonhardt Fund of the
Communities Foundation of Texas, Inc., Dallas, Texas

*4215. **AN APPROACHING STORM, TEPIC** (P1984.1.295)
duplicate of P1984.1.288
Gelatin silver print on tissue. c. 1931
Image: 9 1/8 x 7 1/4 in. (23.2 x 18.4 cm.) sight size
Signed, l.r. overmat recto: "Clara E. Sipprell"
Inscription, overmat recto: "An approaching Storm/Tepic"
mat backing verso: "M-25a//G Mexico//MEX10"
Acquired from: gift of the Dorothea Leonhardt Fund of the
Communities Foundation of Texas, Inc., Dallas, Texas

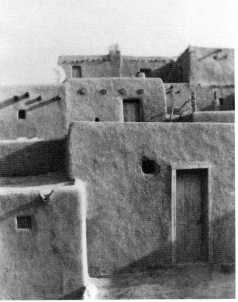

4203

4205

4210

4215

4220

4216. **THE ARCH BISHOP OF SWEDEN** (P1984.1.183)
Gelatin silver print. negative 1938, print c. 1938 or later
Image: 8 9/16 x 6 1/16 in. (21.7 x 15.4 cm.) sight size
Mount: 11 x 8 1/2 in. (28.0 x 21.6 cm.)
Signed, l.r. overmat recto: "Clara E. Sipprell"
Inscription, overmat recto: "The Arch Bishop of Sweden"
mount verso: "SP50"
Acquired from: gift of the Dorothea Leonhardt Fund of the
Communities Foundation of Texas, Inc., Dallas, Texas

4217. **THE ARCHBISHOP OF SWEDEN** (P1984.1.182)
Gelatin silver print. negative 1938, print c. 1938 or later
Image: 8 1/16 x 6 1/8 in. (20.5 x 15.5 cm.) sight size
Sheet: 9 15/16 x 8 in. (25.3 x 20.3 cm.)
Signed, l.r. overmat recto: "Clara E. Sipprell"
Inscription, print verso: "The Archbishop of Sweden//SP49"
overmat recto: "X"
Acquired from: gift of the Dorothea Leonhardt Fund of the
Communities Foundation of Texas, Inc., Dallas, Texas

4218. **THE ARCHBISHOP OF SWEDEN** (P1984.1.184)
Gelatin silver print on Gevaluxe paper. negative 1938,
print c. 1938
Image: 7 13/16 x 5 15/16 in. (19.8 x 15.1 cm.) sight size
Sheet: 9 15/16 x 7 15/16 in. (25.3 x 20.2 cm.)
Signed, l.r. overmat recto: "Clara E. Sipprell"
Inscription, print verso: "SP51"
overmat recto: "The Archbishop of Sweden"
Acquired from: gift of the Dorothea Leonhardt Fund of the
Communities Foundation of Texas, Inc., Dallas, Texas

4219. **[Archway]** (P1984.1.27)
Gelatin silver print on tissue. c. 1924
Image: 9 5/8 x 7 9/16 in. (24.4 x 19.2 cm.)
Sheet: 9 13/16 x 7 7/8 in. (24.9 x 20.0 cm.)
Inscription, print verso: "PF"
mat backing verso: dealer's label
Acquired from: gift of the Dorothea Leonhardt Fund of the
Communities Foundation of Texas, Inc., Dallas, Texas

*4220. **ARIZONA DESERT** (P1984.1.355)
Gelatin silver print on tissue. c. 1928–31
Image: 9 3/16 x 7 3/8 in. (23.3 x 18.7 cm.) sight size
Signed, l.r. overmat recto: "Clara E. Sipprell"
Inscription, print verso: "WL29"
overmat recto, typed on paper label: "Arizona Desert"
overmat verso: "WL29"
mat backing verso: "WL29"
Acquired from: gift of the Dorothea Leonhardt Fund of the
Communities Foundation of Texas, Inc., Dallas, Texas

4221. **[Arthur Dow]** (P1984.1.626)
Gelatin silver print. negative c. 1916, print c. 1916 or later
Image: 8 1/4 x 6 1/4 in. (20.9 x 15.8 cm.)
Sheet: 8 1/2 x 6 1/2 in. (21.6 x 16.5 cm.)
Acquired from: gift of the Dorothea Leonhardt Fund of the
Communities Foundation of Texas, Inc., Dallas, Texas

*4222. **[Arthur Dow]** (P1984.1.627)
Gelatin silver print. c. 1916
Image: 8 1/4 x 6 3/8 in. (20.9 x 16.2 cm.)
Sheet: 8 1/2 x 6 1/2 in. (21.6 x 16.5 cm.)
Acquired from: gift of the Dorothea Leonhardt Fund of the
Communities Foundation of Texas, Inc., Dallas, Texas

4223. **ASAKO TANAKA** (P1984.1.57)
Gelatin silver print. 1953
Image: 9 3/16 x 7 1/2 in. (23.3 x 19.0 cm.) sight size
Sheet: 10 x 8 in. (25.4 x 20.3 cm.)
Mount: same as sheet size
Signed, l.r. overmat recto: "Clara E. Sipprell/1953"
Inscription, overmat recto: "Asako Tanaka" and typed on
paper label "ASAKO TANAKA"
mount verso: "OR7"
overmat verso: "Or7//Or7"
note: a duplicate print is affixed to print verso
Acquired from: gift of the Dorothea Leonhardt Fund of the
Communities Foundation of Texas, Inc., Dallas, Texas

4224. **AT 6 MONTHS** [Learning About Flowers] (P1984.1.197)
duplicate of P1984.1.198
Gelatin silver print. negative c. 1928, print later
Image: 8 15/16 x 7 9/16 in. (22.6 x 19.2 cm.) sight size
Mount: 10 x 8 in. (25.4 x 20.3 cm.)
Signed, l.r. overmat recto: "Clara E. Sipprell"
Inscription, overmat recto: "At 6 months"
overmat verso: "Pf-43//Learning About Flowers/at 6 mos.—
Nina//C5"
mount verso: "C5"
Acquired from: gift of the Dorothea Leonhardt Fund of the
Communities Foundation of Texas, Inc., Dallas, Texas

4225. **AT THE BOAT LANDING, LAKE CHAPALA, MEXICO**
(P1984.1.312)
Gelatin silver print on tissue. c. 1931
Image: 9 1/8 x 7 3/16 in. (23.2 x 18.2 cm.) sight size
Signed, l.r. overmat recto: "Clara E. Sipprell"
Inscription, overmat recto, typed on paper label: "At the
Boat Landing/Lake Chapala, Mexico"
mat backing verso: "M-27//G Mexico//MEX22"
Acquired from: gift of the Dorothea Leonhardt Fund of the
Communities Foundation of Texas, Inc., Dallas, Texas

4226. **AT THE BOTTOM OF THE CANYON, BRYCE CANYON**
(P1984.1.359)
Gelatin silver print on tissue. c. 1928–31
Image: 9 1/8 x 7 3/16 in. (23.2 x 18.2 cm.) sight size
Signed, l.r. overmat recto: "Clara E. Sipprell"
Inscription, overmat recto: "Bryce Canyon" and typed on
paper label "At the Bottom of the Canyon/
Br [in ink] i yce Canyon"
mat backing verso: "A-L-35//Strange formations on the
Floor/of the Canyon//WL33"
Acquired from: gift of the Dorothea Leonhardt Fund of the
Communities Foundation of Texas, Inc., Dallas, Texas

*4227. **AT THE EDGE OF THE ABYSS, GRAND CANYON,
ARIZONA** (P1984.1.351)
Gelatin silver print on tissue. c. 1928–31
Image: 9 1/8 x 7 3/16 in. (23.2 x 18.2 cm.) sight size
Signed, l.r. overmat recto: "Clara E. Sipprell"
Inscription, overmat recto, typed on paper label: "At the
Edge of the Abyss/Grand Canyon, Arizona"
mat backing verso: "Pf-198//WL26"
Acquired from: gift of the Dorothea Leonhardt Fund of the
Communities Foundation of Texas, Inc., Dallas, Texas

4228. **AURATUM LILIES** [The Golden Lily of Japan; Our
Auratum Lilies] (P1984.1.502) duplicate of P1984.1.503 and
P1984.1.504
Gelatin silver print. negative 1950, print c. 1950
Image: 7 9/16 x 9 1/2 in. (19.2 x 24.2 cm.)
Sheet: 7 15/16 x 9 15/16 in. (20.2 x 25.3 cm.)
Mount: same as sheet size
Signed, l.r. old overmat recto: "Clara E. Sipprell/1950"
Inscription, mount verso: "SL18/SL18"
old overmat recto: "Auratum Lillies [sic]"
old overmat verso: "SL18"
note: a print of a young girl is affixed to print verso
Acquired from: gift of the Dorothea Leonhardt Fund of the
Communities Foundation of Texas, Inc., Dallas, Texas

4229. **AXEL HAGERSTRÖM, SWEDISH PHILOSOPHER**
(P1984.1.146)
Gelatin silver print. negative 1938, print c. 1938 or later
Image: 8 9/16 x 6 1/16 in. (21.7 x 15.4 cm.) sight size
Mount: 11 x 8 1/2 in. (28.0 x 21.6 cm.)
Signed, l.r. overmat recto: "Clara E. Sipprell"
Inscription, overmat recto: "Axel Hagerstrom/Swedish
Philosopher"
mount verso: "SP68"
Acquired from: gift of the Dorothea Leonhardt Fund of the
Communities Foundation of Texas, Inc., Dallas, Texas

4230. **AXEL JONSSON—PRESIDENT OF SWEDISH
AMERICAN LINE—GÖTEBORG** (P1984.1.191)
Gelatin silver print on Gevaluxe paper. negative 1938,
print c. 1938
Image: 9 ⁹⁄₁₆ x 7 ⅝ in. (24.3 x 19.4 cm.)
Sheet: 10 x 8 in. (25.4 x 20.3 cm.)
Signed, l.r. overmat recto: "Clara E. Sipprell"
Inscription, print verso: "SP11"
 overmat recto: "Axel Jonsson—President of Swedish
 American Line—/Göteborg"
 mat backing verso: "S-P-57//SP11"
Acquired from: gift of the Dorothea Leonhardt Fund of the
Communities Foundation of Texas, Inc., Dallas, Texas

4231. **BABY WALL** (P1984.1.227)
Gelatin silver print. c. 1940s—50s
Image: 8 ⅞ x 7 ⁷⁄₁₆ in. (22.5 x 18.9 cm.) sight size
Mount: 11 x 8 ½ in. (28.0 x 21.6 cm.)
Signed, l.r. overmat recto: "Clara E. Sipprell"
Inscription, overmat recto: "Baby Wall"
 overmat verso: "C45"
 mount verso: "C45"
Acquired from: gift of the Dorothea Leonhardt Fund of the
Communities Foundation of Texas, Inc., Dallas, Texas

*4232. **BARNS IN WINTER** (P1984.1.30)
Gelatin silver print on tissue. c. 1926
Image: 7 ⅛ x 8 ¹⁵⁄₁₆ in. (18.1 x 22.6 cm.) sight size
Sheet: 7 ⅞ x 10 in. (20.0 x 25.4 cm.)
Signed, l.r. old overmat recto: "Clara E. Sipprell"
Inscription, old overmat recto: "Barns in Winter//12"
 old overmat verso: "PF"
 old mat backing verso: dealer's label
Acquired from: gift of the Dorothea Leonhardt Fund of the
Communities Foundation of Texas, Inc., Dallas, Texas

*4233. **BARNS IN WINTER, VERMONT** (P1984.1.470)
Gelatin silver print on tissue. c. 1920s—30s
Image: 8 ¹⁵⁄₁₆ x 6 ¹⁵⁄₁₆ in. (22.6 x 17.6 cm.) sight size
Signed, l.r. overmat recto: "Clara E. Sipprell"
Inscription, overmat recto: "Barns in Winter/Vermont"
 mat backing verso: "V-L-5//AA11" and rubber stamp
 "CLARA E. SIPPRELL/MANCHESTER,
 VERMONT/200 West 16th St.—New York City"
Acquired from: gift of the Dorothea Leonhardt Fund of the
Communities Foundation of Texas, Inc., Dallas, Texas

4234. **THE BATH** (P1984.1.248)
Gelatin silver print. negative n.d., print c. 1950s—60s
Image: 8 ¹⁵⁄₁₆ x 6 ⅞ in. (22.6 x 17.4 cm.) sight size
Mount: 11 x 8 ⁹⁄₁₆ in. (28.0 x 21.7 cm.)
Signed, l.r. overmat recto: "Clara E. Sipprell"
Inscription, overmat recto: "The Bath"
 mount verso: "C37"
Acquired from: gift of the Dorothea Leonhardt Fund of the
Communities Foundation of Texas, Inc., Dallas, Texas

4235. **BAY OF KOTOR, YUGOSLAVIA** (P1984.1.563)
Gelatin silver print. negative c. 1926, print later
Image: 8 ¹⁵⁄₁₆ x 7 ³⁄₁₆ in. (22.6 x 18.2 cm.) sight size
Signed, l.r. overmat recto: "Clara E. Sipprell"
Inscription, print verso: "YL5"
 overmat recto: "Bay of Koto [sic]/Yugoslavia"
 mat backing verso: "YL5"
Acquired from: gift of the Dorothea Leonhardt Fund of the
Communities Foundation of Texas, Inc., Dallas, Texas

4236. **THE BIG TREES IN MUIR WOODS, CALIFORNIA**
(P1984.1.348)
Gelatin silver print. negative 1949, print c. 1949
Image: 8 ¹⁵⁄₁₆ x 7 ½ in. (22.6 x 19.0 cm.) sight size
Mount: 10 x 8 in. (25.4 x 20.3 cm.)
Signed, l.r. overmat recto: "Clara E. Sipprell/1949"
Inscription, overmat recto: "The Big Trees/in/Muir Woods/
California"
 overmat verso: "A-L-39//ADL12"
 mount verso: "ADL12"
Acquired from: gift of the Dorothea Leonhardt Fund of the
Communities Foundation of Texas, Inc., Dallas, Texas

4222

4227

4232

4237. **BIRCH TREE, VERMONT** (P1984.1.483)
Gelatin silver print. negative c. 1923, print later
Image: 9 ³⁄₁₆ x 7 ⁷⁄₁₆ in. (23.3 x 18.9 cm.)
Mount: 20 x 14 ½ in. (50.8 x 36.8 cm.)
Signed, l.r. old overmat recto: "Clara E. Sipprell"
Inscription, mount verso: "PfV-103//VL18"
old overmat recto: "Birch Tree/Vermont"
old overmat verso: "VL18"
Acquired from: gift of the Dorothea Leonhardt Fund of the
Communities Foundation of Texas, Inc., Dallas, Texas

4238. **THE BIRTHPLACE OF A KING, NJEGUSH,
MONTENEGRO** (P1984.1.602)
Gelatin silver print on tissue. c. 1926
Image: 9 ³⁄₁₆ x 7 ⅛ in. (23.3 x 18.1 cm.) sight size
Signed, l.r. overmat recto: "Clara E. Sipprell"
Inscription, overmat, typed on paper label: "The Birthplace
of a King/Njegush, Montenegro"
mat backing verso: "D-L-33//YL19"
Acquired from: gift of the Dorothea Leonhardt Fund of the
Communities Foundation of Texas, Inc., Dallas, Texas

4239. **THE BLACKSMITH, VERMONT** (P1984.1.243)
Gelatin silver print. c. 1920s
Image: 8 ¹⁵⁄₁₆ x 7 in. (22.6 x 17.8 cm.) sight size
Signed, l.r. overmat recto: "Clara E. Sipprell"
Inscription, overmat recto: "The Blacksmith/Vermont"
mat backing verso: "PfV-106//MIS11"
Acquired from: gift of the Dorothea Leonhardt Fund of the
Communities Foundation of Texas, Inc., Dallas, Texas

*4240. **BONAVENTURA ISLAND, GASPÉ PENINSULA**
(P1984.1.417) duplicate of P1984.1.418
Gelatin silver print. c. 1932
Image: 6 ⅞ x 9 ⅛ in. (17.4 x 23.2 cm.) sight size
Sheet: 8 x 10 in. (20.3 x 25.4 cm.)
Signed, l.r. overmat recto: "Clara E. Sipprell"
Inscription, overmat recto: "Bonaventura Island/Gaspé
Peninsula"
old mat backing verso: "GP-8-a//GP27"
Acquired from: gift of the Dorothea Leonhardt Fund of the
Communities Foundation of Texas, Inc., Dallas, Texas

4241. **BONAVENTURA ISLAND, GASPÉ PENINSULA**
(P1984.1.418) duplicate of P1984.1.417
Gelatin silver print on Gevaluxe paper. negative c. 1932,
print c. late 1930s
Image: 7 ½ x 9 ½ in. (19.1 x 24.3 cm.)
Sheet: 8 x 10 in. (20.3 x 25.4 cm.)
Inscription, print verso: "Bonaventura Island/Gaspé
Peninsula//GP28"
old overmat verso: "GP28"
Acquired from: gift of the Dorothea Leonhardt Fund of the
Communities Foundation of Texas, Inc., Dallas, Texas

4242. **BORIS HAGELIN** (P1984.1.175)
Gelatin silver print. negative 1938, print c. 1938 or later
Image: 8 ⅞ x 7 ³⁄₁₆ in. (22.5 x 18.2 cm.) sight size
Signed, l.r. overmat recto: "Clara E. Sipprell"
Inscription, print verso: "SP22"
overmat recto: "Boris Hagelin"
mat backing verso: "S-P-10//SP22"
Acquired from: gift of the Dorothea Leonhardt Fund of the
Communities Foundation of Texas, Inc., Dallas, Texas

4243. **[Boy pointing at picture in book]** (P1984.1.232)
Gelatin silver print. c. 1950s–60s
Image: 8 ½ x 6 ⅞ in. (21.6 x 17.4 cm.)
1st mount: 10 ½ x 7 ¹³⁄₁₆ in. (26.8 x 19.8 cm.)
2nd mount: 20 x 14 ½ in. (50.9 x 36.6 cm.)
Inscription, 2nd mount verso: "C-5//C46"
Acquired from: gift of the Dorothea Leonhardt Fund of the
Communities Foundation of Texas, Inc., Dallas, Texas

4244. **BRADLEY'S POINT, SAVANNAH—GEORGIA**
(P1984.1.375)
Gelatin silver print on Gevaluxe paper. c. 1942 or before
Image: 9 ³⁄₁₆ x 7 ⅛ in. (23.3 x 18.1 cm.) sight size
Sheet: 10 x 8 in. (25.4 x 20.3 cm.)
Signed, l.r. overmat recto: "Clara E. Sipprell"
Inscription, print recto: "AA27"
overmat recto: "Bradley's Point/Savannah—Georgia"
mat backing verso: "A-L-33//AA27"
Acquired from: gift of the Dorothea Leonhardt Fund of the
Communities Foundation of Texas, Inc., Dallas, Texas

4245. **[Brass urn]** (P1984.1.17)
Gelatin silver print on tissue. c. 1920s
Image: 9 x 7 ¼ in. (22.8 x 18.4 cm.) sight size
Signed, l.r. old overmat recto: "Clara E. Sipprell"
Inscription, mat backing verso: dealer's label
old mat backing verso: "SL-14//PF"
Acquired from: gift of the Dorothea Leonhardt Fund of the
Communities Foundation of Texas, Inc., Dallas, Texas

*4246. **[Bridge]** (P1984.1.32)
Hand-coated platinum print. c. 1915
Image: 8 x 5 ⅞ in. (20.3 x 14.9 cm.)
1st mount: 8 ¾ x 6 ⁵⁄₁₆ in. (22.2 x 16.0 cm.)
2nd mount: 8 ⅞ x 6 ½ in. (22.6 x 16.6 cm.)
Signed, l.r. 1st mount recto: "Clara E. Sipprell"
Inscription, 2nd mount verso: "PK"
old mat backing verso: dealer's label
Acquired from: gift of the Dorothea Leonhardt Fund of the
Communities Foundation of Texas, Inc., Dallas, Texas

4247. **THE BROOK** (P1984.1.208)
Gelatin silver print. negative c. 1932, print later
Image: 7 ³⁄₁₆ x 8 ¹⁵⁄₁₆ in. (18.2 x 22.6 cm.) sight size
Sheet: 8 ¹⁄₁₆ x 9 ¹⁵⁄₁₆ in. (20.5 x 25.3 cm.)
Mount: same as sheet size
Signed, l.r. overmat recto: "Clara E. Sipprell"
Inscription, overmat recto: "The Brook"
overmat verso: "Nina/C22"
mount verso: "C22"
note: a print of Nina with garlands of leaves wrapped
around her is affixed to print verso
Acquired from: gift of the Dorothea Leonhardt Fund of the
Communities Foundation of Texas, Inc., Dallas, Texas

*4248. **BROTHER BENJAMIN** (P1984.1.86)
Gelatin silver print on tissue. c. 1930s–40s
Image: 9 ¾ x 7 ¹¹⁄₁₆ in. (24.8 x 19.6 cm.)
Sheet: 10 x 8 in. (25.4 x 20.3 cm.)
Signed, l.r. old overmat recto: "Clara E. Sipprell"
Inscription, print verso: "B12"
old overmat recto: "Brother Benjamin"
old overmat verso: "B12"
old mat backing verso: "AB-12/B12"
Acquired from: gift of the Dorothea Leonhardt Fund of the
Communities Foundation of Texas, Inc., Dallas, Texas

4249. **BRYCE CANYON FROM THE RIM** (P1984.1.362) duplicate
of P1984.1.661
Gelatin silver print on tissue. c. 1928–31
Image: 9 ³⁄₁₆ x 7 ⁵⁄₁₆ in. (23.3 x 18.5 cm.) sight size
Signed, l.r. overmat recto: "Clara E. Sipprell"
Inscription, overmat recto, typed on paper label: "Brice [sic]
Canyon from the Rim"
mat backing verso: "A-L-37//WL38"
Acquired from: gift of the Dorothea Leonhardt Fund of the
Communities Foundation of Texas, Inc., Dallas, Texas

4233

4240

4246

4248

4251

4250. **BRYCE CANYON FROM THE RIM** (P1984.1.661) duplicate
of P1984.1.362
Gelatin silver print. c. 1928–31
Image: 9 3/8 x 7 1/2 in. (23.8 x 19.0 cm.)
1st mount: 10 9/16 x 7 7/8 in. (26.8 x 20.0 cm.)
2nd mount: 10 7/8 x 8 in. (27.6 x 20.3 cm.)
Signed, l.r. 1st mount recto: "Clara E. Sipprell"
Inscription, 1st mount recto, rubber stamp: "Photograph by/
CLARA E. SIPPRELL/70 Morningside Drive/New York"
Acquired from: gift of the Dorothea Leonhardt Fund of the
Communities Foundation of Texas, Inc., Dallas, Texas

*4251. **BRYCE CANYON FROM THE RIM** (P1984.1.672)
Gelatin silver print. c. 1928–31
Image: 9 3/8 x 7 1/2 in. (23.8 x 19.0 cm.)
1st mount: 10 3/8 x 7 15/16 in. (26.4 x 20.2 cm.)
2nd mount: 11 11/16 x 8 1/8 in. (29.7 x 20.6 cm.)
Signed, l.r. 1st mount recto: "Clara E. Sipprell"
Inscription, 2nd mount verso: "Bryce Canyon/from the Rim//
WL39" and rubber stamp "Photograph by/CLARA E.
SIPPRELL/70 Morningside Drive/New York"
Acquired from: gift of the Dorothea Leonhardt Fund of the
Communities Foundation of Texas, Inc., Dallas, Texas

4252. **BUDDHA AND FLOWERS** (P1984.1.498)
Gelatin silver print. c. 1940s–50s
Image: 9 3/16 x 7 1/8 in. (23.3 x 18.1 cm.) sight size
Signed, l.r. overmat recto: "Clara E. Sipprell"
Inscription, print verso: "SL14"
overmat recto, typed on paper label: "BUDDHA AND
FLOWERS/HERE SITS THE BUDDHA, SHEATHED
IN GOLD,/INSCRUTABLE OF FACE,/HALOED BY
PETALS THAT ENFOLD/HIS QUIETNESS AND
GRACE/FILLED WITH UNSPOKEN WORDS THAT
HOLD/THE SPIRIT TO THIS PLACE.//[in pencil]
Anne Lloyd"
mat backing verso: "Pf-225//SL14"
Acquired from: gift of the Dorothea Leonhardt Fund of the
Communities Foundation of Texas, Inc., Dallas, Texas

4253. **THE BUNA RIVER, HERZEGOVINA** (P1984.1.606)
Gelatin silver print. c. 1926
Image: 7 1/4 x 8 15/16 in. (18.4 x 22.6 cm.) sight size
Signed, l.r. overmat recto: "Clara E. Sipprell"
Inscription, overmat recto, typed on paper label: "The Buna
River/Herzegovina"
mat backing verso: "DL-35//YL12"
Acquired from: gift of the Dorothea Leonhardt Fund of the
Communities Foundation of Texas, Inc., Dallas, Texas

4254. **BUST OF BELLMAN, STOCKHOLM, SWEDEN [Statue
of Bellman at Djurgården]** (P1984.1.541) duplicate of
P1984.1.540
Gelatin silver print. negative c. 1938, print later
Image: 9 1/8 x 7 7/16 in. (23.2 x 18.9 cm.) sight size
Signed, l.r. overmat recto: "Clara E. Sipprell"
Inscription, overmat recto: "Bust of Bellman/Stockholm/
Sweden"
mat backing verso: "S-L-8-a//SwL37"
Acquired from: gift of the Dorothea Leonhardt Fund of the
Communities Foundation of Texas, Inc., Dallas, Texas

*4255. **BY THE WATER FRONT, GRAND VALLEE, GASPÉ
PENINSULA** (P1984.1.403)
Gelatin silver print on tissue. c. 1932
Image: 7 1/8 x 9 3/16 in. (18.1 x 23.3 cm.) sight size
Signed, l.r. overmat recto: "Clara E. Sipprell"
Inscription, overmat recto, typed on paper label: "By the
Water Front, Grand Vallee/Gaspé Peninsula"
mat backing verso: "GP.21//GP7"
Acquired from: gift of the Dorothea Leonhardt Fund of the
Communities Foundation of Texas, Inc., Dallas, Texas

4256. **THE CABOGA GARDEN, DALMATIA** (P1984.1.582)
Gelatin silver print. c. 1926
Image: 7 3/16 x 9 3/16 in. (18.2 x 23.3 cm.) sight size
Signed, l.r. overmat recto: "Clara E. Sipprell"

Inscription, overmat recto: "The Caboga Garden/Dalmatia"
mat backing verso: "D-L-14//YL57"
Acquired from: gift of the Dorothea Leonhardt Fund of the
Communities Foundation of Texas, Inc., Dallas, Texas

4257. **CALIFORNIA—WHEAT [Golden Hills, California]**
(P1984.1.330) duplicate of P1984.1.329
Gelatin silver print. c. 1929–31
Image: 7 3/16 x 8 15/16 in. (18.2 x 22.6 cm.) sight size
Signed, l.r. overmat recto: "Clara E. Sipprell"
Inscription, overmat recto: "California—wheat"
mat backing verso: "ML-2//Golden hills'/California wheat//
WL14" and rubber stamp "CLARA E. SIPPRELL/
MANCHESTER, VERMONT/200 West 16th St.—
New York City"
Acquired from: gift of the Dorothea Leonhardt Fund of the
Communities Foundation of Texas, Inc., Dallas, Texas

*4258. **CALLA LILIES** (P1984.1.442) duplicate of P1984.1.659
and P1984.1.675
Gelatin silver print on tissue. c. 1926
Image: 9 1/4 x 7 1/4 in. (23.5 x 18.4 cm.) sight size
Signed, l.r. overmat recto: "Clara E. Sipprell"
Inscription, overmat recto, typed on paper label:
"Calla Lillies [sic]" and printed paper label "50"
mat backing verso: "SL-22-6//SL5"
Acquired from: gift of the Dorothea Leonhardt Fund of the
Communities Foundation of Texas, Inc., Dallas, Texas

4259. **CALLA LILIES** (P1984.1.659) duplicate of P1984.1.442
and P1984.1.675
Gelatin silver print. negative c. 1926, print c. 1926 or later
Image: 9 7/16 x 7 7/16 in. (24.0 x 18.9 cm.)
Inscription, print verso: "A" and "In the reproduction of this
photograph/give credit to Clara E. Sipprell."
Acquired from: gift of the Dorothea Leonhardt Fund of the
Communities Foundation of Texas, Inc., Dallas, Texas

4260. **CALLA LILIES** (P1984.1.675) duplicate of P1984.1.442
and P1984.1.659
Gelatin silver print. negative c. 1926, print c. 1926 or later
Image: 9 1/2 x 7 1/2 in. (24.1 x 19.0 cm.)
Inscription, print verso, rubber stamp: "Photograph by/
CLARA E. SIPPRELL/70 Morningside Drive
[handwritten] 200 W 16th/New York."
Acquired from: gift of the Dorothea Leonhardt Fund of the
Communities Foundation of Texas, Inc., Dallas, Texas

4261. **CALZADA DEL VERA CRUZ, TEPIC, MEXICO**
(P1984.1.303)
Gelatin silver print on tissue. c. 1931
Image: 7 1/8 x 9 1/8 in. (18.1 x 23.2 cm.) sight size
Signed, l.r. overmat recto: "Clara E. Sipprell"
Inscription, overmat recto: "Calzada del Cruz/Tepic" and
typed on paper label "Calzada del Vera Cruz/Tepic,
Mexico"
mat backing verso: "M-12//Cas/Calsada [sic] del Cruz//
MEX16"
Acquired from: gift of the Dorothea Leonhardt Fund of the
Communities Foundation of Texas, Inc., Dallas, Texas

4262. **CARL ELDH [Carl Eldh—Sculptor, Sweden; Carl Eldh,
Swedish Sculptor]** (P1984.1.160) duplicate of P1984.1.135,
P1984.1.158, and P1984.1.159
Gelatin silver print. negative 1938, print later
Image: 8 15/16 x 6 7/8 in. (22.6 x 17.4 cm.) sight size
Mount: 11 x 8 1/2 in. (28.0 x 21.7 cm.)
Signed, l.r. overmat recto: "Clara E. Sipprell"
Inscription, overmat recto: "Carl Eldh"
mount verso: "SP43"
Acquired from: gift of the Dorothea Leonhardt Fund of the
Communities Foundation of Texas, Inc., Dallas, Texas

4263. **CARL ELDH—SCULPTOR—STOCKHOLM** (P1984.1.157)
Gelatin silver print on Gevaluxe paper. negative 1938,
print c. 1938
Image: 9 5/8 x 7 5/8 in. (24.4 x 19.4 cm.)
Sheet: 9 15/16 x 7 15/16 in. (25.3 x 20.2 cm.)

Signed, l.r. overmat recto: "Clara E. Sipprell"
Inscription, print verso: "SP46"
 overmat recto: "Carl Eldh—Sculptor—Stockholm"
 mat backing verso: "S-P-3-b//SP46"
Acquired from: gift of the Dorothea Leonhardt Fund of the
 Communities Foundation of Texas, Inc., Dallas, Texas

4264. **CARL ELDH—SCULPTOR, SWEDEN [Carl Eldh;**
 Carl Eldh, Swedish Sculptor](P1984.1.135) duplicate of
 P1984.1.158, P1984.1.159, and P1984.1.160
Gelatin silver print on Gevaluxe paper. negative 1938,
 print c. 1938
Image: 8 15/16 x 6 15/16 in. (22.6 x 17.6 cm.)
Sheet: 10 x 8 in. (25.4 x 20.3 cm.)
Signed, l.r. overmat recto: "Clara E. Sipprell"
Inscription, print verso: "SP42"
 overmat recto: "Carl Eldh—sculptor/Swed[en]"
Acquired from: gift of the Dorothea Leonhardt Fund of the
 Communities Foundation of Texas, Inc., Dallas, Texas

4255

4265. **CARL ELDH, SWEDISH SCULPTOR [Carl Eldh;**
 Carl Eldh—Sculptor, Sweden](P1984.1.158) duplicate
 of P1984.1.135, P1984.1.159, and P1984.1.160
Gelatin silver print. negative 1938, print later
Image: 8 15/16 x 6 7/8 in. (22.6 x 17.6 cm.) sight size
Mount: 11 x 8½ in. (28.0 x 21.7 cm.)
Signed, l.r. overmat recto: "Clara E. Sipprell"
Inscription, overmat recto: "Carl Eldh/Swedish Sculptor//x"
 overmat verso: "1938//1938"
 mount verso: "SP45"
Acquired from: gift of the Dorothea Leonhardt Fund of the
 Communities Foundation of Texas, Inc., Dallas, Texas

4266. **CARL ELDH, SWEDISH SCULPTOR [Carl Eldh; Carl**
 Eldh—Sculptor, Sweden](P1984.1.159) duplicate of
 P1984.1.135, P1984.1.158, and P1984.1.160
Gelatin silver print. negative 1938, print later
Image: 8¾ x 6⅛ in. (22.2 x 15.5 cm.) sight size
Mount: 11 x 7 15/16 in. (28.0 x 20.2 cm.)
Signed, l.r. overmat recto: "Clara E. Sipprell"
 u.l. mount verso: "Clara E. Sipprell/1939"
Inscription, overmat recto: "Carl Eldh/Swedish Sculptor"
 mount verso: "SP44"
Acquired from: gift of the Dorothea Leonhardt Fund of the
 Communities Foundation of Texas, Inc., Dallas, Texas

4258

*4267. **CARL MILLES, SWEDISH SCULPTOR** (P1984.1.143)
 duplicate of P1984.1.185 and P1984.1.186
Gelatin silver print. 1939
Image: 8 15/16 x 7 3/16 in. (22.7 x 18.3 cm.)
1st mount: 10¾ x 8 in. (27.2 x 20.4 cm.)
2nd mount: 13 x 10 15/16 in. (33.2 x 27.8 cm.)
Signed, l.r. 1st mount recto: "Clara E. Sipprell/1939"
 l.r. overmat recto: "Clara E. Sipprell"
Inscription, old overmat recto: "Carl Milles/Swedish sculptor"
 2nd mount verso: "SP54" and typed on paper label
 "<u>CARL MILLES</u>, Swedish Sculptor/He came to me one
 morning in New York to be included in/among the portraits
 I had made in/Sweden. He hadn't been in/Sweden for nine
 years. He asked eagerly "Do they remember/me?" I laughed
 for in almost every important garden, in/every place where
 a statue could be, was a statue by him.... x39 pica I had a
 group of pictures I made of his garden in/Stockholm. He
 looked at them with such longing and eagerness./He died
 in Sweden. 60"
Acquired from: gift of the Dorothea Leonhardt Fund of the
 Communities Foundation of Texas, Inc., Dallas, Texas

4268. **CARL MILLES, SWEDISH SCULPTOR** (P1984.1.185)
 duplicate of P1984.1.143 and P1984.1.186
Gelatin silver print. 1939
Image: 8 15/16 x 7 7/16 in. (22.6 x 18.9 cm.) sight size
Mount: 11 x 8½ in. (28.0 x 21.6 cm.)
Signed, l.r. overmat recto: "Clara E. Sipprell"
Inscription, overmat recto: "Carl Milles/Swedish sculptor"
 mount verso: "SP52"
Acquired from: gift of the Dorothea Leonhardt Fund of the
 Communities Foundation of Texas, Inc., Dallas, Texas

4267

4269. **CARL MILLES, SWEDISH SCULPTOR** (P1984.1.186)
duplicate of P1984.1.143 and P1984.1.185
Gelatin silver print. 1939
Image: 8½ x 7 1/16 in. (21.6 x 17.9 cm.)
1st mount: 10 9/16 x 7 7/16 in. (26.8 x 18.9 cm.)
2nd mount: 20 x 14½ in. (50.9 x 36.8 cm.)
Signed, l.r. 1st mount recto: "Clara E. Sipprell"
Inscription, 2nd mount recto: "Carl Milles/Swedish Sculptor"
1st mount verso: "SP53"
2nd mount verso: "Pf-114//SP53"
Acquired from: gift of the Dorothea Leonhardt Fund of the
Communities Foundation of Texas, Inc., Dallas, Texas

4270. **CARMEL VALLEY IN SPRING** (P1984.1.332)
Gelatin silver print. c. 1940s–50s
Image: 8 15/16 x 7 7/16 in. (22.6 x 18.9 cm.) sight size
Sheet: 10 1/16 x 7 15/16 in. (25.5 x 20.2 cm.)
Signed, l.r. overmat recto: "Clara E. Sipprell"
Inscription, overmat recto: "x//Carmel Valley/in Spring"
overmat verso: "WL12"
mount verso: "WL12"
Acquired from: gift of the Dorothea Leonhardt Fund of the
Communities Foundation of Texas, Inc., Dallas, Texas

4271. **[Carved wooden figure by Konenkov]** (P1984.1.491)
Gelatin silver print on tissue. c. 1920s–30s
Image: 9 3/16 x 7 3/16 in. (23.3 x 18.2 cm.) sight size
Signed, l.r. overmat recto: "Clara E. Sipprell"
Inscription, mat backing verso: "Pf-218//SL6"
Acquired from: gift of the Dorothea Leonhardt Fund of the
Communities Foundation of Texas, Inc., Dallas, Texas

4272. **CATHEDRAL ROCK, BRYCE CANYON** (P1984.1.360)
duplicate of P1984.1.361
Gelatin silver print on tissue. c. 1929–31
Image: 8 15/16 x 6 15/16 in. (22.6 x 17.6 cm.) sight size
Signed, l.r. overmat recto: "Clara E. Sipprell"
Inscription, overmat recto: "Cathedral Rock/Bryce Canyon"
mat backing verso: "A-L-38//WL35"
Acquired from: gift of the Dorothea Leonhardt Fund of the
Communities Foundation of Texas, Inc., Dallas, Texas

4273. **CATHEDRAL ROCK, BRYCE CANYON** (P1984.1.361)
duplicate of P1984.1.360
Gelatin silver print. negative c. 1929–31, print later
Image: 8 15/16 x 7 in. (22.6 x 17.8 cm.) sight size
Sheet: 9 15/16 x 7 15/16 in. (25.3 x 20.2 cm.)
Signed, l.r. overmat recto: "Clara E. Sipprell"
Inscription, print verso: "WL36"
overmat recto: "Cathedral Rock/Bryce Canyon"
overmat verso: "WL36"
mat backing verso: "Pf-210//WL36"
Acquired from: gift of the Dorothea Leonhardt Fund of the
Communities Foundation of Texas, Inc., Dallas, Texas

4274. **THE CHAPEL AT WELLESLEY COLLEGE** (P1984.1.443)
Gelatin silver print on tissue. c. 1920s
Image: 9 5/8 x 7 5/8 in. (24.4 x 19.4 cm.) sight size
Signed, l.r. overmat recto: "Clara E. Sipprell"
Inscription, overmat recto, typed on paper label:
"The Chapel at Wellesley College"
mat backing verso: "WC-6//VIII//WC6"
Acquired from: gift of the Dorothea Leonhardt Fund of the
Communities Foundation of Texas, Inc., Dallas, Texas

*4275. **CHAPULTEPEC PARK, MEXICO CITY** (P1984.1.285)
Gelatin silver print on tissue. c. 1931
Image: 6 7/8 x 8 15/16 in. (17.4 x 22.6 cm.) sight size
Sheet: 8 1/16 x 10 3/16 in. (20.5 x 25.8 cm.)
Signed, l.r. overmat recto: "Clara E. Sipprell"
Inscription, overmat recto: "ML4"
overmat recto: "Chapultepec Park/Mexico City"
overmat verso: "ML4"
Acquired from: gift of the Dorothea Leonhardt Fund of the
Communities Foundation of Texas, Inc., Dallas, Texas

*4276. **CHIEF OF THE STONIES** (P1984.1.65)
Gelatin silver print on tissue. c. 1930s–40s
Image: 9 3/16 x 7¼ in. (23.3 x 18.4 cm.) sight size
Signed, l.r. overmat recto: "Clara E. Sipprell"
Inscription, overmat recto, typed on paper label: "Chief of
the Stonies"
mat backing verso: "WC-3//A12//G Bookselection//A11"
Acquired from: gift of the Dorothea Leonhardt Fund of the
Communities Foundation of Texas, Inc., Dallas, Texas

*4277. **CHILD DRINKING MILK** (P1984.1.200)
Gelatin silver print on tissue. c. 1929
Image: 9 1/16 x 5 7/8 in. (23.0 x 14.9 cm.) sight size
Signed, l.r. overmat recto: "Clara E. Sipprell"
Inscription, print verso: "C13"
overmat recto, typed on paper label: "Child
Drinking Milk"
mat backing verso: "Pf-36//Nina/C13"
Acquired from: gift of the Dorothea Leonhardt Fund of the
Communities Foundation of Texas, Inc., Dallas, Texas

4278. **CHURCH AT DANDERYD, SWEDEN [Danderyd Kyrka,
Stockholm Outskirts]** (P1984.1.530) duplicate of P1984.1.533
Gelatin silver print. negative c. 1938, print later
Image: 9 9/16 x 7 11/16 in. (24.3 x 19.5 cm.)
Sheet: 9 15/16 x 8 1/16 in. (25.3 x 20.5 cm.)
Mount: 11 x 8½ in. (28.0 x 21.7 cm.)
Signed, l.r. old overmat recto: "Clara E. Sipprell"
Inscription, mount verso: "SA23"
old overmat recto: "Church at Danderyd/Sweden"
old overmat verso: "SA23"
Acquired from: gift of the Dorothea Leonhardt Fund of the
Communities Foundation of Texas, Inc., Dallas, Texas

4279. **CHURCH AT GASPÉ [Gaspé Peninsula; On the Gaspé
Peninsula]** (P1984.1.400) duplicate of P1984.1.401,
P1984.1.402, and P1984.1.410
Gelatin silver print. negative c. 1932, print later
Image: 8 15/16 x 7¼ in. (22.6 x 18.4 cm.) sight size
Mount: 9 15/16 x 7 15/16 in. (25.2 x 20.2 cm.)
Inscription, overmat recto: "Church at/Gaspé"
overmat verso: "GP10"
note: a duplicate print is affixed to print verso
Acquired from: gift of the Dorothea Leonhardt Fund of the
Communities Foundation of Texas, Inc., Dallas, Texas

4280. **CHURCH AT GASPÉ [Gaspé Peninsula; On the Gaspé
Peninsula]** (P1984.1.401) duplicate of P1984.1.400,
P1984.1.402, and P1984.1.410
Gelatin silver print. negative c. 1932, print later
Image: 9 5/8 x 7½ in. (24.4 x 19.0 cm.)
Sheet: 9 15/16 x 7 15/16 in. (25.3 x 20.2 cm.)
Signed, l.r. overmat recto: "Clara E. Sipprell"
Inscription, overmat recto: "Church at Gaspé"
mat backing verso: "GP-6//GP9"
Acquired from: gift of the Dorothea Leonhardt Fund of the
Communities Foundation of Texas, Inc., Dallas, Texas

4281. **CHURCH BELLS, TZINTZUNTZAN, MEXICO**
(P1984.1.291)
Gelatin silver print on tissue. negative c. 1931, print later
Image: 9 5/8 x 7 5/8 in. (24.4 x 19.4 cm.)
Sheet: 10¼ x 8 in. (26.0 x 20.3 cm.)
Signed, l.r. overmat recto: "Clara E. Sipprell"
Inscription, print verso: "MA4"
overmat recto: "Church bells/Tzintzuntzan/Mexico"
overmat verso: "MA4"
Acquired from: gift of the Dorothea Leonhardt Fund of the
Communities Foundation of Texas, Inc., Dallas, Texas

4282. **CHURCH OF SANTA MONICA, GUADALAJARA,
MEXICO** (P1984.1.293)
Gelatin silver print on tissue. c. 1931
Image: 9 1/8 x 7¼ in. (23.2 x 18.4 cm.) sight size
Signed, l.r. overmat recto: "Clara E. Sipprell"
Inscription, overmat recto, typed on paper label: "Church of
Santa Monica/Guadalajara, Mexico"

mat backing verso: "M31//MA2"
Acquired from: gift of the Dorothea Leonhardt Fund of the
Communities Foundation of Texas, Inc., Dallas, Texas

4275

4283. **CITY FOUNTAIN, PÁTZCUARO** (P1984.1.311)
Gelatin silver print on tissue. 1931
Image: 8 ⅞ x 6 ¹⁵⁄₁₆ in. (22.5 x 17.6 cm.) sight size
Signed, l.r. overmat recto: "Clara E. Sipprell"
Inscription, overmat recto: "City Fountain/Patzcuaro"
and typed on torn paper label "City/Patzc"
mat backing verso: "M-10//G Mexico//MEX23"
Acquired from: gift of the Dorothea Leonhardt Fund of the
Communities Foundation of Texas, Inc., Dallas, Texas

4284. **[Clara in a blue dress]** (P1984.1.694)
Autochrome. c. 1910
Image: 4 x 3 ⅜ in. (10.1 x 8.6 cm.) sight size
Acquired from: gift of the Dorothea Leonhardt Fund of the
Communities Foundation of Texas, Inc., Dallas, Texas

4285. **[Clara in a derby]** (P1984.1.700)
Autochrome. c. 1910
Image: [broken]
Acquired from: gift of the Dorothea Leonhardt Fund of the
Communities Foundation of Texas, Inc., Dallas, Texas

4286. **[Clara in hat and fur coat]** (P1984.1.696)
Autochrome. c. 1910
Image: 7 x 4 ¹⁵⁄₁₆ in. (17.8 x 12.6 cm.)
Acquired from: gift of the Dorothea Leonhardt Fund of the
Communities Foundation of Texas, Inc., Dallas, Texas

4276

4287. **[Clara in middy blouse leaning against tree]** (P1984.1.698)
Autochrome. c. 1910
Image: 6 ¾ x 4 ⅝ in. (17.1 x 11.7 cm.)
Plate: 7 x 5 in. (17.8 x 12.7 cm.)
Acquired from: gift of the Dorothea Leonhardt Fund of the
Communities Foundation of Texas, Inc., Dallas, Texas

4288. **[Clara in middy blouse leaning against tree, looking away]**
(P1984.1.697)
Autochrome. c. 1910
Image: 6 ⅝ x 4 ⅝ in. (16.8 x 11.7 cm.)
Plate: 6 ¹⁵⁄₁₆ x 5 in. (17.6 x 12.7 cm.)
Acquired from: gift of the Dorothea Leonhardt Fund of the
Communities Foundation of Texas, Inc., Dallas, Texas

4289. **[Clara with a rose]** (P1984.1.695)
Autochrome. c. 1910
Image: 3 ¼ x 4 ¹¹⁄₁₆ in. (8.2 x 11.9 cm.)
Plate: 3 ½ x 5 in. (8.9 x 12.7 cm.)
Acquired from: gift of the Dorothea Leonhardt Fund of the
Communities Foundation of Texas, Inc., Dallas, Texas

4290. **CLARENCE DAY, WOODSTOCK, VERMONT**
(P1984.1.242)
Gelatin silver print. c. 1930s–40s
Image: 8 ¹⁵⁄₁₆ x 7 ¼ in. (22.6 x 18.4 cm.) sight size
Signed, l.r. overmat recto: "Clara E. Sipprell"
Inscription, overmat recto: "Clarence Day/Woodstock,
Vermont"
mat backing verso: "V-P-4//ADL2"
Acquired from: gift of the Dorothea Leonhardt Fund of the
Communities Foundation of Texas, Inc., Dallas, Texas

4277

*4291. **[Clarence White]** (P1984.1.638)
Gelatin silver print. c. 1910–13
Image: 4 ½ x 3 ⅛ in. (11.4 x 7.9 cm.)
Acquired from: gift of the Dorothea Leonhardt Fund of the
Communities Foundation of Texas, Inc., Dallas, Texas

4292. **CLEANING CODFISH, GASPÉ PENINSULA** (P1984.1.66)
Gelatin silver print. negative c. 1932, print later
Image: 7¼ x 9¹⁄₁₆ in. (18.4 x 23.0 cm.)
1st·mount: 8¾ x 9¾ in. (22.2 x 24.8 cm.)
2nd mount: 18 x 13 in. (45.7 x 33.0 cm.)
Signed, l.r. 1st mount recto: "Clara E. Sipprell"
Inscription, 2nd mount verso: "GP-20-a//Cleaning Codfish/
Gaspé Peninsula//GP20"
Acquired from: gift of the Dorothea Leonhardt Fund of the
Communities Foundation of Texas, Inc., Dallas, Texas

4293. **CLEANING CODFISH, GASPÉ PENINSULA** (P1984.1.67)
Gelatin silver print. c. 1932
Image: 7⅛ x 8¹⁵⁄₁₆ in. (18.1 x 22.6 cm.) sight size
Signed, l.r. overmat recto: "Clara E. Sipprell"
Inscription, overmat recto, typed on paper label: "Cleaning
Codfish/Gaspé Peninsula" and printed paper label "45"
mat backing verso: "GP-20-b//GP19"
Acquired from: gift of the Dorothea Leonhardt Fund of the
Communities Foundation of Texas, Inc., Dallas, Texas

4294. **CLIO OF TAOS** (P1984.1.63)
Gelatin silver print. negative c. 1949, print 1949
Image: 8¹⁵⁄₁₆ x 7½ in. (22.6 x 19.0 cm.) sight size
Signed, l.r. overmat recto: "Clara E. Sipprell/1949"
Inscription, overmat recto: "Clio of Taos"
overmat verso: "AI3//AI3"
mount verso: "AI3"
mat backing verso: "NM-6//G American Landscape//AI3"
note: an unidentified print is affixed to print verso
Acquired from: gift of the Dorothea Leonhardt Fund of the
Communities Foundation of Texas, Inc., Dallas, Texas

4295. **CLIO'S FARM OUTSIDE THE PUEBLO, TAOS**
(P1984.1.357)
Gelatin silver print. negative 1949, print c. 1949
Image: 9⅝ x 7¹¹⁄₁₆ in. (24.4 x 19.5 cm.)
Sheet: 9¹⁵⁄₁₆ x 8 in. (25.3 x 20.3 cm.)
Mount: same as sheet size
Signed, l.r. overmat recto: "Clara E. Sipprell/1949"
Inscription, overmat recto: "Clio's farm outside the pueblo/
Taos"
overmat verso: "WL31"
mat backing verso: "Pf-196//WL31"
note: a print of a Vermont blacksmith is affixed to
print verso
Acquired from: gift of the Dorothea Leonhardt Fund of the
Communities Foundation of Texas, Inc., Dallas, Texas

*4296. **THE COLORADO RIVER AT THE GRAND CANYON**
(P1984.1.354)
Gelatin silver print. negative c. 1928–31, print later
Image: 8¹⁵⁄₁₆ x 7³⁄₁₆ in. (22.6 x 18.2 cm.) sight size
Sheet: 9¹⁵⁄₁₆ x 8 in. (25.3 x 20.3 cm.)
Mount: same as sheet size
Signed, l.r. 1st overmat recto: "Clara E. Sipprell"
Inscription, 1st overmat recto: "The Colorado River/at the
Grand Canyon"
2nd overmat verso: "WL4"
mount verso: "WL4"
note: a print of a young girl is affixed to print verso
Acquired from: gift of the Dorothea Leonhardt Fund of the
Communities Foundation of Texas, Inc., Dallas, Texas

4297. **COLUMNS IN THE GARDEN OF PALAZZO POZZA,
DUBROVNIK, DALMATIA** (P1984.1.571)
Gelatin silver print on tissue. c. 1926
Image: 7¼ x 9³⁄₁₆ in. (18.4 x 23.3 cm.) sight size
Signed, l.r. overmat recto: "Clara E. Sipprell"
Inscription, overmat recto, typed on paper label: "Columns
in the Garden of Palazzo Pozza/Dubrovnik, Dalmatia"
mat backing verso: "DL-71//YA25"
Acquired from: gift of the Dorothea Leonhardt Fund of the
Communities Foundation of Texas, Inc., Dallas, Texas

4298. **[Concrete fountain with angels]** (P1984.1.678)
Gelatin silver print on tissue. c. 1920s
Image: 9⁹⁄₁₆ x 7⁹⁄₁₆ in. (24.3 x 19.2 cm.)
Sheet: 9⅞ x 7⅞ in. (25.1 x 20.0 cm.)
Acquired from: gift of the Dorothea Leonhardt Fund of the
Communities Foundation of Texas, Inc., Dallas, Texas

4299. **CORNER OF FOUNDERS HALL—WELLESLEY
COLLEGE** (P1984.1.446)
Gelatin silver print on tissue. c. 1920s
Image: 9⅝ x 7⁹⁄₁₆ in. (24.4 x 19.2 cm.) sight size
Signed, l.r. overmat recto: "Clara E. Sipprell"
Inscription, overmat recto, typed on paper label: "Corner of
Founders Hall—Wellesley College"
mat backing verso: "W-C-1//IV//WC1"
Acquired from: gift of the Dorothea Leonhardt Fund of the
Communities Foundation of Texas, Inc., Dallas, Texas

*4300. **COSMOS** (P1984.1.18)
Gelatin silver print on tissue. c. 1927
Image: 9¼ x 7¼ in. (23.5 x 18.4 cm.) sight size
Signed, l.r. old overmat recto: "Clara E. Sipprell"
Inscription, mat backing verso: dealer's label
old overmat recto, typed on paper label: "Cosmos"
old mat backing verso: "S-L-21//SL-21//IG41//PF"
Acquired from: gift of the Dorothea Leonhardt Fund of the
Communities Foundation of Texas, Inc., Dallas, Texas

4301. **COUNT FOLKE BERNADOTTE, 1948 UNITED
NATIONS MEDIATION IN PALESTINE** (P1984.1.164)
Gelatin silver print. negative 1938, print later
Image: 8⅞ x 6¹⁄₁₆ in. (21.4 x 15.4 cm.) sight size
Mount: 10½ x 6¹³⁄₁₆ in. (26.6 x 17.3 cm.)
Signed, l.r. overmat recto: "Clara E. Sipprell"
Inscription, overmat recto: "Count Folke Bernadotte/1948
United States [sic] Mediation in Palestine"
mount verso: "SP17"
Acquired from: gift of the Dorothea Leonhardt Fund of the
Communities Foundation of Texas, Inc., Dallas, Texas

*4302. **COUNT ILYA TOLSTOY** (P1984.1.257)
Gelatin silver print. c. 1920s
Image: 8¹⁄₁₆ x 6⅛ in. (20.5 x 15.5 cm.) sight size
Mount: 8¹⁵⁄₁₆ x 6¹³⁄₁₆ in. (22.6 x 17.3 cm.)
Signed, l.r. mount recto and l.r. overmat recto: "Clara E.
Sipprell"
Inscription, print verso: "MiS12"
overmat recto: "Count Ilya Tolstoy"
overmat verso: "MiS12"
Acquired from: gift of the Dorothea Leonhardt Fund of the
Communities Foundation of Texas, Inc., Dallas, Texas

4303. **COUNTESS BERNADOTTE AF WISBORG,
STOCKHOLM** (P1984.1.115)
Gelatin silver print on Gevaluxe paper. negative 1938,
print c. 1938
Image: 8⅝ x 7³⁄₁₆ in. (21.9 x 18.2 cm.) sight size
Sheet: 10 x 7¹⁵⁄₁₆ in. (25.4 x 20.2 cm.)
Signed, l.r. overmat recto: "Clara E. Sipprell"
Inscription, print verso: "SP94"
overmat recto: "Countess Bernadotta of Wistory [sic]/
Stockholm"
mat backing verso: "S-P-15//SP94"
Acquired from: gift of the Dorothea Leonhardt Fund of the
Communities Foundation of Texas, Inc., Dallas, Texas

4304. **COUNTESS FOLKE BERNADOTTE [Countess Folke
Bernadotte af Wisborg]** (P1984.1.180) duplicate of P1984.1.181
Gelatin silver print. negative 1938, print c. 1938 or later
Image: 7³⁄₁₆ x 7 in. (18.2 x 17.8 cm.) sight size
Sheet: 10 x 8 in. (25.4 x 20.3 cm.)
Signed, l.r. overmat recto: "Clara E. Sipprell"
Inscription, print verso: "SP47"
overmat recto: "Countess Folke Bernadotte"
Acquired from: gift of the Dorothea Leonhardt Fund of the
Communities Foundation of Texas, Inc., Dallas, Texas

4291

4296

4300

4302

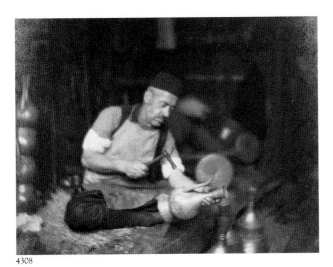

4308

4311

4305. **COUNTESS FOLKE BERNADOTTE AF WISBORG**
[Countess Folke Bernadotte] (P1984.1.181) duplicate of
P1984.1.180
Gelatin silver print. negative 1938, print c. 1938 or later
Image: 9⁹/₁₆ x 7⁵/₈ in. (24.3 x 19.4 cm.)
Sheet: 10 x 7¹⁵/₁₆ in. (25.4 x 20.2 cm.)
Signed, l.r. overmat recto: "Clara E. Sipprell"
Inscription, print verso: "SP48"
 overmat recto: "Countess Folke Bernadotte/of Visboy [sic]"
 mat backing verso: "S-P-28-a"
Acquired from: gift of the Dorothea Leonhardt Fund of the
Communities Foundation of Texas, Inc., Dallas, Texas

4306. **COUNTESS HENRIETTE COYET-TORUP, SKÅNE**
(P1984.1.188)
Gelatin silver print on Gevaluxe paper. negative 1938,
print c. 1938
Image: 9⁹/₁₆ x 7⁵/₈ in. (24.3 x 19.4 cm.)
Sheet: 9¹⁵/₁₆ x 8 in. (25.3 x 20.3 cm.)
Signed, l.r. overmat recto: "Clara E. Sipprell"
Inscription, print verso: "SP6"
 overmat recto: "Countess Henriette Coyet-Torup/Skåne"
 mat backing verso: "S-P-27//SP6"
Acquired from: gift of the Dorothea Leonhardt Fund of the
Communities Foundation of Texas, Inc., Dallas, Texas

4307. **COVERED BRIDGE AT UNION VILLAGE** (P1984.1.433)
Gelatin silver print on tissue. c. 1920s
Image: 8¹⁵/₁₆ x 6¹⁵/₁₆ in. (22.6 x 17.6 cm.) sight size
Signed, l.r. overmat recto: "Clara E. Sipprell"
Inscription, print verso: "VL27"
 overmat recto: "Covered Bridge/at Union Village"
 overmat verso: "VL27"
 mat backing verso: "VL27"
Acquired from: gift of the Dorothea Leonhardt Fund of the
Communities Foundation of Texas, Inc., Dallas, Texas

*4308. **THE CRAFTSMAN, SARAJEVO, BOSNIA** (P1984.1.77)
Gelatin silver print on tissue. c. 1926
Image: 7³/₁₆ x 8⁷/₈ in. (18.2 x 22.5 cm.) sight size
Inscription, print verso: "Y31"
 overmat recto, typed on paper label: "The Craftsman/
 Sarajevo, Bosnia"
 mat backing verso: "D-P-16//PF//$500-//Y31"
Acquired from: gift of the Dorothea Leonhardt Fund of the
Communities Foundation of Texas, Inc., Dallas, Texas

4309. **CYPRESS TREES, DUBROVNIK, DALMATIA** [Dalmatian
Coast, Yugoslavia] (P1984.1.592) duplicate of P1984.1.591
Gelatin silver print on tissue. c. 1926
Image: 8¹⁵/₁₆ x 7¼ in. (22.6 x 18.4 cm.) sight size
Signed, l.r. overmat recto: "Clara E. Sipprell"
Inscription, overmat recto, typed on paper label:
 "Cypress Trees/Dubrovnik, Dalmatia"
 mat backing verso: "DL-100-A//YL40"
Acquired from: gift of the Dorothea Leonhardt Fund of the
Communities Foundation of Texas, Inc., Dallas, Texas

4310. **CYPRESSES AT HADRIAN'S VILLA, ITALY** (P1984.1.555)
Gelatin silver print on tissue. c. 1924
Image: 9³/₁₆ x 7¼ in. (23.3 x 18.4 cm.) sight size
Signed, l.r. overmat recto: "Clara E. Sipprell"
Inscription, overmat recto, typed on paper label:
 "Cypresses at Hadrian's Villa/Italy"
 mat backing verso: "DL-103//MisL6"
Acquired from: gift of the Dorothea Leonhardt Fund of the
Communities Foundation of Texas, Inc., Dallas, Texas

*4311. **CYPRESSES AT MONTEREY, CALIFORNIA** [On the
Seventeen Mile Drive at Monterey, California] (P1984.1.331)
Gelatin silver print on Gevaluxe paper. c. 1928–29
Image: 7 x 8¹⁵/₁₆ in. (17.8 x 22.6 cm.) sight size
Signed, l.r. overmat recto: "Clara E. Sipprell"
Inscription, overmat recto: "Cypresses at Monterey/
 California"

overmat verso: "WL13"
mat backing verso: "Pf-201//WL13"
Acquired from: gift of the Dorothea Leonhardt Fund of the
Communities Foundation of Texas, Inc., Dallas, Texas

4312. **DAG HAMMARSKJÖLD IN HIS APARTMENT AT THE
UNITED NATIONS** [Dag Hammarskjöld, United Nations]
(P1984.1.134) duplicate of P1984.1.133 and P1984.1.141
Gelatin silver print. c. 1953–60s
Image: 8¹⁵/₁₆ x 6¹⁵/₁₆ in. (22.6 x 17.6 cm.) sight size
Signed, l.r. overmat recto: "Clara E. Sipprell"
Inscription, overmat recto: "Dag Hammerskojöld [sic]/in his
 apartment/at the United Nations"
 mount verso: "SP41"
Acquired from: gift of the Dorothea Leonhardt Fund of the
Communities Foundation of Texas, Inc., Dallas, Texas

4313. **DAG HAMMARSKJÖLD IN HIS APARTMENT AT THE
UNITED NATIONS** [Dag Hammarskjöld, United Nations]
(P1984.1.141) duplicate of P1984.1.133 and P1984.1.134
Gelatin silver print. c. 1953–60s
Image: 8¹⁵/₁₆ x 6¹⁵/₁₆ in. (22.6 x 17.6 cm.) sight size
Mount: 10¾ x 8¹⁵/₁₆ in. (27.3 x 22.7 cm.)
Signed, l.r. overmat recto: "Clara E. Sipprell"
Inscription, overmat recto: "Dag Hammarskjöld [sic]/in his
 apartment/at the United Nations"
 mount verso: "SP55"
Acquired from: gift of the Dorothea Leonhardt Fund of the
Communities Foundation of Texas, Inc., Dallas, Texas

4314. **DAG HAMMARSKJÖLD, UNITED NATIONS** [Dag
Hammarskjöld in His Apartment at the United Nations]
(P1984.1.133) duplicate of P1984.1.134 and P1984.1.141
Gelatin silver print. c. 1953–60s
Image: 8¹⁵/₁₆ x 6⁷/₈ in. (22.6 x 17.4 cm.) sight size
Sheet: 10 x 8 in. (25.4 x 20.3 cm.)
Mount: same as sheet size
Signed, l.r. overmat recto: "Clara E. Sipprell"
Inscription, overmat recto: "Dag Hammerskjöld [sic]/United
 Nations"
 overmat verso: "SP40"
 note: a print of Oliver Wendell Holmes is affixed to print
 verso
Acquired from: gift of the Dorothea Leonhardt Fund of the
Communities Foundation of Texas, Inc., Dallas, Texas

4315. **DAISY FIELD BY THE ST. LAWRENCE** (P1984.1.413)
Gelatin silver print on tissue. c. 1932
Image: 7⅛ x 9 in. (18.1 x 22.8 cm.) sight size
Signed, l.r. overmat recto: "Clara E. Sipprell"
Inscription, overmat recto, typed on paper label: "Daisy Field
 by the St. Lawrence"
 mat backing verso: "GP-2-b//GP22"
Acquired from: gift of the Dorothea Leonhardt Fund of the
Communities Foundation of Texas, Inc., Dallas, Texas

4316. **DAISY FIELD BY THE ST. LAWRENCE** [The St. Lawrence
in June, Daisy Field by the St. Lawrence] (P1984.1.414)
duplicate of P1984.1.412
Gelatin silver print on tissue. c. 1932
Image: 7³/₁₆ x 8¹⁵/₁₆ in. (18.2 x 22.6 cm.) sight size
Signed, l.r. overmat recto: "Clara E. Sipprell"
Inscription, overmat recto, typed on paper label: "Daisy Field
 by the St. Lawrence"
 mat backing verso: "GP-2a//GP23"
Acquired from: gift of the Dorothea Leonhardt Fund of the
Communities Foundation of Texas, Inc., Dallas, Texas

4317. **DALÄLVEN AT SUNSET, DALECARLIA—SWEDEN**
(P1984.1.552) duplicate of P1984.1.553
Gelatin silver print on Gevaluxe paper. c. 1938
Image: 8¹⁵/₁₆ x 7 in. (22.6 x 17.8 cm.) sight size
Signed, l.r. overmat recto: "Clara E. Sipprell"
Inscription, overmat recto: "Dalälven at Sunset/
 Dalecarlia—Sweden"
 mat backing verso: "S-L-24-a//SwL17"
Acquired from: gift of the Dorothea Leonhardt Fund of the
Communities Foundation of Texas, Inc., Dallas, Texas

4318. **DALÄLVEN AT SUNSET, DALECARLIA—SWEDEN**
(P1984.1.553) duplicate of P1984.1.552
Gelatin silver print on Gevaluxe paper. c. 1938
Image: 8 15/16 x 6 15/16 in. (22.6 x 17.6 cm.) sight size
Signed, l. r. overmat recto: "Clara E. Sipprell"
Inscription, overmat recto: "Dalälven at Sunset/
Dalecarlia—Sweden"
mat backing verso: "S-L-24-b//SwL16"
Acquired from: gift of the Dorothea Leonhardt Fund of the
Communities Foundation of Texas, Inc., Dallas, Texas

*4319. **DALMATIA, YUGOSLAVIA [Pineas on Dalmatian Coast]**
(P1984.1.599) duplicate of P1984.1.598
Gelatin silver print on tissue. 1924
Image: 8 15/16 x 7 in. (22.6 x 17.8 cm.) sight size
Signed, l. r. overmat recto: "Clara E. Sipprell"
Inscription, overmat recto: "Dalmatia/Yugoslavia"
mat backing verso: "Pinneas [sic] on/Dalmatian Coast
1924//YL27" and rubber stamp "CLARA E. SIPPRELL/
MANCHESTER, VERMONT/200 West 16th St.—
New York City"
Acquired from: gift of the Dorothea Leonhardt Fund of the
Communities Foundation of Texas, Inc., Dallas, Texas

4319

4320. **DALMATIAN COAST, YUGOSLAVIA [Cypress Trees,
Dubrovnik, Dalmatia]** (P1984.1.591) duplicate of P1984.1.592
Gelatin silver print. negative c. 1926, print later
Image: 8 15/16 x 6 15/16 in. (22.6 x 17.6 cm.) sight size
Signed, l. r. overmat recto: "Clara E. Sipprell"
Inscription, overmat recto: "Dalmatian Coast/Yugoslavia"
overmat verso: "YL41"
mat backing verso: "Cypress Trees/YL41"
Acquired from: gift of the Dorothea Leonhardt Fund of the
Communities Foundation of Texas, Inc., Dallas, Texas

4321. **DALMATIAN HILLS** (P1984.1.589)
Gelatin silver print on tissue. c. 1926
Image: 9 3/16 x 7 3/16 in. (23.3 x 18.2 cm.) sight size
Signed, l. r. overmat recto: "Clara E. Sipprell"
Inscription, overmat recto, typed on paper label:
"Dalmatian Hills"
mat backing verso: "D-L-6//YL45"
Acquired from: gift of the Dorothea Leonhardt Fund of the
Communities Foundation of Texas, Inc., Dallas, Texas

4324

4322. **DANDERYD KYRKA, STOCKHOLM OUTSKIRTS
[Church at Danderyd, Sweden]** (P1984.1.533) duplicate of
P1984.1.530
Gelatin silver print on Gevaluxe paper. c. 1938
Image: 9 3/16 x 7 3/16 in. (23.3 x 18.2 cm.) sight size
Mount: 10 x 8 in. (25.4 x 20.3 cm.)
Signed, l. r. overmat recto: "Clara E. Sipprell"
Inscription, print verso: "SA17"
overmat recto: "Danderyd Kyrka/Stockholm outskirts"
and red foil star
mat backing verso: "S-L-44//SA17"
Acquired from: gift of the Dorothea Leonhardt Fund of the
Communities Foundation of Texas, Inc., Dallas, Texas

4323. **DESERT GROWTH ON THE APACHE TRAIL,
ARIZONA** (P1984.1.323)
Gelatin silver print on tissue. c. 1928–31
Image: 7 3/16 x 8 15/16 in. (18.2 x 22.6 cm.) sight size
Signed, l. r. overmat recto: "Clara E. Sipprell"
Inscription, overmat recto, typed on paper label: "Desert
Growth/On the Apache Trail, Arizona"
mat backing verso: "Pf-199//WL23"
Acquired from: gift of the Dorothea Leonhardt Fund of the
Communities Foundation of Texas, Inc., Dallas, Texas

*4324. **A DISTINGUISHED MONTENEGRIN IN HIS HOME, CETINJE, MONTENEGRO** (P1984.1.73)
Gelatin silver print on tissue. c. 1926
Image: 9¼ x 7³⁄₁₆ in. (23.5 x 18.2 cm.) sight size
Sheet: 9⅞ x 7⅞ in. (25.1 x 20.0 cm.)
Signed, l.r. overmat recto: "Clara E. Sipprell"
Inscription, print verso: "Y14"
 overmat recto, typed on paper label: "A Distinguished Monetenegrin [sic] in his Home/Cetinje, Montenegro"
 mat backing verso: "Y14"
Acquired from: gift of the Dorothea Leonhardt Fund of the Communities Foundation of Texas, Inc., Dallas, Texas

4325. **DJUPVIK FISHING VILLAGE WITH ISLAND OF LILLA KARLSÖ IN BACKGROUND, GOTLAND** (P1984.1.525)
Gelatin silver print on Gevaluxe paper. c. 1938
Image: 7⁹⁄₁₆ x 9½ in. (19.2 x 24.1 cm.)
Sheet: 8 x 9¹⁵⁄₁₆ in. (20.3 x 25.3 cm.)
Signed, l.r. old overmat recto: "Clara E. Sipprell"
Inscription, print verso: "SA43"
 old overmat recto: "Djupoik [sic] fishing village with/island of Lilla Carlsö [sic] in background/Gotland"
 old overmat verso: "SA43"
 old mat backing verso: "S-L-42//G Swedish Landsc//SA43"
Acquired from: gift of the Dorothea Leonhardt Fund of the Communities Foundation of Texas, Inc., Dallas, Texas

*4326. **DR. ALBERT SCHWEITZER, PHILOSOPHER** (P1984.1.1)
Gelatin silver print. 1949
Image: 7⅝ x 7⅛ in. (19.4 x 18.1 cm.) sight size
Sheet: 10 x 8 in. (25.4 x 20.3 cm.)
Mount: same as sheet size
Signed, l.r. old overmat recto: "Clara E. Sipprell/1949"
Inscription, mat backing verso: dealer's label
 old overmat recto: "Dr. Albert Schweitzer/philosopher"
 old overmat verso: "IG34"
 old mat backing verso: "ROE-9//IG34/G Book Selection//PF"
note: a print of Albert Schweitzer is affixed to print verso
Acquired from: gift of the Dorothea Leonhardt Fund of the Communities Foundation of Texas, Inc., Dallas, Texas

4327. **DR. ALEX PEEVES** (P1984.1.238)
Gelatin silver print. negative 1972, print c. 1972
Image: 9 x 6¹⁵⁄₁₆ in. (22.8 x 17.6 cm.) sight size
Mount: 11 x 8½ in. (28.0 x 21.7 cm.)
Signed, l.r. overmat recto: "Clara E. Sipprell/1972"
Inscription, overmat recto: "Dr. Alex Peeves"
 overmat verso: "ADL8"
 mount verso: "ADL8"
Acquired from: gift of the Dorothea Leonhardt Fund of the Communities Foundation of Texas, Inc., Dallas, Texas

4328. **DR. ALMA LUNDQUIST, STOCKHOLM** (P1984.1.165)
Gelatin silver print on Gevaluxe paper. negative 1938, print c. 1938
Image: 9⅝ x 7⅝ in. (24.4 x 19.4 cm.)
Sheet: 9¹⁵⁄₁₆ x 7¹⁵⁄₁₆ in. (25.3 x 20.2 cm.)
Signed, l.r. overmat recto: "Clara E. Sipprell"
Inscription, print verso: "SP15"
 overmat recto: "Dr. Alma Lundquist/Stockholm"
 mat backing verso: "S-P-29//SP15"
Acquired from: gift of the Dorothea Leonhardt Fund of the Communities Foundation of Texas, Inc., Dallas, Texas

4329. **DR. & MRS. HIDEKI YUKAWA, NOBEL PRIZE WINNER** (P1984.1.45)
Gelatin silver print. c. 1950s
Image: 8¹⁵⁄₁₆ x 6⅞ in. (22.6 x 17.4 cm.) sight size
Sheet: 10 x 7¹⁵⁄₁₆ in. (25.4 x 20.2 cm.)
Mount: same as sheet size
Signed, l.r. overmat recto: "Clara E. Sipprell"
Inscription, print verso: "Or16//OR16"
 overmat recto: "Dr. & Mrs. Hideki Yukawa/Nobel Prize winner"

 overmat verso: "O-18//Or16//Or16"
 note: a duplicate print is affixed to print verso
Acquired from: gift of the Dorothea Leonhardt Fund of the Communities Foundation of Texas, Inc., Dallas, Texas

4330. **DR. ANDERS ÖSTERLING—POET—CRITIC, 1 OF THE "18"—STOCKHOLM** (P1984.1.171)
Gelatin silver print on Gevaluxe paper. negative 1938, print c. 1938
Image: 9⅝ x 7⅝ in. (24.4 x 19.4 cm.)
Sheet: 10 x 8 in. (25.4 x 20.3 cm.)
Signed, l.r. old overmat recto: "Clara E. Sipprell"
Inscription, print verso: "SP18"
 old overmat recto: "Dr. Anders Österling—poet—critic/1 of the "18"/Stockholm"
 old mat backing verso: "S-P-20//SP18"
Acquired from: gift of the Dorothea Leonhardt Fund of the Communities Foundation of Texas, Inc., Dallas, Texas

4331. **DR. BÖRJE BRILIOTH** (P1984.1.167)
Gelatin silver print on Gevaluxe paper. negative 1938, print c. 1938
Image: 9⅝ x 7⁹⁄₁₆ in. (24.4 x 19.2 cm.)
Sheet: 9¹⁵⁄₁₆ x 8 in. (25.3 x 20.3 cm.)
Signed, l.r. overmat recto: "Clara E. Sipprell"
Inscription, print verso: "SP13"
 overmat recto: "Dr. Börje Brilioth"
 mat backing verso: "S-P-7.a//SP13"
Acquired from: gift of the Dorothea Leonhardt Fund of the Communities Foundation of Texas, Inc., Dallas, Texas

*4332. **DR. BÖRJE BRILIOTH OF STOCKHOLM, SWEDEN** (P1984.1.161)
Gelatin silver print. negative 1938, print later
Image: 8¹⁵⁄₁₆ x 6¹⁵⁄₁₆ in. (22.6 x 17.6 cm.) sight size
Sheet: 10 x 8 in. (25.4 x 20.3 cm.)
Mount: same as sheet size
Signed, l.r. overmat recto: "Clara E. Sipprell"
Inscription, overmat recto: "Dr. Borje Brilioth/of/Stockholm, Sweden"
 overmat verso: "SP9"
Acquired from: gift of the Dorothea Leonhardt Fund of the Communities Foundation of Texas, Inc., Dallas, Texas

4333. **DR. BRUNO LILJEFORS, NATURE PAINTER, SWEDEN** (P1984.1.151)
Gelatin silver print. negative 1938, print c. 1938 or later
Image: 9⁵⁄₁₆ x 7⁷⁄₁₆ in. (23.7 x 18.9 cm.) sight size
Mount: 11 x 8½ in. (28.0 x 21.7 cm.)
Signed, l.r. overmat recto: "Clara E. Sipprell"
Inscription, overmat recto: "x//Dr. Bruno Lilyefors [sic]/nature painter/Sweden"
 mount verso: "SP27"
Acquired from: gift of the Dorothea Leonhardt Fund of the Communities Foundation of Texas, Inc., Dallas, Texas

4334. **DR. CARL ERIK FORSSLUND—WRITER—BRUNNSVIK—DALECARLIA** (P1984.1.190)
Gelatin silver print. 1938
Image: 9⁹⁄₁₆ x 7⁹⁄₁₆ in. (24.3 x 19.2 cm.)
Sheet: 9¹⁵⁄₁₆ x 7¹⁵⁄₁₆ in. (25.3 x 20.2 cm.)
Signed, l.r. overmat recto: "Clara E. Sipprell"
Inscription, print verso: "SP12"
 overmat recto: "Dr. Carl Erik Forsslund—writer/Brunswick [sic]— Dalecarlia"
 mat backing verso: "S-P-48//SP12"
Acquired from: gift of the Dorothea Leonhardt Fund of the Communities Foundation of Texas, Inc., Dallas, Texas

4335. **DR. ELIZABETH HENNINGS, STOCKHOLM** (P1984.1.169)
Gelatin silver print on Gevaluxe paper. negative 1938, print c. 1938
Image: 9⅝ x 7⅝ in. (24.4 x 19.4 cm.)
Sheet: 9¹⁵⁄₁₆ x 7¹⁵⁄₁₆ in. (25.3 x 20.2 cm.)
Inscription, print verso: "SP20"

overmat recto: "Dr. Elizabeth Hennings/Stockholm"
mat backing verso: "S-P-24//SP20"
Acquired from: gift of the Dorothea Leonhardt Fund of the
Communities Foundation of Texas, Inc., Dallas, Texas

4326

4336. **DR. ERIK WETTERGREN, STOCKHOLM** (P1984.1.152)
Gelatin silver print on Gevaluxe paper. negative 1938,
print c. 1938
Image: 9 5/8 x 7 9/16 in. (24.4 x 19.2 cm.)
Sheet: 10 x 8 in. (25.4 x 20.3 cm.)
Signed, l.r. overmat recto: "Clara E. Sipprell"
Inscription, print verso: "SP26"
overmat recto: "Dr. Erik Wettergren/Stockholm"
mat backing verso: "S-P-31//SP26"
Acquired from: gift of the Dorothea Leonhardt Fund of the
Communities Foundation of Texas, Inc., Dallas, Texas

4337. **DR. HIDEKI YUKAWA, NOBEL PRIZE—PHYSICS**
(P1984.1.51)
Gelatin silver print. c. 1950s
Image: 8 15/16 x 7 3/16 in. (22.6 x 18.2 cm.) sight size
Sheet: 10 x 8 in. (25.4 x 20.3 cm.)
Mount: same as sheet size
Signed, l.r. overmat recto: "Clara E. Sipprell"
Inscription, print verso: "Or12//OR12"
overmat recto: "Dr. Hideki Yukawa/Nobel Prize—Physics"
overmat verso: "Or12//Or12"
note: a print of a young Japanese woman in kimono is
affixed to print verso
Acquired from: gift of the Dorothea Leonhardt Fund of the
Communities Foundation of Texas, Inc., Dallas, Texas

4332

4338. **DR. HU SHIH—FORMER AMBASSADOR, CHINA**
(P1984.1.47)
Gelatin silver print. c. 1950s
Image: 8 15/16 x 6 15/16 in. (22.6 x 17.6 cm.) sight size
Signed, l.r. overmat recto: "Clara E. Sipprell"
Inscription, print verso: "Or14"
overmat recto: "Dr. Hu Shih—former ambassador/China"
overmat verso: "Or14"
mat backing verso: "O-16//Or14"
Acquired from: gift of the Dorothea Leonhardt Fund of the
Communities Foundation of Texas, Inc., Dallas, Texas

4339. **DR. HUGO ALFÖEN—COMPOSER—UPPSALA**
(P1984.1.154)
Gelatin silver print on Gevaluxe paper. negative 1938,
print c. 1938
Image: 9 5/8 x 7 5/8 in. (24.4 x 19.4 cm.)
Sheet: 10 x 7 15/16 in. (25.4 x 20.2 cm.)
Signed, l.r. old overmat recto: "Clara E. Sipprell"
Inscription, print verso: "SP34"
mat backing verso: "S-P-42//SP34"
old overmat recto: "Dr. Hugo Alföen—composer—
Uppsala"
Acquired from: gift of the Dorothea Leonhardt Fund of the
Communities Foundation of Texas, Inc., Dallas, Texas

4350

4340. **DR. LOUISA YIEN, KOREAN EDUCATOR** (P1984.1.38)
Gelatin silver print. c. 1950s
Image: 7 5/8 x 6 7/8 in. (19.4 x 17.4 cm.) sight size
Mount: 9 15/16 x 8 in. (25.2 x 20.3 cm.)
Signed, l.r. overmat recto: "Clara E. Sipprell"
Inscription, overmat recto: "x//Dr. Louisa Yien/Korean
Educator"
overmat verso: "Or25//Or25"
mount verso: "Or25"
Acquired from: gift of the Dorothea Leonhardt Fund of the
Communities Foundation of Texas, Inc., Dallas, Texas

4341. **DR. MANFRED BJÖRKQUIST—UPPSALA** (P1984.1.153)
Gelatin silver print on Gevaluxe paper. negative 1938,
 print c. 1938
Image: 9 5/8 x 7 5/8 in. (24.4 x 19.4 cm.)
Sheet: 10 x 7 15/16 in. (25.4 x 20.2 cm.)
Signed, l.r. overmat recto: "Clara E. Sipprell"
Inscription, print verso: "SP35"
 overmat recto: "Dr. Manfred Bjorkquist—/Uppsala"
 mat backing verso: "S-P-53"
Acquired from: gift of the Dorothea Leonhardt Fund of the
 Communities Foundation of Texas, Inc., Dallas, Texas

4342. **DR. SHIVA ROA** (P1984.1.107)
Gelatin silver print. c. 1950s–60s
Image: 7 3/16 x 7 1/8 in. (18.2 x 18.1 cm.) sight size
Sheet: 9 15/16 x 8 in. (25.3 x 20.3 cm.)
Signed, l.r. overmat recto: "Clara E. Sipprell"
Inscription, print verso: "I8"
 overmat recto: "Dr. Shiva Roa"
 overmat verso: "I-12//I8"
Acquired from: gift of the Dorothea Leonhardt Fund of the
 Communities Foundation of Texas, Inc., Dallas, Texas

4343. **DR. SVEN HEDIN, EXPLORER, SWEDEN** (P1984.1.132)
Gelatin silver print on Gevaluxe paper. negative 1938,
 print 1938
Image: 7 3/16 x 6 7/8 in. (18.2 x 17.4 cm.) sight size
Sheet: 9 15/16 x 7 15/16 in. (25.3 x 20.2 cm.)
Signed, l.r. overmat recto: "Clara E. Sipprell"
Inscription, print verso: "SP39"
 overmat recto: "x//Dr. Sven Hedin/explorer/Sweden"
Acquired from: gift of the Dorothea Leonhardt Fund of the
 Communities Foundation of Texas, Inc., Dallas, Texas

4344. **DR. TARAKNATH DAS, INDIA** (P1984.1.109)
Gelatin silver print. c. 1950s–60s
Image: 9 x 6 15/16 in. (22.8 x 17.6 cm.) sight size
Signed, l.r. overmat recto: "Clara E. Sipprell"
Inscription, print verso: "I6"
 overmat recto: "Dr. Taraknath Das/India"
 overmat verso: "I6"
 mat backing verso: "I-2//I6"
Acquired from: gift of the Dorothea Leonhardt Fund of the
 Communities Foundation of Texas, Inc., Dallas, Texas

4345. **DR. WM. E. DUBOIS** (P1984.1.85)
Gelatin silver print. c. 1940s
Image: 9 1/8 x 7 3/8 in. (23.2 x 18.7 cm.)
Signed, l.r. mount recto: "Clara E. Sipprell"
Inscription, mount recto: "Dr. Wm E. DuBois"
 mount verso: "B13"
Acquired from: gift of the Dorothea Leonhardt Fund of the
 Communities Foundation of Texas, Inc., Dallas, Texas

4346. **DOROTHEA PERKINS** (P1984.1.260)
Gelatin silver print. c. 1940s–50s
Image: 9 1/8 x 6 15/16 in. (23.2 x 17.6 cm.) sight size
Sheet: 9 15/16 x 8 in. (25.3 x 20.3 cm.)
Signed, l.r. overmat recto: "Clara E. Sipprell"
Inscription, print verso: "MiS3"
 overmat recto: "Dorothea Perkins"
Acquired from: gift of the Dorothea Leonhardt Fund of the
 Communities Foundation of Texas, Inc., Dallas, Texas

4347. **DORSET INN, DORSET, VERMONT** (P1984.1.424)
Gelatin silver print. n.d.
Image: 9 x 7 in. (22.8 x 17.8 cm.) sight size
Signed, l.r. overmat recto: "Clara E. Sipprell"
Inscription, print verso: "AA20"
 overmat recto: "Dorset Inn/Dorset, Vermont"
 mat backing verso: "V-L-11//AA20"
Acquired from: gift of the Dorothea Leonhardt Fund of the
 Communities Foundation of Texas, Inc., Dallas, Texas

4348. **DORSET INN IN OCTOBER** (P1984.1.482)
Gelatin silver print. n.d.
Image: 9 3/16 x 7 1/2 in. (23.3 x 19.0 cm.) sight size
Sheet: 10 x 8 in. (25.4 x 20.3 cm.)
Mount: same as sheet size
Signed, l.r. overmat recto: "Clara E. Sipprell"
Inscription, overmat recto: "Dorset Inn/in/October"
 mount verso: "AA17"
Acquired from: gift of the Dorothea Leonhardt Fund of the
 Communities Foundation of Texas, Inc., Dallas, Texas

4349. **DORSET, VERMONT** (P1984.1.477)
Gelatin silver print on Gevaluxe paper. negative n.d.,
 print c. 1930s–40s
Image: 8 15/16 x 7 3/16 in. (22.6 x 18.2 cm.) sight size
Signed, l.r. overmat recto: "Clara E. Sipprell"
Inscription, print verso: "VL15"
 overmat recto: "Dorset/Vermont"
 overmat verso: "VL15"
 mat backing verso: "V-L-9//VL15"
Acquired from: gift of the Dorothea Leonhardt Fund of the
 Communities Foundation of Texas, Inc., Dallas, Texas

*4350. **DORSET, VERMONT** (P1984.1.479)
Gelatin silver print on Gevaluxe paper. negative c. 1932,
 print c. 1930s
Image: 7 5/8 x 9 9/16 in. (19.4 x 24.3 cm.)
Sheet: 8 x 10 in. (20.3 x 25.4 cm.)
Signed, l.r. old overmat recto: "Clara E. Sipprell"
Inscription, print verso: "VL16"
 old overmat recto: "Dorset, Vermont"
 old overmat verso: "VL16"
 old mat backing verso: "V-L-29//VL16"
Acquired from: gift of the Dorothea Leonhardt Fund of the
 Communities Foundation of Texas, Inc., Dallas, Texas

4351. **DROTTNINGHOLM** (P1984.1.524)
Gelatin silver print on Gevaluxe paper. c. 1938
Image: 9 5/8 x 7 5/8 in. (24.4 x 19.4 cm.)
Sheet: 10 x 8 in. (25.4 x 20.3 cm.)
Signed, l.r. old overmat recto: "Clara E. Sipprell"
Inscription, print verso: "SA44"
 old overmat recto: "Drottningholm"
 old overmat verso: "SA44"
 old mat backing verso: "S-L-5//SA44"
Acquired from: gift of the Dorothea Leonhardt Fund of the
 Communities Foundation of Texas, Inc., Dallas, Texas

4352. **DUBROVNIK, DALMATIA, YUGOSLAVIA [The Fort at
 Dubrovnik—Yugoslavia]** (P1984.1.595) duplicate of
 P1984.1.596
Gelatin silver print. negative c. 1926, print later
Image: 6 13/16 x 8 7/8 in. (17.3 x 22.5 cm.) sight size
Mount: 8 1/2 x 11 in. (21.7 x 28.0 cm.)
Signed, l.r. overmat recto: "Clara E. Sipprell"
Inscription, overmat recto: "Dubrovnik/Dalmacia [sic]/
 Yugoslavia"
 overmat verso: "YL33"
 mount verso: "YL33"
Acquired from: gift of the Dorothea Leonhardt Fund of the
 Communities Foundation of Texas, Inc., Dallas, Texas

*4353. **DUBROVNIK STREET** (P1984.1.670)
Gelatin silver print. c. 1926
Image: 9 5/16 x 6 9/16 in. (23.7 x 16.7 cm.)
Inscription, print verso: "Dubrovnik/Street"
Acquired from: gift of the Dorothea Leonhardt Fund of the
 Communities Foundation of Texas, Inc., Dallas, Texas

4354. **EARLY MORNING ON THE MARSHES AT GLYNN
 KREMSINCK—GEORGIA** (P1984.1.244)
Gelatin silver print. c. 1930s–40s
Image: 9 5/8 x 7 5/8 in. (24.4 x 19.4 cm.)
Sheet: 10 x 8 in. (25.4 x 20.3 cm.)
Signed, l.r. overmat recto: "Clara E. Sipprell"
Inscription, overmat recto: "Early morning on The marshes at

Glynn/Kremsinck—Georgia"
mat backing verso: "A-L-8//ADL18"
Acquired from: gift of the Dorothea Leonhardt Fund of the
Communities Foundation of Texas, Inc., Dallas, Texas

4355. EARLY MORNING ON THE ST. LAWRENCE
(P1984.1.408)
Gelatin silver print on tissue. c. 1932
Image: 7 1/8 x 8 15/16 in. (18.1 x 22.6 cm.) sight size
Sheet: 7 15/16 x 10 in. (20.1 x 25.3 cm.)
Signed, l.r. overmat recto: "Clara E. Sipprell"
Inscription, print verso: "GP13"
overmat recto, typed on paper label: "Early Morning on
the St. Lawrence"
overmat verso: "GP13"
mat backing verso: "GP-10//GP13"
Acquired from: gift of the Dorothea Leonhardt Fund of the
Communities Foundation of Texas, Inc., Dallas, Texas

4356. EARLY MORNING, THE BRITISH EMBASSY,
WASHINGTON (P1984.1.431)
Gelatin silver print on Gevaluxe paper. c. 1940
Image: 8 7/8 x 7 3/16 in. (22.5 x 18.2 cm.) sight size
Sheet: 10 x 8 in. (25.4 x 20.3 cm.)
Signed, l.r. overmat recto: "Clara E. Sipprell"
Inscription, print verso: "AA24"
overmat recto: "Early morning/The British Embassy/
Washington"
mat backing verso: "A-L-44//AA.24"
Acquired from: gift of the Dorothea Leonhardt Fund of the
Communities Foundation of Texas, Inc., Dallas, Texas

*4357. AN EARLY STILL LIFE [Rose and Glass] (P1984.1.490)
Gelatin silver print. negative 1914, print later
Image: 7 13/16 x 5 1/4 in. (19.8 x 13.3 cm.) sight size
Mount: 11 x 8 7/16 in. (28.0 x 21.5 cm.)
Signed, l.r. overmat recto: "Clara E. Sipprell/1914"
Inscription, overmat recto: "An early still life"
mount verso: "SL4"
Acquired from: gift of the Dorothea Leonhardt Fund of the
Communities Foundation of Texas, Inc., Dallas, Texas

4358. EAST POULTNEY CHURCH, VERMONT (P1984.1.476)
Gelatin silver print. n.d.
Image: 8 15/16 x 7 1/4 in. (22.6 x 18.4 cm.) sight size
Sheet: 10 x 8 in. (25.4 x 20.3 cm.)
Signed, l.r. overmat recto: "Clara E. Sipprell"
Inscription, print verso: "AA14"
overmat recto: "East Poultney Church/Vermont"
mat backing verso: "V-L-27//AA14"
Acquired from: gift of the Dorothea Leonhardt Fund of the
Communities Foundation of Texas, Inc., Dallas, Texas

4359. EASTPORT, MAINE (P1984.1.434)
Gelatin silver print. n.d.
Image: 8 15/16 x 7 3/16 in. (22.6 x 18.2 cm.) sight size
Signed, l.r. overmat recto: "Clara E. Sipprell"
Inscription, overmat recto: "Eastport, Maine"
overmat verso: "MisL1"
mat backing verso: "A-L-53//MisL1"
Acquired from: gift of the Dorothea Leonhardt Fund of the
Communities Foundation of Texas, Inc., Dallas, Texas

4360. ECHO LAKE—WHITE MT. TRIP (P1984.1.691)
Gelatin silver print on tissue. c. 1919
Image: 3 9/16 x 4 1/4 in. (9.0 x 10.8 cm.)
Mount: 4 1/8 x 4 3/4 in. (10.5 x 12.0 cm.)
Inscription, mat backing verso: "From: The Hanoum Camps
for Girls./Thetford, VT. 1919//Echo Lake—White Mt. Trip
ca 1919//PF IG22"
Acquired from: gift of the Dorothea Leonhardt Fund of the
Communities Foundation of Texas, Inc., Dallas, Texas

4353

4357

4361. **EDUCATION** (P1984.1.202)
Gelatin silver print. negative c. 1929, print later
Image: 8 15/16 x 7 in. (22.6 x 17.8 cm.) sight size
Sheet: 10 x 8 in. (25.4 x 20.3 cm.)
Mount: same as sheet size
Signed, l.r. overmat recto: "Clara E. Sipprell"
Inscription, overmat recto: "Education"
 overmat verso: "Nina/C12"
 mount verso: "C12"
Acquired from: gift of the Dorothea Leonhardt Fund of the
Communities Foundation of Texas, Inc., Dallas, Texas

*4362. **EDWARD R. DICKSON, PHOTOGRAPHER** (P1984.1.619)
Gelatin silver print. before 1922
Image: 6¾ x 5 in. (17.1 x 12.7 cm.)
Sheet: 8½ x 6½ in. (21.6 x 16.5 cm.)
Inscription, print verso: "Edward R. Dixon [sic]/
Photographer"
Acquired from: gift of the Dorothea Leonhardt Fund of the
Communities Foundation of Texas, Inc., Dallas, Texas

4363. **EDWARD R. DICKSON, PHOTOGRAPHER** (P1984.1.620)
Gelatin silver print. before 1922
Image: 9¼ x 7 7/16 in. (23.5 x 18.9 cm.)
Mount: 11 1/16 x 8 5/16 in. (28.1 x 21.1 cm.)
Inscription, mount verso: "Edward R. Dixon [sic],
photographer"
Acquired from: gift of the Dorothea Leonhardt Fund of the
Communities Foundation of Texas, Inc., Dallas, Texas

4364. **EDWIN MARKHAM, POET** (P1984.1.618)
Gelatin silver print. c. 1935
Image: 9 5/8 x 7 5/8 in. (24.4 x 19.4 cm.)
Sheet: 9 15/16 x 7 15/16 in. (25.3 x 20.2 cm.)
Inscription, print verso: "Edw Markham/Poet"
Acquired from: gift of the Dorothea Leonhardt Fund of the
Communities Foundation of Texas, Inc., Dallas, Texas

*4365. **EINSTEIN [Albert Einstein]** (P1984.1.2)
Gelatin silver print. c. 1930s–40s
Image: 9 x 6 7/8 in. (22.8 x 17.4 cm.) sight size
Sheet: 10 x 8 in. (25.4 x 20.3 cm.)
Mount: same as sheet size
Signed, l.r. old overmat recto: "Clara E. Sipprell"
Inscription, old overmat recto: "Einstein//28"
 old overmat verso: "PF//IG41//IG41"
 old mat backing verso: dealer's label
 note: an unidentified print is affixed to print verso
Acquired from: gift of the Dorothea Leonhardt Fund of the
Communities Foundation of Texas, Inc., Dallas, Texas

4366. **EL CAPITAN, YOSEMITE VALLEY** (P1984.1.363) duplicate
of P1984.1.364 and P1984.1.365
Gelatin silver print on tissue. c. 1928
Image: 8 15/16 x 7 in. (22.6 x 17.8 cm.) sight size
Signed, l.r. overmat recto: "Clara E. Sipprell"
Inscription, overmat recto: "El Capitan/Yosemite Valley"
 overmat verso: "WL40"
 mat backing verso: "A-L-43//WL40"
Acquired from: gift of the Dorothea Leonhardt Fund of the
Communities Foundation of Texas, Inc., Dallas, Texas

4367. **EL CAPITAN, YOSEMITE VALLEY** (P1984.1.364) duplicate
of P1984.1.363 and P1984.1.365
Gelatin silver print on tissue. c. 1928
Image: 8 15/16 x 6 15/16 in. (22.6 x 17.6 cm.) sight size
Signed, l.r. overmat recto: "Clara E. Sipprell/1928"
Inscription, overmat recto: "El Capitan/Yosemite Valley"
 overmat verso: "WL41"
 mat backing verso: "WL41" and typed on paper label
 "El Capitan. Yosemite Valley./About 1928"
Acquired from: gift of the Dorothea Leonhardt Fund of the
Communities Foundation of Texas, Inc., Dallas, Texas

4368. **EL CAPITAN, YOSEMITE VALLEY** (P1984.1.365) duplicate
of P1984.1.363 and P1984.1.364
Gelatin silver print. c. 1928
Image: 9½ x 7 9/16 in. (24.1 x 19.2 cm.)
Sheet: 9 15/16 x 8 in. (25.3 x 20.3 cm.)
Mount: 11 x 8½ in. (28.0 x 21.6 cm.)
Signed, l.r. old overmat recto: "Clara E. Sipprell"
Inscription, mount verso: "WL42"
 old overmat recto: "El Capitan/Yosemite Valley"
 old overmat verso: "WL42"
Acquired from: gift of the Dorothea Leonhardt Fund of the
Communities Foundation of Texas, Inc., Dallas, Texas

4369. **EL RIO—SANTA FE, NEW MEXICO** (P1984.1.368)
Gelatin silver print. negative 1949, print c. 1949
Image: 9¾ x 7 9/16 in. (24.8 x 19.2 cm.)
Sheet: 10 x 8 in. (25.4 x 20.3 cm.)
Mount: same as sheet size
Signed, l.r. overmat recto: "Clara E. Sipprell/1949"
Inscription, overmat recto: "El Rio—Santa Fe/New Mexico"
 mat backing verso: "A-L-45//AA.2"
 note: an unidentified print is affixed to print verso
Acquired from: gift of the Dorothea Leonhardt Fund of the
Communities Foundation of Texas, Inc., Dallas, Texas

4370. **ELIZABETH GRAY VINING** (P1984.1.261)
Gelatin silver print. c. 1950s–60s
Image: 8 15/16 x 7 7/16 in. (22.6 x 18.9 cm.) sight size
Sheet: 10 1/16 x 7 15/16 in. (25.5 x 20.2 cm.)
Mount: same as sheet size
Signed, l.r. overmat recto: "Clara E. Sipprell"
Inscription, overmat recto: "Elizabeth Gray Vining"
 overmat verso: "MiS4"
 mount verso: "MiS4"
 old mat backing verso: "W-P-20"
 note: a print of three dolls is affixed to mount verso
Acquired from: gift of the Dorothea Leonhardt Fund of the
Communities Foundation of Texas, Inc., Dallas, Texas

4371. **ELLEHOLMS KYRKA—ELLEHOLM—BLEKINGE**
(P1984.1.527)
Gelatin silver print on Gevaluxe paper. c. 1938
Image: 9 9/16 x 7 5/8 in. (24.3 x 19.4 cm.)
Sheet: 10 x 8 in. (25.4 x 20.3 cm.)
Signed, l.r. old overmat recto: "Clara E. Sipprell"
Inscription, print verso: "SA35"
 old overmat recto: "Elleholms Kyrka—Elleholm—
 Blekinge"
 old mat backing verso: "S-L-19//SA35"
Acquired from: gift of the Dorothea Leonhardt Fund of the
Communities Foundation of Texas, Inc., Dallas, Texas

4372. **THE ENCHANTED MESA—ARIZONA** (P1984.1.349)
Gelatin silver print on tissue. c. 1928–31
Image: 7 1/16 x 9 in. (17.9 x 22.8 cm.) sight size
Signed, l.r. overmat recto: "Clara E. Sipprell"
Inscription, overmat recto: "The Enchanted Mesa—Arizona"
 overmat verso: "WL24"
 mat backing verso: "Pf-194//WL24"
Acquired from: gift of the Dorothea Leonhardt Fund of the
Communities Foundation of Texas, Inc., Dallas, Texas

4373. **ENGLISH BOYS** (P1984.1.251)
Gelatin silver print. c. 1950s–60s
Image: 9 x 6 15/16 in. (22.8 x 17.6 cm.) sight size
Signed, l.r. overmat recto: "Clara E. Sipprell"
Inscription, overmat recto: "English Boys"
 mat backing verso: "C-61//ADL22"
Acquired from: gift of the Dorothea Leonhardt Fund of the
Communities Foundation of Texas, Inc., Dallas, Texas

4374. **THE EQUINOX IN OCTOBER, MANCHESTER—VT.**
(P1984.1.426)
Gelatin silver print. c. 1937 or later
Image: 8 7/8 x 7¼ in. (22.5 x 18.4 cm.) sight size
Signed, l.r. overmat recto: "Clara E. Sipprell"
Inscription, overmat recto: "The Equinox in October/

Manchester—Vt."
mat backing verso: "V-L-23//AA21"
Acquired from: gift of the Dorothea Leonhardt Fund of the
Communities Foundation of Texas, Inc., Dallas, Texas

4375. **ERNST NORLIND—PAINTER—BORGEBY—SKÅNE**
(P1984.1.130)
Gelatin silver print on Gevaluxe paper. negative 1938,
print c. 1938
Image: 8 ⁷/₈ x 7 ¹/₁₆ in. (22.5 x 17.9 cm.) sight size
Signed, l.r. overmat recto: "Clara E. Sipprell"
Inscription, print verso: "SP37"
overmat recto: "Ernst Norlind—painter/Borgeby—Skåne"
mat backing verso: "S-P-49//SP37"
Acquired from: gift of the Dorothea Leonhardt Fund of the
Communities Foundation of Texas, Inc., Dallas, Texas

4376. **FALL AT TUNBRIDGE, VERMONT [Fall on the Road to**
Tunbridge, Vermont; Tunbridge in October] (P1984.1.460)
duplicate of P1984.1.457 and P1984.1.458
Gelatin silver print. negative c. 1920s–60s, print c. 1950s–60s
Image: 8 ¹⁵/₁₆ x 6 ¹⁵/₁₆ in. (22.6 x 17.6 cm.) sight size
Signed, l.r. overmat recto: "Clara E. Sipprell"
Inscription, overmat recto: "Fall at Turnbridge [sic]/Vermont"
mat backing verso: "V-L-8-b//Fall on the road to
Turnbridge, Vt//VL4"
Acquired from: gift of the Dorothea Leonhardt Fund of the
Communities Foundation of Texas, Inc., Dallas, Texas

4377. **FALL ON THE ROAD TO TUNBRIDGE, VERMONT**
[Fall at Tunbridge, Vermont; Tunbridge in October]
(P1984.1.458) duplicate of P1984.1.457 and P1984.1.460
Gelatin silver print. negative c. 1920s–60s, print c. 1960s
Image: 9 x 7 in. (22.8 x 17.8 cm.) sight size
Signed, l.r. overmat recto: "Clara E. Sipprell"
Inscription, overmat recto: "Fall on the road to Turnbridge
[sic]/Vermont"
mat backing verso: "V-L-8a//VL2" and partial rubber
stamp "CLARA E. SIPPRELL/MANCHESTER,"
Acquired from: gift of the Dorothea Leonhardt Fund of the
Communities Foundation of Texas, Inc., Dallas, Texas

4378. **[Fanny Sipprell]** (P1984.1.658)
Gelatin silver print. before 1920
Image: 7 ³/₄ x 6 in. (19.7 x 15.2 cm.)
Mount: 8 ¹⁵/₁₆ x 6 ³/₄ in. (22.6 x 17.1 cm.)
Inscription, mount verso: "ADL25"
Acquired from: gift of the Dorothea Leonhardt Fund of the
Communities Foundation of Texas, Inc., Dallas, Texas

4379. **FATHER REEDY—IRISH** (P1984.1.252)
Gelatin silver print. c. 1930s–40s
Image: 9 x 6 ¹⁵/₁₆ in. (22.8 x 17.6 cm.) sight size
Signed, l.r. overmat recto: "Clara E. Sipprell"
Inscription, overmat recto: "Father Reedy/Irish"
mat backing verso: "ROE12//ADL4"
Acquired from: gift of the Dorothea Leonhardt Fund of the
Communities Foundation of Texas, Inc., Dallas, Texas

4380. **FATHER TIRAN—ARMENIAN** (P1984.1.75)
Gelatin silver print. negative c. 1925, print later
Image: 9 ⁹/₁₆ x 7 ⁵/₈ in. (24.3 x 19.4 cm.)
Sheet: 9 ¹⁵/₁₆ x 7 ¹⁵/₁₆ in. (25.3 x 20.2 cm.)
Signed, l.r. old overmat recto: "Clara E. Sipprell"
Inscription, print verso: "Y24"
old overmat recto: "Father Tiran—Armenian"
old mat backing verso: "ROE-5//Y23"
Acquired from: gift of the Dorothea Leonhardt Fund of the
Communities Foundation of Texas, Inc., Dallas, Texas

4381. **A FIESTA, OAXACA, MEXICO** (P1984.1.301)
Gelatin silver print on tissue. c. 1931
Image: 6 ¹⁵/₁₆ x 9 in. (17.6 x 22.8 cm.) sight size
Signed, l.r. overmat recto: "Clara E. Sipprell"
Inscription, overmat recto: "A Fiesta/Oaxaca/Mexico"
mat backing verso: "M-33//MEX18"
Acquired from: gift of the Dorothea Leonhardt Fund of the
Communities Foundation of Texas, Inc., Dallas, Texas

4362

4365

4382. **THE FIRST CHRISTMAS** (P1984.1.193)
Gelatin silver print on tissue. c. 1927
Image: 9⅛ x 7¼ in. (23.2 x 18.4 cm.) sight size
Mount: 9¹³⁄₁₆ x 7¹⁵⁄₁₆ in. (24.9 x 20.1 cm.)
Signed, l.r. overmat recto: "Clara E. Sipprell"
Inscription, overmat recto: "The First Christmas"
mount verso: "C7"
mat backing verso: "Pf-30//Nina/C7"
Acquired from: gift of the Dorothea Leonhardt Fund of the
Communities Foundation of Texas, Inc., Dallas, Texas

4383. **THE FIRST DOLL** (P1984.1.199)
Gelatin silver print. negative c. 1928, print later
Image: 8¹⁵⁄₁₆ x 7⁹⁄₁₆ in. (22.6 x 19.2 cm.) sight size
Sheet: 9¹⁵⁄₁₆ x 8 in. (25.3 x 20.3 cm.)
Mount: same as sheet size
Signed, l.r. overmat recto: "Clara E. Sipprell"
Inscription, overmat recto: "The first doll"
overmat verso: "Nina//C9"
mount verso: "C9"
note: a print of a newborn baby is affixed to print verso
Acquired from: gift of the Dorothea Leonhardt Fund of the
Communities Foundation of Texas, Inc., Dallas, Texas

4384. **THE FISHER WOODS, ARLINGTON—VERMONT**
(P1984.1.459)
Gelatin silver print. c. 1930s–40s
Image: 9 x 7⅜ in. (22.8 x 18.7 cm.) sight size
Signed, l.r. overmat recto: "Clara E. Sipprell"
Inscription, overmat recto: "The Fisher Woods/Arlington—
Vermont"
mat backing verso: "L-V-33//VL1"
Acquired from: gift of the Dorothea Leonhardt Fund of the
Communities Foundation of Texas, Inc., Dallas, Texas

4385. **FISHERMAN'S HUT, GASPÉ PENINSULA** (P1984.1.409)
Gelatin silver print on tissue. c. 1932
Image: 7⅛ x 9³⁄₁₆ in. (18.1 x 23.3 cm.) sight size
Signed, l.r. overmat recto: "Clara E. Sipprell"
Inscription, overmat recto, typed on paper label:
"Fisherman's Hut/Gaspé Peninsula"
mat backing verso: "GP-6//GP12"
Acquired from: gift of the Dorothea Leonhardt Fund of the
Communities Foundation of Texas, Inc., Dallas, Texas

*4386. **FLORENCE, ITALY** (P1984.1.583)
Gelatin silver print on tissue. c. 1924
Image: 9¼ x 4¼ in. (23.5 x 10.8 cm.) sight size
Sheet: 10¹⁄₁₆ x 8¹⁄₁₆ in. (25.5 x 20.5 cm.)
Signed, l.r. overmat recto: "Clara E. Sipprell"
Inscription, overmat verso: "Florence, Italy"
mat backing verso: "Farm Foreground/City Background//
Florence, Italy//YL53"
Acquired from: gift of the Dorothea Leonhardt Fund of the
Communities Foundation of Texas, Inc., Dallas, Texas

4387. **FLOWER MARKET, GUADALAJARA—MEXICO**
(P1984.1.298)
Gelatin silver print. c. 1931
Image: 9⁹⁄₁₆ x 7⁹⁄₁₆ in. (24.3 x 19.2 cm.)
Sheet: 10 x 8 in. (25.4 x 20.3 cm.)
Signed, l.r. overmat recto: "Clara E. Sipprell"
Inscription, print verso: "MEX5"
overmat recto: "Flower Market/Guadalajara—Mexico"
overmat verso: "MEX5"
Acquired from: gift of the Dorothea Leonhardt Fund of the
Communities Foundation of Texas, Inc., Dallas, Texas

4388. **FLOWER MARKET IN GUADALAJARA, MEXICO**
(P1984.1.296)
Gelatin silver print on tissue. negative c. 1931, print later
Image: 6⅞ x 8¹⁵⁄₁₆ in. (17.4 x 22.6 cm.)
Sheet: 7¹⁵⁄₁₆ x 10¹⁵⁄₁₆ in. (20.2 x 27.8 cm.)
Signed, l.r. overmat recto: "Clara E. Sipprell"
Inscription, print verso: "MEX/9"

overmat recto: "Flower Market/in Guadalajara/Mexico"
overmat verso: "MEX9//MEX9"
Acquired from: gift of the Dorothea Leonhardt Fund of the
Communities Foundation of Texas, Inc., Dallas, Texas

4389. **FLOWER VENDORS, CHARLESTON—S.C.** (P1984.1.93)
Gelatin silver print on Gevaluxe paper. negative before 1942,
print c. 1940s
Image: 9⅝ x 7¹¹⁄₁₆ in. (24.5 x 19.5 cm.)
Sheet: 10 x 8 in. (25.4 x 20.3 cm.)
Signed, l.r. old overmat recto: "Clara E. Sipprell"
Inscription, print verso: "Bl8"
overmat verso: "Bl8"
mat backing verso: "A-B-3//Bl8"
old overmat recto: "Flower venders[sic]/Charleston—S.C."
Acquired from: gift of the Dorothea Leonhardt Fund of the
Communities Foundation of Texas, Inc., Dallas, Texas

*4390. **FOGGY DAY AT PERCÉ, GASPÉ PENINSULA** [Percé
Point, Gaspé, Quebec] (P1984.1.416) duplicate of P1984.1.405
and P1984.1.406
Gelatin silver print on tissue. c. 1932
Image: 7³⁄₁₆ x 9⅛ in. (18.2 x 23.2 cm.) sight size
Signed, l.r. overmat recto: "Clara E. Sipprell"
Inscription, overmat recto, typed on paper label: "Foggy Day
at Percé/Gaspé Peninsula"
mat backing verso: "GP-16-b//GP29"
Acquired from: gift of the Dorothea Leonhardt Fund of the
Communities Foundation of Texas, Inc., Dallas, Texas

4391. **THE FORT OF KOTOR, DALMATIA** (P1984.1.594)
Gelatin silver print on tissue. c. 1926
Image: 9¼ x 7⁵⁄₁₆ in. (23.5 x 18.5 cm.) sight size
Sheet: 10 x 8 in. (25.4 x 20.3 cm.)
Signed, l.r. overmat recto: "Clara E. Sipprell"
Inscription, print verso: "YL36"
overmat recto, typed on paper label: "The Fort of Kotor/
Dalmatia"
mat backing verso: "DL-52//YL36"
Acquired from: gift of the Dorothea Leonhardt Fund of the
Communities Foundation of Texas, Inc., Dallas, Texas

4392. **THE FORT AT DUBROVNIK—YUGOSLAVIA**
[Dubrovnik, Dalmatia, Yugoslavia] (P1984.1.596) duplicate
of P1984.1.595
Gelatin silver print. negative c. 1926, print later
Image: 6⅞ x 9 in. (17.4 x 22.8 cm.) sight size
Sheet: 7¹⁵⁄₁₆ x 9¹⁵⁄₁₆ in. (20.1 x 25.3 cm.)
Signed, l.r. overmat recto: "Clara E. Sipprell/19-"
Inscription, print verso: "YL32"
overmat recto: "The forte [sic] at/Dubrovnik—Yugoslavia"
overmat verso: "YL32"
mat backing verso: "YL32"
Acquired from: gift of the Dorothea Leonhardt Fund of the
Communities Foundation of Texas, Inc., Dallas, Texas

4393. **FOUNTAIN IN THE GARDEN OF CARL MILLES**
(P1984.1.385)
Gelatin silver print on Gevaluxe paper. c. 1938
Image: 7⅜ x 9⅛ in. (18.7 x 23.2 cm.) sight size
Signed, l.r. overmat recto: "Clara E. Sipprell"
Inscription, print verso: "SA10"
overmat recto: "Fountain in the Garden of Carl Milles"
mat backing verso: "S-L-7//SA10"
Acquired from: gift of the Dorothea Leonhardt Fund of the
Communities Foundation of Texas, Inc., Dallas, Texas

4394. **4 MONTH** (P1984.1.196)
Gelatin silver print. negative c. 1927, print later
Image: 8¹⁵⁄₁₆ x 7⁹⁄₁₆ in. (22.6 x 19.2 cm.) sight size
Sheet: 10 x 8¹⁄₁₆ in. (25.4 x 20.5 cm.)
Mount: 10⅛ x 8⅛ in. (25.8 x 20.7 cm.)
Signed, l.r. overmat recto: "Clara E. Sipprell"
Inscription, overmat recto: "4 month"
overmat verso: "Nina//C3"
mount verso: "C3"
Acquired from: gift of the Dorothea Leonhardt Fund of the
Communities Foundation of Texas, Inc., Dallas, Texas

4395. **FREESIA MOTIF** (P1984.1.20)
Gelatin silver print. c. 1940s
Image: 8 7/8 x 6 15/16 in. (22.6 x 17.5 cm.) sight size
Sheet: 10 x 8 in. (25.4 x 20.3 cm.)
Signed, l.r. old overmat recto: "Clara E. Sipprell"
Inscription, mat backing verso: dealer's label
old overmat recto: "Freeshia [sic]/motif"
old overmat verso: "Pf-222//Pf-222//IG43//PF"
Acquired from: gift of the Dorothea Leonhardt Fund of the
Communities Foundation of Texas, Inc., Dallas, Texas

4396. **FRÖJEL PARISH CHURCH, WEST GOTLAND**
(P1984.1.531)
Gelatin silver print on Gevaluxe paper. c. 1938
Image: 9 9/16 x 7 9/16 in. (24.3 x 19.2 cm.)
Sheet: 9 15/16 x 8 in. (25.3 x 20.3 cm.)
Signed, l.r. old overmat recto: "Clara E. Sipprell"
Inscription, print verso: "SA20"
old overmat recto: "Fröjel Parish Church/West Gotland"
old overmat verso: "SA20"
Acquired from: gift of the Dorothea Leonhardt Fund of the
Communities Foundation of Texas, Inc., Dallas, Texas

4397. **FRÖKEN MATHILDA STÄELOM HOLSTEIN—LAWYER**
(P1984.1.116)
Gelatin silver print on Gevaluxe paper. negative 1938,
print c. 1938
Image: 9 5/8 x 7 5/8 in. (24.4 x 19.4 cm.)
Sheet: 9 15/16 x 8 in. (25.3 x 20.3 cm.)
Signed, l.r. overmat recto: "Clara E. Sipprell"
Inscription, print verso: "SP96"
overmat recto: "Fröken Mathilda Stäelom Holstein—
lawyer"
mat backing verso: "S-P-18//SP96"
Acquired from: gift of the Dorothea Leonhardt Fund of the
Communities Foundation of Texas, Inc., Dallas, Texas

4398. **FROM MRS. HARLAN MILLER'S COLLECTION OF
FRENCH DOLLS** (P1984.1.506)
Gelatin silver print. negative 1954, print c. 1954
Image: 9 3/16 x 7 1/2 in. (23.3 x 19.0 cm.) sight size
Mount: 10 1/4 x 8 1/4 in. (26.1 x 21.0 cm.)
Signed, l.r. overmat recto: "Clara E. Sipprell/1954"
Inscription, overmat recto: "from/Mrs. Harlan Miller's/
collection of French dolls"
overmat verso: "S-L-6-III//SL28"
mount verso: "SL28"
Acquired from: gift of the Dorothea Leonhardt Fund of the
Communities Foundation of Texas, Inc., Dallas, Texas

4399. **FROM MRS. HARLAN MILLER'S COLLECTION OF
FRENCH DOLLS** (P1984.1.507)
Gelatin silver print. negative 1954, print c. 1954
Image: 9 3/16 x 7 1/2 in. (23.3 x 19.0 cm.) sight size
Mount: 10 5/16 x 8 3/8 in. (26.3 x 21.2 cm.)
Signed, l.r. overmat recto: "Clara E. Sipprell/1954"
Inscription, overmat recto: "from/Mrs. Harlan Miller's/
collection of French dolls"
overmat verso: "SL27"
mount verso: "SL27"
Acquired from: gift of the Dorothea Leonhardt Fund of the
Communities Foundation of Texas, Inc., Dallas, Texas

4400. **FROM MRS. HARLAN MILLER'S COLLECTION OF
FRENCH DOLLS** (P1984.1.508)
Gelatin silver print. negative 1954, print c. 1954
Image: 9 1/8 x 7 1/2 in. (23.2 x 19.0 cm.) sight size
Mount: 9 15/16 x 8 1/16 in. (25.2 x 20.4 cm.)
Signed, l.r. overmat recto: "Clara E. Sipprell/1954"
Inscription, overmat recto: "from/Mrs. Harlan Miller's/
collection of French dolls"
overmat verso: "PF//SL26"
mount verso: "SL26"
note: another print of French dolls is affixed to print verso
Acquired from: gift of the Dorothea Leonhardt Fund of the
Communities Foundation of Texas, Inc., Dallas, Texas

4386

4390

4401. **FRONT OF CHAPEL AT WELLESLEY COLLEGE**
(P1984.1.447)
Gelatin silver print on tissue. c. 1920s
Image: 9 3/8 x 7 3/8 in. (23.8 x 18.7 cm.) sight size
Signed, l.r. overmat recto: "Clara E. Sipprell"
Inscription, overmat recto, typed on paper label: "Front of
Chapel at Wellesley College"
mat backing verso: "W-C-2//IX//WC2"
Acquired from: gift of the Dorothea Leonhardt Fund of the
Communities Foundation of Texas, Inc., Dallas, Texas

4402. **FUJIMA, CHOREOGRAPHER, KABUKI** (P1984.1.46)
Gelatin silver print. c. 1950s
Image: 9 x 6 7/8 in. (22.8 x 17.4 cm.) sight size
Sheet: 10 x 8 in. (25.4 x 20.3 cm.)
Mount: same as sheet size
Signed, l.r. overmat recto: "Clara E. Sipprell"
Inscription, overmat recto: "x//Fujima/Choreographer/
Kabuki//x"
overmat verso: "Or17//Or17"
mount verso: "Or17"
note: a print of a family portrait is affixed to print verso
Acquired from: gift of the Dorothea Leonhardt Fund of the
Communities Foundation of Texas, Inc., Dallas, Texas

4403. **FYRISÅN—UPPSALA** (P1984.1.538)
Gelatin silver print on Gevaluxe paper. c. 1938
Image: 9 3/16 x 7 3/16 in. (23.3 x 18.2 cm.) sight size
Signed, l.r. overmat recto: "Clara E. Sipprell"
Inscription, overmat recto: "Fyris-ån-Upsala [sic]"
mat backing verso: "S-L-9//G/Swedish Landscape//SwL40"
Acquired from: gift of the Dorothea Leonhardt Fund of the
Communities Foundation of Texas, Inc., Dallas, Texas

4404. **GARDEN IN DALMATIA, YUGOSLAVIA [In an
Abandoned Garden, Dalmatia—Yugoslavia]** (P1984.1.587)
duplicate of P1984.1.588
Gelatin silver print. negative c. 1926, print later
Image: 9 x 7 in. (22.8 x 17.8 cm.) sight size
Signed, l.r. overmat recto: "Clara E. Sipprell"
Inscription, overmat recto: "Garden in Dalmatia/Yugoslavia"
mat backing verso: "YL47"
Acquired from: gift of the Dorothea Leonhardt Fund of the
Communities Foundation of Texas, Inc., Dallas, Texas

4405. **THE GARDEN STAIRS, DUBROVNIK, DALMATIA**
(P1984.1.573)
Gelatin silver print. c. 1926
Image: 9 3/16 x 7 3/16 in. (23.3 x 18.2 cm.)
Sheet: 9 15/16 x 7 7/8 in. (25.3 x 20.0 cm.)
Signed, l.r. overmat recto: "Clara E. Sipprell"
Inscription, print verso: "YA17"
overmat recto, typed on paper label: "The Garden Stairs/
Dubrovnik, Dalmatia"
mat backing verso: "DL-43//YA17"
Acquired from: gift of the Dorothea Leonhardt Fund of the
Communities Foundation of Texas, Inc., Dallas, Texas

4406. **[Garden wall, fountain, and door]** (P1984.1.290)
Gelatin silver print. negative c. 1928–31, print later
Image: 9 3/16 x 7 1/2 in. (23.3 x 19.0 cm.) sight size
Mount: 9 7/8 x 8 in. (25.1 x 20.3 cm.)
Inscription, overmat verso: "M-38//MA5"
note: a print of an older woman is affixed to print verso
Acquired from: gift of the Dorothea Leonhardt Fund of the
Communities Foundation of Texas, Inc., Dallas, Texas

4407. **GARDIN DE LAGO** (P1984.1.566)
Gelatin silver print on tissue. c. 1926
Image: 9 1/2 x 7 in. (23.3 x 17.8 cm.) sight size
Signed, l.r. overmat recto: "Clara E. Sipprell"
Inscription, overmat recto, typed on paper label:
"Gardin de Lago"
mat backing verso: "DL-51//YA43"
Acquired from: gift of the Dorothea Leonhardt Fund of the
Communities Foundation of Texas, Inc., Dallas, Texas

*4408. **GASPÉ PENINSULA [Church at Gaspé; On the Gaspé
Peninsula]** (P1984.1.410) duplicate of P1984.1.400,
P1984.1.401, and P1984.1.402
Gelatin silver print on Gevaluxe paper. negative c. 1932,
print late 1930s
Image: 9 3/16 x 7 1/16 in. (23.3 x 17.9 cm.) sight size
Sheet: 10 x 8 in. (25.4 x 20.3 cm.)
Signed, l.r. overmat recto: "Clara E. Sipprell"
Inscription, print verso: "GP11"
overmat recto: "Gaspé Peninsula"
overmat verso: "GP11"
old mat backing verso: "GP-1-C//GP11"
Acquired from: gift of the Dorothea Leonhardt Fund of the
Communities Foundation of Texas, Inc., Dallas, Texas

4409. **[Gaspé Peninsula]** (P1984.1.419)
Gelatin silver print on tissue. c. 1932
Image: 7 1/8 x 8 15/16 in. (18.1 x 22.6 cm.) sight size
Signed, l.r. overmat recto: "Clara E. Sipprell"
Inscription, mat backing verso: "GP-23//GP34"
Acquired from: gift of the Dorothea Leonhardt Fund of the
Communities Foundation of Texas, Inc., Dallas, Texas

4410. **THE GATEWAY TO ZION, ZION NATIONAL PARK**
(P1984.1.327)
Gelatin silver print on tissue. c. 1929–31
Image: 7 3/16 x 9 in. (18.2 x 22.8 cm.) sight size
Signed, l.r. overmat recto: "Clara E. Sipprell"
Inscription, overmat recto, typed on paper label:
"The Gateway to Zion/Zion National Park."
mat backing verso: "WL17"
Acquired from: gift of the Dorothea Leonhardt Fund of the
Communities Foundation of Texas, Inc., Dallas, Texas

4411. **GEORGE NAKASHIMA, CRAFTSMAN** (P1984.1.61)
Gelatin silver print. 1954
Image: 9 5/8 x 7 5/8 in. (24.4 x 19.4 cm.) sight size
Sheet: 10 x 8 in. (25.4 x 20.3 cm.)
Mount: 10 3/16 x 8 1/4 in. (25.9 x 20.9 cm.)
Signed, l.r. old overmat recto: "Clara E. Sipprell/1954"
Inscription, mount verso: "Or1"
old overmat recto: "George Nakashima/craftsman"
old overmat verso: "Or1"
Acquired from: gift of the Dorothea Leonhardt Fund of the
Communities Foundation of Texas, Inc., Dallas, Texas

4412. **GERTRUD PÅHLSSON LOETTERGREN—OPERA
STAR—STOCKHOLM** (P1984.1.120)
Gelatin silver print on Gevaluxe paper. negative 1938,
print c. 1938
Image: 9 5/8 x 7 5/8 in. (24.4 x 19.4 cm.)
Sheet: 10 x 8 in. (25.4 x 20.3 cm.)
Signed, l.r. old overmat recto: "Clara E. Sipprell"
Inscription, print verso: "SP112"
old overmat recto: "Gertrud Påhlsson Loettergren—opera
star—Stockholm"
Acquired from: gift of the Dorothea Leonhardt Fund of the
Communities Foundation of Texas, Inc., Dallas, Texas

*4413. **[Gertrude Käsebier, Clarence White, and F. Holland Day]**
(P1984.1.647)
Platinum print. c. 1910–13
Image: 3 1/4 x 4 1/2 in. (8.2 x 11.4 cm.)
Acquired from: gift of the Dorothea Leonhardt Fund of the
Communities Foundation of Texas, Inc., Dallas, Texas

*4414. **GERTRUDE KÄSEBIER, PHOTOGRAPHER** (P1980.32)
Platinum print. c. 1910–13
Image: 9 x 7 3/16 in. (22.8 x 18.2 cm.)
1st mount: 9 1/2 x 7 1/2 in. (24.1 x 19.1 cm.)
2nd mount: 10 x 8 in. (25.4 x 20.3 cm.)
Signed, l.r. 1st mount recto: "Clara E. Sipprell"
l.r. old overmat recto: "Clara E. Sipprell/1914 [sic]"
Inscription, 2nd mount verso: "PF"
old overmat recto: "Gertrude Kasebier, Photographer"
Acquired from: Marcuse Pfeifer Gallery, New York, New York

4415. **GLACIER POINT, YOSEMITE** (P1984.1.366)
Gelatin silver print on tissue. c. 1928–31
Image: 7 x 9 in. (17.8 x 22.8 cm.) sight size
Signed, l.r. overmat recto: "Clara E. Sipprell"
Inscription, overmat recto: "Glacier Point/Yosemite"
overmat verso: "WL43"
mat backing verso: "ML-1//WL43"
Acquired from: gift of the Dorothea Leonhardt Fund of the
Communities Foundation of Texas, Inc., Dallas, Texas

4416. **GOLDEN HILLS, CALIFORNIA [California—Wheat]**
(P1984.1.329) duplicate of P1984.1.330
Gelatin silver print on tissue. c. 1929–31
Image: 7 ³/₁₆ x 9 ⅛ in. (18.2 x 23.2 cm.) sight size
Signed, l.r. overmat recto: "Clara E. Sipprell"
Inscription, overmat recto, typed on paper label:
"Golden Hills/California"
mat backing verso: "A-L-34//Golden hills'/California
wheat//WL15"
Acquired from: gift of the Dorothea Leonhardt Fund of the
Communities Foundation of Texas, Inc., Dallas, Texas

4417. **THE GOLDEN LILY OF JAPAN [Auratum Lilies; Our
Auratum Lilies]** (P1984.1.504) duplicate of P1984.1.502 and
P1984.1.503
Gelatin silver print. negative 1950, print c. 1950
Image: 7 ³/₁₆ x 9 in. (18.2 x 22.8 cm.) sight size
Mount: 8 ½ x 11 in. (21.6 x 28.0 cm.)
Signed, l.r. overmat recto: "Clara E. Sipprell/1950"
Inscription, overmat recto: "The Golden Lily of Japan"
overmat verso: "SL20"
mount verso: "SL20"
Acquired from: gift of the Dorothea Leonhardt Fund of the
Communities Foundation of Texas, Inc., Dallas, Texas

4418. **THE GOLF COURSE** (P1984.1.449) duplicate of P1984.1.450
Gelatin silver print. c. 1940s–50s
Image: 8 ¹⁵/₁₆ x 7 in. (22.6 x 17.8 cm.) sight size
Signed, l.r. overmat recto: "Clara E. Sipprell"
Inscription, print verso: "The Golf Course/VL29"
overmat verso: "VL29"
mat backing verso: "V-L-25-I-(a)//VL29"
Acquired from: gift of the Dorothea Leonhardt Fund of the
Communities Foundation of Texas, Inc., Dallas, Texas

4419. **THE GOLF COURSE** (P1984.1.450) duplicate of P1984.1.449
Gelatin silver print. c. 1940s–50s
Image: 8 ¹⁵/₁₆ x 7 in. (22.6 x 17.8 cm.) sight size
Signed, l.r. overmat recto: "Clara E. Sipprell"
Inscription, print verso: "VL30"
overmat recto: "The Golf Course"
overmat verso: "VL30"
mat backing verso: "[illegible]//VL30" and rubber stamp
"CLARA E. SIPPRELL/MANCHESTER,
VERMONT/200 West 16th St.—New York City"
Acquired from: gift of the Dorothea Leonhardt Fund of the
Communities Foundation of Texas, Inc., Dallas, Texas

4420. **THE GOLF COURSE** (P1984.1.451)
Gelatin silver print. c. 1940s–50s
Image: 9 x 7 in. (22.8 x 17.8 cm.) sight size
Signed, l.r. overmat recto: "Clara E. Sipprell"
Inscription, print verso: "VL31"
overmat recto: "The Golf Course"
overmat verso: "VL31"
mat backing verso: "V-L-23-III//VL31" and rubber stamp
"CLARA E. SIPPRELL/MANCHESTER,
VERMONT/200 West 16th St.—New York City"
Acquired from: gift of the Dorothea Leonhardt Fund of the
Communities Foundation of Texas, Inc., Dallas, Texas

4408

4413

4414

4421. **THE GOLF COURSE, MANCHESTER** (P1984.1.24)
Gelatin silver print. after 1937
Image: 8 11/16 x 7 in. (22.1 x 17.8 cm.) sight size
Signed, l.r. old overmat recto: "Clara E. Sipprell"
Inscription, mat backing verso: dealer's label
 old overmat recto: "The Golf Course/Manchester//30"
Acquired from: gift of the Dorothea Leonhardt Fund of the
 Communities Foundation of Texas, Inc., Dallas, Texas

*4422. **GOTLAND** (P1984.1.528)
Gelatin silver print on Gevaluxe paper. c. 1938
Image: 9 1/2 x 7 9/16 in. (24.1 x 19.2 cm.)
Sheet: 10 x 8 in. (25.4 x 20.3 cm.)
Signed, l.r. overmat recto: "Clara E. Sipprell"
Inscription, print verso: "SA26"
 overmat recto: "Gotland"
 overmat verso: "SA26"
 mat backing verso: "S-L-22/SA26"
Acquired from: gift of the Dorothea Leonhardt Fund of the
 Communities Foundation of Texas, Inc., Dallas, Texas

4423. **GOV. PROF. HAMMARSKJÖLD, SWEDEN [Gov. Prof. Hjalmar Hammarskjöld]** (P1984.1.142) duplicate of P1984.1.140
Gelatin silver print. negative 1938, print c. 1938 or later
Image: 8 15/16 x 6 7/8 in. (22.6 x 17.4 cm.) sight size
Mount: 11 x 8 1/2 in. (28.0 x 21.7 cm.)
Signed, l.r. overmat recto: "Clara E. Sipprell"
Inscription, overmat recto: "Gov. Prof Hammerskjöld [sic]/
 Swedon [sic]"
 mount verso: "SP56"
Acquired from: gift of the Dorothea Leonhardt Fund of the
 Communities Foundation of Texas, Inc., Dallas, Texas

*4424. **GOV. PROF. HJALMAR HAMMARSKJÖLD [Gov. Prof. Hammarskjöld, Sweden]** (P1984.1.140) duplicate of P1984.1.142
Gelatin silver print on Gevaluxe paper. negative 1938,
 print c. 1938 or later
Image: 8 15/16 x 7 3/16 in. (22.6 x 18.2 cm.) sight size
Signed, l.r. overmat recto: "Clara E. Sipprell"
Inscription, print verso: "SP57"
 overmat recto: "Gov. Prof. Hjalman Hammarskjöld [sic]"
 mat backing verso: "GP57" and typed on paper label
 "Gov. Prof. Hjalman Hammerskjöld [sic]/Made in Sweden
 in 1938. Father/of Dag"
Acquired from: gift of the Dorothea Leonhardt Fund of the
 Communities Foundation of Texas, Inc., Dallas, Texas

4425. **GOV. PROF. HJALMAR HAMMARSKJÖLD, FATHER OF DAG** (P1984.1.677)
Gelatin silver print. negative c. 1938, print c. 1938 or later
Image: 9 9/16 x 7 5/8 in. (24.3 x 19.4 cm.)
Sheet: 9 15/16 x 7 15/16 in. (25.3 x 20.2 cm.)
Signed: see inscription
Inscription, print verso: "Gov. Prof. Hjalman Hammerskjold
 [sic]/Father of Dag.//SP58" and rubber stamp "CLARA E.
 SIPPRELL/Manchester, Vermont"
Acquired from: gift of the Dorothea Leonhardt Fund of the
 Communities Foundation of Texas, Inc., Dallas, Texas

4426. **GRAHOVO POLJE, MONTENEGRO** (P1984.1.604)
Gelatin silver print on tissue. c. 1926
Image: 9 5/16 x 7 3/16 in. (23.7 x 18.2 cm.) sight size
Signed, l.r. overmat recto: "Clara E. Sipprell"
Inscription, overmat recto, typed on paper label: "Grahovo
 Polje/Montenegro"
 mat backing verso: "DL-61//YL13"
Acquired from: gift of the Dorothea Leonhardt Fund of the
 Communities Foundation of Texas, Inc., Dallas, Texas

4427. **GRAND CANYON AT DAWN** (P1984.1.335) duplicate of P1984.1.336
Gelatin silver print. negative 1953, print c. 1953
Image: 8 15/16 x 7 1/4 in. (22.6 x 18.4 cm.) sight size
Mount: 10 x 8 1/16 in. (25.4 x 20.5 cm.)

Signed, l.r. overmat recto: "Clara E. Sipprell/1953"
Inscription, overmat recto: "Grand Canyon at Dawn"
 mount verso: "WL9"
 mat backing verso: "WL9"
Acquired from: gift of the Dorothea Leonhardt Fund of the
 Communities Foundation of Texas, Inc., Dallas, Texas

4428. **THE GRAND CANYON AT DAWN** (P1984.1.336) duplicate
of P1984.1.335
Gelatin silver print on Gevaluxe paper. negative 1953,
 print c. 1953
Image: 9 5/8 x 7 5/8 in. (24.4 x 19.4 cm.)
Sheet: 10 x 8 in. (25.4 x 20.3 cm.)
Signed, l.r. old overmat recto: "Clara E. Sipprell"
Inscription, print verso: "WL8"
 old overmat recto: "The Grand Canyon at Dawn"
 old overmat verso: "A-L-24-b//WL8"
Acquired from: gift of the Dorothea Leonhardt Fund of the
 Communities Foundation of Texas, Inc., Dallas, Texas

4429. **[Grand Canyon valley?]** (P1984.1.333)
Gelatin silver print on tissue. c. 1928–31
Image: 9 1/8 x 7 3/16 in. (23.2 x 18.2 cm.) sight size
Signed, l.r. overmat recto: "Clara E. Sipprell"
Inscription, mat backing verso: "Pf-182//WL11"
Acquired from: gift of the Dorothea Leonhardt Fund of the
 Communities Foundation of Texas, Inc., Dallas, Texas

4430. **GRAVE YARD OF THE SAWS, DATAH ISLAND, BEAUFORT, SOUTH CAROLINA** (P1984.1.377)
Gelatin silver print on Gevaluxe paper. c. 1942 or before
Image: 9 1/8 x 7 1/4 in. (23.2 x 18.4 cm.) sight size
Signed, l.r. overmat recto: "Clara E. Sipprell"
Inscription, overmat recto: "Grave yard of the Saws/Datah
 Island/Beaufort, South Carolina"
 mat backing verso: "LS1" and rubber stamp "CLARA E.
 SIPPRELL/MANCHESTER, VERMONT/200 West 16th
 St.—New York City"
Acquired from: gift of the Dorothea Leonhardt Fund of the
 Communities Foundation of Texas, Inc., Dallas, Texas

4431. **GRIPHOLM CASTLE—MARIEFRED** (P1984.1.520)
Gelatin silver print on Gevaluxe paper. c. 1938
Image: 7 9/16 x 9 5/8 in. (19.2 x 24.4 cm.)
Sheet: 8 x 10 in. (20.3 x 25.4 cm.)
Signed, l.r. overmat recto: "Clara E. Sipprell"
Inscription, print verso: "SA49"
 overmat recto: "Gripholm Castle—Mariefred"
 overmat verso: "SA49"
 mat backing verso: "S-L-28//SA49"
Acquired from: gift of the Dorothea Leonhardt Fund of the
 Communities Foundation of Texas, Inc., Dallas, Texas

4432. **HANDS OF DR. HEINDRIK VAN LOON** (P1984.1.276)
Gelatin silver print. negative 1938, print c. 1938 or later
Image: 7 1/8 x 9 3/16 in. (18.1 x 23.3 cm.) sight size
Sheet: 8 x 10 in. (20.3 x 25.4 cm.)
Signed, l.r. overmat recto: "Clara E. Sipprell"
Inscription, print verso: "H-1"
 overmat recto: "Hands of/Dr. Heindrik van Loon"
 mat backing verso: "S-L-12//H-1"
Acquired from: gift of the Dorothea Leonhardt Fund of the
 Communities Foundation of Texas, Inc., Dallas, Texas

4433. **HANDS OF INA CLAIRE** (P1984.1.267)
Gelatin silver print. c. 1940s–50s
Image: 8 7/8 x 6 1/8 in. (22.5 x 15.5 cm.) sight size
Signed, l.r. overmat recto: "Clara E. Sipprell"
Inscription, overmat recto: "Hands of/Ina Claire"
 mat backing verso: "WP-182//g Bookselection//H4"
Acquired from: gift of the Dorothea Leonhardt Fund of the
 Communities Foundation of Texas, Inc., Dallas, Texas

4434. **HANDS OF TOSHI YOSHIDA, WOOD BLOCK CUTTER**
(P1984.1.55)
Gelatin silver print. c. 1950s
Image: 9 1/16 x 7 7/16 in. (23.0 x 18.9 cm.) sight size
Sheet: 10 x 8 in. (25.4 x 20.3 cm.)
Mount: same as sheet size
Signed, l.r. overmat recto: "Clara E. Sipprell"
Inscription, overmat recto: "Hands of Toshi Yoshida/wood
 block cutter"
 overmat verso: "Or5//Or5"
 mount verso: "OR5//OR5"
 note: a print of Isamu Noguchi is affixed to print verso
Acquired from: gift of the Dorothea Leonhardt Fund of the
 Communities Foundation of Texas, Inc., Dallas, Texas

4435. **HANSA MEHTA, BOMBAY, INDIA** (P1984.1.96)
Gelatin silver print. c. 1950s–60s
Image: 8 15/16 x 6 7/8 in. (22.6 x 17.4 cm.) sight size
Mount: 11 x 8 1/2 in. (28.0 x 21.7 cm.)
Signed, l.r. overmat recto: "Clara E. Sipprell"
Inscription, overmat recto: "Hansa Mehta/Bombay, India"
 overmat verso: "I19"
 mount verso: "I19"
Acquired from: gift of the Dorothea Leonhardt Fund of the
 Communities Foundation of Texas, Inc., Dallas, Texas

4436. **HANSA MEHTA, CHAIRMAN OF THE HUMAN
RIGHTS COM.** (P1984.1.112)
Gelatin silver print. c. 1950s–60s
Image: 8 15/16 x 6 15/16 in. (22.6 x 17.6 cm.) sight size
Sheet: 9 7/8 x 7 15/16 in. (25.1 x 20.2 cm.)
Signed, l.r. overmat recto: "Clara E. Sipprell"
Inscription, overmat recto: "x//Hansa Mehta/Chairman of
 the Human Rights Com."
 overmat verso: "I3"
 print verso: "I3"
Acquired from: gift of the Dorothea Leonhardt Fund of the
 Communities Foundation of Texas, Inc., Dallas, Texas

4437. **HANSA MEHTA'S DAUGHTER** (P1984.1.104) duplicate of
P1984.1.105
Gelatin silver print. c. 1950s–60s
Image: 8 15/16 x 6 7/8 in. (22.6 x 17.4 cm.) sight size
Mount: 11 x 8 1/2 in. (28.0 x 21.7 cm.)
Signed, l.r. overmat recto: "Clara E. Sipprell"
Inscription, overmat recto: "Hansa Mehta's daughter"
 overmat verso: "I11"
 mount verso: "I11"
Acquired from: gift of the Dorothea Leonhardt Fund of the
 Communities Foundation of Texas, Inc., Dallas, Texas

4438. **HANSA MEHTA'S DAUGHTER** (P1984.1.105) duplicate of
P1984.1.104
Gelatin silver print. c. 1950s–60s
Image: 9 x 6 15/16 in. (22.8 x 17.6 cm.) sight size
Sheet: 9 15/16 x 8 in. (25.3 x 20.3 cm.)
Signed, l.r. overmat recto: "Clara E. Sipprell"
Inscription, print verso: "I10"
 overmat recto: "Hansa Mehta's/daughter"
 overmat verso: "I10"
Acquired from: gift of the Dorothea Leonhardt Fund of the
 Communities Foundation of Texas, Inc., Dallas, Texas

*4439. **THE HARBOR IN SPLIT, DALMATIA** (P1984.1.584)
Gelatin silver print on tissue. c. 1926
Image: 9 3/16 x 7 7/16 in. (23.3 x 18.9 cm.) sight size
Signed, l.r. overmat recto: "Clara E. Sipprell"
Inscription, overmat recto, typed on paper label:
 "The Harbor in Split/Dalmatia"
 mat backing verso: "D-L-31//No III No I//The Harbor at
 Split, Dalmatia/by/Clara E. Sipprell/70 Morningside Drive/
 N.Y. City//24//YL52" and printed paper label "Buffalo
 Salon/[Buffalo Camera Club insignia]/1925"
Acquired from: gift of the Dorothea Leonhardt Fund of the
 Communities Foundation of Texas, Inc., Dallas, Texas

4422

4424

4440. **THE HARBOR OF RAB—THE ISLAND OF RAB, DALMATIA** (P1984.1.585)
Gelatin silver print on tissue. c. 1926
Image: 7 3/16 x 8 11/16 in. (18.2 x 22.1 cm.) sight size
Signed, l.r. overmat recto: "Clara E. Sipprell"
Inscription, overmat recto, typed on paper label:
 "The Harbor of Rab/The Island of Rab, Dalmatia"
 mat backing verso: "DL-59//YL51"
Acquired from: gift of the Dorothea Leonhardt Fund of the
Communities Foundation of Texas, Inc., Dallas, Texas

4441. **HEAD OF A BOY** (P1984.1.233)
Gelatin silver print on tissue. c. 1936
Image: 8 15/16 x 6 7/8 in. (22.6 x 17.4 cm.) sight size
Sheet: 9 7/8 x 7 15/16 in. (25.1 x 20.2 cm.)
Signed, l.r. overmat recto: "Clara E. Sipprell"
Inscription, print verso: "C42"
 overmat recto: "Head of a Boy"
 old mat backing verso: "C-31//C42"
Acquired from: gift of the Dorothea Leonhardt Fund of the
Communities Foundation of Texas, Inc., Dallas, Texas

*4442. **HEAD OF A FOUR MONTH BABY** (P1984.1.195)
Gelatin silver print on tissue. c. 1927
Image: 8 15/16 x 7 in. (22.6 x 17.8 cm.) sight size
Signed, l.r. overmat recto: "Clara E. Sipprell"
Inscription, print verso: "C4"
 overmat recto, typed on paper label: "Head of a Four
 Month Baby"
 mat backing verso: "Pf-23//Nina//C4"
Acquired from: gift of the Dorothea Leonhardt Fund of the
Communities Foundation of Texas, Inc., Dallas, Texas

*4443. **[Head of a man]** (P1984.1.639)
Platinum print. c. 1913
Image: 6 3/8 x 4 7/16 in. (16.2 x 11.3 cm.)
Mount: 7 1/4 x 4 3/4 in. (18.4 x 12.0 cm.)
Signed, l.r. mount recto: "Clara E. Sipprell"
Inscription, mount recto: "Ellen J. Windsor"
Acquired from: gift of the Dorothea Leonhardt Fund of the
Communities Foundation of Texas, Inc., Dallas, Texas

4444. **HEAD OF NINA** (P1984.1.205)
Gelatin silver print. negative 1929, print later
Image: 8 15/16 x 6 7/8 in. (22.6 x 17.4 cm.) sight size
Sheet: 9 15/16 x 8 in. (25.3 x 20.3 cm.)
Mount: same as sheet size
Signed, l.r. overmat recto: "Clara E. Sipprell"
Inscription, overmat verso: "Head of Nina//Nina/C19"
 mount verso: "C19"
 note: a print of a man is affixed to print verso
Acquired from: gift of the Dorothea Leonhardt Fund of the
Communities Foundation of Texas, Inc., Dallas, Texas

4445. **HEMBYGDS MUSEUM IN LUDVIKA, DALECARLIA** (P1984.1.522)
Gelatin silver print on Gevaluxe paper. c. 1938
Image: 7 3/16 x 8 7/8 in. (18.2 x 22.5 cm.) sight size
Signed, l.r. overmat recto: "Clara E. Sipprell"
Inscription, print verso: "SA46"
 overmat recto: "Hembygds Museum in Ludoika [sic]/
 Dalecarlia"
 mat backing verso: "S-L-30//SA46"
Acquired from: gift of the Dorothea Leonhardt Fund of the
Communities Foundation of Texas, Inc., Dallas, Texas

*4446. **HER MAJESTY QUEEN LOUISE OF SWEDEN** (P1984.1.127)
Gelatin silver print. negative 1938, print c. 1938
Image: 6 1/2 x 6 7/8 in. (16.5 x 17.4 cm.) sight size
Sheet: 9 15/16 x 8 in. (25.3 x 20.3 cm.)
Signed, l.r. overmat recto: "Clara E. Sipprell"
Inscription, print verso: "SP71"
 overmat recto: "x//Her Majesty/Queen Louise/of Sweden"
Acquired from: gift of the Dorothea Leonhardt Fund of the
Communities Foundation of Texas, Inc., Dallas, Texas

4447. **HILDA YEN** (P1984.1.39)
Gelatin silver print. 1936
Image: 9 1/8 x 7 3/8 in. (23.2 x 18.7 cm.) sight size
Mount: 13 x 10 1/2 in. (33.1 x 26.6 cm.)
Signed, l.r. mount recto: "Clara E. Sipprell/1936"
 l.r. overmat recto: "Clara E. Sipprell"
Inscription, overmat recto: "Carlton Howe//Hilda Yen"
 overmat verso: "Or26"
 mount recto: "5 5/8" BM.//Hilda Yen/Chinese//09//p57//51//
 R61"
 mount verso: "Or26"
Acquired from: gift of the Dorothea Leonhardt Fund of the
Communities Foundation of Texas, Inc., Dallas, Texas

4448. **HIS MAJESTY KING GUSTAF OF SWEDEN [King Gustaf VI]** (P1984.1.122)
Gelatin silver print. negative 1938, print c. 1938 or later
Image: 8 7/16 x 4 13/16 in. (21.4 x 12.2 cm.) sight size
Signed, l.r. overmat recto: "Clara E. Sipprell"
Inscription, overmat recto: "x//His Majesty/King Gustaf of
 Sweden"
 overmat verso: "S-P-34-a"
 mount verso: "SP83"
Acquired from: gift of the Dorothea Leonhardt Fund of the
Communities Foundation of Texas, Inc., Dallas, Texas

4449. **HIS MAJESTY KING OSCAR GUSTAF V ADOLF, SWEDEN [H.R.H. The Late King Gustaf of Sweden]** (P1984.1.118) duplicate of P1984.1.117
Gelatin silver print. negative 1938, print c. 1938 or later
Image: 9 1/8 x 7 7/16 in. (23.2 x 18.9 cm.) sight size
Mount: 11 x 8 1/2 in. (27.9 x 21.6 cm.)
Signed, l.r. overmat recto: "Clara E. Sipprell"
Inscription, overmat recto: "x//His Majesty/King Oscar
 Gustaf V Adolf/Sweden//x"
 mount verso: "SP99"
Acquired from: gift of the Dorothea Leonhardt Fund of the
Communities Foundation of Texas, Inc., Dallas, Texas

4450. **HÖGKLINT, GOTLAND** (P1984.1.607)
Gelatin silver print on Gevaluxe paper. c. 1938
Image: 7 9/16 x 9 9/16 in. (19.2 x 24.3 cm.)
Sheet: 8 x 10 in. (20.3 x 25.4 cm.)
Signed, l.r. 1st overmat recto: "Clara E. Sipprell"
Inscription, 1st overmat recto: "Hogklint/Gotland"
 1st overmat verso: "SwL13"
 print verso: "SwL13"
 mat backing verso: "S-L-26//SwL13"
Acquired from: gift of the Dorothea Leonhardt Fund of the
Communities Foundation of Texas, Inc., Dallas, Texas

4451. **A HOME IN DALECARLIA** (P1984.1.532)
Gelatin silver print on Gevaluxe paper. c. 1938
Image: 7 3/16 x 9 1/8 in. (18.2 x 23.2 cm.) sight size
Mount: 8 x 10 in. (20.3 x 25.4 cm.)
Signed, l.r. overmat recto: "Clara E. Sipprell"
Inscription, overmat recto: "A Home in Dalecarlia"
 mat backing verso: "S-L-34//SA18"
Acquired from: gift of the Dorothea Leonhardt Fund of the
Communities Foundation of Texas, Inc., Dallas, Texas

4452. **HOME OF MRS. CHARLES LANCASTER, MANCHESTER—VERMONT** (P1984.1.422)
Gelatin silver print. n.d.
Image: 9 9/16 x 7 5/8 in. (24.3 x 19.4 cm.)
Sheet: 10 x 7 15/16 in. (25.4 x 20.2 cm.)
Signed, l.r. overmat recto: "Clara E. Sipprell"
Inscription, print verso: "AA19"
 old overmat recto: "Home of Mrs. Charles Lancaster/
 Manchester—Vermont"
 old mat backing verso: "V-L-2//AA19"
Acquired from: gift of the Dorothea Leonhardt Fund of the
Communities Foundation of Texas, Inc., Dallas, Texas

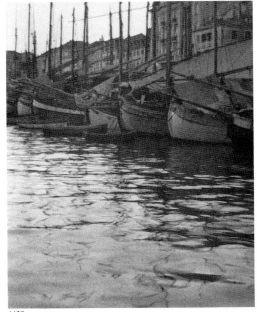

4439

4442

4443

4446

4455

4453. **THE HON. WOLLMAR F. BOSTRÖM, MINISTER OF SWEDEN TO THE U.S.** (P1984.1.172)
Gelatin silver print. negative 1938, print c. 1938 or later
Image: 9 9/16 x 7 9/16 in. (24.3 x 19.2 cm.)
Sheet: 9 15/16 x 7 15/16 in. (25.3 x 20.2 cm.)
Signed, l.r. overmat recto: "Clara E. Sipprell"
Inscription, print verso: "SP25"
 overmat recto: "The Hon. Wollmar F. Boström/Minister of Sweden to the U.S."
 mat backing verso: "S-P-19//SP25"
Acquired from: gift of the Dorothea Leonhardt Fund of the Communities Foundation of Texas, Inc., Dallas, Texas

4454. **HOUSE CHAPEL IN THE COURT OF PALAZZO SORGO, GRUZ, DALMATIA** (P1984.1.577)
Gelatin silver print on tissue. c. 1926
Image: 9 x 7 3/16 in. (22.8 x 18.2 cm.) sight size
Signed, l.r. overmat recto: "Clara E. Sipprell"
Inscription, overmat recto, typed on paper label: "House Chapel in the Court of Palazzo Sorgo/Gruz, Dalmatia"
 mat backing verso: "DL-54//YA8"
Acquired from: gift of the Dorothea Leonhardt Fund of the Communities Foundation of Texas, Inc., Dallas, Texas

*4455. **HOUSE IN WINTER, THETFORD** (P1984.1.468)
Gelatin silver print. negative c. 1923, print later
Image: 9 3/16 x 7 1/2 in. (23.3 x 19.0 cm.) sight size
Signed, l.r. overmat recto: "Clara E. Sipprell"
Inscription, overmat recto: "House in Winter/Thetford"
 mat backing verso: "Pfv 102//AA.10"
Acquired from: gift of the Dorothea Leonhardt Fund of the Communities Foundation of Texas, Inc., Dallas, Texas

4456. **[House, porch, and tree]** (P1984.1.679)
Gelatin silver print on tissue. c. 1920s
Image: 8 3/16 x 6 1/16 in. (20.8 x 15.4 cm.)
1st mount: 8 11/16 x 7 1/8 in. (22.1 x 18.1 cm.)
2nd mount: 10 x 7 7/8 in. (25.4 x 19.9 cm.)
3rd mount: 10 1/4 x 8 in. (26.0 x 20.3 cm.)
Signed, l.r. 2nd mount recto: "Clara E. Sipprell"
Inscription, 3rd mount verso: "AA7" and rubber stamp "Photograph by/CLARA E. SIPPRELL/70 Morningside Drive/New York."
Acquired from: gift of the Dorothea Leonhardt Fund of the Communities Foundation of Texas, Inc., Dallas, Texas

*4457. **HOUSE TOPS, SPLIT, DALMATIA** (P1984.1.559)
Gelatin silver print on tissue. c. 1926
Image: 9 1/2 x 7 9/16 in. (24.1 x 19.2 cm.)
Sheet: 10 3/16 x 8 1/16 in. (25.9 x 20.5 cm.)
Signed, l.r. overmat recto: "Clara E. Sipprell"
Inscription, print verso: "YA15"
 overmat recto, typed on paper label: "House Tops/Split, Dalmatia"
 mat backing verso: "YA15"
Acquired from: gift of the Dorothea Leonhardt Fund of the Communities Foundation of Texas, Inc., Dallas, Texas

4458. **HOWARD THURMAN** (P1984.1.82)
Gelatin silver print. 1963
Image: 8 15/16 x 6 7/8 in. (22.6 x 17.4 cm.) sight size
Signed, l.r. overmat recto: "Clara E. Sipprell/1963"
Inscription, overmat recto: "Howard Thurman"
 overmat verso: "Bl13"
Acquired from: gift of the Dorothea Leonhardt Fund of the Communities Foundation of Texas, Inc., Dallas, Texas

4459. **H.R.H. GUSTAF ADOLF, CROWN PRINCE OF SWEDEN, ULRIKSDAL [King Gustaf VI Adolf of Sweden]** (P1984.1.126) cropped duplicate of P1984.1.125
Gelatin silver print on Gevaluxe paper. negative 1938, print c. 1938
Image: 9 9/16 x 7 5/8 in. (24.3 x 19.4 cm.)
Sheet: 10 x 8 1/16 in. (25.4 x 20.5 cm.)

Signed, l.r. overmat recto: "Clara E. Sipprell"
Inscription, print verso: "SP79"
 overmat recto: "H.R.H. Gustaf Adolf/Crown Prince of Sweden/Ulriksdal"
 mat backing verso: "S-P-34-C//SP79"
Acquired from: gift of the Dorothea Leonhardt Fund of the Communities Foundation of Texas, Inc., Dallas, Texas

4460. **H.R.H. PRINCE CARL OF SWEDEN** (P1984.1.144)
Gelatin silver print on Gevaluxe paper. negative 1938, print c. 1938
Image: 9 x 6 15/16 in. (22.8 x 17.6 cm.) sight size
Signed, l.r. overmat recto: "Clara E. Sipprell"
Inscription, print verso: "SP88"
 overmat recto: "H.R.H. Prince Carl of Sweden"
 mat backing verso: "S-P-8"
Acquired from: gift of the Dorothea Leonhardt Fund of the Communities Foundation of Texas, Inc., Dallas, Texas

4461. **H.R.H. PRINCE EUGENE, SWEDEN** (P1984.1.136)
Gelatin silver print. negative 1938, print c. 1938
Image: 8 15/16 x 6 7/8 in. (22.6 x 17.4 cm.) sight size
Mount: 11 x 8 1/2 in. (28.0 x 21.6 cm)
Signed, l.r. overmat recto: "Clara E. Sipprell/1938"
Inscription, overmat recto: "H.R.H./Prince Eugene/Sweden"
 mount verso: "SP62"
Acquired from: gift of the Dorothea Leonhardt Fund of the Communities Foundation of Texas, Inc., Dallas, Texas

*4462. **H.R.H. THE LATE KING GUSTAF OF SWEDEN [His Majesty King Oscar Gustaf V Adolf, Sweden]** (P1984.1.117) duplicate of P1984.1.118
Gelatin silver print. negative 1938, print c. 1938 or later
Image: 9 x 6 15/16 in. (22.8 x 17.6 cm.) sight size
Mount: 9 15/16 x 8 in. (25.2 x 20.3 cm.)
Signed, l.r. overmat recto: "Clara E. Sipprell"
Inscription, overmat recto: "H.R.H./The late King Gustaf/of Sweden"
 overmat verso: "SP98"
 mount verso: "SP98//SP98"
 note: a print of a young girl is affixed to print verso
Acquired from: gift of the Dorothea Leonhardt Fund of the Communities Foundation of Texas, Inc., Dallas, Texas

4463. **HUGO KORTSCHAK** (P1984.1.253)
Gelatin silver print on tissue. c. 1930s–40s
Image: 8 11/16 x 6 15/16 in. (22.1 x 17.6 cm.) sight size
Signed, l.r. overmat recto: "Clara E. Sipprell"
Inscription, overmat recto: "Hugo Kortschak"
 mat backing verso: "ROE 10//ADL5"
Acquired from: gift of the Dorothea Leonhardt Fund of the Communities Foundation of Texas, Inc., Dallas, Texas

*4464. **IMPLEMENTS FOR THE TEA CEREMONY** (P1984.1.19)
Gelatin silver print. negative c. 1954, print 1954
Image: 6 7/8 x 8 15/16 in. (17.4 x 22.6 cm.) sight size
Sheet: 8 x 9 15/16 in. (20.3 x 25.3 cm.)
Signed, l.r. old overmat recto: "Clara E. Sipprell/1954"
Inscription, mat backing verso: dealer's label
 old overmat recto: "Implements for the tea Ceremony//19"
 old overmat verso: "PF"
Acquired from: gift of the Dorothea Leonhardt Fund of the Communities Foundation of Texas, Inc., Dallas, Texas

4465. **IN A COURTYARD, THE ISLAND OF RAB** (P1984.1.31)
Gelatin silver print. c. 1924
Image: 9 3/16 x 7 3/16 in. (23.3 x 18.2 cm.) sight size
Signed, l.r. old overmat recto: "Clara E. Sipprell"
Inscription, mat backing verso: dealer's label
 old overmat recto: "5" and typed on paper label "In a Courtyard/The Island of Rab"
 old mat backing verso: "DL-58//PF"
Acquired from: gift of the Dorothea Leonhardt Fund of the Communities Foundation of Texas, Inc., Dallas, Texas

4466. **IN AN ABANDONED GARDEN, DALMATIA—
YUGOSLAVIA [Garden in Dalmatia, Yugoslavia]**
(P1984.1.588) duplicate of P1984.1.587
Gelatin silver print. negative c. 1926, print later
Image: 8 15/16 x 7 in. (22.6 x 17.8 cm.) sight size
Signed, l.r. overmat recto: "Clara E. Sipprell"
Inscription, overmat recto: "In an abandoned garden/
Dalmatia—Yugoslavia"
mat backing verso: "YL46" and rubber stamp "CLARA E.
SIPPRELL/MANCHESTER, VERMONT/200 West 16th
St.—New York City"
Acquired from: gift of the Dorothea Leonhardt Fund of the
Communities Foundation of Texas, Inc., Dallas, Texas

4467. **IN THE BLUE CANYON, ARIZONA** (P1984.1.353)
Gelatin silver print on tissue. c. 1928–31
Image: 7 1/8 x 9 1/16 in. (18.1 x 23.0 cm.) sight size
Signed, l.r. overmat recto: "Clara E. Sipprell"
Inscription, overmat recto, typed on paper label: "In the Blue
Canyon/Arizona"
mat backing verso: "Pf-185//WL28"
Acquired from: gift of the Dorothea Leonhardt Fund of the
Communities Foundation of Texas, Inc., Dallas, Texas

4457

4468. **IN THE DOMINICAN MONASTERY, DUBROVNIK,
DALMATIA** (P1984.1.578)
Gelatin silver print on tissue. c. 1926
Image: 8 15/16 x 7 in. (22.6 x 17.8 cm.) sight size
Signed, l.r. overmat recto: "Clara E. Sipprell"
Inscription, overmat recto, typed on paper label: "In the
Dominican Monastery/Dubrovnik, Dalmatia" mat backing
verso: "YA5" and rubber stamp "CLARA E. SIPPRELL/
MANCHESTER, VERMONT/200 West 16th St.—New
York City"
Acquired from: gift of the Dorothea Leonhardt Fund of the
Communities Foundation of Texas, Inc., Dallas, Texas

4469. **IN THE GARDEN OF CARL ELDH—STOCKHOLM**
(P1984.1.383)
Gelatin silver print on Gevaluxe paper. c. 1938
Image: 9 1/8 x 7 1/8 in. (23.2 x 18.1 cm.) sight size
Signed, l.r. overmat recto: "Clara E. Sipprell"
Inscription, print verso: "SA6"
overmat recto: "In the Garden of Carl Eldh—Stockholm"
mat backing verso: "S-L-23//SA6"
Acquired from: gift of the Dorothea Leonhardt Fund of the
Communities Foundation of Texas, Inc., Dallas, Texas

4470. **IN THE GARDEN OF CARL MILLES, LIDINGÖ—
STOCKHOLM** (P1984.1.384)
Gelatin silver print on Gevaluxe paper. c. 1938
Image: 8 7/8 x 7 1/8 in. (22.5 x 18.1 cm.) sight size
Signed, l.r. overmat recto: "Clara E. Sipprell"
Inscription, print verso: "SA7"
overmat recto: "In the Garden of Carl Milles/Jidniugo
[sic]—Stockholm"
mat backing verso: "S-L-32//SA7"
Acquired from: gift of the Dorothea Leonhardt Fund of the
Communities Foundation of Texas, Inc., Dallas, Texas

4462

4471. **IN THE GARDEN OF THE CROWN PRINCE AT
SOFIERO—SKÅNE** (P1984.1.545)
Gelatin silver print on Gevaluxe paper. c. 1938
Image: 9 3/16 x 7 1/16 in. (23.3 x 17.9 cm.) sight size
Signed, l.r. overmat recto: "Clara E. Sipprell"
Inscription, overmat recto: "In the Garden of the Crown
Prince at Sofiero—Skåne"
mat backing verso: "S-L-18//SwL28"
Acquired from: gift of the Dorothea Leonhardt Fund of the
Communities Foundation of Texas, Inc., Dallas, Texas

4464

4472. **IN THE GARDEN OF THE CROWN PRINCE OF SWEDEN, SKÅNE** (P1984.1.546)
Gelatin silver print on Gevaluxe paper. c. 1938
Image: 8 15/16 x 7 3/16 in. (22.6 x 18.2 cm.) sight size
Sheet: 10 x 8 in. (25.4 x 20.3 cm.)
Signed, l.r. overmat recto: "Clara E. Sipprell"
Inscription, print verso: "SwL26"
 overmat recto: "In the/Garden of the Crown Prince of Sweden/Skåne"
 overmat verso: "SwL26"
 mat backing verso: "S-L-13//SwL26"
Acquired from: gift of the Dorothea Leonhardt Fund of the Communities Foundation of Texas, Inc., Dallas, Texas

4473. **IN THE HEART OF THE GRAY ROCKS, MONTENEGRO** (P1984.1.601)
Gelatin silver print on tissue. c. 1926
Image: 9 3/16 x 7 3/16 in. (23.3 x 18.2 cm.) sight size
Signed, l.r. overmat recto: "Clara E. Sipprell"
Inscription, overmat recto, typed on paper label: "In the Heart of the Gray Rocks/Montenegro"
 mat backing verso: "D-L-38//YL20"
Acquired from: gift of the Dorothea Leonhardt Fund of the Communities Foundation of Texas, Inc., Dallas, Texas

4474. **IN THE KITCHEN AT THETFORD HILL, VERMONT [In the Kitchen with Grandparents]** (P1984.1.223) duplicate of P1984.1.222
Gelatin silver print. c. 1933
Image: 8 15/16 x 7 1/4 in. (22.6 x 18.4 cm.) sight size
Signed, l.r. overmat recto: "Clara E. Sipprell"
Inscription, print verso: "MIS6"
 overmat recto: "In the Kitchen at Thetford Hill/Vermont"
 mat backing verso: "V-P-2//G/Vermont//MIS6"
Acquired from: gift of the Dorothea Leonhardt Fund of the Communities Foundation of Texas, Inc., Dallas, Texas

4475. **IN THE KITCHEN WITH GRANDPARENTS [In the Kitchen at Thetford Hill, Vermont]** (P1984.1.222) duplicate of P1984.1.223
Gelatin silver print. negative c. 1933, print later
Image: 8 15/16 x 7 1/4 in. (22.6 x 18.4 cm.) sight size
Sheet: 10 x 8 in. (25.4 x 20.3 cm.)
Mount: same as sheet size
Signed, l.r. overmat recto: "Clara E. Sipprell"
Inscription, overmat recto: "In the kitchen with grandparents"
 overmat verso: "MIS7"
 note: a print of an older woman seated in a chair is affixed to print verso
Acquired from: gift of the Dorothea Leonhardt Fund of the Communities Foundation of Texas, Inc., Dallas, Texas

4476. **IN THE PLAZA, TEPIC** (P1984.1.322)
Gelatin silver print on tissue. c. 1931
Image: 9 1/8 x 7 3/16 in. (23.2 x 18.2 cm.) sight size
Signed, l.r. overmat recto: "Clara E. Sipprell"
Inscription, overmat recto: "In the Plaza/Tepic" and typed on paper label "On/T [remainder of label is missing]"
 mat backing verso: "M-36//G Bookselection//MEX30"
Acquired from: gift of the Dorothea Leonhardt Fund of the Communities Foundation of Texas, Inc., Dallas, Texas

4477. **IN THE PUEBLO OF JUCACOTE, MICHOACÁN, MEXICO** (P1984.1.297)
Gelatin silver print on tissue. c. 1931
Image: 9 3/16 x 7 7/16 in. (23.3 x 18.9 cm.) sight size
Signed, l.r. overmat recto: "Clara E. Sipprell"
Inscription, overmat recto, typed on paper label: "In the Pueblo of Jucacote/Michoacan, Mexico"
 mat backing verso: "M-26//MEX8"
Acquired from: gift of the Dorothea Leonhardt Fund of the Communities Foundation of Texas, Inc., Dallas, Texas

4478. **IN THE SUN [Nina]** (P1984.1.211) duplicate of P1984.1.212
Gelatin silver print on tissue. c. 1930
Image: 9 x 7 1/16 in. (22.8 x 17.9 cm.) sight size
Signed, l.r. overmat recto: "Clara E. Sipprell"
Inscription, print verso: "C24"
 overmat recto, typed on paper label: "In the Sun"
 overmat verso: "Nina/In the Sun"
 mat backing verso: "N-2//Nina/In the Sun//C24"
Acquired from: gift of the Dorothea Leonhardt Fund of the Communities Foundation of Texas, Inc., Dallas, Texas

*4479. **IN THE UPPER TOWN, DUBROVNIK, DALMATIA** (P1984.1.574)
Gelatin silver print on tissue. c. 1926
Image: 9 1/4 x 6 7/16 in. (23.5 x 16.3 cm.) sight size
Sheet: 9 15/16 x 7 7/8 in. (25.2 x 20.0 cm.)
Signed, l.r. overmat recto: "Clara E. Sipprell"
Inscription, print verso: "YA12"
 overmat recto, typed on paper label: "In the Upper Town/Dubrovnik, Dalmatia"
 mat backing verso: "DL-66//YA12"
Acquired from: gift of the Dorothea Leonhardt Fund of the Communities Foundation of Texas, Inc., Dallas, Texas

4480. **IN THE YOSEMITE VALLEY, THE YOSEMITE NATIONAL PARK** (P1984.1.367)
Gelatin silver print on tissue. c. 1929–31
Image: 9 5/8 x 7 5/8 in. (24.4 x 19.4 cm.)
Sheet: 10 x 8 in. (25.4 x 20.3 cm.)
Signed, l.r. overmat recto: "Clara E. Sipprell"
Inscription, print verso: "WL44"
 overmat recto, typed on paper label: "In the Yosemite Valley/The Yosemite National Park"
 overmat verso: "WL44"
 old mat backing verso: "A-L-30//WL44" and typed on paper label ""Luka"/Study of Ivan Moskivin"
Acquired from: gift of the Dorothea Leonhardt Fund of the Communities Foundation of Texas, Inc., Dallas, Texas

4481. **THE INDIAN BOWL, SANTA FÉ, NEW MEXICO** (P1984.1.21)
Gelatin silver print on tissue. c. 1930s
Image: 7 1/8 x 9 1/8 in. (18.1 x 23.2 cm.) sight size
Signed, l.r. old overmat recto: "Clara E. Sipprell"
Inscription, mat backing verso: dealer's label
 old overmat recto, typed on paper label: "The Indian Bowl/Santa Fé, New Mexico"
 old mat backing verso: "SL-26//PF//G Mexico"
Acquired from: gift of the Dorothea Leonhardt Fund of the Communities Foundation of Texas, Inc., Dallas, Texas

4482. **INDIAN GROUP—MEXICAN TYPES, CONTRERAS, MEXICO [Types in Contreras, Mexico]** (P1984.1.305) duplicate of P1984.1.306
Gelatin silver print on tissue. c. 1931
Image: 9 1/8 x 7 1/8 in. (23.2 x 18.1 cm.) sight size
Signed, l.r. overmat recto: "Clara E. Sipprell"
Inscription, overmat recto: "Indian Group" and typed on paper label "Mexican Types/Contreras, Mexico"
 mat backing verso: "M-3-a//MEX14"
Acquired from: gift of the Dorothea Leonhardt Fund of the Communities Foundation of Texas, Inc., Dallas, Texas

4483. **INDIAN WOMAN, NEW MEXICO** (P1984.1.64)
Gelatin silver print on tissue. c. 1949
Image: 9 1/2 x 7 9/16 in. (24.1 x 19.2 cm.)
Sheet: 9 13/16 x 8 in. (24.9 x 20.3 cm.)
Signed, l.r. overmat recto: "Clara E. Sipprell"
Inscription, print verso: "AI4"
 overmat recto: "Indian Women [sic]/New Mexico"
 overmat verso: "AI4//AI4"
Acquired from: gift of the Dorothea Leonhardt Fund of the Communities Foundation of Texas, Inc., Dallas, Texas

4484. **AN INDO-CHINESE PRINCESS** (P1984.1.52)
Gelatin silver print. c. 1950s
Image: 8 15/16 x 7 1/4 in. (22.6 x 18.4 cm.)
Sheet: 9 7/8 x 7 15/16 in. (25.1 x 20.2 cm.)

Signed, l.r. overmat recto: "Clara E. Sipprell"
Inscription, print verso: "Or11"
 overmat recto: "An Indo-Chinese Princess"
 overmat verso: "Or11//Or11"
 mat backing verso: "O-4//Or11"
Acquired from: gift of the Dorothea Leonhardt Fund of the
 Communities Foundation of Texas, Inc., Dallas, Texas

4479

4485. **INNER COURT OF PALAZZO SORGO, GRUZ,
 DALMATIA** (P1984.1.568)
 Gelatin silver print on tissue. c. 1926
 Image: 9 3/16 x 6 15/16 in. (23.3 x 17.6 cm.) sight size
 Signed, l.r. overmat recto: "Clara E. Sipprell."
 Inscription, overmat recto, typed on paper label:
 "Inner Court of Palazzo Sorgo/Gruz, Dalmatia"
 mat backing verso: "DL-78//YA31"
 Acquired from: gift of the Dorothea Leonhardt Fund of the
 Communities Foundation of Texas, Inc., Dallas, Texas

*4486. **INNER COURT OF PALAZZO SORGO, GRUZ,
 DALMATIA** (P1984.1.671)
 Gelatin silver print. c. 1926
 Image: 9 5/16 x 7 7/16 in. (23.7 x 18.9 cm.)
 Inscription, print verso: "Inner Court of Palazzo Sorgo/Gruz,
 Dalmatia//YA32"
 Acquired from: gift of the Dorothea Leonhardt Fund of the
 Communities Foundation of Texas, Inc., Dallas, Texas

4487. **INTERIOR** (P1984.1.394)
 Gelatin silver print on tissue. c. 1922
 Image: 8 15/16 x 6 15/16 in. (22.6 x 17.6 cm.) sight size
 Signed, l.r. overmat recto: "Clara E. Sipprell"
 Inscription, print verso: "IN9"
 overmat recto: "Interior"
 overmat verso: "IN9"
 mat backing verso: "Pf226//IN9"
 Acquired from: gift of the Dorothea Leonhardt Fund of the
 Communities Foundation of Texas, Inc., Dallas, Texas

4486

4488. **IRINA & NINA** (P1984.1.220)
 Gelatin silver print. c. 1929
 Image: 9 1/8 x 7 3/16 in. (23.2 x 18.2 cm.)
 1st mount: same as image size
 2nd mount: 10 1/2 x 8 in. (26.6 x 20.3 cm.)
 3rd mount: 20 x 14 1/2 in. (50.8 x 36.8 cm.)
 Signed, l.r. 2nd mount recto: "Clara E. Sipprell"
 Inscription, 1st mount verso: "Nina//C31"
 3rd mount verso: "Irena [sic] & Nina/C31"
 Acquired from: gift of the Dorothea Leonhardt Fund of the
 Communities Foundation of Texas, Inc., Dallas, Texas

4489. **[Irina Khrabroff]** (P1984.1.652)
 Gelatin silver print. c. 1920s
 Image: 3 1/2 x 2 11/16 in. (8.9 x 6.8 cm.)
 Inscription, print verso: "Irena Krabroff [sic] ?//ADL38"
 Acquired from: gift of the Dorothea Leonhardt Fund of the
 Communities Foundation of Texas, Inc., Dallas, Texas

*4490. **[Irina Khrabroff]** (P1984.1.653)
 Platinum print. c. 1918
 Image: 6 1/2 x 4 11/16 in. (16.5 x 11.9 cm.)
 Mount: 7 3/16 x 5 1/8 in. (18.2 x 13.0 cm.)
 Signed, l.r. mount recto: "Clara E. Sipprell"
 Inscription, mount verso: "Irene Krabroff [sic] ?/platinum?/
 ADL37" and rubber stamp "CLARA E. SIPPRELL/
 Manchester, Vermont"
 Acquired from: gift of the Dorothea Leonhardt Fund of the
 Communities Foundation of Texas, Inc., Dallas, Texas

4491. **[Irina Khrabroff]** (P1984.1.689)
 Gelatin silver print on tissue. c. 1925–33
 Image: 9 1/2 x 7 1/2 in. (24.1 x 19.0 cm.)
 Inscription, mat backing verso: "PF-11//Irene Krabroff [sic]/
 ADL 24"
 Acquired from: gift of the Dorothea Leonhardt Fund of the
 Communities Foundation of Texas, Inc., Dallas, Texas

4492. (IRINA OR CLARA)—BRYCE CANYON—A PINHOLE
(P1984.1.347)
Gelatin silver print on tissue. c. 1928–31
Image: 8 15/16 x 7 1/16 in. (22.6 x 17.9 cm.) sight size
Sheet: 10 1/2 x 7 15/16 in. (26.6 x 20.2 cm.)
Signed, l.r. overmat recto: "Clara E. Sipprell"
Inscription, overmat recto: "(IRena [sic] or Clara)//Bryce
Canyon [sic]/a pinhole"
mat backing verso: "A-L-3//ADL14"
Acquired from: gift of the Dorothea Leonhardt Fund of the
Communities Foundation of Texas, Inc., Dallas, Texas

*4493. IRVING R. LILES (P1984.1.4)
Platinum print. c. 1918
Image: 8 3/4 x 6 3/4 in. (22.2 x 17.1 cm.)
1st mount: 9 1/4 x 6 15/16 in. (23.5 x 17.6 cm.)
2nd mount: 10 x 8 in. (25.4 x 20.3 cm.)
Signed, l.r. print verso and l.r. 1st mount recto:
"Clara E. Sipprell"
Inscription, 1st mount recto: "Irving R. Liles"
2nd mount verso: "IG/33//PF"
mat backing verso: dealer's label
Acquired from: gift of the Dorothea Leonhardt Fund of the
Communities Foundation of Texas, Inc., Dallas, Texas

4494. ISAMU NOGUCHI, SCULPTOR (P1984.1.35)
Gelatin silver print. 1959
Image: 9 5/16 x 7 5/16 in. (23.7 x 18.5 cm.)
Mount: 20 1/16 x 14 1/2 in. (51.0 x 36.8 cm.)
Signed, l.r. mount recto: "Clara E. Sipprell"
Inscription, mount recto: "Isamu Noguchi/Sculptor//1959"
mount verso: "MiS9"
mat backing verso: dealer's label
Acquired from: gift of the Dorothea Leonhardt Fund of the
Communities Foundation of Texas, Inc., Dallas, Texas

4495. ISLAND OF BLED, YUGOSLAVIA (P1984.1.564)
Gelatin silver print. negative c. 1926, print later
Image: 9 9/16 x 7 5/8 in. (24.3 x 19.4 cm.)
Sheet: 9 15/16 x 7 15/16 in. (25.3 x 20.2 cm.)
Signed, l.r. old overmat recto: "Clara E. Sipprell"
Inscription, print verso: "YL2"
old overmat recto: "Island of Bled/Yugoslavia"
old overmat verso: "DL-45-a//YL2"
Acquired from: gift of the Dorothea Leonhardt Fund of the
Communities Foundation of Texas, Inc., Dallas, Texas

*4496. [Ivan Mestrovic's hands] (P1984.1.615)
Gelatin silver print. negative c. 1926, print later
Image: 9 3/8 x 7 9/16 in. (23.8 x 19.2 cm.)
Sheet: 9 15/16 x 8 in. (25.3 x 20.3 cm.)
Mount: 11 x 8 1/2 in. (28.0 x 21.6 cm.)
Inscription, mount verso: "PF//IG4"
Acquired from: gift of the Dorothea Leonhardt Fund of the
Communities Foundation of Texas, Inc., Dallas, Texas

4497. IVORY RABBITS—IN A LEAF BOAT (P1984.1.494)
Gelatin silver print. negative 1954, print c. 1954
Image: 6 7/8 x 8 15/16 in. (17.4 x 22.6 cm.) sight size
Mount: 8 x 10 in. (20.3 x 25.4 cm.)
Signed, l.r. overmat recto: "Clara E. Sipprell/1954"
Inscription, overmat recto: "Ivory Rabbits—in a leaf boat"
mount verso: "SL9"
Acquired from: gift of the Dorothea Leonhardt Fund of the
Communities Foundation of Texas, Inc., Dallas, Texas

4498. IVY AND OLD GLASS (P1984.1.488) duplicate of
P1984.1.495
Gelatin silver print on tissue. negative 1922, print c. 1922
Image: 6 13/16 x 8 15/16 in. (17.3 x 22.6 cm.) sight size
Mount: 8 9/16 x 11 in. (21.7 x 28.0 cm.)
Signed, l.r. overmat recto: "Clara E. Sipprell/1922"
Inscription, overmat recto: "Ivy and Old Glass"
mount verso: "SL10"
Acquired from: gift of the Dorothea Leonhardt Fund of the
Communities Foundation of Texas, Inc., Dallas, Texas

*4499. IVY AND OLD GLASS (P1984.1.495) duplicate of
P1984.1.488
Gelatin silver print. negative 1922, print later
Image: 7 7/16 x 9 5/16 in. (18.9 x 23.7 cm.)
Inscription, print verso: "SL11" and rubber stamp
"CLARA E. SIPPRELL/Manchester, Vermont"
mat backing verso: "SL-8//SL11"
Acquired from: gift of the Dorothea Leonhardt Fund of the
Communities Foundation of Texas, Inc., Dallas, Texas

4500. [Jack in the pulpits] (P1984.1.509)
Gelatin silver print. c. 1950s–60s
Image: 9 5/16 x 7 7/16 in. (23.7 x 18.9 cm.)
Mount: 14 x 11 in. (35.6 x 28.0 cm.)
Inscription, mount verso: "SL3" and rubber stamp
"CLARA E. SIPPRELL/Manchester, Vermont"
Acquired from: gift of the Dorothea Leonhardt Fund of the
Communities Foundation of Texas, Inc., Dallas, Texas

4501. JAPANESE SCHOLAR (P1984.1.56)
Gelatin silver print. c. 1950s
Image: 9 3/16 x 7 7/16 in. (23.3 x 18.9 cm.) sight size
Sheet: 10 x 8 in. (25.4 x 20.3 cm.)
Mount: same as sheet size
Inscription, overmat recto: "Japanese scholar"
overmat verso: "Or6//Or6"
mount recto: "OR6"
note: a print of a woman holding a book is affixed to
print verso
Acquired from: gift of the Dorothea Leonhardt Fund of the
Communities Foundation of Texas, Inc., Dallas, Texas

4502. JERRY OF TAOS (P1984.1.62)
Gelatin silver print. c. 1949
Image: 9 5/8 x 7 5/8 in. (24.4 x 19.4 cm.)
Sheet: 10 x 8 in. (25.4 x 20.3 cm.)
Mount: same as sheet size
Signed, l.r. overmat recto: "Clara E. Sipprell"
Inscription, overmat recto: "Jerry of Taos"
overmat verso: "AI2"
mount verso: "AI2"
mat backing verso: "AI3//AI2"
note: a print of an unknown subject is affixed to print verso
Acquired from: gift of the Dorothea Leonhardt Fund of the
Communities Foundation of Texas, Inc., Dallas, Texas

*4503. JOHN COTTON DANA (P1984.1.258)
Platinum print on tissue. c. 1910s–20s
Image: 9 1/16 x 7 1/8 in. (23.0 x 18.1 cm.)
Sheet: 9 7/8 x 8 in. (25.1 x 20.3 cm.)
Signed, l.r. print recto and l.r. overmat recto:
"Clara E. Sipprell"
Inscription, print verso: "IG38"
overmat recto: "John Cotton Dana"
Acquired from: gift of the Dorothea Leonhardt Fund of the
Communities Foundation of Texas, Inc., Dallas, Texas

4504. [John Finley, editor of the New York Times] (P1984.1.637)
Gelatin silver print. c. 1937
Image: 9 1/8 x 7 3/16 in. (23.2 x 18.2 cm.)
Acquired from: gift of the Dorothea Leonhardt Fund of the
Communities Foundation of Texas, Inc., Dallas, Texas

4505. JOHN FORSELL—DIRECTOR OF ROYAL OPERA
HOUSE, STOCKHOLM (P1984.1.119)
Gelatin silver print on Gevaluxe paper. negative 1938,
print c. 1938
Image: 9 5/8 x 7 5/8 in. (24.4 x 19.4 cm.)
Sheet: 9 15/16 x 8 in. (25.3 x 20.3 cm.)
Signed, l.r. overmat recto: "Clara E. Sipprell"
Inscription, print verso: "SP110"
overmat recto: "John Forsell—Director of Royal Opera
House/Stockholm"
mat backing verso: "S-P-51"
Acquired from: gift of the Dorothea Leonhardt Fund of the
Communities Foundation of Texas, Inc., Dallas, Texas

4490

4493

4499

4496

4503

*4506. **THE JOY OF LIVING** (P1984.1.225) duplicate of P1984.1.226
Gelatin silver print on tissue. negative 1927, print c. 1927
Image: 6¼ x 9⅛ in. (15.8 x 23.2 cm.) sight size
Sheet: 7⅞ x 9⅞ in. (20.0 x 25.1 cm.)
Signed, l.r. overmat recto: "Clara E. Sipprell"
Inscription, print verso: "C1"
 overmat recto, typed on paper label: "The Joy of Living"
 overmat verso: "C1"
Acquired from: gift of the Dorothea Leonhardt Fund of the
Communities Foundation of Texas, Inc., Dallas, Texas

4507. **THE JOY OF LIVING** (P1984.1.226) duplicate of P1984.1.225
Gelatin silver print on tissue. negative 1927, print c. 1927
Image: 7½ x 9½ in. (19.1 x 24.2 cm.)
Sheet: 7⅞ x 9⅞ in. (20.0 x 25.2 cm.)
Mount: 8 x 10 in. (20.3 x 25.4 cm.)
Signed, l.r. overmat recto: "Clara E. Sipprell"
Inscription, overmat recto, typed on paper label: "The Joy of
Living"
 mat backing verso: "Pf-54-a//Nina//C2"
Acquired from: gift of the Dorothea Leonhardt Fund of the
Communities Foundation of Texas, Inc., Dallas, Texas

4508. **JUNEFRUN—(THE MAIDEN) AT LICKERSHAMN,
GOTLAND** (P1984.1.581)
Gelatin silver print on Gevaluxe paper. c. 1938
Image: 9³⁄₁₆ x 7⁷⁄₁₆ in. (23.3 x 17.9 cm.) sight size
Signed, l.r. overmat recto: "Clara E. Sipprell"
Inscription, overmat recto: "Junefrun—(the maiden) at
Lickershamn, Gotland"
 mat backing verso: "S-L-21//G/Swedish Landscape//SwL7"
Acquired from: gift of the Dorothea Leonhardt Fund of the
Communities Foundation of Texas, Inc., Dallas, Texas

*4509. **KACHI HAIADA** (P1984.1.41)
Gelatin silver print on tissue. c. 1950s
Image: 8¼ x 6¼ in. (20.9 x 15.8 cm.)
Mount: 13 x 9 in. (33.1 x 23.0 cm.)
Signed, l.r. overmat recto and l.r. mount recto:
"Clara E. Sipprell"
Inscription, overmat recto: "Kachi Haiada"
 overmat verso: "Or18//Or18"
 mount verso: "Or18"
 mat backing verso: "Pf-213//Or18"
Acquired from: gift of the Dorothea Leonhardt Fund of the
Communities Foundation of Texas, Inc., Dallas, Texas

4510. **KATHY** [Kathy Helms] (P1984.1.230)
Gelatin silver print. c. 1950s
Image: 7⅛ x 6⅞ in. (18.1 x 17.4 cm.) sight size
Mount: 11 x 8½ in. (28.0 x 21.6 cm.)
Signed, l.r. overmat recto: "Clara E. Sipprell"
Inscription, overmat recto: "Kathy"
 overmat verso: "Pf-57B//C34"
 mount verso: "C34"
Acquired from: gift of the Dorothea Leonhardt Fund of the
Communities Foundation of Texas, Inc., Dallas, Texas

4511. **KATHY** [Kathy Helms] (P1984.1.231)
Gelatin silver print. c. 1950s
Image: 9⅛ x 7⅜ in. (23.2 x 18.7 cm.) sight size
Mount: 11 x 8½ in. (28.0 x 21.6 cm.)
Signed, l.r. overmat recto: "Clara E. Sipprell"
Inscription, overmat recto: "Kathy"
 overmat verso: "C33"
 mount verso: "C33"
Acquired from: gift of the Dorothea Leonhardt Fund of the
Communities Foundation of Texas, Inc., Dallas, Texas

4512. **KERSTIN HESSELGREN—MEMBER OF PARLIAMENT**
(P1984.1.177)
Gelatin silver print on Gevaluxe paper. negative 1938,
print c. 1938
Image: 9⅝ x 7⅝ in. (24.4 x 19.4 cm.)
Sheet: 10 x 8 in. (25.4 x 20.3 cm.)
Signed, l.r. overmat recto: "Clara E. Sipprell"

Inscription, print verso: "SP3"
 overmat recto: "Kerstin Hesselgren—Member of
Parliament"
 mat backing verso: "S-P-40//SP3"
Acquired from: gift of the Dorothea Leonhardt Fund of the
Communities Foundation of Texas, Inc., Dallas, Texas

4513. **KING GUSTAF VI ADOLF OF SWEDEN** [H.R.H. Gustav
Adolf, Crown Prince of Sweden, Ulriksdal] (P1984.1.125)
uncropped duplicate of P1984.1.126
Gelatin silver print. negative 1938, print c. 1938 or later
Image: 8⅞ x 7³⁄₁₆ in. (22.5 x 18.2 cm.) sight size
Mount: 9¹⁵⁄₁₆ x 8 in. (25.3 x 20.3 cm.)
Signed, l.r. overmat recto: "Clara E. Sipprell"
Inscription, overmat recto: "King Gustaf VI Adolf/of
Sweden"
 overmat verso: "SP80"
 mount verso: "SP80"
 note: a print of flowers is affixed to print verso
Acquired from: gift of the Dorothea Leonhardt Fund of the
Communities Foundation of Texas, Inc., Dallas, Texas

4514. **KOREAN DANCER** (P1984.1.42)
Gelatin silver print. c. 1940s
Image: 9 x 6¹⁵⁄₁₆ in. (22.8 x 17.6 cm.) sight size
Mount: 11 x 8⁹⁄₁₆ in. (28.0 x 21.8 cm.)
Signed, l.r. overmat recto: "Clara E. Sipprell"
Inscription, overmat recto: "Korean dancer"
 overmat verso: "Or20"
 mount verso: "Or20"
Acquired from: gift of the Dorothea Leonhardt Fund of the
Communities Foundation of Texas, Inc., Dallas, Texas

4515. **KRISHNA—INDIA** (P1984.1.110)
Gelatin silver print. c. 1950s–60s
Image: 9 x 6¹⁵⁄₁₆ in. (22.8 x 17.6 cm.) sight size
Signed, l.r. overmat recto: "Clara E. Sipprell"
Inscription, print verso: "I5"
 overmat recto: "Krishna/India"
 overmat verso: "I5"
 mat backing verso: "I-7//I5"
Acquired from: gift of the Dorothea Leonhardt Fund of the
Communities Foundation of Texas, Inc., Dallas, Texas

4516. **KYOHEI INUKAI** (P1984.1.44)
Gelatin silver print on tissue. c. 1950s
Image: 9⅝ x 7¹¹⁄₁₆ in. (24.4 x 19.5 cm.)
Sheet: 9⅞ x 8 in. (25.1 x 20.3 cm.)
Signed, l.r. old overmat recto: "Clara E. Sipprell"
Inscription, old overmat recto: "Kyohei Inukai"
 old overmat verso: "Or19//Or19"
 old mat backing verso: "O-10//Or19"
Acquired from: gift of the Dorothea Leonhardt Fund of the
Communities Foundation of Texas, Inc., Dallas, Texas

4517. **KYRKA NEAR MARIEFRED** (P1984.1.535)
Gelatin silver print on Gevaluxe paper. c. 1938
Image: 9⅝ x 7⁹⁄₁₆ in. (24.4 x 19.2 cm.)
Sheet: 10 x 8 in. (25.4 x 20.3 cm.)
Signed, l.r. overmat recto: "Clara E. Sipprell"
Inscription, print verso: "SA4"
 overmat recto: "Kyrka near Mariefred"
 mat backing verso: "S-L-10//Swedish Landscape//SA4"
Acquired from: gift of the Dorothea Leonhardt Fund of the
Communities Foundation of Texas, Inc., Dallas, Texas

4518. **KYRKSTALLAR—RÄTTVIK CHURCH—SUNSET—
DALECARLIA** (P1984.1.523)
Gelatin silver print on Gevaluxe paper. c. 1938
Image: 9⁹⁄₁₆ x 7⅝ in. (24.3 x 19.4 cm.)
Sheet: 9¹⁵⁄₁₆ x 8 in. (25.3 x 20.3 cm.)
Signed, l.r. overmat recto: "Clara E. Sipprell"
Inscription, overmat recto: "Kyrkstallar—Rattvik Church—
Sunset/Dalecarlia"
 overmat verso: "SA45"
 mat backing verso: "S-L-2//SA45"
Acquired from: gift of the Dorothea Leonhardt Fund of the
Communities Foundation of Texas, Inc., Dallas, Texas

4506

4519. **LAKE CHAPALA, MEXICO** (P1984.1.281)
Gelatin silver print on tissue. c. 1931
Image: 6 15/16 x 9 in. (17.6 x 22.8 cm.) sight size
Signed, l.r. overmat recto: "Clara E. Sipprell"
Inscription, overmat recto: "Lake Chapala/Mexico"
mat backing verso: "M-32//g Mexico//ML11"
Acquired from: gift of the Dorothea Leonhardt Fund of the
Communities Foundation of Texas, Inc., Dallas, Texas

*4520. **LAKE LOUISE AT DAWN** (P1984.1.343)
Gelatin silver print on tissue. c. 1929
Image: 7 x 8 15/16 in. (17.8 x 22.6 cm.) sight size
Signed, l.r. overmat recto: "Clara E. Sipprell"
Inscription, overmat recto: "Lake Louisa [sic]/at/Dawn"
mat backing verso: "WC-1//GP37" and rubber stamp
"CLARA E. SIPPRELL/ MANCHESTER,
VERMONT/200 West 16th St.—New York City"
Acquired from: gift of the Dorothea Leonhardt Fund of the
Communities Foundation of Texas, Inc., Dallas, Texas

4521. **THE LAKE OF THE FOUR CANTONS, LUZERNE**
(P1984.1.518)
Gelatin silver print on tissue. c. 1924
Image: 7 3/8 x 9 5/16 in. (18.7 x 23.7 cm.) sight size
Signed, l.r. overmat recto: "Clara E. Sipprell"
Inscription, print verso: "MisL5"
overmat recto, typed on paper label: "The Lake of the Four
Cantons/Luzerne"
overmat verso: "MisL5"
mat backing verso: "DL-101//MisL5"
Acquired from: gift of the Dorothea Leonhardt Fund of the
Communities Foundation of Texas, Inc., Dallas, Texas

4522. **THE LAKE OF THE FOUR CANTONS, LUZERNE**
(P1984.1.519)
Gelatin silver print on tissue. c. 1924
Image: 9 3/8 x 7 1/4 in. (23.8 x 18.4 cm.) sight size
Signed, l.r. overmat recto: "Clara E. Sipprell"
Inscription, print verso: "MisL4"
overmat recto, typed on paper label: "The Lake of the Four
Cantons/Luzerne"
overmat verso: "MisL4"
mat backing verso: "Pf-200//MisL4"
Acquired from: gift of the Dorothea Leonhardt Fund of the
Communities Foundation of Texas, Inc., Dallas, Texas

4509

4523. **LAKE PÁTZCUARO, MEXICO [Pátzcuaro, Mexico]**
(P1984.1.283) duplicate of P1984.1.284
Gelatin silver print on tissue. c. 1931
Image: 7 3/16 x 6 15/16 in. (18.2 x 17.6 cm.) sight size
Sheet: 8 x 10 1/8 in. (20.3 x 25.7 cm.)
Signed, l.r. overmat recto: "Clara E. Sipprell"
Inscription, overmat recto: "Lake Patzcuaro/Mexico//x"
overmat verso: "ML2"
Acquired from: gift of the Dorothea Leonhardt Fund of the
Communities Foundation of Texas, Inc., Dallas, Texas

4524. **[Landscape with mountains in background, birch trees in
foreground]** (P1984.1.399)
Gelatin silver print. n.d.
Image: 6 15/16 x 9 in. (17.6 x 22.8 cm.) sight size
Sheet: 8 x 10 in. (20.3 x 25.4 cm.)
Mount: same as sheet size
Inscription, overmat verso: "MisL3"
note: a print of Albert Schweitzer is affixed to print verso
Acquired from: gift of the Dorothea Leonhardt Fund of the
Communities Foundation of Texas, Inc., Dallas, Texas

4525. **[Landscape with river and tree]** (P1984.1.452)
Gelatin silver print. c. 1920s–30s
Image: 7 1/16 x 8 15/16 in. (17.9 x 22.6 cm.) sight size
Signed, l.r. overmat recto: "Clara E. Sipprell"
Inscription, mat backing verso: "V-L-1//VL32"
Acquired from: gift of the Dorothea Leonhardt Fund of the
Communities Foundation of Texas, Inc., Dallas, Texas

4520

4526. **[Landscape with road, trees, and houses]** (P1984.1.453)
Gelatin silver print. c. 1920s–30s
Image: 8 15/16 x 7 1/16 in. (22.6 x 17.9 cm.)
1st mount: 10 1/4 x 7 7/16 in. (26.0 x 18.9 cm.)
2nd mount: 18 x 13 in. (45.7 x 33.0 cm.)
Signed, l.r. 1st mount recto: "Clara E. Sipprell"
Inscription, 2nd mount verso: "VL-35//VL33" and rubber
stamp "CLARA E. SIPPRELL/MANCHESTER,
VERMONT/200 West 16th St.—New York City"
Acquired from: gift of the Dorothea Leonhardt Fund of the
Communities Foundation of Texas, Inc., Dallas, Texas

4527. **[Lantern and plate]** (P1984.1.517)
Gelatin silver print. c. 1930s
Image: 9 1/4 x 5 13/16 in. (23.5 x 14.8 cm.)
Mount: same as image size
Inscription, mount verso: "SL34/PF" and rubber stamp
"CLARA E. SIPPRELL/Manchester, Vermont"
mat backing verso: "SL34"
Acquired from: gift of the Dorothea Leonhardt Fund of the
Communities Foundation of Texas, Inc., Dallas, Texas

*4528. **[Large tree]** (P1984.1.33)
Gelatin silver print on tissue. c. 1920s–30s
Image: 9 1/8 x 7 1/8 in. (23.2 x 18.1 cm.) sight size
Sheet: 10 x 8 in. (25.4 x 20.3 cm.)
Signed, l.r. old overmat recto: "Clara E. Sipprell"
Inscription, mat backing verso: dealer's label
old mat backing verso: "DL-91B//PF"
Acquired from: gift of the Dorothea Leonhardt Fund of the
Communities Foundation of Texas, Inc., Dallas, Texas

4529. **THE LAST OF THE GUSLARS, HERZEGOVINA,
YUGOSLAVIA** (P1984.1.71)
Gelatin silver print. negative c. 1926, print later
Image: 8 15/16 x 6 15/16 in. (22.6 x 17.6 cm.) sight size
Mount: 11 x 8 1/2 in. (28.0 x 21.7 cm.)
Signed, l.r. overmat recto: "Clara E. Sipprell"
Inscription, overmat recto: "The last of the Guslars/
Hersgovina [sic]/Yugoslavia"
overmat verso: "Y7"
mount verso: "Y7"
Acquired from: gift of the Dorothea Leonhardt Fund of the
Communities Foundation of Texas, Inc., Dallas, Texas

4530. **THE LAST OF THE GUSLARS, YUGOSLAVIA**
(P1984.1.70)
Gelatin silver print. negative c. 1926, print later
Image: 8 7/8 x 7 7/16 in. (22.5 x 18.9 cm.) sight size
Mount: 11 x 8 1/2 in. (28.0 x 21.7 cm.)
Signed, l.r. overmat recto: "Clara E. Sipprell"
Inscription, overmat recto: "The last of the Guslars/
Yugoslavia"
overmat verso: "Y9"
mount verso: "Y9"
Acquired from: gift of the Dorothea Leonhardt Fund of the
Communities Foundation of Texas, Inc., Dallas, Texas

4531. **LATE AFTERNOON** (P1984.1.15) cropped duplicate of
P1984.1.245
Gelatin silver print. negative c. 1926, print later
Image: 6 13/16 x 8 15/16 in. (17.3 x 22.6 cm.) sight size
Sheet: 8 x 10 in. (20.3 x 25.4 cm.)
Signed, l.r. old overmat recto: "Clara E. Sipprell"
Inscription, print verso: "PF"
mat backing verso: "IG28" and dealer's label
old overmat recto: "Late afternoon"
old overmat verso: "Late Afternoon, Vermont/About 1926"
Acquired from: gift of the Dorothea Leonhardt Fund of the
Communities Foundation of Texas, Inc., Dallas, Texas

*4532. **LATE AFTERNOON** (P1984.1.245) uncropped duplicate of
P1984.1.15
Gelatin silver print. negative c. 1926, print later
Image: 6 13/16 x 8 7/8 in. (17.3 x 22.5 cm.) sight size
Mount: 8 1/2 x 11 in. (21.7 x 28.0 cm.)

Signed, l.r. overmat recto: "Clara E. Sipprell"
Inscription, overmat recto: "Late afternoon"
overmat verso: "MiS 13"
mount verso: "MiS 13"
Acquired from: gift of the Dorothea Leonhardt Fund of the
Communities Foundation of Texas, Inc., Dallas, Texas

4533. **LEAF DESIGN** (P1984.1.514)
Gelatin silver print on tissue. c. 1920s
Image: 9 1/4 x 7 1/8 in. (23.5 x 18.1 cm.) sight size
Signed, l.r. 1st overmat recto: "Clara E. Sipprell"
Inscription, 1st overmat recto, typed on paper label:
"Leaf Design"
1st mat backing verso: "S-L-15//SL21"
2nd mat backing verso: "Leaf Design/SL21" and dealer's
label
Acquired from: gift of the Dorothea Leonhardt Fund of the
Communities Foundation of Texas, Inc., Dallas, Texas

*4534. **LEARNING ABOUT FLOWERS [At 6 Months]**
(P1984.1.198) duplicate of P1984.1.197
Gelatin silver print on tissue. c. 1928
Image: 9 x 6 15/16 in. (22.8 x 17.6 cm.) sight size
Signed, l.r. overmat recto: "Clara E. Sipprell"
Inscription, print verso: "C6"
overmat recto, typed on paper label: "Learning About
Flowers"
mat backing verso: "Pf-1//Nina//C6"
Acquired from: gift of the Dorothea Leonhardt Fund of the
Communities Foundation of Texas, Inc., Dallas, Texas

4535. **LEKOMBERG (IRON MINE) BRUNNSVIK,
DALECARLIA** (P1984.1.550)
Gelatin silver print on Gevaluxe paper. c. 1938
Image: 9 1/2 x 7 9/16 in. (24.1 x 19.2 cm.)
Sheet: 9 15/16 x 8 in. (25.3 x 20.3 cm.)
Signed, l.r. old overmat recto: "Clara E. Sipprell"
Inscription, print verso: "SwL19"
old overmat recto: "Lekomberg (Iron mine) Brunswick
[sic]/Dalecarlia"
old overmat verso: "SwL19"
old mat backing verso: "S-L-3//SwL19"
Acquired from: gift of the Dorothea Leonhardt Fund of the
Communities Foundation of Texas, Inc., Dallas, Texas

4536. **LEKSAND, DALECARLIA IN JUNE** (P1984.1.554)
Gelatin silver print on Gevaluxe paper. c. 1938
Image: 8 7/16 x 7 1/8 in. (21.4 x 18.1 cm.) sight size
Signed, l.r. overmat recto: "Clara E. Sipprell"
Inscription, overmat recto: "Leksand/Dalecarlia in June"
mat backing verso: "S-L-11//g/Swedish Landscape//SwL15"
Acquired from: gift of the Dorothea Leonhardt Fund of the
Communities Foundation of Texas, Inc., Dallas, Texas

4537. **THE LIBRARY—WELLESLEY COLLEGE** (P1984.1.441)
Gelatin silver print on tissue. c. 1920s
Image: 9 9/16 x 7 1/4 in. (24.3 x 18.4 cm.) sight size
Signed, l.r. overmat recto: "Clara E. Sipprell"
Inscription, overmat recto, typed on paper label:
"The Library—Wellesley College"
mat backing verso: "WC-5//XII//WC5"
Acquired from: gift of the Dorothea Leonhardt Fund of the
Communities Foundation of Texas, Inc., Dallas, Texas

4538. **THE LITTLE MOTHER** (P1984.1.206)
Gelatin silver print on tissue. c. 1930
Image: 8 3/8 x 7 1/8 in. (21.3 x 18.1 cm.) sight size
Sheet: 10 x 7 7/8 in. (25.4 x 20.0 cm.)
Signed, l.r. overmat recto: "Clara E. Sipprell"
Inscription, print verso: "C18"
overmat recto: "The Little Mother"
overmat verso: "Pf-47-I//Nina//C18"
Acquired from: gift of the Dorothea Leonhardt Fund of the
Communities Foundation of Texas, Inc., Dallas, Texas

4539. **LITTLE MOTHER** (P1984.1.210)
Gelatin silver print. negative c. 1930, print later
Image: 8 ¹⁵⁄₁₆ x 7 ⁹⁄₁₆ in. (22.6 x 19.2 cm.) sight size
Sheet: 10 x 8 in. (25.4 x 20.3 cm.)
Mount: same as sheet size
Signed, l.r. overmat recto: "Clara E. Sipprell"
Inscription, overmat recto: "Little Mother"
 overmat verso: "PF-47-II//nina//C21"
 mount verso: "C21"
 note: a print of a newborn baby is affixed to print verso
Acquired from: gift of the Dorothea Leonhardt Fund of the
 Communities Foundation of Texas, Inc., Dallas, Texas

4540. **LITTLE SISTERS** (P1984.1.246)
Gelatin silver print on tissue. c. 1920s–30s
Image: 9 ¼ x 5 in. (23.5 x 12.7 cm.) sight size
Signed, l.r. overmat recto: "Clara E. Sipprell"
Inscription, print verso: "C35"
 overmat recto, typed on paper label: "LITTLE SISTERS"
 mat backing verso: "C-69//C35"
Acquired from: gift of the Dorothea Leonhardt Fund of the
 Communities Foundation of Texas, Inc., Dallas, Texas

4541. **A LITTLE TURKISH GIRL, PODGORICA,**
MONTENEGRO [Little Turkish Girl, Yugoslavia]
(P1984.1.80) duplicate of P1984.1.79
Gelatin silver print on tissue. c. 1926
Image: 8 ⁷⁄₁₆ x 6 ½ in. (21.4 x 16.5 cm.) sight size
Sheet: 9 ¹⁵⁄₁₆ x 7 ⅞ in. (25.2 x 20.0 cm.)
Signed, l.r. overmat recto: "Clara E. Sipprell"
Inscription, print verso: "C43"
 overmat recto, typed on paper label: "A little Turkish Girl/
 Podgorica, Montenegro"
 mat backing verso: "C43"
Acquired from: gift of the Dorothea Leonhardt Fund of the
 Communities Foundation of Texas, Inc., Dallas, Texas

4542. **LITTLE TURKISH GIRL, YUGOSLAVIA [A Little Turkish**
Girl, Podgorica, Montenegro] (P1984.1.79) duplicate of
P1984.1.80
Gelatin silver print. negative c. 1926, print later
Image: 9 x 6 ⅞ in. (22.8 x 17.4 cm.) sight size
Signed, l.r. overmat recto: "Clara E. Sipprell"
Inscription, overmat recto: "Little Turkish Girl/Yugoslavia"
 overmat verso: "C44"
 mount verso: "C44"
Acquired from: gift of the Dorothea Leonhardt Fund of the
 Communities Foundation of Texas, Inc., Dallas, Texas

4543. **LIVE OAKS, GEORGIA** (P1984.1.379) duplicate of
P1984.1.380
Gelatin silver print on Gevaluxe paper. c. 1942 or before
Image: 8 ¹⁵⁄₁₆ x 6 ¹⁵⁄₁₆ in. (22.6 x 17.6 cm.) sight size
Signed, l.r. overmat recto: "Clara E. Sipprell"
Inscription, overmat recto: "Live oaks/Georgia"
 mat backing verso: "Pf-208//LS3"
Acquired from: gift of the Dorothea Leonhardt Fund of the
 Communities Foundation of Texas, Inc., Dallas, Texas

4544. **LIVE OAKS, GEORGIA** (P1984.1.380) duplicate of
P1984.1.379
Gelatin silver print. negative c. 1942 or before, print later
Image: 8 ¹⁵⁄₁₆ x 7 ½ in. (22.6 x 19.0 cm.) sight size
Sheet: 9 ¹⁵⁄₁₆ x 8 in. (25.3 x 20.3 cm.)
Signed, l.r. overmat recto: "Clara E. Sipprell"
Inscription, print verso: "LS5"
 overmat recto: "Live oaks/Georgia//x"
 overmat verso: "LS4"
Acquired from: gift of the Dorothea Leonhardt Fund of the
 Communities Foundation of Texas, Inc., Dallas, Texas

4528

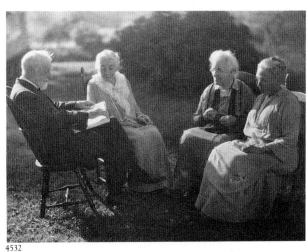
4532

4534

*4545. **LIVEOAKS, GEORGIA** (P1984.1.378)
Gelatin silver print on Gevaluxe paper. c. 1940s
Image: 9 x 6 15/16 in. (22.8 x 17.6 cm.) sight size
Signed, l.r. overmat recto: "Clara E. Sipprell"
Inscription, overmat recto: "Liveoaks/Georgia"
 mat backing recto: "Giovanni Martinelli"
 mat backing verso: "Pf-209//LS2"
Acquired from: gift of the Dorothea Leonhardt Fund of the
 Communities Foundation of Texas, Inc., Dallas, Texas

*4546. **LIVERPOOL HAZARD—108 YEARS OLD** (P1984.1.88)
 duplicate of P1984.1.87
Gelatin silver print. negative c. 1930–42, print later
Image: 7 1/8 x 8 7/8 in. (18.1 x 22.5 cm.) sight size
Mount: 8 1/2 x 11 in. (21.6 x 28.0 cm.)
Signed, l.r. overmat recto: "Clara E. Sipprell"
Inscription, overmat recto: "x//Liverpool Hazard—/
 108 years old"
 overmat verso: "B11"
 mount verso: "B11"
Acquired from: gift of the Dorothea Leonhardt Fund of the
 Communities Foundation of Texas, Inc., Dallas, Texas

4547. **LIVERPOOL HAZARD—108 YEARS OLD—GEORGIA**
 (P1984.1.87) duplicate of P1984.1.88
Gelatin silver print. negative c. 1930–42, print later
Image: 7 1/2 x 9 7/16 in. (19.0 x 24.0 cm.)
1st mount: same as image size
2nd mount: 20 x 14 1/2 in. (50.8 x 36.8 cm.)
Signed, l.r. 2nd mount recto: "Clara E. Sipprell"
Inscription, 2nd mount recto: "Liverpool Hazard—
 108 years old/Georgia"
 2nd mount verso: "AB-14//ADL 7"
Acquired from: gift of the Dorothea Leonhardt Fund of the
 Communities Foundation of Texas, Inc., Dallas, Texas

*4548. **LORADO TAFT AND HIS FOUNTAIN OF TIME**
 (P1984.1.254) duplicate of P1984.1.255 and P1984.1.256
Gelatin silver print. negative 1920, print c. 1921
Image: 8 7/8 x 7 1/4 in. (22.5 x 18.4 cm.) sight size
Signed, l.r. overmat recto: "Clara E. Sipprell"
Inscription, overmat recto: "Lorado Taft/and his/Fountain
 of Time"
 mat backing verso: "IG 37"
Acquired from: gift of the Dorothea Leonhardt Fund of the
 Communities Foundation of Texas, Inc., Dallas, Texas

4549. **LORADO TAFT, SECTION OF HIS FOUNTAIN OF
 TIME** (P1984.1.256) duplicate of P1984.1.254 and
 P1984.1.255
Gelatin silver print. negative 1920, print later
Image: 8 15/16 x 6 7/8 in. (22.6 x 17.4 cm.) sight size
2nd mount: 12 15/16 x 11 in. (33.0 x 27.9 cm.)
note: the 1st mount is glued to the overmat and cannot
 be measured; however, the signature on the 1st mount
 is visible
Signed, l.r. 1st mount recto and l.r. overmat recto:
 "Clara E. Sipprell"
Inscription, overmat recto: "Lorado Taft/Section of his/
 Fountain of Time"
 overmat verso: "MiS14"
 2nd mount verso: "MiS 14"
Acquired from: gift of the Dorothea Leonhardt Fund of the
 Communities Foundation of Texas, Inc., Dallas, Texas

4550. **LORADO TAFT WITH A SECTION OF HIS FOUNTAIN
 OF TIME** (P1984.1.255) duplicate of P1984.1.254 and
 P1984.1.256
Gelatin silver print. 1920
Image: 9 11/16 x 7 11/16 in. (24.6 x 19.5 cm.)
Sheet: 10 x 8 in. (25.4 x 20.3 cm.)
Signed, l.r. old overmat recto: "Clara E. Sipprell"
Inscription, old overmat recto: "Lorado Taft" and typed on
 paper label "Lorado Taft with a section/of his Fountain
 of Time."
 old mat backing verso: "AP-M-2//g Bookselection//MiS15"

Acquired from: gift of the Dorothea Leonhardt Fund of the
 Communities Foundation of Texas, Inc., Dallas, Texas

*4551. **[Madame Brezhkovsky]** (P1984.1.611)
Gelatin silver print. c. 1925
Image: 6 7/16 x 4 1/2 in. (16.3 x 11.4 cm.)
Mount: 7 13/16 x 5 5/16 in. (19.9 x 13.5 cm.)
Signed, l.r. mount recto: "Clara E. Sipprell"
Acquired from: gift of the Dorothea Leonhardt Fund of the
 Communities Foundation of Texas, Inc., Dallas, Texas

4552. **[Madame Brezhkovsky]** (P1984.1.686)
Gelatin silver print. c. 1925
Image: 8 1/8 x 6 in. (20.6 x 15.2 cm.)
Mount: 9 1/16 x 6 5/8 in. (23.0 x 16.8 cm.)
Acquired from: gift of the Dorothea Leonhardt Fund of the
 Communities Foundation of Texas, Inc., Dallas, Texas

4553. **THE MAGNOLIA GARDENS, GEORGIA** (P1984.1.382)
 duplicate of P1984.1.381
Gelatin silver print. c. 1940s–50s
Image: 8 15/16 x 7 1/2 in. (22.6 x 19.0 cm.) sight size
Sheet: 9 15/16 x 7 15/16 in. (25.3 x 20.2 cm.)
Mount: same as sheet size
Signed, l.r. overmat recto: "Clara E. Sipprell"
Inscription, overmat recto: "The Magnolia Gardens/
 Georgia [sic]"
 overmat verso: "LS6"
 note: a print of trees and beach is affixed to print verso
Acquired from: gift of the Dorothea Leonhardt Fund of the
 Communities Foundation of Texas, Inc., Dallas, Texas

*4554. **MAGNOLIA GARDENS, SOUTH CAROLINA**
 (P1984.1.381) duplicate of P1984.1.382
Gelatin silver print. c. 1940s–50s
Image: 9 x 6 15/16 in. (22.8 x 17.6 cm.) sight size
Sheet: 10 x 7 15/16 in. (25.4 x 20.2 cm.)
Mount: same as sheet size
Signed, l.r. overmat recto: "Clara E. Sipprell"
Inscription, overmat recto: "Magnolia Gardens/
 South Carolina [sic]"
 overmat verso: "Pf-192//g/chest//LS5"
 mount verso: "LS5"
Acquired from: gift of the Dorothea Leonhardt Fund of the
 Communities Foundation of Texas, Inc., Dallas, Texas

4555. **MALVINA HOFFMAN, SCULPTOR** (P1984.1.263)
Gelatin silver print. negative c. 1928, print later
Image: 9 3/16 x 7 1/2 in. (23.3 x 19.0 cm.) sight size
Sheet: 9 7/8 x 8 in. (25.1 x 20.3 cm.)
Signed, l.r. overmat recto: "Clara E. Sipprell"
Inscription, print verso: "MiS10"
 overmat recto: "Malvina Hoffman/sculptor//x"
 overmat verso: "MiS 10"
Acquired from: gift of the Dorothea Leonhardt Fund of the
 Communities Foundation of Texas, Inc., Dallas, Texas

4556. **MANCHESTER STREET** (P1984.1.469)
Gelatin silver print. c. 1940s
Image: 8 7/8 x 7 3/16 in. (22.5 x 18.2 cm.) sight size
Signed, l.r. overmat recto: "Clara E. Sipprell"
Inscription, overmat recto: "Manchester Street"
 mat backing verso: "V-L-18//VL10"
Acquired from: gift of the Dorothea Leonhardt Fund of the
 Communities Foundation of Texas, Inc., Dallas, Texas

4557. **MANCHESTER STREET IN OCTOBER** (P1984.1.471)
Gelatin silver print. c. 1940s–50s
Image: 9 7/16 x 7 9/16 in. (24.0 x 19.2 cm.)
Sheet: 9 15/16 x 8 in. (25.3 x 20.3 cm.)
Signed, l.r. overmat recto: "Clara E. Sipprell"
Inscription, overmat recto: "Manchester Street in October"
 mat backing verso: "VL11"
Acquired from: gift of the Dorothea Leonhardt Fund of the
 Communities Foundation of Texas, Inc., Dallas, Texas

4545

4546

4548

4551

4554

4558. **MANCHESTER—VERMONT** (P1984.1.478)
Gelatin silver print. c. 1940s–50s
Image: 8 ⅞ x 7 ¼ in. (22.5 x 18.4 cm.) sight size
Signed, l.r. overmat recto: "Clara E. Sipprell"
Inscription, overmat recto: "Manchester—Vermont"
 mat backing verso: "AA15"
Acquired from: gift of the Dorothea Leonhardt Fund of the
 Communities Foundation of Texas, Inc., Dallas, Texas

4559. **MAPLES—WOODSTOCK—VERMONT** (P1984.1.432)
Gelatin silver print. c. 1940s–50s
Image: 9 ⅛ x 7 3/16 in. (23.2 x 18.2 cm.) sight size
Signed, l.r. overmat recto: "Clara E. Sipprell"
Inscription, print verso: "VL26"
 overmat recto: "Maples/Woodstock—Vermont"
 overmat verso: "VL26"
 mat backing verso: "V-L-31//VL26"
Acquired from: gift of the Dorothea Leonhardt Fund of the
 Communities Foundation of Texas, Inc., Dallas, Texas

4560. **MARGARITA HAGELIN** (P1984.1.174)
Gelatin silver print. negative 1938, print c. 1938 or later
Image: 9 x 7 ⅛ in. (22.8 x 18.1 cm.) sight size
Sheet: 9 15/16 x 7 15/16 in. (25.3 x 20.2 cm.)
Signed, l.r. overmat recto: "Clara E. Sipprell"
Inscription, print verso: "SP23"
 overmat recto: "Margarita Hagelin"
 mat backing verso: "S-P-9//SP23"
Acquired from: gift of the Dorothea Leonhardt Fund of the
 Communities Foundation of Texas, Inc., Dallas, Texas

4561. **MARKET AT URUAPAN, MEXICO** (P1984.1.299) duplicate
 of P1984.1.666
Gelatin silver print on tissue. c. 1931
Image: 9 ⅛ x 7 ⅛ in. (23.2 x 18.1 cm.) sight size
Signed, l.r. overmat recto: "Clara E. Sipprell"
Inscription, overmat recto, typed on paper label: "Market at
 Uruapa [sic]/Mexico"
 mat backing verso: "M-14-a//g Mexico//MEX3"
Acquired from: gift of the Dorothea Leonhardt Fund of the
 Communities Foundation of Texas, Inc., Dallas, Texas

4562. **MARKET AT URUAPAN, MEXICO** (P1984.1.666) duplicate
 of P1984.1.299
Gelatin silver print on tissue. c. 1931
Image: 9 ½ x 7 9/16 in. (24.1 x 19.2 cm.)
Sheet: 10 x 7 15/16 in. (25.4 x 20.2 cm.)
Acquired from: gift of the Dorothea Leonhardt Fund of the
 Communities Foundation of Texas, Inc., Dallas, Texas

4563. **MARKET IN CONTRERAS, MEXICO** (P1984.1.307)
Gelatin silver print. negative c. 1931, print later
Image: 9 ⅜ x 7 ½ in. (23.8 x 19.0 cm.)
Signed, l.r. old 1st mount recto: "Clara E. Sipprell"
Inscription, old 2nd mount verso: "M-17//Market in Contreas
 [sic]/Mexico//MEX 12"
Acquired from: gift of the Dorothea Leonhardt Fund of the
 Communities Foundation of Texas, Inc., Dallas, Texas

*4564. **MARKET IN OAXACA, MEXICO** (P1984.1.309) duplicate
 of P1984.1.310
Gelatin silver print on tissue. c. 1931
Image: 9 3/16 x 7 3/16 in. (23.3 x 18.2 cm.) sight size
Signed, l.r. overmat recto: "Clara E. Sipprell"
Inscription, print verso: "MEX25"
 overmat recto: "Market in Oaxaca/Mexico"
 mat backing verso: "M-24-a//g Mexico//MEX25"
Acquired from: gift of the Dorothea Leonhardt Fund of the
 Communities Foundation of Texas, Inc., Dallas, Texas

4565. **MARKET IN OAXACA, MEXICO** (P1984.1.310) duplicate of
 P1984.1.309
Gelatin silver print on tissue. c. 1931

Image: 9 3/16 x 7 3/16 in. (23.3 x 18.2 cm.) sight size
Signed, l.r. overmat recto: "Clara E. Sipprell"
Inscription, overmat recto: "Market in Oaxaca" and typed on
 paper label "Market in Oaxaca/Mexico"
 mat backing verso: "M-24-b//MEX24"
Acquired from: gift of the Dorothea Leonhardt Fund of the
 Communities Foundation of Texas, Inc., Dallas, Texas

4566. **MARKET ON THE PLAZA, TEPIC, MEXICO**
 (P1984.1.314)
Gelatin silver print on tissue. c. 1931
Image: 9 3/16 x 6 15/16 in. (23.3 x 17.6 cm.) sight size
Signed, l.r. overmat recto: "Clara E. Sipprell"
Inscription, overmat recto, typed on paper label: "Market on
 the Plaza/Tepic, Mexico."
 mat backing verso: "M-13//g Mexico//MEX20"
Acquired from: gift of the Dorothea Leonhardt Fund of the
 Communities Foundation of Texas, Inc., Dallas, Texas

4567. **MARKET PLACE, ZAGREB, YUGOSLAVIA** (P1984.1.579)
Gelatin silver print. negative c. 1926, print later
Image: 8 15/16 x 7 in. (22.6 x 17.8 cm.) sight size
Sheet: 10 x 8 in. (25.4 x 20.3 cm.)
Signed, l.r. overmat recto: "Clara E. Sipprell"
Inscription, print verso: "Y33"
 overmat recto: "Market Place/Zagreb, Yugoslavia"
 mat backing verso: "D-L-26-A//Y33"
Acquired from: gift of the Dorothea Leonhardt Fund of the
 Communities Foundation of Texas, Inc., Dallas, Texas

4568. **MASAYA FUJIMA II, CHOREOGRAPHER-DANCER,
 KABUKI DANCERS** (P1984.1.58)
Gelatin silver print. 1954
Image: 9 ⅛ x 7 7/16 in. (23.2 x 18.9 cm.) sight size
Sheet: 9 15/16 x 8 in. (25.3 x 20.3 cm.)
Mount: same as sheet size
Signed, l.r. overmat recto: "Clara E. Sipprell/1954"
Inscription, overmat recto: "Masaya Fujima II/
 Choreographer-dancer/Kabuki Dancers"
 overmat verso: "Or8//Or8"
 mount verso: "Or8"
 note: a print of a family group is affixed to print verso
Acquired from: gift of the Dorothea Leonhardt Fund of the
 Communities Foundation of Texas, Inc., Dallas, Texas

4569. **[Max Weber]** (P1984.1.629) duplicate of P1984.1.630
Gelatin silver print. c. 1922
Image: 9 ¼ x 7 ½ in. (23.5 x 19.0 cm.)
Mount: 10 ¾ x 8 ¼ in. (27.3 x 20.9 cm.)
Acquired from: gift of the Dorothea Leonhardt Fund of the
 Communities Foundation of Texas, Inc., Dallas, Texas

*4570. **[Max Weber]** (P1984.1.630) duplicate of P1984.1.629
Gelatin silver print. c. 1922
Image: 9 7/16 x 7 ⅜ in. (24.0 x 18.7 cm.)
Mount: 11 x 8 5/16 in. (28.0 x 21.1 cm.)
Signed, l.r. mount recto: "Clara E. Sipprell"
Acquired from: gift of the Dorothea Leonhardt Fund of the
 Communities Foundation of Texas, Inc., Dallas, Texas

*4571. **MAXFIELD PARRISH** (P1984.1.616)
Gelatin silver print on tissue. c. 1923
Image: 7 x 4 ⅞ in. (17.8 x 12.4 cm.)
1st mount: 8 ¾ x 7 ⅛ in. (22.2 x 18.1 cm.)
2nd mount: 10 9/16 x 7 13/16 in. (26.8 x 19.8 cm.)
3rd mount: 10 ¾ x 8 in. (27.3 x 20.3 cm.)
Signed, l.r. 2nd mount recto: "Clara E. Sipprell"
Inscription, 1st mount recto: "mat/11 x 14"
 3rd mount verso: "IG23/MAXFIELD PARRISH//PF" and
 rubber stamp "Photograph by/CLARA E. SIPPRELL/70
 Morningside Drive/New York."
Acquired from: gift of the Dorothea Leonhardt Fund of the
 Communities Foundation of Texas, Inc., Dallas, Texas

4564

4570

4571

4575

4577

4572. **MEDIAEVAL STORE HOUSE IN GRÖTLINGBO PARISH—GOTLAND** (P1984.1.529)
Gelatin silver print on Gevaluxe paper. c. 1938
Image: 7 9/16 x 9 9/16 in. (19.2 x 24.3 cm.)
Sheet: 8 x 9 15/16 in. (20.3 x 25.3 cm.)
Signed, l.r. old overmat recto: "Clara E. Sipprell"
Inscription, print verso: "SA24"
 old overmat recto: "Mediaeval Store house in/Grötlingbo parish—Gotland"
 old overmat verso: "SA24"
 old mat backing verso: "S-L-25//SA24"
Acquired from: gift of the Dorothea Leonhardt Fund of the Communities Foundation of Texas, Inc., Dallas, Texas

4573. **THE MEETING OF THE SAVA AND THE DANUBE, YUGOSLAVIA** (P1984.1.600)
Gelatin silver print. negative c. 1926, print 1964
Image: 6 7/8 x 8 5/16 in. (17.8 x 21.1 cm.)
Mount: 13 1/8 x 10 13/16 in. (33.4 x 27.5 cm.)
Signed, l.r. overmat recto: "Clara E. Sipprell/1964"
Inscription, overmat recto: "The meeting of the Sava/and the Danube/Yugoslavia"
 overmat verso: "YL23"
 mount verso: "YL23"
Acquired from: gift of the Dorothea Leonhardt Fund of the Communities Foundation of Texas, Inc., Dallas, Texas

4574. **[Mestrovic, Yugoslavia's great sculptor]** (P1984.1.621)
Gelatin silver print on tissue. c. 1926
Image: 9 5/8 x 7 1/2 in. (24.4 x 19.0 cm.)
Sheet: 9 15/16 x 8 1/16 in. (25.3 x 20.5 cm.)
Acquired from: gift of the Dorothea Leonhardt Fund of the Communities Foundation of Texas, Inc., Dallas, Texas

*4575. **MEXICAN VILLAGE, MICHOACÁN, MEXICO** (P1984.1.279)
Gelatin silver print on tissue. c. 1931
Image: 7 3/16 x 9 3/16 in. (18.2 x 23.3 cm.) sight size
Signed, l.r. overmat recto: "Clara E. Sipprell"
Inscription, overmat recto, typed on paper label: "Mexican Village/Michoacan, Mexico"
 mat backing verso: "M-29//g Mexico//ML9"
Acquired from: gift of the Dorothea Leonhardt Fund of the Communities Foundation of Texas, Inc., Dallas, Texas

4576. **[Michel Fokine, choreographer]** (P1984.1.625)
Gelatin silver print. c. 1925
Image: 9 1/8 x 7 in. (23.2 x 17.8 cm.)
Acquired from: gift of the Dorothea Leonhardt Fund of the Communities Foundation of Texas, Inc., Dallas, Texas

*4577. **MISS A. SLADE'S GARDEN, CORNISH, N. H.** (P1984.1.480)
Gelatin silver print on tissue. c. 1925
Image: 9 x 7 3/16 in. (22.8 x 18.2 cm.) sight size
Mount: 11 3/4 x 9 in. (29.8 x 22.8 cm.)
Signed, l.r. overmat recto: "Clara E. Sipprell"
Inscription, overmat recto, typed on paper label: "Miss A. Slade's Garden/Cornish, N. H."
 mount verso: "AA16"
 mat backing verso: "A-L-12//AA16"
Acquired from: gift of the Dorothea Leonhardt Fund of the Communities Foundation of Texas, Inc., Dallas, Texas

4578. **[Miss Louise Green]** (P1984.1.608)
Gelatin silver print. c. 1918
Image: 8 x 5 9/16 in. (20.3 x 14.1 cm.)
Mount: 9 1/4 x 6 3/8 in. (23.5 x 16.2 cm.)
Signed, l.r. mount recto: "Clara E. Sipprell"
Acquired from: gift of the Dorothea Leonhardt Fund of the Communities Foundation of Texas, Inc., Dallas, Texas

*4579. **[Mr. and Mrs. Duncan Phillips]** (P1984.1.650)
Gelatin silver print. c. 1920s
Image: 7 5/16 x 9 1/4 in. (18.5 x 23.5 cm.)
Acquired from: gift of the Dorothea Leonhardt Fund of the Communities Foundation of Texas, Inc., Dallas, Texas

4580. **[Mr. and Mrs. Henry Lanier]** (P1984.1.648)
Platinum print. c. 1914
Image: 7 3/16 x 9 in. (18.2 x 22.8 cm.)
Mount: 7 13/16 x 9 1/2 in. (19.8 x 24.1 cm.)
Signed, l.r. mount recto: "Clara E. Sipprell"
Acquired from: gift of the Dorothea Leonhardt Fund of the Communities Foundation of Texas, Inc., Dallas, Texas

4581. **MRS. ARAI** (P1984.1.49)
Gelatin silver print. c. 1950s
Image: 9 11/16 x 7 3/4 in. (24.6 x 19.7 cm.)
Sheet: 10 x 8 in. (25.4 x 20.3 cm.)
Signed, l.r. overmat recto: "Clara E. Sipprell"
Inscription, print verso: "OR9"
 overmat recto: "Mrs. Arai"
 overmat verso: "Or9//Or9"
 mat backing verso: "O-9-II//Or9"
 note: an unknown print is affixed to print verso
Acquired from: gift of the Dorothea Leonhardt Fund of the Communities Foundation of Texas, Inc., Dallas, Texas

4582. **MRS. ARAI—FLOWER ARRANGEMENTS** (P1984.1.60)
Gelatin silver print. c. 1950s
Image: 9 3/16 x 7 7/16 in. (23.3 x 18.9 cm.) sight size
Sheet: 10 x 8 in. (25.4 x 20.3 cm.)
Mount: same as sheet size
Signed, l.r. overmat recto: "Clara E. Sipprell"
Inscription, overmat recto: "Mrs. Arai/flower arrangements"
 overmat verso: "OR2//or2"
 mount verso: "OR2"
 note: a duplicate print is affixed to print verso
Acquired from: gift of the Dorothea Leonhardt Fund of the Communities Foundation of Texas, Inc., Dallas, Texas

4583. **MRS. FREDERICK WALDMAN** (P1984.1.259)
Gelatin silver print. c. 1950s
Image: 9 5/8 x 7 9/16 in. (24.4 x 19.2 cm.)
Sheet: 9 15/16 x 7 15/16 in. (25.3 x 20.2 cm.)
Mount: same as sheet size
Signed, l.r. overmat recto: "Clara E. Sipprell"
Inscription, overmat recto: "Mrs. Frederick Waldman"
 mount verso: "MiS2"
 note: a print of a young girl is affixed to print verso
Acquired from: gift of the Dorothea Leonhardt Fund of the Communities Foundation of Texas, Inc., Dallas, Texas

4584. **MRS. GIDEON SMITH, HAMPTON INSTITUTE, VIRGINIA** (P1984.1.84)
Gelatin silver print. c. 1940s–60s
Image: 8 15/16 x 7 in. (22.6 x 17.8 cm.) sight size
Signed, l.r. overmat recto: "Clara E. Sipprell"
Inscription, print verso: "Bl11"
 overmat recto: "Mrs. Gideon Smith/Hampton Institute/ Virginia"
 overmat verso: "Bl11"
 mat backing verso: "A-B-1//Bl11"
Acquired from: gift of the Dorothea Leonhardt Fund of the Communities Foundation of Texas, Inc., Dallas, Texas

4585. **MRS. JU** (P1984.1.37)
Gelatin silver print. c. 1950s
Image: 7 5/8 x 6 5/8 in. (19.4 x 16.8 cm.) sight size
Mount: 9 3/16 x 7 7/16 in. (23.4 x 18.9 cm.)
Signed, l.r. overmat recto: "Clara E. Sipprell/1935 [sic]"
Inscription, overmat recto: "Mrs. Ju"
 overmat verso: "Or24"
 mount verso: "Or24"
Acquired from: gift of the Dorothea Leonhardt Fund of the Communities Foundation of Texas, Inc., Dallas, Texas

*4586. **[Mrs. Margarita Konenkov, Irina Khrabroff, Nadiejhda Plevitskaya, Sergei Konenkov, and Clara Sipprell]** (P1984.1.646)
Gelatin silver print. c. 1925

Image: 7 ½ x 9 ¼ in. (19.0 x 23.5 cm.)
Sheet: 7 ¹⁵/₁₆ x 9 ⅞ in. (20.2 x 25.1 cm.)
Inscription, print verso: "Clara Sipprell, Sergei Konenkov,
 Nadiejda Plevitzkaya [sic] (Moscow Art Theatre) Irena
 Krobroff [sic]/seated woman?/Sergei Konenkov's studio/
 ca. 1925//ADL 36"
Acquired from: gift of the Dorothea Leonhardt Fund of the
 Communities Foundation of Texas, Inc., Dallas, Texas

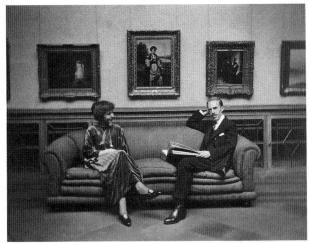

4579

4587. **MRS. PANDIT** (P1984.1.103) duplicate of P1984.1.102
 Gelatin silver print. c. 1950s–60s
 Image: 8 ¹³/₁₆ x 6 ⅞ in. (22.4 x 17.4 cm.) sight size
 Sheet: 10 x 8 in. (25.4 x 20.3 cm.)
 Mount: same as sheet size
 Signed, l.r. 1st overmat recto and l.r. 2nd overmat recto:
 "Clara E. Sipprell"
 Inscription, 1st overmat recto: "Mrs. Pandit"
 2nd overmat recto: "Mrs. Pandit//x"
 1st overmat verso: "I12"
 mount verso: "I12"
 note: another print of Mrs. Pandit is affixed to print verso
 Acquired from: gift of the Dorothea Leonhardt Fund of the
 Communities Foundation of Texas, Inc., Dallas, Texas

4588. **MRS. PANDIT, INDIAN AMBASSADOR TO U.S. IN 1949**
 (P1984.1.102) duplicate of P1984.1.103
 Gelatin silver print. c. 1950s–60s
 Image: 7 ¹¹/₁₆ x 6 ¹⁵/₁₆ in. (19.5 x 17.6 cm.) sight size
 Sheet: 9 ⅞ x 7 ¹⁵/₁₆ in. (25.1 x 20.2 cm.)
 Signed, l.r. overmat recto: "Clara E. Sipprell"
 Inscription, print verso: "Residence/Hotarb 4300/~~Hoylus~~/&/
 Oliver/Hoylen Ave/3000 Conn.//I13"
 overmat recto: "x//Mrs. Pandit/Indian Ambassador to
 U.S./in 1949"
 overmat verso: "I13"
 Acquired from: gift of the Dorothea Leonhardt Fund of the
 Communities Foundation of Texas, Inc., Dallas, Texas

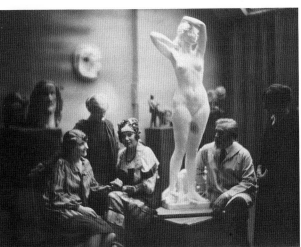

4586

4589. **MRS. SUN, DAUGHTER-IN-LAW OF SUN YAT SEN,
 CHINA** (P1984.1.53)
 Gelatin silver print. c. 1950s
 Image: 8 ⅞ x 6 ¹⁵/₁₆ in. (22.5 x 17.6 cm.) sight size
 Sheet: 9 ⅞ x 7 ⅞ in. (25.1 x 20.0 cm.)
 Signed, l.r. overmat recto: "Clara E. Sipprell"
 Inscription, print verso: "Or13"
 overmat recto: "Mrs. Sun/daughter-in-law of Sun Yat Sen/
 China"
 overmat verso: "Or13//Or13"
 mat backing verso: "O-8//Or13"
 Acquired from: gift of the Dorothea Leonhardt Fund of the
 Communities Foundation of Texas, Inc., Dallas, Texas

4590. **MRS. THEODORE ROOSEVELT, JR.** (P1984.1.613)
 Gelatin silver print. c. 1925
 Image: 9 ¼ x 6 ¾ in. (23.5 x 17.1 cm.)
 Mount: 10 ⅝ x 7 ½ in. (26.9 x 19.0 cm.)
 Signed, l.r. mount recto: "Clara E. Sipprell"
 Inscription, mount recto: "Mrs. Theodore Roosevelt, Jr."
 Acquired from: gift of the Dorothea Leonhardt Fund of the
 Communities Foundation of Texas, Inc., Dallas, Texas

4591. **MRS. WYMAN, OUR VERMONT NEIGHBOR**
 (P1984.1.262)
 Gelatin silver print. c. 1950s–60s
 Image: 8 ¹⁵/₁₆ x 7 ⁷/₁₆ in. (22.6 x 18.9 cm.) sight size
 Sheet: 9 ¹⁵/₁₆ x 8 in. (25.3 x 20.3 cm.)
 Mount: same as sheet size
 Signed, l.r. overmat recto: "Clara E. Sipprell"
 Inscription, overmat recto: "Mrs. Wyman/our Vermont
 neighbor"
 overmat verso: "ADL 3"
 note: a print of a man standing is affixed to print verso
 Acquired from: gift of the Dorothea Leonhardt Fund of the
 Communities Foundation of Texas, Inc., Dallas, Texas

4593

4592. **[Monsignor]** (P1984.1.632)
Gelatin silver print. c. 1922
Image: 9 9/16 x 7 5/8 in. (24.3 x 19.4 cm.)
Sheet: 10 x 7 15/16 in. (25.4 x 20.2 cm.)
Acquired from: gift of the Dorothea Leonhardt Fund of the
 Communities Foundation of Texas, Inc., Dallas, Texas

*4593. **MONTENEGRIN TYPE** (P1984.1.72)
Gelatin silver print on tissue. c. 1926
Image: 9 3/16 x 7 3/16 in. (23.3 x 18.2 cm.) sight size
Sheet: 10 x 8 in. (25.4 x 20.3 cm.)
Signed, l.r. overmat recto: "Clara E. Sipprell"
Inscription, print verso: "Y12"
 overmat recto, typed on paper label: "Montenegrin Type"
 mat backing verso: "Y12"
Acquired from: gift of the Dorothea Leonhardt Fund of the
 Communities Foundation of Texas, Inc., Dallas, Texas

4594. **A MONTENEGRIN VILLAGE—SUBURB OF CETINJE**
(P1984.1.572)
Gelatin silver print on tissue. c. 1926
Image: 7 3/16 x 9 3/16 in. (18.2 x 23.3 cm.) sight size
Signed, l.r. overmat recto: "Clara E. Sipprell"
Inscription, overmat recto: "Suburb of Cetenje [sic]" and
 typed on paper label "A Montenegrin Village"
 mat backing verso: "DL-92//YA18"
Acquired from: gift of the Dorothea Leonhardt Fund of the
 Communities Foundation of Texas, Inc., Dallas, Texas

4595. **MONTENEGRO** (P1984.1.603)
Gelatin silver print on tissue. c. 1926
Image: 8 7/8 x 6 15/16 in. (22.5 x 17.6 cm.) sight size
Sheet: 10 1/8 x 8 in. (25.7 x 20.3 cm.)
Signed, l.r. overmat recto: "Clara E. Sipprell"
Inscription, print verso: "YL16"
 overmat recto: "Montenegro"
 overmat verso: "YL16"
 mat backing verso: "DL-88//YL16"
Acquired from: gift of the Dorothea Leonhardt Fund of the
 Communities Foundation of Texas, Inc., Dallas, Texas

*4596. **A MOSLEM WOMAN, SARAJEVO, BOSNIA** (P1984.1.68)
Gelatin silver print on tissue. c. 1926
Image: 9 3/16 x 7 3/16 in. (23.3 x 18.2 cm.) sight size
Sheet: 9 3/4 x 7 3/4 in. (24.9 x 19.7 cm.)
Signed, l.r. overmat recto: "Clara E. Sipprell"
Inscription, print verso: "Y4"
 overmat recto, typed on paper label: "A Moslem Woman/
 Sarajevo, Bosnia"
 mat backing verso: "D-P-18//Y4"
Acquired from: gift of the Dorothea Leonhardt Fund of the
 Communities Foundation of Texas, Inc., Dallas, Texas

*4597. **MOSQUE AND MOSLEM HOUSES, MOSTAR,
HERZEGOVINA** (P1984.1.576)
Gelatin silver print on tissue. c. 1926
Image: 9 3/16 x 7 3/16 in. (23.3 x 18.2 cm.) sight size
Signed, l.r. overmat recto: "Clara E. Sipprell"
Inscription, overmat recto, typed on paper label: "Mosque
 and Moslem Houses/Mostar, Herzegovina"
 mat backing verso: "D-L-23//YA9"
Acquired from: gift of the Dorothea Leonhardt Fund of the
 Communities Foundation of Texas, Inc., Dallas, Texas

4598. **[Mother and child—possibly Allen and Lucy Sipprell]**
(P1984.1.692)
Autochrome. c. 1919
Image: 6 5/8 x 4 3/4 in. (16.8 x 12.0 cm.)
Plate: 7 x 5 in. (17.8 x 12.7 cm.)
Acquired from: gift of the Dorothea Leonhardt Fund of the
 Communities Foundation of Texas, Inc., Dallas, Texas

4599. **MOTHER & CHILDREN** (P1984.1.237)
Gelatin silver print. c. 1950s–60s
Image: 9 1/4 x 7 1/4 in. (23.5 x 18.4 cm.)
Mount: 10 1/2 x 8 1/8 in. (26.8 x 20.7 cm.)
Signed, l.r. old overmat recto: "Clara E. Sipprell"
Inscription, mount verso: "C32"
 old overmat recto: "Mother & children"
 old overmat verso: "C32"
Acquired from: gift of the Dorothea Leonhardt Fund of the
 Communities Foundation of Texas, Inc., Dallas, Texas

4600. **MT. EISENHOWER, CANADIAN ROCKIES** (P1984.1.341)
duplicate of P1984.1.345
Gelatin silver print. c. 1949
Image: 8 7/8 x 7 3/8 in. (22.5 x 18.7 cm.) sight size
 note: the mount is glued to the overmat and cannot be
 measured; however, the inscription on the mount verso
 is visible
Signed, l.r. overmat recto: "Clara E. Sipprell"
Inscription, overmat recto: "Mt. Eisenhower/Canadian
 Rockies"
 overmat verso: "GP39"
 mount verso: "GP39"
 mat backing verso: "ML-3//GP39"
 note: an unidentified print is affixed to print verso
Acquired from: gift of the Dorothea Leonhardt Fund of the
 Communities Foundation of Texas, Inc., Dallas, Texas

4601. **MT. EISENHOWER, CANADIAN ROCKIES** (P1984.1.345)
duplicate of P1984.1.341
Gelatin silver print. c. 1949
Image: 9 13/16 x 7 11/16 in. (24.9 x 19.5 cm.)
Sheet: 10 x 8 in. (25.4 x 20.3 cm.)
Mount: same as sheet size
Inscription, mount verso: "GP40"
 mat backing verso: "WC-6//Mt. Eisenhower/Canadian
 Rockies//GP40"
Acquired from: gift of the Dorothea Leonhardt Fund of the
 Communities Foundation of Texas, Inc., Dallas, Texas

4602. **MOUSE AND DAIKON—GIANT WHITE RADISH**
(P1984.1.493)
Gelatin silver print. negative 1954, print c. 1954
Image: 6 7/8 x 8 7/8 in. (17.4 x 22.5 cm.) sight size
Sheet: 8 x 10 3/16 in. (20.3 x 25.9 cm.)
Signed, l.r. overmat recto: "Clara E. Sipprell/1954"
Inscription, overmat recto: "Mouse and Daikon/Giant White
 Radish"
 mount verso: "SL7"
Acquired from: gift of the Dorothea Leonhardt Fund of the
 Communities Foundation of Texas, Inc., Dallas, Texas

4603. **MUIR WOODS** (P1984.1.346)
Gelatin silver print. c. 1940s
Image: 8 15/16 x 7 1/4 in. (22.6 x 18.4 cm.) sight size
Mount: 9 15/16 x 8 in. (25.3 x 20.3 cm.)
Signed, l.r. overmat recto: "Clara E. Sipprell"
Inscription, overmat recto: "Muir Woods"
 mat backing verso: "ADL 11"
 note: a print of a young girl's portrait is affixed to
 print verso
Acquired from: gift of the Dorothea Leonhardt Fund of the
 Communities Foundation of Texas, Inc., Dallas, Texas

4604. **MURRAY BAY AT SUNSET** (P1984.1.340)
Gelatin silver print on tissue. c. 1932
Image: 7 3/16 x 8 13/16 in. (18.2 x 22.4 cm.) sight size
Signed, l.r. overmat recto: "Clara E. Sipprell"
Inscription, overmat recto, typed on paper label:
 "Murray Bay at Sunset"
 mat backing verso: "GP-14//GP30"
Acquired from: gift of the Dorothea Leonhardt Fund of the
 Communities Foundation of Texas, Inc., Dallas, Texas

4596

4597

4605

4606

4611

*4620. **NINA WITH A BALL** (P1984.1.194)
Gelatin silver print on tissue. c. 1928
Image: 9 x 7 1/8 in. (22.8 x 18.1 cm.) sight size
note: the mount is glued to the overmat and cannot be
measured; however, the inscription on the mount verso is
visible
Signed, l.r. overmat recto: "Clara E. Sipprell"
Inscription, overmat recto, typed on paper label:
"Nina with a Ball"
mount verso: "C8"
mat backing verso: "Pf-45//C8"
Acquired from: gift of the Dorothea Leonhardt Fund of the
Communities Foundation of Texas, Inc., Dallas, Texas

4621. **NINA WITH CHRISTMAS TREE** (P1984.1.207)
Gelatin silver print. negative c. 1931, print later
Image: 9 x 7 9/16 in. (22.8 x 19.2 cm.) sight size
Sheet: 9 15/16 x 8 in. (25.3 x 20.3 cm.)
Mount: same as sheet size
Signed, l.r. overmat recto: "Clara E. Sipprell"
Inscription, overmat recto: "Nina/With Christmas tree"
overmat verso: "C14"
mount verso: "C14"
note: a print of an older woman is affixed to print verso
Acquired from: gift of the Dorothea Leonhardt Fund of the
Communities Foundation of Texas, Inc., Dallas, Texas

4622. **NINA WITH PETER** (P1984.1.216)
Gelatin silver print. negative 1952, print 1953
Image: 8 7/8 x 7 1/4 in. (22.5 x 18.4 cm.) sight size
Mount: 10 1/2 x 8 1/8 in. (26.7 x 20.7 cm.)
Signed, l.r. overmat recto: "Clara E. Sipprell/1953"
Inscription, overmat recto: "Nina with Peter"
overmat verso: "C28"
mount verso: "C28"
Acquired from: gift of the Dorothea Leonhardt Fund of the
Communities Foundation of Texas, Inc., Dallas, Texas

4623. **NINA WITH PUPPET** (P1984.1.201)
Gelatin silver print. negative c. 1928, print later
Image: 8 7/8 x 7 11/16 in. (22.5 x 19.5 cm.) sight size
Sheet: 10 x 8 in. (25.4 x 20.3 cm.)
Mount: same as sheet size
Signed, l.r. overmat recto: "Clara E. Sipprell"
Inscription, overmat recto: "[torn mat] th puppet"
overmat verso: "Pf-50//Nina//C10"
mount verso: "C10"
note: a print of Nina casting a shadow is affixed to print
verso
Acquired from: gift of the Dorothea Leonhardt Fund of the
Communities Foundation of Texas, Inc., Dallas, Texas

4624. **NITTSJÖ KERAMIK FABRIK—RÄTTVIK—
DALECARLIA** (P1984.1.187)
Gelatin silver print on Gevaluxe paper. negative 1938,
print c. 1938
Image: 9 5/8 x 7 5/8 in. (24.4 x 19.4 cm.)
Sheet: 9 15/16 x 8 in. (25.3 x 20.3 cm.)
Signed, l.r. overmat recto: "Clara E. Sipprell"
Inscription, print verso: "SP7"
overmat recto: "Nittsjö Keramik Fabik [sic]/Rattvik—
Dalecarlia"
mat backing verso: "S-P-32"
Acquired from: gift of the Dorothea Leonhardt Fund of the
Communities Foundation of Texas, Inc., Dallas, Texas

4625. **NORTHERN RIM OF THE GRAND CANYON**
(P1984.1.337)
Gelatin silver print on tissue. c. 1929–31
Image: 9 1/8 x 7 3/16 in. (23.2 x 18.2 cm.) sight size
Signed, l.r. overmat recto: "Clara E. Sipprell"
Inscription, overmat recto: "Northern Rim of the/Grand
Canyon" and typed on paper label "The Grand
C[remainder of label is missing]"

mat backing verso: "A-L-25//P.S.K.//g Bookselection//
WL7"
Acquired from: gift of the Dorothea Leonhardt Fund of the
Communities Foundation of Texas, Inc., Dallas, Texas

4626. **[Old barn and trees]** (P1984.1.472)
Gelatin silver print on tissue. n.d.
Image: 7 3/16 x 9 3/16 in. (18.2 x 23.3 cm.) sight size
Sheet: 7 15/16 x 9 15/16 in. (20.2 x 25.3 cm.)
Signed, l.r. overmat recto: "Clara E. Sipprell"
Inscription, print verso: "AA12"
Acquired from: gift of the Dorothea Leonhardt Fund of the
Communities Foundation of Texas, Inc., Dallas, Texas

4627. **OLD BOTTLE WITH WOODBINE** (P1984.1.489)
Gelatin silver print on tissue. negative 1921, print c. 1921
Image: 9 1/8 x 7 1/8 in. (23.2 x 18.1 cm.) sight size
Sheet: 9 7/8 x 7 7/8 in. (25.1 x 19.9 cm.)
Signed, l.r. overmat recto: "Clara E. Sipprell/1921"
Inscription, mat backing verso: "SL-3-II//g American
Landscape//Old bottle With Woodbine/1921//SL22"
Acquired from: gift of the Dorothea Leonhardt Fund of the
Communities Foundation of Texas, Inc., Dallas, Texas

*4628. **OLD BOTTLE WITH WOODBINES [Vine in Old Bottle]**
(P1984.1.505) duplicate of P1984.1.486 and P1984.1.510
Gelatin silver print. negative 1921, print later
Image: 9 1/8 x 7 7/16 in. (23.2 x 18.9 cm.) sight size
Mount: 11 x 8 1/2 in. (28.0 x 21.7 cm.)
Signed, l.r. overmat recto: "Clara E. Sipprell"
Inscription, mount verso: "SL25"
Acquired from: gift of the Dorothea Leonhardt Fund of the
Communities Foundation of Texas, Inc., Dallas, Texas

4629. **OLD BOTTLE WITH WOODBINES [Vine in Old Bottle]**
(P1984.1.510) duplicate of P1984.1.486 and P1984.1.505
Gelatin silver print. negative 1921, print later
Image: 9 5/16 x 7 7/16 in. (23.7 x 18.9 cm.)
1st mount: 10 3/4 x 8 3/16 in. (27.3 x 20.8 cm.)
2nd mount: 13 3/16 x 10 15/16 in. (33.5 x 27.8 cm.)
Signed, l.r. 1st mount recto: "Clara E. Sipprell/1921"
Inscription, 2nd mount verso: "Old bottle with
Woodbines/1921//SL23"
Acquired from: gift of the Dorothea Leonhardt Fund of the
Communities Foundation of Texas, Inc., Dallas, Texas

4630. **OLD CHURCH, TEPIC, MEXICO** (P1984.1.292)
Gelatin silver print on tissue. c. 1931
Image: 9 3/16 x 7 3/16 in. (23.3 x 18.2 cm.) sight size
Signed, l.r. overmat recto: "Clara E. Sipprell"
Inscription, overmat recto: "Old Church/Tepic" and typed on
paper label "Old Church/Tepic, Mexico"
mat backing verso: "M-11//MA3"
Acquired from: gift of the Dorothea Leonhardt Fund of the
Communities Foundation of Texas, Inc., Dallas, Texas

*4631. **THE OLD DARLING PLACE, DORSET** (P1984.1.436)
duplicate of P1984.1.475
Gelatin silver print. n.d.
Image: 7 1/2 x 9 9/16 in. (19.0 x 24.3 cm.)
Sheet: 7 15/16 x 9 15/16 in. (20.2 x 25.3 cm.)
Mount: 20 1/8 x 14 1/2 in. (51.0 x 36.8 cm.)
Signed, l.r. overmat recto: "Clara E. Sipprell"
Inscription, overmat recto: "The Old Darling Place/Dorset"
overmat verso: "VL14"
mount verso: "PfV-104//VL14"
Acquired from: gift of the Dorothea Leonhardt Fund of the
Communities Foundation of Texas, Inc., Dallas, Texas

4632. **THE OLD DARLING PLACE, DORSET—VERMONT**
(P1984.1.475) duplicate of P1984.1.436
Gelatin silver print. n.d.
Image: 7 x 9 in. (17.8 x 22.8 cm.) sight size
Signed, l.r. overmat recto: "Clara E. Sipprell"
Inscription, overmat recto: "The Old Darling Place/Dorset—
Vermont"
mat backing verso: "VL13"
Acquired from: gift of the Dorothea Leonhardt Fund of the
Communities Foundation of Texas, Inc., Dallas, Texas

4612

4613

4619

4620

*4620. **NINA WITH A BALL** (P1984.1.194)
Gelatin silver print on tissue. c. 1928
Image: 9 x 7 1/8 in. (22.8 x 18.1 cm.) sight size
note: the mount is glued to the overmat and cannot be
measured; however, the inscription on the mount verso is
visible
Signed, l.r. overmat recto: "Clara E. Sipprell"
Inscription, overmat recto, typed on paper label:
"Nina with a Ball"
mount verso: "C8"
mat backing verso: "Pf-45//C8"
Acquired from: gift of the Dorothea Leonhardt Fund of the
Communities Foundation of Texas, Inc., Dallas, Texas

4621. **NINA WITH CHRISTMAS TREE** (P1984.1.207)
Gelatin silver print. negative c. 1931, print later
Image: 9 x 7 9/16 in. (22.8 x 19.2 cm.) sight size
Sheet: 9 15/16 x 8 in. (25.3 x 20.3 cm.)
Mount: same as sheet size
Signed, l.r. overmat recto: "Clara E. Sipprell"
Inscription, overmat recto: "Nina/With Christmas tree"
overmat verso: "C14"
mount verso: "C14"
note: a print of an older woman is affixed to print verso
Acquired from: gift of the Dorothea Leonhardt Fund of the
Communities Foundation of Texas, Inc., Dallas, Texas

4622. **NINA WITH PETER** (P1984.1.216)
Gelatin silver print. negative 1952, print 1953
Image: 8 7/8 x 7 1/4 in. (22.5 x 18.4 cm.) sight size
Mount: 10 1/2 x 8 1/8 in. (26.7 x 20.7 cm.)
Signed, l.r. overmat recto: "Clara E. Sipprell/1953"
Inscription, overmat recto: "Nina with Peter"
overmat verso: "C28"
mount verso: "C28"
Acquired from: gift of the Dorothea Leonhardt Fund of the
Communities Foundation of Texas, Inc., Dallas, Texas

4623. **NINA WITH PUPPET** (P1984.1.201)
Gelatin silver print. negative c. 1928, print later
Image: 8 7/8 x 7 11/16 in. (22.5 x 19.5 cm.) sight size
Sheet: 10 x 8 in. (25.4 x 20.3 cm.)
Mount: same as sheet size
Signed, l.r. overmat recto: "Clara E. Sipprell"
Inscription, overmat recto: "[torn mat] th puppet"
overmat verso: "Pf-50//Nina//C10"
mount verso: "C10"
note: a print of Nina casting a shadow is affixed to print
verso
Acquired from: gift of the Dorothea Leonhardt Fund of the
Communities Foundation of Texas, Inc., Dallas, Texas

4624. **NITTSJÖ KERAMIK FABRIK—RÄTTVIK—
DALECARLIA** (P1984.1.187)
Gelatin silver print on Gevaluxe paper. negative 1938,
print c. 1938
Image: 9 5/8 x 7 5/8 in. (24.4 x 19.4 cm.)
Sheet: 9 15/16 x 8 in. (25.3 x 20.3 cm.)
Signed, l.r. overmat recto: "Clara E. Sipprell"
Inscription, print verso: "SP7"
overmat recto: "Nittsjö Keramik Fabik [sic]/Rattvik—
Dalecarlia"
mat backing verso: "S-P-32"
Acquired from: gift of the Dorothea Leonhardt Fund of the
Communities Foundation of Texas, Inc., Dallas, Texas

4625. **NORTHERN RIM OF THE GRAND CANYON**
(P1984.1.337)
Gelatin silver print on tissue. c. 1929–31
Image: 9 1/8 x 7 3/16 in. (23.2 x 18.2 cm.) sight size
Signed, l.r. overmat recto: "Clara E. Sipprell"
Inscription, overmat recto: "Northern Rim of the/Grand
Canyon" and typed on paper label "The Grand
C[remainder of label is missing]"

mat backing verso: "A-L-25//P.S.K.//g Bookselection//
WL7"
Acquired from: gift of the Dorothea Leonhardt Fund of the
Communities Foundation of Texas, Inc., Dallas, Texas

4626. **[Old barn and trees]** (P1984.1.472)
Gelatin silver print on tissue. n.d.
Image: 7 3/16 x 9 3/16 in. (18.2 x 23.3 cm.) sight size
Sheet: 7 15/16 x 9 15/16 in. (20.2 x 25.3 cm.)
Signed, l.r. overmat recto: "Clara E. Sipprell"
Inscription, print verso: "AA12"
Acquired from: gift of the Dorothea Leonhardt Fund of the
Communities Foundation of Texas, Inc., Dallas, Texas

4627. **OLD BOTTLE WITH WOODBINE** (P1984.1.489)
Gelatin silver print on tissue. negative 1921, print c. 1921
Image: 9 1/8 x 7 1/8 in. (23.2 x 18.1 cm.) sight size
Sheet: 9 7/8 x 7 7/8 in. (25.1 x 19.9 cm.)
Signed, l.r. overmat recto: "Clara E. Sipprell/1921"
Inscription, mat backing verso: "SL-3-II//g American
Landscape//Old bottle With Woodbine/1921//SL22"
Acquired from: gift of the Dorothea Leonhardt Fund of the
Communities Foundation of Texas, Inc., Dallas, Texas

*4628. **OLD BOTTLE WITH WOODBINES [Vine in Old Bottle]**
(P1984.1.505) duplicate of P1984.1.486 and P1984.1.510
Gelatin silver print. negative 1921, print later
Image: 9 1/8 x 7 7/16 in. (23.2 x 18.9 cm.) sight size
Mount: 11 x 8 1/2 in. (28.0 x 21.7 cm.)
Signed, l.r. overmat recto: "Clara E. Sipprell"
Inscription, mount verso: "SL25"
Acquired from: gift of the Dorothea Leonhardt Fund of the
Communities Foundation of Texas, Inc., Dallas, Texas

4629. **OLD BOTTLE WITH WOODBINES [Vine in Old Bottle]**
(P1984.1.510) duplicate of P1984.1.486 and P1984.1.505
Gelatin silver print. negative 1921, print later
Image: 9 5/16 x 7 7/16 in. (23.7 x 18.9 cm.)
1st mount: 10 3/4 x 8 3/16 in. (27.3 x 20.8 cm.)
2nd mount: 13 3/16 x 10 15/16 in. (33.5 x 27.8 cm.)
Signed, l.r. 1st mount recto: "Clara E. Sipprell/1921"
Inscription, 2nd mount verso: "Old bottle with
Woodbines/1921//SL23"
Acquired from: gift of the Dorothea Leonhardt Fund of the
Communities Foundation of Texas, Inc., Dallas, Texas

4630. **OLD CHURCH, TEPIC, MEXICO** (P1984.1.292)
Gelatin silver print on tissue. c. 1931
Image: 9 3/16 x 7 3/16 in. (23.3 x 18.2 cm.) sight size
Signed, l.r. overmat recto: "Clara E. Sipprell"
Inscription, overmat recto: "Old Church/Tepic" and typed on
paper label "Old Church/Tepic, Mexico"
mat backing verso: "M-11//MA3"
Acquired from: gift of the Dorothea Leonhardt Fund of the
Communities Foundation of Texas, Inc., Dallas, Texas

*4631. **THE OLD DARLING PLACE, DORSET** (P1984.1.436)
duplicate of P1984.1.475
Gelatin silver print. n.d.
Image: 7 1/2 x 9 9/16 in. (19.0 x 24.3 cm.)
Sheet: 7 15/16 x 9 15/16 in. (20.2 x 25.3 cm.)
Mount: 20 1/8 x 14 1/2 in. (51.0 x 36.8 cm.)
Signed, l.r. overmat recto: "Clara E. Sipprell"
Inscription, overmat recto: "The Old Darling Place/Dorset"
overmat verso: "VL14"
mount verso: "PfV-104//VL14"
Acquired from: gift of the Dorothea Leonhardt Fund of the
Communities Foundation of Texas, Inc., Dallas, Texas

4632. **THE OLD DARLING PLACE, DORSET—VERMONT**
(P1984.1.475) duplicate of P1984.1.436
Gelatin silver print. n.d.
Image: 7 x 9 in. (17.8 x 22.8 cm.) sight size
Signed, l.r. overmat recto: "Clara E. Sipprell"
Inscription, overmat recto: "The Old Darling Place/Dorset—
Vermont"
mat backing verso: "VL13"
Acquired from: gift of the Dorothea Leonhardt Fund of the
Communities Foundation of Texas, Inc., Dallas, Texas

4596

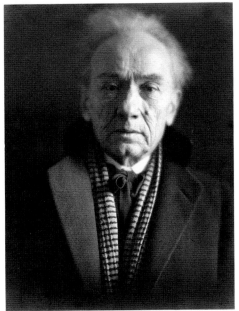

4597

4605

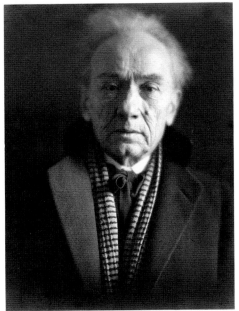

4606

4611

*4605. **MURRAY BAY, QUEBEC** (P1984.1.420)
Gelatin silver print. negative c. 1932, print later
Image: 7 ½ x 9 3⁄16 in. (19.0 x 23.3 cm.)
1st mount: 9 1⁄16 x 9 7⁄8 in. (23.0 x 25.1 cm.)
2nd mount: 18 x 13 in. (45.7 x 33.0 cm.)
Signed, l.r. 1st mount recto: "Clara E. Sipprell"
Inscription, 2nd mount verso: "Murry [sic] Bay/Quebec//
GP31"
Acquired from: gift of the Dorothea Leonhardt Fund of the
Communities Foundation of Texas, Inc., Dallas, Texas

*4606. **THE MUSIC MASTER** (P1984.1.633)
Gelatin silver print. c. 1920s
Image: 9 1⁄8 x 7 in. (23.2 x 17.8 cm.)
Acquired from: gift of the Dorothea Leonhardt Fund of the
Communities Foundation of Texas, Inc., Dallas, Texas

4607. **A MUSULMAN MAUSOLEUM, MOSTAR,
HERZEGOVINA** (P1984.1.387)
Gelatin silver print on tissue. c. 1926
Image: 9 5⁄16 x 7 3⁄8 in. (23.7 x 18.7 cm.) sight size
Sheet: 9 13⁄16 x 7 7⁄8 in. (24.9 x 20.0 cm.)
Signed, l.r. overmat recto: "Clara E. Sipprell"
Inscription, print verso: "IN1"
overmat recto, typed on paper label: "A Musulman
Mausoleum/Mostar, Herzegovina [sic]"
overmat verso: "IN1"
mat backing verso: "DL-57//IN 1" and rubber stamp
"CLARA E. SIPPRELL/MANCHESTER,
VERMONT/200 West 16th St.—New York City"
Acquired from: gift of the Dorothea Leonhardt Fund of the
Communities Foundation of Texas, Inc., Dallas, Texas

4608. **[Nadiejhda Plevitskaya]** (P1984.1.681)
Gelatin silver print on tissue. c. 1925
Image: 9 ½ x 7 7⁄16 in. (24.1 x 18.9 cm.)
Sheet: 9 7⁄8 x 7 7⁄8 in. (25.1 x 20.0 cm.)
Acquired from: gift of the Dorothea Leonhardt Fund of the
Communities Foundation of Texas, Inc., Dallas, Texas

4609. **[Nadiejhda Plevitskaya]** (P1984.1.682)
Gelatin silver print on tissue. c. 1925
Image: 9 9⁄16 x 7 5⁄8 in. (24.3 x 19.4 cm.)
Sheet: 9 7⁄8 x 7 3⁄4 in. (25.1 x 19.7 cm.)
Acquired from: gift of the Dorothea Leonhardt Fund of the
Communities Foundation of Texas, Inc., Dallas, Texas

4610. **[Nadiejhda Plevitskaya]** (P1984.1.683)
Gelatin silver print on tissue. c. 1925
Image: 9 ½ x 7 ½ in. (24.1 x 19.0 cm.)
Sheet: 9 7⁄8 x 7 7⁄8 in. (25.1 x 20.0 cm.)
Acquired from: gift of the Dorothea Leonhardt Fund of the
Communities Foundation of Texas, Inc., Dallas, Texas

*4611. **NATCHEZ** (P1984.1.376)
Gelatin silver print. negative 1949, print c. 1949
Image: 8 15⁄16 x 7 ½ in. (22.6 x 19.0 cm.) sight size
Sheet: 9 15⁄16 x 7 15⁄16 in. (25.3 x 20.2 cm.)
Mount: same as sheet size
Signed, l.r. overmat recto: "Clara E. Sipprell/1949"
Inscription, overmat recto: "Natchez"
overmat verso: "AA28"
mount verso: "AA28"
note: a print of an older man is affixed to print verso
Acquired from: gift of the Dorothea Leonhardt Fund of the
Communities Foundation of Texas, Inc., Dallas, Texas

*4612. **NELSON ROCKEFELLER** (P1984.1.617)
Gelatin silver print. c. 1930
Image: 9 1⁄16 x 7 1⁄8 in. (23.0 x 18.1 cm.)
Inscription, print verso: "Nelson Rockefeller"
Acquired from: gift of the Dorothea Leonhardt Fund of the
Communities Foundation of Texas, Inc., Dallas, Texas

*4613. **NEW YORK HARBOR** (P1980.11.1)
Gelatin silver print. c. 1922
Image: 9 5⁄8 x 7 9⁄16 in. (24.5 x 19.1 cm.)
Sheet: 10 ¼ x 7 15⁄16 in. (26.0 x 20.2 cm.)
Signed, l.r. 1st overmat recto: "Clara E. Sipprell"
Inscription, 1st overmat recto: "New York Harbor//9"
Acquired from: Marcuse Pfeifer Gallery, New York, New York

4614. **NINA** (P1984.1.209)
Gelatin silver print. negative c. 1930, print later
Image: 9 3⁄16 x 7 ½ in. (23.3 x 19.0 cm.) sight size
Sheet: 9 15⁄16 x 8 in. (25.3 x 20.3 cm.)
Mount: same as sheet size
Inscription, overmat recto: "Nina"
overmat verso: "PF-13//C17"
mount verso: "C17"
note: a print of an older woman seated in a chair is affixed
to print verso
Acquired from: gift of the Dorothea Leonhardt Fund of the
Communities Foundation of Texas, Inc., Dallas, Texas

4615. **NINA [In the Sun]** (P1984.1.212) duplicate of P1984.1.211
Gelatin silver print. negative c. 1930, print later
Image: 9 x 7 7⁄16 in. (22.8 x 18.9 cm.) sight size
Sheet: 10 x 8 1⁄8 in. (25.4 x 20.6 cm.)
Mount: same as sheet size
Signed, l.r. overmat recto: "Clara E. Sipprell"
Inscription, overmat recto: "Nina"
overmat verso: "Nina—In the Sun//C25"
mount verso: "C25"
note: a print of Nina reading a book is affixed to
print verso
Acquired from: gift of the Dorothea Leonhardt Fund of the
Communities Foundation of Texas, Inc., Dallas, Texas

4616. **NINA [Nina at 12 Years Old]** (P1984.1.215) duplicate of
P1984.1.214
Gelatin silver print. negative 1939, print later
Image: 9 3⁄16 x 7 1⁄16 in. (23.3 x 17.9 cm.)
1st mount: same as image size
2nd mount: 20 x 14 5⁄16 in. (50.7 x 36.6 cm.)
Signed, l.r. 2nd mount recto: "Clara E. Sipprell"
Inscription, 2nd mount recto: "Nina"
2nd mount verso: "Nina at/12 yrs old//C26"
Acquired from: gift of the Dorothea Leonhardt Fund of the
Communities Foundation of Texas, Inc., Dallas, Texas

4617. **NINA & HER GRANDFATHER** (P1984.1.221)
Gelatin silver print on tissue. negative c. 1929, print 1929
Image: 9 5⁄8 x 7 5⁄8 in. (24.4 x 19.4 cm.)
Sheet: 9 15⁄16 x 8 1⁄16 in. (25.3 x 20.5 cm.)
Inscription, print verso: "C20"
old mount recto: "Nina & her Grandfather"
old mount verso: "Pf-7//C20"
Acquired from: gift of the Dorothea Leonhardt Fund of the
Communities Foundation of Texas, Inc., Dallas, Texas

4618. **NINA AT 40** (P1984.1.217)
Gelatin silver print. 1967
Image: 8 15⁄16 x 6 7⁄8 in. (22.6 x 17.4 cm.) sight size
Mount: 11 x 8 ½ in. (28.0 x 21.7 cm.)
Signed, l.r. overmat recto: "Clara E. Sipprell/1967"
Inscription, overmat recto: "Nina at 40"
mount verso: "MIS5"
Acquired from: gift of the Dorothea Leonhardt Fund of the
Communities Foundation of Texas, Inc., Dallas, Texas

*4619. **NINA AT 12 YEARS OLD [Nina]** (P1984.1.214) duplicate of
P1984.1.215
Gelatin silver print. negative 1939, print later
Image: 9 3⁄16 x 7 ½ in. (23.3 x 19.0 cm.)
Mount: 13 1⁄16 x 11 in. (33.2 x 28.0 cm.)
Signed, l.r. overmat recto: "Clara E. Sipprell"
Inscription, overmat recto: "Nina at 12 years old"
overmat verso: "C27"
mount verso: "C27"
Acquired from: gift of the Dorothea Leonhardt Fund of the
Communities Foundation of Texas, Inc., Dallas, Texas

4633. **OLD ENGLISH CORNER** (P1984.1.393)
Gelatin silver print on tissue. c. 1925
Image: 8 ⅝ x 4 ¹¹/₁₆ in. (21.9 x 11.9 cm.) sight size
Signed, l.r. overmat recto: "Clara E. Sipprell"
Inscription, overmat recto, typed on paper label:
"Old English Corner"
mat backing verso: "S-L-20//IN 7"
Acquired from: gift of the Dorothea Leonhardt Fund of the
Communities Foundation of Texas, Inc., Dallas, Texas

4634. **THE OLD MAN IN TO VERMONT** (P1984.1.427)
Gelatin silver print. n.d.
Image: 9 ³/₁₆ x 7 ⅜ in. (23.3 x 18.7 cm.)
1st mount: 11 ⅛ x 8 ⅜ in. (28.5 x 21.3 cm.)
2nd mount: 19 ⅞ x 14 ³/₁₆ in. (50.5 x 36.0 cm.)
Signed, l.r. 1st mount recto: "Clara E. Sipprell"
Inscription, 1st mount verso: "VL22"
2nd mount recto: "The Old Man in to Vermont"
2nd mount verso: "A-L-2//VL22"
Acquired from: gift of the Dorothea Leonhardt Fund of the
Communities Foundation of Texas, Inc., Dallas, Texas

*4635. **[Old man talking to three children in vaulted archway]**
(P1984.1.316)
Gelatin silver print on tissue. c. 1931
Image: 9 ⅛ x 7 ⅛ in. (23.2 x 18.1 cm.)
Sheet: 10 ¹/₁₆ x 8 in. (25.5 x 20.3 cm.)
Signed, l.r. overmat recto: "Clara E. Sipprell"
Inscription, overmat verso: "DP-20"
mat backing verso: "MEX33"
Acquired from: gift of the Dorothea Leonhardt Fund of the
Communities Foundation of Texas, Inc., Dallas, Texas

4636. **OLD MEXICAN HOUSE, SANTA-FÉ, NEW MEXICO**
(P1984.1.372)
Gelatin silver print on tissue. c. 1928–31
Image: 7 ⅛ x 9 ¹/₁₆ in. (18.1 x 23.0 cm.) sight size
Signed, l.r. overmat recto: "Clara E. Sipprell"
Inscription, overmat recto, typed on paper label:
"Old Mexican House/Santa-Fé, New Mexico"
mat backing verso: "NM-5//AA5"
Acquired from: gift of the Dorothea Leonhardt Fund of the
Communities Foundation of Texas, Inc., Dallas, Texas

*4637. **OLD MOSTAR, HERZEGOVINA** (P1984.1.567) duplicate of
P1984.1.569
Gelatin silver print on tissue. c. 1926
Image: 9 ³/₁₆ x 7 ⅛ in. (23.3 x 18.1 cm.) sight size
Signed, l.r. overmat recto: "Clara E. Sipprell"
Inscription, overmat recto, typed on paper label:
"Old Mostar/Herzegovina"
mat backing verso: "DL-67-B//YA42" and printed paper
label "THIS IS TO CER/TIFY THAT THIS/PRINT
WAS EXHIB/ITED AT THE JOHN/HERRON ART
INS/TITUTE UNDER/THE AUSPICES OF/
THE INDIANAPO/LIS CAMERA CLUB/AT
INDIANAPOLIS/INDIANA IN JUNE/NINETEEN
HUN/DRED AND THIRTY"
Acquired from: gift of the Dorothea Leonhardt Fund of the
Communities Foundation of Texas, Inc., Dallas, Texas

4638. **OLD MOSTAR, HERZEGOVINA** (P1984.1.569) duplicate of
P1984.1.567
Gelatin silver print on tissue. c. 1926
Image: 9 ⅛ x 7 ³/₁₆ in. (23.2 x 18.2 cm.) sight size
Signed, l.r. overmat recto: "Clara E. Sipprell"
Inscription, overmat recto, typed on paper label: "Old
Mostar/Herzogovina [sic]" and printed paper label "22"
mat backing verso: "DL-67-A//YA28"
Acquired from: gift of the Dorothea Leonhardt Fund of the
Communities Foundation of Texas, Inc., Dallas, Texas

4628

4631

4635

*4639. **OLD SOUTH STREET—BATTERY—NEW YORK**
(P1980.11.2)
Gelatin silver print. c. 1921
Image: 9 9/16 x 7 5/8 in. (24.3 x 19.4 cm.)
Sheet: 10 5/16 x 7 15/16 in. (26.2 x 20.2 cm.)
Signed, l.r. old overmat recto: "Clara E. Sipprell"
Inscription, old overmat recto: "Old South Street—Battery—New York"
Acquired from: Marcuse Pfeifer Gallery, New York, New York

4640. **AN OLIVE GROVE, DALMATIA** (P1984.1.593)
Gelatin silver print. negative c. 1926, print later
Image: 6 13/16 x 8 7/8 in. (17.3 x 22.5 cm.) sight size
Mount: 8 1/2 x 11 in. (21.7 x 28.0 cm.)
Signed, l.r. overmat recto: "Clara E. Sipprell"
Inscription, overmat recto: "An olive Grove/Dalmatia"
overmat verso: "YL38"
mount verso: "YL38"
Acquired from: gift of the Dorothea Leonhardt Fund of the Communities Foundation of Texas, Inc., Dallas, Texas

4641. **OLIVER WENDELL HOLMES AT 94** (P1984.1.239)
uncropped duplicate of P1984.1.641
Gelatin silver print. negative 1935, print c. 1935
Image: 8 15/16 x 7 1/4 in. (22.6 x 18.4 cm.) sight size
Signed, l.r. overmat recto: "Clara E. Sipprell"
Inscription, overmat recto: "Oliver Wendell Holmes/at 94"
mat backing verso: "Pf 234//ADL 6"
Acquired from: gift of the Dorothea Leonhardt Fund of the Communities Foundation of Texas, Inc., Dallas, Texas

*4642. **OLIVER WENDELL HOLMES, 3 WEEKS BEFORE HE DIED** (P1984.1.641) cropped duplicate of P1984.1.239
Gelatin silver print. negative 1935, print c. 1935
Image: 8 1/2 x 7 1/16 in. (21.6 x 17.9 cm.)
Mount: 13 3/16 x 11 in. (33.5 x 28.0 cm.)
Signed, l.r. mount recto: "Clara E. Sipprell"
Inscription, mount recto: "750//6 1/4" B.M. [with arrows]//76//49"
mount verso: "PF//ADL1"
attached sheet: "(at 94)//X31 1/2/[illegible]//94//49// P55//1935" and typed "OLIVER WENDELL HOLMES, 3 weeks before he/died.//I was in Washington making pictures of/Harlan Stone. He asked me if I would like/to make pictures of Old Chief Justice Holmes./Naturally, I was very eager. He made the/appointment and I went at once. Mr. Holmes/was quite feeble. The only remark he made/ while I was making his picture was "This/will be good for publicity". It was a/long time before I understood it. He was,/after all, 94 years old. Later a friend/said it was his wonderful humor. Someone/else said that he was still going on"
Acquired from: gift of the Dorothea Leonhardt Fund of the Communities Foundation of Texas, Inc., Dallas, Texas

4643. **ON THE BUNA RIVER, HERZEGOVINA** (P1984.1.561)
Gelatin silver print on tissue. c. 1926
Image: 9 3/16 x 7 3/16 in. (23.3 x 18.2 cm.) sight size
Signed, l.r. overmat recto: "Clara E. Sipprell"
Inscription, overmat recto, typed on paper label: "On the Buna River/Herzegovina"
mat backing verso: "D-L-20//YL11"
Acquired from: gift of the Dorothea Leonhardt Fund of the Communities Foundation of Texas, Inc., Dallas, Texas

*4644. **ON THE EDGE OF THE GRAND CANYON, ARIZONA** (P1984.1.324)
Gelatin silver print on tissue. c. 1929–31
Image: 9 1/8 x 7 1/8 in. (23.2 x 18.1 cm.) sight size
Signed, l.r. overmat recto: "Clara E. Sipprell"
Inscription, overmat recto, typed on paper label: "On the Edge of the Grand Canyon/Arizona"
mat backing verso: "A-L-31//WL22" and typed on paper label "Portrait of Joe Dana"
Acquired from: gift of the Dorothea Leonhardt Fund of the Communities Foundation of Texas, Inc., Dallas, Texas

4645. **ON THE GASPÉ PENINSULA** [Church at Gaspé; Gaspé Peninsula] (P1984.1.402) duplicate of P1984.1.400, P1984.1.401, and P1984.1.410
Gelatin silver print. negative c. 1932, print later
Image: 9 1/16 x 7 7/16 in. (23.0 x 18.9 cm.) sight size
Sheet: 9 15/16 x 8 1/16 in. (25.3 x 20.5 cm.)
Mount: 9 7/8 x 7 15/16 in. (25.1 x 20.2 cm.)
Signed, l.r. overmat recto: "Clara E. Sipprell"
Inscription, overmat recto: "On the/Gaspé Peninsula"
overmat verso: "GP8"
mount verso: "GP8"
Acquired from: gift of the Dorothea Leonhardt Fund of the Communities Foundation of Texas, Inc., Dallas, Texas

4646. **ON THE ISLAND OF ST. SIMEON, GEORGIA** (P1984.1.95)
Gelatin silver print on Gevaluxe paper. c. 1940
Image: 9 1/8 x 7 1/8 in. (23.2 x 18.1 cm.) sight size
Signed, l.r. overmat recto: "Clara E. Sipprell"
Inscription, print verso: "B16"
overmat recto: "On the Island of St. Simeon/Georgia"
mat backing verso: "AL-56//B16"
Acquired from: gift of the Dorothea Leonhardt Fund of the Communities Foundation of Texas, Inc., Dallas, Texas

4647. **ON THE ROOF, NURSERY SCHOOL** (P1984.1.250)
Gelatin silver print on tissue. negative c. 1930–32, print c. 1930s
Image: 9 1/8 x 7 3/16 in. (23.2 x 18.2 cm.) sight size
Signed, l.r. overmat recto: "Clara E. Sipprell"
Inscription, print verso: "C39"
overmat recto, typed on paper label: "On the Roof/Nursery School"
mat backing verso: "Pf-35//C39"
Acquired from: gift of the Dorothea Leonhardt Fund of the Communities Foundation of Texas, Inc., Dallas, Texas

4648. **AN ORCHARD** (P1984.1.287)
Gelatin silver print. n.d.
Image: 6 7/8 x 8 15/16 in. (17.4 x 22.6 cm.) sight size
Mount: 8 x 9 15/16 in. (20.3 x 25.3 cm.)
Inscription, overmat verso: "M-37//An Orchard//ML7"
mount verso: "ML7"
note: a print of an older woman is affixed to print verso
Acquired from: gift of the Dorothea Leonhardt Fund of the Communities Foundation of Texas, Inc., Dallas, Texas

4649. **OSSIAN ELGSTRÖM, VIKING PAINTER OF SWEDEN** (P1984.1.123)
Gelatin silver print. negative 1938, print c. 1938 or later
Image: 9 9/16 x 7 5/8 in. (24.1 x 19.4 cm.)
Sheet: 9 15/16 x 8 1/16 in. (25.1 x 20.4 cm.)
Mount: 11 x 8 9/16 in. (28.0 x 21.7 cm.)
Signed, l.r. old overmat recto: "Clara E. Sipprell"
Inscription, mount verso: "SP85"
old overmat recto: "Ossian Elgström/Viking painter of Sweden"
Acquired from: gift of the Dorothea Leonhardt Fund of the Communities Foundation of Texas, Inc., Dallas, Texas

4650. **OSSIAN ELGSTRÖM—VIKING PAINTER, STOCKHOLM** (P1984.1.124)
Gelatin silver print on Gevaluxe paper. negative 1938, print c. 1938
Image: 9 5/8 x 7 5/8 in. (24.4 x 19.4 cm.)
Sheet: 10 x 7 15/16 in. (25.4 x 20.2 cm.)
Signed, l.r. overmat recto: "Clara E. Sipprell"
Inscription, print verso: "SP86"
overmat recto: "Ossian Elgström—viking painter/Stockholm"
mat backing verso: "S-P-2-6//SP86"
Acquired from: gift of the Dorothea Leonhardt Fund of the Communities Foundation of Texas, Inc., Dallas, Texas

4637

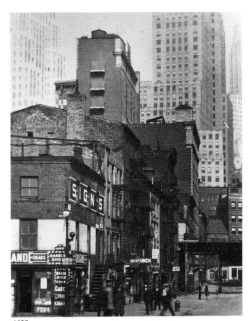

4639

4642

4644

4651

*4651. **OUR AURATUM LILIES [Auratum Lilies; The Golden Lily of Japan]** (P1984.1.503) duplicate of P1984.1.502 and P1984.1.504
Gelatin silver print. negative 1950, print c. 1950
Image: 7 3/16 x 9 in. (18.2 x 22.8 cm.) sight size
Mount: 8 1/2 x 10 15/16 in. (21.4 x 27.8 cm.)
Signed, l.r. overmat recto: "Clara E. Sipprell/1950"
Inscription, l.r. overmat recto: "Our Auratum Lilies"
 overmat verso: "SL19"
 mount verso: "SL19"
Acquired from: gift of the Dorothea Leonhardt Fund of the Communities Foundation of Texas, Inc., Dallas, Texas

4652. **OUR HOSTESS, CETINJE, MONTENEGRO** (P1984.1.69)
Gelatin silver print on tissue. c. 1926
Image: 8 15/16 x 7 3/16 in. (22.6 x 18.2 cm.) sight size
Signed, l.r. overmat recto: "Clara E. Sipprell"
Inscription, print verso: "Y6"
 overmat recto, typed on paper label: "Our Hostess/Cetinje, Montenegro"
 mat backing verso: "D-P-6-6//Y6"
Acquired from: gift of the Dorothea Leonhardt Fund of the Communities Foundation of Texas, Inc., Dallas, Texas

4653. **OUR PLACE IN VERMONT** (P1984.1.465) duplicate of P1984.1.466
Gelatin silver print. negative c. 1940s, print later
Image: 9 5/8 x 7 5/8 in. (24.4 x 19.4 cm.) sight size
Sheet: 10 x 8 in. (25.4 x 20.3 cm.)
Mount: 10 1/4 x 8 1/8 in. (26.1 x 20.6 cm.)
Signed, l.r. old overmat recto: "Clara E. Sipprell"
Inscription, mount verso: "AA8"
 old overmat recto: "Our Place in Vermont"
Acquired from: gift of the Dorothea Leonhardt Fund of the Communities Foundation of Texas, Inc., Dallas, Texas

4654. **OUR PLACE IN VERMONT** (P1984.1.466) duplicate of P1984.1.465
Gelatin silver print. negative c. 1940s, print later
Image: 8 15/16 x 7 3/16 in. (22.6 x 18.2 cm.) sight size
Signed, l.r. overmat recto: "Clara E. Sipprell"
Inscription, overmat recto: "Our Place in Vermont"
 mat backing verso: "V-L-14-a//AA9"
Acquired from: gift of the Dorothea Leonhardt Fund of the Communities Foundation of Texas, Inc., Dallas, Texas

4655. **THE PAINTED DESERT, ARIZONA** (P1984.1.350)
Gelatin silver print on tissue. c. 1928–31
Image: 7 9/16 x 9 9/16 in. (19.2 x 24.3 cm.)
Sheet: 7 7/8 x 9 7/8 in. (20.0 x 25.1 cm.)
Signed, l.r. overmat recto: "Clara E. Sipprell"
Inscription, print verso: "WL25"
 overmat recto: "The Painted Desert, Arizona"
 overmat verso: "A-L-46//WL25"
 mat backing verso: "A-L-46//WL25"
Acquired from: gift of the Dorothea Leonhardt Fund of the Communities Foundation of Texas, Inc., Dallas, Texas

4656. **THE PAINTED DESERT, ARIZONA** (P1984.1.352)
Gelatin silver print on tissue. c. 1928–31
Image: 7 3/16 x 9 3/16 in. (18.2 x 23.3 cm.) sight size
Signed, l.r. overmat recto: "Clara E. Sipprell"
Inscription, overmat recto, typed on paper label: "The Painted Dessert [sic]/Arizona"
 mat backing verso: "Pf-195//WL27"
Acquired from: gift of the Dorothea Leonhardt Fund of the Communities Foundation of Texas, Inc., Dallas, Texas

4657. **PAMELA** (P1984.1.81)
Gelatin silver print. 1929
Image: 8 7/8 x 7 7/16 in. (22.5 x 18.9 cm.) sight size
Mount: 11 x 8 in. (27.9 x 20.3 cm.)
Signed, l.r. overmat recto: "Clara E. Sipprell"
 l.r. mount verso: "Clara E. Sipprell/1929"
Inscription, overmat recto: "Pamela"
 overmat verso: "B114"
 mount verso: "B114"

Acquired from: gift of the Dorothea Leonhardt Fund of the Communities Foundation of Texas, Inc., Dallas, Texas

4658. **PÁTZCUARO, MEXICO [Lake Pátzcuaro, Mexico]** (P1984.1.284) duplicate of P1984.1.283
Gelatin silver print. negative c. 1931, print later
Image: 6 13/16 x 8 7/8 in. (17.3 x 22.5 cm.) sight size
Mount: 13 1/16 x 11 in. (33.3 x 27.9 cm.)
Signed, l.r. mount recto and l.r. overmat recto: "Clara E. Sipprell"
Inscription, overmat recto: "Patzcuaro/Mexico"
 overmat verso: "ML3"
 mount verso: "ML3" and typed on paper label "PATZCUARA [sic] LAKE, MEXICO"
Acquired from: gift of the Dorothea Leonhardt Fund of the Communities Foundation of Texas, Inc., Dallas, Texas

*4659. **PÁTZCUARO TYPES, MEXICO** (P1984.1.321)
Gelatin silver print on tissue. c. 1931
Image: 9 x 7 in. (22.8 x 17.8 cm.) sight size
Signed, l.r. overmat recto: "Clara E. Sipprell"
Inscription, overmat recto: "Patzcuaro Types/Mexico"
 mat backing verso: "M-8//g Mexico//MEX29"
Acquired from: gift of the Dorothea Leonhardt Fund of the Communities Foundation of Texas, Inc., Dallas, Texas

4660. **A PEASANT HOME, TEPIC, MEXICO** (P1984.1.304)
Gelatin silver print on tissue. c. 1931
Image: 7 1/2 x 9 1/2 in. (19.0 x 24.1 cm.)
Sheet: 8 x 10 1/8 in. (20.3 x 25.7 cm.)
Signed, l.r. overmat recto: "Clara E. Sipprell"
Inscription, print verso: "MEX 15"
 overmat recto: "A Peasant Home/Tepic/Mexico"
 overmat verso: "MEX15"
Acquired from: gift of the Dorothea Leonhardt Fund of the Communities Foundation of Texas, Inc., Dallas, Texas

4661. **PEASANTS ON THE ROAD, YUGOSLAVIA** (P1984.1.78)
Gelatin silver print. negative 1924, print c. 1960s
Image: 7 5/16 x 9 1/4 in. (18.5 x 23.5 cm.)
Mount: 13 1/2 x 10 13/16 in. (34.2 x 27.4 cm.)
Signed, l.r. overmat recto: "Clara E. Sipprell"
 l.r. mount recto: "Clara E. Sipprell/1924"
Inscription, overmat recto: "Peasants on the road/Yugoslavia"
 overmat verso: "Y44"
 mount verso: "Y44"
Acquired from: gift of the Dorothea Leonhardt Fund of the Communities Foundation of Texas, Inc., Dallas, Texas

4662. **PERCÉ POINT, GASPÉ, QUEBEC [Foggy Day at Percé, Gaspé Peninsula]** (P1984.1.405) duplicate of P1984.1.406 and P1984.1.416
Gelatin silver print on tissue. c. 1932
Image: 7 1/8 x 8 15/16 in. (18.1 x 22.6 cm.) sight size
Signed, l.r. overmat recto: "Clara E. Sipprell"
Inscription, mat backing verso: "GP-16-a//Percé Point/Gaspé Quebec//GP4"
Acquired from: gift of the Dorothea Leonhardt Fund of the Communities Foundation of Texas, Inc., Dallas, Texas

4663. **PERCÉ POINT, GASPÉ, QUEBEC [Foggy Day at Percé, Gaspé Peninsula]** (P1984.1.406) duplicate of P1984.1.405 and P1984.1.416
Gelatin silver print. negative c. 1932, print later
Image: 7 3/8 x 9 1/4 in. (18.7 x 23.5 cm.)
1st mount: 9 1/16 x 9 7/8 in. (23.0 x 25.1 cm.)
2nd mount: 18 x 13 in. (45.7 x 33.0 cm.)
Signed, l.r. 1st mount recto: "Clara E. Sipprell"
Inscription, 2nd mount verso: "GP-16-c//Percé Point/Gaspé/Quebec//GP3"
Acquired from: gift of the Dorothea Leonhardt Fund of the Communities Foundation of Texas, Inc., Dallas, Texas

*4664. **[Pewter mug, plate, and sampler; Still Life With Copper Bowl]** (P1984.1.23) duplicate of P1984.1.496
Gelatin silver print. c. late 1920s
Image: 9 3/8 x 7 1/2 in. (23.8 x 19.0 cm.)
Sheet: 9 13/16 x 7 15/16 in. (24.9 x 20.2 cm.)

Inscription, print verso: "PF"
 mat backing verso: dealer's label
Acquired from: gift of the Dorothea Leonhardt Fund of the
 Communities Foundation of Texas, Inc., Dallas, Texas

4665. **PHYLLIS FENNER** (P1984.1.268)
 Gelatin silver print. negative c. 1960, print 1960
 Image: 8 $^{15}/_{16}$ x 7 $^{1}/_{2}$ in. (22.6 x 19.0 cm.) sight size
 Mount: 11 x 8 $^{1}/_{2}$ in. (28.0 x 21.5 cm.)
 Signed, l.r. overmat recto: "Clara E. Sipprell/1960"
 Inscription, overmat recto: "Phyllis Fenner"
 overmat verso: "ADL15"
 Acquired from: gift of the Dorothea Leonhardt Fund of the
 Communities Foundation of Texas, Inc., Dallas, Texas

4666. **PHYLLIS FENNER** (P1984.1.269)
 Gelatin silver print. c. 1960
 Image: 8 $^{7}/_{8}$ x 7 $^{1}/_{2}$ in. (22.5 x 19.0 cm.) sight size
 Mount: 11 x 8 $^{1}/_{2}$ in. (28.0 x 21.5 cm.)
 Signed, l.r. overmat recto: "Clara E. Sipprell"
 Inscription, overmat recto: "Phyllis Fenner"
 overmat verso: "ADL 16"
 Acquired from: gift of the Dorothea Leonhardt Fund of the
 Communities Foundation of Texas, Inc., Dallas, Texas

4667. **PHYLLIS FENNER** (P1984.1.270)
 Gelatin silver print. c. 1940s–50s
 Image: 9 x 6 $^{15}/_{16}$ in. (22.8 x 17.6 cm.) sight size
 Signed, l.r. overmat recto: "Clara E. Sipprell"
 Inscription, overmat recto: "Phyllis Fenner"
 mat backing verso: "Pf-130-IV//ADL 10"
 Acquired from: gift of the Dorothea Leonhardt Fund of the
 Communities Foundation of Texas, Inc., Dallas, Texas

4668. **PHYLLIS FENNER** (P1984.1.271)
 Gelatin silver print. negative c. 1940s, print later
 Image: 8 $^{15}/_{16}$ x 6 $^{7}/_{8}$ in. (22.6 x 17.4 cm.) sight size
 Mount: 11 $^{1}/_{16}$ x 8 $^{1}/_{2}$ in. (28.1 x 21.5 cm.)
 Signed, l.r. overmat recto: "Clara E. Sipprell"
 Inscription, overmat recto: "Phyllis Fenner"
 overmat verso: "ADL 19"
 mount verso: "PF"
 mat backing verso: "ADL 19"
 Acquired from: gift of the Dorothea Leonhardt Fund of the
 Communities Foundation of Texas, Inc., Dallas, Texas

* 4669. **PHYLLIS FENNER** (P1984.1.272)
 Gelatin silver print. c. 1940s
 Image: 7 $^{5}/_{8}$ x 6 $^{7}/_{8}$ in. (19.4 x 17.4 cm.) sight size
 Sheet: 9 $^{15}/_{16}$ x 8 in. (25.3 x 20.3 cm.)
 Signed, l.r. overmat recto: "Clara E. Sipprell"
 Inscription, print verso: "ADL13"
 overmat recto: "Phyllis Fenner"
 overmat verso: "ADL 13"
 Acquired from: gift of the Dorothea Leonhardt Fund of the
 Communities Foundation of Texas, Inc., Dallas, Texas

4670. **PHYLLIS'S ROSES** (P1984.1.500)
 Gelatin silver print. c. 1940s–50s
 Image: 8 $^{15}/_{16}$ x 7 $^{7}/_{16}$ in. (22.6 x 18.9 cm.) sight size
 Mount: 11 x 8 in. (28.0 x 20.3 cm.)
 Signed, l.r. overmat recto: "Clara E. Sipprell"
 l.r. mount verso: "Clara E. Sipprell/1925"
 Inscription, overmat recto: "Phyllis's Roses"
 mount verso: "SL16"
 Acquired from: gift of the Dorothea Leonhardt Fund of the
 Communities Foundation of Texas, Inc., Dallas, Texas

4671. **PICTURE BOOK, TOPSY IN WINDOW** (P1984.1.213)
 Gelatin silver print. negative c. 1932, print later
 Image: 8 $^{7}/_{8}$ x 7 $^{9}/_{16}$ in. (22.5 x 19.2 cm.) sight size
 Sheet: 10 $^{1}/_{16}$ x 8 in. (25.5 x 20.3 cm.)
 Mount: 10 $^{1}/_{8}$ x 8 $^{1}/_{8}$ in. (25.8 x 20.7 cm.)
 Signed, l.r. overmat recto: "Clara E. Sipprell"
 Inscription, overmat recto: "Picture book/Topsy in window"
 overmat verso: "Pf-51//Nina//C23"
 mount verso: "C23"
 Acquired from: gift of the Dorothea Leonhardt Fund of the
 Communities Foundation of Texas, Inc., Dallas, Texas

4659

4664

4669

4672. **PINEAS ON DALMATIAN COAST** [Dalmatia, Yugoslavia]
(P1984.1.598) duplicate of P1984.1.599
Gelatin silver print. negative 1924, print c. 1924
Image: 9 ⅜ x 7 ⁵⁄₁₆ in. (23.8 x 18.5 cm.)
1st mount: 10 ½ x 7 ¹³⁄₁₆ in. (26.6 x 19.8 cm.)
2nd mount: 18 ¹⁄₁₆ x 13 in. (45.9 x 33.0 cm.)
Signed, l.r. 1st mount recto: "Clara E. Sipprell/1924"
Inscription, 1st mount recto: "Pinneas on Dalmation [sic]
coast"
2nd mount verso: "Pinnaes [sic]/Dalmatia//YL28" and
typed on paper label "Pinneas [sic] on Dalmatian Coast./
Made 1924."
Acquired from: gift of the Dorothea Leonhardt Fund of the
Communities Foundation of Texas, Inc., Dallas, Texas

4673. **PINEAS ON THE ISLAND OF LOCRUM, DALMATIA**
(P1984.1.586)
Gelatin silver print on tissue. c. 1926
Image: 7 ⁷⁄₁₆ x 9 in. (18.9 x 22.8 cm.) sight size
Sheet: 7 ⅞ x 10 in. (20.0 x 25.4 cm.)
Signed, l.r. overmat recto: "Clara E. Sipprell"
Inscription, print verso: "YL49"
overmat recto, typed on paper label: "Pineas on the Island
of Locrum/Dalmatia"
overmat verso: "YL49"
mat backing verso: "DL-41//YL49"
Acquired from: gift of the Dorothea Leonhardt Fund of the
Communities Foundation of Texas, Inc., Dallas, Texas

4674. **[Plant in a bottle]** (P1984.1.673)
Gelatin silver print on tissue. c. 1920s
Image: 9 ⅝ x 7 ½ in. (24.4 x 19.0 cm.)
Sheet: 9 ⅞ x 7 ¹⁵⁄₁₆ in. (25.1 x 20.2 cm.)
Inscription, print verso: "PF"
Acquired from: gift of the Dorothea Leonhardt Fund of the
Communities Foundation of Texas, Inc., Dallas, Texas

4675. **PLAYING THE NÄVERLUR, TÄLLBERG—
DALECARLIA** (P1984.1.548)
Gelatin silver print on Gevaluxe paper. c. 1938
Image: 9 ⅛ x 7 ⅛ in. (23.2 x 18.1 cm.) sight size
Signed, l.r. overmat recto: "Clara E. Sipprell"
Inscription, overmat recto: "Playing the Näverlur/Tälberg
[sic]— Dalecarlia" and red foil star
mat backing verso: "S-L-29//SwL21"
Acquired from: gift of the Dorothea Leonhardt Fund of the
Communities Foundation of Texas, Inc., Dallas, Texas

*4676. **PLITVIČKA CASCADE, SOUTHERN CROATIA**
(P1984.1.562) duplicate of P1984.1.663
Gelatin silver print on tissue. c. 1926
Image: 8 ¹⁵⁄₁₆ x 4 ¹⁵⁄₁₆ in. (22.6 x 12.6 cm.) sight size
Signed, l.r. overmat recto: "Clara E. Sipprell"
Inscription, overmat recto, typed on paper label:
"Plitvici [sic] Cascade/Southern Croatia"
mat backing verso: "DL-72//YL10"
Acquired from: gift of the Dorothea Leonhardt Fund of the
Communities Foundation of Texas, Inc., Dallas, Texas

4677. **PLITVIČKA CASCADE, SOUTHERN CROATIA**
(P1984.1.663) duplicate of P1984.1.562
Gelatin silver print on tissue. c. 1926
Image: 9 ⁹⁄₁₆ x 7 ½ in. (24.3 x 19.0 cm.)
Sheet: 10 x 8 in. (25.4 x 20.3 cm.)
Acquired from: gift of the Dorothea Leonhardt Fund of the
Communities Foundation of Texas, Inc., Dallas, Texas

4678. **POINTE AU MAQUEREAU, GASPÉ PENINSULA**
(P1984.1.415)
Gelatin silver print on tissue. negative c. 1932, print later
Image: 7 ¼ x 8 ¹⁵⁄₁₆ in. (18.4 x 22.6 cm.) sight size
Signed, l.r. overmat recto: "Clara E. Sipprell"
Inscription, overmat recto, typed on paper label:
"Pointeau [sic] Maquereau/Gaspé Peninsula"
mat backing verso: "GP-9//GP21"
Acquired from: gift of the Dorothea Leonhardt Fund of the
Communities Foundation of Texas, Inc., Dallas, Texas

4679. **[A pond]** (P1984.1.28)
Gelatin silver print. negative c. 1930s, print c. 1960s
Image: 9 x 6 ¹⁵⁄₁₆ in. (22.8 x 17.6 cm.) sight size
Inscription, mat backing verso: dealer's label
old overmat recto: "26"
old overmat verso: "PF"
Acquired from: gift of the Dorothea Leonhardt Fund of the
Communities Foundation of Texas, Inc., Dallas, Texas

4680. **PORTAL OF BRO PARISH CHURCH—GOTLAND**
(P1984.1.537)
Gelatin silver print on Gevaluxe paper. c. 1938
Image: 9 ³⁄₁₆ x 7 ⅛ in. (23.3 x 18.1 cm.) sight size
Signed, l.r. overmat recto: "Clara E. Sipprell"
Inscription, print verso: "SA1"
overmat recto: "Portal of Bro parish church—Gotland"
overmat verso: "SA1"
mat backing verso: "S-L-38//SA1"
Acquired from: gift of the Dorothea Leonhardt Fund of the
Communities Foundation of Texas, Inc., Dallas, Texas

4681. **PORTICO OF EQUINOX HOUSE, MANCHESTER,
VERMONT** (P1984.1.474)
Gelatin silver print. c. 1937 or later
Image: 9 x 7 in. (22.8 x 17.8 cm.) sight size
Signed, l.r. overmat recto: "Clara E. Sipprell"
Inscription, overmat recto: "Portico of Equinox House/
Manchester, Vermont"
mat backing verso: "AA13"
Acquired from: gift of the Dorothea Leonhardt Fund of the
Communities Foundation of Texas, Inc., Dallas, Texas

4682. **THE POST MASTER—YUGOSLAVIA** (P1984.1.74)
Gelatin silver print. negative c. 1926, print later
Image: 8 ¹⁵⁄₁₆ x 6 ⅞ in. (22.6 x 17.4 cm.) sight size
Mount: 11 x 8 ½ in. (28.0 x 21.7 cm.)
Signed, l.r. overmat recto: "Clara E. Sipprell"
Inscription, overmat recto: "The Post master—/Yugoslavia"
overmat verso: "D-P-3-a//Y17"
mount verso: "Y18"
Acquired from: gift of the Dorothea Leonhardt Fund of the
Communities Foundation of Texas, Inc., Dallas, Texas

4683. **PROFESSOR AND MRS. GUBARD DE GEER—
GEOLOGIST—STOCKHOLM** (P1984.1.129)
Gelatin silver print on Gevaluxe paper. negative 1938,
print c. 1938
Image: 9 ¹¹⁄₁₆ x 7 ⅝ in. (24.6 x 19.4 cm.)
Sheet: 10 x 7 ⅞ in. (25.4 x 20.0 cm.)
Signed, l.r. overmat recto: "Clara E. Sipprell"
Inscription, print verso: "SP 36"
overmat recto: "Professor and Mrs. Gubard De Geer—
geologist/Stockholm"
mat backing verso: "S-P-54//SP36"
Acquired from: gift of the Dorothea Leonhardt Fund of the
Communities Foundation of Texas, Inc., Dallas, Texas

4684. **PROFESSOR AXEL HAGERSTRÖM—PHILOSOPHER—
UPPSALA** (P1984.1.145)
Gelatin silver print on Gevaluxe paper. negative 1938,
print c. 1938
Image: 9 ³⁄₁₆ x 7 ⅛ in. (23.3 x 18.1 cm.) sight size
Signed, l.r. overmat recto: "Clara E. Sipprell"
Inscription, print verso: "SP67"
overmat recto: "Professor Axel Hagerstrom—philosopher/
Uppsala"
mat backing verso: "S-P-17-a//SP67"
Acquired from: gift of the Dorothea Leonhardt Fund of the
Communities Foundation of Texas, Inc., Dallas, Texas

4685. **PROF. CHARLES ISHAM—HAMPTON INSTITUTE,
VA.** (P1984.1.90)
Gelatin silver print. c. 1940s—60s
Image: 8 ⅞ x 7 ⅛ in. (22.5 x 18.1 cm.) sight size
Signed, l.r. overmat recto: "Clara E. Sipprell"
Inscription, print verso: "B17"
overmat recto: "Prof. Charles Isham/Hampton
Institute, Va"

overmat verso: "Bl7"
mat backing verso: "AB-11//Bl7"
Acquired from: gift of the Dorothea Leonhardt Fund of the
Communities Foundation of Texas, Inc., Dallas, Texas

4686. **PROF. ELI HECKSCHER—ECONOMIC HISTORY—
SWEDEN** (P1984.1.138) duplicate of P1984.1.139
Gelatin silver print. negative 1938, print c. 1938 or later
Image: 8 ¹⁵/₁₆ x 7 ⁷/₁₆ in. (22.6 x 18.9 cm.) sight size
Sheet: 9 ¹⁵/₁₆ x 8 in. (25.3 x 20.3 cm.)
Mount: same as sheet size
Signed, l.r. overmat recto: "Clara E. Sipprell/1938"
Inscription, overmat recto: "Prof Eli Heckscher/Economic
history/Sweden"
mount verso: "SP59"
note: a print of a Yugoslavian street scene is affixed to
print verso
Acquired from: gift of the Dorothea Leonhardt Fund of the
Communities Foundation of Texas, Inc., Dallas, Texas

4687. **PROF. ELI HECKSCHER—ECONOMIC HISTORY—
SWEDEN** (P1984.1.139) duplicate of P1984.1.138
Gelatin silver print on Gevaluxe paper. negative 1938,
print c. 1938
Image: 9 ⅛ x 7 ½ in. (23.2 x 19.0 cm.) sight size
Sheet: 10 x 7 ¹⁵/₁₆ in. (25.4 x 20.2 cm.)
Signed, l.r. overmat recto: "Clara E. Sipprell"
Inscription, print verso: "SP60"
overmat recto: "x//Prof. Eli Heckscher/economic history/
Sweden"
Acquired from: gift of the Dorothea Leonhardt Fund of the
Communities Foundation of Texas, Inc., Dallas, Texas

4688. **PROFESSOR ERIK STENSIÖ—PALEOXOOLOGISKA—
STOCKHOLM** (P1984.1.166)
Gelatin silver print on Gevaluxe paper. negative 1938,
print c. 1938
Image: 9 ⁹/₁₆ x 7 ⁹/₁₆ in. (24.3 x 19.2 cm.)
Sheet: 10 x 7 ¹⁵/₁₆ in. (25.4 x 20.2 cm.)
Signed, l.r. overmat recto: "Clara E. Sipprell"
Inscription, print verso: "SP14"
overmat recto: "Professor Erik Stensiö—paleoxoologiska/
Stockholm"
mat backing verso: "S-P-55//SP14"
Acquired from: gift of the Dorothea Leonhardt Fund of the
Communities Foundation of Texas, Inc., Dallas, Texas

4689. **PROFESSOR FREDRIK BÖÖK—AUTHOR—LUND**
(P1984.1.149)
Gelatin silver print on Gevaluxe paper. negative 1938,
print c. 1938
Image: 9 ⅝ x 7 ⅝ in. (24.4 x 19.4 cm.)
Sheet: 10 x 7 ¹⁵/₁₆ in. (25.4 x 20.2 cm.)
Signed, l.r. overmat recto: "Clara E. Sipprell"
Inscription, print verso: "SP28"
overmat recto: "Professor Fredrik Böök—author—Lund"
mat backing verso: "S-P-52//SP28"
Acquired from: gift of the Dorothea Leonhardt Fund of the
Communities Foundation of Texas, Inc., Dallas, Texas

4690. **PROFESSOR GÖSTA FORSSELL—
ROENTGENDIAGNOSIS** (P1984.1.150)
Gelatin silver print on Gevaluxe paper. negative 1938,
print c. 1938
Image: 8 ¹⁵/₁₆ x 7 ⅛ in. (22.6 x 18.1 cm.) sight size
Sheet: 10 x 7 ¹⁵/₁₆ in. (25.4 x 20.2 cm.)
Signed, l.r. overmat recto: "Clara E. Sipprell"
Inscription, print verso: "SP29"
overmat recto: "Professor Gösta Forssell—
Roentgendragnosis [sic]"
mat backing verso: "S-P-45//SP29"
Acquired from: gift of the Dorothea Leonhardt Fund of the
Communities Foundation of Texas, Inc., Dallas, Texas

4676

4698

4691. **PROFESSOR GUNNAR ANDERSON—
ANTHROPOLOGY—STOCKHOLM** (P1984.1.163)
Gelatin silver print on Gevaluxe paper. negative 1938,
 print c. 1938
Image: 9 9/16 x 7 5/8 in. (24.3 x 19.4 cm.)
Sheet: 9 15/16 x 7 15/16 in. (25.3 x 20.2 cm.)
Signed, l.r. overmat recto: "Clara E. Sipprell"
Inscription, print verso: "SP16"
 overmat recto: "Professor Gunnar Anderson—
 anthropology/Stockholm"
 mat backing verso: "S-P-46//SP16"
Acquired from: gift of the Dorothea Leonhardt Fund of the
 Communities Foundation of Texas, Inc., Dallas, Texas

4692. **PROFESSOR GUSTAF CASSEL—ECONOMIST—
STOCKHOLM** (P1984.1.192)
Gelatin silver print on Gevaluxe paper. negative 1938,
 print c. 1938
Image: 7 7/8 x 7 1/8 in. (20.0 x 18.1 cm.) sight size
Signed, l.r. overmat recto: "Clara E. Sipprell"
Inscription, print verso: "SP10"
 overmat recto: "Professor Gustaf Cassel—economist—
 Stockholm"
 mat backing verso: "S-P-13//SP10"
Acquired from: gift of the Dorothea Leonhardt Fund of the
 Communities Foundation of Texas, Inc., Dallas, Texas

4693. **PROFESSOR HANNA SVARTZ—MEDICINE—
STOCKHOLM** (P1984.1.156)
Gelatin silver print on Gevaluxe paper. negative 1938,
 print c. 1938
Image: 9 5/8 x 7 11/16 in. (24.4 x 19.5 cm.)
Sheet: 10 x 7 15/16 in. (25.4 x 20.2 cm.)
Signed, l.r. overmat recto: "Clara E. Sipprell"
Inscription, print verso: "SP 32"
 overmat recto: "Professor Hanna Svartz—Medicine/
 Stockholm"
 mat backing verso: "2/S-P-56//SP32"
Acquired from: gift of the Dorothea Leonhardt Fund of the
 Communities Foundation of Texas, Inc., Dallas, Texas

4694. **PROFESSOR HANS LARSSON—PHILOSOPHY—
1 OF THE 18—LUND** (P1984.1.147)
Gelatin silver print on Gevaluxe paper. negative 1938,
 print c. 1938
Image: 9 5/8 x 7 5/8 in. (24.4 x 19.4 cm.)
Sheet: 9 15/16 x 8 in. (25.3 x 20.3 cm.)
Signed, l.r. overmat recto: "Clara E. Sipprell"
Inscription, print verso: "SP31"
 overmat recto: "Professor Hans Larsson—Philosophy—1 of
 the 18/Lund"
 mat backing verso: "S-P-50//SP31"
Acquired from: gift of the Dorothea Leonhardt Fund of the
 Communities Foundation of Texas, Inc., Dallas, Texas

4695. **PROFESSOR HERBERT OLIVECRONA—TRAIN
SPECIALIST—STOCKHOLM** (P1984.1.178)
Gelatin silver print on Gevaluxe paper. negative 1938,
 print c. 1938
Image: 8 7/8 x 7 1/16 in. (22.5 x 17.9 cm.) sight size
Sheet: 10 x 7 15/16 in. (25.3 x 20.2 cm.)
Signed, l.r. overmat recto: "Clara E. Sipprell"
Inscription, print verso: "SP2"
 overmat recto: "Professor Herbert Olivecrona—
 Train specialist/Stockholm"
 mat backing verso: "S-P-44//SP2"
Acquired from: gift of the Dorothea Leonhardt Fund of the
 Communities Foundation of Texas, Inc., Dallas, Texas

4696. **PROFESSOR IVAR TENGBOM—ARCHITECT—
STOCKHOLM** (P1984.1.162)
Gelatin silver print on Gevaluxe paper. negative 1938,
 print c. 1938
Image: 9 5/8 x 7 5/8 in. (24.4 x 19.4 cm.)
Sheet: 9 15/16 x 8 in. (25.3 x 20.3 cm.)
Signed, l.r. overmat recto: "Clara E. Sipprell"

Inscription, print verso: "SP8"
 overmat recto: "Professor Ivar Tengbom—Architect—
 Stockholm"
 mat backing verso: "S-P-25//SP8"
Acquired from: gift of the Dorothea Leonhardt Fund of the
 Communities Foundation of Texas, Inc., Dallas, Texas

4697. **PROFESSOR MANNE SIEGBAHN—PHYSICS—NOBEL
PRIZE—STOCKHOLM** (P1984.1.189)
Gelatin silver print on Gevaluxe paper. negative 1938,
 print c. 1938
Image: 9 5/8 x 7 5/8 in. (24.4 x 19.4 cm.)
Sheet: 9 15/16 x 7 15/16 in. (25.3 x 20.2 cm.)
Signed, l.r. overmat recto: "Clara E. Sipprell"
Inscription, print verso: "SP5"
 overmat recto: "Professor Manne Siegbahn—Physics—
 Nobel prize—/Stockholm"
 mat backing verso: "S-P-22//SP5"
Acquired from: gift of the Dorothea Leonhardt Fund of the
 Communities Foundation of Texas, Inc., Dallas, Texas

*4698. **PROFESSOR MARTIN PIN NILSSON—ARCHEOLOGY
AND ANCIENT HISTORY—LUND** (P1984.1.168)
Gelatin silver print on Gevaluxe paper. negative 1938,
 print c. 1938
Image: 9 1/8 x 7 1/8 in. (23.2 x 18.1 cm.) sight size
Sheet: 10 x 7 15/16 in. (25.4 x 20.2 cm.)
Signed, l.r. overmat recto: "Clara E. Sipprell"
Inscription, print verso: "SP21"
 overmat recto: "Professor Martin Pin Nilsson—Archeology
 and Ancient History/Lund"
 mat backing verso: "S-P-14//SP21"
Acquired from: gift of the Dorothea Leonhardt Fund of the
 Communities Foundation of Texas, Inc., Dallas, Texas

*4699. **PROFESSOR OSKAR LINDBERG—COMPOSER—
STOCKHOLM** (P1984.1.137)
Gelatin silver print on Gevaluxe paper. negative 1938,
 print c. 1938
Image: 9 5/8 x 7 7/16 in. (24.4 x 18.9 cm.)
Sheet: 10 x 7 15/16 in. (25.4 x 20.2 cm.)
Signed, l.r. overmat recto: "Clara E. Sipprell"
Inscription, print verso: "SP65"
 overmat recto: "Professor Oskar Lindberg—composer—
 Stockholm"
 mat backing verso: "S-P-33//SP65"
Acquired from: gift of the Dorothea Leonhardt Fund of the
 Communities Foundation of Texas, Inc., Dallas, Texas

4700. **PROFESSOR OTTE SKÖLD—PAINTER—STOCKHOLM**
 (P1984.1.155)
Gelatin silver print on Gevaluxe paper. negative 1938,
 print c. 1938
Image: 9 11/16 x 7 5/8 in. (24.6 x 19.4 cm.)
Sheet: 10 x 7 15/16 in. (25.4 x 20.2 cm.)
Signed, l.r. overmat recto: "Clara E. Sipprell"
Inscription, print verso: "SP 33"
 overmat recto: "Professor Otte Sköld—painter—
 Stockholm"
 mat backing verso: "S-P-30//SP33"
Acquired from: gift of the Dorothea Leonhardt Fund of the
 Communities Foundation of Texas, Inc., Dallas, Texas

4701. **PROFESSOR RAGNAR JOSEPHSON—DRAMATIC
WRITER—LUND** (P1984.1.148)
Gelatin silver print on Gevaluxe paper. negative 1938,
 print c. 1938
Image: 9 5/8 x 7 5/8 in. (24.4 x 19.4 cm.)
Sheet: 10 x 8 in. (25.4 x 20.3 cm.)
Signed, l.r. overmat recto: "Clara E. Sipprell"
Inscription, print verso: "SP30"
 overmat recto: "Professor Ragnar Josephson—Dramatic
 writer/Lund"
 mat backing verso: "S-P-58//SP30"
Acquired from: gift of the Dorothea Leonhardt Fund of the
 Communities Foundation of Texas, Inc., Dallas, Texas

4702. **PROFESSOR RAGNAR ÖSTBERG—ARCHITECT— STOCKHOLM** (P1984.1.131)
Gelatin silver print on Gevaluxe paper. negative 1938, print c. 1938
Image: 9 ⅝ x 7 ⅝ in. (24.4 x 19.4 cm.)
Sheet: 9 ¹⁵/₁₆ x 8 in. (25.3 x 20.3 cm.)
Signed, l.r. overmat recto: "Clara E. Sipprell"
Inscription, print verso: "SP38"
 overmat recto: "Professor Ragnar Östberg—architect/ Stockholm"
 mat backing verso: "S-P-26//SP38"
Acquired from: gift of the Dorothea Leonhardt Fund of the Communities Foundation of Texas, Inc., Dallas, Texas

4703. **PROFESSOR THE SVEDBERG—PHYSICAL CHEMISTRY—NOBEL PRIZE—UPPSALA** (P1984.1.179)
Gelatin silver print on Gevaluxe paper. negative 1938, print c. 1938
Image: 9 ⅝ x 7 ⅝ in. (24.4 x 19.4 cm.)
Sheet: 9 ¹⁵/₁₆ x 8 in. (25.3 x 20.3 cm.)
Signed, l.r. overmat recto: "Clara E. Sipprell"
Inscription, print verso: "SP1"
 overmat recto: "Professor The Sveberg [sic]—physical chemistry—nobel prize/Uppsala"
 mat backing verso: "S-P-16//SP1"
Acquired from: gift of the Dorothea Leonhardt Fund of the Communities Foundation of Texas, Inc., Dallas, Texas

4704. **[Property man in yellow jacket]** (P1984.1.623)
Gelatin silver print on tissue. c. 1925
Image: 8 ¹⁵/₁₆ x 6 ½ in. (22.6 x 16.5 cm.)
Acquired from: gift of the Dorothea Leonhardt Fund of the Communities Foundation of Texas, Inc., Dallas, Texas

4705. **QUEBEC CITY FROM PORT LÉVIS** (P1984.1.404)
Gelatin silver print. negative c. 1932, print later
Image: 9 ⅜ x 7 ⅜ in. (23.8 x 18.7 cm.)
1st mount: 11 x 8 in. (28.0 x 20.3 cm.)
2nd mount: 18 x 13 in. (45.7 x 33.0 cm.)
Signed, l.r. 1st mount recto: "Clara E. Sipprell"
Inscription, 2nd mount verso: "GP- 13//Quebec City/from/ Port Levis//GP5"
Acquired from: gift of the Dorothea Leonhardt Fund of the Communities Foundation of Texas, Inc., Dallas, Texas

4706. **THE RAB SKYLINE—THE ISLAND OF RAB, DALMATIA** (P1984.1.570)
Gelatin silver print on tissue. c. 1926
Image: 8 ⁷/₁₆ x 7 ¼ in. (21.4 x 18.4 cm.) sight size
Signed, l.r. overmat recto: "Clara E. Sipprell"
Inscription, overmat recto, typed on paper label: "The Rab Skyline/The Island of Rab, Dalmatia"
 mat backing verso: "DL-32//12//YA26"
Acquired from: gift of the Dorothea Leonhardt Fund of the Communities Foundation of Texas, Inc., Dallas, Texas

4707. **RACIĆ MEMORIAL, SAVTAT, DALMATIA** (P1984.1.590)
Gelatin silver print on tissue. negative c. 1926, print c. 1926 or later
Image: 8 ¹⁵/₁₆ x 4 in. (22.6 x 10.1 cm.) sight size
Sheet: 10 x 8 in. (25.4 x 20.3 cm.)
Signed, l.r. overmat recto: "Clara E. Sipprell"
Inscription, print verso: "YL44"
 overmat recto, typed on paper label: "Raciĉ Memorial/ Savtat, Dalmatia"
 mat backing verso: "D-L-12//YL44"
Acquired from: gift of the Dorothea Leonhardt Fund of the Communities Foundation of Texas, Inc., Dallas, Texas

4708. **[Raciĉ Memorial, Savtat, Dalmatia]** (P1984.1.664)
Gelatin silver print. c. 1926
Image: 9 ⁵/₁₆ x 3 ⅞ in. (23.7 x 9.8 cm.)
1st mount: 9 ⅞ x 4 ⅜ in. (25.1 x 11.1 cm.)
2nd mount: 10 x 4 ½ in. (25.4 x 11.4 cm.)
Signed, l.r. 1st mount recto: "Clara E. Sipprell"
Acquired from: gift of the Dorothea Leonhardt Fund of the Communities Foundation of Texas, Inc., Dallas, Texas

4699

4709

4717

*4709. **A RAINY DAY, CONTRERAS, MEXICO** (P1984.1.318)
Gelatin silver print on tissue. c. 1931
Image: 9 3/16 x 7 1/8 in. (23.3 x 18.1 cm.) sight size
Signed, l.r. overmat recto: "Clara E. Sipprell"
Inscription, overmat recto: "Rainy Day/in/Contreras [sic]" and
 typed on paper label "A Rainy Day/Contreras, Mexico"
 mat backing verso: "M-40//MEX32"
Acquired from: gift of the Dorothea Leonhardt Fund of the
 Communities Foundation of Texas, Inc., Dallas, Texas

4710. **RALPH BUNCHE** (P1984.1.8) duplicate of P1984.1.89
Gelatin silver print. c. 1960s
Image: 9 x 7 in. (22.8 x 17.8 cm.) sight size
Sheet: 10 x 8 in. (25.4 x 20.3 cm.)
Mount: same as sheet size
Signed, l.r. old overmat recto: "Clara E. Sipprell"
Inscription, mat backing verso: dealer's label
 old overmat recto: "Ralph Bunche"
 old overmat verso: "IG 36"
 note: a duplicate print is affixed to print verso
Acquired from: gift of the Dorothea Leonhardt Fund of the
 Communities Foundation of Texas, Inc., Dallas, Texas

4711. **RALPH BUNCHE** (P1984.1.89) duplicate of P1984.1.8
Gelatin silver print. c. 1960s
Image: 8 9/16 x 6 1/16 in. (21.7 x 15.4 cm.) sight size
Mount: 11 x 8 1/2 in. (28.0 x 21.7 cm.)
Signed, l.r. overmat recto: "Clara E. Sipprell"
Inscription, overmat recto: "400-//Ralph Bunche"
 overmat verso: "B15"
 mount verso: "B15"
Acquired from: gift of the Dorothea Leonhardt Fund of the
 Communities Foundation of Texas, Inc., Dallas, Texas

4712. **RÄTTVIK KYRKA—DALECARLIA** (P1984.1.549)
Gelatin silver print on Gevaluxe paper. c. 1938
Image: 7 5/8 x 9 9/16 in. (19.4 x 24.3 cm.)
Sheet: 7 15/16 x 9 15/16 in. (20.2 x 25.3 cm.)
Signed, l.r. overmat recto: "Clara E. Sipprell"
Inscription, print verso: "SwL20"
 overmat recto: "Rattvik Kyrka—Dalecarlia"
 overmat verso: "SwL20"
 mat backing verso: "S-L-17//SwL20"
Acquired from: gift of the Dorothea Leonhardt Fund of the
 Communities Foundation of Texas, Inc., Dallas, Texas

4713. **READING CHRISTMAS CARDS** (P1984.1.249)
Gelatin silver print on tissue. c. 1929
Image: 9 x 6 1/8 in. (22.8 x 15.5 cm.) sight size
Signed, l.r. overmat recto: "Clara E. Sipprell"
Inscription, overmat recto, typed on paper label: "Reading
 Christmas Cards"
 mat backing verso: "Pf-44//C38"
Acquired from: gift of the Dorothea Leonhardt Fund of the
 Communities Foundation of Texas, Inc., Dallas, Texas

4714. **THE RED FORT AT RUMELIHISARI, ISTANBUL**
 (P1984.1.565)
Gelatin silver print. negative c. 1926, print later
Image: 8 3/8 x 7 7/16 in. (21.3 x 18.9 cm.) sight size
Sheet: 9 15/16 x 8 in. (25.3 x 20.3 cm.)
Mount: same as sheet size
Signed, l.r. overmat recto: "Clara E. Sipprell"
Inscription, overmat recto: "The red fort at/Rumeli Hissar
 [sic]/Istanbus [sic]"
 overmat verso: "YA51"
 mount verso: "YA51"
Acquired from: gift of the Dorothea Leonhardt Fund of the
 Communities Foundation of Texas, Inc., Dallas, Texas

4715. **[Reflecting pool and hillside]** (P1984.1.665)
Gelatin silver print. c. 1922
Image: 6 x 8 in. (15.2 x 20.3 cm.)
Mount: 6 5/8 x 8 3/8 in. (16.8 x 21.3 cm.)
Signed, l.r. mount recto: "Clara E. Sipprell"
Acquired from: gift of the Dorothea Leonhardt Fund of the
 Communities Foundation of Texas, Inc., Dallas, Texas

4716. **[Reflecting pool and house of Maxfield Parrish]** (P1984.1.680)
Gelatin silver print. c. 1922
Image: 7 7/8 x 5 15/16 in. (20.0 x 15.1 cm.)
Mount: 8 15/16 x 6 9/16 in. (22.6 x 16.7 cm.)
Signed, l.r. mount recto: "Clara E. Sipprell"
Inscription, mount verso: "AA30"
Acquired from: gift of the Dorothea Leonhardt Fund of the
 Communities Foundation of Texas, Inc., Dallas, Texas

*4717. **[Reflecting pool and steps, Maxfield Parrish's house and
 garden]** (P1984.1.26)
Gelatin silver print on tissue. c. 1922
Image: 8 3/4 x 7 in. (22.2 x 17.8 cm.)
Sheet: 9 13/16 x 7 15/16 in. (24.9 x 20.2 cm.)
Signed, l.r. print recto: "Clara E. Sipprell"
Inscription, print verso: "PF"
 old mat backing verso: dealer's label
Acquired from: gift of the Dorothea Leonhardt Fund of the
 Communities Foundation of Texas, Inc., Dallas, Texas

4718. **RIDDARHOLMS KYRKA—STOCKHOLM** (P1984.1.534)
Gelatin silver print on Gevaluxe paper. c. 1938
Image: 8 3/4 x 5 15/16 in. (22.2 x 15.1 cm.) sight size
Signed, l.r. overmat recto: "Clara E. Sipprell"
Inscription, overmat recto: "Riddarholms Kyrkau [sic]—
 Stockholm"
 mat backing verso: "S-L-12//SA5"
Acquired from: gift of the Dorothea Leonhardt Fund of the
 Communities Foundation of Texas, Inc., Dallas, Texas

4719. **RIKSANTIKVARIEN SIGURD CURMAN, STOCKHOLM**
 (P1984.1.170)
Gelatin silver print on Gevaluxe paper. negative 1938,
 print c. 1938
Image: 9 5/8 x 7 5/8 in. (24.4 x 19.4 cm.)
Sheet: 10 x 8 in. (25.4 x 20.3 cm.)
Signed, l.r. overmat recto: "Clara E. Sipprell"
Inscription, print verso: "SP19"
 overmat recto: "Riksantikvarien Sigurd Curman/
 Stockholm"
 mat backing verso: "S-P-21//SP19"
Acquired from: gift of the Dorothea Leonhardt Fund of the
 Communities Foundation of Texas, Inc., Dallas, Texas

4720. **THE RIM OF THE GRAND CANYON** (P1984.1.339)
Gelatin silver print. negative n.d., print c. 1950s
Image: 9 3/4 x 7 5/8 in. (24.8 x 19.4 cm.)
Sheet: 9 15/16 x 7 15/16 in. (25.3 x 20.2 cm.)
Mount: same as sheet size
Signed, l.r. overmat recto: "Clara E. Sipprell"
Inscription, overmat recto: "The Rim of the Grand Canyon"
 overmat verso: "WL6"
 mat backing verso: "Pf-183//WL6"
Acquired from: gift of the Dorothea Leonhardt Fund of the
 Communities Foundation of Texas, Inc., Dallas, Texas

4721. **ROAD THROUGH THE MOUNTAINS** (P1984.1.334)
Gelatin silver print on tissue. c. 1928–31
Image: 9 3/16 x 7 3/8 in. (23.3 x 18.7 cm.) sight size
Signed, l.r. overmat recto: "Clara E. Sipprell"
Inscription, mat backing verso: "A-L-51//Road through the/
 mountains//WL10"
Acquired from: gift of the Dorothea Leonhardt Fund of the
 Communities Foundation of Texas, Inc., Dallas, Texas

*4722. **ROBINSON JEFFERS** (P1984.1.5)
Gelatin silver print. c. 1930s–40s
Image: 9 x 6 15/16 in. (22.8 x 17.6 cm.) sight size
Sheet: 10 x 8 in. (25.4 x 20.3 cm.)
Signed, l.r. old overmat recto: "Clara E. Sipprell"
Inscription, mat backing verso: dealer's label
 old overmat recto: "Robinson Jeffers"
 old overmat verso: "PF//IG32"
Acquired from: gift of the Dorothea Leonhardt Fund of the
 Communities Foundation of Texas, Inc., Dallas, Texas

4723. **ROCKS AT PERCÉ, GASPÉ PENINSULA** (P1984.1.25)
Gelatin silver print on tissue. c. 1932
Image: 7⅛ x 9 3/16 in. (18.1 x 23.3 cm.) sight size
Signed, l.r. old overmat recto: "Clara E. Sipprell"
Inscription, mat backing verso: dealer's label
old overmat recto: "39" and typed on paper label "Rocks at Percé/Gaspé Peninsula"
old mat backing verso: "GP-24//PF//Wre"
Acquired from: gift of the Dorothea Leonhardt Fund of the Communities Foundation of Texas, Inc., Dallas, Texas

4724. **ROCKS BY THE SEA, DALMATIA** (P1984.1.597)
Gelatin silver print on tissue. c. 1926
Image: 9½ x 7 7/16 in. (24.1 x 18.9 cm.) sight size
Signed, l.r. overmat recto: "Clara E. Sipprell"
Inscription, overmat recto, typed on paper label: "Rocks by the Sea/Dalmatia"
mat backing verso: "YL31"
Acquired from: gift of the Dorothea Leonhardt Fund of the Communities Foundation of Texas, Inc., Dallas, Texas

*4725. **ROCKY MT. NATIONAL PARK—MORAINE VALLEY— A "PIN HOLE"** (P1984.1.325)
Gelatin silver print on tissue. c. 1930s—40s
Image: 9 1/16 x 6 15/16 in. (23.0 x 17.6 cm.) sight size
Signed, l.r. overmat recto: "Clara E. Sipprell"
Inscription, overmat recto: "Rocky Mt. National Park/Morain [sic] Valley//A "pin hole" "
mat backing verso: "WL20"
Acquired from: gift of the Dorothea Leonhardt Fund of the Communities Foundation of Texas, Inc., Dallas, Texas

4726. **ROLAND PALMEDO** (P1984.1.235) duplicate of P1984.1.236
Gelatin silver print. negative 1939, print later
Image: 9 3/16 x 7¼ in. (23.3 x 18.4 cm.)
Mount: 12¼ x 9 5/16 in. (31.2 x 23.7 cm.)
Signed, l.r. mount recto and l.r. old overmat recto: "Clara E. Sipprell"
Inscription, mount recto: "D//1939//reduce & crop as per stat/ 82½ %/FEDERATED #F12390//7¾ 10½//E-83.5"
old overmat recto: "Roland Palmedo"
old overmat verso: "ADL 20"
Acquired from: gift of the Dorothea Leonhardt Fund of the Communities Foundation of Texas, Inc., Dallas, Texas

4727. **ROLAND PALMEDO** (P1984.1.236) duplicate of P1984.1.235
Gelatin silver print. negative 1939, print later
Image: 9 x 6 15/16 in. (22.8 x 17.6 cm.) sight size
Mount: 11 x 8 9/16 in. (28.0 x 21.7 cm.)
Signed, l.r. overmat recto: "Clara E. Sipprell"
Inscription, overmat recto: "Roland Palmedo"
overmat verso: "ADL 21"
Acquired from: gift of the Dorothea Leonhardt Fund of the Communities Foundation of Texas, Inc., Dallas, Texas

*4728. **THE ROSE GARDEN** (P1984.1.12)
Platinum print on tissue. c. 1923
Image: 7 13/16 x 6 in. (19.8 x 15.2 cm.)
Sheet: 10 x 8 in. (25.4 x 20.3 cm.)
Signed, l.r. print recto: "Clara E. Sipprell"
Inscription, print verso: "PF"
mat backing verso: dealer's label
Acquired from: gift of the Dorothea Leonhardt Fund of the Communities Foundation of Texas, Inc., Dallas, Texas

4729. **ROSES** (P1984.1.501)
Gelatin silver print. c. 1940s—50s
Image: 9 9/16 x 7 5/8 in. (24.3 x 19.4 cm.)
Sheet: 9 15/16 x 8 in. (25.3 x 20.3 cm.)
Mount: 11 x 8¼ in. (28.0 x 20.9 cm.)
Signed, l.r. old overmat recto: "Clara E. Sipprell/1925 [sic]"
Inscription, mount verso: "SL17"
old overmat recto: "Roses"
old overmat verso: "SL17"
Acquired from: gift of the Dorothea Leonhardt Fund of the Communities Foundation of Texas, Inc., Dallas, Texas

4722

4725

4730. **[Row of trees and stone wall]** (P1984.1.428)
Gelatin silver print. n.d.
Image: 9 3/16 x 7 7/16 in. (23.3 x 18.9 cm.) sight size
Mount: 11 x 8 1/2 in. (28.0 x 21.6 cm.)
Inscription, overmat verso: "VL24"
 mount verso: "VL24"
Acquired from: gift of the Dorothea Leonhardt Fund of the
 Communities Foundation of Texas, Inc., Dallas, Texas

4731. **THE ROYAL PALACE—STOCKHOLM** (P1984.1.521)
Gelatin silver print on Gevaluxe paper. c. 1938
Image: 6 3/8 x 9 3/16 in. (16.2 x 23.3 cm.) sight size
Signed, l.r. overmat recto: "Clara E. Sipprell"
Inscription, overmat recto: "The Royal Palace—Stockholm"
 mat backing verso: "S-L-31//SA 47"
Acquired from: gift of the Dorothea Leonhardt Fund of the
 Communities Foundation of Texas, Inc., Dallas, Texas

4732. **RUFUS JONES' BIBLES** (P1984.1.515)
Gelatin silver print. n.d.
Image: 7 5/8 x 9 1/2 in. (19.4 x 24.1 cm.)
Sheet: 8 x 9 15/16 in. (20.3 x 25.3 cm.)
Inscription, print verso: "SL31/PF" and rubber stamp
 "CLARA E. SIPPRELL/Manchester, Vermont"
 mat backing verso: "SL31/Rufus Jones' Bibles/PF"
Acquired from: gift of the Dorothea Leonhardt Fund of the
 Communities Foundation of Texas, Inc., Dallas, Texas

4733. **RUINS OF THE OLD MONASTERY, TZINTZUNTZAN,
MEXICO** (P1984.1.315)
Gelatin silver print on tissue. c. 1931
Image: 9 x 6 7/8 in. (22.8 x 17.4 cm.) sight size
Sheet: 10 3/16 x 8 in. (25.9 x 20.3 cm.)
Signed, l.r. print recto: "Clara E. Sipprell"
Inscription, print verso: "MEX31"
 overmat recto: "Ruins of the old Monastery/Tzintzuntzan/
 Mexico"
 overmat verso: "MEX31"
Acquired from: gift of the Dorothea Leonhardt Fund of the
 Communities Foundation of Texas, Inc., Dallas, Texas

*4734. **SADJA [Sadja Stokowski]** (P1984.1.229)
Gelatin silver print on tissue. c. 1930s–40s
Image: 8 15/16 x 6 15/16 in. (22.6 x 17.6 cm.) sight size
Mount: 11 x 8 1/2 in. (28.0 x 21.7 cm.)
Signed, l.r. overmat recto: "Clara E. Sipprell"
Inscription, overmat recto: "Sadja"
 overmat verso: "C40"
 mount verso: "C40"
Acquired from: gift of the Dorothea Leonhardt Fund of the
 Communities Foundation of Texas, Inc., Dallas, Texas

*4735. **THE SAGUENAY** (P1984.1.397)
Gelatin silver print on tissue. c. 1932
Image: 7 1/8 x 9 1/8 in. (18.1 x 23.2 cm.) sight size
Signed, l.r. overmat recto: "Clara E. Sipprell"
Inscription, overmat recto, typed on paper label: "The
 Saguenay"
 mat backing verso: "gP-3//GP33"
Acquired from: gift of the Dorothea Leonhardt Fund of the
 Communities Foundation of Texas, Inc., Dallas, Texas

4736. **THE ST. LAWRENCE IN JUNE, DAISY FIELD BY THE
ST. LAWRENCE [Daisy Field by the St. Lawrence]**
(P1984.1.412) duplicate of P1984.1.414
Gelatin silver print. negative c. 1932, print later
Image: 7 1/4 x 9 3/16 in. (18.4 x 23.3 cm.)
1st mount: 9 x 9 7/8 in. (22.8 x 25.1 cm.)
2nd mount: 18 x 13 in. (45.7 x 33.0 cm.)
Signed, l.r. 1st mount recto: "Clara E. Sipprell"
Inscription, 2nd mount verso: "GP-11//The St. Lawrence in
 June/Daisy Field by the/St Lawrence//GP24"
Acquired from: gift of the Dorothea Leonhardt Fund of the
 Communities Foundation of Texas, Inc., Dallas, Texas

4737. **ST. MICHAEL, CHARLESTON, S.C.** (P1984.1.374)
Gelatin silver print on Gevaluxe paper. negative before 1942,
 print c. 1940–42
Image: 9 3/16 x 5 3/16 in. (23.3 x 13.2 cm.) sight size
Sheet: 10 x 8 in. (25.4 x 20.3 cm.)
Signed, l.r. overmat recto: "Clara E. Sipprell"
Inscription, print verso: "AA 25"
 overmat recto: "St. Michael/Charleston, N.C. [sic]"
 mat backing verso: "A-L-52//AA-25"
Acquired from: gift of the Dorothea Leonhardt Fund of the
 Communities Foundation of Texas, Inc., Dallas, Texas

*4738. **ST. PAUL'S, N.Y.** (P1984.1.34)
Gelatin silver print. negative c. 1930s, print later
Image: 9 5/8 x 7 5/8 in. (24.4 x 19.4 cm.)
Sheet: 9 7/8 x 7 15/16 in. (25.1 x 20.2 cm.)
Signed, l.r. old overmat recto: "Clara E. Sipprell"
Inscription, old overmat recto: "St. Pauls/N.Y."
 old mat backing verso: "Pf-191//PF" and dealer's label
Acquired from: gift of the Dorothea Leonhardt Fund of the
 Communities Foundation of Texas, Inc., Dallas, Texas

4739. **SAINT ROCKUS** (P1984.1.388)
Gelatin silver print on tissue. c. 1924
Image: 9 1/8 x 4 1/4 in. (23.2 x 10.8 cm.) sight size
Sheet: 10 1/8 x 7 15/16 in. (25.7 x 20.3 cm.)
Signed, l.r. overmat recto: "Clara E. Sipprell"
Inscription, print verso: "IN 2"
 overmat recto, typed on paper label: "Saint Rockus"
 overmat verso: "DL-9//IN 2"
Acquired from: gift of the Dorothea Leonhardt Fund of the
 Communities Foundation of Texas, Inc., Dallas, Texas

4740. **SAINT-SIMÉON AND THE ST. LAWRENCE** (P1984.1.407)
Gelatin silver print on tissue. c. 1932
Image: 7 1/8 x 9 1/4 in. (18.1 x 23.5 cm.) sight size
Signed, l.r. overmat recto: "Clara E. Sipprell"
Inscription, overmat recto, typed on paper label:
 "Saint Simeon and the St. Lawrence"
 mat backing verso: "GP-15//GP15"
Acquired from: gift of the Dorothea Leonhardt Fund of the
 Communities Foundation of Texas, Inc., Dallas, Texas

*4741. **SAN JUAN CAPISTRANO, CALIFORNIA** (P1984.1.371)
Gelatin silver print on tissue. c. 1928–31
Image: 9 1/8 x 7 3/16 in. (23.2 x 18.2 cm.) sight size
Signed, l.r. overmat recto: "Clara E. Sipprell"
Inscription, overmat recto, typed on paper label:
 "San Juan Capistrano/California"
 mat backing verso: "AA4" and typed on paper label
 "In the Maple Grove"
Acquired from: gift of the Dorothea Leonhardt Fund of the
 Communities Foundation of Texas, Inc., Dallas, Texas

4742. **SANTHA RAMA RAU** (P1984.1.106)
Gelatin silver print. c. 1940s
Image: 9 3/4 x 7 3/4 in. (24.6 x 19.7 cm.)
Sheet: 10 x 8 in. (25.4 x 20.3 cm.)
Mount: 10 15/16 x 8 1/2 in. (27.8 x 21.5 cm.)
Signed, l.r. old overmat recto: "Clara E. Sipprell"
Inscription, mount verso: "I9"
 old overmat recto: "x//Santha Rama Rau"
 old overmat verso: "I9"
Acquired from: gift of the Dorothea Leonhardt Fund of the
 Communities Foundation of Texas, Inc., Dallas, Texas

4743. **SARAH FERNANDEZ, POET** (P1984.1.83)
Gelatin silver print. c. 1940s–60s
Image: 8 15/16 x 7 in. (22.6 x 17.8 cm.) sight size
Signed, l.r. overmat recto: "Clara E. Sipprell"
Inscription, print verso: "Bl12"
 overmat recto: "Sarah Fernandez/Poet"
 overmat verso: "Bl12"
 mat backing verso: "AB-9//Bl12"
Acquired from: gift of the Dorothea Leonhardt Fund of the
 Communities Foundation of Texas, Inc., Dallas, Texas

4728

4734

4735

4738

4741

4746

4744. SAVANNAH WATERFRONT (P1984.1.94)
Gelatin silver print on Gevaluxe paper. negative before 1942,
 print c. 1940–42
Image: 9 5/8 x 7 5/8 in. (24.4 x 19.4 cm.)
Sheet: 10 x 8 in. (25.4 x 20.3 cm.)
Signed, l.r. old overmat recto: "Clara E. Sipprell"
Inscription, print verso: "B14"
 overmat recto: "Savannah waterfront."
 overmat verso: "AB-2//B14"
Acquired from: gift of the Dorothea Leonhardt Fund of the
 Communities Foundation of Texas, Inc., Dallas, Texas

4745. [Saveli Walevitch] (P1984.1.622)
Gelatin silver print. c. 1926
Image: 9 1/4 x 7 1/8 in. (23.5 x 18.1 cm.)
Acquired from: gift of the Dorothea Leonhardt Fund of the
 Communities Foundation of Texas, Inc., Dallas, Texas

*4746. A SCENE FROM THE GREEK PLAY "LYSISTRATA" OR
 "PEACE" (P1984.1.14)
Platinum print on tissue. c. 1917
Image: 4 1/4 x 6 5/8 in. (12.0 x 16.8 cm.)
Mount: 6 1/2 x 7 11/16 in. (16.6 x 19.5 cm.)
Signed, l.r. mount recto: "Clara E. Sipprell"
Inscription, mount verso: "PF"
 mat backing verso: dealer's label
Acquired from: gift of the Dorothea Leonhardt Fund of the
 Communities Foundation of Texas, Inc., Dallas, Texas

4747. THE SCULPTOR'S HANDS (P1984.1.9)
Gelatin silver print. negative c. 1924, print later
Image: 9 3/16 x 7 7/16 in. (23.3 x 18.9 cm.) sight size
Sheet: 10 x 8 in. (25.4 x 20.3 cm.)
Signed, l.r. old overmat recto: "Clara E. Sipprell"
Inscription, mat backing verso: dealer's label
 old overmat recto: "The Sculptor's Hands//15"
 old overmat verso: "PF"
Acquired from: gift of the Dorothea Leonhardt Fund of the
 Communities Foundation of Texas, Inc., Dallas, Texas

4748. THE SEA AT MAZATLÁN, MEXICO (P1984.1.278)
Gelatin silver print. c. 1931
Image: 6 15/16 x 9 in. (17.6 x 22.8 cm.) sight size
Signed, l.r. overmat recto: "Clara E. Sipprell"
Inscription, overmat recto: "The Sea at Mazatlan/Mexico"
 mat backing verso: "M-34//ML8"
Acquired from: gift of the Dorothea Leonhardt Fund of the
 Communities Foundation of Texas, Inc., Dallas, Texas

4749. SEPTEMBER LANDSCAPE (P1984.1.29)
Gelatin silver print on tissue. c. 1920s
Image: 8 11/16 x 6 1/2 in. (22.1 x 16.5 cm.) sight size
Signed, l.r. old overmat recto: "Clara E. Sipprell"
Inscription, mat backing verso: dealer's label
 old overmat recto: "September Landscape//7"
 old mat backing verso: "PF"
Acquired from: gift of the Dorothea Leonhardt Fund of the
 Communities Foundation of Texas, Inc., Dallas, Texas

4750. SHARPLES HOMESTEAD—LONDON GROVE—
 PENNA. (P1984.1.448)
Gelatin silver print on tissue. c. 1920s–30s
Image: 9 3/16 x 7 in. (23.3 x 17.8 cm.) sight size
Sheet: 9 7/8 x 7 15/16 in. (25.1 x 20.2 cm.)
Signed, l.r. overmat recto: "Clara E. Sipprell"
Inscription, print verso: "AA 26"
 overmat recto: "Sharples Homestead—London Grove—
 Penna."
 mat backing verso: "A-L-23//AA 26"
Acquired from: gift of the Dorothea Leonhardt Fund of the
 Communities Foundation of Texas, Inc., Dallas, Texas

4751. SHEEP, UTAH (P1984.1.326)
Gelatin silver print on tissue. c. 1929–31
Image: 7 3/16 x 9 3/16 in. (18.2 x 23.3 cm.) sight size
Signed, l.r. overmat recto: "Clara E. Sipprell"

Inscription, overmat recto: "Utah" and typed on paper label
 "Sheep/Utah."
 mat backing verso: "Street Shrine in Kotor (Cuttaro)/
 Dalmatia//Pf181//WL18"
Acquired from: gift of the Dorothea Leonhardt Fund of the
 Communities Foundation of Texas, Inc., Dallas, Texas

*4752. SHIN-IGHI YUIZE, KOTO PLAYER (P1984.1.59)
Gelatin silver print. c. 1950s
Image: 9 3/16 x 7 1/2 in. (23.3 x 19.0 cm.) sight size
Sheet: 10 x 8 in. (25.4 x 20.3 cm.)
Mount: same as sheet size
Inscription, overmat recto: "Shin-Ighi Yuize/Koto player"
 overmat verso: "Or3//Or3"
 mount verso: "OR3"
 note: a duplicate print is affixed to print verso
Acquired from: gift of the Dorothea Leonhardt Fund of the
 Communities Foundation of Texas, Inc., Dallas, Texas

*4753. THE SHOEMAKER, SARAJEVO, BOSNIA (P1984.1.76)
Gelatin silver print on tissue. c. 1926
Image: 9 3/16 x 7 3/16 in. (23.3 x 18.2 cm.) sight size
Signed, l.r. overmat recto: "Clara E. Sipprell"
Inscription, print verso: "Y30"
 overmat recto, typed on paper label: "The Shoemaker/
 Sarajevo, Bosnia"
 mat backing verso: "D-P-4//Y30"
Acquired from: gift of the Dorothea Leonhardt Fund of the
 Communities Foundation of Texas, Inc., Dallas, Texas

*4754. A SIDE STREET, DUBROVNIK, DALMATIA
 (P1984.1.556)
Gelatin silver print on tissue. c. 1926
Image: 9 1/4 x 5 7/8 in. (23.5 x 14.9 cm.) sight size
Signed, l.r. overmat recto: "Clara E. Sipprell"
Inscription, overmat recto, typed on paper label:
 "A Side Street/Dubrovnik, Dalmatia"
 mat backing verso: "D-L-11//Y40"
Acquired from: gift of the Dorothea Leonhardt Fund of the
 Communities Foundation of Texas, Inc., Dallas, Texas

*4755. SIDE STREET IN URUAPAN, MEXICO (P1984.1.302)
Gelatin silver print on tissue. c. 1931
Image: 9 1/8 x 7 1/4 in. (23.2 x 18.4 cm.) sight size
Signed, l.r. overmat recto: "Clara E. Sipprell".
Inscription, overmat recto, typed on paper label:
 "Side Street in Uruapan/Mexico"
 mat backing verso: "M-20//g Mexico//MEX17"
Acquired from: gift of the Dorothea Leonhardt Fund of the
 Communities Foundation of Texas, Inc., Dallas, Texas

4756. SIGFRIED SIWERTS—WRITER—STOCKHOLM
 (P1984.1.173)
Gelatin silver print on Gevaluxe paper. negative 1938,
 print c. 1938
Image: 9 5/8 x 7 5/8 in. (24.4 x 19.4 cm.)
Sheet: 9 15/16 x 7 15/16 in. (25.3 x 20.2 cm.)
Signed, l.r. overmat recto: "Clara E. Sipprell"
Inscription, print verso: "SP24"
 overmat recto: "Sigfried Siwerts—writer/Stockholm"
 mat backing verso: "S-P-11//SP24"
Acquired from: gift of the Dorothea Leonhardt Fund of the
 Communities Foundation of Texas, Inc., Dallas, Texas

4757. SILJAN LAKE—DALECARLIA (P1984.1.551)
Gelatin silver print on Gevaluxe paper. c. 1938
Image: 7 5/8 x 9 9/16 in. (19.4 x 24.3 cm.)
Mount: 8 x 10 in. (20.3 x 25.4 cm.)
Signed, l.r. overmat recto: "Clara E. Sipprell"
Inscription, overmat recto: "Siljan Lake—Dalecarlia"
 mat backing verso: "S-L-33//SwL18"
Acquired from: gift of the Dorothea Leonhardt Fund of the
 Communities Foundation of Texas, Inc., Dallas, Texas

4752

4753

4754

4755

4758. **[Silver pieces]** (P1984.1.674)
Gelatin silver print. c. 1927
Image: 7 9/16 x 9 9/16 in. (19.2 x 24.3 cm.)
Sheet: 7 15/16 x 9 15/16 in. (20.2 x 25.3 cm.)
Acquired from: gift of the Dorothea Leonhardt Fund of the
Communities Foundation of Texas, Inc., Dallas, Texas

4759. **SIR BENEGAL RAU** (P1984.1.108)
Gelatin silver print. c. 1959
Image: 9 3/4 x 7 3/4 in. (24.6 x 19.8 cm.)
Sheet: 10 x 8 in. (25.4 x 20.3 cm.)
Mount: same as sheet size
Signed, l.r. old overmat recto: "Clara E. Sipprell"
Inscription, mount verso: "17"
old overmat recto: "Sir Benegal Rau"
old overmat verso: "17//17"
note: a duplicate print is affixed to print verso
Acquired from: gift of the Dorothea Leonhardt Fund of the
Communities Foundation of Texas, Inc., Dallas, Texas

4760. **SIR BENEGAL RAU** (P1984.1.114)
Gelatin silver print. 1959
Image: 7 11/16 x 7 1/16 in. (19.5 x 17.9 cm.)
Sheet: 9 15/16 x 8 in. (25.3 x 20.3 cm.)
Mount: same as sheet size
Signed, l.r. overmat recto: "Clara E. Sipprell/1959"
Inscription, overmat recto: "Sir Benegal Rau"
overmat recto: "I-1-6//I1//I1"
mount verso: "I1"
note: a print of a portrait of a man is affixed to print verso
Acquired from: gift of the Dorothea Leonhardt Fund of the
Communities Foundation of Texas, Inc., Dallas, Texas

4761. **SIR RADHAKRISHNAN, INDIAN AMBASSADOR TO
U.S.S.R. [Sir Sarvepali Radhakrishnan, President of India]**
(P1984.1.99) duplicate of P1984.1.98
Gelatin silver print. c. 1950s–60s
Image: 8 15/16 x 6 7/8 in. (22.6 x 17.4 cm.) sight size
Sheet: 9 7/8 x 7 7/8 in. (25.1 x 20.0 cm.)
Signed, l.r. overmat recto: "Clara E. Sipprell"
Inscription, print verso: "I16"
overmat recto: "x//Sir Radakrishna [sic]/Indian
Ambassador to U.S.S.R."
overmat verso: "I16"
Acquired from: gift of the Dorothea Leonhardt Fund of the
Communities Foundation of Texas, Inc., Dallas, Texas

4762. **SIR SARVEPALI RADHAKRISHNAN** (P1984.1.97)
Gelatin silver print. c. 1950s–60s
Image: 9 x 6 15/16 in. (22.8 x 17.6 cm.) sight size
Sheet: 10 x 8 in. (25.4 x 20.3 cm.)
Signed, l.r. overmat recto: "Clara E. Sipprell"
Inscription, print verso: "I18"
overmat recto: "Sir Sarvepalli Radhakrishna [sic]"
overmat verso: "I18"
mat backing verso: "I-5-I//I18"
Acquired from: gift of the Dorothea Leonhardt Fund of the
Communities Foundation of Texas, Inc., Dallas, Texas

4763. **SIR SARVEPALI RADHAKRISHNAN, PRESIDENT OF
INDIA [Sir Radhakrishnan, Indian Ambassador to
U.S.S.R.]** (P1984.1.98) duplicate of P1984.1.99
Gelatin silver print. c. 1950s–60s
Image: 8 7/8 x 7 3/8 in. (22.5 x 18.7 cm.) sight size
Sheet: 10 x 8 in. (25.4 x 20.3 cm.)
Mount: same as sheet size
Signed, l.r. overmat recto: "Clara E. Sipprell"
Inscription, overmat recto: "Sir Sarvepsalli [sic]/
Radhakrishnan/President of India"
overmat verso: "I17"
mount verso: "I17"
note: a print of an unidentified man is affixed to print verso
Acquired from: gift of the Dorothea Leonhardt Fund of the
Communities Foundation of Texas, Inc., Dallas, Texas

4764. **SIRDAR J.J. SINGH [Jaga Jita Singh]** (P1984.1.111)
Gelatin silver print. c. 1950s–60s
Image: 9 x 6 15/16 in. (22.8 x 17.6 cm.) sight size
Signed, l.r. overmat recto: "Clara E. Sipprell"
Inscription, print verso: "I4"
overmat recto: "Sirdar J.J. Singh"
overmat verso: "I4//I4"
mat backing verso: "I-4//I4"
Acquired from: gift of the Dorothea Leonhardt Fund of the
Communities Foundation of Texas, Inc., Dallas, Texas

4765. **THE SISTERS** (P1984.1.247)
Gelatin silver print. negative n.d., print c. 1950s–60s
Image: 8 15/16 x 6 15/16 in. (22.6 x 17.6 cm.) sight size
Mount: 10 11/16 x 7 7/8 in. (27.2 x 20.0 cm.)
Signed, l.r. overmat recto: "Clara E. Sipprell"
Inscription, overmat recto: "The Sisters//x"
overmat verso: "C36"
mount verso: "C36"
Acquired from: gift of the Dorothea Leonhardt Fund of the
Communities Foundation of Texas, Inc., Dallas, Texas

*4766. **6th AVE.—NEW YORK** (P1984.1.395)
Gelatin silver print on tissue. c. 1930
Image: 8 7/8 x 6 15/16 in. (22.5 x 17.6 cm.) sight size
Signed, l.r. overmat recto: "Clara E. Sipprell"
Inscription, overmat recto: "6th Ave—New York"
mat backing verso: "Pf-178//N.Y.1"
Acquired from: gift of the Dorothea Leonhardt Fund of the
Communities Foundation of Texas, Inc., Dallas, Texas

*4767. **SLEEPING BABY** (P1984.1.218)
Gelatin silver print. negative c. 1927, print later
Image: 9 1/16 x 7 7/16 in. (23.0 x 18.9 cm.) sight size
Sheet: 9 15/16 x 8 in. (25.3 x 20.3 cm.)
Mount: same as sheet size
Signed, l.r. overmat recto: "Clara E. Sipprell"
Inscription, overmat recto: "Sleeping baby"
overmat verso: "Irena & Nina//C29"
mount verso: "C29"
note: a print of an Indian man is affixed to print verso
Acquired from: gift of the Dorothea Leonhardt Fund of the
Communities Foundation of Texas, Inc., Dallas, Texas

4768. **A SMALL CHAPEL IN ZIMAPÁN, MEXICO** (P1984.1.390)
Gelatin silver print. negative c. 1931, print later
Image: 9 x 6 15/16 in. (22.8 x 17.6 cm.) sight size
Sheet: 9 15/16 x 8 in. (25.3 x 20.3 cm.)
Mount: same as sheet size
Inscription, overmat recto: "A small chapel/in Zimapan/
Mexico"
overmat verso: "IN 3"
note: an unidentified print is affixed to print verso
Acquired from: gift of the Dorothea Leonhardt Fund of the
Communities Foundation of Texas, Inc., Dallas, Texas

4769. **[Small child in a pink playsuit]** (P1984.1.693)
Autochrome. c. 1917
Image: 6 5/8 x 4 1/2 in. (16.8 x 11.4 cm.)
Plate: 7 x 5 in. (17.8 x 12.7 cm.)
Inscription, plate recto, printed on paper label:
"Clara E. Sipprell"
Acquired from: gift of the Dorothea Leonhardt Fund of the
Communities Foundation of Texas, Inc., Dallas, Texas

4770. **SNOOKS, GEORGIA** (P1984.1.92)
Gelatin silver print. negative c. 1930s–42, print later
Image: 7 9/16 x 6 13/16 in. (19.2 x 17.3 cm.)
1st mount: same as image size
2nd mount: 20 x 14 1/2 in. (50.7 x 36.8 cm.)
Signed, l.r. 2nd mount recto: "Clara E. Sipprell"
Inscription, 2nd mount recto: "Snooks/Georgia"
2nd mount verso: "B19"
Acquired from: gift of the Dorothea Leonhardt Fund of the
Communities Foundation of Texas, Inc., Dallas, Texas

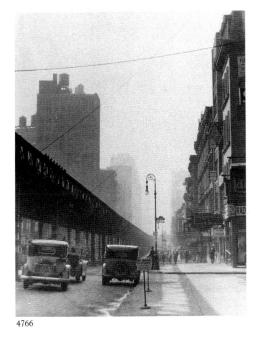

4766

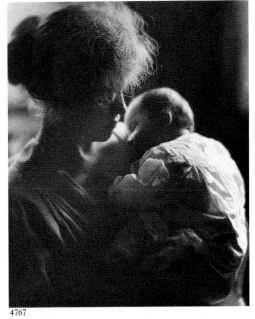

4767

4771

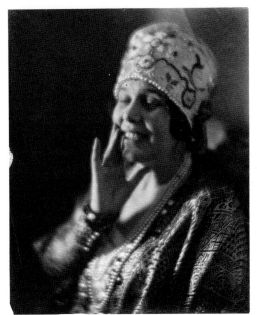

4773

*4771. **SNOWSTORM IN JULY, PLAIN OF THE FOUR GLACIERS, THE CANADIAN ROCKIES** (P1984.1.342)
Gelatin silver print on tissue. c. 1929
Image: 9 3/16 x 7 1/8 in. (23.3 x 18.1 cm.) sight size
Signed, l.r. overmat recto: "Clara E. Sipprell"
Inscription, overmat recto, typed on paper label: "Snowstorm in July/Plain of the Four Glaciers/The Canadian Rockies"
mat backing verso: "Pf204//GP38"
Acquired from: gift of the Dorothea Leonhardt Fund of the Communities Foundation of Texas, Inc., Dallas, Texas

4772. **SON OF MR. & MRS. HARTMAN BEARDSLEY OF SPRINGFIELD, VERMONT** (P1984.1.234)
Gelatin silver print. negative 1951, print c. 1951
Image: 9 1/8 x 7 1/2 in. (23.2 x 19.0 cm.) sight size
Sheet: 10 x 8 1/16 in. (25.4 x 20.5 cm.)
Mount: 10 1/8 x 8 1/8 in. (25.7 x 20.7 cm.)
Signed, l.r. overmat recto: "Clara E. Sipprell/1951"
Inscription, overmat recto: "Son of Mr. & Mrs. Hartman Beardsley/of Springfield, Vermont"
overmat verso: "C-62//ADL 23"
Acquired from: gift of the Dorothea Leonhardt Fund of the Communities Foundation of Texas, Inc., Dallas, Texas

*4773. **THE SONG [Nadiejhda Plevitskaya]** (P1984.1.684)
Gelatin silver print on tissue. c. 1925
Image: 9 5/16 x 7 9/16 in. (23.7 x 19.2 cm.)
Sheet: 9 13/16 x 7 7/8 in. (24.9 x 20.0 cm.)
Acquired from: gift of the Dorothea Leonhardt Fund of the Communities Foundation of Texas, Inc., Dallas, Texas

4774. **THE SOURCE OF THE RIVER, MICHOACÁN MEXICO** (P1984.1.313)
Gelatin silver print on tissue. c. 1931
Image: 9 3/16 x 7 1/8 in. (23.3 x 18.1 cm.) sight size
Signed, l.r. overmat recto: "Clara E. Sipprell"
Inscription, overmat recto, typed on paper label: "The Source of the River/Michoacan, Mexico"
mat backing verso: "M-30//g Mexico//MEX21"
Acquired from: gift of the Dorothea Leonhardt Fund of the Communities Foundation of Texas, Inc., Dallas, Texas

4775. **SOUTHERN RIM OF THE GRAND CANYON** (P1984.1.338)
Gelatin silver print. 1949
Image: 8 7/8 x 7 7/16 in. (22.5 x 18.9 cm.) sight size
Mount: 9 15/16 x 8 in. (25.2 x 20.3 cm.)
Signed, l.r. overmat recto: "Clara E. Sipprell/1949"
Inscription, overmat recto: "Southern rim of the Grand Canyon"
overmat verso: "WL5"
mat backing verso: "Pf-184//WL5"
Acquired from: gift of the Dorothea Leonhardt Fund of the Communities Foundation of Texas, Inc., Dallas, Texas

*4776. **[Spencer Kellogg, Sr.]** (P1984.1.643)
Platinum print. c. 1913
Image: 12 15/16 x 10 1/8 in. (32.9 x 25.7 cm.)
Mount: 14 x 10 1/2 in. (35.6 x 26.6 cm.)
Signed, l.r. mount recto: "Clara E. Sipprell"
Inscription, mount verso: "OP2"
Acquired from: gift of the Dorothea Leonhardt Fund of the Communities Foundation of Texas, Inc., Dallas, Texas

4777. **STADSHUS FROM ÅRSTABRON—STOCKHOLM** (P1984.1.542)
Gelatin silver print on Gevaluxe paper. c. 1938
Image: 9 5/8 x 7 9/16 in. (24.4 x 19.2 cm.)
Sheet: 10 x 8 in. (25.4 x 20.3 cm.)
Signed, l.r. old overmat recto: "Clara E. Sipprell"
Inscription, print verso: "SwL36"
old overmat recto: "Stadshus from Årstabron—Stockholm" and red foil star
old overmat verso: "SwL36"
old mat backing verso: "S-L-6//SwL36"
Acquired from: gift of the Dorothea Leonhardt Fund of the Communities Foundation of Texas, Inc., Dallas, Texas

*4778. **STADSHUS—STOCKHOLM, SWEDEN** (P1984.1.536)
Gelatin silver print on Gevaluxe paper. negative c. 1938, print later
Image: 8 15/16 x 7 in. (22.6 x 17.8 cm.) sight size
Signed, l.r. overmat recto: "Clara E. Sipprell"
Inscription, overmat recto: "Stadshus—Stockholm/Sweden"
mat backing verso: "S-L-14//G/Swedish Landscape//SA3"
Acquired from: gift of the Dorothea Leonhardt Fund of the Communities Foundation of Texas, Inc., Dallas, Texas

*4779. **STANISLAVSKY [Constantin Stanislavsky]** (P1984.1.240)
Gelatin silver print. negative 1925, print later
Image: 9 1/4 x 7 1/2 in. (23.5 x 19.0 cm.)
1st mount: 10 3/4 x 8 5/16 in. (27.3 x 21.1 cm.)
2nd mount: 13 x 10 15/16 in. (33.0 x 27.8 cm.)
3rd mount: 20 x 14 1/2 in. (50.8 x 36.8 cm.)
Signed, l.r. 1st mount recto: "Clara E. Sipprell/1925"
Inscription, print verso: "MIS1"
1st mount recto: "Stanislavsky"
3rd mount verso: "MIS1"
note: a print of an older woman is affixed to print verso
Acquired from: gift of the Dorothea Leonhardt Fund of the Communities Foundation of Texas, Inc., Dallas, Texas

*4780. **STANTON HALL, NATCHEZ—MISSISSIPPI** (P1984.1.373)
Gelatin silver print. negative 1949, print c. 1949
Image: 9 5/8 x 7 5/8 in. (24.4 x 19.4 cm.)
Sheet: 9 15/16 x 8 in. (25.3 x 20.3 cm.)
Mount: same as sheet size
Signed, l.r. overmat recto: "Clara E. Sipprell/1949"
Inscription, overmat recto: "Stanton Hall/Natchez—Mississippi"
mount verso: "AA.22"
mat backing verso: "A-L-20//AA.22"
Acquired from: gift of the Dorothea Leonhardt Fund of the Communities Foundation of Texas, Inc., Dallas, Texas

4781. **STATUE OF BELLMAN AT DJURGÅRDEN [Bust of Bellman, Stockholm, Sweden]** (P1984.1.540) duplicate of P1984.1.541
Gelatin silver print on Gevaluxe paper. c. 1938
Image: 8 15/16 x 6 7/16 in. (22.6 x 16.3 cm.) sight size
Signed, l.r. overmat recto: "Clara E. Sipprell"
Inscription, overmat recto: "Statue of Bellman at Djurgarden"
mat backing verso: "S-L-8b//SwL38"
Acquired from: gift of the Dorothea Leonhardt Fund of the Communities Foundation of Texas, Inc., Dallas, Texas

4782. **STATUE OF CARL XII, STOCKHOLM** (P1984.1.386)
Gelatin silver print on Gevaluxe paper. c. 1938
Image: 9 5/8 x 7 5/8 in. (24.4 x 19.4 cm.)
Sheet: 9 15/16 x 8 in. (25.3 x 20.3 cm.)
Signed, l.r. overmat recto: "Clara E. Sipprell"
Inscription, print verso: "SA28"
overmat recto: "Statue of Carl XII/Stockholm"
mat backing verso: "S-L-27//SA28"
Acquired from: gift of the Dorothea Leonhardt Fund of the Communities Foundation of Texas, Inc., Dallas, Texas

4783. **STILL LIFE WITH COPPER BOWL** (P1984.1.496) duplicate of P1984.1.23
Gelatin silver print on tissue. c. late 1920s
Image: 9 7/16 x 7 5/8 in. (24.0 x 19.4 cm.)
Sheet: 9 13/16 x 7 7/8 in. (24.9 x 20.0 cm.)
Signed, l.r. overmat recto: "Clara E. Sipprell"
Inscription, overmat recto, typed on paper label: "Still Life with Copper Bowl"
old mat backing verso: "S-L-17//g American Landscape// SL12"
Acquired from: gift of the Dorothea Leonhardt Fund of the Communities Foundation of Texas, Inc., Dallas, Texas

4776

4778

4779

4780

4785

4776

4778

4779

4780

4785

4784. **STILL LIFE WITH CRYSTAL** (P1984.1.499)
Gelatin silver print on tissue. c. 1920s
Image: 8 x 6⅜ in. (20.3 x 16.2 cm.) sight size
Signed, l.r. overmat recto: "Clara E. Sipprell"
Inscription, overmat recto, typed on paper label: "Still Life
with Crystal"
1st mat backing verso: "SL15"
2nd mat backing verso: "S-L-25//SL15"
Acquired from: gift of the Dorothea Leonhardt Fund of the
Communities Foundation of Texas, Inc., Dallas, Texas

*4785. **STILL LIFE WITH PITCHER** (P1984.1.497)
Gelatin silver print on tissue. c. 1925
Image: 6¹⁵⁄₁₆ x 8⅜ in. (17.6 x 21.3 cm.) sight size
Signed, l.r. overmat recto: "Clara E. Sipprell"
Inscription, overmat recto, typed on paper label: "STILL
LIFE WITH PITCHER"
mat backing verso: "SL-10//1925//SL13"
Acquired from: gift of the Dorothea Leonhardt Fund of the
Communities Foundation of Texas, Inc., Dallas, Texas

4786. **STILL LIFE WITH ST. FRANCIS** (P1984.1.492)
Gelatin silver print on Gevaluxe paper. c. 1940s
Image: 8¹⁵⁄₁₆ x 7¼ in. (22.6 x 18.4 cm.) sight size
Sheet: 9⅞ x 8 in. (25.1 x 20.3 cm.)
Signed, l.r. overmat recto: "Clara E. Sipprell"
Inscription, print verso: "SL8"
overmat recto: "Still Life/with St. Francis"
Acquired from: gift of the Dorothea Leonhardt Fund of the
Communities Foundation of Texas, Inc., Dallas, Texas

4787. **STILL LIFE WITH SPRIG** (P1984.1.513) duplicate of
P1984.1.516
Gelatin silver print on tissue. c. 1940s–50s
Image: 7¹¹⁄₁₆ x 9⅜ in. (19.5 x 23.8 cm.)
Sheet: 7¹³⁄₁₆ x 9⅞ in. (19.8 x 25.1 cm.)
Signed, l.r. overmat recto: "Clara E. Sipprell"
Inscription, overmat recto, typed on paper label: "Still Life
with Sprig"
overmat verso: "NO/LIST"
mat backing verso: "SL-9//PF//IG 30"
Acquired from: gift of the Dorothea Leonhardt Fund of the
Communities Foundation of Texas, Inc., Dallas, Texas

4788. **STILL LIFE WITH SPRIG** (P1984.1.516) duplicate of
P1984.1.513
Gelatin silver print on tissue. c. 1940s–50s
Image: 7½ x 9½ in. (19.0 x 24.1 cm.)
Sheet: 8³⁄₁₆ x 10¹⁄₁₆ in. (20.8 x 25.5 cm.) irregular
Inscription, print verso: "SL33 PF" and rubber stamp
"CLARA E. SIPPRELL/Manchester, Vermont"
mat backing verso: "Clara Sipprell/Still Life with Sprig//
SL33/PF"
Acquired from: gift of the Dorothea Leonhardt Fund of the
Communities Foundation of Texas, Inc., Dallas, Texas

4789. **STOCKHOLM—MOLIN'S FOUNTAIN—
KUNGSTRÄDGÅRDEN** (P1984.1.543)
Gelatin silver print on Gevaluxe paper. c. 1938
Image: 9⅝ x 7⁹⁄₁₆ in. (24.4 x 19.2 cm.)
Sheet: 10 x 8 in. (25.4 x 20.3 cm.)
Signed, l.r. old overmat recto: "Clara E. Sipprell"
Inscription, print verso: "SwL35"
old overmat recto: "Stockholm—Molins [sic] Fountain—
Kungsträdgården"
old overmat verso: "SwL35"
old mat backing verso: "S-L-37//SwL35"
Acquired from: gift of the Dorothea Leonhardt Fund of the
Communities Foundation of Texas, Inc., Dallas, Texas

*4790. **A STORY** (P1984.1.690)
Gelatin silver print on tissue. c. 1919
Image: 6¹¹⁄₁₆ x 4⅝ in. (17.0 x 11.7 cm.)
Mount: 8¼ x 5¹¹⁄₁₆ in. (20.9 x 14.4 cm.)
Signed, l.r. mount recto: "Clara E. Sipprell"
Inscription, mount verso: "PF"
mat backing verso: "From: The Hanoum Camps for Girls/
Thetford, Vt. 1919//A story ca 1919//PF 1621"
Acquired from: gift of the Dorothea Leonhardt Fund of the
Communities Foundation of Texas, Inc., Dallas, Texas

4791. **THE STREET IN AUTUMN, MANCHESTER**
(P1984.1.467)
Gelatin silver print. c. 1940s–50s
Image: 9⅜ x 7⁹⁄₁₆ in. (23.8 x 19.2 cm.)
Signed, l.r. old overmat recto: "Clara E. Sipprell"
Inscription, print verso: "VL9"
old overmat recto: "The Street in Autumn/Manchester"
old overmat verso: "VL9"
Acquired from: gift of the Dorothea Leonhardt Fund of the
Communities Foundation of Texas, Inc., Dallas, Texas

*4792. **STREET IN KOTOR, DALMATIA** (P1984.1.558)
Gelatin silver print on tissue. c. 1926
Image: 9⁷⁄₁₆ x 7⁷⁄₁₆ in. (24.0 x 18.9 cm.) sight size
Signed, l.r. overmat recto: "Clara E. Sipprell"
Inscription, overmat recto, typed on paper label:
"Street in Kotor/Dalmatia"
mat backing verso: "D-L-10//YA6"
Acquired from: gift of the Dorothea Leonhardt Fund of the
Communities Foundation of Texas, Inc., Dallas, Texas

4793. **[A street in Sarajevo]** (P1984.1.667)
Gelatin silver print. c. 1926
Image: 8¾ x 6½ in. (22.2 x 16.5 cm.)
Inscription, print verso: "Mostar [sic]"
Acquired from: gift of the Dorothea Leonhardt Fund of the
Communities Foundation of Texas, Inc., Dallas, Texas

4794. **[A street in Sarajevo]** (P1984.1.668)
Gelatin silver print. c. 1926
Image: 7³⁄₁₆ x 8¹³⁄₁₆ in. (18.2 x 22.4 cm.)
Acquired from: gift of the Dorothea Leonhardt Fund of the
Communities Foundation of Texas, Inc., Dallas, Texas

4795. **STREET IN URUAPAN, MEXICO** (P1984.1.289)
Gelatin silver print on tissue. c. 1931
Image: 9³⁄₁₆ x 7⅛ in. (23.3 x 18.1 cm.) sight size
Signed, l.r. overmat recto: "Clara E. Sipprell"
Inscription, overmat recto: "Street in Uruapan" and
typed on paper label "Street in Uruapan/Mexico"
mat backing verso: "M-23-a//MEX 1"
Acquired from: gift of the Dorothea Leonhardt Fund of the
Communities Foundation of Texas, Inc., Dallas, Texas

*4796. **STREET ON THE ISLAND OF RAB** (P1984.1.560)
Gelatin silver print on tissue. c. 1926
Image: 9⅝ x 7¾ in. (24.4 x 19.7 cm.)
Sheet: 9¹⁵⁄₁₆ x 8 in. (25.3 x 20.3 cm.)
Signed, l.r. overmat recto: "Clara E. Sipprell"
Inscription, print verso: "YA22"
overmat recto: "Street on the Island of Rab"
mat backing verso: "[illegible] 2//YA22" and rubber
stamp "CLARA E. SIPPRELL/MANCHESTER,
VERMONT/200 West 16th St.—New York City"
Acquired from: gift of the Dorothea Leonhardt Fund of the
Communities Foundation of Texas, Inc., Dallas, Texas

*4797. **[A street scene in Sarajevo]** (P1984.1.669)
Gelatin silver print. c. 1926
Image: 7⁹⁄₁₆ x 9⅝ in. (19.2 x 24.4 cm.)
Sheet: 8 x 10 in. (20.3 x 25.4 cm.)
Acquired from: gift of the Dorothea Leonhardt Fund of the
Communities Foundation of Texas, Inc., Dallas, Texas

549

4790

4792

4796

4797

4798

*4798. **A STREET SHRINE IN KOTOR, MONTENEGRO**
(P1984.1.557)
Gelatin silver print on tissue. c. 1926
Image: 8 7/8 x 5 15/16 in. (22.5 x 15.1 cm.) sight size
Signed, l.r. overmat recto: "Clara E. Sipprell"
Inscription, mat backing verso: "A street shrine in Kotor,
Montenegro/(The Mentor; March 1931; page 31)//YA48"
and rubber stamp "CLARA E. SIPPRELL/
MANCHESTER, VERMONT/200 West 16th St.—
New York City"
Acquired from: gift of the Dorothea Leonhardt Fund of the
Communities Foundation of Texas, Inc., Dallas, Texas

*4799. **STUDIO GROUP—A LAMPLIGHT STUDY** (P1984.1.13)
Gelatin silver print on tissue. c. 1930
Image: 7 3/16 x 9 3/16 in. (18.2 x 23.3 cm.) sight size
Signed, l.r. old overmat recto: "Clara E. Sipprell"
Inscription, mat backing verso: dealer's label
old overmat recto: "ClAra Sipprell, Irena Krabroff
[sic]," and typed on paper label "Studio Group/A
Lamplight Study"
old mat backing verso: "PF-71//PF//g Bookselection"
Acquired from: gift of the Dorothea Leonhardt Fund of the
Communities Foundation of Texas, Inc., Dallas, Texas

4800. **STUDY OF MOTHER AND CHILD** (P1984.1.219)
Gelatin silver print on tissue. c. 1927
Image: 9 3/16 x 7 3/16 in. (23.3 x 18.2 cm.) sight size
Mount: 12 7/8 x 8 3/4 in. (32.7 x 22.2 cm.) irregular
Signed, l.r. overmat recto: "Clara E. Sipprell"
Inscription, overmat recto, typed on paper label: "Study of
Mother and Child H"
mount verso: "C30"
mat backing verso: "Pf-29//S/Vermont//Irena [sic] & Nina//
C30"
Acquired from: gift of the Dorothea Leonhardt Fund of the
Communities Foundation of Texas, Inc., Dallas, Texas

4801. **SUDRET—THE SOUTHERN POINT OF GOTLAND**
(P1984.1.580)
Gelatin silver print on Gevaluxe paper. c. 1938
Image: 6 15/16 x 8 1/2 in. (17.6 x 21.6 cm.) sight size
Signed, l.r. overmat recto: "Clara E. Sipprell"
Inscription, overmat recto: "Sudret—the southern point of
Gotland"
mat backing verso: "S-L-41//g/Swedish Landscape//SwL11"
Acquired from: gift of the Dorothea Leonhardt Fund of the
Communities Foundation of Texas, Inc., Dallas, Texas

4802. **SUMIE MISHIMA, WRITER** (P1984.1.36)
Gelatin silver print. c. 1950s
Image: 9 1/16 x 7 3/8 in. (23.0 x 18.7 cm.) sight size
Sheet: 10 x 8 in. (25.4 x 20.3 cm.)
Mount: same as sheet size
Inscription, overmat recto: "Sumie Mishima/writer"
overmat verso: "Or23//Or23"
mount verso: "Or23"
note: a duplicate print is affixed to print verso
Acquired from: gift of the Dorothea Leonhardt Fund of the
Communities Foundation of Texas, Inc., Dallas, Texas

4803. **SUNDAY MORNING—LEKSAND, DALECARLIA**
(P1984.1.547)
Gelatin silver print on Gevaluxe paper. c. 1938
Image: 9 9/16 x 7 9/16 in. (24.3 x 19.2 cm.)
Sheet: 9 15/16 x 7 15/16 in. (25.3 x 20.2 cm.)
Signed, l.r. old overmat recto: "Clara E. Sipprell"
Inscription, print verso: "SwL22"
old overmat recto: "Sunday Morning—Leksand/Dalecarlia"
old overmat verso: "SwL22"
old mat backing verso: "S-L-20//SwL22"
Acquired from: gift of the Dorothea Leonhardt Fund of the
Communities Foundation of Texas, Inc., Dallas, Texas

4804. **SVEDLUND FAMILY—4 GENERATIONS—**
VIKARBYN—RÄTTVIK—DALECARLIA (P1984.1.121)
Gelatin silver print on Gevaluxe paper. negative 1938,
print c. 1938
Image: 9 5/8 x 7 5/8 in. (24.4 x 19.4 cm.)
Sheet: 10 x 8 in. (25.4 x 20.3 cm.)
Signed, l.r. overmat recto: "Clara E. Sipprell"
Inscription, print verso: "SP123"
overmat recto: "Svedlund Family—4 generations/
Vikarbyn—Rattvik— Dalecarlia"
overmat verso: "SP123"
mat backing verso: "S-L-4//SP123"
Acquired from: gift of the Dorothea Leonhardt Fund of the
Communities Foundation of Texas, Inc., Dallas, Texas

4805. **SVENSTORP, SKÅNE** (P1984.1.544)
Gelatin silver print on Gevaluxe paper. c. 1938
Image: 9 3/16 x 7 1/8 in. (23.3 x 18.1 cm.) sight size
Signed, l.r. overmat recto: "Clara E. Sipprell"
Inscription, print verso: "SwL34"
overmat recto: "Svenstorp/Skåne"
overmat verso: "SwL34"
mat backing verso: "S-L-1//SwL34"
Acquired from: gift of the Dorothea Leonhardt Fund of the
Communities Foundation of Texas, Inc., Dallas, Texas

4806. **SWAMI NIKHILANANDA** (P1984.1.100)
Gelatin silver print. c. 1950s–60s
Image: 8 7/16 x 6 7/8 in. (21.4 x 17.4 cm.) sight size
Mount: 13 x 10 1/2 in. (33.0 x 26.7 cm.)
Signed, l.r. overmat recto: "Clara E. Sipprell"
Inscription, overmat recto: "Swami Nikilananda [sic]"
overmat verso: "I15"
mount verso: "I15"
Acquired from: gift of the Dorothea Leonhardt Fund of the
Communities Foundation of Texas, Inc., Dallas, Texas

4807. **SWAMI NIKHILANANDA** (P1984.1.101)
Gelatin silver print. c. 1950s–60s
Image: 9 1/16 x 6 15/16 in. (23.0 x 17.6 cm.) sight size
Signed, l.r. overmat recto: "Clara E. Sipprell"
Inscription, overmat recto: "Swami Nikilananda [sic]"
mat backing verso: "I-3-I//I14"
Acquired from: gift of the Dorothea Leonhardt Fund of the
Communities Foundation of Texas, Inc., Dallas, Texas

*4808. **TANE AND ASAKO** (P1984.1.43) duplicate of P1984.1.54
Gelatin silver print. c. 1950s
Image: 9 1/8 x 7 7/16 in. (23.2 x 18.9 cm.) sight size
Sheet: 10 x 8 in. (25.4 x 20.3 cm.)
Mount: same as sheet size
Signed, l.r. overmat recto: "Clara E. Sipprell"
Inscription, overmat recto: "Tane and Asako"
overmat verso: "Or21//Or21"
mount verso: "OR21"
note: a print of a woman reading a book is affixed to
print verso
Acquired from: gift of the Dorothea Leonhardt Fund of the
Communities Foundation of Texas, Inc., Dallas, Texas

4809. **TANE AND ASAKO** (P1984.1.54) duplicate of P1984.1.43
Gelatin silver print. c. 1950s
Image: 8 15/16 x 6 15/16 in. (22.6 x 17.6 cm.) sight size
Sheet: 10 1/16 x 8 1/8 in. (25.5 x 20.6 cm.)
Signed, l.r. overmat recto: "Clara E. Sipprell"
Inscription, print verso: "Or4"
overmat recto: "Tane/and/Asako"
overmat verso: "Or4//Or4"
Acquired from: gift of the Dorothea Leonhardt Fund of the
Communities Foundation of Texas, Inc., Dallas, Texas

4810. **TANE TAKAHASHI, TOKIO—JAPAN** (P1984.1.50)
Gelatin silver print. 1962
Image: 9 x 6 7/8 in. (22.8 x 17.4 cm.) sight size
Sheet: 10 x 8 in. (25.4 x 20.3 cm.)
Mount: same as sheet size
Signed, l.r. overmat recto: "Clara E. Sipprell/1962"

Inscription, overmat recto: "Tane Takahashi/Tokio—Japan"
overmat verso: "Or10//Or10"
mount verso: "OR10"
note: a print of "Cypresses at Monterey, California" is
affixed to print verso
Acquired from: gift of the Dorothea Leonhardt Fund of the
Communities Foundation of Texas, Inc., Dallas, Texas

4799

* 4811. **TAOS BACKYARDS, PUEBLO OF TAOS, NEW MEXICO**
(P1980.13.2)
Platinum print on tissue. 1928–29
Image: 9 ¹¹/₁₆ x 7 ½ in. (24.5 x 19.0 cm.)
Sheet: 10 ¹/₁₆ x 8 in. (25.5 x 20.4 cm.)
Signed, l.r. overmat recto: "Clara E. Sipprell"
Inscription, overmat recto, typed on paper label: "Taos
Backyards/Pueblo of Taos, New Mexico"
old mat backing verso: "N. M.-2//242//No. 1/Nino/by/Clara
E. Sipprell/70 Morningside Drive./N.Y.C." and rubber
stamp "CLARA E. SIPPRELL/MANCHESTER,
VERMONT/200 West 16th St.—New York City"
Acquired from: Daniel Wolf, Inc., New York, New York

4812. **TAOS MOUNTAINS, NEW MEXICO** (P1984.1.358)
Gelatin silver print. negative 1949, print c. 1949
Image: 8 ¹⁵/₁₆ x 7 ½ in. (22.6 x 19.0 cm.) sight size
Signed, l.r. overmat recto: "Clara E. Sipprell/1949"
Inscription, overmat recto: "Taos Mountains/New Mexico"
mat backing verso: "Pf-197//WL32"
Acquired from: gift of the Dorothea Leonhardt Fund of the
Communities Foundation of Texas, Inc., Dallas, Texas

4813. **TAOS, NEW MEXICO** (P1984.1.369)
Gelatin silver print on tissue. c. 1928–31
Image: 7 ⁹/₁₆ x 9 ⁹/₁₆ in. (19.2 x 24.3 cm.)
Sheet: 7 ¹⁵/₁₆ x 9 ¹⁵/₁₆ in. (20.2 x 25.3 cm.)
Signed, l.r. overmat recto: "Clara E. Sipprell"
Inscription, overmat recto: "Taos, New Mexico"
mat backing verso: "AA1"
Acquired from: gift of the Dorothea Leonhardt Fund of the
Communities Foundation of Texas, Inc., Dallas, Texas

4808

4814. **TARA PANDIT** (P1984.1.113)
Gelatin silver print. c. 1950s–60s
Image: 8 ¹⁵/₁₆ x 6 ¹⁵/₁₆ in. (22.6 x 17.6 cm.) sight size
Signed, l.r. overmat recto: "Clara E. Sipprell"
Inscription, print verso: "12"
overmat recto: "Tara Pandit"
overmat verso: "12"
mat backing verso: "1-6//12"
Acquired from: gift of the Dorothea Leonhardt Fund of the
Communities Foundation of Texas, Inc., Dallas, Texas

* 4815. **TEPIC TYPE, MEXICO** (P1984.1.308)
Gelatin silver print on tissue. c. 1931
Image: 9 x 7 in. (22.8 x 17.8 cm.) sight size
Sheet: 10 ¼ x 8 in. (26.0 x 20.3 cm.)
Signed, l.r. overmat recto: "Clara E. Sipprell"
Inscription, overmat recto: "Tepic Type/Mexico"
old mat backing verso: "M-7//PF//g Mexico//MEX 11"
Acquired from: gift of the Dorothea Leonhardt Fund of the
Communities Foundation of Texas, Inc., Dallas, Texas

4816. **TETON PASS, WYOMING** (P1984.1.328)
Gelatin silver print. 1949
Image: 8 ¹⁵/₁₆ x 7 ⁷/₁₆ in. (22.6 x 18.9 cm.) sight size
note: the sheet and mount are glued to the overmat and
cannot be measured; however, the inscription on mount
verso is visible
Signed, l.r. overmat recto: "Clara E. Sipprell/1949"
Inscription, overmat recto: "Teton Pass/Wyoming"
overmat verso: "WL16"
mount verso: "WL16"
mat backing verso: "Pf-206//WL16"
note: a print of an unidentified woman is affixed to
print verso
Acquired from: gift of the Dorothea Leonhardt Fund of the
Communities Foundation of Texas, Inc., Dallas, Texas

4811

4817. **THEIR ROYAL HIGHNESSES THE KING AND QUEEN OF SWEDEN** (P1984.1.128)
Gelatin silver print. negative 1938, print c. 1938 or later
Image: 9 5/8 x 7 3/4 in. (24.1 x 19.7 cm.)
Sheet: 10 x 8 in. (25.4 x 20.3 cm.)
Mount: same as sheet size
Inscription, mount verso: "SP70//SP70"
 old overmat recto: "Their Royal Highnesses/The King and Queen of Sweden"
 old mat backing verso: "SP70"
 note: a print of a young girl is affixed to print verso
Acquired from: gift of the Dorothea Leonhardt Fund of the Communities Foundation of Texas, Inc., Dallas, Texas

4818. **[Thetford Congregational Church interior]** (P1984.1.389)
Gelatin silver print. c. 1930s
Image: 9 1/4 x 7 7/16 in. (23.5 x 18.9 cm.)
1st mount: 10 13/16 x 8 1/8 in. (27.3 x 20.7 cm.)
2nd mount: 20 x 14 1/2 in. (50.8 x 36.8 cm.)
Signed, l.r. 1st mount recto: "Clara E. Sipprell"
Inscription, 1st mount verso: "IN4"
 2nd mount verso: "V-L-21-II//IN4"
Acquired from: gift of the Dorothea Leonhardt Fund of the Communities Foundation of Texas, Inc., Dallas, Texas

* 4819. **[Thetford Congregational Church interior]** (P1984.1.391)
Gelatin silver print. c. 1930s
Image: 9 5/16 x 7 1/2 in. (23.7 x 19.0 cm.)
1st mount: 10 13/16 x 8 3/16 in. (27.5 x 20.8 cm.)
2nd mount: 19 7/8 x 14 1/2 in. (50.5 x 36.8 cm.)
Signed, l.r. 1st mount recto: "Clara E. Sipprell"
Inscription, 1st mount verso: "IN"
 2nd mount verso: "V-L-21-I//IN5"
Acquired from: gift of the Dorothea Leonhardt Fund of the Communities Foundation of Texas, Inc., Dallas, Texas

4820. **[Thetford Congregational Church interior]** (P1984.1.392)
Gelatin silver print. c. 1930s
Image: 7 9/16 x 9 7/16 in. (19.2 x 24.0 cm.)
1st mount: 10 x 10 3/16 in. (25.4 x 25.9 cm.)
2nd mount: 20 x 14 1/2 in. (50.8 x 36.8 cm.)
Signed, l.r. overmat recto: "Clara E. Sipprell"
Inscription, 1st mount verso: "IN6"
 2nd mount verso: "V-L-21-III//IN6"
Acquired from: gift of the Dorothea Leonhardt Fund of the Communities Foundation of Texas, Inc., Dallas, Texas

4821. **THETFORD HILL—VERMONT [Thetford, Vermont]**
(P1984.1.463) duplicate of P1984.1.464
Gelatin silver print. negative 1920, print later
Image: 9 3/8 x 7 7/16 in. (23.7 x 18.9 cm.)
1st mount: 10 1/2 x 8 1/4 in. (26.6 x 20.9 cm.)
2nd mount: 13 3/16 x 10 1/2 in. (33.5 x 26.6 cm.)
Signed, l.r. 1st mount recto: "Clara E. Sipprell/1920"
 l.r. old overmat recto: "Clara E. Sipprell"
Inscription, 1st mount recto: "Thetford Hill—Vermont"
 2nd mount recto: "same size//142"
 2nd mount verso: "VL7"
 old overmat recto: "Thetford Green/with church"
 old overmat verso: "VL7"
Acquired from: gift of the Dorothea Leonhardt Fund of the Communities Foundation of Texas, Inc., Dallas, Texas

* 4822. **THETFORD IN WINTER** (P1984.1.224)
Gelatin silver print. negative c. 1930s, print later
Image: 7 5/8 x 6 15/16 in. (19.4 x 17.6 cm.) sight size
Mount: 11 x 8 1/2 in. (28.0 x 21.7 cm.)
Signed, l.r. overmat recto: "Clara E. Sipprell"
Inscription, overmat recto: "Thetford in Winter"
 overmat verso: "$70"
 mount verso: "MIS8//PF"
Acquired from: gift of the Dorothea Leonhardt Fund of the Communities Foundation of Texas, Inc., Dallas, Texas

4823. **THETFORD, VERMONT [Thetford Hill—Vermont]**
(P1984.1.464) duplicate of P1984.1.463
Gelatin silver print. negative 1920, print later
Image: 8 15/16 x 7 in. (22.6 x 17.8 cm.) sight size
Sheet: 9 15/16 x 7 15/16 in. (25.3 x 20.2 cm.)
Signed, l.r. overmat recto: "Clara E. Sipprell"
Inscription, overmat recto: "Thetford, Vermont/1920"
 mat backing verso: "[illegible]//VL8" and partial rubber stamp "200 West 16th St.—New York City"
Acquired from: gift of the Dorothea Leonhardt Fund of the Communities Foundation of Texas, Inc., Dallas, Texas

4824. **[Three glass objects]** (P1984.1.22)
Gelatin silver print. c. 1920s
Image: 9 3/8 x 7 3/8 in. (23.8 x 18.7 cm.)
1st mount: 10 11/16 x 8 1/16 in. (27.3 x 20.5 cm.)
2nd mount: 10 7/8 x 8 1/4 in. (27.6 x 21.0 cm.)
Signed, l.r. 1st mount recto: "Clara E. Sipprell"
Inscription, 2nd mount verso: "PF"
 mat backing verso: dealer's label
Acquired from: gift of the Dorothea Leonhardt Fund of the Communities Foundation of Texas, Inc., Dallas, Texas

4825. **[Three women descendants of the Mayflower immigrants]**
(P1984.1.676)
Gelatin silver print. c. 1938
Image: 7 5/16 x 9 3/8 in. (18.5 x 23.8 cm.)
Mount: 8 3/4 x 10 in. (22.2 x 25.4 cm.)
Signed, l.r. mount recto: "Clara E. Sipprell"
Inscription, mount verso: "Sweden//SP121" and rubber stamp "CLARA E. SIPPRELL/Manchester, Vermont"
Acquired from: gift of the Dorothea Leonhardt Fund of the Communities Foundation of Texas, Inc., Dallas, Texas

4826. **THREE YEARS OLD** (P1984.1.204)
Gelatin silver print. negative 1930, print c. 1930
Image: 9 7/16 x 7 5/8 in. (24.2 x 19.3 cm.)
Sheet: 10 x 8 in. (25.4 x 20.3 cm.)
Mount: 10 3/16 x 8 3/16 in. (25.9 x 20.7 cm.)
Signed, l.r. old overmat recto: "Clara E. Sipprell"
Inscription, mount verso: "C16"
 old overmat recto: "Three years old"
 old overmat verso: "Nina"
Acquired from: gift of the Dorothea Leonhardt Fund of the Communities Foundation of Texas, Inc., Dallas, Texas

4827. **TINMOUTH VALLEY** (P1984.1.421)
Gelatin silver print. n.d.
Image: 6 7/8 x 9 1/8 in. (17.4 x 23.2 cm.) sight size
Signed, l.r. overmat recto: "Clara E. Sipprell"
Inscription, overmat recto: "Tinmouth Valley"
 overmat verso: "VL28"
 mat backing verso: "V-L-3//VL28"
Acquired from: gift of the Dorothea Leonhardt Fund of the Communities Foundation of Texas, Inc., Dallas, Texas

4828. **TOKUKO AZUMA IV—KABUKI** (P1984.1.40)
Gelatin silver print. c. 1950s
Image: 8 15/16 x 6 7/8 in. (22.6 x 17.4 cm.) sight size
Sheet: 10 x 8 in. (25.4 x 20.3 cm.)
Mount: same as sheet size
Signed, l.r. overmat recto: "Clara E. Sipprell"
Inscription, overmat recto: "x//Tokuko Azuma IV/Kabuki//x"
 overmat verso: "Or22//Or22"
 mount verso: "OR22"
 note: a print of a Japanese man in kimono is affixed to print verso
Acquired from: gift of the Dorothea Leonhardt Fund of the Communities Foundation of Texas, Inc., Dallas, Texas

4815

4819

4822

4831

4829. **TOSHI YOSHIDA—WOOD BLOCK** (P1984.1.48)
Gelatin silver print. c. 1950s
Image: 9 x 6⅞ in. (22.8 x 17.4 cm.) sight size
Sheet: 10 x 8 in. (25.4 x 20.3 cm.)
Mount: same as sheet size
Signed, l.r. overmat recto: "Clara E. Sipprell"
Inscription, overmat recto: "x//Toshi Yoshida/wood block//x"
 overmat verso: "Or15//Or15"
 mount verso: "OR15"
 note: a print of Toshi Yoshida in a different pose is affixed
 to print verso
Acquired from: gift of the Dorothea Leonhardt Fund of the
 Communities Foundation of Texas, Inc., Dallas, Texas

4830. **TOWER COURT—WELLESLEY COLLEGE** (P1984.1.445)
Gelatin silver print on tissue. c. 1920s
Image: 7⅛ x 9 3/16 in. (18.1 x 23.3 cm.) sight size
Signed, l.r. overmat recto: "Clara E. Sipprell"
Inscription, overmat recto, typed on paper label:
 "Tower Court— Wellesley College"
 mat backing verso: "W-C-4//XIII//WC4"
Acquired from: gift of the Dorothea Leonhardt Fund of the
 Communities Foundation of Texas, Inc., Dallas, Texas

*4831. **TREE ON THE CALZADA DEL VERA CRUZ**
 (P1984.1.280)
Gelatin silver print on tissue. c. 1931
Image: 9⅛ x 7¼ in. (23.2 x 18.4 cm.) sight size
Signed, l.r. overmat recto: "Clara E. Sipprell"
Inscription, overmat recto, typed on paper label:
 "Tree on the Calzada del Vera Cruz"
 mat backing verso: "M-28//g Mexico//ML10"
Acquired from: gift of the Dorothea Leonhardt Fund of the
 Communities Foundation of Texas, Inc., Dallas, Texas

4832. **[Trees]** (P1984.1.456)
Gelatin silver print. n.d.
Image: 9 x 6 15/16 in. (22.8 x 17.6 cm.) sight size
Mount: 9 15/16 x 8 in. (25.3 x 20.3 cm.)
Signed, l.r. overmat recto: "Clara E. Sipprell"
Inscription, overmat verso: "VL38"
 mount verso: "VL38"
 note: a duplicate print is affixed to print verso
Acquired from: gift of the Dorothea Leonhardt Fund of the
 Communities Foundation of Texas, Inc., Dallas, Texas

4833. **[Trees, snow, and house]** (P1984.1.687)
Gelatin silver print on tissue. c. 1920s
Image: 7 9/16 x 9⅝ in. (19.2 x 24.4 cm.)
Sheet: 8⅛ x 10 3/16 in. (20.6 x 25.9 cm.)
Acquired from: gift of the Dorothea Leonhardt Fund of the
 Communities Foundation of Texas, Inc., Dallas, Texas

4834. **TURE RANGSTRÖM—COMPOSER—STOCKHOLM**
 (P1984.1.176)
Gelatin silver print on Gevaluxe paper. negative 1938,
 print c. 1938
Image: 9½ x 7½ in. (24.1 x 19.0 cm.)
Sheet: 10 x 7 15/16 in. (25.4 x 20.2 cm.)
Signed, l.r. overmat recto: "Clara E. Sipprell"
Inscription, print verso: "SP4"
 overmat recto: "Ture Rangström—composer/Stockholm"
 mat backing verso: "S-P-12//SP4"
Acquired from: gift of the Dorothea Leonhardt Fund of the
 Communities Foundation of Texas, Inc., Dallas, Texas

4835. **TUNBRIDGE IN OCTOBER [Fall at Tunbridge, Vermont]**
 (P1984.1.457) duplicate of P1984.1.458 and P1984.1.460
Gelatin silver print. negative c. 1920s–60s, print c. 1960s
Image: 9 x 6 15/16 in. (22.8 x 17.6 cm.) sight size
Mount: 10½ x 7 9/16 in. (26.6 x 19.3 cm.)
Signed, l.r. overmat recto: "Clara E. Sipprell"
Inscription, overmat recto: "Turnbridge [sic]/in October//x"
 overmat verso: "Fall on the road to/Turnbridge [sic], Vt.//
 VL3" mount verso: "VL3"
Acquired from: gift of the Dorothea Leonhardt Fund of the
 Communities Foundation of Texas, Inc., Dallas, Texas

*4836. **[Two glass balls and pharaoh figurine]** (P1984.1.487)
Gelatin silver print on tissue. c. 1920s
Image: 7 9/16 x 9½ in. (19.2 x 24.1 cm.)
Sheet: 7 15/16 x 9⅞ in. (20.2 x 25.1 cm.)
Inscription, print verso: "SL32/PF" and rubber stamp
 "CLARA E. SIPPRELL/Manchester, Vermont"
 mat backing verso: "SL32/PF"
Acquired from: gift of the Dorothea Leonhardt Fund of the
 Communities Foundation of Texas, Inc., Dallas, Texas

4837. **[Two little sisters]** (P1984.1.649)
Gelatin silver print. c. 1929
Image: 9 5/16 x 7¼ in. (23.7 x 18.4 cm.)
Mount: 11 1/16 x 7 15/16 in. (28.1 x 20.2 cm.)
Signed, l.r. mount recto: "Clara E. Sipprell"
Acquired from: gift of the Dorothea Leonhardt Fund of the
 Communities Foundation of Texas, Inc., Dallas, Texas

4838. **[Two petunias]** (P1984.1.660)
Gelatin silver print on tissue. c. 1930s
Image: 7⅝ x 9½ in. (19.4 x 24.1 cm.)
Sheet: 8 x 9 15/16 in. (20.3 x 25.3 cm.)
Acquired from: gift of the Dorothea Leonhardt Fund of the
 Communities Foundation of Texas, Inc., Dallas, Texas

*4839. **TYPES IN CONTRERAS, MEXICO [Indian Group—**
 Mexican Types, Contreras, Mexico] (P1984.1.306) duplicate
 of P1984.1.305
Gelatin silver print on tissue. c. 1931
Image: 9 9/16 x 7 9/16 in. (24.3 x 19.2 cm.)
Sheet: 10¼ x 7 15/16 in. (26.0 x 20.2 cm.)
Signed, l.r. overmat recto: "Clara E. Sipprell"
Inscription, print verso: "MEX 13"
 overmat recto: "Types in Contreras [sic]/Mexico"
 overmat verso: "MEX 13"
Acquired from: gift of the Dorothea Leonhardt Fund of the
 Communities Foundation of Texas, Inc., Dallas, Texas

4840. **[Unidentified bald man holding figurine]** (P1984.1.635)
Gelatin silver print on tissue. c. 1920s
Image: 9⅛ x 6½ in. (23.2 x 16.5 cm.)
Acquired from: gift of the Dorothea Leonhardt Fund of the
 Communities Foundation of Texas, Inc., Dallas, Texas

4841. **[Unidentified family]** (P1984.1.651)
Gelatin silver print. c. 1920s–30s
Image: 8¾ x 6 13/16 in. (22.2 x 17.3 cm.)
Acquired from: gift of the Dorothea Leonhardt Fund of the
 Communities Foundation of Texas, Inc., Dallas, Texas

*4842. **[Unidentified man]** (P1984.1.628)
Gelatin silver print. c. 1920s
Image: 9⅛ x 6¾ in. (23.2 x 17.1 cm.)
Mount: 10½ x 7⅜ in. (26.6 x 18.7 cm.)
Signed, l.r. mount recto: "Clara E. Sipprell"
Acquired from: gift of the Dorothea Leonhardt Fund of the
 Communities Foundation of Texas, Inc., Dallas, Texas

4843. **[Unidentified man]** (P1984.1.631)
Platinum print. c. 1910s
Image: 9¼ x 7⅜ in. (23.5 x 18.7 cm.)
1st mount: 9½ x 7⅝ in. (24.1 x 19.4 cm.)
2nd mount: 10 x 7 15/16 in. (25.4 x 20.2 cm.)
Signed, u.l. print recto and l.r. 1st mount verso:
 "Clara E. Sipprell"
Acquired from: gift of the Dorothea Leonhardt Fund of the
 Communities Foundation of Texas, Inc., Dallas, Texas

4844. **[Unidentified man holding book]** (P1984.1.634)
Gelatin silver print on tissue. c. 1915–25
Image: 7⅞ x 5 15/16 in. (20.0 x 15.1 cm.)
Sheet: 9 15/16 x 7 15/16 in. (25.3 x 20.2 cm.)
Signed, l.r. sheet recto: "Clara E. Sipprell"
Acquired from: gift of the Dorothea Leonhardt Fund of the
 Communities Foundation of Texas, Inc., Dallas, Texas

4845. **[Unidentified man reading book]** (P1984.1.636)
Gelatin silver print on tissue. c. 1920s
Image: 8 ³/₁₆ x 6 ⁵/₁₆ in. (20.8 x 16.0 cm.)
Sheet: 8 ³/₈ x 6 ½ in. (21.3 x 16.5 cm.)
Acquired from: gift of the Dorothea Leonhardt Fund of the
Communities Foundation of Texas, Inc., Dallas, Texas

* 4846. **[Unidentified man standing by desk]** (P1984.1.644)
Platinum print. before 1915
Image: 13 ⅛ x 9 ¾ in. (33.3 x 24.8 cm.)
Mount: 14 ⁵/₁₆ x 10 ³/₁₆ in. (36.3 x 25.9 cm.)
Signed, l.r. mount recto: "Clara E. Sipprell"
Inscription, mount verso: "OP1"
Acquired from: gift of the Dorothea Leonhardt Fund of the
Communities Foundation of Texas, Inc., Dallas, Texas

* 4847. **[Unidentified old woman]** (P1984.1.645)
Platinum print. before 1915
Image: 13 ³/₈ x 10 in. (34.0 x 25.4 cm.)
Inscription, print verso: "OP3"
Acquired from: gift of the Dorothea Leonhardt Fund of the
Communities Foundation of Texas, Inc., Dallas, Texas

* 4848. **[Unidentified older woman in Whistler's Mother pose]**
(P1984.1.642)
Platinum print. before 1915
Image: 10 ³/₈ x 13 ⅝ in. (26.4 x 34.6 cm.)
Inscription, print verso: "OP4"
Acquired from: gift of the Dorothea Leonhardt Fund of the
Communities Foundation of Texas, Inc., Dallas, Texas

4849. **[Unidentified older woman with glasses]** (P1984.1.612)
Gelatin silver print. c. 1920s–30s
Image: 9 ¼ x 7 ³/₈ in. (23.5 x 18.7 cm.)
Signed, l.r. mount: "Clara E. Sipprell"
Acquired from: gift of the Dorothea Leonhardt Fund of the
Communities Foundation of Texas, Inc., Dallas, Texas

4850. **[Unidentified woman]** (P1984.1.609)
Gelatin silver print. c. 1910s
Image: 4 ⁵/₁₆ x 3 ⅛ in. (11.0 x 7.9 cm.) oval
Acquired from: gift of the Dorothea Leonhardt Fund of the
Communities Foundation of Texas, Inc., Dallas, Texas

4851. **[Unidentified woman]** (P1984.1.610)
Gelatin silver print. c. 1910s
Image: 4 ⅛ x 3 ⅛ in. (10.5 x 7.9 cm.) oval
Acquired from: gift of the Dorothea Leonhardt Fund of the
Communities Foundation of Texas, Inc., Dallas, Texas

4852. **[Unidentified woman in tie, coat, and hat]** (P1984.1.655)
Platinum print. c. 1919
Image: 9 ¼ x 6 ⅞ in. (23.5 x 17.4 cm.)
Inscription, print verso: "ADL 31" and rubber stamp
"CLARA E. SIPPRELL/Manchester, Vermont"
Acquired from: gift of the Dorothea Leonhardt Fund of the
Communities Foundation of Texas, Inc., Dallas, Texas

4853. **[Unidentified woman's profile; possibly Margarita Konenkov]**
(P1984.1.654)
Gelatin silver print. c. 1920
Image: 9 ³/₈ x 7 ³/₈ in. (23.8 x 18.7 cm.)
Inscription, print verso: "Irene?/Adl36"
Acquired from: gift of the Dorothea Leonhardt Fund of the
Communities Foundation of Texas, Inc., Dallas, Texas

4854. **UPPSALA—PART OF CASTLE** (P1984.1.539)
Gelatin silver print on Gevaluxe paper. c. 1938
Image: 9 ⁹/₁₆ x 7 ⅝ in. (24.3 x 19.4 cm.)
Sheet: 10 x 8 in. (25.4 x 20.3 cm.)
Signed, l.r. overmat recto: "Clara E. Sipprell"
Inscription, print verso: "SwL39"
overmat recto: "Upsala [sic]—part of castle"
overmat verso: "SwL39"
mat backing verso: "S-L-15//SwL39"
Acquired from: gift of the Dorothea Leonhardt Fund of the
Communities Foundation of Texas, Inc., Dallas, Texas

4836

4839

4842

4855. **URUAPAN, MEXICO** (P1984.1.317)
Gelatin silver print on tissue. c. 1931
Image: 8 15/16 x 6 15/16 in. (22.6 x 17.6 cm.) sight size
Sheet: 9 15/16 x 8 1/8 in. (25.3 x 20.6 cm.)
Signed, l.r. overmat recto: "Clara E. Sipprell"
Inscription, print verso: "MEX26"
 overmat recto: "Urapan [sic]/Mexico"
 overmat verso: "MEX26"
Acquired from: gift of the Dorothea Leonhardt Fund of the
 Communities Foundation of Texas, Inc., Dallas, Texas

4856. **[V. V. Lushsky, actor—Moscow Art Theatre]** (P1984.1.624)
Gelatin silver print on tissue. c. 1925
Image: 9 1/2 x 7 1/2 in. (24.1 x 19.0 cm.)
Sheet: 9 7/8 x 7 13/16 in. (25.1 x 19.8 cm.)
Mount: same as sheet size
 note: a print of Nina in a hat is affixed to print verso
Acquired from: gift of the Dorothea Leonhardt Fund of the
 Communities Foundation of Texas, Inc., Dallas, Texas

4857. **VERMONT** (P1984.1.203)
Gelatin silver print on tissue. c. 1929
Image: 9 1/8 x 7 1/8 in. (23.2 x 18.1 cm.) sight size
Sheet: 10 x 8 in. (25.4 x 20.3 cm.)
Signed, l.r. overmat recto: "Clara E. Sipprell"
Inscription, print verso: "C11"
 overmat recto: "Vermont//3"
 overmat verso: "Nina"
Acquired from: gift of the Dorothea Leonhardt Fund of the
 Communities Foundation of Texas, Inc., Dallas, Texas

4858. **VERMONT BRIDGE, FAIRLEE** (P1984.1.462)
Platinum print. negative c. 1926, print later
Image: 8 11/16 x 6 15/16 in. (22.1 x 17.6 cm.) sight size
Sheet: 10 x 8 in. (25.4 x 20.3 cm.)
Signed, l.r. overmat recto: "Clara E. Sipprell"
Inscription, print verso: "VL6"
 overmat recto: "Vermont Bridge/Fairlee"
 overmat verso: "VL6"
Acquired from: gift of the Dorothea Leonhardt Fund of the
 Communities Foundation of Texas, Inc., Dallas, Texas

4859. **VERMONT DOOR YARD** (P1984.1.484)
Gelatin silver print. negative c. 1920s–30s, print later
Image: 9 x 6 7/8 in. (22.8 x 17.4 cm.) sight size
Mount: 11 x 8 1/2 in. (28.0 x 21.6 cm.)
Signed, l.r. overmat recto: "Clara E. Sipprell"
Inscription, overmat recto: "Vermont Door yard//x"
 mount verso: "AA18"
Acquired from: gift of the Dorothea Leonhardt Fund of the
 Communities Foundation of Texas, Inc., Dallas, Texas

4860. **[Vermont landscape with waterfall]** (P1984.1.425)
Gelatin silver print on tissue. negative n.d., print c. 1930s
Image: 9 1/4 x 7 5/16 in. (23.5 x 18.5 cm.) sight size
Sheet: 10 1/16 x 8 in. (25.5 x 20.3 cm.)
Signed, l.r. overmat recto: "Clara E. Sipprell"
Inscription, print verso: "VL21"
 overmat verso: "VL21"
 mat backing verso: "VL21"
Acquired from: gift of the Dorothea Leonhardt Fund of the
 Communities Foundation of Texas, Inc., Dallas, Texas

4861. **[Vermont road]** (P1984.1.430)
Gelatin silver print on Gevaluxe paper. c. 1930s–40s
Image: 9 5/8 x 7 9/16 in. (24.4 x 19.2 cm.)
Sheet: 10 1/16 x 7 15/16 in. (25.5 x 20.2 cm.)
Signed, l.r. overmat recto: "Clara E. Sipprell"
Inscription, print verso: "VL25"
 overmat verso: "VL25"
 mat backing verso: "V-L-13//VL25"
Acquired from: gift of the Dorothea Leonhardt Fund of the
 Communities Foundation of Texas, Inc., Dallas, Texas

*4862. **A VERMONTER** (P1984.1.241)
Gelatin silver print on tissue. c. 1920s–30s
Image: 9 5/8 x 7 5/8 in. (24.4 x 19.4 cm.)
Sheet: 9 7/8 x 7 15/16 in. (25.1 x 20.2 cm.)
Signed, l.r. overmat recto: "Clara E. Sipprell"
Inscription, overmat recto: "A Vermonter"
 mount verso: "PFV-100//ADL9"
Acquired from: gift of the Dorothea Leonhardt Fund of the
 Communities Foundation of Texas, Inc., Dallas, Texas

*4863. **A VERY LITTLE BOY [Duncan Phillips' daughter]**
(P1984.1.614)
Gelatin silver print. c. 1923
Image: 7 11/16 x 5 15/16 in. (19.5 x 15.1 cm.)
1st mount: 8 7/8 x 6 11/16 in. (22.5 x 17.0 cm.)
2nd mount: 9 x 6 13/16 in. (22.8 x 17.1 cm.)
Signed, l.r. 1st mount recto: "Clara E. Sipprell"
Inscription, 2nd mount verso: "A Very Little Boy. [sic]" and
 rubber stamp "18496"
 old mat backing verso: "PfV-100//ADL9"
Acquired from: gift of the Dorothea Leonhardt Fund of the
 Communities Foundation of Texas, Inc., Dallas, Texas

4864. **[View of grassy mountains]** (P1984.1.282)
Gelatin silver print. n.d.
Image: 6 13/16 x 8 15/16 in. (17.3 x 22.6 cm.) sight size
Mount: 8 x 9 7/8 in. (20.3 x 25.1 cm.)
Inscription, overmat verso: "M-39//ML1"
 note: a print of a mother and two daughters is affixed to
 print verso
Acquired from: gift of the Dorothea Leonhardt Fund of the
 Communities Foundation of Texas, Inc., Dallas, Texas

4865. **VINE IN OLD BOTTLE [Old Bottle with Woodbines]**
(P1984.1.486) duplicate of P1984.1.505 and P1984.1.510
Gelatin silver print on tissue. negative 1921, print c. 1921
Image: 9 x 6 15/16 in. (22.8 x 17.6 cm.) sight size
Mount: 10 13/16 x 11 1/8 in. (27.4 x 28.2 cm.)
Signed, l.r. old overmat recto: "Clara E. Sipprell/1921"
Inscription, 1st overmat recto: "Vine in old Bottle"
 mount verso: "SL24"
 mat backing verso: "SL24" and dealer's label
Acquired from: gift of the Dorothea Leonhardt Fund of the
 Communities Foundation of Texas, Inc., Dallas, Texas

4866. **VISBY, GOTLAND** (P1984.1.526)
Gelatin silver print. c. 1938
Image: 8 3/8 x 7 1/8 in. (21.3 x 18.1 cm.) sight size
Signed, l.r. overmat recto: "Clara E. Sipprell"
Inscription, overmat recto: "Visby/Gotland"
 overmat verso: "SA36"
 mat backing verso: "S-L-35//SA36"
Acquired from: gift of the Dorothea Leonhardt Fund of the
 Communities Foundation of Texas, Inc., Dallas, Texas

4867. **THE WALLS OF MONTENEGRO** (P1984.1.605)
Gelatin silver print on tissue. c. 1926
Image: 9 1/4 x 7 5/16 in. (23.5 x 18.5 cm.) sight size
Sheet: 10 x 8 in. (25.4 x 20.3 cm.)
Signed, l.r. overmat recto: "Clara E. Sipprell"
Inscription, print verso: "YL14"
 overmat, typed on paper label: "The Walls of Montenegro"
 overmat verso: "YL14"
Acquired from: gift of the Dorothea Leonhardt Fund of the
 Communities Foundation of Texas, Inc., Dallas, Texas

4868. **THE WALTER HARD HOUSE, MANCHESTER,
VERMONT** (P1984.1.473)
Gelatin silver print on Gevaluxe paper. c. 1940
Image: 9 1/8 x 7 5/8 in. (23.2 x 19.4 cm.)
Sheet: 10 x 8 in. (25.4 x 20.3 cm.)
Signed, l.r. old overmat recto: "Clara E. Sipprell"
Inscription, print verso: "VL12"
 old overmat recto: "The Walter Hard House/Manchester,
 Vermont"
 old overmat verso: "V-L-16"
Acquired from: gift of the Dorothea Leonhardt Fund of the
 Communities Foundation of Texas, Inc., Dallas, Texas

4846

4847

4848

4862

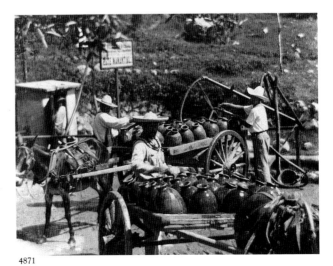

4863

4871

4869. **WASHINGTON MONUMENT, D.C.** (P1984.1.429)
Gelatin silver print on Gevaluxe paper. c. 1940
Image: 9 5/8 x 7 5/8 in. (24.4 x 19.4 cm.)
Sheet: 10 x 8 in. (25.4 x 20.3 cm.)
Signed, l.r. overmat recto: "Clara E. Sipprell"
Inscription, overmat recto: "Washington Monument/D.C."
mat backing verso: "A-L-5//36/21/2|57/28 ½//AA.23"
Acquired from: gift of the Dorothea Leonhardt Fund of the
Communities Foundation of Texas, Inc., Dallas, Texas

4870. **WATER CARRIERS AT ACAYAPAN, TEPIC, MEXICO**
(P1984.1.319) duplicate of P1984.1.320
Gelatin silver print on tissue. c. 1931
Image: 7 1/8 x 9 1/8 in. (18.1 x 23.2 cm.) sight size
Signed, l.r. overmat recto: "Clara E. Sipprell"
Inscription, overmat recto: "Water Carriers/Tepic" and typed
on paper label "Water Carriers at Acayapam [sic]/Tepic,
Mexico"
mat backing verso: "M-2-a//g BookSelection//MEX27"
Acquired from: gift of the Dorothea Leonhardt Fund of the
Communities Foundation of Texas, Inc., Dallas, Texas

*4871. **WATER CARRIERS, TEPIC, MEXICO** (P1984.1.320)
duplicate of P1984.1.319
Gelatin silver print on tissue. c. 1931
Image: 7 1/8 x 9 in. (18.1 x 22.8 cm.) sight size
Signed, l.r. overmat recto: "Clara E. Sipprell"
Inscription, overmat recto: "Water Carriers/Tepic/Mexico"
mat backing verso: "M-2-b//Mexico//MEX 28"
Acquired from: gift of the Dorothea Leonhardt Fund of the
Communities Foundation of Texas, Inc., Dallas, Texas

4872. **WELLESLEY COLLEGE—GUEST HOUSE** (P1984.1.439)
Gelatin silver print on tissue. c. 1920s
Image: 6 7/8 x 9 3/16 in. (17.4 x 23.3 cm.) sight size
Signed, l.r. overmat recto: "Clara E. Sipprell"
Inscription, overmat recto, typed on paper labels:
"Wellesley College" and "Guest House"
mat backing verso: "WC7//V//WC7"
Acquired from: gift of the Dorothea Leonhardt Fund of the
Communities Foundation of Texas, Inc., Dallas, Texas

4873. **WELLESLEY COLLEGE—IVY-TOWER COURT**
(P1984.1.437)
Gelatin silver print on tissue. c. 1920s
Image: 9 5/16 x 7 5/16 in. (23.7 x 18.5 cm.) sight size
Signed, l.r. overmat recto: "Clara E. Sipprell"
Inscription, overmat recto, typed on paper labels:
"Wellesley College" and "Ivy-Tower Court"
mat backing verso: "WC-9//VII//WC9"
Acquired from: gift of the Dorothea Leonhardt Fund of the
Communities Foundation of Texas, Inc., Dallas, Texas

4874. **WELLESLEY COLLEGE—STONE HALL FROM ACROSS
LAKE** (P1984.1.435)
Gelatin silver print on tissue. c. 1920s
Image: 4 15/16 x 9 1/4 in. (12.6 x 23.5 cm.) sight size
Signed, l.r. overmat recto: "Clara E. Sipprell"
Inscription, overmat recto, typed on paper labels:
"Wellesley College" and "Stone Hall from across Lake"
mat backing verso: "WC-11//XI//WC11"
Acquired from: gift of the Dorothea Leonhardt Fund of the
Communities Foundation of Texas, Inc., Dallas, Texas

4875. **WELLESLEY COLLEGE—THE HOMESTEAD**
(P1984.1.438)
Gelatin silver print on tissue. c. 1920s
Image: 9 3/16 x 7 1/2 in. (23.3 x 19.0 cm.) sight size
Signed, l.r. overmat recto: "Clara E. Sipprell"
Inscription, overmat recto, typed on paper labels:
"Wellesley College" and "The Homestead"
mat backing verso: "WC-10//X//WC10"
Acquired from: gift of the Dorothea Leonhardt Fund of the
Communities Foundation of Texas, Inc., Dallas, Texas

*4876. **WELLESLEY COLLEGE—"WHERE GO THE BOATS"**
(P1984.1.444)
Gelatin silver print on tissue. c. 1920s
Image: 9 9/16 x 7 1/2 in. (24.3 x 19.0 cm.) sight size
Signed, l.r. overmat recto: "Clara E. Sipprell"
Inscription, overmat recto: "12" and typed on paper labels
"Wellesley College" and ""Where Go the Boats""
mat backing verso: "W-C-3//VI//WC3"
Acquired from: gift of the Dorothea Leonhardt Fund of the
Communities Foundation of Texas, Inc., Dallas, Texas

4877. **WEST FAIRLEE CENTER, VERMONT** (P1984.1.461)
Gelatin silver print on tissue. c. 1920s–30s
Image: 9 11/16 x 7 5/8 in. (24.6 x 19.3 cm.)
Sheet: 9 15/16 x 7 15/16 in. (25.3 x 20.2 cm.)
Signed, l.r. old overmat recto: "Clara E. Sipprell"
Inscription, print verso: "VL5"
old overmat recto: "West Fairlee Center/Vermont"
old overmat verso: "VL5"
Acquired from: gift of the Dorothea Leonhardt Fund of the
Communities Foundation of Texas, Inc., Dallas, Texas

*4878. **WET WALLS, CONTRERAS, MEXICO** (P1984.1.294)
Gelatin silver print on tissue. c. 1931
Image: 9 3/16 x 7 3/16 in. (23.3 x 18.2 cm.) sight size
Signed, l.r. overmat recto: "Clara E. Sipprell"
Inscription, overmat recto, typed on paper label: "Wet Walls/
Contreras, Mexico" and printed paper label "31"
mat backing verso: "M-15//g Mexico//MA1"
Acquired from: gift of the Dorothea Leonhardt Fund of the
Communities Foundation of Texas, Inc., Dallas, Texas

*4879. **WHERE THE WEALTHIEST MERCHANT LIVED, RAB,
DALMATIA** (P1984.1.575)
Gelatin silver print on tissue. c. 1926
Image: 9 3/16 x 7 3/16 in. (23.3 x 18.2 cm.) sight size
Signed, l.r. overmat recto: "Clara E. Sipprell"
Inscription, overmat recto, typed on paper label: "Where the
Wealthiest Merchant Lived/Rab, Dalmatia"
mat backing verso: "D-L-17//YA10"
Acquired from: gift of the Dorothea Leonhardt Fund of the
Communities Foundation of Texas, Inc., Dallas, Texas

4880. **[The white birch]** (P1984.1.455)
Gelatin silver print. negative c. 1923, print later
Image: 8 7/16 x 6 13/16 in. (21.4 x 17.3 cm.)
Mount: 15 1/16 x 11 in. (38.2 x 28.0 cm.)
Inscription, mount verso: "VL37"
Acquired from: gift of the Dorothea Leonhardt Fund of the
Communities Foundation of Texas, Inc., Dallas, Texas

*4881. **[White dress]** (P1984.1.11)
Gelatin silver print on tissue. c. 1917
Image: 7 3/4 x 5 7/8 in. (19.7 x 14.9 cm.)
Sheet: 9 7/8 x 8 in. (25.1 x 20.3 cm.)
Signed, l.r. print recto: "Clara E. Sipprell"
Inscription, print verso: "PF"
old mat backing verso: dealer's label
Acquired from: gift of the Dorothea Leonhardt Fund of the
Communities Foundation of Texas, Inc., Dallas, Texas

4882. **[William Lathrop, painter]** (P1984.1.640)
Gelatin silver print. c. 1930
Image: 9 1/4 x 7 1/4 in. (23.5 x 18.4 cm.)
Acquired from: gift of the Dorothea Leonhardt Fund of the
Communities Foundation of Texas, Inc., Dallas, Texas

4883. **WILLIAM ZORACH** (P1984.1.6)
Gelatin silver print. c. 1940
Image: 9 13/16 x 7 13/16 in. (24.9 x 19.8 cm.)
Sheet: 9 15/16 x 8 in. (25.2 x 20.3 cm.)
Mount: 10 x 8 1/8 in. (25.4 x 20.7 cm.)
Inscription, mount verso: "IG39" and rubber stamp
"CLARA E. SIPPRELL/Manchester, Vermont"
mat backing verso: dealer's label
Acquired from: gift of the Dorothea Leonhardt Fund of the
Communities Foundation of Texas, Inc., Dallas, Texas

4876

4878

4879

4881

4884. **WILLIAM ZORACH** (P1984.1.7)
Gelatin silver print on Gevaluxe paper. c. 1940
Image: 9 x 7 in. (22.8 x 17.8 cm.) sight size
Sheet: 10 x 8 in. (25.4 x 20.3 cm.)
Signed, l.r. old overmat recto: "Clara E. Sipprell"
Inscription, mat backing verso: dealer's marks and label
 old overmat recto: "William Zorach"
 old mat backing verso: "AP-M-57//PF//IG40"
Acquired from: gift of the Dorothea Leonhardt Fund of the
 Communities Foundation of Texas, Inc., Dallas, Texas

*4885. **WINTER ON MORNINGSIDE DRIVE—NEW YORK**
(P1984.1.396)
Gelatin silver print on tissue. c. 1933 or before
Image: 9 x 7¼ in. (22.8 x 18.4 cm.) sight size
Signed, l.r. overmat recto: "Clara E. Sipprell"
Inscription, overmat recto, typed on paper label:
 "Winter on Mroningside [sic] Drive—New York."
 mat backing verso: "Pf 193//NY3"
Acquired from: gift of the Dorothea Leonhardt Fund of the
 Communities Foundation of Texas, Inc., Dallas, Texas

4886. **[Winter road, snow, trees, and barns]** (P1984.1.688)
Gelatin silver print on tissue. c. 1920s
Image: 6 x 7¹⁵/₁₆ in. (15.2 x 20.2 cm.)
Sheet: 7¹⁵/₁₆ x 9¹⁵/₁₆ in. (20.2 x 25.3 cm.)
Acquired from: gift of the Dorothea Leonhardt Fund of the
 Communities Foundation of Texas, Inc., Dallas, Texas

4887. **WINTER WOODS** (P1984.1.423)
Gelatin silver print. negative c. 1928, print later
Image: 8¹⁵/₁₆ x 6¹⁵/₁₆ in. (22.6 x 17.6 cm.) sight size
Mount: 10⁹/₁₆ x 8¹/₁₆ in. (26.7 x 20.6 cm.)
Signed, l.r. mount recto and l.r. overmat recto:
 "Clara E. Sipprell"
Inscription, overmat recto: "Winter Woods//x"
 overmat verso: "VL20"
 mount verso: "VL20"
Acquired from: gift of the Dorothea Leonhardt Fund of the
 Communities Foundation of Texas, Inc., Dallas, Texas

*4888. **WINTER WOODS** (P1984.1.481)
Gelatin silver print. negative c. 1920s–30s, print later
Image: 8¹⁵/₁₆ x 6⅞ in. (22.6 x 17.4 cm.) sight size
Mount: 11 x 8½ in. (28.0 x 21.7 cm.)
Signed, l.r. overmat recto: "Clara E. Sipprell"
Inscription, overmat recto: "Winter Woods//x"
 overmat verso: "VL17"
 mount verso: "VL17"
Acquired from: gift of the Dorothea Leonhardt Fund of the
 Communities Foundation of Texas, Inc., Dallas, Texas

4889. **[Woman and children in garden]** (P1984.1.662)
Gelatin silver print on tissue. c. 1910s–20s
Image: 5⅛ x 6¹⁵/₁₆ in. (13.0 x 17.6 cm.)
Acquired from: gift of the Dorothea Leonhardt Fund of the
 Communities Foundation of Texas, Inc., Dallas, Texas

4890. **[Woman in a vegetable garden]** (P1984.1.398)
Gelatin silver print on tissue. n.d.
Image: 7⁹/₁₆ x 9⁷/₁₆ in. (19.3 x 24.0 cm.)
Sheet: 8¹/₁₆ x 10¼ in. (20.5 x 26.0 cm.)
Signed, l.r. old overmat recto: "Clara E. Sipprell"
Inscription, print verso: "MisL2"
 old overmat verso: "MisL2"
Acquired from: gift of the Dorothea Leonhardt Fund of the
 Communities Foundation of Texas, Inc., Dallas, Texas

4891. **[Woman in kimono cutting pussywillow]** (P1984.1.657)
Gelatin silver print on tissue. c. 1950
Image: 6 x 8¹/₁₆ in. (15.2 x 20.5 cm.)
1st mount: 6¼ x 8⁵/₁₆ in. (15.8 x 21.1 cm.)
2nd mount: 6⅞ x 8½ in. (17.4 x 21.6 cm.)
Signed, l.r. 2nd mount recto: "Clara E. Sipprell"
Acquired from: gift of the Dorothea Leonhardt Fund of the
 Communities Foundation of Texas, Inc., Dallas, Texas

4892. **[Woman in white dress]** (P1984.1.656)
Gelatin silver print. c. 1917
Image: 8¹/₁₆ x 5 in. (20.5 x 12.7 cm.)
1st mount: 9⅛ x 5¾ in. (23.2 x 14.6 cm.)
2nd mount: 9¼ x 5¹³/₁₆ in. (23.5 x 14.8 cm.)
Signed, l.r. 1st mount recto: "Clara E. Sipprell"
Acquired from: gift of the Dorothea Leonhardt Fund of the
 Communities Foundation of Texas, Inc., Dallas, Texas

4893. **[Woman reading a book in Morningside Drive apartment]**
(P1984.1.10)
Gelatin silver print. c. 1920s
Image: 9½ x 7¼ in. (24.1 x 18.4 cm.)
Mount: 10¾ x 8 in. (27.2 x 20.4 cm.)
Signed, l.r. mount recto: "Clara E. Sipprell"
Inscription, mount verso: "PF"
 mat backing verso: dealer's label
Acquired from: gift of the Dorothea Leonhardt Fund of the
 Communities Foundation of Texas, Inc., Dallas, Texas

4894. **WOODS** (P1984.1.485)
Gelatin silver print on tissue. n.d.
Image: 7⅛ x 9³/₁₆ in. (18.1 x 23.3 cm.) sight size
Sheet: 8 x 10 in. (20.3 x 25.4 cm.)
Signed, l.r. overmat recto: "Clara E. Sipprell"
Inscription, print verso: "VL19"
 overmat verso: "Woods//VL19"
 old mat backing verso: "Woods//VL19"
Acquired from: gift of the Dorothea Leonhardt Fund of the
 Communities Foundation of Texas, Inc., Dallas, Texas

4895. **WRECK ON THE BEACH** (P1984.1.344)
Gelatin silver print on tissue. n.d.
Image: 7³/₁₆ x 9³/₁₆ in. (18.2 x 23.3 cm.) sight size
Signed, l.r. overmat recto: "Clara E. Sipprell"
Inscription, mat backing verso: "A-L-40//Wreck on the
 Beach//GP35"
Acquired from: gift of the Dorothea Leonhardt Fund of the
 Communities Foundation of Texas, Inc., Dallas, Texas

4896. **XOCHIMILCO—FLOATING GARDENS** (P1984.1.277)
Gelatin silver print on tissue. c. 1931
Image: 9³/₁₆ x 7⅛ in. (23.3 x 18.1 cm.) sight size
Signed, l.r. overmat recto: "Clara E. Sipprell"
Inscription, overmat recto: "Xochimilco/Floating Gardens"
 and typed on paper label "At Xochimilco/Mexico"
 mat backing verso: "M-16//Xochimilco//ML12"
Acquired from: gift of the Dorothea Leonhardt Fund of the
 Communities Foundation of Texas, Inc., Dallas, Texas

4897. **YELLOW PINES, VERMONT** (P1984.1.454)
Gelatin silver print. n.d.
Image: 9⅛ x 7⁷/₁₆ in. (23.2 x 18.9 cm.) sight size
Mount: 9¹⁵/₁₆ x 8 in. (25.3 x 20.3 cm.)
Signed, l.r. overmat recto: "Clara E. Sipprell"
Inscription, overmat recto: "Yellow Pines/Vermont"
 overmat verso: "VL34"
 mount verso: "VL34"
 note: a print of a man sitting behind an open book is
 affixed to print verso
Acquired from: gift of the Dorothea Leonhardt Fund of the
 Communities Foundation of Texas, Inc., Dallas, Texas

4898. **ZIMAPÁN, MEXICO** (P1984.1.286)
Gelatin silver print. negative c. 1931, print later
Image: 6⅞ x 8¹⁵/₁₆ in. (17.4 x 22.6 cm.) sight size
Mount: 8 x 9⅞ in. (20.3 x 25.1 cm.)
Signed, l.r. overmat recto: "Clara E. Sipprell"
Inscription, overmat recto: "Zimapan/Mexico"
 overmat verso: "ML6"
 mount verso: "ML6"
Acquired from: gift of the Dorothea Leonhardt Fund of the
 Communities Foundation of Texas, Inc., Dallas, Texas

FRANCIS J. SIPPRELL,
American, born Canada (1878–1958)

When he was fourteen, Frank Sipprell began working after school in the photo studio of his Sunday School teacher. In 1895, Sipprell's family moved to Buffalo, New York, where he worked in the studio of one of the first photographers in the city. With money borrowed from his brother Henry and equipment obtained on credit from Adams Photo Equipment Company, Sipprell opened the Sipprell Studio in 1902. He was an active member of the Buffalo Camera Club from 1909 through the 1930s, and his work was featured in a 1926 issue of Eastman Kodak's *Studio Light.* Although Sipprell and his family moved to Hamburg, New York, in 1928, the studio remained in Buffalo until the Sipprell family moved to East Aurora, New York, in 1938. Sipprell relocated the studio to East Aurora, where his son, Allen, now runs it. Sipprell is responsible for encouraging the photographic careers of his sister, Clara, and his son, Allen.

4899. **[Clara Estelle Sipprell]** (P1984.1.273)
Gelatin silver print. c. 1930s
Image: 9 1/4 x 7 1/8 in. (23.5 x 18.1 cm.)
Signed: see inscription
Inscription, print recto: "Sipprell/Buffalo"
 mat backing verso: "g Bookselection//ADL 17"
Acquired from: gift of the Dorothea Leonhardt Fund of the
 Communities Foundation of Texas, Inc., Dallas, Texas

GAIL SKOFF, American (b. 1949)

Gail Skoff attended the University of California at Berkeley and Boston Museum School before receiving her B.F.A. and M.F.A. from the San Francisco Art Institute. Since 1973 she has worked as a freelance photographer and since 1976 as an instructor. In 1976, Skoff received a National Endowment for the Arts photographer's fellowship. Her work has appeared in numerous individual and group exhibitions throughout the United States. She uses toning and hand-coloring to transform certain aspects of her black and white photographs.

4900. **BADLANDS [South Dakota]** (P1986.22)
Hand-colored gelatin silver print. negative 1981, print 1982
Image: 14 3/8 x 22 5/16 in. (36.4 x 56.6 cm.)
Sheet: 20 x 23 13/16 in. (50.8 x 60.4 cm.)
Signed, l.r. sheet recto: "Gail Skoff 1981/handcolored 1982"
Inscription, print recto: "Badlands//2"
Acquired from: Etherton Gallery, Tucson, Arizona

ERWIN EVANS SMITH, American (1886–1947)

Bonham, Texas, native Erwin E. Smith's first range photographs were made on summer visits to his uncle's ranch in Foard County, Texas. During his recovery from a serious case of typhoid fever at the age of sixteen, Smith decided to become an artist. When he was eighteen, he went to Chicago to study with the noted sculptor Lorado Taft. Smith also had planned to study in Boston, but he postponed this in order to return to Texas and photograph full-time. Working on large ranches, Smith endeavored to dispel the popular misrepresentation of the working cowboy by providing factual images of the cowboy's rigorous life on the range. In 1908 Smith went to Boston to study with Bela Lyon Pratt. Smith used his collection of photographs as the basis of his drawings and sculptures. He remained in

4885

4888

Boston for three years, but each summer he and his friend George Pattullo returned to Texas. Pattullo had written about Smith's western experiences, and as the two men traveled from ranch to ranch, Pattullo produced articles for the *Saturday Evening Post* and other publications. Smith's photographs illustrated these articles. After Smith returned to Bonham in 1911, he decided to begin his own ranching operation on the land in Fannin County that he had inherited from his father, but this venture was never successful. Smith submitted proposals for a book of his photographs to publishers, but negotiations never passed the planning stage. Projects such as a set of "Photographs of the Old West" produced in 1921 brought a good response but not enough cash. Smith and his mother moved into the home of his half-sister Mary Alice Pettis in 1932. Both mother and son died in 1947. During the 1930s Smith's photographs appeared on the cover of *The Cattleman*, published by the Texas and Southwestern Cattle Raisers Association, as well as illustrating articles in the magazine. In 1952 his photographs were reproduced in *Life on the Texas Range*. In 1976 Smith's grave in Honey Grove was marked by an Official Texas Historical Grave Marker.

Note: The Erwin E. Smith Collection (P1986.41 and P1986.42) is being processed at the time of publication of this catalogue. Mary Alice White Pettis, Smith's half-sister, bequeathed Smith's collection of prints, negatives, and books to the Amon Carter Museum. The collection includes approximately 287 glass-plate and nitrate negatives, 10 albums, and 160 individual prints of family portraits, scenes around Smith's home town of Bonham, Texas, and some ranch scenes. The material donated by Pettis complements the collection of Smith negatives on deposit at the Museum from the Library of Congress (Series LC-S6, LC-S61, LC-S611, and LC-S59). The approximately 2,000 glass-plate negatives are mostly ranching and rodeo scenes.

HENRY HOLMES SMITH,
American (1909–1986)

Smith met László Moholy-Nagy in 1937 and through him obtained a teaching job at the New Bauhaus School of Design in Chicago. In 1947 he moved to Indiana University in Bloomington, where he taught photography and design. His teaching was quite influential; his students have included well-known contemporary photographers such as Jerry Uelsmann and Jack Welpott. Most of Smith's images are abstract color prints made by combining water and syrup on glass plates that are then printed photographically, but after 1973 he also worked with silkscreen processes.

* 4901. **ROYAL PAIR** (P1977.14)
Dye-transfer print. 1951–76
Image: 9 3/16 x 5 7/8 in. (23.4 x 14.9 cm.)
Sheet: 10 x 8 1/16 in. (25.4 x 20.5 cm.)
Signed, l.r. print verso: "henry holmes smith"
Inscription, print verso: "C//Royal Pair, 1951–1976" and rubber stamp "Dec. 21 1976"
Acquired from: The Friends of Photography, Carmel, California; gift print with sustaining membership, 1977

MICHAEL A. SMITH, American (b. 1942)

Smith, a self-taught photographer, left a position teaching emotionally disturbed children in 1966 to pursue 35mm photography. In 1967 he abandoned the 35mm camera and now works with both 8 x 10 inch and 8 x 20 inch view cameras. Smith supported himself by teaching photography between 1967 and 1974, but in 1975 he began to support himself through the sale of his original prints. In that year he also began a series of trips to the West that resulted in the publication of *Landscapes 1975–1979*; the book received the Grand Prix du Livre Photographique 1981 at the International Festival of Photography in Arles, France. Smith also received a National Endowment for the Arts photographic fellowship in 1977. In 1982 he served as artist in residence for a short time at Arizona State University in Tempe. In recent years Smith has received prizes from the Print Club, Philadelphia, Pennsylvania, and the Bucks County Council for the Arts, Doylestown, Pennsylvania. He also has been commissioned to photograph the cities of Toledo, Ohio, Princeton, New Jersey, and New Orleans, Louisiana.

* 4902. **BETWEEN JASPER AND BANFF, ALBERTA** (P1977.89.5)
Gelatin silver print. 1975
Image: 7 5/8 x 9 9/16 in. (19.3 x 24.4 cm.)
Mount: 13 x 15 in. (33.0 x 38.2 cm.)
Signed, l.r. mount recto: "Michael A. Smith"
Inscription, mount recto: "1975"
mount verso: "7508-102/511 #2/BETWEEN Jasper and Banff/Alberta 1975"
Acquired from: the photographer

4903. **BRYCE CANYON, UTAH** (P1977.89.4)
Gelatin silver print. 1975
Image: 7 5/8 x 9 9/16 in. (19.3 x 24.4 cm.)
Mount: 13 x 15 in. (33.0 x 38.2 cm.)
Signed, l.r. mount recto: "Michael A. Smith"
Inscription, mount recto: "1975"
mount verso: "7506-73/266 #5/BRYCE CANYON/UTAH 1975//LB 56284 [partially erased]"
Acquired from: the photographer

4904. **CEDAR BREAKS NAT'L MON., UTAH** (P1977.89.9)
Gelatin silver print. 1975
Image: 7 5/8 x 9 9/16 in. (19.3 x 24.4 cm.)
Mount: 13 x 15 in. (33.0 x 38.2 cm.)
Signed, l.r. mount recto: "Michael A. Smith"
Inscription, mount recto: "1975"
mount verso: "7507-04/278 #17/CEDAR BREAKS NAT'L MON./UTAH 1975"
Acquired from: the photographer

4905. **NEAR ASPEN, COLORADO** (P1977.89.1)
Gelatin silver print. 1975
Image: 7 11/16 x 9 5/8 in. (19.5 x 24.4 cm.)
Mount: 13 x 15 in. (33.0 x 38.2 cm.)
Signed, l.r. mount recto: "Michael A. Smith"
Inscription, mount recto: "1975"
mount verso: "7509-82/593 #12/NEAR ASPEN/COLORADO 1975//LB56384"
Acquired from: the photographer

4906. **SHORE ACRES, OREGON** (P1977.89.2)
Gelatin silver print. 1975
Image: 7 5/8 x 9 9/16 in. (19.3 x 24.4 cm.)
Mount: 13 x 15 in. (33.0 x 38.2 cm.)
Signed, l.r. mount recto: "Michael A. Smith"
Inscription, mount recto: "1975"
mount verso: "7508-51/460 #10/SHORE ACRES/OREGON 1975"
Acquired from: the photographer

4907. **VANCOUVER** (P1977.89.6)
Gelatin silver print. 1975
Image: 7 ⅝ x 9 ⁹⁄₁₆ in. (19.3 x 24.4 cm.)
Mount: 13 x 15 in. (33.0 x 38.2 cm.)
Signed, l.r. mount recto: "Michael A. Smith"
Inscription, mount recto: "1975"
 mount verso: "7508-74/483 #1/VANCOUVER 1975"
Acquired from: the photographer

4908. **VANCOUVER** (P1977.89.10)
Gelatin silver print. 1975
Image: 7 ⅝ x 9 ⁹⁄₁₆ in. (19.3 x 24.4 cm.)
Mount: 13 x 15 in. (33.0 x 38.2 cm.)
Signed, l.r. mount recto: "Michael A. Smith"
Inscription, mount recto: "1975"
 mount verso: "7508-75/484 #1/VANCOUVER 1975"
Acquired from: the photographer

4909. **YELLOWSTONE NAT'L PARK, WYOMING** (P1977.89.3)
Gelatin silver print. 1975
Image: 7 ⅝ x 9 ⁹⁄₁₆ in. (19.3 x 24.4 cm.)
Mount: 13 x 15 in. (33.0 x 38.2 cm.)
Signed, l.r. mount recto: "Michael A. Smith"
Inscription, mount recto: "1975"
 mount verso: "7509-51/562 #13/YELLOWSTONE NAT'L
 PARK/WYOMING 1975"
Acquired from: the photographer

*4910. **YELLOWSTONE NAT'L PARK, WYOMING** (P1977.89.8)
Gelatin silver print. 1975
Image: 7 ⅝ x 9 ⁹⁄₁₆ in. (19.3 x 24.4 cm.)
Mount: 13 x 15 in. (33.0 x 38.2 cm.)
Signed, l.r. mount recto: "Michael A. Smith"
Inscription, mount recto: "1975"
 mount verso: "7509-44/555 #6/YELLOWSTONE NAT'L
 PARK/WYOMING 1975"
Acquired from: the photographer

4911. **ZION NAT'L PARK, UTAH** (P1977.89.7)
Gelatin silver print. 1975
Image: 7 ⅝ x 9 ⁹⁄₁₆ in. (19.3 x 24.4 cm.)
Mount: 13 x 15 in. (33.0 x 38.2 cm.)
Signed, l.r. mount recto: "Michael A. Smith"
Inscription, mount recto: "1975"
 mount verso: "7507-13/288 #4/ZION NAT'L PARK/
 UTAH 1975"
Acquired from: the photographer

W. MORRIS SMITH, American (active 1860s)

See *Gardner's Photographic Sketch Book of the War*

LOYD SNEED, American (b. 1952)

Born in Temple, Texas, Sneed studied photography at
Sam Houston State University, receiving his B.F.A.
in 1975. He earned a Ph.D. in molecular biology in
1986 from Texas A & M University and then did
postdoctoral research in the university's College of Vet-
erinary Medicine. Sneed has continued his personal
photographic work as a hobby, using an 8 x 10 inch
view camera.

4912. **BOB L.** (P1974.111.1)
Gelatin silver print. 1974
Image: 4 ⁷⁄₁₆ x 6 ⁹⁄₁₆ in. (11.3 x 16.6 cm.)
Mount: 10 ⅛ x 15 in. (25.7 x 38.1 cm.)
Signed, center mount verso: "Loyd Sneed—74"
Inscription, mount verso: "23//April 9, 1974" and printed
 paper label "IMAGE VI/IDENTIFICATION LABEL/
 Photographer [in ink] LOYD SNEED/School [in ink]
 SHSU/Address [in ink] WHITE HALL RM 122/Division
 [in ink] Black & WHITE/Category [in ink] Informal
 Portrate [sic]/Title [in ink] BOB L."
Acquired from: gift of the photographer

4901

4902

4910

4913. **SEALY, TEXAS** (P1974.111.2)
Gelatin silver print. 1974
Image: 3 11/16 x 4 11/16 in. (9.4 x 11.9 cm.)
Mount: 8 5/8 x 10 5/8 in. (22.0 x 27.0 cm.)
Signed, l.r. on overmat and center mount verso:
"Loyd Sneed/74"
Inscription, overmat verso: "11.8 ½ / 2|237 / 17"
mount verso: "4 x 5 CONTACT PRINT, Normal lens/
SEALY, TEXAS"
Acquired from: the photographer

SOCIETY FOR PHOTOGRAPHIC EDUCATION, SOUTH CENTRAL REGIONAL PHOTOGRAPHY EXHIBITION (P1983.31.1–18)

This exhibition, containing work by eighteen photographers, was organized in 1981 by Richard Tichich, Regional Visual Resources Coordinator for the South Central Region of the Society for Photographic Education. It traveled to sites in Texas, Arkansas, and Louisiana during 1981–82. These prints were the gift of the South Central Region SPE chapter. Full information on the individual prints is listed by print title under the photographer's name.

Ronald Binks, GUY WIRE AND TREES (P1983.31.1)
Gary Cawood, THE POET MARIANNE MOORE WAS PHOTOGRAPHED BY RICHARD AVEDON (P1983.31.2)
Dean Dablow, PHOTOGRAPH OUT OF CONTEXT #7 (P1983.31.3)
Rita DeWitt, PREYING HANDS PURSUING FLOCK OF HEARTS (P1983.31.4)
Rick Gast, GRASSES—GALVESTON (P1983.31.5)
Richard E. Hayes, FROM THE SERIES "FRIENDS," SARAH (P1983.31.6)
Robert Jay Hirsch, "ART" (P1983.31.7)
Diane Hopkins Hughs, CONSTRUCTION/ RECONSTRUCTION SERIES (P1983.31.8)
Melissa Mial, UNTITLED (P1983.31.9)
Robert Mial, UNTITLED (P1983.31.10)
Judy Miller, LOY LAKE (P1983.31.11)
Michael Peven, PNINN PICTURE (P1983.31.12)
Brent Phelps, CROCKETT, TX (P1983.31.13)
Roger Prather, PARKING LOT #69 (P1983.31.14)
Richard Tichich, SOLOMON ARROYO VASQUEZ (P1983.31.15)
Ronald James Todd, OCEAN SPRINGS, MISSISSIPPI (P1983.31.16)
Unknown photographer, [Power lines above city] (P1983.31.17)
Marilyn Zimmerman, UNTITLED (P1983.31.18)

ALBERT SANDS SOUTHWORTH, American (1811–1894), and JOSIAH JOHNSON HAWES, American (1808–1901)

Southworth and Hawes opened a daguerreotype studio in Boston in 1843, leaving their respective careers as druggist and painter to pursue the newly discovered art of photography. They took great care with their work. Sitters were positioned and lighting was arranged so that the likeness was much more natural and sensitive to the character of the individual than daguerreotypes produced by typical studios. The quality of their work led many notable individuals to Boston to have their portraits made at the Southworth and Hawes establishment. Although portraits made up the bulk of their work, the studio also did some landscape views. In 1853 Hawes paid John Adams Whipple for the right to use his process for making paper prints (crystalotypes).

Southworth and Hawes exhibited several of these salted paper prints in 1856 at the Massachusetts Mechanics' Fair. By the time their partnership dissolved in 1862, a good portion of the studio work was making paper prints. Both men continued photographic careers after this, but neither produced work as well known as that done during the partnership.

* 4914. **[Portrait of a young girl]** (P1981.85)
Salt print (crystalotype). c. 1853–62
Image: 8 x 6 in. (20.3 x 15.3 cm.) oval
Mount: 10 7/8 x 9 5/8 in. (27.5 x 24.5 cm.)
Acquired from: Joe Buberger, Gallery of Photographs, Inc., New Haven, Connecticut

EMA SPENCER, American (1857–1941)

See *Camera Work*

PETER STACKPOLE, American (b. 1913)

Peter Stackpole, the son of sculptor Ralph Stackpole, developed an early interest in photography, experimenting with the newly developed 35mm camera while attending Technical High School in Oakland, California. During his high school years he worked for the Oakland *Post-Enquirer* as an apprentice news photographer. Stackpole was the only member of Group f/64 to use a 35mm camera exclusively. He joined the group in 1935, midway through a project documenting the construction of the Golden Gate and San Francisco–Oakland Bay bridges. A number of his boldly patterned images were published in *Vanity Fair* magazine. Stackpole was one of *Life*'s first four staff photographers, working for the magazine from 1936 until 1961. Since leaving *Life*, he has freelanced on the West Coast and has had numerous exhibitions. Stackpole received the George Polk Memorial Award in Journalism in 1953.

* 4915. **ALASKA COLONISTS—SAN FRANCISCO** (P1982.33.3)
Gelatin silver print. negative 1936, print 1982
Image: 9 7/8 x 7 in. (25.1 x 17.7 cm.)
Mount: 16 x 13 5/16 in. (40.7 x 33.8 cm.)
Signed, l.r. mount recto: "Peter Stackpole 1936"
Acquired from: the photographer

* 4916. **CARL MYDANS [Lost Lake, Brewster N. Y.]** (P1985.14)
Gelatin silver print. 1938
Image: 7 7/8 x 9 13/16 in. (20.0 x 24.9 cm.)
Sheet: 8 1/8 x 10 in. (20.7 x 25.4 cm.)
Signed: see inscription
Inscription, print verso, typed label: "Carl Mydans by Peter Stackpole"
Acquired from: gift of Willard Van Dyke, Santa Fe, New Mexico

* 4917. **EASTER SUNDAY PARADE—NYC** (P1982.33.1)
Gelatin silver print. negative 1936, print 1982
Image: 7 1/8 x 9 5/8 in. (18.1 x 24.4 cm.)
Mount: 13 5/16 x 16 3/16 in. (33.8 x 41.0 cm.)
Signed, l.r. mount recto: "Peter Stackpole 1936"
Acquired from: the photographer

4918. **PASSING FERRY FROM TOWER TOP** (P1982.33.6)
Gelatin silver print. negative 1935, print 1982
Image: 6 3/8 x 9 9/16 in. (16.1 x 24.2 cm.)
Mount: 13 5/16 x 16 in. (33.8 x 40.7 cm.)
Signed, l.r. mount recto: "Peter Stackpole 1935"
Acquired from: the photographer

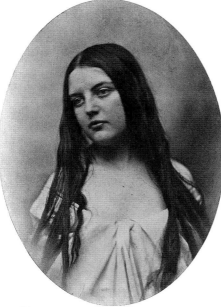

4914

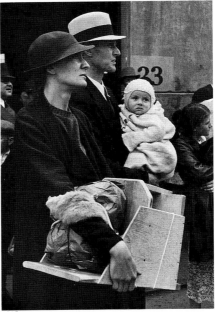

4915

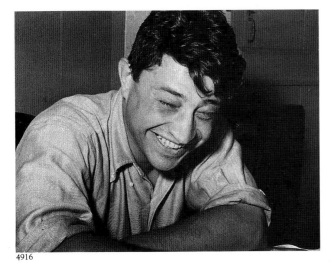

4916

4917

4921

4919. **STEEL BEAM SILHOUETTE—SAN FRANCISCO–OAKLAND, BAY BRIDGE** (P1982.33.4)
Gelatin silver print. negative 1935, print 1982
Image: 6 7/16 x 9 5/8 in. (16.3 x 24.5 cm.)
Mount: 13 5/16 x 16 in. (33.8 x 40.6 cm.)
Signed, l.r. mount recto: "Peter Stackpole 1935"
Acquired from: the photographer

4920. **WHITE FERRY THROUGH BOX TRUSS** (P1982.33.5)
Gelatin silver print. negative 1935, print 1982
Image: 6 5/8 x 9 11/16 in. (16.9 x 24.6 cm.)
Mount: 13 5/16 x 16 3/16 in. (33.8 x 41.0 cm.)
Signed, l.r. mount recto: "Peter Stackpole 1935"
Acquired from: the photographer

*4921. **WILLARD VAN DYKE—PHOTOGRAPHER** (P1982.33.2)
Gelatin silver print. negative 1937, print 1982
Image: 7 13/16 x 9 15/16 in. (19.8 x 25.2 cm.)
Mount: 13 5/16 x 16 in. (33.8 x 40.6 cm.)
Signed, l.r. mount recto: "Peter Stackpole 1937"
Acquired from: the photographer

GEORGE STARK, American (c. 1871–1946)

St. Louis, Missouri, native George Stark was the first photographer for *The St. Louis Globe Democrat* and one of the first news photographers in the United States. Self-taught, Stark made his first photographs of a cyclone in May 1896; it took him a week to develop the images. In 1898 Stark was working as a lithographer for the *Globe Democrat* when he submitted to one of the editors photographs of the First Regiment of the Missouri National Guard preparing to mobilize for the Spanish-American War. The editor accepted Stark's photographs and the images appeared in the paper three days later, replacing the newspaper's usual pen and ink and woodcut illustrations. During Stark's eight-year career as a news photographer, he supplied photographs not only for the *Globe Democrat* but for other newspapers and magazines as well. He obtained numerous exclusive photographs. He covered the 1900 Democratic Convention in Kansas City and took the only indoor photograph at the 1904 Democratic Convention in St. Louis. Stark also documented the 1904 World's Fair, including President Theodore Roosevelt's visit. While the other photographers carried cumbersome view cameras, Stark was equipped with a 4 x 5 inch Graflex, the first such camera in St. Louis. Using this small camera allowed Stark to keep up with the President during his whirlwind visit. About 1903 Stark published *St. Louis View Book*, containing 24 half-tone illustrations. A back injury forced Stark to abandon photography, and he retired to a farm in Arcadia, Missouri.

George Stark photographs (P1985.37.1–68)
The following photographs were apparently part of a group of 73 images sold to the Perry Picture Co. in 1901. A letter to the Perry Picture Co. from George Stark, dated February 25, 1901, accompanies the collection. Individual print titles are inscribed on print verso.
Collodio-chloride prints and gelatino-chloride or gelatin silver prints. c. 1898–1901
Acquired from: gift of Mrs. Albert Schwartz, Newponsit, New York

4922. **HUNTING IN THE OZARKS** (P1985.37.1)

4923. **A GENUINE BACKWOODSMAN** (P1985.37.2)

4924. **HUNTERS PREPARING BREAKFAST** (P1985.37.3)

4925. **DINNER IN CAMP ARK.** (P1985.37.4)

4926. **TRAPPERS HOME** (P1985.37.5)

4927. **FISHING IN ARKANSAS** (P1985.37.6)

*4928. **HOUSEBOAT IN ARKANSAS** (P1985.37.7)

4929. **FISHERMEN'S NETS (ARKANSAS)** (P1985.36.8)

4930. **A TYPICAL HUNTER** (P1985.37.9)

4931. **FISHERMEN'S CAMP** (P1985.37.10)

4932. **STOCKFARM MO.** (P1985.37.11)

4933. **A YOUNG COWBOY** (P1985.37.12)

*4934. **COTTON HANDLERS** (P1985.37.13)

4935. **LILY POND** (P1985.37.14)

4936. **WATERMELON SCENE** (P1985.37.15)

4937. **[Woman on horse in corral, man holding horse's head]** (P1985.37.16)

4938. **DAIRY SCENE** (P1985.37.17)

4939. **A PROSPEROUS TOWN, S.W. MO.** (P1985.37.18)

4940. **[Cattle and horses near wooden feeding trough]** (P1985.37.19)

4941. **[Boy standing by horses at a wooden feeding trough]** (P1985.37.20)

4942. **RANCHMAN'S HOME** (P1985.37.21)

4943. **CATTLE SCENE** (P1985.37.22)

*4944. **A BREATHING SPELL** (P1985.37.23)

4945. **HARVESTING** (P1985.37.24)

4946. **WAITING FOR THE FEED** (P1985.37.25)

4947. **FARM SCENE** (P1985.37.26)

4948. **A FINE BUNCH, DEHORNED CATTLE** (P1985.37.27)

4949. **FARM SCENE** (P1985.37.28)

4950. **CATTLE FEEDING** (P1985.37.29)

*4951. **HOEING POTATOES** (P1985.37.30)

4952. **HOG SHOT** (P1985.37.31)

4953. **SCALDING HOG** (P1985.37.32)

4954. **SCRAPING** (P1985.37.33)

4955. **CLEANING** (P1985.37.34)

4956. **CUTTING UP HOG** (P1985.37.35)

4957. **RAISING HOGS** (P1985.37.36)

4958. **[Cattle grazing in wooded area]** (P1985.37.37)

4959. **WHEAT FIELD IN SHOCKS** (P1985.37.38)

4960. **RURAL SCENE** (P1985.37.39)

4961. **MUEHALL'S CATTLE** (P1985.37.40)

4962. **HARROWING** (P1985.37.41)

4963. **2 EXTREMES—(CALF IS 1 DAY OLD)** (P1985.37.42)

4928

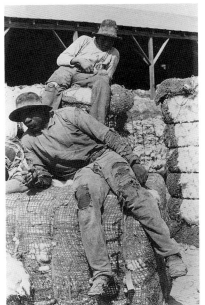

4934

4944

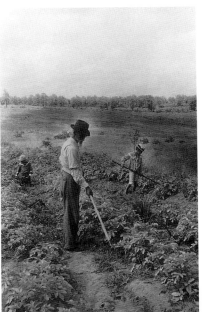

4951

4977

4964. CULTIVATING CORN (P1985.37.43)

4965. CORNFIELD (P1985.37.44)

4966. SAMBO—1 DAY OLD (P1985.37.45)

4967. CALVES (P1985.37.46)

4968. COWBOY (P1985.37.47)

4969. CHERRY ORCHARD (P1985.37.48)

4970. SHROPSHIRE SHEEP (P1985.37.49)

4971. COTTON YARD, GUTHRIE OKLA (P1985.37.50)

4972. BAD CASE OF BIG JAW, CONDEMNED BY GOV'T INSPECTOR (P1985.37.51)

4973. ROPING STEER (P1985.37.52)

4974. READY FOR BRANDING (P1985.37.53)

4975. LASSOING STEER (P1985.37.54)

4976. RANGE HORSES AT STOCKYARDS (P1985.37.55)

*4977. PRETTY AS A PICTURE (P1985.37.56)

4978. LONGHORN CATTLE AT THE STOCKYARDS (P1985.37.57)

4979. A SEA OF HORNS (P1985.37.58)

4980. TEXAS CATTLE (P1985.37.59)

4981. [Herding sheep in the stockyards] (P1985.37.60)

4982. DOWN THE VIADUCT AT THE STOCKYARDS (P1985.37.61)

4983. [Running cattle down a chute in the stockyards] (P1985.37.62)

4984. HEREFORD YEARLINGS (P1985.37.63)

4985. [Unloading horses from boxcars in the stockyards] (P1985.37.64]

4986. UNLOADING TEXAS STEERS AT THE STOCKYARDS (P1985.37.65)

4987. TEXAS CATTLE AT STOCKYARDS (P1985.37.66)

4988. STOCK YARD VIEW (P1985.37.67)

4989. ISN'T THIS A BEAUT? (P1985.37.68)

SUSAN STEFFY, American (b. 1945)

Steffy was born in Laurenburg, North Carolina, and received a bachelor's degree in genetics from the University of California at Berkeley in 1968. She moved to New Mexico in 1976 and began to photograph seriously about 1979. Her photographs have been exhibited throughout New Mexico, including a 1986 exhibition at the Governor's Gallery in Santa Fe. Her prints have been published in two portfolios. Steffy's work focuses on intimate still life and landscape images that explore the tactile and sensual qualities of everyday objects and places.

4990. SQUASH ON BLACK [from Santa Fe Center for Photography, "Portfolio I"] (P1982.35.5)
Gelatin silver print. negative 1979, print 1982
Image: 10⅞ x 8⅞ in. (27.5 x 22.6 cm.)
Sheet: 13¹⁵⁄₁₆ x 10¹⁵⁄₁₆ in. (35.4 x 27.7 cm.)

Signed, bottom center print verso: "Susan Steffy 1979"
right edge print verso: "© Susan Steffy 1981"
l.r. overmat recto: "Susan Steffy"
Inscription, print verso: "Squash on Black"
mat backing verso, printed paper label: "Santa Fe Center for Photography/PORTFOLIO I/Portfolio no. [in ink] 10/ Print no. [in ink] 5"
Acquired from: Santa Fe Center for Photography, Santa Fe, New Mexico

EDWARD STEICHEN,
American, born Luxembourg (1879–1973)

See also *Camera Notes* and *Camera Work*

Steichen came to the United States with his family in 1881 and was apprenticed at the age of fifteen to a Milwaukee lithography studio as a designer. He began to make photographs in 1896, using them as studies for his lithographic work. He exhibited his photographs as Eduard Steichen, and in 1900 Clarence White and Alfred Stieglitz noticed his work in a group show at the Chicago Art Institute. He was subsequently published in both *Camera Notes* and *Camera Work* and was a charter member of the Photo-Secession. Steichen helped Stieglitz open the 291 Gallery and did much of the design work for *Camera Work*. During World War I Steichen supervised aerial photography for the United States Army. He also reevaluated his soft-focus pictorial style and after the war adopted a sharp-focus approach. In 1922 Steichen made a commitment to photography, burning all of his painted canvases. He also joined the staff of Condé Nast publications, which published many of his fashion and portrait photographs in *Vogue* and *Vanity Fair*. He gave up commercial work in 1938, but did accept a military commission as lieutenant commander in World War II and directed combat photography for the Navy. In 1947 Steichen was named director of the Photography Department at the Museum of Modern Art, where he organized the well-known "Family of Man" exhibition in 1955. He retired from the museum in 1962 but continued to do experimental work with color photography.

4991. THE DEMARCO DANCERS (P1985.32)
Gelatin silver print. 1935
Image: 3⅝ x 3¼ in. (9.1 x 8.2 cm.)
Sheet: 4⅞ x 3¹¹⁄₁₆ in. (12.3 x 9.3 cm.)
Signed: see inscription
Inscription, in negative: "1697-11"
print verso: "BL272//1697-11//5" and rubber stamps "Photographed by STEICHEN DEC 9 1935" and "PHOTOGRAPH BY EDWARD STEICHEN"
Acquired from: Paul Hertzmann, San Francisco, California

*4992. GLORIA SWANSON (P1981.68)
Gelatin silver print. negative 1924, print 1965
Image: 13⅝ x 10⅝ in. (34.5 x 27.0 cm.)
Sheet: 13¹¹⁄₁₆ x 10⅞ in. (35.1 x 27.5 cm.)
Mount: 14⁵⁄₁₆ x 11¼ in. (36.3 x 28.6 cm.)
Signed, u.r. print recto: "STEICHEN/1965"
Inscription, mount verso, rubber stamp: "Bernard Walsh/ 14 East 58th St/N.Y. 21 Yu8-4[illegible]"
Acquired from: Edwynn Houk Gallery, Chicago, Illinois

RALPH STEINER, American (1899–1986)

Steiner began making photographs while he was a student at Dartmouth College in 1918, but learned the basics of technique and design at the Clarence White School of Photography in 1921–22. Steiner spent the

summer of 1929 learning to photograph with an 8 x 10 inch view camera after seeing Paul Strand's work done in that format. His subject matter, like that of Strand and Walker Evans, covers the American vernacular—the everyday objects that make up the urban landscape. Steiner also worked as a filmmaker. He was a cameraman on Pare Lorentz's 1935 film *The Plow That Broke the Plains*, worked with Willard Van Dyke on *The City*, and made a number of documentary films. *In Pursuit of Clouds*, a book of Steiner's cloud photographs, was published in 1985. At the time of his death, Steiner was curating an exhibition for the Hood Museum at Dartmouth College. The exhibition, *In Spite of Everything, Yes*, was later published as a book.

*4993. **NEHI SIGN ON A. ESPOSITO'S GROCERY** (P1980.27.2)
Gelatin silver print. 1929
Image: 9⁹/₁₆ x 7⁹/₁₆ in. (24.3 x 19.2 cm.)
Mount: same as image size
Signed, l.r. overmat recto: "ralph steiner"
 bottom edge mount verso: "Ralph Steiner negative and print 1929"
Inscription, mount verso: "Ralph Steiner/83/c.1930"
Acquired from: James Maroney, Inc., New York, New York

4994. **SARATOGA COAL MAKES WARM FRIENDS** (P1980.27.3)
Gelatin silver print. 1929
Image: 7⁵/₈ x 9½ in. (19.4 x 24.1 cm.)
Mount: 10 x 12⁵/₁₆ in. (25.4 x 31.2 cm.)
Signed, l.r. overmat recto: "ralph steiner 1929 print"
 l.r. mount recto: "ralph steiner"
Inscription, mount recto: "old print 1929 not for reproduction in my book"
 overmat verso: "791115"
Acquired from: James Maroney, Inc., New York, New York

*4995. **WICKER CHAIR [American Rural Baroque]** (P1980.27.1)
Gelatin silver print. 1929
Image: 7½ x 9½ in. (19.0 x 24.1 cm.)
Mount: 13¾ x 14 in. (34.9 x 35.6 cm.)
Signed, l.r. mount recto: "ralph steiner 1929"
Acquired from: James Maroney, Inc., New York, New York

ALFRED STIEGLITZ, American (1864–1946)

See also *Camera Notes* and *Camera Work*

Stieglitz was one of the most influential figures in the history of American photography. He spent his early years in New York, moving to Berlin in the early 1880s to study engineering. During this time he also bought his first camera; although he took some technical photochemistry courses, he became a primarily self-taught photographer. He exhibited his photographs in Europe and won several prizes before returning to the United States in 1890. Upon his return he joined two school friends as a partner in a photoengraving firm, but the work left him dissatisfied and he left the business world to promote photography as an art form. From 1897 until 1902 Stieglitz published the journal *Camera Notes* as the official publication of the New York Camera Club. In 1902 he broke with the Camera Club; with Clarence H. White, Edward Steichen, Gertrude Käsebier, and others, he founded a pictorialist group known as the Photo-Secession. Stieglitz also founded a gallery, Little Galleries of the Photo-Secession or "291," and a journal, *Camera Work*, in which he reproduced the work of leading pictorial photographers. *Camera Work* illustrations were usually high-quality photogravure plates tipped into each volume. Although *Camera Work* ceased publication in 1917 as Stieglitz began to reconsider the merits of pictorialism, Stieglitz continued to

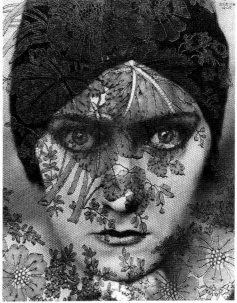
4992

4993

4995

operate galleries throughout his life. In them he exhibited not only photographers but the work of modern American artists such as Arthur Dove, John Marin, Charles Demuth, and Georgia O'Keeffe. O'Keeffe, who became his wife in 1924, was the subject of a serial portrait of several hundred images made over the course of their relationship. Stieglitz rarely manipulated prints or negatives; even in his early pictorial work he shot in the rain or fog to get a soft-focus effect.

*4996. **[Georgia O'Keeffe's hands]** (P1981.87)
Gelatin silver print. 1917
Image: 9¾ x 7¹¹⁄₁₆ in. (24.7 x 19.6 cm.)
Mount: same as image size
Acquired from: Sally Wilder, Fort Worth, Texas

4997. **THE HAND OF MAN** (P1978.112)
Photogravure. 1902
Image: 9¼ x 12⅛ in. (23.5 x 30.8 cm.)
Sheet: 9⅜ x 12¼ in. (23.7 x 31.1 cm.)
Acquired from: Sotheby Parke-Bernet, Inc., New York, New York

*4998. **THE STEERAGE [from 291, September/October 1915]** (P1979.92)
Photogravure. negative 1907, print 1915
Image: 12⅜ x 10⅛ in. (31.5 x 25.6 cm.)
Sheet: 15 x 11⅛ in. (38.1 x 28.2 cm.)
Acquired from: Sally Wilder, Fort Worth, Texas

EDMUND STIRLING, American (1861–1948)

See *Camera Notes*

SENECA RAY STODDARD, American (1843/44–1917)

Stoddard was born in Wilton, New York, and was an editor and magazine publisher as well as a photographer and artist. He traveled widely, although much of his work consisted of landscape scenes done in the Adirondack Mountains, at Lake George, and around his home town of Glen Falls, New York. He frequently gave lectures on his travels illustrated with tinted stereopticon slides and published numerous editions of Adirondack travel guides.

4999. **[Advertising card—composite copy image showing 12 waterfall photographs tacked to a board]** (P1981.84)
Albumen silver print. c. 1880s–90s
Image: 7⅛ x 6¹⁄₁₆ in. (18.0 x 15.5 cm.)
Mount: 10 x 8¹⁄₁₆ in. (25.4 x 20.5 cm.)
Inscription, mount verso: "LW"
Acquired from: gift of Photocollect, New York, New York

*5000. **SARANAC LAKE FROM NORTH [Saranac Lake, New York]** (P1985.42)
Albumen silver print. c. 1880s–90s
Image: 4⁵⁄₁₆ x 7⁵⁄₁₆ in. (11.0 x 18.6 cm.)
Inscription, in negative: "528. Saranac lake from north." print verso: "150" and dealer's mark
Acquired from: Photofind Gallery, Inc., Woodstock, New York

5001. **SUMMIT FALLS, HAVANA GLEN, N. Y.** (P1981.83)
Albumen silver print. c. 1880s–90s
Image: 7⅝ x 4⅜ in. (19.3 x 11.2 cm.)
Mount: 12 x 10 in. (30.6 x 25.4 cm.)
Inscription, in negative: "Summit Falls, Havana Glen, N. Y." mount recto: "Summit Falls,/Havana Glen,/New York."
Acquired from: Photocollect, New York, New York

PAUL STRAND, American (1890–1976)

See also *Camera Work*

Strand studied photography with Lewis Hine at the Ethical Culture School in New York City. Hine introduced Strand to Alfred Stieglitz, who was deeply impressed with his work. Stieglitz felt that Strand was the most significant twentieth-century photographer. He published Strand's work in two issues of *Camera Work*, devoting the final issue published in 1917 completely to him. At first Strand worked in the softly focused pictorial mode, but during the 1910s he began a series of experiments with abstraction, photographing subjects from unusual angles or viewpoints for the design elements they contained. As his straight style developed, Strand turned to people and nature for his subject matter and abstraction became less important in his work. Strand also was a filmmaker, collaborating with Charles Sheeler on *Manhatta*, and filming for *The Plow That Broke the Plains* and *The Wave*. He made the images for the "Mexican Portfolio" during a 1933 trip to Mexico to film *The Wave*.

*5002. **[Bell Rope, Massachusetts]** (P1983.18.2)
Gelatin silver print. 1945
Image: 9⅝ x 7⅝ in. (24.5 x 19.3 cm.)
Mount: same as image size
Signed: see inscription
Inscription, mount verso: "Paul Strand H. S.//N E [illegible]ut- 841//#286//PS-7941 C"
Acquired from: Zabriskie Gallery, New York, New York; Amon Carter Foundation purchase

*5003. **CHURCH, RANCHOS DE TAOS, NEW MEXICO** (P1981.66)
Platinum print. c. 1931
Image: 3⅝ x 4¾ in. (9.3 x 12.1 cm.)
Signed: see inscription
Inscription, print verso: "Paul Strand H S//118 E"
Acquired from: Hirschl and Adler, New York, New York

5004. **FISHING VILLAGE, MAINE** (P1984.36.1)
Gelatin silver print. 1946
Image: 4⅝ x 5¹⁵⁄₁₆ in. (11.7 x 15.0 cm.)
Mount: same as image size
Signed: see inscription
Inscription, mount verso: "NE-SEA-737 FI//275-A// Paul Strand HS"
Acquired from: gift of the Paul Strand Archive, Silver Mountain Foundation, Inc., Millerton, New York

5005. **L'ARMANÇON CRUZY, YONNE, BURGUNDY, FRANCE** (P1984.36.2)
Gelatin silver print. 1951
Image: 5¹⁵⁄₁₆ x 4¹¹⁄₁₆ in. (15.1 x 11.8 cm.)
Sheet: 6⁵⁄₁₆ x 4¹⁵⁄₁₆ in. (16.0 x 12.5 cm.)
Signed: see inscription
Inscription, print verso: "2-44/#312//1F with text ²A//Paul Strand H-S//FR land-994 FI"
Acquired from: gift of the Paul Strand Archive, Silver Mountain Foundation, Inc., Millerton, New York

THE MEXICAN PORTFOLIO (P1967.202.1–20)

This is the second edition of "The Mexican Portfolio," originally published in 1940 and reissued in 1967. For it, the photogravures were reprinted from the original 1940 plates. This is portfolio number 388 of an edition of 1000. The text accompanying the portfolio is signed by Strand, but the individual plates are not signed.

5006. **NEAR SALTILLO** (P1967.202.1)
Photogravure. negative 1932, print 1967
Image: 4¹⁵⁄₁₆ x 6¼ in. (12.5 x 15.9 cm.)
Sheet: 15⅞ x 12⅜ in. (40.3 x 31.4 cm.)
Acquired from: E. Weyhe, Inc., New York, New York

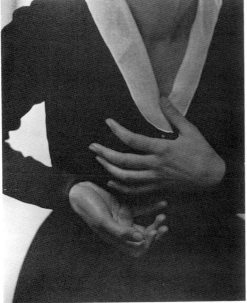

4996

4998

5000

5002

5011

5003

5007. **CHURCH. COAPIAXTLA** (P1967.202.2)
Photogravure. negative 1933, print 1967
Image: 6 3/8 x 4 15/16 in. (16.1 x 12.5 cm.)
Sheet: 15 7/8 x 12 3/8 in. (40.3 x 31.4 cm.)
Acquired from: E. Weyhe, Inc., New York, New York

5008. **VIRGIN. SAN FELIPE. OAXACA** (P1967.202.3)
Photogravure. negative 1933, print 1967
Image: 10 3/8 x 8 in. (26.3 x 20.3 cm.)
Sheet: 15 7/8 x 12 3/8 in. (40.3 x 31.4 cm.)
Acquired from: E. Weyhe, Inc., New York, New York

5009. **WOMEN OF SANTA ANNA. MICHOACAN** (P1967.202.4)
Photogravure. negative 1933, print 1967
Image: 5 x 6 1/4 in. (12.7 x 15.9 cm.)
Sheet: 15 7/8 x 12 3/8 in. (40.3 x 31.4 cm.)
Acquired from: E. Weyhe, Inc., New York, New York

5010. **MEN OF SANTA ANNA. MICHOACAN** (P1967.202.5)
Photogravure. negative 1933, print 1967
Image: 6 5/16 x 4 7/8 in. (16.0 x 12.4 cm.)
Sheet: 15 7/8 x 12 3/8 in. (40.3 x 31.4 cm.)
Acquired from: E. Weyhe, Inc., New York, New York

* 5011. **WOMAN. PATZCUARO** (P1967.202.6)
Photogravure. negative 1933, print 1967
Image: 6 7/16 x 5 1/16 in. (16.3 x 12.8 cm.)
Sheet: 15 7/8 x 12 3/8 in. (40.3 x 31.4 cm.)
Acquired from: E. Weyhe, Inc., New York, New York

5012. **BOY. URUAPAN** (P1967.202.7)
Photogravure. negative 1933, print 1967
Image: 10 1/8 x 8 in. (25.7 x 20.3 cm.)
Sheet: 15 7/8 x 12 3/8 in. (40.3 x 31.4 cm.)
Acquired from: E. Weyhe, Inc., New York, New York

* 5013. **CRISTO. OAXACA** (P1967.202.8)
Photogravure. negative 1933, print 1967
Image: 10 x 7 13/16 in. (25.4 x 19.9 cm.)
Sheet: 15 7/8 x 12 3/8 in. (40.3 x 31.4 cm.)
Acquired from: E. Weyhe, Inc., New York, New York

5014. **WOMAN AND BOY. TENANCINGO** (P1967.202.9)
Photogravure. negative 1933, print 1967
Image: 6 7/16 x 5 1/16 in. (16.4 x 12.8 cm.)
Sheet: 15 7/8 x 12 3/8 in. (40.3 x 31.4 cm.)
Acquired from: E. Weyhe, Inc., New York, New York

* 5015. **PLAZA. STATE OF PUEBLA** (P1967.202.10)
Photogravure. negative 1933, print 1967
Image: 5 x 6 1/4 in. (12.7 x 15.9 cm.)
Sheet: 15 7/8 x 12 3/8 in. (40.3 x 31.4 cm.)
Acquired from: E. Weyhe, Inc., New York, New York

5016. **MAN WITH A HOE. LOS REMEDIOS** (P1967.202.11)
Photogravure. negative 1933, print 1967
Image: 6 5/16 x 4 7/8 in. (16.1 x 12.4 cm.)
Sheet: 15 7/8 x 12 3/8 in. (40.3 x 31.4 cm.)
Acquired from: E. Weyhe, Inc., New York, New York

5017. **CALVARIO. PATZCUARO** (P1967.202.12)
Photogravure. negative 1933, print 1967
Image: 10 1/8 x 7 7/8 in. (25.6 x 20.1 cm.)
Sheet: 15 7/8 x 12 3/8 in. (40.3 x 31.4 cm.)
Acquired from: E. Weyhe, Inc., New York, New York

5018. **CRISTO. TLACOCHOAYA. OAXACA** (P1967.202.13)
Photogravure. negative 1933, print 1967
Image: 10 1/4 x 7 7/8 in. (26.1 x 20.0 cm.)
Sheet: 15 7/8 x 12 3/8 in. (40.3 x 31.4 cm.)
Acquired from: E. Weyhe, Inc., New York, New York

5019. **BOY. HIDALGO** (P1967.202.14)
Photogravure. negative 1933, print 1967
Image: 6 5/16 x 4 7/8 in. (16.1 x 12.4 cm.)
Sheet: 15 7/8 x 12 3/8 in. (40.3 x 31.4 cm.)
Acquired from: E. Weyhe, Inc., New York, New York

5020. **WOMAN AND BABY. HIDALGO** (P1967.202.15)
Photogravure. negative 1933, print 1967
Image: 5 x 6 1/4 in. (12.7 x 15.9 cm.)
Sheet: 15 7/8 x 12 3/8 in. (40.3 x 31.4 cm.)
Acquired from: E. Weyhe, Inc., New York, New York

5021. **GIRL AND CHILD. TOLUCA** (P1967.202.16)
Photogravure. negative 1933, print 1967
Image: 6 7/16 x 5 in. (16.3 x 12.7 cm.)
Sheet: 15 7/8 x 12 3/8 in. (40.3 x 31.4 cm.)
Acquired from: E. Weyhe, Inc., New York, New York

5022. **CRISTO WITH THORNS. HUEXOTLA** (P1967.202.17)
Photogravure. negative 1933, print 1967
Image: 10 1/4 x 7 7/8 in. (26.1 x 20.1 cm.)
Sheet: 15 7/8 x 12 3/8 in. (40.3 x 31.4 cm.)
Acquired from: E. Weyhe, Inc., New York, New York

5023. **MAN. TENANCINGO** (P1967.202.18)
Photogravure. negative 1933, print 1967
Image: 6 1/2 x 5 1/16 in. (16.4 x 12.8 cm.)
Sheet: 15 7/8 x 12 3/8 in. (40.3 x 31.4 cm.)
Acquired from: E. Weyhe, Inc., New York, New York

5024. **YOUNG WOMAN AND BOY. TOLUCA** (P1967.202.19)
Photogravure. negative 1933, print 1967
Image: 5 1/16 x 6 3/16 in. (12.8 x 15.8 cm.)
Sheet: 15 7/8 x 12 3/8 in. (40.3 x 31.4 cm.)
Acquired from: E. Weyhe, Inc., New York, New York

* 5025. **GATEWAY. HIDALGO** (P1967.202.20)
Photogravure. negative 1933, print 1967
Image: 10 1/8 x 7 15/16 in. (25.7 x 20.2 cm.)
Sheet: 15 7/8 x 12 3/8 in. (40.3 x 31.4 cm.)
Acquired from: E. Weyhe, Inc., New York, New York

*** * * ***

* 5026. **NEW YORK [From the Viaduct]** (P1983.17)
Platinum print. 1916
Image: 9 15/16 x 13 in. (25.2 x 33.0 cm.)
Sheet: 10 1/8 x 13 in. (25.7 x 33.0 cm.)
Mount: same as sheet size
Signed, center mount verso: "Paul Strand"
Inscription, mount verso: "New York 1916//No 45-299//1916"
Acquired from: Weston Gallery, Carmel, California; Amon Carter Foundation purchase

* 5027. **PORTRAIT, LUZZARA, ITALY** (P1984.36.3)
Gelatin silver print. 1953
Image: 5 7/8 x 4 11/16 in. (14.9 x 11.8 cm.)
Mount: same as image size
Signed, center mount verso: "Paul Strand"
Inscription, mount verso: "IT-POR-1314 FI//Luzzara 1953/ Italy/[signature]//3 5/8"/# 532//11 11/16 x 14 5/8 [sic]//P83"
Acquired from: gift of the Paul Strand Archive, Silver Mountain Foundation, Inc., Millerton, New York

* 5028. **WASHINGTON HEIGHTS, NEW YORK [New York; from *Camera Work*, No. 48, October 1916]** (P1987.15) duplicate in P1979.153.20, *Camera Work*, No. 48
Photogravure. negative 1915, published 1916
Image: 5 1/2 x 6 5/8 in. (13.9 x 16.8 cm.)
Sheet: 11 1/16 x 7 11/16 in. (28.1 x 19.4 cm.)
Mount: 11 3/8 x 7 3/4 in. (28.9 x 19.6 cm.)
Inscription, mat backing verso: dealer's marks
Acquired from: gift of Paul Brauchle, Dallas, Texas

* 5029. **WHITE HORSE, TAOS, NEW MEXICO** (P1983.18.1)
Platinum print. 1931
Image: 4 5/8 x 5 15/16 in. (11.8 x 15.1 cm.)
Mount: same as image size
Signed, bottom center mount verso: "Paul Strand"
Inscription, mount verso: "White Horse/Taos, New Mexico/1931"
Acquired from: Zabriskie Gallery, New York, New York; Amon Carter Foundation purchase

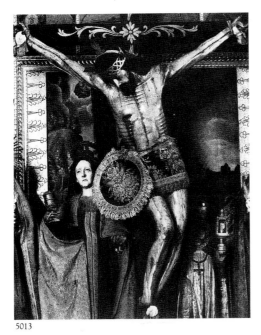

5013

5015

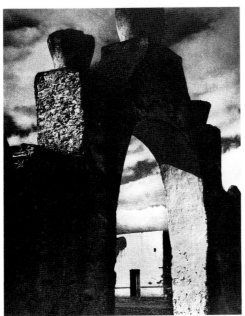

5025

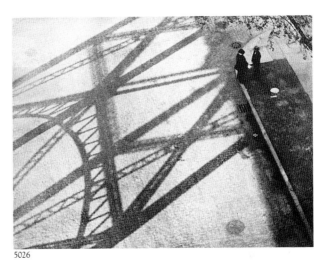

5026

5027

5030. **WILD IRIS, SOUTH UIST, HEBRIDES** (P1984.36.4)
Gelatin silver print. 1954
Image: 9 9/16 x 7 5/8 in. (24.3 x 19.4 cm.)
Sheet: 9 15/16 x 7 15/16 in. (25.2 x 20.2 cm.)
Mount: same as sheet size
Signed: see inscription
Inscription, mount verso: "667//HRB-NF-1634 FII//#1634//
Paul Strand/AK"
Acquired from: gift of the Paul Strand Archive, Silver
Mountain Foundation, Inc., Millerton, New York

KARL STRUSS, American (1886—1981)

See also *Camera Work*

Karl Struss was a native of New York. He studied pho-
tography with Clarence White at Columbia University
while working for his father's manufacturing firm. In
1913 Struss rented studio space from Gertrude Käsebier
and from 1914 to 1917 took over White's studio opera-
tion. During this period he specialized in portraits and
advertising material for publications like *Vogue, Vanity
Fair*, and *Harper's Bazaar*. Struss also made many photo-
graphs of the streets, bridges, and pier areas around New
York. He worked in the soft-focus pictorial style and de-
veloped the "Struss Pictorial lens," which was used by
many major pictorial photographers. In 1919 he moved
to Hollywood, where he worked with Cecil B. DeMille
as a still photographer. Within a few months he became
DeMille's main cinematographer, working on classic
films such as *Ben Hur, Dr. Jekyll and Mr. Hyde*, and
Charlie Chaplin's *The Great Dictator*. Struss received
the first Academy Award given for cinematography
for his work on the 1927 film *Sunrise*. Although Struss
continued to make a few still photographs during this
period, he was known mainly for his motion picture
work. In 1983 the Amon Carter Museum purchased
Karl Struss' photographic estate of master prints,
autochromes, contact prints, negatives, and artifacts.
In addition to the following catalogued photographs,
the Karl Struss Collection includes 500 movie stills
and 5,058 negatives.

5031. [Adolph Bolm in an elaborate blue and green costume with a
tall hat] (P1983.24.48)
Autochrome. c. 1916
Image: 8 x 6 1/16 in. (20.3 x 15.4 cm.)
Plate: 8 1/2 x 6 1/2 in. (21.5 x 16.5 cm.)
Acquired from: Stephen White Gallery of Photography, Inc.,
Los Angeles, California

5032. [Adolph Bolm in an elaborate red costume standing in front of
a curtain] (P1983.24.49)
Autochrome. c. 1916
Image: 8 1/16 x 6 1/16 in. (20.5 x 15.4 cm.)
Plate: 8 1/2 x 6 1/2 in. (21.5 x 16.5 cm.)
Acquired from: Stephen White Gallery of Photography, Inc.,
Los Angeles, California

5033. **AGNES AYRES** [still from *Forbidden Fruit*] (P1983.23.144)
Platinum print. c. 1919—20
Image: 9 5/16 x 7 7/16 in. (23.6 x 18.9 cm.)
1st mount: 10 1/2 x 8 1/4 in. (26.5 x 21.0 cm.) irregular
2nd mount: 16 5/8 x 12 3/4 in. (42.2 x 32.4 cm.) irregular
3rd mount: 17 x 13 in. (43.2 x 33.1 cm.)
Signed, l.l. print recto and l.r. 1st mount recto: "Karl Struss"
Inscription, 1st mount recto: "1920."
3rd mount verso: "#35./#51./"Agnes Ayres."/Platinum
Print./$15.//25" and rubber stamp "PHOTOGRAPHED
BY/KARL STRUSS/HOLLYWOOD, CALIF." and printed
paper label "THIS PRINT HAS BEEN EXHIBITED/
In the Gallery. ∴ of the/CALIFORNIA CAMERA
CLUB—/during the Month of [in ink] June 1929/[in ink]

Mr Ralph Smith/CHAIRMAN PRINT COMMITTEE./
San Francisco California."
Acquired from: Stephen White Gallery of Photography, Inc.,
Los Angeles, California

[Album] (P1983.23.196—218)
This album was compiled for Struss' personal use and is
presumably unique. It contains 23 prints of New York and the
Albright Art Gallery in Buffalo, New York. Struss exhibited
at the "International Exhibition of Pictorial Photography"
arranged by Alfred Stieglitz and held at the Albright Art
Gallery in November and December of 1910. The images of
the gallery and the exhibition were probably made during the
exhibition period.

* 5034. [New York—people walking down street; trees on right]
(P1983.23.196)
Platinum print. 1911
Image: 4 3/8 x 3 9/16 in. (11.1 x 9.0 cm.)
1st mount: 4 7/16 x 3 5/8 in. (11.3 x 9.2 cm.)
2nd mount: 5 x 4 3/16 in. (12.6 x 10.6 cm.)
3rd mount: 11 3/4 x 8 in. (29.8 x 20.3 cm.) album sheet,
irregular
Inscription, 2nd mount recto: "1911."
Acquired from: Stephen White Gallery of Photography, Inc.,
Los Angeles, California

5035. [New York—people looking over a balustrade in front of a
monument] (P1983.23.197)
Platinum print. 1911
Image: 4 11/16 x 3 11/16 in. (11.9 x 9.3 cm.)
1st mount: 3 13/16 x 4 13/16 in. (9.6 x 12.2 cm.)
2nd mount: 4 5/16 x 5 3/8 in. (10.9 x 13.6 cm.)
3rd mount: 11 7/8 x 8 in. (30.1 x 20.3 cm.) album sheet,
irregular
Inscription, 2nd mount recto: "1911."
Acquired from: Stephen White Gallery of Photography, Inc.,
Los Angeles, California

5036. [New York—people walking beside a river] (P1983.23.198)
Platinum print. 1910
Image: 4 7/16 x 3 11/16 in. (11.2 x 9.3 cm.)
1st mount: 4 9/16 x 3 13/16 in. (11.5 x 9.7 cm.)
2nd mount: 4 15/16 x 4 1/8 in. (12.5 x 10.5 cm.)
3rd mount: 11 3/4 x 8 in. (29.8 x 20.3 cm.) album sheet,
irregular
Inscription, 2nd mount recto: "1910."
Acquired from: Stephen White Gallery of Photography, Inc.,
Los Angeles, California

5037. [New York—looking past apartments toward the river at the
intersection of Riverside Drive and 116th Street]
(P1983.23.199)
Platinum print. 1911
Image: 4 7/16 x 3 11/16 in. (11.2 x 9.4 cm.)
1st mount: 4 5/8 x 3 13/16 in. (11.6 x 9.7 cm.)
2nd mount: 5 1/16 x 4 5/16 in. (12.9 x 10.9 cm.)
3rd mount: 11 3/4 x 8 in. (29.8 x 20.3 cm.) album sheet,
irregular
Inscription, 2nd mount recto: "1911."
Acquired from: Stephen White Gallery of Photography, Inc.,
Los Angeles, California

* 5038. [New York—Columbia University—steps and wall topped
with urns] (P1983.23.200)
Platinum print. 1910—11
Image: 4 5/8 x 3 11/16 in. (11.7 x 9.4 cm.)
Sheet: 4 11/16 x 3 13/16 in. (11.9 x 9.6 cm.)
1st mount: 5 x 4 1/16 in. (12.6 x 10.3 cm.)
2nd mount: 11 13/16 x 8 in. (29.9 x 20.3 cm.) album sheet,
irregular
Inscription, 1st mount recto: "1910."
Acquired from: Stephen White Gallery of Photography, Inc.,
Los Angeles, California

5028

5029

5034

5038

5043

5054

5039. [New York—Columbia University, Henry Krumb School of
Mines] (P1983.23.201)
Platinum print. 1910
Image: 4 9/16 x 3 9/16 in. (11.6 x 9.1 cm.)
1st mount: 4 3/4 x 3 3/4 in. (12.0 x 9.5 cm.)
2nd mount: 5 1/8 x 4 1/8 in. (13.0 x 10.4 cm.)
3rd mount: 11 7/8 x 8 in. (30.1 x 20.3 cm.) album sheet,
irregular
Inscription, 2nd mount recto: "1910"
Acquired from: Stephen White Gallery of Photography, Inc.,
Los Angeles, California

5040. [New York—Waldorf Astoria in the foreground]
(P1983.23.202)
Platinum print. 1910
Image: 4 7/16 x 3 11/16 in. (11.3 x 9.3 cm.)
Sheet: 4 9/16 x 3 3/4 in. (11.5 x 9.5 cm.)
1st mount: 4 15/16 x 4 1/8 in. (12.4 x 10.4 cm.)
2nd mount: 11 3/4 x 8 in. (29.8 x 20.3 cm.) album sheet,
irregular
Inscription, 1st mount recto: "1910."
Acquired from: Stephen White Gallery of Photography, Inc.,
Los Angeles, California

5041. [Albright Art Gallery, Buffalo, New York, west facade and
terrace] (P1983.23.203)
Platinum print. 1910
Image: 4 1/2 x 3 11/16 in. (11.4 x 9.4 cm.)
Sheet: 4 5/8 x 3 13/16 in. (11.7 x 9.6 cm.)
1st mount: 4 15/16 x 4 1/4 in. (12.5 x 10.8 cm.)
2nd mount: 11 3/4 x 8 1/16 in. (29.8 x 20.5 cm.) album sheet,
irregular
Inscription, 1st mount recto: "1910."
Acquired from: Stephen White Gallery of Photography, Inc.,
Los Angeles, California

5042. [Albright Art Gallery, Buffalo, New York, west facade]
(P1983.23.204)
Platinum print. 1910
Image: 3 7/8 x 3 11/16 in. (9.8 x 9.4 cm.) dome-topped
1st mount: 4 5/16 x 4 3/16 in. (10.9 x 10.6 cm.) dome-topped
2nd mount: 11 7/8 x 8 in. (30.1 x 20.3 cm.) album sheet,
irregular
Inscription, 1st mount recto: "1910."
Acquired from: Stephen White Gallery of Photography, Inc.,
Los Angeles, California

*5043. [Albright Art Gallery, Buffalo, New York, colonnade]
(P1983.23.205)
Platinum print. 1910
Image: 4 1/2 x 3 11/16 in. (11.4 x 9.4 cm.)
1st mount: 4 5/8 x 3 7/8 in. (11.7 x 9.6 cm.)
2nd mount: 4 13/16 x 4 in. (12.2 x 10.1 cm.)
3rd mount: 5 5/16 x 4 7/16 in. (13.4 x 11.3 cm.)
4th mount: 11 13/16 x 8 in. (29.9 x 20.3 cm.) album sheet,
irregular
Inscription, 3rd mount recto: "1910"
Acquired from: Stephen White Gallery of Photography, Inc.,
Los Angeles, California

5044. [Albright Art Gallery, Buffalo, New York, base of column and
terrace] (P1983.23.206)
Platinum print. 1910
Image: 4 5/16 x 3 11/16 in. (11.0 x 9.4 cm.)
Sheet: 4 7/16 x 3 3/4 in. (11.3 x 9.6 cm.)
1st mount: 4 15/16 x 4 3/16 in. (12.5 x 10.7 cm.)
2nd mount: 11 13/16 x 8 in. (29.9 x 20.3 cm.) album sheet,
irregular
Inscription, 1st mount recto: "1910."
Acquired from: Stephen White Gallery of Photography, Inc.,
Los Angeles, California

5045. [Albright Art Gallery, Buffalo, New York, east facade—central
section and wing] (P1983.23.207)
Platinum print. 1910
Image: 4 1/8 x 3 9/16 in. (10.4 x 9.1 cm.)
1st mount: 4 9/16 x 4 1/8 in. (11.6 x 10.5 cm.)
2nd mount: 11 13/16 x 8 in. (29.9 x 20.3 cm.) album sheet,
irregular
Inscription, 1st mount recto: "1910."
Acquired from: Stephen White Gallery of Photography, Inc.,
Los Angeles, California

5046. [Albright Art Gallery, Buffalo, New York, detail of east facade
and stairs] (P1983.23.208)
Platinum print. 1910
Image: 4 3/8 x 3 5/8 in. (11.1 x 9.1 cm.)
1st mount: 4 9/16 x 3 3/4 in. (11.5 x 9.3 cm.)
2nd mount: 4 15/16 x 4 1/8 in. (12.5 x 10.4 cm.)
3rd mount: 11 13/16 x 8 in. (29.9 x 20.3 cm.) album sheet,
irregular
Inscription, 2nd mount recto: "1910"
Acquired from: Stephen White Gallery of Photography, Inc.,
Los Angeles, California

5047. [Albright Art Gallery, Buffalo, New York, central section of
east facade and main stairway from circular drive]
(P1983.23.209)
Platinum print. 1910
Image: 4 9/16 x 3 11/16 in. (11.5 x 9.3 cm.)
Sheet: 4 11/16 x 3 13/16 in. (11.9 x 9.6 cm.)
1st mount: 5 1/8 x 4 3/16 in. (12.9 x 10.6 cm.)
2nd mount: 11 7/8 x 8 in. (30.1 x 20.3 cm.) album sheet,
irregular
Acquired from: Stephen White Gallery of Photography, Inc.,
Los Angeles, California

5048. [Albright Art Gallery, Buffalo, New York, east facade]
(P1983.23.210)
Platinum print. 1910
Image: 3 5/16 x 4 1/4 in. (8.4 x 10.9 cm.)
1st mount: 3 13/16 x 4 3/4 in. (9.6 x 12.0 cm.)
2nd mount: 11 13/16 x 8 in. (29.9 x 20.3 cm.) album sheet,
irregular
Inscription, 1st mount recto: "1910"
Acquired from: Stephen White Gallery of Photography, Inc.,
Los Angeles, California

5049. [Albright Art Gallery, Buffalo, New York, west facade and
stairway] (P1983.23.211)
Platinum print. 1910
Image: 3 1/2 x 4 3/8 in. (9.0 x 11.0 cm.)
1st mount: 3 11/16 x 4 1/2 in. (9.5 x 11.5 cm.)
2nd mount: 4 1/8 x 4 13/16 in. (10.4 x 12.3 cm.)
3rd mount: 11 13/16 x 8 in. (29.9 x 20.3 cm.) album sheet,
irregular
Inscription, 1st mount recto: "1910."
Acquired from: Stephen White Gallery of Photography, Inc.,
Los Angeles, California

5050. [Albright Art Gallery, Buffalo, New York, colonnade]
(P1983.23.212)
Platinum print. 1910
Image: 4 9/16 x 3 9/16 in. (11.5 x 9.0 cm.)
1st mount: 4 15/16 x 3 15/16 in. (12.5 x 10.0 cm.)
2nd mount: 11 13/16 x 8 in. (29.9 x 20.3 cm.) album sheet,
irregular
Inscription, 1st mount recto: "1910."
Acquired from: Stephen White Gallery of Photography, Inc.,
Los Angeles, California

5051. [Albright Art Gallery, Buffalo, New York, colonnade on west
side of building] (P1983.23.213)
Platinum print. 1910
Image: 4 1/2 x 3 11/16 in. (11.4 x 9.3 cm.)
1st mount: 4 5/8 x 3 13/16 in. (11.7 x 9.6 cm.)
2nd mount: 4 15/16 x 4 1/16 in. (12.5 x 10.4 cm.)
3rd mount: 11 7/8 x 8 in. (30.1 x 20.3 cm.) album sheet,
irregular

Inscription, 2nd mount recto: "1910."
Acquired from: Stephen White Gallery of Photography, Inc.,
Los Angeles, California

5052. [Albright Art Gallery, Buffalo, New York, curving colonnade
on west facade] (P1983.23.214)
Platinum print. 1910
Image: 4 11/16 x 3 5/8 in. (11.8 x 9.3 cm.)
1st mount: 4 13/16 x 3 13/16 in. (12.2 x 9.7 cm.)
2nd mount: 5 5/8 x 4 1/2 in. (14.2 x 11.4 cm.)
3rd mount: 11 13/16 x 8 in. (29.9 x 20.3 cm.) album sheet,
irregular
Acquired from: Stephen White Gallery of Photography, Inc.,
Los Angeles, California

5053. [Albright Art Gallery, Buffalo, New York, east facade from
below] (P1983.23.215)
Platinum print. 1910
Image: 4 11/16 x 3 11/16 in. (11.8 x 9.4 cm.)
1st mount: 4 3/4 x 3 3/4 in. (12.0 x 9.5 cm.)
2nd mount: 4 15/16 x 3 15/16 in. (12.5 x 10.0 cm.)
3rd mount: 11 13/16 x 8 in. (29.9 x 20.3 cm.) album sheet,
irregular
Inscription, 2nd mount recto: "1910"
Acquired from: Stephen White Gallery of Photography, Inc.,
Los Angeles, California

5055

*5054. [Albright Art Gallery, Buffalo, New York, gallery interior
showing "International Exhibition of Pictorial
Photography"] (P1983.23.216)
Platinum print. 1910
Image: 3 9/16 x 4 9/16 in. (9.1 x 11.7 cm.)
1st mount: 3 3/4 x 4 11/16 in. (9.4 x 11.9 cm.)
2nd mount: 4 1/8 x 5 1/16 in. (10.5 x 12.9 cm.)
3rd mount: 11 13/16 x 8 in. (29.9 x 20.3 cm.) album sheet,
irregular
Inscription, 2nd mount recto: "1910"
Acquired from: Stephen White Gallery of Photography, Inc.,
Los Angeles, California

*5055. [Albright Art Gallery, Buffalo, New York, west facade, curving
colonnade] (P1983.23.217)
Platinum print. 1910
Image: 4 11/16 x 3 3/4 in. (11.9 x 9.5 cm.)
Sheet: 5 1/16 x 4 in. (12.8 x 10.1 cm.)
Signed, center print verso: "Karl Struss./1910"
Inscription, print verso: "4"
Acquired from: Stephen White Gallery of Photography, Inc.,
Los Angeles, California

5057

5056. [Albright Art Gallery, Buffalo, New York, silhouette of east
facade] (P1983.23.218)
Platinum print. 1910
Image: 3 5/8 x 4 1/2 in. (9.1 x 11.3 cm.)
1st mount: 3 13/16 x 4 11/16 in. (9.6 x 11.9 cm.)
2nd mount: 4 5/16 x 5 3/16 in. (10.9 x 13.1 cm.)
3rd mount: 11 15/16 x 8 1/4 in. (30.3 x 20.8 cm.) album sheet,
irregular
Acquired from: Stephen White Gallery of Photography, Inc.,
Los Angeles, California

* * * *

*5057. AMY WHITTEMORE AT WINDOW—PLANT AT LEFT
(P1983.23.136)
Platinum print. 1911
Image: 6 5/8 x 4 5/8 in. (16.7 x 11.8 cm.)
1st mount: 6 11/16 x 4 13/16 in. (17.1 x 12.3 cm.)
2nd mount: 7 7/16 x 5 1/2 in. (18.9 x 13.9 cm.)
Inscription, 2nd mount recto: "1911."
2nd mount verso: "AMY·WHITTEMORE/at Window/Plant
at L/1911 NYC.//#49"
Acquired from: Stephen White Gallery of Photography, Inc.,
Los Angeles, California

5058. **ANNA KINDLUND, ARTIST, LONG ISLAND [Garden Time]** (P1983.24.47) print from this autochrome is in the "Dawn of Color" portfolio, P1983.23.189
Autochrome. c. 1910
Image: 8 x 6 in. (20.3 x 15.1 cm.)
Plate: 8 1/2 x 6 1/2 in. (21.5 x 16.5 cm.)
Acquired from: Stephen White Gallery of Photography, Inc., Los Angeles, California

* 5059. **ARRIVAL OF ADM. DEWEY** (P1983.23.16)
Platinum print. 1909
Image: 4 11/16 x 3 11/16 in. (11.8 x 9.4 cm.)
Mount: 5 1/16 x 4 1/8 in. (12.9 x 10.5 cm.)
Inscription, mount recto: "1909"
mount verso: "Arrival of Adm. Dewey//#16//1909."
Acquired from: Stephen White Gallery of Photography, Inc., Los Angeles, California

5060. **ARVERNE, L. I. FISHERMAN** (P1983.23.54) duplicate of P1983.23.65
Platinum print. 1909
Image: 4 1/4 x 3 1/4 in. (10.8 x 8.2 cm.)
1st mount: 4 3/8 x 3 5/16 in. (11.1 x 8.4 cm.)
2nd mount: 4 13/16 x 3 13/16 in. (12.2 x 9.7 cm.)
Inscription, print verso: "Arv"
2nd mount recto: "1909."
2nd mount verso: "Arverne, L. I. Fisherman/1909//#105"
Acquired from: Stephen White Gallery of Photography, Inc., Los Angeles, California

5061. **ARVERNE, L. I. FISHERMAN** (P1983.23.65) duplicate of P1983.23.54
Hand-coated sepia-toned multiple platinum print. 1909
Image: 8 7/8 x 6 3/4 in. (22.6 x 17.1 cm.)
Mount: 13 3/4 x 9 5/8 in. (35.0 x 24.5 cm.)
Signed, l.l. print recto: "Karl Struss 1909."
Acquired from: Stephen White Gallery of Photography, Inc., Los Angeles, California

* 5062. **ARVERNE, L. I.—MISTY GRASSES** (P1983.23.88)
Platinum print. 1909
Image: 3 3/16 x 4 7/16 in. (8.1 x 11.2 cm.)
1st mount: 3 1/4 x 4 1/2 in. (8.3 x 11.4 cm.)
2nd mount: 3 11/16 x 4 7/8 in. (9.3 x 12.4 cm.)
Inscription, print verso: "Arv"
2nd mount recto: "1909."
2nd mount verso: "Arverne, L. I./Misty Grasses//#52"
Acquired from: Stephen White Gallery of Photography, Inc., Los Angeles, California

* 5063. **AT THE WINDOW—TWILIGHT [Silhouette of Ethel Struss]** (P1983.23.142)
Palladium print. 1921
Image: 13 x 10 7/16 in. (32.9 x 26.5 cm.)
1st mount: 16 3/4 x 12 3/8 in. (42.3 x 31.4 cm.)
2nd mount: 19 1/2 x 15 1/16 in. (49.5 x 38.2 cm.)
Signed, l.l. print recto: "Karl Struss. 1921."
l.r. 1st mount recto and l.r. 2nd mount recto: "Karl Struss."
Inscription, print verso, rubber stamp: "PHOTOGRAPHED BY/KARL STRUSS/HOLLYWOOD, CALIF."
2nd mount verso: "#3//#92./#17—"AT·THE·WINDOW—TWILIGHT."//#9//(PINHOLE)/PALLADIO·PRINT.// A/106" and rubber stamps "591" and "KARL STRUSS/ ARTIST PHOTOGRAPHER/HOLLYWOOD :: CALIFORNIA" and "PITTSBURGH/SALON OF/ PHOTOGRAPHY/-1923-/[PSP insignia]" and printed paper labels "THIS PRINT HAS BEEN EXHIBITED/ In the Gallery. ·.·.· of the/CALIFORNIA CAMERA CLUB—/during the Month of [blank]/[blank]/ CHAIRMAN PRINT COMMITTEE./San Francisco California." and "Los Angeles Camera Club/108-12 Stimson Bldg.·· 129 West Third St./LOS ANGELES, CALIFORNIA/(Affiliated with the Associated/Camera Clubs of America)/[LACC insignia]/EXHIBITED AT THE LOS/ANGELES CAMERA CLUB"
Acquired from: Stephen White Gallery of Photography, Inc., Los Angeles, California

5064. **AUTUMN, LONG ISLAND, NEW YORK** (P1983.24.43) print from this autochrome is in the "Dawn of Color" portfolio, P1983.23.187
Autochrome. c. 1910
Image: 8 x 6 1/16 in. (20.3 x 15.3 cm.)
Plate: 8 1/2 x 6 1/2 in. (21.5 x 16.5 cm.)
Acquired from: Stephen White Gallery of Photography, Inc., Los Angeles, California

5065. **BACK OF PUBLIC LIBRARY [New York Public Library]** (P1983.23.2)
Platinum print. 1912
Image: 4 1/4 x 3 3/4 in. (10.8 x 9.6 cm.)
Mount: 4 7/16 x 3 15/16 in. (11.2 x 10.0 cm.)
Inscription, mount verso: "Back of Pub. Library//2."
Acquired from: Stephen White Gallery of Photography, Inc., Los Angeles, California

5066. **BALCONY, SORRENTO** (P1983.23.113) duplicate of P1980.3.1 in "Karl Struss: A Portfolio"
Platinum print. 1909
Image: 5 9/16 x 7 7/16 in. (14.1 x 18.8 cm.)
Mount: 5 3/4 x 7 5/8 in. (14.7 x 19.3 cm.)
Signed, center mount verso: "Karl Struss"
Inscription, mount verso: "Balcony, Sorrento/'09/Plat."
Acquired from: Stephen White Gallery of Photography, Inc., Los Angeles, California

5067. **[Bay Bridge, New York]** (P1980.54)
Platinum print. c. 1911–13
Image: 3 5/8 x 4 1/2 in. (9.2 x 11.5 cm.)
1st mount: 3 3/4 x 4 11/16 in. (9.6 x 11.9 cm.)
2nd mount: 4 5/16 x 5 1/4 in. (11.0 x 13.4 cm.)
Signed, center 2nd mount verso: "Karl Struss"
Inscription, 2nd mount recto: "26"
Acquired from: Stephen White Gallery of Photography, Inc., Los Angeles, California

* 5068. **THE BEACH** (P1983.23.77)
Hand-coated multiple platinum print. c. 1909–10
Image: 9 5/16 x 6 7/8 in. (23.5 x 17.4 cm.)
Mount: 15 1/8 x 13 in. (38.4 x 33.0 cm.)
Signed, l.l. print recto: "Karl Struss 1909."
l.r. print recto: "Karl Struss."
Inscription, print recto: "1910"
mount verso: ""The Beach."/Karl Struss. 5 W 31 St. N. Y./ Hand coated/Multiple platinum print./$" and rubber stamp "KARL STRUSS/1943 N. ORANGE GROVE AVE./ HOLLYWOOD, CALIF. 90046"
Acquired from: Stephen White Gallery of Photography, Inc., Los Angeles, California

* 5069. **BEBE DANIELS [The Siren—fantasy sequence from the film Male and Female]** (P1983.23.169)
Gelatin silver print. 1919
Image: 9 1/8 x 7 3/8 in. (23.1 x 18.7 cm.)
Mount: 13 5/8 x 11 1/2 in. (34.6 x 29.1 cm.)
Signed, l.r. print recto and l.r. mount recto: "Karl Struss."
Inscription, print recto: "1919"
print verso, rubber stamp: "PHOTOGRAPHED BY/KARL STRUSS/Famous Players—Lasky Corp./HOLLYWOOD, CALIF."
mount recto: ""BEBE·DANIELS""
mount verso, rubber stamp: "KARL STRUSS/ARTIST PHOTOGRAPHER/HOLLYWOOD :: CALIFORNIA"
Acquired from: Stephen White Gallery of Photography, Inc., Los Angeles, California

5070. **BELLAGIO, LAKE COMO, ITALY** (P1983.23.100)
Platinum print. 1909
Image: 3 9/16 x 3 15/16 in. (9.1 x 10.0 cm.)
Mount: 3 11/16 x 4 1/16 in. (9.4 x 10.3 cm.)
Inscription, mount verso: "Bellagio, Lake Come [sic], Italy/1909//#95"
Acquired from: Stephen White Gallery of Photography, Inc., Los Angeles, California

5059

5062

5068

5063

5069

*5071. **BELLAGIO, PATH [A Byway—Bellagio]** (P1983.23.105)
duplicate of P1983.23.116
Platinum print. 1909
Image: 4 5/16 x 3 1/2 in. (10.9 x 9.0 cm.)
1st mount: 4 3/8 x 3 5/8 in. (11.1 x 9.1 cm.)
2nd mount: 4 13/16 x 4 in. (12.1 x 10.2 cm.)
Inscription, print verso: "Arv"
2nd mount recto: "1909."
2nd mount verso: "Ballegio [sic], Path/1909//#135"
Acquired from: Stephen White Gallery of Photography, Inc.,
Los Angeles, California

*5072. **BENEATH THE SECOND AVENUE ELEVATED. NEW YORK** (P1983.23.80)
Bromide print. 1912
Image: 4 1/4 x 3 5/8 in. (10.7 x 9.2 cm.)
1st mount: 4 7/16 x 3 13/16 in. (11.2 x 9.7 cm.)
2nd mount: 5 x 4 3/8 in. (12.7 x 11.1 cm.)
Signed, l.r. 2nd mount recto: "Karl Struss."
Inscription, 1st mount verso: "43//(43)/84."
2nd mount recto: "1912."
Acquired from: Stephen White Gallery of Photography, Inc.,
Los Angeles, California

5073. **BERLIN, GARDEN PATH, GIRL READING** (P1983.23.99)
Platinum print. 1909
Image: 2 3/8 x 3 7/8 in. (6.0 x 9.9 cm.)
1st mount: 2 1/2 x 4 1/16 in. (6.4 x 10.2 cm.)
2nd mount: 3 x 4 1/2 in. (7.6 x 11.6 cm.)
Inscription, 2nd mount recto: "1909."
2nd mount verso: "Berlin, Garden Path, Girl reading/1901
[sic]//#94"
Acquired from: Stephen White Gallery of Photography, Inc.,
Los Angeles, California

5074. **BERMUDA [Hamilton, Bermuda—view across Hamilton
Harbor with fishing boat]** (P1983.24.28)
Autochrome. 1914
Image: 3 7/16 x 4 1/2 in. (8.8 x 11.4 cm.)
Plate: 4 x 5 in. (10.1 x 12.6 cm.)
Inscription, on wrapper accompanying autochrome:
"Not possible to remove stain//4 x 5· AUTOCHROME/
BERMUDA· 1914//Remove stain. & bind./If not possible,
do/not touch./Karl Struss"
Acquired from: Stephen White Gallery of Photography, Inc.,
Los Angeles, California

5075. **[Bermuda (?)—bird's-eye view of beach from hilltop covered
with vegetation]** (P1983.24.39)
Autochrome. c. 1913–14
Image: 3 5/8 x 4 5/8 in. (9.1 x 11.7 cm.)
Plate: 4 x 5 in. (10.1 x 12.6 cm.)
Acquired from: Stephen White Gallery of Photography, Inc.,
Los Angeles, California

5076. **[Bermuda—bird's-eye view of town and harbor]** (P1983.24.30)
Autochrome. c. 1913–14
Image: 3 9/16 x 4 9/16 in. (9.0 x 11.5 cm.)
Plate: 4 x 5 in. (10.1 x 12.6 cm.)
Acquired from: Stephen White Gallery of Photography, Inc.,
Los Angeles, California

5077. **[Bermuda—woman carrying a tray of oranges and
bananas on her head]** (P1983.24.23)
Autochrome. c. 1913–14
Image: 4 5/16 x 3 5/8 in. (10.9 x 9.3 cm.)
Plate: 5 x 4 in. (12.6 x 10.1 cm.)
Inscription, left edge: "+"
Acquired from: Stephen White Gallery of Photography, Inc.,
Los Angeles, California

5078. **BERMUDA—DANCING AT THE HAMILTON**
(P1983.23.55)
Platinum print. c. 1912–14
Image: 3 1/4 x 4 1/4 in. (8.3 x 10.8 cm.)
1st mount: 3 7/16 x 4 1/2 in. (8.8 x 11.4 cm.)

2nd mount: 3 11/16 x 4 11/16 in. (9.4 x 11.9 cm.)
Inscription, 2nd mount verso: "Dancing, Hotel at Arverne,
L. I. [sic]/1909 [sic]//#107"
Acquired from: Stephen White Gallery of Photography, Inc.,
Los Angeles, California

5079. **[Bermuda—horse standing beside stucco wall]** (P1983.24.34)
Autochrome. c. 1913–14
Image: 3 9/16 x 4 9/16 in. (9.1 x 11.5 cm.)
Plate: 4 x 5 in. (10.1 x 12.6 cm.)
Acquired from: Stephen White Gallery of Photography, Inc.,
Los Angeles, California

5080. **[Bermuda—house and gateway surrounded by vegetation]**
(P1983.24.32)
Autochrome. c. 1913–14
Image: 3 9/16 x 4 9/16 in. (9.1 x 11.5 cm.)
Plate: 4 x 5 in. (10.1 x 12.6 cm.)
Inscription, left edge: "+"
Acquired from: Stephen White Gallery of Photography, Inc.,
Los Angeles, California

5081. **[Bermuda—one-story white stucco house seen from driveway
gate]** (P1983.24.36)
Autochrome. c. 1913–14
Image: 3 1/2 x 4 7/16 in. (8.9 x 11.3 cm.)
Plate: 4 x 5 in. (10.1 x 12.6 cm.)
Acquired from: Stephen White Gallery of Photography, Inc.,
Los Angeles, California

5082. **[Bermuda—raised house with arched openings below; lattice
work porch railings]** (P1983.24.33)
Autochrome. c. 1913–14
Image: 3 11/16 x 4 5/8 in. (9.3 x 11.8 cm.)
Plate: 4 x 5 in. (10.1 x 12.6 cm.)
Acquired from: Stephen White Gallery of Photography, Inc.,
Los Angeles, California

5083. **[Bermuda—rocky coastline]** (P1983.24.41)
Autochrome. c. 1913–14
Image: 3 5/8 x 4 5/8 in. (9.3 x 11.7 cm.)
Plate: 4 x 5 in. (10.1 x 12.6 cm.)
Acquired from: Stephen White Gallery of Photography, Inc.,
Los Angeles, California

5084. **[Bermuda—South Shore beach]** (P1983.24.37)
Autochrome. c. 1913–14
Image: 3 9/16 x 4 9/16 in. (9.1 x 11.5 cm.)
Plate: 4 x 5 in. (10.1 x 12.6 cm.)
Acquired from: Stephen White Gallery of Photography, Inc.,
Los Angeles, California

5085. **[Bermuda (?)—trees by beach]** (P1983.24.38)
Autochrome. c. 1913–14
Image: 3 9/16 x 4 9/16 in. (9.1 x 11.5 cm.)
Plate: 4 x 5 in. (10.1 x 12.6 cm.)
Acquired from: Stephen White Gallery of Photography, Inc.,
Los Angeles, California

5086. **[Bermuda (?)—trees by beach, houses in the background]**
(P1983.24.40)
Autochrome. c. 1913–14
Image: 3 9/16 x 4 9/16 in. (9.1 x 11.5 cm.)
Plate: 4 x 5 in. (10.1 x 12.6 cm.)
Acquired from: Stephen White Gallery of Photography, Inc.,
Los Angeles, California

5087. **[Bermuda (?)—two-story pink stucco house with green and
white trim]** (P1983.24.31)
Autochrome. c. 1913–14
Image: 3 9/16 x 4 9/16 in. (9.1 x 11.5 cm.)
Plate: 4 x 5 in. (10.1 x 12.6 cm.)
Inscription, right edge: "+"
Acquired from: Stephen White Gallery of Photography, Inc.,
Los Angeles, California

5088. **[Bermuda (?)—two-story white stucco house surrounded by flowering trees]** (P1983.24.35)
Autochrome. c. 1913–14
Image: 3 9/16 x 4 9/16 in. (9.1 x 11.5 cm.)
Plate: 4 x 5 in. (10.1 x 12.6 cm.)
Acquired from: Stephen White Gallery of Photography, Inc., Los Angeles, California

5089. **BOARD WALK, L. I.** (P1983.23.53)
Platinum print. 1910
Image: 3 3/8 x 4 5/16 in. (8.5 x 11.0 cm.)
Mount: 3 1/2 x 4 1/2 in. (8.9 x 11.5 cm.)
Inscription, mount verso: "Board Walk, L. I./1910//#61"
Acquired from: Stephen White Gallery of Photography, Inc., Los Angeles, California

*5090. **BOARD WALK, L. I.—BEACH CHAIRS, UMBRELLAS** (P1983.23.52)
Platinum print. 1910
Image: 3 9/16 x 4 5/16 in. (9.0 x 11.0 cm.)
Mount: 3 15/16 x 4 1/2 in. (10.0 x 11.5 cm.)
Inscription, mount verso: "Board Walk, L. I.//Beach Chairs, Umbrellas/1910//#60"
Acquired from: Stephen White Gallery of Photography, Inc., Los Angeles, California

5091. **BOARDWALK, LONG ISLAND** (P1983.24.50) print from this autochrome is in the "Dawn of Color" portfolio, P1983.23.191
Autochrome. c. 1910
Image: 6 x 6 1/16 in. (15.2 x 15.4 cm.)
Plate: 8 1/2 x 6 1/2 in. (21.5 x 16.5 cm.)
Acquired from: Stephen White Gallery of Photography, Inc., Los Angeles, California

5092. **[Boardwalk, Long Island; three women on balcony overlooking the beach]** (P1983.24.51)
Autochrome. c. 1910
Image: 6 x 6 1/16 in. (15.2 x 15.4 cm.)
Plate: 8 1/2 x 6 1/2 in. (21.5 x 16.5 cm.)
Acquired from: Stephen White Gallery of Photography, Inc., Los Angeles, California

5093. **THE BROOK** (P1983.23.128)
Hand-coated gum platinum print. c. 1905–10
Image: 6 13/16 x 8 5/8 in. (17.2 x 21.9 cm.)
Signed, l.l. print recto: "Karl Struss 1905"
Inscription, print verso: "Bromide [sic]//#31//The Brook/ Hand Coated Gum Plat./1910//2"
Acquired from: Stephen White Gallery of Photography, Inc., Los Angeles, California

5094. **BROOKLYN BRIDGE. DOCKS ON LEFT** (P1983.23.32)
Platinum print. 1912
Image: 3 5/8 x 4 7/16 in. (9.1 x 11.3 cm.)
1st mount: 3 3/4 x 4 9/16 in. (9.5 x 11.6 cm.)
2nd mount: 4 7/16 x 5 5/16 in. (11.3 x 13.6 cm.)
Inscription, 2nd mount recto: "1912."
2nd mount verso: "Brooklyn Br. Docks on Left/1912//#32"
Acquired from: Stephen White Gallery of Photography, Inc., Los Angeles, California

*5095. **BROOKLYN BRIDGE FROM FERRY SLIP. LATE AFTERNOON** (P1983.23.82)
Platinum print. 1912
Image: 4 7/8 x 3 11/16 in. (12.3 x 9.4 cm.)
Mount: 5 x 3 13/16 in. (12.7 x 9.7 cm.)
Inscription, mount verso: "65//(65)/83"
Acquired from: Stephen White Gallery of Photography, Inc., Los Angeles, California

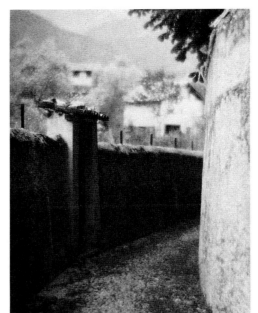
5071

5072

5090

* 5096. **BROOKLYN BRIDGE, NOCTURNE** (P1983.23.75)
duplicate of P1980.3.11 in "Karl Struss: A Portfolio 1909/29"
Palladium print. c. 1912–13
Image: 10 1/16 x 12 15/16 in. (25.5 x 32.8 cm.)
Mount: 13 7/8 x 17 1/4 in. (35.3 x 43.8 cm.)
Signed, l.l. print recto: "Karl Struss 1912"
l.r. mount recto: "Karl Struss., 1912."
Inscription, print verso, rubber stamp: "PHOTOGRAPHED BY/KARL STRUSS/HOLLYWOOD, CALIF."
mount recto: "1912."
mount verso: "#12-"BROOKLYN BRIDGE, NOCTURNE"/1912./PALLADIO-PRINT//1.1" and rubber stamp "PHOTOGRAPHED BY/KARL STRUSS/HOLLYWOOD, CALIF." and printed paper labels "MUSEUM OF THE CITY OF NEW YORK/"VIEWS OF NEW YORK—OLD AND NEW"/Exhibited By/PICTORIAL PHOTOGRAPHERS of AMERICA/November 9th to November 23, 1936" and "EXHIBITED AT/THE/LONDON SALON/OF PHOTOGRAPHY/[LSP insignia]/1921" and "MEMBER/[PPA insignia]/PICTORIAL/PHOTOGRAPHERS/OF AMERICA"
Acquired from: Stephen White Gallery of Photography, Inc., Los Angeles, California

5097. **BROOKLYN BRIDGE—SHIP PASSING UNDER—N.Y.** (P1983.23.31)
Platinum print. c. 1911–13
Image: 3 1/2 x 4 9/16 in. (8.9 x 11.6 cm.)
1st mount: 3 5/8 x 4 11/16 in. (9.2 x 11.9 cm.)
2nd mount: 4 5/16 x 5 3/8 in. (10.9 x 13.7 cm.)
Signed, l.r. print recto: "Karl Struss 1913."
Inscription, 2nd mount recto: "1911."
2nd mount verso: "Brook-Br—Ship passing Under—1911/NY.//#31"
Acquired from: Stephen White Gallery of Photography, Inc., Los Angeles, California

5098. **BUILDING LIGHTED AROUND TOP. SILHOUETTE ON RIGHT. N.Y.C [Lower New York—Vanderbilt Hotel at night]** (P1983.23.48)
Platinum print. 1912
Image: 3 11/16 x 4 9/16 in. (9.3 x 11.5 cm.)
1st mount: 3 13/16 x 4 11/16 in. (9.7 x 11.9 cm.)
2nd mount: 4 9/16 x 5 3/8 in. (11.6 x 13.6 cm.)
Inscription, 2nd mount recto: "1912."
2nd mount verso: "Bldg. Lighted around Top. Silhoute [sic] on R./1912 NYC.//#48"
Acquired from: Stephen White Gallery of Photography, Inc., Los Angeles, California

5099. **A BYWAY—BELLAGIO [Bellagio, Path]** (P1983.23.116)
duplicate of P1983.23.105
Platinum print. 1909
Image: 9 3/8 x 7 9/16 in. (23.8 x 19.2 cm.)
1st mount: 9 7/8 x 8 in. (25.0 x 20.3 cm.)
2nd mount: 16 5/8 x 12 1/2 in. (42.2 x 31.7 cm.)
3rd mount: 16 15/16 x 13 in. (43.0 x 33.1 cm.)
Signed, l.l. print recto: "Karl Struss 1909."
l.r. 1st mount recto: "Karl Struss."
Inscription, 3rd mount verso: "#45/#52.//#25 "A Byway—Bellagio."/1909//564D//Platinum Print." and rubber stamp "KARL STRUSS ARTIST PHOTOGRAPHER/HOLLYWOOD :: CALIFORNIA" and printed paper labels "XXIIᵉ Salon International/D'ART PHOTOGRAPHIQUE/PARIS/OCTOBRE 1927/ÉPREUVE ADMISE/sous le no/DU CATALOGUE/Société Française de Photographie/51, Rue de Clichy, Paris" and "THIS PRINT HAS BEEN EXHIBITED/In the GALLERY.·.·.·of the/CALIFORNIA CAMERA CLUB—/during the Month of [blank]/CHAIRMAN PRINT COMMITTEE./San Francisco California."
Acquired from: Stephen White Gallery of Photography, Inc., Los Angeles, California

* 5100. **CABLES** (P1983.23.72)
Gum platinum print. c. 1910–12
Image: 13 1/4 x 10 7/16 in. (33.7 x 26.5 cm.)
1st mount: 16 3/4 x 12 1/2 in. (42.5 x 31.6 cm.)
2nd mount: 16 7/8 x 13 3/4 in. (42.8 x 34.8 cm.)
Signed, l.l. print recto: "Karl Struss 1910."
l.r. 1st mount recto: "Karl Struss."
Inscription, print verso, rubber stamp: "PHOTOGRAPHED BY/KARL STRUSS/HOLLYWOOD, CALIF."
1st mount recto: "1910."
1st mount verso: "1312//#671"
2nd mount recto: "23"
2nd mount verso: "1312//#671//# #//#15—"CABLES"//#/"GUM-PLATINUM."//106//249//A//1.9" and rubber stamps "593" and "PHOTOGRAPHED BY/KARL STRUSS/HOLLYWOOD, CALIF." and printed paper labels "MUSEUM OF THE CITY OF NEW YORK/"VIEWS OF NEW YORK—OLD AND NEW"/Exhibited By/PICTORIAL PHOTOGRAPHERS of AMERICA/November 9th to November 23, 1936" and "EXHIBITED AT/THE/LONDON SALON/OF PHOTOGRAPHY/[LSP insignia]/1921" and "MEMBER/[PPA insignia]/PICTORIAL/PHOTOGRAPHERS/OF AMERICA"
Acquired from: Stephen White Gallery of Photography, Inc., Los Angeles, California

5101. **THE CANYON—LATE AFTERNOON** (P1983.23.153)
Platinum print. 1919
Image: 13 3/8 x 9 3/8 in. (33.8 x 23.8 cm.)
Mount: 15 1/8 x 11 in. (38.4 x 27.9 cm.)
Signed, l.l. print recto and l.r. mount recto: "Karl Struss."
Inscription, mount recto: "1919"
mount verso: "3//#4./1616 Vine St/$ [amount erased]/"The Canyon—Late Afternoon"/X/14" and rubber stamp "PHOTOGRAPHED BY/KARL STRUSS/HOLLYWOOD, CALIF."
Acquired from: Stephen White Gallery of Photography, Inc., Los Angeles, California

5102. **THE CANYON—WINTER** (P1983.23.154)
Platinum print. 1919
Image: 13 9/16 x 9 in. (34.4 x 22.8 cm.)
Mount: 15 x 10 1/4 in. (38.0 x 26.0 cm.)
Signed, l.r. mount recto: "Karl Struss."
Inscription, print recto: "©"
mount recto: "1919."
mount verso: "The Canyon—Winter//from H W Struss//3" and rubber stamp "KARL STRUSS/ARTIST PHOTOGRAPHER/HOLLYWOOD :: CALIFORNIA"
Acquired from: Stephen White Gallery of Photography, Inc., Los Angeles, California

5103. **CARMEL MYERS [probably from the film *The Poisoned Paradise*]** (P1983.23.162)
Platinum print. c. 1924
Image: 9 7/16 x 7 5/16 in. (23.9 x 18.6 cm.)
Inscription, print verso: "Carmel Myer [sic]//8" and rubber stamp "PHOTOGRAPHED BY/KARL STRUSS/PREFERRED PICTURES/HOLLYWOOD, CALIF."
Acquired from: Stephen White Gallery of Photography, Inc., Los Angeles, California

5104. **CARMELITA** (P1983.23.143)
Bromide print. c. 1917
Image: 13 9/16 x 9 13/16 in. (34.3 x 24.8 cm.)
Signed, l.r. print recto: "Karl Struss"
Inscription, print verso: "#14//Bro.//CARMELITA//13" and rubber stamp "KARL STRUSS/ARTIST PHOTOGRAPHER/HOLLYWOOD :: CALIFORNIA"
Acquired from: Stephen White Gallery of Photography, Inc., Los Angeles, California

5095

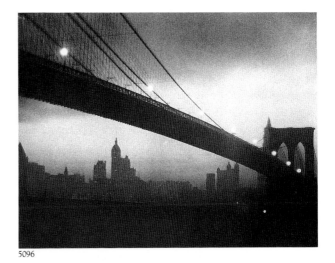

5096

5100

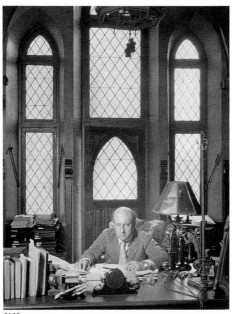

5105

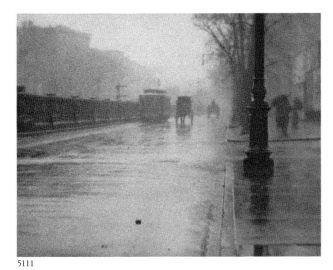

5111

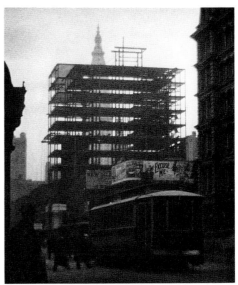

5112

*5105. [Cecil B. DeMille in his studio office] (P1983.23.165)
Toned gelatin silver print. 1919
Image: 9 ½ x 7 ¼ in. (24.0 x 18.3 cm.)
Mount: 14 ⅝ x 11 ⁵⁄₁₆ in. (37.1 x 28.7 cm.)
Signed, l.r. print recto: "Karl Struss"
l.r. mount recto: "Karl Struss."
Inscription, mount recto: "1919."
mount verso, rubber stamp: "KARL STRUSS/ARTIST
PHOTOGRAPHER/HOLLYWOOD :: CALIFORNIA"
Acquired from: Stephen White Gallery of Photography, Inc.,
Los Angeles, California

5106. CHATHAM SQUARE—EL-TRAINS—N.Y.C. [close-up of
train] (P1983.23.23)
Platinum print. 1911
Image: 3 ¹¹⁄₁₆ x 4 ⅝ in. (9.4 x 11.8 cm.)
1st mount: 3 ¹³⁄₁₆ x 4 ¾ in. (9.6 x 12.0 cm.)
2nd mount: 4 ³⁄₁₆ x 5 ³⁄₁₆ in. (10.7 x 13.1 cm.)
Inscription, 2nd mount recto: "1911."
2nd mount verso: "Chatham Square—El-Trains/1911—
NYC.//#23"
Acquired from: Stephen White Gallery of Photography, Inc.,
Los Angeles, California

5107. CHATHAM SQUARE—EL-TRAINS—N.Y.C. [A Misty
Day, Chatham Square, New York] (P1983.23.24)
Platinum print. 1911
Image: 4 ⅛ x 3 ¹¹⁄₁₆ in. (10.4 x 9.4 cm.)
1st mount: 4 ³⁄₁₆ x 3 ¹³⁄₁₆ in. (10.7 x 9.6 cm.)
2nd mount: 4 ⁹⁄₁₆ x 4 ³⁄₁₆ in. (11.5 x 10.6 cm.)
Inscription, 2nd mount recto: "1911."
2nd mount verso: "Chatham Square—El-Trains/1911—
NYC—//#24"
Acquired from: Stephen White Gallery of Photography, Inc.,
Los Angeles, California

5108. CHESTER, NOVA SCOTIA (P1983.23.133)
Platinum print. c. 1910–11
Image: 4 ⁹⁄₁₆ x 3 ¹¹⁄₁₆ in. (11.7 x 9.3 cm.)
Sheet: 4 ¹¹⁄₁₆ x 3 ¾ in. (11.9 x 9.6 cm.)
Mount: 5 ⁷⁄₁₆ x 4 ⁷⁄₁₆ in. (13.8 x 11.3 cm.)
Inscription, mount recto: "1910."
mount verso: "Chester, N. Scotia/1911//#71"
Acquired from: Stephen White Gallery of Photography, Inc.,
Los Angeles, California

5109. COLBY HILL, SALEM, MASSACHUSETTS [Two Girls—
N. H.] (P1983.23.118)
Platinum print. c. 1912–13
Image: 4 ⅝ x 3 ¾ in. (11.8 x 9.5 cm.)
Signed, l.l. print recto: "Karl Struss 1913."
Inscription, print verso: "Two Girls—N. H./1913//#66"
Acquired from: Stephen White Gallery of Photography, Inc.,
Los Angeles, California

5110. COLD & MISTY—MAN, CAB & HORSE (P1983.23.18)
Platinum print. 1911
Image: 4 ⁵⁄₁₆ x 3 ½ in. (11.0 x 8.9 cm.)
1st mount: 4 ⁹⁄₁₆ x 3 ¾ in. (11.6 x 9.6 cm.)
2nd mount: 5 x 4 ³⁄₁₆ in. (12.7 x 10.7 cm.)
Inscription, 1st mount recto: "1911."
2nd mount verso: "Cold & Misty—/Man, cab &
horse//1911//#18"
Acquired from: Stephen White Gallery of Photography, Inc.,
Los Angeles, California

*5111. COLD & MISTY—N.Y.C. (P1983.23.61)
Platinum print. c. 1911–12
Image: 3 ⁹⁄₁₆ x 4 ½ in. (9.1 x 11.4 cm.)
1st mount: 3 ¾ x 4 ⅝ in. (9.5 x 11.7 cm.)
2nd mount: 4 ⅜ x 5 ¼ in. (11.0 x 13.3 cm.)
Inscription, 2nd mount verso: "Cold & Misty—NYC—
1912//#117"
Acquired from: Stephen White Gallery of Photography, Inc.,
Los Angeles, California

*5112. CONSTRUCTION—"EXCUSE ME." LEXINGTON
WITH METROPOLITAN TOWER IN DISTANCE
(P1983.23.5)
Platinum print. 1911
Image: 4 ⁵⁄₁₆ x 3 ¾ in. (11.0 x 9.6 cm.)
1st mount: 4 ⁷⁄₁₆ x 3 ⅞ in. (11.3 x 9.8 cm.)
2nd mount: 4 ⅞ x 4 ⁵⁄₁₆ in. (12.5 x 10.9 cm.)
Inscription, 2nd mount recto: "1911."
2nd mount verso: "Construction/"Excuse Me."/Lexington
w./Met. in distance/1911//#5" and rubber stamp "KARL
STRUSS/INTERPRETIVE PHOTOGRAPHS/5 WEST
31st STREET/NEW YORK/Madison Sq. 674"
Acquired from: Stephen White Gallery of Photography, Inc.,
Los Angeles, California

5113. COUCH, WARD'S HOUSE, LONG ISLAND (P1983.24.16)
print from this autochrome is in the "Dawn of Color"
portfolio, P1983.23.193
Autochrome. c. 1910
Image: 3 ⁹⁄₁₆ x 2 ¼ in. (9.0 x 7.0 cm.)
Plate: 4 x 3 ¼ in. (10.1 x 8.2 cm.)
Acquired from: Stephen White Gallery of Photography, Inc.,
Los Angeles, California

*5114. [Dancer, Hollywood Hills (Diana Miller?)] (P1983.23.163)
Bromide print. c. 1920s
Image: 12 ¹³⁄₁₆ x 9 ¹⁵⁄₁₆ in. (32.5 x 25.2 cm.)
Signed, l.l. print recto: "Karl Struss"
Inscription, print verso: "3" and rubber stamp
"PHOTOGRAPHED BY/KARL STRUSS/HOLLYWOOD,
CALIF."
Acquired from: Stephen White Gallery of Photography, Inc.,
Los Angeles, California

*5115. DANCER IN THE ROUND [Diana Miller?] (P1983.23.141)
Platinum print. c. 1919
Image: 9 ⁷⁄₁₆ in. (23.9 cm.) diameter
1st mount: 9 ¾ x 9 ¹³⁄₁₆ in. (24.7 x 24.9 cm.)
2nd mount: 17 ⅞ x 14 ¼ in. (45.4 x 36.1 cm.)
Signed, l.r. 2nd mount recto: "Karl Struss"
Inscription, 2nd mount recto: "©//22"
2nd mount verso: "Dancer in the Round//#14-Plat."
Acquired from: Stephen White Gallery of Photography, Inc.,
Los Angeles, California

DAWN OF COLOR (P1983.23.186–193)

This portfolio was printed in Germany by Stephen White
Gallery and PPS. Galerie F. C. Gundlach about 1981 from
Karl Struss' original autochrome plates. This is set number 4
of a signed edition of 20 portfolios. A second edition of 100
stamped portfolios was also produced.

5116. TENNIS MATCH, HAMILTON, BERMUDA (P1983.23.186)
printed from autochrome P1983.24.24
Dye-transfer print. autochrome c. 1913, print c. 1981
Image: 7 ⁹⁄₁₆ x 9 ⁹⁄₁₆ in. (19.1 x 24.2 cm.)
Sheet: 16 ½ x 12 ⁹⁄₁₆ in. (41.8 x 31.9 cm.)
Signed, center print verso: "Karl Struss"
Inscription, print verso: "24" and rubber stamp "THIS IS
SET #4/A DYE-TRANSFER PRINT PRODUCED/FROM
THE ORIGINAL AUTOCHROME/IN AN EDITION
OF 20."
Acquired from: Stephen White Gallery of Photography, Inc.,
Los Angeles, California

5117. AUTUMN, LONG ISLAND, NEW YORK (P1983.23.187)
printed from autochrome P1983.24.43
Dye-transfer print. autochrome c. 1910, print c. 1981
Image: 10 ⅛ x 7 ½ in. (25.7 x 19.1 cm.)
Sheet: 16 ½ x 13 ⅜ in. (41.8 x 34.1 cm.)
Signed, center print verso: "Karl Struss"
Inscription, print verso: "98//22" and rubber stamp "THIS IS
SET #4/A DYE-TRANSFER PRINT PRODUCED/FROM
THE ORIGINAL AUTOCHROME/IN AN EDITION
OF 20."
Acquired from: Stephen White Gallery of Photography, Inc.,
Los Angeles, California

5118. **ETHEL PRAGUE WITH UMBRELLA, LONG ISLAND**
(P1983.23.188) printed from autochrome P1983.24.46
Dye-transfer print. autochrome c. 1910, print c. 1981
Image: 10⅛ x 7⁹⁄₁₆ in. (25.7 x 19.2 cm.)
Sheet: 16½ x 13⁷⁄₁₆ in. (41.8 x 34.0 cm.)
Signed, center print verso: "Karl Struss"
Inscription, print verso: "131//17" and rubber stamp "THIS IS
 SET #4/A DYE-TRANSFER PRINT PRODUCED/FROM
 THE ORIGINAL AUTOCHROME/IN AN EDITION
 OF 20."
Acquired from: Stephen White Gallery of Photography, Inc.,
 Los Angeles, California

5119. **ANNA KINDLUND, ARTIST, LONG ISLAND**
(P1983.23.189) printed from autochrome P1983.24.47
Dye-transfer print. autochrome c. 1910, print c. 1981
Image: 10¹⁄₁₆ x 7⁷⁄₁₆ in. (25.5 x 18.9 cm.)
Sheet: 16⁷⁄₁₆ x 13⁵⁄₁₆ in. (41.7 x 33.7 cm.)
Signed, center print verso: "Karl Struss"
Inscription, print verso: "77//18" and rubber stamp "THIS IS
 SET #4/A DYE-TRANSFER PRINT PRODUCED/FROM
 THE ORIGINAL AUTOCHROME/IN AN EDITION
 OF 20."
Acquired from: Stephen White Gallery of Photography, Inc.,
 Los Angeles, California

5120. **STILL LIFE WITH PEWTER VASE, NEW YORK**
(P1983.23.190) printed from autochrome P1983.24.52
Dye-transfer print. autochrome c. 1910, print c. 1981
Image: 10¹⁄₁₆ x 7⅜ in. (25.5 x 18.7 cm.)
Sheet: 16½ x 13³⁄₁₆ in. (41.9 x 33.5 cm.)
Signed, center print verso: "Karl Struss"
Inscription, print verso: "44" and rubber stamp "THIS IS
 SET #4/A DYE-TRANSFER PRINT PRODUCED/FROM
 THE ORIGINAL AUTOCHROME/IN AN EDITION
 OF 20."
Acquired from: Stephen White Gallery of Photography, Inc.,
 Los Angeles, California

5121. **BOARDWALK, LONG ISLAND** (P1983.23.191) printed from
autochrome P1983.24.50
Dye-transfer print. autochrome c. 1910, print c. 1981
Image: 9⁷⁄₁₆ x 9⁵⁄₁₆ in. (23.9 x 23.6 cm.)
Sheet: 16⁷⁄₁₆ x 13³⁄₁₆ in. (41.6 x 33.5 cm.)
Signed, center print verso: "Karl Struss"
Inscription, print verso: "141" and rubber stamp "THIS IS
 SET #4/A DYE-TRANSFER PRINT PRODUCED/FROM
 THE ORIGINAL AUTOCHROME/IN AN EDITION
 OF 20."
Acquired from: Stephen White Gallery of Photography, Inc.,
 Los Angeles, California

5122. **LOWER BROADWAY, NEW YORK** (P1983.23.192) printed
from autochrome P1983.24.53
Dye-transfer print. autochrome c. 1910, print c. 1981
Image: 10⅛ x 7⁷⁄₁₆ in. (25.7 x 18.9 cm.)
Sheet: 16½ x 13³⁄₁₆ in. (41.8 x 33.4 cm.)
Signed, center print verso: "Karl Struss"
Inscription, print verso: "33//21" and rubber stamp "THIS IS
 SET #4/A DYE-TRANSFER PRINT PRODUCED/FROM
 THE ORIGINAL AUTOCHROME/IN AN EDITION
 OF 20."
Acquired from: Stephen White Gallery of Photography, Inc.,
 Los Angeles, California

5123. **COUCH, WARD'S HOUSE, LONG ISLAND** (P1983.23.193)
printed from autochrome P1983.24.16
Dye-transfer print. autochrome c. 1910, print c. 1981
Image: 9¹³⁄₁₆ x 7⁹⁄₁₆ in. (24.9 x 19.2 cm.)
Sheet: 16⁷⁄₁₆ x 13⁹⁄₁₆ in. (41.8 x 34.3 cm.)
Signed, center print verso: "Karl Struss"
Inscription, print verso: "23" and rubber stamp "THIS IS
 SET #4/A DYE-TRANSFER PRINT PRODUCED/FROM
 THE ORIGINAL AUTOCHROME/IN AN EDITION
 OF 20."
Acquired from: Stephen White Gallery of Photography, Inc.,
 Los Angeles, California

* * * *

5114

5115

5127

5124. **DETAIL—GRAND CANYON** (P1983.23.152)
Platinum print. 1919
Image: 12 7/8 x 10 5/16 in. (32.6 x 26.1 cm.)
Mount: 17 3/16 x 14 in. (43.6 x 35.6 cm.)
Signed, l.l. print recto: "Karl Struss"
l.r. mount recto: "Karl Struss."
Inscription, print verso, rubber stamp: "PHOTOGRAPHED
BY/KARL STRUSS/HOLLYWOOD, CALIF."
mount recto: "1919."
mount verso: "#10//#670-281//#1.8."Detail—grand
Canyon."/Platinum//BSR" and rubber stamps
"PHOTOGRAPHED BY/KARL STRUSS/HOLLYWOOD,
CALIF." and printed paper label "This Certifies/that THIS
PRINT was one of/three hundred and thirteen/prints
exhibited at the/Eleventh/International/Salon of
Photography/held by the/CAMERA PICTORIALIST/OF
LOS ANGELES, CALIFORNIA/January third to thirty-
first/1·9·2·8"
Acquired from: Stephen White Gallery of Photography, Inc.,
Los Angeles, California

5125. **DEWEY** (P1983.23.17)
Platinum print. 1909
Image: 3 1/16 x 4 7/16 in. (7.8 x 11.2 cm.)
1st mount: 3 1/8 x 4 1/2 in. (8.0 x 11.4 cm.)
2nd mount: 3 1/4 x 4 9/16 in. (8.2 x 11.6 cm.)
Inscription, print recto: "1909"
print verso: "Arv"
2nd mount verso: "Dewey 1909//#17"
Acquired from: Stephen White Gallery of Photography, Inc.,
Los Angeles, California

5126. **DRAY HORSES UNDER BRIDGE [under Manhattan
Bridge, New York]** (P1983.23.60)
Platinum print. 1912
Image: 4 1/8 x 3 7/8 in. (10.5 x 9.7 cm.)
1st mount: 4 5/16 x 4 in. (10.9 x 10.1 cm.)
2nd mount: 4 7/8 x 4 9/16 in. (12.4 x 11.6 cm.)
Inscription, 2nd mount recto: "1912."
2nd mount verso: "Dray Horses under Bridge/1912//#116"
Acquired from: Stephen White Gallery of Photography, Inc.,
Los Angeles, California

*5127. **DRESDEN** (P1983.23.102)
Platinum print. 1909
Image: 2 1/4 x 3 1/8 in. (5.7 x 7.9 cm.)
1st mount: 2 5/16 x 3 3/16 in. (5.9 x 8.2 cm.)
2nd mount: 2 7/16 x 3 3/8 in. (6.1 x 8.5 cm.)
3rd mount: 2 9/16 x 3 7/16 in. (6.4 x 8.7 cm.)
Inscription, 3rd mount verso: "Dresden/1909//#132"
Acquired from: Stephen White Gallery of Photography, Inc.,
Los Angeles, California

5128. **DRESDEN, TRIMMED PLANTS** (P1983.23.107)
Platinum print. 1909
Image: 3 9/16 x 4 1/2 in. (9.0 x 11.4 cm.)
1st mount: 3 11/16 x 4 5/8 in. (9.3 x 11.7 cm.)
2nd mount: 4 3/16 x 5 1/8 in. (10.7 x 13.1 cm.)
Inscription, 2nd mount recto: "1909"
2nd mount verso: "Dresden, 1909/Trimmed plants//#137"
Acquired from: Stephen White Gallery of Photography, Inc.,
Los Angeles, California

*5129. **EARL HALL, COLUMBIA UNIVERSITY, NIGHT**
[Columbia University, Night] (P1983.23.73) duplicate of
P1983.23.74
Gum-platinum print. 1910
Image: 9 1/2 x 7 5/8 in. (24.0 x 19.3 cm.)
Mount: 17 x 13 in. (43.2 x 33.0 cm.)
Signed, l.l. print recto: "© Karl Struss 1910."
l.r. mount recto: "Karl Struss"
Inscription, print verso: "Platinum/1/111 Gum//COLUMBIA
UNIVERSITY, NIGHT" and rubber stamp "COPYRIGHT
1910. KARL STRUSS"
mount recto: "1910."
mount verso: "#39./"Earl Hall, Columbia University,

Night."/Blue Gum-Platinum Print." and rubber stamp
"PHOTOGRAPHED BY/KARL STRUSS/HOLLYWOOD,
CALIF." and rubber stamp "PHOTOGRAPHED BY/KARL
STRUSS/HOLLYWOOD, CALIF." and printed paper labels "THIS PRINT/WAS
EXHIBITED BY/SPECIAL INVITATION/AT THE/
4th SAN ANTONIO/SALON of PICTORIAL/
PHOTOGRAPHY/INTERNATION[al]/*/San Antonio
Pictorial/Camera Club" and "Los Angeles Camera
Club/108-12 Stimson Bldg.: 129 West Third St./LOS
ANGELES, CALIFORNIA/(Affiliated with the
Associated/Camera Clubs of America)/[LACC insignia]/
EXHIBITED AT THE LOS/ANGELES CAMERA
CLUB" and "THIS PRINT HAS BEEN EXHIBITED/In
the GALLERY·∴·of the/CALIFORNIA CAMERA
CLUB—/during the Month of [blank]/[blank]/
CHAIRMAN PRINT COMMITTEE./San Francisco
California." and "MUSEUM OF THE CITY OF NEW
YORK/"VIEWS OF NEW YORK—OLD AND NEW"/
Exhibited By/PICTORIAL PHOTOGRAPHERS
of AMERICA/November 9th to November 23, 1936"
and "MEMBER/[PPA insignia]/PICTORIAL/
PHOTOGRAPHERS/OF AMERICA"
Acquired from: Stephen White Gallery of Photography, Inc.,
Los Angeles, California

5130. **EARL HALL, COLUMBIA UNIVERSITY, NIGHT**
[Columbia University, Night] (P1983.23.74) duplicate of
P1983.23.73
Van Dyke-gum-platinum print. 1910
Image: 9 3/16 x 7 1/4 in. (23.3 x 18.4 cm.)
Mount: 17 3/8 x 13 3/16 in. (44.0 x 33.5 cm.)
Signed, l.r. print recto: "Karl Struss 1910"
l.r. mount recto: "Karl Struss."
Inscription, print recto: "© [Karl Struss' colophon] 1910."
print verso: ""Earl Hall'/"Columbia University, Night."/
Copt Karl Struss 1910./Gum Platinum."
mount verso: "#38//VAN·DYKE-GUM-PLATINUM./
#22—EARLE [sic] HALL—NIGHT. C. U." and rubber
stamp "KARL STRUSS/ARTIST PHOTOGRAPHER/
HOLLYWOOD :: CALIFORNIA"
Acquired from: Stephen White Gallery of Photography, Inc.,
Los Angeles, California

5131. **EAST RIVER AT 36 ST. LOOKING SOUTHEAST
(OFF 1 STAVE)** (P1983.23.8)
Platinum print. 1912
Image: 4 7/16 x 3 3/4 in. (11.3 x 9.5 cm.)
1st mount: 4 5/8 x 3 7/8 in. (11.7 x 9.8 cm.)
2nd mount: 5 3/8 x 4 5/8 in. (13.6 x 11.7 cm.)
Inscription, 2nd mount recto: "1912."
2nd mount verso: "East River/at 36 St. looking/
Southeast/(off 1 stave)/1912//#8"
Acquired from: Stephen White Gallery of Photography, Inc.,
Los Angeles, California

*5132. **EAST SIDE PROMENADE** (P1983.23.94)
Platinum print. 1911
Image: 4 1/4 x 3 13/16 in. (10.7 x 9.7 cm.)
1st mount: 4 3/8 x 3 15/16 in. (11.1 x 10.0 cm.)
2nd mount: 5 x 4 1/2 in. (12.8 x 11.5 cm.)
Signed, l.l. print recto: "Karl Struss 1911."
Inscription, 1st mount verso: "219"
2nd mount recto: "1911"
2nd mount verso: "45//(45)/69"
Acquired from: Stephen White Gallery of Photography, Inc.,
Los Angeles, California

*5133. **EASTSIDE, NEW YORK [Chimneys—Consolidated Edison.
New York]** (P1983.23.84)
Platinum print. 1912
Image: 4 5/16 x 3 5/8 in. (10.9 x 9.2 cm.)
Mount: 4 7/16 x 3 3/4 in. (11.2 x 9.5 cm.)
Signed, l.l. print recto: "Karl Struss 1912"
Inscription, mount verso: "Eastside, New Yo[rk]//(37)/85"
and rubber stamp "KARL STRUSS/INTERPRETIVE
PHOTOGRAPHS/5 WEST 31st STREET/NEW YORK/
Madison Sq. 674"
Acquired from: Stephen White Gallery of Photography, Inc.,
Los Angeles, California

5134. **ETHEL PRAGUE WITH UMBRELLA, LONG ISLAND**
(P1983.24.46) print from this autochrome is in the "Dawn of Color" portfolio, P1983.23.188
Autochrome. c. 1910
Image: 8 x 6 in. (20.3 x 15.3 cm.)
Plate: 8½ x 6½ in. (21.5 x 16.5 cm.)
Acquired from: Stephen White Gallery of Photography, Inc., Los Angeles, California

5135. **EUCALYPTUS** (P1983.23.156)
Bromide print. 1922
Image: 10¹¹/₁₆ x 13⁵/₁₆ in. (27.0 x 33.8 cm.)
Mount: 14 x 17 in. (35.6 x 43.2 cm.)
Signed, l.l. print recto: "Karl Struss 1922"
l.r. mount recto: "Karl Struss 1922—"
Inscription, mount recto: "Eucalyptus/Bromide//1"
mount verso: "©/not to be reproduced//#70." and rubber stamp "KARL STRUSS/ARTIST PHOTOGRAPHER/ HOLLYWOOD :: CALIFORNIA" and printed paper label "THIS PRINT HAS BEEN EXHIBITED/In the GALLERY.∴˙of the/CALIFORNIA CAMERA CLUB— /during the Month of [in ink] June 1929./[in ink] Mr Ralph Smith/CHAIRMAN PRINT COMMITTEE./ San Francisco California."
Acquired from: Stephen White Gallery of Photography, Inc., Los Angeles, California

5129

* 5136. **EUCALYPTUS, POEMS** (P1983.23.158)
Bromide print. 1921
Image: 12¼ x 9⅜ in. (31.0 x 23.8 cm.)
Sheet: 13¹³/₁₆ x 10¹³/₁₆ in. (35.2 x 27.4 cm.)
Mount: 16¾ x 14¹/₁₆ in. (42.4 x 35.7 cm.)
Signed, l.l. print recto: "Karl Struss. 1921."
l.r. sheet recto: "Karl Struss."
Inscription, mount recto: "9⅞ / 12⅞"
mount verso: "#4//85 [illegible]//"Poems"//#7— "EUCALYPTUS, POEMS"//B//5th/[W]ESTERN SALON Of/[Pic]TORIAL·PHOTOGRAPHY/1926/ [L]OS·ANGELES—24//5//109//#1//A//[illegible]" and rubber stamp "KARL STRUSS/ARTIST PHOTOGRAPHER/HOLLYWOOD :: CALIFORNIA" and printed paper labels "THIS PRINT/WAS HUNG/AT THE SCOTTISH/INTERNATIONAL SALON/OF PICTORIAL PHOTOGRAPHY/PEOPLES PALACE/ GLASGOW/1926 Dec–Jan 1927" and "SOUTHERN CALIFORNIA/CAMERA CLUB/OF THE SOUTHWEST MUSEUM/MAÑANA/FLOR DE/SUS/ AYERES/LOS ANGELES//Fifth Annual/WESTERN SALON/OF/PICTORIAL/PHOTOGRAPHY/1926/LOS ANGELES CALIFORNIA" and "THE SEVENTEENTH/ PITTSBURGH SALON/OF PHOTOGRAPHIC ART// This picture was accepted by the/jury of selection and was ex-/hibited in the Fine Arts Gal-/leries of Carnegie Institute from/March 21st to April 20th, 1930/THE JURY/ Howard D. Beach, Buffalo/G. W. Harting, New York/ Charles Lederle, Cleveland" and "MEMBER/PICTORIAL/ PHOTOGRAPHER[s]/OF AMERICA"
Acquired from: Stephen White Gallery of Photography, Inc., Los Angeles, California

5132

* 5137. **EVERY DAY IS KODAK DAY [Hilda Wright]** (P1983.23.174)
Bromide print. 1915
Image: 12⅞ x 7⅞ in. (32.6 x 20.1 cm.)
Sheet: 13 x 8¹/₁₆ in. (32.9 x 20.4 cm.)
Inscription, in negative: "KODAK//EVERY DAY/IS KODAK DAY"
print verso: "Every Day is Kodak Day/Karl Struss/#13— Bro·/Plat//2" and rubber stamp "KARL STRUSS/ARTIST PHOTOGRAPHER/HOLLYWOOD :: CALIFORNIA"
Acquired from: Stephen White Gallery of Photography, Inc., Los Angeles, California

5133

587

5138. **[Female nude]** (P1983.23.194) duplicate of P1983.23.195
Hess-Ives color print. c. 1917
Image: 4 3/8 x 3 3/16 in. (11.2 x 8.1 cm.) oval
Sheet: 4 7/8 x 3 3/8 in. (12.3 x 8.5 cm.) oval
Mount: same as sheet size
Inscription, mount verso: [trimmed]OTOGR[trimmed]/
THE [trimmed] Corpora[trimmed]/1201 Race [St.]/
Philadelphia.P[a.]"
Acquired from: Stephen White Gallery of Photography, Inc.,
Los Angeles, California

* 5139. **[Female nude]** (P1983.23.195) duplicate of P1983.23.194
Hess-Ives color print. c. 1917
Image: 4 3/8 x 3 1/8 in. (11.2 x 7.9 cm.) oval
Sheet: 5 x 3 1/2 in. (12.5 x 8.9 cm.) oval
Inscription, mount verso: "First" and "[trimmed]E/
[trimmed]GRAPH//1201 Race St./Philadelphia.Pa."
Acquired from: Stephen White Gallery of Photography, Inc.,
Los Angeles, California

5140. **[Female nude]** (P1983.23.219)
Hess-Ives color print. c. 1917
Image: 8 3/4 x 5 3/4 in. (22.3 x 14.7 cm.)
Sheet: 9 1/8 x 6 in. (23.0 x 15.3 cm.)
Mount: same as image size
Acquired from: Stephen White Gallery of Photography, Inc.,
Los Angeles, California

5141. **THE FERRY—BERMUDA** (P1983.23.161)
Platinum print. 1912
Image: 8 15/16 x 7 1/8 in. (22.6 x 18.1 cm.)
Mount: 17 1/8 x 13 in. (43.5 x 33.0 cm.)
Signed, l.l. print recto: "Karl Struss 1912."
l.r. mount recto: "Karl Struss."
Inscription, mount verso: "#32/"THE·FERRY—
BERMUDA."/#24//564 B" and rubber stamp "KARL
STRUSS/ARTIST PHOTOGRAPHER/HOLLYWOOD ::
CALIFORNIA"
Acquired from: Stephen White Gallery of Photography, Inc.,
Los Angeles, California

5142. **5TH AVE. & 34TH ST.** (P1983.23.70)
Gelatin silver print. 1912
Image: 12 1/16 x 10 1/8 in. (30.6 x 25.7 cm.)
Mount: 17 x 14 in. (43.2 x 35.6 cm.)
Signed, l.r. mount recto: "Karl Struss."
Inscription, mount recto: "1912./"5" AVE·&·34" ST.""
mount verso: "#55.//(30)/12" and rubber stamp "KARL
STRUSS/ARTIST PHOTOGRAPHER/HOLLYWOOD ::
CALIFORNIA" and printed paper label "THIS PRINT
HAS BEEN EXHIBITED/In the Gallery.·.·.·of the/
CALIFORNIA CAMERA CLUB—/during the Month of
[blank]/[blank]/CHAIRMAN PRINT COMMITTEE./San
Francisco California."
Acquired from: Stephen White Gallery of Photography, Inc.,
Los Angeles, California

5143. **FIRE—POLO GROUNDS—N.Y.C.** (P1983.23.62)
Platinum print. 1911
Image: 3 11/16 x 4 11/16 in. (9.4 x 11.9 cm.)
Mount: 3 15/16 x 4 7/8 in. (10.0 x 12.3 cm.)
Inscription, mount verso: "Fire—Polo Field [sic]—
NYC.//#119"
Acquired from: Stephen White Gallery of Photography, Inc.,
Los Angeles, California

5144. **[Flower bed]** (P1983.24.20)
Autochrome. c. 1910–17
Image: 2 13/16 x 3 9/16 in. (7.1 x 9.0 cm.)
Plate: 3 1/4 x 4 in. (8.2 x 10.1 cm.)
Acquired from: Stephen White Gallery of Photography, Inc.,
Los Angeles, California

5145. **[Flower bed of purple and yellow iris]** (P1983.24.17)
Autochrome. c. 1910–17
Image: 2 3/4 x 3 9/16 in. (7.1 x 9.1 cm.)
Plate: 3 1/4 x 4 in. (8.2 x 10.1 cm.)

Inscription, plate edge: "+"
Acquired from: Stephen White Gallery of Photography, Inc.,
Los Angeles, California

* 5146. **FROM RIVERSIDE DRIVE, 3 SCULLS ON HUDSON**
(P1983.23.37)
Platinum print. 1911
Image: 3 1/8 x 4 7/16 in. (7.9 x 11.3 cm.)
1st mount: 3 1/4 x 4 9/16 in. (8.2 x 11.6 cm.)
2nd mount: 3 5/8 x 5 in. (9.2 x 12.6 cm.)
Inscription, 2nd mount recto: "1911."
2nd mount verso: "fr./Riverside Drive/3 sculls on
Hudson//1911//#37"
Acquired from: Stephen White Gallery of Photography, Inc.,
Los Angeles, California

5147. **GATEWAY TO VILLA CARLOTTA** (P1983.23.101)
Platinum print. 1909
Image: 3 15/16 x 2 13/16 in. (10.0 x 7.2 cm.)
Inscription, print verso: "Gateway to/Villa Carlotta/1909//
#130"
Acquired from: Stephen White Gallery of Photography, Inc.,
Los Angeles, California

* 5148. **GLORIA SWANSON IN THE LION'S DEN—FANTASY
SEQUENCE FROM "MALE AND FEMALE"**
(P1983.23.171)
Gelatin silver print. 1919
Image: 6 7/8 x 8 15/16 in. (17.4 x 22.6 cm.)
Sheet: 7 x 9 1/8 in. (17.8 x 22.9 cm.)
Mount: 11 7/8 x 14 in. (30.1 x 35.6 cm.)
Signed, l.l. print recto: "Karl Struss 1919"
l.r. mount recto: "Karl Struss."
Inscription, print recto, embossed: "KARL STRUSS"
print verso, rubber stamps: "PHOTOGRAPHED BY/
KARL STRUSS/Famous Players—Lasky Corp./
HOLLYWOOD, CALIF." and "KARL STRUSS"
mount recto: "1919"
mount verso, rubber stamp: "PHOTOGRAPHED BY/
KARL STRUSS/HOLLYWOOD :: CALIFORNIA"
Acquired from: Stephen White Gallery of Photography, Inc.,
Los Angeles, California

5149. **GLORIA SWANSON WITH BALL** (P1983.23.168)
Gelatin silver print. 1919
Image: 9 1/8 x 7 1/16 in. (23.0 x 17.9 cm.)
Mount: 14 x 12 15/16 in. (35.6 x 32.8 cm.)
Signed, l.l. print recto and l.r. mount recto: "Karl Struss."
Acquired from: Stephen White Gallery of Photography, Inc.,
Los Angeles, California

5150. **GLORIA SWANSON WITH BALL—III** (P1983.23.167)
Gelatin silver print. 1919
Image: 9 3/8 x 7 7/16 in. (23.8 x 18.6 cm.)
Mount: 14 5/16 x 12 15/16 in. (36.3 x 32.9 cm.)
Signed, l.l. print recto: "Karl Struss"
l.r. mount recto: "Karl Struss."
Inscription, mount recto: "1919."
Acquired from: Stephen White Gallery of Photography, Inc.,
Los Angeles, California

* 5151. **GRAND CENTRAL—MEN WALKING** (P1983.23.11)
Platinum print. c. 1911–14
Image: 4 5/8 x 3 5/8 in. (11.8 x 9.3 cm.)
Mount: 4 15/16 x 3 15/16 in. (12.5 x 10.0 cm.)
Inscription, mount verso: "10 1/2/Doublet F5//Grand Central—
men walking/1911//#11"
Acquired from: Stephen White Gallery of Photography, Inc.,
Los Angeles, California

5152. **GRAND CENTRAL N.Y.C., TROLLEY ON RIGHT**
(P1983.23.10)
Platinum print. c. 1911–14
Image: 4 7/16 x 3 11/16 in. (11.2 x 9.3 cm.)
Inscription, print verso: "Grand Central NYC/Trolley on
right—1911//#10"
Acquired from: Stephen White Gallery of Photography, Inc.,
Los Angeles, California

5136

5137

5139

5146

5148

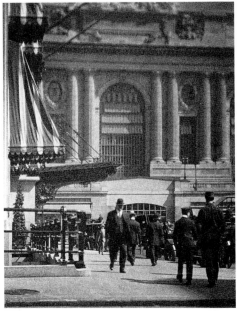

5151

5153. **GRAND CENTRAL STATION, N.Y.C.** (P1983.23.1)
Platinum print. c. 1911–14
Image: 4¼ x 3⅝ in. (10.8 x 9.2 cm.)
1st mount: 4½ x 3⅞ in. (11.5 x 9.9 cm.)
2nd mount: 5⅛ x 4⁵⁄₁₆ in. (13.0 x 11.0 cm.)
Inscription, 1st mount verso: "Doublet 10½"/F5."
2nd mount verso: "1911.//Grand Central Station/
NYC—/#1"
Acquired from: Stephen White Gallery of Photography, Inc.,
Los Angeles, California

5154. **GRANT'S TOMB—N.Y.C.** (P1983.23.25)
Platinum print. c. 1911–12
Image: 3⅛ x 2¹⁵⁄₁₆ in. (7.9 x 7.5 cm.)
1st mount: 3¾ x 3⁹⁄₁₆ in. (9.5 x 9.0 cm.)
2nd mount: 3¹³⁄₁₆ x 3¹¹⁄₁₆ in. (9.7 x 9.3 cm.)
Inscription, 2nd mount verso: "Grant's Tomb—NYC./
1911–12//#25"
Acquired from: Stephen White Gallery of Photography, Inc.,
Los Angeles, California

5155. **[Hamilton, Bermuda—across Hamilton Harbor]** (P1983.24.29)
Autochrome. c. 1913–14
Image: 4⁹⁄₁₆ x 3⁹⁄₁₆ in. (11.6 x 9.1 cm.)
Plate: 5 x 4 in. (12.6 x 10.1 cm.)
Acquired from: Stephen White Gallery of Photography, Inc.,
Los Angeles, California

5156. **[Hamilton, Bermuda—close-up of the *Bermudian* docked in Hamilton Harbor]** (P1983.24.21)
Autochrome. c. 1913–14
Image: 4⁷⁄₁₆ x 3½ in. (11.3 x 8.9 cm.)
Plate: 5 x 4 in. (12.6 x 10.1 cm.)
Acquired from: Stephen White Gallery of Photography, Inc.,
Los Angeles, California

5157. **[Hamilton, Bermuda—the *Bermudian* docked in Hamilton Harbor]** (P1983.24.22)
Autochrome. c. 1913–14
Image: 3½ x 4½ in. (8.9 x 11.5 cm.)
Plate: 4 x 5 in. (10.1 x 12.6 cm.)
Acquired from: Stephen White Gallery of Photography, Inc.,
Los Angeles, California

5158. **[Hamilton, Bermuda—view across Hamilton Harbor showing the cathedral and Bermuda parliament building]** (P1983.24.26)
Autochrome. c. 1913–14
Image: 4⁹⁄₁₆ x 3½ in. (11.5 x 9.0 cm.)
Plate: 5 x 4 in. (12.6 x 10.1 cm.)
Acquired from: Stephen White Gallery of Photography, Inc.,
Los Angeles, California

5159. **[Hamilton, Bermuda—view across Hamilton Harbor showing the cathedral and Bermuda parliament building]** (P1983.24.27)
Autochrome. c. 1913–14
Image: 3½ x 4⁹⁄₁₆ in. (8.9 x 11.5 cm.)
Plate: 4 x 5 in. (10.1 x 12.6 cm.)
Acquired from: Stephen White Gallery of Photography, Inc.,
Los Angeles, California

5160. **[Hamilton, Bermuda—view of the town across Hamilton Harbor, shaded lane in foreground]** (P1983.24.25)
Autochrome. c. 1913–14
Image: 3⁹⁄₁₆ x 4½ in. (9.1 x 11.5 cm.)
Plate: 4 x 5 in. (10.1 x 12.6 cm.)
Acquired from: Stephen White Gallery of Photography, Inc.,
Los Angeles, California

5161. **HARVESTING, NOVA SCOTIA [around Chester]** (P1983.23.134)
Platinum print. 1911
Image: 3⁹⁄₁₆ x 4⁷⁄₁₆ in. (9.0 x 11.3 cm.)
1st mount: 3¹¹⁄₁₆ x 4⁹⁄₁₆ in. (9.4 x 11.6 cm.)
2nd mount: 4³⁄₁₆ x 5¹⁄₁₆ in. (10.5 x 12.8 cm.)

Inscription, 2nd mount recto: "1911."
2nd mount verso: "Harvesting/Nova Scotia—1911//#72"
Acquired from: Stephen White Gallery of Photography, Inc.,
Los Angeles, California

5162. **HEMLOCK BEACH—STRUSS BOYS SAILING** (P1983.23.179)
Bromide print. 1915
Image: 4⅝ x 3¹¹⁄₁₆ in. (11.8 x 9.4 cm.)
Sheet: 4¹⁵⁄₁₆ x 4 in. (12.5 x 10.2 cm.)
Acquired from: Stephen White Gallery of Photography, Inc.,
Los Angeles, California

5163. **[Henry W. Struss and Marie Fischer Struss—Karl Struss' parents]** (P1983.24.5)
Autochrome. c. 1910–17
Image: 3½ x 2⅞ in. (8.8 x 7.3 cm.)
Plate: 4 x 3¼ in. (10.1 x 8.2 cm.)
Acquired from: Stephen White Gallery of Photography, Inc.,
Los Angeles, California

* 5164. **HORSE-DRAWN RIG BENEATH EL. N.Y.C.** (P1983.23.21)
Platinum print. 1911
Image: 4⁷⁄₁₆ x 3⅞ in. (11.3 x 9.7 cm.)
1st mount: 4⁹⁄₁₆ x 3¹⁵⁄₁₆ in. (11.5 x 10.0 cm.)
2nd mount: 5 x 4⁷⁄₁₆ in. (12.7 x 11.3 cm.)
Inscription, 2nd mount recto: "1911."
2nd mount verso: "Horse-drawn rig beneath El./1911
NYC.//#21"
Acquired from: Stephen White Gallery of Photography, Inc.,
Los Angeles, California

* 5165. **HOTEL BILTMORE. NEW YORK** (P1983.23.81)
Bromide print. c. 1913
Image: 4¹⁄₁₆ x 3¹¹⁄₁₆ in. (10.3 x 9.3 cm.)
1st mount: 4¼ x 3¹³⁄₁₆ in. (10.7 x 9.7 cm.)
2nd mount: 5¹⁄₁₆ x 4⅜ in. (12.7 x 11.1 cm.)
Inscription, 1st mount verso: "Doublet 10½"/F5."
2nd mount verso: "46//(46)/94"
Acquired from: Stephen White Gallery of Photography, Inc.,
Los Angeles, California

5166. **HOTEL PLAZA** (P1983.23.57)
Platinum print. 1912
Image: 3⁹⁄₁₆ x 2⅞ in. (9.0 x 7.2 cm.)
1st mount: 3¹¹⁄₁₆ x 3 in. (9.4 x 7.5 cm.)
2nd mount: 4¹⁄₁₆ x 3⅜ in. (10.2 x 8.6 cm.)
Signed, bottom center 2nd mount verso: "Karl Struss"
Inscription, 2nd mount verso: "Hotel Plaza.//1912//#110"
Acquired from: Stephen White Gallery of Photography, Inc.,
Los Angeles, California

* 5167. **HOUSETOPS—WINTER** (P1983.23.85)
Platinum print. 1915
Image: 4⁹⁄₁₆ x 3¹¹⁄₁₆ in. (11.6 x 9.4 cm.)
Mount: 10¼ x 9 in. (26.0 x 22.8 cm.)
Signed, l.l. print recto: "Karl Struss"
l.r. mount recto: "Karl Struss."
Inscription, mount recto: "1915."
mount verso: ""Housetops—Winter,"/Platinum Print.//36"
and rubber stamps "PHOTOGRAPHED BY/KARL
STRUSS/HOLLYWOOD, CALIF." and "Accepted and
Hung/January, 1923/Southwest Museum/Southern
California Camera Club/Los Angeles" and printed
paper labels "MUSEUM OF THE CITY OF NEW YORK/
"VIEWS OF NEW YORK—OLD AND NEW"/Exhibited
By/PICTORIAL PHOTOGRAPHERS of AMERICA/
November 9th to November 23, 1936" and "THIS PRINT
HAS BEEN EXHIBITED/In the GALLERY.˙.˙.˙of the/
CALIFORNIA CAMERA CLUB—/during the Month of
[blank]/[blank]/CHAIRMAN PRINT COMMITTEE./San
Francisco California."
Acquired from: Stephen White Gallery of Photography, Inc.,
Los Angeles, California

5168. **HUDSON—RIVERSIDE DRIVE PARK** (P1983.23.87)
Platinum print. 1911
Image: 3⅝ x 4¼ in. (9.2 x 10.8 cm.)
1st mount: 4⁷⁄₁₆ x 4⁷⁄₁₆ in. (11.2 x 11.2 cm.)
2nd mount: 9 x 6⅜ in. (22.9 x 16.2 cm.)
Signed, l.r. 2nd mount recto: "Karl Struss"
Inscription, 2nd mount verso: "Hudson—Riverside Drive/ Park"
Acquired from: Stephen White Gallery of Photography, Inc., Los Angeles, California

* 5169. **JAPANESQUE** (P1983.23.159)
Platinum print. 1919
Image: 9½ x 7½ in. (24.1 x 19.1 cm.)
1st mount: 9⅝ x 7¹¹⁄₁₆ in. (24.4 x 19.5 cm.)
2nd mount: 17⅛ x 13¹⁄₁₆ in. (43.5 x 33.2 cm.)
Signed, l.l. print recto: "Karl Struss 1919."
l.r. 2nd mount recto: "Karl Struss."
Inscription, 2nd mount recto: "6"
2nd mount verso: "#23 "JAPANESQUE."//Platinum Print//BSR" and rubber stamp "KARL STRUSS/ARTIST PHOTOGRAPHER/HOLLYWOOD :: CALIFORNIA" and printed paper label "THIS PRINT HAS BEEN EXHIBITED/In the GALLERY.˙.˙.˙of the/CALIFORNIA CAMERA CLUB—/during the Month of [blank]/[blank]/ CHAIRMAN PRINT COMMITTEE./San Francisco California."
mat backing recto: "1913"
note: this may be a reused mat backing
Acquired from: Stephen White Gallery of Photography, Inc., Los Angeles, California

5170. **[Johannes Sembach in costume standing beside lake]** (P1983.24.11)
Autochrome. c. 1918
Image: 4⅝ x 3⅝ in. (11.7 x 9.1 cm.)
Plate: 5 x 4 in. (12.6 x 10.1 cm.)
Acquired from: Stephen White Gallery of Photography, Inc., Los Angeles, California

KARL STRUSS: A PORTFOLIO 1909/29
(P1980.3.1—15)

This portfolio was published in 1979 by Photofolio of Ann Arbor, Michigan. It consists of an edition of 75 portfolios plus 15 artist's proof copies. This is portfolio number 27. The prints are modern platinum prints made by Phil Davis from the original negatives under Struss' supervision.

* 5171. **THE BALCONY, SORRENTO** (P1980.3.1) duplicate of P1983.23.113
Platinum print. negative 1909, print 1979 by Phil Davis
Image: 2⅞ x 3¹³⁄₁₆ in. (7.3 x 9.6 cm.)
Mount: 12 x 9 in. (30.6 x 22.8 cm.)
Signed, l.r. print verso: "Karl Struss."
Inscription, mount recto: "27/75"
Acquired from: The Witkin Gallery, New York, New York

5172. **ARVERNE, LOW TIDE** (P1980.3.2)
Platinum print. negative 1912, print 1979 by Phil Davis
Image: 4¼ x 3⁹⁄₁₆ in. (10.8 x 9.1 cm.)
Mount: 12 x 9 in. (30.6 x 22.8 cm.)
Signed, l.r. print verso: "Karl Struss."
Inscription, mount recto: "27/75"
Acquired from: The Witkin Gallery, New York, New York

5173. **MERCEDES AUTOBUS. FIFTH AVENUE & 38TH STREET, NEW YORK** (P1980.3.3)
Platinum print. negative c. 1912, print 1979 by Phil Davis
Image: 3⅝ x 4⅝ in. (9.3 x 11.7 cm.)
Mount: 12 x 9 in. (30.6 x 22.8 cm.)
Signed, l.r. print verso: "Karl Struss."
Inscription, mount recto: "27/75"
Acquired from: The Witkin Gallery, New York, New York

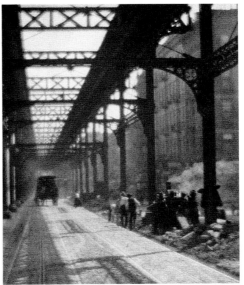
5164

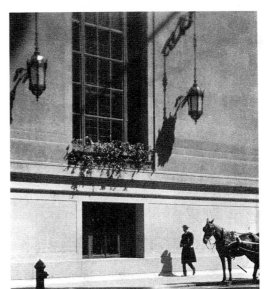
5165

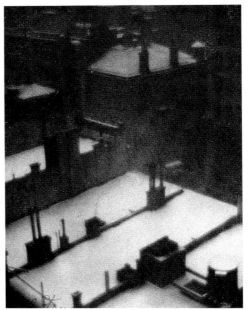
5167

5174. **SHADOWS. NEW YORK [Lower Broadway, New York]**
(P1980.3.4) duplicate of P1983.23.96
Platinum print. negative 1909, print 1979 by Phil Davis
Image: 4 ⅝ x 3 9/16 in. (11.7 x 9.0 cm.)
Mount: 12 x 9 in. (30.6 x 22.8 cm.)
Signed, l.r. print verso: "Karl Struss"
Inscription, mount recto: "27/75"
Acquired from: The Witkin Gallery, New York, New York

*5175. **CONSOLIDATED EDISON FROM THE SECOND
AVENUE ELEVATED. NEW YORK** (P1980.3.5)
Platinum print. negative c. 1912, print 1979 by Phil Davis
Image: 3 ¾ x 4 ½ in. (9.4 x 11.4 cm.)
Mount: 12 x 9 in. (30.6 x 22.8 cm.)
Signed, l.r. print verso: "Karl Struss."
Inscription, mount recto: "27/75"
Acquired from: The Witkin Gallery, New York, New York

5176. **METROPOLITAN LIFE INSURANCE TOWER. NEW
YORK** (P1980.3.6)
Platinum print. negative 1909, print 1979 by Phil Davis
Image: 4 ½ x 2 15/16 in. (11.4 x 7.5 cm.)
Mount: 12 x 9 in. (30.6 x 22.8 cm.)
Signed, l.r. print verso: "Karl Struss."
Inscription, mount recto: "27/75"
Acquired from: The Witkin Gallery, New York, New York

5177. **PENNSYLVANIA STATION. NEW YORK** (P1980.3.7)
duplicate of P1983.23.95
Platinum print. negative 1911, print 1979 by Phil Davis
Image: 4 9/16 x 3 ½ in. (11.6 x 8.9 cm.)
Mount: 12 x 9 in. (30.6 x 22.8 cm.)
Signed, l.r. print verso: "Karl Struss."
Inscription, mount recto: "27/75"
Acquired from: The Witkin Gallery, New York, New York

5178. **LOWER BROADWAY. NEW YORK** (P1980.3.8)
Platinum print. negative 1912, print 1979 by Phil Davis
Image: 2 ⅞ x 3 7/16 in. (7.2 x 8.7 cm.)
Mount: 12 x 9 in. (30.6 x 22.8 cm.)
Signed, l.r. print verso: "Karl Struss."
Inscription, mount recto: "27/75"
Acquired from: The Witkin Gallery, New York, New York

5179. **"THE GHOST SHIP"—WATERFRONT, EAST SIDE.
NEW YORK** (P1980.3.9)
Platinum print. negative 1912, print 1979 by Phil Davis
Image: 4 7/16 x 3 13/16 in. (11.2 x 9.6 cm.)
Mount: 12 x 9 in. (30.6 x 22.8 cm.)
Signed, l.r. print verso: "Karl Struss."
Inscription, mount recto: "27/75"
Acquired from: The Witkin Gallery, New York, New York

*5180. **VANISHING POINT II: BROOKLYN BRIDGE FROM
NEW YORK SIDE** (P1980.3.10) duplicate of P1983.23.93
Platinum print. negative 1912, print 1979 by Phil Davis
Image: 3 13/16 x 4 ⅝ in. (9.6 x 11.7 cm.)
Mount: 12 x 9 in. (30.6 x 22.8 cm.)
Signed, l.r. print verso: "Karl Struss."
Inscription, mount recto: "27/75"
Acquired from: The Witkin Gallery, New York, New York

5181. **BROOKLYN BRIDGE, NOCTURNE** (P1980.3.11) duplicate
of P1983.23.75
Platinum print. negative c. 1912–13, print 1979 by Phil Davis
Image: 3 ⅝ x 4 9/16 in. (9.3 x 11.6 cm.)
Mount: 12 x 9 in. (30.6 x 22.8 cm.)
Signed, l.r. print verso: "Karl Struss."
Inscription, mount recto: "27/75"
Acquired from: The Witkin Gallery, New York, New York

5182. **BROOKLYN BRIDGE FROM FERRY SLIP, EVENING**
(P1980.3.12)
Platinum print. negative 1912, print 1979 by Phil Davis
Image: 4 9/16 x 3 ¾ in. (11.6 x 9.6 cm.)
Mount: 12 x 9 in. (30.6 x 22.8 cm.)

Signed, l.r. print verso: "Karl Struss."
Inscription, mount recto: "27/75"
Acquired from: The Witkin Gallery, New York, New York

5183. **CABLES—NEW YORK SKYLINE THROUGH
BROOKLYN BRIDGE** (P1980.3.13)
Platinum print. negative c. 1910–12, print 1979 by Phil Davis
Image: 4 ½ x 3 11/16 in. (11.4 x 9.4 cm.)
Mount: 12 x 9 in. (30.6 x 22.8 cm.)
Signed, l.r. print verso: "Karl Struss."
Inscription, mount recto: "27/75"
Acquired from: The Witkin Gallery, New York, New York

5184. **STORM CLOUDS. LA MESA, CALIFORNIA** (P1980.3.14)
Platinum print. negative 1921, print 1979 by Phil Davis
Image: 4 ½ x 3 ⅝ in. (11.4 x 9.3 cm.)
Mount: 12 x 9 in. (30.6 x 22.8 cm.)
Signed, l.r. print verso: "Karl Struss."
Inscription, mount recto: "27/75"
Acquired from: The Witkin Gallery, New York, New York

*5185. **SAILS: EN ROUTE TO CATALINA** (P1980.3.15) duplicate
of P1983.23.160
Platinum print. negative 1929, print 1979 by Phil Davis
Image: 4 11/16 x 3 ⅝ in. (11.9 x 9.3 cm.)
Mount: 12 x 9 in. (30.6 x 22.8 cm.)
Signed, l.r. print verso: "Karl Struss."
Inscription, mount recto: "27/75"
Acquired from: The Witkin Gallery, New York, New York

* * * *

5186. **[Karl Struss, on right, standing outdoors with three other
people]** (P1983.24.6)
Autochrome. c. 1910–17
Image: 2 13/16 x 3 9/16 in. (7.1 x 9.1 cm.)
Plate: 3 ¼ x 4 in. (8.2 x 10.1 cm.)
Acquired from: Stephen White Gallery of Photography, Inc.,
Los Angeles, California

5187. **[Karl Struss, second from left, with a group at a picnic on the
beach]** (P1983.24.7)
Autochrome. c. 1910–17
Image: 2 7/16 x 3 ¼ in. (6.2 x 8.3 cm.)
Plate: 3 ¼ x 4 in. (8.2 x 10.1 cm.)
Acquired from: Stephen White Gallery of Photography, Inc.,
Los Angeles, California

5188. **[Karl Struss, wearing gray suit]** (P1983.24.1)
Autochrome. c. 1910–17
Image: 4 9/16 x 3 ⅝ in. (11.6 x 9.2 cm.)
Plate: 5 x 4 in. (12.6 x 10.1 cm.)
Acquired from: Stephen White Gallery of Photography, Inc.,
Los Angeles, California

5189. **[Karl Struss, wearing gray suit]** (P1983.24.2)
Autochrome. c. 1910–17
Image: 3 ⅝ x 2 ¾ in. (9.1 x 7.0 cm.)
Plate: 4 x 3 ¼ in. (10.1 x 8.2 cm.)
Acquired from: Stephen White Gallery of Photography, Inc.,
Los Angeles, California

5190. **LA FAYETTE BOULEVARD** (P1983.23.69)
Platinum print. 1914
Image: 8 ⅞ x 7 ⅜ in. (22.5 x 18.7 cm.)
1st mount: 9 x 7 ½ in. (22.9 x 19.0 cm.)
2nd mount: 17 x 13 in. (43.2 x 33.2 cm.)
Signed, l.l. print recto: "Karl Struss 1914.//Karl Struss
1910 [sic]."
l.r. 2nd mount recto: "Karl Struss."
Inscription, 2nd mount verso: "#26—LA
FAYETTE·BOULEVARD." and rubber stamp "KARL
STRUSS/ARTIST PHOTOGRAPHER/HOLLYWOOD ::
CALIFORNIA"
Acquired from: Stephen White Gallery of Photography, Inc.,
Los Angeles, California

5169

5171

5175

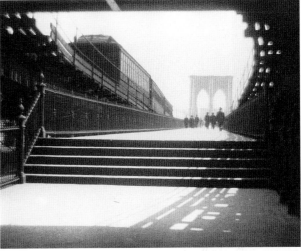

5180

5185

5191

*5191. **THE LANDING PLACE—VILLA CARLOTTA**
(P1983.23.117)
Hand-coated multiple platinum print. 1909
Image: 4 9/16 x 6 13/16 in. (11.5 x 17.2 cm.)
Mount: 15 7/8 x 12 13/16 in. (40.3 x 32.6 cm.)
Signed, l.l. print recto: "Karl Struss 1909."
l.r. mount recto: "Karl Struss."
Inscription, mount recto: "1909.//5 1/8/7 1/4//12"
mount verso: "#27/#76/#14 "The Landing Place—Villa
Carlotta."//Hand-coated Multiple Platinum Print./$500"
and rubber stamp "PHOTOGRAPHED BY/KARL
STRUSS/HOLLYWOOD, CALIF." and printed paper labels
"THIS PRINT HAS BEEN EXHIBITED/In the
GALLERY.∴ of the/CALIFORNIA CAMERA CLUB—
/during the Month of [in ink] June 1929/[in ink] Mr Ralph
Smith/CHAIRMAN PRINT COMMITTEE./San
Francisco California." and "Los Angeles Camera
Club/108-12 Stimson Bldg.: 129 West Third St./LOS
ANGELES, CALIFORNIA/(Affiliated with the
Associated/Camera Clubs of America)/[LACC insignia]/
EXHIBITED AT THE LOS/ANGELES CAMERA CLUB"
and "MEMBER/[PPA insignia]/PICTORIAL/
PHOTOGRAPHERS/OF AMERICA"
Acquired from: Stephen White Gallery of Photography, Inc.,
Los Angeles, California

5192. [Landscape—bird's-eye view of harbor from lush,
tree-covered hilltop] (P1983.24.55)
Autochrome. c. 1910–17
Image: 8 x 6 in. (20.3 x 15.2 cm.)
Plate: 8 1/2 x 6 1/2 in. (21.5 x 16.5 cm.)
Acquired from: Stephen White Gallery of Photography, Inc.,
Los Angeles, California

5193. [Landscape—looking across water at a pass between two hills]
(P1983.24.54)
Autochrome. c. 1910–17
Image: 8 1/16 x 6 in. (20.4 x 15.2 cm.)
Plate: 8 1/2 x 6 1/2 in. (21.5 x 16.5 cm.)
Acquired from: Stephen White Gallery of Photography, Inc.,
Los Angeles, California

5194. **LILIAN STRUSS—STUDY—N.Y.C.** (P1983.23.138)
Platinum print. 1911
Image: 5 13/16 x 4 1/8 in. (14.8 x 10.5 cm.)
1st mount: 5 15/16 x 4 1/4 in. (15.0 x 10.8 cm.)
2nd mount: 6 5/16 x 4 5/8 in. (16.0 x 11.7 cm.)
Inscription, 2nd mount recto: "1911."
2nd mount verso: "Lilian Struss—Study/1911—NYC.//#51"
Acquired from: Stephen White Gallery of Photography, Inc.,
Los Angeles, California

*5195. **"LINES"—ON TOWER AT LEFT—GATE
FOREGROUND—N.Y. [view showing Woolworth
Building]** (P1983.23.46)
Platinum print. c. 1913
Image: 4 1/4 x 3 9/16 in. (10.7 x 9.1 cm.)
1st mount: 4 3/8 x 3 11/16 in. (11.1 x 9.4 cm.)
2nd mount: 4 15/16 x 4 1/4 in. (12.5 x 10.8 cm.)
Inscription, 2nd mount verso: ""Lines"—on Tower at L—
Gate foreground/1911 [sic] N.Y.//#46"
Acquired from: Stephen White Gallery of Photography, Inc.,
Los Angeles, California

5196. **LOOKING UPTOWN—FROM ROOF** (P1983.23.19)
Platinum print. c. 1911
Image: 4 9/16 x 3 5/8 in. (11.7 x 9.2 cm.)
1st mount: 4 11/16 x 3 3/4 in. (11.9 x 9.5 cm.)
2nd mount: 5 1/4 x 4 3/8 in. (13.4 x 11.1 cm.)
Inscription, 2nd mount verso: "Looking Uptown—
from roof.//#19"
Acquired from: Stephen White Gallery of Photography, Inc.,
Los Angeles, California

5197. [Los Angeles Museum of History, Science and Art]
(P1983.23.181)
Platinum print. 1921
Image: 3 5/8 x 4 3/4 in. (9.2 x 12.1 cm.)
Sheet: 3 3/4 x 5 in. (9.4 x 12.7 cm.)
Acquired from: Stephen White Gallery of Photography, Inc.,
Los Angeles, California

5198. [Los Angeles Museum of History, Science and Art—
front entrance] (P1983.23.180)
Platinum print. 1921
Image: 3 11/16 x 4 3/4 in. (9.4 x 12.2 cm.)
Sheet: 3 11/16 x 5 in. (9.4 x 12.7 cm.)
Acquired from: Stephen White Gallery of Photography, Inc.,
Los Angeles, California

5199. **LOWER BROADWAY, NEW YORK** (P1983.24.53) print from
this autochrome is in the "Dawn of Color" portfolio,
P1983.23.192
Autochrome. c. 1910
Image: 8 1/16 x 6 1/16 in. (20.4 x 15.4 cm.)
Plate: 8 1/2 x 6 1/2 in. (21.5 x 16.5 cm.)
Acquired from: Stephen White Gallery of Photography, Inc.,
Los Angeles, California

5200. **LOWER BROADWAY, NEW YORK [Shadows. New York]**
(P1983.23.96) duplicate of P1980.3.4 in "Karl Struss: A
Portfolio 1909/29"
Bromide print on Japanese tissue. 1909
Image: 12 13/16 x 10 1/16 in. (32.5 x 25.6 cm.)
1st mount: same as image size
2nd mount: 15 x 12 in. (38.1 x 30.5 cm.)
Inscription, 2nd mount verso: "56//(56)/105" and rubber
stamp "KARL STRUSS/1343 N. ORANGE GROVE AVE/
HOLLYWOOD 48 CALIF/90046"
Acquired from: Stephen White Gallery of Photography, Inc.,
Los Angeles, California

*5201. **MADISON AVE., N.Y.C.** (P1983.23.14)
Platinum print. 1912
Image: 4 7/16 x 3 11/16 in. (11.2 x 9.3 cm.)
1st mount: 4 9/16 x 3 13/16 in. (11.6 x 9.7 cm.)
2nd mount: 5 1/4 x 4 7/16 in. (13.3 x 11.3 cm.)
Inscription, 2nd mount recto: "1912."
2nd mount verso: "Madison Ave./1912 NYC.//#14"
Acquired from: Stephen White Gallery of Photography, Inc.,
Los Angeles, California

5202. **MANHATTAN, BROOKLYN BRIDGES, WOOLWORTH
[On the Pier, Brooklyn Side of the East River, New York]**
(P1983.23.86)
Platinum print. 1912
Image: 4 5/8 x 3 3/4 in. (11.7 x 9.6 cm.)
1st mount: 4 3/4 x 3 15/16 in. (12.0 x 9.9 cm.)
2nd mount: 5 3/8 x 4 1/2 in. (13.6 x 11.4 cm.)
3rd mount: 9 1/8 x 7 1/4 in. (23.2 x 18.5 cm.)
Signed, l.r. 3rd mount recto: "Karl Struss"
Inscription, 2nd mount recto: "1912."
2nd mount verso: "Manhattan/B. B./Woolworth.//#3"
Acquired from: Stephen White Gallery of Photography, Inc.,
Los Angeles, California

*5203. **MANHATTAN & BROOKLYN BRIDGES LIGHTED.
REFLECTIONS ETC. N.Y.** (P1983.23.47)
Platinum print. 1912
Image: 3 3/16 x 4 5/16 in. (8.0 x 10.9 cm.)
1st mount: 3 3/8 x 4 7/16 in. (8.5 x 11.3 cm.)
2nd mount: 4 x 5 3/16 in. (10.1 x 13.1 cm.)
Inscription, 2nd mount recto: "1912."
2nd mount verso: "Man. & Br. Brs. lighted. Reflections
etc./1912 NY//#47"
Acquired from: Stephen White Gallery of Photography, Inc.,
Los Angeles, California

595

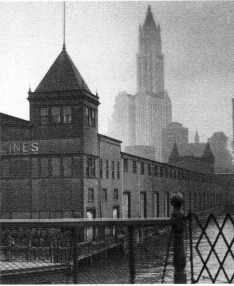

5195

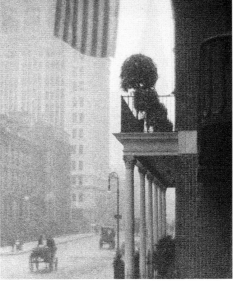

5201

5203

5204

5207

*5204. MANHATTAN AT DUSK [Fifth Ave., Twilight]
(P1983.23.92)
Platinum print. c. 1914–15
Image: 12⅛ x 9⁵⁄₁₆ in. (30.8 x 23.7 cm.)
1st mount: 16⅞ x 12⅜ in. (42.8 x 31.4 cm.)
2nd mount: 18¹¹⁄₁₆ x 15¹⁄₁₆ in. (47.4 x 38.2 cm.)
Signed, l.l. print recto: "Karl Struss 1915."
l.r. 1st mount recto: "Karl Struss."
l.r. 2nd mount recto: "Karl Struss"
Inscription, 1st mount recto: "1914."
2nd mount verso: "90//5"/#4/"THE·AVENUE—DUSK"/
PLATINUM·PRINT./$120.//#673//(55)/48/1.7//1923" and
rubber stamps "NATIONAL SALON/[Buffalo Camera
Club insignia]/BUFFALO, N.Y." and "PHOTOGRAPHED
BY/KARL STRUSS/HOLLYWOOD, CALIF." and printed
paper labels "MUSEUM OF THE CITY OF NEW YORK/
"VIEWS OF NEW YORK—OLD AND NEW"/
ExhibitedBy/PICTORIAL PHOTOGRAPHERS of
AMERICA/November 9th to November 23, 1936" and
"ACCEPTED/SAN FRANCISCO-OAKLAND/
INTERNATIONAL SALON/1923/Catalog Number/203"
and "MEMBER/[PPA insignia]/PICTORIAL/
PHOTOGRAPHERS/OF AMERICA"
note: the second mount may be a reused mount
Acquired from: Stephen White Gallery of Photography, Inc.,
Los Angeles, California

5205. MANHATTAN BRIDGE, BROOKLYN SIDE (P1983.23.30)
Platinum print. c. 1911–13
Image: 4⅜ x 3¹³⁄₁₆ in. (11.0 x 9.6 cm.)
Mount: 4½ x 4 in. (11.4 x 10.1 cm.)
Inscription, mount verso: "M. Bridge/Brooklyn
Side//#30//#12"
Acquired from: Stephen White Gallery of Photography, Inc.,
Los Angeles, California

5206. MANHATTAN BRIDGE, 2 HORSE VEHICLE, N.Y.
(P1983.23.45)
Platinum print. 1911
Image: 3¹¹⁄₁₆ x 4⁹⁄₁₆ in. (9.3 x 11.6 cm.)
1st mount: 3¹³⁄₁₆ x 4¹¹⁄₁₆ in. (9.6 x 11.9 cm.)
2nd mount: 4¼ x 5³⁄₁₆ in. (10.7 x 13.1 cm.)
Inscription, 2nd mount recto: "1911."
2nd mount verso: "Manhattan Bridge/2 Horse Vehicle/1911
NY·//#45//#1"
Acquired from: Stephen White Gallery of Photography, Inc.,
Los Angeles, California

*5207. MAN'S CONSTRUCTION AT DOCKS, N.Y.C. [A Glimpse
of Lower New York from Brooklyn Freight Docks. Brooklyn
Bridge in the Foreground] (P1983.23.36)
Platinum print. 1909
Image: 3¾ x 4⁹⁄₁₆ in. (9.5 x 11.5 cm.)
Mount: 4³⁄₁₆ x 5 in. (10.6 x 12.7 cm.)
Inscription, mount verso: "1909.//Man's Construction at
Docks/NYC—//#36"
Acquired from: Stephen White Gallery of Photography, Inc.,
Los Angeles, California

5208. [Marie Fischer Struss—Karl Struss' mother] (P1983.24.3)
Autochrome. c. 1910–17
Image: 3⅝ x 2¹³⁄₁₆ in. (9.1 x 7.1 cm.)
Plate: 4 x 3¼ in. (10.1 x 8.2 cm.)
Acquired from: Stephen White Gallery of Photography, Inc.,
Los Angeles, California

5209. [Marie Fischer Struss—Karl Struss' mother] (P1983.24.4)
Autochrome. c. 1910–17
Image: 3⅝ x 2¹³⁄₁₆ in. (9.1 x 7.1 cm.)
Plate: 4 x 3¼ in. (10.1 x 8.2 cm.)
Acquired from: Stephen White Gallery of Photography, Inc.,
Los Angeles, California

5210. "MARY ELIZABETH" TEA ROOM, N.Y.C. (P1983.23.35)
Platinum print. 1912
Image: 4⁹⁄₁₆ x 3⁹⁄₁₆ in. (11.5 x 9.0 cm.)
Inscription, print verso: ""Mary Elizabeth" Tea Room/1912
NYC—//#35"
Acquired from: Stephen White Gallery of Photography, Inc.,
Los Angeles, California

5211. MEISSEN FROM THE ALBRECHTEBURG (P1983.23.104)
Platinum print. 1909
Image: 3¹³⁄₁₆ x 2¾ in. (9.7 x 6.9 cm.)
1st mount: 3¹⁵⁄₁₆ x 2⅞ in. (10.0 x 7.2 cm.)
2nd mount: 4½ x 3⁷⁄₁₆ in. (11.4 x 8.7 cm.)
Inscription, 2nd mount recto: "1909."
2nd mount verso: "Meissen/from the/Albrechteburg//
#134"
Acquired from: Stephen White Gallery of Photography, Inc.,
Los Angeles, California

*5212. MEISSEN ROOFTOPS [Over the Housetops, Meissen]
(P1983.23.103)
Platinum print. 1909
Image: 3¹⁵⁄₁₆ x 2⅛ in. (10.1 x 5.4 cm.)
1st mount: 4¹⁄₁₆ x 2³⁄₁₆ in. (10.3 x 5.6 cm.)
2nd mount: 4½ x 2⅝ in. (11.3 x 6.7 cm.)
Inscription, 2nd mount recto: "1909."
2nd mount verso: "Meissen Rooftops/1909//#133"
Acquired from: Stephen White Gallery of Photography, Inc.,
Los Angeles, California

5213. MILDRED M. BELL (P1983.23.176)
Platinum print. c. 1920s
Image: 4⁵⁄₁₆ x 3⁷⁄₁₆ in. (10.9 x 8.7 cm.)
Acquired from: Stephen White Gallery of Photography, Inc.,
Los Angeles, California

*5214. MILDRED M. BELL (P1983.23.177)
Platinum print. c. 1920s
Image: 4⁹⁄₁₆ x 3½ in. (11.6 x 8.9 cm.)
Signed, l.l. print recto: "Karl Struss."
Acquired from: Stephen White Gallery of Photography, Inc.,
Los Angeles, California

5215. MILDRED M. BELL (P1983.23.178)
Platinum print. c. 1920s
Image: 4⅜ x 3⅝ in. (11.1 x 9.2 cm.)
Acquired from: Stephen White Gallery of Photography, Inc.,
Los Angeles, California

5216. MOTHER STRUSS REFLECTED IN MIRROR OF
FIREPLACE 729 ST. MICH. AVE.—N.Y.C. [Karl Struss'
grandmother] (P1983.23.137) duplicate of P1983.23.140
Platinum print. c. 1909–11
Image: 4⁹⁄₁₆ x 3⅝ in. (11.5 x 9.2 cm.)
1st mount: 4⅝ x 3¾ in. (11.7 x 9.5 cm.)
2nd mount: 5¼ x 4⁵⁄₁₆ in. (13.2 x 11.0 cm.)
Inscription, 2nd mount recto: "1909."
2nd mount verso: "Mother Struss reflected in mirror of/
fireplace 729 St. Mich. Ave.—NYC/1911//#50"
Acquired from: Stephen White Gallery of Photography, Inc.,
Los Angeles, California

5217. MOTHER STRUSS REFLECTED IN MIRROR OVER
FIREPLACE [Karl Struss' grandmother] (P1983.23.140)
duplicate of P1983.23.137
Sepia-toned platinum print. c. 1909–11
Image: 4³⁄₁₆ x 3⅜ in. (10.6 x 8.5 cm.)
Inscription, print verso: "Mother Struss Reflected/in mirror
over fireplace//#120"
Acquired from: Stephen White Gallery of Photography, Inc.,
Los Angeles, California

5218. MT. BALDY (P1983.23.155)
Bromide print. c. 1921–22
Image: 13½ x 10⅝ in. (34.2 x 27.0 cm.)
Mount: 17 x 14 in. (43.2 x 35.6 cm.)

Signed, l.l. print recto: "Karl Struss"
l.r. mount recto: "Karl Struss."
Inscription, mount verso: "#19/"MT. BALDY"/~~PLATINUM~~
PRINT/Bro.//#59//BSR//8//3" and rubber stamp "KARL
STRUSS/ARTIST PHOTOGRAPHER/HOLLYWOOD ::
CALIFORNIA" and printed paper label "THIS PRINT
HAS BEEN EXHIBITED/In the GALLERY.·.·of the/
CALIFORNIA CAMERA CLUB—/during the Month of
[blank]/[blank]/CHAIRMAN PRINT COMMITTEE./San
Francisco California."
Acquired from: Stephen White Gallery of Photography, Inc.,
Los Angeles, California

5212

*5219. **NEAR H.W. STRUSS FACTORY N.Y.C.** (P1983.23.15)
Platinum print. c. 1911–13
Image: 3 11/16 x 4 5/8 in. (9.3 x 11.7 cm.)
1st mount: 3 3/4 x 4 3/4 in. (9.5 x 12.0 cm.)
2nd mount: 4 1/4 x 5 3/16 in. (10.7 x 13.2 cm.)
Inscription, 2nd mount recto: "1911."
2nd mount verso: "Near H.W. Struss Factory NYC./
1911//#15"
Acquired from: Stephen White Gallery of Photography, Inc.,
Los Angeles, California

5220. **NEW HAMPSHIRE LANDSCAPE** (P1983.23.121) duplicate
of P1983.23.122–127
Platinum print on tissue. negative 1907, print c. 1909–10
Image: 6 3/4 x 8 9/16 in. (17.0 x 21.8 cm.)
Mount: 10 7/8 x 12 5/8 in. (27.5 x 32.1 cm.)
Signed, l.l. print recto: "Karl Struss 1907./1907."
Inscription, mount verso: "(5)"
Acquired from: Stephen White Gallery of Photography, Inc.,
Los Angeles, California

5221. **NEW HAMPSHIRE LANDSCAPE** (P1983.23.122) duplicate
of P1983.23.121, P1983.23.123–127
Platinum print. negative 1907, print c. 1909–10
Image: 7 x 8 5/8 in. (17.7 x 22.0 cm.)
Mount: 7 1/8 x 8 13/16 in. (18.1 x 22.3 cm.)
Signed, l.l. print recto: "Karl Struss 1907."
Inscription, print verso, rubber stamp: "KARL STRUSS/
ARTIST PHOTOGRAPHER/HOLLYWOOD ::
CALIFORNIA"
mount verso: "7″ PLATINUM/PRINTED·THRU· GAUZE"
mat backing verso: "Landscape/Printed through a screen"
Acquired from: Stephen White Gallery of Photography, Inc.,
Los Angeles, California

5214

5222. **NEW HAMPSHIRE LANDSCAPE** (P1983.23.123) duplicate
of P1983.23.121–122, P1983.23.124–127
Gum print. negative 1907, print 1910
Image: 7 1/8 x 8 3/4 in. (18.1 x 22.2 cm.)
Mount: 12 3/4 x 13 in. (32.3 x 33.0 cm.)
Signed, l.l. print recto: "Karl Struss 1907."
l.r. mount recto: "Karl Struss, 1910"
Inscription, mount verso: "GUM·PRINT.//(9)/55"
and rubber stamp "KARL STRUSS/ARTIST
PHOTOGRAPHER/HOLLYWOOD :: CALIFORNIA"
Acquired from: Stephen White Gallery of Photography, Inc.,
Los Angeles, California

5223. **NEW HAMPSHIRE LANDSCAPE** (P1983.23.124) duplicate
of P1983.23.121–123, P1983.23.125–127
Gum-platinum print. negative 1907, print 1910
Image: 6 1/2 x 8 11/16 in. (16.4 x 22.1 cm.)
Mount: 8 5/8 x 13 in. (21.9 x 33.0 cm.) irregular
Signed, l.r. print recto and l.r. mount recto: "Karl Struss,
1910."
Inscription, mount verso: "#82.//"NEW·HAMPSHIRE·
LANDSCAPE"//GUM·PLATINUM·PRINT." and rubber
stamp "KARL STRUSS/ARTIST PHOTOGRAPHER/
HOLLYWOOD :: CALIFORNIA"
Acquired from: Stephen White Gallery of Photography, Inc.,
Los Angeles, California

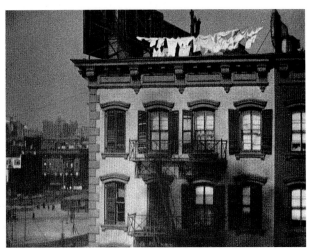

5219

5224. **NEW HAMPSHIRE LANDSCAPE** (P1983.23.125) duplicate
of P1983.23.121–124, P1983.23.126–127
Hand-stippled gum print. negative 1907, print 1910
Image: 7⅛ x 9 in. (18.1 x 22.8 cm.)
Signed, l.l. print recto: "Karl Struss, 1907."
l.r. print recto: "Karl Struss"
Inscription, mat backing verso: " "New Hampshire
Landscape"//HAND·STIPPLED·GUM·PRINT./
$1,000.00//Lantern Slide" and rubber stamp "KARL
STRUSS/ARTIST PHOTOGRAPHER/HOLLYWOOD ::
CALIFORNIA"
Acquired from: Stephen White Gallery of Photography, Inc.,
Los Angeles, California

5225. **NEW HAMPSHIRE LANDSCAPE** (P1983.23.126) duplicate
of P1983.23.121–125, P1983.23.127
Unidentified process. negative 1907, print c. 1909–10
Image: 7 x 8⅝ in. (17.7 x 22.0 cm.)
Mount: 7³⁄₁₆ x 8¹³⁄₁₆ in. (18.1 x 22.3 cm.)
Signed, l.l. print recto: "Karl F. Struss 1907."
Acquired from: Stephen White Gallery of Photography, Inc.,
Los Angeles, California

5226. **NEW HAMPSHIRE LANDSCAPE** (P1983.23.127) duplicate
of P1983.23.121–126
Gum print. negative 1907, print c. 1909–10
Image: 6¾ x 8⅝ in. (17.1 x 21.9 cm.)
Mount: 11⁵⁄₁₆ x 12⅝ in. (28.6 x 32.2 cm.)
Signed, l.l. print recto: "Karl Struss 1907."
Acquired from: Stephen White Gallery of Photography, Inc.,
Los Angeles, California

5227. **NEW HAMPSHIRE—2 GIRLS STANDING MID TREE
TRUNKS [Elm Hill/Sunset Hill]** (P1983.23.120)
Platinum print. c. 1911–12
Image: 4⁹⁄₁₆ x 3⅞ in. (11.5 x 9.8 cm.)
1st mount: 4¹¹⁄₁₆ x 4 in. (11.9 x 10.2 cm.)
2nd mount: 5½ x 4⅝ in. (13.9 x 11.7 cm.)
Inscription, 2nd mount recto: "1911"
2nd mount verso: "New Hampshire—1911/2 Girls standing
mid Tree Trunks//#74"
Acquired from: Stephen White Gallery of Photography, Inc.,
Los Angeles, California

5228. **NEW HAMPSHIRE—WOODSY SCENE—2 ON ROAD
[Springfield/Pleasant Lake, N. H.]** (P1983.23.119)
Platinum print. c. 1910–12
Image: 4⅝ x 3⅞ in. (11.6 x 9.7 cm.)
1st mount: 4¾ x 4 in. (12.1 x 10.1 cm.)
2nd mount: 5⁹⁄₁₆ x 4¹¹⁄₁₆ in. (14.1 x 11.9 cm.)
Inscription, 2nd mount recto: "1910"
2nd mount verso: "New Hampshire/Woodsy Scene—
2 on Road/1910//#73"
Acquired from: Stephen White Gallery of Photography, Inc.,
Los Angeles, California

5229. **N.Y.C. [Cathedral of St. John the Divine]** (P1983.23.26)
Platinum print. 1911
Image: 3¹¹⁄₁₆ x 4¹¹⁄₁₆ in. (9.3 x 11.8 cm.)
1st mount: 3¾ x 4¾ in. (9.5 x 12.1 cm.)
2nd mount: 4¼ x 5³⁄₁₆ in. (10.7 x 13.2 cm.)
Inscription, 2nd mount recto: "1911."
2nd mount verso: "NYC—1911//#26"
Acquired from: Stephen White Gallery of Photography, Inc.,
Los Angeles, California

5230. **NEW YORK HARBOR, BROOKLYN BRIDGE**
(P1983.23.78)
Platinum print. c. 1911–12
Image: 4⁷⁄₁₆ x 3¹¹⁄₁₆ in. (11.2 x 9.4 cm.)
Mount: 4⁹⁄₁₆ x 3¹³⁄₁₆ in. (11.6 x 9.7 cm.)
Inscription, mount verso: "1912//(59)/34"
Acquired from: Stephen White Gallery of Photography, Inc.,
Los Angeles, California

*5231. **N. Y. HARBOR, EAST RIVER** (P1983.23.58)
Platinum print. 1909
Image: 4⅝ x 3¹¹⁄₁₆ in. (11.7 x 9.4 cm.)
1st mount: 4¹¹⁄₁₆ x 3¾ in. (11.9 x 9.5 cm.)
2nd mount: 4¹³⁄₁₆ x 3¹³⁄₁₆ in. (12.1 x 9.7 cm.)
3rd mount: 5⅜ x 4⁷⁄₁₆ in. (13.7 x 11.3 cm.)
Inscription, 3rd mount verso: "N. Y. Harbor/East
River//#114"
Acquired from: Stephen White Gallery of Photography, Inc.,
Los Angeles, California

5232. **NEWS-BOARD—N.Y.C.** (P1983.23.27)
Platinum print. c. 1907–11
Image: 3⅛ x 4⁵⁄₁₆ in. (7.9 x 11.0 cm.)
1st mount: 3⅜ x 4⁹⁄₁₆ in. (8.6 x 11.6 cm.)
2nd mount: 3¹¹⁄₁₆ x 4⅞ in. (9.4 x 12.5 cm.)
Inscription, 2nd mount recto: "1907."
2nd mount verso: "News-Board—1907—NYC—//#27"
Acquired from: Stephen White Gallery of Photography, Inc.,
Los Angeles, California

5233. **NOVA SCOTIA, GROUP OF TREES & FIGURE**
(P1983.23.130)
Platinum print. 1910
Image: 3⅝ x 4⁷⁄₁₆ in. (9.2 x 11.2 cm.)
1st mount: 3¹¹⁄₁₆ x 4⁹⁄₁₆ in. (9.4 x 11.6 cm.)
2nd mount: 4³⁄₁₆ x 5¹⁄₁₆ in. (10.7 x 12.8 cm.)
Inscription, 2nd mount recto: "1910."
2nd mount verso: "Nova Scotia, Group of Trees/& Figure
1910//#68"
Acquired from: Stephen White Gallery of Photography, Inc.,
Los Angeles, California

5234. **NOVA SCOTIA, 1 TREE—1 FIGURE** (P1983.23.131)
Platinum print. 1911
Image: 4½ x 3¹¹⁄₁₆ in. (11.5 x 9.4 cm.)
Sheet: 4⅝ x 3¾ in. (11.7 x 9.6 cm.)
Mount: 5¹⁄₁₆ x 4⅛ in. (12.8 x 10.4 cm.)
Inscription, mount recto: "1911."
mount verso: "Nova Scotia—1911/1 Tree—1 figure.//#69"
Acquired from: Stephen White Gallery of Photography, Inc.,
Los Angeles, California

5235. **NOVA SCOTIA, ROLLING HILLS** (P1983.23.132)
Platinum print. 1911
Image: 3⁹⁄₁₆ x 4³⁄₁₆ in. (9.0 x 10.6 cm.)
1st mount: 3⅝ x 4¼ in. (9.2 x 10.8 cm.)
2nd mount: 4¹⁄₁₆ x 4¹¹⁄₁₆ in. (10.2 x 11.8 cm.)
Inscription, 2nd mount recto: "1911."
2nd mount verso: "Nova Scotia, 1911/Rollings [sic]
Hills//#70"
Acquired from: Stephen White Gallery of Photography, Inc.,
Los Angeles, California

5236. **NOVA SCOTIA, 3 TREES & FIGURE [Around Chester—
Hilda Behind Three Trees]** (P1983.23.129)
Platinum print. 1911
Image: 4⁷⁄₁₆ x 1¹⁵⁄₁₆ in. (11.3 x 5.0 cm.)
1st mount: 4⁹⁄₁₆ x 2¹⁄₁₆ in. (11.6 x 5.2 cm.)
2nd mount: 4¹⁵⁄₁₆ x 2⁷⁄₁₆ in. (12.6 x 6.2 cm.)
Inscription, 2nd mount recto: "1911."
2nd mount verso: "Nova Scotia/3 Trees & figure/1911//#67"
Acquired from: Stephen White Gallery of Photography, Inc.,
Los Angeles, California

*5237. **ON DOCKS N.Y.C.—SNOW** (P1983.23.9)
Platinum print. c. 1911
Image: 4⅝ x 3¾ in. (11.7 x 9.5 cm.)
1st mount: 4¾ x 3⅞ in. (12.1 x 9.9 cm.)
2nd mount: 5¼ x 4⁷⁄₁₆ in. (13.3 x 11.2 cm.)
Inscription, 2nd mount verso: "On Docks NYC—snow//#9."
Acquired from: Stephen White Gallery of Photography, Inc.,
Los Angeles, California

*5238. **ON LAKE COMO [Atmospheric Perspective]** (P1983.23.114)
duplicate of P1983.23.115
Hand-coated multiple platinum print. 1909
Image: 6 ⅞ x 9 ⅜ in. (17.4 x 23.8 cm.)
1st mount: 8 ⁵⁄₁₆ x 10 ⅝ in. (21.1 x 27.0 cm.)
2nd mount: 17 x 13 in. (43.2 x 33.0 cm.)
Signed, l.l. print recto: "Karl Struss 1909."
l.r. 1st mount recto: "Karl Struss."
Inscription, 2nd mount recto: "21//B"
2nd mount verso: "C/#26—"ON·LAKE·COMO,"
1909/(HAND·COATED·MULTIPLE·PLATINUM)/
$140—//551//Karl Struss//316" and rubber stamp "KARL
STRUSS/ARTIST PHOTOGRAPHER/HOLLYWOOD ::
CALIFORNIA"
Acquired from: Stephen White Gallery of Photography, Inc.,
Los Angeles, California

5239. **ON LAKE COMO [Atmospheric Perspective]** (P1983.23.115)
duplicate of P1983.23.114
Platinum print. 1909
Image: 7 ¼ x 9 ⅜ in. (18.4 x 23.7 cm.)
1st mount: 8 ³⁄₁₆ x 10 ⅜ in. (20.8 x 26.3 cm.)
2nd mount: 12 ¾ x 15 ⁷⁄₁₆ in. (32.4 x 39.2 cm.)
Signed, l.r. print recto: "Karl Struss 1909."
l.r. 1st mount recto: "Karl Struss"
Acquired from: Stephen White Gallery of Photography, Inc.,
Los Angeles, California

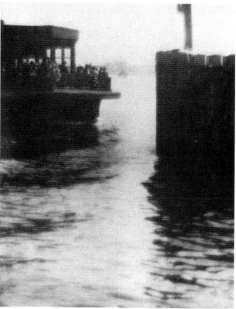

5231

5240. **ON THE PIER. (LATE AFTERNOON, ARVERNE) [The
Pier, Arverne Moonlight]** (P1983.23.66) duplicate of
P1983.23.76
Hand-coated multiple platinum print. 1909
Image: 7 ¼ x 9 ³⁄₁₆ in. (18.5 x 23.4 cm.)
Mount: 13 x 12 ¹⁵⁄₁₆ in. (33.0 x 32.8 cm.)
Signed, l.r. print recto: "Karl Struss 1909."
Inscription, mount verso: "#75/"On the Pier."/(Late
afternoon, Arverne,)/Karl Struss./Hand coated multiple
platinum.//297//C" and rubber stamp "PHOTOGRAPHED
BY/KARL STRUSS/HOLLYWOOD, CALIF." and printed
paper labels "THIS PRINT HAS BEEN EXHIBITED/In
the GALLERY.·.·.·of the/CALIFORNIA CAMERA
CLUB—/during the Month of [in ink] June 1929/[in ink]
Mr Ralph Smith/CHAIRMAN PRINT COMMITTEE./
San Francisco California." and "Los Angeles Camera
Club/108-12 Stimson Bldg.:·129 West Third St./LOS
ANGELES, CALIFORNIA/(Affiliated with the
Associated/Camera Clubs of America)/[LACC insignia]/
EXHIBITED AT THE LOS/ANGELES CAMERA CLUB"
Acquired from: Stephen White Gallery of Photography, Inc.,
Los Angeles, California

5237

5241. **ON THE PINCIAN HILL—ROME [Summer on the Pincian
Hill, near Villa Borghese, Rome]** (P1983.23.111) duplicate of
P1983.23.112
Hand-coated multiple platinum print. 1909
Image: 7 ¾ x 5 ¹⁵⁄₁₆ in. (19.6 x 15.1 cm.)
Mount: 16 ⁵⁄₁₆ x 12 ⅞ in. (41.4 x 32.7 cm.)
Signed, l.l. print recto: "© Karl Struss"
l.r. mount recto: "Karl Struss."
Inscription, mount recto: "1909."
mount verso: "#8//C//#25—"On the Pincian Hill—
Rome."/Handcoated Multiple Platinum Print.//551/315/Lori
Ann" and rubber stamp "PHOTOGRAPHED BY/KARL
STRUSS/HOLLYWOOD, CALIF." and printed paper
labels "THIS PRINT HAS BEEN EXHIBITED/In the
GALLERY.·.·.·of the/CALIFORNIA CAMERA
CLUB—/during the Month of [in ink] June 1929/[in ink]
Mr. Ralph Smith/CHAIRMAN PRINT COMMITTEE./
San Francisco California." and "Los Angeles Camera
Club/108-12 Stimson Bldg.:·129 West Third St./LOS
ANGELES, CALIFORNIA/(Affiliated with the
Associated/Camera Clubs of America)/[LACC insignia]/
EXHIBITED AT THE LOS/ANGELES CAMERA CLUB"
and "MEMBER/[PPA insignia]/PICTORIAL/
PHOTOGRAPHERS/OF AMERICA"
Acquired from: Stephen White Gallery of Photography, Inc.,
Los Angeles, California

5238

5242. **ON THE PINCIAN HILL, ROME [Summer on the Pincian Hill, near Villa Borghese, Rome]** (P1983.23.112) duplicate of P1983.23.111
Platinum print. 1909
Image: 9⅛ x 6¹³⁄₁₆ in. (23.1 x 17.3 cm.)
1st mount: 9⁷⁄₁₆ x 7³⁄₁₆ in. (24.0 x 18.2 cm.)
2nd mount: 10⅛ x 7¹³⁄₁₆ in. (25.6 x 19.8 cm.)
3rd mount: 18 x 14 in. (45.7 x 35.6 cm.)
Signed, l.l. print recto: "Karl Struss 1909."
l.r. 3rd mount recto: "Karl Struss."
Inscription, 2nd mount verso: " "On the Pincian Hill, Rome."/1909/Karl Struss./$100.—/PLATINUM·PRINT"
3rd mount recto: "ROME. 1909—//223"
3rd mount verso: "223/852/Brittany Gables [partially erased]/Karl Struss/#9/14//BSR//32" and rubber stamp "KARL STRUSS/ARTIST PHOTOGRAPHER/HOLLYWOOD :: CALIFORNIA"
Acquired from: Stephen White Gallery of Photography, Inc., Los Angeles, California

5243. **110TH ST. EL STATION** (P1983.23.38)
Platinum print. n.d.
Image: 4⁹⁄₁₆ x 3⅝ in. (11.6 x 9.2 cm.)
Inscription, print verso: "110″ St. El·Station//#38"
Acquired from: Stephen White Gallery of Photography, Inc., Los Angeles, California

*5244. **OUTWARD BOUND** (P1983.23.157)
Bromide print. 1928
Image: 13 x 10³⁄₁₆ in. (32.9 x 25.9 cm.)
Sheet: 13½ x 10¹³⁄₁₆ in. (34.3 x 27.4 cm.)
Mount: 17 x 14 in. (43.2 x 35.6 cm.)
Signed, l.l. sheet recto: "Karl Struss. 1928—"
Inscription, print recto, embossed: "KARL STRUSS"
mount verso: "#6//143//"Outward Bound."//Exhibited Royal Photo Society 1933.//19" and rubber stamp "KARL STRUSS/ARTIST PHOTOGRAPHER/HOLLYWOOD :: CALIFORNIA" and printed paper labels "Certificate of Selection/The/All-American/PHOTOGRAPHIC/SALON/NINETEEN HUNDRED/THIRTY-ONE/[Los Angeles Camera Club insignia]/THIS BEING ONE OF ONE HUNDRED/AND SEVENTY-EIGHT PRINTS EX-/HIBITED IN THE PRINT ROOMS OF THE/LOS ANGELES MUSEUM OF HISTORY./SCIENCE AND ART, JUNE 13–30, 1931." and "LOS ANGELES COUNTY FAIR/POMONA, CALIFORNIA/PICTORIAL PHOTOGRAPHY/Annual Exhibit/SALON [blank]/ACCEPTED/TITLE [blank]/EXHIBITOR [blank]" and "MEMBER/[PPA insignia]/PICTORIAL/PHOTOGRAPHERS/OF AMERICA"
Acquired from: Stephen White Gallery of Photography, Inc., Los Angeles, California

5245. **PARK AVE. SOUTH FROM 42ND ST.** (P1983.23.33)
Platinum print. 1911
Image: 4⁹⁄₁₆ x 3¹¹⁄₁₆ in. (11.5 x 9.4 cm.)
Sheet: 4⅝ x 3¹³⁄₁₆ in. (11.7 x 9.6 cm.)
Mount: 5⅛ x 4³⁄₁₆ in. (13.0 x 10.7 cm.)
Inscription, mount recto: "1911."
mount verso: "Park Ave./So fr/42″ St//#33"
Acquired from: Stephen White Gallery of Photography, Inc., Los Angeles, California

5246. **PASSING THRONG [Knickerbocker Trust Building, northwest corner of Fifth Avenue and 34th Street]** (P1983.23.91)
Sepia-toned platinum print. c. 1912
Image: 12⅜ x 9¹³⁄₁₆ in. (31.5 x 24.9 cm.)
Signed, l.l. print recto: "Karl Struss"
Inscription, print verso, rubber stamp: "PHOTOGRAPHED BY/KARL STRUSS/HOLLYWOOD, CALIF."
Acquired from: Stephen White Gallery of Photography, Inc., Los Angeles, California

*5247. **PENNSYLVANIA STATION. NEW YORK** (P1983.23.95)
duplicate of P1980.3.7 in "Karl Struss: A Portfolio 1909/29"
Platinum print. 1911
Image: 4¹¹⁄₁₆ x 3¹¹⁄₁₆ in. (11.9 x 9.3 cm.)

Mount: 5⁵⁄₁₆ x 4⁵⁄₁₆ in. (13.4 x 10.9 cm.)
Signed: see inscription
Inscription, print verso, rubber stamps: "COPYRIGHT 1915. KARL STRUSS." and "KARL STRUSS/1343 N. ORANGE GROVE AVE./HOLLYWOOD, CALIF. 90046"
mount recto: "1911."
mount verso: "1912/1912//1911/1911/1911/1911"
Acquired from: Stephen White Gallery of Photography, Inc., Los Angeles, California

*5248. **PIER, ARVERNE L.I., SPARKLING WATERS, 2 COUPLES FACING** (P1983.23.49)
Platinum print. 1909
Image: 4⅜ x 3⅝ in. (11.1 x 9.2 cm.)
1st mount: 4¹¹⁄₁₆ x 3¾ in. (11.8 x 9.5 cm.)
2nd mount: 5⅛ x 4³⁄₁₆ in. (12.9 x 10.6 cm.)
Inscription, 2nd mount verso: "Pier, Arverne L.I./Sparkling Waters/2 Couples (facing//#53"
Acquired from: Stephen White Gallery of Photography, Inc., Los Angeles, California

5249. **THE PIER, ARVERNE MOONLIGHT [On the Pier. (Late Afternoon, Arverne)]** (P1983.23.76) duplicate of P1983.23.66
Gum platinum print. 1909
Image: 7⁹⁄₁₆ x 9¹⁄₁₆ in. (19.2 x 23.0 cm.)
Signed, l.l. print recto: "Karl Struss 1909."
Inscription, print verso: "gum Platinum/The Pier, Arverne Moonlight" and rubber stamp "KARL STRUSS/ARTIST PHOTOGRAPHER/HOLLYWOOD :: CALIFORNIA"
Acquired from: Stephen White Gallery of Photography, Inc., Los Angeles, California

5250. **PIER, 3 MEN BELOW SIGN, ARVERNE, L.I.** (P1983.23.51)
Platinum print. 1910
Image: 3⁹⁄₁₆ x 4⁵⁄₁₆ in. (9.0 x 10.9 cm.)
1st mount: 3⅝ x 4⁷⁄₁₆ in. (9.3 x 11.3 cm.)
2nd mount: 4¼ x 5¹⁄₁₆ in. (10.8 x 12.8 cm.)
Inscription, 2nd mount recto: "1910"
2nd mount verso: "Pier, 3 men below Sign 1910/Arverne, L. I.//#55"
Acquired from: Stephen White Gallery of Photography, Inc., Los Angeles, California

*5251. **[Pinhole for United Artists Studio Lot—Gas Tank?]** (P1983.23.166)
Bromide print. 1929
Image: 13⁷⁄₁₆ x 10½ in. (34.0 x 26.6 cm.)
Sheet: 13¹¹⁄₁₆ x 10¾ in. (34.7 x 27.2 cm.)
Mount: 17 x 14 in. (43.2 x 35.6 cm.)
Signed, l.r. mount recto: "Karl Struss—1929"
Inscription, print recto, embossed: "KARL STRUSS"
mount recto: "9"
mount verso: "Pin Hole Bromide Print" and rubber stamp "PHOTOGRAPHED BY/KARL STRUSS/HOLLYWOOD, CALIF."
Acquired from: Stephen White Gallery of Photography, Inc., Los Angeles, California

5252. **[Pink carnation—single bloom]** (P1983.24.19)
Autochrome. c. 1910–17
Image: 2⅞ x 3½ in. (7.3 x 9.0 cm.)
Plate: 3¼ x 4 in. (8.2 x 10.1 cm.)
Acquired from: Stephen White Gallery of Photography, Inc., Los Angeles, California

5253. **THE POISONED PARADISE** (P1983.23.172)
Gelatin silver print. 1923
Image: 9⅜ x 7½ in. (23.8 x 19.0 cm.)
Mount: 15⁵⁄₁₆ x 11⁹⁄₁₆ in. (38.9 x 29.3 cm.)
Signed, l.r. mount recto: "Karl Struss."
Inscription, print verso, rubber stamp: "PHOTOGRAPHED BY/KARL STRUSS/PREFERRED PICTURES/HOLLYWOOD, CALIF."
mount recto: "The Poisoned Paradise."
mount verso, rubber stamp: "PHOTOGRAPHED BY/KARL STRUSS/PREFERRED PICTURES/HOLLYWOOD, CALIF."
Acquired from: Stephen White Gallery of Photography, Inc., Los Angeles, California

5244

5247

5248

5251

5255

5254. **PORTRAIT OF FLORENCE** (P1983.23.150)
Hess-Ives color print. 1917
Image: 9 1/4 x 7 1/2 in. (23.5 x 19.0 cm.)
Laminated film sheets: 9 13/16 x 7 13/16 in. (24.8 x 19.8 cm.)
Mount: 14 x 10 11/16 in. (35.6 x 27.2 cm.)
Signed, l.r. overmat recto: "Karl Struss, 1917."
Inscription, mount verso: "Portrait of Florence//#11" and
rubber stamp "KARL STRUSS/ARTIST
PHOTOGRAPHER/HOLLYWOOD :: CALIFORNIA"
Acquired from: Stephen White Gallery of Photography, Inc.,
Los Angeles, California

* 5255. **[Reflections, moonlight, Arverne]** (P1983.23.67)
Platinum print. 1910
Image: 9 11/16 x 11 1/2 in. (24.6 x 29.1 cm.)
1st mount: 10 9/16 x 12 7/16 in. (26.8 x 31.6 cm.)
2nd mount: 15 7/16 x 17 1/2 in. (39.1 x 44.5 cm.)
Signed, l.l. print recto: "Karl Struss 1910."
l.r. 1st mount recto: "Karl Struss 1910."
Acquired from: Stephen White Gallery of Photography, Inc.,
Los Angeles, California

* 5256. **REFLECTIONS—VENICE** (P1983.23.109)
Multiple gum print. 1909
Image: 7 11/16 x 5 13/16 in. (19.5 x 14.7 cm.)
Mount: 12 11/16 x 10 7/8 in. (32.2 x 27.7 cm.)
Signed, l.l. print recto and l.r. mount recto: "Karl Struss."
Inscription, print verso: "IIII gum/Karl Struss"
mount recto: "1909."
mount verso: "#79./"Reflections— Venice".//1343·N·
ORANGE· GROVE· AVE/-90046-//Multiple gum
Print, 3·Printings.//$1,000.—" and rubber stamp
"PHOTOGRAPHED BY/KARL STRUSS/HOLLYWOOD,
CALIF." and printed paper labels "THIS PRINT HAS
BEEN EXHIBITED/In the GALLERY.·.·. of the/
CALIFORNIA CAMERA CLUB—/during the Month
of [in ink] June 1929/[remainder of label is cut off]" and
"[T]HIS PRINT/[WA]S EXHIBITED BY/[SPE]CIAL
INVITATION/AT THE/SAN ANTONIO/[SA]LON OF
PICTORIAL/[PH]OTOGRAPHY/[IN]TERNATIONAL/
[Sa]n Antonio Pictorial/Camera Club" and "XXII^e Salon
International/D'ART PHOTOGRAPHIQUE/PARIS/
OCTOBRE 1927/ÉPREUVE ADMISE/sous le no/DU
CATALOGUE/Société Française de Photographie/51, Rue
de Clichy, Paris" and "Los Angeles Camera Club/108-12
Stimson Bldg.:·129 West Third St./LOS ANGELES,
CALIFORNIA/(Affiliated with the Associated/Camera
Clubs of America)/[LACC insignia]/EXHIBITED AT
THE LOS/ANGELES CAMERA CLUB"
Acquired from: Stephen White Gallery of Photography, Inc.,
Los Angeles, California

5257. **[Release of the Hamadryad; dancer, Hollywood Hills]**
(P1983.23.170)
Bromide print. c. 1919–21
Image: 13 1/16 x 10 1/16 in. (33.2 x 25.6 cm.)
Mount: 17 x 14 in. (43.2 x 35.6 cm.)
Signed, l.l. print recto and l.r. mount recto: "Karl Struss."
Inscription, mount recto: "10"
mount verso: "Bromide" and rubber stamp "KARL
STRUSS/ARTIST PHOTOGRAPHER/HOLLYWOOD ::
CALIFORNIA"
Acquired from: Stephen White Gallery of Photography, Inc.,
Los Angeles, California

5258. **REMEMBER TO KODAK [Hilda Wright; ad for Eastman
Kodak]** (P1983.23.175)
Gelatin silver print. 1915
Image: 12 7/8 x 7 15/16 in. (32.6 x 20.1 cm.)
Sheet: 13 1/16 x 8 3/16 in. (33.2 x 20.8 cm.)
Mount: 18 x 12 in. (45.7 x 30.5 cm.)
Signed, l.r. print recto: "Karl Struss"
Inscription, in negative: "KODAK//REMEMBER TO
KODAK"
mount verso: "'AD'·FOR·EASTMAN-KODAK" and
rubber stamp "KARL STRUSS/ARTIST
PHOTOGRAPHER/HOLLYWOOD :: CALIFORNIA"
Acquired from: Stephen White Gallery of Photography, Inc.,
Los Angeles, California

5259. **[Residential interior—dining room]** (P1983.24.13)
Autochrome. c. 1910
Image: 3 5/8 x 4 5/8 in. (9.3 x 11.8 cm.)
Plate: 4 x 5 in. (10.1 x 12.6 cm.)
Acquired from: Stephen White Gallery of Photography, Inc.,
Los Angeles, California

5260. **[Residential interior—living room]** (P1983.24.14)
Autochrome. c. 1910
Image: 3 1/2 x 4 9/16 in. (9.0 x 11.6 cm.)
Plate: 4 x 5 in. (10.1 x 12.6 cm.)
Acquired from: Stephen White Gallery of Photography, Inc.,
Los Angeles, California

5261. **[Residential interior—side parlor]** (P1983.24.15)
Autochrome. c. 1910
Image: 3 5/8 x 4 5/8 in. (9.3 x 11.7 cm.)
Plate: 4 x 5 in. (10.1 x 12.6 cm.)
Acquired from: Stephen White Gallery of Photography, Inc.,
Los Angeles, California

5262. **[Rhododendron plants]** (P1983.24.18)
Autochrome. c. 1910–17
Image: 2 7/8 x 3 9/16 in. (7.3 x 9.1 cm.)
Plate: 3 1/4 x 4 in. (8.2 x 10.1 cm.)
Acquired from: Stephen White Gallery of Photography, Inc.,
Los Angeles, California

* 5263. **SAILBOATS—VENICE [Venice, Sail Boats]** (P1983.23.110)
duplicate of P1983.23.98
Multiple gum print. 1909
Image: 7 3/4 x 5 7/8 in. (19.7 x 14.8 cm.)
Mount: 16 1/4 x 12 7/8 in. (41.3 x 32.6 cm.)
Signed, l.l. print recto and l.r. mount recto: "Karl Struss."
Inscription, print verso: "IIII gum/Karl Struss"
mount recto: "1909."
mount verso: "Peter/Brunsel/Ruth Ester//#26//#27—
"Sailboats—Venice, 1909."/#16//Multiple gum Print,
3 printings.//$1,500.—" and rubber stamp
"PHOTOGRAPHED BY/KARL STRUSS/HOLLYWOOD,
CALIF." and printed paper labels "THIS PRINT HAS
BEEN EXHIBITED/In the GALLERY.·.·. of the/
CALIFORNIA CAMERA CLUB—/during the Month of
[in ink] June 1929./[in ink] Mr. Ralph Smith/CHAIRMAN
PRINT COMMITTEE./San Francisco California." and
"Los Angeles Camera Club/108-12 Stimson Bldg.:·129 West
Third St./LOS ANGELES, CALIFORNIA/(Affiliated with
the Associated/Camera Clubs of America)/[LACC
insignia]/EXHIBITED AT THE LOS/ANGELES
CAMERA CLUB" and "MEMBER/[PPA insignia]/
PICTORIAL/PHOTOGRAPHERS/OF AMERICA"
Acquired from: Stephen White Gallery of Photography, Inc.,
Los Angeles, California

5264. **SAILS [Sails: En Route to Catalina]** (P1983.23.160) duplicate
of P1980.3.15 in "Karl Struss: A Portfolio 1909/29"
Bromide print. c. 1929–30
Image: 13 7/16 x 10 7/16 in. (34.1 x 26.5 cm.)
Sheet: 13 9/16 x 10 9/16 in. (34.5 x 26.8 cm.)
Mount: 14 15/16 x 12 7/16 in. (37.9 x 31.5 cm.)
Signed, l.r. print recto: "Karl Struss"
l.r. mount recto: "Karl Struss."
Inscription, mount recto: "SAILS", 1930—"
mount verso: " "SAILS" 1930./Karl Struss.//BSR//9"
and rubber stamp "KARL STRUSS/ARTIST
PHOTOGRAPHER/HOLLYWOOD :: CALIFORNIA"
and printed paper label "Los Angeles Camera Club/108-12
Stimson Bldg.:·129 West Third St./LOS ANGELES,
CALIFORNIA/(Affiliated with the Associated/Camera
Clubs of America)/[LACC insignia]/EXHIBITED AT THE
LOS/ANGELES CAMERA CLUB"
Acquired from: Stephen White Gallery of Photography, Inc.,
Los Angeles, California

5265. **SAND DUNES, ARVERNE** (P1983.23.64)
Hand-coated multiple platinum print. 1909
Image: 6 5/16 x 9 1/8 in. (16.0 x 23.2 cm.)
1st mount: 6 7/16 x 9 1/4 in. (16.3 x 23.4 cm.)

2nd mount: 17 x 13 ⅞ in. (43.2 x 35.2 cm.)
Signed, l.l. print recto: "Karl Struss.—1909."
 l.r. overmat recto: "Karl Struss."
Inscription, 2nd mount verso: "#19—"SAND DUNES,
 ARVERNE"/Karl Struss/Hand coated multiple platinum"
 and rubber stamp "KARL STRUSS/ARTIST
 PHOTOGRAPHER/HOLLYWOOD :: CALIFORNIA"
Acquired from: Stephen White Gallery of Photography, Inc.,
 Los Angeles, California

5266. **[Seven people on ship's deck; woman at right holding a
 camera]** (P1983.24.12)
 Autochrome. c. 1913–14
 Image: 2 ¾ x 3 ⁹⁄₁₆ in. (7.0 x 9.0 cm.)
 Plate: 3 ¼ x 4 in. (8.2 x 10.1 cm.)
 Acquired from: Stephen White Gallery of Photography, Inc.,
 Los Angeles, California

*5267. **SILHOUETTE OF SKYLINE—MOON BEHIND
 FLAGPOLE, N.Y.C.** (P1983.23.42)
 Platinum print. 1911
 Image: 4 ½ x 3 ⅝ in. (11.4 x 9.2 cm.)
 1st mount: 4 ⅝ x 3 ¾ in. (11.7 x 9.6 cm.)
 2nd mount: 5 ¼ x 4 ⅜ in. (13.4 x 11.2 cm.)
 Inscription, 2nd mount verso: "Silhouette of Skyline—Moon/
 behind Flagpole 1911 NYC.//#42"
 Acquired from: Stephen White Gallery of Photography, Inc.,
 Los Angeles, California

5256

5268. **SILHOUETTE ROW BOATS—MOONLIGHT—
 ARVERNE** (P1983.23.50)
 Platinum print. 1910
 Image: 3 x 4 ³⁄₁₆ in. (7.7 x 10.6 cm.)
 Mount: 3 ½ x 4 ¹¹⁄₁₆ in. (9.0 x 11.8 cm.)
 Inscription, mount recto: "1910."
 mount verso: "Silhouette Row Boats/Moonlight—
 Arverne/1910//#54"
 Acquired from: Stephen White Gallery of Photography, Inc.,
 Los Angeles, California

*5269. **THE SPAN AT TWILIGHT. MANHATTAN BRIDGE**
 (P1983.23.68)
 Platinum print. 1915
 Image: 10 ³⁄₁₆ x 12 ⅝ in. (25.8 x 32.1 cm.)
 Mount: 14 ⅜ x 16 ¼ in. (36.5 x 41.1 cm.)
 Signed, l.l. print recto and l.r. mount recto: "Karl Struss
 1915."
 Inscription, mount verso: "#17/#94/"The Span at Twilight."/
 Manhattan Bridge//PLATINUM·PRINT.//75//1923" and
 rubber stamps "PHOTOGRAPHED BY/KARL STRUSS/
 HOLLYWOOD, CALIF." and "NATIONAL SALON
 BUFFALO, N.Y." and printed paper labels "THIS PRINT
 HAS BEEN EXHIBITED/In the GALLERY.∴·of the/
 CALIFORNIA CAMERA CLUB—/during the Month of
 [blank]/[blank]/CHAIRMAN PRINT COMMITTEE./
 San Francisco California." and "Los Angeles Camera
 Club/108-12 Stimson Bldg.:·129 West Third St./LOS
 ANGELES, CALIFORNIA/(Affiliated with the
 Associated/Camera Clubs of America)/[LACC insignia]/
 EXHIBITED AT THE LOS/ANGELES CAMERA CLUB"
 Acquired from: Stephen White Gallery of Photography, Inc.,
 Los Angeles, California

5263

5270. **SPRINGTIME [Ethel Struss]** (P1983.23.151)
 Gelatin silver print. 1921
 Image: 12 ¹¹⁄₁₆ x 9 ¹⁵⁄₁₆ in. (32.1 x 25.2 cm.)
 Sheet: 13 ¹³⁄₁₆ x 10 ¹³⁄₁₆ in. (35.0 x 27.4 cm.)
 Mount: 17 x 14 in. (43.2 x 35.6 cm.)
 Inscription, mount recto: "10 ⅜//13 ¼//15"
 mount verso: "SPRINGTIME" and printed paper label
 "Los Angeles Camera Club/108-12 Stimson Bldg.:·129 West
 Third St./LOS ANGELES, CALIFORNIA/(Affiliated with
 the Associated/Camera Clubs of America)/[LACC
 insignia]/EXHIBITED AT THE LOS/ANGELES
 CAMERA CLUB"
 Acquired from: Stephen White Gallery of Photography, Inc.,
 Los Angeles, California

5271. **STATION ON HUDSON N.Y.C.** (P1983.23.22)
Platinum print. 1911
Image: 3 9/16 x 4 9/16 in. (9.0 x 11.5 cm.)
1st mount: 3 5/8 x 4 5/8 in. (9.2 x 11.8 cm.)
2nd mount: 4 1/16 x 5 1/16 in. (10.3 x 12.9 cm.)
Inscription, 2nd mount recto: "1911."
2nd mount verso: "Station on Hudson 1911 NYC.//#22"
Acquired from: Stephen White Gallery of Photography, Inc.,
Los Angeles, California

5272. **STILL LIFE** [made on the set of *Something to Think About*]
(P1983.23.173)
Platinum print. 1920
Image: 7 1/4 x 9 1/8 in. (18.4 x 23.2 cm.)
1st mount: 8 3/8 x 10 1/8 in. (21.3 x 25.7 cm.)
2nd mount: 17 1/16 x 13 1/16 in. (43.4 x 33.2 cm.)
Signed, l.l. print recto and l.r. 1st mount recto: "Karl Struss"
Inscription, 2nd mount recto: "14"
2nd mount verso: " "Still Life."//520/112//A" and rubber
stamp "PHOTOGRAPHED BY/KARL STRUSS/
HOLLYWOOD, CALIF." and printed paper label
"EXHIBITED AT/THE/LONDON SALON/OF
PHOTOGRAPHY/[LSP insignia]/1924."
Acquired from: Stephen White Gallery of Photography, Inc.,
Los Angeles, California

5273. **STILL LIFE WITH PEWTER VASE, NEW YORK**
(P1983.24.52) print from this autochrome is in the
"Dawn of Color" portfolio, P1983.23.190
Autochrome. c. 1910
Image: 8 1/16 x 6 1/16 in. (20.4 x 15.4 cm.)
Plate: 8 1/2 x 6 1/2 in. (21.5 x 16.5 cm.)
Acquired from: Stephen White Gallery of Photography, Inc.,
Los Angeles, California

* 5274. **STREET SCENE—FIRST AVENUE AND 36TH STREET**
(P1983.23.90)
Platinum print. c. 1910
Image: 3 13/16 x 4 5/8 in. (9.6 x 11.8 cm.)
1st mount: 3 7/8 x 4 3/4 in. (9.9 x 12.1 cm.)
2nd mount: 4 9/16 x 5 3/8 in. (11.7 x 13.7 cm.)
Inscription, 2nd mount verso: "41//(41)/79"
Acquired from: Stephen White Gallery of Photography, Inc.,
Los Angeles, California

5275. [Struss Family—six women seated on porch steps; Marie
Fischer Struss on far right] (P1983.24.8)
Autochrome. c. 1910–17
Image: 2 7/8 x 3 9/16 in. (7.4 x 9.0 cm.)
Plate: 3 1/4 x 4 in. (8.2 x 10.1 cm.)
Acquired from: Stephen White Gallery of Photography, Inc.,
Los Angeles, California

5276. **SUNLIGHT ON HUDSON RIVER. TREES, RIVERSIDE
PARK** (P1983.23.71)
Sepia-toned bromide print. 1911
Image: 13 3/8 x 10 9/16 in. (33.8 x 26.8 cm.)
Signed, center print verso: "Karl Struss."
Inscription, print verso: " "Sunlight on Hudson River"/
Trees, Riverside Park.//Sepia Bromide/1911//BSR" and
rubber stamp "KARL STRUSS/PORTRAITS BY
PHOTOGRAPHY/AT HOME AND IN THE STUDIO/5
WEST 31st STREET/NEW YORK/Madison Sq. 674"
Acquired from: Stephen White Gallery of Photography, Inc.,
Los Angeles, California

* 5277. **SUNLIGHT ON SURF** [Arverne Pier] (P1983.23.83)
Platinum print. 1912
Image: 4 7/16 x 3 13/16 in. (11.2 x 9.8 cm.)
1st mount: 4 1/2 x 4 in. (11.5 x 10.1 cm.)
2nd mount: 5 1/8 x 4 1/2 in. (12.9 x 11.3 cm.)
Inscription, 2nd mount verso: "25//(25)/89"
Acquired from: Stephen White Gallery of Photography, Inc.,
Los Angeles, California

5278. **SUNRISE** [village building on *Sunrise* set] (P1983.23.164)
Gelatin silver print. c. 1927
Image: 12 5/8 x 9 7/8 in. (32.0 x 25.1 cm.)
Mount: 17 x 14 in. (43.2 x 35.6 cm.)
Signed: see inscription
Inscription, mount recto: " "Sunrise" " and embossed
"KARL STRUSS"
mount verso: "(88)//11//108" and rubber stamp
"PHOTOGRAPHED BY/KARL STRUSS/HOLLYWOOD
:: CALIFORNIA"
Acquired from: Stephen White Gallery of Photography, Inc.,
Los Angeles, California

5279. **SUNSET PASSING THE AZORES ON A STEAMER**
(P1983.23.97)
Platinum print. 1909
Image: 1 3/4 x 3 5/16 in. (4.5 x 8.4 cm.)
1st mount: 2 x 3 9/16 in. (5.0 x 9.0 cm.)
2nd mount: 2 7/16 x 4 in. (6.1 x 10.2 cm.)
Inscription, l.r. 2nd mount recto: "1909."
2nd mount verso: "Sunset passing the/Azores on a
Steamer/1909//#56//#2"
Acquired from: Stephen White Gallery of Photography, Inc.,
Los Angeles, California

* 5280. **SUNSET, SIMPLON PASS** (P1983.23.108)
Hand-coated multiple platinum print. 1909
Image: 4 3/4 x 7 11/16 in. (12.0 x 19.5 cm.)
1st mount: same as image size
2nd mount: 7 13/16 x 10 3/4 in. (19.9 x 27.3 cm.)
Signed, l.l. print recto: "Karl Struss 1909."
Inscription, 2nd mount verso: "Sunset, Simplon Pass."/Karl
Struss./Hand coated/Multiple Platinum Print,—13
printings/$1,000.—//14//[illegible]" and rubber stamp
"PHOTOGRAPHED BY/KARL STRUSS/HOLLYWOOD,
CALIF." and printed paper labels "[THIS] PRINT/[WAS
EX]HIBITED BY/[SPECIAL] INVITATION/[AT] THE/
[SA]N ANTONIO/[SALON] of PICTORIAL/
[PHOT]OGRAPHY/[INTER]NATIONAL/[San Ant]onio
Pictorial/[Cam]era Club" and "Los Angeles Camera Club/
[remainder of label is cut off]"
Acquired from: Stephen White Gallery of Photography, Inc.,
Los Angeles, California

5281. **TENNIS MATCH, HAMILTON, BERMUDA** (P1983.24.24)
print of this autochrome is in the "Dawn of Color"
portfolio, P1983.23.186
Autochrome. c. 1913
Image: 3 9/16 x 4 9/16 in. (9.1 x 11.6 cm.)
Plate: 4 x 5 in. (10.1 x 12.6 cm.)
Acquired from: Stephen White Gallery of Photography, Inc.,
Los Angeles, California

5282. **3 PAIR DRAYS ON DOCK, CRATE HANGING**
(P1983.23.6)
Platinum print. c. 1911–13
Image: 3 1/4 x 4 5/8 in. (8.3 x 11.7 cm.)
1st mount: 3 3/8 x 4 11/16 in. (8.5 x 11.9 cm.)
2nd mount: 3 7/8 x 5 1/4 in. (9.8 x 13.4 cm.)
Inscription, 2nd mount recto: "1911."
2nd mount verso: "3 pair Drays on Dock/Crate
hanging//#6"
Acquired from: Stephen White Gallery of Photography, Inc.,
Los Angeles, California

5283. **3 STATUES DANCING** (P1983.23.106)
Platinum print. 1909
Image: 4 7/16 x 3 5/8 in. (11.3 x 9.2 cm.)
Sheet: 4 1/2 x 3 3/4 in. (11.5 x 9.4 cm.)
Mount: 5 x 4 1/4 in. (12.8 x 10.8 cm.)
Inscription, mount recto: "1909."
mount verso: "3 Statues Dancing/1909//#136"
Acquired from: Stephen White Gallery of Photography, Inc.,
Los Angeles, California

5267

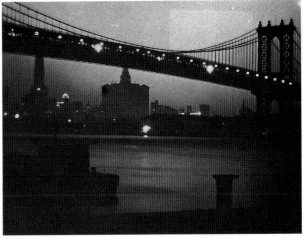

5269

5274

5277

5280

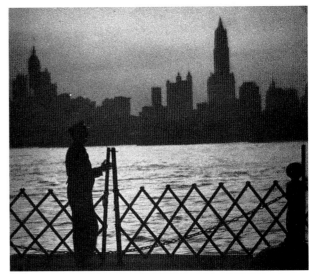

5285

5284. **TONY IN FACTORY [Tony in Dad's Factory]** (P1983.23.139)
Platinum print. 1911
Image: 4 1/8 x 3 1/2 in. (10.5 x 8.9 cm.)
1st mount: 4 3/16 x 3 5/8 in. (10.7 x 9.1 cm.)
2nd mount: 4 11/16 x 4 1/8 in. (11.8 x 10.4 cm.)
Inscription, 2nd mount recto: "1911."
2nd mount verso: "Tony in/Factory//1911//#118"
Acquired from: Stephen White Gallery of Photography, Inc.,
Los Angeles, California

*5285. **TOWARD N.Y.C., MAN AT GATE, HUDSON RIVER**
(P1983.23.56)
Platinum print. 1911
Image: 3 9/16 x 4 in. (9.0 x 10.2 cm.)
Mount: 3 11/16 x 4 1/8 in. (9.3 x 10.5 cm.)
Inscription, mount verso: "Toward NYC, 1911, Man at/Gate,
Hudson River//#108"
Acquired from: Stephen White Gallery of Photography, Inc.,
Los Angeles, California

*5286. **TRACKS—EL—BROOKLYN BRIDGE TOWARDS N. Y.**
(P1983.23.13)
Platinum print. 1911
Image: 3 13/16 x 4 7/16 in. (9.7 x 11.2 cm.)
1st mount: 3 15/16 x 4 9/16 in. (9.9 x 11.5 cm.)
2nd mount: 4 7/16 x 5 1/8 in. (11.2 x 12.9 cm.)
Inscription, 2nd mount recto: "1911."
2nd mount verso: "track—El//B. Bridge/towards N. Y.//
#15//#13"
Acquired from: Stephen White Gallery of Photography, Inc.,
Los Angeles, California

5287. **TROLLEY, HORSE-DRAWN VEHICLE & EL. N.Y.C.**
(P1983.23.3)
Platinum print. 1911
Image: 3 3/16 x 4 1/8 in. (8.0 x 10.4 cm.)
1st mount: 3 1/4 x 4 3/16 in. (8.3 x 10.7 cm.)
2nd mount: 3 3/4 x 4 11/16 in. (9.5 x 11.9 cm.)
Inscription, 2nd mount recto: "1911."
2nd mount verso: "Trolley, horse-drawn vehicle/& El.
NYC—1911//3."
Acquired from: Stephen White Gallery of Photography, Inc.,
Los Angeles, California

*5288. **2 MEN, 2 CRATES ON DOCK, N.Y.C.** (P1983.23.7)
Platinum print. c. 1911–13
Image: 4 1/2 x 3 3/4 in. (11.3 x 9.5 cm.)
1st mount: 4 5/8 x 3 15/16 in. (11.7 x 9.9 cm.)
2nd mount: 5 1/4 x 4 9/16 in. (13.2 x 11.5 cm.)
Inscription, 2nd mount recto: "1911"
2nd mount verso: "2 Men, 2 Crates on Dock, NYC.//#7."
Acquired from: Stephen White Gallery of Photography, Inc.,
Los Angeles, California

*5289. **291 [The Open Window]** (P1983.23.89)
Platinum print. c. 1910–11
Image: 3 11/16 x 4 5/16 in. (9.4 x 10.9 cm.)
Mount: 7 7/8 x 9 1/16 in. (19.9 x 23.0 cm.)
Signed, l.r. mount recto: "Karl Struss"
Inscription, mount verso: " "291" " and rubber stamp
"PHOTOGRAPHED BY/KARL STRUSS/HOLLYWOOD,
CALIF." and printed paper label "MUSEUM OF THE
CITY OF NEW YORK/"VIEWS OF NEW YORK—
OLD AND NEW"/Exhibited by/PICTORIAL
PHOTOGRAPHERS of AMERICA/November 9th
to November 23, 1936"
Acquired from: Stephen White Gallery of Photography, Inc.,
Los Angeles, California

5290. **TWO ON-COMING CARS ONE PARKED ON RIGHT
N.Y.C.** (P1983.23.41)
Platinum print. 1911
Image: 4 5/16 x 3 9/16 in. (10.9 x 9.0 cm.)
1st mount: 4 3/8 x 3 5/8 in. (11.1 x 9.2 cm.)
2nd mount: 4 13/16 x 4 1/8 in. (12.3 x 10.5 cm.)
Inscription, 2nd mount recto: "1911."

2nd mount verso: "Two On-Coming cars one/parked on
R. 1911 NYC.//#41"
Acquired from: Stephen White Gallery of Photography, Inc.,
Los Angeles, California

5291. **TWO RIGS—2 WHITE HORSES EACH—N.Y.C.**
[Fifth Avenue] (P1983.23.28)
Platinum print. 1911
Image: 3 1/16 x 2 9/16 in. (7.7 x 6.5 cm.)
1st mount: 3 3/16 x 2 11/16 in. (8.0 x 6.8 cm.)
2nd mount: 3 5/8 x 3 3/16 in. (9.2 x 8.0 cm.)
Inscription, 2nd mount recto: "1911."
2nd mount verso: "Two Rigs—2 wh. Horses/each—
NYC./1911//#28"
Acquired from: Stephen White Gallery of Photography, Inc.,
Los Angeles, California

5292. **[Two ships in a harbor; walkway in foreground]** (P1983.24.42)
Autochrome. c. 1910–17
Image: 2 7/8 x 3 9/16 in. (7.3 x 9.1 cm.)
Plate: 3 1/4 x 4 in. (8.2 x 10.1 cm.)
Acquired from: Stephen White Gallery of Photography, Inc.,
Los Angeles, California

*5293. **2 WHEELS AT DOCK—BROOKLYN BRIDGE
BACKGROUND** (P1983.23.29)
Platinum print. 1911
Image: 4 5/16 x 3 13/16 in. (10.9 x 9.7 cm.)
1st mount: 4 1/2 x 3 15/16 in. (11.3 x 10.0 cm.)
2nd mount: 5 1/16 x 4 9/16 in. (12.8 x 11.6 cm.)
Inscription, 2nd mount recto: "1911"
2nd mount verso: "2 Wheels at Dock—1911—Br. Br./
Background//#29"
Acquired from: Stephen White Gallery of Photography, Inc.,
Los Angeles, California

5294. **[Two women in front of a vine-covered country store]**
(P1983.24.44)
Autochrome. c. 1910
Image: 8 x 6 1/16 in. (20.3 x 15.3 cm.)
Plate: 8 1/2 x 6 1/2 in. (21.5 x 16.5 cm.)
Acquired from: Stephen White Gallery of Photography, Inc.,
Los Angeles, California

5295. **[Two women standing beside a lake]** (P1983.24.45)
Autochrome. c. 1910
Image: 8 x 6 in. (20.3 x 15.2 cm.)
Plate: 8 1/2 x 6 1/2 in. (21.5 x 16.5 cm.)
Acquired from: Stephen White Gallery of Photography, Inc.,
Los Angeles, California

*5296. **UPPER HALF BROOKLYN BRIDGE, LOWER—
CITY SKYLINE, N.Y.C.** (P1983.23.43)
Bromide print. 1911
Image: 6 3/16 x 4 1/2 in. (15.6 x 11.4 cm.)
Inscription, print verso: "Upper half Brook- Bridge/
Lower—City Skyline, NYC./1911//#43"
Acquired from: Stephen White Gallery of Photography, Inc.,
Los Angeles, California

*5297. **UPTOWN. N.Y.C.** (P1983.23.4)
Platinum print. c. 1911–12
Image: 2 13/16 x 3 7/8 in. (7.1 x 9.8 cm.)
1st mount: 2 15/16 x 4 in. (7.5 x 10.2 cm.)
2nd mount: 3 1/2 x 4 1/2 in. (8.9 x 11.4 cm.)
Inscription, 2nd mount recto: "1911."
2nd mount verso: "Uptown. NYC.//4"
Acquired from: Stephen White Gallery of Photography, Inc.,
Los Angeles, California

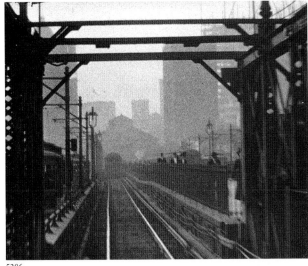

5286

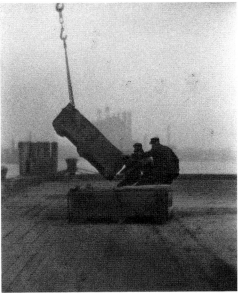

5288

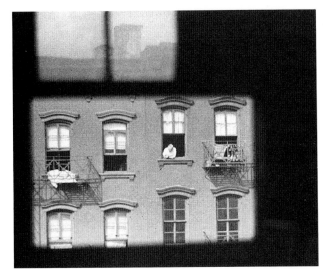

5289

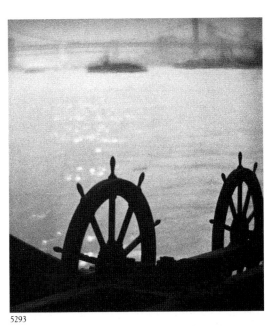

5293

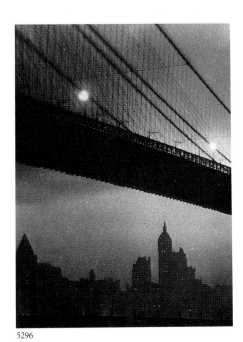

5296

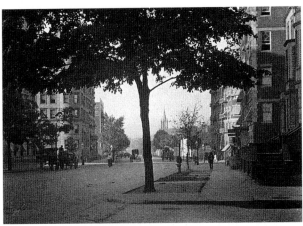

5297

5298. **VANISHING POINT II: BROOKLYN BRIDGE FROM NEW YORK SIDE** (P1983.23.93) duplicate of P1980.3.10 in "Karl Struss: A Portfolio 1909/29"
Platinum print. 1912
Image: 3 13/16 x 4 5/8 in. (9.6 x 11.7 cm.)
1st mount: 3 15/16 x 4 3/4 in. (10.0 x 12.1 cm.)
2nd mount: 4 1/2 x 5 1/4 in. (11.5 x 13.4 cm.)
Inscription, 2nd mount recto: "1912."
2nd mount verso: "61//(61)/72"
Acquired from: Stephen White Gallery of Photography, Inc., Los Angeles, California

5299. **VENICE, SAIL BOATS** [Sailboats—Venice] (P1983.23.98) duplicate of P1983.23.110
Platinum print. 1909
Image: 3 15/16 x 2 7/8 in. (10.0 x 7.3 cm.)
1st mount: 4 x 3 in. (10.2 x 7.5 cm.)
2nd mount: 4 1/2 x 3 7/16 in. (11.3 x 8.7 cm.)
Inscription, 2nd mount recto: "1909."
2nd mount verso: "Venice, Sail Boats/1909//#92"
Acquired from: Stephen White Gallery of Photography, Inc., Los Angeles, California

5300. **VESSEL PASSING UNDER BRIDGE, N.Y.** (P1983.23.44)
Platinum print. 1912
Image: 4 7/16 x 3 3/4 in. (11.3 x 9.6 cm.)
1st mount: 4 5/8 x 3 15/16 in. (11.7 x 9.9 cm.)
2nd mount: 5 5/16 x 4 9/16 in. (13.5 x 11.6 cm.)
Inscription, 2nd mount recto: "1912."
2nd mount verso: "Vessell [sic] passing under Br./1912 NY.//#44"
Acquired from: Stephen White Gallery of Photography, Inc., Los Angeles, California

*5301. **[View of Brooklyn Bridge from Ferry Slip]** (P1983.23.79)
Platinum print. 1912
Image: 3 1/2 x 4 5/8 in. (8.8 x 11.7 cm.)
Mount: 3 5/8 x 4 3/4 in. (9.2 x 12.1 cm.)
Inscription, mount verso: "(64)//80"
Acquired from: Stephen White Gallery of Photography, Inc., Los Angeles, California

5302. **WEST SHORE—N.Y.C.** (P1983.23.40)
Platinum print. c. 1910–12
Image: 4 1/2 x 3 in. (11.5 x 7.6 cm.)
1st mount: 4 11/16 x 3 3/16 in. (12.0 x 8.0 cm.)
2nd mount: 5 5/16 x 3 3/4 in. (13.4 x 9.6 cm.)
Inscription, 2nd mount verso: "1910–12//"West Shore"—NYC—1911//#40//#8"
Acquired from: Stephen White Gallery of Photography, Inc., Los Angeles, California

5303. **WESTWARD—36TH ST. & 1ST AVE.** (P1983.23.59)
Bromide print. 1909
Image: 3 5/8 x 4 7/16 in. (9.2 x 11.3 cm.)
1st mount: 3 11/16 x 4 9/16 in. (9.4 x 11.5 cm.)
2nd mount: 4 3/8 x 5 3/16 in. (11.0 x 13.2 cm.)
Inscription, 2nd mount recto: "1909."
2nd mount verso: "Westward—36″ St & 1st Ave.//#115"
Acquired from: Stephen White Gallery of Photography, Inc., Los Angeles, California

5304. **WHITE FERRY BOAT—N.Y.C.** (P1983.23.12)
Platinum print. c. 1910–15
Image: 4 9/16 x 3 3/4 in. (11.6 x 9.6 cm.)
Mount: 4 3/4 x 3 15/16 in. (12.0 x 10.0 cm.)
Inscription, mount recto: "Struss"
mount verso: "White Ferry Boat—NYC.//#12"
Acquired from: Stephen White Gallery of Photography, Inc., Los Angeles, California

*5305. **WILLARD WHITE N.Y.C.—3 POTTED PLANTS IN WINDOW** (P1983.23.39)
Platinum print. 1911
Image: 4 9/16 x 3 11/16 in. (11.6 x 9.4 cm.)
1st mount: 4 11/16 x 3 13/16 in. (11.9 x 9.7 cm.)
2nd mount: 5 3/16 x 4 5/16 in. (13.2 x 11.0 cm.)

Inscription, 2nd mount verso: "Willard White NYC—1910–11/3 Potted Plants/in window//#39"
Acquired from: Stephen White Gallery of Photography, Inc., Los Angeles, California

5306. **WINDSWEPT, NOVA SCOTIA** [Around Chester, Hilda Among Trees] (P1983.23.135)
Hand-coated multiple platinum print. 1911
Image: 7 7/16 x 9 5/16 in. (18.8 x 23.6 cm.)
1st mount: 7 9/16 x 9 7/16 in. (19.2 x 23.9 cm.)
2nd mount: 8 1/2 x 10 1/4 in. (21.5 x 26.1 cm.) irregular
3rd mount: 16 15/16 x 13 1/16 in. (43.0 x 33.2 cm.)
Signed, l.l. print recto: "Karl Struss 1911"
l.r. 2nd mount recto: "Karl Struss"
Inscription, 1st mount verso, rubber stamp: [illegible]
3rd mount verso: "#21—"Windswept, Nova Scotia"/Hand Coated Multiple Platinum Print./Karl Struss, 1911—" and rubber stamp "PHOTOGRAPHED BY/KARL STRUSS/HOLLYWOOD, CALIF." and printed paper label "THIS PRINT HAS BEEN EXHIBITED/IN the GALLERY.·.·.· of the/CALIFORNIA CAMERA CLUB—/during the Month of [blank]/[blank]/CHAIRMAN PRINT COMMITTEE./San Francisco California."
Acquired from: Stephen White Gallery of Photography, Inc., Los Angeles, California

5307. **[Woman and two children in flowing costumes dancing beside a lake]** (P1983.24.10)
Autochrome. c. 1910–17
Image: 4 9/16 x 3 1/2 in. (11.6 x 9.0 cm.)
Plate: 5 x 4 in. (12.6 x 10.1 cm.)
Acquired from: Stephen White Gallery of Photography, Inc., Los Angeles, California

5308. **[Woman and two children in flowing costumes looking at their reflections in a lake]** (P1983.24.9)
Autochrome. c. 1910–17
Image: 4 5/8 x 3 5/8 in. (11.7 x 9.2 cm.)
Plate: 5 x 4 in. (12.6 x 10.1 cm.)
Acquired from: Stephen White Gallery of Photography, Inc., Los Angeles, California

*5309. **WOMAN, LEAVING GROUP, N.Y.C.** [Sunshine and Shadow, Park Row, New York] (P1983.23.34)
Platinum print. c. 1909–11
Image: 4 5/16 x 3 5/8 in. (11.0 x 9.2 cm.)
Mount: 4 3/4 x 3 7/8 in. (12.1 x 9.8 cm.)
Signed, l.r. print recto: "Karl Struss"
Inscription, mount recto: "1910."
mount verso: "2nd//Woman, Leaving Group/1911 NYC.//#34"
Acquired from: Stephen White Gallery of Photography, Inc., Los Angeles, California

5310. **WOMAN WALKING ALONG HUDSON** [Riverside Park] (P1983.23.20)
Platinum print. 1911
Image: 3 11/16 x 4 5/8 in. (9.4 x 11.8 cm.)
1st mount: 3 3/4 x 4 11/16 in. (9.6 x 11.9 cm.)
2nd mount: 4 3/16 x 5 1/8 in. (10.7 x 13.1 cm.)
Inscription, 2nd mount recto: "1911."
2nd mount verso: "Woman walking along Hudson/1911//#20"
Acquired from: Stephen White Gallery of Photography, Inc., Los Angeles, California

5311. **WORKMEN ON DOCKS, N.Y.** (P1983.23.63)
Platinum print. 1911
Image: 4 9/16 x 3 9/16 in. (11.5 x 9.1 cm.)
Mount: 13 1/4 x 11 5/16 in. (33.7 x 28.9 cm.) irregular
Inscription, print verso: "Workmen on Docks, NY./1911//#127"
Acquired from: Stephen White Gallery of Photography, Inc., Los Angeles, California

NANCY SUTOR, American (b. 1953)

Nancy Sutor was born in Chicago, Illinois, and attended the School of the Art Institute of Chicago and Northern Illinois University. Sutor's work has appeared in exhibitions in New York, Chicago, Santa Fe, and elsewhere. In 1983 a selection of her pastel drawings and cyanotype prints was displayed in Santa Fe.

5312. **SKELETON [from the Santa Fe Center for Photography "Portfolio II"]** (P1984.4.3)
Cyanotype with hand coloring. 1982–83
Image: 10 3/16 x 8 13/16 in. (25.8 x 22.3 cm.) irregular
Signed, l.r. print recto: "Sutor 1983"
 note: portfolio title sheet lists the date as 1982
Acquired from: Santa Fe Center for Photography, Santa Fe, New Mexico

ISAIAH WEST TABER, publisher, American (1830–1912)

Taber was born in New Bedford, Massachusetts. After working as a gold miner, rancher, and dentist, he opened one of the first photographic studios in Syracuse, New York. In 1864 Taber moved to San Francisco, where he joined the photographic publishing firm of Bradley and Rulofson. Leaving the firm in 1871, he opened his own studio and photographic publishing company. In 1876 Taber acquired the negatives of the bankrupt photographer Carleton Watkins and subsequently published many of them under his own imprint. Taber hired many staff photographers whose work was also published with the Taber logo. In 1888 he was named a commissioner of the Yosemite Valley area. Taber's negatives were destroyed in the San Francisco fire and earthquake of 1906.

*5313. **A CHINESE BAGNIO, SAN FRANCISCO** (P1981.86)
Albumen silver print. c. 1880s
Image: 4 11/16 x 7 11/16 in. (11.9 x 19.5 cm.)
Sheet: 4 7/8 x 7 11/16 in. (12.4 x 19.5 cm.)
Signed: see inscription
Inscription, in negative: "B 3018 A Chinese bagnio, San Francisco.//Taber Photo., San Francisco."
Acquired from: Ken and Jenny Jacobson Victorian Photography, Essex, England

5314. **COURT, PALACE HOTEL, SAN FRANCISCO, CAL.** (P1972.32.6)
Albumen silver print. c. 1880
Image: 12 3/16 x 8 1/16 in. (30.9 x 20.5 cm.)
Mount: 13 1/16 x 11 1/16 in. (33.1 x 28.0 cm.)
Signed: see inscription
Inscription, in negative: "A 146 Court, Palace Hotel, San Francisco, Cal.//Taber Photo., San Francisco."
 mount verso: "97"
Acquired from: John Howell—Books, San Francisco, California

5315. **GOV. STANFORD'S RESIDENCE, SAN FRANCISCO, CAL.** (P1972.32.9)
Albumen silver print. c. 1880
Image: 8 1/8 x 12 1/16 in. (20.7 x 30.6 cm.)
Mount: 11 x 13 1/16 in. (28.0 x 33.1 cm.)
Signed: see inscription
Inscription, in negative: "A 161 Gov. Stanford's Residence, San Francisco, Cal//Taber Photo., San Francisco."
 mount verso: "96"
Acquired from: John Howell—Books, San Francisco, California

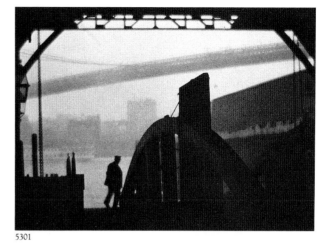

5301

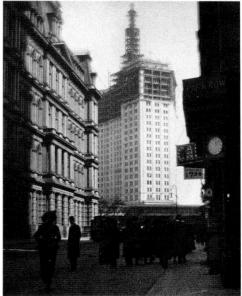

5305

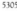

5309

5316. J. C. FLOOD'S RESIDENCE, MENLO PARK, CAL.
(P1972.32.7)
Albumen silver print. c. 1880
Image: 7¹³⁄₁₆ x 9½ in. (19.8 x 24.2 cm.)
Mount: 11 x 12¹⁵⁄₁₆ in. (28.0 x 32.8 cm.)
Signed: see inscription
Inscription, in negative: "B 1075 J. C. Flood's Residence,
Menlo Park, Cal.//Taber Photo., San Francisco."
mount verso: "95"
Acquired from: John Howell—Books, San Francisco,
California

**5317. MR. D. O. MILLS' RESIDENCE AT MILBRAE, CAL.,
LIVE OAK WITH ROOTED BRANCH** (P1972.32.8)
Albumen silver print. c. 1880
Image: 7¹³⁄₁₆ x 9¹¹⁄₁₆ in. (19.8 x 24.6 cm.)
Mount: 11 x 12¹⁵⁄₁₆ in. (28.0 x 32.8 cm.)
Signed: see inscription
Inscription, in negative: "B 2054 Mr. D. O. Mills' Residence
at Milbrae, Cal., live oak with rooted branch.//Taber
Photo., San Francisco."
mount verso: "98"
Acquired from: John Howell—Books, San Francisco,
California

***5318. YOSEMITE STAGE BY THE FALLEN MONARCH.
MARIPOSA GROVE** (P1981.51)
Platinum print. 1894
Image: 7³⁄₁₆ x 9⁵⁄₁₆ in. (18.2 x 23.6 cm.)
Sheet: 7⅜ x 9⁵⁄₁₆ in. (18.7 x 23.6 cm.)
Signed: see inscription
Inscription, in negative: "6619 Yosemite Stage by the
Fallen Monarch. Mariposa Grove, 1894.//Taber Photo.,
San Francisco, Cal."
print verso: "92/92//92//3"
Acquired from: John Howell—Books, San Francisco,
California

PAUL SCHUSTER TAYLOR,
American (1895–1984)

Taylor was an economist, not a professional photographer, but he recognized the impact documentary photographs could have and made a number of photographs to accompany his study of migrant labor written during the early 1930s. He taught economics at the University of California from 1922 until his retirement in 1962. Taylor met the photographer Dorothea Lange when he hired her to photograph migrant workers for the California State Emergency Relief Administration; the two were married in 1935. Taylor also worked as an advisor to the Resettlement Administration, later known as the Farm Security Administration, for which Lange also photographed. Taylor wrote numerous books on economics and with Lange produced *An American Exodus* (1939), documenting the dust bowl.

**5319. DOROTHEA LANGE [photographer's portrait accompanying
"The American Country Woman"]** (P1965.172.29)
Gelatin silver print. 1953
Image: 8⅜ x 6¾ in. (21.3 x 17.0 cm.)
Mount: same as image size
Inscription, mount verso: "Dorothea Lange"
Acquired from: Dorothea Lange, Berkeley, California

***5320. DOROTHEA LANGE** (P1977.43)
Gelatin silver print mounted on wooden block. 1935
Image: 4 x 3⁹⁄₁₆ in. (10.2 x 9.0 cm.)
Mount: same as image size
Inscription, mount verso: "DOROTHEA LANGE/
BY PAUL S. TAYLOR/1935"
Acquired from: unknown source

GEORGE A. TICE, American (b. 1938)

Tice has been active in several New Jersey camera clubs since his teens, participating in salon exhibitions. From 1956 to 1959 he was an official navy photographer. He has compiled photographic essays on the Amish; the ghost town of Bodie, California; and Paterson, New Jersey. He uses a view camera and frequently prints in platinum or palladium. Tice's publications include *Fields of Peace*; *Goodbye, River, Goodbye*; *Paterson*; *Hometowns: An American Pilgrimage*; *Seacoast Maine*; *George A. Tice, Photographs, 1953–1973*; *Urban Landscapes*, and *Urban Romantic*, along with several limited-edition portfolios. Tice also teaches and conducts workshops.

BODIE (P1971.88.1–12)
Tice published this portfolio of views of the ghost town of Bodie, California, in Colonia, New Jersey, in 1971. This is number 6 of an edition of 50 portfolios. The title page contains Tice's signature, but the individual prints bear only his embossed stamp.

***5321. WAGON AND BUILDINGS** (P1971.88.1)
Gelatin silver print. negative 1965, print 1971
Image: 4½ x 5⅞ in. (11.3 x 14.8 cm.)
Mount: 14 x 11 in. (35.6 x 28.0 cm.)
Signed: see inscription
Inscription, mount recto, embossed: "George A. Tice/
Photograph"
mount verso: "1"
Acquired from: The Witkin Gallery, New York, New York

5322. CAMERON HOUSE (P1971.88.2)
Gelatin silver print. negative 1965, print 1971
Image: 4¾ x 4⁷⁄₁₆ in. (12.1 x 11.3 cm.)
Mount: 14 x 11 in. (35.6 x 28.0 cm.)
Signed: see inscription
Inscription, mount recto, embossed: "George A. Tice/
Photograph"
mount verso: "2"
Acquired from: The Witkin Gallery, New York, New York

5323. WARD'S CEMETERY (P1971.88.3)
Gelatin silver print. negative 1965, print 1971
Image: 4⁷⁄₁₆ x 5¹³⁄₁₆ in. (11.3 x 14.7 cm.)
Mount: 14 x 11 in. (35.6 x 28.0 cm.)
Signed: see inscription
Inscription, mount recto, embossed: "George A. Tice/
Photograph"
mount verso: "3"
Acquired from: The Witkin Gallery, New York, New York

5324. SHOP FRONTS (P1971.88.4)
Gelatin silver print. negative 1965, print 1971
Image: 5⁵⁄₁₆ x 4½ in. (13.5 x 11.4 cm.)
Mount: 14 x 11 in. (35.6 x 28.0 cm.)
Signed: see inscription
Inscription, mount recto, embossed: "George A. Tice/
Photograph"
mount verso: "4"
Acquired from: The Witkin Gallery, New York, New York

5325. ROCKING CHAIR (P1971.88.5)
Gelatin silver print. negative 1965, print 1971
Image: 4⁷⁄₁₆ x 5¾ in. (11.3 x 14.6 cm.)
Mount: 14 x 11 in. (35.6 x 28.0 cm.)
Signed: see inscription
Inscription, mount recto, embossed: "George A. Tice/
Photograph"
mount verso: "5"
Acquired from: The Witkin Gallery, New York, New York

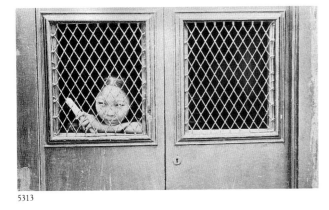

5313

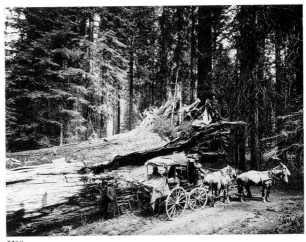

5318

5320

5321

5330

5326. **WOOD DETAIL** (P1971.88.6)
Gelatin silver print. negative 1965, print 1971
Image: 5 13/16 x 4 7/16 in. (14.8 x 11.3 cm.)
Mount: 14 x 11 in. (35.6 x 28.0 cm.)
Signed: see inscription
Inscription, mount recto, embossed: "George A. Tice/
Photograph"
mount verso: "6"
Acquired from: The Witkin Gallery, New York, New York

5327. **SHACKS AND MAIN ST. BUILDINGS** (P1971.88.7)
Gelatin silver print. negative 1965, print 1971
Image: 3 7/16 x 6 7/16 in. (8.7 x 16.4 cm.)
Mount: 14 x 11 in. (35.6 x 28.0 cm.)
Signed: see inscription
Inscription, mount recto, embossed: "George A. Tice/
Photograph"
mount verso: "7"
Acquired from: The Witkin Gallery, New York, New York

5328. **CHURCH STEPS AND BLACKSMITH SHOP** (P1971.88.8)
Gelatin silver print. negative 1965, print 1971
Image: 4 5/8 x 4 7/16 in. (11.8 x 11.3 cm.)
Mount: 14 x 11 in. (35.6 x 28.0 cm.)
Signed: see inscription
Inscription, mount recto, embossed: "George A. Tice/
Photograph"
mount verso: "8"
Acquired from: The Witkin Gallery, New York, New York

5329. **MINERS' UNION HALL** (P1971.88.9)
Gelatin silver print. negative 1965, print 1971
Image: 4 1/2 x 5 3/4 in. (11.4 x 14.7 cm.)
Mount: 14 x 11 in. (35.6 x 28.0 cm.)
Signed: see inscription
Inscription, mount recto, embossed: "George A. Tice/
Photograph"
mount verso: "9"
Acquired from: The Witkin Gallery, New York, New York

*5330. **TOMBSTONE, CATHERINE HOLLAND** (P1971.88.10)
Gelatin silver print. negative 1965, print 1971
Image: 4 7/16 x 4 7/16 in. (11.3 x 11.3 cm.)
Mount: 14 x 11 in. (35.6 x 28.0 cm.)
Signed: see inscription
Inscription, mount recto, embossed: "George A. Tice/
Photograph"
mount verso: "10"
Acquired from: The Witkin Gallery, New York, New York

5331. **CAIN HOUSE AND METHODIST CHURCH** (P1971.88.11)
Gelatin silver print. negative 1965, print 1971
Image: 4 7/16 x 6 7/16 in. (11.3 x 16.4 cm.)
Mount: 14 x 11 in. (35.6 x 28.0 cm.)
Signed: see inscription
Inscription, mount recto, embossed: "George A. Tice/
Photograph"
mount verso: "11"
Acquired from: The Witkin Gallery, New York, New York

5332. **CEMETERY GATES** (P1971.88.12)
Gelatin silver print. negative 1965, print 1971
Image: 4 1/2 x 4 1/2 in. (11.4 x 11.4 cm.)
Mount: 14 x 11 in. (35.6 x 28.0 cm.)
Signed: see inscription
Inscription, mount recto, embossed: "George A. Tice/
Photograph"
mount verso: "12"
Acquired from: The Witkin Gallery, New York, New York

* * * *

5333. **EVENING FOG, JONESPORT, MAINE** (P1978.36.1)
Gelatin silver print. 1971
Image: 6 1/4 x 9 7/16 in. (15.9 x 23.9 cm.)
Mount: 14 x 17 in. (35.6 x 43.2 cm.)
Signed, l.r. mount recto: "GEO. A. TICE"
Inscription, mount verso: "EVENING FOG, JONESPORT,
MAINE, 1971"
Acquired from: The Afterimage, Dallas, Texas

*5334. **OAK TREE, HOLMDEL, N. J.** (P1978.36.2)
Palladium print. 1970
Image: 7 11/16 x 9 5/8 in. (19.5 x 24.5 cm.)
Mount: 14 x 17 in. (35.6 x 43.2 cm.)
Signed, l.r. mount recto: "GEO. A. TICE"
Inscription, mount verso: "OAK TREE, HOLMDEL,
N. J. 1970//PALLADIUM PRINT/ON CRESCENT
DRAWING PAPER"
Acquired from: The Afterimage, Dallas, Texas

5335. **PORCH, MONHEGAN ISLAND, MAINE** (P1980.4.2)
Gelatin silver print. 1971
Image: 9 7/16 x 6 3/16 in. (24.0 x 15.7 cm.)
Mount: 17 x 14 in. (43.2 x 35.6 cm.)
Signed, l.r. mount recto: "GEO. A. TICE"
Inscription, mount verso: "PORCH, MONHEGAN
ISLAND, MAINE, 1971//PORTRIGA/SELENIUM"
Acquired from: The Halsted Gallery, Birmingham, Michigan

*5336. **SHAKER INTERIOR, SABBATH DAY LAKE, MAINE**
(P1980.4.1)
Gelatin silver print. negative 1971, print 1978
Image: 9 1/4 x 13 7/16 in. (23.4 x 34.1 cm.)
Mount: 16 x 20 in. (40.7 x 50.8 cm.)
Signed, l.r. mount recto: "GEO. A. TICE"
Inscription, mount verso: "SHAKER INTERIOR,
SABBATH DAY LAKE, MAINE, 1971//PRINT: 11/29/78"
Acquired from: The Halsted Gallery, Birmingham, Michigan

RICHARD TICHICH, American (b. 1947)

Richard Tichich was Visual Coordinator for the South
Central region of the Society for Photographic Educa-
tion in 1981 when he organized an exhibition of work
by eighteen photographers in that region. At that time
he was teaching at the Galveston Arts Center on the
Strand in Galveston, Texas. He has since taught at
Virginia Commonwealth University.

5337. **SOLOMON ARROYO VASQUEZ [from the Society for
Photographic Education's "South Central Regional
Photography Exhibition"]** (P1983.31.15)
Gelatin silver print. 1979
Image: 9 x 10 1/16 in. (22.8 x 25.5 cm.)
Sheet: 14 x 10 15/16 in. (35.6 x 27.8 cm.)
Signed, l.r. sheet recto: "Richard Tichich"
l.r. overmat recto: "Richard Tichich '79"
Inscription, sheet recto: "ARK" and typed on paper label
"Solomon Arroyo Vasquez/Presidente Municipal/Xuchiapa,
Puebla/Population: 2,800/Occupation: Farmer/Photograph
by: Richard Tichich/Date: July 1979"
mat backing, rubber stamp: "PRESIDENTES
MUNICIPALES DE MEXICO/ESTADOS
UNIDOS MEXICANOS"
Acquired from: gift of the Society for Photographic
Education, South Central Region

RONALD JAMES TODD, American (b. 1947)

Ron Todd received a B.F.A. in photography from the
Dayton Art Institute in 1972, studying with Emmet
Gowin, and an M.F.A. in photography from the School
of the Art Institute of Chicago in 1974. Todd was cura-
tor of photography at the New Orleans Museum of Art
from 1974 to 1976 and has taught photography at the
University of New Orleans since 1982.

5338. **OCEAN SPRINGS, MISSISSIPPI [from the Society for
Photographic Education's "South Central Regional
Photography Exhibition"]** (P1983.31.16)
Gelatin silver print. 1981
Image: 7 1/16 x 10 in. (17.9 x 25.4 cm.)
Sheet: 10 15/16 x 14 in. (27.8 x 35.6 cm.)
Acquired from: gift of the Society for Photographic
Education, South Central Region

CHARLES TREMEAR
American (c. 1866–1943)

Charles Tremear was the staff photographer for the Edison Institute Museum at Greenfields Village, New Jersey. He made tintypes of museum visitors in a studio on the grounds. Tremear was one of the first individuals to revive the daguerreotype process in the twentieth century, reacquiring the necessary photographic techniques about 1929.

*5339. **[William Henry Jackson]** (P1971.73.1)
Daguerreotype, ninth-plate. c. 1939
Image: 2½ x 2 in. (6.4 x 5.1 cm.)
Case: 3 x 2⅝ in. (7.6 x 6.6 cm.)
Acquired from: Fred Mazzulla, Denver, Colorado

DORIS ULMANN, American (1882–1934)

Doris Ulmann began to photograph with a simple box camera about 1914. She studied with Clarence White, first at Columbia University and then at the Clarence White School of Photography. Her early work consisted of portraits made in the living room of her New York apartment, but she began a body of work to document the people of Appalachia in the mid-1920s and continued it until her death. In 1932 Allen H. Eaton suggested that Ulmann expand her documentation of Appalachia to provide illustrative photographs for his book *Handicrafts of the Highlands*. Her photographs for the book include portraits and demonstrations of traditional craft techniques. She also made a study of African Americans living in South Carolina in 1929–30, collaborating with writer Julia Peterkin. Their project was published in 1933 as *Roll, Jordan, Roll*.

5340. **[African-American man with wooden mortar and pestle]**
(P1986.8.1)
Platinum print. c. 1929–30
Image: 8 1/16 x 6⅛ in. (20.5 x 15.5 cm.)
Mount: 14¼ x 11 5/16 in. (36.2 x 28.6 cm.)
Signed, l.r. mount recto: "Doris Ulmann"
Inscription, mount verso: "1088a//142//5"
Acquired from: Mrs. John Jacob Niles, Lexington, Kentucky

*5341. **EVENTIDE [Appalachian woman in bonnet]** (P1986.8.2)
Platinum print. c. 1918–25
Image: 8 1/16 x 6⅛ in. (20.5 x 15.5 cm.)
1st mount: 13 1/16 x 9 9/16 in. (33.1 x 24.2 cm.)
2nd mount: 13 13/16 x 10 13/16 in. (35.1 x 27.4 cm.)
Signed, l.r. print recto: "DUJ"
l.r. mount recto: "Doris Ulmann"
note: "Ulmann" appears to have been written over "Jaeger," which has been partially erased
Inscription, 2nd mount verso: "86-A//Eventide/Doris U.
Jaeger/129 West 86th Street/N.Y. City//11X14/11X14//307"
Acquired from: Mrs. John Jacob Niles, Lexington, Kentucky

5342. **[Family on porch]** (P1980.12)
Platinum print. c. 1925–34
Image: 7 15/16 x 6 in. (20.1 x 15.2 cm.)
Mount: 14 x 11 in. (35.6 x 28.0 cm.)
Signed, l.r. mount recto: "Doris Ulmann"
Acquired from: The Witkin Gallery, New York, New York

5334

5336

5339

UNKNOWN PHOTOGRAPHERS

5343. **[Angeline Fitch Austin]** (P1975.66.2)
Tintype, quarter-plate. c. 1860s
Image: 4 ¼ x 3 ³/₁₆ in. (10.7 x 8.1 cm.)
Case: 4 ¹¹/₁₆ x 3 ¹¹/₁₆ in. (11.8 x 9.3 cm.)
Inscription, in case well: "~~Albert & Melvin~~/Angeline Fitch
Austin/My Great Grandmother/Harriet Bush
Duffield/1942"
Acquired from: gift of Sally Wilder, Fort Worth, Texas

5344. **[Angeline Fitch Austin and bearded man]** (P1981.33)
note: the same man is depicted in P1975.66.1, "Bearded
man in dark suit"
Two daguerreotypes in false watch locket. c. 1850
Image: 1 ¼ in. diameter (3.2 cm.)
Case (including stem): 2 ⁵/₁₆ x 1 ⅝ in. (5.9 x 4.1 cm.)
Inscription, on stem: "5"
Acquired from: Sally Wilder, Fort Worth, Texas

Autochromes, Mazzulla Collection (P1980.59.1–41)
c. 1908–16
Slide size: 3 ¼ x 4 in. (8.3 x 10.2 cm.) or reverse
A lot of 41 autochromes depicting scenes in Denver,
Colorado, general Colorado landscapes, and several
portraits and still life scenes.
Acquired from: Mazzulla Collection, Fred Mazzulla,
Denver, Colorado

5345. **ELECTRIC SHOW 1911 [Curtis Street, Denver Colorado]**
(P1980.59.1)

5346. **ESTES PARK 1916** (P1980.59.2)

5347. **COLUMBINE, JUNE 1916** (P1980.59.3)

5348. **ELECTRIC SHOW 1911 [Denver]** (P1980.59.4)

5349. **SWEET PEAS 1910** (P1980.59.5)

5350. **KNIGHT CHAMPA SQ CONCLAVE AUG 1913 [Denver]**
(P1980.59.6)

5351. **MOUNT ZION OCT 5-1913** (P1980.59.7)

5352. **HICKS PASTURE 10-1-1915** (P1980.59.8)

5353. **GENNESSR (?) ROAD OCT 1916** (P1980.59.9)

5354. **[Mountains and lake]** (P1980.59.10)

5355. **[Long's Peak, Colorado]** (P1980.59.11)

5356. **[Orchids in vase]** (P1980.59.12)

5357. **[Woman sitting by the roadside]** (P1980.59.13)

5358. **MT EVANS 5/1916** (P1980.59.14)

5359. **LOOKOUT MOUNTAIN OCT 5-13** (P1980.59.15)

5360. **[Bedtime story]** (P1980.59.16)

5361. **ANNETTE MARCH 12TH, 1908** (P1980.59.17)

5362. **D.D. GOODS NIGHT CONCLAVE AUG 1913/6-9-1914**
(P1980.59.18)

5363. **IDAHO SPRINGS ROAD OCT. 5-13** (P1980.59.19)

5364. **GALARDIA 7-1916** (P1980.59.20)

5365. **LOOKOUT OCT 1916 [Looking down road]** (P1980.59.21)

5366. **LOOKOUT OCT 1916 [Beside tree, overlooking meadow]**
(P1980.59.22)

5367. **[Mountaintop tree]** (P1980.59.23)

5368. **[Woman in rust-colored dress]** (P1980.59.24)

5369. **WINTER OCT. 1914** (P1980.59.25)

5370. **TIGER LILLY [sic] 6-1916** (P1980.59.26)

5371. **GEO. WASHINGTON 12/10/13** (P1980.59.27)

5372. **COLORADO PEACHES 1908** (P1980.59.28)

5373. **COURT HOUSE CONCLAVE 1913** (P1980.59.29)

5374. **SO. BOULDER CANON OCT. 1911** (P1980.59.30)

5375. **LOOKOUT MTN OCT 5-1913** (P1980.59.31)

5376. **EMBLEM COLFAX CONCLAVE AUG 1913** (P1980.59.32)

5377. **LOOKOUT MTN PARK OCT 12-1913** (P1980.59.33)

5378. **WELCOME ARCH, CONCLAVE AUG 1913** (P1980.59.34)

5379. **MT EVANS FROM LOOKOUT MTN OCT 12 1913**
(P1980.59.35)

5380. **MISS HILL JUNE 1912** (P1980.59.36)

5381. **COLUMBINE JUNE 1912** (P1980.59.37)

5382. **LOOKOUT OCT 1916** (P1980.59.38)

5383. **GARDEN OF GODS 5/30/13** (P1980.59.39)

5384. **TOWNSENDIA** (P1980.59.40)

5385. **[Tree and distant mountains]** (P1980.59.41)

* * * *

5386. **[Balding young man]** (P1970.67.6)
Ambrotype, ninth-plate. c. 1855–65
Image: 2 ½ x 2 in. (6.3 x 5.1 cm.)
Case: 2 ⅞ x 2 ⅜ in. (7.2 x 6.0 cm.)
Inscription, mat verso, stamped: "Holmes Booth & Hayden
Patent Applied for."
Acquired from: Caroline Smurthwaite, Phoenix, Arizona

*5387. **[Ballet dancer]** (P1985.19)
Gum platinum print. c. 1904–06
Image: 9 ⅞ x 7 ¹⁵/₁₆ in. (25.0 x 20.2 cm.)
Sheet: 11 ¹⁵/₁₆ x 9 ⅝ in. (30.3 x 24.4 cm.)
Acquired from: Paul Katz, North Bennington, Vermont

*5388. **[Bearded man in dark suit]** (P1975.66.1)
note: the same man is depicted in P1981.33, "Angeline Fitch
Austin and bearded man"
Daguerreotype, half-plate. c. 1850
Image: 4 ¾ x 3 ½ in. (12.0 x 8.8 cm.)
Plate: 5 ½ x 4 ³/₁₆ in. (14.0 x 10.7 cm.)
Acquired from: gift of Sally Wilder, Fort Worth, Texas

5389. **[Boy in dress clothes]** (P1975.66.3)
Tintype, sixth-plate. c. 1870s
Image: 3 x 2 ½ in. (7.8 x 6.3 cm.)
Case: 3 ⅝ x 3 ¼ in. (9.3 x 8.2 cm.)
Inscription, in case well: "With the/compliments of/D"
Acquired from: gift of Sally Wilder, Fort Worth, Texas

*5390. **[California Forty-Niner]** (P1983.20)
Daguerreotype with applied coloring, quarter-plate. c. 1850
Image: 3 ⁹/₁₆ x 2 ⅝ in. (9.0 x 6.7 cm.)
Plate: 4 ¼ x 3 ¼ in. (10.7 x 8.2 cm.)
Acquired from: George Rinhart, Colebrook, Connecticut;
Amon G. Carter Foundation purchase

5341

5387

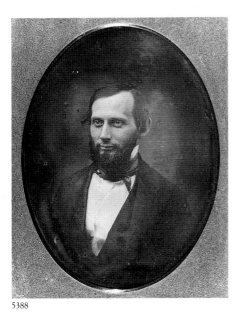

5388

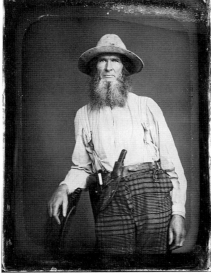

5390

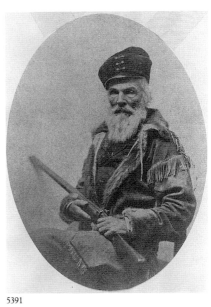

5391

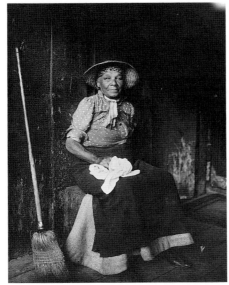

5393

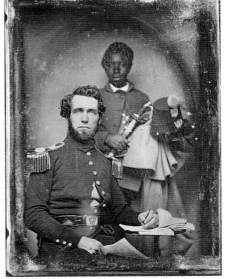

5394

*5391. CAPT. JOS. WALKER [Captain Joseph Walker] (P1983.21)
Salt print. c. early 1860s
Image: 7 5/16 x 5 3/8 in. (18.6 x 13.6 cm.) oval
Inscription, print verso: "Capt Jos. Walker/The oldest
Mountaineer now/living 43 year [sic] since he left/
St. Louis//this is a inferior Print/G"
Acquired from: Rinhart Galleries, Inc., Colebrook,
Connecticut; Amon G. Carter Foundation purchase

5392. CHARLES M. RUSSELL IN HIS STUDIO PAINTING HIS
FAMOUS PICTURE "THE BUFFALOES" (P1979.66)
Toned gelatin silver print. c. 1900
Image: 9 1/2 x 12 3/8 in. (24.2 x 31.4 cm.)
Sheet: 9 11/16 x 12 9/16 in. (24.6 x 31.8 cm.)
Inscription, overmat recto: "Charles M. Russell in his Studio
painting his Famous Picture/"The Buffaloes""
Acquired from: Mazzulla Collection, Fred Mazzulla,
Denver, Colorado

*5393. [Charwoman, Durango, Colorado] (P1980.60)
Gelatin silver print. c. 1900
Image: 9 1/2 x 7 5/8 in. (24.1 x 19.3 cm.)
Mount: same as image size
Inscription, mount verso: "Mrs. Knous said this lady was
well known in/Durango in the early days. One of the
charwomen/there./She said she would give this to Mr.
Mazzulla/if it could work in some of his collections./
Clarence Burton"
Acquired from: Mazzulla Collection, Fred Mazzulla,
Denver, Colorado

*5394. [Colonel and manservant; Officer and Manservant] (P1986.9)
Daguerreotype with applied coloring, quarter-plate. c. 1851
Plate: 3 15/16 x 3 1/8 in. (10.0 x 8.0 cm.)
Case: 4 15/16 x 4 in. (12.5 x 10.1 cm.)
Inscription, in case well, printed: "LITTLEFIELD,
PARSONS & CO.,/MANUFACTURERS OF/
Daguerreotype Cases./L., P. & CO.,/Are the sole
Proprietors and only/legal Manufacturers of/UNION
CASES,/WITH THE/Embracing Riveted Hinge./
Patented,/Oct. 14, 1856 & April 21, 1857"
note: the case is not original to the daguerreotype
Acquired from: Joe Buberger, New Haven, Connecticut

Daguerreotypes, ambrotypes, and tintypes
(P1970.66.1–48)
c. 1840s–70s
A lot of five daguerreotypes, nineteen ambrotypes, twenty
tintypes, one album containing twenty-three tintypes, two
paper prints mounted in cases, and one empty case. All are
individual or group portraits. Most are undated images of
unknown individuals by unknown photographers.
Acquired from: purchased by Mitchell A. Wilder in Martha's
Vineyard, Massachusetts, in 1967

5395. JOSEPH SYLVIER (P1970.66.1), daguerreotype

*5396. [Older woman in dark dress and shawl and lace bonnet]
(P1970.66.2), daguerreotype
note: P1970.66.1 and P1970.66.2 are in the same case

5397. [Seated couple, man in dark suit with light vest, woman in
plaid dress] (P1970.66.3), daguerreotype

5398. AUNT CLARA EATON AND EMMA RUNDLETT
GEBARD (P1970.66.4), daguerreotype

5399. EZRA HUBBARD (P1970.66.5), ambrotype

5400. [Young woman in dark dress seated at desk] (P1970.66.6),
ambrotype

5401. [Young man with goatee and cravat] (P1970.66.7), ambrotype

5402. [Infant in christening gown supported by black-gloved hand]
(P1970.66.8), ambrotype

*5403. [Young girl wearing gold necklace, seated in chair]
(P1970.66.9), ambrotype

5404. [Young woman wearing plaid dress] (P1970.66.10), ambrotype

5405. [Young woman wearing plaid dress] (1970.66.11), ambrotype

5406. UNCLE STEPHEN (P1970.66.12), ambrotype

5407. [Young girl seated on chair, holding a rocking horse]
(P1970.66.13), tintype

5408. [Baby girl in christening gown on tassled seat] (P1970.66.14),
ambrotype
note: P1970.66.13 and P1970.66.14 are in the same case

5409. [Young woman in dark dress with lace collar] (P1970.66.15),
tintype

*5410. [Woman in dark dress and bonnet with net veil] (P1970.66.16),
tintype

5411. [Bearded man in dark suit] (P1970.66.17), tintype

5412. [Young girl holding woven basket, seated on stool that is
perched on chair] (P1970.66.18), tintype

5413. [Man in suit] (P1970.66.19), albumen print glued in a case

[Empty case] (P1970.66.20)

5414. [Older woman wearing wire-rimmed glasses, bonnet, and dark
dress with lace collar] (P1970.66.21), daguerreotype

5415. [Young woman in dark dress with lace collar, wearing cameo
pendant] (P1970.66.22), ambrotype

5416. DANIEL DENNISON STREETER (P1970.66.23),
ambrotype

5417. DANIEL DENNISON STREETER (P1970.66.24),
ambrotype

*5418. [Child wearing white shirt and plaid skirt, standing beside
table] (P1970.66.25), ambrotype

5419. [Seated young woman in dark dress and shawl, hands folded in
lap] (P1970.66.26), ambrotype

5420. [Young woman in dark dress holding cased photograph]
(P1970.66.27), ambrotype

*5421. [Older woman in dark dress with shawl-like collar]
(P1970.66.28), ambrotype

5422. [Older woman in dark dress wearing wire-rimmed glasses]
(P1970.66.29), ambrotype

5423. [Two young women, one in a plaid dress, the other in a
checked dress] (P1970.66.30), tintype

5424. [Bust-length portrait of a young woman wearing a lace dress]
(P1970.66.31), gelatin silver print?

*5425. [Two young men smoking cigars] (P1970.66.32), tintype

5426. [Young man in striped tie and dark jacket] (P1970.66.33),
tintype
note: P1970.66.32 and P1970.66.33 are in the same case

5427. [Tintype album containing 23 studio portraits] (P1970.66.34)

5428. [Young man with short beard] (P1970.66.35), ambrotype

5429. [Young girl with scarf draped around her neck] (P1970.66.36),
ambrotype

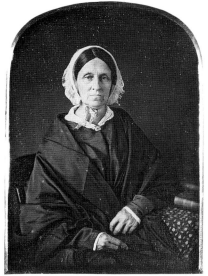

5396

5403

5410

5418

5421

5425

5434

5430. [Young woman in dark dress, cameo brooch at neck]
(P1970.66.37), tintype

5431. [Young woman in ornate hat] (P1970.66.38), tintype

5432. [Woman in dark dress, wearing ribbon around her neck]
(P1970.66.39), tintype

5433. **LINDA COREY** [bust-length portrait] (P1970.66.40), tintype

*5434. [Two young women, one seated, the other standing and holding
a parasol] (P1970.66.41), tintype

5435. [Two women in dark dresses standing by a pedestal]
(P1970.66.42), tintype

5436. [Two couples, women standing, men seated] (P1970.66.43),
tintype

*5437. [Young man standing by small table] (P1970.66.44), tintype

5438. [Couple outdoors, standing by bench] (P1970.66.45), tintype

5439. [Two young men, one seated on the other's knee]
(P1970.66.46), tintype

5440. [Two men with mustaches, one seated, the other standing]
(P1970.66.47), tintype

5441. [Two young men standing] (P1970.66.48), tintype

* * * *

*5442. [Drummer boy] (P1985.20)
Albumen silver print. c. 1860–65
Image: 3 7/16 x 2 3/16 in. (8.6 x 5.5 cm.)
Mount: 3 11/16 x 2 3/8 in. (9.4 x 6.1 cm.)
Acquired from: gift of Paul Katz, North Bennington, Vermont

*5443. **EXETER, N. H.** [Exeter, New Hampshire, volunteers leaving
for the Mexican War] (P1979.33)
Daguerreotype, quarter-plate. c. 1846
Image: 2 9/16 x 3 9/16 in. (6.5 x 9.1 cm.)
Plate: 3 3/4 x 4 1/4 in. (9.5 x 10.7 cm.)
Case: 4 1/4 x 4 13/16 in. (10.7 x 12.2 cm.)
Inscription, plate verso: "Exeter, N. H."
Acquired from: C. Krainik, Graphic Antiquity, Arlington
Heights, Illinois

*5444. [Four women in ribbon-striped dresses] (P1970.67.5)
Ambrotype, half-plate. c. 1857
Image: 5 1/2 x 4 1/4 in. (14.0 x 10.7 cm.)
Case: 6 3/16 x 5 in. (15.7 x 12.6 cm.)
Inscription, in case well, printed: "Littlefield, Parsons &
Co.,/—Manufacturers of—/Daguerreotype Cases./L.,P. &
Co./are the sole Proprietors/and only legal Manufacturers
of/Union Cases,/with the/Embracing Riveted Hinge./
Patented/Oct. 14, 1856, and April 21, 1857"
Acquired from: Caroline Smurthwaite, Phoenix, Arizona

5445. **THE GATHERING CROWD OF VISITORS—
CELEBRATION OF SAN GERONIMO PUEBLO DE
TAOS N. M.** (P1978.55)
Toned gelatin silver print. 1892
Image: 4 3/4 x 7 13/16 in. (12.0 x 19.7 cm.)
Mount: 8 1/16 x 10 in. (20.4 x 25.4 cm.)
Inscription, mount recto: "The gathering crowd of visitors/
Celebration of San Geronimo Pueblo de Taos N. M/
Sept 30/92."
Acquired from: Hastings Gallery, New York, New York

*5446. [Gold mining scene] (P1981.88)
Ambrotype, half-plate. c. 1850s
Image: 3 7/16 x 4 3/4 in. (8.7 x 12.0 cm.) sight size
Plate: 4 1/4 x 5 9/16 in. (10.8 x 14.0 cm.)
Acquired from: John Howell—Books, San Francisco,
California

5447. [Harkness family (?), Anderson County, South Carolina]
(P1978.4)
Ambrotype, sixth-plate. c. 1850s
Image: 2 3/4 x 3 1/4 in. (7.0 x 8.3 cm.)
Case: 3 1/4 x 3 3/4 in. (8.3 x 9.5 cm.)
Inscription, on card backing ambrotype: "Copyed [sic] by/
M. M. Marable/March. 21. 1892"
Acquired from: gift of Nancy Wynne, Fort Worth, Texas

5448. [Hotel/boarding house] (P1967.3356)
Albumen silver print. n.d.
Image: 10 3/16 x 13 3/8 in. (25.8 x 34.0 cm.)
Mount: 16 x 20 in. (40.7 x 50.8 cm.)
Acquired from: Fred Rosenstock, Denver, Colorado

5449. **INDIAN MOUND, KANAWHA VALLEY, W. VA.**
[Kanawha Valley] (P1975.103.32)
Albumen silver print. c. 1880s
Image: 9 13/16 x 13 in. (24.9 x 33.0 cm.)
Mount: 16 1/16 x 20 1/16 in. (40.8 x 50.9 cm.)
Inscription, mount verso: "Indian Mound/Kanawa [sic]
Valley/W Va"
Acquired from: Fred Mazzulla, Denver, Colorado

5450. **INDIAN MOUND, KANAWHA VALLEY, W. VA.**
[Kanawha Valley] (P1975.103.33)
Albumen silver print. c. 1880s
Image: 9 7/8 x 13 in. (25.1 x 33.0 cm.)
Mount: 16 1/16 x 20 1/16 in. (40.8 x 50.9 cm.)
Inscription, mount verso: "Indian Mound/Kanawaha [sic]
Valley/W. Va"
Acquired from: Fred Mazzulla, Denver, Colorado

*5451. **INDIAN MOUND, KANAWHA VALLEY, W. VA.**
[Kanawha Valley] (P1975.103.34)
Albumen silver print. c. 1880s
Image: 9 7/8 x 13 1/16 in. (25.1 x 33.2 cm.)
Mount: 16 1/16 x 20 1/16 in. (40.8 x 50.9 cm.)
Inscription, mount verso: "Indian Mound/Kanawaha [sic]
Valley/W. Va."
Acquired from: Fred Mazzulla, Denver, Colorado

5452. **INDIAN MOUND, KANAWHA VALLEY, W. VA.**
[Kanawha Valley] (P1975.103.35)
Albumen silver print. c. 1880s
Image: 9 7/8 x 13 in. (25.1 x 33.0 cm.)
Mount: 16 1/16 x 20 1/16 in. (40.8 x 50.9 cm.)
Inscription, mount recto: "[illegible]an Mound Kanawaha
[sic] Valley W. Va.//INDIAN MOUND KANAWAHA [sic]
VALLEY, W. VA."
Acquired from: Fred Mazzulla, Denver, Colorado

*5453. **JOEL P. WALKER** (P1985.6.2)
Albumen silver print. c. mid-1870s
Image: 3 5/16 x 2 3/16 in. (8.3 x 5.5 cm.)
Mount: 3 3/8 x 2 7/16 in. (8.5 x 6.2 cm.)
Inscription, mount verso: "For Miss Young family of/five
Newt, Joel John/Isabella, Mary.//Walker, Joel P./Pioneer//
HAVE NEG #958/Only known photograph/extant.//Gift
(loan) of Carrol [sic] M./Walker, (great-grandson)/12/3/43
//Joel P. Walker" and rubber stamp "CALIFORNIA/STATE
LIBRARY/CALIFORNIA, DEPT"
Acquired from: gift of Carroll M. Walker, Sacramento,
California

Mexican War Daguerreotypes (P1981.65.1–53,
P1983.9.1–4, and P1984.5)

This lot of daguerreotypes contains 50 images and 8
apparently blank plates made c. 1847–49 in the United States
and Mexico. There are a number of portraits of United States
military personnel who were stationed in Mexico during the
Mexican War and several scenes of Mexican towns. Two are
views of the burial place of Henry Clay, Jr., who was killed in
February of 1847 during the battle of Buena Vista. Several
images show United States troops in Mexican towns. A
number of the images are of American scenes, including

5437

5442

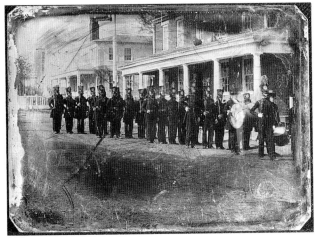

5443

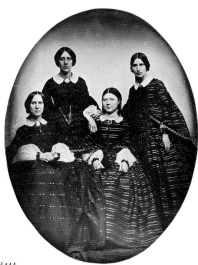

5444

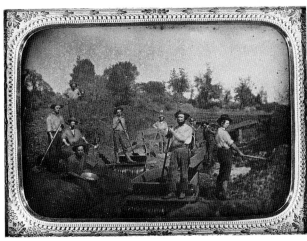

5446

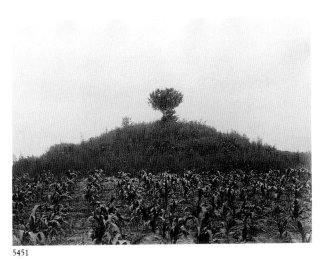

5451

several shots of the Robert Hallowell Gardiner house in Gardiner, Maine, and a very faint view of that town. One of the most significant images is a portrait of James Knox Polk, president of the United States during the Mexican War. Although the complete history of this group of images is not known, and not all may relate directly to the Mexican War, all belonged historically to a single collection. The Amon Carter Museum's 1989 exhibition "Eyewitness to War: Prints and Daguerreotypes of the Mexican War, 1846–1848" highlighted these daguerreotypes. The accompanying book contains historical and curatorial information for each image.

Note: Since none of the daguerreotypes had original cases or mats when they were acquired, only plate measurements are given. The image size is the same as the plate size unless otherwise noted.

*5454. [American volunteer infantry in a street in Saltillo, Mexico] (P1981.65.21)
Daguerreotype, sixth-plate. c. 1847
Plate: 2 ¾ x 3 ³⁄₁₆ in. (7.0 x 8.1 cm.)
Inscription, plate recto, stamped: "30"
Acquired from: George and Audrey Lower, Biglerville, Pennsylvania

5455. [American volunteer infantry standing along a street in Saltillo, Mexico] (P1981.65.25)
Daguerreotype, quarter-plate. c. 1847
Plate: 3 ¼ x 4 ¼ in. (8.3 x 10.8 cm.)
Inscription, plate recto, stamped: "E. WHITE MAKER N.Y.//FINEST QUALITY"
plate verso, paper label: "Mexican Soldiers"
Acquired from: George and Audrey Lower, Biglerville, Pennsylvania

5456. BATTLE OF THE NILE ON THE ENSUING MORNING [copy of an engraving] (P1981.65.43)
Daguerreotype, quarter-plate. c. 1847
Plate: 3 ³⁄₁₆ x 4 ¹⁵⁄₁₆ in. (8.1 x 12.6 cm.)
Acquired from: George and Audrey Lower, Biglerville, Pennsylvania

Blank plates (P1981.65.46–53)
Daguerreotypes, one quarter-plate and seven sixth-plates
Acquired from: George and Audrey Lower, Biglerville, Pennsylvania

5457. BURIAL PLACE OF SON OF HENRY CLAY IN MEXICO (P1981.65.40)
Daguerreotype, sixth-plate. 1847
Plate: 2 ¾ x 3 ¼ in. (7.0 x 8.3 cm.)
Inscription, plate recto, stamped: "SCOVILLS"
plate verso, paper label: "Burial Place of son of/Henry Clay in Mexico"
Acquired from: George and Audrey Lower, Biglerville, Pennsylvania

*5458. [Burial site of Lieutenant Colonel Henry Clay, Jr.] (P1981.65.41)
Daguerreotype with applied coloring, sixth-plate. 1847
Plate: 2 ¾ x 3 ¼ in. (7.0 x 8.3 cm.)
Inscription, plate recto, stamped: "SCOVILLS"
Acquired from: George and Audrey Lower, Biglerville, Pennsylvania

5459. CATHEDRAL IN DURANGO, MEXICO (P1981.65.35)
Daguerreotype, quarter-plate. c. 1847
Plate: 3 ¼ x 4 in. (8.3 x 10.2 cm.)
Inscription, plate recto, stamped: "SCOVILLS"
plate verso, paper label: "Cathedral in/Durango Mexico/large enough to/contain 20 churches/of ordinary dimensions"
Acquired from: George and Audrey Lower, Biglerville, Pennsylvania

5460. [Colonel Edward George Washington Butler] (P1981.65.15)
Daguerreotype with applied coloring, sixth-plate. c. 1847
Plate: 3 ¼ x 2 ¾ in. (8.3 x 7.0 cm.)
Acquired from: George and Audrey Lower, Biglerville, Pennsylvania

*5461. COL. HAMTRAMCK, VIRGINIA VOL. [Colonel John Francis Hamtramck] (P1981.65.3)
Daguerreotype with applied coloring, quarter-plate. c. 1847
Plate: 4 ¼ x 3 ¼ in. (10.8 x 8.3 cm.)
Inscription, plate recto, stamped: "SCOVILLS no. 2"
plate verso, paper label: "Col. Hamtrammack [sic]/ Virginia Vol."
Acquired from: George and Audrey Lower, Biglerville, Pennsylvania

*5462. COL. PAINE, N.C. REG. IN MEXICAN WAR [Colonel Robert Treat Paine] (P1981.65.17)
Daguerreotype, quarter-plate. c. 1847
Plate: 4 ³⁄₁₆ x 3 ³⁄₁₆ in. (10.6 x 8.1 cm.)
Inscription, plate recto, stamped: "SCOVILLS"
plate verso, paper label: "Col. Payne [sic] N.C. Reg./ in Mexican War"
Acquired from: George and Audrey Lower, Biglerville, Pennsylvania

*5463. [General Wool and staff in the Calle Real, Saltillo, Mexico] (P1981.65.22)
Daguerreotype, sixth-plate. c. 1847
Plate: 2 ¾ x 3 ¼ in. (7.0 x 8.3 cm.)
Inscription, plate recto, stamped: "E. WHITE MAKER NY// FINEST QUALITY A N[Y]"
Acquired from: George and Audrey Lower, Biglerville, Pennsylvania

*5464. GEO. EVANS (P1983.9.1)
Daguerreotype, sixth-plate. 1848
Plate: 3 ³⁄₁₆ x 2 ¾ in. (8.1 x 7.0 cm.)
Inscription, plate recto, stamped: "SCOVILLS"
plate verso: "Geo. Evans/1848"
Acquired from: gift of Grace Kellogg, North Granby, Connecticut

*5465. GERMAN COTTON MANUFACTURER IN DURANGO, MEXICO (P1981.65.24)
Daguerreotype, quarter-plate. c. 1847
Plate: 3 ⅛ x 4 ⅛ in. (8.0 x 10.5 cm.)
Inscription, plate verso, paper label: "German Cotton/ Manufacturer/in Durango/Mexico/income $300 per diem/ + tannery & stores"
Acquired from: George and Audrey Lower, Biglerville, Pennsylvania

*5466. [James Knox Polk] (P1981.65.12)
Daguerreotype with applied coloring, sixth-plate. c. 1847–49
Plate: 3 ¼ x 2 ¹¹⁄₁₆ in. (8.3 x 6.9 cm.)
Inscription, plate recto, stamped: "30"
Acquired from: George and Audrey Lower, Biglerville, Pennsylvania

5467. JOEL WHITE'S COAT OF ARMS 1650 (P1983.9.4)
Daguerreotype, sixth-plate. c. 1847
Plate: 3 ¼ x 2 ¾ in. (8.3 x 7.0 cm.)
Inscription, scratched on plate recto: "Maximum praeli impetum et/Sustinere/Joel White's coat of arms 1650"
Acquired from: gift of Grace Kellogg, North Granby, Connecticut

5468. [Landscape, trees in foreground, church building in distance] (P1981.65.39)
Daguerreotype, quarter-plate. c. 1847
Plate: 3 ¼ x 4 ¼ in. (8.3 x 10.8 cm.)
Inscription, plate recto, stamped: "SCOVILLS"
Acquired from: George and Audrey Lower, Biglerville, Pennsylvania

5453

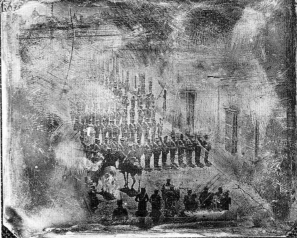

5454

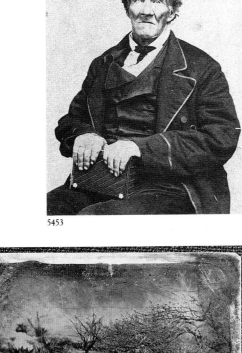

5458

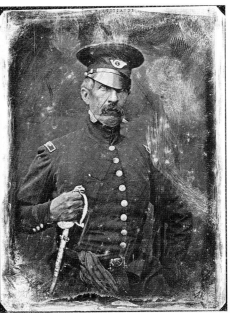

5461

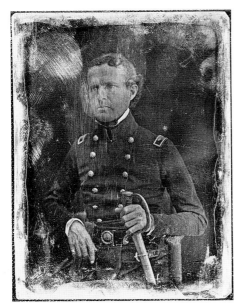

5462

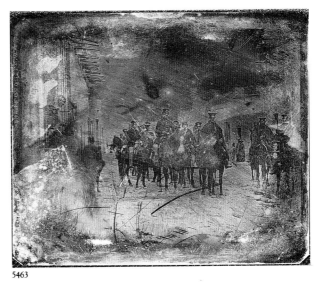

5463

5469. **LIEUT. DONALDSON, REG. ARMY [Captain James Lowry Donaldson]** (P1981.65.6)
Daguerreotype, sixth-plate. c. 1847
Plate: 3¼ x 2¾ in. (8.3 x 7.0 cm.)
Inscription, plate recto, stamped: "SCOVILLS"
plate verso, paper label: "Lieut Dolholson [sic]/Reg. Army/ promoted for bravery/at Battle of Monterrey/to Brevet Major/comander [sic] of a Battery/at Buena Vista under/ Taylor"
Acquired from: George and Audrey Lower, Biglerville, Pennsylvania

5470. **[Major John Macrae Washington]** (P1981.65.10)
Daguerreotype with applied coloring, sixth-plate. c. 1847
Plate: 3¼ x 2¾ in. (8.3 x 7.0 cm.)
Acquired from: George and Audrey Lower, Biglerville, Pennsylvania

5471. **MAJ. LEWIS CASS, JR.** (P1981.65.1)
Daguerreotype, quarter-plate. c. 1847
Plate: 4¼ x 3¼ in. (10.8 x 8.3 cm.)
Inscription, plate recto, stamped: "SCOVILLS"
plate verso, paper label: "Maj Lewis Cass Jr"
Acquired from: George and Audrey Lower, Biglerville, Pennsylvania

5472. **[Major Lewis Cass, Jr.]** (P1981.65.7)
Daguerreotype, sixth-plate. c. 1847
Plate: 3³⁄₁₆ x 2¹¹⁄₁₆ in. (8.1 x 6.9 cm.)
Inscription, plate recto, stamped: "SCOVILLS"
Acquired from: George and Audrey Lower, Biglerville, Pennsylvania

5473. **MAJ. LEWIS CASS, JR.** (P1981.65.8)
Daguerreotype, quarter-plate. c. 1847
Plate: 4³⁄₁₆ x 3³⁄₁₆ in. (10.6 x 8.1 cm.)
Inscription, plate recto, stamped: "SCOVILLS"
plate verso, paper label: "Maj Lewis Cass Jr"
Acquired from: George and Audrey Lower, Biglerville, Pennsylvania

5474. **[Major Lucien Webster's battery—mountains just north of Buena Vista]** (P1981.65.42)
Daguerreotype, sixth-plate. c. 1847
Plate: 2¾ x 3³⁄₁₆ in. (7.0 x 8.1 cm.)
Inscription, plate recto, stamped: "[E.] WHITE MAKER N.Y.//FINEST QUALITY A"
Acquired from: George and Audrey Lower, Biglerville, Pennsylvania

*5475. **MAJ. WASHINGTON, CHIEF OF ARTILLERY [Major John Macrae Washington]** (P1981.65.4)
Daguerreotype, quarter-plate. c. 1847
Plate: 4¼ x 3¼ in. (10.8 x 8.3 cm.)
Inscription, plate recto, stamped: "SCOVILLS"
plate verso, paper label: "Maj Washington/chief of artillery in/Gen Taylor's Division/and Gov. of Saltillo/Grand nephew of Gen/Washington/lost with his Reg/in steamer San/Francisco en route/for California"
Acquired from: George and Audrey Lower, Biglerville, Pennsylvania

*5476. **MEXICAN FAMILY** (P1981.65.18)
Daguerreotype, quarter-plate. c. 1847
Plate: 3¼ x 4¼ in. (8.3 x 10.8 cm.)
Inscription, plate recto, stamped: "[Z]OA//GARANTIN//40"
plate verso, paper label: "Mexican Family"
Acquired from: George and Audrey Lower, Biglerville, Pennsylvania

5477. **MEXICAN LADY** (P1981.65.5)
Daguerreotype with applied coloring, quarter-plate. c. 1847
Plate: 4¼ x 3¼ in. (10.8 x 8.3 cm.)
Inscription, plate verso, paper label: "Mexican Lady $10"
Acquired from: George and Audrey Lower, Biglerville, Pennsylvania

5478. **MISSISSIPPI LIEUTENANT** (P1981.65.2)
Daguerreotype with applied coloring, quarter-plate. c. 1847
Plate: 4¼ x 3⁵⁄₁₆ in. (10.8 x 8.4 cm.)
Inscription, plate verso, stamped: "SCOVILLS"
plate verso, paper label: "Mississippi Lieutenant"
Acquired from: George and Audrey Lower, Biglerville, Pennsylvania

5479. **[Oaklands, Gardiner, Maine]** (P1981.65.36)
Daguerreotype, near sixth-plate. c. 1847
Plate: 3 x 2⅛ in. (7.6 x 5.3 cm.)
Acquired from: George and Audrey Lower, Biglerville, Pennsylvania

5480. **[Oaklands, Gardiner, Maine]** (P1981.65.37)
Daguerreotype, sixth-plate. c. 1847
Plate: 3⅛ x 2¾ in. (8.0 x 7.0 cm.)
Inscription, plate recto, stamped: "N—YORK"
Acquired from: George and Audrey Lower, Biglerville, Pennsylvania

5481. **[Oaklands, Gardiner, Maine]** (P1981.65.38)
Daguerreotype, sixth-plate. c. 1847
Plate: 2¾ x 2¼ in. (7.0 x 5.7 cm.)
Acquired from: George and Audrey Lower, Biglerville, Pennsylvania

5482. **[Oaklands, Gardiner, Maine]** (P1983.9.3)
Daguerreotype, near sixth-plate. c. 1847
Plate: 2¾ x 2⁷⁄₁₆ in. (7.0 x 6.2 cm.)
Acquired from: gift of Grace Kellogg, North Granby, Connecticut

5483. **PARRAS, MEXICO [obscured view]** (P1981.65.19)
Daguerreotype, quarter-plate. c. 1847
Plate: 3³⁄₁₆ x 4³⁄₁₆ in. (8.1 x 10.6 cm.)
Inscription, plate verso, paper label: "Parras Mexico"
Acquired from: George and Audrey Lower, Biglerville, Pennsylvania

5484. **[Parroquia de Santiago, Saltillo, Mexico]** (P1981.65.33)
Daguerreotype, quarter-plate. c. 1847
Plate: 3 x 4¼ in. (7.6 x 10.8 cm.)
Inscription, plate recto, stamped: "ZOA//GARANT[IN]//40"
Acquired from: George and Audrey Lower, Biglerville, Pennsylvania

5485. **[Parroquia de Santiago, Saltillo, Mexico]** (P1981.65.34)
Daguerreotype, quarter-plate. c. 1847
Plate: 3 x 4⅛ in. (7.6 x 10.5 cm.)
Acquired from: George and Audrey Lower, Biglerville, Pennsylvania

5486. **[Post-mortem; body in bed with feet toward camera]** (P1981.65.45)
Daguerreotype with applied coloring, sixth-plate. c. 1847
Plate: 3⅛ x 2¼ in. (7.9 x 5.7 cm.)
Inscription, plate recto, stamped: "E. WHITE MAKER// FINEST QUALITY"
Acquired from: George and Audrey Lower, Biglerville, Pennsylvania

5487. **[Sailing ships at dock]** (P1981.65.44)
Daguerreotype, sixth-plate. c. 1847
Plate: 2¹¹⁄₁₆ x 3³⁄₁₆ in. (6.9 x 8.1 cm.)
Inscription, plate recto, stamped: "E. WHITE MAKER N.Y.//FINEST QUALITY A. N.Y."
Acquired from: George and Audrey Lower, Biglerville, Pennsylvania

*5488. **[St. James Episcopal Church and Burgwyn-Wright (Cornwallis) House, Wilmington, North Carolina]** (P1981.65.28)
Daguerreotype, sixth-plate. c. 1847
Plate: 3¼ x 2¾ in. (8.3 x 7.0 cm.)
Acquired from: George and Audrey Lower, Biglerville, Pennsylvania

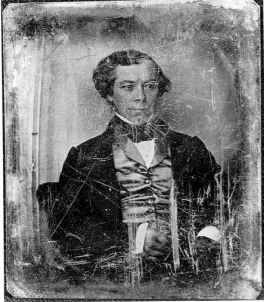

5464

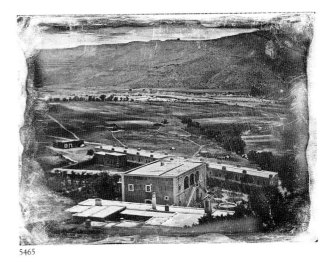

5465

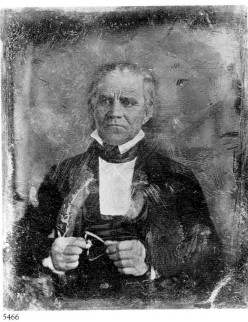

5466

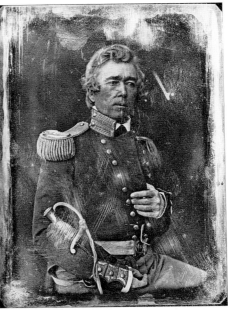

5475

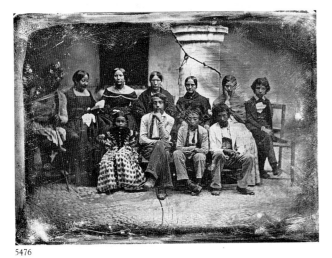

5476

5488

5489. [Saltillo, Mexico, bird's-eye view] (P1981.65.27)
Daguerreotype, sixth-plate. c. 1847
Plate: 2 ¾ x 3 ¼ in. (7.0 x 8.3 cm.)
Acquired from: George and Audrey Lower, Biglerville,
Pennsylvania

5490. [Saltillo, Mexico, bird's-eye view] (P1981.65.29)
Daguerreotype, sixth-plate. c. 1847
Plate: 2 ¾ x 3 ¼ in. (7.0 x 8.3 cm.)
Inscription, plate recto, stamped: "SCOVILLS"
Acquired from: George and Audrey Lower, Biglerville,
Pennsylvania

5491. [Street scene in Durango, Mexico, with the Church of Santa
Ana and the Cerro de Mercado in distance] (P1981.65.20)
Daguerreotype, quarter-plate. c. 1847
Plate: 3 3/16 x 4 ½ in. (8.1 x 11.4 cm.)
Acquired from: George and Audrey Lower, Biglerville,
Pennsylvania

5492. [Street scene in Gardiner, Maine] (P1981.65.32)
Daguerreotype, sixth-plate. c. 1847
Plate: 3 ⅛ x 2 ¾ in. (8.0 x 7.0 cm.)
Inscription, plate recto, paper label: "[illegible]r. Me."
Acquired from: George and Audrey Lower, Biglerville,
Pennsylvania

5493. [Unidentified captain] (P1981.65.14)
Daguerreotype with applied coloring, sixth-plate. c. 1847
Plate: 3 3/16 x 2 ⅝ in. (8.1 x 6.6 cm.)
Inscription, plate recto, stamped: "E. WHITE MAKER N Y//
FINEST QUALITY A NY"
Acquired from: George and Audrey Lower, Biglerville,
Pennsylvania

5494. [Unidentified civilian, arm resting on rug-covered table top]
(P1981.65.11)
Daguerreotype, sixth-plate. c. 1847
Plate: 3 ¼ x 2 ¾ in. (8.3 x 7.0 cm.)
Acquired from: George and Audrey Lower, Biglerville,
Pennsylvania

*5495. [Unidentified civilian, seated at desk, pen in hand] (P1984.5)
Daguerreotype, sixth-plate. c. 1847
Plate: 3 ¼ x 2 ¾ in. (8.3 x 7.0 cm.)
Inscription, plate recto, stamped: "LEE & Co"
Acquired from: gift of Paul Katz, North Bennington, Vermont

5496. [Unidentified civilian with badge on left lapel] (P1981.65.13)
Daguerreotype, sixth-plate. c. 1847
Plate: 3 ¼ x 2 ¾ in. (8.3 x 7.0 cm.)
Acquired from: George and Audrey Lower, Biglerville,
Pennsylvania

5497. [Unidentified infantry colonel] (P1981.65.9)
Daguerreotype, quarter-plate. c. 1847
Plate: 4 ¼ x 3 3/16 in. (10.8 x 8.1 cm.)
Inscription, plate recto, stamped: "[SC]OVILLS"
Acquired from: George and Audrey Lower, Biglerville,
Pennsylvania

5498. [Unidentified man in military dress—obscured view]
(P1981.65.16)
Daguerreotype, sixth-plate. c. 1847
Plate: 3 ¼ x 2 ¾ in. (8.3 x 7.0 cm.)
Acquired from: George and Audrey Lower, Biglerville,
Pennsylvania

5499. [Unidentified Mason] (P1983.9.2)
Daguerreotype with applied coloring, quarter-plate. c. 1847
Plate: 4 ¼ x 3 ¼ in. (10.8 x 8.3 cm.)
Acquired from: gift of Grace Kellogg, North Granby,
Connecticut

5500. [View along a street in Saltillo, Mexico] (P1981.65.23)
Daguerreotype, quarter-plate. c. 1847
Plate: 3 ¼ x 4 ¼ in. (8.3 x 10.8 cm.)
Inscription, plate recto, stamped: "E. WHITE MAKER
N[Y]//FINEST QUALITY A"
plate verso, paper label: "View in Parras [sic]/Mexico"
Acquired from: George and Audrey Lower, Biglerville,
Pennsylvania

5501. [View in Durango, Mexico, with the Church of Santa Ana and
the Cerro de Mercado in distance] (P1981.65.30)
Daguerreotype, quarter-plate. c. 1847
Plate: 3 ¼ x 4 ¼ in. (8.3 x 10.8 cm.)
Inscription, plate recto, stamped: "E. WHITE MAKER
N.Y.//FINEST QUALITY A"
Acquired from: George and Audrey Lower, Biglerville,
Pennsylvania

5502. [View of Durango, Mexico, with Cerro de los Remedios and
Templo de los Remedios in distance] (P1981.65.31)
Daguerreotype, sixth-plate. c. 1847
Plate: 2 ¾ x 3 3/16 in. (7.0 x 8.1 cm.)
Acquired from: George and Audrey Lower, Biglerville,
Pennsylvania

5503. [View of Saltillo, Mexico, from the southwest, Cerro del
Pueblo in middle distance] (P1981.65.26)
Daguerreotype, sixth-plate. c. 1847
Plate: 2 ¾ x 3 ¼ in. (7.0 x 8.3 cm.)
Inscription, plate recto, stamped: "[S]COVILLS"
Acquired from: George and Audrey Lower, Biglerville,
Pennsylvania

* * * *

*5504. [Mexican War Soldier] (P1980.19)
Daguerreotype, ninth-plate. c. mid-1840s
Image: 1 ⅞ x 1 7/16 in. (4.9 x 3.7 cm.)
Plate: 2 7/16 x 2 in. (6.2 x 5.0 cm.)
Case: 2 15/16 x 2 9/16 in. (7.4 x 6.4 cm.)
Inscription, overmat recto, embossed: "BY G. W. RIDER"
note: overmat is not original to the daguerreotype
Acquired from: S. L. Heritage Co., New Haven, Connecticut

5505. [Mission Isleta, New Mexico?] (P1970.20.14)
Albumen silver print. c. early 1880s
Image: 10 ¼ x 13 9/16 in. (26.0 x 34.4 cm.)
Mount: 16 1/16 x 20 1/16 in. (40.8 x 50.9 cm.)
Acquired from: Fred Rosenstock, Denver, Colorado

5506. [Mission Isleta, New Mexico?] (P1970.20.15)
Albumen silver print. c. early 1880s
Image: 10 3/16 x 13 7/16 in. (25.9 x 34.1 cm.)
Mount: 16 1/16 x 20 1/16 in. (40.8 x 50.9 cm.)
Acquired from: Fred Rosenstock, Denver, Colorado

Montana and Anaconda Mine cyanotypes (P1981.74.1-30)
Cyanotypes, c. 1880s

A lot of thirty cyanotypes of buildings in Helena, min-
ing operations (flumes, assay office, etc.), landscapes of
Boulder River, Prickly Pear Canyon, the Benton Road, and
unidentified Montana scenery. These works recently have
been attributed to Frederick A. Greenleaf (1853-1885), an
amateur photographer from Bath, Maine, who moved to
Helena, Montana, in 1875 and became assistant assayer in
the U.S. Assay Office in Helena.
Acquired from: Americana Arts Auction, Denmark, Maine

*5507. **ANACONDA MINE [Montana]** (P1981.74.1)

5508. **PLACER MINING, CHESSMANS FLUME, HELENA**
(P1981.74.2)

*5509. **MELTING FURNACES HELENA ASSAY OFF.** (P1981.74.3)

5510. **BRIDGE FEB 4TH \ 86 [bridge under construction]**
(P1981.74.4)

5495

5504

5507

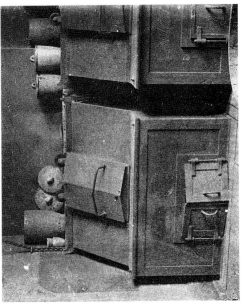

5509

5533

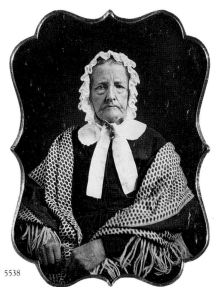

5538

5511. INTERIOR OF OLD BLOCK HOUSE, ST PETERS MISSION, DEARBORN RIVER (P1981.74.5)

5512. HELENA FROM CATHOLIC HILL 1884 (P1981.74.6)

5513. PRESBYTERIAN CHURCH, COURTHOUSE SQUARE 1884 (P1981.74.7)

5514. [Church in Helena, Montana] (P1981.74.8)

5515. [Railroad track through rock cut, one man standing by track, another at top of rocks at right] (P1981.74.9)

5516. PRICKLY PEAR CANON [view of railroad track] (P1981.74.10)

5517. ROCK CUT, M.C. RY., P.P. CANON (P1981.74.11)

5518. KING AND GILLETT'S TOLL ROAD P.P. CANON (P1981.74.12)

5519. KING AND GILLETT'S OLD TOLL ROAD IN PRICKLY PEAR CANON (P1981.74.13)

5520. ON BOULDER RIVER BET. BOULDER AND BASIN (P1981.74.14)

5521. BOULDER RIVER (P1981.74.15)

5522. ERODED SAND ROCKS, BENTON ROAD (P1981.74.16)

5523. SAND CLIFFS, OLD ROAD, HELENA TO BENTON (1981.74.17)

5524. LOG JAMB, P.P. CANON (P1981.74.18)

5525. P.P. CANON (P1981.74.19)

5526. PRICKLY PEAR CANON [road with wagon] (P1981.74.20)

5527. PRICKLY PEAR CANON [river] (1981.74.21)

5528. [View of hilly canyon from rocky hillside] (P1981.74.22)

5529. [Tent and log cabin camp by side of stream] (P1981.74.23)

5530. [Snow on tree-covered hillside] (P1981.74.24)

5531. [Men in wagon fording stream running between low hills] (P1981.74.25)

5532. [Tree-covered valley, boulder-covered hill in foreground] (P1981.74.26)

*5533. [River rapids cascading between low hills] (P1981.74.27)

5534. [Dirt road running through valley; braced X-shaped poles supporting wires along road] (P1981.74.28)

5535. [Five buck deer inside log pen] (P1981.74.29)

5536. ON 10 MILE CREEK NEAR HELENA MONT. [cows] (P1981.74.30)

* * * *

5537. [Nicholas Kay (?) from South Carolina] (P1979.2)
Tintype with applied coloring, whole-plate. c. 1870s
Image: 8 7/16 x 6 1/2 in. (21.4 x 16.5 cm.)
Inscription, plate recto: "93613"
Acquired from: gift of Nancy Wynne, Fort Worth, Texas

*5538. [Older woman wearing lace bonnet and shawl] (P1970.67.3)
note: in case with P1970.67.4, "Two women seated, holding hands"
Daguerreotype, quarter-plate. c. 1840–60
Image: 4 1/4 x 3 1/4 in. (10.8 x 8.2 cm.)
Case: 4 5/8 x 3 11/16 in. (11.8 x 9.3 cm.)
Acquired from: Caroline Smurthwaite, Phoenix, Arizona

5539. [Older woman with dark shawl and white bonnet] (P1970.67.7)
Ambrotype, ninth-plate. c. 1855–65
Image: 2 1/2 x 2 in. (6.3 x 5.1 cm.)
Case: 2 7/8 x 2 3/8 in. (7.3 x 6.1 cm.)
Acquired from: Caroline Smurthwaite, Phoenix, Arizona

5540. [Power lines above city; from the Society for Photographic Education's "South Central Regional Photography Exhibition"] (P1983.31.17)
Type C color print. c. 1978–80
Image: 6 13/16 x 9 1/4 in. (17.3 x 23.5 cm.)
Sheet: 7 15/16 x 9 15/16 in. (20.2 x 25.3 cm.)
Acquired from: gift of the Society for Photographic Education, South Central Region

5541. [Pueblo courtyard] (P1975.103.53)
Albumen silver print. c. 1870s–90s
Image: 7 1/8 x 9 1/8 in. (18.1 x 23.1 cm.)
Mount: 13 x 15 in. (33.1 x 38.1 cm.)
Acquired from: Fred Mazzulla, Denver, Colorado

5542. [Springs and hotel near Wagon Wheel Gap, Colorado] (P1967.3353)
Albumen silver print. c. 1880s
Image: 10 3/16 x 13 5/8 in. (25.9 x 34.6 cm.)
Mount: 16 x 20 in. (40.7 x 50.8 cm.)
Acquired from: Fred Rosenstock, Denver, Colorado

5543. A STREET SCENE AT EL RENO DURING RUSH FOR FREE HOMES [El Reno, Oklahoma] (P1978.56)
Toned gelatin silver print. c. 1889–1901
Image: 4 3/8 x 7 in. (11.2 x 17.7 cm.)
Inscription, print verso: "A Street Scene at El Reno/During Rush For Free Homes//11478140//$3.00//Pro 6 3/8 inches/wide/ Weekly/N. M.//From W R Draper./Wichita Kansas." and rubber stamp "COMPOSING ROOM/JUL 29 1901"
Acquired from: Hastings Gallery, New York, New York

5544. [Two men] (P1984.1.699)
Tintype, little gem. c. 1860s
Image: 1 13/16 x 1 5/16 in. (4.6 x 3.3 cm.) sight size
Case: 2 7/8 x 2 7/16 in. (7.3 x 6.0 cm.)
Acquired from: gift of the Dorothea Leonhardt Fund of the Communities Foundation of Texas, Inc., Dallas, Texas

5545. [Two women seated, holding hands] (P1970.67.4)
note: in case with P1970.67.3, "Older woman wearing lace bonnet and shawl"
Daguerreotype, quarter-plate. c. 1840–60
Image: 4 1/8 x 3 1/8 in. (10.5 x 8.0 cm.)
Case: 4 5/8 x 3 11/16 in. (11.8 x 9.3 cm.)
Acquired from: Caroline Smurthwaite, Phoenix, Arizona

5546. [View of low rocky hills across shrub-covered plain] (P1975.103.54)
Albumen silver print. c. 1870s–90s
Image: 10 3/8 x 13 1/4 in. (26.3 x 33.7 cm.)
Mount: 13 x 15 in. (33.1 x 38.1 cm.)
Acquired from: Fred Mazzulla, Denver, Colorado

5547. [View of mountains across grass-covered plain] (P1975.103.55)
Albumen silver print. c. 1870s–90s
Image: 9 13/16 x 13 3/8 in. (24.9 x 34.0 cm.)
Mount: 13 x 15 in. (33.1 x 38.1 cm.)
Acquired from: Fred Mazzulla, Denver, Colorado

5548. [View of rocky mesas across shrub-covered plain] (P1975.103.56)
Albumen silver print. c. 1870s–90s
Image: 10 3/16 x 13 1/8 in. (25.9 x 33.3 cm.)
Mount: 13 x 15 in. (33.1 x 38.1 cm.)
Acquired from: Fred Mazzulla, Denver, Colorado

5549. **W. H. JACKSON** (P1978.114.2)
Toned gelatin silver print. 1930
Image: 6 x 4¼ in. (15.3 x 10.8 cm.)
Sheet: 6⅞ x 4¾ in. (17.5 x 12.0 cm.)
Inscription, print verso: "W H Jackson/1930//Born Apr 4, 1843"
Acquired from: Frontier America Corporation, Bryan, Texas

5550. **[Wagon Wheel Gap, Colorado, Denver and Rio Grande Railroad Station]** (P1967.3348)
Albumen silver print. c. 1880s
Image: 10⅛ x 13⁷⁄₁₆ in. (25.8 x 34.2 cm.)
Mount: 16 x 20 in. (40.7 x 50.8 cm.)
Acquired from: Fred Rosenstock, Denver, Colorado

*5551. **WALPI, ARIZONA** (P1978.52)
Gelatin silver print. 1900
Image: 2³⁄₁₆ x 3³⁄₁₆ in. (5.4 x 8.1 cm.)
Mount: 4⅝ x 4 in. (11.7 x 10.2 cm.) irregular
Inscription, mount recto: "ARIZONA./1900//WALPI."
mount verso: "ARIZONA/1900//SAND PAINTING [illegible]"
Acquired from: Hastings Gallery, New York, New York

*5552. **[Water flowing over rocks in river]** (P1975.103.52)
Albumen silver print. c. 1870s–90s
Image: 8¹⁵⁄₁₆ x 6¾ in. (22.7 x 17.2 cm.)
Mount: 15 x 13 in. (38.1 x 33.1 cm.)
Acquired from: Fred Mazzulla, Denver, Colorado

5553. **[William Henry Jackson]** (P1971.73.2)
Tintype, sixth-plate. c. 1873
Image: 3¼ x 2³⁄₁₆ in. (8.3 x 5.6 cm.)
Acquired from: Fred Mazzulla, Denver, Colorado

*5554. **[Woman and child]** (P1970.67.2)
Daguerreotype, near half-plate. c. 1850s
Image: 5½ x 4¼ in. (14.0 x 10.7 cm.)
Case: 6¹⁄₁₆ x 4¾ in. (15.4 x 12.1 cm.)
Acquired from: Caroline Smurthwaite, Phoenix, Arizona

5555. **ZACATÉCAS [Zacatécas, Mexico]** (P1978.98)
Albumen silver print. c. 1865
Image: 10¹³⁄₁₆ x 16⁵⁄₁₆ in. (27.5 x 41.4 cm.)
Mount: 11¾ x 18¾ in. (29.8 x 47.7 cm.) irregular
Inscription, mount recto: "Zacatécas"
Acquired from: Walter Ruben, Inc., Austin, Texas

WILLARD VAN DYKE, American (1906–1986)

Van Dyke learned photography as a teenager, using the darkroom of John Paul Edwards, his girlfriend's father. While an undergraduate at the University of California at Berkeley, Van Dyke was profoundly impressed by two Edward Weston photographs. Edwards introduced Van Dyke to Weston and a year later Weston invited Van Dyke to Carmel to work with him. In 1928 Van Dyke set up a studio and gallery at 683 Brockhurst in Oakland, California, the studio that formerly belonged to photographer Annie Brigman. There Van Dyke, along with Ansel Adams, Weston, Imogen Cunningham, and others, formed Group f/64, dedicated to the principles of straight (sharply focused, unmanipulated) photography. In 1935 Van Dyke moved to New York and for the next thirty years pursued a filmmaking career. He worked with Pare Lorenz on *The River* and with Ralph Steiner on *The City*, and in 1947 he made *The Photographer* about his friend Edward Weston. He also filmed Walter Cronkite's "Twentieth Century" series for television. In 1964 Van Dyke became the director of the film department at the Museum of Modern Art. After he retired in 1974, he rekindled his interest in

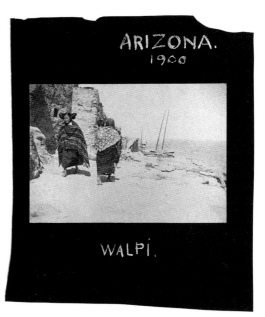

5551

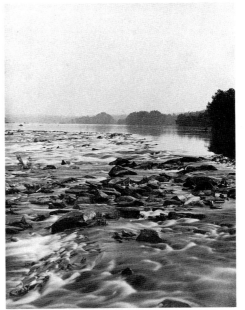

5552

still photography, printing his older negatives and making a number of new ones. In 1979 he received a Ford Foundation grant to work in Ireland.

5556. **BARN, RAMONA, CALIFORNIA [from the Santa Fe Center for Photography's "Portfolio II"]** (P1984.4.4)
Gelatin silver print. negative c. 1933–34, print c. 1983
Image: 7¾ x 9¾ in. (19.6 x 24.8 cm.)
Sheet: 7¹⁵⁄₁₆ x 9¹⁵⁄₁₆ in. (20.1 x 25.2 cm.)
Signed, u.l. print verso: "Willard Van Dyke ca 1934"
note: portfolio title page gives negative date as 1933
Acquired from: Santa Fe Center for Photography, Santa Fe, New Mexico

5557. **BERKELEY STOREFRONT** (P1982.10.2)
Gelatin silver print. negative c. 1933, print 1980
Image: 7½ x 9⁹⁄₁₆ in. (19.1 x 24.2 cm.)
Mount: 14 x 17 in. (35.6 x 43.2 cm.)
Signed, center mount verso: "Willard Van Dyke"
Inscription, mount verso: "Berkeley Storefront ca 1933/
Barbara's print 1980, September 7.//2/50//VDMP29-01//
GEH NEG#25368" and printed paper label "Negative &
Print by/Willard/Van Dyke"
Acquired from· gift of Barbara Van Dyke, New York,
New York

*5558. **BOY, NEW MEXICO** (P1982.10.5)
Gelatin silver print. negative 1937, print 1980
Image: 9½ x 7⁷⁄₁₆ in. (24.1 x 18.9 cm.)
Mount: 17 x 14 in. (43.2 x 35.6 cm.)
Signed, u.l. mount verso: "Willard Van Dyke"
Inscription, mount verso: "Boy, New Mexico 1937/3/50//
Barbara's print/September 1980//VDMP 43-3" and printed
paper label "Negative & Print by/Willard/Van Dyke"
Acquired from: gift of Barbara Van Dyke, New York,
New York

5559. **CEMENT FACTORY, MONOLITH, CALIFORNIA**
(P1984.26)
Gelatin silver print. c. 1930
Image: 9½ x 7½ in. (24.2 x 19.0 cm.)
Mount: 18 x 13¹⁵⁄₁₆ in. (45.7 x 35.4 cm.)
Signed, u.l. mount verso: "Willard Van Dyke"
Inscription, mount verso: "Vintage, 1930 (ca)//VDV-14-10"
Acquired from: Andrew Smith Gallery, Albuquerque,
New Mexico

*5560. **DEATH VALLEY DUNES** (P1982.12.2)
Gelatin silver print. negative c. 1930, print 1982
Image: 7³⁄₈ x 9³⁄₈ in. (18.7 x 23.8 cm.)
Mount: 14 x 17 in. (35.6 x 43.2 cm.)
Signed, u.l. mount verso: "Willard Van Dyke"
Inscription, mount verso: "Death Valley Dunes, ca. 1930"
and printed paper label "Negative & Print by/Willard/
Van Dyke"
Acquired from: the photographer

5561. **HAYWARD, CALIFORNIA [Milpitas]** (P1982.12.1)
duplicate of P1982.38.2
Gelatin silver print. negative c. 1932–33, print later
Image: 9⁹⁄₁₆ x 7⁵⁄₁₆ in. (24.2 x 18.6 cm.)
Mount: 17 x 14 in. (43.2 x 35.6 cm.)
Signed, u.l. mount verso: "Willard Van Dyke"
Inscription, mount verso: "Hayward, California ca 1933/3/50"
and printed paper label "Negative & Print by/Willard/
Van Dyke"
Acquired from: the photographer

*5562. **HITCHING POST, BERKELEY** (P1982.38.6)
Gelatin silver print. negative c. 1933, print 1979
Image: 7⁹⁄₁₆ x 9⁹⁄₁₆ in. (19.1 x 24.3 cm.)
Mount: 14 x 17 in. (35.6 x 43.2 cm.)
Signed, center mount verso: "Willard Van Dyke"
Inscription, mount verso: "Hitching Post, Berkeley
ca 1933/4/50//For Ralph/February 8th 1979//VDMP24-4"
and printed paper label "Negative & Print by/Willard/
Van Dyke"
Acquired from: gift of Ralph Steiner, Thetford Hill, Vermont

5563. **IRELAND** (P1985.4)
Dye-transfer print. 1980
Image: 7¹³⁄₁₆ x 9⁵⁄₈ in. (19.7 x 24.4 cm.)
Sheet: 10⅛ x 16⁹⁄₁₆ in. (25.6 x 42.1 cm.)
Signed, l.r. sheet recto: "Willard Van Dyke '80"
Inscription, mat backing verso: "Ireland, 1980/Dye transfer"
Acquired from: gift of the photographer

5564. **IRISH SHOP** (P1982.10.6)
Dye-transfer print. negative 1979, print 1980
Image: 11⅞ x 9⅞ in. (30.2 x 25.0 cm.)
Sheet: 16¹⁵⁄₁₆ x 14¹⁄₁₆ in. (43.0 x 35.7 cm.)
Signed, l.r. sheet recto: "W.V.D 1979/Dye Transfer"
Inscription, print verso: "For Barbara/Sept 1980//Irish shop./
Willard Van Dyke 1979"
Acquired from: gift of Barbara Van Dyke, New York,
New York

5565. **LIFEBOAT** (P1982.10.1)
Gelatin silver print. negative c. 1931, print 1980
Image: 9½ x 7⁷⁄₁₆ in. (24.1 x 18.8 cm.)
Mount: 17 x 14 in. (43.2 x 35.6 cm.)
Signed, u.l. mount verso: "Willard Van Dyke"
Inscription, mount verso: "Lifeboat ca 1931/[signature]//
Barbara's print/September 1980//VDMP6-7" and printed
paper label "Negative & Print by/Willard/Van Dyke"
Acquired from: gift of Barbara Van Dyke, New York,
New York

5566. **LLOYD LA PAGE ROLLINS AT 683 CA. 1933** (P1982.38.5)
Gelatin silver print. negative c. 1933, print 1979
Image: 9⁵⁄₁₆ x 7⁵⁄₁₆ in. (23.6 x 18.5 cm.)
Mount: 17 x 14 in. (43.2 x 35.6 cm.)
Signed, l.r. mount recto: "W.V.D '33"
Inscription, mount recto: "BK.10,27//21"
mount verso: "Lloyd LaPage Rollins at 683 ca 1933/negative
and print by/Willard Van Dyke//27//Rollins was director of
the M. H. de Young Memorial Museum/in San Francisco
when Group f64 had its exhibition there.//For Ralph/Feb 8,
1979//VDMP 31-3" and printed paper label "Negative &
Print by/Willard/Van Dyke"
Acquired from: gift of Ralph Steiner, Thetford Hill, Vermont

5567. **MILPITAS [Hayward, California]** (P1982.38.2) duplicate of
P1982.12.1
Gelatin silver print. negative c. 1932–33, print 1979
Image: 9⁵⁄₈ x 7⁷⁄₁₆ in. (24.5 x 18.9 cm.)
Mount: 17 x 14 in. (43.2 x 35.6 cm.)
Signed, center mount verso: "Willard Van Dyke"
Inscription, mount verso: "Milpitas, Ca 1932//#39//X//
For Ralph/February 8th/1979" and printed paper label
"Negative & Print by/Willard/Van Dyke"
Acquired from: gift of Ralph Steiner, Thetford Hill, Vermont

5568. **MONTEREY, CALIF. HOUSE AND CHAIR** (P1982.38.7)
Gelatin silver print. negative c. 1933, print 1977
Image: 9⁹⁄₁₆ x 7½ in. (24.3 x 19.0 cm.)
Mount: 17 x 14 in. (43.2 x 35.6 cm.)
Signed, center mount verso: "Willard Van Dyke 1977"
Inscription, mount verso: "Monterey Calif. ca 1933/House
and Chair//24//X//For Ralph/February 8th 1979//
C1733//178:086:60//GEH NEG#25325" and printed
paper label "Negative & Print by/Willard/Van Dyke"
Acquired from: gift of Ralph Steiner, Thetford Hill, Vermont

5569. **NEW MEXICO** (P1982.11)
Gelatin silver print. 1981
Image: 7⅝ x 9⁹⁄₁₆ in. (19.4 x 24.3 cm.)
Mount: 14 x 17 in. (35.6 x 43.2 cm.)
Signed, u.l. mount verso: "Willard Van Dyke"
Inscription, mount verso: "New Mexico, 1981"
Acquired from: gift of the photographer

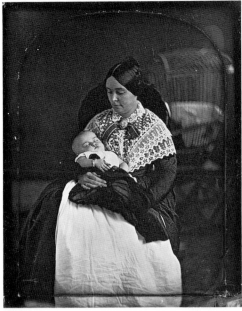

5554

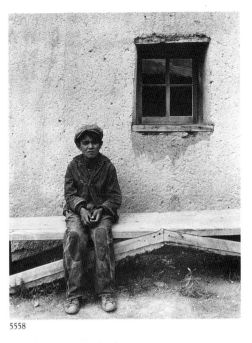

5558

5560

5562

5574

5579

5570. **NINTH STREET, NEW YORK** (P1982.10.3)
Gelatin silver print. negative 1936, print 1980
Image: 9 ⅛ x 7 ½ in. (23.2 x 19.0 cm.)
Mount: 17 x 14 in. (43.2 x 35.6 cm.)
Signed, u.l. mount verso: "Willard Van Dyke"
Inscription, mount verso: "Ninth Street, New York, 1936//
Barbara's print/September 1980//VDMP 36-9" and printed
paper label "Negative & Print by/Willard/Van Dyke"
Acquired from: gift of Barbara Van Dyke, New York,
New York

5571. **NORTHCOAST** (P1982.38.1)
Gelatin silver print. negative 1937, print 1979
Image: 7 ⁷⁄₁₆ x 9 ⅝ in. (18.9 x 24.5 cm.)
Mount: 14 x 17 in. (35.6 x 43.2 cm.)
Signed, u.l. mount verso: "Willard Van Dyke"
Inscription, mount verso: "Northcoast 1937/For Ralph,
February 1979//3/50//VDMP 41-1" and printed paper label
"Negative & Print by/Willard/Van Dyke"
Acquired from: gift of Ralph Steiner, Thetford Hill, Vermont

5572. **OVENS, TAOS, N. M.** (P1982.10.4)
Gelatin silver print. negative 1932, print 1980
Image: 7 ⅜ x 9 ½ in. (18.8 x 24.2 cm.)
Mount: 14 x 17 in. (35.6 x 43.2 cm.)
Signed, u.l. mount verso: "Willard Van Dyke"
Inscription, mount verso: "X//Ovens, Taos, N. M. 1932//For
Barbara/September 1980//VDMP 15-4" and printed paper
label "Negative & Print by/Willard/Van Dyke"
Acquired from: gift of Barbara Van Dyke, New York,
New York

5573. **PRESTON HOLDER** (P1982.38.4)
Gelatin silver print. negative c. 1934, print 1979
Image: 9 ⁹⁄₁₆ x 7 ⁷⁄₁₆ in. (24.3 x 18.9 cm.)
Mount: 17 x 14 in. (43.2 x 35.6 cm.)
Signed, top mount verso: "Willard Van Dyke"
Inscription, mount verso: "X//Preston Holder/2/50 ca 1934/
Preston was one/of the four photo-/graphers who/exhibited
with/Group f64.//For Ralph/February 8th 1979//VDMP
30-5" and printed paper label "Negative & Print by/
Willard/Van Dyke"
Acquired from: gift of Ralph Steiner, Thetford Hill, Vermont

*5574. **SINK AT 683 BROCKHURST** (P1982.10.7)
Gelatin silver print. negative 1931, print 1980
Image: 7 ⁵⁄₁₆ x 9 ⁷⁄₁₆ in. (18.5 x 24.0 cm.)
Mount: 14 x 17 in. (35.6 x 43.2 cm.)
Signed, u.l. mount verso: "Willard Van Dyke 1931"
Inscription, mount verso: "Sink at 683 Brockhurst//4/50//For
Barbara/September 1980//VDMP5-3" and printed paper
label "Negative & Print by/Willard/Van Dyke"
Acquired from: gift of Barbara Van Dyke, New York,
New York

TEN PHOTOGRAPHS (P1980.2.1–10)

This portfolio was published in 1977 by Van Productions of
New York, New York. It consists of an edition of 25 portfolios
plus 5 artist's proofs.

5575. **MUSHROOMS** (P1980.2.1)
Gelatin silver print. negative c. 1934, print 1977
Image: 7 ½ x 8 ¹⁵⁄₁₆ in. (19.0 x 22.6 cm.)
Mount: 14 x 17 in. (35.6 x 43.2 cm.)
Signed, u.l. mount verso: "Willard Van Dyke"
Inscription, mount verso: "Mushrooms ca. 1934" and printed
paper label "Negative & Print by/Willard/Van Dyke"
Acquired from: The Witkin Gallery, New York, New York

5576. **BOXER'S HANDS** (P1980.2.2)
Gelatin silver print. negative c. 1933, print 1977
Image: 7 ⁷⁄₁₆ x 9 ⅜ in. (18.9 x 23.8 cm.)
Mount: 14 x 17 in. (35.6 x 43.2 cm.)
Signed, u.l. mount verso: "Willard Van Dyke"
Inscription, mount verso: "Boxer's Hands ca 1933/negative
and print by/[signature]"
Acquired from: The Witkin Gallery, New York, New York

5577. **HOUSE AND CHAIR, NORTHCOAST** (P1980.2.3)
Gelatin silver print. negative 1937, print 1977
Image: 7 ⁹⁄₁₆ x 9 ⁹⁄₁₆ in. (19.2 x 24.3 cm.)
Mount: 14 x 17 in. (35.6 x 43.2 cm.)
Signed, u.l. mount verso: "Willard Van Dyke"
Inscription, mount verso: "House and Chair, Northcoast
1937/negative and print by/[signature]"
Acquired from: The Witkin Gallery, New York, New York

5578. **CARSON HOUSE** (P1980.2.4)
Gelatin silver print. negative 1937, print 1977
Image: 9 ⁷⁄₁₆ x 7 ⁷⁄₁₆ in. (24.0 x 18.9 cm.)
Mount: 17 x 14 in. (43.2 x 35.6 cm.)
Signed, u.l. mount verso: "Willard Van Dyke"
Inscription, mount verso: "Carson House 1937/negative and
print by/[signature]"
Acquired from: The Witkin Gallery, New York, New York

*5579. **VENTILATORS** (P1980.2.5)
Gelatin silver print. negative c. 1930, print 1977
Image: 9 ½ x 5 ⅞ in. (24.1 x 15.0 cm.)
Mount: 17 x 13 ¹³⁄₁₆ in. (43.2 x 35.1 cm.)
Signed, u.l. mount verso: "Willard Van Dyke"
Inscription, mount verso: "Ventilators ca 1930/negative and
print by/[signature]"
Acquired from: The Witkin Gallery, New York, New York

5580. **ANGEL'S CAMP** (P1980.2.6)
Gelatin silver print. negative c. 1932, print 1977
Image: 9 ⁹⁄₁₆ x 7 ½ in. (24.2 x 19.0 cm.)
Mount: 17 x 14 in. (43.2 x 35.6 cm.)
Signed, u.l. mount verso: "Willard Van Dyke"
Inscription, mount verso: "Angel's Camp ca 1932/negative
and print by/[signature]"
Acquired from: The Witkin Gallery, New York, New York

*5581. **ANSEL ADAMS AT 683 BROCKHURST** (P1980.2.7)
Gelatin silver print. negative c. 1932, print 1977
Image: 9 ⅜ x 7 ¼ in. (23.8 x 18.4 cm.)
Mount: 17 x 14 in. (43.2 x 35.6 cm.)
Signed, u.l. mount verso: "Willard Van Dyke"
Inscription, mount verso: "Ansel Adams at 683 Brockhurst
ca 1932/negative and print by/[signature]"
Acquired from: The Witkin Gallery, New York, New York

5582. **CANNA LEAF** (P1980.2.8)
Gelatin silver print. negative c. 1933, print 1977
Image: 9 ½ x 7 ⁹⁄₁₆ in. (24.1 x 19.2 cm.)
Mount: 17 x 14 in. (43.2 x 35.6 cm.)
Signed, u.l. mount verso: "Willard Van Dyke"
Inscription, mount verso: "Canna Leaf ca 1933/negative and
print by/[signature]"
Acquired from: The Witkin Gallery, New York, New York

5583. **JOSEPH SHERIDAN AT 683 BROCKHURST** (P1980.2.9)
Gelatin silver print. negative c. 1932, print 1977
Image: 9 ⅛ x 7 ¼ in. (23.2 x 18.4 cm.)
Mount: 17 x 14 in. (43.2 x 35.6 cm.)
Signed, u.l. mount verso: "Willard Van Dyke"
Inscription, mount verso: "Joseph Sheridan at 683
Brockhurst, ca 1932/negative and print by/[signature]"
Acquired from: The Witkin Gallery, New York, New York

*5584. **ITINERANT WORKERS** (P1980.2.10)
Gelatin silver print. negative c. 1934, print 1977
Image: 9 ⁷⁄₁₆ x 7 ⁷⁄₁₆ in. (24.0 x 18.9 cm.)
Mount: 17 x 14 in. (43.2 x 35.6 cm.)
Signed, u.l. mount verso: "Willard Van Dyke"
Inscription, mount verso: "Itinerant Workers ca 1934/7/50"
and printed paper label "Negative & Print by/Willard/
Van Dyke"
Acquired from: The Witkin Gallery, New York, New York

✴ ✴ ✴ ✴

5585. **VIRGINIA CITY** (P1982.38.3)
Gelatin silver print. negative c. 1931, print 1979
Image: 9 5/8 x 7 1/2 in. (24.4 x 19.0 cm.)
Mount: 17 x 14 in. (43.2 x 35.6 cm.)
Signed, u.l. mount verso: "Willard Van Dyke"
Inscription, mount verso: "Virginia City, ca 1931/negative and
print by/[signature]//X//For Ralph/February 8th 1979/This
photograph was made/on a trip with E. W.//C1734"
Acquired from: gift of Ralph Steiner, Thetford Hill, Vermont

CAROLINE VAUGHAN, American (b. 1949)

Caroline Vaughan studied photography from 1969 until
1971 with John Menapace, production manager at Duke
University Press. She also studied with Murray Riss and
was a special graduate student at Massachusetts Insti-
tute of Technology with Minor White. Vaughan worked
as a photography instructor and darkroom technician
and did commercial work for Duke University. In 1977
she was selected as one of forty-three promising young
photographers for Time-Life's *Photography Year—1977*.
Although much of her work is in black and white,
she has photographed in color as a participant in
the Polaroid Museum Collection Program.

*5586. **AN LABARRE, BONNIE AND JODY** (P1976.98.24)
duplicate of P1976.98.35
Gelatin silver print. 1972
Image: 8 5/16 x 11 3/8 in. (21.1 x 28.8 cm.)
Mount: 14 x 17 in. (35.6 x 43.2 cm.)
Signed, l.r. mount recto: "Caroline Vaughan"
Inscription, mount recto: "An LaBarre, Bonnie and Jody"
mount verso: "31" and typed on paper label "Caroline
Vaughan/2305 Prince Street/Durham, NC 27707"
Acquired from: gift of Dr. and Mrs. Steven Wainwright,
Durham, North Carolina

5587. **AN LABARRE, BONNIE AND JODY** (P1976.98.35)
duplicate of P1976.98.24
Gelatin silver print. 1972
Image: 9 1/4 x 12 1/16 in. (23.5 x 30.7 cm.)
Mount: 16 x 20 in. (40.7 x 50.8 cm.)
Signed, l.r. mount recto: "Caroline Vaughan"
Inscription, mount recto: "An LaBarre, Bonnie and Jody"
Acquired from: the photographer

*5588. **ANTEDILUVIAN DREAM [False Bay, San Juan Islands]**
(P1976.98.39)
Gelatin silver print. 1975
Image: 6 13/16 x 8 13/16 in. (17.3 x 22.4 cm.)
Mount: 14 x 17 in. (35.6 x 43.2 cm.)
Signed, l.r. mount recto: "Caroline Vaughan"
Inscription, mount recto: "Antediluvian Dream October
1975"
mount verso: "8"
Acquired from: gift of Dr. and Mrs. Steven Wainwright,
Durham, North Carolina

*5589. **BIG SUR, CALIFORNIA** (P1976.98.22)
Gelatin silver print. 1975
Image: 10 15/16 x 8 9/16 in. (27.8 x 21.8 cm.)
Mount: 17 x 14 in. (43.2 x 35.6 cm.)
Signed, l.r. mount recto: "Caroline Vaughan"
Inscription, mount recto: "Big Sur California"
mount verso: "9"
Acquired from: gift of Dr. and Mrs. Steven Wainwright,
Durham, North Carolina

5590. **BRISTOL, VERMONT** (P1976.98.17)
Gelatin silver print. 1971
Image: 8 1/8 x 10 3/4 in. (20.7 x 27.3 cm.)
Mount: 14 x 17 in. (35.6 x 43.2 cm.)
Signed, l.r. mount recto: "Caroline Vaughan"
Inscription, mount recto: "Bristol, Vermont"
mount verso: "29"
Acquired from: gift of Dr. and Mrs. Steven Wainwright,
Durham, North Carolina

5581

5584

5586

5591. **CAVE, DEADMAN'S HOLE, AUSTIN, TEXAS**
(P1976.98.31)
Gelatin silver print. 1976
Image: 9⁷⁄₁₆ x 7¼ in. (23.9 x 18.3 cm.)
Mount: 17 x 14 in. (43.2 x 35.6 cm.)
Signed, l.r. mount recto: "Caroline Vaughan"
Inscription, mount recto: "Cave Deadman's Hole Austin, Texas"
 mount verso: "7"
Acquired from: gift of Dr. and Mrs. Steven Wainwright, Durham, North Carolina

5592. **CONSTRUCTIVIST DOUBLE PORTRAIT** (P1976.98.52)
Gelatin silver print. 1974
Image: 12⅛ x 7¾ in. (30.8 x 19.6 cm.)
Mount: 17 x 14 in. (43.2 x 35.6 cm.)
Signed, l.r. mount recto: "Caroline Vaughan"
Inscription, mount recto: "Constructivist Double Portrait"
 mount verso: "15"
Acquired from: gift of Dr. and Mrs. Steven Wainwright, Durham, North Carolina

*5593. **COTTONWOOD, WHITE SANDS, NEW MEXICO**
(P1976.98.4)
Gelatin silver print. 1976
Image: 7¹³⁄₁₆ x 9⁹⁄₁₆ in. (19.8 x 24.3 cm.)
Mount: 14⅛ x 17 in. (35.9 x 43.2 cm.)
Signed, l.r. mount recto: "Caroline Vaughan"
Inscription, mount recto: "Cottonwood, White Sands New Mexico"
 mount verso: "45"
Acquired from: gift of Dr. and Mrs. Steven Wainwright, Durham, North Carolina

*5594. **CRANE'S BEACH** (P1976.98.14)
Gelatin silver print. 1971
Image: 5¹¹⁄₁₆ x 8⅝ in. (14.4 x 21.9 cm.)
Mount: 14 x 17 in. (35.6 x 43.2 cm.)
Signed, l.r. mount recto: "Caroline Vaughan"
Inscription, mount recto: "Crane's Beach November 5 1971"
 mount verso: "47"
Acquired from: gift of Dr. and Mrs. Steven Wainwright, Durham, North Carolina

5595. **DEADMAN'S HOLE, TEXAS** (P1976.98.33)
Gelatin silver print. 1976
Image: 7⅜ x 9¼ in. (18.8 x 23.4 cm.)
Mount: 14 x 17 in. (35.6 x 43.2 cm.)
Signed, l.r. mount recto: "Caroline Vaughan"
Inscription, mount recto: "Deadman's Hole Texas"
 mount verso: "49"
Acquired from: gift of Dr. and Mrs. Steven Wainwright, Durham, North Carolina

*5596. **DESERT CAMOUFLAGE** (P1976.98.8)
Gelatin silver print. 1976
Image: 8 x 10⅜ in. (20.3 x 26.4 cm.)
Mount: 14 x 17 in. (35.6 x 43.2 cm.)
Signed, l.r. mount recto: "Caroline Vaughan"
Inscription, mount recto: "Desert Camouflage"
 mount verso: "39"
Acquired from: gift of Dr. and Mrs. Steven Wainwright, Durham, North Carolina

5597. **DEVIL'S SINKHOLE, ROCK SPRINGS, TEXAS**
(P1976.98.44)
Gelatin silver print. 1976
Image: 8¹⁄₁₆ x 10⁵⁄₁₆ in. (20.4 x 26.1 cm.)
Mount: 14 x 17 in. (35.6 x 43.2 cm.)
Signed, l.r. mount recto: "Caroline Vaughan"
Inscription, mount recto: "Devil's Sinkhole Rock Springs Texas"
 mount verso: "19"
Acquired from: gift of Dr. and Mrs. Steven Wainwright, Durham, North Carolina

5598. **DIANA'S BATH [New Hampshire]** (P1976.98.18)
Gelatin silver print. 1975
Image: 6⅛ x 7⅞ in. (15.6 x 19.9 cm.)
Mount: 14 x 17 in. (35.6 x 43.2 cm.)
Signed, l.r. mount recto: "Caroline Vaughan"
Inscription, mount recto: "Dianna's [sic] Bath"
 mount verso: "26"
Acquired from: gift of Dr. and Mrs. Steven Wainwright, Durham, North Carolina

5599. **DREAM WATERFALL** (P1976.98.13)
Gelatin silver print. 1973
Image: 8³⁄₁₆ x 10⁷⁄₁₆ in. (20.8 x 26.4 cm.)
Mount: 14 x 17 in. (35.6 x 43.2 cm.)
Signed, l.r. mount recto: "Caroline Vaughan"
Inscription, mount recto: "Dream Waterfall"
 mount verso: "48"
Acquired from: gift of Dr. and Mrs. Steven Wainwright, Durham, North Carolina

*5600. **ESKIMO SPIRIT** (P1976.98.25) duplicate of P1976.98.61
Gelatin silver print. 1975
Image: 8¹⁄₁₆ x 10¼ in. (20.4 x 26.0 cm.)
Mount: 14 x 17 in. (35.6 x 43.2 cm.)
Signed, l.r. mount recto: "Caroline Vaughan"
Inscription, mount recto: "Eskimo Spirit"
 mount verso: "43" and typed on paper label "Caroline Vaughan/2305 Prince Street/Durham, NC 27707"
Acquired from: gift of Dr. and Mrs. Steven Wainwright, Durham, North Carolina

5601. **ESKIMO SPIRIT, MAMMAL BREATH** (P1976.98.61)
duplicate of P1976.98.25
Gelatin silver print. 1975
Image: 7⁹⁄₁₆ x 9⁹⁄₁₆ in. (19.2 x 24.2 cm.)
Mount: 14 x 17 in. (35.6 x 43.2 cm.)
Signed, l.r. mount recto: "Caroline Vaughan"
Inscription, mount recto: "Eskimo Spirit, Mammal Breath January 1975"
Acquired from: gift of the photographer in honor of Ms. Katherine B. "Chula" Reynolds

5602. **FIREHOLE RIVER, WYOMING** (P1976.98.34)
Gelatin silver print. 1975
Image: 7⁹⁄₁₆ x 10⁵⁄₁₆ in. (19.2 x 26.1 cm.)
Mount: 14⅛ x 17 in. (35.9 x 43.2 cm.)
Signed, l.r. mount recto: "Caroline Vaughan"
Inscription, mount recto: "Firehole River Wyoming"
 mount verso: "42"
Acquired from: gift of Dr. and Mrs. Steven Wainwright, Durham, North Carolina

5603. **GALISTEO, NEW MEXICO** (P1976.98.23)
Gelatin silver print. 1976
Image: 7⅞ x 10¼ in. (20.0 x 26.0 cm.)
Mount: 14 x 17 in. (35.6 x 43.2 cm.)
Signed, l.r. mount recto: "Caroline Vaughan"
Inscription, mount recto: "Galisteo, New Mexico July 1976"
 mount verso: "34"
Acquired from: gift of Dr. and Mrs. Steven Wainwright, Durham, North Carolina

5604. **GEORGANN** (P1976.98.30)
Gelatin silver print. 1978
Image: 7⅜ x 9⁷⁄₁₆ in. (18.7 x 24.0 cm.)
Mount: 14 x 17 in. (35.6 x 43.2 cm.)
Signed, l.r. mount recto: "Caroline Vaughan"
Inscription, mount recto: "Georgann June 1978"
 mount verso: "53"
Acquired from: gift of Dr. and Mrs. Steven Wainwright, Durham, North Carolina

5588

5589

5593

5594

5596

5600

5605. **GERALD VAUGHAN** (P1976.98.43)
Gelatin silver print. 1976
Image: 9 ¾ x 7 ¹³⁄₁₆ in. (24.7 x 19.7 cm.)
Mount: 17 x 14 in. (43.2 x 35.6 cm.)
Signed, l.r. mount recto: "Caroline Vaughan"
Inscription, mount recto: "Gerald Vaughan February 1976"
 mount verso: "38"
Acquired from: gift of Dr. and Mrs. Steven Wainwright,
 Durham, North Carolina

5606. **GOING DOWNSTREAM** (P1976.98.26)
Gelatin silver print. 1974
Image: 8 x 10 ¼ in. (20.3 x 26.0 cm.)
Mount: 14 x 17 in. (35.6 x 43.2 cm.)
Signed, l.r. mount recto: "Caroline Vaughan"
Inscription, mount recto: "Going Downstream"
 mount verso: "44"
Acquired from: gift of Dr. and Mrs. Steven Wainwright,
 Durham, North Carolina

*5607. **GOLDEN, NEW MEXICO** (P1976.98.53)
Gelatin silver print. 1976
Image: 7 ⅞ x 10 ¹¹⁄₁₆ in. (20.0 x 27.2 cm.)
Mount: 14 ⅛ x 17 in. (35.9 x 43.2 cm.)
Signed, l.r. mount recto: "Caroline Vaughan"
Inscription, mount recto: "Golden, New Mexico"
 mount verso: "32"
Acquired from: gift of Dr. and Mrs. Steven Wainwright,
 Durham, North Carolina

*5608. **HUNTER** (P1976.98.6)
Gelatin silver print. 1970
Image: 8 ¼ x 6 ⅞ in. (20.9 x 17.5 cm.)
Mount: 17 x 14 in. (43.2 x 35.6 cm.)
Signed, l.r. mount recto: "Caroline Vaughan"
Inscription, mount recto: "Hunter"
 mount verso: "5"
Acquired from: gift of Dr. and Mrs. Steven Wainwright,
 Durham, North Carolina

5609. **IMAGE FROM A PAST LIFE** (P1976.98.57)
Gelatin silver print. 1974
Image: 11 ¾ x 9 ⅛ in. (29.9 x 23.1 cm.)
Mount: 17 x 14 in. (43.2 x 35.6 cm.)
Signed, l.r. mount recto: "Caroline Vaughan"
Inscription, mount recto: "Image from a Past Life"
 mount verso: "13" and typed on paper label "Caroline
 Vaughan/2305 Prince Street/Durham, NC 27707"
Acquired from: gift of Dr. and Mrs. Steven Wainwright,
 Durham, North Carolina

*5610. **IMOGEN CUNNINGHAM AT 88** (P1976.98.32)
Gelatin silver print. 1971
Image: 4 ¾ x 7 in. (12.1 x 17.8 cm.)
Mount: 14 ⅛ x 17 in. (35.9 x 43.2 cm.)
Signed, l.r. mount recto: "Caroline Vaughan"
Inscription, mount recto: "Imogen Cunningham at 88"
 mount verso: "51"
Acquired from: gift of Dr. and Mrs. Steven Wainwright,
 Durham, North Carolina

*5611. **ISA LAKE, CONTINENTAL DIVIDE, WYOMING**
 (P1976.98.41)
Gelatin silver print. 1975
Image: 7 ⁷⁄₁₆ x 9 ½ in. (18.8 x 24.1 cm.)
Mount: 14 x 17 in. (35.6 x 43.2 cm.)
Signed, l.r. mount recto: "Caroline Vaughan"
Inscription, mount recto: "Isa Lake Continental Divide
 Wyoming"
 mount verso: "20"
Acquired from: gift of Dr. and Mrs. Steven Wainwright,
 Durham, North Carolina

5612. **JEMEZ, NEW MEXICO** (P1976.98.11)
Gelatin silver print. 1976
Image: 7 ³⁄₁₆ x 8 ¹³⁄₁₆ in. (18.3 x 22.3 cm.)
Mount: 14 x 17 in. (35.6 x 43.2 cm.)
Signed, l.r. mount recto: "Caroline Vaughan"
Inscription, mount recto: "Hemez [sic], New Mexico"
 mount verso: "33"
Acquired from: gift of Dr. and Mrs. Steven Wainwright,
 Durham, North Carolina

5613. **JOEY AND BARBARA DEMAIO** (P1976.98.16)
Gelatin silver print. 1971
Image: 3 ¹¹⁄₁₆ x 4 ¾ in. (9.3 x 12.0 cm.)
Mount: 13 ¹¹⁄₁₆ x 16 ¹¹⁄₁₆ in. (34.9 x 42.4 cm.)
Signed, l.r. mount recto: "Caroline Vaughan"
Inscription, mount recto: "Joey and Barbara DeMaio"
 mount verso: "30"
Acquired from: gift of Dr. and Mrs. Steven Wainwright,
 Durham, North Carolina

5614. **JOSÉ ORTIZ Y PINO III, GALISTEO, NEW MEXICO**
 (P1976.98.47)
Gelatin silver print. 1976
Image: 7 ¼ x 9 ¼ in. (18.4 x 23.4 cm.)
Mount: 14 ⅛ x 17 in. (35.9 x 43.2 cm.)
Signed, l.r. mount recto: "Caroline Vaughan"
Inscription, mount recto: "José Ortiz Y Pino III Galisteo,
 New Mexico"
 mount verso: "36"
Acquired from: gift of Dr. and Mrs. Steven Wainwright,
 Durham, North Carolina

5615. **LEAF SYNCHRONICITY** (P1976.98.21)
Gelatin silver print. 1973
Image: 10 ⁵⁄₁₆ x 8 ⅛ in. (26.1 x 20.6 cm.)
Mount: 17 x 14 in. (43.2 x 35.6 cm.)
Signed, l.r. mount recto: "Caroline Vaughan"
Inscription, mount recto: "Leaf Synchronicity"
 mount verso: "54" and typed on paper label "Caroline
 Vaughan/2305 Prince Street/Durham, NC 27707"
Acquired from: gift of Dr. and Mrs. Steven Wainwright,
 Durham, North Carolina

*5616. **LINDSAY DEARBORN HUPPÉ** (P1976.98.46)
Gelatin silver print. 1973
Image: 11 ¾ x 8 ⁹⁄₁₆ in. (29.8 x 21.8 cm.)
Mount: 17 x 14 in. (43.2 x 35.6 cm.)
Signed, l.r. mount recto: "Caroline Vaughan"
Inscription, mount recto: "Lindsay Dearborn Huppé"
 mount verso: "27"
Acquired from: gift of Dr. and Mrs. Steven Wainwright,
 Durham, North Carolina

5617. **MAMMOTH HOT SPRINGS, WYOMING** (P1976.98.58)
Gelatin silver print. 1975
Image: 7 ⁷⁄₁₆ x 9 ½ in. (18.9 x 24.1 cm.)
Mount: 14 ⅛ x 17 in. (35.8 x 43.2 cm.)
Signed, l.r. mount recto: "Caroline Vaughan"
Inscription, mount recto: "Mammoth Hot Springs Wyoming"
 mount verso: "23"
Acquired from: gift of Dr. and Mrs. Steven Wainwright,
 Durham, North Carolina

5618. **MOONRISE AT THREE RIVERS, NEW MEXICO**
 (P1976.98.54)
Gelatin silver print. 1976
Image: 7 ¼ x 9 in. (18.4 x 22.8 cm.)
Mount: 14 ³⁄₁₆ x 17 in. (36.0 x 43.2 cm.)
Signed, l.r. mount recto: "Caroline Vaughan"
Inscription, mount recto: "Moonrise at Three Rivers
 New Mexico"
 mount verso: "35"
Acquired from: gift of Dr. and Mrs. Steven Wainwright,
 Durham, North Carolina

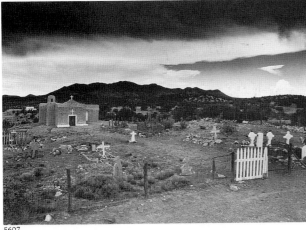
5607

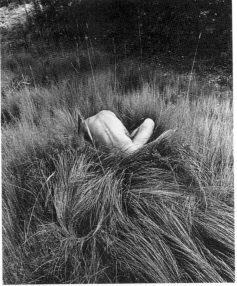
5608

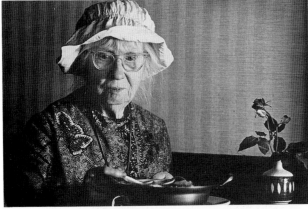
5610

5611

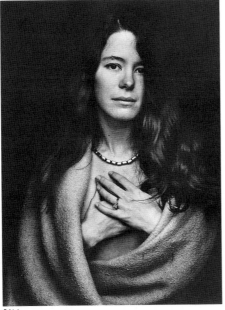
5616

5622

5619. **NEWFOUNDLAND [Sunspot]** (P1976.98.45)
Gelatin silver print. 1974
Image: 8½ x 10¹³⁄₁₆ in. (21.5 x 27.4 cm.)
Mount: 14 x 17 in. (35.6 x 43.2 cm.)
Signed, l.r. mount recto: "Caroline Vaughan"
Inscription, mount recto: "NewFoundLand"
 mount verso: "4" and typed on paper label "Caroline
 Vaughan/2305 Prince Street/Durham, NC 27707"
Acquired from: gift of Dr. and Mrs. Steven Wainwright,
 Durham, North Carolina

5620. **NORTH FLORIDA** (P1976.98.12)
Gelatin silver print. 1974
Image: 10⁷⁄₁₆ x 8³⁄₁₆ in. (26.5 x 20.7 cm.)
Mount: 17 x 14 in. (43.2 x 35.6 cm.)
Signed, l.r. mount recto: "Caroline Vaughan"
Inscription, mount recto: "North florida"
 mount verso: "17" and typed on paper label "Caroline
 Vaughan/2305 Prince Street/Durham, NC 27707"
Acquired from: gift of Dr. and Mrs. Steven Wainwright,
 Durham, North Carolina

5621. **OKEFENOKEE SWAMP** (P1976.98.49) duplicate of
P1976.98.60
Gelatin silver print. 1974
Image: 7⁵⁄₁₆ x 9⁵⁄₁₆ in. (18.5 x 23.7 cm.)
Mount: 14 x 17 in. (35.6 x 43.2 cm.)
Signed, l.r. mount recto: "Caroline Vaughan"
Inscription, mount recto: "Okefenokee [sic] Swamp
 May 1974"
 mount verso: "12"
Acquired from: gift of Dr. and Mrs. Steven Wainwright,
 Durham, North Carolina

*5622. **OKEFENOKEE SWAMP, GEORGIA** (P1976.98.60) duplicate
of P1976.98.49
Gelatin silver print. 1974
Image: 7³⁄₈ x 9³⁄₈ in. (18.6 x 23.8 cm.)
Mount: 14 x 17 in. (35.6 x 43.2 cm.)
Signed, l.r. mount recto: "Caroline Vaughan"
Inscription, mount recto: "Okefenokee [sic] Swamp,
 Georgia"
 mount verso, typed on paper label "Caroline
 Vaughan/2305 Prince Street/Durham, NC 27707"
Acquired from: the photographer

5623. **OSSABAW ISLAND** (P1976.98.38)
Gelatin silver print. 1974
Image: 10⁵⁄₈ x 8³⁄₈ in. (27.0 x 21.2 cm.)
Mount: 17 x 14 in. (43.2 x 35.6 cm.)
Signed, l.r. mount recto: "Caroline Vaughan"
Inscription, mount recto: "Ossabaw Island"
 mount verso: "22"
Acquired from: gift of Dr. and Mrs. Steven Wainwright,
 Durham, North Carolina

5624. **OSSABAW ISLAND, GEORGIA** (P1976.98.48)
Gelatin silver print. 1974
Image: 9¹¹⁄₁₆ x 7½ in. (24.6 x 19.1 cm.)
Mount: 17 x 14 in. (43.2 x 35.6 cm.)
Signed, l.r. mount recto: "Caroline Vaughan"
Inscription, mount recto: "Ossabaw Island, Georgia"
 mount verso: "18"
Acquired from: gift of Dr. and Mrs. Steven Wainwright,
 Durham, North Carolina

5625. **PEGGY'S COVE: SEPARATE REALITIES** (P1976.98.29)
Gelatin silver print. 1974
Image: 7¹⁵⁄₁₆ x 10⅛ in. (20.1 x 25.7 cm.)
Mount: 14 x 17 in. (35.6 x 43.2 cm.)
Signed, l.r. mount recto: "Caroline Vaughan"
Inscription, mount recto: "Peggy's Cove: Separate Realities"
 mount verso: "24"
Acquired from: gift of Dr. and Mrs. Steven Wainwright,
 Durham, North Carolina

5626. **PERSONA [Prospect Bay, Nova Scotia]** (P1976.98.2)
Gelatin silver print. 1975
Image: 9⅝ x 7⁹⁄₁₆ in. (24.4 x 19.2 cm.)
Mount: 17 x 14 in. (43.2 x 35.6 cm.)
Signed, l.r. mount recto: "Caroline Vaughan"
Inscription, mount recto: "Persona January 1975"
 mount verso: "11."
Acquired from: gift of Dr. and Mrs. Steven Wainwright,
 Durham, North Carolina

5627. **PHOENIX ROCKS, GLOUCESTER, MASS.** (P1976.98.50)
Gelatin silver print. 1974
Image: 9⁵⁄₁₆ x 11¹⁵⁄₁₆ in. (23.6 x 30.4 cm.)
Mount: 14 x 17 in. (35.6 x 43.2 cm.)
Signed, l.r. mount recto: "Caroline Vaughan"
Inscription, mount recto: "Phoenix Rocks Glouster [sic],
 Mass."
 mount verso: "6"
Acquired from: gift of Dr. and Mrs. Steven Wainwright,
 Durham, North Carolina

5628. **POCKET BASIN, WYOMING** (P1976.98.55)
Gelatin silver print. 1975
Image: 7¹¹⁄₁₆ x 9¹³⁄₁₆ in. (19.4 x 24.8 cm.)
Mount: 14 x 17 in. (35.6 x 43.2 cm.)
Signed, l.r. mount recto: "Caroline Vaughan"
Inscription, mount recto: "Pocket Basin Wyoming"
 mount verso: "40"
Acquired from: gift of Dr. and Mrs. Steven Wainwright,
 Durham, North Carolina

*5629. **POINT LOBOS [Bluefish Cove, Carmel, California]**
(P1976.98.27)
Gelatin silver print. 1971
Image: 3¹⁵⁄₁₆ x 6¹⁄₁₆ in. (10.0 x 15.3 cm.)
Mount: 14 x 17 in. (35.6 x 43.2 cm.)
Signed, l.r. mount recto: "Caroline Vaughan"
Inscription, mount recto: "Point Lobos"
 mount verso: "50" and typed on paper label "Caroline
 Vaughan/2305 Prince Street/Durham, NC 27707"
Acquired from: gift of Dr. and Mrs. Steven Wainwright,
 Durham, North Carolina

*5630. **[Pomegranate]** (P1976.98.3)
Gelatin silver print. 1974
Image: 4⅛ x 3¹⁵⁄₁₆ in. (10.5 x 10.0 cm.)
Mount: 17 x 14 in. (43.2 x 35.6 cm.)
Signed, l.r. mount recto: "Caroline Vaughan"
Inscription, mount recto: "November 1974"
 mount verso: "1."
Acquired from: gift of Dr. and Mrs. Steven Wainwright,
 Durham, North Carolina

5631. **SAN JUAN ISLANDS, KELP** (P1976.98.42)
Gelatin silver print. 1975
Image: 8 x 10⁵⁄₁₆ in. (20.3 x 26.1 cm.)
Mount: 14 x 17 in. (35.6 x 43.2 cm.)
Signed, l.r. mount recto: "Caroline Vaughan"
Inscription, mount recto: "San Juan Islands Kelp"
 mount verso: "14"
Acquired from: gift of Dr. and Mrs. Steven Wainwright,
 Durham, North Carolina

5632. **SHACKLEFORD ISLAND** (P1976.98.19)
Gelatin silver print. 1972
Image: 5¼ x 7⅞ in. (13.4 x 19.9 cm.)
Mount: 14 x 17 in. (35.6 x 43.2 cm.)
Signed, l.r. mount recto: "Caroline Vaughan"
Inscription, mount recto: "ShackleFord Island"
 mount verso: "46"
Acquired from: gift of Dr. and Mrs. Steven Wainwright,
 Durham, North Carolina

5633. **THE SINKS, GREAT SMOKY MOUNTAINS** (P1976.98.56)
Gelatin silver print. 1973
Image: 10⅛ x 8⅛ in. (25.7 x 20.6 cm.)
Mount: 17 x 14 in. (43.2 x 35.6 cm.)

Signed, l.r. mount recto: "Caroline Vaughan"
Inscription, mount recto: "The Sinks Great Smokey [sic]
 Mountains"
 mount verso: "28"
Acquired from: gift of Dr. and Mrs. Steven Wainwright,
 Durham, North Carolina

5634. **THE SINKS, GREAT SMOKY MOUNTAINS,
 TENNESSEE** (P1976.98.36)
 Gelatin silver print. 1973
 Image: 7½ x 9⅝ in. (19.0 x 24.3 cm.)
 Mount: 14 x 17 in. (35.6 x 43.2 cm.)
 Signed, l.r. mount recto: "Caroline Vaughan"
 Inscription, mount recto: "The Sinks Great Smokey [sic]
 Mountains Tennessee October 1973"
 mount verso: "10"
 Acquired from: gift of Dr. and Mrs. Steven Wainwright,
 Durham, North Carolina

5629

5635. **THE SINKS, SMOKY MOUNTAINS** (P1976.98.1)
 Gelatin silver print. 1973
 Image: 9½ x 7⅟₁₆ in. (24.2 x 17.9 cm.)
 Mount: 17 x 14 in. (43.2 x 35.6 cm.)
 Signed, l.r. mount recto: "Caroline Vaughan"
 Inscription, mount recto: "The Sinks, Smokey [sic]
 Mountains"
 mount verso: "52" and typed on paper label "Caroline
 Vaughan/2305 Prince Street/Durham, NC 27707"
 Acquired from: gift of Dr. and Mrs. Steven Wainwright,
 Durham, North Carolina

5636. **SPIRIT GUARDIAN [White Mountains, New Hampshire]**
 (P1976.98.15)
 Gelatin silver print. 1977
 Image: 9⁹⁄₁₆ x 7⅝ in. (24.3 x 19.3 cm.)
 Mount: 17 x 14 in. (43.2 x 35.6 cm.)
 Signed, l.r. mount recto: "Caroline Vaughan"
 Inscription, mount recto: "SPIRIT GUARDIAN"
 mount verso: "55//55"
 Acquired from: gift of Dr. and Mrs. Steven Wainwright,
 Durham, North Carolina

5630

5637. **TENNESSEE [curved road]** (P1976.98.28)
 Gelatin silver print. 1974
 Image: 7⁵⁄₁₆ x 9½ in. (18.5 x 24.1 cm.)
 Mount: 14⅛ x 17 in. (35.9 x 43.2 cm.)
 Signed, l.r. mount recto: "Caroline Vaughan"
 Inscription, mount recto: "Tennessee"
 mount verso: "25"
 Acquired from: gift of Dr. and Mrs. Steven Wainwright,
 Durham, North Carolina

5638. **THREAD WATERFALL** (P1976.98.10)
 Gelatin silver print. 1973
 Image: 10³⁄₁₆ x 8⅟₁₆ in. (25.8 x 20.6 cm.)
 Mount: 17 x 14 in. (43.2 x 35.6 cm.)
 Signed, l.r. mount recto: "Caroline Vaughan"
 Inscription, mount recto: "Thread Waterfall"
 Acquired from: the photographer

*5639. **TWO CALLAS** (P1976.98.9) duplicate of P1976.98.20
 Gelatin silver print. 1974
 Image: 10⁹⁄₁₆ x 8⁵⁄₁₆ in. (26.8 x 21.1 cm.)
 Mount: 17 x 14 in. (43.2 x 35.6 cm.)
 Signed, l.r. mount recto: "Caroline Vaughan"
 Inscription, mount recto: "Two Callas"
 mount verso: "16"
 Acquired from: gift of Dr. and Mrs. Steven Wainwright,
 Durham, North Carolina

5639

5640. **TWO CALLAS** (P1976.98.20) duplicate of P1976.98.9
 Gelatin silver print. 1974
 Image: 12½ x 9⅞ in. (31.8 x 25.0 cm.)
 Mount: 20 x 16 in. (50.8 x 40.7 cm.)
 Signed, l.r. mount recto: "Caroline Vaughan"
 Inscription, mount recto: "Two Callas"
 Acquired from: gift of the photographer in honor of
 Ms. Katherine B. "Chula" Reynolds

5641. **VALLEY OF FIRE** (P1976.98.37)
Gelatin silver print. 1976
Image: 7¾ x 9⁹⁄₁₆ in. (19.7 x 23.1 cm.)
Mount: 14⅛ x 17 in. (35.9 x 43.2 cm.)
Signed, l.r. mount recto: "Caroline Vaughan"
Inscription, mount recto: "Valley of Fire"
 mount verso: "2"
Acquired from: gift of Dr. and Mrs. Steven Wainwright,
 Durham, North Carolina

5642. **VALLEY OF FIRE, NEW MEXICO, JOURNEY TO
 INACCESSIBLE PLACES** (P1976.98.51)
Gelatin silver print. 1976
Image: 6¹⁵⁄₁₆ x 10⅝ in. (17.5 x 27.0 cm.)
Mount: 14 x 17 in. (35.6 x 43.2 cm.)
Signed, l.r. mount recto: "Caroline Vaughan"
Inscription, mount recto: "Valley of Fire New Mexico Journey
 To Inaccessible Places June 1976"
 mount verso: "41"
Acquired from: gift of Dr. and Mrs. Steven Wainwright,
 Durham, North Carolina

5643. **WATERLILIES, NORTH FLORIDA** (P1976.98.7) duplicate of
 P1976.98.62
Gelatin silver print. 1974
Image: 10¼ x 8⅛ in. (26.0 x 20.6 cm.)
Mount: 17 x 14⅛ in. (43.2 x 35.9 cm.)
Signed, l.r. mount recto: "Caroline Vaughan"
Inscription, mount recto: "Waterlilies, North Florida"
 mount verso: "21"
Acquired from: gift of Dr. and Mrs. Steven Wainwright,
 Durham, North Carolina

5644. **WATERLILIES, NORTH FLORIDA** (P1976.98.62) duplicate
 of P1976.98.7
Gelatin silver print. 1974
Image: 12¾ x 10 in. (32.3 x 25.4 cm.)
Mount: 20 x 16 in. (50.8 x 40.7 cm.)
Signed, l.r. mount recto: "Caroline Vaughan"
Inscription, mount recto: "Waterlilies North Florida"
Acquired from: the photographer

5645. **WATERLILY CELEBRATION** (P1976.98.5) duplicate of
 P1976.98.59
Gelatin silver print. 1973–74
Image: 10⅜ x 8⅛ in. (26.3 x 20.6 cm.)
Mount: 17 x 14 in. (43.2 x 35.6 cm.)
Signed, l.r. mount recto: "Caroline Vaughan"
Inscription, mount recto: "Waterlily Celebration"
 mount verso: "3"
Acquired from: gift of Dr. and Mrs. Steven Wainwright,
 Durham, North Carolina

5646. **WATERLILY CELEBRATION** (P1976.98.59) duplicate of
 P1976.98.5
Gelatin silver print. 1973–74
Image: 10⁷⁄₁₆ x 8⅛ in. (26.4 x 20.7 cm.)
Mount: 17 x 14 in. (43.2 x 35.6 cm.)
Signed, l.r. mount recto: "Caroline Vaughan"
Inscription, mount recto: "Waterlily Celebration"
Acquired from: gift of the photographer in honor of Whitney
 Hyder (Mrs. Doug Moore)

5647. **WYOMING [Pocket Basin]** (P1976.98.40)
Gelatin silver print. 1975
Image: 9½ x 7⅜ in. (24.1 x 18.8 cm.)
Mount: 17 x 14 in. (43.2 x 35.6 cm.)
Signed, l.r. mount recto: "Caroline Vaughan"
Inscription, mount recto: "Wyoming"
 mount verso: "37"
Acquired from: gift of Dr. and Mrs. Steven Wainwright,
 Durham, North Carolina

DAVID VESTAL, American (b. 1924)

Vestal studied painting at the Art Institute of Chicago
from 1941 to 1944. He studied photography under Sid
Grossman and worked as an assistant to Ralph Steiner.
He also was a member of New York City's Photo
League. In addition, Vestal has taught at several private
schools and universities, including the New York Insti-
tute of Photography, the School of Visual Arts in New
York, the Art Institute of Chicago, Columbia College,
the University of New Mexico, the College of Santa
Fe, Parsons School of Design, and the Pratt Institute.
He has worked as a travel and camera editor for *Popular
Photography* and *Camera 35* magazines and received
Guggenheim Fellowships in photography in 1966
and 1973.

*5648. **[Three kittens]** (P1976.171)
Gelatin silver print. c. 1976
Image: 3¹⁄₁₆ x 4½ in. (7.8 x 11.5 cm.)
Sheet: 3⁵⁄₁₆ x 4¾ in. (8.4 x 12.1 cm.)
Acquired from: gift of Mitchell A. Wilder, Fort Worth, Texas

ADAM CLARK VROMAN,
American (1856–1916)

Vroman was born in LaSalle, Illinois, and worked for
the railroad in Rockford before moving to Pasadena,
California, in 1892. He became a book dealer and,
about 1894, began to travel and make photographs of
Indians. His friend and fellow photographer Charles F.
Lummis urged him to pursue a photographic career.
Over the next fifteen years Vroman returned many
times to Indian villages to make photographs of daily
life and special ceremonies. He had a great respect
for Indian tradition and frequently spoke out against
attempts to assimilate Indians into white culture.

*5649. **CAÑON DE CHELLY** (P1982.23)
Platinum print. 1904
Image: 6¹⁄₁₆ x 8¹⁄₁₆ in. (15.3 x 20.5 cm.)
Sheet: 6¼ x 8¼ in. (15.9 x 21.0 cm.)
Acquired from: Andrew Smith, Inc., Albuquerque,
 New Mexico

*5650. **[Two women by pots]** (P1979.81)
Platinum print. c. 1910
Image: 7¼ x 5½ in. (18.4 x 14.0 cm.)
Sheet: 9¹⁵⁄₁₆ x 7¹¹⁄₁₆ in. (25.2 x 19.5 cm.)
Inscription, print recto: "532"
Acquired from: Andrew Smith, Inc., Albuquerque,
 New Mexico

ELIZABETH WADE, American (d. 1915)

See *Camera Notes*

E. O. WAITE, American (active 1880s)

Little information about photographer E. O. Waite can
be located. Waite made images during the Worcester
Excursion Car Company's annual hunting trip and tour
of Yellowstone Park in 1883. (F. Jay Haynes took photo-
graphs on the company's annual trips in 1876, 1878,
and 1884.)

*5651. **MAMMOTH HOT SPRINGS, YELLOWSTONE PARK**
 (P1980.52.2)
Albumen silver print. 1883
Image: 4⅛ x 6⅜ in. (10.5 x 16.2 cm.)
Mount: 4½ x 7¹⁄₁₆ in. (11.4 x 17.9 cm.)

Signed: see inscription
Inscription, mount recto: "VIEWS FROM A PALACE
 CAR.//JEROME MARBLE,/PRES'T AND GEN'L
 MANAGER.//WORCESTER EXCURSION CAR CO./
 WORCESTER, MASS.//CHAS. B. PRATT,/
 TREASURER.//PHOTOGRAPHED BY E. O. WAITE."
 mount verso: "WORCESTER EXCURSION CAR CO'S/
 ANNUAL HUNTING TRIP,/AND A/TOUR OF THE
 YELLOWSTONE PARK./1883//[list of titles]"
Acquired from: Kamp Gallery, St. Louis, Missouri

5652. **UPPER FALLS OF THE YELLOWSTONE, HOT
 SPRINGS, YELLOWSTONE PARK** (P1980.52.3)
 Albumen silver print. 1883
 Image: 4 1/16 x 6 5/16 in. (10.4 x 16.0 cm.)
 Mount: 4 1/2 x 7 1/16 in. (11.4 x 17.9 cm.)
 Signed: see inscription
 Inscription, mount recto: "VIEWS FROM A PALACE
 CAR,//JEROME MARBLE,/PRES'T AND GEN'L
 MANAGER.//WORCESTER EXCURSION CAR CO./
 WORCESTER, MASS.//CHAS. B. PRATT,/
 TREASURER.//PHOTOGRAPHED BY E. O. WAITE."
 mount verso: "WORCESTER EXCURSION CAR CO'S/
 ANNUAL HUNTING TRIP,/AND A/TOUR OF THE
 YELLOWSTONE PARK./1883//[list of titles]"
 Acquired from: Nicholas Vahlkamp, St. Louis, Missouri

5653. **YELLOWSTONE RIVER NEAR LIVINGSTON,
 MONTANA** (P1980.52.4)
 Albumen silver print. 1883
 Image: 4 1/8 x 6 3/8 in. (10.5 x 16.2 cm.)
 Mount: 4 9/16 x 7 1/16 in. (11.5 x 17.9 cm.)
 Signed: see inscription
 Inscription, mount recto: "VIEWS FROM A PALACE
 CAR.//JEROME MARBLE,/PRES'T AND GEN'L
 MANAGER.//WORCESTER EXCURSION CAR CO./
 WORCESTER, MASS.//CHAS. B. PRATT,/
 TREASURER.//PHOTOGRAPHED BY E. O. WAITE."
 mount verso: "WORCESTER EXCURSION CAR CO'S/
 ANNUAL HUNTING TRIP,/AND A/TOUR OF THE
 YELLOWSTONE PARK./1883.//[list of titles]"
 Acquired from: Nicholas Vahlkamp, St. Louis, Missouri

5654. **YELLOWSTONE VALLEY NEAR TOWER FALLS,
 HOT SPRINGS, YELLOWSTONE PARK** (P1980.52.1)
 Albumen silver print. 1883
 Image: 4 1/8 x 6 5/16 in. (10.5 x 16.0 cm.)
 Mount: 4 1/2 x 7 1/16 in. (11.5 x 17.9 cm.)
 Signed: see inscription
 Inscription, mount recto: "VIEWS FROM A PALACE
 CAR,//JEROME MARBLE,/PRES'T AND GEN'L
 MANAGER.//WORCESTER EXCURSION CAR CO./
 WORCESTER, MASS.//CHAS. B. PRATT,/
 TREASURER.//PHOTOGRAPHED BY E. O. WAITE."
 mount verso: "WORCESTER EXCURSION CAR CO'S/
 ANNUAL HUNTING TRIP,/AND A/TOUR OF THE
 YELLOWSTONE PARK./1883//[list of titles]"
 Acquired from: Nicholas Vahlkamp, St. Louis, Missouri

CARLETON E. WATKINS,
American (1829–1916)

Watkins was born in Oneonta, New York, and moved
to California in 1851. There he worked in a store in
Sacramento, then learned to make daguerreotypes from
Robert Vance and opened his own studio a few years
later. Watkins had a special interest in and skill for
landscape photography. In 1861 he made the first of sev-
eral trips to Yosemite, where he made photographs that
gained him great professional acclaim. He also did por-
trait work in his San Francisco studio and accepted
commercial assignments from ranchers, mine owners,
and businessmen. He worked with Clarence King
on the 1870 California Geological Survey expedition

5648

5649

5650

to Mount Shasta. Watkins frequently worked with
mammoth-plate cameras that yielded negatives as
large as 18 x 22 inches and was one of the first to have
a mammoth-plate camera constructed for his use. A
lack of business skill and intense competition in the
photography business led him to declare bankruptcy
in 1876. Photographic publisher I. W. Taber bought
his negatives, forcing Watkins to rephotograph many
of the scenes depicted in earlier views. He continued
travels that took him to the Columbia River in Oregon,
along the route of the Southern Pacific Railroad as far
as Tombstone, Arizona, and throughout California.
His negatives were destroyed by the San Francisco
earthquake in 1906; Watkins was declared mentally
incompetent a few years later and spent the last years
of his life in the Napa State Hospital for the Insane.

5655. **ASH FIELDS ON LASSENS BUTTE** [from the album
"California Views 1876"] (P1975.94.13)
Albumen silver print. negative 1870, print c. 1876
Image: 8 1/8 x 12 1/4 in. (20.6 x 31.1 cm.)
Mount: 15 3/8 x 18 15/16 in. (39.0 x 48.2 cm.)
Inscription, mount recto: "Ash Fields on Lassens Butte"
Acquired from: Fred Rosenstock, Denver, Colorado

5656. **BALDWINS** [copy print of drawing of hotel; from the album
"California Views 1876"] (P1975.94.7)
Albumen silver print. negative c. 1866–76, print c. 1876
Image: 8 1/2 x 14 5/16 in. (21.6 x 36.3 cm.)
Mount: 15 3/8 x 18 15/16 in. (39.0 x 48.2 cm.)
Inscription, in negative: "Jno R. Wilkins/Pinx"
 mount recto: "Baldwins"
Acquired from: Fred Rosenstock, Denver, Colorado

5657. **THE BRIDAL VEIL, 900 FEET. YOSEMITE** [from the
album "California Views 1876"] (P1975.94.25)
Albumen silver print. negative c. 1865–66, print c. 1876
Image: 12 1/8 x 8 3/16 in. (30.8 x 20.8 cm.)
Mount: 18 15/16 x 15 3/8 in. (48.2 x 39.0 cm.)
Inscription, mount recto: "The Bridal Veil, 900 Feet.
Yosemite."
Acquired from: Fred Rosenstock, Denver, Colorado

*5658. **CALIFORNIA OAK IN THE GROUNDS OF M. L.
LATHAM, MENLO PARK, CAL.** [from the album
"California Views 1876"] (P1975.94.32)
Albumen silver print. negative 1874, print c. 1876
Image: 10 11/16 x 14 1/16 in. (27.1 x 35.7 cm.)
Mount: 15 3/8 x 18 15/16 in. (39.0 x 48.2 cm.)
Inscription, mount recto: "California Oak in the Grounds of
M L Latham, Menlo Park, Cal."
Acquired from: Fred Rosenstock, Denver, Colorado

5659. **CAPE HORN, CENTRAL PACIFIC R.R.** [from the
album "California Views 1876"] (P1975.94.4)
Albumen silver print. negative c. 1875, print c. 1876
Image: 10 1/16 x 14 1/4 in. (25.5 x 36.2 cm.)
Mount: 15 3/8 x 18 1/2 in. (39.0 x 47.0 cm.)
Inscription, mount recto: "Cape Horn, Central Pacific R.R."
Acquired from: Fred Rosenstock, Denver, Colorado

*5660. **CASTLE ROCK, COLUMBIA RIVER, OREGON** [from the
album "California Views 1876"] (P1975.94.33)
Albumen silver print. negative 1867, print c. 1876
Image: 10 x 14 in. (25.5 x 35.6 cm.)
Mount: 15 3/8 x 18 1/2 in. (39.0 x 47.0 cm.)
Inscription, mount recto: "Castle Rock, Columbia River,
Oregon."
Acquired from: Fred Rosenstock, Denver, Colorado

5661. **CATHEDRAL ROCK, 2600 FEET** [from the album
"California Views 1876"] (P1975.94.21)
Albumen silver print. negative 1866, print c. 1876
Image: 8 3/16 x 12 1/8 in. (20.8 x 30.8 cm.)
Mount: 15 3/8 x 18 15/16 in. (39.0 x 48.2 cm.)
Inscription, mount recto: "Cathedral Rock 2600 Feet."
Acquired from: Fred Rosenstock, Denver, Colorado

5662. **THE CATHEDRAL SPIRES, YOSEMITE** [from the album
"California Views 1876"] (P1975.94.9)
Albumen silver print. negative 1866, print c. 1876
Image: 12 1/8 x 8 5/16 in. (30.8 x 21.1 cm.)
Mount: 18 15/16 x 15 3/8 in. (48.2 x 39.0 cm.)
Inscription, mount recto: "The Cathedral Spires, Yosemite."
Acquired from: Fred Rosenstock, Denver, Colorado

5663. **CLIFF HOUSE AND SEAL ROCKS** [from the album
"California Views 1876"] (P1975.94.39)
Albumen silver print. negative c. 1870–72, print c. 1876
Image: 10 3/16 x 14 1/8 in. (25.9 x 35.8 cm.)
Mount: 15 3/8 x 18 15/16 in. (39.0 x 48.2 cm.)
Inscription, mount recto: "Cliff House and Seal Rocks."
Acquired from: Fred Rosenstock, Denver, Colorado

5664. **COAST VIEW FROM CYPRESS POINT, BIRD AND
OWL ROCK IN THE DISTANCE, MONTEREY**
(P1978.114.1)
Albumen silver print. 1881
Image: 4 9/16 x 6 15/16 in. (11.5 x 17.5 cm.)
Sheet: 4 13/16 x 8 3/16 in. (12.2 x 20.7 cm.)
Mount: 5 3/8 x 8 1/2 in. (13.7 x 21.6 cm.)
Signed: see inscription
Inscription, mount recto: "WATKINS' NEW BOUDOIR
SERIES YO SEMITE AND PACIFIC COAST, 427
Montgomery Street, San Francisco."
 mount verso: "Coast view from Cypress Point Bird and/
Owl Rock in the Distance/Monterey"
Acquired from: Frontier America Corporation, Bryan, Texas

5665. **COMMENCEMENT OF THE WHITNEY GLACIER,
SUMMIT OF MT. SHASTA** [from the album "California
Views 1876"] (P1975.94.10)
Albumen silver print. negative 1870, print c. 1876
Image: 8 1/4 x 12 1/4 in. (21.0 x 31.1 cm.)
Mount: 15 3/8 x 18 15/16 in. (39.0 x 48.2 cm.)
Inscription, mount recto: "Commencement of the Whitney
Glacier, Summit of Mt Shasta"
Acquired from: Fred Rosenstock, Denver, Colorado

*5666. **THE DEVILS GATE, C.P.R.R.** [Utah] (P1981.64.3)
Albumen silver print. c. 1873–74
Image: 4 15/16 x 6 3/8 in. (12.6 x 16.2 cm.) oval
Sheet: 6 x 7 1/4 in. (15.3 x 18.3 cm.)
Inscription, print verso: "The Devils Gate/W.P.R.R. [sic]/
Watkins"
Acquired from: Peter Palmquist, Arcata, California

5667. **DONNER LAKE, VIEW FROM THE SUMMIT, C.P.R.R.**
[from the album "California Views 1876"] (P1975.94.44)
Albumen silver print. negative c. 1873–76, print c. 1876
Image: 10 3/16 x 14 1/16 in. (25.9 x 35.7 cm.)
Mount: 15 3/8 x 18 15/16 in. (39.0 x 48.2 cm.)
Inscription, mount recto: "Donner Lake, View from
The Summit, C.P.R.R."
Acquired from: Fred Rosenstock, Denver, Colorado

*5668. **DOWN THE VALLEY, YOSEMITE** [from the album
"California Views 1876"] (P1975.94.20)
Albumen silver print. negative 1866, print c. 1876
Image: 8 1/4 x 12 1/8 in. (20.9 x 30.8 cm.)
Mount: 15 3/8 x 18 1/2 in. (39.0 x 47.0 cm.)
Inscription, mount recto: "Down the Valley, Yosemite."
Acquired from: Fred Rosenstock, Denver, Colorado

5651

5658

5660

5666

5668

5673

5669. **EL CAPITAN, 3600 FEET [from the album "California Views 1876"]** (P1975.94.26)
Albumen silver print. negative c. 1865–66, print c. 1876
Image: 12 ⅛ x 8 ¼ in. (30.8 x 20.9 cm.)
Mount: 18 ¹⁵⁄₁₆ x 15 ⅜ in. (48.2 x 39.0 cm.)
Inscription, mount recto: "El Capitan, 3600 Feet."
Acquired from: Fred Rosenstock, Denver, Colorado

5670. **EMERALD BAY, LAKE TAHOE [from the album "California Views 1876"]** (P1975.94.45)
Albumen silver print. negative c. 1873–76, print c. 1876
Image: 10 ³⁄₁₆ x 14 ¹⁄₁₆ in. (25.9 x 35.7 cm.)
Mount: 15 ⅜ x 18 ¹⁵⁄₁₆ in. (39.0 x 48.2 cm.)
Inscription, mount recto: "Emerald Bay, Lake Tahoe."
Acquired from: Fred Rosenstock, Denver, Colorado

5671. **THE FARALLONS, PACIFIC OCEAN [from the album "California Views 1876"]** (P1975.94.34)
Albumen silver print. negative c. 1868–72, print c. 1876
Image: 10 ¹⁄₁₆ x 14 in. (25.5 x 35.6 cm.)
Mount: 15 ⅜ x 18 ½ in. (39.0 x 47.0 cm.)
Inscription, mount recto: "The Farralones [sic], Pacific Ocean."
Acquired from: Fred Rosenstock, Denver, Colorado

5672. **FILLING IN THE TRESTLE WORK OF THE C.P.R.R., SECRET TOWN TRESTLE [from the album "California Views 1876"]** (P1975.94.48)
Albumen silver print. 1876
Image: 10 ³⁄₁₆ x 14 ⅛ in. (25.8 x 35.8 cm.)
Mount: 15 ⅜ x 18 ¹⁵⁄₁₆ in. (39.0 x 48.2 cm.)
Inscription, mount recto: "Filling in the Tressle [sic] Work of the C.P.R.R. Secret Town Tressle [sic]."
Acquired from: Fred Rosenstock, Denver, Colorado

Attributed to Carleton E. Watkins

*5673. **GLACIER POINT, 3700 FT., YO SEMITE** (P1980.40)
Albumen silver print. c. 1876–77
Image: 20 ⁷⁄₁₆ x 16 in. (51.9 x 40.7 cm.)
Mount: 28 x 21 ⅞ in. (71.2 x 55.6 cm.)
Inscription, sheet verso: "HOUSEWORTH/Photographer/SAN FRANCISCO"
mount recto: "Houseworth & Co. Photos.//Glacier Point 3700 ft./Yo Semite/34.//Nos. 9. & 12 Montgomery st."
Acquired from: John Howell—Books, San Francisco, California

5674. **GLENBROOK BAY. LAKE TAHOE [from the album "California Views 1876"]** (P1975.94.5)
Albumen silver print. negative 1873, print c. 1876
Image: 10 ¹⁄₁₆ x 14 ⅜ in. (25.5 x 36.4 cm.)
Mount: 15 ⅜ x 18 ¹⁵⁄₁₆ in. (39.0 x 48.2 cm.)
Inscription, mount recto: "Glenbrook Bay. Lake Tahoe."
Acquired from: Fred Rosenstock, Denver, Colorado

5675. **GOLD HILL, NEVADA [from the album "California Views 1876"]** (P1975.94.37)
Albumen silver print. negative c. 1875–76, print c. 1876
Image: 10 ⁵⁄₁₆ x 14 ¹⁄₁₆ in. (26.1 x 35.7 cm.)
Mount: 15 ⅜ x 18 ½ in. (39.0 x 47.0 cm.)
Inscription, mount recto: "Gold Hill, Nevada."
Acquired from: Fred Rosenstock, Denver, Colorado

5676. **THE GOLDEN GATE, SAN FRANCISCO, CAL. [from the album "California Views 1876"]** (P1975.94.43)
note: forms panorama when paired with P1975.94.42, "Sausalito and Mt. Tamalpais, Bay of San Francisco"
Albumen silver print. negative c. 1867–72, print c. 1876
Image: 10 ¼ x 14 ¹⁄₁₆ in. (26.1 x 35.7 cm.)
Mount: 15 ⅜ x 18 ¹⁵⁄₁₆ in. (39.0 x 48.2 cm.)
Inscription, mount recto: "The Golden Gate, San Francisco, Cal."
Acquired from: Fred Rosenstock, Denver, Colorado

*5677. **THE GRANITE FALLS, 2630 FEET [from the album "California Views 1876"]** (P1975.94.28)
Albumen silver print. negative c. 1865–66, print c. 1876
Image: 12 ⅛ x 8 ¼ in. (30.8 x 20.9 cm.)
Mount: 18 ¹⁵⁄₁₆ x 15 ⅜ in. (48.2 x 39.0 cm.)
Inscription, mount recto: "The Granite Falls, 2630 Feet."
Acquired from: Fred Rosenstock, Denver, Colorado

5678. **THE HALF DOME FROM GLACIER POINT, YOSEMITE [from the album "California Views 1876"]** (P1975.94.19)
Albumen silver print. negative 1866, print c. 1876
Image: 8 ¼ x 12 ⅛ in. (20.9 x 30.8 cm.)
Mount: 15 ⅜ x 18 ¹⁵⁄₁₆ in. (39.0 x 48.2 cm.)
Inscription, mount recto: "The Half Dome from Glacier Point, Yosemite"
Acquired from: Fred Rosenstock, Denver, Colorado

5679. **IN THE GROUNDS OF M. L. LATHAM, MENLO PARK, CALIFORNIA [from the album "California Views 1876"]** (P1975.94.31)
Albumen silver print. negative 1874, print c. 1876
Image: 10 ³⁄₁₆ x 14 ¹⁄₁₆ in. (25.9 x 35.7 cm.)
Mount: 15 ⅜ x 18 ¹⁵⁄₁₆ in. (39.0 x 48.2 cm.)
Inscription, mount recto: "In the grounds of M L Latham, Menlo Park, California"
Acquired from: Fred Rosenstock, Denver, Colorado

*5680. **LAKE MARY, SUMMIT OF THE SIERRAS, CAL. [from the album "California Views 1876"]** (P1975.94.49)
Albumen silver print. negative c. 1869–76, print c. 1876
Image: 10 ³⁄₁₆ x 14 ¹⁄₁₆ in. (25.8 x 35.7 cm.)
Mount: 15 ⅜ x 18 ¹⁵⁄₁₆ in. (39.0 x 48.2 cm.)
Inscription, mount recto: "Lake Mary, Summit of the Sierras, Cal."
Acquired from: Fred Rosenstock, Denver, Colorado

5681. **THE LEFT SENTINEL, CALAVERAS GROVE [from the album "California Views 1876"]** (P1975.94.3)
Albumen silver print. negative c. 1873, print c. 1876
Image; 14 ⁵⁄₁₆ x 10 ¹⁄₁₆ in. (36.4 x 25.5 cm.)
Mount: 18 ¹⁵⁄₁₆ x 15 ⁵⁄₁₆ in. (48.2 x 38.9 cm.)
Inscription, mount recto: "The Left Sentinel, Calaveras Grove."
Acquired from: Fred Rosenstock, Denver, Colorado

5682. **[Mirror View, El Capitan, Yosemite]** (P1982.39.2)
Albumen silver print. c. 1865–66
Image: 20 ⅝ x 15 ¹³⁄₁₆ in. (52.3 x 40.1 cm.)
Mount: 26 ⅛ x 20 ⅞ in. (66.3 x 53.1 cm.)
Acquired from: gift of Dr. C. G. Stephens, Brownsville, Texas

5683. **MIRROR VIEW OF THE HALF DOME** (P1979.79)
Albumen silver print. c. 1878–81
Image: 3 ⁹⁄₁₆ x 5 ⅞ in. (9.1 x 14.9 cm.)
Sheet: 3 ¾ x 6 ⅛ in. (9.4 x 15.5 cm.)
Mount: 4 ¼ x 6 ½ in. (10.8 x 16.5 cm.)
Signed: see inscription
Inscription, mount recto: "WATKINS NEW CABINET SERIES, Yosemite and Pacific Coast, 427 Montgomery St., San Francisco."
mount verso: "Mirror view of the Half Dome//3129"
Acquired from: Andrew Smith, Albuquerque, New Mexico

5684. **MIRROR VIEW OF THE TWO BROTHERS, 4480 FEET. YOSEMITE [from the album "California Views 1876"]** (P1975.94.23)
Albumen silver print. negative c. 1865–66, print c. 1876
Image: 12 ⁵⁄₁₆ x 8 ³⁄₁₆ in. (31.3 x 20.8 cm.)
Mount: 18 ½ x 15 ⅜ in. (47.0 x 39.0 cm.)
Inscription, mount recto: "Mirror View of the Two Brothers, 4480 Feet. Yosemite"
Acquired from: Fred Rosenstock, Denver, Colorado

5685. **MIRROR VIEW OF WASHINGTON COLUMN,
YOSEMITE** [from the album "California Views 1876"]
(P1975.94.24)
Albumen silver print. negative c. 1865–66, print c. 1876
Image: 12⅛ x 8 3/16 in. (30.8 x 20.8 cm.)
Mount: 18 15/16 x 15⅜ in. (48.2 x 39.0 cm.)
Inscription, mount recto: "Mirror View of Washington
Column, Yosemite."
Acquired from: Fred Rosenstock, Denver, Colorado

5686. **MISSION OF SAN FERNANDO REY, CAL. BUILT 1797**
[from the album "California Views 1876"] (P1975.94.52)
Albumen silver print. 1876
Image: 10 3/16 x 14 1/16 in. (25.9 x 35.7 cm.)
Mount: 15⅜ x 18 15/16 in. (39.0 x 48.2 cm.)
Inscription, mount recto: "Mission of San Fernando Rey,
Cal. Built 1797."
Acquired from: Fred Rosenstock, Denver, Colorado

5687. **MISSION OF SAN GABRIEL NEAR LOS ANGELES,
CAL. BUILT 1771** [from the album "California Views
1876"] (P1975.94.51)
Albumen silver print. c. 1876
Image: 10 3/16 x 14 1/16 in. (25.9 x 35.7 cm.)
Mount: 15⅜ x 18 15/16 in. (39.0 x 48.2 cm.)
Inscription, mount recto: "Mission of San Gabriel near
Los Angelos [sic], Cal. Built 1771."
Acquired from: Fred Rosenstock, Denver, Colorado

5688. **MISSION OF SAN LUIS REY, SAN DIEGO CO. CAL.
BUILT 1798** [from the album "California Views 1876"]
(P1975.94.35)
Albumen silver print. c. 1876
Image: 10 3/16 x 14 1/16 in. (25.9 x 35.7 cm.)
Mount: 15⅜ x 18 15/16 in. (39.0 x 48.2 cm.)
Inscription, mount recto: "Mission of San Louis [sic] Rey,
San Diego Co. Cal. Built 1798."
Acquired from: Fred Rosenstock, Denver, Colorado

5689. **THE MOTHER OF THE FOREST SEEN THROUGH
THE TORREY GROUP, CALAVERAS GROVE** [from the
album "California Views 1876"] (P1975.94.40)
Albumen silver print. negative 1875, print c. 1876
Image: 10 1/16 x 14¼ in. (25.5 x 36.2 cm.)
Mount: 15⅜ x 18 15/16 in. (39.0 x 48.2 cm.)
Inscription, mount recto: "The Mother of the Forest seen
through the Torrey Group, Calaveras Grove."
Acquired from: Fred Rosenstock, Denver, Colorado

*5690. **MOUNT SHASTA FROM SHEEP ROCKS** [from the album
"California Views 1876"] (P1975.94.11)
Albumen silver print. negative 1867 or 1870, print c. 1876
Image: 8⅛ x 12¼ in. (20.6 x 31.1 cm.)
Mount: 15⅜ x 18 15/16 in. (39.0 x 48.2 cm.)
Inscription, mount recto: "Mount Shasta from Sheep Rocks"
Acquired from: Fred Rosenstock, Denver, Colorado

5691. **MUD VOLCANO, HOT SPRINGS, LASSENS BUTTE,
CAL.** [from the album "California Views 1876"]
(P1975.94.16)
Albumen silver print. negative 1870, print c. 1876
Image: 8 1/16 x 12¼ in. (20.5 x 31.1 cm.)
Mount: 15⅜ x 18 15/16 in. (39.0 x 48.2 cm.)
Inscription, mount recto: "Mud Volcano, Hot Springs, Lassen
[sic] Butte, Cal."
Acquired from: Fred Rosenstock, Denver, Colorado

*5692. **OBSERVATORY POINT, LAKE TAHOE. VIEW NEAR
TAHOE CITY** [from the album "California Views 1876"]
(P1975.94.46)
Albumen silver print. negative c. 1873–76, print c. 1876
Image: 10¼ x 14 1/16 in. (26.0 x 35.7 cm.)
Mount: 15⅜ x 18 15/16 in. (39.0 x 48.2 cm.)
Inscription, mount recto: "Observatory Point, Lake Tahoe.
View near Tahoe City."
Acquired from: Fred Rosenstock, Denver, Colorado

5677

5680

5690

5693. **OLD DOMINION AND UNCLE TOMS CABIN, CALAVERAS GROVE [from the album "California Views 1876"]** (P1975.94.41)
Albumen silver print. negative 1875, print c. 1876
Image: 10 1/16 x 14 1/4 in. (25.5 x 36.2 cm.)
Mount: 15 3/8 x 18 15/16 in. (39.0 x 48.2 cm.)
Inscription, mount recto: "Old Dominion and Uncle Toms Cabin, Calaveras Grove."
Acquired from: Fred Rosenstock, Denver, Colorado

5694. **OLIVES AND PALMS FROM THE MISSION OF SAN DIEGO [from the album "California Views 1876"]** (P1975.94.36)
Albumen silver print. c. 1876
Image: 10 3/16 x 14 1/16 in. (25.9 x 35.7 cm.)
Mount: 15 3/8 x 18 15/16 in. (39.0 x 48.2 cm.)
Inscription, mount recto: "Olives and Palms from The Mission of San Diego."
Acquired from: Fred Rosenstock, Denver, Colorado

Attributed to Carleton E. Watkins
*5695. **[Outdoor view with tomb]** (P1982.5)
Albumen silver print. c. 1870s
Image: 15 1/2 x 20 11/16 in. (39.4 x 52.5 cm.)
Mount: 21 7/8 x 27 15/16 in. (55.6 x 70.9 cm.)
Acquired from: gift of Mark Zaplin, Classic Gravure Corporation, Santa Fe, New Mexico

5696. **THE RIGHT SENTINEL, CALAVERAS GROVE [from the album "California Views 1876"]** (P1975.94.2)
Albumen silver print. negative c. 1873, print c. 1876
Image: 14 5/16 x 10 1/16 in. (36.4 x 25.5 cm.)
Mount: 18 15/16 x 15 5/16 in. (48.1 x 38.9 cm.)
Inscription, mount recto: "The Right Sentinel, Calaveras Grove."
Acquired from: Fred Rosenstock, Denver, Colorado

5697. **RIVER MINING. CALAVERAS CO. CALIFORNIA [from the album "California Views 1876"]** (P1975.94.1)
Albumen silver print. negative c. 1873, print c. 1876
Image: 10 1/16 x 14 5/16 in. (25.5 x 36.4 cm.)
Mount: 15 3/8 x 18 9/16 in. (39.0 x 47.2 cm.)
Inscription, mount recto: "River Mining. Calaveras Co. California."
Acquired from: Fred Rosenstock, Denver, Colorado

*5698. **[Rock formation, Utah]** (P1981.64.4)
Albumen silver print. c. 1873-74
Image: 4 5/8 x 6 1/8 in. (11.7 x 15.5 cm.) oval
Sheet: 6 x 7 5/16 in. (15.3 x 18.6 cm.)
Acquired from: Peter Palmquist, Arcata, California

5699. **SAUSALITO AND MT. TAMALPAIS, BAY OF SAN FRANCISCO [from the album "California Views 1876"]** (P1975.94.42)
note: forms panorama when paired with P1975.94.43, "The Golden Gate, San Francisco, Cal."
Albumen silver print. negative c. 1867-72, print c. 1876
Image: 10 1/4 x 14 1/16 in. (26.1 x 35.7 cm.)
Mount: 15 3/8 x 18 15/16 in. (39.0 x 48.2 cm.)
Inscription, mount recto: "Sancolito [sic] and Mt Tamalpain [sic], Bay of San Francisco."
Acquired from: Fred Rosenstock, Denver, Colorado

*5700. **SECTION OF THE GRIZZLY GIANT, MARIPOSA GROVE. 33 FT. DIAM. [Galen Clark standing at base of tree]** (P1980.43)
Albumen silver print. c. 1866
Image: 8 1/16 x 12 1/16 in. (20.5 x 30.6 cm.)
Mount: 8 3/16 x 12 1/8 in. (20.8 x 30.8 cm.)
Inscription, mount verso: "24//Section of the Grizzly Giant,/ Mariposa Grove..33 ft diam./N° A.62 Watkins"
Acquired from: John Howell—Books, San Francisco, California

5701. **THE SENTINEL, 3270 FEET. YOSEMITE [from the album "California Views 1876"]** (P1975.94.6)
Albumen silver print. negative c. 1866, print c. 1876
Image: 12 5/16 x 8 1/8 in. (31.2 x 20.6 cm.)
Mount: 18 15/16 x 15 3/8 in. (48.2 x 39.0 cm.)
Inscription, mount recto: "The Sentinel, 3270 Feet. Yosemite."
Acquired from: Fred Rosenstock, Denver, Colorado

5702. **THE SHASTA BUTTES [from the album "California Views 1876"]** (P1975.94.12)
Albumen silver print. negative 1870, print c. 1876
Image: 8 1/8 x 12 1/4 in. (20.6 x 31.1 cm.)
Mount: 15 3/8 x 18 15/16 in. (39.0 x 48.2 cm.)
Inscription, mount recto: "The Shasta Buttes."
Acquired from: Fred Rosenstock, Denver, Colorado

5703. **SNOW SHEDS ENTERING THE TUNNEL AT THE SUMMIT. C.P.R.R. [from the album "California Views 1876"]** (P1975.94.47)
Albumen silver print. negative c. 1869-75, print c. 1876
Image: 10 3/16 x 14 1/16 in. (25.8 x 35.7 cm.)
Mount: 15 3/8 x 18 5/8 in. (39.0 x 47.3 cm.)
Inscription, mount recto: "Snow Sheds entering The Tunnel at the Summit. C.P.R.R."
Acquired from: Fred Rosenstock, Denver, Colorado

*5704. **THE SUMMIT OF LASSENS BUTTE [from the album "California Views 1876"]** (P1975.94.15)
Albumen silver print. negative 1870, print c. 1876
Image: 8 1/8 x 12 5/16 in. (20.6 x 31.2 cm.)
Mount: 15 3/8 x 18 15/16 in. (39.0 x 48.2 cm.)
Inscription, mount recto: "The Summit of Lassens Butte"
Acquired from: Fred Rosenstock, Denver, Colorado

5705. **TUTOCANULA PASS, YOSEMITE [from the album "California Views 1876"]** (P1975.94.8)
Albumen silver print. negative 1866, print c. 1876
Image: 12 1/8 x 8 3/16 in. (30.8 x 20.8 cm.)
Mount: 18 15/16 x 15 3/8 in. (48.2 x 39.0 cm.)
Inscription, mount recto: "Tutocanula Pass, Yosemite."
Acquired from: Fred Rosenstock, Denver, Colorado

5706. **UP THE VALLEY. YOSEMITE [from the album "California Views 1876"]** (P1975.94.27)
Albumen silver print. negative c. 1865-66, print c. 1876
Image: 8 3/16 x 12 1/8 in. (20.8 x 30.8 cm.)
Mount: 15 3/8 x 18 15/16 in. (39.0 x 48.2 cm.)
Inscription, mount recto: "Up the Valley. Yosemite."
Acquired from: Fred Rosenstock, Denver, Colorado

5707. **THE VALLEY AT MENLO PARK, CALIFORNIA [from the album "California Views 1876"]** (P1975.94.30)
Albumen silver print. negative 1874, print c. 1876
Image: 10 3/16 x 14 1/16 in. (25.9 x 35.7 cm.)
Mount: 15 3/8 x 18 15/16 in. (39.0 x 48.2 cm.)
Inscription, mount recto: "The Valley at Menlo Park, California."
Acquired from: Fred Rosenstock, Denver, Colorado

*5708. **THE VERNAL AND NEVADA FALLS FROM GLACIER POINT, YOSEMITE [from the album "California Views 1876"]** (P1975.94.29)
Albumen silver print. negative 1866, print c. 1876
Image: 8 1/4 x 12 1/8 in. (20.9 x 30.8 cm.)
Mount: 15 3/8 x 18 15/16 in. (39.0 x 48.2 cm.)
Inscription, mount recto: "The Vernal and Nevada Falls from Glacier Point, Yosemite."
Acquired from: Fred Rosenstock, Denver, Colorado

*5709. **THE VERNAL FALL, 300 FEET, YOSEMITE [from the album "California Views 1876"]** (P1975.94.22)
Albumen silver print. negative c. 1865-66, print c. 1876
Image: 12 5/16 x 8 1/8 in. (31.3 x 20.6 cm.)
Mount: 18 15/16 x 15 3/8 in. (48.2 x 39.0 cm.)
Inscription, mount recto: "The Vernal Fall, 300 Feet, Yosemite."
Acquired from: Fred Rosenstock, Denver, Colorado

5692

5695

5698

5700

5704

5708

5710. **VIEW OF THE LOOP, S.P.R.R.** [from the album "California Views 1876"] (P1975.94.50)
Albumen silver print. c. 1876
Image: 10 3/16 x 14 1/16 in. (25.8 x 35.7 cm.)
Mount: 15 3/8 x 18 15/16 in. (39.0 x 48.2 cm.)
Inscription, mount recto: "View of the Loop, S.P.R.R."
Acquired from: Fred Rosenstock, Denver, Colorado

*5711. **VIEW ON THE CARSON. THE MERIMAC MILL AND SCUM POOLS** (P1980.41)
Albumen silver print. c. 1876
Image: 14 15/16 x 21 1/16 in. (38.0 x 53.5 cm.)
Inscription, print verso: "View on the Carson. 1040/ The Merimac Mill and Scum Pools"
Acquired from: John Howell—Books, San Francisco, California

5712. **VIEW ON THE S.P.R.R. FROM COLTON** [from the album "California Views 1876"] (P1975.94.53)
Albumen silver print. c. 1876
Image: 10 3/16 x 14 1/16 in. (25.8 x 35.7 cm.)
Mount: 15 3/8 x 18 15/16 in. (39.0 x 48.2 cm.)
Inscription, mount recto: "View on the S.P.R.R. from Colton."
Acquired from: Fred Rosenstock, Denver, Colorado

5713. **VIRGINIA CITY. NEVADA** [from the album "California Views 1876"] (P1975.94.38)
Albumen silver print. negative c. 1875–76, print c. 1876
Image: 10 1/4 x 14 1/16 in. (26.1 x 35.7 cm.)
Mount: 15 3/8 x 18 5/8 in. (39.0 x 47.0 cm.)
Inscription, mount recto: "Virginia City. Nevada."
Acquired from: Fred Rosenstock, Denver, Colorado

5714. **VOLCANIC SLOPES OF LASSENS BUTTE** [from the album "California Views 1876"] (P1975.94.14)
Albumen silver print. negative 1870, print c. 1876
Image: 8 1/8 x 12 in. (20.6 x 30.5 cm.)
Mount: 15 3/8 x 18 15/16 in. (39.0 x 48.2 cm.)
Inscription, mount recto: "Volcanic Slopes of Lassens Butte"
Acquired from: Fred Rosenstock, Denver, Colorado

5715. **VOLCANO ROCK, SLOPES OF LASSENS BUTTE** [from the album "California Views 1876"] (P1975.94.17)
Albumen silver print. negative 1870, print c. 1876
Image: 8 1/8 x 12 7/16 in. (20.6 x 31.6 cm.)
Mount: 15 3/8 x 18 15/16 in. (39.0 x 48.2 cm.)
Inscription, mount recto: "Volcano Rock, Slopes of Lassens Butte."
Acquired from: Fred Rosenstock, Denver, Colorado

*5716. **[Watkins' photographic wagon along the C.P.R.R. tracks, Utah]** (P1981.64.1)
Albumen silver print. c. 1873–74
Image: 4 15/16 x 6 3/8 in. (12.6 x 16.2 cm.) oval
Sheet: 6 x 7 in. (15.3 x 17.8 cm.)
Acquired from: Peter Palmquist, Arcata, California

5717. **WITCHES ROCK, C.P.R.R., UTAH** (P1981.64.2)
Albumen silver print. c. 1873–74
Image: 4 15/16 x 6 3/8 in. (12.6 x 16.2 cm.) oval
Sheet: 5 5/8 x 7 1/2 in. (14.3 x 19.0 cm.)
Inscription, print verso: "Witches Rock/U.P.R.R. [sic], Utah,/Watkin's,/427 Montgomery st,/San Francisco,/Cal."
Acquired from: Peter Palmquist, Arcata, California

*5718. **THE WRECK OF THE VISCATA** (P1980.33)
Albumen silver print. 1868
Image: 15 3/4 x 20 9/16 in. (40.1 x 52.2 cm.)
Mount: 21 5/8 x 26 7/8 in. (54.9 x 68.3 cm.)
Inscription, printed mount recto: "The Wreck of the Viscata."
Acquired from: Fraenkel Gallery, San Francisco, California

5719. **YOSEMITE VALLEY FROM BEST GENERAL VIEW, MARIPOSA TRAIL, NO. 2** (P1982.39.1)
Albumen silver print. negative c. 1865–66, print c. 1876
Image: 15 3/4 x 20 11/16 in. (39.9 x 52.5 cm.)
Mount: 21 x 26 in. (53.4 x 66.1 cm.)
Signed, l.l. print verso: [print is mounted, but signature is visible in reverse] "C E Watkins"
Inscription, print verso: "Yosemite Valley from Best General View/Mariposa Trail/No 2"
Acquired from: gift of Dr. C. G. Stephens, Brownsville, Texas

5720. **YOSEMITE VALLEY, FROM INSPIRATION POINT** [from the album "California Views 1876"] (P1975.94.18)
Albumen silver print. negative c. 1865–66, print c. 1876
Image: 8 1/4 x 12 3/16 in. (20.9 x 30.9 cm.)
Mount: 15 3/8 x 18 15/16 in. (39.0 x 48.2 cm.)
Inscription, mount recto: "Yosemite Valley, from Inspiration Point."
Acquired from: Fred Rosenstock, Denver, Colorado

MARGARET WATKINS, Canadian (1884–1969)

Pictorialist Margaret Watkins was born at Hamilton, Ontario, to Scottish parents. Little is known about her early life. Watkins began photographing in 1900; in 1914 she began studying at the Clarence H. White School of Photography and two years later became a teacher at the school. Her students included Paul Outerbridge, Anton Bruehl, Laura Gilpin, and Doris Ulmann. Watkins' photographs appeared in pictorial salons in New York, San Francisco, Seattle, Paris, and London. In 1920 she edited the Annual Journal published by the Pictorial Photographers of America and made advertising photographs for Macy's Department Store. In 1929 she visited her aunts in Scotland and took the opportunity to travel throughout Europe, including the Soviet Union. Her photographs made in Moscow and Leningrad capture post-revolutionary life in these cities. Watkins abandoned photography in 1931 and returned to Scotland to care for her aunts. Before her death in 1969, Watkins established a foundation to help the poor.

*5721. **DESIGN—ANGLES** (P1983.41.3)
Gaslight (chloride) print. 1919
Image: 8 1/8 x 6 1/8 in. (20.6 x 15.5 cm.)
Mount: 14 x 11 in. (35.6 x 28.0 cm.)
Signed, l.l. print recto: "Margaret Watkins."
l.l. mount recto: "Margaret Watkins 1919."
Inscription, mount verso: "70/Margaret Watkins,/46 Jane St./New York City.//2//Design—Angles./Gaslight Print.//$5.00//B//12//82//43"
Acquired from: Second Light, Inc., New York, New York

*5722. **INTERIOR** [Domestic Symphony] (P1983.41.4)
Gaslight (chloride) print. 1917
Image: 8 3/8 x 6 3/8 in. (21.3 x 16.2 cm.)
1st mount: 10 3/8 x 8 in. (26.3 x 20.3 cm.)
2nd mount: 14 x 11 in. (35.6 x 28.0 cm.)
Signed, l.r. 1st mount recto: "Margaret Watkins 1917."
Inscription, print verso: "29"
2nd mount verso: "52//5 Interior./Margaret Watkins/460 W 144/N.Y. City//OK/hm 83"
Acquired from: Second Light, Inc., New York, New York

5723. **SELF-PORTRAIT** (P1983.41.1)
Gaslight (chloride) print. 1919
Image: 8 1/4 x 6 3/16 in. (20.9 x 15.7 cm.)
1st mount: 8 7/16 x 6 3/8 in. (21.4 x 16.2 cm.)
2nd mount: 14 1/16 x 11 1/16 in. (35.7 x 28.1 cm.)
Signed, l.l. 2nd mount recto: "Margaret Watkins 1919."
Inscription, 2nd mount verso: "128//3. Self-Portrait/Margaret Watkins/460 W. 144/N.Y.C.//81//OK//58"
Acquired from: Second Light, Inc., New York, New York

5709

5711

5716

5718

5722

5721

5724. [Still life, cabbage] (P1983.41.2)
Platinum print. 1923
Image: 6 3/16 x 7 15/16 in. (15.7 x 20.2 cm.)
Sheet: 6 5/16 x 8 1/8 in. (16.0 x 20.6 cm.)
Mount: 8 1/16 x 9 13/16 in. (20.5 x 24.9 cm.)
Signed, l.l. mount recto: "Margaret Watkins/1923"
Inscription, mount verso: "57"
note: photograph is mounted on verso of a book page with a halftone reproduction of the photograph "Detail of California Building" by Florence Burton Livingston, Mohegan Lake, N. Y., printed on it
Acquired from: Second Light, Inc., New York, New York

WENDY V. WATRISS, American (b. 1943), and FREDERICK C. BALDWIN, American, born Switzerland (b. 1929)

See also Frederick C. Baldwin

Wendy Watriss worked as a newspaper reporter, a television producer and writer, a radio correspondent, and a stringer for *Newsweek* before becoming a freelance photojournalist and writer in 1970. Among her awards for photojournalism are Third Prize, Magazine Published Picture Story, Pictures of the Year, the School of Journalism at the University of Missouri; Oskar Barnack Prize and News Features Award, World Press Foundation Awards, Amsterdam, the Netherlands; and Silver Medal, News Features, and Award, Women's International Democratic Federation, Interpress Photo, Damascus, Syria. Watriss has documented life and conditions in Africa, Nicaragua, and the United States. Most recently she has photographed at the Vietnam War Memorial in Washington, D.C. Watriss and her husband Fred Baldwin began working together in 1971. Much of their work documents various aspects of life in Texas.

5725. COWBOY'S PRAYER [from "Contemporary Texas: A Photographic Portrait"] (P1985.17.13)
Gelatin silver print. 1984
Image: 9 7/16 x 13 3/8 in. (24.0 x 34.0 cm.)
Sheet: 10 15/16 x 14 in. (27.7 x 35.6 cm.)
Signed, u.l. print verso: "Wendy Watriss/Frederick Baldwin 1984"
Inscription, print verso: " "Cowboy's Prayer" northeast [sic] Texas//455-4(25)/#2 [illegible]/[illegible]27+27/+6 +980+100"
Acquired from: gift of the Texas Historical Foundation with support from a major grant from the Du Pont Company and Conoco, its energy subsidiary, and assistance from the Texas Commission on the Arts and the National Endowment for the Arts

5726. FAMILY REUNION [from "Contemporary Texas: A Photographic Portrait"] (P1985.17.18)
Gelatin silver print. 1984
Image: 9 1/16 x 13 5/16 in. (23.0 x 33.8 cm.)
Sheet: 10 15/16 x 13 15/16 in. (27.8 x 35.4 cm.)
Signed, u.l. print verso: "Wendy Watriss/Frederick Baldwin 1984"
Inscription, print verso: " "Family Reunion" east central Texas//554-3(216)/#2 31 1/25/−faces/+top corners/+white dress & baby"
Acquired from: gift of the Texas Historical Foundation with support from a major grant from the Du Pont Company and Conoco, its energy subsidiary, and assistance from the Texas Commission on the Arts and the National Endowment for the Arts

5727. KOJAK'S BAR [from "Contemporary Texas: A Photographic Portrait"] (P1985.17.15)
Gelatin silver print. 1984
Image: 9 3/16 x 13 5/16 in. (23.3 x 33.8 cm.)
Sheet: 11 x 14 in. (28.0 x 35.6 cm.)
Signed, u.l. print verso: "Wendy Watriss/Frederick Baldwin 1984"
Inscription, print verso: " "Kojak's Bar" east-central Texas//582-5 6/#3 30s [illegible]/−mark & eyes"
Acquired from: gift of the Texas Historical Foundation with support from a major grant from the Du Pont Company and Conoco, its energy subsidiary, and assistance from the Texas Commission on the Arts and the National Endowment for the Arts

***5728. LEAVING HOME [from "Contemporary Texas: A Photographic Portrait"]** (P1985.17.11)
Gelatin silver print. 1984
Image: 9 7/16 x 13 3/8 in. (24.0 x 34.0 cm.)
Sheet: 11 x 14 in. (28.0 x 35.6 cm.)
Signed, u.l. print verso: "Wendy Watriss/Frederick Baldwin 1984"
Inscription, print verso: " "Leaving Home" east central Texas//544-1/11//20 #3/t8/t20"
Acquired from: gift of the Texas Historical Foundation with support from a major grant from the Du Pont Company and Conoco, its energy subsidiary, and assistance from the Texas Commission on the Arts and the National Endowment for the Arts

5729. LOCKER ROOM [from "Contemporary Texas: A Photographic Portrait"] (P1985.17.16)
Gelatin silver print. 1984
Image: 9 3/16 x 13 5/16 in. (23.3 x 33.8 cm.)
Sheet: 10 15/16 x 14 in. (27.8 x 35.6 cm.)
Signed, u.l. print verso: "Wendy Watriss/Frederick Baldwin 1984"
Inscription, print verso: " "Locker Room" east-central Texas//541-13 (30)/#3 39s 2 [illegible]/−face/+belt/rt"
Acquired from: gift of the Texas Historical Foundation with support from a major grant from the Du Pont Company and Conoco, its energy subsidiary, and assistance from the Texas Commission on the Arts and the National Endowment for the Arts

5730. SATURDAY NIGHT [from "Contemporary Texas: A Photographic Portrait"] (P1985.17.19)
Gelatin silver print. 1984
Image: 9 3/16 x 13 5/16 in. (23.3 x 33.8 cm.)
Sheet: 10 15/16 x 13 15/16 in. (27.8 x 35.4 cm.)
Signed, u.l. print verso: "Wendy Watriss/Frederick Baldwin 1984"
Inscription, print verso: " "Saturday Night", East-central Texas//553-2 (3a) m/#325 +4 face/−head + back/+bottle and shoe/2 [illegible]"
Acquired from: gift of the Texas Historical Foundation with support from a major grant from the Du Pont Company and Conoco, its energy subsidiary, and assistance from the Texas Commission on the Arts and the National Endowment for the Arts

***5731. SATURDAY NIGHT [from "Contemporary Texas: A Photographic Portrait"]** (P1985.17.20)
Gelatin silver print. 1984
Image: 8 7/8 x 13 3/8 in. (22.5 x 34.0 cm.)
Sheet: 10 15/16 x 14 in. (27.8 x 35.6 cm.)
Signed, u.l. print verso: "Wendy Watriss/Frederick Baldwin 1984"
Inscription, print verso: " "Saturday Night" east central Texas//550-2 (4)/#2 33s 2 [illegible]"
Acquired from: gift of the Texas Historical Foundation with support from a major grant from the Du Pont Company and Conoco, its energy subsidiary, and assistance from the Texas Commission on the Arts and the National Endowment for the Arts

5732. **VISITING DEACON [from "Contemporary Texas:
A Photographic Portrait"]** (P1985.17.14)
Gelatin silver print. 1984
Image: 9⅛ x 13⁵⁄₁₆ in. (23.2 x 33.8 cm.)
Sheet: 10¹⁵⁄₁₆ x 14 in. (27.8 x 35.6 cm.)
Signed, u.l. print verso: "Wendy Watriss/Frederick Baldwin
1984"
Inscription, print verso: ""Visitig [sic] Deacon" east-central
Texas//170-1 (15)/#2 50S"
Acquired from: gift of the Texas Historical Foundation with
support from a major grant from the Du Pont Company
and Conoco, its energy subsidiary, and assistance from
the Texas Commission on the Arts and the National
Endowment for the Arts

5733. **WEDDING RECEPTION [from "Contemporary Texas:
A Photographic Portrait"]** (P1985.17.12)
Gelatin silver print. 1984
Image: 8⅞ x 13⅜ in. (22.5 x 34.0 cm.)
Sheet: 10¹⁵⁄₁₆ x 14 in. (27.8 x 35.6 cm.)
Signed, u.l. print verso: "Wendy Watriss/Frederick Baldwin
1984"
Inscription, print verso: ""Wedding Reception" east-central
Texas//549-4 (20)/#2 [illegible]/[illegible]"
Acquired from: gift of the Texas Historical Foundation with
support from a major grant from the Du Pont Company
and Conoco, its energy subsidiary, and assistance from
the Texas Commission on the Arts and the National
Endowment for the Arts

5734. **WELCOME TO MILLER TIME [from "Contemporary
Texas: A Photographic Portrait"]** (P1985.17.17)
Gelatin silver print. 1984
Image: 9⁷⁄₁₆ x 13⁵⁄₁₆ in. (24.0 x 33.8 cm.)
Sheet: 10¹⁵⁄₁₆ x 13¹⁵⁄₁₆ in. (27.8 x 35.4 cm.)
Signed, u.l. print verso: "Wendy Watriss/Frederick Baldwin"
Inscription, print verso: ""Welcome To Miller Time", East
Texas 1984//550-2 (7)/#2"
Acquired from: gift of the Texas Historical Foundation with
support from a major grant from the Du Pont Company
and Conoco, its energy subsidiary, and assistance from
the Texas Commission on the Arts and the National
Endowment for the Arts

EVA L. WATSON, American (1867–1935)

See *Camera Notes*

HANS WATZEK, Austrian (1848–1906)

See *Camera Notes*

TODD WEBB, American (b. 1905)

Todd Webb worked as a bank teller, prospector, and forest ranger before taking up photography while working in the export division of the Chrysler Corporation. Webb and his good friend Harry Callahan took a ten-day photographic workshop with Ansel Adams in 1940 and made several photographic trips together. World War II brought Webb into photography professionally when he was assigned a position as a Navy combat photographer. After the war he had an exhibition of his work at the Museum of the City of New York and was commissioned to do an article for *Fortune* magazine. As a result of this work, he was hired by Roy Stryker to work for the Standard Oil of New Jersey photographic project. In 1948 Webb moved to Paris, where he operated a studio until 1952. In 1955 he received a Guggenheim grant to make photographs along early western

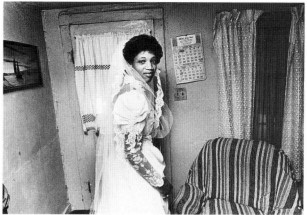

5728

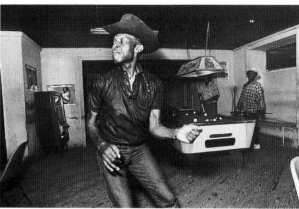

5731

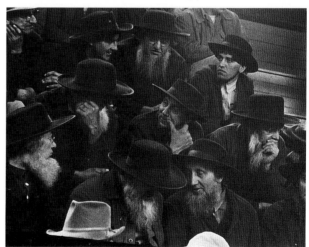

5736

ghost trails. Other projects included a long-standing assignment to photograph the United Nations General Assembly, documentation of United Nations projects in developing countries, a commission by the Amon Carter Museum for photographs of several hundred early Texas buildings (the Texas Architectural Survey negatives are on file at the Museum), and a 1979 National Endowment for the Arts grant to photograph in Europe. Webb also has published a book of photographs entitled *Georgia O'Keeffe: The Artist and Her Landscape.*

5735. **ALFRED STIEGLITZ AT AN AMERICAN PLACE—NEW YORK** (P1967.2)
Gelatin silver print. 1946
Image: 13 ½ x 10 ⅝ in. (34.2 x 27.0 cm.)
Mount: 19 ¹⁵/₁₆ x 15 ¹⁵/₁₆ in. (50.6 x 40.5 cm.)
Signed, u.l. mount verso, paper label: "Todd Webb"
Inscription, mount verso, typed on paper label: "ALFRED STIEGLITZ/AT AN AMERICAN/PLACE—NEW YORK/ MARCH 19, 1946" and ACM label
Acquired from: the photographer

*5736. **AMISH FARMERS AT A HORSE AUCTION IN NEW HOLLAND, PA.** (P1977.61.1)
Gelatin silver print. 1955
Image: 7 ¹¹/₁₆ x 9 ⅝ in. (19.5 x 24.4 cm.)
Sheet: 8 x 10 in. (20.3 x 25.4 cm.)
Signed: see inscription
Inscription, sheet verso, rubber stamp: "TODD WEBB/ P. O. Box 361/Santa Fe, New Mexico/Phone YU.3-9495"
Acquired from: gift of Mitchell A. Wilder

*5737. **DOROTHEA LANGE AT HOME IN BERKELEY, CALIFORNIA** (P1967.1.1) duplicate of P1967.1.2
Gelatin silver print. 1955
Image: 13 ⁹/₁₆ x 10 ⅝ in. (34.6 x 26.9 cm.)
Mount: 20 x 15 ¹⁵/₁₆ in. (50.8 x 40.6 cm.)
Signed, u.l. mount verso, paper label: "Todd Webb"
Inscription, mount verso, typed on paper label: "DOROTHEA LANGE AT/HOME IN BERKELEY,/ CALIFRONIA [sic] AUG. 12,/1955." and ACM label
Acquired from: gift of the photographer

5738. **DOROTHEA LANGE, BERKELEY, CALIF.** (P1967.1.2)
duplicate of P1967.1.1
Gelatin silver print. 1955
Image: 13 ⅝ x 10 ⁹/₁₆ in. (34.7 x 26.8 cm.)
Mount: 14 ⅝ x 13 ⅞ in. (37.1 x 35.2 cm.)
Signed, center mount verso: "Photo by Todd Webb"
Inscription, mount verso: "Dorothea Lange/Berkley [sic], Calif./August, 1955"
Acquired from: gift of the photographer

5739. **LOOKING OUT OF THE WINDOW OF THE METHODIST CHURCH IN THE GHOST TOWN OF BODIE, CALIFORNIA** (P1977.61.3)
Gelatin silver print. 1960
Image: 9 ¾ x 7 ¹³/₁₆ in. (24.7 x 19.8 cm.)
Sheet: 10 x 8 ¹/₁₆ in. (25.4 x 20.5 cm.)
Signed: see inscription
Inscription, sheet verso, rubber stamp: "TODD WEBB/ P. O. Box 361/Santa Fe, New Mexico/Phone YU.3-9495"
Acquired from: gift of Mitchell A. Wilder

5740. **PATIO DOOR AT GEORGIA O'KEEFFE'S ABIQUIU HOUSE** (P1977.61.4)
Gelatin silver print. 1962
Image: 9 ⅝ x 7 ¾ in. (24.4 x 19.6 cm.)
Sheet: 10 x 8 ¹/₁₆ in. (25.4 x 20.5 cm.)
Signed: see inscription
Inscription, sheet verso, rubber stamp: "TODD WEBB/ P. O. Box 361/Santa Fe, New Mexico/Phone YU.3-9495"
Acquired from: gift of Mitchell A. Wilder

5741. **RUINS OF ANTHRACITE BREAKER AT THE OLD MINING TOWN OF MADRID, NEW MEXICO** [View of Ghost Coal Mining Town of Madrid, N. M.] (P1977.61.2)
Gelatin silver print. 1963
Image: 7 ¹¹/₁₆ x 9 ⅝ in. (19.5 x 24.4 cm.)
Sheet: 8 x 10 in. (20.3 x 25.4 cm.)
Signed: see inscription
Inscription, sheet verso, rubber stamp: "TODD WEBB/ P. O. Box 361/Santa Fe, New Mexico/Phone YU.3-9495"
Acquired from: gift of Mitchell A. Wilder

5742. **WATER TOWER AT WALDO, N. M.** (P1978.47)
Gelatin silver print. 1963
Image: 13 ⁹/₁₆ x 10 ¹¹/₁₆ in. (34.4 x 27.1 cm.)
Mount: same as image size
Signed, center mount verso: "Todd Webb"
Inscription, mount verso: "WATER TOWER AT WALDO, N. M./MADRID GOT IT'S [sic] WATER SUPPLY FROM/ THIS TANK. IT IS ON THE MADRID SPUR./1963"
Acquired from: Hastings Gallery, New York, New York

CHARLES LEANDER WEED,
American (1824–1903)

Weed was born in New York; by 1854 he had made his way westward and was working in George J. Watson's Sacramento, California, daguerreotype studio. In 1858 he was working with Robert Vance, one of California's foremost early photographers. In June of 1859 Weed made the first photographs of the Yosemite region for the Vance and Weed studio. He left the partnership in 1860 to establish a business in Hong Kong, but left after only one year and returned to California. There he purchased the Vance studio but sold it in 1863 and went to work for the photographic publishing firm of Lawrence and Houseworth, returning to photograph Yosemite for the firm in 1864. In 1865 Weed moved to Hawaii and in 1866 returned to Asia, where he ran a Hong Kong studio for a little over two years. Returning to California about 1869, he rejoined Houseworth for a time; in 1872 Weed probably made another photographic trip to Yosemite with Eadweard Muybridge, although a switch in employers for both men obscures most facts about the expedition. Indeed, throughout most of Weed's career his images were not signed or credited to him. He faded into relative obscurity, becoming a photoengraver in the 1880s, a profession that he followed until his retirement in the 1890s.

*5743. **BRIDAL VEIL FALL, AND THREE GRACES. 940 FEET HIGH. 3750 FEET HIGH. YO-SEMITE VALLEY, MARIPOSA COUNTY, CAL.** (P1984.6.2)
Albumen silver print. negative 1864, print c. 1872
Image: 15 ¹¹/₁₆ x 20 ⁵/₁₆ in. (39.8 x 51.6 cm.)
Mount: 20 ⅛ x 23 ½ in. (51.1 x 59.6 cm.)
Inscription, mount recto: "Thomas Houseworth & Co., Photographers,//No. 9 Montgomery St., Lick House, San Francisco//Bridal Veil Fall, and Three Graces./940 Feet High./3750 Feet High./Yo-Semite Valley, Mariposa County, Cal./No. 3."
Acquired from: Jane Oliver-Cruthis, Denton, Texas; purchased in memory of Amon G. Carter, Jr.

Attributed to Charles Leander Weed
5744. **[Hong Kong scene]** (P1982.40)
Albumen silver print. c. 1866–68
Image: 16 ¹³/₁₆ x 20 ¾ in. (42.7 x 52.7 cm.)
Mount: 21 ⁷/₁₆ x 25 ⅞ in. (54.5 x 65.8 cm.)
Inscription, mount recto: "The mat wants to cover/picture about 1/11'[illegible] while mat outside as large as paper"
Acquired from: gift of Dr. C. G. Stephens, Brownwood, Texas

Attributed to Charles Leander Weed

5745. **U. S. GRANT, 80 FT. CIRC., MARIPOSA GROVE**
[portrait of Eadweard Muybridge] (P1982.8)
Albumen silver print. 1872
Image: 20½ x 15¹⁵/₁₆ in. (52.1 x 40.4 cm.)
Mount: 25¹⁵/₁₆ x 20⅝ in. (65.9 x 52.4 cm.)
Signed: see inscription
Inscription, mount recto: "Thomas Houseworth & Co.
Photographers.//No. 9. &. 12 Montgomery St. San
Francisco.//U. S. Grant 80 ft. circ./Mariposa Grove/87."
Acquired from: Krainik Gallery, Washington, D. C.

*5746. **THE VERNAL FALL, 350 FEET HIGH. YO-SEMITE
VALLEY, MARIPOSA COUNTY, CAL.** (P1984.6.3)
Albumen silver print. negative 1864, print c. 1867
Image: 20⁵/₁₆ x 15⅝ in. (51.6 x 39.7 cm.)
Mount: 24⁷/₁₆ x 18¹³/₁₆ in. (62.1 x 47.8 cm.)
Inscription, mount recto: "Thomas Houseworth & Co.,
Publishers,//317-319 Montgomery St., San Francisco.//
THE VERNAL FALL, 350 feet high./Yo-Semite Valley,
Mariposa County, Cal./No. 18."
Acquired from: Jane Oliver-Cruthis, Denton, Texas; Amon
G. Carter Memorial Fund Purchase

*5747. **YO-SEMITE VALLEY, FROM THE MARIPOSA TRAIL.
MARIPOSA COUNTY, CAL.** (P1984.6.1)
Albumen silver print. negative 1864, print c. 1867
Image: 15¹¹/₁₆ x 20³/₈ in. (39.8 x 51.7 cm.)
Mount: 19⅝ x 23½ in. (49.8 x 59.6 cm.)
Inscription, mount recto: "Thomas Houseworth & Co.,
Publishers,//317-319 Montgomery St., San Francisco.//Yo-
Semite Valley, from the Mariposa Trail./Mariposa County,
Cal./No. 1."
Acquired from: Jane Oliver-Cruthis, Denton, Texas; Amon
G. Carter Memorial Fund Purchase

WEEGEE (ARTHUR H. FELLIG),
American, born Austria-Hungary (1899–1968)

Arthur Fellig (born Usher H. Fellig) held a number of
jobs, including tintype operator, street photographer,
and passport photographer, before working for Acme
Newspictures (now UPI) in New York from 1924 to
1935. When he left Acme, he established himself as a
freelance photographer, working for the Manhattan po-
lice and supplying photographs to several newspapers
and press syndicates. He also assumed the nickname
"Weegee," a reference to his ability to predict where
disaster would next occur. After his police department
work, Weegee joined the staff of *PM* magazine
(1940–45) and later did advertising photography for
Vogue, Holiday, Life, and *Fortune.* From 1947 to 1952
he lived in Hollywood, consulting and acting in films.
During the 1950s and 1960s, Weegee himself made
three films and was the subject of two others. From
1958 until his death he worked as a freelance photogra-
pher for European newspapers and lectured throughout
the United States, Europe, and the Soviet Union.
Weegee published several books, *Naked City,* a popular
book of crime photographs and images of New York's
lonely and dispossessed, *Naked Hollywood,* and *Weegee
by Weegee.* The International Center of Photography
held a major retrospective of his work in 1977.

5748. **THE CRITIC** (P1984.21)
Gelatin silver print. 1943
Image: 10⅜ x 13⁵/₁₆ in. (26.4 x 33.8 cm.)
Sheet: 11 x 13⅞ in. (28.0 x 35.3 cm.)
Signed: see inscription
Inscription, print verso, rubber stamp: "CREDIT PHOTO
BY/WEEGEE/THE FAMOUS"
Acquired from: The Witkin Gallery, New York, New York

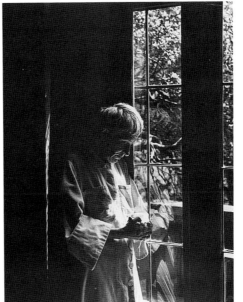

5737

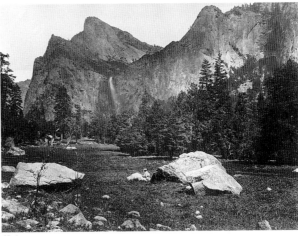

5743

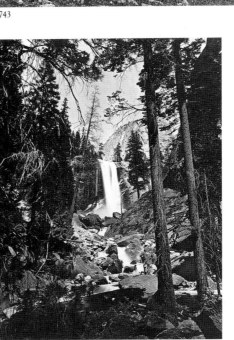

5746

*5749. **[Woman eating popcorn]** (P1984.22)
Gelatin silver print. c. 1945
Image: 10½ x 13½ in. (26.6 x 34.2 cm.)
Sheet: 10⅞ x 14 in. (27.6 x 35.5 cm.)
Signed: see inscription
Inscription, print verso: "9074" and rubber stamps
"WEEGEE/451 WEST 47th STREET/NEW YORK CITY,
U.S.A./TEL: 265-1955" and "CREDIT PHOTO BY/
WEEGEE/THE FAMOUS"
Acquired from: Daniel Wolf, Inc., New York, New York

MATHILDE WEIL,
American (active 1896–1900s)

See *Camera Notes*

DAN WEINER, American (1919–1959)

Photojournalist Dan Weiner received his first camera as
a birthday present in 1934. However, he wanted to be a
painter and spent 1937 through 1940 studying painting
at the Art Students League in New York and the Pratt
Institute. Weiner began making photographic portraits
in 1940 to earn money to buy art supplies. At the same
time he joined the Photo League, where he was influ-
enced by social documentary photographers such as
Jacob Riis, Lewis Hine, Dorothea Lange, Walker Evans,
and Ben Shahn. Weiner decided to make photography
his career and worked two years as a New York commer-
cial photographer's assistant. During World War II he
served as photographer and instructor in the United
States Air Force. In 1946 he returned to New York
and opened a commercial studio, but he soon became
dissatisfied with commercial photography and turned
to photojournalism. As a freelance photojournalist,
Weiner traveled throughout the world often accom-
panied by his wife, Sandra, covering events for publica-
tions such as *Collier's*, *Fortune*, and the *New York Times*.
In 1953 he and Alan Paton went to South Africa. In
1956 Weiner covered the Montgomery, Alabama, bus
boycott and the civil rights movement. During 1956 and
1957 *Fortune* published photographs Weiner made on
his travels through the U.S.S.R. and Eastern Europe.
Weiner was killed in a plane crash near Versailles,
Kentucky, in 1959. During his lifetime, numerous ex-
hibitions featured his work in different countries. His
photographs appeared in several books including *South
Africa in Transition*, *The Concerned Photographers*, *Dan
Weiner 1919-1959*, and *America Worked: The 1950s Photo-
graphs of Dan Weiner*.

*5750. **EAST END AVENUE, NEW YORK CITY** (P1985.44)
Gelatin silver print. c. 1948
Image: 10⁹⁄₁₆ x 13½ in. (26.8 x 34.2 cm.)
Sheet: 10¹⁵⁄₁₆ x 13¹⁵⁄₁₆ in. (27.8 x 35.4 cm.)
Signed: see inscription
Inscription, print verso, rubber stamp: "DAN WEINER/
20 East 84th Street, New York, N.Y. 10028"
mat backing verso: dealer's mark
Acquired from: Photofind Gallery, Inc., Woodstock,
New York

5751. **NEW YEAR'S EVE, NEW YORK CITY** (P1985.45)
Gelatin silver print. 1950
Image: 10⁹⁄₁₆ x 13⁹⁄₁₆ in. (26.7 x 34.4 cm.)
Sheet: 10¹⁵⁄₁₆ x 14 in. (27.8 x 35.5 cm.)
Inscription, mat backing verso: dealer's mark
Acquired from: Photofind Gallery, Inc., Woodstock,
New York

SANDRA WEINER, American (b. 1921)

Sandra Weiner studied photography at Moultrie Air
Force Base in Moultrie, Georgia, and at the Photo
League where her teachers included Paul Strand and
Dan Weiner. From 1950 to 1959 Weiner worked as a
team with her husband, photojournalist Dan Weiner.
She originated ideas for photo essays, conducted re-
search, edited, wrote captions, and worked in the lab.
After her husband's death, she worked on the editorial
staff of *Sports Illustrated*. In 1961 she coordinated and
produced an exhibition of her husband's work for the
Time-Life Building, and in 1974 she and Cornell Capa
published *Dan Weiner 1919–1959*. Sandra Weiner has
done freelance photography for the National Council of
Christians and Jews, the *Boston Globe*, and the Com-
munity Service Society. She also writes and photo-
graphs for children; her books include *It's Wings That
Make Birds Fly*, *Small Hands, Big Hands*, *They Call Me
Jack*, *I Want to Be a Fisherman*, and *The Dhammapada*.

*5752. **EAST 26TH STREET, NEW YORK CITY** (P1985.43)
Gelatin silver print. 1940
Image: 8⁵⁄₁₆ x 7⁹⁄₁₆ in. (21.1 x 19.1 cm.)
Sheet: 9¹⁵⁄₁₆ x 8 in. (25.2 x 20.2 cm.)
Signed, center print verso: "Sandra Weiner/1940"
Inscription, print verso: "SANDRA WEINER/~~448~~
~~CENTRAL PARK WEST/NEW YORK 25, N.Y.~~//M" and
dealer's mark
mat backing verso, typed on dealer's label: "WEINER,
Sandra/Untitled, 1940/silver print/10x8/001269" and
partially erased dealer's mark
Acquired from: Photofind Gallery, Inc., Woodstock,
New York

BRETT WESTON, AMERICAN (1911-1993)

Edward Weston's second son, Brett, learned photogra-
phy from his father while the two were in Mexico in
1923. After returning from Mexico Brett worked for his
father, then opened his own studio in Santa Barbara in
1930. His style, focusing on abstract elements in natural
forms, began to develop in the 1940s. Weston spent
time during World War II as an army photographer, but
one of his officers, Arthur Rothstein, gave him time to
make a series of views of New York City. Weston re-
ceived a 1947 Guggenheim grant to photograph along
the East Coast, but shortly after completing the project
he moved back to California to assist with the printing
of his father's negatives. Many of Brett Weston's photo-
graphs were made with a large-format camera and cap-
ture extremely detailed images.

BAJA CALIFORNIA (P1967.229.1–15)

This portfolio, one of an unnumbered edition of 50, was
published by Brett Weston in 1967.

5753. **[Rock formation with strata lines]** (P1967.229.1)
Gelatin silver print. 1967
Image: 7⅝ x 9⅝ in. (19.4 x 24.4 cm.)
Mount: 13¼ x 15 in. (33.7 x 38.1 cm.)
Signed, l.r. mount recto: "Brett Weston 1967"
Acquired from: the photographer

5754. **[Wrinkled cactus leaves]** (P1967.229.2)
Gelatin silver print. negative 1964, print 1967
Image: 9¹¹⁄₁₆ x 7¹¹⁄₁₆ in. (24.5 x 19.5 cm.)
Mount: 15 x 13¼ in. (38.1 x 33.7 cm.)
Signed, l.r. mount recto: "Brett Weston 1964"
Acquired from: the photographer

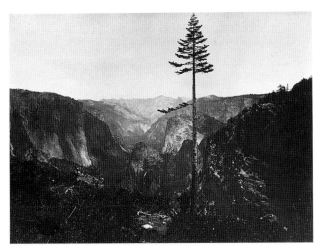
5747

5749

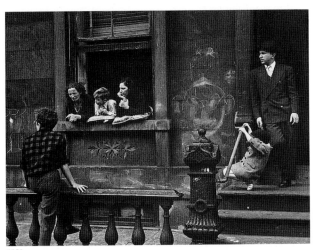
5750

5752

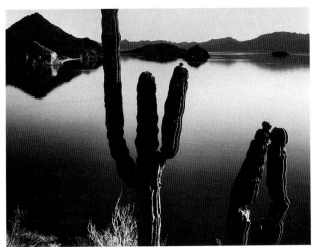
5755

5764

*5755. **[Cactus in front of lake]** (P1967.229.3)
Gelatin silver print. negative 1964, print 1967
Image: 7 ⁵⁄₈ x 9 ¹¹⁄₁₆ in. (19.4 x 24.5 cm.)
Mount: 13 ¼ x 15 in. (33.7 x 38.1 cm.)
Signed, l.r. mount recto: "Brett Weston 1964"
Acquired from: the photographer

5756. **[Dried plant]** (P1967.229.4)
Gelatin silver print. negative 1965, print 1967
Image: 7 ⁵⁄₈ x 9 ⁵⁄₈ in. (19.4 x 24.5 cm.)
Mount: 13 ¼ x 15 in. (33.7 x 38.1 cm.)
Signed, l.r. mount recto: "Brett Weston 1965"
Acquired from: the photographer

5757. **[Boats moored in cove]** (P1967.229.5)
Gelatin silver print. negative 1964, print 1967
Image: 7 ⁵⁄₈ x 9 ⁵⁄₈ in. (19.4 x 24.5 cm.)
Mount: 13 ¼ x 15 in. (33.7 x 38.1 cm.)
Signed, l.r. mount recto: "Brett Weston 1964"
Acquired from: the photographer

5758. **[Cacti]** (P1967.229.6)
Gelatin silver print. 1967
Image: 7 ⁵⁄₈ x 9 ¹¹⁄₁₆ in. (19.4 x 24.6 cm.)
Mount: 13 ¼ x 15 in. (33.7 x 38.1 cm.)
Signed, l.r. mount recto: "Brett Weston 1967"
Acquired from: the photographer

5759. **[Landscape with cacti and rocks]** (P1967.229.7)
Gelatin silver print. 1967
Image: 9 ¹¹⁄₁₆ x 7 ¹¹⁄₁₆ in. (24.6 x 19.5 cm.)
Mount: 15 x 13 ¼ in. (38.1 x 33.7 cm.)
Signed, l.r. mount recto: "Brett Weston 1967"
Acquired from: the photographer

5760. **[Tubelike plant on sand]** (P1967.229.8)
Gelatin silver print. 1967
Image: 9 ¹¹⁄₁₆ x 7 ⁵⁄₈ in. (24.6 x 19.4 cm.)
Mount: 15 x 13 ¼ in. (38.1 x 33.7 cm.)
Signed, l.r. mount recto: "Brett Weston 1967"
Acquired from: the photographer

5761. **[Rock with cracks and scratches]** (P1967.229.9)
Gelatin silver print. 1967
Image: 9 ¹¹⁄₁₆ x 7 ¹¹⁄₁₆ in. (24.6 x 19.5 cm.)
Mount: 15 x 13 ¼ in. (38.1 x 33.7 cm.)
Signed, l.r. mount recto: "Brett Weston 1967"
Acquired from: the photographer

5762. **[Banyan roots]** (P1967.229.10)
Gelatin silver print. negative 1964, print 1967
Image: 9 ⁵⁄₈ x 7 ¹¹⁄₁₆ in. (24.4 x 19.5 cm.)
Mount: 15 x 13 ¼ in. (38.1 x 33.7 cm.)
Signed, l.r. mount recto: "Brett Weston 1964"
Acquired from: the photographer

5763. **[Podlike plant leaves]** (P1967.229.11)
Gelatin silver print. 1967
Image: 9 ¹¹⁄₁₆ x 6 ³⁄₈ in. (24.6 x 16.2 cm.)
Mount: 15 x 13 ¼ in. (38.1 x 33.7 cm.)
Signed, l.r. mount recto: "Brett Weston 1967"
Acquired from: the photographer

*5764. **[Natural formations in gridlike pattern]** (P1967.229.12)
Gelatin silver print. negative 1965, print 1967
Image: 7 ⁵⁄₈ x 9 ⁵⁄₈ in. (19.4 x 24.4 cm.)
Mount: 13 ¼ x 15 in. (33.7 x 38.1 cm.)
Signed, l.r. mount recto: "Brett Weston 1965"
Acquired from: the photographer

5765. **[Cactus sprinkled with drops of water]** (P1967.229.13)
Gelatin silver print. 1967
Image: 9 ⁹⁄₁₆ x 7 ¹¹⁄₁₆ in. (24.3 x 19.5 cm.)
Mount: 15 x 13 ¼ in. (38.1 x 33.7 cm.)
Signed, l.r. mount recto: "Brett Weston 1967"
Acquired from: the photographer

5766. **[Natural forms in white starburst patterns]** (P1967.229.14)
Gelatin silver print. negative 1964, print 1967
Image: 7 ¹¹⁄₁₆ x 9 ⁹⁄₁₆ in. (19.5 x 24.3 cm.)
Mount: 13 ¼ x 15 in. (33.7 x 38.1 cm.)
Signed, l.r. mount recto: "Brett Weston 1964"
Acquired from: the photographer

5767. **[White gnarled tree limbs]** (P1967.229.15)
Gelatin silver print. 1967
Image: 7 ⁵⁄₈ x 9 ¹¹⁄₁₆ in. (19.4 x 24.5 cm.)
Mount: 13 ¼ x 15 in. (33.7 x 38.1 cm.)
Signed, l.r. mount recto: "Brett Weston 1967"
Acquired from: the photographer

* * * *

5768. **[Broken glass]** (P1974.18.8)
Gelatin silver print. 1955
Image: 7 ⁵⁄₈ x 9 ¹¹⁄₁₆ in. (19.4 x 24.6 cm.)
Mount: 13 ³⁄₈ x 15 ¹⁄₁₆ in. (33.9 x 38.2 cm.)
Signed, l.r. mount recto and l.r. mount verso:
 "Brett Weston 1955"
Inscription, mount verso: ACM exhibition label, which states
 that this is image number nine of Weston's portfolio of
 fifteen prints
Acquired from: unknown source

5769. **BROKEN GLASS, CALIFORNIA** (P1978.141) duplicate of
 P1965.156.6 in portfolio "Ten Photographs"
Gelatin silver print. c. 1954—55
Image: 13 ½ x 10 ⁵⁄₁₆ in. (34.3 x 26.2 cm.)
Mount: 14 ½ x 11 ¹⁄₁₆ in. (36.9 x 28.2 cm.)
Inscription, mount recto: "7 ⅞//58%"
 mount verso: "Brett Weston, Broken Glass, 1955./(contact
 print)/Gift of Diane Hopkins-Hughs, 11-17-78//A//H 316"
Acquired from: gift of Diane Hopkins-Hughs, Kerrville,
 Texas

5770. **[Coastline—sea and rocks]** (P1974.18.10)
Gelatin silver print. 1952
Image: 7 ⁵⁄₈ x 9 ⁹⁄₁₆ in. (19.4 x 24.2 cm.)
Mount: 13 ¾ x 16 ¹⁄₁₆ in. (34.8 x 41.0 cm.)
Signed, l.r. mount recto and l.r. mount verso:
 "Brett Weston 1952"
Inscription, mount verso: "B 25.00//L A 2 8"
Acquired from: unknown source

*5771. **EDWARD WESTON** (P1978.23)
Gelatin silver print. 1941
Image: 13 ⁹⁄₁₆ x 10 ⁹⁄₁₆ in. (34.5 x 26.8 cm.)
Mount: 18 x 15 in. (45.7 x 38.1 cm.)
Signed, l.r. mount recto: "Brett Weston 1941"
Inscription, mount recto: "Edward Weston"
Acquired from: The Halsted Gallery, Birmingham, Michigan

5772. **[European scene, city wall]** (P1974.18.3)
Gelatin silver print. 1960
Image: 9 ⁵⁄₈ x 7 ⁵⁄₈ in. (24.4 x 19.4 cm.)
Mount: 15 x 13 ¼ in. (38.1 x 33.7 cm.)
Signed, l.r. mount recto: "Brett Weston 1960"
Inscription, mount verso: "P5" and ACM exhibition label
Acquired from: unknown source

*5773. **[Garrapata Beach, California]** (P1974.18.5)
Gelatin silver print. 1954
Image: 7 ⁵⁄₈ x 9 ⁵⁄₈ in. (19.4 x 24.4 cm.)
Mount: 13 ⁵⁄₁₆ x 15 ¹⁄₁₆ in. (33.8 x 38.2 cm.)
Signed, l.r. mount recto and l.r. mount verso: "Brett Weston
 1954"
Inscription, mount verso: ACM exhibition label, which states
 that this is print number seven of Weston's portfolio of
 fifteen prints
Acquired from: unknown source

5774. **MONTEREY PINES** (P1974.18.1)
Gelatin silver print. 1962
Image: 13 ⅝ x 10 ⅜ in. (34.6 x 26.4 cm.)
Mount: 18 x 15 in. (45.7 x 38.1 cm.)
Signed, l.r. mount recto: "Brett Weston 1962"
Acquired from: Friends of Photography, Carmel, California;
gift print with sustaining membership, 1973

*5775. **[Nude—torso]** (P1974.18.6)
Gelatin silver print. 1963
Image: 7 ½ x 9 ⅝ in. (19.1 x 24.4 cm.)
Mount: 13 ⁵⁄₁₆ x 15 ¹⁄₁₆ in. (33.8 x 38.2 cm.)
Signed, l.r. mount recto: "Brett Weston 1963"
Inscription, mount verso: "N1/N2"
Acquired from: unknown source

5776. **[Piece of rusted iron on sand]** (P1974.18.7)
Gelatin silver print. 1964
Image: 7 ⅝ x 9 ¹¹⁄₁₆ in. (19.4 x 24.6 cm.)
Mount: 13 ¼ x 15 in. (33.6 x 38.1 cm.)
Signed, l.r. mount recto: "Brett Weston 1964"
Inscription, mount verso: "B7" and ACM exhibition label
Acquired from: unknown source

5777. **[Reeds, France]** (P1974.18.2)
Gelatin silver print. 1960
Image: 7 ¹¹⁄₁₆ x 9 ⅝ in. (19.4 x 24.4 cm.)
Mount: 13 ¹¹⁄₁₆ x 16 in. (34.8 x 40.7 cm.)
Signed, l.r. mount recto and l.r. mount verso:
"Brett Weston 1960"
Inscription, mount verso: "C//Jim//12//F10/McH"
Acquired from: unknown source

*5778. **[Rooftops]** (P1974.18.4)
Gelatin silver print. 1960
Image: 7 ¹¹⁄₁₆ x 9 ⅝ in. (19.5 x 24.4 cm.)
Mount: 13 ⁵⁄₁₆ x 15 ¹⁄₁₆ in. (33.8 x 38.2 cm.)
Signed, l.r. mount recto and l.r. mount verso:
"Brett Weston 1960"
Inscription, mount verso: ACM exhibition label
Acquired from: unknown source

5779. **[Sky, sea, sand, and rocks]** (P1974.18.9)
Gelatin silver print. 1962
Image: 7 ⅝ x 9 ⅝ in. (19.4 x 24.5 cm.)
Mount: 13 ⁵⁄₁₆ x 15 in. (33.8 x 38.1 cm.)
Signed, l.r. mount recto and l.r. mount verso:
"Brett Weston 1962"
Inscription, mount verso: "083" and printed paper label
"S.F.M.A./Reg. No. [in ink] 17/64/17" and ACM
exhibition label
Acquired from: unknown source

5780. **[Storefront, San Francisco, California]** (P1985.12)
Gelatin silver print. 1960
Image: 7 ⅝ x 9 ½ in. (19.4 x 24.1 cm.)
Mount: 7 ¹⁵⁄₁₆ x 9 ¹³⁄₁₆ in. (20.1 x 24.9 cm.)
Inscription, mount verso: ACM exhibition label, which states
that this is print number one of Weston's portfolio of fifteen
prints
Acquired from: unknown source

TEN PHOTOGRAPHS (P1965.156.1–10)

This portfolio was published by Brett Weston in Carmel,
California, in 1958 in an edition of 50 portfolios. Correspon-
dence in Amon Carter Museum files indicates that some of
the prints were damaged when the portfolio arrived at the
Museum and were replaced by Weston; this could account
for the later dates of two of the prints.

*5781. **OLD ADOBE, MARIPOSA, CALIFORNIA** (P1965.156.1)
Gelatin silver print. negative 1950, print 1958
Image: 10 ½ x 13 ⁹⁄₁₆ in. (26.7 x 34.5 cm.)
Mount: 15 x 18 in. (38.1 x 45.7 cm.)
Signed, l.r. mount recto: "Brett Weston 1950"
Inscription, mount verso: ACM exhibition label
Acquired from: the photographer

5771

5773

5775

5782. **[Rock formation]** (P1965.156.2)
Gelatin silver print. negative 1954, print 1958
Image: 10 3/8 x 13 5/8 in. (26.4 x 34.6 cm.)
Mount: 15 x 18 in. (38.1 x 45.7 cm.)
Signed, l.r. mount recto: "Brett Weston 1954"
Inscription, mount verso: ACM exhibition label
Acquired from: the photographer

*5783. **PLASTIC PAINT, CALIFORNIA** (P1965.156.3)
Gelatin silver print. negative 1956, print 1958
Image: 13 5/8 x 10 3/8 in. (34.6 x 26.3 cm.)
Mount: 18 x 15 in. (45.7 x 38.1 cm.)
Signed, l.r. mount recto: "Brett Weston 1956"
Inscription, mount verso: ACM exhibition label
Acquired from: the photographer

5784. **PINES IN FOG, MONTEREY, CALIFORNIA** (P1965.156.4)
Gelatin silver print. 1962
Image: 13 1/2 x 10 7/16 in. (34.3 x 26.5 cm.)
Mount: 18 x 15 in. (45.7 x 38.1 cm.)
Signed, l.r. mount recto: "Brett Weston 1962"
Inscription, mount verso: ACM exhibition label
Acquired from: the photographer

5785. **[Seaweed]** (P1965.156.5)
Gelatin silver print. negative 1952, print 1958
Image: 10 7/16 x 13 5/8 in. (26.5 x 34.7 cm.)
Mount: 15 x 18 in. (38.1 x 45.7 cm.)
Signed, l.r. mount recto: "Brett Weston 1952"
Inscription, mount verso: ACM exhibition label
Acquired from: the photographer

5786. **BROKEN GLASS, CALIFORNIA** (P1965.156.6) duplicate
of P1978.141
Gelatin silver print. negative c. 1954–55, print 1958
Image: 13 5/8 x 10 3/8 in. (34.7 x 26.3 cm.)
Mount: 18 x 15 in. (45.7 x 38.1 cm.)
Signed, l.r. mount recto: "Brett Weston 1954"
Inscription, mount verso: ACM exhibition label
Acquired from: the photographer

5787. **[Cacti on sand dune]** (P1965.156.7)
Gelatin silver print. negative 1947, print 1958
Image: 10 5/16 x 13 5/8 in. (26.2 x 34.5 cm.)
Mount: 15 x 18 in. (38.1 x 45.7 cm.)
Signed, l.r. mount recto: "Brett Weston 1947"
Inscription, mount verso: ACM exhibition label
Acquired from: the photographer

5788. **[Tree on ground]** (P1965.156.8)
Gelatin silver print. negative 1951, print 1958
Image: 10 3/8 x 13 7/16 in. (26.3 x 34.2 cm.)
Mount: 15 x 18 in. (38.1 x 45.7 cm.)
Signed, l.r. mount recto: "BW. 1951"
Inscription, mount verso: ACM exhibition label
Acquired from: the photographer

5789. **[Street sweeper's tools]** (P1965.156.9)
Gelatin silver print. negative 1945, print 1958
Image: 10 3/8 x 13 5/8 in. (26.3 x 34.7 cm.)
Mount: 15 x 18 in. (38.1 x 45.7 cm.)
Signed, l.r. mount recto: "Brett Weston 1945"
Inscription, mount verso: ACM exhibition label
Acquired from: the photographer

*5790. **[Cedar trees and fallen limbs]** (P1965.156.10)
Gelatin silver print. 1963
Image: 10 1/2 x 13 9/16 in. (26.6 x 34.5 cm.)
Mount: 15 x 18 in. (38.1 x 45.7 cm.)
Signed, l.r. mount recto: "Brett Weston 1963"
Inscription, mount verso: ACM exhibition label
Acquired from: the photographer

EDWARD WESTON, American (1886–1958)

Edward Weston was born in Illinois and made his first photographs in 1902. He moved to California in 1906 and supported himself through commercial portrait work, establishing a studio in Tropico (Glendale), California, in 1911. His photographs made during the 1910s were done in a soft-focus pictorial style. In 1922 he met Alfred Stieglitz in New York; on this trip Weston made his first series of sharply focused images at the Armco Steel plant in Ohio. From that point on, his work was characterized by a strongly composed, sharply focused style; his images were unmanipulated contact prints made with view cameras and the simplest printing equipment. The time Weston spent in Mexico with Tina Modotti and his son Brett in 1923–24 and a later trip in 1926 were important to the maturation of this style. Later in his life Weston disavowed and destroyed his early pictorial negatives. In 1932 Weston, Willard Van Dyke, Ansel Adams, Imogen Cunningham, and others founded Group f/64, dedicated to the principles of straight photography. In 1937 Weston received the first Guggenheim fellowship given to a photographer and with his second wife, Charis Wilson, made a photographic trip through California and the western United States. Although his work received much attention, Weston never made a great deal of money from his photography. Late in his life he developed Parkinson's disease and was forced to give up photography. His sons Brett and Cole continued to print their father's negatives under his supervision until his death, and Cole continued the printing as executor of his father's estate until the collection was sold to the Center for Creative Photography in Tucson, Arizona.

5791. **ANSEL ADAMS** (P1973.6)
Gelatin silver print. 1943
Image: 7 9/16 x 9 5/8 in. (19.3 x 24.5 cm.)
Signed, center print verso: "Edward Weston 1943"
Inscription, print verso: "—Ansel Adams—//[illegible]//
PO43-A-1"
overmat recto: "Ansel Adams/Carmel 5-29-73 [Ansel
Adams' autograph]"
Acquired from: Herbert B. Palmer, Los Angeles, California

5792. **[Arizona lake near Coolidge Dam]** (P1964.153)
Gelatin silver print. 1938
Image: 7 9/16 x 9 9/16 in. (19.2 x 24.3 cm.)
Mount: 11 1/16 x 14 in. (28.1 x 35.6 cm.)
Signed, l.r. mount recto: "EW 1938"
Inscription, mount verso: "A-CD-10G" and ACM exhibition
label
Acquired from: Brett Weston, Carmel, California

*5793. **ARMCO** (P1980.23.3)
Gelatin silver print. 1941
Image: 9 9/16 x 7 9/16 in. (24.2 x 19.1 cm.)
Mount: same as image size
Signed: purportedly signed on print verso
before dry mounting
Acquired from: James Maroney, Inc., New York, New York

5794. **ASPEN VALLEY [New Mexico, mountainside with clouds]**
(P1964.183)
Gelatin silver print. 1937
Image: 7 1/2 x 9 1/2 in. (19.0 x 24.2 cm.)
Mount: 11 1/8 x 13 15/16 in. (28.2 x 35.5 cm.)
Signed, l.r. mount recto: "EW 1937"
Inscription, mount verso: "NM-AV-6G/1937" and
ACM exhibition label
Acquired from: Brett Weston, Carmel, California

5778

5781

5783

5790

5803

5793

5795. **ASPENS, N. MEXICO** (P1975.108)
Gelatin silver print. 1937
Image: 9 ½ x 7 ⅝ in. (24.2 x 19.3 cm.)
Mount: 11 x 8 ⅞ in. (28.0 x 22.5 cm.)
Signed, l.r. mount recto: "Edward Weston 1937"
Inscription, mount verso: "Aspens/N. Mexico//NM-AV-3G"
Acquired from: Mitchell A. Wilder, Fort Worth, Texas

5796. **BACK LOT, METRO-GOLDWYN-MAYER,
HOLLYWOOD** (P1964.159)
Gelatin silver print. 1939
Image: 9 ⅝ x 7 ⅝ in. (24.4 x 19.4 cm.)
Mount: 17 x 14 in. (43.2 x 35.6 cm.)
Signed, l.r. mount recto: "Edward Weston 1939"
Inscription, mount recto: "46"
mount verso: "LA-MGM-8g//Back Lot/Metro-Goldwyn-
Mayer/Hollywood" and ACM exhibition label
Acquired from: Brett Weston, Carmel, California

5797. **BILL ROGERS** [Will Rogers, Jr.] (P1965.159)
Gelatin silver print. 1934
Image: 4 ½ x 3 ⅝ in. (11.5 x 9.2 cm.)
Mount: 11 x 9 1/16 in. (28.0 x 23.0 cm.)
Signed, l.r. mount recto: "Edward Weston 1934"
Inscription, mount recto: "This picture was made in
Monterrey [sic], Cal./My wife called it "Give Your Heart/to
the Hawks"/Will Rogers Jr. 12/11/78 //—Bill Rogers—"
mount verso: "Bill Rogers" and ACM exhibition label
Acquired from: unknown source

5798. **CACTUS** (P1964.190)
Gelatin silver print. 1932
Image: 9 ⅝ x 7 9/16 in. (24.5 x 19.3 cm.)
Mount: 14 1/16 x 11 1/16 in. (35.7 x 28.1 cm.)
Signed, l.r. mount recto: "Edward Weston 1932"
Inscription, mount recto: "3/50"
mount verso: "[illegible]4//14C/—Cactus—"
Acquired from: Brett Weston, Carmel, California

5799. **[Cloud Formations in Death Valley]** (P1964.156)
Gelatin silver print. 1939
Image: 7 ⅝ x 9 9/16 in. (19.4 x 24.3 cm.)
Mount: 11 x 13 15/16 in. (28.0 x 35.4 cm.)
Signed, l.r. mount recto: "EW 1938 [sic]"
Inscription, mount verso: "DV-39C-15G" and
ACM exhibition label
Acquired from: Brett Weston, Carmel, California

5800. **CLOUDS AT OCEANO** (P1964.185)
Gelatin silver print. 1936
Image: 7 ⅝ x 9 ⅝ in. (19.3 x 24.4 cm.)
Mount: 13 ⅞ x 14 ⅞ in. (35.3 x 37.8 cm.)
Signed, l.r. mount recto: "Edward Weston 1936"
Inscription, mount verso: "[illegible]9 Cl/25.00//Clouds at
Oceano 1936/by/Edward Weston" and printed paper label
"SAN FRANCISCO MUSE[um of Art]/EXHIBITION
[typed] E. WESTON/ARTIST [typed] " [E. Weston]/
TITLE [typed] series 1936, clouds/NO. [typed] 1914.37L
DATE IN [typed] 9/14/37/LENDER [typed] artist/
ADDRESS" and ACM exhibition label
Acquired from: Brett Weston, Carmel, California

5801. **[Connecticut, barn with silo, cow in foregound]** (P1964.173)
Gelatin silver print. 1941
Image: 7 ⅝ x 9 ⅝ in. (19.3 x 24.4 cm.)
Mount: 15 1/16 x 16 ½ in. (38.2 x 42.0 cm.)
Signed, l.r. mount recto: "EW 1941"
Inscription, mount verso: ACM exhibition label
Acquired from: Brett Weston, Carmel, California

5802. **DAVID McALPIN, NEW YORK** (P1964.187)
Gelatin silver print. 1941
Image: 9 ⅝ x 7 ⅝ in. (24.4 x 19.4 cm.)
Mount: 10 1/16 x 8 in. (25.5 x 20.4 cm.)
Signed, l.r. mount recto: "EW 1940 [sic]"
Inscription, mount verso: "Print by Edward Weston/BW" and
ACM exhibition label
Acquired from: Brett Weston, Carmel, California

*5803. **DEAD TREE** (P1964.166)
Gelatin silver print. 1930
Image: 9 7/16 x 7 9/16 in. (24.0 x 19.2 cm.)
Mount: 14 1/16 x 11 1/16 in. (35.7 x 28.1 cm.)
Signed, l.r. mount recto: "Edward Weston 1930"
Inscription, mount recto: "4/50"
mount verso: "Dead Tree/NX 49T" and
ACM exhibition label
Acquired from: Brett Weston, Carmel, California

5804. **[Death Valley, rock formation in Golden Canyon]** (P1964.168)
Gelatin silver print. 1937
Image: 7 ⅝ x 9 ⅝ in. (19.4 x 24.5 cm.)
Mount: 11 1/16 x 14 in. (28.1 x 35.6 cm.)
Signed, l.r. mount recto: "EW 1937"
Inscription, mount verso: "DV-GC-15G" and
ACM exhibition label
Acquired from: Brett Weston, Carmel, California

*5805. **DIEGO RIVERA** (P1964.162)
Gelatin silver print. 1924
Image: 7 ½ x 9 ¼ in. (19.0 x 23.5 cm.)
1st mount: same as image size
2nd mount: 14 9/16 x 15 ½ in. (37.0 x 39.4 cm.)
Signed, l.r. 2nd mount recto: "Edward Weston 1924"
Inscription, 2nd mount recto: "1—Diego Rivera—"
2nd mount verso: ACM exhibition label
Acquired from: Brett Weston, Carmel, California

5806. **EEL RIVER RANCH** (P1964.160)
Gelatin silver print. 1938
Image: 7 ½ x 9 7/16 in. (19.0 x 24.0 cm.)
Mount: 11 ⅛ x 14 in. (28.3 x 35.6 cm.)
Signed: see inscription
Inscription, mount recto: "BW 1938"
mount verso: "Print by Edward Weston/BW" and
ACM exhibition label
Acquired from: Brett Weston, Carmel, California

5807. **EUCALYPTUS** (P1964.181)
Gelatin silver print. 1929
Image: 9 ½ x 7 ½ in. (24.1 x 19.0 cm.)
Mount: 16 7/16 x 13 11/16 in. (41.7 x 34.8 cm.)
Signed, l.r. mount recto: "Edward Weston 1929"
Inscription, mount recto: "11-50//7"
mount verso: ACM exhibition label
Acquired from: Brett Weston, Carmel, California

5808. **FURNACE CREEK WASH, DEATH VALLEY** (P1964.171)
Gelatin silver print. 1937
Image: 7 ⅝ x 9 ⅝ in. (19.3 x 24.4 cm.)
1st mount: same as image size
2nd mount: 14 x 15 ½ in. (35.6 x 39.4 cm.)
Signed, l.r. 2nd mount recto: "EW 1937"
Inscription, 1st mount recto: "Furnace Creek Wash/Death
Valley/Edward Weston 1938 [sic]"
2nd mount verso: "46.202.7" and rubber stamp "[illegible]
[illegible]ugharen Hamburg B5" and ACM exhibition label
Acquired from: Brett Weston, Carmel, California

*5809. **THE GOLDFISH (YVONNE VERLAINE)** [Yvonne
Sinnard?] (P1979.90.2)
Platinum print. 1916
Image: 9 5/16 x 6 9/16 in. (23.7 x 16.7 cm.)
Signed, l.r. print recto: "Weston."
Inscription, old mount verso: " "The Goldfish" (Yvonne
Verlaine)/Edward Henry Weston/Tropico—Calif"
Acquired from: Zeitlin & VerBrugge Booksellers,
Los Angeles, California

*5810. **GULF OIL—PT. ARTHUR** [Port Arthur, Texas—loops]
(P1980.23.1)
Gelatin silver print. 1941
Image: 7 ½ x 9 ⅝ in. (19.0 x 24.3 cm.)
Signed, top print verso: "Edward Weston"
Inscription, print verso: "Gulf Oil—Pt Arthur"
Acquired from: James Maroney, Inc., New York, New York

5811. **GULF OIL, PT. ARTHUR** [Port Arthur, Texas—spherical
tanks] (P1980.23.2)
Gelatin silver print. 1941
Image: 7½ x 9½ in. (19.3 x 24.2 cm.)
Signed, u.l. print verso: "Edward Weston"
Inscription, print verso: "Gulf Oil, Pt. Arthur//Shoot
somewhat/lighter/2½"/LAST WORD//80//52/5519/3-3//
30/8 //1752/19" and rubber stamp "Minicam"
Acquired from: James Maroney, Inc., New York, New York

5812. **HARALD KREUTZBERG** (P1964.188)
Gelatin silver print. 1932
Image: 8¹³/₁₆ x 7¾ in. (22.4 x 19.7 cm.)
1st mount: same as image size
2nd mount: 10¹/₁₆ x 8⅛ in. (25.5 x 20.6 cm.)
Signed, l.r. 2nd mount recto: "EW 1932"
Inscription, 2nd mount verso: "Print by Edward Weston/BW"
and ACM exhibition label
Acquired from: Brett Weston, Carmel, California

5813. **HIGHWAY 60, COLORADO DESERT** (P1964.164)
Gelatin silver print. 1937
Image: 7½ x 9½ in. (19.0 x 24.2 cm.)
Mount: 13¹/₁₆ x 15¹³/₁₆ in. (33.2 x 40.2 cm.)
Signed, l.r. mount recto: "EW 1937"
Inscription, mount verso: "CD-Mi-7G"
Acquired from: Brett Weston, Carmel, California

5814. **JAMES CAGNEY** (P1965.161)
Gelatin silver print. 1933
Image: 4⅝ x 3⅝ in. (11.7 x 9.2 cm.)
Mount: 11 x 9 in. (28.0 x 22.9 cm.)
Signed, l.r. mount recto: "Edward Weston/1933"
Inscription, mount recto: "16//—James Cagney—"
mount verso: ACM exhibition label
Acquired from: unknown source

5815. **[Joshua tree, Mojave Desert]** (P1964.172)
Gelatin silver print. 1937
Image: 9⅝ x 7⅝ in. (24.4 x 19.3 cm.)
Mount: 13⅞ x 11¹/₁₆ in. (35.3 x 28.1 cm.)
Signed, l.r. mount recto: "EW 1937"
Inscription, mount verso: ACM exhibition label
Acquired from: Brett Weston, Carmel, California

5816. **JUNIPER—LAKE TENAYA** (P1964.161)
Gelatin silver print. 1937
Image: 9⁹/₁₆ x 7⁹/₁₆ in. (24.3 x 19.2 cm.)
Mount: 14 x 11 in. (35.6 x 28.0 cm.)
Signed, l.r. mount recto: "EW 1937"
Inscription, mount verso: "J1-1G" and ACM exhibition label
Acquired from: Brett Weston, Carmel, California

5817. **JUNIPER—LAKE TENAYA** (P1964.189)
Gelatin silver print. 1937
Image: 9⁹/₁₆ x 7⅝ in. (24.3 x 19.4 cm.)
Mount: 13¹⁵/₁₆ x 10¹⁵/₁₆ in. (35.4 x 27.8 cm.)
Signed, l.r. mount recto: "EW 1937"
Inscription, mount verso: "No. 401/Juniper/Lake
Tenaya//J2-Clg/No. 401/Juniper—/Lake Tenaya"
and ACM exhibition label
Acquired from: Brett Weston, Carmel, California

*5818. **[Karl Struss]** (P1983.23.183)
Toned platinum print. c. 1922–23
Image: 7½ x 9⅜ in. (18.9 x 23.7 cm.)
Mount: 18 x 14 in. (45.7 x 35.6 cm.)
Signed, l.r. mount recto: "Edward Weston 1923"
Inscription, print verso: "X"
mount verso: "82//(82)/65"
Acquired from: Stephen White Gallery of Photography, Inc.,
Los Angeles, California

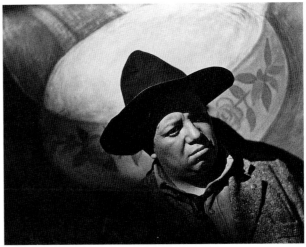

5805

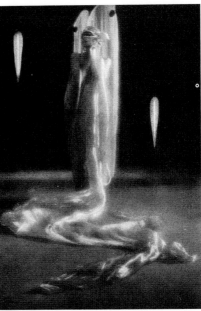

5809

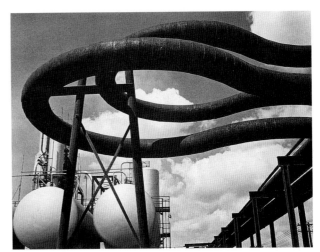

5810

5819. **KARL STRUSS—LOS ANGELES** (P1983.23.184)
Toned platinum print. c. 1922–23
Image: 7 1/8 x 9 3/16 in. (18.1 x 23.2 cm.)
Mount: 18 x 14 in. (45.7 x 35.6 cm.)
Signed, l.r. mount recto: "Edward Weston 1923"
Inscription, mount verso: "85//(85)/63"
Acquired from: Stephen White Gallery of Photography, Inc.,
Los Angeles, California

5820. **LAKE HOLLYWOOD RESERVOIR [Los Angeles,
California]** (P1964.147)
Gelatin silver print. 1936
Image: 7 9/16 x 9 9/16 in. (19.2 x 24.3 cm.)
1st mount: same as image size
2nd mount: 11 x 14 in. (28.0 x 35.6 cm.)
Signed, l.r. 2nd mount recto: "EW 1937 [sic]"
Inscription, 2nd mount verso: ACM exhibition label
Acquired from: Brett Weston, Carmel, California

5821. **[Landscape with fences, barn, and shed]** (P1964.178)
Gelatin silver print. 1935
Image: 7 9/16 x 9 9/16 in. (19.2 x 24.3 cm.)
Mount: 11 x 14 in. (28.0 x 35.6 cm.)
Signed, l.r. mount recto: "Edward Weston 1935"
Inscription, mount verso: ACM exhibition label
Acquired from: Brett Weston, Carmel, California

5822. **LIGHTHOUSE, POINT SUR** (P1964.163)
Gelatin silver print. 1934
Image: 7 9/16 x 9 9/16 in. (19.2 x 24.3 cm.)
Mount: 14 7/8 x 15 1/2 in. (37.7 x 39.4 cm.)
Signed, l.r. mount recto: "Edward Weston 1934"
Inscription, mount recto: "1-50"
mount verso: "23 Mi/1934//JEAN"
Acquired from: Brett Weston, Carmel, California

5823. **LOW TIDE, POINT LOBOS** (P1964.165)
Gelatin silver print. 1939
Image: 7 9/16 x 9 9/16 in. (19.2 x 24.3 cm.)
Mount: 11 x 14 in. (28.0 x 35.6 cm.)
Signed, l.r. mount recto: "EW 1939"
Inscription, mount verso: "PL 39-R-4" and
ACM exhibition label
Acquired from: Brett Weston, Carmel, California

5824. **MEXICO** (P1965.160)
Gelatin silver print. 1925
Image: 7 5/16 x 9 1/4 in. (18.5 x 23.5 cm.)
Mount: 11 1/8 x 14 1/16 in. (28.2 x 35.7 cm.)
Signed, l.r. mount recto: "EW 1925"
Inscription, mount verso: "Print by Edward Weston/BW//—
Mexico 1925" and ACM exhibition label
Acquired from: unknown source

5825. **MGM STUDIOS [MGM movie lot props]** (P1964.179)
Gelatin silver print. 1939
Image: 7 11/16 x 9 5/8 in. (19.4 x 24.4 cm.)
Mount: 11 1/16 x 14 in. (28.1 x 35.6 cm.)
Signed, l.r. mount recto: "Edward Weston 1939"
Inscription, mount verso: "LA-MGM-12g" and
ACM exhibition label
Acquired from: Brett Weston, Carmel, California

*5826. **MONNA ALFAU DE SALA [Monna Alfau
de Sala de Teixidor]** (P1980.46)
Gelatin silver print. c. 1924
Image: 3 7/8 x 2 15/16 in. (9.8 x 7.4 cm.)
Inscription, print verso: "14//Teixidor"
Acquired from: Prakapas Gallery, New York, New York

*5827. **MOONSTONE BEACH, CALIFORNIA** (P1964.158)
Gelatin silver print. 1937
Image: 7 1/2 x 9 1/2 in. (19.0 x 24.1 cm.)
Mount: 11 x 14 in. (28.0 x 35.6 cm.)
Signed, l.r. mount recto: "EW 1937"

Inscription, mount verso: "37//NC-MB-2G/1937" and
ACM exhibition label
Acquired from: Brett Weston, Carmel, California

5828. **NEW JERSEY** (P1964.177)
Gelatin silver print. 1941
Image: 7 5/8 x 9 11/16 in. (19.4 x 24.6 cm.)
Mount: 13 7/8 x 15 5/8 in. (35.2 x 39.7 cm.)
Signed, l.r. mount recto: "EW 1941"
Inscription, mount verso: "XXXXX//New Jersey"
Acquired from: Brett Weston, Carmel, California

*5829. **[Nude]** (P1965.157)
Gelatin silver print. 1933
Image: 3 5/8 x 4 5/8 in. (9.2 x 11.7 cm.)
Mount: 7 15/16 x 10 1/16 in. (20.2 x 25.6 cm.)
Signed, l.r. mount recto: "Edward Weston 1933"
Inscription, mount recto: "2-50"
mount verso: "176N//176N" and ACM exhibition label
Acquired from: unknown source

5830. **[Nude—legs]** (P1965.158)
Gelatin silver print. 1934
Image: 3 5/8 x 4 11/16 in. (9.2 x 11.9 cm.)
Mount: 8 1/8 x 10 1/16 in. (20.6 x 25.6 cm.)
Signed, l.r. mount recto: "Edward Weston 1934"
Inscription, mount recto: "2-50"
mount verso: "197N//197N" and ACM exhibition label
Acquired from: unknown source

5831. **NUDE ON SAND, OCEANO DUNES** (P1985.7)
Gelatin silver print. 1936
Image: 7 9/16 x 9 9/16 in. (19.2 x 24.3 cm.)
Mount: 14 15/16 x 16 7/16 in. (37.9 x 41.7 cm.)
Signed, l.r. mount recto: "Edward Weston 1936"
Inscription, mount verso: "237N//Nude on Sand/Oceano
Dunes 1936"
Acquired from: Alison Van Dyke, Brooktondale, New York

*5832. **NO. 10—PEPPER** (P1964.155)
Gelatin silver print. 1930
Image: 9 9/16 x 7 3/16 in. (24.3 x 18.2 cm.)
Mount: 17 x 14 in. (43.2 x 35.6 cm.)
Signed, l.l. mount recto: "EW 4/50"
Inscription, mount verso: "No. 10—"Pepper"" and printed
paper label "EDWARD WESTON/CARMEL-BY-THE-
SEA, CALIFORNIA/RE-ORDER BY/NO. [in pencil]
29P" and ACM exhibition label
Acquired from: Brett Weston, Carmel, California

*5833. **OVENS—TAOS PUEBLO** (P1965.47)
Gelatin silver print. 1933
Image: 7 9/16 x 9 1/2 in. (19.2 x 24.1 cm.)
Mount: 13 1/8 x 15 5/16 in. (33.3 x 38.9 cm.)
Signed, l.r. mount recto: "Edward Weston 1933"
Inscription, mount verso: "2/50"
mount verso: " "Ovens—Taos Pueblo" "
Acquired from: Brett Weston, Carmel, California

5834. **OWEN'S VALLEY** (P1964.152)
Gelatin silver print. 1937
Image: 9 9/16 x 7 9/16 in. (24.3 x 19.2 cm.)
Mount: 14 1/16 x 11 1/8 in. (35.6 x 28.2 cm.)
Signed, l.r. mount recto: "Edward Weston 1937"
Inscription, mount verso: "Owen's Valley//ES-OV-13g"
and ACM exhibition label
Acquired from: Brett Weston, Carmel, California

5835. **POINT LOBOS** (P1964.146)
Gelatin silver print. 1946
Image: 7 9/16 x 9 5/8 in. (19.2 x 24.4 cm.)
Mount: 11 x 14 in. (28.0 x 35.6 cm.)
Signed, l.r. mount recto: "EW 1946"
Inscription, mount verso: "—Point Lobos—/PL46-L-3"
and ACM exhibition label
Acquired from: Brett Weston, Carmel, California

5818

5826

5827

5829

5832

5833

5836. **PT. LOBOS** (P1964.149)
Gelatin silver print. 1940
Image: 7 9/16 x 9 5/8 in. (19.2 x 24.5 cm.)
Mount: 11 x 14 in. (28.0 x 35.6 cm.)
Signed, l.r. mount recto: "EW 1940"
Inscription, mount verso: "Pt Lobos/Edward Weston 1940//
PL40-K-6" and ACM exhibition label
Acquired from: Brett Weston, Carmel, California

5837. **PORTRAIT OF GEORGE J. HOPKINS** (P1979.90.1)
Toned platinum print. 1915
Image: 9 9/16 x 7 9/16 in. (24.3 x 19.3 cm.)
Signed, l.l. print recto: "Weston"
Inscription, old mount verso: "Portrait of George J. Hopkins"
Acquired from: Zeitlin & VerBrugge Booksellers,
Los Angeles, California

5838. **RED ROCK CAÑON** (P1964.169)
Gelatin silver print. 1937
Image: 7 5/8 x 9 5/8 in. (19.3 x 24.4 cm.)
Mount: 14 x 15 9/16 in. (35.6 x 39.5 cm.)
Signed, l.r. mount recto: "Edward Weston 1937"
Inscription, mount verso: "RRC-2-G//Red Rock Cañon//
RRC-2 G"and ACM exhibition label
Acquired from: Brett Weston, Carmel, California

*5839. **[Red Rock Canyon, car chassis in sand]** (P1964.184)
Gelatin silver print. 1937
Image: 7 5/8 x 9 9/16 in. (19.3 x 24.3 cm.)
Mount: 15 1/16 x 16 1/2 in. (38.2 x 41.9 cm.)
Signed, l.r. mount recto: "EW 1937"
Inscription, mount verso: "RRC-4 G"
Acquired from: Brett Weston, Carmel, California

5840. **RHYOLITE, NEVADA [Ruins of 1906 H.D. and
L.D. Porter building, Rhyolite, Nevada]** (P1964.175)
Gelatin silver print. 1937
Image: 7 11/16 x 9 5/8 in. (19.5 x 24.4 cm.)
Mount: 11 1/8 x 14 in. (28.2 x 35.6 cm.)
Signed, l.r. mount recto: "EW 1937"
Acquired from: Brett Weston, Carmel, California

5841. **ROCK AND DRIFTWOOD [Point Lobos]** (P1964.148)
Gelatin silver print. 1938
Image: 7 5/8 x 9 3/4 in. (19.4 x 24.7 cm.)
Mount: 15 x 16 9/16 in. (38.1 x 42.1 cm.)
Signed, l.r. mount recto: "EW 1938"
Inscription, mount verso: "[P]L-R-8G//M" and
ACM exhibition label
Acquired from: Brett Weston, Carmel, California

5842. **ROCK—POINT LOBOS** (P1964.167)
Gelatin silver print. 1929
Image: 7 5/8 x 9 9/16 in. (19.3 x 24.3 cm.)
Mount: 11 1/16 x 14 in. (28.1 x 35.6 cm.)
Signed, l.l. mount recto: "EW 5/50"
Inscription, mount verso: "Rock—Point Lobos//R22/1929"
and ACM exhibition label
Acquired from: Brett Weston, Carmel, California

5843. **ROSEMARIE SYRINGA ON TOP** (P1964.176)
Gelatin silver print. 1944
Image: 7 9/16 x 9 9/16 in. (19.2 x 24.3 cm.)
Mount: 14 x 15 9/16 in. (35.6 x 39.5 cm.)
Signed, l.r. mount recto: "EW 1944"
top center mount verso: "Edward Weston/1944"
Inscription, mount verso: "C44-CTS-11//Rosemarie Syringa
on top//M" and ACM exhibition label
Acquired from: Brett Weston, Carmel, California

*5844. **RUTH ST. DENIS WITH PARASOL** (P1978.66)
Toned gelatin silver print. 1915
Image: 12 3/4 x 10 3/8 in. (32.3 x 26.3 cm.)
Mount: 13 9/16 x 11 1/4 in. (34.5 x 28.6 cm.)
Signed, u.r. print recto: "Weston—"
Inscription, mount verso: "RUTH ST. DENIS W/PARASOL
1915"
Acquired from: Edward Kaufman, Chicago, Illinois

5845. **SAN CRISTOBAL ECATEPEC** (P1982.31)
Platinum print. 1924
Image: 6 11/16 x 9 in. (17.0 x 22.9 cm.)
Signed, top center print verso: "Edward Weston"
Inscription, print verso: "San Cristobal Ecatepec/1924"
Acquired from: Daniel Wolf, Inc., New York, New York

5846. **SAND STONE CONCRETION** (P1964.150)
Gelatin silver print. 1936
Image: 9 5/8 x 7 1/4 in. (24.5 x 18.5 cm.)
Mount: 17 1/16 x 14 in. (43.3 x 35.6 cm.)
Signed, l.r. mount recto: "Edward Weston 1936"
Inscription, mount verso: "109 R/20^00//Sand Stone
Concretion" and ACM exhibition label
Acquired from: Brett Weston, Carmel, California

5847. **SANDSTONE CONCRETIONS, SALTON SEA** (P1964.170)
Gelatin silver print. 1938
Image: 7 1/2 x 9 1/2 in. (19.1 x 24.1 cm.)
Mount: 10 15/16 x 13 15/16 in. (27.9 x 35.4 cm.)
Signed, l.r. mount recto: "Edward Weston 1938"
Inscription, mount verso: "Sandstone Concretions/
Salton Sea"
Acquired from: Brett Weston, Carmel, California

*5848. **SHIPYARD DETAIL** (P1964.182)
Gelatin silver print. 1935
Image: 7 5/8 x 9 1/4 in. (19.3 x 23.5 cm.)
Mount: 13 x 15 1/2 in. (33.0 x 39.4 cm.)
Signed, l.r. mount recto: "Edward Weston 1935"
Inscription, mount recto: "8-40"
mount verso: "EW Po MC Nov./"Shipyard detail""
and San Francisco Museum of Art label and ACM
exhibition label
Acquired from: Brett Weston, Carmel, California

5849. **[Snow on trees, Three Brothers region, Yosemite National
Park]** (P1964.157)
Gelatin silver print. 1938
Image: 7 5/8 x 9 5/8 in. (19.4 x 24.5 cm.)
Mount: 14 7/16 x 16 1/2 in. (36.6 x 41.9 cm.)
Signed, l.r. mount recto: "EW 1938"
Inscription, mount verso: "YS-TB-9G" and ACM exhibition
label
Acquired from: Brett Weston, Carmel, California

5850. **TAOS, N.M.** (P1965.46)
Gelatin silver print. 1937
Image: 7 1/2 x 9 9/16 in. (19.0 x 24.3 cm.)
Mount: 13 3/16 x 15 in. (33.5 x 38.1 cm.)
Inscription, mount verso: "NM-T-3g" and ACM exhibition
label
Acquired from: Brett Weston, Carmel, California

5851. **TAOS PUEBLO** (P1964.180)
Gelatin silver print. 1933
Image: 7 9/16 x 9 9/16 in. (19.2 x 24.3 cm.)
Mount: 14 7/16 x 15 9/16 in. (36.6 x 39.4 cm.)
Signed, l.r. mount recto: "Edward Weston 1933"
Inscription, mount recto: "1/50"
mount verso: "39 A/1933//39 A/1933//Taos Pueblo" and
printed paper label "Exhibited by/THE PHOTOGRAPHIC
ARTS SOCIETY, INC./in/THE PHOTOGRAPHIC
ARTS BUILDING/BALBOA PARK·SAN DIEGO,
CALIFORNIA"and ACM exhibition label
Acquired from: Brett Weston, Carmel, California

5839

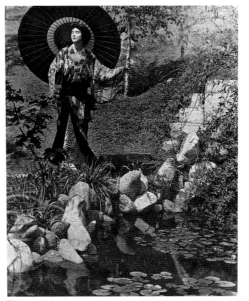

5844

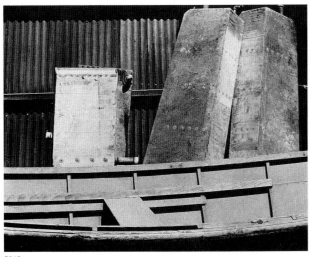

5848

5854

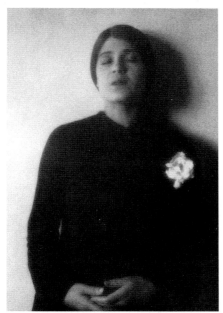

5852

*5852. [Tina Modotti] (P1986.4)
Toned gelatin silver print. 1923
Image: 8 x 5 ¹¹/₁₆ in. (20.3 x 14.3 cm.)
Inscription, print verso: "A"
Acquired from: Nancy Medwell Fine Arts, Seattle,
Washington

5853. WILLIE (P1964.186)
Gelatin silver print. 1941
Image: 9 ⁹/₁₆ x 7 ⁹/₁₆ in. (24.2 x 19.2 cm.)
Mount: 10 ⅛ x 8 ⅛ in. (25.6 x 20.4 cm.)
Signed, l.r. mount recto: "EW 1940 [sic]"
Inscription, mount verso: "Print by Edward Weston/1940
[sic]/BW" and ACM exhibition label
Acquired from: Brett Weston, Carmel, California

*5854. WIND EROSION, DUNES—OCEANO (P1964.174)
Gelatin silver print. 1936
Image: 7 ⁹/₁₆ x 9 ⁹/₁₆ in. (19.2 x 24.3 cm.)
Mount: 14 ⅜ x 15 ½ in. (36.6 x 39.4 cm.)
Signed, l.r. mount recto: "Edward Weston 1936"
Inscription, mount verso: "23S0/20.00/NY//Wind Erosion/
Dunes— Oceano/23-S0" and ACM exhibition label
Acquired from: Brett Weston, Carmel, California

5855. YOSEMITE (P1964.154)
Gelatin silver print. 1938
Image: 9 ½ x 7 ⁹/₁₆ in. (24.1 x 19.2 cm.)
Mount: 17 x 14 ¼ in. (43.2 x 36.2 cm.)
Signed, l.r. mount recto: "Edward Weston 1938"
Inscription, mount verso: "YS-C-6G//MMA//Yosemite"
and ACM exhibition label
Acquired from: Brett Weston, Carmel, California

5856. YOSEMITE VALLEY (P1964.151)
Gelatin silver print. 1938
Image: 7 ⁹/₁₆ x 9 ⁹/₁₆ in. (19.2 x 24.3 cm.)
Mount: 14 ⅜ x 15 ¹³/₁₆ in. (36.5 x 40.2 cm.)
Signed, l.r. mount recto: "EW 1938"
Inscription, mount recto: "35"
mount verso: "Y40-GP-1//Yosemite Valley 1938//Y40-GP-1"
and ACM exhibition label
Acquired from: Brett Weston, Carmel, California

NEIL WESTON, American (b. 1916)

Neil Weston, youngest son of Edward Weston, was born
in Los Angeles and raised in Carmel, California. As
a child he was occasionally a model for his father's
photographic studies. Although Neil Weston has made
photographs, his main area of interest has been custom
woodworking. Self-taught, he has worked as a boat
builder, furniture and cabinet maker, and house builder.

5857. DAD [Edward Weston] (P1978.22)
Gelatin silver print. 1945
Image: 9 ¹¹/₁₆ x 7 ¾ in. (24.6 x 19.6 cm.)
Mount: 15 x 13 ¼ in. (38.1 x 33.7 cm.)
Signed, l.r. mount recto: "Neil Weston 1945"
Inscription, mount recto: "Dad"
Acquired from: The Halsted Gallery, Birmingham, Michigan

CLARENCE H. WHITE, JR., American (1871–1925)

See also Camera Notes and Camera Work

Clarence White, one of America's most influential pho-
tography teachers, began experimenting with photogra-
phy while working in Ohio as a bookkeeper. In 1896 he
won the Ohio Photographers Association gold medal
and began to exhibit his work in salons. In 1899 he was
named an honorary member of the Camera Club of
New York, and in 1902 joined with Alfred Stieglitz to

establish the Photo-Secession movement. He moved
to New York in 1906 and taught for a time at Columbia
University, but was most influential as the founder and
director of the Clarence H. White School of Photogra-
phy, established in 1914. White was a pictorialist and
broke with Stieglitz when the latter embraced the prin-
ciples of straight photography. White became the first
president of the Pictorial Photographers of America,
founded in 1916, and continued to teach at the Clar-
ence White School until his death in 1925. Among his
students were major American photographers such as
Laura Gilpin, Karl Struss, Margaret Bourke-White,
Dorothea Lange, and Paul Outerbridge.

*5858. THE ORCHARD [from Camera Work No. 9, January 1905]
(P1978.61)
Photogravure on tissue. 1905
Image: 8 ⅛ x 6 ⅛ in. (20.7 x 15.6 cm.)
Sheet: 11 ½ x 7 ⅞ in. (29.2 x 19.9 cm.)
Inscription, sheet verso: "WHITE—THE ORCHARD//600"
Acquired from: Edward Kaufman, Chicago, Illinois

5859. PORTRAIT OF KARL STRUSS N. Y. (P1983.23.182)
Platinum print. 1912
Image: 9 ³/₁₆ x 6 ¹⁵/₁₆ in. (23.2 x 17.5 cm.)
1st mount: 9 ⁵/₁₆ x 7 ¹/₁₆ in. (23.7 x 18.0 cm.)
2nd mount: 13 ⅝ x 12 ¹⁵/₁₆ in. (34.6 x 32.8 cm.)
Signed, l.r. print recto: "CHW"
Inscription, 2nd mount verso: "Clarence White. Portrait of
Carl [sic] Struss N. Y. 1912/Plat./#6//Karl Struss"
note: print is mounted on old signed Struss mount
Acquired from: Stephen White Gallery of Photography, Inc.,
Los Angeles, California

*5860. [Store interior, possibly Fleek and Neal Company, Newark,
Ohio] (P1986.35)
Gelatino-chloride or gelatin silver print. 1898
Image: 4 ¹³/₁₆ x 9 ½ in. (12.2 x 24.1 cm.)
Signed, u.r. print recto: "C.H.White—A.A."
Acquired from: Paul Katz, North Bennington, Vermont

MINOR WHITE, American (1908–1976)

White studied botany and English at the University of
Minnesota and upon graduation took up writing poetry.
Later, in 1937, he revived a youthful interest in pho-
tography and pursued this endeavor after moving to
Portland, Oregon, that year. During 1938–39 he was a
"creative photographer" for the Works Progress Admin-
istration. He taught for many years at the Rochester In-
stitute of Technology and the Massachusetts Institute of
Technology. He founded Aperture magazine in 1952 and
served as its editor until 1975. White thought of photo-
graphs in groups or sequences and much of his work
consists of series of images that capture a particular
concept or metaphor.

5861. BARN, LINCOLN, VERMONT (P1978.29.2)
Gelatin silver print. 1968
Image: 5 ⁹/₁₆ x 8 ⁹/₁₆ in. (14.1 x 21.8 cm.)
Sheet: 10 ⅛ x 12 ¹⁵/₁₆ in. (25.7 x 32.9 cm.)
Mount: same as sheet size
Inscription, mount verso: "Minor White Barn Side and
Grass, 1968"
Acquired from: The Halsted Gallery, Birmingham, Michigan

*5862. BARNACLES, LOBOS STATE PARK [Barnacles, Point
Lobos State Park; from "Sequence 8"] (P1978.29.1)
Gelatin silver print. 1963
Image: 10 ¾ x 12 ¾ in. (27.3 x 32.4 cm.)
Sheet: 13 ⅞ x 16 ⅞ in. (35.3 x 42.9 cm.)
Signed, bottom edge print verso: "Minor White"
Inscription, print verso: "Barnacles Lobos State Park 1963"
Acquired from: The Halsted Gallery, Birmingham, Michigan

5863. **FOG BANK, SAN MATEO COUNTY, CALIFORNIA**
[from the sequence "Song Without Words"] (P1982.6)
Gelatin silver print. 1947
Image: 3 ¾ x 4 ¹¹⁄₁₆ in. (9.5 x 11.9 cm.)
Mount: 8 ¼ x 10 in. (21.0 x 25.4 cm.)
Inscription, mount verso: "700//80(527)//30//200.80//Song
without words—Fog Bank ca.1947//700—" and typed on
paper label: "MW3"
Acquired from: The Halsted Gallery, Birmingham, Michigan

*5864. **LAKE TENAYA, YOSEMITE NATIONAL PARK,
CALIFORNIA** (P1980.28)
Gelatin silver print. 1963
Image: 7 ⅜ x 9 ⁹⁄₁₆ in. (18.7 x 24.3 cm.)
Mount: 14 ¹³⁄₁₆ x 17 ¾ in. (37.6 x 45.0 cm.)
Signed, l.r. mount recto: "Minor White"
Inscription, mount recto: "1963"
 mount verso: "RK 18,1//Tree & Rock Lake Tenaya,
 Yosemite National Park 1963 Minor White"
Acquired from: gift of James Maroney, Inc., New York,
 New York

[Peony portfolio] (P1983.39.1–11)

This portfolio was produced by Minor White in collaboration
with Bill Gratwick of Pavilion, New York. Gratwick raised
peonies; over a period of two to three years he grew
specimens for White to photograph. The two decided to
produce ten copies of a portfolio of the peony photographs in
1960. The portfolios were divided among White, Gratwick,
and members of Gratwick's family. Five of the portfolios were
destroyed when Gratwick's house burned but this copy, one
of two owned by Minor White, survives.

5865. **[Peony; single light blossom with ruffled edges]** (P1983.39.1)
Gelatin silver print. negative 1958, print 1960
Image: 7 ⁷⁄₁₆ x 8 ¹³⁄₁₆ in. (18.8 x 22.4 cm.)
Mount: 15 x 18 in. (38.1 x 45.7 cm.)
Acquired from: Photocollect, New York, New York

5866. **[Peony; single dark blossom in glass filled with water]**
(P1983.39.2)
Gelatin silver print. negative 1958, print 1960
Image: 7 ³⁄₁₆ x 9 ¹⁄₁₆ in. (18.3 x 23.0 cm.)
Mount: 15 ¼ x 18 in. (38.7 x 45.7 cm.)
Acquired from: Photocollect, New York, New York

5867. **[Peony; single light blossom]** (P1983.39.3)
Gelatin silver print. negative 1958, print 1960
Image: 7 ½ x 9 ⁷⁄₁₆ in. (19.1 x 24.0 cm.)
Mount: 15 x 18 in. (38.1 x 45.7 cm.)
Acquired from: Photocollect, New York, New York

Attributed to Minor White
*5868. **[Peony; husk and unopened bud]** (P1983.39.4)
Gelatin silver print. negative c. 1957–60, print 1960
Image: 7 ³⁄₁₆ x 9 ⅛ in. (18.2 x 23.2 cm.)
Mount: 15 ³⁄₁₆ x 18 in. (38.5 x 45.7 cm.)
Acquired from: Photocollect, New York, New York

5869. **[Peony; one large dark bloom and three small light blooms
surrounded by leaves]** (P1983.39.5)
Gelatin silver print. negative 1958, print 1960
Image: 7 ⅜ x 7 ⅛ in. (18.7 x 18.1 cm.)
Mount: 15 x 18 in. (38.1 x 45.7 cm.)
Acquired from: Photocollect, New York, New York

5870. **[Peony; single striped bloom against bark]** (P1983.39.6)
Gelatin silver print. negative 1957, print 1960
Image: 6 ⅝ x 9 ⁹⁄₁₆ in. (16.8 x 24.3 cm.)
Mount: 15 ³⁄₁₆ x 18 in. (38.6 x 45.7 cm.)
Acquired from: Photocollect, New York, New York

5871. **[Peony; two light blooms nestled among rocks]** (P1983.39.7)
Gelatin silver print. negative 1954, print 1960
Image: 6 ½ x 9 in. (16.5 x 22.8 cm.)
Mount: 15 ¼ x 18 in. (38.7 x 45.7 cm.)
Acquired from: Photocollect, New York, New York

5858

5860

5862

*5872. **[Peony; single white blossom against board wall, circled by electrical wire]** (P1983.39.8)
Gelatin silver print. negative 1958, print 1960
Image: 6 5/16 x 9 5/8 in. (16.1 x 24.4 cm.)
Mount: 15 x 18 in. (38.1 x 45.7 cm.)
Acquired from: Photocollect, New York, New York

5873. **[Peony; single white blossom against patterned floor]** (P1983.39.9)
Gelatin silver print. negative 1954, print 1960
Image: 7 1/8 x 7 9/16 in. (18.1 x 19.2 cm.)
Mount: 15 x 18 in. (38.1 x 45.7 cm.)
Acquired from: Photocollect, New York, New York

5874. **[Peony; large softly colored bloom against foliage]** (P1983.39.10)
Gelatin silver print. negative 1954, print 1960
Image: 7 11/16 x 9 9/16 in. (19.5 x 24.3 cm.)
Mount: 15 x 18 in. (38.1 x 45.7 cm.)
Acquired from: Photocollect, New York, New York

5875. **[Peony; two light blooms with droplets of water on the petals]** (P1983.39.11)
Gelatin silver print. negative 1957, print 1960
Image: 6 3/8 x 8 1/8 in. (16.3 x 20.7 cm.)
Mount: 15 1/8 x 18 in. (38.5 x 45.7 cm.)
Acquired from: Photocollect, New York, New York

＊ ＊ ＊ ＊

5876. **SNOW ON GARAGE DOOR, ROCHESTER, NEW YORK [from "Sequence 16"]** (P1975.192)
Gelatin silver print. negative 1960, print 1975
Image: 9 3/16 x 8 9/16 in. (23.4 x 21.8 cm.)
Sheet: 13 x 10 3/4 in. (33.0 x 27.3 cm.)
Mount: 20 x 16 in. (50.8 x 40.7 cm.)
Signed, l.r. sheet recto: "Minor White"
Inscription, mount verso: "Snow on Garage Door—1960"
Acquired from: Friends of Photography, Carmel, California; gift print with sustaining membership, 1975

*5877. **STAR DOOR, SAN JUAN, PUERTO RICO** (P1982.37)
Gelatin silver print. 1973
Image: 12 x 8 5/16 in. (30.5 x 21.1 cm.)
Sheet: 13 7/8 x 10 15/16 in. (35.3 x 27.8 cm.)
Signed, bottom center print verso: "Minor White"
Inscription, print verso: "Star Door, San Juan, Puerto Rico, 1973"
Acquired from: gift of Paul Brauchle, Dallas, Texas

MITCHELL A. WILDER, American (1913−1979)

Mitchell A. Wilder was a museum curator and director and a scholar of the American Southwest, as well as a serious amateur photographer. Born in Colorado Springs, he studied at McGill University before returning to Colorado Springs as the curator of the Taylor Museum at the Colorado Springs Fine Arts Center. He later directed the Colorado Springs Fine Arts Center, the Abby Aldrich Rockefeller Collection, and the Amon Carter Museum. Wilder was a strong advocate of photography and arranged many photographic exhibitions. Much of his own photographic work was made in conjunction with museum projects or exhibitions. In 1936−37 he and Laura Gilpin, a personal friend, made photographs for George Kubler's *Religious Architecture of New Mexico*. Other work included portraits of artists and photographers with whom Wilder worked and travel scenes made on museum trips.

5878. **ADOLF DEHN** (P1971.35.1) duplicate of P1977.66.1
Gelatin silver print. 1940
Image: 13 3/8 x 10 5/16 in. (34.0 x 26.2 cm.)
Mount: 20 x 15 7/8 in. (50.8 x 40.4 cm.)
Inscription, mount verso: "ADOLF DEHN"
Acquired from: gift of the photographer

*5879. **ADOLF DEHN** (P1977.66.1) duplicate of P1971.35.1
Gelatin silver print. 1940
Image: 13 7/16 x 10 7/16 in. (34.1 x 26.5 cm.)
Mount: 20 x 15 7/8 in. (50.8 x 40.4 cm.)
Signed, l.r. mount recto: "M. A. Wilder"
Inscription, mount recto: "Adolf Dehn, 1940"
Acquired from: gift of the photographer

5880. **[Boardman Robinson]** (P1977.66.14)
Gelatin silver print. 1940
Image: 9 3/4 x 7 13/16 in. (24.7 x 19.8 cm.)
Mount: 20 x 16 in. (50.8 x 40.7 cm.)
Acquired from: gift of the photographer

5881. **[Ferenc (Franz) Berko]** (P1981.58.1)
Gelatin silver print. c. 1949−54
Image: 9 3/4 x 7 3/4 in. (24.7 x 19.7 cm.)
Sheet: 10 x 8 in. (25.4 x 20.3 cm.)
Inscription, print verso: "S-70-84-24"
Acquired from: gift of Sally Wilder, Fort Worth, Texas

5882. **GEORGE VAN DER SLUIS** (P1977.66.5)
Gelatin silver print. 1945
Image: 13 7/16 x 10 7/16 in. (34.1 x 26.4 cm.)
Mount: 20 x 15 15/16 in. (50.8 x 40.5 cm.)
Inscription, mount recto: "George van der Sluis—1945"
Acquired from: gift of the photographer

5883. **LAURENCE BARETT** (P1981.58.5)
Gelatin silver print. 1942
Image: 9 13/16 x 7 7/8 in. (24.9 x 20.0 cm.)
Inscription, print verso: "Laurence Barett/by MAW 1942— Col. Springs"
Acquired from: gift of Sally Wilder, Fort Worth, Texas

5884. **[Otis Dozier]** (P1977.66.6)
Gelatin silver print. 1945
Image: 13 7/16 x 10 7/16 in. (34.1 x 26.4 cm.)
Mount: 20 x 16 in. (50.8 x 40.7 cm.)
Signed, l.r. mount recto: "M A Wilder"
Acquired from: gift of the photographer

5885. **[Otis Dozier]** (P1977.66.9)
Gelatin silver print. 1945
Image: 13 5/16 x 10 7/16 in. (33.8 x 26.4 cm.)
Mount: 20 x 16 in. (50.8 x 40.7 cm.)
Signed, l.r. mount recto: "M A Wilder"
Acquired from: gift of the photographer

*5886. **[Otis Dozier]** (P1977.66.10)
Gelatin silver print. 1945
Image: 13 7/16 x 10 7/16 in. (34.1 x 26.4 cm.)
Mount: 20 x 16 in. (50.8 x 40.7 cm.)
Signed, l.r. mount recto: "M A Wilder"
Acquired from: gift of the photographer

5887. **[Otis Dozier in the Garden of the Gods, Colorado Springs, Colorado]** (P1977.66.7) uncropped duplicate of P1977.66.8
Gelatin silver print. 1945
Image: 13 7/16 x 10 3/8 in. (34.1 x 26.3 cm.)
Mount: 20 x 16 in. (50.8 x 40.7 cm.)
Acquired from: gift of the photographer

5888. **[Otis Dozier in the Garden of the Gods, Colorado Springs, Colorado]** (P1977.66.8) cropped duplicate of P1977.66.7
Gelatin silver print. 1945
Image: 13 5/16 x 10 7/16 in. (33.8 x 26.4 cm.)
Mount: 20 x 16 in. (50.8 x 40.7 cm.)
Acquired from: gift of the photographer

5889. **[Pepino Mangravite]** (P1977.66.11)
Gelatin silver print. 1941
Image: 13 7/16 x 10 3/8 in. (34.1 x 26.3 cm.)
Mount: 20 x 15 15/16 in. (50.8 x 40.5 cm.)
Acquired from: gift of the photographer

5864

5868

5872

5877

5879

5886

5890. [Pepino Mangravite] (P1977.66.12) duplicate of P1977.66.13
Gelatin silver print. 1941
Image: 13 7/16 x 10 1/2 in. (34.1 x 26.6 cm.)
Mount: 20 x 15 15/16 in. (50.8 x 40.5 cm.)
Acquired from: gift of the photographer

5891. [Pepino Mangravite] (P1977.66.13) duplicate of P1977.66.12
Silver bromide print on Gevaluxe paper. 1941
Image: 13 1/2 x 10 1/2 in. (34.2 x 26.6 cm.)
Sheet: 14 x 11 in. (35.6 x 28.0 cm.)
Signed, l.r. old overmat recto: "M A Wilder 1941"
Acquired from: gift of the photographer

5892. RICO LE BRUN (P1977.66.2)
Gelatin silver print. 1945
Image: 13 3/8 x 10 1/2 in. (34.0 x 26.6 cm.)
Mount: 20 x 15 15/16 in. (50.8 x 40.5 cm.)
Inscription, mount recto: "Rico Lebrun [sic]—1945"
Acquired from: gift of the photographer

5893. RICO LE BRUN (P1977.66.3)
Gelatin silver print. 1945
Image: 13 3/8 x 10 7/16 in. (34.0 x 26.5 cm.)
Mount: 20 x 15 15/16 in. (50.8 x 40.5 cm.)
Inscription, mount recto: "Rico Lebrun [sic]—1945"
Acquired from: gift of the photographer

5894. RICO LE BRUN (P1977.66.4)
Gelatin silver print. 1945
Image: 13 7/16 x 10 7/16 in. (34.1 x 26.5 cm.)
Mount: 20 x 15 15/16 in. (50.8 x 40.5 cm.)
Inscription, mount recto: "Rico Lebrun [sic]—1945"
Acquired from: gift of the photographer

5895. RICO LE BRUN (P1981.58.2)
Gelatin silver print. 1942
Image: 9 3/4 x 7 11/16 in. (24.8 x 19.4 cm.)
Inscription, print verso: "Rico Le Brun/taken 1942/in Col.
Springs/by MAW"
Acquired from: gift of Sally Wilder, Fort Worth, Texas

*5896. RICO LE BRUN—ARTIST, AND LAURENCE
BARETT—LITHOGRAPHER (P1981.58.3)
Gelatin silver print. 1942
Image: 9 11/16 x 7 13/16 in. (24.6 x 19.8 cm.)
Inscription, print verso: "taken by MAW Col Springs 1942/
Rico Le Brun—artist/and/Laurence Barett—lithographer"
Acquired from: gift of Sally Wilder, Fort Worth, Texas

5897. RICO LE BRUN AND LAURENCE BARETT (P1981.58.4)
Gelatin silver print. 1942
Image: 9 13/16 x 7 3/4 in. (24.9 x 19.7 cm.)
Inscription, print verso: "Rico-Le Brun and Laurence Barett/
by MAW—1942/lithographer"
Acquired from: gift of Sally Wilder, Fort Worth, Texas

RICHARD WILDER, American (b. 1952)

Richard Wilder graduated from Utah State University
in 1974 with a B.F.A. in photography and art history. In
1981 he received a National Endowment for the Arts
Photography Survey Grant. Wilder's photographs docu-
menting changes in Santa Fe over a brief period of time
were included in *The Essential Landscape* (1985).

5898. NAMBE, NEW MEXICO [from the Santa Fe Center for
Photography's "Portfolio II"] (P1984.4.5)
Gelatin silver print. negative 1982, print c. 1983
Image: 7 5/8 x 9 9/16 in. (19.3 x 24.3 cm.)
Mount: 11 x 14 in. (28.0 x 35.6 cm.)
Signed, l.r. mount recto: "R Wilder"
Acquired from: Santa Fe Center for Photography, Santa Fe,
New Mexico

RICK WILLIAMS, American (b. 1946)

Rick Williams received a degree in advertising and
journalism in 1970 from the University of Texas. Since
1973 he has run a commercial photographic studio and
divides his time between corporate photography and his
personal documentary work focusing on rural commu-
nities of Texas. He taught photography at St. Edward's
University in Austin from 1977 to 1980 and developed
the University's first Photo Communication degree pro-
gram. A member of the Board of Directors of the Texas
Photographic Society since 1974, he received a Texas
Committee for the Arts grant to produce a group ex-
hibition of work by Texas photographers to tour in
Mexico.

5899. A.V. JONES, JONES OIL COMPANY, ALBANY [from
"Contemporary Texas: A Photographic Portrait"]
(P1985.17.146)
Gelatin silver print. 1984
Image: 8 9/16 x 13 in. (21.7 x 33.0 cm.)
Sheet: 11 x 13 15/16 in. (28.0 x 35.4 cm.)
Signed, l.r. print recto: "© Rick Williams '84"
Acquired from: gift of the Texas Historical Foundation with
support from a major grant from the Du Pont Company
and Conoco, its energy subsidiary, and assistance from
the Texas Commission on the Arts and the National
Endowment for the Arts

5900. BENNIE PEACOCK, FOREMAN, GREEN RANCH,
ALBANY [from "Contemporary Texas: A Photographic
Portrait"] (P1985.17.150)
Gelatin silver print. 1984
Image: 8 9/16 x 13 in. (21.7 x 33.0 cm.)
Sheet: 11 x 14 in. (28.0 x 35.6 cm.)
Signed, l.r. print recto: "© Rick Williams '84"
Acquired from: gift of the Texas Historical Foundation with
support from a major grant from the Du Pont Company
and Conoco, its energy subsidiary, and assistance from
the Texas Commission on the Arts and the National
Endowment for the Arts

5901. BOB GREEN, GREEN RANCH, ALBANY [from
"Contemporary Texas: A Photographic Portrait"]
(P1985.17.149)
Gelatin silver print. 1984
Image: 8 1/2 x 13 1/16 in. (21.6 x 33.2 cm.)
Sheet: 10 15/16 x 14 in. (27.8 x 35.6 cm.)
Signed, l.r. print recto: "© Rick Williams '84"
Acquired from: gift of the Texas Historical Foundation with
support from a major grant from the Du Pont Company
and Conoco, its energy subsidiary, and assistance from
the Texas Commission on the Arts and the National
Endowment for the Arts

5902. BRANDING AND CUTTING, MATADOR [from
"Contemporary Texas: A Photographic Portrait"]
(P1985.17.147)
Gelatin silver print. 1984
Image: 8 1/2 x 13 in. (21.6 x 33.0 cm.)
Sheet: 10 15/16 x 14 in. (27.8 x 35.6 cm.)
Signed, l.r. print recto: "© Rick Williams '84"
Acquired from: gift of the Texas Historical Foundation with
support from a major grant from the Du Pont Company
and Conoco, its energy subsidiary, and assistance from
the Texas Commission on the Arts and the National
Endowment for the Arts

5903. DERRICK HAND STACKING PIPE, JONES RIG #51,
NEAR ALBANY [from "Contemporary Texas: A
Photographic Portrait"] (P1985.17.148)
Gelatin silver print. 1984
Image: 8 9/16 x 13 in. (21.7 x 33.0 cm.)
Sheet: 10 15/16 x 14 in. (27.8 x 35.6 cm.)
Signed, l.r. print recto: "© Rick Williams '84"

Acquired from: gift of the Texas Historical Foundation with
support from a major grant from the Du Pont Company
and Conoco, its energy subsidiary, and assistance from
the Texas Commission on the Arts and the National
Endowment for the Arts

5904. **GIRLS' SOFTBALL GAME, ALBANY** [from
"Contemporary Texas: A Photographic Portrait"]
(P1985.17.144)
Gelatin silver print. 1984
Image: 8 9/16 x 13 in. (21.7 x 33.0 cm.)
Sheet: 11 x 14 in. (28.0 x 35.6 cm.)
Signed, l.r. print recto: "© Rick Williams '84"
Acquired from: gift of the Texas Historical Foundation with
support from a major grant from the Du Pont Company
and Conoco, its energy subsidiary, and assistance from
the Texas Commission on the Arts and the National
Endowment for the Arts

* 5905. **JERRY LEE ARNOLD, CLERK, CITY GROCERY,
ALBANY** [from "Contemporary Texas: A Photographic
Portrait"] (P1985.17.151)
Gelatin silver print. 1984
Image: 8 1/2 x 13 1/16 in. (21.6 x 33.2 cm.)
Sheet: 10 15/16 x 14 in. (27.8 x 35.6 cm.)
Signed, l.r. print recto: "© Rick Williams '84"
Acquired from: gift of the Texas Historical Foundation with
support from a major grant from the Du Pont Company
and Conoco, its energy subsidiary, and assistance from
the Texas Commission on the Arts and the National
Endowment for the Arts

* 5906. **ROUNDING UP STRAYS, MATADOR** [from
"Contemporary Texas: A Photographic Portrait"]
(P1985.17.142)
Gelatin silver print. 1984
Image: 8 9/16 x 13 in. (21.7 x 33.0 cm.)
Sheet: 11 x 13 15/16 in. (28.0 x 35.4 cm.)
Signed, l.r. print recto: "© Rick Williams '84"
Acquired from: gift of the Texas Historical Foundation with
support from a major grant from the Du Pont Company
and Conoco, its energy subsidiary, and assistance from
the Texas Commission on the Arts and the National
Endowment for the Arts

5907. **ROY HURD MOORE CLEANING STABLE, DAVIS
RANCH, MERKEL** [from "Contemporary Texas: A
Photographic Portrait"] (P1985.17.143)
Gelatin silver print. 1984
Image: 8 9/16 x 13 in. (21.7 x 33.0 cm.)
Sheet: 11 x 13 15/16 in. (28.0 x 35.4 cm.)
Signed, l.r. print recto: "© Rick Williams '84"
Acquired from: gift of the Texas Historical Foundation with
support from a major grant from the Du Pont Company
and Conoco, its energy subsidiary, and assistance from
the Texas Commission on the Arts and the National
Endowment for the Arts

5908. **SADDLE BLANKET AND HARNESS, GREEN RANCH,
ALBANY** [from "Contemporary Texas: A Photographic
Portrait"] (P1985.17.145)
Gelatin silver print. 1984
Image: 8 9/16 x 13 in. (21.7 x 33.0 cm.)
Sheet: 11 x 13 15/16 in. (28.0 x 35.4 cm.)
Signed, l.r. print recto: "© Rick Williams '84"
Acquired from: gift of the Texas Historical Foundation with
support from a major grant from the Du Pont Company
and Conoco, its energy subsidiary, and assistance from
the Texas Commission on the Arts and the National
Endowment for the Arts

WILLIAM WILMERDING,
American (1858–1932)

See *Camera Work*

5896

5905

5906

GARRY WINOGRAND, American (1928–1984)

Winogrand began photographing while in the U. S. Air Force. After his service commitment was over, he studied painting at the City College of New York and Columbia University. He returned to photography in 1951 and studied photojournalism with Alexey Brodovitch at the New School for Social Research in New York City. Although he worked as a commercial photographer after 1953, Winogrand is best known for his images of contemporary American life. Many of his images are historical in nature but capture a unique or humorous element of his subject. Winogrand taught photography at the University of Texas at Austin from 1973 until 1978.

*5909. **ALBUQUERQUE, N. M.** (P1986.2)
Gelatin silver print. negative 1957, print later by
 Garry Winogrand or Tom Consilvio
Image: 8⅝ x 13 in. (21.9 x 33.1 cm.)
Sheet: 11 x 13¹⁵⁄₁₆ in. (27.9 x 35.4 cm.)
Inscription, print verso: dealer's mark and rubber stamps
 "•FROM THE ESTATE OF•GARRY WINOGRAND/
 G. W." and "Printed by or under the supervision of
 Garry Winogrand./Copyright © 1984, The Estate of
 Garry Winogrand./All rights reserved./Executor
 [in pencil] Eileen Adele Hale"
Acquired from: Fraenkel Gallery, San Francisco, California

GARRY WINOGRAND (LP1980.65.1 and P1980.65.2–15)

This portfolio was published in 1978 by Hyperion Press Limited. The edition consists of 100 portfolios and 13 artist's proofs. This is portfolio number 67.

*5910. **CAPE KENNEDY, FLORIDA** (LP1980.65.1)
Gelatin silver print. negative 1969, print 1978
Image: 9 x 13½ in. (22.9 x 34.2 cm.)
Sheet: 11 x 14 in. (28.0 x 35.6 cm.)
Signed, l.l. print verso: "Garry Winogrand"
Inscription, print verso: "67"
 mat backing recto, embossed: "1"
Acquired from: long-term loan from George A. Peterkin, Jr.,
 Houston, Texas

5911. **NEW YORK CITY** (P1980.65.2)
Gelatin silver print. negative 1968, print 1978
Image: 9¹⁄₁₆ x 13½ in. (23.0 x 34.2 cm.)
Sheet: 11 x 14 in. (28.0 x 35.6 cm.)
Signed, l.l. print verso: "Garry Winogrand"
Inscription, print verso: "67"
 mat backing recto, embossed: "2"
Acquired from: gift of George A. Peterkin, Jr., Houston,
 Texas

5912. **UTAH** (P1980.65.3)
Gelatin silver print. negative 1964, print 1978
Image: 9¹⁄₁₆ x 13½ in. (23.0 x 34.2 cm.)
Sheet: 11 x 14 in. (28.0 x 35.6 cm.)
Signed, l.l. print verso: "Garry Winogrand"
Inscription, print verso: "67"
 mat backing recto, embossed: "3"
Acquired from: gift of George A. Peterkin, Jr., Houston,
 Texas

5913. **NEW YORK CITY** (P1980.65.4)
Gelatin silver print. negative 1967, print 1978
Image: 9 x 13½ in. (22.9 x 34.2 cm.)
Sheet: 11 x 14 in. (28.0 x 35.6 cm.)
Signed, l.l. print verso: "Garry Winogrand"
Inscription, print verso: "67"
 mat backing recto, embossed: "4"
Acquired from: gift of George A. Peterkin, Jr., Houston,
 Texas

*5914. **NEW YORK CITY** (P1980.65.5)
Gelatin silver print. negative 1969, print 1978
Image: 9 x 13½ in. (22.9 x 34.2 cm.)
Sheet: 11 x 14 in. (28.0 x 35.6 cm.)
Signed, l.l. print verso: "Garry Winogrand"
Inscription, print verso: "67"
 mat backing recto, embossed: "5"
Acquired from: gift of George A. Peterkin, Jr., Houston,
 Texas

5915. **NEW YORK CITY** (P1980.65.6)
Gelatin silver print. negative 1968, print 1978
Image: 9 x 13⁷⁄₁₆ in. (22.9 x 34.1 cm.)
Sheet: 11 x 13⁷⁄₈ in. (28.0 x 35.3 cm.)
Signed, l.l. print verso: "Garry Winogrand"
Inscription, print verso: "67"
 mat backing recto, embossed: "6"
Acquired from: gift of George A. Peterkin, Jr., Houston,
 Texas

5916. **NEW YORK CITY** (P1980.65.7)
Gelatin silver print. negative 1964, print 1978
Image: 13⅜ x 9¹⁄₁₆ in. (34.0 x 23.0 cm.)
Sheet: 14 x 11 in. (35.6 x 28.0 cm.)
Signed, right edge print verso: "Garry Winogrand"
Inscription, print verso: "67"
 mat backing recto, embossed: "7"
Acquired from: gift of George A. Peterkin, Jr., Houston,
 Texas

5917. **NEW YORK CITY** (P1980.65.8)
Gelatin silver print. negative 1971, print 1978
Image: 9 x 13⁷⁄₁₆ in. (22.9 x 34.1 cm.)
Sheet: 11 x 13⁷⁄₈ in. (28.0 x 35.3 cm.)
Signed, l.l. print verso: "Garry Winogrand"
Inscription, print verso: "67"
 mat backing recto, embossed: "8"
Acquired from: gift of George A. Peterkin, Jr., Houston,
 Texas

5918. **NEW YORK CITY** (P1980.65.9)
Gelatin silver print. negative 1963, print 1978
Image: 9¹⁄₁₆ x 13⁷⁄₁₆ in. (23.0 x 34.1 cm.)
Sheet: 11 x 13⁷⁄₈ in. (28.0 x 35.3 cm.)
Signed, l.l. print verso: "Garry Winogrand"
Inscription, print verso: "67"
 mat backing recto, embossed: "9"
Acquired from: gift of George A. Peterkin, Jr., Houston,
 Texas

5919. **TORONTO** (P1980.65.10)
Gelatin silver print. negative 1969, print 1978
Image: 9¹⁄₁₆ x 13⁷⁄₁₆ in. (23.0 x 34.1 cm.)
Sheet: 11 x 13⁷⁄₈ in. (28.0 x 35.3 cm.)
Signed, l.l. print verso: "Garry Winogrand"
Inscription, print verso: "67"
 mat backing recto, embossed: "10"
Acquired from: gift of George A. Peterkin, Jr., Houston,
 Texas

5920. **NEW YORK CITY** (P1980.65.11)
Gelatin silver print. negative 1972, print 1978
Image: 9 x 13⁷⁄₁₆ in. (22.9 x 34.1 cm.)
Sheet: 11 x 14 in. (28.0 x 35.6 cm.)
Signed, l.l. print verso: "Garry Winogrand"
Inscription, print verso: "67"
 mat backing recto, embossed: "11"
Acquired from: gift of George A. Peterkin, Jr., Houston,
 Texas

5921. **AUSTIN, TEXAS** (P1980.65.12)
Gelatin silver print. negative 1974, print 1978
Image: 9¹⁄₁₆ x 13⁷⁄₁₆ in. (23.0 x 34.1 cm.)
Sheet: 11 x 14 in. (28.0 x 35.6 cm.)

Signed, l.l. print verso: "Garry Winogrand"
Inscription, print verso: "67"
 mat backing recto, embossed: "12"
Acquired from: gift of George A. Peterkin, Jr., Houston,
 Texas

5922. **FORT WORTH, TEXAS** (P1980.65.13)
Gelatin silver print. negative 1974, print 1978
Image: 9 x 13 ½ in. (22.9 x 34.2 cm.)
Sheet: 11 x 14 in. (28.0 x 35.6 cm.)
Signed, l.l. print verso: "Garry Winogrand"
Inscription, print verso: "67"
 mat backing recto, embossed: "13"
Acquired from: gift of George A. Peterkin, Jr., Houston,
 Texas

*5923. **CASTLE ROCK, COLORADO** (P1980.65.14)
Gelatin silver print. negative 1960, print 1978
Image: 8 ⅞ x 13 ⅞₆ in. (22.6 x 34.1 cm.)
Sheet: 11 x 14 in. (28.0 x 35.6 cm.)
Signed, l.l. print verso: "Garry Winogrand"
Inscription, print verso: "67"
 mat backing recto, embossed: "14"
Acquired from: gift of George A. Peterkin, Jr., Houston,
 Texas

5924. **NEW YORK CITY** (P1980.65.15)
Gelatin silver print. negative 1968, print 1978
Image: 13 ⅞₆ x 9 ⅛₆ in. (34.1 x 23.0 cm.)
Sheet: 14 x 11 in. (35.6 x 28.0 cm.)
Signed, right edge print verso: "Garry Winogrand"
Inscription, print verso: "67"
 mat backing recto, embossed: "15"
Acquired from: gift of George A. Peterkin, Jr., Houston,
 Texas

GEORGE BEN WITTICK, American (1845–1903)

Wittick, born in Huntingdon, Pennsylvania, enlisted in
the Union army at the outbreak of the Civil War and
was stationed at Fort Snelling, Minnesota. Afterward
he moved to Moline, Illinois, where he ran a photo stu-
dio during the late 1870s. He then took a job with the
Atlantic and Pacific Railway (later the Atchison, Tope-
ka, and Santa Fe) and moved to New Mexico about
1878. There he formed a photographic partnership with
R. W. Russell that lasted from 1880 until 1884. Wittick
specialized in outdoor views, while Russell handled
most of the studio portrait work. It is quite likely that
many of the partnership's Indian portraits made during
this period are by Russell rather than Wittick. After the
partnership dissolved, Wittick moved to Gallup, New
Mexico, where he worked until 1900, eventually selling
his studio to the Imperial Photograph Gallery. He then
moved his operation to Fort Wingate, New Mexico,
where, assisted by his son, he ran the business until his
death in 1903.

5925. **AT THE SNAKE DANCE, MOQUI PUEBLO OF HUALPI,
ARIZONA** (P1979.83)
Toned gelatin silver print. 1897
Image: 7 ⁹⁄₁₆ x 9 ½ in. (19.2 x 24.2 cm.)
Mount: 7 ¹³⁄₁₆ x 9 ¾ in. (19.8 x 24.8 cm.)
Signed, l.r. in negative: "Copyright 1897/by/Ben Wittick/
 Photo"
Inscription, in negative: "No 695//At the Snake Dance,
 Moqui Pueblo of Hualpi, Arizona./The beginning of
 the Dance. August 21st 1897"
Acquired from: Bob Kapoun, Photo-Graphics, Ltd.,
 Santa Fe, New Mexico

5909

5910

5914

5923

5926. **FORT WINGATE [Fort Wingate, New Mexico]** (P1978.54)
Albumen silver print. c. 1900
Image: 4 15/16 x 7 3/4 in. (12.5 x 19.6 cm.)
Mount: 5 1/4 x 8 1/2 in. (13.4 x 21.7 cm.)
Signed: see inscription
Inscription, mount recto: "R-576//Fort Wingate//Pen inside"
mount verso, printed: "—VIEWS IN—/New Mexico,
Arizona and Old Mexico./Photographed by WITTICK &
SON./Ancient Ruins of the Caves and Cliff Dwellers, the
Pueblos, Grand Canon of/the Colorado, Walapai Indians,
Supias, Apaches, Navajos, Mojaves/Curiosities, etc., etc.
Views along the Atlantic & Pacific/Railroad in Arizona.
Views of the Petrified/Forest of Arizona./PUBLISHED BY/
WITTICK & SON,/ALBUQUERQUE, N. M./No.——"
Acquired from: Hastings Gallery, New York, New York

*5927. **A TRIP TO ZUNI. THE CEREMONY OF THE KA-KILA.
ARRIVAL OF THE KA-KILA AT THE CENTRAL
ESTUFA** (P1978.68)
Gelatin silver print. 1897
Image: 7 9/16 x 9 1/2 in. (19.2 x 24.1 cm.)
Mount: 7 13/16 x 9 5/8 in. (19.8 x 24.5 cm.)
Signed, l.r. in negative: "Ben Wittick/Photo"
Inscription, in negative: "A trip to Zuni. The ceremony of
the Ka-kila. Arrival of the Ka-kila at the central Estufa"
mount verso: "No 1/Arrival of the Ka-ki-la at Central
Estufa [remainder of inscription cut off]"
Acquired from: Photo-Graphics, Ltd., Santa Fe, New Mexico

MARION POST WOLCOTT,
American (1910–1990)

Marion Post Wolcott studied at both the New School
for Social Research and New York University before at-
tending the University of Vienna, Austria, where she
received her B.A. in 1934. In 1935 Wolcott studied pho-
tography with Ralph Steiner and worked as a freelance
photographer. During 1937 and 1938 she worked as a
staff photographer for the *Philadelphia Evening Bulletin*;
from 1938 to 1941 she worked in the Documentary Pho-
tography Section of the Farm Security Administration.
After 1942 Wolcott devoted herself to raising her family,
but in 1974 she resumed her career as a freelance pho-
tographer. She participated in a 1979 documentary film
project about the FSA. Wolcott's work has appeared in
volumes such as *Washington* (1939), *Hometown* (1940),
Vermont: The Green Mountain State (1941), *12 Million
Black Voices: A Folk History of the Negro in the United
States* (1941), and *Fair Is Our Land* (1942).

5928. **BAPTISM NEAR MOREHEAD, KY.** (P1983.35.13)
Gelatin silver print. negative 1940, print 1980
Image: 8 7/16 x 11 5/8 in. (21.4 x 29.5 cm.)
Sheet: 10 15/16 x 13 15/16 in. (27.8 x 35.4 cm.)
Signed, l.r. print verso: "Marion Post Wolcott"
Inscription, print verso: "Baptism near Morehead, Ky./
Photographed for FSA by MPW 1940/Archivally printed
by MPW 1980//55314 D"
Acquired from: gift of Dr. John Wolcott, Los Alamos,
New Mexico

5929. **BENNIE'S GROCERY STORE, SYLVANIA, GEORGIA**
(P1983.35.14)
Gelatin silver print. negative 1939, print 1977
Image: 9 1/16 x 11 15/16 in. (23.0 x 30.3 cm.)
Sheet: 11 x 13 15/16 in. (28.0 x 35.4 cm.)
Signed, l.r. print verso: "Marion Post Wolcott"
Inscription, print verso: "S.L.//Bennie's grocery store,
Sylvania, Georgia/Photographed 1939, for FSA/Archivally
Printed 1977, by MPW//51905 D"
Acquired from: gift of Dr. John Wolcott, Los Alamos,
New Mexico

5930. **BOY IN DOORWAY OF MOUNTAIN CABIN, HAND
HEWN LOGS, NEAR JACKSON, KY.** (P1983.35.18)
Gelatin silver print. negative 1939, print 1978
Image: 8 1/8 x 11 in. (20.6 x 27.9 cm.)
Sheet: 10 15/16 x 13 15/16 in. (27.8 x 35.4 cm.)
Signed, l.r. sheet recto and l.r. print verso: "Marion Post
Wolcott"
Inscription, print verso: "ST//Boy in doorway of mountain
cabin, hand hewn logs, near Jackson, Ky./Ky./Photographed
for FSA 1939/Printed by MPW 1978/Selenium toned MPW
1978//55829 D"
Acquired from: gift of Dr. John Wolcott, Los Alamos,
New Mexico

5931. **BUYERS & SALESMEN WAITING OUTSIDE MULE &
HORSE AUCTION, MONTGOMERY, ALA.** (P1983.35.6)
Gelatin silver print. negative 1939, print later
Image: 8 1/16 x 12 3/8 in. (20.6 x 31.4 cm.)
Sheet: 10 15/16 x 14 in. (27.8 x 35.6 cm.)
Signed, l.r. print verso: "Marion Post Wolcott"
Inscription, print verso: "STsp//Buyers & salesmen waiting
outside mule & horse auction, Montgomery, Ala.//30323
M3//FSA photo 1939"
Acquired from: gift of Dr. John Wolcott, Los Alamos,
New Mexico

5932. **CAMDEN, ALA. [Old Negro, near Camden, Ala. Clothes and
Shoes Badly Worn]** (P1983.35.2)
Gelatin silver print. negative 1939, print later
Image: 9 1/2 x 13 1/16 in. (24.1 x 33.1 cm.)
Sheet: 10 15/16 x 13 15/16 in. (27.8 x 35.4 cm.)
Signed, l.r. sheet recto and l.r. print verso:
"Marion Post Wolcott"
Inscription, print verso: "ST//Camden, Ala.//30350 M4"
Acquired from: gift of Dr. John Wolcott, Los Alamos,
New Mexico

5933. **DAUGHTER OF UNEMPLOYED COAL MINER
CARRYING HOME A CAN OF KEROSENE.
COMPANY HOUSING, SCOTTS RUN, W. VA.**
(P1983.35.10)
Gelatin silver print. negative 1938, print 1978
Image: 8 1/4 x 11 3/16 in. (20.9 x 28.4 cm.)
Sheet: 10 15/16 x 13 15/16 in. (27.8 x 35.4 cm.)
Signed, l.r. sheet recto and l.r. print verso:
"Marion Post Wolcott"
Inscription, print verso: "ST//Daughter of unemployed coal
miner carrying home a can/of Kerosene. Company housing,
Scotts Run, W. Va./Photographed for FSA 1938/Printed by
MPW 1978/Selenium toned, MPW 1978//30180 M2//?
ICP 71A"
Acquired from: gift of Dr. John Wolcott, Los Alamos,
New Mexico

5934. **DAY CARE CENTER ON FSA PROJECT, GEE'S BEND,
ALA. HOT LUNCH IN COMMUNITY BUILDING**
(P1983.35.9)
Gelatin silver print. negative 1939, print 1979
Image: 8 3/16 x 11 1/16 in. (20.7 x 28.1 cm.)
Sheet: 10 7/8 x 13 15/16 in. (27.7 x 35.4 cm.)
Signed, l.r. print verso: "Marion Post Wolcott"
Inscription, print verso: "Day care center on FSA project,
Gee's Bend, Ala. 1939/Hot lunch in community building/
Photographed for FSA by MPW 1939/Printed archivally
by MPW 1979//57238 D"
Acquired from: gift of Dr. John Wolcott, Los Alamos,
New Mexico

5935. **GUESTS OF SARASOTA TRAILER PARK, SARASOTA,
FLORIDA, ENJOYING THE SUN AND SEA BREEZE
AT THE BEACH** (P1983.35.5)
Gelatin silver print. negative 1941, print 1979
Image: 8 1/4 x 11 1/16 in. (20.9 x 28.1 cm.)
Sheet: 11 x 14 in. (28.0 x 35.6 cm.)

Signed, l.r. print verso: "Marion Post Wolcott/Marion Post Wolcott"

Inscription, print verso: "ST//Photographed for FSA 1939 (or 1940?)/Archivally printed by MPW 1979/Selenium toned by MPW 1979//56924E"

Acquired from: gift of Dr. John Wolcott, Los Alamos, New Mexico

*5936. **MAIN STREET, BRATTLEBORO, VT. DURING BLIZZARD** (P1983.35.1)
Gelatin silver print. negative 1940, print 1978
Image: 8 3/16 x 11 1/16 in. (20.8 x 28.1 cm.)
Sheet: 10 15/16 x 13 15/16 in. (27.8 x 35.4 cm.)
Signed, l.r. print verso: "Marion Post Wolcott"
Inscription, print verso: "ST//Main street, Brattleboro, Vt. during blizzard./Photographed for FSA 1940/Printed by MPW 1978/Selenium toned " [MPW] " [1978]//53014 D"
Acquired from: gift of Dr. John Wolcott, Los Alamos, New Mexico

5937. **MIAMI BEACH, FLA. THE ENTRANCE TO ONE OF THE BETTER HOTELS** (P1983.35.12)
Gelatin silver print. negative 1939, print later
Image: 11 3/8 x 8 9/16 in. (28.8 x 21.7 cm.)
Sheet: 13 15/16 x 11 in. (35.4 x 27.9 cm.)
Signed, l.r. print verso: "Marion Post Wolcott"
Acquired from: gift of Dr. John Wolcott, Los Alamos, New Mexico

5938. **MIGRANT VEGETABLE PICKERS WAITING IN LINE BEHIND TRUCK TO BE PAID OFF. NEAR BELLE GLADE, FLA.** (P1983.35.19) cropped duplicate of P1983.35.20
Gelatin silver print. negative 1939, print later
Image: 8 5/8 x 12 in. (21.9 x 30.5 cm.)
Sheet: 10 15/16 x 14 in. (27.8 x 35.5 cm.)
Signed, l.r. sheet recto and l.r. print verso: "Marion Post Wolcott"
Inscription, print verso: "Migrant vegetable pickers waiting in line behind truck/to be paid off. Near Belle Glade, Fla.//29//30491M3"
Acquired from: gift of Dr. John Wolcott, Los Alamos, New Mexico

5939. **MIGRANT VEGETABLE PICKERS WAITING IN LINE IN FIELD, BEHIND TRUCK NEAR BELLE GLADE, FLA.** (P1983.35.20) uncropped duplicate of P1983.35.19
Gelatin silver print. negative 1939, print 1978
Image: 8 3/8 x 12 3/8 in. (21.3 x 31.4 cm.)
Sheet: 11 x 14 in. (28.0 x 35.6 cm.)
Signed, l.r. sheet recto and l.r. print verso: "Marion Post Wolcott"
Inscription, print verso: "ST//Migrant vegetable pickers waiting in line in field, behind truck/near Belle Glade, Fla./Photographed for FSA 1939/Printed by MPW 1978/Selenium toned " [MPW] 1978//5/Dec. 78/C//30491M5 //835"
Acquired from: gift of Dr. John Wolcott, Los Alamos, New Mexico

5940. **MIGRANT VEGETABLE PICKERS WAITING IN LINE TO BE PAID OFF. MANY ARE TRUCKED IN DAILY FROM NEARBY TOWNS TO THE FIELDS. BELLE GLADE, FLA.** (P1983.35.16)
Gelatin silver print. negative 1939, print later
Image: 8 1/16 x 11 1/2 in. (20.5 x 29.2 cm.)
Sheet: 10 15/16 x 13 15/16 in. (27.8 x 35.4 cm.)
Signed, l.r. print verso: "Marion Post Wolcott"
Inscription, print verso: "ST//Migrant vegetable pickers waiting in line to be paid/off. Many are trucked in daily from nearby towns/to the fields. Belle Glade, Fla. 1939//30491 M1"
Acquired from: gift of Dr. John Wolcott, Los Alamos, New Mexico

5927

5936

5942

5941. **NEAR WADESBORO, N. C. SHARECROPPER'S CHILDREN YOUNGER ONE WITH RICKETS, FROM MALNUTRITION, ON POOR ERODED LAND EXHAUSTED FROM TOBACCO-COTTON CULTURE** (P1983.35.3)
Gelatin silver print. negative 1938, print 1980
Image: 8 5/8 x 8 15/16 in. (21.8 x 22.7 cm.)
Sheet: 14 x 11 in. (35.6 x 28.0 cm.)
Signed, bottom center print verso: "Marion Post Wolcott"
Inscription, print verso: "Near Wadesboro, N. C./ Sharecropper's children younger one with/rickets, from malnutrition, on poor eroded/land exhausted from tobacco-cotton culture./Photographed for FSA by MPW 1938/ Archivally processed " " [by MPW] 1980//50720 E"
Acquired from: gift of Dr. John Wolcott, Los Alamos, New Mexico

*5942. **PACKING HOUSE WORKERS' OR PICKERS' (MIGRANTS) CHILD IN ENTRANCE TO SHACK. THEY MUST CLEAR LAND, PAY $5 A MONTH, NO SANITARY FACILITIES OR LIGHTS, WATER MUST BE HAULED SOME DISTANCE. NEAR BELLE GLADE, FLA.** (P1983.35.15)
Gelatin silver print. negative 1939, print 1978
Image: 8 3/16 x 11 1/4 in. (20.8 x 28.5 cm.)
Sheet: 10 15/16 x 13 15/16 in. (27.8 x 35.4 cm.)
Signed, l.r. print verso: "Marion Post Wolcott"
Inscription, print verso: "Packing house workers' or pickers' (migrants) child in entrance to/shack. They must clear land, pay $5 a month, no sanitary facilities/or lights, water must be hauled some distance. Near Belle Glade, Fla./1939/ Photographed for FSA by MPW/Archivally printed by MPW 1978//51159 D"
Acquired from: gift of Dr. John Wolcott, Los Alamos, New Mexico

*5943. **SIGNS AT CARNIVAL, STRAWBERRY FESTIVAL, PLANT CITY, FLA.** (P1983.35.4)
Gelatin silver print. negative 1939, print 1978
Image: 8 x 11 1/2 in. (20.3 x 29.1 cm.)
Sheet: 10 15/16 x 14 in. (27.8 x 35.6 cm.)
Signed, l.r. print verso: "Marion Post Wolcott"
Inscription, print verso: "ST//Signs at carnival, strawberry festival, Plant City, Fla./Photographed for FSA by MPW 1939/Archivally printed by MPW 1978/Selenium toned " " [by MPW] 1978//30477M4"
Acquired from: gift of Dr. John Wolcott, Los Alamos, New Mexico

*5944. **TWO OF UNEMPLOYED MIGRANT PICKERS' CHILDREN ON BED IN THEIR QUARTERS, NEAR BELLE GLADE, FLA.** (P1983.35.17)
Gelatin silver print. negative 1940, print 1978
Image: 8 7/16 x 11 1/4 in. (21.4 x 28.5 cm.)
Sheet: 10 15/16 x 14 in. (27.8 x 35.5 cm.)
Signed, l.r. print verso: "Marion Post Wolcott"
Inscription, print verso: "ST//Two of unemployed migrant pickers' children on bed/in their quarters, near Belle Glade, Fla./Photographed for FSA 1940/Printed by MPW 1978/Selenium toned " [1978]//50119 D"
Acquired from: gift of Dr. John Wolcott, Los Alamos, New Mexico

5945. **UNEMPLOYED MINER'S WIFE, WITH TUBERCULOSIS. COMPANY HOUSING, MARINE, W. VA.** (P1983.35.11)
Gelatin silver print. negative 1938, print 1978
Image: 10 5/8 x 8 3/8 in. (27.0 x 21.3 cm.)
Sheet: 14 x 10 15/16 in. (35.6 x 27.8 cm.)
Signed, l.r. print verso: "Marion Post Wolcott"
Inscription, print verso: "Unemployed miner's wife, with tuberculosis./Company housing, Marine, W. Va. 1938/ Photographed for FSA by MPW 1938/Archivally printed by MPW 1978//50243E"
Acquired from: gift of Dr. John Wolcott, Los Alamos, New Mexico

*5946. **WINTER TOURISTS PICNICKING ON BEACH NEAR SARASOTA, FLA.** (P1983.35.7)
Gelatin silver print. negative 1941, print 1980
Image: 8 3/4 x 11 3/4 in. (22.2 x 29.9 cm.)
Sheet: 10 15/16 x 14 in. (27.8 x 35.6 cm.)
Signed, l.r. print verso: "Marion Post Wolcott"
Inscription, print verso: "Winter tourists picnicing on beach near Sarasota, Fla./Photographed for FSA by MPW 1941/ Printed, archivally by MPW 1980//56952D"
Acquired from: gift of Dr. John Wolcott, Los Alamos, New Mexico

5947. **WINTER VISITOR BEING SERVED BRUNCH IN A PRIVATE CLUB, PALM BEACH, FLA.** (P1983.35.8)
Gelatin silver print. negative 1940, print 1980
Image: 8 3/16 x 11 5/16 in. (20.7 x 28.7 cm.)
Sheet: 11 x 14 in. (28.0 x 35.6 cm.)
Signed, l.r. print verso: "Marion Post Wolcott"
Inscription, print verso: "Winter visitor being served brunch in a private club,/Palm Beach, Fla./Photographed for FSA by MPW 1940/Archivally printed by MPW 1980// 30493 M2"
Acquired from: gift of Dr. John Wolcott, Los Alamos, New Mexico

JOHN WOOD, American (active 1860s)

See *Gardner's Photographic Sketch Book of the War*

MYRON WOOD, American (b. 1921)

Myron Wood studied with Edward Weston before embarking on a career as a photographer. Beginning in the early 1950s his work focused on Colorado and the Southwest. From 1951 to 1961 Wood was the photographer and assistant curator for photography at the Taylor Museum of the Colorado Springs Fine Arts Center. He also became the photographer for The Colorado College in 1958. In 1973 he began a project commissioned by the Public Library of the City and County of Pueblo, Colorado, to document the architecture, landscape, people, and culture of the area. Wood photographed Georgia O'Keeffe in New Mexico from 1979 to 1981 and began a project photographing prominent Hopi, Zuni, and Navajo women in 1986. Wood's photographs were made using 35mm cameras to produce finely detailed prints.

5948. **FRED MAZZULLA; DENVER** (P1981.48.2)
Gelatin silver print. negative 1975, print 1981
Image: 9 1/2 x 6 5/16 in. (24.1 x 16.1 cm.)
Mount: 15 1/2 x 12 5/8 in. (39.3 x 32.1 cm.)
Signed, l.r. mount recto: "Myron Wood"
Inscription, mount recto: "3·75"
mount verso: "37513-24/Fred Mazulla [sic]; Denver/1975/ Myron Wood/(pr. '81)/MW"
Acquired from: the photographer

5949. **LAURA GILPIN [seated, holding a book]** (P1985.9.1)
Gelatin silver print. 1974
Image: 5 7/8 x 4 3/16 in. (14.9 x 10.6 cm.)
Sheet: 10 x 8 in. (25.3 x 20.3 cm.)
Signed: see inscription
Inscription, print verso: "2743-22" and rubber stamp "MYRON WOOD/20 WEST COLUMBIA [in pencil] 413 E. Bijou/COLO. SPRINGS, COLO. 80907 [in pencil] 3/ (303) 635-7844 [in pencil] 475-1602"
Acquired from: gift of the photographer

5950. **LAURA GILPIN [in front of her father's highboy]** (P1985.9.2)
Gelatin silver print. 1973
Image: 9½ x 6⁷⁄₁₆ in. (24.1 x 16.4 cm.)
Sheet: 10 x 8 in. (25.3 x 20.3 cm.)
Signed: see inscription
Inscription, print verso: "2743-33" and rubber stamp
"MYRON WOOD/20 WEST COLUMBIA [in pencil] 413
E. Bijou/COLO. SPRINGS, COLO 80907 [in pencil] 3/
(303) 635-7844 [in pencil] 475-1602"
Acquired from: gift of the photographer

5951. **LAURA GILPIN** (P1985.9.3)
Gelatin silver print. negative 1973, print 1974
Image: 8⅜ x 5¾ in. (21.2 x 14.5 cm.)
Sheet: 10 x 8¹⁄₁₆ in. (25.3 x 20.4 cm.)
Signed, center print verso: "Myron Wood"
Inscription, print verso: "J7312-12/[signature]/303-475-1602"
Acquired from: gift of the photographer

*5952. **LOS HERMANOS DE NUESTRO PADRE JESUS**
(P1981.48.4)
Gelatin silver print. negative 1976, print 1981
Image: 12⁷⁄₁₆ x 17⅝ in. (31.6 x 44.8 cm.)
Mount: 19¹⁄₁₆ x 23¹¹⁄₁₆ in. (48.4 x 60.2 cm.)
Signed, l.r. mount recto: "Myron Wood"
Inscription, mount recto: "4'76"
mount verso: "47617-31/Los Hermanos de Nuestro Padre
Jesus/Myron Wood/(pr. '81)/MW"
Acquired from: the photographer

5953. **MITCHELL A. WILDER** (P1981.49)
Gelatin silver print. negative 1975, print 1979
Image: 9⅜ x 6³⁄₁₆ in. (23.8 x 15.7 cm.)
Mount: 15½ x 12⅝ in. (39.3 x 32.1 cm.)
Signed, l.r. mount recto: "Myron Wood"
Inscription, mount recto: "4'75"
mount verso: "4759-24/Mitchell A. Wilder. 1975/
Myron Wood/(pr. 1979)/MW"
Acquired from: gift of Sally Wilder, Fort Worth, Texas

5954. **SHEEP, STORM; SOUTH PARK, COLORADO**
(P1981.48.3)
Gelatin silver print. negative 1967, print 1981
Image: 8⅛ x 12¼ in. (20.6 x 31.1 cm.)
Mount: 14 x 18 in. (35.6 x 45.7 cm.)
Signed, l.r. mount recto: "Myron Wood"
Inscription, mount recto: "6'67"
mount verso: "66735-7/Sheep, storm; South Park,
Colorado/Myron Wood/(pr. '81)/M.W."
Acquired from: the photographer

*5955. **SNOWY FIELDS & CATTLE: TAOS, N. MEX.** (P1981.48.1)
Gelatin silver print. negative 1973, print 1981
Image: 6⁵⁄₁₆ x 9½ in. (16.0 x 24.1 cm.)
Mount: 12⅝ x 15½ in. (32.1 x 39.3 cm.)
Signed, l.r. mount recto: "Myron Wood"
Inscription, mount recto: "3'73"
mount verso: "3738-7/Snowy fields & cattle: Taos, N. Mex.
1973/Myron Wood/(pr. '81)/MW"
Acquired from: the photographer

LOUISE DESHONG WOODBRIDGE,
American (1848–1925)

Louise Deshong Woodbridge was a wealthy society
woman and arts patron. A resident of Chester, Penn-
sylvania, Woodbridge began to make photographs
about 1884 with the help of friends John G. Bullock,
Robert S. Redfield, and Henry Troth, who were all pho-
tographers. Woodbridge exhibited her work at the
Sixth Annual Joint Exhibition of Photography in Phil-
adelphia and at the 1893 World Columbian Exhibition.
She also had a strong interest in science and supported
a series of botanical lectures at the University of Penn-
sylvania for twenty-five years.

5943

5944

5946

*5956. **YELLOWSTONE "GRAND VIEW"** (P1981.70)
Platinum print. c. 1912
Image: 3 7/16 x 4 11/16 in. (8.8 x 11.9 cm.)
Inscription, print verso: "Louise Deshong Woodbridge/
Yellowstone/Platinum c.1912//xx7 Yellowstone "Grand
View-M.P."
Acquired from: Janet Lehr, Inc., New York, New York

DAVID B. WOODBURY,
American (active 1860s)

See *Gardner's Photographic Sketch Book of the War*

WILLARD E. WORDEN, American (1873–1946)

Worden was born in Delaware and moved to Phila-
delphia to study painting just before the Spanish-
American War broke out. He left his studies and
joined the Third Pennsylvania Infantry, taking a small
camera with him to the front. He returned an enthusi-
astic photographer; after a second military assignment
in the Philippines with the Eleventh U. S. Volunteers,
he settled in San Francisco and opened a studio in the
Cliff House in 1902. He ran the studio operation for the
next thirty years, making photographs of West Coast
landscapes, San Francisco and Chinatown, and the
1906 earthquake. In 1915 Worden was the official pho-
tographer for the Panama Pacific Exhibition. He died
in relative obscurity, leaving his collection to the Wells
Fargo Bank Room in San Francisco.

5957. **[Cliffs and stream]** (P1979.84.3)
Toned platinum print. c. 1902–10
Image: 4 x 6 in. (10.2 x 15.2 cm.)
Signed: see inscription
Inscription, print verso, rubber stamp: "—212—/
WILLARD E. WORDEN/PHOTO, S. F. CAL."
Acquired from: Stephen White Gallery, Los Angeles,
California

*5958. **[Flooded Meadow; or Pillars of Hercules, Columbia River,
Oregon]** (P1979.84.1)
Toned platinum print. c. 1902–10
Image: 6 7/8 x 4 15/16 in. (17.4 x 12.5 cm.)
Sheet: 7 x 5 in. (17.7 x 12.6 cm.)
Signed: see inscription
Inscription, print verso, rubber stamp: "—227—/
WILLARD E. WORDEN/PHOTO, S. F. CAL."
Acquired from: Stephen White Gallery, Los Angeles,
California

5959. **[Lake reflections]** (P1979.84.5)
Toned platinum print. c. 1902–10
Image: 4 9/16 x 7 in. (11.6 x 17.7 cm.)
Sheet: 4 15/16 x 7 in. (12.6 x 17.7 cm.)
Inscription, in negative: "TURNE[illegible]/C.F."
Acquired from: Stephen White Gallery, Los Angeles,
California

*5960. **[Mount Shasta, California]** (P1979.84.6)
Toned platinum·print. c. 1902–10
Image: 7 x 5 in. (17.7 x 12.7 cm.)
Signed: see inscription
Inscription, print verso, rubber stamp: "—2054—/
WILLARD E. WORDEN/PHOTO, S. F. CAL."
Acquired from: Stephen White Gallery, Los Angeles,
California

5961. **[Oneonta Gorge, Oregon]** (P1979.84.2)
Toned platinum print. c. 1902–10
Image: 6 13/16 x 4 15/16 in. (17.3 x 12.5 cm.)
Sheet: 7 x 5 in. (17.7 x 12.7 cm.)
Signed: see inscription

Inscription, print verso, rubber stamp: "—210—/
WILLARD E. WORDEN/PHOTO, S. F. CAL."
Acquired from: Stephen White Gallery, Los Angeles,
California

5962. **[Railroad through forest]** (P1979.84.4)
Toned platinum print. c. 1902–10
Image: 4 7/8 x 6 13/16 in. (12.3 x 17.3 cm.)
Sheet: 5 x 7 in. (12.7 x 17.7 cm.)
Signed: see inscription
Inscription, print verso, rubber stamp: "—219—/
WILLARD E. WORDEN/PHOTO, S. F. CAL."
Acquired from: Stephen White Gallery, Los Angeles,
California

MAX YAVNO, American (1911–1985)

After earning a B.S.S. and doing graduate work in po-
litical economics, Max Yavno began studying photogra-
phy at the Photo League. In 1937 he joined the Works
Progress Administration as a photographer and worked
there until 1942, when he became an Army Air Force
photographer. After his discharge in 1945 he settled in
San Francisco and began a career as a freelance land-
scape, documentary, and commercial photographer.
In 1952 Yavno sold twenty photographs to the Museum
of Modern Art in New York, and the next year he re-
ceived a Guggenheim Fellowship. Financial hardship
forced him to open a commercial photography studio,
which he ran until 1974. His advertising photographs
appeared in magazines such as *Vogue* and *Harper's Ba-
zaar*, and he won two New York Art Directors Club
Gold Medals (1954 and 1955). In 1975 Yavno returned
to his personal work. He traveled to Israel and Egypt
in 1979 on a National Endowment for the Arts grant.
Yavno's work has been published in several books, in-
cluding *The San Francisco Book* (1948), *The Los Angeles
Book* (1950), and *The Photography of Max Yavno* (1981),
and in three portfolios.

*5963. **HOT DOG [Tail o' the Pup, Los Angeles]** (P1985.18)
Gelatin silver print. negative 1949, print c. 1983
Image: 10 7/16 x 13 9/16 in. (26.4 x 34.4 cm.)
Sheet: 10 15/16 x 14 in. (27.8 x 35.6 cm.)
Signed, l. r. print verso: "yavno"
Inscription, print verso: "C 150/#1/12 sec f16/−2 B/−5 rt/+12
TC/+2 BR/+2 BL//#3795-C"
Acquired from: The Afterimage, Dallas, Texas

MARILYN ZIMMERMAN, American (b. 1952)

Marilyn Zimmerman received a B.A. from Purdue
University in 1974 and an M.F.A. from the School of
the Art Institute of Chicago in 1979, where she stud-
ied with Barbara Crane, Ken Josephson, and Joyce
Neimanas. Since 1978 Zimmerman has taught pho-
tography at Wayne State University. She has received
research grants from Austin Peay State University and
Wayne State University and an MCA Creative Artist
grant. Zimmerman recently began research on Comtal
distorted video-generated photographic color imagery.
She describes her work as "formally composed images
of fabric camouflaged in natural environments."

5964. **UNTITLED [from the Society for Photographic Education's
"South Central Regional Photography Exhibition"]**
(P1983.31.18)
Type C color print. 1980
Image: 9 1/4 x 9 1/4 in. (23.5 x 23.5 cm.)
Sheet: 14 x 11 in. (35.6 x 28.0 cm.)
Acquired from: gift of the Society for Photographic
Education, South Central Region

5952

5955

5956

5958

5960

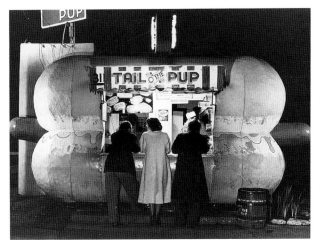

5963

Bibliography

The intent of this bibliography is to cite the most comprehensive published works about each photographer represented in the catalogue. These entries, therefore, concentrate on publications which contain bibliographies of writings about and by the photographer, plus exhibition chronologies. Recent contributions to the literature for each photographer have been added where appropriate. In many instances the most concise and up-to-date bibliography for each photographer may be found in the biographical directories noted at the head of each entry (complete titles listed below). Researchers interested in the history of photography are advised to consult the standard surveys, such as Beaumont Newhall's *The History of Photography, from 1839 to the Present*, 5th edition (New York: Museum of Modern Art, 1982) and Naomi Rosenblum's *A World History of Photography*, revised edition (New York: Abbeville, 1989). For those photographers represented in the Amon Carter Museum about whom little is known, some unpublished materials may exist in the archives of the Museum. This is indicated by the acronym ACM.

Auer = Michèle Auer and Michel Auer. *Photographers Encyclopaedia International, 1839 to the Present.* 2 vols. Geneva, Switzerland: Editions Camera Obscura, 1985.

ICP = International Center of Photography. *Encyclopedia of Photography.* New York: Crown Publishers, Inc., 1984.

Johnson = William S. Johnson. *Nineteenth-Century Photography: An Annotated Bibliography, 1839-1879.* Boston: G.K. Hall, 1990.

Macmillan = Turner Browne and Elaine Partnow. *Macmillan Biographical Encyclopedia of Photographic Artists & Innovators.* New York: Macmillan, 1983.

Naylor = Colin Naylor, ed. *Contemporary Photographers.* 2nd edition. Chicago: St. James Press, 1988.

WWAA 19 = *Who's Who in American Art, 1991–92.* 19th edition. New Providence, New Jersey: R.R. Bowker, 1990.

MILAN R. HUGHSTON, Librarian

ABBOTT, BERENICE
Auer, ICP, Macmillan, Naylor

Lyons, Nathan, ed. *Photographers on Photography.* Englewood Cliffs, New Jersey: Prentice-Hall, 1966.

Mitchell, Margaretta K. *Recollections: Ten Women of Photography.* New York: Viking Press, 1979.

O'Neal, Hank. *Berenice Abbott: American Photographer.* New York: McGraw-Hill, 1982.

Van Haaften, Julia. *Berenice Abbott.* New York: Aperture, 1988.

ADAMS, ANSEL
Auer, ICP, Macmillan, Naylor

Adams, Ansel. *Ansel Adams: Images 1923–1974.* Boston: New York Graphic Society, 1974.

Alinder, James, ed. "Ansel Adams, 1902–1984." *Untitled* 37 (1984): 1–56.

Alinder, Mary Street, and Andrea Gray Stillman, eds. *Ansel Adams: Letters and Images, 1916–1984.* Boston: New York Graphic Society, 1988.

Ansel Adams: An Autobiography. Boston: New York Graphic Society, 1985.

De Cock, Liliane, ed. *Ansel Adams.* Hastings-on-Hudson, New York: Morgan & Morgan, 1972.

Myers, Roger, comp. *Guide to Archival Materials of the Center for Creative Photography.* Tucson: Center for Creative Photography, University of Arizona, 1986.

ADAMS, ROBERT
Auer, Macmillan, Naylor, WWAA 19

Adams, Robert. *Beauty in Photography: Essays in Defense of Traditional Values.* Millerton, New York: Aperture, 1981.

Adams, Robert. *To Make it Home: Photographs of the American West.* New York: Aperture, 1989.

Baltz, Lewis, ed. *Contemporary American Photographic Works.* Houston: Museum of Fine Arts, 1977.

ALVAREZ BRAVO, MANUEL
Auer, ICP, Macmillan, Naylor

Alvarez Bravo, Manuel. *Manuel Alvarez Bravo.* New York: Aperture, 1987.

Livingston, Jane. *M. Alvarez Bravo.* Boston: David R. Godine, 1978.

Museum of Photographic Arts. *Revelaciones: The Art of Manuel Alvarez Bravo.* San Diego: Museum of Photographic Arts, 1990.

ANDERSON, PAUL L.
Macmillan

Anderson, Paul L. *The Fine Art of Photography.* Philadelphia: J.P. Lippincott, 1919.

———. *Photography: Its Principles and Practices.* Philadelphia: J.P. Lippincott, 1917.

———. *Pictorial Landscape-Photography.* Boston: Wilfred A. French, 1914.

Bender, Donna, comp. *Paul Anderson: Photographs.* Tucson: Center for Creative Photography, University of Arizona, Guide Series No. 7, 1983.

Myers, Roger, comp. *Guide to Archival Materials of the Center for Creative Photography.* Tucson: Center for Creative Photography, University of Arizona, 1986.

Pitts, Terence R. "Paul Lewis Anderson: A Life in Photography." *Archive,* no. 18 (May 1983): 4–36.

ANGLE, LEE
"Lee Angle Photography Stars Fort Worth Skyline." *Fort Worth Star Telegram*, September 12, 1983, p. 6D.

ARBUS, DIANE
Auer, ICP, Macmillan, Naylor

Arbus, Diane. *Diane Arbus*. Millerton, New York: Aperture, 1972.

Arbus, Doon, and Marvin Israel, eds. *Diane Arbus Magazine Work*. Millerton, New York: Aperture, 1984.

Bosworth, Patricia. *Diane Arbus: A Biography*. New York: Alfred A. Knopf, 1984.

"Diane Arbus: A Monograph of Seventeen Photographs." *Picture Magazine*, no. 16 (1980).

Livingston, Jane. *The New York School: Photographs 1936–1963*. New York: Stewart, Tabori and Chang, 1992.

ARMSTRONG, FRANK
Macmillan

Armstrong, Frank. *Photography in the West: A Modern View*. Corning, New York: The Rockwell Museum, 1987.

Sandweiss, Martha A., ed. *Contemporary Texas: A Photographic Portrait*. Austin: Texas Monthly Press, 1986.

AUBERT, FRANCOIS
Auer

Ceysenes, Alain. "Francois Aubert et la photographie au Mexique." In *Charlotte et Maximilien: Les Belges au Mexique, 1864–1867*, pp. 113–142. Woluwe-Saint-Lambert: Fondation Albert Marinus, 1987.

Gimon, Gilbert. "Le 19 Juin 1867, Maximilien 1er, Empereur du Mexique, est execute a l'aube. Francois Aubert 'couvre' l'evenement." *Prestige de la Photographie*, no. 3 (December 1977): 80–107.

AVEDON, RICHARD
Auer, ICP, Macmillan, Naylor, WWAA 19

Avedon, Richard. *Avedon: Photographs, 1947–1977*. New York: Farrar, Straus & Giroux, 1978.

————. *In the American West*. New York: Harry N. Abrams, 1985.

Livingston, Jane. *The New York School: Photographs 1936–1963*. New York: Stewart, Tabori and Chang, 1992.

Tucker, Anne W., ed. *Target III: In Sequence*. Houston: Museum of Fine Arts, 1982.

BAER, MORLEY
ACM, Macmillan, WWAA 19

Baer, Morley. *Light Years: The Photographs of Morley Baer*. Carmel, Calif.: Photography West Graphics, 1988.

Fink, Augusta. *Adobes in the Sun: Portraits of a Tranquil Era*. San Francisco: Chronicle Books, 1972.

BALDWIN, FREDERICK C.
Auer

Baldwin, Frederick C. "...We Ain't What We Used to Be." Savannah, Ga.: Telfair Academy of Arts and Sciences, 1983.

Sandweiss, Martha A., ed. *Contemporary Texas: A Photographic Portrait*. Austin: Texas Monthly Press, 1986.

Williams, Rick. *Visiones de Tejanos/Visions of Texas*. Austin: Texas Photographic Society, Inc., 1989.

BARKER, GEORGE
Johnson

Bannon, Anthony. *The Taking of Niagara: A History of the Falls in Photography*. Buffalo: Media Study/Buffalo, 1982.

Barker, George. "The Ice Bridge at Niagara." *Harper's Weekly*, February 3, 1884, pp. 74, 76.

"George Barker Dead—The Eminent Photographer." *Niagara Falls Gazette*, November 27, 1894, sec. 1, p. 7.

"A Good Citizen Gone." [Niagara Falls, New York] *Daily Cataract*, November 27, 1894, sec. 8, p. 4.

BARNARD, GEORGE N.
Auer, ICP, Johnson, Macmillan

Barnard, George N. *Photographic Views of Sherman's Campaign*. New York: Dover Publications, Inc., 1977.

Davis, Keith F. " 'The Chattanooga Album' and George N. Barnard." *Image* 23 (December 1980): 20–27.

————. *George N. Barnard: Photographer of Sherman's Campaign*. Kansas City: Hallmark Cards, Inc., 1990.

Davis, William C., ed. *The Image of War, 1861–1865*. 6 vols. Garden City, New York: Doubleday & Co., 1984.

Pare, Richard. *Photography and Architecture: 1839–1939*. Montreal: Canadian Center for Architecture, 1982.

Slosek, Anthony M. *Oswego County, New York, in the Civil War*. Oswego, New York: Oswego County Civil War Centennial Committee, 1964.

Sweet, Timothy. *Traces of War: Poetry, Photography, and the Crisis of the Union*. Baltimore: The Johns Hopkins University Press, 1990.

BARNBAUM, BRUCE
ACM, Macmillan

Barnbaum, Bruce. *Visual Symphony: A Photographic Work in Four Movements*. New York: Alfred Van Der Marck Editions, 1986.

BEATO, FELICE
Auer, ICP, Johnson, Macmillan

Felice Beato in Japan: Photographien zum Ende der Feudalzeit, 1863–1873. Heidelberg: Edition Braus, 1991.

Osman, Colin. "The Beato Brothers: An Attempt at Nomenclature." *Royal Photographic Society Historical Group Quarterly*, no. 79 (Winter 1987): 2–3.

White, Stephen. "Felix Beato and the First Korean War, 1871." *Photographic Collector* 3 (Spring 1982): 76–85.

BELL, WILLIAM
Johnson

Cahn, Robert, and Robert Glenn Ketchum. *American Photographers and the National Parks*. New York: Viking Press, 1981.

Finkel, Kenneth. *Nineteenth-Century Photography in Philadelphia*. New York: Dover Publications, 1980.

Pitts, Terence Randolph. *William Bell: Philadelphia Photographer*. Master's thesis, University of Arizona, 1987.

Wheeler, George M. *Wheeler's Photographic Survey of the American West, 1871–1893*. New York: Dover Publications, 1983.

BENRIMO, DOROTHY
ACM

Benrimo, Dorothy, Rebecca Salsbury James, and E. Boyd. *Camposantos*. Fort Worth: Amon Carter Museum, 1966.

Pasadena Art Museum. *Dorothy S. Benrimo*. Pasadena, Calif.: Pasadena Art Museum, 1972.

BERNHARD, RUTH
Auer, Macmillan, Naylor, WWAA 19

Alinder, James. *Collecting the Light: The Photographs of Ruth Bernhard*. Untitled, 20. Carmel, Calif.: Friends of Photography, 1979.

Bernhard, Ruth. *The Eternal Body: A Collection of Fifty Nudes*. Carmel, Calif.: Photography West Graphics, 1986.

Mitchell, Margaretta K. *Recollections: Ten Women of Photography*. New York: Viking Press, 1979.

BINKS, RONALD C.
ACM, Macmillan, WWAA 19

BLACKSTONE, RENNY
ACM

BLOCK, GAY
Auer, Macmillan, WWAA 19

Sandweiss, Martha A., ed. *Contemporary Texas: A Photographic Portrait*. Austin: Texas Monthly Press, 1986.

BONAR, AVE

Bonar, Ave. *Paradise*. McAllen, Texas: McAllen International Museum, 1986.

Leissner, Bill. "An Interview with Ave Bonar." *Photo Letter* 7 (Summer 1986): 5–8.

Sandweiss, Martha A., ed. *Contemporary Texas: A Photographic Portrait*. Austin: Texas Monthly Press, 1986.

Williams, Rick. *Visiones de Tejanos/Visions of Texas*. Austin: Texas Photographic Society, Inc., 1989.

BOND, HOWARD

ACM, Macmillan

Bond, Howard. *Light Motifs*. Ann Arbor, Mich.: Goodrich Press, 1984.

BONES, JIM

Macmillan

Sandweiss, Martha A., ed. *Contemporary Texas: A Photographic Portrait*. Austin: Texas Monthly Press, 1986.

BOORNE, W. HANSON

ACM

Koltun, Lilly, ed. *Private Realms of Light: Amateur Photography in Canada, 1839–1940*. Markham, Ontario: Fitzhenny & Whiteside, 1984.

"Life in the Old West: Boorne & May, 1836–1889." *Farm and Ranch Review* 56, no. 10 and 12 (October-December 1960): 18–19, 16–17, respectively.

BOUGHTON, ALICE

Macmillan

Naef, Weston J. *The Collection of Alfred Stieglitz: Fifty Pioneers of Modern Photography*. New York: Metropolitan Museum of Art/Viking Press, 1978.

BOURKE-WHITE, MARGARET

Auer, ICP, Macmillan, Naylor

Brown, Theodore M. *Margaret Bourke-White, Photojournalist*. Ithaca, New York: Andrew Dickson White Museum of Art, Cornell University, 1972.

Goldberg, Vicki. *Bourke-White*. New York: United Technologies Corp., for the International Center for Photography, 1988.

————. *Margaret Bourke-White: A Biography*. New York: Harper & Row, 1986.

Silverman, Jonathan. *For the World to See: The Life of Margaret Bourke-White*. New York: Viking Press, 1983.

BRADY, MATHEW

Auer, ICP, Johnson, Macmillan

Davis, William C., ed. *The Image of War, 1861–1865*. 6 vols. Garden City, New York: Doubleday & Co., 1984.

Horan, James D. *Mathew Brady: Historian with a Camera*. New York: Crown Publishers, Inc., 1955.

Meredith, Roy. *Mr. Lincoln's Camera Man: Mathew B. Brady*. New York: Dover Publications, Inc., 1974.

Sennett, Robert S. *Photography and Photographers to 1900: An Annotated Bibliography*. New York: Garland Publishing, Inc., 1985.

BREWER, T. M.

ACM

BRIGMAN, ANNE W.

Auer, Macmillan

Garner, Gretchen. *Reclaiming Paradise: American Women Photograph the Land*. Duluth: Tweed Museum of Art, University of Minnesota, 1987.

Heyman, Therese Thau. *Anne Brigman*. Oakland, Calif.: Oakland Museum, 1974.

Homer, William Innes. *Alfred Stieglitz and the Photo-Secession*. Boston: New York Graphic Society, 1983.

BUBLEY, ESTHER

Naef, Weston J. *The Collection of Alfred Stieglitz: Fifty Pioneers of Modern Photography*. New York: Metropolitan Museum of Art/Viking Press, 1978.

Dieckmann, Katharine. "A Nation of Zombies." *Art in America* 77 (November 1989): 55–61.

Fisher, Andrea. *Let Us Now Praise Famous Women*. New York: Pandora Press, 1987.

Fleischhauer, Carl, and Beverly W. Brannan, eds. *Documenting America, 1935–1943*. Berkeley: University of California Press, 1988.

Lemann, Nicholas. *Out of the Forties*. Austin: Texas Monthly Press, 1983.

Plattner, Steven W. *Roy Stryker: U.S.A., 1943–1950*. Austin: University of Texas Press, 1983.

Reed, Henry Hope, and Esther Bubley. *Rockefeller New York*. New York: Greensward Foundation, Inc., 1988.

BULLOCK, JOHN G.

Beck, Tom. *An American Vision: John G. Bullock and the Photo-Secession*. New York: Aperture, 1989.

Naef, Weston J. *The Collection of Alfred Stieglitz: Fifty Pioneers of Modern Photography*. New York: Metropolitan Museum of Art/Viking Press, 1978.

BULLOCK, WYNN

Auer, ICP, Macmillan, Naylor

Bullock, Barbara. *Wynn Bullock*. San Francisco: Scrimshaw Press, 1971.

Bullock, Wynn. *Wynn Bullock*. Millerton, New York: Aperture, 1976.

De Cock, Liliane, ed. *Wynn Bullock, Photography: A Way of Life*. Dobbs Ferry, New York: Morgan & Morgan, 1973.

Dilley, Clyde H. *The Photography and Philosophy of Wynn Bullock*. Ph.D. diss., University of New Mexico, 1980.

Lamb, Charles, and Cynthia Ludlow. *Wynn Bullock Archive*. Tucson: Center for Creative Photography, Guide Series, no. 6, University of Arizona, 1982.

Lyons, Nathan, ed. *Photographers on Photography*. Englewood Cliffs, New Jersey: Prentice-Hall, 1966.

Myers, Roger, comp. *Guide to Archival Materials of the Center for Creative Photography*. Tucson: Center for Creative Photography, University of Arizona, 1986.

"Wynn Bullock: American Lyric Tenor." *Center for Creative Photography* 2 (September 1976): 1–16.

BURTON, CAROL COHEN

Armstrong, Frank. *Photography in the West: A Modern View*. Corning, New York: The Rockwell Museum, 1987.

Sandweiss, Martha A., ed. *Contemporary Texas: A Photographic Portrait*. Austin: Texas Monthly Press, 1986.

CAKEBREAD, JOHN E.

ACM

Cakebread, John E. *1970 Calendar of the Natural Scene*. Oakland, Calif.: Color Art Press, [1970].

CALLAHAN, HARRY

Auer, ICP, Macmillan, Naylor, WWAA 19

Davis, Keith, F. *Harry Callahan, New Color: Photographs 1978–1987*. Kansas City, Mo.: Hallmark Cards, Inc., 1988.

Lyons, Nathan, ed. *Photographers on Photography*. Englewood Cliffs, New Jersey: Prentice-Hall, 1966.

Myers, Roger, comp. *Guide to Archival Materials of the Center for Creative Photography*. Tucson: Center for Creative Photography, University of Arizona, 1986.

Szarkowski, John, ed. *Callahan*. Millerton, New York: Aperture, in association with The Museum of Modern Art, 1976.

CAPONIGRO, PAUL

Auer, ICP, Macmillan, Naylor, WWAA 19

Caponigro, Paul. *Seasons*. Boston: New York Graphic Society, 1988.

———. *The Wise Silence: Photographs by Paul Caponigro.* Boston: New York Graphic Society, 1983.

Myers, Roger, comp. *Guide to Archival Materials of the Center for Creative Photography.* Tucson: Center for Creative Photography, University of Arizona, 1986.

CARPENTER, WILLIAM JEFFERSON

ACM

Mangan, Terry W. *Colorado on Glass.* Denver: Sundance Limited, 1975.

CARTER, KEITH

ACM

Carter, Keith. *The Blue Man.* Houston: Rice University Press, 1990.

———. *From Uncertain to Blue.* Austin: Texas Monthly Press, 1988.

Foote, Horton, and Keith Carter. "The Trip to Paradise." *Texas Monthly* 15 (December 1987): 140–151.

CAWOOD, GARY

ACM, WWAA 19

Mhire, Herman. *A Century of Vision: Louisiana Photography, 1884–1984.* Lafayette: University Art Museum, University of Southwestern Louisiana, 1986.

CLAYTON, JAMES ATKINS

ACM, Johnson

Foote, H.S., ed. *Pen Pictures from the Garden of the World, or Santa Clara County, California.* Chicago: Lewis Publishing Co., 1888.

Sawyer, Eugene T. *History of Santa Clara County, California.* Los Angeles: Historic Record Co., 1922.

CLIFT, WILLIAM

Auer, Macmillan, Naylor, WWAA 19

Clift, William. *Certain Places: Photographs by William Clift.* Santa Fe: William Clift Editions, 1987.

Coke, Van Deren. *Photography in New Mexico.* Albuquerque: University of New Mexico Press, 1979.

Danese, Renato, ed. *American Images: New Work by Twenty Contemporary Photographers.* New York: McGraw-Hill, 1979.

Pare, Richard, ed. *Court House: A Photographic Portrait.* New York: Horizon Press, 1978.

Rose, Barbara, and William Clift. *Juan Hamilton.* New York: Robert Miller Gallery, 1987.

Tucker, Jean S. *The Modernist Still Life—Photographed.* St. Louis: University of Missouri, 1989.

Zwingle, Erla. "Romancing the Stones." *American Photographer* 18 (June 1987): 42–53.

COBURN, ALVIN LANGDON

Auer, ICP, Macmillan, Naylor

Bogardus, Ralph F. *Pictures and Text: Henry James, A. L. Coburn, and New Ways of Seeing in Literary Culture.* Ann Arbor, Michigan: UMI Research Press, 1984.

Lyons, Nathan, ed. *Photographers on Photography.* Englewood Cliffs, New Jersey: Prentice-Hall, 1966.

Naef, Weston J. *The Collection of Alfred Stieglitz: Fifty Pioneers of Modern Photography.* New York: The Metropolitan Museum of Art/Viking Press, 1978.

Weaver, Mike. "Alvin Langdon Coburn, Symbolist Photographer." *Aperture* 144 (Fall 1986): 1–80.

COLLIER, JOHN, JR.

Auer, Naylor

Collier, John, Jr., and Malcolm Collier. *Visual Anthropology: Photography as a Research Method.* Revised and expanded edition. Albuquerque: University of New Mexico Press, 1986.

Dixon, Penelope. *Photographers of the Farm Security Administration: An Annotated Bibliography, 1930–1980.* New York: Garland Publishing, Inc., 1983.

Fleischhauer, Carl, and Beverly W. Brannan, eds. *Documenting America, 1935–1943.* Berkeley: University of California Press, 1988.

CONNELL, WILL

Coke, Van Deren. *Photographs by Will Connell: California Photographer and Teacher (1898–1961).* San Francisco: San Francisco Museum of Modern Art, 1981.

Connell, Will. *About Photography.* New York: Maloney, 1949.

Halsted Gallery, The, Inc. *Will Connell-Interpreter of Intangibles, 1898–1961.* Birmingham, Michigan: The Halsted Gallery, Inc., 1991.

Jacobs, Lou, Jr. "Will Connell: Practical Photographer." *Westways* 68 (August 1976): 23–26ff.

Mann, Margery. *California Pictorialism.* San Francisco: San Francisco Museum of Modern Art, 1977.

CONNOR, LINDA

Auer, Macmillan, Naylor, WWAA 19

Connor, Linda. *Solos.* Millerton, New York: Apeiron Workshops, Inc., 1979.

———. *Spiral Journey: Photographs 1967–1990.* Chicago: Museum of Contemporary Photography, Columbia College, Chicago, 1990.

Davis, Keith F. *Wanderlust: Work by Eight Contemporary Photographers from the Hallmark Photographic Collection.* Kansas City: Hallmark Cards, Inc., 1987.

Danese, Renato, ed. *American Images: New Work by Twenty Contemporary Photographers.* New York: McGraw-Hill, 1979.

Foresta, Merry A. *Exposed and Developed: Photography Sponsored by the NEA.* Washington, D.C.: Smithsonian Institution Press, 1984.

Garner, Gretchen. *Reclaiming Paradise: American Women Photograph the Land.* Duluth: Tweed Museum of Art, University of Minnesota, 1987.

Livingston, Jane. *Linda Connor.* Washington, D.C.: Corcoran Gallery of Art, 1982.

CORPRON, CARLOTTA

Macmillan, Naylor

Grundberg, Andy, and Kathleen McCarthy Gauss. *Photography and Art: Interactions Since 1946.* New York: Abbeville, 1987.

Mitchell, Margaretta K. *Recollections: Ten Women of Photography.* New York: Viking Press, 1979.

Sandweiss, Martha A. *Carlotta Corpron: Designer With Light.* Austin: University of Texas Press, 1980.

Tucker, Jean S. *Light Abstractions.* St. Louis: University of Missouri, 1980.

CORSINI, HAROLD

Plattner, Steven W. *Roy Stryker: U.S.A., 1943–1950.* Austin: University of Texas Press, 1983.

CUNNINGHAM, IMOGEN

Auer, ICP, Macmillan, Naylor

Dater, Judy. *Imogen Cunningham: A Portrait.* Boston: New York Graphic Society, 1979.

Mann, Margery, intro. *Imogen! Imogen Cunningham Photographs, 1910–1973.* Seattle: University of Washington Press, 1974.

Rule, Amy, ed. *Imogen Cunningham.* Boston: G. K. Hall, 1992.

Tsujimoto, Karen. *Images of America: Precisionist Painting and Modern Photography.* San Francisco: San Francisco Museum of Modern Art, 1982.

CURRENT, WILLIAM R.

Current, William R., and Karen Current. *Greene & Greene: Architects in the Residential Style.* Fort Worth: Amon Carter Museum, 1974.

Current, William R., and Vincent Scully. *Pueblo Architecture of the Southwest: A Photographic Essay.* Austin: University of Texas Press, for the Amon Carter Museum, 1971.

CURTIS, EDWARD S.

Auer, ICP, Macmillan

Davis, Barbara A. *Edward S. Curtis: The Life and Times of a Shadow Catcher*. San Francisco: Chronicle Books, 1985.

Lyman, Christopher M. *The Vanishing Race and Other Illusions: Photographs of Indians by Edward S. Curtis*. New York: Pantheon Books, in association with the Smithsonian Institution Press, 1982.

Sennett, Robert S. *Photography and Photographers to 1900: An Annotated Bibliography*. New York: Garland Publishing, Inc., 1985.

DABLOW, DEAN

Macmillan, WWAA 19

Mhire, Herman. *A Century of Vision: Louisiana Photography, 1884–1984*. Lafayette: University Art Museum, University of Southwestern Louisiana, 1986.

DANE, BILL

ACM, Auer, Macmillan, WWAA 19

Dane, Bill. *Little Known*. San Francisco: n.p., 1984.

Heyman, Therese. *Slices of Time: California Landscapes 1860–1880 and 1960–1980*. Oakland, Calif.: Oakland Museum, 1981.

Rubinfien, Leo. "Love/Hate Relations." *Artforum* 16 (Summer 1978): 46–51.

DAY, JIM

ACM

DE COCK, LILIANE

ACM, Naylor

Garner, Gretchen. *Reclaiming Paradise: American Women Photograph the Land*. Duluth: Tweed Museum of Art, University of Minnesota, 1987.

De Cock, Liliane. *Liliane De Cock: Photographs*. Hastings-on-Hudson, New York: Morgan & Morgan, Inc., 1973.

DELLA ROCCA DE CANDAL, GERI

ACM, Macmillan

Della Rocca de Candal, Geri. *Effects and Experiments in Photography*. London: Focal Press, 1973.

DE MENIL, ADELAIDE

ACM

De Menil, Adelaide, and William Reid. *Out of the Silence*. New York: Outerbridge and Dienstfrey, for the Amon Carter Museum, 1971.

DEWITT, RITA

ACM

Coleman, A.D., intro. *Subjective Vision: The Lucinda W. Bunnen Collection of Photographs*. Atlanta: High Museum of Art, 1983.

DISNEY, WESLEY E.

ACM

DISRAELI, ROBERT

ACM, ICP

Disraeli, Robert. *Preserved in Black and White: Views of Life in America*. Dobbs Ferry, New York: Morgan & Morgan, 1986.

DORR, NELL

Mann, Margery. *Women of Photography: An Historical Survey*. San Francisco: San Francisco Museum of Modern Art, 1975.

Mitchell, Margaretta K. *Recollections: Ten Women of Photography*. New York: Viking Press, 1979.

EAKINS, THOMAS

Auer, Macmillan

Hendricks, Gordon. *The Photographs of Thomas Eakins*. New York: Grossman Publishers, 1972.

Thomas Eakins: His Photographic Works. Philadelphia: Pennsylvania Academy of the Fine Arts, 1969.

Tucker, Anne W., ed. *Target III: In Sequence*. Houston: Museum of Fine Arts, 1982.

EASTMAN, MICHAEL

ACM

Steefel, L.D. *Michael Eastman Photographer*. Mount Vernon, Ill.: Mitchell Museum, 1987.

ECKSTROM, TOM

Dater, Judy. *Imogen Cunningham: A Portrait*. Boston: New York Graphic Society, 1979.

EDGERTON, HAROLD

Auer, ICP, Macmillan, Naylor

Kayafas, Gus, ed. *Stopping Time: The Photographs of Harold Edgerton*. New York: Harry N. Abrams, 1987.

EDWARDS, JOHN PAUL

ACM

Edwards, John Paul. "Group f.64." *Camera Craft* 42 (March 1935): 107–108.

———. "The Sierras—In Sunshine and Shadow." *Camera Craft* 33 (January 1926): 3–13.

———. "The Soft Focus Lens." *Camera Craft* 21 (July 1914): 313–322.

Rabe, W.H. "The Work of John Paul Edwards." *Camera Craft* 25 (December 1918): 467–469.

Tsujimoto, Karen. *Images of America: Precisionist Painting and Modern Photography*. San Francisco: San Francisco Museum of Modern Art, 1982.

Tucker, Jean S. *Group f.64*. St. Louis: University of Missouri, 1978.

ENGEL, MORRIS

ACM, ICP, Macmillan

Bellow, Saul. "The Art of Going It Alone." *Horizon* 5 (September 5, 1962): 108–110.

ERWITT, ELLIOTT

Auer, ICP, Macmillan, Naylor

Danese, Renato, ed. *American Images: New York by Twenty Contemporary Photographers*. New York: McGraw-Hill, 1979.

Erwitt, Elliott. *Personal Exposures*. New York: W.W. Norton, 1988.

EVANS, RON

ACM

EVANS, WALKER

Auer, ICP, Macmillan, Naylor

Baier, Lesley K. *Walker Evans at **Fortune**, 1945–1965*. Wellesley, Mass.: Wellesley College Museum, 1977.

Dixon, Penelope. *Photographers of the Farm Security Administration: An Annotated Bibliography, 1930–1980*. New York: Garland Publishing, Inc., 1983.

Fleischhauer, Carl, and Beverly W. Brannan, eds. *Documenting America, 1935–1943*. Berkeley: University of California Press, 1988.

Southall, Thomas W. *Of Time & Place: Walker Evans and William Christenberry*. San Francisco: Friends of Photography, 1990.

Szarkowski, John, intro. *Walker Evans*. New York: Museum of Modern Art, 1971.

Thompson, Jerry L. *Walker Evans at Work*. New York: Harper & Row, 1982.

FARDON, GEORGE ROBINSON

Johnson

Fardon, George Robinson. *San Francisco in the 1850s*. New York: Dover Publications, 1977.

Schwartz, Joan M. "G.R. Fardon, Photographer of Early Vancouver." *Afterimage* 6 (December 1978): 5, 21.

FENNEMORE, JAMES

Johnson

Fleming, Paula R., and Judith Luskey. *The North American Indians in Early Photographs*. New York: Harper & Row, 1986.

Fowler, Don D., ed. *"Photographed All the Best Scenery": Jack Hillers' Diary of the Powell Expeditions, 1871–1875*. Salt Lake City: University of Utah Press, 1972.

Stephens, Hal G., and Eugene M. Shoemaker. *In the Footsteps of John Wesley Powell*. Boulder, Colorado: Johnson Books, 1987.

FENNER, PHYLLIS

"Fenner, Phyllis Reid." *Contemporary Authors*, volume 106. Detroit: Gale Research Company, 1982.

"Fenner, Phyllis Reid." *Who's Who of American Women*, 9th edition, 1975–1976. Chicago: A.N. Marquis Co., 1975.

"Phyllis Fenner." *Publisher's Weekly* 221 (April 2, 1982): 24.

FERESTON, PETER

Littlefield, Kinney. "Flashes of Insight: The Inspired Images of Photographer Peter Feresten." *Dallas Life Magazine* (*Dallas Morning News*), June 18, 1989, pp. 8–15.

Sandweiss, Martha A., ed. *Contemporary Texas: A Photographic Portrait*. Austin: Texas Monthly Press, 1986.

Williams, Rick. *Visiones de Tejanos/Visions of Texans*. Austin: Texas Photographic Society, Inc., 1989.

FERGUSON, JIM

ACM, Macmillan

FISKE, GEORGE

ACM, Johnson, Macmillan

Cahn, Robert, and Robert Glenn Ketchum. *American Photographers and the National Parks*. New York: Viking Press, 1981.

Hickman, Paul, and Terence Pitts. *George Fiske: Yosemite Photographer*. Flagstaff, Ariz.: Northland Press, 1980.

FOWX, EGBERT GUY

ACM, Johnson

Cooney, Charles F. "Andrew J. Russell, the Union Army's Forgotten Photographer." *Civil War Times Illustrated* 21 (April 1982): 32–35.

FRANK, ROBERT

Auer, ICP, Macmillan, Naylor

Alexander, Stuart. *Robert Frank: A Bibliography, Filmography, and Exhibition Chronology, 1946–1985*. Tucson: Center for Creative Photography, University of Arizona, with the Museum of Fine Arts, Houston, 1986.

Livingston, Jane. *The New York School: Photographs 1936–1963*. New York: Stewart, Tabori and Chang, 1992.

Lyons, Nathan, ed. *Photographers on Photography*. Englewood Cliffs, New Jersey: Prentice-Hall, 1966.

Tucker, Anne W., ed. *Robert Frank: New York to Nova Scotia*. Boston: New York Graphic Society, 1986.

FRISSELL, TONI

Macmillan

Mitchell, Margaretta K. *Recollections: Ten Women of Photography*. New York: Viking Press, 1979.

GAGLIANI, OLIVER

Auer, Macmillan, Naylor

Gagliani, Oliver. *Oliver Gagliani: A Retrospective, 1937–1984*. Fresno, Calif.: Fresno Arts Center, 1984.

GARDNER, ALEXANDER

Auer, ICP, Johnson, Macmillan

Ciampoli, Judith. "Alexander Gardner, Photographer: Along the 35th Parallel in the 1860s." *Gateway Heritage* 1 (Winter 1980): 14–17.

Cobb, Josephine. "Alexander Gardner." *Image* 7 (June 1958): 124–136.

Davis, William C., ed. *The Image of War, 1861–1865*. 6 vols. Garden City, New York: Doubleday & Co., 1984.

De Mallie, Raymond J. "Scenes in the Indian County." *Montana: The Magazine of Western History* 31 (Summer 1981): 42–59.

Fleming, Paula R., and Judith Luskey. *The North American Indians in Early Photographs*. New York: Harper & Row, 1986.

Gardner, Alexander. *Gardner's Photographic Sketch Book of the Civil War*. New York: Dover Publications, Inc., 1959.

Johnson, Brooks. *An Enduring Interest: The Photographs of Alexander Gardner*. Norfolk, Virginia: The Chrysler Museum, 1991.

Katz, D. Mark. *Witness to an Era: The Life and Photographs of Alexander Gardner*. New York: Viking, 1991.

Sobieszek, Robert. "Alexander Gardner's Photographs Along the 35th Parallel." *Image* 14 (June 1971): 6–13.

Sweet, Timothy. *Traces of War: Poetry, Photography, and the Crisis of the Union*. Baltimore: The Johns Hopkins University Press, 1990.

Walther, Susan Danly. *The Landscape Photographs of Alexander Gardner and Andrew Joseph Russell*. Ph.D. diss., Brown University, 1983.

GARDNER, JAMES T.

Johnson

Davis, William C., ed. *The Image of War, 1861–1865*. 6 vols. Garden City, New York: Doubleday & Co., 1984.

Fleming, Paula R., and Judith Luskey. *The North American Indians in Early Photographs*. New York: Harper & Row, 1986.

Katz, D. Mark. *Witness to an Era: The Life and Photographs of Alexander Gardner*. New York: Viking, 1991.

Naef, Weston J. *Era of Exploration: The Rise of Landscape Photography in the American West, 1860–1885*. Boston: New York Graphic Society, 1975.

GARNETT, WILLIAM

Auer, ICP, Naylor, WWAA 19

Cahn, Robert, and Robert Glenn Ketchum. *American Photographers and the National Parks*. New York: Viking Press, 1981.

Garnett, William. *The Extraordinary Landscape: Aerial Photographs of America*. Boston: New York Graphic Society, 1982.

GAST, RICK

ACM

GENTHE, ARNOLD

Auer, ICP, Macmillan, Naylor

Naef, Weston J. *The Collection of Alfred Stieglitz: Fifty Pioneers of Modern Photography*. New York: The Metropolitan Museum of Art/Viking Press, 1978.

Patterson, Jerry E. *Arnold Genthe, 1869–1942*. Staten Island, New York: Staten Island Museum, 1975.

Tchen, John Kuo Wei. *Genthe's Photographs of San Francisco's Old Chinatown*. New York: Dover Publications, Inc., 1984.

GILPIN, HENRY

ACM, Macmillan, WWAA 19

Photographs of Richard Garrod and Henry Gilpin. Privately published, 1970.

GILPIN, LAURA

Auer, ICP, Macmillan, Naylor

Forster, Elizabeth W., and Laura Gilpin. *Denizens of the Desert: A Tale in Word and Picture of Life Among the Navaho Indians*. Albuquerque: University of New Mexico Press, 1988.

Sandweiss, Martha A. *Laura Gilpin: An Enduring Grace*. Fort Worth: Amon Carter Museum, 1986.

GOHLKE, FRANK

Auer, Macmillan, Naylor, WWAA 19

Coke, Van Deren. *Photography in New Mexico*. Albuquerque: University of New Mexico Press, 1979.

Danese, Renato, ed. *American Images: New Work by Twenty Contemporary Photographers*. New York: McGraw-Hill, 1979.

Gohlke, Frank. *Frank Gohlke: Landscapes from the Middle of the World, Photographs 1982–1987*. Untitled, 46. San Francisco: Friends of Photography, 1988.

Gohlke, Frank. *Measure of Emptiness: Grain Elevators in the American Landscape.* Baltimore: Johns Hopkins University Press, 1992.

Kalil, Susie. *The Texas Landscape, 1900–1986.* Houston: Museum of Fine Arts, 1986.

Pare, Richard, ed. *Court House: A Photographic Document.* New York: Horizon Press, 1978.

Sandweiss, Martha A., ed. *Contemporary Texas: A Photographic Portrait.* Austin: Texas Monthly Press, 1986.

GRABILL, JOHN C.H.

Current, Karen. *Photography and the Old West.* New York: Harry N. Abrams, in association with the Amon Carter Museum, 1978.

Fleming, Paula R., and Judith Luskey. *The North American Indians in Early Photographs.* New York: Harper & Row, 1986.

"John C.H. Grabill's Photographs of the Last Conflict Between the Sioux and the United States Military, 1890–1891." *South Dakota History* 14 (Fall 1984): 222–237.

GROSSMAN, SIDNEY

Livingston, Jane. *The New York School: Photographs 1936–1963.* New York: Stewart, Tabori and Chang, 1992.

GROTZ, PAUL

"Paul Grotz's Photographs from 1920s and '30s Subject of New Exhibition." Press Release, Prakapas Gallery, New York, December 1988.

GUTMANN, JOHN

Auer, Macmillan, WWAA 19

Sutnik, Maia-Mari. *Gutmann.* Toronto: Art Gallery of Ontario, 1985.

Thomas, Lew, ed. *The Restless Decade: John Gutmann's Photographs of the Thirties.* New York: Harry N. Abrams, 1984.

HALSMAN, PHILIPPE

Halsman, Philippe. *Halsman © 79.* New York: International Center of Photography, 1979.

———. *Philippe Halsman's Jump Book.* New York: Harry N. Abrams, 1986.

Halsman, Yvonne. *Halsman at Work.* New York: Abrams, 1989.

HAMMERBACK, WANDA LEE

Auer, ICP, Macmillan, WWAA 19

Johnson, Deborah J., ed. *California Photography.* Providence, R.I.: Museum of Art, Rhode Island School of Design, 1982.

HARDING, GOODWIN

Macmillan

Simon, Howard. *A Breath of Life: The Contemporary Platinum Print.* Trenton, New Jersey: New Jersey State Museum, 1986.

HARKEY, JOHN

ACM

San Antonio: Mirror of the Past, Window to the Future. San Antonio: University of Texas Health Science Center, 1976.

HAYES, RICHARD E.

ACM

HAYNES, FRANK JAY

Johnson, Macmillan

Fleming, Paula R., and Judith Luskey. *The North American Indians in Early Photographs.* New York: Harper & Row, 1986.

Lang, William L. "'At the Greatest Peril to the Photographer': The Schwatka-Haynes Winter Expedition in Yellowstone, 1887." *Montana: The Magazine of Western History* 33 (Winter 1983): 14–29.

Montana Historical Society. *F. Jay Haynes Photographer.* Helena: Montana Historical Society Press, 1981.

Tilden, Freeman. *Following the Frontier with F. Jay Haynes.* New York: Alfred A. Knopf, 1964.

HERSHORN, SHEL

ACM

Tyler, Ronnie C. "Photography & Texas Traditions." In Francis E. Abernethy, ed., *Observations & Reflections on Texas Folklore,* pp. 21–29. Austin: The Encino Press, 1972.

HESTER, PAUL

Foresta, Merry A. *Exposed and Developed: Photography Sponsored by the NEA.* Washington, D.C.: Smithsonian Institution Press, 1984.

Sandweiss, Martha A., ed. *Contemporary Texas: A Photographic Portrait.* Austin: Texas Monthly Press, 1986.

HILL, DAVID OCTAVIUS, AND ROBERT ADAMSON

Auer, Johnson, Macmillan

Ford, Colin, ed. *An Early Victorian Album.* New York: Alfred A. Knopf, 1976.

Naef, Weston J. *The Collection of Alfred Stieglitz: Fifty Pioneers of Modern Photography.* New York: The Metropolitan Museum of Art/Viking Press, 1978.

HILLERS, JOHN K.

Johnson, Macmillan

Cahn, Robert, and Robert Glenn Ketchum. *American Photographers and the National Parks.* New York: Viking Press, 1981.

Current, Karen. *Photography and the Old West.* New York: Harry N. Abrams, in association with the Amon Carter Museum, 1978.

Fowler, Don D., ed. *"Photographed All the Best Scenery": Jack Hillers' Diary of the Powell Expeditions, 1871–1875.* Salt Lake City: University of Utah Press, 1972.

Fowler, Don D. *The Western Photographs of John K. Hillers: Myself in the Water.* Washington, D.C.: Smithsonian Institution Press, 1989.

Klett, Mark, et al. *Second View: The Rephotographic Survey Project.* Albuquerque: University of New Mexico Press, 1984.

Stephens, Hal G., and Eugene M. Shoemaker. *In the Footsteps of John Wesley Powell.* Boulder, Colo.: Johnson Books, 1987.

HILLYER, HAMILTON BRISCOE

Johnson

Crofford, Ava. *The Diamond Years of Texas Photography.* Austin: W. Frank Evans, 1975.

Taft, Robert. *Photography and the American Scene.* New York: Macmillan, 1938.

Young, William Russell, III. *H.B. Hillyer: Life and Career of a Nineteenth Century Texas Photographer.* Master's thesis, The University of Texas at Austin, 1985.

HINE, LEWIS

Auer, ICP, Macmillan, Naylor

Curtis, Verna P., and Stanley Mallach. *Photography and Reform: Lewis Hine and the National Child Labor Committee.* Milwaukee: Milwaukee Art Museum, 1984.

Doherty, Jonathan L., comp. *Lewis Wickes Hine's Interpretive Photography: The Six Early Projects.* Chicago: University of Chicago Press, 1978.

Trachtenberg, Alan, et al. *America & Lewis Hine: Photographs 1904–1940.* Millerton, New York: Aperture, 1977.

HIRSCH, H.S. "BOB"

ACM

HOLMES, H.S. "BERT"

ACM

Blonk, Hu. "Bert Holmes: He Aims to Please." *The Wenatchee [Washington] World,* December 24, 1971, p. 9.

Holmes, H.S. "Excavation Documentation—the Grand Coulee Approach." *Industrial Photography* 28 (July 1979): 42–43.

HUFFMAN, LATON ALTON

Johnson, Macmillan

Brown, Mark H., and W.R. Felton. *Before Barbed Wire: L.A. Huffman, Photographer on Horseback.* New York: Henry Holt and Co., 1956.

————. *The Frontier Years*. New York: Branhall House, 1955.

Current, Karen. *Photography and the Old West*. New York: Harry N. Abrams, in association with the Amon Carter Museum, 1978.

Fleming, Paula R., and Judith Luskey. *The North American Indians in Early Photographs*. New York: Harper & Row, 1986.

Haley, J. Evetts. "Huffman of Montana." In *Focus on the Frontier*, pp. 2–17. Amarillo, Texas: The Shamrock Oil and Gas Corp., 1957.

HUGHS, DIANE HOPKINS

ACM, Macmillan

Tyler, Ronnie C. "Photography & Texas Traditions." In Francis E. Abernethy, ed., *Observations & Reflections on Texas Folklore*, pp. 21–29. Austin: The Encino Press, 1972.

HUGO, LEOPOLD

ACM

HUMPHRIES, W.R.

Vaughan, Tom. *Bisbee 1880–1920: The Photographer's View*. Bisbee, Ariz.: Cochise Fine Arts and the Bisbee Council on the Arts and Humanities, Inc., 1980.

————. "Bisbee's Early Photographers." *Bisbee [Arizona] Daily Review*, February 20, 1983.

JACKSON, WILLIAM HENRY

Auer, ICP, Johnson, Macmillan

Current, Karen. *Photography and the Old West*. New York: Harry N. Abrams, in association with the Amon Carter Museum, 1978.

Hales, Peter B. *William Henry Jackson and the Transformation of the American Landscape*. Philadelphia: Temple University Press, 1988.

Klett, Mark, et al. *Second View: The Rephotographic Survey Project*. Albuquerque: University of New Mexico Press, 1984.

Newhall, Beaumont, and Diana E. Edkins. *William H. Jackson*. Dobbs Ferry, New York: Morgan & Morgan, 1974.

JACOBI, LOTTE

Auer

Grundberg, Andy, and Kathleen McCarthy Gauss. *Photography and Art: Interactions Since 1946*. New York: Abbeville, 1987.

Lotte Jacobi: A Selection of Vintage and Modern Photographs. Los Angeles: Stephen White Gallery of Photography, 1986.

Mitchell, Margaretta K. *Recollections: Ten Women of Photography*. New York: Viking Press, 1979.

Wise, Kelly, ed. *Lotte Jacobi*. Danbury, New Hampshire: Addison House, 1978.

JOHNSTON, FRANCES BENJAMIN

Auer, ICP, Macmillan

Daniel, Pete, and Raymond Smock. *A Talent for Detail: The Photographs of Miss Frances Benjamin Johnston, 1889–1910*. New York: Harmony Books, 1974.

Doherty, Amy S. "Francis Benjamin Johnston, 1864–1952." *History of Photography* 4 (April 1980): 97–111.

Glenn, Constance W., and Leland Rice. *Frances Benjamin Johnston: Women of Class and Station*. Long Beach, Calif.: The Art Museum and Galleries, California State University, 1979.

Tucker, Anne, ed. *The Woman's Eye*. New York: Alfred A. Knopf, 1976.

JONES, PIRKLE

ACM, Auer, Macmillan, Naylor, WWAA 19

Lange, Dorothea, and Pirkle Jones. "Death of a Valley." *Aperture* 8 (1960): 127–165.

Pare, Richard. *Court House: A Photographic Document*. New York: Horizon Press, 1978.

KALES, ARTHUR F.

Mann, Margery. *California Pictorialism*. San Francisco: San Francisco Museum of Modern Art, 1977.

KANAGA, CONSUELO

Auer, Macmillan

Kanaga, Consuelo. *Consuelo Kanaga Photographs: A Retrospective*. New York: Blue Moon Gallery and Lerner-Heller Gallery, 1974.

Millstein, Barbara Head, and Sarah M. Lowe. *Consuelo Kanaga: An American Photographer*. Brooklyn: The Brooklyn Museum in association with University of Washington Press, 1992.

Mitchell, Margaretta K. *Recollections: Ten Women of Photography*. New York: Viking Press, 1979.

Tucker, Jean S. *Group f.64*. St. Louis: University of Missouri, 1978.

KARSH, YOUSUF

Auer, ICP, Macmillan, Naylor, WWAA 19

Borcoman, James. *Yousuf Karsh: The Art of the Portrait*. Chicago: University of Chicago Press, 1989.

Karsh, Yousef. *In Search of Greatness*. New York: Knopf, 1962.

————. *Karsh: A Fifty-Year Retrospective*. Boston: New York Graphic Society, 1983.

KASEBIER, GERTRUDE

Auer, ICP, Macmillan

Homer, William Innes. *Alfred Stieglitz and the Photo-Secession*. Boston: New York Graphic Society, 1983.

————. *A Pictorial Heritage: The Photographs of Gertrude Kasebier*. Newark: The University of Delaware and Delaware Art Museum, 1979.

Michaels, Barbara L. *Gertrude Kasebier: The Photographer and Her Photographs*. New York: H. N. Abrams, 1992.

Naef, Weston J. *The Collection of Alfred Stieglitz: Fifty Pioneers of Modern Photography*. New York: The Metropolitan Museum of Art/Viking Press, 1978.

KEILEY, JOSEPH T.

Auer, Macmillan

Homer, William Innes. *Alfred Stieglitz and the Photo-Secession*. Boston: New York Graphic Society, 1983.

Naef, Weston J. *The Collection of Alfred Stieglitz: Fifty Pioneers of Modern Photography*. New York: The Metropolitan Museum of Art/Viking Press, 1978.

KENNEDY, GIBSON, JR.

ACM

Hafey, John, and Tom Shillea. *The Platinum Print*. Rochester, New York: Rochester Institute of Technology, 1979.

KEPPLER, VICTOR

ACM, ICP, Naylor

Goldsmith, Arthur. "The Private Vision of Victor Keppler." *Popular Photography* 90 (July 1983): 66–75, 154.

Keppler, Victor. *A Life of Color Photography*. New York: W. Morrow and Co., 1938.

————. *Man + Camera: A Photographic Autobiography*. New York: Amphoto, 1970.

Sobieszek, Robert A. *The Art of Persuasion: A History of Advertising Photography*. New York: Harry N. Abrams, 1988.

KERTESZ, ANDRE

Auer, ICP, Macmillan, Naylor

Ducrot, Nicolas, ed. *Andre Kertesz: Sixty Years of Photography, 1912–1972*. New York: Grossman Pub., 1972.

Kertesz, Andre. *Andre Kertesz: Diary of Light 1912–1985*. New York: Aperture, 1987.

Phillips, Sandra S., et al. *Andre Kertesz: Of Paris and New York*. New York: Thames and Hudson, 1985.

KINSEY, DARIUS

Auer, Macmillan

Bohn, Dave, and Rodolfo Petschek. *Kinsey Photographer: A Half Century of Negatives by Darius and Tabitha May Kinsey*. 3 vols. in 2. San Francisco: Chronicle Books, 1982–1984.

Krakauer, Jon. "Reopening the Northwest Log of Darius Kinsey." *American Photographer* 20 (June 1988): 45–53.

KIRKLAND, CHARLES D.

ACM

Fleming, Paula R., and Judith Luskey. *The North American Indians in Early Photographs.* New York: Harper & Row, 1986.

Taylor, Lonn, and Ingrid Maar. *The American Cowboy.* Washington, D.C.: Library of Congress, 1983.

KLETT, MARK

ACM, Macmillan

Galassi, Peter. "Mark Klett: Present and Past in the American West." *Close-Up* 14 (Spring 1984): 3–13.

Gauss, Kathleen McCarthy. *New American Photography.* Los Angeles: Los Angeles County Museum of Art, 1985.

Klett, Mark. *Revealing Territory: Photography of the Southwest by Mark Klett.* Essays by Patricia Nelson Limerick and Thomas W. Southall. Albuquerque: University of New Mexico Press, 1992.

Klett, Mark. *Traces of Eden: Travels in the Desert Southwest.* Boston: David R. Godine, 1986.

Klett, Mark, et al. *Second View: The Rephotographic Survey Project.* Albuquerque: University of New Mexico Press, 1984.

Pitts, Terence, et al. *Central Arizona Project Photographic Survey.* Tucson: Center for Creative Photography, University of Arizona, 1986.

Roth, Evelyn. "Mark Klett." *American Photographer* 15 (September 1985): 52–57.

KLIPPER, STUART

Macmillan, WWAA 19

Armstrong, Frank. *Photography in the West: A Modern View.* Corning, New York: The Rockwell Museum, 1987.

Davis, Keith F. *Wanderlust: Work by Eight Contemporary Photographers from the Hallmark Photographic Collection.* Kansas City: Hallmark Cards, Inc., 1987.

Sandweiss, Martha A., ed. *Contemporary Texas: A Photographic Portrait.* Austin: Texas Monthly Press, 1986.

KNEE, ERNEST

ACM

Coke, Van Deren. *Photography in New Mexico.* Albuquerque: University of New Mexico Press, 1979.

Knee, Ernest. *Santa Fe, N.M.* New York: Hastings House, 1942.

Work Projects Administration Writers' Program. *New Mexico: A Guide to the Colorful State.* New York: Hastings House, 1940.

KNOX, DAVID

Gardner, Alexander. *Gardner's Photographic Sketch Book of the Civil War.* New York: Dover Publications, Inc., 1959.

KOSTIUK, MICHAEL

ACM, WWAA 19

Tyler, Ronnie C., "Photography & Texas Traditions." In Francis E. Abernethy, ed., *Observations & Reflections on Texas Folklore,* pp. 21–29. Austin: The Encino Press, 1972.

KRAUSE, GEORGE

Macmillan, Naylor, WWAA 19

Foresta, Merry A. *Exposed and Developed: Photography Sponsored by the NEA.* Washington, D.C.: Smithsonian Institution Press, 1984.

Sandweiss, Martha A., ed. *Contemporary Texas: A Photographic Portrait.* Austin: Texas Monthly Press, 1986.

Tucker, Anne. *George Krause.* Houston: Rice University Press, 1991.

KUMLER, KIPTON

Macmillan, Naylor, WWAA 19

Hafey, John, and Tom Shillea. *The Platinum Print.* Rochester, New York: Rochester Institute of Technology, 1979.

Kumler, Kipton. *Photographs.* Boston: David R. Godine, 1975.

_____. *Plant Leaves.* Boston: David R. Godine, 1978.

LANGE, DOROTHEA

Auer, ICP, Macmillan, Naylor

Amon Carter Museum. *Dorothea Lange Looks at the American Country Woman.* Fort Worth: Amon Carter Museum, 1967.

Coles, Robert. *Dorothea Lange: Photographs of a Lifetime.* Millerton, New York: Aperture, 1982.

Curtis, James C. "Dorothea Lange, Migrant Mother, and the Culture of the Great Depression." *Winterthur Portfolio* 21 (Spring 1986): 1–20.

Dixon, Penelope. *Photographers of the FSA: An Annotated Bibliography, 1930–1980.* New York: Garland Publishing, Inc., 1983.

Fleischhauer, Carl, and Beverly W. Brannan, eds. *Documenting America, 1935–1943.* Berkeley: University of California Press, 1988.

Heyman, Therese Thau. *Celebrating a Collection: The Work of Dorothea Lange.* Oakland, Calif.: Oakland Museum, 1978.

Hunter, Jefferson. *Image and Word: The Interaction of Twentieth-Century Photography and Text.* Cambridge, Mass.: Harvard University Press, 1987.

Lyons, Nathan, ed. *Photographers on Photography.* Englewood Cliffs, New Jersey: Prentice-Hall, 1966.

Meltzer, Milton. *Dorothea Lange: A Photographer's Life.* New York: Farrar Straus Giroux, 1978.

Ohrn, Karin Becker. *Dorothea Lange and the Documentary Tradition.* Baton Rouge: Louisiana State University Press, 1980.

LANGHAM, ROBERT B., III

ACM

"Along the Creeks: Landscape Photographs by Robert Langham III." *Tyler [Texas] Museum of Art Review* (November 1990–January 1991): 2–3.

LAUGHLIN, CLARENCE JOHN

Auer, ICP, Macmillan, Naylor

"Clarence John Laughlin." *Center for Creative Photography* 10 (October 1979): 1–24.

Davis, Keith F. *Clarence John Laughlin: Visionary Photographer.* Kansas City, Mo.: Hallmark Cards, Inc., 1990.

Leighten, Patricia. "Clarence John Laughlin: The Art and Thought of an American Surrealist." *History of Photography* 12 (April–June 1988): 129–146.

Williams, Jonathan, intro. *Clarence John Laughlin: The Personal Eye.* Millerton, New York: Aperture, 1973.

LEE, RUSSELL

Auer, Macmillan, Naylor

Dixon, Penelope. *Photographers of the Farm Security Administration: An Annotated Bibliography, 1930–1980.* New York: Garland Publishing, Inc., 1983.

Fleischhauer, Carl, and Beverly W. Brannan, eds. *Documenting America, 1935–1943.* Berkeley: University of California Press, 1988.

Hurley, F. Jack. *Russell Lee Photographer.* Dobbs Ferry, New York: Morgan & Morgan, 1978.

Lemann, Nicholas. *Out of the Forties.* Austin: Texas Monthly Press, 1983.

Plattner, Steven W. *Roy Stryker: U.S.A., 1943–1950.* Austin: University of Texas Press, 1983.

LERNER, NATHAN

ICP, Macmillan, WWAA 19

Lerner, Nathan. *Fifty Years of Photographic Inquiry.* Chicago: Columbia College, 1984.

_____. *Nathan Lerner: A Photographic Retrospective, 1932–1979.* Boston: Institute of Contemporary Art, 1979.

_____. *The New Bauhaus: Photographs 1935–1945.* Chicago: Alan Frumkin Gallery, 1976.

Tucker, Jean S. *Light Abstractions.* St. Louis: University of Missouri, 1980.

LEVITT, HELEN

Auer, ICP, Macmillan, Naylor, WWAA 19

Corcoran Gallery of Art. *Helen Levitt.* Washington, D.C.: Corcoran Gallery of Art, 1980.

Foresta, Merry A. *Exposed and Developed: Photography Sponsored by the NEA.* Washington, D.C.: Smithsonian Institution Press, 1984.

Kozloff, Max. "A Way of Seeing and the Act of Touching: Helen Levitt's Photographs of the Forties." In *The Privileged Eye: Essays on Photography,* pp. 29–42. Albuquerque: University of New Mexico Press, 1987.

Levitt, Helen. *In the Street: Chalk Drawings and Messages, New York City, 1938–1948.* Durham, North Carolina: Duke University Press, 1987.

———. *A Way of Seeing.* Enlarged edition. New York: Horizon Press, 1981.

Livingston, Jane. *The New York School: Photographs 1936–1963.* New York: Stewart, Tabori and Chang, 1992.

Phillips, Sandra S. *Helen Levitt.* San Francisco: San Francisco Museum of Modern Art, 1991.

LINK, O. WINSTON

Chrysler Museum. *Ghost Trains: Railroad Photographs of the 1950s by O. Winston Link.* Norfolk, Va.: The Chrysler Museum, 1983.

Hensley, Tim. *Steam, Steel, & Stars: Photographs by O. Winston Link.* New York: Harry N. Abrams, 1987.

LUMMIS, CHARLES FLETCHER

Bingham, Edwin R. *Charles F. Lummis, Editor of the Southwest.* San Marino, Calif.: Huntington Library, 1955.

Current, Karen. *Photography and the Old West.* New York: Harry N. Abrams, in association with the Amon Carter Museum, 1978.

Fiske, Turbese Lummis. *Charles F. Lummis: The Man and His West.* Norman: University of Oklahoma Press, 1975.

Fleming, Paula R., and Judith Luskey. *The North American Indians in Early Photographs.* New York: Harper & Row, 1986.

Gordon, Dudley. *Charles F. Lummis: Crusader in Corduroy.* Los Angeles: Cultural Assets Press, 1972.

Houlihan, Patrick T. *Lummis in the Pueblos.* Flagstaff, Arizona: Northland Press, 1986.

Moneta, Daniela P., ed. *Charles F. Lummis: The Centennial Exhibition.* Los Angeles: Southwest Museum, 1985.

Williams, Bradley B. "Charles F. Lummis: Crusader With a Camera." *History of Photography* 5 (July 1981): 207–221.

LYON, DANNY

Auer, Macmillan, Naylor

Lyon, Danny. *The Paper Negative.* Bernalillo, New Mexico: Bleak Beauty, 1980.

———. *Pictures from the New World.* Millerton, New York: Aperture, 1981.

MCAULEY, SKEET

WWAA 19

McAuley, Skeet. *Sign Language: Contemporary Southwest Native America.* New York: Aperture, 1989.

Sandweiss, Martha A., ed. *Contemporary Texas: A Photographic Portrait.* Austin: Texas Monthly Press, 1986.

MCFARLAND, LAWRENCE

Macmillan

Kindraka, Monica F. *New Works by Austin Photographers.* Austin: Laguna Gloria Art Museum, 1987.

Morand, Ruthe. "Lawrence McFarland." *Northlight* 15 (1985): 26–43.

Pitts, Terence, et al. *Central Arizona Project Photographic Survey.* Tucson: Center for Creative Photography, University of Arizona, 1986.

MACWEENEY, ALEN

Auer, Macmillan, WWAA 19

Court, Artelia. "Yeats, MacWeeney, Ireland." *American Photographer* 6 (March 1981): 56–68.

Moolman, Valerie. "Alen MacWeeney: An Irish Odyssey." *Aperture* 82 (1979): 54–65.

MAN RAY

Auer, ICP, Naylor

Foresta, Merry A., et al. *Perpetual Motif: The Art of Man Ray.* New York: Abbeville, for the National Museum of American Art, 1988.

Krauss, Rosalind, and Jane Livingston. *L'Amour Fou: Photography & Surrealism.* New York: Abbeville, 1985.

Lyons, Nathan, ed. *Photographers on Photography.* Englewood Cliffs, New Jersey: Prentice-Hall, 1966.

Martin, Jean-Hubert, intro. *Man Ray Photographs.* New York: Thames and Hudson, 1981.

MANG, FRED E., JR.

ACM

Mang, Fred E., Jr. "The View Camera in Archaeological Photography." In Douglas Osborne, ed., *Contributions of the Wetherill Mesa Archaeological Project,* pp. 227–230. Salt Lake City: Memoirs of the Society for American Archaeology, Number 19, 1965.

MARCUS, ELLI

ICP, Macmillan

"Elli Marcus, Photographer of Theatrical Subjects, 77." *New York Times,* August 9, 1977, p. 36.

Thornton, Gene. "Photographs of German Theatrical Personalities of the 20s and 30s at Witkin Gallery." *New York Times,* September 5, 1976, sect. 2, p. 23.

MARTIN, IRA

Martin, Ira. "Evolution of Modern Photography." *Light and Shade* 4 (February–March 1932): 4ff.

———. *40 Years of Fun in Photography.* New York: Camera Club of New York, March 1939.

MEATYARD, RALPH EUGENE

Auer, ICP, Macmillan, Naylor

Hall, James Baker, ed. *Ralph Eugene Meatyard.* Millerton, New York: Aperture, 1974.

Janis, Eugenia Parry, et al. *Vanishing Presence.* Minneapolis, Minn.: Walker Art Center, 1989.

Meatyard, Diane, and Christopher Meatyard. *Ralph Eugene Meatyard: Caught Moments, New Viewpoints.* London: Olympus Gallery, 1983.

MELLEN, GEORGE

ACM

Mangan, Terry W. *Colorado on Glass.* Denver: Sundance Limited, 1975.

Mellen, George E. *Panoramic Photography.* Second edition. Chicago: George E. Mellen, 1897.

MILLEA, TOM

ACM, Macmillan, WWAA 19

Hafey, John, and Tom Shillea. *The Platinum Print.* Rochester, New York: Rochester Institute of Technology, 1979.

Simon, Harold. *A Breath of Life: The Contemporary Platinum Print.* Trenton, New Jersey: New Jersey State Museum, 1986.

MILLER, JUDY

ACM

Armstrong, Frank. *Photography in the West: A Modern View.* Corning, New York: The Rockwell Museum, 1987.

Kutner, Janet. "Collage Life." *Dallas Morning News,* June 8, 1989, p. 5C.

Littlefield, Kinney. "The Slick Kitsch of Judy Miller." *Dallas Life Magazine, Dallas Morning News,* October 26, 1986, pp. 14–16.

MITCHELL, ERIC

ACM

MODEL, LISETTE
Livingston, Jane. *The New York School: Photographs 1936–1963.* New York: Stewart, Tabori and Chang, 1992.

MODOTTI, TINA
Auer, ICP, Macmillan, Naylor

Caronia, Maria, and Vittorio Vidali, trans. by C.H. Evans. *Tina Modotti, Photographs.* Westbury, New York: Idea Editions & Belmark Book Co., 1981.

Constantine, Mildred. *Tina Modotti: A Fragile Life.* Revised edition. New York: Rizzoli, 1983.

Pultz, John, and Catherine B. Scallen. *Cubism and American Photography, 1910–1930.* Williamstown, Mass.: Sterling and Francine Clark Art Institute, 1981.

Stark, Amy, ed. "The Letters from Tina Modotti to Edward Weston." *Archive* 22 (January 1986): 3–81.

MONSEN, FREDERICK I.
Current, Karen. *Photography and the Old West.* New York: Harry N. Abrams, in association with the Amon Carter Museum, 1978.

Fleming, Paula R., and Judith Luskey. *The North American Indians in Early Photographs.* New York: Harper & Row, 1986.

Vander Meulen, Thomas. *F.I. Monsen.* Tempe, Arizona: History of Photography Monograph Series 13, Arizona State University, Spring 1985.

MONTHAN, GUY
ACM, WWAA 19

Monthan, Guy, and Doris Monthan. *Art and Indian Individualists.* Flagstaff, Arizona: Northland Press, 1975.

MORAN, JOHN
Reilly, Bernard F., Jr. "The Early Work of John Moran, Landscape Photographer." *American Art Journal* 11 (January 1979): 65–75.

MORGAN, BARBARA
Auer, ICP, Macmillan, Naylor, WWAA 19

Bunnell, Peter, intro. *Barbara Morgan.* Hastings-on-Hudson, New York: Morgan & Morgan, 1972.

Carter, Curtis L., and William C. Agee. *Barbara Morgan: Prints, Drawings, Watercolors and Photographs.* Dobbs Ferry, New York: Morgan & Morgan, for the Patrick & Beatrice Haggerty Museum of Art, Marquette University, Milwaukee, 1988.

Mitchell, Margaretta K. *Recollections: Ten Women of Photography.* New York: Viking Press, 1979.

MORGAN, WILLARD D.
Morgan, Willard D., ed. *The Complete Photographer.* 10 vols., September 20, 1941–March 20, 1943.

———, gen. ed. *Encyclopedia of Photography.* 20 vols. New York: Greystone Press, 1963–1964.

———. *Famous Photographs.* New York: National Educational Alliance, 1948.

———. *100 Lessons in Photography.* New York: National Educational Alliance, 1947.

———, and Henry M. Lester. *Correct Exposure in Photography.* New York: Morgan & Lester, 1944.

———. *The Leica Manual.* New York: Morgan & Lester, 1938.

———. *Miniature Camera Work.* New York: Morgan & Lester, 1938.

MOSES, GUSTAVE A., AND EUGENE A. PIFFET
Johnson

Mahe, John A., II, and Roseanne McCaffery, eds. *Encyclopaedia of New Orleans Artists, 1718–1918.* New Orleans: Historic New Orleans Collection, 1987.

Smith, Margaret Denton, and Mary Louise Tucker. *Photography in New Orleans: The Early Years, 1840–1865.* Baton Rouge: Louisiana State University Press, 1982.

MURPHY, MICHAEL
Armstrong, Frank. *Photography in the West: A Modern View.* Corning, New York: The Rockwell Museum, 1987.

Sandweiss, Martha A., ed. *Contemporary Texas: A Photographic Portrait.* Austin: Texas Monthly Press, 1986.

Williams, Rick. *Visiones de Tejanos/Visions of Texans.* Austin: Texas Photographic Society, Inc., 1989.

MUYBRIDGE, EADWEARD
Auer, ICP, Johnson, Macmillan

Burns, E. Bradford. *Eadweard Muybridge in Guatemala, 1875: The Photographer as Social Recorder.* Berkeley: University of California Press, 1986.

Current, Karen. *Photography in the Old West.* New York: Harry N. Abrams, in association with the Amon Carter Museum, 1978.

Fleming, Paula R., and Judith Luskey. *The North American Indians in Early Photographs.* New York: Harper & Row, 1986.

Hendricks, Gordon. *Eadweard Muybridge: The Father of the Motion Picture.* New York: Grossman Publishers, 1975.

Tucker, Anne W., ed. *Target III: In Sequence.* Houston: Museum of Fine Arts, 1982.

MYDANS, CARL
Auer, ICP, Macmillan, Naylor

Bailey, Ronald H. "The History of Carl Mydans." *American Photographer* 15 (August 1985): 42–57.

Dixon, Penelope. *Photographers of the Farm Security Administration: An Annotated Bibliography, 1930–1980.* New York: Garland Publishing, Inc., 1983.

Mydans, Carl. *Carl Mydans, Photojournalist.* New York: Harry N. Abrams, 1985.

MYERS, JOAN
Auer, Macmillan

Garner, Gretchen. *Reclaiming Paradise: American Women Photograph the Land.* Duluth: Tweed Museum of Art, University of Minnesota, 1987.

Hafey, John, and Tom Shillea. *The Platinum Print.* Rochester, New York: Rochester Institute of Technology, 1979.

Myers, Joan. *Along the Santa Fe Trail.* Albuquerque: University of New Mexico Press, 1986.

Simon, Harold. *A Breath of Life: The Contemporary Platinum Print.* Trenton, New Jersey: New Jersey State Museum, 1986.

Yates, Steven A., ed. *The Essential Landscape: The New Mexico Photographic Survey.* Albuquerque: University of New Mexico Press, 1985.

NEWHALL, BEAUMONT
Auer, ICP, Macmillan

Myers, Roger, comp. *Guide to Archival Materials of the Center for Creative Photography.* Tucson: Center for Creative Photography, University of Arizona, 1986.

Newhall, Beaumont. *In Plain Sight: The Photographs of Beaumont Newhall.* Salt Lake City: Gibbs M. Smith, Inc., 1983.

NIXON, NICHOLAS
Naylor, WWAA 19

Nixon, Nicholas. *Pictures of People.* Boston: New York Graphic Society, 1988.

NOGGLE, ANNE
Auer, Macmillan, WWAA 19

Coke, Van Deren. *Photography in New Mexico.* Albuquerque: University of New Mexico Press, 1979.

Coke, Van Deren, and Diana C. Du Pont. *Photography: A Facet of Modernism.* New York: Hudson Hills Press, 1986.

Noggle, Anne. *For God, Country, and the Thrill of It.* College Station: Texas A&M University Press, 1990.

———. *Silver Lining: Photographs by Anne Noggle.* Albuquerque: University of New Mexico Press, 1983.

Yates, Steven A., ed. *The Essential Landscape: The New Mexico Photographic Survey.* Albuquerque: University of New Mexico Press, 1985.

NORDENSKIOLD, GUSTAF

Nordenskiold, Gustaf. *The Cliff Dwellers of the Mesa Verde*. Reprint of 1893 ed. Glorieta, New Mexico: The Rio Grande Press, 1979.

NORMAN, DOROTHY

Macmillan, WWAA 19

Myers, Roger, comp. *Guide to Archival Materials of the Center for Creative Photography*. Tucson: Center for Creative Photography, University of Arizona, 1986.

Norman, Dorothy. *Beyond a Portrait: Photographs*. Millerton, New York: Aperture, 1984.

NORTH, WILLIAM C.

Rinhart, Floyd, and Marion Rinhart. *The American Daguerreotype*. Athens: University of Georgia Press, 1981.

NOTMAN, WILLIAM

Auer, ICP, Johnson, Macmillan

Fleming, Paula R., and Judith Luskey. *The North American Indians in Early Photographs*. New York: Harper & Row, 1986.

Harper, J. Russell, and Stanley Triggs. *Portrait of a Period: A Collection of Notman Photographs, 1856–1915*. Montreal: McGill University Press, 1967.

Triggs, Stanley G. *William Notman: The Stamp of a Studio*. Toronto: Coach House Press, for the Art Gallery of Ontario, 1985.

OLLMAN, ARTHUR

Auer, Macmillan, WWAA 19

Johnson, Deborah J., ed. *Contemporary Photography*. Providence, Rhode Island: Museum of Art, Rhode Island School of Design, 1982.

Katzman, Louise. *Photography in California, 1945–1980*. New York: Hudson Hills Press, 1984.

ORLAND, TED

ACM, Macmillan, WWAA 19

Cahn, Robert, and Robert Glenn Ketchum. *American Photographers and the National Parks*. New York: Viking Press, 1981.

Orland, Ted. *Scenes of Wonder & Curiosity*. Boston: David R. Godine, 1988.

O'SULLIVAN, TIMOTHY H.

Auer, ICP, Johnson, Macmillan

Current, Karen. *Photography and the Old West*. New York: Harry N. Abrams, in association with the Amon Carter Museum, 1978.

Dingus, Rick. *The Photographic Artifacts of Timothy O'Sullivan*. Albuquerque: University of New Mexico Press, 1982.

Horan, James D. *Timothy O'Sullivan: America's Forgotten Photographer*. Garden City, New York: Doubleday & Co., 1966.

Klett, Mark, et al. *Second View: The Rephotographic Survey Project*. Albuquerque: University of New Mexico Press, 1984.

Newhall, Beaumont, and Nancy Newhall. *T.H. O'Sullivan, Photographer*. Rochester, New York: George Eastman House, in collaboration with the Amon Carter Museum, 1966.

Snyder, Joel. *American Frontiers: The Photographs of Timothy O'Sullivan, 1867–1874*. Millerton, New York: Aperture, 1981.

OUTERBRIDGE, PAUL

Auer, ICP, Macmillan, Naylor

Barnes, Lucinda, ed. *A Collective Vision: Clarence H. White and His Students*. Long Beach, Calif.: University Art Museum, California State University, 1985.

Dines, Elaine, ed. *Paul Outerbridge: A Singular Aesthetic*. Laguna Beach, Calif.: Laguna Beach Museum of Art, 1981.

Howe, Graham, and G. Ray Hawkins, eds. *Paul Outerbridge, Jr.: Photographs*. New York: Rizzoli, 1980.

Tsujimoto, Karen. *Images of America: Precisionist Painting & Modern Photography*. San Francisco: San Francisco Museum of Modern Art, 1982.

PECK, MARY

Armstrong, Frank. *Photography in the West: A Modern View*. Corning, New York: The Rockwell Museum, 1987.

Garner, Gretchen. *Reclaiming Paradise: American Women Photograph the Land*. Duluth: Tweed Museum of Art, University of Minnesota, 1987.

Kalil, Susie. *The Texas Landscape, 1900–1986*. Houston: Museum of Fine Arts, 1986.

Sandweiss, Martha A., ed. *Contemporary Texas: A Photographic Portrait*. Austin: Texas Monthly Press, 1986.

Yates, Steven A., ed. *The Essential Landscape: The New Mexico Photographic Survey*. Albuquerque: University of New Mexico Press, 1985.

PENN, IRVING

Auer, ICP, Macmillan, Naylor, WWAA 19

Penn, Irving. *Moments Preserved*. New York: Simon and Schuster, 1960.

Penn, Irving. *Passage, a Work Record*. New York: Knopf, 1991.

Szarkowski, John. *Irving Penn*. New York: Museum of Modern Art, 1984.

PEVEN, MICHAEL

ACM, Macmillan, WWAA 19

PHELPS, BRENT

ACM

PLOSSU, BERNARD

Auer, Macmillan, Naylor, WWAA 19

Myers, Roger, comp. *Guide to Archival Materials in the Center for Creative Photography*. Tucson: Center for Creative Photography, University of Arizona, 1986.

Plossu, Bernard. *The African Desert*. Tucson: University of Arizona Press, 1987.

Yates, Steven A., ed. *The Essential Landscape: The New Mexico Photographic Survey*. Albuquerque: University of New Mexico Press, 1985.

PORTER, ELIOT

Auer, ICP, Macmillan, Naylor, WWAA 19

Porter, Eliot. *Eliot Porter*. Boston: New York Graphic Society, in association with the Amon Carter Museum, 1987.

———. *Intimate Landscapes*. New York: The Metropolitan Museum of Art, 1979.

POST, HELEN

ACM

Clark, Ann. *Brave Against the Enemy*. Lawrence, Kansas: Haskell Institute, 1944.

La Farge, Oliver. *As Long as the Grass Shall Grow*. New York: Alliance Book Corp., 1940.

Modley, Peter. "Biography of Helen Post." *Photo Metro* 4 (February 1986): 20–21.

PRATHER, ROGER

ACM

PRATHER, WINTER

ACM

Prather, Winter. "Oil Field 'Abstracts'." *Empire: The Magazine of the Denver Post* 7 (October 14, 1956): 8.

———. "The West of North America." *Camera* 46 (July 1967): 4–21.

PYWELL, WILLIAM R.

Johnson

Davis, William C., ed. *The Image of War, 1861–1865*. 6 vols. Garden City, New York: Doubleday & Co., 1984.

Gardner, Alexander. *Gardner's Photographic Sketch Book of the Civil War*. New York: Dover Publications, Inc., 1959.

Katz, D. Mark. *Witness to an Era: The Life and Photographs of Alexander Gardner*. New York: Viking, 1991.

RABE, WILLIAM HENRY

"The Passing of W.H. Rabe." *Camera Craft* 26 (February 1919): 73.

RANNEY, EDWARD

Auer, Macmillan

Ranney, Edward. *Stonework of the Maya*. Albuquerque: University of New Mexico Press, 1974.

Ranney, Edward, and John Hemming. *Monuments of the Incas*. Boston: New York Graphic Society, 1982.

Yates, Steven A., ed. *The Essential Landscape: The New Mexico Photographic Survey*. Albuquerque: University of New Mexico Press, 1985.

RAU, WILLIAM H.

Johnson, Macmillan

Coke, Van Deren. *Photography in New Mexico*. Albuquerque: University of New Mexico Press, 1979.

Finkel, Kenneth. *Nineteenth-Century Photography in Philadelphia*. New York: Dover Publications, Inc., 1980.

Grundberg, Andy. "William Rau's Scene was the Railroad." *New York Times*, August 2, 1987, sec. H, pp. 29, 34.

Panzer, Mary. *Philadelphia Naturalistic Photography*. New Haven, Conn.: Yale University Art Gallery, 1982.

Pare, Richard. *Photography and Architecture: 1839–1939*. Montreal: Canadian Center for Architecture, 1982.

Ruby, Jay, Gerald Bastoni, and Charles Isaacs. *Reflections on 19th-Century Pennsylvania Landscape Photography*. Bethlehem, Penn.: Lehigh University Art Galleries, 1986.

REDFIELD, ROBERT S.

Homer, William Innes. *Alfred Stieglitz and the Photo-Secession*. Boston: New York Graphic Society, 1983.

Keiley, Joseph T. "Robert S. Redfield and the Photographic Society of Philadelphia." *Camera Notes* 5 (July 1901): 59–61.

Panzer, Mary. *Philadelphia Naturalistic Photography*. New Haven, Conn.: Yale University Art Gallery, 1982.

REECE, JANE

Macmillan

Brannick, John A. "Jane Reece and Her Autochromes." *History of Photography* 13 (January–March 1989): 1–4.

"Jane Reece Memorial Exhibition: The Wonderful World of Photography." *Dayton Art Institute Bulletin* 21 (March–April 1963): 1–8.

Mann, Margery. *Women of Photography: An Historical Survey*. San Francisco: San Francisco Museum of Modern Art, 1975.

REEKIE, JOHN

Davis, William C., ed. *The Image of War, 1861–1865*. 6 vols. Garden City, New York: Doubleday & Co., 1984.

Gardner, Alexander. *Gardner's Photographic Sketch Book of the Civil War*. New York: Dover Publications, Inc., 1959.

RICE, TED, III

ACM, Auer

RINEHART, FRANK A.

Bigart, Robert, and Clarence Woodcock. "The Rinehart Photographs: A Portfolio." *Montana: The Magazine of Western History* 29 (October 1979): 24–37.

Fleming, Paula R., and Judith Luskey. *The North American Indians in Early Photographs*. New York: Harper & Row, 1986.

Sutton, Royal. *The Face of Courage: The Indian Photographs of Frank A. Rinehart*. Fort Collins, Colo.: Old Army Press, 1972.

ROGERS, BYRON

ACM

ROSSKAM, EDWIN

Plattner, Steven W. *Roy Stryker: U.S.A., 1943–1950*. Austin: University of Texas Press, 1983.

ROTHSTEIN, ARTHUR

Auer, ICP, Macmillan, Naylor

Dixon, Penelope. *Photographers of the Farm Security Administration: An Annotated Bibliography, 1930–1980*. New York: Garland Publishing, Inc., 1983.

Fleischhauer, Carl, and Beverly W. Brannan, eds. *Documenting America, 1935–1943*. Berkeley: University of California Press, 1988.

Plattner, Steven W. *Roy Stryker: U.S.A., 1943–1950*. Austin: University of Texas Press, 1983.

ROTKIN, CHARLES

Plattner, Steven W. *Roy Stryker: U.S.A., 1943–1950*. Austin: University of Texas Press, 1983.

RUBENSTEIN, MERIDEL

Auer, Naylor, WWAA 19

Armstrong, Frank. *Photography in the West: A Modern View*. Corning, New York: The Rockwell Museum, 1987.

Garner, Gretchen. *Reclaiming Paradise: American Women Photograph the Land*. Duluth: Tweed Museum of Art, University of Minnesota, 1987.

Rubenstein, Meridel. *La Gente de la Luz: Portraits from New Mexico*. Santa Fe: Museum of Fine Arts, Museum of New Mexico, 1977.

Yates, Steven A., ed. *The Essential Landscape: The New Mexico Photographic Survey*. Albuquerque: University of New Mexico Press, 1985.

RUBINCAM, HARRY C.

Naef, Weston J. *The Collection of Alfred Stieglitz: Fifty Pioneers of Modern Photography*. New York: The Metropolitan Museum of Art/Viking Press, 1978.

RULOFSON, WILLIAM H.

Johnson

Haas, Robert B. "William Herman Rulofson, Pioneer Daguerreotypist and Photographic Educator." *California Historical Society Quarterly* 34 (December 1955): 288–300, and 35 (March 1956): 47–58.

RUMEL, HAL

ACM

RUSSELL, ANDREW J.

Johnson, Macmillan

Combs, Barry B. *Westward to Promontory*. Palo Alto, Calif.: American West Publishing Co., 1969.

Cooney, Charles F. "Andrew J. Russell: The Union Army's Forgotten Photographer." *Civil War Times Illustrated* 21 (April 1982): 32–35.

Current, Karen. *Photography and the Old West*. New York: Harry N. Abrams, in association with the Amon Carter Museum, 1978.

Davis, William C., ed. *The Image of War, 1861–1865*. 6 vols. Garden City, New York: Doubleday & Co., 1984.

Fels, Thomas Weston. *Destruction and Destiny: The Photographs of A.J. Russell*. Pittsfield, Mass.: The Berkshire Museum, 1987.

Naef, Weston J. *Era of Exploration: The Rise of Landscape Photography in the American West, 1860–1885*. Boston: New York Graphic Society, 1975.

Russell, Andrew J. *Russell's Civil War Photographs*. New York: Dover Publications, Inc., 1982.

Walther, Susan Danly. *The Landscape Photographs of Alexander Gardner and Andrew Joseph Russell*. Ph.D. diss., Brown University, 1983.

SARONY, NAPOLEON

Auer, Johnson, Macmillan,

Bassham, Ben L. *The Theatrical Photographs of Napoleon Sarony*. Kent, Ohio: Kent State University Press, 1978.

Taft, Robert. *Photography and the American Scene*. New York: Macmillan, 1938; reprint ed., New York: Dover Publications, Inc., 1964.

SAVAGE, CHARLES R.

Johnson, Macmillan

Andrews, Ralph W. *Picture Gallery Pioneers, 1850–1875.* Seattle: Superior Publishing Co., 1964.

Fleming, Paula R., and Judith Luskey. *The North American Indians in Early Photographs.* New York: Harper & Row, 1986.

Naef, Weston J. *Era of Exploration: The Rise of Landscape Photography in the American West, 1860–1885.* Boston: New York Graphic Society, 1975.

Wadsworth, Nelson B. *Through Camera Eyes.* Provo, Utah: Brigham Young University Press, 1975.

SCHEINBAUM, DAVID

ACM, Auer

Armstrong, Frank. *Photography in the West: A Modern View.* Corning, New York: The Rockwell Museum, 1987.

Scheinbaum, David. *Bisti.* Albuquerque: University of New Mexico Press, 1987.

————. *Miami Beach.* Miami: Florida International University Press, 1990.

SEELEY, GEORGE H.

Macmillan

Dimock, George, and Joanne Hardy. *Intimations and Imaginings: The Photographs of George H. Seeley.* Pittsfield, Mass.: The Berkshire Museum, 1986.

Homer, William Innes. *Alfred Stieglitz and the Photo-Secession.* Boston: New York Graphic Society, 1983.

Naef, Weston J. *The Collection of Alfred Stieglitz: Fifty Pioneers of Modern Photography.* New York: The Metropolitan Museum of Art/Viking Press, 1978.

SHAHN, BEN

Auer, Macmillan, Naylor

Dixon, Penelope. *Photographers of the Farm Security Administration: An Annotated Bibliography, 1930–1980.* New York: Garland Publishing, Inc., 1983.

Fleischhauer, Carl, and Beverly W. Brannan, eds. *Documenting America, 1935–1943.* Berkeley: University of California Press, 1988.

Pratt, Davis, ed. *The Photographic Eye of Ben Shahn.* Cambridge, Mass.: Harvard University Press, 1975.

SHEELER, CHARLES

Auer, ICP, Macmillan, Naylor

Stebbins, Theodore, E., Jr., and Norman Keyes, Jr. *Charles Sheeler: The Photographs.* Boston: New York Graphic Society, 1987.

SHULTZ, PHIL

ACM

SINSABAUGH, ART

Auer, ICP, Macmillan, Naylor

Sinsabaugh, Art, and Sherwood Anderson. *6 Mid-American Chants/11 Mid-West Photographs.* Highlands, N.C.: J. Williams, 1964.

Thornton, Gene. "Apropos: Art Sinsabaugh's Landscapes." *Camera* 58 (April 1979): 36–37.

SIPPRELL, CLARA E.

Bannon, Anthony. *The Photo-Pictorialists of Buffalo.* Buffalo, New York: Media Study/Buffalo, 1981.

Garner, Gretchen. *Reclaiming Paradise: American Women Photograph the Land.* Duluth: Tweed Museum of Art, University of Minnesota, 1987.

McCabe, Mary Kennedy. *Clara E. Sipprell: Pictorial Photographer.* Fort Worth: Amon Carter Museum, 1990.

Vining, Elizabeth Gray. *Moment of Light: Photographs by Clara Sipprell.* New York: John Day Co., 1966.

SMITH, ERWIN E.

De Booy, H.T. "Pioneer Photographers." *New Mexico Magazine* 37 (February 1959): 22ff.

Haley, J. Evetts. "Smith of the Southwestern Range." In *Focus on the Frontier,* pp. 27–48. Amarillo, Texas: The Shamrock Oil and Gas Corp., 1957.

McKeen, Ona Lee. "Erwin Evans Smith, Cowboy Photographer." In *A Century of Photographs, 1846–1946,* pp. 156–162. Washington, D.C.: Library of Congress, 1980.

Smith, Erwin E., and J. Evetts Haley. *Life on the Texas Range.* Austin: University of Texas Press, 1952.

SMITH, HENRY HOLMES

Auer, Macmillan, Naylor

Enyeart, James, and Nancy Solomon, eds. *Henry Holmes Smith: Collected Writings 1935–1985.* Tucson: Center for Creative Photography, University of Arizona, 1986.

Lamb, Charles, and Mary Ellen McGoldrick, comps. *Henry Holmes Smith Papers.* Tucson: Center for Creative Photography, Guide Series No. 8, University of Arizona, 1983.

Lyons, Nathan, ed. *Photographers on Photography.* Englewood Cliffs, New Jersey: Prentice-Hall, 1966.

Myers, Roger, comp. *Guide to Archival Materials of the Center for Creative Photography.* Tucson: Center for Creative Photography, University of Arizona, 1986.

SMITH, MICHAEL A.

ACM, Macmillan, WWAA 19

Cahn, Robert, and Robert Glenn Ketchum. *American Photographers and the National Parks.* New York: Viking Press, 1981.

Gohlke, Frank. *Measures of Emptiness: Grain Elevators in the American Landscape.* Baltimore: Johns Hopkins University Press, 1992.

Michael A. Smith: A Visual Journey; Photographs from Twenty-Five Years. Revere, Penn.: Lodima Press, 1992.

Smith, Michael A. *Landscapes 1975–1979.* Otisvile, Penn.: the author, 1979.

————. "On Teaching Photography." *Exposure* 14 (February 1976): 8–9.

SMITH, W. EUGENE

Willumson, Glenn G. *W. Eugene Smith and the Photographic Essay.* London and New York: Cambridge University Press, 1992.

SMITH, W. MORRIS

Davis, William C., ed. *The Image of War, 1861–1865.* 6 vols. Garden City, New York: Doubleday & Co., 1984.

Gardner, Alexander. *Gardner's Photographic Sketch Book of the Civil War.* New York: Dover Publications, Inc., 1959.

SOUTHWORTH, ALBERT SANDS, AND JOSIAH JOHNSON HAWES

Auer, ICP, Johnson, Macmillan

Hower, Rachel Johnston, ed. *The Legacy of Josiah Johnson Hawes: 19th Century Photographs of Boston.* Barre, Mass.: Barre Publishers, 1972.

Sobieszek, Robert A., and Odette M. Appel. *The Spirit of Fact: The Daguerreotypes of Southworth & Hawes, 1843–1862.* Boston: David R. Godine, for the International Museum of Photography at George Eastman House, 1976.

STACKPOLE, PETER

ICP, Macmillan

Stackpole, Peter. *The Bridge Builders: Photographs and Documents of the Raising of the San Francisco Bay Bridge, 1934–1936.* Corte Madera, Calif.: Pomegranate Artbooks, 1984.

Tsujimoto, Karen. *Images of America: Precisionist Painting and Modern Photography.* San Francisco: San Francisco Museum of Modern Art, 1982.

STEFFY, SUSAN

ACM

STEICHEN, EDWARD

Auer, ICP, Macmillan, Naylor

Longwell, Dennis. *Steichen: The Master Prints, 1895–1914, The Symbolist Period.* New York: Museum of Modern Art, 1978.

Lyons, Nathan, ed. *Photographers on Photography*. Englewood Cliffs, New Jersey: Prentice-Hall, 1966.

Naef, Weston J. *The Collection of Alfred Stieglitz: Fifty Pioneers of Modern Photography*. New York: The Metropolitan Museum of Art/Viking Press, 1978.

Steichen, Edward. *A Life in Photography*. Garden City, New York: Doubleday & Co., 1963.

Steichen the Photographer. New York: Museum of Modern Art, 1961.

STEINER, RALPH

ICP, Macmillan, Naylor

Barnes, Lucinda, ed. *A Collective Vision: Clarence H. White and His Students*. Long Beach, Calif.: University Art Museum, California State University, 1985.

Myers, Roger, comp. *Guide to Archival Materials of the Center for Creative Photography*. Tucson: Center for Creative Photography, University of Arizona, 1986.

Steiner, Ralph. *A Point of View*. Middletown, Conn.: Wesleyan University Press, 1978.

_____. *Ralph Steiner: A Retrospective Exhibition*. Hanover, New Hampshire: Dartmouth College Museum and Galleries, 1979.

_____. "The Twentieth Century." *Camera Arts* 1 (March-April 1981): 14–16ff.

Tsujimoto, Karen. *Images of America: Precisionist Painting and Modern Photography*. San Francisco: San Francisco Museum of Modern Art, 1982.

Zuker, Joel Stewart. *Ralph Steiner: Filmmaker and Still Photographer*. Ph.D. diss., New York University, 1976.

STEIGLITZ, ALFRED

Auer, ICP, Macmillan, Naylor

Bry, Doris. *Alfred Stieglitz: Photographer*. Boston: Museum of Fine Arts, 1965.

Greenough, Sarah, and Juan Hamilton. *Alfred Stieglitz: Photographs and Writings*. Washington, D.C.: National Gallery of Art, 1983.

Homer, William Innes. *Alfred Stieglitz and the Photo-Secession*. Boston: New York Graphic Society, 1983.

Lyons, Nathan, ed. *Photographers on Photography*. Englewood Cliffs, New Jersey: Prentice-Hall, 1966.

Naef, Weston J. *The Collection of Alfred Stieglitz: Fifty Pioneers of Modern Photography*. New York: The Metropolitan Museum of Art/Viking Press, 1978.

STODDARD, SENECA RAY

Johnson

Crowley, William. *Seneca Ray Stoddard: Adirondack Illustrator*. Blue Mountain Lake, New York: Adirondack Museum, 1982.

De Sormo, Maitland C. *Seneca Ray Stoddard: Versatile Camera-Artist*. Saranac Lake, New York: Adirondack Yesteryears, Inc., 1972.

STRAND, PAUL

Auer, ICP, Macmillan, Naylor

Greenough, Sarah. *Paul Strand: An American Vision*. Washington: National Gallery of Art, 1990.

Lyons, Nathan, ed. *Photographers on Photography*. Englewood Cliffs, New Jersey: Prentice-Hall, 1966.

Myers, Roger, comp. *Guide to Archival Materials of the Center for Creative Photography*. Tucson: Center for Creative Photography, University of Arizona, 1986.

Naef, Weston J. *The Collection of Alfred Stieglitz: Fifty Pioneers of Modern Photography*. New York: The Metropolitan Museum of Art/Viking Press, 1978.

Stange, Maren, ed. *Paul Strand: Essays on His Life and Work*. New York: Aperture, 1990.

Strand, Paul. *Paul Strand: A Retrospective Monograph*. 2 vols. Millerton, New York: Aperture, 1971.

_____. *Paul Strand: Sixty Years of Photographs*. Millerton, New York: Aperture, 1976.

Tsujimoto, Karen. *Images of America: Precisionist Painting and Modern Photography*. San Francisco: San Francisco Museum of Modern Art, 1982.

STRUSS, KARL

ICP, Macmillan

Barnes, Lucinda, ed. *A Collective Vision: Clarence J. White and His Students*. Long Beach, Calif.: University Art Museum, California State University, 1985.

Eyman, Scott. *Five American Cinematographers*. Metuchen, New Jersey: Scarecrow Press, 1987.

Harvith, John, and Susan Harvith. *Karl Struss: Man With a Camera*. Bloomfield Hills, Mich.: Cranbrook Academy of Art Museum, 1976.

Homer, William Innes. *Alfred Stieglitz and the Photo-Secession*. Boston: New York Graphic Society, 1983.

Mann, Margery. *California Pictorialism*. San Francisco: San Francisco Museum of Modern Art, 1977.

Pultz, John, and Catherine B. Scallen. *Cubism and American Photography, 1910–1930*. Williamstown, Mass.: Sterling and Francine Clark Art Institute, 1981.

Struss, Karl. *The Dawn of Color*. Los Angeles: Stephen White Gallery, 1981.

SUTOR, NANCY

ACM

TABER, ISAIAH W.

Johnson

Andrews, Ralph W. *Picture Gallery Pioneers, 1850 to 1875*. Seattle: Superior Publishing Co., 1964.

Hales, Peter B. *Silver Cities: The Photography of American Urbanization, 1839–1915*. Philadelphia: Temple University Press, 1984.

TAYLOR, PAUL S.

ICP, Macmillan

Janis, Eugenia Parry, and Wendy McNeil. *Photography Within the Humanities*. Wellesley, Mass.: Art Department, Jewett Arts Center, Wellesley College, 1977.

Lange, Dorothea, and Paul Taylor. *An American Exodus: A Record of Human Erosion in the Thirties*. New Haven, Conn.: Yale University Press, for the Oakland Museum, 1969.

Street, Richard S. "Paul S. Taylor and the Origins of Documentary Photography in California, 1927–1934." *History of Photography* 7 (October-December 1983): 293–304.

Taylor, Paul S. *On the Ground in the Thirties*. Salt Lake City: Peregrine Smith Books, 1983.

TICE, GEORGE

Auer, Macmillan, Naylor, WWAA 19

Myers, Roger, comp. *Guide to Archival Materials of the Center for Creative Photography*. Tucson: Center for Creative Photography, University of Arizona, 1986.

Tice, George A. *George A. Tice Photographs, 1953–1973*. New Brunswick, New Jersey: Rutgers University Press, 1975.

Tice, George. *Urban Romantic: The Photographs of George Tice*. Boston: David R. Godine, 1982.

TICHICH, RICHARD

ACM

TODD, RONALD JAMES

ACM, Macmillan

ULMANN, DORIS

Auer, Macmillan, Naylor

Barnes, Lucinda, ed. *A Collective Vision: Clarence H. White and His Students*. Long Beach, Calif.: University Art Museum, California State University, 1985.

Clift, William, ed. *The Darkness and the Light: Photographs by Doris Ulmann*. Millerton, New York: Aperture, 1974.

Featherstone, David. *Doris Ulmann, American Portraits*. Albuquerque: University of New Mexico Press, 1985.

VAN DYKE, WILLARD

Auer, ICP, Macmillan, Naylor

Engle, Harrison. "Thirty Years of Social Inquiry: An Interview with Willard van Dyke." *Film Comment* 3 (Winter 1965): 24–37.

Tsujimoto, Karen. *Images of America: Precisionist Painting and Modern Photography.* San Francisco: San Francisco Museum of Modern Art, 1982.

Tucker, Jean S. *Group f.64.* St. Louis: University of Missouri, 1978.

VAUGHAN, CAROLINE

ACM

Eubanks, Georgann. "Angling for the Elusive." [Durham, North Carolina] *Independent Weekly* (July 27–August 2, 1989): 7–9.

"Young Photographers." *Camera* 54 (August 1975): 37.

VESTAL, DAVID

Auer, Macmillan, Naylor, WWAA 19

Vestal, David. *The Craft of Photography.* New York: Harper & Row, revised ed., 1975.

———. *The Art of Black-and-White Enlarging.* New York: Harper & Row, 1984.

VROMAN, ADAM CLARK

ICP, Macmillan

Current, Karen. *Photography and the Old West.* New York: Harry N. Abrams, in association with the Amon Carter Museum, 1978.

Fleming, Paula R., and Judith Luskey. *The North American Indians in Early Photographs.* New York: Harper & Row, 1986.

Mahood, Ruth I., ed. *Photographer of the Southwest: Adam Clark Vroman, 1856–1916.* Los Angeles: Ward Ritchie Press, 1961.

Webb, William, and Robert A. Weinstein. *Dwellers at the Source: Southwestern Indian Photographs of A.C. Vroman, 1895–1904.* New York: Grossman Publishers, 1973.

WATKINS, CARLETON E.

ICP, Johnson, Macmillan

Current, Karen. *Photography and the Old West.* New York: Harry N. Abrams, in association with the Amon Carter Museum, 1978.

Palmquist, Peter E. *Carleton E. Watkins: Photographer of the American West.* Albuquerque: University of New Mexico, for the Amon Carter Museum, 1983.

Rule, Amy, ed. *Carleton Watkins.* Boston: G. K. Hall, 1992.

———. *Carleton E. Watkins: Photographs, 1861–1874.* San Francisco: Fraenkel Gallery, in association with Bedford Arts, Publishers, 1989.

WATKINS, MARGARET

Auer

Mulholland, Joseph. "A Sad Strange Gleam of Vision." *Photographic Collector* 3 (Spring 1982): 50–63.

Mulholland, Joseph, and George Oliver. *Margaret Watkins Photographs, 1917–1930.* Glasgow, Scotland: Third Eye Center, 1981.

WATRISS, WENDY V.

Auer

Sandweiss, Martha A., ed. *Contemporary Texas: A Photographic Portrait.* Austin: Texas Monthly Press, 1986.

Williams, Rick. *Visiones de Tejanos/Visions of Texans.* Austin: Texas Photographic Society, Inc., 1989.

WEBB, TODD

Auer, Naylor, WWAA 19

Alexander, Drury Blakeley, and Todd Webb. *Texas Homes of the 19th Century.* Austin: University of Texas Press, for the Amon Carter Museum, 1966.

Davis, Keith. *Todd Webb: Photographs of New York and Paris, 1945–1960.* Kansas City: Hallmark Cards, Inc., 1986.

Myers, Roger, comp. *Guide to Archival Materials of the Center for Creative Photography.* Tucson: Center for Creative Photography, University of Arizona, 1986.

Plattner, Steven W. *Roy Stryker: U.S.A., 1943–1950.* Austin: University of Texas Press, 1983.

Robinson, Willard B., and Todd Webb. *Texas Public Buildings of the Nineteenth Century.* Austin: University of Texas Press, for the Amon Carter Museum, 1974.

Webb, Todd. *Georgia O'Keeffe: The Artist's Landscape.* Pasadena, Calif.: Twelvetrees Press, 1984.

———. *Looking Back: Memoirs and Photographs.* Albuquerque: University of New Mexico Press, 1991.

———. *Todd Webb Photographs: Early Western Trails and Some Ghost Towns.* Fort Worth: Amon Carter Museum, 1965.

WEED, CHARLES L.

Johnson

Andrews, Ralph W. *Picture Gallery Pioneers, 1850 to 1875.* Seattle: Superior Publishing Co., 1964.

Naef, Weston J. *Era of Exploration: The Rise of Landscape Photography in the American West, 1860–1885.* Boston: New York Graphic Society, 1975.

Palmquist, Peter. "California's Peripatetic Photographer, Charles Leander Weed." *California History* 58 (Fall 1979): 194–219.

Pare, Richard. *Photography and Architecture: 1839–1939.* Montreal: Canadian Center for Architecture, 1982.

WEEGEE (ARTHUR FELLIG)

Auer, ICP, Macmillan, Naylor

Livingston, Jane. *The New York School: Photographs 1936–1963.* New York: Stewart, Tabori and Chang, 1992.

Martin, Peter. *Weegee.* San Francisco: San Francisco Museum of Modern Art, 1984.

Stettner, Louis. *Weegee.* New York: Knopf, 1977.

Weegee. Millerton, New York: Aperture, 1978.

WESTON, BRETT

Auer, ICP, Macmillan, Naylor

Tsujimoto, Karen. *Images of America: Precisionist Painting and Modern Photography.* San Francisco: San Francisco Museum of Modern Art, 1982.

Tucker, Jean S. *Group f.64.* St. Louis: University of Missouri, 1978.

Weston, Brett. *Brett Weston: Master Photographer.* Carmel, Calif.: Photography West Graphics, 1989.

———. *Brett Weston: A Personal Selection.* Carmel, Calif.: Photography West Graphics, 1986.

———. *Brett Weston Photographs.* Fort Worth: Amon Carter Museum, 1966.

———. *Brett Weston: Photographs from Five Decades.* Millerton, New York: Aperture, 1980.

WESTON, COLE

Auer, Macmillan, Naylor

Weston, Cole. *Fifty Years: Cole Weston.* Layton, Utah: Gibbs Smith, 1991.

WESTON, EDWARD

Auer, ICP, Macmillan, Naylor

Bunnell, Peter C., and David Featherstone, eds. *EW: 100; Centennial Essays in Honor of Edward Weston.* Carmel, Calif.: Friends of Photography, *Untitled* 41, 1986.

Bunnell, Peter C., ed. *Edward Weston on Photography.* Salt Lake City: Gibbs M. Smith, Inc., 1983.

Conger, Amy. *Edward Weston: Photographs from the Collection of the Center for Creative Photography.* Tucson: Center for Creative Photography, The University of Arizona, 1992.

Maddow, Ben. *Edward Weston: Fifty Years.* Millerton, New York: Aperture, 1973.

Myers, Roger, comp. *Guide to Archival Materials of the Center for Creative Photography.* Tucson: Center for Creative Photography, University of Arizona, 1986.

Newhall, Beaumont. *Supreme Instants: The Photography of Edward Weston*. Boston: New York Graphic Society, 1986.

Newhall, Beaumont, and Amy Conger, eds. *Edward Weston Omnibus: A Critical Anthology*. Salt Lake City: Gibbs M. Smith, Inc., 1984.

Stark, Amy, comp. *Edward Weston Papers*. Tucson: Center for Creative Photography, Guide Series no. 13, University of Arizona, 1986.

WESTON, NEIL

Maddow, Ben. *Edward Weston: Fifty Years*. Millerton, New York: Aperture, 1973.

Weston, Edward. *Six Nudes of Neil, 1925*. [A Witkin Gallery Portfolio, Printed in Palladium by George A. Tice, New York, 1977].

WHITE, CLARENCE H.

Auer, ICP, Macmillan

Barnes, Lucinda, ed. *A Collective Vision: Clarence H. White and His Students*. Long Beach, Calif.: University Art Museum, California State University, 1985.

Bunnell, Peter C. *Clarence H. White: The Reverence for Beauty*. Athens, Ohio: Ohio University Gallery of Fine Art, 1986.

Delaware Art Museum. *Symbolism of Light: The Photographs of Clarence H. White*. Wilmington: Delaware Art Museum, 1977.

Naef, Weston J. *The Collection of Alfred Stieglitz: Fifty Pioneers of Modern Photography*. New York: The Metropolitan Museum of Art/Viking Press, 1978.

White, Maynard P. *Clarence H. White*. Millerton, New York: Aperture, 1979.

Yochelson, Bonnie. "Clarence H. White Reconsidered: An Alternative to the Modernist Aesthetic of Straight Photography." *Studies in Visual Communication* 9 (Fall 1983): 24–44.

WHITE, MINOR

Auer, ICP, Macmillan, Naylor

Bunnell, Peter. *Minor White: The Eye That Shapes*. Boston: New York Graphic Society, 1989.

Myers, Roger, comp. *Guide to Archival Materials of the Center for Creative Photography*. Tucson: Center for Creative Photography, University of Arizona, 1986.

White, Minor. *Mirrors, Messages, Manifestations*. New York: Aperture, 1969.

_____. *Rites & Passages*. Millerton, New York: *Aperture 80*, 1976.

WILDER, MITCHELL A.

ACM

Kubler, George. *The Religious Architecture of New Mexico*. Colorado Springs: The Taylor Museum, 1940.

Wilder, Mitchell. *Santos: The Religious Folk Art of New Mexico*. Colorado Springs: The Taylor Museum of the Colorado Springs Fine Arts Center, 1943.

"Wilder, Mitchell Armitage." in *Who's Who in American Art 1978* (New York: R.R. Bowker, 1978): 759.

WILDER, RICHARD

ACM

Yates, Steven A., ed. *The Essential Landscape: The New Mexico Photographic Survey*. Albuquerque: University of New Mexico Press, 1985.

WILLIAMS, RICK

Sandweiss, Martha A., ed. *Contemporary Texas: A Photographic Portrait*. Austin: Texas Monthly Press, 1986.

Williams, Rick. *Visiones de Tejanos/Visions of Texans*. Austin: Texas Photographic Society, Inc., 1989.

WINOGRAND, GARRY

Auer, ICP, Macmillan, Naylor

Myers, Roger, comp. *Guide to Archival Materials of the Center for Creative Photography*. Tucson: Center for Creative Photography, University of Arizona, 1986.

Szarkowski, John. *Winogrand: Figments from the Real World*. New York: Museum of Modern Art, 1988.

WITTICK, GEORGE BEN

ICP, Johnson, Macmillan

Broder, Patricia Janis. *Shadows on Glass: The Indian World of Ben Wittick*. Savage, Maryland: Rowman & Littlefield, 1990.

Fleming, Paula R., and Judith Luskey. *The North American Indians in Early Photographs*. New York: Harper & Row, 1986.

Packard, Gar, and Maggy Packard. *Southwest 1880: With Ben Wittick, Pioneer Photographer of Indian and Frontier Life*. Santa Fe: Packard Publications, Inc., 1970.

Volkenburgh, Richard Van. "Pioneer Photographer of the Southwest." *Arizona Highways* 18 (August 1942): 36–39.

WOLCOTT, MARION POST

Auer, Macmillan, Naylor, WWAA 19

Dixon, Penelope. *Photographers of the Farm Security Administration: An Annotated Bibliography, 1930–1980*. New York: Garland Publishing, Inc., 1983.

Fleischhauer, Carl, and Beverly W. Brannan, eds. *Documenting America, 1935–1943*. Berkeley: University of California Press, 1988.

Hendrickson, Paul. *Looking for the Light: The Hidden Life and Art of Marion Post Wolcott*. New York: Knopf, 1992.

Hurley, F. Jack. *Marion Post Wolcott*. Albuquerque: University of New Mexico Press, 1989.

Stein, Sally, intro. *Marion Post Wolcott: FSA Photographs*. Carmel, Calif.: Friends of Photography, *Untitled 34*, 1983.

WOOD, JOHN

Johnson

Gardner, Alexander. *Gardner's Photographic Sketch Book of the Civil War*. New York: Dover Publications, 1959.

Waldsmith, Thomas. "James F. Gibson: Out from the Shadows." *Stereo World* 2 (January–February 1976): 1ff.

WOOD, MYRON

Macmillan

Armstrong, Frank. *Photography in the West: A Modern View*. Corning, New York: The Rockwell Museum, 1987.

Jay, Bill. "Southwest: The Petrified Forest." *Camera Arts* 1 (April 1981): 12–13, 107–108.

Wood, Myron. *Central City: A Ballad of the West*. Colorado Springs: Chaparral Press, 1963.

_____. *Colorado-New Mexico*. Rochester, New York: International Museum of Photography at George Eastman House, 1978.

WOODBRIDGE, LOUISE DESHONG

Panzer, Mary. *Philadelphia Naturalistic Photography*. New Haven, Conn.: Yale University Art Gallery, 1982.

Wilmerding, John, ed. *American Light: The Luminist Movement*. Washington, D.C.: National Gallery of Art, 1980.

WOODBURY, D.B.

Davis, William C., ed. *The Image of War, 1861–1865*. 6 vols. Garden City, New York: Doubleday & Co., 1984.

Gardner, Alexander. *Gardner's Photographic Sketch Book of the Civil War*. New York: Dover Publications, Inc., 1959.

WORDEN, WILLIAM

Andrews, Ralph W. *Photographers of the Frontier West*. Seattle: Superior Publishing Co., 1965.

YAVNO, MAX

Macmillan, Naylor

Maddow, Ben. *Max Yavno*. Berkeley: University of California Press, 1981.

ZIMMERMAN, MARILYN

ACM, Macmillan

Appendix

Photographic Exhibitions
at the Amon Carter Museum

This list includes all exhibitions at the Amon Carter Museum with a significant emphasis on photography (excluding small, informal, or non-thematic displays of works from the permanent collection). Exhibitions organized by the Amon Carter Museum are in bold type. Publications are indicated by an asterisk.

April 24–June 5, 1962 *"A. C. Vroman: Photographer of the Southwest" Organized by Los Angeles County Museum

April 16–June 7, 1964 *"Bitter Years: 1935–1941" Farm Security Administration photographs of the United States during the Depression Years, organized by the Museum of Modern Art

November 6–December 31, 1964 *"Sam Houston's Texas"

January 29–April 4, 1965 *"Standing Up Country: The Canyon Lands of Utah and Arizona"

January 29–April 4, 1965 "Texas Ranch Life, 1914–1965" Photographs by Frank Reeves

April 11–May 9, 1965 *"The Photographer and the American Landscape" Organized by the Museum of Modern Art

July 7–August 5, 1965 "Photographs by Edward Weston"

November 25, 1965–January 16, 1966 *"Early Western Trails and Some Ghost Towns" Photographs by Todd Webb

April 22–May 25, 1966 *"Camposantos" Photographs by Dorothy Benrimo

May 2–June 4, 1966 *"Brett Weston Photographs"

May 12–June 26, 1966 *"The World from the Air" A century of aerial photography, organized by the George Eastman House

July 4–September 12, 1966 *"T. H. O'Sullivan Photographer" Organized by the George Eastman House

September 15–October 17, 1966 "Photography from Five Years of Space" Organized by the National Aeronautics and Space Administration

October 27, 1966–January 1967 *"Texas Homes of the Nineteenth Century" Photographs by Todd Webb

February 14–March 1967 "The Three Leaves" Photographs by Lynn G. Fayman, organized by the artist

June 29–September 5, 1967 "Patterns of Beauty" Photographs by Ferenc Berko, organized by the Cincinnati Museum of Contemporary Art

November 28, 1967 *"Dorothea Lange Looks at the American Country Woman"

January 8–February 26, 1968

"Illusions for Sale" and "Haight-Ashbury 1967" Photographs by Ruth-Marion Baruch

September 12–October 14, 1968

*"The Eloquent Light" Photographs by Ansel Adams, organized by the George Eastman House

December 22, 1968–February 10, 1969

*"The Enduring Navaho" Photographs by Laura Gilpin

July 13–August 1969

"Portfolio One" Photographs by Winter Prather

July 17–August 1969

"The Mexican Portfolio" Photographs by Paul Strand

November 15–December 31, 1969

*"Vision and Expression" Contemporary photographs, organized by the George Eastman House

November 25–December 31, 1969

*"A Personal Country" Photographs of West Texas by Shel Hershorn

March 19–April 26, 1970

"Thomas Eakins: His Photographic Works" Organized by the Pennsylvania Academy of Fine Arts

April 30–June 14, 1970

"Southwest Color: Photographs by E. J. Poulsen"

September 15–October 15, 1970

*"Just Before the War" Photographs of urban life in America during the Depression, from the files of the Farm Security Administration and organized by the Newport Harbor Museum

October 22–December 13, 1970

"The Ephemeral Image" Photographs of scarecrows, snowmen, and harvest figures, organized by the Museum of Folk Art in New York City

November 3–December 13, 1970

"The Ballad of Baby Doe" Photographs from the Colorado State Historical Society exhibited in conjunction with the Fort Worth Opera Association performance of "The Ballad of Baby Doe"

December 15, 1970–January 10, 1971

"Wynn Bullock Photographs" Organized by the San Francisco Museum of Art

March 4–April 19, 1971

"Photographs by Diane Hopkins"

May 20–July 16, 1971

*"Pueblo Architecture of the Southwest" Photographs by William R. Current

July 8–September 5, 1971

*"Out of the Silence" Photographs by Adelaide de Menil

September 9–October 24, 1971

"The Big Thicket: A Way of Life" Photographs by Michael Kostiuk

October 26–November 12, 1971

"Indian Images" Organized by the Smithsonian Institution

November 9, 1972–January 21, 1973

*"Barbara Morgan Photographs"

February 29–April 15, 1973

*"Historic Fort Worth"

March 22–April 29, 1973

*"Photographs by Liliane De Cock"

July 4–September 4, 1973	"Eliot Porter Retrospective" Organized by the University of New Mexico Art Museum	October 15–November 28, 1976	"Thomas Eakins— A Family Album" Organized by the Hendricks and Coe Kerr Gallery
May 16–July 7, 1974	***"Greene & Greene: Architects in the Residential Style"** Photographs by William Current		*"Dean Brown Photographs" Organized by the artist
July 11–September 1, 1974	"The Photographs of Laton Alton Huffman" Organized by the Art Institute of Chicago	April 8–May 22, 1977	*"Ansel Adams: Photographs of the Southwest" Organized by the Center for Creative Photography
September 6–October 20, 1974	***William H. Jackson Photographs"**	**January 12–March 5, 1978**	***"Rodeo of John A. Stryker"**
November 14, 1974– January 5, 1975	***"Texas Public Buildings of the Nineteenth Century"** Photographs by Todd Webb	**April 4–May 7, 1978**	**"Texas Architectural Survey"** **"Wheeler Expedition Photos, 1871–1873"** **"California Redwood Industry Photos, 1893"**
March 27–May 11, 1975	***"The King Ranch, 1939–1944: A Photographic Essay"** Photographs by Toni Frissell	May 11–June 25, 1978	"Laura Gilpin Retrospective" Organized by the Museum of New Mexico
May 15–June 15, 1975	*"Eadweard Muybridge: The Stanford Years, 1872–1882" Organized by the Stanford University Museum of Art	**September 28– November 12, 1978**	**Nineteenth Century Photographs from Permanent Collection**
June 20–August 3, 1975	**"Frank Gohlke Photographs"**	**September 28– November 19, 1978**	**"Caroline Vaughan Photographs"**
August 7–October 5, 1975	***"The Big Bend: A History of the Last Texas Frontier"** Photographs by Bank Langmore, National Park Service	**October 26–December 3, 1978**	***"Photography and the Old West"**
		December 7, 1978– January 21, 1979	***"The Utah Photographs of George Edward Anderson"**
April 16–May 30, 1976	**Ferenc Berko: Images of Nature**	June 21–July 29, 1979	*"Myron Wood Photographer" Organized by the International Museum of Photography at George Eastman House
		August 2–September 2, 1979	*"Courthouse Photographs" Organized by American Federation of Arts and Seagram Corporation

November 6, 1980–January 11, 1981	*"Carlotta Corpron: Designer with Light"	September 14–November 17, 1985	*"In the American West: Photographs by Richard Avedon"
January 15–March 1, 1981	"Carleton Watkins Photographs"	January 24–March 9, 1986	"Clarence White/Laura Gilpin"
May 27–July 11, 1982	*"American Photographers and the National Parks" Organized by National Park Foundation	January 24–April 13, 1986	*"Laura Gilpin: An Enduring Grace"
		May 23–June 22, 1986	*"People of the Forest: Photographs of the Maya by Gertrude Blom"
January 21–March 19, 1983	*"Out of the Forties" Photographs of Texas from the Standard Oil Collection, Photographic Archives, University of Louisville	June 27–August 24, 1986	*"Contemporary Texas: A Photographic Portrait"
		August 29–October 26, 1986	"Berenice Abbott: Paris Portraits"
April 1–May 22, 1983	*"Carleton E. Watkins: Photographer of the American West"	September 27–October 26, 1986	"A Celebration of Collecting: Photography, Watercolors and Drawings"
May 27–July 10, 1983	"Ranchos de Taos" Organized by Sheldon Memorial Art Gallery	October 31–December 14, 1986	"New Landscapes" Photographs by Mark Klett, William Clift, and Chip Pankey
October 12–December 31, 1983	"Selections from the Karl Struss Estate"	December 19, 1986–February 15, 1987	"Looking at America: Documentary Photographs from the 1930s and 1940s"
January 13–March 11, 1984	"An Emerging Tradition in American Photography"		
May 11–July 29, 1984	"Three Documentary Photographers" Marion Post Wolcott, Robert Frank, Morris Engel	January 10–March 1, 1987	*"W. Eugene Smith: 'Let Truth be the Prejudice'" Organized by the Center for Creative Photography, University of Arizona
August 3–September 23, 1984	"New York, New York: Prints and Photographs, 1900–1940"	April 17–May 31, 1987	"The Modern Aesthetic in American Photography"
November 9, 1984–January 6, 1985	*"Weston in Mexico" Organized by San Francisco Museum of Modern Art	June 5–July 12, 1987	"A Woman's Eye: Photographs from the Permanent Collection"
January 18–March 3, 1985	*"Cervin Robinson: Photographs, 1958–1983" Organized by Wellesley College	July 11–September 6, 1987	*"Certain Places: Photographs by William Clift" Organized by the artist in conjunction with the Art Institute of Chicago
July 19–September 1, 1985	*"Carl Mydans: A Photojournalist's Journey through War and Peace"	September 4–October 18, 1987	"Architectural Photographs from the Permanent Collection"

October 31, 1987–
January 3, 1988

*"Eliot Porter"

January 15–March 6, 1988

"Laton A. Huffman:
Frontier
Photographer"

March 5–April 24, 1988

*"Supreme Instants:
The Photography
of Edward Weston"
Organized by the
Center for Creative
Photography, Uni-
versity of Arizona

March 11–May 15, 1988

"Western City
Views: Prints and
Photographs"

July 22–October 23, 1988

"Images of Plants
from the Photogra-
phy Collection"

October 28, 1988–
February 5, 1989

"Evidence of Man:
Landscape Photo-
graphs from the
Amon Carter
Museum"

February 10–April 9, 1989

*"Where Images
Come From:
Drawings and
Photographs by
Frederick Sommer"
Organized by the
Denver Art Museum

April 14–June 11, 1989

"Changing Perspec-
tives: Photographs
of Indians from
the Collection"

April 14–June 11, 1989

"Early Photographic
Portraits"

July 22–September 10,
1989

*"Sign Language:
Contemporary
Southwest Native
America: Photo-
graphs by Skeet
McAuley"

September 16–
November 12, 1989

*"Bourke-White:
A Retrospective"
Organized by the In-
ternational Center
for Photography

November 18, 1989–
January 14, 1990

*"Eyewitness to War:
Prints and Daguerre-
otypes of the Mexi-
can War, 1846–
1848"

January 20–March 18, 1990

*"Robert Adams:
To Make It Home:
Photographs of
the American West"
Organized by
the Philadelphia
Museum of Art

April 27–June 24, 1990

*"Of Time and
Place: Walker Evans
and William
Christenberry"

June 29–August 26, 1990

*"Clara Sipprell:
Pictorial
Photograp- her"

September 29–November 25,
1990

*"George N. Bar-
nard: Photographer
of Sherman's
Campaign"
Organized by Hall-
mark Cards, Inc.

January 11–March 10, 1991

*"Arthur Wesley
Dow and His
Influence"
Organized by the
Herbert F. Johnson
Museum of Art

March 15–June 16, 1991

*"Portraits of
Women Airforce
Service Pilots by
Anne Noggle: For
God, Country, and
the Thrill of It"

June 22–October 13, 1991

*"Nature's Chaos:
Photographs by
Eliot Porter"

October 26, 1991–
January 5, 1992

*"Photography in
Nineteenth-Century
America"

March 14–May 10, 1992

*"Revealing Terri-
tory: Photographs
of the Southwest
by Mark Klett"

September 26, 1992–
January 10, 1993

*"Intimate Images"

Credits

2, 4, 6, 11, 23, 25, 26, 27, 32, 41, 50, 51, 59, 61, 63, 71, 73, 75, 78, 82, 83, 84, 85, 89, 93, 98, 102, 108, 115, 116, 118, 128, 133, 138, 143, 154, 158, 159, 165, 166, 169, 170, 173, 178, 180, 189, 190, 197, 205, 208, 210, 213, 215, 216, 221, 222, 225, 233, 234, 243, 246, 247, 250, 251, 253, 257, 262, 267, 269, 280, 282, 284, 293, 296, 297, 298, 318, 323, 330, 334, 336, 342, 343, 344, 345, 346, 354, 362, 366, 379, 380, 384, 389, 391, 394, 396, 407, 411, 413, 417, 420, 425, 429, 431, 433, 437, 440, 447, 448, 451, 454, 471, 486, 489, 494, 499, 507, 509, 512: Reproduction Courtesy of Commerce Graphics Ltd, Inc.

513, 515, 517, 519, 520, 521, 523, 526, 532, 540, 545, 549, 553, 554, 556: Reproduced courtesy of the Trustees of The Ansel Adams Publishing Rights Trust. All Rights Reserved.

558: Copyright © 1977 by Robert Adams

583: Copyright © Estate of Diane Arbus

722: © 1973 Morley Baer

864, 867: © 1985 Ave Bonar, 905 Christopher, Austin, TX 78704

868: © 1976 Howard Bond

918: Courtesy Bourke-White Estate

926, 929, 930, 935, 937, 940, 947, 953, 955, 960, 967, 975, 980, 984: Courtesy of the University of Louisville Photographic Archives

989, 992: Copyright: Wynn and Edna Bullock Trust

998, 1001, 1003: Carol Cohen Burton, Copyright: © 1984, All Rights Reserved

1052, 1055: © Harry Callahan, 1960

1330, 1334: Copyright Paul Caponigro

1348: © William Clift 1975, PO Box 6035, Santa Fe, NM 87502

1354: Courtesy of the University of Louisville Photographic Archives

1411: Courtesy of the University of Louisville Photographic Archives

1416, 1419: © 1978 The Imogen Cunningham Trust

1417: © 1974 The Imogen Cunningham Trust

1421, 1425, 1432, 1436, 1437, 1439, 1440, 1441, 1442, 1446, 1452, 1455, 1456, 1458, 1460, 1463, 1465, 1469, 1476, 1478, 1480, 1490, 1492, 1498, 1500, 1512, 1514, 1515: © William R. Current Estate

2101, 2106: Copyright 1980 Liliane De Cock

2184, 2186, 2188, 2189, 2193, 2206, 2210, 2218: © 1980 by Morris Engel

2238, 2239, 2243, 2248: Courtesy of the Estate of Walker Evans

2281: © Douglas Frank 1984

2282, 2303: © Robert Frank, Courtesy Pace/MacGill Gallery, NY

2416: William Garnett ©

2701, 2702: 1987 © John Gutmann

2704, 2712, 2716, 2718, 2723: © Yvonne Halsmann

2724: © 1982 Wanda Lee Hammerbeck

3261: © 1965, Yousuf Karsh

3275, 3279, 3280: Courtesy of the Estate of Victor Keppler

3283: © Estate of André Kertész. All Rights Reserved.

3286: © 1981 Robert Glenn Ketchum

3308: © 1983 Mark Klett

3323: © 1986 Estate of Ernest Knee

3362, 3365, 3368, 3374, 3380, 3381, 3384, 3390, 3393: Courtesy of the Dorothea Lange Collection. © The City of Oakland, The Oakland Museum, 1992.

3403: Copyright 1981, The Historic New Orleans Collection

3405: © Alma Lavenson Associates

3408, 3410, 3415, 3424, 3425, 3430, 3431, 3435, 3436, 3438, 3439, 3444, 3445, 3447: Courtesy of the University of Louisville Photographic Archives

3449, 3451: © 1965 by Helen Levitt. All Rights Reserved.

3453: © 1975 by Helen Levitt. All Rights Reserved.

3457: © O. Winston Link

3515, 3516: Copyright 1990 ARS N.Y./ADAGP

3523: © Christopher Meatyard

3684, 3691: © 1985 Carl Mydans

3708: Carl Mydans/LIFE Magazine, © 1940 Time Inc. All rights reserved.

3698, 3798, 3824: Carl Mydans/LIFE Magazine, © 1944 Time Inc. All rights reserved.

3727, 3752, 3741: Carl Mydans/LIFE Magazine, © 1945 Time Inc. All rights reserved.

3735, 3800, 3802: Carl Mydans/LIFE Magazine, © 1948 Time Inc. All rights reserved.

3716: Carl Mydans/LIFE Magazine, © 1950 Time Inc. All rights reserved.

3759, 3808: Carl Mydans/LIFE Magazine, © 1951 Time Inc. All rights reserved.

3715: Carl Mydans/LIFE Magazine, © 1982 Time Inc. All rights reserved.

3685, 3686, 3688, 3701, 3707, 3710, 3712, 3721, 3724, 3740, 3742, 3743, 3751, 3758, 3762, 3767, 3771, 3772, 3776, 3783, 3785, 3790, 3791, 3805, 3815, 3817, 3818: Carl Mydans/LIFE Magazine, © 1985 Time Inc. All rights reserved.

3842, 3844: From the Collection of Dorothy Norman

3854: © 1978 Ruth Orkin, Courtesy of the Estate of Ruth Orkin